The American Collections

COLUMBUS MUSEUM OF ART

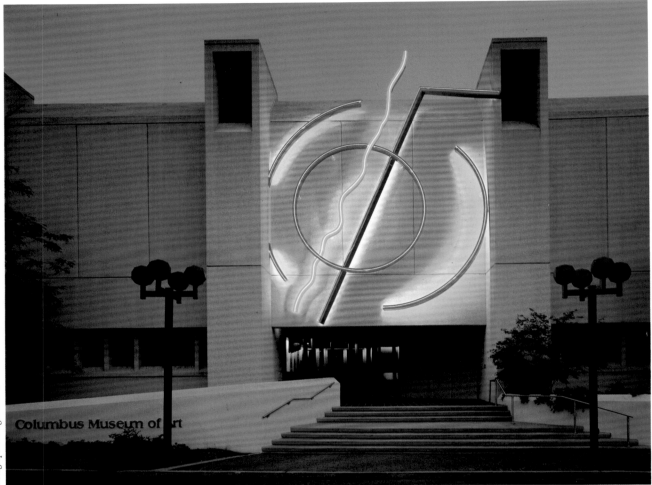

The American Collections
COLUMBUS MUSEUM OF ART

CONSULTANTS

William C. Agee
John I. H. Baur (1909–1987)
Doreen Bolger

CONTRIBUTORS

Nannette V. Maciejunes Laura L. Meixner
E. Jane Connell Debora A. Rindge
William Kloss Steven W. Rosen
Richard L. Rubenfeld

EDITED BY

Norma J. Roberts

COLUMBUS MUSEUM OF ART
IN ASSOCIATION WITH
HARRY N. ABRAMS, INC.
NEW YORK

ISBN 0–918881–20–x (paper)
ISBN 0–8109–1811–0 (cloth)

LIBRARY OF CONGRESS CATALOGING IN PUBLICATION DATA

Columbus Museum of Art.
The American collections, Columbus Museum of Art / consultants,
William C. Agee, John I. H. Baur, Doreen Bolger; contributors,
Nannette V. Maciejunes . . . [et al.]; edited by Norma J. Roberts.
p. cm.
Bibiliography: p.
ISBN 0–8109–1811–0 ISBN 0–918881–20–X (pbk.)
1. Art, American—Catalogs. 2. Art—Ohio—Columbus—Catalogs.
3. Columbus Museum of Art—Catalogs.
I. Maciejunes, Nannette
V. (Nannette Vicars) II. Roberts, Norma J.
III. Title.
N6505.C64 1988
709'.73'07401715—dc 1988–23774

This catalogue is made possible by a generous grant from the Luce Fund for Scholarship
in American Art, a program of the Henry Luce Foundation, Inc. Additional support for the
catalogue was provided by a grant from the National Endowment for the Arts. Funds for
support of museum publications have been provided by
The Andrew W. Mellon Foundation.

PHOTOGRAPHY CREDITS
All black and white photographs in this book are from the museum's files unless otherwise
noted with the reproduction. Color photography, with the exception of catalogue numbers
40, 71, and 82 (which are from the museum's files),
has been provided by the following:

Lee Clockman
51

Greg Heins
86, frontispiece

Jon McDowell
24

Warren Motts
21, 23, 30, 32, 35, 69

Todd Weier
1–18, 20, 22, 25–29, 31, 33–34, 36–39,
41–50, 52–68, 70, 72–81, 83–85

Designed by Stephen Harvard and Paul Hoffmann
Typesetting and printing by Meriden-Stinehour Press,
Lunenburg, Vermont, and Meriden, Connecticut
The catalogue has been set in Palatino type with Diotima italic display
and printed on Warren's Lustro Offset Enamel.

Table of Contents

Part One: Highlights of the American Collections

Part Two: Catalogue of the American Collections

Preface and Acknowledgments

The catalogue *The American Collections, Columbus Museum of Art* documents more than a century of assembling and studying what one prominent scholar describes as a "national treasure." Since its founding in 1878, the Columbus Museum of Art, the oldest art museum in the state of Ohio, has been acquiring and exhibiting the works of American artists. By the time its new Renaissance-revival building was opened in 1931, the museum housed what was considered to be one of the finest collections of American art in the country. Many of the works came from the distinguished collection of early modernist paintings formed by Ferdinand Howald, a long-time resident of Columbus, who was instrumental in realizing his own dream of a "real art museum in Columbus." Over the last fifty years the museum's American holdings have continued to expand until today over half of the collection is dedicated to American visual arts of the nineteenth and twentieth centuries.

In 1985 the Henry Luce Foundation, which had set aside funds for much needed research and publication in the field of American art through its Luce Fund for Scholarship in American Art, invited this museum to undertake research on its collections and to publish a catalogue. The project has been further assisted by the National Endowment for the Arts, which provided additional funds for the production of the catalogue, and by The Andrew W. Mellon Foundation, which provided support for the museum's publications program. We are at once proud and grateful for the support and recognition of these important agencies.

This catalogue represents the culmination of efforts by generations of serious collectors, scholars, benefactors, and museum leaders to nurture and develop an important artistic resource. It seems fitting to acknowledge at this writing our profound gratitude for their enlightenment and dedication, and equally to recognize the contributions of generous donors and civic-minded men and women who have defined this museum, bestowing upon it a special character. The names of those who have made possible the American collections catalogued herein appear with the works that have come to us through their generosity.

In carrying out this project the museum has been especially fortunate to enlist the fine minds and expertise of some of today's most prominent scholars in American art. Among those who served as consultants were the late John I. H. Baur, former director of the Whitney Museum of American Art, whose participation in the early stages of the project constitutes one of his last contributions to the study of American art. Doreen Bolger, associate curator of American paintings and sculpture and manager of The Henry R. Luce Center for the Study of American Art at the Metropolitan Museum of Art, continued superbly the work begun by Mr. Baur. William C. Agee, former director of the Museum of Fine Arts, Houston, and editor of the Stuart Davis catalogue raisonné, was with the project from beginning to end. The consultants helped in the planning process, reviewed the texts prepared for the highlights section, and provided insights, advice, and encouragement at every step.

Narratives on the eighty-six works selected as a representative sampling of the museum's American holdings were prepared by William Kloss, Laura L. Meixner, Debora A. Rindge, Richard L. Rubenfeld, and museum staff members. We are grateful to each of them for their informative texts and for their willingness to follow the work through various drafts.

Members of the curatorial, publications, and registration staff of the Columbus Museum of Art deserve special thanks for three years of steadfast dedication to the catalogue project. In particular, Assistant Curator Nannette V. Maciejunes, who served as project director for research, marshalled numerous forces to compile documentation of works and to prepare catalogue entries. The catalogue was edited by Norma J. Roberts, who indefatigably coordinated, incorporated, and edited the contributions of seven authors and three consultants. The work of these two principal project leaders was assisted and facilitated by the good work of many colleagues: in curatorial, Chief Curator Steven Rosen, Associate Curator E. Jane Connell, Curatorial Assistant Kathy Ferguson-Nell, and research volunteers Linda Fisher, Jan Leja, Elaine Tulanowski, Jeanette Cerney, Charles A. Brophy, Jr., Bernard Derr, and Caroline Russell; in registration, Registrar Christy Putnam and staff members Jane Isaacs, Maureen Alvim, and Rod Bouc; in publications, assistants Jean Kelly, Virginia Bettendorf, Kathleen Kopp, computer specialist Jenifer Roulette, and secretary Marveen Ahrendt. Former director Budd Harris Bishop administered the project in its initial stages, and former director of programs Craig McDaniel coordinated production and distribution of the catalogue.

In compiling the documentation of provenance, exhibition, and publications histories for eighty-six works, museum staff were especially grateful for the groundwork laid by former archivists, in particular Catherine C. Glasgow, and

for the generous cooperation of independent scholars, artists and their descendants, collectors, dealers, librarians, and staff members of other institutions. The following individuals deserve special thanks: Stephen Antonakos, Richard Anuszkiewicz, Walter Bareiss, Joseph H. Davenport, Jr., Earl Davis, Alvord L. Eiseman, Dan Flavin, Benjamin Garber, Thomas H. Garver, Mary Adam Landa, Peter Manigault, Clement Meadmore, Thomas N. Metcalf family, Ann Lee Morgan, Bernard B. Perlman, George Rickey, Kenneth Snelson, and Roberta Tarbell. Many others cheerfully searched through their institution's archives to provide answers to countless questions. The following were especially generous in their assistance: Kathy Hess of the Public Library of Columbus and Franklin County; Lisa Hubeny of the Carnegie Institute Museum of Art; Carol Clark, Gwendolyn Owens and Pamela Ivinski of the Maurice and Charles Prendergast Systematic Catalogue Project of the Williams College Museum of Art; Linda Ayres and Jane Myers of Amon Carter Museum of Art; Amy McEwen of the American Federation of Arts; Colleen Hennessey and Cynthia Ott of the Archives of American Art; Bruce Weber and Nancy Jo Barrow of the Norton Gallery and School of Art; Erica E. Hirshler of the Museum of Fine Arts, Boston; James L. Yarnall of the John La Farge Catalogue Raisonné Project; Bella Fishko of Forum Gallery; Elizabeth Broun of the National Museum of American Art; James and Timothy Keny of Keny and Johnson Gallery; Jennifer Saville of the M. H. de Young Memorial Museum; Katherine Kaplan of Kraushaar Galleries; Warren Adelson of Coe Kerr Gallery; Mary Ushay of Berry-Hill Galleries; Martha R. Severens of the Gibbes Art Gallery; Paul E. Cohen of the New York Historical Society; and Rowland P. Elzea of the Delaware Art Museum.

It is our hope that the research provided here will generate further study in American art and significantly expand our understanding of America's contributions in the visual arts. It is our further hope that this book will inspire readers to visit the Columbus Museum of Art to enjoy firsthand these unique, fascinating, and brilliant works of art.

Merribell Parsons
Director
Columbus Museum of Art

History of the Columbus Museum of Art

1878 On October 30 The Columbus Gallery of Fine Arts (CGFA) registered its charter with the State of Ohio. The document bears the signatures of trustees Joseph R. Swan, Francis C. Sessions, Alfred Kelley, James A. Wilcox, William B. Hayden, William G. Deshler, and Pelatiah W. Huntington. Joseph R. Swan (d. 1887) is elected the first president.

 Almost concurrently, the Columbus Art Association, which was to play a critical role in the development of the CGFA, is formed by a women's group to promote the arts "theoretically and practically," and to establish an art school. Mrs. Alfred Kelley is elected president.

1879 In January, the women of the Art Association establish the Columbus Art School.

1887 Because the CGFA is incorporated and the Art Association is not, the women of the Association decide against becoming a rival corporation and instead agree to become a legal agency of the CGFA. Three members of the Art Association are appointed trustees of the CGFA.

1888 In March the CGFA holds its first exhibition—at G. W. Early's Piano Parlors, Columbus.

1901 $30,000 is raised for art acquisitions and for the construction of a building at a future date.

1913 Monypeny property (mansion and barn) at East Broad Street and Washington is purchased for the art school and special exhibitions.

1919 The Francis C. Sessions home and property at 478 East Broad Street is deeded to the CGFA.

 Sessions, a founder of the CGFA and one of its first presidents (from February 1890 to 1892), was a descendant of the original colonists. Arriving from England in 1630, the Sessions family settled in Massachusetts. Francis's grandfather took part in the Boston Tea Party and fought in the Revolution. The young Sessions came to Columbus in 1840 and earned his living as a dry goods clerk. After serving in the Civil War he returned to Columbus and helped found the Commercial National Bank, becoming its first president. An art lover, humanitarian, collector, benefactor, author, traveler, as well as a successful businessman, Sessions was an early mover in establishing the arts in Columbus. He died in 1892, naming the museum as a beneficiary of his estate.

Entrance to Francis Sessions house.

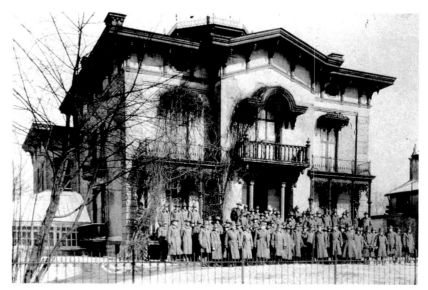

Francis Sessions house, ca. 1917.

1923	The Columbus Art Association is dissolved, and its membership, along with the Columbus Art School, merge under the name of The Columbus Gallery of Fine Arts.

1923 The Columbus Art Association is dissolved, and its membership, along with the Columbus Art School, merge under the name of The Columbus Gallery of Fine Arts.

 William M. Hekking is appointed the first director of the Gallery and the Art School.

 The first Honorary Member is named: Warren G. Harding, President of the United States.

1926 Karl S. Bolander is appointed director.

1928 The Sessions house is torn down to make way for a new building.

1931 The new building is opened to the public. It is designed in the Renaissance revival style by Columbus architects Richards, McCarty and Bulford, after drawings by Charles Platt of New York City, designer of the National Gallery of Art, Washington, D.C.

 The opening exhibition celebrates the acquisition of the Ferdinand Howald Collection (a gift to the museum) and also features the Frederick W. Schumacher Collection (on extended loan), a group of George Bellows paintings (lent by his widow), and other loans from people in the community.

> Ferdinand Howald, a native of Switzerland who was raised in Columbus, Ohio, graduated from The Ohio State University in 1881, entered the coal mining industry in West Virginia, and through shrewd investments in Chesapeake and Ohio Railroad stock during the panic of 1893 made his fortune. He retired early—in 1906—and moved to New York, maintaining a residence in Columbus. Howald's interest in American art was sparked by a visit to the Armory Show in 1913. He began collecting in 1914. When his collection came to the museum in 1931 it included 280 works: 180 American paintings by artists such as Maurice Prendergast, Charles Demuth, Charles Sheeler, and Marsden Hartley; Flemish and Italian paintings of the fourteenth through sixteenth centuries; and works by European moderns such as Picasso, Degas, Derain, Braque, and Matisse. Howald also contributed a fifth of the money needed to pay for construction of the museum's new building and bequeathed additional funds earmarked primarily for the purchase of works by American artists.

1935 Phillip Adams is appointed director.

1937 The Amelia White collection of Southwestern American Indian artifacts is given to the museum.

1938 Frederick W. Schumacher commissions sculptor Robert Aiken to produce a frieze depicting artists from Leonardo daVinci to George Bellows for the museum's facade on East Broad Street.

1942 The Edward Bradford Titchener Collection of Polynesian and African art is given to the museum.

1946 Lee H. B. Malone is appointed director.

1954 Mrs. Earl C. Derby provides funds for the covering of an outdoor court at the center of the building, expanding exhibition space and, in later years, with the addition of tables and chairs, providing an all-weather, gardenlike setting for special events, lunches and conversation.

 Mahonri Sharp Young is appointed director.

1957 The Earl C. Derby and Lillie G. Derby Fund is established for the purchase of art objects by the masters.

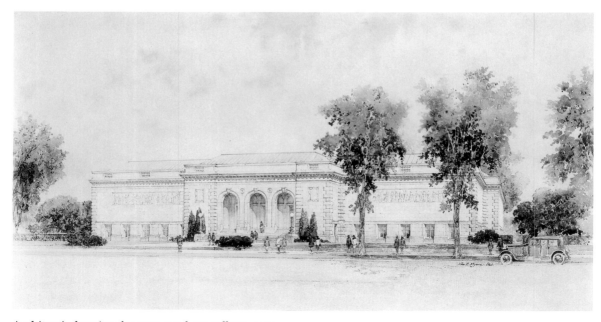

Architect's drawing for proposed art gallery, 1930.

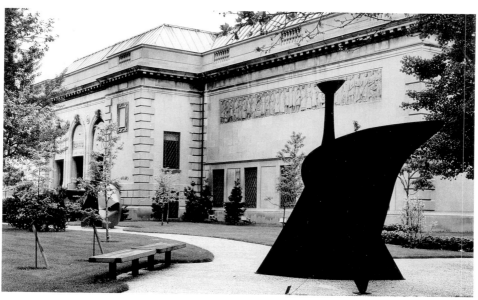

Columbus Museum of Art, Broad Street entrance, and portion of Sculpture Park.

1957 The Earl C. Derby and Lillie G. Derby Fund is established for the purchase of art objects by the masters.
 The Frederick W. Schumacher Collection of 167 works becomes a permanent part of the museum's collections, adding paintings and sculpture by Dutch, Flemish, English, French, Italian, and American masters—artists such as Ingres, Moroni, Jordaens, Van Ruysdael, Lely, Gainsborough, Turner, Whistler, and others.

> Schumacher, who made his fortune as Vice President of the Peruna Drug Manufacturing Company in Columbus and in Canadian mining ventures, began collecting in 1899—mostly old masters. As he put it:
> In visiting European public and private galleries I came to the conviction that it would be best to concentrate on the Old Masters because there was little likelihood of their depreciation. I always believed that it should be possible with good judgment to find art works which would endure and remain objects of merit through the change of fashion. For this reason I acquired only a comparatively small number of modern paintings, intended for contrast with the classical periods as well as to indicate the future development of art, which never stands still.

1960 The Columbus Art School becomes the Columbus College of Art and Design.

1974 A 30,000 square-foot addition, now called the Ross Wing, is opened, providing space for temporary exhibitions, art storage, exhibition preparation, and offices. The Columbus Foundation authorizes grants to help with construction costs.

1976 Budd Harris Bishop is named director.

1977 Battelle Memorial Foundation provides funds for renovation of existing buildings to increase exhibition space.
 The National Endowment for the Humanities provides a challenge grant to stimulate local giving to the renovation project and to the museum's operating fund.

1978 The museum's centennial year is celebrated, and the name is changed from The Columbus Gallery of Fine Arts to Columbus Museum of Art.
 Ground is broken for a sculpture park and gardens on property surrounding the museum. Further renovations take place and a museum restaurant, the Palette, is established.
 The John F. Oglevee bequest establishes a fund for the acquisition of Chinese and Japanese objects.

1979 The Sculpture Park and Gardens, designed by English landscape architect Russell Page, is dedicated.

1980 Funded through a grant from the National Endowment for the Arts, a reinstallation of the permanent collection is carried out.

1982 The Columbus College of Art and Design becomes an independent institution.

1983 Announcement is made that the Howard and Babette Sirak Collection of seventy-six works by French Impressionists, Post-Impressionists, German Expressionists, and others, will come to the museum in 1991 in a part-gift, part-purchase arrangement.

1985 A collection of Elijah Pierce woodcarvings is acquired by the museum.

1987 Merribell Parsons is appointed director.

Explanations

The catalogue is in two parts. Part One focuses in detail on eighty-six works by seventy artists selected to represent the museum's American collections. Catalogue entries in this section consist of biographical sketches on the artists, essays on the works, and full-page color reproductions. The works are arranged in approximate chronological sequence; variations have been dictated by stylistic considerations and the need to group together two or more works by a single artist over a long period of development. The title of each work is preceded by its catalogue number and followed by its date (if known) and the accession number assigned by the Columbus Museum of Art. Each work is fully documented (provenance, exhibition history, references, additional remarks) on pages 178 to 208.

Part Two of the catalogue is a checklist of nearly 800 works, citing dates (if known), medium and dimensions, signatures and inscriptions, and museum credit lines. Entries are in alphabetical order by artist's last name; works by anonymous artists are at the end, in chronological sequence, to the best of our knowledge. The checklist is followed by a summary of collections either too large to enumerate, such as prints, which include more than 2,500 works, or are only presently being developed by this museum (decorative arts, for example).

In measurements throughout the catalogue, height precedes width. In the case of most three-dimensional works, only the most prominent dimension is given (H. meaning height, L. meaning length, D. meaning diameter).

The signature or inscription line is included in cases where writing or other markings appear on any part of the work. The word "signed" is used only when the work is known to have been signed by the artist. The word "inscribed" is used for markings other than the signature and date applied by the artist.

Catalogue entries in Part One have been prepared by the following authors, whose initials appear at the end of their texts.

E. JANE CONNELL is associate curator at the Columbus Museum of Art. She is exhibitions organizer and author of the catalogues *More than Meets the Eye: The Art of Trompe l'Oeil* and *Made in Ohio: Furniture 1788–1888*.

WILLIAM KLOSS, an independent art historian in Washington, D.C., often writes and lectures on nineteenth- and early twentieth-century American art. He is the author of *Treasures from the National Museum of American Art* (Smithsonian Institution, 1985), and *Samuel F. B. Morse* (Harry N. Abrams, Inc., New York, 1988). He is preparing a catalogue of painting and sculpture in the White House, and another on the fine art belonging to the Department of State.

LAURA L. MEIXNER, assistant professor at Cornell University since 1983, has written and lectured on the inter-relationship of American and French Barbizon and Impressionist painting. She was guest curator and catalogue author for the exhibition *An International Episode: Millet, Monet, and Their North American Counterparts*, organized for the Worcester Art Museum (Massachusetts), and is presently completing a book concerning nineteenth-century American cultural responses to French realism and Impressionism.

NANNETTE VICARS MACIEJUNES, assistant curator at the Columbus Museum of Art, is the exhibition organizer and author of the catalogue *A New Variety, Try One: De Scott Evans or S. S. David* and exhibition organizer and contributor to the catalogue *The Early Works of Charles E. Burchfield 1915–1921*.

DEBORA A. RINDGE, formerly director of duPont Gallery at Washington and Lee University, is pursuing doctoral studies in American art history at the University of Maryland. Her dissertation concerns the body of landscape subjects produced by artists and photographers on the major western surveys conducted after the Civil War.

STEVEN WHITE ROSEN has been chief curator at the Columbus Museum of Art since 1977. He is exhibition organizer and a contributor to the catalogue *Henry Moore: The Reclining Figure*.

RICHARD L. RUBENFELD received his Ph.D. from The Ohio State University in 1985. His dissertation is titled, "Preston Dickinson: An American Modernist," and includes a catalogue of selected works. He is presently associate professor of art history at Eastern Michigan University.

Part One

Highlights of The American Collections

Endnotes, along with collections, exhibitions, and publications histories,
for works in Part One are to be found on pages 178 to 208.

Winslow Homer, 1836–1910

In an era characterized by a taste for cosmopolitan cultural influences, Winslow Homer emerged as a strong proponent of the American scene, recording his impressions in both landscape and genre paintings. Homer was born in Boston, where he was apprenticed to the lithography shop of J.H. Bufford at the age of eighteen. In 1857 he became a freelance illustrator, selling his scenes of fashionable Boston and New England rural life to Ballou's Pictorial *and* Harper's Weekly. *He moved to New York City in 1859 and worked as a freelance illustrator while attending classes in Brooklyn and then, in 1861, at the National Academy of Design. His wood engravings of Civil War scenes, which rank among the finest records of wartime activity, were first published in* Harper's Weekly *in 1862, the year he completed* Yankee Sharpshooter *(private collection), his first painting based on the war. From 1863 through 1866 Homer exhibited war and home-front pictures annually at the National Academy of Design while continuing to illustrate for periodicals (*Our Young Folks *and* Frank Leslie's Chimney Corner*). In 1866 he departed for France, and in 1867 exhibited* Bright Side *(1865, private collection) and* Prisoners from the Front *(1866, Metropolitan Museum of Art) at the Universal Exposition in Paris.*

Homer returned to America in late 1867, again took up magazine illustration, and in his summer excursions to New England, the Adirondacks, the Jersey shore, and elsewhere painted some of his early masterpieces of summer resort life and rural genre scenes. In spring 1881, he made a second trip abroad, this time to Tynemouth, England, near Newcastle. The austere life of this North Sea fishing community inspired a series of oils and watercolors that were striking in their immediacy and heroic content—a complete departure from his earlier works. The English experience proved to be a turning point for Homer. After a brief return to New York City in 1882, he quit his residence there and in the summer of 1883 moved to the barren seacoast town of Prout's Neck, Maine, where he lived in increasing isolation for the rest of his life.

Man in contest with the sea became Homer's favorite theme and the one for which he is perhaps best known. The emotional content of Homer's paintings as well as his mastery of both watercolor and oil earned him recognition as one of America's leading painters and brought numerous honors and prizes worldwide. His brilliant tropical marines of Nassau, Cuba, and Bermuda, and enchanting studies of woods and lakes in the northern United States and Canada remain unequalled in American art.

1 *Haymaking*, 1864 42.83

Oil on canvas, 16 x 11 in. (40.6 x 27.9 cm.). Signed and dated lower left: Homer/64. Museum Purchase: Howald Fund, 1942

Among Homer's first oils are subjects drawn from the artist's love of country and his experience as a chronicler of the American Civil War. A war correspondent, and before that a lithographer's draftsman, Homer initially approached painting with a concern for the anecdotal qualities of time, place, and activity. In *Haymaking*, an early rural scene, the artist records his direct observations in a bold arrangement of crisp forms set against a simplified landscape background. The proximity of the subject to the viewer's space and the literal pose of the figure suggest the influence of the battlefield photography of Mathew Brady and his colleagues, whose work Homer may have seen while on assignment at the front. In choice of subject Homer's portrayal follows the example of William Sidney Mount and other pre-Civil War genre painters whose sunlit farm scenes captured the optimism of youth and bountiful nature.

Homer's remarkable feeling for color and light are both richly demonstrated in *Haymaking*. Through strong tonal contrasts and vibrant saturated colors he captures the brightness, warmth, and perhaps even the recollected aroma of a hayfield bathed in full summer sunlight. Choosing to record the view from a position marked by leafy shadows, the artist allows the viewer too to revel in the contrast of hot sun and cool shade. Homer's sensuous display of tones and colors is orchestrated to create a harmonious ambience that is in perfect accord with the optimism of harvest and plenty. The rustic lad goes about his labor with quiet authority. Young and hale, he personifies the American yeoman farmer and speaks to a nation's abiding faith in the myths of rural bounty and peace. But, as it reasserts a national pride in agrarian values, the painting also celebrates a rapidly vanishing rural innocence in the face of war and its implications for the human spirit.

Haymaking is the first work in a group of paintings and drawings that culminate with Homer's well-known *Veteran in a New Field* (1865, Metropolitan Museum of Art).[1] The subject of the later work is no longer the self-confident youthful farmer of *Haymaking* who confronts the viewer head-on. Instead, an older survivor of the war, with face averted, gratefully resumes the act of mowing a field. Like Homer's subjects, the nation, too, returned to the rhythmic comforts to be found in the natural cycles of life.

L.L.M.

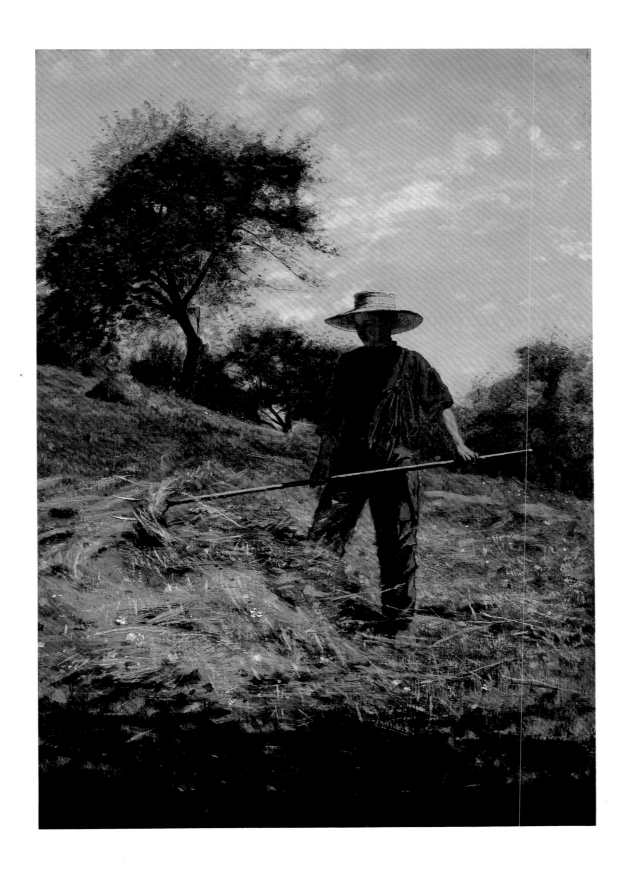

Winslow Homer, 1836–1910

2 *Girl in the Orchard*, 1874 48.10

Oil on canvas, 15⅝ x 22⅝ in. (39.7 x 57.5 cm.). Signed and dated lower right: Winslow Homer 1874. Inscribed upper left on stretcher frame: Winslow Homer/51 W 10th/N.Y. Museum Purchase: Howald Fund, 1948

Girl in the Orchard is as inviting as it is enigmatic. Homer has placed his attractive model in a cool, protective bower, against horizontal bands of lush green and golden fields, creamy sky, and dense orchard foliage. The young woman stands with eyes downcast, absently holding by her side a hat whose ribbons barely respond to a gentle summer breeze. The contemplative charm of the model and geometric clarity of the composition establish a mood of serenity and calm, which is enlivened by realist vignettes of scratching chickens and colorful daisies. Homer's careful draftsmanship is evident here, but his paint is thicker and more freely applied than in his paintings of the mid-1860s. Long strokes of pigment highlight the model's dress, as bold impasto highlights on her hat and the shoulder of her dress capture the sunlight that filters through the trees.

Homer devoted several oils and watercolors to the theme of a young woman isolated in a timeless landscape or interior setting. Because the model's features are not strictly portraitlike, her identity is a matter of speculation.[1] The girl in *Girl in the Orchard* must have occupied a very special place in Winslow Homer's life and career, judging from the number of times she appears in works throughout the 1870s. In an oil painting dating from 1872, entitled *Waiting an Answer* (Peabody Institute of Music, Baltimore), she appears in a pose and setting similar to those in *Girl in the Orchard*. Beside her on this occasion is a young farmer who momentarily turns away from his work as she approaches, perhaps implying that this scene describes a rural courtship. The girl appears alone in a series of watercolors beginning in 1874 in which she is typically engaged in various quiet activities such as reading, sewing, playing with a deck of cards, or simply lost in private thoughts. It has been suggested that her wistful or preoccupied gestures and poses may indicate psychological withdrawal from and eventual rejection of a present but unseen suitor—possibly Homer himself.[2] To heighten the mystery of the lovely model's identity and her apparent significance to Homer, it is known that he kept the painting *Girl in the Orchard* all his life, hanging it in a cottage near Kettle Cove, Maine, which he intended to occupy during his later years of self-imposed detachment and solitude.

L.L.M.

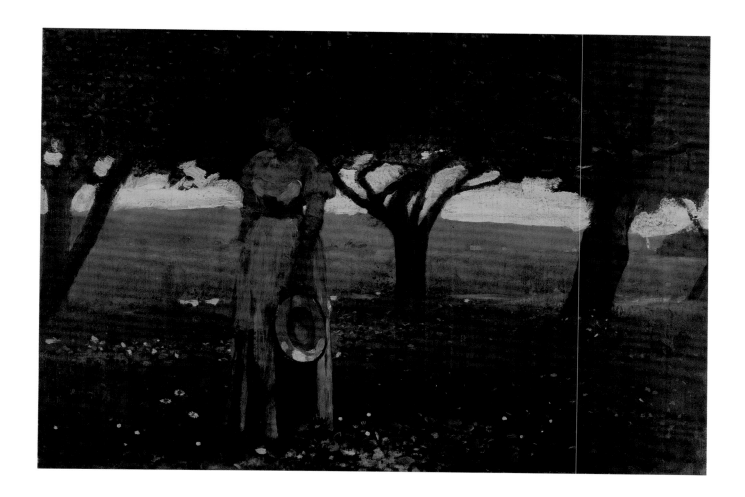

George Inness, 1825–1894

George Inness was a prolific artist who departed from the descriptive foundations of the prevailing Hudson River School to develop an independent style. His works introduced to American landscape painting a modern means of poetic expression. Inness's approach to painting is best reflected in his own words on the purpose of a work of art: "Its aim is not to instruct, not to edify, but to awaken emotion."[1]

Born in Newburgh, New York, and raised in Newark, New Jersey, Inness received only limited formal training—from John Jesse Barker, an itinerant artist, and from Regis Gignoux, a French artist living in this country. Nevertheless, Inness's professional career developed rapidly, beginning with his 1844 debut at the National Academy of Design and his establishment of a studio in New York City four years later. In 1850 Inness made the first of three sojourns in Europe, spending fifteen months in Italy and studying the landscapes of two seventeenth-century masters, Claude Lorrain and Nicholas Poussin. On a second trip abroad in 1853, Inness went to France and directed his attention to the works of early modern artists such as Theodore Rousseau and Camille Corot, two leaders of the Barbizon school of plein air landscape painting. From his assimilation of French art came such atmospheric, vibrant compositions as Clearing Up (1860, George Walter Vincent Smith Art Museum, Springfield, Massachusetts) and The Road to the Farm (1862, Museum of Fine Arts, Boston). Beautiful works in their own right, paintings such as these led to more expressive allegorical paintings, which reveal Inness's intensely spiritual response to nature.

In 1860 Inness moved from New York City to Medfield, Massachusetts, and four years later to Eaglewood, New Jersey (near Perth Amboy), where he came in contact with a community of artists that included William Page. Page encouraged Inness to follow the teachings of Swedish mystic Emanuel Swedenborg; as a result, during the mid-1860s, Inness painted symbolic landscapes with religious overtones, most notably the famous allegory Peace and Plenty (1865, Metropolitan Museum of Art), inspired by the Civil War, and others more directly influenced by the Barbizon school.

In the spring of 1870 Inness embarked upon his third trip to Europe, this time living in Rome and touring Tivoli, Albano, and Venice. In 1878 he took a studio in the New York University Building; purchased a home in Montclair, New Jersey; participated in the Universal Exposition, Paris; and published art criticism in the New York Evening Post and Harper's New Monthly Magazine. A major retrospective organized by the American Art Association in 1884 brought Inness acclaim in the United States, and the Paris exposition of 1889 garnered him a gold medal abroad. His masterworks of the late 1880s and 1890s became increasingly expressive, nearly abstract.

Inness died in 1894 at Bridge-of-Allan in Scotland. His achievements were commemorated in this country at a public funeral held at the National Academy of Design and by a memorial exhibition at the Fine Arts Building in New York City.

3 *The Pasture*, 1864 54.36

Oil on canvas, 11½ x 17½ in. (29.2 x 44.5 cm.). Signed and dated lower right: G. Inness 1864. Bequest of Virginia H. Jones, 1954

The Pasture exemplifies Inness's adaptation of the Barbizon style to the various moods of our native scene, in this case the rural tranquility of Medfield, Massachusetts. The painting shows the artist's appreciation of Corot, whom he numbered with Rousseau and Charles Daubigny among the landscapists he most admired. In *The Pasture*, Inness emulated Corot's mastery of poetic expression and aesthetic truths. Like Corot, he unified his composition with broad, loose handling of the brush.

Atmosphere is more important than detail, and color than line in Inness's lush field of green shades and tones. The light emanating from a bright blue sky suffuses the open pasture with a harmonious glow that is contrasted to the somber forest greens in the shadowed foreground. Inness maintains control of pictorial space through this conscious placement of vertical elements against the horizontal thrust of lake, stream, and pasture. The two trees that rise in the middle ground gently enframe the pastoral idyll in the center of the composition, and spatial balance overall lends a sense of psychological equilibrium, of hushed serenity. For Inness, this particular pasture represented isolated terrain momentarily untouched by the Civil War.

In scale and subject matter the picture is an eloquent demonstration of what Inness referred to as "civilized landscape." Drawn to scenes that quietly proclaim the imprint of man on natural surroundings, Inness here shows not an untamed wilderness but a clearing prepared for domesticated animals. A farmhouse in the background and a crude walking bridge in the foreground further attest to a human presence though no figures appear. Explaining his purpose in selecting such motifs, Inness wrote:

> Some persons suppose that landscape has no power of communicating human sentiment. But this is a great mistake. The civilized landscape peculiarly can; and therefore I love it more and think it more worthy of reproduction than that which is savage and untamed. It is more significant. Every act of man, every thing of labor, effort, suffering, want, anxiety, necessity, love, marks itself wherever it has been.[2]

L.L.M.

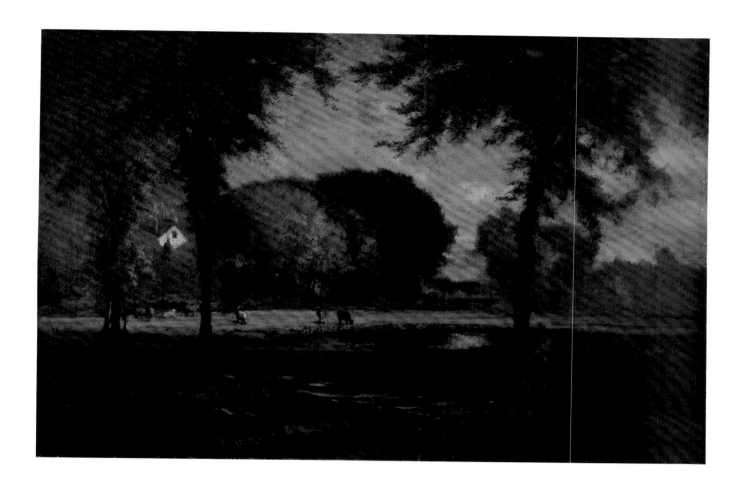

George Inness, 1825–1894

4 *Shower on the Delaware River*, 1891 54.2

Oil on canvas, 30¼ x 45⅛ in. (76.8 x 114.6 cm.). Signed and dated lower right: G. Inness 1891. Museum Purchase: Howald Fund, 1954

The expressive power of Inness's landscapes was never derived solely from the artist's imagination but was rooted in reality. As he maintained, "The poetic quality is not obtained by eschewing any truths of fact or of Nature. Poetry is the vision of reality."[1] In *Shower on the Delaware River* Inness gives form to his profound belief in a harmony of God, nature, and man.

In its simplicity, the scene possesses a moving universal symbolism. A cowherd watches as cattle graze in a meadow, a peaceful terrain undisturbed by the bordering village. In the distance are the symbols of regeneration and redemption: a rainbow, which suggests the renewal of the earth after rain; and a church steeple, which symbolizes man's union with God. The rainbow was a particularly meaningful motif for Inness, who had used it in a more literal way in earlier works such as *Delaware Water Gap* (1861, Metropolitan Museum of Art) and *A Passing Shower* (1860, Conajoharie Library and Art Gallery, New York). Its function in *Shower on the Delaware River* is more poetic, closer to the style of French Barbizon painter Camille Corot. As Inness said, "Let Corot paint a rainbow, and his work reminds you of the poet's description, 'The rainbow is the spirit of the flowers.' "[2]

Inness's perceptions of nature were intensified by his faith in Swedenborgianism. Swedenborg held that the spiritual world differed only slightly from the natural world in two regards: forms in the spiritual world were not subject to the law of gravity, and all colors were luminous and vibrant. Inness's late style suggests his artistic response to these beliefs. In *Shower on the Delaware River*, for example, the broad tonal areas that typified the style of his middle period are replaced by amorphous masses of color that float within pictorial space. Pronounced texture now creates an atmospheric veil that obliterates detail, and the scene is unified with blue-green sequences that evoke a sense of nature's burgeoning life forces. Aesthetic and emotional harmony transcend descriptive concerns in this metaphorical image.

Yet aside from its visionary effect and spiritual dimension, *Shower on the Delaware River* is modern in its bold, nearly autonomous, use of formal elements. Critics of his own era recognized Inness's works for this quality. In one famous instance, a critic referred to one of Inness's works as "more of a painting than a picture."[3]

<div align="right">L.L.M.</div>

Albert Bierstadt, 1830–1902

Bierstadt, who was born in Solingen, Germany, came to the United States at the age of two and was raised in New Bedford, Massachusetts. In 1853 he began a period of study in Dusseldorf and Rome, returning to the United States in 1857. The next year he exhibited at the National Academy of Design, and in 1859 he established his studio in New York City. That same year he had his first encounter with the Western landscape as he traveled to Wyoming with the Pacific Coast Railway Survey team. His reputation was made with the 1864 exhibition of his Rocky Mountains *at the Metropolitan Museum of Art.*

Bierstadt's polished technique and majestic subject matter made him popular with patrons both at home and abroad. He was presented to Queen Victoria and decorated by Napoleon III. His epic canvases conveyed to easterners and foreigners alike the awesome power of the untamed American wilderness.

Toward the end of the century Bierstadt's popularity waned as tastes changed, and his works fell into obscurity.

5 *Landscape* 29.3

Oil on canvas, 27¾ x 38½ in. (70.5 x 100.3 cm.). Signed lower left: A Bierstadt. Bequest of Rutherford H. Platt, 1929

Though modest in size, this painting effectively captures the sweep of a lake ringed with mountains. An ominous storm cloud in the upper left portion sets the mood and dominates the painting as it shadows the rocky slope at the lower left. The dark edges frame a brilliantly lit central area, where the shining water and light-suffused clouds are spellbinding. Everything, even the placement of the lone bird, is calculated to attract the eye to this focus. The sharp contrast between the dark, cleanly etched foreground and the lighter, softer background modifies the sensation of distances. It is not the massive aspect of a real mountain landscape which Bierstadt chooses to express, but the other-worldly, pantheistic character of his own vision.

Man is utterly absent. Save for the soaring bird and the possible faint indication of a swimming deer, the animal world, too, is unrepresented. Nature is seen in Bierstadt's works as pure and inviolate, a poetic, spiritual transcendence. In this he may have been inspired by Goethe, who had written of the artist's need to "produce something spiritually organic, and to give his work of art a content and a form through which it appears both natural and beyond Nature."[1]

Bierstadt treated the American West with considerable topographical latitude in his paintings. In the museum's picture he depicted a scene that is similar to another in a much larger canvas called *Among the Sierra Nevada Mountains, California* (1868, National Museum of American Art).[2] Like the larger work, the untitled picture may have been painted during the artist's European travels of 1867–1869, raising the likelihood that both are composites of various scenes, whether in the Sierras or elsewhere.

W. K.

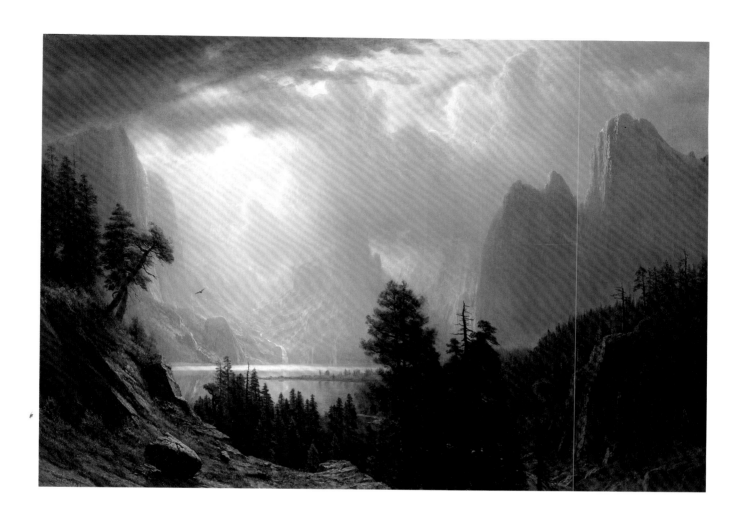

Martin Johnson Heade, 1819–1904

Martin Johnson Heade, who is now considered a major nineteenth-century American artist, achieved only a modest reputation during his lifetime and was forgotten almost entirely in the years following his death. Interest in his work revived in 1943 when his painting Thunderstorm Over Narragansett Bay *(1868, Amon Carter Museum, Fort Worth) appeared in the exhibition* Romantic Painting in America *at the Museum of Modern Art in New York and drew the attention of critics.*

Born in Lumberville, Pennsylvania, in 1819, Heade received his first artistic training in neighboring Newton, Pennsylvania, from noted primitive painter Edward Hicks and possibly from Thomas Hicks, Edward's cousin. Heade's earliest known work is a portrait from 1839. He began to exhibit his portraits and genre paintings in 1841 at the Pennsylvania Academy of the Fine Arts and subsequently—in 1843—at the National Academy of Design in New York. A compulsive traveler most of his life, Heade had visited Europe twice and lived in seven American cities by 1859, when he returned to New York. His mature style developed during the early to mid-1860s, when he experimented widely and introduced the subjects that would concern him for the remainder of his career. Between 1863 and 1870 he made three trips to South America, which inspired his many tropical paintings of hummingbirds and orchids. In 1883, at the age of sixty-four, he married and settled in St. Augustine, Florida, continuing to paint until his death in 1904.

Heade's earliest dated landscape is from 1855. In 1859 he established a New York studio in the famed Tenth Street Studio Building along with noted landscape artists Albert Bierstadt, Sanford Gifford, and, most significantly for Heade, Frederic Church, who became a lifelong friend. Contact with these second generation Hudson River School artists stimulated Heade's interest in landscape painting and brought about a turning point in his career. Landscapes make up one-third of Heade's total oeuvre; more than 120 are marsh landscapes. Through the marsh scenes it is possible to trace the artist's entire development as a landscape painter.[1] Heade was the first to paint the marshes for their own sake,[2] as vast, lonely expanses where the dramas of nature are played out. The power of his understatement is as riveting as the grandeur of Hudson River School painting.

6 *Marsh Scene: Two Cattle in a Field*, 1869 80.2

Oil on canvas, 14⅜ x 30¼ in. (36.5 x 76.8 cm.). Signed and dated lower right: M/Heade · 69. Acquired through exchange: Bequest of J. Willard Loos, 1980

Whether defined by its broad philosophical implications or in terms of its narrower stylistic tendencies, the aesthetic of luminism, which flourished in America in the third quarter of the nineteenth century, is evident in Heade's marsh landscapes. The highly polished surfaces of his paintings; the meticulous detail that reveals no trace of brushwork; the clearly ordered, balanced compositions with their measured spatial recession; the intimate scale and horizontality of his canvases, which usually conform to a height:width ratio of 1:2; the palpable silence and brooding tranquility; and, most important, the smooth radiant glow of light created by minute tonal modulations make many of Heade's landscapes paradigms of luminism.[3] The format rarely varies. Working within the confines of a restricted vocabulary Heade experimented with selective pictorial elements over several decades, creating a series of works that are variations on a central compositional theme and a study in the unity of tone and atmosphere.

Marsh Scene: Two Cattle in a Field of 1869, one of Heade's first twilight marsh scenes,[4] represents a critical period of transition in the development of the marsh landscapes. Between 1860 and 1870, Heade narrowed his focus of interest—no longer experimenting with a wide variety of atmospheric effects but choosing to paint the twilight and the bright sunsets of clear days. The palette changes accordingly, with the cool tones of the 1860s giving way to brighter, warmer shades of red and orange in the 1870s and 1880s, and as a consequence the mood also changes. The museum's marsh scene is distinguished by the luminist pink-to-raspberry colored sky, which differs markedly from the orange sunsets of his later paintings.[5]

Unlike his Hudson River School colleagues, Heade seems to have done comparatively little sketching. The few drawings that have survived in his sketchbooks include favored motifs that were later incorporated into paintings. The scene depicted in the museum's painting, for example, is linked to two sketches from the decade of the 1860s: one of a covered haystack and another of two cattle.[6]

The museum's picture most likely depicts the marshes of Hoboken, New Jersey,[7] with their broad, flat topography and covered haystacks, which distinguish these from the Newburyport, Massachusetts, marshes that inspired some of the artist's earlier canvases. Following his return to New York in 1867 from his second trip to South America, he chose to paint the conveniently located marshes of a neighboring state.

Heade's vision was highly personal. His mysterious, poetic landscapes have a haunting, almost surrealistic quality that appeals to a particularly modern sensibility. A peripheral figure, overshadowed by the greater names of his day, Heade was little understood by his contemporaries. Clement and Hutton noted in the 1884 edition of their encyclopedia of American Artists that Heade had achieved a degree of popular success with his marsh landscapes, and "the demand has been so great that he has probably painted more of them than [of] any other class of subjects." The same paintings, however, were dismissed by other critics for their uninteresting subject matter and "hard and chilling" manner, which everyone agreed was "very peculiar."[8]

<div align="right">N.V.M.</div>

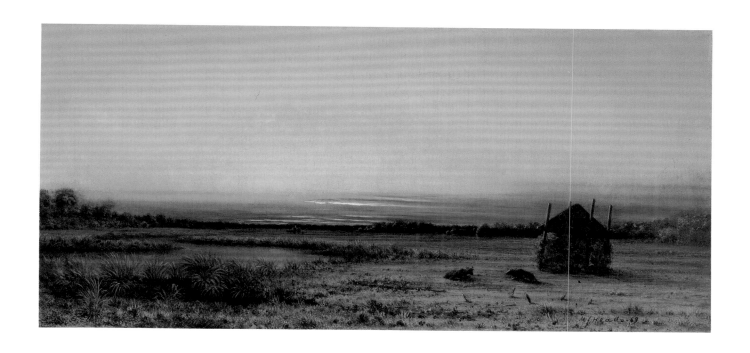

Severin Roesen, 1815 or 1816 – after 1872

Severin Roesen was one of the most ambitious and prolific still-life painters of nineteenth-century America. While only the bare outlines of the artist's life are known, it is believed that he was born in or near Cologne and that he is the porcelain painter who exhibited a floral painting at the local art club of Cologne in 1847.[1]

Roesen immigrated to the United States in 1848, possibly as a result of political upheavals in Germany. Between 1848 and 1852 he exhibited and sold eleven paintings through the American Art-Union in New York. Other exhibitions of his work include those at the Maryland Historical Society in Baltimore in 1858, the Pennsylvania Academy of the Fine Arts in 1863, and the Brooklyn Art Association in 1873.[2] He remained in New York until 1857, when he abandoned his young family and moved to Pennsylvania. After a brief stay in Philadelphia, he moved on to the rural, strongly German communities of Harrisburg, Huntingdon, and finally Williamsport, where he arrived around 1863. His last known dated picture is from 1872, the year he is thought to have left Williamsport to return to New York.[3] The date and location of Roesen's death are unknown.

More than three hundred of Roesen's lavish floral and fruit still lifes have been recorded. Because no more than two dozen or so are dated, it is difficult to establish a chronology of his paintings. His works demonstrate little stylistic development, though there is some indication that his still lifes became increasingly elaborate until 1855, after which their

complexity apparently depended upon his patrons' preferences.[4] The belief that the quality of his later work declined as a result of his excessive drinking has recently been called into question.[5] He seems rather to have been an artist of uneven abilities who has been aptly described as "a part-time perfectionist" capable of demonstrating both skill and carelessness, sometimes within the same picture.[6] His choice of subjects was limited and his paintings at times border on formulistic monotony. Favored objects and, in fact, whole compositional groups appear again and again in his paintings. A contemporary description of Roesen's studio suggests he worked on numerous still lifes simultaneously: "there were about a hundred pictures, mostly half finished and covered with dust, standing about the room, and about a half dozen easels holding canvases on which he worked alternately."[7]

His rich still lifes reflect the tradition of late seventeenth- and early eighteenth-century Dutch still lifes and the influence of contemporary painting in Dusseldorf—particularly the still lifes of Johann Wilhelm Preyer, with whose work Roesen's is closely associated. In addition, the elaborate character of Roesen's still lifes, with their proliferation of objects, embodies the taste and optimism of mid-nineteenth-century America. An underlying theme of the works is abundance—specifically, the endless bounty of nature in the New World and the secure good life in Victorian America.[8]

7 *Still Life* 80.32

Oil on canvas, 21¾ x 26¾ in. (55.3 x 67.9 cm.). Signed lower right: S. Roesen. Acquired through exchange: Bequest of J. Willard Loos, 1980

Roesen's consummate ability to visually represent abundance is demonstrated in the museum's still life. A small-scale work by the artist's standards, it nonetheless typifies his version of the well-stocked table. The luscious fruit on a marble ledge spills over the edge into the viewer's space. The large, metallic compote overflowing with peaches and grapes, the pilsner filled with effervescent champagne, and the bird's nest cradling three eggs are all familiar objects that populate countless Roesen still lifes. It has been suggested that the artist's repetition of objects and his use of fruits from different seasons in the same composition may indicate that he used templates or relied on botanical prints as models.[9]

Whatever its source, the fruit in the painting is tantalizingly fresh, with translucent drops of dew still clinging to it. Roesen's colors are bright, clear, and almost naive in their radiance. The fruit is carefully modeled and crisply delineated; twisting, serpentine vines and stems form an elegant calligraphy that unites and frames the intricate design. Another characteristic feature of his work is the solitary tendril extending over the ledge, whimsically forming the artist's script signature, with the initial S inside the R of Roesen.

N.V.M.

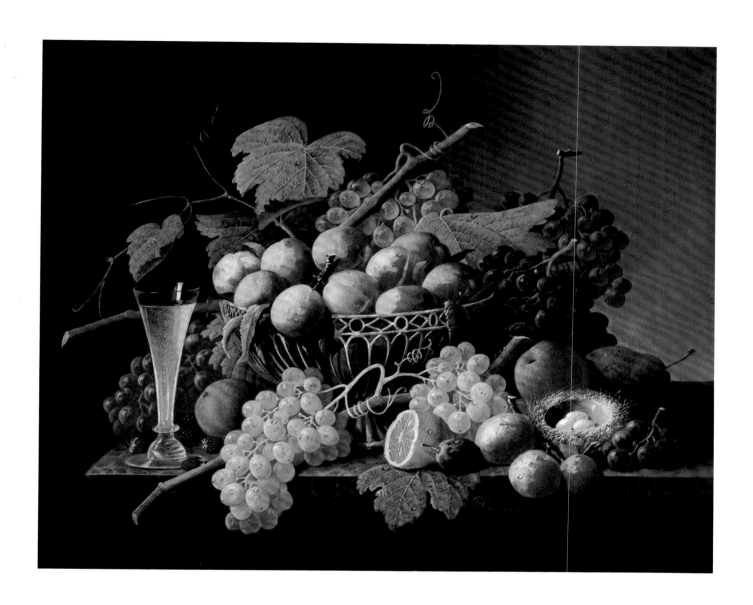

William Michael Harnett, ca. 1848–1892

Harnett, who was born in Ireland, was raised in Philadelphia. He trained as a silverware engraver, and then began his study of art at the Pennsylvania Academy of the Fine Arts in 1867. After moving to New York City in 1869, he studied at the Cooper Union and the National Academy of Design while supporting himself as a jewelry craftsman. He devoted his full attention to painting beginning in 1875, the year of his first exhibition at the National Academy. He moved back to Philadelphia the next year, opened a studio, and once again enrolled at the Pennsylvania Academy, where it is likely that he studied still-life painting with Thomas Eakins. He left for Europe in 1880, going first to London, then to Frankfurt, then (probably early in 1881) to Munich, where he remained until late 1884 or early 1885. He left Munich for sojourns in Paris and London before returning to New York in April 1886. Following a second European trip in 1889, he died in New York City at the age of forty-four.

From the outset of his career, Harnett was a specialist in the exacting art of still-life painting, producing numerous tabletop as well as trompe l'oeil compositions. Though he was considered old-fashioned by critics of his time, today he is recognized as the leading practitioner of late nineteenth-century American still-life painting.

8 *After the Hunt*, 1883 19.1

Oil on canvas, 52½ x 36 in. (133.4 x 91.4 cm.). Signed with monogram and dated lower left: W.M.Harnett/München/1883.
Bequest of Francis C. Sessions, 1919

Harnett painted four trompe l'oeil still lifes that bear the title *After the Hunt*. The version in the Columbus Museum of Art is one of the first two similar compositions painted in Munich in 1883 (the other is in the Amon Carter Museum, Fort Worth).[1] These paintings in all probability were inspired by the Alsatian Adolphe Braun's very large photographs of dead game and hunting gear hanging on a door or wall. The compositions established the artist's reputation and are still his most famous works. All were painted in Europe, where hunting subjects were especially popular. Coiled hunting horns and Tyrolean hats, needless to say, are a step closer to William Tell than to Daniel Boone.

Harnett is solidly within the tradition of trompe l'oeil painting in his hunt series. Such works, to have the maximum effect, must be strikingly realistic and must avoid the depiction of deep pictorial space. In *After the Hunt* the canvas appears to be a wooden door on which objects hang. The illusionistic birds and hunter's paraphernalia project relief-like from the "door" into our space. We are first attracted to Harnett's work by its bold forms, but it is through the tactility of the objects that the artist convinces us of their "reality." Imitative details of compelling naturalism abound: the dents in the horn, especially in the small coil; the rust stains below the lock plate and bolt on the left side; and the running stag carved into the rifle stock.

The painting is also remarkable for its unity of design. Curved shapes are played against strong diagonals within the triangle formed by the hunting objects. Balance is achieved by the subtle disposition of light and dark: for example, the large expanse of light on the mallard's breast is effectively balanced by the more intense light striking the feather in the hat. The echoing curves of birds' wings, powder horn, hunting horn, hat, feather, and corn tassel are visually sophisticated and compelling.

Curiously, the components in the Columbus hunt picture are placed so that they seem to suggest a figure. At the top, the hat becomes a head, and the horn next to it is ready to be sounded. The powderhorn slung below mimics an arm holding the gun to the shoulder. Just as there are many portraits in which objects associated with the sitter's profession or avocations are depicted to better express personality, here the things themselves seem to stand in place of the sitter. The painting is richly ambiguous.

It is also stylistically and emotionally in accord with the character of much American art of the last quarter of the nineteenth century. For there was another side to the Gilded Age's comfortable, sociable art, a dark counterpart of inward-turning late romanticism. In Harnett's picture, this mood is embodied in the somber lighting and the bold swellings and curves that push against the enveloping darkness. Dense and portentous, the picture has affinities with otherwise quite different paintings of the era: the nocturnal broodings of Ralph Blakelock; the paintings of hunted animals and hooked fighting fish by Winslow Homer; and, not least, Thomas Eakins's rigidly isolated portraits. While optimism and prosperity abounded in late nineteenth-century America, artists such as Harnett and others sounded their notes of melancholy counterpoint.

W.K.

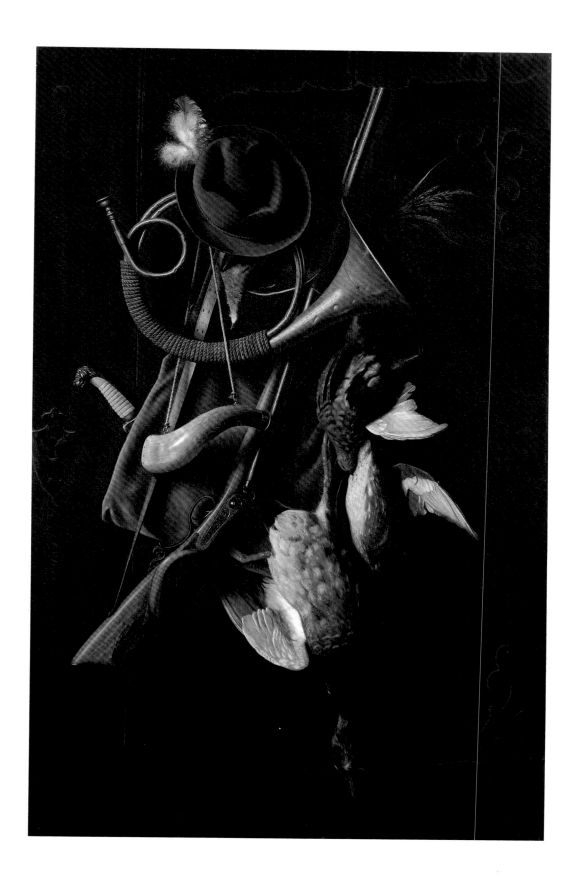

Attributed to De Scott Evans, 1847–1898

A Midwesterner by birth, De Scott Evans was a mainstream portrait and genre painter who worked first in rural Indiana, then in Cincinnati and Cleveland, Ohio. Between 1873 and 1875 he taught at Mount Union College in Alliance, Ohio, and between 1882 and 1887 at the Cleveland Academy of Art. He spent a year in Paris, from 1877 to 1878, studying with Adolphe William Bouguereau. In 1887, at the age of forty, he left the Midwest for the art world of New York. He died tragically in 1898, drowned in the shipwreck of the Paris-bound liner La Bourgogne.

Evans was best known for his genre paintings of modish young women in ornate settings. He was "a consummate master of stuffs," according to a critic of his times.[1] But interest in his work declined soon after his death and did not revive until a number of related trompe l'oeil still lifes bearing the signature S. S. David, or variations of that name, were attributed to him.[2] The attributions are based in particular on two virtually identical trompe l'oeil compositions of pears, one signed De Scott Evans and the other Scott David. Because an artist named David could not be identified in connection with the time and place of any of these works, it is assumed that they are by a single artist and that he is Evans. The attribution is by no means a certainty, however.[3] It is equally tenable that the two paintings were produced by two artists and that one copied the work of the other, or that both painted the same subject.

While many questions remain concerning the authenticity of the attribution, there is no doubt about the quality of the paintings themselves. These small, exquisitely realistic works, are genuinely appealing for their inventiveness, whimsical presentation, and conceptual integrity.

9 *A New Variety, Try One* 76.42.2

Oil on canvas, 12⅛ x 10 in. (30.8 x 25.4 cm.). Signed lower right: S.S. David. Gift of Dorothy Hubbard Appleton, 1976

Ordinary nuts, especially peanuts, which entered the commercial food market in quantities after the Civil War, became the subject of a number of trompe l'oeil works by artists such as John Frederick Peto, Joseph Decker, and Victor Dubreuil. The theme of nuts behind broken glass, as in *A New Variety, Try One*, is particularly associated with a group of trompe l'oeil works attributed to De Scott Evans. These nuts do not appear to be accessible like those in Decker's *A Hard Lot* (present location unknown), or in Peto's *Peanuts—Fresh Roasted, Well Toasted* (private collection). Instead, these nuts are contained in a rough-hewn wooden niche, protected from surreptitious nibblers by a piece of broken glass. Moreover, there is often a menacing written invitation tempting the passerby to risk the jagged, dirty glass for the sake of a sample. The artist nearly always incorporates an unusual compositional device: one nut, balanced precariously on the edge of the niche and projecting into the viewer's space appears to be accessible, but if that nut could be removed the entire contents would cascade out of the niche.

As is typical of trompe l'oeil painting, the deception in *A New Variety, Try One* is achieved by meticulous illusionistic rendering of the actual-size image. Nearly all traces of brushwork are suppressed as the painter uses his technical virtuosity to hide any sense of his own presence. The illusion is enhanced by an unusual device: the edges of the canvas, where it wraps around the stretchers, are exposed, and these have been painted to look like the sawed and planed sides of a thick board. The top edge is darkened as if dust and dirt had accumulated on it.

A New Variety, Try One is one of more than twenty nut still lifes attributed to Evans.[4] The meaning, if one exists beyond the fascination of their visual deception, remains elusive. The ready market for these trompe l'oeil works (which were immensely popular despite the disdain of contemporary critics) no doubt accounts for the numerous replicas. Nevertheless, each is a masterful *tour de force* of illusion that continues to intrigue the viewer long after the visual deception has lost its initial power.

N.V.M.

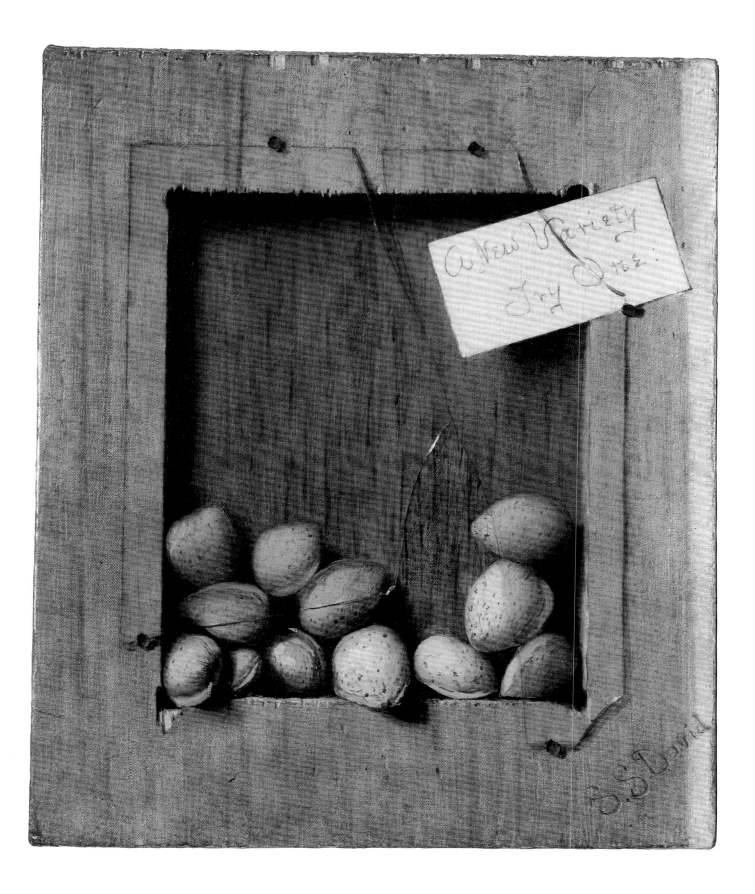

Albert Pinkham Ryder, 1847–1917

Albert Pinkham Ryder began to paint landscapes in his hometown of New Bedford, Massachusetts, while still a youth. He received no formal training until in his early twenties he moved with his family to New York. There he studied first with William Edgar Marshall (1837–1906), a portraitist and engraver, and then at the National Academy of Design for four years. Ryder made the first of four trips to Europe in 1877.

Recent scholarship has challenged the traditional beliefs that Ryder was a recluse whose style developed in nearly total isolation, unaffected by contemporary currents in either American or European art, and that he was unappreciated outside a coterie of artist friends.[1] Only during the later years of his life did he retreat into the reclusive, nearly destitute, existence in which Marsden Hartley discovered him. His art was intensely personal, drawn from his own inner reality, but nevertheless rooted in his training and experience. Ryder was deeply influenced by the Barbizon school of painting as well as the Dutch Hague School with whose work he became familiar through his travels and through his association with Daniel Cottier, his dealer. A founding member of the Society of American Artists in 1877, Ryder also became closely associated with a circle of artists—among them painters Julian Alden Weir and Wyatt Eaton and the sculptor Olin Warner—who resided at the Benedick Building on New York's Washington Square East during the 1880s. Robert Loftin Newman (1827–1912), who shared Eaton's studio, was particularly important to Ryder's development and is be-lieved to have influenced his shift from pastoral landscapes to imaginary and mystical-religious themes.[2] Ryder exhibited extensively through the 1880s and received favorable critical recognition at the time. His work enjoyed a particular popularity among the early twentieth-century American avant-garde, who heralded him as a harbinger of modernism in America. Ten of Ryder's paintings were exhibited in the Armory Show of 1913.

Ryder completed less than two hundred paintings and produced few, if any, new works after 1900. Although he always insisted on the preeminence of an artist's original inspiration, he often kept paintings in his studio for several years, reworking them again and again, building up successive layers of pigment and glazes. He never dated his pictures and only rarely signed them. Because he lacked certain technical knowledge and experimented with materials such as wax, candle-grease, and bitumen, his paintings suffered severe cracking and marked deterioration even during his own lifetime. He spent his later years attempting to restore and rework some of them.

The very personal nature of Ryder's artistic search is characterized in his own words:

> *Have you ever seen an inchworm crawl up a leaf or twig, and then clinging to the very end, revolve in the air, feeling . . . to reach something? That's like me, I am trying to find something out there beyond the place on which I have footing.[3]*

10 *Spirit of Autumn*, ca. 1875 [57]47.68

Oil on panel, 8½ x 5¼ in. (21.6 x 13.3 cm.). Signed lower left: A.P. Ryder. Bequest of Frederick W. Schumacher, 1957

Spirit of Autumn, painted by Ryder during his first years in New York when he was still a student, is the earliest documented work by the artist. Ryder apparently attempted to make a gift of the small picture, which is painted on a wooden cigar box panel, to his friend and fellow student Stephen G. Putnam. Putnam, it seems, did not accept the gift initially but later offered Ryder $5.00 for the painting; as a compromise Ryder agreed to sign the work and accept the payment.[4]

Ryder's works are haunting visual metaphors for the elemental forces of nature. In *Spirit of Autumn* the artist evokes the elegiac mood of the season. There is only a hint of landscape. The composition is dominated by the solitary figure of a woman standing at the edge of a wood, framed by russet foliage. She seems an apparition emerging only momentarily from the fall landscape. Her shoulders and bowed head are silhouetted against the blue sky that casts a halo-like aura around the upper half of her figure. Her contemplative pose and featureless anonymity enhance her visionary presence as an allegorical figure who is both eternal and elusive.

The thick encrusted pigment usually associated with the artist's works is not seen here. The warm reddish-brown of the thinly painted mahogany panel is visible throughout the background, much of which is covered only with varnish or an extremely thin wash. Only in the slight build-up of pigment on the tree trunk did Ryder create texture with a palette knife or the end of his brush.

The formative influences of American painters John LaFarge, George Inness, and William Morris Hunt, through whom Ryder first became acquainted with the Barbizon tradition, is evident in the painting. The work precedes by several years the turning point in Ryder's career, when around 1880 his interest in mystical and imaginative themes became more pronounced. In *The Spirit of Spring* (Toledo Museum of Art, Ohio), painted in 1880, Ryder further elaborated on the theme of the seasons. The composition in the later canvas, which places the figure in an expansive landscape, is more carefully conceived than that in the Columbus picture. In both, the cloaked female figure standing beneath a tree has been cast in the allegorical role of a season.

N.V.M.

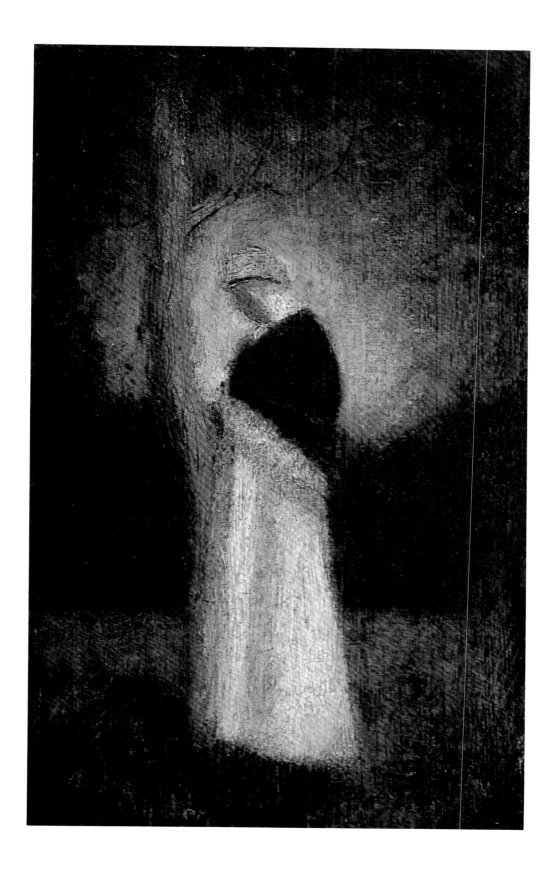

Ralph Albert Blakelock, 1847–1919

Ralph Blakelock was born in New York City. The son of a well-to-do physician, he was given to introspection, which in turn predisposed him to explore a visionary world in his paintings. His art was influenced by the French Barbizon school of landscape painting, both in his favorite subject matter—the interiors of dark forests—and in obsessively worked surfaces. These characteristics can also be found, for instance, in the paintings of Theodore Rousseau, as well as in works by the independent artist Adolphe Monticelli, both of whom were represented in the collections of Blakelock's patrons.[1]

Blakelock was essentially a self-taught artist, a technical explorer who learned through trial and error, guided by instinct. Working on pictures over a period of years, he would build up layers of paint, adding fresh pigment with his palette knife after an earlier application had just begun to set, then scoring the surface with a meat skewer. Occasionally he would rub through the upper layers of paint with a pumice stone until the lighter tones of the underpaint glowed through with magical luminosity. He was often inspired by the accidental patterns of color he found in everyday objects.[2] Improvisation was his method. An accomplished musician who also improvised at the piano to develop themes for his paintings, he would place a canvas on the piano or nearby easel, play until inspired, then work further on the painting.

The actual source material of Blakelock's mature art was drawn from three years of solitary travels in the West between 1869 and 1872. He wandered widely, painting and filling notebooks with sketches for future use and forming impressions of the American wilderness. His subsequent works were drawn as much from his remembered and internalized experience as from his sketches and may be characterized as poetic interweavings of the American wilderness and the Indians who were an inseparable part of it.

11 *Moonlight*, ca. 1885–1890 45.20

Oil on board, 12 x 16 in. (30.5 x 40.6 cm.). Signed lower right: R. A. Blakelock. Bequest of John R. and Louise Lersch Gobey, 1945

Moonlight, one of the artist's nocturnal meditations, is not about the passage of time, does not hint of the day to come. Instead, Blakelock engraves the very idea of night and the moon that reigns over it on his panel and in the mind's eye. Dark and light areas alike are marked by brush and palette knife. Though the green of the night sky is seen "through" the dark foliage of the trees at the right, in fact the green is laid on over the black mass. Time has darkened Blakelock's pigments, rendering two figures on horseback at the right nearly invisible, but they seem always to have been more acquainted with the night than with the light. In the scarred sky, the moon just holds its own, as though it had with difficulty burned through the blue-green and brown veils of paint. Blakelock has here reduced nature to few and basic components: the substantial sky, the fixed moon and its eerie shimmer on the foreground pond, the stratified trees clinging fast to their places, the unspecific barrier of the horizon.

In 1891, soon after *Moonlight* was painted, Blakelock, who was locked in unknowable psychic conflicts, suffered his first mental breakdown. Late in 1899, on the day his ninth child was born, he had his final collapse, which kept him in mental institutions for twenty years until nearly the end of his life. His paintings came to be increasingly admired, and in 1916—three years before he died—he was made an Academician of the National Academy of Design.

W. K.

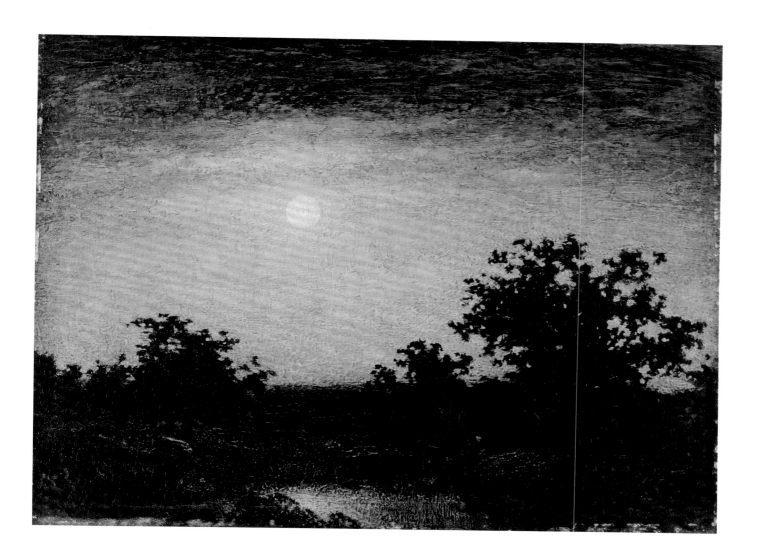

Elihu Vedder, 1836–1923

Elihu Vedder emerges as one of the most strikingly original American artists of the late nineteenth century. A friend of the English Pre-Raphaelites and Italian Macchiaioli painters, he was versed in Neoclassic form and imbued with the aura of Romanticism. He exhibited varied talents as a figure painter, landscapist, illustrator, muralist, and writer. By virtue of his innate, profoundly melancholic personality and his reliance on mystical inspiration, he managed to avoid either pedantry or imitation in his works. Through his decorative commissions—notably for the Library of Congress (1895)—Vedder contributed enormously to the development of the national consciousness of American art, though for most of his working life he was an expatriate in Italy. He is perhaps best known for his famous illustrations of 1883–1884 for the Fitzgerald translation of The Rubaiyat of Omar Khayyam.

12 *The Venetian Model*, 1878 69.7

Oil on canvas, 18 x 14⅞ in. (45.7 x 37.8 cm.). Signed and dated lower left: Vedder/1878. Museum Purchase: Schumacher Fund, 1969

The Venetian Model, a painting regarded by Vedder himself as one of his best works,[1] is much more than a studio painting of a nude model. In this picture the attributes of painting and sculpture, the ideal beauty of the nude, the artistic images of the Venetian past are carefully collated by the artist to suggest both irretrievable glories and present potentialities. Treated almost like a relief, the model is posed in a shallow space against the studio wall, seated on a Renaissance-style sideboard draped with a tapestry carpet, and resting her feet on a stool also partially covered with carpet (the right foot additionally propped up by a posing block). On a tapestry-covered wall behind the figure hang two paintings: a sketch of a gondola and a larger painting of an ancient Venetian state barge. The model leans upon the shoulder of a ship's wooden figurehead, beside which is a late sixteenth-century Venetian maiolica pharmacy jar containing the artist's brushes.

Painted in Venice, the picture seems intended to evoke a nostalgic daydream of that pearl of the Adriatic. The constrained profile pose creates tension in the upper body of the model, which vivifies the meditative, almost prayerful, pose. If we imagine a line extending upward from the model's upper left arm to the top right corner and downward to the midpoint of the left side of the painting, we will find that everything essential to the painting's mood and meaning is contained in the triangle above that line. The images of Venetian boats, especially the glorious barges of former days, are reiterated by the wooden figurehead, which seems to glance over its shoulder at those images. The melancholy mien of the sculpture echoes that of the model, and indeed they seem like spiritual and physical sisters.

The prominence of the artist's brushes in a maiolica container of bright blue, red, and yellow—the strongest passage of color in the painting—proclaims the artist's presence in this meditative compilation. Just as striking in this context is the parrot in the tapestry behind the sculpture's head, a time-honored symbol of eloquence—especially of imitative eloquence.

The Venetian Model did not immediately sell, as Vedder's daughter Carrie had predicted, "on account of its [model] being totally nude, although it is as modest as modest can be."[2] The artist, too, recorded that an "eminent heiress of Ithaca, New York . . . was so fearful of the public opinion of Ithaca that she dared not gratify her individual taste."[3] He briefly considered adding some drapery to placate Victorian opinion, but, he said, "I began to get ashamed of myself and *stopped*. It seemed like putting on the providential leaf in the creation of Adam and Eve and I did not feel as if I was that kind of Providence, *tutto al contrario*."[4]

W.K.

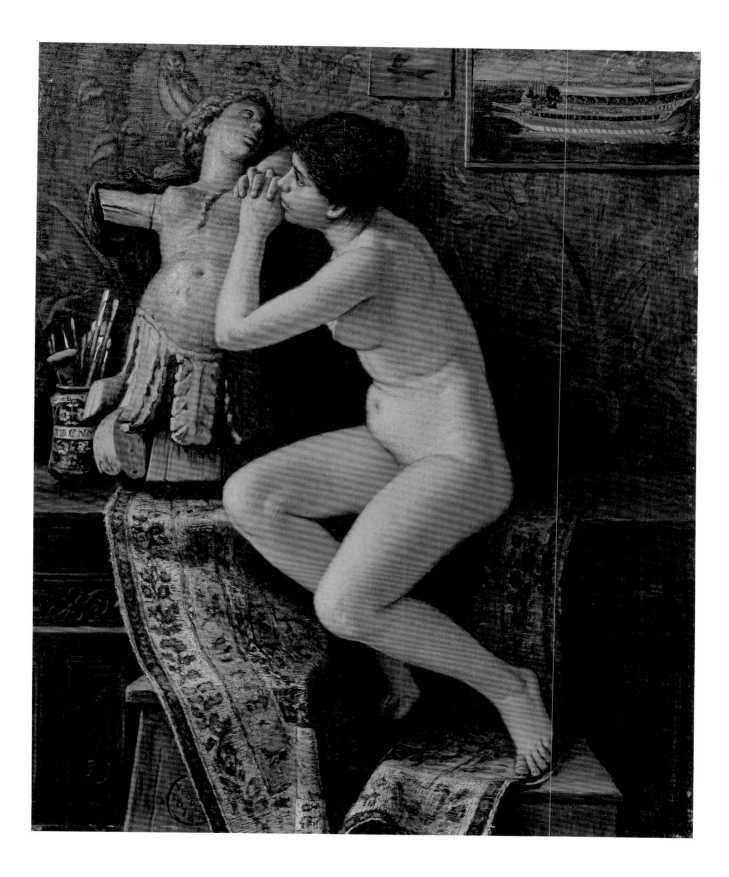

John La Farge, 1835–1910

John La Farge was nearly thirty years old when he decided to become a professional artist. Born in New York City to wealthy French parents, he was educated bilingually, with particular emphasis on literature and art. He also studied law. But in 1856 he left for Europe to develop his painting skills primarily by copying the old masters and sketching from nature. Back in the United States, he studied with William Morris Hunt in Newport, Rhode Island, and befriended fellow students William and Henry James. He became known particularly for his architectural decorations, such as painted panels and stained glass, and received important commissions like that in 1876 for the decoration of Trinity Church, Boston. He was one of the first American artists to show an interest in Japanese art, but his enthusiasm waned after a trip to Japan in 1886 with Henry Adams. During 1890 and 1891, also in the company of Adams, La Farge visited the South Seas, following in the footsteps of Robert Louis Stevenson and preceding the more famous journey of Paul Gauguin.

A celebrated, middle-aged artist by the time he visited the tropics, La Farge quickly immersed himself in the exotic, seeming paradise of Tahiti. The works he produced there reflect the particular climate and customs of the place. His Polynesian landscapes are often remarkably similar in color to Gauguin's of the same locale, and his figure paintings mingle ethnography and a foreigner's poetic fascination with the aura of place. Like other Western visitors, La Farge was continually comparing East and West, often to the disadvantage of the West. Of the Christianized Polynesians he came to know, he wrote: "the people [are] yet nearer to nature than Millet's peasants."[1] Such yearning for lost innocence, for a return to nature and purity, is a recurrent theme in the nineteenth century, especially poignant as the century closed.

13 Girl in Grass Dress (Seated Samoan Girl), 1890 66.39

Oil on panel, 12 x 10 in. (30.5 x 25.4 cm.). Museum Purchase: Schumacher Fund, 1966

Otaota, the model in this small sketch, was the daughter of a Samoan Christian Protestant preacher. In an 1895 exhibition catalogue La Farge noted that while in her own mind Otaota was sitting for her portrait, he was more interested in getting "a memorandum of the peculiar dress made of leaves and brilliant colors, cut into shape and sewed on to a foundation of bark cloth, then rubbed with perfumed cocoanut oil."[2] He further recorded that "this costume had been worn the day before at a great feast, and is 'missionary' in complement to the European prejudice for clothing."[3]

One is struck by the power of this small painting. The room in which Otaota sits is suggested by the mahogany-stained or painted panel whose tone is the basis for the background. Strokes of green alternate with the dark wood to suggest the forest seen through strips of curtain. Within this ambience the figure is a small explosion of color applied in short, rather broad strokes. The treatment of the profile head is at once bold and restrained, the mass of black hair pulled back into a conspicuous shape while the face is blurred and indistinct, an area of transition from foreground to background rather than a focus of attention.

La Farge implied that Otaota's chatting friends were responsible for the unfinished face;[4] it may be, however, that the picture owes much of its dreamy charm to that elision of the features. Such avoidance of the literal or overly-descriptive is like the allusions of lyric poetry.

W. K.

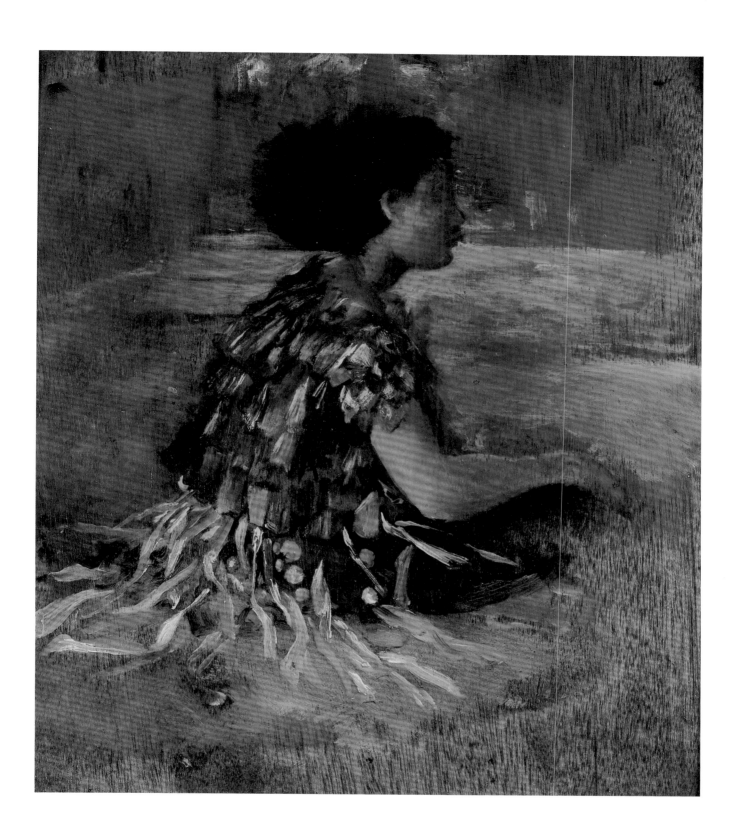

James A. McNeill Whistler, 1834–1903

During his entire career as a painter James McNeill Whistler lived and worked in Europe. Born in Lowell, Massachusetts, he received his first artistic training at the Imperial Academy of Fine Arts in St. Petersburg, Russia. Then as a cadet at the United States Military Academy at West Point he studied drawing under Robert W. Weir. After leaving West Point and working briefly as a surveyor and cartographer, he decided to become an artist. In 1855, at the age of twenty-two, he sailed for Europe, and began his training in Paris in the studio of Charles Gleyre, a teacher of the Impressionists. Soon the young artist was drawn to avant-garde circles, where he became acquainted with painters Gustave Courbet, Henri Fantin-Latour, Edouard Manet, and Edgar Degas, and critic Theophile Gautier. After 1859 he made London his home and developed close ties with Dante Gabriel Rosetti and other Pre-Raphaelites, who influenced his developing artistic sensibilities.

By the early 1860s Whistler had become firmly identified with the most radical trends in modern painting. His Symphony in White No. 1: The Girl in White scandalized viewers and critics alike at the Salon des Refusés in 1863. Ostensibly a portrait of his mistress, the painting embodies the artist's rebellion against nineteenth-century sentimental genre subjects and proclaims his commitment to the purely visual aesthetics of painting. Whistler shared Gautier's belief in "art for art's sake" and sought to strip his pictures of their narrative context so that they could be evaluated solely on their formal merits. He adopted musical titles for his paintings beginning in the late 1860s, explaining: "as music is the poetry of sound, so is painting the poetry of sight and the subject-matter has nothing to do with harmony of sound or of color."[1] During the following two decades, when he produced his most notable works, his aesthetics reached fruition. Keenly sensitive to a wide range of European painting styles, Whistler developed a distinctive personal mode of expression. He was fascinated with Oriental art, from which he borrowed motifs and colors, flat, decorative shapes, and asymmetrical compositions. The hallmark of his oeuvre—compositions subtly orchestrated in a limited range of tones—now identifies him as a leading exponent of tonalism, a dominant trend in American painting during the late nineteenth century.

Wide recognition and acceptance of his work—as well as financial success—did not come until after 1900, when Whistler was beginning to be acknowledged as a critical forerunner of Symbolism and Art Nouveau.

14 Study of a Head, ca. 1881–1885 [57] 43.8

Oil on canvas, 22⅝ x 14½ in. (57.5 x 36.8 cm.). Signed center right with butterfly symbol. Bequest of Frederick W. Schumacher, 1957

Study of a Head is a Whistlerian arrangement in brown and black in which the artist reveals his masterful handling of a nearly monochromatic range of muted tones. The figure emerges from the neutral background as a diffused pattern, with the white impasto of the shirt collar and a few touches of red in the cheek and mouth alone accenting the somber palette. Even the artist's butterfly signature,[2] just visible to the right of the figure's mouth, seems to have been painted over by Whistler in order to maintain the picture's uniform tonal harmony.[3]

The painting has the freshness of a rapidly executed oil sketch. With the exception of rare touches of impasto, the paint has been thinly applied; the texture of the coarse canvas is clearly visible. Handling the paint quickly and with economy, Whistler captured the essentials of the figure. Stylistically, the work is related to Whistler's watercolors executed in the mid-1880s.[4]

The identity of the sitter is not certainly known. The painting was exhibited by Parke-Bernet Galleries in 1942 as Mr. Graves, Printseller,[5] referring to Henry Graves (1806–1892), founder of a London firm of printsellers and of the publications Art Journal and Illustrated London News. The age and appearance of the subject soon led scholars to believe that the portrait was more likely of Henry's son Algernon (1845–1922), who worked in his father's firm (becoming president upon Henry's death). Both father and son were close to Whistler beginning in the mid-1870s, and Whistler continued to have dealings with the Graves family through the early 1890s. However, because no mention of such a portrait is found in the extensive surviving correspondence between Whistler and the family, doubts persist that the portrait is of either of the Graveses.[6]

A comparison of this work with the 1878 portrait of Algernon Graves by Rosa Corder, which Whistler supposedly knew and liked, raises additional questions. Though there is a similarity in the profiles of the two subjects, the thirty-three-year-old Graves of Corder's portrait appears older than the sitter in Whistler's later portrait, which scholars have variously dated from the early 1880s to the mid-1890s.

If Study of a Head is of Algernon Graves, it is surely a tribute to someone to whom Whistler was very grateful. He wrote to Graves in December 1890:

> You have shown that you understand how an artist whose work is without the pale of gross popularity, & whose purse is consequently not heavy with ill-gotten gold, may be met with, even great, patience, . . . and hereafter in history this shall not be forgotten.[7]

In any case, it is unlikely that Whistler would be sympathetic to arguments concerning the identity of the sitter. Whatever the personal significance of the portrait, one is reminded of Whistler's comment about Arrangement in Grey and Black: Portrait of the Painter's Mother:

> To me it is interesting as a picture of my mother; but can or ought the public care about the identity of the portrait? It must fall or stand on its merit as an arrangement.[8]

N.V.M.

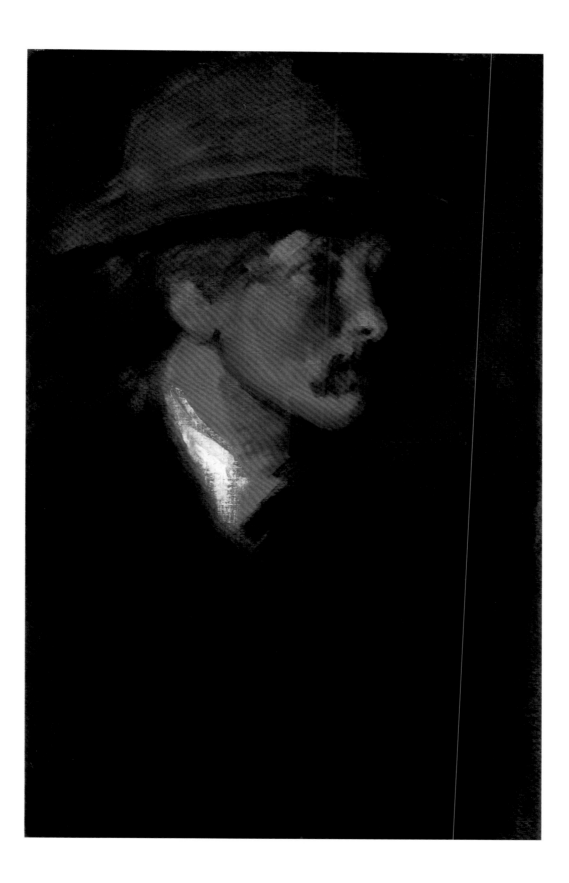

John Henry Twachtman, 1853–1902

A native of Cincinnati, where he studied with the influential artist and teacher Frank Duveneck, Twachtman showed an artistic temperament very different from the painterly robustness of his mentor. Instead, a refined aestheticism marks his mature style. Twachtman studied in Munich between 1875 and 1877, but it was not until his second trip to Europe in 1880–1885 and his contact with the French Impressionists and J.A.M. Whistler that he decisively formed his style. A painter of poetic moods, he was attuned to the special atmosphere of a place, and his residence on a farm at Cos Cob, Connecticut, from 1889 until his death provided him with a deeply felt subject to which he tuned his exquisitely subtle palette.

15 *Court of Honor, World's Columbian Exposition, Chicago,* 1893 [57]43.10

Oil on canvas, 25 x 30 in. (63.5 x 76.2 cm.). Signed lower right: J. H. Twachtman. Bequest of Frederick W. Schumacher, 1957

An unusual subject in Twachtman's oeuvre, *Court of Honor* was surely a *pièce d'occasion*, possibly commissioned by one John Bannon Esq., from whose 1905 sale it was purchased by Victor Harris. Twachtman was in Chicago in 1893 to accept a silver medal in painting at the Columbian Exposition, but the details of the supposed commission are not known. It was a significant year for the artist in another way too: he exhibited at a New York gallery with Claude Monet, whose daring minimization of the object in favor of the pictorial dominance of light Twachtman shared perhaps more than any other American painter.

Despite the ostensible architectural subject, some eighty percent of the surface of the museum's painting is devoted to sky and water. In this the work resembles innumerable paintings of Venice, whether by Monet, Renoir, or Turner. Twachtman's recollections of Venice, city of light and water, derive from his visits to the great city in 1877 and 1880. But instead of San Giorgio Maggiore floating on an island in a lagoon, there is Richard Morris Hunt's similarly domed Administration Building situated at the end of an artificial pond designed for the Exposition by Frederick Law Olmstead. To the left of the Administration Building is the Machinery Building; to the right, behind the exposition pennants, the Electricity Building. Also discernible is Frederick MacMonnies's enormous (sixty-foot long), many-figured Columbian Fountain, which stands directly in front of the Administration Building. Something of the concern with refined taste and European precedent that motivated the exposition's architects affected Twachtman too. This and other paintings by the artist are closely allied with the high aestheticism of European art and letters at the end of the century, a bias that was widespread among American artists of the day.

While photographs of the exposition invariably emphasize the buildings, in Twachtman's picture the architecture is no more material than the surrounding atmosphere. Except for the pale yellow dome of the Administration Building, the bright light green of a half dome on the building just to its left, and a scattering of pinks in banners and one roof, the architecture is absorbed into the overall blue-gray scheme imposed by the artist. Brushed over a mauve ground color, the brilliant white plaster facades seem to merge with the atmosphere. The asymmetry of the composition is reinforced by the direction of the dry, thin brushstrokes that represent the surface of the pond, their drifting parallels precisely capturing the appearance of windblown currents on a shallow basin. This sensation of moving water combines with a subtle modulation of light on the surface and the receding space to convey an effect of buoyancy beneath the darker form of the Administration Building.

Court of Honor was long thought to be unique in Twachtman's oeuvre, but recently a related, smaller painting (12½ x 16 inches) appeared on the art market: Twachtman's *The Chicago World's Fair, Illinois Building*.[1] More informal than the museum's picture, it stresses a parklike setting that is likewise little evident in photographs of the exposition.

<div align="right">W.K.</div>

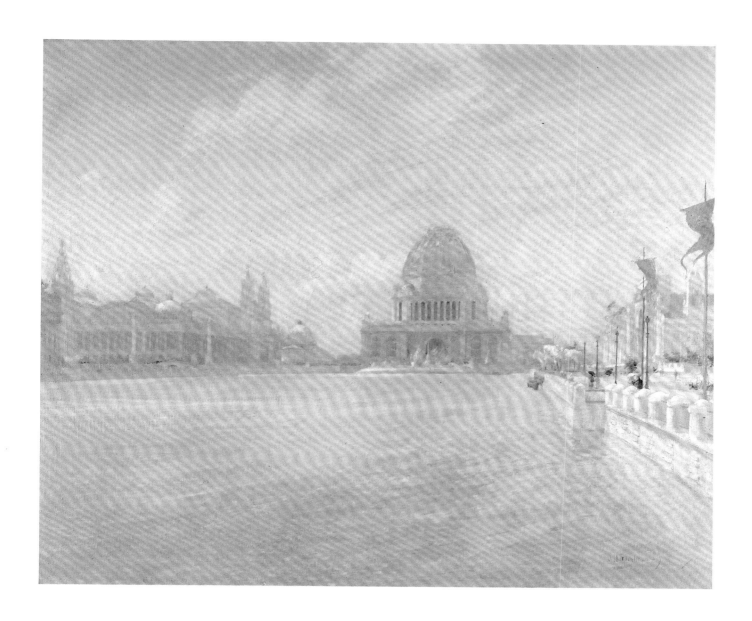

Childe Hassam, 1859–1935

One of the country's foremost exponents of Impressionist painting, Hassam enjoyed a long and productive career marked with many honors and awards. Born in Dorchester, Massachusetts, he began his training at the Boston Arts Club and the Lowell Institute. Early on, he worked as an engraver's draftsman, designing compositions for Harper's, Century, and Scribner's Magazine. He first went abroad in 1883, traveling to The Netherlands and Italy. Returning to Boston that same year, he began to develop atmospheric city scenes such as Rainy Day, Columbus Avenue, Boston (1885, The Toledo Museum of Art), which today are among his most popular and endearing works.

During his second trip abroad, from 1886 to 1889, Hassam studied in Paris at the Académie Julian under Gustave Boulanger and Jules Lefébvre. He was awarded a gold medal at the 1888 Paris Salon and a bronze medal at the 1889 Paris Exposition. While in France he initiated lifelong friendships with American Impressionists Theodore Robinson and Willard Metcalf. Upon his return to the United States, Hassam established himself in New York City and painted Impressionist urban genre scenes, particularly the activity around Washington Square and Fifth Avenue. Following another trip abroad in 1897, Hassam joined

with John Twachtman, J. Alden Weir, and others in the founding of Ten American Painters, an organization of American Impressionists that mounted a series of independent exhibitions. At the end of the century Hassam taught at the Art Students League and painted some of his most successful landscapes in the New England coastal regions of Gloucester, Newport, and Provincetown. After a fourth stay in Paris in 1910, he turned his attention to the American scene once more, painting at Cos Cob and Old Lyme, Connecticut; Easthampton, New York; and, Appledore, Isles of Shoals, Maine.

Hassam, an exhibitor in the 1913 Armory Show, was not a revolutionary in style or temperament. His embrace of Impressionism came at a time when—in Boston, at least—the movement had found favor. His memberships include the American Water Color Society, the Society of American Artists, the National Academy of Design, and the Association of American Painters and Sculptors. A generous spirit, at the end of his life he bequeathed 450 of his works to the American Academy of Arts and Letters, stipulating that they were to be sold to create a fund for the purchase of works by young artists.

16 *The North Gorge, Appledore, Isles of Shoals*, 1912 [57]43.9

Oil on canvas, 20 x 14 in. (50.8 x 35.6 cm.). Signed and dated in lower right: Childe Hassam 1912. Bequest of Frederick W. Schumacher, 1957

The North Gorge, Appledore, Isles of Shoals is one of many works by Hassam devoted to the rocky prominences of an island off the coast of Maine. Hassam began to spend summers at Appledore during the mid-1880s, when writer Celia Thaxter invited him to join the group of artists who summered there at her island home. Thaxter, the daughter of a lighthouse keeper, recorded life along the Maine coast in memoirs such as *Among the Isles of Shoals* (1873) and a later work entitled *An Island Garden* (1894), which Hassam illustrated.

The Impressionist nature of this painting lies largely in Hassam's handling of space and in his brushwork. Here, as in other Appledore pictures, Hassam invokes his French predecessors Jean-François Millet and Claude Monet, who portrayed the rugged coastlines of Normandy and Brittany. His brushstrokes are lively, tightly woven, rhythmic in texture. His colors, from the myriad red-orange and russet tones of the rocks to the vivid turquoise of the sparkling sea, draw the viewer's attention upward. These devices supplant traditional spatial perspective with flat registers of paint and call attention to the canvas surface, much like the works of the earlier Impressionists.

But Hassam's response to Impressionism typifies the American preference for solidity and definition. No film of light between the painter and the subject dissolves the form of the great rocks that frame the sea view in this painting. In the ebb and flow of the waters too there is substance. Here, light illuminates structure, does not break it down. Typical of American Impressionism is the insistence on strong elements of design: the vertical format, the high horizon line, the severely cropped view, and the upward thrust of the composition.

The North Gorge, Appledore, Isles of Shoals is part of a continuing American tradition of dynamic seascapes. One is reminded in particular of Winslow Homer's many scenes of Prout's Neck, Maine, and of John Marin's explosive seascapes, also painted in Maine.

L.L.M.

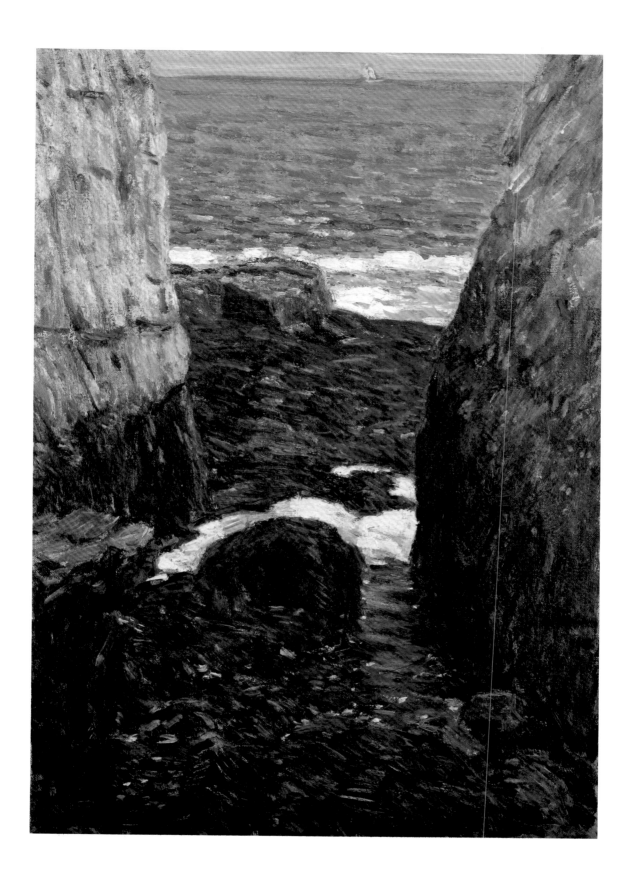

John Singer Sargent, 1856–1925

John Singer Sargent was born in Florence to American parents, expatriates who constantly traveled the European continent. He did not make his first visit to the United States until 1877. Sargent received his first artistic training in Italy, where he was tutored in Rome by German-American artist Carl Welsch in 1868–1869. From 1871 to 1872 he studied at the Accademia di Belle Arti in Florence; two years later in Paris he joined the atelier of Emile Carolus-Duran and attended drawing classes at the Ecole des Beaux Arts. He made his Salon debut in 1877 and in the following year's Salon received honorable mention for the Oyster Gatherers of Cancale (1878, Corcoran Gallery of Art). While still living abroad he participated in the founding of the Society of American Artists, a group of young, progressive artists who were inspired by current European painting styles. He began to exhibit at the National Academy of Design in 1879. In Spain and The Netherlands during 1879–1880 he copied works by Velázquez and Hals, further assimilating their stylistic lessons. In Morocco on the same journey he absorbed the influence of Mediterranean portrait subjects.

Despite his formidable early success in France, Sargent abruptly departed for England in 1884 because of the controversy surrounding the Salon exhibition of his Madame X (1884, Metropolitan Museum of Art). England became his permanent home. He rented Whistler's former studio in London and divided his time between there and the village of Broadway, an artist colony on the River Avon, where in summers he painted outdoors. He maintained contact with French artists, exhibiting with Monet and other Impressionists at the Galerie Georges Petit in Paris in 1884 and working with Monet at Giverny in the late 1880s. Sargent explored the Impressionists' handling of light and color in his own work, but he never thoroughly embraced their style, refusing to abandon the modeling of forms through value contrasts.

In the United States in 1887 Sargent was offered numerous portrait commissions. In 1890 he accepted a major commission to produce a series of murals for the Boston Public Library. In 1897, two years after the installation of the first murals, he was elected a full member of the Royal Academy and of the National Academy of Design and was named an officier of the French Legion d'Honneur. Many other honors followed, including British knighthood, which Sargent declined rather than forfeit his American citizenship. By the turn of the century, he was the most celebrated portraitist in Europe and America, and his style was a dominating influence in the art world. He almost completely abandoned portraiture in his late career, choosing to concentrate on watercolor and oil landscapes and murals such as those in the rotunda of the Museum of Fine Arts, Boston, and the Widener Library at Harvard University.

After a major retrospective exhibition in 1924 at the Grand Central Galleries in New York City, Sargent returned to England. In April of the same year he died of heart disease and was buried at Woking, near London. The year following his death Sargent was honored with memorial exhibitions at the Metropolitan Museum of Art and at the Royal Academy in London.

17 Carmela Bertagna, ca. 1880 [57]43.11

Oil on canvas, 23½ x 19½ in. (59.7 x 49.5 cm.). Signed upper right: John S. Sargent. Inscribed upper left: à mon ami Poirson. Inscribed lower left: Carmela Bertagna/Rue du/16 Maine. Bequest of Frederick W. Schumacher, 1957

Carmela Bertagna bears the full imprint of Sargent's discerning study of the paintings of Velázquez and Hals and shows Mediterranean influences garnered from his 1880 journey to Tangiers. The artist's bravura brushwork is tempered here by his observation of the elegant painting in works by the Baroque masters, particularly Velázquez. Also evident in this portrait is the influence of Emile Carolus-Duran, from whom Sargent learned to use the brush to create shape and add color simultaneously, articulating form through summary passages of light and dark rather than by linear definition.

A vital aspect of the work is the dynamic coalescence of underpainting and surface brushwork, particularly effective where the blue underpainting delineates the shadowed areas of the model's face. Sargent's sketchlike brushwork and his vigorous paint application evoke a feeling of spontaneity, and the fluid character of the paint contributes to the vitality of the composition. His palette is arranged around warm blue-grays, siennas, and umbers heightened with pink. He enlivens the painting with the rose tints and white highlights of the young girl's shawl, sending cascades of light across the model's shoulders. In this portrait Sargent conveys the mystery and innocence of his model and the allure of an elegance yet to be.

Sargent noted the model's name on the lower left corner of the canvas followed by the address "rue du 16 Maine," most probably her residence. An inscription in the upper left corner of the portrait reads "à mon ami Poirson," a reference to Paul Poirson, Sargent's landlord and patron, who later commissioned from Sargent portraits of his daughter Suzanne (private collection, Paris) and of Madame Poirson (Detroit Institute of Arts).

L.L.M.

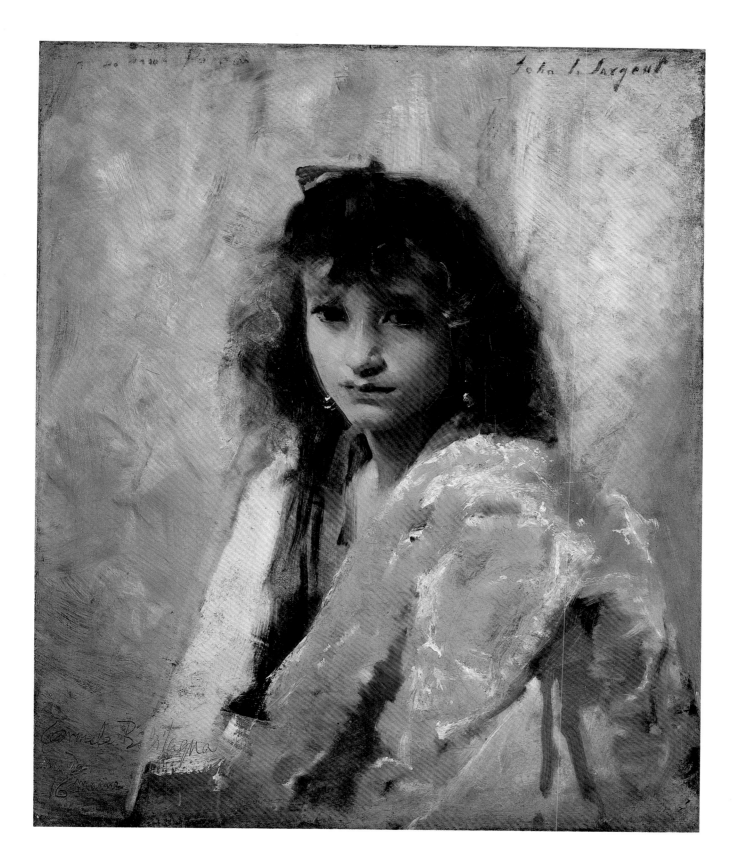

Mary Cassatt, 1845–1926

Mary Cassatt was one of the first American painters to seek the training of Paris ateliers in the period immediately following the Civil War. Her achievements are formidable, given the obstacles faced by women artists at the time. Both the struggle and the triumph of her life are encompassed in Edgar Degas's well-known remark about her aquatints: "I am not willing to admit that a woman can draw that well."

Cassatt, who is most closely associated with Paris and the French avant-garde circle that included Degas as well as Monet, was born in Allegheny City (near Pittsburgh). She began her career at the Pennsylvania Academy of the Fine Arts, where she studied from 1861 until 1865. She was in Paris from 1866 to 1870, studying at the atelier of Charles Chaplin and independently at the Louvre. Subsequently drawn to Italy, she studied the works of Correggio and Parmagianino, then continued on to Spain, Belgium, and Holland, where she studied the paintings of Velázquez, Rubens, and Hals. Cassatt exhibited in the French Salon on four occasions between 1872 and 1876. But she was growing increasingly restive with academic art, and in 1877, when Degas invited her to join the Impressionists (then called the Independents), she ended her participation in the official Salon. The only American ever to exhibit with the French Impressionists, Cassatt contributed to their fourth, fifth, sixth, and eighth exhibitions of 1879, 1880, 1881, and 1886, respectively.

18 *Susan Comforting the Baby No. 1*, ca. 1881 [57]54.4

Oil on canvas, 17 x 23 in. (43.2 x 58.4 cm.). Signed lower right: Mary Cassatt. Bequest of Frederick W. Schumacher, 1957

Susan Comforting the Baby No. 1 is an early product of Cassatt's lengthy and prodigious engagement with the familial theme. The company of her nieces and nephews, beginning with their arrival in France in 1880, is usually counted among the more prominent reasons why Cassatt turned her attention specifically to the world of women and children. The identity of the child pictured here is still a matter of speculation, but Susan has been identified as the cousin of Mathilde Vallet, Cassatt's housekeeper at Marly.[1] A larger version of the subject, *Susan Comforting the Baby* (Museum of Fine Arts, Houston)[2] includes a partial view of the Marly villa.

Susan Comforting the Baby No. 1 reveals Cassatt's debt to Japanese prints, her commitment to Impressionism, and her striking ability to use modern techniques to invigorate traditional subject matter. While the cropped figures and elevated viewpoint emanate from Japanese examples, the fluid brushwork and fresh treatment of light that activate the portrayal derive from French Impressionism, and the quiet restraint of a limited palette adds an element of classic control. Elegant passages of pearl-gray and blue-gray form cool shadows against the warm rose tints of Susan's face and that of the baby, amply demonstrating Cassatt's studied command of the sources of Impressionism, particularly the art of Rubens.

The scene is both spontaneous and penetrating. To sustain the effect of immediacy, and to enhance the illumination of the scene, Cassatt incorporates areas of exposed canvas into the composition, for instance in Susan's body, which is defined in part by the canvas surface itself. Cassatt controls these dynamic aspects of her style with an authoritative sense of design and draftsmanship. Thus she could depict the sitter's clothing, giving free reign to a rapid sequence of brushstrokes and colors, while preserving a rhythmic unity of form, stylistically and psychologically, in the linked ovals defining the heads of Susan and the baby.

Although Cassatt never married, never bore children, she developed and expressed through her art a profound understanding of the mother and child relationship. Moreover, she had the ability to see and clearly record children as individuals. The wary expression and the beginnings of a pout which Cassatt captures in the portrayal of this infant conveys something truthful about all children even as it depicts a particular baby with a mind and personality of her own. What is remarkable about Cassatt's achievement is that she was able to distance her art from the sentimentality typically associated with her subject matter.

L.L.M.

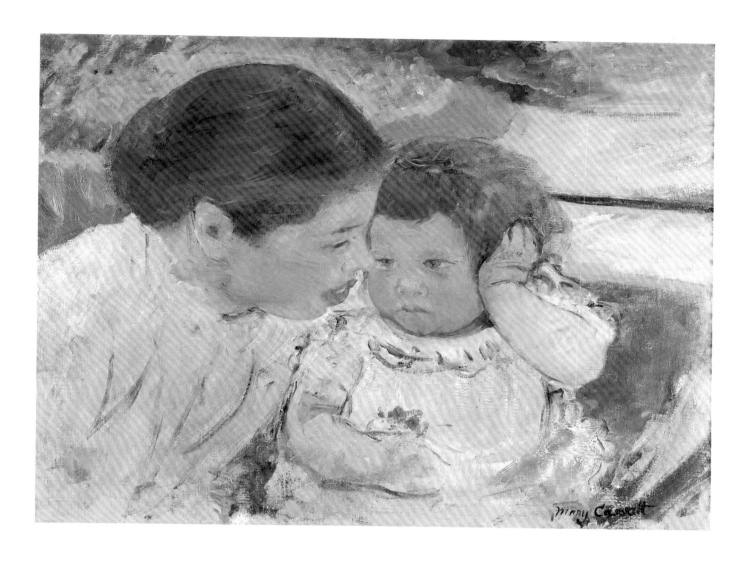

Theodore Robinson, 1852–1896

Theodore Robinson, an important American Impressionist, spent much of his life abroad and became one of several Americans to share a warm friendship with Claude Monet. A native of Vermont, Robinson lived in Wisconsin until 1874, when he moved to New York City to train at the National Academy of Design and to take classes at the newly formed Art Students League. In 1876, Robinson went to Paris where he and other American painters, including John Singer Sargent, joined the atelier of the popular independent artist Emile-Auguste Carolus-Duran. Subsequently, Robinson enrolled with the prominent academician Jean-Léon Gérôme, one of the influential French masters who taught American pupils at the Ecole des Beaux-Arts. Robinson first exhibited at the annual Salon of the French Academy in 1877.

Following a trip to Venice, where he met Whistler, Robinson returned to New York in late 1879. In 1884 he began a period of travel between France and the United States. Robinson visited Monet at Giverny briefly in 1887 and summered there annually until 1892. He was not a pupil of Monet in the traditional sense, and indeed took exception to such an identification.[1] Not content to rely on plein air studies entirely, as the French Impressionists did, Robinson used photographs as preliminary studies, which may account in part for the greater solidity and structure in his adaptations of the Impressionist style. His works from these years of travel in France, particularly his Seine Valley series of 1892, are thoughtful amalgams of Impressionism and its Barbizon sources.

By the time Robinson returned permanently to the United States in 1892, he had won signal honors in this country for his personal adaptation of Impressionism. He devoted the remainder of his brief career to painting the American scene. Toward the end of his life, he said rather wistfully to a friend: "You go 'round the earth; you come back to find the things nearest at hand the sweetest and best of all. All I have done seems cold and formal to me now. What I am trying to do this year is to express the love I have for the scenes of my native town."[2]

19 *Fifth Avenue at Madison Square*, 1894–1895 31.260

Oil on canvas, 24⅛ x 19¼ in. (61.3 x 48.9 cm.). Signed lower left: Th. Robinson. Gift of Ferdinand Howald, 1931

In 1894, two years before Robinson's death at the age of forty-five, August Jaccaci, the art editor of *Scribner's Magazine*, commissioned the artist to paint a view of Fifth Avenue. Robinson recorded the circumstances surrounding the project in three diary entries. The first, dated November 23, 1894, reads: "Lunch with Jaccaci—he wants me to do a Fifth Ave.—looking up from 22d St.—showing Fifth Ave. Hotel, etc." Four days later he wrote: "Met a photographer at Scribner's and went with him to take some views of 5th Av. from 22d St." The last reference, dated May 8, 1895, indicates that Jaccaci's response to the completed painting was less than enthusiastic: "Took my '5th Ave' to Jaccaci who said it wasn't as bad as he thought it was going to be—we had some squabble over the price."[3] Scribner's paid Robinson $75.00 for the painting,[4] which was reproduced in the November 1895 edition of the magazine with several illustrations accompanying an article entitled "Landmarks of Manhattan," by Royal Cortissoz.[5]

The picture recalls the delightful boulevard scenes of Impressionist contemporaries such as Monet, Renoir, Pissarro, and the American Impressionist Childe Hassam. But in this, as in other Robinson works, there is evidence of the artist's struggle to reconcile realism and Impressionism—a hallmark of his oeuvre. He balances the composition and structures its components by the repeated vertical accents that punctuate pictorial space and by his meticulous draftsmanship and abundant detail. These journalistic qualities are played against a luminous Impressionist sky, in which pastel pinks, blues, and white form a lively coalescence of color and light, unrestrained except for the linear pattern of telegraph wires cutting across the painterly field.

Though he was eminently successful in what he attempted to do in this picture, his temperament was ill-suited to such commissions, and he decided to accept no more. On May 9, 1895, the day following his delivery of the painting to Jaccaci, he recorded in his journal: "I got away determined to avoid illustration—and paint . . . and not try to get commissions for work that other men will do much better."[6] Thus, despite the engaging results, *Fifth Avenue at Madison Square* was to remain a rare achievement in the artist's oeuvre.[7]

L.L.M.

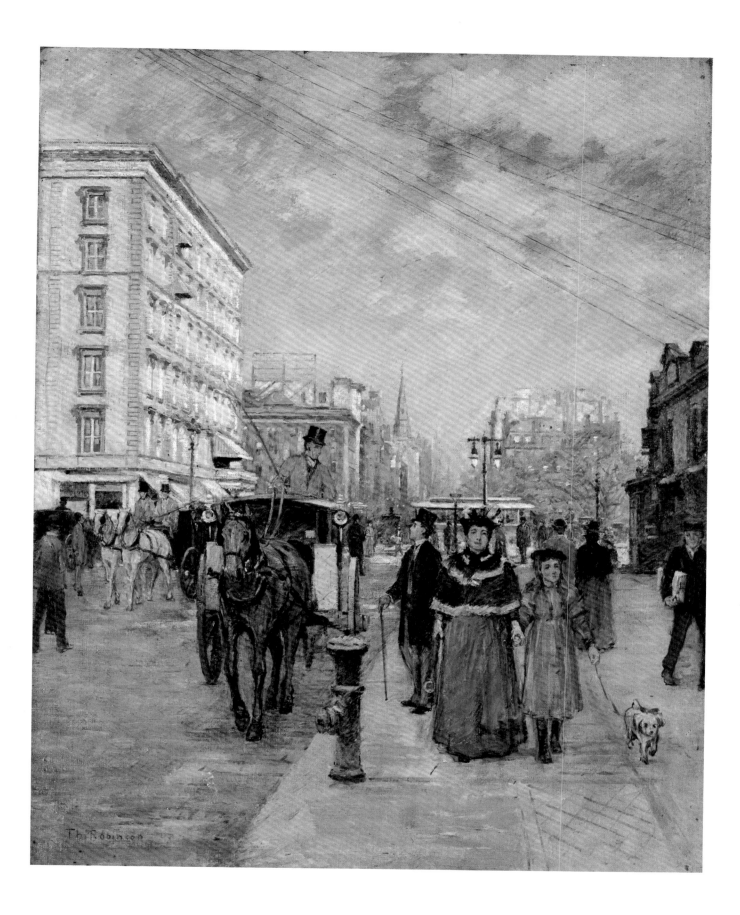

Thomas Eakins, 1844–1916

Thomas Eakins spent four years studying figure drawing at the Pennsylvania Academy of the Fine Arts, primarily working with antique casts rather than live models. During that same time he became thoroughly grounded in anatomy in the dissecting rooms at Jefferson Medical College in Philadelphia. Stemming in part from his interest in anatomy, he developed a fascination for sporting subjects. The sports world of Philadelphia provided ample opportunity to render scenes showing the human figure in action: amateur and professional rowing, boxing, baseball, and wrestling were all popular spectator sports, and there were also the recreational pastimes of swimming, sailing, skating, and hunting.

In the fall of 1866 Eakins left for Paris, where he studied at the Ecole des Beaux-Arts with Jean-Léon Gérôme and at the Louvre, furthering his skills in figure painting. After his return from Paris in 1870, he began to paint scenes of rowing on the Schuylkill River. By 1875 he turned his attention primarily to portraiture, his ambitious plans to paint subjects from contemporary life frustrated by lack of critical or popular favor.

20 *Weda Cook*, 1891[6?] 48.17

Oil on canvas, 24 x 20 in. (61 x 50.8 cm.). Signed and dated lower right: Eakins/1891[6?]. Initialed on reverse lower right: T.E.
Museum Purchase: Howald Fund, 1948

As a portrait artist Thomas Eakins had no equal in late nineteenth- and early twentieth-century America. His likenesses seem uncompromising in their descriptive honesty, yet whether they are as starkly realistic as they are sometimes said to be is questionable. The artist was not literal-minded; his probing of character takes precedence over faithful reproduction. Weda Cook's features, as revealed in a series of photographs probably taken by Eakins in 1892, were fuller and rounder than shown here, and her jawline less pronounced.[1] She had a straight nose but not as aquiline as the painting would indicate. The realism of this portrayal is emotional and psychological rather than imitative.

In 1892 Eakins painted Cook in the full-length picture he called *The Concert Singer* (Philadelphia Museum of Art).[2] In that work, Cook, a contralto who had achieved a notable reputation in the Philadelphia-Camden area, appears ingenuous and soulful, a youthful figure immersed in music-making. Eakins's relationship with the sitter had been ruptured before this picture was finished, apparently due to his importunings for her to pose in the nude (a request he made of other sitters as well), combined with rumors of the artist's sexual improprieties. Later, her doubts allayed, she consented to sit for this portrait, possibly about the same time her new husband, the pianist Stanley Addicks, whom she married in 1895, sat for his portrait.

In the museum's bust-length portrayal, Weda Cook appears melancholy and distant rather than absorbed and concentrated. The tilt of the head, back into the picture and down to the right; the fixed gaze; the *profil perdu*; and the slightly parted lips contribute to this effect. Abrupt cropping and the advancing warm tones of the flesh and blouse bring the figure close to the viewer, while the funnels and gatherings of the cloth create an impression of tactility. The right arm is broadly modeled with two brown and gray columns of shadow which initiate a sense of abrupt recession. The scumbled warm brown background on the right absorbs the loosely brushed contour of the left arm. Above, the brushwork at the right, playing against the contour of the face, is varied, with the long brushstrokes echoing the profile but at some distance from it.

Both this portrait and *The Concert Singer* share one detail of treatment: the beautifully drawn ear, accented by the lock of hair which lies across it. The attention paid to this ear seems to stress the faculty of listening, the phenomenon of sound. The vaguely floral markings in red, green, yellow, and black on the rose-pink dress add their own pensive melody to the singer's presence. It is at this point that doubts about Eakins's "realism" arise, for the melancholy that pervades this splendid work distinguishes it from both the full-length portrait and the photographs while linking it firmly to most of the artist's other portraits of women. The sadness, which is often felt in the company of Eakins's female subjects, may be the projection of the artist's own keen sense of isolation and mortality.

W.K.

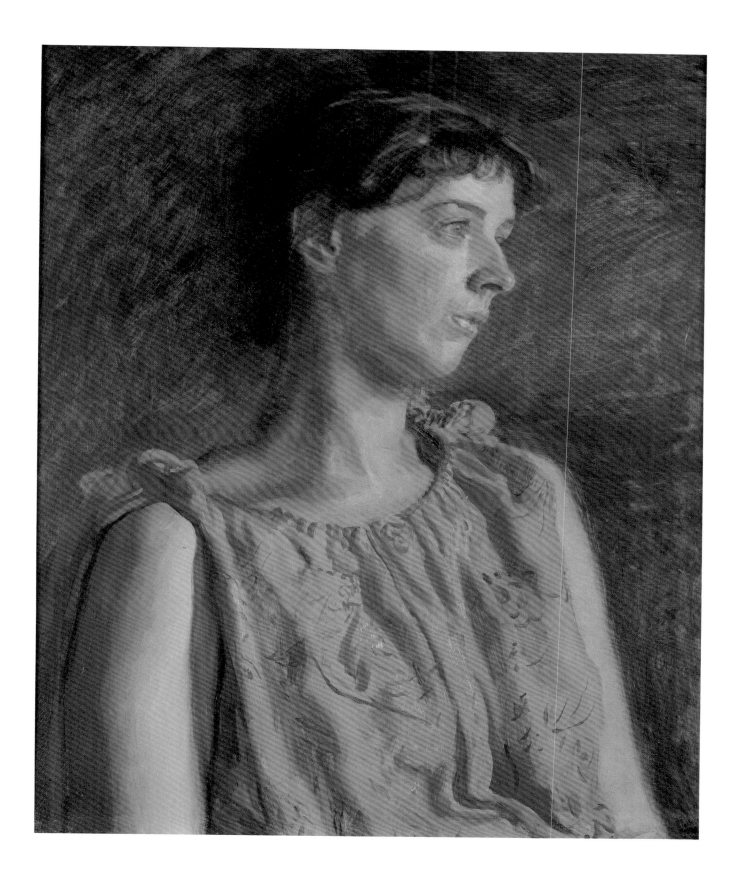

Thomas Eakins, 1844–1916

21 *The Wrestlers*, 1899 70.38

Oil on canvas, 48⅜ x 60 in. (122.9 x 152.4 cm.). Signed and dated upper right: Eakins/1899. Museum Purchase: Derby Fund, 1970

In 1898–1899 Eakins painted several boxing and wrestling pictures which are notable for their paradoxical qualities of stillness and repose. In Eakins's boxing pictures there is no contact between combatants; instead, the artist has chosen to depict moments between rounds, or after the knockdown, or after the fight. His wrestlers, intertwined in combat, are described with little feeling of action. Similarly, in Eakins's early rowing pictures there is also a suppression of motion. Laid out on perspective grids and locked into place by a variety of other devices, his rowers are poised to move but do not convey an impression of motion. Such inactivity—unusual in rowing scenes—is far more remarkable in combative scenes such as Eakins produced in the late nineties.

The models for *The Wrestlers* were members of the Quaker City Athletic Club. They were selected and posed by a Philadelphia sportswriter, Clarence Cranmer, who later described the occasion: "Joseph McCann is the man on top—being a [boxing] champion I had to pose him in the winning position, with a half nelson and crotch hold. . . . Tho not a champion wrestler, he was a very good one and a fine, most modest upstanding chap as well."[1]

Eakins first took a photograph of the two wrestlers nude, in the pose described. He made two oil studies: the first (Los Angeles County Museum) is small (16 x 20 inches), the second (Philadelphia Museum of Art) much larger (40 x 50 inches). Eakins may have painted the smaller study from life during the session when the photograph was taken, because the position of the top man differs slightly from the photograph. The figures in the larger study are virtually the same size as those in the Columbus museum's picture. In each of the larger works, the figures are nearly identical to the photograph. Traces of a squaring grid—which aided the enlargement from photograph to canvas—can be seen in both of the larger pictures.

Working from a photograph as well as other factors contribute to the stasis of this painting. Eakins has placed the prominent left scapula of the top wrestler almost at the center of the canvas, beneath the central vertical of a post that seems to "pin" him in place. The canvas is thus roughly divided into three areas: the upper left portion in which an athlete exercises on a rowing machine, the upper right with the cropped standing figures, and the entire lower half dominated by the foreground wrestlers. Dramatic foreshortenings are seen in the main group, reminiscent of Renaissance masters like Luca Signorelli. The strongly marked spine and extended right arm of the bottom man reiterates the horizontal of the rope and the boundary of the wrestling ring. The sharp triangles of his flexed left arm and his left leg are like symmetrical brackets that project into the upper parts of the painting and thus help unify the composition. The position of the left leg is the only significant deviation from the photographed pose; it is bent at a markedly more acute angle in order to strengthen the pictorial structure. Much of the wrestlers' immediacy derives from the low viewpoint, like that of a kneeling or crouching referee. Despite the fact that one of the wrestlers is in the dominant position a fall does not seem imminent, for contrary forces, pictorial as well as physical, hold everything in balance as though frozen in time.

One wonders why Eakins went to so much trouble to picture immobilized grapplers. To Eakins, the physical discipline of the athlete was perhaps an analogy for moral discipline. In *The Wrestlers* he offers not so much a sporting event as a symbol of persistent struggle with the real, material world. Locked ineluctably together, his wrestlers present a stoic image of unceasing resistance in the face of defeat and tireless effort in the determination to prevail.

Only as his brilliant career neared its end was Eakins belatedly (1902) elected to the National Academy of Design. Often embittered by official snubs, he was surely making a symbolic statement when he presented *The Wrestlers* as his requisite "diploma picture" to the Academy.

W.K.

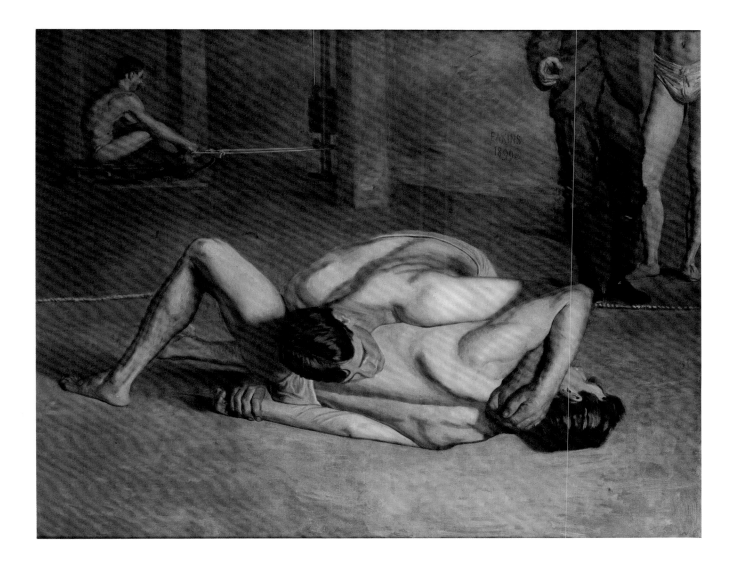

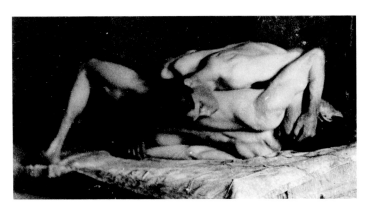

Thomas Eakins, *Wrestlers in Eakins' Studio*, ca. 1899,
platinum print on paper, 3⅝ x 6 in. (9.0 x 15.2 cm.).
Hirshhorn Museum and Sculpture Garden,
Smithsonian Institution.

Cecilia Beaux, 1855–1942

During her lifetime Cecilia Beaux achieved an international reputation as a skilled portraitist. William Merritt Chase's now celebrated remark that "Miss Beaux is not only the greatest living painter but the best that ever lived" reflected critical and popular opinion at the turn of the century, when the artist was at the height of her powers and her talents were in demand.

Born in Philadelphia, the child of an American mother and a French father, Beaux was raised by her maternal relatives after her mother's early death. She received her formative art training in various private classes in Philadelphia. Her instructors included her cousin Katherine Drinker; Dutch artist Adolf van der Whelen; and, in 1881–1883, William Sartain from New York. Though in her autobiography (Background with Figures, published in 1930) she denied it, Beaux apparently studied at the Pennsylvania Academy of the Fine Arts from 1877 to 1879, during Thomas Eakins's tenure there.[1] Certainly the Academy was to play a significant role in her career, for it was there she exhibited for the first time, in 1879, and taught from 1895 to 1915 (long after her move to New York City in the 1890s).

Beaux enjoyed her first critical success with Les Derniers Jours d'Enfance (private collection), which she completed in 1884 and exhibited at the Paris Salon in 1887. She first went abroad in 1888, at the age of thirty-two, and spent nineteen months traveling in France, Italy, and England. She studied at the Académie Julian and the Académie Colarossi in Paris and copied the old masters in the Louvre and in the National Gallery, London. Upon her return she opened a studio in Philadelphia and enjoyed success and critical acclaim from that time on.

Beaux's European experience led her to abandon her early tonal realism, influences of Thomas Eakins and the Munich school. Her palette lightened, her brushwork became freer, and she demonstrated a heightened concern for composition and the textural possibilities of oil paint, all of which resulted in her acknowledged masterpieces of the 1890s.[2] After her second trip to Europe in 1896, Beaux began to adopt the ubiquitous international style of portraiture championed by John Singer Sargent. Her works increasingly were characterized by a painterly, fluid style and by the fashionable opulence of the sitters who became her subjects. Quite possibly, however, her reliance on this style to the growing exclusion of her own painterly instincts contributed to a decline in the quality of some of her later works. Due to failing health she painted very little after 1924.

Beaux was a sensitive portraitist who was able to capture both the likeness and the state of mind of her sitters. To her way of thinking, portraiture was "the idea of a soul to be given a body to be made of paint, turpentine, and canvas."[3] Beaux was always very careful in her choice of sitters, often refusing lucrative commissions because of her belief that portraiture should be a collaboration involving the artist, the sitter's personality, and the medium of paint. As a consequence, she thought a portraitist should not paint strangers.[4] The art of portraiture, she believed, was in the artist's imagination and the treatment of the subject, not in the subject alone. She sought in her works "to give veritable shape to a personality" through her treatment and design of the entire painted surface.[5]

22 *Mrs. Richard Low Divine, Born Susan Sophia Smith*, 1907 47.80

Oil on canvas, 74¾ x 48 in. (189.9 x 121.9 cm.). Signed lower left: Cecilia Beaux. Bequest of Gertrude Divine Webster, 1947

The portrait *Mrs. Richard Low Divine, Born Susan Sophia Smith* is a striking image of elegant simplicity, a harmonious blending of figure and setting.[6] The spare interior with its Oriental furnishings and the subject's unfocused, contemplative stare enhance the painting's mood of tranquil reverie. Beaux's placement of the settee along a sharp diagonal moves Mrs. Divine and her King Charles Spaniel, Peggy, into the viewer's space. The sitter's pose echoes the gentle undulating curves of the settee. Her folded hands, resting at the intersection of two strong compositional diagonals, are symbolic of her poise and bearing.

The figure of Mrs. Divine is painted with fluid, facile brushwork and is luminous with color. Her iridescent white dress, with its rich range of pastel hues, shimmers with light. Beaux's fascination with "the idea of light on an object as well as its effect" is evident in the work. A second light source from behind the figure illuminates her shoulder, rimming her upper body with an aura that suggests a clever visual pun on the sitter's last name.[7]

The portrait was painted in the summer of 1907, at Beaux's Gloucester, Massachusetts home, called Green Alley, when Beaux was fifty-two and her sitter sixty-three. There is a quiet strength in the representation of the sitter which may be attributed to Beaux's understanding of graceful aging and her preoccupation with thoughts on mortality. The previous year her beloved Aunt Elize Leavitt, whom she had painted in 1905 seated in the same settee, had died.

Meditating on the themes of the painting—aging and mortality—Beaux wrote in 1930:

> There is only one remedy [for growing old] and only one palliative: to have a character that has absorbed the discipline of life as part of its nourishment and draws its happiness from the reflection its environment radiates, of what itself has bestowed.[8]

N.V.M.

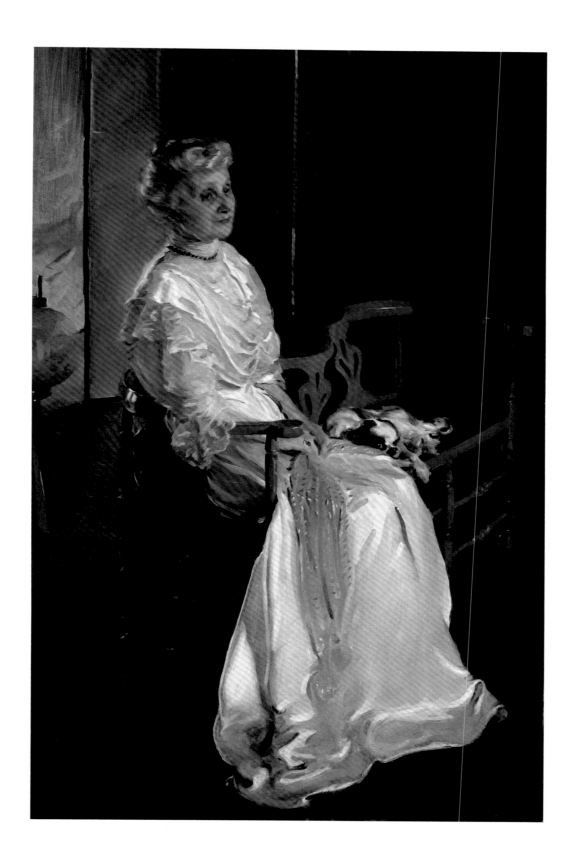

Robert Henri, 1865–1929

In the history of twentieth-century American art, few artists have left as indelible a mark as Robert Henri, champion of the common man, proponent of individuality, and crusader against academic restrictions in artmaking and exhibiting. His art education varied in emphasis and prepared him for his future independent stance. At the Pennsylvania Academy of the Fine Arts he studied under Thomas Eakins's protégé Thomas P. Anshutz, gaining a profound respect for subjects taken from everyday life. His education in Paris, under such conservative masters as Adolphe William Bouguereau, was less satisfying due to its emphasis on conventional techniques and literary subjects. But during his years abroad he traveled extensively, studying and absorbing in his memory the works of Rembrandt, Hals, Velázquez, and Manet, which were to have a strong influence on his art.[1]

Henri's accomplishments were manifold. Teaching at the Art Students League, the radical Ferrer school,[2] and elsewhere, he broke with the conventions of his day, and reacting against academic concentration on craftsmanship he refused to emphasize the mastering of skills and techniques. Rather, he encouraged his students to become directly involved in interpreting subjects from life and to regard aesthetic issues as secondary to that purpose. Henri claimed that "Art cannot be sepa-rated from life. . . . We value art not because of the skilled product, but because of its revelation of a life's experience."[3] A list of Henri's students reads like a "Who's Who" of twentieth-century American artists, including, among others, George Bellows, Rockwell Kent, Stuart Davis, and Edward Hopper.

As leader of the so-called Ashcan School, Henri was instrumental in gaining acceptance for urban genre imagery in American art. His compositions were realistic, often socially conscious in their emphasis on the working class. To him, vigor and truthfulness were more important than sentimentality and storytelling.

Henri also challenged the academic monopoly on exhibiting. In 1908 he organized the Macbeth Galleries Exhibition of The Eight, which included—in addition to his own paintings—works by John Sloan, William Glackens, Arthur B. Davies, Ernest Lawson, Maurice Prendergast, Everett Shinn, and George Luks. The show proved that Americans could exhibit successfully outside the confines of the powerful National Academy of Design. Two years later—in 1910—Henri was a major force behind the Exhibition of Independent Artists, the first major nonjuried show in America and an important prototype for the 1913 Armory Show.

23 *Dancer in a Yellow Shawl*, ca. 1908 10.2

Oil on canvas, 42 x 33½ in. (106.7 x 85.1 cm.). Signed lower left center: Robert Henri. Museum Purchase, 1910

Henri was at his best in portraiture because of his profound respect for the individual. He responded positively to each sitter's appearance, energy, and personality. Although he avoided compositional formulas, he generally posed and illuminated his subjects in a dramatic way. In addition, he paid close attention to costume as a means of bringing out the character of his subject.

Dancer in a Yellow Shawl is characteristic of Henri's portraits between 1900 and 1910.[4] With its dark brown background, spotlighted form, and broad, painterly brushwork, it is reminiscent of the psychological portraits of Hals and Manet. The identity of the dancer is not known, but Henri successfully conveys her personality through her pose, costume, and facial expression. She stands with her right hand on her hip and left arm at her side, resplendent in a rich yellow shawl draped over one shoulder. The shawl, similar to the tasseled "mantillas" Henri would have seen in Spain, gives the subject a theatrical, exotic quality, and is suggestive of the kinds of dances she most probably performed. Fluid brushstrokes energize her figure, implying her capacity for graceful movement. The brushstrokes in the face are most tightly handled to bring attention to the expression. The woman's elevated gaze and full smile seem public, not private. They evoke the pride and concentration of a performer on stage at curtain call.

Ordinary people such as this dancer most clearly revealed for Henri the sense of the universal spirit. Portraying them with love, Henri did not wish them to be reproductions of himself. He said:

> I do not wish to explain these people. I do not wish to preach through them. I only want to find whatever of the great spirit there is. . . . Each man must seek for himself the people who hold the essential beauty, and each man must eventually say as I do, "these are my people, and all that I have I owe to them."[5]

R.L.R.

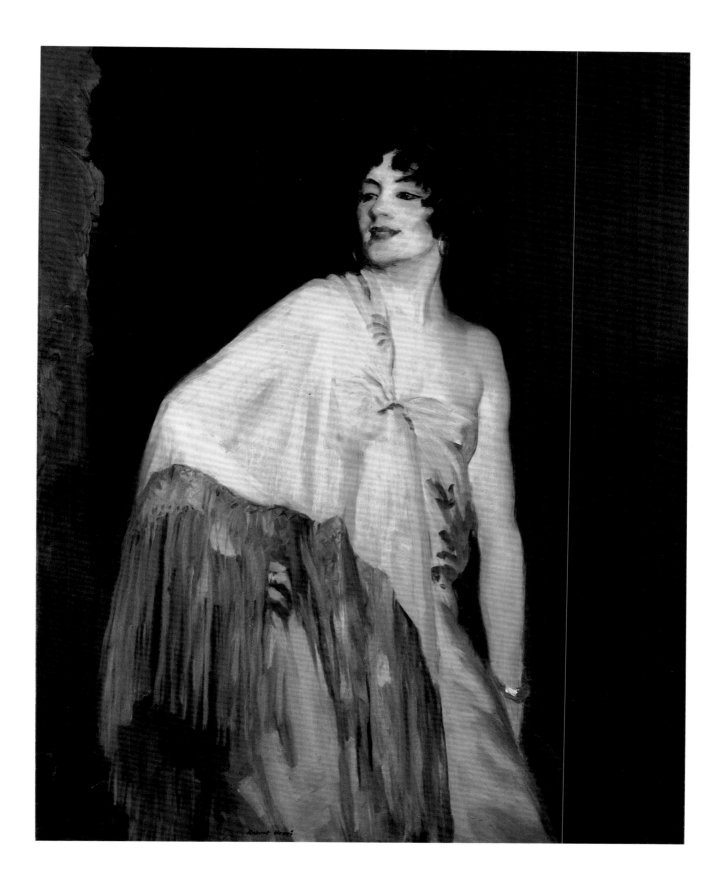

John Sloan, 1871–1951

John Sloan grew up in Philadelphia. After he left school in 1888, he was employed in the shop of Porter and Coates, Philadelphia booksellers and dealers in fine prints. Inspired by the Rembrandt and Dürer prints he saw there, he taught himself printmaking. By 1890 he was working as a freelance artist, designing calendars and novelties. He began formal studies in art the same year in a night class in drawing at the Spring Garden Institute. In 1892 he became an illustrator for the Philadelphia Inquirer, *recording the subject matter of the city's streets in the direct, spontaneous manner that characterizes much of his subsequent work. From 1892 to 1894 he studied at the Pennsylvania Academy of the Fine Arts, where through his teacher Thomas Anshutz he absorbed the realist tradition that had begun there with Thomas Eakins.*

Through friends at the Academy, Sloan met Robert Henri, who was to have considerable influence on his art. In 1893, Sloan and Henri helped found the Charcoal Club, a group of artists, including newspaper illustrators William Glackens, George Luks, and Everett Shinn, who met to draw under Henri's guidance. Sloan moved to New York in 1904. Four years later, he and his Philadelphia friends, Henri, Glackens, Luks, and Shinn, joined with three others, Maurice Prendergast, Ernest Lawson, and Arthur B. Davies to exhibit together at the Macbeth Galleries in New York City. After the Macbeth exhibition, they were known collectively as The Eight, a stylistically diverse group of artists united by their insistence on artistic freedom and their opposition to the conservative policies of the National Academy of Design.

Though he exhibited frequently after 1900, Sloan did not sell a painting until 1913, when he was forty-two years old.

24 *East Entrance, City Hall, Philadelphia*, 1901 60.6

Oil on canvas, 27¼ x 36 in. (69.2 x 91.4 cm.). Signed and dated upper right: John/Sloan/1901. Museum Purchase: Howald Fund, 1960

In 1901, this announcement appeared in the *New York Times*:

> John Sloan, an artist whose pictures at the last Carnegie, Chicago, and New York American Fellowship exhibits brought him into prominence, is at work upon a series of studies of city scenes which will appear in the Fall exhibitions. Mr. Sloan is a believer in the capabilities of the modern city for artistic work, a theory which he shares with his friend Everett Shinn.[1]

One of Sloan's city scenes from this period, *East Entrance, City Hall, Philadelphia*, includes a portion of a prominent Philadelphia landmark and describes a commonplace street scene before the turn of the century. Reflecting on the picture, Sloan recalled:

> In the late 90's a load of hay, a hansom cab, and a Quaker lady were no rare sight in the streets of Philadelphia. A sample of each appears in this painting made when I was still drawing for the "Philadelphia Press."[2]

The painterly surface, earthy colors, and dominant architecture of the composition are typical of Sloan's early work, in which he emphasized structures rather than people. In this ambitious picture, figures bustle about in the street, dwarfed by the monumental scale of the building with its deftly rendered architectural detail and the dark looming arch at its center.

Sloan mused about the work and its relation to the mainstream of his time:

> This picture [was] made from memory and a few pencil notes. . . . My work in those days was not in line with the fashionable trend. The Impressionists were winning first place among the avant-garde of the time but my influences were Hals, Velásquez, Goya, Manet, and Whistler, mostly by way of Henri and photographs in black and white.[3]

Indeed, the subdued tonality and rich brushwork of the painting bear this out.

When Sloan moved to New York in 1904, he was immediately confronted with the vitality of his new home. Responding to Henri's teaching and encouragement, he began to emphasize the life of the city in his paintings. He adopted a brighter and more vibrant palette and turned his attention to human subjects in works such as *Spring Planting, Greenwich Village* (cat. no. 25) of 1913.

D.A.R.

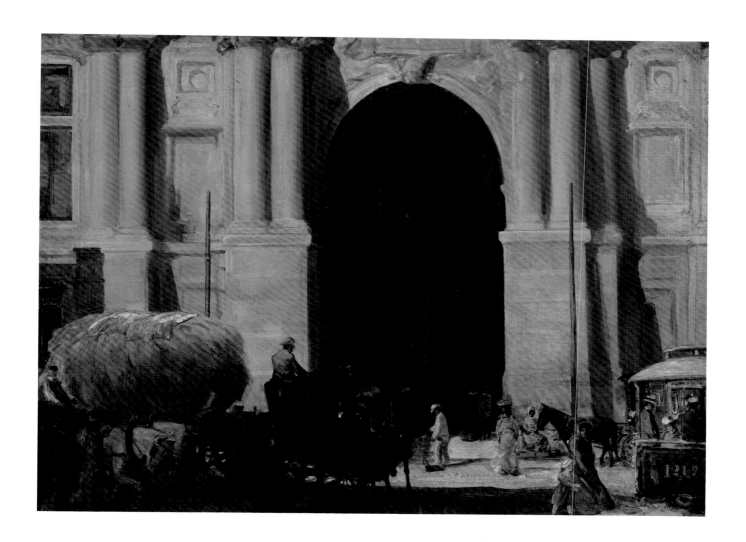

John Sloan, 1871–1951

25 *Spring Planting, Greenwich Village*, 1913 80.25

Oil on canvas, 26 x 32 in. (66 x 81.3 cm.). Signed lower right: John Sloan. Signed and inscribed on reverse of canvas: Spring Planting/ John Sloan. Inscribed along top of stretcher: SPRING PLANTING GREENWICH VILLAGE N.Y./John Sloan. Inscribed along bottom of stretcher: Spring Planting Greenwich Vill/John Sloan. Museum Purchase: Howald Fund II, 1980

Reflecting on this view of a neighboring garden from his New York apartment, the artist recalled: "The picture fixes a lovely spring day and a group of merry boarders in the next door yard filled with momentary energy to till the soil."[1]

A happy genre scene, the picture represents Sloan's developing interest in figural representation and the subjects surrounding the lives and activities of ordinary people. Here, the artist has captured the camaraderie of his Greenwich Village neighbors, whose behavior and dress suggest very different personalities and attitudes. The two at the left work closely with the soil, wearing suitable, simple dresses, while the third, too dressed-up for gardening, leans back comfortably against a laundry post with an upended rake in her hand. The fences that border the yards provide only a pretense of privacy; as the three young women work, they are observed by another woman in a nearby window and even by a crouching cat peering down from the top of a fencepost. This intimate backyard scene is played out in conscious contrast to life in the world beyond the fence. In the upper third of the composition are images of the crowded city: the back walls and fire escapes of surrounding buildings, drying laundry, trees, fence planks, a utility pole.

Sloan enlivens this springtime scene by his use of color contrasts: the pale greens and cool blues that suggest the brisk air of spring, the warm rosy glow of cheeks and arms, and the bright red hair of the gardener on the left. His heightened colors show the influence of color theorist Hardesty Maratta, whose palette and color system Robert Henri introduced to Sloan in 1909. In effect, Sloan's use of this system was to brighten and expand his palette considerably. The lively hues and throbbing energy of the painting suggest another probable influence—that of Vincent van Gogh, whose works Sloan saw at the Armory Show in February 1913 (Sloan helped to hang the exhibit, which included several of his own paintings).

Sloan painted many views of the neighborhood outside his apartment window. In another, similar, composition— *Backyards, Greenwich Village* (Whitney Museum of American Art), of 1914—the season is winter, and children are building a snowman beneath the ever-present lines of laundry, while a cat crouches on the fence and a little red-haired girl watches the scene from a window.

<div align="right">D.A.R.</div>

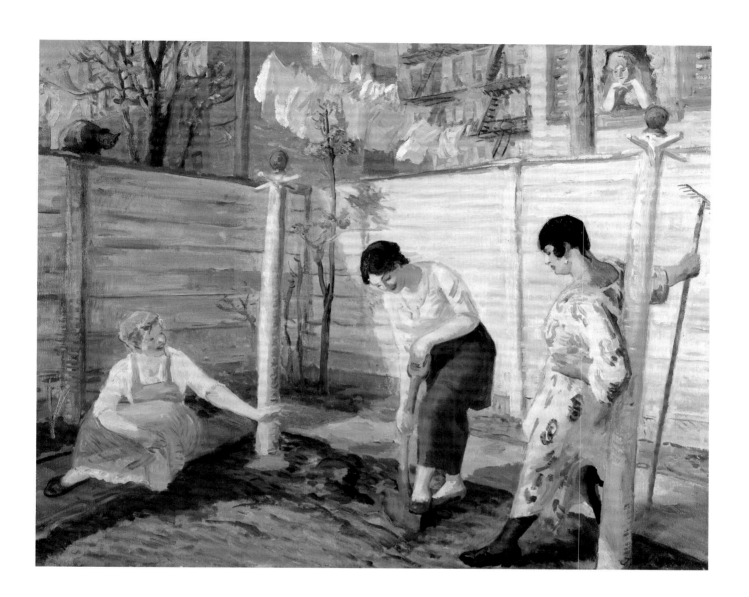

Ernest Lawson, 1873–1939

In his novel Of Human Bondage, *Somerset Maugham is believed to have modeled his character Frederick Lawson on the Canadian-born artist Ernest Lawson, with whom he shared a Paris studio in 1894. In his portrayal of the fictitious twenty-one-year-old painter, Maugham identified the two intertwined passions that define his friend's life as an artist—Impressionism and a devotion to nature.*

Lawson was a member of the generation of American artists who reached maturity in the last years of the nineteenth century and were responsible for continuing the development of Impressionism in the next century. He was introduced to the style as a student of John Henry Twachtman, first at the Art Students League in New York in 1891 and then at a sketching class conducted by Twachtman and Julian Alden Weir in Cos Cob, Connecticut, early in the summer of 1892. Lawson was in France from 1893 to 1896, studying briefly at the Académie Julian in Paris, then devoting himself to plein air *painting in southern France and at Moret-sur-Loing near Fontainebleau. At Moret-sur-Loing, he met the English Impressionist Alfred Sisley, who—along with Twachtman—had a profound influence on the development of his style. In 1894 Lawson exhibited two of his canvases in the Paris Salon.*

Lawson considered himself a traditionalist and his work a continua-tion of the Hudson River School. Though his style and choice of subject matter were unlike those of the urban realists, his friendship with William Glackens, whom he met in 1904, led to his inclusion in The Eight and participation in their 1908 exhibition at Macbeth Galleries. In 1913 he exhibited three works in the Armory Show.

A trip to Spain in 1916 brought about some significant changes in his style. His subsequent compositions reflect a more pronounced Cézannesque structure, and the range and brightness of his colors increased dramatically. Lawson's biographer, the critic Frederick Newlin Price, attributed the luminous results to the artist's "palette of crushed jewels."[1]

Lawson received several awards and prizes at the height of his career, and William Merritt Chase hailed him as America's greatest landscape painter, but he was not widely acclaimed in the United States during his lifetime. He was plagued with financial problems, poor health, and discouragement during his last years. Though he never abandoned Impressionism, his late works became increasingly expressionistic. Lawson died in Florida, where he had lived since 1936, of an apparent heart attack.

26 *The Hudson at Inwood* 31.201

Oil on canvas, 30 x 40 in. (76.2 x 101.6 cm.). Signed lower right: E. Lawson. Gift of Ferdinand Howald, 1931

In 1898, Lawson moved to New York City, settling in Washington Heights, where he lived for eight years. He concentrated on subjects in the neighborhoods of Upper Manhattan, along the Hudson and Harlem Rivers, for much of the next two decades. *The Hudson at Inwood* depicts an area at the northernmost tip of Manhattan which, during the artist's lifetime, was sparsely populated, wooded, and dotted with small farms. In choosing his subject matter, Lawson deliberately avoided picturesque sites. Certain contemporary critics faulted his choice, seeing in it, no doubt, a suggestion of the urban realist subjects of the Ashcan painters with whom Lawson was closely allied. He was criticized for his refusal "to disguise the more rugged elements in his canvases,"[2] and at the same time he was praised for his ability to "bring beauty out of a region infested with squalid cabins, dissoluted trees, dumping grounds and all the other important familiarities of any suburban wilderness."[3]

Nevertheless, there is a quiet lyricism in the lonely, uninhabited landscape of *The Hudson at Inwood*. While it is grounded in truth to location and season, the work is also an expression of the artist's personal response to a scene and his belief in the abiding beauty of nature. In this, it reflects the influence of Twachtman; in strength of form and composition it echoes the influence of Cézanne. Cézannesque structure, which began to influence Lawson after the Armory Show of 1913, is most notable in the form-defining brushstrokes in the roofs of the houses and in the trees that follow the contour of the hill in the background. The strength and vigor of Lawson's technique are evident in his thick strokes of pure and variegated colors, frequently applied with a palette knife to create a richly textured surface.

Ferdinand Howald purchased a small version of the painting in April 1918 and exchanged it a year later for the larger canvas of the same title now in the museum's collection. The smaller version (private collection) depicts the same scene from a nearly identical viewpoint but with a cover of snow.

N.V.M.

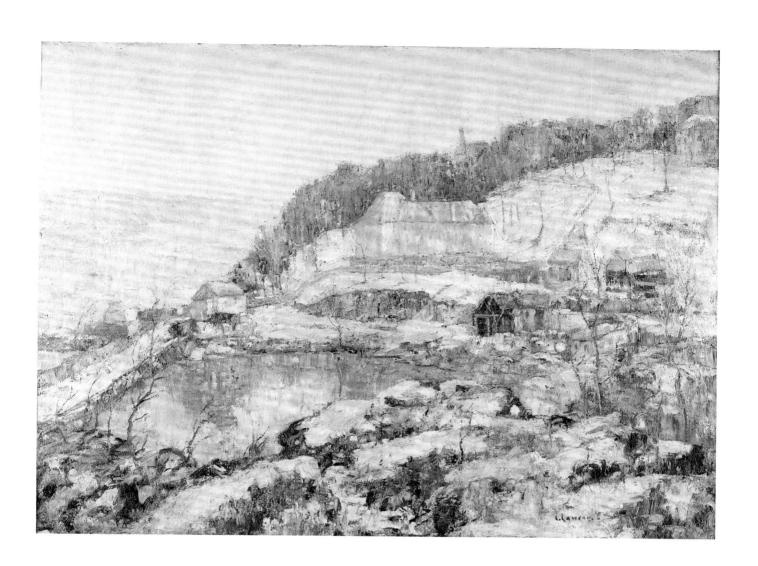

Maurice Prendergast, 1858–1924

Maurice Prendergast is considered to be America's first Post-Impressionist painter—probably the most modernist painter working in the United States between 1895 and 1909. He and his twin sister Lucy were born at the family's trading post in St. John's, Newfoundland. Raised in Boston's South End, he was apprenticed as a youth to a local art firm specializing in card painting. From his beginnings in graphic art and popular illustration, Prendergast, who was a self-taught painter, progressed to the study of fine art between 1891 and 1895 when in Paris he studied at the Académie Julian and the Académie Colarossi with Gustave Courtois and Benjamin Constant. French influences remained central to Prendergast's style throughout his career. During his years abroad, his friend, Canadian painter James Willson Morrice, introduced him to an abundance of fermenting modern styles, including Impressionism and Post-Impressionism, particularly the work of the Nabis. He also gained helpful insights from the Van Gogh and Seurat retrospectives in Paris in 1891 and 1892, respectively. Prendergast's personal style evolved rapidly in works produced during these critical years in Paris, moving from tonal paintings inspired by Whistler to brilliant colorist works in the vein of Vuillard and Bonnard.

In 1895 Prendergast returned to Boston. His early works were mostly watercolors or monotypes of idyllic beach and park scenes, subjects with which he would become most closely identified. He continued to paint in watercolor throughout his career but produced his more than two hundred monotypes between 1895 and 1902. He experimented with oils in the 1890s but did not concentrate on the medium until after the turn of the century. His mature style in oil, which developed as rapidly as his watercolor technique, is characterized by rich, bold color and layers of heavy impasto woven together with short rhythmic brushstrokes. His later oils have a drier and denser surface and an overall structural unity that was inspired by his growing awareness of Cézanne after 1907. His watercolors, though marked by greater color intensity in later years, always retain their clear, fresh color.

Prendergast earned critical acclaim as the result of two major exhibitions of his watercolors and monotypes in 1900, at the Art Institute of Chicago and at Macbeth Galleries in New York. In 1904 he participated in the National Arts Club exhibition, which brought him into contact with William Glackens, Robert Henri, and John Sloan. Glackens remained Prendergast's lifelong friend; in 1908 the two artists exhibited together again, this time as members of The Eight, at Macbeth Galleries. Critics found Prendergast's use of vibrant color and abstracted form more disconcerting than the dark urban realism of Sloan and Henri, in one case derisively likening this painting to "whirling arabesques that tax the eye."

Poor health during the final years of his life restricted his output. His formidable reputation, however, was sustained through major exhibitions such as those at the Carroll Gallery and the Daniel Gallery, which gained him the patronage of Albert Barnes and Ferdinand Howald. In 1916 the Montross Gallery exhibited Prendergast's works alongside those of Cézanne, Seurat, Van Gogh, and Matisse in the exhibition Fifty at Montross, and in 1921 the Joseph Brummer Gallery held a major retrospective, the climax of an important career.

27 St. Malo No. 2, ca. 1907–1910 31.247

Watercolor and graphite on paper, 12¾ x 19¼ in. (32.4 x 48.9 cm.). Signed lower left center: Prendergast. Gift of Ferdinand Howald, 1931

Prendergast's depictions of St. Malo date from the summers he spent in Brittany in 1907 and 1909. A medieval fortress, St. Malo became during Prendergast's era a popular resort and an artist colony. Its lively variety of architectural and landscape subjects, including its lighthouse, beaches, and ramparts, captured Prendergast's imagination. He frequently painted the famous high tides of St. Malo, but on this occasion he portrayed the beach at ebb tide, fully capitalizing upon the festive qualities of the scene.[1]

In Prendergast's depiction, the populated beach becomes a luminous array of delightful patterns. Striped cabanas, circular parasols carried by women on their promenades, and the square mosaics of the brick walkway are diverse motifs that receive varied applications of paint. Yet the composition is united by the flood of light emanating from the white watercolor paper. Prendergast's light and color gives shape to the cabanas, and the background is filled with fluid washes of blue-green representing gentle sea waves. Opaque accents and translucent masses weave a blend of textural variation as one technique is used for genre elements, man and man-made structures, and the other for the natural elements of sea and sky.

Unlike its more Impressionist counterpart St. Malo No. 1 (also in the Columbus Museum of Art), St. Malo No. 2 shows Prendergast's assimilation of Post-Impressionist and Fauve influences. Of particular significance are the examples of Cézanne's watercolors, which Prendergast praised as compositions that "leave everything to the imagination," and the works of Raoul Dufy and Albert Marquet, members of the LeHavre Fauve contingent who also recorded the gaiety of surrounding resort life.

Prendergast's contribution to the 1908 exhibition of The Eight at Macbeth Galleries included a number of St. Malo oil paintings and watercolors that drew an emphatic critical response. One writer imagined St. Malo to be, "a place where the sun shines in a curious manner, where color is wonderfully made manifest . . . and where everything else is a jumble of riotous pigment such as one does not see elsewhere. Hung in a group these canvases of Mr. Prendergast look for all the world like an explosion in a color factory."[2] Another critic dismissed the paintings as "so-called pictures that can only be the product of the cider much drunk at St. Malo," but he had the foresight to allow, "Prendergast may take heart . . . these pictures may be the Monets of a quarter century hence."[3]

L.L.M.

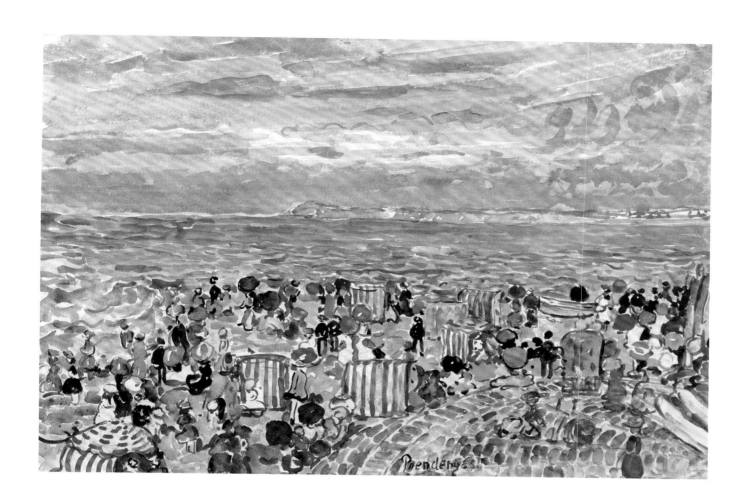

Maurice Prendergast, 1858–1924

28 *The Promenade*, ca. 1912–1913 31.244

Oil on canvas, 28 x 40¼ in. (71.1 x 102.2 cm.). Signed lower left: Prendergast. Gift of Ferdinand Howald, 1931

Maurice Prendergast's *The Promenade* exemplifies the artist's distinctive American modernism both in style and choice of subject. Repeatedly throughout his career Prendergast returned to the promenade theme, creating in each a personal arcadia that transcends the specifics of time and place. His vision is unique, setting his work apart from contemporary urban realist scenes of its kind, such as Glackens's *Beach Scene, New London* (cat. no. 29), which treats the subject as vernacular genre. Instead, Prendergast conjures an idyllic seaside scene inspired by his annual summer trips to the New England coast. Here he summons several sources with which his own creative instincts had a natural and enthusiastic affinity. Among these are the Italian Renaissance tradition of the pastoral or poetic, seen for example in works by Giorgionne and Botticelli; the wistful eighteenth-century *fêtes galantes* of Watteau, depicting elegantly dressed people at play in parklike settings; and the modern French decorative school of Pierre Puvis de Chavannes and Henri Matisse. Like Matisse's *Joy of Life* (1905, Barnes Foundation), Prendergast's *The Promenade* is plausible as an observed scene though it owes as much to the realm of poetic imagination.

An evocation of a pleasurable seaside experience, *The Promenade* is richly painted, its patterns of emphatic color applied with a daring that few artists of Prendergast's generation had yet achieved. In his oil paintings, Prendergast increasingly defined his subjects in terms of two-dimensional, simplified shapes, organizing these through color and brushstroke into a seamless structural entity. Both the figures and the surroundings become part of a rhythmic continuum of rolling, looping strokes that undulate throughout the canvas. To Prendergast, pattern and texture were of utmost importance. His brushwork combines smooth strokes with daubs and scumbling—a technique that is often described as stitchlike—to achieve an overall effect of tapestry or mosaic. In this he shares the sensibility of Vuillard and Bonnard, Nabis who brought to bear upon modern art the influences of the fourteenth-century pastoral frescoes at the Papal Palace of Avignon and the Dame à la Unicorne tapestry at the Musée de Cluny.

The Promenade is one of several Prendergast works purchased by Ferdinand Howald through the Daniel Gallery in New York City. When Howald bought the painting in 1916, he also acquired the original frame made by Prendergast's brother Charles, a decorative artist and craftsman. Among the many works in which Prendergast focuses on the promenade theme are those in the Meyer Potamkin Collection and the Whitney Museum of American Art.

L.L.M.

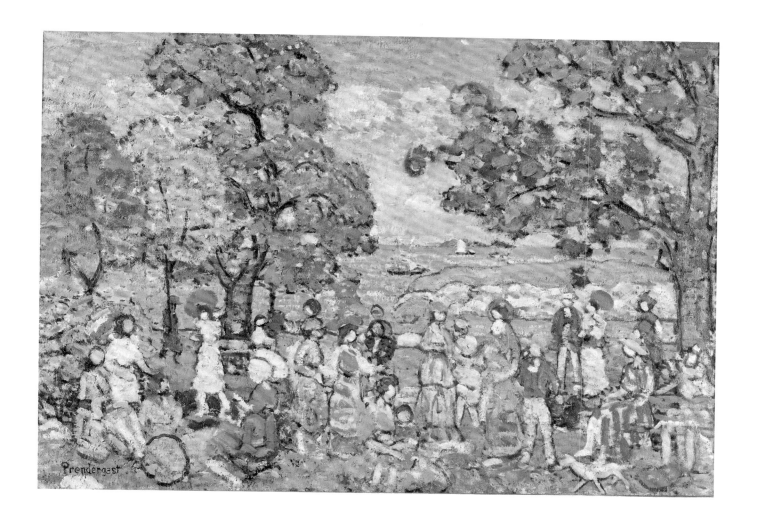

William Glackens, 1870–1938

William Glackens was born in Philadelphia, where in 1891 he began his career as an artist-reporter for the Philadelphia Record *and the* Philadelphia Press. *While employed as a newspaperman, he attended evening classes at the Pennsylvania Academy of the Fine Arts, studying under Thomas Anshutz, and he became acquainted with Robert Henri, with whom he shared a studio. Responding to Henri's advice to travel abroad, Glackens left in 1896 for a tour of Belgium, Holland, and France. A year later he returned to New York and worked as an illustrator for* Scribner's *and* McClure's. McClure's *sent him to Cuba in 1898 to cover the Spanish-American War, after which he returned home to paint.*

The pivotal event in Glackens's career came in 1908 when he exhibited as one of The Eight at Macbeth Galleries; thereafter his commitment to the advancement of modernism in this country led him to assume a variety of important roles. In 1912, he traveled to Paris to purchase art on behalf of his friend Alfred Barnes and returned with works by Cézanne, Renoir, Manet, and Matisse, which formed the nucleus of the Barnes Foundation Collection. The following year, Glackens assisted in the organization of the Armory Show and chaired the jury for the American section of the exhibition. He also served as the president of the Society of Independent Artists in 1916. Not neglectful of his art, between 1925 and 1932 Glackens frequently traveled to France, where he refined his study of the Impressionists, the Post-Impressionists, and the Nabis. His adaptation of the French styles in his figure painting and lyrical landscape-genre scenes was well received in this country. He received two gold medals from the Pennsylvania Academy of the Fine Arts, one in 1933 and another in 1936.

29 *Beach Scene, New London,* 1918 31.170

Oil on canvas, 26 x 31⅞ in. (66 x 81 cm.). Signed lower left: W. Glackens. Gift of Ferdinand Howald, 1931

According to the artist's son Ira, his father was particularly fond of painting public beach scenes during summers at the shore with the family.[1] In 1918, while passing the season at Pequot, near New London, Connecticut, Glackens painted *Beach Scene, New London*. While the work was clearly inspired by the immediate surroundings, it may also be viewed as an American variant of a French Impressionist theme: the urban middle class gathered for leisure bathing. Scenes such as *La Grenouillere*, painted in 1869 by both Monet (Metropolitan Museum of Art) and Renoir (National Museum, Stockholm, Sweden), and George Seurat's *Sunday Afternoon on the Island of La Grand Jatte* (1866, Art Institute of Chicago), are direct precedents. Such images must have struck a responsive chord in Glackens, who, like other members of The Eight, was interested in portraying ordinary people at labor or leisure.

With respect to temperament and style, Glackens is closer in spirit to Renoir than to The Eight—or any one of his fellow American artists. Indeed he came to be called the "American Renoir." Like his French counterpart, Glackens portrayed the middle class with an elegance and grace that emanated more from his artistic vision and sensibility than from the observation of reality. In paintings such as *Beach Scene, New London* he retains the primacy of the figure yet avoids likenesses or descriptive anecdotes. His figures, because of their amorphous nature, coalesce with the landscape surroundings. The salmon-toned sand provides a neutral yet lively background against which the artist plays the myriad color accents of the figures. Violet, turquoise, and pink tints dominate his palette. With his dry, delicate application of pigment, he catches the warm vibrancy of an atmospheric summer afternoon and conveys a sense of well-being.

Glackens's twentieth-century pastoral, *Beach Scene, New London*, is—in addition to being a descendant of French tradition—a precursor of American scenes from the Social Realist period, most notably Reginald Marsh's trenchant records of Rockaway Beach and Coney Island.

<div align="right">L.L.M.</div>

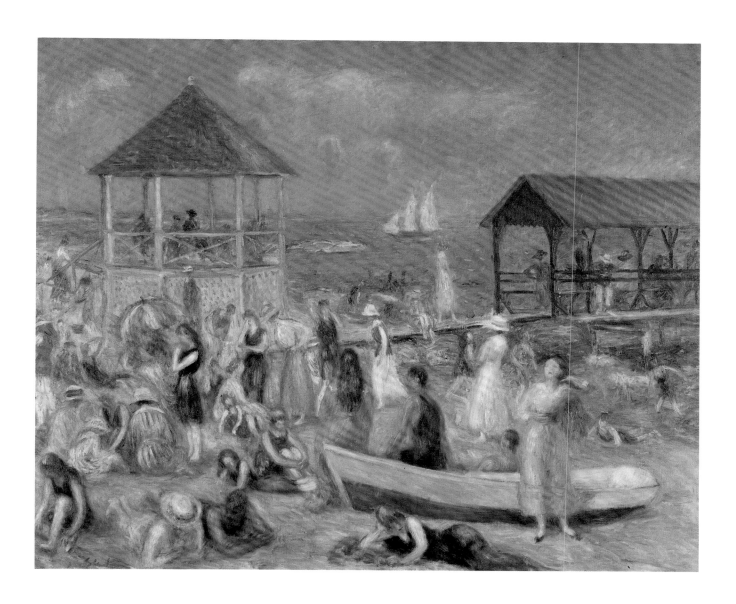

George Wesley Bellows, 1882–1925

A painter best known for his vigorous realism, George Bellows, a Columbus, Ohio, native, moved to New York City in 1904. He studied under Robert Henri at the New York School of Art from 1904 to 1906, along with Edward Hopper, Rockwell Kent, and others. Though he became a close associate of The Eight, or the Ashcan School as they were later called, he did not exhibit with those artists in their famous—and only—exhibition as a group at the Macbeth Galleries in 1908. Nevertheless, Henri, the leader of The Eight, had a profound influence on Bellows's art. Like Henri and others in his circle, Bellows painted dynamic city scenes. An avid sportsman who played semi-professional baseball, Bellows also painted athletic events that throb with energy and excitement. His portraits are no less vital. And because he had always been interested in drawing it was perhaps natural that he would experiment with lithography and produce a considerable body of works in that medium.

Bellows's career progressed very rapidly. He had been in New York only two years when he rented a studio of his own on Broadway in 1906. Within a year, he exhibited at the National Academy of Design for the first time and painted the first of his boxing scenes, Club Night (private collection) and Stag at Sharkey's (Cleveland Museum of Art). The following year the Academy awarded him the Hallgarten Prize for North River, which was the first of his paintings to enter a major public collection (Pennsylvania Academy of the Fine Arts). In 1909 Bellows was named an Associate in the Academy, becoming the youngest Associate in the history of that institution. As testimony to his almost universal acceptance, in 1913 he became a full member of the conservative Academy and at the same time exhibited in the revolutionary Armory Show of modernist art.

Peritonitis brought about Bellows's death in 1925, a year marked by numerous retrospectives held at major galleries and museums, such as Durand-Ruel Gallery, the Worcester Art Museum, the Metropolitan Museum of Art, and the Corcoran Gallery of Art.

30 *Blue Snow, The Battery,* 1910 58.35

Oil on canvas, 34 x 44 in. (86.4 x 111.8 cm.). Signed lower right: Geo. Bellows. Museum Purchase: Howald Fund, 1958

Blue Snow, The Battery is solidly within the urban realist tradition of city snow scenes. Works such as Robert Henri's *New York Street Scene in Winter* (1902, National Gallery of Art), a precedent from Bellows's immediate circle, surely helped direct the artist's attention to the subject. The appeal of snow scenes was twofold: snow obscured the less picturesque aspects of the city in winter, and provided a white, neutral background upon which the artist could develop varied effects of light and color reflection.

In *Blue Snow, The Battery* Bellows makes ample use of these advantages. Using a limited palette, largely confined to a range of blue shades and tones, the artist enlivens the composition by means of value contrasts and tonal accents set against a white field. Bellows, whose earlier works utilize a tonal palette usually of brown tones and white, had begun about this time to experiment with a color system devised by painter Hardesty Maratta, who manufactured premixed pigments in the full value range of each primary color. Bellows's use of Maratta's lively color schemes is seen in paintings after 1909.

The museum's city snow scene is articulated by Bellows's characteristic paint application in which the brushstrokes are broad and controlled and the brush is heavy with pigment. There is an ordered structural quality to the composition. Bellows carefully balances the horizontal expanses of snow with vertical elements such as trees to give the scene visual stability and, consequently, a sense of peace and stillness.

Despite its measured colors and spaces *Blue Snow, The Battery* is a vigorous work. So exuberant, in fact, is the artist's brushwork that a critic of the time thought the picture should be called "Assault and Battery."[1] Today Bellows is admired for the same energetic quality of his works, which, ironically, is as evident in this peaceful scene of a cold wintry day as it is in his forceful depictions of sporting events.

L.L.M.

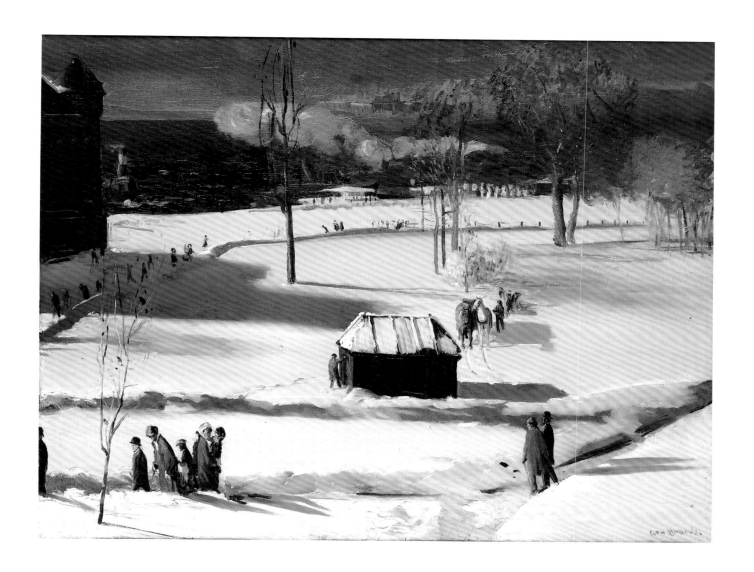

George Wesley Bellows, 1882–1925

31 *Riverfront No. 1*, 1915 51.11

Oil on canvas, 45⅜ x 63⅛ in. (115.3 x 160.3 cm.). Signed lower left: Geo. Bellows. Museum Purchase: Howald Fund, 1951

Concerning his choice of subject matter, Bellows remarked:

> I am always amused with people who talk about the lack of subject matter for painting. The great difficulty is that you cannot stop and sort [subjects] out enough. Wherever you go they are waiting for you. The men of the docks, the children at the river edge . . . prize fights . . . the beautiful, the ugly.[1]

Children swimming at a dockside, the urban equivalent of the "old swimming hole," provided Bellows and the urban realists an opportunity to depict the camaraderie of the lower classes. Bellows had made use of the theme earlier in his *River Rats* (1907, Everett D. Reese, Columbus, Ohio), a similar scene that he exhibited as his debut painting at the National Academy of Design.

Riverfront No. 1 is animated with tangled groups of young men and boys arranged to lead the viewer's eye back into space and forward once more. The figures are forcefully modeled, with heightened attention to anatomical structure—unlike the artist's typical, cursory figure style. Because the stages in which he applied his paint are discernible, the painting reveals much of his technique. First he drew the figures with his brush; then he worked the green underpainting into shadowed areas of the skin; and finally, he accentuated the figures with vivid red highlights that draw forward the complementary green tones. The dynamic quality of the scene is both enhanced and controlled by the diagonal lines of the pier to the right and the rocky ledge to the left which funnel toward the center of the scene. To offset these diagonal rhythms, Bellows added a horizontal dock and sailboats in the distance.

Bellows believed that successful pictures depended on a geometric basis. *Riverfront No. 1* suggests the beginnings of his growing interest in the systematic geometric ordering of compositions.[2] In subsequent years this interest led him to experiment with Jay Hambidge's theory of dynamic symmetry, which held that geometric ratios found in Greek and Egyptian art could be expressed in formulas for use by modern artists. As a consequence of these investigations he placed greater emphasis on mathematical divisions of the picture plane.

Riverfront No. 1 was awarded the gold medal at the Panama-Pacific Exposition in San Francisco in 1915. Frequently exhibited thereafter, the painting is one of Bellows's most significant and ambitious achievements.

L.L.M.

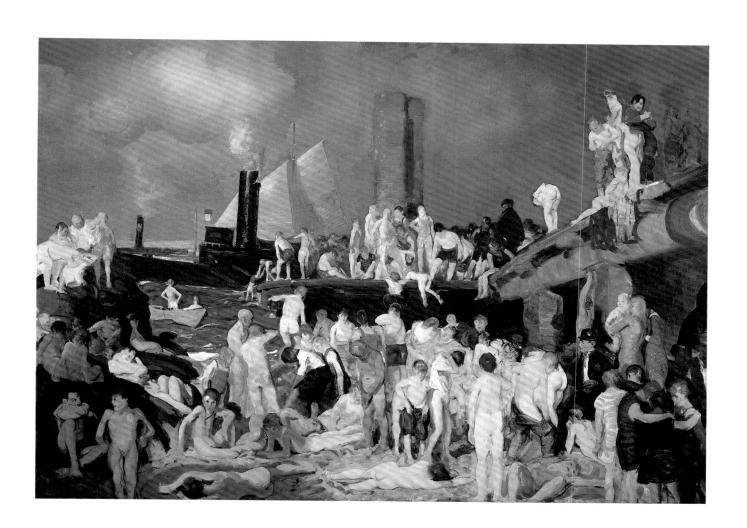

George Wesley Bellows, 1882–1925

32 *Portrait of My Mother No. 1*, 1920 30.6

Oil on canvas, 78¼ x 48¼ in. (198.7 x 122.5 cm.). Inscribed lower left: Geo. Bellows/E.S.B. [Emma S. Bellows]. Gift of Emma S. Bellows, 1930

At his summer home in Woodstock, New York, Bellows painted this portrait of his mother in September 1920. The following spring he completed a second version, now in the Art Institute of Chicago. Both portraits evince the warm relationship between Bellows and his mother, the former Anna Wilhelmina Smith. The daughter of a whaling captain, she married Bellows's father in 1878 when she was forty and he was fifty. Bellows, an only child, was born four years later.

With his characteristically rapid brushwork Bellows defines the rich, dark warmth of his mother's parlor in his childhood home at 265 East Rich Street, Columbus. The diffuse russet light that filters through shuttered windows permits only a selective view of her surroundings. Details such as her desk and writing materials emerge from the darkness as suggestions of her intellectual and social life. In contrast to the comparatively amorphous treatment of the interior, a more authoritative technique characterizes the portrayal of the artist's mother. Her figure dominates the space; she is positioned squarely in the center, enframed by the curving back of her parlor chair. A striking triangular form is created by her hands and head, suggesting perhaps the artist's feeling for her solidity and strength. In the Baroque portrait tradition of Velázquez, Rembrandt, and Hals, Bellows reserved the areas of highest finish, definition, and texture for the head and hands of his sitter while only evoking the figure beneath the dress. With a heavily loaded brush, he laid down the impasto passages of red and green that form luminous shadows on her skin and contribute to the modeling of form.

While the portrait recalls those of the seventeenth century, it is also true to American tradition. As a pupil of Robert Henri, the artist surely fell heir to the legacy of realist portraiture that Thomas Eakins passed on to Thomas Anshutz, who passed it on to Henri. In many ways this portrait is a reflection of Henri's teachings, particularly his advocacy of rapid execution and the creation of form by modeling with color. Henri's teachings had an emotional dimension that would likely appeal to Bellows's ebullient temperament. "Realize that your sitter has a state of being, that this state of being manifests itself to you through form, color, gesture . . . that your work will be the statement of what have been your emotions,"[1] Henri urged, and Bellows most certainly took it to heart.

L.L.M.

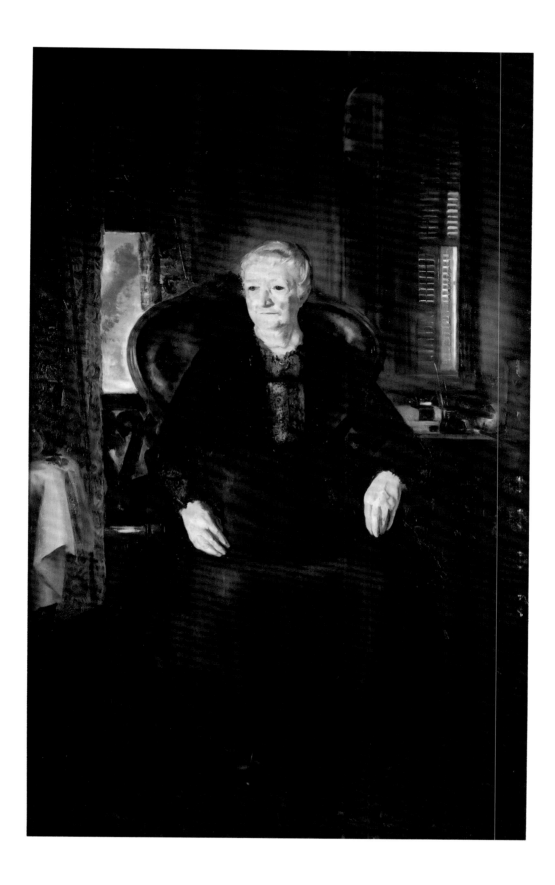

Rockwell Kent, 1882–1971

Rockwell Kent's life story is a saga that is fraught with conflicts both personal and political. In particular, Kent, an ardent and outspoken socialist, was falsely condemned as a Communist in 1936—at considerable cost to his career. He studied painting with William Merritt Chase during the summers from 1897 to 1900, and in 1902 he entered the celebrated class of Robert Henri at Chase's New York School of Art. He was apprenticed in 1903 to Abbott Thayer, whose vigorous application of paint he emulated and with whom he shared a spiritual affinity for an unpampered existence in wilderness outposts. Kent, one of the organizers of the Exhibition of Independent Artists *in 1910—spent much of his life in solitary, often forbidding natural surroundings: Monhegan Island, Maine; Newfoundland; Alaska; rural Vermont; Minnesota; Greenland; or the southern seas.*

Kent's painting Men and Mountains *was purchased by Ferdinand Howald from the Daniel Gallery in New York in 1917, before the collector and the artist had met. It was perhaps Howald's German-speaking Swiss heritage that cemented their friendship, for Kent spoke German from childhood and found many of his closest companions among persons of German culture. Owing in part to Howald's enlightened and committed patronage, Kent was able to travel to Alaska in 1918 to record the magisterial wilderness of that northernmost state.*

33 *Men and Mountains*, 1909 31.190

Oil on canvas, 33 x 43¼ in. (83.8 x 109.9 cm.). Signed and dated lower left: ROCKWELL KENT 1909. Gift of Ferdinand Howald, 1931

"Great things are done when Men & Mountains meet/This is not Done by Jostling in the Street."[1] The couplet, by William Blake, whose writing and art were among Kent's lifelong enthusiasms, is found amid Blake's verses about painting and painters and is quite probably the inspiration for the title of this painting. In 1913, when Kent exhibited *Men and Mountains* and other paintings in the town library of Winona, Minnesota, it was seen by composer, conductor, and amateur painter Charles Ruggles, who later composed an orchestral suite called *Men and Mountains.*[2] To his work Ruggles appended the epigraph from Blake, suggesting that perhaps he knew of a similar borrowing by Kent.[3]

Painted in the Berkshires in 1909, *Men and Mountains* evokes an idyllic Arcadian antiquity. Against a magnificent sweep of plain and mountain range and a sky bursting with massive cloudbanks the artist places pairs of naked men, the most prominent pair wrestling in the foreground. The landscape, wrote Kent, "was, to me, suggestive of Old Greece, of Mt. Olympus; so to enforce that thought, and with the struggle between Hercules and Antaeus in mind, I showed two naked wrestlers in combat."[4] Behind them a second pair of men may be seen sunbathing or, in the case of one of them, sunworshiping, for he stands with arms outstretched, head and torso thrown back, and his face turned to the heavens. Not as immediately apparent as the foreground figures are another twenty or so naked men—also in pairs—ranged all along the distant base of the hills. Kent introduces an ominous note of decay in this pagan paradise in the form of a dead dog lying on its back between two pairs of men in the foreground. Another duality, a powerful earth-sky dichotomy, strongly divides the canvas at its horizontal midpoint with a dark blue-gray band of shadow beneath the cloud bank.

Like Cézanne, who was also preoccupied with the theme of nudes in a landscape,[5] Kent obscured or eliminated the primary sexual characteristics of his male nudes (and did so throughout all his later work). Despite such tact, when *Men and Mountains* was first exhibited in Columbus in 1911, in a show organized by Robert Henri, it was "found so offensive to mid-western sensibilities and potentially so corruptive of the morals of the young, and of the fair both young and elderly, as to have been banned; and then, on Henri's threat to withdraw the entire show, hung in a separate room: for 'MEN ONLY.'"[6]

<div align="right">W.K.</div>

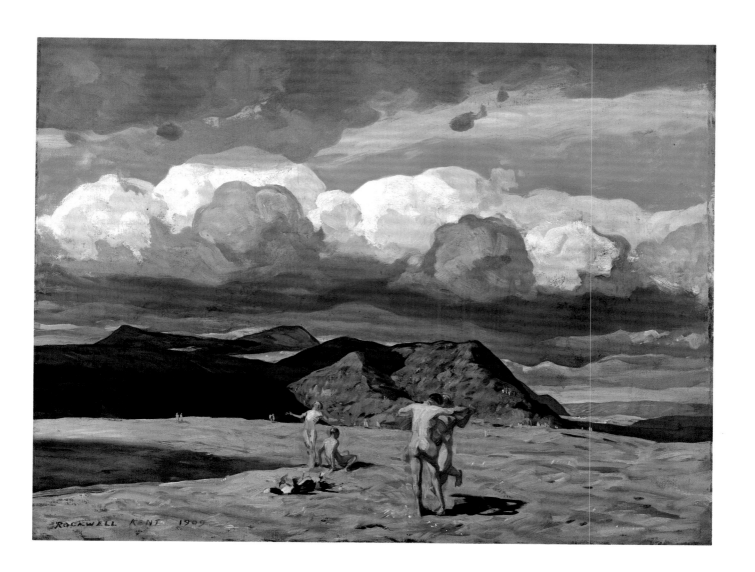

Edward Middleton Manigault, 1887–1922

Manigault's brief painting career coincided with the critical years of emerging American modernism. Interest in his work was eclipsed after his death at the age of thirty-five and did not revive until 1946, when his paintings were included in the exhibition Pioneers of Modern Art in America 1903–1918 *at the Whitney Museum of American Art.*

Born in London, Ontario, in 1887 to American parents from Charleston, South Carolina, Manigault left home in 1905 to study at the Art Students League in New York, where he became a student and close friend of Kenneth Hayes Miller. He made his New York exhibition debut in 1909 and in April of the following year participated in the Exhibition of Independent Artists, *organized by Robert Henri. Manigault traveled and worked abroad briefly in England and France in the spring of 1912. His first one-artist show at Charles Daniel Gallery in the spring of 1914 met with significant critical and popular acclaim for the startling originality of the works on exhibit. During World War I he joined the British expeditionary forces, serving in Flanders as an ambulance driver from April to November of 1915, when he was discharged for medical reasons.*

Although he worked steadily until the final year of his life, only a few of his works survive, for he himself destroyed numerous canvases (possibly as many as two hundred). The notebook record he kept of his works begins in 1906 and ends abruptly in 1919, when he and his wife—whom he married in 1915, two days before he was shipped abroad—moved to Los Angeles. Little of his late work satisfied him, least of all

the Cubist and abstract experiments he attempted after 1919, and later, for the most part, destroyed.[1] After 1915 he increasingly earned money from artistic endeavors other than painting, such as ceramics, which he began to produce in 1916.

Manigault's deteriorating health was possibly complicated by fasting, which he believed would enable him "to approach the spiritual plane and see colors not perceptible to the physical eye."[2] Apparently he became too weak to transfer his visions to canvas. He collapsed and died while working in San Francisco in September 1922.

Manigault's career is characterized by insistent experimentation; his works are striking for their imaginative, decorative sense. His early works are grounded in the real world, but later works show that he became increasingly entranced by the world of the imagination. Before his war service he completed a series of fantastic visionary landscapes (for example, Mountainous, Landscape, [Wide Valley], *1913, Arnot Art Museum, Elmira, New York) and allegories (such as* Nymph and Pierrot [Eyes of Morning], *1913, Norton Gallery of Art, West Palm Beach, Florida) that align him with American symbolists and visionaries such as Arthur B. Davies. These works foreshadow the mystical themes of his late paintings, which reflect the influence of the Orient. Much of the potential of Manigault's prewar painting, heralded by the critics in 1914, was unrealized in the abstract experiments and visionary excesses of his late work.*

34 *The Rocket*, 1909 81.9

Oil on canvas, 20 x 24 in. (50.8 x 61 cm.). Signed and dated lower left: Manigault 09. Museum Purchase: Howald Fund II, 1981

Manigault painted *The Rocket* in October of the year he made his exhibition debut in New York. It is the work he selected for the *Exhibition of Independent Artists* the following year.

A painting of dazzling vibrancy and distinctive originality, *The Rocket* attests to the power of Manigault's artistic imagination and his instincts as a colorist in the early years of his career. The legacy of Impressionism, which Kenneth Hayes Miller identified as the source of Manigault's earliest canvases, is clearly apparent in the painting. A palette of pure color—dominated by red, blue, yellow, and orange—is used to create a brilliant array of short strokes and dots on a dark blue ground. Manigault has made the divisionist's brushstroke his own in order to explore the decorative potential of the scene and capture the intensity of his visual experience. Everything in the painting is orchestrated to achieve an impact of immediacy. An exploding shower of rhythmic color dominates the picture, illuminating a small boat floating on water that vibrates with reflections. Manigault's use of thick impasto and his juxtapositions of harmonious colors give palpable weight to the clouds and enliven patterns of color throughout the canvas. The infectious spontaneity of the painting belies its richly complex composition—the result of a calculated interplay of horizontal and vertical elements. Dark blue clouds rimmed with vermilion hover above the fireworks and frame the upper limits of the composition while vertical streaks of vermilion frame the clouds on either side. The lower fifth of the painting is executed entirely in short horizontal strokes, in sharp contrast to the upward thrust of vertical strokes in the rest of the picture. The horizontal strokes in effect provide a powerful compositional anchor to the work.

The inspiration for this subject may have been Whistler's *Nocturne in Black and Gold: The Falling Rocket* of 1875, which was on loan to the Metropolitan Museum of Art from 1907 to 1910. *The Rocket* and another painting by Manigault entitled *Battleship Firing Salute* (whereabouts unknown), both executed in October 1909, most likely commemorate an event from the Hudson-Fulton Celebration held along the Hudson River in New York State in the fall of 1909 in honor of Henry Hudson's discovery of the river (1609) and Robert Fulton's inauguration of steam navigation (1807). The festive occasion included numerous firework displays. Such scenes of New York and the surrounding area, together with an Impressionist's enthusiasm for rain, snow, and times of day, characterize Manigault's painting until about 1912, after which his subjects became increasingly visionary in concept.

N.V.M.

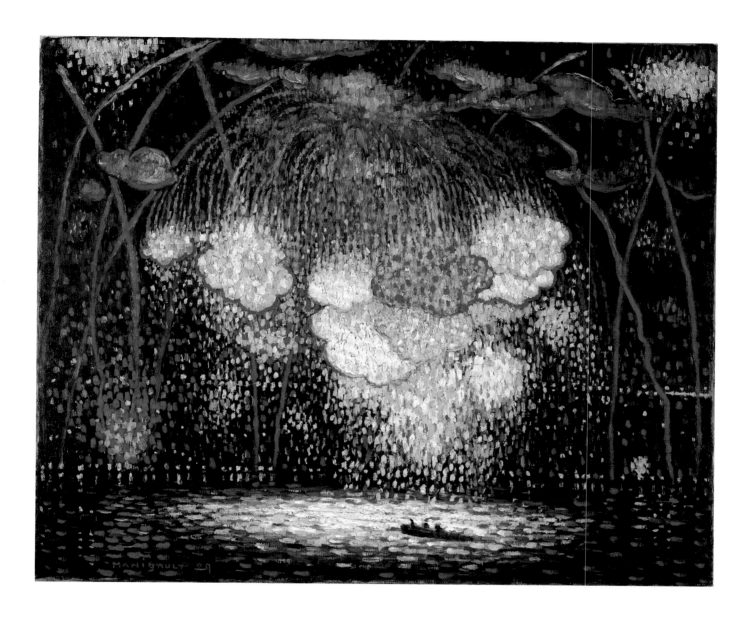

Edward Middleton Manigault, 1887–1922

35 *Procession*, 1911 31.208

Oil on canvas, 20 x 24 in. (50.8 x 61 cm.). Signed and dated lower right: Manigault 1911. Gift of Ferdinand Howald, 1931

The activities along the terraced paths of New York's Central Park are the subject of *Procession*, executed in May 1911. The original title of the painting, recorded in the artist's notebook as *In the Park—Late Afternoon*, reflects Manigault's lingering fascination with the specifics of time and place. By the time the painting appeared—with its current, amended title—in the exhibition at the Charles Daniel Gallery in March 1914, Manigault's visionary imagination had begun to dictate the direction of his work. Exhibited among the artist's 1913 works, *Procession* impressed contemporary critics with its decorative sumptuousness reminiscent of Persian miniatures, prompting one critic to write that the painting "betrays the spiritual significance of an art far removed from that of modern times."[1] Another critic wrote that the hint of Persian influence only quickened the artist's imagination, for "the feeling is of today and New York."[2] Numerous other reviews of the Daniel exhibition also singled out the work for particular praise.

The painting, with its pervasive mood of reverie, recalls the park processionals of Maurice Prendergast, another artist whose works were exhibited by Charles Daniel. The two painters had been part of the same artistic circle since 1908 or 1909, when Manigault first met Daniel. The tone of Manigault's daydream, however, is distinctly personal and much darker than that of Prendergast's compositions, for the dramatic sky and the web of trees that seems to imprison the figures hint of ominous overtones.

Procession represents a refinement of Manigault's decorative skills. The boldness of *The Rocket* (cat. no. 34) has here given way to intricate patterns and rhythms, investing an ordinary day in the park with the power of an elaborate contemporary ritual. Carefully segregated paths flow in alternating directions. The layered composition interweaves a tracery of tree branches, a flat, patterned landscape, and prominently outlined forms to provide an overall decorative quality to the work.

Manigault's *Procession* was the first work Ferdinand Howald acquired from the Charles Daniel Gallery. The transaction marks the forging of a link between dealer and collector that would insure the success of the four-month-old gallery and influence Howald's collecting pattern in American art for more than a decade. According to Daniel's recollection years later, Howald did not introduce himself at the time he visited the exhibition; he just looked. A month later he wrote from Columbus and asked that *Procession* be sent if it was still available.[3]

<div align="right">N.V.M.</div>

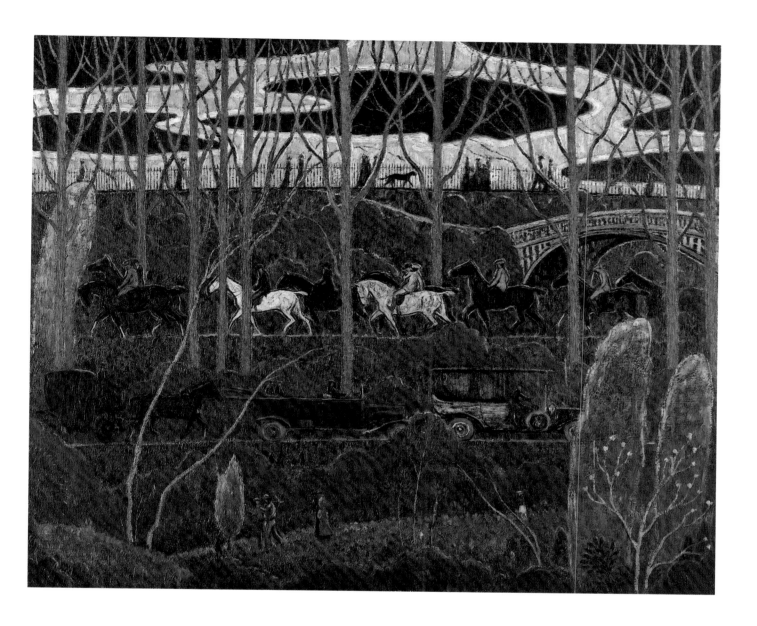

Arthur G. Dove, 1880–1946

Arthur G. Dove is generally recognized as the first American artist to develop an abstract style. His imagery, while derived from nature, does not replicate the appearance of the visual world but instead represents subjective responses to natural forms. He is thus a link between earlier artists who painted in the realist tradition and later artists who expressed feelings or moods or dealt mainly with problems of structure and design.

Born in Upstate New York, Dove attended Hobart College and Cornell University, graduating from Cornell in 1903. In New York City, he enjoyed success as an illustrator for Harper's and the Saturday Evening Post. Deciding to become a painter, Dove went to France in 1907 and remained there until 1909, during which time he became acquainted with modern art. His Lobster (private collection), with its bright Fauve colors and Cézannesque structure, was exhibited at the Salon d'Automne of 1909.

After returning to New York City in 1910, Dove met Alfred Stieglitz and came in touch with the group of avant-garde artists who gathered at the 291 gallery. That same year he exhibited in Younger American Painters, a major early American modernist show that included works by John Marin, Edward Steichen, and Marsden Hartley. Stieglitz, a lifelong friend and advocate, gave Dove his first one-artist show in 1912. Dove experimented increasingly between 1924 and 1930, producing, among other things, assemblages and witty collages containing visual and verbal puns, inspired by Cubist and Dada examples.

During the late 1930s, Dove was afflicted with a heart condition and Bright's disease, an inflammation of the kidney. Though slowed by deteriorating health, he nevertheless continued to paint, aided toward the end by his wife, the artist Helen Torr Weed. During the final two decades of his life, he exhibited annually at Stieglitz's An American Place and at major museums.

36 *Movement No. 1*, ca. 1911 31.166

Pastel on canvas, 21⅜ x 18 in. (54.3 x 45.7 cm.). Gift of Ferdinand Howald, 1931

Movement No. 1 dates from the outset of Dove's involvement with Stieglitz. It may be one of a series of pastels called The Ten Commandments, which Dove exhibited at Stieglitz's gallery in 1912.[1] In medium, dimensions, and style, the picture corresponds to other pastels in the series, but its inclusion cannot be confirmed with certainty because titles for individual works were not documented.

In *Movement No. 1* Dove does not attempt to describe an external reference point found in nature. Instead, he gives form to motion with hard-edged and organic shapes that establish a swirling visual rhythm. In an unpublished notebook he explains his artistic purpose: "I would like to make something that is real in itself, that does not remind anyone of any other thing, and that does not have to be explained—like the letter A for instance."[2]

In his passion for representing forms in motion, Dove acknowledges his debt to the Italian Futurists, the modernist group whose aggressive variations on Cubism emphasized violent pictorial rhythms and dynamic sequential movement. When describing his technique, he frequently used terms such as "force lines," which to his way of thinking conveyed a sense of energy and of the inner structure of objects, and "character lines," which, he said, mark the intersection of planes of color and give a sense of dimension to the forms.[3]

Movement No. 1 also attests to Dove's close study of Cubism. George Braque's designation of Cubist form as "inseparable from the space it engenders" surely influenced Dove's treatment of the picture plane as a volatile spatial field actuated by the emergence and dissolution of forms in motion. Like most avant-garde painters of his era, Dove was also keenly aware of contemporaneous scientific research into the kinetic nature of matter conducted by theorists such as Albert Einstein and Henri Bergson.

L.L.M.

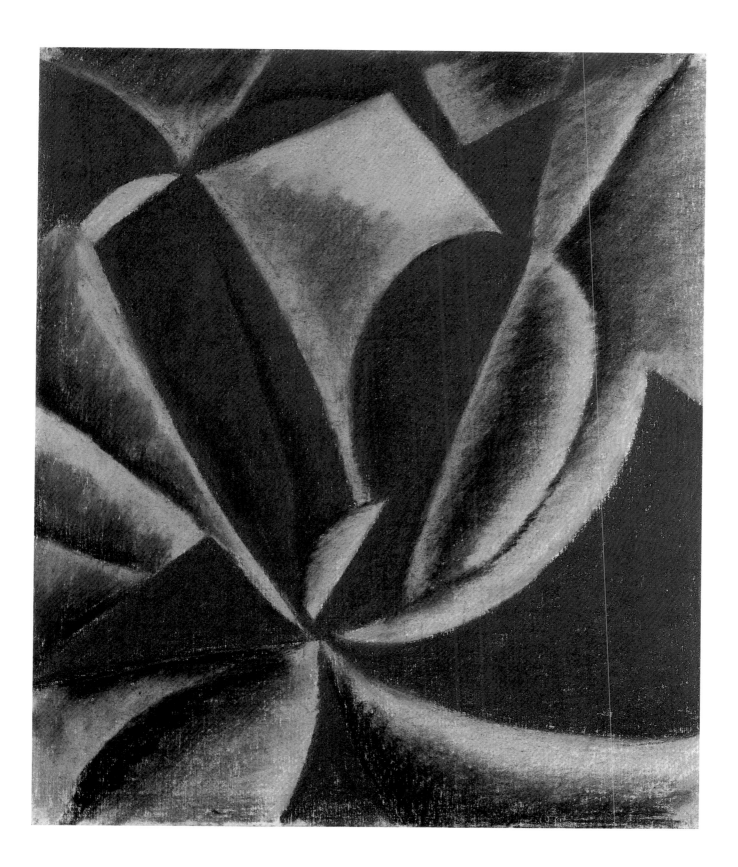

Arthur G. Dove, 1880–1946

37 *Thunderstorm*, 1921 31.167

Oil and metallic paint on canvas, 21½ x 18⅛ in. (54.6 x 46 cm.). Signed and dated on reverse, center: Dove/1921. Gift of Ferdinand Howald, 1931

Dove portrayed his impressions of thunderstorms in diverse media including charcoal (University of Iowa Art Museum) and oil and wax emulsion (Amon Carter Museum, Texas). The Columbus composition, an oil version with metallic paint, vividly summons the electric atmosphere and the fearful drama of a natural phenomenon. A sawtoothed silver form cuts through the scene vertically with the searing effect of a lightning bolt. Surrounding clouds, heavy with rain, are suspended ominously above the landscape. Black outlines and dense pigment reinforce a sense of foreboding as the brooding sky pelts the earth with rain.

Like other works by Dove, *Thunderstorm*, though it has its origins in external reality, demonstrates the artist's philosophy of "extraction"—that is, the distillation of the essential spirit of an object or a scene as opposed to overt description. The painting also illustrates the principle of synaesthesia: the evocation of one type of sensory experience through another—in this case, the visual evocation of a thunderclap.

Despite Dove's avoidance of descriptive details, his treatments of the American landscape convey a certain elemental rapport with the land. As Georgia O'Keeffe observed, "Dove is the only American painter who is of the earth."[1]

L.L.M.

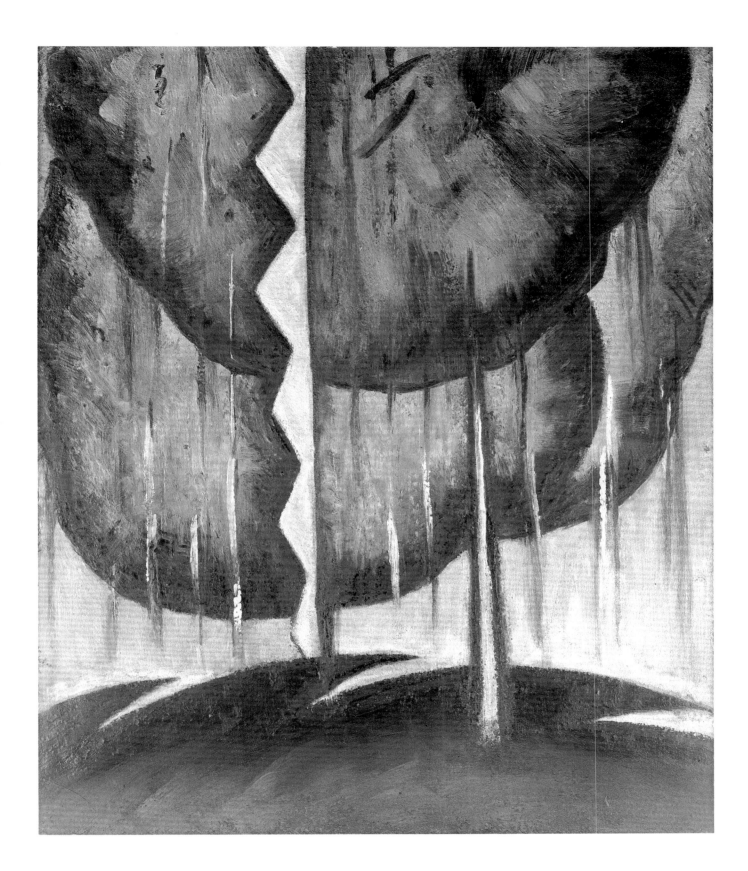

Georgia O'Keeffe, 1887–1986

Born near Sun Prairie, Wisconsin, Georgia O'Keeffe spent her childhood in the rural Middle West. By the time she was ten years old she was determined to be an artist. She studied at the Art Institute of Chicago in 1905–1906 and then in 1907–1908 at the Art Students League in New York. Dissatisfied because she felt she had only learned to paint as everyone else was painting, she stopped painting for four years, until in 1912 she attended a summer drawing class at the University of Virginia. The course, taught by a student of Arthur Wesley Dow, exposed her to an entirely new approach to art. O'Keeffe went to New York to study directly under Dow at the Teachers College of Columbia University beginning in the fall of 1914 and again in the spring of 1916. In between, working in the isolation of North Texas and strongly influenced by Dow, who told her to "fill space in a beautiful way," O'Keeffe declared her stylistic independence in the fall of 1915 in a series of remarkably abstract charcoal drawings in which she demonstrated her intent "to strip away what I had been taught" and to "satisfy no one but myself." She sent the drawings to a friend, who showed them to Alfred Stieglitz. In May 1916, her works were included in an exhibition at Stieglitz's 291, and in the spring of 1917 Stieglitz sponsored her first one-artist exhibition there—the last show held at the galleries before they closed in July.

Through her association with Stieglitz, whom she married in 1924, O'Keeffe became part of New York's pioneering modernist circle and helped shape the course of American art. She did not go abroad to seek inspiration, as many others had done, but maintained her independence and initial commitment to her own intensely personal vision. Her works were accorded nearly universal approval from the start. She, however, often disagreed with the critical interpretation of her subjects, particularly the large flower paintings she began to produce in 1924, to which many critics attributed strong sexual overtones.

O'Keeffe's art encompasses the opposite poles of abstraction and representation. Seeing no conflict between the two, she invested all her works with the same vital spirit that speaks directly to the viewer. Her intuitive sense of abstraction lends to her most realistic works a purity of formal design. Hers is an art of essentials defined by strong, simplified forms and prismatic brilliance.

38 *Autumn Leaves—Lake George, N.Y.*, 1924 81.6

Oil on canvas, 20¼ x 16¼ in. (51.4 x 41.3 cm.). Museum Purchase: Howald Fund II, 1981

Between 1918 and 1928 O'Keeffe worked primarily in New York City and at the Stieglitz family's summer home at Lake George. O'Keeffe particularly enjoyed the autumns at Lake George. After a summer of entertaining guests and family, O'Keeffe, left alone with Stieglitz, was able to return to painting. Her spiritual kinship with the season is fully felt in *Autumn Leaves*, in which she captures the very essence of autumn.

In all her paintings O'Keeffe explores the line of demarcation between abstraction and representation. This tension between the two accounts in some measure for the vitality of her paintings. In *Autumn Leaves*, as in other works, she uses the natural object—in this case the leaf—as her point of departure, creating brilliant, semi-abstract compositions from the interlocking design of contours and silhouettes. Subtle nuances of color as well as distinct contrasts accentuate the rhythmic movement of the leaf forms in *Autumn Leaves*. To O'Keeffe the leaves are simultaneously living things and abstract miracles of shape, texture, and color. Hers is a selective realism. She isolates the leaves from their natural setting and magnifies them until they fill the space of the canvas. Her explanation of the magnified flowers, painted during the same decade, is equally applicable to the leaf paintings:

> Nobody sees a flower—really—it is so small—we haven't time—and to see takes time. . . . So I said to myself—I'll paint what I see—what the flower is to me but I'll paint it big and they will be surprised into taking time to look at it.[1]

As scholars have noted, Arthur Dove's painting of fall leaves, *Based on Leaf Forms and Spaces* (reproduced in Arthur Jerome Eddy's 1914 book *Cubists and Post-Impressionism*), anticipates O'Keeffe's leaf paintings.[2] Dove enlarged his leaves, slightly cropping them at the edges of the canvas, as O'Keeffe would do later. In addition, O'Keeffe's concern for isolating forms and cropping magnified details, her use of a strict frontal viewpoint, and her interest in abstract patterning were anticipated in photographs by Stieglitz, Edward Steichen, and Paul Strand.

O'Keeffe was intrigued with the idea of exploring a single theme through a series of pictures, as she did, for example, in six series of paintings on the jack-in-the-pulpit dating from 1930. While the Lake George leaf paintings, which she did throughout the 1920s, do not constitute a series, it is possible to trace through them O'Keeffe's evolving sense of the season. Commenting on the repetition of certain subjects in her work, O'Keeffe said: "I work on an idea for a long time. It's like getting acquainted with a person and I don't get acquainted easily."[3]

N.V.M.

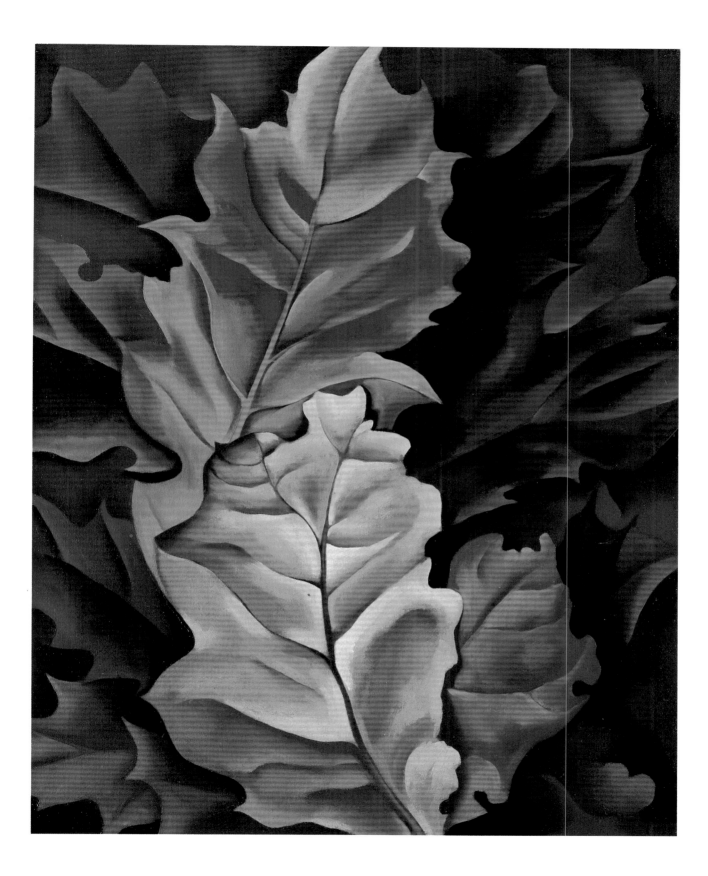

Marsden Hartley, 1877–1943

Marsden Hartley was one of America's pioneer modernists and one of the country's first abstract painters. Though he was deeply influenced by European modernist movements and restlessly experimented with a number of styles over the length of his career, he maintained a particularly American artistic vision. Born in Lewiston, Maine, he received his first training in Cleveland, Ohio, in 1892, and won a scholarship to the Cleveland School (now Institute) of Art. He went to New York in 1898 to study at William Merritt Chase's New York School of Art, then at the National Academy of Design. Inspired by the writings of Ralph Waldo Emerson, Henry Thoreau, and Walt Whitman, Hartley came to think of art as a spiritual quest, a view that was strengthened by his acquaintance with Albert Pinkham Ryder and later, in Germany, with Wassily Kandinsky.

In the spring of 1909 Alfred Stieglitz gave Hartley his first one-artist show, at the 291 gallery. Through Stieglitz, Hartley became aware of European modernists, most significantly Cézanne, Picasso, and Matisse. In April 1912 he made his first trip to Europe. He was welcomed by the avant-garde society of Paris, especially the circle of Gertrude Stein, but was soon drawn to Germany, particularly to Kandinsky and Franz Marc.

Hartley's initial experiments resulted in an eclectic style he called "cosmic" or "subliminal" Cubism, which utilized a Cubist vocabulary but attempted to incorporate expressions of the "art of spiritual necessity," the latter an influence of Kandinsky. Always insistent on the power of his own intuitive mysticism, however, Hartley did not fully embrace Kandinsky's intellectual theorizing. In his late 1912 or early 1913 works (which he called Intuitive Abstractions), he experimented with "automatic" painting methods, eliminating all references to the outside world and drawing only upon his own emotional resources.

Hartley moved to Berlin in 1913, where he remained for the most part until 1915. In Berlin he was able to develop a distinctive abstract style. Inspired by the city's military pageantry—which enthralled him, at least until the outbreak of World War I—he produced a series of brightly colored and richly decorative works. Although Hartley often claimed that he used these identifiable military motifs in order to express "vivid sensations of finite and tangible things," most scholars agree that these images are invested with Hartley's own mystical symbolism which he steadfastly refused to explain.

After his return to the United States in early 1916, Hartley abandoned mysticism temporarily as well as the style of expressionism and abstraction he had developed in Europe. He returned to Europe in 1921 and remained until 1930, experimenting with various styles throughout this period, but with little success or satisfaction. Once back in the United States to stay, Hartley developed a highly personal response to American regionalism. In the final decade of his life he produced a series of expressive landscapes of Maine that equaled in power and intensity the abstract works he produced in Germany from 1913 to 1915.

39 *Cosmos* (formerly *The Mountains*), 1908–1909 31.179

Oil on canvas, 30 x 30⅛ in. (76.2 x 76.5 cm.). Signed lower right: MARSDEN HARTLEY. Gift of Ferdinand Howald, 1931

In the fall of 1908 Marsden Hartley moved to an abandoned farm outside North Lovell, Maine, where he painted what he considered to be his first mature works. Impressed by the strength of these works, in May 1909 Alfred Stieglitz gave Hartley his first one-artist show at the 291 gallery. *Cosmos* was among the works exhibited.

Hartley's art had evolved quickly during the three years before the Stieglitz show. In 1905 he was still painting in a derivative realist style, but by the autumn of 1908 he had assimilated not only Impressionism but aspects of Neo-Impressionism as well, and he had discovered in a color illustration from the January 1903 issue of the magazine *Jugend* the distinctive "stitch stroke" of Italian divisionist painter Giovanni Segantini. According to Hartley, Segantini's idiosyncratic technique showed him "how to begin painting my own Maine mountains."[1]

In *Cosmos* Hartley has used short interwoven strokes of intense color to create a vibrant autumnal mountainscape of coloristic vigor and compositional boldness. The paint is applied in a heavy impasto, creating a rich tapestry-like effect that captures the intricacies of a dense Maine woodland. A brilliant decorative pattern covers the entire surface of the canvas. Hartley began his compositions outdoors, completing them later in the studio and often reworking them over an entire season. He first painted mountainous landscapes in 1908–1909 and frequently returned to the motif throughout his career. To him, mountains represented the strength and constancy of nature in the face of human transience.[2] In *Cosmos*, undulating mountains push against the sky, dominating the composition. A single pine tree pierces the clouds, uniting earth and sky. This exuberant view of nature was to give way in the next year under the brooding influence of Albert Pinkham Ryder as Hartley turned to more ominous interpretations of nature in the "dark landscapes."

Cosmos is distinctive for its stylistic inventiveness, which placed its young creator—who had little direct experience with European avant-garde art at this point—in a very select company of American artists working in a Neo-Impressionist manner. The painting is also an early example of Hartley's intuitive mysticism in which the artist drew upon interior visions.[3] The title, which may have been inspired by lines from Walt Whitman's poem "Song of Myself," reinforces the visionary mood of the work and verifies Hartley's intention.[4] Hartley described such landscapes as "little visions of the great intangible," adding that "some will say he's gone mad—others will look and say he's looked in at the lattices of Heaven and come back with the madness of splendor on him."[5]

N.V.M.

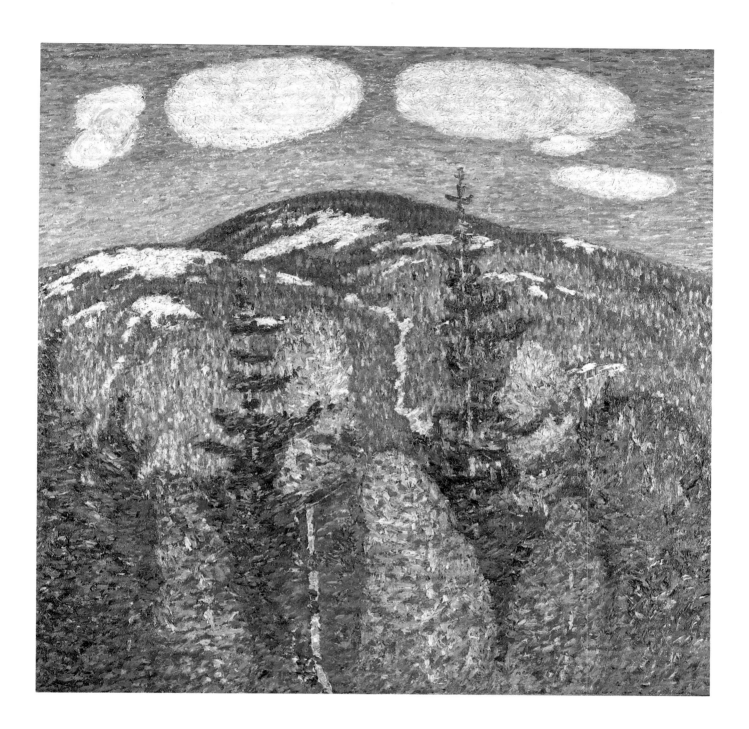

Marsden Hartley, 1877–1943

40 *Berlin Ante War*, 1914 31.173

Oil on canvas with painted wood frame, 41¾ x 34½ in. (106 x 87.6 cm.). Gift of Ferdinand Howald, 1931

Marsden Hartley's Berlin paintings can be divided into two stylistic periods: the earlier works are characterized by the euphoria of military pageantry, and the later, emblematic works by a greater overall decorative effect. *Berlin Ante War* dates from the second part of Hartley's stay in Berlin, from March 1914 to December 1915. By the summer of 1914 Germany had declared war on Russia and France. War, Hartley observed, was no longer "a romantic but a real reality."[1] The simple pageantry of the earlier pictures was supplanted by an intense expressiveness in his later War Motif paintings, as he called them, which reflected his simultaneous fascination with and revulsion for war.

Though its title indicates that the subject is prewar, the painting was probably executed after the outbreak of hostilities and most likely after the death of Hartley's close friend Karl Von Freyburg, who was killed in action in early October. The painting depicts an Imperial Prussian Horse Guardsman—probably Von Freyburg—enveloped in clouds beneath the heraldic image of a kneeling white horse branded on the flank with the number 8. In this veiled tribute to his friend Hartley's symbolism is private and probably never will be fully understood. The motif of the cloud may have been drawn from Bavarian votive paintings published in the *Blaue Reiter* almanac, where clouds are symbols of the heavenly spirit.[2] In standard numerology, which Hartley never acknowledged as his source of inspiration, the number 8 represents spiritual and cosmic transcendence.[3] Greek crosses inscribed in roundels also appear, floating among the clouds. In spite of this abundant use of symbolism, Hartley insisted:

> The forms are only those which I have observed casually from day to day. There is no hidden symbolism whatsoever in them; there is no slight intention of that anywhere. Things under observation, just pictures of any day, any hour. I have expressed only what I have seen. They are merely consultations of the eye . . . my notion of the purely pictorial.[4]

Scholars however, have continually doubted Hartley's assertion since the paintings were exhibited at Stieglitz's 291 gallery in the spring of 1916. As Charles Caffin wrote in the *New York American*, "The motive of these is scarcely what has been seen, unless it be in the mind's eye."[5]

Though the symbolic meaning of the museum's painting remains elusive, we do know that Von Freyburg's death was a deep emotional blow to Hartley, who subsequently idealized the relationship, claiming that his friend was the sole icon of his artistic life.[6] Von Freyburg is certainly the emblematic subject of several other War Motif paintings, most notably *Portrait of a German Officer* (1914, Metropolitan Museum of Art).

Stylistically, the flat, clearly delineated color areas and the hieratic composition are extensions of what Hartley employed in his Amerika series just prior to the war.[7] Paintings in this group relied on a ritualistic imagery inspired by Native American themes epitomizing human nobility. Like these paintings, *Berlin Ante War* also exudes a mood of idyllic peacefulness. The compartmentalized tableau composition, on the other hand, may have its origins elsewhere—perhaps in the Bavarian folk art that Hartley appreciated and collected.[8]

Despite the originality of Hartley's late Berlin works, the continuing influence of Kandinsky, and of Franz Marc (an artist whom Hartley also came to know in Berlin) is still in evidence. Hartley's fascination with Marc's "rendering of the souls of animals" is reflected in his depictions of kneeling animals, such as the white horse in the museum's painting. *Berlin Ante War* has been linked to Marc's *White Bull* (Guggenheim Museum) of 1911.[9]

In late Berlin paintings such as *Berlin Ante War* Hartley finally achieved the personal artistic statement he had been pursuing since his arrival in Europe. He wrote to Stieglitz in the fall of 1914 saying that he was finally expressing himself truly:

> I have perfected what I believe to be pure vision and that is sufficient. Then too I am on the verge of real insight into the imaginative life. . . . I am no longer that terror stricken thing with a surfeit of imaginative experience undigested. . . . I am well on the verge of understanding which is beyond knowledge.[10]

N.V.M.

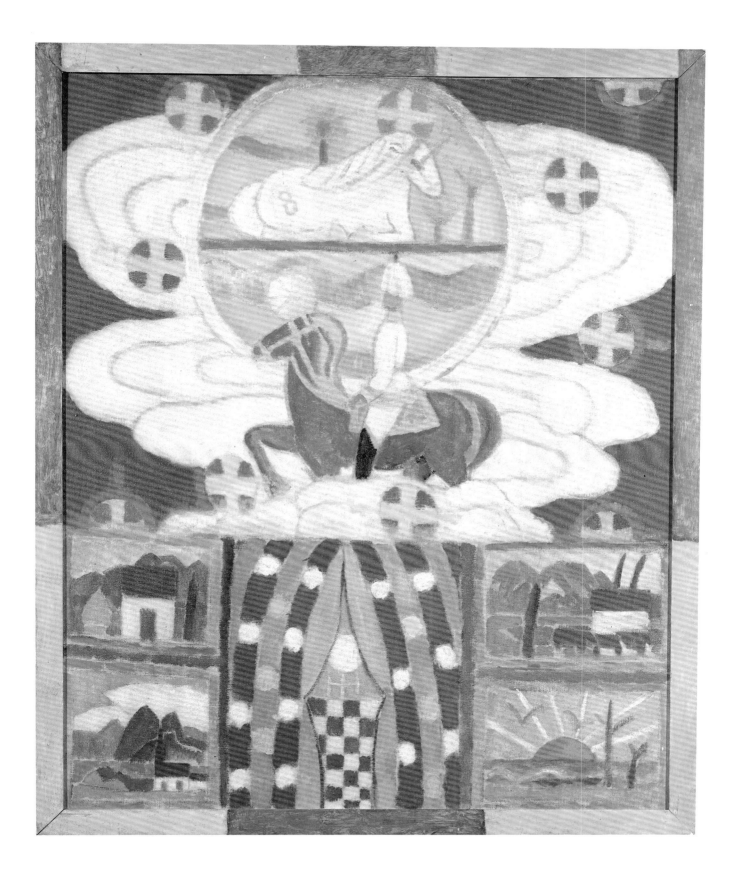

Marsden Hartley, 1877–1943

41 *The Spent Wave, Indian Point, Georgetown, Maine, 1937–1938* 81.13

Oil on academy board, 22½ x 28½ in. (57.1 x 72.4 cm.). Signed, dated, and inscribed paper label on reverse in artist's hand: THE SPENT WAVE/INDIAN POINT/GEORGETOWN/MAINE 1937–38/Marsden Hartley. Museum Purchase: Howald Fund II, 1981

In the spring of 1936 Marsden Hartley announced the final philosophical stance of his art in the introduction to a catalogue of his exhibition at Alfred Stieglitz's An American Place: "This quality of nativeness [in my paintings] is colored by heritage, birth and environment, and it is therefore for this reason that I wish to declare myself the painter from Maine."[1] After years of wandering, he returned to Maine in the summer of 1937.

Hartley's artistic homecoming had actually begun in 1930, when he returned from Europe to a country that was by then considerably changed. In its newfound nationalism, which was often expressed in isolationist and xenophobic terms, Hartley found himself an outsider and saw his art regarded with suspicion. Certainly Hartley's new regionalism was influenced by this atmosphere, as well as by the opinions of writers like Paul Rosenfield, who claimed that Hartley's special gift as a painter was his ability "to record the genius of a place" and that only in Maine, where he had already painted with such conviction, could he restore cohesion to his art.[2]

In their rugged power and stark monumentality, Hartley's Maine landscapes from 1937 echo Winslow Homer's heroic marines painted at Prout's Neck, Maine, in the late nineteenth century. The works also recall Hartley's own paintings executed in New Hampshire during the summer of 1930 and in Dogtown Common, outside Gloucester, Massachusetts, in the summer of 1931. It was during his summer in Dogtown—following a devastating illness that made him keenly aware of his mortality—that the artist began what has been described as a process of personal integration and philosophical reassessment. His belief in himself and his inner vision revived, and again he began to produce intensely expressive landscapes.[3]

The Spent Wave, Indian Point, Georgetown, Maine fulfills the promise of early Maine landscapes such as *Cosmos* (cat. no. 39). Through works such as these Hartley attempted to reestablish the mystical bonding with nature he had experienced as a youth. Once again the influence of Albert Pinkham Ryder appears in his paintings as he attempts to recapture his imaginative expressiveness. The success of Hartley's late works lies in the artist's ability to reconcile the objective realism of a specific place with his own need to find personal meaning in art and to further develop as an abstract painter. His achievement was acknowledged by one Melville Upton, writing in *The Sun* in 1938: "What impresses one particularly in Mr. Hartley's exhibit is the fact that he seems to have struck a happy balance between the intellectual rigors of pure abstraction and the camera-like damnation of rigorous representation."[4]

Like other Georgetown seascapes executed in 1937–1938, the museum's painting depicts waves pounding against rugged brown and black rocks. In a letter to Hudson Walker, Hartley described such paintings as "crashing in their quality, as they are all granite up against the sea."[5] The foreground is compressed with powerful forms; the horizon line is high, with only a touch of slate-blue sea and sky visible. All the elements have been reduced to essential forms; details have been omitted in favor of bold patterns. The vital energy of the scene is transmitted through broad, agitated brushwork and dramatic contrasts between dark and light. The thick impasto and heavy black outlining gives the forms a palpable weight. Even the surf spray has a tangible density. The almost primitive quality of Hartley's approach and the stark monumentality of his composition confirms that he was, as he said, no longer interested in trivial existence.

The underlying theme of all the Georgetown seascapes is the relationship between man and the forces of nature.[6] Though the human figure does not appear in these works, there is a sense of pervading melancholy and tragedy that permeates many of the subjects, ascribing to nature human conditions and emotions. The paintings follow the drowning deaths of the sons of the Mason family, with whom Hartley had lived in Nova Scotia and to whom he was deeply attached.[7] In letters written at the time, Hartley compared his grief to that which he experienced at the death of Karl von Freyburg more than twenty years before. Death, like the relentless waves, exerts a power that is indifferent to man.

Hartley also found in nature a regenerative power, a strength and constancy that "makes us cling to it as a relief from the vacuities of human experience."[8] Maine was an anchor for Hartley throughout much of his life. He saw in the land a mythic quality; in his view, the rigor of a life lived there endowed those who endured it with a kind of moral superiority. It is fitting that his final works—the landscapes of Maine—have become recognized by many as his greatest masterpieces. By coming home, he finally satisfied his search for a pictorial statement uniquely his own.

N.V.M.

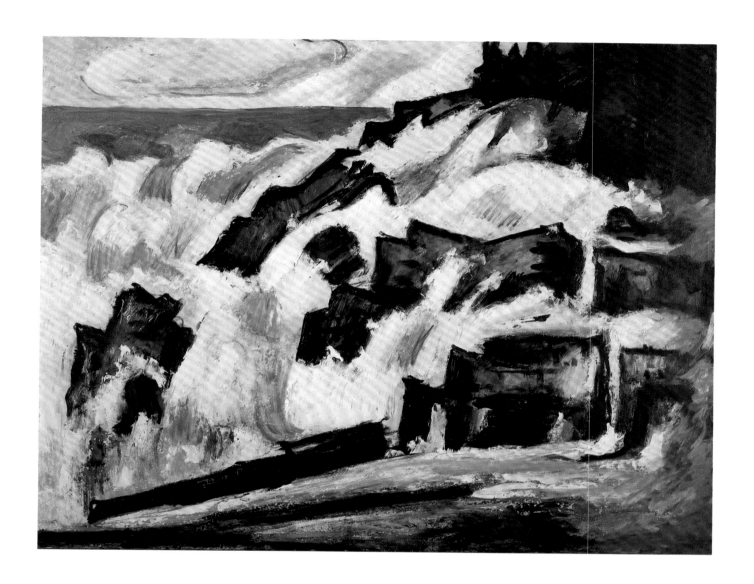

John Marin, 1870–1953

Educated at the Pennsylvania Academy of the Fine Arts in Philadelphia and the Art Students League in New York, Marin, like many of his contemporaries, also benefited from a prolonged sojourn abroad. He exhibited his early watercolors, oil paintings, and etchings—reminiscent of the works of James A. M. Whistler—in the official Paris Salons, where he got a firsthand exposure to modern art. A regular contributor to the modern art exhibitions at Alfred Stieglitz's 291 gallery in New York and a participant in the Armory Show in 1913, Marin began working in his mature expressionist style in the mid-1910s. Although the influences on his art were manifold—among them, Chinese painting, Impressionism, Fauvism, and Cubism—his approach was instinctive, not theoretical.

One of the first American artists to gain general public recognition for a highly personal, abstract style, Marin was able to capture in his art the very core of an experience. Representing the precise external appearance of a subject was less important to him than his heartfelt sensitivity to its underlying forces. His brushwork is reminiscent of calligraphy. The disposition of forms is active, not static; details are abbreviated; and the picture surface is an arena where the artist struggles to achieve a dynamic equilibrium among the various components of the composition. Remarkably consistent in intent and style over a long career, Marin explained the focus of his art as follows:

> *I see great forces at work—great movements . . . the warring of the great and small—influences of one mass on another greater or smaller mass. Feelings are aroused which give me the desire to express the reaction of these pull forces—those influences which play with one another. . . . In life all things come under the magnetic influence of other things. . . . While these powers are at work pushing, pulling, sideways, downwards, upwards, I can hear the sound of their strife and there is great music being played.[1]*

42 *Sunset, Maine Coast*, ca. 1919 31.233

Watercolor on paper, 15½ x 18½ in. (39.4 x 47 cm.). Gift of Ferdinand Howald, 1931

Marin was at his best when working in the watercolor medium. Among his most effective works are the seascapes he produced in Maine. An elemental composition of sky, surf, and shore, *Sunset, Maine Coast* deals with the eternal interaction among the forces of nature. Though the composition is symmetrical, this is no static icon, for everything is in motion. The painting is composed of three horizontal bands that differ in color, density, and brushwork. The passage from day to night is conveyed by the interaction of reds and blues in the sky. A long streak of red-orange at the horizon indicates that the sun has just set, releasing diagonal bursts of color before darkness takes over. The tones of dusk are evident in the water, a deep turquoise streaked with dark blues, where areas of exposed white paper indicate sea spray. In the turbulent middle ground are the most varied colors and the most active brushwork. The pounding of the waves on the shore is expressed by wriggling and diagonal strokes as shifts in value from dark blues, purples, and red-orange tones to pale turquoise and grays reinforce the violent confrontation between water and earth. The intermittent exposure of textured white paper in the immediate foreground is reminiscent of pebbles strewn along the rocky shore.

Sunset, Maine Coast is devoid of superfluous details. The picture is at once universal in its exposition of nature's energy and personal in the artist's identification with the subject. As Marin wrote:

> Seems to me the true artist must perforce go from time to time to the elemental big forms—Sky Sea Mountain Plain—and those things pertaining thereto—to sort of retrue himself up to recharge the battery. For these big forms have everything. But to express these you have to love these to be a part of these in sympathy.[2]

R.L.R.

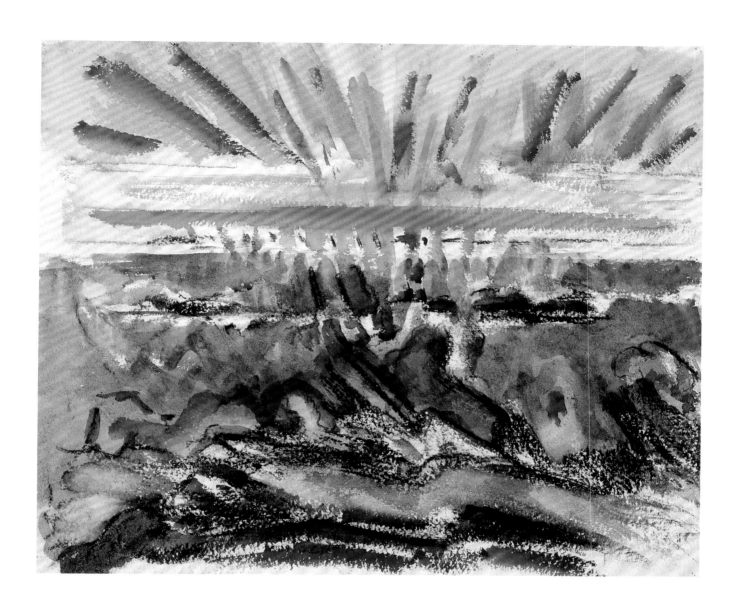

Man Ray, 1890–1976

Man Ray has a secure position in the history of modern art because of the originality of his ideas, images, and working methods. A major figure in the New York Dada group prior to 1920, he was an accomplished draftsman, painter, sculptor, photographer, and film director who continually experimented with media and technique in order to stimulate his imagination. With his close friends Marcel Duchamp and Katherine S. Dreier, he became a founder of the Société Anonyme, an American organization whose purpose was to exhibit, collect, and interpret modern art. After 1921, with the exception of a ten-year residence in California (1940–1951), the artist pursued his career in Paris, where he was active in Dada and Surrealist groups. The recognition he received was unusual for an American in the European avant-garde world.

While still a young man in his twenties, Man Ray was stimulated by the radical art he saw exhibited at the Armory Show in 1913 and at Alfred Stieglitz's 291 gallery in New York City. These early years were,

he said, a time of "greediness for everything: literature, music, art, painting, poetry."[1] While he was working as a commercial artist in New York and exploring the possibilities of Cubism and Fauvism in his personal art, he met Marcel Duchamp. The artists were kindred spirits in their desire to extend the limits of painting and to deal with content that was not restricted to literal interpretation. Dada artworks created after 1915 were cerebral in effect and often made with new methods and materials. In their acceptance of mechanical processes and readymade objects and in their affirmation of chance and irrationality, the Dada artists were a liberating force in art; they were instrumental in breaking down the traditional limitations of subjects, styles, and media. The new art celebrated life's variety and even its absurdities and was therefore thought by some to be closer to real life than traditional idealistic art. Man Ray believed that "perhaps the final goal desired by the artist is a confusion or merging of all the arts, as things merge in real life."[2]

43 Jazz, 1919 31.253

Tempera and ink (aerograph) on paper, 28 x 22 in. (71.1 x 55.9 cm.). Gift of Ferdinand Howald, 1931

Jazz is a superb example from a series of abstract "aerograph" paintings that Man Ray executed before 1920.[3] In these works the artist attempted to eliminate "the easel, brushes, and other paraphernalia of the traditional painter."[4] Using an airbrush and stencils and varying the flow and density of the paint, in Jazz he has created an elegant visual metaphor for music. The modulated blues, greens, yellows, oranges, tans, and grays evoke the sounds, from warm to cool, from soft to blaring, of different instruments, while the size, variety, and repetition of shapes suggest duration of tones, pitch, and rhythm. The vitality of the work is dependent upon shifts in focus from vague and atmospheric to crisply geometric. In this, as in other works in the series, Man Ray exploited the interplay of the abstract and the specific, allowing the images to develop as he worked. He said "the results were astonishing—they had a photographic quality, although the subjects were anything but figurative. . . . The result was always an abstract pattern. It was thrilling to paint a picture, hardly touching the surface—a purely cerebral act, as it were."[5]

Stylistically, Jazz is akin to Cubist paintings in its overlapping flat shapes, shifts from transparency to opacity, and inconsistent lighting. Its strong abstract design anticipates the formal emphasis of Man Ray's "rayographs"—photographic prints of the early 1920s, made without a camera by placing objects on photosensitive paper and exposing the materials to light.

Man Ray's visual interpretation of jazz is not unique in modern art. Artists such as Pablo Picasso, Henri Matisse, and Stuart Davis also created paintings inspired by jazz music.[6] Man Ray as film director used jazz as the inspiration for his 1926 film Emak Bakia, in which the music determined the varied rhythms and tempo of the shots.[7]

R.L.R

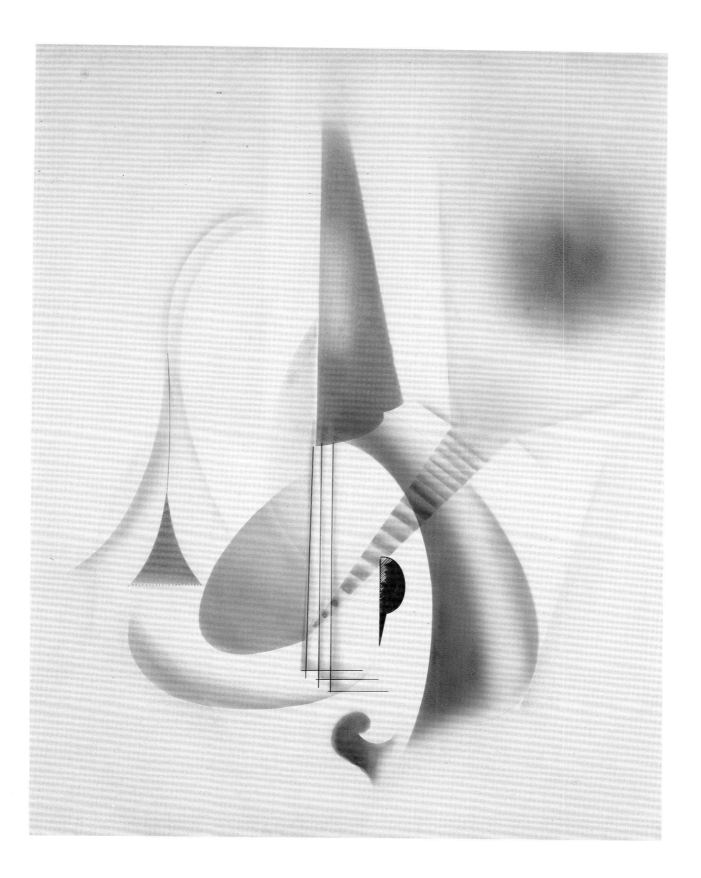

Man Ray, 1890–1976

44 *Regatta*, 1924 31.256

Oil on canvas, 20 x 24¼ in. (50.8 x 62.2 cm.). Signed and dated lower right: Man Ray 1924. Gift of Ferdinand Howald, 1931

In his desire to expand the possibilities of artistic expression, Man Ray dispensed with safe choices in favor of innovative media, techniques, and subjects. His reputation was built primarily on the quality of his Dada and Surrealist works as well as his photography. In addition, he produced works that are less known but equally intriguing—works such as *Jazz* (cat. no. 43) and *Regatta*, which reveal his inventive approach to artmaking. Man Ray refused to be an imitator, even of himself. He said that he wished "to paint as much as possible unlike other painters. Above all to paint unlike myself, so that each succeeding work, or series of works, shall be entirely different from preceding works."[1]

Unlike other paintings the artist executed during the 1920s, *Regatta* combines forceful execution and dramatic lighting contrasts. Man Ray painted the scene when he was living in Paris, supporting himself by photographing his friends and their artworks. He maintained his liaison with Marcel Duchamp while active in the Parisian Dada group and, in 1925, participated in the first Surrealist exhibition. He was inclined to create fantasies, or intellectually conceived artworks, while he also continued to make works that would be acceptable to his patrons. Ferdinand Howald, who had purchased a number of Man Ray's paintings, helped to finance the artist's trip to France in 1921.[2] Not particularly drawn to Dada, Surrealism, or photography, Howald chose works by Man Ray that were stylistically related to Cubism, Fauvism, and Expressionism. The emotional forcefulness of *Regatta* suited the collector's tastes for energetic, moody seascapes similar in intent to the work of one of Howald's favorite artists, John Marin.

The essence of *Regatta* is its dynamism as it successfully conveys the excitement of a sailboat race. The large dark shapes of the sails and sun, dispersed erratically across the picture surface, are urgent and restless. Perhaps Man Ray was experimenting here with the Surrealist process of automatism, in which configurations are produced "automatically," seemingly without conscious control, as in a dream state. In such works the artist deploys shapes on a canvas without a preconceived idea of subject matter, and then, seeing what the arrangement resembles—a race at sea, in this case—proceeds to develop the suggested theme.

In *Regatta*, Man Ray's brushwork is active and varied. Many long, nearly horizontal strokes in the boats and sea create the effect of fast, lateral movement, which is tempered only by the slashing vertical strokes in the riggings and masts. The wavy and feathery brushwork used for the water produces a choppy, murky appearance. The artist's thin, light strokes in the sky do not entirely cover the dark underpainting, thus suggesting the dissipating mists of morning. As a final touch he has scratched lines on the sails and wharf to refine these bold forms and to reinforce the sense of movement across the surface.

The composition is bold and unexpected, with boats silhouetted against a dramatic background in which glorious bands of pure white, red, and yellow appear below a blackened sun. Such contrasts and energy produce an aura of mystery and feeling as potent as that in any seascape by John Marin or Albert Pinkham Ryder.

R.L.R.

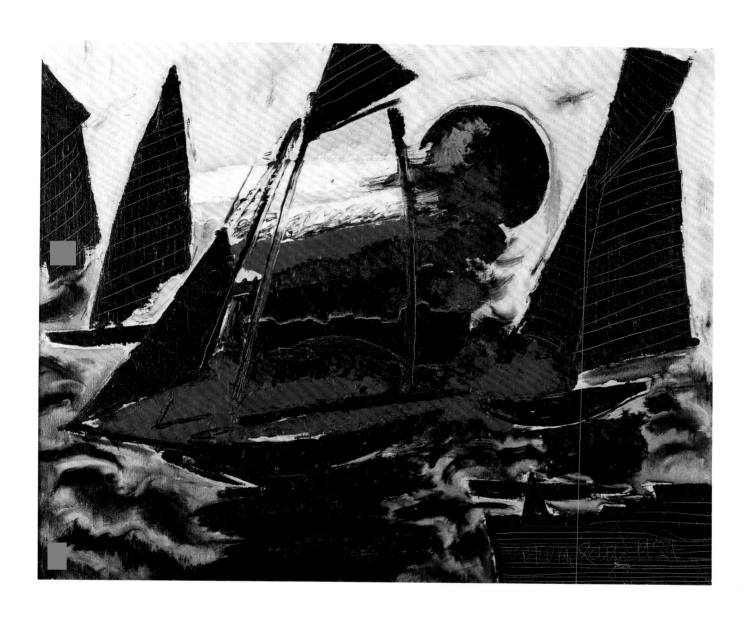

Morton Livingston Schamberg, 1881–1918

His life tragically cut short by the Spanish influenza epidemic that followed the First World War, Morton Livingston Schamberg, one of the first American painters to find beauty and meaning in industrial forms, made a major contribution to modern painting in the United States. A student of William Merritt Chase at the Pennsylvania Academy of the Fine Arts, he began his career producing works reminiscent of those by Chase and the artists who had influenced Chase's development, James A. M. Whistler and Edouard Manet. Commencing in 1905 Schamberg made several prolonged trips abroad, where he was awakened to the aesthetic possibilities of abstraction and intense, nonassociative color. Eventually a participant in the circle of avant-garde artists, writers, and intellectuals associated with Leo and Gertrude Stein in Paris, Schamberg probably came to know the Steins' collection of modern art. From 1909 to 1912 he created works that are stylistically related to those of Cézanne, Matisse, and Picasso; five works from this period were included in the Armory Show in 1913.

A crucial shift in imagery occurred in Schamberg's art by 1915. Possibly influenced by French Dada artists Marcel Duchamp and Francis Picabia, whom he had met in New York through collector Walter Arensberg, Schamberg started painting pictures that concentrate on mechanical forms.[1] His mechanistic images occasionally share the Dada predisposition for irony and mechanomorphic qualities (as for example, in God, *ca. 1917, an assemblage of plumbing pipes on a miter box, in the Philadelphia Museum of Art). More typically, however, his emphasis is analytical. Clearly articulated geometric shapes, occasionally faceted and shifting, as in the Cubist style, are presented in a manner which varies in completeness, lighting, and nondescriptive color. Stylistically, Schamberg's late paintings run the gamut from objectively rendered studies of cogs, belts, and wheels—reminiscent of engineers' drawings—to more dynamic hybrids of Cubism, Fauvism, and Futurism.*

45 *Telephone*, 1916 31.263

Oil on canvas, 24 x 20 in. (61 x 50.8 cm.). Signed and dated upper right: Schamberg/1916. Gift of Ferdinand Howald, 1931

Schamberg has here selected an ordinary household object as a suitable subject for a painting, a choice that was later echoed both in the Precisionists' fascination for mechanical artifacts and Pop Art's focus on everyday items. In Cubist style Schamberg represents a telephone resting on a tabletop to the right of a window, but even though he has reduced the base, speaker, receiver, and wire to severe geometric shapes, these elements remain recognizable. The composition is enlivened in various ways: through asymmetry; diversity of surfaces, textures, and treatment; and richness of color. The components of the telephone appear to be alternately transparent or opaque, flat or tubular. Precisely indicated contour lines occasionally extend beyond the forms they delineate, asserting the dominance of the picture plane, as crisp edges are juxtaposed with patchy application of paint to intermittently shift the focus in the work from sharp to blurred. The modulated background is dark at the top and bottom and shifts inexplicably from blue to green. Most of the telephone is shown in dull metallic grays, with occasional black components hovering on a plane even with that of the black table below. The bright yellow parts of the speaker and receiver and a small, brilliant red patch on the telephone's base seem to advance toward the viewer but exist on the same plane as the white portions of the telephone.

In composition and details, *Telephone* is similar to a painting (now lost) exhibited at the Montross Gallery in 1915.[2] The work may have been the inspiration for a later work by Schamberg's friend Charles Sheeler—*Self-Portrait* (1923, Museum of Modern Art), in which Sheeler appropriates the telephone as a personal symbol,[3] perhaps referring to the imagery of resourcefulness and proclaiming artistic independence.

R.L.R.

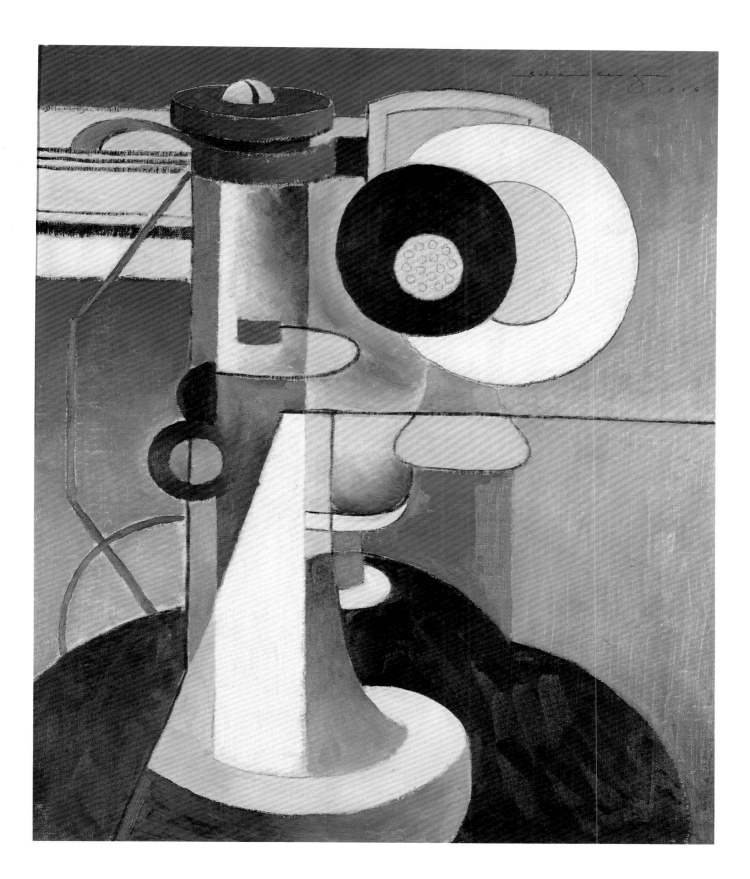

Thomas Hart Benton, 1889–1975

As a young painter in Paris (1908–1911) and New York (intermittently until 1918–1919), Thomas Hart Benton was a committed modernist. He subsequently turned to representational painting of the American regional scene, which—while popular during the thirties—has been severely judged by post–World War II critics as a betrayal of the avant-garde in American art. In truth, Benton, a prolific writer as well as artist, disassociated himself from the movers and innovators, but he did so with the conviction that a significant American art should be founded on the artist's sympathetic relationship to the environment, not upon theories of abstraction.

Nevertheless, as a young artist in Paris, Benton was thoroughly immersed in modernism. He had become friendly with Synchromist painters Stanton Macdonald-Wright and Morgan Russell, two Americans whose fascination with theories of color harmony led them to develop a system of painting in which form is derived from the organization of color planes. Of particular interest to Thomas Hart Benton were the dynamic "Baroque" rhythms he observed in Synchromist paintings, particularly the early studies using Michelangelo's sculptures as subjects. Much later he wrote:

> *Through its use of these rhythms Synchromism seemed to offer a more logical connection between the orderly form of the past and the coloristic tendencies of the present than any other of the Parisian schools. . . . I could not accept the repudiation of all representational art, which was the core of Synchromist dogma, but its procedures were interesting enough to induce experimentation.*[1]

Thus Benton, basing his experiments on Synchromist practices and to some extent on the art of the past, began to explore alternative systems of order and rhythm. Since the 1970s, he and other realist painters who worked outside the mainstream of modern art have been accorded a much deserved second look by revisionist scholars.

46 *Constructivist Still Life*, ca. 1917–1918 63.6

Oil on paper, 17½ x 13⅝ in. (44.4 x 34.6 cm.). Signed lower right: Benton. Gift of Carl A. Magnuson, 1963

Since many of Benton's modernist works have been lost or were destroyed in a fire in 1913, the museum's *Constructivist Still Life* assumes major historical importance. Here Benton depicts the sculptured planes of a three-dimensional construction which he created as the subject for painting. A jumbled arrangement of strikingly colored irregular geometric forms—cubes of red and green, a yellow metronome-like pyramid, and a silver-gray slab shaped like a stele or gravestone—strongly lit from the left, the composition suggests a landscape. The handsome palette and its disposition is related to Ogden Rood's theories of color triads, but Benton's adaptation of Rood's system is not as methodical or analytical as those of Morgan Russell and Stanton Macdonald-Wright. Some of Benton's color planes overlap and interpenetrate in the Synchromist manner, but these passages seem more interesting for their spatial ambiguity than for their color harmonies and thus seem close to Cubist practice, particularly in the paintings of Georges Braque from around 1908–1909.

Ultimately the comparisons with American or European painting of the same period fail to explain Benton's modernism. One of the main thrusts of contemporary art was the consciousness of the painted surface and the tension between that surface and any illusion of space. Such space was not only ambiguous but shallow. Benton, however, in his *Constructivist Still Life* intentionally retains the notion of foreground and background. He wrote:

> As you can see, the sketch is not "truly abstract" but is a sort of free representation of real objects in a real space. I judge [the museum's] painting was made in late 1917 or early 1918, at which time I began to try to compose in depth, using sculptural means.[2]

Benton also explained his subject:

> The "real" objects in this case were folded or cut out pieces of colored paper or cardboard set up like a "constructivist" sculpture. Several interpretations of such constructions could be made, and were, by slightly changing the angle of vision.[3]

Rather than a mainstream modern abstraction—which style, according to critics, he later abandoned for a "retrogressive" representationalism—the painting is instead a highly accomplished exploration of traditional spatial construction drawing upon some aspects of the modern vocabulary. Writing in 1962—with hindsight and a career to defend—Benton in his words about *Constructivist Still Life* lays claim to wholeness and consistency in his life's work.

> Whatever the nature of its color combinations [the museum's] painting belongs "formally" to the kind of "objective," "realistic," "sculptural" work I began after the War . . . and which I still pursue.[4]

W.K.

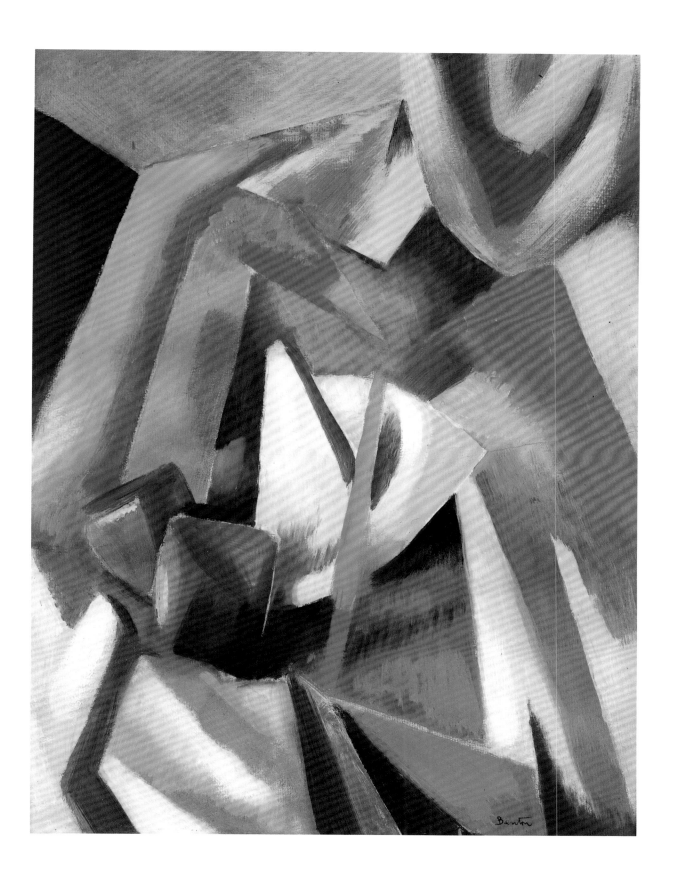

Stanton Macdonald-Wright, 1890–1973

Stanton Macdonald-Wright is best remembered as the cofounder, with Morgan Russell, of Synchromism, a style of painting which orchestrated prismatic colors in abstract shapes to suggest form and space.[1] The first American avant-garde art movement to gain international recognition, Synchromism was developed in Paris in the early 1910s. The Synchromists were profoundly influenced by the coloristic emphasis in the art of Cézanne, Matisse, and the Impressionists, and like Gauguin, Whistler, and Kandinsky before them, they also believed in an analogy between music and painting. In their attempts to liberate painting from its descriptive role, they were guided by purely intellectual choices of color to produce compositions which like music were perceived to be in harmonious balance.

An important impetus for the development of Synchromism was the color theory of Canadian painter Percyval Tudor-Hart, with whom Macdonald-Wright and Russell studied between 1911 and 1913. Tudor-Hart's system was based on the notion that the twelve intervals of the musical octave could be seen to correspond to twelve colors; tones of sound could thus be equated with hues, pitch with luminosity, and intensity of sound with color saturation.[2]

The term "synchromism" was coined by Russell in 1912 as an attempt to connect the disciplines of painting and music. According to Russell:

The word was born . . . by my searching [for] a title for my canvas . . . that would apply to painting and not to the subject. My first idea was of course, Synphonie, but on looking it up to see if it could reasonably be applied to a picture I found that Syn was "with" and "phone" sound—the word "chrome" (why I don't know) immediately flashed in my mind—(I knew it meant color).[3]

The sources of Synchromism are varied. The early works are Fauve-like, but the earliest Synchromist abstractions have a certain stylistic similarity to those of the contemporary French Orphist painters Robert and Sonia Delaunay, whose works Macdonald-Wright and Russell undoubtedly knew. The Synchromists, however, eschewed the Orphists's predilection for flatness and simultaneity, preferring the nonillusory evocation of light, form, and depth through choice of color.[4]

The Synchromists first exhibited their color abstractions in Munich in June 1913. Additional exhibitions in Paris in October 1913 and New York in March 1914 made them an influential force in modern art well into the 1920s.[5] Although the collaboration with Russell ceased after Macdonald-Wright moved back to the United States in 1914, both artists continued to paint abstract synchromies that were either nonrepresentational or based on specific subjects.

47 *California Landscape*, ca. 1919 31.275

Oil on canvas, 30 x 22⅛ in. (76.2 x 56.2 cm.). Gift of Ferdinand Howald, 1931

California Landscape was painted by Macdonald-Wright shortly after he moved from New York to California. The work is a synchromy that celebrates in a nonspecific way the sights and feelings experienced during a day at the shore. The artist seems to revel in his new home. The radiant colors and open geometry of the painting suggest fresh air, warm sunlight, cool water, and gentle breezes. This view of the Pacific Ocean, seen through a grouping of buildings and trees from an elevated vantage point, is dazzling in its color and light.

While the composition is similar in conception to Cézanne's many images of L'Estaque (for example, *The Bay from L'Estaque*, ca. 1886, Art Institute of Chicago), it is in contrast to the solid, architectonic quality of the Cézanne works. Macdonald-Wright's forms seem to dissolve in an atmosphere of rich colored light, like objects viewed through a prism. The intermittent contour lines stretch beyond the natural and architectural forms they establish, giving the effect of shifting planes in space. In counterpoint to these open faceted shapes are the modulated passages of color that gradually or sharply shift into other hues or white, making the images appear to move in and out of focus. The artist accentuates colors by taking advantage of the effects of complementary and analogous hues. For example, the dominant blues of the sky and water are intensified by small areas of complementary orange interspersed throughout the composition, and in turn the blue enlivens the orange. Elsewhere, smaller juxtapositions of complements interact in sometimes subtle, sometimes percussive ways. Sequences of analogous colors, such as the blue-greens and blue-violets in the upper left of the canvas, are gentle in their visual energy as they blend and shift from one predominant color to another like the sounds of musical lines and arpeggios.

R.L.R.

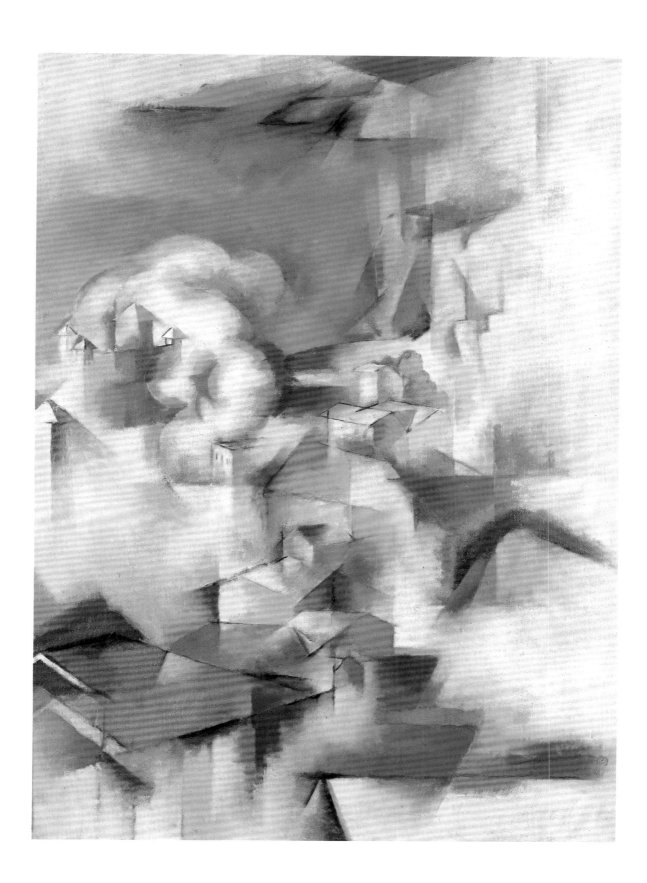

Preston Dickinson, 1889–1930

Although he explored a variety of traditional and avant-garde stylistic modes during his short career, Preston Dickinson is best remembered as a proponent of Precisionism, a major trend in early twentieth-century American art which takes its imagery predominantly (but not exclusively) from the world of technology, artifacts, and urban architecture. Dickinson was one of the first American modernists to choose industrial subjects for his drawings and paintings. His earliest Precisionist images of factory complexes and granaries, dating from 1914 to 1915, preceded such subjects in the works of Charles Sheeler and Charles Demuth by several years. According to his close friend Moritz Jagendorf, Dickinson was intensely interested in the forms of the technological world, and he believed that industry was beneficial to humanity.[1]

The emphasis in Dickinson's compositions varies; his response may be to the visual purity of industrial forms, or to their architectonic structure, or to their inherent dynamism, or even to their visionary qualities. His range of subject matter is also broad: from the dynamic and imaginary factory scenes of the early 1920s, such as Factory, to the severe inorganic still lifes of 1925, such as Hospitality (also in the Columbus Museum of Art). Adamant in his insistence on artistic freedom, Dickinson preferred an eclectic, nontheoretical approach to his work. The lessons he learned at the Art Students League in New York and the Académie Julian and the Ecole des Beaux-Arts in Paris were augmented by private experiments based upon the modern art with which he was familiar. His abstract works are generally tempered by a respect for time-honored techniques and compositional devices, but the strength of his most expressive works is in their innovative and sometimes inventive imagery and unusual blend of styles.

48 Factory, ca. 1920 31.153

Oil on canvas, 29⅞ x 25¼ in. (75.9 x 64.1 cm.). Signed and dated lower right: P. Dickinson '2[?]. Gift of Ferdinand Howald, 1931

Factory, a majestic oil painting of an activated dynamo, is one of four closely related paintings from the early 1920s that clearly demonstrate Dickinson's reverence for technology.[2] Openly extolling the beauty of industrial architecture and power, these paintings predate Le Corbusier's influential treatise Vers Une Architecture, in which the celebrated architect lauds the pure functional beauty of American factories and grain elevators as the harbingers of a new architectural age.

The major sources for the style of Factory are Cubism, Futurism, Fauvism, and Synchromism, but the expressiveness of the work is primarily dependent on the intensity of the artist's fantasy. The composition is a dense arrangement of tanks, conduits, ramps, smokestacks, and a shed. Elements occasionally merge with one another to occupy the same space. Densest near the center, the configuration avoids the rationality of linear perspective but replaces that with the rationality of the Cubist grid. The distinctly geometric mechanical forms shift from transparency to opacity. Nonillusionistic lighting is randomly reflected or absorbed by the facets of the dynamo's parts. High-key colors heighten the visionary effects of the scene: strong yellows, oranges, and reds glow in a picture field of deep blue, suggesting the heat and light of an inferno. The artist is not concerned with describing an industrial process or transcribing a specific industrial complex; rather, he gives visual form to the apotheosis of machine power.

R.L.R.

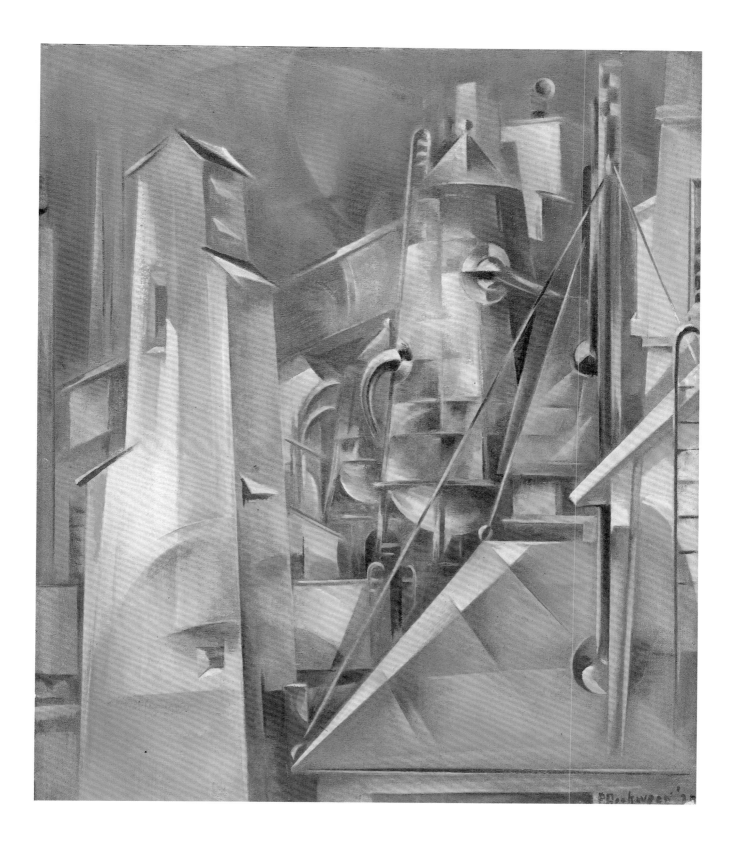

Preston Dickinson, 1889–1930

49 *Still Life with Yellow-Green Chair*, 1928 31.164

Oil on canvas, 15 x 21 in. (38.1 x 53.3 cm.). Signed lower left center: Dickinson. Gift of Ferdinand Howald, 1931

Near the end of his career Preston Dickinson became increasingly concerned with going beyond the limits of the Precisionist aesthetic he was instrumental in formulating. Most of his drawings and paintings after 1926 retain the kind of imagery he favored in earlier works—bridges, urban and industrial architecture, and still lifes made up primarily of artifacts. By virtue of their antiseptic appearance, hard-edged geometric planes, flatness, simplified lighting, and economy of detail, these works are ostensibly Precisionist in style. Yet there is clearly a shift in emphasis. By the late 1920s Dickinson moved away from the clarity, simplicity, and equilibrium of works such as *Factory* (cat. no. 48) and *Hospitality* (1925, also in the Columbus Museum of Art). Though he continued to design complex pictorial arrangements, his later compositions are often idiosyncratic and unsettling in effect. These energetic, crowded compositions are made up of steep angles, diagonals, and forms that tend to move toward the perimeters of the picture field. The combination of forms included in these works is often eccentric, and frequently the surfaces are embellished with unusual colors or reflecting light. In these effects Dickinson's late drawings and paintings share an affinity with sixteenth-century Italian Mannerist works, which, in turn, were personal responses to the purity, balance, and order of High Renaissance classicism.

Still Life with Yellow-Green Chair, purchased by Ferdinand Howald in 1928, is characteristic of Dickinson's late work and is perhaps his best known oil painting. The asymmetrical composition, focusing on an arrangement of objects on a table cut off by the lower edge of the picture, is derived from the artist's love of Japanese woodblock prints and is reminiscent of his earlier still lifes. In Precisionist fashion, Dickinson presents ordinary household utensils as sharply focused geometric shapes, rendered in a technique that suppresses the sense of the artist's touch. Although they are carefully arranged, the objects on the table do not seem firmly implanted because they are crowded near a corner of the table and the tabletop seems far too steep for anything to rest upon it.

Yet Dickinson has achieved a precarious equilibrium in this work by echoing the shapes of the utensils and table with those of the upholstered chair and the framed picture on the wall behind it. He relies on diagonals to direct the viewer's eye throughout the painting. Colors emphasize the shallowness of the picture field because they are close to one another in value. The grayed blues and greens of the knife, parfait glass, plate, and bottle are not far removed from the yellow-green of the chair, the tan of the roll, or even the colors of the butter squares and the red book. These medium-value areas are played against the slightly lighter gray wall behind the table and the bright whites of the tablecloth and matted picture.

Still Life with Yellow-Green Chair is memorable for the interaction of Precisionist order and compositional tension. The unusual array of objects is visually arresting but somewhat threatening for a domestic vignette. The plant is cleanly sliced off by the top picture edge; the jagged knife seems to defy gravity in its placement and to cancel out the book; and, finally, the empty chair asserts the absence of the artist, an effect in accord with the flawless, impersonal finish of the painting.

R.L.R.

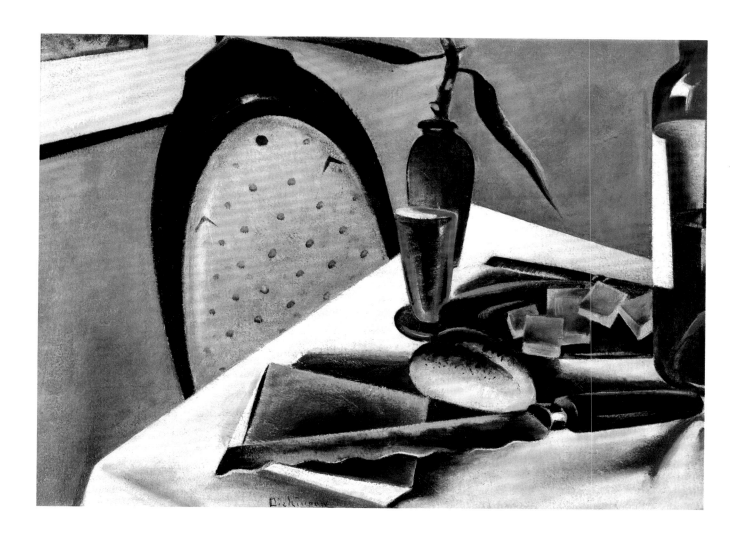

Charles Sheeler, 1883–1965

The quintessential Precisionist who sought to understand the underlying structure of his subjects, Charles Sheeler once commented on his concern for objectivity in his art: "The pictures I reproduce are attempts to put down the inherent beauty of the subject with as little personal interference as possible."[1] More than any other American artist of the twentieth century, Sheeler promoted a realist style of uncompromising purity, and in so doing helped pave the way for Pop Art and Super Realism.

A photographer as well as a painter, Sheeler saw no conflict between photography and painting. "Photography," he said, "is nature seen from the eyes outward, painting from the eyes inward."[2] Nor did he see any conflict between mass-produced, mechanical forms and hand-crafted items. To his way of thinking, a dynamo or a piece of Shaker furniture could equally serve as the basis for orderly designs of majestic simplicity. During the 1920s and 1930s Sheeler worked in his most classical Precisionist style. In contrast to the abstraction and experimentation of works such as Lhasa, his Precisionist drawings and paintings—mostly depictions of factories, engines, and still lifes—are more concrete and representational. Taking advantage of what he learned from Cézanne's art and Cubism, Sheeler focused on the basic configurations of his images, eliminating distracting details, varying vantage points, and manipulating lights and shadows to enliven his compositions in a variety of ways. Rendered in flawless technique, they reveal a world that is remarkably clean and free from the effects of time.

50 *Lhasa*, 1916 31.100

Oil on canvas, 25½ x 31¾ in. (64.8 x 80.6 cm.). Signed and dated lower right: Sheeler/1916. Gift of Ferdinand Howald, 1931

Lhasa, a view of the Buddhist holy city in Tibet, was most likely painted in January or February of 1916. It was shown in the *Forum Exhibition of Modern American Painters* held March 13–25 that same year, having been chosen by a jury that included Alfred Stieglitz and Robert Henri.[3] The painting is based on a photograph by John Claude White,[4] from which Sheeler made a conté crayon drawing (private collection, Philadelphia), presumably a preparatory sketch for the painting.[5]

Painted before Sheeler began to produce his Precisionist works, *Lhasa* nevertheless reveals the artist's propensity for architectural subjects and highly controlled compositions. The mountaintop shrine is conceived by the artist as a grouping of lucid, geometric forms, seemingly devoid of human occupants. Emphasizing parallels, Sheeler establishes the dominant axis from the lower left to the upper right by a series of long diagonals punctuated by intermittent stairs and ledges that provide measured increments in the ascension.

Countering the straight-edged architecture are the graceful curves and diagonals of the mountain. These intersect with the major axis, again with a preponderance of parallels. Sheeler simplifies his lighting and color to reinforce the solidity of his subject and to achieve a kind of graceful chiaroscuro. As in the art of Juan Gris, whose paintings Sheeler might have seen in Paris, the lighting (in this case coming from the upper left) is consistent but avoids the complexity of reflections and shadows.

Relying on the relative energy and brilliance of his colors, Sheeler also achieves a nonillusionistic sense of depth. To make up the prominent wall of the shrine, he uses a rich, flat orange that forcefully projects toward the viewer; at the same time he juxtaposes a rich blue for the receding shadows and lower portion of the mountain. Paler areas of modulated grayed blues and tans recede into space, merging with the large expanses of white that frame the scene and emphatically assert the prominence of the picture plane.

Inherent in *Lhasa* is Sheeler's belief that man's structures and nature are in perfect accord. The climb to the top of the shrine appears arduous, but the methodical organization and execution of the painting seem to suggest that a difficult ascension sometimes is appropriate for a meaningful experience.

R.L.R.

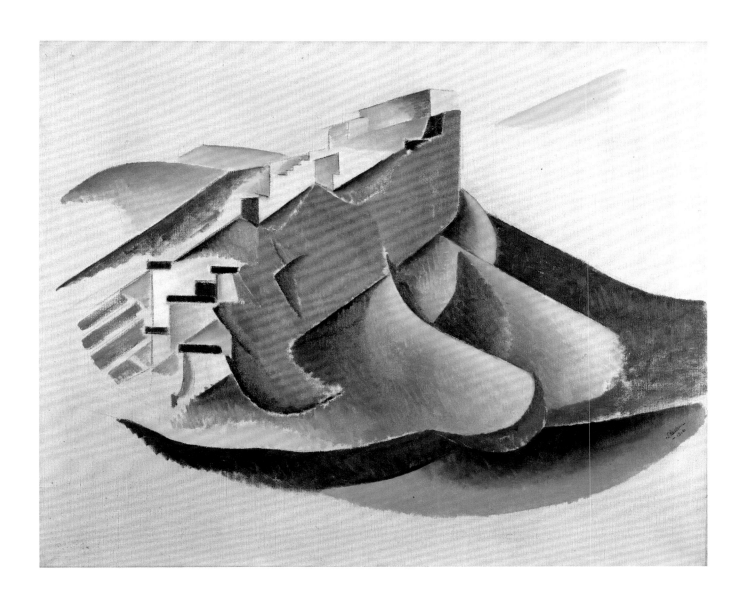

Charles Sheeler, 1883–1965

51 *Still Life and Shadows*, 1924 31.106

Conté crayon, watercolor, and tempera on paper, 31 x 21 in. (78.7 x 53.3 cm.). Signed and dated lower right: Sheeler 1924. Gift of Ferdinand Howald, 1931

Still Life and Shadows is part of a series of interior scenes in which Charles Sheeler concentrated on objects from his own home. A noted collector of American folk art and crafts—particularly Shaker objects—Sheeler looked for simplicity and grace even in common household objects. Choosing still life because he could leave his arrangements undisturbed for long periods when his painting was interrupted by photography commissions, he responded no less profoundly to humble domestic subjects than he did to factories and machinery.[1]

A seemingly straightforward presentation of a glass, a plate, and a teapot on a small table, the composition of *Still Life and Shadows* is animated in a number of ways. Sheeler uses several artificial light sources simultaneously, varying the prevalent axes and the tones of the playful shadows as they crisscross one another and the wall and tabletop, in marked contrast to the solemnity of the artifacts and table. The shapes of the cast shadows—most notably, those of the table, glass, and teapot—seem to have more substance and energy than the objects themselves. The shadows stabilize the design by echoing the verticals of the table legs (there is even a shadow for a leg that is not seen), and at the same time energize the composition by leading the eye upward to the objects on the table. Sensitive to subtle details, Sheeler wraps the shadows around the wall molding and introduces a diagonal shaft of light running counter to other diagonals to draw the eye back to the left. According to Sheeler, "the table is the result of all the things that are happening around it. It stands out in space, not through the subterfuge or suppression of environment . . . but through the use of projected shadows."[2]

Sheeler's ingenuity is also noticeable in other ways. The interaction between straight-edged and curving forms provides diversity within the design. Subtly changing viewpoints from the center to the side or upward or downward, he prevents an illusionistic reading of the work. The perspective of the table is askew; objects on it do not quite rest on its surface and are shown from a slightly lower vantage point, thus asserting the flatness of the picture and suggesting some pictorial tension.

Sheeler's use of chiaroscuro is exquisite in its refinement. His colors—primarily sober browns, grays, and greens—give the work an effect of quietude, while the richer touches of color in the Persian carpet below keep the composition from becoming static. The carpet, an afterthought, according to Sheeler, also adds textural variety.[3]

Still Life and Shadows is unusual in Precisionist art, which often tends to emphasize the purity of industrial forms. Sheeler's love of household objects and crafts is crucial to his style and imagery, and as he said, "as influential in directing the course of my work as anything in the field of painting."[4]

<div align="right">R.L.R.</div>

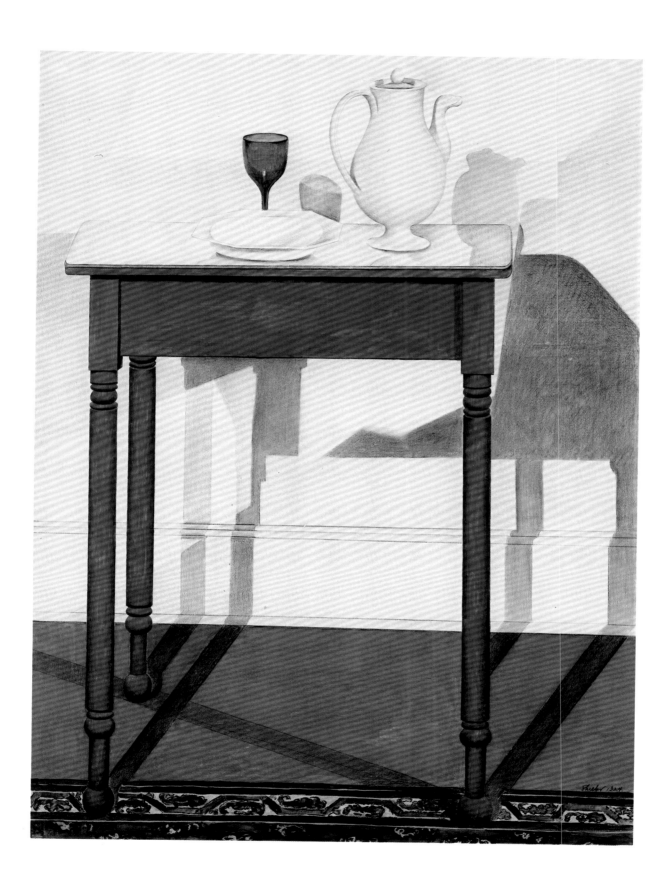

Charles Demuth, 1883–1935

A painter of extraordinary technical virtuosity, Charles Demuth left a body of work that is noteworthy for its clarity, sensitivity and refinement, and broad range of imagery. He was undoubtedly in the vanguard of Precisionism, yet many of his best works—the lively figurative watercolors, symbolic poster portraits, and gracefully sensual still lifes—are only tangentially related to Precisionism through their disciplined technique and subtlety. According to his friends, Demuth was a complex individual;[1] he was alternately austere or flamboyant, reclusive or socially active, disciplined or hedonistic, and all of these diverse qualities of his personality are seen in his art.

A native of Lancaster, Pennsylvania, where he executed many of his most important works, Demuth studied painting at the Pennsylvania Academy of the Fine Arts, working under two of that institution's most important teachers: Thomas P. Anshutz and William Merritt Chase. Like most of the other major American modernists of his generation, Demuth gained much from traveling abroad. He was in Europe for a brief period in 1904, and lived in Paris in 1907–1908 and 1912–1914. He attended classes at the Académie Julian and Académie Colarossi. His exposure to modern painting, particularly Post-Impressionism and Cubism, and his participation in the artistic and literary circle associated with Leo and Gertrude Stein contributed considerably to his cosmopolitan spirit and sophistication. He traveled to Bermuda in 1916, visited New York City often, and spent many summers in Gloucester and Provincetown, Massachusetts. After 1922 he remained, for the most part, at his family home in Lancaster.

52 *The Circus*, 1917 31.127

Watercolor and graphite on paper, 8 x 10⅝ in. (20.3 x 27 cm.). Signed and dated lower left: C. Demuth/1917. Gift of Ferdinand Howald, 1931

Between 1915 and 1919 Demuth executed a series of watercolors inspired by vaudeville, the circus, and the night life of New York City. He was certainly aware of similar scenes produced in France by artists such as Watteau, Degas, and Toulouse-Lautrec. Like them, Demuth reveled in the vigorous energy and sometimes showy banality of public spectacles, and he was master of a watercolor technique well-suited for capturing their fast pace.

The Circus, one of these energetic watercolors, is among Demuth's most entrancing works. The effectiveness of the painting is dependent on the artist's swift, delicate touch. Virtually everything in the scene is rendered in curving lines that keep the viewer's eye moving throughout the composition. The concentric movement of the arena is reinforced in the curve of the horse's back; played against the momentum of these elements are the sweeping arcs of the woman's arms and the red, yellow, and green banners that festoon a pole at the center of the arena. The tighter, wiry curves of the male acrobat suggest a wobbly movement appropriate for the uncertainty of his equilibrium. Demuth underplays the mass of his forms to accentuate their buoyancy; rather than appearing firmly implanted, the figures seem to float as if unaffected by gravity, their insubstantiality dependent on a technique called "softening off," in which the watercolor pigments are applied on wet paper and carefully blotted to create a mottled, atmospheric effect. With the exceptions of the inky blacks of the entertainers' garments, the brightly colored festoons, and the green band across the male performer's chest, the colors—mostly pinks and tans—are muted by the blotting and by the exposed areas of white paper.

In *The Circus* Demuth pays homage to the pleasures of popular, live entertainment. The appearance of this and so many images like it in the later 1910s indicates a growing nostalgia for forms of entertainment that were declining in popularity due to the success of film. As scholar Betsy Fahlman pointed out, Demuth would have agreed with the lament of his close friend Marsden Hartley:

> Where is our once charming acrobat—our minstrel of muscular music? What has become of these groups of fascinating people gotten up in silk and spangle? Who may the evil genius be who has taken them and their fascinating art from our stage, who the ogre of taste that has dispensed with them and their charm? . . . What are they doing since popular and fickle notions have removed them from our midst?[2]

R.L.R.

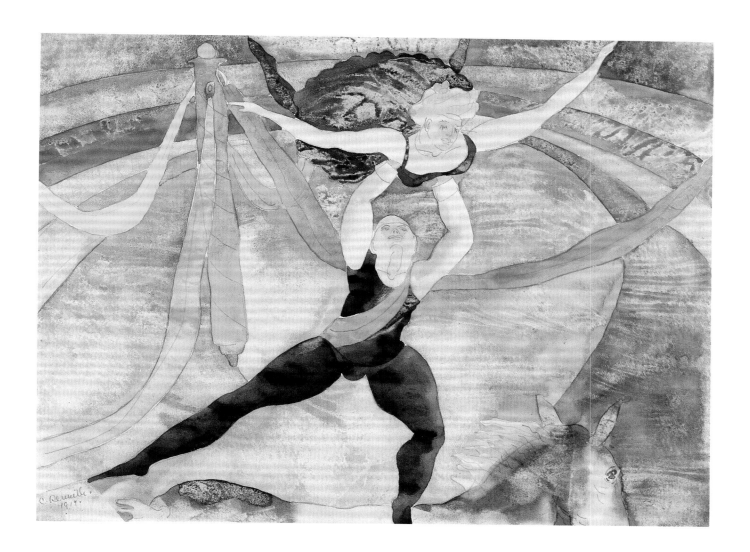

Charles Demuth, 1883–1935

53 *Modern Conveniences*, 1921 31.137

Oil on canvas, 25¾ x 21⅜ in. (65.4 x 54.3 cm.) Signed and dated lower left center: C. Demuth 1921. Gift of Ferdinand Howald, 1931

Charles Demuth's first experiments with a Precisionist style began during a prolonged visit to Bermuda with Marsden Hartley in the autumn of 1916, when he executed a series of watercolors based on architectural themes. In contrast to the figurative works he was doing around that time—such as *The Circus* (cat. no. 52)—his Bermuda paintings are structural in emphasis and related stylistically to the art of Cézanne and the Cubists. In his concern for the definition of hard-edged, angular, geometric planes in space, Demuth composed in a more calculating, impersonal way than he had ever before attempted. His friendship with Marcel Duchamp was also a factor in the development of this new aesthetic.

Modern Conveniences, which Demuth painted in Lancaster, is an excellent example of the artist's architectural compositions. It is Precisionist in its sharp delineation, geometric clarity, and crystalline lighting, yet it is far from being a celebration of the beauty of a structure. To the contrary, the painting is a tongue-in-cheek commentary on the limitations of a particular building. Based upon a view of the rear facade of a house seen from the garden of Demuth's home in Lancaster, the painting is an effective blend of realistic components and abstract forms.[1] A later photograph of the building indicates that Demuth generally respected the specific details of the structure but modified them to assert the picture's flatness or to make the work more dynamic.[2] The windows and doors, for example, are slightly askew, suggesting that the house is not in the best condition. Moreover, all of the horizontals are slightly off so that the building seems to lean toward the left. Demuth further accentuates the rickety appearance of the structure by making the diagonals too extreme or awry. Only a chimney, along with other vertical elements, provides some feeling of stability.

In contrast to the building, the space it occupies seems open and majestic. Several paired diagonals, which traverse the scene like searchlights or the force lines in Futurist paintings, energize the space and open it up beyond the perimeter of the picture. Occasional arcs, mostly near the bottom of the painting, are evocative of foliage but also provide diversity in a composition dominated by straight lines. The predominant colors—pinks, reddish browns, grays, and white—are characteristic of the domestic architecture seen around Demuth's Lancaster home.

Like Duchamp, Demuth made the titles of his works an integral part of the works themselves. Humorous, ironic, or ambiguous, the titles were clever counterpoints to the refined visual forms, and they were meant to cause the viewer to think about the meaning of the works. What are the modern conveniences of this building? Its shaky appearance is more indicative of the problems than the advantages of living there. The emphasis on the fire escape suggests that the building is a fire trap. Perhaps the ambivalence of the painting is related to Demuth's attitude toward his native city, which was hardly known in his time for its modernity. Despite the claims of a friend that Demuth loathed Lancaster,[3] life there was convenient and comfortable, and as his biographer noted, "to him the city's landscape was endlessly beautiful, so that he was always going home from Paris or elsewhere to paint."[4]

R.L.R.

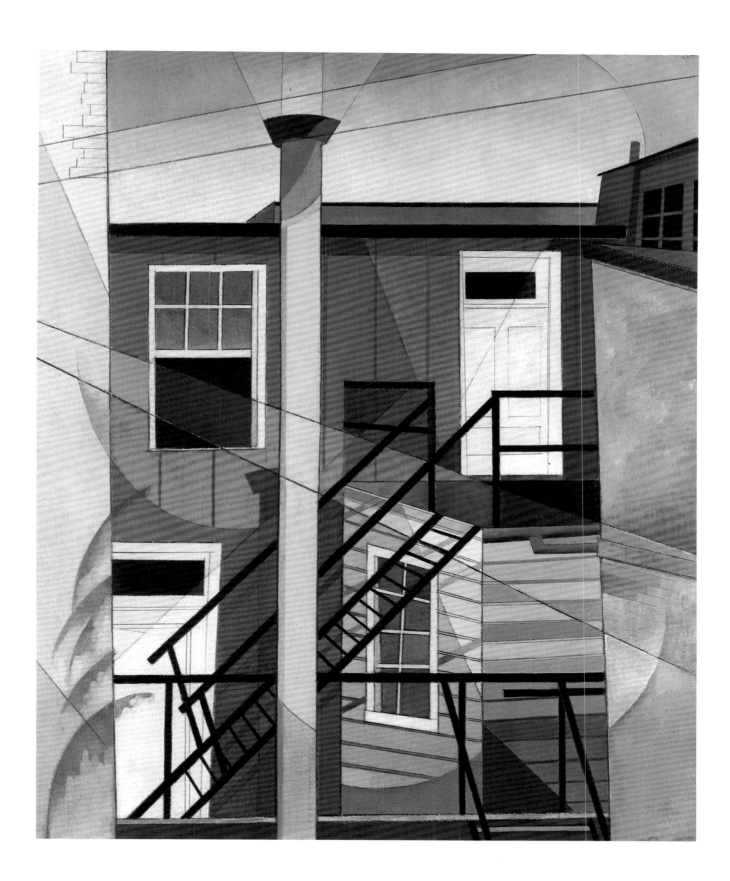

Charles Demuth, 1883–1935

54 *Bowl of Oranges*, 1925 31.125

Watercolor on paper, 14 x 20 in. (35.6 x 50.8 cm.). Signed, dated, and inscribed lower center: Lancaster Pa. C. Demuth 1925. Gift of Ferdinand Howald, 1931

The primary source of Charles Demuth's income during the 1920s,[1] and certainly among his most successful works, were the still lifes he undertook largely as a result of his failing health. The debilitating effects of diabetes severely affected his activities as a painter but not the quality of his artworks. At times unable to work at all, when his strength began to return he turned to watercolor and to still-life subjects. He had always admired the beauty of the flowers in his garden and was also inspired by the fruits and vegetables his mother brought regularly from farmers' markets near the family home.[2] Arrangements of these objects could be set up for prolonged times and were easily accessible during periods of confinement. Devoid of irony and ambiguity of meaning, Demuth's still lifes are positive responses to the beauty of nature and consummate examples of the artist's compositional skills and refined technique.

Despite his wistful observation that "I get more out of my watercolors than anybody else,"[3] *Bowl of Oranges* is full of rewards for the viewer. Once again, the effectiveness of the picture is largely dependent on the artist's subtle touch. He depicts recognizable components—a bowl of oranges, a goblet holding an orange flower, and two bananas on a table in front of rich blue curtains—using devices introduced by Cézanne and the Cubists: the tabletop is seen from more than one vantage point; the forms seem to shift from transparency to opacity; and the shadows are given comparable weight to the forms themselves. Like his earlier figurative watercolors, such as *The Circus* (cat. no. 52), *Bowl of Oranges* is a graceful composition with curving graphite lines and fluid design. The symmetrical organization is energized by the curves that create a prominent "U" in the center of the picture. The interplay of the circular and oval fruit, the scalloped bowl, the drapery, and the shadows keeps the viewer's eye moving through the composition. The straight contours of the table divide the picture into two major horizontal bands, but these do not disrupt the flow between the forms in the foreground and those further back. As a result of Demuth's mottled application of paint, portions of the work seem to move in and out of focus. These suggestive passages of color that vary in hue, value, and intensity, together with the large areas of white paper, assert the flatness of the picture and at the same time, give the impression that the scene is forming before our eyes.

Demuth's colors are intense and sumptuous. He relies on the interaction of complementary colors—oranges and blues—to heighten the visual experience. The rich, warm colors, most intense near the center of the painting, project strongly from the receding blues in the drapery. The colors of the fruit are so highly saturated that the food seems overripe.

Thus in many ways Demuth takes a modest theme and makes it significant and memorable. An encounter with such a work is a rewarding visual experience, and that was precisely the artist's objective. He wrote:

> Paintings must be looked at and looked at. . . . They must be understood, and that's not the word either, through the eyes. No writing, no talking, no singing, no dancing will explain them. They are the final, the 'nth whoopee of sight.[4]

R.L.R.

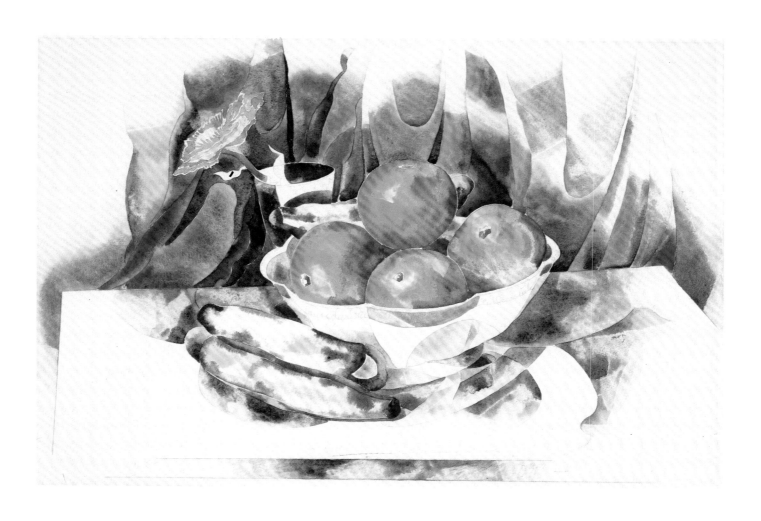

Niles Spencer, 1893–1952

Niles Spencer created a body of drawings and paintings in the Precisionist style that are noteworthy for their consistency of imagery, unrelenting discipline, and laconic impersonality. Educated at the Rhode Island School of Design between 1913 and 1915, Spencer gained an appreciation for careful craftsmanship and rigorous organization. His brief study with Robert Henri and George Bellows at the Ferrer Center in New York City in 1915 did little to advance his technical skills but alerted him to the beauty inherent in the modern urban and industrial world. Subsequent trips to Italy and France provided opportunities to examine firsthand the formal purity of Italian Renaissance art and Cubism; in particular, he was impressed by the lucid, monumental classicism of Giotto, Piero della Francesca, and Andrea Mantegna, as well as by the structural abstractions of Paul Cézanne, Georges Braque, and Juan Gris.[1]

Spencer's compositions of flattened geometric planes are the result of thoughtful observation and analysis of his subjects. Each work is an amalgam of reductive realistic components—almost always architectural—and pristine geometry. Temporal effects, weather conditions, and human figures are rejected in favor of timeless, architectonic designs. Although Spencer often used linear perspective, he was not concerned with creating an illusion of three-dimensionality. His paintings are emphatically two-dimensional, with simplified lighting and chiaroscuro and little internal detail. These works are hermetic entities in themselves, subject only to their own formal logic. A prolonged study of such a work is a meditative experience in which subtle relationships of forms and colors as well as a sense of the intelligent, reticent personality of the artist slowly become apparent. As his close friend, the painter Ralston Crawford, remarked:

> *Niles was relaxed, perhaps without much sense of time, [without] anxiety. In his best work he takes us to a world of charming nuance, of solid construction, always charged with his fine, subtle sense of colour. His search was, at times, slow, as meaningful searches often are. Occasionally he seemed to falter. But now that his work has been completed, we may say that he went toward a fuller and clearer statement.[2]*

55 *Buildings* 31.268

Oil on canvas, 24 x 30 in. (61 x 76.2 cm.). Signed lower left: Niles Spencer. Gift of Ferdinand Howald, 1931

Buildings, a forthright presentation of rooftops, building facades, chimneys, and smokestacks, is characteristic of Niles Spencer's many cityscapes. Human figures or details that would suggest the presence of people are absent. In this stable, grid-like composition, horizontal and vertical contours are only occasionally opposed by steep parallel diagonals, and the application of paint is strictly controlled and impersonal. The artist's palette, however, with its many warm browns, prevents the work from appearing cold and inhospitable. Color is also important in conveying depth and in regulating the movement within the painting. In a manner owing much to Cézanne, Spencer suggests planar connections between forms in different areas by using tones of the same value. Because the shifts in color are never abrupt, the viewer's eye moves smoothly, though guardedly, throughout the work. Vertical forms—the chimneys and smokestacks—are visual resting points as the eye follows the rhythm of the fenestration across the surface.

Spencer's continual choice of urban and industrial architecture for subjects suggests that he, like Charles Sheeler and Preston Dickinson, was attracted to the visual clarity and beauty of the forms. His oeuvre also includes landscapes, still lifes, and interior scenes, which—like the architectural subjects—are observations of the beauty to be found in structure.

R.L.R.

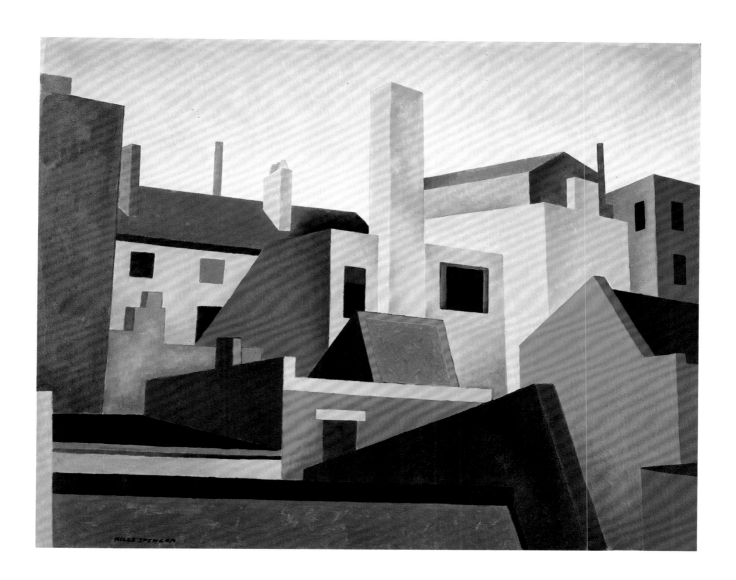

Yasuo Kuniyoshi, 1889–1953

Charles Daniel, in a letter of June 22, 1923, to the collector Ferdinand Howald, noted that Kuniyoshi had returned to Maine as he had done for many summers since 1918. "If his development continues," he wrote, "which I believe it will, he will have interesting stuff for next season." There is no formal reply from Howald, but his ledger book carefully records the purchases of three works by Kuniyoshi: Boy Stealing Fruit *and* Cock Calling the Dawn *in 1924, and* The Swimmer *in 1925. These works were among Howald's legacy to the Columbus Museum of Art in 1931.*

Kuniyoshi, who was born in Okayama, Japan, came to the United States in 1906. He studied first at the Los Angeles School of Art and Design, from 1907 to 1910. After moving to Brooklyn, he studied briefly at the National Academy of Design, then at Robert Henri's school, which was conducted in the master's studio, and at the Independent School of Art. In 1913, for unknown reasons, he left New York City for Syracuse and as a consequence missed much of the daily excitement surrounding the seminal Armory show. Returning to New York in the years 1914–1920 he continued his studies at the Independent School, the Art Students League, and briefly at the Woodstock Summer School. He had his first one-artist exhibition at the Daniel Gallery in January 1922, and continued to exhibit there until the gallery closed in 1931. He also exhibited his works in other major cities, including Philadelphia, Chicago, and Tokyo. From 1933 until he died, Kuniyoshi taught at the Art Students League and continued to exhibit his works—paintings, drawings, prints, and photographs. In 1948 he was the subject of the first ever one-artist exhibition to be organized by the Whitney Museum of American Art. Posthumous exhibitions of his work have been held at New York's Museum of Modern Art and Metropolitan Museum of Art, and at the National Museum of Modern Art in Tokyo.

56 *The Swimmer*, ca. 1924 31.196

Oil on canvas, 20½ x 30½ in. (52.1 x 77.5 cm.). Gift of Ferdinand Howald, 1931

The viewer who sees only a buoyant swimmer, a rocky island, and a rising sun illuminating a cloud bank overhead might well miss the subtleties in Kuniyoshi's *The Swimmer*. While it is thoroughly modernist in its stylized rendition and spatial manipulation, the picture also hints of precedents from ancient Egyptian and Assyrian bas reliefs in which swimmers or sea nymphs gambol among water weeds. Here as in the ancient examples the figure and architecture seem to float within a vacuous space having neither beginning nor end. And while the work is grounded in Western aesthetic traditions it also reflects a kinship with those of East Asia. Kuniyoshi's objects are suspended in a non-recessional space infused with subtle low-key colors in a manner reminiscent of eighteenth- and nineteenth-century Japanese landscape paintings.

Certainly there is mystery and perhaps fantasy in the artist's depiction of a swimming figure and her enigmatic relation to the island and the lighthouse. All are impossibly suspended on a celadon-colored ocean. Half-submerged, the generously proportioned swimmer peers at the spectator with large, exaggerated, almond-shaped eyes, apparently surprised to have been discovered at her balletic performance. The work is purposefully primitive in its execution, as are most works by the artist around 1925. The perspective view of the figure includes not only the top and bottom but one side as well. There is an aura of quietude and passiveness—unusual for a subject that seems to promise action—achieved in part by the swimmer's arrested motion, in part by the low-key palette. Unlike his contemporaries, such as Georgia O'Keeffe and Arthur Dove, who used color expressively, Kuniyoshi carefully selected and modulated his colors to focus attention on discrete compositional details while yet creating overall unity. The viewer takes a journey through the composition, first making eye contact with the unathletic, motionless swimmer, then taking in other elements of the composition one at a time, as one takes in a Japanese landscape.

Kuniyoshi's iconography is broad yet personal. The viewer can only speculate on the logic of this visual compilation of seemingly disparate parts. For the Western eye accustomed to accurate depictions of three-dimensional space, Kuniyoshi's space seems distorted and untrue. But it is as a blend of Eastern and Western, ancient and modern that the work succeeds. Kuniyoshi's remarkable achievement is unmatched in modern American art.

S.W.R.

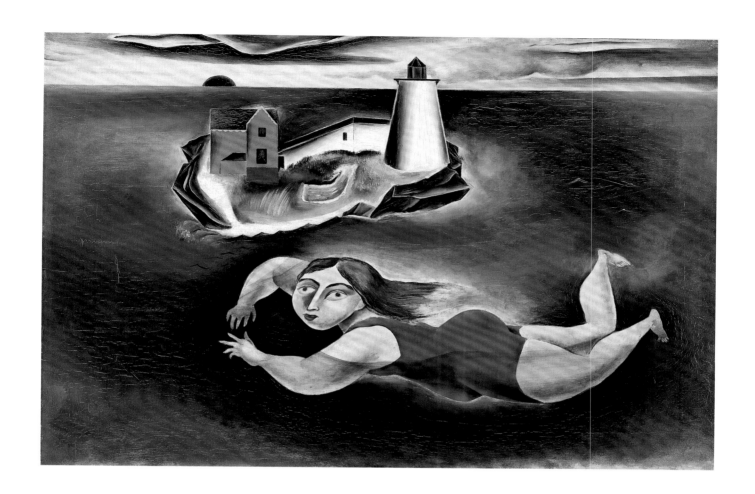

Paul Manship, 1885–1966

At the age of seven, Paul Manship began his studies at the Institute of Art in St. Paul, Minnesota, his hometown. He entered the Art Students League in New York in 1905, and later that year transferred to the Pennsylvania Academy of the Fine Arts. In 1909 he won the Prix de Rome, which enabled him to study at the American Academy in Rome. During his three years in Italy, he became absorbed in Classical art, especially stylized forms of Archaic Greek sculpture. He also studied the ancient sculptures of other Mediterranean countries, particularly Egypt. Manship returned to New York in 1912 and shortly thereafter held his first exhibition, a critical and financial success during which he sold nearly one hundred bronzes.

Throughout his career Manship worked predominantly in bronze, his fluid forms evoking the liquid origin of his chosen material. In the stylized rendition of mythological subjects he saw a way to infuse new vitality into modern art, somewhat as the Cubists had done in their adaptation of the simplified, geometric forms of African sculpture. In 1913, critic Kenyon Cox wrote of Manship's work: "To see this archaistic manner applied to figures with a quite unarchaic freedom of movement, doing things that no archaic sculptor would have thought of making them do, is oddly exhilarating."[1] Such subtleties, however, were probably not grasped by the general public, who knew nothing of the stylistic nuances separating Manship's archaism from more traditional neoclassicism. Instead, his works were appreciated both for their streamlined, modern appearance and their ties to ancient cultures. His work was so enormously popular that he maintained studios in both Europe and the United States to keep up with the demand. Manship's best known work probably is the Prometheus (1933), which he created for the fountain in New York's Rockefeller Plaza.

57 Diana, 1921 80.24

Bronze (cast 7), H. 37½ in. (95.3 cm.). Inscribed and dated on underside of leaves: Paul Manship 1921 © / No. 7. Foundry stamp on base: Roman Bronze Works N.Y. Museum Purchase: Howald Fund II, 1980

Manship's Diana is based on a mythological story recounted in Ovid's Metamorphoses in which Diana, the goddess of the hunt, transforms the young hunter prince Actaeon into a stag after he accidentally sees the virgin goddess at her bath. Diana then shoots and wounds Actaeon, who is immediately devoured by his own hunting dogs.

In this idealized depiction, Diana is armed as a huntress. Manship has chosen to portray her at the moment she has fired an arrow at her target, Actaeon. In one, smooth movement, Diana springs forward in graceful flight as she casts a backward look to determine the fate of Actaeon; her every move is echoed in the turned head and suspended leap of the dog. The dynamism of the figures is enhanced by their smooth tapering limbs. Only the vertical lines of the bow and the sinuous plant visually restrain the forward motion of the composition.

The museum's Diana is the first of several versions of the subject made by the artist between 1921 and 1925. In 1923, Manship made an Actaeon,[2] which was intended as a companion piece for the Diana. In the Actaeon, the hunter prince, sprouting stag's horns, reacts to the perfect marksmanship of the goddess with a strong, diagonal thrust of his body as two dogs leap to attack him. In both the Diana and the Actaeon, the influence of the artist's studies of Archaic Greek vase painting and sculpture can be seen in style as well as in choice of subject matter. There is, for example, an emphasis on silhouette, which tends to flatten the compositions, as do the incised linear details, which recall drawing more than modeling. In addition, the smooth, glistening surfaces and streamlined, mannerist poses make Manship's garden sculptures, such as Diana, and large-scale works and portraits elegant contributions to the Art Deco style, which perfectly reflects the prevailing popular taste of the 1920s and 1930s.

D.A.R.

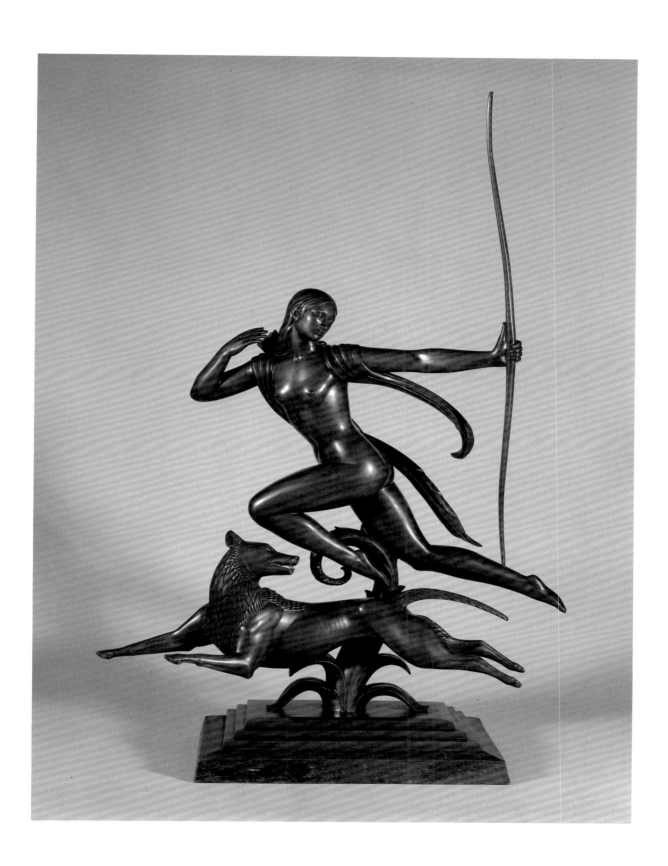

Charles E. Burchfield, 1893–1967

A romantic in spirit, Charles Burchfield was an American expressionist painter who responded deeply—even passionately and personally—to the landscape and to nature's moods and seasons. In general, during the early and late phases of his career he painted landscapes, and in between he portrayed the drab houses and industrial buildings of northeastern Ohio and Upstate New York. He often reworked earlier paintings. His chosen medium was watercolor but he also painted a few oils; only rarely did he combine gouache and oil, as he did in the museum's painting.

Born in Ashtabula Harbor, Ohio, Burchfield received his art education between 1912 and 1916 at the Cleveland School (now Institute) of Art. Henry G. Keller, one of Burchfield's teachers in Cleveland, nurtured the artist's love of nature and fostered his interests in contemporary painting, traditional Chinese and Japanese art, literature, and especially music. Early in his life Burchfield discovered the writings of the naturalist John Burroughs, whose fascination with the sights and sounds of the forest inspired the artist to attempt synesthetic effects in his art.[1]

Like his contemporaries, John Marin, Georgia O'Keeffe, and Edward Hopper, Burchfield concentrated on American places and the emotions they inspire. But in his interpretations, Burchfield often relied on remembrances of visual, emotional, and even aural aspects of a scene, adding imaginative touches to intensify the effect. He wrote:

> *The best work is done in retrospection. Even when working directly from nature, I am painting from memory, for not only am I trying to recapture the first vision or impression that attracted me (and which is all that is worth going after) but also the distillation of all previous experiences.[2]*

Burchfield's reverence for nature was profound, but in his art he was more concerned with the expressive possibilities of a scene than he was with representing appearances. He said:

> *While I feel strongly the personality of a given scene, its "genius loci" as it were, my chief aim in painting it is the expression of a completely personal mood.[3]*

58 *October*, ca. 1922–1924 31.116

Oil and gouache on paper glued to board, 31 x 42¾ in. (78.7 x 108.6 cm.). Signed lower right: C BURCHFIELD. Signed and dated on reverse: 2-October/Chas. Burchfield. Gift of Ferdinand Howald, 1931

Painted after Burchfield moved from Ohio to Buffalo, New York, in 1921, *October* is indicative of the artist's interest in the passage of time. Seasonal change is a recurring theme in his art[4] and was to him a subject of endless fascination:

> I love the approach of winter, the retreat of winter, the change from snow to rain and vice versa; the decay of vegetation and the resurgence of plant life in the spring. These to me are exciting and beautiful, an endless panorama of beauty and drama.[5]

A work from the middle phase of Burchfield's career, when his paintings were characterized by an interest in realistic imagery and representational details, *October* is unusual for its reliance on fantasy. Four galloping wild horses move mysteriously through a bleak forest setting in which barren trees and heavy clouds evoke the season. Vulture-like birds perch on high branches, adding a sense of foreboding. In this work Burchfield relies on the interplay between curving and angular forms and is particularly sensitive to the visual pacing of these elements. The trees are unevenly positioned; their varied diagonals play against the energetic curves of horses and clouds, suggesting the opposition of nature's unbridled forces. Burchfield's palette contributes to the dynamic effect: he juxtaposes warm oranges and cool blues to intensify the clash of curves and angles and perhaps to symbolize the yielding of the warmth of summer to the approaching cold of winter. Heavy lines, active brushwork, and strong value contrasts add to the raw vitality of the scene.

In *October* Burchfield delves beyond particular experience to embrace the visionary and mystical. In his intuitive expressions of nature's mysteries, he reveals his spiritual kinship with the transcendentalist philosophy of Ralph Waldo Emerson, but his fantasies are always subject to the natural scheme of things. As Burchfield said,

> The artist must come to nature, not with a ready-made formula, but in humble reverence to learn. The work of an artist is superior to the surface appearance of nature, but not to its basic laws.[6]

R.L.R.

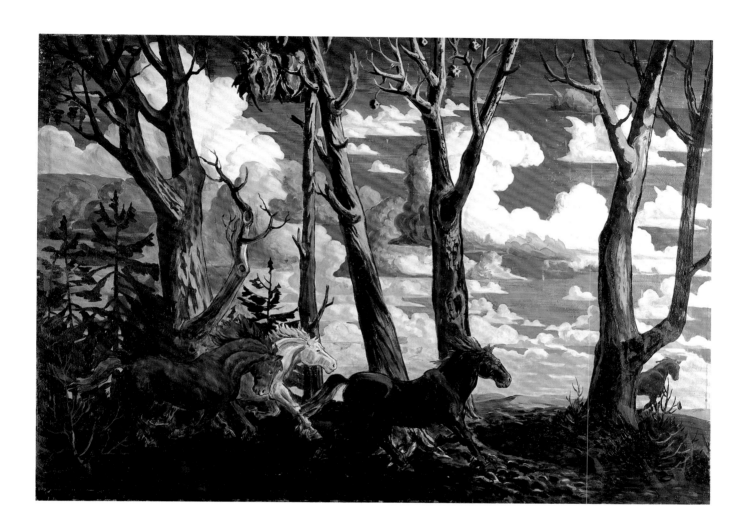

Guy Pène du Bois, 1884–1958

Guy Pène du Bois was born in Brooklyn, New York, to a Creole family still closely tied to its French heritage. Named after a family friend, the French writer Guy de Maupassant, Pène du Bois was raised in a sophisticated French literary environment; he did not speak English until the age of nine. In 1899 his father, writer and critic Henri Pène du Bois, enrolled him in William Merritt Chase's New York School of Art, where he began his studies under Chase. But it was the powerful influence of Robert Henri, who began to teach at the school in 1902, that made a lasting impression on the young artist. Henri's realist philosophy of "art for life's sake" became the foundation of Pène du Bois's own work.

Between the spring of 1905 and the summer of 1906, Pène du Bois studied briefly at the Académie Colarossi in Paris and privately with Theophile Steinlen. While in Paris he began to discover his own subject matter by sketching and painting scenes of fashionable cafe society. His keen interpretations of the spectacle of modern life very early earned him a reputation as a satirist in the tradition of Forain and Daumier, with whose work his was often compared. Throughout his career Pène du Bois focused on the international social set; capturing his subjects with cool detachment in revealing moments from their daily lives.

Pène du Bois supported his painting career through his activities as a writer and teacher. As an art critic for various New York newspapers and journals, he aligned himself with American modernism. In 1912 he joined the Association of American Painters and Sculptors and served on the publicity committee for the Armory Show. Pène du Bois, the critic, edited the special edition of Arts and Decoration commemorating the Armory Show; Pène du Bois the painter exhibited six works in the exhibition.

After the Armory Show he increasingly committed himself to the support of contemporary realism to the exclusion of other modernist trends. He resigned from the Association of American Painters and Sculptors but continued to be active in progressive circles. In 1917 he became a founding member of the Society of Independent Artists. Through his friendship with Gertrude Vanderbilt Whitney, he became a charter member of the Whitney Studio Club, which gave him his first one-artist show during its inaugural year in 1918.

His work as a critic left Pène du Bois little time to devote to painting during the early years of his career. It was not until the early 1920s that he developed the style that characterizes his mature works, a style that is dominated by solid, simplified figures that are minimally modeled. A critical five-year sojourn in France beginning in December 1924 presented Pène du Bois with his first opportunity in nearly two decades to concentrate on painting and to perfect his individual style.

59 *Woman Playing Accordion*, 1924 80.3

Oil on canvas, 48 x 38⅛ in. (122 x 96.8 cm.). Signed and dated lower right: Guy Pène du Bois '24. Acquired through exchange: Bequest of J. Willard Loos, 1980

Woman Playing Accordion was completed in the spring of 1924, before Pène du Bois returned to France for an extended stay. The essentials of his mature style can be seen in the attitude and distinctive stylization of the figure in this painting. The subject, a solitary musician, appears to be engrossed in a private performance. Lost in self-absorption, she gazes blankly into space. Shadows at the outer edge of the setting form a dark barrier between her and the outside world. The glare of the spotlight heightens the model's sense of physical isolation and emotional aloofness.

Despite the seemingly calm immobility of the subject, the painting abounds with visual tensions. The solidly modeled figure is placed slightly off center in the picture plane but in line with the edge of a blue shadow on the right-hand wall. This device, which draws attention to the musician's face, also acts to flatten the space, thrusting the figure forward. The woman's curving left arm functions visually to complete the back and arm of the chair. The heavily worked impasto of the flesh tones contrasts with the quickly applied brushstrokes that define the neckline of the sitter's dress and the shadow from the accordion strap, which add touches of spontaneity to the otherwise palpable stillness of the painting.

The work epitomizes Pène du Bois's ability to capture the essence of characters who conceal their emotions and personalities behind artificial masks of sophistication. In such works, the artist appeals to the reflective viewer to look beneath the facade, where the truths of their lives may be found.

N.V.M.

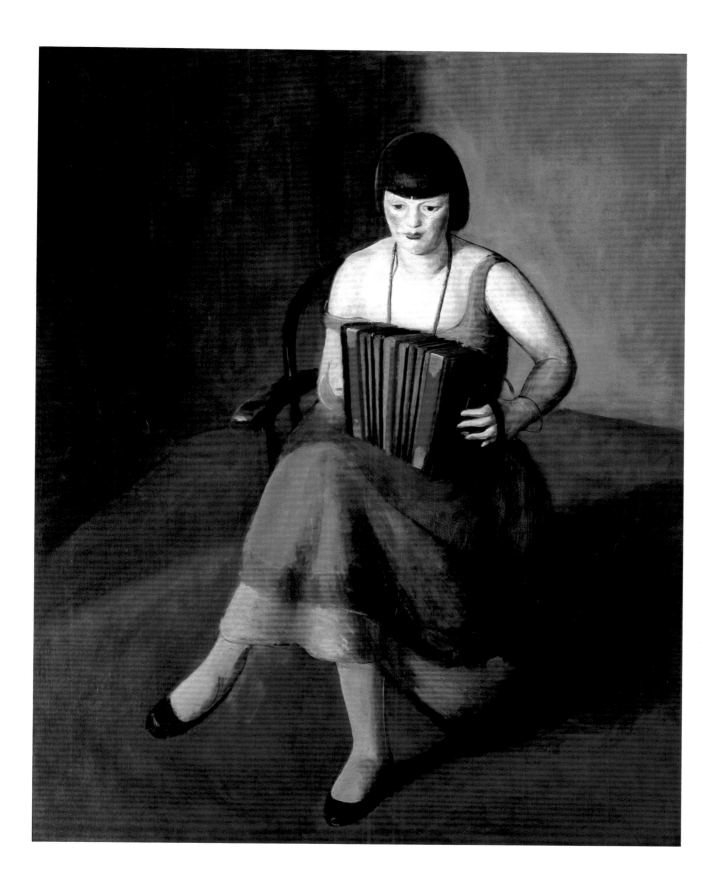

Peter Blume, born 1906

A Russian by birth, Peter Blume grew up in Brooklyn, where his family settled after emigrating in 1911. He studied art briefly between 1921 and 1925 in various schools in New York—the Educational Alliance, the Beaux Arts Institute of Design, and the Art Students League—before deciding to paint independently.

Blume first caught the attention of critics in 1934, when his picture South of Scranton (Metropolitan Museum of Art) was awarded first prize at the Carnegie International Exhibition of Painting, in Pittsburgh. The work drew both praise and derision, not unlike the critical response to much of the artist's subsequent work. In 1937 he completed his most famous work, The Eternal City (Museum of Modern Art), which is the product of his experiences in—and reaction to—Mussolini's Fascist Italy. The painting established Blume as a painter of expressive power whose thematic range includes statements of political and social protest, as well as mysterious and enigmatic subjects that border on the surreal. In his mature works he created conscious amalgamations of past and present, of memory and observation, meticulously painted to achieve the effects of fantastic realism.

60 *Home for Christmas*, 1926 31.109

Oil on canvas, 23½ x 35½ in. (59.7 x 90.2 cm.). Signed lower right: Peter Blume. Gift of Ferdinand Howald, 1931

Home for Christmas, one of Blume's earliest works, was painted in March 1926,[1] when the artist was nineteen. That same year, the picture was exhibited at the Charles Daniel Gallery and was purchased by Columbus collector Ferdinand Howald. Showing foresight and an eye for originality, Howald was the first prominent collector to purchase a work by Blume.[2]

Years after he painted *Home for Christmas*, Blume recalled that he had spent the winter of 1925–1926 in Northampton, Massachusetts, the home of Smith College. Intrigued by the college town atmosphere,[3] he chose to depict a young woman, perhaps from the college, attired in proper riding habit and silhouetted against a flat geometric landscape. The crisp, simplified forms reflect the influence of Precisionism. Blume and others in the Daniel Gallery milieu who painted in the Precisionist style (Charles Sheeler, Preston Dickinson, Charles Demuth, and Niles Spencer) saw physical realities as geometric forms which they could manipulate at will in their paintings. Blume has here created a painting of surprising visual and spatial complexity. Some elements of the design in effect flatten the composition: the sloping roof line of the building in the right foreground is continuous with the ridge line of the snow-covered mound in the background; and the crest line of the blue mountain in the distance is a continuation of the roof line of the tallest building. Other elements, however, combine to reestablish an implication of depth: the juxtaposition of receding and advancing colors, the subtle modeling of certain facades, and some unexpected passages of impasto.

The figures in the painting (unusual in a Precisionist work) and the flatness of the overall pattern suggest the additional influence of European and American primitive and naive art. Both horse and rider appear to be paper-thin cutouts. They float on the white surface, neither leaving footprints in the snow nor casting shadows, anchored to the landscape only by the tree silhouette and the slope that almost coincides with the top of the young woman's head. The horse, with its slightly pinched smile and arched eyebrow, gazes directly at the viewer like a fanciful hobby horse.

As a mature artist Blume developed a reputation as an exceptional technician and craftsman. His compositions evolved slowly, over a period of several months, through a series of sketches and studies. This process of methodical experimentation is apparent even in the early work *Home for Christmas* in which several pentimenti are visible. The most striking pentimento is the ghostly left rear leg of the horse, which Blume originally included and then painted over. His painstaking underdrawing is also clearly visible, especially in the contour of the young woman's chin and the four-finger hand holding the reins. According to Blume:

> The "idea" for a painting, even if you see it in your mind completely, goes through innumerable transformations. It goes through, in a sense, the process of being and becoming. Its state of being is determined by its own needs, while its state of becoming is related to some future work dimly visualized.[4]

There is a subtle disquiet in the silent, suspended world of *Home for Christmas* which is prelude to the mysterious power in Blume's later work. The disjunction between the lively figures and the stylized architectural backdrop becomes, in later works, a more conscious compilation of representation and abstraction. This early scene, however, is informed by simplicity and an inner cohesion seldom found in the artist's later compositions.

N.V.M.

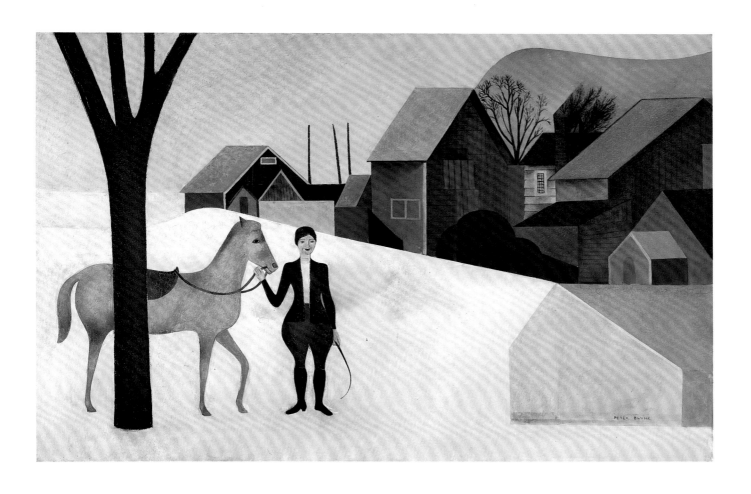

Elijah Pierce, 1892–1984

Elijah Pierce never had a lesson in woodcarving and never thought of himself as an artist, yet he created more than one thousand boldly carved and brightly painted wood sculptures which today are acknowledged as a significant contribution to American folk art.

Pierce was born in 1892 near Baldwin, Mississippi "in a log cabin, right out almost in the cotton field."[1] The son of a former slave and one of nine children, Pierce grew up on his father's farm. He did not like farming and left home as a young man "to see the bright city lights,"[2] traveling extensively in the South and Midwest before settling in Columbus, Ohio, in 1924. A licensed minister, Pierce resisted the ministry as a full-time profession and chose instead to be a barber. He established his own shop in 1954 at 534 East Long Street, only two blocks from the art museum.

Even as a child Pierce loved to whittle, first carving figures and animals into the bark of trees and later fashioning walking sticks from wood. He began carving in earnest in the 1920s when he made an elephant as a gift for his wife. She was so pleased that he created a zoo for her. And he kept on carving—works inspired by pictures, comic strips, stories, songs, sermons, and events of everyday life. By the 1930s, most of his carvings were based on biblical and religious subjects.

Pierce's powerful carvings were discovered quite unexpectedly in 1971 at a Y.M.C.A. exhibition in Columbus. Since his first exhibition at the Ohio State University that same year, his works have been included in solo and group exhibitions in New York, Washington, Philadelphia, and Columbus. In 1973, he won first prize at the International Meeting of Naive Art in Zagreb, Yugoslavia. In 1980, at the age of 88, he received an honorary Doctorate of Fine Arts from Franklin University in Columbus. The National Endowment for the Arts in 1982 awarded him a National Heritage Fellowship as one of fifteen master traditional artists.

61 *Crucifixion*, mid-1930s 85.3.1

Carved and painted wood mounted on panel, 47½ x 30½ in. (120.65 x 77.47 cm.). Signed lower right: E. P. Pierce. Museum Purchase, 1985

Crucifixion, created in the mid 1930s, is today counted among Pierce's masterpieces. The work consists of more than forty carved and painted figures, trees, flowers, and other objects. In its original form it was a tableau much like a stage set, with freestanding figures arranged on six levels of narrow step-like ledges.[3] Later, Pierce decided to mount the figures on a panel, two thirds of which is painted blue, a color that symbolizes both sky and heaven. The lower third of the panel is painted a brilliant red, the color of blood, martyrdom, and hellfire, which are traditionally associated with the Passion of Christ.

The apparently random distribution of figures across this colorful field has been carefully calculated by Pierce. The main characters of the story are aligned in the form of a cross—the primary symbol of the Passion. Centrally placed against the heavenly blue are the figures of Christ and the two thieves who were crucified with him. The vertical axis is formed by three elements: the cross, which is superimposed on a tree sparkling with glitter; a grief-stricken woman who kneels with hands raised in prayer; and Satan, his feet planted firmly in the red ground, sporting horns and a pointed tail and brandishing a sword and pitchfork. Many other characters from the Passion story are carefully woven into the composition. Blacksmiths forge nails for the cross, a centurion pierces Christ's side with a spear, and Mary, the mother of Christ, is comforted by the Apostle John. The drama is proclaimed an event of cosmic proportions by the presence of a crescent moon raining blood and the black, eclipsed sun, which withheld its light from the earth at the moment of Christ's death.

Though the composition is complex and the figures are many, Pierce's personal vision is direct and powerful. In addition to the Gospel accounts of Christ's sacrificial death, the artist includes symbolic allusions to the biblical themes of good and evil, sin and salvation. Christ's cross is grafted to the Tree of Knowledge of Good and Evil, from which Adam and Eve partook of the forbidden fruit. Satan, in a modern suit, stands with his arms outstretched, ironically imitating Christ's pose, yet seeming to gesture in triumph. Two seated figures gamble with dice, like the soldiers nearby who cast lots for Christ's robe. These visual parables emphasize the human aspects of the religious events, and are the instruments of Pierce's preaching.

Crucifixion is one of the greatest of the "sermons in wood." Though Pierce was only a preacher occasionally, he atoned for his reluctance to preach through his vocation as a woodcarver. He explained: "I ran from the ministry. I had a calling to preach, so God put me on the woodpile. I have to carve every sermon I didn't preach. Even after I'm dead I'll still be preaching these."[4]

E.J.C.

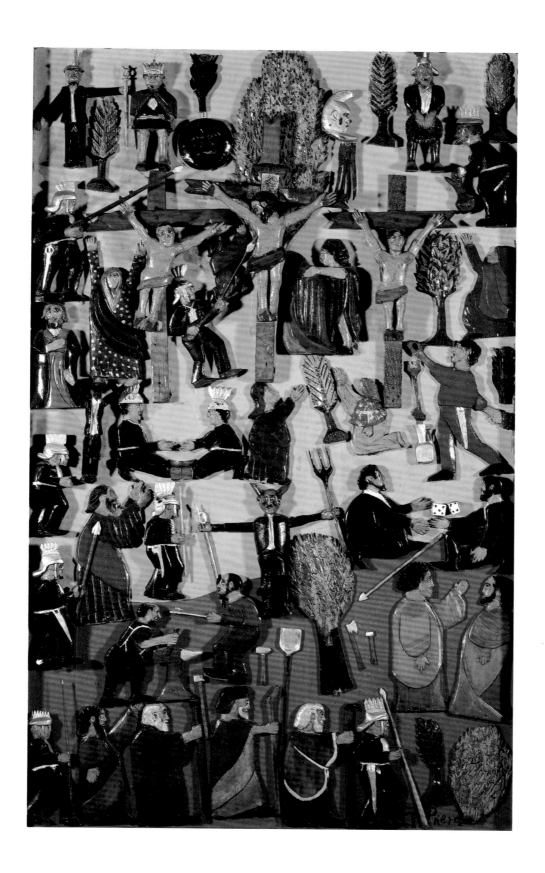

Reginald Marsh, 1898–1954

Reginald Marsh was born in Paris to American parents, both of whom were artists. The family returned to the United States in 1900, and lived first in Nutley, New Jersey, then in New Rochelle, New York. Marsh entered Yale University in 1916, and began art studies in his senior year. Throughout his college years he was a popular illustrator for the Yale Record. *He graduated in 1920 and moved to New York City, where he did freelance illustration for* Vanity Fair *and* Harper's Bazaar. *He took courses at the Art Students League, working under John Sloan and George Luks, among others. In 1922 Marsh was hired as an artist for the* New York Daily News; *in 1924 he joined the staff of the newly formed* New Yorker *and continued to be a contributor for the next seven years. His first one-artist show was held at the Whitney Studio Club in 1924.*

A major factor in the development of Marsh's art was his sojourn in Europe from 1924 to 1926, when he copied works by Rubens, Delacroix, Titian, and Rembrandt and was inspired by their masterful execution of form and anatomy. When he returned to New York, he studied with Kenneth Hayes Miller, who shared his interest in the old masters. At the time, Miller was painting subjects observed in the neighborhood of his Fourteenth Street studio—in one of the less fashionable areas of the city. Marsh adopted the same subjects, rendering them according to his own vision. His paintings express the vibrant, animated quality of New York city life and continue the tradition of realism advocated by The Eight. *In their spontaneity and caricatural style they also reflect Marsh's experience as a newspaper artist.*

62 *Hudson Bay Fur Company*, 1932 56.1

Egg tempera on muslin mounted to particle board, 30 x 40 in. (76.2 x 101.6 cm.). Signed and dated lower right: Reginald Marsh 1932.
Museum Purchase: Howald Fund, 1956

The subject of *Hudson Bay Fur Company* is a provocative scenario performed by live models in an overhead window of a shop on Union Square. A sign below the window indicates the establishment had a Broadway entrance. Fashion shows such as that pictured here were often presented by the Hudson Bay Company furriers. Women passing by may have looked up at the window with the dream of owning an inexpensive fur in the midst of the Depression, but the power of the scene lies in its appeal to male voyeurism. As these buxom young models display the furs, they become objects of consumption themselves. Heavy black brushwork emphasizes their curvaceous figures in clinging dresses. Marsh recalled that "the girls were beautiful, and attracted considerable attention before [a] lower sign was put on to obscure their ankles and thighs."[1]

All of this is very like burlesque, a favorite subject of Marsh's because he considered it one of the few forms of entertainment accessible to the poor man. In Marsh's work, modern gods and goddesses reveal their heroic proportions to the strollers of Fourteenth Street. The elevated placement and monumental form of the figures in *Hudson Bay Fur Company* and the close vantage point, which would be impossible from the street below, are elements of distorted reality. Bodies and faces are idealized and sexual attributes greatly exaggerated; the subjects seem larger than life. A 1930s fantasy, the work evokes memories of the film posters plastered everywhere in New York and the films themselves that provided momentary escape from the hard times of the Depression.

The visual power of this painting owes as much to Marsh's passion for drawing strong outlines as it does to textural brushwork and a rich buildup of thin washes of color. Also apparent is the artist's command of anatomy, which he studied at the College of Physicians and Surgeons in New York in 1931 and at Cornell Medical College in 1934. To enliven the setting, Marsh uses strong diagonals and offsets the blue dress worn by the model in the center with the yellow skirt of another model and accents of green and gold. This work is in tempera, a medium Marsh used extensively throughout his career. He found that tempera lent itself to layering, had sufficient body for a rich, textured surface, and was capable of the subtle translucency of watercolor.

Marsh also photographed a display-window fashion show and, in 1940 painted a watercolor, *Modeling Furs on Union Square* (private collection, New York), which includes a window washer cleaning the outside of the showroom glass. Among the numerous other signs and nearby buildings portrayed in this version, the window with posed models is just one of many visual stimuli.

To be nearer to his favored subject matter, Marsh established his studio on Fourteenth Street in 1929, and eight years later, in 1937, he moved the studio to 1 Union Square, even closer to the vicinity of the Hudson Bay Fur Company.

D.A.R.

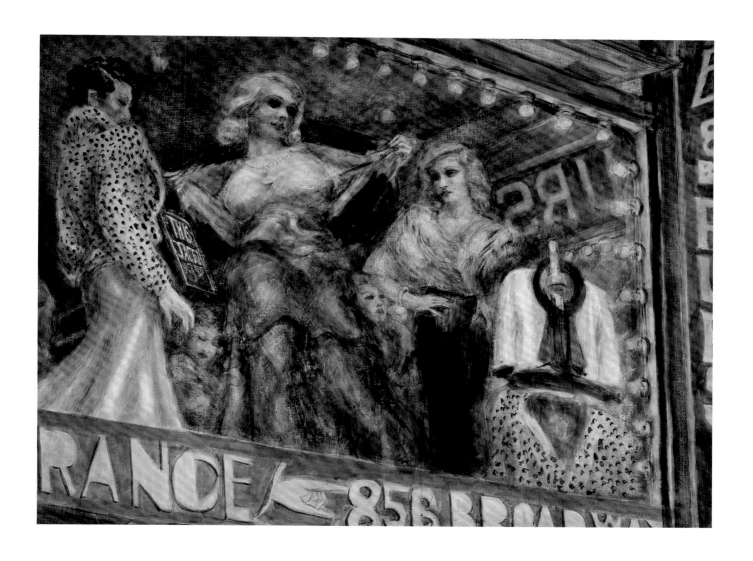

Walt Kuhn, 1877–1949

Two significant circumstances that influenced Walt Kuhn's life as an artist were his involvement in the organization of the 1913 Armory Show and his work in circuses, vaudeville, and stage reviews. The first was the culmination of his immersion in modern European art, and the second provided him with his favorite subject matter.

Kuhn began his artistic career as a cartoonist and subsequently studied in such conservative institutions as the Academy of Fine Arts, Munich, and the Académie Colarossi, Paris. With his contemporaries he shared an enthusiasm for Velázquez and Hals among the old masters. Kuhn typified the art-historically conscious artist, a phenomenon

increasingly apparent from Manet on, and it was his openness to many stylistic currents that initiated his responses to modernist art.

As one of the prime movers in the realization of the epochal International Exhibition of Modern Art *(the Armory Show of 1913), Kuhn was most responsible for the remarkable representation of works by Matisse. In addition, he responded to the works of Cézanne, about whom he wrote an intelligent essay published in conjunction with the exhibition, and to the works of Van Gogh, whose landscape style was echoed in one of Kuhn's own paintings in the exhibition.*

63 *Veteran Acrobat*, 1938 42.84

Oil on canvas, 24 x 20 in. (61 x 50.8 cm.). Signed and dated upper right: Walt Kuhn/1938. Purchased by special subscription, 1942

Veteran Acrobat, a late work, reflects the impact of European modernism on American art. The contrast of the broad, immobile mass of the sitter's head with the linear verve of the embroidered costume and the compression of the whole into a shallow space recalls Matisse, though Kuhn never permitted himself to flatten forms to the degree that Matisse did. The solemnity of the head with its dark brown pools of eyes is reminiscent of some of Cézanne's figures, but there is no hint of Cézanne's obsessive exploration of surface tensions. Instead, the acrobat's passive pose suggests reticence or stoicism. His volumetric, trapezoidal head and somewhat two-dimensional torso (only its vivid green and silver pulls it forward), both almost frontal, are blocked in and restricted by the frame as the subject confronts the viewer.

Kuhn's fascination with circus people follows an honored artistic tradition with roots in the Italian *commedia dell'arte*. The characters are archetypes of the human condition, borrowed by many artists outside the Italian comedy. Very often the subjects are performers—understood to represent all creative artists—whose true selves are concealed by costumes and masks, entertainers who must be entertaining regardless of their inner condition or the mood of the times.

Kuhn's model, the Italian acrobat Mario Venendi, embodied just such conflicts. A veteran of the First World War, Venendi was still morbidly affected by his wartime experiences.[1] Kuhn's representation of the hieratic, hypnotic rigor of Venendi's face conveys these undercurrents, while the archaic symmetry of the whole combines with striking economy of means to achieve a somber dignity. Unpretentious, not too insistent, the work is a Kuhn triumph, a vibrantly painted complex of meaning and emotion.

W.K.

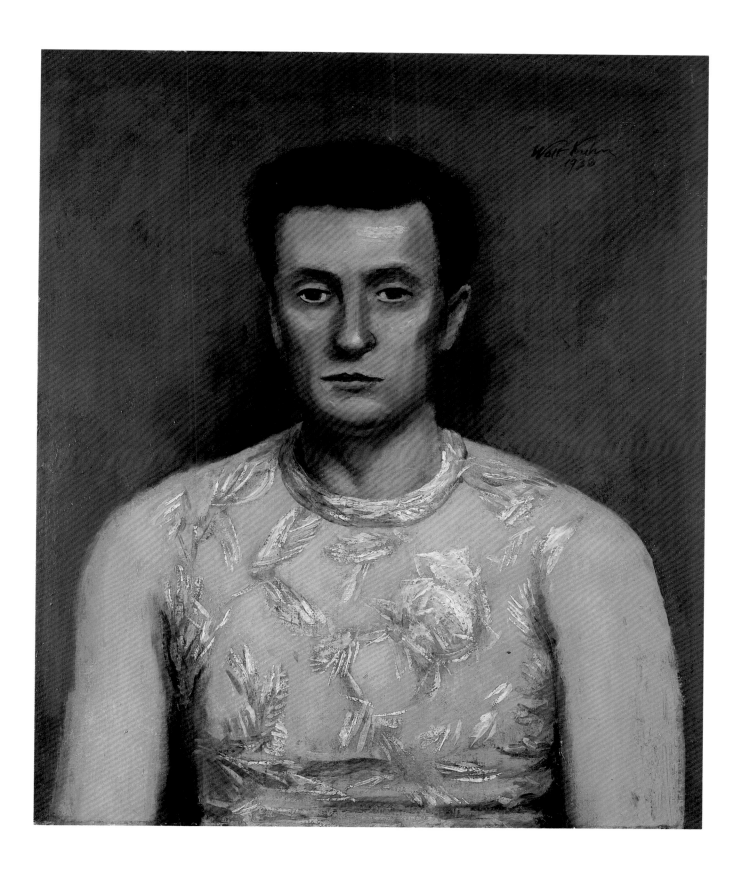

Alfred Maurer, 1868–1932

"I admit," confided Alfred Maurer in a rare statement about his art, "that for the moment I am all in doubt. I believe that I saw right before, but I am equally sure that I see right now. I can't explain the difference."[1] *As an expatriate in Paris in 1908, Maurer expressed a cautious but confident excitement about his conversion to European modernism. Like many American artists of the early twentieth century, especially those studying in European cultural centers like Paris and Munich, Maurer stood at the crossroads of a wide range of artistic styles and concepts. In his mid-thirties, he chose to leave the security of a promising career in traditional painting to follow the revolutionary innovations of Cézanne, Matisse, and later Picasso. Maurer, it was said, produced "the first real painting seen from an American brush."*[2]

Alfred Maurer was born in New York City in 1868—one year before Matisse, thirteen years before Picasso, and more than a decade before Arthur Dove, Stanton Macdonald-Wright, and other pioneering American modernists with whom he later associated. Maurer worked first in the family's lithographic business and studied art in his spare time at the National Academy of Design under Edgar Ward. In 1897, he left for Paris, where he lived until 1914, studying briefly at the Académie Julian and thereafter working alone, inspired by the works of Hals and Velázquez, and those of fellow Americans Sargent, Chase, and Whistler. He exhibited at the Paris Salon in 1899 and 1900 and won important prizes in the United States in the early twentieth century. Despite his successes, Maurer decisively changed his course between 1905 and 1907, probably as the result of his friendship with Leo and Gertrude Stein and his introduction to the paintings of Cézanne. His works began to reflect the emphatic brushwork and bold color and design he had observed in the works of the Fauves, while retaining a strong sense of Cézannesque structure. Maurer first exhibited his modernist works in 1909 in a joint exhibition with John Marin at Alfred Stieglitz's 291 gallery.

The outbreak of World War I forced Maurer to return home. He remained in New York for the rest of his life, maintaining and expanding his modernist vision in the face of conservative criticism and an often unsympathetic public. On August 4, 1932, Alfred Maurer committed suicide by hanging. Only after his death was he hailed as a leader of American modernism. As a New York art critic said in 1937: "Alfred Maurer is dead but his pictures are still asking questions."[3]

64 *Still Life with Red Cheese*, ca. 1929–1930 83.30

Oil on board, 18 x 21¾ in. (45.7 x 55.2 cm.). Signed lower right: A. H. Maurer. Acquired through exchange: Gift of Ione and Hudson D. Walker and the Howald Fund, 1983

Maurer began to paint still lifes perhaps as early as 1908. Some he painted with a rich, vibrant impasto; others he executed with thin glazes and muted tones; in still others he explored the transparent nature of gouache.[4] The representative still lifes he produced through the mid-1920s reflect an affinity with works by Matisse, Vlaminck, and other Fauve painters, and show the artist's receptiveness to the early Cubism of Picasso and Braque. Ultimately, however, it was the sculptural concerns of Cézanne that continued to challenge Maurer's imagination.

From 1928 to 1932 Maurer painted a distinguished group of abstract still lifes which were probably his most significant contributions to American modernism. *Still Life with Red Cheese*, one of these works, probably dates from the first half of this period.[5] It shows Maurer's full understanding of Synthetic Cubism and his delight in its pictorial syntax. A tabletop subject, it is founded on the geometric structure of a series of rectangles, triangles, and circular shapes. Consistent with Cubist vocabulary, the space is radically compressed, with the tabletop tilted forward to emphasize the flatness of the picture plane. Specific architectural elements such as sill, molding, and column have been reduced to bold outlines. The fluting of the column and the checkered patterning of the napkin add implications of texture, while the shadows—echoing both the angular forms of the table and napkins and the abundant curves of the braided bread—take on a lively, decorative existence of their own.

In brilliantly colored works like *Still Life with Red Cheese*, Maurer's love of painting is particularly evident. He drew with paint and modeled form with color. Pigments applied in a rich impasto are made more luminous and the objects given more substance through the use of transparent and semi-transparent glazes: for example, in the center of the picture, green-tinted glazing over the braided bread gives the effect of illumination through a stained-glass window. Perhaps symbolically, Maurer praises the act of painting by lending physical reality to the positioning, layering, and overlapping of one form and substance with another. He also celebrates the act of seeing, for the shift of opaque to glazed areas of color modifies the viewer's perceptions of surface and depth—at once "dissolving" the picture plane while also asserting its tangible presence.

In their completeness and resolution, Maurer's late still lifes surpass all his other works. The best liked and least controversial, they received critical praise during his lifetime and are still highly favored today.

<div align="right">E.J.C.</div>

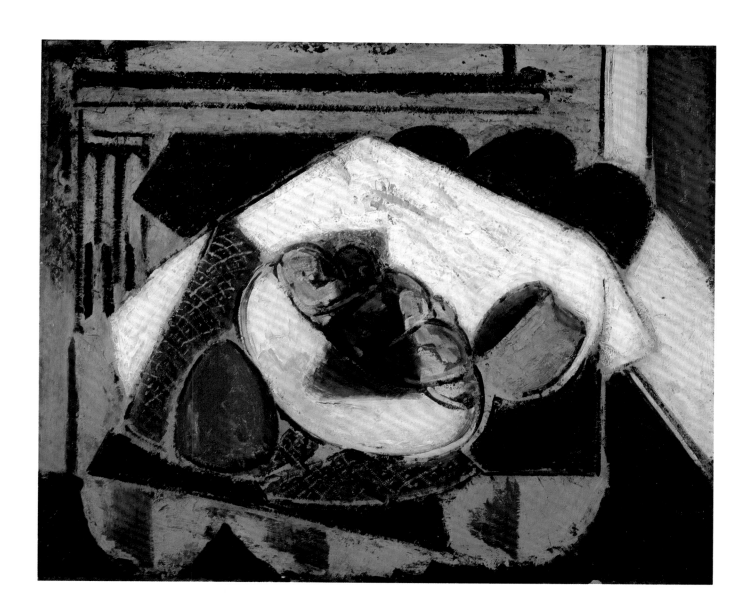

Stuart Davis, 1892–1964

Stuart Davis was born in Philadelphia, where his father was art director for the Philadelphia Press. *He grew up in a milieu that included American realist painter Robert Henri and newspaper illustrators John Sloan, George Luks, William Glackens, and Everett Shinn. After high school, he went to New York City to study with Henri. Although Davis's Cubist-influenced style is very different from Henri's, there is in his work an emphasis on the signs, colors, and rhythms of the urban environment that owes much to Henri's teaching.*

By 1913, Davis was contributing cartoons to Harper's Weekly *and* The Masses *and was one of the youngest exhibitors in the Armory Show, an exhibit that influenced him profoundly. The nonreferential color and simplified forms he saw in the works of Matisse, Van Gogh,*

and Gauguin were particularly inspiring, as he had already begun similar explorations. Confirmed in his purposes by these examples, he resolved "quite definitely . . . to become a 'modern' artist."[1]

His first solo exhibit was held in New York in 1917. In 1921 he experimented with collage and simulated collage, incorporating such elements as cigarette papers and advertising labels, and by 1922 he was investigating the multiple views and overlapping color planes of Cubism. In Paris for a year beginning in 1928, he studied the origins of the Cubist style, and absorbed the images of the city that appear in many of his works. Of the Parisian Cubists, he admired Fernand Léger for his emphasis on bold color and stylized forms.

65 *Landscape with Drying Sails*, 1931–1932 81.12

Oil on canvas, 32 x 40 in. (81.3 x 101.6 cm.). Signed top right: Stuart Davis. Museum Purchase: Howald Fund II, 1981

Landscape with Drying Sails was painted after Davis returned from Paris, during one of the many summers he spent in Gloucester, Massachusetts, between 1915 and 1934. The composition records a series of mental images—a dockside jumble of ships, sails, and buildings—gleaned from a long acquaintance with the picturesque seaside community. When asked to comment on the painting, Davis wrote:

> All that comes to mind is that I spent a great many years in Gloucester, Mass., always found it visually exciting, and eventually learned to organize some of this response in terms of Color-Space configurations. This picture, "Drying Sails," along with others of the same years after my return from one year in Paris, objectifies my intuitive preferences for certain aspects of that then exciting panorama. What is communicated of course has little or no factual content but is nevertheless directly referential to the Gloucester locale. The method of expression, the colors and shapes, were product[s] of experiences in life and art that were not confined to my Gloucester residence. In that sense the painting is not a "Gloucester" painting. But although the "Idea" in this painting is non-local in character, its application is realized in relation to a specific Gloucester subject matter. It has New York, Philadelphia, and Paris in it too, but remains Gloucester.[2]

Although Stuart Davis's images are recognizable, they do not mirror reality. In landscape scenes such as the museum's painting, Davis's forms are unmodulated and two-dimensional, obedient to a pictorial logic that relies on form and color relationships and on paint and canvas rather than on the external appearance of the subject matter. In spite of the presence of linear perspective in portions of the picture, there is little feeling of depth. The images advance and recede according to the artist's design and based in part on his choice of colors, but for the most part they seem to be flattened against the picture plane. Davis insisted that a painting should have a life of its own, equal to that observable in nature. Painting to him was "the extension of experience on the plane of formal invention."[3]

Sign imagery is a familiar aspect of his work and an important precursor to the commercial focus of Pop Art. He often made witty use of partial messages abstracted from the clutter of an urban environment. Here a sign on a building offers a tantalizing, because incomplete, explanation of the building's purpose. A preparatory sketch (private collection) for the painting shows the complete lettering to read, "Net and Seine Loft."

Landscape with Drying Sails exemplifies Davis's strong preference for representative American subject matter while at the same time it resounds with the influence of European modernism. In this Davis had few, if any, peers.

D.A.R.

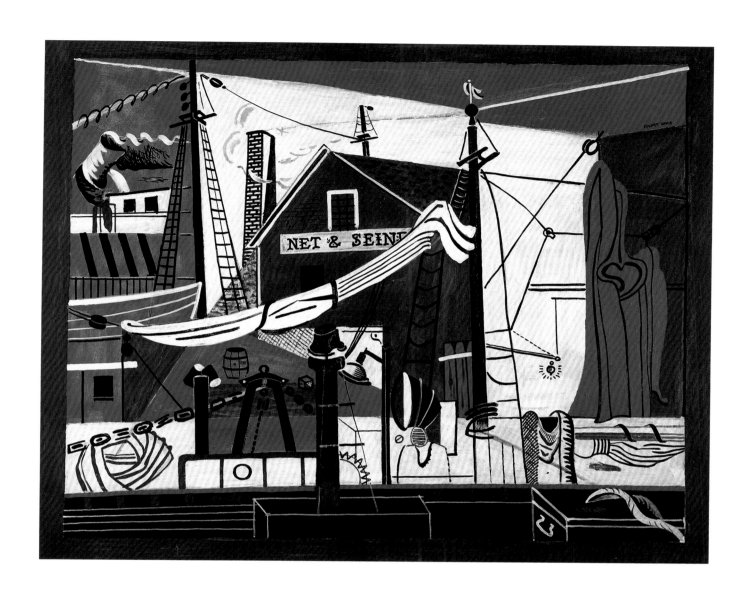

Lyonel Feininger, 1871–1956

In 1887, Feininger, who was born in New York City, returned to his parents' homeland, Germany, to study violin. Despite intentions to return to New York, he remained in Germany for fifty years, but he did not become a violinist. Disregarding the example of his parents, both professional musicians, Feininger turned to the study of art. He became proficient as a caricaturist and began a career as a political cartoonist. Having taught himself to draw, he said, "I am prouder of that fact, and take more pleasure in pen drawing than anything else."[1]

His delight in drawing remained constant throughout his life, and he achieved extraordinary subtlety and judgment in the use of line. Combining his drawing skills with an early fascination for watercolor effects, he had the technical elements of his mature art ready and waiting when at last he turned his attention solely to painting. There remained only an encounter with Cubism to complete the equation. That occurred in 1911 on his third visit to Paris.

In that Spring I had gone to Paris for two weeks and found the art world there agog with cubism—a thing I had never heard even mentioned before, but which I had already striven after for years. . . . [In] 1912 I worked entirely independently, striving to wrest the secrets of atmospheric perspective and light and shade gradation, likewise rhythm and balance between various objects, from Nature.[2]

His version of Cubism was unlike that of the French painters, whose works he said, "verge into chaotic dispersal of form."[3] *Though his objects are always recognizable, there can be no doubt that it was French Cubism—specifically, the art of Robert Delaunay—that crystallized his own artistic vision. With Delaunay he shared interests in the emotional aspects of color and in architectural subject matter. His works are characterized by the use of lines threading surely through washes of color (watercolor or oil). From Analytic Cubism he assimilated the devices of transparencies and overlapping and interpenetration of atmospheric planes or facets. When Feininger was forty years old, his style was whole; as he aged, his style became increasingly poetic and contemplative.*

66 *Blue Coast*, 1944 51.13

Oil on canvas, 18 x 34 in. (45.7 x 86.4 cm.). Signed upper left: Feininger. Museum Purchase: Howald Fund, 1951

In 1937, after his work was banned by the Nazis and included in the infamous Degenerate Art Exhibition in Munich, Feininger returned to the United States. Seven years later he painted *Blue Coast*, an almost archetypical example of his late work which also demonstrates the expressive possibilities of Cubism. It is less concerned with the formal analysis of objective reality than "with the problems of awareness, recollection and nostalgia," for, as the artist has said, "longing is the impulse and mainspring of creative achievement."[4]

Feininger had drawn and painted ships, especially sailing ships, all his life, made and sailed models of them, voyaged in them, and obviously regarded them in a fundamentally symbolic way in his art. In *Blue Coast* his ghostly fleet is sparse. A full-rigged ship dominates the left background, two smaller sailing craft are in the foreground, and a distant boat at the right is marked only by a black sail. The riggings are drawn with a taut linearity, like the strings of a violin. Their vibrations are visible in the sky, where the lines of the masts mark tonal shifts from dark blues to lighter blues. Together with the horizontals of the hills and water, these lines give rhythmic order to the surface of the composition.

At times a sponge or other tool seems to have been used to blot the paint, its imprint becoming part of the surface pattern. Elsewhere, thinly brushed orange and blue pigment over a pale cream primer give the effect of a watery atmosphere. Such improvisatory handling of paint lends an element of spontaneity and immediacy to the work. But Feininger's lyrical seascape is not so much an impression of a fleeting scene as it is a recollection drawn from the depths of the artist's life and experience and grounded in innumerable visual memories.

W.K.

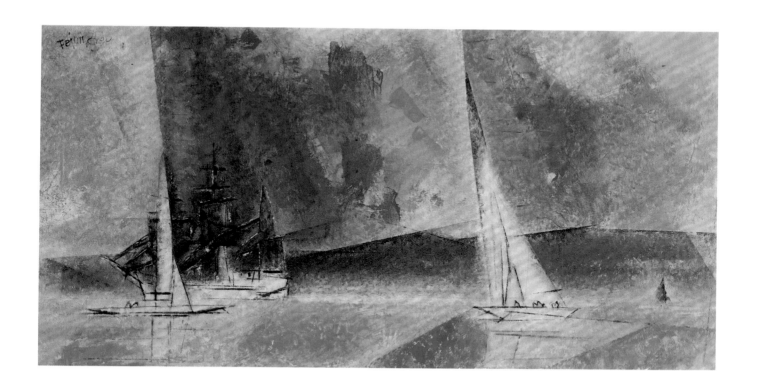

Edward Hopper, 1882–1967

Born in Nyack, New York, Edward Hopper began the study of art as a teenager through the Correspondence School of Illustrating. He also spent six years at the New York School of Art, where he was taught by Kenneth Hayes Miller, Robert Henri, and William Merritt Chase. Supporting himself as a commercial artist, he spent as much time as possible painting. He was included in the first Exhibition of Independent Artists, organized by Henri in 1910. He visited Europe twice, once in 1906 and again in 1910, spending time in London, Holland, Spain, Berlin, and Paris. In Paris he absorbed influences of French Impressionism, which appear in his paintings of 1907 to 1909. Back in the United States to stay, he established a home and studio at 3 Washington Square North in Manhattan, where—except for summers in New England—he remained for more than half a century.

The fixed and steady nature of Hopper's residence was a reflection of his tenacious character, which in turn is reflected in his unswerving, coherent style and fascination with clearly delimited, though infinitely resonant, subjects. His mature style was formed by 1924, the year of his marriage to painter Josephine Nivison and of the first financially successful exhibition of his paintings. From the late 1920s Hopper exhibited in major museums nationwide, including the Whitney Museum of American Art, which organized two retrospective exhibitions, one in 1950 and another in 1964.

67 *Morning Sun*, 1952 54.31

Oil on canvas, 28⅛ x 40⅛ in. (71.4 x 101.9 cm.). Signed lower right: Edward Hopper. Museum Purchase: Howald Fund, 1954

> The morning comes to consciousness
>
>
>
> One thinks of all the hands
> That are raising dingy shades
> In a thousand furnished rooms.
>
> T.S. ELIOT, *Preludes*

Edward Hopper's people pass their time, more often than not, in waiting. For the night to end, for the day to begin, for arrival, for departure, for something to happen. His women, especially, frequently face intently into the sun, which often has more of brightness than of warmth, and they face it impassively, without pleasure.

In *Morning Sun*, painted in February 1952, according to the artist's notebook,[1] a no longer young woman (probably the artist's wife Josephine) sits stiffly, almost primly, on a bed facing—without seeing, one feels—an open window. All that is seen of the city outside is the top of a neighboring building reminiscent of that in other Hopper paintings, such as *Early Sunday Morning* (Whitney Museum of American Art) and *Room in Brooklyn* (Museum of Fine Arts, Boston). High above the street, the room is a barren enclosure.

Much of the pressing sense of confinement we feel in the presence of this woman is the result of her placement and pose. Her flattened, tense face lies almost on the vertical midline of the painting; her chin marks the horizontal crossing, effectively locking her in place. The most striking manipulation of her pose is in her left arm, which is illogically concealed; only the left hand is visible. So, too, the heel and toe of the left foot appear, though the left leg below the knee does not. This suppression of the left side is contrary to visual logic since our viewpoint is slightly to the left of the woman. We see part of her back and the underside of the right leg; we should also see the lower contour of the left leg. These rigorous adjustments or suppressions of reality project a disturbing tension.

So also the palette, which is based on altered primary colors, presents a litany of opposing and balancing color. The reds are shifted toward pink or purple. Yellows and blues are mixed for an extraordinary range, from the sunlit and shadowed green of the wall to the dark emerald window shade, to a gamut of saturated greens and pale or deep blues in the vertical strips of window molding. Even the woman's cream-colored flesh is modeled with yellow, blue, violet, and green; her warm pink hand is set off by dark red shadows (the color also of the shadowed left heel).

Similarly, the geometric design of the canvas presents its own contradictions. The triangular form of the woman in a light-defined rectangular space, for example, projects an obstinate passivity. This varied world of the painter's imagination, encompassing both harmonies and dissonances, is used to project the tensions Hopper sees in his subject: a woman alone and unoccupied in a busy city. Of inner currents there is no lack, for as Hopper knew so well "the inner life of a human being is a vast and varied realm."[2]

W.K.

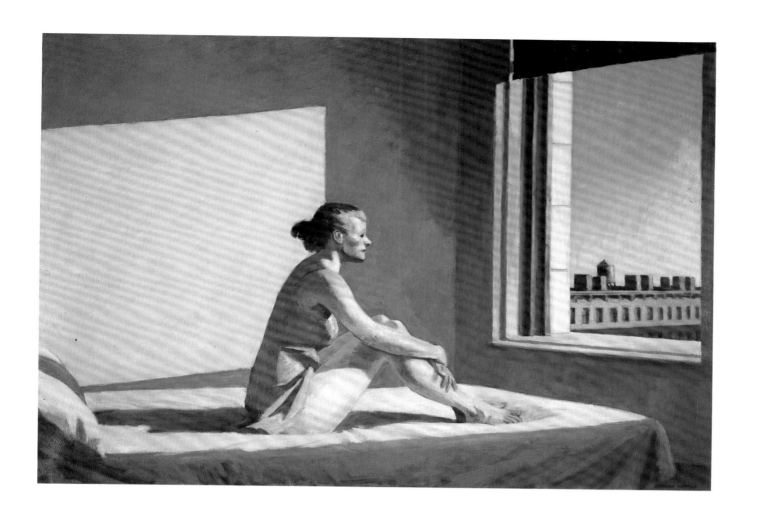

Isabel Bishop, 1902–1988

To capture the appearance of a subject in a particular instant in such a way that the result seems to be truthful as an experience, transitory in effect, and fresh in conception is a major concern in modern art which connects artists as diverse as, for example, Edgar Degas, Henri Toulouse-Lautrec, Henri Cartier-Bresson, and Isabel Bishop. Despite the differences in their attitudes, imagery, and working methods, each demonstrates an interest in the fleeting nature of life and how the passing moments are sensed. Choosing subjects which at first glance look mundane and unplanned, they produced works of art that celebrate brief events as essential parts of life.

Isabel Bishop, a keen observer of both life and art, was constantly in search of the exact moment to portray. She said, "I try to limit everything in order to get down to something in my work. . . . I struggle for months to make it look as momentary as it really is."[1] In contrast to the rapid and spontaneous execution that characterizes the art of the Impressionists, Isabel Bishop's execution was deliberate and methodical. Beginning with on-the-spot drawings of ordinary people, she would transform these into effective compositions in black and white etchings. Then, using the etchings and photographic enlargements of them, she developed her paintings, working usually in egg tempera with oil glazes over a brown or gray gesso ground. Her observations are not polished

in their final form; rather, they remain vital because of their sketchy appearance.[2] As Bishop said, "Incompleteness is the essence of the matter."[3]

Her technique is based on careful study of the great traditions of Western art since the Renaissance. An important foundation for her development was her education between 1922 and 1924 at the Art Students League in New York, where she worked under Guy Pène du Bois and Kenneth Hayes Miller. She made four trips to Europe to study the works of the old masters and became acquainted with Baroque art, in particular the oil sketches of Peter Paul Rubens, which were to have a lasting influence on her work. Following Rubens's example, Bishop produced a body of works that are notable for their fusion of figure and ground, open form, emphasis on the momentary, and respect for humanity. "Everything I have tried to do is Baroque, within my concept of the Baroque," she said, adding that "The essence of the Baroque style to me is its 'continuity,' a seamless web."[4]

Along with artists such as Kenneth Hayes Miller, Reginald Marsh, and the Soyer brothers, Isabel Bishop is considered part of the "Fourteenth Street School," a name given to a group of urban realists who worked in the vicinity of Union Square in New York City.

68 *Snack Bar*, ca. 1954 54.47

Oil on masonite, 13½ x 11⅛ in. (34.3 x 28.2 cm.). Museum Purchase: Howald Fund, 1954

A characteristic work by Bishop, *Snack Bar* is essentially a glimpse at two working-class women in an informal everyday situation. The women do not communicate with one another; their proximity is physical only, the result of a chance encounter. Like Edward Hopper's people, Bishop's subjects seem to be alone in a crowd.

Bishop's incomplete lines, as well as her application and occasional removal of paint, give the figures only a shadowy existence. They are distinct yet part of the setting; they fade into the grayed gesso ground only to emerge again in areas of light and color, giving the painted surface a dynamism of its own. "Color," Bishop said, "is not the original motif for me. My fundamentals are form, space, and light."[5] The colors in *Snack Bar*—orange, green, and yellow—while unusually bright for Bishop's works, constantly advance and recede as they effectively characterize a garish fast food culture. A vivid distillation of an ordinary event, the painting has an element of *déjà vu*, depicting something at once familiar yet ultimately elusive in memory.

R.L.R.

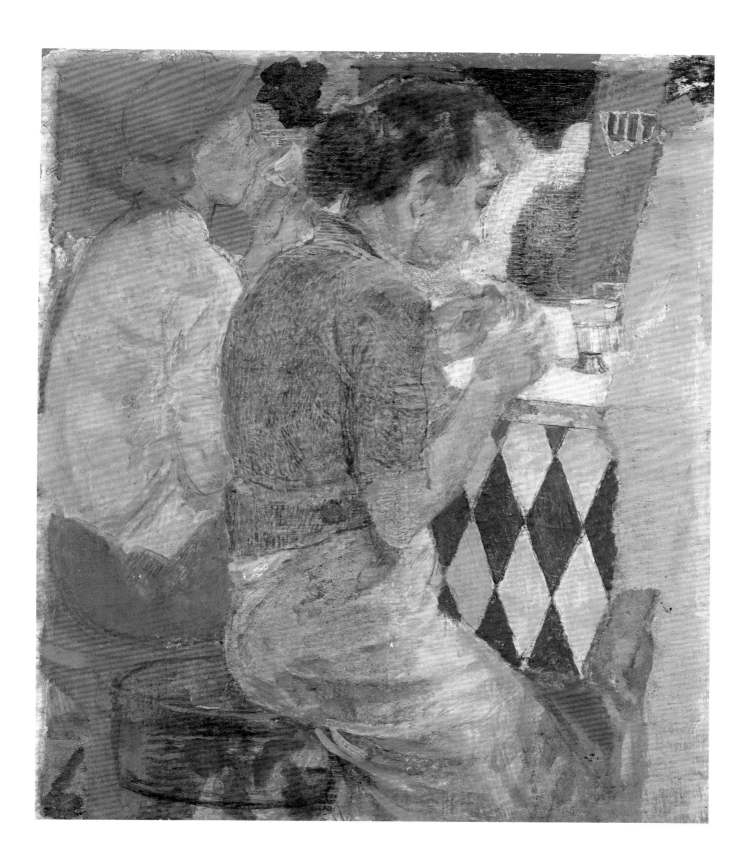

Hugo Robus, 1885–1964

Hugo Robus, who was born in Cleveland, attended the Cleveland School (now Institute) of Art as a young man. Both there and at the National Academy of Design in New York from 1910 to 1911 he worked primarily as a painter and was also active as a jewelry designer. He studied in Paris with Emile-Antoine Bourdelle until the outbreak of World War I. Experienced then in both modern painting and sculpture, he did not commit himself to a single medium until 1920, when he decided to concentrate on sculpture.

Robus's works are indebted to the polished elegance of Constantin Brancusi's sleek abstractions, as well as to the more assertive but complexly curvilinear works of Umberto Boccioni and the lithe, smooth figures of Bourdelle's late manner. But in his concern with creating responses to the sorrows and joys of the human condition Robus stayed closer than they to the literal appearance of the figure. Only during the 1940s did he depart for a while from his smooth, refined style to practice a rougher, more agitated manner.

Robus returned from Europe in 1915 and settled in New York, supporting himself there with a variety of teaching positions (appointments at Columbia University and Hunter College, among others) while developing and refining his art. Recognition came slowly. The first important show to include his works was the Whitney Museum annual in 1933, when the artist was forty-eight years old. Robus produced a large body of distinguished works during the last fifteen years of his life. In 1958 he was honored with a major retrospective at the Corcoran Gallery of Art, Washington, D.C.

69 *Figure in Grief*, original plaster 1952, cast ca. 1963 68.6

Bronze (from edition of 6), H. 12 in. (30.5 cm.). Signed on back of figure: Hugo Robus. Foundry mark: Fonderia Battaglia & C. Milano. Gift of Hugo Robus, Jr., in memory of his father, 1968

Figure in Grief is one of Robus's late creations. The sculpture was modeled in plaster in 1952, but the first of the six bronze casts was not produced until about 1962, by a foundry in Milan, Italy.

From the back, the sculpture looks more like a large helmet than a figure. The head is invisible from that point of view, the arms largely so. The piece seems inorganic; its smooth surface looks machined and tooled, and the dark, coppery patina enhances its abstract appearance.

The figure's right side only partially reveals the sculpture's true form and meaning. The right arm and the crossing left forearm for the most part obscure the head. The left hand lies weakly against the right arm, and only the thumb seems to speak of tension. Despair is the prevailing emotion expressed in this view.

The nearly symmetrical front view, showing the figure with angular crossed arms, is the most complete anatomically and structurally. While continuing the emphasis on abstract design, the pose suggests exhaustion as much as grief.

It is the view of the figure's left side that most fully reveals the impact of Robus's conception. As the grieving figure shrinks inward, head upon breasts, the "skin" becomes tauter, like some evolutionary adaptation for defense, and the helmet-like case of the back and arms appears to provide protection for the vulnerable head. It is this sense of active grieving rather than passive despair that makes this view the most resolved, the most expressive, and the most satisfying.

W. K.

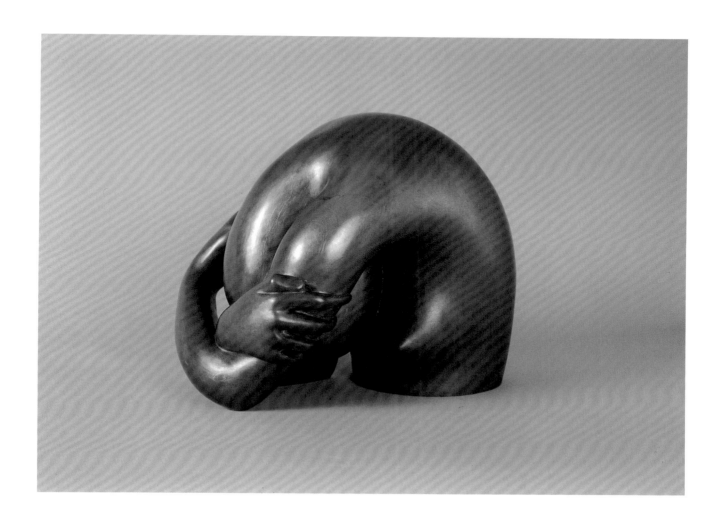

Chaim Gross, born 1904

Chaim Gross, an Austrian by birth, immigrated to New York City in 1921 when he was seventeen. He worked as a delivery boy, saving money to attend the Educational Alliance Art School and the Beaux-Arts Institute of Design, where he studied sculptural modeling briefly with Elie Nadelman. He first studied carving with Robert Laurent at the Art Students League in 1926–1927.

When Gross began direct carving, he favored hard wood but sometimes carved in stone as well. His interest in wood began in childhood, when he lived in a village surrounded by forest and where most of the community, including his father, worked in a lumber mill. He loved the smell of wood, and he remembered peasants carving toys, figures, and household objects for relaxation at the end of the working day. His involvement in the W.P.A. (Works Progress Administration) Federal Art Project and other Depression-era programs gave him opportunities to develop his distinctive style and to gain critical recognition. In 1957, as he was turning increasingly to the use of bronze in his work, he published The Technique of Woodcarving.

Bronze permitted greater freedom for the sculptor's imagination. Not limited by the boundaries of a block of wood, he was able to open up his compositions. Given his lifelong interest in wood, however, it is not surprising that many of his bronze works are translations from the woodcarver's art.

70 *Happy Mother*, 1958 82.2

Bronze (from edition of 6), L. 82 in. (208.2 cm.). Signed and dated top left of base: Chaim Gross 1958. Foundry mark on left side of base: Bedi-Makky Art Foundry N.Y. Gift of Ashland Oil, Inc., 1982

Typically, Gross's earlier sculptures are figures in active poses, with simplified masses that are often rounded and bulging. In *Happy Mother*, a mature work, he gave the principal figure elongated angular limbs that recall the hard-edged forms of Cubism. Like Picasso, Gross was inspired by the directness and vitality of African wood carvings and even in his bronze pieces sought to achieve the primitive character of a carved object. *Happy Mother*, for example, though it was modeled in plaster and cast in bronze, has the appearance of woodcarving in its "chiseled" edges and rough surface texture. Gross had begun to cast some of his woodcarvings in bronze in the late 1950s, when he discovered that modeling in plaster permitted him to work more rapidly and with greater ease and still retain some of the visual characteristics of woodcarving. Works cast from plaster in this period are more open, lyrical, and horizontal than the earlier carved sculptures.

During his childhood Gross was enchanted by circus people, especially the acrobats, whose grace and agility he later captured in his work. The nimble group in *Happy Mother* is from a long tradition of acrobatic family groups which he began to depict in the 1930s. The children, tiny versions of their mother, strike a circus-like pose, supported by the mother. The long, low arc of the mother's body suggests a gentle rocking motion and serves both to unify the composition and to give rhythm and strength to the idea of family. The theme of happy families recurs often in the artist's work, reflecting the circumstances of his own experience. His works are thus celebrations of the stability and joy of family life.

D.A.R.

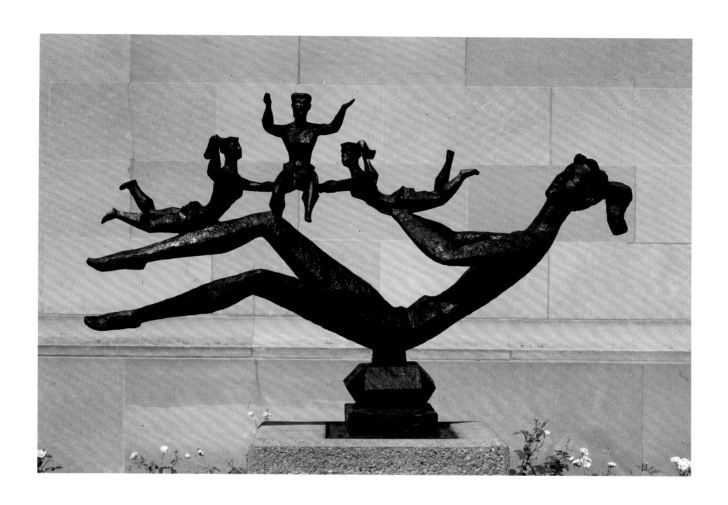

George Tooker, born 1920

Tooker was born in Brooklyn and educated at Phillips Academy and Harvard, where he was a literature major with a passion for poetry. He began his study of art in 1943 at the Art Students League in New York. His teachers, Reginald Marsh and Kenneth Hayes Miller, encouraged him to adopt the tempera technique, which he further developed under the guidance of Paul Cadmus.

Tooker's themes and moods are his alone. He forgoes topical social satire and moral commentary in favor of nonspecific but portentous tableaux in which his figures do not act out plots but embody feelings of alienation, isolation, and self-preservation. At once hero and victim, each insistently anonymous character is a modern Everyman.

Tooker was elected to the American Academy of Arts and Letters in 1983. His small oeuvre (he has often produced no more than two pictures a year), however, has precluded wider public recognition.

71 *Cornice*, ca. 1949 80.26

Tempera on panel, 24 x 15½ in. (61 x 39.4 cm.). Signed lower right: Tooker. Museum Purchase: Howald Fund II, 1980

The impact of Tooker's *Cornice* far exceeds its modest size. A young man on a ledge is being inexorably squeezed out of the picture, pressed forward by the wall behind him. With means at once subtle and insistent, the artist evokes sensations of claustrophobia, aversion, and fear. Of these claustrophobia is the most unexpected, given that the figure is not indoors, as are those in most of Tooker's paintings. He is, however, assuredly enclosed, caught between the wall and the picture plane. Nor is there any sense of openness or release in the flat, airless sky.

The low viewpoint (eye level is centered beneath the man's right foot) persuades us of a great height even though we don't see the ground, and it makes the man seem to loom. A literal reading of the subject might suggest an imminent leap, an approaching suicide, but instead the figure seems irrevocably anchored to the building. His muscular right arm and hand grip and adhere to the corner quoins; his body retreats from the corner; his left arm attaches itself to the quoins at the right edge of the picture (the little finger overlapping a quoin vividly projects a desire for security). Although the man is neither tall nor fully erect, he fills the space between the ledge and the top cornice with his shoulder pressing against the egg-and-dart molding. Attic half-stories such as this can be found, but this one is a Tooker invention to compress and stifle the figure.

The most significant objection to a literal reading of the picture as the moment before suicide is the hermetic stasis of the painting. The cross axes of the composition, like the cross hairs of a gunsight, track and fix the image. The horizontal midline crossing through the knuckles of the man's hands, and the vertical midline passing through his hypnotic left eye stop any imagined action. The artist is concerned here with a paralysis of will, a suspended moment of fearful indecision. This figure on the verge is an archetype of man faced with the unknown, whose future will be determined by choice not fate.

Tooker has said that the painting was inspired by W. H. Auden's *The Sea and the Mirror: A Commentary on Shakespeare's The Tempest*.[1] The relevant passage is found in Caliban's epilogue:

> Yet, at this very moment when we do at last see ourselves as we are, neither cozy nor playful, but swaying out on the ultimate wind-whipped cornice that overhangs the unabiding void—we have never stood anywhere else.[2]

To stop with this passage, on this too-literal cornice, would misrepresent both Auden's and Tooker's intent, for both have spiritual urgings at heart. Caliban's monologue goes on:

> Our shame, our fear, our incorrigible staginess, all wish and no resolve, are still, and more intensely than ever, all we have: only now . . . we are blessed by that Wholly Other Life from which we are separated by an essential emphatic gulf.[3]

Caliban has another line that Tooker, still at the beginning of his life and art, may well have identified with: "So, strange young man. . . . you have decided on the conjurer's profession."[4] A conjurer George Tooker was and is, an artist whose imaginings, steeped in mystery and expressed with infinite care, are among the most original and profound works of art of our time.

W.K.

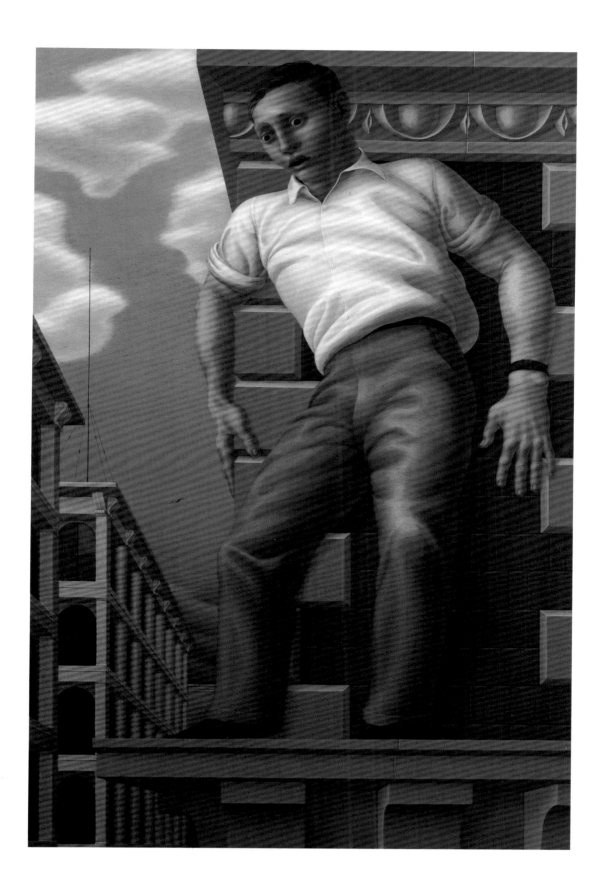

Andrew Wyeth, born 1917

Fifty years ago at the Macbeth Galleries in New York City, Andrew Wyeth, who was then twenty years old, first exhibited his paintings. Thus began a career that would propel the artist and his works into the very select ranks of America's most renowned painters. The son of illustrator N. C. Wyeth, Andrew is the leading member of a dynasty of painters that includes his sisters Carolyn and Henriette, their husbands John McCoy and Peter Hurd respectively, and his own two sons Nicholas and Jamie. Andrew, more than any of the others, was destined to capture the imagination and confound the sensibilities of legions of admirers and detractors from every corner of the world and from all walks of life.

Andrew Wyeth studied with his father and was strongly influenced by the elder Wyeth's predilection for a style of illustration that expresses sentimentality and strives for absolute reality. But very early the young artist gravitated away from his teacher to find inspiration in the quietly emotive works of Winslow Homer, and in the muscular strength and expressive conviction of works by Thomas Eakins. Wyeth's wide-ranging themes and special narrative content, like Edward Hopper's, are taken to represent a real sense of national character, both in figural subjects and topography. His personal interpretation of an American aesthetic has bred a lineage of images that are unmistakably his own.

72 *Inland Shell*, 1957 82.15

Watercolor and gouache on paper, 13½ x 21½ in. (34.3 x 54.6 cm.). Signed lower right: Andrew Wyeth. Gift of Mr. and Mrs. Harry Spiro, 1982

Wyeth's paintings are neither wholly photographic nor scenographic but a little of each. The result of this combination is a pictorial style that isolates a specific object or group of objects within an expansive, often panoramic, vista, whether an interior or exterior space. And Wyeth accomplishes this as well in portraiture, landscapes, domestic scenery, or seascapes. The technique results in haunting compositions, imbued with mystery and the hint of portentous events. One of the artist's most famous works, *Christina's World* (Museum of Modern Art, New York), is such a picture. So also is the museum's *Inland Shell*.

Inland Shell and related works such as *Sea Shell* (1953), *Beached Crab* (1955), and *Quaker Ladies* (1956) all belong to a program of works utilizing the shell motif. The picture is quintessential Wyeth, for it illustrates the artist's considerable technical expertise in wet and dry watercolor painting. Wyeth, whose preferred media are tempera and watercolor, has said: "the only virtue of a watercolor is to put down an idea quickly without too much thought about what you feel at the moment."[1] He added that his watercolors, unlike his oils, " . . . express the free side of my nature."[2]

In *Inland Shell* the artist has created a landscape, though it might seem more like an abstract watercolor from a generation later than Wyeth's. The work also recalls an earlier generation of photographers such as Edward Weston and Walker Evans, who made succinct, unemotional studies of natural phenomena. But Wyeth's work adds an emotional dimension simply by placing a shell in apparent suspension above the leafy forest floor and heightening its presence with whites and grays that have caught the sunlight. The contrast between the shell and the natural elements surrounding it is stark. How the shell arrived in this forest or why it is there Wyeth typically does not explain or interpret visually. One of the keys to his works is that he creates mysteries that defy resolution, and this is as apparent in *Inland Shell* as it is in *Christina's World* or the newly discovered "Helga pictures" of the 1980s.

<div align="right">S.W.R.</div>

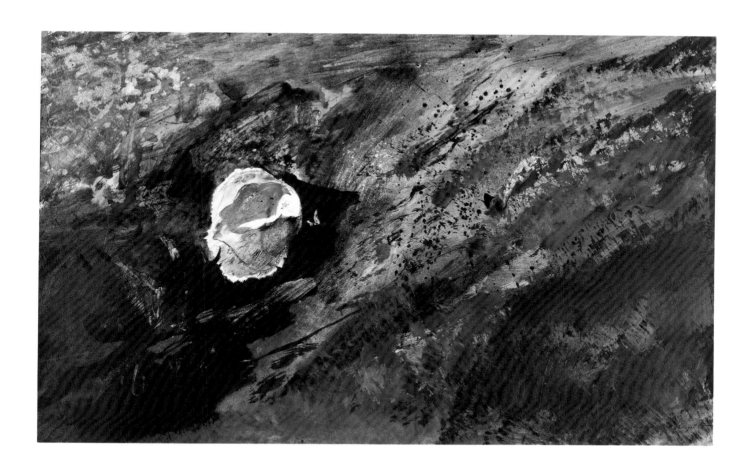

Tom Wesselmann, born 1931

An important figure in the American Pop Art movement, Tom Wesselmann was born and raised in the suburbs of Cincinnati. He attended the University of Cincinnati and Hiram College in Ohio and was drafted into the army in 1952. While in the service he began to draw cartoons about military life. He received a B.A. in psychology at the University of Cincinnati in 1954 and began taking courses at the Art Academy of Cincinnati. After he sold several cartoons, he decided to go to New York to be in closer contact with the growing commercial art market. In 1956 Wesselmann enrolled at Cooper Union, where he studied with Alex Katz and Nicolas Marsicano. His stylistic development was profoundly affected by the confrontational power of Willem de Kooning's paintings of women and Robert Motherwell's Elegy to the Spanish Republic, which he saw at the Museum of Modern Art. By the time Wesselmann graduated from Cooper Union in 1959, he had lost all interest in cartooning and commercial art and had decided to devote his energies to painting.

At first, he began to experiment with abstract collages. Gradually he developed more literal portrait collages, which usually consisted of a single female figure set against a vividly colored, boldly patterned background. Wesselmann emphasized the erotic aspects of figures to make the paintings as visually aggressive as the Abstract Expressionist imagery he had admired as a student. In his Great American Nude series, for which he is best known, he began to isolate parts of the figure and to exaggerate their scale. Wesselmann has said,

> I view art as an aggressive activity—that is, you're asserting something in the face of resistance. The nude, I feel, is a good way to be aggressive, figuratively. I want to stir up intense, explosive reactions in the viewers. . . . As for the erotic elements, I use them formally, without any embellishment. I like to think my work is about all kinds of pleasure.[1]

Wesselmann's work from the 1960s was linked with Pop Art because of its hard-edged forms, the impersonality of his models, and his use of commercial food containers. The women in his Great American Nude compositions are depersonalized sex objects set in commonplace environments, often along with elements from a contemporary consumer culture. The enlarged and simplified forms in both the Great American Nude and Seascape series are reminiscent of billboards and slick posters, with their hard edges and clean, shiny, flat surfaces.

73 Study for Seascape #10, 1966 76.33

Acrylic on corrugated cardboard mounted on particle board, 48 x 62 in. (121.9 x 157.5 cm.). Purchased with the aid of funds from the National Endowment for the Arts and an anonymous donor, 1976

From the Great American Nude series Wesselmann went on to develop his Seascape series, which focuses entirely on isolated areas of the human anatomy. Study for Seascape #10 is a portrayal of a single limb. A painted assemblage, the work consists of a cut-out cardboard leg form and two schematized cloud shapes, one of which is also cut from cardboard and applied to the corrugated cardboard oval. The use of applied forms indicates Wesselmann's continuing interest in collage. He says that he likes to "use the third dimension to intensify the two-dimensional experience."[2] His concern with three-dimensionality is more apparent in the final version of Seascape #10 (1966, collection of the artist), which is a molded and painted plastic relief. Just slightly smaller than the study, the final version consists of a single sheet of plexiglass out of which a leg form rises.

Wesselmann began his Seascape series in 1965, the year he made his first foot composition from a leftover fragment of a Great American Nude collage-painting. The idea for the beach setting came about after a vacation in Cape Cod, when the artist made a number of watercolor sketches. To give the feet a bolder presence, he simplified and stylized the coastal background, as in Study for Seascape #10.

Wesselmann has continued the Seascape series into the 1980s in paintings, collages, silkscreen, and molded plastic editions. His subject matter now includes other isolated areas of the female body such as breasts, torsos, and facial profiles. He has also begun to portray isolated areas of the male body, showing, for example, a penis against the coastline.

D.A.R.

Kenneth Snelson, born 1927

Kenneth Snelson's lifelong interest in structure began in childhood when he created model airplanes and other miniatures in the basement of his family home in Pendleton, Oregon. He took his first art courses in 1945 at the Corcoran School of Art when he was stationed in Washington, D.C, with the navy. From 1946 to 1948 he attended the University of Oregon in Eugene, studying accounting, English, architecture, and design before deciding to major in painting. But a summer program at Black Mountain College in North Carolina in 1948 was to set him on a very different course. Among the resident faculty that summer were Josef Albers, Willem de Kooning, Richard Lippold, and—most important to Snelson—the visionary designer Buckminster Fuller.

During that summer at Black Mountain, Fuller was exploring the principles of compression and tension. Stimulated by Fuller's ideas, Snelson invented and constructed his Wooden Floating Compression Column consisting of two X-shaped forms, one suspended over the other. The forms did not touch but were connected by tightly strung nylon; all components were entirely interdependent. Such a system would eventually be called "tensegrity," a word Fuller coined in 1955 from "tension" and "integrity." In Snelson's structures, the members (rods or tubes) push while tightened cables or cords pull; everything depends on the equilibrium of these opposing forces. The sculptures, which in subsequent years have become more and more daring, literally defy gravity.

Snelson's works were first shown in 1959, at the Museum of Modern Art. He has received numerous commissions for public sculptures in cities such as Baltimore, Buffalo, San Diego, and Hamburg and Hanover, Germany.

74 V-X, 1974 85.1

Stainless steel and wire (edition of 2), H. 96 in. (243.8 cm.). Given to the Columbus Museum of Art by friends in memory of Frances N. Lazarus, 1985

In works such as *V-X*, Snelson uses industrial materials such as aluminum or, as here, stainless steel. The idea for this sculpture grew in stages, beginning in 1960 with a small study for a helical tension structure. In 1967 Snelson picked up the idea once more and made a second study—this time using longer tubes (about 30 inches). A third model, made in 1968, added two tubes for a total of ten. That same year Snelson made his first *V-X* sculpture, which is six feet high and ten feet in diameter; this piece, which is in the artist's collection, became the basis for two monumental sculptures he made in 1974, one in the collection of the Columbus Museum of Art and the other belonging to the Hunter Museum, Chattanooga, Tennessee.

Snelson customarily begins with a maquette, which to his way of thinking is not an ancillary work but a small sculpture itself, with the same structural unity as the large piece. After establishing the desired dimensions for the full-scale piece and planning the engineering aspects, he is ready to assemble the materials. At the installation site he lays out a webbing of cable, and fits drilled and notched metal tubes in place before tightening the whole system to maximum tension. Of his process he says:

> When I direct my attention toward structure I concern myself with the actual physical forces which give rise to the form. The necessary ingredients of my kind of space are the minimum number of lines of force which must be present in order for the system to exist.[1]

The feat of orchestrating the intricate interdependency of cable and steel rods is complex. Each component is essential and must be in its exact place in relation to all other components. There is no mathematical formula for creating these intricate systems, for they depend as much on artistic instincts as they do on engineering prowess. In *V-X*, with its ten diagonal rods leaning counter-clockwise in a fourteen-foot diameter circle, there is a rhythmic dynamism that recalls the movement of dancers in a ring. The rods appear to fall forward, but are securely held in place by the cable, as the polished stainless steel catches and reflects light in changing patterns.

The idea for *V-X* is based on helix forms found in nature, in plants, shells, bones, and other objects. The helix, Snelson says, "appears in one form or another in all of my sculptures . . . quite especially in *V-X*."[2]

Situated in Columbus's Bicentennial Park, *V-X* is on permanent loan from the museum to the City of Columbus. The maquette, a gift from the artist, is also owned by the museum.

D.A.R.

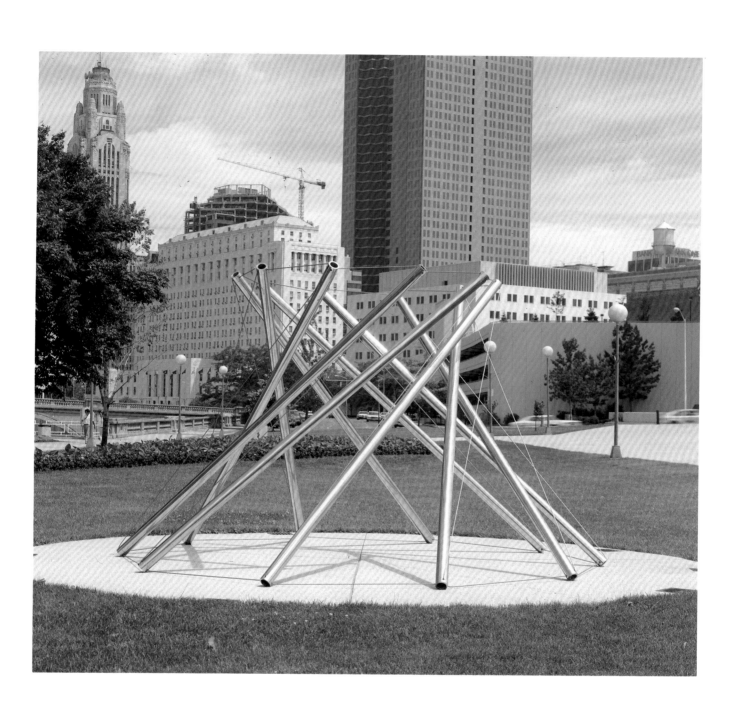

Helen Frankenthaler, born 1928

A native of New York City, Helen Frankenthaler became familiar with the city's museums and galleries as she grew up. She studied art at Bennington College in Vermont with Paul Feeley, through whom she developed a strong consciousness of Cubist composition and space. After graduating in 1949, she returned to New York. She studied briefly with Hans Hofmann in Provincetown in 1950, and associated with many New York art and literary figures including Willem de Kooning, Franz Kline, and Clement Greenberg. Her work was first exhibited in New York in 1950.[1]

Frankenthaler is known for her innovative soak-stain technique in which she gently pours thinned paint onto unsized and unprimed canvas. She developed this style after seeing Jackson Pollock's dynamic Action Paintings exhibited at the Betty Parsons Gallery in 1951 when she was already using large canvases and studying the spontaneous approach of earlier artists such as Wassily Kandinsky and Joan Miró. Prompted by Pollock's example, she began to use large expanses of canvas rolled out on the floor, but instead of adopting Pollock's drip painting method, she devised her own method of pouring luminous washes of color onto raw canvas and manipulating the paint with a sponge. In Frankenthaler's paintings an illusion of depth is achieved in the organic flow of color and the overlapping of forms. At the same time, the literal flatness and physical character of the canvas is also emphasized, for the thinned oil paint soaks into unprimed canvas, merging image with ground.

Frankenthaler's paintings were daring innovations in the early 1950s, when stark, heavily painted canvases predominated in Abstract Expressionism. In her style and technique one sees the combined effects of the translucent structure of Cézanne's watercolors, the open format and sensations of light and atmosphere in the work of Claude Monet and Henri Matisse, the calligraphic markings of Wassily Kandinsky, and the biomorphic forms and fluid space of Joan Miró and Arshile Gorky. Frankenthaler is considered a leader of the second generation of Abstract Expressionists, who influenced much of the Color-Field painting that followed, especially the work of Morris Louis and Kenneth Noland.

75 *Captain's Paradise*, 1971 72.27

Acrylic on canvas, 60 x 156 in. (152.4 x 396.2 cm.). Signed and dated lower left: Frankenthaler '71. Purchased with the aid of funds from the National Endowment for the Arts and two anonymous donors, 1972

Beginning in the 1960s Frankenthaler chose to work in acrylic instead of oil, seeking brighter and more intense colors. In the transition she lost the fragile edges and some of the translucency of oil washes, but she maintained the soft natural flow that had become characteristic of her style. In *Captain's Paradise*, an acrylic painting, the edges of the brilliantly colored forms show more control than was possible in the earlier oils. The composition is bold and direct, its large central form sharpened against raw white canvas and accented with smaller edge-defining accents of color. Acrylic pigments, which are thicker and more opaque than oil, endow the colorful forms with an added dimension of mass, density, and gravity and make possible a new approach to considerations of flatness and illusionism.

Frankenthaler's works are spontaneous, evolving from her creative and innovative use of the media and materials. She names her paintings after they are completed according to the imagery suggested in the final composition. Though her forms are abstract—not engendered by references to external reality—analogies to landscapes or seascapes are often seen in her work, as she herself indicates by her choice of titles. The title *Captain's Paradise* conjures images of a lake or sea, and indeed the large expanse of blue also evokes such an impression. Even Frankenthaler's method of applying color implies the energies of nature, for in the sweep of blue paint across the length of the canvas there are varying degrees of color intensity and saturation, somewhat like the appearance of the ebb and flow of a body of water.

Against the larger fields of color, red and black lines are penned onto the surface with a marker. Some of these link land and sea forms or bridge apparent gulfs, resulting in the simultaneous perception of both aerial and land views of the seascape. Other lines scattered throughout the blue field serve as small animated accents. The influence of Frankenthaler's training is revealed in the subtle structural strength and spatial tension generated by these carefully placed markings.

D.A.R.

Kenneth Noland, born 1924

A native of Asheville, North Carolina, Kenneth Noland attended Black Mountain College in his home state and studied with Josef Albers and Ilya Bolotowsky. He was one of the first major painters to be educated solely in nonobjective art. In Paris from 1948 to 1949, Noland studied under sculptor Ossip Zadkine. When he returned to the United States, he moved to Washington, D.C., where he formed a friendship with Morris Louis. The two artists were to become important members of the Washington Color School, a name given to a group of painters who lived in the District of Columbia and whose work was primarily concerned with the exploration of color. In 1953, Noland and Louis visited the New York studio of Helen Frankenthaler, the progenitor of the soak-stain technique in painting. Noland recalled the significance of this occasion: "We were interested in Pollock, but could gain no lead from him. He was too personal. But Frankenthaler showed [us] a way to think about, and use color."[1] Emulating Frankenthaler's technique, they too poured thinned paint on unprimed canvas, producing a translucent, stained ground.

Noland and Louis went in different directions before Louis died in 1962. By the late 1950s Noland's work had become more hard-edged, a reaction against Abstract Expressionism, as were his emphasis on formal values and his elimination of emotion in his paintings. The only element he retained from Expressionism was the large canvas. What Noland gained from Frankenthaler, as well as from the works of Henri Matisse and Paul Klee, was luminous intensity and a fascination for color as structure.

While living in New York City after 1961, Noland became known as one of the Color-Field painters, whose works are characterized by their large scale and use of bold, geometric shapes. His early paintings consisted of single shapes, such as chevrons or diamonds, set boldly against a white ground. Sometimes the canvas itself was shaped and painted a single color to function almost as a sculptural object. Toward the end of the 1960s, Noland returned to color staining rectangular canvases much as he had done early in the previous decade. For a short time in the early 1970s he experimented with stained fields framed by overlapping strips of color before resuming his work with shaped canvases and juxtaposed bands of flat color.

76 *Shadow on the Earth*, 1971 72.28

Acrylic on canvas, 93 x 64¼ in. (236.2 x 163.2 cm.). Purchased with the aid of funds from the National Endowment for the Arts and two anonymous donors, 1972

Shadow on the Earth is representative of a format that Noland used only briefly. The works, which are referred to as "plaids," are vertically oriented canvases with overlapping ribbons of color along the borders. At the center is a vaporous wash that contrasts with the clarity and intensity of the edge treatment. The technique introduces subtle spatial complexities not previously explored by the artist. Crisp, interlacing bands of color establish a sense of depth in contrast to the flatness of the soft, saturated ground. Because border colors are either analogous (yellow, pink, ivory) or complementary (lavender, green, gray-blue) to the dominant field of orange, visual unity is maintained.

In the plaids Noland moved away from the bold, confrontational presence of his earlier works to showcase his ability to create intense luminosity. In succeeding years, he developed a format that grew out of the plaids. By 1973, using smaller canvases shaped as diamonds or tondos, he was painting crisscrossing bands clustered in the central area of the composition.

D.A.R.

Louise Nevelson, 1899–1988

Louise Nevelson, born Louise Berliowsky in Kiev, Russia, came with her family to Maine in 1905. In 1920 she married Charles Nevelson and moved to New York City, where she undertook private study in painting, drawing, voice, and drama. She attended the Art Students League between 1928 and 1933, studying briefly during that time with Hans Hofmann in Munich in 1931.

Nevelson worked predominantly as a painter until 1933, when she made her first sculptures. Her early works, executed in a variety of media, derive stylistically from both Cubism and Expressionism and always display a strong geometric orientation. She had her first solo sculpture exhibit in New York in 1941 at the Karl Nierendorf Gallery. Her stacked box sculptures were shown for the first time in the 1950s.

Constructed of found wooden objects and scrap lumber and painted in a single color, the artist's relief walls consist of compartmented assemblages of urban detritus. In these constructions Nevelson utilizes a vocabulary of commonplace objects — chair seats, finials, turned posts, wood scraps. Far removed from their original context and arranged within a created environment, these forms take on new and unexpected meaning.

77 *Sky Cathedral: Night Wall*, 1963–1976 77.20

Painted wood, 114 x 171 in. (289.6 x 434.3 cm.). Gift of Eva Glimcher and Derby Fund Purchase, 1977

In *Sky Cathedral: Night Wall*, rows of boxes frame arrangements of wooden fragments — from familiar objects to abstract geometric forms. Louise Nevelson dated the work 1963–1976, a period during which it stood in her studio in various stages of development until it evolved to its present configuration. The work thus may be viewed as a chronology of Nevelson's work during that thirteen-year period. Reading from left to right, there are first the tightly controlled compositions of smaller, detailed pieces, similar to other constructions she was producing in the mid-sixties. In the boxes forming the central area are the larger forms of chair segments and other found objects such as are seen in works of the late sixties and early seventies. To the far right are yet larger forms that may have been cut especially for the composition, for during the mid-seventies Nevelson was experimenting with compositions of machine-fabricated components. The progression is thus from found to fabricated, from small to medium to large, mirroring the artist's production in roughly three periods.[1]

Black monochrome, used for all works in the Sky Cathedral series, unifies the composition, intensifies its powerful presence, and emphasizes its imposing architectonic quality. The whole is made more dramatic by lighting effects and cast shadows. As the artist said, "The shadow, you know, is as important as the object. . . . I arrest it and I give it architecture as solid as anything can be."[2]

Nevelson used black often in the 1950s and 1960s: "I fell in love with black [because] it contained all color. It wasn't a negation of color. It was an acceptance. Because black encompasses all colors. Black is the most aristocratic color of all."[3] Entirely different effects, unlike the mysterious and surreal effects of black, are projected by the rich gold or pure white monochromes of Nevelson's later works.

Whatever their color, whether they are rendered in wood, mirrors, plexiglass, or welded steel, Nevelson's relief walls are intricate arrangements of forms made abstract by alteration and by context. In this her work is a descendant of Cubist tradition. She has said, "In all my work is the Image and the Symbol. I compose my work pretty much as a poet does, only instead of the word I use the plastic form for my images."[4]

D.A.R.

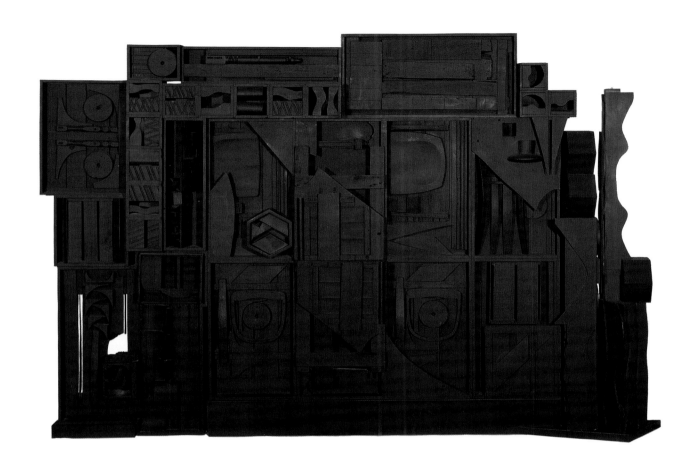

Dan Flavin, born 1933

Self-taught as an artist, Dan Flavin studied for a time at the New School for Social Research and at Columbia University but in 1959 decided to devote full time to a career in art. His first solo exhibition, held at the Judson Gallery in New York in 1961, consisted of watercolors and sculptures. That same year he began to make what he calls "electric light icons," boxes illuminated with or framed by electric lights. Flavin used light in his sculptures almost from the beginning; eventually, light became his only medium. He began working with fluorescent tubes in 1963. In the mid-1960s, Marcel Duchamp, who used readymade objects, personally encouraged Flavin's work with pre-existing components.

Flavin's earliest fluorescent sculptures were minimalist forms in which tubes were arranged in patterns or as components of geometric shapes. In his mature work the artist is more concerned with the compositional effects of light within a given space. His designs literally transform a room, illusionistically altering its appearance through carefully orchestrated mixtures of colored light. The fluorescent tubes, placed on walls or in corners, are arranged according to the effects their illumination will have on the space in which they are exhibited; they are not shown as objects in themselves.

78 *Untitled (to Janie Lee) one*, 1971 79.53

Blue, pink, yellow, and green fluorescent light (from edition of 5), L. 96 in. (243.8 cm.). Gift of Mr. and Mrs. William King Westwater, 1979

Flavin's composition in the museum's collection is a superb example of the artist's mature work. It consists of a single long tube that emits blue light and three smaller unseen tubes that cast pink, yellow, and green lights. The tubes are mounted in a corner; illuminated they cast blended colors on the architectural components of the space, in both geometric configurations and amorphous washes.

What Flavin accomplishes in this work is not the apotheosis of an industrially produced object but the dematerialization of the object as art. While the work is sculptural—that is, its components are three-dimensional and affect an environmental space—its impact lies not in its materiality but in the intangible properties of cast light.

A companion piece known as *Untitled (to Janie Lee) two* consists of the same elements, but the unseen smaller tubes cast green, yellow, and pink light, in reverse order of the colors in *Untitled (to Janie Lee) one*. These two works, which are usually shown independently, exhibited together provide an interesting variation on the way they visually transform an exhibit space. Mounted in adjacent corners of a room, they are like mirror images of each other, and the blue glow emitted by the larger tubes is intensified.

Flavin often dedicates his works to historical figures or to people he knows. This work is dedicated to an art dealer in Dallas, Texas.

D.A.R.

Clement Meadmore, born 1929

Australian-born sculptor Clement Meadmore initially studied engineer-
ing and industrial design. He executed his first sculptures in 1949
while still a student at the Royal Melbourne Institute of Technology. He
had his first one-artist show in Melbourne in 1954 at the age of twenty-
five. His first significant exposure to modern sculpture came during a
trip to Europe in 1953, after which he decided to make welded steel
sculptures. On a trip to Tokyo in 1959 he became acquainted with the
work of the Abstract Expressionists, in particular Barnett Newman,
whose work was especially important to the development of Meadmore's
individual aesthetic.

Meadmore moved to the United States in 1963 and settled in New
York. Within three years he abandoned the use of welded steel and
began to create what he called "single form" sculptures made from a
single section of squared metal tubing. In the ensuing decade, his
investigations of the complexities of this simple twisting form ranged
from the solitary angle of Bent Column (1966) to the undulating
gordian knots of Out Of There. Meadmore resumed work on multi-
piece sculptures in 1976.

79 *Out of There*, 1974 79.15

Painted aluminum (edition of 2), L. 201 in., H. 78 in. (L. 510.5 cm., H. 198.12 cm.). Gift of Ashland Oil, Inc., 1979

Meadmore has said he is "interested in using geometric forms to achieve the expressive energy which no longer
seems possible with modeling or carving. This entails finding the rare combinations for forms which transcend their
geometric origins."[1] Thus in his work he has sought to synthesize the geometric forms of Minimalism and the gestural
movement of Expressionism in configurations that hold the forces of both in a vital equilibrium.

Works such as *Out of There* depend on this underlying tension. Its convoluted rectilinear form loops and twists and
thrusts dramatically into space. At a distance, it has a calligraphic quality—as though the artist had drawn in space
with "a very thick line." Up close, it becomes a precariously balanced mass of smooth black industrial aluminum;
alert in its repose, it seems to defy gravity. Meadmore's title emphasizes the importance of directional movement in
his conception of sculpture; movement in his works becomes a metaphor for that of the human body.

Meadmore's single-form sculptures originate as small hand-size maquettes. After the model is complete, and the
artist has experimented with "letting it come to rest wherever it comes," he selects the position that gives the sculpture
the greatest appearance of spontaneity.[2] The model is then enlarged and fabricated either of painted steel or aluminum
or of Cor-ten steel, which has a rich brown patina.

Meadmore's mature works are monumental in scale. He believes a sculpture must be able to inhabit a space the
way a person does. His pieces situated in outdoor urban settings create a bridge between the scale of passersby and
that of contemporary multi-story buildings. He has even envisioned a series of sculptures, which—like the Eiffel
Tower—would be visual bridges to an entire city.

N.V.M.

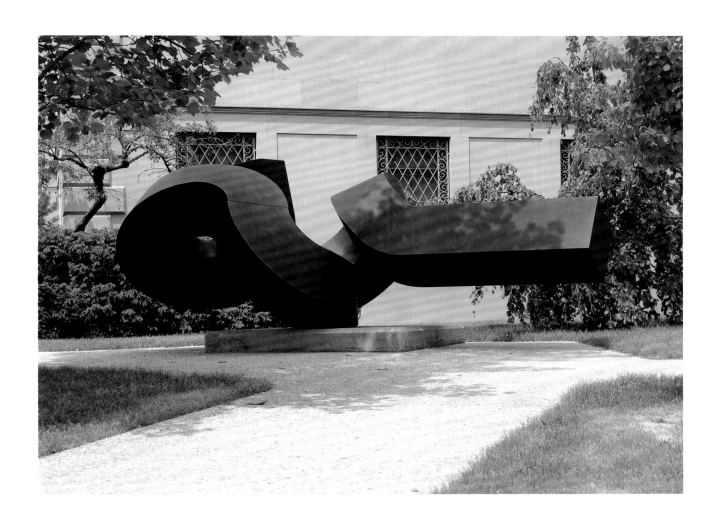

Alexander Calder, 1898–1976

Alexander Calder is one of this country's most renowned sculptors. The son of Alexander Stirling Calder (1870–1945), a sculptor who worked in the Beaux-Arts style, he earned a degree in mechanical engineering from the Stevens Institute of Technology in 1919, then worked for four years at various jobs related to his studies. His grasp of the theory and practice of engineering eventually became the most important influence in his approach to art, which he began to study at the Art Students League in New York in 1923. After three years of study, he went to Paris in 1926 and remained there for seven years. It was in Paris, where he conducted performances of his hand-animated Circus *(Whitney Museum of American Art), that his work first attracted attention.*

Calder's meeting with Piet Mondrian in Paris in 1930 was a major factor in his conversion to an abstract style. Adopting the biomorphic forms of the Surrealists (in particular his friends Jean Arp and Joan Miró), and the restrictive palette of primary colors and black and white used by Mondrian, Calder made his first moving sculptures in 1931.

These constructions, which were powered by hand or by motor, were called "mobiles" by Marcel Duchamp, as were the sculptures activated by air currents which Calder constructed later that same year. By the mid-1930s Calder was making nonmoving, large-scale outdoor sculptures in sheet metal and steel plates, which Jean Arp called "stabiles." Today Calder's large pieces stand in public plazas across the United States and in many other countries throughout the world. The stabiles are a kind of anthropomorphic architecture themselves, approaching contemporary buildings in both scale and physical presence.

Calder's career was long and his oeuvre is enormous, embracing a variety of subjects and styles and ranging in scale from the miniature Circus *to the monumental stabiles. His works are ingenious amalgams of modern technology and the organic forms of nature—at times playful and exuberant, or formal and dignified, but always imaginative and almost universally appreciated.*

80 *Intermediate Model for the Arch*, 1975 80.36

Painted steel, H. 144 in. (365.6 cm.). Museum Purchase: Derby Fund, 1980

In designing stabiles such as *The Arch*, Calder's goal was to create massive large-scale sculptures which appear to rest lightly on the ground. To achieve such contradictions of mass and scale required partial welding of the bolted metal plates and careful technical planning and supervision. First, Calder created a maquette of sheet aluminum, a material he could cut with shears, bend, manipulate, and bolt together. Technicians then would enlarge the piece to one-fifth the size of the monumental work so the artist could study the aesthetics and stability of the structure and make needed adjustments. The final piece utilizes the machinery and techniques of industrial metalwork, but even the largest works are designed so that they can be easily disassembled and shipped for reassembly at another site.

The museum's *Intermediate Model for the Arch* is one-fifth the size of the fifty-two-foot-high final version at Storm King Art Center, Mountainville, New York. Its bold, hulking presence is contradicted by the graceful pointed "foot" that provides equilibrium as it opens up the interior space and invites the viewer's explorations. The subject was one of the last that Calder executed before he died.

D.A.R.

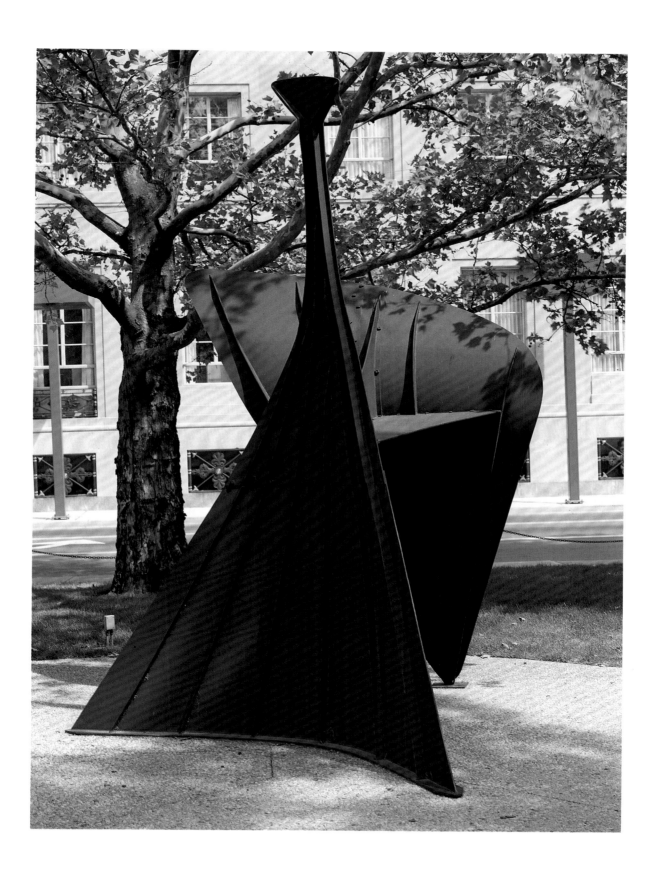

George Rickey, born 1907

Born in South Bend, Indiana, George Rickey moved with his family to Scotland in 1913, when he was six. He studied history at colleges in Scotland and England before attending the Ruskin School of Drawing at Oxford University in 1928–1929. In 1930 he took up residence in the United States, leaving briefly in 1933 to study painting in Paris with André Lhote, Fernand Léger, and Amédée Ozenfant. Rickey's interest in sculpture began during World War II, when he learned welding while serving with the United States Air Force.

Rickey was forty-two years old when he made his first steel sculptures with moving parts in 1949. Of his transition to kinetic sculpture, he said, "I had to learn to be a mechanic and to recall the physics I had learned at 16. . . . I wanted movement which would declare itself quietly, slowly, deliberately . . . I rejected jerks, bumps, bounces, vibration, and for the most part, all sound."[1] Using Alexander Calder's mobiles as a point of departure, Rickey simplified form in order to emphasize movement. His format is expressive of modern technology; the precise nature of the tapered shapes recalls both the machine aesthetic and the purist notions of Constructivism. An articulate writer as well as a sculptor, in 1967 he published a book entitled Constructivism: Origins and Evolution.

81 *Two Lines Up Excentric Variation VI*, 1977 78.31

Stainless steel (1 of 3), H. 264 in. (670.6 cm.). Signed, dated, and inscribed on base: 1/3 Rickey 1977. Given by the family of the late Albert Fullerton Miller in his honor and memory, 1978

George Rickey's sculptures consist of free-moving stainless steel blades with precisely engineered counterweights and bearings. The long, slender arms move slowly and gracefully, powered by currents of air and the pull of gravity.

Two Lines Up Excentric Variation VI is one of nine versions of two-blade sculptures made by Rickey between 1975 and 1983. The museum's version has two three-sided blades mounted side by side, turning and rotating independently on separate swivels. The blades move in silence following predetermined paths, with the wind choreographing their sweeps and spins, the sun glancing off the sleek steel. The dynamics are mesmerizing. Though it often seems the blades will collide, they never do. The sculpture, which is designed to withstand winds up to eighty miles per hour,[2] is a synthesis of contrasts in which technical precision is juxtaposed with unpredictable movement as fickle winds play with rigid industrial materials and gravity imposes its dependable restraints.

Rickey has said, "I do not imitate nature. . . . If my sculptures sometimes look like plants or clouds or waves of the sea, it is because they respond to the same laws of motion and follow the same mechanical principles."[3]

D.A.R.

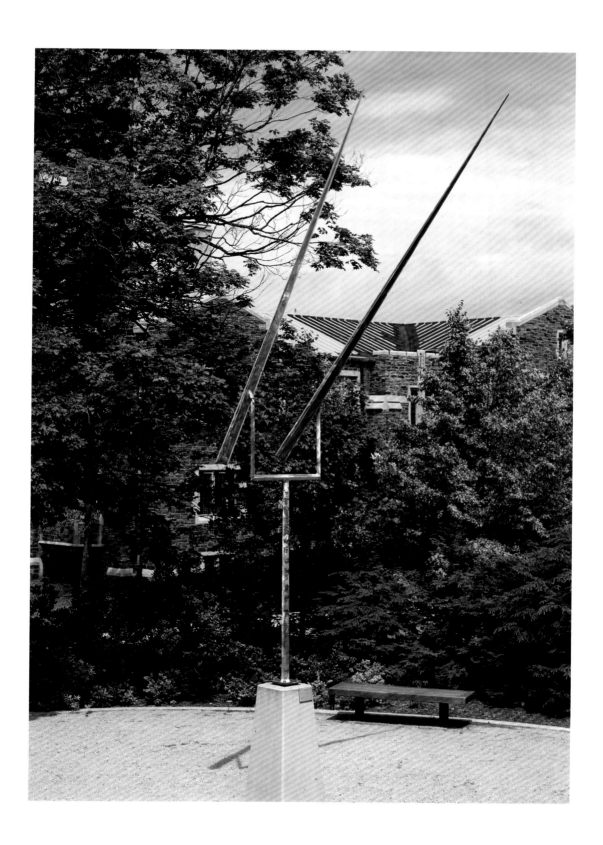

George Segal, born 1924

George Segal's art is in many respects traditional. His unvarying subject is the human being, and the condition of being human. Early in his career, when he was a painter, Segal's subjects were allegorical and Old Testament themes, which were then utterly out of favor. In his later sculptures he has sometimes dealt with significant narrative or symbolic motifs: for example, The Holocaust (1986), commissioned by the City of San Francisco. Through most of his career as a sculptor, however, he has been able to internalize and generalize the emotions generated by themes of this sort, to focus them upon the body, as it were, without specific narrative. In the process he has become a master of the language of the body.

The artist's chosen material is plaster. Its whiteness reminds us of marble sculptures of the Classical and Renaissance past as well as casts so prominent in studios, art schools, and museums from the seventeenth century to the present. Segal's "casts," however, are very different. His method is to apply plaster-impregnated cheesecloth over the living model and, when it has dried, to remove it in sections, then reassemble it. At first he did not produce casts from the smooth inside of this mold but presented us with the outside. Now he also casts from the inside of the mold. In either case, the surface is rough and full of accidents and marked by the artist's hand. The body is, in a sense, seen through the intervening plaster, veiled and protected by it.

82 *Girl on Blanket, Full Figure*, 1978 80.7

Painted plaster, H. 76 in. (193 cm.). Purchased with funds from the Livingston Taylor Family and the National Endowment for the Arts, 1980

Girl on Blanket, Full Figure is an absorbing and sophisticated work. The figure lies on the blanket as on a bed, the blanket seeming to gather itself to the girl, echoing her contour and enfolding her lean body. Her right elbow nests in it as though held by an unseen hand—a striking example of the way the artist intervenes with his cast to heighten expression.

Unexpectedly, the sculpture has a strong vertical presentation; a relief, it is intended to hang on the wall. Though the figure seems to hug or cling to the wall, there is nothing tentative or tenuous about it. Segal purposefully distances the figure from the viewer, presenting it pictorially rather than sculpturally. He disrupts the visual logic of a girl lying on a blanket. No perspective recession draws us into the space; rather it is "as though [the sculptor] were putting pictures into three dimensions, playing volumes against planes as a painter does."[1]

Beds figure prominently in Segal's sculptures. In a manner reminiscent of Edward Hopper's paintings, he makes us aware of our dependence on them. His men and women sit or lie, alone or together, on beds which are their only observable possessions, beds which seem more like islands or prisons. Occasionally, blessedly, they sleep. This girl is pressed into her bed; the seeming naturalness of her pose is belied by willful adjustments. The top, or right leg, retreats while the bottom, or left leg, seems to advance. The strong right angle of the girl's left arm and back, while by no means impossible, must be less than sleep-inducing. These pondered manipulations both create and allay tensions, as advancing the elements expose and retreating they safeguard. The result is an indelible image of the contrapposto of sleep.

W.K.

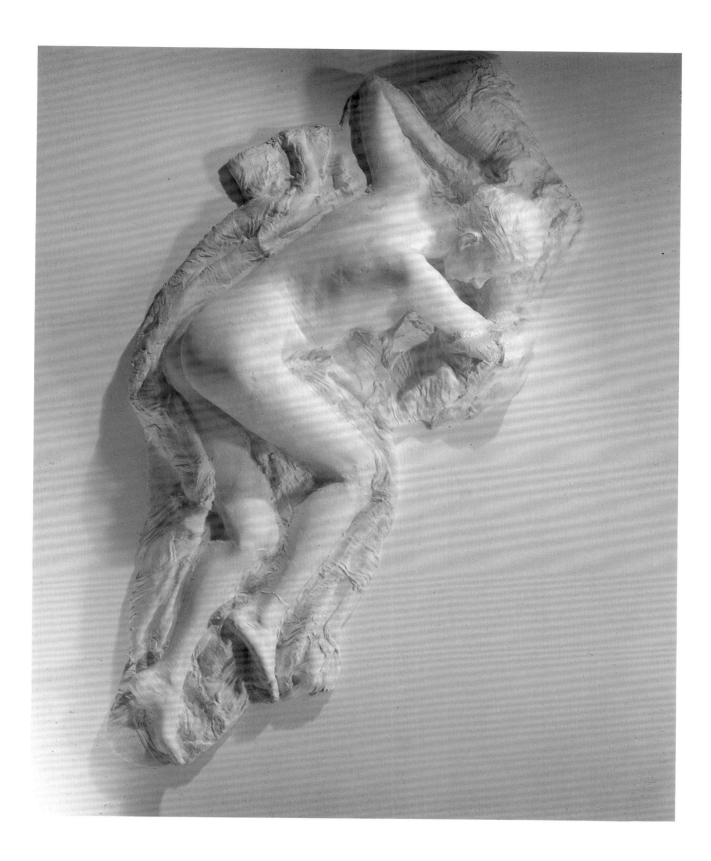

Richard Stankiewicz, 1922–1983

Richard Stankiewicz taught himself painting and sculpture while serving in the navy from 1941 to 1947. He began formal studies in art in 1948 when he enrolled at the Hans Hofmann School of Fine Arts in New York City. In 1950 he went to Paris and studied briefly under Fernand Léger and Ossip Zadkine. Returning to New York in 1951, he set aside his sculptural work in clay and began to create abstract forms in wire coated with plaster. This led to the production of witty assemblages of junk metal, for which the artist first became known in the 1950s.

A native of Philadelphia, Stankiewicz grew up in Detroit. An inventive youth, he made toys from scraps of metal scavenged in a foundry dump next to the apartment building where he lived. Later, in New York, while preparing a garden behind his studio, which was located on the site of a former scrap dump, he excavated large pieces of rusted and eroded metal. Inspired perhaps by the welding techniques of sculptor David Smith and recognizing the aesthetic possibilities of castoffs, Stankiewicz taught himself to weld in order to use the material for sculpture. The resulting junk metal sculptures were first exhibited in 1953.

Stankiewicz's compositions, with their raw and energetic forms, are often considered sculptural counterparts to Abstract Expressionist painting. His use of found materials associates him as well with the Dadaist tradition of the 1950s, which led to the development of Pop Art and its celebration of readymade and found objects. Stankiewicz, however, developed his own style of innovative, satirical personages using discarded mechanical equipment and scrap metal. His work is unusual in that he does not alter the scrap pieces in any way.

After a 1969 trip to Australia there was a decided change in Stankiewicz's work. The only metal objects easily accessible to him there were new building materials such as steel I-beams, metal tubes, and pipes. These materials dictated a completely different aesthetic from that of the rough scraps he had used previously. Though the resulting sculptures are not as playful as his earlier pieces, these cool, classical compositions have the same formal strength that is intrinsic to all of Stankiewicz's work.

83 Untitled, 1979–21, 1979 80.21

Steel, H. 63⅞ in. (162.2 cm.). Purchased with funds from an anonymous donor and the National Endowment for the Arts, 1980

Untitled, 1979–21, a late work in Stankiewicz's oeuvre, combines elements of the artist's earlier methods and styles. In this composition he uses both junk metal and new industrial steel, juxtaposing dynamic, twisted, rough-edged scraps with crisp geometric form. The rectangular frame set on a plinth harks back to Stankiewicz's experience as a painter in the early 1950s, for the emphasis here is on line rather than mass. Scrap metal forms, torn and curving into space, exert vitality and introduce spatial tension as they project away from the tight austerity of the two-dimensional frame. Using metal that rusts, the artist makes nature a part of his creative process. In time, as the work ages, it takes on richness of color and texture.

Unlike the artist's earlier works, those from 1979 utilize discarded elements that are not easily identified with their former existence but are chosen more for their form and texture. These found metal fragments in combination with new materials become a newly created formal abstraction, a lyrical statement about the aesthetics of open-form relationships, about old and new, about time and aging.

D.A.R.

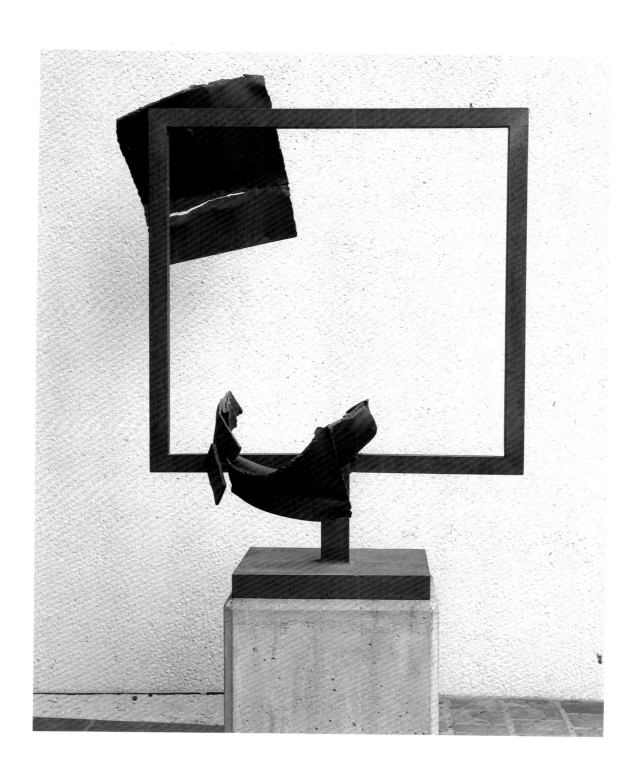

Richard Anuszkiewicz, born 1930

After graduating in 1953 from the Cleveland Institute of Art, Richard Anuszkiewicz went to Yale University, where he studied color theory and abstract art under Josef Albers and received the M.F.A. degree in 1955. While with Albers he studied the color-space interrelationships that effectively produce optical illusions. Albers's work in this area in the 1960s became the foundation for Op Art, which Anuszkiewicz helped develop.

In his M.F.A. thesis, Anuszkiewicz used design exercises completed under Albers's tutelage to explore theories of visual perception based on Rudolph Arnheim's studies of perceptual psychology. His early paintings—an outgrowth of his thesis studies—explored the figure-ground relationships of freely shaped forms in two or three complementary colors. These works are completely abstract—their subject, the investigation of the dynamics of color.

Reacting against the spontaneity and gestural nature of action painting, Anuszkiewicz makes tight compositions with hard-edged geometric forms. Paradoxically, however, he retains from Abstract Expressionism a sense of continuous action, derived in his case from optical vibrations rather than gesture. He achieves this effect by juxtaposing intense complementary colors, which when optically mixed produce a sensation of visual movement as well as an enhanced after-image. For maximum effectiveness he uses fast-drying acrylic paint and masking tape to sharpen the edges of his colors.

84 *Dual Red*, 1979 80.20

Acrylic on canvas, 90 x 180 in. (228.6 x 457.2 cm.). Museum Purchase: Howald Fund II, 1980

The electrifying *Dual Red* by Anuszkiewicz is one of the largest works the artist has ever painted on a single canvas. Its basic compositional format is derived from Albers's Homage to the Square series and is typical of the "centered square" imagery Anuszkiewicz developed in the 1960s. In *Dual Red* the format is doubled. Within each centered square are other sharply rendered squares layered one over the other in progressively larger dimensions from the center to the outside edge. Arranged side by side, the layered squares simultaneously advance and recede. Within each square format there is intense competition between complementary colors. The tension is heightened by razor-sharp lines at precisely calculated intervals, and the result is a visual fluctuation between figure and ground that cannot be resolved. There is nowhere for the eye to rest.

Op Art's momentum waned in the late 1960s, and most of the artists who were involved in the movement became interested in developing other ideas and styles. Anuszkiewicz, however, continues to explore optical illusion through the interrelationship of color and shape, placing more and more emphasis on sophisticated color mixes in his late paintings, such as *Dual Red*. "I really love color," he has said. "I try to manipulate it in schemes that give the viewer a particular feeling of excitement."[1]

D.A.R.

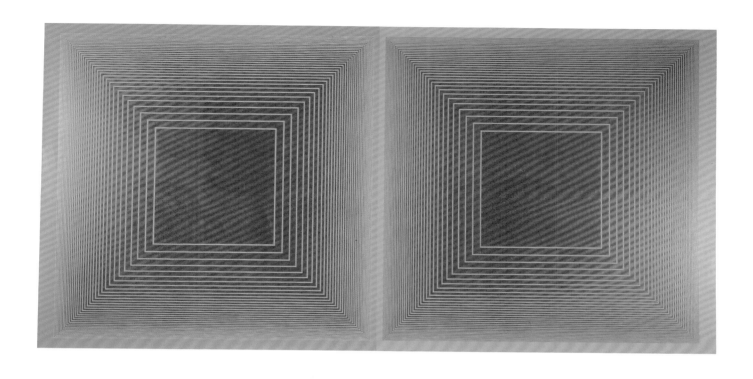

Robert Natkin, born 1930

A native of Chicago, Robert Natkin frequently visited the city's museums and movie houses as a child, and lingering impressions from these visits have influenced his work in many important ways ever since. From 1948 to 1952 he studied painting at the Art Institute of Chicago, where he came to admire and emulate the subtle colors in works by Claude Monet and Pierre Bonnard, and the decorative patterns in works by Henri Matisse and Paul Klee. The artist's continuing interest in color and decorative patterns is also rooted in other aspects of his Chicago experience: the Peruvian textiles he saw in the collection of the Field Museum of Natural History, and the rich architectural ornamentation of Chicago's famous turn-of-the-century buildings.

In 1949 Natkin discovered Abstract Expressionism and painted in that style throughout the 1950s. In the early 1960s, beginning with his Apollo series, he began to simplify his compositions by organizing colored textural forms into quasi-geometric patterns. Then in 1971, he began painting with a loosely woven cloth wrapped around a sponge, which made it possible to achieve meshlike textures. In the resulting compositions, Natkin uses overlapping shapes and complex decorative patterns for their expressive potential, adding dreamy, glowing color and rich textures to convey a mood or to create an environment for personal reflection.

85 *Hitchcock Series: Anticipation of the Night*, 1984 85.11

Acrylic on canvas, 84 x 94 in. (213.2 x 238.6 cm.). Signed lower edge: Natkin. Museum Purchase: Howald Fund, 1985

Anticipation of the Night is from a series named for film director Alfred Hitchcock. The composition embodies the fabric-like texture of stage curtains illuminated by a warm glow of colored lights—similar in effect to what Natkin had seen in childhood visits to vaudeville theaters and picture palaces. Natkin began his Hitchcock series in the 1980s. Influenced by his own recent printmaking experiments, he approached this new series with more forethought and less dependence on spontaneous reaction than are evident in his earlier paintings. He had discovered that the technical requirements of printmaking forced the artist to adopt a more disciplined working style and to conceptualize the finished work from the beginning. When he used this approach in painting, he saw analogies between the role of a painter and that of a movie director. He named the series after Hitchcock because he admired the filmmaker's ability to thread the darker aspects of human behavior through a playful and romantic storyline. In adapting Hitchcock's methods to painting, Natkin was able to deal with personal inner conflict in a pleasing visual context.

Like good film and theater, Natkin's paintings are filled with allusions. The titles are clues to their meanings. In *Anticipation of the Night* there is something of the suspense and fear that accompany the expectation of darkness, the shadows, the potential dreams and even nightmares that are not strangers to the night. Natkin translates these harbingers, which are as dramatic and entertaining as those of Hitchcock's thrillers, into the expressive language of light, color, texture, and pattern.

The large, nearly square canvas of luminous midnight blues and purples is filled with multicolored patterns of stripes, checks, dots, and grids. Opaque geometric shapes, bright yet somehow formidable, seem to float above the shimmering, textured ground. Repeated patterns pulsate throughout the picture, advancing and receding, appearing large then small, light then dark. Just below the center of the picture, there is a checkered shape that looks like a building—cozily lit, or seemingly aflame. Nearby, there is a sinuous path that disappears in misty darkness on its way to an unseen destination. Even Natkin's signature, which extends nearly the length of the picture's lower edge, becomes part of the composition. The emotional and psychological power of *Anticipation of the Night* lies in its contradictions, which create tension and strain for resolution. Ultimately, conclusions are delightfully left to the viewer's imagination.

D.A.R.

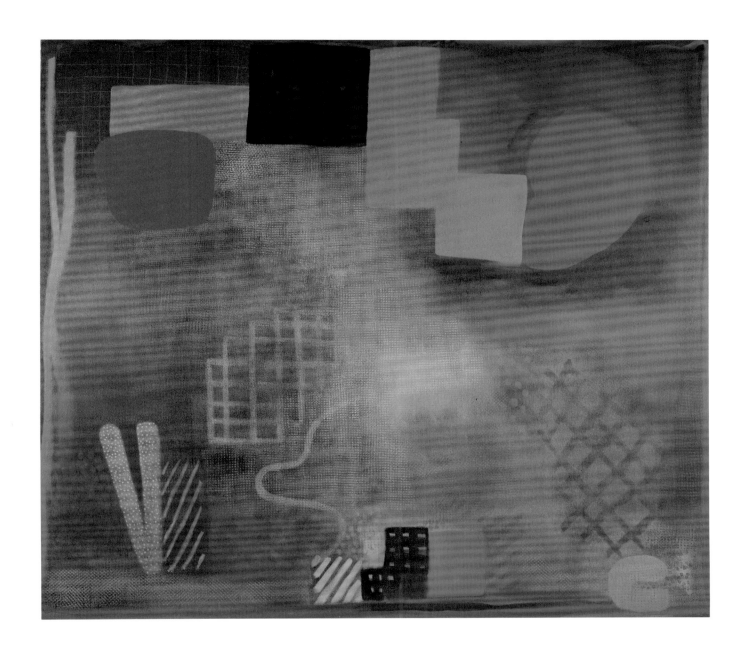

Stephen Antonakos, born 1926

When Steven Antonakos was four years old, his family emigrated from Greece to the United States, settling in New York City. He graduated from the New York Institute of Applied Arts and Sciences in 1947 and worked as a freelance illustrator. As time permitted, he began painting and making assemblages with found objects. By the late 1950s he was working with a variety of linear forms in wood. In the next few years, he incorporated electric lights in the wooden constructions and in a series of pillow constructions, which consist simply of pillows covered or split open to reveal various additional elements such as buttons, dowels, balls, nails, lights, rings, letters forming words such as "yes," "no," and "dream," and found objects.

Because of their intense color, linear form, and flexibility, neon tubes became the artist's chosen medium in 1962. At first he created simple geometric forms, which he mounted on pedestals and presented as sculptural objects. By 1965 he was designing works that interact with the environment. In later works there is always an involvement with the walls and other architectural forms on which the neons are positioned. Both the indoor and outdoor neons engage the very space which contains them, through the effects of the ambient color glow around the tubes and through the crucial placements which the artist determines. Since the 1970s, Antonakos has been completing commissions for large-scale works in public sites.

One of the artists Antonakos admires most is Matisse, because in his cutouts "he took a simple idea and went so far with it, making his forms and colors so alive."[1] To Antonakos, neon too allows forms and colors to come alive; it is "a controlled paradise"[2] that lends itself to an infinite variety of scale and spatial designs. His work always reflects an abstract, geometric aesthetic. He is not interested in making reference to narrative subjects or to the traditional use of neon in commercial signs. He says:

> *I thought neon was many things, had many voices. . . . I wanted to use neon for itself, for its own qualities and I wanted to find new forms for neon which would give it new and rich uses and meanings. . . . I do not think of neon as being aggressive, but I do know that it can be very affecting.[3]*

86 *Neon for the Columbus Museum of Art*, 1986 86.1

Neon, glass, and stainless steel, 336 x 294 in. (853.4 x 746.8 cm.) Gift of Artglo Sign Company, Inc., and Museum Purchase: Howald Fund, 1986

In 1985 the Columbus Museum of Art commissioned Stephen Antonakos to create a neon sculpture for the exterior wall above the museum's north entrance. The artist prepared sketches of his design which were enlarged by computer to the size of the finished work. Artisans of the Artglo Sign Company of Columbus then formed the tubes to size. A joint cultural endeavor between the museum and a local company that donated its time and skills, the creation of the piece also exemplifies an extraordinary understanding between artist and skilled fabricators, a longstanding tradition in the history of sculpture.

Neon for the Columbus Museum of Art is an orchestration of shapes and radiating colors, in which the artist's characteristic incomplete circles and squares and straight and wavy lines are drawn by neon tubes mounted on both the fronts and backs of brightly painted steel raceways. The work, which is partially framed by the architecture, has been described by the artist as probably his most painterly work. Some of the components extend outward beyond the support so that they are not parallel to the surface of the wall on which they are mounted, giving a feeling of depth to an essentially linear work. In bright daylight the playful forms cast delicate washes on a small area of the building, but as the sky darkens, the composition becomes a bold, powerful presence, with an intense ambient light that colors and transforms a landscaped parking area and surrounding buildings.

Speaking of the changing dynamics of the sculpture, Antonakos said "it will change from hour to hour, from winter to summer, from a rainy day to a snowy day. . . . The people who see the museum every day will notice specific changes."[4]

D.A.R.

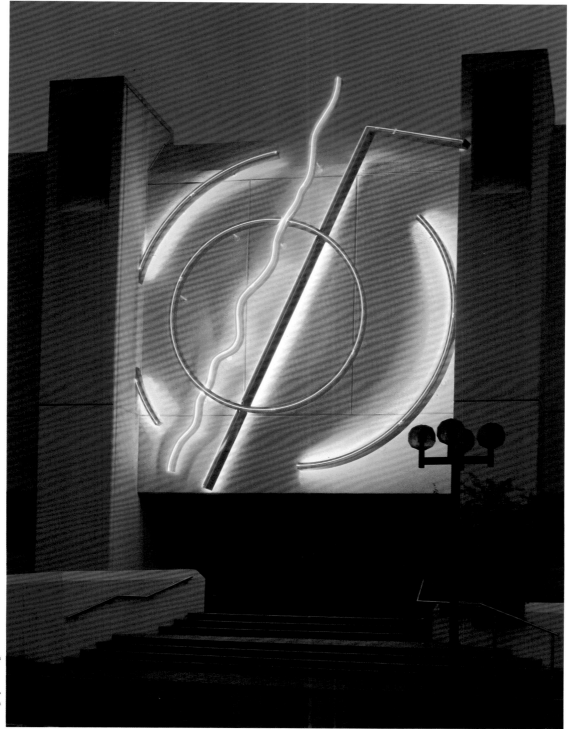

Endnotes and Documentation

Entries under Provenance, Exhibition History, and References are arranged in chronological sequence, from earliest to latest.

Under Provenance, specific dates of ownership are given, if known, but in many cases the dates are only the verified times of ownership, not necessarily the entire duration of ownership. Sales or other details of transfer are noted parenthetically.

The institution whose name begins an entry in the Exhibitions History is the organizer and, if dates follow the name, an exhibitor during the time specified. Exhibition titles are italicized if known; descriptive titles are in roman type. If the exhibition is documented by a catalogue or checklist, the catalogue or checklist number and other publication information is given following the name of the exhibition. Inclusive dates of a tour, if any, follow, with names of the venues (in a few cases only the city or country is known).

Exhibition catalogues cited under the Exhibitions History are not repeated under References.

Bracketed entries in any category signify that the information given is likely accurate with respect to the museum's work but is not confirmed beyond doubt.

Names of institutions cited in the entries are to the best of our knowledge the names used by the institutions at the time of the exhibition or publication. The Columbus Gallery of Fine Arts, for example, became the Columbus Museum of Art in 1978, and citations up to that date are under the earlier name.

ABBREVIATIONS USED IN DOCUMENTATION

INSTITUTIONS

AFA	American Federation of Arts (New York)
Carnegie Institute	Museum of Art, Carnegie Institute (Pittsburgh)
CGFA	Columbus Gallery of Fine Arts (Ohio)
CMA	Columbus Museum of Art (Ohio)
MMA	Metropolitan Museum of Art (New York)
MoMA	Museum of Modern Art (New York)
PAFA	Pennsylvania Academy of the Fine Arts (Philadelphia)
SITES	Smithsonian Institution Traveling Exhibition Service (Washington, D.C.)
WMAA	Whitney Museum of American Art (New York)

EXHIBITIONS

AFA (1948–1949)	American Federation of Arts, *Early Twentieth Century American Watercolors*, no cat.; toured, September 5, 1948 – May 31, 1949, to Dayton Art Institute (Ohio), Rochester (New York), Western College (Oxford, Ohio), Williamstown (Massachusetts), Manchester (New Hampshire), Cambridge (Massachusetts), Minneapolis Institute of Arts.

CGFA (1931)

Columbus Gallery of Fine Arts, *Inaugural Exhibition*, January–February 1931; exh. cat., *Bulletin of the Columbus Gallery of Fine Arts* 1 (January 1931).

CGFA (1935)

Columbus Gallery of Fine Arts, *Paintings from the Howald Collection*, January 6 – February 3, 1935, to Cincinnati Art Museum (Ohio).

CGFA (1941)

Columbus Gallery of Fine Arts, *Early Works from Ten Well-Known Contemporary American Painters* (or *Selections from the Permanent Collection of The Columbus Gallery of Fine Arts*); toured, December 2–31, 1941, to Dayton Art Institute (Ohio).

CGFA (February 1952)

Columbus Gallery of Fine Arts, *The Howald Collection from the Columbus Gallery of Fine Arts*, February 28 – April 13, 1952, to Museum of Art, Carnegie Institute (Pittsburgh).

CGFA (October 1952)

Columbus Gallery of Fine Arts, *One Man Collects: Selections from the Howald Collection*, October 7 – November 2, 1952, to Art Institute of Zanesville (Ohio).

CGFA (1956)

Columbus Gallery of Fine Arts, *Watercolors from the Ferdinand Howald Collection*, February 7 – May 27, 1956, to Philbrook Art Center (Tulsa, Oklahoma), Pasadena Art Museum (California), San Diego Fine Arts Gallery.

CGFA (1958)

Columbus Gallery of Fine Arts, *Howald Collection of Paintings*, January 6–29, 1958, to Albany Institute of History and Art (New York).

CGFA (1958–1960)

Columbus Gallery of Fine Arts, and American Federation of Arts (New York), *Adventure in Collecting*; toured, September 22, 1958 – November 5, 1960, to Wells College (Aurora, New York), Andrew Dickson White Art Museum (Ithaca, New York), Antioch College (Yellow Springs, Ohio), Charles and Emma Frye Museum (Seattle), J. B. Speed Art Museum (Louisville, Kentucky), Time, Inc. (New York), Brooks Memorial Art Gallery (Memphis, Tennessee), Miami Beach Art Center (Florida), John Jacob Astor House (Newport, Rhode Island), Slater Memorial Museum (Norwich, Connecticut), Watkins Institute (Nashville, Tennessee), Art Museum of the New Britain Institute (New Britain, Connecticut), Quincy Art Club (Illinois), Georgia Institute of Technology (Atlanta), Pensacola Art Center (Florida), Southwestern University (Georgetown, Texas), Art Gallery of Greater Victoria (British Columbia), University of Oregon Museum of Art (Eugene), Tacoma Art League (Washington), Eastern Illinois University (Charleston).

CGFA (1961)

Columbus Gallery of Fine Arts, *Watercolors from the Ferdinand Howald Collection*, April 1–18, 1961, to Allentown Art Museum (Pennsylvania).

CGFA (1968)

Columbus Gallery of Fine Arts, *Works from the Howald Collection*, April 19 – May 18, 1968, to Museum of Fine Arts, St. Petersburg (Florida).

CGFA (1969)

Columbus Gallery of Fine Arts, *Selections from the Ferdinand Howald Collection of the Columbus Gallery of Fine Arts*, March 2–30, 1969, to Butler Institute of American Art (Youngstown, Ohio).

CGFA (January 1970)

Columbus Gallery of Fine Arts, *The Ferdinand Howald Collection of the Columbus Gallery of Fine Arts*, January 11 – February 16, 1970, to Dayton Art Institute (Ohio).

CGFA (May 1970)

Columbus Gallery of Fine Arts, *The Ferdinand Howald Collection*, May 19 – July 3, 1970, to Wildenstein & Co. (New York).

CGFA (1970–1971)

Columbus Gallery of Fine Arts, and American Federation of Arts (New York), *Selections from the Ferdinand Howald Collection*; toured, September 20, 1970 – June 27, 1971, to Witte Memorial Museum (San Antonio, Texas), Cummer Gallery of Art (Jacksonville, Florida), Georgia Museum of Art (University of Georgia, Athens), Phoenix Art Museum (Arizona), Milwaukee Art Center (Wisconsin).

CGFA (1973)	Columbus Gallery of Fine Arts, *Ferdinand Howald: Avant-Garde Collector*; toured, June 20 – October 28, 1973, to Wildenstein & Co., Ltd. (London, England), National Gallery of Ireland (Dublin), National Gallery of Wales (Cardiff).
CGFA (1975)	Columbus Gallery of Fine Arts, *Selections from the Ferdinand Howald Collection*, February 7 – March 2, 1975, to Society of the Four Arts (Palm Beach, Florida).
CGFA (1977)	Columbus Gallery of Fine Arts, *Ferdinand Howald: Avant-Garde Collector*, April 21 – June 5, 1977, to Elvehjem Art Center (University of Wisconsin, Madison).
CMA (1983)	Columbus Museum of Art, and Art Gallery of Ontario (Toronto), *Chefs-d'Oeuvre from the Columbus Museum of Art Frederick W. Schumacher Collection*; toured, May 27 – December 4, 1983, to Timmins Museum, National Exhibition Centre (Ontario); Thunder Bay National Exhibition Centre (Ontario), Art Gallery of Windsor (Ontario); Art Gallery of Ontario.
CMA (1986)	Columbus Museum of Art, *Selections from the Frederick W. Schumacher Collection at the Columbus Museum of Art*, September 7 – October 7, 1986, to Paramount Arts Center Gallery (Ashland, Kentucky).
CMA (1986–1987)	Columbus Museum of Art, November 9, 1986 – January 4, 1987, *Choice by Choice: Celebrating Notable Acquisitions 1976–1986*.
Denison University (1962)	Visual Art Department, Denison University (Granville, Ohio), September 15 – November 15, 1962, *Modern American Painting*.
Indiana University (1964)	Fine Arts Gallery, Indiana University (Bloomington), April 19 – May 10, 1964, *American Painting 1910 to 1960: A Special Exhibition Celebrating the 50th Anniversary of the Association of College Unions*.
Ohio State University (1973)	Hopkins Hall Art Gallery, Ohio State University (Columbus), January 9 – February 2, 1973, *Six Centuries of Painting from the Columbus Gallery of Fine Arts*.
Ohio University (1977)	Trisolini Gallery of Ohio University (Athens), November 8–22, 1977, *Masters of the Nineteenth Century*, cat. by M. Barry Katz.

REFERENCES

Bishop (1981)	Budd Harris Bishop, "Nineteenth-century American Paintings at the Columbus Museum of Art," *The Magazine Antiques* 120 (November 1981).
CGFA (1976)	Columbus Gallery of Fine Arts, *The Frederick W. Schumacher Collection* (1976).
CMA (1986)	Columbus Museum of Art, *Modern Sculpture* (1986).
CMA, *Catalog* (1978)	Columbus Museum of Art, *Catalog of the Collection* (1978).
CMA, *Selections* (1978)	Columbus Museum of Art, *200 Selections from the Permanent Collection* (1978).
Tucker (1969)	Marcia Tucker, *American Paintings in the Ferdinand Howald Collection* (1969).
Valentiner (1955)	William R. Valentiner, *The Frederick W. Schumacher Collection* (privately printed, 1955).
Young (1973)	Mahonri Sharp Young, *The Eight: The Realist Revolt in American Painting* (1973).
Young (1974)	Mahonri Sharp Young, *Painters of the Stieglitz Group: Early American Moderns* (1974).
Young (1977)	Mahonri Sharp Young, *American Realists: Homer to Hopper* (1977).

1 *Haymaking* 42.83

ENDNOTES:

1. For a discussion of these and other related works, see John Wilmerding, "Winslow Homer's Creative Process," *The Magazine Antiques* 108 (November 1975): 965–971.

PROVENANCE:

(Sale: auction, March 23, 1866 [Somerville Galleries?]); F. H. Whitmore, New York and Farmington, Connecticut, 1866; Frederic Whitmore, Springfield, Massachusetts; Snedecor & Co., New York, 1916; Frederic Fairchild Sherman, Westport, Connecticut, ca. 1918; (consigned to Babcock Galleries, New York, October 19, 1927–January 22, 1929, returned to owner); Frederic Fairchild Sherman; (sale: Parke-Bernet Galleries, New York, June 4, 1942, sale no. 382, lot no. 14); CMA, 1942.

EXHIBITION HISTORY:

[Artist's Fund Society of New York, December 30, 1864, *5th Annual Exhibition*, cat. no. 97 (as *In the Hayfield*).]

Pennsylvania Museum of Art (Philadelphia), May 2–June 8, 1936, *Winslow Homer Centennial*, cat. no. 2.

George Walter Vincent Smith Art Gallery (Springfield, Massachusetts), March 31–May 4, 1941, *The Private Collection of Frederic Fairchild and Julia Munson Sherman—A Memorial Exhibit*, cat. no. 30, illus.

WMAA, October 3–November 2, 1944, *Oils and Watercolors by Winslow Homer*, no cat.

CGFA, October 9–November 28, 1948, *Romantic America*, cat. no. 22, p. 4.

CGFA (February 1952), no cat.

Hiestand Hall Gallery, Miami University (Oxford, Ohio), October 1–31, 1959, *The American Scene in 150 Years of American Art*, cat.

AFA, *Major Work in Minor Scale*, checklist no. 13; toured, December 4, 1959–December 22, 1960, to Jacksonville Art Museum (Florida), Des Moines Art Center (Iowa), Philbrook Art Center (Tulsa, Oklahoma), Charles and Emma Frye Museum (Seattle), Art Gallery of Greater Victoria (British Columbia, Canada), Andrew Dickson White Museum of Art (Ithaca, New York), Miami Beach Art Center (Florida), Spiva Art Center (Joplin, Missouri), Evansville Museum of Arts and Sciences (Indiana), Chatham College (Pittsburgh), Art Museum of the New Britain Institute (Connecticut).

University of Delaware and Wilmington Society of Fine Arts, Delaware Art Center, January 10–February 18, 1962, *American Painting 1857–1869*, cat. by Wayne Craven, no. 37, pp. 69, 78, illus. no. 37.

University of Arizona Art Gallery (Tucson), October 11–December 1, 1963, *Yankee Painter*, cat. no. 36, p. 82.

Springfield Art Association (Ohio), March 14–April 17, 1967, *Opening Exhibition of the Springfield Art Center*, no cat.

Indiana University Art Museum (Bloomington), January 18–February 28, 1970, *The American Scene 1820–1900*, cat. by Louis Hawes, no. 85, illus.

WMAA, April 3–June 3, 1973, *Winslow Homer*, cat. by Lloyd Goodrich, no. 2, p. 134; toured, July 3–October 21, 1973, to Los Angeles County Museum of Art, Art Institute of Chicago.

Terra Museum of American Art (Evanston, Illinois), September 11–November 15, 1981, *Life in 19th Century America*, cat. by David M. Sokol, no. 48, pp. 24, 31, illus.

REFERENCES:

Frederic Fairchild Sherman, "The Early Oil Paintings of Winslow Homer," *Art in America* 6 (June 1918): 205, 207, illus.

Frederic Fairchild Sherman, *American Painters of Yesterday and Today* (1919), pp. 28, 32, illus.

Ralph Henry Gabriel, "Toilers of Land and Sea," *The Pageant of America*, Vol. 3 (1926), p. 76, illus. no. 152.

Paintings by American Artists—An Illustrated Catalogue of the Paintings Owned by Frederic Fairchild Sherman (1930).

"Winslow Homer—Painter," *Index of Twentieth Century Artists* 1 (November 1933), reprinted in *The Index of Twentieth Century Artists 1933–1937* (1970): 33.

Nelson C. White, "Sherman Memorial Exhibition," *Art in America* 29 (July 1941): 162, 168, illus.

Forbes Watson, *Winslow Homer* (1942), p. 87, illus.

Warren Beach, "'Girl in an Orchard' by Winslow Homer," *The Columbus Gallery of Fine Arts Monthly Bulletin* 19 (fall 1948): 11, 12, illus.

Richard Hofstadter, "The Myth of the Happy Yeoman," *American Heritage* 7 (April 1956): 44, illus.

Lloyd Goodrich, *Winslow Homer* (1959), pl. 4.

John Wilmerding, *Winslow Homer* (1972), pp. 47, 75, pl. 2–25.

Julian Grossman, *Echo of a Distant Drum: Winslow Homer and the Civil War* (1974), p. 165, illus. no. 173.

Melinda Dempster Davis, *Winslow Homer: An Annotated Bibliography of Periodical Literature* (1975), p. 83.

John Wilmerding, "Winslow Homer's Creative Process," *The Magazine Antiques* 108 (November 1975): 966, fig. 2.

Young (1977), p. 17, illus.

CMA, *Catalog* (1978), pp. 58–59, 142, illus.

CMA, *Selections* (1978), pp. 58–59, illus.

Gordon Hendricks, *The Life and Work of Winslow Homer* (1979), no. CL–566, p. 319, illus.

Bishop (1981), p. 1174, pl. 2.

2 *Girl in the Orchard* 48.10

ENDNOTES:

1. See Henry Adams, "Winslow Homer's Mystery Woman," *Art and Antiques* (November 1984): 39–45.

2. Ibid., p. 43.

PROVENANCE:

The artist, until ca. 1910; Charles L. Homer, Quincy, Massachusetts; Thomas N. and Elizabeth P. Metcalf, Boston, Massachusetts, ca. 1940; John Nicholson Gallery, New York, ca. 1945; John Levy Galleries, New York; CMA, 1948.

EXHIBITION HISTORY:

John Nicholson Gallery (New York), ca. 1945, *Exhibition of American Paintings*, cat. no. 1, illus.

John Nicholson Gallery (New York), ca. 1945, *Important Examples from Three Centuries of Fine Landscape Paintings*, cat. no. 3, illus.

CGFA (February 1952), no cat.

Ohio University (1977), cat. no. 18, illus.

Mansfield Art Center (Ohio), March 11–April 8, 1984, *The American Figure: Vanderlyn to Bellows*, cat. no. 9, cover illus.

REFERENCES:

William Howe Downes, *The Life and Works of Winslow Homer* (1911), p. 116.

Art Quarterly 9 (Spring 1946): 185, illus.

Warren Beach, "'Girl in an Orchard' By Winslow Homer," *The Columbus Gallery of Fine Arts Fall Bulletin* 19, no. 1 (1948): 10–12, 15, cover illus.

Melinda Dempster Davis, *Winslow Homer: An Annotated Bibliography of Periodical Literature* (1975), p. 80.

Eloise Spaeth, *American Art Museums: An Introduction to Looking*, 3rd ed. (1975), p. 344.

Young (1977), p. 39, illus.

CMA, *Catalog* (1978), p. 142, illus.

Gordon Hendricks, *The Life and Work of Winslow Homer* (1979), pp. 299, 319, illus.

Bishop (1981), pp. 1172, 1174, fig. 4.

RELATED WORKS:

Waiting an Answer, 1872, oil on canvas, Peabody Institute of Music (Baltimore, Maryland).

Hunting for Eggs, 1874, watercolor, Sterling and Francine Clark Art Institute (Williamstown, Massachusetts).

Summer, 1874, watercolor, Sterling and Francine Clark Art Institute (Williamstown, Massachusetts).

Fresh Eggs, 1874, watercolor, WMAA.

REMARKS:

Attached to the stretcher frame is a paper label that reads: Addison Gallery/Phillips Academy/Andover, Massachusetts/GIRL IN ORCHARD/by Winslow Homer/Property of/ Mrs. Thomas N. Metcalf/(Elizabeth P.). The painting may have been included in an exhibition at the Addison Gallery, but this has not been confirmed.

3 *The Pasture* 54.36

ENDNOTES:

1. George Inness, "A Painter on Painting," *Harper's New Monthly Magazine* 56 (February 1878): 458. Reprinted in N. Cikovsky, Jr., and M. Quick, *George Inness* (exh. cat., Los Angeles County Museum of Art, 1985), p. 205.

2. Ibid., p. 209.

PROVENANCE:

Howard Young Galleries, New York; Mrs. Joshua Cosden, New York; Newhouse Galleries, New York; Mr. and Mrs. R. W. Lyons, Washington, D.C.; (sale: Parke-Bernet Gallery, New York, January 1945, cat. no. 48, p. 56); Virginia H. Jones, 1945; CMA, 1954 (bequest of Virginia H. Jones).

REFERENCES:

Leroy Ireland, *The Works of George Inness: An Illustrated Catalogue Raisonné* (1965), cat. no. 283, pp. 71–72, illus.

Nicolai Cikovsky, Jr., *George Inness* (1971) p. 38, illus. no. 27 (as *Landscape*).

CMA, *Catalog* (1978), p. 142.

Bishop (1981), pp. 1174, 1175, fig. 3.

4 *Shower on the Delaware River* 54.2

ENDNOTES:
1. George W. Sheldon, *American Painters* (1979), p. 34.
2. N. Cikovsky, Jr., and M. Quick, *George Inness* (exh. cat., Los Angeles County Museum of Art, 1985), p. 205.
3. "Some Living American Painters: Critical Conversations by Howe and Torrey," *Art Interchange* 32 (April 1894): 102.

PROVENANCE:
James William Ellsworth, Chicago and New York, by 1895 (acquired from the artist); Clare Ellsworth Prentice, New York, ca. 1925; Bernon S. Prentice, New York, ca. 1929; (sale: Parke-Bernet Galleries, New York, April 19, 1952, cat. no. 657, p. 124, illus.); Kleeman Galleries, New York, 1952; [John Nicholson Galleries, New York]; (sale: Parke-Bernet Galleries, New York, January 27, 1954, cat. no. 77, p. 41, illus.); CMA, 1954.

EXHIBITION HISTORY:
Art Association of Columbus, May 1895, *Columbus Art Loan Exhibition*, cat. no. 21, p. 7 (as *Shower, Delaware River*).

M. Knoedler & Co. (New York), November 16–28, 1953, *A Half Century of Landscape Paintings by George Inness (1825–1894)*, cat.

Paine Art Center and Arboretum (Oshkosh, Wisconsin), October 2–28, 1962, *Paintings by George Inness*, cat. no. 26, illus.

Oakland Museum Art Department (California), November 28, 1978–January 28, 1979, *George Inness Landscapes: His Signature Years 1884–1894*, cat. by Marjorie Dakin Arkelian and George W. Neubert, p. 58.

Nassau County Museum of Fine Art (New York), October 4, 1981–January 17, 1982, *Animals in American Art: 1880's–1980's*, cat. no. 92 and introduction (unpag.).

University Art Gallery, State University of New York at Binghamton, January 21–February 13, 1983, *19th-Century Painters of the Delaware Valley*, cat. essay by Matthew Baigell, no. 27, pp. 18, 41, illus.; toured, March 12–April 24, 1983, to New Jersey State Museum (Trenton).

REFERENCES:
George Inness, Jr., *Life, Art and Letters of George Inness* (1917), pp. 245, 248, illus.

"George Inness—Painter," *Index of Twentieth Century Artists* 4 (December 1936), reprinted in *The Index of Twentieth Century Artists 1933–1937* (1970): 660.

Leroy Ireland, *The Works of George Inness* (1965), pp. 355–356, illus.

CMA, *Catalog* (1978), pp. 61–62, 142, illus.

CMA, *Selections* (1978), pp. 61–62, illus.

Bishop (1981), pp. 1174, 1178, pl. 8.

REMARKS:
Shower on the Delaware River may have been included in an exhibition (dates unknown) at the John Nicholson Galleries (New York), according to Leroy Ireland, *The Works of George Inness* (1965), p. 356. It is likely that the painting was at Nicholson Galleries until January 1954 when it was consigned by Nicholson to Parke-Bernet.

In a copy of the catalogue for the Knoedler exhibition of November 1953 (WMAA Papers, Archives of American Art, Smithsonian Institution, Washington, D.C., Roll N667, Frames 257–259) there is a handwritten notation as follows: Shower on the Delaware River 1891: (Pot of Gold): [Rainbow].

5 *Landscape* 29.3

ENDNOTES:
1. From "Introduction to the Propylaen" (1798), anonymous translation published in *The Harvard Classics*, Vol. 39: *Prefaces and Prologues*, Charles W. Eliot, ed. (1938), p. 255.
2. Another painting which parallels the views recorded in these two works is *In the Mountains* (1867, Wadsworth Atheneum, Hartford, Connecticut), reproduced in Matthew Baigell, *Albert Bierstadt* (1981), pl. 14 (in reverse; correct on the jacket).

PROVENANCE:
Rutherford H. Platt, Columbus; CMA, 1929 (bequest of Rutherford H. Platt).

EXHIBITION HISTORY:
[Columbus, May 1895, *Columbus Art Loan Exhibition*, cat. no. 73, p. 16 (as *King Lake, California*)].

[CGFA and Art Association of Columbus, May 1–15, 1907, *Loan Exhibition of Paintings*, cat. no. 4, p. 5 (as *King Lake, California*)].

University Gallery, University of Minnesota, February 1–March 1, 1939, *Survey of Colonial and Provincial Painting*, cat. no. 3, pp. 26, 36, illus. (as *Yosemite Valley*).

CGFA, Exhibition of American Paintings from the CGFA, no cat.; February 27–March 20, 1941, to Johnson-Humrickhouse Memorial Museum (Coshocton, Ohio).

National Collection of Fine Arts (Washington, D.C.), April 30–November 7, 1976, *America as Art*, cat. by Joshua C. Taylor, no. 148 (as *Yosemite Valley*, after 1860).

Ohio University (1977), cat. no. 14, illus. (as *Yosemite Valley*, ca. 1870–1875).

SITES, *New Horizons: American Painting 1840–1910*, cat. no. 4, pp. 26, 28, 140, illus.; toured, November 16, 1987–July 10, 1988, to State Tretyakov Museum (Moscow, USSR), State Russian Museum (Leningrad, USSR), Minsk State Museum of Belorussiya Russia (Minsk, USSR), State Museum of Russian Art (Kiev, USSR).

REFERENCES:
Gordon Hendricks, "The First Three Western Journeys of Albert Bierstadt," *Art Bulletin* 46 (September 1964): 363, no. 223 (as *Yosemite Valley*).

John Maass, *The Glorious Enterprise, The Centennial Exhibition of 1876 and H. J. Schwarzmann, Architect-in-Chief* (1973), p. 78 (as *Yosemite Valley*; erroneously said to have been exhibited at the Centennial Exhibition, 1876).

Gordon Hendricks, *Albert Bierstadt: Painter of the American West* (1973), no. CL-189, illus. (as *Yosemite Valley* "[incorrect title]").

Joshua C. Taylor, *America as Art* (1976), p. 125, illus. (as *Yosemite Valley*, after 1860).

CMA, *Catalog* (1978), pp. 18, 19, 136, illus. (as *Yosemite Valley*).

CMA, *Selections* (1978), pp. 18, 19, illus. (as *Yosemite Valley*).

Bishop (1981), pp. 1173, 1174, pl. 1 (as *Yosemite Valley*).

Robert C. Frazier, Arnold M. Horwitch, and Lewis R. Marquardt, *The Humanities: A Quest for Meaning in Twentieth Century America* (1982), p. 123, fig. 8.7 (as *Yosemite Valley*).

Otto G. Ocvirk, et al., *Art Fundamentals: Theory and Practice* (5th ed., 1985), pp. 101, 102, illus. 7.14.

6 *Marsh Scene: Two Cattle in a Field* 80.2

ENDNOTES:
1. Theodore Stebbins, *The Life and Work of Martin Johnson Heade* (1975), p. 42.
2. Ibid.
3. Barbara Novak, "On Defining Luminism," in *American Light: The Luminist Movement, 1850–1875* (exh. cat., National Gallery of Art, 1980), pp. 23–29.
4. Letter from T. Stebbins to Jerald Fessenden, February 24, 1978 (CMA files).
5. Ibid.
6. Stebbins, pp. 49–50.
7. Stebbins letter to Fessenden.
8. "G.T.C.," *National Academy of Design Exhibition of 1868* (1868), p. 87; *Brooklyn Daily Eagle*, March 21, 1868.

PROVENANCE:
Private collector, Massachusetts; Robert C. Vose, Jr., Boston; Vose Galleries, Boston, 1976; Coe Kerr Gallery, New York, 1977; CMA, 1980.

EXHIBITION HISTORY:
Coe Kerr Gallery, New York, October 25–November 25, 1978, *American Luminism*, cat. no. 21, illus. (as *Sunset on the Marshes*).

CMA (1986–1987), cat. no. 34, pp. 18, 19, 32, illus.

REFERENCES:
Bishop (1981), p. 1174, pl. 3.

Ann Bremner, "From the Editor: The Lay of the Land," *Dialogue: An Art Journal* 10 (March/April 1987): 6, illus.

Theodore E. Stebbins, Jr., *The Life and Work of Martin Johnson Heade* (rev. ed., forthcoming, 1988).

RELATED WORKS:
Two Sketches of Cattle, pencil on paper, illus. in Theodore E. Stebbins, Jr., *The Life and Work of Martin Johnson Heade* (1975), cat. no. 395–39, fig. 20, p. 48.

Covered Haystack, pencil on paper, Museum of Fine Arts, Boston; illus. in Stebbins, cat. no. 395–4, fig. 21, p. 50.

7 *Still Life* 80.32

ENDNOTES:
1. Richard B. Stone, "Not Quite Forgotten: A Study of the Williamsport Painter, S. Roesen," *Lycoming Historical Society: Proceedings and Papers* 9 (November 1951): 7–8, 12–13.
2. William Gerdts, *Painters of the Humble Truth* (1981), p. 84.
3. Lois Goldreich Marcus, *Severin Roesen: A Chronology* (Lycoming County Historical Society and Museum, 1976), p. 7.
4. Ibid., p. 32.
5. Maurice A. Mook, "Severin Roesen, The Williamsport Painter," *Lycoming College Magazine* 25 (June 1972): 36; and Marcus, pp. 43, 47.
6. Stone, p. 26.

7. "August [Severin] Roesen, Artist: An Interesting Williamsport Genius Recalled by His Works," *Williamsport Sun and Banner*, June 27, 1895; reprinted in Stone, p. 32.

8. Gerdts, p. 87.

9. Ibid., pp. 87, 88.

PROVENANCE:
Johanna Schroeder, New York; private collection; (sale: Sotheby Parke Bernet, New York, October 27, 1978, cat., lot no. 4, illus. as *Still Life with Fruit*); Peter Findlay, New York, 1978; Coe Kerr Gallery, New York (as *Still Life with Bird's Nest*); CMA, 1980.

EXHIBITION HISTORY:
Mansfield Art Center (Ohio), March 10 – April 7, 1985, *The American Still Life: From the Peales to C. A. Meurer*, cat. no. 5, illus.

CMA (1986–1987), cat. no. 42, pp. 18, 32.

REFERENCES:
Bishop (1981), pp. 1173, 1179, fig. 2.

8 After the Hunt 19.1

ENDNOTES:
1. The third version (1884, Butler Institute of American Art, Youngstown, Ohio) and the fourth and largest version (1885, California Palace of the Legion of Honor) are more elaborate variants. For a further discussion of American trompe l'oeil painting and Harnett's hunt series, see *More than Meets the Eye: The Art of Trompe l'Oeil* (CMA, 1983), pp. 25–31.

PROVENANCE:
[Earles' Galleries and Looking Glass Warerooms, Philadelphia]; Francis C. Sessions, Columbus; Mary J. Sessions, Columbus, 1892 (bequeathed by Francis C. Sessions to Mary J. Sessions with the provision that upon her death the work should be given to the CGFA; CMA, 1919 (bequest of Francis C. Sessions).

EXHIBITION HISTORY:
CGFA, April 8–30, 1937, *Victorian Painting and Sculpture*, no cat.

Johnson-Humrickhouse Memorial Museum (Coshocton, Ohio), February 27–March 20, 1941, *Exhibition of American Painting*, no cat.

California Palace of the Legion of Honor (San Francisco), September 1 – November 21, 1948, *William Harnett and His Followers*, no cat.

PAFA, January 15 – March 13, 1955, *The One Hundred and Fiftieth Anniversary Exhibition*, cat. no. 66, pp. 53, 56, illus. (as second version) [toured, April 21 – November 26, 1955, to Sala de la Direccion (Madrid, Spain), Palazzo Strozzi (Florence, Italy), Tiroler Landesmuseum Ferdinandeum (Innsbruck, Austria), Museum voor Schone Kunsten (Ghent, Belgium), Royal Swedish Academy (Stockholm, Sweden)].

Sports Illustrated and AFA, *Sport in Art*, cat. no. 45; toured, January 5 – October 28, 1956, to Corcoran Gallery of Art (Washington, D.C.), J. B. Speed Art Museum (Louisville, Kentucky), Dallas Museum of Fine Arts, Denver Art Museum, Los Angeles County Museum of Art, California Palace of the Legion of Honor (San Francisco), Dayton Art Institute (Ohio).

La Jolla Museum of Art (California), July 11 – September 19, 1965, *The Reminiscent Object: Paintings by William Michael Harnett, John Frederick Peto and John Haberle*, cat. essay by Alfred Frankenstein, no. 14, illus.; toured, September 28 – October 31, 1965, to Santa Barbara Museum of Art (California).

AFA, *A Century of American Still Life Painting: 1813-1913*, cat. by William H. Gerdts, no. 22; toured, October 1, 1966 – November 12, 1967, to University of Alabama (Tuscaloosa), Sterling and Francine Clark Art Institute (Williamstown, Massachusetts), Des Moines Art Center (Iowa), Hollywood Art Center (Florida), Portland Museum of Art (Maine), Pomona College (Claremont, California), Triton Museum of Art (San Jose, California), Charles and Emma Frye Art Museum (Seattle), Minneapolis Institute of Arts, University of Maryland College of Arts and Sciences (College Park).

MMA, April 16 – September 7, 1970, *19th-Century America: Paintings and Sculpture*, cat. no. 171, illus. (as first version).

Northern Illinois University Art Gallery (Dekalb), October 27 – November 22, 1974, *Near Looking: A Close-Focus Look at a Basic Thread of American Art*, cat. by Dorathea Beard, et al., no. 25, pp. 52, 53, illus. (as second version); toured, December 1, 1974 – January 26, 1975, to University of Notre Dame Art Gallery (South Bend, Indiana).

Wildenstein & Co. (New York), April 4 – May 3, 1975, *The Object as Subject: Still Life Paintings from the Seventeenth to the Twentieth Century*, cat. no. 33.

Taft Museum (Cincinnati), January 22 – March 28, 1976, *Look Again*, cat. essay by Marsha Semmel, unpag.

Milwaukee Art Center, October 15 – November 28, 1976, *From Foreign Shores: Three Centuries of Art by Foreign Born American Masters*, cat. no. 25, pp. 60, 61, illus.

CMA, December 7, 1985 – January 22, 1986, *More than Meets the Eye: The Art of Trompe l'Oeil*, cat. by William Kloss and E. Jane Connell, no. 51, pp. 6, 28, 36, 77, 105, illus.; toured, March 21 – April 27, 1986, to Norton Gallery and School of Art (West Palm Beach, Florida).

REFERENCES:
Harold Stacy, "Study in Similarity of Opposites," *Columbus Sunday Dispatch Magazine* (August 24, 1941), illus.

Hermann W. Williams, Jr., "Notes on William M. Harnett," *The Magazine Antiques* 43 (June 1943): 260, 261, fig. 2.

Wolfgang Born, "William M. Harnett: Bachelor Artist," *Magazine of Art* 39 (October 1946): 250.

Wolfgang Born, *Still Life Painting in America* (1947), p. 31.

Alfred V. Frankenstein, "*After the Hunt*—and After," *California Palace of the Legion of Honor Bulletin* 6 (August – September 1948): unpag., illus.

Alfred V. Frankenstein, *After the Hunt: William Harnett and Other American Still Life Painters, 1870–1900* (1953), cat. no. 81, pp. 66, 67, 169, pl. 58 (as first version); rev. ed. (1969), cat. no. 81, pp. x, 66, 67, 174–175, 191, pl. 58 (as first version).

Albert Teneyck Gardner, "Harnett's *Music and Good Luck*," *Metropolitan Museum of Art Bulletin* 22 (January 1964): 162, 164, fig. 5.

Alfred V. Frankenstein, "Harnett, Peto, and Haberle," *Artforum* 4 (October 1965): 28, illus.

Alfred V. Frankenstein, "The American 19th Century, Part 2: Saloon Salons," *ARTnews* 67 (September 1968): 46 (as second version).

Alfred V. Frankenstein, *The Reality of Appearance: The Trompe l'Oeil Tradition in American Painting* (1970), no. 44, pp. 80, 81, illus. (as second version).

Donald W. Graham, *Composing Pictures* (1970): 18, illus.

William H. Gerdts and Russell Burke, *American Still-Life Painting* (1971), pp. 140, 142, pl. 10–8 (as second version).

Maurice Grosser, *Painter's Progress* (1971), pp. 223, 224, fig. 57.

Eloise Spaeth, *American Art Museums: An Introduction to Looking*, 3rd ed., expanded (1975), p. 344.

M. L. d'Otrange Mastai, *Illusion in Art: Trompe l'Oeil, A History of Pictorial Illusionism* (1975), pp. 290, 291, 296, pl. 330.

Carol J. Oja, "The Still-Life Paintings of William Michael Harnett (Their Reflections Upon Nineteenth-Century American Musical Culture)," *The Musical Quarterly* 63 (October 1977): 514, 521.

Robert F. Chirico, "John Haberle and Trompe l'Oeil," *Marsyas* 19 (1977–1978): 38, pl. 17, fig. 2.

William H. Gerdts, *Painters of the Humble Truth: Masterpieces of American Still Life 1801–1939* (1981), pp. 159, 160, 177–178, fig. 8.5.

CMA, *Catalog* (1978), pp. 51, 141, illus.

CMA, *Selections* (1978), pp. 51–52, illus.

Bishop (1981), p. 1177, pl. 6 (as first version).

American Paintings, Drawings and Sculpture of the 19th and 20th Centuries (sale cat. EDITH-5238, Christie, Manson & Woods International, New York, December 3, 1982), p. 54 (as second version).

Hirschl and Adler Galleries (New York), *The Art of Collecting* (exh. cat., 1984), p. 29 (as second version).

Olive Bragazzi, "The Story Behind the Rediscovery of William Harnett and John Peto by Edith Halpert and Alfred Frankenstein," *The American Art Journal* 16 (spring 1984): 59, 60, 61, fig. 7 (as first version).

Janet Wilson, "What You See is What You Get . . . Or is It?" *MD Magazine* (February 1987): 86, illus.

Henri La Borie, *Otis Kaye: The Trompe l'Oeil Vision of Reality* (Soutines, Inc., Oaklawn, Illinois, 1987), pp. 11, 35, fig. 4.

RELATED WORKS:
After the Hunt, 1883, oil on canvas, Amon Carter Museum (Fort Worth, Texas).

After the Hunt, 1884, oil on canvas, Butler Institute of American Art (Youngstown, Ohio).

After the Hunt, 1885, oil on canvas, M. H. de Young Memorial Museum (Fine Arts Museums of San Francisco).

REMARKS ON PROVENANCE:
A paper label on the frame (believed to be the original) reads "Earles' Galleries and Looking Glass Warerooms, 816 Chestnut Street, Philadelphia." Earles' may have sold the picture to Francis Sessions. If so, the transaction must have taken place between April 1886 (when Harnett returned, with his paintings, to New York after a six-year stay in Europe) and March 1892 (when Sessions died).

REMARKS ON EXHIBITIONS:
Earles' Galleries (Philadelphia), organized an exhibition in the fall of 1892 entitled *Paintings of the Late WM Harnett*, which included as cat. no. 32 a version, as yet unidentified, of *After the Hunt* (see Alfred Frankenstein Papers, Archives

of American Art, Smithsonian Institution, Washington, D.C., Roll 1374, Frames 273–277). It is possible that the CMA 1883 version was the one exhibited, even though Mr. Sessions is not cited in the catalogue as a lender. Most probably, however, it was the version presently owned by the Butler Institute; Monroe Smith, a former owner of this painting, is listed as a lender (Frankenstein Papers, Frame 276). None of the works were reproduced in the catalogue.

Born (1946 and 1947) erroneously lists the CMA painting among works exhibited at the Paris Salon, 1885.

Frankenstein (1948) states that the CMA painting was included in the annual exhibition of the Munich Academy in 1884, but this has not been confirmed.

REMARKS ON REFERENCES:

See also Thomas Birch's Sons, auctioneers, *Catalogue of Exquisite Examples in Still Life Being Oil Paintings By the Late William Michael Harnett including the Furnishings of His Studio*, sale, Philadelphia, Pennsylvania, February 23 and 24, 1893, p. 8, cat. nos. 38 and 40, illus.; p. 18, cat. no. 181 (Frankenstein Papers, Archives of American Art, Smithsonian Institution, Washington, D.C., Roll 1374, Frames 293, 307, 308), in which three objects depicted in *After the Hunt*—an old sword, a combination shotgun and rifle, and a felt hat—are described. In the archival copy of the Birch auction catalogue, there are anonymous hand-written annotations such as "After the Hunt #1 '83." Because these objects are depicted in both the CMA and Amon Carter versions of 1883, it is not clear to which of the two paintings the annotator was referring.

9 *A New Variety, Try One* 76.42.2

ENDNOTES:

1. Cromwell Childe, "A Painter of Pretty Women," *The Quarterly Illustrator* 1 (1893), 279–282. Reprinted in *Essays on American Art and Artists* (1895), pp. 105–108.

2. By William H. Gerdts and Russell Burke, in *American Still-Life Painting* (1971), pp. 167–168. Gerdts further explained the attribution in *Painters of the Humble Truth: Masterpieces of American Still Life Painting 1801–1939* (1981), pp. 200–203.

3. See Nannette V. Maciejunes, *A New Variety, Try One: De Scott Evans or S. S. David* (exh. cat., CMA, 1985).

4. Ibid., p. 8.

PROVENANCE:

Dorothy Hubbard Appleton, ca. 1955; CMA, 1976 (gift of Dorothy Hubbard Appleton).

EXHIBITION HISTORY:

CMA, December 7, 1985–January 22, 1986, *More than Meets the Eye: The Art of Trompe l'Oeil*, cat. by E. Jane Connell and William Kloss, no. 20, pp. 64, 65, 71, illus.; toured March 21–April 27, 1986, to Norton Gallery and School of Art (West Palm Beach, Florida).

CMA, December 7, 1985–January 22, 1986, *A New Variety, Try One: The Art of De Scott Evans*, cat.: *A New Variety, Try One: De Scott Evans or S. S. David*, by Nannette V. Maciejunes, pp. 2, 4, 5, 7, 8, 10, cover illus.

CMA (1986–1987), cat. no. 31, pp. 10, 31.

REFERENCES:

Bishop (1981), fig. 8.

Nannette V. Maciejunes, "A New Variety, Try

One: The Art of De Scott Evans," *Western Reserve Studies: A Journal of Regional History and Culture* 3 (1988), pp. 93, 100, fig. 1.

Nannette V. Maciejunes, "A Tangled Web, A Trompe l'Oeil Mystery," *Timeline* 5 (October–November 1988), pp. 34–43.

RELATED WORKS:

See CMA exh. cat., *A New Variety, Try One: De Scott Evans or S. S. David* (1986), p. 8.

10 *Spirit of Autumn* [57] 47.68

ENDNOTES:

1. Elizabeth Broun, *Albert Pinkham Ryder* (forthcoming, 1989).

2. Albert Boime, *Thomas Couture and the Eclectic Vision* (1980), p. 608.

3. Lloyd Goodrich, *Albert P. Ryder* (1959), p. 22.

4. Various versions of this story were published by Frederic Fairchild Sherman. See, for example, "Notes on Albert P. Ryder," *Art in America* 25 (October 1937): 168 (where the author also intimates that he gave the Columbus picture its title); and George Walter Vincent Smith Art Gallery (Springfield, Massachusetts), *The Private Collection of Frederic Fairchild and Julia Munson Sherman—A Memorial Exhibit* (exh. cat., 1941), cat. no. 69.

PROVENANCE:

Stephen G. Putnam, New York, ca. 1875 (acquired from the artist); Frederic Fairchild and Julia Munson Sherman, New York, 1920; Julia Munson Sherman, New York, 1940; Jacob Schwartz, Brookline, Massachusetts, 1944; (sale: Parke-Bernet Galleries, New York, February 26, 1947, cat. no. 32, pp. 9–10, illus.; Frederick W. Schumacher, Columbus, 1947; CMA, 1957 (bequest of Frederick W. Schumacher).

EXHIBITION HISTORY:

Fairchild Sherman Studio (New York), January 16–28, 1922, *Oil Paintings by Albert Pinkham Ryder*, cat. no. 7.

Fairchild Sherman Studio (New York), January 1925, *Paintings by Albert Pinkham Ryder*, cat. no. 6.

George Walter Vincent Smith Art Gallery (Springfield, Massachusetts), March 31–May 4, 1941, *The Private Collection of Frederic Fairchild and Julia Munson Sherman—A Memorial Exhibit*, cat. no. 69, illus.

California Palace of the Legion of Honor (San Francisco), January 22–April 2, 1972, *The Color of Mood: American Tonalism, 1880–1910*, cat. by Wanda M. Corn, no. 38, p. 30.

Ohio State University (1973), cat. no. 18, illus.

Ohio University (1977), cat. no. 16, illus.

REFERENCES:

Frederic Fairchild Sherman, *Albert Pinkham Ryder* (privately printed, 1920), illus. opp. p. 54.

Frederic Newlin Price, *Ryder: A Study of Appreciation* (1932), no. 168.

"Albert Pinkham Ryder—Painter," *Index of Twentieth Century Artists* 1 (February 1934), reprinted in *The Index of Twentieth Century Artists 1933–1937* (1970): 100.

Frederic Fairchild Sherman, "Notes on the Art of Albert P. Ryder," *Art in America* 25 (October 1937): 168.

Valentiner (1955), cat. no. 5, pp. 12, 13, illus.

"From Business Wealth: Great Gifts of Art, 1958," *Fortune* 58 (December 1958): 113, illus.

CGFA (1976), pp. 26–28, illus.

CMA, *Catalog* (1978), p. 149.

Bishop (1981), pp. 1175, 1176, fig. 5.

11 *Moonlight* 45.20

ENDNOTES:

1. Lloyd Goodrich, *Ralph Albert Blakelock Centenary Exhibition* (exh. cat., WMAA, 1947), p. 22.

2. For more on Blakelock's technique, see Goodrich, pp. 17–20.

PROVENANCE:

John R. and Louise Lersch Gobey; CMA, 1945 (bequest of John R. and Louise Lersch Gobey).

EXHIBITION HISTORY:

CGFA (1931), cat. no. 324, p. I, 18.

REFERENCES:

CMA, *Catalog* (1978), p. 156.

Bishop (1981), pp. 1175, 1179, fig. 10.

REMARKS:

In 1974 *Moonlight* was examined by Norman A. Geske, Nebraska Blakelock Project, Sheldon Memorial Art Gallery, University of Nebraska, Lincoln, and catalogued as Inventory no. 34 in category II: "stylistically and technically correct attribution but painting does not have a complete provenance history."

12 *The Venetian Model* 69.7

ENDNOTES:

1. Regina Soria, *Elihu Vedder, American Visionary Artist in Rome (1836–1923)* (1970), p. 319.

2. Quoted in Regina Soria, "Elihu Vedder's Mythical Creatures," *Art Quarterly* 26 (summer 1963): 192.

3. Ibid.

4. Ibid.

PROVENANCE:

Mr. and Mrs. Davis Johnson, Staten Island, New York, March 1879 (purchased in Rome from the artist); George P. Guerry, New York; Ferdinand H. Davis, New York; Kennedy Galleries, New York, ca. 1964–1966; CMA, 1969.

EXHIBITION HISTORY:

Palace of Fine Arts (Chicago), August 5, 1892–October 30, 1893, *World's Columbian Exposition*, cat. no. 1038.

SITES, *Paintings and Drawings by Elihu Vedder*, cat. by Regina Soria, no. 47 (as *The Little Venetian Model*); toured October 3, 1966–February 4, 1968, to Cummer Gallery of Art (Jacksonville, Florida), Virginia Museum of Fine Arts (Richmond), Wichita Art Museum (Kansas), Oklahoma Art Center (Oklahoma City), M.H. de Young Memorial Museum (San Francisco), Long Beach Museum of Art (California), Seattle Art Museum, Allentown Art Museum (Pennsylvania), Albany Institute of History and Art (New York), Minneapolis Institute of Arts, Hopkins Center Art Galleries (Dartmouth College, Hanover, New Hampshire).

New York Cultural Center in association with Fairleigh Dickinson University (Rutherford, New Jersey), May 9–July 13, 1975, *Three Centuries of the American Nude*, cat. by William H. Gerdts and Leslie Cohen, no. 28, p. 7; toured August 6–November 16, 1975, to Minneapolis Institute of Arts, University of Houston Fine Art Center.

National Collection of Fine Arts, Smithsonian Institution (Washington, D.C.), October 13, 1978 – February 4, 1979, *Perceptions and Evocations: The Art of Elihu Vedder*, checklist no. 125, also cat. (1979), no. 127, p. 107, illus. (as *The Little Venetian Model*); toured, April 28 – July 9, 1979, to Brooklyn Museum (New York).

Mansfield Art Center (Ohio), March 11 – April 8, 1984, *The American Figure: Vanderlyn to Bellows*, cat. no. 10.

REFERENCES:

W. H. Bishop, "Elihu Vedder," *American Art Review* 1 (1880): 328, 372, 373, engraving of painting by Gustav Kruell; also published in Walter Montgomery, ed., *American Art and American Art Collections*, Vol. 1 (1889), pp. 175, 176, illus.

Elihu Vedder's Pictures Reproduced in Photograph and Phototype (ca. 1887), cat. no. 22, illus.

Ernest Radford, "Elihu Vedder, and his Exhibition," *Magazine of Art* 23 (1899): 368.

Elihu Vedder, *The Digressions of V.*, Vol. 2 (1910), p. 476 (as *Venetian Model [small]*).

Regina Soria, "Elihu Vedder's Mythological Creatures," *Art Quarterly* 26 (summer 1963): 189, 192, fig. 11.

Kennedy Quarterly 4 (April 1964): no. 184, p. 175, illus. (as *The Venetian Model, small*).

Regina Soria, *Elihu Vedder, American Visionary Artist in Rome (1836–1923)* (1970), no. 322, pp. 121, 128–129, 319, pl. 26.

William H. Gerdts, *The Great American Nude* (1974), p. 137.

CGFA (1976), pp. 29–31, illus.

Bishop (1981), pp. 1175, 1176, fig. 6.

CMA, *Catalog* (1978), pp. 120–121, 152, fig. 6.

CMA, *Selections* (1978), pp. 120–121, illus.

REMARKS:

The Venetian Model is no. 95 in "A List of the Works of V. Sold Since the Year 1856," compiled by the artist (Elihu Vedder Papers, Archives of American Art, Smithsonian Institution, Washington, D.C., Roll 528, Frames 852–872).

13 *Girl in Grass Dress (Seated Samoan Girl)*
66.39
ENDNOTES:
1. John La Farge, *Reminiscences of the South Seas* (1912), p. 125.
2. Durand-Ruel, New York, February 25 – March 5, 1895, *Paintings, Studies, Sketches and Drawings; Mostly Records of Travel by John La Farge, 1886 and 1890–1891*, cat. by John La Farge, no. 89 (as *Girl in Grass Dress*).
3. Ibid.
4. Ibid.

PROVENANCE:
Henry Lee Higginson, Boston, Massachusetts, 1893 (purchased from the artist); Dr. William Sturgis Bigelow, Boston, by 1919; Samuel K. Lothrop, Cambridge, Massachusetts, gift or bequest of Bigelow by 1926; Mrs. Samuel K. Lothrop (Joy Mahler), 1965; Graham Gallery, New York, 1966; CMA, 1966.

EXHIBITION HISTORY:
Durand-Ruel (New York), February 25 – March 5, 1895, *Paintings, Studies, Sketches and Drawings; Mostly Records of Travel by John La Farge, 1886 and 1890–1891*, cat. by John La Farge, no. 89 (as *Girl in Grass Dress*).

Graham Gallery (New York), May 4 – June 10,

1966, *John La Farge*, cat. no. 39 (as *Seated Samoan Girl*).

REFERENCES:
Salon, Champs de Mars (Paris), *Etudes, esquisses, dessins: Souvenirs et notes de voyage (1886 et 1890–91) par John La Farge* (exh. cat. for Paris version of Durand-Ruel exhibition, 1895), cat. no. 88 (catalogued as *Jeune fille revetue d'un costume de feuilles*, but not exhibited).

CGFA (1976), pp. 44–46, illus.

Letterpress Book of Bancel La Farge (1896), La Farge Family Papers, in Sterling Memorial Library, Yale University, New Haven, Connecticut, p. 77, no. 26 (as *Girl in grass dress Samoa*).

Henry A. La Farge, "Catalogue Raisonné of the Works of John La Farge" (1934–1974), La Farge Family Papers, in Sterling Memorial Library, Yale University, New Haven, Connecticut, p. 77 (as *Seated Samoan Girl, or 'Girl in Grass Dress'*).

CMA, *Catalog* (1978), p. 144.

Bishop (1981), pp. 1175, 1177, pl. 7.

Henry A. La Farge, James L. Yarnall, and Mary A. La Farge, *Catalogue Raisonné of the Works of John La Farge*, Vol. 1 (forthcoming), entry P1890.2.

14 *Study of a Head* [57]43.8
ENDNOTES:
1. James McNeill Whistler, *The Gentle Art of Making Enemies* (1890; reprinted 1967), p. 127; as quoted in Theodore E. Stebbins, Carol Troyen, and Trevor J. Fairbrother, *A New World: Masterpieces of American Painting 1760–1910* (exh. cat., Museum of Fine Arts, Boston, 1983), p. 144.
2. The butterfly symbol that appears in the CMA portrait was used as a signature by Whistler beginning in 1889. But Whistler did not always sign a painting when he finished it; he is known to have signed some works five to seven years later, or at the time he retouched them.
3. Pointed out by Andrew McLaren Young in a letter to CMA dated December 20, 1974.
4. Few of Whistler's paintings are dated. The portrait in the Columbus museum has been dated by most scholars to the early to mid-1880s (Young, letter of December 20, 1974), when Whistler was particularly interested in watercolor and demonstrated his interest even in oils such as the CMA portrait.
 The catalogue raisonné of Whistler's works, completed after the death of Andrew McLaren Young, dates the picture 1895. See Andrew McLaren Young, Margaret MacDonald, Robin Spencer, and Hamish Miles, *The Paintings of James McNeill Whistler* (1980), p. 190.
5. Parke-Bernet's title may be based on an inscription (date unknown) in ink found on the painting's wooden stretcher that reads "Portrait of Graves, Printseller/by J. McN. Whistler."
6. After examining the painting, Andrew McLaren Young expressed the likelihood that the portrait is of Algernon Graves (letter of December 20, 1974). The catalogue raisonné of Whistler's work, however, expresses reservations about the identity of the sitter; see Young, et al., p. 190.
7. Letter dated December 1890; quoted in Stan-

ley Weintraub, *Whistler: A Biography* (1974), p. 265.

8. Ibid., p. 148.

PROVENANCE:
Charles A. Walker, Boston, 1898 (according to 1942 Parke-Bernet cat.); Francis Bartlett, Boston, 1904; Herbert M. Sears, Boston, 1913; (sale: Parke-Bernet Galleries, New York, October 17, 1942, cat. no. 137, p. 46, illus. [as *Mr. Graves, Printseller*]); Frederick W. Schumacher, Columbus, 1942; CMA, 1957 (bequest of Frederick W. Schumacher).

EXHIBITION HISTORY:
Copley Society, Copley Hall (Boston), February 1904, *Memorial Exhibition of the Works of Mr. Whistler: Oil Paintings, Water Colors, Pastels, and Drawings*, cat. no. 52, p. 8 (as *Study of a Head*).

Art Institute of Chicago, January 14 – February 25, 1954, *Sargent, Whistler and Mary Cassatt*, cat. by Frederick A. Sweet, no. 110, p. 96, illus. (as *Mr. Graves, the Printseller*, 1880); March 25 – May 23, 1954, to MMA.

Grand Rapids Art Gallery (Michigan), September 15 – October 15, 1955, *Cassatt, Whistler, Sargent Exhibition*, cat. no. 47, illus. (as *Mr. Graves, Printseller*).

Art Institute of Zanesville (Ohio), October 7 – 30, 1960, *Eleven Americans — 1860–1960*, checklist (as *Portrait of a Man*).

Ohio University (1977), cat. no. 15, illus.

University of Michigan Museum of Art (Ann Arbor), August 27 – October 8, 1978, *Whistler: The Later Years*, unpublished cat. no. 101 (as *Portrait of Algernon Graves* [?]).

CMA (1983), cat., pp. 40, 41, illus.

CMA (1986), no. cat.

REFERENCES:
Elisabeth Luther Cary, *The Works of James McNeill Whistler* (1907, reprinted 1913, 1971), p. 164, no. 52 (as *Study of a Head*).

Valentiner (1955), cat. no. 4, pp. 10, 11, illus. (as *Portrait of Mr. Graves, printseller*, 1880).

CGFA (1976), pp. 38–40, illus.

CMA, *Catalog* (1978), p. 152 (as *Algernon Graves*).

Andrew McLaren Young, Margaret MacDonald, and Robin Spencer, with Hamish Miles, *The Paintings of James McNeill Whistler* (1980), no. 427, p. 190, pl. 264 (as *Study of a Head*).

Bishop (1981), pp. 1177, 1180, fig. 7.

15 *Court of Honor, World's Columbian Exposition, Chicago* [57]43.10
ENDNOTES:
1. Sotheby's, New York, *American Impressionist and 20th Century Paintings, Drawings and Sculpture*, sale June 4, 1982, cat. no. 84.

PROVENANCE:
John Bannon, esq.; (sale: Fifth Avenue Art Galleries, New York, February 23–24, 1905, cat. no. 131, p. 99, as *A Bit of the World's Fair, 1893*); Victor Harris, New York, 1905; (sale: Parke-Bernet Galleries, New York, April 1, 1942, cat. no. 20, p. 6, illus.); Frederick W. Schumacher, Columbus, 1942; CMA, 1957 (bequest of Frederick W. Schumacher).

EXHIBITION HISTORY:
Ohio Wesleyan University Press (Delaware, Ohio), on loan February 2 – May 25, 1960.

CMA (1983) cat., pp. 46, 47, illus.

CMA (1986), no cat.

REFERENCES:
Valentiner (1955), cat. no. 8, p. 18.

John Douglass Hale, "The Life and Creative Development of John H. Twachtman," Ph.D. diss., Ohio State University, 1957, Vol. 2, no. 157, p. 547 (as *World's Columbian Exposition, Court of Honor*).

CGFA (1976), pp. 41–43, illus.

CMA, *Catalog* (1978), p. 151.

Bishop (1981), pp. 1179, 1180, fig. 11.

16 *The North Gorge, Appledore, Isles of Shoals* [57]43.9

PROVENANCE:
(Sale: American Art Galleries, New York, donated by the artist[?], to *American Paintings and Sculpture: Contributed in Aid of the Relief Fund of the American Artists' Relief Committee of One Hundred*, May 3–4, 1917, cat. no. 116, illus. as *The North Gorge, Appledore*, 1916); Victor Harris, New York, 1917; (sale: Parke-Bernet Galleries, New York, April 1, 1942, cat. no. 23); Frederick W. Schumacher, Columbus, 1942; CMA, 1957 (bequest of Frederick W. Schumacher).

EXHIBITION HISTORY:
Fine Arts Gallery of San Diego, December 6, 1962–January 6, 1963, *Modern American Painting: 1915*, cat. no. 15, pp. 14, 15, illus. (as *The North Gorge*).

CMA (1983), cat., pp. 50, 51, illus.

CMA (1986), no cat.

REFERENCES:
Valentiner (1955), cat. no. 9 (as *The North Gorge*), p. 19.

CGFA (1976), pp. 50–52, illus.

CMA, *Catalog* (1978), p. 142.

Bishop (1981), pp. 1180, 1182, pl. 12.

RELATED WORKS:
South Gorge, Appledore, Isles of Shoals, 1912, Newark Museum (New Jersey).

17 *Carmela Bertagna* [57]43.11

PROVENANCE:
Mother of the sitter to her son in Paris, or to Maurice or Paul Poirson (in Paris); Albert Milch (E. and A. Milch Gallery), New York, spring 1927; Harold Somers, Brooklyn, New York, October 1927; Lillian Somers, New York; (sale: Parke-Bernet Galleries, New York, May 26, 1943, cat. no. 49, pp. 34, 35, illus.); Frederick W. Schumacher, Columbus, 1943; CMA, 1957 (bequest of Frederick W. Schumacher).

EXHIBITION HISTORY:
Akron Art Institute (Ohio), November 30–December 28, 1945, *40 American Painters*, cat. no. 21.

Art Institute of Chicago, January 14–February 25, 1954, *Sargent, Whistler, and Mary Cassatt*, cat. by Frederick A. Sweet, no. 51, p. 53, illus.; March 25–May 23, 1954, to MMA.

Grand Rapids Art Gallery (Michigan), September 15–October 15, 1955, *Cassatt, Whistler, Sargent Exhibition*, cat. no. 23, illus. (as dated 1884).

Carnegie Institute, October 17–December 1, 1957, *American Classics of the Nineteenth Century*, cat. no. 111 (as dated 1916).

Fort Worth Art Center (Texas), November 7–December 4, 1960, *Drawings, Watercolors, and Oils of John Singer Sargent*, no cat.

Joslyn Art Museum (Omaha, Nebraska), April 10–June 1, 1969, *Mary Cassatt Among the Impressionists*, cat. no. 45, pp. 51, 74, illus. (as dated 1884).

Coe Kerr Gallery (New York), May 28–June 27, 1980, *John Singer Sargent, His Own Work*, cat. no. 9, unpag., illus.

CMA (1983), cat., pp. 48, 49, illus.

CMA (1986), no cat.

REFERENCES:
International Studio 88 (November 1927): 71, illus. (as *A Spanish Girl*).

Milch Art Notes (1927–1928), p. 13.

"John Singer Sargent—Painter," *Index of Twentieth Century Artists* 2 (February 1935), reprinted in *The Index of Twentieth Century Artists 1933–1937* (1970): 363 (as *Carmela Bertagna* [sometimes called *Spanish Girl*]).

Allen S. Weller, "Expatriates' Return," *Art Digest* 28 (January 1954): 25.

Valentiner (1955), cat. no. 10, pp. 20, 21, illus. (as *Portrait Study of a Spanish Girl*).

David McKibbin, *Sargent's Boston* (1956), p. 84.

George Moore, *Esther Waters* (1960), cover illus.

Charles Merrill Mount, *John Singer Sargent: A Biography* (1969), p. 462, no. 8013.

CGFA (1976), pp. 32–34, illus.

Young (1977), p. 84, illus. (as *Carmela Bertagna*).

CMA, *Catalog* (1978), p. 149, illus.

Bishop (1981), pp. 1175, 1180, pl. 4.

Carter Ratcliff, *John Singer Sargent* (1982), fig. 85, p. 60.

Dean M. Larson, *Studying with the Masters* (1986), p. 96, illus.

RELATED WORKS:
Beggar Girl, a portrait of Carmela Bertagna, 1880, oil (also called *The Parisian Beggar Girl* or *Spanish Bride*), exhibited in the MMA, *Memorial Exhibition of the Work of John Singer Sargent* (exh. cat. [1926], no. 3).

18 *Susan Comforting the Baby No. 1* [57]54.4

ENDNOTES:
1. Letter from Adelyn D. Breeskin, April 1973 (CMA files).
2. Cited in Adelyn D. Breeskin, *Mary Cassatt: A Catalogue Raisonné of the Oils, Pastels, Watercolors and Drawings* (1970), as *Susan Comforting the Baby (No. 2)*, cat. no. 112, p. 69, illus.

PROVENANCE:
Durand-Ruel, New York; Harris Whittemore, Sr., 1898; J. H. Whittemore Co., Naugatuck, Connecticut, November 20, 1926 (deeded to, by Harris Whittemore, Sr.); (sale: Parke-Bernet Galleries, New York, May 19, 1948, sale no. 973, cat. no. 83, p. 23, illus. as *Mother and Child*, ca. 1882); Frederick W. Schumacher, Columbus, 1948; CMA, 1957 (bequest of Frederick W. Schumacher).

EXHIBITION HISTORY:
Baltimore Museum of Art, on loan 1941–1948 (as *Two Heads*).

Baltimore Museum of Art, November 28, 1941–January 11, 1942, *Mary Cassatt*, cat. no. 11 (as *Two Heads*, ca. 1882).

Grand Rapids Art Gallery (Michigan), September 15–October 15, 1955, *Cassatt, Whistler, Sargent Exhibition*, cat. no. 3, illus. (as *Mother and Child*).

Carnegie Institute, October 17–December 1, 1957, *American Classics of the Nineteenth Century*, cat. no. 72 (as *Mother and Child*, ca. 1882); toured, January 5–July 1, 1958, to Munson-Williams-Proctor Institute (Utica, New York), Virginia Museum of Fine Arts (Richmond), Baltimore Museum of Art, Currier Gallery of Art (Manchester, New Hampshire).

Art Institute of Zanesville (Ohio), October 7–30, 1960, *Eleven Americans: 1860–1960*, checklist (as *Mother and Child*).

Ohio University (1977), cat. no. 19, illus.

CMA (1983), cat., pp. 44–45, illus.

Coe Kerr Gallery (New York), October 3–27, 1984, *Mary Cassatt: An American Observer*, cat., fig. 13.

CMA (1986), no cat.

REFERENCES:
Valentiner (1955), cat. no. 7, pp. 16, 17, illus. (as *Mother and Child*).

Adelyn D. Breeskin, *Mary Cassatt: A Catalogue Raisonné of the Oils, Pastels, Watercolors, and Drawings* (1970), cat. no. 111, p. 67, illus.

CGFA (1976), pp. 35, 36, 37, illus.

Young (1977), p. 24, illus. (as *Susan Comforting the Baby*, ca. 1882).

CMA, *Catalog* (1978), p. 136, illus.

Frank Getlein, *Mary Cassatt: Paintings and Prints* (1980), pp. 40, 41, illus.

Bishop (1981), pp. 1176, 1180, pl. 5.

RELATED WORKS:
Susan Comforting the Baby, ca. 1881, oil on canvas, Museum of Fine Arts (Houston).

19 *Fifth Avenue at Madison Square* 31.260

ENDNOTES:
1. John I. H. Baur, *Theodore Robinson 1852–1896* (1947), p. 27.
2. Hamlin Garland, "Theodore Robinson," *Brush and Pencil* 4 (1899): 285–286.
3. Unpublished diaries, Frick Art Reference Library, New York City; quoted in Baur, p. 62.
4. Scribner's Magazine files, in the Brandywine River Museum.
5. *Scribner's Magazine* 18 (November 1895): 539.
6. Unpublished diaries; quoted in Baur, p. 62.
7. Robinson's *World's Fair View* (of which he made two versions) was also a commissioned illustration. See Baur, pp. 38, 94.

PROVENANCE:
Charles Scribner's Sons, New York, 1894 (commissioned from the artist); Robert Hosea; (sale: American Art Association, New York, February 7, 1918, cat. no. 18, as *Looking Up Fifth Avenue from Twenty-third Street*); Ferdinand Howald, New York and Columbus, 1918, inv. no. 101; CMA, 1931 (gift of Ferdinand Howald).

EXHIBITION HISTORY:
CGFA (1931), cat. no. 203, p. 1, 12 (as *Fifth Avenue at Twenty-third Street*).

Brooklyn Museum (New York), November 12–January 5, 1947, *Theodore Robinson 1852–1896*, cat. by John I. H. Baur, no. 66, p. 44 (as *Fifth Avenue at 23rd Street*, 1895).

Dayton Art Institute (Ohio), October 19–November 11, 1951, *America and Impressionism*,

no cat. (as *Fifth Avenue at 23rd Street* or *Looking Up 5th Avenue from 23rd Street*); toured, November 18 – December 16, 1951, to CGFA.

Memorial Union Gallery, University of Wisconsin (Madison), October 29 – November 10, 1964, *Theodore Robinson*, cat. no. 20, illus. (as *3rd Ave. at 23rd Street*).

CGFA (January 1970), no cat. (as *Fifth Avenue at Twenty-third Street*).

CGFA (May 1970), no cat. (as *Fifth Avenue at Twenty-third Street*).

ACA Galleries (New York), March 30 – April 17, 1971, *New York, N.Y.*, cat. no. 57, cover illus. (as *Fifth Avenue & 23rd Streets*, 1895).

Ohio State University (1973), cat. no. 21, illus. (as *Fifth Avenue at Twenty-Third Street*).

Baltimore Museum of Art, May 1 – June 10, 1973, *Theodore Robinson, 1852–1896*, cat. no. 57, p. 57, illus. (as *Fifth Avenue at Twenty-Third Street*, 1895); toured, July 12, 1973 – February 24, 1974, to CGFA, Worcester Art Museum (Massachusetts), Joslyn Art Museum (Omaha, Nebraska), Munson-Williams-Proctor Institute (Utica, New York).

Paine Art Center and Arboretum (Oshkosh, Wisconsin), April 12 – June 7, 1987, *The Figural Images of Theodore Robinson: American Impressionist*, cat. no. 42, pp. 37, 38, 86, illus.; toured June 28 – November 29, 1987, to Dixon Gallery and Gardens (Memphis, Tennessee), and Indianapolis Museum of Art.

REFERENCES:
Artist's diary, entries dated November 13, 1894, November 27, 1894, and May 8, 1895, Frick Art Reference Library, New York.

Royal Cortissoz, "Landmarks of Manhattan," *Scribner's Magazine* 18 (November 1895): 539, illus.

Forbes Watson, "American Collections No. 1: The Ferdinand Howald Collection," *The Arts* 8 (August 1925): 64, 84, illus. (as *Fifth Avenue at 23rd Street*).

Kennedy Galleries (New York), *Theodore Robinson, American Impressionist (1825–1896)* (exh. cat.), 1966), p. 15 (as *Fifth Avenue at 23rd Street*).

Tucker (1969), cat. no. 153, pp. 92, 94, illus. (as *Fifth Avenue at Twenty-third Street*, 1895).

CMA, *Catalog* (1978), p. 148 (as *Fifth Avenue at Twenty-third Street*).

Bishop (1981), pp. 1179, 1180, pl. 9 (as *Fifth Avenue at Twenty-third Street*).

20 *Weda Cook* 48.17
ENDNOTES:
1. See Lloyd Goodrich, *Thomas Eakins*, 2 vols. (1982), I, p. 236, figs. H182–184.
2. For a discussion of *The Concert Singer*, see Elizabeth Johns, *Thomas Eakins: The Heroism of Modern Life* (1983), pp. 115–143.

PROVENANCE:
Charles Bregler, Eakins's pupil; Stephen C. Clark, New York, ca. 1933; William Macbeth Galleries, New York; M. Knoedler & Co., New York, September 22, 1944 (as dated ca. 1895); CMA, 1948.

EXHIBITION HISTORY:
M. Knoedler & Co. (New York), June 5 – July 31, 1944, *A Loan Exhibition of the Works of Thomas Eakins, 1844–1944, Commemorating the Centennial of his Birth*, not in cat.; toured, Oct. 1 –

December 31, 1944, to Delaware Art Center (Wilmington), Doll and Richards (Boston, Massachusetts), Museum of Raleigh (North Carolina).

Person Hall Art Gallery, University of North Carolina (Chapel Hill), April 12–28, 1946, *American Painting*, cat. no. 20.

CGFA, October 9 – November 28, 1948, *Romantic America*, cat. no. 12, p. 4.

Birmingham Museum of Art (Alabama), April 8 – June 3, 1951, *Opening Exhibition*, cat., p. 38.

Syracuse Museum of Fine Arts (New York), September 16 – October 11, 1953, *125 Years of American Art*, cat. no. 19, p. 7.

Birmingham Museum of Art (Alabama), April 28 – May 31, 1961, *10th Anniversary Exhibition*.

National Gallery of Art (Washington, D.C.), October 8 – November 12, 1961, *Thomas Eakins: A Retrospective Exhibition*, cat. no. 63, p. 96, illus. (as dated ca. 1895); toured, December 1, 1961 – March 18, 1962, to Art Institute of Chicago, Philadelphia Museum of Art.

Portraits (New York), April 24 – May 21, 1968, *Portraits of Yesterday and Today*, cat. no. 36, illus. (as dated 1895).

San Jose Museum of Art (California), December 5, 1975 – January 10, 1976, *Americans Abroad: Painters of the Victorian Era*, brochure, illus.; also published in exhibition series catalogue *American Series: A Catalogue of Eight Exhibitions, April, 1974 – December, 1977* (1978), unpag.

Ohio University (1977), cat. no. 17, illus.

Brandywine River Museum (Chadds Ford, Pennsylvania), March 15 – May 18, 1980, *Eakins at Avondale and Thomas Eakins: A Personal Collection*, cat. no. 16, p. 37.

REFERENCES:
"Catalogue of the Works of Thomas Eakins," *Pennsylvania Museum Bulletin* 25 (March 1930), cat. no. 169, p. 26.

Lloyd Goodrich, *Thomas Eakins: His Life and Work* (1933), no. 277, p. 186 (as dated ca. 1895).

Jacob Getlar Smith, "The Enigma of Thomas Eakins," *American Artist* 20 (November 1956): 33.

Gordon Hendricks, *The Life and Work of Thomas Eakins* (1974), no. 201, pp. 192–194, 336, illus. (as dated ca. 1895).

Young (1977), p. 27, illus. (as dated 1895).

CMA, *Catalog* (1978), p. 139.

Bishop (1981), p. 1180, pl. 10.

Lloyd Goodrich, *Thomas Eakins: Critical Biography and Catalogue Raisonné*, Vol. 2 (1982), p. 92, illus. no. 187.

RELATED WORKS:
The Concert Singer, 1892, oil on canvas, Philadelphia Museum of Art (Pennsylvania).

21 *The Wrestlers* 70.38
ENDNOTES:
1. Letter to Fiske Kimball, April 23, 1935, Philadelphia Museum of Art archives; quoted in Theodor Siegl, *The Thomas Eakins Collection* (1978), p. 149.

PROVENANCE:
National Academy of Design, New York, 1902 (gift of the artist, diploma picture upon election as academician); (sale: Hirschl & Adler Gal-

leries, New York, November 27, 1970); CMA, 1970.

EXHIBITION HISTORY:
Brooklyn Museum (New York), January 18 – February 28, 1932, *Paintings by American Impressionists and Other Artists of the Period 1880–1900*, cat. no. 46.

National Academy of Design (New York), December 3–23, 1951, *The American Tradition 1800–1900*, cat. by Eliot Clark, no. 49, p. 9.

Sports Illustrated, and AFA, *Sport in Art*, cat. no. 30, illus.; toured, October 31, 1955 – November 1956, to Time-Life Building Reception Hall (New York), Museum of Fine Arts (Boston), Corcoran Gallery of Art (Washington, D.C.), J.B. Speed Art Museum (Louisville, Kentucky), Dallas Museum of Fine Arts, Denver Art Museum, Los Angeles County Museum of Art, California Palace of the Legion of Honor (San Francisco), Dayton Art Institute (Ohio), unknown venue in Australia.

Cummer Gallery of Art (Jacksonville, Florida), November 10 – December 31, 1961, *The American Tradition in Painting: A Selection from the Permanent Collection of the National Academy of Design*, cat., pp. 12, 23, illus.

Hirschl and Adler Galleries (New York), October 29 – November 22, 1969, *The American Scene: A Survey of the Life and Landscape of the 19th Century*, cat. no. 25, p. 27, illus.

PAFA, January 7 – February 15, 1970, *Thomas Eakins: His Photographic Works*, cat. by Gordon Hendricks, no. 95, pp. 52, 56, 71, fig. 62.

National Museum of Western Art (Tokyo, Japan), September 11 – October 17, 1976, *Masterpieces of World Art from American Museums*, cat. no. 59, illus.; toured, November 2 – December 5, 1976, to Kyoto National Museum (Japan).

Mansfield Art Center (Ohio), March 11 – April 8, 1984, *The American Figure: Vanderlyn to Bellows*, cat. no. 12, illus.

REFERENCES:
Elizabeth Hamlin, "Painters of the Nineties," *Brooklyn Museum Quarterly* 19 (April 1932): 53, illus.

Lloyd Goodrich, *Thomas Eakins, His Life and Work* (1933), no. 317, p. 189.

"Thomas Cowperthwait Eakins—Painter," *Index of Twentieth Century Artists* 1 (January 1934), reprinted in *The Index of Twentieth Century Artists 1933–1937* (1970): 73, 81.

Eliot Clark, *History of the National Academy of Design* (1954), p. 176.

Fairfield Porter, *Thomas Eakins* (1959), illus. no. 58 (as dated 1889).

Sylvan Schendler, *Eakins* (1967), pp. 155, 158, fig. 74.

Henry A. LaFarge, "The Quiet Americans," *ARTnews* 68 (November 1969): 35, 72, illus.

Elisabeth Stevens, "The American Scene at Hirschl and Adler," *Arts Magazine* 44 (November 1969): 47, illus.

"Recent Accessions of American and Canadian Museums, January-March 1971," *Art Quarterly* 34 (autumn 1971): 372, 382, illus.

Lincoln Kirstein, "Walt Whitman and Thomas Eakins: A Poet's and a Painter's Camera-Eye," *Aperture* 16, no. 3 (1972): 382, illus.

William H. Gerdts, *The Great American Nude* (1974), p. 124 (as dated 1889).

Gordon Hendricks, *The Life and Work of Thomas*

Eakins (1974), no. 202, pp. 239–240, 336, fig. 260.

Eloise Spaeth, *American Art Museums: An Introduction to Looking*, 3rd ed. (1975), p. 344.

"Editorial: Problems and Pleasures of American Art," *Apollo* 104 (September 1976): 164, 165, pl. 2.

Benjamin Lowe, *The Beauty of Sport: A Cross-Disciplinary Inquiry* (1977), p. 132.

Young (1977), p. 29, illus.

CMA, *Catalog* (1978), pp. 43–44, 139, illus.

CMA, *Selections* (1978), pp. 43–44, illus.

Carl S. Smith, "The Boxing Paintings of Thomas Eakins," *Prospects* 4 (1979): 417, note 22, illus.

Bishop (1981), p. 1180, fig. 12.

Lloyd Goodrich, *Thomas Eakins: Critical Biography and Catalogue Raisonné*, 2 Vols. (1982), Vol. 1, p. 251, Vol. 2, pp. 156–159, illus. no. 219.

RELATED WORKS:
Wrestlers, ca. 1898, photograph, Hirshhorn Museum and Sculpture Garden, Smithsonian Institution (Washington, D.C.).

The Wrestlers, 1898, oil on canvas, Philadelphia Museum of Art.

The Wrestlers (sketch of CMA version), 1899, oil on canvas, Los Angeles County Museum of Art.

22 *Mrs. Richard Low Divine, Born Susan Sophia Smith* 47.80
ENDNOTES:
1. Frank H. Goodyear, Jr., *Cecilia Beaux: Portrait of an Artist* (1974–1975), p. 21.
2. Dorinda Evans, "Cecilia Beaux, Portraitist: Exhibition Review," *American Art Review* 2 (January-February 1975): 92–94.
3. Cecilia Beaux, lecture at Simmons College, May 14, 1907, typed transcript in Cecilia Beaux Papers, Archives of American Art, Smithsonian Institution, Washington, D.C.
4. Goodyear, p. 30.
5. Beaux, lecture at Simmons College.
6. The portrait was commissioned by the sitter's daughter Gertrude (later Gertrude Divine Webster) and son-in-law William McClelland Ritter. References to the portrait are found in Beaux's journals from early July through mid-August 1907. It is also listed in her journal summary list of works executed in 1907.
7. Evans, p. 98
8. Cecilia Beaux, *Background with Figures* (1930); quoted in Elizabeth Graham Bailey, "Cecilia Beaux: Background with a Figure," *Arts and Antiques* 3 (March/April 1980): 61.

PROVENANCE:
Commissioned from the artist by the sitter's daughter, Gertrude Divine Ritter (Mrs. William McClelland Ritter), Columbus, later Gertrude Divine Webster, Manchester, Vermont; estate of Gertrude Divine Webster, March 31, 1947; CMA, 1947 (bequest of Gertrude Divine Webster).

EXHIBITION HISTORY:
Carnegie Institute, April 13 – June 13, 1908, *Twelfth Annual Exhibition*, cat. no. 17, illus.

CGFA and Art Association of Columbus, *Exhibition of Paintings by American Artists*, cat. no. 3, p. 6 (as *Portrait—Mrs. D.*); February 1910, at Columbus Public Library.

23 *Dancer in a Yellow Shawl* 10.2
ENDNOTES:
1. William Innes Homer, *Robert Henri and His Circle* (1969), p. 237.
2. An experiment in fusing revolutionary anarchist and socialist ideologies with the arts, the Ferrer Center, a school on 107th Street in New York City, was open between 1912 and 1915. The school was named after the Spanish anarchist Francisco Ferrer, whose modernist schools in Spain defied government control of the arts. For further elaboration see Ann Uhry Abrams, "The Ferrer Center: New York's Unique Meeting of Anarchism and the Arts," *New York History* 59 (July 1978): 306–325.
3. Quoted in "The New York Exhibition of Independent Artists," *Craftsman* 18, no. 2 (1910); reprinted in Barbara Rose, *Readings in American Art Since 1900* (1968), p. 41.
4. Homer, p. 237.
5. Quoted in "My People," *Craftsman* 27 (1915): 459–460; reprinted in William Yarrow and Louis Bouché, *Robert Henri: His Life and Works* (1921), p. 32.

PROVENANCE:
CMA, March 3, 1910 (purchased from the artist?).

EXHIBITION HISTORY:
CGFA and Art Association of Columbus, February 1910, *Exhibition of Paintings by American Artists*, cat. no. 27, p. 17.

CGFA, July–August, 1923, *Paintings from the*

M. Knoedler & Co. (New York), February 2–14, 1914, *Exhibition of the National Association of Portrait Painters*, no. 11, p. 28, illus. (as *Mrs. William McC. Ritter*).

American Academy of Arts and Letters (New York), 1935, *Exhibition of Paintings by Cecilia Beaux*, cat. no. 37, p. 16.

Deshler-Hilton Hotel (Columbus), on loan January 1954 – July 1963.

PAFA, *Cecilia Beaux: Portrait of an Artist*, cat. no. 63, pp. 104, 105, illus. (as *Mrs. Richard Low Divine [Susan Sophia Smith]*); toured, September 6, 1974 – March 2, 1975, to Museum of the Philadelphia Civic Center and Indianapolis Museum of Art.

Grey Art Gallery and Study Center, New York University, November 13 – December 22, 1984, *Giovanni Boldini and Society Portraiture: 1880–1920*, cat. by Gary A. Reynolds, no. 33, illus.

Hoyt L. Sherman Gallery, Ohio State University (Columbus), May 19 – June 29, 1986, *Memorable Dress: Ohio Women*, no cat.

REFERENCES:
Cecilia Beaux Diaries, entries of July 5 – August 16, 1907, Archives of American Art, Smithsonian Institution, Washington, D.C., Cecilia Beaux Papers, Roll 427; Painting List of 1907, Roll 428.

Henry S. Drinker, *The Paintings and Drawings of Cecilia Beaux* (1955), pp. 41–42 (as *Mrs. Richard Low Divine [Susan Sophia Smith]*).

Dorinda Evans, "Cecilia Beaux, Portraitist: Exhibition Review," *American Art Review* 2 (January – February 1975): 98, 99, illus.

CMA, *Catalog* (1978), p. 135.

Bishop (1981), pp. 1180, 1182, fig. 14.

Collections of Columbus Residents, checklist no. 61 (as *Spanish Dancer*).

CGFA (1931), cat. no. 428, p. 1, 21 (as *Woman in the Yellow Shawl*).

CGFA, January 1937, *Paintings by Robert Henri*, no cat.

Johnson-Humrickhouse Memorial Museum (Coshocton, Ohio), February 27 – March 20, 1941, *Exhibition of American Paintings*, no cat.

Ohio State Fair, Columbus, August 28 – September 4, 1953(?).

Buckeye Federal Building and Loan Co. (Columbus), June 30 – August 1, 1967, *Selections from the Gordian Knot Exhibit*, no cat.

Gallery of Modern Art, New York Cultural Center, in association with Fairleigh Dickinson University, October 14 – December 14, 1969, *Robert Henri, Painter-Teacher-Prophet*, cat. by Alfredo Valente, p. 92, illus. (as dated 1924).

Ohio State University (1973), cat. no. 24, illus.

REFERENCES:
Dorothy Grafly, "Robert Henri," *American Magazine of Art* 22 (June 1931): 444, illus.

"Robert Henri—Painter," *Index of Twentieth Century Artists* 2 (January 1935), reprinted in *The Index of Twentieth Century Artists 1933–1937* (1970): 312 (as *Woman in the Yellow Shawl*), 317 (as *Dancer in a Yellow Shawl*).

Paul Sherlock, "Robert Henri," *Ohio State Grange Monthly* 58 (March 1955): 15, 16, cover illus.

Mahonri Sharp Young, *The Eight* (1973), pp. 6, 32, 33, illus. (as dated 1908).

George W. Knepper, *An Ohio Portrait* (1976), pp. 215, 278, illus.

CMA, *Catalog* (1978), pp. 56, 142, illus.

CMA, *Selections* (1978), p. 56, illus.

Bishop (1981), pp. 1172, 1180, 1183, fig. 15.

24 *East Entrance, City Hall, Philadelphia* 60.6
ENDNOTES:
1. "Notes and News-Items from Philadelphia," *New York Times Saturday Review of Books and Art*, September 7, 1901.
2. John Sloan, *Gist of Art* (1939), p. 201.
3. University of Minnesota (Minneapolis), *Forty American Painters, 1940–1950* (exh. cat., 1951), unpag.

PROVENANCE:
Helen Farr Sloan, the artist's wife (acquired from the artist), 1951; John Sloan Trust, 1956; CMA, 1960 (acquired through Mrs. Sloan and Kraushaar Galleries).

EXHIBITION HISTORY:
Philadelphia Art Club, exhibition (title not known), closing December 15, 1901.

PAFA, January 20 – March 1, 1902, *Seventy-first Annual Exhibition*, cat. no. 553, p. 46 (as *East Entrance, City Hall*).

Kraushaar Art Galleries (New York), April 11–30, 1921, *Exhibition of Paintings by John Sloan*, checklist no. 10.

City of Philadelphia, March 27 – April 3, 1922, *Philadelphia Art Week*.

Philadelphia Museum of Art, December 17, 1931 – January 18, 1932, *Some Living Pennsylvania Artists*, no cat.

Hunt Hall, Bucknell University (Lewisburg, Pennsylvania), January 19 – February 1, 1935, *Contemporary Pennsylvania Artists*, no cat.

Wanamaker Galleries (New York), November 4 – December 1939, *Retrospective Exhibition: John Sloan Paintings, Etchings and Drawings*, checklist no. 29.

Wanamaker Galleries (Philadelphia), January 8–29, 1940, *John Sloan: Paintings, Etchings, and Drawings*, checklist no. 29.

Philadelphia Museum of Art, October 14 – November 18, 1945, *Artists of the Philadelphia Press*, cat. no. 48, p. 14.

Carpenter Galleries, Dartmouth College (Hanover, New Hampshire), June 1 – September 1, 1946, *John Sloan Painting and Prints*, cat. no. 1.

Kraushaar Galleries (New York), February 2–28, 1948, *John Sloan: Retrospective Exhibition*, checklist no. 1.

WMAA, January 10 – March 2, 1952, *John Sloan 1871–1951*, cat. by Lloyd Goodrich, no. 2, pp. 15, 81, illus.; toured, March 15 – June 8, 1952, to Corcoran Gallery of Art (Washington, D.C.), Toledo Museum of Art (Ohio).

Mineral Industries Gallery, Pennsylvania State University (University Park), October 7 – November 6, 1955, *Pennsylvania Painters*, cat. no. 40, illus.

Denver Art Museum, June 4–29, 1958, *Collector's Choice*, cat. no. 20, illus. (as *East Entrance—City Hall*).

Cincinnati Art Museum, October 4 – November 4, 1958, *Two Centuries of American Painting*, cat. no. 39 (as *East Entrance City Hall*).

Denison University (1962), no cat.

National Gallery of Art (Washington, D.C.), September 18 – October 31, 1971, *John Sloan 1871–1951*, cat. by David W. Scott and E. John Bullard, no. 21, p. 67, illus.; toured, November 20, 1971 – October 22, 1972, to Georgia Museum of Art (University of Georgia, Athens), M. H. de Young Memorial Museum (San Francisco), City Art Museum of St. Louis, CGFA, PAFA.

Philadelphia Museum of Art, April 11 – October 10, 1976, *Philadelphia: Three Centuries of American Art*, cat. no. 395, pp. 463–464, illus.

Delaware Art Museum (Wilmington), July 15 – September 4, 1988, *John Sloan: Spectator of Life*, cat. by Rowland Elzea and Elizabeth Hawkes, no. 6, pp. 14, 42, illus.; toured April 26 – December 31, 1988, to IBM Gallery of Science and Art (New York), CMA, Amon Carter Museum (Fort Worth, Texas).

REFERENCES:

John Sloan, *Gist of Art* (1939), p. 201, illus.

Ben Wolf, "Philadelphia Story—Told by Four Artists," *Art Digest* 20 (October 1945): 14, illus. (as *Philadelphia City Hall* and *City Hall, East Entrance*).

University of Minnesota (Minneapolis), *Forty American Painters, 1940–1950* (exh. cat., 1951), unpag.

Milton W. Brown, "The Two John Sloans," *ARTnews* 50 (January 1952): 25, 27, illus. (as *City Hall, Philadelphia*).

Van Wyck Brooks, *John Sloan: A Painter's Life* (1955), p. 38 (as *East Entrance, City Hall*).

"Accessions of American and Canadian Museums, October–December, 1959," *Art Quarterly* 23 (spring 1960): 96.

"Accessions of American and Canadian Museums, April–June, 1960," *Art Quarterly* 23 (autumn 1960): 309.

Walker Art Museum, Bowdoin College

(Brunswick, Maine), *The Art of John Sloan: 1871–1951* (exh. cat., 1962), p. 12.

Bruce St. John, "John Sloan in Philadelphia, 1888–1904," *American Art Journal* 3 (fall 1971): 86.

Mahonri Sharp Young, "Letter from U.S.A.: The American Hogarth," *Apollo* 94 (November 1971): 411, fig. 2.

Bruce St. John, *John Sloan* (1971), pl. 2.

Mahonri Sharp Young, *The Eight* (1973), p. 52, illus.

David Scott, *John Sloan* (1975), pp. 35, 42–43, illus.

Richard F. Snow, "The American City," *American Heritage* 27 (April 1976): 33, illus.

Stuart Preston, "The Confident Culture of Philadelphia," *Apollo* 104 (September 1976): 206, 207, fig. 16.

Anthony N. B. Garvan, *City Chronicles: Philadelphia's Urban Image in Painting and Architecture* (1976), p. 29, fig. 36.

CMA, *Catalog* (1978), pp. 111–112, 150, illus.

CMA, *Selections* (1978), pp. 111–112, illus.

Bernard B. Perlman, *The Immortal Eight: American Painting from Eakins to the Armory Show, 1870–1913* (1979), p. 70, illus.

Bishop (1981), pp. 1180–1181, fig. 13.

Rowland Elzea, *John Sloan's Oil Paintings: A Catalog Raisonné* (forthcoming), cat. no. 38.

25 *Spring Planting, Greenwich Village* 80.25

ENDNOTES:

1. John Sloan, *Gist of Art* (1939), p. 238.

PROVENANCE:

W. B. Maxwell; J. Alice Maxwell; (sale: Parke-Bernet Galleries, New York, October 8, 9, and 10, 1942, sale no. 392, estate of J. Alice Maxwell, cat., lot. no. 462, p. 74); Major Edward J. Bowes; Kraushaar Galleries, New York, 1946; Mrs. Cyrus McCormick, 1948; (sale: Sotheby Parke-Bernet, New York, April 25, 1980, sale no. 4365, estate of Mrs. Cyrus McCormick, cat., lot. no. 112, illus.); CMA, 1980.

EXHIBITION HISTORY:

PAFA, February 6 – March 26, 1916, *111th Annual Exhibition of the Pennsylvania Academy of the Fine Arts*, checklist no. 172.

Chicago Art Institute, November 2 – December 7, 1916, *Twenty-ninth Annual Exhibition of American Oil Painting and Sculpture*, cat. no. 251 (as *Spring Planting, Greenwich Village, Manhattan*).

Corcoran Gallery of Art (Washington, D.C.), December 17, 1916 – January 21, 1917, *Sixth Exhibition: Oil Paintings by Contemporary American Artists*, cat. no. 140 (as *Spring Planting, Greenwich Village, Manhattan*).

C. W. Kraushaar Art Galleries (New York), March 19 – April 7, 1917, *Exhibition of Paintings, Drawings and Etchings by Joan Sloan*, cat. no. 15.

Albright Art Gallery (Buffalo, New York), May 12 – September 17, 1917, *Eleventh Annual Exhibition of Selected Paintings by American Artists*, cat. no. 122, p. 18 (as *Spring Planting, Greenwich Village, Manhattan*).

Art Institute (Milwaukee), March 1918, *Exhibition of Paintings by George Luks, Augustus Vincent Tack and John Sloan*, checklist no. 46.

Galeries Georges Petit (Paris), July 4–30, 1921, *Exposition d'une Groupe de Peintre Americains*, cat. no. 96, illus.

Whitney Studios (New York), November 2–17, 1921, *Overseas Exhibition*, cat. no. 96.

Carnegie Institute, April 26 – June 17, 1923, *Twenty-Second Annual International Exhibition of Paintings*, cat. no. 8.

Peabody Gallery (Baltimore), January 29 – March 2, 1924, *15th Annual Exhibition of the Charcoal Club*, cat., illus.

Kraushaar Galleries (New York), February 2–28, 1948, *John Sloan: Retrospective Exhibition*, cat. no. 7 (as *Spring Planting*).

WMAA, January 10 – March 2, 1952, *John Sloan 1871–1951*, cat. by Lloyd Goodrich, no. 36, p. 39, illus. (as *Spring Planting*); toured, March 15 – June 8, 1952, to Corcoran Gallery of Art (Washington, D.C.), Toledo Museum of Art (Ohio).

CMA (1986–1987), cat. no. 39, pp. 18, 19, 32, illus.

Delaware Art Museum (Wilmington), July 15 – September 4, 1988, *John Sloan: Spectator of Life*, cat. by Rowland Elzea and Elizabeth Hawkes, no. 70, p. 106, illus.; toured April 26 – December 31, 1988, to IBM Gallery of Science and Art (New York), CMA, Amon Carter Museum (Fort Worth, Texas).

REFERENCES:

A. E. Gallatin, *John Sloan* (1925), unpag., illus.

"John Sloan—Painter and Graver," *Index of Twentieth Century Artists* 1 (August 1934), reprinted in *The Index of Twentieth Century Artists 1933–1937* (1970): 231, 237.

John Sloan, *Gist of Art* (1939), p. 238, illus.

Walker Art Museum, Bowdoin College (Brunswick, Maine), *The Art of John Sloan: 1871–1951* (exh. cat., 1962), p. 13.

David Scott, *John Sloan* (1975), p. 122, illus.

Art at Auction: The Year at Sotheby Parke Bernet 1979–80 (1980), p. 156, illus.

Rowland Elzea, *John Sloan's Oil Paintings: A Catalog Raisonné* (forthcoming) cat. no. 226.

26 *The Hudson at Inwood* 31.201

ENDNOTES:

1. "Lawson of the Crushed Jewels," *International Studio* 78 (February 1924): 367–510.
2. Ira Glackens, *William Glackens and the Ashcan Group* (1957), p. 90.
3. Adeline Lee Karpiscak, *Ernest Lawson 1873–1939* (exh. cat., University of Arizona Museum of Art, 1979), p. 7.

PROVENANCE:

Daniel Gallery, New York; Ferdinand Howald, New York and Columbus, April 1919, inv. no. 141, in exchange for earlier, smaller version (Howald inv. no. 117); CMA, 1931 (gift of Ferdinand Howald).

EXHIBITION HISTORY:

Detroit Museum of Art, December 1917, *Group Exhibition of Paintings by Ernest Lawson, Hayley Lever, Karl Anderson and Leopold Seyffert*, cat. no. 128, p. 12 (as *The Hudson at Ironwood*); toured, November 8, 1917 – May 31, 1918, to Albright Art Gallery (Buffalo, New York), cat. no. 1 (separate cat. published); Milwaukee Art Institute; City Art Museum (St. Louis, Missouri), checklist no. 21 (separate publication, as *The Hudson at Ironwood*); Cincinnati Museum Association; John Herron Art Institute (Indianapolis); Carnegie Institute.

[Musée National du Luxembourg (Paris), Oc-

tober–November 1919, *Exposition d'Artistes de l'Ecole Americaine*, cat. no. 154 (version unknown), p. 28].

CGFA (1931), cat. no. 117, p. 1, 10.

Dayton Art Institute (Ohio), October 19 – November 11, 1951, *America and Impressionism*, no cat.; toured November 18 – December 16, 1951, to CGFA.

CGFA (May 1970), no cat.

CGFA (1970–1971), cat. no. 31, illus.

Henry Art Gallery, University of Washington (Seattle), January 3 – March 2, 1980, *American Impressionism*, cat. by William H. Gerdts, pp. 117, 133, illus.; toured, March 9 – August 31, 1980, to Frederick S. Wight Gallery (University of California at Los Angeles), Terra Museum of American Art (Evanston, Illinois), Institute of Contemporary Art (Boston).

Mansfield Art Center (Ohio), March 8 – April 5, 1981, *The American Landscape*, cat. no. 37, illus.

Parkersburg Art Center (West Virginia), March 21 – May 17, 1987, *Exhibition of American Impressionist Painting*, no cat.

REFERENCES:

C.B., "Four American Painters," *American Magazine of Art* 9 (March 1918): 185, illus. (as *Hudson River at Ironwood*).

"The Paintings of Anderson, Lawson, Lever and Seyffert," *Academy Notes* 13 (January–October 1918): 2, 3, 6, illus.

Forbes Watson, "American Collections: No. 1—The Ferdinand Howald Collection," *The Arts* 8 (August 1925): 73, 86, illus. (as *Landscape*).

Henry and Sidney Berry-Hill, *Ernest Lawson: American Impressionist 1873–1939* (1968), pl. 75.

Tucker (1969), cat. no. 94, pp. 62, 63, illus.

John Wilmerding, ed., *The Genius of American Painting* (1973), pp. 188, 189, illus.

Richard J. Boyle, *American Impressionism* (1974), pp. 222–223, illus.

CMA, *Catalog* (1978), p. 144.

William H. Gerdts, *American Impressionism* (1984), p. 278, fig. 364.

RELATED WORKS:

The Hudson at Inwood, ca. 1913, oil on canvas (SITES, *Impressionistes Americaines*, exh. cat., 1982–1983, no. 135, p. 101, illus. [as measuring 20 x 24 in.]; and *American Paintings IV* [Berry-Hill Galleries, 1986], pp. 78–79, illus.).

REMARKS:

There are at least two paintings by Lawson entitled *The Hudson at Inwood*, but there is no known painting by Lawson entitled *The Hudson at Ironwood*; references to the latter are in reality to one of the other paintings. Howald purchased a smaller version of *The Hudson at Inwood* from Daniel on April 19, 1918, for $700; in April 1919, he exchanged this painting for a larger work with the same title (now in the CMA), noting that he paid Daniel $1,500 for this version. The Detroit Museum of Art attempted to purchase the larger painting in December 1917, offering $750 for it; Daniel accepted the offer on Lawson's behalf, but for unknown reasons the painting never entered the Detroit collection and was thus available to Howald.

It is not known to whom Daniel resold the smaller version of the painting. A smaller version—presumably the one previously owned by Howald—was included in the 1982–1983 SITES exhibition and the 1986 Berry-Hill Gal-

leries catalogue (see Related Works above); this painting was executed from the same viewpoint as the larger version, but the small picture is a snow scene and the larger is not.

27 *St. Malo No. 2* 31.247

ENDNOTES:

1. For a further discussion of Prendergast's St. Malo tide scenes, see Helen Cooper, "American Watercolors from the Collection of George Hopper Fitch," *Yale University Art Gallery Bulletin* 37 (spring 1980): 11– 12.

2. Quoted by Eleanor Green, *Maurice Prendergast* (exh. cat., University of Maryland Art Gallery, 1976), p. 54.

3. Ibid.

PROVENANCE:

Daniel Gallery, New York; Ferdinand Howald, New York and Columbus, January 1916, inv. no. 45 (as *St. Malo*); CMA, 1931 (gift of Ferdinand Howald).

EXHIBITION HISTORY:

[Macbeth Galleries (New York), February 3–15, 1908, *Exhibition of "The Eight"*, no cat.].

[Boston Water Color Club, January 6–29, 1909, *22nd Annual Exhibition*, cat. no. 111 (as *Plage des Bains St. Malo*)].

[CGFA, July–August 1923, *Paintings from the Collections of Columbus Residents*, cat. no. 22 (as *St. Malo Beach*)].

[Gallery of Living Art, New York University, December 13, 1927 – January 25, 1928, *Opening Exhibition*, cat. (as *St. Malo*)].

CGFA (1931), cat. no. 189, p. 1, 11.

Dayton Art Institute (Ohio), February 1–28, 1948, *Maurice Prendergast, Paintings*, no cat.

CGFA, *30 Pictures from the Ferdinand Howald Collection*, no cat.; ca. May 1951, to Cleveland Institute of Art.

CGFA, *Pictures from the Ferdinand Howald Collection*, no cat.; June 9 – August 31, 1951, Hilltop Public Library (Columbus).

CGFA (1958), no cat.

CGFA (1958–1960), no cat.

CGFA, *Watercolors from the Ferdinand Howald Collection*, no cat.; June 22 – July 10, 1964, to School of Art, Ohio State University (Columbus).

CGFA (May 1970), no cat.

CGFA (1970–1971), cat. no. 57 (as dated ca. 1910).

University of Maryland Art Gallery (College Park), September 1 – October 6, 1976, *Maurice Prendergast*, cat. by Eleanor Green et al., no. 54, pp. 25, 54, 122, illus.; toured, October 17, 1976 – May 28, 1977, to University Art Museum (University of Texas, Austin), Des Moines Art Center (Iowa), CGFA, Herbert F. Johnson Museum of Art (Cornell University, Ithaca, New York), Davis and Long, Co. (New York).

Parkersburg Art Center (West Virginia), March 21 – May 17, 1987, *Exhibition of American Impressionist Paintings*, no cat.

REFERENCES:

"Maurice Brazil Prendergast—Painter," *Index of Twentieth Century Artists* 2 (March 1935), reprinted in *The Index of Twentieth Century Artists 1933–1937* (1970): 358.

Tucker (1969), cat. no. 146, p. 91 (as dated ca. 1910).

Eleanor Green, "Maurice Prendergast: Myth

and Reality," *American Art Review* (July 1977): 97, illus.

[Eleanor Green, *Maurice Prendergast* (1977), p. 122].

CMA, *Catalog* (1978), p. 166.

Helen A. Cooper, "Maurice Prendergast, *Rising Tide, St. Malo*," *Yale University Art Gallery Bulletin* 37 (spring 1980): 11, fig. 2.

Gwendolyn Owens, *The Watercolors of David Milne* (exh. cat., Herbert F. Johnson Museum, Cornell University, 1984), p. 14.

Gail Levin, *Twentieth-Century American Painting: The Thyssen-Bornemisza Collection* (1987), pp. 50, 51, fig. 1.

RELATED WORKS:

St. Malo No. 1, ca. 1907, watercolor on paper, Columbus Museum of Art.

Rising Tide, St. Malo, ca. 1907, watercolor, Yale University Art Gallery (New Haven, Connecticut).

St. Malo, 1909, watercolor (see *The Arts* 9 [April 1926]: 190).

The Lighthouse, St. Malo, 1909, oil, William Benton Museum of Art, University of Connecticut (Storrs).

The Sands at St. Malo (see *International Studio* 73 [May 1921]: 76).

Resting, St. Malo, oil (see *The Magazine Antiques* 118 [October 1980]: 611).

28 *The Promenade* 31.244

PROVENANCE:

Daniel Gallery, New York; Ferdinand Howald, New York and Columbus, October 1916, inv. no. 25; CMA, 1931 (gift of Ferdinand Howald).

EXHIBITION HISTORY:

[Memorial Art Gallery (Rochester, New York), February 16 – March 7, 1915, *A Collection of Paintings Representative of the Modern Movement in American Art*, cat. no. 62 (version unknown)].

[CGFA, July–August 1923, *Paintings from the Collections of Columbus Residents*, cat. no. 15 (as *Picnic by the Sea*)].

CGFA (1931), cat. no. 186, p. 1, 11.

Horace H. Rackham School of Graduate Studies, University of Michigan (Ann Arbor), July 1–31, 1940, *Exhibition of American Painting*, cat. no. 34, p. 12.

Dayton Art Institute (Ohio), February 1–28, 1948, *Maurice Prendergast, Paintings*, no cat.

Dayton Art Institute (Ohio), October 19 – November 11, 1951, *America and Impressionism*, no cat.; toured, November 18 – December 16, 1951, to CGFA.

Brooks Memorial Union, Marquette University (Milwaukee), April 22 – May 3, 1956, *75 Years of American Painting*, cat. no. 59.

AFA, *Children of the City*, checklist no. 19; toured, January 11, 1957 – March 30, 1958, to Atlanta Public Library, New Britain Institute (Connecticut), Art Gallery of Canada (Hamilton, Ontario), J. B. Speed Art Museum (Louisville, Kentucky), Jacksonville Art Museum (Florida), Miami Beach Art Center, Springfield Art Museum (Missouri), Quincy Art Club (Illinois), Dickinson College (Carlisle, Pennsylvania), Greenwich Library (Connecticut), Des Moines Art Center (Iowa), Oklahoma Art Center (Oklahoma City), Philbrook Art Center (Tulsa, Oklahoma).

Art Institute of Zanesville (Ohio), October 7–30, 1960, *Eleven Americans—1860–1960*, checklist.

American Embassy, Belgrade, Yugoslavia, January 16, 1962 – October 14, 1963, *Art in Embassies Project of the International Council of the Museum of Modern Art*.

American Embassy, Buenos Aires, Argentina, on loan November 1965 – June 1966.

CGFA (January 1970), no cat.

CGFA (May 1970), no cat.

CGFA (1970–1971), cat. no. 58 (as dated ca. 1913).

CGFA (1973), cat. no. 45, illus. (as dated ca. 1913).

CGFA (1975), no cat.

San Jose Museum of Art (California), December 5, 1975 – January 10, 1976, *Americans Abroad: Painters of the Victorian Era*, cat., unpag.; also in series catalogue: *American Series: A Catalogue of Eight Exhibitions, April 1974 – December 1977* (1978), unpag.

University of Maryland Art Gallery (College Park), September 1 – October 6, 1976, *Maurice Prendergast*, cat. by Eleanor Green et al., no. 82, pp. 120, 142–144, illus.; toured, October 17, 1976–April 15, 1977, to University Art Museum (University of Texas, Austin), Des Moines Art Center (Iowa), CGFA, Herbert F. Johnson Museum of Art (Cornell University, Ithaca, New York).

CGFA (1977), no cat.

Tacoma Art Museum (Washington), November 15 – December 30, 1979, *The American Eight*, cat. no. 48, unpag.

SITES, *New Horizons: American Painting 1840–1910*, cat. no. 41, pp. 96, 97, 98, 141, illus.; toured, November 16, 1987 – May 13, 1988, to State Tretyakov Museum (Moscow, USSR), State Russian Museum (Leningrad, USSR), Minsk State Museum of Belorussiya Russia (Minsk, USSR).

REFERENCES:
Forbes Watson, "American Collections No. 1—The Ferdinand Howald Collection," *The Arts* 8 (August 1925): 70, illus.

Margaret Breuning, *Maurice Prendergast*, American Artists Series (1931), pp. 9, 28, 29, illus. (as dated 1915 and erroneously as belonging to the Barnes Foundation).

"Maurice Prendergast—Painter," *Index of Twentieth Century Artists* 2 (March 1935), reprinted in *The Index of Twentieth Century Artists 1933–1937* (1970): 358, 361.

Mahonri Sharp Young, "Letter from Columbus, Ohio: Ferdinand Howald: The Art of the Collector," *Apollo* 90 (October 1969): 340, 341, illus.

Tucker (1969), pp. 90, 91, 148, illus. (as dated ca. 1913?).

Kasha Linville, "The Howald Collection at Wildenstein," *Arts Magazine* 44 (summer 1970): 16, 18, illus. (as dated ca. 1913).

Mahonri Sharp Young, *The Eight* (1973), p. 131, illus.

Richard J. Boyle, *American Impressionism* (1974), pp. 198, 226–227, illus.

Mahonri Sharp Young, "Letter from the U.S.A.: Explosion in a Colour Factory," *Apollo* 105 (March 1977): 207, fig. 2.

CMA, *Catalog* (1978), p. 147, illus.

William H. Gerdts, *American Impressionism* (1984), pp. 288, 289, pl. 383.

Gail Levin, *Twentieth-Century American Painting: The Thyssen-Bornemisza Collection* (1987), pp. 52, 53, illus.

RELATED WORKS:
Landscape with Figures, ca. 1912–1913, oil on canvas, Munson-Williams-Proctor Institute (Utica, New York).

Promenade, 1913, oil on canvas, WMAA.

Promenade, 1913–1915, oil on canvas, Meyer Potamkin Collection.

REMARKS:
Fragments of a label found on the back of the stretcher cite Prendergast's address as "56 Mt. Vernon St., Boston, Mass.," where Maurice and his brother Charles lived from 1903 to December 1914, when they moved to New York. The frame was made by Charles Prendergast.

29 *Beach Scene, New London* 31.170

ENDNOTES:
1. Ira Glackens, *William Glackens and the Ashcan Group* (1957), p. 189.

PROVENANCE:
Daniel Gallery, New York; Ferdinand Howald, New York and Columbus, May 2, 1919, inv. no. 160 (as *The Beach at New London*); CMA, 1931 (gift of Ferdinand Howald).

EXHIBITION HISTORY:
Memorial Art Gallery (Rochester, New York), February 16 – March 7, 1915, *The Modern Movement in American Art*, cat. no. 50, illus.

CGFA (1931), cat. no. 82-a, p. 1, 9 (as *Beach Scene near London*).

WMAA, December 14, 1938 – January 15, 1939, *William Glackens Memorial Exhibition*, cat. no. 42, p. 12 (as *Beach Scene near New London*).

Department of Fine Arts, Carnegie Institute, February 1–March 15, 1939, *Memorial Exhibition of Works by William J. Glackens*, cat. no. 12, p. 12 (as *Beach Scene near New London*).

CGFA (February 1952), no cat.

Brooks Memorial Union, Marquette University (Milwaukee), April 22–May 3, 1956, *Festival of American Arts: 75 Years of American Painting*, cat. no. 28.

Contemporary Arts Center and Cincinnati Art Museum, October 12 – November 17, 1957, *An American Viewpoint: Realism in Twentieth Century American Painting*, cat. essay by Alfred Frankenstein, unpag.; toured, November 27 – December 29, 1957, to Dayton Art Institute (Ohio).

Thiel College (Greenville, Pennsylvania), May 5 – June 5, 1961, *Painting of the Month*, no cat.

Denison University (1962), no cat.

AFA, *American Impressionists: Two Generations*, cat. no. 11; toured, October 1, 1963 – May 3, 1965, to Fort Lauderdale Art Center (Florida), Brooks Memorial Art Gallery (Memphis, Tennessee), Cummer Gallery of Art (Jacksonville, Florida), Delaware Art Center (Wilmington), Michigan State University (East Lansing), Evansville Public Museum (Indiana), Roanoke Fine Arts Center (Virginia), Vancouver Art Gallery (British Columbia, Canada), Beaverbrook Art Gallery (Fredericton, New Brunswick, Canada), Queen's University (Kingston, Ontario, Canada), Norman MacKensie Art Gallery (Regina, Saskatchewan, Canada), University of Newfoundland (St. John's, Canada), London

Public Library and Art Museum (London, Ontario, Canada), Art Gallery of Greater Victoria (British Columbia, Canada).

City Art Museum of St. Louis (Missouri), November 18 – December 13, 1966, *William Glackens in Retrospect*, cat. no. 54, illus.; toured, February 1 – June 11, 1967, to National Collection of Fine Arts (Smithsonian Institution, Washington, D.C.), WMAA.

CGFA (1968), no cat.

CGFA (January 1970), no cat.

CGFA (May 1970), no cat.

CGFA (1970–1971), cat. no. 20, illus.

CGFA (1973), cat. no. 15, illus.

CGFA (1975), no cat.

CGFA (1977), no cat.

REFERENCES:
Forbes Watson, "American Collections No. 1—The Ferdinand Howald Collection," *The Arts* 8 (August 1925): 74, illus.

"William J. Glackens—Painter," *Index of Twentieth Century Artists* 2 (January 1935), reprinted in *The Index of Twentieth Century Artists 1933–1937* (1970): 323, 325 (as *Beach Scene Near London*).

Ira Glackens, *William Glackens and the Ashcan Group* (1957), illus. (as *Beach Scene near New London*).

Tucker (1969), cat. no. 63, pp. 44, 46, illus.

Gerald Carson, "Once More on to the Beach," *American Heritage* 22 (August 1971): 79, illus.

Matthew Baigell, *A History of American Painting* (1971), pp. 193, 277, illus. no. 9–19.

Journal of the American Medical Association 221 (July 1972): 123, cover illus.

Mahonri Sharp Young, *The Eight* (1973), p. 99, illus.

CMA, *Catalog* (1978), pp. 47–49, 140, illus.

CMA, *Selections* (1978), pp. 47–49, illus.

William H. Gerdts, *American Impressionism* (1984), p. 281, pl. 372.

30 *Blue Snow, The Battery* 58.35

ENDNOTES:
1. Charles H. Morgan, *George Bellows: Painter of America* (1965), p. 125.

PROVENANCE:
Emma Bellows, the artist's wife, ca. 1925; Frank Rehn Gallery, New York; Mr. and Mrs. Otto L. Spaeth, New York, 1930s; Spaeth Foundation, New York; CMA, 1958.

EXHIBITION HISTORY:
MMA, October 12 – November 22, 1925, *Memorial Exhibition of the Work of George Bellows*, cat., p. 50, illus. no. 12.

Albright Knox Gallery (Buffalo, New York), January 10 – February 10, 1926, *Memorial Exhibition of the Work of George Bellows*, cat. no. 4, p. 9.

Art Institute of Chicago, January 31 – March 10, 1946, *George Bellows: Paintings, Drawings, and Prints*, cat. no. 11, pp. 20, 39, illus.

CGFA, June 8 – September 1955, *The Spaeth Collection*, cat. no. 2 (as *Battery*).

National Gallery of Art (Washington, D.C.), January 19 – February 24, 1957, *George Bellows: A Retrospective Exhibition*, cat. no. 20, pp. 17, 54, illus.

CGFA, March 21 – April 21, 1957, *Paintings by George Bellows*, cat. no. 17, illus.

United States Information Agency (Moscow, USSR), July 25 – September 5, 1959, *American National Exhibition*, no cat.

Akron Art Institute (Ohio), February 2–28, 1965, *Masterpieces from Our Neighbor Museums*, no cat.

Gallery of Modern Art (New York), March 15 – May 1, 1966, *George Bellows: Paintings, Drawings, Lithographs*, cat. no. 22.

Ohio State Fair, Columbus, August 24 – September 4, 1967, *George Bellows*, cat. no. 6 (as *Along the Battery* or *Blue Snow*).

CMA, April 1 – May 8, 1979, *George Wesley Bellows: Paintings, Drawings, and Prints*, cat. no. 13, p. 24, illus.; toured, June 29 – December 28, 1979, to Virginia Museum (Richmond), Des Moines Art Center (Iowa), Worcester Art Museum (Massachusetts).

Cummer Gallery of Art (Jacksonville, Florida), January 22 – March 8, 1981, *George Bellows: 1882–1925*, cat. no. 17, p. 29, illus.

WMAA (Downtown Branch), February 23 – April 30, 1982, *Lower Manhattan from Street to Sky*, checklist, no. 5.

REFERENCES:
George Bellows, "Studio Books," Book A, p. 88 (H. V. Allison and Co., New York).

Emma S. Bellows, *The Paintings of George Bellows* (1929), no. 24, illus. (as *Blue Snow, The Battery, N.Y.*).

"George Wesley Bellows—Painter and Graver," *Index of Twentieth Century Artists* 1 (March 1934), reprinted in *The Index of Twentieth Century Artists 1933–1937* (1970): 122.

Charles H. Morgan, *George Bellows: Painter of America* (1965), 125.

Mahonri Sharp Young, "George Bellows: Master of the Prize Fight," *Apollo* 89 (February 1969): 135, 137, fig. 5 (as *Along the Battery, Blue Snow*).

Donald Braider, *George Bellows and the Ashcan School of Painting* (1971), pp. 66–67.

Mahonri Sharp Young, *The Paintings of George Bellows* (1973), pp. 54, 55, pl. 17.

Eloise Spaeth, *American Art Museums: An Introduction to Looking*, 3rd ed. (1975), p. 344.

Young (1977), p. 150, illus.

CMA, *Catalog* (1978), p. 135.

James Atlas, "New York for Real," *ARTnews* 82 (September 1983): 72, illus.

Seymour Chwast and Steven Heller, eds., *The Art of New York* (1983), p. 17, illus.

REMARKS:
According to the records of former owner Otto Spaeth, *Blue Snow, The Battery* was exhibited as follows: Madison Gallery, 1911; Columbus, 1912; Copley Gallery (Boston), 1913; Westchester (Pennsylvania), 1915; Addison Gallery, 1944. These exhibitions have not been confirmed. An exhibition of Bellows's work held at the Columbus Public Library in November 1912 did not include this painting.

31 *Riverfront No. 1* 51.11
ENDNOTES:
1. M.C.S. Christman and M. Sadik, *Portraits by George Bellows* (1981), p. 13.
2. Frederick S. Wight, *New Art in America: Fifty Painters of the Twentieth Century*, ed. John I. H. Baur (1957), p. 25.

PROVENANCE:
Emma S. Bellows, the artist's wife; CMA, 1951.

EXHIBITION HISTORY:
Palace of Fine Arts (San Francisco), summer 1915, *Panama-Pacific International Exposition*, Vol. 2, cat. no. 4441, illus. (as *Riverfront*).

Rhode Island School of Design (Providence), October 3–24, 1917, *Autumn Exhibition*, cat. no. 2.

CGFA and Art Association of Columbus, January 30 – February 13, 1918, *Exhibition of Paintings by George Bellows*, cat. no. 9 (as *Riverfront*).

Detroit Museum of Art, April 9 – May 30, 1918, *Fourth Annual Exhibition of Selected Paintings by American Artists*, cat. no. 13; toured, June–July 31, 1918, to Toledo Museum of Art (Ohio), cat. no. 155 (separate cat. published).

Art Gallery of Toronto (Ontario, Canada), 1918, *Canadian National Exhibition*, cat. no. 3.

Art Students League (New York), 1943, *50 Years on 57th Street*, no cat.

Art Institute of Chicago, January 31 – March 10, 1946, *George Bellows: Paintings, Drawings and Prints*, cat. no. 24, pp. 34, 41, illus.

Art Gallery of Toronto (Ontario, Canada), August 26 – September 10, 1949, *Canadian National Exhibition*, cat. no. 61.

National Gallery of Art (Washington, D.C.), January 19 – February 24, 1957, *George Bellows: A Retrospective Exhibition*, cat. no. 27, p. 61, illus.

CGFA, March 21 – April 21, 1957, *Paintings by George Bellows*, cat. no. 33.

M. H. de Young Memorial Museum, California Palace of the Legion of Honor, and San Francisco Museum of Art, November 10, 1964 – January 3, 1965, *Man: Glory, Jest and Riddle*, cat. no. 235 (as *Riverboat #1*).

Gallery of Modern Art (New York), October 19 – November 15, 1965, *About New York: Night and Day*, cat., p. 11.

New York State Exposition (Syracuse), August 30 – September 5, 1966, *125 Years of New York State Painting and Sculpture*.

Grand Rapids Art Museum (Michigan), April 1–30, 1967, *Twentieth Century American Painting*, cat. no. 9 (as *Riverfront*).

Ohio State Fair, Columbus, August 24 – September 4, 1967, *George Bellows*, cat. no. 18.

Akron Art Institute (Ohio), September 27 – November 7, 1971, *Celebrate Ohio*, cat.

Carnegie Institute, October 26, 1974 – January 5, 1975, *Celebration*, cat. no. 53, illus.

Katonah Gallery (New York), November 1, 1975 – January 4, 1976, *American Painting 1900–1976: The Beginning of Modernism 1900–1934*, cat. by John I. H. Baur, no. 1, illus.

CMA, April 1 – May 8, 1979, *George Wesley Bellows: Paintings, Drawings, and Prints*, cat. no. 29, p. 40, illus.; toured, June 29 – December 28, 1979, to Virginia Museum (Richmond), Des Moines Art Center (Iowa), Worcester Art Museum (Massachusetts).

National Gallery of Art (Washington, D.C.), September 5, 1982 – January 2, 1983, *Bellows: The Boxing Pictures*, cat. by E. A. Carmean, Jr., John Wilmerding, Linda Ayres, Deborah Chotner, p. 23, illus. no. 19.

REFERENCES:
George Bellows, "Studio Books," Book A, p. 286 (H. V. Allison and Co., New York).

"Exhibitions in the Galleries," *Arts and Decoration* 5 (April 10, 1915): 238.

"Bellows' Estate," *Art Digest* 1 (January 1927): 11.

"George Wesley Bellows—Painter and Graver," *Index of Twentieth Century Artists* 1 (March 1934), reprinted in *The Index of Twentieth Century Artists 1933–1937* (1970): 128.

"Art Students League Sends Out S.O.S.," *Art Digest* 17 (February 1943): 5, illus. (as *Water Front Number One*).

Richard Graham, "The A.S.L.'s First 50 Years on 57th Street," *ARTnews* 42 (February 1943): 11, illus.

"Recent Acquisitions," *Pictures on Exhibit* 13 (June 1951): 44.

Charles Z. Offin, "Gallery Previews in New York," *Pictures on Exhibit* 13 (July 1951): 11, illus. (as *Riverfront*).

"Columbus' 'Bellows Room,'" *Art Digest* 25 (July 1951): 11, illus.

Frederick S. Wight, "George Bellows," *New Art in America: Fifty Painters of the Twentieth Century*, ed. John I. H. Baur (1957), p. 23, illus.

Charles H. Morgan, *George Bellows: Painter of America* (1965), pp. 180, 185.

Mahonri Sharp Young, "Master of the Prize Fight," *Apollo* 89 (February 1969): 133, 134, fig. 3.

Donald Braider, *George Bellows and the Ashcan School of Painting* (1971), p. 95.

Mahonri Sharp Young, *The Paintings of George Bellows* (1973), p. 90, pl. 35.

George W. Knepper, *An Ohio Portrait* (1976), p. 214, illus. no. 16.

CMA, *Catalog* (1978), pp. 14, 135, illus.

CMA, *Selections* (1978), p. 14, illus.

Seymour Chwast and Steven Heller, eds., *The Art of New York* (1983), pp. 62–63, illus.

REMARKS:
According to the artist's "Studio Books," Book A, p. 286 (H. V. Allison and Co., New York), the painting was also exhibited as follows: MacDowell Club, 1915; Rochester, New York, 1916; Arts Club of Chicago, Illinois, 1917; Newport, Rhode Island, 1917; Lynchburg, Virginia, 1919. No additional information is known concerning these.

32 *Portrait of My Mother No. 1* 30.6
ENDNOTES:
1. Robert Henri, *The Art Spirit* (1960), pp. 26–28.

PROVENANCE:
Emma S. Bellows, the artist's wife; CMA, 1930 (gift of Emma S. Bellows).

EXHIBITION HISTORY:
Galerie de la Chambre Syndicale des Beaux-Arts (Paris), June 9 – July 5, 1924, *Exhibition of American Art*.

CGFA (1931), cat. no. 262, pp. 1, 15 and 1, 16, illus.

CGFA, March 21 – April 21, 1957, *Paintings by George Bellows*, cat. no. 53.

Butler Institute of American Art (Youngstown, Ohio), April 4–30, 1967, *Pageant of Ohio Painters*, cat. no. 7.

Ohio State Fair, Columbus, August 24 – September 4, 1967, *George Bellows*, cat. no. 25, cover illus.

Guild Hall of East Hampton (New York), August 14 – October 3, 1976, *Artists and East Hampton: A 100 Year Perspective*, cat., illus.

CMA, April 1 – May 8, 1979, *George Wesley Bellows: Paintings, Drawings, and Prints*, cat. no. 45, p. 56, illus.; toured, June 19 – December 28, 1979, to Virginia Museum (Richmond), Des Moines Art Center (Iowa), Worcester Art Museum (Massachusetts).

National Portrait Gallery (Washington, D.C.), November 4, 1981 – January 3, 1982, *Portraits by George Bellows*, cat., pp. 9, 48, 49, illus.

REFERENCES:

George Bellows, "Studio Books," Book B, p. 261 (H. V. Allison and Co., New York).

MMA, *George Bellows Memorial Exhibition Catalog* (1925), p. 29.

Emma S. Bellows, *The Paintings of George Bellows* (1929), no. 109, illus.

"A Group of Museum Exhibitions," *Parnassus* 3 (February 1931): 46.

"George Wesley Bellows—Painter and Graver," *Index of Twentieth Century Artists* 1 (March 1934), reprinted in *The Index of Twentieth Century Artists 1933–1937* (1970): 118, 127, 133.

V. M. Hillyer, and E. G. Huey, *A Child's History of Art* (1934), p. 155, illus.

Frank J. Roos, Jr., *An Illustrated Handbook of Art History* (1937), p. 250, fig. B.

Peyton Boswell, Jr., *George Bellows* (1942), p. 77, illus.

Frederick A. Sweet, and Carl O. Schniewind, *George Bellows: Paintings, Drawings and Prints* (exh. cat., Art Institute of Chicago, 1946), p. 23.

"Columbus Honors its Famous Son—Bellows," *Art Digest* 22 (October 1947): 12.

"Columbus' 'Bellows Room,'" *Art Digest* 25 (July 1951): 11.

Eloise Spaeth, *American Art Museums: An Introduction to Looking* (1960), p. 127; 2nd ed. (1969), p. 197; 3rd ed. (1975), p. 344.

[Charles H. Morgan, *George Bellows—Painter of America* (1965), pp. 244, 300].

Mahonri Sharp Young, "George Bellows: Master of the Prize Fight," *Apollo* 89 (February 1969): 141, illus.

Donald Braider, *George Bellows and the Ashcan School of Painting* (1971), fig. 29.

Mahonri Sharp Young, *The Paintings of George Bellows* (1973), p. 138, illus.

Harold Spencer, "Criehaven: A Bellows Pastoral," *Bulletin of The William Benton Museum of Art, The University of Connecticut* 1 (1976–1977): 36.

RELATED WORKS:

My Mother, 1921, oil on canvas, Art Institute of Chicago.

REMARKS:

According to the artist's "Studio Books," Book B, p. 261 (H. V. Allison and Co., New York), the painting was also exhibited as follows: New Society, New York, 1921; Boston Art Club, 1922; Worcester; Pittsburgh, Pennsylvania, 1925; Buffalo, New York, 1926. No additional information is known concerning these.

33 *Men and Mountains* 31.190

ENDNOTES:

1. David V. Erdman, ed., *The Complete Poetry & Prose of William Blake* (rev. ed., 1982), p. 511.

2. Rockwell Kent, *It's Me O Lord: The Autobiography of Rockwell Kent* (1955), p. 269.

3. Ruggles's composition with its lines from Blake was pointed out by pianist Charles Timbrell.

4. Kent, p. 233.

5. Conceptual affinities also appear in contemporaneous scenes by Kent's friend Arthur B. Davies, in particular *Girdle of Ares* (1908, Metropolitan Museum of Art); see Doreen Bolger Burke, *American Paintings in the Metropolitan Museum of Art*, Vol. 3 (1980), p. 426. See also *Dream Vision: The Work of Arthur B. Davies* (exh. cat., Institute of Contemporary Art, Boston, 1981), unpag.

6. Kent, p. 233.

PROVENANCE:

Daniel Gallery, New York; Ferdinand Howald, New York and Columbus, March 14, 1917, inv. no. 80; CMA, 1931 (gift of Ferdinand Howald).

EXHIBITION HISTORY:

CGFA and Art Association of Columbus, January 1911, *Exhibition of Paintings by American Artists*, checklist no. 38, illus.

Gallery of the Society of Beaux Arts Architects (New York), March 26 – April 21, 1911, *Independent Exhibition of the Paintings and Drawings of Twelve Men*, cat. no. 8.

CGFA (1931), cat. no. 106, p. I, 10.

Bowdoin College Museum of Art (Brunswick, Maine), August 15 – October 15, 1969, *Rockwell Kent: The Early Years*, not in cat.

CGFA (May 1970), no cat.

Santa Barbara Museum of Art (California), June 29 – September 1, 1985, *"An Enkindled Eye": The Paintings of Rockwell Kent*, cat. by Richard V. West, et al., no. 17, pp. 17–18, 44, illus.; toured, October 12, 1985 – May 18, 1986, to CMA, Portland Museum of Art (Maine), Everson Museum of Art (Syracuse, New York).

REFERENCES:

Forbes Watson, "American Collections: No. 1—The Ferdinand Howald Collection," *The Arts* 8 (August 1925): 76, 89, illus. (as *Landscape with Figures*).

"Rockwell Kent—Painter and Graver," *Index of Twentieth Century Artists* 1 (April 1934), reprinted in *The Index of Twentieth Century Artists 1933–1937* (1970): 146, 151 (as *Landscape with Figures*).

Frank J. Roos, Jr., *An Illustrated Handbook of Art History* (1937), p. 275, fig. C (as *Man and Mountains*).

Rockwell Kent, *It's Me O Lord: The Autobiography of Rockwell Kent* (1955), pp. 233, 239, illus. opp. p. 43.

Tucker (1969), cat. no. 82, pp. 55, 57, illus.

Mahonri Sharp Young, "Ferdinand Howald and His Artists," *American Art Journal* 1 (fall 1969): 126, fig. 5.

Richard V. West, "Rockwell Kent Reconsidered," *American Art Review* 4 (December 1977): 132, 133, illus.

CMA, *Catalog* (1978), pp. 64, 143, illus.

CMA, *Selections* (1978), p. 64, illus.

David Traxel, *An American Saga: The Life and Times of Rockwell Kent* (1980), p. 62, illus.

James R. Mellow, "Not Norman Rockwell: An American Saga," *New York Times Book Review*, August 31, 1980, p. 10.

Fridolf Johnson, ed., *Rockwell Kent, An Anthology of His Works* (1982), pp. 27, 258, illus.

34 *The Rocket* 81.9

ENDNOTES:

1. Edward Middleton Manigault Papers, Archives of American Art, Smithsonian Institution, Washington, D.C., Roll D234.

2. "Starves to See New Color," *New York Times*, September 7, 1922.

PROVENANCE:

Alexander Morten, 1910 (purchased from the artist); Earl Luick, New York and Hollywood; Christian Aubosson, New York; Benjamin Garber, ca. 1957; Joan Washburn Gallery, 1980; CMA, 1981.

EXHIBITION HISTORY:

Galleries 29–31 West Thirty-Fifth Street (New York), April 1–27, 1910, *Exhibition of Independent Artists*, cat. no. 7.

Butler Institute of American Art (Youngstown, Ohio), September 14 – October 26, 1986, *Fireworks: American Artists Celebrate the Eighth Art*, cat., unpag., illus. (as *Untitled Landscape [Fireworks]*).

CMA (1986–1987), cat. no. 51, pp. 20, 32 (as *Untitled Landscape [Fireworks]*).

REFERENCES:

Louis A. Zona, "Fireworks: American Artists Celebrate the Eighth Art," *Dialogue* (September–October 1986), p. 65 (as *Untitled Landscape: Fireworks*).

REMARKS:

Listed in artist's notebook: no. 64, The Rocket, Alexander Morten, sold November 20–24, $40.00; also in accounts section of notebook as having been sold in 1910 for $40.00 (E. M. Manigault Papers, Archives of American Art, Smithsonian Institution, Washington, D.C., Roll D234, Frame 760).

35 *Procession* 31.208

ENDNOTES:

1. "Manigault at Daniel Gallery," *American Art News* (March 21, 1914).

2. Charles H. Caffin, "Invention and Artistry Displayed by Manigault," *The New York American* (March 23, 1914).

3. Tracey Atkinson, Elizabeth J. Morris, and James Slagle, "Notes from Interview with Charles Daniel" (CMA archives).

PROVENANCE:

Daniel Gallery, New York, 1913 (acquired from the artist); Ferdinand Howald, New York and Columbus, April 1914, inv. no. 65; CMA, 1931 (gift of Ferdinand Howald).

EXHIBITION HISTORY:

Daniel Gallery (New York), March 1 – April 7, 1914, *Exhibition of Paintings by Middleton Manigault*, cat. no. 3.

CGFA (1931), cat. no. 124, p. I, 10.

CGFA (1969), checklist no. 19.

CGFA (1970–1971), cat. no. 35, illus.

CGFA (May 1970), no cat.

Grey Art Gallery and Study Center, New York University, October 24 – December 8, 1979, *American Imagination and Symbolist Painting*, cat. by Charles C. Eldredge, no. 36, pp. 113, 114, 156–157, fig. 75; toured, January 20 – March 2,

1980, to Helen Foresman Spencer Museum of Art (University of Kansas, Lawrence).

High Museum of Art (Atlanta), March 4 – May 11, 1986, *The Advent of Modernism: Post-Impressionism and North American Art, 1900–1918*, cat. essays by Peter Morris, Judith Zilezer, William C. Agee, pp. 114–115, 186, illus.; toured, June 22, 1986 – April 19, 1987, to Center for the Fine Arts (Miami), Brooklyn Museum (New York), Glenbow Museum (Calgary, Alberta, Canada).

REFERENCES:

Review of Manigault Exhibition, *New York Times*, March 21, 1914.

"Manigault at Daniel Gallery," *American Art News*, March 21, 1914.

"Exhibits Scenes in Fifth Avenue: Middleton Manigault Presents Familiar Views in Water Color Work," *New York Press*, March 22, 1914.

"What is Happening in the World of Art," *New York Sun*, March 22, 1914.

Charles H. Caffin, "Invention and Artistry Displayed by Manigault," *New York American*, March 23, 1914.

Forbes Watson, "American Collections No. 1— The Ferdinand Howald Collection," *The Arts* 8 (August 1925): 79, illus.

Elizabeth McCausland, "The Daniel Gallery and Modern American Art," *Magazine of Art* 44 (November 1951): 281.

William H. Pierson, Jr., and Martha Davidson, eds., *Arts of the United States: A Pictorial Survey* (1960), p. 351, illus. no. 3249.

Tucker (1969), cat. no. 107, pp. 70, 71, illus.

CMA, *Catalog* (1978), p. 145.

REMARKS:

Procession is recorded in the artist's notebook, p. 6, as *In the Park—Late Afternoon (Procession)*, painted May 1911; on pp. 33, 37, Manigault recorded the sale of the painting to Daniel Gallery for $20.00 in 1913, and on p. 37 he later recorded receipt of a bonus of $80 from Daniel, apparently related to Howald's purchase in March 1914 (E. M. Manigault Papers, Archives of American Art, Smithsonian Institution, Washington, D.C., Roll D234, Frame 765).

36 *Movement No. 1* 31.166

ENDNOTES:

1. Possibly it is the work described in the *New York Evening Mail* review of the exhibition. See William Innes Homer, "Identifying Arthur Dove's The Ten Commandments," *American Art Journal* 12 (summer 1980): 30.

2. Quoted in Barbara Haskell, *Arthur Dove* (exh. cat., San Francisco Museum of Art, 1975), p. 16.

3. Haskell, pp. 21, 24.

PROVENANCE:

Daniel Gallery, New York; Ferdinand Howald, New York and Columbus, April 28, 1920, inv. no. 175 (as *Movement*); CMA, 1931 (gift of Ferdinand Howald).

EXHIBITION HISTORY:

CGFA (1931), cat. no. 79, p. 1, 9.

Cincinnati Art Museum, February 2 – March 4, 1951, *Paintings: 1900–1925*, cat. no. 49.

CGFA (February 1952), no cat.

Art Galleries of the University of California (Los Angeles), May 1 – June 15, 1959, *Arthur G. Dove*, cat. by Frederick S. Wight, no. 5, pp. 35, 93; toured, September 30, 1958 – September 30,

1959, to WMAA, Phillips Gallery (Washington, D.C.), Museum of Fine Arts (Boston), Marion Koogler McNay Art Institute (San Antonio, Texas), La Jolla Art Center (California), San Francisco Museum of Art.

Denison University (1962), no cat.

Corcoran Gallery of Art (Washington, D.C.), April 27 – June 2, 1963, *The New Tradition: Modern Americans Before 1940*, cat. no. 34, pp. 24, 58, illus.

Public Education Association (New York), *Seven Decades 1895–1965: Crosscurrents in Modern Art*, cat. by Peter Selz, no. 100, p. 62, illus.; April 26 – May 21, 1966, at M. Knoedler & Co. (New York).

Bernard Danenberg Galleries (New York), March 24 – April 12, 1969, *The Second Decade*, cat.

CGFA (January 1970), no cat.

CGFA (May 1970), no cat.

CGFA (1970–1971), cat. no. 18.

Fine Arts Gallery of San Diego, November 20, 1971 – January 2, 1972, *Color and Form 1909–1914*, cat. by Henry G. Gardiner, no. 17, pp. 55, 93, illus.; toured, January 25 – May 7, 1972, to Oakland Museum (California), Seattle Art Museum.

Ohio State University (1973), cat. no. 25, illus.

CGFA (1973), cat. no. 14, illus.

Delaware Art Museum and University of Delaware (Wilmington), April 4 – May 18, 1975 (Delaware Art Museum), *Avant-Garde Painting and Sculpture in America 1910–25*, cat., pp. 66, 67, illus.

AFA, *American Master Drawings and Watercolors: Works on Paper from Colonial Times to the Present*, checklist, p. 6 (book published simultaneously; see References: Stebbins, 1976); toured, September 1, 1976 – April 17, 1977, to Minneapolis Institute of Arts, WMAA, Fine Arts Museums of San Francisco.

Grey Art Gallery and Study Center, New York University, October 24 – December 8, 1979, *American Imagination and Symbolist Painting*, cat. by Charles Eldredge, no. 20, pp. 120, 148, fig. 82 (as one of *The Ten Commandments*); toured, January 20 – March 2, 1980, to Helen Foresman Spencer Museum of Art (University of Kansas).

Phillips Collection (Washington, D.C.), June 13 – August 16, 1981, *Arthur Dove and Duncan Phillips: Artist and Patron*, cat. by Sasha M. Newman, no. 7, pp. 65, 145, pl. 1; toured, September 11, 1981 – November 14, 1982, to High Museum of Art (Atlanta), William Rockhill Nelson Gallery of Art—Atkins Museum of Fine Arts (Kansas City, Missouri), Museum of Fine Arts (Houston), CMA, Seattle Art Museum, New Milwaukee Art Center.

REFERENCES:

"Arthur G. Dove—Painter," *Index of Twentieth Century Artists* 3 (January 1936), reprinted in *The Index of Twentieth Century Artists 1933–1937* (1970): 512.

Tucker (1969), cat. no. 59, pp. 42, 43, illus.

Kasha Linville, "Critique: The Howald Collection at Wildenstein," *Arts Magazine* 44 (summer 1970): 16, 18, illus.

Kasha Linville, "Howald's American Line," *ARTnews* 69 (summer 1970): 55.

"Art Across North America: Outstanding Exhibitions," *Apollo* 95 (March 1972): 222, fig. 5.

Marina Vaizey, "Ferdinand Howald: Avant-

Garde Collector," *Arts Review* 25 (June 1973): 440.

Christopher Neve, "A Crucial American Collection," *Country Life* 154 (July 1973): 25, fig. 4.

Ann Lee Morgan, "Toward the Definition of Early Modernism in America: A Study of Arthur Dove," Ph.D. diss., University of Iowa, 1973, Vol. 1, cat. no. 11.11, pp. 233, 234, 450, illus.

Young (1974), pp. 90, 91, pl. 34.

Theodore E. Stebbins, Jr., *American Master Drawings and Watercolors* (1976), pp. 6, 302, 303, fig. 262.

William Innes Homer, *Alfred Stieglitz and the American Avant-Garde* (1977), pp. 118, 120, 121, fig. 58 (as one of *The Ten Commandments*).

William Innes Homer, "Identifying Arthur Dove's The Ten Commandments," *American Art Journal* 12 (summer 1980): 30, fig. 9 (as one of *The Ten Commandments*, 1911–1912).

CMA, *Catalog* (1978), pp. 40–41, 159, illus.

CMA, *Selections* (1978), pp. 40–41, illus.

Ann Lee Morgan, *Arthur Dove: Life and Work, With a Catalogue Raisonné* (1984), cat. no. 11/12.3, pp. 43, 44, 104, 105, illus.

REMARKS:

Tucker (1969), p. 43 notes: "*Movement No. 1* was later entitled *Nature Symbolized*; it was shown by Stieglitz in 1912 with other undated works of the same name." The belief that the work was included in Dove's first one-artist show at Stieglitz's 291 Gallery (February 27 – March 12, 1912, *Arthur G. Dove First Exhibition Anywhere*, and March 14–30, 1912, at the W. Scott Thurber Galleries, Chicago) as one of the pastels that have become known as "The Ten Commandments" (see Homer, 1980) is based on the painting's stylistic compatibility with other pastels in the proposed group. In addition, a white label banded in red on the work's reverse reads: "Arthur G. Dove/291 Fifth Avenue/New York/C." And another inscription in pencil reads: "4–20/Daniel/Forum Exhibition/Dove/Arthur G. Dove/Feb. to. . . . (?) June with slip fill in blank."

If the work was renamed *Nature Symbolized*, in all probability it was shown in the Anderson Galleries (New York), March 13–25, 1916, *Forum Exhibition of Modern American Painters*, cat. no. 19 (as *Nature Symbolized C*); and in the National Arts Club (New York), February 5 – March 7, 1914, *Exhibition of Contemporary Art*, cat. no. 22 (as *Nature Symbolized No. 3*).

37 *Thunderstorm* 31.167

ENDNOTES:

1. Quoted in B. Haskell, *Arthur Dove* (exh. cat., San Francisco Museum of Art, 1975), p. 118.

PROVENANCE:

(Sale: Anderson Galleries, New York, February 23, 1922, cat. no. 171); Ferdinand Howald, New York and Columbus, 1922, inv. no. 216; CMA, 1931 (gift of Ferdinand Howald).

EXHIBITION HISTORY:

CGFA (1931), cat. no. 80, p. 1, 9.

CGFA (1935), no cat.

Taft Museum (Cincinnati), January 31 – March 18, 1951, *History of an American: Alfred Stieglitz: "291" and After*, cat. no. 96, p. 15.

CGFA (February 1952), no cat.

CGFA (October 1952), no cat.

Norfolk Museum (Virginia), March 1953, *Significant American Moderns*, cat., unpag.

Art Galleries of the University of California (Los Angeles), May 1 – June 15, 1959, *Arthur G. Dove*, cat. by Frederick S. Wight, no. 13, p. 93; toured, September 30, 1958 – September 30, 1959, to WMAA, Phillips Collection (Washington, D.C.), Museum of Fine Arts (Boston), Marion Koogler McNay Art Institute (San Antonio, Texas), La Jolla Art Center (California), San Francisco Museum of Art.

CGFA (May 1970), no cat.

CGFA (1970–1971), cat. no. 19, illus.

University Art Museum, University of Texas at Austin, October 15 – December 17, 1972, *Not So Long Ago: Art of the 1920s in Europe and America*, cat., p. 37, illus.

Minneapolis Institute of Arts, *Painters and Photographers of Gallery 291* (also entitled *I Am An American: Artists of Gallery 291*); Artmobile Tour, August 1, 1973 – August 1, 1974, statewide.

CGFA (1977), no cat.

Phillips Collection (Washington, D.C.), June 13 – August 16, 1981, *Arthur Dove and Duncan Phillips: Artist and Patron*, cat. by Sasha M. Newman, no. 14, pp. 76, 146, pl. 12; toured, September 11, 1981 – November 14, 1982, to High Museum of Art (Atlanta), William Rockhill Nelson Gallery of Art–Atkins Museum of Fine Arts (Kansas City, Missouri), Museum of Fine Arts (Houston), CMA, Seattle Art Museum, New Milwaukee Art Center.

Birmingham Museum of Art (Alabama), September 12 – November 4, 1987, *The Expressionist Landscape: North American Landscape Painting 1920–1945*, cat. no. 38, p. 30, fig. 75; toured November 24, 1987 – August 21, 1988, to IBM Gallery of Science and Art (New York), Akron Art Museum (Ohio), Vancouver Art Gallery (British Columbia).

REFERENCES:

"Arthur G. Dove—Painter," *Index of Twentieth Century Artists* 3 (January 1936), reprinted in *The Index of Twentieth Century Artists 1933–1937* (1970): 512 (as watercolor).

Wallace Spencer Baldinger, "Formal Change in Recent American Painting," *Art Bulletin* 19 (December 1937): 586, 588, fig. 13.

Raymond Sites, *The Arts and Man* (1940), p. 812.

Tucker (1969), cat. no. 60, pp. 43, 45, illus.

Ann Lee Morgan, "Toward the Definition of Early Modernism in America: A Study of Arthur Dove," Ph.D. diss., University of Iowa, 1973, no. 21.5, p. 240.

Young (1974), pp. 96, 97, pl. 37.

CMA, *Catalog* (1978), p. 139.

Ann Lee Morgan, *Arthur Dove: Life and Work, With a Catalogue Raisonné* (1984), cat. no. 21.5, pp. 124–125, illus.

RELATED WORKS:

Thunderstorm, 1917–1920, charcoal on paper, University of Iowa Art Museum (Iowa City).

Thundershower, 1939–1940, oil and wax emulsion on canvas, Amon Carter Museum of Western Art (Fort Worth, Texas).

REMARKS:

An unpublished list of Dove's paintings, annotated by the artist (and still in his family's possession in 1978) includes the entry, "Thunder Storm, oil," followed by the note "1920, Howald, Westport."

38 *Autumn Leaves—Lake George, N.Y.* 81.6

ENDNOTES:

1. *Georgia O'Keeffe* (1977), illus. p. 27.
2. Susan Fillin Yeh, "Innovative Moderns: Arthur G. Dove and Georgia O'Keeffe," *Art Magazine* 52 (June 1982): 69.
3. Lloyd Goodrich and Doris Bry, *Georgia O'Keeffe* (exh. cat., WMAA, 1970), p. 19.

PROVENANCE:

An American Place, New York, until 1946 (acquired from the artist); Doris Bry, New York; Martin Diamond, New York; John Berggruen Gallery, San Francisco, November 1977; Coe Kerr Gallery, New York, October, 1978; private collection, after October 1979; Coe Kerr Gallery, New York, 1981; CMA, 1981.

EXHIBITION HISTORY:

[An American Place (New York), January 27 – March 11, 1935, *Georgia O'Keeffe: Exhibition of Paintings (1919–1934)*, checklist no. 7 (as *Autumn Leaves*, 1926)].

CMA (1986–1987), cat. no. 49, pp. 20, 32.

REFERENCES:

[Inventory of Georgia O'Keeffe works, WMAA papers, 1946, Archives of American Art, Smithsonian Institution, Washington, D.C., Roll N678, Frame 002–003 (as *Autumn Leaves*, 1924)].

Fine Art Reproductions of Old and Modern Masters (1978), p. 340, fig. 5030.

REMARKS:

According to John Berggruen, when the painting was in his possession there was an unfinished painting on the reverse of the canvas. The painting has since been relined.

39 *Cosmos* (formerly *The Mountains*) 31.179

ENDNOTES:

1. Samuel M. Kootz, *Modern American Painters* (1930), p. 40; quoted in Barbara Haskell, *Marsden Hartley* (exh. cat., WMAA, 1980), p. 13.
2. Haskell, p. 17.
3. Ibid., p. 14.
4. Gail Levin, "Marsden Hartley and Mysticism," *Arts Magazine* 60 (November 1985), p. 16.
5. Hartley to Seumus O'Sheel, October 19, 1908, quoted in Haskell, p. 17.

PROVENANCE:

Alfred Stieglitz, New York (acquired from the artist); Daniel Gallery, New York; Ferdinand Howald, New York and Columbus, January 1917 (as *Mountain [Cosmos]*), inv. no. 69; CMA, 1931 (gift of Ferdinand Howald).

EXHIBITION HISTORY:

Little Galleries of the Photo-Secession (New York), May 8–18, 1909, *Exhibition of Paintings in Oil by Mr. Marsden Hartley of Maine*, no. 2.

CGFA (1931), cat. no. 94, p. 1, 9 (as *The Mountains*).

Cincinnati Modern Art Society, October 24 – November 24, 1941, *Marsden Hartley / Stuart Davis*, cat., p. 10 (as *The Mountains*, ca. 1908).

CGFA, Paintings from the Columbus Gallery of Fine Arts, no cat.; March 1965, to Otterbein College (Westerville, Ohio) (as *The Mountains*).

University Galleries, University of Southern California (Los Angeles), November 20 – December 20, 1968, *Marsden Hartley: Painter/Poet*

1877–1943, cat. no. 21, illus. (as *The Mountains*, 1908); toured, January 10 – April 27, 1969, to Tucson Art Center (Arizona), Art Museum (University of Texas, Austin).

CGFA (January 1970), no cat.

CGFA (May 1970), no cat.

Corcoran Gallery of Art (Washington, D.C.), October 9 – November 14, 1971, *Wilderness*, cat. no. 94 (as *The Mountains*, 1909).

CGFA (1973), cat. no. 20, illus.

CGFA (1975), no cat.

CGFA (1977), no cat.

WMAA, March 4 – May 25, 1980, *Marsden Hartley 1877–1943*, cat. by Barbara Haskell, no. 3, pp. 14, 17, 146, 212, pl. 71; toured, June 10, 1980 – January 4, 1981, to Art Institute of Chicago, Amon Carter Museum of Western Art (Fort Worth, Texas), University Art Museum (University of California, Berkeley).

Art Gallery of Ontario (Toronto, Canada), January 14 – March 11, 1984, *The Mystic North: Symbolist Landscape Painting in Northern America, 1890–1940*, cat. by Ronald Nasgaard, no. 136, pp. 205, 206, 207, illus.; toured, April 1 – May 15, 1984, to Cincinnati Art Museum.

Salander-O'Reilly Galleries (New York), March 6 – April 27, 1985, *Marsden Hartley: Paintings and Drawings*, cat. essay by Karen Wilkin, no. 1, illus.

REFERENCES:

"Marsden Hartley—Painter," *Index of Twentieth Century Artists* 3 (January 1936), reprinted in *The Index of Twentieth Century Artists 1933–1937* (1970): 514 (as *Mountains*).

Tucker (1969), no. 65, pp. 51, 53, illus.

Kasha Linville, "Howald's American Line," *ARTnews* 69 (summer 1970): 54, 55, illus. (as *The Mountains*, 1909).

Kasha Linville, "The Howald Collection at Wildenstein," *Arts Magazine* 44 (summer 1970): 16 (as *The Mountains*, 1909).

David W. Scott, et al., "Marsden Hartley," *Britannica Encyclopedia of American Art* (1973), p. 270 (as *The Mountains*, 1909).

Young (1974), pp. 68, 69, pl. 23 (as *The Mountains*, 1909).

CMA, *Catalog* (1978), pp. 53–54, 141, illus. (as *The Mountains*, 1909).

CMA, *Selections* (1978), pp. 53–55, illus. (as *The Mountains*, 1909).

Karin Anhold Rabbito, "Man Ray in Quest of Modernism," *Rutgers Art Review* (January 1981): 59, 60, fig. 2 (as dated 1908).

Susan Fillin Yeh, "Innovative Moderns: Arthur G. Dove and Georgia O'Keeffe," *Arts Magazine* 56 (June 1982): 68.

William H. Gerdts, *American Impressionism* (1984), pp. 291, 298, fig. 394 (as *The Mountains*, 1909).

Gail Levin, "Marsden Hartley and Mysticism," *Arts Magazine* 60 (November 1985): 16, fig. 1.

RELATED WORKS:

Carnival of Autumn, 1908–1909, oil on canvas, Museum of Fine Arts (Boston).

The Summer Camp, 1908–1909, oil on canvas, Fine Arts Museums of San Francisco.

40 *Berlin Ante War* 31.173

ENDNOTES:

1. Hartley, in a letter to Stieglitz dated July 31–August 1, 1914, as cited by Barbara Haskell, *Marsden Hartley, 1877–1943* (exh. cat., WMAA, 1980), p. 42.

2. Gail Levin, "Hidden Symbolism in Marsden Hartley's Military Pictures," *Arts Magazine* 54 (October 1979): 158; illus. in Haskell, p. 43.

3. In August 1913 Hartley wrote Stieglitz that he was exploring the mystical significance of the number 8, which he saw everywhere in Berlin (see William Innes Homer, *Alfred Stieglitz and the American Avant-garde* [1977], p. 222).

4. "Hartley's Exhibition," *Camera Work* 48 (October 1916): 12; Levin, p. 154.

5. Ibid., p. 59 (Levin, p. 155).

6. Haskell, p. 43.

7. Ibid., pp. 42–43.

8. Ibid., p. 43.

9. Gail Levin, "Marsden Hartley and The European Avant-Garde," *Arts Magazine* 54 (September 1979): 160–161.

10. Letter of November 8, 1914; quoted in Haskell, p. 44.

PROVENANCE:

Arthur B. Davies, New York (acquired from the artist); (sale: American Art Association, New York, April 17, 1929, estate of Arthur B. Davies, cat. no. 436, as *Berlin Anti-War*); Ferdinand Howald, New York and Columbus, April 17, 1929, inv. no. 354; CMA, 1931 (gift of Ferdinand Howald).

EXHIBITION HISTORY:

[Münchener Graphik—Verlag (Berlin, Germany), October 1915, *Marsden Hartley*].

[Little Galleries of the Photo-Secession (New York), April 4–22, 1916, *Paintings by Marsden Hartley*].

CGFA (1931), cat. no. 88, p. 1, 9 (as *Berlin Anti War*).

Cincinnati Modern Art Society, October 24 – November 24, 1941, *Marsden Hartley: Stuart Davis*, cat., p. 10 (as dated 1915).

CGFA (1968), no cat.

Ohio State University (1973), cat. no. 26, illus.

CGFA (May 1970), no cat.

CGFA (1970–1971), cat. no. 25, illus. (as dated ca. 1914–1915).

CGFA (1973), cat. no. 23, illus. (as dated ca. 1914–1915).

CGFA (1975), no cat.

CGFA (1977), no cat.

C.W. Post Art Gallery, Long Island University (Greenvale, New York), November 6 – December 14, 1977, *Marsden Hartley, 1877–1943*, cat. no. 8, p. 32, cover illus. (as dated ca. 1914–1915).

WMAA, March 4 – May 25, 1980, *Marsden Hartley, 1877–1943*, cat. by Barbara Haskell, no. 23, pp. 43, 47, 214, fig. 38, pl. 17 (as dated 1914); toured, June 10, 1980 – January 4, 1981, to Art Institute of Chicago, Amon Carter Museum of Western Art (Fort Worth, Texas), University Art Museum (University of California, Berkeley).

REFERENCES:

"Marsden Hartley—Painter," *Index of Twentieth Century Artists* 3 (January 1936), reprinted in *The Index of Twentieth Century Artists 1933–1937* (1970): 514 (as *Berlin Anti War*).

Tucker (1969), cat. no. 72, pp. 50, 52, illus. (as dated 1914–1915).

Mahonri Sharp Young, "The Man from Ohio: Ferdinand Howald and His Painters," *The Arts in Ireland* 2, no. 3 (1974): 7, illus. (as *Berlin, Anti-War*).

Young (1974), pp. 78, 79, pl. 28 (as dated 1915).

Arthur B. Davies: Artist and Collector (exh. cat., Rockland Center for the Arts and Edward Hopper Landmark Preservation Foundation, 1977), illus. under cat. no. 62.

CMA, *Catalog* (1978), pp. 53, 141, illus.

CMA, *Selections* (1978), p. 53, illus.

Gail Levin, "Marsden Hartley and The European Avant-Garde," *Arts Magazine* 54 (September 1979): 160, 161, fig. 6.

Rosana Barry, "The Age of Blood and Iron: Marsden Hartley in Berlin," *Arts Magazine* 54 (October 1979): 171.

Gail Levin, "Hidden Symbolism in Marsden Hartley's Military Pictures," *Arts Magazine* 54 (October 1979): 157, 158, fig. 11.

J. P. Forsthoffer, "Building on Existing Strengths," *Horizon* (November 1984): 31, illus.

41 *The Spent Wave, Indian Point, Georgetown, Maine* 81.13

ENDNOTES:

1. Marsden Hartley, "On the Subject of Nativeness—A Tribute to Maine" (1917), published in *Marsden Hartley: Exhibition of Recent Paintings* (exh. cat., An American Place, 1936); reprinted in *On Art*, ed. Gail R. Scott (1982), p. 115.

2. Gail R. Scott, "Marsden Hartley at Dogtown Common," *Arts Magazine* 54 (October 1979): 160.

3. Barbara Haskell, *Marsden Hartley, 1877–1943* (exh. cat., WMAA, 1980), p. 82.

4. "Not to 'Dilate Over the Wrong Emotion,'" *Art Digest* 12 (March 15, 1938): 21.

5. Letter dated October 1, 1937, Archives of American Art, Smithsonian Institution, Washington, D.C., Roll D268.

6. Ronald Nasgaard, *The Mystic North: Symbolist Landscape Painting in Northern Europe and North America, 1890–1940* (1984). p. 213.

7. Haskell, p. 111.

8. Hartley, "On the Subject of Mountains," unpublished essay, quoted in Haskell, p. 17.

PROVENANCE:

Hudson D. Walker Gallery, New York, 1938; Museum of Modern Art, New York, 1940; (sale: Parke-Bernet Galleries, New York, May 11, 1944, *Notable Paintings and Sculptures, Property of the Museum of Modern Art*, cat. no. 41, p. 15, illus. [as *The Spent Wave*]); Walter Bareiss, New York and Greenwich, Connecticut, 1944 – ca. 1962; E. V. Thaw and Company, New York; Mr. and Mrs. Harry W. Anderson, Atherton, California, mid-1960s; Hirschl and Adler Galleries, 1981; CMA, 1981.

EXHIBITION HISTORY:

Hudson D. Walker Gallery (New York), February 28 – April 2, 1938, *Marsden Hartley: Recent Paintings of Maine*, cat. no. 16 (as *The Spent Wave [Indian Point, Georgetown]*).

MMA, April 19–27, 1941, *Contemporary Painting in the United States*, cat. no. 68, p. 14 (as *The Spent Wave*); Spanish version of cat. *La Pintura Contemporanea Norteamericana*, p. 57 (as *The Spent Wave*); toured, July 3 – December 8, 1941, to Museo Nacional de Bellas Artes (Buenos Aires, Argentina), Galeria del Teatro Solis (Montevideo, Uruguay), Museu de Belas Artes (Rio de Janeiro, Brazil).

MoMA, *Thirty European and American Paintings* (as *The Spent Wave*); toured, September 7, 1943 – April 3, 1944, to State University of Iowa (Iowa City), Vanderbilt University (Nashville, Tennessee), Vassar College (Poughkeepsie, New York), Amherst College (Massachusetts), Society for the Four Arts (Palm Beach, Florida), Wellesley College (Massachusetts).

Stedelijk Museum (Amsterdam, Holland) and AFA, December 1, 1960 – March 25, 1962, *Marsden Hartley*, cat. essay by Elizabeth McCausland (*The Spent Wave* not cited in cat.); European tour, December 1960 – March 1962 (*The Spent Wave* not included); American tour (including *The Spent Wave*), August 12, 1961 – April 8, 1962, to Portland Museum of Art (Maine), Walker Art Center (Minneapolis), City Art Museum (St. Louis, Missouri), Cincinnati Art Museum, WMAA.

Taft Museum (Cincinnati), September 25 – December 5, 1982, *1930s Remembered: "The Fine Arts"*, cat., unpag.

CMA (1986–1987), cat. no. 53, pp. 20, 33.

REFERENCES:

"Marsden Hartley, Noted Artist, Dies," *New York Times*, Friday, September 3, 1943 (as *The Spent Wave*).

Vivian Endicott Barnett, "Marsden Hartley's Return to Maine," *Arts Magazine* 54 (October 1979): 175 (as *The Spent Wave*).

Barbara Haskell, *Marsden Hartley, 1877–1943*, (exh. cat., WMAA, 1980), p. 199.

RELATED WORKS:

Rising Wave, Indian Point, Georgetown, Maine, 1937–1938, oil on academy board, Baltimore Museum of Art (Maryland).

42 *Sunset, Maine Coast* 31.233

ENDNOTES:

1. John Marin, "Notes on '291': The Water Colors of John Marin," *Camera Work* (April–July 1913): 18.

2. Quoted from a manuscript dated August 26, 1928, in *John Marin by John Marin*, ed. Cleve Gray (no copyright date), p. 161.

PROVENANCE:

Daniel Gallery, New York; Ferdinand Howald, New York and Columbus, CMA, 1931 (gift of Ferdinand Howald).

EXHIBITION HISTORY:

CGFA (1931), cat. no. 149, p. 1, 11 (as *Sunset*).

CGFA (1935), no cat.

Dudley Peter Allen Memorial Art Museum, Oberlin College (Ohio), January 7 – January 29, 1941, *John Marin Watercolors*, no cat.

Colorado Springs Fine Arts Center, April 4 – June 11, 1947, *Exhibition of the Work of Homer, Sargent, and Marin*.

University of Michigan Museum of Art (Ann Arbor), May 4–25, 1948, *John Marin Watercolor Exhibition*; toured, January 7 – June 23, 1948, to Cranbrook Academy of Art (Detroit), Grand Rapids Art Gallery (Michigan), Hackley Art Gallery (Muskegon, Michigan), Michigan State

College (East Lansing), Flint Institute of Fine Arts (Michigan).

Norton Gallery of Art (West Palm Beach, Florida), February 3–26, 1950, *Masters of Water Color: Marin, Demuth, and Prendergast*, checklist no. 1 (as *Sunset*, 1919).

Venice (Italy), June 8 – October 15, 1950, *XXV Biennale Internazionale d'Arte di Venezia*, cat. no. 36 (as *Tramonto*, 1919).

CGFA, Ferdinand Howald Collection Pictures; May 1951, to Cleveland Institute of Art, no cat.

CGFA (October 1952), no cat.

Kalamazoo Institute of Arts (Michigan), April 5–30, 1953, *John Marin*, no cat.

AFA, *Pioneers of American Abstract Art*, cat. no. 22, p. 6 (as *Sunset*, 1919); toured, December 1, 1955 – January 9, 1957, to Atlanta Public Library, Louisiana State Exhibit Museum (Shreveport), J.B. Speed Art Museum (Louisville, Kentucky), Lawrence Museum (Williamstown, Massachusetts), George Thomas Hunter Gallery (Chattanooga, Tennessee), Rose Fried Gallery (New York).

CGFA (1958–1960), no cat.

St. Paul Episcopal Church, Chillicothe (Ohio), June 16–18, 1961, *Festival of the Arts*, cat. no. 2 (as *Sunset*).

MoMA, *The Stieglitz Circle*, checklist (as dated 1919); toured, February 1, 1962 – June 9, 1963, to J.B. Speed Art Museum (Louisville, Kentucky), Quincy Art Club (Illinois), Charles and Emma Frye Art Museum (Seattle), University of Oregon Museum of Art (Eugene), Boise Art Association (Idaho), Allentown Art Museum (Pennsylvania), Gibbes Art Gallery (Charleston, South Carolina), Brooks Memorial Art Gallery (Memphis, Tennessee), Public Library of Winston-Salem and Forsyth County (North Carolina), Duke University (Durham, North Carolina), Rochester Memorial Art Gallery (New York), Augustana College (Rock Island, Illinois), Fine Arts Patrons of Newport Harbor (California).

Montclair Art Museum (New Jersey), February 23 – March 29, 1964, *John Marin: America's Modern Pioneer (A Retrospective Exhibition of the Watercolors and Oil Paintings from 1903–1953)*, cat. no. 13 (as dated 1919).

Huntington, West Virginia, Arts Festival, July 20 – August 20, 1966, no. cat.

Springfield Art Association (Ohio), March 14 – April 17, 1967, *Opening Exhibition of Springfield Art Center*, no cat.

Allen County Museum Gallery (Lima, Ohio), January 12 – February 11, 1968, *Freedom and Order Exhibit*, checklist no. 19 (as dated 1919).

Cincinnati Art Museum, February 14 – March 16, 1969, *Three American Masters of Watercolor: Marin, Demuth, Pascin*, cat. essay by Richard J. Boyle, no. 13, pp. 11, 15, illus. (as dated 1919).

CGFA (May 1970), no cat.

CGFA (1970–1971), cat. no. 44 (as *Sunset Coast*, 1919).

CGFA (1973), cat. no. 31, illus. (as dated 1919).

CGFA (1975), no cat.

PAFA, April 22 – December 31, 1976, *In This Academy: The Pennsylvania Academy of the Fine Arts, 1805–1976*, cat. no. 291, p. 310 (as dated 1919).

CGFA (1977), no cat. (as dated 1919).

Hudson River Museum (Yonkers, New York), October 30, 1983 – January 8, 1984, *The Book of Nature: American Painters and the Natural Sublime*, cat., pp. 60, 66, 108, illus. fig. 50 (as dated 1919).

REFERENCES:

CGFA (1931), cat. no. 149, p. 1, 11.

"John Marin—Painter," *Index of Twentieth Century Artists* 1 (October 1933), reprinted in *The Index of Twentieth Century Artists 1933–1937* (1970): 12, 23 (as *Sunset*).

E. M. Benson, *John Marin: The Man and His Work* (1935), p. 41, pl. 17 (as dated 1919).

E. M. Benson, "John Marin: The Man and His Work (Part 1: Marin, the Man)," *American Magazine of Art* 28 (October 1935): 606, illus. (as dated 1919).

Tucker (1969), cat. no. 124, pp. 77, 79, illus. (as dated 1919).

Sheldon Reich, *John Marin: A Stylistic Analysis and Catalogue Raisonné*, Part II (1970), cat. no. 19.41, p. 474, illus.

Young (1974), p. 34, pl. 6 (as dated 1919).

CMA, *Catalog* (1978), p. 164 (as dated 1919).

Christopher Finch, *American Watercolors* (1986), p. 184, illus. no. 236 (as dated 1919).

43 *Jazz* 31.253

ENDNOTES:

1. Quoted in Arturo Schwarz, *New York Dada: Duchamp, Man Ray, Picabia* (1973), p. 87.

2. Quoted in Zabriskie Gallery (New York), *Man Ray: Publications and Transformations* (1982), unpag.

3. *Jazz* was dated 1919 by Arturo Schwarz (in letter of May 9, 1977, to the CGFA).

4. Man Ray, *Self Portrait* (1963), p. 72. Man Ray's desire to eliminate the traditional tools and methods of painters anticipates Jackson Pollock's concerns of the later 1940s.

5. Ibid.

6. See Mona Hadler, "Jazz and the Visual Arts," *The Arts* (June 1983): 91–101.

7. Ibid., p. 94.

PROVENANCE:

Daniel Gallery, New York; Ferdinand Howald, New York and Columbus, April 1926, inv. no. 314; CMA, 1931 (gift of Ferdinand Howald).

EXHIBITION HISTORY:

Daniel Gallery (New York), November 17 – December 1, 1919, *Man Ray: An Exhibition of Selected Drawings and Paintings Accomplished During the Period 1913–1919*, checklist no. 18.

CGFA (1931), cat. no. 194, p. 1, 12.

CGFA (1935), no cat.

CGFA, *Pictures from the Ferdinand Howald Collection*, June 9 – August 31, 1951, Hilltop Public Library (Columbus, Ohio), no cat.

Junior Art Gallery (Louisville, Kentucky), September 16 – November 15, 1957, *The Big City*, cat. no. 31.

University of Minnesota Art Gallery, April 4 – May 18, 1958, *Music in Art*, no cat.; toured, June 15 – July 29, 1958, to Grand Rapids Art Gallery (Michigan).

CGFA (1961), no cat.

New Gallery, University of Iowa (Iowa City), May 24 – August 2, 1962, *Vintage Moderns: American Pioneer Artists 1903–1932*, cat. essay by Frank Seiberling, no. 58, pp. 23, 26, illus.; WMAA, February 27 – April 14, 1963, *The Dec-*

ade of The Armory Show: New Directions in American Art 1910–1920, cat. essay by Lloyd Goodrich, no. 80, pp. 60, 74, illus.; toured, June 1, 1963 – February 23, 1964, to City Art Museum of St. Louis, Cleveland Museum of Art, PAFA, Art Institute of Chicago, Albright-Knox Art Gallery (Buffalo, New York).

Los Angeles County Museum of Art, October 27, 1966 – January 1, 1967, *Man Ray*, cat. no. 30, p. 55.

Grand Rapids Art Museum (Michigan), April 1–30, 1967, *20th Century American Painting*, cat. essay by Anne E. Warnock, no. 15, pp. 11, 12, 40, illus.

CGFA (1969), checklist no. 32.

CGFA (January 1970), no cat.

CGFA (May 1970), no cat.

CGFA (1970–1971), cat. no. 33, illus. (as dated ca. 1919).

Birmingham Museum of Art (Alabama), January 16 – February 13, 1972, *American Watercolors 1850–1972*, cat., pp. 35, 70, illus. (as dated ca. 1919); toured, February 22 – March 13, 1972, to Mobile Art Gallery (Alabama).

Ohio State University (1973), cat. no. 30, illus.

New York Cultural Center, in association with Fairleigh Dickinson University (Rutherford, New Jersey), December 19, 1974 – March 2, 1975, *Man Ray: Inventor, Painter, Poet*, cat. no. 218, illus.; toured, April 11 – September 30, 1975, to Institute of Contemporary Arts (London, England), Il Palazzo delle Esposizioni di Roma (Italy), Italian cat. no. 38, pp. 60, 125, 126.

Solomon R. Guggenheim Museum (New York), January 23 – March 21, 1976, *Twentieth-Century American Drawing: Three Avant-Garde Generations*, cat. essay by Diane Waldman, no. 44, p. 48, illus. (as dated ca. 1919).

AFA, *American Master Drawings and Watercolors: Works on Paper from the Colonial Times to the Present*, checklist, p. 14; toured, September 1, 1976 – April 17, 1977, to Minneapolis Institute of Arts, WMAA, Fine Arts Museums of San Francisco.

Grand Rapids Art Museum (Michigan), October 1 – November 30, 1977, *Themes in American Painting*, cat. by J. Gray Sweeney, pp. 172, 173, pl. 86.

Tate Gallery (London, England), February 6 – April 13, 1980, *Abstraction: Towards a New Art: Painting 1910–1920*, cat. no. 446, p. 120.

REFERENCES:

Milton W. Brown, *American Painting from the Armory Show to the Depression* (1955, reprinted 1970), p. 105, illus.

Carl Belz, *The Role of Man Ray in the Dada and Surrealist Movements* (1963), pp. 94–95, fig. 47.

Lloyd Goodrich, *Pioneers of Modern Art in America: The Decade of the Armory Show, 1910–1920* (1963), p. 60, illus.

Tucker (1969), cat. no. 104, pp. 68, 69, illus. (as dated ca. 1919).

Mahonri Sharp Young, "Ferdinand Howald and His Artists," *American Art Journal* 1 (fall 1969), p. 122, fig. 3.

George Heard Hamilton, *19th and 20th Century Art* (1970), p. 295, fig. 273.

Kasha Linville, "Howald's American Line," *ARTnews* 69 (summer 1970): 55.

Roland Penrose, *Man Ray* (1975), pp. 46–48, 50, illus. no. 23.

Theodore E. Stebbins, Jr., *American Master*

Drawings and Watercolors (1976), pp. 308, 309, fig. 268.

Arturo Schwarz, *Man Ray: The Rigour of Imagination* (1977), pp. 47, 51, illus. no. 47.

C M A, *Catalog* (1978), pp. 73–74, 164, illus.

C M A, *Selections* (1978), pp. 73–74, illus.

Victoria Thorson, ed., *Great Drawings of All Time: The Twentieth Century*, Vol. 2 (1979), cat. no. 259, illus. (as dated ca. 1919).

Howard Risatti, "Man Ray: The Work," *Man Ray: Photographs and Objects* (exh. cat., Alabama: Birmingham Museum of Art, 1980), pp. 23, 24, fig. 13.

Elizabeth Turner, "The Great American Artistic Migration to Paris between the Great War and the Great Depression," Ph.D. diss., University of Virginia, 1985; see Turner, *American Artists in Paris 1919–1929* (1988, forthcoming).

Christopher Finch, *American Watercolors* (1986), pp. 206, 207, fig. 264.

44 *Regatta* 31.256

ENDNOTES:

1. Man Ray, quoted in *Phaidon Encyclopedia of Art and Artists* (1978), p. 542.

2. Man Ray, *Self Portrait* (1963), p. 103.

PROVENANCE:

Ferdinand Howald, New York and Columbus, March 1927, inv. no. 335 (purchased from the artist); C M A, 1931 (gift of Ferdinand Howald).

EXHIBITION HISTORY:

C G F A (1931), cat. no. 197, p. I, 12.

C G F A (1935), no cat.

C G F A (February 1952), no cat.

C G F A (October 1952), no cat.

Denison University (1962), no cat.

C G F A (1969), checklist no. 31.

C G F A (May 1970), no cat.

C G F A (1970–1971), cat. no. 34.

New York Cultural Center, in association with Fairleigh Dickinson University (Rutherford, New Jersey), December 19, 1974 – March 2, 1975, *Man Ray: Inventor, Painter, Poet*, cat. no. 24, illus.; toured, April 11 – September 30, 1975, to Institute of Contemporary Arts (London, England), Il Palazzo delle Esposizioni di Roma (Italy).

REFERENCES:

Tucker (1969), cat. no. 105, pp. 66, 69, illus.

Mahonri Sharp Young, "Ferdinand Howald and His Artists," *American Art Journal* 1 (fall 1969): p. 122, fig. 2.

C M A, *Catalog* (1978), p. 145.

45 *Telephone* 31.263

ENDNOTES:

1. Ben Wolf, *Morton Livingston Schamberg* (1963), pp. 30–33; William C. Agee, *Morton Livingston Schamberg* (exh. cat., New York: Salander-O'Reilly Galleries, Inc., 1982), pp. 5–10.

2. Agee, p. 10.

3. Agee, pp. 10–11.

PROVENANCE:

M. Knoedler & Co., New York; John Quinn, New York, June 3, 1919, Quinn ledgers, 1913–1924, vol. 1, p. 287; John Quinn estate, 1924; (sale: American Art Association, New York,

February 9–12, 1927, cat. no. 106, p. 46, as *The Telephone*); Ferdinand Howald, New York and Columbus, 1927, inv. no. 331; C M A, 1931 (gift of Ferdinand Howald).

EXHIBITION HISTORY:

M. Knoedler & Co. (New York), May [10]–24, 1919, *Paintings and Drawings by Morton L. Schamberg*, cat. no. 8.

C G F A (1931), cat. no. 207, p. I, 12.

Walker Art Center (Minneapolis), November 13 – December 31, 1960, *The Precisionist View in American Art*, cat. by Martin L. Friedman, p. 57; toured, January 24 – August 6, 1961, to W M A A, Detroit Institute of Art, Los Angeles County Museum of Art, San Francisco Museum of Art.

New Gallery, University of Iowa (Iowa City), May 24 – August 2, 1962, *Vintage Moderns: American Pioneer Artists: 1903–1932*, cat. no. 60, p. 24.

P A F A, November 21 – December 24, 1963, *Paintings by Morton L. Schamberg (1881–1918)*, checklist no. 32 (as *The Telephone*).

Zabriskie Gallery (New York), January 6–25, 1964, *Morton L. Schamberg (1881–1918)*, cat. no. 17, illus. (as *The Telephone*).

Milwaukee Art Center, April 9 – May 9, 1965, *Pop Art and the American Tradition*, cat. by Tracy Atkinson, no. 57, pp. 2, 12, 15, illus. (as *The Telephone*).

National Collection of Fine Arts (Washington, D.C.), December 2, 1965 – January 9, 1966, *Roots of Abstract Art in America 1910–1930*, cat. no. 146, illus.

University of New Mexico Art Museum (Albuquerque), February 10 – March 19, 1967, *Cubism: Its Impact in the USA 1910–1930*, cat. by Clinton Adams, no. 51, pp. 50, 51, illus.; toured, April 9 – August 27, 1967, to Marion Koogler McNay Art Institute (San Antonio, Texas), San Francisco Museum of Art, Los Angeles Municipal Art Gallery.

C G F A (1969), checklist no. 33.

C G F A (January 1970), no cat.

C G F A (May 1970), no cat.

C G F A (1970–1971), cat. no. 63, illus.

Museum of Fine Arts (St. Petersburg, Florida), October 6 – November 4, 1973, *The City and the Machine*, cat. (printed in *Pharos* 40, no. 2 [1973]), by Bradley Nickels and Margie Miller, no. 26, pp. 37, 41, illus.; toured, November 15, 1973 – February 10, 1974, to Loch Haven Art Center (Orlando, Florida), Cummer Gallery of Art (Jacksonville, Florida).

National Collection of Fine Arts (Washington, D.C.), May 9 – July 6, 1975, *Pennsylvania Academy Moderns 1910–1940*, cat. no. 39, p. 34, illus.; toured, July 30 – September 6, 1975, to School of the Pennsylvania Academy of the Fine Arts.

Museum of Fine Arts (Houston), July 1 – September 25, 1977, *Modern American Paintings 1910–1940: Toward a New Perspective*, cat. by William C. Agee, no. 66, pp. 12, 24, illus.

Hirshhorn Museum and Sculpture Garden, (Washington, D.C.), June 15 – September 4, 1978, *"The Noble Buyer:" John Quinn, Patron of the Avant-Garde*, cat. by Judith Zilczer, no. 68, pp. 139, 183, illus.

Salander-O'Reilly Galleries (New York), November 3 – December 31, 1982, *Morton Livingston Schamberg (1881–1918)*, cat. by William C. Agee and Pamela Ellison, no. 33, illus. (as *Painting 1 [Telephone]*); toured, January 22, 1983 – March 27, 1984, to C M A, School of the

Pennsylvania Academy of the Fine Arts, Milwaukee Art Museum.

Brooklyn Museum (New York), October 17, 1986 – February 16, 1987, *The Machine Age in America, 1918–1941*, checklist, unpag.; toured, April 4, 1987 – February 14, 1988, to Carnegie Institute, Los Angeles County Museum of Art, High Museum of Art (Atlanta).

REFERENCES:

Estate of John Quinn, Deceased, "Catalogue of the Art Collection Belonging to Mr. Quinn," July 28, 1924, John Quinn Memorial Collection, New York Public Library, inv., unpag.

John Quinn, 1870–1925, Collection of Paintings, Water Colors, Drawings and Sculpture (1926), p. 25 (as *The Telephone*).

"Sale of the Quinn Collection is Completed," *Art News* 25 (February 1927): 1 (as *The Telephone*).

Milton W. Brown, *American Painting from the Armory Show to the Depression* (1955, reprinted 1970), p. 117, illus.

William H. Pierson, Jr., and Martha Davidson, eds., *Arts of the United States: A Pictorial Survey* (1960), no. 3353, p. 358, illus.

Ben Wolf, *Morton Livingston Schamberg* (1963), no. 42, pp. 52, 97, illus. (as *The Telephone*).

Lillian Natalie Dochterman, "The Stylistic Development of the Work of Charles Sheeler," Ph.D. diss., State University of Iowa, 1963, pp. 26, 133, fig. 23.

Vivien Raynor, "In the Galleries," *Arts Magazine* 38 (March 1964): 61, illus. (as *The Telephone*).

Tucker (1969), cat. no. 155, pp. 95, 98, illus.

George Heard Hamilton, *19th and 20th Century Art* (1970), p. 300, fig. 278.

Matthew Baigell, *A History of American Painting* (1971), pp. 213, 281, fig. 10–16.

Marshall B. Davidson, *The Artists' America* (1973), p. 293, illus.

Perry London, *Beginning Psychology* (1975), p. 571, illus. (as *The Telephone*); rev. ed. (1978), p. 619, illus.

Henry F. Graff and Paul Bohannan, *The Promise of Democracy* (1978), p. 662, illus.

Susan Fillin Yeh, "Charles Sheeler's 1923 'Self-Portrait,'" *Arts Magazine* 52 (January 1978): 108, illus.

C M A, *Catalog* (1978), pp. 106–107, 149, illus.

C M A, *Selections* (1978), pp. 106–107, illus.

Julie Wosk, "Artists on Technology," *Technology Review* 82 (December–January 1980): 68, fig. b.

Susan Fillin Yeh, "Charles Sheeler and the Machine Age," Ph.D. diss., City University of New York, 1981, pp. 85–86, 268, pl. 16.

William C. Agee, "Morton Livingston Schamberg (1881–1918): Color and the Evolution of His Painting," *Arts Magazine* 57 (November 1982): 116–119, illus. (as *Painting I [Telephone]*).

Horace Freeland Judson, "Reweaving the Web of Discovery," *The Sciences* 23 (November–December 1983): 53, illus.

Board of Governors of the Federal Reserve System, *Morton Livingston Schamberg: Color and Evolution of His Painting*, unpag., fig. 1; reprinted from Agee (exh. cat., 1982).

46 *Constructivist Still Life* 63.6

ENDNOTES:

1. Thomas Hart Benton, *An American in Art: A Professional and Technical Autobiography* (1969), p. 33.
2. Benton in a letter to the CGFA, August 6, 1962.
3. Ibid.
4. Ibid.

PROVENANCE:

[Sale: Anderson Galleries, New York, February 23, 1922]; [Ferdinand Howald, New York and Columbus, 1922, inv. no. 217 (*Still life*)]; Carl A. Magnuson, Columbus, ca. 1943; CMA, 1963 (gift of Carl A. Magnuson).

EXHIBITION HISTORY:

Indiana University (1964), cat. no. 5, illus. (as *Early Abstraction*, 1917, oil on cardboard).

M. Knoedler & Co. (New York), October 12 – November 6, 1965, *Synchromism and Color Principles in American Painting 1910–1930*, cat. by William C. Agee, no. 1, pp. 10, 28 (as dated 1919), 49, illus. (as *Constructivist Still Life: Synchromist Color*, 1917).

ACA Heritage Gallery (New York), March 14 – April 9, 1966, *Commemorating the 50th Anniversary of The Forum Exhibition of Modern American Painters*, cat. no. 4 (as *Constructivist, Still Life*).

MoMA, *Synchromism and Related American Color Painting 1910–1930*, organized by William C. Agee (based on Knoedler's 1965 exhibition), checklist no. 2, illus. (as *Constructivist Still Life: Synchromist Color*, 1917); toured, February 4, 1967 – June 17, 1968, to State University College (Oswego, New York), Santa Barbara Museum of Art (California), California Institute of Arts (Los Angeles), Allen Memorial Art Museum (Oberlin College, Ohio), Rose Art Museum (Brandeis University, Waltham, Massachusetts), Museum of Art (Rhode Island School of Design, Providence), Goucher College (Towson, Maryland), Cummer Gallery of Art (Jacksonville, Florida), San Francisco Museum of Art.

Madison Art Center (Wisconsin), March 22 – April 12, 1970, *Thomas Hart Benton*, checklist.

Ohio Exposition Center, Fine Arts Exhibition at ExpOhio '71 (Columbus), August 26 – September 6, 1971, *Thomas Hart Benton: Profiles of America*, checklist no. 31 (as *Constructivist Still Life, Synchromist*, 1917).

Fine Arts Gallery of San Diego, November 20, 1971 – January 2, 1972, *Color and Form 1909–1914*, cat. by Henry G. Gardiner with contributions by Joshua C. Taylor, Peter Selz, Lilli Lonngren, Herschel B. Chipp, and William C. Agee, no. 3, pp. 46, 93, illus. (as *Constructivist Still Life, Synchromist Color*, 1917); toured, January 25 – May 7, 1972, to Oakland Museum (California), Seattle Art Museum (Pavilion, Washington).

University Art Gallery, Rutgers University (New Brunswick, New Jersey), November 19 – December 30, 1972, *Thomas Hart Benton: A Retrospective of His Early Years, 1907–1929*, cat. no. 19, fig. 8 (as *Constructivist Still Life*, 1917–1918).

Ohio State University (1973), cat. no. 29, illus. (as *Constructivist Still Life, Synchromist Color*).

Delaware Art Museum and the University of Delaware (Wilmington), April 4 – May 18, 1975, *Avant-Garde Painting and Sculpture in America 1910–1925*, cat., pp. 32, 33, illus. (as *Constructivist Still Life, Synchromist Color*).

San Jose Museum of Art (California), October 19 – November 28, 1976, *America VII: America Between the Wars*, checklist, unpag.; also in catalogue of exhibition series: *American Series: A Catalogue of Eight Exhibitions, April 1974 – December 1977* (1978), unpag., illus. (as *Constructivist Still Life, Synchromist Color*).

WMAA, January 24 – March 26, 1978, *Synchromism and American Color Abstraction 1910–1925*, book accompanying exh. by Gail Levin (1978), p. 137, pl. 120 (as *Constructivist Still Life: Synchromist Color*, 1917); toured, April 20, 1978 – March 24, 1979, to Museum of Fine Arts (Houston), Des Moines Art Center (Iowa), San Francisco Museum of Modern Art, Everson Museum of Art (Syracuse, New York), CMA.

REFERENCES:

William C. Agee, "Synchromism: The First American Movement," *ARTnews* 64 (October 1965): 30, illus. (as *Constructivist Still-Life*, 1917, subtitled *Synchromist Color*).

Thomas Hart Benton, "An American in Art: A Professional and Technical Autobiography," *Kansas Quarterly* 1 (spring 1969): 83, illus.

Matthew Baigell, "Thomas Hart Benton in the 1920's," *Art Journal* 29 (summer 1970): 424, fig. 4.

Sam Hunter, *American Art of the 20th Century* (1972), p. 87, fig. 152; rev. ed. (1973), p. 107, fig. 184 (as *Constructivist Still Life, Synchromist Color*, 1917).

Matthew Baigell, *Thomas Hart Benton* (1973), p. 45, pl. 21.

Sumio Kuwabara, "American Art from the Beginning of the Twentieth Century until the Eve of World War II," *Mizue* 1 (January 1976): 31, illus.

CMA, *Selections* (1978), p. 17, illus.

Milton W. Brown, et al., *American Art* (1979): 384, pl. 402 (said to have been in Forum Exhibition of Modern American Painting in 1916).

Gail Levin, "Thomas Hart Benton, Synchromism and Abstract Art," *Arts Magazine* 56 (December 1981): 145, 148, fig. 7 (as *Constructivist Still Life, Synchromist Color*, 1917).

"Thomas Hart Benton," *The Oxford Companion to Twentieth-Century Art*, ed. by Harold Osborne (1981), p. 53.

Abraham A. Davidson, *Early American Modernist Painting 1910–1935* (1981), p. 133.

James M. Dennis, *Grant Wood: Still Lifes as Decorative Abstractions* (exh. cat., Elvehjem Museum of Art, University of Wisconsin, 1985), pp. 4, 5, fig. 2.

47 *California Landscape* 31.275

ENDNOTES:

1. William C. Agee, *Synchromism and Color Principles in American Painting 1910–1930* (exh. cat., M. Knoedler & Co., 1965), pp. 7–12, 19.
2. Gail Levin, *Synchromism and American Color Abstraction 1910–1925* (exh. cat., WMAA, 1978), p. 14; Alastair Alpin MacGregor, *Percyval Tudor-Hart 1873–1954: Portrait of an Artist* (1969), p. 114.
3. Morgan Russell letter to Andrew Dasburg, March 12, 1914, quoted in Agee, p. 19.
4. See Levin, p. 27, for additional commentary on Orphism and Synchromism.
5. Agee, p. 2; Levin, p. 9.

PROVENANCE:

Daniel Gallery, New York; Ferdinand Howald, New York and Columbus, November 8, 1920,

inv. no. 188 (*California Landscape [Blue and Green Fantasy]*), or July 1923, inv. no. 262 (*California Landscape*); CMA, 1931 (gift of Ferdinand Howald).

EXHIBITION HISTORY:

CGFA (1931) cat. no. 234, p. I, 12.

Rose Fried Gallery (New York), November 20 – December 31, 1950, *3 American Pioneers of Abstract Art*, checklist no. 2.

CGFA (February 1952), no cat.

Denison University (1962), no cat.

New Gallery, University of Iowa (Iowa City), May 24 – August 2, 1962, *Vintage Moderns: American Pioneer Artists: 1903–1932*, cat. essay by Frank Seiberling, no. 28, pp. 13, 15, illus.

Corcoran Gallery of Art (Washington, D.C.), April 27 – June 2, 1963, *The New Tradition: Modern Americans Before 1940*, cat. essay by Gudmund Vigtel, no. 68, p. 62 (as dated ca. 1916).

Indiana University (1964), cat. no. 44, illus. (as dated 1916).

National Collection of Fine Arts (Washington, D.C.), December 2, 1965 – January 9, 1966, *Roots of Abstract Art in America 1910–1930*, cat. no. 102 (as dated ca. 1916).

National Collection of Fine Arts (Washington, D.C.), May 4 – June 18, 1967, *The Art of Stanton Macdonald-Wright*, cat. no. 9, pp. 27, 28, illus. (as dated 1916).

PAFA, January 31 – March 3, 1968, *Early Moderns*, checklist no. 12 (as dated ca. 1916).

CGFA (1969), checklist no. 18 (as dated ca. 1916).

CGFA (January 1970), no cat.

CGFA (May 1970), no cat.

CGFA (1970–1971), cat. no. 32, illus.

CGFA (1973), cat. no. 26, illus.

CGFA (1975), no cat.

CGFA (1977), no cat.

WMAA, January 24 – March 26, 1978, *Synchromism and American Color Abstraction 1910–1925*, book accompanying exh. by Gail Levin (1978), p. 140, pl. 118 (as dated ca. 1916); toured, April 20, 1978 – March 24, 1979, to Museum of Fine Arts (Houston), Des Moines Art Center (Iowa), San Francisco Museum of Modern Art, Everson Museum of Art (Syracuse, New York), CMA.

Allentown Art Museum (Pennsylvania), March 3 – May 30, 1987, *Modernist Idylls: Nature and the Avant-Garde, 1905–1930*, cat. no. 20, illus.

REFERENCES:

Tucker (1969), cat. no. 177, pp. 110, 113, 115, illus.

Helen Mullaly, "Certainties in Twentieth-Century Art," *Apollo* 98 (July 1973): 51, fig 3.

UNESCO (Paris, France), *Catalogue of Reproductions of Paintings 1860 to 1973* (1974), p. 194, fig. 700 (as *Paysage de Californie*).

New York Graphic Society, *Fine Art Reproductions of Old and Modern Masters* (1978), p. 363, illus.

CMA, *Catalog* (1978), pp. 72–73, 144, illus.

CMA, *Selections* (1978), pp. 72–73, illus.

48 *Factory* 31.153

ENDNOTES:

1. Interview with Moritz Jagendorf, conducted

by Richard Rubenfeld, New York City, July 29, 1978.

2. The other three works, all from the early 1920s, are: *Modern Industry* (Dartmouth College Museum and Galleries, Hanover, New Hampshire), which is the study for the Columbus Museum's *Factory; Industry II* (WMAA); and *Industry* (Museum of Fine Arts, Houston).

PROVENANCE:
Daniel Gallery, New York; Ferdinand Howald, New York and Columbus, April 1922, inv. no. 224; CMA, 1931 (gift of Ferdinand Howald).

EXHIBITION HISTORY:
[Daniel Gallery (New York), closing March 20, 1923, *Paintings and Drawings by Preston Dickinson*, cat. no. 1 (as *Factories*)].

CGFA (1931), cat. no. 67, p. 1, 9.

[Knoedler Galleries (New York), February 8–27, 1943, *Preston Dickinson Exhibition of Paintings*, cat. no. 25 (as *Factories*, 1925)].

CGFA (October 1952), no cat.

Walker Art Center (Minneapolis), November 13 – December 25, 1960, *The Precisionist View in American Art*, cat. essay by Martin L. Friedman, pp. 41, 55, illus. (as dated 1924); toured, January 24 – August 6, 1961, to WMAA, Detroit Institute of Art, Los Angeles County Museum of Art, San Francisco Museum of Art.

MoMA (administered by), American Embassy, Belgrade, Yugoslavia, January 16, 1962 – October 14, 1963, *Art in Embassies Program of the International Council of the Museum of Modern Art*, no cat.

School of the Pennsylvania Academy of the Fine Arts, January 31 – March 3, 1968, *Early Moderns*, cat. no. 8.

CGFA (1969), checklist no. 9 (as dated 1924).

CGFA (May 1970), no cat.

CGFA (1970–1971), cat. no. 15 (as dated 1924).

University Art Museum, University of Texas at Austin, October 15 – December 17, 1972, *Not So Long Ago: Art of the 1920s in Europe and America*, cat., p. 35, illus. (as dated 1924).

CGFA (1973), cat. no. 12, illus. (as *Factories*, 1924).

CGFA (1975), no cat. (as *Factories*).

Delaware Art Museum, and University of Delaware (Wilmington), April 4 – May 18, 1975 (at Delaware Art Museum), *Avant-Garde Painting & Sculpture in America 1910–25*, cat., p. 172 (as dated 1920?).

National Collection of Fine Arts (Washington, D.C), April 30 – November 7, 1976, *America as Art*, cat. essay by Joshua C. Taylor, no. 223 (as dated 1924).

CGFA (1977), no cat. (as *Factories*).

Heckscher Museum (Huntington, New York), July 7 – August 20, 1978, *The Precisionist Painters 1916–1949: Interpretations of a Mechanical Age*, cat., p. 29.

Sheldon Memorial Art Gallery, University of Nebraska—Lincoln, September 4 – October 7, 1979, *Preston Dickinson 1889–1930*, cat. essay by Ruth Cloudman, no. 21, pp. 25, 52, 53, pl. 4; toured, December 18, 1979 – August 10, 1980, to WMAA, University Art Museum (University of New Mexico, Albuquerque), Colorado Springs Fine Arts Center, Georgia Museum of Art (University of Georgia, Athens).

Hirschl and Adler Galleries (New York), October 29 – November 29, 1980, *Buildings: Ar-*chitecture in American Modernism*, cat. no. 27, pp. 5, 30–31, illus. (as dated ca. 1921).

Cedar Rapids Museum of Art (Iowa), June 25 – September 19, 1982, *Twentieth Century American Masters 1911–1957*, cat. by Joseph S. Czestochowski, no. 20, illus.; toured, January 16 – November 14, 1982, to Miami University Museum of Art (Oxford, Ohio), Tennessee Botanical Gardens and Fine Arts Center (Nashville), Springfield Art Museum (Missouri).

Brooklyn Museum (New York), October 7, 1986 – February 16, 1987, *The Machine Age in America 1918–1941*, checklist, unpag. (as dated 1924); toured, April 4, 1987 – February 14, 1988, to Carnegie Institute, Los Angeles County Museum of Art, High Museum of Art (Atlanta).

REFERENCES:
Forbes Watson, "Preston Dickinson," *The Arts* 5 (May 1924): 288, illus. (as *Factories*, Daniel Galleries).

Tucker (1969), cat. no. 50, pp. 37, 39, illus. (as *Factories*, 1924).

"Preston Dickinson—Painter," *Index of Twentieth Century Artists* 3 (January 1936), reprinted in *The Index of Twentieth Century Artists 1933–1937* (1970): 510, 511, 525 (as *Factories*).

John Wilmerding, ed., *The Genius of American Painting* (1973), p. 241, illus. (as dated 1924).

Marina Vaizey, "Ferdinand Howald: Avant-Garde Collector," *Arts Review* 25 (June 1973): 440 (as *Factories*, 1924).

Joshua C. Taylor, *America as Art* (1976), p. 200, illus.

CMA, *Catalog* (1978), pp. 37–38, 138, illus.

CMA, *Selections* (1978), pp. 37–38, illus.

Abraham A. Davidson, *Early American Modernist Paintings, 1910–1935* (1981), pp. 210, 211, fig. 109.

49 *Still Life with Yellow-Green Chair* 31.164

PROVENANCE:
Daniel Gallery, New York; Ferdinand Howald, New York and Columbus, November 1928, inv. no. 349; CMA, 1931 (gift of Ferdinand Howald).

EXHIBITION HISTORY:
MoMA, December 13, 1929 – January 12, 1930, *Paintings by Nineteen Living Americans*, cat. no. 17, pp. 21, 23, illus. (as *Still Life*).

CGFA (1931), cat. no. 77, p. 1, 9.

MoMA, September 14 – October 18, 1936, *American Art Portfolios*, checklist; published simultaneously: *American Art Portfolios: The First Series* (1936), no. 11, illus. (as *Still Life*).

MoMA, May 24 – October 15, 1944, *Art in Progress: Fifteenth Anniversary Exhibition*, cat., pp. 78, 220, illus.

CGFA (February 1952), no cat.

Contemporary Arts Center, Cincinnati Art Museum, October 12 – November 17, 1957, *An American Viewpoint: Realism in Twentieth Century American Painting*, cat. essay by Alfred Frankenstein, illus.; toured, November 27 – December 29, 1957, to Dayton Art Institute (Ohio).

Walker Art Center (Minneapolis), November 13 – December 25, 1960, *The Precisionist View in American Art*, cat. essay by Martin L. Friedman, pp. 44, 47, 55, illus.; toured, January 24 – August 6, 1961, to WMAA, Detroit Institute of Arts, Los Angeles County Museum of Art, San Francisco Museum of Art.

Indiana University (1964), cat. no. 20, p. 37, illus.

National Collection of Fine Arts (Washington, D.C.), December 2, 1965 – January 9, 1966, *Roots of Abstract Art in America 1910–1930*, cat. no. 41.

University of New Mexico Art Museum and Junior League of Albuquerque, February 10 – March 19, 1967, *Cubism: Its Impact in the USA, 1910–1930*, cat. no. 26, p. 28, illus.; toured, April 9 – August 27, 1967, to Marion Koogler McNay Art Institute (San Antonio, Texas), San Francisco Museum of Art, Los Angeles Municipal Art Gallery.

AFA, *American Still Life Painting 1913–1967*, cat. by William H. Gerdts, no. 8, illus.; toured, October 6, 1967 – November 14, 1968, to Cedar Rapids Art Center (Michigan), Roberson Memorial Center (Binghamton, New York), Huntington Galleries (West Virginia), Portland Museum of Art (Maine), Flint Institute of Arts (De Waters Art Center, Michigan), Mansfield Fine Arts Guild (Ohio), Allentown Art Museum (Pennsylvania), Kalamazoo Institute of Art (Michigan), Cornell University (Ithaca, New York), Dulin Gallery of Art (Knoxville, Tennessee), University of Maryland (College Park).

CGFA (January 1970), no cat.

CGFA (May 1970), no cat.

CGFA (1970–1971), cat. no. 16, illus.

CGFA (1973), cat. no. 13, illus.

CGFA (1975), no cat.

CGFA (1977), no cat.

Sheldon Memorial Art Gallery, University of Nebraska–Lincoln and Nebraska Art Association (Lincoln), September 4 – October 7, 1979, *Preston Dickinson 1889–1930*, cat. by Ruth Cloudman, no. 67, Foreword, and pp. 34, 35, 62, 63, illus.; toured, December 18, 1979 – August 10, 1980, to WMAA, University Art Museum (University of New Mexico, Albuquerque), Colorado Springs Fine Arts Center, Georgia Museum of Art (University of Georgia, Athens).

Taft Museum (Cincinnati), April 4 – June 7, 1981, *Small Paintings from Famous Collections*, cat. unpag.

REFERENCES:
The Art News 28 (December 14, 1929): 7, illus. (as *Still Life*, as lent by Cleveland Museum of Art).

Forbes Watson, "The All American Nineteen," *The Arts* 16 (January 1930): 306, illus. (as *Still Life*).

Samuel M. Kootz, *Modern American Painters* (1930), pl. 15 (as *Still Life with Chair*).

"A Group of Museum Exhibitions," *Parnassus* 3 (February 1931): 46 (as *Still Life with Bottle*).

Samuel M. Kootz, "Preston Dickinson," *Creative Art* 8 (May 1931): 340, illus. (as *Still Life*).

"Preston Dickinson—Painter," *Index of Twentieth Century Artists* 3 (January 1936), reprinted in *The Index of Twentieth Century Artists 1933–1937* (1970): 510, 511, 525 (as *Still Life with Chair*).

Catalogue of Selected Color Reproductions Prepared for the Carnegie Corporation of New York, Vol. 1 (1936), unpag.

Walter Pach, "A First Portfolio of American Art," *ARTnews* 35 (October 1936): 12, illus. (as *Still Life in Oils*).

Philip McMahon, "New Books on Art," *Parnassus* 8 (December 1936): 35, illus. (as *Still Life*).

Fine Art Reproductions, Old & Modern Masters

(New York Graphic Society, 1951), p. 274, no. 6676.

Lee H. B. Malone, "He Chose with Conviction," *Carnegie Magazine* 26 (March 1952): 79, illus.

Lillian Natalie Dochterman, "The Stylistic Development of the Work of Charles Sheeler," Ph.D. diss., State University of Iowa, 1963; pp. 19–20, 130, fig. 17.

Milton W. Brown, *American Painting from the Armory Show to the Depression* (1955, reprinted 1970), p. 129, illus.

William H. Pierson, Jr., and Martha Davidson, eds., *Arts of the United States: A Pictorial Survey* (1960), p. 338, illus. no. 3078.

Tucker (1969), cat. no. 58, pp. 36, 40, fig. 58.

Phaidon Dictionary of Twentieth-Century Art (1973), p. 96.

"NRTA Treasury of American Painting," *NRTA Journal* 28 (November–December 1977): 47, illus.

CMA, *Catalog* (1978), pp. 39–40, 138, illus.

CMA, *Selections* (1978), pp. 39–40, illus.

Abraham A. Davidson, *Early American Modernist Painting 1910–1935* (1981), pp. 207, 208, fig. 106.

Matthew Baigell, *Dictionary of American Art* (Harper and Row Icon Editions, 1979; reprinted 1982), p. 96.

50 *Lhasa* 31.100

ENDNOTES:

1. *Charles Sheeler Papers*, Archives of American Art, Smithsonian Institution, Washington, D.C., Roll NSH-1, Frame 3.

2. Charles Sheeler, quoted in Constance Rourke, *Charles Sheeler: Artist in the American Tradition* (1938), p. 119; see also Martin Friedman, *Charles Sheeler* (1975), p. 71.

3. Theodore E. Stebbins, Jr., and Norman Keyes, Jr., *Charles Sheeler: The Photographs* (exh. cat., Museum of Fine Arts, Boston, 1987), pp. 3, 53, n. 10.

4. John Claude White, *Tibet and Lhasa*. See Stebbins and Keyes, p. 4, fig. 6.

5. Friedman, pp. 30–31.

PROVENANCE:

Modern Gallery, New York; John Quinn, New York, November 9, 1917, Quinn ledgers, 1913–1924, vol. 1, p. 264 (as *Landscape*); Quinn Estate, New York, 1924; (sale: American Art Association, New York, February 9–12, 1927, cat. no. 496, p. 194, as *Landscape No. 3*); Ferdinand Howald, New York and Columbus, 1927, inv. no. 334; CMA, 1931 (gift of Ferdinand Howald).

EXHIBITION HISTORY:

CGFA (1931), cat. no. 214, p. 1, 12 (as *Impressionism*).

MoMA, October 4 – November 1, 1939, *Charles Sheeler: Paintings, Drawings, Photographs*, intro. by William Carlos Williams, cat. no. 8, pp. 10, 46.

CGFA, Paintings from the Howald Collection, no cat.; November 23 – December 10, 1941, to Art Center (Parkersburg, West Virginia).

Cincinnati Art Museum, March 12 – April 14, 1941, *A New Realism: Crawford, Demuth, Sheeler, Spencer*, cat. no. 24, p. 14.

Dayton Art Institute (Ohio), November 2 – December 2, 1944, *Paintings by Charles Sheeler*, no cat.

WMAA, April 9 – May 19, 1946, *Pioneers of Modern Art in America*, cat. by Lloyd Goodrich, no. 139, p. 27, illus. (as *Impressionism [Lhasa]*); toured, July 1, 1946 – May 30, 1947, to University of Michigan (Ann Arbor), George Walter Vincent Smith Art Museum (Springfield, Massachusetts), Wilmington Society of Fine Arts (Delaware), Baltimore Museum of Art, Phillips Memorial Gallery (Washington, D.C.), Isaac Delgado Museum of Art (New Orleans, Louisiana), M. H. de Young Memorial Museum (San Francisco), St. Paul Gallery and School of Art (Minnesota), CGFA, Munson-Williams-Proctor Institute (Utica, New York), Smith College Museum of Art (Northampton, Massachusetts).

Cincinnati Art Museum, February 2 – March 4, 1951, *Paintings: 1900–1925*, cat. no. 58 (as *Impressionism*).

CGFA (February 1952), no cat.

Art Galleries, University of California (Los Angeles), October 11 – November 7, 1954, *Charles Sheeler: A Retrospective Exhibition*, cat. no. 2, pp. 9, 45 (as *Impressionism*); toured, November 18, 1954 – June 15, 1955, to M. H. de Young Memorial Museum (San Francisco), Fine Arts Gallery of San Diego, Fort Worth Art Center (Texas), PAFA, Munson-Williams-Proctor Institute (Utica, New York).

AFA, *Pioneers of American Abstract Art*, cat. no. 40, p. 11 (as *Lhasa [or Impressionism]*); toured, December 1, 1955 – January 9, 1957, to Atlanta Public Library (Georgia), Louisiana State Exhibition Museum (Shreveport), J. B. Speed Art Museum (Louisville, Kentucky), Lawrence Museum (Williamstown, Massachusetts), George Thomas Hunter Gallery (Chattanooga, Tennessee), Rose Fried Gallery (New York).

Allentown Art Museum (Pennsylvania), November 17 – December 31, 1961, *Charles Sheeler Retrospective Exhibition*, cat. no. 3, pp. 8, 17.

Downtown Gallery (New York), March 19 – April 21, 1962, *American Abstraction, 1903–1923*, no cat.

New Gallery, Department of Art, University of Iowa (Iowa City), May 24 – August 2, 1962, *Vintage Moderns: American Pioneer Artists: 1903–1932: Plus 4 Related Photographers*, cat. no. 61, pp. 25, 27, illus.

Denison University (1962), no cat.

Corcoran Gallery of Art (Washington, D.C.), April 27 – June 2, 1963, *The New Tradition: Modern Americans Before 1940*, cat. essay by Gudmund Vigtel, no. 89, p. 65.

Poses Institute of Fine Arts, Rose Art Museum, Brandeis University (Waltham, Massachusetts), October 4 – November 10, 1963, *American Modernism: The First Wave*, cat. no. 2, illus.

National Collection of Fine Arts (Washington, D.C.), December 2, 1965 – January 9, 1966, *Roots of Abstract Art in America 1910–1930*, cat. no. 151, illus.

ACA Heritage Gallery (New York), March 14 – April 9, 1966, *Commemorating the 50th Anniversary of "The Forum Exhibition of Modern American Painters" March 1916*, cat. no. 34, illus.

University of New Mexico Art Museum (Albuquerque), February 10 – March 19, 1967, *Cubism: Its Impact in the USA 1910–1930*, cat. no. 53, p. 52, illus.; toured, April 9 – August 27, 1967, to Marion Koogler McNay Art Institute (San Antonio, Texas), San Francisco Museum of Art, Los Angeles Municipal Art Gallery.

CGFA (1968), no cat.

National Collection of Fine Arts (Washington, D.C.), October 10 – November 24, 1968, *Charles Sheeler*, cat. essays by Martin Friedman, Bartlett Hayes, and Charles Millard, no. 13, pp. 12, 71, 73, illus.; toured, January 10 – April 27, 1969, to Philadelphia Museum of Art, WMAA.

CGFA (May 1970), no cat.

CGFA (1970–1971), cat. no. 64, illus.

National Collection of Fine Arts (Washington, D.C.), May 9 – July 6, 1975, *Pennsylvania Academy Moderns 1910–1940*, cat. no. 40, p. 35, illus.; toured, July 30 – September 6, 1975, to PAFA.

Grand Rapids Art Museum (Michigan), September 17 – November 1, 1981, *Pioneers: Early Twentieth Century Art from Midwestern Museums*, cat. no. 29, illus.

REFERENCES:

Estate of John Quinn, Deceased, "Catalogue of the Art Collection Belonging to Mr. Quinn," July 28, 1924, John Quinn Memorial Collection, New York Public Library, unpag. (as *Landscape*).

Forbes Watson, "Charles Sheeler," *The Arts* 3 (May 1923): 337, illus. (as *Landscape*).

John Quinn 1870–1925: Collection of Paintings, Water Colors, Drawings and Sculpture (1926), p. 25 (as *Landscape*).

"Sale of the Quinn Collection is Completed," *ARTnews* 25 (February 1927): 10 (as *Landscape No. 3*).

AFA, *American Art Annual* (1927), no. 496, p. 385 (as *Landscape No. 3*).

Constance Rourke, *Charles Sheeler: Artist in the American Tradition* (1938), pp. 66–67.

["Charles Sheeler—Painter and Photographer," *Index of Twentieth Century Artists* 3 (January 1936), reprinted in *The Index of Twentieth Century Artists 1933–1937* (1970): 521 (as *Impressionism*); see also p. 523 (*Landscape*).

Lillian Natalie Dochterman, "The Stylistic Development of the Work of Charles Sheeler," Ph.D. diss., State University of Iowa, 1963, no. 16.049, pp. 16, 24, 38, 51, 197, illus. (as *Lhasa* [formerly called "Impressionism"]).

Tucker (1969), cat. no. 159, pp. 96, 99, 101, illus.

Sam Hunter and John Jacobus, *Art of the Twentieth Century* (1973), p. 138, fig. 232.

Martin Friedman, *Charles Sheeler* (1975), pp. 31, 52, illus. pl. 4.

CMA, *Catalog* (1978), p. 150, illus.

Judith Zilczer, "The Noble Buyer:" John Quinn, Patron of the Avant-Garde* (1978), p. 187 (as *Lhasa [Landscape no. 3]*).

Susan Fillin-Yeh, "Charles Sheeler and the Machine Age," Ph.D. diss., City University of New York, 1981, pp. 99, 125, 216.

Theodore E. Stebbins, Jr., and Norman Keyes, Jr., *Charles Sheeler: The Photographs* (exh. cat., Museum of Fine Arts, Boston, 1987), pp. 3, 4, fig. 5, 53 n. 10.

RELATED WORKS:

Lhasa, 1916, pencil and crayon, collection of Mrs. Earle Horter (Doylestown and Philadelphia, Pennsylvania).

Landscape, 1916, black crayon on white paper, Fogg Art Museum, Harvard University (Cambridge, Massachusetts).

Untitled (Lhasa), photograph by John Claude White, published in White, *Tibet and Lhasa* (Calcutta, 1907–1908).

REMARKS:

Lhasa has been exhibited under the titles *Landscape*, *Landscape No. 3*, and *Impressionism*. Sheeler may have changed the title to *Lhasa* at the time of the retrospective held at MoMA in 1939. See Sheeler's remarks in the 1939 MoMA exhibition catalogue, p. 10.

51 *Still Life and Shadows* 31.106

ENDNOTES:

1. Patterson Sims, *Charles Sheeler: A Concentration of Works From the Permanent Collection of the Whitney Museum of American Art* (1980), p. 18.
2. Charles Sheeler, quoted in Constance Rourke, *Charles Sheeler: Artist in the American Tradition* (1938), p. 106.
3. Rourke, p. 106.
4. Charles Sheeler, quoted in Sims, p. 18.

PROVENANCE:

Daniel Gallery, New York; Ferdinand Howald, New York and Columbus, October 1925, inv. no. 298; CMA, 1931 (gift of Ferdinand Howald).

EXHIBITION HISTORY:

Gallery of Living Art, New York University, December 13, 1927 – January 25, 1928, *Opening Exhibition*, cat.

CGFA (1931), cat. no. 215, p. 1, 12 (as *Still Life, No. 1*).

CGFA (1935), no cat. (as *Still Life No. 1*).

MoMA, October 4 – November 1, 1939, *Charles Sheeler: Paintings, Drawings, Photographs*, cat. no. 65, pp. 21, 50, illus. (as *Still Life with White Teapot*).

Dayton Art Institute (Ohio), November 2 – December 2, 1944, *Paintings by Charles Sheeler*, no cat.

Ohio State Fair, Columbus, August 23–30, 1946.

AFA (1948–1949), no cat.

CGFA (February 1952), no cat.

Art Galleries, University of California (Los Angeles), October 11 – November 7, 1954, *Charles Sheeler: A Retrospective Exhibition*, cat. no. 8, p. 45 (as *Objects on a Table*); toured, November 18, 1954 – June 15, 1955, to M. H. de Young Memorial Museum (San Francisco), Fine Arts Gallery of San Diego, Fort Worth Art Center (Texas), PAFA, Munson-Williams-Proctor Institute (Utica, New York).

CGFA (1956), no cat.

CGFA (1958), no cat.

CGFA (1958–1960), no cat.

CGFA (1961), no cat.

University of Iowa Museum of Art (Iowa City), March 17 – April 14, 1963, *The Quest of Charles Sheeler*, cat. essay by Lillian Dochterman, no. 26, pp. 16, 17, 48, fig. 9 (as *Objects on a Table*).

Flint Institute of Arts (Michigan), April 28 – May 29, 1966, *Realism Revisited*, cat. no. 45, pp. 4, 15, illus. (as *Objects on a Table*).

Cedar Rapids Art Center (Iowa), October 25 – November 26, 1967, *Charles Sheeler: A Retrospective Exhibition*, cat. essay by Donn L. Young, no. 8 (as *Objects on Table*).

CGFA (1968), no cat.

National Collection of Fine Arts (Washington, D.C.), October 10 – November 24, 1968, *Charles Sheeler*, cat. essays by Martin Friedman, Bartlett Hayes, and Charles Millard, no. 33, pp. 16, 115,

illus. (as *Objects on a Table*); toured, January 10 – April 27, 1969, to Philadelphia Museum of Art, WMAA.

CGFA (May 1970), no cat.

Carnegie Institute, November 18, 1971 – January 9, 1972, *Forerunners of American Abstraction*, cat. essay by Herdis Bull Teilman, no. 89 (as *Objects on a Table*).

University Art Museum, University of Texas at Austin, October 15 – December 17, 1972, *Not So Long Ago: Art of the 1920s in Europe and America*, cat., p. 87, cover illus. (as *Objects on a Table*).

Museum of Art, Pennsylvania State University (University Park), February 10 – March 24, 1974, *Charles Sheeler: The Works on Paper*, cat. by John P. Driscoll, no. 24, pp. 50, 54, 55, 56, cover illus. (as *Objects on a Table*); toured, April 12 – 20, 1974, to Terry Dintenfass (New York).

Northern Illinois University Art Gallery (Dekalb), October 27 – November 22, 1974, *Near-Looking: A Close Focus Look at a Basic Thread of American Art*, cat. by Dorothea K. Beard, et al., no. 34, pp. 65, 66, illus. (as *Objects on a Table [Still Life with Teapot]*); toured, December 1, 1974 – January 26, 1975, to University of Notre Dame Art Gallery (South Bend, Indiana).

Philadelphia Museum of Art, April 11 – October 10, 1976, *Philadelphia: Three Centuries of American Art*, cat. no. 448, pp. 526, 527, illus. (as *Objects on a Table*).

Terry Dintenfass (New York), May 10–30, 1980, *Charles Sheeler (1883–1965)*, cat. no. 15, pp. 20, 27, illus.

Yale University Art Gallery (New Haven, Connecticut), April 1 – May 31, 1987, *Charles Sheeler: American Interiors*, cat. by Susan Fillin-Yeh, no. 4, pp. 9, 10, 25, 27, 28, illus. (as *Objects on a Table [Still Life with White Teapot]*).

Museum of Fine Arts (Boston), October 13, 1987 – January 3, 1988, *Charles Sheeler: Paintings, Drawings, and Photographs*, cat. Vol. 1: *Charles Sheeler: Paintings and Drawings*, by Carol Troyen and Erica E. Hirshler, no. 27, pp. 15, 100, 101, illus.; toured, January 28 – July 10, 1988, to WMAA, Dallas Museum of Art.

REFERENCES:

"'Living Art' Now on View," *Art News* 26 (December 17, 1927): 4.

"Charles Sheeler—Painter and Photographer," *Index of Twentieth Century Artists* 3 (January 1936), reprinted in *The Index of Twentieth Century Artists 1933–1937* (1970): 521 (as *Still Life No. 1*).

Frank J. Roos, Jr., *An Illustrated Handbook of Art History* (1937), 3rd ed. (1970), p. 304, fig. D (as *Still Life Number One*).

Constance Rourke, *Charles Sheeler: Artist in the American Tradition* (1938), pp. 73, 106, 107, 110, 111, 179, illus. (as *Still Life with White Teapot*).

Wolfgang Born, *Still Life Painting in America* (1947), fig. 131 (as *Still Life with Teapot*).

Lillian Natalie Dochterman, "The Stylistic Development of the Work of Charles Sheeler," Ph.D. diss., State University of Iowa, 1963, no. 24.108, pp. 32, 256, illus. (as *Objects on a Table*).

Hilton Kramer, "Charles Sheeler: American Pastoral," *Artforum* 7 (January 1969): 39, illus. (as *Objects on a Table*).

Tucker (1969), cat. no. 166, pp. 102, 104, 105, illus. (as *Objects on a Table [Still Life with White Teapot]*).

"Art Across the U.S.A.: Outstanding Exhibitions," *Apollo* 89 (March 1969): 239, fig. 1 (as *Objects on a Table*).

Kasha Linville, "The Howald Collection at Wildenstein," *Arts Magazine* 44 (summer 1970): 16, illus. (as *Objects on a Table*).

John Wilmerding, ed., *The Genius of American Painting* (1973), p. 240, illus.

Martin Friedman, *Charles Sheeler* (1975), p. 59, pl. 11 (as *Objects on a Table*).

CMA, *Catalog* (1978), pp. 109–111, 168, illus.

CMA, *Selections* (1978), pp. 109–111, illus.

Van Deren Coke, *Andrew Dasburg* (1979), pp. 66, 70, fig. 35.

Susan Fillin-Yeh, "Charles Sheeler and the Machine Age," Ph.D. diss., City University of New York, 1981, pp. 125, 281, pl. 29 (as *Objects on a Table*).

William Carlos Williams: Selected Poems, introduction by Randall Jarrell and a portfolio of paintings by Charles Sheeler (1984), unpag.

John Baker, *Henry Lee McFee and Formalist Realism in American Still Life, 1923–1936* (1987), p. 100, fig. 127.

52 *The Circus* 31.127

ENDNOTES:

1. Emily Farnham, *Charles Demuth: Behind a Laughing Mask* (1971), pp. 5–29.
2. Betsy Fahlman, in *Pennsylvania Modern: Charles Demuth of Lancaster* (exh. cat., Philadelphia Museum of Art, 1983), p. 31. The Hartley statement originally appeared in Marsden Hartley, *Adventures in the Arts: Informal Chapters on Painters, Vaudeville, and Poets* (1921), p. 155.

PROVENANCE:

Daniel Gallery, New York; Ferdinand Howald, New York and Columbus, October 15, 1917, inv. no. 90; CMA, 1931 (gift of Ferdinand Howald).

EXHIBITION HISTORY:

CGFA (1931), cat. no. 34, p. 1, 8.

Cleveland Museum of Art, June 23 – October 4, 1937, *American Painting from 1860 until Today*, cat. no. 43, p. 18, pl. 28.

WMAA, December 15, 1937 – January 16, 1938, *Charles Demuth Memorial Exhibition*, cat. no. 69, illus. (as dated 1919).

MoMA, May 10 – September 30, 1939, *Art in Our Time: An Exhibition to Celebrate the Tenth Anniversary of the Museum of Modern Art*, cat. no. 215, illus.

Phillips Memorial Gallery (Washington, D.C.), May 3 – 25, 1942, *Charles Demuth Exhibition of Water Colors and Oil Paintings*, checklist no. 46.

Dayton Art Institute (Ohio), February 2 – March 4, 1945, *19 Paintings by Charles Demuth*, no cat.

Walker Art Center (Minneapolis), and Inter-American Office of the National Gallery of Art (Washington, D.C.), April 24 – May 8, 1946 (at Walker Art Center), *Watercolor—U.S.A.*, cat. no. 37, p. 54; toured, May 18 – December 1946(?), to Pan American Union (Washington, D.C.), Buenos Aires (Argentina), Rio de Janeiro (Brazil), Sao Paulo (Brazil), Montevideo (Uruguay), Santiago (Chile), Lima (Peru), Mexico City.

AFA (1948–1949), no cat.

Albertina Gallery (Vienna, Austria), October

1949, *Amerikanische Meister des Aquarells*, cat. no. 20, p. 14 (as dated 1919).

MoMA, March 7 – June 11, 1950, *Charles Demuth*, cat. by Andrew Carnduff Ritchie, no. 68, pp. 35, 91, illus.

Museum of Art, University of Michigan (Ann Arbor), November 9–29, 1950, *Sport and Circus*, cat. no. 12.

CGFA (1952), no cat.

Norfolk Museum (Virginia), March 1953, *Significant American Moderns*, cat., unpag.

AFA, *American Watercolor Exhibition*, cat. (for Tokyo showing); toured, October 11, 1954 – August 14, 1955, to New Delhi (India), Calcutta (India), Bombay (India), Madras (India), Lahore (Pakistan), Peshawar (Pakistan), Karachi (Pakistan), Colombo National Museum (Ceylon), Manila (The Philippines), Tokyo (Japan).

CGFA (1956), no cat.

CGFA (1958–1960), no cat.

CGFA (1958), no cat.

Milwaukee Art Center, September 21 – November 5, 1961, *10 Americans*, cat. no. 8.

WMAA, February 27 – April 14, 1963, *The Decade of the Armory Show: New Directions in American Art 1910–1920*, cat. no. 25, pp. 23, 72, illus.; toured, June 1, 1963 – February 23, 1964, to City Art Museum of Saint Louis, Cleveland Museum of Art, PAFA, Art Institute of Chicago, Albright-Knox Art Gallery (Buffalo, New York.)

CGFA, *Watercolors from the Ferdinand Howald Collection*, no cat.; June 22 – July 10, 1964, to Ohio State University (Columbus).

WMAA, September 27 – November 27, 1966, *Art of the United States: 1670–1966*, cat. no. 66.

Cincinnati Art Museum, February 14 – March 16, 1969, *Three American Masters of Watercolor: Marin, Demuth, Pascin*, cat. essay by Richard J. Boyle, no. 29, p. 12.

CGFA (January 1970), no cat.

CGFA (May 1970), no cat.

CGFA (1970–1971), cat. no. 5.

Birmingham Museum of Art (Alabama), January 16 – February 13, 1972, *American Watercolors 1850–1972*, cat., p. 33, illus.; toured, February 22 – March 31, 1972, to Mobile Art Gallery (Alabama).

CGFA (1973), cat. no. 5, illus.

Andrew Crispo Gallery (New York), May 16 – June 30, 1974, *Ten Americans*, cat. no. 30, illus. (as not dated).

CGFA (1975), no cat.

CGFA (1977), no cat.

Cleveland Museum of Art, on loan May 1978.

REFERENCES:

"Charles Demuth—Painter," *Index of Twentieth Century Artists* 2 (July 1935), reprinted in *The Index of Twentieth Century Artists 1933–1937* (1970): 430.

"Watercolors to Serve as Good-Will Guests," *Art Digest* 20 (June 1, 1946): 17.

Emily Farnham, "Charles Demuth: His Life, Psychology and Works," Ph.D. diss., Ohio State University, 1959; Vol. 1, pp. 269–271, 367, 388, fig. 5, Vol. 2, no. 248, pp. 505, 794, fig. 38.

Tucker (1969), cat. no. 20, pp. 20–22, illus.

Emily Farnham, *Charles Demuth: Behind a Laughing Mask* (1971), pl. 1.

Alvord L. Eiseman, "A Study of the Development of an Artist: Charles Demuth," Ph.D. diss., New York University, 1974, pp. 277-279, illus. no. 159.

Young (1974), pp. 50, 51, pl. 14.

Allen S. Weller, et al., *Watercolor U.S.A. National Invitational Exhibition* (exh. cat., Springfield [Missouri] Art Museum, 1976), p. 28, illus.

Donelson F. Hoopes, *American Watercolor Painting* (1977), pp. 133, 149, pl. 37.

Alvord Eiseman, *Charles Demuth* (1982), p. 45, pl. 11.

REMARKS:
The Circus is no. w-399 in the scrapbooks of Richard C. Weyand (died 1956), a close associate of Demuth's and the compiler of this early "catalogue raisonné" of the artist's works.

53 *Modern Conveniences* 31.137

ENDNOTES:
1. S. Lane Faison, "Fact and Art in Charles Demuth," *Magazine of Art* 43 (April 1950): 126.

2. Ibid.

3. George Biddle, in response to a questionnaire on Demuth, commented on his friend's antipathy toward Lancaster. See Emily Farnham, *Charles Demuth: Behind a Laughing Mask* (1971), p. 38.

4. Farnham, p. 38.

PROVENANCE:
Daniel Gallery, New York; Ferdinand Howald, New York and Columbus, January 1923, inv. no. 246; CMA, 1931 (gift of Ferdinand Howald).

EXHIBITION HISTORY:
Daniel Gallery (New York), December [1], 1922 – January 2, 1923, *Recent Paintings by Charles Demuth*, cat. no. 9, illus.

Société Anonyme, *International Exhibition of Modern Art*, cat. no. 236; November 19 – December 20, 1926, Brooklyn Museum (New York).

MoMA, December 13, 1929 – January 12, 1930, *Paintings by Nineteen Living Americans*, cat. no. 11, p. 17 (as dated 1922).

CGFA (1931), cat. no. 44, p. I, 9.

Smith College Museum of Art (Northampton, Massachusetts), May 19 – June 19, 1934, *Five Americans*, not in checklist.

CGFA (1935), no cat.

WMAA, December 15, 1937 – January 16, 1938, *Charles Demuth Memorial Exhibition*, cat. no. 16.

Cincinnati Modern Art Society, and Cincinnati Art Museum, March 12 – April 14, 1941, *A New Realism: Crawford, Demuth, Sheeler, Spencer*, cat. no. 14, p. 13.

Phillips Memorial Gallery (Washington, D.C.), May 3–25, 1942, *Charles Demuth*, cat. no. 47.

WMAA, April 9 – May 19, 1946, *Pioneers of Modern Art in America*, cat. by Lloyd Goodrich, no. 31, p. 21; toured, July 1, 1946 – May 30, 1947, to University of Michigan (Ann Arbor), George Walter Vincent Smith Art Museum (Springfield, Massachusetts), Wilmington Society of Fine Arts (Delaware), Baltimore Museum of Art, Phillips Memorial Gallery (Washington, D.C.), Isaac Delgado Museum of Art (New Orleans, Louisiana), M. H. DeYoung Memorial Museum (San Francisco), St. Paul Gallery and

School of Art (Minnesota), CGFA, Munson-Williams-Proctor Institute (Utica, New York), Smith College Museum of Art (Northampton, Massachusetts).

Corcoran Gallery of Art (Washington, D.C.), January 9 – February 20, 1949, *De Gustibus: An Exhibition of American Paintings Illustrating a Century of Taste and Criticism*, cat. by Eleanor B. Swenson, no. 45, illus.

MoMA, March 7 – June 11, 1950, *Charles Demuth*, cat. by Andrew Carnduff Ritchie, no. 113, p. 92 (exhibition toured, but *Modern Conveniences* exhibited only at MoMA).

Smith College Museum of Art (Northampton, Massachusetts), [May–October] 1951, no cat.

Norfolk Museum (Virginia), March 1953, *Significant American Moderns*, cat., illus.

Wildenstein & Co. (New York), May 4–28, 1955, *Special Exhibition of Paintings by American and French Modern Masters for the Benefit of the La Napoule Art Foundation Henry Clews Memorial*, cat. no. 7 (as dated 1920).

Brooks Memorial Union, Marquette University (Milwaukee, Wisconsin), April 22 – May 3, 1956, *75 Years of American Painting: Festival of American Arts*, cat. no. 18.

Davison Art Center, Wesleyan University (Middletown, Connecticut), September 15 – [October 10] 1957, *America Seen*, no cat.

Ohio Wesleyan University (Delaware, Ohio), November 13 – December 13, 1959 (exhibition title unknown).

Walker Art Center (Minneapolis), November 13 – December 25, 1960, *The Precisionist View in American Art*, cat. by Martin L. Friedman; toured, January 24 – August 6, 1961, to WMAA, Detroit Institute of Arts, Los Angeles County Museum of Art, San Francisco Museum of Art.

Denison University (1962), no cat.

WMAA, February 27 – April 14, 1963, *The Decade of the Armory Show: New Directions in American Art 1910–1920*, cat. no. 27, pp. 49, 72, illus.; toured, June 1, 1963 – February 23, 1964, to City Art Museum of St. Louis, Cleveland Museum of Art, PAFA, Art Institute of Chicago, Albright-Knox Art Gallery (Buffalo, New York).

Indiana University (1964), cat. no. 18, illus.

AFA, *Realism and Reality*, cat. no. 14; toured, January 2, 1965 – January 24, 1966, to Quincy Art Center (Illinois), Laguna Gloria Art Museum (Austin, Texas), Tougaloo College (Mississippi), Art Department of the University of Rhode Island (Kingston), Oak Ridge Community Art Center (Tennessee), Mobile Art Gallery (Alabama), Evansville Public Museum (Indiana), Charles and Emma Frye Art Museum (Seattle, Washington), Witte Memorial Museum (San Antonio, Texas), Wichita Art Museum (Kansas).

WMAA, September 27 – November 27, 1966, *Art of the United States: 1670–1966*, cat. no. 68.

Grand Rapids Art Museum (Michigan), April 1–30, 1967, *Twentieth Century American Painting*, cat. no. 32, p. 41.

CGFA (1969), no cat.

CGFA (January 1970), no cat.

CGFA (May 1970), no cat.

CGFA (1970–1971), cat. no. 10.

Art Galleries, University of California at Santa Barbara, October 5 – November 14, 1971, *Charles Demuth: The Mechanical Encrusted on the Living*,

cat. by David Gedhard and Phyllis Plous, no. 76, p. 83; toured, November 22, 1971 – April 16, 1972, to University Art Museum (University of California, Berkeley), Phillips Collection (Washington, D.C.), Munson-Williams-Proctor Institute (Utica, New York).

Hathorn Gallery, Skidmore College (Saratoga Springs, New York), October 12–29, 1972, *The Americans Circa 1922*, cat. no. 5, pp. 11, 15, 17, 20, illus.

Terry Dintenfass (New York), November 4–29, 1975, *Shapes of Industry: First Images in American Art*, cat. by Roxana Barry, no. 7.

Contemporary Arts Center (Cincinnati), October 13 – November 25, 1979, *The Modern Art Society: The Center's Early Years 1939–1954*, cat. by Ruth K. Meyer, no. 34, illus.

San Francisco Museum of Modern Art, September 9 – November 7, 1982, *Images of America: Precisionist Painting and Modern Photography*, cat. by Karen Tsujimoto, no. 38, pp. 57, 233, pl. 2; toured, December 6, 1982 – October 9, 1983, to Saint Louis Art Museum, Baltimore Museum of Art, Des Moines Art Center (Iowa), Cleveland Museum of Art.

REFERENCES:
Forbes Watson, "Charles Demuth," *The Arts* 3 (January 1923): 75, illus.

Samuel M. Kootz, *Modern American Painters* (1930), fig. 6 (as dated 1922).

William Murrel, *Charles Demuth: American Artist Series* (1931), no. 32, illus. (as dated 1920).

"Charles Demuth—Painter," *Index of Twentieth Century Artists* 2 (July 1935), reprinted in *The Index of Twentieth Century Artists 1933–1937* (1970): 430, 432.

Frank J. Roos, Jr., *An Illustrated Handbook of Art History* (1937), p. 273, fig. E (as dated 1922).

Martha Davidson, "Demuth, Architect of Painting," *ARTnews* 36 (December 1937): 7, illus.

S. Lane Faison, Jr., "Fact and Art in Charles Demuth," *Magazine of Art* 43 (April 1950): 125, 126, fig. 8.

Emily Farnham, "Charles Demuth: His Life, Psychology and Works," Ph.D. diss., Ohio State University, 1959: Vol. 1, pp. 17, 108, 152–153, 325–326; Vol. 2, p. 571; Vol. 3, pp. 852, 909, fig. 99.

Tucker (1969), cat. no. 29, pp. 23, 24, 27, illus.

George Heard Hamilton, *19th and 20th Century Art* (1970), pp. 277, 298, 299, illus.

Kasha Linville, "The Howald Collection at Wildenstein," *Arts Magazine* 44 (summer 1970): 16.

Kasha Linville, "Howald's American Line," *ARTnews* 69 (summer 1970): 55.

Matthew Baigell, *A History of American Painting* (1971), pp. 218, 275, fig. 11–2.

Emily Farnham, *Charles Demuth: Behind a Laughing Mask* (1971), pp. 120, 148, 205.

Alvord L. Eiseman, "A Charles Demuth Retrospective Exhibition," *Art Journal*, 31 (spring 1972): 284–285.

Mahonri Sharp Young, "The Man from Ohio: Ferdinand Howald and his Painters," *The Arts in Ireland* 2, no. 3 (1974): 11, illus.

Abraham A. Davidson, *The Story of American Painting* (1974), p. 132, pl. 120.

Alvord L. Eiseman, "A Study of the Development of an Artist: Charles Demuth," Ph.D. diss., New York University, 1974, pp. 357, 359, 360, illus. no. 214.

Young (1974), pp. 62, 63, pl. 20.

Daniel Catton Rich, ed., *The Flow of Art: Essays and Criticisms of Henry McBride* (1975), illus. no. 6 (as watercolor and as MoMA).

CMA, *Catalog* (1978), p. 138, illus.

Abraham A. Davidson, *Early American Modernist Painting 1910–1935* (1981), p. 175, 194.

Frank Getlein, "The Paintings and Photographs of 'Precisionism' " (or "In paint and film they saw a precise image of America"), *Smithsonian* 13 (November 1982): 130–141, illus.

Betsy Fahlman, *Pennsylvania Modern: Charles Demuth of Lancaster* (exh. cat., Philadelphia Museum of Art, 1983), pp. 11, 20.

Alvord L. Eiseman, *Charles Demuth* (1982), pp. 21, 25, 65, pl. 27.

Betsy Fahlman, "Charles Demuth of Lancaster, Pennsylvania," *Art and Antiques* 6 (July-August 1983): 82–89, illus.

Betsy Fahlman, "Charles Demuth's Paintings of Lancaster Architecture: New Discoveries and Observations," *Arts Magazine* 61 (March 1987): 25.

REMARKS:
Modern Conveniences is no. w-353 in the scrapbooks of Richard C. Weyand (died 1956), a close associate of Demuth's and the compiler of this early "catalogue raisonné" of the artist's works.

54 *Bowl of Oranges* 31.125

ENDNOTES:
1. Betsy Fahlman, *Pennsylvania Modern: Charles Demuth of Lancaster* (exh. cat., Philadelphia Museum of Art, 1983), p. 62.

2. Ibid., p. 53.

3. Quoted by Darrell Larson, in Emily Farnham, "Charles Demuth: His Life, Psychology and Works," Ph.D. diss., Ohio State University, 1959: Vol. 3, p. 994.

4. Charles Demuth, "Across a Greco Is Written," *Creative Art* 5 (September 1929): 634.

PROVENANCE:
Daniel Gallery, New York; Ferdinand Howald, New York and Columbus, April 1925, inv. no. 293 (as *Oranges and Bananas*); CMA, 1931 (gift of Ferdinand Howald).

EXHIBITION HISTORY:
CGFA (1931), cat. no. 32, p. 1, 8.

Smith College Museum of Art (Northampton, Massachusetts), May 19 – June 19, 1934, *5 Americans*, checklist no. 15 (as *Still Life*).

CGFA (1935), no cat.

CGFA, Paintings from the Howald Collection, no cat.; November 23 – December 10, 1941, to Art Center (Parkersburg, West Virginia).

University of Minnesota, November 29 – December 20, 1942, *Our Leading Watercolorists*, checklist.

Dayton Art Institute (Ohio), February 2 – March 4, 1945, *19 Paintings by Charles Demuth*, no cat.

AFA, *Early Twentieth Century American Watercolors*, no. cat.; toured, September 5, 1948–May 31, 1949, to Dayton Art Institute (Ohio), Rochester (New York), Western College (Oxford, Ohio), Williamstown (Massachusetts), Manchester (New Hampshire), Cambridge (Massachusetts), Minneapolis Institute of Arts.

MoMA, March 7 – June 11, 1950, *Charles Demuth*, cat. by Andrew Carnduff Ritchie, no. 131, p. 92; toured, October 1, 1950 – May 5, 1951, to

Detroit Institute of Art, University of Miami (Coral Gables), Winnipeg Art Gallery (Manitoba, Canada), Williams College (Williamstown, Massachusetts), University of Delaware (Newark), Oberlin College (Ohio).

CGFA (October 1952), no cat.

CGFA (1956), no cat.

CGFA (1958), no cat.

CGFA (1958–1960), no cat.

CGFA (1961), no cat.

Corcoran Gallery of Art (Washington, D.C), April 27 – June 2, 1963, *The New Tradition: Modern Americans Before 1940*, cat. essay by Gudmund Vigtel, no. 28, p. 57.

Pennsylvania Historical and Museum Commission, William Penn Memorial Museum (Harrisburg), September 24 – November 6, 1966, *Charles Demuth of Lancaster*, cat. essay by Emily Genauer, no. 104.

Cincinnati Art Museum, February 14 – March 16, 1969, *Three American Masters of Watercolor: Marin, Demuth, Pascin*, cat. essay by Richard J. Boyle, no. 42, p. 13.

CGFA (May 1970), no cat.

CGFA (1970–1971), cat. no. 13.

Art Galleries, University of California at Santa Barbara, October 5 – November 14, 1971, *Charles Demuth: The Mechanical Encrusted on the Living*, cat. by David Gedhard and Phyllis Plous, no. 92, p. 84; toured, November 22, 1971 – April 16, 1972, to University Art Museum (University of California, Berkeley), Phillips Collection (Washington, D.C.), Munson-Williams-Proctor Institute (Utica, New York).

Minneapolis Institute of Arts, *Painters and Photographers of Gallery 291* (also entitled *I am an American: Artists of Gallery 291*); Artmobile Tour, August 1, 1973 – August 1, 1974, statewide.

Taft Museum (Cincinnati), March 24 – May 8, 1977, *Best of 50*, cat., illus.

WMAA, October 15, 1987 – January 17, 1988, *Charles Demuth*; toured, February 25–July 10, 1988, to Los Angeles County Museum of Art, CMA (*Bowl of Oranges* exhibited only at CMA).

REFERENCES:
"Charles Demuth—Painter," *Index of Twentieth Century Artists* 2 (July 1935), reprinted in *The Index of Twentieth Century Artists 1933–1937* (1970): 430.

Emily Farnham, "Charles Demuth: His Life, Psychology and Works," Ph.D. diss., Ohio State University, 1959: Vol. 2, no. 457, p. 592; Vol. 3, p. 866, fig. 113.

Tucker (1969), cat. no. 41, p. 34.

Thomas E. Norton, ed., *Homage to Charles Demuth: Still Life Painter of Lancaster* (1978), p. 109, illus.

CMA, *Catalog* (1978), p. 158.

Alvord L. Eiseman, "A Study of the Development of an Artist: Charles Demuth," Ph.D. diss., New York University, 1974, pp. 393–394, illus. no. 237.

Alvord L. Eiseman, *Charles Demuth* (1982), pp. 18, 71, pl. 31.

REMARKS:
Bowl of Oranges is no. w-471 in the scrapbooks of Richard C. Weyand (died 1956), a close associate of Demuth's and the compiler of this early "catalogue raisonné" of the artist's works.

55 *Buildings* 31.268

ENDNOTES:

1. Richard B. Freeman, *Niles Spencer* (exh. cat., University of Kentucky Art Gallery, 1965), p. 13.

2. Ralston Crawford, "Niles Spencer: A Tribute," in Freeman, p. 21.

PROVENANCE:

Daniel Gallery, New York; Ferdinand Howald, New York and Columbus, December 1924, inv. no. 290; CMA, 1931 (gift of Ferdinand Howald).

EXHIBITION HISTORY:

CGFA (1931), cat. no. 220, p. 1, 12.

CGFA (1935), no cat.

Cincinnati Modern Art Society, and Cincinnati Art Museum, March 12 – April 14, 1941, *A New Realism: Crawford, Demuth, Sheeler, Spencer*, cat. no. 32, p. 15.

CGFA, Paintings from the Howald Collection, no cat.; November 23 – December 10, 1941, to Art Center (Parkersburg, West Virginia).

CGFA (February 1952), no cat.

MoMA, June 23 – August 15, 1954, *Niles Spencer: A Retrospective Exhibition*, checklist (as dated ca. 1926); toured, February 1 – October 1, 1954, to Akron Art Institute (Ohio), Cincinnati Art Museum, Currier Gallery of Art (Manchester, New Hampshire), Walker Art Center (Minneapolis).

CGFA, Paintings from the Columbus Gallery of Fine Arts, no cat.; March 1965, to Otterbein College (Westerville, Ohio).

University of Kentucky Art Gallery, October 10 – November 6, 1956, *Niles Spencer*, cat. by Richard B. Freeman, no. 42, pp. 32, 65, illus. no. 14 (as dated 1926); toured, November 16, 1965 – June 12, 1966, to Munson-Williams-Proctor Institute (Utica, New York), Portland Museum of Art (Maine), WMAA, Allentown Art Museum (Pennsylvania), Currier Gallery of Art (Manchester, New Hampshire), Museum of Art (Rhode Island School of Design, Providence).

University of New Mexico (Albuquerque), February 10 – March 19, 1967, *Cubism: Its Impact in the USA, 1910–1930*, cat. no. 57, pp. 53, 54, illus. no. 57 (as dated 1926); toured, April 9 – August 27, 1967, to Marion Koogler McNay Art Institute (San Antonio, Texas), San Francisco Museum of Art, Los Angeles Municipal Art Gallery.

CGFA (May 1970), no cat.

REFERENCES:

Tucker (1969), cat. no. 168, pp. 105–107, illus. (as dated 1926).

State of Ohio Department of Education, *Guidelines for Planning Art Instruction in the Elementary Schools of Ohio* (1970), illus.

CMA, *Catalog* (1978), p. 151.

Abraham A. Davidson, *Early American Modernist Painting, 1910–1935* (1981), pp. 215–217, 218, illus. no. 116 (as dated 1926).

Frank Anderson Trapp, *Peter Blume* (1987), p. 25, illus.

56 *The Swimmer* 31.196

PROVENANCE:

Daniel Gallery, New York; Ferdinand Howald, New York and Columbus, February 1925, inv.

no. 292; CMA, 1931 (gift of Ferdinand Howald).

EXHIBITION HISTORY:

Daniel Gallery (New York), January 3–31, 1925, *Paintings by Yasuo Kuniyoshi*.

CGFA (1931), cat. no. 112, p. 1, 10.

Art Institute of Chicago, June 1 – November 1, 1933, *A Century of Progress: Exhibition of Paintings and Sculpture*, cat. no. 587, p. 72.

CGFA (1935), no cat.

CGFA (1941), no cat.

Downtown Gallery (New York), May 5–29, 1942, *Kuniyoshi Retrospective Loan Exhibition, 1921–1941*, checklist no. 4.

WMAA, March 27 – May 9, 1948, *Yasuo Kuniyoshi Retrospective Exhibition*, cat. essay by Lloyd Goodrich, no. 21, p. 52 (as dated 1924).

Museum of Art, University of Michigan (Ann Arbor), November 9–29, 1950, *Sport and Circus*, cat. no. 23 (as dated 1922).

CGFA (February 1952), no cat.

Junior Art Gallery (Louisville, Kentucky), January 31 – April 21, 1956, *Exercise: Art About Action*, checklist no. 18, illus. (detail).

Ohio Wesleyan University (Delaware, Ohio), November 13 – December 13, 1959 (exhibition title unknown).

Corcoran Gallery of Art (Washington, D.C.), April 27 – June 2, 1963, *The New Tradition: Modern Americans Before 1940*, cat. essay by Gudmund Vigtel, no. 56, pp. 34, 61, illus. (as dated 1922).

Bixler Art and Music Center, Colby College Museum of Art (Waterville, Maine), June 25 – September 30, 1964, *Maine: 100 Artists of the Twentieth Century*, cat., p. 36.

CGFA (January 1970), no cat.

CGFA (May 1970), no cat.

CGFA (1970–1971), cat. no. 29, illus.

University Art Museum, University of Texas at Austin, February 9 – March 23, 1975, *Yasuo Kuniyoshi 1889–1953, A Retrospective Exhibition*, cat., pp. 16, 30, 31, 65, illus.; toured, April 13, 1975 – February 8, 1976, to Elvehjem Art Center (University of Wisconsin, Madison), Georgia Museum of Art (University of Georgia, Athens), Prefectural Museum of Aichi (Nagoya, Japan), Bridgestone Museum Tokyo (Japan), Hyogo Prefectural Museum (Kobe, Japan), Art Gallery of Windsor (Ontario, Canada).

Flint Institute of Arts (Michigan), November 16, 1978 – January 21, 1979, *Art of the Twenties: American Painting at the Crossroads*, cat. no. 27, pp. 38, 40, illus.

WMAA, April 11 – June 19, 1986, *Yasuo Kuniyoshi*, checklist (as dated 1924).

REFERENCES:

Dudley Poore, "Current Exhibitions," *The Arts* 7 (February 1925): 114.

"Yasuo Kuniyoshi—Painter," *Index of Twentieth Century Artists* 1 (April 1934), reprinted in *The Index of Twentieth Century Artists 1933–1937* (1970): 153.

"Art," *Time* 51 (April 12, 1948): 53, illus.

Eloise Spaeth, *American Art Museums and Galleries* (1960), p. 125, illus.

Donelson F. Hoopes, "Maine: A Faith in Nature," *Art in America* 51, no. 3 (1963): 74, illus. (as dated 1924).

John I. H. Baur, "The Beginnings of Modernism, 1914–1940," in Gertrude A. Mellon and Elizabeth F. Wilder, eds., *Maine and Its Role in American Art, 1740–1963* (1963), pp. 139, 144, illus.

Tucker (1969), cat. no. 89, pp. 58, 59, illus.

Irma B. Jaffe, "The Forming of the Avant-Garde 1900–30," in John Wilmerding, ed., *The Genius of American Painting* (1973), pp. 240, 241, illus.

Akira Muraki, *Masters of Modern Japanese Art 10: Yasuo Kuniyoshi*, Vol. 8 (1976), p. 112, pl. 8.

Benjamin Lowe, *The Beauty of Sport: A Cross-Disciplinary Inquiry* (1977), pp. 131, 147, pl. 10a.

Hideo Tomiyam, ed., *The Works of Yasuo Kuniyoshi* (1977).

CMA, *Catalog* (1978), p. 143.

Franklin Riehlman, Tom Wolf, and Bruce Weber, *Yasuo Kuniyoshi: Artist as Photographer* (exh. cat., Edith C. Blum Art Institute, Milton and Sally Avery Arts Center, Bard College Center with the Norton Gallery and School of Art, 1983), pp. 12, 13, fig. 5.

Frank Anderson Trapp, *Peter Blume* (1987), pp. 29, 49, illus.

RELATED WORKS:

The Swimmer, 1924, ink with pen and dry brush, WMAA.

57 *Diana* 80.24

ENDNOTES:

1. Kenyon Cox, "Art: A New Sculptor," *The Nation* 96 (February 13, 1913): 163; quoted in Susan Rather, "The Past Made Modern: Archaism in American Sculpture," *The Arts* (November 1984): 116.

2. See Edwin Murtha, *Paul Manship* (1957), no. 155.

PROVENANCE:

(Sale: Sotheby Parke Bernet, April 25, 1980, lot no. 192); CMA, 1980.

EXHIBITION HISTORY:

[Smithsonian Institution (Washington, D.C.), February 23 – March 16, 1958, *A Retrospective Exhibition of Sculpture by Paul Manship*, cat. no. 38].

CMA (1986–1987), cat. no. 38, pp. 18, 19, 32, illus.

CMA, October 11 – November 29, 1987, *Accent on Sculpture: Small-scale Works from the Permanent Collection*, checklist, illus.

REFERENCES:

[Edwin Murtha, *Paul Manship* (1957), cat. no. 138, p. 161].

CMA (1986), p. 31, illus.

RELATED WORKS:

Diana (same edition as CMA work), bronze, Minnesota Museum of Art (St. Paul).

Diana (same edition as CMA work), bronze, National Museum of American Art (Washington, D.C.).

Diana (same edition as CMA work), bronze, Snite Museum of Art, University of Notre Dame (South Bend, Indiana).

Diana (same edition as CMA work), bronze [Hudson River Museum (Yonkers, New York)].

Diana (same edition as CMA work), bronze, Carnegie Institute (Pittsburgh, Pennsylvania).

Actaeon, 1923, bronze (see Edwin Murtha, *Paul Manship* [1957], no. 155).

REMARKS:

The CMA cast is the original and smallest version of the subject, which was intended as a companion piece for the artist's *Actaeon*. A heroic-size group, cast in 1924, is presently in the Brookline Gardens, South Carolina. An intermediate version was cast in 1925.

58 *October* 31.116

ENDNOTES:

1. John I. H. Baur, *Charles Burchfield* (1956), p. 19; and Matthew Baigell, *Charles Burchfield* (1976), pp. 25–26, 31. Baur also cites the writings of Thoreau as influences on the art of Burchfield.
2. Charles Burchfield, foreword to *Charles Burchfield* (1945), unpag.
3. Ibid.
4. Burchfield's interest in presenting the light, colors, and weather of the seasons is also seen in earlier works such as *February Thaw* (1920, Brooklyn Museum). For other examples, see *The Early Works of Charles E. Burchfield 1915–1922* (exh. cat., Columbus Museum of Art, 1987).
5. Quoted in Baur, p. 70.
6. Burchfield, unpag.

PROVENANCE:

Montross Gallery, New York (acquired from the artist); Ferdinand Howald, New York and Columbus, April 1924, inv. no. 279; CMA, 1931 (gift of Ferdinand Howald).

EXHIBITION HISTORY:

Montross Gallery (New York), March 18 – April 5, 1924, *Exhibition: Water Colors by Charles Burchfield*, checklist no. 2.

Carnegie Institute, October 16 – December 7, 1930, *Twenty-ninth International Exhibition of Paintings*, cat. no. 107, pl. 19.

CGFA (1931), cat. no. 21-a, p. I, 8.

CGFA (1941), no cat.

Frank K. M. Rehn Galleries (New York), January 3–28, 1961.

Art Gallery, University of Arizona (Tucson), November 14, 1965 – January 9, 1966, *His Golden Year: A Retrospective Exhibition of Watercolors, Oils and Graphics by Charles E. Burchfield*, cat. no. 37, pp. 92, 116, illus.

Museum of Art, Munson-Williams-Proctor Institute (Utica, New York), April 9 – June 14, 1970, *The Nature of Charles Burchfield: A Memorial Exhibition 1893–1967*, cat. no. 144.

Ohio Expositions Center, ExpOhio 70 (Columbus), August 27 – September 7, 1970, *Charles Burchfield*, checklist no. 3.

Corcoran Gallery of Art (Washington, D.C.), October 9 – November 14, 1971, *Wilderness*, checklist.

Schumacher Gallery, Capital University (Columbus, Ohio), September 1 – October 3, 1983, *Charles Burchfield*, no cat.

Butler Institute of American Art (Youngstown, Ohio), December 11, 1983 – January 8, 1984, *Charles Burchfield in Ohio*, no cat.

REFERENCES:

William B. M'Cormick, "A Small Town in Paint," *International Studio* 80 (March 1925): 470, illus.

"The International Exhibition at Pittsburgh," *American Magazine of Art* 21 (December 1930): 674, illus.

"Charles E. Burchfield—Painter," *Index of Twentieth Century Artists* 2 (December 1934), reprinted in *The Index of Twentieth Century Artists 1933–1937* (1970): 293, 295.

John W. Straus, "Inventory of Burchfield's Work," Ph.D. diss., Harvard College, 1942, no. 530.

Milton W. Brown, "The Early Realism of Hopper and Burchfield," *College Art Journal* 7 (autumn 1947): 11.

Milton W. Brown, *American Painting from the Armory Show to the Depression* (1955, reprinted 1970), p. 181, illus. (as dated 1924).

Tucker (1969), cat. no. 10, pp. 14, 15, illus.

Joseph S. Trovato, *Charles Burchfield: Catalogue of Paintings in Public and Private Collections* (1970), cat. no. 693, pp. 114, 116, illus. (as painted October 2, 1922–1924, in Buffalo).

CMA, *Catalog* (1978), p. 157.

59 *Woman Playing Accordion* 80.3

PROVENANCE:

Graham Gallery, New York (probably acquired from the artist's estate); Harry Spiro, New York, before 1970; Coe Kerr Gallery, New York, 1980; CMA, 1980.

EXHIBITION HISTORY:

C. W. Kraushaar Art Galleries (New York), March 17 – April 2, 1924, *Paintings and Drawings by Guy Pène du Bois*, cat. no. 6 (as *Girl with Accordion*).

Art Institute of Chicago, October 29 – December 13, 1925, *The Thirty-Eighth Annual Exhibition of American Paintings and Sculpture*, cat. no. 53 (as *The Accordeon Player*).

Graham Gallery (New York), January 6–31, 1970, *Guy Pene du Bois*, cat. no. 30 (as *Woman with Accordian*).

CMA (1986–1987), cat. no. 35, p. 32.

60 *Home for Christmas* 31.109

ENDNOTES:

1. Letter dated November 9, 1934, from the artist to Phillip Adams, director of CGFA.
2. Ibid.
3. Ibid.
4. Museum of Contemporary Art (Chicago), *Peter Blume* (exh. cat., 1976), unpag.

PROVENANCE:

Daniel Gallery, New York (purchased from the artist); Ferdinand Howald, New York and Columbus, April 17, 1926, inv. no. 315; CMA, 1931 (gift of Ferdinand Howald).

EXHIBITION HISTORY:

Daniel Gallery (New York), spring exhibition [April] 1926.

CGFA (1931), cat. no. 14, p. I, 8.

CGFA (1935), no cat.

CGFA (1941), no cat.

Art Gallery of Toronto (Ontario, Canada), February 1945, *Museum's Choice: Paintings by Contemporary Americans*, cat. no. 37.

CGFA (February 1952), no cat.

Currier Gallery of Art (Manchester, New Hampshire), April 18 – May 31, 1964, *Paintings and Drawings: Peter Blume in Retrospect 1925–1964*, cat. essay by Charles E. Buckley, no. 3, pp. 21, 43; toured, July 9 – August 16, 1964, to Wadsworth Atheneum (Hartford, Connecticut).

CGFA (1969), checklist no. 1.

CGFA (May 1970), no cat.

CGFA (1970–1971), cat. no. 1, illus. (as dated ca. 1926).

Museum of Contemporary Art (Chicago), January 10 – February 29, 1976, *Peter Blume: A Retrospective Exhibition*, cat. essay by Dennis Adrian, unpag., illus.

Metropolitan Museum and Art Centers (Miami), February 18 – March 27, 1977, *American Magic Realists*, cat., p. 4 (as dated ca. 1926).

REFERENCES:

Lloyd Goodrich, "New York Exhibitions," *The Arts* 9 (May 1926): 283, 286, illus.

"Peter Blume—Painter," *Index of Twentieth Century Artists* 3 (May 1936), reprinted in *The Index of Twentieth Century Artists 1933–1937* (1970): 583, 584.

Milton W. Brown, "Cubist-Realism: An American Style," *Marsyas* 3 (1946): 154.

Lee H. B. Malone, "He Chose with Conviction," *Carnegie Magazine* 26 (March 1952): 79.

Milton W. Brown, *American Painting from the Armory Show to the Depression* (1955, reprinted 1970), p. 125, illus.

Tucker (1969), cat. no. 3, pp. 9–10, 12, illus. (as dated ca. 1926).

John Wilmerding, ed., *The Genius of American Painting* (1973), p. 241, illus. (as dated ca. 1926).

CMA, *Catalog* (1978), pp. 19–20, 136, illus.

CMA, *Selections* (1978), pp. 19–20, illus.

Abraham A. Davidson, *Early American Modernist Painting 1910–1935* (1981), pp. 185, 220–222, fig. 120.

Frank S. Trapp, *Peter Blume* (1987), pp. 18, 27, 29, illus.

61 *Crucifixion* 85.3.1

ENDNOTES

1. *Elijah Pierce: Wood Carver* (exh. cat., CGFA, 1973), unpaginated.
2. Ibid.
3. The original configuration is documented by two period photographs of Pierce standing beside the *Crucifixion* (in private collection, Columbus, Ohio).
4. Richard A. Aschenbrand, "Elijah Pierce: Preacher in Wood," *American Craft Magazine* (June/July 1982): 25.

PROVENANCE:

Collection of the artist; Mrs. Elijah Pierce; CMA, 1985.

EXHIBITION HISTORY:

Krannert Art Museum, University of Illinois at Urbana-Champaign, December 12, 1971 – January 2, 1972, *Elijah Pierce*, no cat.

MoMA, January 25 – March 13, 1972, Untitled III (Art Lending Service Exhibition and Sale), no cat.

Bernard Danenberg Galleries (New York), June 6–24, 1972, *Elijah Pierce: Painted Carvings*, cat. no. 4, p. 5, illus. (as dated 1933).

PAFA, December 21, 1972 – January 28, 1973, *An Exhibition of Painted Carvings by Elijah Pierce*, checklist no. 9.

CGFA, November 30 – December 30, 1973, *Elijah Pierce: Wood Carver*, cat., unpag.

Ohio State Fair, Columbus, August 12–24, 1980, *American Folk Art from Ohio Collections*, cat. no. 187, p. 114, illus. (as dated 1930).

Corcoran Gallery of Art (Washington, D.C.), January 15 – March 28, 1982, *Black Folk Art in America 1930–1980*, cat. by Jane Livingston, John Beardsley, and Regenia Perry, no. 203, pp. 118, 119, 120, 174, illus. (as dated 1940), April 26, 1982 – May 15, 1983, to J. B. Speed Art Museum (Louisville, Kentucky), Brooklyn Museum (New York), Craft and Folk Art Museum (Los Angeles), Institute for the Arts (Rice University, Houston).

CMA (1986–1987), cat. no. 89, pp. 29, 34, illus.

Akron Art Museum (Ohio), June 13 – August 16, 1987, *On Earth as it is in Heaven: The Carvings of Elijah Pierce*, no cat.

Southern Ohio Museum and Cultural Center (Portsmouth), February 12 – March 13, 1988, *Elijah Pierce: Woodcarver*, no cat.

REFERENCES:

Herbert W. Hemphill, Jr., and Julia Weissman, *Twentieth-Century American Folk Art and Artists* (1974), pp. 100, 101, illus. (as dated ca. 1933).

Gaylen Moore, "The Vision of Elijah," *New York Times Magazine* (August 26, 1979): 28, 30, illus. (as dated 1933).

Sue Gorisek, "Folk Art," *Ohio Magazine* 3 (November 1980): 20.

Mary Schmidt Campbell, "Black Folk Art in America," *Art Journal* 42 (winter 1982): 346.

Robert Hughes, "Finale for the Fantastical," *Time* 119 (March 1, 1982): 70, 71, illus. (as dated 1940).

Richard A. Aschenbrand, "Elijah Pierce: Preacher in Wood," *American Craft Magazine* 42 (June–July 1982): 25, cover illus. (as dated 1940).

C. Kurt Dewhurst, Betty MacDowell, and Marsha MacDowell, *Religious Folk Art in America: Reflections of Faith* (1983), pp. 93, 128, 129, fig. 173 (as dated ca. 1933).

Gary Schwindler, "Elijah Pierce (1892–1984)," *Dialogue* 9 (January–February 1986): 18, 19, illus. (as unknown date).

REMARKS:

A paper label on the back of the relief is inscribed: By E. Pierce/N.F.S./1930 [the "3" in 1930 is overlaid by a "4"].

62 Hudson Bay Fur Company 56.1

ENDNOTES:

1. Lloyd Goodrich, *Reginald Marsh* (1972), p. 36.

PROVENANCE:

Estate of the artist, 1954; (sale: Frank K. M. Rehn Galleries, New York, 1956); CMA, 1956.

EXHIBITION HISTORY:

PAFA, January 28 – February 25, 1934, *129th Annual Exhibition*, cat. no. 272, p. 61, illus.

Currier Gallery of Art (Manchester, New Hampshire), July 6 – September 26, 1938, *Midsummer Exhibition*, no cat.

Berkshire Museum (Pittsfield, Masachusetts), August 3–31, 1944, *Works by Reginald Marsh: A Retrospective Exhibition*, cat. no. 23.

WMAA, September 21 – November 6, 1955, *Reginald Marsh*, cat. no. 6, p. 21, illus.; toured, November 27, 1955 – October 14, 1956, to CGFA, Detroit Institute of Arts, City Art Museum of Saint Louis, Dallas Museum of Fine Arts, Los Angeles County Museum, Santa Barbara Museum of Art (California), San Francisco Museum of Art.

CGFA, Paintings from the Columbus Gallery of Fine Arts, no cat.; March 1965, to Otterbein College (Westerville, Ohio).

University of Arizona Museum of Art (Tucson), March 14 – April 13, 1969, *East Side, West Side, All Around the Town: A Retrospective Exhibition of Paintings, Watercolors and Drawings by Reginald Marsh*, cat. no. 62, p. 76, illus.

Newport Harbor Art Museum (Newport Beach, California), November 2 – December 10, 1972, *Reginald Marsh: A Retrospective Exhibition*, cat. no. 11, illus.; toured, January 8 – May 31, 1973, to Des Moines Art Center (Iowa), Fort Worth Art Center Museum (Texas), University Art Museum (University of Texas, Austin).

REFERENCES:

"Reginald Marsh—Painter and Graver," *Index of Twentieth Century Artists* 3 (November 1935), reprinted in *The Index of Twentieth Century Artists 1933–1937* (1970): 487.

Maude Riley, "Reginald Marsh Featured by Berkshire," *Art Digest* 18 (August 1944): 8, illus.

"Accessions of American and Canadian Museums," *Art Quarterly* 19 (January–March 1956): 311.

Lloyd Goodrich, *Reginald Marsh* (1972), pp. 36, 53, illus.

CMA, *Catalog* (1978), pp. 79, 145, illus.

CMA, *Selections* (1978), p. 79, illus.

Marilyn Cohen, *Reginald Marsh's New York: Paintings, Drawings, Prints and Photographs* (exh. cat., WMAA, 1983), pp. 24, 25, 27, fig. 43.

Mark Bockrath, "A Tempera Technique of Reginald Marsh," *Intermuseum Conservation Association Newsletter* 15 (June 1984): 1, 2, fig. 1.

RELATED WORKS:

Modeling Furs on Union Square, 1940, watercolor, private collection.

63 Veteran Acrobat 42.84

ENDNOTES:

1. Paul Bird, *Fifty Paintings by Walt Kuhn* (1940), unpag.

PROVENANCE:

Collection of the artist, until 1942; CMA, 1942.

EXHIBITION HISTORY:

CGFA, April 3 – May 4, 1942, *Paintings by Walt Kuhn*, checklist no. 9.

Dayton Art Institute, October 1943, *Paintings by Walt Kuhn*, no cat.; toured, November 1943, to Art Institute of Zanesville (Ohio).

Art Gallery of Ontario (Toronto, Canada), February 2–25, 1945, *Museums' Choice: Paintings by Contemporary Americans*, cat. no. 35.

Akron Art Institute (Ohio), November 30 – December 28, 1945, *40 American Painters: A Survey of American Painting from Colonial to Modern Times, for the Opening of the Institute, December 1945*, cat. no. 29, illus.

Cincinnati Art Museum, October 1 – November 5, 1948, *An American Show*, cat. no. 30.

Birmingham Museum of Art (Alabama), April 8 – June 3, 1951, *Opening Exhibition*, cat., p. 45.

Cincinnati Art Museum, October 5 – November 9, 1960, *Walt Kuhn 1877–1949*, cat. no. 78, illus.

CGFA, Paintings from the Columbus Gallery of Fine Arts, no cat.; March 1965, to Otterbein College (Westerville, Ohio).

Amon Carter Museum (Fort Worth, Texas), August 6 – September 10, 1978, *Walt Kuhn: A Classic Revival*, checklist no. 39; toured, September 30, 1978 – April 15, 1979, to Joslyn Art Museum (Omaha, Nebraska), Wichita Art Museum (Kansas), Colorado Springs Fine Arts Center (Colorado).

Milwaukee Art Center (Wisconsin), May 7 – June 28, 1981, *Center Ring, The Artist: Two Centuries of Circus Art*, cat. by Dean Jensen, no. 54, pp. 62, 72, 91, illus.; toured, August 30, 1981 – June 6, 1982, to CMA, New York State Museum (Albany), Corcoran Gallery of Art (Washington, D.C.).

REFERENCES:

Paul Bird, *Fifty Paintings by Walt Kuhn* (1940), p. 39, illus.

"American Museums Acquire Americans," *ARTnews* 41 (June–July 1942): 28, illus.

"Sensitive Kuhn Acrobat Goes to Columbus," *Art Digest* 16 (August 1942): 7, illus.

"The Year in Art: A Review of 1942," *ARTnews* 41 (January 1943): 25, illus.

Eloise Spaeth, *American Art Museums: An Introduction to Looking*, 3rd ed. (1975), p. 344.

Philip R. Adams, *Walt Kuhn, Painter: His Life and Work* (1978), pp. 182, 187, 201, 225, 267, no. 384.

CMA, *Catalog* (1978), pp. 65, 143, illus.

CMA, *Selections* (1978), p. 65, illus.

REMARKS:

According to Adams (1978), p. 266, *Veteran Acrobat* may have been included in the following exhibitions: Grace Horne Gallery (Boston), 1941; Denver Art Museum, 1941.

64 Still-Life with Red Cheese 83.30

ENDNOTES:

1. Elizabeth McCausland, *A. H. Maurer* (1951), p. 95.

2. Ibid., p. 32.

3. Henry McBride, "The Art of Alfred Maurer," *New York Sun*, November 27, 1937.

4. See Reich, pp. 62–76, figs. 53–79; Salander-O'Reilly Galleries, *Alfred H. Maurer (1868–1932): Modernist Paintings* (1983), figs. 11, 33–36, 41–51; Stephanie Terenzio, *Alfred H. Maurer: Watercolors 1926–1928* (exh. cat., The William Benton Museum of Art, University of Connecticut, Storrs, 1983), figs. 5, 10, and cover.

5. Regarding the dating of Maurer's still lifes, see Elizabeth McCausland Papers, Archives of American Art, Smithsonian Institution, Washington, D.C., Roll D379, Frame 506. The degree of representation in the museum's picture, the regular positioning of architectural features, the patterning of shadows, and the textures of cloth closely relate to Maurer's *Still Life* in the Brooklyn Museum of Art, which appeared in a November 1928 photo of the artist's studio (see McCausland, p. 198). The museum's picture also relates to descriptions of still lifes in an article in the *New York Times* of July 15, 1928 (See McCausland, p. 211).

PROVENANCE:

Bertha Schaefer, New York; Mr. William Dean, New York; Salander-O'Reilly Galleries, New York; CMA, 1983.

EXHIBITION HISTORY:

[Uptown Gallery Continental Club (New

York), October 30 – December 3, 1934, *Memorial Exhibition: Works of the Late Alfred Maurer*, cat. intro. by Robert Ulrich Godsoe, no. 20 (as *Still Life with Cheese*)].

Wichita Museum of Art (Kansas), October 27 – December 1, 1985, *American Art of the Great Depression: Two Sides of the Coin*, cat. by Howard E. Wooden, pp. 43 (as dated 1930), 66, 126, fig. 116.

CMA (1986–1987), cat. no. 82, p. 33.

65 *Landscape with Drying Sails* 81.12
ENDNOTES:
1. James Johnson Sweeney, *Stuart Davis* (exh. cat., Museum of Modern Art, 1945), p. 10.
2. Letter dated October 18, 1946, from Stuart Davis to Mr. D. S. Defenbacher, Director, Walker Art Center, Minneapolis.
3. Quoted in Matthew Baigell, *Dictionary of American Art* (1980), p. 89.

PROVENANCE:
Downtown Gallery, New York; Walker Art Center, Minneapolis, 1946; Downtown Gallery, New York, 1955 (acquired from Walker Art Center in exchange for Davis's *Colonial Cubism*, 1954); Stuart Davis; Mrs. Stuart Davis, New York, 1964; (sale: Grace Borgenicht Gallery, New York, 1981); CMA, 1981.

EXHIBITION HISTORY:
Downtown Gallery (New York), March 8–21, 1932, *"The American Scene": Recent Paintings New York and Gloucester by Stuart Davis*, checklist no. 4 (as *Drying Sail*).
Corcoran Gallery of Art (Washington, D.C.), March 24 – May 5, 1935, *The Fourteenth Biennial Exhibition of Contemporary American Oil Paintings*, cat. no. 389, pp. 44, 120, illus.
Arts Council of Great Britain, *The Modern Spirit: American Painting, 1908–1935*, cat. by Milton W. Brown, no. 125, p. 72; toured, August 20 – November 20, 1977, to Royal Scottish Academy (Edinburgh), Hayward Gallery (London, England).
Grace Borgenicht Gallery (New York), February 6 – March 4, 1982, *The Gloucester Years*, cat., pp. 5, 11, 22, illus.
Rahr-West Museum (Manitowoc, Wisconsin), March 31 – May 8, 1983, *Stuart Davis: The Formative Years 1910–1930*, cat. no. 30, unpag., illus.
CMA (1986–1987), cat. no. 52, pp. 20, 21, 32, illus.

REFERENCES:
Edward Alden Jewell, "Stuart Davis Offers a Penetrating Survey of the American Scene—Native Talent in Drawing Shown," *New York Times*, March 10, 1932 (as *Drying Sail*).
Melvin Geer Shelley, "Around the Galleries: Downtown Galleries," *Creative Art* 10 (April, 1932): 302 (as *Drying Sail*).
Famous Artists Magazine 4 (autumn, 1955): unpag., illus.
Bruce Weber, *Stuart Davis' New York* (exh. cat., Norton Gallery and School of Art, 1985), pp. 13, 18, fig. 4.
William C. Agee, "Cézanne, Color, and Cubism: The Ebsworth Collection and American Art," in *The Ebsworth Collection, American Modernism, 1911–1947* (exh. cat., Saint Louis Art Museum, 1987), p. 26, fig. 6.
William C. Agee, *Stuart Davis: A Catalogue Raisonné* (forthcoming 1989–1990).

RELATED WORKS:
Drawing for *Landscape with Drying Sails*, ink on paper, private collection (see *Stuart Davis: Provincetown and Gloucester Paintings and Drawings* [1986], illus. [as dated ca. 1933]).

REMARKS:
Two labels on the back of the painting give the dates "1931–32" and "1931 or 1932." According to William Agee, who is preparing the catalogue raisonné of Davis's work, the painting is stylistically consistent with others of the dates given. The picture is known to have been completed by March 1932, when it was exhibited at Downtown Gallery (New York).

66 *Blue Coast* 51.13
ENDNOTES:
1. Quoted in Ernst Scheyer, *Lyonel Feininger, Caricature and Fantasy* (1964), p. 36.
2. Ibid., p. 128.
3. Ibid.
4. Ibid., p. 152.

PROVENANCE:
Van Diemen-Lilienfeld Galleries, New York; CMA, 1951.

EXHIBITION HISTORY:
[Fine Arts Gallery of San Diego (California), 1945, Exhibition of Contemporary American Painting].
PAFA, January 26 – March 2, 1947, *142nd Annual Exhibition of Painting and Sculpture*, checklist no. 37.
Toledo Museum of Art (Ohio), June 1 – August 31, 1947, *34th Annual Exhibition of Contemporary American Paintings*, checklist no. 29.
Baltimore Museum of Art, April 15 – May 23, 1948, *Themes and Variations in Painting and Sculpture*, cat. no. 105, p. 67.
College of Fine and Applied Arts, University of Illinois (Urbana), February 26 – April 2, 1950, *National Exhibition of Contemporary American Painting*, cat. essay by Allen S. Weller, no. 40, p. 23, pl. 89.
CGFA, March 9 – April 8, 1951, *"Few Are Chosen*," cat. no. 2, p. 7 (as dated ca. 1941).
Cleveland Museum of Art, November 2 – December 16, 1951, *The Work of Lyonel Feininger*, cat. no. 35, p. 17.
Junior Art Gallery, Louisville Free Public Library (Kentucky), October 4 – December 27, 1954, *What is an Art Reproduction?*, no. 9.
CGFA, February 10 – March 9, 1961, *German Expressionism*, cat. no. 12, p. 9 (as dated ca. 1941).
Pasadena Art Museum (California), April 26 – May 29, 1966, *Lyonel Feininger, 1871–1956: A Memorial Exhibition*, cat. no. 55; toured, July 10 – October 23, 1966, to Milwaukee Art Center, Baltimore Museum of Art.
Lima Art Association, Allen County Museum (Ohio), January 12 – February 11, 1968, *Freedom and Order*, checklist no. 8 (as dated 1930).
Institut für Auslandsbeziehungen (Stuttgart, West Germany), Württembergischer Kunstverein (Stuttgart, West Germany), and Bauhaus-Archiv (Darmstadt, Germany), *50 Years Bauhaus*, cat. no. 12 (as dated 1940); toured, December 6, 1969 – March 28, 1971, to Art Gallery of Toronto (Ontario, Canada), Pasadena Art Museum (California), Museo Nacional de Bellas Artes (Buenos Aires, Argentina), Museum of Modern Art (Tokyo, Japan).
Oklahoma Art Center (Oklahoma City), May 7 – June 20, 1982, *American Masters of the Twentieth Century*, cat. intro. by John I. H. Baur, no. 18, pp. 25, 54, 55, 102, illus.; toured, July 11 – September 15, 1982, to Terra Museum of American Art (Evanston, Illinois).

REFERENCES:
Allen S. Weller, "Illinois Annual, Comprehensive in Aim, Accents the Advanced," *Art Digest* 24 (March 1950): 7–8.
"Columbus Acquires a Feininger," *Art Digest* 25 (September 1951): 14.
"Art News of the Year," *Art News Annual* (1953): 190, 191, illus.
Twentieth Century Highlights of American Painting (1958), cat. no. 22, pp. 52, 53, illus.
Hans Hess, *Lyonel Feininger* (1961), no. 443, p. 291, illus.
René Huyghe, ed., *Larousse Encyclopedia of Modern Art* (1961, reprinted 1967), p. 415, no. 1135, illus.
Donald Herberholz, *A Child's Pursuit of Art* (1966), illus.
G. Robert Carlsen, et al., *Perceptions: Themes in Literature* (1969, reprinted 1976), p. 479, illus.
Fine Art Reproductions of Old and Modern Masters (1978), p. 357 (as dated 1920).
CMA, *Catalog* (1978), pp. 44, 139, illus.
CMA, *Selections* (1978), pp. 44, illus.
Werner Haftmann, *Verfemte Kunst: Bildende Künstler der inneren und äuberen Emigration in der Zeit des Nationalsozialismus* (1986), p. 202, illus.

67 *Morning Sun* 54.31
ENDNOTES:
1. WMAA.
2. Quoted in Gail Levin, *Edward Hopper: The Art and the Artist* (1980), p. 9.

PROVENANCE:
F.K.M. Rehn Galleries, New York, 1954 (acquired from the artist); CMA, 1954.

EXHIBITION HISTORY:
Worcester Art Museum (Massachusetts), February 17 – April 3, 1955, *Five Painters of America*, cat., p. 2.
Museum of Art, Rhode Island School of Design (Providence), March 7–28, 1956, *Paintings by Hopper and Corbino*, no cat.
Brooks Memorial Union, Marquette University (Milwaukee), April 22 – May 3, 1956, *Festival of American Arts: 75 Years of American Painting*, cat. no. 39, illus.
Butler Institute of American Art (Youngstown, Ohio), June 29 – September 1, 1958, *23rd Annual Midyear Show*, cat. no. 70.
Boston Arts Festival, June 5–28, 1959, *New England Invitational*, cat. no. 8.
Heistand Hall Gallery, Miami University (Oxford, Ohio), October 1–31, 1959, *The American Scene in 150 Years of American Art*, checklist, unpag.
University of Arizona Art Gallery (Tucson), April 20 – May 19, 1963, *A Retrospective Exhibition of Oils and Watercolors by Edward Hopper*, cat. no. 46, pp. 16, 17, 36, illus.
Edward W. Root Art Center, Hamilton College (Clinton, New York), May 10 – June 7, 1964,

Edward Hopper: Oils, Watercolors, Prints, cat. no. 10.

WMAA, September 29 – November 29, 1964, *Edward Hopper*, cat. by Lloyd Goodrich, no. 58; toured, December 18, 1964 – May 9, 1965, to Art Institute of Chicago, Detroit Institute of Arts, City Art Museum of Saint Louis.

Fine Arts Gallery of San Diego, February 23 – March 24, 1968, *Twentieth Century American Art*, cat. no. 30, illus.

William A. Farnsworth Library and Art Museum (Rockland, Maine), July 9 – September 5, 1971, *Edward Hopper 1882–1967*, cat. no. 44 (as dated 1954); toured, September 24 – October 31, 1971, to PAFA.

Newport Harbor Art Museum (Newport Beach, California), January 12 – February 23, 1972, *Edward Hopper*, no cat.; toured, March 7 – April 30, 1972, to Pasadena Art Museum (California).

WMAA, September 16, 1980 – January 25, 1981, *Edward Hopper: The Art and the Artist*, cat. by Gail Levin, p. 42, pl. 400 [the exhibition toured, but *Morning Sun* was not included in the tour].

Haus der Kunst (Munich, West Germany), November 14, 1981 – January 31, 1982, *Amerikanische Malerei 1930–1980*, cat. no. 145, p. 140, fig. 145.

Neuberger Museum, State University of New York at Purchase, September 21, 1986 – January 18, 1987, *The Window in Twentieth-Century Art*, cat. by Suzanne Delehanty, pp. 74, 101, illus.; toured, April 24 – June 29, 1987, to Contemporary Arts Museum (Houston).

REFERENCES:
John S. Still, ed., *Midwest Museums Quarterly* 15 (January 1955): 35.

Lawrence Campbell, "Hopper: Painter of 'Thou Shalt Not,'" *ARTnews* 63 (October 1964): 43, illus.

Mahonri Sharp Young, "Letter from the U.S.A.: Of Kings and Things," *Apollo* 86 (August 1967): 150, fig. 5 (as dated 1954).

Lloyd Goodrich, *Edward Hopper* (1971), pp. 104–105, 151, 153, illus.

Young (1977), p. 201, illus. (as dated 1954).

John Baker, "Voyeurism in the Art of John Sloan: The Psychodynamics of a 'Naturalistic' Motif," *Art Quarterly* 1, no. 4 (1978): 391, 395, fig. 19.

CMA, *Catalog* (1978), pp. 59–60, 142, illus.

CMA, *Selections* (1978), pp. 59–60, illus.

Erwin Leiser, "Zur Wanderausstellung des Amerikanischen Realisten Edward Hopper," *Welwoche Kultur* 21 (May 20, 1980): 29, illus.

Ann Barry, "The Full Range of Edward Hopper," *The New York Times*, September 21, 1980.

Peter Selz, *Art in Our Times: A Pictorial History 1890–1980* (1981), pp. 412, 413, fig. 1122 (as dated 1954).

Anna Bing Arnold, "Cross Country," *Horizon* (April 1981): 6 (as *Morning Sunlight*).

J. P. Forsthoffer, "Building on Existing Strengths," *Horizon* (November 1984): 32, illus.

Raymond Carney, *American Vision: The Films of Frank Capra* (1986), pp. 10, 219, 220, 443, illus.

John Wilmerding, *Andrew Wyeth, The Helga Pictures* (1987), p. 18, illus.

Robert Hobbs, Edward Hopper (1987), pp. 139, 142, 143, illus.

Heinz Liesbrock, *Edward Hopper: Vierzig Meisterwerke* (Berlin, 1988), p. 27, fig. 35.

RELATED WORKS:
Two drawings for *Morning Sun*, conté crayon on paper, WMAA.

Drawing for painting, *Morning Sun*, conté crayon and pencil on paper, WMAA.

68 *Snack Bar* 54.47

ENDNOTES:
1. Quoted in "They Drink and Fly Away," *Time* (May 23, 1949): 63.
2. For a discussion of Bishop's working methods and techniques, see Sheldon Reich, *Isabel Bishop* (exh. cat., University of Arizona Museum, 1974), p. 23.
3. Quoted in Karl Lunde, *Isabel Bishop* (1975), p. 43.
4. Quoted in Lunde, pp. 42–43. For a fuller explanation and discussion of Bishop's ideas concerning Baroque art, see her essay, "Concerning Edges," *Magazine of Art* (May 1945): 168–173.
5. Quoted in E. Harms, "Light is the Beginning—The Art of Isabel Bishop," *American Artist* 25 (February 1961): 28–33.

PROVENANCE:
Midtown Galleries, New York (acquired from the artist); CMA, 1954.

EXHIBITION HISTORY:
Midtown Galleries (New York), October 25 – November 19, 1955, *Bishop: Paintings and Drawings*, checklist no. 8.

Ohio Wesleyan University Press (Delaware, Ohio), on loan December 1964 – March 1966.

Akron Art Institute (Ohio), September 27 – November 7, 1971, *Celebrate Ohio*, cat., unpag.

University of Arizona Museum of Art (Tucson), November 3 – December 1, 1974, *Isabel Bishop Retrospective*, cat. by Sheldon Reich, no. 43, p. 199, illus. no. 31; toured, January 17 – July 31, 1975, to Ulrich Museum (Wichita State University, Kansas), WMAA, Brooks Memorial Art Gallery (Memphis, Tennessee).

Butler Institute of American Art (Youngstown, Ohio), May 2–23, 1976, *Salute the Women*, cat. no. 2.

REFERENCES:
John S. Still, ed., "News of the Museums—Ohio," *Midwest Museums Quarterly* 15 (January 1955): 35.

Charles McCurdy, ed., *Modern Art: A Pictorial Anthology* (1958), p. 166, illus. no. B60.

Ernest Harms, "Light is the Beginning: The Art of Isabel Bishop," *American Artist* 25 (January 1961): 62, illus.

Karl Lunde, *Isabel Bishop* (1975), pl. 131.

CMA, *Catalog* (1978), pp. 19, 136, illus.

CMA, *Selections* (1978), pp. 19, illus.

RELATED WORKS:
Snack Bar, n.d., etching (see Una E. Johnson, *Isabel Bishop, Prints and Drawings, 1925–1964* [1964], p. 17, pl. 38).

69 *Figure in Grief* 68.6

PROVENANCE:
Hugo Robus, Jr., New York; CMA, 1968 (gift of Hugo Robus, Jr., through Forum Gallery, New York).

EXHIBITION HISTORY:
[Forum Gallery (New York), 1963, cat. no. 14].

[Sculptor's Guild, Lever House (New York), October 18 – November 26, 1964, *Sculpture 1964*, cat., illus.].

[Forum Gallery (New York), 1966, cat. no. 3].

CMA, October 11 – November 29, 1987, *Accent on Sculpture: Small-Scale Works from the Permanent Collection*, checklist.

REFERENCES:
[*Today's Art* (March 1965), cover illus.].

George W. Knepper, *An Ohio Portrait* (Ohio Historical Society, 1976), pp. 215, 278, illus.

Roberta K. Tarbell, *Hugo Robus (1885–1964)* (1980), pp. 99, 101, 208, 209, fig. 82.

CMA, *Catalog* (1978), p. 198, illus.

CMA (1986), pp. 5, 6, 32, illus.

RELATED WORKS:
Figure in Grief (same edition as CMA work), bronze, University of Delaware (Newark).

Figure in Grief (same edition as CMA work), bronze, private collection (acquired from Forum Gallery, New York).

Figure in Grief (same edition as CMA work), bronze, private collection.

Figure in Grief (same edition as CMA work), bronze, private collection.

Figure in Grief (same edition as CMA work), bronze, unknown location, sold at auction to benefit WMAA, 1966.

70 *Happy Mother* 82.2

PROVENANCE:
Forum Gallery, New York (acquired from the artist); Ashland Oil, Kentucky, 1980; CMA, 1982 (gift of Ashland Oil, Inc.).

EXHIBITION HISTORY:
[WMAA, January 14 – March 1, 1959, *Four American Expressionists: Doris Caesar, Chaim Gross, Karl Knaths and Abraham Rattner*, cat. by Lloyd Goodrich and John I. H. Baur, pp. 66–67, illus.; toured, April 8, 1959 – January 3, 1960, to Currier Gallery of Art (Manchester, New Hampshire), Colorado Springs Fine Arts Center (Colorado), CGFA, Dallas Museum of Fine Arts].

[Forum Gallery (New York), October 1–25, 1974, *Chaim Gross Sculpture: Retrospective Exhibition*, no cat.].

CMA (1986–1987), cat. no. 64, pp. 22, 23, 33, illus.

REFERENCES:
CMA (1986), p. 30, illus.

RELATED WORKS:
Happy Mother (same edition as CMA work), bronze, private collection, Milwaukee (Wisconsin).

Happy Mother (same edition as CMA work), bronze, private collection, Southampton (New York).

Happy Mother (same edition as CMA work), bronze, Albert Einstein College of Medicine, Yeshiva University (New York).

Happy Mother (same edition as CMA work), bronze, Forum Gallery (New York).

Mother Playing (sketch for sculpture), 1957, pen, brush, and ink (see Alfred Werner, *Chaim Gross: Watercolors and Drawings* [1979], p. 129).

71 *Cornice* 80.26

ENDNOTES:

1. See Thomas H. Garver, *George Tooker* (1985), p. 29.
2. *The Collected Poetry of W. H. Auden* (1945), p. 402.
3. Ibid.
4. Ibid., p. 384.

PROVENANCE:

[Edwin Hewitt Gallery, New York]; Theodore Starkowski, New York, ca. 1951; (sale: Sotheby Parke Bernet, April 25, 1980, estate of Theodore Starkowski, lot no. 271); CMA, 1980.

EXHIBITION HISTORY:

WMAA, December 16, 1949 – February 5, 1950, *1949 Annual Exhibition of Contemporary American Painting*, cat. no. 152 (as *The Cornice*).

Edwin Hewitt Gallery (New York), February 20 – March 10, 1951, *Paintings by George Tooker*, checklist no. 12 (as *The Cornice*).

Jaffe-Friede Gallery, Hopkins Center, Dartmouth College (New Hampshire), August 5 – September 5, 1967, *George Tooker*, cat. essay by Robert L. Isaacson, no. 3.

Emerson Gallery, Hamilton College (Clinton, New York), January 4 – February 10, 1986, *The Surreal City: 1930–1950s*, no cat. [Note: This was an expanded version of an exhibition organized by WMAA at Philip Morris].

Gibbes Art Gallery (Charleston, South Carolina), in conjunction with Spoleto Festival USA, May 21 – June 28, 1987, *George Tooker* cat. (reprint of Garver [1985]; see refs. below).

CMA (1986–1987), cat. no. 40, p. 32.

REFERENCES:

"Egg Tempera Painting with Technical Commentary by Frederic Taubes and Illustrated with Selected Examples by George Tooker," *American Artist* 21(May 1957): 21, illus.

Thomas H. Garver, *George Tooker* (1985), pp. 29, 132, illus.

72 *Inland Shell* 82.15

ENDNOTES:

1. Canton Art Institute, *Andrew Wyeth: From Public and Private Collections* (exh. cat., 1985), p. 7.
2. Ibid.

PROVENANCE:

R. Frederick Woolworth, New York, ca. 1956 (purchased from the artist); (sale: Coe Kerr Gallery); Joseph H. Davenport, Lookout Mountain, Tennessee, 1970; Kennedy Galleries, New York, ca. 1972; Harry Spiro, New York; CMA, 1982 (gift of Mr. and Mrs. Harry Spiro through Coe Kerr Gallery).

EXHIBITION HISTORY:

Canton Art Institute (Ohio), September 15 – November 3, 1985, *Andrew Wyeth from Public and Private Collections*, cat., p. 73, illus.

CMA (1986–1987), cat. no. 73, pp. 23, 33, illus.

Southern Ohio Museum and Cultural Center (Portsmouth), May 27 – June 28, 1987, *Contemporary Landscape*, no cat.

73 *Study for Seascape #10* 76.33

ENDNOTES:

1. Paul Gardner, "Tom Wesselmann," *ARTnews* 81 (January 1982): 69.

2. Slim Stealingworth [Tom Wesselmann], *Tom Wesselmann* (1980), p. 47.

PROVENANCE:

Sidney Janis Gallery, New York (acquired from the artist), 1966; CMA, 1976.

EXHIBITION HISTORY:

Sidney Janis Gallery (New York), May 10 – June 4, 1966, *New Paintings by Wesselmann*, cat. no. 28, illus.

Swarthmore College Art Gallery (Pennsylvania), 1968, *The Big Detail*, no cat.

CGFA, January 1976 – April 1977, *Recent Acquisitions*, no cat.

CMA (1986–1987), cat. no. 3, pp. 10, 31.

REFERENCES:

CMA, *Catalog* (1978), pp. 127, 169, illus.

CMA, *Selections* (1978), p. 127, illus.

RELATED WORKS:

Seascape #10, 1966, painted molded plastic, collection of the artist.

74 *V–X* 85.1

ENDNOTES:

1. Deborah Perlberg, "Snelson and Structure," *Artforum* (May 1977): 48.
2. Letter dated September 29, 1986 (CMA files).

PROVENANCE:

CMA, 1985 (acquired from the artist).

EXHIBITION HISTORY:

Public Arts Council (New York), November 1974 – April 1975 (at Waterside Plaza, New York), *Kenneth Snelson*.

Nationalgalerie Berlin, and Neuen Berliner Kunstverein und Berliner programs des DAAD (West Germany), March 31 – May 8, 1977, *Kenneth Snelson Skulpturen*, cat., p. 10, illus.; toured, July 29 – September 4, 1977, to Wilhelm-Lehmbruck-Museum (Duisburg, West Germany).

Albright-Knox Art Gallery (Buffalo, New York), September 12 – November 8, 1981, *Kenneth Snelson*, cat. by Douglas G. Schultz and Howard N. Fox, pp. 25, 38, illus.; toured, June 4, 1981 – February 21, 1982, to Hirshhorn Museum and Sculpture Garden (Washington, D.C.), Sarah Campbell Blaffer Gallery (University of Houston).

Construct Gallery, Chicago, 1982.

CMA (1986–1987), cat no. 88, pp. 28, 34.

REFERENCES:

CMA (1986), pp. 22, 23, 32, illus.

RELATED WORKS:

V–X (same edition as CMA work), 1974, stainless steel and wire, Hunter Museum (Chattanooga, Tennessee).

Study for V–X, 1968, stainless steel and wire, collection of the artist.

Maquette of Study for V–X, 1968, aluminum and wire (edition of 4).

Drawing for V–X, 1968–1973, pencil on paper (see exh. cat. by Schultz and Fox [1981], p. 65).

Working Model for V–X, 1974– 1984, aluminum and wire, artist's proof, CMA.

75 *Captain's Paradise* 72.27

ENDNOTES:

1. Jacques Seligmann and Co., *Bennington Col-*

lege Alumnae Paintings (May 1950); Samuel Kootz Gallery, *Fifteen Unknowns* (also called *Twelve Unknowns*) (December 1950).

PROVENANCE:

André Emmerich Gallery, New York, 1971 (acquired from the artist); CMA, 1972.

EXHIBITION HISTORY:

André Emmerich Gallery (New York), November 6 – December 1, 1971, *Helen Frankenthaler*, cat.

REFERENCES:

Lawrence Alloway, "Frankenthaler as Pastoral," *ARTnews* 70 (November 1971): 68, 89, illus.

CMA, *Catalog* (1978), pp. 45, 140, illus.

CMA, *Selections* (1978), p. 45, illus.

76 *Shadow on the Earth* 72.28

ENDNOTES:

1. James McC. Truitt, "Art—Arid D. C. Harbors Touted 'New' Painters," *The Washington Post*, December 21, 1961.

PROVENANCE:

André Emmerich Gallery, New York, 1971 (acquired from the artist); CMA, 1972.

EXHIBITION HISTORY:

André Emmerich Gallery (New York), October 9 – November 3, 1971, *Kenneth Noland: New Paintings*, cat. no. 6.

REFERENCES:

CMA, *Catalog* (1978), pp. 85, 147, illus.

CMA, *Selections* (1978), p. 85, illus.

77 *Sky Cathedral: Night Wall* 77.20

ENDNOTES:

1. The author is indebted to Chief Curator Steven Rosen for his observations on the reading of this work.
2. From a taped conversation with Diana Mackown, in Louise Nevelson, *Dawns and Dusks* (1976), p. 127.
3. Ibid., p. 126.
4. Claude Marks, *World Artists: 1950–1980* (1984), p. 607.

PROVENANCE:

Pace Gallery, New York and Columbus, March 1976 (acquired from the artist).

EXHIBITION HISTORY:

CMA (1986–1987), cat. no. 6, pp. 12, 13, 31, illus.

REFERENCES:

CMA, *Catalog* (1978), pp. 84, 197, illus.

CMA, *Selections* (1978), p. 84, illus.

CMA (1986), pp. 12, 13, 21–22, 32, illus.

78 *Untitled (to Janie Lee) one* 79.53

PROVENANCE:

Sperone, Westwater, Fischer, New York, ca. 1977 (acquired from the artist); Mr. and Mrs. William King Westwater, Columbus, September 11, 1979; CMA, 1979 (gift of Mr. and Mrs. William King Westwater).

EXHIBITION HISTORY:

[Janie C. Lee Gallery (Dallas), April 1971, *Dan Flavin*].

[Rice University Institute of Arts (Houston), October 5 – November 26, 1972, *cornered Fluorescent light from Dan Flavin*].

[Leo Castelli (New York), September 19 – October 16, 1973, *Group Exhibition*].

[Saint Louis Art Museum, January 26 – March 11, 1973, *Drawings and Diagrams from Dan Flavin, 1963–1972*, cat. Vol. 2: *corners, barriers and corridors in fluorescent light from Dan Flavin*, by Emily S. Rauh and Dan Flavin, no. 35, pp. 27, 34, 35, illus.].

REFERENCES:
CMA (1986), pp. 14, 28, 30, illus.

RELATED WORKS:
Untitled (to Janie Lee) one, 1971, four (same edition as CMA work), in private collections.

Untitled (to Janie Lee) two, 1971, blue, green, yellow, and pink fluorescent light (edition of 5).

79 *Out of There* 79.15
ENDNOTES:
1. Colin Naylor and Genesis P-Orridge, eds., *Contemporary Artists* (1977), p. 631.
2. Jeanne Siegel, "Clement Meadmore: Circling the Square," *ARTnews* 70 (February 1972): 56.

PROVENANCE:
Hamilton Gallery of Contemporary Art, New York (acquired from the artist); Knoedler & Co., New York, 1979; CMA, 1979.

EXHIBITION HISTORY:
Galerie Denise René-Hans Mayer (Düsseldorf, West Germany), June 1974, *Clement Meadmore*, no cat.

On loan to Galerie Alfred Schmela Sculpture Park (Düsseldorf, West Germany), 1976–1979.
CMA (1986–1987), cat. no. 24, pp. 16, 31.

REFERENCES:
Hugh M. Davies, "Clement Meadmore," *Arts Magazine* 51 (March 1977): 7.
CMA (1986), p. 31, illus.
[H. H. Arnason, *History of Modern Art: Painting, Sculpture and Architecture* (2nd ed., 1979), pp. 655, 657, fig. 1181].

RELATED WORKS:
Out of There, 1974, painted aluminum (edition of 2), Hale Boggs Building (New Orleans).

80 *Intermediate Model for the Arch* 80.36
PROVENANCE:
M. Knoedler & Co., New York, 1978; CMA, 1980.

EXHIBITION HISTORY:
CMA (1986–1987), cat. no. 44, pp. 18, 32.

REFERENCES:
CMA (1986), pp. 25, 28, illus.

RELATED WORKS:
The Arch, 1975, steel plate (painted black), H. 56 feet, Storm King Art Center (New York).

81 *Two Lines Up Excentric Variation VI* 78.31
ENDNOTES:
1. John Gruen, "The Sculpture of George Rickey: Silent Movement Performing in a World of Its Own," *Art News* (April 1980): 95.
2. Letter of November 25, 1987, from George Rickey Workshop to CMA.
3. George Rickey, "The Metier," *Contemporary Sculpture, Arts Yearbook* 8, ed. James R. Mellow (1965), pp. 164–166; quoted in Herschel

B. Chipp, *Theories of Modern Art* (1968), p. 588.

PROVENANCE:
CMA, 1978 (acquired from the artist).

EXHIBITION HISTORY:
CMA (1986–1987), cat. no. 17, pp. 14, 15, 31, illus.

REFERENCES:
CMA (1986), pp. 6, 9, 25, 27, 32, illus.

RELATED WORKS:
Two Lines Up Excentric Variation VI, 1977, stainless steel (same edition as CMA work), private collection, Plano, Illinois.

Two Lines Up Excentric Variation VI, 1977, stainless steel (same edition as CMA work), Scottish National Gallery of Modern Art, Edinburgh, Scotland.

Two Lines Up Excentric, 1975 (edition of 5).

Two Lines Up Excentric Variation II, 1975.

Two Lines Up Excentric Variation III, 1975–1977.

Two Lines Up Excentric Variation IV, 1975 (edition of 3).

Two Lines Up Excentric Variation V, 1976 (edition of 3).

Two Lines Up Excentric Variation VII, 1977 (edition of 1).

Two Lines Up Excentric Variation VIII, 1978 (edition of 3).

Two Lines Up Excentric Variation IX, 1983 (edition of 3).

82 *Girl on Blanket, Full Figure* 80.7
ENDNOTES:
1. Ellen Johnson, "Cast from Life," in *Modern Art and the Object* (1976), p. 168.

PROVENANCE:
Sidney Janis Gallery, New York, 1978 (acquired from the artist); CMA, 1980.

EXHIBITION HISTORY:
Sidney Janis Gallery (New York), November 30 – December 30, 1978, *New Sculpture by George Segal*, cat. no. 12, illus.

Hope Makler Gallery (Philadephia), February 9 – March 17, 1979, *George Segal*, no cat.

Neuberger Museum, State University of New York at Purchase, April 1 – May 21, 1979, *Christo, Mark di Suvero, Robert Irwin and George Segal on Sculpture*.

REFERENCES:
Jan Van der Marck, *George Segal* (1979), p. 2, fig. 173.
CMA (1986), pp. 17–18, 32, illus.

RELATED WORKS:
Girl on Blanket: Finger to Chin, 1973, plaster, Collection Xavier Fourcade (New York).

Girl on Blanket, Hand on Leg, 1973, plaster, Sidney Janis Gallery (New York).

Red Girl in Blanket, 1975, painted plaster, Collection Baron H. H. Von Thyssen-Bornemisza (Lugano, Italy).

83 *Untitled, 1979–21* 80.21
PROVENANCE:
Zabriskie Gallery, New York (acquired from the artist), 1979; CMA, 1980.

EXHIBITION HISTORY:
Ohio State Fair, Columbus, August 1–17, 1986, *Assemblage: Piece by Piece*, checklist no. 106.

REFERENCES:
CMA (1986), pp. 13, 28, 32, illus.

84 *Dual Red* 80.20
ENDNOTES:
1. Quoted by Grace Glueck in "Art Notes: Blues and Greens on Reds," *The New York Times*, February 21, 1965.

PROVENANCE:
CMA, 1980 (purchased from the artist).

EXHIBITION HISTORY:
CMA (1986–1987), cat. no. 37, p. 32.

85 *Hitchcock Series: Anticipation of the Night* 85.11
PROVENANCE:
Gimpel & Weitzenhoffer, New York, 1984 (acquired from the artist); CMA, 1985.

EXHIBITION HISTORY:
CMA (1986–1987), cat. no. 93, p. 34.

RELATED WORKS:
Hitchcock Series: Anticipation of the Night, 1984, acrylic on paper, Gimpel & Weitzenhoffer, New York (see *Robert Natkin: Recent Paintings from Hitchcock Series* [Gimpel & Weitzenhoffer, 1984], p. 12, illus.).

Hitchcock Series: Variation of Anticipation of Night, 1985, acrylic on canvas, Gimpel & Weitzenhoffer, New York (see *Robert Natkin: Recent Paintings from Hitchcock Series* [Gimpel & Weitzenhoffer, 1984], p. 21, illus.).

86 *Neon for the Columbus Museum of Art* 86.1
ENDNOTES:
1. David Shapiro, *Stephen Antonakos New Works/1982* (exh. cat., Roslyn Harbor, New York: Nassau County Museum of Fine Art, 1982), unpag.
2. Ibid.
3. From a talk given at the Conference on Glass in London, sponsored by the Crafts Council of Great Britain, April 1986.
4. Quoted by Nancy Gilson in "Neon for the Columbus Museum of Art," *The Columbus Dispatch*, April 13, 1986.

PROVENANCE:
CMA, 1986 (commissioned from the artist).

EXHIBITION HISTORY:
CMA (1986–1987), cat. no. 99, pp. 30, 34, 36, illus.

REFERENCES:
Robert Arnold, "Stephen Antonakos: Neon for the Columbus Museum of Art: Columbus Museum of Art Permanent Installation," *Columbus Art* 7 (summer 1986): 10, cover illus.
CMA (1986), pp. 2, 3, 27–28, 29, cover illus.
"Neon Art and Display," *Signs of the Times* 208 (September 1986): 94, cover illus. (detail).

RELATED WORKS:
Maquette of *Neon for the Columbus Museum of Art*, 1985, mat board, balsa wood, and wire, CMA.

Four study drawings for *Neon for the Columbus Museum of Art*, 1985, private collections.

Part Two

Catalogue of The American Collections

Checklist—Paintings, Sculpture, Works on Paper

Robert Ingersoll Aitken, 1878–1949
George Bellows, ca. 1910 31.305
Bronze, H. 20 in. (50.8 cm.)
Signed on right shoulder: Aitken Fecit
Gift of the artist, 1931

Robert Ingersoll Aitken, 1878–1949
Ralph Beaton 31.306
Bronze, H. 24½ in. (62.2 cm.)
Signed lower right: Aitken
Gift of the Board of Trustees, 1931

Dianne Almendinger, born 1931
My Kitchen Table, 1973 73.31
Graphite and tempera on paper, 17¼ x 25½ in. (43.8 x 64.8 cm.)
Signed and dated lower right: Almendinger '73
Purchased with funds from the Alfred L. Willson Charitable Fund of The Columbus Foundation, 1973

Carl Andre, born 1935
Steel-Steel Plain, 1969 73.13 A-Z, a-j
Steel, 72 in. (182.9 cm.) square
Museum Purchase: Howald Fund, 1973

Stephen Antonakos, born 1926
Maquette of *Neon for the Columbus Museum of Art* 85.29
Mat board, balsa wood, and wire, H. 16 in. (40.6 cm.)
Gift of Stephen Antonakos, 1985

Stephen Antonakos, born 1926
Neon for the Columbus Museum of Art, 1986 86.1

Neon, glass, stainless steel, 336 x 294 in. (853.4 x 746.8 cm.)
Gift of Artglo Sign Company, Inc., and Museum Purchase: Howald Fund, 1986
Cat. no. 86

Richard Anuszkiewicz, born 1930
Dual Red, 1979 80.20
Acrylic on canvas, 90 x 180 in. (228.6 x 457.2 cm.)
Museum Purchase: Howald Fund II, 1980
Cat. no. 84

Alexander Archipenko, 1887–1964
Flat Torso, 1914 81.26.2
Gilded bronze, H. 19½ in. (49.5 cm.)
Signed bottom front: Archipenko 1914
Gift of Philip V. Oppenheimer, 1981

Alexander Archipenko, 1887–1964
Walking, ca. 1958 65.6
Bronze, H. 52 in. (132.1 cm.)
Signed, dated, and inscribed lower left: 2/8 Archipenko Paris 1912/Après moi viendront des/jours quand cette oeuvre gui-/dera et les artistes sculpte/ront l'espace et le temps
Museum Purchase: Howald Fund, 1965

Jane B. Armstrong, born 1921
Flamingo Fledgling, 1971 72.43
Marble, H. 13¾ in. (34.9 cm.)
Gift of Dr. and Mrs. Lewis Basch, 1972

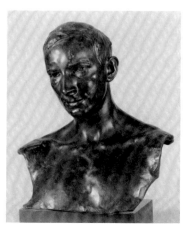

Aitkin, *George Bellows*

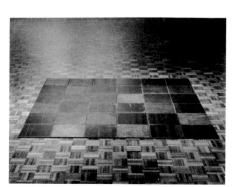

Andre, *Steel-Steel Plain*

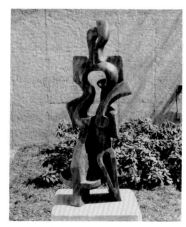

Archipenko, *Walking*

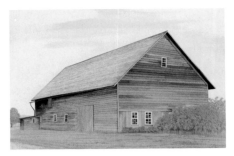

Ault, *Rick's Barn, Woodstock*

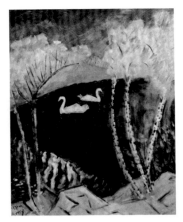

Avery, *The Swans*

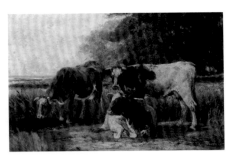

Barber, *Cows Grazing*

Jane B. Armstrong, born 1921
Sleeping Otter, 1973 73.3
Marble, H. 8 in. (20.3 cm.)
Signed on bottom left: J B A
Museum Purchase: Howald Fund, 1973

Carlton Atherton, 1900–1964
Untitled, ca. 1950 85.15.6
Ink on paper, 3½ x 4⅝ in. (8.9 x 11.7 cm.)
Gift of Browne Pavey, 1985

Tracy Atkinson, born 1928
Experimental Drawing, 1960 60.51
Ink on paper, 18 x 15⅞ in. (45.7 x 40.3 cm.)
Signed and dated on reverse: Tracy Atkinson/11–29–60
Gift of the artist, 1960

George C. Ault, 1891–1948
Rick's Barn, Woodstock, 1939 61.90
Gouache on paper, 18 x 25½ in. (45.7 x 64.8 cm.)
Signed and dated lower right: G. C. Ault '39
Gift of Louise Ault, 1961

Milton Avery, 1885–1965
The Swans, 1940 81.32.1
Oil on canvas, 36 x 28¼ in. (91.5 x 71.8 cm.)
Signed lower left: Milton Avery
Gift of Mr. and Mrs. Harry Spiro, 1981

Brian Baker, born 1945
Penelope, 1971 72.19
Graphite on paper, 22½ x 30 in. (57.1 x 76.2 cm.)
Signed, dated, and inscribed lower left to right:
 Brian Baker '71 Penelope
Purchased with funds from the Alfred L. Willson Charitable Fund of The Columbus Foundation, 1972

John Jay Barber, 1840–after 1905
The Loitering Herd, 1883 19.47
Oil on canvas, 20 x 40 in. (50.8 x 101.6 cm.)
Signed and dated lower left: J. Jay Barber/1883
Bequest of Francis C. Sessions, 1919

John Jay Barber, 1840–after 1905
Cows Grazing 76.42.1
Oil on canvas, 12 x 18 in. (30.5 x 45.7 cm.)
Signed lower right: J. Jay Barber
Gift of Dorothy Hubbard Appleton, 1976

Will Barnet, 1911
Dark Balustrades, 1971 74.2
Oil on canvas, 73½ x 23½ in. (186.7 x 59.7 cm.)
Signed lower right: Will Barnet
Museum Purchase: Howald Fund, 1974

Victoria Barr, born 1937
A Green Thought in a Green Shade, 1970 71.12
Acrylic on canvas, 69 x 80½ in. (175.3 x 204.5 cm.)
Signed lower right: V. Barr
Museum Purchase: Howald Fund, 1971

John Joseph Barsotti, born 1914
Bateson's Farm, 1950–1951 54.45
Watercolor on paper, 11⅛ x 17⅛ in. (28.3 x 43.5 cm.)
Museum Purchase: Howald Fund, 1954

John Joseph Barsotti, born 1914
Of Wandering Forever and The Earth Again, 1940–1941
 41.9
Oil on canvas, 12¼ x 18¼ in. (31.1 x 46.3 cm.)
Signed and dated lower left: J. Barsotti 40–41
Gift of Orlando A. Miller, 1941

Paul Wayland Bartlett, 1865–1925
Head No. 62, 1930 59.22
Bronze, H. 15 in. (38.1 cm.)
Signed and dated lower left: 1930 P W B
Gift of Mrs. Armstead Peter III, 1959

Paul Wayland Bartlett, 1865–1925
Lion No. 41 59.23
Bronze, H. 5¾ in. (14.6 cm.)
Signed on base: Bartlett/P W
Gift of Mrs. Armstead Peter III, 1959

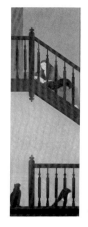

Barnet, *Dark Balustrades*

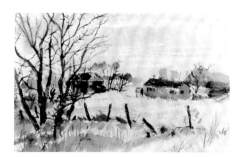

Barsotti, *Bateson's Farm*

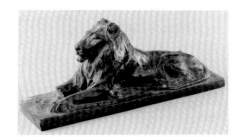

Bartlett, *Lion No. 58*

Paul Wayland Bartlett, 1865–1925
Lion No. 58 59.23
Bronze, H. 6¼ in. (15.9 cm.)
Signed on base: PWB
Gift of Mrs. Armstead Peter III, 1959

Leonard Baskin, 1922
Horseback-Comanche Civil Chief, 1971 71.32
Ink on paper, 40 x 27½ in. (101.6 x 69.8 cm.)
Signed, dated, and inscribed lower right: Baskin/
 HORSEBACK-COMANCHE CIVIL CHIEF/1971
Museum Purchase: Howald Fund, 1971

Mary Bauermeister, born 1934
SHE-RA, 1969 80.5
Wood, glass, plaster, and ink, H. 11⅞ in. (30.2 cm.)
Inscribed top center: 197A SHE-RA Mary Bauermeister
 1969
Gift of Mr. and Mrs. Arthur J. Kobacker, 1980

Lucie Bayard, born 1899
White Peonies 56.16

Oil on canvas, 28½ x 24 in. (72.4 x 60.9 cm.)
Signed lower left: Lucie Bayard
Gift of Emma S. Bellows, 1956

Gifford Beal, 1879–1956
Circus Day, Elephants 65.35
Oil on composition board, 13½ x 21½ in. (34.3 x 54.6 cm.)
Museum Purchase: Howald Fund, 1965

Cecilia Beaux, 1855–1942
Mrs. Richard Low Divine, Born Susan Sophia Smith, 1907
 47.80
Oil on canvas, 74¾ x 48 in. (189.9 x 121.9 cm.)
Signed lower left: Cecilia Beaux
Bequest of Gertrude Divine Webster, 1947
Cat. no. 22

C. Ronald Bechtle, born 1924
One Primal Instant, 1970 71.22
Gouache on paper, 17½ x 23½ in. (44.4 x 59.7 cm.)
Signed and dated lower right: Bechtle/LXX
Gift of the artist, 1971

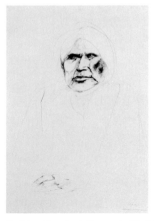

Baskin, *Horseback-Comanche Civil Chief*

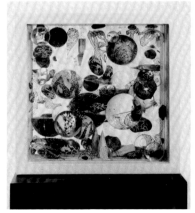

Bauermeister, *SHE-RA*

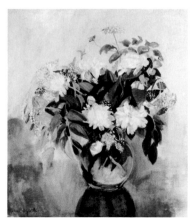

Bayard, *White Peonies*

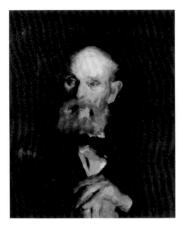

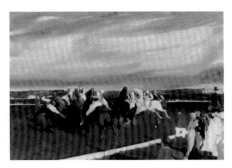

Bellows, *Polo at Lakewood*

Bellows, *Portrait of My Father*

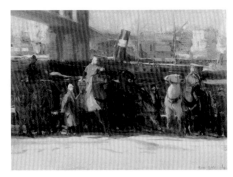

Bellows, *Snow Dumpers*

George Wesley Bellows, 1882–1925
Portrait of My Father, 1906 52.48
Oil on canvas, 28⅜ x 22 in. (72.1 x 55.9 cm.)
Gift of Howard B. Monett, 1952

George Wesley Bellows, 1882–1925
Summer Night, Riverside Drive, 1909 [57]37.24
Oil on canvas, 35½ x 47½ in. (90.2 x 120.6 cm.)
Signed lower center: Geo. Bellows
Bequest of Frederick W. Schumacher, 1957

George Wesley Bellows, 1882–1925
Blue Snow, The Battery, 1910 58.35
Oil on canvas, 34 x 44 in. (86.4 x 111.8 cm.)
Signed lower right: Geo. Bellows
Museum Purchase: Howald Fund, 1958
Cat. no. 30

George Wesley Bellows, 1882–1925
Polo at Lakewood, 1910 11.1
Oil on canvas, 45¼ x 63½ in. (114.9 x 161.3 cm.)
Signed lower left: Geo. Bellows
Columbus Art Association Purchase, 1911

George Wesley Bellows, 1882–1925
An Island in the Sea, 1911 52.25
Oil on canvas, 34¼ x 44⅜ in. (87 x 112.7 cm.)
Signed lower right: Geo. Bellows. Signed and inscribed
 on reverse: An Island in the Sea/Geo. Bellows/
 146 E. 19/N.Y.
Gift of Howard B. Monett, 1952

George Wesley Bellows, 1882–1925
Snow Dumpers, 1911 41.1
Oil on canvas, 36⅛ x 48⅛ in. (91.8 x 122.2 cm.)
Signed lower right: Geo. Bellows
Museum Purchase: Howald Fund, 1941

George Wesley Bellows, 1882–1925
Arcady, 1913 [57]42.2
Oil on panel, 15 x 19 in. (38.1 x 48.3 cm.)
Signed lower left: Geo. Bellows
Bequest of Frederick W. Schumacher, 1957

George Wesley Bellows, 1882–1925
Churn and Break, 1913 48.53
Oil on panel, 17¾ x 22 in. (45.1 x 55.9 cm.)
Signed lower right: Geo. Bellows
Gift of Mrs. Edward Powell, 1948

George Wesley Bellows, 1882–1925
The Grey Sea, 1913 [52]40.35
Oil on panel, 12⅞ x 19⅜ in. (32.7 x 49.2 cm.)
Signed lower right: Bellows
Gift of Jessie Marsh Powell in memory of Edward Thom-
 son Powell, 1952

George Wesley Bellows, 1882–1925
Mrs. Albert M. Miller (or *White Dress*), 1913 74.30
Oil on canvas, 77 x 40¼ in. (195.6 x 102.2 cm.)
Signed lower left: Geo. Bellows. Dated lower right: 1913
Gift of Barbara Miller Arnold (Mrs. H. Bartley Arnold),
 1974

George Wesley Bellows, 1882–1925
Mrs. H. B. Arnold, 1913 55.58
Oil on canvas, 77½ x 37 in. (196.8 x 94 cm.)
Signed lower right: Geo. Bellows
Gift of H. Bartley Arnold, 1955

George Wesley Bellows, 1882–1925
Riverfront No. 1, 1915 51.11
Oil on canvas, 45⅜ x 63⅛ in. (115.3 x 160.3 cm.)
Signed lower left: Geo. Bellows
Museum Purchase: Howald Fund, 1951
Cat. no. 31

George Wesley Bellows, 1882–1925
Romance of Autumn, Sherman's Point, 1916 60.2
Oil on panel, 17¾ x 21⅞ in. (45.1 x 55.6 cm.)
Inscribed lower right: Geo. Bellows/ESB [Emma S.
 Bellows]
Signed, dated, and inscribed on reverse: Romance of
 Autumn/by/George Bellows/Painted in Camden Oct.
 1916/Pg. 96 Bellows catalogue
Museum Purchase: Howald Fund, 1960

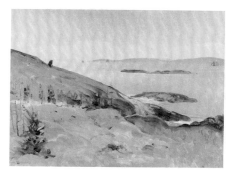

Bellows, *Arcady*

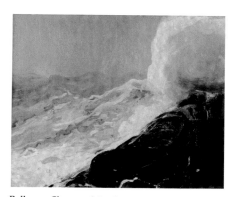

Bellows, *Churn and Break*

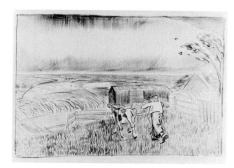

Bellows, *Boy with Calf*

George Wesley Bellows, 1882–1925
Boy and Calf, Coming Storm, 1919 76.45
Oil on canvas, 26¼ x 38¼ in. (66.7 x 97.1 cm.)
Inscribed lower left: Geo. Bellows, J.B.B. [Jean Bellows
 Booth]
Gift of Mr. and Mrs. Everett D. Reese, 1976

George Wesley Bellows, 1882–1925
Boy with Calf, ca. 1919 79.99
Graphite on paper, 17¼ x 20¼ in. (43.8 x 51.4 cm.)
Gift of Mr. and Mrs. Everett D. Reese, 1979

George Wesley Bellows, 1882–1925
Children on the Porch (or *On the Porch*), 1919 47.94
Oil on canvas, 30¼ x 44 in. (76.8 x 111.8 cm.)
Signed lower left: Geo. Bellows
Museum Purchase: Howald Fund, 1947

George Wesley Bellows, 1882–1925
Hudson at Saugerties, 1920 47.95
Oil on canvas, 16½ x 23¾ in. (41.9 x 60.3 cm.)
Signed lower left: Geo. Bellows
Museum Purchase: Howald Fund, 1947

George Wesley Bellows, 1882–1925
Portrait of My Mother No. 1, 1920 30.6
Oil on canvas, 78¼ x 48¼ in. (198.7 x 122.5 cm.)
Inscribed lower left: Geo. Bellows/E.S.B. [Emma S.
 Bellows]
Gift of Emma S. Bellows, 1930
Cat. no. 32

George Wesley Bellows, 1882–1925
Cornfield and Harvest, 1921 47.96
Oil on masonite, 18 x 22 in. (45.7 x 55.9 cm.)
Signed lower right: Geo. Bellows
Museum Purchase: Howald Fund, 1947

George Wesley Bellows, 1882–1925
John Carroll, 1921 72.25
Conté crayon on paper, 11¾ x 9¾ in. (29.8 x 24.8 cm.)
Inscribed lower left: Geo. Bellows/J.B.B. [Jean Bellows
 Booth]
Museum Purchase: Howald Fund, 1972

George Wesley Bellows, 1882–1925
Life Study, Standing Nude, ca. 1923 73.4
Conté crayon on paper, 13 x 10 in. (33 x 25.4 cm.)
Initialed lower left: GB. Inscribed on reverse: Life Study
 Standing Nude
Museum Purchase: Howald Fund, 1973

George Wesley Bellows, 1882–1925
Charles E. Albright 47.100
Ink on paper, 9⅜ x 7¼ in. (23.8 x 18.4 cm.)
Signed lower right: Bellows
Gift of Rose L. Fullerton, 1947

George Wesley Bellows, 1882–1925
I Remember Being Initiated Into the Frat 40.20
Graphite, conté crayon, and ink on paper, 19 x 23½ in.
 (48.3 x 59.7 cm.)
Signed lower left: Geo. Bellows
Gift of Mrs. Joseph R. Taylor, 1940

George Wesley Bellows, 1882–1925
Tugboat and Steamer 86.13
Graphite on paper, 4¼ x 5¼ in. (10.8 x 13.3 cm.)
Inscribed bottom right: Geo Bellows/J.B.B. [Jean Bellows
 Booth]
Gift of James and Timothy Keny, 1986

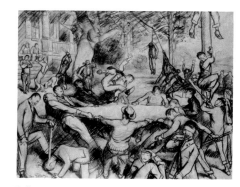

Bellows, *I Remember Being Initiated into the Frat*

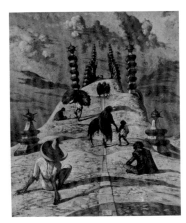

Berman, *The Steep Bridge II*

Bidner, *Embassy Bay Window*

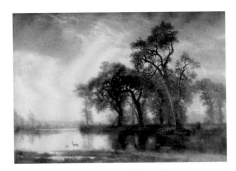

Bierstadt, *Landscape on the Platte River*

Thomas Hart Benton, 1889–1975
Constructivist Still Life, ca. 1917–1918 63.6
Oil on paper, 17½ x 13⅝ in. (44.4 x 34.6 cm.)
Signed lower right: Benton
Gift of Carl A. Magnuson, 1963
Cat. no. 46

Eugene Berman, 1899–1972
The Steep Bridge II, 1948 49.48
Oil on canvas, 32 x 25 in. (81.3 x 63.5 cm.)
Signed and dated lower center: E.B. 1948.
Signed, dated, and inscribed on reverse, upper left: EB/
 August 1948 September/Los Angeles/Salida Del Puente
 II (The Steep Bridge II)
Gift of Knoedler & Co., 1949

Patrick V. Berry, 1843–1913
Landscape with Cattle 64.23
Oil on canvas, 26 x 22⅛ in. (66 x 56.2 cm.)
Signed lower left: P. V. Berry
Gift of the Hildreth Foundation in memory of
 Mr. and Mrs. Louis R. Hildreth, 1964

Richard Berry, born 1927
Still Life, 1965 65.31
Oil on paper, 23¾ x 47½ in. (60.3 x 120.7 cm.)
Museum Purchase: Howald Fund, 1965

Robert D. H. Bidner, 1930–1983
Embassy Bay Window, 1978 79.7
Acrylic on illustration board, 36 x 23⅝ in. (91.4 x 60 cm.)
Signed lower center: Bidner
Museum Purchase: Robert H. Simmons Memorial Fund,
 1979

Albert Bierstadt, 1830–1902
Landscape on the Platte River 19.57
Oil on board, 17½ x 23½ in. (44.5 x 59.7 cm.)
Signed lower left: A Bierstadt
Bequest of Francis C. Sessions, 1919

Albert Bierstadt, 1830–1902
Landscape 29.3
Oil on canvas, 27¾ x 38½ in. (70.5 x 100.3 cm.)
Signed lower left: A Bierstadt
Bequest of Rutherford H. Platt, 1929
Cat. no. 5

Isabel Bishop, 1902–1988
Girl at Lunch Counter, ca. 1954 60.35
Ink and wash on paper, 5¾ x 2¹³⁄₁₆ in. (14.6 x 7.1 cm.)
Signed lower right: Isabel Bishop
Museum Purchase: Howald Fund, 1960

Isabel Bishop, 1902–1988
Snack Bar, ca. 1954 54.47
Oil on masonite, 13½ x 11⅛ in. (34.3 x 28.2 cm.)
Museum Purchase: Howald Fund, 1954
Cat. no. 68

Isabel Bishop, 1902–1988
Two Girls at Lunch Counter, ca. 1954 60.34
Ink and wash on paper, 5¾ x 2¹³⁄₁₆ in. (14.6 x 7.1 cm.)
Signed lower left: Isabel Bishop
Museum Purchase: Howald Fund, 1960

David Black, born 1928
Now Showing, 1961 65.5
Ceramic, H. 20 in. (50.8 cm.)
Signed and dated center front: BLACK 61
Museum Purchase: Howald Fund, 1965

Ralph Albert Blakelock, 1847–1919
Indian Encampment, ca. 1885 78.47
Oil on canvas, 11¼ x 15¼ in. (28.6 x 38.7 cm.)
Signed lower left: R. A. Blakelock
Gift of Dr. Bernard Cohen, 1978

Ralph Albert Blakelock, 1847–1919
Moonlight, ca. 1885–1890 45.20
Oil on board, 12 x 16 in. (30.5 x 40.6 cm.)
Signed lower right: R. A. Blakelock
Bequest of John R. and Louise Lersch Gobey, 1945
Cat. no. 11

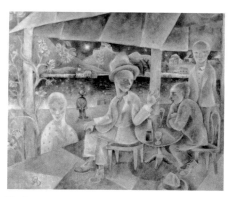

Block, *Veranda*

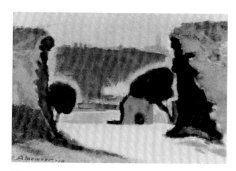

Bluemner, *Somewhere in Harlem, Along the Harlem River*

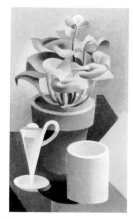

Blume, *Cyclamen*

Albert Bloch, 1882–1961
Veranda, 1920 31.108
Oil on paper, 17¼ x 20⅝ in. (43.8 x 52.4 cm.)
Signed lower left: A B. Signed, dated, and inscribed on
 reverse: Albert-Bloch/Ascona—1920/"Veranda"
Gift of Ferdinand Howald, 1931

Oscar Bluemner, 1867–1938
Somewhere in Harlem, Along the Harlem River, 1910
 79.81
Watercolor on paper, 6⅝ x 9⅜ in. (16.8 x 23.8 cm.)
Signed lower left: O. Bluemner/10
Gift of Coe Kerr Gallery, Inc., 1979

Peter Blume, born 1906
Cyclamen, 1926 31.110
Oil on canvas, 17 x 10 in. (43.2 x 25.4 cm.)
Signed lower right: Peter Blume
Gift of Ferdinand Howald, 1931

Peter Blume, born 1906
Home for Christmas, 1926 31.109
Oil on canvas, 23½ x 35½ in. (59.7 x 90.2 cm.)
Signed lower right: Peter Blume
Gift of Ferdinand Howald, 1931
Cat. no. 60

Peter Blume, born 1906
Cafe, 1957 60.47
Ink on paper, 5⅜ x 8⅜ in. (13.6 x 21.3 cm.)
Signed and dated lower right: P. Blume 1957
Museum Purchase: Howald Fund, 1960

Peter Blume, born 1906
Farmyard, 1957 60.46
Ink on paper, 5½ x 8¼ in. (14 x 20.9 cm.)
Signed and dated lower right: P. Blume 1957
Museum Purchase: Howald Fund, 1960

Paul Bogatay, 1905–1972
Blue Horse 36.41

Ceramic, H. 8⅝ in. (21.9 cm.)
Source unknown, 1936

Louis Bouché, 1896–1969
Still Life with Flowers, 1919 31.111
Oil on canvas, 24 x 20 in. (61 x 50.8 cm.)
Signed and dated lower right: L. Bouché 1919
Gift of Ferdinand Howald, 1931

Louis Bouché, 1896–1969
Still Life with Brown Pitcher, 1924 31.112
Oil on canvas, 20⅛ x 24 in. (51.1 x 61 cm.)
Signed and dated upper center: Louis Bouché 1924
Gift of Ferdinand Howald, 1931

Isabelle Bowerman, died 1971
Winter Competition, St. John Arena, O.S.U., 1960 63.37
Gouache on paper, 29⅝ x 35⅝ in. (75.2 x 90.5 cm.)
Signed lower right: Isabelle Bowerman
Museum Purchase: Howald Fund, 1963

Fiske Boyd, 1895–1975
Composition, 1923 31.113
Oil on canvas, 32⅜ x 24¼ in. (82.2 x 61.6 cm.)

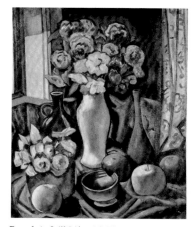

Bouché, *Still Life with Flowers*

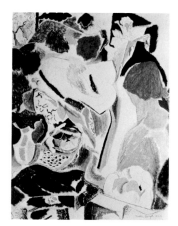

Boyd, *Composition*

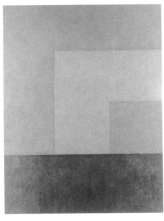

Bruss, *Laurentian Summer No. 6*

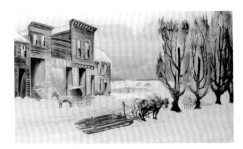

Burchfield, *Winter Solstice*

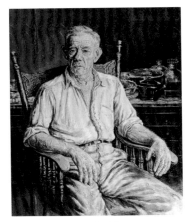

Burkhart, *Portrait of a Man*

Signed and dated lower right: Fiske Boyd 1923
Gift of Ferdinand Howald, 1931

Emile Pierre Branchard, 1881–1938
Moonlight 31.114
Oil on paper, 8⅞ x 11⅞ in. (22.5 x 30.2 cm.)
Signed lower right: EMILE/BRANCHARD
Gift of Ferdinand Howald, 1931

Katherine Bell Brown, born 1902
Color, 1955 76.23
Watercolor on paper, 20¾ x 16 in. (52.7 x 40.6 cm.)
Purchased with funds from the Alfred L. Willson
 Charitable Fund of The Columbus Foundation, 1976

James Bruss, born 1944
Final Curtain, 1974 74.16
Watercolor and photo-silkscreen on paper, 24 x 33 in.
 (61 x 83.8 cm.)
Signed and dated lower right: Bruss 74
Theodore R. Simson Purchase Award, 1974

James Bruss, born 1944
Laurentian Summer No. 6, 1974 76.16
Acrylic on canvas, 84 x 60¼ in. (213.4 x 153 cm.)
Signed, dated, and inscribed on reverse: Laurentian
 Summer No. 6 (Series of 6), Dec. 74, Jim Bruss
Howald Memorial Purchase Award, 1976

Charles E. Burchfield, 1893–1967
Winter Solstice, ca. 1920–1921 31.117
Watercolor on paper, 21½ x 35½ in. (54 6 x 90.2 cm.)
Signed lower right: C. BURCHFIELD
Gift of Ferdinand Howald, 1931

Charles E. Burchfield, 1893–1967
The Visit, ca. 1920–1924 31.115
Watercolor and graphite on paper, 22 x 29⅞ in.
 (55.9 x 75.9 cm.)
Signed lower right: C. BURCHFIELD
Gift of Ferdinand Howald, 1931

Charles E. Burchfield, 1893–1967
October, ca. 1922–1924 31.116
Oil and gouache on paper glued to board, 31 x 42¾ in.
 (78.7 x 108.6 cm.)
Signed lower right: C. BURCHFIELD. Signed and dated
 on reverse: 2-October/Chas. Burchfield
Gift of Ferdinand Howald, 1931
Cat. no. 58

Emerson C. Burkhart, 1905–1969
Arthur J. Packard, 1946 71.31
Oil on canvas, 36 x 30 in. (91.4 x 76.2 cm.)
Signed upper left: Emerson C. Burkhart.
 Signed and dated on reverse, upper left:
 Oct. 1946/E.C.B.
Gift of Arthur J. Packard, 1971

Emerson C. Burkhart, 1905–1969
Portrait of a Man, 1950 55.9
Oil on canvas, 49¼ x 38¼ in. (125.1 x 95.2 cm.)
Signed upper left: Emerson C. Burkhart
Museum Purchase: Howald Fund, 1955

Emerson C. Burkhart, 1905–1969
Eastside Columbus, ca. 1951 86.18
Oil on panel, 8½ x 10¾ in. (21.6 x 27.3 cm.)
Signed bottom right: EMERSON BURKHART
Gift of Daniel Arnold, M.D., 1986

Emerson C. Burkhart, 1905–1969
Canary Islands, 1963 84.8
Acrylic on canvas, 28 x 35 in. (71.1 x 88.9 cm.)
Signed and dated lower right: E. Burkhart 63
Bequest of Lucille Mercer, 1984

Emerson C. Burkhart, 1905–1969
Hong Kong, 1965 67.1
Oil on canvas, 31½ x 40 in. (80 x 101.6 cm.)
Signed and dated lower left: E. Burkhart 65
Museum Purchase: Howald Fund, 1967

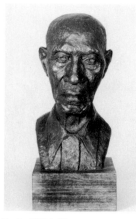

Bush, *Elijah Pierce*

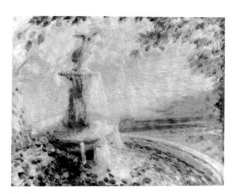

Butler, *Fountain, Central Park*

Camp, *Benicia*

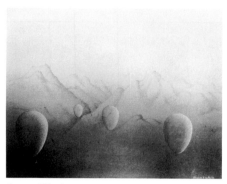

Carter, *Pilgrimage No. 2*

Elwyn Bush, born 1931
Elijah Pierce, 1974 75.3
Bronze, H. 15½ in. (39.4 cm.)
Signed, dated, and inscribed left shoulder:
ELIJAH PIERCE/BY ELWYN BUSH '74
Gift of the artist, 1975

Theodore Earl Butler, 1860–1936
A Tiller of Soil, 1894 41.39
Oil on canvas, 23½ x 28¾ in. (59.7 x 73 cm.)
Signed and dated lower left: T. E. Butler 94
Bequest of Alfred L. Willson, 1941

Theodore Earl Butler, 1860–1936
Fountain, Central Park, 1915 79.10
Oil on canvas, 23¾ x 28¾ in. (60.3 x 73 cm.)
Signed and dated lower right: T. E. Butler '15
Gift of Mr. and Mrs. Harry William Hind, 1979

Alexander Calder, 1898–1976
Snake and Butterfly, 1966 67.69
Gouache on paper, 22⅞ x 30⅝ in. (58.1 x 77.8 cm.)
Signed and dated lower right: Calder 66
Gift of Mr. and Mrs. Joseph H. Hirshhorn, 1967

Alexander Calder, 1898–1976
Intermediate Model for the Arch, 1975 80.36
Painted steel, H. 144 in. (365.6 cm.)
Museum Purchase: Derby Fund, 1980
Cat. no. 80

Kenneth Callahan, 1905–1986
Woods Interior No. 1, 1954 60.38
Ink and wash on paper, 24 x 18¾ in. (61 x 47.5 cm.)
Signed and dated lower right: Kenneth Callahan '54
Museum Purchase: Howald Fund, 1960

Larry R. Camp, born 1939
Benicia, 1974 74.13
Acrylic on canvas, 81 x 105 in. (205.7 x 266.7 cm.)
Howald Memorial Purchase Award, 1974

David M. Campbell, born 1931
Toledo, 1964 68.24
Oil on canvas, 34 x 48¼ in. (86.4 x 122.5 cm.)
Signed and dated lower right: 14-4-64 DMC
Gift of Mrs. Harold J. Andreae, 1968

Harriet Dunn Campbell, 1873–1959
Huron, Ohio 60.57
Watercolor on paper, 9¹⁵⁄₁₆ x 11¾ in. (25.1 x 29.9 cm.)
Signed lower right: HARRIET-DUNN-CAMPBELL
Gift of Ernest Zell, 1960

Joseph V. Canzani, born 1915
The Violinist, 1968 70.1
Oil on canvas, 36 x 49¹¹⁄₁₆ in. (91.4 x 126.2 cm.)
Signed and dated lower right: joseph v. canzani '68
Gift of the artist, 1970

Jon Carsman, born 1944
A Forgotten View, ca. 1980 83.35
Watercolor on paper, 23½ x 16½ in. (59.7 x 41.9 cm.)
Signed and dated lower left: Carsman 78
Gift of Mr. and Mrs. Stanley Gottlieb, 1983

Clarence H. Carter, born 1904
Pilgrimage No. 2, 1973 74.32
Mixed media, 21½ x 29¼ in. (54.6 x 74.3 cm.)
Signed and dated lower right: Clarence H. Carter 73
Museum Purchase: Howald Fund, 1974

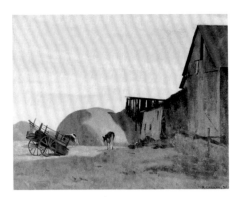

Chadeayne, *Barnyard*

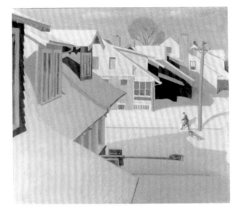

Chadeayne, *Cliffside Drive*

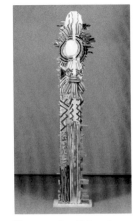

Chavous, *Jazz Totem #4*

Aldo J. Casanova, born 1929
Bird 55.16
Metal, H. 36½ in. (92.7 cm.)
Museum Purchase: Howald Fund, 1955

Mary Cassatt, 1845–1926
Susan Comforting the Baby No. 1, ca. 1881 [57]54.4
Oil on canvas, 17 x 23 in. (43.2 x 58.4 cm.)
Signed lower right: Mary Cassatt
Bequest of Frederick W. Schumacher, 1957
Cat. no. 18

John Cavanaugh, 1921–1985
Boy in Sling Chair, 1952 55.21
Ceramic, H. 7½ in. (19 cm.)
Museum Purchase: Howald Fund, 1955

Robert O. Chadeayne, 1897–1981
Winter Wash, 1921 73.5
Oil on canvas, 28 x 36 in. (71.1 x 91.4 cm.)
Signed and dated lower right: R O CHADEAYNE '21
Museum Purchase: Howald Fund, 1973

Robert O. Chadeayne, 1897–1981
Barnyard, 1931 31.283
Oil on canvas, 26 x 31 in. (66 x 78.7 cm.)
Signed and dated lower right: R.O. CHADEAYNE '31
Columbus Art League Purchase Award, 1931

Robert O. Chadeayne, 1897–1981
The Big Sky, 1970 72.16
Pastel on paper, 18¾ x 24¾ in. (47.6 x 62.9 cm.)
Signed and dated lower right: R. O. Chadeayne '70
Chet Long Memorial Purchase Award and Howald Fund
 Purchase, 1972

Robert O. Chadeayne, 1897–1981
Cliffside Drive 37.9
Oil on canvas, 24 x 26 in. (61 x 66 cm.)
Gift of Orlando A. Miller, 1937

Robert O. Chadeayne, 1897–1981
Trees with Red Buildings 38.5

Oil on canvas, 26 x 36 in. (66 x 91.4 cm.)
Gift of Frederick W. Schumacher, 1938

Adele Chafetz, born 1922
City Houses, 1953 56.30
Watercolor and ink on paper, 16½ x 13½ in.
 (41.9 x 34.3 cm.)
Museum Purchase: Howald Fund, 1956

Adelaide Cole Chase, 1869–1944
Mrs. Ralph Adams Cram, 1905 06.1
Oil on canvas, 75¾ x 35½ in. (192.4 x 90 cm.)
Signed and dated upper left: Adelaide Chase 1905
Museum Purchase, 1906

Barbara Chavous, born 1936
Jazz Totem #2, 1979 79.36
Painted wood, metal, H. 85 in. (215.9 cm.)
Inscribed lower right: J.T.2
Purchased with funds from the Alfred L. Willson
 Charitable Fund of The Columbus Foundation, 1979

Barbara Chavous, born 1936
Jazz Totem #4, 1979 79.37
Painted wood, metal, H. 110 in. (279.4 cm.)
Inscribed lower right: J.T.4
Purchased with funds from the Alfred L. Willson
 Charitable Fund of The Columbus Foundation, 1979

Barbara Chavous, born 1936
Jazz Totem #11, 1979 79.38
Painted wood, rope, H. 94 in. (238.8 cm.)
Inscribed lower right: J.T.11
Purchased with funds from the Alfred L. Willson
 Charitable Fund of The Columbus Foundation, 1979

Edward Christiana, born 1912
Amsterdam from Thruway No. 2, 1962 63.13
Oil on canvas, 38 x 44 in. (96.5 x 111.8 cm.)
Signed and dated lower right: EDWARD CHRISTIANA/'62
Museum Purchase: Howald Fund, 1963

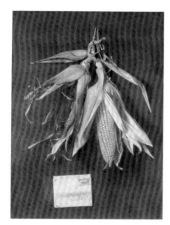

Christy, *Corn and Wheat*

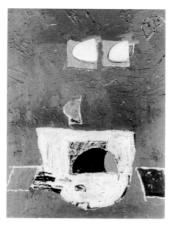

Cieslewski, *Imaginative Introverts*

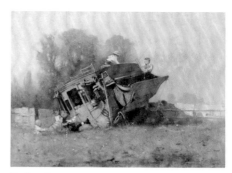

Cocks, *The Stagecoach*

Howard Chandler Christy, 1873–1952
Corn and Wheat, 1893–1894 85.15.1
Oil on canvas, 29 x 20¼ in. (73.6 x 51.4 cm.)
Signed bottom center: Howard Chandler Christy
Gift of Browne Pavey, 1985

Howard Chandler Christy, 1873–1952
Captain Edward V. Rickenbacker, 1943 43.5
Oil on canvas, 49 x 37½ in. (124.4 x 95.2 cm.)
Signed and dated lower left: Howard Chandler Christy/
 March 1943
Gift of Ralph H. Beaton, Orlando A. Miller and Frederick
 W. Schumacher, 1943

Joseph M. Cieslewski, born 1953
Imaginative Introverts, 1977 77.5
Mixed media on paper, 29⅝ x 21¼ in. (75.2 x 53.9 cm.)
Theodore R. Simson Purchase Award for Painting from
 the 67th Annual Columbus Art League May Show,
 1977

Nicolai Stepanovich Cikovsky, 1894–1984
Before the Storm, 1959 59.14
Oil on paper, 11⅞ x 16 in. (30.2 x 40.6 cm.)
Signed lower right: Nicolai Cikovsky
Purchased with funds from the Alfred L. Willson
 Foundation, 1959

Benton Henderson Clark, 1895–1964
Sunday Visitors 74.38.35
Oil on canvas, 22 x 55 in. (55.9 x 139.7 cm.)
Signed lower left: Benton/Clark
Bequest of J. Willard Loos, 1974

Evelyn Clark, born 1914
The Mood is Love 71.9
Watercolor, 16 x 21 in. (40.6 x 53.3 cm.)
Signed lower right: E. Clark
Purchased with funds from the Alfred L. Willson
 Charitable Fund of The Columbus Foundation, 1971

Matt Clark, born 1903
Sheriff Shooting Outlaw 74.38.32
Gouache on paper, 5⅝ x 15¾ in. (14.3 x 40 cm.)
Signed upper right: Matt Clark
Bequest of J. Willard Loos, 1974

T. Cocks
The Stagecoach, 1879 86.14
Oil on canvas, 9⅞ x 13 in. (25 x 33 cm.)
Signed and dated bottom right: Th. Cocks—79
Gift of Charlotte Curtis in honor of Lucile Atcherson
 Curtis, her mother, 1986

May Elizabeth Cook, 1881–1951
Molly Brown, 1914 63.26
Plaster, H. 10 in. (25.4 cm.)
Signed and dated on back: M. E. Cook—1914
Gift of Mr. and Mrs. John M. Caren, 1963

May Elizabeth Cook, 1881–1951
Joseph Jeffrey, 1927 55.10
Marble, H. 23½ in. (59.7 cm.)
Signed and dated on base: M. E. Cook—1927
Gift of Mrs. Charles Harris, 1955

Kathleen McKeith Cooke, 1908–1978
Buffalo 85.24.4
Cast plaster, H. 5 in. (12.6 cm.)
Gift of the Betty Parsons Foundation, 1985

Kathleen McKeith Cooke, 1908–1978
Elephant 86.2.2
Graphite on paper, 5⅛ x 6⅞ in. (13 x 17.3 cm.)
Gift of the Betty Parsons Foundation, 1986

Kathleen McKeith Cooke, 1908–1978
Goat 85.24.11
Cast plaster, H. 4¼ in. (10.6 cm.)
Gift of the Betty Parsons Foundation, 1985

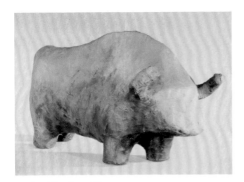

Cooke, *The Great Bison*

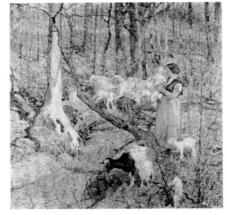

Costigan, *Landscape with Flowers*

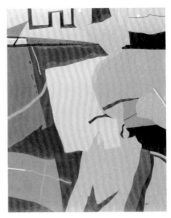

Crawford, *First Avenue No. 4*

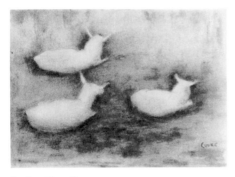

Cooke, *Three Goats*

Kathleen McKeith Cooke, 1908–1978
The Great Bison 86.2.1
Papier-mâché, H. 20 in. (50.8 cm.)
Gift of the Betty Parsons Foundation, 1986

Kathleen McKeith Cooke, 1908–1978
Three Goats 86.2.3
Charcoal on paper, 9 x 11¾ in. (22.9 x 29.8 cm.)
Signed lower right: Cooke
Gift of the Betty Parsons Foundation, 1986

Kathleen McKeith Cooke, 1908–1978
Untitled (sketchbook with eight drawings) 86.2.4 a-h
Graphite on paper, each 24 x 18 in. (61 x 45.7 cm.)
Inscribed on sketchbook cover: Kathleen Cooke/Sketches
Gift of the Betty Parsons Foundation, 1986

Kathleen McKeith Cooke, 1908–1978
Yak 85.24.1
Oil on canvas, 14 x 18 in. (35.6 x 45.7 cm.)
Signed lower right: Cooke
Gift of the Betty Parsons Foundation, 1985

John Edward Costigan, 1888–1972
Landscape with Flowers, 1924 45.12
Oil on canvas, 44¼ x 44¼ in. (112.4 x 112.4 cm.)
Signed and dated lower left: J. E. Costigan/1924
Bequest of Edward D. and Anna White Jones, 1945

Robert Cottingham, born 1935
Blues, 1987 87.13
Watercolor on paper, 18 x 18 in. (45.7 x 45.7 cm.)
Gift of the American Academy and Institute of Arts and
 Letters/Hassam and Speicher Purchase Fund, 1987

Laura Cowman, died 1981
Lost Pavilion 67.10
Oil and collage on canvas, 32 x 48 in. (81.3 x 122 cm.)
Signed lower left: Cowman
Museum Purchase: Howald Fund, 1967

Ralston Crawford, 1906–1978
First Avenue No. 4, 1968 73.8
Oil on canvas, 40 x 30 in. (101.6 x 76.2 cm.)
Signed lower right: R C
Museum Purchase: Howald Fund, 1973

José de Creeft, 1884–1982
Two Girls, 1958 70.23
Ink on paper, 13¾ x 20¾ in. (34.9 x 52.7 cm.)
Signed and dated lower right: José de Creeft/'58
Purchased with funds from the Alfred L. Willson
 Foundation, 1970

Jasper Francis Cropsey, 1823–1900
Fishing, 1868 85.22
Oil on canvas, 10 x 15 in. (25.4 x 38.1 cm.)
Dated lower left: 1868
Museum Purchase: J. Willard Loos Bequest, 1985

Stephen Csoka, born 1897
Fatherless, 1947 48.9
Oil on canvas, 40 x 34 in. (101.6 x 86.4 cm.)
Signed and dated lower right: S. Csoka/1947
Gift of Gallery Links, 1948

Charles Csuri, born 1922
Wanderers 57.31
Oil on canvas, 34⅛ x 40¼ in. (86.7 x 102.2 cm.)
Museum Purchase: Howald Fund, 1957

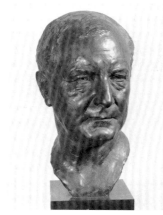

Davidson, *William Guthrie*

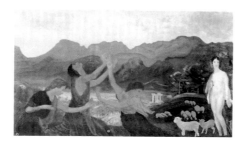

Davies, *Sicily, Flowering Isle*

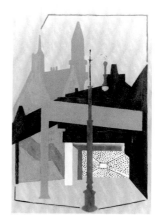

Davis, *Street Scene*

Lee Csuri, born 1927
King Bacchus, 1960 61.29
Ink and graphite on paper, 26 x 19¾ in. (66 x 50.2 cm.)
Signed and dated lower right: Lee Csuri/21/11/60
Museum Purchase: Howald Fund, 1961

Lee Csuri, born 1927
St. George 57.30
Oil on masonite, 34⅛ x 28½ in. (86.7 x 72.4 cm.)
Museum Purchase: Howald Fund, 1957

Jay Norwood Darling, 1876–1962
There Must Be a Reason 34.39.2
Ink on paper, 27½ x 22 in. (69.9 x 55.9 cm.)
Signed lower right: Ding
Gift of the artist, 1934

Jay Norwood Darling, 1876–1962
Three Hitchhikers Look for a Lift 34.39.1
Ink on paper, 27½ x 22 in. (69.9 x 55.9 cm.)
Signed lower right: Ding
Gift of the artist, 1934

Jo Davidson, 1883–1952
William Guthrie, 1924 56.56
Bronze, H. 14½ in. (36.8 cm.)
Signed and dated on reverse: J. Davidson/New York—
 1924
Gift of Mrs. William D. Guthrie, 1956

Arthur B. Davies, 1862–1928
Untitled (reclining female nude), ca. 1910 60.37
Charcoal, crayon, and pastel on paper, 11¾ x 16³⁄₁₆ in.
 (29.8 x 41.1 cm.)
Purchased with funds from the Alfred L. Willson
 Foundation, 1960

Arthur B. Davies, 1862–1928
Coming of Summer 31.119
Oil on canvas, 18 x 30 in. (45.7 x 76.2 cm.)
Signed lower center: A. B. Davies
Gift of Ferdinand Howald, 1931

Arthur B. Davies, 1862–1928
Italian Landscape 60.8
Watercolor on paper, 9 x 12 in. (22.9 x 30.5 cm.)
Museum Purchase: Howald Fund, 1960

Arthur B. Davies, 1862–1928
Nude 60.9
Pastel on paper, 12 x 10 in. (30.5 x 25.4 cm.)
Museum Purchase: Howald Fund, 1960

Arthur B. Davies, 1862–1928
Reluctant Youth 31.118
Oil on canvas, 17¼ x 22½ in. (43.8 x 57.2 cm.)
Signed lower left: A. B. Davies
Gift of Ferdinand Howald, 1931

Arthur B. Davies, 1862–1928
Sicily, Flowering Isle 31.120
Oil on canvas, 18 x 30¼ in. (45.7 x 76.8 cm.)
Signed lower left: A. B. Davies. Inscribed on reverse, on
 stretcher: Sicily Flowering Isle
Gift of Ferdinand Howald, 1931

Arthur B. Davies, 1862–1928
Untitled (standing female nude) 60.36
Charcoal, crayon, and pastel on paper, 16⅜ x 11¾ in.
 (41.6 x 29.8 cm.)
Purchased with funds from the Alfred L. Willson
 Foundation, 1960

Stuart Davis, 1892–1964
Street Scene, 1926 81.32.2
Oil on panel, 24 x 16⅛ in. (61 x 41 cm.)
Inscribed on reverse: Stuart Davis 1926
Gift of Mr. and Mrs. Harry Spiro, 1981

Stuart Davis, 1892–1964
Landscape with Drying Sails, 1931–1932 81.12
Oil on canvas, 32 x 40 in. (81.3 x 101.6 cm.)
Signed top right: Stuart Davis
Museum Purchase: Howald Fund II, 1981
Cat. no. 65

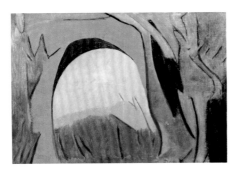

Dawson, *Sun Through the Arch*

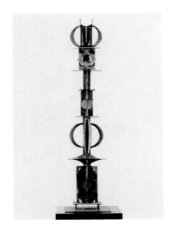

Dehner, *Viking II*

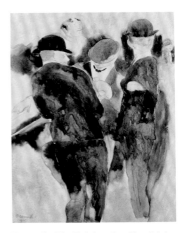

Demuth, *The Drinkers* (or *Chez Ritz*)

Manierre Dawson, 1887–1969
Sun Through the Arch, 1910 80.35
Oil on panel, 10³⁄₁₆ x 13⅞ in. (25.9 x 35.2 cm.)
Signed and dated lower right: Dawson '10
Purchased with funds from the Alfred L. Willson
 Charitable Fund of The Columbus Foundation, 1980

Leo Dee, born 1931
Eroding Dunes, Truro, 1977 79.82
Silverpoint on paper, 12 x 18 in. (30.5 x 45.7 cm.)
Signed lower right: Leo Dee. Inscribed on lower left:
 Eroding Dunes, Truro
Gift of Coe Kerr Gallery, Inc., 1979

Franklin DeHaven, 1856–1934
October 64.21
Oil on canvas, 29½ x 23½ in. (74.9 x 59.7 cm.)
Signed lower right: F. DeHaven
Gift of the Hildreth Foundation in memory of
 Mr. and Mrs. Louis R. Hildreth, 1964

Virginia Dehn, born 1922
Peacock Cloud, 1970 71.5
Oil on canvas, 40 x 40 in. (101.6 x 101.6 cm.)
Signed lower right: Virginia Dehn
Museum Purchase: Howald Fund, 1971

Dorothy Dehner, born 1908
Drawing, 1961 63.11
Ink and wash on paper, 34¼ x 22¾ in. (87 x 57.8 cm.)
Signed and dated lower right: Dehner '61
Museum Purchase: Howald Fund, 1963

Dorothy Dehner, born 1908
Viking II, 1969 70.30
Steel and bronze, H. 76 in. (193 cm.)
Museum Purchase: Howald Fund, 1970

Charles Demuth, 1883–1935
Poppies, ca. 1915 31.141
Watercolor on paper, 17½ x 11⅜ in. (44.5 x 28.9 cm.)

Signed upper left: C. Demuth
Gift of Ferdinand Howald, 1931

Charles Demuth, 1883–1935
The Drinkers (or *Chez Ritz*), 1915 31.122
Watercolor on paper, 10¾ x 8¼ in. (27.3 x 21 cm.)
Signed, dated, and inscribed on lower left: C. Demuth
 1915/Chez Ritz. Inscribed on reverse: C. Philadelphia
 Pa.
Gift of Ferdinand Howald, 1931

Charles Demuth, 1883–1935
Bermuda Landscape, 1916 31.124
Watercolor on paper, 9½ x 13½ in. (24.1 x 34.3 cm.)
Signed and dated lower left: C. Demuth/1916
Gift of Ferdinand Howald, 1931

Charles Demuth, 1883–1935
The Nut, Pre-Volstead Days, 1916 31.138
Watercolor on paper, 10⁹⁄₁₆ x 7¹³⁄₁₆ in. (26.9 x 19.9 cm.)
Signed and dated lower left: C. Demuth 1916
Gift of Ferdinand Howald, 1931

Charles Demuth, 1883–1935
The Circus, 1917 31.127
Watercolor and graphite on paper, 8 x 10⅝ in.
 (20.3 x 27 cm.)
Signed and dated lower left: C. Demuth/1917
Gift of Ferdinand Howald, 1931
Cat. no. 52

Charles Demuth, 1883–1935
Landscape, 1917 31.136
Watercolor on paper, 9⅞ x 13⅞ in. (25.1 x 35.2 cm.)
Signed and dated lower left: C. Demuth/1917
Gift of Ferdinand Howald, 1931

Charles Demuth, 1883–1935
Houses, 1918 31.121
Watercolor on paper, 13¾ x 9¾ in. (34.9 x 24.8 cm.)
Signed and dated lower left: C. Demuth/1918
Gift of Ferdinand Howald, 1931

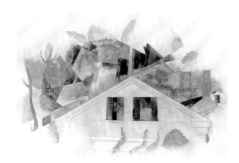

Demuth, *Housetops*

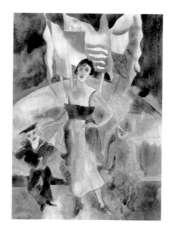

Demuth, *In Vaudeville: Columbia*

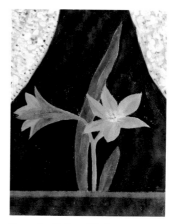

Demuth, *Cottage Window*

Charles Demuth, 1883–1935
Housetops, 1918 31.134
Watercolor on paper, 9¾ x 13½ in. (24.8 x 34.3 cm.)
Signed and dated lower left: C. Demuth/1918
Gift of Ferdinand Howald, 1931

Charles Demuth, 1883–1935
In Vaudeville: Columbia, 1919 31.128
Watercolor and graphite on paper, 11¹⁵⁄₁₆ x 8 in.
 (30.3 x 20.3 cm.)
Signed and dated lower left: C. Demuth 1919
Gift of Ferdinand Howald, 1931

Charles Demuth, 1883–1935
Cottage Window, ca. 1919 31.129
Tempera on pasteboard, 15⅜ x 11⁵⁄₁₆ in. (39 x 28.7 cm.)
Signed on reverse: Charles Demuth
Gift of Ferdinand Howald, 1931

Charles Demuth, 1883–1935
Zinnias and Snapdragons, ca. 1919 31.148
Watercolor and graphite on paper, 9⅝ x 12¹¹⁄₁₆ in.
 (24.5 x 32.2 cm.)
Gift of Ferdinand Howald, 1931

Charles Demuth, 1883–1935
Flowers, 1919 31.131
Watercolor on paper, 13¾ x 9¹¹⁄₁₆ in. (34.9 x 25 cm.)
Signed and dated lower right: C.D./1919
Gift of Ferdinand Howald, 1931

Charles Demuth, 1883–1935
The Tower (or *After Sir Christopher Wren*), ca. 1920
 31.146
Tempera on pasteboard, 23¼ x 19½ in. (59 x 49.5 cm.)
Initialed and inscribed in pencil on reverse: After Sir
 Christopher Wren[?] Provincetown, Mass./1 B O[?]—
 C.D.
Gift of Ferdinand Howald, 1931

Charles Demuth, 1883–1935
Aucassin and Nicolette, 1921 31.123
Oil on canvas, 24⅛ x 20 in. (61.3 x 50.8 cm.)
Signed and dated on back center: C. Demuth/1921
Gift of Ferdinand Howald, 1931

Charles Demuth, 1883–1935
Incense of a New Church, 1921 31.135
Oil on canvas, 26 x 20⅛ in. (66 x 51.1 cm.)

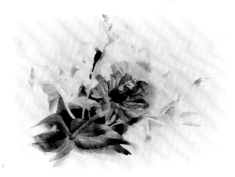

Demuth, *Zinnias and Snapdragons*

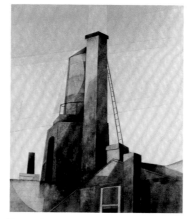

Demuth, *Aucassin and Nicolette*

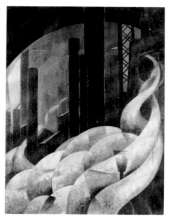

Demuth, *Incense of a New Church*

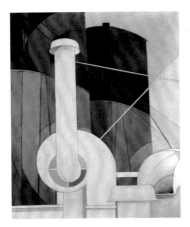

Demuth, *Paquebot "Paris"*

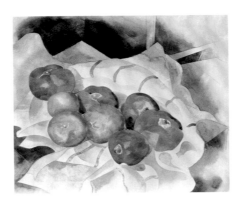

Demuth, *California Tomatoes*

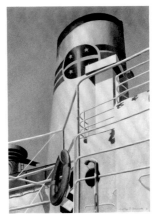

Dennison, *Steamer Stack*

Signed, dated, and inscribed on reverse: C. Demuth
 Lancaster Pa. 1921
Gift of Ferdinand Howald, 1931

Charles Demuth, 1883–1935
Modern Conveniences, 1921 31.137
Oil on canvas, 25¾ x 21⅜ in. (65.4 x 54.3 cm.)
Signed and dated lower left center: C. Demuth 1921
Gift of Ferdinand Howald, 1931
Cat. no. 53

Charles Demuth, 1883–1935
Paquebot "Paris", 1921–1922 31.139
Oil on canvas, 25 x 20 in. (63.5 x 50.8 cm.)
Gift of Ferdinand Howald, 1931

Charles Demuth, 1883–1935
Fruit No. 1, 1922 31.132
Watercolor and graphite on paper, 9¼ x 12¾ in.
 (23.5 x 32.4 cm.)
Signed and dated lower center: C. Demuth/1922
Gift of Ferdinand Howald, 1931

Charles Demuth, 1883–1935
Pears and Plums, 1924 31.140
Watercolor and graphite on paper, 11½ x 17¼ in.
 (29.2 x 43.8 cm.)
Signed, dated, and inscribed lower center:
 C. Demuth—1924—Lancaster
Gift of Ferdinand Howald, 1931

Charles Demuth, 1883–1935
Bowl of Oranges, 1925 31.125
Watercolor on paper, 14 x 20 in. (35.6 x 50.8 cm.)
Signed, dated, and inscribed lower center: Lancaster Pa.
 C. Demuth 1925
Gift of Ferdinand Howald, 1931
Cat. no. 54

Charles Demuth, 1883–1935
California Tomatoes, ca. 1925 31.126

Watercolor on paper, 11½ x 13¾ in. (29.2 x 34.9 cm.)
Gift of Ferdinand Howald, 1931

Charles Demuth, 1883–1935
Still Life No. 1 31.143
Watercolor and graphite on paper, 11¾ x 17¾ in.
 (29.8 x 45.1 cm.)
Gift of Ferdinand Howald, 1931

N. Penney Denning, born 1941
Cloth Construction No. 7708, 1977 77.8
Cloth/mixed media, 13¾ x 19½ in. (35 x 49.5 cm.)
Signed lower right: © Denning
Jean Lamb Hall Memorial Purchase Award from the 67th
 Annual Columbus Art League May Show, 1977

Dorothy Dell Dennison, born 1908
Steamer Stack, 1967 68.27
Oil on canvas, 20 x 14³⁄₁₆ in. (50.8 x 36 cm.)
Signed and dated lower right: Dorothy D. Dennison 67.
 Inscribed on reverse: MAR. 67
Museum Purchase: Howald Fund, 1968

Gertrude Derby, active twentieth century
Studio for Rent 65.30
Charcoal on paper, 17 x 22½ in. (43.2 x 57.1 cm.)
Signed lower right: Derby
Museum Purchase: Howald Fund, 1965

Ann Dewald, born 1930
Beyond the Limit, 1977 77.19
Neon and aluminum, H. 24 in. (60.9 cm.)
Jean Lamb Hall and The Alfred L. Willson Charitable
 Fund of The Columbus Foundation, 1977

Thomas Wilmer Dewing, 1851–1938
Portrait 45.23
Pastel on paper, 15½ x 11½ in. (39.4 x 29.2 cm.)
Signed lower right: T. W. Dewing
Bequest of John R. and Louise Lersch Gobey, 1945

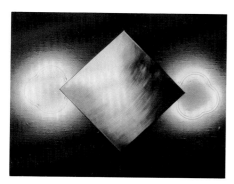
Dewald, *Beyond the Limit*

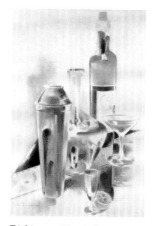
Dickinson, *Hospitality*

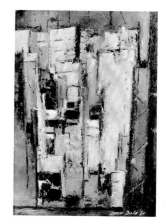
Dodd, *Stone Structures*

Preston Dickinson, 1889–1930
A Bridge, 1918 31.151
Oil on canvas, 20 x 26 in. (50.8 x 66 cm.)
Signed and dated lower right: P. Dickinson '18
Gift of Ferdinand Howald, 1931

Preston Dickinson, 1889–1930
Hillside, 1919 31.155
Watercolor and graphite on paper, 16⅜ x 11 in.
 (41.6 x 27.9 cm.)
Signed and dated lower right: P. Dickinson 19
Gift of Ferdinand Howald, 1931

Preston Dickinson, 1889–1930
Factory, ca. 1920 31.153
Oil on canvas, 29⅞ x 25¼ in. (75.9 x 64.1 cm.)
Signed and dated lower right: P. Dickinson '2[?]
Gift of Ferdinand Howald, 1931
Cat. no. 48

Preston Dickinson, 1889–1930
Grain Elevators, 1924 31.154
Pastel and graphite on paper, 24⅝ x 17¾ in.
 (62.5 x 45.1 cm.)
Signed and dated lower left: Dickinson '24
Gift of Ferdinand Howald, 1931

Preston Dickinson, 1889–1930
Hospitality, 1925 31.157
Pastel on paper, 21¼ x 13½ in. (54 x 34.3 cm.)
Signed lower left: Preston Dickinson
Gift of Ferdinand Howald, 1931

Preston Dickinson, 1889–1930
Still Life with Yellow-Green Chair, 1928 31.164
Oil on canvas, 15 x 21 in. (38.1 x 53.3 cm.)
Signed lower left center: Dickinson
Gift of Ferdinand Howald, 1931
Cat. no. 49

Preston Dickinson, 1889–1930
The Black House 31.150
Watercolor and pastel on paper, 16½ x 10¾ in.
 41.9 x 27.3 cm.)
Signed center right: P. Dickinson
Gift of Ferdinand Howald, 1931

Preston Dickinson, 1889–1930
Outskirts of the City 31.160
Watercolor on paper, 9⅞ x 14⅞ in. (25.1 x 37.8 cm.)
Signed lower left: Preston Dickinson
Gift of Ferdinand Howald, 1931

Preston Dickinson, 1889–1930
Still Life with Vegetables 31.162
Oil on canvas, 20 x 18 in. (50.8 x 46.7 cm.)
Signed lower right: P. Dickinson
Gift of Ferdinand Howald, 1931

Lamar Dodd, born 1909
Stone Structures, 1951 52.19
Oil on canvas, 18 x 12 in. (45.7 x 30.5 cm.)
Signed and dated lower right: Lamar Dodd '51
Museum Purchase: Howald Fund, 1952

Thomas Doughty, 1793–1856
Stenton Hall, Orange County, New Jersey, ca. 1840
Oil on canvas, 26 x 36 in. (66 x 91.4 cm.)
Signed lower right: T DOUGHTY
Gift of Mr. and Mrs. Harry Spiro, 1893

Arthur G. Dove, 1880–1946
Movement No. 1, ca. 1911 31.166
Pastel on canvas, 21⅜ x 18 in. (54.3 x 45.7 cm.)
Gift of Ferdinand Howald, 1931
Cat. no. 36

Arthur G. Dove, 1880–1946
Thunderstorm, 1921 31.167
Oil and metallic paint on canvas, 21½ x 18⅛ in.
 54.6 x 46 cm.)

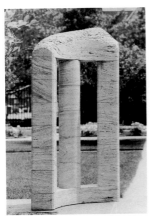

DuVall, *Sunset over Hills*

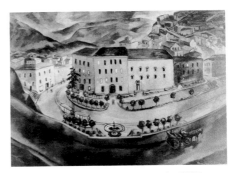

Eastman, *Perugia Looking Down on the Old Town*

Dusenbery, *Lopeglia*

Signed and dated on reverse, center: Dove/1921
Gift of Ferdinand Howald, 1931
Cat. no. 37

Elsie Driggs, born 1898
Cineraria, ca. 1926 31.168
Pastel on paper, 16⅝ x 13⁵⁄₁₆ in. (42.2 x 35.4 cm.)
Signed lower right: Elsie Driggs
Gift of Ferdinand Howald, 1931

Elsie Driggs, born 1898
Illustration for Dante's Inferno, ca. 1932 65.24
Watercolor and graphite on paper, 11¾ x 9⅞ in.
 (29.8 x 25.1 cm.)
Signed lower right: Elsie Driggs
Gift of Robert Schoelkopf Gallery, 1965

Donald Drum, born 1935
Untitled, 1973 75.26
Aluminum with mirror, H. 57 in. (144.8 cm.)
Purchased with funds from the Alfred L. Willson
 Charitable Fund of The Columbus Foundation, 1975

James Dupree, born 1950
Untitled, ca. 1972 72.17
Acrylic on canvas, 58 x 72 in. (147.3 x 182.9 cm.)
Museum Purchase: Howald Fund, 1972

Walter Dusenbery, born 1939
Lopeglia, 1980 81.4
Yellow travertine, H. 89 in. (226.1 cm.)
Given in loving memory of Mr. H. Richard Peterson
 Niehoff by Mrs. H. Richard Peterson Niehoff, H. R.
 Peterson Niehoff, Christopher Will Niehoff, Patricia
 LeVeque Niehoff, and Elsa Will Niehoff, with
 additional assistance from the National Endowment
 for the Arts, 1981

Charles William DuVall, 1865–1966
Landscape, 1911 79.12
Oil on canvas, 16 x 20 in. (40.6 x 50.8 cm.)

Signed and dated lower left: Chas. DuVall—1911
Gift of Dr. and Mrs. Robert H. Magnuson, 1979

Charles William DuVall, 1865–1966
Sunset over Hills, 1928 37.145
Oil on canvas, 27¾ x 36 in. (70.5 x 91.4 cm.)
Signed and dated lower left: Ch. Wm. DuVall—1928
Bequest of Dr. Hervey Williams Whitaker, 1937

Charles William DuVall, 1865–1966
The Glory of the Day, 1928 37.147
Oil on canvas, 28 x 36 in. (71.1 x 91.4 cm.)
Signed lower right: Ch. Wm. DuVall 1928
Bequest of Dr. Hervey Williams Whitaker, 1937

Frank Duveneck, 1848–1919
Sketch for *Reading of Tasso*, ca. 1884 57.26
Oil on canvas, 27⅝ x 39¾ in. (70.2 x 101 cm.)
Gift of Josephine W. Duveneck, 1957

Thomas Eakins, 1844–1916
Weda Cook, 1891[6?] 48.17
Oil on canvas, 24 x 20 in. (61 x 50.8 cm.)
Signed and dated lower right: Eakins/1891[6?].
 Initialed on reverse, lower right: T.E.
Museum Purchase: Howald Fund, 1948
Cat. no. 20

Thomas Eakins, 1844–1916
The Wrestlers, 1899 70.38
Oil on canvas, 48⅜ x 60 in. (122.9 x 152.4 cm.)
Signed and dated upper right: Eakins/1899
Museum Purchase: Derby Fund, 1970
Cat. no. 21

William Joseph Eastman, 1888–1950
Perugia Looking Down on the Old Town 52.49
Oil on canvas, 35¼ x 49⅝ in. (89.5 x 126.1 cm.)
Signed lower right: William Joseph Eastman
Gift of Mabel M. Eastman, 1952

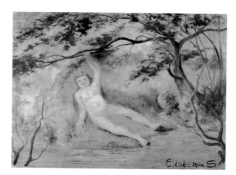

Eilshemius, *Nymph with Pink Scarf*

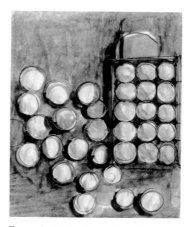

Estes, *Aerial: Loading Red Truck with Oil Drums*

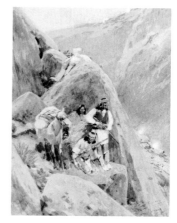

Farny, *Apache Indians in the Mountains*

Levi B. Eberly, 1840–1917
Deer Running 61.25
Ink on paper, 18⅜ x 25⅜ in. (46.7 x 64.5 cm.)
Gift of friend of Alvan Tallmadge, 1961

Louis Michel Eilshemius, 1864–1941
Nymph with Pink Scarf, 1916 64.42
Oil on composition board, 31 x 40¾ in. (78.7 x 103.5 cm.)
Signed lower right: Eilshemius
Gift of Roy R. Neuberger, 1964

Raphael T. Ellender, 1906–1972
Untitled 71.18
Ink on paper, 16¾ x 13⅜ in. (42.5 x 34 cm.)
Signed lower center: Ellender
Gift of the artist, 1971

Dean Ellis, born 1922
Evening, Spain, 1958 59.1
Oil on masonite, 20 x 30 in. (50.8 x 76.2 cm.)
Signed lower right: Dean Ellis
Gift of the American Academy of Arts and Letters: Childe
 Hassam Fund, 1959

Richard Estes, born 1936
Aerial: Loading Red Truck with Oil Drums 84.18
Watercolor on paper, 7¾ x 9½ in. (19.7 x 24.1 cm.)
Gift of Katherine K. Goodman, 1984

De Scott Evans (attributed to), 1847–1898
A New Variety, Try One 76.42.2
Oil on canvas, 12⅛ x 10 in. (30.8 x 25.4 cm.)
Signed lower right: S. S. David
Gift of Dorothy Hubbard Appleton, 1976
Cat. no. 9

Ralph Fabri, 1894–1975
Houses of Bangkok 75.37
Acrylic on panel, 19 x 32 in. (48.3 x 81.3 cm.)
Signed lower left: Ralph Fabri
Gift of Donald Holden, 1975

Alfeo Faggi, 1885–1966
Descent from the Cross, 1942 45.2
Bronze, H. 24½ in. (62.2 cm.)
Signed and dated lower left: A. Faggi/1942
Gift of Sylvia Shaw Judson, 1945

Ralph Fanning, 1889–1971
Building the Art Museum, 1929 72.24
Conté crayon on paper, 14¼ x 11¼ in. (36.2 x 28.6 cm.)
Signed, dated, and inscribed lower right: Building the
 Art Museum/Columbus, O. Nov. 22/29/Ralph Fanning
Gift of the College of the Arts, Ohio State University,
 1972

Henry F. Farny, 1847–1916
Apache Indians in the Mountains, 1895–1898 37.146
Gouache on paper, 21⅞ x 16¼ in. (55.6 x 41.3 cm.)
Signed, dated, and inscribed lower right: To Colonel
 Minor/in friendly remembrance/from/H. F. Farny/95/98
Bequest of Dr. Hervey Williams Whitaker, 1937

Heide Fasnacht, born 1951
Pell Mell II, 1985 86.9
Wood and India ink, H. 58⅝ in. (148.8 cm.)
Purchased with funds made available from the Awards
 in the Visual Arts program, 1986

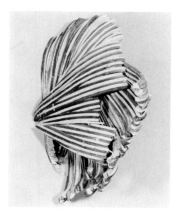

Fasnacht, *Pell Mell II*

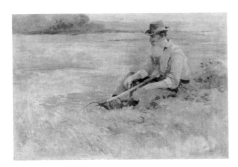

Fauley, *Rest*

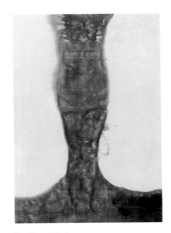

Feeley, *Aludra*

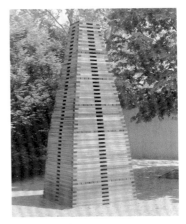

Ferrara, *Breaktower*

Albert C. Fauley, 1858–1919
Rest, 1900 20.15
Oil on canvas, 14 x 20 in. (35.6 x 50.8 cm.)
Signed and dated lower right: Albert C. Fauley/1900
Source unknown, 1920

Albert C. Fauley, 1858–1919
Sail Boat 37.12
Oil on canvas, 20 x 16 in. (50.8 x 40.6 cm.)
Signed lower left: A. C. Fauley
Bequest of Dr. Hervey Williams Whitaker, 1937

Paul Terence Feeley, 1910–1966
Aludra, ca. 1960 85.24.2
Enamel on canvas, 80½ x 55 in. (204.5 x 139.7 cm.)
Gift of the Betty Parsons Foundation, 1985

Paul Terence Feeley, 1910–1966
El 20, 1965 85.24.5
Painted wood, H. 8 in. (20.3 cm.)
Gift of the Betty Parsons Foundation, 1985

Lyonel Feininger, 1871–1956
Blue Coast, 1944 51.13
Oil on canvas, 18 x 34 in. (45.7 x 86.4 cm.)
Signed upper left: Feininger
Museum Purchase: Howald Fund, 1951
Cat. no. 66

Jackie Ferrara, born 1929
Breaktower, 1984 84.1
Cedar, H. 144 in. (365.8 cm.)
Gift of Cardinal Industries, Inc., 1984

E. Loyal Field, 1856–1914
A Day in November 64.29
Oil on canvas, 30 x 25 in. (76.2 x 63.5 cm.)
Signed lower left: E. LOYAL FIELD
Gift of the Hildreth Foundation in memory of
 Mr. and Mrs. Louis R. Hildreth, 1964

Joseph Fitzpatrick, born 1925
The Umbrella, ca. 1964–1965 67.8
Oil on canvas, 54 x 48 in. (137.2 x 121.9 cm.)
Museum Purchase: Howald Fund, 1967

Joseph Fitzpatrick, born 1925
Promenade 70.6
Mixed media, H. 7¾ in. (19.7 cm.)
Signed and inscribed on bottom: Joseph Fitzpatrick/
 Promenade
Museum Purchase: Howald Fund, 1970

Dan Flavin, born 1933
Untitled (to Janie Lee) one, 1971 79.53
Blue, pink, yellow, and green fluorescent light
 (from edition of 5), L. 96 in. (243.8 cm.)
Gift of Mr. and Mrs. William King Westwater, 1979
Cat. no. 78

Helen Frankenthaler, born 1928
Captain's Paradise, 1971 72.27
Acrylic on canvas, 60 x 156 in. (152.4 x 396.2 cm.)
Signed and dated lower left: Frankenthaler '71
Purchased with the aid of funds from the National
 Endowment for the Arts and two anonymous donors,
 1972
Cat. no. 75

Ron Franks, born 1937
Whistle Stop Three, 1971 71.16
Acrylic on canvas, 31¾ x 46 in. (80.6 x 116.8 cm.)
Signed and dated lower right: RON FRANKS 371
Theodore R. Simson Purchase Award, 1971

John Freeman, born 1922
Engine II, 1955 55.59
Oil on composition board, 36 x 24 in. (91.4 x 61 cm.)
Signed lower right: J. Freeman
Purchased with funds from the Alfred L. Willson
 Foundation, 1955

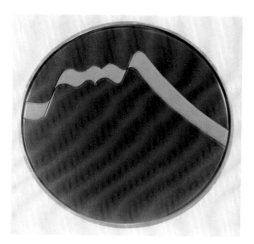

Freeman, *Red Ribbon*

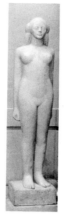

Frey, *Figure of a Girl*

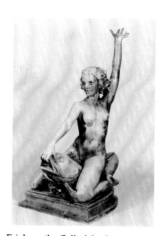

Frishmuth, *Call of the Sea*

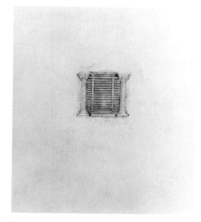

Gagnon, *Her Powers of Observation Were the Key to Her Intellect*

John Freeman, born 1922
Landscape, 1962 63.12
Oil on wood, 24⅝ x 23¾ in. (62.5 x 60.3 cm.)
Museum Purchase: Howald Fund, 1963

John Freeman, born 1922
Intruder, 1966–1967 67.22
Acrylic lacquer and mirror on masonite, 51 x 27½ in.
 (129.5 x 69.8 cm.)
Howald Memorial Purchase Award, 1967

John Freeman, born 1922
Red Ribbon, 1969 70.5
Acrylic lacquer on masonite, D. 16½ in. (41.9 cm.)
Museum Purchase: Howald Fund, 1970

Erwin F. Frey, 1892–1967
Woman with Bird, 1927 73.22
Bronze, H. 35½ in. (90.2 cm.)
Signed and dated on base: E. Frey/1927
Bequest of Gerald Fenton, 1973

Erwin F. Frey, 1892–1967
Resignation, 1939 41.12
Marble, H. 77¼ in. (196.2 cm.)
Museum Purchase: Howald Fund, 1941

Erwin F. Frey, 1892–1967
Christ After the Resurrection, 1945–1955 60.21
Limestone, H. 78 in. (198.1 cm.)
Museum Purchase: Howald Fund, 1960

Erwin F. Frey, 1892–1967
Figure of a Girl, 1946 64.3
Marble, H. 89 in. (226.1 cm.)
Signed and dated on base: Erwin F. Frey/1946
Gift of Gerald B. Fenton, 1964

Erwin F. Frey, 1892–1967
Female Torch Bearer 86.22

Cast plaster, H. 15 in. (38.1 cm.)
Gift of Thomas R. Smith, 1986

Harriet Whitney Frishmuth, 1880–1980
Call of the Sea, 1924 84.4
Bronze, H. 46½ in. (118.1 cm.)
Inscribed on base: ©/Harriet W.Frishmuth.1924./
 GORHAM CO. FOUNDERS
Bequest of Rachel Hanna Fulton Allard, 1984

Sue Fuller, born 1914
Noren-Gai, 1955 59.18
Collage on paper, 18 x 14¾ in. (45.7 x 37.5 cm.)
Signed and dated lower left: Sue Fuller '55
Purchased with funds from the Alfred L. Willson
 Foundation, 1959

Kathleen Gagnon, born 1954
*Her Powers of Observation Were the Key to Her
 Intellect*, 1982 83.19
Plaster relief, 25⅝ x 22¾ in. (65 x 57.7 cm.)
Ferdinand Howald Memorial Purchase Award from the
 73rd Annual Columbus Art League Exhibition, 1983

Albert Eugene Gallatin, 1881–1952
Forms, 1949 53.9
Oil on canvas, 25 x 30 in. (63.5 x 76.2 cm.)
Signed and dated on reverse, upper left: A.E. Gallatin/
 Dec. 1949
Gift of Rose Fried, 1953

Emil Ganso, 1895–1941
Nude Back, 1931 69.13
Crayon on paper, 15 x 19⅞ in. (38.1 x 50.5 cm.)
Signed and dated lower right: Ganso/31/31
Purchased with funds from the Alfred L. Willson
 Foundation, 1969

Henry M. Gasser, 1909–1981
Bluff House 68.26

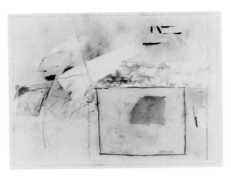

Gatins, *Landscape for a Columbus Summer*

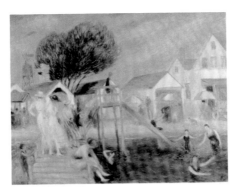

Glackens, *Pier at Blue Point*

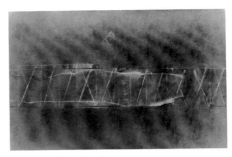

Golfinopoulos, *Number 7*

Watercolor on paper, 21¾ x 29¾ in. (55.2 x 75.6 cm.)
Signed lower right: H. Gasser
Gift of the artist and Grand Central Art Galleries, 1968

Eglé Gatins, born 1950
Landscape for a Columbus Summer, 1974 74.27
Mixed media, 36½ x 48½ in. (92.7 x 125.7 cm.)
Purchased with funds from the Alfred L. Willson
 Charitable Fund of The Columbus Foundation, 1974

Eglé Gatins, born 1950
And Don't Go, 1975 75.30
Collage, 50¼ x 38 in. (127.6 x 98.5 cm.)
Frances Piper Memorial Purchase Award, 1975

Marion T. Gatrell, 1909–1984
Night Watch, 1950 76.7
Oil on masonite, 14½ x 17½ in. (36.8 x 44.5 cm.)
Museum Purchase: Howald Fund, 1976

Marion T. Gatrell, 1909–1984
Corridor No. 2, 1965 66.21
Oil on canvas, 25¾ x 38 in. (65.4 x 96.5 cm.)
Signed lower right: Marion Gatrell
Purchased with funds from the Alfred L. Willson
 Foundation, 1966

Robert M. Gatrell, 1906–1982
View of Bowback Lake, 1952 54.46
Oil on masonite, 26 x 38 in. (66 x 96.5 cm.)
Signed lower right: R. M. Gatrell
Museum Purchase: Howald Fund, 1954

Robert M. Gatrell, 1906–1982
Copse #54, 1967 73.11
Ink on paper, 23¾ x 34 in. (60.3 x 86.4 cm.)
Signed lower right: R. M. Gatrell
Theodore R. Simson Purchase Award, 1973

Dorothy Getz, born 1901
Standing Woman, 1966 66.24
Bronze, H. 8 in. (20.3 cm.)
Purchased with funds from the Alfred L. Willson
 Foundation, 1966

Charles Dana Gibson, 1867–1944
Mark Twain 59.34
Ink on paper, 7⅞ x 5⅞ in. (20 x 14.9 cm.)
Signed lower center: C. D. Gibson
Gift of Ralph L. Appleton and W. E. Benua, 1959

Robert Swain Gifford, 1840–1905
At Anchor, 1875 64.27
Oil on canvas, 24¼ x 18¼ in. (61.6 x 46.4 cm.)
Signed and dated lower right: R. Swain Gifford/1875
Gift of the Hildreth Foundation in memory of
 Mr. and Mrs. Louis R. Hildreth, 1964

William Glackens, 1870–1938
The Riot in Bombay, ca. 1897–1899 68.30
Ink on paper, 17⅛ x 18⅛ in. (43.5 x 46 cm.)
Signed and inscribed lower right: W. J. Glackens/The
 Riot in Bombay
Gift of Mr. and Mrs. James Fullington, 1968

William Glackens, 1870–1938
Pier at Blue Point, 1914 31.171
Oil on canvas, 25⅞ x 32 in. (65.7 x 81.3 cm.)
Signed lower left: W. Glackens
Gift of Ferdinand Howald, 1931

William Glackens, 1870–1938
Beach Scene, New London, 1918 31.170
Oil on canvas, 26 x 31⅞ in. (66 x 81 cm.)
Signed lower left: W. Glackens
Gift of Ferdinand Howald, 1931
Cat. no. 29

William Glackens, 1870–1938
Bathing Near the Bay, 1919 31.169
Oil on canvas, 18 x 23⅞ in. (45.7 x 60.6 cm.)
Signed lower right: W. Glackens
Gift of Ferdinand Howald, 1931

Peter Golfinopoulos, born 1928
Number 7, 1963 75.27
Oil on canvas, 49¾ x 74⅛ in. (37.5 x 190.8 cm.)
Museum Purchase: Howald Fund, 1975

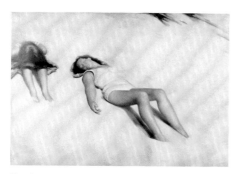

Goodman, *Figures on a Dune*

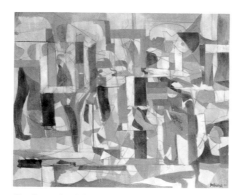

Goodnough, *Subway*

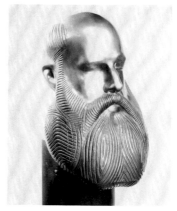

Grausman, *Portrait Bust of Edward Gorey*

Sidney Goodman, born 1936
Figures on a Dune, 1977–1978 86.12.1
Oil on canvas, 58¼ x 80 in. (147.9 x 203.2 cm.)
Signed and dated lower left: Goodman 77– 78
Gift of Arthur J. and Sara Jo Kobacker, 1986

Robert Goodnough, born 1917
Subway, 1959 71.4
Oil on canvas, 59 x 69¾ in. (149.9 x 177.2 cm.)
Signed and dated lower right: Goodnough 59
Museum Purchase: Howald Fund, 1971

J. Jeffrey Grant, 1883–1960
Sea Gulls' Rock, 1921 45.16
Oil on canvas, 30 x 40 in. (76.2 x 101.6 cm.)
Signed and dated lower right: J. JEFFREY GRANT 1921
Bequest of Edward D. and Anna White Jones, 1945

Walter Granville-Smith, 1870–1938
Autumn, 1922 54.50
Watercolor on paper, 11⅝ x 15½ in. (29.5 x 39.4 cm.)
Signed, dated, and inscribed lower left:
 To Mrs. Kirkpatrick / W. Granville-Smith/1922
Gift of Mrs. W. A. Kirkpatrick, 1954

Philip Grausman, born 1935
Portrait Bust of Edward Gorey, 1977 80.8
Bronze, H. 17 in. (43.2 cm.)
Purchased with funds from the Livingston Taylor Family
 and the National Endowment for the Arts, 1980

Philip Grausman, born 1935
Nude Reclining, 1980 86.15
Graphite on paper, 13½ x 20¼ in. (34.3 x 51.4 cm.)
Signed and dated lower left: Grausman/1980
Gift of an anonymous donor, 1986

Morris Graves, born 1910
Duck, 1954 57.40
Ink and wash on paper, 12¾ x 18⅝ in. (32.4 x 47.3 cm.)
Signed and dated lower right: Graves '54
Purchased with funds from the Alfred L. Willson
 Foundation, 1957

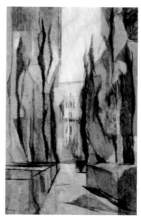

Gray, *Gardens of the Villa
d'Este*

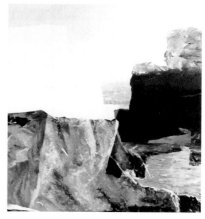

Greene, *Rock Harbor*

Cleve Gray, born 1918
Gardens of the Villa D'Este, 1949 52.31
Oil on canvas, 47¼ x 29½ in. (120 x 74.9 cm.)
Signed and dated lower left: Gray—'49
Museum Purchase: Howald Fund, 1952

Joseph Green (Joseph G. Butler III), 1901–1981
Tortola, 1945 46.56
Watercolor and ink on paper, 13⅝ x 20¾ in.
 (34.6 x 52.7 cm.)
Signed and dated lower left: JOS GREEN/45
Museum Purchase: Howald Fund, 1946

Balcomb Greene, born 1904
Morning Sun, 1970 76.2
Oil on canvas, 62 x 50 in. (157.5 x 127 cm.)
Signed lower right: Balcomb Greene
Anonymous gift, 1976

Balcomb Greene, born 1904
Rock Harbor, 1972 75.52
Oil on canvas, 60 x 54 in. (152.4 x 137.2 cm.)
Museum Purchase: Howald Fund, 1975

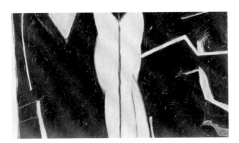
Griffith, *Yellow Legs*

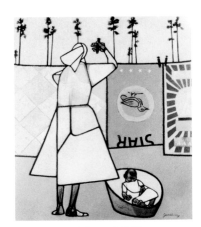
Gwathmey, *Mother and Child*

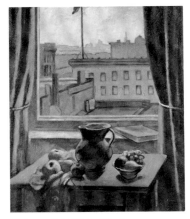
Halpert, *Still Life by Window*

Gertrude Greene, 1911–1956
Composition D, 1948 76.3
Oil on canvas, 40 x 29¾ in. (101.6 x 75.6 cm.)
Gift of Balcomb Greene, 1976

Dennison W. Griffith, born 1952
Yellow Legs, 1983 83.1.1 &.2
Acrylic, enamel, oilstick on canvas, 60¹⁄₁₆ x 96¹⁄₁₆ in.
 (152.6 x 244 cm.)
Signed upper right: Dennison W. Griffith
Bevlyn and Theodore Simson Purchase Award from the
 73rd Annual Columbus Art League Exhibition, 1983

Chaim Gross, born 1904
Happy Mother, 1958 82.2
Bronze (from edition of 6), L. 82 in. (208.2 cm.)
Signed and dated top left of base: Chaim Gross 1958.
 Foundry mark on left side of base: Bedi-Makky Art
 Foundry N.Y.
Gift of Ashland Oil, Inc., 1982
Cat. no. 70

George Grosz, 1893–1959
Group of Figures, ca. 1921 68.3
Ink on paper, 7 x 8½ in. (17.8 x 21.6 cm.)
Signed lower right: Grosz
Museum Purchase: Howald Fund, 1968

Robert Gwathmey, 1903–1988
Mother and Child, 1980 86.12.2
Oil on canvas, 40¼ x 34 in. (102.2 x 86.4 cm.)
Signed bottom right: Gwathmey
Gift of Arthur J. and Sara Jo Kobacker, 1986

Maurice Stewart Hague, 1862–1943
After the Storm 15.1
Oil on canvas, 30 x 40 in. (76.2 x 101.6 cm.)
Signed lower right: Maurice S. Hague
Museum purchase, 1915

Gilbert Hall, born 1926
Birds on a Limb, 1959 60.33

Oil on canvas, 56 x 42¾ in. (142.2 x 108.6 cm.)
Signed and dated lower right: Hall '59
Museum Purchase: Howald Fund, 1960

Samuel Halpert, 1884–1930
Still Life by Window, 1913 70.19
Oil on canvas, 30 x 25 in. (76.2 x 63.5 cm.)
Signed and dated lower right: S. Halpert—13
Museum Purchase: Howald Fund, 1970

Adolfo Halty-Dubé, born 1915
The Fish Eats the Fish 55.11
Oil on masonite, 26 x 44¼ in. (66 x 112.4 cm.)
Signed lower left: Halty
Gift of the artist, 1955

Edward Wilbur Dean Hamilton, 1864–1943
Mrs. Earle C. Derby, 1895 58.39
Watercolor and pastel on paper, 37½ x 23 in.
 (95.2 x 73.7 cm.)
Signed and dated lower left: E.W.D. Hamilton 1895
Gift of Mrs. Earle C. Derby, 1958

Edward Wilbur Dean Hamilton, 1864–1943
Mrs. Earle C. Derby, 1908 58.38
Oil on canvas, 42 x 30 in. (106.7 x 76.2 cm.)
Signed and dated lower right: Wilbur Dean Hamilton/
 1908
Gift of Mrs. Earle C. Derby, 1958

William Michael Harnett, ca. 1848–1892
After the Hunt, 1883 19.1
Oil on canvas, 52½ x 36 in. (133.4 x 91.4 cm.)
Signed with monogram and dated lower left:
 W.M.Harnett/München/1883
Bequest of Francis C. Sessions, 1919
Cat. no. 8

George Overbury "Pop" Hart, 1868–1933
West Indies Market, 1922 63.36
Watercolor on paper, 11⅞ x 14½ in. (30.2 x 36.8 cm.)
Inscribed lower left: West Indies
Museum Purchase: Howald Fund, 1963

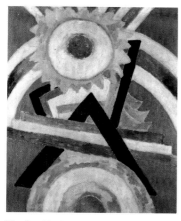

Hartley, *Pre-War Pageant*

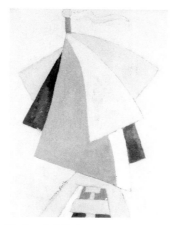

Hartley, *Sail Boat*

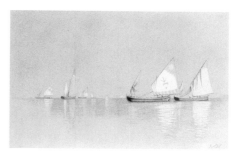

Haseltine, *Venice*

Marsden Hartley, 1877–1943
Cosmos (formerly *The Mountains*), 1908–1909 31.179
Oil on canvas, 30 x 30⅛ in. (76.2 x 76.5 cm.)
Signed lower right: MARSDEN HARTLEY
Gift of Ferdinand Howald, 1931
Cat. no. 39

Marsden Hartley, 1877–1943
New England Farm, ca. 1909–1911 31.181
Oil on panel, 11½ x 11½ in. (29.2 x 29.2 cm.)
Signed lower right: MARSDEN HARTLEY
Gift of Ferdinand Howald, 1931

Marsden Hartley, 1877–1943
The Mountain, Autumn, ca. 1910–1911 31.180
Oil on panel, 11⅝ x 11½ in. (29.5 x 29.2 cm.)
Signed lower right: MARSDEN HARTLEY
Gift of Ferdinand Howald, 1931

Marsden Hartley, 1877–1943
Still Life No. 1, 1912 31.184
Oil on canvas, 31½ x 25⅝ in. (77.5 x 65.1 cm.)
Signed lower left: Marsden Hartley
Gift of Ferdinand Howald, 1931

Marsden Hartley, 1877–1943
Berlin Ante War, 1914 31.173
Oil on canvas with painted wood frame, 41¾ x 34½ in.
 (106 x 87.6 cm.)
Gift of Ferdinand Howald, 1931
Cat. no. 40

Marsden Hartley, 1877–1943
Pre-War Pageant, 1914 31.175
Oil on canvas, 40 x 32 in. (101.6 x 81.3 cm.)
Gift of Ferdinand Howald, 1931

Marsden Hartley, 1877–1943
Sail Boat, ca. 1916 31.183
Oil on pasteboard, 15⅝ x 11½ in. (39.7 x 29.2 cm.)
Signed lower left: Marsden Hartley
Gift of Ferdinand Howald, 1931

Marsden Hartley, 1877–1943
The Blue Cup (or *Color Analogy*), ca. 1918 31.174
Oil on panel, 19¾ x 15⅝ in. (50.2 x 39.7 cm.)
Gift of Ferdinand Howald, 1931

Marsden Hartley, 1877–1943
Lilies in a Vase, ca. 1920 31.178
Oil on pasteboard, 27 x 19⅛ in. (68.6 x 48.6 cm.)
Gift of Ferdinand Howald, 1931

Marsden Hartley, 1877–1943
New Mexico Recollections, 1923 31.182
Oil on canvas, 17½ x 30 in. (44.5 x 76.2 cm.)
Signed, dated, and inscribed on reverse: Recollection
 1923 Marsden Hartley
Gift of Ferdinand Howald, 1931

Marsden Hartley, 1877–1943
The Window, ca. 1924 31.187
Oil on canvas, 35⅝ x 25⅝ in. (90.5 x 65.1 cm.)
Inscribed on reverse, on stretcher: The Window, Marsden
 Hartley
Gift of Ferdinand Howald, 1931

Marsden Hartley, 1877–1943
*The Spent Wave, Indian Point, Georgetown,
 Maine*, 1937–1938 81.13
Oil on academy board, 22½ x 28½ in. (57.1 x 72.4 cm.)
Signed, dated, and inscribed paper label on reverse in
 artist's hand: THE SPENT WAVE/INDIAN POINT/
 GEORGETOWN/MAINE 1937–38/Marsden Hartley
Museum Purchase: Howald Fund II, 1981
Cat. no. 41

William Stanley Haseltine, 1835–1900
Venice 52.8
Watercolor on paper, 11¾ x 18¼ in. (29.8 x 46.4 cm.)
Signed lower right: WSH
Gift of Helen Haseltine Plowden, 1952

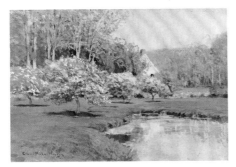

Hayden, *Apple Blossoms, No. 1*

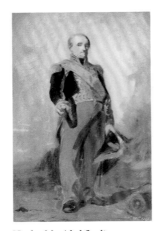

Healy, *Maréchal Soult*

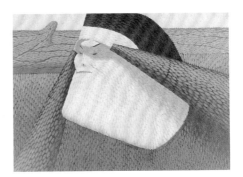

Heimdal, *Scanning the Horizon*

Childe Hassam, 1859–1935
The North Gorge, Appledore, Isles of Shoals, 1912
 [57]43.9
Oil on canvas, 20 x 14 in. (50.8 x 35.6 cm.)
Signed and dated lower right: Childe Hassam 1912
Bequest of Frederick W. Schumacher, 1957
Cat. no. 16

Earl Hassenpflug, born 1926
Setting Sun, ca. 1968 69.5
Charcoal on paper, 29 x 22⅞ in. (73.7 x 58.1 cm.)
Museum Purchase: Howald Fund, 1969

Duayne Hatchett, born 1925
Flight No. 1, 1959 65.38
Bronze, H. 9 in. (22.9 cm.)
Signed on bottom: Duayne Hatchett
Purchased with funds from the Alfred L. Willson
 Foundation, 1965

Duayne Hatchett, born 1925
Flight No. 2, ca. 1964 65.39
Bronze, H. 7¾ in. (19.7 cm.)
Signed on bottom: Duayne Hatchett
Purchased with funds from the Alfred L. Willson
 Foundation, 1965

William Hawkins, born 1895
Red Dog Running III, 1986 86.24
Oil on board, 48 x 60 in. (121.9 x 152.4 cm.)
Gift of an anonymous donor, 1986

Edward Parker Hayden, 1858–1921
Apple Blossoms, No. 1, 1899 76.42.6
Watercolor on paper, 14 x 19 in. (35.6 x 48.3 cm.)
Signed lower left: Edward Parker Hayden 99
Gift of Dorothy Hubbard Appleton, 1976

Edward Parker Hayden, 1858–1921
The Coming Storm, 1914 64.32
Oil on canvas, 18 x 24⅛ in. (45.7 x 61.3 cm.)

Signed and dated lower left: E. P. Hayden/1914
Gift of Eleanor Hayden MacLean, 1964

Edward Parker Hayden, 1858–1921
Landscape 76.42.8
Oil on panel, 7⅞ x 13¹/₁₆ in. (20 x 33.2 cm.)
Gift of Dorothy Hubbard Appleton, 1976

Edward Parker Hayden, 1858–1921
Landscape 76.42.7
Watercolor on paper, 12⅞ x 19⅛ in. (32.7 x 48.6 cm.)
Signed lower left: Edward Parker Hayden
Gift of Dorothy Hubbard Appleton, 1976

David Hayes, born 1931
Centaur, 1973 74.35
Steel, H. 135 in. (343 cm.)
Signed and dated on rear leg: Hayes 1973
Purchased with the aid of funds from the National
 Endowment for the Arts and the Women's Board
 of the Columbus Gallery of Fine Arts, 1974

David Hayes, born 1931
Fisher's Island, 1974 74.36
Gouache on paper, 30 x 22¼ in. (76.2 x 56.5 cm.)
Signed and dated lower right: David Hayes 1974
Gift of the artist, 1974

David Hayes, born 1931
Drawing for Landscape Sculpture, 1980 81.8
Ink and gouache on paper, 22¼ x 30 in. (56.5 x 76.2 cm.)
Signed and dated lower right: David Hayes 1980
Gift of the artist, 1981

Martin Johnson Heade, 1819–1904
Marsh Scene: Two Cattle in a Field, 1869 80.2
Oil on canvas, 14⅜ x 30¼ in. (36.5 x 76.8 cm.)
Signed and dated lower right: M/Heade · 69
Acquired through exchange: Bequest of J. Willard Loos,
 1980
Cat. no. 6

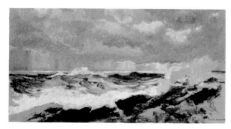

Hekking, *Winter Seas at Lobster Cove, Monhegan Island, Maine*

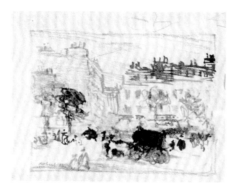

Henri, *Street in Paris*

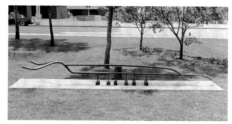

Herndon, *I-690*

George P. A. Healy, 1813–1894
Maréchal Soult, 1840 62.85
Oil on panel, 21¾ x 14 in. (54.9 x 35.6 cm.)
Dated lower right: Sept. 25th 1840
Museum Purchase: Schumacher Fund, 1962

Erwin F. Hebner, born 1926
Singer, 1961 62.65
Ink on paper, 17½ x 23⅜ in. (44.5 x 59.4 cm.)
Signed and dated lower center: Hebner/'61
Museum Purchase: Howald Fund, 1962

Georg Heimdal, born 1943
Scanning the Horizon, 1985 85.26
Acrylic on canvas, 36 x 48 in. (91.4 x 121.9 cm.)
Ferdinand Howald Memorial Purchase Award from the
 75th Annual Columbus Art League Exhibition, 1985

Wilmot Emerton Heitland, 1893–1969
Quince Street 57.3
Watercolor on paper, 21¼ x 29¼ in. (54 x 74.3 cm.)
Signed lower right: Heitland
Gift of the National Academy of Design: Ranger Fund,
 1957

William M. Hekking, 1885–1970
Winter Seas at Lobster Cove, Monhegan Island, Maine
 67.17
Oil on masonite, 23⅞ x 42 in. (60.6 x 106.7 cm.)
Signed lower right: Wm. M. Hekking
Museum Purchase: Howald Fund, 1967

John Edward Heliker, born 1909
Sketching 71.17
Watercolor and graphite on paper, 7⅜ x 11 in.
 (18.7 x 27.9 cm.)
Signed lower center: Heliker
Museum Purchase: Howald Fund, 1971

Robert Henri, 1865–1929
Street in Paris, 1894 61.31

Ink on paper, 4½ x 5½ in. (11.4 x 14 cm.)
Signed lower left: Robert Henri
Museum Purchase: Howald Fund, 1961

Robert Henri, 1865–1929
Miss Jesseca Penn, 1907 71.3
Oil on canvas, 32 x 26 in. (81.3 x 66 cm.)
Museum Purchase: Howald Fund, 1971

Robert Henri, 1865–1929
Dancer in a Yellow Shawl, ca. 1908 10.2
Oil on canvas, 42 x 33½ in. (106.7 x 85.1 cm.)
Signed lower left center: Robert Henri
Museum purchase, 1910
Cat. no. 23

Robert Henri, 1865–1929
Self-Portrait 62.84
Graphite on paper, 8⅞ x 5½ in. (22.5 x 14 cm.)
Museum Purchase: Howald Fund, 1962

Robert Henri, 1865–1929
Sketch of a Girl 66.38
Ink on paper, 10 x 8 in. (25.4 x 20.3 cm.)
Inscribed lower right by executor of the artist's estate:
 Robert Henri/JCL [John C. LeClair]
Museum Purchase: Howald Fund, 1966

Carolyn Herbert, active twentieth century
Afternoon 46.55
Watercolor on paper, 11¾ x 17⅝ in.
 (29.9 x 44.8 cm.)
Signed lower right: C. Herbert
Museum Purchase: Howald Fund, 1946

Charles Laylin Herndon, born 1947
I-690, 1971 74.11
Iron, L. 144 in. (365.8 cm.)
Purchased with funds from the Alfred L. Willson
 Charitable Fund of The Columbus Foundation, 1974

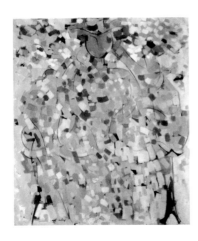

Horwood, *Phonograph*

Holty, *Figure*

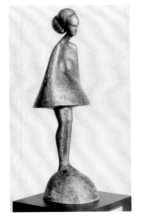

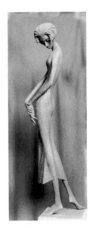

Hostetler, *Standing Woman* Iselin, *Eve*

Richard A. Hickham, born 1944
Tribute to Genet, 1969 71.20
Graphite on paper, 24 x 36 in. (61 x 91.4 cm.)
Signed and dated lower right: Richard A. Hickham 69
Museum Purchase: Howald Fund, 1971

Adrienne Hoard, born 1949
Blue Nun, 1978 80.30
Acrylic on canvas, 48 x 96 in. (121.9 x 243.8 cm.)
Signed and dated top center: a.w. hoard 1978
Gift of the artist, 1980

Carl Holty, 1900–1973
Figure, 1948 73.10.1
Oil on masonite, 47¾ x 39¾ in. (121.3 x 101 cm.)
Signed lower left: Carl Holty. Signed, dated, and
 inscribed on reverse: Carl Holty—1948—Athens
 Georgia/—Figure—
Gift of Lewis Galantiére in memory of Nancy Galantiére,
 1973

Carl Holty, 1900–1973
Violet and Green Study, 1957 73.10.2
Oil on canvas, 18 x 32 in. (45.7 x 81.3 cm.)
Signed, dated, and inscribed on reverse, upper left:
 Carl Holty—57/Violet and Green Study
Gift of Lewis Galantiére in memory of Nancy Galantiére,
 1973

Winslow Homer, 1836–1910
Haymaking, 1864 42.83
Oil on canvas, 16 x 11 in. (40.6 x 27.9 cm.)
Signed and dated lower left: Homer/64
Museum Purchase: Howald Fund, 1942
Cat. no. 1

Winslow Homer, 1836–1910
Girl in the Orchard, 1874 48.10
Oil on canvas, 15⅝ x 22⅝ in. (39.7 x 57.5 cm.)
Signed and dated lower right: Winslow Homer 1874.

Inscribed upper left on stretcher frame: Winslow
 Homer/51 W 10th/N.Y.
Museum Purchase: Howald Fund, 1948
Cat. no. 2

James R. Hopkins, 1877–1969
Seated Nude, ca. 1915 72.46
Oil on canvas, 26 x 31¾ in. (66 x 80.7 cm.)
Signed lower left: James R. Hopkins
Museum Purchase: Howald Fund, 1972

Stella Ruth Hopkins, active twentieth century
Battle of Manila Bay 42.88
Oil on canvas, 22⅛ x 48 in. (56.2 x 121.9 cm.)
Signed lower right: S.R.H.
Gift of Walter W. Hamilton, 1942

Edward Hopper, 1882–1967
Morning Sun, 1952 54.31
Oil on canvas, 28⅛ x 40⅛ in. (71.4 x 101.9 cm.)
Signed lower right: Edward Hopper
Museum Purchase: Howald Fund, 1954
Cat. no. 67

Robert Horwood, ca. 1900–1955
Phonograph, ca. 1925 85.21
Oil on canvas, 8 x 15 in. (20.3 x 38.1 cm.)
Signed bottom left: Horwood
Gift of the Salander-O'Reilly Galleries, 1985

David Hostetler, born 1926
Standing Woman, ca. 1974 80.31
Bronze, H. 28 in. (71.1 cm.)
Inscribed on right of base: D. Hostetler
Gift of Mr. and Mrs. David J. Baker, 1980

Anna Hyatt Huntington, 1876–1973
Yawning Panther 38.22
Bronze, H. 8⅜ in. (21.3 cm.)
Gift of the artist, 1938

Jenkins, *Phenomena: Hoisting the Colors*

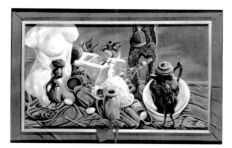

Johnson, *Still Life with Torso*

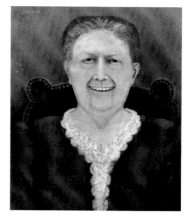

Kane, *Portrait of Maggie*

Peter Hurd, 1903–1984
Festival of San Patricio, 1966 67.4
Watercolor on paper, 24 x 38¾ in. (61 x 98.4 cm.)
Museum Purchase: Howald Fund, 1967

George Inness, 1825–1894
The Pasture, 1864 54.36
Oil on canvas, 11½ x 17½ in. (29.2 x 44.5 cm.)
Signed and dated lower right: G. Inness 1864
Bequest of Virginia H. Jones, 1954
Cat. no. 3

George Inness, 1825–1894
Shower on the Delaware River, 1891 54.2
Oil on canvas, 30¼ x 45⅛ in. (76.8 x 114.6 cm.)
Signed and dated lower right: G. Inness 1891
Museum Purchase: Howald Fund, 1954
Cat. no. 4

Lewis Iselin, born 1913
Dorothy Sefton, 1958 60.32
Bronze, H. 14½ in. (36.8 cm.)
Museum Purchase: Howald Fund, 1960

Lewis Iselin, born 1913
Eve, 1959 64.1
Bronze, H. 72 in. (182.9 cm.)
Signed on base: L. Iselin
Gift of the artist, 1964

Karl Jaeger, born 1930
Astrid J 65.32
Plexiglas and wood light box, 22 x 36 in. (55.9 x 66 cm.)
Museum Purchase: Howald Fund, 1965

Henrietta Lewis Jamison, 1862–1895
The Lanterns 50.36
Oil on canvas, 16 x 12¾ in. (40.6 x 32.4 cm.)
Signed lower left: H. L. Jamison
Bequest of Effie Duncan, 1950

Paul Jenkins, born 1923
Phenomena: Hoisting the Colors, 1973 74.28
Acrylic on canvas, 76 x 141 in. (193 x 358.1 cm.)
Purchased with the aid of funds from the National
 Endowment for the Arts and the Women's Board of
 The Columbus Gallery of Fine Arts, 1974

John Christen Johansen, 1876–1964
Interior with Figures, 1921 24.2
Oil on canvas, 30 x 35 in. (76.2 x 88.9 cm.)
Signed and dated lower left: J. C. Johansen 1921
Gift of the National Academy of Design: Ranger Fund,
 1924

Carlyle D. Johnson, born 1950
Adinka Landscape Assemblage #2, ca. 1977 77.6
Acrylic on canvas, 23½ x 17½ in. (59.7 x 44.5 cm.)
Jean Lamb Hall Memorial Purchase Award from the 67th
 Annual Columbus Art League May Show, 1977

Roman Johnson, born 1917
Still Life with Torso, 1976 77.10
Oil on canvas, 29½ x 49⅝ in. (74.9 x 126 cm.)
Signed upper right: ROMAN.76
Gift of Mrs. Ursel White Lewis, 1977

Murray Jones, 1915–1964
Nara I, 1961 64.34
Lacquer collage on masonite, 47¼ x 51¼ in.
 (120 x 130.2 cm.)
Signed and dated on reverse, center: Murray Jones 1961
Gift of the Roy R. & Marie S. Neuberger Foundation and
 funds from the Alfred L. Willson Foundation, 1964

Juris A. Kakis, born 1938
Orangeman, 1970 70.27
Acrylic on canvas, 60 x 48 in. (152.4 x 121.9 cm.)
Theodore R. Simson Purchase Award, 1970

John Kane, 1860–1934
Portrait of Maggie, ca. 1929 80.23

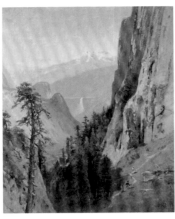

Keith, *Yosemite Valley*

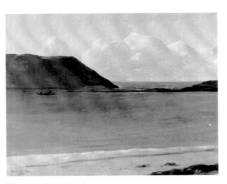

Kent, *Pollock Seining*

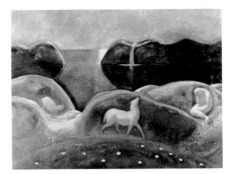

Kent, *Pastoral*

Oil on canvas, 23 x 19⁵⁄₁₆ in. (58.4 x 49.1 cm.)
Signed upper left: John Kane
Museum Purchase: Howald Fund II, 1980

William Keith, 1839–1911
Yosemite Valley, 1882 19.7
Oil on canvas, 30 x 24½ in. (76.2 x 62.2 cm.)
Signed and dated lower right: W. Keith/82
Bequest of Francis C. Sessions, 1919

Rockwell Kent, 1882–1971
Pollock Seining, 1907 31.193
Oil on canvas, 34⅛ x 43⅞ in. (86.7 x 111.4 cm.)
Signed and dated lower left: Rockwell Kent/1907
Gift of Ferdinand Howald, 1931

Rockwell Kent, 1882–1971
Men and Mountains, 1909 31.190
Oil on canvas, 33 x 43¼ in. (83.8 x 109.9 cm.)
Signed and dated lower left: ROCKWELL KENT 1909
Gift of Ferdinand Howald, 1931
Cat. no. 33

Rockwell Kent, 1882–1971
Pastoral, 1914 31.192
Oil on canvas, 33 x 43½ in. (83.8 x 110.5 cm.)
Signed, dated, and inscribed lower right: Rockwell
 Kent—Newfoundland—1914
Gift of Ferdinand Howald, 1931

Rockwell Kent, 1882–1971
Newfoundland Ice, 1915 31.191
Oil on panel, 11⅞ x 16 in. (30.2 x 40.6 cm.)
Signed and dated lower right: Rockwell Kent 1915
Gift of Ferdinand Howald, 1931

Rockwell Kent, 1882–1971
Angel, ca. 1918 31.189
Oil on glass, 7½ x 9⅝ in. (19.1 x 24.5 cm.)
Gift of Ferdinand Howald, 1931

Rockwell Kent, 1882–1971
Maid and Bird, ca. 1918 31.188
Oil on glass, 9⅝ x 7⅜ in. (24.5 x 18.7 cm.)
Gift of Ferdinand Howald, 1931

Michael Kessler, born 1954
The Nagual's Time, 1985 86.10
Oil on canvas, 67 x 86 in. (170.2 x 218.4 cm.)
Purchased with funds made available from the Awards
 in the Visual Arts program, 1986

Hal Kinder, active twentieth century
A Wet Day at Allen's Cove 61.104
Watercolor on paper, 20¼ x 27½ in. (51.4 x 69.9 cm.)
Signed lower right: Kinder [with illegible markings]
Museum Purchase: Howald Fund, 1961

Robert D. King, born 1915
Dawn, 1960 62.64
Ink and wash on paper, 21¾ x 26¾ in. (55.2 x 67.9 cm.)
Signed lower left: R. King
Howald Memorial Purchase Award, 1962

Robert D. King, born 1915
Equals 56.35
Pastel and watercolor on paper, 31⅛ x 25 in.
 (79.1 x 63.5 cm.)
Signed lower left: R. King
Museum Purchase: Howald Fund, 1956

William King, born 1925
Twins, 1973 79.54
Sheet aluminum, H. 144 in. (365.8 cm.)
Given in loving memory of H. Richard Peterson Niehoff
 by Mrs. H. Richard Peterson Niehoff, H. R. Peterson
 Niehoff, Christopher Will Niehoff, Patricia LeVeque
 Niehoff and Elsa Will Niehoff, 1979

Dong Kingman, born 1911
From My Hotel Window, Japan, 1954 58.8

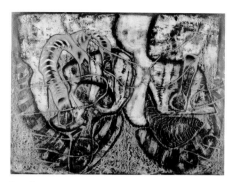

Kessler, *The Nagual's Time*

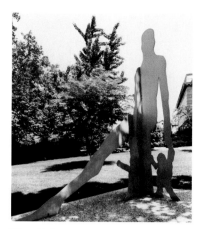

King, *Twins*

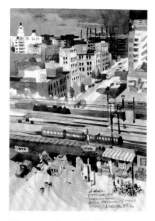

Kingman, *From My Hotel Window, Japan*

Watercolor on paper, 21¾ x 14½ in. (55.3 x 36.8 cm.)
Signed, dated, and inscribed lower right: A sketch/from Room 828/Marimouchi/Hotel Morning of Manis/1954/ Kingman
Purchased with funds from the Alfred L. Willson Foundation, 1958

Mary Kinney, born 1929
Outdoors No. 20, 1974 74.12
Watercolor on paper, 22 x 30 in. (55.9 x 76.2 cm.)
Signed lower right: M. Kinney
Purchased with funds from the Alfred L. Willson Charitable Fund of The Columbus Foundation, 1974

Ray Kinsman-Waters, 1887–1962
Flood Refugees, 1937 37.5
Gouache on paper, 19⅝ x 25 in. (49.9 x 63.5 cm.)
Signed and dated upper left: R. KINSMAN-WATERS/1937
Gift of the Columbus Art League, 1937

Vance Kirkland, 1904–1981
Vibrations of Turquoise on Yellow, 1967 67.49
Oil on canvas, 60 x 60 in. (152.4 x 152.4 cm.)
Signed, dated, and inscribed on reverse, upper center:
 VIBRATIONS OF TURQUOISE ON YELLOW/No. 20 1967/
 60 x 60/VANCE KIRKLAND/(Kirkland)
Museum Purchase: Howald Fund, 1967

Harriet R. Kirkpatrick, 1877–1962
Berchtesgaden 60.55
Watercolor on paper, 12 x 9¹⁄₁₆ in. (30.5 x 23.7 cm.)
Signed lower right: H. Kirkpatrick
Gift of Ernest Zell, 1960

Josephine Klippart, 1848–1936
Tulips 19.54
Oil on canvas, 20 x 27 in. (50.8 x 68.6 cm.)
Signed lower left: Josephine Klippart
Bequest of Francis C. Sessions, 1919

Daniel Ridgway Knight, 1839–1924
The Gathering, 1882 82.14.1
Watercolor on paper, 14¼ x 10 in. (36.2 x 25.4 cm.)
Signed, dated, and inscribed bottom left: D. Ridgway Knight Paris 1882
Gift of Mrs. Leon Watters, in memory of her daughter, Frances Nathan Lazarus, 1982

Daniel Ridgway Knight, 1839–1924
The Water Carrier, 1883 82.14.2

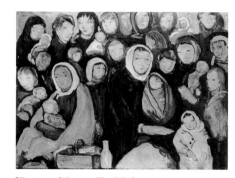

Kinsman-Waters, *Flood Refugees*

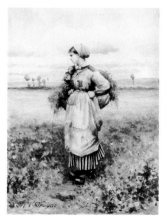

Knight, *The Gathering*

Kohlmeyer, *Symbols 82-1*

Kuehn, *Still Life with Flowers*

Kuhn, *Salt Mists*

Watercolor on paper, 13¾ x 10 in. (35 x 25.4 cm.)
Signed and dated on bottom right: Ridgway Knight 1883
Gift of Mrs. Leon Watters, in memory of her daughter,
 Frances Nathan Lazarus, 1982

Daniel Ridgway Knight, 1839–1924
Village Scene, 1884 (?) 82.14.3
Watercolor on paper, 14 x 10 in. (35.6 x 25.4 cm.)
Signed and dated bottom right: D. Ridgway Knight Paris
 1884[?]
Gift of Mrs. Leon Watters, in memory of her daughter,
 Frances Nathan Lazarus, 1982

Daniel Ridgway Knight, 1839–1924
The Idler 76.42.9
Oil on canvas, 21⅞ x 18⅜ in. (55.6 x 46.7 cm.)
Signed and inscribed lower left: D. Ridgway Knight,
 Paris
Gift of Dorothy Hubbard Appleton, 1976

Ida Kohlmeyer, born 1912
Symbols 82–1, 1982 85.14
Mixed media on canvas, 36 x 35½ in. (91.4 x 90.1 cm.)
Signed and dated bottom right: Kohlmeyer 1982
Gift of Victoria E. Schonfeld, 1985

William Kortlander, born 1925
Shelter, 1963 63.41
Charcoal on paper, 18½ x 24½ in. (47 x 62.2 cm.)
Museum Purchase: Howald Fund, 1963

William Kortlander, born 1925
A Sparrow for Mom, 1964 64.7
Casein on paper, 18 x 24¼ in. (45.7 x 61.6 cm.)
Museum Purchase: Howald Fund, 1964

William Kortlander, born 1925
Study for *A Sparrow for Mom*, 1964 66.26
Graphite on paper, 17¾ x 12 in. (45.1 x 30.5 cm.)
Purchased with funds from the Alfred L. Willson
 Foundation, 1966

Doris Barsky Kreindler, 1901–1974
Hardinger Fjord, ca. 1965 76.38.1
Oil on canvas, 50⅛ x 40⅛ in. (127.2 x 101.9 cm.)
Signed bottom right: Kreindler
Gift of Harry E. Kreindler, 1976

Doris Barsky Kreindler, 1901–1974
St. Maarten Sunset, ca. 1970 76.38.2
Oil on canvas, 41⅞ x 46 in. (106.4 x 116.9 cm.)
Signed bottom right: Kreindler
Gift of Harry E. Kreindler, 1976

Edmund Kuehn, born 1916
Still Life with Flowers, 1939 66.7
Oil on canvas, 20⅛ x 14⅛ in. (51.1 x 35.9 cm.)
Museum Purchase: Howald Fund, 1966

Edmund Kuehn, born 1916
Okinawa No. 1, 1946 47.98
Casein on paper, 14⅜ x 18⅜ in. (36.5 x 46.7 cm.)
Signed, dated, and inscribed lower right: Okinawa '46
 Edmund Kuehn/J.19
Purchased with funds from the Alfred L. Willson
 Foundation, 1947

Edmund Kuehn, born 1916
Okinawa No. 2, 1946 47.99
Casein on paper, 14½ x 19½ in. (36.9 x 49.5 cm.)
Signed, dated, and inscribed lower right: Edmund
 Kuehn '46 / Okinawa F 17
Purchased with funds from the Alfred L. Willson
 Foundation, 1947

Walt Kuhn, 1877–1949
Salt Mists, 1910–1911 83.22
Oil on canvas, 25 x 30 in. (63.5 x 76.2 cm.)
Signed bottom left: Walt Kuhn
Gift in memory of Derrol R. Johnson from his family,
 1983

Kuniyoshi, *Boy Stealing Fruit*

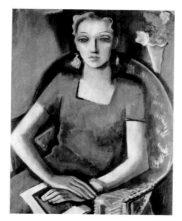

Kutchin, *Girl in Green*

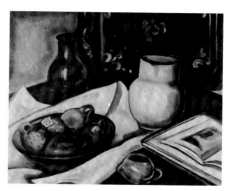

Kutchin, *Still Life*

Walt Kuhn, 1877–1949
Veteran Acrobat, 1938 42.84
Oil on canvas, 24 x 20 in. (61 x 50.8 cm.)
Signed and dated upper right: Walt Kuhn/1938
Purchased by special subscription, 1942
Cat. no. 63

Yasuo Kuniyoshi, 1889–1953
Boy Stealing Fruit, 1923 31.194
Oil on canvas, 20 x 30 in. (50.8 x 76.2 cm.)
Signed and dated lower left: Yasuo Kuniyoshi '23
Gift of Ferdinand Howald, 1931

Yasuo Kuniyoshi, 1889–1953
Cock Calling the Dawn, 1923 31.195
Oil on canvas, 30 x 25 in. (76.2 x 63.5 cm.)
Gift of Ferdinand Howald, 1931

Yasuo Kuniyoshi, 1889–1953
The Swimmer, ca. 1924 31.196
Oil on canvas, 20½ x 30½ in. (52.1 x 77.5 cm.)
Gift of Ferdinand Howald, 1931
Cat. no. 56

Lucius Brown Kutchin, 1901–1936
Portrait of Harriett Evans (nee Heller), ca. 1920 85.15.4
Oil on board, 11 x 9½ in. (27.9 x 24.1 cm.)
Gift of Browne Pavey, 1985

Lucius Brown Kutchin, 1901–1936
Untitled (Pink Surry), ca. 1928 85.15.10
Monotype with pastel, graphite, and watercolor on
 paper, 11 x 16½ in. (27.9 x 41.9 cm.)
Signed bottom right: Lucius Kutchin
Gift of Browne Pavey, 1985

Lucius Brown Kutchin, 1901–1936
Still Life, ca. 1929 85.15.3
Oil on board, 20 x 24 in. (50.8 x 61 cm.)
Signed bottom right: Lucius Kutchin
Gift of Browne Pavey, 1985

Lucius Brown Kutchin, 1901–1936
Girl in Green, ca. 1930 79.84
Oil on panel, 35⅞ x 28 in. (91.2 x 71.1 cm.)
Gift of Miss Stella Milburn, 1979

Lucius Brown Kutchin, 1901–1936
Untitled Portrait, ca. 1930 85.15.7
Monotype with graphite on paper, 14¼ x 10 in.
 (36.2 x 25.4 cm.)
Signed bottom right: Lucius Kutchin
Gift of Browne Pavey, 1985

Lucius Brown Kutchin, 1901–1936
Untitled Portrait, ca. 1930 85.15.8
Monotype with graphite on paper, 13½ x 10 in.
 (34.3 x 25.4 cm.)
Signed bottom right: Lucius Kutchin
Gift of Browne Pavey, 1985

Lucius Brown Kutchin, 1901–1936
Untitled Portrait, ca. 1930 85.15.9
Monotype with pastel on paper, 14 x 10 in.
 (35.6 x 25.4 cm.)
Signed bottom right: L Kutchin
Gift of Browne Pavey, 1985

Lucius Brown Kutchin, 1901–1936
Mother and Child, ca. 1932 55.7
Oil on masonite, 36 x 28 in. (91.4 x 71.1 cm.)
Signed lower right: Lucius Kutchin
Gift of Harriet Kirkpatrick, 1955

Lucius Brown Kutchin, 1901–1936
Girl in Cafe, ca. 1935 70.41
Oil on canvas, 32¼ x 30¼ in. (81.9 x 76.8 cm.)
Signed lower right: Lucius Kutchin
Museum Purchase: Howald Fund, 1970

Lucius Brown Kutchin, 1901–1936
Boy with Guitar—Santa Fe, 1936 37.23

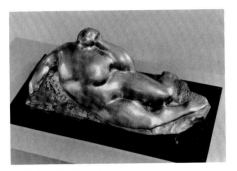

Lachaise, *The Mountain*

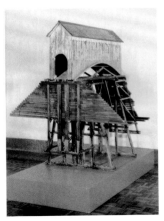

Lamie, *Everybody Needs Going Out*

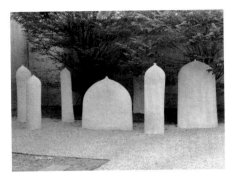

La Verdiere, *Memorial*

Oil on composition board, 38 x 29¼ in. (96.5 x 74.3 cm.)
Signed and dated lower right: Lucius Kutchin — 36
Gift of Mrs. E. Louise Kutchin, 1937

Lucius Brown Kutchin, 1901–1936
Still Life　47.82
Oil on canvas, 36⅝ x 34½ in. (93 x 87.6 cm.)
Signed lower right: Lucius Kutchin
Gift of Mrs. E. Louise Kutchin, 1947

Gaston Lachaise, 1886–1935
The Mountain, 1924　83.13
Bronze, H. 7¹⁵⁄₁₆ in. (20.8 cm.)
Inscribed on reverse: LACHAISE ESTATE 9/11
Museum Purchase: Bequest of George S. McElroy, 1983

John La Farge, 1835–1910
Girl in Grass Dress (Seated Samoan Girl), 1890　66.39
Oil on panel, 12 x 10 in. (30.5 x 25.4 cm.)
Museum Purchase: Schumacher Fund, 1966
Cat. no. 13

Mabel La Farge, 1875–1944
Water Lilies　86.16
Watercolor on paper, 9¼ x 10¼ in. (23.5 x 26 cm.)
Signed bottom right: Mabel La Farge
Gift of Coe Kerr Gallery in honor of Budd Harris Bishop, 1986

Richard Lahey, 1893–1978
A Summer in Ogunquit, 1961　63.18
Oil on masonite, 45¼ x 72 in. (114.9 x 182.9 cm.)
Signed upper right: Richard Lahey
Museum Purchase: Howald Fund, 1963

William W. Lamb, Jr., born 1934
Untitled, 1966　66.23
Steel, H. 78 in. (198.1 cm.)
Howald Memorial Purchase Award, 1966

Philip Lamie, born 1960
Everybody Needs Going Out　86.20

Wood, H. 62 in. (157.5 cm.)
Ferdinand Howald Memorial Purchase Award from the
76th Annual Columbus Art League Exhibition, 1986

Bruno La Verdiere, born 1937
Memorial, 1972–1974　80.18.1-.7
Stoneware, largest piece H. 57½ in. (146.1 cm.)
Purchased with funds from the Alfred L. Willson
Charitable Fund of The Columbus Foundation and the
National Endowment for the Arts, 1980

Ernest Lawson, 1873–1939
Hills at Inwood, 1914　31.200
Oil on canvas, 36 x 50 in. (91.4 x 127 cm.)
Signed and dated lower right: E. Lawson/1914
Gift of Ferdinand Howald, 1931

Ernest Lawson, 1873–1939
Cathedral Heights, ca. 1915　31.198
Oil on canvas, 25⅜ x 30¼ in. (64.5 x 76.8 cm.)
Signed lower left: E. Lawson
Gift of Ferdinand Howald, 1931

Ernest Lawson, 1873–1939
The Hudson at Inwood　31.201
Oil on canvas, 30 x 40 in. (76.2 x 101.6 cm.)
Signed lower right: E. Lawson
Gift of Ferdinand Howald, 1931
Cat. no. 26

Rico Lebrun, 1900–1964
Centurion's Horse, 1948　53.8
Oil on canvas, 80 x 36 in. (203.2 x 91.4 cm.)
Signed and dated lower left: Lebrun 1948
Museum Purchase: Howald Fund, 1953

Rico Lebrun, 1900–1964
Crucifixion Series, 1948　81.11.2
Ink on paper, 18¼ x 24⅞ in. (46.4 x 63.2 cm.)
Signed and dated upper right: Lebrun 1948
Gift of Regina Kobacker Fadiman, 1981

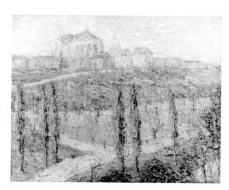

Lawson, *Cathedral Heights*

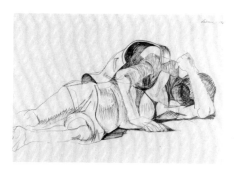

Lebrun, *Crucifixion Series*

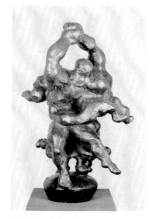

Lipchitz, *The Dance*

Doris Leeper, born 1929
Sculptural Shapes: 6, 1978 81.10.2
Oil and graphite on paper, 13 x 13 in. (33 x 33 cm.)
Signed in pencil (twice) upper left: D. Leeper
Gift of the American Academy and Institute of Arts and
 Letters, Hassam and Speicher Purchase Fund, 1981

Doris Leeper, born 1929
Sculptural Shapes: 7, 1978 81.10.1
Oil on paper, D. 15⅜ in. (39.1 cm.)
Signed in pencil along lower center edge: Leeper
Gift of the American Academy and Institute of Arts and
 Letters, Hassam and Speicher Purchase Fund, 1981

Norbert Lenz, born 1900
Untitled 85.5.1
Pencil, India ink, and colored pencil on paper,
 7¾ x 9¾ in. (19.7 x 24.7 cm.)
Signed top left: Norbert Lenz
Gift of Mr. Joseph Erdelac, 1985

David Levine, born 1926
Auguste Rodin, 1965 66.43
Ink on paper, 14 x 11 in. (35.6 x 27.9 cm.)
Signed and dated lower right: D. Levine '65
Museum Purchase: Howald Fund, 1966

David Levine, born 1926
Susan Sontag, 1966 66.44
Ink on paper, 13⅝ x 11 in. (34.6 x 27.9 cm.)
Signed and dated lower right: D. Levine '66
Museum Purchase: Howald Fund, 1966

Jack Levine, born 1915
The Trial (study), 1953–1954 54.50
Oil on canvas, 40 x 36 in. (101.6 x 91.4 cm.)
Signed lower left: J. Levine
Museum Purchase: Howald Fund, 1954

Jack Levine, born 1915
The Judgement of Paris (study), 1963 63.39

Ink on paper, 11¼ x 16¾ in. (28.6 x 42.5 cm.)
Signed lower left: J Levine
Museum Purchase: Howald Fund, 1963

Victor Liguori, born 1931
Descent, 1962 62.87
Oil on canvas, 72 x 53¾ in. (182.9 x 136.5 cm.)
Signed lower right: V. Liguori
Purchased with funds from the Alfred L. Willson
 Foundation, 1962

Jacques Lipchitz, 1891–1973
The Dance, 1936 79.76
Bronze, H. 41 in. (104.1 cm.)
Signed on base: J. Lipchitz
Given in memory of E. Paul Messham by his daughter
 Paula Messham Watkins, 1979

Dotti Lipetz, born 1922
Through the Back Door, 1956 56.32
Gouache on paper, 29 x 17¾ in. (73.7 x 45.1 cm.)
Signed and dated center left: Dotti '56
Museum Purchase: Howald Fund, 1956

Seymour Lipton, 1903–1987
Tower of Music 85.24.6
Bronze, H. 10½ in. (26.7 cm.)
Gift of the Betty Parsons Foundation, 1985

Simon Lissim, 1900–1981
The Yellow Sultan, 1939 76.12
Gouache on paper, 39⅜ x 28 in. (100 x 71.1 cm.)
Signed and dated lower right: Simon Lissim, 1939
Museum Purchase: Howald Fund, 1976

Edgar Littlefield, 1905–1970
Pisces, 1936 36.37
Stoneware, H. 10¼ in. (26 cm.)
Signed under fin: E.L.
Gift of Frederick W. Schumacher, 1936

Littlehale, *Barn Roofs*

Luks, *Gossip*

Luks, *The Harlem River*

Dorothy Moody Littlehale, 1903–1987
Barn Roofs, 1975 75.15
Oil on canvas, 48 x 60 in. (121.9 x 152.4 cm.)
Theodore R. Simson Purchase Award, 1975

George Luks, 1867–1933
Bridge over the Seine, ca. 1900 63.15
Ink on paper, 7½ x 9¾ in. (19 x 24.8 cm.)
Museum Purchase: Howald Fund, 1963

George Luks, 1867–1933
Gossip, 1915 31.204
Pastel and watercolor on board, 13⅜ x 14¾ in.
 (34 x 37.5 cm.)
Signed lower left: George Luks
Gift of Ferdinand Howald, 1931

George Luks, 1867–1933
The Harlem River, 1915 31.205
Pastel and watercolor on paper, 13¾ x 14⅞ in.
 (34.9 x 37.8 cm.)
Signed lower right: George Luks
Gift of Ferdinand Howald, 1931

George Luks, 1867–1933
Playing Soldiers, 1915 31.206
Pastel and watercolor on paper, 13½ x 14⅜ in.
 (34.3 x 36.5 cm.)
Signed lower right: George Luks
Gift of Ferdinand Howald, 1931

George Luks, 1867–1933
Eugene Higgins, ca. 1915 73.34
Oil on canvas, 30 x 25 in. (76.2 x 61 cm.)
Signed lower right: George Luks
Gift of Norman Hirschl, 1973

George Luks, 1867–1933
Heavy Load 61.32
Lithographic crayon on paper, 6⅜ x 10¼ in.
 (16.2 x 26 cm.)
Signed and inscribed lower left:
 To Mrs. Buckner/ George Luks
Museum Purchase: Howald Fund, 1961

August F. Lundberg, 1878–1928
Self-Portrait, 1917 73.15
Oil on canvas, 40 x 30 in. (101.6 x 76.2 cm.)
Signed and dated lower center: A. F. Lundberg, 1917
Museum Purchase: Howald Fund, 1973

Stanton Macdonald-Wright, 1890–1973
Still Life No. 2, 1917 31.277
Watercolor on paper, 12½ x 15⅜ in. (31.8 x 39.1 cm.)
Signed, dated, and inscribed lower right: S. Macdonald
 Wright/New York 1917
Gift of Ferdinand Howald, 1931

Stanton Macdonald-Wright, 1890–1973
California Landscape, ca. 1919 31.275
Oil on canvas, 30 x 22⅛ in. (76.2 x 56.2 cm.)
Gift of Ferdinand Howald, 1931
Cat. no. 47

Stanton Macdonald-Wright, 1890–1973
Still Life No. 1 31.276
Oil on pasteboard, 16 x 20 in. (40.6 x 50.8 cm.)
Signed upper right: S Macdonald Wright
Gift of Ferdinand Howald, 1931

Reino Mackie, born 1913
Untitled (Head) 37.149
Wood, H. 15¹⁵⁄₁₆ in. (40.5 cm.)
Source unknown

Alan Magee, born 1947
Three Envelopes, 1982 82.9
Watercolor and colored pencil on paper, 20¾ x 18⅛ in.
 (52.7 x 46 cm.)
Signed lower right: Alan Magee
Purchased with funds from the Alfred L. Willson
 Charitable Fund of The Columbus Foundation, 1982

Benjamin Lee Mahmoud, born 1935
Seated Personage, 1960 60.61
Oil on canvas, 60 x 50 in. (152.4 x 127 cm.)
Signed and dated upper left: Mahmoud 2/60. Signed and
 inscribed on reverse, upper left: 6.7–6–5/Mahmoud.
 Inscribed on reverse, upper right: Seated Personage

Lundberg, *Self-Portrait*

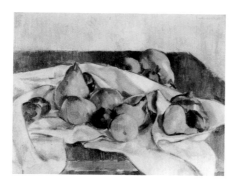

Macdonald-Wright, *Still Life No. 1*

Magee, *Three Envelopes*

Purchased with funds from the Alfred L. Willson
Foundation, 1960

Edward Middleton Manigault, 1887–1922
The Rocket, 1909 81.9
Oil on canvas, 20 x 24 in. (50.8 x 61 cm.)
Signed and dated lower left: Manigault 09
Museum Purchase: Howald Fund II, 1981
Cat. no. 34

Edward Middleton Manigault, 1887–1922
Procession, 1911 31.208
Oil on canvas, 20 x 24 in. (50.8 x 61 cm.)
Signed and dated lower right: Manigault 1911
Gift of Ferdinand Howald, 1931
Cat. no. 35

Edward Middleton Manigault, 1887–1922
Nude, 1913 70.33
Graphite on paper, 11¼ x 8¾ in. (28.6 x 22.2 cm.)
Signed and dated lower left: Manigault/1913
Purchased with funds from the Alfred L. Willson
Foundation, 1970

Man Ray, 1890–1976
Still Life No. 1, 1913 31.257
Oil on canvas, 18 x 24 in. (45.7 x 61 cm.)
Signed and dated lower right: Man Ray 1913
Gift of Ferdinand Howald, 1931

Man Ray, 1890–1976
Madonna, 1914 31.255
Oil on canvas, 20⅛ x 16⅛ in. (51.1 x 41 cm.)
Signed lower left: Man Ray. Inscribed upper left to right:
 IN/ANNO D MCMXIV
Gift of Ferdinand Howald, 1931

Man Ray, 1890–1976
Still Life No. 3, 1914 31.259
Oil on canvas, 10⅛ x 8⅛ in. (25.7 x 20.6 cm.)
Signed and dated lower left: Man Ray/1914
Gift of Ferdinand Howald, 1931

Man Ray, 1890–1976
Jazz, 1919 31.253
Tempera and ink (aerograph) on paper, 28 x 22 in.
 (71.1 x 55.9 cm.)
Gift of Ferdinand Howald, 1931
Cat. no. 43

Man Ray, 1890–1976
Regatta, 1924 31.256
Oil on canvas, 20 x 24¼ in. (50.8 x 62.2 cm.)
Signed and dated lower right: Man Ray 1924
Gift of Ferdinand Howald, 1931
Cat. no. 44

Man Ray, 1890–1976
Le Grand Palais, ca. 1924 31.254
Oil on canvas, 19⅝ x 24 in. (49.8 x 61 cm.)
Gift of Ferdinand Howald, 1931

Man Ray, 1890–1976
Still Life No. 2 31.258
Oil on canvas, 13½ x 9½ in. (34.3 x 24.1 cm.)
Signed upper right: Man Ray
Gift of Ferdinand Howald, 1931

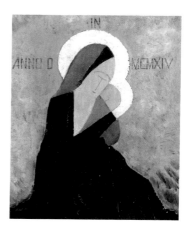

Man Ray, *Madonna*

Paul Manship, 1885–1966
Diana, 1921 80.24
Bronze (cast 7), H. 37½ in. (95.3 cm.)
Inscribed and dated on underside of leaves: Paul
 Manship 1921 ©/No. 7. Foundry stamp on base:
 Roman Bronze Works N.Y.
Museum Purchase: Howald Fund II, 1980
Cat. no. 57

John Marin, 1870–1953
Tyrolean Mountains, 1910 31.234
Watercolor on paper, 14½ x 17¾ in. (36.8 x 45 cm.)
Signed and dated lower left: Marin 10
Gift of Ferdinand Howald, 1931

John Marin, 1870–1953
Summer Foliage, 1913 31.232
Watercolor on paper, 15½ x 18½ in. (39.4 x 47 cm.)
Signed and dated lower right: Marin 13
Gift of Ferdinand Howald, 1931

John Marin, 1870–1953
Landscape, 1914 31.219
Watercolor on paper, 18½ x 16 in. (47 x 40.6 cm.)
Signed and dated lower left: Marin/14
Gift of Ferdinand Howald, 1931

John Marin, 1870–1953
Seaside, An Interpretation, 1914 31.227
Watercolor and graphite on paper, 15½ x 18½ in.
 (39.4 x 47.3 cm.)
Signed and dated lower left: Marin 14
Gift of Ferdinand Howald, 1931

John Marin, 1870–1953
The Violet Lake, 1915 31.235
Watercolor on paper, 15½ x 18⅝ in. (39.4 x 47.3 cm.)
Signed and dated lower left: Marin 15
Gift of Ferdinand Howald, 1931

John Marin, 1870–1953
Breakers, Maine Coast, 1917 31.211
Watercolor on paper, 15⅞ x 18⅝ in. (40.3 x 47.3 cm.)
Signed and dated lower right: Marin/17
Gift of Ferdinand Howald, 1931

John Marin, 1870–1953
Study of the Sea, 1917 31.231
Watercolor and charcoal on paper, 16 x 19 in.
 (40.6 x 48.3 cm.)
Signed and dated lower right: Marin/17
Gift of Ferdinand Howald, 1931

John Marin, 1870–1953
Autumn, 1919 31.209
Watercolor on paper, 18¾ x 16 in. (47.6 x 40.6 cm.)
Signed and dated lower left: Marin 19
Gift of Ferdinand Howald, 1931

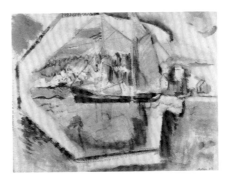

Marin, *Ship, Sea and Sky Forms (An Impression)*

John Marin, 1870–1953
From the Ocean, 1919 31.215
Watercolor and charcoal on paper, 15⅞ x 19 in.
 (40.3 x 48.2 cm.)
Signed and dated lower left: Marin 19
Gift of Ferdinand Howald, 1931

John Marin, 1870–1953
Red Sun, 1919 31.223
Watercolor and charcoal on paper, 16 x 19 in.
 (40.6 x 48.3 cm.)
Signed and dated lower left: Marin 19
Gift of Ferdinand Howald, 1931

John Marin, 1870–1953
Sunset, Maine Coast, ca. 1919 31.233
Watercolor on paper, 15½ x 18½ in. (39.4 x 47 cm.)
Gift of Ferdinand Howald, 1931
Cat. no. 42

John Marin, 1870–1953
Sailboat in Harbor, ca. 1920 31.224
Watercolor on paper, 19 x 16 in. (48.3 x 40.6 cm.)
Gift of Ferdinand Howald, 1931

John Marin, 1870–1953
Off Stonington, 1921 31.228
Watercolor and charcoal on paper, 16 x 19 in.
 (40.6 x 48.3 cm.)
Signed and dated lower right: Marin/21
Gift of Ferdinand Howald, 1931

John Marin, 1870–1953
A Piece of Stonington, 1922 31.222
Watercolor, graphite, and charcoal on paper, 14⅝ x
 17⅜ in. (36.9 x 44.1 cm.)
Signed and dated lower right: Marin 22
Gift of Ferdinand Howald, 1931

John Marin, 1870–1953
A Study on Sand Island, 1922 31.230
Watercolor and charcoal on paper, 14⅛ x 17 in.
 (36 x 43.2 cm.)

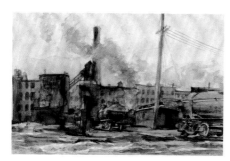

Marsh, *Untitled* (Buildings)

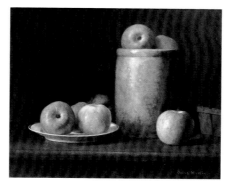

Martin, *Still Life with Apples*

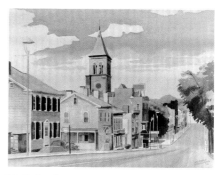

McClelland, *Lancaster, Main Street*

Signed and dated lower right: Marin 22
Gift of Ferdinand Howald, 1931

John Marin, 1870–1953
Ship, Sea and Sky Forms (An Impression), 1923 31.218
Watercolor on paper, 13½ x 17 in. (34.3 x 43.2 cm.)
Signed and dated lower right: Marin 23
Gift of Ferdinand Howald, 1931

Reginald Marsh, 1898–1954
Untitled (Factories), 1931 79.34.4
Watercolor on paper, 14 x 20 in. (35.5 x 50.8 cm.)
Signed and dated lower right: Reginald Marsh '31
Bequest of Felicia Meyer Marsh, 1979

Reginald Marsh, 1898–1954
Untitled (Buildings), ca. 1931 79.34.3
Watercolor on paper, 14 x 20 in. (35.5 x 50.8 cm.)
Bequest of Felicia Meyer Marsh, 1979

Reginald Marsh, 1898–1954
Hudson Bay Fur Company, 1932 56.1
Egg tempera on muslin mounted to particle board,
 30 x 40 in. (76.2 x 101.6 cm.)
Signed and dated lower right: Reginald Marsh 1932
Museum Purchase: Howald Fund, 1956
Cat. no. 62

Reginald Marsh, 1898–1954
Untitled (Girl Walking Down Street), ca. 1948 (recto)
 79.34.1.1
Untitled (Cigarette Girl), ca. 1948 (verso) 79.34.1.2
Egg tempera on paper, 31½ x 23 in. (80 x 58.5 cm.)
Bequest of Felicia Meyer Marsh, 1979

Reginald Marsh, 1898–1954
Untitled (Beach Scene) (recto) 79.34.2.1
Untitled (Beach, People in Surf) (verso) 79.34.2.2
Ink wash on paper, 21⅞ x 29⅞ in. (55.6 x 76 cm.)
Bequest of Felicia Meyer Marsh, 1979

Silas Martin, 1841–1906
The Lesson 19.76

Oil on canvas, 20 x 15⅛ in. (50.8 x 38.4 cm.)
Signed lower left: Silas Martin
Bequest of Francis C. Sessions, 1919

Silas Martin, 1841–1906
Still Life with Apples 40.53
Oil on canvas, 18 x 22 in. (45.7 x 55.9 cm.)
Signed lower right: Silas Martin
Gift of Orlando A. Miller, 1940

Bill Mauldin, born 1921
Heat Rash 72.39
Graphite and ink on paper, 8 x 10 in. (20.3 x 25.4 cm.)
Signed and inscribed lower left: Bill Mauldin/Heat Rash
Museum Purchase: Howald Fund, 1972

Alfred Maurer, 1868–1932
Still-Life with Red Cheese, ca. 1928–1930 83.30
Oil on board, 18 x 21¾ in. (45.7 x 55.2 cm.)
Signed lower right: A. H. Maurer
Acquired through exchange: Gift of Ione and Hudson D.
 Walker and the Howald Fund, 1983
Cat. no. 64

Leland S. McClelland, born 1914
Lancaster, Main Street, 1965 66.22
Watercolor on paper, 19 x 24 in. (48.3 x 61 cm.)
Signed and dated lower right: Leland S./McClelland/'65
Purchased with funds from the Alfred L. Willson
 Foundation, 1966

Leland S. McClelland, born 1914
North Broadway United Methodist Church, 1982 87.2
Watercolor on paper, 23 x 16½ in. (sight)
 (58.4 x 41.9 cm.)
Gift of Dr. and Mrs. William E. Smith, 1987

Helen McCombs, active twentieth century
Owl 61.47
Watercolor on paper, 17½ x 13¾ in. (44.5 x 34.9 cm.)
Signed lower right: Helen McCombs, 1961
Purchased with funds from the Alfred L. Willson
 Foundation, 1961

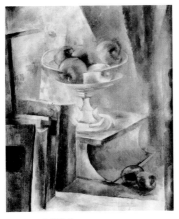

McFee, *Still Life*

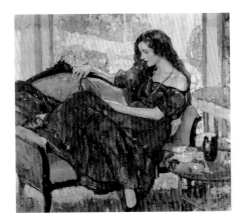

Miller, *Miss V. in Green*

Morris, *"Still Point, Holding Place, Bedrock"*
Series 72

Henry Lee McFee, 1886–1952
Still Life, 1916 31.207
Oil on canvas, 20 x 16 in. (50.8 x 40.6 cm.)
Signed and dated lower left: McFee/1916
Gift of Ferdinand Howald, 1931

Clement Meadmore, born 1929
Out of There, 1974 79.15
Painted aluminum (edition of 2), L. 201 in., H. 78 in.
 (L. 510.5 cm., H. 198.12 cm.)
Gift of Ashland Oil, Inc., 1979
Cat. no. 79

Clement Meadmore, born 1929
All of Me, 1977 80.39
Bronze, H. 10⅜ in. (26.3 cm.)
Signed and dated near bottom: Meadmore '77 9/10
Acquired through exchange, 1980

John Liggett Meigs, born 1916
Valley, Autumn, 1966 67.5
Watercolor on paper, 21 x 28 in. (53.3 x 71.1 cm.)
Signed and dated lower right: John Meigs/66
Museum Purchase: Howald Fund, 1967

Waldo Midgley, 1888–?
Winter Street 69.6
Watercolor on paper, 14 x 19¹⁵⁄₁₆ in. (35.6 x 50.6 cm.)
Signed lower right: Waldo Midgley. Signed and inscribed
 on reverse, lower right: Winter Street by Waldo
 Midgley
Museum Purchase: Howald Fund, 1969

Kenneth Hayes Miller, 1876–1952
Recumbent Figure, ca. 1910–1911 31.237
Oil on paper, 12½ x 16⅝ in. (31.8 x 42.2 cm.)
Signed lower left: Hayes Miller
Gift of Ferdinand Howald, 1931

Richard Miller, 1875–1943
Miss V. in Green 45.8
Oil on canvas, 33¾ x 35½ in. (85.7 x 90.2 cm.)

Signed lower left: Miller
Bequest of Edward D. and Anna White Jones, 1945

Fred Mitchell, born 1923
Figure in Autumn Landscape, 1957 62.44
Oil on canvas, 40 x 40 in. (101.6 x 101.6 cm.)
Signed and dated lower right: Fred Mitchell 57
Museum Purchase: Howald Fund, 1962

Georgette Monroe, active twentieth century
El Atoron 48.31
Watercolor and ink on paper, 13⅜ x 18½ in. (34 x 47 cm.)
Signed lower right: G. Monroe
Purchased with funds from the Alfred L. Willson
 Foundation, 1948

Edward Moran, 1829–1901
The Bell-Buoy 19.56
Oil on canvas, 26¼ x 36¼ in. (66.7 x 92 cm.)
Signed lower left: Edward Moran
Bequest of Francis C. Sessions, 1919

Peter Moran, 1842–1914
The Orchard 19.31
Oil on canvas, 12 x 16 in. (30.5 x 40.6 cm.)
Signed lower right: P. Moran
Bequest of Francis C. Sessions, 1919

Carl A. Morris, born 1911
"Still Point, Holding Place, Bedrock" Series 72, 1972 73.7
Oil on canvas, 63 x 76¼ in. (160 x 193.9 cm.)
Signed and dated lower right: Carl Morris 72
Museum Purchase: Howald Fund, 1973

George L. K. Morris, 1905–1975
Crossed Triangles, 1953 79.14
Oil on canvas, 29 x 23½ in. (73.6 x 59.7 cm.)
Signed lower right: Morris
Museum Purchase: Howald Fund, 1979

Philip Morsberger, born 1933
The Children's Hour 68.23

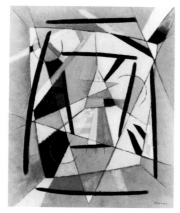

Morris, *Crossed Triangles*

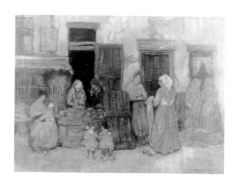

Myers, *An Interlude*

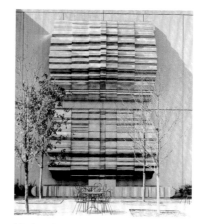

Naylor, *Streams*

Acrylic, oil, and collage on canvas, 42½ x 72 in.
(107.3 x 182.9 cm.)
Howald Memorial Purchase Award, 1968

Philip Mullen, born 1942
Feininger II, 1982 85.17
Acrylic on canvas, 72 x 52 in. (182.8 x 132 cm.)
Gift of the artist, 1985

John Francis Murphy, 1853–1921
Sunset, 1889 45.24
Oil on canvas, 14 x 19 in. (35.6 x 48.3 cm.)
Signed and dated lower left: J. Francis Murphy 89
Bequest of John R. and Louise Lersch Gobey, 1945

John Francis Murphy, 1853–1921
The Mill Race, Arkville, 1897 72.38
Oil on canvas, 11¼ x 15¾ in. (28.6 x 40 cm.)
Signed and dated lower left: J. Francis Murphy 97. Dated
and inscribed on reverse, upper left: The Mill Race/
1897 Arkville
Museum Purchase: Howald Fund, 1972

John Francis Murphy, 1853–1921
The Little Bridge (or *Autumn Woods*), 1898 75.49
Oil on canvas, 11¹/₁₆ x 16 in. (28.1 x 40.6 cm.)
Signed and dated lower left: J. Francis Murphy/98
Museum Purchase: Howald Fund, 1975

Jerome Myers, 1867–1940
An Interlude, 1916 31.238
Oil on canvas, 18 x 24 in. (45.7 x 61 cm.)
Signed, dated, and inscribed lower right: Jerome Myers,
1916/N.Y.
Gift of Ferdinand Howald, 1931

Jerome Myers, 1867–1940
Blind Man's Bluff 60.29
Conté crayon on paper, 8½ x 11 in. (21.6 x 27.9 cm.)
Signed lower right: Jerome Myers
Purchased with funds from the Alfred L. Willson
Foundation, 1960

Jerome Myers, 1867–1940
Horses 60.30
Graphite and watercolor on paper, 8½ x 11¼ in.
(21.6 x 28.6 cm.)
Signed lower left: Jerome Myers/Em
Purchased with funds from the Alfred L. Willson
Foundation, 1960

Jerome Myers, 1867–1940
The Tenor 70.32
Charcoal and ink on paper, 7½ x 9¾ in. (19 x 24.8 cm.)
Signed and inscribed lower left to right: 380 Jerome
Myers/The Tenor
Purchased with funds from the Alfred L. Willson
Foundation, 1970

Elie Nadelman, 1882–1946
Figurine, ca. 1940–1945 76.8
Plaster, H. 7 in. (17.8 cm.)
Museum Purchase: Howald Fund, 1976

Robert Natkin, born 1930
Apollo Series, 1978 82.1
Acrylic on paper, 35 x 45½ in. (88.8 x 115.5 cm.)
Signed lower center: Natkin
Gift of Max Weitzenhoffer, 1982

Robert Natkin, born 1930
Hitchcock Series: Anticipation of the Night, 1984 85.11
Acrylic on canvas, 84 x 94 in. (213.2 x 238.6 cm.)
Signed lower left: Natkin
Museum Purchase: Howald Fund, 1985
Cat. no. 85

John Geoffrey Naylor, born 1928
Streams, 1982 82.6
Stainless steel, H. 384 in. (975.4 cm.)
Given by The Wasserstrom Foundation and the
Wasserstrom Companies on behalf of their Associates;
Design partially funded by the National Endowment
for the Arts, 1982

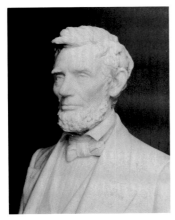

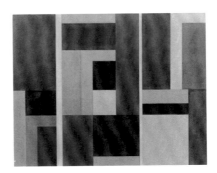

Novros, *Untitled (No. 2)*

Niehaus, *Abraham Lincoln*

O'Keeffe, *Canna Lily*

Louise Nevelson, 1899–1988
Landscape in the Sky, 1956 71.7
Graphite on paper, 20 x 26 in. (50.8 x 66 cm.)
Signed, dated, and inscribed lower left to right:
 Landscape in the Sky Louise Nevelson 56
Museum Purchase: Howald Fund, 1971

Louise Nevelson, 1899–1988
Sky Cathedral: Night Wall, 1963–1976 77.20
Painted wood, 114 x 171 in. (289.6 x 434.3 cm.)
Gift of Eva Glimcher and Derby Fund Purchase, 1977
Cat. no. 77

Louise Nevelson, 1899–1988
Collage, 1974 78.7
Cardboard and black painted wood, H. 60½ in.
 (153.5 cm.)
Signed and dated lower right: Louise Nevelson—74
Gift of Mr. Arnold Glimcher in honor of his mother,
 Mrs. Eva Glimcher, 1978

Charles Henry Niehaus, 1855–1935
Abraham Lincoln, 1890 43.1
Marble, H. 29 in. (73.7 cm.)
Museum Purchase: Howald Fund, 1943

Alice E. Nissen, active twentieth century
Queen Anne's Lace, 1943 59.28
Tempera on paper, 19⅜ x 12¹/₁₆ in. (49.2 x 30.6 cm.)
Signed and dated lower right: Alice E. Nissen/1943
Gift of F. Stanley Crooks, 1959

John Noble, 1874–1934
The Path of the Moon, 1927 69.9
Oil on canvas, 8¼ x 11 in. (21 x 27.9 cm.)
Signed lower left: J. Noble
Museum Purchase: Howald Fund, 1969

Kenneth Noland, born 1924
Shadow on the Earth, 1971 72.28
Acrylic on canvas, 93 x 64¼ in. (236.2 x 163.2 cm.)

Purchased with the aid of funds from the National
 Endowment for the Arts and two anonymous
 donors, 1972
Cat. no. 76

David Novros, born 1941
Untitled (No. 2), 1971 80.1
Oil on canvas, 84 x 108 in. (213.4 x 274.3 cm.)
Gift of Samuel P. Reed, 1980

Ervin S. Nussbaum, born 1914
The Synagogue, ca. 1939 39.9
Oil on canvas, 22¼ x 26 in. (56.5 x 66 cm.)
Signed lower right: Nussbaum
Gift of the Patrons of the Columbus Art League, 1939

Georgia O'Keeffe, 1887–1986
Canna Lily, 1919 77.23
Watercolor on paper, 23 x 12⅞ in. (58.4 x 32.7 cm.)
Museum Purchase: Derby Fund, 1977

Georgia O'Keeffe, 1887–1986
Autumn Leaves—Lake George, N.Y., 1924 81.6
Oil on canvas, 20¼ x 16¼ in. (51.4 x 41.3 cm.)
Museum Purchase: Howald Fund II, 1981
Cat. no. 38

Charles I. Okerbloom, Jr., born 1908
View of Garapan from Japanese Bank Building, 1944 46.57
Watercolor on paper, 14 x 20¼ in. (35.6 x 51.4 cm.)
Signed and dated lower left: Charles Okerbloom Jr./Nov.
 1944
Museum Purchase: Howald Fund, 1946

Richard F. Outcault, 1863–1928
Buster Brown 72.41
Ink and watercolor on paper, 23⁷/₁₆ x 19¾ in.
 (59.5 x 50.2 cm.)
Signed lower right: R. F. Outcault/Jan. 16
Museum Purchase: Howald Fund, 1972

Walter Pach, 1883–1958
Old Sod, 1905 56.45
Oil on canvas, 19 x 14 in. (48.3 x 35.6 cm.)

Pascin, *Oyster Bar*

Pène du Bois, *Table Top and Chair*

Signed, dated, and inscribed lower right: Walter Pach/
 1905/d'apres/W. Magrath
Gift of Marion Swickard, 1956

Albert Paley, born 1944
Plant Stand, 1984 86.4
Mild steel, slate top, H. 49½ in. (125.7 cm.)
Stamped on bottom: PALEY
A Gift from Beaux Arts, family, and friends in memory
 of Mary Lou Chess and Donna Gifford Walker, 1986

Fred Pallini, born 1942
Construction #1, 1963 63.40
Steel, H. 66 in. (167.6 cm.)
Museum Purchase: Howald Fund, 1963

William C. Palmer, born 1906
February Fields, 1958 59.17
Oil on canvas, 20 x 24 in. (50.8 x 61 cm.)
Signed and dated lower center: William C. Palmer 58
Museum Purchase: Howald Fund, 1959

Jules Pascin, 1885–1930
Lunch Room, ca. 1917 31.73
Charcoal, ink, and watercolor on paper, 9⅝ x 12⅝ in.
 (24.5 x 32.2 cm.)
Signed lower right: pascin
Gift of Ferdinand Howald, 1931

Jules Pascin, 1885–1930
Oyster Bar, ca. 1917 31.76
Ink, graphite, and watercolor on paper, 8 x 11¾ in.
 (20.3 x 29.8 cm.)
Signed lower left: pascin
Gift of Ferdinand Howald, 1931

Jules Pascin, 1885–1930
Street in Havana, ca. 1917 31.81
Graphite, watercolor, and pastel on paper, 9¾ x 8¼ in.
 (24.8 x 21 cm.)
Signed and inscribed lower left to center: pascin Saurnon
 c-ihon
Gift of Ferdinand Howald, 1931

Jules Pascin, 1885–1930
*The Lord God Appears to Brigham Young Commanding Him
 to Increase and Multiply*, ca. 1927–1928 78.4

Carbon transfer on paper, 14¾ x 19¾ in. (37.5 x 50.2 cm.)
Gift of David L. Hite, 1978

Jules Pascin, 1885–1930
Nude 31.74
Ink and watercolor on paper, 9¾ x 14¾ in. (25 x 37.5 cm.)
Signed lower right: pascin
Gift of Ferdinand Howald, 1931

Donald Peake, born 1932
The Eve Before Eden, 1972 72.18
Mixed media on canvas, 45⅞ x 50 in. (116.5 x 127 cm.)
Signed and dated on reverse: Peake 72
Theodore R. Simson Purchase Award, 1972

Mel Pekarsky, born 1934
Horizons, 1973 73.16
Oil and graphite on paper, 15 x 15 in. (38.1 x 38.1 cm.)
Signed and dated lower right: MP 73
Purchased with funds from the Alfred L. Willson
 Charitable Foundation of The Columbus Foundation,
 1973

Guy Pène du Bois, 1884–1958
Table Top and Chair, 1905 61.23
Graphite on paper, 8⅛ x 9½ in. (20.6 x 24.1 cm.)
Museum Purchase: Howald Fund, 1961

Guy Pène du Bois, 1884–1958
Seated Figures on Deck of Shop, ca. 1905 61.22
Graphite on paper, 7¾ x 5 in. (19.7 x 12.7 cm.)
Signed lower right center: G. Pène du Bois
Museum Purchase: Howald Fund, 1961

Guy Pène du Bois, 1884–1958
Woman Playing Accordion, 1924 80.3
Oil on canvas, 48 x 38⅛ in. (122 x 96.8 cm.)
Signed and dated lower right: Guy Pène du Bois '24
Acquired through exchange: Bequest of J. Willard Loos,
 1980
Cat. no. 59

Joseph Pennell, 1857–1926
Washington Square, New York, 1908 66.42

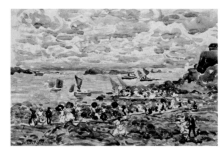

Prendergast, *St. Malo No. 1*

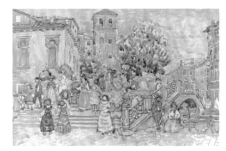

Prendergast, *Venice*

Poor, *Still Life—Pears*

Pastel on paper, 11 x 8⅜ in. (27.9 x 21.3 cm.)
Purchased with funds from the Alfred L. Willson
 Foundation, 1966

James Penney, born 1910
Green Stockings, 1961 61.24
Oil on canvas, 29¾ x 48 in. (75.6 x 121.9 cm.)
Signed lower right: Penney
Museum Purchase: Howald Fund, 1961

James Penney, born 1910
Freighter 56.46
Watercolor on paper, 27 x 19½ in. (68.6 x 49.5 cm.)
Signed lower right: James Penney
Museum Purchase: Howald Fund, 1956

Stephen Pentak, born 1951
Pool, 1984.8, 1984 84.19
Oil on paper, 30 x 22 in. (76.2 x 55.9 cm.)
Bevlyn and Theodore Simson Purchase Award from the
 74th Annual Columbus Art League Exhibition, 1984

Herbert Perr, born 1941
Actin, 1970 71.13
Acrylic on canvas, 96 x 72 in. (243.8 x 182.9 cm.)
Museum Purchase: Howald Fund, 1971

Gabor Peterdi, born 1915
Flowers, 1981 85.27.1
Ink on paper, 11 x 13 in. (27.9 x 33 cm.)
Signed and dated lower right: Peterdi 81
Gift of Dr. and Mrs. Arthur E. Kahn, 1985

Richard J. Phipps, born 1928
Kitty Hawk, 1971 71.10
Watercolor on paper, 17⅝ x 23½ in. (44.8 x 59.7 cm.)
Signed lower right: R. Phipps
Museum Purchase: Howald Fund, 1971

Jack Piper, born 1927
Persephone, 1963 63.32
Oil on canvas, 20 x 16 in. (50.8 x 40.6 cm.)
Museum Purchase: Howald Fund, 1963

Robert Pitton, born 1921
Floor Piece No. 1, 1976 76.15

Acrylic, H. 50¾ in. (128.9 cm.)
Theodore R. Simson Purchase Award, 1976

Ogden M. Pleissner, born 1905
Roof Tops, Carcassonne, 1969 70.2
Watercolor on paper, 6¾ x 9¹¹⁄₁₆ in. (17.1 x 24.6 cm.)
Signed lower left: Pleissner
Museum Purchase: Howald Fund, 1970

Henry Varnum Poor, 1888–1970
Still Life—Pears 34.1
Oil on panel, 9⅞ x 11⅞ in. (25.1 x 30.2 cm.)
Signed lower left: H V Poor
Purchased by popular subscription, 1934

Maurice Prendergast, 1858–1924
St. Malo No. 1, ca. 1907–1910 31.246
Watercolor and graphite on paper, 13½ x 19¼ in.
 (34.3 x 48.9 cm.)
Signed lower left: Prendergast
Gift of Ferdinand Howald, 1931

Maurice Prendergast, 1858–1924
St. Malo No. 2, ca. 1907–1910 31.247
Watercolor and graphite on paper, 12¾ x 19¼ in.
 (32.4 x 48.9 cm.)
Signed lower left center: Prendergast
Gift of Ferdinand Howald, 1931
Cat. no. 27

Maurice Prendergast, 1858–1924
Venice, ca. 1911–1912 31.251
Watercolor and graphite on paper, 14⅝ x 21¼ in.
 (37.2 x 54 cm.)
Signed lower right center: Prendergast
Gift of Ferdinand Howald, 1931

Maurice Prendergast, 1858–1924
Seashore, ca. 1912–1913 86.19
Oil on canvas, 19¾ x 28 in. (50.2 x 71.1 cm.)
Gift of Mr. and Mrs. Frederick Jones, 1986

Maurice Prendergast, 1858–1924
The Promenade, ca. 1912–1913 31.244
Oil on canvas, 28 x 40¼ in. (71.1 x 102.2 cm.)
Signed lower left: Prendergast
Gift of Ferdinand Howald, 1931
Cat. no. 28

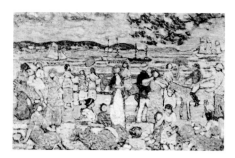

Prendergast, *Along the Shore*

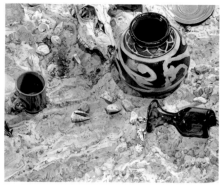

Ransom, *Earthscape: Dry Lake Bed*

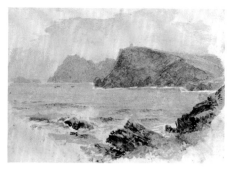

Richards, *Glen Head, County Donegal, Ireland*

Maurice Prendergast, 1858–1924
Playtime, ca. 1913–1915 31.243
Watercolor and pastel on paper, 14¾ x 22 in.
 (37.5 x 55.9 cm.)
Gift of Ferdinand Howald, 1931

Maurice Prendergast, 1858–1924
Outskirts of the Village, 1916–1918 31.242
Watercolor and pastel on paper, 13¹¹⁄₁₆ x 19¹¹⁄₁₆ in.
 (34.8 x 50 cm.)
Signed lower center: Prendergast
Gift of Ferdinand Howald, 1931

Maurice Prendergast, 1858–1924
Along the Shore, ca. 1921 31.252
Oil on canvas, 23¼ x 34 in. (59.1 x 86.4 cm.)
Signed lower left center: Prendergast
Gift of Ferdinand Howald, 1931

Damian Priour, born 1949
Stonelith #105, 1986 87.1
Limestone and glass, H. 71⅛ in. (180.64 cm.)
Gift of Burgess and Niple, Limited, 1987

Milne Ramsay, 1847–1915
End of Day, ca. 1895 86.17
Oil on panel, 6⅝ x 11½ in. (16.8 x 29.2 cm.)
Signed lower right: Milne Ramsay
Gift of Warren Adelson in honor of Budd Harris Bishop,
 1986

Kay Randolph, born 1916
Still Life, 1964 65.4
Oil on canvas, 23½ x 17½ in. (59.7 x 44.5 cm.)
Museum Purchase: Howald Fund, 1965

Henry Ransom, born 1942
Earthscape: Dry Lake Bed, 1978 79.6
Oil on canvas, 38 x 44 in. (96.5 x 111.8 cm.)
Museum Purchase: Trustees Fund, 1979

Flora MacLean Reeder, 1887–1965
Lilacs and Tulips 66.45

Oil on canvas, 38 x 30⅛ in. (96.5 x 76.5 cm.)
Signed lower right: Flora MacLean Reeder
Gift of William T. Emmet, Jr. and Thomas A. Emmet,
 1966

Sophy Pollak Regensburg, 1885–1974
Lowesdorf Mug with Flowers 87.3
Casein on canvas, 14 x 11¾ in. (35.6 x 29.8 cm.)
Gift of Mr. and Mrs. Leonard Feist, 1987

Harry A. Rich, active twentieth century
Requiem, 1955 58.19
Oil on composition board, 27½ x 48 in. (69.9 x 121.9 cm.)
Signed and dated lower left: H. Rich '55
Frederick W. Schumacher Purchase Award, 1958

William Trost Richards, 1833–1905
Glen Head, County Donegal, Ireland, ca. 1890 53.74
Watercolor on paper, 5⅜ x 7⅜ in. (13.7 x 18.9 cm.)
Gift of the National Academy of Design: Mrs. William T.
 Brewster Bequest, 1953

William Trost Richards, 1833–1905
The Wave, 1900 19.100
Oil on canvas, 30 x 52 in. (76.2 x 132.1 cm.)
Signed and dated lower left: Wm. T. Richards, 1900
Source unknown, 1919

Constance Richardson, born 1905
Duluth, Minnesota, 1954 66.40
Oil on masonite, 20 x 31½ in. (50.8 x 79 cm.)
Museum Purchase: Howald Fund, 1966

George Rickey, born 1907
Two Lines Up Excentric Variation VI, 1977 78.31
Stainless steel (1 of 3), H. 264 in. (670.6 cm.)
Signed, dated, and inscribed on base: 1/3 Rickey 1977
Given by the family of the late Albert Fullerton Miller in
 his honor and memory, 1978
Cat. no. 81

Christopher Ries, born 1952
Wave in Space, 1978 80.6

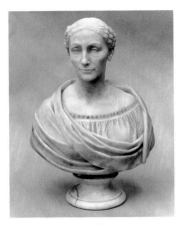

Rinehart, *Mrs. Ezra Bliss*

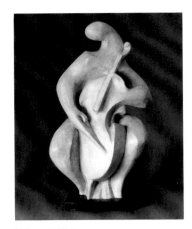

Robus, *Cellist*

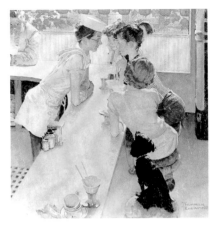

Rockwell, *Soda Jerk* (cover, *Saturday Evening Post*, August 22, 1953)

Lead crystal, H. 15½ in. (39.4 cm.)
Inscribed bottom right: Christopher Ries 1978
A Gift from Beaux Arts and friends in memory of Nancy
 Howe Michael and Marcia Walker Diwik, 1980

William Henry Rinehart, 1825–1874
Mrs. Ezra Bliss, 1869 47.104
Marble, H. 27 in. (68.6 cm.)
Signed, dated, and inscribed on reverse: WM. H.
 RINEHART/SCULPT ROMA. 1869
Gift of Dr. Ezra Bliss, 1947

Donald Roberts, born 1923
Tall Pines, 1955 56.33
Watercolor and ink on paper, 30⅛ x 21⅛ in.
 (76.5 x 53.7 cm.)
Signed and dated lower left: Donald Roberts—55
Museum Purchase: Howald Fund, 1956

Boardman Robinson, 1876–1952
On the Rialto 68.37
Ink and graphite on paper, 9¾ x 5 in. (25 x 12.7 cm.)
Signed and inscribed lower left to center: Boardman
 Robinson "On the Rialto"/Boardman Robinson
Museum Purchase: Howald Fund, 1968

Theodore Robinson, 1852–1896
Fifth Avenue at Madison Square, 1894–1895 31.260
Oil on canvas, 24⅛ x 19¼ in. (61.3 x 48.9 cm.)
Signed lower left: Th. Robinson
Gift of Ferdinand Howald, 1931
Cat. no. 19

Hugo Robus, 1885–1964
Cellist, 1950 53.12
Plaster, H. 17½ in. (44.4 cm.)
Signed on back: Hugo/Robus
Purchased with funds from the Alfred L. Willson
 Foundation, 1953

Hugo Robus, 1885–1964
Figure in Grief, original plaster 1952, cast ca. 1963 68.6
Bronze (from edition of 6), H. 12 in. (30.5 cm.)
Signed on back of figure: Hugo Robus. Foundry mark:
 Fonderia Battaglia & C. Milano
Gift of Hugo Robus, Jr. in memory of his father, 1968
Cat. no. 69

Norman Rockwell, 1894–1978
Soda Jerk (cover, *Saturday Evening Post*, August 22, 1953),
 ca. 1953 74.38.4
Oil on canvas, 36 x 34 in. (91.4 x 86.4 cm.)
Signed lower right: Norman/Rockwell
Bequest of J. Willard Loos, 1974

Norman Rockwell, 1894–1978
Morning After the Wedding (or *The Chambermaids*) (cover
 Saturday Evening Post, June 29, 1957), ca. 1957
 74.38.16
Oil on canvas, 33 x 31 in. (83.8 x 78.7 cm.)
Signed upper left: Norman/Rockwell
Bequest of J. Willard Loos, 1974

Kurt Ferdinand Roesch, 1905–1984
Girl with Moths, 1948 53.10
Watercolor and charcoal on paper, 18⅜ x 14 in.
 (46.7 x 35.6 cm.)
Signed, dated, and inscribed lower left: To Rose Fried,
 Dec. 1948, Roesch
Gift of Rose Fried, 1953

Kurt Ferdinand Roesch, 1905–1984
Juggling, 1969 70.3
Oil on canvas, 50 x 42⅛ in. (127 x 107 cm.)
Signed lower left: Roesch
Gift of the artist, 1970

Severin Roesen, 1815 or 1816–after 1872
Still Life 80.32

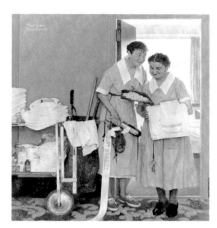

Rockwell, *Morning After the Wedding* (or *The Chambermaids*) (cover, *Saturday Evening Post*, June 29, 1957)

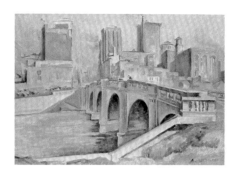

Rosen, *Broad Street Bridge*

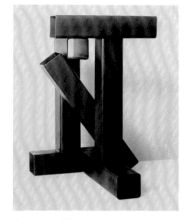

Rosenthal, *Rosenthal Suite #21*

Oil on canvas, 21¾ x 26¾ in. (55.3 x 67.9 cm.)
Signed lower right: S Roesen
Acquired through exchange: Bequest of J. Willard Loos, 1980
Cat. no. 7

Robert H. Rohm, born 1934
Well Fleet, 1956 57.33
Charcoal on paper, 28 x 22 in. (71.1 x 55.9 cm.)
Signed and dated lower center: Rohm 56
Museum Purchase: Howald Fund, 1957

Charles Rosen, 1878–1950
Broad Street Bridge, ca. 1924 38.4
Oil on canvas, 24 x 32 in. (61 x 81.3 cm.)
Signed lower right: Charles Rosen
Gift of Mrs. Edward W. Campion in memory of John L. V. Bonney, 1938

Bernard Rosenthal, born 1914
Rosenthal Suite #21 80.28.1–.5
Painted steel, largest piece H. 30⅛ in. (76.5 cm.)
Gift of Barbara and Larry J. B. Robinson, 1980

Doris Rosenthal, ca. 1900–1971
En La Tarde 76.37.2
Charcoal and pastel on paper, 24 x 18¾ in. (60.9 x 47.6 cm.)
Signed and inscribed lower center: Doris Rosenthal/ Ocotlan/Oaxaca. Inscribed lower left: En la Tarde
Bequest of Doris Rosenthal, 1976

Doris Rosenthal, ca. 1900–1971
Girl with Banana Leaf Stalk 76.37.1
Charcoal on paper, 23⅞ x 18¾ in. (60.6 x 47.6 cm.)
Signed left center: Doris Rosenthal
Bequest of Doris Rosenthal, 1976

Doris Rosenthal, ca. 1900–1971
Hillside Huchnetanango 76.37.3

Charcoal and pastel on paper, 18¾ x 23¾ in. (47.6 x 60.3 cm.)
Signed and inscribed lower left: Hillside Huchnetanango, Doris Rosenthal
Bequest of Doris Rosenthal, 1976

Mel Rozen, born 1942
Double Dipper, 1978 79.16
Watercolor dye and acrylic on canvas, 72 x 48 in. (182.9 x 122 cm.)
Theodore R. Simson Memorial Purchase Award from the Columbus Art League 69th Annual Spring Show, 1979

Jon Rush, born 1935
Composition, 1961 62.30
Bronze, H. 7¼ in. (18.4 cm.)
Museum Purchase: Howald Fund, 1962

Walter Russell, 1871–?
Autumn 76.43
Oil on canvas, 25 x 30 in. (63.5 x 76.2 cm.)
Gift of Mr. and Mrs. Michael C. Palmer, 1976

Albert Pinkham Ryder (attributed to), 1847–1917
Returning Home 31.261
Oil on canvas, 6⅞ x 12 in. (17.5 x 30.5 cm.)
Gift of Ferdinand Howald, 1931

Albert Pinkham Ryder, 1847–1917
Spirit of Autumn, ca. 1875 [57]47.68
Oil on panel, 8½ x 5¼ in. (21.6 x 13.3 cm.)
Signed lower left: A. P. Ryder
Bequest of Frederick W. Schumacher, 1957
Cat. no. 10

Annette Johnson St. Gaudens, 1869–1943 and Louis St. Gaudens, 1845–1913
Portrait Relief of Paul St. Gaudens, ca. 1900 39.49

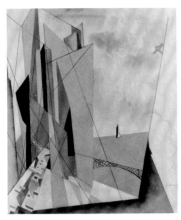

Schary, *Abstraction, New York*

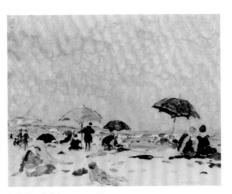

Schille, *Midsummer Day*

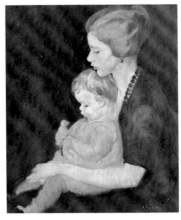

Schille, *Anne and Beau* (formerly *Babe and Bird*)

Bronze, D. 4⅛ in. (10.5 cm.)
Gift of Annette Johnson St. Gaudens, 1939

John Singer Sargent, 1856–1925
Carmela Bertagna, ca. 1880 [57]43.11
Oil on canvas, 23½ x 19½ in. (59.7 x 49.5 cm.)
Signed upper right: John S. Sargent. Inscribed upper
 left: à mon ami Poirson. Inscribed lower left:
 Carmela Bertagna/Rue du/16 Maine
Bequest of Frederick W. Schumacher, 1957
Cat. no. 17

Morton Livingston Schamberg, 1881–1918
Composition, 1916 31.262
Watercolor and graphite on paper, 11½ x 9½ in.
 (29.2 x 24.1 cm.)
Signed and dated upper right: Schamberg/1916
Gift of Ferdinand Howald, 1931

Morton Livingston Schamberg, 1881–1918
Telephone, 1916 31.263
Oil on canvas, 24 x 20 in. (61 x 50.8 cm.)
Signed and dated upper right: Schamberg/1916
Gift of Ferdinand Howald, 1931
Cat. no. 45

Saul Schary, 1904–1978
Abstraction, New York 31.264
Watercolor and ink on paper, 13 x 10⅜ in. (33 x 26.4 cm.)
Signed lower right: Schary
Gift of Ferdinand Howald, 1931

Saul Schary, 1904–1978
At Daniel's Dinner, 1948 71.2
Graphite on paper, 10¼ x 9 in. (26 x 22.9 cm.)
Signed and inscribed center: At Daniel's/dinner/Schary
Gift of Zabriskie Gallery, 1971

Fredi Schiff, born 1915
The Studio 38.3

Oil on canvas, 24 x 20 in. (61 x 50.8 cm.)
Gift of Robert W. Schiff, 1938

Alice Schille, 1869–1955
Dutch Village Gossip, ca. 1905 60.56
Watercolor on paper, 8½ x 11 in. (21.6 x 27.9 cm.)
Signed lower right: Alice Schille
Gift of Ernest Zell, 1960

Alice Schille, 1869–1955
Early Morning in an Old Church, ca. 1908 37.20
Watercolor on paper, 20¾ x 17½ in. (52.7 x 44.4 cm.)
Signed lower right: A. Schille
Bequest of Josephine Klippart, 1937

Alice Schille, 1869–1955
Marketplace at Le Puy, ca. 1911 12.1
Watercolor, gouache, and conté crayon on paper,
 23 x 18 in. (53.4 x 45.7 cm.)
Signed lower left: A. Schille
Museum Purchase, 1912

Alice Schille, 1869–1955
The Passing Years (formerly *Madame Deschamps*),
 ca. 1913 78.19.4
Watercolor, gouache, and conté crayon on paper,
 20 x 23¾ in. (50.8 x 60.3 cm.)
Signed lower left: A. Schille
Gift of Mrs. Ralph H. Trivella, 1978

Alice Schille, 1869–1955
Midsummer Day, ca. 1916 31.265
Watercolor, gouache, and conté crayon on paper,
 11½ x 13⅝ in. (29.2 x 34.6 cm.)
Signed lower right: A. Schille
Gift of Ferdinand Howald, 1931

Alice Schille, 1869–1955
Sea and Tidal River, 1916 31.266

Watercolor, gouache, and conté crayon on paper,
 11½ x 13⅝ in. (29.2 x 34.6 cm.)
Signed lower right: A. Schille
Gift of Ferdinand Howald, 1931

Alice Schille, 1869–1955
Grandmother, ca. 1920 56.50
Oil on canvas, 30 x 25⅞ in. (76.2 x 65.7 cm.)
Signed lower right: A. Schille
Gift of Mrs. Hugh Doyle, 1956

Alice Schille, 1869–1955
Straw Hats, ca. 1923 66.2
Watercolor, gouache, and conté crayon on paper,
 17⅜ x 20⅜ in. (44.1 x 52 cm.)
Signed lower right: Alice S. Schille
James F. Merkle Memorial Fund Purchase, 1966

Alice Schille, 1869–1955
Anne and Beau (formerly *Babe and Bird*),
 ca. 1925 80.4
Oil and gouache on panel, 30 x 24⅞ in. (76.2 x 63.2 cm.)
Signed lower right: A. Schille
Gift of Mrs. Henry S. Ballard, 1980

Alice Schille, 1869–1955
Three Lazarus Daughters (Charlotte, Jean, and Babette),
 ca. 1929 52.50
Oil on canvas, 40 x 50 in. (101.6 x 127 cm.)
Signed lower left: A. Schille
Gift of Robert Lazarus, Sr., 1952

Alice Schille, 1869–1955
Guatemalan Scene, ca. 1930 75.31
Watercolor on paper, 14¾ x 19¾ in. (37.5 x 50.1 cm.)
Signed lower right: A. Schille
Gift of Heritage Gallery in memory of Carlton S.
 Dargusch, Jr., Frederick W. LeVeque and Edgar T.
 Wolfe, Jr., 1975

Tobias Schneebaum, born 1921
Untitled, 1969 72.2
Oil on canvas, 11⅞ x 9 in. (30.1 x 22.9 cm.)
Signed and dated on reverse: Schneebaum/'69
Museum Purchase: Howald Fund, 1972

Jason Schoener, born 1919
Sunion, Greece, 1962 63.14
Oil and wax on canvas, 40 x 30 in. (101.6 x 76.2 cm.)
Signed lower left center: Schoener
Museum Purchase: Howald Fund, 1963

Jason Schoener, born 1919
Isola Del Giglio, Italy 68.2
Watercolor on paper, 9½ x 12⅝ in. (24.1 x 32 cm.)
Signed lower right: Schoener
Museum Purchase: Howald Fund, 1968

Karl Schrag, born 1912
Full Moon After the Rain, 1973 74.3

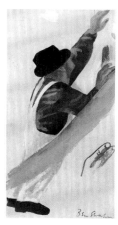

Shahn, *Carpenter's
Helper #2*

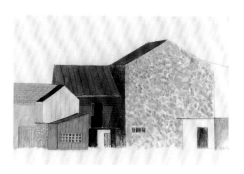

Sheeler, *Bucks County Barn*

Gouache on paper, 25½ x 33¾ in. (64.8 x 85.7 cm.)
Signed lower left: Karl Schrag
Gift of the American Academy of Arts and Letters:
 Childe Hassam Fund, 1974

George Segal, born 1924
Girl on Blanket, Full Figure, 1978 80.7
Painted plaster, H. 76 in. (193 cm.)
Purchased with funds from the Livingston Taylor Family
 and the National Endowment for the Arts, 1980
Cat. no. 82

Virginia Seitz, active twentieth century
Moon Run 77.7
Oil and mixed media on panel,
 24½ x 24½ in. (62.2 x 62.2 cm.)
Etched in wood lower right: Seitz
Howald Memorial Purchase Award from the 67th Annual
 Columbus Art League May Show, 1977

Ben Shahn, 1898–1969
Carpenter's Helper #2, ca. 1940–1942 72.37
Gouache on paper, 10⅝ x 5½ in. (27 x 14 cm.)
Signed lower right: Ben Shahn
Museum Purchase: Howald Fund, 1972

Charles Sheeler, 1883–1965
Lhasa, 1916 31.100
Oil on canvas, 25½ x 31¾ in. (64.8 x 80.6 cm.)
Signed and dated lower right: Sheeler/1916
Gift of Ferdinand Howald, 1931
Cat. no. 50

Charles Sheeler, 1883–1965
Bucks County Barn, 1918 31.101
Gouache and conté crayon on paper, 16⅛ x 22⅛ in.
 (41 x 56.2 cm.)
Signed and dated lower right: Sheeler 1918
Gift of Ferdinand Howald, 1931

Shineman, *Smoke and Ash*

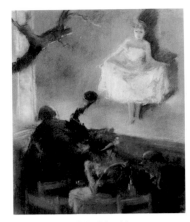

Shinn, *Girl with Red Stockings*

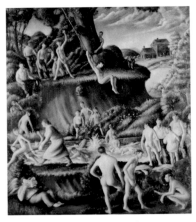

Singer, *The Old Swimming Hole*

Charles Sheeler, 1883–1965
Barns, ca. 1918 72.40
Conté crayon on paper, 6 x 8 in. (15.2 x 20.3 cm.)
Museum Purchase: Howald Fund, 1972

Charles Sheeler, 1883–1965
Chrysanthemums (formerly *Dahlias and White Pitcher*),
 1923 31.104
Gouache, conté crayon, and graphite on paper,
 25½ x 19 in. (64.8 x 48.3 cm.)
Signed and dated lower right: Sheeler 1923
Gift of Ferdinand Howald, 1931

Charles Sheeler, 1883–1965
Still Life with Peaches, 1923 31.105
Pastel on paper, 15⅝ x 11¼ in. (39.7 x 28.6 cm.)
Signed and dated lower right: Sheeler 1923
Gift of Ferdinand Howald, 1931

Charles Sheeler, 1883–1965
Still Life and Shadows, 1924 31.106
Conté crayon, watercolor, and tempera on paper,
 31 x 21 in. (78.7 x 53.3 cm.)
Signed and dated lower right: Sheeler 1924
Gift of Ferdinand Howald, 1931
Cat. no. 51

Hoyt Leon Sherman, 1903–1981
Morning Light, 1924 37.7
Oil on canvas, 26 x 32 in. (66 x 81.3 cm.)
Signed lower right: Hoyt Leon Sherman
Robert W. Schiff Purchase Award, 1937

Hoyt Leon Sherman, 1903–1981
Spanish Boy (Cosecha), 1935 36.23
Oil on canvas, 20⅛ x 16⅛ in. (51.1 x 41 cm.)
Gift of C. Seissel Rindfoos, 1936

Hoyt Leon Sherman, 1903–1981
Traffic Patterns—60 MPH, 1962 65.25
Oil on canvas, 26 x 32 in. (66 x 81.3 cm.)
Anonymous gift, 1965

Larry Shineman, born 1943
Smoke and Ash, 1974 74.15
Mixed media on canvas, 65½ x 98½ in.
 (166.4 x 250.2 cm.)
Purchased with funds from the Alfred L. Willson
 Charitable Fund of The Columbus Foundation, 1974

Everett Shinn, 1876–1953
Luxembourg Gardens, Paris, 1900 57.1
Graphite and watercolor on paper, 4¾ x 7½ in.
 (12.1 x 19.1 cm.)
Signed and dated lower left: E. Shinn/1900
Museum Purchase: Howald Fund, 1957

Everett Shinn, 1876–1953
Arrangement for Louis IV Ceiling, 1906 77.22
Red crayon on paper, 14¹¹⁄₁₆ x 22⁹⁄₁₆ in.
 (37.2 x 57.3 cm.)
Signed and dated lower left: Everett Shinn/1906.
 Signed and inscribed lower right: Arrangement for
 Louis IV Ceiling, Everett Shinn, 112 Waverly Place,
 New York City
Gift of Mr. and Mrs. Everett D. Reese, 1977

Everett Shinn, 1876–1953
Girl with Red Stockings, 1930 55.24
Pastel on paper, 11¼ x 10 in. (28.6 x 25.4 cm.)
Signed and dated lower center: E. Shinn/1930
Museum Purchase: Howald Fund, 1955

Bevlyn Simson, born 1917
Pie in the Sky, 1970 71.34
Acrylic on canvas, 23¾ x 29¾ in. (60.2 x 75.6 cm.)
Gift of Mr. and Mrs. Sheldon Ackerman, 1971

Bevlyn Simson, born 1917
Triptych II (Cincinnati Triptych), 1970 72.14
Acrylic on canvas, 48 x 72 in. (121.9 x 182.9 cm.)
Museum Purchase: Howald Fund, 1972

Clyde Singer, born 1908
The Old Swimming Hole, 1937 38.2

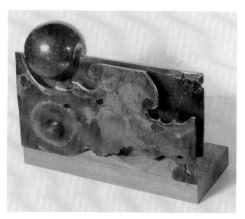

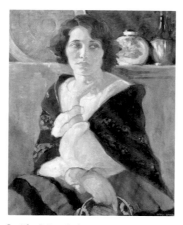

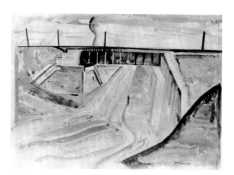

Sommer, *Landscape*

Slaughter, *Beached*

Smith, *Intermission*

Oil on canvas, 46⅛ x 40¼ in. (117.2 x 102.2 cm.)
Signed and dated lower left: Singer Oct. 1937
Gift of Orlando A. Miller, 1938

Todd Slaughter, born 1942
Duet, 1969 69.11
Epoxy, H. 20½ in. (52.1 cm.)
Howald Memorial Purchase Award, 1969

Todd Slaughter, born 1942
Beached, 1971 72.22
Bronze and wood, H. 7 in. (17.8 cm.)
Purchased with funds from the Alfred L. Willson
 Charitable Fund of The Columbus Foundation, 1972

John Sloan, 1871–1951
East Entrance, City Hall, Philadelphia, 1901 60.6
Oil on canvas, 27¼ x 36 in. (69.2 x 91.4 cm.)
Signed and dated upper right: John/Sloan/1901
Museum Purchase: Howald Fund, 1960
Cat. no. 24

John Sloan, 1871–1951
Spring Planting, Greenwich Village, 1913 80.25
Oil on canvas, 26 x 32 in. (66 x 81.3 cm.)
Signed lower right: John Sloan. Signed and inscribed on
 reverse of canvas: Spring Planting/John Sloan.
 Inscribed along top of stretcher: SPRING PLANTING
 GREENWICH VILLAGE N.Y./John Sloan. Inscribed
 along bottom of stretcher: Spring Planting Greenwich
 Vill/John Sloan.
Museum Purchase: Howald Fund II, 1980
Cat. no. 25

Hunt Slonem, born 1951
Red Mask, 1983 84.17
Oil on canvas, 72 x 72 in. (182.9 x 182.9 cm.)
Gift of Captain and Mrs. Charles E. Slonim, 1984

F. Sterling Smith, born 1917
Spring Landscape, ca. 1951 52.47
Oil on panel, 8 x 22⅝ in. (20.3 x 57.5 cm.)

Signed on reverse, right center: F. S. Smith
Museum Purchase, 1952

Vincent Smith, born 1929
The Black Family, 1972 75.17
Oil and collage on canvas, 50 x 40 in. (127 x 101.6 cm.)
Signed lower right: Vincent
Museum Purchase: Howald Fund, 1975

Yeteve Smith, 1888–1957
Intermission, ca. 1926 69.16
Oil on canvas, 32¼ x 26 in. (81.9 x 66 cm.)
Signed lower right: Yeteve Smith
Bequest of Roswitha C. Smith, 1969

Kenneth Snelson, born 1927
V-X, 1974 85.1
Stainless steel and wire (edition of 2),
 H. 96 in. (243.8 cm.)
Given to the Columbus Museum of Art by friends in
 memory of Frances N. Lazarus, 1985
Cat. no. 74

Kenneth Snelson, born 1927
Working Model for V-X, 1968 85.2
Aluminum and stainless steel wire, H. 10¼ in. (26 cm.)
Gift of the artist, 1985

Kenneth Snelson, born 1927
Free Ride Home (Model), 1974–1978 81.14
Aluminum with stainless steel cable, H. 22¾ in.
 (57.7 cm.)
Purchased with funds from the Alfred L. Willson
 Charitable Fund of The Columbus Foundation, 1981

William Sommer, 1867–1949
Landscape, ca. 1935 85.5.2
Watercolor on paper, 11 x 15 in. (28 x 38.1 cm.)
Signed lower right: Wm Sommer
Gift of Joseph Erdelac, 1985

William Sommer, 1867–1949
Brandywine Landscape, ca. 1935 85.5.3

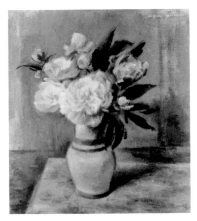

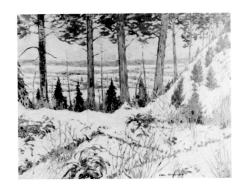

Springer, *Forest Scene*

Stamos, *Mandrake Echo*

Speicher, *Peonies in a Pottery Vase*

Watercolor on paper, 12½ x 18 in. (31.7 x 45.7 cm.)
Signed lower center: Wm Sommer
Gift of Joseph Erdelac, 1985

William Sommer, 1867–1949
Country Landscape, 1943 50.38
Watercolor on paper, 11¾ x 17 in.
 (29.8 x 43.2 cm.)
Signed and dated lower right: Wm. Sommer/1943
Purchased with funds from the Alfred L. Willson
 Foundation, 1950

Raphael Soyer, 1899–1987
Odalisque, 1928 31.267
Oil on canvas, 25⅛ x 20⅛ in. (63.8 x 51.1 cm.)
Signed and dated lower right: Raphael Soyer/1928
Gift of Ferdinand Howald, 1931

Eugene E. Speicher, 1883–1962
The Nude Back 58.34
Oil on canvas, 29¼ x 36¼ in. (74.3 x 92 cm.)
Signed upper left: Eugene Speicher
Museum Purchase: Howald Fund, 1958

Eugene E. Speicher, 1883–1962
Peonies in a Pottery Vase 55.23
Oil on canvas, 22 x 19⅛ in. (55.9 x 48.6 cm.)
Signed upper right: Eugene Speicher
Museum Purchase: Howald Fund, 1955

Eugene E. Speicher, 1883–1962
Spring Bouquet 55.22
Oil on canvas, 17½ x 16¼ in. (44.4 x 41.3 cm.)
Signed lower left: Eugene Speicher
Museum Purchase: Howald Fund, 1955

Niles Spencer, 1893–1952
Corporation Shed, ca. 1928 31.269
Oil on canvas, 20 x 33¼ in. (50.8 x 84.4 cm.)

Signed lower left: Niles Spencer
Gift of Ferdinand Howald, 1931

Niles Spencer, 1893–1952
Buildings 31.268
Oil on canvas, 24 x 30 in. (61 x 76.2 cm.)
Signed lower left: Niles Spencer
Gift of Ferdinand Howald, 1931
Cat. no. 55

Carl Springer, 1874–1935
Forest Scene, 1912 28.1.2
Oil on canvas, 32 x 40¼ in. (81.3 x 102.2 cm.)
Signed and dated lower right: Carl Springer/12
Source unknown

Carl Springer, 1874–1935
Edge of the Woods 28.1.1
Oil on canvas, 30 x 36 in. (76.2 x 91.4 cm.)
Signed lower right: Carl Springer
Gift of Claude Meeker and Edward Orton, Jr., 1928

Frederick M. Springer, born 1908
Johnathan Creek, 1931 32.3
Oil on canvas, 40 x 48 in. (101.6 x 121.9 cm.)
Signed lower right: Frederick M. Springer
Gift of the artist, 1932

Theodoros Stamos, born 1922
The Greek Islands, 1959 (?) 85.24.3
Pastel on board, 16 x 13½ in. (40.1 x 34.3 cm.)
Signed, dated, and inscribed lower center: (The Greek
 Islands)/For Betty with Appreciation/Stamos 1959[?]
Gift of the Betty Parsons Foundation, 1985

Theodoros Stamos, born 1922
Mandrake Echo, ca. 1962–1964 66.30
Oil on canvas, 68 x 60 in. (172.7 x 152.4 cm.)
Gift of the artist and purchased with funds from the
 Alfred L. Willson Foundation, 1966

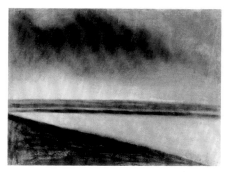

Stella, *Nocturne*

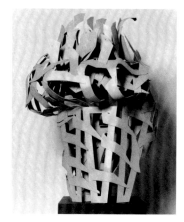

Sugarman, *Cade*

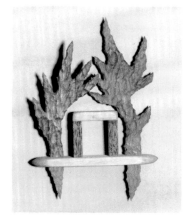

Taaffe, *Plant Sociology*

Julian Stanczak, born 1928
Enclosed, 1970 82.13
Acrylic on canvas, 47½ x 71½ in. (120.7 x 181.6 cm.)
Signed and dated on reverse: J. Stanczak 1970
Gift of Norman and Carolyn Carr, 1982

Richard Stankiewicz, 1922–1983
Untitled, 1979–21, 1979 80.21
Steel, H. 63⅞ in. (162.2 cm.)
Purchased with funds from an anonymous donor and
 the National Endowment for the Arts, 1980
Cat. no. 83

Joseph Stella, 1880–1946
Nocturne 64.52
Pastel on paper, 18 x 24 in. (45.7 x 61 cm.)
Signed lower right: Joseph Stella
Museum Purchase: Howald Fund, 1964

Jarvis Anthony Stewart, 1914–1981
Farm, 1951 56.29
Oil on canvas, 26¾ x 35 in. (67.9 x 88.9 cm.)
Signed lower right: Stewart
Museum Purchase: Howald Fund, 1956

Ary Stillman, 1891–1967
Rhythm in Depth, 1953 76.46
Oil on canvas, 39¾ x 30 in. (101 x 76.2 cm.)
Signed lower left: Stillman
Gift of the Stillman-Lack Foundation, 1976

Gilbert Stuart (attributed to), 1755–1828
George Washington, ca. 1802 [57]39.29
Oil on canvas, 48 x 37 in. (121.9 x 94 cm.)
Bequest of Frederick W. Schumacher, 1957

Walter Stuempfig, Jr., 1914–1970
Three Glasses, 1966 68.32
Oil on canvas, 8¾ x 12 in. (22.2 x 30.5 cm.)
Signed upper left: W.S.
Museum Purchase: Howald Fund, 1968

George Sugarman, born 1912
Cade, 1975–1977 78.23
Sandblasted aluminum, H. 56 in. (142.2 cm.)
Signed front lower right: Sugarman
Purchased with funds from the Alfred L. Willson
 Charitable Fund of The Columbus Foundation and the
 National Endowment for the Arts, 1978

Thomas Sully (attributed to), 1783–1872
A Baltimore Girl [57]31.299
Oil on canvas, 29½ x 24½ in. (74.9 x 62.2 cm.)
Bequest of Frederick W. Schumacher, 1957

Thomas Sully, 1783–1872
Portrait of a Woman 55.1
Oil on canvas, 30 x 25 in. (76.2 x 63.5 cm.)
Gift of Mrs. Earle C. Derby, 1955

Robert Swain, born 1940
Untitled, 1975 76.1
Acrylic on canvas, 84 x 84 in. (213.4 x 213.4 cm.)
Museum Purchase: Howald Fund, 1976

Susan Taaffe, born 1957
Plant Sociology, 1986 86.21
Oil on wood, H. 30 in. (76.2 cm.)
Ferdinand Howald Memorial Purchase Award from the
 76th Annual Columbus Art League Exhibition, 1986

Alvan Tallmadge, 1893–ca. 1970
Iglesia La Salud, San Miguel, 1969 71.11
Ink and watercolor on paper, 14½ x 10⅜ in.
 (36.8 x 26.3 cm.)
Signed and dated lower left: Tallmadge '69
Museum Purchase: Howald Fund, 1971

Ralston Carlton Thompson, 1904–1975
Gullies, 1946 77.2.1
Charcoal on watercolor paper, 19½ x 27 in.
 (49.5 x 68.6 cm.)
Signed bottom right: Ralston Thompson
Gift from the Estate of Ralston Thompson, 1977

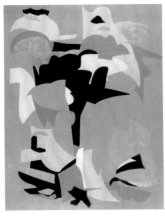

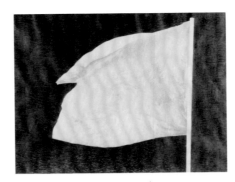

Tolstedt, *Flag Sequence Series III*

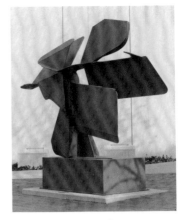

Thompson, *Trees and Rock Forms*

Trova, *Profile Canto A/S*

Ralston Carlton Thompson, 1904–1975
Menemsha No. 2, 1947 77.2.2
Ink and wash on watercolor paper, 10⅜ x 16½ in.
 (26.4 x 41.9 cm.)
Signed bottom right: Ralston Thompson
Gift from the Estate of Ralston C. Thompson, 1977

Ralston Carlton Thompson, 1904–1975
Village Square—Zocalo, 1952 77.2.4
Oil on canvas, 30¼ x 40 in. (76.8 x 101.6 cm.)
Gift from the Estate of Ralston C. Thompson, 1977

Ralston Carlton Thompson, 1904–1975
Tidal Pool No. 3, 1966 77.2.6
Oil on canvas, 35¾ x 47½ in. (90.8 x 120.7 cm.)
Gift from the Estate of Ralston C. Thompson, 1977

Ralston Carlton Thompson, 1904–1975
Cholula #3 54.44
Ink on paper, 12½ x 19 in. (31.8 x 48.3 cm.)
Signed lower right: Ralston Thompson
Museum Purchase: Howald Fund, 1954

Ralston Carlton Thompson, 1904–1975
Trees and Rock Forms 64.35x
Oil on canvas, 39¾ x 29⅜ in. (101 x 74.6 cm.)
Museum Purchase: Howald Fund, 1964

William J. Thompson, born 1926
Angel, 1958 60.31
Bronze, H. 6¾ in. (17.1 cm.)
Beaux Arts Purchase Award, 1960

William Thon, born 1906
Windy Mykonos, 1959 60.20
Watercolor and resist on paper, 20 x 26¼ in.
 (50.8 x 66.7 cm.)
Signed lower right: Thon
Gift of Mr. and Mrs. Gerald B. Fenton, 1960

James Thurber, 1894–1961
Football (for *The New Yorker*, October 29, 1932), 1932
 60.24

Ink on paper, 7⅜ x 8⅜ in. (18.7 x 21.3 cm.)
Signed lower right: Th. Inscribed upper right: Football.
 Inscribed and dated on reverse center: Lineup of
 Football Players/from New Yorker/10/29/32
Purchased with funds from the Alfred L. Willson
 Foundation, 1960

James Thurber, 1894–1961
Signals (for *The New Yorker*, October 5, 1932), 1932
 60.25
Ink on paper, 6¾ x 10½ in. (17.2 x 26.7 cm.)
Signed and inscribed lower right: Th/Signals. Inscribed
 and dated on reverse: 2 football players/Published in
 New Yorker/10/5/32
Purchased with funds from the Alfred L. Willson
 Foundation, 1960

James Thurber, 1894–1961
Happy New Year (or *Dogs*), ca. 1932 60.23
Graphite on paper, 5¼ x 8¾ in. (13.3 x 22.2 cm.)
Signed lower right: Jim Thurber. Inscribed upper right:
 Happy/New/Year
Purchased with funds from the Alfred L. Willson
 Foundation, 1960

James Thurber, 1894–1961
Two Men in a Doorway, ca. 1933 60.26
Ink on paper, 8½ x 6¾ in. (21.6 x 14.6 cm.)
Inscribed on reverse: drawn about 1933
Purchased with funds from the Alfred L. Willson
 Foundation, 1960

James Thurber, 1894–1961
Thurber and His Circle 60.22
Ink on paper, 8¼ x 10¾ in. (21 x 27.3 cm.)
Signed and inscribed lower center to right: Thurber and
 His Circle / James Thurber
Purchased with funds from the Alfred L. Willson
 Foundation, 1960

Lowell Tolstedt, born 1939
History of an Anonymous Blueberry Muffin, 1969 71.21

Tworkov, *SR-Pt-70-#6*

Graphite and watercolor on paper, 22¾ x 34 in.
 (57.8 x 86.4 cm.)
Signed and inscribed lower center to right: Lowell
 Tolstedt, History of an Anonymous Blueberry Muffin
Purchased with funds from the Alfred L. Willson
 Charitable Fund of The Columbus Foundation, 1971

Lowell Tolstedt, born 1939
Flag Sequence Series III, 1973–1974 75.19
Graphite on paper, 39⅝ x 50½ in. (100.7 x 128.3 cm.)
Signed lower right: Lowell Tolstedt. Inscribed lower left:
 Flag Sequence
Purchased with funds from the Alfred L. Willson
 Charitable Fund of The Columbus Foundation, 1975

George Tooker, born 1920
Cornice, ca. 1949 80.26
Tempera on panel, 24 x 15½ in. (61 x 39.4 cm.)
Signed lower right: Tooker
Museum Purchase: Howald Fund II, 1980
Cat. no. 71

Ernest Trova, born 1927
Profile Canto A/S, 1976 81.25
Welded and painted steel plate, H. 142 in. (360.6 cm.)
Gift of the Siteman Organization, 1981

John Henry Twachtman, 1853–1902
Court of Honor, World's Columbian Exposition, Chicago,
 1893 [57]43.10
Oil on canvas, 25 x 30 in. (63.5 x 76.2 cm.)
Signed lower right: J. H. Twachtman
Bequest of Frederick W. Schumacher, 1957
Cat. no. 15

John Henry Twachtman, 1853–1902
Branchville 79.104
Oil on canvas, 60 x 80 in. (152.4 x 203.2 cm.)
Gift of Mr. and Mrs. Harry Spiro, 1979

Stanley Jan Twardowicz, born 1917
Fishing Shacks, 1946 48.7
Casein on paper, 12¼ x 19 in. (31.1 x 48.3 cm.)

Signed and dated lower right: Stanley '46
Purchased with funds from the Alfred L. Willson
 Foundation, 1948

Stanley Jan Twardowicz, born 1917
Fetish, 1960 63.7
Oil on canvas, 71½ x 48¼ in. (181.6 x 122.5 cm.)
Signed on reverse: Stanley Twardowicz
Museum Purchase: Howald Fund, 1963

Jack Tworkov, 1900–1982
SR-Pt-70-#6, 1970 76.18
Charcoal and conté crayon, 25½ x 19¾ in.
 (64.8 x 50.2 cm.)
Inscribed in pencil lower left: A SR-Pt-70-#6.
 Inscribed in conté crayon lower right: J2/70
Purchased with funds from the Alfred L. Willson
 Charitable Fund of The Columbus Foundation, 1976

Walter Ugorski, born 1932
Olentangy Landscape 67.9
Oil on canvas, 50¼ x 60½ in. (127.6 x 153.7 cm.)
Signed lower left: Ugorski
Museum Purchase: Howald Fund, 1967

John Ulbricht, born 1926
Earthscape II, 1961 62.79
Oil on canvas, 43½ x 56½ in. (110.5 x 143.5 cm.)
Signed lower right: Ulbricht. Signed, dated, and
 inscribed on reverse: 1961/Earthscape II John Ulbricht.
Museum Purchase: Howald Fund, 1962

Stanbery Van Buren, died 1926
Venetian Square, 1909 09.1
Oil on canvas, 31 x 22⅛ in. (78.7 x 56.2 cm.)
Signed and dated lower left: Stanbery Van Buren 1909
Museum Purchase, 1909

Anne Gatewood Van Kleeck, active twentieth century
Standing Woman 59.6
Bronze, H. 14 in. (35.6 cm.)
Museum Purchase: Howald Fund, 1959

Barbara Veatch, born 1949
Angel of Darkness, 1983 83.20
Pastel on paper, 26 x 39¾ in. (66 x 101 cm.)
Signed lower right corner: Veatch
Bevlyn and Theodore Simson Purchase Award from the
 73rd Annual Columbus Art League Exhibition, 1983

Elihu Vedder, 1836–1923
The Venetian Model, 1878 69.7
Oil on canvas, 18 x 14⅞ in. (45.7 x 37.8 cm.)
Signed and dated lower left: Vedder/1878
Museum Purchase: Schumacher Fund, 1969
Cat. no. 12

Robert Vickers, born 1924
Vezélay Revisited, 1956 56.47
Oil on canvas, 22 x 30 in. (53.3 x 76.2 cm.)

Signed lower right: R. Vickers. Signed and dated on
reverse center: R. Vickers/1956
Museum purchase: Howald Fund, 1956

Angela von Neumann, born 1928
Undersea, 1964 64.33
Oil on canvas, 39 x 31⅜ in. (99.1 x 79.7 cm.)
Signed lower left center: Angela von Neumann. Signed,
 dated, and inscribed on reverse upper right: Undersea/
 Jan.-1964/Angela Von Neumann
Museum Purchase: Howald Fund, 1964

Horatio Walker, 1858–1938
Barnyard Scene 59.32
Watercolor on paper, 7¾ x 10⅝ in. (19.7 x 27 cm.)
Signed lower left: Horatio Walker
Museum Purchase: Howald Fund, 1959

Abraham Walkowitz, 1880–1965
Figure Studies, 1905 75.28
Graphite on paper, 14 x 8½ in. (35.6 x 20.4 cm.)
Signed and dated lower center: A. Walkowitz/1905.
 Signed on reverse, upper left: A. Walkowitz
Museum Purchase: Howald Fund, 1975

Abraham Walkowitz, 1880–1965
Trees and Flowers, 1917 31.273
Watercolor and graphite on paper, 15½ x 29½ in.
 (39.4 x 74.9 cm.)
Signed and dated lower left: A. Walkowitz 1917
Gift of Ferdinand Howald, 1931

Abraham Walkowitz, 1880–1965
Bathers 31.271
Watercolor and graphite on paper, 15¼ x 29 in.
 (38.4 x 73.7 cm.)
Signed lower left: A. Walkowitz
Gift of Ferdinand Howald, 1931

Abraham Walkowitz, 1880–1965
Bathers Resting 31.270
Watercolor and charcoal on paper, 14½ x 21⅛ in.
 (36.8 x 53.7 cm.)
Signed lower right: A. Walkowitz
Gift of Ferdinand Howald, 1931

Abraham Walkowitz, 1880–1965
Decoration—Figures in Landscape 31.272
Watercolor on paper, 12⅝ x 37 in. (32.1 x 94 cm.)
Signed lower left: A. Walkowitz
Gift of Ferdinand Howald, 1931

Martha Walter, 1875–1976
Two on the Beach, ca. 1914 78.1
Oil on canvas mounted on panel, 6 x 8¼ in.
 (15.2 x 20.9 cm.)
Gift of Mr. and Mrs. John Connally in memory of
 Jack Schmidt, 1978

Max Weber, 1881–1961
Still Life, 1921 31.274
Oil on canvas, 15⅛ x 21¼ in. (38.4 x 54 cm.)

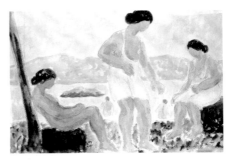

Walkowitz, *Bathers Resting*

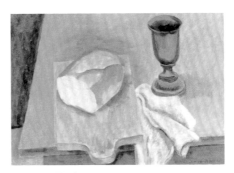

Weber, *Still Life*

Signed and dated lower right: Max Weber 1921
Gift of Ferdinand Howald, 1931

Max Weber, 1881–1961
The Wayfarers, ca. 1940 58.33
Oil on canvas, 26¼ x 32¼ in. (66.7 x 81.9 cm.)
Signed lower right: MAX WEBER
Museum Purchase: Howald Fund, 1958

Elbert Weinberg, born 1928
Dog House Outgrown, 1973 76.5
Bronze, H. 6¼ in. (15.9 cm.)
Signed on base: Weinberg
Museum Purchase: Howald Fund, 1976

Mac Wells, born 1925
Untitled #6, 1970 71.14
Acrylic on canvas, 78 x 78 in. (198.1 x 198.1 cm.)
Museum Purchase: Howald Fund, 1971

Richard Wengenroth, born 1928
Alma Mater, ca. 1953 58.42
Tempera on paper, 24¾ x 18⅞ in. (62.9 x 47.9 cm.)
Museum Purchase, 1958

Byron F. Wenger, 1898–1976
Bull Calf (pair), 1929 44.1.1 & .2
Ceramic, H. 10½ in. (26.7 cm.)
Signed and dated on base: Wenger 29
Gift of Mrs. Ralph H. Beaton, 1944

Byron F. Wenger, 1898–1976
Thundergod, ca. 1929 81.17
Bronze, H. 17 in. (43.2 cm.)
Signed on base: Wenger
Gift of Hermine Summer, 1981

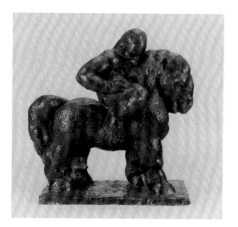

Wenger, *Thundergod*

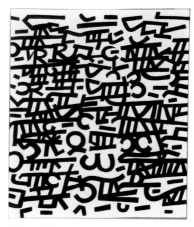

Wilke, *California*

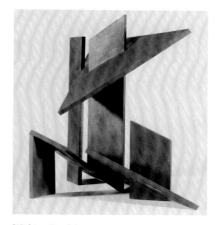

Witkin, *Excelsior*

Byron F. Wenger, 1898–1976
Male Nude 36.16
Plaster, H. 29½ in. (75 cm.)
Signed on base: BFW
Gift of Friends of Art, 1936

Tom Wesselmann, born 1931
Study for Seascape #10, 1966 76.33
Acrylic on corrugated cardboard mounted on particle
 board, 48 x 62 in. (121.9 x 157.5 cm.)
Purchased with the aid of funds from the National En-
 dowment for the Arts and an anonymous donor, 1976
Cat. no. 73

Benjamin West, 1738–1820
Study of a Chair and Drapery 65.45
Chalk on paper, 12⅛ x 8½ in. (30.8 x 21.6 cm.)
Purchased with funds from the Alfred L. Willson
 Foundation, 1965

James A. McNeill Whistler, 1834–1903
Study of a Head (Portrait of Algernon Graves),
 ca. 1881–1885 [57]43.8
Oil on canvas, 22⅝ x 14½ in. (57.5 x 36.8 cm.)
Signed center right with butterfly symbol
Bequest of Frederick W. Schumacher, 1957
Cat. no. 14

Harry Wickey, 1892–1968
The Otter Kill 56.22
Ink on paper, 7⅞ x 11⅞ in. (20 x 30.2 cm.)
Signed lower right: Wickey
Museum Purchase: Howald Fund, 1956

Harry Wickey, 1892–1968
Women on the Beach 56.27
Conté crayon on paper, 4¾ x 6⅝ in.
 (12.1 x 16.8 cm.)
Signed lower right: Wickey
Museum Purchase: Howald Fund, 1956

Ulfert Wilke, 1907–1987
California, 1967 71.8
Acrylic on canvas, 69 x 56 in. (175.3 x 142.2 cm.)
Signed with monogram and dated on reverse, upper
 right and upper left: A/UW/67
Museum Purchase: Howald Fund, 1971

Ralph E. Williams, born 1946
The Kiss, 1972 75.5
Oil on canvas, 39¾ x 46 in. (101.6 x 116.8 cm.)
Signed lower right: Ralph E. Williams
Purchased with funds from the Alfred L. Willson
 Charitable Fund of The Columbus Foundation, 1975

Roger Williams, born 1946
Paint Brush, 1970 70.17
Graphite, pastel, and brass screws, 31 x 24½ in.
 (78.7 x 62.2 cm.)
Signed, dated, and inscribed lower right: 2x52 Roger
 Williams 70
Purchased with funds from the Alfred L. Willson
 Foundation, 1970

Roger Williams, born 1946
Pie Man, 1970 70.26
Acrylic on canvas, 59½ x 60 in. (151.1 x 152.4 cm.)
Howald Memorial Purchase Award, 1970

Roger Williams, born 1946
Color Freeway #116, 1972 73.12
Acrylic on canvas, 60¼ x 92⅝ in. (153 x 235.3 cm.)
Museum Purchase: Howald Fund, 1973

Robb Wilson, born 1932
Fountain, ca. 1969 70.29
Stoneware, H. 16½ in. (41.9 cm.)
Signed on base: Robb Wilson
Beaux Arts Purchase Award, 1970

Isaac Witkin, born 1936
Excelsior, 1978 78.22

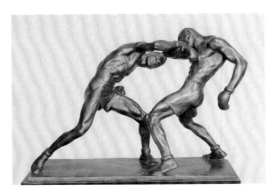

Young, *Right to the Jaw*

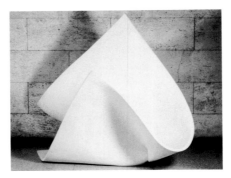

Youngerman, *Juba*

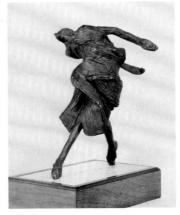

Zajac, *Metamorphosis, Rome Series*

Steel, H. 25 in. (63.5 cm.)
Signed and dated: Witkin 1978
Purchased with funds from the Alfred L. Willson
 Charitable Fund of The Columbus Foundation and the
 National Endowment for the Arts, 1978

Andrew Wyeth, born 1917
Inland Shell, 1957 82.15
Watercolor and gouache on paper, 13½ x 21½ in.
 (34.3 x 54.6 cm.)
Signed lower right: Andrew Wyeth
Gift of Mr. and Mrs. Harry Spiro, 1982
Cat. no. 72

Henriette Wyeth, born 1907
Easter Lilies, 1964 67.3
Oil on canvas, 35 x 30 in. (88.9 x 76.2 cm.)
Signed lower left: Henriette Wyeth
Museum Purchase: Howald Fund, 1967

John Wynne, born 1921
Interior with Figure, 1952–1953 55.14
Ink on paper, 19¾ x 29¼ in. (50.2 x 74.3 cm.)
Signed and dated on mat lower right: John Wynne,
 Winter, 1952–53. Inscribed lower left: Interior with
 figure
Museum Purchase: Howald Fund, 1955

Mahonri M. Young, 1877–1957
The Knock-Down, original plaster 1928, posthumous
 cast 1960 60.49
Bronze, H. 22¾ in. (57.8 cm.)
Signed on base: © Mahonri
Museum Purchase: Howald Fund, 1960

Mahonri M. Young, 1877–1957
Right to the Jaw, original plaster 1928, posthumous
 cast 1960 60.50
Bronze, H. 16 in. (40.6 cm.)
Signed on base: © Mahonri
Museum Purchase: Howald Fund, 1960

Jack Youngerman, born 1926
Juba, 1980 81.23
Cast fiberglass, H. 67 in. (170.2 cm.)
Signed and dated lower edge: J Y 1980 1/3
Gift of Mr. and Mrs. Sidney M. Feldman, 1981

Jack Zajac, born 1929
Metamorphosis, Rome Series, 1959 82.5.1
Bronze, H. 9 in. (22.9 cm.)
Gift of Regina Kobacker Fadiman, 1982

Laura Ziegler, born 1927
The Friar, ca. 1949 57.39
Bronze, H. 18½ in. (47 cm.)
Museum Purchase: Howald Fund, 1957

Laura Ziegler, born 1927
The Friar, 1954 59.30
Ink on paper, 7⅞ x 5¼ in. (20 x 13.3 cm.)
Signed and dated lower right: '54 L. Ziegler
Purchased with funds from the Alfred L. Willson
 Foundation, 1959

Laura Ziegler, born 1927
Raphello, 1956 58.43
Ink on paper, 7¾ x 5¼ in. (19.7 x 13.3 cm.)
Signed, dated, and inscribed lower right: Laura
 Ziegler/Rome 1956
Purchased with funds from the Alfred L. Willson
 Foundation, 1958

Laura Ziegler, born 1927
Walking Friar, ca. 1965 68.7
Bronze, H. 34 in. (86.4 cm.)
Museum Purchase: Howald Fund, 1968

Laura Ziegler, born 1927
Study for a Fountain I, 1972 73.30
Bronze, H. 18 in. (45.7 cm.)

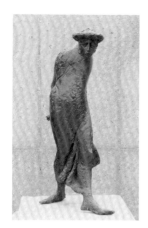

Ziegler, *Walking Friar*

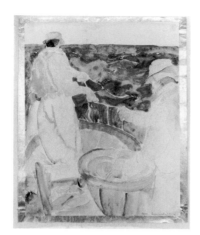

Zorach, *The Fishermen*

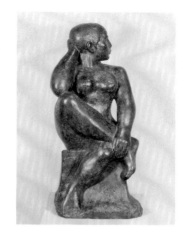

Zorach, *Seated Dancer*

Purchased with funds from the Alfred L. Willson
 Charitable Fund of The Columbus Foundation and the
 Howald Fund, 1973

William Zimmerman, born 1937
American Woodcock, 1975 75.45
Watercolor on paper, 13¾ x 12¾ in. (34.9 x 32.4 cm.)
Signed lower right: Wm. Zimmerman
Purchased with funds from the Alfred L. Willson
 Charitable Fund of The Columbus Foundation, 1975

Marguerite Zorach, 1887–1968
Rendezvous in Yosemite, 1921 73.18
Oil on canvas, 25 x 20⅛ in. (63.5 x 51.1 cm.)
Signed and dated lower right: M. Zorach/1921
Museum Purchase: Howald Fund, 1973

William Zorach, 1887–1966
Cart and Horse at Water's Edge, 1916 31.278
Watercolor and graphite on paper, 11⅞ x 9¼ in.
 (30.2 x 23.5 cm.)
Signed and dated lower right: Wm. Zorach 1916
Gift of Ferdinand Howald, 1931

William Zorach, 1887–1966
The Fishermen, 1916 31.279
Watercolor and graphite on paper, 12 x 9⅞ in.
 (30.5 x 25.1 cm.)
Signed and dated lower right: Wm. Zorach, 1916
Gift of Ferdinand Howald, 1931

William Zorach, 1887–1966
Marine, 1916 31.280
Watercolor on paper, 13⅜ x 15⅝ in. (34 x 39.7 cm.)
Signed and dated lower right: William Zorach—1916—
Gift of Ferdinand Howald, 1931

William Zorach, 1887–1966
Seated Dancer, 1964 85.10
Bronze, H. 33 in. (83.8 cm.)
Signed, dated, and inscribed top back of seat: © 1964
 William Zorach/4/6. Inscribed bottom back of seat:
 BEDI-MAKKY N.Y.
Museum Purchase: Howald Fund, 1985

Anonymous (after Edward Savage), early 19th century
The Family of George Washington [57]48.32
Oil on canvas, 28 x 35½ in. (71.1 x 89.2 cm.)
Bequest of Frederick W. Schumacher, 1957

Anonymous, 19th century
Kneeling Figure x.501
Marble, H. 25½ in. (64.8 cm.)
Anonymous gift

Anonymous
Landscape 76.42.4
Watercolor on paper, 11¼ x 15¼ in. (28.6 x 38.7 cm.)
Signed lower left: Everett
Gift of Dorothy Hubbard Appleton, 1976

Anonymous
Seascape 76.42.5
Watercolor on paper, 11¼ x 15½ in. (28.6 x 39.4 cm.)
Gift of Dorothy Hubbard Appleton, 1976

Anonymous (formerly attributed to George Bellows),
 early 20th century
The Mastermind (Melvin F. Bragdon), 1912 62.73
Oil on canvas, 22¼ x 16 in. (56.5 x 40.6 cm.)
Inscribed by unknown hand, lower right: George Bellows
Bequest of Eloise Bragdon, 1962

Other American Collections—a Summary

FOLK ART

The museum's collection of American folk art includes paintings, drawings, watercolors, Fraktur, coverlets, and carvings by nineteenth- and twentieth-century artisans.

The centerpiece of this collection is a group of one hundred woodcarvings by Elijah Pierce, the son of a former slave, who settled in Columbus, Ohio, in the 1920s. Pierce has been honored by exhibitions in this country and abroad and is today acknowledged as one of the country's foremost folk artists. The museum's collection of Pierce objects is comprehensive, including both biblical and secular works from 1927 to the early 1980s. One of his masterpieces, *The Crucifixion* (cat. no. 61), is highlighted in Part One of this catalogue.

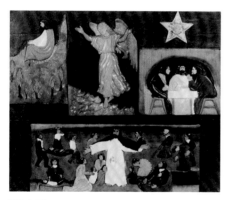

Elijah Pierce, 1892–1984
The Book of Wood (detail), 1932–1936
Painted wood relief, 28 x 35 in. (71.1 x 88.9 cm.)
Museum Purchase
85.3.2. b

DECORATIVE ARTS AND POTTERY

Art glass from New England and representative examples by Steuben, Tiffany, and Millville craftsmen form the basis of the museum's holdings in American decorative arts. Featured in this collection are signed works by prominent makers such as Dominick Labino and Isamu Noguchi.

The museum's ceramic collection is representative of both modern and contemporary crafts movements, with earlier works by Arthur Baggs, Edgar Littlefield, Otto and Gertrude Natzler, and contemporary works by Jack Earl, David Snair, and Ban Kajitani, among others.

Pottery by Native Americans of the Southwest includes examples by the Anasazi, the Acoma, and the Mericopa tribes, and from the pueblos of Santa Clara, Santa Domingo, and Santa Ildefonso. Watercolors, nineteenth-century saddle blankets, rugs, and jewelry round out this part of the collection.

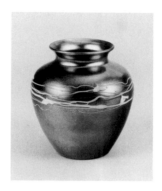

Steuben Glass Works,
 twentieth century
Vase (Blue Aurene)
Blown glass, H. 6¼ in. (15.9 cm.)
Gift of Audrey Prine Bussert in
 memory of Edna Miller Prine
81.30

PRINTS AND PHOTOGRAPHY

The museum's print collection, numbering more than 2,500 works, includes lithographs by George Bellows, woodblock prints by Rockwell Kent, and etchings by Childe Hassam and John Sloan. Contemporary printmakers such as Sam Francis, Red Grooms, Philip Pearlstein, Edward Ruscha, Frank Stella, and Roy Lichtenstein are prominently represented, as are local and regional artists. Among the photography holdings are works by Edward Steichen, Walker Evans, and Bernard and Hilda Becher.

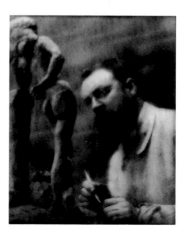

Edward Steichen, 1879–1973
Henri Matisse
Black and white photograph,
 11 x 8 in. (27.9 x 20.3 cm.)
Museum Purchase: Howald
 Fund
76.28

GESCHICHTE
DER DEUTSCHEN LITERATUR

Josef Nadler

GESCHICHTE DER DEUTSCHEN LITERATUR

Zweite ergänzte Auflage

VERLAG JOSEF HABBEL · REGENSBURG

VORSCHULE

1. LITERATURWISSENSCHAFT

Ob Wissenschaft sei oder nicht sei, hängt von der Anerkennung zweier Spielregeln ab. 1. Der Finder ist für die gefundene Wahrheit nicht haftpflichtig. Er kann nichts dafür, daß zwei mal zwei vier ist. 2. Die gefundene Wahrheit gilt für jede Weltanschauung. Gegen das Erwiesene gibt es keine Berufungsinstanz. Wie die Literaturwissenschaft dieses oberste Doppelrecht in Anspruch nehmen darf, so ist sie auch an das dreifache Grundgesetz alles Erkennens gebunden. 1. Sie muß wie jede andere Wissenschaft beweisen. Beweispflicht ist keine nur positivistische Forderung. 2. Sie darf keine Voraussetzungen machen. Was Geist und was Seele ist, sind für sie keine Vorfragen, deren Lösung sie zunächst einmal abwarten müßte. 3. Sie hat kein bevorzugtes Recht auf die intuitive Erkenntnis. Dem diskursiven Denken kommt vor dem intuitiven kein anderer Vorteil zu als der, daß es allein lehrbar und beweisbar ist. Jede Wissenschaft muß intuitiv gefundene Erkenntnisse in rational beweisbare verwandeln.

Ob Literaturwissenschaft sei oder nicht sei, kann nicht von Standpunkten aus erörtert werden, die selber strittig sind und erst noch des Erweises bedürfen. Es gibt nur eine Möglichkeit, Einsicht in Wesen, Weg und Ziel der Literaturwissenschaft zu gewinnen. Man stellt sich auf den Standpunkt des Erkennenden, der sich völlig voraussetzungslos und ohne vorgängiges Wissen seinem Gegenstand gegenüber findet und nun Schritt für Schritt alle die Erkenntnisse vollzieht, die sich logich aus einander ergeben. Man versetzt sich also in die Lage, in der sich jeder befindet, der als erster einer ihm völlig fremden Literatur gegenübersteht, mit keiner andern Vorkenntnis als einer sehr ungefähren der Sprache, in der diese Literatur geschrieben ist.

I. Erkenntnisstufe. In meine unmittelbare Wahrnehmung fallen „Werke", nicht „Dichter". Damit ist schon über den ganzen weiteren Erkenntnisweg entschieden. Ich habe keine Ursachen vor mir, sondern Wirkungen. Ich kann nicht von Ursachen auf Wirkungen, sondern lediglich von Wirkungen auf Ursachen schließen. Ich kann nur „induzieren", nicht „deduzieren". An der ungeordneten Masse der Werke, die meiner Wahrnehmung unmittelbar

gegeben sind, kann ich nichts anderes tun, als mittels des begriffsbildenden Verfahrens dreierlei logische Operationen zu vollziehen. Ich „ordne" nach wiederkehrenden Merkmalen diese ungeordnete Masse.

1. Ich ordne nach dem Grade der Sprachvertrautheit diese Werke von mir weg bis zu den fremdesten und mir gerade noch verständlichen in eine Reihe. Ich beschränke mich dabei auf den Oberbegriff deutsch und entschließe mich, die Literatur in deutscher Sprache zu meinem Wissenschaftsgegenstande zu machen. Ob die so gewonnene Ordnungsreihe zeitliche oder räumliche „Bedeutung" hat, kann ich auf dieser Erkenntnisstufe nicht sagen.

2. Ich finde auf Grund der innern Form Gruppen heraus, die durch die ganze Sprachreihe hindurchgehen. Ich kann diese Gruppen „Gattungen" nennen und sie auf drei vereinfachen: Lieder, Erzählungen, Spiele. Alle drei Gruppen zusammen erschöpfen dem Umfang nach die ganze Reihe. Über diese einfache Feststellung hinaus tritt freilich die Frage an mich heran: was hat diese Gleichartigkeit der gattungsmäßigen Form innerhalb der allgemeinen Reihe verursacht? Auch darüber vermag ich auf dieser Erkenntnisstufe nichts auszusagen.

3. Ich finde durch auffallende Merkmale andere Gruppen heraus, die sprachlich ganz eng zusammengehören. Es ergibt sich, daß in diese Gruppen Vertreter aller Literaturgattungen gehören, also Lieder, Erzählungen, Spiele. Auch diese anders bestimmten sprachlichen Einheitsgruppen erschöpfen, zusammen genommen, dem Umfange nach die gesamte Reihe. Auf die Frage, was wohl diese ganz enge Sprachgleichheit innerhalb dieser bestimmten Gruppen bewirkt, vermag ich jetzt noch keine Antwort zu geben.

Ist auf dieser Erkenntnisstufe Wissenschaft möglich? Um das entscheiden zu können, muß man sich über die Natur der Denkoperationen klar sein, die ich auf dieser Stufe vollziehe. Es sind rein logische Operationen der Begriffsbildung, die völlig im Bereich der innern Wahrnehmung spielen und die ich mit Gewißheit vollziehe. Es sind nichts als Operationen der begrifflichen Ordnung. Sie stellen Sachverhalte fest, die irgendwie bewirkt sein müssen, ohne daß ich noch auf ihre Ursachen schließen könnte. Denn meine Denkoperationen sind völlig ahistorisch und reichen nicht in die geschichtliche Wirklichkeit hinein, aus der etwa diese Werke hervorgegangen sind. Was sich auf dieser Erkenntnisstufe gewinnen läßt, ist eine lediglich beschreibende Wissenschaft. Wir schätzen sie nicht gering, aber sie ist nicht mehr als das. Sie kann nicht mehr als die sprachlichen Unterschiede inner-

halb der Gesamtreihe von Werken feststellen. Sie kann lediglich die innern Formgesetze der Gattungen ergründen. Sie kann also die Arbeit der Poetik leisten. Und sie kann nicht mehr als sich wundern über die gemeinsamen Züge, die diese oder jene Gruppe von Werken, ohne Rücksicht auf die Gattungen, denen sie angehören, verbinden. Auf dieser Stufe der Erkenntnis findet sich die Wissenschaft begrifflich genau erfaßbaren, innern und äußern Übereinstimmungen — gemeinsamen Zügen — bestimmter Werke gegenüber, die auf keine andere Weise als kausal zu deuten sind, das heißt als Wirkungen aus Ursachen. Man kann über das Kausalgesetz so oder so philosophieren. Das ändert nichts an dem Sachverhalt, daß diese gemeinsamen Züge einen zureichenden Grund haben müssen. Ich habe nur die eine Wahl. Entweder bleibe ich auf dieser Stufe stehen und bescheide mich bei einem rein beschreibenden Verfahren, oder ich gebe meinem Erkenntnistriebe nach und frage nach den Ursachen dieser gemeinsamen Züge. Dann aber muß ich den Fuß zu einer höheren Erkenntnisstufe heben, ob ich nun diese Ursachen im Sprachlichen, Gattungsmäßigen oder Personalen vermute.

II. Erkenntnisstufe. Das Verfahren, das sie mir vorschreibt, unterscheidet sich fundamental von dem der ersten Stufe. Dort hatte ich meinen Gegenstand in der unmittelbaren Wahrnehmung, und die Denkoperationen, die ich an ihm vornahm, vollzog ich mit absoluter Gewißheit. Jetzt bin ich an eine Wirklichkeit außer mir gewiesen, wenn ich nach den Ursachen für die begrifflich bestimmten gemeinsamen Züge suche. Denn daß diese Ursachen nicht in mir liegen, weiß ich. Und so habe ich keine andere Wahl. Ich muß all diese Werke als „Quellen" nehmen, die mir über die jenseits meiner liegende Wirklichkeit aussagen. Ich muß „historisch" denken. Das bedeutet eine ganz andere Spielregel. Ich setze mir Kriterien, nach denen ich den Quellen ihre inhaltliche Aussage bezüglich der jenseitigen Wirklichkeit „glaube". Dieser Glaube ist unvergleichbar verschieden von der Gewißheit meiner inneren Wahrnehmungen und der Denkoperationen, die ich daran vornehme. Was jenseits meiner Wahrnehmung liegt, ist und bleibt eine imaginäre Welt. Die Glaubwürdigkeit der Quellen hängt nicht nur von der Kraft ihrer Bezeugtheit ab, sondern ebensosehr von ihrer Fähigkeit, mir ein gestelltes Rätsel zu erklären. Ich höre auf dieser Erkenntnisstufe nicht auf, begrifflich zu denken. Aber ich fange zusätzlich an, die Werke historisch zu nehmen. Die anfänglich nur deskriptive Wissenschaft wird pragmatisch. Sie erlaubt mir nun, die zureichenden Gründe für die begrifflich gefundenen gemeinsamen Züge der Werke zu erschließen. Erschließen ist das Wort.

Denn es handelt sich hier und weiterhin um nichts mehr als um ein Schluß-
verfahren.

1. Die sprachlich geordnete Werkreihe — Gesamtliteratur — gibt sich
mir nun als eine Wirklichkeit außer mir zu erkennen, die zeitlich und räum-
lich bestimmt ist. Was also sprachgleich oder sprachverwandt in dieser ge-
ordneten Reihe beisammensteht, erweist sich als zeitlich und räumlich
benachbart.

2. Die gattungsmäßigen Gruppen können aus ihrer geschichtlichen Her-
kunft und nach der bewahrenden Pflege ihrer Überlieferung erkannt wer-
den.

3. Die gemeinsamen Züge in bestimmten Werkgruppen, die Zeit, Raum
und Gattung überschneiden, können kausal und personal erklärt werden.
Und das ist die entscheidende Erkenntnis. Denn dem Raum und der Zeit
können wirkende Kräfte höchstens redensartlich zugeschrieben werden. Real
wirken sie gar nichts. Was sie zu wirken scheinen, das wirken sie tatsächlich
nur durch die Persönlichkeit der Lebenden und Schaffenden. Und sosehr
die Gattungen ein überpersönliches Formgesetz in sich haben, es vollzieht
sich nur durch die Persönlichkeit. Alle Ursache und alle Wirkung im geisti-
gen Leben ist Persönlichkeit und kann auf keine Weise anders als personal
erklärt werden.

Man stellt sich vielfach vor, die Persönlichkeit sei Gegenstand der Lite-
raturwissenschaft. Das ist ein Mißverständnis. Den Ausschlag gibt nicht,
was primär *ist*, sondern was primär erkannt werden kann. Meiner unmittel-
baren Wahrnehmung ist nicht die Persönlichkeit, sondern das Werk gegeben.
Das Werk kann nicht aus der Persönlichkeit „abgeleitet" werden, sondern
die Persönlichkeit kann allein aus dem Werk „erschlossen" werden. Alle
Wirkungen und Ursachen laufen in der Persönlichkeit zusammen. Keine
vermag an ihr vorbeizukommen. Doch manche führen über sie hinaus. Denn
das begriffsbildende Verfahren zeigt mir eine Fülle überpersönlicher Züge,
die personal verschiedene Werke und die verschiedene Persönlichkeiten ge-
meinsam haben. Was ist für diese überpersönlichen Züge der zureichende
Grund? Darüber kann ich auf dieser Erkenntnisstufe nichts aussagen.

III. Erkenntnisstufe. Sie soll es mir ermöglichen, für diese überpersön-
lichen Gemeinsamkeiten eine einleuchtende Erklärung, das heißt einen zu-
reichenden Grund zu finden. Ich kann nicht aufhören, begrifflich und histo-
risch zu denken. Aber ich muß darüber hinaus nun zusätzlich soziologisch
denken. Dieses neue Verfahren hat eine gewisse Ähnlichkeit mit dem Ex-

periment und mit der Wahrscheinlichkeitsrechnung. Denn ich versuche mög-
lichst viele Gründe, um den zu finden, der mir die gegebenen Tatsachen am
besten erklärt. Man muß sich einer abermals andern Spielregel unterwer-
fen. Auf dieser Stufe kann ich nicht mit Quellen und deren Glaubwürdigkeit
arbeiten. Hier gibt es nur eine annähernd richtige Rechnung, deren Maß
der „Richtigkeit" von der Wahrscheinlichkeit des Indizienbeweises abhängt.
Denn Indizienbeweis, das ist in diesem Falle das Wort. Es gibt nicht mehr
als zwei Bereiche, innerhalb deren der gesuchte Grund für die überpersön-
lichen Übereinstimmungen der Werke liegen kann.

1. Der Bereich der willkürlichen Gemeinschaft. Das sind alle die überper-
sönlichen Bindungen, denen sich die Persönlichkeit nach freiem Willensent-
schluß unterwirft, die sie also „küren" kann. Solche sind die freie Gemein-
schaft der Schaffenden, alle soziologischen Ordnungen wie Staat und Kirche
und die geistige Überlieferung, inbegriffen die frei wählbare Sprachgemein-
schaft. Das ist das weite Gebiet der „Beeinflussungen" von außen her. Sehr
viele dieser überpersönlichen Übereinstimmungen unter den Werken und
Persönlichkeiten ergeben sich und erklären sich aus solchen Beeinflussungen
von Werk zu Werk, von Mann zu Mann, durch die Bindung von Staat und
Kirche, aus der Macht der Überlieferung und Sprache. Erklären diese Ab-
hängigkeiten, wo sie nachweisbar vorhanden sind, zureichend, dann ist mein
Verstand befriedigt. Er hat „erkannt". Ist aber die Sachlage so, daß sie gar
nichts oder zu wenig erklären, dann muß ich mich nach anderen Gründen
umsehen.

2. Der Bereich der unwillkürlichen Gemeinschaft. Das sind die Bindun-
gen, die jenseits des menschlichen Willens liegen, die man aus Natur hat,
die man nicht „küren" kann. Das sind alle Bindungen der Persönlichkeit,
die sich aus ihrer Naturanlage ergeben. Man spricht hier gern von dem
„Typus", zu dem eine beliebige Reihe von Persönlichkeiten gehört. Sie sind
eben gleich geartet und äußern sich darum innerhalb gewisser Grenzen auch
gleich. Doch dieser Typus vermag mir diese überpersönlichen Übereinstim-
mungen nicht zu erklären, sofern er nicht selber erklärt wird oder erklärbar
ist. Das kann er aber nicht, wenn ich ihn als ein reines Spiel der Natur auf-
fasse, das aus dem Zufall kommt. Denn dann könnte ich mir ebensogut
Goethes „Faust" als eine Zufallskombination von sinngebenden Worten er-
klären. Nicht viel anders steht es mit „Rasse", auf die im Grunde dieser
„Typus" hinausläuft. Rasse ist keine geisteswissenschaftliche „Erklärungs"-
möglichkeit.

Um die Erörterung darüber abzukürzen, genügen zwei Argumente. Ein-

mal: Rasse ist keine soziologische Wirklichkeit; die Menschen leben nicht unter dem Gesichtspunkt bestimmter Typennormen zusammen. Und sodann: der rassische Befund geistesgeschichtlich verglichener Persönlichkeiten ist in den Jahrhunderten vor der Photographie gar nicht und selbst im Zeitalter des Films nicht durchwegs zu erbringen.

Es gibt nur einen Bereich, in dem ich hinreichende Gründe für das nachgewiesene Auftreten überpersönlicher Gemeinsamkeiten erwarten darf: die biologische Gemeinschaft. Diese ist das Leben selber und in Person; jenes Leben, aus dem die Persönlichkeit eine zeitliche und individuelle Erscheinung ist; die wahrhafte Überpersönlichkeit, in der die gewesenen und gleichzeitig lebenden Persönlichkeiten ein völlig reales Ganzes bilden. Die biologische Disziplin, die den Menschen zum Gegenstande hat, heißt Familienkunde. Die familienkundliche Gemeinschaft im weitesten Sinne, das heißt der Lebensverband, dem die Persönlichkeit in der zeitlichen Tiefe und räumlichen Gleichzeitigkeit angehört, ist der Bereich, in dem sich die überpersönlichen Gemeinsamkeiten, die sich nicht anders erklären lassen, zureichend begründet finden. Eine andere Sache ist es, in wieviel Fällen sich diese Gemeinsamkeiten konkret auf die begründenden Tatsachen zurückführen lassen. Vor einem jeden solchen Ignoramus endet die weitere Erkenntnismöglichkeit der Literaturwissenschaft. Doch früher oder später auf den schillernden Schleier zu stoßen, hinter dem das Unerforschliche drohend oder lächelnd sein Geheimnis hütet, nach dem sich unser armes, erkenntnissüchtiges Herz verzehrt, das ist Schicksal einer jeden und aller Wissenschaft. Solange wir leben, werden wir uns von dieser Erkenntnissucht ausbrennen lassen. Erst wenn uns die letzte Handvoll Erde nachgeworfen ist, begehren wir, „sehend" geworden, nichts mehr zu „wissen".

Aus dem Aufriß des logischen Erkenntnisvorganges ergibt sich nun zwingend die Natur der Literaturwissenschaft und ihr Verhältnis zu den beiden großen Sachgebieten: Stoff und Geist.

1. Literaturwissenschaft ist eine induktive und keine deduktive Disziplin. Sie leitet nicht aus Ursachen Wirkungen ab, sondern sie schließt aus Wirkungen auf Ursachen. Aber wo sie Wirkungen feststellt, da muß sie den Ursachen nachgehen. Sie gewinnt nicht aus der Wirklichkeit „Volk" den Begriff „Literatur", sondern sie bildet aus der Wirklichkeit Literatur den Begriff Volk.

2. Literaturwissenschaft steht in einem objektiv bestimmbaren Verhältnis zu den Geisteswissenschaften und zu den Naturwissenschaften. Dieses Ver-

hältnis ist nicht durch Apriori-Sätze zu bestimmen, sondern ergibt sich logisch aus ihrem Erkenntnisvorgange.

Bei der Frage nach diesem Verhältnis spielt die „Methode" keine Rolle. Um das zu erkennen, braucht man sich nur zweierlei vor Augen zu halten.

1. „Methode" wird durch den laienhaften und leider oft genug auch fachmännischen Sprachgebrauch vielfach mit „Problem" verwechselt. Problem heißt: was will ich wissen? Methode heißt: wie bringe ich es heraus? Zwischen Problem und Methode besteht eine feste Beziehung. Denn die Methode richtet sich nach der aufgeworfenen Frage. Zwischen der Wissenschaft als Ganzem und der Methode besteht eine solche Beziehung nicht. Denn keine Wissenschaft kann heute sagen, welche Fragen ihr morgen aufstoßen werden. Sie weiß daher auch nicht, welcher Methoden sie morgen bedürfen wird.

2. „Methode" wird ähnlich oft genug mit „Instrument" verwechselt. Ob Spiegelteleskop, elektrisches Mikroskop oder Lupe, das ist kein Unterschied. Entscheidend sind die Denkvorgänge, die diese Werkzeuge in Bewegung setzen oder aus denen sie Nutzen ziehen. Die menschliche Vernunft ist immer die eine und gleiche, und so gibt es nur eine einzige Wissenschaft, deren elementare rationale Erkenntnismittel die gleichen sind. Von der „Methode" her kann man keinen Wesensunterschied zwischen Naturwissenschaften und Geisteswissenschaften aufstellen. Alles, was darüber behauptet wird, beruht zumeist auf falschen oder schiefen Vergleichspunkten. Der Unterschied zwischen beiden Wissenschaftsgruppen gründet sich auf den fundamentalen Unterschied ihrer Gegenstände, hier den Geist und dort die Natur.

Das Verhältnis der Literaturwissenschaft einerseits zu den Geisteswissenschaften, andererseits zu den Naturwissenschaften kann also weder durch Apriori-Sätze noch durch Argumente von der Methode her erörtert werden. Es ergibt sich durchaus nur aus dem logischen Ablauf ihres Erkenntnisvorganges. Entscheidend dafür sind der Ansatz und das Ergebnis ihrer Rechnung. Der Ansatz ist das Werk, ein geistiges Phänomen, und das Ergebnis der Mensch, ein Natur-Geist-Wesen.

1. Der Ansatz, das Objekt der Literaturwissenschaft, bestimmt ihr Verhältnis zu den Geisteswissenschaften. Dieses Objekt ist das Werk, zunächst nicht in seiner materiellen Erscheinung als Buch, sondern lediglich als rein geistiges Sprachgebilde. Da die Literaturwissenschaft es primär mit dem individuellen Sprachwerk zu tun hat, Sprache aber der menschlich vollkom-

menste Ausdruck des Geistes ist, so nimmt die Literaturwissenschaft inner-
halb der Geisteswissenschaften eine Schlüsselstellung ein. Sie ist die Gei-
steswissenschaft schlechthin. Sie ist in *einem* Sprachwissenschaft, Kunst-
wissenschaft, Geschichtswissenschaft. Doch sie ist es gegenüber diesen
nächstverwandten Schwesterdisziplinen mit je einem besonderen Vorzug.

Das Objekt der Sprachwissenschaft ist die gesprochene Sprache. Da sie
die aber nur in einem zeitlich sehr begrenzten Umfang unmittelbar wahr-
nehmen kann, muß sie sich an ein sehr unvollkommenes Ersatzobjekt, an
die schriftlich überlieferte Sprache, halten. Das Objekt der Literaturwissen-
schaft ist das persönliche Sprachwerk, das mit Absicht schriftlich geformt
ist. Ihr spielt es keine Rolle, wie Goethe seinen „Faust" gesprochen hat.
Denn er hat ihn nicht gesprochen. „Faust" ist nicht als Sprechwerk schrift-
lich aufgenommen, sondern anfänglich schon „geschrieben" worden. Welch
einen Vorteil für die Disziplin das bedeutet, daß sie das Objekt selber in
der gewollten Gestalt vor sich hat, braucht nicht weiter erläutert werden.
Das Objekt der Kunstwissenschaft, sei es ein Gemälde, eine Plastik, ein
Bauwerk, ist gleichfalls selber da und fällt in die unmittelbare Wahrneh-
mung. Doch es ist in jedem Sinne nur ein einziges Mal da. Es kann nicht
„gelesen" oder „nachgesprochen" werden wie beliebig oft jedes Gedicht.
Ein Gemälde kann nicht innerlich nachgemalt werden, wie ein Gedicht
innerlich beliebig nachgedichtet werden kann. Und weiter. Kein Kunstwerk
kann vervielfältigt werden. Denn das vervielfältigte Kunstwerk ist nicht
mehr Original, sondern Kopie. Und die Kopie ist nur Ersatzobjekt von
unterschiedlichem Wert. Dagegen ist die tausendste Vervielfältigung von
Goethes „Faust" noch immer genau das Original wie die Handschrift. Was
dieser Unterschied im Objekt für einen Einfluß auf Betrieb und Erkenntnis
der beiden schwesterlichen Disziplinen hat, leuchtet doch wohl ein. Am
gegensätzlichsten sind Gunst wie Ungunst des Objekts zwischen Literatur-
wissenschaft und Geschichtswissenschaft verteilt. Das Objekt der Geschichts-
wissenschaft ist durchaus imaginär, liegt außerhalb aller unmittelbaren
Wahrnehmung und muß zur Gänze aus schriftlichen und gegenständlichen
Bezeugungen selber erst erschlossen werden.

Das Objekt der Literaturwissenschaft liegt so real und sinnlich wie gei-
stig in der unmittelbaren Wahrnehmung, daß es vom Erlebnis des Betrach-
ters gar nicht getrennt werden kann. Denn ich bin es, der „liest", und durch
mich erst ersteht das Objekt immer wieder und beliebig oft von neuem.
Es ist durch mich überhaupt erst da. Denn ein unauffindbar vergrabenes
Gedicht oder ein Gedicht, dessen Sprache niemand kennt, ist so wenig vor-

handen wie ein Standbild, das noch ungeschaffen im rohen Stein steckt. Aus all diesen Gründen ist die Literaturwissenschaft gegenüber Sprach- wissenschaft und Kunstwissenschaft nur im Vorteil. Gegenüber der Ge- schichtswissenschaft ist der Vorteil des Objekts weitaus auf seiten der Lite- raturwissenschaft. Daß es, reproduziert, in der Seele dort des Historikers ein imaginäres und hier des Literaturwissenschafters ein subjektives Dasein führt, gleicht sich aus. Das ist die Stellung der Literaturwissenschaft inner- halb der historsich denkenden Disziplinen.

2. Das Erkenntnisziel, der Mensch, bestimmt das Verhältnis der Litera- turwissenschaft zu den Naturwissenschaften. Wer dieses Verhältnis anders als negativ erörtert, wird immer mit einem gewissen weltanschaulichen Res- sentiment zu rechnen haben. Es gilt wohl da und dort als zweckmäßig, Naturwissenschaften und Geisteswissenschaften in keine zu nahe Arbeits- nachbarschaft kommen zu lassen, damit sich die unvereinbare Wesensver- schiedenheit von Stoff und Geist bei der Arbeit nicht verwische. Doch ver- wischt denn die gemeinsame Anatomie den Unterschied von Tier und Mensch? Das wesentliche Kapitel aus diesem ganzen Fragenkreis ist die Freiheit des menschlichen Willens. Sie gilt und muß gelten auf sittlichem Gebiet, wenn der Mensch für sein sittliches Handeln verantwortlich sein soll. Aber daß man durch bestimmte leiblich-seelische Anlagen zu gewissen Fertigkeiten geboren sein muß, das widerspricht, ganz abgesehen von dem beständig erhärtbaren Tatbestand, keiner sittlichen Forderung. Wenn die Literaturwissenschaft diese Determination zu bestimmten Künsten, Stilen, Ausdrucksmitteln in das Kalkül ihrer Erkenntnis einbezieht, so verpflichtet sie sich damit zu keinerlei Entscheidung bezüglich der Frage, wie wir uns dieses Zusammenwirken von Leib-Seele-Geist vorzustellen haben. Wir rechnen einfach mit dem Was, ohne verhalten zu sein, diesem Was das nähere Vorzeichen eines bestimmten Wie voranzusetzen.

Die Beziehungen der Literaturwissenschaft zu den Naturwissenschaften sind in gar keiner Weise methodischer Natur, sondern einfach durch die Erkenntnisrichtung auf den Menschen, seine persönlichen und überpersön- lichen Kräfte gegeben. Ihr geht es nur um eine Dreiheit von Disziplinen, unter denen die Anthropologie und die Familienkunde, wie sie selber, den Menschen zum Ziel haben und also alle zusammen auf die Biologie gewie- sen sind. Doch der Literaturwissenschaft geht es nicht gleichermaßen um diese Dreiheit. Die Anthropologie als Naturgeschichte des Menschen steht der Literaturwissenschaft am fernsten und kann ihr höchstens wichtig wer-

dende Fragen aus dem Bereich des Urtümlichen beantworten, falls dafür nicht eher die Völkerkunde zuständig ist. Die Instanz, an die sich die Literaturwissenschaft bei ihren letzten Erkenntniszielen, bei der Frage nach dem Leib-Geist-Wesen des Menschen, wenden kann, ist die Biologie. Es scheint, als wolle man neuestens die Geisteswissenschaften durch einen magischen Kreis von der Biologie abgrenzen. Es ist nicht gut, die verschiedenen Wissenschaften sozusagen aus grundsätzlichen Bedenken voreinander zu warnen. Über die wechselseitigen Bindungen der Wissenschaften und den Austausch ihrer Erkenntnisse entscheidet doch nur die Erkenntnis selber. Etwas ist oder es ist nicht. Ist es, dann ist die Lösung eben „biologistisch". Soll aber schon eine grundsätzliche Erwägung Platz haben, dann kann man sich schwer vorstellen, wie irgendeine Wissenschaft vom Menschen ohne Biologie möglich sein könnte. Nicht nur, daß der Mensch ein Bürger beider Reiche, der Natur und des Geistes, ist. Von der Art und Dauer seines leiblichen Lebens hängt Art und Dauer seines geistigen und seelischen Lebens ab, soweit sie uns erfahrbar sind. Und so gleichen denn Literaturkunde und Lebenskunde zwei voneinander abgekehrten Parabeln, die sich mit ihren Scheiteln überschneiden. In diesem gemeinsamen Scheitel ihrer Bahnen steht als Erkenntnisziel der Mensch. Von ihm aus, dem beseelten und durchgeistigten Lebewesen, umfaßt die Biologie alle Erscheinungen des Lebens. Von ihm aus, der Kreatur mit der Gabe des Wortes, öffnet sich die Philologie in das ganze geheimnisvolle Reich der Sprache, des „Logos". In diesem gemeinsamen Scheitel, wo der Mensch steht, finden wir uns in der rechten Mitte, wo, mit Johann Georg Hamann zu reden, alles menschlich zugleich und göttlich ist: *das* Leben.

Die Arbeitsgemeinschaft von Biologie und Geisteswissenschaften heißt Familienkunde. Irrtum und Frevel haben dieses Gebiet der Forschung und Erkenntnis schwer mißbraucht. Darum muß die Ehre dieser Disziplin wieder hergestellt werden. In der Familienkunde wirken durch die Biologie die Naturwissenschaften und durch die Historie die Geisteswissenschaften unmittelbar zusammen. Nur das Urkundenmaterial, das die Historie aufgespürt, geordnet und pragmatisch verknüpft hat, kann die Biologie interpretieren. Und ohne diese biologische Interpretation bleibt das pragmatisch geordnete Material eine stumme Liste, die allenfalls rechtliche und nur begrenzt soziologische Bedeutung hat. Freilich wird in die Vergangenheit hinab dieses Material immer spärlicher und fragwürdiger. Denn es hängt mehr als ein anderes vom Zufall der Überlieferung und Erhaltung ab, vom früheren oder späteren Einsetzen der Standesregister und anderer Quellen.

Und auch soweit es historisch brauchbar ist, bietet es zumeist für die bio-
logische Deutung keine Handhaben. So wird es begreiflich, daß diese trotz
ihrem hohen Alter junge, ja unmündige Disziplin, die keineswegs nur Otto-
kar Lorenz geschaffen hat, sich nie recht entwickeln konnte. Denn sie setzt
ein Quellenmaterial voraus, das erst in die Zukunft hinein bereitgestellt wer-
den könnte. Die Ehe ist die Urzelle aller menschlichen Lebensvorgänge. In
der Familie lösen sich die Antinomien von Natur und Geist, Trieb und Wille,
Gesetz und Freiheit zu der Harmonie des Menschentums auf. Wie immer
der Zustand der Familienkunde sein mag und welche Aussichten sie gewin-
nen oder verlieren könnte: ohne Familienkunde kein Einblick in die Ge-
schichte der Völker, der Staaten, der Gesellschaft und ihre tatsächlichen Ver-
änderungen. Ohne Familienkunde keine Aussagen von den überpersönlichen
Kräften, deren Wirkungen von der schaffenden Persönlichkeit her in den
Schriftwerken, das ist im Objekt der Literaturwissenschaft, sichtbar werden.
Und es sind nur die sonst unerklärbaren Wirkungen aus einem überpersön-
lichen Bereich, von denen die Literaturwissenschaft gezwungen wird, ihren
Ursachen nachzugehen. Literaturwissenschaft kann nicht nach freiem Er-
messen so oder so getrieben werden, sondern nur so, wie es ihr der logische
Gang der Erkenntnisse und die jeweils auftretenden Probleme vorschreiben.

Sie ist auf der I. Erkenntnisstufe begrifflich. Sie geht vom Lesen, Aneig-
nen, Verstehen, Deuten aus. Sie strebt nach Einsicht in die sprachliche und
künstlerische Gestalt des Werks. Sie vergleicht und erfaßt im Zusammenhang
ganze Werkgruppen. Sie „charakterisiert", das heißt sie bringt auf allge-
meine Begriffe und Wesensmerkmale. Ihr Gegenstand ist das Werk in seiner
reinen geistigen Gestalt. Sie ist im wesentlichen Poetik.

Sie ist auf der II. Erkenntnisstufe historisch. Sie wendet sich von der
inneren Wahrnehmung zur äußeren bewirkenden Wirklichkeit. Sie nimmt
das Werk nun in seiner körperlichen Gestalt als Buch und rollt damit alle
geistigen, technischen und wirtschaftlichen Ereignisse auf, die das Buch aus-
löst und die in ihm zusammenlaufen. Sie versteht die Sprachreihe als eine
geschichtliche Entwicklung und räumliche Erscheinung. Sie begreift die Gat-
tungen und Stilarten als Ergebnis geschichtlicher Kunstübung. Sie erfaßt
aus Werk und Urkunde die schöpferische Persönlichkeit als Verursacher des
Werks und Träger der Geistesgeschichte. Sie ist im wesentlichen Persönlich-
keitsgeschichte.

Sie ist auf der III. Erkenntnisstufe soziologisch. Sie wendet sich von den
persönlichen zu den überpersönlichen Mächten. Sie erkennt die Persönlich-
keit als das geistige Ergebnis zeitgenössischer und geschichtlicher Einwir-

kungen, als gleichartige Erscheinung zu verwandten Persönlichkeiten. Sie
ist jetzt Literaturgeschichte.

So gehört denn die Frage, was „Literatur" sei, nicht als Postulat an den
Anfang, sondern als Ergebnis an den Schluß. Literatur ist nicht die mecha-
nische Summe, sondern der geistige Organismus aus Büchern, die zusammen
ein gegliedertes Lebensganzes bilden. Alle verwebt ein dichtes Geflecht
ungezählter Fäden, deren die Wissenschaft nur einen kleinen Teil sichtbar
machen kann. Literatur ist der Inbegriff des Lebens aus Natur, Seele und
Geist.

2. DIE DEUTSCHEN STÄMME

Die Geistesgeschichte der Deutschen wurde bewegt durch den gekreuzten Rhythmus von Norden und Süden, Westen und Osten. Er war auferlegtes Schicksal, das sie in ihren Willen aufgenommen haben. Norden war für sie Skandinavien und Süden war das Mittelmeer. Westen waren ihnen die britischen Inseln nordwärts wie südwärts von Rom und Osten die große Ebene im Norden wie im Süden von Hellas.

Nach Süden drängte schon der Lebenswille des Urvolkes, aus dem die Deutschen herausgewachsen sind. Zwischen Nordsee und Oder saß zur Steinzeit, um 3500 vor Christus, ein nordisches Volk, aus dem sich zur Bronzezeit, in den Jahren von 2000 bis 750 vor unserer Zeitrechnung, die Altgermanen abgesondert haben. Ostsee, Ems, die mitteldeutschen Berge und Oder waren die Grenzen ihrer Heimat. Hier gingen sie zum Gebrauch des kriegstüchtigen und hausfreundlichen Eisens über, ein Volk des Pfluges mit einer kunstfertigen und geistig urtümlichen Bauernkultur. Hier begannen sie sich nach Westen und Osten hin zu unterscheiden. Hier brachen um das Jahr 100 vor Christus die ersten Wanderscharen ins römische Reich auf. Hier wehrte im Jahre 9 nach Christus Hermann der Cherusker den Rückstoß der römischen Legionen gegen die Elbe ab. Diese westgermanischen Völkerschaften gliederten sich in den ersten Jahrhunderten nach Christi Geburt wandernd und einander mannigfach überschichtend zu den deutschen Stämmen um.

Der Kern des *fränkischen Stammes*, die Salier, siedelten ursprünglich an der Scheldemündung. Ihr Gaukönig Chlodowech unterwarf 491 die fränkischen Kleinstämme und wurde durch friedliche Schilderhebung König der ripwarischen Franken. Sein Sohn bezwang die Hessen und Thüringer. Nachdem 418 die Moselfranken mit Trier das ganze Flußtal erobert hatten, wurde zu Anfang des sechsten Jahrhunderts auch das Maintal eine fränkische Landschaft. Die Slaven an der Regnitz und Redwitz wurden auf friedliche Weise dem fränkischen Stammesverbande eingefügt. So ist den Franken das niedere und mittlere Rheintal, das Tal der Mosel und des

Mains zur neuen Heimat geworden. Der Franke hat unter seinen mero-
wingischen und karlingischen Königen dem deutschen Volk und dem neuen
Europa ihre politische Gestalt gegeben. Er hat alle deutschen Stämme mit
seinem Blut durchsetzt. Er ist der formbegabteste der deutschen Stämme.
Der Kern des *alamannischen Stammes* hatte seine älteste Heimat an der
mittleren Elbe. Er hat sich dann mit mancherlei Beständen anderer Gaue
zu einem volkreichen Stamm zusammengewachsen. Dieser Zusammenschluß
scheint am oberen Main geschehen zu sein. Am Beginn des fünften Jahr-
hunderts durchbrachen die Alamannen den römischen Grenzwall, drangen
an den Rhein und die Donau vor und erreichten mit einem neuen Schwung
die Vogesen, den Jura, die Hochkämme der Alpen. Nach Herkunft und
Siedelung sind die Alamannen ein Stamm der Mitte, in manchem den Nie-
dersachsen, in anderem den Baiern verwandt. In der Zucht der vielgestal-
tigen Landschaft beiderseits des oberen Rheins haben sie sich zu vielerlei
Wirtschaftsformen bequemen müssen. Sie sind unter den Deutschen aus-
gezeichnet durch politischen Sinn. Sie haben die großen Herrschergeschlech-
ter der älteren deutschen Geschichte erzeugt. Sie haben sich je nach Raum
und Zeit die mannigfachsten und gemäßesten staatlichen Einrichtungen
geschaffen. Sie sind weniger formbegabt, aber desto innerlicher schöpferisch
veranlagt, Denker und Grübler. Der *bairische Stamm* gehörte mit seinen
Vorfahren dem gemeinswebischen Kulturverbande an der Mittelelbe an.
Als Markomannen waren sie um Christi Geburt in der Bergfeste Böhmen
ein Staatsvolk geworden. Seit dem sechsten Jahrhundert siedelten sie auf
der Hochfläche südlich der Donau. Im Westen drangen sie bis an den Lech,
im Osten zunächst bis an die Enns. Jenseits der Donau besetzten sie den
Nordgau bis an das Fichtelgebirge. Um 550 stiegen sie die schmalen Täler
Tirols empor. Sie gingen über die Enns. Und als sie seit der Mitte des
elften Jahrhunderts Kärnten und Steiermark erreicht hatten, waren sie der
volkreichste und mächtigste der deutschen Stämme geworden. So haben die
Baiern seit mehr als tausend Jahren die gleichen völkischen und staatlichen
Grenzen festgehalten. Ihre Lage im Raum hat sie zu einem Grenzvolk, zu
einem Stamm der Wasserstraßen und Pässe gemacht. Sie sind ein aus-
gesprochenes Bauernvolk, ein Volk des Hofes, kein Volk der Städte. Fast
alle bairischen Städte sind ursprünglich Fürstensitze gewesen. Die Welt ein
Schauspiel, das ist der Gedanke, der alle Jahrhunderte hindurch die künst-
lerischen Vorstellungen des bairischen Volkes beherrscht hat. Sich selbst und
die Welt zu spielen, darauf lief alle bairische Kunst hinaus. Die *Thüringer*,
swebischer Herkunft wie die Alamannen und Baiern, stammen von den

Hermunduren ab, die um Christi Geburt von der mittleren Elbe an die Saale gezogen waren. Drusus machte sie römisch. Aber 531 wurden auch sie von den Franken bezwungen. Ihr Name Hermunduren klingt seit dem fünften Jahrhundert in ihrem neuen Namen Thüringer fort. Landschaftlich, sprachlich und volkhaft steht Thüringen in der Mitte zwischen Norden und Süden, Osten und Westen. In ihrer heimatlichen Mulde zwischen Harz und Thüringer Wald sind die Thüringer das rechte deutsche Volk der Mitte geworden. Alle Straßen durch Europa kreuzen einander mit einem Strang in dieser Landschaft.

Die Linie, auf der die jungen deutschen Stämme von Norden nach Süden drängten, wurde von einer westöstlichen Linie geschnitten. Die wurde von den Niedersachsen ausgemessen und beherrscht.

Die *Sachsen* waren in ihrer Urheimat südlich der jütischen Halbinsel sitzengeblieben und hatten den Zug nach Süden nicht mitgemacht. Sie wandten sich, als alle ihre deutschen Brüder in Bewegung gekommen waren, gegen Westen. Truppweise gingen Angeln und Sachsen seit dem frühen fünften Jahrhundert auf die britischen Inseln, als die von der letzten römischen Kohorte geräumt worden waren, besiedelten ihre größte, bauten auf ihr seit dem neunten Jahrhundert einen mächtigen Staat auf und hatten also die Hauptkraft ihres Volkes nach England verlegt. Inzwischen waren dort, wo die deutschen Stämme nach Süden abgesunken waren, nach dem Gesetz der Schwere die beiden Bruchstellen nachgesunken. Zuerst die östliche. Die Slaven lagerten sich über den ganzen leer gewordenen Raum bis zur Elbe und wurden dort die Anrainer der Sachsen. Diese erwiderten den Druck von Westen her, stürzten nach und begannen seit dem Jahr 1000 den ganzen Raum östlich der Elbe bis an den Peipussee zu durchsetzen. In ihre Ostbewegung strömte dann das ganze deutsche Volk von Südwesten her ein.

Die deutschen Stämme waren also weltgeschichtlich auf das gekreuzte Kräftespiel nordsüdlich zwischen germanischem Skandinavien und nachantikem Mittelmeer, westöstlich zwischen England und dem Slaventum festgelegt.

Die germanischen und südwestdeutschen Stämme, die zwischen dem Atlantischen Ozean und dem Schwarzen Meer das Imperium der Caesaren und Auguste zu ihrer neuen Heimat gemacht hatten, fanden dieses selber in zwei westöstliche Bestände aufgegliedert: Hellas und Italien. Von Athen war die künstlerische, von Rom die staatliche Kultur der antiken Welt ausgegangen. Sie waren im Imperium unlösbar verschmolzen. Allein jedes der

beiden Glieder gewann zuletzt doch wieder im römischen Westreich und im byzantinischen Ostreich seine eigentümliche Gestalt. Die deutschen Stämme zogen die letzte geschichtliche Folge aus dieser Lage, indem sie aus Mitbesitz und Anspruch des lateinischen Westreiches ihr römisches Reich deutscher Nation schufen. Weder Ostgermanen noch Slaven konnten im gleichen Sinne aus dem byzantinischen Ostreich ein römisches Reich, sei es germanischer, sei es slavischer Nation machen. Diese mißglückte Harmonie im Erbgang von der antiken Welt zu den beiden abendländischen Jungvölkern der Germanen und Slaven hat der europäischen Geschichte das Gesicht gemacht. Die Deutschen aber haben diesen westöstlichen Rhythmus der antiken Kultur von lateinischem und hellenischem Wesen in die Bildung ihres Geistes aufgenommen, indem sie bevorzugt jetzt die Antike in ihrer lateinischen und dann in ihrer hellenischen Gestalt nacherlebten.

Die ehemals westgermanischen Stämme übersiedelten also, zu Deutschen werdend, von Norden her nach Süden auf den Boden des römischen Reiches und bildeten sich zunächst aus der lateinischen Schöpfung der antiken Welt ihr neues Wesen aus. Indem sie mit den keltisch-lateinischen Vorbewohnern verschmolzen, veränderte sich ihre Sprache nicht nur durch die Verschiebung der Mitlaute klanglich. Sie nahm auch den Gehalt der antiken Kultur und den Stil ihrer Wortkunst auf. Wie vorerst die lateinische, so machten sie sich später auch die hellenische Schöpfung der antiken Bildung zu eigen. Wie vom Süden, so strömten den Deutschen auch von Norden her immer wieder Bildungsgüter zu. Die skandinavischen Völker, ihr Vätererbe und der Zuwachs ihrer späteren Geistesgeschichte haben die Deutschen geistig zwischen Norden und Süden im Gleichgewicht erhalten. Und also übersiedelten die Sachsen nach England westwärts, und sie schoben ihre Höfe und Dörfer, bald in Gemeinschaft mit den anderen deutschen Stämmen, immer tiefer in den Osten vor. Die britische Insel fanden sie von den Römern geräumt. Dem lateinisch gesitteten Reich Kaiser Karls wurden sie mit Gewalt eingegliedert. Sie haben die lateinische Bildung nur widerwillig und aus zweiter Hand angenommen. Dagegen empfanden sie sich schon früh als wesensverwandt mit hellenischer Art, und ihre aufgeschlossensten Söhne haben durch alle Jahrhunderte griechische Art und Kunst mehr geliebt als lateinische. Im Osten sind sie dann zusammen mit ihren andersstämmigen Siedlergenossen und den Vorbewohnern, die völlig außerhalb der antiken Welt gelebt hatten, zu neuen deutschen Stämmen zusammengewachsen. So auf ganz anderen Grundlagen bildete sich im Osten auch aus ihnen und den anderen Beständen eine wesentlich andere Geisteshaltung

heraus. Die Sachsen haben seit der Landung in England aus Nachbarschaft und Stammesverwandtschaft mit der englischen Bildung sehr eng zusammengelebt. Durch den Osten waren sie näher an die Heimat der Griechen und an das Morgenland herangekommen. Das alles machte, daß das Geistesleben, wie es in Niedersachsen und Ostdeutschland auflebte, sehr stark von England und vom Morgenlande her bestimmt war.

Das sind die Voraussetzungen, die uns zwingen, bei den südwestdeutschen Stämmen von der einen und bei den nordostdeutschen Stämmen von der anderen Art Bildung und Dichtung zu sprechen. Die Unterschiede zwischen der Literatur, die im älteren Mutterlande, und jener, die im neueren Siedelgebiet entstanden ist, sind von der Art, daß wir sie nur aus der Lebensgeschichte der beiderseitigen Stammesgruppen verstehen können. Diese Unterschiede werden mit zusammenfassenden Worten als klassisch und romantisch darum bezeichnet, weil von den beiden abschließenden Bewegungen die klassische vom altdeutschen Mutterlande und die romantische von dem neudeutschen Siedelgebiet ausgegangen ist.

Erstes Buch

ROMANIK UND GOTIK

DAS IST DIE EPOCHE DES AUFWUCHSES. DIE GERMANISCHEN
*Stammesverbände wachsen zum deutschen Volk zusammen. In der Schule
der spätrömischen Kultur und der christlichen Kirche bilden diese Acker-
völker über die höfische Oberschicht ihr bäuerliches Gemeinleben in ein
reichgegliedertes Gesellschaftswesen hinauf. Die landschaftlichen Mund-
arten werden zunächst jede für sich am Musterbeispiel der lateinischen
Sprache grammatisch durchgeformt und literaturfähig gemacht. In wenig
Menschenaltern klärt sich aus ihnen eine gemeinsame Dichtersprache ab,
die wenigstens innerhalb der geistigen Oberschicht über den ganzen Volks-
bereich hin verstanden wird. Die heimischen Dichtungsgattungen werden
sehr rasch von den literarischen Hochformen abgelöst, wie sie sich seit vielen
Jahrhunderten rings um das Becken des Mittelmeeres bei Griechen und
Römern zu gültiger Gestalt entwickelt hatten. Diese Hochformen werden
zunächst in lateinischer Sprache deutsches Eigentum, und als die deutsche
Sprache weit genug ist, auch dieser gefügig. Das deutsche und französische
Volk, im gemeinsamen karlingischen Staatsverband ursprünglich vereinigt
und ihm dann entwachsend, bleiben einander nicht nur nachbarlich nahe,
sondern sie entfalten sich zu einem einzigartigen geistigen und literarischen
Wechselleben, in dem auf weite Sicht der Vorzug des Schenkens auf seiten
Frankreichs ist. Die Dichtung der Stauferzeit ist der Gipfel dieses Aufwuchses.*

I. FRANKENREICH

8. bis 11. Jahrhundert

Auf dem Grunde, den der salische Gaukönig Chlodowech, 481 bis 511, *Fränkisch-römischer Ursprung* mit seinem gallisch-fränkischen Staat gelegt hatte, baute Karl der Große durch Staatskunst und Kriegsglück aus allen deutschen Stämmen das Deutsche Reich. Die Kaiserkrone, die ihm der Papst zu Rom am Weihnachtstage des Jahres 800 aufs Haupt setzte, machte ihn im Glauben der Deutschen und Römer zum Erben und Nachfolger des Caesar und Augustus. Ihr Reich war als römisches Reich deutscher Nation nach der herrenlosen Zeit von vier Jahrhunderten wieder auferstanden. Die deutsche Dichtung hat aus dieser Vorstellung, gleichgültig wieviel an ihr staatsgeschichtliche Wirklichkeit wurde, durch ein Jahrtausend Gehalt und Stil geschöpft.

1. DER FRÄNKISCHE KREIS

Das Reich Kaiser Karls und seiner unmittelbaren Nachfolger, ob es nun Karlinge oder Salier waren, vermochte nicht einmal politisch, um wieviel weniger geistig, die Spannung zwischen Franken und Sachsen zu lösen. Sie wird in den beiden Kulturkreisen sichtbar, die einander von Süden und Norden her überschneiden. Aber innerhalb des fränkischen Kulturkreises rundet sich das geistige Werk der Franken, Alamannen und Baiern zu einem einverständlichen Ganzen, mit dem die klassische Bildung der Deutschen zum erstenmal in die Welt tritt.

Die *Franken.* Als erstgeborener Sohn der römischen Kirche und der antiken Kultur unter den südwestdeutschen Stämmen übernahm der Franke für sich und seine jüngeren Brüder den Nachlaß der Alten aus den Händen des gallischen Romanentums. Die gallischen Schulen für Grammatik und Redekunst schlugen die Brücke von der spätantiken zur frühfränkischen Literatur. Noch gegen Ende des sechsten Jahrhunderts lebte der Lateiner *Fränkisch-Gallische Übergänge* Venantius Honorius Fortunatus als Hofdichter bei dem fränkischen König Sigibert. In lateinischer Sprache schrieb des Fortunatus Freund, der Bischof Gregor von Tours, die erste Geschichte der Franken. Lateinisch zeichneten die salischen Franken ihr Volksrecht auf und lateinisch ist in der Vorrede

1*

Karl der Große dazu das älteste Denkmal fränkischer Dichtung überliefert. *Karl der Große* machte aus dieser gallisch-fränkischen Liebhaberei Ernst und Größe eines weltbedeutenden Vorganges. Denn erst die überkommenen Beziehungen seiner Vorfahren zu den Angelsachsen und die Eroberung des langobardischen Oberitalien führten an seinem Hofe zur Wiedergeburt der klassischen Bildung aus der Seele des fränkischen Volkes.

Vier Männer am Hofe Karls des Großen, seine kaiserliche Akademie der Wissenschaften, lebten dem Ehrgeiz, die Dichtung des ersten römischen Kaiserhofes, des Augustus, unter den Deutschen zu erneuern. Der Angelsachse *Alkuin,* der erste Lehrer des lateinisch-germanischen Abendlandes,

Der geistige Hofstaat der Schulbücher und Lehrbriefe für den Kaiser schrieb, schuf nach dem Vorbilde Ovids und Vergils die ersten neuen Gebilde einer rein weltlichen Dichtung. Der Langobarde *Paul Warnefried,* noch in seiner Heimat Verfasser einer Langobardengeschichte, die eigentlich eine Geschichte Italiens ist, fügte sich als Griechischlehrer in den Unterrichtsbetrieb des Hofes ein und diente dem Kaiser mit Gelegenheitsgedichten. Der vornehme Franke *Angilbert,* mehr Staatsmann und Dichter als Geistlicher und Gelehrter, drückte mit seinen Hirtengedichten und Versbriefen die literarische Haltung des Hofes am deutlichsten und liebenswürdigsten aus. Sein Sinn für das Schauspiel vermittelte von der Antike zur neuen Zeit. Der Gote *Theodulf,* unter allen Dichtern seiner Tage der erste, der kunstfertigste und wirklichkeitsnächste, Meister des Briefgedichts, war am größten in den Versen aus seiner Gefangenschaft, in die ihn die Ungnade des Kaisers gestürzt hatte. In der Schule dieser Männer lernte der Kaiser mit und nahm einen Hauch der antiken Bildung an. Das neue römisch-deutsche Schrifttum ist vom Hofe

Einhards Bild des Kaisers und nicht von der Kirche ausgegangen. Der Mainfranke *Einhard* aber, der vertrauteste Rat des Kaisers, der klügste und gelehrteste Mann unter seinesgleichen, ein Kenner des Griechischen, Baumeister und Dichter, schrieb das kunstvolle „Leben Karls", in dem er die Form des römisch-fränkischen Heiligenlebens auf einen weltlichen Gegenstand übertrug und, das Kaiserbüchlein des Suetonius im Auge, daraus das Bild eines Imperators machte. Die deutsche Volkwerdung in der Schule der Antike war zum erstenmal klar erfaßt und in ihrer ganzen Bedeutung geschichtlich dargestellt.

Der erste Sprachlehrer Hrabanus Der Kaiser betrieb also die Ausbreitung einer allgemein klassisch gerichteten Bildung unter Weltleuten und Geistlichen. Am treuesten bewahrte und am tatkräftigsten förderte den Gedanken des Kaisers das Kloster, das älter als Karl und sein Werk war: *FULDA,* im hessischen Urwald 744 erbaut. Unter Hrabanus Maurus, einem Mainzer, der 822 Abt von Fulda

wurde, einem bahnbrechenden Schulmann und Erzieher, löste das Kloster den Hof als geistige Vormacht ab. Die lateinische Bildung war schließlich dem Kaiser doch nur ein Mittel gewesen, dem Volk eine deutsche und christliche Gesittung anzuerziehen. Dem dienten die deutschsprachlichen Behelfe für den Glaubensunterricht, die nun entstanden. Dem und der Ausbildung einer geistig hochstehenden deutschen Prosa dienten die Übersetzungen, die zu Fulda unter den Augen des gelehrten Abtes gearbeitet wurden: die deutsche Fassung der Schrift Isidors von Sevilla „De fide catholica" und der Evangelienharmonie Tatians.

Die rheinfränkische Mundart, die Sprache Karls des Großen, die Sprache, in der seine Erben und Enkel Eide schwuren, war nach so trefflichen Vorübungen kühn genug, sich an ein großes Gedicht deutsch-christlichen und deutsch-antikischen Stiles zu wagen. Es wurde von einem Schüler Hrabans, *Otfried von Weissenburg*, um 870 zu Weissenburg geschrieben: „Liber evangeliorum theotisce conscriptus". Es ist ein „Messias" in deutschen Reimversen, die der lateinischen Hymnendichtung und dem romanischen Volksliede nachgebildet sind. Das war die neue Verskunst, die den germanischen Stabreimlangvers ablöste. Es war als Lesebuch gedacht, ein gelehrtes Werk, das die Reihe der spätrömischen Bibeldichter unmittelbar fortsetzt. Trocken und nüchtern ringt es mit Stoff und Stil und Vers. Doch Otfried war sich seines Auftrages, der ihn auf die Schwelle der deutschen Dichtung stellte, stolz bewußt.

Der erste Dichter. Otfried

Die Kunstpflege des germanischen Heldenliedes ist mehr durch den sozialen und politischen als den geistigen Umschwung des Zeitalters zerstört worden. Mit dem Untergang der zahlreichen Gaufürstenhöfe hatte die Kunst der scope, der wandernden Sänger, Gönner und Zuhörer verloren. Das *Lied von Hildebrand* und Hadubrand, das zwei Fuldaer Mönche um 820 aus dem Gedächtnis und aus Zufall auf die leeren Vorder- und Hinterblätter einer Handschrift schrieben, nur ein Bruchstück, ist der einzige Zeuge, der uns ahnen läßt, wie dieser germanische Liederschatz wohl ausgesehen haben muß. Der scop war gezwungen, mit den Zuhörern auch Stoff und Stil zu wechseln. Er tischte seinen Gönnern von der Landstraße nun Schwänke und Märlein auf: vom Grafen Immo, der seinen Gegnern listig die Schweine wegtrieb, vom Graf Konrad von Niederlahnstein, den man als Kurzibold belachte. Er trug politische Zeitung durchs Land: von Hattos Verrat an Adalbert von Bamberg und von der Schlacht bei Eresburg. Das „*Ludwigslied*", das Ludwigs III. Sieg über die Normannen bei Saucourt 881 feiert, gibt mit seinen gereimten Langzeilen eine gute Vor-

Lied von Hildebrand

Kulturwandel im Liede

stellung von dem Kunstwandel, der sich unter den Händen der Fahrenden vollzog.

Die *Alamannen*. Nach dem Niedergang des karlingischen Hauses übernahmen sie die Führung am Werk, das dem Aufbau einer deutsch-christlichen und deutsch-antiken Gesittung galt. Zwei alamannische Klöster am Oberrhein wurden die Pflanzstätten der neuen deutschen Bildung.

Das Kloster *REICHENAU*, um 724 von Bischof Pirmin auf der Insel des Untersees gegründet, wurde wieder durch Hraban geistig aufgeweckt. Hier
wirkte in seinem Sinne sein Schüler Walahfried Strabo, als Briefdichter, Fortsetzer von Karls weltlicher Hofliteratur, in Hymnen der spätantiken Überlieferung folgend, mit seinen geversten Heiligenleben bewußt ein Nacheiferer des antiken Epos. Auf drei Wegen zu künftigen Dichtungen war er der erste: mit seinem Gedicht über Dietrich von Bern „De imagine Tetrici"; mit seiner dichterischen Schilderung einer Reise durch Hölle, Fegefeuer und Himmel „De visionibus Wettini"; mit seinem anmutigen Pflanzengedicht „Hortulus". Dem Reichenauer Schutzheiligen galt um 900 das deutsche „Lied auf den heiligen Georg". Zu den vielseitigen Gelehrten gehörte Hermann der Lahme, der sich auch in geistlicher Dichtung erprobte, aber als seine größte Leistung um die Mitte des elften Jahrhunderts die erste umfassende Weltchronik geschaffen hat.

Das Kloster *SANKT GALLEN* ist seit der Mitte des siebenten Jahrhunderts in der Waldwildnis südlich des Bodensees über dem Grabe des heiligen Gallus entstanden. An dieser Stätte, die sich mit der Zeit zu einem geistlichen Fürstentum auswuchs, ist für die Bildung des deutschen Geistes
das Folgenreichste und Entscheidende getan worden. Notker der Stammler schuf um 900 mit seinen lateinischen Sequenzen ein kirchliches Liederbuch von einzigartiger dichterischer Schönheit. Sequenzen, das sind kunstvolle lyrische Versgebilde, die er, westfränkischen Versuchen folgend, den wortlosen Tonreihen des gottesdienstlichen Vokalgesanges unterlegte. Auf das weltliche und volksmäßige Lied haben die Sequenzen durch fahrende
Sänger unabsehbar eingewirkt. Ekkehard I. schuf um 930 in lateinischen Sechsfüßlern und im Stil Vergils mit seinem „Waltharius" die erste epische Darstellung aus der deutschen Heldensage. Notkar III., mit der großen Lippe oder der Teutsche zubenannt, legte mit seiner sprachwissenschaftlichen Arbeit und Lehrweise den Grund zum Deutschen als einer geistigen und künstlerischen Kultursprache. Seine Übersetzungen klassischer Dichter
der Römer und spätantiker Denker sind aus der Schule hervorgegangen und waren für die Schule bestimmt. Er folgte jedem dieser Werke mit

wohl abtönender Stilsicherheit. Er hat als erster deutsche Ausdrücke für die schwierigen und geistfremden Worte der römischen und christlichen Kultur gefunden. Er hat die bäuerliche Natursprache der Deutschen zu einem geschmeidigen und fügsamen Werkzeug höherer Bildung gemacht. Wie mit Otfrieds Versen so beginnt mit Notkers Prosa das geistige Eigenleben der Deutschen. Ekkehard IV., der letzte Sprachmeister des Klosters, schrieb um die Mitte des elften Jahrhunderts, indem er die „Casus Sancti Galli" aufnahm und fortführte, die Geistesgeschichte der klösterlichen Gemeinschaft, in einem Latein, das zuweilen fast schon in das junge Romanisch hinüberklingt, künstlich schwer und gedrungen, aber mit einer unglaublichen Lebendigkeit, die völlig modern ist. *Ekkehard. Das Geschichtbuch*

Die *Baiern*. Von den Weltstraßen ihres Landes vermittelte der Brenner zum langobardischen Italien und die Donau in die ungarische Tiefebene. Die bairischen Bistümer bauten zunächst nur bescheiden nach dem Grundriß weiter, der am kaiserlichen Hofe entworfen worden war. *SALZBURG*, 696 gegründet, steuerte hübsche kleine Gedichte zur karlingischen Lateinliteratur bei *FREISING*, 724 errichtet, hat im neunten Jahrhundert eine geringe deutschsprachige Literatur erzeugt wie den „Bittgesang an den heiligen Petrus". Am unternehmungslustigsten war man zu *PASSAU*. In der Stadt der fünften batavischen Kohorte wurde 738 ein Bistum errichtet. Der Ehrgeiz der Bischöfe wurde durch das Buch des Eugippius über das Leben des heiligen Severin, das man 903 erwarb, angestachelt. Denn aus ihm erfuhr man, lange vor Salzburg habe das benachbarte Lorch einen Bischof gehabt. Die Passauer Kirchenfürsten betrachteten sich seitdem als unmittelbare Erben der Römerkirche zu Lauriacum und als geistliche Anwärter auf Ungarn. Diesem Ehrgeiz zu dienen, wurden gegen Ende des zehnten Jahrhunderts die falschen Papstbullen und die älteste Nibelungennot lateinisch zu Pergament gebracht. *Die Baiern* *Severins Leben*

Indessen die Schöpfer des bairischen Schrifttums saßen nicht auf den Bischofsstühlen, sondern in den Klöstern. In dreien von ihnen wurde, dem fränkischen Entwurf getreu und im Wettbewerb mit den alamannischen Abteien, an dem großen Werk der deutsch-lateinischen Bildung gearbeitet. *WESSOBRUNN*, 753 gegründet, knüpfte an Notkers Spracharbeit an. Die drei Predigtsammlungen aus der ersten Hälfte des elften Jahrhunderts enthalten wirkliche Pfarrpredigten für das Volk. Ein Denkmal von hoher Schönheit ist die Bearbeitung des „Psalms 138" um 950 wohl im Kloster entstanden. Das „Wessobrunner Gebet" aus dem Anfang des neunten Jahrhunderts geht von einer angelsächsischen Vorlage aus und rückt sehr vor- *Wessobrunner „Gebet"*

sichtig die christliche an Stelle der germanischen Vorstellung von der
Schöpfung der Welt. *SANKT EMERAM* zu Regensburg, um 750 gegrün-
det, hat nach 821 das Bruchstück „Muspilli" hervorgebracht, das Gedicht
vom Untergange der Welt. Über eine reiche Glossenliteratur hinweg wölbt
sich in diesem Kloster die größte Spannweite der Entwicklung vom Dichter
„Muspilli" des „Muspilli", der einen letzten Nachhall der germanischen Stabreim-
dichtung auffing, zu Otloh, dem bedeutenden geistlichen Schriftsteller des
elften Jahrhunderts. *TEGERNSEE*, 719 gegründet, zeigt gegenüber dem
deutschen Streben zu Wessobrunn und Sankt Emeram die stärkeren klassi-
schen Züge. Die Dichter und Redner der Römer wurden hier bezeugt ge-
lesen und abgeschrieben. Das Kloster besaß die gereimte Vorfassung des
lateinischen Romans „Apollonius von Tyrus". Und im Kloster wurde der
„Ruodlieb" erste deutsche Roman gedichtet, um das Jahr 1000, der „Ruodlieb", der in
lateinischen Versen eigentlich eine Novellensammlung innerhalb eines Rah-
menromans darstellt. Die Dichtung ist nur in schwer verbindbaren Bruch-
stücken erhalten.

 Fernab dem Beginnen der fränkischen Hofdichter war in Baiern und Ala-
mannien völkisches Gut und klassisches Erbe lebendig verschmolzen wor-
Römische
Bildung — den. Das lateinische Waltherlied Sankt Gallens, der Ruodliebroman von
Deutscher Tegernsee, der nur in Bruchstücken bewahrt wurde, die erste Nibelungen-
Geist dichtung von Passau, die ganz verlorenging: drei Adern, in denen zum
erstenmal das Leben der römisch-deutschen Einheit zu kreisen begann,
römische Form und Bildung, deutscher Geist und Gehalt.

2. DER SÄCHSISCHE KREIS

 Was die Schule Galliens für die Franken, das bedeutete die Schule Eng-
lands für die Sachsen. Und was Kaiser Karl für Europa geschaffen hatte,
das schuf innerhalb engerer Grenzen König Aelfred für England. Und was
die Franken dichterisch für die südwestdeutschen Stämme geworden sind,
England und das wurden die Inselsachsen für die zurückgelassenen Sachsen des Festlan-
der sächsische des. Die Angelsachsen haben jene lateinisch-christliche Bildungsliteratur,
Einsatz jene junge eigensprachige Dichtung geschaffen, jene altgermanischen Stoffe
überliefert, die den festländischen Sachsen Vorbild und Quelle waren. Mit
der Rätseldichtung Aldhelms, dem umfassenden kirchenlateinischen Bil-
dungsschrifttum Bedas, mit der angelsächsischen Christdichtung, mit der
Sage von „Beowulf" und dem Völkerbericht „Widsith" beginnt jenes geistige

Zusammenleben, das nun durch alle Jahrhunderte Niedersachsen so eng mit England verschwisterte.

WESTFALEN. Mit seinen ersten Wurzeln treibt das Schrifttum aller sächsischen Landschaften in jener südlichen Grenzmark empor, die der Sachse bei seinem ersten Vorstoß fränkischen Stämmen abgenommen hatte. Auch die ältesten sächsischen Sprachdenkmäler haben der Seelsorge gedient. So Beichten und Psalmenerklärungen und die Übersetzung einer Homilie Bedas. Die Freckenhorster und Essener Heberolle zählt für die Essener Brauknechte die landwirtschaftlichen Einkünfte des Klosters auf.

Ein Sachse hat die einzige große Dichtung dieser Landschaften und dieses Zeitraumes geschaffen. Das ist der *„Heliand"*. Die Dichtung ist von einem Unbekannten zwischen 825 und 835 wohl in der Benediktinerabtei Werden geschrieben worden. Es ist eine Umdichtung des Lebens Christi in den Stabreimstil, in Sprache und Vorstellung des vorchristlichen Sachsen, um ihm die frohe Botschaft mundgerecht zu machen. Otfrieds fränkischer „Christ" steht in der Reihe, die von der spätantiken Bibeldichtung herkam. Der sächsische „Heliand" folgt der angelsächsischen Bibeldichtung, Kaedmons Hymnen über die biblische Geschichte, den Stabreimepen zu Genesis und Exodus, Cynewulfs „Krist". Otfrieds romanisch-fränkische Endreimkunst, in der das antike Homoioteleuton fortklingt, und des „Heliand" angelsächsische Stabreimkunst, als Spätling germanischer Kunstweise: in beiden Gedichten setzt sich zum erstenmal und sofort in den Anfängen schrifttümlicher Pflege der herrschende Gegensatz zwischen gallisch-fränkischem und sächsich-ostdeutschem Literaturwillen durch. An nicht minder entscheidender Stelle wird sich der gleiche Fall zwischen Milton und Klopstock wiederholen.

„Heliand"

Gemeinsächsische Bibeldichtung

Als Pflegestätte fränkisch-lateinischer Geistesart war 822 auf dem Königshofe zu Höxter das Kloster Korvey gegründet worden. Hier vollendete um 967 der Mönch *Widukind* die drei Bücher „Rerum gestarum Saxonicarum", über Ursprung und Schicksal des sächsischen Volkes unter den Kaisern Heinrich und Otto. Widukind betonte den Gegensatz zwischen dem römisch-fränkischen und dem sächsisch-nordischen Kulturkreise mit der erkennenden Schärfe des geschichtlichen Bewußtseins. Er lehnte es ab, an das römische Reich anzuknüpfen, und ging von der Urgeschichte des sächsischen Volkes aus. Ihn hebt der Stolz, daß nun mit den Liudolfingern die Sachsen Herren geworden sind, über alle Deutschen und zuvörderst über den herrischen Franken. Ein sächsischer Volkskönig ist ihm Otto, der von sich aus, nicht als Erbe des Augustus, die Christenheit beherrscht. Mit stolzem Stillschwei·

Widukinds Sachsen- geschichte

gen überschlägt er dessen Kaiserkrönung. Wie tief prägt sich die Ursprünglichkeit der sächsischen Jugend ein gegenüber der römischen Reife etwa des Alamannen, wenn man Ekkehards IV. ausgemeißelte ruhende Mönchsbilder neben die Helden Widukinds stellt, deren Wesensganzes erst Zug um Zug in fortrollender Handlung erkennbar gemacht ist.

*Der
erste Dichter,
der erste
Geschichts-
schreiber* So erscheinen der erste Dichter und der erste Geschichtsschreiber des sächsischen Volkes als Brüder. Weit entfernt, sich an das zu verlieren, was ihnen als neuer Glaube und neue Staatsmacht entgegentrat, übertrugen sie sich die geistige und weltliche Geschichte in sächsische Vorstellungen, malten den Heiland als sächsischen Herzog, den Herrscher des Abendlandes als sächsischen Volkskönig und blieben sich bewußt, daß weder der Glaube noch die Sprache der Lateiner die Wege verbinden könnten, die Franken und Sachsen nun einmal angeschritten hatten.

Die Liudolfinge *OSTFALEN.* Das ist die Landschaft, in der sich der Gegensatz der beiden Kulturkreise durch das eingeborene Fürstenhaus der Liudolfinge zu dem sächsischen Königtum und Kaisertum Heinrichs, Ottos I., Ottos II., Ottos III. verstärkte und erhöhte. Das Verhältnis zur Antike entwickelte sich ihnen erst im Laufe ihrer Geschlechtsfolge, und zwar als tragisches Verhängnis aus dem Abfall des Hauses von seinen ursprünglichen und notwendigen Sendungen: vom Zusammenspiel mit Angelsachsen und vom ostdeutschen Siedelwerk. Das griechisch-römische Erlebnis der letzten Liudolfinge war keine Angelegenheit des sächsischen Volkes, sondern blieb geistig an die ostfälischen Hausstiftungen des Geschlechtes gebunden. Es erlosch mit ihnen ohne jede Nachwirkung oder gar Umbildung der sächsischen Seelenlage.

*Gandersheim.
Hrotswith* Von diesen ostfälischen Hausstiftungen der Liudolfinge war Quedlinburg, dessen Jahrbücher die berühmten Zeugnisse zur deutschen Heldensage enthalten, die jüngste, Gandersheim, seit 852, die älteste und vornehmste. Dem Kloster Gandersheim gehörte *Hrotswith* an, aus vornehmem Hause um 935 geboren. Von den drei Büchern, in die ihre lateinischen Dichtungen gegliedert sind, geben die geschichtlichen des dritten anmutigen Aufschluß über ihre Stellung zur kaiserlichen Familie. Sie behandeln die geschichtlichen Vorgänge unter Otto I. als Familienereignisse und sind eine Familienfeier der Liudolfinge. Die acht Verslegenden ihres zweiten Buches sind im Grunde Novellen. Entwicklungsgeschichtlich am bedeutsamsten sind das fünfte und sechste Stück der Sammlung vom Vicedom Theophilus und vom Sklaven des Proterius. Beide schließen ein Bündnis mit dem Teufel und werden am Ende gerettet. Hrotswiths zweites Buch enthält die Gespräche. Denn nur das, Prosagespräche, keine Dramen sind es. Hatte sie doch keine Vorstellung vom

Spielmäßigen. Sie hielt die Lustspiele des Terenz für gesprächsweise erzählte Lügengeschichten und wollte sie durch ihre Legenden gleichen Stiles verdrängen. Sie sind weder in Aufzüge noch in Auftritte gegliedert. Die Vorwürfe sind erzählt und nicht in Handlung umgesetzt. Der ununterbrochene Ortswechsel läßt keinen Zweifel an der rein epischen Absicht und an dem dramatischen Unvermögen der Dichterin. Es sind gesprächsweise erzählte fromme Novellen und Schwänke. Hrotswith war das Abbild der gelehrten sächsischen Frau, deren es auf der großen Insel so viele gab. Sinnvoll und feinfühlig wählte und gruppierte sie ihre Stoffe. Stil und Sprache schimmern in echter Weiblichkeit. So gering ihr lateinischer Wortschatz ist, sie schrieb die Sprache der Römer mit einer gewissen eigentümlichen Besonderheit. Ihr Klassizismus gehört zum Wesen der letzten Liudolfinge, aber nicht zum Wesen des sächsischen Volkes.

Legenden gegen Terenz

Das Hochstift Hildesheim und seine Domschule wurden im elften Jahrhundert die Pflegstätte der „neumodischen französisch-süddeutschen Gelehrsamkeit". In seiner Residenz zu Merseburg schrieb zu Anfang des elften Jahrhunderts ein Verwandter der Liudolfinge, Bischof *Thietmar*, die abgeschlossene Geschichte des sächsischen Kaiserhauses. Ruhmlos erlosch mit dem Letzten, Otto III., 1002, das gewaltige Geschlecht ins Dunkel, und ruhmlos war das bescheidene Buch, in dem der gute, aber beschränkte Merseburger Bischof die Taten der Ottonen verzeichnete. Keine Spur der klassischen Träume, in die sich die letzten Ottonen verzehrten, blieb an sächsischer Erde haften.

Thietmars Abgesang der sächsischen Kaiser

II. STAUFFERREICH

12. und 13. Jahrhundert

Von den karlingischen und salischen Franken, zwischen denen die sächsischen Liudolfinge ihr deutsches Königtum im Traum eines römischen Kaisertums vergeudeten, ging das Reich durch die Staufer an die Alamannen über. Deutschland gärt vor Verwandlung. Aus den Gaugrafen und Grundherren der karlingischen Zeit beginnen durch manigfache Verschiebung und Verflechtung der Rechte größere und kleinere Landesherren zu werden nach dem Vorbild der Stammesherzöge. Die verwickelten Beziehungen aller zu allen und zum Reich, wie sie sich aus Grundbesitz und Recht ergeben, gliedern sich zu einer umfassenden Lehensordnung aus. Grundwirtschaft geht *Lehensordnung.* allmählich in Geldwirtschaft über, die durch das Gewerbe und den Handel *Rittertum.* der neuen Städte durchgesetzt und verkörpert wird. Die Städte wachsen in *Frau Minne* diese Lehensordnung hinein und suchen in ihr nach einem gemäßen politischen Dasein. Die festbegründete Herrschaft des Christentums und der kirchenlateinischen Bildung enthebt den Geistlichen seines Führeramts, gibt dem Laien Spielraum und erlaubt der Frau Welt ein lebensfrohes aber angemessenes Regiment über die Herzen. Dieses also verwandelte Deutschland findet im Rittertum seine gehobene, ausgleichende und verbindende Gesellschaft. Sehr verschiedene militärische, wirtschaftliche, rechtliche, ständische Wandlungen fließen im Rittertum zu einem gemeinsamen Ausdruck zusammen. Das Rittertum löst den Klerus in der sichtbaren Führung und Verkörperung der Nation ab. Rittertum ist kein Beruf, sondern eine Idee, nicht Stand, sondern Rang, nicht vererbbarer Besitz, sondern verdientes und zuerkanntes Lehen. Zum Ritter wurde man geschlagen. Er ist der Inbegriff edler Männlichkeit. Der Gegenstand, auf den sein höheres Streben inbegrifflich gerichtet ist, das ist die zum Ideal erhobene Frau, die Herrin, der man dient. Die Beziehung des Ritters zu seiner Herrin, die Minne, ist, über alles Geschlechtliche hinaus, Eros, das Verlangen aus der geistig-seelischen Hingabe an das andere und höhere Ich erfüllt und vollendet wieder hervorzugehen. Das Rittertum ist der Schöpfer der neuen deutschen Dichtung und dieses sein Lebensgefühl ihr ausschließlicher Gegenstand.

Das war die Welt, die das staufische Kaisergeschlecht mit seinem Reich verwirklichen wollte. Was Gallien den Karlingen, das war für sie Italien. Norden *Italien*

und Süden, Deutschland und Italien sollten in einem übergeordneten Ganzen vereinigt werden, in ein Kaisertum, von dem alle Macht als nachgeordnet zu Lehen ginge. Wie die Karlinge, so hatten auch die Staufer bei ihrem südwärts gezielten Wurf einen Gegenpart. Das waren die Welfen.

1. DER RHEINLÄNDISCHE KREIS

Geistesleben und Dichtung des Stauferreiches gliedern sich scharf erkennbar in drei Bereiche. Am Rhein rücken Franken und Alamannen auch künstlerisch enger aneinander, gegenüber jedem Dritten. Über die Elbe hinweg wächst Sachsen sich nun mit dem werdenden Osten zu einem neuen Ganzen aus. Die Donau abwärts löst sich Österreich aus seinem Mutterkörper zu einem in sich geschlossenen und eigenen Dasein ab.

RHEINFRANKEN. Die einstige gallisch-fränkische Einheit nimmt jetzt *Frankreich* in den engen geistigen Wechselbeziehungen zwischen Frankreich und Deutschland nur eine andere Gestalt an. Das Rheintal ist und bleibt in diesen Beziehungen der natürliche und nachbarlichste Vermittler. Aus Frankreich kamen die beiden entgegengesetzten Bewegungen, in deren Zusammenstoß sich die Zeitalter schieden: von Cluny die erneuerte Strenge der benediktinischen Klosterzucht, deren asketischer Geist in einer ziemlich breiten religiösen Dichtung des Rheintales zu spüren ist; von der Provence der ritterliche Lebensstil, der im Rheintal zuerst nachgebildet wurde. Zur Wiege der neuen Dichtung wurde die Landschaft durch zwei Schöpfungen, deren eine aus der asketischen Legendenliteratur herauswuchs, aber schon deutlich den *Annolied.* neuen Kunststil zeigte, das Annolied, um 1120 im Kloster Siegburg bei Bonn *Alexanderlied* entstanden; deren andere zum erstenmal das junge französische ritterlich gesinnte Epos herüberbildete, das Alexanderlied, das um 1130 der mittelfränkische Geistliche Lambrecht geschrieben hat.

Heinrich Beide Richtungen liefen sehr glücklich in dem ersten deutschen Meister der *von Veldeke,* ritterlichen Dichtung zusammen. Das war *Heinrich von Veldeke* auf dem *Der Roman* Dorf bei Maastricht, das bis auf seine Mühle verschollen ist. Noch in seiner niederrheinischen Heimat gelang ihm nach einer lateinischen Vorlage die „Legende vom heiligen Servatius", dem Schutzheiligen der Maastrichter Reichspropstei. Der Versroman des neuen französisch-deutschen Stiles ist die „Eneide" nach dem gleichen Roman des Dichters Benoit von Saint More. Die Dichtung wurde vor 1190 am Thüringer Hofe vollendet. Der Stoff ist völlig auf die neue Gesellschaft gestimmt. Aeneas und seine Helden sind Ritter, und

die Schlachten werden wie Turniere geschlagen. Die Bildung der Zeit hat Veldeke wie wenige in sich aufgenommen. Allein sein Werk hat mehr den Vorzug der Erstgeburt als den der dichterischen Leistung.

Das ritterliche Lebensgefühl, dessen erste Stimme Veldeke gewesen ist, drückte sich am vollkommensten im höfischen Liede aus. Und das ist in der Rheinpfalz geschaffen worden. Die neue abendländische Gesellschaftsdichtung stammt aus der Provence, jenem griechisch-römischen Siedelgebiet, in dem dann Westgoten und Ostgoten, Burgunder und Franken einander wechselvoll überschichtet hatten. Die provenzalischen Schöpfer dieser edlen Kunst waren die Trobador. Zu frühest im Abendlande hatte sich die gesellschaftliche und künstlerische Form des Minnedienstes zu Cordova am Hofe der andalusischen Muslimenfürsten ausgebildet. Die hatten ihn von den Persern. Und von denen führt die goldene Spur auf die späten Hellenen zurück. Doch aus der Antike sind in diese Liedkunst durch das lateinische Lied der Fahrenden unmittelbar Bestände der römischen Lyrik und aus dem Morgenlande durch die Kirche Stilzüge des Hohen Liedes eingegangen. In Deutschland selber hat die Gefühlsweise der deutschen Frauenmystik am ritterlichen Liede mitgebildet. Mag noch so viel am Minnegesang der Herkunft nach fremd sein. In Spanien wie an der gallischen Südküste waren es Germanen, die als Mitschaffende oder Miterlebende den letzten Aushauch antiken Lebens eingeatmet hatten, Germanen, deren gedämpftes Blut durch keltische und arabische Anreize schwärmerisch erhitzt worden war, und in Deutschland waren es Deutsche, die durch die Mystik in das innerste Geheimnis des Eros eingedrungen sind. Vier Pfälzer, Freiherren gleichen Standes, haben aus der Fülle dieser Stimmungsweisen und Formen zuerst das deutsche Minnelied gebildet. *Friedrich von Hausen,* ein Gefährte der Staufer, hatte seine Burg bei Kreuznach und fiel 1190 im Morgenlande. Seine Lieder, die ersten im Stil der Trobador, lieben den elegischen Ton des Trûren und lassen früher als irgendein anderes die Sehnsucht nach dem Rhein spüren. Sein Freund, *Ulrich von Gutenburg,* aus Bergzabern, doch von rheinfränkischer Herkunft und um 1200 gestorben, gewann für die Liebeslyrik den durchkomponierten Leich. Er pflegte das durchgehende Bild und konnte seine gelehrte Bildung nicht ganz unterdrücken. *Bligger von Steinach,* aus der Burg oberhalb Heidelberg und bald nach 1209 gestorben, glänzt mit den überraschenden Eingängen seiner Lieder. Sein Novellenbuch „Umbehang" — Teppich der Mären — ist verloren. *Friedrich von Leiningen,* um 1220 gestorben, hat allen staufischen Kaisern seiner Zeit gedient. Sein einziges erhaltenes Lied, empfindsamer als die andern, sagt manches zum erstenmal, was dann Gemeingut

Das Lied.
Provence
und Spanien

Die Pfälzer
Liederdichter

wurde. Dieser älteren Pfälzer Kameradschaft folgte um 1250 eine jüngere,
der *Freiherr von Wisenlo, Konrad II. von Bickenbach, Wilhelm von Heinzen-
berg,* die alle schon die Schule Heinrichs von Mohrungen und Reinmars von
Hagenau verraten. Diese Pfälzer bildeten eine geschlossene Gesellschaft von
Freiherren. Kein einziger Dienstmann war unter ihnen. Alle waren treue
staufische Gefolgsleute. Sie waren nie zu Hause, fielen im Morgenlande, star-
ben in Italien und sandten Liebesgrüße über Meer und Alpen. Sie sind die
ersten Meister und Vorsänger des höfischen Liedes.

Mystik Aus dem gleichen Niederfranken wie der Erstgestalter des ritterlichen
Romans Heinrich von Veldeke, kam der Ordner eines neuen fraulichen Ge-
meinschaftslebens, der Priester *Lambert le Beghe,* der 1184 bei Lüttich ein
Haus für Frauen gründete, wo sie unter Verzicht auf feste Gelübde durch
Betrachtung der göttlichen Geheimnisse und durch uneigennützige Hand-
arbeit der Zeit ein Vorbild stiften sollten. In Köln faßte die Bewegung Bo-
den. In der Rheinpfalz, an derselben Stelle und um die gleiche Zeit, da die
fränkischen Freiherren ihr Reich der feinen Liebe stifteten, begannen zwei
Frauen gleichen Sinnes aus dem Geist der jungen deutschen Mystik zu leben.
Hildegard Das war im Kloster auf dem Rupertsberge bei Bingen. *Hildegard von Bin-
von Bingen gen,* 1104 bis 1178, durch weite Reisen und staatsmännisches Wirken uner-
schrocken um das Heil der Gesellschaft bemüht, legte ihre Gesichte und Er-
kenntnisse in einem umfassenden Schrifttum von geistlichen, heilkundlichen
und naturwissenschaftlichen Büchern nieder. Ihre tiefsinnigen Dichtungen
hat sie selber vertont. Wie sie hat ihre Landsmännin *Elisabeth von Schönau,*
1141 bis 1164, durch ihre Sendschreiben und Gesichte gewirkt.

Und um dieselbe Zeit, da aus Spanien über die Provence der höfische
Frauendienst nach Deutschland kam und Italien sich mit Deutschland zu
einem höheren Ganzen zu verbinden schien, zogen aus Spanien und Italien
Die Bettel- in den jungen deutschen Städten die ersten Sendboten zweier neuer Orden
orden ein. Dominikus aus Caleruega, um 1175 bis 1221, hatte, um die provenza-
lischen Ketzer in die Kirche zurückzuführen, den Orden der Predigerbrüder
gestiftet. Franz von Assisi, 1182 bis 1226, hatte, um die Nachfolge Christi
durch vollkommene Armut wahrzumachen, den Orden der Minderen Brüder
um sich versammelt. Indem beide Orden gleichermaßen predigten, was mein
ist, das ist dein, wandten sie sich an beide, den neuen Reichtum und die neue
Armut der rasch anwachsenden Städte. Beide Orden haben entscheidend auf
Das die Ausbildung einer neuen Dichtung aus Wort und Gebärde, das Mysterien-
Mysterienspiel spiel, eingewirkt. Auch diese Kunst ist unter gleichmäßigen Antrieben von
Frankreich und Italien her in den Städten wie der Minnesang in den Burgen

des Rheintales entstanden. Den Keim zum geistlichen Schauspiel hatte der Mönch Tutilo in Sankt Gallen mit seinen Tropen zum weihnächtlichen und österlichen Gottesdienst gelegt. Hatten sich Rede und Antwort ursprünglich auf Chor und Altar verteilt, so wurden sie bald an eigene Rollen gegeben und so die einfache Anlage nach Wortlaut und Spielraum gestreckt. Durch Erweiterung der Handlung und Aufnahme weltlicher Szenen gedieh die Osterfeier zum Osterspiel. Indem man den Vorwurf auf die ganze Heilsgeschichte ausdehnte, wurde das Osterspiel zum Passionspiel. Ähnliche Wege ging das Weihnachtsspiel. Das Rheintal hatte durch die Predigerbrüder ebenso lebhafte Beziehungen zu Frankreich wie durch die Minderen Brüder zu Italien. Durch beide Länder und beide Orden stark beeinflußt, hat das Rheintal in Wort und Szene die neue Kunst des geistlichen Spieles ausgebildet. Die gelehrte Schriftauslegung der Predigerbrüder hat am Inhalt und die Bildfreude der ihrem Wesen nach musischen Minderen Brüder hat an der Szene dieser Spiele mitgestaltet. Im Rheintal haben sich die dichterischen Spielbücher ent- *Die Spielbücher* wickelt, die wir freilich nur aus den späteren Fassungen des vierzehnten Jahrhunderts erraten können, aus einer Trierer Handschrift, aus dem Wetterauer Leben Jesu, aus der Frankfurter Spielrolle des Baldemar von Petersweil. Spielort waren zunächst die Kathedralen. Bei fortschreitender Ablösung vom Gottesdienst, durch das Eindringen weltlicher Bestände und die erhöhte Teilnahme der Bürgerschaft verschob sich die Bühne aus den Domen auf die geräumigen Plätze der Städte. So ist die gesamte geistige und geistliche Bildung des Zeitalters in die Mysterien eingegangen.

Als die beiden Stimmen des staufischen Reiches klingen Minnelied und Mysterienspiel einander nicht nur ständisch entgegen, sie klingen auch harmonisch zusammen als die Stimme der einen Idee, des Eros und der Ritterschaft.

OSTFRANKEN UND THÜRINGEN. Mitten im Niedergange des karlingischen Reiches wurde in Ostfranken Bamberg, Bistum seit 1007, unter Bischof Gunther ein Hort strengen kirchlichen Lebens. Ein Zeugnis dieser Gesinnung ist das „*Ezzolied*", das hier um 1050 ein Domherr für fromme *„Ezzolied" und* Edelleute geschrieben hat. Christus, das Licht der Welt, dieses Gleichnis des *„Merigario"* Johannesevangeliums, beherrscht die Dichtung, die einen Aufriß der Welt bis zur Geburt des göttlichen Kindes gibt. In Würzburg entstand um 1085 „*Merigarto*", ein Bruchstück zweifellos aus einer gereimten Erdbeschreibung und voll seltsamer Nachrichten, die ihren Zauber aus dem Unverbürgten ziehen. Der Ehrgeiz, ein umfassendes frommes Geschichtenbuch zu schaffen, ließ um 1120 einen Dichter Heiligendichtungen zu seinem „*Mittelfränkischen*

Legendar" zusammentragen. Nimmt man alles in allem, so ist diese landsmannschaftliche Vorgeschichte sehr wohl dem großen Dichter gemäß, der auf der Höhe des staufischen Zeitalters Sinn und Ziel des Rittertums in seinen gedankenschweren Dichtungen auslegte.

Wolfram von Eschenbach *Wolfram von Eschenbach* war ein kleiner unfreier Ritter aus der Gegend von Ansbach, der später auf einer windigen Burg hauste, an Weib und Kind sich freuend. Er ist weit herumgekommen, bis Steiermark, und war ein Ritter, der sein Schildamt wie einen Gottesdienst schätzte. Am Hofe des Landgrafen Hermann von Thüringen war auch er zu Gaste. Dort ist Walther von der Vogelweide sein Freund geworden. Wolfram von Eschenbach ist um 1225 gestorben. Unter all seinen Mitstrebenden hat er das umfänglich größte und stilistisch vielseitigste Werk geschaffen oder entworfen. Ein Mann wie er verschmähte das herkömmliche Liebeslied. Von seinen Gedichten, deren sich sieben erhalten haben, sind die meisten Tageweisen und verraten ein leidenschaftliches Herz. Er hat an Stelle der hohen Herrin die eheliche Liebe gepriesen. Seine Lieder sind der anmutige Kranz um ein ernst und schwer gefügtes episches Werk. Zwei nicht mindere, aber besonders geartete Dichtungen geleiten zur Rechten und zur Linken die erhabenste, aus der sich der zweieinige Geist des Mittelalters verkündet.

„Willehalm" Von den beiden ist der „Willehalm von Oranje" dem bewegenden zeitgeschichtlichen Erlebnis zugewendet, dem Kampf zwischen den beiden völkerweiten Religionen des Abendlandes und des Morgenlandes, zwischen Christentum und Islam. Das Gedicht schildert die beiden großen Schlachten bei Alischanz, 793, wo Wilhelm der Heilige, Graf von Toulouse, erst ein Besiegter, dann ein Sieger, die Sarazenen vernichtete. Was an der Gesinnung des Gedichts versöhnlich erscheint, ist die überlegene Menschlichkeit des Weltweisen und nicht die Kameradschaft des europäischen Rittertums. Die „Titurel" andere der beiden Dichtungen, „Titurel", gilt der Geschichte einer Kinderliebe und also Eros in seiner menschlich reinsten Offenbarung. Die Unschuld selber spricht aus Sigune und Schionatulander vom unbegreiflichen Urgeheimnis der Minne. Willehalms kriegerische Taten werden in den geläufigen gereimten viertonigen Verspaaren der Zeit erzählt. Was den beiden Kindern geschieht, ist in das melodische Rankenwerk kunstvoller lyrischer Strophen verzaubert. Beide Dichtungen lassen den Hintergrund des Thüringer Hofes erkennen. Vom Landgrafen Hermann hatte der Dichter die französische Vorlage zum „Willehalm". Und „Titurel" erzählt verdeckt von den fürstlichen Kinderehen, in die die heilige Hedwig nach Breslau und die heilige Elisabeth nach Eisenach geführt wurde.

„Parzival" ragt aus der Mitte von Wolframs Dichtungen als der vielgestaltige Gipfel staufischen Weltbewußtseins auf. Fremder Herkunft ist an diesem Werk nicht mehr als die keltische Stammsage, aus der es gebildet ist, wie das Bild aus dem Metall. Mag der Dichter sonst was immer genützt haben, es fällt gegenüber seiner schöpferischen Leistung gar nicht ins Gewicht. Von der geängstigten Mutter weltfern und weltfremd erzogen, tritt der Jüngling als reiner Tor ins Leben, wird schuldlos-schuldig durch eine versäumte Frage und nun auf der Suche nach Gott durch alle Abenteuer der Welt getrieben, findet bei der dritten Rückkehr in die ritterliche Artusrunde endlich den Gral und wird Gralskönig. So dichterisch gegenständlich und wirklich dieses ritterliche Leben dargestellt ist, gleichwohl ist es nur ein Gleichnis des mittelalterlichen Menschen an dem Punkte, wo er über Raum und Zeit hinweg der Mensch gegenüber dem Gottgeheimnis der Welt ist. Frage nicht, sondern antworte erst, wenn du gerufen bist, diese mütterliche Lehre besteht zu Recht. Parzival hat nicht eine Frage versäumt, sondern die Antwort auf den berufenden Ruf, den er nicht verstanden hat. Erst als er die Liebe hatte, verstand er den Ruf, gab ihm fragend Antwort und hatte also das schöpferische Wort gefunden, das in einem Frage und Antwort ist. Eros und Logos sind nicht eines und dasselbe. Doch Eros macht den Logos erst beredt. Erkenntnis kommt durch Liebe, im Sinne des Geschlechts wie im Sinne der Vernunft. Die Dichtung muß im Zusammenhange mit der zeitgenössischen provenzalischen Katharerbewegung verstanden werden, über die Wolfram unterrichtet war. Wolfram von Eschenbach hat seinen Helden und dessen Irrfahrten nach dem Gral mit der fröhlichen Laune eines wahrhaft Wissenden dargestellt, aus der Allgegenwart seiner ostfränkischen Heimat und in der Erinnerung an mancherlei germanisches Erbgut, in einer Sprache, die zuweilen gesucht dunkel und gewollt schwierig ist. Hier spielt der Tiefsinn mit sich selber. Denn hier legt ein geborener Grübler und Liebhaber seltsamen Wissens sich selber das Gottgeheimnis der Welt aus. So ist das ganze staufische Zeitalter fragend und wissend, handelnd und liebend in dieses Gedicht von den beiderlei Ritterschaften der Welt und Gottes eingegangen. Beide gelten nicht gleichviel als lediglich zwei Hälften eines Ganzen. Auch hier ist das Weltliche nur ein Gleichnis des Göttlichen. Aller Ritterschaft echteste sind die Ritter vom Gral und der höchste der Gralskönig. Wolfram von Eschenbach hat den Sinn des Rittertums nicht gefunden, sondern nur ausgesprochen.

In Ostfranken rundet die Welt sich aus, deren Mitte Wolframs Geist und Werk gegründet hat. Graf *Otto II. von Botenlauben,* der Sohn aus einer fränkisch-morgenländischen Ehe, lebte Parzivals geistliches Rittertum nach

„Parzival"

Parzivals Abenteuer

Eros und Logos

Botenlauben und Grafenberg

2*

und sang von seinem Leben in mystisch angehauchten Liedern. Wolframs
Schüler, *Wirnt von Grafenberg*, ein Kreuzfahrer, hatte mit seinem Artus-
roman „Wigalois" noch vor Wolfram begonnen. Aber als er den „Parzifal"

Ostfränkische
Lehrdichtung kennenlernte, schloß er ihn im Stil des Meisters ab. In der Art der Lehren, die
bei Wolfram der alte Gurnemanz dem jungen Parzifal erteilt, schrieb um
1225 ein fränkischer Ritter die beiden Sittenspiegel „*Winsbeke*" und „*Wins-
bekin*". Der arme Schulmeister aus der Bamberger Vorstadt Teuerstadt aber,
Hugo von Trimberg, 1235 bis 1315, ein sehr fruchtbarer Schriftsteller, gab
mit seiner Spruchsammlung „Renner" einen bescheidenen Teil des Vermächt-
nisses dieser ritterlichen Zeit an das aufkommende Bürgertum weiter.

THÜRINGEN war durch den Landgrafen Hermann I., 1190 bis 1217, im
Lehensgefüge des staufischen Reiches eine kleine, aber einflußreiche Macht
geworden. Das geistige Leben der Landschaft hielt mit dem staatsmänni-
schen Ansehen gleichen Schritt. Es gewann seinen eigenen dichterischen

Thüringer
Ritterdichtung Reichtum. *Heinrich von Morungen*, zwischen 1213 und 1221 urkundlich be-
zeugt, steht mit seinen Liedern unter seinesgleichen eigenartig und rühmlich
da. Sie haben leise Züge von der Antike und sind voll Wirklichkeit ohne den
gespielten Kummer und den blassen Ton der Mode. Nach der Sitte der Pro-
venzalen, die er in deren Heimat kennengelernt hatte, ließ er seine Lieder
von andern vortragen. So wissen diese Thüringer von der römischen Dich-
tung mehr als die meisten ihrer Zeitgenossen. *Herbort von Fritzlar* schrieb
zwischen 1210 und 1217 nach einer französischen Vorlage das „Lied von
Troja" in sehr anmutigen Versen und in der Darstellung des Seelenlebens
von einer fast modernen Genauigkeit. *Albrecht von Halberstadt* übertrug
um 1210 Ovids Verwandlungen in deutsche Verse. *Otto*, wohl von hessischer
Herkunft, ein sehr belesener Dichter, erzählte nach einer französischen Vor-
lage und im Stil Wolframs um 1204 die Legende „Eraclius". Diesem höfi-
schen Kreise fügte sich der Erfurter Bürger *Ebernand*, angeregt durch die
Bamberger Heiligsprechungsfeier der Kaiserin Kunigunde von 1201, mit sei-
nem Gedicht „Kaiser und Kaiserin" ein.

Thüringer
Mystik Mit dieser ritterlichen Dichtung spielte nicht minder artenreich ein geist-
liches Schrifttum zusammen. *Mechtild von Magdeburg*, die als Begine gelebt
hatte, bis sich ihr das Kloster Helfta bei Erfurt öffnete, zeichnete um die
Mitte des dreizehnten Jahrhunderts ihre Gesichte in niederdeutscher Sprache
auf. Sie sind nur in der hochdeutschen Übersetzung Heinrichs von Nörd-
lingen als „Das fließende Licht der Gottheit" erhalten. Es ist ein über-
schwängliches mystisches Tagebuch, das in der Sprache des ritterlichen Min-
neliedes geheimnisvolle Begebenheiten der Seele durch völlig sinnliche An-

schauungen ausdrückte. Der Ausgang des Jahrhunderts reifte zwei große Legendenwerke. Das *„Buch der Väter"* schilderte die Wirksamkeit der ersten Mönche. Das *„Passionale"*, aus der Legenda aurea schöpfend, faßte Leiden und Wunder Christi und Marias, die Schicksale der Apostel, Evangelisten und Heiligen in den Rahmen des Kirchenjahres ein.

Das Gottgeheimnis der Welt, auf das Wolfram seinen Parzival ausschickte, *Meister Eckhart* das die mystischen Frauen in ihre Gesichte zu bannen suchten, machte nun der Denker zum Gegenstande der geschulten Vernunft. *Meister Eckhart*, um 1260 bis 1327, aus Hochheim bei Gotha, Predigerbruder in Erfurt, Lehrer an der Kölner Hochschule und Prior zu Erfurt, später in Straßburg tätig, hat über Nikolaus von Kues und Jakob Böhme dem deutschen Denken immer wieder die Richtung gegeben. Seine Lehre, das ist die Lehre seines Ordens, der Predigerbrüder, aber gedacht in den Gedanken Plotins. Sein und Erkennen sind eines und dasselbe. Jedwedes Geschehen ist ein Erkennen. Gott als Urgrund aller Dinge muß jenseits, das ist außerhalb alles Geschehens stehen, alles Seins und alles Erkennens. Er ist „Nichts". Selbsterkenntnis und Selbstoffenbarung Gottes, das ist die Entfaltung Gottes aus der Alleinigkeit seines Wesens zur Vielheit und Mannigfaltigkeit der Welt. Auf der Gegenseite zu Gott steht die geschaffene Seele. Doch auch sie ist göttlichen Wesens. In ihr liegt der geheimnisvolle Punkt, in dem sich, gleich dem Lichtstrahl im Spiegel, der ganze Weltwerdevorgang umkehrt. Durch Selbstentäußerung von allem Geschehen, Sein und Erkennen kehrt Gott durch die Kraft der Seele wieder zu sich selbst in sein „Nichts" zurück. Von Gott aus dem „Nichts" werdend, geht es also durch Selbsterkenntnis zum „Ich" der Welt, und durch die Seele geht es aus dem „Ich" der Welt entwerdend durch Selbstaufhebung der Erkenntnis zurück zu Gott ins „Nichts". Von Gott zur Welt und aus der Welt zu Gott, das ist also zugleich ein Vorgang des Denkens und des Wollens, Erkenntnis und Sittlichkeit in einem. Mit diesem Bilde von schlichter Gewaltigkeit, das Eckhart, beispiellos wortschöpferisch, dem einfachen Manne mit immer neuen Wendungen einprägte, ist Gedanke und Gemüt, die ganze Frömmigkeit der deutschen Mystik immerwährend ausgedrückt.

Thüringen war auf der Wartburg bei Eisenach beidemal die Hochburg *Die Wartburg* des ritterlichen und des fraulichen Deutschlands, um 1200 unter Hermann I., der um sich die führenden Dichter des Reiches versammelte und an den meisten ihrer Werke persönlichen Anteil nahm, um 1220 unter Ludwig IV., der in seiner Gemahlin, der heiligen Elisabeth, die frauliche Blüte des geistlichen Deutschlands in seinem Garten hatte. In dem Gedicht *„Der Wartburg-*

krieg" und in einem reichen geistlichen Schrifttum ist die Wartburg des
dienenden Rittertums und der dienenden Herrin zur Legende geworden.

*Alamannische
Kleindichtung*

ALAMANNIEN. Im schwäbischen Stammlande der Staufer, wo das Klo-
ster Hirsau an der Nagold zum Träger des strengen Geistes von Cluny
wurde, setzte sich gegen ein asketisches Schrifttum von der Art wie Nokers
„Memento mori" oder wie der *„Skop von dem Lohne"* und gegen eine volks-
mäßige Tierdichtung wie *Heinrichs des Glichezare* „Isengrin", die neue Rit-
terdichtung scharf und schroff ab. Als Übergänge mögen rein dichterisch gel-
ten die ziemlich rohe Augsburger *„Servatiuslegende"* und *Bruder Wernhers*
schönes und schon sehr minnigliches „Marienleben". Es sind Übergänge,
aber zu sehr weltlichen Dingen, zur ritterlichen Legendendichtung.

Den zwei fränkischen Schöpfern des höfischen Versromans treten zwei ala-
mannische zur Seite, einer aus Schwaben und einer aus Elsaß.

*Hartmann
von Aue*

Hartmann von Aue stammte aus einer ritterlichen Familie von Dienst-
leuten. Auf einer Schule, vielleicht in der Reichenau, erwarb er sich, glück-
licher als der Selbstbildner Wolfram, eine genauere Kenntnis der Antike und
all des Wissenswerten, das die Zeit zu vermitteln hatte. Was er dann in der
Welt gelebt hat, war das ritterliche Leben eines freiherrlichen Beamten. Mit
Friedrich dem Rotbart ging er auf Kreuzfahrt. Vor 1220 ist der erst Fünfzig-
jährige gestorben. In der Mitte seines vielfältigen, reichen und schön geglie-
derten Werkes stehen die beiden legendenhaften Dichtungen von der Höl-
lenfahrt und Himmelfahrt der Liebe, von „Gregorius", dem Schicksalsgenos-
sen des Ödipus, der den schauervollen Irrtum seines Blutes büßt, und vom
„Armen Heinrich", wo zweifach Menschenliebe sich ins Göttliche verklärt.
Beide sind Dichtungen des heiligen Opfers. Beiden zur Seite, am Anfang und
am Beschluß, stehen abermals gepaart und aufeinander bezogen die beiden
Ritterromane „Erec", der über der Liebe die Ritterschaft versäumt, und

*Hartmanns
Werk*

„Iwein", der um der Ritterschaft willen die Liebe vergißt. Das „Büchlein",
das den Widerstreit zwischen dem seelischen und geistigen Menschen in
Form eines Rechtshandels zu schlichten sucht, und drei Kreuzlieder runden
dieses Werk zu einem vollkommen ausgegliederten Ganzen ab. Hartmann
ist der einzige Dichter älterer Zeit, der mit Überlegung von einem Gedanken
her sein Gesamtwerk als eine beziehungsvolle und mit allen Teilen harmo-
nische Einheit angelegt hat. Es macht keinen Unterschied, daß er im „Hein-
rich" frei erzählte, im „Gregorius" einem Stoff der Weltliteratur folgte und
in seinen beiden Romanen die Artusbücher des Chrestien de Troyes nach-
dichtete. Er ist ein Dichter. Er ist nach der Vorschule, die allein Veldeke be-
deutete, der eigentliche Schöpfer des deutschen Romans und er ist unwider-

ruflich der Schöpfer der deutschen Novelle. Er ist ganz und gar Erzähler, Meister des stetig fortrückenden Gewebes, aus dem die bunten Bilder seiner Begebenheiten herauswachsen, alle so wirklich und doch voll Bezug ins Ewige, womit er das menschlich Gültige meint. Die Sprache, mit der er erzählt, ist die zwar gehobene aber lautere und gemeinverständliche Rede des Lebens wie es ist. Auch ihn beschäftigen die letzten Dinge, aber nicht mit ihrem jenseitigen Warum, sondern mit ihrem diesseitigen Wie, nicht der schöne, sondern der gerechte Einklang von oben und unten und der irdischen Dinge untereinander. Ihn beschäftigt die sittliche und darum auch rechtliche Ordnung der Welt. Er ist der Dichter des rechten und darum gegen Gott und Mensch gerechten Maßes, darum der „Buße" im religiösen und zugleich rechtlichen Sinne als der Wiedergutmachung und des „Opfers" als des freiwilligen Beitrages zur göttlich-menschlichen Gerechtigkeit. Also ist er der Dichter der menschlichen Wirklichkeit. Jetzt und hier, an jedem Tage, der kommt und geht, von Mensch zu Mensch wirkt sich das Droben und Drüben aus und will vollzogen sein. Rittertum heißt nach rechtem Maße leben und handeln. Eros ist nicht nur der Urgrund der Welt, sondern auch das Gesetz ihrer Ordnung, Sinn der Buße, Sinn des Opfers, Ursache und Absicht der Gerechtigkeit. Das ist die Liebe, in deren Dienst der Ritter sein Wappen zeigt und die Waffen führt.

Gottfried von Straßburg, jünger als Wolfram und Hartmann, war schon der Bürger einer mächtig aufstrebenden Stadt. Er stammte sichtlich aus guter Familie, war wirtschaftlich unabhängig, trefflich gebildet und zeigt sich mit Staatsgeschäften vertraut. Man muß sich ihn wohl als Stadtschreiber denken. Er diente keinem Herren, sondern einer vielköpfigen Bürgerschaft und also auch nicht auf Ritterweise einer Herrin. Er war ein Weltmann, der erste Kavalier, der uns als Dichter begegnet. Und also hat er das ritterliche Lebensgefühl ins Weltmännische umgestimmt. Das hieß, es entritterlichen und verweltlichen, es aufgeklärten Sinnes aus allen seinen „Schwärmereien" zu entzaubern. Diesem Stadtjunker ist Liebe der einzige Quell von Tugend und Ehre. Der Kampf, in den Neigung und Pflicht geraten können und müssen, ist seiner Natur nach ungleich und von Anbeginn zugunsten der Liebe entschieden. Aus einem Märchen von der Jungfrau mit den goldenen Haaren hatten anglo-normannische und bretonische Dichter die Liebessage von „Tristan und Isolde" gemacht. Die hat Gottfried in seinem Liebesroman gleichen Namens seit etwa 1210 dem Anglo-Normannen Thomas nachgedichtet. Bei ihm ist es das Liebeslied der „edlen Herzen", das hoch über der gemeinen Welt des alltäglichen Menschen im irdischen Jenseits der Allschönheit spielt.

Gottfried von Straßburg

Die große Passion In dieser Welt des Kavaliers lebt man nach dem Gesetz der Liebe und Höfischkeit. Die Kunst, das Instrument des Herzens zu spielen, die macht in dieser Welt den Meister. Gleichwohl wissen diese Auserwählten, daß es in dieser Kunst keine Vollendung und keine Bestätigung gibt, denn durch die Meisterschaft des Todes. So ist denn diese Geschichte der großen „Passion" zugleich ein hoher Bildungsroman des adeligen Seelenmenschen, der sich erst in der Zweiheit des gemeinsamen Todes vollendet. Es hat nicht viele Deutsche gegeben, die in solchen Begebenheiten zwischen zwei Herzen so gut Bescheid wußten und die so glaubhaft von ihnen zu künden verstanden wie Meister Gottfried. Der Mann hat wahrhaftig als ein erprobter Geselle die Kunstschule der Antike verlassen, wenn es je möglich ist, zu verlassen, was einem angeboren ist. Er malt freihändig die schönsten Szenen, seien es solche des Lebens oder der Natur. Sein beherrschter Verstand spiegelt sich mit gleichem Vergnügen in zugespitzten Unterscheidungen und in gepaarten Ähnlichkeiten, in diskreter Bildlichkeit und in Wortspielen, die durchschaut sein wollen. Und welche Sauberkeit des Verses, der so spürbar nach regelmäßigem Wechsel zwischen rhythmischen Höhen und Tiefen strebt und die vollkommenste Prosa ist, weil sie mit der unauffälligen Kunst dem natürlichen Tongefälle der Worte und Sätze folgt. Meister Gottfried, das ist leibhaftig die gepflegte Anmut eines Geistes, dem gute Laune und glitzernder Witz mit gleicher Natürlichkeit zu Gesichte stehen. Gottfried hat von Hartmann in allem, was dichterisches Handwerk heißt, viel gelernt. Doch er steht, wie gegen Veldekes noch altmodische Handfertigkeit ebenso wie gegen Wolframs schwerflüssige Gottdunkelheit und Hartmanns menschengläubige Sittlichkeit. Gottfrieds musischer Kavaliersinn kräuselte über sie alle die Lippen, weil er sie als Hinterwäldler und Hinterweltler empfand.

Die vier Meister des Romans So haben Heinrich von Veldeke, Hartmann von Aue, Wolfram von Eschenbach und Gottfried von Straßburg dem deutschen Leben der Stauferzeit im großen Roman den gemäßen dichterischen Ausdruck geschaffen. Will man sich ihre Stellung innerhalb dieses gemeinsamen Werks und zueinander aus einer jüngeren und uns näheren Lage deutlich machen, so müßte man bei dem Vorläufer und Niederdeutschen Veldeke an den Begründer und Niederdeutschen Klopstock denken, bei dem schwäbischen Dichter der sittlich geordneten Menschenwelt Hartmann an den schwäbischen Herold der Gerechtigkeit, Schiller, bei dem tiefsinnig-dunklen Ostfranken Wolfram an den abgründigen Weltsinn des Ostfranken Richter und bei dem aufgeklärten Entzauberer der ritterlichen Empfindsamkeit, dem Alamannen Gottfried, an den Alamannen Wieland, der seinem bürgerlichen Zeitalter dichterisch den glei-

chen Dienst geleistet hat. Der Goethe der staufischen Monarchie ist nicht in
Deutschland, sondern in Italien geboren worden.

Aus der Schule dieser drei jüngeren Meister ging nun über ganz Alaman- *Die kleinen*
nien hin eine üppige Romanliteratur ritterlichen Stiles auf: *Ulrich von Zatzik-* *Leute*
hofen aus dem Thurgau um 1195 mit seinem „Lanzelet"; *Konrad Fleck* aus
Basel um 1220 mit „Flore und Blancheflore"; *Ulrich von Türheim* aus der
Augsburger Gegend um 1240 mit seinen Fortsetzungen zu Gottfrieds „Tri-
stan" und Wolframs „Willehalm"; *Konrad von Stoffeln* aus Schwaben um
1280 mit seinem „Gauriel von Muntabel". Die Legende, wie sie um 1230 bei
dem Schwaben *Konrad von Heimesfurt* — „Von unserer Frau Hinfahrt und
Urstende" — und um 1285 bei dem Hegauer *Hugo von Langenstein* —
„Martina" — erscheint, hat sich von diesem ritterlichen Stil freigehalten. Aus
ritterlicher Liebhaberei an der Kunst wurde Beruf und literarisches Hand-
werk mit Marktwert. Es blühte um die Mitte des dreizehnten Jahrhunderts
durch Konrad von Würzburg und Rudolf von Ems auf. Beider Gesamtwerk
sieht einander im Aufriß sehr ähnlich. Der bürgerliche Ostfranke *Konrad von* *Konrad*
Würzburg wurde in Basel heimisch. Er hat die Erzählkunst bevorzugt in klei- *von Würzburg*
nen Gebilden gepflegt, in Legenden wie „Silvester", „Alexius", „Pantaleon"
und in Novellen wie „Kaiser Otto", „Herzmäre", „Engelhard und Engel-
trud", „Pantonopier". Den „Trojanerkrieg" hat er noch einmal geschrieben.
Die ungemeine Leichtigkeit, mit der er arbeitete, verführte ihn in seinen
Tageliedern, Tanzweisen und Sprüchen zu jenen Künsteleien, die man sich
allgemach schuldig zu sein glaubte. Seine Gesprächbüchlein „Der Lohn der
Welt" und „Die Klage der Kunst" kommen von Hartmann her und wandten
sich an den Geschmack eines schon scholastisch gebildeten Geschlechts. Der
oberrheinische Alamanne *Rudolf von Ems* begann gleichermaßen mit den
Legenden „Der gute Gerhard", „Josaphat" und dem verlorenen „Eustachius".
Er versuchte sich in der Kindernovelle „Wilhelm von Orlens". Sein „Alexan-
der" ist eher eine geschichtliche als eine romanhafte Darstellung. So hat er
denn den Weg zu seiner „Weltchronik" gefunden, die unvollendet geblieben
ist aber weit verbreitet und das beliebteste Lesebuch dieses und des folgen-
den Menschenalters wurde.

So schöpferisch eigentümlich wie den ritterlichen Roman hat der Alamanne *Das*
die ritterliche Lyrik ausgebildet. Begonnen zu haben war das einzige Ver- *alamannische*
dienst des Grafen *Rudolf II. von Neuenburg*, dessen Burg Fenis nächst dem *Ritterlied*
Bieler See stand und dessen Lieder lediglich aus romanischen Strophen zu-
sammengebastelt sind. Den elegischen Stimmton und die kunstvolle Form
hat der Elsässer *Reinmar von Hagenau* dem ritterlichen Liede erst in Öster-

reich gefunden. Die Landschaften, die der höfischen Lyrik ihre vielfältige Gestalt gegeben haben, sind Schwaben und der Bodensee gewesen.

Das schwäbische Lied, das ist die ritterliche Stimme der Staufen selber und ihrer bevorzugten Dienstleute. *Heinrich VI.,* der gewaltige Kaiser, der mit seinen harten Händen die staufische Monarchie aus Deutschland und Italien zusammenfügte, eröffnete den Reigen mit den drei Liedern, die er wohl vor 1190 als Kronprinz gesungen hat, zwei kürzere altertümlichen und ein längeres modernen Stiles. Der gräfliche Dienstmann *Meinloh von Sevelingen* sang um dieselbe Zeit seine kunstvolleren Strophen, in denen der Ton des Volksliedes zu hören ist. Das träumerische Sichselbstverlieren und das verliebte Heimlichtun können kaum in schöneren Worten ausgedrückt werden *Schwäbische* als die seinen sind. Der gräfliche Dienstmann *Heinrich von Rugge* liebte in *Minnesänger* seinen Liedern das volksmäßige Sprichwort. Lebensfroh und gut gelaunt nimmt er die Wechselfälle der Liebe hin, liebenswürdig und gern in Erfahrung kramend. Sein größtes Gedicht ist der Kreuzleich. Der staufische Dienstmann *Hiltpolt von Schwangau,* gleichen Alters wie Sevelingen und Rugge, hat noch Einzelstrophen älterer Art, und doch gelingen ihm schon wohlgesetzte längere Gedichte in der Weise der Stanze. Er liebt den hüpfenden tanzmäßigen Tonfall. Das, war wir Moderne Erlebnis nennen, macht das Wesen seiner Liedkunst aus. Man kann nicht reizvoller die feinen Farbtöne des Gefühls ineinander schimmern lassen. Wie der Kaiser die erste, so leitet der letzte Staufer *Konradin* mit seinen weichen und wehmütigen Liedern die zweite Altersgenossenschaft dieser schwäbischen Sänger ein. Doch nicht Konradin, sondern der deutsche Stauferkönig Heinrich war der Tonangeber und Gesinnungsführer dieser jüngeren Gruppe. Wie politisch gegen den kaiserlichen Vater des Königs so meuterten sie auch dichterisch gegen die gute alte ritterliche Art und spielten halb spöttisch, halb ernst den Bauer gegen den Ritter aus, wie es ihnen eben Neidhard von Reuental vorgemacht hatte. Aus einer dieser Familien, die bis zum bitteren Ende bei König Heinrich aushielten, stammte *Gottfried von Neifen.* Er blühte um die Mitte des dreizehnten Jahrhunderts. Ein Redekünstler und Meister des Verses, hat er dem ritterlichen Liede beides gegeben, die gesunde Natur und die derbe Sinnlichkeit des Volksgesanges, ohne den gefühlvollen Ernst des eingebürgerten Stils preiszugeben. Der Schenk *Ulrich von Winterstetten,* aus einer der mächtigsten Reichsbeamtenfamilien, war der Sohn des Erziehers und getreuen Eckharts König Heinrichs. Er ist der eigentliche Kunstkünstler dieses Kreises und hat in einer Elegie, obwohl er auch das Tanzlied Reuentals nachbildete, den Verfall des höfischen Liedes beklagt. Seine Dichtung ist fast nur gereimtes

Gesellschaftsgespräch. Schon jünger stand auch *Hug von Werbenwag* durch seinen Vater in Verbindung mit König Heinrich. Er liebt Binnenreime und droht seiner Geliebten mit einem Rechtshandel vor König, Kaiser und Papst. Ostfränkischer Herkunft war die Familie des *Schenken von Limburg* und von König Heinrich an den Kocher verpflanzt, um die Anhänger des Kaisers, seines Vaters Friedrich II., die Hohenlohe, niederzuhalten. Der Dichter kämpfte mit Konradin in Italien und ist wahrscheinlich mit ihm zugrunde gegangen. Seine Kunst sind die frisch einsetzenden und lebendigen Liedanfänge, sinnliche und volksmäßige Unmittelbarkeit, der wahrhaft erlebte elegische Ton.

In Basel, im Elsaß, Breisgau, Thurgau und Aargau tummelten sich, bunt gemischt, die Nachahmer und Mitläufer. Wohin immer er gehören mag, *Freidank* war der erste kraftvolle Vertreter bürgerlicher und volkstümlicher Art. *Freidank* Zum Teil in Syrien, wohin er mit Kaiser Friedrich II. gekommen war, entstand 1229 eines der gelesensten deutschen Bücher, die Sammlung von Denksprüchen „Bescheidenheit". Verständnisvoll unterscheidender Überblick über alle Beziehungen des Lebens, das meinte der Titel. In den bequemen Bau des Buches, das gesinnungsmäßig mit Walther von der Vogelweide völlig übereinstimmt, ist die Spruchweisheit des Volkes und der zeitgenössischen Dichtung verarbeitet. Bei dem trinkfrohen Spötter *Berthold Steinmar* von Klingenau, der bereits Kaiser Rudolf diente, haben wir schon das Volkslied und bei dem Stadtschreiber *Rudolf von Augsburg* beinahe schon den Meistergesang.

Die andere Entfaltung des ritterlichen Liedes geschah um den Bodensee. Hier südlich von Stühlingen war *Bernger von Horheim* zu Hause, aus einem *Dichter am* kleinen Beamtengeschlecht. Hausen und Gutenberg innerlich verwandt, diente *Bodensee* er wie sie den ersten Staufern. Aus der natürlichen Schwermut seiner Seele spielt er seine Lieder über die ganze Tonleiter des Schmerzes. Sein Abschiedslied schlägt schon den Ton jenes echt romantischen „fern und nahe" an. Aber man hört auch, wie zuweilen der Schlußvers seiner Strophen mit Absicht die Stimmung zerstört, die er eben angeschlagen hat. Ob Sipplingen hatte *Burkart von Hohenfels* seine Burg, einer der größten Lieddichter des alamannischen Volkes. Er gehörte zu König Heinrichs Freundeskreis, hat ihn aber wahrscheinlich vor seinem Falle verlassen. Der Dichter ist vielleicht der Held der Sage von jenem Hohenfels, der nachts über den See schwamm zu seiner Geliebten, Fortunata von Kargeck, und in den Fluten ertrank. Den Stil Wolframs, der Rheinpfälzer, Neidharts hat er lebendig aufgenommen. Später geläufige lyrische Bilder hat er zu frühest geformt und zu frühest hat er den Rhythmus des Schnadahüpfels auf die ernste Gefühlsdichtung übertragen.

Die Einheit des Bildes in jedem Gedicht, das einheitliche Leben all seiner
Bilder und die engste Heimat als Anschauungsquelle seiner Dichtung, das

Das Höflein
Sankt Gallen
hebt Hohenfels vor anderen heraus. Er ist der Meister, der in dieser natur-
fremden Zeit Seele, Erde und Himmel zusammenzustimmen verstand. Am
Südufer des Sees war aus dem Patrimonium Sancti Galli ein äbtlicher Herren-
staat geworden, der die ritterlichen Lebensformen anzunehmen begann. Die
Äbte selber gaben den Ton an. *Abt Wilhelm* um 1290 soll die schönsten Tage-
lieder gedichtet haben. Andere, wie Abt Heinrich von Klingen und Ulrich VI.
von Sax, stammten aus Dichterfamilien. Meist waren es ritterliche Kloster-
beamte, die im Reigen der Dichter schreiten, so der Truchseß *Ulrich von Sin-*
genberg, der Meier *Konrad von Altstätten*, der Schenk *Konrad von Landegg.*
Sie folgten alle fremden Weisen, Neidharts, Neifens, Winterstettens. So auch
in der Bischofsstadt Konstanz. Der Wandel zur höfisch-ritterlichen Lebens-
art prägte sich hier am Bischof selber aus, Heinrich von Klingenberg, der
1293 Bischof wurde. Heinrich sammelte an seinem Konstanzer Hofe einen
angeregten Kreis um sich: die adeligen Männer und Frauen der Landschaft,
Stiftsgeistliche und Stadtjunker. Die dichteten, trieben die Tonkunst, pfleg-
ten die Wissenschaft und vertieften sich in jenes dunkle Wissen, dessen Klin-
genberg, Dichter und Tonsetzer, als gewiegter Kenner galt.

Das Konstanzer
Inselkloster
Neue Kräfte spielten herein. Auf der Konstanzer Insel hatte sich der junge
Orden der Prediger ein Kloster errichtet. An der Aufgabe des Klosterschmucks
waren unter den weißen Mönchen kunstfertige Meister der Wandmalerei
herangediehen. Heinrich von Klingenberg scheint sie durch größere Buchauf-
träge auch auf die Herstellung von Handschriften gewiesen zu haben. Der
Predigerbruder *Eberhard von Sax*, der um 1309 und jedenfalls zu Zeiten in
Konstanz gelebt hat, selbst Dichter eines Marienliedes, könnte persönlich
zwischen Bischof und Kloster vermittelt haben. Und so ist es wohl auch der
Bischof gewesen, der aus umlaufenden Liederbüchern zwei große prachtvoll
verzierte Sammelhandschriften anlegen ließ, die unberechtigt nach Manesse
genannte Heidelberger und die Weingartner. Unzweifelhaft in Konstanz ent-
standen, sind sie ein Zeugnis bürgerlicher Kunstfertigkeit, wie sie sich in der
Malschule des Inselklosters ausgebildet hatte. Durch Bruder Eberhard wäre
die eine Handschrift in die oberrheinische Familie Sax gekommen, wo sie
durch Menschenalter gehütet wurde.

2. DER DONAULÄNDISCHE KREIS

Gegenüber dem rheinländischen Kulturkreis, in dem, wie durch eine gemeinsame Mitte zusammengehalten, Franken und Alamannen, wenn auch unterschieden, doch als höhere Einheit sich geistig auslebten, hebt sich der donauländische mit wesentlich anderen dichterischen Daseinsformen ab.

BAIERN. Während der ersten Salierzeit mit dem Herzogtum Franken in der Hand des Königs vereinigt, gewann Baiern unter den Welfen seine Selbständigkeit innerhalb des Reiches wieder. Regensburg wurde der Hochsitz des wiedererstandenen Herzogtums, die Pflegestätte seines geistigen Lebens. Das Beste dazu hat Bischof Kuno, 1126 bis 1138, getan. Die bairische Dichtung im Stammlande wie in der Ostmark wird im Gegensatz zu Franken und Alamannien nicht vom Ritter, sondern vom Spielmann gemacht oder doch kunstmäßig beherrscht. *Der bairische Spielmann*

Den Grund zu dieser Dichtung legte noch unter den Augen des Bischofs der *Geistliche Kuno*, ein Baier oder doch bairisch redender Franke, der an der rheinischen Spielmannsdichtung geschult war, um 1130 mit seinem „Rolandslied". Morgenland und Kreuzzugsgedanke, der erste Abglanz der neuen ritterlichen Gesellschaft, machten die Dichtung, der eine französische Handschrift vorlag, zeitgemäß. Der Dichter verwandelte Roland aus einem Sarazenenkämpfer in einen Ostlandhelden und verlieh dem Ganzen den feinen Adel höfischer Sitte. Noch unter Bischof Kunos Antrieb ist um 1150 von einem Baier die „Kaiserchronik" geschaffen worden, das dichterische Buch, das dann Meister Konrad überarbeitet und bis zu seiner Gegenwart geführt hat. Es ist Geschichte des römischen Reiches, wie es im deutschen fortlebt „unze an disen hiutegen tac". Aber es ist ein bairisches Buch, in das die Heimat mit Sage und Landschaft eingegangen ist. Die Baiern hatten ehedem mit den nachbarlichen Langobarden jenseits des Brenners in Gutem und Bösem zusammengelebt. Diesem Gedächtnis stiftete ein rheinischer Spielmann um 1150 mit seinem Roman „König Rother" ein Denkmal. Auch diese Dichtung, ein Preislied auf die gegenseitige Treue von Fürstentum und Vasallentum, hat die Kreuzzüge mitgedacht. Und ein Lobgesang auf die Freudestreue wie auf die Abenteuerlust der Kreuzzüge war der Spielmannsroman „Herzog Ernst", der in seiner ältesten Gestalt um 1175 entstanden ist. Das nun waren zugleich Ort und Zeit, um 1160, da einer dieser Spielleute, seines Schlages ein Baier, ein großer Dichter und „Künstler von außergewöhnlicher Sprachgewalt", im Zuge dieser fränkisch-bairischen Formenprägung das alte Passauer sangbare Burgunderlied zu einem Lesebuch in Langzeilenstrophen weiterdichtete. So *„Rolandslied" und „Kaiserchronik"* *„König Rother" und „Herzog Ernst"* *Bairische Ritterdichtung*

Epische Gedichte ging es in Baiern ohne Bruch und Lücke vom Spielmannsroman zum Ritterbuch. Doch nicht ohne einen gewissen zeitlichen Abstand. Baiern wird im ritterlichen Stil völlig von Ostfranken und Schwaben überschattet. Der höfische Roman „*Wigamur*", der gegen 1230 an der fränkisch-schwäbischen Grenze entstanden ist, folgt wirklich auch schulmäßig dem fränkischen Stil Wolframs und der schwäbischen Art Hartmanns. Mit Wolfram eng verwandt ist „Der heilige Georg" des *Reinbot von Durne,* den Herzog Otto von Baiern, 1231 bis 1253, angeregt hat. *Albrecht von Scharfenberg* vollends empfand so sehr Wolfram von Eschenbach als Eigentümer der Stoffe, die dieser gestaltet hatte, daß er selber in seinem eigenen „Titurel" um 1260 im Namen des Meisters spricht. Der Dichter gibt hier die Vorgeschichte des Gralkönigtums und eine Beschreibung des Graltempels, die auf die Einbildung der Baumeister mächtig eingewirkt hat. Die andern Romane Scharfenbergs, „Merlin" und „Seifried de Ardemont", sind nur in späten Überarbeitungen erhalten. Die ritterlichen *Lieder* Lieder, wie sie in Baiern zu hören sind, klingen um 1170 bei dem *Burggrafen von Regensburg,* der vielleicht Heinrich von Rietenburg gewesen ist, volksmäßig, um 1190 bei *Albrecht von Johansdorf* religiös-feierlich, um 1200 bei *Engelhard von Adelnburg* und *Hartwig von Raute* beinahe im Ton Walthers von der Vogelweide. *Reinmar von Brennenberg,* aus der Familie der Regensburger Truchsessen, gibt sich schon ganz als Schüler Walthers. Er hat unter anderm ein Gedicht in zwölf sonettartigen Gesätzen geschrieben, das mit seinem Tonfall an die Litanei anklingt.

Die schöpferische Kraft des bairischen Stammes gefiel sich an ganz anderen Aufgaben. Deren vier, groß und neuartig, sind während dieses staufischen Zeitalters in Baiern einem späteren Geschlecht vorgeleistet worden. Das erste *Otto von* sinndeutende Geschichtswerk schuf *Otto von Babenberg,* um 1114 bis 1158, *Babenberg* Bischof von Freising, der Sohn des heiligen Markgrafen Leopold, der Enkel *„De duabus* Kaiser Heinrichs IV., der Halbbruder König Konrads, der Oheim Kaiser Fried*civitatibus"* richs I. So mit Leben und Wirken der Großen dieser Erde vertraut, fühlte Otto sich gedrängt, im Ablauf der Geschichte die bewegenden Kräfte sichtbar zu machen. Das ist sein Buch „De duabus civitatibus". Es knüpft an Augustinus an. Es ist dramatisch gedacht. Denn es sieht in allem irdischen Geschehen die beiden Urmächte der Welt Gut und Böse miteinander tragisch verstrickt und in den beiden mystischen Städten Babel und Jerusalem verkörpert. Am Ende steht der Widerchrist. Das erste moderne Drama gehörte *Spiel* dem Kloster Tegernsee. Es ist das *Spiel vom Widerchrist,* wie es um 1168 *vom Antichrist* ein sehr gebildeter und staatsmännisch denkender Dichter in der Umgebung des Kaisers Friedrich mit dem roten Barte geschrieben hat. Hier sind der

Kaiser und der Widerchrist die beiden Gegenspieler, die Otto Jerusalem und
Babel genannt hatte, der eine wie der andere Menschen mit menschlichen
Leidenschaften und mit menschlichen Kräften handelnd. Der Kaiser legt als
Sieger der Welt Krone und Zepter auf dem Altar des Tempels zu Jerusalem
nieder und der Widerchrist wird, da er sich als Weltsieger diese Krone aufs
Haupt setzen will, vom Blitz zerschmettert. Die erste Kunstgestalt der geist-
lichen Beredsamkeit ist in Baiern geschaffen worden. Der Barfüßermönch
Berthold von Regensburg, vor 1221 bis 1272, der wie ein geistlicher Eroberer *Berthold*
alle deutschen Landschaften predigend durchzog, hat aus der urtümlichen *von Regensburg*
Kraft des bairischen Wortes der deutschen Predigt großen Stil gegeben. Er
war ganz Volk und in der Art seines Ordensvaters Franz von Assisi voll Bild-
lichkeit. Er kannte das Volk in Sitte und Brauchtum, wie es wirklich lebte
und handelte so, wie es nur wenige gekannt haben, und er sprach es mit sei-
nen Bildern aus der Wirklichkeit so wörtlich an, wie Bilder nur genommen
werden können. In seinen Predigten gab es weder verzücktes Gefühl und
Abenteuer des Gedankens, sondern nichts als das tatkräftige Wort, das die
Herzen zerbricht und verwandelt. Während die Ritter ins Morgenland zogen
und seine eigenen Ordensbrüder im fernsten Asien die Mongolen zu Christen
machen wollten, führte er seine Kreuzzüge und Missionsfahrten mitten durch
Deutschland, um das geistige Reich zu verwirklichen. Die erste Dorfgeschichte *Die erste*
ist in Baiern geschrieben worden. Üppiger Bauernübermut, das war der ur- *Dorfgeschichte*
alte Vers, den die Nachbarn dem Baier immer wieder ins Stammbuch setz-
ten. Je mehr der Ritter im dreizehnten Jahrhundert verarmte und der Bauer
emporkam, desto eifriger strebte der kleine Grundbesitzer, es dem Reisigen *„Meier*
an Lebensart gleichzutun. Wie diese Eitelkeit zwei junge Köpfe, Sohn und *Helmbrecht"*
Tochter, verwirrt, den Burschen unter die Strauchritter führt und das Mäd-
chen in den Arm eines adeligen Buhlen, das erzählte dem Leben nach zwi-
schen 1236 und 1250 der *Klosterbruder Wernher*, der vielleicht zu Ranshofen
Gärtner war, in seiner ergreifenden Geschichte „Meier Helmbrecht". Mit
ihrer völlig anderen und neuen Art hat sie in diesem Zeitalter nicht ihres-
gleichen, es seien denn die Kleinbilder aus dem echten Leben, die Berthold
seinen Zuhörern vor Augen hielt. Das ist die rechte bairische Literatur des
Stauferreiches, das Drama der Weltgeschichte und des persönlich handeln-
den Menschen, die undichtbare Wirklichkeit, wie sie im Leben und zumal
auf dem bäuerlichen Hofe geschieht. Das ist der Spielmann in jedem Sinne,
wie er auf der Straße mitten durchs Volk wandert und über die Bühne durch
Wirklichkeit hindurchschreitet, doch immer ein Spieler im Spiel. Diese Lite-
ratur ist Aktion: des redenden Wortes wie des dargestellten Lebens. Sie ist

es in Baiern und sie ist es in Österreich, zwar in zweierlei Gestalt, aber aus gleicher Natur.

ÖSTERREICH. Ostarrichi hieß seit 996 die Ostmark an der Donau, wo sich um die Gestalt des Markgrafen der Kern eines neuen Stammes zusammenballte, eines bairischen Stammes, unbeschadet der fränkischen und alamannischen Siedler, ja der wenigen Sachsen, die sich unter die ostwärts drängenden Baiern mischten. Seine erste Ordnung empfing das werdende Neuland von Bamberg. Dort stand die Burg der Neubabenberger, die als Fürsten in die Donaumark kamen. Von dorther erhielten Kärnten und Steiermark ihr Klosterleben. Denn es war Neuland und wurde nach dem Geiste der Zeit zunächst auf kirchliche Weise geordnet. So ist in den Klöstern der östlichen Alpen die früheste Literatur des Landes entstanden, wie sich versteht eine geistliche Literatur. Um dem Spielmann gleich den ersten Wind aus den Segeln zu nehmen, richteten gegen Ende des elften Jahrhunderts gebildete Weltgeistliche Ausschnitte aus der Bibel wie *„Genesis"* und *„Exodus"* auf Spielmannsweise her. Aber man suchte auch den Geschmack an einer gleichnisweise ausgelegten Bibel zu wecken, so *„Die babylonische Gefangenschaft"*,

Alpenländische Bibeldichtung *„Das himmlische Jerusalem", „Die Hochzeit"*. Um 1125 fand es ein Dichter schon an der Zeit, in seinem *„Recht"* für den dienenden Stand das Wort zu nehmen und zeitgemäß gewordene Forderungen an den Adel zu richten. Und um 1173 machte ein Dichter den Versuch, in seinem Buch *„Anegenge"* von der Weltschöpfung bis zur Himmelfahrt das göttliche Heilswerk geschichtlich

Donauländische Betrachtungs- literatur darzustellen. Im Donautal scheint es wenigstens um Melk schon eine wirkliche Leserschaft für diese Literatur gegeben zu haben. Hier treten bereits die ersten wirklichen Persönlichkeiten erkennbar in das volle Licht der Geschichte: um 1120 die Klausnerin *Frau Eva* mit ihrer schlichten und innigen Darstellung der Heilsgeschichte von der Geburt Christi bis zum Ende der Welt, „Leben Jesu", „Antichrist", „Jüngstes Gericht"; um 1160 der Melker *Laienbruder Heinrich,* der Geißler weltfroher Ritter, putzsüchtiger Frauen und schlechter Priester, „Die Erinnerung an den Tod" und „Priesterleben"; um 1130 *Adelbracht* mit einem „Johann Baptista"; um 1150 der *Priester Arnold* mit seiner Deutung der heiligen Zahl Sieben auf den Heiligen Geist; der kunstvolle Dichter des *„Melker Marienleich",* der für den Chorgesang bestimmt war. Es sind alles Dichtungen, in deren früheren man den Sinn, in deren späteren die Wirkung der „Zwei Städte" Ottos von Freising zu spüren meint.

Österreich, Osten, Westen Österreich heißt seit 1156 das neue Herzogtum, in dem der neue Volksbestand der Ostmark staatliche Gestalt gewinnt. Denn das Volk von Ost-

arrichi ist weder durch volkhafte noch durch kirchliche, sondern durch staatliche Wehen geboren worden. Der Herzog von Österreich ist durch kluge Staatskunst und zeitgerechte Gunst der Geschichte wahrhaft Landesfürst und der erste Eigenherr im deutschen Reiche. Österreich stand zwischen Westen und Osten. Drei Herzöge hatten griechische Prinzessinnen aus Ostrom zu Frauen. Griechische Kunst wurde rings um Wien in den Kirchen der Lateiner heimisch. Griechische und lateinische Bildung schickten sich an, am Hofe der Babenberger ihre Rollen zu tauschen.

Das ritterliche Lied ist zu Österreich Eigenwuchs, aus dem Lande entsprungen, unter seiner westöstlichen Witterung ausgereift. In der Landschaft ob der Enns haben um 1150 zwei Ritter von sehr unterschiedlichem Wesen und Stil die ersten höfischen Weisen gesungen. *Dietmar von Aist* hat mitten in *Das bodenständige Lied. Dietmar von Aist* seinen ritterlichen Strophen noch den Ton des Volksliedes festgehalten. Altertümliche und moderne Verse stehen nebeneinander. Sinnig verträumt, zart und leise ist seine Grundstimmung. Wunderschön weben seine Rhythmen zwischen den Menschen und Dingen hin und wieder hoch über das Herz hinaus, dem Fernblick des Auges oder dem horchenden Ohr nach. Dietmar hat das erste Tagelied gesungen. Der *Kürnberger* ist der Mann der überlegenen *Das bodenständige Lied. Der Kürnberger* Erfahrung und des mit Spott gewappneten Herzens. Gegenüber Dietmars epischem Stil ist der seine dramatisch. Mann und Weib spielen bei ihm gern eine Begebenheit, die ganz Szene ist. Jede Strophe umrundet ein bestimmtes Erlebnis. Jedes Gedicht setzt eine sichtbare Situation voraus und nur diese eine. Seine Erfahrung stellt bevorzugt eine unumstößliche Spruchzeile an die Spitze des Gedichts. So schlägt denn auch der Rhythmus immer und sogleich kräftig ein. Seine sinnliche und ironische Art, die Frauen zu nehmen, hält auch dichterisch die jeweiligen Herrinnen seines Herzens, wenn er überhaupt zu „dienen" vermag, deutlich auseinander. Seine Frauen leben nicht im Himmelblauen hoch über ihm, sondern sehr wirklich und dicht an seiner Seite.

Am Wiener Hofe, vielleicht unter Herzog Leopold V., 1177 bis 1194, hat sich durch *Reinmar von Hagenau* eine denkwürdige Wiederbegegnung in der *Der neue Liedstil. Reinmar von Hagenau* Geschichte des ritterlichen Liedes begeben. Spätgriechische Liedkunst hatte sich rings um das Becken des Mittelmeers durch spanische Mauren und provenzalische Goten in die ritterliche Lyrik der Deutschen verwandelt. Auf geradem Wege donauaufwärts war die griechische Liedkunst von Byzanz durch die griechischen Frauen der Babenberger Herzöge am Wiener Hofe bekannt geworden. Reinmar von Hagenau, der erste deutsche Meister dieses Liedes von westöstlicher Herkunft, schloß zu Wien diesen Ring. Er ist der Hofdichter der österreichischen Herzöge gewesen. Er hat mit dem landestümlichen

volksmäßigen Ritterliede begonnen. Doch er lernte es bald, prächtig flutende
Rhythmen aufzubauen, Klagegesänge unbeglückter Liebe, in denen es schön
verflochten glänzte und tönte. Weich, überreizt, empfindsam war er in seinen
künstlichen Schmerz verliebt und trug ihn wie einen Mantel nach der neue-
sten Mode, der immer in gleichen sorgfältigen Falten den kummervollen
Gang seiner Glieder umfloß. Seine Kunst ist es, dem Rätsel der Liebe in den
geheimnisvollen Bewegungen des Herzens nachzuspüren. Sein überlegener
Verstand, der mit allen Kunstgriffen und Denkmitteln arbeitete, beherrschte
den Stil des Redners in all seinen Finten. Das war eine Geistigkeit, die an
den lateinischen Westen ebenso erinnerte wie an den späten griechischen
Osten. So hat Reinmar das volksmäßige Ritterlied Österreichs in das verwir-
rende und bestrickende westöstliche Denkspiel der Seele verwandelt. Er
hatte damit das Herz der Stadt getroffen, gerade zu der einmaligen Stunde,
da es zwischen Rom und Byzanz schwang.

Walther von der Vogelweide, vielleicht der jüngere oder jüngste Sohn eines
kleinen Ritters, war um 1185 zu Wien Reinmars Schüler. Nach dem Tode
Herzog Leopolds V., 1194, verließ Walther die Heimat und wanderte als
Spielmann durch Deutschland. Als der größte Staufer Heinrich VI. 1196 so
tragisch vor seiner Stunde gestorben war, hielt der Dichter, durch Heimat
und Überzeugung staufisch gesinnt, zum Staufer Philipp. Und erst als Philipp
1208 durch Mörderhand gefallen war, trat er allein um der deutschen Krone
willen auf die Seite des welfischen Gegenkönigs. Das ist die Zeit von Wal-
thers Strophen gegen den Papst. Kaum aber war 1212 Friedrich II. diesseits
der Alpen erschienen, um auch sein deutsches Staufererbe anzutreten, so flog
ihm Walther zu. Dann ging er wieder auf Spielmannsfahrt. Als er den her-
zoglichen Hof Leopolds VI. 1219 aufsuchte, fand er schon neue Leute in
Gunst. Man gab ihm dann ein kleines Lehen. Das Letzte sind seine scharfen
Verse gegen Kaiser Friedrichs II. treulosen Sohn, den deutschen König Hein-
rich, und die Kreuzlieder für 1227, nach denen er bald gestorben ist. Walther
von der Vogelweide ist die literarische Großmacht des staufischen Reiches ge-
wesen. Er hat, wie es Heimat und Schule fügten, das volksmäßige Lied Öster-
reichs mit Reinmars neuem Stil wie durch ein Propfreis veredelt. Die Frucht,
die Walthers Baum dann trug, kann weder Ritterlied noch Volkslied heißen.
Es ist ohne Bezug und ohne Beisatz das männliche Lied der menschlichen
Seele. Es ist das vollkommene lyrische Gedicht schlechthin, weder einer „ho-
hen" noch einer „niederen" Minne, Lieder eines Gefühls, das nichts ist als
eben die Liebe, wirkliches Erlebnis mit einer wirklichen Frau. Die schönsten
dieser Gedichte bilden ein Liederbuch für sich, das offenbar einem einfachen

*Walther von der
Vogelweide*

*Das lyrische
Gedicht*

Mädchen gegolten, und wenn wir Walther recht verstehen, ein spätes Glück bedeutet hat. Stil ist hier der Stil des Liebesliedes aller Zeiten, wenn man den einfachen und natürlichen Ausdruck dessen, was empfunden wurde, als Stil bezeichnen will. Liebe verwandelt sich ganz in ihren Gegenstand. Walthers schönste Liebeslieder sind Mädchenlieder, die erdichteten Lieder seines Mädchens, schelmisch-naiv, schalkhaft-verschwiegen und neckisch-offenherzig. Sie singen auch dann, wenn sie nur reden, und man hört aus ihnen Klang und Tonfall der Stimme, die den Dichter verliebt gemacht hat. Das war Walthers Kunst. Doch die Macht, die er ausgeübt hat, die lag in seinem politischen Spruch. Er ist, ob Ritter oder Lehensträger, Spielmann gewesen. Er ritt seine Straße landauf und -ab. Wo er auch einkehrte, auf Burgen und an Höfen, da teilte er Zeitung aus und stellte die Uhr der politischen Meinung auf richtig. Seine Uhr schlug immer die Zeit des Kaisers und des Reiches. Im staufischen Wien, am Hofe des stolzesten Reichsfürsten, war nicht nur seine Kunst geschult, sondern auch sein politischer Sinn geschärft worden. Er stand zu den Staufern, weil das die Sache des Reiches war. Darum focht er mit dem Kaiser gegen den Papst bis ans Ende. Er hatte in einer wunderbaren Weise die Gabe des rechten Worts zur rechten Stunde und hat in jeder der schwierigen Lagen, die der Anteil seiner Zeit waren, den Nagel auf den Kopf getroffen. Walther von der Vogelweide hatte in seinen Tagen unter seinesgleichen nur einen, der seiner Freundschaft würdig gewesen ist. Das war Wolfram von Eschenbach. Die beiden Männer sind einander um 1203 am Thüringer Hofe des Landgrafen Hermann begegnet. Walthers Gedichte lassen erraten, daß sie einander rechte Freunde gewesen sind. Der Dichter war eine schwierige Natur, gut gelaunt und spottlustig, rasch gekränkt und so grundehrlich, daß er immer auf einer Seite stehen mußte. Vor seinen Grobheiten schützte kein Herzogsmantel. Er war kein Schönfärber und kein Schwarzseher. Aber er sah die Welt wie sie wirklich ist und nahm die Menschen wie sie sind. So ist er seine Straße gefahren, der Spielmann des staufischen Reiches.

Walther von der Vogelweide. Der Spruch

Hinter ihm kamen viele her. Aber er war zu groß, um Schüler zu haben. Den politischen Spruch vererbte er dem Rheinländer *Reinmar von Zweter*, der in Österreich eingebürgert war und in Böhmen wirkte, ohne zwischen Politik und Religion so peinlich getrennt wie Walther Buch zu führen. Das Lied sah ihm *Ulrich von Sachsendorf* ab, ein Dienstmann der Herren von Kuenring, der auch persönlich mit manchem seiner Züge an Walther erinnert. Fast eine geschlossene Schule hat sich um Walthers Kunst unter den Tirolern gebildet. *Walther von Metz*, um 1271 bezeugt, ist unter ihnen der Begabteste. Sehr hübsch ist sein Spiel mit dem geteilten Selbst. Wie die Natur in

Das Lied der österreichischen Länder

Steirer und Kärntner seinen Versen erscheint, das zeugt von guten Augen. Die Kärntner und die Steirer, die untereinander immer irgendeine Eifersucht abzurechnen hatten, brachen in diesen Jahren wörtlich und bildlich, dichterisch und kriegerisch zugleich unter den gleichen Dichtern und Feldhauptleuten ihre Speere. Auf steirischer Seite ragten hervor die beiden Freunde und Waffengefährten *Herrand II. von Wildonie,* ein Liedersänger von noch reinen Formen, ein Erzähler hübscher Versgeschichten, und *Ulrich von Lichtenstein,* der die Empfindsamkeit seiner Standesgenossen überschwärmte, seine verspielten Torheiten ins Leben übertrug, sich lyrisch bevorzugt in Tanzweisen, Marschliedern, gereimten Büchlein ausdrückte, um schließlich seine dichterischen Tagebücher zu den beiden Selbstdarstellungen „Frauendienst" und „Frauenbuch" in eins zu fassen. Auf Kärntner Seite hatten den Vortritt die derben Spötter, die Männer der Wirklichkeit *Zachäus von Himmelberg* und *der Scharfenberger,* der es mit dem Verhöhner der Ritter und Bauern hielt, mit Neidhart von Reuental. Als Lichtenstein 1227, Frau Venus spielend, die Alpenländer durchzog, trat ihm Himmelberg als Mönch verkleidet entgegen und forderte ihn zu einem Gange. Und 1258 schlugen an den Radstädter Tauern Wildonie und Lichtenstein mit ihren Steirern im ernsten Kampfe die Kärntner unter dem Scharfenberger und wurden bald darauf selber von dem geschlagen. So machten diese späten alpenländischen Dichter den Ernst zum Spiel und Spiel zu Ernst im Liede wie mit den Waffen.

Verfall des Standes Wie sehr es zu Ende war, erwies sich im Donautal. Herzog Friedrich II. von Österreich, der letzte Babenberger, brach der österreichischen Ritterschaft, seinen unzuverlässigen und treulosen Dienstleuten, politisch und wirtschaftlich das Genick. Er war ein harter Kriegsherr, der stets den Fuß im Steigbügel hatte, und sammelte, ähnlich wie zur gleichen Zeit der staufische König Heinrich, die letzten Ritter und ritterlichen Dichter um sich, die ihrem Stand den Kehraus zu tanzen gesonnen waren. Dem Führer in diesem Reigen, *Neidhart von Reuental,* der in der Landshuter Gegend mit der Gunst seines Herrn zugleich sein Gut verloren hatte, gab der Herzog mit seiner Gunst zuerst bei Melk und dann bei Wien ein neues Gut. Neidhart machte aus den beiden urtümlichen bairischen Formen der Lyrik, Tanzlied und Trutzstrophe, als ein Neues die Reigentänze seiner Sommerlieder. In sie fing er szenisch und liedhaft das wirklichkeitsechte Leben des Dorfes ein. So verkehrte er mit einem einzigen spöttischen Griff den bäuerlichen Gernegroß, der sich so unecht als Ritter gebärden wollte, ins Ritterliche und den Ritter, der in seinen Augen trotz aller gespreizten vornehmen Empfindsamkeit doch nur ein Bauer war, ins Bäuerliche. Neidharts Lieder halten einfach wie

Neidhart von Reuental

Ritter und Bauer

„Meier Helmbrecht" den geistig-sozialen Verfall des Zeitalters fest, der den reichgewordenen Bauern und den verarmten Ritter durch die gleiche Gosse des Unechten hinwegspülte. Es ist die Dichtung aller, die ihren Stand verloren oder preisgegeben hatten, und sie war im Sinne Herzog Friedrichs II. auch politisch gemeint. Faßt man den Dichter selber ins Auge, der ja mit seinem eigenen Schicksal durch diese Verwandlung hindurchgeschritten war, so ist man Zeuge einer grotesken Selbstverhöhnung, die man, zwiespältigen Eindrucks, als überlegenen Geist oder würdelose Haltung empfinden kann. Höfisch dienstfertig ist der eine wie die andere gewesen. Ein standesloser Ritter aus dem Salzburgischen, ein fahrender Spielmann, *der Tannhäuser*, *Tannhäuser* ein ungebändigter Stimmungsmensch, der zwischen 1228 und 1265 lebte, setzte auf dieses groteske Bild einer verfallenen Ordnung das Siegel der dämonischen Verblendung. Tannhäusers krause Gelehrsamkeit hat alles verwertet, was sich auf der Landstraße und in der Herberge lohnte. Er hat den ersten lobenden Leich auf Gönner und Rätsel auf Zeitereignisse gedichtet. Er hat die Minne und die Frauen verhöhnt. Er hat mit seinen Tanzweisen, die nur noch der entfesselten Zucht und der sinnlichen Lust galten, betörend in ihrer Wirkung, bei Zuhörern und späteren Lesern offensichtlich einen nachwirkenden Eindruck hinterlassen. Denn als beide, Neidhart und Tannhäuser, in die Sage eingingen, schuf sich die rastlose Einbildung aus Neidhart einen narrenden und genarrten Helden des Schwanks, Tannhäuser aber versetzte sie in den Minneberg als tragischen Liebhaber der Frau Venus. Sie hat beide Männer richtig gedeutet. Was denen, die nur lachen können, am Untergang der staufischen Weltordnung wie ein Schwank erschien, war eine Tragödie des Menschen: der Abfall des Herzens von Eros zu Venus.

So hatte es denn der Italiener *Thomasin von Circlaria*, Kanonikus und Dienstmann des Patriarchen von Aquileia, gut gemeint und schlecht getrof- *„Der welsche Gast"* fen, als er 1215 mit seinem „Welschen Gast" aus gelehrten Quellen ein anmutiges höfisches Zuchtbüchlein für die deutschen Ritter der Alpenlandschaft *Der Spielmann in Österreich* schrieb. Denn anders als im fränkisch-alamannischen Westen war im bairischen Osten die Dichtung weder lyrisch noch episch ritterlichen Standes. *Heinrich von dem Türlin* hat diese Dichtung „Der Mantel" nur mit Bruchstücken auf die Nachwelt gebracht. Sein Buch „Der Abenteuer Krone" ist der einzige höfische Roman, den die Landschaft hervorgebracht hat. Und Heinrich ist ein Kärntner Bürger aus Sankt Veit. *Der Stricker* aber um 1190, der das Rolandslied zu seinem „Karl" verarbeitete, der Dichter des Artusromans „Daniel von dem blühenden Tal", ist ein bürgerlicher Franke. Im Donautal jedoch hat er sich zu einem Schwankdichter entwickelt und die Schwanknovelle

wurde sein eigentliches Feld, von dem er später zum Bispel wie zu satirischen und geistlichen Gedichten hinüberschritt. Wie den großen lyrischen, so hat in Österreich auch den epischen Stil der Spielmann geschaffen.

Gemeinsame Landschaft und allgegenwärtiger Kulturraum, auf die all die mächtigen Dichtungen unbekannter Verfasser, Nibelungen und Kudrun, Ortnit und Wolfdietrich, Rabenschlacht und Wolfdietrichs Flucht sich beziehen, ist nicht das Reich des Westens gewesen, sondern der Raum, den einst Hunnen und Goten staatlich gemarkt hatten, der seit dem späten achten Jahrhundert von Baiern, Böhmen und Ungarn her politisch umworben wurde, der seit dem zehnten Jahrhundert in die großen Entwürfe der Zukunft hineinwuchs: Ostreich. Die Sagen der Rheinfranken, der Goten und Langobarden, der Hunnen und Magyaren sind in diesem Raum literarisch immer sorgfältiger gemischt worden, nicht nur aus unbezweckten dichterischen Launen, sondern auch unter dem Wechseldruck staatsbildender Gedanken, in denen sich Pläne der Gegenwart und Zukunft aus der Legende der Hunnen und Goten zu rechtfertigen suchten.

Das Nibelungenlied hat um 977 durch einen Spielmann seine frühest erdeutbare Gestalt empfangen: ein gereimtes deutsches Lied, das nach einem älteren fränkischen Liede die Rache erzählte, die Etzels Gattin Kriemhild verräterisch an den Mördern ihres ersten Gatten Siegfried nahm, unter Einfügung von Dietrichs und Erfindung von Rüdigers Gestalt. Dieses Gedicht ist durch die begleitende Urform der „Klage" als dem Burgundenuntergange gleichzeitig ausgegeben und in gleicher Richtung wie die gleichzeitigen falschen Passauer Bullen darauf berechnet worden, den ungarischen König Geisa I., 972 bis 997, endgültig für das Christentum und für den Gedanken eines Passauer Patriarchats des Ostens zu gewinnen. Als Anreger dieser dichterischen Umbildung fränkischer Sagen in zeitgemäße Gestalt nennt die Überlieferung denselben Passauer Bischof Pilgrim, 971 bis 991, der das Bekehrungswerk im Ungarn Geisas leitete, der mit erdichteten Papstbullen in Ungarn staatmännisch arbeitete und der im Nibelungenlied als Oheim von Etzels Gemahlin Kriemhild erscheint. Diese alte „Nibelungennot" ist zu Anfang des elften Jahrhunderts in Baiern neu aufgefrischt verbreitet worden. Als um 1200 manche deutsche Landschaft und mancher Hof in Romanen einen Ausdruck ihrer gesellschaftlichen Kultur schufen, empfanden der Wiener Hof und seine Dienstleute dasselbe Bedürfnis. Unter ihnen weilte ein berufener Dichter, ein Ritter und Lyriker, der Schüler eines Spielmannes. Aus den Händen der Spielleute übernahm dieser Dichter die beiden Liederbüchlein, deren eines vom Untergange der Burgunder, deren anderes ebenso

Das Nibelungenlied

Der Ritter und der Spielmann

von Brünhild handelte und machte um 1160 aus dem knappen altbairischen Liederbuch von der Burgunden Untergang ein umfangreiches Lesegedicht, das die Reimpaarverse in Kürnbergerstrophen, die Erzählverse in lyrischen Stil umgoß, zu den alten Helden neue Gestalten fügte und von der höfischen Pracht Wiens die Farben nahm, um Etzels und Kriemhilds Hochzeit zu schildern. Diesem lyrisch gestimmten Ritter folgte um 1205 ein tatsachenfroher Spielmann und gab dem Nibelungenliede die letzte Gestalt, indem er aus anderen Vorlagen die Erwerbung des Nibelungenhortes und den Roman zwischen Siegfried und Kriemhild nachtrug. Dieser Spielmann vertiefte und veredelte Sitte und Seele im Sinn des österreichischen Ritterstandes. Er rückte, eben wie es Spielmannsart war, das Wirkliche ein wenig ins Märchenhafte, übersteigerte Taten und Zahlen, glänzte im Erfinden von Zwischenspielen und machte aus dem Gedicht ein vollkommenes Kunstwerk im Stil der Gegenwart.

Gleichwohl lebt noch in dieser letzten Gestalt des Gedichts die Welt, aus der seine Sage hervorgegangen ist, das Germanentum in all den Beziehungen *Kulturschichten* des Einzelnen zum Ganzen, zum Stamm, zur Sippe, zur Natur. Altgerma- *im* *Nibelungenlied* nische Rechtsverhältnisse verwirren die christliche Ordnung. Aber ein Lied der Treue ist es im germanischen wie im mittelalterlichen Sinne. Das Gedicht hat den ganzen Hort der germanischen Sage geborgen. Den Rahmen bildet der hunnische Kreis, der durch das deutsche Erlebnis der Kriege mit Awaren *Vom Passauer-* *Lied zum* und Magyaren immer wieder aufs neue im Bewußtsein der jeweiligen Ge- *Babenbergerepos* genwart festgehalten worden war. Fränkisch ist der Hauptteil der Sage, Held und Heldin und die Landschaft des ersten Teiles. Gotisch sind die letzten Gesänge, gotisches Gedächtnis Gegenwart der ungarischen Landschaft. Österreich ist in Rüdiger von Bechelaren verkörpert. Indessen beides, die Mark zwischen Osten und Westen und Rüdiger zwischen Herrn und Gastfreunden, hat vom Passauer Lied bis zum Babenbergerepos einen völligen Bedeutungswandel durchgemacht. Die Zwischenstellung der Donaumark war im Passauer Liede politisch vom ungarischen Osten her gedacht, dem König Geisa ein Lockmittel. Dem Babenberger Herzog grenzte sie sich mit gleicher Schärfe gegen Westen wie gegen Osten ab als ein Wunschbild, wie er sich die Stellung seines Herzogtums dachte. Rüdiger war im Sinne Pilgrims ein Versprechen an König Geisa und ein Hinweis auf die Treue der deutschen Gäste zu Gran. Der Babenberger Herzog aber konnte in Rüdiger höchstens sich selber und den tragischen Zwiespalt seiner Wünsche mit dem westlichen Reich gespiegelt sehen.

Das Nibelungenlied ist nur ein Gedicht aus der Fülle gleichgearteter Ge-

Die Dietrichlieder bilde. Und wie dieses, so müssen auch sie aus der Raumgeschichte ihrer Zeit mitverstanden werden. Tief in Südtirol standen langobardische Vorposten. Wie die Langobarden in Ungarn sich auf altgotischem Boden angesiedelt hatten, so hatten sie auf Theoderichs Bautrümmern in Oberitalien ein neues Reich aufgerichtet. Der Franke zerschlug auch dieses. So sind gotische, langobardische und fränkische Sagen die Quellen der beiden Dichtungen „*Ortnit*" und „*Wolfdietrich*". Ihr Gedanke ist ein geeinigtes Italien, wie es Theoderich erstrebte und Kaiser Friedrich II. so glänzend zu erfüllen schien. Die Dichtungen spiegeln den Kreuzzug Leopolds von Österreich und Ottos von Meran im Jahr 1217 wieder. Die Vermählung Kaiser Friedrichs mit der Königin Isabella von Jerusalem 1225 mag die Dichtungen angeregt haben. Beide leiten eine neue Blüte der Spielmannsdichtung ein. Sie sind um 1230 entstanden. Die Dichter mögen Baiern oder Österreicher gewesen sein, ihre Stoffe und Gedanken konnten sich nur zwischen Bozen und Gardasee entwickeln. Die Landschaft des Etschtals ging um die Gestalt Dietrichs von Bern in einer Dichtung der Berge und deren Reichtums, in Zwergmärchen und Riesensagen auf: „*Laurin*" und „*Alpharts Tod*" um 1250, „*Dietrichs Flucht*" und „*Rabenschlacht*" um 1280 gedichtet. Diese Gedichte sind es, in denen der Zusammenhang Oberitaliens mit dem Osten und der Gedanke eines Gesamtreiches gar nicht überhörbar laut wird. Helden des ganzen Ostlandes treten auf: Tibald und Marholt von Siebenbürgen, Wolfger von Gran, Isolt von Ungarn. In Steiermark verband das Spielmannsgedicht „*Biterolf*", das gegen 1235 entstanden ist, das Tiroler *Rosengarten*märchen mit dem alten Gedanken von einem Kampf zwischen Siegfried und Dietrich. Um die Mitte des *Kudrun* dreizehnten Jahrhunderts goß ein Spielmann, der Dichter der „*Kudrun*", Stoffe der Fahrenden in die Form der Nibelungen. Aus einem Märchen, in das der alte Mythus hinübergebildet worden war, flossen die Grundzüge der Dichtung. Kudruns Geschichte ist in freier Gestaltung aus einem Apolloniusroman, einem Volkslied und der Salomosage gebildet. Die Küsten und Burgen des Mittelmeers geben die Umwelt. Die letzten Kreuzzüge tragen die allgemeinen Vorstellungen.

Der österreichische Stil des Herzogtums ist das volksnahe Heldenlied, von alters her gesungen, dann in Bücher gesammelt, in Tirol auf bürgerlichen Bühnen gespielt, am Abend des Mittelalters noch in späte Abschriften gerettet. Die Herkunft dieses gehäuften germanischen Sagengutes im Herzogtum Österreich wird nur verständlich aus einer gewissen Beständigkeit der *Bestand* germanischen vorbairischen Bevölkerung über die Römerzeit hinweg. Die *im Wandel* verharrende Lage Österreichs im Raume und ähnlich wiederkehrende ge-

schichtliche Vorgänge gaben dem Fortleben der Sage Gedächtnisstützen und den gestaltenden Dichtern immer neuen Anreiz zu zeitgeschichtlichen Bezügen. Sie sind aus älteren Fassungen des Nibelungenliedes nicht zu verkennen. Das Mainzer Hoffest von 1184 scheint im „Rosengarten" und die Belehnung der Babenberger mit der Steiermark im „Biterolf" die dichterische Anlage wesentlich beeinflußt zu haben. Die Reckengestalt Friedrichs II., der 1246 als letzter Babenberger gefallen ist, und seine hochfliegenden politischen Pläne glaubt man da und dort in den jüngeren Dietrichsliedern gegenwärtig. Doch da sind auch dichterische Zeitbücher, wie das Wiener von Jans Enenkel und die Steirische Reimchronik, und man ist betroffen von der Fülle sagenhafter oder novellenartiger Einzellieder, aus alter Zeit herkommend und als dichterische Sondergebilde noch in der sammelnden Überarbeitung erkennbar. Da sind die vielen Novellenbüchlein und eine üppige Schwankdichtung, von frühesten Tagen immer nebenher laufend bis in die neue Zeit *Die* *österreichische* einer gemeineuropäischen Gemeinbildung. Was die österreichische Helden- *Novelle* dichtung ursprünglich war, was die Sagen bei Enenkel und dem Steirer einst gewesen sind, das sind diese Novellen und Schwänke immer noch, abgerundete, leicht behaltsame, mündlich überlieferbare, gesellige Kleingebilde. Wenn wir nach dem Träger dieser allgemeinen und gemeinsamen Kunst des Herzogtums Österreich fragen, gleichviel, ob es Sagen waren oder Schwänke, erfundene oder überlieferte Novellen, so stoßen wir auf den, der uns diese ganze Kunstübung, ihren Stil und ihr stammliches Gepräge begreiflich macht. Das ist der große Ungenannte. Das ist der Spielmann. Und also erscheinen Walther von der Vogelweide und der Vollender des Nibelungenliedes, Ritter zwar, doch nicht als Ritter, sondern als Spielleute, das ist als Dichter von Sendung und Beruf, auf einer Szene, die Österreich hieß und zugleich das Stauferreich bedeutete.

3. DER ELBLÄNDISCHE KREIS

Das schüttere Geistesleben, das im Osten aufgeht, folgt wie der grüne *Aussaat im Osten* Flaum der Felder der vorausgegangenen Aussaat der Menschenkörner erst in gemächlichem Abstande. Wie leer ist auf weiten Strecken die Flur und wie arm gegen die gedeihende Fruchtbarkeit an Rhein und Donau. Zweierlei Volk stand hinter Elbe und Saale zum Aufbruch bereit: Niederdeutsche und Mitteldeutsche. In einem breiten Streifen landeinwärts der Küste schoben die Niederdeutschen und von der Saale her die Mitteldeutschen ihre Höfe

gegen den Osten vor. So ordnet sich das neu erwachsende Leben um die Elbe. Und nur in gleichem Maße wie es sich zu staatlichen Formen bildet, nimmt es auch in sich geschlossene geistige Gestalt an.

Böhmen *DIE MITTELDEUTSCHEN LANDSCHAFTEN.* Böhmen, das unter dem Fürstengeschlecht der Przemysliden zuerst ein Staat von abendländischer Haltung wurde, gewann auch zuerst ein geistig gezeichnetes Gesicht. Das Land fügte sich aufnehmend und nachschaffend dem staufischen Geistesleben ein. Die tschechischen Fürsten schufen sich mit deutschem Blut einen Bürgerstand. Deutsch wurde die Hofsprache. Deutsche Prinzessinnen zogen in Prag ein. Zu Prag und in den Burgen der Großen blühte die mitteldeutsche

Der ritterliche
Roman
in Böhmen Dichtung auf. König Ottokar II. nutzte die Stunde, die ihm mit dem gleichzeitigen Untergange der Staufer und Babenberger geschlagen hatte, und baute sich aus Böhmen und Mähren, aus Donaumark und Alpenländern ein mächtiges deutsch-tschechisches Ostreich.

So war denn auch ein Kärntner aus Sankt Veit, *Ulrich von dem Türlin,* der Erwecker der deutschen Dichtung dieses Landes. Aus Wolframs „Willehalm", aus der „Krone" seines Kärntner Namensvetters Heinrich und dem Stil des donauländischen Spielmannsepos bildete er, frei nachschaffend, seinen eigenen „Willehalm" und widmete ihn um 1269 König Ottokar. Sein

Ulrich von
Eschenbach Schüler *Ulrich von Eschenbach,* wohl aus der Gegend von Leitmeritz oder Ossegg, ist der Hofdichter des Königs gewesen, dessen Glanz und Fall er miterlebte. Er hatte zu ihm ein persönliches Verhältnis. Ulrich stimmte seine Dichtungen auf Geist und Stil des Thüringer Dichterkreises. Der Held seines „Alexander", der gegen 1287 entstand, ist König Ottokar. Er hat der Antike deutsche Züge gegeben. Sein „Wilhelm von Wenden" ist die Legende von Placidus, ein hohes Lied auf König Wenzel und dessen Gattin Guta, die Tochter Rudolfs von Habsburg. Dieser Sucher nach dem menschgewordenen Wort, das ist ein Bruder Parzivals und Wolframs Seele lebt in ihm. Aus allem aber, was Ulrich von Eschenbach geschrieben hat, spürt man die unmittelbare Nähe des Landes, das seine Heimat gewesen ist.

Ulrichs Wirkung strahlte von zwei Punkten aus. Im mitteldeutschen Nordwesten, auf der Riesenburg seines Gönners Borso, fand er um 1300 seine letzte Heimstätte. Hier dichtete er noch ein elftes Buch zu seinem Alexanderlied. Im bairischen Süden des Landes ließ der dichtungsfrohe Ulrich II. von Neuhaus aus dem Geschlecht der Wittigonen von Eschenbachs Alexanderlied eine prachtvolle Handschrift fertigen. Und so nahm das Gedicht von Neuhaus weg in bairischer Lautgebung seine Ausfahrt. Beziehungen zu Neuhaus hatte *Heinrich der Klausner,* der Dichter einer lieblichen Marienlegende.

Auf den Burgen des tschechischen Adels stand *Heinrich von Freiberg* in Gunst. Er war wohl in Böhmen aus einer bürgerlichen Familie Obersachsens geboren. Raimund von Lichtenberg, in dessen Gütern viele Deutsche saßen, trug ihm die Vollendung von Gottfrieds „Tristan" auf. Sie wurde um 1310 gedichtet. In seinem Stil hat Heinrich einen gewissen Ausgleich zwischen Wolfram und Gottfried, zwischen Ostfranken und dem Elsaß vollzogen.

König Wenzel II. ließ in drei Liebesliedern noch einmal die Stimme der verhallenden staufischen Dichtung aufklingen, seltsam zwiespältig gezeichnet wie im Leben so in der Dichtung von Weltflucht und Frauenfreude.

Das deutsche Schrifttum Böhmens hat mitteldeutsches Gepräge. Ihm steht in der bairischen Landschaft des Südrandes kein anderes Werk entgegen als bestenfalls *„Das Märterbuch"*, das am Anfang des vierzehnten Jahrhunderts im Auftrag einer Gräfin von Rosenberg und in mittelbairischer Mundart gedichtet wurde.

Meißen war von den Elsterauen her als Mark des Reiches seit dem elften Jahrhundert erst mählich im Werden. Dafür zeugt vorerst nicht mehr als die *Wiprechtlegende,* die gegen Ende des zwölften Jahrhunderts im Kloster Pegau ein Mönch auf Lateinisch und im Spielmannsstil literarisch geformt hat.

Schlesien, seit 1202 selbständig, wurde wie vom Hofe her, so von unten auf durch Bauern und Bürger deutsch. In den höfischen Kreisen war schon seit 1150 deutsche Sitte und Sprache heimisch.

Der Enkel der heiligen Hedwig, Heinrich III., wird von Tannhäuser gefeiert. Heinrich IV., gestorben 1290, diese prächtige Rittergestalt, hat die schönsten Lieder seiner Zeit gedichtet. Erhalten sind deren zwei, in jugendlichem Alter geschrieben, vielleicht nur Bruchstück eines reicheren Schaffens. Sie sind bestechend geformt. Die Mundart des Landes klingt nur leise durch.

DIE NIEDERDEUTSCHEN LANDSCHAFTEN. Westfalen schweigt, wie unter den Liudolfingen, so unter den Welfen. Und Ostfalen redet wie einst durch die Liudolfinge so jetzt durch die Welfen. Wie ehedem die ostfälische Lateinliteratur liudolfingische Hausdichtung war, so ist nun das hochdeutsche Schrifttum Ostfalens welfische Hofdichtung. Ostfalen ist in diesem Zeitalter der sächsische Gegenspieler des staufischen Reiches. Die Welfen, alamannischer und norditalienischer Herkunft, hatten sich seit dem Anfang des zwölften Jahrhunderts in Sachsen festgesetzt, Lüneburg, Braunschweig und Wolfenbüttel erheiratet, in raschem Fluge freigewordene sächsische Güter und Ämter erworben, dies alles mit den ererbten schwäbischen und bairischen Hausgütern vereinigt und so eine gewaltige Macht aufgebaut, die gesammelt in den Händen Heinrichs des Löwen, 1129 bis 1195, ruhte. Ihm

Heinrich von Freiberg

Wenzel II.

Meissen

Schlesien

Ostfalen

Heinrich der Löwe

fehlte nur die Krone der deutschen Könige. Denn nach Italien gelüstete es ihn nicht. Er nahm die ursprüngliche Sendung der Liudolfinge mit harter Folgerichtigkeit in dem einen wieder auf, daß er aus Deutschland und dem wiederbesiedelten Osten eine abendländische Großmacht schaffen wollte, wie die Staufer Deutschland und Italien zusammenfügten. Aus diesem unvereinbaren Gegensatz des staatlichen Entwurfs entsprang der Kampf zwischen Staufern und Welfen. Heinrich der Löwe unterlag und faßte sich nach dem Zusammenbruch seiner riesigen Macht völlig auf den verbliebenen ostfälischen Besitz zusammen.

Ritterroman in Braunschweig Nur im sächsischen Stammlande der Welfen, in Braunschweig, bildete sich allein im ganzen Bereich des sächsischen Volkes ein höfisch-ritterliches Schrifttum aus. Es ist eine Schöpfung Heinrichs des Löwen. Zumal die Jahre vor seinem Tode brachte er im Braunschweiger Schlosse zu, mit den kleinen Sorgen um seine Kirchen und Klöster beschäftigt, am Genuß von kostbaren Büchern, mit dem Durchkramen der Lieder und Sagen seines Volkes und dämpfte so die Bitternis der verlorenen Macht. Einer seiner Dienstleute, *Eilhart von Oberge*, schrieb um 1170 einen „Tristan", der als Ganzes und in seiner ursprünglichen Fassung verloren ist. Die Dichtung muß sehr beliebt gewesen sein. Denn es sind von ihr Bruchstücke einer Fassung des späten zwölften Jahrhunderts, eine Überarbeitung aus derselben Zeit, Teile einer tschechischen Übersetzung und eine späte Prosafassung bekannt. Es ist das erste Tristangedicht auf deutschem Boden und vielleicht eine Frucht von Heinrichs engen Beziehungen zu England. Aus dem Kreise der Geistlichen an seinem Hofe und wahrscheinlich von ihm angeregt, ist der „*Lucidarius*" hervorgegangen, der „Erleuchter", eine zusammenfassende Darstellung des zeitgenössischen Wissens von der Welt, dem Menschen und der Christenheit.

Berthold von Holle Unter den Erben Heinrichs des Löwen blieb Braunschweig der einzige Standort der höfischen Literatur in Sachsen. *Berthold von Holle,* von 1251 bis 1270 bezeugt, stammte aus einem Hildesheimischen Rittergeschlecht. Seine höfischen Romane „Demantin", „Crane", „Darifant" sind im wesentlichen frei erfunden. *Rumsland,* den Herzog Albrecht um 1270 begönnerte und der in Braunschweig, wie es scheint, seine feste Herberge hatte, ist schon ein Fahrender von bürgerlicher Herkunft, ein Gelegenheitsdichter und Zeitungsmann, ein sehr geschickter Gleichnisredner. Für die welfischen Ritter und Fürstensöhne schrieb gegen Ende des dreizehnten Jahrhunderts der herzogliche *Kaplan Bruno* die „Braunschweiger Reimchronik", die wie ein ritterliches Epos angelegt ist und die Kunst des Spielmanns für den höfischen Geschmack zurichtete.

Hochdeutsch ist Ostfalen durch die Welfen. Die sächsische Prosa hat ein *Das Rechtsbuch*
Rechtsbuch schreibfähig gemacht. *Eike von Repgow,* von 1209 bis 1233 be-
zeugt, hatte um 1222 ein Rechtsbuch in lateinischer Sprache abgeschlossen.
Sein Lehensherr, der Stiftsvogt von Quedlinburg, Graf Hoyer von Falken-
stein, ermutigte ihn, es als „Spiegel der Saxen" ins Deutsche zu übertragen.
Der Wortlaut ist gehobene Prosa, die Reimvorreden hochdeutsch mit säch-
sischem Einschlage. Eikes Gesinnung war unrömisch und auf einen deutschen
Volkskönig gerichtet. Seine Quellen waren das Rechtsbewußtsein des Volkes.
Er wollte das Recht des sächsischen Volkes geben aber mit Ausschluß der
Westfalen. Das Soester Stadtrecht, das sich die ganze baltische Küste er-
oberte, und Eikes Sachsenspiegel, der nach Osten hin allgemeines Ansehen
gewann, drücken das Wesen des sächsischen Volkes deutlicher aus als alles,
was sonst zwischen Rhein und Elbe geschrieben wurde.

Magdeburg, von Otto dem Großen gegründet und seit 968 die erzbischöf- *Magdeburg*
liche Mutterkirche für alle ostwärts zu schaffenden Kirchensprengel, schöpfte
aus dieser weiten Sendung und aus einem städtischen Bewußtsein die Kraft
zu seiner frühen Literatur. Der Lesemeister an der Magdeburger Ordens-
schule der Minderen Brüder, *Bartholomäus Anglicus,* schuf um 1240 das
allesumfassende Buch des Wissens „De Proprietatibus rerum" von Gott und
der Welt, Himmelskunde und Erdkunde, Arzneiwissenschaft und Natur-
geschichte. Das unglaublich verbreitete Buch wurde in mehrere Landesspra-
chen übersetzt, in zahllosen Handschriften und Wiegendrucken verbreitet.
Auch das ist ein Zeugnis für den geistigen Austausch zwischen der sächsischen
Insel und dem sächsischen Festlande. Auch in Magdeburg bestand das Bür-
gertum nicht bloß aus Handwerkern, sondern auch aus eingebürgerten Rit-
tern.

Wenn hier der stadtsässig gewordene Adel turnierte, so gab er sich als
ritterlicher, nicht als großbürgerlicher Adel. Der „Gral", das Ritterfest, das *Brun von*
Brun von Sconebeck um 1272 in Magdeburg zusammenbrachte, war kein *Sconebeck*
Fest der Kaufmannschaft, sondern des Magdeburger Adels innerhalb und
außerhalb der Mauern. Dies Spiel und die „höfischen Briefe", mit denen er
dazu einlud, sind aber ebensowenig bezeichnend für seine Seelenlage wie
seine Nachbildung eines Gedichts Reinmars von Zweter. Was er bildungs-
mäßig war, das verraten die zwölftausend Verse seines „Hohen Liedes", mit
denen er sich die langen Winterabende auf 1276 verkürzte. Bruns Bildung
ist nicht ritterlich, sondern geistlich gewesen. In Magdeburg ist um 1237 die
sogenannte „Sächsische Weltchronik" entstanden, das erste geschichtliche
Prosawerk in deutscher Sprache. Mit der verständigen Sachlichkeit des säch-

sischen Volkes wird die alte Geschichte und die Reichsgeschichte erzählt, quellengetreu, ein mächtiges Gegenstück zum „Sachsenspiegel".

Hansastädte Die Hansastädte, mit Bremen seit 788, mit Hamburg seit 831, mit Lübeck seit 1157 sich durch immer neue Zerstörungen hindurchkämpfend und seit dem Ende des dreizehnten Jahrhunderts in dem großen Bunde vereinigt, wurden ihrer zunächst nur in lateinischen Zeitbüchern bewußt: Bremen um 1075 in der Kirchengeschichte *Adams,* die zuerst in das Dunkel des werdenden Ostens hineinleuchtete; Lübeck, das Herz der Hansa, um 1172 in *Helmolds* Slawengeschichte, dem ersten Bericht über das beginnende ostdeutsche Siedelwerk.

Wendensachsen Unter den mit Waffengewalt bezwungenen Ostseewenden empfanden die Fürsten von Rügen den frühesten Ehrgeiz nach deutschen Versen. *Wizlaw I.,* der Sohn des unterworfenen Jaromar, dichtete schon zu Anfang des dreizehnten Jahrhunderts Sprüche, von denen sich keiner erhalten hat. *Wizlaw III.,* durch seine Mutter welfischen Blutes, hatte seine ritterliche Bildung sicher von Braunschweig. Von ihm sind 14 Lieder und 13 Sprüche erhalten, die wohl in seiner Prinzenzeit um 1290 und am Braunschweiger Hofe entstanden sind. Sie sind oberdeutschen Vorbildern nachgesprochen und verraten da und dort das Gezettel nordischer Staatskunst. Wizlaw scheint manchen Fahrenden an seinem Höflein gespeist zu haben.

Brandenburg Die Mark Brandenburg, die seit dem letzten Fall der namengebenden Stadt 1157 wirklich zu stehen begann, hatte im Markgrafen *Otto IV.,* der 1309 starb, einen der tüchtigsten unter ihren askanischen Fürsten. Seine sieben hochdeutschen Lieder sind ein Zeugnis für die persönlichen Neigungen des Mannes, ein Zeugnis auch für die gesellschaftlichen Farbtöne an seinem Hofe, aber kein Zeugnis für eine märkische Literatur.

Der matte Glanz des ritterlichen Reiches, der gegen Abend noch am Himmel der Ostsee stand, war nicht staufisch, sondern welfisch.

Zweites Buch

RENAISSANCE
UND BAROCK

DAS IST DIE EPOCHE DER SPALTUNG. WIE SICH DAS ABEND-
land in nationale Volkspersönlichkeiten aufgliedert, so beginnt sich Deutsch-
land in zwei große Äste zu gabeln und zu verzweigen. Die Führung des Rei-
ches verschiebt sich aus dem Westen in den Osten: zuerst in das Böhmen der
Luxemburger, dann in das Österreich der Habsburger, schließlich in das
Preußen der Hohenzoller. Die Reformation spaltet die Einheit der Kirche in
Deutschland, und wenn sich die Trennung des Glaubens auch nicht längs
einer eindeutigen Raumgrenze ausspricht, so drängen sich doch die entgegen-
gesetzten Bekenntnisse auf Süden und Norden zusammen. Der Humanismus
spaltet in seinen Folgen die Kultureinheit der Nation in eine Schicht des
Volkes und in eine Schicht der Gebildeten, die Einheit der Sprache in eine
deutsche und in eine lateinische Literatur. Was sich gabelte und verzweigte,
war das Leben selber. Was reif zur Geburt ist, kann man nicht halten und
das Geborene nicht in den Mutterschoß zurückführen. Doch in der Tiefe des
Lebens begann sich zugleich mit all diesen Spaltungen eine neue, die deutsche
Gemeinsprache zu bilden. Sie schoß in all diese Äste und Zweige ein und
erfüllte sie mit dem einen und gemeinsamen Leben.

I. LUXEMBURGERREICH

14. und 15. Jahrhundert

Das Ereignis, das alle anderen aus sich hervorgehn läßt, sie bewegt und lenkt, ist der Übergang des Reiches vom Mutterland auf das Siedelgebiet, vom staufischen Alamannien auf das luxemburgische Böhmen. Der Familientod der Staufer hatte für einen solchen Erbgang Raum geschaffen. Er rief zunächst die Habsburger und dann die Luxemburger. Der Familientod der Babenberger und Przemysliden hatte Österreich und Böhmen als Hausmacht für die neuen Kaiserfamilien freigemacht, Österreich für die Habsburger und Böhmen für die Luxemburger. Und so schien es abermals auf ein dramatisches Gegenspiel in Deutschland angelegt. Doch die Luxemburger hatten Glück. Die Zeit war reif für zweierlei Staaten einer ganz neuen Art, die den Umschwung des Abendlandes beschleunigten. Im Süden des Reiches bildet sich mit der Eidgenossenschaft ein freier Volksstaat und im Nordosten des Reiches mit dem deutschen Orden ein ritterlicher Herrenstaat heraus. Beide entlasteten die böhmische Hausmacht der Luxemburger und sicherten ihnen ihr Kaisertum. Die Eidgenossenschaft band in vieljährigen Kämpfen die Habsburger an die oberrheinischen Schlachtfelder und legte sie in Deutschland lahm. Der deutsche Ordensstaat sicherte die Luxemburger gegen alle gefährlichen staatlichen Neubildungen im Nordosten. Also hatte das neue Kaisergeschlecht freies Feld. Das war die politische Lage und sie gedieh entscheidend ins Geistige.

Der Verfall des staufischen Kaisertums reißt die ganze abendländische Ordnung mit. Das Abendland gliedert sich in nationale Eigenstaaten auf. Der mittelalterliche Innenbau des Abendlandes zerbröckelt. Aber eine neue Ordnung der Geister und der Seelen kündigt sich an. Der absterbende Träger der mittelalterlichen Gemeinschaft, das Rittertum, vererbt seine dichterischen Formen an das junge Bürgertum der siegreich aufstrebenden Städte. Die Kirche verjüngt sich in den beiden Bettelorden und diese tragen von eben diesen Städten her den Gedanken des miles christianus in neuer Gestalt unter die Völker. Zwischen der zerfallenen ritterlichen Bildung und der verjüngten Kirche kommt eine neue geistige Macht empor, die Wissenschaft. Auch sie geht von den neuen Orden des Dominikus und Franziskus, von Predigerbrüdern und Minderen Brüdern aus, die es drängt, die kirchliche For-

Verwandlung des Abendlandes

Der Osten führt

Die Kirche verjüngt

Die Wissenschaft

derung des credere in scire und intellegere umzusetzen. Sie bilden in der
Scholastik jene denkmäßig-begriffliche Forschungsart aus, die dem Zeitalter
das Gesicht macht. Scholastik bezeichnet nicht einen Denkinhalt, sondern eine
Schulform. An all diesen Bewegungen wirkt der fürstliche Landesstaat, an
den nun in beschleunigtem Wandel die öffentliche Gewalt aus der Hand des
Kaisers übergeht, in seiner Art mit. Ritterliche Grundherren und neue Städte
fallen in den Besitz des Landesherrn, soweit er nicht selber Stadtgründer
gewesen war. Der neu entstehende Staat geht vom deutschen zum römischen
Recht über und baut eine moderne Verwaltung aus, die eine Kunst wird. Als
Träger dieser Verwaltungskunst entwickelt sich der Beamte und mit ihm ein
Verwaltungs- neuer Stand, in dem sich Adel und Bürgertum zu einer höheren Einheit ab-
kunst schleifen. Dieser Beamte bedarf einer zuverlässigen Kenntnis des kirchlichen
wie des römischen Rechts und einer allgemeinen Bildung. Also vereinigen
sich die Kirche um der Theologie und der Staat um der Rechtskunde willen
und geben der Wissenschaft eine zeitgemäße Gestalt: die Universität.

Das verfeinerte Seelenleben des Rittertums wird Gemeingut aller Stände.
Durch die neuen Orden wird das Verhältnis zum Erlöser eine persönliche
Sache des Einzelnen. Die neue Wissenschaft macht die überlegene Kraft des
Geistes zu einem überzeugenden Erlebnis jedes ihrer Jünger. Der Staat be-
ginnt alle Unterscheidungen in einem gemeinsamen Recht auszugleichen. Das
sind die vier Kräfte, die durch den allgemeinen Wandel aller Verhältnisse
den modernen Menschen erzeugen, der sich als ein eigenartiges Sonder-
wesen seiner inneren Freiheit und Selbstbestimmung bewußt wird. In sei-
nem Verlangen, überall auf die erste Ursache und die Quellen zu dringen,
wendet er sich unmittelbar an die älteste Ursache und erste Quelle der abend-
ländischen Gesittung, an die Antike, und schöpft aus ihr die Vorbilder und
Maße seines eigenen und des öffentlichen Lebens. Er fühlt sich wiedergebo-
ren, ein neuer Mensch.

Der Stimmführer und literarischer Träger dieser allgemeinen Verwandlung
Kanzleibeamte wird der Kanzleibeamte der kaiserlichen, landesfürstlichen, städtischen
Schreibstuben. Von den neuen Universitäten geschult, mit der Antike ver-
Humanismus traut, durch die Staatsverwaltung eingeweiht in die Welt, wie sie von oben
aus Böhmen und unten aussieht, führt er in jedem Sinne die Feder. Er führt sie mit Ehr-
geiz als eine Kunst, die gelernt und gekonnt sein will. Er ist der „Schreiber".

All diese Verwandlungen sind in Böhmen, am Hochsitz der luxembur-
gischen Könige und Kaiser zuerst ausgelöst und sichtbar und literarisch wirk-
sam geworden.

1. DER BÖHMISCHE KREIS

Das fränkische Gallien war für die Karlinge, das angelsächsische Britannien
für Liudolfinge und Welfen, das langobardisch-normannische Italien für die
Staufer der vorwärtstreibende oder anregende Mitspieler in geistigen Dingen
gewesen. Die Luxemburger und ihr Land schöpften fast gleichmäßig aus
ihren Beziehungen zu England, Frankreich und Italien. Die neue Bildung,
die aus Böhmen hervorgegangen ist, hat ein europäisches Gesicht.

BÖHMEN. Peter von Aspelt, noch unter Wenzel II. Kanzler und leitender *Der Staat der Luxemburger*
Staatsmann in Böhmen, hat als Mainzer Erzbischof die kleinen Luxemburger
Grafen in den Sattel gesetzt, indem er 1308 die Wahl Heinrichs VII. zum
deutschen, 1310 die Wahl von Heinrichs Sohn Johann zum böhmischen König
machte. König Johann schuf aus Böhmen wieder eine große Macht durch den
Rückgewinn Mährens, durch Erwerb des Egerlandes sowie des Lehensrechts
über Schlesien und die Lausitz. Er baute 1330 einen ansehnlichen ober-
italienischen Staat auf. Sein Sohn Karl IV., 1316 bis 1378, vollendete dieses
Gebilde, indem er ihm die Oberpfalz, die letzten Reste von Schlesien und
der Lausitz und die Mark Brandenburg hinzufügte, zu einem gewaltigen
Oststaat, dem nur noch Meißen fehlte, um alles zu umfassen. Die Luxem-
burger kamen aus dem niederfränkisch-romanischen Kulturraum. König Karl *Karl IV.*
war in Paris französisch erzogen und hatte als Statthalter seines Vaters in
Italien auch die italienische Bildung schätzen gelernt. Das war der Geist, aus
dem er seinem Staat die geistige Inneneinrichtung schuf.

Der Kaiser und König Karl fand in seinem Lande bereits die erste Vor-
arbeit getan. Der Bischof von Prag seit 1342, Ernst Malowetz von Pardubitz, *Ernst Malowetz*
war ein Zögling der Schulen von Bologna und Padua, ein ungewöhnlich viel-
seitiger Mensch als Staatsmann und Feldherr, als Dichter und Tonsetzer, als
Weltweiser und Holzschnitzer. Er schickte seine jungen Geistlichen mit Vor-
liebe nach Italien. Er war der Freund Petrarcas und wechselte Briefe mit
Cola di Rienzo. Aber die „reformatio" betrieb er in seinem Sprengel im Sinne
einer religiösen Erneuerung und an die „rinascita" dachte er lediglich als an
die Wiedergeburt eines innerlich zunehmenden Menschen. Dieser Mann
wurde der Helfer des Königs, als der daran dachte, mit einer Hochschule dem
kunstvollen Uhrwerk seiner vielspältigen Staaten die einheitlich treibende,
rastlos spielende Feder der deutsch-lateinischen Wissenschaft einzusetzen.
So wurde am 7. April 1438 zu Prag ein „studium generale", die erste Uni- *Die Prager Universität*
versität im deutschen Reich, gegründet. Sie war eine Schöpfung der gemein-
europäischen christlich-lateinischen Bildung, dazu gestiftet, um den deutsch-

slawischen Osten mit ihr zu durchsetzen. Sie war den Luxemburgern weder ein Mittel zum Deutschtum noch eine Frucht des italienischen Frühhumanismus.

„Rinascita" Die Träger der italienischen „rinascita" suchten in Prag nicht den böhmischen König, sondern den deutschen Kaiser. Denn sie kamen zu ihm mit ihren Sorgen um ihr italienisches Vaterland. So kam Petrarca als Gesandter nach Prag. Und darum saß Cola di Rienzo, der „Ritter durch den Heiligen Geist, Tribun der Freiheit, des Friedens und der Gerechtigkeit, der Befreier und Augustus der römischen Republik", wie er sich nannte, zu Raudnitz gefangen.

Johannes Die Seele dieser französisch-italienischen Bildung in Prag war der kaiser-
von Neumarkt liche Kanzleibeamte und spätere Kanzler *Johannes von Neumarkt*, um 1310 bis 1380, aus Hohenmaut. Mit den italienischen Frühhumanisten war er persönlich bekannt. Er besaß Dantes „Divina commedia". Aber auch die deutsche Heldensage war ihm geläufig. Er eiferte Cicero nach und dichtete zugleich Marienlieder. Bücher waren seine Lust. Er sandte sie an seine Freunde und ließ sie überall aufspüren. Für die frommen Frauen des kaiserlichen Hofes übersetzte er spätantike Erbauungsschriften. Sein Reisebrevier um 1355 strahlt bereits mit Wort und Bild vom Stil der neuen Zeit. Er war der lateinischen und deutschen Sprachkunst Meister, bildete in ihr seine Beamten und zog an seiner Kanzlei eine ganze Schule humanistisch gesinnter Jünger heran. Ihr dauerhaftes Vorbild für einen künstlerisch anspruchsvollen Stil war die „Summa cancellariae Caroli IV", eine Sammlung von Musterbriefen, die er für seine Kanzlei anlegte. Johannes von Neumarkt hat sich und sein ganzes Einflußgebiet zum erstenmal dem modernen Italien als dem Lehrmeister der Welt in allen Künsten des Daseins unterworfen.

Karl IV. amtete von Prag aus nicht bloß über Böhmen und die böhmischen Länder, sondern waltete auch als Kaiser des Reiches. Wie sich in seinen Kanzleien die französisch-italienische Bildung entfaltete, so lagen auch im Geschäftsverkehr seiner Schreibstuben für die deutsche Sprache Keime zu großen Dingen. Das Stauferreich hatte das Deutsche lediglich zu einer formvollendeten Dichtersprache ausgebildet. Die Geschäftssprache war das Lateinische. Hier eben vollzog sich ein grundlegender Wandel. Amtliche Rücksicht auf den Gebrauch der deutschen Sprache geboten den luxemburgischen Kanzleien zwei Geschäftskreise des deutschen Kaisers: die Gesetze bezüglich des Landfriedens und die Urkunden des Reichsgerichtshofes. Mit dem wach-
Die deutsche senden Einfluß des Stadtbürgertums ergab sich ein weiteres Anschwellen des
Gemeinsprache amtlichen deutschen Sprachgebrauchs. Zu jener Zeit nun, da die Mutter-

sprache von unten her in den Amtsverkehr der kaiserlichen Schreibstube ein-
drang, saß der König der Deutschen im mitteldeutschen Sprachgebiet zu
Prag. Wesentlich mitteldeutsch war die Mundart aller Länder der Wenzels-
krone. Mitteldeutsch war gewissermaßen die gegebene Staatssprache. Der
deutsche König folgte hierin dem böhmischen, die Reichsbeamten in Prag
den böhmischen Landesbeamten in Prag, keineswegs unter dem Zwange
eines Bedürfnisses, sondern im Geleise der Gewohnheit und vertrauten
Übung. Damit vollzog sich vom Stauferreich zum Luxemburgerreich ein drei-
facher Bruch. Als Kanzleisprache wird das Latein der Staufer vom Deutsch
der Luxemburger abgelöst, als Mundart das Oberdeutsche vom Mitteldeut-
schen, als Stil eine Dichtersprache von einer Prosasprache. Mundartlich unter-
schied sich dieses neue Mitteldeutsch vom Oberdeutschen dadurch, daß die
langen Einlaute des Alamannischen im Mitteldeutschen als Zwielaute und
die oberdeutschen Zwielaute im Mitteldeutschen als lange Einlaute erschie-
nen. Und da die Kanzleibeamten ihr Geschäftsdeutsch am Bau der lateini-
schen Prosa schulten, so unterschied sich dieses mitteldeutsche Prosadeutsch
von der staufischen Dichtersprache, die einfache Beiordnung liebte, durch
eine wohldurchdachte Unterordnung der Satzglieder und Nebensätze unter
die Hauptsätze. Es war ein weltgeschichtliches Ereignis von unabsehbarer
Tragweite, daß dieses Mitteldeutsch zunächst schriftliche Gemeinsprache des
Ostens und sodann der ganzen deutschen Nation wurde.

Aus den Schreibstuben hervorgegangen, am klassischen Stil der römischen *Die böhmische*
Prosa und im Übersetzen von einer Sprache in die andere geschult, wurde *Bibel, deutsch*
das werdende Gemeindeutsch von religiösen Bedürfnissen mitgefördert. Sie
wurde vom Ringen um eine deutsche Bibel mitergriffen und wuchs an dieser
Aufgabe zur neuen Sprache der christlichen Gemeinde heran. *Das Neue
Testament* aus dem Ende des vierzehnten Jahrhunderts, wie es in der Hand-
schrift des böhmischen Prämonstratenserklosters Tepl vorliegt, ist kirchlichen
Ursprungs und diente einem katholischen Prediger. Doch mag es auch von
Waldensern benutzt worden sein, die in zahlreichen Gemeinden von Frank-
reich bis Böhmen lebten. Die ersten gedruckten deutschen Bibeln stimmen
mit der Tepler Fassung überein. Gegen Schluß des vierzehnten Jahrhunderts
wurde für König Wenzel eine wundervolle Bilderhandschrift der deutschen
Bibel gefertigt. Die Arbeit ging auf Kosten des Richters und Münzmeisters
Martin Rotlev. Der war in Prag und Kuttenberg begütert und stellte Bibel-
handschriften gewerbsmäßig her.

So von allen Seiten vorbereitet, erhob sich endlich aus der Mitte des böh-
mischen Kulturkreises im Jahr 1400 die schönste Dichtung des Zeitalters. Das

„Der Ackermann aus Böhmen" ist „Der Ackermann aus Böhmen"". Dem Saazer Notar *Johannes von Tepl* war die junge Frau gestorben. Der Schmerzbetäubte suchte sich Luft zu machen in dem Augenblick, da Herz und Verstand noch miteinander hadern. Er stellte sie beide aus sich heraus und gab ihnen Rollen. Sein Herz ließ er den Beraubten spielen und nach Ersatz schreien. Dem Verstande teilte er die Maske des Todes zu, klagte ihn an und ließ ihn Vernunftgründe sprechen. Dies Spiel seines geteilten Ich kleidete der Kenner des germanischen Rechts in eine peinliche Gerichtsklage wider den Allzerstörer Tod. Unter der Arbeit glitt dem Dichter die Klage auf Leben und Tod in ein Gedankengefecht schulgewandter Gegner auseinander. Verstand und Herz, die ursprünglichen Wortführer, lugen aus den halbverschobenen Masken. Schließlich entscheidet *Der Mensch, Gottes schönstes Kunstwerk* Gott zwischen den Rechtsuchern. Aber es ist kein Strafhandel mehr, sondern ein bürgerliches Verfahren, das Ja und Nein billig verteilt. Ein Gebet schließt das Büchlein. Hier spielt auf der Waage des Gerichts das Für und Wider um den Menschen als das schönste Kunstwerk Gottes. Vom gellenden Schrei der Verzweiflung bis zur beruhigten Hingabe an Gottes Willen reinigt sich hier eine Menschenseele in wahrhaft spielmäßiger Entwicklung von aller Wirrnis, die ein großes Erlebnis aufstörte. Wenn je Gespräche des Mittelalters Dramen heißen dürfen, so wäre es dieses. Hier ist zum erstenmal eine innere Handlung in Wort und Gestalt umgesetzt. Der Dichter lebt noch aus der ritterlichen Weltanschauung und aus der mittelalterlichen kirchenlateinischen Schulbildung. Das gelehrte Wortgefecht, das er so meisterlich durchführt, hat seine Vorbilder in den scholastischen Waffengängen der Hochschulen. Die antike Literatur kennt der Dichter nur vom Hörensagen, und der italienische Humanismus hat ihn höchstens mittelbar berührt. Deutlich zu spüren ist die geistige Nähe Englands. Ihr Dauerträger war der Austauschverkehr zwischen *Prag und Oxford* den Schulen von Prag und Oxford. Ein englisches Buch, William Langlands Gedicht in stabreimenden Langzeilen, „Piers the Plowman", „Peter der Pflüger", gab dem Ackermanndichter das Vorbild für die Aufschrift und die beherrschende Gestalt des Menschenadam. Der schöpferische Sprachkünstler ist durch die Schule der böhmischen Kanzleien gegangen. Der ebenmäßige Aufbau gleichbedeutender Worte, Stabreimverbindungen und die beliebte Dreizahl der Satzglieder und Sätze deuten ebenso sichtlich auf den Sprachgebrauch der Schreibstuben wie der Gerichtsstätten und ahmen den Tonfall der deutschen Rechtsbücher nach. Die Sprechart aus dem Munde des Volkes, ausgenommen der Wortschatz, ist nicht zu verkennen. Die Dichtung ist aber auch ohne die sprachschöpferische Schule der Mystik nicht zu denken. „Der Ackermann" lebt aus der kirchenlateinischen Bildung der Zeit, aus dem Stil-

gefühl der böhmischen Schreibstuben. Er feiert das junge Selbstbewußtsein eines neuen Menschentums. Es ist die erste Dichtung auf dem Boden des ostdeutschen Siedellandes, die den Gedanken der „reformatio", den Vorläufer der „Wiedergeburt" späterer Geschlechter, ausformte. *„reformatio"*

Als „Der Ackermann" entstand, trugen schon die Tschechen, nicht mehr die Deutschen, den Würfelbecher in der Hand. Die tschechische Literatur hielt ungefähr gleichen Schritt nach dem Zeitmaß, das die deutsche angab. Aller Wille war auf „reformatio" gestimmt. König Wenzel IV., seit 1363 böhmischer, seit 1376 deutscher König, brachte die Zustände zur Entscheidung. *Wenzel IV.* Er liebte Kunst und Dichtung. Er legte sich eine Sammlung prachtvoller Bilderhandschriften an. Der Hochschullehrer Jan Hus, bei Hofe beliebt, begann sich in die Schriften des Oxforder Gelehrten John Wiclef zu versenken und an der Bethlehemkapelle gegen die Verderbnis des Kirchenlebens zu predigen. Die englisch-böhmischen Beziehungen näherten sich der tragischen Wende. Die Deutschen verließen 1409 die Prager Universität. Wenzels Bruder, Kaiser Sigmund, brachte die Kirchenversammlung zu Konstanz zusammen, die dem Abendlande den Religionsfrieden stiften sollte. Jan Hus wurde *Jan Hus* am 6. Juli 1415 verbrannt. Der Hussitenkrieg brach los und legte den Wohlstand des Landes in Asche. Dem Kaiser Sigmund glückte auch die andere Kirchenversammlung zu Basel und ein fauler Friede, der die Entscheidung den kommenden Geschlechtern zuschob. Im August 1436 hielt der Kaiser und König Sigmund seinen feierlichen Einzug in Prag. Im folgenden Jahr starb er zu Znaim. Über das tschechische Königtum Georgs von Podiebrad war den hartnäckigsten Nebenbuhlern der Luxemburger, den Habsburgern, in Böhmen und Ungarn die Straße freigegeben.

In den böhmischen Nebenländern fand das verlockende Beispiel der Prager Prosakunst noch keine Nacheiferer. Doch bildete sich in den fürstlichen und städtischen Schreibstuben Schlesiens die mitteldeutsche Prosa nach dem Vorbild der Prager zu künftigen Leistungen heraus. In der Lausitz, deren sechs Städte sich 1346 gegen die Übergriffe der Grundherren zu einem Trutzbunde vereinigt hatten, klang das lebendig gewordene bürgerliche Selbstbewußtsein lediglich in bescheidenen Liedern auf.

MEISSEN hatte sich gegen die Macht und Staatskunst der Luxemburger behauptet und schuf sich, zwar in enger geistiger Verbindung mit Böhmen, ein doch selbständiges deutsches Schrifttum. Mit dem Meißner Dom zugleich und der aufstrebenden Stadt wird auch eine Knabenschule entstanden sein. *Meißner Schule* Aber erst eine klösterliche Gründung machte Burg und Stadt zur Schule des Landes. Bischof Dietrich II. von Kittlitz, 1191 bis 1207, errichtete das Stift

Sankt Afra. Täuscht nicht alles, so ist aus dieser Klosterschule die deutsche

Heinrich
von Meißen
Literatur des Landes mittelbar hervorgegangen. *Heinrich von Meißen,* der
Frauenlob genannt, kann das gelehrte Wissen, von dem seine Dichtungen
zehrten, nur an der Afraschule geholt haben, wenn er Meißner Herkunft war.
Er war ein schulgelehrter Spruchschreiber, dem Zeitungsmann von heute
vergleichbar. Scholastisch war seine Freude an verzwickten Fragen und spitz-
findigen Antworten. Dem entsprach der verkünstelte Stil seiner Gedichte.
Die Leiche auf Kreuz und Minne zeugen dafür, daß dieses wunderlich ver-
schnürte Wesen ein Ergebnis zielbewußter Schulzucht war. Seine Richtung
wurde wesenhaft für die literarischen Ansätze der Landschaft. Ihm, wie Kon-

Heinrich
von Mügeln
rad von Würzburg, folgte *Heinrich von Mügeln,* der nach 1369 gestorben ist
und wohl aus dem Ort südwestlich Oschatz stammt. Auch er wird seine ge-
lehrte Bildung Sankt Afra verdanken und auch er war ein Fahrender, der
weit herumkam, aber am längsten bei Karl IV. zu Prag herbergte. Die Fülle
seiner Gedichte, seiner Lieder und Fabeln, gelehrt und verkünstelt, zeigt ihn
mit den Sammelbüchern der Fahrenden aus seiner und der früheren Zeit ver-
traut. Sein Lobgedicht auf Karl IV., „Der Meide Kranz", reicht unter allen
Wissenschaften der Theologie den Preis. Seine Übersetzungen aus lateini-
scher in deutsche Prosa gehören in die Schule der Prager Kanzlei. Wilhelm I.
machte aus Meißen ein abgerundetes und modernes Staatswesen. Er gab ihm
Dresden zur Hauptstadt. Er löste sein Land aus der geistigen Verbindung
mit dem nun hussitisch gewordenen Böhmen. Das deutsche Leben, das von
dort zurückflutete, fing Leipzig auf. Dort hatte das Thomasstift, 1213 ge-
gründet, eine äußere Schule und ihr gesellte 1395 der Stadtrat mit der Niko-
laischule eine weltliche Anstalt. Seit der Mitte des dreizehnten Jahrhunderts
wirkten die Predigerbrüder in Leipzig. Ein Mönch dieses Predigerhauses
löste zweihundertfünfzig Jahre später das Rad des deutschen Schicksals zu
seinem rollenden Laufe aus. Nach Leipzig also lenkten Schüler und Lehrer
ihr Schritte, als sie die ungastliche Hochschule zu Prag verließen. Das neue
„studium generale" wurde im Advent 1409 in der Thomasschule zu Leipzig

Die Leipziger
Hochschule
eröffnet. Gegen Hus und die „reformatio" gegründet, hat die Leipziger Uni-
versität diese Haltung auch gegenüber der deutschen Reformation behaup-
tet.

DER DEUTSCHE RITTERORDEN, mit Vollmacht des Kaisers und des

Der Deutsche
Orden und seine
Literatur
Papstes ausgestattet, hatte sich mit ganzer Macht 1230 von der Oder aus
gegen Osten hin in Bewegung gesetzt, gerufen von dem masovischen Herzog
Konrad. Der große gemeindeutsche Kreuzzug unter König Ottokar von Böh-
men machte 1254 dem bedrängten Ritterorden Luft. Nach Ottokar benannt,

erstand 1256 an der Pregelmündung der erste Waffenplatz, Königsberg. Und nun wuchs aus Unterwerfung, deutschen Höfen und deutschen Städten am Baltischen Meer bis tief ins Hinterland der mächtige Staat des Ritterordens zusammen, eine völlig neue Schöpfung inmitten einer neuen Zeit. Auch das geistige Leben, das er sich in seiner Literatur schuf, ist von unvergleichbarer Art. Landesherr war die ganze geistliche Ritterschaft als Inbegriff der streitenden Kirche, doch mit Gelübden, die eine ritterliche Liebesdichtung nicht erlaubten. An der Spitze dieser Ritterschaft stand ein Heerführer, der als Erwählter und Beauftragter seiner Brüder die Würde des Landesfürsten trug und landesfürstlichen Hof hielt. So wirkten denn am Schrifttum des deutschen Ordens in Preußen, dem Lande der eingeborenen Pruzzen, zwei Mächte von gegensätzlicher Art zusammen: geistliche Gemeinde und landesherrlicher Hof.

Die Welfen hatten das höfisch-ritterliche Schrifttum Ostfalens geschaffen. Ein Welfe, Herzog *Luther von Braunschweig*, Hochmeister von 1331 bis 1335, ist der Schöpfer der preußischen Ordensliteratur. Der Orden sollte nicht im bloßen Waffenhandwerk versinken, sondern seiner als einer geistigen Gemeinschaft bewußt bleiben. Waffenruhe und Wintertage waren die größten Feinde der ritterlichen Zucht. Ihre leeren Stunden zu füllen, gab der Hochmeister seinen Brüdern ein Beispiel edlen Zeitvertreibs und gleichmäßiger Übung aller Kräfte, indem er den Kirchengesang förderte, eine gereimte Barbaralegende und anderes schrieb, indem er die Anlage einer Bücherei betrieb und anregend auf die schreibgewandten Männer seiner Umgebung wirkte. Unter seinen Augen und Zusprüchen ist die Literatur des Deutschen Ordens entstanden. *(margin: Hochmeister Luther von Braunschweig)*

Aus den frühen geschichtlichen Aufzeichnungen des Ordens hatte der Priesterbruder *Peter von Dusburg* bis 1326 seine lateinische „Cronica Prussie" geschöpft. Herzog Luther wies den dichterisch erprobten Ordenskaplan *Nikolaus von Jeroschin* an, es für die latein-unkundigen Ritter zu bearbeiten. Es wurde daraus um 1340 die „Kronika von Pruzinland", ein behagliches Lesebuch in mitteldeutschen Reimpaaren, novellistisch ausgeschmückt und ein Gesamtbild des preußischen Kulturlebens. Von da wurde nun nach allen Seiten ausgeholt. Einmal entstand eine künstlerisch anspruchsvolle Erbauungsliteratur: um 1300 mit dem „*Väterbuch*" und dem „*Passional*" eines begabten unbekannten Dichters und 1355 mit dem gereimten Schachbuch des *Pfarrers zum Hechte* in mitteldeutscher Sprache und nach der lateinischen Vorlage Jakobs von Cessole. Sie konnte auch den mit der Ritterdichtung vertrauten Brüdern genügen. Und dann begann man der ritterlichen Gemeinde *(margin: Preußische Zeitbücher)* *(margin: Preußische Bibeldichtung)*

die heiligen Bücher in deutscher Sprache zu erschließen. Der Thüringer *Heinrich Hesler* machte aus einer Prosaübersetzung sein Reimwerk über das Evangelium des Nikodemus und die Geheime Offenbarung. Der Magister *Thilo von Kulm* vollendete 1331 nach einer lateinischen Vorlage und Herzog Luther zu Ehren sein Gedicht „Die sieben Siegel", eine Gesamtdarstellung des Heilswerkes. Der Barfüßermönch *Klaus Cranc* übertrug um 1350 die Kleinen Propheten und vielleicht auch die Königsberger Apostelgeschichte in mitteldeutsche Prosa. Wie Böhmen, so steht auch Preußen im Werderaum der neuen Bibel. *Wigand von Marburg,* kein Dichter, sondern ein Geschichtschreiber, der lediglich die überkommene Reimform festhielt, setzte das Zeitbuch des Nikolaus von Jeroschin bis 1394 fort und schloß diese ganze Literatur ab. Nach ihren wesentlichen Beständen ist die deutsche geschichtliche und geistige Literatur des Ordenslandes ein Ableger des ostfälisch-thüringer Kulturkreises und eine Schöpfung Herzog Luthers. Das Vorbild seiner Braunschweiger Heimat hat ihn beeifert, unter seinen rauhen Rittern und an seinem hochmeisterlichen Hofe die Künste des Wortes und geschriebener Bücher in gleicher Weise heimisch zu machen. Diese Hausliteratur des Deutschen Ordens war ein mitteldeutsches Schrifttum.

Dem kirchlichen Aufbau des Landes entsprach eine kirchenlateinische Bildung und in ihr traten unmittelbare Beziehungen zu Böhmen an den Tag. Die Universität, die zu Kulm 1386 geplant war, blieb ungegründet. Und so *Johannes von* war das Land an Prag gewiesen. In Prag machte Meister *Johannes von Marienwerder* *rienwerder,* 1343 bis 1417, seine ganze wissenschaftliche Laufbahn. In Prag entstanden seine gelehrten scholastischen Schriften. Seiner preußischen Heimat gehört er mit dem deutschen Prosabuch an, in dem er die Gesichte der Dorothea von Montau aufzeichnete. Das war das erste Buch, das 1492 zu Marienburg eine preußische Druckerpresse verlassen hat. Da ist nun auch *Konrad Bitschin* der Kanzleibeamte. Das war der Stadtschreiber von Kulm *Konrad Bitschin* und sein „Labyrinthus vitae conjugalis", 1432, das große gemeinwissenschaftliche Handbuch dieser Zeit, das unter dem Blickpunkt der Ehe alle Bereiche des menschlichen Daseins abhandelte. Bitschin steht zwischen Scholastik und Humanismus. In seinem Buch waltet jener Geist, dem der „Ackermann aus Böhmen" ein unerreichtes Vorbild war.

Durch die Schlacht bei Tannenberg 1410 stürzte Preußen in die gleichen Wirren, die zur selben Zeit Böhmen erschütterten. Nun erwies es sich, welche Mächte der Ordensstaat durch seine Gründung und seinen Bestand zugunsten des Luxemburgerreiches gebunden hatte.

2. DER NIEDERDEUTSCHE KREIS

In Böhmen wurde die mittelalterliche Welt aus der einen Angel gehoben, in Niederfranken aus der andern. Hier wie dort war der eine und gleiche Geist am Werke, einen neuen Menschen zu bilden und durch ihn die devotio moderna einer neuen Frömmigkeit und die urchristliche Lebensform zu verwirklichen. Die böhmische Bewegung geht zeitlich voran, und viele Träger des gleichen Geistes in den Niederlanden haben die Prager Hochschule besucht, haben dort akademische Grade erworben oder ihrer Bildung einen letzten Schliff gegeben. Gleichwohl zeigt die vita nuova Niederfrankens zu eigentümliche Haltung und gehen die Bestrebungen beider Landschaften zu selbständige Wege, als daß man sie von Böhmen ableiten könnte. Aber wie die böhmische Bewegung den mitteldeutschen Raum durchsetzte, so die niederländische alle niederdeutschen Landschaften.

devotio moderna

NIEDERFRANKEN. Vom Niederrhein, wo die Salier zu Hause waren, die ersten Träger der fränkischen Einheit und sodann des karlingischen Reiches, sind den Deutschen immer wieder starke Antriebe zugekommen. Diesmal durch die Brüder vom gemeinsamen Leben.

Die Brüder vom gemeinsamen Leben

Was Johann von Neumarkt für den böhmischen, das bedeutet *Gerit Groote,* 1340 bis 1384, aus Deventer für den niederfränkischen Kulturkreis. Groote, aus gutem Hause geboren, war Schüler zu Paris und Prag und dann, mit Pfründen wohlversorgt, einem genußfrohen Leben verfallen. Der Vierunddreißigjährige sah sich in einer Stunde der Gnade überwältigt, tat von sich, was er bisher geliebt hatte, und wurde ein aufrüttelnder Laienprediger ohne Priesterweihe. In das Netz seiner Worte und in die Falle seines Beispiels gingen ihm die Menschen weitum. Den Besten fing er sich in *Florentius Radewynsz,* um 1350 bis 1400, der wie Groote reich bepfründet war und gut gelebt hatte. Sie waren fortan wie eine Seele in zwei Körpern. Auch Radewynsz war ein Schüler der Prager Universität. Milic von Kremsier hatte mit seiner Prager Priester-Laienstiftung „Jerusalem" das erste Beispiel einer neuen religiösen Hausgemeinschaft gegeben. Es hat wohl auf Groote und seinen Freund gewirkt. Sein Wille stand gegen die überlieferten Mönchsgemeinschaften, insbesondere gegen die immer wieder verfallenden Bettelorden. Er wollte nicht bettelhafte, sondern werktätige Armut, bedingungslosen Arbeitsbeitrag eines jeden Mitgliedes der Hausgemeinschaft, Arbeit zugunsten der Hausgemeinschaft bei persönlicher Armut des einzelnen Hausgenossen, Handarbeit als Mittel der Vergeistigung und Verseelung des neuen Menschen, der ein Mensch der Gemeinschaft sein sollte. Hand-

Gerit Groote und Floretius Radewynsz

Handarbeit und Mystik

arbeit ist Seelenadel. Groote und seine Freunde verwirklichten so auf eine werktätige und fast nüchterne Weise die Mystik, wie *Johannes Ruisbroek*, 1283 bis 1381, im Augustinerkloster Groendal bei Brüssel, sie in seinen Betrachtungsbüchern offenbarte. Grootes Hausgemeinschaften waren kein Orden, sondern persönliche Arbeitsbünde, keine bewußte Gründung, sondern natürlicher Aufwuchs. Es entstanden zwei Formen solcher Gemeinschaft. Aus dem Meester-Geerts-Huis, das Groote 1379 zu Deventer eröffnete, entstand die freie Hausgemeinschaft der Brüder vom Gemeinsamen Leben, die sich binnen kurzem über alles niederdeutsche Land ausbreiteten und am Ende des fünfzehnten Jahrhunderts 120 Häuser für Männer und Frauen hatten. Aus dem Kanonikerhause des Radewynsz zu Zwolle, einem Zufluchtsort *Windesheimer* für bedrängte Brüder, entwickelte sich die Windesheimer Kongregation, die *Kongregation* schließlich 155 Häuser für Mönche und Nonnen umfaßte. In den Windesheimer Satzungen klingen die „Consuetudines Rudnicenses", die Einrichtungen des böhmischen Stiftes zu Raudnitz an. So erscheinen denn aus einem und demselben Geiste heraus die böhmischen und die niederfränkischen Erneuerer des geistlichen Zusammenlebens als Beweger der einen und gleichen Tat. Wenn von Böhmen her verdeckte und sichtbare Pfade mitten in Luthers *Deutscher* Werk hineinführen, aus dem Niederfranken der Brüderherren laufen nicht *Kulturkreis der* *Brüderherren* minder zahlreiche Spuren auf den Augustiner zu, der die Arbeit an die Spitze seiner Pflichtenlehre stellte. Von Prag aus gliederte sich der Nordosten zu einem geistigen Gefüge auf, das seine eigene Zukunft in sich trug. Und Deventer strahlte in den niedersächsischen Nordwesten Gemeinschaft und Willen zu tätiger Selbstvollendung. Im Raume der Ostsee kreuzten sich die Bewegungskräfte, die von Deventer und Prag auf einander zuliefen.

Religiöse Aufgaben, keine anderen, hatten sich die Brüderherren gesetzt. Gleichwohl erlangten sie unabsehbaren Einfluß auf das niederdeutsche Geistesleben des fünfzehnten und frühen sechzehnten Jahrhunderts. Das machten die drei Bereiche ihrer Tätigkeit: Buch, Sprache, Schule. In allen dreien erstrebten sie das eine: werktätige und lebensnahe Fürsorge.

Buchindustrie Das Buch stand als „Predigt durch die Feder" im Mittelpunkt ihrer Lebensordnung. Die Bucherzeugung der Brüderhäuser hatte zugleich wirtschaftliche und sittliche Zwecke, war Dienst und Erwerb. Sie ist aus der Schreibstube zu Zwolle, die zunächst für die Schule arbeitete, und aus der Schreibstube zu Deventer, die Grootes persönlichen Bedürfnissen diente, herausgewachsen zu einem streng geregelten Buchbetriebe, der die wirtschaftliche und geistige Grundlage eines jeden Brüderhauses bildete. Man sah weniger auf Ausstattung als auf sorgfältige Wortlaute. Bei bestellten Büchern richtete

man sich in der Ausstattung nach den Wünschen des Bestellers. Besondere Sorgfalt widmete man genauen Abschriften der Bibel und der Kirchenväter.

Die Brüderherren machten sofort den Übergang von der Handschrift zum Buchdruck mit. Ihre Schreibstuben wurden von eigenen Druckereien abgelöst. Ihre Schriftsätze eroberten sich sogleich den Markt. Der frühe Buchdruck in Niedersachsen ist zum guten Teil ihr Werk.

Die Sprache war nächst dem Buch der wichtigste Arbeitsbereich der Brüderherren. Sie waren Seelsorger und wollten das Volk in seinen breiten Massen gewinnen. Sie übersetzten und verbreiteten große Mengen von Volksliteratur. Sie bildeten vor allem die schrifttümlichen Gattungen aus, die dem Seelenleben, der Seelsorge und dem Gottesdienst zugehörten. Groote selbst war ein großer Prediger, nicht der Schule aber des Herzens, und die deutsche Predigt haben die Brüderherren wieder zu einer volkstümlichen Kunst gemacht. Sie pflegten das einfache Kirchenlied in der Landessprache, ja, sie haben es im Bereich der deutschen Zunge neu geschaffen. Die mystische Erbauungsliteratur überwältigte von den Brüderhäusern aus ganz Niederdeutschland. So sind die Brüder vom gemeinsamen Leben, indem sie das gesamte Buchwesen in ihren Händen zusammengezogen und zu einem mächtigen Großbetriebe ausbauten, die Träger der Volkssprachenbewegung geworden. Während sich von Böhmen her das Ostmitteldeutsche gegen Oberdeutschland zu als gemeinsame Hochsprache durchzusetzen beginnt, breitet sich von Niederfranken her, die deutsche Küste entlang, der Wille zu einer gemeinniederdeutschen Schriftsprache aus. Zwei junge Schriftsprachen, miteinander im Wettbewerb, es sind tragische Jahrzehnte der Hochgefahr für die geistige Einheit des deutschen Volkes.

Volkssprache

Kirchenlied und Erbauungsliteratur

Die Schule war den Brüderherren anfänglich nur ein Gegenstand der sozialen Fürsorge. Sie begannen die fahrenden Schüler von den Landstraßen in geordnete Heime zu retten und den Verwahrlosten Arbeitsgelegenheit zu schaffen. Es war dann Johannes Cele, um 1350 bis 1417, aus einem guten Bürgerhause zu Zwolle, ein früher Freund Groots, der aus dem Geiste der Brüderherren deren neue Schule geschaffen hat. Durch ihn wurde die Stadtschule in Zwolle zu einer Pflanzstätte für das ganze Reich, indem er den Unterricht auf acht Klassen verteilte, indem er den Lehrstoff der Artistenfakultät von den Hochschulen weg an die Mittelschule nahm, indem er beim Unterricht überall einen gesicherten Wortlaut der Schulschriftsteller anstrebte und eine neue Art der Bucherklärung forderte. Die Schulstadt Deventer hat dann das Erbe von Zwolle angetreten und der ganzen Welt vermittelt. So

Die Schule der Brüderherren

sind die Brüderherren, ohne selber Humanisten zu sein, Wegbereiter des deutschen Humanismus geworden.

Ihre Schüler　　Durch drei ihrer Schüler haben sie entscheidend auf den Wandel der deutschen Seele und des deutschen Geistes eingewirkt: durch *Thomas Hamerken,* 1380 bis 1471, aus Kempen bei Köln, der mit seinem Handbüchlein des geistlichen Lebens „Von der Nachfolge Christi" die gesamte Seelenerfahrung der Brüderherren in klassische Form brachte und damit in die Weltliteratur einging; durch *Nikolaus von Kues,* 1401 bis 1464, aus dem Moselstädtchen, von dem er sich nannte, den ersten großen modernen Philosophen, der die unterschiedliche Zweiheit von Stoff und Gestalt bestritt, einen göttlichen Monismus und die Vernünftigkeit alles Seienden lehrte, die Unendlichkeit der Welt in Raum und Zeit, die Verhältnismäßigkeit von Bewegung und Ruhe, der Erkenntnis nur als unendliche Annäherung an das Wesen der Dinge zugab; durch *Desiderius Erasmus,* 1467 bis 1536, aus Rotterdam, den Schöpfer der humanistischen Wissenschaft und Literatur in Deutschland.

Das deutsche Werk der Brüderherren ist nicht in Niederfranken selber, sondern in Niedersachsen zur vollen Entfaltung und zur Wirkung auf die Herzen gekommen. Wenn Köln den neuen Geist der Brüderherren rheinaufwärts in die oberdeutschen Landschaften weiterstrahlte, Münster und Hildesheim waren seine Treuhänder in Niedersachsen.

Westfälische Publizisten　　*ALTSACHSEN.* Westfalen und Ostfalen bieten auch im Zeitalter der Luxemburger das gleiche Bild wie unter den Staufern. Westfalen schweigt und was geschrieben wird, das ist eine kirchenlateinische Literatur staatsrechtlichen und zeitgeschichtlichen Inhalts, wie sie von den beiden Paderbornern *Dietrich von Nieheim* und *Gobelinus Person* sowie von dem Osnabrücker *Dietrich Vrye* vertreten wird. Sie alle forderten eine maßvolle Erneuerung der Kirche. Auferweckt zu seinem deutschen Schrifttum ist Westfalen durch die Brüderherren worden, auferweckt vorerst zu einem geistlichen Schrifttum. Das waren Predigt und mystisches Betrachtungsbuch. Es schoß eine reiche Literatur auf. Ihr Mittelpunkt war das Brüderhaus zu Münster, das 1400 auf dem Honekamp gegründet und bald auf den Bispinghof verlegt wurde. Hier war das Buchgewerbe in der Art aller Brüderhäuser fest geordnet. Aufgegangen ist die neue westfälische Literatur erst im Zeitalter der Habsburger.

Ostfälische Erbauungsliteratur　　Die welfische Ritterdichtung Ostfalens wird abgelöst von einer geistlichen Dichtung, als deren Pflegestätte sich Goslar auftut. Eine ganze Reihe von Gedichten geben ein Bild dieses frommen Reimvergnügens. In Goslar schrieb der Geistliche *Konemann* das Werbegedicht „Der Kaland" zugunsten der so

genannten sächsischen Bruderschaft, die ihren Mitgliedern ein erbauliches Begräbnis und Seelenmessen stiftete. Sein mystisches Gedicht „Sunte Marien Wortegarde", 1304, Mariä Wurzgärtlein, eine Heilsgeschichte mit lyrischen Zwischenspielen und von sichtlich dramatischer Anlage. In diesem Stil hatte er Gesellschaft. Zu Gandersheim und Quendlinburg war im zehnten Jahrhundert die Theophiluslegende lateinisch behandelt worden. Das wird auch die Heimat des *Theophilusspiels* sächsischer Mundart gewesen sein. Nicht mehr als drei Bilder werden vorgeführt: wie Theophilus sich dem Teufel verschreibt, wie der Reuige Maria anruft, wie die ihm Gnade erwirkt. Szenisch weiter gespannt war schon das „Spiel von der Geburt Maria" des *Arnold Immessen,* der im fünfzehnten Jahrhundert als Geistlicher in Einbeck bezeugt ist. Es ist unverkennbar der Ansatz zu einem breiten Osterspiel, wie sie in dieser Zeit beliebt wurden. Immessen ist nur über die Geburt Marias nicht hinausgekommen. Das Spiel ist kräftig und in Nebenbildern volkstümlich. Salomon streitet sich mit seiner Frau und schlemmt mit seinem Diener Einbecker Bier. Das ostfälische Bürgertum, das sich 1384 im sächsischen Städtebund politisch zusammenfaßte, ließ sich literarisch zunächst nur in geschichtlichen Aufzeichungen vernehmen. Als ein bürgerliches Gegenstück zur Braunschweiger Fürstenchronik schloß um 1425 der Ratsherr *Dietrich Bromes* seine „Lüneburger Chronik" ab, eine Geschichte des Herzogtums, wie sie eben einem Ratsherrn erschien. Die geschichtlichen Lieder, die er einflocht, rücken das Buch in die Nähe oberdeutscher Geschichtswerke. Es war eines der am meisten gelesenen sächsischen Bücher, solange man abschreiben mußte, was man zu besitzen wünschte.

Ostfälische Spiele und Zeitbücher

Die Hansastädte suchten erst nach dem rechten Wort. Vielleicht daß in einem Bremer Nonnenkloster das lyrische Gegenstück zum Lübecker Totentanz entstanden ist, das Lied *„Vom andern Land",* von der Herrschaft des Todes über alle Stände und von der Reise ins andere Land. Zu den neuen Ratsstühlen, die der Bürgermeister *Johann Hemeling* entwarf, schrieb er auch die eingeschnittenen Sprüche. Aus Hamburg ist nicht viel mehr zu hören, als die niedersächsischen *Lieder* über die Seeräuber Godeke Michelsson und Klaus Störtebeker, von deren Schiffen Hamburg 1403 das Wasser reinigte. Am weitesten war Lübeck. In die kaum entwirrbaren Wechselbeziehungen von bildender Kunst, Schauspiel und Denkvers, wie sie die gemeineuropäischen Totentänze darstellen, gehört der *„Lübecker Totentanz".* In Lübeck wagte man, allen sächsischen Landschaften voran, eine genossenschaftliche Pflege des Schauspiels. Hier hatte sich in der zweiten Hälfte des fünfzehnten Jahrhunderts eine adelige Stubengesellschaft gebildet, die *„Zirkelbru-*

Hansastädte

Lübecker Zirkelbruderschaft

derschaft". Sie verfolgte kirchliche und gesellige Ziele. Während des großen

Lübecker Spielplan Aufstandes, 1408 bis 1416, hatten Lübecker Bürger in Oberdeutschland, wohin sie geflüchtet waren, das Fastnachtspiel kennen gelernt — das muß wohl in Nürnberg gewesen sein — und in ihre Heimat gebracht. Die Zirkelbruderschaft übernahm diese Aufführungen. Bis 1537 wurde gespielt und 73 Stücke sind bekannt, darunter 1438 „Die Hölle" und „Frau Crimolt", 1450 „Wie König Karl stehlen ging", 1453 „König Artus", 1454 „Das Goldene Vlies", 1472 von Troja und dem hölzernen Pferd. Der Spielplan zeigt Beziehungen zum ältesten bairischen Volksstück, und, da man auf fahrbaren Gerüsten spielte, zu den niederfränkischen dramatischen Aufzügen.

NEUSACHSEN. Die Landschaften östlich der Elbe, deren Besiedlung langsam abgeschlossen wurde, blieben noch immer eine Brache. Die über-

Brandenburg und Mecklenburg wiegend niederfränkisch bevölkerte Mark Brandenburg erhielt nach dem Zwischenreich der Wittelsbacher und Luxemburger 1411 in Friedrich von Hohenzollern ihren neuen Herrn. Er beugte bald Grundadel und Stadtbürgertum unter seine landesfürstliche Macht. Gereimte Zeitbücher, geschichtliche Lieder und geistliche Bühnenspiele sind alles, was wir aus der luxemburgischen Zeit des Landes kennen oder wovon wir hören. Dagegen machten Mecklenburg und Pommern einen weitern Schritt nach vorwärts. Die wendischen Seestädte, Rostock vor allem, hatten sich 1370 gegen Dänemark und dessen mächtigen Bund den siegreichen Frieden von Stralsund erkämpft. Diese stolze Stimmung lebt in dem geschichtlichen Reimwerk, das ein Thüringer von Geburt, *Ernst von Kirchberg,* 1378, auf den Wunsch des Herzogs Albrecht II. von Mecklenburg zu Rostock begann. In hochdeutscher Sprache und übersetzend reimte er zunächst die Wendengeschichte Helmolds und führte dann die Geschichte Mecklenburgs bis gegen 1350 herauf. Das Buch wurde mit Kleinbildern köstlich ausgeschmückt. Wenn es auch dem Stadtbürger nicht zur Hand lag, sondern dem Nachlesen des Hofes diente, es stärkte doch das geschichtliche Bewußtsein von der fortzeugenden Kraft des Werkes, das sich vor den Augen Helmolds vollzogen hatte. Am 12. November 1419 wurde in der Marienkirche zu Rostock feierlich eine neue Hochschule eröffnet, die erste im ganzen Gebiet des sächsischen Stammes. An der

Hochschule Rostock herzoglichen Gründung war durch den Rat die Rostocker Bürgerschaft mitbeteiligt. Der Entschluß zu dieser Gründung wurde aus der allgemeinen Sehnsucht nach kirchlicher Erneuerung geboren, aus der eben tagenden Konstanzer Kirchenversammlung. Die Basler Kirchenversammlung verhängte

Hochschule Greifswald 1435 über Rostock den Bann. Die Hochschule übersiedelte nach Greifswald. Nach Aufhebung des Bannes 1440, kehrte nur ein Teil der Lehrer nach

Rostock zurück. Die anderen blieben in Greifswald als Kern einer neuen Universität, die am 17. Oktober 1456 in der Nikolaikirche eröffnet wurde.

Es bedurfte eines weltgeschichtlichen Witterungsumschlages, bis dem ganzen sächsischen Raume die böhmische und niederländische Saat ausreifte.

3. DER OBERDEUTSCHE KREIS

Der Untergang des staufischen Reiches mußte die Landschaften am folgenreichsten treffen, die es politisch getragen und geistig erfüllt hatten. Sie lagen nun, politisch verwaist und geistig enterbt, im Spielfeld der von Böhmen und den Niederlanden andrängenden Wende der Zeit. Sie verharren noch unsicher im Widerspruch ihrer Lage, arbeiten auf, was noch zu tun war, und tasten nach Auswegen in die Zukunft. Doch sie sind die ersten, die von den Kirchenversammlungen zu Konstanz und Basel das Stichwort aufnehmen.

THÜRINGEN. Zwei Dramen fassen dieses Zeitalter ein und künden seinen zweifachen Sinn: mystische Bußfertigkeit und scholastischen Erkenntnisdrang. Landgraf Friedrich ließ 1322 zu Eisenach von Schülern und Klerikern sich das Gleichnis *von den klugen und törichten Jungfrauen* vorspielen. Der Mahnruf zur Einkehr klang so erschütternd aus den deutschen Reimen, daß der Landgraf an den Folgen des aufregenden Eindrucks starb. Das Drama zeugte von einem ungewöhnlichen Bühnensinn. Szenische Lichtwirkungen —die Jungfrauen mit ihren Lampen— Gesang und Tanz spielten wundersam in dem traumhaften Sinnspiel zusammen. Der Thüringer Geistliche *Dietrich Schernberg* aber spielte um 1480 mit seiner „Päpstin Jutta" das Drama des wissensstolzen Menschen. Die Pariser Wissenschaft ist der Nährboden des Hochmutes, der das Mädchen Jutta umgarnt. Doch sie findet, anders als die törichten Jungfrauen, im Tod Gnade. *Johannes Rothe* aus Kreuzberg an der Werra, Priester und später Stadtschreiber zu Eisenach, schloß um 1400 ab, was überliefert war. Vielleicht einem Thüringer Prinzen hielt er noch einmal einen gereimten „Ritterspiegel" vor und reimweise schilderte er das Leben der heiligen Elisabeth. Die neue Zeit aber ging der Landschaft mit der Hochschule auf, die Erfurt sich 1392 gründete.

OSTFRANKEN. Das ostfränkische Wesen, das man zum erstenmal bei Wolfram von Eschenbach auf seinen Wegen ins Absonderliche beobachten konnte, vergrübelte sich nun auf scholastische Weise in Fragen, wie der Tiefsinn oder der Spott sie liebt. *Der König von Odenwald,* wie er heißt, gewiß

Spiel von den Jungfrauen

und von der Päpstin Jutta

Hochschule Erfurt

ein Koch, schrieb das älteste Kochbuch in deutscher Sprache, „Ein Buch von
guter Speise", und handelte um 1340 beinahe schon in der Art der späteren
akademischen Scherzfragen von den Küchentieren und vom Nutzen des Strohs.
Ein Unbekannter verlief sich um 1350 in die gedanklichen Irrgänge seiner
„Minneburg", absonderlich auch im Schwulst seines Stiles und seiner unge-
wöhnlichen Reimwörter. Doch das sind Arabesken am Rande. Was die Zeit
verkörpert, das ist auch in Ostfranken eine Literatur von mystischer Haltung.
Von einem wahren Dichter des Klosters Heilsbronn stammen um 1320 die
Gedichte „Das Buch von den sieben Graden" und „Von den sechs Namen des
Mystische Fronleichnams". Gedanklich stehen sie im Banne des Meisters Eckhart. Mit
Literatur
Ostfrankens einer Absage an die ganze Kultur der Stauferzeit, die in allem so sehr auf
Stil und Freigebigkeit hielt, verwies der Dichter den Menschen auf das in-
wendige Reich Gottes. Das hat die Frau am leidenschaftlichsten gesucht. Die
Ritterburgen wurden von den Nonnenklöstern abgelöst, in denen vor allem
die ritterbürtigen Frauen, weggewendet vom weltlichen Spiel des Herzens,
sich aus Herrinnen des ritterlichen zu Dienerinnen des göttlichen Eros mach-
ten. Ihre frommen Verzückungen sammeln sich zu einer ganzen Literatur,
die so wenig ihresgleichen hat wie zuvor die ritterliche Lyrik. Im Kloster
Engeltal schrieb *Christina Ebner*, 1277 bis 1356, aus einem vornehmen
Nürnberger Bürgergeschlecht, das denkwürdigste Büchlein dieser Art, weil
es diesem erotischen Herrendienst der Frau die sprachlich gültigen Ausdrucks-
formen gefunden hat. Es ist in einem Tagebuch, Klostergeschichte, Lebens-
beschreibung. Gleichzeitig beginnt sich aus der Landschaft Ostfranken die
große Stadt Nürnberg auch geistig abzuheben. Das geschah auf eine merk-
würdige Weise. Das Nürnberger Katharinenkloster, 1295 eingeweiht, war
von frühauf ein Stapelplatz der mystischen Literatur. Als Aussteuer brachten
die jungen Nonnen Bücher mit, Katharina Tucher allein dreißig Bände. Der
Bienenfleiß der Frauen vervielfältigte unermüdlich, manche Werke doppelt
Nürnberger und dreifach. Diese Bücherei enthielt so gut wie alles, was damals an solcher
Familien-
literatur Literatur vorhanden war, angefangen von Eckhart, Tauler, Seuse bis zu den
kleinen Nachzüglern. Aus diesem Schrifttum der Nonnen zogen die Wur-
zeln der städtischen Literatur ihre erste Nahrung. Von *Ulman Stromer* des
frühen vierzehnten bis zu *Nikolaus Muffel* des späten fünfzehnten Jahrhun-
derts entstand zu Nürnberg eine reiche tagebücherliche und familiengeschicht-
liche Literatur, die durch die Schärfe Erstaunen erregt, mit der all diese
Selbstbetrachter ihr Seelenleben zergliedern. Die Töchter der Nürnberger
Ratsfamilien hatten sich in ihren Klöstern längst in der hohen Kunst ge-
schult, mit Bewußtsein zu erleben und als Selbstbeobachter diese Erlebnisse

aufzuzeichnen. Also ist diese Kunst von den klösterlichen Frauen auf die weltlichen Männer der Stadt übergegangen. Das sind die Anfänge des Nürnberger Schrifttums.

SCHWABEN. Die schwäbische Natur bezeugt sich in diesem Zeitalter seltsam gleichgerichtet mit der ostfränkischen. Sie spiegelt sich in einer mystischen Literatur von hohem Rang und sie erzeugt ein städtisches Gemeinwesen, das beinahe wie ein guter Vetter des ostfränkischen aufwächst. Das ostfränkische Schauspiel des göttlichen Eros ist ein Selbstgespräch. Das schwäbische spielt zwischen Mann und Frau wie ein Wechselgesang. *Margaretha Ebner,* um 1291 bis 1351, stammte aus Donauwörth und trat in das Kloster Medingen bei Dillingen. Sie lernte 1332 *Heinrich von Nördlingen* kennen, ihren Seelenführer. Beide haben das mystische Dasein in Gott aneinander zur Vollendung ausgelebt. In den Briefen, die sie miteinander wechselten, und in dem Büchlein, in das Margaretha ihr inhaltsreiches Leben aufzeichnete, hat dieses Doppelerlebnis auch gedoppelte literarische Gestalt gewonnen. Das Selbstbildnis ist mit schweren und fast stockenden Worten gezeichnet, aber voll anmutiger Einzelzüge. Der Briefwechsel ist nach Gehalt und Stil reine Dichtung, lautere lyrische Prosa. Das ritterliche Seelenwort dringt nicht mehr heran. Das kirchlich geformte, Schmuckworte der Litanei und des Hohen Liedes, halten und tragen den Ton. Die Stadt war hier Augsburg. Seit sich 1368 die Zünfte im Rat zur Macht durchgekämpft hatten, schritt Augsburg kraftvoll seinen Weg. In dieser Stadt war beinahe von Anbeginn alles da, was eine Literatur bedeutet. Das höfische Lied ist vom *Stadtschreiber Rudolf* her an die Bürgerschaft übergegangen. Der Meistergesang erscheint schon um die Mitte des fünfzehnten Jahrhunderts voll ausgebildet. Die höfische Erzählung verwandelte um die Mitte des vierzehnten Jahrhunderts der Stadtschreiber *Hermann Fressant* in die bürgerliche Novelle. Und also stand auch hier der Stadtschreiber am Beginn und führte als erster in jedem Sinne die Feder. Aus dem Predigtmärlein Bertolds machte der Augsburger Fahrende *Heinrich Kaufringer* um 1400 den bürgerlich behäbigen Schwank. Geistliche und Bürger bildeten die geistliche Geschichtskunst zumal der erneuerten Schwarzwaldklöster so zeitgerecht ins Bürgerliche um, daß gegen Ende des vierzehnten Jahrhunderts ein ungenannter Meister das wohlgelungene erste Jahrbuch der Stadt schreiben konnte. Alles hatte hier seine Art und war zusammen eine Literatur.

FRÄNKISCHE UND ALAMANNISCHE RHEINLANDE. Den ganzen Rhein entlang drängen sich, sinnvoll aufeinander abgestimmt, die Ereignisse. Großes geschieht und Großes bereitet sich vor, um die fränkischen und ala-

Margaretha Ebner und Heinrich von Nördlingen

Augsburger Anfänge

Augsburger bürgerliche Novelle

mannischen Landschaften wieder mit einem Schlage in den Vorkampf des deutschen Geisteslebens zu setzen. Die fränkischen Rheinlande vollziehen

den Übergang von der ritterlichen zur bürgerlichen Dichtung, geben dem deutschen Denken und dem europäischen Buchwesen ein völlig neues Gesicht und ermöglichen erst, das zu verwirklichen, was die böhmischen Kanzleien und die Schreibstuben der niederländischen Brüderherren erstrebten. Die ritterliche Dichtung geht auf den Bürger zu einen zweifachen Weg. Die hö-

fische Lyrik wird zum bürgerlichen Meistergesange. *Heinrich von Meißen,* um 1250 bis 1318, lebte zuletzt und starb in Mainz. Aus Mainz oder Speier stammte der Wettbewerber, mit dem sich Frauenlob in spitzfindigen Streitversen maß, das Urbild des bürgerlichen Spruchdichters, *Regenbogen.* Mainz ist wahrscheinlich der Ort gewesen, wo zuerst der schulmäßige Unterricht im Singen und Sagen geübt wurde. Es ist möglich, daß Singbruderschaften, wie es Bruderschaften zur Aufführung geistlicher Spiele gab, die erste Stufe zum zünftigen Meistergesange gebildet haben. So ist an derselben Stelle, wo das höfische Lied als ständischer Ausdruck ritterlicher Gefühlskultur geschaffen wurde, eben diese Kunst an das Stadtbürgertum übergegangen. Das höfische Versepos geht in dreifacher Gestalt an den Bürger über: als umfassendes Lesebuch; als Kleingebilde der Novelle; als Prosaroman. Unter dem Einfluß des niederländischen Epos wurden im vierzehnten Jahrhundert um Aachen einige Karlsepen zu dem breiten Sammelwerk „*Karlmeinet*" ver-

einigt. *Hans von Bühel* übersetzte 1412 die berühmte Novellensammlung „Historia septem sapientum" als „Leben des Diokletian" in deutsche Reimverse. *Elisabeth von Nassau-Saarbrücken,* eine geborene Prinzessin von Lothringen, übersetzte um 1440 vier französische Ritterlieder in deutsche Prosaromane. Und so wie überall entwickelt sich, zumal in Köln, auf dem Untergrunde der erzählenden Ritterdichtung zunächst das gereimte und dann das prosaische Zeitbuch. Das schönste ist die kulturgeschichtlich gehaltene „Lim-

burger Chronik", die der kaiserliche Notar *Tilemann Elhem von Wolfhagen* zwischen 1377 und 1398 geführt hat. Ihn fesselten die umlaufenden Lieder und Verse, zuvörderst deren Singweisen. Zum Jahr 1360 vermerkt er, der Meistergesang sei verändert worden. Auch wenn er ein sonderlicher Liebhaber dieser Kunst war, wenn er auch mit diesen Kreisen Verbindung hatte, so muß schon um die Mitte des vierzehnten Jahrhunderts die „holdselige Kunst" Pfleger die Fülle gehabt haben, da sie die Aufmerksamkeit eines Zeitbuchschreibers erregte.

Der letzte Denker der alten und der erste der neuen Zeit, das war *Nikolaus von Kues,* 1401 bis 1464, der Deventerschüler, Kardinal und federmäch-

tige Vorkämpfer der Kurie. Er dachte, vom Mangel des Vernunfterkennens überzeugt und der Erkenntniskraft des mystischen Entwerdens und Nichtwissens vertrauend, den neuen Gedanken: Gott und Welt sind eins und nur dadurch geschieden, daß das gleiche Sein in der Welt nur endlich, in Gott unendlich ist. Was im Endlichen nebeneinander nur auf Gegensätze verteilt bestehen kann, das ist in Gottes Unendlichkeit zur Einheit ausgeglichen. Alles ist in allem und jedwedes Einzelwesen, die Welt im Kleinen. So von Eckhardt ausgehend und von Albertus, wirkte der Kusaner auf Reuchlin, Giordano Bruno, Leibniz.

Die völlige Veränderung des europäischen Buchwesens geschah abermals zu Mainz und durch die Erfindung des Buchdrucks. In Mainz kam um 1440 einem Rheinfranken, *Johann Gutenberg*, der Gedanke, die Holztafeln, mit *Der Buchdruck* denen man bisher Bilder und selbst Unterschriften gedruckt hatte, in einzelne Buchstaben zu zerschneiden und so für jede mögliche Verbindung untereinander frei zu machen. Er krönte diesen Gedanken, indem er gegossene Lettern, Metall zum Guß und eine Druckerpresse erfand. So ist denn in Mainz das erste große, gedruckte Buch 1455 erschienen, die 42zeilige Bibel. Buch und Schrifttum, Bildung und Wissenschaft schöpften aus dem ersten gedruckten Buch einen neuen Sinn.

Mit der Hochschule, die 1388 zu Köln gegründet wurde, erstand eine Hochburg der scholastischen Wissenschaft. Ganz Niederfranken war der *Hochschule* Raum, aus dem sie bevorzugt beschickt wurde. Sie war längst ein Begriff, als *Köln* um sie die erschütternden Bildungskämpfe des humanistischen Zeitalters entbrannten.

Die alamannischen Rheinlande geben der mystischen Bewegung ihren höchsten und letzten Ausdruck, erzeugen eine zeitgemäße Form des staat- *Alamannische* lichen Daseins und erleben mit den beiden Kirchenversammlungen auf ihrem *Mystik* Boden zuerst den Anbruch eines abermals neuen Tages.

Die deutsche Mystik in ihrer innerlichsten Tiefe und sprachkünstlerischen Vollendung, das ist die alamannische Mystik. Mit Heinrich Seuse und Elisabeth Stagel wiederholte sich auf einer höheren Stufe, was Heinrich von Nörd- *Heinrich Seuse* lingen und Margaretha Ebner geschehen war. *Heinrich Seuse*, 1295 bis 1366, *und* hatte einen Hegauer Ritter zum Vater und eine Edle von Sus zur Mutter. *Elisabeth Stagel* Als Schüler und Lesemeister in dem kunstfrohen Inselkloster der Konstanzer Predigerbrüder entfaltete sich seine Seelenbildnerkunst. Er übte sie aus als Meister der Einzelseelsorge und Gewissensführer vornehmer Frauen rheinauf und rheinab. Es wurde daraus ein abenteuerliches Leben, reich an inneren und äußeren Begebenheiten, die ungewöhnlich waren. Er strebte zum

schauenden Erkennen des verstandesmäßig Unerkennbaren und hatte Gesichte, die zum guten Teil ein Spiel des gespaltenen Ichs waren. Der Betrachtende und Schauende sah sich selber beim Fluge in die Unendlichkeit zu. Als er über diese Dinge zu reden begann, konnte es nicht anders geschehen als in der Sprache alles Geschöpflichen. Er zog nach dem Vorbilde der beiden Bettelorden die bildhaften Anschauungsmittel, die seinen Stil ausmachen, aus dem ganzen Reich der Natur. Aber er redete auch in der Sprache des ritterlichen Standes, dem er durch Geburt angehörte, und der bürgerlichen Umwelt, die er auf seinen Seelsorgerfahrten kennengelernt hatte. Sein inhaltsreichstes Gleichnis war das vom miles christianus. Über alle Stufen, vom Geistigsten bis an die Grenze des Geschlechtlichen, führte er das Bild im Dienste der göttlichen Weisheit durch. Die Vertraute seiner Gesichte war Elisabeth Stagel. Seuse war der erste Dichter, der seine Werke in eine Aus-

Seuses Werk gabe letzter Hand zusammenfaßte. Voran die Selbstbeschreibung seines Lebens, die er ungewollt seiner geistlichen Tochter Elisabeth Stagel in die Feder erzählt hatte und dann übertuschte; sein Hauptwerk, das „Buch der ewigen Weisheit"; die Verteidigungsschrift für seinen Lehrer Eckhart, das „Buch der Wahrheit"; vielleicht sein Köstlichstes, die Briefe. Seuse hat offensichtlich selber die Urschrift seiner Gesamtausgabe mit Bildern des Stiles geschmückt, den die Malerschule des Konstanzer Inselklosters eben ausgebildet hatte. Seuse hat der wunderbar entwickelten feinfädigen Seele seiner Zeit eine Sprache gegeben, die heimlichste Falte des Erlebens mit Worten zu enthüllen. Der Rittersprößling und Predigerbruder Seuse hat den gepaarten Vorgang der höfischen Lyrik und deutschen Mystik auf die Höhe schrift-

Das Tösser tümlichen Ausdrucks geführt. Seine geistliche Tochter *Elisabeth Stagel*, aus
Schwesternbuch edlem Zürcher Hause und Insassin des Klosters zu Töß, hatte Seuses Leben vom erzählenden Mund weg aufgezeichnet. So beschrieb sie auch das Seelenleben von etwa dreißig Klosterfrauen ihres Hauses aus den Jahren 1250 bis 1350, die jüngeren aus eigenem Augenschein, die älteren nach Quellen. Die mystische Kunst, helldunkle Seelenzustände in Worten wiederzugeben, war hier durch weibliches Feingefühl und triebartiges Einfühlen zu vollendeter Meisterschaft gesteigert. Das ist das berühmte „Tösser Schwesternbuch".

Johann Tauler *Johann Tauler*, um 1300 bis 1361, aus Straßburg und von bürgerlicher Herkunft, Predigerbruder und Eckharts Schüler, hatte kein geringeres Verlangen nach „Vergottung". Aber er hat anders als Seuse den Menschen innerhalb der geschöpflichen Welt wieder stärker betont. Er hielt die Erregungen der Seele in Zucht und Maß und muß innerhalb des Chores all dieser Verzückten beinahe nüchtern erscheinen. Er atmet eine Stille und Milde, die von

hoher Selbstvollendung zeugt. Tauler hat die mystische Predigt künstlerisch auf die gleiche Höhe gehoben, wie die beiden mystischen Seelenpaare das Seelenbild und den Brief.

Wie Nürnberg und Augsburg, so hebt sich auch Straßburg mit seiner *Straßburg* eigenen geistigen Gestalt aus seiner landschaftlichen Umwelt heraus. Der Übergang von der ritterlichen Dichtung zum bürgerlichen Schrifttum vollzog sich ähnlich wie im fränkischen Rheintal. Wie der Verfasser des „Karlmeinet", so arbeiteten um 1335 auch *Klaus Wisse* und *Philipp Colin* in Wolframs „Parzival" alles hinein, was irgendwie stofflich damit zusammenhing. *Egenolf von Staufenberg* und *Kunz Kistener* bildeten im Stil Konrads von Würzburg an der Novelle weiter. Der Mittelpunkt der adeligen Mystik war das Johanniterhaus zum Grünen Wörth, das der Bankherr Rulman Merswin 1366 stiftete. Merswins Schreiber *Nikolaus von Löwen* machte nach dem Tode seines Herrn um dieses Haus eine künstliche Legende, indem er je nach den *Der* Bedürfnissen des Hauses dem geheimnisvollen Gottesfreund aus dem Ober- *Gottesfreund* lande, den er erfunden hatte, immer neue Schriften andichtete. Nicht wenig, was in Straßburg geschrieben wurde, wies schon nach vorwärts auf Gengenbach und Murner, so nach 1350 *Meister Altswert* mit seinem Gedicht von der Fahrt zum Venusberg und um 1432 der Predigerbruder *Ingolt*, der in seinem „Goldenen Spiel" eine Reihe von Spielen sittlich-sinnbildlich auslegte. Der glänzende Sieg der Straßburger Bürgerschaft 1262 bei Hausbergen über die Reisigen des Bischofs erweckte die bürgerliche Geschichtschreibung. Sie gipfelte zunächst um 1382 in dem deutschen Zeitbuch *Jakob Twingers von* *Twingers* *Königshofen*. Er gab kirchliche und weltliche Geschichte nebeneinander, *Zeitbuch* unterschied zwischen deutschen und gallisch gewordenen Franken und wandte sich gegen die Ansprüche der Franzosen.

Dies alles geschah, während im großen Knie des Oberrheins sich ein bundesgenössisches Gemeinwesen herauszubilden begann, das alle Stände und Arten des politischen Zusammenlebens in einer höheren Einheit zusammenfaßte und diese Glieder mit einem gleichartigen Geiste zu durchdringen strebte. Die Habsburger hatten, mit dem Schwerpunkt in Aargau, als Grund- *Habsburg und* besitzer, Landgrafen und Schirmvögte aus so mannigfachen Rechten und *die Eidgenossen* Ansprüchen den Kern eines landesfürstlichen Staates geschaffen, der wuchs und eine große Zukunft zu haben schien. Die deutschen Könige habsburgischen Geschlechts Rudolf I. und Albrecht I. hatten mit dieser Hausmacht das deutsche Reich regiert und ihr die bairische Ostmark hinzugewonnen. Da begannen sich seit der Mitte des dreizehnten Jahrhunderts vom Vierwaldstätter See aus kleine, volksfreie Gemeinwesen gewaltsam von diesem wer-

denden Herrenstaat abzulösen, zu einem bäuerlichen und bürgerlichen Staatenbund zusammenzuschließen und den landesfürstlichen Staat, dem sie entsprungen waren, in sich aufzusaugen. Das ist der Vorgang, der südlich des alamannischen Rheines die Jahre von 1300 bis 1450 ausfüllt.

Einwanderungs-
sage

Gleichen Schritts wie die alamannische Eidgenossenschaft sich staatlich entfaltete, schuf sie sich ein Prosaheldenbuch, in dem sich ihr Ursprung, ihre Gesinnung und ihre Frühgeschichte legendenhaft spiegelte. Die kleine Landschaft um den See der Waldstätte hat den ältesten Kern dieser Sage bewahrt und in immer neuen Bildern ausgestrahlt. Die Sage von der Einwanderung der Alamannen aus dem Norden, wie sie bereits ein ungenannter lateinischer Bericht des zwölften Jahrhunderts enthält, war in der ältest überlieferten schriftlichen Gestalt eine geschichtliche Auslegung zu gotisch-langobardisch-sächsischen Sagen. Ihr Kern war der Mythus vom Totenfergen, der die Seelen überführt. Dieser Mythus war die Vorstufe zum Meisterfährmann Tell. Dieser Mythus vom Totenfergen war, wie sich aus Etterlins Zeitbuch ergibt, am See der Waldstätte bei Brunnen örtlich festgelegt, noch ehe das Volk von

Meisterschütze
und Meisterferge

Tell wußte. Auch eine Sage vom Meisterschützen muß es gleichzeitig in derselben Landschaft gegeben haben. Dieses ursprüngliche germanische Sagengut ist durch Alamannen oder im obern Rheintal durch Goten, Langobarden oder Sachsen mündlich festgehalten worden. Diese Mythen vom Meisterfährmann und Meisterschützen sind nun, in der Gestalt Tells vereinigt, seit dem dreizehnten Jahrhundert immer wieder auf Ereignisse der sich bildenden Eidgenossenschaft bezogen und aus ihnen geschichtlich gedeutet worden. Daran haben alle drei Landschaften des ersten eidgenössischen Bundes, Uri, Schwyz, Unterwalden, ihren Anteil. Aus dem fünfzehnten Jahrhundert, da man Vorzeit und Entwicklung der Eidgenossenschaft rechtsgeschichtlich auszulegen begann, stammen die frühesten Niederschriften. Die ältere Wandersage und die weit jüngere Befreiungssage erscheinen nun verknüpft. Nach älteren Niederschriften erzählte der Obwaldner *Landschreiber Schälly* zuerst diesen Ursprung der Eidgenossenschaft am Schluß einer abschriftlichen Urkundensammlung. Von da ging der Bericht in alle Zeitbücher über. Er

Tellballade
und Tellspiel

wurde schon früh auch dichterisch geformt. Aus der ältest bekannten Tellballade von der Mitte des fünfzehnten Jahrhunderts ging das spätere Lied „*Vom Ursprung der Eidgenossenschaft*" hervor. Diese Tellballade ist in Uri entstanden. Nur Spuren des alten Waldstätter Stegreifspieles, das im Sinne Uris Tell an die Spitze der Erhebung stellte, haben sich in dem Urner *Tellenspiel* erhalten, das auf 1512 zu und wohl in Zürich zusammengearbeitet wurde. Als Prosabuch, als Lied, als Drama ist auch die eidgenössische Hel-

densage noch im fünfzehnten Jahrhundert schrifttümlich gestaltet worden. See und Ufergebirge, landschaftlich die Mitte der Eidgenossenschaft, staatlich die Wiege ihres politischen Gedankens, waren zugleich auch stofflich ein Urquell ihres Schrifttums.

Über diese dichterische Mitgift hinaus, die von dem ländlich urtümlichen Schwurbunde der Waldstätte in die Eidgenossenschaft eingebracht wurde, hat der wachsende Staatenbund als Ganzes schrifttümlich lange nicht mehr bedeutet, als seine einzelnen Glieder besaßen oder schufen. Von den beiden Klöstern hatte Engelberg in Unterwalden aus dem Jahr 1372 ein *Osterspiel* sowie eine reiche Sammlung von mystischen Handschriften und Liedern aller Art, während Einsiedeln in Schwyz, seit dem neunten Jahrhundert aus der Zelle des heiligen Meinrad entstanden, das lateinische Schrifttum pflegte und seit 1450 in Blockbüchern seine *Meinradlegende* durch das ganze eidgenössische Volk verbreitete. *Engelberg und Einsiedeln*

Die alte Habsburgerstadt Luzern, die den Anstoß zum letzten Kampf mit Habsburg 1386 gab und damit die Entscheidung herbeiführte, brachte dem Bunde eine reiche *Liederliteratur* zu. Sie hatte den vornehmsten Anteil an den Liedern über die Schlacht bei Sempach, die 1386 die Blüte der österreichischen Ritterschaft auf das Schlachtfeld streckte. Und sie behielt in dieser Kunst fortan die Führung. Zu einer staatlichen Macht reckte sich der Bund der Waldstätte erst, als ihm von den beiden starken Städten 1351 Zürich und 1353 Bern beitraten. Seitdem begann der städtische Geist die bäuerliche Ursprünglichkeit zu überflügeln. Bern, 1191 durch Berchtold von Zähringen als Brückenkopf an der Aare auf Reichsboden gegründet, betrieb mit Nachdruck das Aufgehen des ritterlichen Standes in sein junges Bürgertum. Ansätze zu einem eigenen Geistesleben boten vorerst die Klöster, zumal das der Predigerbrüder. Einer von ihnen, *Ulrich Boner* aus einer Berner Bauernfamilie, bearbeitete um 1350 in seinem Buch „Edelstein" nach den verschiedensten lateinischen Vorlagen hundert Fabeln in der Sprache seiner Vaterstadt. Der Anteil Berns an der eidgenössischen Liederdichtung war nicht groß. Das Berner Zeitbuch, das der Stadtschreiber *Konrad Justinger* aus Rottweil seit 1420 über Auftrag des Rates schrieb, legte den Grund zu der mächtigen Zeitbuchliteratur der Stadt. Zürich erschütterte durch seinen Beitritt den Bestand der Eidgenossenschaft bis auf den Grund. Auf römischem Boden gewachsen, hatte diese geistig regsamste aller oberrheinischen Städte seit den Karlingen ein eigentümliches Schrifttum entwickelt von später ritterlicher Haltung. Zur höfischen Zeit spielte die Stadt mit dem künstlerisch und ritterlich bewegten Konstanz zusammen. Der Erbschaftsstreit um *Luzerner Lieder*

Berns Schrifttum

Zürich

die verwaiste Grafschaft Toggenburg trieb Zürich wieder an Habsburgs
Seite und in den eidgenössischen Bürgerkrieg von 1440 bis 1450, bei dem
es um Sein oder Nichtsein der Eidgenossenschaft ging. Denn es war ein Krieg
um das bäuerliche oder herrenmäßige Wesen des Bundes. Dieses hoch-
gestimmte, im Grunde rittermäßige Kulturbewußtsein gegenüber der länd-
lich urtümlichen Art der Waldstätte brachte niemand besser zum Ausdruck
Felix als der federmächtige Zürcher Chorherr *Felix Hemmerlin,* 1389 bis 1458,
Hemmerlin mit seiner ebenso leidenschaftlichen wie erbarmungslosen Streitschrift über
Adel und Bauerntum „De nobilitate et rusticitate", die gerade der eid-
genössischen Gründungssage der Waldstätte an die Wurzel ging und mit
ihrem Hohngelächter den sittlichen Grundgedanken des ältesten Bundes
treffen wollte: den Uradel und die unverjährbare Freiheit des bäuerlichen
Hofes. Die Niederlage Zürichs und Habsburgs rettete die geistige Einheit
und die neue Ordnung, die im Reich wie in Europa Eidgenossenschaft hieß.
Diese gewaltigen weltanschaulichen Kämpfe zwischen Mittelalter und neuer
Zeit brannten in dem umfangreichen Gedicht aus, das um 1450 entstanden
und unter dem Namen *Heinrich Wittenweiler* überliefert ist. Es heißt „Der
Heinrich Ring". Mit Benützung älterer Gedichte baute der Künstler aus einem bäuer-
Wittenweiler lichen Hochzeitsessen und dem daraus entspringenden Krieg zweier Dörfer
„Der Ring" eine Handlung auf, in die er nach scholastischer Art einen „Ring" — so will
er das Wort Enzyklopädie übersetzen — alles Wissens einlegte: Sittenlehre,
Haushalt, Kindererziehung; Gesundheitslehre, Arzneiwissenschaft, Kriegs-
kunst. Es ist ein gewaltiges Zeitgemälde, in dem die erschütternden Kämpfe
der Eidgenossenschaft zuerst höhnisch zum Streit zweier Dörfer verkleinert
und dann durch die Stilmittel des Spielmannsepos ins Groteske gesteigert
werden. Es ist das Bild des Untergangs einer alten Welt. Hinter ihm steht
ein Unbekannter, der die gesamte Literatur des Mittelalters von ritterlicher,
mystischer und scholastischer Haltung kennt, ein überlegener Geist und kein
geringer Dichter.

So war es am Oberrhein nicht nur mit Habsburgs Herrschaft, sondern auch
mit einem großen staatlichen Gedanken und mit der ganzen Zeit, aus der er
geboren wurde, zu Ende. Die habsburgische Ritterschaft trat auch in der
Abgesang der Dichtung ab: mit den *Truchsessen von Diessenhofen,* die man durch das
Ritterdichtung ganze vierzehnte Jahrhundert verfolgen kann vom Hauslehrer der herzog-
lichen Kinder bis zum bürgerlichen Liedersänger; mit dem verarmten Land-
ritter *Konrad von Ammenhausen,* der 1337 seine gereimte Bearbeitung des
Schachbuchs Jakobs von Cessole abschloß zu einem Bild aller Stände; mit
einem der letzten österreichischen Landvögte über Aargau, Thurgau und

Schwarzwald, *Hugo von Montfort,* 1357 bis 1423, der mühsam einige Lieder reimte und von seinem Knappen vertonen ließ. In der bis zum Ende getreuen kleinen Reußfeste Bremgarten aber wurde noch unter Habsburg aus einem ritterlichen Beamtengeschlecht jener Nikolaus von Wile geboren, der unter den ersten das Zeitalter des Humanismus über Deutschland heraufführen half.

Es brach an und ging langsam auf mit den beiden Kirchenversammlungen auf alamannischem Boden. Die erste tagte 1414 bis 1418 in Konstanz. Sie *Die Konzile* zielte auf Ausrottung der Irrlehre und Einheit der Kirche. Sie führte die *von Konstanz* Deutschen mit den Wortführern des humanistischen Italien, so mit Poggio Bracciolini, zusammen. Entdeckungsfahrten durch die oberdeutschen Klöster brachten seltene Handschriften antiker Literaturwerke an das Licht. Die andere tagte 1431 bis 1449 zu Basel. Hier trafen einander die späteren kir- *von Basel* chenpolitischen Widersacher: einer der ersten deutschen Humanisten, Gregor von Heimburg; Nikolaus von Kues, der erste moderne Denker; Aeneas Silvius, der Schriftführer der Versammlung, das Haupt eines Freundeskreises von Deutschen und Romanen, die seine Dichtung, seine Beredsamkeit und sein zieres Latein bewunderten. Eine Frucht der Versammlung war die neue Basler Universität, deren Urkunde Aeneas Silvius, nun als Papst Pius II. zu Mantua am 12. November 1459 unterzeichnete. Die beiden Kirchenversammlungen, die Päpste entthronten und krönten, entschleierten dem deutschen Auge aus nächster Nähe jene Gewalt, deren Verfall bisher die romanische Ferne verhüllt hatte. Und so war auf deutschem Boden zu Konstanz und Basel dem Deutschen sein Baum der Erkenntnis gewachsen.

BAIERN und *ÖSTERREICH.* Eindrucksvoller als die Büchlein und Gedichte, in denen das ritterliche und scholastische Mittelalter ausatmete, war der literarische Zweikampf zwischen München und Regensburg, als gegen 1320 unter Papst und Barfüßern der Streit um die Armut entbrannte, in dem *Streit* zu München italienische Barfüßer für die eigene Sache und die Kaiser Lud- *um die Armut* wigs des Baiern fochten, während Regensburg auf der Gegenseite stand, sowie der Übergang der literarischen Vormacht von Regensburg auf Salzburg. Pilgram aus dem Hause Puchheim hielt zu Salzburg von 1365 bis 1396 erzbischöflich Hof, wie es weltlicher nicht gut gedacht werden konnte. Als Dichterfreund umgab er sich mit einer Art Minnehof, an dem vom Kanzler bis zum Türhüter jeder Rang und Ordnung hatte. Gleichzeitig herrschte auch im Benediktinerkloster Sankt Peter ein klangfrohes Leben. Abt Johann II. tat nach 1350 viel für den Kirchengesang. Einer seiner Brüder, der *Mönch* *Der Mönch* *Hermann,* verstand die große Kunst, beiden Herren zu dienen. Für seinen *von Salzburg*

Abt übersetzte er, der früheste Meister in diesem Fache, lateinische Hymnen und Sequenzen. Im Auftrag des Erzbischofs dichtete er neben geistlichen Liedern die weltlichsten, die zu hören waren. Mögen seine dichterischen Anreger die späten Dienstleute der Babenberger oder die frühen Kriegsknechte der Habsburger gewesen sein, im Ohr hatte er schon den Tanzschritt des bairischen Schnadahüpfels. Wenn er aus dem Wächterlied der Ritter eine volksmäßige Gutenachtweise machte und entgegen der höfischen Herrin das Bauernmädchen mit seinen Liebesliedern umwarb, so läßt sich gar nicht so sicher ausnehmen, ob das Spott auf einen alten Ton oder Mut zu einer neuen Saite sein sollte. Auf alle Fälle war dieser Mönch ein echter Dichter. Und darum wird er es beiden Herren, denen er zu dienen verstand, recht gemacht haben.

Aufbau Österreichs Habsburg hatte die Verwandlung seines Hausbesitzes aus einem alamannisch-oberrheinischen in einen bairisch-donauländischen Herrenstaat überstanden. Für das, was ihnen die Eidgenossen Stück um Stück abjagten, rundete sich endlich mit Tirol, Kärnten, Krain, Triest bis 1382 das ganze große Österreich in die Hand. Das Haus Wittelsbach war aus dem Wettbewerb um die Kaiserkrone ausgeschieden. Nun ging das Spiel zwischen Luxemburg und Habsburg. Karl IV. war den Habsburgern 1438 mit seiner Prager Universität zuvorgekommen. Da setzte Herzog Rudolf IV. 1365 in Avignon die Universität für seine Hauptstadt Wien durch. Es war die zweite auf deutschem Boden. Ein Freund der beiden habsburgischen Herzöge Albrecht und Otto, schrieb *Abt Johann* des Zisterzienserklosters Viktring bei Klagenfurt um 1350 die Geschichte des Reiches von Karl dem Großen bis zu Rudolf I. Das kunstvoll angelegte und klassisch geformte lateinische Buch liest sich wie ein aufmunternder Zuspruch in die Zukunft, die dem Lande bestimmt war. Das Österreich des luxemburgischen Reiches gehörte auch dichterisch, ohne große Worte und ohne falsche Ehrfurcht, dem Leben, wie es gelebt sein will. Die Herzöge Albrecht II. und Otto der Fröhliche hatten allerlei Dichtervolk um sich und hielten es mit ihm. Dieser sehr unhöfische Hof spiegelt sich in den *Schwänke* Schwänken, die der Wiener *Philipp Frankfürter* in das Buch „Der Pfaffe vom Kalenberg" sammelte. Aber er bot auch einem Fahrenden wie *Peter Suchenwirt* Anlässe zu seinen Ehrenreden und Totenfeiern. Und eine legendenhafte Novelle wie „Der Littauer" *Schondochs* schöpfte aus einer Erinnerung an die Preußenfahrt des Herzogs Albrecht. Diesem volksnahen Hofe entsprachen die beiden literarischen Formen, die das Wien dieser Zeit eigentümlich hervorgebracht hat: das weltliche Spiel und die Reimrede. Von den *Neidhartspiel* Schwänken, die sich an die Fersen Neidharts von Reuental geheftet hatten,

Margin notes: *Hochschule Wien*

gewann einer die Szene, die man sich im Freien denken muß. Der Hof sucht in den Donauauen das erste Veilchen. Der Finder muß den Hof rufen, damit das sittsamste Mädchen es pflücke und sich an den Busen stecke. Dieser Finder ist Neidhart. Er bedeckt das Veilchen mit seiner Mütze und eilt zum Herzog. Als der Hof zur Stelle kommt, ergibt sich, daß die rachesüchtigen Bauern Neidhart etwas unter die Mütze gelegt haben, wovon man besser schweigt. Das Spiel hat in Nürnberg und Tirol seine volle Ausbildung empfangen. Die Reimreden, in denen der Ritter „*Seifried Helbling*" 1282 bis 1299 die fremdländischen Sitten im Lande geißelt, und die *Heinrich der Teichner* zwischen 1350 und 1377 gegen das Hofleben alten Stiles und gegen das Rittertum richtet, sind gereimte Aufsätze von Zeitbetrachtern, in denen die Art von Walthers Sprüchen fortlebt. Es ist eine moderne Form für die altmodische, der *Hans Vintler* 1411 mit seinen „Blumen der Tugend" noch immer anhing. Doch das war weit draußen in Tirol. *Reimreden*

Allein aus Tirol kam auch der erste moderne Liederdichter. Denn *Oswald von Wolkenstein*, um 1367 bis 1445, aus dem Eisacktal, hat mit der höfischen Dichtung längst nichts mehr zu tun. Nach einem abenteuerlichen Wanderleben kehrte er auf den heimatlichen Hauenstein zurück. Er hat das heimatliche Landschaftsbild in getreuer Wiedergabe der Lyrik gewonnen, der erste moderne Mensch, der sich in Liedern ausspricht. *Oswald von Wolkenstein*

Durch staatsmännische Mittel kam Habsburg ans Ziel. Dem letzten Luxemburger Kaiser Sigmund folgte sein Schwiegersohn Albrecht II. Herzog von Österreich 1437 als König von Ungarn, 1438 als König in Böhmen und Deutschland. Da mischte sich noch einmal der Tod ins Spiel. Der nachgeborene Sohn Albrechts II., Ladislaus, starb, fast noch ein Knabe, 1457 und raubte damit seinem Hause Böhmen und Ungarn. Doch die deutsche Krone blieb durch Kaiser Friedrich III. fortan bei Habsburg. *Erbgang von Luxemburg zu Habsburg*

II. HABSBURGERREICH
15. bis 18. Jahrhundert

Durch Staatskunst und die unberechenbaren Würfe des Todes glückte es Habsburg, um den Kern des Reiches den Großraum einer märchenhaften Hausmacht zu spannen. Kaiser Maximilian I. gewann mit der Hand Marias von Burgund 1482 die Niederlande und Luxemburg. Der Sohn dieser Ehe, Philipp der Schöne, erheiratete 1506 mit Johanna Spanien, Sardinien, Neapel, Sizilien und Neuspanien jenseits des Weltmeeres. Der Sohn dieser Ehe, Ferdinand I., erbte 1526 mit seiner Gattin Anna Böhmen und Ungarn. Gewinn und Verlust dieses Großraumes sind zugleich auch die Grenzen des Zeitalters, das Habsburg über das Reich der Deutschen herauf und hinweg führte. Mit Burgund und Spanien geht es 1482 und 1506 glückverheißend auf. Mit dem spanischen und deutschen Erbkrieg geht es 1700 und 1740 tragisch zu Ende. *Das Großreich Habsburg*

Wie die staatliche Gestalt, so heißt auch der geistige Inhalt dieses Zeitalters in seinen weltgeschichtlichen Antrieben und Zielen nach Habsburg. Die beiden geistigen Bewegungen, die dem deutschen Reich dieses Zeitalters Gepräge und Ausdruck schufen, Humanismus und Barock, bilden zusammen eine einzige Handlung. Nur die beiden sozialen Mächte, die als Träger einander ablösten, und die beiden religiösen Gedanken, die sie wie Stoß und Gegenstoß abwechselnd vorwärts trieben, kerbten der geschlossenen Handlung in der Mitte eine Zäsur ein, die aber den Rhythmus der Handlung nicht bricht, sondern erst vollendet. Das Bürgertum als Träger und die „reformatio" von unten her als Antrieb ging vom offenen Land, von den Universitäten und Städten aus. Sie machten den Humanismus zu einer landschaftlich aufgegliederten und vielfältig unterschiedlichen Bewegung. Kirche und Kaisertum als Träger und die „reformatio" von oben her gingen von ihrem gemeinsamen Mittelpunkt aus über die Höfe und Klöster herab und machten aus dem Barock eine zusammenfassende Ordnung des Gedankens und des Stiles, in der die landschaftliche Vielfalt wie die Größe des Gesamtraumes einheitlich aufgingen. So wanderten die großen Akzente der Handlung vom Rhein nach Mitteldeutschland und Wien, während die kleinen sinnvoll von Landschaft zu Landschaft und von Stadt zu Stadt schwangen. *Humanismus und Barock* *reformatio von unten und von oben* *Eine geistliche Handlung*

Da das Reich durch den Kaiser nun im Kraftfelde seiner so weiträumigen

Hausmacht lag, hatte alles, was im Reich oder in den Eigenländern Habs-
burgs geschah, Bezug aufeinander. Denn es folgte europäischen Antrieben
oder hatte Wirkungen in Europa. Europa aber, aus seiner abendländischen
Gemeinschaft längst ein Chaos einander widerstreitender Nationalstaaten
werdend, begann in Habsburgs Hand aus Reich und Erbländern zu einer
neuen Gemeinschaft zusammenzuwachsen. Sie beginnt in einer gemeinschaft-
lichen Kunst und Literatur sichtbar zu werden. Humanismus und Barock
erscheinen abermals nur als die beiden Tonarten der gleichen Weise. Hu-

Gemeinsame
Sprache,
einheitlicher Stil
manismus ist die gemeinsame Sprache und Barock ist der einheitliche Stil
dieser Gemeinschaftskunst. Hier vertieft sich nun abermals die Zäsur zwi-
schen Barock und Humanismus, diesmal durch nationale zu den religiösen
Kräften. Die aus der abendländischen Gemeinschaft entstandenen National-
staaten drängten sich zu nationalsprachlichen Kulturen auszuformen. Der
Gedanke der „reformatio" hatte sich in drei große Bekenntnisse gespalten,
die ihn auf lutherisch, kalvinistisch und katholisch zu verwirklichen suchten.
Alle drei Bekenntnisse hatten, auch wenn sie wie Luthertum und Kalvinis-
mus nationaler Herkunft waren, europäische Geltung behauptet oder er-
rungen. Der Humanismus als eine Bewegung von Mensch zu Mensch hatte
der sondernden Macht der Bekenntnisse durch seinen Willen zum reinen

Nationalsprachige
Dichtung
Menschentum und den Ansprüchen der noch geringen nationalsprachlichen
Leistungen durch die Kraft der antiken Dichtung standhalten und alle
Gegensätze noch in seiner einheitlichen Lateinliteratur ausgleichen können.
Der Barock als eine kirchlich und staatlich gelenkte Bewegung besaß gegen-
über den gleichfalls staatlich aufgerüsteten Gegenbekenntnissen und den
nun großgewordenen nationalsprachlichen Leistungen trotz seinem anfäng-
lichen Kunstlatein diese ausgleichende Übermacht nicht mehr. Er beschränkte
sich auf einen gemeinschaftlichen Stil, der eine bekenntnismäßige und natio-
nalsprachliche Abwandlung erlaubte und sie auch erfahren hat. Doch auch
diese nationalsprachliche und bekenntnismäßige Zäsur zwischen Humanis-
mus und Barock bricht den Rhythmus der einheitlichen Handlung nicht, son-
dern rückt lediglich an deren Anfang einen starken humanistischen und an
deren Schluß einen nicht minder starken barocken Akzent. Die Handlung
geht, wie sie den Tonfall vom Bürgertum zu den Höfen gewechselt hatte,
so gewissermaßen aus dem trochäisch fallenden in den jambisch steigenden
Rhythmus über.

Die
Gemeinsprache
 Wie sah nun im besonderen die Aufgabe aus, die dem deutschen Schrift-
tum gestellt war, und wie war sie zu lösen? Habsburg beerbte Luxemburg
in jedem, und das in wörtlichstem Sinne. Es erbte von Luxemburg die

deutsche Krone und die luxemburgischen Hausländer einschließlich des ur-
sprünglichen Heimsitzes. Habsburg erbte von Luxemburg alle ungelösten
und ausgelösten Fragen, um ihnen eine Antwort zu finden. Und der Erbgang
wurde in aller Form vollzogen. Die Reichskanzlei übersiedelte buchstäblich
von Prag nach Wien mit den gleichen führenden Beamten. So blieb die neu-
hochdeutsche Sprachbewegung an den gleichen Raum der böhmisch-öster- *Erbgang von Prag zu Wien*
reichischen Länder gebunden, aber die Führung ging von der Prager an die
Wiener Kanzlei über. Das bedeutete eine zweifache Aufgabe. Einmal mußte
die Durchdringung der ursprünglich ostmitteldeutschen Schriftsprache mit
bairischen Lautformen abgeschlossen werden. Das geschah im österreichi-
schen Besitz der Habsburger. Und dann mußte die Ausbildung dieser ur-
sprünglichen Prosasprache in eine Dichtersprache vollzogen werden. Das
gelang in der schlesischen Landschaft der Habsburger. Der noch unfertige
dichtungssprachliche Ausdruck machte die deutsche Sprache unterlegen und
anfällig gegenüber den schon hochentwickelten Literaturen der westeuro- *Die deutsche und die westeuropäischen Literaturen*
päischen Völker. Es kam also dazu, daß die deutsche Literatur durch Über-
setzer und Nachbildner von den europäischen Nationalliteraturen weit mehr
empfangen mußte als sie zurückerstatten konnte. Das betraf weniger den
zeitweiligen Stil als die dauernden und überpersönlichen Dichtungsgattun-
gen. Das staufische Zeitalter hatte sich mit dem Ritterlied, dem höfischen
Roman und dem Mysterienspiel eigentümliche Formen der Lyrik, des Epos
und des Dramas herausgebildet. Als das Reich an den Osten, an die Luxem-
burger und Habsburger, überging, waren mit der neuen Dichtersprache auch
diese drei Gattungen von neuem zu schaffen. Es gab gewisse Übergänge.
Aber das habsburgische Zeitalter knüpfte nicht in einem zeitgemäßen Wan- *Die modernen Dichtungs-gattungen*
del an diese alten staufischen Gattungen an, sondern ging über das Mittel-
alter hinweg auf die antiken drei Urformen der Lyrik, des Epos und des
Dramas zurück. Der Humanismus hat in lateinischer wie in deutscher Sprache
bereits den Grund zu den drei Dichtungsgattungen modernen Stils gelegt,
ohne ein anderes Vorbild als das der Antike. Alle europäischen Kulturvölker
haben dann aus diesen neuen humanistischen Gattungen ihre eigensprach-
lichen Formen entwickelt, auch die Deutschen. Aber in Deutschland wirkten
dann zu den antiken noch die nationalsprachlichen Vorbilder der anderen
Völker mit. Die barocke Lyrik, das barocke Epos und Drama in Deutschland
sind Früchte aus diesem gesamteuropäischen Bildungsgang. So hat das habs-
burgische Zeitalter zwar das luxemburgische beerbt, aber unter gänzlich ge-
wandelten Verhältnissen Deutschland so in eine humanistisch-barocke Form
gebracht wie die Staufer das ihre in eine ritterlich-höfische.

Die Gegenpole So verlaufen die geistigen Rhythmen des Habsburgerreiches zwischen ent-
gegengesetzten Spannungskräften. Sie heißen weltpolitisch Frankreich und
Osmanentum, religiös reformierte und katholische Kirche, sozial Bürger-
schaft und Fürstenhof, gesellschaftlich Schulmann und Kavalier, künstlerisch
Dichtung und Theater. Diese Spannungen haben sich gleichermaßen im Hu-
manismus und im Barock entladen. Der gesamte Herrschaftsbereich Habs-
burgs ist ihr Spielfeld. Und nicht anders als Karlinge und Liudolfinge, als
Staufer und Welfen und Luxemburger haben auch die Habsburger unmittel-
bar anregend und mitschaffend dieses Reich des Geistes und der Kunst ge-
lenkt, von Maximilian I. bis zu Karl VI., dem ersten und dem letzten Kaiser
zugleich und Künstler in diesem Reiche.

1. DER ÖSTERREICHISCH-SÜDDEUTSCHE KREIS

Auch nach dem Verlust des Aargaues und Thurgaues an die Eidgenossen
hatte Habsburg noch durch Jahrhunderte am Oberrhein Besitzungen, die
unter dem Namen Vorderösterreich zusammengefaßt wurden. In den Bur-
gunderkriegen seit 1476 focht Habsburg auf seiten der Eidgenossen, und im
Schwabenkrieg 1499 kreuzte es mit ihnen zum letztenmal die Waffen. Doch
Donautal weit über Besitz und politische Beziehungen, die von Madrid und Wien her
und Oberrhein in den katholischen Staaten der Eidgenossenschaft zusammenliefen, hielt der
geistige Wechselverkehr zwischen dem alamannischen Oberrhein und dem
österreichischen Donautal allem Wandel der Jahrhunderte stand. Er fand in
den beiden habsburgischen Universitäten Wien und Freiburg sichtbaren
Ausdruck. An den Universitäten Wien und Basel sind die Männer humani-
stisch erzogen worden, die dann am Oberrhein Geschichte gemacht haben.
Die Bildung des Frühhumanismus hat sich in dem Raum zwischen Wien und
Basel abgespielt. Die beiden oberrheinischen Kirchenversammlungen haben
die Saat gelegt, die dann zu Wien und Basel in die Scheuern reifte. Den gan-
zen Raum umrundet ein in sich geschlossener Kulturkreis.

Maximilian I. WIEN. *Maximilian I.*, 1459 bis 1519, der Sohn Kaiser Friedrichs III.,
Seine Werke 1486 deutscher König, 1493 römischer Kaiser, war der Begründer der habs-
und Mitarbeiter burgischen Weltmacht und Mitschöpfer der frühhumanistischen Bildung. Er
war ritterlich erzogen, ein leidenschaftlicher Sportsmann und Liebhaber der
Künste. Er umgab sich mit Gelehrten, Dichtern, Tonkünstlern und behan-
delte die Erlesenen als seine Freunde. Sei es als Anreger oder Entwerfer der
Pläne oder als Mitarbeiter: der Kaiser nahm an fast allen Schöpfungen seiner

Umgebung tätigen Anteil. Seine dichterischen Werke sind Selbstdarstellung. „Weisskunig", bis 1514 durch seinen Schreiber Max Treizsauerwein in letzte Form gebracht und erst 1775 gedruckt, ist Zeitbuch und Roman zugleich, der die Geschichte Friedrichs III. und die Jugend Maximilians I. anziehend und kulturgeschichtlich wertvoll erzählt. „Teuerdank" ist vom Kaiser selbst entworfen und in den meisten Abschnitten auch ausgeführt. Sein Schreiber, der Nürnberger Melchior Pfintzing, hat diese erste Fassung nachgeglättet und in Verse gebracht. Es ist ein Sportbuch, Jagdabenteuer und Kriegserlebnisse, vom Kaiser schlicht und wirklichkeitsnahe und spannend erzählt, vom Überarbeiter zu einer Allegorie verpfuscht in dem Bemühen, dem frischlebendigen Prosabuch eine „höhere Bedeutung" zu geben. Die Sprache des Buches ist erstaunlich modern. Denn es ist die ostmitteldeutsch-österreichische Sprache der Reichskanzlei. Als ein wahrhaft kaiserliches Buch wurde der „Teuerdank" reich bebildert 1517 zu Nürnberg gedruckt. Maximilian I. verkörpert die neue Welt, die in Wien heranwuchs, weil er an ihr und wiederum sie an ihm lebendigsten Anteil nahm.

Begründerinnen und erste Trägerinnen der humanistischen Bildung waren in Wien Reichskanzlei und Universität. Den Umzug der Kanzlei von Prag nach Wien hatte Kaspar Schlick, 1400 bis 1449, durchgeführt. Er war aus einer ostfränkischen Familie zu Eger geboren, ein glänzender Redner und erfolgreicher Staatsmann. Schlick hat so dem laufenden sprachlichen Bildungsgang die ungebrochene Stete gesichert. In diese Kanzlei hatte noch Friedrich III. einen der begabtesten Männer seines Zeitalters berufen, *Aeneas Silvius Piccolomini* aus Siena, einen der ersten Kenner der Antike, auf der Basler Kirchenversammlung ein hinreißender Redner, der spätere Papst Pius II. Die beiden Schreibstuben, denen er angehörte, die kaiserliche und die österreichische, wurden die ersten Pflegestätten, seine Amtsgenossen die ersten Träger der neuen Bildung in Deutschland. Er schrieb die Geschichte Böhmens, schilderte das Leben Friedrichs III. und erzählte nach einem italienischen Abenteuer seines Freundes Schlick die rührende Liebesnovelle „Eurialus und Lucretia", die für ihre Zeit gewesen ist, was Goethes „Werther" der seinen war. An der Universität begann der Kanzler Friedrichs III., Bernhard Perger, ein Steirer, den Humanismus seit 1455 durchzusetzen. Aufgeblüht ist er und eine Macht wurde er durch eine ganze Gruppe junger Ostfranken: durch den Archimedes seiner Zeit, den Mathematiker und Astronomen Johannes Müller, Regiomontanus; durch Johannes Spießheimer, Lehrer der römischen Literatur, Geschichtschreiber Österreichs und Staatsmann Maximilians I. Ihr aller Gönner war der Staatsmann des Kaisers, der Passauer

Reichskanzlei und Universität

Aeneas Silvius

Humanismus zu Wien

Hans Krachenberger, Soldat und Rechtsgelehrter, Dichter und Geschicht-
schreiber, der über der Arbeit zu einer deutschen Sprachlehre hinwegstarb.

Ein Ostfranke und ein Alamanne haben Wien zur kaiserlichen Hauptstadt
des deutschen Humanismus gemacht. Der Ostfranke war Konrad Celtis, der
Alamanne Joachim von Watt.

Konrad Celtis

Konrad Bickel, Celtis, 1459 bis 1508, aus Wipfeld, eines Winzers Sohn
und selber ein Freund des Weines, hat als ein wahrer Pilgrim der Weisheit
lernend und lehrend, die meisten deutschen Universitäten abgewandert. Er
folgte 1486 dem Lockruf der Ewigen Stadt. Es gab in Italien keinen berühm-
ten Lehrstuhl, in dessen Inhaber er nicht das Handwerk begrüßt hätte. Wie
er von Rom aus die lateinische Welt durchstreifte, so 1488 von Krakau aus
die sarmatische, die Karpaten, Böhmen und Ungarn. Es hat wenig Deutsche

Seine Wanderungen

gegeben, die so wie er ganz Deutschland erwandert und erfahren hatten.
Durch Krachenberger wurde er endlich 1497 als Lehrer der Dichtkunst und
Beredsamkeit, das war der klassischen Philologie, an die Wiener Universität
berufen. Also war er mitten in den europäischen Raum hineingestellt, den
er aus der Beute seiner Augen wie keiner seiner Zeitgenossen kannte. Von
Wien aus hat er als akademischer Lehrer am weitesten und tiefsten auf die
Jugend eingewirkt. Er war ein geborener Ordner. Die „Sodalitates", die er

Seine „Sodalitates"

in verschiedenen deutschen Landschaften gegründet hatte, waren sicherlich
im Sinne der platonischen Akademien Italiens als zeitgemäße wissenschaft-
liche Körperschaften gedacht, entgegen den Universitäten, die man für un-
rettbar der Scholastik verfallen ansah. So auch die Sodalitas Danubiana, die
Celtis im Herbst 1497 zu Wien aufrichtete. Das Gewicht seiner Lehrtätigkeit
lag außerhalb der Universität in dem Collegium poetarum et mathemati-
corum, das er 1502 feierlich eröffnen ließ. Es war eine neuartige Arbeits-

Seine akademische Tätigkeit

gemeinschaft von Lehrenden und Lernenden, ein modernes Hochschulsemi-
nar. Konrad Celtis ist in Wien zum ersten großen akademischen Lehrer neuen
Stils herangereift. Er hat wie kein anderer wahrhaft schulbildend gewirkt.
Er schuf die besten Lehrbücher. Er hat die herkömmliche Fachgruppe der
Artisten aus einem vorbereitenden Lehrgang zu der modernen philosophi-
schen Fakultät gemacht. Er hat diese mit einer Allseitigkeit lehrend ver-
treten, wie sie damals noch möglich war. Aus jeder seiner Vorlesungen sprach
die ganze philosophische Fakultät. Darum war er Leiter des Collegium poe-
tarum und Vorsitzender der Prüfungen mit der Vollmacht, den Lorbeerkranz

Sein Weltbild

des Dichters zu verleihen. Und er war selber der erste Dichter seiner Zeit.
Aus der Philosophie Platos und des Nikolaus von Kues wie der italienischen
Renaissance hat Celtis sich ein persönliches Weltbild geschaffen. Gott ver-

bunden fühlte er sich allein durch die Natur. Der Blick hinter die Dinge und die Geduld auf einen jenseitigen Lohn hatten für ihn keinen Reiz. Gott und die Welt sind eins. Die Welt besteht aus einer unendlichen Fülle von Urkörperchen. Eine geheimnisvolle Kraft, die Liebe, die das Gesetz aller Wesen ist, ordnet diese Urkörperchen aus dem Chaos zur belebten Gestalt. Der Tod wacht über dem Gleichgewicht der Welt. Die Gestirne lenken die Mischung der Urstoffe. Das Gesetz der Zahl waltet auf eine geheimnisvolle Weise in *Konrad Celtis* allen Dingen und Verhältnissen. Der Mensch lebt aus dem Blute. Die Witterung gibt ihm wechselnde Gestalt. So liegt seine Weltanschauung beinahe im Gleichgewicht zwischen dem Glauben an die Strahlungskraft der Gestirne und dem Wissen um die ewige Mutterschaft der Erde. In seinem All steht noch die Erde im Mittelpunkt und auf seiner Erde der Mensch. Das gegenwärtige Weltalter aber wird vom Gestirn des deutschen Volkes regiert. Denn in den Händen des deutschen Volkes befinden sich die beiden Grundmächte der geordneten Welt: imperium, das allumfassende Reich, und philo- *Imperium und Philosophia* sophia, die Ganzheit der Geistesbildung. Beide wechseln im Laufe der Menschheitsgeschichte von Volk zu Volk, nicht durch Erbgang, sondern durch freie Wahl der Berufung. Die Antike der Griechen und Römer ist nur eine Stufe in diesem Bildungsgang der Menschheit. Diese Gedanken sollten in einem großgeplanten Gemeinschaftswerk dargestellt werden, in einer „Germania illustrata", die den Gelehrten und Dichter seit etwa 1491 beschäftigte. Diesem Werk galten seine Reisen. Für dieses Werk setzte er die Mitarbeit seiner Schüler und Freunde ein. Der Gedanke blieb in ein paar kleineren Werken stecken: in der Ausgabe der „Germania" des Tacitus und in des Celtis „Germania generalis", beide 1500, in der „Norimberga", 1495, und in den „Quatuor libri amorum", 1502, dem schönsten dieser Gestaltungsversuche. Des Celtis Weltanschauung, Wissenschaft und Deutschkunde gipfelt in dem Lockbild des erneuerten Kaisertums und also in einer Tat, die mit allen Kräften zu tun ist. Die „Vier Bücher Liebesgedichte", 1502, er- *„Vier Bücher Liebesgedichte"* fassen das deutsche Volk in seiner kosmischen Ganzheit und in jener heiligen Vierzahl, durch die sich uns alle Natur offenbart. Das Deutschland seiner vier Ströme und Himmelsgegenden erscheint uns hier in seiner ganzen vierfachen Vielfältigkeit der Temperamente und des Klimas, jede der Vier bezogen auf eines der vier Elemente, auf eine der vier Tageszeiten und Jahreszeiten, auf eines der vier Lebensalter, und jede der Vier schicksalsvoll bestrahlt von dem ihm zugeordneten Sternbild. Mit vier Mädchen erlebt der Dichter dieses vierfältige Menschtum und Deutschland: zu Krakau, der damals deutschen Stadt, den deutschen Osten in lenzhafter Natur und Jugend;

den deutschen Süden in sommerlicher Reife der Natur und des Lebens zu
Regensburg; den deutschen Westen in herbstlichem Genuß der Weinlese zu
Mainz; den deutschen Norden zu Lübeck, vom Winter bedrängt und des
Todes gewärtig. Das persönliche Dasein des einzelnen Menschen ist erlebnis-
haft und auf mystische Weise eins mit den hier vierfältig gedachten Erschei-
nungsweisen des deutschen Volkes und seines Landes. Konrad Celtis ist der
erste deutsche Dichter, der mit einem kühnen Gesamtbild das deutsche Volk
und in diesem sich selbst persönlich dargestellt hat. Seine Festspiele und das
unvollendete Epos „Theodoricus" — Dietrich von Bern — lassen ahnen,
was mit diesem früh verbrauchten Mann unterging, der noch nicht fünfzig
Jahre alt war, als er sterben mußte.

Joachim *Joachim von Watt*, Vadianus, 1484 bis 1551, aus Sankt Gallen, war der
von Watt Schüler des Cuspinianus und Celtis, der Erbe beider und nach dem Tod des
Celtis der anerkannte Führer des Wiener Humanismus. Er war nur einer
von den vielen jungen Eidgenossen an der Wiener Universität, der er seine
ganze Ausbildung als Schüler und Lehrer verdankt. Er wurde 1516 auf 1517
ihr Rektor. Ähnlich wie Celtis mit Europa, so war Watt durch seine Reisen
und seinen umfassenden Briefwechsel mit dem geistigen Schaffen der neuen
Habsburger Großmacht vertraut und vielfältig verbunden. Und wie Celtis
war er bemüht, als akademischer Lehrer die gesamte philosophische Fakul-
tät zu vertreten. Joachim von Watt hat im Winterhalbjahr 1512 auf 1513 im
Rahmen eines literaturwissenschaftlichen Gesamtaufrisses — „De poetica
Die Heldensage et carminis ratione", 1518 gedruckt — die ersten Vorlesungen über deutsche
Literatur gehalten. Im Anschluß an die antiken Literaturen und aus eigener
Kenntnis gab er hier einen Überblick über die deutsche Dichtung des Mittel-
alters, zumal der Heldensage, und des frühen humanistischen Schrifttums.
Damit hat er die Wiener Universität zur Wiege der deutschen Literatur-
geschichte gemacht. Watt kehrte 1518 in seine Heimat zurück.

Die Gestalt des Kaisers Maximilian I. wird hinter allem sichtbar, was der
Wiener Humanismus geschaffen hat. Seine Liebe zur mittelalterlichen Hel-
dendichtung, die auch seine Abschreiber beschäftigte, ist mittelbar in dem
„Theodoricus" des Celtis und in Watts Literaturvorlesung zu spüren. Auch
Die Hofkapelle die Hofkapelle des Kaisers war humanistisch gerichtet. Ihr Leiter war der
Laibacher Humanist Georg von Slatkonia, der spätere Wiener Bischof. An
ihr wirkte der Flame Heinrich Isaak sowie dessen Schüler und seit 1515
Nachfolger, der Schweizer Ludwig Senfl. Der Salzburger Paul Hofhaimer
und der Tiroler Tritonius Athesinus vertonten klassische und humanistische
Dichtungen.

Vom Kaiser und seinen humanistischen Dichtern gingen die Anfänge des *Ursprünge des Wiener Theaters* späteren Wiener Barocktheaters aus. Das älteste und ausdauernde Bühnenleben Österreichs hat sich in dem Tiroler Städtchen Sterzing am Südfuß des Brenners seit 1455 entwickelt. Ganze Spielgesellschaften entstanden hier und in den Nachbardörfern Gossensaß wie Stilfes. An ihrer Spitze standen *Stöffl Schopfer* und *Vigil Raber*. Aufgeführt wurden eine Passion nach einem *Volksspiele* eigenen Spielbuch von etwa 1490, ein Tanzspiel von den sieben Farben, das aus Nürnberg stammte, „Der tote König", nach dessen Herzen die drei Söhne mit Pfeilen um das Erbe des Reiches schießen, und „Das Reckenspiel", der Kampf um den Rosengarten. Offensichtlich wirkt hier der Einfluß Sigmunds des Münzreichen, der 1463 das „Reckenbuch" abschreiben ließ und zu Innsbruck auf eine sehr prächtige Art herzoglichen Hof hielt. Von dieser Tiroler Überlieferung wurde nichts übernommen, als die humanistischen Dichter Wiens der Kaiserstadt ein zeitgemäßes Drama zu schaffen begannen, obwohl gerade ihnen die deutsche Heldensage bekannt war. Konrad Celtis knüpfte bei seinen Kaiserspielen, die er 1501 zu Linz und 1504 zu Wien durch Studenten vor Maximilian aufführen ließ, an die Hofmaskenkomödie der italienischen Renaissance an. Der Freund des Celtis, der spätere Abt des Schottenklosters Benedictus Chelidonius ging auf die alten Streitgespräche zurück, als er 1515 vor Erzherzogin Maria und deren Bräutigam Ladislaus von Ungarn seine „Voluptatis cum virtute disceptatio" spielen ließ. Und des Celtis Schüler Joachim von Watt folgte mit seinem „Hahnenkampf", „Gallus pugnans" 1514 der akademischen Übung des gelehrten Redekampfes. Doch jede der drei Stilarten hat dem späteren Wiener Theater vorgearbeitet: Celtis mit seinen Staatshandlungen, die mit Gesang und Tanz und derb- *Schottenspiele* komischen Szenen ausgelegt waren; Chelidonius mit seinen persönlich verkörperten sittlichen Kräften und Begriffen; Watt mit seiner possenhaften Hanswurstweisheit und dem Zusammenspiel von Bühne und Zuschauer. Das deutsche Spiel der Stadt, wie es *Wolfgang Schmeltzl*, um 1500 bis um 1560, aus Kemnat in der Oberpfalz, Musiker im Schottenkloster und Wiener Bürger, geschaffen hat, machte naturgemäß um diesen Humanistenstil einen weiten Bogen. Seine sieben biblischen Stücke aus den Jahren 1540 bis 1551, die im Schottenkloster und im Rathaus vor der Bürgerschaft gespielt wurden, haben schon den Stil des evangelischen Dramas und folgen entweder Wilhelm Gnaphaeus oder Paul Rebhun oder gehen unmittelbar auf die Bibel zurück.

So hatte die humanistische Bühnenschöpfung der Kaiserstadt im Augenblick noch die alte Volksspielüberlieferung und den neuen evangelischen

Bühnenstil gegen sich. Aber der Humanismus hatte in Wien den Grund zu den beiden barocken Arten des Dramas gelegt: Festspiel und Volksposse.

Hochschule Basel *BASEL.* Die Universität, die am 4. April 1460 feierlich eröffnet wurde, hatte zunächst die Szene für sich. In die Wiege gelegt war ihr das Vorbild von Bologna. Bemannt hat sie sich aus den deutschen Hochschulen von Heidelberg und Erfurt, entschieden für die geistige Richtung von Paris. Der Basler Frühhumanismus hat sich ohne wesentliche Erschütterung gegen den scholastischen Schulbetrieb durchgesetzt. Einer ihrer frühen und langen Vorzüge war die Pflege der griechischen Sprache, um deretwillen sie viele spätere Humanisten von Rang aufgesucht haben. Diese Universität hatte das Glück, daß sich zu ihr als verbündete Großmacht der Basler Buchdruck ge-

Basler Buchdruck sellte. Der Schwabe Johannes Amerbach, seit etwa 1475 und der Franke Johannes Froben, seit 1491 selbständig, seit 1514 Amerbachs Nachfolger in der Druckerei „Zum Sessel" auf dem Fischmarkt, machten nebst dem Basler Johann Oporinus Basel zur ersten Druckerstadt in Deutschland.

Die Allmende zwischen Universität und Druckerei gehörte *Sebastian Brant,* 1458 bis 1521, aus Straßburg und Jakob Locher, 1471 bis 1528, aus

Sebastian Brant Ehingen, die, Lehrer und Schüler, das erste Beispiel voller Ausnützung aller Möglichkeiten gaben, wie sie die Verbindung von akademischem Lehramt und buchhändlerischer Unternehmungslust darboten. Einsichtig und klug ihre Kräfte teilend, suchten sie durch deutsche und lateinische Ausgaben gemeinsamer Werke gleichmäßig auf Gelehrte und Ungelehrte zu wirken. Brant war von den beiden der vielseitige Zeitungsmann, Locher der lyrisch Gestimmte. So ließ Brant 1494 sein „Narrenschiff" erscheinen, in guten deutschen Versen, die dem neuen Gemeindeutsch schon sehr nahe standen und Locher gab die Dichtung 1497 als „Stultifera navis" in lateinischer Übersetzung heraus. Aus dem einen Bilde, daß alle menschlichen Narrheiten in leibhaftiger Gestalt auf ein Schiff verfrachtet und außer Land gebracht werden, wird ein Gemälde des ganzen Zeitalters hervorgezaubert. Die Dichtung hat die Menschen bestrickt und sie wurde ein Welterfolg durch Locher. Das Buch, bis ins einzelne buchkünstlerisch durchstilisiert, mit nicht ganz gleichwertigen Holzschnitten ausgestattet, gehört zu den schönsten des Jahrhunderts. Und so waren wohl auch Brant und Locher die ungenannten Verfasser der Terenzübersetzung, die 1499 in Straßburg erschienen ist.

Humanismus in Basel Nicht die Universität, aber die Stadt Basel hat Wien als Vorort des deutschen Humanismus beerbt. Hier nahm der König im Reich der freien und schönen Geister seinen Wohnsitz. Hier hat der erste humanistische Arzt der Verachtung seines Jahrhunderts getrotzt.

Desiderius Erasmus von Rotterdam, 1467 bis 1536, kam 1513 zum ersten-
mal nach Basel und bezog dann bei seinem königlichen Vetter, dem Drucker-
herrn Johannes Froben, eine eigens für ihn erbaute Stube. Solche Wohn-
gemeinschaft hatte einen tiefen Sinn. Denn zu Hause war der deutsche
Humanismus nicht in der Basler Universität, sondern in den Werkstätten der
Basler Presse. Nach einer traurigen Jugend war Erasmus Augustinerchorherr
geworden und wurde dann auf Betreiben Heinrichs von Berghes, Bischof
von Cambrai, aus der Klausur entlassen, weil der ihn als Reisebegleiter nach
Italien wünschte. In Paris, in England, in Italien, überall war er zu Hause,
wo man humanistisch dachte, weil das Reich des Humanismus sein Vaterland
war. Er galt diesem Zeitalter, was Voltaire dem seinen gegolten hat. Mitten
im Streit der Meinungen und Parteien hüllte er sich in ein undurchdring-
liches staatsmännisches Schweigen. Seine Verse waren Adelsbriefe, um die
jede Stadt die andere beneidete. Sein Lob entschied über den Rang der Gei-
ster und galt im Kreise der Eingeweihten als Schutzzeichen. Es war eine
Selbstverständlichkeit in seinen Erfolgen, die weder in seiner Person noch in
seinen Werken ganz begründet ist. Unter seinen Dichtungen war das „Morie
Encomion" 1512 der Vater einer neuen Gattung, der satirischen Lobschrift.
Von seinen Plänen wurden verwirklicht eine Ausgabe des Hieronymus, des
Seneca, die 1515, das griechische Neue Testament, das 1516 erschien, ein
Buch, das die Arbeit eines ganzen Zeitalters bedeutete. Wie ein Feldherr der
Philologie umgab er sich mit einem ganzen Stabe junger Offiziere, als er seit
1518 die lange Reihe seiner Kirchenväter und Klassiker erscheinen ließ. Aber
er hatte nicht ungestraft jenseits des Streites stehen wollen. In der Stunde
der Entscheidung mußte er, von beiden Seiten gestellt, Farbe bekennen. Er
tat es in seiner Weise, indem er von Luther abrückte, ohne sich eindeutig für
dessen Gegner zu bekennen.

Theophrast Bombast von Hohenheim, 1493 bis 1541, aus Einsiedeln in
Schwyz, kam 1526 nach Basel als Arzt und Hochschullehrer. Er heilte wie ein
Wundertäter den gelähmten Fuß des Druckerherrn Froben. Seine Basler Vor-
lesungen bedeuteten einen Frevel gegen alles Herkommen. Rücksichtslos
brachte er das Ansehen der Antike und den philologischen Schlendrian auf
dem einen Gebiet, der Heilkunde, zum Einsturz. Statt die Schriften der anti-
ken Heilkünstler auf humanistische Weise auszulegen, lehrte er die ärztliche
Kunst an der gesunden und kranken Natur. Er begann das chemische Zer-
setzen und Verbinden unter ganz neuen Gesichtspunkten zu betrachten: „Der
wahre Gebrauch der Chemie ist nicht, Gold zu machen, sondern Arzneien".
So trat er an den Anfang der ärztlichen Chemie. Seine deutschen Schriften,

zumal das Büchlein über das Heilbad Pfäffers, 1535, gehören in die Ge-
schichte der alamannischen Prosa. Hohenheim lernte und lehrte im Befahren
der Landstraßen. Wie er als Arzt, ein Verächter des humanistischen Bücher-
glaubens, nur seinen eigenen Augen traute, so ging er auch in seinen theolo-
gischen Schriften eigene Wege, ohne daß er einer der neuen Kirchen ange-
hörte. Seine Philosophie war neuplatonisch, vom silbernen Geäder der deut-
schen Mystik durchsetzt. Durch seine neue Scheidekunst, seine Naturlehre,
seinen mystischen Neuplatonismus hat Hohenheim über die zahllosen Ärzte,
die auf ihn schwuren, das deutsche Denken, zumal des Ostens, im Zusam-
menwirken mit dem Gedankenerbe Meister Eckharts unabsehbar beeinflußt.
Hohenheim ist zu Salzburg gestorben.

Der Sieg der Kirchenbewegung in Basel 1529 bedeutet die Wende vom
Humanismus zu einer deutschsprachigen Dichtung. Auch sie ist, wie wört-
Basler lich so bildlich gesprochen, aus der Basler Druckerkunst hervorgegangen. Sie
Totentanz las sich ihren eigentümlichen Stil von der Kirchhofmauer des Predigerklosters
in Großbasel ab, wo seit alters allvertraut die launigernste Folge der Toten-
tanzbilder zu den Menschen redete. Dieses alte Tanzspiel, das einfach in
bildhaften Darstellungen erstarrt war, begann aus diesen Bildern und ihren
Beischriften, sich rückläufig entwickelnd, wieder dramatisch aufzuwachen.
Das Basler Spiel Der Basler Drucker *Pamphilus Gengenbach,* ein Nürnberger, Verfasser von
Zeitungen, die er im Meistersängerton reimte, hatte offenbar diese Toten-
tanzbilder im Kopf, als ihm der buchhändlerische Einfall kam, eine gedank-
lich einheitliche Bilderfolge mit zugehörigen erklärenden Beischriften derart
ins Bühnenmäßige zu übertragen, daß die Bilder nach Art der stummen
Komödie gespielt und die Beischriften dazu gesprochen werden konnten.
Diese Kunstweise, Buchbilder mit Beischriften ins Bühnenhafte umzusetzen,
liegt den zwei ältesten Bilderfolgen Gengenbachs zugrunde. „Der welsch
Fluß" — ein Kartenspiel der Zeit und kurz vor 1514 entstanden — stellt die
Kriege um Italien dar. Die handelnden Mächte spielen Karten, und jede wirft
ihr Blatt mit drei gleichgereimten Versen aus, deren Form aus Brants „Nar-
renschiff" stammt. „Der alt Eydgenoss", vor Abschluß des eidgenössischen
Vertrags mit England 1514 entstanden, wollte in gleichem Stil die Orte vor
allem Bündniswesen warnen. Der Buchhändler, der Zeitungsmann, der Be-
trachter der Basler Totentanzbilder, der reifende Spielbuchdichter waren in
gleicher Weise an diesen dramatisch gestalteten Leitaufsätzen beteiligt. Es
wurden wirklich aufgeführte kleine Dramen daraus: „Die zehn Alter", 1515,
wo der Einsiedler die Vertreter der Zehnerlebensstufen an sich vorbeiziehen
läßt, jedem seine Alterssünden abfragt und zur Buße mahnt; „Gouchmat",

1516, wo die Brünstigen nach Stand und Alter geordnet um Venus werben; „Nollhart", 1517, wo die Mächte Europas den Bruder Methodius, die heilige Brigitta und die Sibylle von Cumä um ihre eigene Zukunft befragen. Einheitliche Holzschnittreihen mit Beischriften, die szenisch lebendig geworden sind, das war Gengenbachs dramatischer Fund.

Inzwischen hatte sich auch die Bildkraft des Malers, *Hans Holbein*, an den Totentanzbildern des Predigerfriedhofes entzündet. Unter dem Eindruck des Bauernkrieges vollendete er spätestens 1526 seine „Bilder des Todes", 40 Blätter, im Triumph des Todes von einem spöttischen Lächeln begleitet, der Triumph der ausgleichenden sozialen Gerechtigkeit. Unter dem Eindruck dieser Basler Bilder Holbeins brach nun auch im Basler Drama der Totentanzgedanke unmittelbar durch. Ein Totentanzspiel sind die „Fünferlei Betrachtnisse", 1532, des Basler Schulmeisters *Johannes Kolros*, der aus Hochdorf bei Luzern stammte und das erste deutsche Rechtschreibbüchlein verfaßte. Ein Totentanzspiel war „Der Weltspiegel", des Elsässers *Valentin Boltz*. Als Terenzübersetzer war er mit der antiken Spielweise vertraut. Er war bei den Barfüßern ein scharfer Kanzelredner und galt besonnenen Baslern als Volksaufwiegler. Daß er Freude an der leidenschaftlich bewegten Menge hatte, bezeugen die Massenszenen seiner Stücke, worunter „Pauli Bekehrung", 1546, mit nicht geringer Kunst Sinn und Vorgang der Kirchenerneuerung vor Augen stellte. „Der Weltspiegel" nun, 1550 im Angesicht der Totentanzmauer gespielt, ist ein mächtig angelegtes dramatisches Bilderbuch, eine Auslese aus damals beliebten und gespielten Stücken, ein Weltbild, auf die Eidgenossenschaft bezogen. Nur ein Held beherrscht die Bühne, der Tod mit Pfeil und Bogen.

Dieser einzigartige und beinahe persönliche Bühnenstil entsprach allein einer Stadt, die von dichtenden Buchdruckern und dramatisch veranlagten Buchbildkünstlern beherrscht war. Der Basler Buchdruck hat den Basler Humanismus und das Basler Bühnenspiel großgezogen. Das evangelisch-antikische Humanistendrama kam gegen den eingeborenen Basler Stil nicht auf. Es lag in den Händen eines zugezogenen Schwaben. *Sixt Birk*, 1501 bis 1554, ein Webersohn von Augsburg, wirkte einige Jahre als Lehrer bei Sankt Theodor in Kleinbasel und als Schulleiter im Predigerkloster zu Großbasel. In dieser Zeit, 1530 bis 1535, wurden seine deutschen Bibelstücke gespielt, worunter eine „Susanna", ein „Josef", eine „Judith", alles Dichtungen eines klassisch gebildeten Kunstverstandes, mit Chören, eingelegten antiken Strophen, einer straff geführten Handlung, Dramen also nach dem Vorbild der attischen Tragödie und des in Mitteldeutschland ausgebildeten Bühnenstils.

Hans Holbein

Valentin Boltz

Sixt Birk

Es fehlte diesem unglaublich geschlossenen geistigen Stadtbilde nicht an einer bedeutsamen Schmuckleiste, die es in das weite Rund der Welt einfaßte. Der Setzer, Buchführer und Anwalt *Johann Wetzel* verdeutschte 1583 „Die Reisen der drei Söhne Giaffers", eine Rahmenerzählung mit sieben *Sebastian* morgenländischen Geschichten. Und der Rheinfranke *Sebastian Münster* ließ *Münster* als Basler Hochschullehrer 1543 von Basel seine „Cosmographia" ausgehen. Das war, oft gedruckt und viel übersetzt, die erste umfassende Erdkunde in deutscher Sprache, mit vielen Bildern und Karten ausgestattet und zur Hälfte der Darstellung Deutschlands gewidmet.

Der *DIE ALAMANNISCHEN STÄDTE.* Im Kraftfeld von Wien und Basel, *Kanzleibeamte* von Universität und Buchdruck, haben die alamannischen Städte den deutschen Humanismus zu dem gemacht, was er galt und für Deutschland wert war. Erste Heimat und frühestes Spielfeld waren die landesfürstlichen und reichsstädtischen Kanzleien.

Nikolaus *Nikolaus von Wile,* um 1410 bis 1478, aus dem Habsburger Städtchen *von Wile* Bremgarten im Aargau, war Eßlinger Stadtschreiber und württembergischer Kanzler. Er gehörte zu den engsten Schülern des Aeneas Silvius. Als Staatsmann, Maler und Übersetzer prägte er diesseits der Alpen das italienische Vorbild der Vielbegabten am frühesten und getreuesten aus. Er war einer der ersten Wegbereiter und erfolgreichsten Werber für die Sache des Humanismus. Diese Werbeschrift sind die „Translationen", an denen er seit 1461 arbeitete. Sie sind, achtzehn Stück, eine wohlerwogene Auswahl aus den ersten Schriften des italienischen Frühhumanismus, ein Lehrgang von Petrarca bis Aeneas Silvius. Durch Aeneas Silvius stand er, selbst Kanzleibeamter, in der Überlieferung der Prager und Wiener Schreibstube. In alle ständischen Kreise am Oberrhein suchte er dem neuen Geist Wege zu bahnen, indem er die einzelnen Stücke Fürsten und Fürstinnen widmete, Kanzleibeamten, Ratsherren und Stadtbürgern. Er rollte das Vorbild eines schöneren und höheren Lebensstiles auf und rief damit die Menschen bei ihren heimlichen Wünschen an. Sprachlich suchte er den römischen Satzbau, römische Fügung und Wortstellung, römischen Tonfall in der „Tütsche" seines alamannischen Stammes nachzubilden.

Johann *Johann Reuchlin,* 1455 bis 1522, aus Pforzheim trägt einen alamannischen *Reuchlin* Namen. In Paris und Basel trieb er Griechisch. In Italien lernte er Picus von Mirandula kennen, der einen Ausweg zwischen Glauben und Wissen suchte. Bei einem Linzer Juden lernte er Hebräisch. Er war an der Tübinger Hochschule Lehrer für Griechisch und Hebräisch. Graf Eberhart von Württemberg machte ihn zu seinem geheimen Rat. Nicht durch Tiefe, sondern durch

Vielseitigkeit hat Reuchlin seine Zeit geblendet und seine Stellung als Haupt *Reuchlins* *Werke* und Führer des deutschen Humanismus nach Celtis und neben Erasmus nicht erzwungen, sondern bescheiden hingenommen. Als dem Dreisprachenkenner huldigten ihm Mitstrebende und Schüler. Lateinische und deutsche Übersetzungen griechischer Werke — so des Demosthenes und Lukian —, griechische Ausgaben und hebräische Lehrbücher trugen seinen Einfluß in alle Kreise. Als Lustspieldichter streifte er sichtlich am deutschen Fastnachtsstück hin. „Henno" gestaltete den geläufigen Vorwurf, wie sich ein Angeklagter auf Anraten seines Rechtsbeistandes vor Gericht taubstumm stellt und die Rolle erfolgreich weiterspielt, als der Anwalt Bezahlung fordert. In „Sergius" wird der Schädel eines Elenden als vorgeblicher Kopf eines Heiligen mißbraucht, bis der Trug enthüllt wird. Aufschlußreiche alamannische Zusammenhänge erhellen Reuchlins philosophische Hauptwerke „De verbo mirifico", 1494, und „De arte cabbalistica", 1517, vom wundertätigen Wort und von der kabbalistischen Kunst. Wenn sie zunächst auch Reuchlins hebräischen Bemühungen entsprangen, so lassen sie doch die alte mystische Überlieferung Alamanniens nicht verkennen. Reuchlin blieb bei der alten Kirche und war doch einer der Begründer der modernen Wissenschaft.

Die Tübinger Universität hat, obwohl sie erst 1477 mitten im Siege der *Hochschule* *Tübingen* humanistischen Bewegung gegründet wurde, doch in der Geschichte des Humanismus nur eine bescheidene Rolle gespielt. Das humanistische Schwaben, das sind nach der württembergischen Kanzlei zwei große städtische Gemeinwesen.

ULM wirkte zuvörderst durch Buchdruck und Kanzlei. Johannes Zainer, *Die Ulmer* *Kanzlei* ein Reutlinger von Geburt, betrieb in der Stadt seit 1468 seine Druckerei. Wie der Augsburger Günther Zainer diente er der Geistlichkeit und dem einfachen Volk in gleichem Maße. Bereits 1476 besaß die Stadt eine Buchhandlung und 1486 hielt der Venezianer Buchhändler Justus de Albano in Ulm eine Zweigstelle. Felix Fabri erzählt, daß „in die städtische Kanzlei Ulms junge Leute aus ehrbaren Familien von weit her gesandt werden, damit sie daselbst wie auf einer Universität studieren und vorwärts kommen; und die daselbst geschult worden sind, die sind in andern Städten für erprobte Stadtschreiber geachtet". Das war das Verdienst der Ulmer Familie Neidhart. Peter, der Vorsteher der städtischen Schreibstube, pflegte mit seinen Beamten den Stil des Nikolaus von Wile.

Mit der Ulmer Presse arbeitete *Heinrich Steinhöwel,* 1412 bis um 1483, *Heinrich* *Steinhöwel* aus Weil in Schwaben zusammen, indem er Zainer mit Geld und Handschriften unterstützte. In Wien, Padua und Heidelberg gebildet, wurde er Stadt-

arzt in Eßlingen und Ulm. Steinhöwel übersetzte unter anderm 1471 Boc-
caccios Novelle „Griseldis" und gegen 1480 die Fabelsammlung „Esop", die
ein europäischer Bucherfolg wurde. Wenn Wile sich so eng als möglich an
das lateinische Satzgefüge hielt, so hat Steinhöwel, obwohl auch er der Kanz-
leisprache folgte, mit seinem Blick für das Wesentliche und Mögliche der alt-
deutschen Art, die Sätze beigeordnet zu fügen, den Vorzug gegeben. Mit der

Hans Neithart Ulmer Kanzlei arbeitete der städtische Beamte *Hans Neithart* zusammen. In
der römischen Literatur vorzüglich belesen, übersetzte er den „Eunuchus" des
Terenz. Angeregt vielleicht durch die berühmten Aufführungen antiker Stücke
zu Rom 1484 und Ferrara 1486, ließ der Ulmer Drucker Dinkmut Bühnen-
bilder zu der Handschrift schneiden und legte sie 1486 unter die Presse.
Den beiden Übersetzern stehen zwei Männer der Volkskunde gegenüber.

Johannes Der Deutschordenskaplan *Johannes Boemus* aus Würzburg lebte gegen Ende
Boemus des fünfzehnten Jahrhunderts in Ulm. Sein lateinisches Büchlein „Aller Völ-
ker Sitten, Satzungen und Bräuche", Augsburg 1520, beispiellos beliebt und
gelesen, war der erste Versuch einer allgemeinen Volkskunde. Die volkstüm-
lichen Überlieferungen der Deutschen sind darin nach Stämmen dargestellt.

Felix Fabri *Felix Fabri,* um 1442 bis 1502, aus Zürich, Seelsorger und Kanzelredner in
Ulm, machte 1482 die erste deutsche Seuseausgabe, beschrieb 1484 seine
Wallfahrt ins Heilige Land und schied aus dieser Beschreibung 1488 als Son-
derbüchlein die meisterhafte Darstellung der Stadt Ulm aus. Gemeinwesen
und Bürgerschaft, Verfassung, Handel und Wandel sind mit einer erstaun-
lichen Beobachtungsgabe und in einem ungemein lebendigen Stil anschau-
lich gemacht. Sein Antlitz ist nach rückwärts gewendet, doch von einem leich-
ten Schimmer der neuen Bildung gerötet, die diesem treuherzigen Manne
echt und schmuck ansteht.

Die Die Stadt war lange bemüht, sich unentschieden in der Mitte zwischen
Freistatt Ulm Zwingli und Luther zu behaupten. Das machte Ulm zu einer Freistatt für
Ketzer und Freidenker aus allen Lagern. Auf katholischer Seite führte die
neue Waffe der Streitschrift *Hieronymus Emser,* 1477 bis 1527, aus Ulm.
Der deutschen Bibel Luthers, mit dem er zuerst befreundet und dann ent-
zweit war, setzte er 1527 sein verdeutschtes Neues Testament entgegen. Der

Johann Eberlin Wortführer auf evangelischer Seite war *Johann Eberlin,* um 1465 bis nach
1530, aus Günzburg. In Basel gebildet, war er ein berühmter Barfüßerpre-
diger geworden, bis er zu Ulm von Luthers Wort getroffen wurde. Von Ulm
aus führte er seinen Krieg gegen das päpstliche Rom. Er hatte die Witterung
des geborenen Staatsmannes für den rechten Augenblick und das zuverlässige
Auge des wahren Volksfreundes für das Gebot der Wirklichkeit. So suchte er

zwischen Luther und Zwingli, zwischen dem „großen Haufen" und den „großen Hansen" jene Eintracht zu stiften, die Deutschland heißen wollte. Von seinen zahlreichen Flugschriften war keine schöner gerüstet als „Die fünfzehn Bundesgenossen", die er 1521 von Basel aus unter dem Namen Kaiser Karls V. für die staatliche, kirchliche und gesellschaftliche Erneuerung Deutschlands in Bewegung setzte. Eberlin war ein Sprecher der öffentlichen Meinung von Rang. Er schrieb die werdende Gemeinsprache mit zuverlässiger Sicherheit, ohne seine Mundart zu verleugnen. Johann Eberlin ist einer der vielen sprachmächtigen und staatsmännisch begabten schwäbischen Publizisten, in deren Gesamterscheinung sich ein so großer Wesenszug des alamannischen Volkes offenbart. *Sebastian Franck,* 1499 bis 1542, aus der schwäbischen Reichsstadt Donauwörth, hatte als römischer Priester Luther gesucht und ungestillten Herzens wieder verlassen, um mit einem bekenntnisfreien Christentum allen geistlichen Beruf von sich zu tun und als Handwerker zu leben. So, um der Freiheit willen der Armut vermählt, hatte er zu Ulm eine Zuflucht gefunden. Schriftsteller und Buchdrucker zugleich, ist Franck zu Ulm in einer seltenen Berufseinheit geworden. Mit zahlreichen Flugschriften kämpfte er warmherzig für den armen Mann und leidenschaftlich gegen die Volkslaster der Deutschen. In seinen Zeitbüchern erzählte er, ein sehr geschickter Aneigner und Verwerter, die Geschichte der Welt, der Türken und Deutschen. Und von Ulm aus hat er den Deutschen ein Weltbild aufgerollt, in dem sich das deutsche Volksbewußtsein weltbürgerlich spiegeln konnte. Das eine tat sich mit des Erasmus von Rotterdam „Morie Enkomion" auf, das Franck 1534 als „Lob der Torheit" übersetzte, ein weiser Blick in das bunte Fastnachtsspiel des Lebens. Das andere öffnet sich mit dem „Weltbuch", 1534, das Franck zum guten Teil seinem Ulmer Vorgänger Johannes Boemus nacherzählte. Hier spiegelt sich die Erde mit der ganzen Vielfalt ihrer Völker, im Vordergrunde Deutschland. Die Tiefe des Lebens zugleich und die Weite der Welt, das sind Sebastian Francks „Sprichwörter", 1541, Spruchweisheit der Völker und Sprachen, in der Weise aufgezeichnet und ausgelegt, daß am Kopf jedes Abschnittes die sinngleichen Sprichwörter zusammengestellt und dann gemeinsam gedeutet werden. So bedeutet das Ulm dieses Zeitalters deutsches Buch, Pflege der deutschen Sprache, Kunde des deutschen Volkes, Freiheit des deutschen Geistes, Waffe des zeitgewaltigen deutschen Wortes.

Sebastian Franck

AUGSBURG hielt sich schwesterlich neben Ulm, ähnlich mit manchen Zügen und doch eine ganz andere Persönlichkeit. Buchdruck und Humanismus gingen gleichermaßen zusammen. Die Stadt hat als einzige in Deutsch-

Augsburger Buchdruck und Humanismus

land den Buchdruck von seinen Uranfängen miterlebt. Hier wurde wahrscheinlich der Stempeldruck erfunden. Mit geschnittenen festen Schrifttafeln wurde jedenfalls schon sehr früh gearbeitet. Jörg Scapf druckte bereits 1448 ein Buch der Schwarzkunst. Der Augsburger Erhard Rathold, der in Venedig 1476 begonnen hat, war einer der berühmtesten Drucker Italiens und Deutschlands. Johannes Froschauer, Hans Schönsperger, Heinrich Steiner waren in der Zeit vor und nach 1500 große Drucker. Die Stadt gab ein Beispiel. Max Welser bildete aus Gelehrten und Kaufleuten verschiedenen Standes und Bekenntnisses eine Genossenschaft, die herrliche Lettern gießen und Klassiker auf das sorgfältigste nach den Handschriften drucken ließ. Die meisten besorgte der Schulleiter David Höschel. Der frühe Humanismus ist um 1450 aus dem Kreise des Stadtjunkers Sigismund Gossembrot und des Bischofs Peter von Schaumburg hervorgegangen. Aus diesem Kreise ist Augsburg ein Hauptort der frühhumanistischen Geschichtschreibung geworden. Der Benediktiner bei Sankt Ulrich und Afra, *Sigmund Meisterlin,* vollendete 1456 seine „Chronographia Augustensium" für Gossembrot. Das Benediktinerkloster war denn auch die eigentliche Pflegestätte des Humanismus und besonders der Mathematik und der Astronomie zugewandt.

Konrad
Pentinger

Die vita nuova Augsburgs verkörperte sich im Stadtschreiber. *Konrad Peutinger,* 1465 bis 1547, war an den italienischen Universitäten rechtswissenschaftlich gebildet. Zum Stadtschreiber wurde er 1497 auf Lebenszeit berufen. Er hat 1507 die neue Verfassung des Stadtgerichts mitgeschaffen. Als Staatsmann wirkte er für Kaiser Maximilian I. und für den Schwäbischen Bund. Vermittelnd stand er innerhalb der kirchlichen Bewegung. Eine Erneuerung etwa im Sinne des Erasmus war das Äußerste, was ihm behagte. Sein Werkzeug, an dem er seinen ganzen Freundeskreis zusammenführte, war die „Societas Augustana", eine Gesellschaft zur Herausgabe und Bearbeitung geschichtlicher Quellenschriften. Hier ging Peutinger vorbildlich voran. Auf kaiserliche Anregung sammelte er altrömische Inschriften. Die Straßenkarte des römischen Reiches, die Tabula Peutingeriana, wurde sein Besitz. Die habsburgischen Regesten konnte er nur beginnen. Seine geschichtsforschende Gesellschaft wurde der Mittelpunkt der ganzen humanistischen Geschichtschreibung. Am vollkommensten hat Peutinger den Humanismus gelebt, im Verkehr mit seinen Freunden und durch einen ausgebreiteten Briefwechsel.

Augsburger
Meistergesang

Wie die Stadt des frühen Buchdrucks und des jungen Humanismus war Augsburg auch die Stadt des deutschen Meistergesangs. Hier hat er seine längste und reichste Entwicklung durchgemacht. Schon 1449 bestand in Augs-

burg die erste eingerichtete Singschule. Daß Mainz der Ausgangspunkt ihrer
Kunst war, dessen waren die Augsburger Meister sich bewußt. Von dort her
entliehen sie sich „das große Buch" zu Nutz und Vorbild. Erst 1534 baten
sie den Rat, am Sonntag vor der Abendpredigt ihre Schule halten zu dürfen.
Sie bedienten sich anfangs der Zürcher, das ist der alamannischen Bibel und
nahmen die Wittenberger erst an, als ihnen der Verdacht der Ketzerei drohte.
Ihr Versammlungsort war anfangs die Barfüßerkirche, dann die von Sankt
Stephan, das Predigerhaus zum heiligen Kreuz und schließlich die Jakobs-
kirche, bis sie sich in der Unteren Stadt ein eigenes Zunfthaus kauften. Die
Zunft stand durch das ganze Jahrhundert in hoher Blüte. Von 1535 bis 1614
sind 262 Namen von Mitgliedern bekannt. *Onofferus Schwarzenbach* sam-
melte 1565 den ersten, *Daniel Holzmann* 1576 den zweiten Band ihrer Mei-
sterlieder. In Augsburg gingen Meistergesang und Humanismus zusammen.
Johann Spreng, 1524 bis 1601, von Augsburg, Notar und deutscher Über-
setzer der Aeneis und Ilias, war der bedeutendste Meister der Zunft.

In Augsburg hat sich fast restlos der Übergang vom Meisterliede zum *Augsburger*
Drama innerhalb und im Rahmen der Zunft vollzogen, nachdem auch hier *Drama*
vorerst das Schuldrama, wie der Schulleiter bei Sankt Anna, Sixt Birk, es
pflegte, die Szene beherrscht hatte. Die Meistersänger spielten 1540 ihr erstes
Stück von den fünf Betrachtnussen. Und nun entspann sich ein lebhafter Wett-
kampf. Die Neigung zu spielen begann bald die Lust am Singen zu über-
wiegen. Seit 1540 spielten sie meist in der Martinsschule, später in einem
eigenen Stadel. Die Zunft strebte das alleinige Aufführungsrecht in Augs-
burg an und setzte es endlich 1650 durch. Nur das Jesuitentheater teilte sich
mit ihnen in die Stadt.

Die drei Städte Schlettstadt, Straßburg und Kolmar lösten einander wie
auf Stichwort ab im Werk an einer deutschen Dichtung, die wesentlich anders
aussah als in Ulm und Augsburg.

SCHLETTSTADT hatte eine alte Schule, deren Unterricht um 1450 durch
Ludwig Dringenberg, einen Deventerschüler, im Geiste der Brüderherren
neu gestaltet wurde. Aus den Lehrern und Schülern dieser Anstalt ist die
humanistische Bildung der ganzen Landschaft hervorgegangen. Einer ihrer
Schüler war *Beatus Rhenanus*, 1485 bis 1547, ein Schlettstädter, dessen Vater
von Rheinau im Elsaß stammte. Zu Paris geschult, in Basel der Mitarbeiter *Rhenanus:*
des Erasmus, schloß Rhenanus sich dann in seiner Vaterstadt ein, zu glück- *Deutsche*
lichem Behagen an seiner Arbeit. Er gab die klassischen Werke der alten Ge- *Geschichte*
schichtschreiber und Kirchenväter heraus und schrieb das Leben des Eras-
mus. Sein Hauptwerk sind die „Rerum Germanicarum libri tres", „Drei Bü-

cher deutscher Geschichte", im Grunde eine Geschichte der Franken und Ala-
mannen, die als Träger des deutschen Schicksals dargestellt sind. Hier teilt
er zum erstenmal Stellen aus Otfrieds Evangelienbuch mit, das er 1530 auf
einer Gastfahrt zu Peutinger in Freising entdeckt hatte. Neben Rhenanus
Ringmann: steht der Schlettstädter *Matthias Ringmann Philesius,* jung verstorben, in
Lateinische
Lyrik lateinischen Versen ein gemütvoller Sänger seiner Elsässer Heimat. Mit zwei
Gedichten ist Ringmann an dem Buch beteiligt, das 1507 Amerigo Vespuccis
Reisebericht brachte, der „Cosmographiae introductio". Auf der beigegebe-
nen Karte, die Martin Waldseemüller lieferte, hieß der neuentdeckte Erdteil
zum erstenmal Amerika. Und neben beiden, Rhenanus und Ringmann, steht
Gart: der Schlettstädter *Thiebolt Gart,* dessen seelenkundlich feines und wortge-
Deutsches Spiel wandtes Drama „Josef" die Schlettstädter Bürger am Weißen Sonntag 1540
aufführten.

Straßburg STRASSBURG focht die Geisteskämpfe der Zeit aus. Die Stadt hatte den
Buchdruck beinahe aus erster Hand. Denn der Schlettstädter Johannes Men-
telin, der die Kunst der Presse nach Straßburg brachte, hatte schon 1460 seine
lateinische Bibel fertig. Mentelin wurde von der Familie Schott beerbt. Sein
Enkel *Johannes Schott,* Verfasser humanistischer Werke, brachte auf dieser
Presse 1513 die große Ptolemäusausgabe heraus und zwanzig Karten, das
erste moderne Kartenwerk. Die Familie Schott gab dem geistigen Leben der
Stadt die entscheidenden Antriebe. Peter Schott, 1458 bis 1490, in Schlett-
stadt geschult, Weltpriester und der erste strenge Humanist des Landes, ver-
trat noch die kirchentreue Gesinnung der älteren Gruppe. Durch die Familie
Predigt Schott wurde 1477 der Schaffhausner *Johann Geiler von Kaisersberg,* 1445
bis 1510, als Prediger an die Straßburger Lorenzkirche gezogen. Seine Pre-
digten, unermüdlich um Besserung der Sitten und das Wohl der Armen be-
mühlt, hielten noch an der Überlieferung Bertholds von Regensburg fest.
Seine Bilder geraten mehr zur Unterhaltung als zur Erbauung. So hielt er
142 Predigten über das „Narrenschiff". Er deutet den Ameisenstaat auf das
kirchliche Leben. Mit der Feder war Geiler nicht minder geschickt als mit
dem Wort auf der Kanzel. An seinen Predigten übte sich eine ganze Gruppe
von Schriftstellern als Nachschreiber, Übersetzer und Ausleger. Von diesem
Kreise führte der Straßburger Franziskanerguardian *Johannes Pauli* und seine
Schwänke Schwanksammlung „Schimpf und Ernst" 1522 Geilers Predigtmärlein in die
sehr unheilige Gesellschaft der alamannischen Schwankbücher von *Jörg Wick-
rams* „Rollwagenbüchlein" 1555 bis zu der „Gartengesellschaft" 1556 des
Stadtschreibers von Maursmünster *Jakob Frei* und dem „Wegkürzer" 1557
des Straßburgers *Martin Montanus.*

Der Humanismus der Stadt erhielt in dem einen gleichen Jahr 1501 seine *Humanismus*
Führer, da Sebastian Brant als Kanzler in seine Heimat zurückkehrte und
Jakob Wimpfeling aus Schlettstadt nach Straßburg kam.

Jakob Wimpfeling, 1450 bis 1528, von Dringenberg in Schlettstadt erzo- *Jakob*
gen, an deutschen Universitäten gebildet, hatte als akademischer Lehrer, *Wimpfeling*
Kanzelredner und humanistischer Schriftsteller bereits ein reiches Leben hin-
ter sich, durch seine Erneuerung mittelalterlicher Schriften, durch seine ge-
schichtlichen Werke mit ihren zahlreichen literarischen Stellen, durch grund-
legende Arbeiten zur Erziehungskunst. Als er 1501 in Straßburg seine Aus-
gabe der „Germania" erscheinen ließ, gleichzeitig mit der Ausgabe des Celtis
in Wien, gab er ungewollt das Zeichen zu einem leidenschaftlichen Feder-
krieg mit Thomas Murner um das Volkstum der Landschaft. Aus dem Kampf
klärte sich eine vertiefte und warme Gesinnung für Kaiser und Reich ab. Ihr
gab zuerst ein einfacher Mann, *Friedrich Fürer*, in seinem Gedicht von 1513,
„Die Welsch-Gattung", Ausdruck, wo der Kaisergedanke als Heilmittel ge-
gen alle sozialen Übel der Zeit gepriesen wurde. Aus dieser Stimmung, die
planmäßig von Maximilian I. gelenkt wurde, erwuchs die ganze Literatur
der Kaiserbüchlein. Zu solchen hatte er schon 1508 Peutinger und dann Cus- *Kaiserbüchlein*
pininanus angeregt, der 1522 seine „Caesares" vollendete. Die solche Kai-
serbüchlein schrieben, waren fast alle Alamannen. Der Freiburger Jakob
Memel schrieb eines, 1525 eines der Straßburger Johann Huttich, 1532 eines
Pirminius Gaßner in Basel, 1538 Sebastian Franck das seine in seiner „Ger-
mania". Hans Sachsens Volksbuch gehört in die Reihe und das späte Werk
des Eilenburgers Johannes Zschorn von Westhofen 1559, der es im Elsaß
schrieb.

Dieses ganze humanistische, volksmäßige und religiös entzweite Leben
der Stadt rollt wortgewaltig aus den Dichtungen *Thomas Murners*, 1475 bis *Thomas Murner*
1537, der zu Straßburg geboren wurde und durch den Vater aus Oberehn-
heim stammte. Murner war Schüler an der Pariser, Prager und an deutschen
Universitäten gewesen. Er wurde Guardian seines Franziskanerklosters und
war es zu Zeiten auch in Speier. Im Streit mit Wimpfeling verkostete er zum
erstenmal das Behagen an der Leidenschaft des Meinungskampfes. Die hef-
tigsten Fehden focht er in der Urschweiz aus, für die er als öffentlicher Wort-
führer wirkte. Er übersetzte und schrieb Zeitungen. Schon 1513 erschien er
Kaiser Maximilian I. wichtig genug, daß dieser einen eigenen Beamten nach
Straßburg schickte, um zu sehen, ob Murner für ihn zu haben wäre. Als Dich-
ter, der Murner wirklich war, kam er aus Brants und Geilers Schule. Sein Stil
ist das beherrschende Bild, in das sich fast alles fügt, was er schrieb. So schon

Das Zeitgedicht 1512 die „Narrenbeschwörung" und die „Schelmenzunft". Den Grundge-
danken der Minnehöfe, Minneorden, Minneburgen, die einst in Alamannien
und Ostfranken gedichtet worden waren, verzerrt seine „Gäuchmatt" 1519
ins Höhnisch-Groteske. Murner selber ist der Kanzler der Gäuche. Er ordnet
seine Zunft nach 22 Grundsätzen. Mystische Literaturzüge, die durch alle
seine Werke hindurchgehen, erscheinen in dem Büchlein „Eine andächtige
Badefahrt" 1514 am reinsten. Das Bad ist das einigende Bild aller Vorstel-
lungen. Christus ist der Bader der Seele. Die „Mühle von Schwindelsheim"
1515 deutet alle Vorgänge im Müllerhause spottlustig aus. Seine mächtigste
Schöpfung war 1522 das zeitgemäße Epos „Von dem großen lutherischen
Narren, wie ihn Doktor Murner beschworen hat". Es steht unter dem Ein-
fluß des französischen Gedichts „La bataille des sept-arts", wo ein unbekann-
ter Dichter des dreizehnten Jahrhunderts die sprachliche und begriffliche
Richtung innerhalb der Scholastik wie Menschen gegeneinander kämpfen
ließ. So macht es auch Murner. Gegen Luthers Heerscharen bietet er die Ver-
teidiger des alten Glaubens auf. Was aus dem Kampfe übrig bleibt, ist eine
Narrenkappe, und die setzt sich Murner selber auf. Es ist die Scholastik und
der volkstümliche Barfüßergeist, der in Murner in unverwüstlicher Gesund-
heit die humanistische Bildungsschicht durchbrach. Murners Seele war reicher
an Irrgängen, als wir sehen. Seine göttliche Laune und beispiellose Gewalt
über die Sprache verdecken ein Herz voller Rätsel und eine angeborene Gut-
mütigkeit, die der künstliche Ingrimm nicht ganz vergiften kann. Nieman-
dem war er als Dichter verwandter, denn dem Manne, der Wittenweilers
„Ring" geschrieben hat.

Straßburger
Schule Dem Freundeskreis um Geiler und Wimpfeling war die Gründung einer
modernen höheren Schule mißglückt. Der Straßburger Jakob Sturm, 1489
bis 1553, der führende Staatsmann der Stadt, der sie dem neuen Glauben
zuführte und 1552 ein letztes Mal vor dem Zugriff Frankreichs rettete, schuf
ihr auch diese Schule, wobei ihm der berühmte Erzieher Johannes Sturm
aus Schleiden in der Eifel die ausführende Hand lieh. Die um 1508 ge-
gründete Münsterschule wurde 1538 mit den später geschaffenen zum alten
Sankt Peter und im Predigerkloster zu einer Akademie vereinigt und Sturms
Leitung übertragen. Er zog ein Geschlecht von Rednern und Stilkünstlern
heran, ohne den sittlichen Ernst, die Tiefe und Strenge der alten Schule, wie
die Brüderherren sie geschaffen hatten, mit in seine Schöpfung aufzunehmen.
Gleichviel, das ist die Straßburger Akademie, deren Theater wenige Jahre
später so mächtig am Kunstbau des deutschen Dramas mitgeschaffen hat.

KOLMAR fielen die letzten Meisterschläge am Werk der deutschen Dich- *Kolmarer*
Übersetzungen
tung zu. Die Stadt trat ziemlich jäh ans Licht. Der Stadtschultheiß *Hierony-*
mus Boner übte sich zwischen 1531 und 1552 als Übersetzer. Über lateinische
Zwischenglieder hinweg verdeutschte er Thukydides, Herodot, Xenophon,
Demosthenes. Er übertrug Ovids „Verwandlungen" und Schriften italieni-
scher Humanisten, wie des Angelus Politianus. *Jörg Wickram,* um 1505 bis
gegen 1562, war ein außerehelicher Sohn des Kolmarer Schultheissen Kon- *Konrad*
Wickram
rad Wickram. In Kolmar diente er bei der Polizei. In Burgheim war er Stadt-
schreiber. Das ist der Mann, der eigentlich die früheste Form des modernen
Romans geschaffen hat. Auch er ist zunächst vom höfischen Roman ausgegan-
gen: „Ritter Galmy", 1539, die Geschichte einer unschuldig verfolgten Frau;
„Der Goldfaden", 1557, die Geschichte des Küchenjungen, der sich in die *Erzähler*
Brustwunde einen goldenen Faden einheilen läßt, um die Grafentochter von
seiner Liebe zu überzeugen. Und er folgte humanistischen Erzählern mit
„Gabriotto", 1551, der Erzählung von der Liebe zwischen vier Menschen.
Schließlich wandte er sich dem Leben zu, wie es täglich geschieht, und also
gelang ihm als erstem der moderne Sittenroman: „Knabenspiegel", 1554, ein
beispielhaftes Kolmarer Jugendschicksal, der emporsteigende Bauernsohn
und der sinkende Rittersprößling, belohnter Fleiß der Armut und bestrafte
Faulheit des Reichen. Nur Beiwerk sind Ovids „Verwandlungen", 1545,
gereimt nach dem Buch Albrechts von Halberstadt, und „Das Rollwagen-
büchlein", Schwänke, die zumeist in das Elsaß verlegt sind. Nicht minder
bedeutend als der Dichter war der Meistersänger und Spielleiter. Wickram *Meistersänger*
und Spielleiter
hat den Meistergesang zu Kolmar eingeführt und geordnet. Aus Schlettstadt
kaufte er die dann so berühmte Kolmarer Meisterliederhandschrift und dem
Freiburger Stiftungsbrief von 1513 entnahm er die Einrichtung der Kol-
marer Schule. Zum erstenmal wurde 1546 gesungen. Die Tabulatur und
Singschulordnung schrieb er 1549 nieder. Meisterlieder sind von ihm keine
erhalten. In Kolmar wurde seit dem bezeugten Jahr 1443 fleißig gespielt. In
diese Übung fügte sich Jörg Wickram ein, indem er 1531 Gengenbach, 1532
Hans Sachs und 1537 ein Stück Straßburger Stils, „Das Narrengießen", auf-
führte. Seine eigenen Stücke, „Der verlorene Sohn" und „Tobias" wurden
1540 und 1550 gespielt. In dieser vielseitigen Tätigkeit steckt eine unge-
wöhnliche Unternehmungslust. Jörg Wickram war der modernste Schrift-
steller seiner Zeit, der sich auf alles verstand, was zum Handwerk gehört, der
gut zu erzählen und einen flotten Vers zu machen wußte. Er hatte in dem
Schauspiel, das Schlettstadt, Straßburg, Kolmar gaben, die letzte Szene, auf
die es ankommt.

Die
Eidgenossenschaft
Die Beute der Burgunderschlachten, der Solddienst der städtischen Geschlechter und ländlichen Kraftburschen, die Heerfahrten nach Italien verwandelten in wenigen Jahrzehnten die Eidgenossenschaft politisch, wirtschaftlich und seelisch. Nun rollte das Geld und mit ihm begann das Kunstgewerbe zu blühen. Die städtischen Geschlechter lernten Französisch und Italienisch. Sie lernten in Frankreich und Italien die neue Bildung kennen. Diese Eidgenossenschaft, die sich eben anschickte, eine europäische Großmacht zu werden, hielt der Benediktinermönch von Einsiedeln, *Albrecht von Bonstetten,* ein Freund des Nikolaus von Wile, 1479 in seinem Bilde fest, lateinisch und deutsch: „Superioris Germaniae confoederationis descriptio", „Der Obertütschheit Eidgenossaft stett und lender". Diese landschaftliche Schilderung, die ins Wesen des Volkes ging, erweckte als ein völlig Neues Staunen und Bewunderung.

Humanismus
in Zürich
ZÜRICH wurde mit einem Schlage die geistig und wie es schien auch politisch führende Stadt der Eidgenossenschaft. Es war, wie wenn ein Stichwort gefallen wäre. In dem einen und gleichen Jahr 1518 kehrte eine ganze Gruppe junger Zürcher von fremden Hochschulen, zumeist aus Wien, volle Humanisten, in ihre Vaterstadt zurück und wurde Huldreich Zwingli als Leutpriester an das Großmünster berufen.

Huldreich
Zwingli
Huldreich Zwingli, 1484 bis 1531, ein Toggenburger aus dem Gehöftedorf Wildhaus, in Wien und Basel gebildet, war 1506 Pfarrer zu Glarus geworden und mit den Glarnern als Feldprediger 1515 nach Italien gezogen. In einem wurde er von den erschütternden politischen Ereignissen gepackt und von dem Drange überfallen, Schrift und Heilslehre der Kirche selbständig zu erkennen. Zu Einsiedeln tritt er 1516 in einen Kreis humanistisch gesinnter Freunde. Seine Bildung vertieft sich und beginnt den Priester und Prediger umzuwandeln. Auf der Kanzel legt er nun ausschließlich, wie der Humanismus es wollte, Wort und Sinn des jeweiligen Bibelabschnittes aus. In Zürich tritt er 1518 auf die große Bühne einer Stadt mit reicher geistiger Vergangenheit, eines Stadtstaates mit mächtigen Mitteln. Jetzt erklärt er von der Kanzel aus die Schrift fortlaufend als ein Ganzes. Auch das war erst noch humanistische Gesinnung. Im Herbst 1519 befällt ihn die Pest und ergreift ihn Luthers Tat. Seine Stunde ist gekommen. In Sachen des Solddienstes *Die*
Abstimmung
von 1525 erfolgt 1521 der erste Zusammenstoß mit dem Papst. Fastenstreit und Priesterehe folgen. Seine Lehre formt sich und beginnt weitausholend zu wirken. Durch Handmehr wird 1525 Zwinglis Bekenntnis Zürcher Staatsbekenntnis. Eine neue Tatsache stand in der Welt. Ein ganzer Staat und seine Kirche, mochten sie auch nur klein erscheinen, waren zu einer Einheit umgeschaffen.

Mensch und Gottheit waren reinlich geschieden und ihr Verhältnis zuein- *Zwinglis Predigten und Schriften*
ander, Rechte und Pflichten, ausschließlich durch die Schrift bestimmt, im
Ganzen und im Einzelnen ein Ergebnis jener Wissenschaft, die an der Be-
handlung der antiken Literatur gewonnen worden war. Humanismus und
neues Kirchentum in wechselweiser Umbildung bestimmten im Zürich dieser
Jahrzehnte das ganze Leben. Zwinglis Predigten und Schriften zeigen nach
der Vorbereitung durch die mystische Literatur, durch Nikolaus von Wile
und die eidgenössischen Zeitbücher die alamannische Prosa wieder auf voller
Höhe. Lautstand, Wortschatz, Fügungen waren alamannisch. Sie wurden
erst in den späteren Ausgaben langsam dem Gemeindeutschen angenähert.
Seine Tagesschriften sind Meisterstücke volkstümlicher Prosa. Nicht durch
zwingende Gedankenfolgen, durch überzeugende Bilder suchten sie zu wir-
ken. Seine gedruckten Predigten sind schöne Denkmäler aus dem Bestande
der alamannischen Beredsamkeit. Die Eitelkeit des Sprechens hat ihn nie
verlockt, so fleißig er Demosthenes gelesen hatte. Er sprach mit dem beschei-
denen Munde des schlichten Mannes, von dem er verstanden zu werden
wünschte. Humanistisch war an seiner Predigt nicht die äußere Form, son-
dern der Geist. Die größten volkstümlichen Wirkungen gingen mittelbar von
der theologischen Lehranstalt aus, die 1525 aus dem Chorherrnstift gebildet *Die Zürcher Bibel*
worden war. Aus ihrem genossenschaftlichen Sprachbetrieb ist die alaman-
nische Bibel der neugläubigen Eidgenossenschaft erwachsen. Fünfmal ist die
ganze alamannische Bibel in Zürich gedruckt worden, bis Luthers Gesamt-
ausgabe 1534 erschien. Von 1538 an verglich Leo Jud, Zwinglis Gehilfe, diese
Bibel Wort für Wort mit dem ursprünglichen Wortlaut, und seit 1540 erschien
das Werk in dieser Fassung. Die Zürcher Schrift war als Frucht gemeinsamer
Arbeit des ganzen Kreises ein glänzender Erfolg humanistischen Schulbetrie-
bes, neben den großen Ausgaben des Erasmus das erste Beispiel für ein Zu-
sammenwirken an einem einheitlichen literarischen Unternehmen. Für sein
Werk ist Huldreich Zwingli gegen die altgläubigen Orte 1531 auf dem
Schlachtfeld von Kappel mit der Blüte der Zürcher Bürgerschaft gefallen.

Zwinglis Werk aber hatte in Zürich Bestand. Vor der überragenden Per-
sönlichkeit seines Schöpfers trat die Dichtung in den Hintergrund. Das
Kannegießen des einfachen Mannes hob sich inhaltlich am Beispiel der zahl- *Zürcher Gesprächsbüchlein*
reichen öffentlichen Religionsgespräche und gewann am Beispiel der kanzel-
mäßigen Schriftauslegung Stil und Haltung. Für die Gebildeten boten Eras-
mus und Hutten die anspruchsvollen Vorbilder. So entwickelt sich zu Zürich
aus dem Streitgespräch des Mannes der Werkstatt und des Zinshofes eine
Literaturform, in der sich der ganze Lauf der Welt gesprächsweise abspie-

gelte. Mit dem Namen Utz Eckstein wird diese Tagesliteratur der Stadt von 1523 bis 1526 verknüpft. Aus feinerem Holze war der unbekannte Verfasser des Gedichts „Eine Badenfahrt guter Gesellen" 1526, was schon der Grund-gedanke bezeugt, daß Zürich hier jedem der eidgenössischen Orte über seine Kirchenpolitik Rede und Antwort steht. Die hübsche Einkleidung in den Aargauer Badegebrauch, daß jeden Tag ein anderer die geschlossene Gesell-schaft bewirtet und daß der Kranz des Gastgebers und das Recht, eine Frage zu stellen, im Kreise herumgeht, das verrät einen feinen Kopf, der künst-lerische Mittel wohlüberlegt zu meistern weiß. Von diesen Gesprächsbüch-lein zum Drama war es nur ein Schritt.

Mit den Jahren 1529 und 1531 setzt das Bühnenleben der Stadt ein, Volks-spiel und Humanistendrama. Beide gehn zeitlich von der sozialen Not aus, was mit den wirtschaftlichen Wirren in Zürich 1523 zusammenhängt. Das *Lazarusspiel* einfach-große Spiel von 1529 *„Der reiche Mann und der arme Lazarus"*, eine Predigt der Barmherzigkeit, gehört zu den reinsten Dichtungen des Jahrhunderts. Die Bühnenbilder sind mit voller Klarheit geschaut und immer sind alle Gestalten auf den Brettern an dem eben gespielten Vorgange be-teiligt. Zu Neujahr 1531 führten Zwinglis humanistische Freunde in grie-*„Plutos"* chischer Sprache die Komödie „Plutos" auf, die Aristophanes auf die all-gemeinen wirtschaftlichen Verhältnisse Athens bezogen hatte und die in Zürich bildhaft gleichermaßen die gleiche Frage stellte und die gleiche Ant-wort erteilte. Der erblindete Gott des Reichtums wird von dem attischen Bauern Chremylos sehend gemacht. Nun verteilt er seine Gaben gerecht und wird im Festzuge in das Schatzhaus der Akropolis geleitet. Zwingli hatte die Chöre des Stückes vertont. An beide Aufführungen reihte sich eine ziemliche Bühnenliteratur, in der Heinrich Bullinger das Humanistendrama und Jakob Ruff das volksmäßige Spiel vertrat.

Joachim Die Stadt *SANKT GALLEN* war Zwinglis treueste Verbündete durch *von Watt* einen Mann, der sie geistig so erfüllte wie Zwingli sein Zürich. Das war *Joachim von Watt*, 1484 bis 1551, an der Wiener Hochschule von 1502 bis 1518 Schüler und Lehrer, von Kaiser Maximilian I. zu Linz 1514 mit eigener Hand zum Dichter gekrönt, Herausgeber antiker Schriftwerke, ein gewandter Stegreifdichter und vielbegehrter Arzt. Er kehrte 1518 als Stadtarzt nach Sankt Gallen zurück, wurde Bürgermeister und Zwinglis klügster, maß-vollster, gelehrtester Mitarbeiter. Wie die Erdkunde und die Literatur-wissenschaft, so hat Watt auch die kritische Geschichtswissenschaft mitbe-gründet durch sein Zeitbuch aus der Mitte der vierziger Jahre, in dem er sich bemühte, von der Geschichte der Abtei und Vaterstadt eine allgemeine kul-

turgeschichtliche Darstellung zu geben. Bei bedeutsamen Anlässen erwies sich Watt als Redner: 1515 zu Wien vor dem Kaiser in lateinischer Wortpracht; 1523 zu Zürich beim zweiten Religionsgespräch und 1532 zu Sankt Gallen vor dem Rat über den Frieden mit dem Abt in schlicht gewinnendem Alamannisch. Die drei alamannischen Eidgenossen Huldreich Zwingli, Joachim von Watt, Theophrast von Hohenheim haben auf der breiten Unterlage alamannischer Sprachvorarbeit die deutsche Prosa zum allgemeinen Ausdrucksmittel theologischer, geschichtlicher, naturwissenschaftlicher Gedankengänge umgeschaffen.

BERNS war und Berns blieb die politische Führung im Bunde. Der Staat gab dem Schrifttum zu Bern Inhalt, der Staatsmann und Staatsbeamte gab ihm Form. In jedem Sinne steht am Eingange des neuen Berner Schrifttums Thüring Fricker, um 1492 bis 1519, der Sohn des Brugger und Berner Stadtschreibers, seit 1470 selber Stadtschreiber Berns, der sich gerne und stolz „Kantzler" schrieb. Denn Fricker hat die entscheidenden literarischen Urkunden Berns entweder angeregt oder geschrieben, und er war der Großvater des einzigen wahren Dichters, den die Stadt in Jahrhunderten hervorgebracht hat.

Thüring Fricker hat das große Berner Zeitbuch vorhumanistischen Stiles angeregt. *Diebold Schilling* aus altem Solothurner Geschlecht, amtete 1460 bis 1476 auf der Berner Schreibstube. Infolge Ratsbeschlusses von 1474 schrieb er die Geschichte der Stadt und schenkte am Stephanstage 1484 das dreibändige, prachtvoll geschmückte Buch Räten und Bürgern Berns zu einem „seligen Jahr". Er hatte es als Lehrbuch für Heerführer und Staatsmänner gedacht. Denn die geschichtlichen Begebenheiten erscheinen ihm als unmittelbarer Ausfluß guter und böser Leidenschaften der führenden Männer. Er schiebt geschichtliche Lieder ein als Quellen wie als Zeugnisse unmittelbaren menschlichen Anteils. Dem Mann war es zuzutrauen, daß er selber die Bilder zu den Burgunderkriegen des dritten Bandes geschaffen hätte. Das Kleinbildartige beherrscht Wort wie Bild dieses eindrucksvollen Geschichtswerkes, das vom ersten Schmuckbuchstaben bis zur letzten Zeile den Geist des waffenmächtigen, stolzen und zukunftsfrohen Bern atmet. *Thüring Fricker* hat das Buch der Berner Staatsreden geschrieben. Die Stadt wurde 1470 von dem schweren Streit über die Vorrechte des Adels erschüttert. Die Redeschlachten, die um diese Sache im Rat abrollten, hat er in seinem Buch vom Twingherrnstreit überliefert. Es sind Reden aus den verschiedenen Bildungskreisen und politischen Lagern des damaligen Bern. Jeder der Volksmänner und Edelleute, die einander gegenüberstanden, ist

Berner Zeitbuch

Berner Staatsrede

mit seiner eigentümlichen Redeweise lebendig festgehalten. Das ist Bern. Ein mächtiges Zeitbuch und eine Sammlung von Staatsreden, seine besten Literaturwerke des fünfzehnten Jahrhunderts.

Die Träger des humanistischen Schrifttums Berns waren zwei Fremde, ein wieder deutsch gewordener Romane und ein Schwabe, ein Dichter und ein Zeitbuchschreiber.

Niklaus Manuel

Niklaus Manuel, 1484 bis 1530, war durch seine Mutter ein Enkel Thüring Frickers. Die Familie seines natürlichen Vaters stammte aus Chieri bei Turin und hieß Aleman, wie in Italien wohl nur ein Deutscher genannt worden sein kann. Manuel war von Haus aus bildender Künstler. Er malte auf Holz, Leinwand und Mauer. Er zeichnete für Glas und schnitt in Holz. Er baute das Netzgewölbe im Chor des Berner Münsters. An die Kirchhofmauer des Berner Predigerklosters malte er einen Totentanz. Die Gesichter waren Bilder nach dem Leben. Die Versbeischriften zu den einzelnen Gruppen, Gespräche zwischen Tod und Opfer, zeigen dramatischen Ansatz und bereiten Manuels Übergang vom Bilderaufzug zum gespielten Aufzug vor. Und also lief an ihm die Basler Entwicklung noch einmal ab. Äußere Antriebe führten ihn zur Literatur. Als Feldschreiber ging er 1522 mit den eidgenössischen Söldnern nach Italien, machte die Schlachten von Novara und Bicocca mit, wurde

Maler, Dichter, Staatsmann

1523 Landvogt in Erlach am Bieler See. Hier wurde der Einsame zum Dichter. Gegen die siegesübermütigen deutschen Lanzknechte richtete er 1522 das kräftigderbe Bicoccalied. Dem römischen Hof galt Ende 1522 die dichterische Bilderfolge „Vom Papst und seiner Priesterschaft". Obwohl sich eine gewisse Handlung nicht verkennen läßt, so spricht sich eigentlich auch hier wie bei Gengenbach nur eine Folge bildhafter Gruppen redend und nicht handelnd aus. Noch deutlicher werden die Zusammenhänge mit der bildenden Kunst in dem knappen Aufzug „Von Papsts und Christi Gegensatz". Wie Manuel den Einfall dazu aus einem verbreiteten Bilde schöpfte, so wiederholte er sein Spiel selbst in einer eigenen Federzeichnung. „Barbali", 1526, ist ein bloßes Gespräch über das Verwerfliche des Klosterlebens. Lediglich „Der Ablaßkrämer", 1525, ist der Ansatz zu einem Fastnachtsspiel. Und ein wirkliches Bühnenstück ist nur „Elsli Tragdenknaben", 1529, in dem der Dichter das neu eingeführte Ehegericht volkstümlich machen wollte. Die kleine Parodie „Krankheit und Testament der Messe" ist unter dem unmittelbaren Eindruck des entscheidenden Berner Religionsgespräches von 1528 entstanden, mit dem — Joachim von Watt führte den Vorsitz — die Kirchenbewegung in Bern siegte. Niklaus Manuel trat in den kleinen Rat ein. So nun aus einem Dichter ein Staatsmann wie einst aus einem Maler ein Dich-

ter geworden, vertrat er, oft gegen Zwinglis ungestümen Willen, besonnen und milde die Sache seiner Vaterstadt und konnte noch 1529, kurz vor seinem Tode, den ersten Kappeler Frieden schließen. Das Bild, in dem sich der Künstler selbst gemalt hat, stellt uns seine liebenswürdige und anmutige Erscheinung ungemein lebendig vor Augen.

Valerius Anshelm, des Familiennamens Rüd und aus Rottweil, Stadtarzt und ein früher Anhänger Zwinglis, hat bis zu seinem Tode zwischen 1543 und 1546 das letzte große Zeitbuch Berns „vom burgundischen Krieg bis uff diese Stund" geschrieben. Es ist fast nur aus Urkunden, im ständigen Gedanken an die gleichläufige Entwicklung Roms und im Stil der römischen Historie gearbeitet. Römisch sind die Satzfügungen, taciteisch die schwergerüsteten Beiwörter, die erregenden Gegensatzpaare und die ätzenden Wortspiele. Der einzige Geschichtschreiber, den das Berner Volk seinem wortschweren Ernst und seiner verschlossenen Kraft gemäß hatte, das war Valerius Anshelm, der sich aus der Wucht römischen Sprachgeistes und der überlegsamen Fülle des Berners einen angemessenen Stil schuf, um von der Geschichte dieser Stadt zu reden.

Anshelms Berner Geschichte

Die literarische Vormacht der altgläubigen Orte war *LUZERN*. Eine ganze Schule geschichtlicher Liederdichter begleitete die Taten der Eidgenossen von den Burgunderkriegen bis zur Kirchenbewegung, meist Mitkämpfer der Schlachten, die sie besangen. Noch vor 1500 verarbeitete ein gewandter Dichter die älteren Lieder über den Tag von Sempach zu einem umfangreichen Ganzen, dem sogenannten Halbsuterliede. Es leitet über zu der Reimchronik vom Schwabenkriege des Schwaben Nikolaus Schrader, die 1500 gedruckt wurde. Der Luzerner Gerichtsschreiber *Peter Etterlin* gewann mit seiner „Kronika von der loblichen Eidgenossenschaft" darum so großen Einfluß auf die Literatur, weil sie als erstes und lange einziges derartiger Bücher 1507 gedruckt wurde. *Diebold Schilling*, der Neffe des Berner Zeitbuchschreibers, arbeitete von 1509 bis 1512 sein Luzerner Zeitbuch, das zwei Maler, einer spätgotischen und einer modern sachlichen Stiles, mit Bildern schmückten.

Luzerner Zeitbuch

Als Vormacht führte Luzern den literarischen Kampf gegen die neue Kirche Zürichs und Berns. Die bescheidene Gruppe junger Luzerner Humanisten, Schüler von Wien und Basel, wurde, weil zwinglisch gesinnt, ausgewiesen. Für diesen literarischen Kampf betrieb 1525 bis 1529 Thomas Murner im Barfüßerkloster eine eigene Presse. Sein Nachfolger in diesem Vorkampf war *Hans Salat*, 1498 bis 1561, aus Sursee im alten Aargau, ein gelernter Seiler. Als Reisläufer machte er 1522 bis 1527 sechs Züge mit und

Glaubenskampf

Hans Salat

war wie Niklaus Manuel bei Bicocca Feldschreiber. Auf eigene Faust ge-
wann er eine anständige Bildung, erlernte das Gewerbe eines Wundarztes
und wurde in Luzern als Nachfolger einer ganzen Reihe literarisch tätiger
Männer Gerichtsschreiber. Er schulte sich an Wiles Übersetzungen und
übte sich im Übertragen aus Erasmus und Hieronymus. Sein zügelloses Le-
ben warf ihn immer wieder aus der Bahn. Er war der geborene öffentliche
Stimmführer. Seine geschichtlichen Lieder waren Luzerner Überlieferung.
Im Anschluß an die siegreiche Schlacht bei Kappel 1531 weitete er die Form
des geschichtlichen Liedes zu einer Rechtfertigungsschrift aus für den Feld-
zug der Fünf Orte: „Tanngrotz", Tannenreis, nach dem Feldabzeichen der
Altgläubigen. Seine ganze Kraft setzte er an das Gedicht „Triumphus Her-

Luzerner culi "Helvetici", 1532, das Handschrift blieb. Im Bilde des schwerverwun-
Theater deten Führers Herkules läßt er Zwingli und mit ihm seine Anhänger in den
Berg des Todes ziehen. Der germanische Glaube, daß die Toten in den Berg
gehen, die Sage von der Wilden Jagd und eine beliebte Darstellung der bil-
denden Kunst waren so zu einer gespenstigen Totenschau der Opfer von
Kappel vereinigt. Salat ließ sein literarisches Schaffen, rühmlich für einen
Mann wie er, in das Volksbuch von Bruder Klaus und in das versöhnliche

Hans Salat „Biechlein in Warnung wyss an de 13 Ort" auslaufen. Hans Salat war oft als
Spielleiter tätig. Sein Schaustück von 1537, „Der verlorene Sohn", erwies,
daß er den Beruf dazu hatte. Es ist selbständig gearbeitet, mit seiner ergrei-
fenden Wahrhaftigkeit aus den eigenen Erlebnissen geschöpft, über die sein
Tagebuch ungefärbte Auskunft gibt. Der Bau einfach, aber folgerichtig und
glatt gefügt, die Sprache blendend ursprünglich und belebt, die Verse für die
Zeit von unnachahmlicher Glätte. Eingelegt ist die wunderschöne Vers-
novelle „Franziskus von Cursit". Sie wird als Warnung beim Gelage dem
schlemmenden Helden erzählt. Welch ein Licht wirft diese feine Kunst auf
das zerrissene Antlitz des Dichters, der sich, ein Lanzknecht der Feder und
des Feldlagers, Handwerker, Arzt und Schreiber, Schulmeister und Wahr-
sager, an allen Steinen des Lebens wundstieß und als Vierzigjähriger den
letzten Strahl seines ringenden Geistes und seiner reichen Gabe zu vielfach
gebrochenem buntem Lichte auffing.

Die Landschaft Luzern besaß aus Volksbräuchen und Fastnachtsaufführ-
rungen eine alte Spielüberlieferung. Die Stadt Luzern stellte dieser Masken-
freude eine große und würdige Aufgabe. Seit etwa 1450 wurde das geistliche

Die Spiel- Spiel gepflegt. Da bildete sich 1470 eine Bruderschaft „Bekrönung unseres
bruderschaft Herrn". Sie rüstete zu Ehren der fünf Wunden Christi alle fünf Jahre ein
festliches Spiel, das bald in zweitägiger Aufführung die ganze Heilsgeschichte

vom Sündenfall bis zur Himmelfahrt in eine bunte und bedeutungsvolle Bilderfolge gestaltete. Luzern machte, wie einst Athen, daraus eine heilige Liturgie. Das Festspiel von Jahrfünft zu Jahrfünft wurde zu einer feierlichen Kundgebung der Staatshoheit. Sie wurde getragen von der ganzen Bürgerschaft und geleitet von den ersten Staatsbeamten und Staatsmännern. Luzern legte mit diesen Spielen, die anfangs nur das Solothurner Bürgertheater unter *Johannes Aal* und mit dessen Spiel „Johannes der Täufer" 1549 neben sich hatte, den Grund zur ersten Theaterstadt der Eidgenossenschaft.

2. DER FRÄNKISCH-MITTELDEUTSCHE KREIS

Zwischen Wien und Basel rundete sich der eine, um Wittenberg der andere Kulturkreis von den beiden heraus, in denen die Bildung des Zeitalters wie in einer weitausholenden Achterschleife ab und zu sich zurücklief. Über die Wiener Universität und die Kanzlei hat Oberdeutschland das eine Erbe des luxemburgischen Böhmen empfangen: humanitas, reformatio, gemeines Deutsch. Über die Wittenberger Universität und Ostfranken gelangte das andere Vermächtnis des luxemburgischen Böhmen reformatio, Recht der Handarbeit und gemeines Deutsch nach Mitteldeutschland. Hier kam der Kampf um eine neue Zeit zur letzten Entscheidung. Die hussitischen Lehren hatten in Ostfranken am frühesten Anklang gefunden. Hus war im Oktober 1414 in Nürnberg gewesen. Der Bamberger Rat war gezwungen, von seiner Bürgerschaft einen hussitischen Absageeid zu verlangen. Zu Heilsbronn richtete um 1440 Friedrich Reiser, der lange für den Verfasser des aufwühlenden Buches *„Reformation des geistlichen und weltlichen Standes"* 1438 entstanden, 1476 gedruckt, galt, eine Brüdergemeinde ein. In den Bergstädten des Erzgebirges erhoben sich zum ersten Male die Arbeiter. Zu Niklashausen in Franken spielte 1476 ein junger Hirt, Hans Böhm, den ersten Aufzug des Bauernkrieges, indem er das wahre Reich Gottes ohne Obrigkeit und Steuer, ein Reich der Gütergemeinschaft verkündete. Aus Ostfranken kam Andreas Bodenstein, der Träger des sozialrevolutionären Gedankens innerhalb der humanistischen und evangelischen Bewegung. So forderten in Mitteldeutschland die humanistischen, religiösen und sozialen Reformationskräfte im Widerstreit miteinander einen Austrag, der um Leben oder Tod ging und schließlich in einem vertagten Ausgleich steckenblieb.

FRANKEN, THÜRINGEN, MEISSEN. Der Humanismus ist in diesen Landschaften aus zahlreichen Einzelzellen hervorgegangen, deren keine sich

Der Wittenberger Kulturkreis

Bewegungsherd Ostfranken

zu einem Mittelpunkt von Leistung und Ansehen verdichten konnte, wie es
Wien oder Basel waren.

Eichstätt Eichstätt wurde durch Johann III., seit 1445 Bischof, einen Freund des
Aeneas Silvius, zu einer der frühesten Herbergen des Humanismus. Hier
wirkte als Domherr, Staatsmann und Rechtsbeistand der Hohenzoller *Al-
brecht von Eyb*, 1420 bis 1475, von Schloß Sommersdorf bei Ansbach. Er war
in Erfurt und an italienischen Hochschulen gebildet. Als der erste Deutsche
schrieb er auf deutschem Boden die ersten humanistischen Büchlein. Seine
Albrecht „Margarita poetica" — poetica im Sinne von „humanistisch" — war ein
von Eyb Lesebuch von klassischen Stücken, mit dem er die noch fehlenden Ausgaben
ersetzen wollte. Die Handschrift wurde 1472 sofort gedruckt. Mit seinem
„Ehebüchlein" 1472 wollte er für eine Besserung der Ehegesetzgebung wir-
ken. Er ist der früheste Mitschöpfer der deutschen Erzählung und Prosa.

Nürnberg Nürnberg ging schon einen stattlichen Schritt weiter. Hier bildeten um
1450 der städtische Beamte Gregor von Heimburg, ein Ostfranke, und der
Stadtschreiber Nikolaus von Wile, der Alamanne, mit ihren Freunden den
ersten humanistischen Gesinnungskreis. In Padua schulte sich 1465 eine
ganze Gruppe von Nürnberger Stadtjunkern. Heimgekehrt fanden sie die
Vaterstadt schon vorbereitet. Johannes Regiomontanus richtete sich eine
Sternwarte ein. Sein Schüler Martin Behaim ging mit dem Rüstzeug des
Lehrers auf Weltentdeckungen aus. Seitdem wurde Nürnberg die Werkstube
für Mechaniker, die im Dienst der Geographie und Mathematik arbeiteten.
Bernhard Walther gründete 1472 eine eigene Druckerei, wo vor allem grie-
chische und mathematische Schriften hergestellt wurden. Durch Schenkungen
und Käufe wurde die Ratsbücherei aus einer scholastischen eine humani-
Willibald stische. Mit der dritten Altersfolge führte endlich *Willibald Pirkheimer* den
Pirkheimer Humanismus in Nürnberg zum Siege, als er 1495 von seiner ritterlichen Aus-
bildung am Eichstätter Hofe und von seiner humanistischen an den italieni-
schen Hochschulen heimkehrte. Sogleich in den Rat gewählt, trat er wie ein
König seine Herrschaft an. Der Humanismus hatte gesiegt, als am 24. März
1496 im Stadtrat bei einer entscheidenden Abstimmung die Gründung einer
humanistischen Schule für die Söhne des Stadtadels beschlossen wurde. Willi-
bald Pirkheimer verkörperte fortan weithin sichtbar mit seinem gastlichen
Hause als Staatsmann, Heerführer und Gelehrter Gesinnung und Haltung
des deutschen Humanismus.

Heidelberg bot abermals ein anderes Bild. Kurfürst Friedrich I., der die
Pfalz seit 1449 für seinen Neffen Philipp verwaltete, faßte die Sache des
Humanismus als eine eigene und persönliche auf. Er unterzeichnete mit dem

29. Mai 1452 eine Urkunde, durch die er der Artistengruppe an der Universität Lehr- und Lernfreiheit gewährleistete und damit den Humanismus zum erstenmal an einer deutschen Universität amtlich anerkannte. Vom Kurfürsten berufen und besoldet eröffnete Peter Luder im Sommer 1456 die ersten humanistischen Vorlesungen. Kurfürst Philipp, seit 1476 der Nachfolger seines Oheims, machte das Schloß zu einem Musenhofe. Sein Rat und Gesandter, der schwäbische Ritter Dietrich von Plieningen, diente ihm als Übersetzer römischer Schriften. Neben dem Schloß behauptete sich das gastliche Haus, das der Dompropst zu Worms und Kanzler der Heidelberger Hochschule, Johann von Dalberg, 1445 bis 1503, führte. Auch er war in Erfurt und Italien gebildet, sammelte mit Leidenschaft Bücher und hatte den Ehrgeiz, von seinen gepflegten Versen, ziersamen Reden, dunklen Büchern und mathematischen Schriften nichts drucken zu lassen. Unter Dalbergs Vorsitz gründete Konrad Celtis 1495 zu Heidelberg die Sodalitas literaria Rhenana. An der großen Familie des Kurfürsten konnten sich die besten Schulmänner Deutschlands als Prinzenerzieher erproben. Da waren Adam Werner von Themar, der Verdeutscher Vergils und Xenophons, des Horaz und der Hrothswitha sowie Johannes Reuchlin, der Redner, Staatsmann und gute Zecher. Und in Heidelberg hat sich Jakob Wimpfeling zweimal während eines mehrjährigen Aufenthaltes zum Erzieher und Lehrmeister der Erziehungskunst gebildet, wie sie in den Schriften „Agatharchia" und „Adolescentia" niedergelegt ist. Heidelberg ist wohl die Heimat jenes Georg Helmstetter gewesen, der in der Gestalt des geschichtlichen Faust steckt, und ein Zögling Heidelbergs war Philipp Schwarzert, Melanchthon, der Mitarbeiter Luthers und praeceptor Germaniae. *Johann von Dalberg*

Erfurt, Stadt und Hochschule, zeigen Rundblick und Tiefengründe der Kämpfe, aus denen ein neues Zeitalter geboren wurde. Alte Gegensätze loderten im Kampf der beiden Hochschulen Köln und Erfurt auf und setzten die humanistisch gesinnte Jugend in Brand. Die Anfänge des Thüringer Humanismus führten unmittelbar auf die Brüder vom gemeinsamen Leben zurück. Denn auf der berühmten Schule zu Deventer saßen nebeneinander der Hesse Konrad Mut und der Rotterdamer Gerhard Gerhards, die unter den Namen Mutianus Rufus und Desiderius Erasmus berühmt wurden. Mit dem Einfluß der Brüderherren kreuzte sich das Wirken italienischer Lehrer, die gerade in Erfurt stark vertreten waren. Doch die Stärke und der Ruhm der Erfurter Hochschule gründete sich nicht auf die Lehrer, sondern auf die Schüler. Unter denen die dichterisch bedeutendsten zwei Hessen waren: Eoban Koch, 1488 bis 1540, aus Halgehausen, der sich Eobanus Hessus, und *Erfurt* *Erfurt und Gotha*

Heinrich Solde, 1486 bis 1535, aus Simtshausen, der sich Euricius Cordus nannte. Zu ihnen fanden sich Johannes Jäger, um 1480 bis 1539, Crotus Rubianus und Jodocus Koch, 1493 bis 1555, Justus Jonas genannt, beide Thüringer. *Eobanus Hessus* war der weitaus Begabteste, der das Zeug zu einem großen Dichter hatte, in Stegreifversen gewandt, der Dichter eines kleinen Gesprächsromans „Vom Unglück der Liebenden", von elf Hirtengedichten im Stil Vergils und der „Briefe christlicher Heldinnen", mit denen er Ovid nacheiferte. *Euricius Cordus* wurde ein klassischer Epigrammdichter

Der Kreis um Konrad Mut nach dem Vorbild Martials. *Crotus Rubianus* war der Zyniker des Kreises, der Heidnisches und Christliches keck vermischte und in seinen Fuldaer Festkalender etwa statt der Heiligen Götternamen einschwärzte. *Justus Jonas* wurde ein stiller Gelehrter. *Konrad Mut,* 1471 bis 1526, aus Homberg, war nach seiner deutschen und italienischen Hochschulzeit 1503 Domherr zu Gotha geworden, wo er in seinem Häuschen hinter dem Dom die Musenstille fand, die er sich immer gewünscht hatte. Er dichtete und schrieb wenig. Dafür lebte er ganz in Gesprächen und Briefen. Nicht selten hatte er die jungen Erfurter Freunde bei sich. Da erging man sich in Scherzen, Versen, Gesprächen über Bücher und Ereignisse. Zuweilen wurde scharf gebechert. Der Kreis zerstreute sich und fand sich 1515 wieder zusammen. Inzwischen hatte die Szene gewechselt. Johann Pfefferkorn war an der Kölner Hochschule mit dem Eifer jung Bekehrter gegen den Talmud aufgetreten. Johannes Reuch-

Johann Reuchlin tritt auf lin, der Berater der Zeit in hebräischen Dingen, setzte sich für die Talmudliteratur ein. Der alles aufwühlende Meinungsstreit aller gegen alle setzte viele Universitäten mit Gutachten in Bewegung und kam vor Kaiser und Papst. Er war der erste Anlaß, bei dem sich der glimmende Brand zwischen Humanismus und Scholastik zu einem lohenden allgemeinen Brande der Geister entfachte, in dem dieser erste Anlaß rasch verknistert war. Reuchlin stellte 1514 Humanistenbriefe, die ihm Recht gaben, zu dem Büchlein zu-

Epistolae obscurorum virorum sammen: „Clarorum virorum epistolae". Da fiel der große Schlag, den die Erfurter und ihre Gesinnungsgenossen in aller Stille vorbereitet hatten. Mit dem falschen Druckort Venedig erschienen 1516 und 1517 die beiden Teile der „*Epistolae obscurorum virorum*", was man mit der gewollten Beziehung auf Reuchlins Briefbuch mit „Briefe von Pfifferlingen" übersetzen müßte. Denn gemeint waren die Leute, nach deren Meinung kein Hahn kräht. Es waren erfundene Briefe, die den Leipziger und Kölner humanistenfeindlichen Scholastikern unterschoben wurden, um deren Menschlichkeit und Latein lächerlich zu machen, eine Stilparodie, die bei aller komischen Übertreibung so echt und vertraulich wirkte, daß die Angegriffenen im ersten

Augenblick glaubten, eine wirkliche Briefsammlung aus ihrer Mitte vor sich zu haben. Der erste Teil war von Crotus, der schwächere zweite von Hutten. Andere hatten den Stoff sammeln helfen. Das Buch schied die Geister. Reuchlin, dessen Sache es führte, war peinlich getroffen. Denn so wollte er Ziel und Angriff nicht gestellt wissen. Der vorsichtige Erasmus wich klug aus. Selbst die Freunde sahen einander überrascht in die Gesichter, als die Katze aus dem Sack war. Unter den Männern, die hier als Leute, auf deren Urteil man pfeifen kann, verhöhnt wurden, waren nicht wenige von Rang und Leistung. Und schließlich, man brauchte nicht einmal zwischen den Zeilen lesen um zu sehen, daß Köln und Leipzig gesagt und Rom gemeint war.

Erfurts größter Schüler überbot dieses kühne Wort sogleich durch die noch kühnere Tat. Doch nicht der Erfurter Humanismus, die Erfurter Scholastik hatte diese Tat zum Kinde und die alamannische Mystik Taulers stand ihm Pate. *Martin Luther*, 1483 bis 1546, kam 1501 auf die Erfurter Hochschule. *Martin Luther*
Eisleben war seine Wiege, doch nicht seine Heimat. Möhra, der Stammsitz der Luther am Westhang des Thüringer Waldes, gehörte um diese Zeit zum Kurfürstentum Sachsen-Wittenberg. Luthers Mutter war eine Fränkin. Ihr glich der Sohn in aller äußerer Erscheinung. Luthers Geschlecht waren wohlhabende, alteingesessene Bauern, der Vater gut gestellt und Bergmann. An der Erfurter Hochschule folgte Luther dem scholastischen Unterrichtsgange. Daß er sich daneben in den Schriften der Alten umtat und sich unter humanistisch gesinnten Freunden bewegte, will wenig besagen. Er wurde 1505 Magister und wandte sich jetzt der Rechtswissenschaft zu. Aus Heilssorgen *Luther in Erfurt*
und von einem äußeren Erlebnis bewogen, trat er 1505 in das Erfurter Augustinerkloster, trieb hier Theologie und wurde 1507 Priester. Johann von Staupitz, aus altadeligem Geschlecht Meissens und Vikar des Ordens, lernte den jungen Bruder bei einem Besuch in Erfurt kennen, besprach mit Ruhe und Milde seine Zweifel und verschaffte ihm 1508 einen Ruf als Lehrer an die Wittenberger Universität.

Die Leipziger Hochschule empfing ihre ersten Antriebe zum Humanismus durch Franken, die ja auch großen Anteil am stammheitlichen Aufbau des Volkes hatten. Zwei Franken waren die Führer eines Leipziger Schülerkränzchens, das sich um 1455 der Pflege antiker Literatur ergeben hatte. Franken waren es, die an der Universität als erste humanistische Vorlesungen hielten, von Peter Luder bis zu Konrad Celtis. Und Franken waren die beiden Männer, deren Streit um die Stellung der Poesie so schicksalhafte Folgen für die Universität hatte: der Arzt Martin Polich und sein Schüler Konrad *Zwist in Leipzig*
Koch, der sich Wimpina nannte. Sie gerieten aus belanglosem Anlaß anein-

ander, wobei Polich sich für den Humanismus und Wimpina für die Scho-
lastik einsetzte. Als Polich 1501 den entscheidenden Ruf nach Wittenberg
erhielt, entwickelte sich aus dem Streit der beiden Franken der geschichtliche
Wettbewerb der beiden Hochschulen, der Leipziger mit Wimpina, der Wit-
tenberger mit Polich als Wortführer: hie Leipziger Scholastik, hie Witten-
berger Humanismus. Und weit über Anlaß und Inhalt des Streites hinaus
verschärfte sich der Wettbewerb zu dem aufregenden Zweikampf zwischen
der Hochschule, die sich als Hüterin des alten Glaubens gegen Hus gebildet
hatte, und der Hochschule, die zur Trägerin der neuen Kirche wurde.

WITTENBERG und der MITTELDEUTSCHE OSTEN. An Wittenberg
haftete von den Askaniern her die Kurwürde. Mit Wittenberg kam sie 1423

Kurfürstentum
Wittenberg
an die Wettiner. Durch den Erbvergleich der beiden Wettiner Brüder Ernst
und Albrecht von 1485 fiel Wittenberg mit der Kurwürde an Ernst. Zum
Kurfürstentum gehörten Gotha, die geistig betriebsamen Städte des Erz-
gebirges und Möhra, die Stammheimat Luthers. Diesem politisch und geistig
so ansehnlichen Gebilde erweckte Kurfürst Friedrich III., Ernsts Sohn, das
schlagende Herz, indem er am 18. Oktober 1502 die neue Hochschule zu

Hochschule
Wittenberg
Wittenberg eröffnete. Ihr hatte nur noch der Kaiser und nicht mehr der
Papst Pate gestanden. Auch an ihr überwogen weitaus die Franken. Durch
Johann von Staupitz stand sie in einem engen Verhältnis zu den Augustinern
und durch die Augustiner zu Tübingen. Mit Erfurt gab es einen lebhaften
Wechselverkehr. Die Auswahl der Lehrkräfte ging durch die Hände des kur-
fürstlichen Leibarztes Martin Polich aus Mellrichstadt in Franken. Der eigent-
liche Mittler zwischen Hochschule und Kurfürsten wurde dessen Geheim-
schreiber, der Franke Georg Burkhard, der sich von seiner Heimat Spalt bei
Nürnberg Spalatinus nannte. Die neue Hochschule war eine scholastische
Anstalt, der lediglich die humanistisch gerichtete Fachgruppe der Artisten
einen klassischen Einschlag gab. Aber Wittenberg war eine fortschrittliche

Augustinus und
die Augustiner
Hochschule. Sie huldigte im Sinne der Oxforder Barfüßer der sprachwissen-
schaftlichen Lehrweise und stand zu Augustinus, der die englische Richtung
der Scholastik immer wieder befruchtet hatte, gegen Aristoteles und Thomas,
die beiden Kirchenväter der Predigerbrüder. Der Widerstreit zwischen Ox-
ford und Paris, zwischen der englischen und französischen Richtung war zu-
erst in Böhmen mit geschichtlichen Taten wirksam geworden. Er wurde jetzt
zum Schicksal der Wittenberger Hochschule und verkörperte sich offenkun-
dig in dem Gegensatz der beiden Bettelorden, der Dominikaner und Augu-
stiner. Es sind geistesgeschichtliche Zusammenhänge von unermeßlichem
Umfange, die in Namensgebung und Ordensbezeichnung der Augustiner zu

Augustinus ein äußerliches Sinnbild fanden. Was nun in Wittenberg geschah, erhob das ältere englisch-böhmische Zusammenspiel im Ostraum zu einem kulturbildenden Werk von dauersamer Wirkung.

Martin Luther begann also im Winterhalbjahr 1508 auf 1509 in Witten- berg über Philosophie zu lesen. Nach einer kurzen Zwischentätigkeit in Er- furt und einer Sendung nach Rom, wo er weder ein klassisches Erlebnis hatte noch in seinem Glauben an das göttliche Recht des Oberhirten erschüttert wurde, erhielt er im Herbst 1512 mit dem Doktorhut die ersehnte Lehrkanzel an der theologischen Fachgruppe. Sogleich lehrte er die Theologie im Lesen und Ausdeuten des biblischen Wortlautes. Das war eine Lehrweise, die wohl mit dem humanistischen Betriebe zusammentraf, aber lediglich alten scho- lastischen Strebungen moderne Geltung gab. Aber auch dem Inhalt nach konnte es noch immer scholastisch heißen, wenn er an Augustinus und über Augustinus hinaus am Sendboten Paulus seine Rechtfertigungslehre ent- wickelte. Dazu stimmte es, wenn Luther 1516 mit Tauler und der Abhand- lung „Deutsche Theologie" eines Ungenannten bekannt wurde und aus den neu entdeckten Büchern herauslas: auf den eigenen Willen und die eigene Gerechtigkeit zu verzichten, um so zur Seligkeit in Gott zu gelangen. So hatte er lediglich die herrschende Scholastik überwunden, als er sich aus der älteren Scholastik und Mystik eine eigene Lehrweise und einen persönlichen Ge- dankeninhalt gebildet hatte. Seine Tatkraft formte in diesem seinem Sinne die ganze Theologische Fachgruppe um. Er gewann die Schüler der Hoch- schule und durch Burkhard den Hof.

Zu einer humanistischen Universität ist Wittenberg nicht durch Martin Luther, sondern durch *Philipp Melanchthon* gemacht worden. Mit dem Rheinfranken Melanchthon zog in Wittenberg der Humanismus ein, als er 1518 sein griechisches Lehramt mit der Vorlesung „Über die Verbesserung des Unterrichts" antrat. Er verlangte eine Erneuerung des ganzen Schul- betriebes durch Rückkehr zu den unverfälschten Quellen. Er nannte die Sprachwissenschaft den Schlüssel zum Christentum. Seit dieser Antrittsrede wurde er der Begründer der evangelischen Geistesbildung. Das Griechische trat zu Wittenberg in den Mittelpunkt der Schule. Um den Nachwuchs im mündlichen und schriftlichen Ausdruck zu fördern, setzte Melanchthon zwei Lehrer für Redekunst durch und richtete an Stelle der scholastischen Denk- gefechte öffentliche Sprechübungen ein, zwar auch nur Redeversuche, doch sie weckten Stilgefühl und Sinn für Wohllaut. Er herrschte in der Artisten- gruppe wie Luther in der theologischen. Beide Männer von fränkischer Her- kunft fanden einander sofort. Jeder spielte sich auf den andern ein.

Luther in Wittenberg

„Deutsche Theologie"

Melanchthon und der Wittenberger Humanismus

So war in Luther vorerst nur der Bruch mit der herrschenden Schultheologie vollzogen, und in Melanchthon hatte der Humanismus von der Hochschule Besitz ergriffen. Was weiter geschah, erfolgte Schritt für Schritt mit Antrieben von außen her. Gegen Johann Tetzels unkluge und kirchenwidrige Ablaßpredigt schlug Luther am 31. Oktober 1517 seine fünfundneunzig Sätze an. Damit war kein Widerspruch gegen die kirchliche Lehre beabsichtigt. Im Leipziger Gespräch mit Johannes Eck 1519 ging es schon um die Schlüsselgewalt, die Luther dem Papst entzog und für die Kirche im Ganzen beanspruchte. Er bekannte sich zu Hus. Er verlangte den Kelch, gab die meisten Heilsmittel preis und ließ nur Wort, Taufe und Abendmahl gelten. Seine Flugschrift „An den christlichen Adel deutscher Nation" 1520 sprach von einem allgemeinen Priestertum aller Getauften. Die Bannbulle, die inzwischen ergangen war, verbrannte Luther am 10. Dezember 1520, und 1521 vor dem Wormser Reichstag berief er sich schon nicht mehr auf die Schrift allein, sondern auch auf die ratio evidens. Noch lebte er im Augustinerkloster nach seinen Gelübden. Mit seiner Heirat 1525 tat er innerlich und äußerlich den letzten Schritt. Nun führte er auch den Aufbau seiner Kirche durch. Er gründete sie auf die an das Wort glaubende Gemeinde und beschränkte deren Gottesdienst auf Predigt und Gesang.

Die Wittenberger Thesen

„An den christlichen Adel deutscher Nation"

Eine evangelisch deutsche Bibel und ein evangelisches Liederbuch waren daher das Wichtigste, was getan werden mußte. Und Luther tat es. Die deutsche Bibel begann er zu Weihnachten 1521 während der unfreiwilligen Muße auf der Wartburg. Es erschienen 1522 das Neue Testament, 1534 die ganze Bibel, 1541 in neuer Bearbeitung, 1545 in der Ausgabe letzter Hand. Die Bibel befand sich längst geschrieben und gedruckt und in mannigfachen deutschen Mundarten in den Händen wenigstens der Lesekundigen, die ein Buch erwerben konnten. Luther hat seine deutsche Bibel einmal im Sinne der humanistischen Sprachwissenschaft nicht aus der lateinischen Zwischenfassung der Vulgata, sondern unmittelbar aus den hebräischen oder griechischen Urfassungen übersetzt und er hat sodann seine Bibel in dem schon geltenden Gemeindeutsch der Kanzleien geschrieben. Er hat damit den laufenden Sprachvorgang nicht abgeschlossen, sondern eher zunächst gehemmt, weil seiner mitteldeutschen Bibel aus Gründen des Bekenntnisses eine bairische und eine alamannische entgegen und aus sprachlichen Gründen eine niedersächsische zur Seite trat. Daß aber aus der Bibel überhaupt, nicht nur aus der seinen, ein Volksbuch werden konnte, das war eine Frage, deren Lösung von der Technik, vom Kaufmann und vom Schulmeister abhing. Groß ist an Luthers deutscher Bibel also die sprachwissenschaftliche und sprach-

Die Bibel deutsch

schöpferische, das ist die persönliche Leistung, der noch vieles zu Hilfe kommen mußte, was nicht in seiner Macht stand und doch unerläßlich war, sein Buch zum Gemeingut zu machen. Das deutsche Liederbuch, das er geschaffen hat, in seiner ältesten Gestalt, ist das Wittenberger von 1524, eine Gemeinschaftsarbeit mit dem Kapellmeister Johann Walther. Es ist aus dem längst gebräuchlichen lateinischen und deutschen Kirchenliede herausgewachsen und in diese Überlieferung immer mehr eingedrungen. Er hat seine Sammlungen aus verdeutschten lateinischen Hymnen und aus dem älteren deutschen Liederbuch der böhmisch-mährischen Brüder geschöpft. Von seinen eigenen Liedern ist keines vor 1521 nachweisbar. Wohl am 15. April 1521 im Gasthaus zur Kanne in Oppenheim, auf dem Wege nach Worms und in Stunden der Bangnis, dichtete er den Schlachtgesang der evangelischen Bewegung: „Ein' feste Burg ist unser Gott". Das Jahr 1523 ist der Frühling des evangelischen Liedes. Das Jahr 1524 war Luthers fruchtbarstes. Er hatte wie wenige die Kraft zum Erleben. Alle seine eigenen Lieder stehen unter dem Eindruck unmittelbarer Anlässe. Das Volkslied war ihm vertraut. Er hatte das Gefühl für den Pulsschlag des Werdenden und war der berufene Dichter der Gemeinde. Persönliches Gefühl hat er nur selten ausgedrückt. Er hat und formt das Wort der gläubigen Gemeinde. Luther war der stärkste Tagesschriftsteller des deutschen Volkes. Zu solchem Berufe brachte er alles mit: das untrüglich sichere Gefühl für die Witterungen der Volksseele, für Stimmungen, die in der Luft lagen. Jede aus der Masse seiner Flugschriften findet sofort den Tonfall zu der Weise, die eben gespielt werden wollte. Das derbanschauliche, das grelle Witzwort, der knappe Spott, vernichtender Hohn, Übertreibung und Scheltwort gehören zu dem Stimmführer der öffentlichen Meinung, der wie der Lanzknecht am Mörser hoch schießen muß, weil er weit treffen will. Dichterisch ausgeformt hat sich Luthers Werk, so sehr es auch in das gesamte Schrifttum ausstrahlte, vor allem in Mitteldeutschland. Hier hat es seinen eigentümlichen kunstmäßigen Stil gefunden.

Das Kirchenlied

Luthers Flugschriften

HESSEN wurde durch die Hand des Landgrafen Philipp I. das Rüstzeug von Luthers Wort und Werk. Hessen stellte ihm die treuesten und opferfreudigsten Jünger. *Erasmus Alberus,* um 1500 bis 1553, aus der Wetterau, focht überall, wohin ihn sein beispiellos bewegtes Leben fegte, für Luthers Person und Sache. Seine gesprächsartigen und streitbaren Schriften mischten sich in jeden Handel. Seine flott gereimten Fabeln nach Aesopus, Steinhöwel und Luther, „Das Buch von der Tugend und Weisheit" 1534, sind beinahe Heimatgeschichten, so treu spiegeln sie den Taunus und die Wetterau wider.

Das Rüstzeug Hessen

Burkard Waldis, 1490 bis um 1556, aus Allendorf, hat sich als Franziskaner im Kerker zu Riga an Luther ergeben. Ein niederdeutsches Drama „De Parabell vam vorlorn Szohn", 1527 zu Riga gespielt, eine gereimte Fabelsammlung nach Martinus Dorpius „Esopus" 1548 und sein reinstes Werk „Der Psalter" 1552 sind die Dichtungen der Rigaer Zeit. Kaum hatte ihn die hessische Heimat wieder, so steckte sie ihn auch mit ihren Streitschriften und kriegerischen Reimen an. Aber er hat auch den „Tewerdanck" 1553 erneuert.

Hochschule
Die Schöpfung
MEISSEN hatte durch Herzog Georg von Sachsen mit Hof und Universität dem Luthertum standgehalten und ergab sich erst 1539 nach erbitterten Geisteskämpfen. Die Universität Leipzig wurde durch den Ostfranken Joachim Kammermeister, 1500 bis 1574, Camerarius genannt, in Luthers Geist zeitgemäß erneuert. Auch der Leipziger Buchdruck war eine starke Stütze der katholischen Partei gewesen und nahm nun bald eine andere Haltung an. Der literarische Ertrag der Landschaft war gering und hing mit Universität wie Buchdruck zusammen. Das eine war das Bühnenspiel, das seit dem „Eunuchus" von 1515 an der Universität gepflegt wurde. Es muß auffallen, daß das Bibelstück beinahe gemieden wurde und erst 1553 ein „Simson" bezeugt ist. Das andere waren die Schwankbücher, die sich als reine buchhändlerische Unternehmungen verraten. Sowohl *Valentin Schumann* mit seinem „Nachtbüchlein" 1558 als auch *Michael Lindner* mit „Katzibori" und „Rastbüchlein" 1558 waren wandernde Druckergehilfen. Weder die Universitätsspiele noch die Schwankbücher können den literarischen Auswirkungen der Reformation zugerechnet werden.

Leipzig
des evangelischen
Dramas
In *MAGDEBURG* und im Erzgebirge hat das Luthertum seinen schönsten dichterischen Stil durch Lied und Spiel gefunden. Zum Magdeburger Schützenfest 1534 führten *Joachim Greff* und *Georg Major* ihr biblisches Drama „Jakob und seine Söhne" auf, ein kleiner, aber ein glücklicher Anfang. Greff schickte ihm 1535 eine deutsche Fassung von der „Aulularia" des Plautus und 1536 eine „Judith" nach. Als Schüler und Nachstrebende gingen *Valentin Voith* mit einem „Tobias" und *Georg Rollenhagen* mit einem „Abraham" in der einmal ausgetretenen Spur. Nicht daß es biblische Stücke waren und aus Luthers Buch schöpften, machte diesen Anfang bedeutsam, sondern daß sie die attische Tragödie, wenn auch vorerst nur im rohen Aufriß, nachzubilden strebten. Da bedurfte es freilich eines Meisters und der fand sich unter den Pfarrherren, die für Luther die jungen, reichen, schulfreundlichen Städte des *ERZGEBIRGES* gewannen. Unter diesen war Zwickau die schönste und geistig regsamste, eindrucksvoll verkörpert durch ihren Stadtschreiber Stephan Roth, den Humanisten, Übersetzer, Herausgeber und

Druckberater landauf und landab. In diesem Zwickau und als Freund Roths wirkte 1531 bis 1538 an der Ratsschule *Paul Rebhun,* um 1500 bis 1546, der Sohn eines Rotgerbers aus Waidhofen an der Ybbs. Er hatte im Hause Luthers gelebt, war vor Zwickau Schulmeister zu Kahla und nachher in Plauen. So bescheiden an Umfang Rebhuns Werk ist, so vielfältige Neigungen bezeugt es. Da sind ein lateinisches Lehrbüchlein und eine deutsche Grammatik, von der man nicht weiß, ob sie bloß geplant oder nicht gedruckt wurde. Da ist „Hausfried" 1546, eine Ehepredigt, und „Klagred des armen Mannes" 1540, ein soziales Gespräch, dessen Gesinnung sich in den beiden Dramen dichterisch bewährt hat. Die aber stehen frei und geräumig in der Mitte. „Ein Hochzeitsspiel auf die Hochzeit zu Cana" 1538, atmet die Luft von Rebhuns jungem Pfarramt. Die biblische Handlung wird zum erlebten deutschen Alltag. Eine Gemeinschaft, die sich wie die evangelische Kirche erst bilden wollte, mußte alle Ehrfurcht und Verantwortung auf die Familie, ihre Grundzelle, legen. Rebhuns große Leistung und dichterisch der Inbegriff des Wittenberger Kulturkreises ist das Drama „Susanna". Es wurde 1535 zu Kahla von Bürgern gespielt. Die biblische Novelle ist mit einer ganz modernen Kunst zu einem wahren Drama gestaltet, wie es in diesem Jahrhundert nicht seinesgleichen hat. Das ist der Dichter und das ist die Dichtung, in denen der antike Lehrgang des Zeitalters in ein reines deutsches Kunstwerk umgesetzt ist. Das griechische Schauspiel und seine Kunstgesetze sind zum erstenmal deutsche Erscheinung geworden: in einer planvoll geführten Handlung, in den persönlich gezeichneten Gestalten, in den Chorliedern, deren eines den berühmten Erosgesang in der „Antigone" des Sophokles deutsch aufklingen läßt. Rebhuns „Susanna" ist die erste Dichtung in deutscher Sprache, die das rhythmische Gesetz der Antike, nämlich regelmäßigen Wechsel der Takteinheiten, auf das neue Deutsch und seine Verskunst übertragen hat, indem er nur tonstarke Silben in die sogenannte Hebung setzt und zwischen guten und schlechten Taktteilen regelmäßig abwechselt. Er hat in seinem Drama bereits alle geläufigen Versarten durchgebildet. Rebhun hat diesen neuen Vers nicht aus einem dunklen Gefühl, sondern mit klarem Bewußtsein geschaffen, wie aus seinen gelegentlichen Bemerkungen hervorgeht. Ausführlicher sollte über diese Dinge in seiner geplanten Grammatik gehandelt werden. Daß dieses Buch nicht zustande kam, jedenfalls nicht erschien, hat ihn um das Recht einer Erstgeburt gebracht, die ein Jahrhundert später Opitz zufiel. Paul Rebhun ist der erste künstlerische Sprecher der evangelischen Gesinnung und der Vollender des evangelischen Dramas. Er ist der erste Gestalter der neuen deutschen Dich-

Paul Rebhun

Das Drama

Der neue deutsche Vers

tung aus dem Geiste des Humanismus. Er hat dem gemeinsprachigen Prosa-deutsch zum erstenmal wahrhaft dichterischen Ausdruck verliehen. Er hat als erster den deutschen Vers zu regelmäßigem rhythmischem Wechsel durch-gebildet und die beiden vorherrschenden dramatischen Versarten der Deut-schen, den fünffüßigen Jambus und den vierfüßigen Trochäus stilvoll ver-

Rebhuns Schüler — wendet. Mit Paul Rebhun beginnt das moderne deutsche Drama, der mo-derne deutsche Vers, die moderne Dichtung ostdeutsch gemeinsprachigen Stils. Er hat Schüler gefunden und Schule gemacht und so fortgewirkt: durch den Zwickauer Joachim Greff, der in Magdeburg, durch Hans Tiroloff aus Kahla, der in Wittenberg tätig war; durch die Zwickauer Hans Ackermann

Joachimstaler Dichtung — und Hans Thym. Unter den Städten des Erzgebirges war Joachimstal die allerjüngste, eine Stadt von Bergknappen und eben erst gegründet, als sie auch schon geistig zu leben begann. Hier schuf der Gesangmeister *Nikolaus Herman,* um 1490 bis 1561, aus Altdorf, die volksliedhafte Kunstform des evangelischen Kirchenliedes und stellte diese Lieder in den beiden Büchern „Sonntagsevangelien" 1560 und „Historien von der Sintflut" 1562 zusam-men. Und hier gab der Schulmann und Prediger *Johannes Mathesius,* 1504 bis 1565, aus Rochlitz, mit seinen Fastenpredigten der „Bergpostill" 1552, mit seinen „Leichenreden" 1559 und seinen „Hochzeitspredigten" 1563, der evangelischen Kanzelrede bodenständigen und künstlerischen Stil.

Luthers Kirchentum war in der ostmitteldeutschen Gemeinsprache dich-terisch Erscheinung geworden.

NÜRNBERG und der MITTELDEUTSCHE OSTEN. Hartmann Sche-dels Buch „der Chroniken und Geschichten", das 1493, ein wuchtiger Band, mit Holzschnitten überreich ausgestattet, Koburgers Presse verließ, eine Welt-chronik humanistischen Geistes, bildet den tiefen Hintergrund, vor dem das Nürnberger Leben dieses Jahrhunderts vorüberzieht.

Die Nürnberger Junker — Den Humanismus hatte *Willibald Pirkheimer,* 1470 bis 1530, in Nürnberg zum Siege geführt. Der Sieger genoß und verkörperte ihn auf eine fürstliche Weise. In seinem Hause wurden Symposien von platonischer Art gefeiert. Was damals in Deutschland Rang und Namen hatte, nahm unsichtbar be-kränzt daran teil. Pirkheimer hat mit durchwegs kleinen Schriften das weite Gebiet seiner Neigungen beherrscht, Wesen der Geschichtschreibung und Wirken der Kirchenväter, Münzwesen und Theologie, Staatsverfassung und Leben der Gegenwart. Er hat den Liebling des Jahrhunderts, den spät-griechischen Spötter des Morgenlandes, Lukian, übersetzt, und er hat, ein Lobredner der deutschen Sprache, von Deutschland ein gedrängtes Bild ent-worfen. Der Kunstform des Briefes war Pirkheimer vielseitig mächtig, wenn-

gleich sein Latein nur von mittelmäßiger Schönheit war. Als ein Liebhaber *Willibald* der kleinen ironischen Form hat er in lateinischer Prosa und mit spöttischer *Pirkheimer* Miene „Das Lob des Zipperleins" gesungen und „Die Hobelung Ecks" geschildert. Aber wie Konrad Mut hat Pirkheimer nicht durch Bücher, sondern durch sein Menschenwesen gewirkt, dem man schwer widerstehen konnte. Mit Albrecht Dürer verband ihn eine hintergründige Freundschaft. Pirkheimer hat mit vollen Zügen das Leben des Staatsmannes gelebt. Er betreute die Nürnberger Schulen. Er war als Gesandter tätig. Dem Kaiser Maximilian I. führte er 1499 den Nürnberger Auszug für den Schweizer Krieg zu, 400 Fußknechte und 60 Reiter. Sein „Bellum Suitense" beschrieb in Caesars Geist und Stil die Heerfahrt. Im Reuchlinstreit schien es fast, als fiele Pirkheimer die Rolle des Führers zu. Der stürmische Verlauf der Kirchenbewegung, der er zugeneigt war, drängte ihn wieder auf die rechte Seite. In allem getäuscht, was er gewollt hatte, zog er sich endlich von allem zurück. Der Nürnberger Humanismus ging im Lebensstil der Nürnberger Stadtjunker auf.

Die eigentümliche Dichtung der Stadt hat das kleine Stadtbürgertum geschaffen. Wie auf vorwärtsdrängenden Stufen geht es von Hans Schnepperer *Die Nürnberger* über Hans Folz zu Hans Sachs empor, damit sich auch hier in den drei Hän- *Handwerker* sen die ewige Dreizahl erfülle.

Hans Schnepperer, um 1400 bis gegen 1460, aus Nürnberg, hat sich schö- *Die drei Hänse.* ner Rosenblüt genannt. Er hat als Büchsenmacher die Hussitenschlachten bei *Schnepperer* Mies und Taus mitgeschlagen und auch in den Scharmützeln der Stadt seinen Mann gestanden. Das Lügenmärchen des Priamels, Wappenreden und Lehrgedichte, alles lag ihm gut in der Hand, da er Sprache und Witz des Volkes vollkommen innehatte. Schnepperer war mit seinen Sprüchen der anerkannte Zeitungsmann seiner Vaterstadt und er hat dem Fastnachtsspiel die erste Form von der Art gegeben, daß man es in den Trinkstuben vortragen konnte: kurze Schwänke, derb und eindeutig, gesprächsweise auf ganz wenige Aufsager verteilt.

Hans Folz, um 1433 bis 1513, von Worms, Wundarzt und Barbier, betrieb *Folz* sein literarisches Handwerk mit modernem Bedacht. Wie es scheint, besaß er selber eine kleine Druckerei zur Verbreitung seiner Sachen. Er hat beides gepflegt, Fastnachtsspiel und Meistergesang, jenes in jüngeren, dieses bei verständigeren Jahren. Seine Fastnachtsspiele vertrugen schon eine richtige Aufführung. Die hat er selber, wenn auch nur vielleicht im häuslichen Kreise, geleitet. Er gab dem alten Gesprächsschwank einen kunstvolleren Aufbau und machte beinahe ein Drama daraus. Später wuchs er in den aufblühenden

Meistergesang hinein. Man muß sich Hans Folz und die Dichterei, wie er sie trieb, als sehr privat vorstellen.

Sachs *Hans Sachs,* 1494 bis 1576, aus Nürnberg, eines zugewanderten Schneiders Sohn und selber Schustermeister, ist ohne einschränkenden oder steigernden Zusatz der Dichter seines Zeitalters gewesen. Er hat nicht einfach die ungeheuren Stoffquellen, die der Humanismus erschlossen hatte, in Verse gebracht, damit seinesgleichen zu lesen hätte. Er hat die moderne Bildung und den Lauf der Welt, wie er sie durch geschulte Männer und aus Büchern kannte, für sich selbst und für das Volk verarbeitet. Homer, Livius und Ovid, Schwänke und Novellen aus dem scholastischen Mittelalter und dem italienischen Humanismus sind durch seine Verse hindurch erst Volksgut geworden, wie das Weltbild der evangelischen Gesinnung allein durch seine Gespräche und Spiele wahrhaft Volksdichtung geworden ist. Freilich, der Meistersinger und Meisterspieler ist Hans Sachs geworden, weil er gerade im rechten Augenblick die eben zugerüstete Szene betrat. Der Meistergesang ist in Nürnberg weit jünger gewesen als in Augsburg. Die Ratsbücher sprechen erst 1503 von ihm. Es scheint, daß Hans Folz, der ja aus der rheinischen Heimat des Meistergesanges kam, hier als Vermittler seine Hand im Spiele hatte. Wie überall wurde alle vier Wochen die gemeine und an den drei großen Kirchenfesten die öffentliche Singschule gehalten. Die Gedichte wurden vorgetragen ohne Begleitung. Die Schule wechselte ihren Ort sehr häufig. Um 1540 war es Sankt Lorenz. Durch Lienhard Nunnenpeck war Hans Sachs in die schon geltende Übung eingeführt worden. Auf seinen Gesellenfahrten an Rhein und Donau hatte er in auswärtigen Schulen hinzugelernt. Hans Sachs ist der Meister der Nürnberger Schule und durch sie des ganzen *Meistergesang* deutschen Meistergesangs. Er hat 1540 die älteste Nürnberger Singordnung niedergeschrieben. Er hat das weltliche und geistliche Gedicht geübt. Luther begrüßte er 1523 mit seiner „Wittenbergischen Nachtigall". Der erste Großband seiner Gedichte, 1558 erschienen, stiftete der ganzen Zunft ein weithin sichtbares Ehrenmal. Das Fastnachtsspiel hatte durch Schnepperer und Folz seine literarische Vorgestalt empfangen. Die Stadtjunker wandten sich von ihm ab und dem modischen Lateinspiel zu. Sie traten in den antiken Stücken der humanistischen Schule auf. Deutsche Dramen wurden dann, zunächst vor geladenen Gästen, in der Spitalschule und im alten Kartäuserkloster gehalten. Durch Hans Sachs gewann die alte Handwerkerkomödie, neu geformt, wieder Oberwasser und durch ihn wurde die Singschule zugleich eine Spielgemeinde für das neumodische ernste Bürgerdrama evangelischen Stiles. Er zog sich eine Spielschar heran und führte sie. Selber aufgetreten ist er kaum.

Als Spielleiter und Spielbuchdichter hat Hans Sachs dreierlei von Bedeutung getan. Einmal hat er dem heimischen Fastnachtsspiel den letzten Schliff zu einem wirklichen Drama gegeben, indem er die Handlung in Aufzügen durchgliederte, den Hauptspieler herausarbeitete und den Inhalt ehrbarer machte, damit die Stücke vor aller Augen und Ohren aufgeführt werden könnten. Sodann hat er das evangelische Drama, wie es in Mitteldeutschland nach dem Vorbild der attischen Tragödie gestaltet worden war, aus den stofflichen Grenzen der Bibel heraus auf die grüne Weide der Weltliteratur geführt. Aus einer Sache des evangelischen Pfarrhauses und der evangelischen Schule hat er eine rein künstlerische Angelegenheit des Bürgertums gemacht. Und schließlich suchte er für die deutsche Heldensage mit seinem „Spiel vom hürnen Seufried" 1557 einen gemäßen Bühnenstil: die erzählende Bilderfolge. *Handwerkertheater*

Auf dem gesicherten Grunde der Nürnberger Stadt hat Hans Sachs dem Bürgertum seiner Zeit eine geistige Welt aufgebaut, in der sichs zu leben lohnte. Hier war die Kunst ein ehrbares Handwerk. Die Singschule der Meistersinger war eine soziale Tat. Sie war ein erster Versuch handwerklicher Freizeitgestaltung. Wie Wittenberg durch Martin Luther die Stadt des evangelischen Christentum, so ist Nürnberg die Stadt der bürgerlichen Dichtung durch Hans Sachs. Im mitteldeutschen Osten überschnitten sich die Wirkungsbereiche der beiden Städte.

In *BÖHMEN* war Eger eine Heimstatt der Dichtung. Hier war der älteste Humanist des Landes zu Hause, *Paul Schneevogel*, Niavis genannt, der Verfasser von ungemein lebensechten Schülergesprächen, und um 1495 der Gesprächsnovelle „Judicium Jovis", wo die Erde den Menschen als Muttermörder vor Jupiters Richterstuhl belangt. Vorbild waren Lukians Totengespräche. Erschien der Menschenadam bei Johannes von Tepl als Ackermann, hier, wo es um den Schneeberger Bergbau geht, ist er als Knappe mit Hammer und Haue aufgefaßt. Eger war seit etwa 1442 reich an geistlichen und weltlichen Spielen aller Art. Hier wirkte also der begabteste Spielbuchdichter des Landes als Lehrer, *Klemens Stephani*, um 1530 bis 1592, aus Buchau bei Karlsbad. Sein frühestes Drama, „Historia von der Königin aus Lamparden", 1551, zeigt auch stofflich Beziehungen zu Hans Sachs. Es ist die Geschichte Rosamundes und Alboins. Den Stoff des Spieles von „Jedermann" verarbeitete er 1568 zu seinem dramatischen Gleichnis „Eine geistliche Aktion". Die Geschichte vom fahrenden Schüler als Teufelsbanner liegt seinem Lustspiel von 1568 zugrunde: „Satyra oder Bawrenspiel". An seinem Werk schlägt Wittenberg deutlicher durch als Nürnberg. Aus Trautenau, wo 1585 ein Lein- *Böhmischer Humanismus*

Böhmisches Spielbuch

Meistergesang weber von Meißen Schule hielt, sind Fastnachtsspiele und Meistersänger be-
kannt. Die Meistersängerschule zu Mährisch-Schönberg liegt im Dunkel. Sehr
reich bezeugt ist die Iglauer Singschule, die auf die Zeit um 1565 zurückgeht
und bis tief ins siebzehnte Jahrhundert blühte. In Schlesien, das ein sehr
bewegtes und dichterisch beschwingtes humanistisches Leben führte, spiel-
ten die Städte ganz im Stil des evangelischen Schuldramas. In der Lausitz
hatte Bautzen sein Schuldrama und Görlitz zu seiner vortrefflichen huma-
nistischen Schule den einzigen Meistersänger des Ostens, *Adam Zacharias
Puschmann*, 1532 bis 1600, der seine Kunst an den zwei führenden Stätten,
in Augsburg und Nürnberg, und bei dem Meister selber, bei Hans Sachs,
übte. Er lernte nicht weniger als 250 Töne und was er trieb, war nur die
vergebliche Arbeit, worttreu und gewissenhaft erstarrende Formen zu hüten.

So steht dieser fränkisch-mitteldeutsche Raum der humanitas und refor-
matio in schönem Ebenmaß vor uns. Die beiden Nürnberger Willibald Pirk-
heimer und Hans Sachs verkörpern innerhalb entgegengesetzter Gesellschafts-
schichten doch in der einen und gleichen Stadt die beiden Lebensstile und
Geisteshaltungen. Dem siegreichen Führer der kirchlichen Erhebung, dem
Franken Martin Luther, tritt der andere Franke gegenüber, Ulrich von Hut-
ten, dem Mönch der Ritter, dem die Erhebung des Reiches mißglückte.

*Ulrich von
Hutten* *Ulrich von Hutten*, 1488 bis 1523, war nur in seiner Jugend auf Burg
Steckelberg daheim. Die Härte des Vaters und eignes Ungefähr machten ihn
dann heimatlos. Aus dem Kloster Fulda, wohin man den Zehnjährigen gegen
seinen Willen gebracht hatte, floh Hutter zurück in die Welt. Es gab kaum
eine Hochschule Deutschlands oder Italiens, an der er nicht zugespro-
chen hätte. Die Fehde seiner Familie gegen Herzog Ulrich von Württem-
berg, der 1515 seinen Vetter Hans von Hutten ermordet hatte, erweckte in
ihm die Gabe des Wortes. Fünf Reden und die aufreizende Gesprächsschrift
„Phalarismus" schleuderte er gegen den Mörder. Das Jahr 1517 stellte Hut-
ten an seinen Scheideweg. Er war gerade wieder aus Italien zurück und zum
Dichter gekrönt. Der ritterliche Schriftsteller Johann von Schwarzenberg
wollte ihn für seine Übersetzungen aus den alten Sprachen einspannen und
nach Bamberg ziehen. Albrecht von Brandenburg, Erzbischof von Mainz,
wünschte ihn unter seine humanistischen Höflinge. Er schoß den zweiten
Teil der „Epistolae obscurorum virorum" gegen die Feinde Reuchlins ab
und entschied sich für Mainz. Mit Huttens Eintritt zu Mainz fiel der ent-
scheidende Erbgang auf dem deutschen Throne zusammen. Maximilian I.
starb und es galt, den neuen Kaiser zu küren, von dem das Schicksal der Kir-
chenbewegung und die Erneuerung des Reiches abhingen. Der spanische

Habsburger Karl V. gewann die Krone. Fiebernd erwartet kommt er 1520 nach Deutschland, wird zu Aachen gekrönt und schreibt für 1521 den Reichstag nach Worms aus. Das sind die Jahre von Huttens staatsmännischen Schriften, mit denen er das Ohr des Kaisers für einen völligen Neubau des Reiches zu gewinnen hoffte. An kleinen Anlässen aus dem Alltag des Mainzer Hoflebens machte er sich die Gesprächsform Lukians, die ihm wie wenigen *Der Schüler Lukians* lag, handgerecht, steigerte sie durch seine Redegewalt zu dramatischer Bildkraft und machte sich daraus die Waffe für seine staatsmännischen Kämpfe. In den beiden Gesprächen „Fieber" griff er das verfaulte sittliche Leben der *Huttens Flugschriften lateinisch* Geistlichen an und richtete den „Vadiscus" gegen Haupt und Herrschaft, nun schon der Vorkämpfer einer romfreien deutschen Volkskirche. Das Gespräch „Die Anschauenden" traf den päpstlichen Gesandten Cajetanus ins Antlitz. Aus Luthers Gedanken von der Freiheit des Christenmenschen und der päpstlichen Fremdherrschaft auf der einen Seite, aus dem eigenen Wunsch, ein starkes Deutschland zu schaffen und der Zuversicht auf den neuen Kaiser anderseits, entwarf Hutten den Grundriß eines neuen Reiches. Aus den Geldmitteln, die bisher nach Rom flossen, aus aufgehobenen Klöstern und sonst freiwerdenden Gütern soll der Reichsschatz gebildet werden. Durch ihn wird die allgemeine Not gelindert, die Bildung gespeist, ein kaiserliches Volksheer aus Rittern und Lanzknechten gebildet. Der Sold wird tausende von Unbeschäftigten löhnen. Im Reichsdienst wird die bisher durch Einzelfehden zerriebene Überkraft nach außen abgelenkt. Das war ein kaiserlicher Einheitsstaat, gestützt auf Geldkraft und ein stehendes Heer, das alte deutsche Volkskönigtum der unteren Stände, der Tod reichsfürstlichen Sonderwillens. Staatliche und kirchliche Einheit im Innern und nach außen. Inzwischen hatte Hutten 1519 auf dem Feldzug gegen Württemberg Franz *Hutten und Sickingen* von Sickingen kennengelernt, einen Großunternehmer, der sich für seine politischen Geschäfte ein kleines stehendes Heer hielt. Hutten und Sickingen, jeder glaubte am andern ein Werkzeug seiner Pläne gefunden zu haben. Sickingens Ohren tat es wohl, Feldhauptmann des freien Evangeliums und Deutschlands gegen Rom und Reichsfürsten und, wenn es sein mußte, gegen den Kaiser zu heißen, da er doch seine dunklen Geschäfte bisher lediglich im Namen der Unterdrückten und der Ritterschaft geführt hatte, und Hutten beglückte sich an der Erwartung, daß nun zwar nicht der Kaiser, aber immerhin Franz von Sickingen ausführen würde, was in seinen Plänen so großartig dastand. Also richtete man auf Sickingens Ebernburg 1520 bis 1521 Feldquartier und Reichskanzlei des neuen Deutschlands ein. Dem Freunde zum besten verdeutschte Hutten nun seine lateinischen Kampfgespräche. Er

machte den letzten Schritt vom Humanisten zum Stimmführer des Volkes, vom Ritter zum Bundesgenossen der Städte, vielleicht daß er nicht einmal das Letzte scheute, die Waffenbrüderschaft mit den Bauern. Da war es schon zu Ende. Hutten floh aus der Ebernburg, auf der Sickingen 1522 fiel, nachdem beide dem Kaiser aufgesagt hatten, und starb 1523 den Tod der Vernichtung auf der Insel Ufnau bei Zürich unter Zwinglis Schutz.

Luther, Hutten, und daß der Dritte nicht fehle, Zwingli. Nur was alle drei gewollt und jeder allein für sich getan hatte, ergibt das Ganze dieses Zeitalters. Reformatio und vita nuova waren in Huttens Plänen eine Staatskirche. Zwingli machte daraus einen kleinen Kirchenstaat, der seinen Schlachtentod nicht lange überdauerte. Luther beschied sich bei einer religiösen Gemeinde, jeder politischen Ordnung fügsam, in welcher immer der landesfürstliche Staat das alte Lehensreich beerbte. Humanismus und Reformation hatten sich in einem Bildungsideal ausgeglichen, das aus den Kanzleien stammte, auf die erziehende Kraft der Sprache vertraute und vom schreibkundigen Bücherfreund verkörpert wurde. Die Literatur dieses Bildungsideals wurde von den lehrenden oder arbeitenden Trägern der Gemeinde gemacht, sei es der kirchlichen oder weltlichen. Sie hatte ihren Bestand nur in Willen und Aussicht auf den Volksstaat, zu dem sich die geistlichen und weltlichen Gemeindezellen aufgliedern sollten. Mit der Reichsreform war auch die Kirchenreform gescheitert und die Dichtung, die aus dem Willen zu beiden hervorgegangen war, hatte ihren Sinn verloren.

HEIDELBERG, KASSEL und KÖTHEN. Da kehrten im fränkisch-mitteldeutschen Raum die Spielfiguren wieder in ihre Ausgangsstellung zurück. Die Führung ging vom lutherischen auf das kalvinistische Bekenntnis über. Die Lehre Calvins war auf deutschem Boden eine fränkische Bewegung und brach sich vom Rhein her eine breite Bahn durch ganz Mitteldeutschland, indem sie sich 1560 die Rheinpfalz, 1597 Anhalt, 1599 Baden-Durlach, 1605 Hessen-Kassel, 1613 Brandenburg und schlesische Kleinhöfe eroberte. Gerade in diesem Raume wurde nach einem neuen Plane die Arbeit an einer deutschen Nationalliteratur wieder aufgenommen, diesmal von den Höfen selber, und dem Träger ihres Bildungsideals, dem Kavalier.

Heidelberg erlebte gegen Ende des sechzehnten Jahrhunderts eine schöne Nachblüte des Humanismus. Aus ihm heraus bahnte sich nun anders als zuvor im deutschen Bürgertum der höfische Stil der deutschen Dichtung an. *Ambrosius Lobwasser*, 1515 bis 1585, aus Schneeberg, und *Paul Schede*, 1539 bis 1602, Melissus genannt, aus dem fränkischen Mellrichstadt, hatten in Frankreich und Genf den kalvinistischen Kirchengesang kennengelernt

und von dem neuen Psalter, wie Marot und Beza ihn 1562 geschaffen hatten, einen tiefen Eindruck empfangen. Ohne voneinander zu wissen, übertrugen sie gleichzeitig, der Tonsätze wegen, den Hugenottenpsalter in deutsche Verse, die den französischen so getreu als möglich entsprachen. *Der Hugenotten-psalter* Schedes Psalter kam 1572, der Lobwassers 1573 heraus. Beide haben vor allem durch ihre Verskunst in der deutschen Dichtung der kommenden Zeit tief und lange nachgewirkt. Der letzte Anstoß zu der neuen höfischen Dichtung ging von den jungen Freunden des kurprinzlichen Erziehers Georg Michael Lingelsheim aus, der von Straßburg stammte, ein Pfleger und Gönner des schöngeistigen Lebens. Durch Friedrich Lingelsheim, seinen dichterisch begabten, aber früh verstorbenen Sohn, sammelte sich in seinem Hause ein Kreis junger Dichter, als dessen Führer *Julius Wilhelm Zinkgref*, 1591 bis 1635, ein Heidelberger, bald mit dichterischen Kleinformen hervortrat, so 1618 mit satirischen Geschichtchen, den „Schulbossen", und 1619 mit Sinnsprüchen, den „Emblemata". Eben um diese Zeit, 1619, gewann Lingelsheim als Erzieher für seine jüngeren Kinder einen Bunzlauer, *Martin* *Martin Opitz* *Opitz*, 1597 bis 1639, der sich mit seiner Schutzschrift für die deutsche Sprache, „Aristarchus", 1617 bekannt gemacht hatte und in seinem Gepäck nicht sehr verstohlen allerlei Verse mitführte. Diese bestachen die neugewonnenen Heidelberger Freunde solchermaßen, daß Zinkgref nicht nur selber hinter dem schlesischen Ankömmling zurücktrat, sondern ihn zum Musenführer und Vorsänger einer neuen Dichtung ausrief. Er stellte die Gedichte Opitzens geschlossen voran und die ausgewählten Verse der anderen Freunde bescheiden in den Anhang. Um ja nicht mißverstanden zu werden mit seinem Heroldsruf, fügte er diesem Anhang Verse auch nicht befreundeter und älterer Dichter ein. So sieht Zinkgrefs Buch von 1624 aus: „Martini Opicii Teutsche Poemata . . . Sampt einem Anhang." Martin Opitz soll nicht nur als der Erste unter den zeitgenössischen Seinesgleichen, sondern als Erfüller des vorangegangenen Jahrhunderts erscheinen. Indessen Opitz war unzufrieden mit der Art, wie Zinkgref seinen Wortlaut behandelt hatte. Zur Rechtfertigung der eigenen Ausgabe schrieb er 1624 das kleine „Buch von der deutschen Poeterei". Martin Opitz in Heidelberg, sein Gedichtbuch und seine Lehrschrift: das war keine Leistung, sondern ein Anspruch. *„Buch von der deutschen Poeterei"*

Kassel erhielt durch den Landgrafen Moritz I., 1592 bis 1627, der ein *Kassel. Moritz I.* humanistisch gebildeter, dichterisch begabter, unternehmungslustiger Fürst war, sein geistiges Gesicht. Aus der Hofschule, die er 1595 gründete, entwickelte sich über das Collegium Mauritianum die Ritterakademie, die für den jungen Hofadel, für Junker und Kapellknaben bestimmt war. Sie suchte

humanistische und höfische Bildungsziele miteinander zu vereinigen, indem sie zu den alten Sprachen die Naturwissenschaften und die Leibesübungen in den Lehrplan miteinbezog. Vor dem Schloß wurde eine Rennbahn geschaffen, auf der seit 1593 Ritterspiele aufgeführt wurden. Der Landgraf baute 1605 am Zwerentor das erste stehende Bühnenhaus im Stil römischer Amphitheater. Hier spielten die englischen Komödianten und die Ritterschüler die „Antigone" in griechischer Sprache. Der Landgraf selber schrieb für die Zöglinge seiner Ritterakademie lateinische Stücke in der Art des Terenz. Sie sind verlorengegangen.

Köthen. Ludwig von Anhalt Köthen war dem Fürsten *Ludwig von Anhalt,* 1579 bis 1650, als Erbe zugefallen. Seine europäische Bildungsreise hatte ihn nach London geführt, wo er Shakespeares Stücke spielen sah, nach Orleans und Genf, wo er dem Kalvinismus nahe kam, nach Rom und Prag. Den befreundeten Landgrafen Moritz suchte er nicht selten in Kassel auf. Wenige Deutsche hatten so wie Fürst Ludwig ein gleich unmittelbares Gefühl für die Überfremdung des deutschen Lebens durch die westeuropäischen Nationalkulturen. Niemanden konnte es auch näher angehen denn ihn, dessen Bruder Christian als pfälzischer Statthalter in Amberg diese Überfremdung auch durch politische Mittel betrieb. Da kam ihm ein glücklicher Gedanke und der Entschluß zur Tat. Nach dem Begräbnis seiner Schwester, der verwitweten Herzogin von Weimar, traf er sich mit deren Söhnen im August 1617 auf dem Weimarer Schloß Hornstein. In ihrer Liebe zur deutschen Sprache und aus Sorge um ihren Fortbestand beschlossen sie nach dem Vorbild der italienischen Akademien *Fruchtbringende Gesellschaft* die Gründung eines gleichen Schutzbundes. Sie nannten ihn die Fruchtbringende Gesellschaft, wählten als Sinnbild den „Indianischen Palmbaum" und versprachen sich, die deutsche Sprache rein zu erhalten, Fremdwörter zu meiden, gute Aussprache und Schreibweise zu üben. Fürst Ludwig wurde und blieb der geistige Führer des Bundes. Köthen wurde sein Sitz. Hier bildete sich sein Formwesen aus und wurde das Stammbuch angelegt. Mehrere Anhalter Edelleute traten dem Bunde 1618 bei und 1619 schon Mitglieder *Kalvinisten und böhmische Brüder* der befreundeten Höfe. Dann sammelte der Bund allmählich die geistige Auslese des deutschen Volkes. Von großer Bedeutung wurde der Beitritt des Fürsten Christian von Anhalt, der als einer der Vorbereiter des böhmischen Aufstandes Beziehungen zum tschechischen Großadel unterhielt. Böhmische Edelleute, die zugleich Mitglieder der Brüdergemeinde waren, kamen nun in den Bund und mit ihnen also zugleich das Gedankengut des Johann Amos Komensky.

In diesem Raum zwischen Heidelberg, Kassel und Köthen, untereinander

in lebhafter Wechselbeziehung, bildet sich nun zuerst die neue höfische Dichtung weltmännischen Stiles heraus. In diesem Raume wird die neuhochdeutsche Gemeinsprache, wie die luxemburgischen und habsburgischen Kanzleien sie geschaffen, wie Luthers Bibel und die Dichtung seines Jahrhunderts sie ergriffen hatten, planvoll und schulmäßig in Zucht genommen. Die Tat, die zu tun war, ist zufrühest nicht durch Opitz, sondern durch die Weltleute von Kassel und Köthen geschehen.

Durch die Fruchtbringende Gesellschaft faßte Fürst Ludwig von Anhalt *Deutsche Schule* alle verfügbaren Kräfte zu dem gemeinsamen Unternehmen zusammen, das Spracherziehung des deutschen Volkes hieß. Die humanistische Schule hatte alle Sprache von der lateinischen her gelehrt. Die deutsche Schule, wie sie dem Fürsten Ludwig vorschwebte, sollte die Muttersprache in den Mittelpunkt des Unterrichts stellen und alle Sprache von ihr aus lehren. *Wolfgang Ratich*, dem in Holland der Gedanke gekommen war, das ganze Unterrichtswesen durch eine zweckmäßige Verbindung von Sprachwissen und Sachwissen neu zu gestalten, schien dem Fürsten der rechte Mitarbeiter. Er gab Ratich die Vollmacht und ließ ihn 1619 mit 432 Kindern eine Probeschule eröffnen. Gleichzeitig wurde der erste Entwurf einer deutschen Sprachlehre *Deutsche* ausgearbeitet. Hier war des Fürsten Mitarbeiter *Wilhelm Gueintzius*, der den *Grammatik* Auftrag erhielt, das maßgebliche Sprachbuch auszuarbeiten. Es wurde dann unter den ausgewiesenen Sprachkennern der Gesellschaft gutachtlich herumgegeben. Da aber schieden sich die Geister aller, die mit der Sache zu tun bekamen: Justus Georg Schottel aus Einbeck, Georg Philipp Harsdörfer aus Nürnberg, Philipp von Zesen aus Dessau. Man fand sich einer Sprachbewegung gegenüber, die noch in vollem Flusse war. Was galt bereits, das heißt, was war sprachrichtig? Man kam aus einem Fehlkreis nicht heraus. Sollte sich die Literatur nach der Umgangssprache richten, und wenn, dann nach welcher? War die Umgangssprache an die Literatur gewiesen, und wenn, *Sprechen,* welche Werke waren dann mustergültig? Das führte auf die erste aller Fra- *wie man schreibt* gen, die zuvor entschieden sein mußte: soll man sprechen wie man schreibt *oder schreiben* oder schreiben wie man spricht? Man stritt mit Eifer hin und her und kam *wie man spricht?* angesichts so vieler Mundarten und Sprachen auf den Gedanken, daß es doch eine Ursprache geben müßte, die zugleich die Natursprache sei, in der jedes Ding seine eingeborene und notwendige Bezeichnung und jeder Laut seine geheimnisvolle Bedeutung haben müßte. Am Anfang aber ist wirklich das Wort. Je tiefer man also in die Sprachphilosophie geriet, desto mehr erkannte man, daß Spracherkenntnis die Wurzel der Welterkenntnis ist. Und so entwickelt sich der Bund, der zur Pflege der deutschen Sprache gegründet

worden war, zu einer Gesellschaft, die vom Wesen des Wortes her jene all-
gemeine Reformation der Welt in neuen Fluß zu bringen versuchte, die bei
Luther, Zwingli und Hutten steckengeblieben war. Der praktischen Auf-
gabe aber, um derentwillen man zusammengekommen war, stand man ratlos
gegenüber, weil man aneinander vorbeiredete. Was den einen als Sache des
Verstandes erschien, berechenbar und lenkbar, das nahmen die andern als
Offenbarung des Lebens, als unergründbar und keiner Regel gefügig. Der
Sprachlehrer wollte durch Gründe „richtig" stellen, was doch allein der
Sprachschöpfer durch Tatsachen „gültig" machen kann. Soviel die Frucht-
bringende Gesellschaft als erwachtes Gewissen des deutschen Volkes an der
Sprache gewirkt hat, über die Fortbildung der Gemeinsprache hat der Dich-
ter, das ist der Sprachschöpfer, entschieden.

Übersetzungs-
kunst

 So hat denn der Dichter in dem Raum, den Heidelberg, Kassel und Köthen
bestrahlen, den Dingen ihren Lauf gegeben: durch eine abermals neue Über-
setzungskunst, die zur kalvinistischen Literatur Frankreichs und zur epischen
Dichtung Italiens vermittelte; durch den Roman, in dem sich das Hofleben
dieses Bildungskreises einen belehrenden und ergötzenden Spiegel seiner
selbst geschaffen hat; durch das Liederbuch, in dem dieses Zeitalter mit allen
seinen Gesichtszügen lebendig wurde; durch ein Bühnenspiel, in dem das
Humanistendrama nicht so sehr fortentwickelt als vielmehr abgelöst wurde.

Hübner und
Frankreich

 Die Übersetzungskunst lag in den Händen zweier Männer, von denen der
eine Frankreich und der andere Italien zugewandt war. *Tobias Hübner,*
1577 bis 1636, aus Dessau, war als Prinzenerzieher und Leiter von Ritter-
spielen mit dem Hofleben vertraut. Er war Opitzens Gegner und hielt den
Befehdeten zunächst vom Palmenorden fern. In den Jahren 1619 bis 1631
übertrug er die Werke des Hugenotten Guilleaume Salluste Seigneur du

Werder
und Italien

Bartas in deutsche Verse von französischer Tonart. *Diederich von dem Wer-*
der, 1584 bis 1657, aus Werdershausen nächst Köthen, war in Kassel als
Kammerjunker erzogen, Truppenführer schon vor Jülich 1610, Erzieher der
landgräflichen Kinder in Kassel, 1631 Oberst eines schwedischen Regiments,
noch ein halber Humanist und dichterisch der Schüler Hübners. Diederich
von dem Werder verdeutschte 1622 bis 1626 Torquato Tassos „Befreites
Jerusalem" in kunstfertig gereimte, modern gebaute Alexandriner, die sich
zu gewandten Stanzen zusammenfügen. Er verdeutschte im Lager und auf
Gesandtschaftsreisen drei Gesänge des „Rasenden Roland" 1632 und 1644
den Roman des Giovanni Francesco Loredano. Keine Dichtungen konnten
das Lebensgefühl der mitteldeutschen Kalvinistenhöfe so echt ausdrücken
wie diese italienischen Ritterbücher in Diederichs Kavalierdeutsch.

Der Roman, das ist das Werk *Philipps von Zesen,* 1619 bis 1689, eines *Der Roman Zesen*
Dessauers, der auf Reisen und in der Fremde gelebt hat und gestorben ist.
Zesen hat den Ton des Volksliedes bestrickend getroffen und ein wirklicher
Sprachkenner, wenn auch allzu kühner Sprachdenker, mit seinen Lehrbüchern
verdienstlich im Geiste der Fruchtbringenden Gesellschaft gewirkt. Zesen
hat dem spanisch-französischen Amadisroman, der seit 1569 den deutschen
Geschmack beherrschte, den Abschied gegeben und aus der Schule des Fräu-
leins Madeleine de Scuderi den neuen deutschen Hofroman geschaffen.
„Ibrahim" 1645 und „Sofonisbe" 1646, nach französischen Vorbildern,
„Assenat" 1670 und „Simson" 1679, nach der Bibel, sind sehr ungleichartige
Gebilde: vielverschlungene und schlicht geführte Liebesgeschichten, barocke
Überfülle der Sätze und einfache Natürlichkeit des Wortes. „Die Adriatische
Rosamunde" 1645 ist mehr ein Roman des Gesprächs und der tragischen
Verwicklung als der epischen Begebenheiten und der Erzählung. Mit seinen
Romanen wollte Zesen der Fremde den heimischen Markt sperren. Sie soll-
ten eine hohe Schule sein der allgemeinen Bildung, der höfischen Sitte, der
Staatskunst.

Das Liederbuch stammt von dem Thüringer *Kaspar Stieler,* 1632 bis 1707, *Das Lied. Stieler*
aus Erfurt. Akademisch gebildet, fand er sich in vielen Sätteln zurecht, nicht
nur als Feldrichter des Reitergeschwaders, mit dem er in den schwedisch-
polnischen Krieg ritt. Seine vielbeschäftigte Feder wußte jeden Markt zu
nutzen, vom Briefsteller bis zu sprachphilosophischen Schriften. „Gehar- *„Geharnischte Venus"*
nischte Venus" 1660 nannte er das sinnliche, derbe, zynische Buch, in dem
das Lebensgefühl des Leipziger Burschen und des weltmännischen Soldaten
zusammenfloß. Es ist das erste Liederbuch, das die einzelnen Gedichte kunst-
voll gruppiert und durch Zusammenstellen fertiger Einheiten neue Wirkun-
gen erzielt. Es spricht die Sprache eines vielleicht verwilderten, aber doch
eines natürlichen Herzens. Und entgegen allen Künstlichkeiten des Jahr-
hunderts ist es ein Buch der Kunst.

Das Bühnenspiel des Raumes ist von den Höfen gespeist und von bürger-
lichen Kräften gepflegt worden. Es läßt sich gut beobachten, wie sich da und
dort ein Pfarrer mit seinen Dramen aus der biblischen Zeit des Kirchen-
humanismus in die heldische des Barocks herübertastet. Die stellvertretende
Bühne dieses Raumes stand zu Rudolstadt, wo seit 1622 Herzog Albrecht *Rudolstädter Spiele*
Anton für sein festliches Vergnügen spielen ließ. In der Zeit der eigentlichen
Blüte, 1663 bis 1666, war Kaspar Stieler Hofbeamter. Er wird wohl auch die
Spiele geleitet haben, die seit 1665 zu Familienfesten regelmäßig gegeben
wurden. Neben Lustspielen standen geschichtliche Dramen auf der Liste, die

Helden der engeren Heimat nicht vergaßen, aber zuweilen auch einen alten deutschen Kaiser über die Szene führten und in Türkenstücken der östlichen Not des Reiches gedachten. Die Rudolstädter Festspiele schließen die Reihe vom alten Humanistendrama lateinischer Zunge bis zum neuen deutschen Klassikerstück.

Die Köthener Sprachgesellschaft hatte innerhalb dieses kalvinistisch-französischen Kulturkreises ihre Aufgabe erfüllt, die vom Osten her ausreifende deutsche Gemeinsprache gegen den Zudrang der Fremde zu schützen. So konnte der Bund nach dem Tode des Fürsten 1650 ohne Schaden Sinn und Bedeutung verlieren. Gegen 1680 löste er sich auf.

Ausgang der Fruchtbringenden Gesellschaft

LEIPZIG und DRESDEN. Die Kirchenbewegung hatte also 1539 im Herzogtum Sachsen gesiegt. Da entschloß sich der neue Herzog Moritz, das gesamte mittlere Bildungswesen des Landes in drei Staatsschulen zusammenzufassen, wofür Pforte, Meißen und Grimma als Schulstädte bestimmt wurden. Als Gründungsjahr kann 1543 gelten. Allgemeines Vorbild war die Straßburger Schule Johannes Sturms. Die letzte Fassung erhielt dieser Entwurf durch das Schulgesetz von 1580 und den Kurfürsten August I. Der kurfürstliche Beauftragte, der Tübinger Kanzler Jakob Andreae, glich in dieser Schulordnung geschickt schwäbische Einrichtungen und Meißner Bedürfnisse aus. Das gesamte Schulwesen Meißens war ein wohlbedachter, schön und widerspruchslos gegliederter Körper geworden, in dem jede Stunde und jeder Lehrer ihre festumschriebene Aufgabe hatten. Den drei Fürstenschulen verdankt das Land jene ausgeglichene und gleichmäßige Bildung, durch die es sich mit so vielen innerlich verwandten Leistungen im deutschen Schrifttum abzeichnet.

Die Meißner Fürstenschulen

Die offene Landschaft zeigte seit der Blüte des Humanismus ein eigentümliches literarisches Gesicht. Im Übergang vom Humanismus zum Barock trägt es *Johann Friedrich von Schönberg*, 1543 bis 1614, aus Sitzenroda bei Schilda, ein Zögling der Fürstenschule von Grimma, der erste aus den drei Anstalten, der im deutschen Schrifttum erscheint, mit einem Schwankbuch, das 1597 zweimal gedruckt wurde, zuerst als „Lalenbuch" und sodann als „Schiltbürger". Es führt die Sache der Meißner Ritterschaft, die wenigstens die kleinen Städte mit Sitz und Stimme vom Landtage verdrängen wollte.

„Schiltbürger"

An der Schwelle des neuen Jahrhunderts trägt dieses Gesicht *Martin Rinkart*, 1586 bis 1649, aus Eilenburg, und evangelischer Geistlicher. Er ist der Dichter des Kirchenliedes „Nun danket alle Gott". Er hat unter dem Einfluß der Jesuiten Herz-Jesu-Lieder geschrieben. Und er hat seit 1612 die hundertjährigen Gedenktage von Luthers Leben mit einer Folge von sieben ge-

Martin Rinkart

schichtlich entsprechenden Stücken begleitet, von denen nur wenige gedruckt, nicht alle aber vollendet und ausgeführt wurden. Der Stil dieser Dramen ist über das Humanistenspiel nicht wesentlich hinausgekommen, wie auch der Vers noch dem Meistersinger-Rhythmus entspricht. Und beinahe schon auf der Höhe des barocken Zeitalters trägt dieses Gesicht *Paul Fleming*, 1609 bis 1640, aus Hartenstein. Mit seinen ersten Gedichten hat Fleming sich noch, nicht nur in der Sprache, an die späthumanistische Liebeslyrik gehalten, wofür man sein Büchlein „Rubella sive Suaviorum liber" 1632 zum Zeugen anrufen kann. Sein großes Erlebnis wurde die Gesandtschaftsreise nach Persien, die er als Truchseß mitmachte und von der er 1639 zurückkehrte. Seine Gedichte sind in die Beschreibung jener Reise eingebettet, die Adam Olearius 1647 erscheinen ließ. Flemings Liedertagebuch hat die Stimmungen und Erlebnisse dieses Schicksalsweges aufgenommen. Die Gesamtausgabe seiner Gedichte kam 1647 heraus. Die dunklen Töne überdecken die helleren. Aber seine Verse fangen doch das Leben ein, voll behaglicher Freude und mit gelassenem Ernst, feine und sittsame Verse, ohne allen offenbaren Ehrgeiz, aber desto anmutiger in ihrer fast selbstverständlichen Kunst.

Paul Fleming

Dieser bürgerlich-geistlichen Dichtung des offenen Landes stand eine höfische in Dresden und eine studentische in Leipzig gegenüber.

Der Dresdner Hof verriet erst seit dem siebzehnten Jahrhundert künstlerische Neigungen und sie waren ausschließlich auf das Theater gerichtet. Der Dresdner Theaterstil ging einerseits auf die beliebten Reitfeste zurück, deren jedes nach einem bestimmten Gedanken angelegt war, und andrerseits auf die Singtänze, die man dem französischen Hofe nachmachte. So war das Dresdner Theater mit Vorliebe Oper. Das erste Singspiel mit deutschem Wortlaut war die „Daphne", die 1627 in Torgau gespielt wurde. Ihr Dichter war Martin Opitz und ihr Tonsetzer Heinrich Schütz, 1585 bis 1672, ein Landeskind, das seine ganze Kunst dem heimischen Hofe opferte. In August Buchner und David Schirmer fand Schütz stets gefällige Spielbuchschreiber.

Der Dresdner Hof und die Oper

Das Leipziger Bürgertum, wie es dichterisch durch Flemings Freunde Gottfried Finkeltaus und Christian Brehme vertreten wurde, kam gegen die Studentenschaft nicht auf, die in Leipzig auch künstlerisch den Ton angab. Sie beherrschte vor allem das Theater mit ihren eigenen Spielgemeinden. Gegen Ende des siebzehnten Jahrhunderts trat die Oper anspruchsvoller hervor. Sie hat nicht nur Freunde gefunden, wie der Gesangmeister der Thomas-Schule *Johann Kuhnau*, 1667 bis 1722, aus Geising im Erzgebirge, mit seinem satirischen Roman „Der musikalische Quacksalber" 1700 bezeugt. Die Studentenschaft gab im Leipziger Schrifttum auch stofflich den Ton an. Es

Leipziger Dichtung

entwickelte sich eine ganze Studentenliteratur, angefangen von *Johann Georg Schoch* und seiner berühmten „Komödie vom Studentenleben" bis zu dem vielseitigen verbummelten Burschen *Christian Reuter,* 1665 bis 1712, aus Kütten bei Halle, der seine Quartierfrau mit groben Possen verhöhnte und in seinem satirischen Reiseroman „Schelmuffsky" 1697 das ganze zeitgenössische Bürgertum, wie der Fahrende es sah, zu seinem Stichblatt machte.

Von ihrem weiten Umwege wird die deutsche Dichtung im achtzehnten Jahrhundert nach Leipzig und Dresden zurückkehren.

3. DER ÖSTERREICHISCH-OSTDEUTSCHE KREIS

Katholische Reformation
Der Umschwung vom Humanismus zum Barock wird durch den Szenenwechsel bewirkt, der sich in Wien vollzieht. Mit den alamannischen Landschaften, die ehedem oder noch immer zu Habsburg gehörten, hatte Österreich die humanistische Gemeinschaft der Geister gebildet. Um 1550 trennte es sich von seinem alamannischen Gefährten und gesellte sich zu seinem ostdeutschen Begleiter. Mit den ostdeutschen Landschaften, die eben durch die böhmische Krone an Habsburg gekommen waren, schuf Österreich den barocken Stil des Lebens und der Kunst. Die evangelische Reformation hatte aus der humanistischen Weltanschauung heraus eine neue umfassende Ordnung der Kirche und des Reiches stiften wollen. Ihr setzten Kaiser und Papst eine katholische Reformation entgegen, die sich weltanschaulich und künstlerisch im Barock verkörperte. Wie an den Barock auch die literarischen Bestände übergingen, die evangelischer Herkunft waren, so ist der barocke Stil selbst mit dem, was an ihm katholisch war, Gemeingut der evangelischen Bekenntnisse geworden.

Schlesischer Humanismus
BRESLAU und GÖRLITZ. Der schlesische Humanismus hat seine ersten Wurzeln in der Tätigkeit des Breslauer Bischofs von 1482 bis 1506, Johannes IV. Roth, eines Schwaben, der durch Aeneas Silvius in die Schreibstube Kaiser Friedrichs III. gekommen war und dort die humanistische Kanzleischule durchgemacht hatte. Diese frühen geistigen Beziehungen zwischen Wien und dem neugewonnenen Erblande Schlesien machte *Kaspar Velius Ursinus,* wohl 1493 bis 1539, aus Schweidnitz, der glänzende Wiener Hochschullehrer, zu einer vollendeten und unanfechtbaren Tatsache. Er war ein hochbegabter Dichter und Stilkünstler, Erzieher der königlichen Kinder, Geschichtschreiber Ferdinands I. und Maximilians II. von Österreich. Mit den Habsburgern kamen die schlesischen Humanisten in alle Teile des Rei-

ches. Sie spielten im Collegium poetarum des Konrad Celtis und am Wiener *Aus dem Humanismus* Hofe die gebührende Rolle. Das Blatt schien sich zu wenden, als 1524 sich Breslau dem Luthertum zuwandte und damit dem ganzen Lande ein Beispiel gab. Der Stadtschreiber von Breslau, *Franciscus Faber*, 1497 bis 1565, aus Ottmachau, verfocht mit geschichtlichen Arbeiten und landestümlich gefärbten lateinischen Gedichten die Sache der schlesischen Städte gegen den habsburgischen Statthalter Friedrich von Redern. Aus dieser humanistischen Überlieferung des Landes und vorab der Stadt Breslau ist der erste schlesische Dichter von Rang hervorgegangen.

Martin Opitz, 1597 bis 1639, stammte aus einer offenbar alten Bunzlauer *Martin Opitz* Familie. Tiefer als Bunzlau es vermochte, griff Breslau, wo Opitz von Herbst 1614 bis Ende 1615 Hauslehrer war, in die Entwicklung des jungen Mannes ein. Er kam mit dem Arzt Kaspar Cunrad zusammen, der in Basel und Heidelberg gebildet war und schon 1611 die Forderung vertrat, die Dichtung müsse nicht bloß auf die Reime achten, sondern auch auf Tonstärke und Silbenmaß. Paul Schede besaß persönliche Freunde in diesem Breslauer Kreise. Durch sie wie durch Cunrad wird Opitz zuerst auf Straßburg und Heidelberg gewiesen worden sein. Nach seinem Heidelberger Jahr war Opitz zunächst kurze Zeit Lehrer zu Weißenburg in Siebenbürgen, wurde fürstlicher Rat beim Herzog von Liegnitz, gab 1625 selber seine Gedichte heraus und erhielt von Kaiser Ferdinand II. den Lorbeer. Obwohl Kalvinist, trat Opitz 1626 in die Dienste des Burggrafen Karl Hannibal von Dohna, in dessen harter Hand die katholische Reformation des Landes lag. In Paris lernte Opitz 1630 Hugo Grotius kennen. Ronsards Schule war bereits im Sinken. Zurückgekehrt, begleitete er den Herzog von Liegnitz nach Danzig, wo der kaum Vierzigjährige von der Pest hinweggerafft wurde. Mit Martin Opitz beginnt die Umbildung der humanistischen gelehrten in die barocke weltmännische Dichtung und der ostmitteldeutschen Prosasprache in eine gemeindeutsche Dichtersprache. Mit seinem Schriftlein „Aristarchus", 1617, *„Aristarchus" und „Poeterey"* einer Werberede für den allgemeinen und verantwortlichen Gebrauch der deutschen Sprache, hatte er seine Reife für den Hörsaal erwiesen. Die Ausgabe seiner eigenen Gedichte und deren Stil wollte er mit dem „Buch von der deutschen Poeterey" 1624 rechtfertigen. Das Buch ist nur ein ganz dünnes und schnell zusammengerafftes Büchlein, das sich beinahe wortgetreu die anerkannten Kunstlehrbücher romanischer Herkunft zunutze macht. Es ist *Die Dichtung des Kavaliers* nichts anderes als ein später und bescheidener Ableger der humanistischen Poetiken. Zeitwichtig waren nur zwei Abschnitte: der sechste forderte das, „welches wir Hochdeutsch nennen", als gemeingültigen Sprachgebrauch und

der siebente verlangte regelmäßigen Wechsel von stark und schwach be-
tonten Silben im Rhythmus des Verses. Beide Sätze wiederholten nur, was
längst erkannt war und ernstlich geübt wurde. Opitz kann nur mit dem
gelten, was er als Dichter gilt. Gattungsmäßig setzte er in deutscher Sprache
die lateinische Übung des Humanismus fort. Das „Lob des Kriegsgottes
Martii" ist nichts anderes als das humanistische Enkomion, das ironische
Preisgedicht. Eine ganze humanistische Literatur von dichterischen Land-
schaftsschilderungen liest man mit in seinen Gedichten „Zlatna" 1623 — auf
ein Goldbergwerk bei Weißenburg — und „Vielgut" 1629 — auf einen
herzoglichen Meierhof — und nicht einmal dichterisch kann die dürre Be-
schreibung „Vesuvius" 1633 heißen. Kirchenhumanistisch sind von seinen
Übersetzungen das Hohe Lied, der Prophet Jonas und der geplante Psalter.
Doch nach vorwärts weisen „Daphne" 1627 und „Judith" 1635, die beiden
Singspielbücher. Als Dichter gilt Martin Opitz durch seine weltmännische
Lyrik, die, aller antiken und romanischen Formen Meister, standesgemäße
Stimmungen in tadellosen Versen ausdrückt. Vielleicht das Beste ist seine
dichterische Prosa. Von der klassischen Idylle, dem griechischen und römi-
schen Hirtengedicht, war die Schäferdichtung gekommen, Maske und Rolle,
wie das ganze Wesen dieses Zeitalters. Indessen Opitzens „Schäferei von der
Nymphe Hercynia" 1639, Prosa mit eingelegten Gedichten, ist eher heimat-
künstlerische Landeskunde, die humanistische Landeskunde in neuer und
hübscher Form, fast auf Eichendorffs romantische Art die Begegnung mit
dem Wunderbaren, das gar nicht wunderbar, sondern als selbstverständliche
Wirklichkeit genommen wird.

Lausitzer Mystik Die lausitzische Mystik, die dem Wesen dieses Volkes eingeboren ist, hat
um diese Zeit aus mehrfacher Richtung neue Antriebe empfangen. *Kaspar
von Schwenckfeld*, 1489 bis 1561, von Ossig bei Lüben, hatte weder in der
katholischen noch in der evangelischen Kirche gefunden, was er gesucht hatte,
die wirkliche Erneuerung des inwendigen Menschen. Er stellte die unmittel-
bare innere Erleuchtung des wiedergeborenen Menschen über die abge-
schlossene Offenbarung der Schrift und pflegte in seiner freien Gemeinde von
Freunden und Anhängern ein ganz persönliches Glaubensleben. *Bombast*
Chemie und Theosophie *Paracelsus*, 1493 bis 1541, aus Einsiedeln, hatte das Buch der Natur zu einer
Quelle der Offenbarung gemacht, das Ineinanderwirken aller Kräfte des
Weltalls erkannt und gelehrt, daß alles kreatürliche Wesen ein Mikrokosmos,
eine Kleinwelt, als Abbild des Makrokosmos, der Großwelt, sei. Von Meister
Eckhart her mündeten diese Gedanken des Schwenckfeld und Paracelsus in
die mystischen Schriften *Valentin Weigels*, 1533 bis 1588, ein, der aus Naun-

dorf stammte und Pfarrer zu Tschopau war. Durch Weigels Anhänger wurden sie Gemeingut aller Gleichgesinnten in der Fassung: wir erkennen die Welt, weil unser Leib ihre Quintessenz ist. Sie fanden in und um Görlitz eine Heimstatt unter den Pfarrern, die Weigels Schriften besaßen, wie unter den Ärzten, bei denen des Paracelsus Büchlein abschriftlich die Runde machten. Einer dieser Görlitzer Heilkünstler, Tobias Kober, Feldarzt beim ungarischen Heere Kaiser Rudolfs II., hat um 1600 in einer Siebenerreihe von Dramen die astrologischen und alchimistischen Bedingnisse und Bezüge geschichtlicher Helden und Taten zu erfassen gesucht.

Jakob Böhme, 1575 bis 1624, aus Altseidenberg, dicht an der böhmischen *Jakob Böhme* Grenze, mußte, weil zum Bauer ungeeignet, Schusterlehrling werden und war 1595 bis 1599 auf Wanderschaft, wo ihn die Landstraßen, Herbergen und Werkstätten in jenes unverbürgte Wissen einweihten, wie es zu allen Zeiten beim einfachen Volke umläuft. In Görlitz wurde er 1599 Meister und konnte sich ein Häuschen erwerben. In Geschäften kam er später immer einmal nach Prag, der Stadt Kaiser Rudolfs II., seiner Naturgelehrten, Scheidekünstler und Goldmacher. Das merkwürdige Erlebnis, das er im Jahr 1600 hatte und das er „Durchbruch des Geistes bis in die innerste Geburt der Gottheit" nannte, ist wohl nichts anderes gewesen, als eine schauhafte Eingebung und Einsicht in den geistigen Ursprung der Welt. Sein ganzes Leben war dann auf das Ziel gerichtet, diese Eingebung verstandesmäßig begreiflich und vernunftgerecht auszusprechen. Die erste Niederschrift „Aurora *„Aurora"* oder Morgenröte im Aufgang" 1612 blieb stecken. Die geistliche Behörde, die ernstliche Unruhen befürchtete, verpflichtete ihn zum Stillschweigen. Es wurden daraus sechs Jahre der inneren Sammlung und eines erhöhten Ausdrucksvermögens. Gelehrte Freunde, Geistliche und Ärzte, waren aufmerksam geworden und suchten sich Gewißheit zu verschaffen von der Natur seines Wissens und seiner Aussagen. Er lehnte es ab, den Propheten zu spie- *Die reifen* len. Sie vermittelten ihm die Bücher, die er selbst nicht lesen oder verstehen *Schriften* konnte. Sie erzogen ihn zu einem Organ der Offenbarung. So konnte er nach der heilsamen Pause, innerlich gereift und der mitteilsamen Sprache in einem erstaunlichen Maße Meister, unbegreiflich fruchtbar, sein Weltbild nun in einer Fülle von Schriften aufrollen. Einige von ihnen beschäftigten sich bevorzugt mit Fragen der Seelenkunde, andere der Sittenlehre. Die große Mittelgruppe dient seiner Darstellung von Wesen, Herkunft und Endschaft der Welt. Unter diesen Schriften die schönsten und besten sind jene vier kleineren Büchlein, in denen er viermal mit anderen Worten wunderbar schlicht und einfach seine metaphysische Lehre erläutert. Dem gleichen Zweck, sich

seinen Freunden und Schülern gemeinverständlich zu machen, galten zumeist die sechsundsechzig theosophischen Sendbriefe aus den Jahren 1621 bis 1624, zugleich die kurze Zeitspanne, in die sich die Masse seiner Aufzeichnungen *Die Welt* zusammendrängt. Jakob Böhmes Lehre liegt Meister Eckharts Weltgedanke *aus dem Eros* zugrunde, wie er ihn durch die späten Vermittler des sechzehnten Jahrhunderts empfangen hatte, abgetönt und vermehrt durch den Zugewinn aus Paracelsus, Schwenckfeld und Weigel. Der metaphysische Urgrund der Welt ruht in dem Gottgeheimnis der Dreifaltigkeit, das Böhme beinahe mit den Worten Meister Eckharts erläutert. In Gott ist zugleich von Ewigkeit das schaffende Wort und das Verlangen zur Entfaltung seiner selbst, die Liebe. Aus diesem dunklen Urgrund der Liebe gebiert Gott sich selbst in die Zeitlichkeit und Stofflichkeit der Welt, offenbart und gestaltet sich durch sie. Weil die Welt aus der Liebe stammt, aus dem Bedürfnis nach einem Gegensatz zum eigenen göttlichen Selbst, darum ist sie von der Wurzel auf und von Gott her gut und böse in allem. Das ewige Sein muß also in Gestalt des Werdens durch den Gegensatz hindurch, die Schöpfung. Die Schöpfung aber wird erlöst durch das menschgewordene Wort und alles, was an ihr Mensch und Seele ist, kann aus dem Werden zurück zum göttlichen Sein, sofern es durch die Wiedergeburt aus der Liebe sich der Erlösung teilhaftig macht. *Die* Der schuldlos-schuldige Ursprung der Welt aus der Liebe, die Vermischung *Wiedergeburt* von Gut und Böse in allem, was Schöpfung ist, und die Befreiung vom Bösen *des Menschen* durch die Wiedergeburt, das sind die drei eigentümlichen Gedanken, mit denen sich Jakob Böhme das überkommene Geistesgut zurechtgelegt hat. *Kosmogonie* Seine Kosmogonie verläuft in die christliche Heilsgeschichte. Die Heilsge- *und* *Heilsgeschichte* schichte beginnt beim göttlichen Eros und nicht bei der menschlichen Begierlichkeit. Metaphysik und Ethik bedingen einander wechselseitig. Wiedergeburt ist Aufhebung des Schöpfungsaktes und also Rückkehr zur Einheit in Gott. Nur der Wiedergeborene wird teilhaftig des sich offenbarenden und des schaffenden Wortes. Der Wiedergeborene ist nicht bloß im Wissen ein Seher, er ist auch im Schaffen ein Künstler. Auch Metaphysik und Sprachenphilosophie, Metaphysik und Ästhetik bedingen bei Jakob Böhme einander wechselseitig. Mit Jakob Böhme war das Größte geschehen, was in der Geschichte des deutschen Geistes bezeugt ist. Ein Handwerker ohne eigentliche Schulbildung ist des schwierigsten Wissens, der Denkkraft und des sprachlichen Ausdrucks in einem solchen Maße mächtig geworden, daß er in deutscher Sprache das erste in sich gerundete und abgeschlossene Lehrgebäude der deutschen Philosophie entwerfen konnte, in das alles eingegangen ist, was vor ihm gedacht worden, in dem alles vorweg genommen wurde, was

nach ihm gedacht worden ist. Begreiflicherweise vermuteten seine gelehrten Freunde in diesem Naturgenie übernatürliche Fähigkeiten. Sie haben ihn nur desto mehr verehrt und bewundert, als sie erkannten, daß das einzige Wunder an ihm die unbegreifliche Eingebung des Geistes war. Jakob Böhmes Sprache in seinen besten und reinsten Schriften ist ein so vollkommenes Gemeindeutsch, wie es neben ihm und noch lange nach ihm kein Deutscher zu schreiben vermocht hat. Neben die Bildung der deutschen Dichtersprache hat er die Schöpfung der deutschen Denkersprache gestellt.

Schlesische Dichtung

Das Ereignis mitten im Umschwung des Zeitalters ist nicht Martin Opitz, sondern Jakob Böhme. Das wurde sogleich durch die Schüler offenbar, die beide hatten. Die Schule, die Opitz in seiner eigenen Vaterstadt Bunzlau gemacht hat, Andreas Tscherning, Christoph Köler, Andreas Scultetus, reimte einen anständigen und nichts als mittelmäßigen Vers. Andere, die es besser konnten, gingen ganz andere Wege, wie der Leobschützer *Wenzel Scherffer von Scherffenstein*, 1603 bis 1674, Schloßorganist zu Brieg, der aus der polnischen Dichtung vermittelte, das Gedicht von der alten Deutschen Abkunft, Stärke und Gottesdienst schrieb und sich mit seinen Versen in der Nähe der Mundart hielt. Der einzige aber, der auf einem begrenzten Eigenfelde wirklich Meister war, der ist nicht Opitzens Schüler gewesen. *Friedrich von Logau*, 1604 bis 1655, aus Brockut bei Nimptsch, ein edler, keuscher, liebenswürdiger Mensch, mußte Hofdienste suchen, obwohl er ein Feind des Hoflebens war. Die Liebeslyrik seiner Jugend ist verloren. Doch 1654 erschienen seine Sinngedichte. Sie waren in Deutschland ohne Beispiel. Aber sie sind auch keine selbständige Schöpfung. Ihre Väter und Vorfahren sind die deutschen und europäischen Sinnspruchdichter humanistischen Lateinstils und deren Meister, die antiken Liebhaber der behaglichen oder giftigen Doppelzeile. Daher hatte Logau die Gattung. Sein Eigentum aber ist der Inhalt. Fremdensucht und Modewesen sind das Stichblatt, die Leiden des Vaterlandes der Kummer dieser guten Alexandriner, die ein Werk des ersten Wurfs und nicht der geduldigen Feile sind. Ihr Ton ist Schärfe der Gesinnung, gemildert durch gute Laune des Herzens. Die Gestalten, in denen er die Schäden des Zeitalters verkörpert, sind keine persönlichen Menschen, sondern allgemein gültige Vertreter von Gattung und Art. Logaus Kunst reicht vom volkstümlichen Spruchvers und Einfall des Augenblicks bis zu Gedichten, die Gefühl haben und Lyrik heißen müssen. Die Form des Spruchverses, die Logau, keineswegs von Opitz her gelungen ist, hat wahrhaft Bedeutung erst dadurch gefunden, daß sie sich von Böhme her mit Gehalt füllte.

Wenzel Scherffer

Friedrich von Logau

Die Doppelzeile

Jakob Böhme hatte nicht nur zahlreiche Freunde und Schüler, er hatte

eine Gemeinde, deren Meister zu spielen ihm Klugheit und Gewissen ver-
boten. Der erste unter ihnen, zugleich Böhmes Bildner und Jünger, war der
Arzt Balthasar Walther. Den stärksten Anhang hatte er unter den Edelleu-
ten der Landschaft, die wie Karl von Ender seine Büchlein abschriftlich oder,
wie Siegmund von Schweinitz, gedruckt verbreiten ließen. Abraham von
Sommerfeld führte Böhme den opferfreudigsten Schüler zu, seinen Neffen
Abraham von Franckenberg aus Ludwigsdorf bei Oels. Jakob Böhme machte
aus ihm einen anderen Menschen. Als er 1645 um seiner Überzeugung willen
nach Amsterdam auswanderte, ließ er dort die Handschriften des Meisters,
die er gesammelt hatte, als erste Gesamtausgabe drucken. Der selbständigste,
nicht unter den persönlichen, sondern unter den geistigen Schülern Böhmes,
war *Daniel von Czepko*, 1605 bis 1660, aus einer mährischen Familie zu
Koischwitz bei Liegnitz geboren, Gutsbesitzer und Hausbürger in Schweid-
nitz. Seine Werke, die sich in jeder dichterischen Gestalt versuchten, sind,
weil zumeist ungedruckt, dem Zeitalter verlorengegangen. Das Singspiel
„Pierie" 1636 ist mit der Vielfalt seiner Rhythmen und Töne fast schon ein
romantisches Drama. „Coridon und Phyllis", 1636, drei schäferliche Bücher
epischen Stiles, setzen dem Verderben des Zeitalters die volkerhaltende Acker-
lehre Vergils entgegen. Kaiserliche Gesinnung und ein kräftiges Deutsch-
gefühl geben dem Gedicht eindeutige Züge. „Semita amoris divini: das hei-
lige Drey Eck" 1657 ist eine Art Kantate über die schwierigste Frage, die der
abendländischen Vernunft gestellt war, über die Dreifaltigkeit. Fruchtbar
ist Czepko als mystischer Denker und Formbereiter des kommenden mysti-
schen Dichters. Er hat Eckharts Kernsätze über Paracelsus und Weigel selb-
ständig zu Böhme heraufgedacht und mit der magischen Geheimlehre der
Kabbala verflochten. Das sind, 1632 bis 1647 entstanden, in der gleichen
Form des religiösen Denkspruches die drei Bücher: „Das Innwendige Him-
mel Reich", „Gegenlage der Eitelkeit", „Monodisticha". Czepko ist eigenen
Willens vom schlesischen Späthumanismus ausgegangen. Er hat mit seinen
Denksprüchen das Wort an den Breslauer *Johannes Scheffler*, 1624 bis 1677,
weitergegeben. Nicht in Schlesien, sondern als Hochschüler zu Leyden hat
Scheffler die Schriften Jakob Böhmes kennengelernt. Schon hier wird er mit
den wichtigsten Urkunden der mittelalterlich-deutschen und der spanisch-
katholischen Mystik bekannt geworden sein. Nach seiner Heimkehr wurde
er 1649 Leibarzt des Herzogs von Oels. Czepko und Franckenberg wurden
seine Freunde. Er lebte sich in die Gedanken der drei großen deutschen
Mystiker Eckhart, Tauler, Seuse sowie der neueren Naturphilosophen Gior-
dano Bruno und Valentin Weigel ein. Er wurde katholisch und aus dem kai-

serlichen Leibarzt von 1654 wurde 1661 ein Priester der römischen Kirche. Mit fünfundfünfzig Streitschriften focht er im Getümmel der religiösen Kämpfe des Jahrhunderts. Scheffler ist der Dichter, der den gedanklichen Gemeinbesitz der Kreise um Franckenberg und Czepko in letzte Form ge- *Philosophie* bracht hat. Sein Buch hieß 1657 zuerst „Geistreiche Sinn- und Schlußreime" *in Denksprüchen* und sodann 1674 „Der cherubinische Wandersmann". Es sind meist zwei- zeilige Sprüche in Alexandrinern, zwanglos aufgereiht und nicht zu einem geschlossenen Lehrgedicht aufgegliedert. Sie wandeln alle den gedanklichen Kehrreim ab, der seit Meister Eckhart das deutsche Denken gefangenhält: vom Hervorgehen der Welt aus Gott, von der Rückkehr der Dinge in Gott, von der Einheit also, die Erkenntnis und Sein darstellen. Dem Inhalt gegen- über war Scheffler nicht Erzeuger, sondern Treuhänder. Als Künstler ist er über Czepko hinausgekommen durch die dichterische Vollkommenheit der Doppelzeile, durch ihren endgültigen Stil und die unvergeßliche Schlagkraft seiner Prägungen. Alle drei Jahrhunderte nach Scheffler haben mit Schefflers *Das geistliche* Worten die deutsche Mystik im Gedächtnis behalten. Das andere Versbuch *Hirtenlied* Schefflers, „Heilige Seelenlust oder geistliche Hirtenlieder", 1657 und ver- mehrt 1668, übertrug, wie die Kirche das immer getan hatte, die Beziehun- gen zwischen Seele und Gott in die Sprache des Eros, nach dem Geschmack seiner Zeit in die Maskensprache des Hirtengedichts. Man fühlt sich an Czep- kos „Semita" erinnert, wenn Scheffler sein Buch in die drei Kreise gliedert: Advent, Passion, Auferstehung. Doch welch ein Abstand von der beherrsch- ten Denksicherheit Czepkos zu der erregten Sinnlichkeit Schefflers.

Das Gemeindelied beider Bekenntnisse ist diesen Bewegungen des gläu- *Das* bigen Herzens nur zögernd gefolgt, im Abstand des Mißtrauens, das alles *Gemeindelied* kirchliche Behördentum gegenüber den persönlichen Ansprüchen so vieler Unbefriedigter hegte. Aber der Bann wurde doch gebrochen. *Johann Franck*, *Franck* 1618 bis 1677, aus Guben, Ratsherr und Bürgermeister seiner Vaterstadt, ist zuerst als Hochschüler in Königsberg zu seinen Kirchenliedern angeregt worden. Sie bilden mit Vorliebe altkirchliche Lateinhymnen nach. Sie neh- men volkstümliche Bräuche auf. Unter ihnen sind mystische Jesuslieder von der Art Schefflers und Rinkarts. Und er hat Marienlieder gewagt, die nach Stimmung und Lehre von katholischen nicht zu unterscheiden sind. *Paul* *Gerhardt*, 1607 bis 1676, aus Gräfenhainichen bei Wittenberg und ein Zög- *Gerhardt* ling der Fürstenschule von Grimma, hat, nachdem er um Luthers willen zu Berlin sein Amt verloren hatte, in der Lausitz zu Lübben seine Zuflucht ge- funden. Schon seine ersten Lieder von 1647 „Nun ruhen alle Wälder", „Nun danket all und bringet Ehr", „Auf, auf, mein Herz mit Freuden" wirkten

wie die Offenbarung einer neuen Kunst. Aus dem ursprünglichen Gemeinde-
liede ist bei ihm ein persönliches Stimmungsgedicht geworden. Es hat die
ganz natürliche Frömmigkeit des Gefühls und verschmäht den Ton weder
Reformation der Ballade noch des Wanderliedes. Paul Gerhardt hat dem Kirchenliede
des Herzens mystischen Gehalt und weltliche Form eingeschaffen. Er hat es damit für
den Stil des Barock empfänglich gemacht.

So hat sich in Schlesien und der Lausitz entgegen dem amtlichen Luther-
tum eine Reformation des Herzens vollzogen. Sie ging überall auf die alt-
deutsche Mystik zurück und also über die Kirchentrennung hinweg. Sie nahm
Vorstellungen und Ausdrucksformen der katholischen Frömmigkeit an. Ja,
sie bekannte sich wieder zur römischen Kirche. Nicht der kavaliermäßige
Humanismus Martin Opitzens, sondern die Dichtung dieser Reformation des
Herzens verkörpert das Zeitalter und stimmt es auf den Stil des Barock.

Lebensstil WIEN. Das beschauliche Leben der humanistischen Gelehrten wendet
des Barock sich zu der hochgespannten Tatkraft der barocken Staatsmänner und Krieger.
Der Rausch des Handelns, der Jagd nach hohen Zielen, das bewegte Lebens-
gefühl ringt nach Ausdruck und setzt sich monumentale Gleichnisse seiner
selbst. Unstillbare Genußfreude ergibt sich dem breit hereinflutenden Son-
nenglanz des Lebens und verströmt sich in weit geschwungenen Gebärden.
Dichterisch erlebt und erfüllt hat sich der Mensch des barocken Zeitalters
vor allem auf dem Theater. Die einzige Form des schöpferischen Wortes, die
im Wettbewerb der monumentalen und festlichen Künste gleichen Schritt
halten konnte, war die im Theater schauhaft und hörbar verwirklichte, die
machtvolle Gebärde des wirklichen Lebens, die monumentale Haltung des
menschlichen Leibes. Es ist die schauhafte, hochstilisierte Gebärde, aus der
man alle barocke Kunst ableiten muß. Kampf, Sieg und Tod, Verdammnis
und Triumph sind die Urgefühle, die alle barocke Kunst bewegen. Das gilt
ohne Unterschied für den weltlichen wie für den geistlichen Bereich. Die
ganze Geschichte des Barocktheaters hat sich mit allen entscheidenden Wen-
dungen in Wien abgespielt. Aus dem gewaltigen Machtbereich Habsburgs
strömten die theaterbildenden Einflüsse in Wien zusammen und das herr-
schende Kaiserhaus tauschte sie untereinander.

Wiener Drama In den festlichen Schaustellungen Brabants und Flanderns, wie sie 1496
aus Brüssel beim Einzug der spanischen Königin Johanna und 1541 aus
Brügge beim Besuch Karls V. bezeugt sind, war nur die ältere „stumme Ko-
mödie" Burgunds bildmäßig erstarrt. Burgund ist also der Mittelpunkt, von
dem diese Art theatralischer Schaustellungen auf die Niederlande und Spa-
nien ausgriff. Auf dieser dreifach überschichteten Grundlage Burgund, Bra-

bant, Spanien entwickelten sich in Wien die neuen Aufzüge, die Wirtschaften, Kostümfeste, die mit Musik, Tanz und Vortrag reichlich ausgestattet, ihren Höhepunkt in dem „Roßballett" erreichten, das am 24. Jänner 1667 zur Vermählung Kaiser Leopolds I. mit der spanischen Infantin Margaretha Elisabeth aufgeführt wurde. Die vier Elemente, kostbar gewandete Ritter, von sinnbildlichen Gestalten aus der Antike begleitet, kämpften mit Worten und ritterlichen Waffen um das Goldene Vließ.

Der humanistische Bühnenstil der Niederlande wurde zuerst von den Jesuiten gepflegt. Sie kamen 1551 nach Wien und hatten 1588 in ihrem eigenen Haus Am Hof bereits 800 Schüler. Vom lateinischen Humanistenstück gingen sie schon 1566 zur Aufführung antiker Dramen über. Es waren reine Schulkomödien, Vortragsstücke im Hof des Kollegs unter freiem Himmel. Von da gingen sie dann zu eigenen Spielbüchern über und gestalteten diese, als sie seit 1620 eine besondere Bühne und seit 1650 ein kleines Übungstheater hatten, zu reich ausgestatteten Schaustellungen. Den Höhepunkt dieser Kunst erreichte die „Pietas victrix" 1659 von dem Trientiner *Nikolaus Avancinus*, 1612 bis1686, der mit seinen zahlreichen Dramen einer der größten Dichter des Ordens ist. Das Stück behandelte den Entscheidungskampf um das Christentum zwischen Konstantin und Maxentius. Begriffe des Verstandes und Kräfte der Seele erscheinen hier als sichtbare Menschen, die reden und handeln. Belagerungen und Schlachten, Erscheinungen in den Wolken, Phaeton auf seinem Sonnenwagen, das waren erstaunliche Leistungen der Szenenkunst. Diese Jesuitenbühne wurde endlich kaiserliches Hoftheater und spielte nun mächtige Staatsdramen wie „Artaxerxes", „Canutus", „Semiramis", schon 1657 eine Türkenbelagerung, dann Stücke aus der heimischen Sage und Geschichte, 1682 eine Griseldis, 1701 einen Arminius, 1704 einen Konradin. Aus diesem Staatsdrama entwickelte sich das neue deutsche Volksspiel. Nachdem 1655 in einem solch lateinischen Staatsdrama als erste deutsche Einlage eine Bauernszene in Wiener Mundart aufgetaucht war, erschienen bereits 1672 und 1685 schon ausgebildete Lustspiele als Wiener Marktaufzüge mit deutschen Liedern. Der schlesische Jesuit *Johann Baptist Adolph*, 1657 bis 1708, machte aus diesen Einlagen richtige Volksspiele im späteren Stil Ferdinand Raimunds. Es gab im Wiener Jesuitenkolleg eine ganze Schule von Theaterdichtern dieser Art. Vom niederländischen Humanistenstück her und über die Schulkomödie war das Wiener Jesuitentheater weltlicher Hochbarock geworden. Der Spielplan und die Spielkunst der Wiener Jesuiten waren der Mittelpunkt, wo aus dem ganzen Weltreichverbande Spielplan und Spielkunst getauscht wurden.

Vom Schultheater zum Hoftheater

Avancinus

Adolph

Die Wiener Zu den burgundischen und deutschen Vorstufen kamen Italien und die
Oper italienische Oper. Sie hat in Wien ihr höchstes Leben gelebt. In der Zeit von
1657 bis 1705 sind fast 400 Opern und Oratorien gegeben worden. Die Spiel-
bücher wurden zugleich in deutscher und italienischer Sprache gedruckt. Ge-
spielt wurde in dem großen Opernhaus am äußeren Burgplatz, das bald nach
1659 gebaut wurde. Man spielte aber auch abwechselnd in Schönbrunn, in
der Favorita, im Augarten. Josef I. baute auf dem Platz der heutigen Redou-
tensäle ein neues Opernhaus, das prächtigste in Europa, das am 21. April
1708 eröffnet wurde. Der Gipfel der Leistung war hier „Il pomo d'oro" 1666,
das Spielbuch von *Francesco Sbarra*, die Musik von Antonio Cesti. Es war
die Geschichte vom Urteil des Paris, aushallend in eine Ruhmesfeier Öster-
reichs. Auch in der italienischen Oper setzte sich um 1660 das deutsche Zwi-
schenspiel fest. *Nicola Graf Minato*, Hofdichter von 1669 bis 1698, der schon
die deutsche Sage zu Spielbüchern verarbeitete, Tänze von Heuschrecken
und Fröschen auf die Bühne brachte, ja den „Kräutel-Marckt auff dem Gra-
ben" mitsamt seinen Marktweibern vorführte, hat die Wiener Hofoper schon
dicht an den Stil des Wiener Volkstheaters herangebracht.

Der Kaiser Von den letzten vier Kaisern aus dem Mannesstamme Habsburg hatte
dirigiert jeder sein persönliches Verhältnis zu seinen Hofbühnen. Ferdinand III., 1637
bis 1657, schrieb italienische Dichtungen und Tonwerke im Geiste Neapels.
Leopold I., 1658 bis 1705, humanistisch gebildet und tonkünstlerisch begabt,
fand unter Weltplänen und Weltsiegen Zeit, Theaterdichtungen zu wählen,
Sänger zu prüfen und aus Wien eine Weltstadt der Musik zu machen. Josef I.,
1705 bis 1711, war der beste Tonkünstler seines Hauses. Karl VI., 1711 bis
1740, leitete selber das Spiel seiner eigenen Hofoper.

Unter diesen Kaisern hat sich jener barocke Stil der beiden Hofbühnen
herausgebildet, der das gesamte Theater des österreichischen Volkes durch-
drang und sich in seiner Bühnendichtung bis in die Gegenwart behauptet hat.
Das religiöse Doppelgesicht Diesseits-Jenseits bedingt den Zweiwelten-
Der Kunststil charakter des Barockspiels im Wortlaut wie in der bühnenmäßigen Darstel-
der Barockbühne lung. Zweiheit und Gegensatz sind daher die wesentlichen Merkmale des
barocken Stils. Die Idee ist das wahre Wirkliche. Die gemeine Wirklichkeit
ist nur ein Gleichnis des Überwirklichen. Diese beiden Welten, die sinn-
gebende überwirkliche und die gleichnisbildende irdische, spielen immer zu-
sammen. Entweder machte man aus rein gedanklichen Vorgängen eine sicht-
bare Handlung unter Begriffen in menschlicher Gestalt oder man stellte in
Art der lebenden Bilder das überwirkliche und das irdische Geschehnis
nebeneinander dar, oder man schob, was die irdische Handlung bedeuten

sollte, in Form von Zwischenspielen und Tänzen in diese irdische Handlung ein. Aus diesen Allegorien entwickelten sich ganz neue und künstliche Mythen und Märchen. Der Kampf zwischen Himmel und Hölle um die menschliche Seele ist der große Gegenstand der Barockbühne. Dieser Kampf spielt sich in der noch unzulänglichen Kunstweise der älteren Bühne ganz gesprächsweise ab, bis man endlich fähig wird, ihn szenisch zu einer gegenständlichen Handlung zu verdichten. Für dies Messen der Kräfte aus überweltlichen Bezirken erfindet man später gerne Geschicklichkeitsproben, die *Helden* *und Mächte* sich zu ganzen varietémäßigen Auftritten weiten. Das Eingreifen außerwirklicher Kräfte und Mächte in die dramatische Wirklichkeitshandlung gibt auf der Barockbühne dem Wunder ein weites Feld. Die geborenen Verbindungsleute zwischen der jenseitigen und diesseitigen Welt sind die Geister, die fleißig beschäftigt werden. Sie sind unabhängig von Raum und Zeit. Das ermöglichte einerseits zahlreiche Verkleidungsszenen und zwang anderseits dazu, schwierige Beförderungsmaschinen zu erfinden. Unter den Mitteln, diese Erscheinungen ins Grauenhafte zu steigern oder ins Liebliche zu mildern, spielen Beleuchtungsvorrichtungen eine große Rolle. Ein solcher Vermittler zwischen Diesseits und Jenseits war auch der Traum. Wachhandlung und Traumhandlung gehen oft unvermittelt ineinander über. Die Helden werden aus dem Jenseits durch Talismane unterstützt, die als Gleichnisse der Gnade aus dem Redensartlichen durch Wörtlichmachen entwickelt wurden: der Schild der Gnade. In den gleichen Bezirk gehören die Schicksalsgeräte. Die Verwandlungen der menschlichen Gestalt sind vielfach nur ein bühnenhaft schaubares Gleichnis für die seelische Verwandlung des Menschen. Hier ist der Grenzrain zwischen Tragödie und Komödie, die sich all dieser Spielarten zum wesenseigenen Gebrauch bedienen. Verkleidungen sind schon ein abgeblaßter Behelf für die metahpysische Verwandlung seiner *Tausch* *der Masken* Wesenheit und Gestalt. Der Gestaltentausch zwischen Mensch und Tier ist das äußerste szenische Wagnis und der Auslauf eines Gedankens, für den alle irdischen Erscheinungen nur Wort und Buchstabenzeichen der echten Wirklichkeit der Idee sind. Dieses Theater, dessen Spielgestalten im beständigen Tausch der Masken ineinander übergehen, ist künstlerisch der Ausdruck eines völlig irrational gerichteten Zeitalters. Gleichwohl ist dieses Theater der Verwandlungen, der Verzauberungen, der Doppelgänger, der ausgetauschten Gesichter doch auch wiederum nicht so problemlos, wie es sub specie aeternitatis erscheinen könnte. In den letzten Jahrzehnten dieses Zeitalters spürt man durch das Spiel der Masken schon deutlich den Umschlag der geistigen Witterung. Das Wissen, daß alles Vergängliche nur ein Gleich-

nis sei, wandelt sich zu dem Zweifel an der Wirklichkeit überhaupt, zum
Glauben an das blinde Walten des Ungefähr, ja zum Zweifel an der Gültig-
keit der Vernunft. Und so bereitet sich auf der Bühne jene gewaltige Er-
schütterung des Geistes und der Seele vor, die im achtzehnten Jahrhundert
zu einer neuen Prüfung des Verhältnisses Vernunft—Wirklichkeit—Erkennt-
nis treibt.

Bühne und Szene Die Bühne, von der die Geschichte des Barocktheaters ausgehen muß, ist
die im sechzehnten Jahrhundert noch übliche Bühne des Nebeneinander.
Das war der offene Raum etwa des Marktplatzes. Die Spielplätze waren alle
fest und lagen gleichzeitig nebeneinander. Die Schauspieler begaben sich,
wie der Ortswechsel der Handlung es verlangte, von einem Spielplatz zum
andern. Dann ordnete man die einzelnen Spielorte flächenhaft an der einen
Seite des Marktplatzes an, so daß auf die Gegenseite sich die Zuschauer ab-
sondern konnten. Die Fläche des Nebeneinander wurde allmählich derart
vereinfacht, daß man die Szenenorte längs der Wand auf drei verminderte.
Durch Vorhänge und Versatzstücke wurden sie verwandelbar gemacht. Sie
waren noch Bühne des Nebeneinander und des Nacheinander zugleich. Als
man in den geschlossenen Saal übersiedelte, machte man aus den drei
Szenenorten einen einzigen, der Ortswechsel nur noch durch Verwandlung
der Szene andeuten konnte. Aus dem reinen Nebeneinander war das reine
Nacheinander geworden. Die Ausstattung war auch bei den kleinen Bühnen
reich. Man unterschied Zeit und Land vor allem durch die Kostüme. Die
Dekorationsmalerei wagte sich an die schwierigsten architektonischen Auf-
Perspektive gaben. Sie gab Durchsichten durch Innenräume in Diagonalperspektive und
lichtdurchflutete Treppenhäuser. Die Verwandlung der Szene geschah viel-
fach durch Telari, das waren an den Seiten der Bühne angeordnete drehbare
Prismen, die einen raschen Szenenwechsel ermöglichten. Mit Maschinen zum
Schweben und Fliegen konnte man den schwierigsten Ansprüchen des Spiel-
buches gerecht werden. Lichtwirkungen am Himmel wurden durch Lampen
hinter dem Wolkenrahmen erzeugt, Erscheinungen in den Wolken durch die
Laterna magica hervorgebracht. Die Zwischenspiele, zumeist Träger der
außerwirklichen Handlung, gaben zuerst dem Andrange komischer Einfälle
Raum. Bei ihnen scheint das Stegreifspiel eingesetzt zu haben. Dieser merk-
würdige Widerspruch zu der strengen, überwirklichen, sinngebenden Rolle,
die den Zwischenspielen zukam, erklärt sich daraus, daß das Zwischenspiel
im vorbarocken Drama eine Einlage zur Entspannung der Zuschauer gewe-
Stil der Gebärde sen war. Der Gebärdenstil war überdeutlich und getragen. Das Barockthea-
ter war Gesamtkunstwerk. Daher schon früh der große Anteil der Musik.

Vom Chor aus drang sie in alle Teile des Dramas ein. Die stumme Szene ent-
wickelt sich gleichläufig zum Tanzspiel. Tanzspiele werden zuletzt ein wesent-
licher Bestandteil jeder Aufführung. Tanzmeister und Tonsetzer werden
ebenbürtig zusammen mit dem Dichter des Stückes genannt. Das ober-
deutsche Barocktheater war die künstlerische Ausgangsstellung der neuen
Wandertruppen, und es hat den Stil des deutschsprachigen evangelischen
Theaters in hohem Maße beeinflußt. Die Bühnenentwicklung des späten
achtzehnten Jahrhunderts im mittleren und nördlichen Deutschland ist ohne
oberdeutsches Barocktheater nicht zu denken. In der barocken Theaterkunst
wurzelt die deutsche.

Nicht der künstlerische Geschmack der Kaiser, sondern die gewaltigen
Wandlungen ihrer Staaten haben innerhalb des nun gleichbleibenden Stiles
die Form des Dramas verwandelt. Von den Bürgern und Bauern hatten die
geistlichen Orden und ihre Schulen das Theater übernommen, der Verteidi-
gung und Festigung des Glaubens zuliebe. Sie spielten das Reich des zeit-
losen göttlichen Seins, das sich ohne Grenzen über Diesseits und Jenseits er-
streckt. Auf ihrer Bühne steht, an der Wirklichkeit leidend, mit seiner Seele
handelnd, der Heilige. Das Walten der Vorsehung und Gnade sind die Hand- *Der Heilige*
lungen, die sich auf dieser Bühne begeben. Dann nahmen die Kaiser dieses
Theater an sich in dem Maße, als auch Kirchenpolitik Staatspolitik wurde.
Die klösterliche Schulbühne wurde zum Hoftheater, zunächst ohne Ände-
rung der Spielpläne. Karnevalspiel und große Oper bilden dann die Kunst-
weise der Schulbühne in hohen Hofstil um. Und es kommt ein neuer Um-
schwung. Mit der Zunahme der kulturschöpferischen Aufgaben für den Staat
wird aus dem Hoftheater ein Staatstheater. Das Reich des zeitlosen gött-
lichen Seins wird zu Begebenheiten der Geschichte vermenschlicht, und aus
dem Drama des Gottesgedankens wird das Historienspiel. An Stelle des Hei-
ligen tritt der Held. Handlung des Leidens wird Handlung der Tat. Und mit *Der Held*
diesem Wandel vom Überwirklichen zum Wirklichen geht das Theater vom
gesungenen zum gesprochenen Drama über. Dieser Übergang vom barocken
Gesangstheater zum klassizistischen Sprechdrama war zugleich der Um-
schwung von den seelsorgerischen zu den staatsmännischen Aufgaben der
Bühne. Stellvertretende Helden der Weltgeschichte spielen nun dem Kaiser
vor, was die Staatsmänner und Heerführer in seinem Namen geleistet haben.
Die Kriegsfahrten kaiserlicher Heere in den nahen Osten und in das ferne
Spanien werden im Bilde der römischen Scipionen, ihrer spanischen und
afrikanischen Feldzüge dargestellt. *Apostolo Zeno*, 1668 bis 1750, aus Vene-
dig, und *Pietro Metastasio*, 1698 bis 1782, aus Rom, haben auf der Wiener

Bühne das barocke Gesangtheater zum klassizistischen Sprechstück umge-
bildet.

So wird das Wiener Staatstheater, Festspiel und Weihehandlung, vom
Kulturverband eines Weltreiches getragen und es strahlt seine Wirkungen
in Reich und Erbländer der Habsburger hinein.

Reformation des Herzens. Reformation des Geistes ÖSTERREICH und SCHLESIEN. Im mitteldeutschen Osten hatte mit
Jakob Böhme die Reformation des Herzens begonnen, die eine persönliche
Angelegenheit jedes einzelnen war, und die Gottes Entfaltung durch die
Welt des Guten und Bösen zu einem Drama der denkenden Vernunft machte.
Von Wien aus wurde die Reformation des Geistes mit allen geistigen und
staatlichen Kräften betrieben und dem Drama der denkenden Vernunft der
hohe Stil des barocken Schauspiels geschaffen. Wiederum im mitteldeutschen
Osten wurde aus dem lateinisch-italienischen Spielbuch des Barocktheaters
der kaiserlichen Hauptstadt die Tragödie deutscher Sprache und deutschen
Stils gemacht. Das ist jener Wechsel der Rollen, der die staatliche Lands-
mannschaft von Österreich und Schlesien zugleich als eine innerliche Ge-
meinschaft der Geister erscheinen läßt.

Die Länder Die Städte und Klöster der österreichischen Länder haben die barocke
Oberösterreich Hofkunst ins Volk gespielt. Von den drei ländlichen Hauptstädten der Habs-
burger hat jede auf ihre besondere Art den Umschwung der Rhythmen vom
Humanismus zum Barock durchgelebt. Oberösterreich verkörperte sich huma-
nistisch und lutherisch in dem Soldaten, kaiserlichen Truchseß und Statthalter
Christoph von Schallenberg, 1561 bis 1597, dessen anmutige Lateinverse
noch humanistische Formzucht zeigen und sich doch schon der barocken Will-
kür öffnen. Mit überlegenem Geiste prägte er Sinngedichte, in denen sich die
Spottlust vergeistigter Gelehrtenköpfe des frühen sechzehnten Jahrhunderts
mit der satten Laune des Kavaliers aus dem siebzehnten verschwistert. Seine
Gedichte berühren sich noch mit der ritterlichen Lyrik und sie streben schon
mit überraschendem Glück dem Volkstümlichen nach. Die lateinische Enge
des blühenden Humanismus weitet sich bereits zu der unbegrenzten Freude
an allem, was romanisch klingt. In der Hauptstadt Linz ging das humani-
stische Schuldrama evangelischen Stils fugenlos seit 1608 in das barocke
Steiermark Schultheater der Jesuiten über. Die Steiermark sah sich von der Mittelschule
der lutherischen Landstände in die Hochschule der Jesuiten verwandelt. Am
1. Jänner 1585 gegründet, war sie die ausgesprochene Adelsschule der habs-
burgischen Länder. Die Jesuiten hielten hier ihr übliches Theater. Doch
Graz hatte auch besonderen Einfluß auf den Spielplan der englischen Wan-
dertruppen, die seit 1607 am erzherzoglichen Hofe spielten. Am 10. Februar

1608 fand mit Marlowes Stück die erste Faustaufführung des Festlandes statt und das Grazer Spielbuch des „Kaufmann von Venedig" wurde durch das ganze Jahrhundert in Deutschland benützt. Hier schließt ein Dichter barokken Stiles, der Arzt *Adam von Lebenwaldt*, 1624 bis 1696, aus Sarleinsbach, mit seiner Sammlung „Poetischer Frühlingsspaziergang" das Zeitalter ab. Tirol wird durch *Erzherzog Ferdinand II.*, 1529 bis 1595, der auf Schloß Ambras eine kostbare Bücherei mittelalterlicher Dichtungen sammelte und 1584 sein deutsches Prosaspiel „Speculum vitae humanae" drucken ließ, auf humanistisch vertreten und auf barock durch *Johannes Martin*, 1636 bis 1702, aus Schnüffis, den Kapuziner Laurentius, mit seinen wundersamen schäferlichen Gottesliedern und der Geschichte seiner Seele, „Philotheus" 1678, die er mit den goldenen Fäden seiner Lieder durchflocht. Die Innsbrucker Hochschule um 1677 und das Jesuitentheater spielten keine Rolle. Hier waren es die beiden Hoftheater am Hofgarten und am Rennplatz, die zu Zeiten eben Johannes Martin leitete, ehe er der Kapuziner Laurentius wurde. Ritterfeste, großartige Tanzspiele und italienische Komödien gaben zu Innsbruck den Ton an. Von den zahlreichen Klosterbühnen ist die der Piaristen zu Horn seit 1659 durch ihren Spielplan für die Vorgeschichte vieler österreichischer Theaterstücke wichtig. Die Königin der österreichischen Klosterbühnen war Kremsmünster. Die Abtei, längst eine besondere Pflegestätte der Tonkunst, erhielt eine Oper, die mit der Wiener Hofbühne, und eine Ritterakademie, die mit mancher alten Universität wetteifern konnte. Von 1651 bis 1780 sind mehr als hundert Spielbücher erhalten. Seit der Mitte des achtzehnten Jahrhunderts wurde in deutscher Sprache und gelegentlich in Mundart gespielt. Dieser Abtei gehörte einer der größten Barockdichter an, *Simon Rettenbacher*, 1634 bis 1706, aus Aigen bei Salzburg. Er hat deutsche und lateinische Gedichte, Zeitsatiren in glänzender lateinischer Prosa, Singspiele und Tragödien geschrieben, aus dem Spanischen und Französischen übersetzt und seinem Meister Horaz weniger als Schüler denn als Bruder nachgesungen. Die getragene Sprache einer echten Gesinnung, die starken Gedanken weltreifer Mannheit, der edle vaterländische Zorn, ein schamhaftes tiefes Gefühl und klassische Form machen diesen Forscher, Hochschullehrer und Theaterdichter zu einer der bedeutendsten Persönlichkeiten seines Zeitalters. Die erzbischöfliche Fürstenstadt Salzburg war in diesem Zeitalter beides, Hof und Universität. Das eben gestiftete akademische Gymnasium wurde vom Kaiser am 9. März 1620 zur Hochschule erhoben und 1626 feierlich eröffnet, für anderthalb Jahrhunderte ein Hort der Wissenschaft und eine Heimstätte barocker Bühnenkunst. Die Benediktiner machten ihr Theater, dessen kleines

Tirol

Kremsmünster

Salzburg

Haus 1657, dessen großes 1661 gebaut wurde, zum künstlerischen Mittel-
punkt der süddeutschen Benediktinerklöster. Pflegestätten des Theaters wa-
ren ursprünglich die Domschule und die Petersschule gewesen. Durchs ganze
sechzehnte Jahrhundert wurde deutsch gespielt. Das Theater ging dann an
die Hochschule über. Von 1620 bis 1715 sind mehr als hundert Auszüge von
Spielbüchern erhalten. Aus dieser Zeit sind 29 Benediktinerdichter und von
1661 bis 1767 wieder 22 Tonsetzer bekannt. Gespielt wurde lateinisch,
deutsch und italienisch. Kein anderes Barocktheater spiegelt die Wiener Ent-
wicklung vom Humanismus über das Stegreifstück zum regelmäßigen Drama
so klar und in allen Einzelheiten wider wie das Salzburger. Diese Bühne be-
schäftigte eine ganze Reihe von Dichtern persönlichen Gepräges, darunter
Simon Rettenbacher. Die akademische Spielkunst Salzburgs verzweigte sich,
nachdem sie selber volkstümliche Art angenommen hatte, in viele Täler des
Landes.

Schlesien So hatten die Wiener Hofbühnen die ursprünglich mannigfaltige Theater-
weise der österreichischen Landschaften zu einem gemeinsamen Stil umge-
prägt. So verwandelten sie auch das Humanistendrama Schlesiens in barocke
Bühnenkunst. In Breslau hatte sich, Glaube zu Glaube, zu Beginn des sieb-
zehnten Jahrhunderts das Schuldrama Straßburger Stiles eingebürgert. Es
wies aber schon allgemeine barocke Züge auf. Dann setzte sich die öster-
reichische Bühnenkunst durch. Der Wiederaufbau der römischen Kirche lag
in den Händen der Jesuiten. Sie schufen sich überall Schulen, und wo sie
Schulen hatten, da spielten sie auch Theater. Die schlesische Jesuitenbühne
aber bedeutete wie überall Barock. Mit diesen Jesuitenbühnen besaß die
Wiener Theaterkunst in Schlesien ihre gesicherten Vorwerke. Wenn sie Feste
feierten und Schauspiele gaben, so eiferten die Fürstenhöfe im Lande dem
kaiserlichen Vorbilde nach. Schlesische Landeskinder wiederum, wie der
Liegnitzer Johann Adolph, waren im Wiener Bühnenbetriebe schöpferisch
Knorr tätig. *Christian Knorr von Rosenroth,* 1636 bis 1689, aus Alt-Rauten bei
Wohlau, ein Alchimist von vielen Graden, schrieb zur Hochzeitsfeier Kaiser
Leopolds I. 1666 das barocke „Chymische Prachtspiel" „Coniugium Phoebi
et Palladis". Es gehört mit den Dramen des Görlitzers Tobias Kober in eine
Hallmann Gedankenreihe. *Johann Christian Hallmann,* um 1640 bis 1704, ein Bres-
lauer, der zur römischen Kirche zurückkehrte, meisterte bereits alle Formen
der Wiener Kaiserbühne, wußte in seinen Dramen Musik und Tanz sehr ge-
schickt zu behandeln und ging zu mundartlichen Zwischenspielen über. Das
sind Beginn und Beschluß der schlesischen Wandlung vom Straßburger
Akademietheater zur Wiener Hofbühne.

Noch mitten inne steht *Andreas Gryphius*, 1616 bis 1664, aus Großglogau. *Andreas Gryphius*
Der Vater stammte aus der Goldenen Aue, jener Thüringer Landschaft, die
im wesentlichen durch Niederfranken besiedelt worden war. Die frühesten
Bühnenanregungen empfing er zu Glogau von der evangelischen Schule. Und
da die Jesuiten hier 1626 eine Anstalt gründeten, wird er zum erstenmal ihre
Stücke gesehen haben. Auf dem Schultheater zu Fraustadt, 1632 bis 1634,
spielte er mit und zu Fraustadt erhielt er als Schulpreis die „Tragoediae *Lehr- und Wanderjahre*
sacrae" des französischen Jesuiten Nikolaus Caussinus. Vom Danziger Gym-
nasium ging er 1638 nach Holland an die Universität Leiden. Die Kavaliers-
reise machte er 1644 als Begleiter junger Edelleute. Wenn er im Hofe des
Collège Clermont die großartigen Jesuitenspiele und zu Rom das besonders
gut ausgestattete Jesuitentheater gesehen hat, so vertiefte er lediglich die
Kenntnisse, die er bereits von der Heimat her besaß. In Straßburg schrieb
oder entwarf er seine ersten deutschen Stücke, ohne vom Straßburger Aka-
demietheater wesentliche Anregungen zu empfangen. Zum Bühnendichter
gebildet und berufen, ist Gryphius als Sachwalter der Stände im Fürstentum
Glogau vor seiner Zeit und unterhalb des erreichbaren Gipfels gestorben.
Die religiösen Lateingedichte seiner frühen Schulzeit bezeugen lediglich
seine späthumanistische Bildung. Die lyrischen Gedichte des reifenden Jüng- *Lyrische Gedichte*
lings und Mannes, „Tränen" 1636, „Sonn- und Feiertagssonette" 1639,
„Kirchhofgedanken" 1656, verraten seine mystisch vergrübelte, asketisch
weltabgewandte Seele, die völlig vom Rätsel des Todes und dem Geheimnis
der Verwesung gefangen ist. Die Witterung seines Herzens weht von Jakob
Böhme her. Zum Spielbuchdichter hat er sich an Übersetzungen aus mancher-
lei Sprachen, darunter „Die Gibioniter" des holländischen Dichters Jost van *Dramenschule der Holländer und Jesuiten*
den Vondel, geschult. Doch ausgegangen ist er mit seinem ersten Stück, der
byzantinischen Hoftragödie „Leo Armenius" 1646, vom Jesuitendrama. Alle
seine Trauerspiele, „Carolus Stuardus" 1649, nach Zeitungsberichten ge-
schrieben, die Tragödie der letzten Stunden eines Königs, das Märtyrerstück
„Katharina von Georgien" 1657, nach Vondels „Jungfrau", die Tragödie der
Gerechtigkeit, „Papinianus" 1659 nach Vondels „Palamedes", das Studenten-
stück „Cardenio und Celinde" 1649, um den Gegensatz von irdischer und
himmlischer Liebe, die beiden höfischen Festspiele, von denen „Majuma"
der Krönung König Ferdinands IV. galt, und „Piastus" die Hoffnung auf
einen rettenden Stammhalter der sterbenden Piasten aussprach: sie alle
stehen nur als Dichtungen zwischen dem holländischen und jesuitischen
Drama, während sie als Bühnenspiele immer klarer dem Stil des kaiserlichen
Hoftheaters zustreben. Die duldenden Helden aller dieser Tragödien stam-

Die Stoa men zu sichtbar von den Märtyrern der frühen Barockbühne ab und ihre Tragik ist die stoische Weltüberwindung, wie sie in den römischen Tragödien des Seneca sich bewährt. Es sind Chordramen in rednerisch und pathetisch gebauten Alexandrinern, zu denen man sich ein hochstilisiertes Ge-

Gryphius und sein Lustspiel bärdenspiel denken muß. Es sind Verse des humanistisch geschulten Wortgefechts, jetzt zum Wurf in gewichtige Sprüche geballt und dann wieder wie blitzschnell wechselnde Hiebe in einer Zeile viermal, fünfmal von Sprecher zu Sprecher hin und her blitzend. Ein ganz anderes Gesicht zeigen die Lustspiele. „Peter Squenz", nach einem „Sommernachtstraum", trägt mit einer Parodie der Handwerkerkomödie den Kampf des kunstbewußten Barockstils gegen die naive Liebhaberei des Meistersingertheaters auf die offene Szene. „Horribilicribrifax" exerziert den miles gloriosus der römischen Komödie auf dem Theater des Dreißigjährigen Krieges. Zwei Stücke in eins gefügt, „Das verliebte Gespenst", ein Singspiel in Alexandrinern, und „Die geliebte Dornrose", in schlesischer Mundart, zeigen die allmenschliche Liebe in einem Doppelspiegel: Liebe unter Gebildeten und unter Bauern. Es wurde 1660 in Glogau gespielt zu Ehren der Braut des Herzogs Georg III. von Brieg. Die Dramen des Andreas Gryphius waren wirkliche Spielbücher. Sie haben das schaulustige Zeitalter in seiner ganzen Breite ergriffen: die Bühne der fahrenden Leute, selbst der Engländer, der schlesischen Schlösser und evangelischen Schulen, der Salzburger Benediktiner. Sie waren auf die verwandlungsfähige Jesuitenbühne berechnet. Sie haben die schlesische Reformation des Herzens auf die Bühne, den werdenden Stil des Wiener Hoftheaters ins Schlesische, die fremdländische Bühnensprache ins Deutsche übertragen. Sie haben die Umbildung des gemeinen Prosadeutsch in eine gemeine Dichtersprache um einen mächtigen Sprung nach vorwärts getrieben.

Zum Singspiel und Sprechstück Aus der Vollendung des barocken Gesamtkunstwerks gab es nur zwei Wege nach vorwärts und weiter ins Abenteuer des ewigen Werdens: ins volksmäßige Singspiel und zum kunstgerechten Sprechstück. Der eine wurde in Wien, der andere in der Lausitz beschritten.

Zittau Zittau war die eigentliche lausitzische Schulstadt. Ihre humanistische Lateinschule war 1586 zu einem Gymnasium geadelt und dieses 1686 mit einer stehenden Bühne beschenkt worden, für die drei regelmäßigen Fastnachtsspiele des Schuljahres. Vor dieser Bühne sah sich der Schulmann *Christian Weise*, 1642 bis 1708, einer reizvollen Aufgabe gegenüber. Er stammte von böhmischen Glaubensflüchtlingen ab und brachte aus seiner Leipziger Hochschulzeit den frischen Schwung der dortigen Studentenliteratur und studentischen Bühnenkunst mit. In diese Richtung schlugen seine lehrhaften und

kultursatirischen Romane. Aus dieser Richtung fand er die Lösung für die *Christian Weise* Aufgabe, die ihm als Spielleiter gestellt war. Er machte dem Schlendrian des herkömmlichen Schuldramas an seiner Anstalt ein Ende. Er machte aus seiner Bühne ein richtiges Theater, auf dem seine Jungen sich bewegen und Deutsch sprechen lernten. Darum kehrte er im Stil zum evangelischen Schuldrama zurück, wobei er sich an die moderne französische Bühne hielt und schuf das zeitgemäße Sprechdrama im lebendigen Unterhaltungston. Er gab nur eigene Arbeiten und stets Neuheiten. Seine 55 Stücke bilden einen um- *Seine* fassenden Spielplan, der stofflich die ganze Theatergeschichte bis auf seine *Schulbühne* Zeit beherrscht. Da erscheinen die Vorwürfe des alten Bibeldramas, der französischen Klassikerbühne, des barocken Jesuitentheaters. Da begegnet man einem „König Wenzel", der sich eine lausitzische Volkssage zunutze macht und in reizenden Kinderszenen das tägliche Leben der Stadt Zittau abspielt. Die Lustspiele halten sich an Molière und zeigen das Leben in allen seinen Bezirken, wie es dem Schüler erscheint und zugänglich ist. Auf Weises Sprechbühne gilt nur „Das Gläubliche", die Dinge, wie sie wirklich sind, und der Mensch, wie er im täglichen Leben spricht. Sein Sprechdrama ist also ein Prosadrama.

WIEN, wie es wirklich redete und hantierte, sah sich schon in den volksmäßigen Zwischenspielen des kaiserlichen Theaters auf der Szene. Wonach es dem Volk der Stadt gelüstete, das suchten auf eine sehr rohe Weise die kleinen Bretterbuden zu befriedigen, wie sie auf den Plätzen der Stadt von fah- *Theater am* rendem Volk deutscher und italienischer Zunge aufgeschlagen wurden. Das *Kärntnertor* geschah vor allem zur Zeit der großen Märkte. Damit diese Fahrenden und ihre Zuschauer es besser hätten, wurden ihnen drei von den vier Ballhäusern der Stadt geöffnet und 1708 baute die Gemeinde beim Kärntnertor den fahrenden Truppen und ihrer Kunst ein eigenes Theater. Am 30. November 1709 wurde es eröffnet, der Geburtstag des Wiener und mit dem Wiener des deutschen Volkstheaters. Diese Bühne fand sogleich den Mann, der sie meisterte. *Josef Anton Stranitzky*, um 1676 bis 1726, ein Steirer, vielleicht aus *Josef Anton* Knittelfeld, nicht ohne akademische Bildung, hatte anfänglich auf roher *Stranitzky* Bühne, wie damals üblich, mit einem wandernden Arzt zusammengearbeitet. In Wien tauchte er 1705 auf und im April 1712 übernahm er das Theater am Kärntnertor. Stranitzky ist nicht Dichter, sondern Schauspieler und Spielleiter. Die Stücke, die unter seinem Namen gehen, sind Spielfassungen seiner Bühne, die nach Stranitzky mit dem gleichen Recht wie nicht wenige Stücke nach Shakespeare heißen. Er spielte am Kärntnertor die volkstümliche Staatstragödie, wie sie sich aus dem englischen Geschichtsspiel vor allem Shake-

speares und aus dem italienischen Renaissancestück durch die Wiener Kaiser-
bühne entwickelt hatte. Vierzehn solcher Dramen sind von Stranitzky über-
liefert, wahre Kunstwerke, zu denen er sich vielleicht am Salzburger Aka-
demietheater geschult hat, Stücke mit einer folgerichtig geführten und ge-
schlossenen Handlung und lebhafter, schlagender, persönlich klingender
Wechselrede. Aus den komischen Zwischenspielen der Kaiserbühne ist in
Stranitzkys Staatstragödien ein organischer Bestandteil, das Gegenspiel ge-
worden. Für den Träger dieses Zwischenspiels schuf er sich eine neue Cha-

Hanswurst raktermaske aus dem Salzburger Bauern, seinen Hanswurst. Hanswurst aber
spielte sein Gegenspiel aus dem Stegreif. Skizzen zu solchen Stegreifszenen
liegen in Stranitzkys Handbüchlein „Ollapatrida" 1711 vor und sie sind viel-
leicht auch in seinen „Lustigen Reisebeschreibungen" 1717 und „Hannss-
Wursts vermischten Gedanken über die vier Jahreszeiten" 1721 zu erkennen.
Stranitzkys Spielbücher bestehen also aus dem festen Wortlaut der Haupt-
handlung und aus dem stegreifmäßigen Gegenspiel Hanswursts. Das ist in
einem neuen Stil nichts anderes als die alte Doppelwelt der barocken Bühne.
Die zwei Welten, die bei ihm durcheinanderspielen, das ist die eine Welt der
Staatsgewalt und die andere Welt des einfachen Mannes aus dem Volke.
Hanswurst ist in leibhaftiger Gestalt das Wiener Vergnügen an der Parodie.
Hanswurst verkörpert den Wirklichkeitssinn gegenüber dem Idealismus sei-
ner Mitspieler, die pfiffige Kritik des Volkes an dem, was es über sich hat.
Hanswurst ist in der Staatstragödie, was das Satyrspiel im griechischen
Drama, Stimme aus dem Zuschauerraum und zuweilen beinahe der antike
Chor. Er belauscht seine Mitspieler, verwechselt Briefe, schürzt und löst den
Knoten. Er spricht Mundart und ergeht sich in Sprichwörterweisheit wie die
Boten der griechischen Tragödie. Seine Philosophie ist die Weltweisheit des
Wiener Buben, die fortan durch alle Wiener Bühnen und so viele Wiener

Ausblicke vom Stücke die Runde macht. Stranitzky hat am Kärntnertor die Urform der Wie-
Kärntnertor ner Volksbühne geschaffen, aus der die gesamte bunte Fülle aller Wiener
Spielarten hervorgegangen. Wolfgang Amadeus Mozarts Singspiel, Franz
Grillparzers Sprechdrama, Ferdinand Raimunds Märchenkomödie sind nur
der Grundakkord dieser vielstimmigen Melodie, in der die Ludi Caesarei
unvergänglich fortklingen.

Daß im Waffenlärm die Musen schweigen, ist niemals weniger wahr ge-
wesen als in diesen zweihundert Jahren fast ununterbrochenen Kampfes.
Das Reichsbewußtsein aber und der Gedanke des deutschen Kaisertums
flammten zwischen dem Entsatz von Wien 1683 und dem Frieden von Passa-
rowitz 1718 noch einmal auf und schlugen im Schrifttum Feuer. Das bezeu-

gen die beiden Männer, die verschiedenen Welten angehören und zusammen doch nur die eine bedeuten, die Deutschland heißt. Der eine ist *Abraham a Sancta Clara,* 1644 bis 1709, aus Kreenheinstetten im Hegau, Ulrich Megerle, der Augustinermönch und seit 1677 Hofprediger Kaiser Leopolds I. und Sprecher der Monarchie in geistlichen Dingen. Sein Gesamtwerk umspannt die ganze gattungsmäßige Fülle der Literatur seiner Zeit. Seine Spielbücher sind verlorengegangen. Alle seine Schriften wimmeln von Verslein und Gedichten eigener Prägung. Er war ein Fabeldichter von Gottes Gnaden. Er ist der Meister der Kurzgeschichte. Nur eine andere Art dieses wunderbaren Fabuliervermögens sind seine Sittenbilder. Abrahams Hauptwerk in diesem Sinne ist das vierbändige Buch „Judas der Erzschelm", um den Kern eines Romans die Kultursatire des ganzen Zeitalters. Er ist der große Prediger seiner Zeit und der größte deutsche Publizist zwischen Luther und Görres. In seinen Kanzelreden, so „Paradeisblume" 1675 und „Predigt vom heiligen Georg" 1680 war er der volksmäßige Sprecher des österreichischen Kulturbewußtseins und Staatswillens. Er zog die Standarte des Miles christianus von neuem auf und setzte dem Staat mit seiner Schrift „Auf, auf, ihr Christen" 1683 sein weltpolitisches Ziel. Alle seine Volksschriften sind inszeniert, sei es schauhaft, sei es hörbar. Es sind Hochgebilde der barocken Kunst des Zeitalters. Der andere ist *Gottfried Wilhelm Leibnitz.* Er wollte die harmonische Einheit der Welt im Denken und Handeln. Daher arbeitete er sein Leben lang an einer Wiedervereinigung aller christlichen Bekenntnisse. Immer wieder bemüht, als Geschichtschreiber, als Gesetzgeber, als Buchwart am Kaiserhof einen Wirkungskreis zu finden und viermal in Wien zu Gaste, wollte er die Stadt des Kaisers zum geistigen Mittelpunkt des Deutschen Reiches machen: durch eine Akademie der Wissenschaften, um die er seit 1668 Eingabe um Eingabe und Entwurf um Entwurf nach Wien richtete. Während Gottfried Wilhelm Leibniz und Abraham a Sancta Clara noch auf der Szene stehen, erscheint zwischen ihnen Prinz Eugen von Savoyen, der Staatsmann und Feldherr, und vollstreckt, was sie in Rede und Schrift geraten, gefordert, verheißen hatten.

Die schlesische Reformation des Herzens wird durch *Johann Christian Günther,* 1695 bis 1723, aus Striegau, der so unglückselig am Leben gescheitert ist, lyrische Dichtung der Seele. Günther war in Schlesien der letzte Herold der alten Reichsgesinnung. Mit seinem Gedicht auf den Frieden von Passarowitz 1718 rollte er in unerhört neuer Sprache das Bild des letzten Türkenkrieges auf. Das Gedicht ist in einer glücklichen Stunde aus der ganzen Breite der Nation gesprochen. Und Günther ist in seinen geistlichen und

Abraham a Sancta Clara

Leibniz in Wien

Schlesien
Günther

erotischen Gedichten der erste Bekenner der ausgereiften modernen Seele des deutschen Ostens. Er hat den Wandel vollzogen von der barocken Überlast des redensartlichen Bildes zur schlichten Wörtlichkeit des Volksliedes. Ausgedient hat das alttestamentliche Gerät, das dem religiösen Dichter so unentbehrlich war, wie dem gelehrten Verskünstler die Maschine der olympischen Götter. Ausgetilgt ist die Unterscheidung von Volk und Dichter, von Dichter und Mensch. Erlebnis ist alles und Bekenntnis, beides aus den ursprünglichen Trieben des Herzens, und beide angerührt von Ganzheit und Jenseits der Welt. Die Heilssehnsucht dieses vielgequälten Menschen formt sich zu so erschütternden Bildern und drückt zuweilen eine so willenlose Hingabe an den selbsterlebten Heiland aus, daß der Verfolgte und grausam Zerstörte von der mystisch-pietistischen Bewegung nicht losgelöst werden kann. Die schlesische Reformation des Herzens wird durch Graf *Nikolaus Ludwig* *Zinzendorf* *von Zinzendorf*, 1700 bis 1760, aus Dresden, durch den Vater von österreichischer, durch die Mutter von lausitzischer Herkunft, Wille zum Handeln und christliche Tat. Auf seinen Gütern schlug 1722 Christian David den ersten Baum zum Pilgerhause Herrnhuts nieder. Das wurde, von Zinzendorf *Herrnhut* betreut und geführt, die Gemeinde, wo die böhmisch-mährischen Brüder ihre letzte Verwandlung zu einem urchristlichen Leben der Werkgemeinschaft *Ausblick von* durchgemacht haben. Graf Zinzendorf, einer der größten Stegreifdichter des *Herrnhut* deutschen Volkes, hat in Sprache und Bildschmuck der alten ritterlichen und mystischen Dichtung sich und seiner Gemeinde ein Lied geschaffen, dessen Todesliebelei und Schmerzenswonne, aufdunkelnd aus Abgründen der Seele, in der deutschen Romantik wieder lebendig wurden. So hat sich in Herrnhut der Ring von Hus zu Luther, von Luther zu Schwenckfeld, von Schwenckfeld zu Böhme, von Böhme zu Zinzendorf geschlossen.

Wie um 1550 die österreichisch-alamannische, so hat sich um 1740 die österreichisch-schlesische Gemeinschaft geistig ausgelebt.

4. DER ALAMANNISCH-SÜDDEUTSCHE KREIS

Alamannische *Übergänge vom* *Humanismus* *zum Barock* In der alten Kulturlandschaft zwischen der oberen Donau und dem oberen Rhein überschneiden einander die Kräftefelder, die vom Wiener Barocktheater und von der Köthener Sprachgesellschaft geladen sind. Doch der Raum hat sich eine sehr selbständige Haltung bewahrt. Hier gleitet überall auf eine eigentümliche Weise das Humanistendrama in das Barocktheater hin-

über. Aus eigenem sucht die deutsche Kunstdichtung nach ihrem Wort. Die alten Gemeinwesen atmen zu Ende, um in das große Schweigen ihrer Vergangenheit einzugehen. Das ganze Zeitalter aber tritt in das mächtige Rundgemälde, das ihm der wahre Volksdichter aufgespannt hat.

SCHWABEN. Der Dichter des Übergangs vom Humanistendrama zum *Frischlin* Barocktheater war *Nikodemus Frischlin,* 1547 bis 1590, aus Erzingen, vielleicht der letzte Humanist, den es gelüstete zu hören, was wohl die Römer zu dem neuen Deutschland sagen würden. So führte er denn in seiner Gesprächsnovelle „Julius Caesar redivivus" 1572 Caesar und Cicero zu Besuch nach Deutschland. Herzog Hermann zeigt ihnen die kriegerischen, Eobanus Hessus die geisten Machtmittel des Reiches. Mit einem dreifachen Einsatz des Jahres 1576 führte er das humanistische Streitgespräch, das evangelische Bibelstück und das deutschsprachige Lustspiel dem Barocktheater entgegen. Der Gefangene auf Hohenurach begann in seinen letzten Tagen einen weitgespannten Kranz von christlichen Dramen, der im Entwurf an Kunstgedanken des Barock gemahnt. In seinem Drang nach geschichtlichen Stoffen, in seiner Redepracht und mit seinem starken oberschwäbischen Einschlage erinnert Frischlin an Schiller.

Der Dichter des Überganges vom Humanistendrama zum mystisch-alchi- *Andreae* mistischen Spiel des Barock ist *Johann Valentin Andreae,* 1586 bis 1654, aus Herrenberg, der vielgereiste württembergische Hofprediger und Abt von Bebenhausen. Was er schon 1617 mit seiner societas solis gewollt hatte, einer geplanten Gesellschaft zur Pflege der unverfälschten Religion, Besserung der Sitten, Erneuerung der Literatur, das suchte er später als Mitglied der Köthener Gesellschaft zu verwirklichen. Er hat noch vor seinem zwanzigsten Lebensjahr mit Komödien nach englischen Mustern und lateinischen Kampfgesprächen begonnen. Und in dramatischen Gebilden — „Turris Babel" 1619 — führte er die Sache der Rosenkreuzer. Sein klassisches Büchlein „Christianopolis" entwarf bis in alle Einzelheiten ein Wunschbild der künf- *Der Rosenkreuzer* tigen Welt, wie sie seinen Gesinnungsgenossen, den gedanklichen Vorkämpfern der Weltreformation von Jakob Böhme bis Gottfried Wilhelm Leibniz vorschwebte.

Pflegestätten des Theaterbarocks waren die Jesuitenhochschule zu Dillingen, das Benediktinerkloster Ottobeuren, der Stuttgarter Hof. In Stuttgart wurden zunächst die Stücke Frischlins regelmäßig gespielt. Dann kamen prunkvolle Ritterfeste auf. Tanzspiele seit 1660 gingen in Opern über. Sie führten um 1700 die Herrschaft. Die drei schwäbischen Spielbuchdichter, der Lutheraner und die beiden Jesuiten, Nikodemus Frischlin, Jakob Gret-

ser, Jakob Bidermann, haben alle Wendungen des Dramas vom Humanismus zum Barock durchschritten.

Der Hofkavalier als Dichter ist in Schwaben früher denn irgendwo mit seiner vollen Persönlichkeit und Leistung in Erscheinung getreten. *Georg* *Rudolf Weckherlin*, 1584 bis 1653, aus einer Ulmer Familie zu Stuttgart geboren, hat auf Hochschulen und weiten Reisen die volle Bildung der Zeit genossen. Er hat dem württembergischen und dem englischen Hofe gedient, wurde in London Unterstaatssekretär und so gut wie zum Engländer. Von seinen Gedichten erschienen 1618 die „Oden und Gesänge", 1641 die „Geistlichen und weltlichen Gedichte", 1648 die Gesamtausgabe. Seine Muster waren Ronsard, Du Bellay und die Engländer. Nicht wenige seiner Gedichte waren Nachdichtungen. Er ist der erste Deutsche gewesen, der alle, auch die schwierigsten Strophen der antiken und der romanischen Lyrik nachgebildet hat. Seine Verskunst ist die mittelalterliche, die mit den tonschwachen Silben nach freiem rhythmischem Ermessen verfuhr. In den späteren Ausgaben suchte er sich hierin Opitz anzupassen. Aber er hat im Vers der höfischen Lyrik, die er kannte, mit vollem Wissen nachgeeifert. Ebenso nahe stand ihm das Volkslied. Schön und zeitlos klingt die schwäbische Mundart aus einigen seiner Gedichte. Weckherlin ist ein wirklicher Dichter. Was er gewollt hat, das ist in seinem Gegenbilde Hölderlin aufgegangen.

BAIERN. München hat die Rolle Wiens im engeren aber auf eine sehr persönliche Art gespielt. Das Schauspiel der Jesuiten, die 1559 ihr herzogliches Gymnasium gründeten, wurde sofort Hoftheater und Stadttheater. Es war Festspiel und zunächst Naturbühne. Zur Aufführung einer „Esther" 1557 verwandelte sich München auf drei Tage in eine assyrische Stadt. Drei Jesuiten waren in München die einflußreichsten Vertreter dieser Kunst: Andreas Fabricius, Georg Agricola, Jakob Bidermann. Diese geschlossene Reihe von Spielbuchdichtern hat München vor Wien voraus. *Andreas Fabri-* *cius* ließ 1568 zur Hochzeit Herzog Wilhelms seine mächtige Tragödie „Samson" spielen, deren wundervolle Chöre Orlandus Lassus vertont hatte. *Georg* *Agricola* ist der Dichter jenes „Konstantin", der 1574 in einer zweitägigen Aufführung und von über tausend Mitwirkenden gegeben wurde. *Jakob* *Bidermann*, 1577 bis 1648, aus Ehingen, war unter den dreien der Fruchtbarste und modernste Meister. Seine Dramen, Märtyrerstücke und Staatstragödien, wurden 1665 gesammelt. Die vollkommenste Dichtung dieses Stiles war sein „Cenodoxus, der Doktor von Paris", 1609 in München gespielt und 1625 durch Joachim Meichel aus Braunau ins Deutsche übersetzt. Es ist die Tragödie des ehrgeizigen Gelehrten, der als Heiliger stirbt und seine

Weckherlin

Münchner
Jesuitenspiel

Fabricius,
Agricola,
Bidermann

Verdammnis selber verkünden muß. Der sichere Sinn für Bühnenwirkungen, sittlicher Ernst und Kenntnis der Seele, weit ausschwingende Bilder, Sätze, Rhythmen, hinreißende Wirkungen lassen die beiden Alamannen Bidermann und Schiller wie Brüder erscheinen. Jakob Bidermanns künstlerischer Gegen- *Jakob Balde* spieler war der Alamanne *Jakob Balde*, 1604 bis 1668, aus Ensisheim. Dessen Fastnachtspiele im Ton des Plautus sind verloren. Balde konnte auch die große Tragödie. Aber sein persönlicher Stil war, wie wir sagen würden, das Kammerspiel, in dem er lyrisch-dramatische Vorgänge innerhalb der Seele sichtbar auf die Szene brachte. Denn er war der Meister des lateinischen Liedes. Seine „Lyrica", 1638 bis 1645, die vier Bücher Oden, das Buch Epoden, die Bücher der lyrischen Wälder sind völlig moderne Offenbarungen eines Naturgefühls, das gerade auf den Seelenton der Natur gestimmt ist, auf das Ziehen und Wogen der Nebelbilder, auf das stimmungsvolle Anschwellen des nächtlichen Dunkels, auf den Vogellaut, auf den diskreten Tonfall des Wortes. Er war der große Lyriker der barocken Kunst wie Bidermann ihr großer Spieldichter.

Was Kremsmünster unter den österreichischen, das war Ettal unter den *Ettal* bairischen Benediktinerabteien, die Königin. Einer der größten Benediktineräbte, Plazidus Seiz, aus Landsberg, gründete hier 1711 eine Ritterakademie, die modernste Anstalt dieser Art, die es damals in Deutschland gab. Für das Haustheater dieser Akademie arbeitete eine ganze Schule von Spielbuchdichtern. Von München und Ettal aus drang die barocke Bühnenkunst *Ammergau* ins ganze Volk. Die Oberammergauer hatten im Pestjahr 1633 ein Passionsspiel gelobt und sie lösten 1634 dieses Gelübde zum erstenmal ein. Das älteste Spielbuch, wie es von 1662 erhalten ist, stammt aus dem Augsburger Handwerkertheater. Es wurde fortlaufend umgebildet und näherte sich schon gegen Ende des siebzehnten Jahrhunderts dem barocken Stil. Ferdinand Rosner aus der Ettaler Abtei, ein Wiener von Geburt, schuf das Oberammergauer Spielbuch 1750 völlig neu in Sinn und Gestalt des bairischen Barock. Durch ihn sind Bühne und Spielbuch von Oberammergau volkstümliches Barockkunstwerk geworden. Ähnlich spielte man in ganz Oberbaiern. In Kiefersfelden bildete sich unter den Schmieden und Gesellen des österreichischen Hammerwerkes seit 1596 ein stehendes Dorftheater, das durch dreihundert Jahre geblüht hat.

Die deutsche Literatur des Landes stand wie das Theater im Dienst der katholischen Reformation. So der sprachmächtige Barfüßer *Johannes Nas*, 1534 bis 1590, aus Eltmann bei Bamberg, mit seinen Predigten und Schriften, ein Meister der Parodie, der sehr wohl die Urfassung des Faustbuches

von Johann Spieß 1587 geschrieben haben kann, die zweifellos eine Parodie auf Martin Luther war. So *Aegidius Albertinus,* 1560 bis 1620, aus Deventer, Hofschreiber in München, mit seinen zahlreichen Übersetzungen aus dem Französischen, Italienischen, Spanischen — 1615 des Schelmenromans „Guzman de Alfarache des Mateo Aleman" — und seinem Buch von 1616 „Lucifers Königreich und Seelengejaidt", das als Zeitspiegel ein Gegenbild zum „Judas" des Abraham a Sancta Clara darstellt.

Die Ablösung des barocken Zeitalters durch eine neue, deutsch-gerichtete Haltung in Art und Sprache ging von München und einem Kreis von Augustinern aus, der durch *Gelasius Hieber,* 1691 bis 1731, aus Dinkelsbühl in Franken, geführt wurde. Sie nahmen vor Gottsched und Haller die Vorarbeit auf, die durch die Münchner Gesellschaft von 1702 „Die vertrauten Nachbarn am Isarstrom" geleistet worden war, planten eine bairische Akademie und gaben 1722 bis 1740 die Zeitschrift „Parnassus Boicus" heraus. Hier wurde die Geschichte der deutschen Sprache gepflegt, eine neue deutsche Poetik erörtert, gegen den Hanswurst geeifert und auf die Dichtung der Stauferzeit hingewiesen. Zeitlich vor Königsberg, Leipzig und Zürich setzt in München der Wille zu einem nationalen deutschen Geistesleben ein.

LUZERN und ZUG. Das eidgenössische Schrifttum zwischen 1550 und 1700 steht ganz unter dem Einfluß der katholischen Reformation. Und es ist völlig Theater. Die Spannweite der Entwicklung gibt der Malerdichter *Tobias Stimmer,* 1539 bis 1584, aus Schaffhausen, doch von Salzburger Herkunft, mit seinem Renaissancelustspiel „Von zwei jungen Eheleuten" 1580 und der Stadtbeamte *Josua Wetter,* 1622 bis 1656, aus Sankt Gallen, mit seiner deutschen Alexandrinertragödie „Karl von Burgund", die 1653 gespielt wurde. Vollzogen aber hat sich diese Entwicklung in den beiden altgläubigen Gemeinwesen Luzern und Zug.

Der geistige und staatliche Vorort der katholischen Schweiz war seit dem Tage von Kappel, 1531, da Zwingli fiel, und von Vilmergen, 1656, der den Altgläubigen den Kappeler Sieg bestätigte, Luzern. Luzern aber war die erste Theaterstadt der Eidgenossenschaft. Ohne Bruch wurde das große Spiel vom Leben und Leiden Christi aus dem fünfzehnten Jahrhundert weitergepflegt. Der Wortlaut wurde von Aufführung zu Aufführung gemehrt und gemindert. Der Stadtschreiber und durch dreißig Jahre Beherrscher des kleinen Staates, *Renwart Cysat,* 1545 bis 1604, hat dann als Spielleiter diesen Aufführungen sein Gepräge gegeben. Aus dem ursprünglich genossenschaftlichen war ein Staatstheater geworden. Schauplatz war der heutige Weinmarkt. Nur in den Grundzügen blieb von 1545 bis 1616 das Spielbuch

das gleiche, gegen 12 000 Verse, die das ganze Heilswerk umfaßten. Erst nach Cysats Tode gelang es den Jesuiten, die auch in Luzern ein mächtiges Gymnasium hatten, dieses Theater ganz an sich zu ziehen. Ihre Bühne machte alle Stilwandlungen durch. Die letzten Jesuiten, wie *Ignaz Zimmermann,* 1737 bis 1797, gingen zum deutschen und regelmäßigen Schauspiel über.

In Zug, wo es gleichfalls eine alte Spielüberlieferung gab, setzte sich das *Zuger Spiel* deutsche Barockdrama durch. Der Obervogt *Johann Kaspar Weißenbach,* 1633 bis 1678, aus Zug, folgte beinahe Balde mit dem Karfreitagsdrama „Trauergedanken einer christlichen Seele" 1678, das Spiel von der Seele, die in Bildern Christi Leiden erlebt. Indessen äußerste und letzte Gestalt dessen, was die Barockbühne wollte, das hat sein „Eydgenössisches Contra-feth" 1672 verwirklicht. An zwei Tagen gab das Stück in scharfem Ebenmaß den Aufgang der Eidgenossenschaft von der Gründung bis zu den Burgun-derkriegen und ihren Abgang seit der Glaubenstrennung. Eine unglaubliche Vielfalt von Kunstmitteln und Kunstgriffen ist aufgeboten. Das Stück gleicht einem Schautanz von Gleichnissen. Weißenbachs Heldin ist Helvetia, der verkörperte eidgenössische Staatsgedanke. Ihre Stimme ist die Friedens-stimme des einen und gleichen Bundesgedankens: Freiheit und Einheit. Es ist ein Bildermythus der eidgenössischen Geschichte.

NÜRNBERG. Das Theater trat in Hans Sachsens Vaterstadt unter eine *Hans Sachsens* ganz andere Spielleitung. Die Meistersänger wollten schon früh Beziehung *Nachlaß* zu England anknüpfen und ihrer eine ganze Anzahl hatten sich 1542 nach England anwerben lassen, als der Rat dazwischentrat. Nun fügte es sich doch auf andere Weise. Robert Browne, der berühmteste Führer englischer Spiel-banden, trat 1593 zum erstenmal in Nürnberg auf. Ihm folgten immer wie-der andere bis tief ins siebzehnte Jahrhundert. Ihre Bühne war meist im Heilsbronner Hof. Sie brachten das neue Sing-Tanz-Spiel mit, Jig, das 1596 am Hofe der Königin Elisabeth entstanden war. Um diese Zeit war *Jakob Ayrer,* gegen 1543 bis 1605, aus Bamberg nach Nürnberg gekommen und *Jakob Ayrer* Verwalter am Stadtgericht geworden. Er griff sogleich das Jig auf und machte daraus Ende 1598 seine Singspiele, kleine, derbe, lustige Dinger mit ganz wenigen Rollen und an Umfang zwischen fünfzig und hundert Strophen *Nürnberger* wechselnd. Aber er hielt sich auch mit rund siebzig Stücken an den Stil des *Theater* Hans Sachs. Mehr als einen Vorwurf hat er mit Shakespeare gemeinsam. In der Masse sind es Dramen aus der römischen Geschichte und griechischen Sage. Nach dem Beispiel, das Hans Sachs gegeben hatte, wagte er sich an einen „Hugdietrich", „Ortnit", „Wolfdietrich". Der Rat kam einem so leb-haften Spielbetriebe entgegen und baute auf der Schüttinsel ein festes Schau-

11

spielhaus, das am 16. Juni 1628 eröffnet wurde. Englische, einheimische, handwerkliche Wandertruppen und Spielgesellschaften wetteiferten in diesem Hause miteinander, bis gegen 1660 die Engländer weichen mußten. Auf dieser Bühne führte 1679 und 1681 Johannes Velten, der Vorläufer der modernen Schauspielkunst, seinen Spielplan nach englischem und französischem Muster vor. Der Oper wurde 1667 bei Sankt Lorenz ein eigenes Haus gebaut. Hier wurde das neue Nürnberg hörbar.

Der Blumenorden — Dem Meistergesang trat die bürgerliche Genossenschaft der Schulgebildeten entgegen, um auf ihre Weise zu pflegen, was die Handwerker langsam fahren lassen mußten. Seit 1645 bestand in Nürnberg nach dem Vorbild der Intronati zu Siena ein Dichterkreis, der sich „Pegnesischer Blumenorden" nannte, aber keine Sprachgesellschaft, sondern ein Dichterkränzchen war. Zu Köthen bestanden Beziehungen. Sprachmystische und alchimistische Neigungen verbargen sich nicht. Was ihnen vor allem am Herzen lag, war eine genossenschaftliche Pflege des Gesangs und der Dichtung, wie sie in anderer Weise der Meistergesang betrieben hatte. Aus diesem Kreise, dem *Sigmund Birken,* 1626 bis 1681, von Nürnberg, doch aus Eger stammend, mit seinen Gedichten die eigentümliche Note gab, sind besondere Wege zum Melodrama beschritten worden. Der Lehrer *Johann Klaj,* 1616 bis 1656, aus Meißen, und der Lehrer *Johann Michael Dilherr,* 1604 bis 1669, aus Themar, fanden sich in diesem Streben zusammen. Sie nannten ihre Vorträge aus Tonstücken und gesprochenem Wortlaut „Lesekonzerte". Sie erinnerten an die alten Mysterien ebenso wie an die Singschulen der Meistersänger und waren *Oratorium und Melodrama* eine Vorstufe zum Oratorium und zum Melodrama. Harsdörfer versuchte mit seinen „Andachtsgemälden", eine Mischform aus geistlichem Lied und Prosagebet, etwas Ähnliches. Diese Aufführungen fanden wie die der Meistersänger in der Kirche statt.

Philipp Harsdörffer — *Georg Philipp Harsdörfer,* 1607 bis 1658, aus Nürnberg, doch von böhmischer Herkunft, war das Haupt des Kreises. Auf Reisen gebildet und mit den italienischen Akademien vertraut, machte er seinen Weg bis in den Kleinen Rat der Stadt. Harsdörfer war ein glänzender Erzähler, der beste seiner Zeit. Er hat eine unabsehbare Fülle kleiner Geschichten aus der ganzen Weltliteratur in Sammelbänden aufgestapelt, um der Gesellschaft edlen Stoff für ihre Unterhaltungen zu bieten. Denn darum ging es ihm und insbesondere um die Bildung der Frau. Das Zeitalter war bemüht, die Frau wieder in die roh gewordene Gesellschaft der Männer zurückzuführen und aufs neue zum Mittelpunkt der Geselligkeit zu machen. Dieser Aufgabe dienten Harsdörfer „Frauenzimmergesprächsspiele", 1641 bis 1649, in der Art der Briefsteller,

Sammlungen von Mustergesprächen, an denen die Frauen lernen sollten, gesellschaftliche Unterhaltungen anregend und fesselnd zu lenken. Als Sprachforscher und Sprachlehrer hat Harsdörfer große Verdienste. Er eiferte für die Reinhaltung der deutschen Sprache und hat manche Forderung ausgesprochen, die erst spätere Zeiten erfüllen konnten.

STRASSBURG. Auf derselben Kanzel des Münsters, von der herab einst **Pietismus** Geiler von Kaisersberg gepredigt hatte, stand in den Jahren 1663 bis 1666 *Philipp Jakob Spener,* 1635 bis 1705, aus Rappoltsweiler, ein Seelenführer, der anders als Jakob Böhme mit der Reformation des Herzens ernst machen wollte, der Begründer des deutschen Pietismus. Soviel hatte sich seit den Tagen Martin Luthers und Huldreich Zwinglis geändert. Wie zu Zeiten Johannes Taulers und Heinrich Seuses nahm der Alamanne die Bildung der deutschen Seele wieder in seine Hände.

Die Stadt spielte indessen noch sehr kräftig und auf zweierlei Weise Thea- **Meistergesang** ter. Da waren die Meistersänger. Sie hatten sich 1492 zuerst zu einer Singschule vereinigt, hatten dann lange geschlafen und waren endlich 1591 neu erwacht und vom Rate in ihrer Ordnung bestätigt worden. Ihnen widmete 1597 *Cyriakus Spangenberg* aus Nordhausen sein schönes handschriftliches Büchlein „Von der edlen und hochberüemten Kunst der Musica". Und ihnen schrieb der Sohn, *Wolfhart Spangenberg* aus Mansfeld, von 1608 bis 1611, eine Reihe von anziehenden Lustspielen, als sie wie anderswo ihre eigene Bühne aufgemacht hatten. Da war das Akademietheater. Es mußte seinem **Akademie-** Wesen nach Schultheater sein und hatte keinen Hof in der Nähe, der es aus **theater** diesen heilsamen Grenzen herausgelockt hätte. Es pflegte unveränderlich das humanistische Sprechstück und nur durch die antiken Chöre ließ es die Tonkunst mitspielen. Das Theater wurde schon ganz modern betrieben und holte sich aus ganz Deutschland die Stücke, die es für seinen Spielplan brauchte. Es nahm von nah und fern eine wahre Gesellschaft von Übersetzern in Anspruch. So hat es durch das siebzehnte Jahrhundert hindurch geblüht, hat seinen eigentümlichen Stil gegen den andrängenden Barock behauptet und über Deutschland einen stillen aber steten Einfluß ausgeübt.

Doch alles, was die Stadt auf der Bühne vermochte, wird durch die Drei- **Drei Meister** heit von Meistern der Prosa überschattet, die persönlich und durch ihr Werk **der Prosa** mit Stadt und Bistum in Verbindung stehen. Die Abfolge ihrer Werke ist zugleich die Geschichte der deutschen Prosa ihres Zeitalters.

Johann Fischart, um 1547 bis 1590, ein Straßburger von fränkischer Her- **Johann Fischart** kunft, war sein Leben lang ein Mann des innern Widerspruchs, für Luther wortreich bemüht und ein Anhänger Calvins, aufgeklärt und abergläubisch,

deutschgesinnt und doch immer wieder wälschem Schrifttum hörig. In Straß-
burg und Basel gebildet, in Flandern, Frankreich, Italien bewandert, hat er
dem Buchhandel gedient und ist endlich Amtmann zu Forbach geworden.
Keines seiner Büchlein und Bücher ist ein selbständiges Werk. Jedes schloß
sich an irgendeine Vorlage an. „Der Binenkorb" 1579 und „Das Jesuiterhüt-
lein" 1580, „Der Eulenspiegel" 1572 und „Die Flöhhatz" 1573, „Das Poda-
gramische Trostbüchlein" und „Das philosophische Ehezuchtbüchlein" 1578,
alle sind Ableger der zeitgenössischen Literatur, für den Meinungskampf
zurechtgemacht oder buchgeschäftlich ausgenützt. Ganz besonders stand
Fischart zu dem französischem Spötter Franz Rabelais. Ihm machte er das
ironische Kalenderschriftchen „Aller Praktik Großmutter" nach. Und dann
verfing er sich in dem Zauberwald des Romans „Gargantua", in dem Rabe-
lais 1532 bis 1552 die Geschichte einer Riesenfamilie so erzählt hatte, daß
daraus ein Spottbild des französischen Volkes wurde. Dieses Buch schrieb
„Gargantua" Fischart in seinem „Gargantua und Pantagruel" 1575 in deutscher Sprache
und auf deutsche Verhältnisse um. Nach der ersten Fassung erschienen 1582
und 1590 Erweiterungen, „Geschichtklitterung", die aber zumeist nur Papier
füllten. Fischarts Roman ist ein Rundgemälde des deutschen Lebens im Zeit-
alter der Kirchenbewegung. Johann Fischart hat auf eine beispiellose Weise
die Kunst verstanden, durch Laute und Lautverbindungen Gedanken hinter
sich her zu locken und mit ihnen einen grotesken Wettlauf um den Sinn vor-
zuführen. Seine Bücher gleichen Kindern, die mit dem Reden spielen, und
können nur im Ohr ausgekostet werden.

Michael
Moscherosch *Hans Michael Moscherosch,* 1601 bis 1669, aus Willstätt bei Offenburg,
stammte von Hagenau. Er ist als Kavalier und Hofmeister gereist, diente
als Amtmann verschiedenen Herren und wurde von der Geißel des Großen
Krieges schwer getroffen. Ihm haben es, dem Ablauf der Zeit gemäß, schon
die Spanier angetan. Don Francisco de Quevedo hinterließ neben einer Ge-
schichte des großen Schelms Paul von Segovia auch „Suenos", „Träume",
die 1635 zuerst vollständig erschienen. Durch eine französische Übersetzung
wurde Moscherosch darauf gewiesen. Dies Buch „visierte er auf den deut-
schen Meridian", indem er Quevedos ironischen Träumen Deutschland un-
terschob. Da tanzen im grotesken Dreischritt und sprachlich fantastisch ver-
mummt die Ausgeburten des entarteten deutschen Lebens an uns vorüber
und Moschenrosch ruft mit jeder die deutsche Scham an. „Wunderliebe und
„Gesichte" wahrhafte Gesichte Philanders von Sittewald" um 1640 nannte Moscherosch
sein deutschgesinntes Buch, das mit Stil und Vorsatz zwischen seinem Vor-
gänger Fischart und seinem Nachfolger Grimmelshausen steht.

Hans Jakob Christof von Grimmelshausen, um 1622 bis 1676, von Geln- *Christoph von Grimmelshausen*
hausen, hat im Elsaß nicht seine zweite, sondern seine erste und wahre Hei-
mat gefunden. Denn eine andere hat der früh entwurzelte Junge, der mit
kaiserlichen Völkern durchgegangen war, nicht besessen. Als Feldschreiber
zu Offenburg, 1640 bis 1647, lernte der anstellige Bursche in jedem Sinn
schreiben. Über Futterzettel und Berichte gebückt, von der Hast und dem
Jähzorn einer Feldkanzlei umstampft, gewann er sich jenen Tatsachenstil,
der seinen größten Ruhm ausmacht. Das Leben spielte ihm täglich die Fülle
bizarrer Züge zu, indem es Reitknechte und Luntenschützen, Kriegsherren
und Feldhauptleute, Gerichtete und Geächtete an ihm vorübertrieb. Hier
wurde er zum Dichter. Er ging an die ersten literarischen Versuche. Im letz-
ten Kriegsjahr machte er beim kaiserlichen Heer den Vormarsch nach Fran-
ken und den Rückzug hinter den Inn mit. Er wurde, jung verheiratet, Schaff-
ner, 1650 zu Gaisbach, 1662 auf der Ullenburg bei Gaisbach. Als Wirt im *Der Wirt zum Silbernen Sternen*
Silbernen Sternen zu Gaisbach 1666 schrieb er einen ansehnlichen Teil seiner
Bücher und als bischöflich Straßburger Schultheiß zu Renchen 1667 gab er
sie heraus. Nachdem er so in einer Feldkanzlei schreiben gelernt, in Feld-
lager und Wirtsstube das Buch des Lebens lesen gelernt hatte, gab er sich,
in allem Wissenswerten sein eigener Lehrer, der Verführung hin, die Men-
schen besser und die Deutschen ihrer selbst bewußt zu machen. Diesem und
keinem andern Zweck, außer etwa dem, sein eigenes verworrenes Leben rück-
betrachtend zu begreifen, dienen seine zahlreichen und mannigfaltigen Schrif-
ten. Man muß auf die eine Seite stellen „Dietwald und Amelinde" 1669,
„Der keusche Joseph" 1670, „Proximus und Lympida" 1672, die drei heroisch- *Moderomane*
galanten Moderomane. Dann stehen auf der anderen Seite die volksmäßigen
Flugschriften. Von ihnen folgen die Traumgeschichten der beliebten spani-
schen Gattung. Der „Kalender" 1670, satirisch wie sein Fischartscher Bruder,
gibt eine Lebensgeschichte des Verfassers. „Gaukeltasche" 1670, Bilder mit
Versen, war zur Vorführung von Taschenspielerkunststückchen bestimmt.
„Der erste Bärenhäuter" 1670 ist eine Kurzgeschichte von des Lanzknechts *Kleine Schriften*
Teufelsbündnis. „Galgenmännlein" 1673 gibt, parodistisch in gelehrter Weise
aufgemacht, Anleitung, ein Geldmännlein zu finden und zu warten. „Der
stolze Melcher" 1673 erzählt als Warnung an die deutsche Jugend die bitter-
böse Geschichte eines Kriegssöldners. „Der teutsche Michel" 1673 ist eine
Sprachschrift gegen Bildungsdünkel, Sprachverderbnis und Sprachdumm-
heiten, gegen die ostdeutsche Gemeinsprache und für das rheinische Schrift-
deutsch, geschrieben aus dem Glauben an den göttlichen Ursprung und an
die Unantastbarkeit der Sprache. Das „Ratstübel Plutonis" 1672 versammelt

die Gestalten der verschiedenen Bücher des Dichters zu einer vergnüglichen Aussprache über Erwerb und Besitz. In der Mitte dieses Gesamtwerkes aber *„Simplicissimus"* steht der eigene Lebensroman „Simplicissimus" 1668 und eine Sippe ihm stofflich verwandter Erzählungen. Sie drehen sich alle um das eine grausame Erlebnis des Großen Krieges. Sie sind Bruchstücke einer umfassenden Konfession. Und sie ringen um die Gestalt des selbsterlebten Bildungsromans. Nicht mit dem überschauenden Blick aus der Höhe, sondern mitten aus dem Drang des Erlebten wird ein Rundgemälde des ganzen Zeitalters aufgerollt, wie der einfache Mann es sehen konnte. Ein Charakter bildet sich im Strom *Bildungsroman* der Welt. Das ist der Vorwurf des Romans und für seine Zeit ein völlig *und* *Abenteuerroman* neues künstlerisches Unternehmen. Es ist ein seltsames Nebeneinander von innerlich zunehmenden Menschen, wie ihn der Mystiker Heinrich Seuse literarisch zuerst erfaßt hatte, und von der Ausbildung zum Kavalier, wie sie im Sinne der Zeit lag. Die Zustände werden gescholten nicht aus sittlichen, sondern aus sozialen Gründen. Der Dichter denkt nicht an den einzelnen, sondern an die Gemeinschaft. Der einzelne ist schlecht, weil es die Einrichtungen sind. Ungerechtigkeit ist die Wurzel des Bösen in der Welt. Wie zu Wolframs „Parzival" der „Simplicissimus" ein Gegenstück als Gottsucherroman ist, so zu Fischarts „Gargantua" als Kulturbild eines ganzen Zeitalters. Indessen, man muß Johann Jakob Christof von Grimmelshausen und Abraham a Sancta Clara ins gleiche Blickfeld rücken. Grimmelshausen hat im süddeutschen Westen aus nächster Nähe Frankreichs und im Zeitalter des Großen Krieges das Leid der Nation und eines friedlosen Friedens erlebt und in die Gesichte seiner Dichtungen abgerückt. Abraham hat im süddeutschen Osten und aus nächster Nähe des türkischen Erbfeindes den Umschwung und Aufstieg zu neuer Macht erlebt und ihm in seinen Reden und Büchern monumentalen Ausdruck gegeben. Beide sind Sprecher des deutschen Reichsgedankens und leibhafte Erscheinungen der barocken Prosakunst.

Mit dem Fall Straßburg 1681 ging das Reich im Westen unter und mit der Rettung Wiens 1683 ging es im Osten wieder auf.

5. DER SÄCHSISCH-PREUSSISCHE KREIS

Man betritt eine andere Welt, wenn man, gleichviel wann in diesem Zeit-
alter des habsburgischen Reiches, vom Süden her nach dem Norden kommt.
Während Humanismus und Barock weithin über Europa eine gemeinsame
Witterung der Kunst schaffen, macht die Absonderung Niedersachsens zu-
sammen mit der Niederfrankens bedrohliche Fortschritte. Und während das
Deutsche Reich durch die Waffenerfolge des Kaisers im Osten und Westen
sich von neuem festigt, bereitet sich in Preußen politisch und weltanschau-
lich der letzte Erbgang von Macht zu Macht vor.

Erbgang von Macht zu Macht

NIEDERSACHSEN. Die alte Lebensgemeinschaft von Niederfranken
und Niedersachsen beginnt in diesem Zeitalter durch die Brüderherren
Früchte zu tragen. Überall bildet sich eine neue Literatur sächsischer Zunge.
In Westfalen ist das Brüderhaus zu Münster die treibende Kraft. Hier gibt
Johannes Veghe, um 1430 bis 1504, aus Münster und Leiter des Hauses, der
Predigt ihren vollkommenen sächsischen Stil. Im Brüderhaus zu Münster ist
um 1500 das Büchlein „Status mundi" gedichtet. Es rügt den allgemeinen
Verfall des Lebens und atmet spürbar den Geist, der Grootes Predigten
durchwehte. Ohne sichtbaren Zusammenhang mit den Brüderherren, aber
mit ihnen eines Sinnes wirkt der gewaltige Prediger *Dietrich Kolde,* 1435
bis 1515, aus Münster, mit seinem „Christenspiegel" 1480 und Werner Role-
vinck, 1425 bis 1502, aus Horstmar, mit seiner lateinisch geschriebenen Lan-
deskunde Westfalens, die um 1478 zum erstenmal gedruckt wurde. Kolde
war Augustiner und Rolevinck Kartäuser, beides die Orden, denen Groote
geistlich nahegestanden ist.

Das Brüderhaus zu Münster

Das Hauptquartier der Brüderherren in Niedersachsen war zu Rostock, ihr
Haus bei Sankt Michael. Jedenfalls unter dem Einfluß der Brüderherren
schrieb hier 1472 der Ostfranke *Kaspar von der Rön* für den mecklenbur-
gischen Herzog Balthasar den Sammelband „Das Heldenbuch", vielleicht ein
Auftrag, den die Schreibstube des Hauses an Kaspar weitergab. Der Leiter
des Rostocker Brüderhauses, Nikolaus van Deer, wandelte 1475 die Schreib-
stube des Hauses in eine Druckerwerkstatt um, die unabsehbaren Einfluß
auf das Geistesleben Niedersachsens gewann. Diese Presse vermittelte in
sächsischer Sprache dem Niederdeutschen den wesentlichen Bestand der
älteren oberdeutschen Literatur, so zumal fast alle Volksbücher. So wurde
aber auch 1519 Brants „Narrenschiff" und 1529 Emsers Neues Testament
auf Sächsisch nachgedruckt. Dieser volkssprachliche Buchbetrieb im Rostok-

Das Brüderhaus zu Rostock

ker Brüderhaus ist der allgemeine Hintergrund auch für andersartige Dichtungen, wie das *Redentiner Osterspiel* 1464 des Doberaner Mönchs Peter Kalff und das *Rostocker Liederbuch* um 1487 von drei verschiedenen Schreibern.

Hansavorort Lübeck

Im Hansabund war das Haupt Lübeck der Vorort auch des Buchdrucks. Wenn auch 1475 der erste Drucker aus Meißen kam, so gehört gleichwohl auch Lübeck in den allgemeinen Wirkungsbereich der Brüderherren und der niederländischen Bewegung. Auf ein niederfränkisches Werk, die Kölner Bibel von etwa 1478, ging die zeitgültige sächsische Bibel zurück, wie sie 1494 zu Lübeck gedruckt wurde, und eine Übersetzung aus dem Niederfränkischen war der größte Bucherfolg, zu dem Lübeck den Anstoß gegeben hat. Ein Lübecker Kleriker hatte in heimischer Mundart nach dem „Reinaert" des Niederländers Hinrek van Alkmer noch einmal die Geschichte des *„Reynke*

„Reynke de Vos"

de Vos" erzählt und in Lübeck kam 1498 das Buch heraus. Es wurde bald in hochdeutschen und skandinavischen Fassungen verbreitet. Allein in Rostock erschienen fünf Ausgaben.

Eine große Dichtung ist aus all diesen Strebungen nicht hervorgegangen. Die einzige, die es hätte werden können, hat keine formende Hand gefunden. Seit dem vierzehnten Jahrhundert liefen in den braunschweigischen Städten Spottgeschichten um, einem Helden angehängt, das erzählend über-

„Till Eulenspiegel"

lieferte lustige Epos *„Till Eulenspiegel"*. Mit diesen Geschichten, die alles falsch verstehen und alle Befehle wörtlich ausführen, rächte sich der ungelernte Handwerker an den bevorzugten Meistern der Zunft. Die buntgereihten Geschichten hatten das Zeug zu einer großen Dichtung. Till Eulenspiegels urgesundes Lachen schlägt wider eine deutsche Welt auf, die sich in den Wirrwarr aller Sprachen verloren hat, die sich in der Wildnis von Redensartlich und Wörtlich verläuft und über der ordnenden Vernunft die irrationale Vielheit und den unausrottbaren Widerspruch des Lebens vergißt. Der Mann, der aus diesen umlaufenden Geschichten 1500 ein Buch machte, war kein Dichter. Es wurde kein deutsches Weltgedicht. Aber es wurde in der Werkstätte des Straßburger Druckers Johannes Grieninger 1515 ein Welterfolg.

Auch der sächsische Humanismus ist da und dort noch aus der Bewegung der Brüderherren herausgewachsen wie in Münster, wo er in dem Domherrn Rudolf von Langen, der 1500 die neue Domschule zu Münster gründete, einen bedeutenden Führer fand. Der Mittelpunkt der humanistischen Schulbildung in den Hansastädten wurde die Hamburger Johannisschule, die Johann Bugenhagen 1529 gründete. Die beiden Hochschulen Rostock und

Greifswald erhielten ihren humanistischen Lehrbetrieb von Oberdeutschland. Das Humanistendrama war dünn gesät und lebte von oberdeutschen Anregungen. Das bezeugen die Spiele des Dortmunders *Jakob Schöpper* und vor allem des Hamburgers *Heinrich Knaust*, der in Erfurt wirkte. *Johannes Stricker*, um 1540 bis 1598, aus Grobe bei Eutin, nahm sich noch einmal den Vorwurf des allverbreiteten „Jedermann" vor und machte daraus die Tragödie eines holsteinischen Edelmannes, „De düdesche Slömer" 1584, den Vorläufer des kommenden sächsischen Theaters Hamburgs. *Sächsisches Humanistendrama*

Die niederdeutsche Dichtung behielt durch den Schulhumanismus hindurch ihre Richtung auf die heimische Mundart. Das war die Sprache, in der *Johann Lauremberg*, 1590 bis 1658, aus Rostock seine „Vier Scherzgedichte", 1652, schrieb. Sächsisch hat auch *Joachim Rachel*, 1618 bis 1669, aus Lunden, noch das eine oder andere seiner Lieder angestimmt. In seinen Satiren freilich ging er zur Schriftsprache über. *Sächsische Mundartdichtung*

HAMBURG. Das ist die Stadt, in der sich die Wendung von der niederländischen zur angelsächsischen Kulturgemeinschaft vollzogen hat. Sie vollzog sich zunächst durch das Drama. Und den ersten Schritt tat *Johann Rist*, 1607 bis 1667, von Ottensen, doch aus einer Nördlinger Familie. Rist war der ausgeprägte Mensch des Überganges, von Jugend an körperlich reizbar und mystischen Stimmungen hingegeben, pietistisch in seinen Liedern, barock in seinen Dramen. Er hat mehr als dreißig Stücke geschrieben, darunter einen „Wallenstein". Nur fünf sind erhalten. Die „Irenaromachia", 1630 gespielt und gedruckt, brachte Bauernszenen in holsteinischer Mundart und zeichnete stürmisch bewegte Zeitbilder. Mit den beiden Festspielen, die den Dreißigjährigen Krieg verabschiedeten, „Das friedewünschende Deutschland" und „Das friedejauchzende Deutschland", leitete er zur Hamburger Oper hinüber. *Johann Rists Dramen*

In den Kreisen der fremden Staatsmänner und Gesandten regte sich zuerst der Wunsch nach einer Oper. Ihn zu erfüllen bildete sich 1677 ein Verein von Unternehmern, der am Gänsemarkt ein festes Gebäude errichtete. Es wurde am 2. Jänner 1678 mit der biblischen Oper eröffnet: „Der geschaffene, gefallene und wieder aufgerichtete Mensch". Pietistische Anschläge auf die Oper wurden im Staatsrat abgewehrt. Ihre hohe Zeit begann 1686 mit „Cara Mustapha". Sie hatte den barocken Stil der Wiener Oper. Die eingelegten Lieder wurden in sächsischer Mundart gesungen. *Christian Henrich Postel* machte in seinen zahlreichen Spielbüchern aus diesen Liedern bereits ganze Zwischenspiele, und 1708 wurde das erste mundartliche Singspiel „Die lustige Hochzeit" aufgeführt. *Johann Philipp Praetorius* gab dieser mund- *Die Hamburger Oper*

artlichen Form den stadttümlichen Inhalt und wurde also der Vollender der
heimischen Posse. So gingen denn 1725 seine beiden Singspiele „Hamburger
ger Jahrmarkt" und „Hamburger Schlachtzeit" über die Bühne am Gänse-
markt. Dann verbot der Senat aus Gründen der öffentlichen Sicherheit solche
Stücke und 1728 wurde die letzte Oper mit mundartlichen Einlagen gespielt.

Das Epos Postel *Christian Henrich Postel,* 1658 bis 1705, aus Freiburg im Lande Handeln,
hatte den Ehrgeiz, als epischer Dichter gleichen Ranges neben seine Opern
zu treten. Er begann mit Homer, indem er zweihundert Verse aus dem
14. Gesang der „Ilias" 1700 in die schlüpfrigen deutschen Alexandriner über-
trug: „Die listige Juno." Er brachte die große epische Bewegung Sachsens
wieder in Fluß. „Der große Wittekind", 1698 bis 1701 gearbeitet, konnte
1724 nur als Bruchstück gedruckt werden. Die Handlung ist dürftig und
stammt aus einem zeitgenössischen Roman. Homer, Vergil, Tasso, Ariost sind
weitherzig genützt. Wittekind ist mit heimatlicher Begeisterung als säch-
sischer Volksheld aufgefaßt und der fränkisch-sächsische Widerstreit als euro-
päischer französisch-deutscher Gegensatz gedeutet. „Aller niedersächsischen
Poeten Großvater", das ist Postel wenigstens im geschichtlichen Sinne ge-
wesen.

Dichtung der Welfen *BRAUNSCHWEIG und HANNOVER.* Die Welfen fühlten sich wie
immer als erste berufen. *Herzog Heinrich Julius,* 1564 bis 1613, ein Schüler
des ruhmreichen Gandersheim, übte selbst das Hofrichteramt, trieb Chemie
und verstand zu bauen. Er war einer der ersten Fürsten, die sich eine ste-
hende Bühne schufen. Unter englischem Einfluß, in Prosa, schrieb er 1593
und 1594 seine elf Dramen, die es mit ihren Tänzen und Gesängen auf die
Oper abgesehen haben. Die lustige Person spricht Niederdeutsch. Der Her-
zog legte Zwischenspiele ein, in denen etwa ein Baier, Thüringer und Sachse,
jeder in seiner Mundart, wohlgetroffen reden. Der *Herzog Anton Ulrich* von
Braunschweig-Wolfenbüttel, 1633 bis 1714, hatte Dichter um sich: den
Sprachforscher und Spracherzieher *Justus Georg Schottel* und den Roman-
schreiber *Andreas Heinrich Buchholz.* Der Herzog selber, Anton Ulrich, ein
prachtliebender Fürst, schrieb die Singspiele für seine Feste und die Romane
für seine Unterhaltung. Die blühende Braunschweiger Oper, die 1691 ein
neues Haus erhielt, hatte einen ungemein reichen Spielplan, der auf Be-
ziehungen zu Hamburg wie zu Wien deutet.

Wahres Christentum und Ketzerhistorie Das Land der Welfen wurde durch *Johann Arndt,* 1555 bis 1621, und sein
Buch „Vom wahren Christentum", durch *Christian Hohburg,* 1607 bis 1675,
und sein Buch „Aergerliches Christentum", durch *Gottfried Arnold,* 1666 bis
1714, und seine Bücher „Kirchen- und Ketzer-Historie" wie „Das Geheimnis

der göttlichen Sophia" ein Asyl der Verfolgten aller Bekenntnisse, des mysti- schen Heilsverlangens, der Sehnsucht nach dem ersten Christentum, des Willens zur alten kirchlichen Einheit. In diese gewaltige Bewegung war das Haus der Welfen verstrickt. Eine Reihe seiner Mitglieder bekannten sich wieder zum römischen Glauben. Herzog Johann Friedrich von Braunschweig-Lüneburg, 1625 bis 1679, machte sich zum Sachwalter dieser Bestrebungen. Und indem er 1676 Gottfried Wilhelm Leibniz an seinen Hof rief, machte er Hannover zu einer Pflegstätte gemein-europäischer Bildung. Leibniz half die Krone von Großbritannien 1714 an das Haus der Welfen bringen. Den geistigen Beziehungen zwischen England und Hannover sollte die neue Hochschule dienen, die am 17. September 1737 zu Göttingen feierlich eröffnet wurde.

PREUSSEN und BRANDENBURG. Die Mark Brandenburg kam durch *Märkische* den Kurfürsten Joachim I., 1499 bis 1535, rasch in den Rhythmus des all- *Literatur* gemeinen deutschen Geisteslebens hinein. Eine bescheidene humanistische Dichtung geht auf. An die Namen Georg Rollenhagen, Bartholomäus Krüger, Bartholomäus Ringwaldt knüpft sich im sechzehnten Jahrhundert eine kleine volksgerechte Literatur. Schulmeister und Pfarrer, meist Fremde, pflegen in Berlin mit Erfolg das geistliche Festspiel. Leonhard Thurneiser aus Basel richtet sich 1571 im Grauen Kloster ein als Leibarzt des Kurfürsten, Chemiker und Drucker und Unternehmer sonstiger nicht ganz deutlicher Geschäfte. Aber seine Persönlichkeit gibt diesem Berlin so etwas wie großstädtischen Schwung. Das reichte aber alles bei weitem nicht, um das Schwergewicht von Königsberg herüberzuziehen.

Die Städte und Bischofssitze des Ordenslandes glänzten von humanistischem Eifer, nachdem einmal der ferne Stoß herangekommen war. Doch der Ruhm, der von dem Frauenburger Domherrn *Nikolaus Koppernigk* und seinem weltbewegenden Buch „De revolutionibus orbium caelestium" 1543 ausging, war nicht zu überstrahlen. Königsberg war jetzt Residenz des Hochmeisters und seit 1525, da das Ordensland ein weltlicher Staat geworden war, des Herzogs in Preußen. Am 17. August 1544 stiftete Herzog Albrecht *Die* von Preußen in seiner Hauptstadt eine Hochschule. Und nun war Königsberg *Königsberger* weitum auch in geistigen Dingen der Mittelpunkt. Vom deutschen Orden her *Albertina* gab es schon eine tonkünstlerische Überlieferung. Herzog Albrecht machte daraus eine Aufgabe und Verpflichtung. Johannes Eccard, 1553 bis 1611, aus Mühlhausen, erster Kapellmeister, nahm beide auf sich. Seine preußischen Festlieder machten in Königsberg Schule. Aus der Tonkunst kam in Preußen die Dichtung.

Simon Dach, 1605 bis 1659, aus Memel, Lehrer der Dichtkunst an der hei-
mischen Hochschule und in der Gunst des Hofes, durfte der Hochschule zur
ersten Jahrhundertfeier 1644 das Festspiel „Prussiarchus" schreiben. Er lebte
sehr angenehm mit Freunden zusammen, die einander verstanden: Robert
Robertin, Beamter am Hofgericht und ein liebenswürdiger Dichter; der Ge-
sangmeister Johann Stobäus; der Tonkünstler Heinrich Albert. Simon Dach
war ein Mann des Liedes. Robertin hat ihn zweifellos in seine dichterische
Ausgangsstellung gebracht. Das gab sich als Kenntnis des Lobwasserpsalters
und behutsame Nachfolge Opitzens kund. Damit aber auch genug. Denn
Dach steht auf der andern Seite. Er dichtet, was er wirklich erlebte: den klei-
nen Alltag, den Umkreis der Stadt, das mit seinesgleichen zu Tragende. Dach
und seine Freunde, ein Männerbund ohne erotische Wünsche und Traum-
spiele, lagen im Grünen und genossen weisen Maßes, was der Tag bescherte.
Wie aber das bei solchen Massen von Sterbegedichten? Sie sind fast alle von
äußeren Anlässen gerufen. Mystische Bestände fehlen nicht. Doch für Leben
und Tod herrschen andere Sinnbilder vor. Leben ist ein ritterlicher Kampf
und Tod wie ein Anruf der Feldwache. Tod ist immer etwas Schweres und
Schmerzliches, kein verliebter Taumel. War den Schlesiern der Tod eine Stufe
im allgöttlichen Weltwerden, Geburt zum Entwerden in Gott, bei Dach und
seinen Freunden ist er Abschlußprobe der Bewährung. Dachs Dichtung ist
ganz lutherisch und unbarock, nach Stil und Weltanschauung christlicher Hu-
manismus, Stil und Weltanschauung des evangelischen Kirchenliedes. Und
wenn gleichviel wer, Albert oder Robertin, der Dichter des berühmten Liedes
„Anke von Tharau" war, Dach gehört ein anderes nicht minder schönes und
nicht minder plattdeutsches zu: „Grethke, war umb heffstu mi."

Kurfürst Johann Sigismund, 1608 bis 1619, vereinigte am Abend des Gro-
ßen Krieges Brandenburg und Preußen durch Erbgang. Berlin, vom Gegen-
gewicht Königsbergs entlastet, wird alleinige Hauptstadt und Lager des Ho-
fes. Die geistigen Taten, aus denen sich dieser Anspruch der Stadt rechtfer-
tigte, kamen nicht von der Dichtung. Denn was hätten die beiden Hofdichter
Friedrich Rudolf Ludwig von Canitz und *Johann Besser* dafür tun können?
Man gründete. So wurde 1691 Philipp Jakob Spener als Propst an die Nikolai-
kirche berufen, Preußen zur Schutzstätte des Pietismus und der Pietismus
zum Bekenntnis des Staates gemacht. So wurde in Halle die Ritterakademie
als Universität 1694 feierlich eröffnet und zur Hohen Schule des preußischen
Pietismus erhoben. So wurde 1700 in Berlin die Preußische Akademie der
Wissenschaften gegründet.

Preußen aber und Königsberg waren trotz allem weder durch Branden-

burg noch durch Berlin aus dem Sattel zu heben. Denn die Königskrone, die alles krönen sollte, mußte sich der Kurfürst Friedrich I. 1701 zu Königsberg aufs Haupt setzen und nach Preußen heißen. In der Tat, es ist Preußen und Königsberg, die den vereinigten Staat der Hohenzoller mit Idee und Geist erfüllen. Vorerst schien auch in Königsberg dem wiedererstarkten Reich eine neue Welle der Begeisterung zuzuströmen. *Johann Valentin Pietsch,* 1690 bis 1733, aus Königsberg, bringt die römische Ideologie seiner Bilder, den barocken weitausladenden Schwung seiner Rhythmen, die rednerische Tonfülle seiner Strophen dem Kaiser und dessen Reichsfeldherrn entgegen. Das war 1716 sein Gedicht „Über den ungarischen Feldzug des Prinzen Eugen" und „Karls des Sechsten im Jahre 1717 erfochtener Sieg über die Türken". Aber daß es in Wahrheit ein Abgesang des Reiches und ein Aufgesang der neuen Monarchie ist, hört man schon am Unterton seiner Türkenkriegsstimmung, die nach altpreußischer Kreuzfahrergesinnung klingt und nicht nach dem Reichsgefühl Eugenscher Kriegslager. Und es war sein Schüler, der diesem neuen preußischen Staatsgedanken ein Herold und Vorkämpfer geworden ist. Dieser Schüler war *Johann Christoph Gottsched,* 1700 bis 1766, aus Judithenkirch bei Königsberg. Ein Zögling seiner heimischen Hochschule hat Gottsched alles auf sich genommen, was geistig zu tun war und von Leipzig aus ins Werk gesetzt, wohin er sich 1724 vor den Soldatenfängern seines Königs in Sicherheit brachte. Gottsched war in Leipzig nur der Vorläufer der geballten geistigen Kraft, die Ostpreußen mit ihm über Deutschland auszusenden beginnt.

Doch mit dem Auszug Gottscheds und mit dem Einbruch Altpreußens in das gemeindeutsche Leben begibt sich viel mehr als nur eine Wende des deutschen Schrifttums. Im Leipziger Werk des Literaturerziehers und Kulturpolitikers Johann Christoph Gottsched vollzieht sich in der deutschen Dichtung gefühlsmäßig, gedanklich und politisch der Umschwung vom alten Deutschen Reich zum neuen preußischen Königtum. Die letzte Entscheidung war Fügung und kam aus der mystischen Welttiefe des Schicksals. Der kaiserliche Thronerbe Erzherzog Leopold, an dessen Dasein das friedliche Gedeihen des wiedererrungenen Reiches geknüpft war, starb 1716, kaum daß er geboren war. Und so verschob der Weltkrieg um das Erbe des letzten Habsburgers 1740 bis 1763 mit dem Machtgefüge des Reiches auch die Gedankenbahn und Willensrichtung der deutschen Dichtung aus dem Bereich der deutschen Kaiserkrone in das Neuland der preußischen Königskrone.

Die Königsberger Krone

Pietsch: Abgesang des Reiches

Gottsched: Herold Preußens

Weltwende

KLASSIK
UND ROMANTIK

DAS IST DIE EPOCHE DER HARMONIE. DIE NACH DEM OSTEN
abgewanderte Führung hatte das Reich in zwei Deutschland, die Reforma-
tion in zweierlei Glauben, der Humanismus in zweierlei Bildung gespalten.
Mit der neuen deutschen Gemeinsprache war im Augenblick der Trennung
der erste Schritt zur wiederhergestellten Einheit getan. Aus der Gemein-
sprache entfaltet sich die neue gemeinsame Dichtung. Sie ergreift wie ein
junges Erlebnis die Antike und überbrückt damit die Erlebnislücke zwischen
Osten und Westen. Sie kehrt zur Sprache des Mittelalters zurück, verschmilzt
die alte mit der modernen Dichtersprache und hebt damit den Unterschied
der beiden Sprachzeiten auf. Sie erneuert das alte Volksgut in Sage, Spiel,
und Lied und gleicht also den Abstand aus, den der Humanismus zwischen
Volk und Bildung gelegt hatte. Und je mehr die Abneigung hinwegschmilzt,
die Humanismus und Reformation zwischen dem Mittelalter und dem mo-
dernen Menschen aufgerichtet hatten, desto kräftiger wird wieder das Ver-
langen nach dem alten Reich und seiner Auferstehung, desto unbefangener
das Verständnis für die Kirche des Mittelalters, ihre Lehre und Einrichtun-
gen. Soweit also die Dichtung des Klassizismus und der Romantik nach Ge-
halt und Form voneinander abstehen, so sehr sie die vollzogenen Spaltungen
seit dem Ausgange des Mittelalters zu bestätigen scheinen: in Wahrheit klingt
durch sie harmonisch jenes Deutschland zusammen, das völlig aufgehört hat,
eine politische Wirklichkeit zu sein und nur noch die geistige Erscheinung
seiner selbst ist.

I. GEISTNATION
1740 bis 1814

In dem Maße, nach dem seit den Glaubenskriegen der staatliche Körper der Deutschen verfiel, wandte sich ihr nationales Leben nach Innen. Der Familientod der Habsburger und der Aufstieg der Hohenzollern in dem gemeinsamen Jahr 1740, der Sturz der Deutschen in die Ohnmacht des Wettkampfes zwischen Preußen und Österreich, das ist zugleich die Epoche ihres höchsten geistigen Daseins. Die äußere Vernichtung erweckt den Ehrgeiz, vor sich und der Welt als Sprachvolk und Geistnation zu gelten. Und das zurückgewonnene Selbstbewußtsein der geistigen Leistung ermutigt und berechtigt die Nation, sich wieder einen staatlichen Leib zu schaffen. Das ist mit zwei Worten die Geschichte der Deutschen im achtzehnten und neunzehnten Jahrhundert. *Geistnation Staatsnation*

1. DIE DREI BILDUNGSHERDE

Der Spanische Erbfolgekrieg löst mit der staatlichen auch die geistige Gemeinschaft von Madrid und Wien. Die Kunst des Barock verliert den Boden, auf den sie sich gründete. Überall in den barocken Landschaften, die längst dabei waren, den herrschenden Stil völlig einzudeutschen, bricht ein urtümliches Verlangen nach deutscher Art und Sprache durch. Gleichzeitig macht in den wesenhaft barockfreien Landschaften der Aufbau einer nationalen Bildung erstaunliche Fortschritte. Die Schöpfung der deutschen Geistnation nimmt ihren Aufgang von drei Bildungsherden her, die alle räumlich und staatlich am Rande des alten deutschen Reiches lagen. Die Eidgenossenschaft gehörte seit dem westfälischen Frieden wie längst tatsächlich so nun rechtens nicht mehr zum Reich. Ostpreußen stand seit Anbeginn seines Daseins außerhalb des Reiches. Und die Hansastadt war mit dem Reich nur lose verbunden. Wirklich sind es landschaftlich bedingte und begrenzte Bewegkräfte, die in jedem der drei Räume den Schwung zu neuen geistigen Taten auslösen. *Eidgenossenschaft, Hansastadt, Preußentum*

DIE EIDGENOSSENSCHAFT, der alte Bund freier Landgemeinden, war durch das Junkertum der großen Stadtstaaten zum Widerspiel seiner selbst geworden, eine Zwangsgemeinschaft von Herren und Untertanen, die sich nichts anzurühmen und anderen gar nichts vorzuwerfen hatte. Das Ver- *Der erste Bildungsherd*

langen, zur Ursprünglichkeit und Reinheit des alten Schwurbundes vom Rütli zurückzukehren, entdeckt sich bald als die alte Menschensehnsucht nach dem Paradies der naturhaften Unschuld. So macht man sich auf den Weg zum alten Eidgenossen und man begegnet ihm beschämt in der gesunden Natur des untertänigen Bauern.

Zürich, Bodmer, Breitinger In Zürich kam man darauf durch den alten Zürcher Umweg über die Literatur. Am 3. Mai 1721 erschien das erste Stück einer Zeitschrift, die sich „*Diskurse der Mahlern*" nannte; „Diskurse", weil sie gleichsam Buch führte über die mündlichen Verhandlungen einer Gesellschaft; und „Maler", weil sie mit Sittengemälden der Vaterstadt einen Spiegel des Schlechten und des Guten vorzuhalten gedachte. Sie wollte einen neuen sittlichen Willen und einen bessern künstlerischen Geschmack bilden, indem sie die falsche anerzogene zweite Natur durch die echte angeborene erste auszutreiben gedachte. Ihr Vorbild war Richard Steeles „Zuschauer", den man aus Italien in einer französischen Übersetzung bezogen hatte. Die Herausgeber waren *Johann Jakob Bodmer*, 1698 bis 1793, ein sehr tüchtiger Kaufmann, der beinahe ein ganzer Gelehrter, Lehrer am Collegium Carolinum und Mitglied des Großen Rates wurde, sowie *Johann Jakob Breitinger,* 1701 bis 1776, Lehrer an der gleichen Anstalt und dann Chorherr. Das sind die beiden Freunde, die Zürich neben Hamburg und Königsberg zum Eckstein im Aufbau der deutschen Geistnation gemacht haben.

Das verlorene Paradies Bodmer stieß auf John Miltons „Verlorenes Paradies", fand hier den gesuchten Urmenschen, da er noch nackt war und allen Tieren ihren ersten und ewigen Namen gab, hinreißend geschildert und übersetzte das Gedicht 1732 in deutsche Prosa. Da er auf Samuel Butlers Spottepos „Hudibras" traf, so übersetzte er auch dieses 1737, um den „Feuerbläsern" des Zürcher Staatskirchentums eins auszuwischen. Und als er auf der letzten Stufe seines Lebens übersah, was ihm auferlegt gewesen und was er geleistet hatte, da übersetzte er 1780 und 1781 auch die „Altenglischen Balladen" des Thomas Percy. Als Herold der englischen hat Bodmer der deutschen Dichtung die hinaufziehenden Vorbilder aufgesteckt.

„Critische Dichtung" Bodmer und Breitinger zusammen haben die wegweisende Kunstlehre geschaffen, indem Breitinger die Ergebnisse meist gemeinsamer Einzelschriften zu dem Buch „Critische Dichtung" 1740 zusammenfaßte. Die Dichtung ist Bürgerin beider Reiche, des Überwirklichen und des Wirklichen. Das Überwirkliche macht der Dichter durch eine „Art Schöpfung" sichtbar, indem er es als inneres Bild schaut und dieses vorgeschaute Bild darstellerisch der Wirklichkeit annähert. Dies Kunstvermögen, das vorgeschaute Urbild durch

ein nachgezeichnetes Abbild sichtbar zu machen, nannten die beiden Freunde „malen". Malen, das heißt in Bildern reden, muß der Dichter, nicht von den Dingen erzählen. Das Wirkliche aber muß der Dichter auf die Höhe des Überwirklichen heben, indem er es künstlich entfernt und wunderbar macht. *Das Wirkliche fremd und wunderbar machen* Dichtung also geht, ob dem Wirklichen, ob dem Überwirklichen gegenüber, allein aus schöpferischer Einbildungskraft hervor. Sich ein Bild vom Überwirklichen und das Wirkliche wunderbar machen, das kann die Dichtung allein durch eine höhere, dem Alltag entrückte Sprache, eine sakrale Dichtersprache. Die Schöpfungskraft des Dichters liegt in der Sprache, mit der er das Überwirkliche zum Bilde und das Wirkliche zum Wunder macht. Eine solche Dichtersprache der Leidenschaft, der Machtworte, der Entfernung aus dem *Entdeckung der mittelalterlichen Dichtung* Alltag ins Wunderbare entdeckte er in der mittelalterlichen Sprache der Ritterdichtung. Aus ihr gab Bodmer 1748 „Proben", Bearbeitungen des Parzival und des Nibelungenliedes und 1758 die „Sammlung der Minnesänger". Er forderte und betrieb die Auffrischung der gemeindeutschen Dichtersprache aus der höfischen Sprache der Stauferzeit.

John Milton war Bodmers staatsbürgerliches Urbild. Denn Milton war der Anwalt jeglicher Freiheit, der häuslichen, der bürgerlichen, der kirchlichen. Unter Miltons Stern steht Bodmers Geschichtsforschung und staatsbürgerliche Tätigkeit. Beide sind aus einer Gesinnung hervorgegangen: die ältesten *Bodmers Dichtung* Zeugnisse der drei verschworenen Orte werden als das verlorene goldene Zeitalter geglaubt. Natur, Urmenschheit und Urbund der Waldstätte verschwimmen zu einem aus Reue, Sehnsucht und Tatwillen gemischten Grundgefühl, in dem sich der erste Pulsschlag der eidgenössischen Erneuerung regt. Seine epischen Gedichte, die biblischen wie das indianische, sind ihm eingegeben von der Sehnsucht nach der Unschuld eines geträumten Naturvolkes. In seinen letzten Jahren suchte er sich mit geschichtlichen Schauspielen das Gehör zu verschaffen, das der große Rat ihm verweigerte.

Die Kunstlehre der beiden Freunde machte den Dichter zum Erneuerer *Die Zürcher Kunstlehre* der Sprache, des Volkes, des Staates. Aber diese Erneuerung heißt nicht Flucht aus der Kultur in den Urzustand der Natur. Sie heißt Rückkehr in die gute alte Zeit, Wiederkehr verlorener Kulturgröße, des schwäbischen Zeitalters der Sprache, der reinen Vätersitte des Volkes, des alteidgenössischen Staatsrechts. Der Entwurf einer neuen deutschen Dichtung war zugleich ein umfassender eidgenössischer Kulturplan.

Von Bodmers Schülern und Freunden wurde der eine wie der andere ausgeführt. Die Kunstlehre verwirklichte *Johann Georg Sulzer*, 1720 bis 1779, *Kunst* aus Winterthur, in seiner „Allgemeine Theorie der schönen Künste" 1771

12*

Fabel bis 1774, und gab damit Bodmers Gedanken kanonische Geltung. Die Fabel nach Bodmers Sinne schuf *Ludwig Meyer von Knonau,* 1705 bis 1785, ein feiner Landedelmann, Jäger, Maler, Dichter, ein verliebter Beobachter der Tiere in seinem Buch „Ein halbes Hundert Fabeln" 1744, die das Tier als Tier und nicht als Maske des Menschen geben. Die reine Natur des Landlebens, durch Entrückung in eine zeitlose Antike fremd und wunderbar ge-

Idylle macht, erschien in den „Idyllen" 1756/1772 von *Salomon Gessner,* 1730 bis 1788, der mit gleicher Geschicklichkeit Maler und Dichter und Buchhändler und Ratsherr war, der in seinen Dichtungen wirklich „Gemälde" gab und „Bilder" fand und zu „malen" verstand, wie Bodmer das gefordert hatte. Was für die Menschenrechte und die wirtschaftliche Hebung des untertäni-

Wirtschaft gen Bauern zu tun war, das besorgte der Arzt *Johann Kaspar Hirzel,* 1725 bis 1803, indem er in seinem Buch „Die Wirtschaft eines philosophischen Bauers" 1761 den Musterbetrieb des Bauern Jakob Gujer von Wermetswil

Mutter / Familie / Staat schilderte. Die Erziehung aber führte *Johann Heinrich Pestalozzi,* 1746 bis 1827, zur Natur zurück mit seinen vorbildlichen Schulen und mit dem Buch „Lienhard und Gertrud" 1781/1783, in dem er wie in einer Legende äußerer Armut und inneren Reichtums das Gleichnis seiner Erziehungskunst erzählt hat. Denn Pestalozzi predigte die Erneuerung des Staates durch Erneuerung der Familie von jenem Mittelpunkte her, wo die Mutter steht, und brachte die hierarchische Ordnung Mutter—Familie—Staat wieder zu Ehren.

Der andere Pol So hatte die Kraft, die von dem Mittelpunkt Johann Jakob Bodmer ausging, einen immer weiteren Ring von Wellen durch das ganze Leben hin aufgeworfen. Ihm trat mit einem ziemlichen Abstande in Johann Kaspar Lavater ein anderer Mittelpunkt entgegen, von dem wiederum Wellenringe anderer Art ausgingen. Die geistigen Bewegungen, die Bodmer und Lavater erzeugten, liefen also, wenn nicht gegeneinander, so doch aufeinander zu und bildeten jenen Gedankenwirbel, der um die Entscheidung Vernunft oder Offenbarung rang.

Offenbarung des Herzens *Johann Kaspar Lavater,* 1741 bis 1801, hat in der Kirche Zwinglis neben dem offenbarenden Wort der Schrift die offenbarende Stimme des Herzens wieder hörbar gemacht. Dem Reich der alamannischen Mystik wurde nach Heinrich Seuse, Johann Tauler, Philipp Jakob Spener wieder ein Verweser. Lavater ist der „Betrachtung der Natur" des Genfers Charles Bonnet, der „Abhandlung von den Empfindungen" des Franzosen Etienne de Condillac und zumal dem englischen Pietismus verpflichtet. Der tätige und menschenfreundliche Seelsorger, der auf der Kanzel ebenso fleißig das Wort nahm, wie er die Feder rührte, behandelte jedes Gewissen und jede Herzensnot

nach ihrer besonderen Art. Lavater war der geborene Mystiker und in seltener Weise der erkenntnisschaffenden Bildnisvorstellung mächtig. Er hat seinen Gott immer mehr im Sehnen als im Haben besessen, was manchen an ihm irre machte. Für Lavater war alles ein Bild der Seele und alles Bild nach Gottes Ebenbilde. Lavater hat dem, was eben in Zürich so dämonenhaft lebendig wurde, den erkennenden Begriff und das bezeichnende Wort gefunden: Genie. Genie ist für ihn ein Abglanz göttlichen Geistes, Teilhaber an Gottes Schöpferkraft, ein Mittelbegriff von Göttlichem und Menschlichem zugleich, Abbild des göttlichen „Poietes". Lavater hat keine der gültigen Literaturformen seines Zeitalters unversucht an seinem Wege gelassen. Aber der Inbegriff seines Geistes und das Zürcher Werk aus seinen Händen, das sind von 1775/1778 die vier Großbände, seine „Physiognomischen Fragmente". Da ihm alles Gleichnis und redendes Bild des Göttlichen war, so unternahm er es, das abgebildete Antlitz seiner Zeitgenossen wie ein Buch Gottes zu lesen und zu deuten. Die göttlichen Geheimnisse, die Schriftzüge eines außervernünftigen Geistes gelüstet es ihn, aus dem Gewölbe der Stirn, der rätselhaften Tiefe des Auges, den Linien des Mundes und dem Bau des Kinnes zu entziffern. Da ist alles: die verschwisterten Zürcher Künste des zeichnenden und schreibenden Griffels, Bodmers neue Vorstellungen vom redenden Bild und Hamanns neuer Begriff vom bildenden Wort, die neue Anschauung vom Genie als dem gleichnishaften Vermögen zum göttlichen Wortbild und Bildwort. Bodmers und Breitingers anweisender Kunstlehre aus der Vernunft steht Lavaters schauhafte Schriftkunde vom Göttlichen im Menschengesicht entgegen. Das Reich der Vernunft und des außervernünftigen Geistes grenzen in Zürich, soweit die Welt reicht, wieder aneinander und zwischen ihnen ist Handel und Wandel.

Das Genie

Offenbarung des Antlitzes

Wortbild und Bildwort

Zürich hat für die neue Eidgenossenschaft den Grund gelegt. In ihrer gemeindeutschen Aufgabe aber spielte die Stadt mit dem fernen Königsberg zusammen, gegnerisch mit Gottsched, bundesgenossenschaftlich mit Hamann und Herder.

Basel, das nichts mehr als seine Hochschule hatte, schlug eine Brücke zwischen Zürich und Bern. Denn hier wirkte *Karl Friedrich Drollinger*, 1688 bis 1742, aus Durlach, der Barthold Brockes, den Hamburger Dichter des irdischen Vergnügens in Gott, und das philosophische Lehrgedicht des Engländers Alexander Pope an die Schweiz vermittelte. Auch Drollinger las die Natur als Buch Gottes und war der erste Dichter in Deutschland, der als Meister des philosophischen Gedichts der Dichtung wieder große Aufgaben stellte. Und in Basel wirkte *Isaak Iselin*, 1728 bis 1782, den in seinen ge-

Basel: Drollinger und Iselin

schichtsphilosophischen Schriften die soziale Frage, das Verhältnis von Natur und Kultur, das Wesen der Stadt beschäftigte und der aus der Geschichte die Grundsätze entwickelte, nach denen die Völker glücklich werden können. Er eiferte also gegen Städte und Handelschaft und bekannte sich doch in dem geistvollen Gespräch „Palaemon oder von der Üppigkeit" zu dem richtigen Gedanken, daß es ohne einen vernünftigen Aufwand keine Kunst geben könne.

Bern:
Muralt und
Haller
Dem verwälschten Bern wurde durch *Beat Ludwig von Muralt,* 1665 bis 1749, zuerst die entscheidende Frage des Jahrhunderts Frankreich oder England gestellt. Das war seine Schrift „Briefe über die Engländer und Franzosen". Sie lief in zahlreichen Abschriften um, wurde aber erst 1725 gedruckt. In französischer Sprache machte er seinen Zeitgenossen deutlich: die französische Bildung erzeugt den Durchschnittsmenschen, dessen ganze Kunst Lebensmeisterschaft ist, die englische Erziehung aber führt zur Natur und macht groß im Guten wie im Bösen. Die Berner Dichtung der Zeit hat sich nach dieser Einsicht geformt.

Der erste
Dichter
Albrecht Haller, 1708 bis 1777, war ein kleiner Berner Arzt, ehe er an der Göttinger Hochschule ein weltberühmter Gelehrter wurde, und zunächst wieder nur ein kleiner Berner Beamter, als ihn das Heimweh in seine Vaterstadt zurücktrieb. Schließlich vertraute ihm Bern die Aufsicht über das gesamte Gesundheitswesen an. Der junge Haller hatte Homer und Vergil mit einem Heldengedicht über den Ursprung der Eidgenossenschaft nachgeeifert. Vergil und Horaz wurden dann in einem andern Sinne seine Meister. Haller hatte 1727 Paris und London besucht und war zu Muralts Entscheidung gekommen. Er hatte in Basel Karl Drollinger gesehen und war von dem zur Dichtung ermutigt worden. „Versuch schweizerischer Gedichte" 1732 war Probe und Bewährung. Denn dieser ersten Ausgabe folgten bis 1768 vierzehn berechtigte Auflagen und sieben Nachdrucke. Die Sammlung bietet neben wenigen Bekenntnissen des Herzens einen Kreis von sieben
Die Alpen
und die alten
Eidgenossen
größeren Gedichten, die gedanklich ein Ganzes bilden. „Die Alpen" 1729, die im Mittelpunkt stehen, müßten eigentlich „Die Älpler" oder besser „Die alten Eidgenossen" heißen. Denn die Alpenbewohner sind Gegenstand und nur die zweite kleinere Hälfte gibt, von oben gesehen, einen Alpenrundblick, damit das zuvor geschilderte reiche und einfach große Leben einen ebenbürtigen Hintergrund habe. Wie der altgriechische Bauerndichter Hesiodos schildert Haller die Werke und Tage, die Wochen und Feste der Alpenbewohner, die Bauern, Hirten und Jäger. Es ist kein „Lehrgedicht". Ein natürliches Leben, im Sinne Muralts einfach groß, wird beispielhaft aufgerollt.

Es ist, mit Bodmer zu reden, ein Sittengemälde. Vergils Vorwürfe der Hirtenlieder und des Landbaugedichtes, die strenge Ahnensitte aus des Horaz Römeroden werden aufgeboten, um mit der Absicht des Tacitus das Stadtvolk in den Spiegel eines Naturvolkes blicken zu lassen. Man vergleiche Albrecht Haller und Salomon Gessner, und man hat das Bern und Zürich nicht nur dieses Zeitalters. Um die Kernfrage der „Alpen" kreisen die Gedanken der sechs anderen Gedichte. „Die verdorbenen Sitten" und „Der *Essay* *in Versen* Mann nach der Welt" wenden sich gegen das anfechtbare Leben der Stadtbürger. „Vernunft, Aberglauben, Unglauben" und „Die Falschheit menschlicher Tugenden" werfen die Frage auf: was ist der Kulturmensch als erkennendes und handelndes Wesen? Beides, das Wesen der Dinge wie das Wesen der Tugend liegen außerhalb der menschlichen Faßbarkeit. Gottes Wesenheit und Gottes Willen kann man nicht erkennen, sondern nur als innere Stimme „hören". Von den beiden letzten gepaarten Gedichten meint das eine, Gott fordert von uns nicht zu wissen, sondern zu handeln, und weil wir handeln sollen, muß er uns die Freiheit der Wahl zwischen Gut und Böse geben: „Über den Ursprung des Übels". Das andere aber, „Über die Ewig- *Vom Ursprung* *des Bösen* keit", feiert die hohe Einheit von Natur und Mensch, die nicht im Gefühl, sondern durch Wissen und Glauben besteht. Haller hat das bildhafte Alpengleichnis vom ursprünglich reinen, schönen und glücklichen Menschen von allen Seiten mit seinen erkennenden Gedanken umkreist, indem er den Verfall der Sitten auf seine Ursachen prüfte, die Reichweite der Vernunft abschätzte, die Bedingnis der Tugend und die Herkunft des Übels auslotete. Der größte deutsche Gelehrte seiner Zeit erkannte das Naturglück im seligen „Nichtwissen", und der öffentlich nie gehandelt hat, sah das Glück der Zukunft im freien Handeln nach Gottes Willen. Der also Überzeugte schien bereit, sich in die Geborgenheit des Einsseins mit der Natur zu stürzen. Das war der dreißigjährige Haller. Der Sechzigjährige überdachte noch einmal *Hallers* *Staatsromane* in anderer Form die Frage, die immer dringlicher an seine Vaterstadt gestellt wurde. Hallers „Staatsromane" sind in Wahrheit staatsbürgerliche Denkschriften in geschichtlicher oder gesprächsweiser Gestalt. „Usong" 1771 handelt an der Geschichte eines Mongolenstaates vom Gewaltherrscher, „Alfred" 1773 an England von der gemäßigten Monarchie, „Fabius und Cato" 1774 von den freistaatlichen Einrichtungen. Albrecht Haller ist aus dem Barock und aus der Mundart heraus ein Mitschöpfer der neueren Dichtersprache geworden. Sein Werk ist die philosophische Kunstsprache der Deutschen. Haller war der Überzeugung, wer Gott ausschließlich in seinem Verhältnis zu den Menschen betrachtet, der mache ihn klein. Er bekannte,

ihn habe die Natur gelehrt, höher von Gott zu denken. Seine Weltanschau-
ung ist mathematisch-naturwissenschaftlich untergründet, und auf diesem
Leibnitz,
Haller, Kant Untergrunde ruht auch seine Dichtung. Er vermittelt von Leibniz zu Kant
durch seinen Gottesbegriff, durch seine Erkenntnislehre, durch seine Sitten-
lehre, wie die Zürcher zwischen Leibniz auf der einen, Hamann und Herder
auf der andern Seite stehen. Kant fühlt sich durch Hallers Gedicht von der
Ewigkeit besonders angesprochen, wie Hamann und Herder die Arbeiten
des Bodmer-Kreises zu würdigen wußten.

Bern war noch in seinem Niedergange groß und bestrickte hochgemute
Geister. Gestalt und Geschichte Berns fanden in Schaffhausen ihren Wort-
Der erste
Geschichtschreiber führer. *Johannes Müller,* 1752 bis 1809, war schon als Kind für die Geschichte
begeistert und als Knabe ein anmutiger Erzähler. Zur geschichtlichen For-
schung wurde er in Göttingen, zur geschichtlichen Darstellung an den Alten
gebildet. Sein Dämon hat ihn einen steilen und widerspruchsvollen Weg
geführt: 1786 in den staatsmännischen Dienst des Mainzer Kurfürsten, 1792
in die Wiener Hofkanzlei, 1804 in das Amt des Königs von Preußen nach
Berlin, 1807 in das Ministerium des neuen Königreiches Westfalen. Gleich-
viel welchem Herrn er diente, welche Bücherei er nützen konnte, an welchem
staatsmännischen Gezettel er mitwirkte, alles mußte seinem Lebenswerk,
„Die
Geschichten der Geschichte seines Vaterlandes dienen. Er hat sie, „Die Geschichten der
der Schweizer" Schweizer", aus den Urkundenschreinen und der lebendigen Anschauung
der Heimat in den Jahren 1770 bis 1807 aufgezeichnet und sie ist mit der
ersten Hälfte des fünften Bandes Bruchstück geblieben. Das Werk bricht
dort ab, wo die Gefährten, das sind die große Zeit des Bundes und die gro-
ßen eidgenössischen Zeitbücher, zurückbleiben mußten nach dem Abschluß
der Burgunderkriege. Müllers Gewährsmänner und Vorbilder waren die
alten Zeitbuchschreiber seines Vaterlandes. Sein Werk ist ein Buch der Liebe
zu Bern. Er hat das alte Zürich nicht geliebt, weil er die eidgenössische Tra-
gik dieser Stadt nicht verstanden hat. Johannes Müller hatte den Ehrgeiz
zum großen Kunstwerk. Allein diese Kunst offenbart sich im Einzelnen und
nicht im Aufbau des Ganzen. Dort, wo er sich nachdenkend über das Ganze
erhebt, spricht er in zugespitzten Denksprüchen und läßt er einen gallischen
Witz sprühen. Dort, wo er hingerissen ist, spricht er mit dem Munde der
antiken Redner und zieht alle Register eines hochgetragenen Tones. Muß
er aber nichts als erzählen, da setzt er die spielenden Lichter kleiner Ge-
schichten auf, untermalt er seine Sätze mit schmückenden Beiworten, färbt
er seine Sprache aus der Mundart und dem Wortschatz alter Zeitbücher.
Das Kunstwerk Müllers Schweizergeschichte lebt aus der Tat und dem Mythus der Wald-

stätte. Sie ist nach Geist, Sprache und Kunstgestalt die Eidgenossenschaft ganz und gar, der Inbegriff ihrer mehrhundertjährigen Leistung auf diesem Gebiet.

In Zürich und Bern hatte man dem ersehnten großen Dichter vorgearbeitet. Der Dichter kam und hieß Klopstock und war kein Schweizer. Der Schweizer, der kam, war nach altem Schicksal ein Geschichtschreiber und Meister der Prosa.

PREUSSEN und MEISSEN. Von Preußen geht in immer neuen Wellen die andere Erschütterung aus, die der deutschen Geistnation ins Leben hilft: Gottsched, Hamann, Herder, Kant. Ihre Wirkungen zielen auf die gleiche Mitte wie Bodmer und Lavater, Haller und Müller: der Dichter und seine Sprache; die Nation in ihrem vernunftgeordneten und natürlich begründeten und geschichtlich bedingten Dasein; der Mensch zwischen Vernunft und Offenbarung. Die beiden Universitäten Leipzig und Halle, die beiden Höfe Berlin und Dresden sind die Organe, durch die der deutsche Osten in die Nation wirkt, bis der reine Geist, in Königsberg Gestalt geworden, unmittelbar die Deutschen ergreift. *(margin: Der zweite Bildungsherd)*

Leipzig hat sich *Johann Christoph Gottsched* zum Werkzeug seiner weitausgreifenden Pläne geschmiedet. Als er 1724 die Stadt betrat, fand er sie schon vom Osten her im Aufbruch: durch Studenten und Lehrer der Universität, die einander gefunden hatten. Der Geschichtsprofessor Johann Burkhard Mencke leitete einen Kreis von lausitzischen Studenten, der sich 1697 als „Görlitzische Poetengesellschaft" aufgetan hatte und sich 1717 in die „Deutschübende poetische Gesellschaft" umwandelte. In dieser Gesellschaft faßte Gottsched sogleich Fuß, wurde ihr Vorsitzender und lenkte fortan ihre Arbeiten. Mit gleicher Geschicklichkeit wie unter den Studenten schuf er sich unter den Lehrern der Universität eine Stellung. Er wurde 1730 außerordentlicher Professor der Poesie und bereits 1734 erhielt er den ordentlichen Lehrstuhl der Logik und Metaphysik. Auf diese beiden Stellungen baute er Zug um Zug eine Macht, die in wenigen Jahren das geistige Leben der Deutschen beherrschte. *(margin: Gottsched in Leipzig)*

Gottsched ist Spracherzieher, Kunstlehrmeister, Dichtungsgeschichtler. Aus guter Kenntnis der älteren deutschen Sprachlehren und der deutschen Mundarten schuf er seine wohlgegliederte Sprachlehre nicht um wissenschaftlicher Absicht willen, sondern um zu richtigem Sprechen und Schreiben anzuleiten. Das Gesetz der Sprachrichtigkeit floß ihm aus zwei Quellen: aus der vorbildlichen meißnischen Mundart und aus der Überlieferung der Schriftsprache. Seine „Sprachkunst" wurde 1748/1762 fünfmal aufgelegt und *(margin: „Sprachkunst")*

„Dichtkunst" übersetzt. Sein lehrhaftes Hauptwerk, „Versuch einer critischen Dichtkunst vor die Deutschen" 1730 ist aus Vorlesungen erarbeitet und in nicht ganz dreißig Jahren fünfmal aufgelegt worden. Nach den herkömmlichen allgemeinen Betrachtungen erörtert Gottsched Wesen und Geschmack des Dichters, den Begriff des Wunderbaren und Wahrscheinlichen, die Bilder, die Figuren, den Rhythmus. Im Mittelpunkt steht die Fabel, das ist die Erfindungskunst. Die hohe Fabel, das sind Heldengedicht und Tragödie. Roman, Komödie, Schäfergedicht, das sind die niedern Fabeln. Für das Drama anerkannte er die drei Einheiten der Handlung, des Ortes und der Zeit. Nach Wolffs Philosophie und Pietschens Poetik leitete er alles aus dem Satze ab: *Nachahmung der Natur* das innere Wesen der Poesie bestehe in einer Nachahmung der Natur. Denn die Wissenschaft könne nur gelten lassen, was aus der Erfahrung stammt und alle Vorstellungen fließen aus Sinneseindrücken. Die von den Alten überlieferten oder aus ihren Werken abgezogenen Sätze sind allein gültig. Da *Nachahmung der Alten* die Franzosen die vernünftigsten und glücklichsten Nachahmer der Alten sind, so geht die beste Schule der Deutschen durch die Vorschule der Franzosen zurück auf die Alten. Gottscheds Sprachkunde und Dichtungslehre vereinigen sich in seinen dichtungsgeschichtlichen Arbeiten. Sie entwickelten sich aus einem stehenden Abschnitt der Renaissancepoetiken, der vom Ursprung und Wachstum der Dichtung zu handeln pflegte. Dichtung ist Ausdruckskunst und daher vom Urbeginn Gefühlsentladung. Aus dem Urliede haben sich die einzelnen Dichtungsarten abschattiert, indem sie sich immer weiter von der Musik entfernten. Was ihn bei diesen dichtungsgeschichtlichen Arbeiten leitete, war der Wille, die deutsche Literatur gegen die überheblichen Angriffe Eleazar Mauvillons und des Jesuiten Dominikus Bouhours zu verteidigen. Mit diesen Studien schuf er Vorarbeit für eine geplante Geschichte der deutschen Sprache und Literatur.

Um seine Erkenntnisse und Gedanken durchzusetzen, ließ er seine Machtmittel auf drei Gebieten spielen. Das eine waren die Deutschübenden Gesellschaften. Solche ließ er nach dem Vorbilde seiner Leipziger Gesellschaft überall, wo er nur konnte, durch seine Anhänger, Schüler und Freunde gründen. Das andere war die Zeitschrift, wie die Engländer und Hamburger sie *Die Wochenschriften* entwickelt hatten. Diesem Beispiele folgten „Die vernünftigen Tadlerinnen" 1725/1726 sowie „Der Biedermann" 1727/1729, beide vom Stil der moralischen Wochenschriften. Eine neue Gattung schuf er mit dem Unternehmen *Die kritische Zeitschrift* „Beiträge zur kritischen Historie der deutschen Sprache, Poesie und Beredsamkeit", 1732/1744, und anderen ähnlicher Art, die Bericht und Forschung verbanden. In diesen Zeitschriften focht er die entscheidenden Kämpfe um

Wesen und Gestalt der deutschen Dichtung aus, vor allem mit den Schweizern. Das dritte war die Bühne, für die er sich mit der Gesellschaft der Friederike Karoline Neuber eine Mustertruppe schuf. Auf dieser Bühne entschied er zunächst den Kampf gegen die Stegreifkomödie und die Staatstragödie für das gelehrte Drama französischen Stils, das sogenannte Regelstück. Er bot dafür einen Spielplan mit siebenunddreißig Musterstücken, die er 1740 bis 1745 in sechs Bänden sammelte. Seine eigene Tragödie „Der sterbende Cato" 1732, nach einem englischen und einem französischen Stück, sollte zeigen, wie es gemacht werden müsse. Zumal für das Lustspiel war ihm seine Frau Luise Kulmus aus Danzig eine begabte und geschickte Mitarbeiterin. Das war alles zusammen ein großzügiger literarischer und kulturpolitischer Entwurf, der auf eine geschlossene und gelenkte Nationalkultur zielte und bereits an Preußen als die kommende politische Vormacht der Deutschen dachte.

In Halle, wo mit dem Leibnizschüler Christian Wolff 1727 die Philosophie der Aufklärung gegen den Pietismus und die Machtmittel des preußischen Staates zunächst unterlegen war, bis Wolff 1740 unter dem Schutz des neuen Königs Friedrich II. siegreich nach Halle zurückkehren konnte, stand gegen Gottsched das entgegengesetzte Wunschbild einer neuen deutschen Dichtung auf. *Immanuel Pyra*, 1715 bis 1744, aus Kottbus in der Lausitz, war 1734 von dem pietistisch gesinnten Bautzener Gymnasium nach Halle gekommen und stand auch hier zum Pietismus. Er hatte damit begonnen, Vergils „Aeneis" in deutsche Alexandriner zu übersetzen, lernte 1736 die Schriften der beiden Zürcher Freunde kennen und schwor nun auf ihre Fahne. Das wurde mit seinem Gedicht „Der Tempel der wahren Dichtkunst" 1737, fünf Gesänge reimloser Alexandriner, offenbar. Das ist die Dichtung, die zwischen Hallers „Alpen" und Klopstocks „Messias" die Mitte hält, des Übergangs und des Zieles. Gesichte und eine Wanderung, das ist der Inhalt des Gedichts, das immer wieder an Dante erinnert. Dem Dichter erscheint die wahre Dichtung und sie führt ihn, unbeirrt von den Lockungen des falschen Trugbildes, durch ihr Reich, durch die Wohnungen der antiken Dichter in ihren Tempel. Jede Wissenschaft und Kunst hat hier ihre eigene Halle. Die Formen und Gattungen der Dichtung sind leibhaftig verkörpert. Hier weilen die biblischen Sänger und Dichter der Neuzeit. Die Dichtung im Dienste des höchsten, des göttlichen Gedankens, eine Kunst des Pietismus, eine wirkliche Dichtung, nicht bloß fromme Gesinnung, das ist Pyras Forderung. Der Humanist Hieronymus Vida und der Engländer John Milton sind Pyras Gewährsmänner. Klopstock war sein Nachfolger. Bodmer und Breitinger hatten

in Pyra einen Jünger gefunden. So wurde auch Pyra bald mit Gottsched handgemein. Er gab 1741 die Wochenschrift „Gedanken der unsichtbaren Gesellschaft" heraus. Er entwarf ein komisches Epos „Bibliotartarus". Er wagte die Streitschrift „Erweis, daß die Gottschedianische Sekte den Geschmack verderbe" 1743, in der er zwar die Sache Miltons und Hallers führt, aber das Drama in den Mittelpunkt stellte. Man sieht ihn schon in der Mitte zwischen Aristoteles und Lessing, wenn er erläutert, daß die Fehler des Helden den Ausgang des Trauerspiels bedingen müssen. Als Lehrer am Köllnischen Gymnasium zu Berlin ist Pyra gestorben, noch nicht dreißig Jahre alt, in raschem Reifen, einer der vielen frühvollendeten Deutschen. Immanuel Pyra und sein Laublinger Freundeskreis um *Samuel Gotthold Lange* haben die pietistische Stimmungskunst zur lyrischen Empfindsamkeit verweltlicht. Pyras und Langes gemeinsame Gedichte „Thirsis' und Damons freundschaftliche Lieder" 1745 sind dafür das erste Zeugnis. In Laublingen verkehrte neben Johann Peter Uz und Johann Nikolaus Götz auch *Ludwig Gleim*, 1719 bis 1813, von Ermsleben, der spätere Domherr zu Halberstadt, der Freund und Gönner aller dichterischen Jugend, in dessen mittelmäßigen, aber zahlreichen Versen und Versbüchlein dieser verweltlichte gefühlsselige Pietismus ausklang.

Der Laublinger Kreis

Die sächsischen Fürstenschulen Pforta und Meißen haben die Jugend herangebildet, die, was Gottsched wollte, überwand und nur zum Teil verwirklichte, was Pyra anstrebte. Das sind in einem Kranz bescheidener Gestirne Friedrich Gottlieb Klopstock, Johann Elias Schlegel, Gotthold Ephraim Lessing.

Die meißnischen Fürstenschulen

Wie es sich gebührte, wurde der Älteste von ihnen, *Johann Elias Schlegel*, 1719 bis 1749, aus Meißen zuerst flügge. Er stammte aus einer sehr fruchtbaren und geistig lebendigen Familie. Vater und Großvater wußten ihren Vers zu machen. Zwei seiner Brüder waren Dichter und Schriftsteller. Und durch seinen Bruder Johann Adolf waren die beiden Führer der romantischen Bewegung August Wilhelm und Friedrich Schlegel seine Neffen. Die berühmteste der drei sächsischen Fürstenschulen, Pforta, nahm Johann Elias Schlegel 1733 unter ihre Zöglinge auf. Seine Mitschüler, die den Kunstreichen bewunderten, beobachteten an ihm sehr sprechend und anschaulich „feuerreichen Witz" und „gezwungenen Gang". Mit achtzehn Jahren war er damals schon weiter als die reifsten unter seinen Zeitgenossen. Zum erstenmal wieder ging ein deutscher Dichter unmittelbar auf die Antike zurück, als er aus den „Trojanerinnen" des Euripides und aus dessen „Hekuba" seine eigene Tragödie „Hekuba" arbeitete. In den „Geschwistern in Tau-

Johann Elias Schlegel

Das erste antike Stück

rien" 1737 spannte er bereits vor Goethe den Gegensatz von Urzustand und Gesittung. Schlegel kam 1739 nach Leipzig, fand Anschluß an Gottsched, verkehrte in dessen Hause und half ihm als Übersetzer. Allein er ging eigene Wege. Zwischen Massen lyrischer Gedichte schrieb er Aufsätze voll dunkler Ahnungen, so die „Abhandlung von der Nachahmung" und „Vergleichung Shakespeares und Andreas Gryphs", die erste deutsche Aussage von Rang über Shakespeare. Indessen als Dichter war er noch nicht so weit. Sein Trauerspiel „Hermann" 1741 konnte, obwohl es um einen so volkhaften Vorwurf ging, der französischen Kunstweise noch nicht entraten. Gleichwohl hat das Stück auf Klopstock und noch tiefer auf Goethe gewirkt, der es 1766 in Leipzig gesehen hat. Groß zu werden schien Schlegel erst an der großen Aufgabe, die ihm das dänische Theater stellte, als er 1742 nach Kopenhagen ging. Dort gab er 1745 und 1746 die stolze Wochenschrift „Der Fremde" heraus. Er half das dänische Theater schaffen. Sein Lustspiel „Der Geheim- *Das dänische* *Theater* nisvolle" 1746 baute den Vorwurf aus, daß zwei, von den Vätern füreinander bestimmt, sich als Unbekannte lieben lernen. Das Trauerspiel „Canut" 1746 bietet in Uffo dem Empörer die erste Gestalt einer deutschen Tragödie, die mit wirklicher Kunst gezeichnet ist. In das eine Jahr 1748 drängte sich seine letzte Lebenskraft zusammen. Er schuf das fesselnde Lustspiel „Die stumme Schönheit" und das erste Kunstwerk zugleich im englischen Tra- gödienstil und in fünffüßigen Jamben „Die Braut in Trauer". Wenige Tage *Die erste* *Tragödie* vor Goethes Geburt, im August 1749, ist auch dieser Frühvollendete dem *neuen Stils* Neid der Götter erlegen. Neben dänischen Königen liegt er in der alten Klosterkirche zu Soroe begraben.

Der Magdeburger *Johann Joachim Schwabe*, 1714 bis 1784, leitete für *Johann Joachim* *Schwabe* Gottsched seit Juli 1741 eine neue Zeitschrift „Belustigungen des Verstandes und Witzes". Für diese Zeitschrift und also für den Meister fing Schwabe die Jugend ein, die von den Schulen an die Leipziger Universität strömte: die drei Fürstenschüler Christian Fürchtegott Gellert, 1715 bis 1769, aus Hainichen, Gottlieb Wilhelm Rabener, 1714 bis 1771, aus Wachau, Karl Christian Gärtner, 1712 bis 1791, aus Freiberg im Erzgebirge; den Lüne- burger Konrad Arnold Schmid, 1716 bis 1789, und Johann Adolf Schlegel, 1721 bis 1793, aus Meißen; Johann Arnold Ebert, 1723 bis 1795, aus Ham- burg, und Just Friedrich Wilhelm Zachariä, 1726 bis 1777, aus Franken- hausen; Nikolaus Dietrich Giseke, 1724 bis 1765, eines Hamburgers Sohn aus Güns in Ungarn. Sie taten eine Weile mit, tunlichst ohne Partei zu er- greifen. Dann gaben sie ihrer Unzufriedenheit nach und sonderten sich zu *Die Bremer* einem eigenen Unternehmen ab, den „Neuen Beiträgen zum Vergnügen des *Beiträge*

Verstandes und Witzes", deren erstes Stück am „1. Weinmonats 1744" bei
Sauermann in Bremen erschien. Man wollte sich jeglichen Streites enthalten,
zwischen Ernst und Scherz, Eigenwerken und Übersetzungen angenehm ab-
wechseln und brachte, was eben jeder von den Freunden auf der Kunkel
hatte. Von den beiden anderen Fürstenschülern kam Klopstock 1745, Lessing
1746 nach Leipzig. Lessing hielt es lieber mit dem, was sich vor und hinter
den Kulissen der Bühne abspielte. Von Klopstock aber erscheinen zu Anfang
1748 im vierten und fünften Stück der „Neuen Beiträge" die ersten drei Ge-
sänge des „Messias". Die große Dichtung, die das ganze Zeitalter erwartet
hatte, war da, war in den Bremer Beiträgen da und entschied für Bodmer
und gegen Gottsched.

Gellert und Rabener Die übrigen Mitarbeiter aber fielen in den sächsischen Alltag des literari-
schen Kleinwerks zurück. *Christian Fürchtegott Gellert* wurde in Leipzig ein
beliebter Hochschullehrer, der Seelenfreund aller, die seiner Güte bedurften,
in seinen beiden Fabelsammlungen 1746 und 1748 von umständlichem Witz,
in seinen Lustspielen ohne Spannung, ohne Leben, ohne Persönlichkeit, mit
seinem Roman „Das Leben der schwedischen Gräfin G..." 1747 um eine
christlich-sittliche Bildung bemüht. *Gottlieb Wilhelm Rabener* stand als
Steuerbeamter mitten im Leben. Er schilderte es in seinen Fabeln und ge-
reimten Kurzgeschichten mit Offenheit und verständigem Witz, seinen gan-
Zwei Kleinmeister zen Ehrgeiz an einen abwechslungsreichen Rahmen seiner Anekdoten set-
zend. Neben ihnen hatten zwei schon erheblich Jüngere ihre Zuschauer und
Leser. *Christian Felix Weisse*, 1726 bis 1804, aus Annaberg, bildete Horaz,
Hagedorn und Gleim in seinen lyrischen Gedichten nach und hatte mit sei-
nen Komödien, Tragödien und Singspielen eine starke Stellung in den Spiel-
plänen der Zeit. Sein Schüler *Moritz August von Thümmel*, 1738 bis 1817,
von einem Gut bei Leipzig, schrieb in einem zierlichen mühelosen Stil und
als Roman die „Reise in die mittägigen Provinzen Frankreichs", ein wenig
lüstern und empfindsam wie in all seinen Büchern.

Nun traten Berlin und Dresden ins Spiel, längst Nebenbuhler um die
Macht über den Osten und bald auf dem Kriegstheater im Handgemenge.
Geistig lagen sie in ganz anderen Himmelsgegenden, die schreibfrohe Haupt-
stadt des Kurfürsten von Brandenburg, der ein König in Preußen, und die
kunstblühende Residenz des Kurfürsten von Sachsen, der ein König in Po-
len war. Ins Spiel aber traten sie auf eine nichts als geistige Weise durch
Gotthold Ephraim Lessing und Johann Joachim Winckelmann, den jede von
ihnen auf ihre Weise gebildet hat.

Der junge Gelehrte *Gotthold Ephraim Lessing*, 1729 bis 1781, aus Kamenz, stammte von

einer Familie, die wahrscheinlich von Böhmen her ins Erzgebirge eingewandert war, und aus einem Pfarrhause, dem es wirtschaftlich nicht sehr gut ging. Ein sehr tüchtiger und frühreifer Schüler, hat er alle Gunst der humanistischen Fürstenschule Sankt Afra in Meißen genossen. Sein aufsteigendes Leben hat er in Sachsen und Preußen, sein absteigendes in Niederdeutschland gelebt. Zweimal war er in Leipzig, zweimal in Berlin, zweimal in Breslau. In Leipzig lebte er dem Theater, in Berlin der Zeitung, in Breslau der Wissenschaft. Zu Hamburg hat er beidem in einem gedient, dem Theater und der Presse. Zu Wolfenbüttel begrub er sich vor seiner Zeit in Bücher. Es ist nicht leicht, aus Lessings Leben und Schaffen ein Ganzes zu machen, da es fast nur in der Einheit der Persönlichkeit besteht, aber aus dem Stegreif gelebt und gearbeitet wurde. Die zweimal drei Leipziger Jahre von 1746 bis 1748 und von 1755 bis 1758 waren dem Theater gewidmet. Der Hochschüler führte ein forsches Weltleben, tanzte und focht und bewegte sich unter Schauspielern, auch unter solchen weiblichen Geschlechts. Von den kleinen Stücken, in denen er sich humanistisch nach Terenz und Plautus versuchte, wurde „Der junge Gelehrte" 1748 auf der Bühne der Karoline Neuber gespielt, deren Gunst er sich durch Übersetzen französischer Spiele verdient hatte. Nur nebenbei frönte er dem Ehrgeiz, der Klopstock hieß, im Entwurf eines philosophischen Gedichts „Die Religion". Diesen und den zweiten Leipziger Aufenthalt überbrückte sein erstes größeres Werk, das Prosastück „Miß Sara Sampson", eine Spätfrucht aus der Maienblüte der moralischen Wochenschriften: ein verführtes Mädchen, ein vornehmer Taugenichts, eine abgedankte Geliebte, der verfolgende Vater. Es ist in Potsdam geschrieben und 1755 in Frankfurt an der Oder gespielt worden. Das zweite Mal kam er im Herbst 1755 nur nach Leipzig, um einen reichen Bürgersohn auf Reisen zu führen. In Amsterdam wurden sie vom Einfall der Preußen in Sachsen überrascht und kehrten heim. Nun verzettelte sich Lessing in hundert Entwürfe, sann an einem Faustplan, entwarf die „Emilia Galotti" und brachte nicht mehr fertig als das Spielchen „Philotas" 1759, eine Feier der neu erprobten preußischen Soldatentugenden. In Berlin ist Lessing ein ganz anderer Mann. Mit Ausnahme der zwischenliegenden drei Leipziger Jahre und kleiner Abstecher hat Lessing von 1748 bis 1760 in Berlin gelebt. Hier führte er im Dienst des Tages die Feder. Mit seinem Vetter, Schrittmacher und Freund, dem frühverstorbenen Christlob Mylius, der schon in Leipzig keinen guten Einfluß auf ihn ausgeübt hatte, gab er 1750 die Zeitschrift „Beiträge zur Historie und Aufnahme des Theaters" heraus. Von 1751 an führte Lessing den gelehrten Abschnitt und seit 1752 die ganze „Vossische

Lessing im Dienst der Presse

Zeitung". Er schulte sich zum Kritiker, lernte Menschen und Bücher kennen,
bildete seinen Stil und gab seinem stets gepflegten Selbstbewußtsein Grund
und Inhalt. Er wurde 1751 Voltaires Tischgenosse und übersetzte dessen
kleine Schriften. Dann aber kam es zu einem sehr heftigen Bruch. Es eröff-
nete sich ihm 1752 die Berliner Montagsgesellschaft, der Leute aller Stände
angehörten. Lessing kam mit dem ganzen literarischen Berlin zusammen,
vorab mit dem philosophischen Schriftsteller Moses Mendelssohn und mit
dem Buchhändler Christoph Friedrich Nicolai, dem Zeugmeister der deut-
schen Aufklärung, der 1757 die „Bibliothek der schönen Wissenschaften und
der freien Künste" sowie 1765 das Blatt für Literaturberichte, die „Allge-
Opera omnia meine deutsche Bibliothek", gründete. Schon 1753 bis 1755 sammelte Les-
sing in zierliche Bändchen seine Schriften. Während des zweiten Berliner
Aufenthalts ließ er seinem Ingenium die Zügel und machte 1759 zwei Bücher
seines Wesens fertig: die Ausgabe „Friedrichs von Logau Sinngedichte" und
Lessings kleine das kritisch aufbauende Werklein „Fabeln. Drei Bücher". Die Leipziger und
Arbeiten die Berliner Zeit überbrückte ein Unternehmen, das die Berliner Mitstreben-
den zusammenfaßte und dem einzigen wahren Freunde zugedacht war, den
Lessing in Leipzig gefunden hatte. Das war Ewald von Kleist, 1715 bis
1759, aus Zeblin, preußischer Offizier, der Mann des berühmten Gedichts
„Der Frühling" 1749, des matten Dramas „Seneca" aus Lessings Schule und
des schönen kleinen Heldengedichtes „Cissides und Paches". Kleist starb an
den Wunden, die er in der vernichtenden Schlacht bei Kunersdorf erlitten
hatte. An ihn dachte Lessing, als ihm 1759 der sofort verwirklichte Gedanke
kam, eine kleine kritische Zeitschrift herauszugeben, die an einen verwun-
deten Offizier gerichtet, den und die Öffentlichkeit über die neu erscheinende
Die Literatur auf dem laufenden halten sollte. Sie hieß „Briefe, die neueste Lite-
Literaturbriefe ratur betreffend" und erschien 1759 in Nicolais Verlag. Lessing steuerte bis
September 1760 fünfzig Briefe bei. Sie ließen nichts gelten, weder das Leip-
zig Gottscheds noch das Zürich Bodmers. Der Schwärmer Wieland wurde
ebenso verspottet wie Klopstocks zerfließende Gestalten. Hier spielten sich
die Kämpfe gegen den „Nordischen Aufseher" der Kopenhagener ab. Allein
hier wurden auch Lessings erste gewichtige Worte in Sachen Shakespeares
gesprochen. Lessing verschwand 1760 geheimnisvoll aus Berlin und wo er
auftauchte, das war Breslau. Da war preußische Etappe des Siebenjährigen
Krieges. Lessing diente als Verwaltungsbeamter des Generals Bogislav
Urlaub ins Leben Friedrich von Tauentzin. Er spannte wieder einmal aus unter Menschen, bei
Breslau Bechern und Würfeln. Er sammelte Bücher. Er ging mit den noch ein wenig
barock verzopften schlesischen Gelehrten um. Hier war Lessing zum ersten-

mal voll und rein beides: Gelehrter und Dichter. Der Gelehrte, das war
„Laokoon" 1766 und der Dichter, das war „Minna von Barnhelm" 1767,
jedes von ihnen ein Meisterwerk in seiner Art. Diese fünf nur kurz unter-
brochenen Breslauer Jahre 1760 bis 1765 sind menschlich und schöpferisch
Lessings hohe Zeit gewesen. „Laokoon" ist eine schön gerahmte Sammlung
von einzelnen Versuchen über einen gemeinsamen Gegenstand. Den Rahmen
bilden die kunstwissenschaftlichen Betrachtungen über die Laokoongruppe,
Betrachtungen, gegen Winckelmann zielend und mit dem Ergebnis: Die
griechische Kunst geht nicht auf Sittlichkeit, sondern auf Schönheit. Die Bin-
nenstücke des Rahmens aber bilden die Betrachtungen über die Grenzen der
Malerei und Dichtung. Sie suchen diese Grenze in den Darstellungsmitteln. *„Laokoon"*
Der Dichter arbeitet mit Worten. Das Wort ist ein Nacheinander von Tönen.
Dem Nacheinander von Tönen entspricht das Nacheinander von Handlungen.
Handlungen sind der Gegenstand der Dichtung. Der Maler arbeitet mit Far-
ben. Farbe ist ein Nebeneinander von Eindrücken. Dem Nebeneinander von
Eindrücken entspricht das Nebeneinander der Körper. Körper sind der Ge-
genstand der Malerei. Wenn der Dichter Körper darstellen will, so muß er
sie aus dem Nebeneinander des Raumes in das Nacheinander der Zeit, das
ist des Wortes, das ist in Handlungen verwandeln. Und wenn der Maler
Handlungen darstellen will, so muß er sie aus dem Nacheinander der Zeit
in das Nebeneinander des Raumes, das ist der Farbe, das ist in einen Körper
dauersam machen. Der Dichter kann nur erzählen, was ein Körper tut oder
was mit ihm geschieht und der Maler eine Handlung nur in dem Augenblick
festhalten, in dem das Vorher und Nachher erkennbar ist. Der Dichter kann
nicht malen und der Maler nicht erzählen. Weder zuvor noch später ist Les-
sing ein so vollkommenes Gebilde seines denkenden Verstandes gelungen,
was immer gegen die Ergebnisse seiner Betrachtungen eingewendet werden
mag. „Minna von Barnhelm" ist noch im bewegten Kriegsleben der schle- *„Minna*
sischen Hauptstadt entworfen worden. Man kann das Stück kein Lustspiel *von Barnhelm"*
nennen, denn es ist ein Schauspiel um die ernsteste Sache von der Welt, um
Stolz und Ehre des Mannes, und lustspielhaft sind daran nur jene komischen
Beiszenen und Nebengestalten, wie sie auch der Tragödie nicht fehlen. Es ist
ein Regelstück, aber man spürt ihm beinahe noch die Doppelwelt von Herr
und Diener, Herrin und Dienerin an, jene Doppelwelt, in der Hanswurst zu
Hause war. Viel bewundert wird die fein begründete und verbundene Hand-
lung, die abgetönte Wechselrede, das frische gegenwärtige Leben. Die er-
greifende Gestalt Ewalds von Kleist schreitet stilvoll verschwiegen über den
Hintergrund. Die preußische Regierung suchte die Aufführung des Stückes

zu hindern, soweit ihr Arm reichte. Denn es stellte die Abrüstung des preu-
ßischen Staates auf die Szene und hatte die Tausende von Kriegswitwen und
abgedankten Offizieren zu heimlichen Mitspielern. Niemals ist Lessing so
nahe daran gewesen, ein wahrer Dichter zu sein. Lessing wäre gern an eine
Hamburger
Bühne
Bücherei oder an ein Museum in Berlin gekommen. Der König von Preußen
hatte diesen Wunsch nicht. So ging er denn im April 1767 nach Hamburg als
Dramaturg an das neugegründete sogenannte Nationaltheater. Auch hier
traten zwei Werke von der gleichen Art wie in Breslau nebeneinander: ein
kunstkritisches und ein dichterisches. Das kunstkritische Werk war die „Ham-
„Dramaturgie"
burgische Dramaturgie", 1767 bis 1769, eine freie Folge von Theaterblättern,
die Lessing herausgab. Das ist kein Werk des berechnenden Aufbaus, son-
dern des Stegreifs. Lessing beschränkte sich bald von einer Besprechung der
Aufführungen auf die der Stücke und allgemeine Fragen, zu denen sie ihm
Anlaß gaben. Im Mittelpunkt standen Shakespeares „Hamlet" und die Poetik
des Aristoteles. Unter der Losung Hamlet schlug Lessing die Entscheidungs-
schlacht gegen den französischen Klassizismus siegreich zu Ende und an den
Rand des Aristoteles schrieb er seine geistreichen Glossen über das Wesen
„Emilia Galotti"
der Tragödie. Das dichterische Werk war „Emilia Galotti" 1772, zu Ham-
burg aus einer längst geplanten Virginiatragödie entwickelt. Dieses Trauer-
spiel, Schiller und den Romantikern so zuwider, war das Meisterstück seiner
Kunstlehre. Aus der Anlage der Gestalten entfalten sich mit unerbittlicher
Notwendigkeit die treibenden Leidenschaften und aus den Leidenschaften
ihre Schicksale. Der Stil ist ein durchsichtiges Gefüge von Gedankenschlüssen,
eine schöne Kunstfigur, glashell und eiskalt. Auch dieses Stück hat seine
heimliche Spitze. Sie ist vom bürgerlichen Freisinn geschärft und richtet sich
gegen den deutschen Fürsten der Zeit. Von den Möglichkeiten, die Lessing in
Wien geboten wurden, ergriff er auch dann keine, als er auf seiner hastigen
und glücklosen Italienfahrt durch Wien kam. Zu Neujahr 1770 trat er in
Wolfenbüttler
Bibliothek
Wolfenbüttel als herzoglicher Büchereibeamter an. Er führte sich mit kleinen
archäologischen Arbeiten ein. In Wolfenbüttel gab er 1774 bis 1777 einige
„Fragmente" aus der Schrift des Hermann Samuel Reimarus heraus, „Apo-
logie oder Schutzschrift für die vernünftigen Verehrer Gottes". Und wieder
stehen in Wolfenbüttel ein dichterisches und ein denkerisches Werk ein-
„Fragmente"
und „Nathan"
ander gegenüber. Das dichterische Werk ist „Nathan der Weise" 1779, in
fünffüßigen Jamben die alte Geschichte von den drei Ringen, die Christen-
tum, Mosaismus und Islam bedeuten. Die Frage, welcher dieser Ringe echt
sei, wird bündig damit beantwortet: keiner. Das denkerische Werk war „Die
Erziehung des Menschengeschlechts" 1780, das die alte Frage schon weniger

bündig beantwortet. Wie Lessing Philosophie und Dichtung, Dichtung und Malerei gegeneinander abgegrenzt hatte, so schied er hier Religion und Philosophie, das ist Offenbarung und Vernunft. Offenbarung hat die Menschheit zu dem künftigen Evangelium der Vernunft zu erziehen, sich selbst durch diese Erziehung überflüssig zu machen. Offenbarung gibt der Vernunft nichts, was sie nicht aus sich selber haben könnte. Aber sie gibt es früher und rascher. Offenbarung und Christentum sind lediglich geschichtliche Tatsachen. Die werden am Ziel der Menschheitserziehung durch das dritte Testament der Vernunft und Humanität abgelöst sein. Mit dieser Deutung der menschlichen Geschichte und der Endschaft der Dinge hat Lessing Abschied genommen. Es war ein stolzes Leben, das in selbstgewählter Stille zu Ende ging. Lessing war ein Kunstlehrmeister, der seine Lehre mit Glück durch eigene dichterische Beispiele erläuterte. Er folgt, freilich riesengroß, auf Opitz und Gottsched. Er ist kein Anfang, sondern ein Ende. Johann Georg Hamann, einer der gerechtesten Beurteiler Lessings, hat es so ausgedrückt: „Nichts als Ideenwanderung in neue Formen und Wörter . . . keine Empfängnis, die ein Magnifikat verdiente."

„Erziehung des Menschengeschlechts"

Johann Joachim Winckelmann, 1717 bis 1768, aus Stendal, stammte durch den Vater aus Brieg und ist also ein Schlesier, ein Ostdeutscher wie Lessing und Herder. Nach Lernjahren an märkischen Schulen und an den Universitäten Halle wie Jena kam der Arme in noch bessere Armut, als er 1743 Lehrer zu Seehausen in der Altmark wurde. Seine Sehnsucht heißt Griechenland. In der Kirche liest er Homer, homerische Gleichnisse betet er vor seinen dumpfen Jungen, verdämmert eine Stunde der Nacht auf dem Stuhl vor seinen Büchern und reist zur Messe nach Leipzig, nur um Bücher von außen zu sehen. Alles wies auf einen gelehrten Bücherwurm und nichts auf den künftigen Vertrauten der Standbilder, als Winckelmann sich 1748 dem Grafen Heinrich von Bünau zu Nöthnitz bei Dresden antrug und die Stelle als wissenschaftlicher Hilfsarbeiter und Büchereiwart erhielt. Doch es war Dresden, die Stadt der Künste, der Standbilder und Gemälde. Am Kunstbesitz dieser Stadt wandelte Winckelmann sich vom Buchliebhaber zum Kunstliebhaber. Wichtig waren die ersten Antiken, die er hier sah, wichtiger die Gemälde, am wichtigsten der Umgang mit kunstgelehrten Männern. Einer unter vielen, Adam Friedrich Oeser, der Maler und Kunstlehrer, lehrte ihn zeichnen, Kunstwerke sehen, begreifen, beurteilen. Daraus wurde Winckelmanns erste Schrift „Gedanken über die Nachahmung der griechischen Werke in der Malerei und Bildhauerkunst" 1755 in ganz kleiner Auflage gedruckt. Hier steht der unvergängliche Satz vom Klassischen als der „edlen Einfalt und

Die ewigen Griechen

Winkelmanns Federprobe

stillen Größe". In Bünaus Bücherei ebnete der Kardinal Graf Alberigo von Archinto dem kleinen Beamten den Weg nach Rom, der zuerst in die Kapelle der päpstlichen Botschaft zu Dresden führte, wo Winckelmann im Juli 1754 zur römischen Kirche zurückkehrte. Mit einem sächsischen Ehrensolde brach er im September 1755 nach Italien auf. Am 8. November dieses Jahres fuhr er durch Porta del Popolo, ein roter Tag für den Kalender der deutschen Geistesgeschichte. Er sah und erlebte Rom. Das Gastmahl der Augen verekelte ihm alles, was nach Gedrucktem schmeckte. Indessen im Bilderhofe des Belvedere überkam ihn wieder die Lust zu schreiben. Er versuchte, den

Der Apollo von Belvedere

Eindruck dieser Standbilder in Worte zu fassen. Der Apollo von Belvedere wurde ein Hymnus. Das Bruchstück des Herkules, die Laokoongruppe, der vermeintliche Antinous gerieten schon in sachlich berichtende Sätze. Jede Bildsäule war in eigener Stimmung gesehen, in besonderem Ton beschrieben und als Sonderwerk gezeichnet. Dann hatten ihn auch die Bücher wieder. Er wurde Buchwart des Kardinals Archinto und trat in die große römische Welt. Er schulte sich zum Meister des Kunstgesprächs. Er wurde Römer und ging seitdem als Abbate gewandet. Er maß sich mit den besten Griechen und Lateinern der Ewigen Stadt. Dann brach Winckelmann 1757 nach Neapel auf, die Welt zu sehen, die am Vesuv eben aus der Asche gegraben wurde. Die farbigen Wandbilder, die wie von gestern leuchteten, ihm leuchteten sie nicht. Er hatte nur Sinn für das, was aus Marmor gemeißelt war. Durch Philipp von Stosch, dessen Sammlung von geschnittenen Steinen er 1758 verzeichnete und beschrieb, wurde Winckelmann mit dem Kardinal Alessandro Albani bekannt. Beide wurden einander wie Brüder. Albani machte den Freund zum Aufseher der Büchersammlung Klemens XI. Und Winckelmann half dem Kardinal die Villa Albani zu einem Wohnraum von Kunstwerken zu machen. Immer wieder einmal besuchte er die toten Römerstädte am Vesuv. Dann war das Höchste erreicht, als man Winckelmann 1763 zum

Der Oberaufseher der römischen Altertümer

Oberaufseher der römischen Altertümer und Beamten der Vatikanischen Bücherei machte. In Dresden war inzwischen 1761 sein Buch „Anmerkungen über die Baukunst der Alten" gedruckt worden, ein Vorläufer dessen, das da

„Geschichte der Kunst des Altertums"

kommen sollte. Das aber war die „Geschichte der Kunst des Altertums", wie sie 1759 und 1764 erschienen ist. Mit seinen zwei Teilen war es beides, Kunstlehre und Kunstgeschichte. Unabsehbares war hier an den Griechen getan. Bisher kannte man sie nur aus ihrer Literatur, aus Büchern und durch Bücher. Winckelmann hatte sie in ihren Bildwerken gesehen und auf ihre Bildwerke gründete er nun das Bild, mit dem sie den Deutschen völlig neu erschienen. Die Kunst der Alten war den Deutschen ein Gegenstand emp-

findsamer Wunschträume. Winckelmann machte sie ihnen als eine lebendige
Wirklichkeit auf eine schlichte und menschliche Weise verständlich. Noch
mehr bedeutet sein Buch, abgesehen von dem besonderen Bezug auf die
Griechen schlechthin, als erstes Beispiel einer nationalen Geistesgeschichte.
An einem Musterfall wurde hier gezeigt, wie sich aus Landesart und Volks-
natur das geistige Leben eines Volkes bildet und in landschaftlichen Kultur-
kreisen absetzt.

So stehen Lessing und Winckelmann nebeneinander als die beiden Deu-
ter griechischer Geistesart, der eine, der sie aus Büchern liest und der andere,
der sie an Bildwerken schaut, beide um an ihr Wesen und Gesetz der Dich-
tung und der Kunst schlechthin zu erkennen. Sie ergänzen einander, aber sie
schreiten aneinander vorbei.

Und also nun Königsberg selber. Im geistigen Wohnraum der Stadt, aus *Königsberg*
der 1701 die preußische Königskrone stammte, vollzog sich der innere Ablauf
dieses preußischen Jahrhunderts als eine einzige in sich geschlossene Hand-
lung. Sie setzt mit Johann Christoph Gottsched ein. Sie gabelt sich durch
Johann Georg Hamann und Immanuel Kant fast gegensätzlich und läuft mit
Johann Gottfried Herder aus Mohrungen wieder zu einem Menschenwesen
zusammen, um sich in diesem auszuwirken und fast tragisch zu verstricken.

Johann Georg Hamann, 1730 bis 1788, stammte durch den Vater aus der *Der Magus*
Lausitz. Die Mutter war von Lübeck. Nach kurzer Hochschulzeit in der Vater- *in Norden*
stadt, da der gleichalterige Rigaer Stadtjunker und Kaufmannssohn Johann
Christoph Berens auf ihn anregenden Einfluß gewann, kam Hamann als
Hofmeister auf zwei baltische Güter. Das war die erste Schule des unersätt-
lichen Lesekünstlers. Er nahm den wesentlichen Bestand der französischen
und das erste Erlebnis der englischen Literatur in sich auf. Er übersetzte für
sich die philosophischen Betrachtungen des französischen Jesuiten René de *Hamanns*
Rapin und die beiden größten Essays des englischen Weltmannes Anthony *Lehrmeister*
Shaftesbury. Gab ihm Rapin ein Gesamtbild der europäischen Philosophie
seit Sokrates, so Shaftesbury den eigentümlichen ironischen Stil zu philo-
sophieren. Freund Berens, eben aus Paris zurückgekehrt, nahm ihn in die
hohe Schule der gelehrten und handelnden Volkswirtschaft. Hamann trat zur
Rigaer Handelsfirma Berens in ein vertragliches Verhältnis und ging mit
einem handelspolitischen Auftrag des Hauses im Herbst 1756 nach London.
Seine Sendung erwies sich als gescheitert, schon da er ankam. In London *Das Londoner*
aber, bei der zweiten Lesung der Bibel, überfiel ihn im Frühjahr 1758 Offen- *Erlebnis*
barung und Auftrag seines Lebens. In Gestalt eines religiösen Tagebuchs
schrieb er wie auf Diktat die Gedanken nieder, die ihm über der Bibel zur

Offenbarung und Religion, zur Philosophie und Sprache, zur Volkswirtschaft und Geschichte kamen. Der Heimgekehrte, nun zu dem ausschließlichen Geschäft seiner Bildung und Seele entschlossen, geriet darüber in Zwist mit seinen Freunden Berens und Kant, die ihn zu einem tätigen und vernünftigen Leben zurückbekehren wollten. Seit 1759 lebte Hamann, ohne Absicht auf einen bürgerlichen Beruf, in seinem Königsberger Vaterhause, völlig versenkt in das Studium der antiken und morgenländischen Sprachen und Literaturen. Nach dem Tode seines Vaters trat er 1767 als Sekretär und Übersetzer in den Dienst der französischen Zollverwaltung am Königsberger Lizent, brachte es 1777 zum Packhofverwalter, wurde 1787 schnöde in den Ruhestand versetzt, reiste zu seinen westfälischen und rheinischen Freunden und ist 1788 zu Münster gestorben und begraben worden, im Garten seiner geistlichen Freundin und Tochter, der Fürstin Amalie von Gallitzin.

„Charon"
am Lizent

Das war der Mann, der zusammen mit Lessing und Winckelmann durch winzige Flugschriften über Deutschland ein neues Klima gemacht hat. Die „Sokratischen Denkwürdigkeiten" 1759 nehmen das Amt des Sokrates für dieses Zeitalter auf sich, rechtfertigen es gegen Berens und Kant, zeigen an einem klassischen Beispiel, wie fortan Geschichte der Philosophie geschrieben werden müsse. Das Nachspiel „Wolken" 1761, eine aristophanische Komödie in Prosa, erledigt die literarischen Gegner, die dem neuen Sokrates entgegengetreten waren. „Kreuzzüge des Philologen" 1762 sammeln zu neuen Beiträgen die Essays aus einem Königsberger Anzeigeblättchen um die Mitte der „Aesthetica in nuce", jener Verkündigung eines neuen Geistes, die in die zeitgenössische Tiefe und geschichtliche Ferne eine unfaßbare Wirkung ausgeübt hat. Die „Essais à la Mosaique" 1762 leiten Hamanns Dreißigjährigen Krieg gegen die absolute und totale Vernunft, um die Zukunft Preußens und Deutschlands, gegen Friedrich II. und Voltaire in deren eigener Sprache ein. Inzwischen war ihm die Zeit so nahe gekommen, sein eigener Schüler Johann Gottfried Herder, sein Beichtvater und Gegner Johann August Starck, daß er sich mit ihnen, wie vordem mit Berens und Kant, auseinandersetzen mußte. Das erste waren die Schriften über Ursprung und Wesen der Sprache: 1772 „Zwo Recensionen", 1772 „Ritter Rosencreuz", 1772 „Philologische Einfälle und Zweifel", 1773 „Neue Apologie des Buchstaben h". Sie galten, ausgenommen die „Apologie", Herder und dessen Straßburger Preisschrift über den Ursprung der Sprache. Außerhalb der logischen Reihe von Hamanns Schriften stehen und lediglich um die Druckgeschichte der „Philologischen Einfälle" drehen sich: 1772 „Bittschrift an die Loge", 1772 „Selbstgespräch", 1773 „An die Hexe zu Kadmonbor". Das zweite war die Gruppe kirchen-

„Denkwürdig-
keiten"
und „Wolken"

„Kreuzzüge"
und „Essais"

Die Sprach-
schriften

geschichtlicher Schriften: 1773 „Beilage zu Denkwürdigkeiten", 1774 „Prolegomena über die neueste Auslegung der ältesten Urkunde", 1775 „Hierophantische Briefe". Die „Prolegomena" stimmten begeistert Herder zu, die „Briefe" wandten sich gegen Starck. Das dritte war die Gruppe der Mysterienschriften. Mit Nicolai rechneten „Zweifel und Einfälle" 1775 ab, ein ironisches Selbstbildnis Hamanns auf dem tiefen Hintergrunde des Mysteriums der Trinität. „Sibylle über die Ehe" 1775, ein Hochzeitsschriftchen für den Verleger Johann Friedrich Hartknoch, betrachtete das Geheimnis des Geschlechts im Zusammenhange mit der Trinität. Der unvollendete Essay „Schürze von Feigenblättern" 1777 gibt den letzten Einblick in das verschlossene Innere von Hamanns Kerngedanken: das Geschlecht die Feuerwurzel der Welt. Das vierte sind die Schriften über Vernunft und Offenbarung. „Konxompax" 1779 richtet sich gegen Starck und Lessing, indem Hamann die Frage Menschwerdung Gottes—Vergottung des Menschen gegen die alten und neuen Mysterien aus der Offenbarung beantwortet. „Zwey Scherflein" 1780, im wesentlichen gegen Klopstocks „Otographie", das ist Schreibung nach dem Gehör, münden bereits in die Erwartung der letzten Dinge und weisen auf den „neuen Menschen". Nur ein Zwischenspiel war Hamanns Übersetzung von Humes Dialogen über die natürliche Religion 1780, die er zusamt einer endgültigen Abrechnung mit Starck herausgeben wollte. Aus dieser preisgegebenen Schrift entwickelte sich die „Metakritik" 1784 gegen Kants „Kritik der reinen Vernunft" sowie „Golgatha und Scheblimini" 1784 gegen Mendelssohns „Jerusalem". Hamann war von der Genesis ausgegangen, von der Herkunft des Lebens, der Sprache, der Vernunft aus dem Geschlecht, dem zeugenden Wort. Nun war er bei dem Verstummen des Lebens, der Sprache, der Vernunft in der Endschaft des Logos angekommen, in der Parusia. Hamanns letzte Schrift „Entkleidung und Verklärung" 1786 bezieht sich nur anläßlich auf die Besprechung, die Nicolais „Allgemeine deutsche Bibliothek" von Hamanns „Golgatha und Scheblimini" gebracht hatte. Tatsächlich gibt sie Rechenschaft von Hamanns Leben und Wirken. Sie ist persönliche Vorbereitung auf die Ankunft des Herrn, Rüstung auf die Parusia. Hamann hatte sein Leben lang gegen Friedrich II. als den Inbegriff des Zeitgeistes und als die machtgekrönte Vernunft gekämpft. Hamanns letzte Schrift war in diesem Kampfe das letzte Gefecht. „Entkleidung und Verklärung" war im Todesjahr Friedrichs II. der apokalyptische Nachruf auf das Zeitalter des Königs.

Johann Georg Hamann hat auf sein Zeitalter unermeßlich eingewirkt. Diese Wirkung ist zum geringeren Teil von seinen Schriften, zum entschei-

Die kirchen-geschichtlichen Schriften

Die Mysterien-schriften

Hamanns „Neuer Mensch"

„Entkleidung und Verklärung"

denden durch seine Persönlichkeit, Briefe und Freunde ausgegangen. Hamann hat in den Denkformen und in den Begriffen des Hellenentums philosophiert, des Hellenentums von Sokrates über Paulus und Johannes bis zu den Kirchenvätern. Seine Lehre ist diese. Alles Lebendige ist ein Leib. Leben kommt nur aus Leben. Leben entspringt durch das zeugende Wort aus dem Geist. Alles Leben stammt durch das Geschlecht aus dem dreieinigen Gott. Durch das Geschlecht sind Leben, Sprache, Vernunft eines und dasselbe. Sie sind Logos und Pneuma. Alle Erkenntnis ist Offenbarung und am Anfang aller Erkenntnis steht im Sinne David Humes der Glaube. Offenbarung ist alles, was uns gegeben ist und was uns „anspricht". Diese Offenbarung geschieht dreifältig: durch die Natur, die Geschichte, die Schrift. Der Baum im Garten ist die selbstherrliche Vernunft, die, über die Grenze der Menschheit hinausdringend, das zeugende Wort in ihre Macht zu bringen sucht. Genie aber ist Teilhaberschaft am schaffenden Wort. Alles Erkennen und Schaffen ist Vermögen, das dreifache Buch der Offenbarung zu lesen. Der Schrift liegt als gemeinsame Wissensquelle aller Völker die älteste Urkunde der Uroffenbarung voraus. Am kostbarsten ist, was dieser Uroffenbarung am nächsten steht. Und ihr am nächsten stehen Sprache, Mythus, Dichtung, die zusammen uranfänglich eins sind. Ihr Ursprung und ihr Wesen sind göttlich, das heißt vernunftmäßig nicht erkennbar. Sprache, Mythus, Dichtung stehen außerhalb der Vernunft und selbstherrlich über deren Regeln. Sprache, das ist Dichtung, das ist Kunst, sind ihrer Natur nach Bild und Handlung. Durch die Genesis geht es über die Menschwerdung Gottes zur Erlösung und von der Erlösung zur Vergottung des Menschen in der Parusia. Wie sich vom Anfang der Tage her das Geschlecht des Logos in Leben, Sprache, Vernunft entfaltet, so wird das Geschlecht durch Verstummen von Leben, Sprache, Vernunft wieder aufgehoben durch den Rückzug des Logos am Ende der Tage. Hamanns Philosophie ist die Philosophie des Logos, des Lebens, des corpus mysticum von Gott und Mensch.

Kant und Hamann müssen einander seit spätestens Juli 1756 gekannt haben. Sie sind seit 1759 bis zum Sommer des Abschieds 1787 miteinander häufig und zu Zeiten sehr vertraulich umgegangen. Beiden ist um annähernd dieselbe Zeit von England das erschütternde Erlebnis gekommen, das ihnen das Antlitz nach vorwärts und auf den rechten Weg gekehrt hat. Sie haben einander an wichtigen Abschnitten ihres Lebens geholfen. Sie haben in eigener Sache und schließlich über den gemeinsamen Schüler Herder hinweg um dessentwillen und also um ihr eigenes Selbst die Waffen gekreuzt, daß es allen dreien Ehre machte, den anderen zum Gegner zu haben.

Immanuel Kant, 1724 bis 1804, stammte durch den Vater aus einer schot- *„Das Gesetz in mir"* tischen Familie. Die mütterlichen Vorfahren kamen aus Nürnberg. Kant ist einen geraden Weg gegangen über das Königsberger Friedrichskolleg durch die Albertus-Universität und über eine Hauslehrerstelle zu einer akademischen Kanzel. Nach seiner Erstlingsarbeit „De igne" 1755 hielt er Vorlesungen über Mathematik und Physik, entwickelte seine Lehre von der Entstehung der Weltkörper durch den kreisenden Schwung, ging zu völkerkundlichen Vorlesungen über und hatte 1765 an den Schriften David Humes *Kants Erlebnis an Hume* jenes umwandelnde Erlebnis, das ihn zunächst in Zweifel an der bisher gültigen Philosophie stürzte und ihm dann den Weg zu seiner eigenen Entdeckung ebnete. Erst 1770 erhielt Kant den wirklichen Lehrstuhl für Logik. Er stand im siebenundfünfzigsten Lebensjahre, als er 1781 sein Buch der Bücher „Kritik der reinen Vernunft" erscheinen ließ.

Kant wollte nicht eine erlernbare Philosophie, sondern das Philosophieren lehren. Er hat seine Art zu philosophieren kritisch oder transzendental genannt und meinte damit: meine Erkenntnis wendet sich nicht den Gegenständen selber zu, sondern der Art, wie wir sie erkennen können, den Begriffen, die wir von den Dingen haben. In diesem Sinne war es gemeint, wenn er sagte, die Erkenntnis könnte sich nicht nach den Gegenständen, die Gegenstände müssen sich nach unserer Erkenntnis richten. Da er also von den Begriffen ausging, war seine Philosophie idealistisch. Sie folgte hierin den Fußtapfen, die Plato, Descartes, Leibniz auf dem Weg des europäischen Denkens hinterlassen hatten. Kants Gedanke darf nicht dahin ausgelegt werden, als hätte er das wirkliche Dasein der Dinge außerhalb des Menschen bezweifeln wollen. Kants Denkweise geht demnach auf jene Art der Erkenntnis, die „a priori möglich sein soll". Ihn bewegt nicht die Frage, wie unsere *Die reine Vernunft* Vorstellungen von den Dingen außer uns erstmalig, das heißt geschichtlich und psychologisch entstanden sind. Ihm kommt es allein auf diejenigen Erkenntnisse an, deren wir uns „von vornherein" — a priori — gewiß fühlen, weil sie nicht von all dem abhängen, was uns von außen her „anspricht", sondern allein von den nicht weiter ableitbaren Grundtatsachen unseres Bewußtseins. Um zu diesem „Vonvornherein" vorzudringen, muß unsere Vernunft von all dem „gereinigt" werden, was sie der Überlieferung, der Erfahrung, den Sinnen verdankt. Das ist seine gereinigte, seine „reine" Vernunft. Dieses Apriori-Denken nannte er metaphysisch im Gegensatz zu der Erkenntnis, die auf die psychologisch-historische Entstehung unserer Vorstellungen gerichtet ist. Mit solchen von aller Erfahrung gereinigten Apriori-Sätzen glaubte Kant die Grundlage aller Wissenschaft und menschlichen

Kultur gefunden zu haben. Denn wir selbst sind es, die dieses Apriori in die Dinge legen. Der Gegenstand von Kants kritischem Verfahren ist die gesamte wissenschaftliche, sittliche, künstlerische Erfahrung der Menschheit. Denn allerdings ist Kants Erkenntnis auf das Apriori gerichtet, das aller Erfahrung „vorhergeht", doch in keiner andern Absicht als durch Erkenntnis dieses Apriori die Erkenntnis der Erfahrung erst möglich zu machen. Mit dieser Art des Verfahrens hat Kant den Grund gelegt zu seiner Naturlehre, seiner Sittenlehre, seiner Kunstlehre.

Das Drama Hamann/Kant Hamann und Kant müssen in Beziehung aufeinander verstanden werden. Zweimal sahen beide Männer einander in dramatischen Auftritten gegenübergestellt, wie nur das Schicksal sie zu fügen vermag. Das war 1759, als Kant, Freund Berens zu Gefallen, sich bemühte, Hamann vom Geschäft seiner „wiedergeborenen" Seele weg und auf eine nutzbare Mitarbeit am Diesseits hinzulenken. Gegen diese ihm ungemäße Zumutung schrieb Hamann seine „Sokratischen Denkwürdigkeiten". Und 1784, am Ende seiner Laufbahn, als Hamanns geistige Leistung bereits feststand, als Kant mit seiner „Kritik der reinen Vernunft" 1781 dem Zeitalter soeben ins Bewußtsein zu treten begann, sah Hamann sich das andere Mal Kant gegenüber. Er nahm *„Kritik" und „Metakritik"* gegen Kant das Wort mit seinem Essay „Metakritik über den Purismum der Vernunft". Hamann warf hier die Frage auf nach Rang und Abhängigkeit von Sprache und Vernunft. Im Wort sind Sinnliches und Begriffliches, die Kant geschieden haben wollte, eine Einheit. Die Sprache ist die „Gebärmutter der Begriffe". Sprache ist „die Mutter der Vernunft". Das ganze Vermögen zu denken beruht auf Sprache. Nur auf eine Grammatik der Sprache kann eine Grammatik der Vernunft gegründet werden. Damit hatte Hamann aus seinem Mittelpunkt auf Kants Mittelpunkt zielend den entscheidenden Einwand gegen Kants angeblich von der Erfahrung gereinigte Vernunft gefunden und zugleich den Versuch gemacht, Kants Erkenntnislehre der Vernunft eine Erkenntnislehre der Sprache entgegenzusetzen.

Vernunft und Offenbarung Hamann und Kant standen sicherlich einander gegenüber. Im Sinne der alten Scholastik war Kant Realist, weil für ihn die Begriffe das Wirkliche waren, Hamann aber Nominalist, weil sie dem nur als Worte galten. Nimmt man aber den Gegensatz Idealismus—Realismus, dann war Kant, der von den Begriffen ausging, der Idealist, Hamann aber der Realist, weil er von den Dingen ausging. Bei Kant hieß es: cogito, ergo sum. Bei Hamann hieß es: sum, ergo cogito. Hamann kam es auf den geschichtlich-psychologischen Ursprung unserer Vorstellungen von den Dingen an, Kant aber auf die Begriffe, die unsere Vernunft angeblich vorgängig von den Dingen hat. Da uns

nach Hamann alles „geoffenbart" ist, das heißt uns durch Natur, Geschichte, *Hamann* *und Kant*
Schrift „anspricht", so war alle Sprache und Erkenntnis nichts als Philologie.
Nach Kant trägt unsere Vernunft die Dinge von vornherein begrifflich in sich
und daher ist alle Erkenntnis eine Art höherer Mathematik. Kants Ästhetik
blieb gemäß seiner Philosophie in einer psychologischen Erläuterung des
kunstwerklichen Eindrucks stecken. Hamann dagegen, der alle schöpferische
Tat in die Sprache verlegte und als Sprache verstand, machte im Einklang
mit der älteren Poetik den Dichter wieder zum schaffensmächtigen Nach-
bildner Gottes. „Poesie ist die Muttersprache des menschlichen Geschlechts".
Mit dieser Einsicht und der Folge daraus, daß Sprache, Mythus, Dichtung
urtümlich eins seien, gab Hamann der Poetik und der geschichtlichen Lite-
raturbetrachtung eine neue Richtung. Kant dachte sich die Geschichte welt-
bürgerlich, verstand unter ihr eine ursächlich verknüpfte Entwicklung der
menschlichen Gesellschaft und mußte, weil er an einen ansteigenden Fort-
schritt der Menschheit glaubte, ein rückwärtsliegendes goldenes Zeitalter
leugnen. Auch Hamann war der Ansicht, daß man das Vergangene nur aus
dem Gegenwärtigen und dieses nur aus dem Zukünftigen deuten könne. Ihm
war Geschichte also das Buch, dessen sieben Siegel erst am Ende der Tage
fallen würde. Aber wenn Gott am Anfange der Tage durch das Wort gespro-
chen hat und wenn daher—trotz alten und fortdauernden Offenbarungen —
die ältesten Zeugnisse die Gott nächsten und also treuesten sind, so folgte
daraus in Wirklichkeit ein höherer Geltungswert wie Erkenntniswert des
urzeitlichen Menschengeschlechts. Das goldene Zeitalter liegt am Anfang der
Tage. So begegnen einander Hamann von der Sprachphilosophie und Kant *Sprach-*
von der Naturphilosophie her, die jedem das eigentümliche Feld sind, in der *philosophie* *und Natur-*
Mitte, vor allem im Bereich der Geschichte, zu mancherlei mehr oder minder *philosophie*
übereinstimmenden Grundansichten.

Hamann und Kant haben den geistigen Grund zu diesem größten deut-
schen Jahrhundert gelegt, jeder zum Klassizismus wie zur Romantik, doch
der eine bevorzugt zum Klassizismus und der andere vornehmlich zur Ro-
mantik. Kants Schöpfung der idealistischen Philosophie, die er selber eine
„Revolution der Denkungsart" genannt und mit der Tat des Koppernik ver-
glichen hat, ist über Fichte und Schleiermacher der Romantik zugute gekom-
men. Doch in dieser Richtung bedurfte es immerhin des Durchganges durch
zwei lichtbrechende Prismen. Dagegen hat der Strahl, den Kant auf Schiller *Klassik*
aussandte, unmittelbar getroffen und durch Schiller die klassische Kunst- *und Romantik*
lehre erzeugt. Hamanns hellenistische Philosophie steht zusammen mit Les-
sings aristotelischer Poetik und Winckelmanns griechischer Kunstgeschichte

im Ursprung des neuen deutschen Hellenismus. Durch Herder und durch Hamanns Schriften ist Goethe Hamanns Zögling geworden. Hamanns Erkenntnis „Alles Leben ist Leib" reift einerseits zu Goethes „Geist-Natur" und andererseits zum Organismusgedanken der Romantik aus. Und über Herders Volkslieder, über Reichardts Zöglinge Wackenroder und Tieck ist Hamann der wahre Erzeuger der deutschen Romantik geworden. Er ist der Vater des humoristischen und ironischen Stils der Romantik. Und sein Glaube an die Una Sancta, der in Münster die letzte Bestätigung erfahren hat, ist im romantischen Christentum wirksam geworden. Seine ars sacra ist die Kunstfrömmigkeit der deutschen Romantik.

Der kategorische Imperativ und die docta ignorantia

Man kann weder berechnen noch ermessen, wie tief das Denken, Meinen, Empfinden des deutschen Volkes durch Hamann und Kant verwandelt und gelenkt worden ist. Doch wieviel Dichtungen des kommenden Zeitalters auch vom Pneuma dieser beiden Männer durchweht sein mögen, unwägbar bleibt das sittliche Beispiel, das von ihnen ausstrahlte. Kants kategorischer Imperativ und Hamanns docta ignorantia, in der das sokratische „Erkenne dich selbst" und die paulinische „Torheit des Evangeliums" einander begegnen, sind der faßlichste Ausdruck höchster Sittlichkeit im Handeln wie im Erkennen. Durch Hamann und Kant ist Königsberg eine moralische Macht geworden.

Der Dolmetsch

Hamann und Kant hatten einen gemeinsamen Schüler. Das war *Johann Gottfried Herder*, 1744 bis 1803, aus Mohrungen und von mitteldeutscher Herkunft. Seinen wunderlichen Lesehunger stillte der Knabe in der Bücherei des Pfarrers Sebastian Friedrich Trescho, den auch Hamann kannte. In Königsberg wurde er 1762 der Schüler Hamanns persönlich und amtlich Kants. Herders unmittelbarer Umgang mit den zwei Männern wurde bald menschlich warm und begann die Abstände des Alters und der Lebensstellung zu verwischen. Kant faßte rasch eine hohe Meinung von dem schwärmerisch teilnehmenden Jüngling. Und Hamann umfing den Anschmiegsamen mit

Herder und Hamann

mehr mütterlicher als väterlicher Zärtlichkeit. Bei Hamann war damals die hohe Zeit der inneren Sammlung, da seine Autorschaft ruhte, bei Kant die Zeit des Ringens um den kritischen Gedanken, beide also in jenem Zustande, da sie auf einen jungen Mann, der wie Herder die Gabe, sich anregen zu lassen, in so hohem Maße besaß, unendlich einwirken konnten. Was beide Herdern in dieser einzigartigen Lage gaben, widersprach sich so wenig wie nur irgendeinmal in ihrem gleichlaufenden Dasein. Herder hat denn auch, als er 1764 Lehrer an der Domschule zu Riga und später Prediger geworden war, seine beiden ersten Bücher aus dem gemeinsamen Geiste seiner Lehrer geschrieben. Das waren 1766/1767 „Fragmente über die neuere deutsche

Literatur" und 1768/1769 „Kritische Wälder". In diesen ersten Urkunden
einer neuen Literaturkritik wurde von Kant her das analytische Verfahren
der werdenden deutschen Philosophie und von Hamann her das nachzeu-
gende, auf den Geist eines Buches gerichtete Schaffen fruchtbar. Doch wenn
man auf den Gedankengehalt der zwei Schriften sieht, so überwog bereits
Hamanns Mitgabe. Denn der große Gegenstand der „Fragmente" lautete: *„Fragmente"*
und „Wälder"
Sprache als Grundlage der Literatur. Schon ist der Kerngedanke von der
ursprünglichen Einheit Sprache-Mythus-Dichtung aus Hamanns Anregungen
entwickelt. Schon geht es um die morgenländische Dichtung. Schon fallen die
ersten Hinweise auf das Volkslied. Herder wehrt sich gegen den Humanis-
mus und fordert eine Erneuerung unserer älteren Dichtung. Und er stellt
das hinaufziehende Wunschbild des Kunstrichters auf, wie er sein soll: ein
Deuter des Kunstwerkes aus allen seinen geschichtlichen Bedingnissen, nicht
aus Regeln, und ein Nachschöpfer des Geschaffenen. Die „Wälder" sind von
kunstwissenschaftlicher Art. Hier geht es in Hamanns Weise um Homer, um
Kunstphysiologie und Kunstpsychologie der menschlichen Sinneswerkzeuge.
Herder hat begonnen, Hamanns aphoristische Gedanken in wirksame Form zu
bringen, für sie werbend und kämpfend zu Felde zu ziehen. Sie leiteten eine
Stilbeschreibung Winckelmanns und Lessings ein, wie sie noch kein Deutscher
in deutsche Worte gebildet hatte. Sie stachen Lessing die besten Beweis-
trümpfe weg und nahmen im wesentlichen Winckelmanns Seite. Mehr orga-
nisch als logisch und das mit der sinnvollen Kraft des Wachstums gingen in
Herder nun aus diesen Erstlingsarbeiten die Vorwürfe auf, einer aus dem
vorangegangenen andern und auf den andern folgenden zu. Die Preisschrift
„Über den Ursprung der Sprache" 1770 griff die Doppelfrage vom Ursprung *„Über*
den Ursprung
der Sprache"
der Dichtung in den „Fragmenten" und von der Sinnespsychologie in den
„Wäldern" aus neuer Tiefe auf und stellte dem Philosophen wie dem Ge-
schichtler und dem Seelenkenner eine gemeinsame Aufgabe. Indem Herder
ausführte, daß der Ursprung der Sprache weder auf göttlichen Unterricht
noch auf menschliches Übereinkommen zurückgehen könne, sondern in der
geistigen Natur des Menschen wurzle, in dem, was den Menschen zum Men-
schen mache, da Herder ferner die Entwicklung des Menschen selber, den
Gesellschaftscharakter des Menschen, die Spaltung des Menschengeschlechts
in Gruppen, die einheitliche Entwicklung des Menschengeschlechts als die
Weiterbildungskräfte der Sprache nachwies, hatte er den Grund zur moder-
nen Sprachgeschichte gelegt. Aber die Schrift bedeutete zugleich den Ge-
fahrenpunkt in seinem Verhältnis zu Hamann wie zu Kant. Eine Schrift, die
den göttlichen Ursprung der Sprache bestritt, mußte Hamann als Abfall von

seinen Gedanken empfinden. Sie haben sich freilich freundschaftlich ausge-
glichen. Gegenüber Kant aber gab es weder so noch so ein Zurück. Aber-
mals aus neuer Tiefe griff Herder die Frage Ursprache-Urdichtung in seinen
Arbeiten über das Volkslied auf. An den Merkmalen der ursprünglichen
Sprache, zumal unter Letten und Esten, war ihm das Wesen des Volksliedes
deutlich geworden. An den Liedern Ossians, gleichviel ob sie unecht oder
echt waren, formten sich ihm diese Vorstellungen zu einer Poetik des primi-
tiven Liedes. Lebendigkeit, Sinnlichkeit, lyrische Handlung, das Musikalische
und Tanzmäßige. Gegenwart der Bilder, Gleichmaß der Worte, Silben, Buch-
staben, kraftvoller Gang der Melodie erkannte Herder als artbildende Merk-
male des Volksliedes. Nach einer Vorfassung von 1773 legte er endlich 1778
„Volkslieder" und 1779 seine zwei Bände „Volkslieder" vor, ein umfassendes Liederbuch
aller Völker und Zeiten. Gleichzeitig wandelte sich seine Sprachphilosophie
zur Geschichtsphilosophie, als er während seiner Bückeburger Seelsorgerzeit
zur frommen Gläubigkeit Hamanns zurückfand. Da entstand, abermals ein
weitzielendes Prolegomenon, die Abhandlung „Auch eine Philosophie der
Geschichte". Sie war in Hamanns Sinn eine Streitschrift gegen das aufge-
klärte ungläubige Jahrhundert. Gerechtigkeit für das deutsche Mittelalter,
Herders „Ideen" das war die eine Wirkung dieser kleinen Schrift, die Hamann und Kant be-
richtigte und weit über beide hinausführte. Sie war die Einleitung zu einer
mächtigen geschichtsphilosophischen Anthropologie. Das sind die „Ideen
zur Philosophie der Geschichte der Menschheit", 1784/1787, der schöpfe-
rische Inbegriff von Herders Lebensarbeit. Die Titelbezeichnung „Geschichts-
philosophie" darf nicht überspannt werden. Denn es ist ein Werk der Er-
fahrungswissenschaft, und Herder gab nicht von einer Idee her oder mit
Kant zu reden, analytisch, sondern von der Erfahrung aus oder, abermals
mit Kant, synthetisch das ganze unbegrenzte Bild des Menschen in seinem
menschlichen Kosmos. Herder zeigte in gewaltigem Stufenbau den kosmi-
schen und irdischen Wohnraum des Menschengeschlechts, die Geschwister-
schaft des Menschen mit den übrigen Erdengeschöpfen, die körperliche Anlage
des Menschen, seinen Beruf zur Humanität und Unsterblichkeit, die ganze
Stufenleiter unterhalb und oberhalb des Menschen. Und indem er dann auf
die zwei großen Bildungskräfte der Menschheit, auf Natur und Kultur, hin-
wies, rollte er in einem kraftvoll schreitenden Weltgange die Entwicklungs-
geschichte der Menschheit auf, vom Morgenlande, von den Griechen und
Römern in das neue christliche Europa und ins Mittelalter mit seiner festge-
fügten Hierarchie. Herders „Ideen" und Kants „Kritik" sind die beiden
ebenbürtigen Grundbücher, in denen dieses Jahrhundert sich an seinem

Ausgange erfüllte. Kant lehnte Herders Werk öffentlich ab aus vielen Gründen, die alle eine Quelle hatten. Der Metaphysiker griff ein Werk der Erfahrungswissenschaft an mit Einwänden, die auf diesem Gebiete keine waren, und aus Kenntnissen, die er auf diesem Gebiete nicht hatte. Herder wehrte sich mit der „Metakritik" 1799, die er Hamann abgeborgt hatte. In der „Kalligone" 1800 ging Herder insbesondere gegen Kants Kunstlehre vor, gegen dessen Überspannung der Form, des Verstandes und der Sittlichkeit in Sachen der Kunst. Herder bestimmte seinerseits die Schönheit als tatsächlichen Ausdruck des Seins. Er bestimmte Form und Inhalt, Erhabenes und Schönes als untrennbare Einheit, die Natur als vernunftvolle Künstlerin und den Menschen als höchstes Kunstgeschöpf. Kunst ist das Streben des Menschen, die Natur und sich der Natur ebenförmig zu machen. *„Metakritik und „Kalligone"*

So war durch Herder erst der Gegensatz Hamann - Kant zu der vollen Schärfe Realismus-Idealismus ausgegoren. In diesem Sinne gab es für Herder keinen Ausgleich zwischen dem Geiste Hamanns und Kants. Dennoch ist Herder eine Annäherung der beiden Grundanschauungen insoweit gelungen, als er Natur und Geschichte zu einem einheitlichen Kosmos zu denken versuchte. Überblickt man Herders Gesamtleistung, seine Sprachforschung, die Erkenntnis vom Volk als dem Nährboden der großen Kulturvorgänge, von den Mundarten als dem Brunnen fortströmenden Sprachgeistes; betrachtet man seine Begründung der Volksliedforschung und Volksliedsammlung, seine Schöpfung der geisteswissenschaftlichen Literaturgeschichte und allgemeinen Volkskunde, seine Entdeckung des Mittelalters und des Barocks, die Umwälzung der Erfahrungswissenschaften durch seine „Ideen", seine Kunstlehre und seine genialen Nachdichtungen, seine kunstwissenschaftliche Begründung des Musikdramas, seine umfassende Tätigkeit als Denker, Dichter, Schulmann und Seelsorger, so rücken die beiden Stufen dieser Entwicklung Gottsched und Herder zu naher Beziehung aneinander. Herder hat den allgemeinen kulturpolitischen Arbeitsplan Gottscheds von neuem aufgenommen und über Hamann und Kant empor auf einer höheren Ebene verwirklicht. *Herder, Hamann, Kant*

Die schöne Literatur geht fließend durch diesen weltverwandelnden Vorgang hindurch und nimmt in kaum unterscheidbaren Übergängen seine Farbe an. *Johann George Scheffner*, 1736 bis 1820, aus Königsberg, war ein tapferer Soldat, vortrefflicher Beamter, musterhafter Gutsherr und den Großen dieses Kreises ebenbürtig an umfassender Bildung, weitem Weltblick, strengem Pflichtgefühl. Der Soldat des späten Siebenjährigen Krieges stimmte in zwei Sammlungen seine ungeschulte Leier auf Fridericus, Freundschaft, Frie- *Der Soldat, der Beamte, der Gutsherr*

densspiele. Der Beamte und Gutsherr fand seinen eigentümlichen Stil in erotischen Gedichten von sanfter Empfindsamkeit bis zum Wörtlichen und Zweideutigen. Der zur Ruhe Gesetzte, der Freund Hamanns und Kants, suchte, was er mit beiden dachte, in den Aphorismen auszusprechen, die seit 1802 erschienen: „Gedanken und Meinungen über Manches im Dienst".

Der Bürgermeister von Königsberg

Theodor Gottlieb Hippel, 1741 bis 1796, aus Gerdauen, ist, von starkem Ehrgeiz getrieben und von rücksichtsloser Klugheit gefördert, einen raschen Weg gegangen, der ihn 1780 ins Bürgermeisteramt zu Königsberg führte. Sein seelisches Doppelleben, in dem Sinnlichkeit und Frömmigkeit gleich echt waren, ging fast allen seinen Zeitgenossen über das Gesichtsfeld hinaus. Er

Hippel „Über die Ehe"

bemühte sich mit zwei herkömmlichen Stücken um das Theater. Er gehört mit seinen zwei Büchern „Über die Ehe" 1774 und „Über die bügerliche Verbesserung der Weiber" 1792 zu den Bahnbrechern der Frauenbewegung. Seine dichterische Leistung sind zwei Romane, wenn der Ausdruck Roman hier am Platz ist. Die „Lebensläufe nach aufsteigender Linie" 1778 sind der erste preußische Heimatroman. Er gibt sich alle Mühe, den humoristischen

Der humoristische Roman

krausen, bilderschweren Stil Hamanns mit all seinen abschweifenden, kreuz und quer schießenden Einfällen nachzubilden. Der humoristische Roman der Deutschen geht nicht von Lawrence Sterne aus, dem er nur den Mut zur Gattung verdankt, sondern durch Hippel von Hamann. Denn Hippel hat Hamanns Stil zu einer dichterischen Form gesteigert und diesen neuen humoristischen Stil Johann Paul Richter in Griffnähe gespielt. Die „Kreuz- und Querzüge des Ritters A bis Z" 1793 sind eine Satire auf den Gedanken des deutschen Ritterordens, als dessen Abkömmlinge im freien Spiel der Phantasie die geheimen Gesellschaften der Zeit erscheinen. Sie weitet sich zu einem Spottbilde auf die irrende Ritterschaft des Mystizismus jener Tage überhaupt. Verfassungsrechtliche Fragen um das Verhältnis Preußens zur Berliner Regierung, freimaurerischer Widerstreit gegen die beiden Rosenkreuzer Friedrich Wilhelm II. und dessen mächtigen Berater Johann Christoph Woellner sind der geistige Untergrund des satirischen Zeitbildes.

Königsberger Antinomien

Dieses preußische Zeitalter bietet ein seltenes Schauspiel. Gleichartige und einheitliche Gedanken sind durch Satz und Gegensatz, durch ausgleichende Übergänge in eine reizvolle Handlung verstrickt: der Gedanke von der menschlichen Sprache und von der menschlichen Vernunft; aus der Erlebnisnähe der Urmitbewohner des Landes, die Hamann und Herder, die Kant bis in dessen letzte Jahre gefühlsmäßig wertvoll waren, die Offenbarung des ursprünglichen Volkswesens in all seinen Äußerungen; der Gedanke des Gesetzes, auferlegt oder anerkannt, die Erfahrung, das Denken, das Schaffen

ordnend. Ein fortlaufender und ebenmäßiger Stil, in dem Hamanns und
Kants Lebensgesetz zusammenwirken, beherrscht diese Literatur in solchem
Maße, daß er mannigfache Autorschaftsverwechslungen ermöglichte, ein Stil
gesuchter Verfassermasken. Schließlich war da die Verwandtschaft der Staats-
auffassung und Staatsgesinnung, die in einer durch Herzogtum und König-
tum geschaffenen pruzzisch-protestantischen Denkweise wurzelte. Was im
achtzehnten Jahrhundert Preußen heißt und Preußen geistig ist, hatte sich
um Königsberg zusammengeballt und für sich selber aufgespeichert.

HAMBURG und NIEDERSACHSEN. Hamburg war im siebzehnten Jahr- *Der dritte*
hundert der deutsche Hauptort des Tagesschrifttums geworden. Mitten in *Bildungsherd*
diese Entfaltung wirkte die neue englische Wochenschrift. Die Gesellschaf-
ten, die in Deutschland mittelbar auf dem sechzehnten Jahrhundert weiter-
bauten, trieben in England neues Leben in die regelmäßigen Zeitblätter. In
dieser Umwelt wurzelte Steele, der am 12. April 1709 das Probeblatt seines
„Plauderers" — „The Tatler" — ausgehen ließ. Zusammen mit Addison
arbeitete er dann am „Zuschauer" — „The Spectator" —, der wiederum vom
„Vormund" — „The Guardian" — abgelöst wurde. Das neue Bürgertum des
frühen achtzehnten Jahrhunderts war der Träger dieser Zeitschriftenliteratur.
Zu belehren, die Sitten zu bessern, den Menschheitsgedanken durchzuset-
zen, war der Zweck dieser moralischen Wochenschriften. Hamburg war der
Hafen, wo diese englische Zeitschriftenliteratur gelandet wurde, um von da
an das Binnenland weitergegeben zu werden. Am 31. Mai 1713 erschien das
erste Blatt des „Vernünftlers", an dem der Musiker Mattheson hervorragend *Hamburger*
beteiligt war. Den größten Einfluß auf Deutschland erzielte „Der Patriot", *Wochenschriften*
dessen erstes Blatt am 5. Jänner 1724 ausgegeben wurde. Der geistige Leiter
war Brockes, seine Mitarbeiter Richey und Fabricius. Das Blatt erschien in
4500 Stücken, geistreich geschrieben, erntete selbst in England Erfolge und
wurde in allen deutschen Landschaften nachgeahmt.

Von englischen Gesellschaften waren die Wochenschriften ausgegangen.
Mit Brockes' „Patrioten" mündete die Bewegung in die Hamburger Gesell-
schaft ein. Schon im siebzehnten Jahrhundert waren zu Hamburg Sprach-
gesellschaften gegründet worden. Da kreuzten sich niederländische und süd-
deutsche Bestrebungen. Mitglied der „Teutschgesinnten Gesellschaft" —
auch „Rosenzunft" —, die 1643 Philipp von Zesen ins Leben gerufen hatte,
war Jost van den Vondel. Brockes und seine Freunde traten 1715 mit ihrer
„Deutschübenden Gesellschaft" hervor. Ihr folgte 1725 die „Vaterländische
Gesellschaft" des gleichen Kreises. Man führte im Rundgespräch, das sofort
zu Buch genommen wurde, Untersuchungen über Kunstlehre, Sprachlehre,

Wörterbücher und suchte sich über neue Bücher zu einigen. Man wollte sich gemeinschaftlich in Sprachgebrauch und Federführung üben.

Das irdische Vergnügen in Gott

Der führende Kopf also bei all diesen Bestrebungen war *Barthold Brockes,* 1680 bis 1747, aus einem alten Hamburger Geschlecht. Er war in Halle und auf weiten Reisen gebildet. In Leiden erwarb er die akademischen Grade, der letzte bedeutendere deutsche Dichter, der in den Niederlanden seine Bildung abschloß. Sehnsüchtig erwartete Ehren wurden dem Manne zuteil, der im Behagen seiner Vaterstadt das vornehme Leben eines wohlhabenden Weltmannes führte. Er wurde 1720 Senator, mit staatsmännischen Sendungen betraut und konnte so nach allen Seiten wirken. Ihm schwebte so etwas wie eine Vereinigung aller Künste zu einheitlicher Wirkung, der Dichtung, der Musik, der Malerei vor. Unwesentlich war 1715 seine Übersetzung von Marinos „Kindermord". Denn unterdessen hatte die englische Literatur zu entscheidenden Taten ausgeholt. Während John Miltons Gedicht „Das verlorene Paradies" 1655 die fernen Ursprünge der Menschheit ins Licht gestellt hatte, nahm James Thomson an den Wegen, die man täglich geht, bisher übersehene Wunder wahr. Seine Gedichte „Der Winter" 1726 und „Die Jahreszeiten" 1730 knüpfen ganz neue Beziehungen zwischen dem Herzen und der Natur. Sie kamen Brockes erst allmählich zugute, als er 1721/1748 seine neun Bücher „Irdisches Vergnügen in Gott" erscheinen ließ. Hier war Gott als ein Werkmeister in allen Gebilden seiner Schöpfung, verständig und mit dem nachprüfenden Auge des Sachkenners, bewundert. Hier war es beinahe gelungen, aus Bild und Ton ein Ganzes zu machen. Denn diese unglaublich wahr und fast auf holländisch gemalten Bilder von Blumen und Tieren wurden wie Kantaten eines groß angelegten „Lesekonzerts" vorgetragen. Dieses „Irdische Vergnügen" war das, was Harsdörfer mit seinen „Andachtsgemälden" vorgeschwebt hatte. Es war auf die eine Möglichkeit dichterischer Stil der Hamburger Oper.

Der Lebenskünstler

Die andere Möglichkeit dieses Stiles bildete *Friedrich von Hagedorn,* 1680 bis 1754, von einer kunstfrohen Hamburger Familie aus. Zu Jena Hochschüler, Beamter in London und dann zu Hamburg, war Hagedorn ein Lebenskünstler, dem daran lag, den innern Wert des Menschen zu steigern. Er hatte im „Patrioten" mit Gedichten begonnen. Die Sammlung seiner Oden und Satiren 1729, seiner Fabeln und Erzählungen 1738 pflegte alles, was der Humanismus aus dem Nachlaß der Antike zu europäischem Gemeingut gemacht hatte. In einer Musikstadt wie Hamburg ist ihm das sangbare Lied zur eigentlichen Ausdrucksform geworden. Seine Erlebnisse gingen so wenig tief, daß sie sich leicht in die flachen und zierlichen Formen füllen ließen.

Nach Inhalt und Form waren Horaz und Anakreon in französischer Umbildung seine Muster. Der Stil des Singspiels war die natürlichste Musik zu diesen leichten Gebilden der Lust und Laune.

Kopenhagen war die Hauptstadt eines deutschen Fürstengeschlechts und eines Staates mit deutschem Bürgeranteil. Aber es waren religiöse und nicht nationale Beweggründe, die Kopenhagen unter Christian VI., 1730 bis 1746, zu einer Stadt deutschen Geisteslebens machten. Der König war pietistisch erzogen und hatte eine pietistisch gesinnte Frau. Er wollte das Reich Gottes auf Erden verwirklichen und holte sich seine Mitarbeiter aus den pietistischen Kreisen Deutschlands. Der allmächtige Staatsmann des Königs Johann Hartwig Graf Bernstorff, 1712 bis 1772, der 1750 die Geschäfte übernommen hatte, führte diese Kulturpolitik des Königs durch. So kamen zahlreiche Deutsche nach Kopenhagen, die hier eine Kleinwelt der deutschen Bildung und Dichtung aufbauten, so Johann Elias Schlegel, der Mitschöpfer des dänischen Nationaltheaters, so der Hofprediger Johann Andreas Cramer, so der Schulmann Johann Bernhard Basedow. Und so wurde *Friedrich Gottlieb Klopstock* 1751 nach Kopenhagen berufen, der Schöpfer des „Messias", der erwartete große religiöse Dichter. Er wurde der geistige Vertreter dieses deutsch-dänisch-norwegischen Staates, außer allem Wettbewerb von dänischer oder norwegischer Seite. Klopstock war viel um den König, sein Reisebegleiter und Ratgeber in geistigen Dingen, nicht Gast und nicht Bürger, sondern der Dichter ebenbürtig neben dem König, Sinnbild der Rangerhöhung, die durch ihn der Dichtung geworden war. Von Hamburg brachte Klopstock 1754 Meta Moller als seine Frau mit nach Seeland. Der Dichter hatte in Kopenhagen keine andere Aufgabe als diese eine königliche, sein Gedicht, den „Messias" zu vollenden. Das Gedicht war auch der Inhalt dieser Ehe. Als Meta Moller 1754 dem Dichter an ihrem ersten Kinde hinwegstarb, ging sie als Cidli in die Unsterblichkeit der Dichtung ein. Auf Kosten des Königs wurde 1755 die erste Hälfte des Epos gedruckt und 1764 konnte der dritte Band erscheinen.

Unter den Eingeborenen führte *Heinrich Wilhelm von Gerstenberg*, 1737 bis 1823, aus Tondern, die Sache der deutschen Dichtung. In Jena war dem Hochschüler ein lyrisches Bändchen, „Tändeleien", gelungen. Lessing in seinen Literaturbriefen hatte die Zeitschrift der Kopenhagener Freunde, den „Nordischen Aufseher", in seiner unbekümmerten Art angegriffen. Gerstenberg hatte sich 1765 als Herausgeber einer dänischen Zeitschrift geübt und wollte nun 1766 mit einer deutschen dem ganzen deutschen Kopenhagen Stimme verleihen. Das waren seine „Briefe über Merkwürdigkeiten der Lite-

<div style="text-align: right;">

Kopenhagen
Klopstock

Klopstocks
Messias

</div>

*Die
Kopenhagener
Literaturbriefe* ratur". Sie sind die wirkungsvollste Zeitschrift des Jahrhunderts. Denn ihr Geist verdichtete sich zur Literaturbewegung der siebziger Jahre. Die Abhandlung über das Lied kam zu dem glücklichen Ergebnis, daß Lied und lyrische Dichtung getrennt werden müßten. Die Briefe 14 bis 18 stammen von Gerstenberg und handeln über Shakespeares Wesen. Der unbekannte Verfasser des zwanzigsten Briefes vollzog die gedankliche Wendung vom Pietismus über Pyra und Klopstock zur Literaturbewegung der siebziger Jahre. In Homer hatte Lessing den berechnenden Künstler gesehen. Für den Verfasser dieses Briefes ist er das Genie, das aus göttlicher Eingebung schafft. Als Lessing im „Laokoon" die beschreibende Dichtung verwarf, hatte er Klopstocks Stil treffen wollen. Hier wurde zugunsten des „Messias" das rechte Wort gefunden: „Stoff der Dichtung sind Handlungen und Empfindungen", mit starkem „Ton" auf dem „und". Verse seien kein unerläßliches Merkmal der Dichtung. Neben dem Wunschbild Homer wird die Botschaft Shakespeare verkündet. Der Engländer sei nicht als Tragiker, sondern als Darsteller der sittlichen Natur zu beurteilen. Gerstenberg war der erste, der vor Goethe und Herder Shakespeares Wesen verständig zu deuten wußte. Hier fiel das große Wort, ein Vorwurf auch an Herder: „Warum Shakespeare

*Ossian
und die Edda* mit den Griechen vergleichen?" Eine Feier von Percys „Reliquies of ancient English poetry" 1765, eine Feier Ossians, die freilich auch Bedenken nicht zurückhielt, schlossen den Kreis der ungewöhnlich fruchtbaren Gedanken. Peder Hansen Resenius hatte 1665 die jüngere Edda und Bruchstücke der älteren herausgegeben. Dazu kam die redende Kraft des Bodens. Auf Cramers Gut Sandholm lag ein Hünengrab, das die Bildkraft der Jungen und Alten erregte. Und Gerstenberg hatte wie auf Ossian so auf die „Kjaempe Viiser" und die altnordische Runendichtung gewiesen. Damit ging nun die skandinavische Dichtung in der deutschen auf. In seinem „Gedicht eines Skalden" 1766 ließ Gerstenberg aus Cramers Hünengrab den Geist des Skalden emporsteigen. Es war der erste kühne Versuch, den germanischen Mythus an Stelle des antiken zu setzen. Die „Ariadne auf Naxos" von Gerstenberg ist ein gesungenes Trauerspiel. Die Tragödie „Ugolino" 1768 mit ihrer grauenhaften Einheit des Ortes hob eine Szene aus Dantes göttlichem Gedicht aus und formte daran das erste Drama des neuen Jugendstils.

*Auszug aus
Kopenhagen* Der Tod des Dichterkönigs Friedrich V. 1766, die Unglückszeit des willenlosen Christian VII. und seines Lenkers Johann Friedrich Struensee, die Entlassung Bernstorffs 1770 veröcteten diese schöne Welt, ohne sie völlig zerstören zu können. Wie Hamburg einst den Flüchtigen aus den Niederlanden eine Freistatt gewesen war, so wurde die Stadt es nun den Männern, die

erhobenen Hauptes die kaltgewordene Gastlichkeit Dänemarks verließen. Der Staatsmann Bernstorff und der Dichter Klopstock folgten ihren Hausgöttern nach Hamburg. Doch es war ein Umzug in eine fremde Welt.

Denn Hamburg hieß mit der ganzen Einseitigkeit der Kunst Theater, blühendes Diesseits, entgöttlichte Szene, Spiel des Verstandes und die Gesetze des Spiels. Karoline Neuber war es nicht gelungen, die Hamburger Bühne für Gottsched zu gewinnen. Denn der Hamburger *Hinrich Borkenstein* fing das Herz der Stadt mit seinem hochdeutschen Lustspiel „Der Bookesbeutel" 1741 für das Hamburger Volksstück ein. Inzwischen war, ein Ereignis von seltener Art, eine ganze Altersgenossenschaft bedeutender niedersächsischer Schauspieler für ein großes Unternehmen reif geworden: Konrad Ernst Ackermann von Schwerin, Hans Konrad Dietrich Eckhof von Hamburg, Sophie Schröder von Berlin. Ackermann als Unternehmer und Führer der Truppe führte 1765 auf dem Grunde des alten Opernhauses einen Holzbau mit einer stattlichen Bühne auf und gewann dafür eine glänzende Ausstattung. Er spielte mit Erfolg, mußte aber einer Genossenschaft von Geschäftsleuten weichen. Sie pachtete ihm Oktober 1766 sein Haus ab und eröffnete darin am 22. April 1767 das „Hamburger Nationaltheater", das Johann Elias Schlegels Gedanken verwirklichen sollte. Das war die Bühne, der Lessing diente. Gespielt wurden aber zumeist französische Stücke. Nach zwei Jahren war die Herrlichkeit zu Ende. Konrad Ackermann nahm seine Bühne noch 1769 zurück. Die künstlerische Leitung übernahm sein Stiefsohn *Friedrich Ludewig Schröder*, 1744 bis 1816, der nach einer harten Schule ein großer Charakterspieler geworden war. Seit 1774 gab Schröder eine eigene Zeitschrift „Theatralisches Wochenblatt" heraus. Und von 1777 an kann sein Unternehmen als das stehende Theater Hamburgs gelten. Unerhört kam ihm das Glück zu Hilfe. Denn eben als er zu spielen begonnen hatte, ging die Aussaat vieler Jahre und verfrühter Begabungen in der jungen dramatischen Dichtung des Jahrhunderts auf: Wagner, Klinger, Lenz, Leisewitz, Goethe. Es war keine Kunst, daraus einen mitreißenden Spielplan zu machen. Indessen Deutschland war nur die eine Hälfte. Die andere hieß England. In Prag 1776 sah Schröder das erste Stück Shakespeares, den „Hamlet", spielen. Das wurde ihm die letzte Offenbarung. Schlegel und Gerstenberg mit ihren Weissagungen, Lessing mit seinen denkscharfen Ableitungen gingen nun künstlerisch in Erfüllung. Am 20. September 1776 spielte Schröder in seinem Hamburger „Hamlet" den Geist. In rascher Folge ließ er nun die großen Tragödien Shakespeares, vorsichtig erst noch mit gutem Ausgange, und einige Königsdramen über seine Bühne gehen. Eine Tat war gelungen. Das neue

Das Hamburger Volksstück

Das Hamburger Nationaltheater

deutsche und das ewige englische Drama wurden dem deutschen Volke eingespielt. Schröders Hamburger Theater war die führende deutsche Bühne.

*Der
Wiederhersteller
der Dichtung* *Friedrich Gottlieb Klopstock,* 1724 bis 1803, hat von seiner Vaterstadt Quedlinburg bis in seine letzte Heimstatt Hamburg den Gipfel eines jähen Ruhmes überstiegen und überlebt. Quedlinburg, die Lieblingsstadt der sächsischen Kaiser, gab ihm das tiefe nationale Bewußtsein, die Fürstenschule Pforta eine vollkommene humanistische Bildung, der Freundeskreis von Leipzig die Gewißheit seiner dichterischen Sendung, der Besuch in Zürich Geselligkeit, der königliche Hof zu Kopenhagen einen würdigen Rahmen des Lebens, die Stadt Hamburg den letzten Hintergrund, vor dem er sich in der Kunst des Vergessens üben konnte. Klopstock ist ostfälischer Herkunft, ein Erbe niedersächsischer und thüringischer Eigenschaften; niedersächsisch neben anderem seine gemessene und würdevolle Haltung, seine stolze Einsamkeit, sein Sinn für das Weite des Raumes und Gedankens, die nordische Dunkelheit seiner Sprache, das Schwergefügte seiner dichterischen Formen; thüringisch der musische Grundzug, die lyrische Bewegtheit, die Anfälligkeit für Sinnenreiz und Seelenstimmung, das tonkünstlerische Vermögen, das irgendwie alle seine Dichtungen zu heimlichen Musikwerken macht. Klopstocks Werke stehen im Schatten seiner Persönlichkeit, die immer größer gewesen ist als das, was sie schuf, und die zu allen Zeiten den gültigen Wert ihrer Werke verbürgt. Sie stellen sich in vierfacher Gestalt dar: das christliche Heldengedicht, die Oden, die Festspiele, die
„Der Messias" Sprachschrift. Das christliche Heldengedicht „Der Messias" hat zwischen Beginn und Beschluß fünfundzwanzig Jahre durchlaufen, jene zweieinhalb Jahrzehnte, die das deutsche Volk geistig und seelisch völlig verwandelten. Das antike Epos Homers und Vergils sollte in christlicher aber auch in deutscher Gestalt und durch den höchsten Vorwurf, der denkbar war, erscheinen. Zwischen den Gebilden eines Stammes und eines Volkes, dem altsächsischen „Heliand" und dem neusächsischen „Messias" lassen sich manche Gemeinsamkeiten des Gefühls und des Stils erkennen, die sächsische und deutsche Gemeinsamkeiten sind. In Klopstocks Gedicht scheint immer wieder Umriß und Farbe der heimatlichen Harzwelt durch. Was aber ist sein Stil? Es ist der Stil einer musikalisch empfundenen Dichtung. Der Dichter sucht das Überweltliche und Übersinnliche nicht für das Auge bildhaft, sondern für das Gehör der Seele durch Gefühl und Stimmung gewissermaßen musikalisch darzustellen. Seine „Bilder" vergleichen Erdachtes mit Erdachtem, Unschaubares mit ebenso Unschaubarem, ja das Sinnliche mit dem Unsinnlichen. Sicherlich war Klopstocks sechsfüßiger Vers eine große künstlerische Lei-

stung. Aber der Vers Homers ist der Vers des epischen Stiles, der sinnlichen *„Oden"*
Anschauung, der gleichmäßig und gemessen strömenden Handlung und
Rede. Klopstocks Vers aber ist gezwungen, ratloser Unruhe standzuhalten,
mit Katarakten zu stürzen, mit deutender Gebärde auf Dinge zu zeigen, die
kein Auge wahrzunehmen vermag. Klopstocks Gedicht, das ist die Sonne
Homers in frühem Aufgange. Sie hängt tief und rot über dem Gesichtskreis.
Aber siehe, sie leuchtet noch nicht. Die Oden Klopstocks, die römische Form,
die er der deutschen Lyrik gefunden hat, waren lange in unechten Drucken
verbreitet, gingen als kostbare Abschriften von Hand zu Hand, bis sie 1771
in wahrhaft monumentaler Gestalt gedruckt wurden. Hier ist der Mensch in
seiner ganzen vornehmen und zuchtvollen Haltung. Seine Themen sind die *Klopstocks*
urtümlichsten, die unwandelbaren, die ewigen der Menschheit: Freundschaft, *lyrischer Gesang*
Liebe, Gott, Natur und Vaterland. Durch sie vollzieht Klopstock die preis-
würdige Verwandlung der deutschen Nation von den erotischen Handgreif-
lichkeiten des Rokokos zu der ernsten Empfindung des Herzens, von der
kühlen und matten Eleganz bezopfter Kleinmeister zum Enthusiasmus des
Herzens und Wortes. Klopstocks Oden der Liebe wie der Freundschaft sind
mit bewegter Zartheit, aber mit farbiger Buntheit wie auf Glas gemalt, dem
Schein der Sonne entgegen. Das schamhaft junge Nationalgefühl empfand
dieses unsinnige Verhältnis von Geschlecht zu Geschlecht als dem deutschen
Wesen gemäßer und der deutsche Pietismus setzte gern erotische und reli-
giöse Stimmungswerte für einander. Eros und Sophia verschwimmen zu
einem Antlitz. Die helldunklen Worte einer Sinnlichkeit, die nichts als Seele
ist, hat Klopstock mit unnachahmlicher Sicherheit getroffen. Gleichermaßen
zeitbetont ist sein Erlebnis der Gottnatur. Denn es mischt in transparenter
Schale die fromme Leidenschaft des Gottesdienstes mit einem Naturgefühl
von sportlicher Sachlichkeit. Gott fährt wahrhaft königlich im prächtigen
Aufruhr des Gewitters daher und erklingt aus dem beschwingten Hochgefühl
des Eislaufes. Wenn Klopstock zuletzt sein Naturerlebnis ebenso wie seine
Freundschaften und seinen Gottesdienst mit den Worten eines noch dunkel
verstandenen nordischen Mythus reden ließ, seine vaterländischen Oden be-
durften dieser Bestätigung aus dem nordischen Mythus nicht, weil sie aus
der vollen Kraft der Seele das Bekenntnis eines nationalen Weltbewußtseins
sind. Klopstocks vaterländische Oden sind der letzte Ausdruck jener kaiser-
lichen Reichsgesinnung, die in den vergeblichen Hoffnungen auf Josef II. un-
widerruflich ausbrannte. Klopstock ist einer der größten lyrischen Meister
der Deutschen aller Zeiten, der den Wettlauf mit dem Herold griechischer
Sporthelden, mit Pindaros ebenso aufnahm, wie mit Horatius, der wieder-

um die Stimme des bäuerlichen Gewissens Roms und der Sänger des augu-
steischen Kaisertums gewesen ist. Klopstock beherrscht alle Rhthmen von
der durchgegliederten Horazischen Ode bis zur schlichten Einfachheit der
deutschen Strophe. Er beherrscht mit der gleichen Sicherheit die Archi-
tektur des Versgefüges wie die Melodie der Worte. Klopstocks drei Her-
mannspiele sind alle wechselweise aufeinander bezogen und zum Teil von

*Das nationale
Naturtheater*
den gleichen Personen getragen. Die Stücke sind nicht in Akte gegliedert.
Sie bilden lose Szenen, die durch Chorgesänge umgrenzt sind. Die Schlacht
Hermanns umbrandet von außen die Bühne. Sie wird durch Boten und
Zuschauer geschildert und nicht auf offener Szene gespielt. Klopstock dachte
an eine Freilichtaufführung. Er strebte einen monumentalen Stil an. Er
wollte mit ihnen den Deutschen geben, was die Griechen an ihrem Theater
besessen hatten. Prosarede und Gesangstück klingen in ihnen zusammen.
Von Gluck, der mit dem Entwurf zur Vertonung starb, in Musik gesetzt,
wären sie das große künstlerische Ereignis des achtzehnten Jahrhunderts
geworden. Das sind die Weihefestspiele, in denen zum erstenmal der Ge-
danke des nationalen Musikdramas anschlägt, ein Gedanke, den Herder
aufgriff und prophetisch Richard Wagner zuspielte. Der Dichter fühlte sich
als Treuhänder und Sachverwalter der Nation. Er sah sich berufen zum Ge-

*„Die deutsche
Gelehrten-
republik"*
setzgeber der geistigen Gemeinschaft aller Deutschen. „Die deutsche Gelehr-
tenrepublik" 1774 ist der Inbegriff alles dessen, was Klopstock erstrebt hat.
Sprache bedeutet ihm den geistigen Bestand der Nation und die Gewähr
ihres unsterblichen Lebens. Er hat, wobei nicht einmal seine vereinfachte
und lautgetreue Rechtschreibung ausgenommen werden braucht, einsichts-
voll und klug über Fragen der Sprachgestaltung geschrieben. Nicht anders
als Leibniz wollte er durch eine Akademie der Künste und Wissenschaften,
der eine Nationaldruckerei angegliedert werden sollte, die kaiserliche Haupt-
stadt des Reiches zum geistigen Mittelpunkt der Nation machen. Der mäch-
tige Entwurf blieb im Gedanken stecken. Also führte er ihn mit seiner „Ge-
lehrtenrepublik" im Gedanken aus. Die Gesamtheit aller Deutschen, die
schaffend und empfangend das deutsche Geistesleben tragen, wird als staat-
liches Gemeinwesen gedacht, das seine eigenen Gesetze, seine Beamten und
Landtage hat. Mit unerbittlicher Strenge gilt das Gebot, die Sprache rein zu
halten. Dem Deutschen wird das Ziel gesetzt, aller Wissenschaften, Erfin-
dungen und Entdeckungen Herr zu werden. Denn Klopstock sah die Her-
aufkunft eines welterschütternden politischen und geistigen Umsturzes. Es
werden sehr lebenswirkliche Vorschläge gemacht: für ein deutsches Wörter-
buch und eine deutsche Sprachlehre, für Völkerkunde und Literaturge-

schichte. Man braucht die mannigfaltigen Wunderlichkeiten dieses Buches nicht zu verteidigen. Es bleibt ihm das volle Eigentum des ersten Gedankens in den wichtigsten Lebensfragen der Nation. Klopstock war der erste Dichter, der die Umbildung des Gemeindeutschen aus Prosakunst in eine Dichtersprache vollendet hat. Es war eine Sprache des leidenschaftlichen Gefühls, die verstandesmäßige Hilfe verschmähte, eine Sprache des edelsten, neuesten, unerhörten Wortes, eine Sprache des Ausrufes und Anrufes, heilige Freiheit im Binden und Lösen der Sätze und Satzglieder. Der Dichter hat das Recht der persönlichen Sprachschöpfung wieder an sich genommen.

Konnte ein Mann wie dieser Erben haben? Der Edelmann von Natur, der *Jünger* Grieche aus deutscher Gesinnung, der Diener des Herrn durch die dichterische Sendung.

Der erste und ihm persönlich nächste war der Edelmann *Friedrich Leopold* *Stolberg* *Graf zu Stolberg*, 1750 bis 1819, aus Bramstedt, der mit seinem Bruder in Dänemark unter Klopstocks Augen aufgewachsen war. Er hat als der erste wirkliche Dichter die Bücher der Juden und Griechen übersetzt, das Buch Hiob, die attischen Dramen und 1778 seine deutsche Ilias erscheinen lassen. Er hat ein großes Epos, „Die Zukunft", entworfen und begonnen, eine Gesamtschau der menschlichen Geschichte. Wahrhaft beerbt hat Stolberg seinen väterlichen Freund und Erzieher in der hohen Kunst des lyrischen Gedichts. Der Stil der antiken Ode ist in seinen Händen zarter und feiner geworden, menschlich wärmer und dem Alltag näher. Diese Ode braucht nicht mehr nur erfühlt, sie kann verstanden werden. Indessen er geht mit der Ode sparsamer um. Das Lied ist der geläufige Ausdruck seiner Stimmung. Die „Hymne an die Erde" preist mit der Leidenschaft eines Gottesdienstes die ewige Jugend alles Lebens. Stolberg ist der Dichter eines kosmisch-erotischen, kosmogonisch-sinnlichen, gottnatürlichen Weltgefühls, das wie aus nordischer Dunkelheit aufbricht.

Der zweite stand Klopstock nach Lebenshaltung und Seelenstil am fern- *Voß* sten und ist doch im wirklichsten Sinne sein epischer Schüler gewesen. *Johann Heinrich Voß*, 1751 bis 1826, aus Sommersdorf in Mecklenburg, war noch der Sohn eines Leibeigenen. Früh hing das Ohr des Knaben an „allem, was klangt und klappte". An der Göttinger Hochschule wurde er Stolbergs Freund, mit dem er um den deutschen Homer zu wetteifern begann. Und er wurde der Freund des Matthias Claudius. Voß hat sich dann aus dem Vernunftstolz des aufgeklärten Bürgers eines aufgeklärten Jahrhunderts wieder von Stolberg und Claudius getrennt, den beiden gläubigsten Menschen ihres Zeitalters. Voß war kein Urdichter. Aber er hatte glückliche Stunden, in

denen er aus dem derben Werkstoff seiner bäuerlichen Seele das Leben sei-
ner Heimat zu irdenen Idyllen formte: „Der Morgen", „Der siebzigste Ge-
burtstag", „Luise". Voß war kein Urdichter aber ein begnadeter Nachdich-

Der deutsche Homer ter. Er hat die englischen Bemühungen um ein neu verstandenes Griechen-
tum aufgefangen und daraus den Deutschen ihren deutschen Homer ge-
schaffen. In Ottendorf, vor seinen Augen die rollenden Fluten, brachte er
den Kummer der Sehnsucht seines weitverschlagenen Helden in deutsche
Verse und Seeluft würzte ihm die Arbeit. Zu Hamburg kam die deutsche
Odyssee 1781, zu Altona kamen 1789 beide Gedichte Odyssee und Ilias zu-
sammen heraus. Ohne Klopstock kein deutscher Homer. Denn von Klopstock
stammte der Mut zum großen Epos und der antike epische Vers. Voß über-
setzte Satz für Satz, Vers für Vers, Wort für Wort. So wurde er also, befugt
durch die hellenenverwandte Sprachnatur des Deutschen, zum Schöpfer des
Mittelwortes, dieses kostbaren Sparers, und zum Schöpfer des Beiwortes,
dieses köstlichen Verschwenders. Zuletzt legte er mit altertümlichen und
mundartlichen Worten über den frischen Guß seines Werkes jene künstliche
Patina, die ihm den edlen Mattglanz des Altertums gab. Im deutschen Ho-
mer von Voß verbanden sich eine urtümliche innere Verwandtschaft zwischen
althellenischem und niederdeutschem Wesen, altsächsisches Bauerntum,
nordländische Landseenatur, göttingische Sprachmeisterschaft zu einem Gan-
zen von Einklang und selbstverständlichem Dasein.

Claudius Der dritte war Klopstock, bei allem Gegensatz der Lebenserscheinung,
am nächsten seelenverwandt. *Matthias Claudius,* 1740 bis 1815, aus Rein-
feld in Holstein war eines Pfarrers Sohn. Er wurzelt wie eine Pflanze in der
heimatlichen Erde, sättigt sich täglich aus dem Volke, zu dem er gehört, aus
der Natur, die ihn festhält, und wiegt sich mit seiner Seele in dunklen Ge-
danken und Träumen. Er wird Hamann immer ähnlicher. Nach kurzer Hoch-
schulzeit in Jena war es auch ihm gegönnt, die Spätreife seiner frühen Man-
nesjahre im Vaterhause abzuwarten. Und dieses tatenlose Leben des Nicht-
Säens und Nicht-Erntens sieht fast wie Vorbereitung auf eine religiöse Sen-
dung aus. Die unscheinbare Aufgabe, die er seit 1768 in der Schreibstube der

Claudius „Wandsbecker Bote" Hamburger „Adreßcomptoirnachrichten" zu leisten hat, macht ihn zum
Schriftsteller, der längst ein Dichter war und das gar nicht wußte. Hier rückte
er seine ersten unsterblichen Gedichte ein. Er wird mit Lessing bekannt und
findet an Herder einen Freund. Der „Wandsbecker Bote", den Claudius 1771
übernahm, war das Blättchen des Grundherren: die ersten drei Seiten Nach-
richten, die vierte Literatur und Lotto. So was hat es nie mehr gegeben. Ein
solches Blättchen, von einem Claudius geleitet, von Männern wie Gersten-

berg und Klopstock, Lessing und Herder mit Beiträgen versehen. Claudius
gab diesen vier Seiten im Handumdrehen sein persönliches Gepräge. Das
war eine ganz einmalige Ausdrucksweise, ein naiver und launiger Ton, der
sich ganz mundartlich in Bildern und Vergleichen erging und mit dem
Munde der natürlichen Einfalt redete. Klopstock, Hamann und Herder be-
grenzen die Welt, die Claudius mit Verstand und Herz bewohnte. Er hat
seinem Zeitalter beispielhaft den deutschen Hausvater vorgelebt, der als *Der Hausvater*
Hausvater Staat und Welt betrachtet und dem das Genie der Wahrheit
immer das treffende Wort eingibt. Dieser Mann war beides, ein Meister der
Prosa und des Liedes. In der Prosa war Claudius ein Bruder Mösers. Seine
Prosa hat den Stil des mündlichen Plauderns. Als lebenskluger Denker und
hausväterlicher Warner hat er dem deutschen Volk mitten durch die verwir-
renden Geisteskämpfe des späten Jahrhunderts den Weg gewiesen, der immer
ein gerader ist, und ginge er auch durch Krümmungen, den Weg der Wahr-
heit. Als Meister des Liedes steht Claudius in seiner Zeit bei sich allein und
für alle Zeit außerhalb aller Literatur. „Asmus omnia sua secum portans
oder sämtliche Werke des Wandsbecker Boten", acht Bändchen, 1775 bis
1812, ist ein Sammlung ohnegleichen, nicht gemacht, sondern die natürliche
Frucht eines guten und treuen Lebens. Claudius ist der wahre Naturdichter *Der Naturdichter*
gewesen. Seine Lieder, das ist die Welt als ein ewig neues Wunder ergrif-
fen und von einem Kinde erlebt. Sie sind Lieder des Volkes. Matthias Clau-
dius hat den lyrischen Gesang von Klopstocks hochstilisiertem Pathos wieder
zum schlichten Ton des Volkes herabgestimmt. Er hat die priesterliche Sen-
dung des Dichters von den königlichen Höhen der Menschheit an den schlich-
ten Altar des Hausvaters zurückgeführt.

Durch Stolberg, Voß, Claudius ist Klopstocks Werkgeist verjüngt und
einer neuen Zeit aufbewahrt worden.

Braunschweig und Hannover standen einander mit ihren beiden Schulen,
dem Braunschweiger Collegium Carolinum seit 1745 und der Göttinger Uni-
versität seit 1737 gegenüber. Am Carolinum fanden sich nicht wenige der
Bremer Beiträger als Lehrer wieder zusammen. Mit manchem von ihnen
freundschaftlich verbunden, lebte hier *Johann Anton von Leisewitz*, 1752 bis
1806, aus Hannover, der Dichter des Prosatrauerspiels „Julius von Tarent",
einer Dichtung der feindlichen Brüder, und dramatischer Bilder in Prosa wie
„Die Pfandung" und „Der Besuch um Mitternacht". Die Göttinger Hoch-
schule schmückten mit ihrem Geist *Abraham Gotthelf Kaestner*, 1719 bis *Die Göttinger*
1800, aus Leipzig und *Georg Christoph Lichtenberg*, 1742 bis 1799, aus *Hochschule*
Oberamstädt bei Darmstadt. Kaestner war, wie seine „Vermischten Schrif-

ten" 1755 und 1772 erweisen, ein Meister der Prosa und des Witzwortes. Lichtenberg aber, ein fleißiger Mitarbeiter am „Göttinger Taschenkalender", hat ein einheitliches Gebäude seiner Gedankenwelt in den Aphorismen aufgerichtet, deren künstlerischen Stil er in Deutschland nicht geschaffen aber vollkommen ausgebildet hat.

„Musen-Almanach" Nach dem Muster des französischen „Almanac des Muses" von 1765 gründeten Heinrich Christian Boie aus Meldorp und Friedrich Wilhelm Gotter aus Gotha den *Göttinger „Musenalmanach"*, der zum erstenmal für das Jahr 1770 herauskam. Gleichzeitig fand sich an der Universität eine Gruppe von Hochschülern freundschaftlich zusammen, in denen die Schule Klopstocks, vertreten durch Friedrich Leopold Graf zu Stolberg, und die Lyrik der Stauferzeit, wie der Schwabe Johann Martin Miller sie kannte und nachbildete, einander begegneten. Dieser Austausch zwischen Norden und Süden, an dem sich auch Johann Heinrich Voß beteiligte, gibt dieser Gruppe junger Leute eine gewisse geschichtliche Bedeutung. Sie ergriffen leidenschaftlich Partei gegen Wieland und für Klopstock. Und es war eben der Göttinger „Musenalmanach", in dem sie sich mit ihren Oden und Minneliedern verewigten.

Hölty In dem geistigen Raum zwischen der Göttinger Hochschule und dem Braunschweiger Carolinum bildete sich dieses niedersächsische Zeitalter auf eine dreifache Weise tragisch ab. *Ludwig Heinrich Christoph Hölty,* 1748 bis 1776, aus Mariensee an der Leine war durch eine frühe Krankheit zu einem vorzeitigen Tode bestimmt. Er fand an Voß seinen besten Freund. Miller führte ihn in die altschwäbische Lyrik ein. Antik-odenhaft und minnesängerlich-volkstümlich ist denn auch der Stil seiner lyrischen Gebilde, in die *Unzer* seine tiefe Schwermut eingegangen ist. *Ludwig August Unzer,* 1748 bis 1774, von Wernigerode wurde durch Eleazar Mauvillon am Braunschweiger Carolinum zu einem Freigeist gemacht. Er ist den Tod des Spötters gestorben. Seine Vorbilder waren Ariost und Petrarca. Die Stimmung quillt ihm aus der sehr dunklen Tiefe des Herzens. Vers und Sprache seiner Lieder sind von meisterlicher Glätte. Als literarischer Bildstürmer und Umwerter der geltenden dichterischen Werte fand er mit seinen kleinen kritischen Schriften bereits den Beifall der kunstrichterlichen Zwillinge Merck-Goethe in den Frank- *Bürger* furter „Gelehrten Anzeigen". *Gottfried August Bürger,* 1747 bis 1794, aus Molmerswende südlich von Quedlinburg, an Gleim und durch Boie dichterisch zuerst geschult, hat als Lehrer an der Göttinger Hochschule vergeblich um einen deutschen Homer gerungen, indem er es zuerst in Jamben und dann in Hexametern versuchte. Das epische Großgedicht mußte sich einem

Manne verweigern, dessen innerste Natur darauf gerichtet war, seinen Stil
ins Niedliche und Szenische, seine erhabene Gesinnung ins Komische und
Burleske zu ziehen. Gleims Volksromanzen hatten die Verse der Bänkel-
sänger ersetzen wollen. Durch einen Bänkelsängerkehrreim wurde Bürger
zu seinem Gedicht „Leonore" hingerissen, einem völlig neuartigen Gebilde,
mit dem er sein Zeitalter berückt hat. Die Art und Kunst dieser Ballade be-
herrschte Bürgers erste Gedichtsammlung von 1778, die ernsten Balladen wie
die komischen Romanzen dieses Buches. Das komische Heldengedicht, vor-
gedeutet durch das ostfälische, erzählend überlieferte Epos von Eulenspie-
gel, war gewissermaßen das Satyrspiel zu den großen epischen Gedichten
der sächsischen Welt. So ist Bürger mit einem kleinen Schritt von der eng-
lischen Ballade Percys zur komischen Romanze der eigentliche Dichter dieses
Stiles geworden. Hölty, Unzer und Bürger sind tragische Naturen durch Le-
ben, Sterben und Dichten, unglücklich durch Verhängnis wie Hölty, durch
Schuld wie Bürger, durch beides wie Unzer.

Fast alle Strömungen des sächsisch-ostdeutschen Raumes spiegeln sich in
Friedrich Matthisson, 1761 bis 1831, der aus einer schwedischen Familie und *Matthisson*
von einer Mutter, die jedenfalls einen slawischen Namen trug, zu Hohen-
dodeleben bei Magdeburg geboren wurde. Er hat fast alles, was zu seiner
Zeit eigentümlichen Geistes war, in sich aufgenommen: den Pietismus, die
Lieder der Herrnhuter, die Gesinnung der Freimaurer; Horaz, Anakreon,
die Engländer; Werther, Minnesang und Hölty. Die Naturbeschreibung in
Matthissons ersten Versbüchern „Lieder" 1781 und „Gedichte" 1787 war
nicht Kunstweise, sondern Seelenlage, fast Weltansicht. Mit gleichgeteiltem
Herzen schwärmte er für die englische Gartenkunst und empfand er Gott
in pietistischem Naturgefühl. Antike Züge in Bild und Form gehen nirgend
über das rein Schulmäßige hinaus und dürfen nicht als klassizistisch ange-
sprochen werden. Die Empfindsamkeit des Pietismus und die Gottnatur der
Aufklärung flossen in dieser Lyrik zusammen, um sich schon der Romantik
zu nähern. Weit gespannt aber überbrückt sein Prosawerk, die „Erinnerun-
gen", dieses Zeitalters. Denn novellenhaft, brieflich, tagebuchartig erzählt
es seine europäischen Wanderungen: vom englischen Stil der Empfindsam-
keit über die Romantik zur jungdeutschen Sachlichkeit.

Was in Hamburg und Kopenhagen begonnen wurde, das wendet sich in
Westfalen zur Romantik hinüber und beginnt sich mit den vom Osten her- *Westfalen*
kommenden Strömungen zu verbinden.

Justus Möser, 1720 bis 1794, aus Osnabrück, der leitende Staatsmann des *Der Volksmann*
Hochstifts, gab in seinem Trauerspiel „Arminius" 1748 bereits ein ziemlich

richtiges Bild der germanischen Verhältnisse, verfocht in der geistvollen Schrift „Harlekin" 1761 den gleichberechtigten Anspruch der komischen Dichtung gegenüber der ernsten und nahm mit der Abhandlung „Über die deutsche Sprache und Literatur" 1781 die deutsche Dichtung vor dem absprechenden Urteil Friedrichs II. von Preußen in Schutz. Möser wurde durch seine „Osnabrückische Geschichte" einer der Mitbegründer der germanischen Altertumskunde. Seine kleinen Aufsätze, als „Patriotische Phantasien" gesammelt, ursprünglich zumeist Beiträge zu Zeitschriften, eröffnen in Deutschland die Kunstgeschichte des politischen Buches und des persönlichen Zeitungsstiles. Zu Klopstock, dem Meister des Verses und einer Kunst der getragenen Gebärde, gehört Möser, der Verteidiger des übermütigen Lachens

Das komische Epos und der Künstler des gefälligen Alltagswortes. *Karl Arnold Kortum,* 1745 bis 1824, aus Mühlheim an der Ruhr und Arzt in dem gesunden Bochum, hat die „Jobsiade" 1799 und mit ihr das komische Epos geschaffen. Die Vorgeschichte dieser Kunstart verliert sich über den humoristischen Roman der Engländer und über Grimmelshausens „Simplicissimus" in die abenteuerlichen Schelmenromane der Franzosen und Spanier. Das Epos zeichnet ein Gesamtbild deutschen Lebens um die große Zeitwende, Kleinstadt und Kleinstaat des Jahrhunderts. Künstliche Stillosigkeit und künstliches Unvermögen sind mit meisterlicher Fertigkeit zum einheitlichen Stil des Buches

Der Mann, der sehend macht erhoben. *Johann Heinrich Jung,* 1740 bis 1817, aus dem westfälischen Dorfe Grund und später Stilling zubenannt, las sich als Schneidergeselle aus seiner westfälischen Waldeinsamkeit in die Volksbücher und mystische Literatur von Paracelsus bis zu Böhme ein, wurde als Straßburger Hochschüler mit Goethe und Herder bekannt, ein berühmter Augenarzt und wirkte wie ein Herold Christi auf die Menschen. Er wirkte durch seine mystische Weltanschauung, für die seine berühmte „Geisterkunde" Zeugnis gibt. Und er wirkte durch die romanhaften Selbstbeschreibungen seines Lebens, „Jugend" 1777, „Jünglingsjahre" 1778, „Wanderschaft" 1778, deren ersten Band Goethe anregte, entdeckte und herausgab. Jung und Claudius, aus den entgegengesetzten Winkeln des sächsischen Stammesgebietes, sind die Führer jener großen und stillen Gemeinde, in der sich eine neue Frömmigkeit sammelte und aufbewahrte. Ihr schlichtes und lauteres Wesen strömte mehr durch persönlichen Umgang auf ihre Zeitgenossen über, wenngleich ihre Schriften, weltfern von absichtsvollem Weltgetriebe, gleichwohl so weit durch das ganze deutsche Volk verbreitet worden sind.

Das war auch die Gesinnung, die den münsterländischen Staatsmann Franz von Fürstenberg und die Fürstin Amalia von Gallitzin zu einer wah-

ren Seelenfreundschaft verband. Um sie sammelte sich ein ganzer Kreis von durchaus nicht gleichgesinnten Freunden. Die Fürstin las 1784 Hamanns „Sokratische Denkwürdigkeiten" und war so stark bewegt, daß sie den Magus im Norden zu sich nach Münster einlud. Hamann kam, ist 1788 in Münster gestorben und im Garten der Fürstin begraben worden. Sie betete über dem Hügel des Lutheraners wie am Grabe eines Heiligen. *Hamann in Münster*

Die christliche Seelenbewegung Niedersachsens und des deutschen Ostens haben einander gefunden. Das ist der Sinn der Begegnung zwischen Johann Hamann und der Fürstin Amalia von Gallitzin.

2. WESTDEUTSCHE LANDSCHAFTEN

Die drei Kraftfelder, von denen der geistige Umschwung des deutschen Volkes seit dem Anfang des achtzehnten Jahrhunderts ausging, lagen alle am Rande der deutschen Welt. Sie suchten also mit Notwendigkeit eine gemeinsame Mitte. Sie trafen auf sie in der fränkischen und schwäbischen Landschaft beiderseits des Mains und des Neckars. Indessen tiefer als Zürich wirkte auf die fränkische und schwäbische Jugend der Zuruf aus Hamburg. Klopstocks Kunst des feierlich getragenen Gesanges wühlte sie auf und riß sie mit. Alles, was über Hamburg von England kam, wurde durch sie mit leidenschaftlicher Bereitschaft aufgenommen. Sie überkamen es aber schon nicht mehr aus Hamburg. Ob es nun Hamann oder Herder oder Kant waren, sie überkamen es aus Königsberg. Goethe wird der Schüler Hamanns und Herders, Schiller der Zögling Kants, beide wahrhaft erweckt durch die frühe und scharfe Luft, die von Königsberg herwehte. *Fernwirkung von Königsberg*

Die Wahl zwischen Frankreich und England bedeutete zugleich Entscheidung zwischen der französischen und englischen Art, die Antike zu besitzen, zu werten, nachzugestalten. Den ganzen Rhein entlang hatte der französische Klassizismus den absterbenden Barock beerbt. Gegen dieses französische Gesicht der Antike stand der deutsche Osten auf, nicht weil er ein eigenes Bild der Antike gehabt hätte, sondern weil er von der englischen Art, mit der Antike zu reden, besessen war. Lessing hin, Winckelmann her. Am verständnisvollsten in die englische Schule der Antike waren Hamann und Herder gegangen. Und Herder sprach so gut in Hamanns Namen wie in seinem eigenen, als er vor Goethe einer englisch verstandenen Antike gegen die Antike französischen Geistes das Wort redete. Doch was Hamann und Herder wollten, zielte viel tiefer und überhaupt an der Antike vorbei auf eine Kunst *Von Frankreich zu England*

aus der reinen Land-Volk-Natur, auf eine Kunst aus jenem urtümlich Volk-
haften, das allem unterschiedlich Nationalen vorausliegt. In der persönlichen
und geistigen Begegnung zwischen Goethe hier, Hamann und Herder dort
war der deutsche Osten gedanklich am weitesten in den eigentümlichen Be-
reich des Mutterlandes vorgestoßen. Desto kräftiger spielte der Abstoß zu-
rück. Denn das unmittelbare Erlebnis der lateinischen Kultur und Kunst an
Rom, der hellenischen Natur und Kunst in Sizilien stellten bei Goethe und

*Um die
deutsche Gestalt
der Antike* im deutschen Mutterlande die Lage zugunsten der Antike wieder her. In
anderer Weise ist es Schiller ergangen. Seine geistige Begegnung mit Kant
zu Jena bedeutete für ihn keine geringere Begebenheit als für Goethe in
Straßburg die persönliche Begegnung mit Herder. Bei ihm war es Rousseau,
der Franzose, der zu überwinden war. Und wenn Goethe durch Herder aus
seinem lateinischen Geistbereiche weggelockt werden sollte, durch Kant ist
Schiller in den antiken Gedankenraum zurückgeleitet worden. Denn Schillers
Kunstüberzeugung ist Geist vom Geiste Plotins, weil sie zwischen gut und
schön und wahr keinen wesenhaften Unterschied macht, weil sie die äußerste
Befreiung vom Stoff fordert und weil ihr die Natur lediglich in übertrage-
nem Sinne für schön gilt. So haben Franken und Alamannen, auf Ja und
Nein in Wechselrede mit dem ostdeutschen Gedanken von Königsberg, durch
den deutschen Klassizismus das Wunschbild eines Jahrtausends verwirk-
licht: die deutsche Gestalt der Antike. Wie Goethes Leben, so ist der Klassi-
zismus des Mutterlandes zwischen deutschem Westen, antikem Süden, deut-
schem Osten zu triangulieren, und innerhalb dieses vollkommenen Dreieckes
liegt sein Schwerpunkt.

*Goethes Vater-
haus und Vor-
fahren* FRANKEN. Frankfurt hatte noch kein geistiges Gesicht, das sich etwa in
seinen Söhnen hätte wiederholen können. Aber es hatte als deutsche Reichs-
stadt und patrizisch geführtes Gemeinwesen eine Gesinnung, die sich durch
keine Geburt verleugnen ließ. *Johann Wolfgang Goethe,* vom 28. August
1749 bis zum 28. März 1832, ist sein Leben lang ein Frankfurter gewesen
durch Gesinnung und Mundart, durch Haltung und Lebensstil, ein Reichs-
städter und Stadtjunker. Aber er war das nicht durch den Vater, den wirk-
lichen kaiserlichen Rat Johann Kaspar Goethe, 1710 bis 1782, dessen Vor-
fahren zufrühest in Thüringen bezeugt sind, der wohl in Frankfurt geboren
aber Frankfurter Bürger erst seit dem 25. Juni 1749 geworden ist. Ein Frank-
furter war der Dichter durch seine Mutter Katharina Elisabeth Textor, 1731
bis 1808, die Tochter des mächtigsten Mannes der Vaterstadt, des wirklichen
kaiserlichen Rats, Bürgermeisters, Reichs-, Stadt- und Gerichtsschultheißen
Johann Wolfgang Textor. Was aber der Dichter mit seiner Natur leiblich und

geistig geworden ist, dafür hat er die Anlagen durch seine mütterliche Groß- *Die Lindheimer*
mutter empfangen, Anna Margaretha Lindheimer, 1711 bis 1783, die zu
Wetzlar geboren war und einen gebürtigen Frankfurter, den Advokaten
und Prokurator am Wetzlarer Reichskammergericht Cornelius Lindheimer,
zum Vater hatte. Die Lindheimer waren eine alte bürgerliche Familie, in
Frankfurt und Sachsenhausen ansässig und seit dem späten vierzehnten Jahr-
hundert urkundlich bezeugt. Sie haben ihren Namen wohl von der Ortschaft
Lindheim in Oberhessen. Sie liegt nahe am ehemaligen römischen Grenz-
wall. In dieser Gegend wurde die Menschenart der Anna Margaretha Lind-
heimer, die Menschenart des Dichters mit ihren deutlich römerhaften Zügen
häufig getroffen. Die Gesichtsformen und die Gestalt des Dichters erscheinen
oft genug an Mitgliedern der Familie Lindheimer. Durch die mütterlichen
Vorfahren Anna Margarethas kommt man auf eine Reihe literarisch tätiger
Männer, die an den Hochschulen Marburg und Gießen wirkten, weiter hin-
auf aber in die Familie des humanistischen Dichters Euricius Cordus und des
ostfränkischen Malers Lukas Kranach. Das sind Vorfahren des Forschens und
Bauens, des Malens und Meißelns, der Verskunst und des Schauens und des
Schilderns, Familien aus der römerdurchsetzten Wetterau, aus Hessen und
Franken. Es hat seinen Reiz, zu sehen, wie der Dichter zu Weimar in die
thüringische Heimat seiner väterlichen Vorfahren zurückkehrte. Aber stam-
mestümlich ist der Dichter nicht durch den Vater bestimmt. Johann Wolfgang
Goethe ist durch Mutter und Großmutter, wie es auch seine Vaterstadt an-
zeigt, ein hessischer Franke.

Goethes männliche Art gehört dem Vater, die menschliche aber und die *Der Vater*
künstlerische der Mutter. Von ihm hatte er das bedächtige und pedantische *Die Mutter*
Wesen, das Bedürfnis nach Ordnung und Schema, den Sinn für Soll und
Haben. Sie sprach zu ihm: nimm die Dinge, wie sie sind; bück dich, wo's zu
hoch ist und weich aus, wo es Steine gibt; nimm, was zur Hand liegt, und greif
nicht ins Leere; was dir auf die Nägel brennt, das schaff dir vom Halse, so
oder so, und was dir nicht ruft, das laß liegen. Mit einer Wortfülle und Wort-
kraft, die an der Bibel geschult war, in lebendiger Bildlichkeit erzählte sie
dem Knaben ihre Märchen und Histörchen. Mutter und Sohn verstanden
einander ohne Worte.

Die ersten Kenntnisse und den schulmäßigen Untergrund seiner späteren
Bildung hatte Goethe von seinem Vater. Das waren die alten und geläufigen
modernen Sprachen, und da die Bibel noch immer das Buch der Bücher war,
auch die hebräische Sprache. Das übrige tat Frankfurt selber, so wie der
Knabe seine Vaterstadt erlebte: ihre volksmäßige Hinterwelt, die franzö-

sische Besatzung und ihr Theater, der politische Zwiespalt, der den kaiser-
lichen Großvater Textor und den preußischen Vater Goethe trennte, im April
1764 die Krönung Kaiser Josefs II. An den Büchern, die im Hause herum-
standen, fand der Nachahmungstrieb des Knaben reiche Nahrung. Die Lite-
ratur vor und neben Gottsched, die allein des Vaters Gnade hatte, war schon
veraltet. Der Vater haßte mit Gottsched alle reimlosen Bücher. So mußte
Klopstock eingeschmuggelt werden. Der Knabe ließ sich von Gleims Tände-
leien verlocken, reimte 1762 feierlich getragen seine „Höllenfahrt Christi"
und versuchte sich an französisch gehaltenen Dramen. Dann entließ ihn der
Vater ins Leben und schickte ihn an die Leipziger Universität, wo er Mitte
Oktober 1765 eingeschrieben wurde.

Leipzig lag bereits hinter der Front. Indessen Gottsched zu besuchen,
empfand der junge Fuchs noch immer als Pflicht. Bei Gellert lernte er saubere
Briefe schreiben. Oeser lehrte ihn zeichnen und Kunstwerke betrachten. Anna
Katharina Schönkopf, in deren Vaterhaus er speiste, gab ihm ein Privatissi-
mum in der Leidenschaft, die mit Eifer sucht, was Leiden schafft. Ehe er
sichs versah, war er ein feiner Stutzer geworden, den man beneidete und be-
wunderte. Der gesollte Rechtsgelehrte hatte sich als Dichter erkannt. Das
hatte nicht zuletzt an ihm das Leipziger Theater getan. Was außer den nur
geplanten Bibeldramen fertig wurde, war ein Abbild seines verworrenen
Lebens: das Schäferspiel „Die Laune des Verliebten" und das Sittenstück
„Die Mitschuldigen", deren keiner dem andern etwas vorzuwerfen hat, beide
in Alexandrinern und nach französischer Regel mit frühreifer Geschicklichkeit
gemacht. Die Leipziger Lieder, 1768/1769, im folgenden Jahr gedruckt,
geben kein anderes Bild. Doch durch das Übereinkommen und die fremden
Muster bricht schon Persönliches und Eigenwüchsiges auf. Da ist noch Ro-
koko und schon wieder junge Natur. „Gern verlaß ich diese Hütte, / Meiner
Liebsten Aufenthalt, / Wandle mit verhülltem Tritte / Durch den ausgestorb-
nen Wald. / Luna bricht die Nacht der Eichen, / Zephirs melden ihren Lauf, /
Und die Birken streun mit Neigen / Ihr den süßten Weihrauch auf."

Schwer krank kehrte der Zwanzigjährige ins Vaterhaus zurück. Dem Leibe
half Doktor Metz wieder auf und um die Seele bemühte sich Susanna Katha-
rina von Klettenberg, eine pietistisch gestimmte Freundin seiner Mutter. Eine
leidliche Frömmigkeit kam über ihn. Glaube, Offenbarung und Wunder
spannen ihn beschaulich ein. Zu dritt lasen sie, die Mutter, das Fräulein und
der Genesende, mystisch-naturphilosophische Bücher, Paracelsus und Swe-
denborg. Arnold trat in den Reigen und schloß ihn. An seinem Windofen
braute der Jüngling in Tiegeln mißratene Wunder zusammen. Er war auf

dem Wege zu Jakob Böhme, zu Hamann und Herder, zu seinem „Faust", dessen geistig-seelische Welt in diesen Frankfurter Wochen kosmisch geordnet aus dem Chaos stieg. Da fuhr der Vater dazwischen und schickte ihn, damit endlich der Rechtsgelehrte aus ihm werde, im ersten Frühling 1770 nach Straßburg.

Johann Gottfried Herder war auf einem verschwenderischen aber fördersamen Umwege von Riga über Paris und Hamburg nach Kiel, von Kiel über Hamburg und Darmstadt, wo er in Karoline Flachsland seine Braut fand, Anfang September 1770 zu Straßburg angekommen, um an seinen Augen einen kleinen ärztlichen Eingriff vornehmen zu lassen. Goethe war seit April 1770 in Straßburg und hatte sich, dank einer anregenden Freundesrunde, zu der Heinrich Jung-Stilling gehörte, längst eingelebt. Was Goethe in Frankfurt an Paracelsus und Herder in Paris an Montesquieu erlebt hatte, das hatte sie beide füreinander reif gemacht. Goethe erzählt: „Ich war in den Gasthof zum Geist gegangen, ich weiß nicht welchen bedeutenden Fremden aufzusuchen. Gleich unten an der Treppe fand ich einen Mann, der eben auch hinaufzusteigen im Begriff war und den ich für einen Geistlichen halten konnte. Sein gepudertes Haar war in eine runde Locke aufgesteckt, das schwarze Kleid bezeichnete ihn gleichfalls, mehr aber noch ein langer, schwarzer, seidener Mantel, dessen Ende er zusammengenommen und in die Tasche gesteckt hatte." Der Besucher sprach den Fremden an und erhielt freundliche Antwort. Herder und Goethe in Straßburg.

Herders Krankenstube wurde seit dem Herbst 1770 die Hohe Schule Goethes. Der Leidende, an Jahren und Reife Überlegene tat an dem übermütig Gesunden zunächst ein wahres Werk der Barmherzigkeit, indem er ihm die Stachel seines Spottes, seines spitzen Urteils ins Fleisch bohrte, den Flattersinn und die vorlaute Keckheit des „guten Jungen" mit Ruten züchtigte. Dann aber teilte Herder dem also Zurechtgestriegelten aus der werdenden Preisschrift „Über den Ursprung der Sprache" mit und ließ ihn teilhaben. Ein solcher Lehrer und ein solcher Schüler sind selten beisammen gesessen. Herder machte Goethe klar, Dichtung sei keine Einzelarbeit einiger weniger, die sich darauflegen, es sei eine „Welt- und Völkergabe", Gemeinschaftsarbeit. Herder nennt und deutet dem jüngern Freunde Hamann. Herder stimmt ihm die Seele für Homer, Platon, Pindar. Herder reißt ihn von den Franzosen los und gibt ihm englische Bücher in die Hand, die von Swift, von Goldsmith und von noch Größeren. Und da Herder, von der Liebe neu beflügelt, wieder zu dichten begann, da er von Klopstock auf Ossian und Shakespeare, auf die altenglischen Balladen kam, da er Gerstenberg zu schät-

Goethe und Herder

Goethes Straßburger Erweckung

zen anfing und selber an die Arbeit der Sachsen in Kopenhagen anknüpfte: Herder vermittelte seinem Zögling das Deutschgefühl des Kopenhagener Kreises. Herder verurteilte Wielands Shakespeare-Übersetzung, zerpflückte das Bild des englischen Weltdichters, wie sichs Goethe bereits in Leipzig dargestellt hatte, und zeigte ihm den wahren und echten Shakespeare. Hier war der Stoff für die einzigartige Sammlung „Von deutscher Art und Kunst", hier die Keime für Herders spätere „Volkslieder". Das „Silberne Buch", die Abschriften Karoline Flachslands von Herders Übersetzungen aus Ossian, Shakespeare und Percy, die Auslese aus seinen älteren Gedichten, war der Vorklang von „Stimme der Völker in Liedern".

Das Erlebnis Elsaß Um Herders Krankenstube reiften Stadt und Land in ihren letzten deutschen Herbst. Zur Zeit der langen Tage und kurzen Nächte 1770 durchstreifte Goethe das Unterelsaß bis nach Lothringen. In Niederbronn grüßten den Wanderer nach den Heiligtümern der Antike Säulenreste des Altertums mitten in Bauernhöfen. Das Münster wurde „bis zur letzten Kreuzblume" erklettert. Nun war ihm die Gotik der echte und einzige deutsche Stil. In fast mystischer Verzückung feierte er das Werk aus Geist und Stein Erwins von Steinbach. Er horchte dem elsässischen Volkslied nach. Im Boot die Ill hinab las er Homer und Ossian. Von Jeremias Jakob Oberlin, der in seinen Hochschulvorlesungen Literaturgeschichte und Wappenkunde verband, ließ er sich in die Minnesänger und in das Nibelungenlied einführen. Zu Ostern 1771 wurde Johann Gottfried Herder, der die Stadt ungeheilt und ohne Heiterkeit verließ, durch den Balten Reinhold Lenz abgelöst, der als Hofmeister zweier Herren von Kleist einzog. Auch er schwärmte für Homer, Ossian, Shakespeare. Goethe bot ihm zwar die Hand, aber noch nicht in Freundschaft. Lenz löste in Straßburg nicht nur Herder, sondern auch Goethe ab.

Sesenheim Goethe hatte Herder manches verborgen, vor allem, daß er dann und wann verliebten Herzens in das nahe Sesenheim zur Tochter Friederike des Pfarrers Brion geritten war. Von Weihnachten 1770 bis Pfingsten 1771 dauerte das Verhältnis, für Friederike eine große Passion, für Goethe ein langes und schmerzliches Gedächtnis. Das Sesenheimer Liederbuch und der weihevolle „Faust"-Schluß bewahren über Goethes ganzes Leben hinweg Gewinn und Verlust dieses Liebesjahres. Goethe verließ im August 1771 die Stadt als Lizentiat der Rechte, der sich Doktor nannte, Götz, Faust und Caesar im Herzen.

Frankfurt und Darmstadt Er war zu Frankfurt wieder daheim. Der Vater schien zufrieden. Die Schwester war beinahe schon erwachsen. Cornelias bewundernde Zweifel mit einer Leistung zu übertrumpfen, warf Goethe gegen Ende 1771 in wenig

Wochen das ungebärdige Drama „Götz von Berlichingen" aufs Papier. Zu den übrigen Gestalten seiner Straßburger Träume gesellte sich von Hamann her Sokrates. Die Aufsätze über Shakespeare und über die Deutsche Baukunst wurden niedergeschrieben. Um an der Fülle der Gesichte nicht zu ersticken, durchwanderte Goethe das Mainland und sang nach den Rhythmen Pindars dunkle unverständliche Lieder dem Wind und Regen entgegen. An dem Darmstädter Kriegsrat Johann Heinrich Merck, 1741 bis 1791, fand Goethe einen neuen Freund, der an ihm Herders Werk auf eine weltliche Weise fortsetzte. Merck führte ihn in die „Gemeinschaft der Heiligen" zu Darmstadt ein, das waren die empfindsam schwärmenden Männer und Mädchen, unter denen Karoline Flachsland nicht die mindeste war. Und Merck spannte Goethe in die „Frankfurter Gelehrten Anzeigen" ein, die am 1. Jänner 1772 erneuert zu erscheinen begannen. Wie Johann Georg Hamann soeben in den „Königsbergischen gelehrten und politischen Zeitungen" ein Beispiel gab, so wurde unter Herders Beihilfe in dem Frankfurter Blatt die Tenne der Literatur gefegt. Der Stil von Hamanns „Aesthetica in nuce", ein Stil der Ausrufe und Wunschformeln, der Stil stammelnder Leidenschaft, die in atemlosem Wechsel ihre schnellfüßigen, lose gekoppelten Sätzchen vor sich herjagte, das wurde in den Frankfurter Anzeigen zum erstenmal der Stil dieser Jugend. Das Gebot Rousseaus von der Rückkehr zur Natur wird verkündet. Homer wird den Händen der marternden Schulmeister entrissen. Mit Hamanns und Gerstenbergs Griffel wird das Antlitz des Genies gezeichnet. Hier wird das Gesetz ausgerufen: der Künstler ist sein eigener Herr und Richter. Die Zeltgemeinschaft der Frankfurter Anzeigen hielt nur bis Juli 1772 aus. Denn inzwischen war Goethe nach Wetzlar gegangen, um sich am Reichskammergericht den letzten Schliff zu holen. Ziemlich flügellahm von der Geschichte mit Charlotte Buff, vorzeitig und ohne die rechte reichskammergerichtliche Weihe kehrte Goethe zu Vater und Mutter heim.

Die Tennenfeger

Goethe in Wetzlar

Frankfurt aber bekam nun wirklich ein ganz anderes Gesicht. Das machte ihm Goethe. Im Mai 1773 wurde „Götz von Berlichingen" gedruckt, auf Kosten des Verfassers. Die Wetzlarer Leidenschaft, noch immer mit Briefen fortgehätschelt, färbte sich von Lotte Buff, die inzwischen Frau Kestner geworden, nicht minder einseitig auf Maximiliane von La Roche um, die bereits Frau Brentano war. Das beste war, aus dem und jenem einen Roman und also gute Miene zum bösen Spiel zu machen. Der Roman erschien im Herbst 1774 und hieß „Die Leiden des jungen Werthers". Über den Unfrieden im Hause konnte nur den Sohn die Literatur hinwegtrösten, aber nicht den Vater, dem sie ja eben die Quelle allen Kummers war. Als Dichter aber bekam

Frankfurter Kameraden und Nebenbuhler Goethe Frankfurter Gesellschaft. Da war der Straßburger Heinrich Leopold Wagner, 1747 bis 1779, anders als Goethe nun richtiger Rechtsanwalt in Frankfurt und der Dichter einer Tragödie, wie sie dem Verteidiger ziemte, „Die Kindermörderin". Da war aber auch der Nebenbuhler, der es als Dichter Goethen beinahe und als Weltmann wirklich gleichgetan hat, obwohl er keines Bürgermeisters Enkel, sondern der Sohn nur eines Stadtsoldaten war. Friedrich Maximilian Klinger, 1752 bis 1831, ein schöner, prächtig gewachsener junger Mann, hat gleichwohl den üblichen Schulweg gemacht durch das Frankfurter Gymnasium und die Gießener Universität. Aber er hat sich dann auch als Theaterdichter mit Wandertruppen durchs Leben schlagen müssen, bis er über ein österreichisches Freikorps seinen rechten Beruf entdeckte und in der russischen Armee seine große Laufbahn machte. Jetzt und hier war Klinger, den ein ungeheures Kraftgefühl beherrschte und der wahre Kyklopenarbeit schuf, der zeitgerechte Spielbuchdichter. All seine Dramen dieser Zeit, „Otto", „Das leidende Weib", „Die Zwillinge", „Simsone Grisaldo", inmitten aber „Wirrwarr" 1776, von Christoph Kaufmann „Sturm und Drang" umbenannt, drückten nur sein eigenes Lebensgefühl aus. Sie gestatteten aber gleichwohl auch denen, die sich als Kraftnaturen nur gebärdeten, sich in Klingers Dramen mitgespielt zu sehen. Gleichviel, welche Nebenbuhler es noch mit Goethe aufnehmen wollten, wenn Klinger schließlich nicht aushielt, vermochte es auch kein anderer.

„Götz" Schon war Johann Wolfgang Goethe der erste. Seinen Rang bezeugten wie seine lyrischen Gedichte so das Drama und der Roman. „Götz von Berlichingen" ist ein geschichtliches Zeitgemälde im Stil von Shakespeares Königsdramen. Und der es aufrollt ist kein Schauspieler, sondern ein rechtsgeschichtlich geschulter Betrachter. Der Gegenstand des Dramas ist zwischen Humanismus und Reformation der Kampf um eine neue Gestalt des Reiches im Sinne Ulrichs von Hutten. Nicht was an persönlicher Beichte in der Dichtung steckt, noch wie glücklich sie der eigenen Gegenwart nach dem Munde redet, bestimmt ihren Rang, sondern allein die getroffene Echtheit des geschichtlichen Zeitbildes, das sie ja sein will. Darin aber ist sie in der Tat eine erstaunliche Leistung, die mit dem zeitgenössischen Radau der Gesinnung nichts gemein hat. Friedrich Schröder hatte in Hamburg Shakespeare für die Bühne, Goethe hatte ihn zu Frankfurt für das Spielbuch gewonnen. Goethes „Götz von Berlichingen" stand gegen Lessings „Emilia Galotti". Das ganze Drama bewegte sich, Bild an Bild, in unbegrenzten Lebensszenen und durch Gestalten, die mit Theater nichts, sondern alles mit der Wirklichkeit zu tun hatten. So ist auch die Sprache kein gleichfarbiges Schriftdeutsch, sondern die gespro-

chene Sprache des Alltags, nicht altertümlich gemacht, sondern mundartlich gemeint. Klopstocks sakrale ist durch Goethes profane Dichtersprache abgelöst. „Die Leiden des jungen Werthers" sind ein zeitgenössisches Seelengemälde im Stil des englischen Briefromans. Was die Dichtung in einem künstlichen Fieber zum Ausdruck brachte und unschädlich machte, war die weitverzweigte Empfindsamkeit vom Pietismus her. Es ist die Geschichte eines Lebensuntüchtigen, der sich selber aus Schwäche krank gemacht hat und anfällig für beide Witterungen: zu große Wärme des Gefühls und die jahreszeitliche Kälte der sozialen Verhältnisse. Wie das Kunstwerk „Götz" in der Echtheit der geschichtlichen, so besteht das Kunstwerk „Werther" in der Echtheit der zeitgenössischen Farben. Und gleich wahr ist hier wie dort die Sprache. In beiden Fällen ist es die abtönende Wortlust, Wortgewalt, Wortgewandtheit des genialen rheinfränkischen Sprachvermögens. Unerschöpflich sind die Beziehungen, die aus den beiden Dichtungen ein Ganzes machen, zu dem jede die andere ergänzt. *„Werther"*

Von so scharfer Arbeit flogen Späne ab: die Satire „Götter, Helden und Wieland", die dramatischen Günstlinge des Augenblicks „Clavigo" und „Stella"; der Versuch in einem burlesken Versepos vom Ewigen Juden. „Cäsar", von dem so gut wie nichts erhalten ist, scheiterte an der zwiespältigen Liebe des Dichters zu Cäsar dem Herrn und Brutus dem Befreier. Am weitesten schritt „Prometheus" vor, in dem sich das Allgottgefühl und der Menschheitstrotz jener Tage abbildete. Am aufschlußreichsten ist die Posse „Satyros oder der vergötterte Waldteufel". Goethe hatte es sich mit Hamanns Schriften, die er gerade im letzten Frankfurter Herbst von 1775 vollständig zu besitzen wünschte, nicht leicht gemacht. Vor allem hatten ihn die „Sokratischen Denkwürdigkeiten" gepackt. Wenn nun Hamann in den „Frankfurter Anzeigen" — sicherlich mit Bezug auf die Panvignette der „Kreuzzüge" — der „Sokratische Faun in Königsberg" heißt, so wird man wohl im dichterischen Halbdunkel des „Satyros" Hamanns verkappte Gestalt erkennen müssen. *Kleine Dinge*

Große Pläne

So berühmt war Goethe geworden, daß sich die Besuche in seinem Vaterhause die Türschnalle reichten. Unter ihnen waren im Dezember 1774 die Weimarer Prinzen Karl August und Konstantin mit ihrem Gefolge. Neuen Liebeswirren, diesmal mit der vornehmen Lili Schönemann, wich Goethe Mai 1775 aus, indem er mit den beiden Brüdern Stolberg einen Ausflug in die Schweiz machte, aus dem beinahe eine Reise nach Italien geworden wäre. Er kehrte um, damit das Spiel mit Lili zu Ende käme. Der Herzog Karl August von Weimar kam mit seiner angetrauten Gemahlin wieder durch

Frankfurt, versprach, seinen Wagen zu schicken. Als der nicht kommen wollte, brach Goethe am 30. Oktober wirklich nach Italien auf. In Heidelberg aber wurde er von dem herzoglichen Wagen eingeholt und nun ging es statt nach *Weimar* Italien nach Weimar.

SCHWABEN. Die Landschaft, auf die nun der Akzent überging, bedeutet zweierlei: Reichsstadt und Herzogtum. Beide nahmen ihren gebührenden Anteil am literarischen Schaffen des Landes.

Die schwäbische Reichsstadt ist mit bedeutenden Köpfen vorangegangen. *Der Sieg der Natur über die Schwärmerei* *Christoph Martin Wieland,* 1733 bis 1813, zu Oberholzheim geboren, aber in Biberach aufgewachsen, stammt aus einer alten landesbürtigen Pfarrerfamilie. Die anerzogene pietistische Gesinnung hat allen Bildungseinflüssen lange standgehalten. Sie beherrscht seine frühen Dichtungen: seine philosophischen Gedichte, seine Erzählungen, das Epos „Hermann" von 1751, die biblischen Gedichte, die er als Gast in Bodmers Hause geschrieben hat. Aber eben diese Zürcher Zeit um 1755 bereitete bereits den Umschwung seiner Weltanschauung vor. Er las Shakespeare und gewann davon das Drama „Lady Johanna Gray", das 1756 in Winterthur gespielt wurde. Er las Plato, Lukian, Xenophon und erntete das Epos „Cyrus", das 1759 erschienen ist. Diesen Umschwung vom christlichen Idealismus Pyras und Klopstocks zur schönen Sinnlichkeit der französischen Aufklärung hat Wieland zu Bern 1759 im Umgang mit Rousseaus Freundin Julie Bondeli vollzogen und als Stadtschreiber zu Biberach seit 1760 als Gast des Grafen Friedrich von Stadion auf Schloß Warthausen wahrhaft ausgelebt. Wieland machte sich der gräflichen Hofgesellschaft unentbehrlich. Er leitete ihre Liebhaberaufführungen und arbeitete, so angeregt, 1762 bis 1766 seine Shakespeare-Übersetzung. In rascher Folge schrieb er die Bekenntnisbücher und Werbeschriften für seine Lebensphilosophie: „Der Sieg der Natur über die Schwärmerei oder die Abenteuer des Don Sylvio von Rosalva" 1764, seinen Don Quixote des Pietismus und Wunderglaubens; „Geschichte des Agathon" 1766 bis 1773, den Bildungsroman eines hellenisch verkleideten Franzosentums: „Musarion oder die Philosophie der Grazien", das abschließende Bekenntnis zur schönen Sinnlichkeit. Zwischendurch schlang sich ein Kranz von mehr oder minder freien sinnlichen Gedichten nach Lukian, von denen 1765 ein Teil als „Komische Erzählungen" gedruckt wurde. Diese Dichtungen aus Wielands Bi- *Lukian und Cervantes* beracher Zeit haben einen gemeinsamen Grundgedanken: Erziehung von „Schwärmern" und „Weltfremden" zur Philosophie dieser Welt, zu kluger Lebenskunst, zur „gesunden Natur". Mit seinem „Don Quixote" hatte Cervantes eine ähnliche Einbildung und Schwärmerei zur gesunden Wirklich-

keit zurückführen wollen. Wieland hat im Deutschland der religiösen Askese, des pietistischen Idealismus, der schwärmerischen Empfindsamkeit Raum geschaffen für die Vernunft, den Wirklichkeitssinn und die Sinnlichkeit der Antike. Wie Klopstock den Stil des Großgedichtes und des lyrischen Verses geschaffen hat, so Wieland den dichterischen Kunststil der erzählenden Prosa in jedem Bereiche.

Christian Friedrich Daniel Schubart, 1739 bis 1791, ist zu Obersontheim geboren aber in der Reichsstadt Aalen aufgewachsen. Er hat sich sein Leben lang in den Kneipen bei Spielleuten und Handwerksburschen am wohlsten gefühlt. Bald war er bei den Großen in Gunst, bald saß er im Schuldturm oder im Gefängnis. Er gab Zeitungen heraus, hielt Vorlesungen über Literatur und Kunst, trug als Rhapsode Klopstocks „Messias" vor. Endlich machte ihn der Herzog von Württemberg auf seinem Asperg mürbe. Die herzogliche Druckerei der Karlsschule brachte 1785 und 1786 in zwei Bänden seine Gedichte und gleichzeitig seine Tonstücke „Musikalische Rhapsodien". Der Freigelassene wurde 1787 Hofdichter und Schauspielleiter. Schubart war der geborene Volkstribun in Wort und Schrift. Sein ungestümes Gemüt drängte ihn zu Klopstock, den er in Schwaben eigentlich durchgesetzt hat. Er war ein hochbegabter Musiker wie Dichter, der den schwäbischen Schwung der Rede ebenso meisterte, wie ihm einfältige, unmittelbare Volkslieder zuströmten. Der Stil des leidenschaftlichen Redners beherrschte seine Dichtungen. Er war einer unserer bedeutendsten Schriftsteller, die dem Tage dienten, allseitig, vielgebildet und belesen, nie verlegen um die augenblicklich beste Form, ein Stegreifkünstler. Was er Großes plante, blieb in Trümmern liegen.

Volkstribun und Rhapsode

Das Herzogtum Württemberg wurde unter den unsanften Händen des weitdenkenden und fürsorglichen Karl Eugen nach bitteren Verfassungskämpfen ein moderner, geistig wohlausgerüsteter Staat. Stuttgart erhielt 1750 eine Oper, die verschwenderisch ausgestattet und vom Herzog selber bis ins einzelne geleitet wurde. Die politischen Kämpfe zwischen dem Herzog und den Ständen förderte im Lande eine Presse, in der es die geborenen Zeitungsleute Schwabens lernten, das Wort als Waffe zu führen. Aus zwei Schulen des Herzogtums blühte das geistige Leben auf und wirkte bis tief ins neunzehnte Jahrhundert: aus dem Tübinger Stift und aus der Karlsschule. Das Stift war die Schule des deutschen Humanismus und hatte seine alte Überlieferung. Die Karlsschule, 1770 in Stuttgart gegründet, 1773 Akademie, 1781 durch Kaiser Josef II. Hochschule, war ganz und gar eine persönliche Schöpfung des Herzogs, die unter seinen Augen den Nachwuchs des Landes an Beamten, Ärzten und Künstlern heranbilden sollte.

Das Herzogtum und sein Herzog

Der Karlsschüler Aus dieser Schule ist *Friedrich Schiller*, 1759 bis 1805, hervorgegangen. Aus einer schon lange bezeugten landesbürtigen Familie zu Marbach geboren, wuchs Schiller in Ludwigsburg und Lorch heran, da sein Vater, ein Hauptmann, in wechselnden Standorten lag. Der Geist des Vaterhauses war pietistisch fromm. Theaterspielen, Predigten und Dichten, das war die lebhafte Sehnsucht des Jungen. Der Vater nahm ihn oft in die Oper mit. Lateinische und deutsche Verse gerieten ihm leicht und flüssig. Anfang 1773 kam er in die Karlsschule, anfangs als Rechtsschüler, dann zum Arzt bestimmt. Aus eigener Not und aus Anteil am Volke erstanden ihm die Bedrücker und Befreier, die Sprecher großer Worte, die in der Brust des Jünglings ihre Kämpfe um Freiheit und Völkerglück austrugen. Einsichtige Lehrer ließen den jungen Dichter gewähren, der ausdauernd wie nur einer die neue deutsche Dichtung von Haller über Klopstock, Lessing, Wieland bis Herder und Goethe durchlas. Mitstrebende Freunde waren um ihn und waren Zeuge, was in ihm vorging. Festreden und Festgedichte machten seine Dichterkraft höfischen Diensten nutzbar. Zum Geburtstag des Herzogs 1780 leitete er die Festaufführung — es war „Clavigo" — und spielte selber den Haupthelden. Schiller hatte früh zwei Trauerspiele begonnen, „Der Student von Nassau" und „Cosmus von Medici", aber wieder vernichtet. Auch aus einem philosophischen Roman, „Briefe Julius' an Raphael" haben sich Bruchstücke in späteren Werken erhalten. Zu Weihnachten 1780 wurde der Dichter von der Karlsschule entlassen und als Feldarzt bei einem Grenadierregiment eingeteilt.

Der Regimentsarzt Schon 1777 hatte Schiller eine guten Fund getan, den Stoff der „Räuber". Seit 1780 begann er erfolgreich daran zu arbeiten. Im Frühjahr 1781 wurde das Stück unter Verschweigung des Verfassernamens gedruckt und am 13. Jänner 1782 auf der Mannheimer Hofbühne gespielt. Der Regimentsarzt saß ohne Urlaub unter den hingerissenen Zuschauern. Das Drama „Die Räuber" war die persönliche Abrechnung des Dichters mit dem Herzog, wie er ihn sah, der künstlerische Abschluß der Württemberger Verfassungskämpfe, die Lösung der Frage, wie sie sich im Kopf des Regimentsfeldschers malte: Heilung mit Eisen und Feuer. Weder hat das Stück mit „Götz von Berlichingen" etwas zu tun, noch der Dichter mit den sogenannten und angeblichen „Stürmern und Drängern". Jede Jugend, die hochkommt, hat zu allen Zeiten „gestürmt" und „gedrängt". Mit dem jungen Schiller aber schwingt ein einmaliges geschichtliches Ereignis aus, der Württemberger Kulturkampf um Freiheit und Kunst.

Neben dem Dichter begann sich der nicht minder begabte Zeitungsmann

zu regen. Ostern 1782 gab er sein „Wirtembergisches Repertorium" heraus, in dem er nach Herzenslust kunstrichtete und sich in Aufsätzen vernehmen ließ. Und im Februar 1782 bot er gegen die Tübinger Stiftler, die sich unter dem Stuttgarter Gotthold Friedrich Stäudlin im Schwäbischen Musenalmanach sammelten, seine Karlsschüler in der „Anthologie" auf. Die meisten Beiträge stammten von Schiller selber, der so sein lyrisches Jugendbekenntnis vorlegte. Es fehlte fast kein Ton seiner aufgewühlten Stimmung: Andacht, Verzweiflung, Entzücken, Schwärmen und Lachen, und alles fremder und unverständlicher, weil der Dichter immer nach der jüngsten, neuesten, ungewohntesten Form rang. Das Unternehmen mißlang. Stäudlin blieb Sieger. Die wiederholte heimliche Fahrt nach Mannheim, die Unzufriedenheit mit dem jungen Soldatenarzt, der mehr Komödie schrieb als dem Dienst gut schien, und anderes bestimmten den Herzog, Schiller den Verkehr mit dem Auslande und das Komödienschreiben zu untersagen. Schubart saß damals auf dem Asperg. Schiller verließ also in der Nacht des 22. September 1782 mit einem Freunde unter falschem Namen und fahnenflüchtig die Stadt. *Schiller im heimatlichen Wettbewerb*

Die Rheinpfalz blühte damals eben wieder dichterisch auf. Sie hatte neben den beiden Lyrikern Johann Nikolaus Götz und Johann Friedrich Hahn in Friedrich Müller, 1749 bis 1825, aus Kreuznach, dem Maler und Dichter, Auge und Stimme empfangen. Müller warf, gleichviel ob mit dem Stift oder mit der Feder, lebendige kleine Sachen hin, entzückend einfältige, wie sie nur einem Begnadeten gelingen konnten. In Gessners Art begann er mit biblischen Idyllen, folgte seinem Vorbilde in die schöne Ferne der Antike — „Der Faun", „Satyr Mopsus", „Bacchidon und Milon" — und versah sich schließlich heiter und fröhlich in den Anblick des pfälzischen Volkslebens: „Die Schafschur", „Das Nußkernen". Fast fünfzig Jahre lebte er in Rom, ohne jemals aus einem Pfälzer ein Römer zu werden. Das bezeugen seine römischen Dichtungen, die beiden Dramen „Golo und Genoveva", „Fausts Leben". Und die Rheinpfalz blühte in dem Theater auf, das Wolfgang Heribert von Dalberg seit 1778 in Mannheim führte, als eben die Pfälzer Kurfürsten nach München übersiedelt waren. An dieser Bühne entfaltete sich die Schauspielkunst August Wilhelm Ifflands, Heinrich Becks, Johann David Beils. *Pfälzer Dichtung und Mannheimer Bühne*

An diese Bühne, auf der seine „Räuber" triumphiert hatten, flüchtete sich Schiller. Gleich nach seiner Ankunft, am 25. September, las er im Theaterausschuß sein neues Stück „Fiesco" vor. Denn mit diesem Stück, mit Plänen für „Kabale und Liebe" wie für „Don Carlos" war Schiller in Mannheim eingetroffen. Indessen Dalberg wollte zunächst mit dem Soldatenflüchtling des *Schiller und seine Premieren*

Herzogs nichts zu tun haben. Der Dichter zog sich also mit all seiner Not und
den fortgedeihenden Dichtungen zuerst nach Oggersheim bei Mannheim und
dann nach Bauerbach bei Meiningen zu Henriette von Wolzogen, der Mutter
eines Schulkameraden, zurück. Ostern 1783 erschien „Fiesco" als Buch. Es
sah so aus, als legte Herzog Karl Eugen auf seinen entlaufenen Regiments-
arzt weiter keinen Wert. Das gab Dalberg Mut und er machte am 1. Septem-
ber 1783 Schiller für ein Jahr zu seinem Theaterdichter. Auch die Deutsche
Gesellschaft nahm ihn auf und hörte seinen Antrittsvortrag: „Was kann eine
gute stehende Schaubühne eigentlich wirken?" Die Mannheimer Bühne

„Räuber", spielte am 11. Januar 1784 seinen „Fiesco", am 15. April 1784 „Kabale und
„Fiesco", Liebe", am 6. April 1788 seinen „Don Carlos". Die Mannheimer Bühne also
„Kabale und hat den jungen Schiller zuerst der Nation eingespielt. „Fiesco" wie „Kabale
Liebe" und Liebe" waren abermals gesellschaftliche und staatliche Vorwürfe von
schwerem Gewicht: das Verhältnis des einzelnen zur Gesellschaft, gleiches
Recht für alle, oder einer als Bevorzugter und Gewalthaber; ständische Gren-
zen innerhalb der Gesellschaft, die wie unzerbrechliche Gesetze wirken soll-
ten und dem Herzen dennoch keine Schranke bieten. Der junge Schwabe war
in Jahren aufgewachsen, da all diese Mächte in dem engen Raum seiner
Heimat auf Tod und Leben rangen. Das Staatsgenie des Alamannen hatte
seinen Dichter gefunden, der fortan die größten und letzten Gedanken der
menschlichen Gesellschaft gestalten sollte. Jetzt hatte er sein Traumland ver-
lassen und die Wirklichkeit, die Geschichte, gefunden. So gemeint war „Ka-
bale und Liebe" gleichermaßen ein geschichtliches Drama wie „Fiesco".
Allein so sah die Welt nur aus, wenn man sie in Haß und Liebe ansah. So
wollte sie der junge Schiller haben, damit endlich eine Tat geschehen müsse.
Noch immer steht er im Banne des herzoglichen Schwabens.

Schillers Not hatte nie aufgehört. Mit dem Ablauf des Vertrages am
31. August 1784 blieb keine andere Wahl, als abermals eine Zeitschrift. So
gab er denn im März 1785 das erste Heft seiner „Rheinischen Thalia" aus.
Inzwischen kündigte sich manches an, was nur Geduld verlangte. Zu Weih-
nachten 1784 hatte Schiller in Darmstadt dem Herzog Karl August von Wei-
mar den ersten Aufzug des „Don Carlos" vorgelesen und war dafür Wei-
marer Rat geworden. Und dann luden ihn Leipziger Verehrer aus der Ferne,

Schillers Christian Gottfried Körner und die Seinen, nach Meißen ein. Schiller bezog
Meißner im April 1785 die freundschaftliche Herberge in Gohlis bei Leipzig und dann
Freunde in Dresden. Die liebenswürdig Begeisterten fügten ihn, der ein literarischer
Freibeuter zu werden drohte, wieder in die Gesellschaft. Der Dichter der
„Räuber" gewann Augenmaß für die Dinge und Haltung im Leben. Körner

wies ihn auf Kant. Schillers Gedanken begannen sich zu ordnen. Ein Sinnbild seiner Auferstehung war der schöne Hymnus „An die Freude". Gewissenhafte Arbeit der Selbsterziehung ging neben dem Abschluß alter und den Entwürfen zu neuen Arbeiten einher. Das neue Trauerspiel „Don Carlos" wurde fertig. Ein Roman, „Der Geisterseher" wurde begonnen und widerwillig gefördert. Es hing mit dem Stoff des „Don Carlos" zusammen, daß Schiller aus seiner Darstellung „Der Abfall der Niederlande" einige spannende Zwischenspiele im „Merkur" 1788 und in der „Thalia" 1789 drucken ließ. Indessen, das war schon die Schrift, mit der er sich für seine neue Stellung auswies. Denn am 11. Mai 1789 zog er in Jena als der neue Professor für Geschichte ein. *Professor in Jena*

THÜRINGEN. Zwei Hochschulen, Erfurt und Jena, und zwei Höfe, Gotha und Weimar, lösten einander auf Thüringer Boden um 1780 ab. Jena und Weimar traten an die Stelle Erfurts und Gothas. Jede dieser Städte hatte ihren Auftrag. Erfurt sammelte die letzten Ausläufer des alten und die ersten Kräfte des neuen Humanismus, Gotha die große sächsische Bühnenkunst, Jena die moderne Wissenschaft der Zeit. Von allem strömte das Beste nach Weimar.

Was vor diesem Szenenwechsel gespielt wurde, das sagte unter lauter Landesfremden der Landesbürtige ohne Scheu und Zugeständnis aus. *Johann Jakob Wilhelm Heinse*, 1746 bis 1803, aus Langewiesen bei Ilmenau war *Kunst um der Kunst willen* eines Organisten Sohn und zu manch anderm auch musikbegabt. Der arme Jüngling fand immer zur rechten Zeit den richtigen Gönner. Durch alle Schulen, die er geführt wurde, folgte der junge Heinse, dem es keiner an hellenischer Gesinnung gleichtun konnte, nicht dem Knaben Eros, sondern der Göttin Hedone. An der Erfurter Hochschule ging er durch Wielands, in Halberstadt durch Gleims Hände. In Düsseldorf genoß er die Farbenpracht der Gemäldegalerie, in Rom das Nachgefühl des antiken Lebens und am Mainzer Hofe war er ein Höfling. Heinse war ein Sprachkünstler von hohem Rang. Der Romantik ist er vorangegangen als neuer Übersetzer von Ariosts „Rasendem Roland" und Tassos „Befreitem Jerusalem", vorangegangen mit den „Briefen aus der Düsseldorfer Gemäldegalerie" 1777, die Farben in Worte, und mit dem Roman „Hildegard von Hohental" 1795, der Musik in Sprache übersetzte. Aber Heinse ist der Schöpfer des ersten deutschen Künstlerromans. Indem er dem Petronius die „Begebenheiten des Enkolp" 1773 nacherzählte, indem er zu dem hellenischen Kulturroman „Laidion oder die Eleusinischen Geheimnisse" 1774 fortschritt, kam er zu seiner eigentümlichsten Dichtung „Ardinghello oder die Inseln der Glückseligen" 1786, der

Die Insel
der Glückseligen

Künstlerroman der italienischen Renaissance. Ardinghello ist Maler und Sänger, Fechter und Staatsmann, Kunstschöpfer und Kunstgenießer und seine Botschaft eine hohe apollinische Kunst. Künstlergespräche, wie Plato sie führen läßt, beleben und verzögern die Handlung. Der freie Gebrauch aller sinnlichen und geistigen Anlagen bildet das Grundgesetz des urbildlichen Staates, der auf den seligen Inseln der Kykladen, Naxos im Mittelpunkte, aufgerichtet werden soll. Heinse war Sinnenmensch und Künstler um der Kunst willen. Hellenentum war ihm gleich Menschentum und gleich Natur. Wort ist an seinem Stil nur das Unerläßlichste, alles andere sichtbare Farbe und greifbare Gestalt. Das also, wovon Heinse in den attischen Tag hinein träumte, wollte in Weimar gespielt werden.

Der Hof
zu Weimar

Die Domina zu Weimar, Herzogin Anna Amalie, die für ihren minderjährigen Ältesten die Zügel führte, hatte sich einen netten kleinen musischen Hofstaat eingerichtet. Die Junker, Prinzenerzieher und Kammerherren, die nach und nach zusammenkamen, Hildebrand von Einsiedel, Karl Ludwig von Knebel, Karl Sigmund von Seckendorff, waren alle zur Rechten oder zur Linken irgendwie mit der Dichtung verschwägert. Andere gehörten nur in mehr oder minder übertragener Bedeutung zum Hofe. *Johann Karl August Musäus*, 1735 bis 1787, aus Jena, gebot über die kleinen Junker. Er verulkte mit seinem satirischen Roman „Grandison der Zweite" 1760 die Mode des englischen Romans um Richardson und mit seinen „Physiognomischen Reisen" 1778, echt bis in die Rechtschreibung, das Treiben der Genieburschen. Die vernünftigen und aufgeklärten „Volksmärchen der Deutschen" 1782 bis 1787 waren das vielgelesene und einflußreiche Buch, an dem der Name Mu-

Einheimische
Dichtung

säus rühmlich haftet. *Friedrich Justin Bertuch,* 1747 bis 1822, aus Weimar, gehörte zum Hof wie der ganze Handel und Wandel der Stadt. Mit nie versagendem Glück schuf er eine Reihe wirtschaftlicher Unternehmungen. Seine Übersetzung des „Don Quixote" 1777 war ein Markterfolg. Von bedeutendem Einfluß wurden seine Zeitschriften: das „Magazin der spanischen und portugiesischen Literatur" seit 1780; die Modezeitschrift seit 1785; die „Blaue Bibliothek aller Nationen" seit 1790, Volksmärchen, Sagen, Ritterromane; die „Allgemeine Literaturzeitung", deren erstes Blatt, täglich vier Seiten, am 3. Jänner 1785 erschien.

Doktor Goethe

Das eine berechenbare Ereignis zog ein unberechenbares nach. Am 3. September 1775 wurde der Erbprinz Karl August großjährig und Herzog. Er führte im Oktober Luise von Hessen-Darmstadt als Gemahlin heim. Und am 7. November 1775 brachte die Postkutsche den jungen Doktor Goethe, zunächst als einen allen sehr angenehmen Gast. Im Dezember war Goethe zum

Bleiben entschlossen. Das sprach sich herum. Und bald erhielt er in seinen
Freunden Friedrich Maximilian Klinger und Michael Reinhold Lenz Neben-
buhler, die in das gleiche Schifflein wollten. Doch Goethe wußte sie los-
zuwerden, als ihn der Herzog nicht ohne Widerstand der Eingesessenen und
mit Hilfe seiner Mutter Juni 1776 ins Ministerium geleitet hatte. Im Sep-
tember ging Klinger freiwillig und im November wurde Lenz ausgewiesen.
Goethe hatte endlich ein Amt, das ihn erzog und zu arbeiten zwang, und zum
Amt bekam er in Frau Charlotte von Stein eine Freundin, die ihm das Amt
ertragen half und die seinem unstillbaren Mitteilungsbedürfnis, einsam und
gedrückt wie sie war, gern die Zuhörerin und Briefempfängerin machte.

Doch auch nach den glücklich entfernten Klinger und Lenz mußte Goethe
sich zwischen zwei freilich älteren Genossen einrichten. Den einen, Christoph
Martin Wieland, fand er vor, den andern, Johann Gottfried Herder, zog er
selber nach.

Christoph Martin Wieland war 1768 nach Erfurt berufen worden in ein *Prinzenerzieher*
ziemlich freies Verhältnis zur Universität. Mit dem verlangenden Auge auf *a. D.*
Wien und in der Hoffnung Kaiser Josef II. zu gefallen, schrieb er den Staats-
roman „Der goldene Spiegel" 1772, ein Spiegel, in dem sich ein aufgeklärter
Fürst nicht ohne Zufriedenheit beschauen konnte. Statt nach Wien zum Kai-
ser brachte ihn das Buch 1772 zu Herzogin Anna Amalie nach Weimar. Doch
seine Einnahmequelle war das Blatt, das 1773/1789 als „Deutscher Merkur",
bis 1810 als „Neuer Deutscher Merkur" erschien nach dem Vorbilde des
„Mercure de France". Sie hat den Gebildeten ihrer Zeit die ganze neu ent-
stehende deutsche Literatur vermittelt. Wielands Bühnenarbeiten wie die
Spielbücher „Alceste" 1773 und „Rosamunde" 1778 sind ohne sonderliche
Bedeutung. Ein eifriger Dolmetsch, suchte Wieland in den achtziger Jahren
dem deutschen Volk vor allem Horaz und seinen ihm selber wesensverwand-
ten Liebling Lukian näherzubringen. Wielands große Dichtungen der sieb-
ziger Jahre waren „Die Abderiten", die 1774, und das Epos „Oberon", das *Wielands*
1780 im „Merkur" abgedruckt wurde. Der Held der „Abderiten" war das *große Dichtungen*
alte Stadtbürgertum, ein Greis, der kindischen Sinnes das Leben seiner kraft-
vollen Mannesjahre auf Kinderart und Torenweise weiterspielt. Die Ver-
fassung Abderas setzt schwäbisch-reichsstädtische Verhältnisse voraus, das
fünfte Buch die selbsterlebten Erfurter Zustände. „Oberon", dieses feinste
unter den deutschen Großgedichten, hat Wieland gleich den höfischen Dich-
tern gearbeitet: nach einem französischen Prosaroman. Der Stil, das Zu-
sammenspielen zweier Welten, des Märchens um Oberon, der Wirklichkeit
um Hüon, und der leise spöttische Hauch, der kaum zu spüren ist, dieser Stil

schafft der Dichtung ihre österreichische Verwandtschaft. Nirgends hat Wieland ein so verständliches Echo ausgelöst wie in Österreich. Die spöttisch-überlegene Prosa der „Abderiten" ist kein geringeres Kunststück als die anmutig-heiteren, mit schöner Willkür gebauten Stanzen des „Oberon".

Johann Gottfried Herder war 1771 als Oberpfarrer nach Bückeburg gekommen und hatte 1773 Karoline Flachsland als Gattin heimgeführt. Goethe gelang die erste Kraftprobe, als er am 23. Mai 1776 die Berufung Herders nach Weimar in das Amt eines Oberhofpredigers und Oberpfarrers durchsetzte. Herder widmete sich dienstlich vor allem der Schule. Es gelang ihm 1785 das Weimarer Gymnasium zeitgemäß zu erneuern, gerade auf der rechten Mitte zwischen einseitiger Lateinschule und modischer Realschule. Im „Deutschen Museum" ließ er 1777 den wichtigen Aufsatz drucken „Von Ähnlichkeit der mittleren englischen und deutschen Dichtkunst". Gegen Nicolais satirisch gemeinte Volksliedsammlung sollte er den Boden bereiten für Herders eigenes Volksliederbuch, dessen zwei Hefte 1778 und 1779 erschienen. Herders Werk dieser Weimarer Zeit sind die „Ideen zur Philosophie der Geschichte der Menschheit", seit 1782 gearbeitet, 1784 bis 1791 herausgegeben. Seit Konrad Celtis den Plan einer „Germania illustrata" entworfen hatte, war in Deutschland nichts gearbeitet worden, was diesem Buch Herders gleichkäme. Hier sammelten sich nicht bloß seine eigenen Gedanken, alte, neue, zukünftige, hier trug die ganze volkhafte Geistesarbeit des siebzehnten und achtzehnten Jahrhunderts Früchte. Die philosophische Grundlage bot Leibniz, und Montesquieu hat das Werk nicht wenig gefördert. Erdkundliche Quellen waren die Sammelwerke und Reisebeschreibungen der Zeit. So stand Herder auch unter dem Eindruck, den die Schriften des Weltumseglers Georg Forster auf die Zeit machten und der naturwissenschaftlichen Entdeckungen Samuel Sömmerings — beide seine engeren Landsleute. Der Gedanke dieses Werkes war so einfach wie der Gedanke des Kopernik, der auch ein Landsmann Herders und Forsters und Sömmerings war: zwischen Naturgeschehen und Menschenleben walten gleichgerichtete Wechselwirkungen. Für die Gesamtheit der landschaftlichen Einflüsse auf den Menschen setzt Herder den Gesamtbegriff „Klima". Das Klima beeinflußt die sinnliche Natur des Menschen und damit alles, was er auch geistig schafft. Herder suchte also nach einem einheitlichen Weltgesetz gegen die Zweiheit in der Weltanschauung, wie sie durch Cartesius an das achtzehnte Jahrhundert vermittelt worden war. „Indem Herder überall die Örtlichkeit der Erscheinungen in Erwägung zieht, sichert er seiner Betrachtung einen einheitlichen und gerechten Maßstab."

Der Mann der Herzogin

„Ideen zur Philosophie der Geschichte"

„Klima"

So inmitten Wielands und Herders lebte und wirkte *Johann Wolfgang Goethe*. Wieland gehörte zum Hofstaat der Herzogin-Mutter Anna Amalie. Herder hielt sich enger an die Herzogin-Gattin Luise. Goethe hatte den Sohn und Gatten, den Herzog, ganz persönlich für sich. Von Frankfurt hatte Goethe drei weiträumig gedachte Werke mitgebracht: Faust, in groben Umrissen gestaltet; den Ewigen Juden und Wiederkehrenden Heiland in Bruchstücken; Wilhelm Meisters theatralische Sendung in flüchtigen Plänen. Zum vorläufigen Abschluß gedieh nur der Roman „Wilhelm Meisters theatralische Sendung". Spätestens im Februar 1777 hatte er ernstlich damit begonnen. Mit dem sechsten Buch war 1785 der erste Teil vollendet. Sechs weitere Bücher waren geplant. Nun ruhte das Werk durch fast zehn Jahre. Die unbestimmte Sehnsucht, die Goethe seit seiner Leipziger Zeit zum Theater als der Brücke aus der wirklichen in die geistige Welt getrieben hatte, und die Vollendung der deutschen Schauspielkunst des Jahrhunderts sind in Goethes Dichtung eingegangen. So ist daraus der Theaterroman des Zeitalters geworden, der alle Arten der Bühnenkunst, die ganze deutsche Bühnengeschichte und jede Gattung von Schauspieler vorführt. Der Roman ist schlechtweg die Dichtung dieses Weimarer Jahrzehnts. Im Stil läßt sich das ruckweise Reifen vom Werther zu den Wahlverwandtschaften spüren. Noch klingt an vielen Stellen der natürlich belebte, unfaßbar anschauliche, vielgebrochene, stürmende Stil der Frühzeit. Darüber liegen schon Schichten, die hell und allgemein sachlich sind, kunstvolle, nicht immer sicher gefügte Satzreihen, vielverschlungen und alles zusammenlegend, was an dieser Stelle gesagt werden muß. Oft ist in zwei Sätzen nacheinander hier der junge Goethe und da schon der reife, der herrschende Mann. Die Bühne, das Liebhabertheater im Ballhaus der Esplanada, Aufführungen des Hofes zu Tiefurt und Ettersburg nahmen Goethe mehr in Anspruch als ihm lieb war. Er versorgte den Spielplan. Ernste Pläne gediehen nur allgemach. „Iphigenie", 1776 bedacht, in raschem Zuge vollendet, wurde sogleich 1779 vor dem Hofe gespielt. Er goß das Stück 1781 um und warf es beiseite. Er ging 1778 an ein neues Werk: „Egmont". April 1782 schloß er es vorläufig ab und fand es 1786 abermals unfertig. Das dritte große Drama „Tasso" begann er 1780, ohne von der Stelle zu kommen. „Iphigenie", „Tasso" und das Bruchstück von 1781 „Elpenor" zeigen Goethes Willen zur Antike. Übersichtlicher und greifbarer wird dieser Wandel aus den Liedern des Jahrzehnts. Feine Ausklänge der Frühstimmungen sind die „Lieder des Friedens, der Versöhnung, des sehnsüchtigen Aufgehens in die zauberhafte Natur" aus den siebziger Jahren: „Der du von dem Himmel bist", „Füllest wieder Busch und Tal", die Ballade

Der Mann des Herzogs

„Wilhelm Meisters theatralische Sendung"

Liebhaberbühne

Goethes Dramen

„Der Fischer". Mit seinem Herzog war Goethe inzwischen 1778 in Berlin,
von September 1779 bis Jänner 1780 in der Schweiz gewesen, wobei in
Sesenheim Friederike, in Straßburg Lili besucht wurden. Vor den Sturz-
wassern des Staubbaches faßte er im reifen Bewußtsein nahender Stille sein
verrauschtes Jugendleben zusammen: „Gesang der Geister über den Was-

„Ilmenau" sern". Später stellte er in den Gesätzen des Gedichts „Ilmenau" 1783 behag-
lich und gesichert die ganze Welt, in der er seit Jahren lebte, vor seine Blicke.
Und wenige Tage darauf schrieb er auf die Wand des Bretterhäuschens am
Gickelhahn die Urverse „Über allen Gipfeln ist Ruh". Erschreckend fremd,
still und goethefern war das Epos „Die Geheimnisse", das er 1785 auszufüh-
ren begann, unter Herders einflußreicher Nähe, und der „Erziehung des
Menschengeschlechts" von Lessing benachbart. Und Äolus löste das ängst-
liche Band. In kleinen Gedichten der Jahre 1782 bis 1785 fand er den fast
zerrissenen Faden wieder, der zurück zur Antike leitete. Im Juli 1786 brach
er nach Karlsbad auf, und hier, fern von Weimar, in neuer Umgebung, stürzte
es mit Gewalt über ihn. Fort aus drohendem Untergang. Nach Italien!

Auf der Fahrt von der Oberpfalz bis Rom zog an Goethes Augen in um-
gekehrter Folge die ganze Entwicklung von der Antike zum Barock vorüber,
die glücklichsten Übergänge vom Dumpfen in die Helle Roms: in Regens-

Italienische burg letzte barocke Jesuitenspiele; in Verona letzte Spuren der Renaissance;
Reise in Vicenza Frühbarock und Spätrenaissance; in Venedig die ersten Antiken;
in Bologna die Cäcilie Raffaels, der ihm als der tiefste Erfasser der Antike
gilt; in Florenz und Perugia nur noch Sehnsucht nach dem alten Rom. In der
Ewigen Stadt schließt er die Augen für das moderne Rom, das Rom des
Barock und der Renaissance. Er sieht nur das römische Rom und vor allem
das, worin eine Reihe von Künsten vereinigt waren: Theater, Paläste, Tem-
pel, Rennbahnen, Wasserleitungen. An der Hand Winckelmanns suchte er
sich die antiken Künste geschichtlich bewußt zu machen. Am 22. Februar
1787 brach er nach Süden auf, von Rom nach Hellas, von der Kunst und Größe
zur Einfachheit und Natur. Er sammelt Pflanzen, Steine, Seetiere und be-
steigt den Vesuv dreimal. In Pompeji und Paestum hat er endlich griechische
Kunst vor Augen. Auf Sizilien findet er sich inmitten der antiken Natur und

Römische träumt an einem Trauerspiel „Nausikaa". Seit Anfang Juni 1787 wieder in
Werkstatt Rom, beginnt er seine Pflicht zu tun. Durch Nachzeichnen und Nachmessen
glaubte er sich in die römischen Kunstwerke eingedrungen und nahm sich
nun seine Dichtungen vor. „Torquato Tasso" gedieh noch nicht zu Ende.
„Faust" rückte mit der „Hexenküche" ein wenig vorwärts. „Nausikaa" blieb
ein kleines Bruchstück. „Egmont" wurde fertig gemacht. Das Schauspiel

„Iphigenie" wurde in die unvergleichlichen Jamben umgegossen. Diese Verse sind die lauterste Prosa, so selbstverständlich, notwendig und naturgemäß floß hier der künstlich bearbeitete Rhythmus aus dem natürlichen Sinn des Satzes, aus dem Rhythmus der Stimmung.

Im Jahr 1788 den 22. April reiste Goethe von Rom ab und am 18. Juni war er wieder in Weimar. Goethe war kein anderer Mensch, aber er war ein reiner Künstler geworden. Es erwies sich nun, daß er die Antike nicht anders angesehen hatte als der Barock und die Renaissance: mit den Augen Michelangelos, des modernen Menschen. Goethe hatte gegenüber Heinse, dem Wunschhellenen, das Maß des Möglichen und gegenüber Winckelmann, dem bloßen Kenner, die Gabe des Könnens voraus. Die Antike konnte weder geträumt noch gewußt, sondern nur nach dem Maß des modernen Lebens schöpferisch gemeistert in die deutsche Dichtung eingehen. *Aus Italien zurück*

Als Goethe in solcher Gestalt wieder unter den Deutschen erschien, am Erlebnis des Südens rein gegoren, war ihm *Friedrich Schiller* aus dem Gedanken des Ostens entgegengereift. Das akademische Lehramt zu Jena, das Schiller im Mai 1789 antrat und mit zunehmenden Unterbrechungen tatsächlich nur bis 1794 ausübte, warf ihm weder wissenschaftliche noch wirtschaftliche Erträgnisse ab. Er wagte darauf im Februar 1790 seinen Hausstand mit Charlotte von Lengefeld zu gründen, wäre aber ohne ein rechtzeitiges Gnadengehalt aus Kopenhagen leiblich und wirtschaftlich zugrunde gegangen. Sinn und Inhalt dieser Jenaer Jahre bildet die gedankliche Vorbereitung auf seine dichterische Sendung. Die Weltweisheit und Kunstwissenschaft Schillers, wie sie in den Schriften dieser Jahre niedergelegt wurden, sind das Ergebnis sehr verwickelter Erfahrungen, zu denen ihn der Übergang von Leibniz und Rousseau zu Immanuel Kant zwangen. In drei Gedankenringen kreiste seine Entwicklung. Der Stufe der Selbstbildung vor Kant gehören das Gedicht „Die Künstler" sowie die Aufsätze „Über den Grund des Vergnügens an tragischen Gegenständen" und „Über die tragische Kunst", beide 1792 in der „Thalia". Auf der Stufe des Widerspruchs zu Kant stehen die Vorarbeit zu „Kallias oder über die Schönheit" und die „Briefe über die ästhetische Erziehung des Menschen" 1794 sowie die Briefe an Körner. Die letzte Stufe der Einigung mit Kant stellen die Schriften „Über Anmut und Würde" 1793 sowie „Über naive und sentimentalische Dichtung" 1795 dar. Die Wurzel von Schillers Kunstlehre ist der Satz: die Schönheit ist nichts Gedachtes und nichts Erfahrenes, sondern eine Daseinsform des Menschen. Schillers Begriff der Schönheit hob den Gegensatz von Sinnlich und Sittlich auf, ein Gegensatz, auf den sich die Kunstfeindschaft des Pietismus gegrün- *Schiller in Jena* *Schillers Kunstlehre*

det hatte. Schiller schloß also mit seiner pietistischen Vergangenheit ab. Der Begriff der Schönheit wird gewonnen von der menschlichen Erscheinung als dem Ausdruck eines Zustandes, in dem sich die sinnlichen und sittlichen Kräfte des Menschen das Gleichgewicht halten. Die höchste Schönheit ist nicht Gott, sondern der Mensch, der Mensch des Einklangs von Sinnen und Seele. Das war hellenisch zugleich und humanistisch gedacht. Die Natur kann nur im übertragenen Sinne schön genannt werden, sofern sie als frei vom Knechtsgesetz der Schwere gedacht wird. Die Wirkung des Kunstwerkes auf den Menschen darf nicht vom Stoff ausgehen. Der Stoff muß ganz in Form aufgegangen sein. Schiller sagt das alles mit der ihm eigenen Begriffssprache. Die sinnliche Welt im Menschen ist ihm gleich Stofftrieb, die sittliche gleich Formtrieb. Beide Triebe im Gleichgewicht nennt er Spielbetrieb. Da Stoff*Schönheit ist* trieb gleich Leben, Formtrieb gleich Gestalt ist, so ist ihm Spieltrieb gleich *lebende Gestalt* lebende Gestalt. Schönheit ist lebende Gestalt.

Aus wirtschaftlichen Gründen und mit der Absicht auf geistige Wirkung dachte Schiller an die Herausgabe einer neuen Zeitschrift „Die Horen". Am 13. Juni 1794 wandte er sich brieflich an Goethe um Mitarbeit. Dieser sagte zu und im Juli trafen sich zu Jena die beiden Männer. Von Weimar nach Jena *Goethe* verband sie zunächst ein schriftlicher Gedankenaustausch. War Schillers Ent*und Schiller* wicklung aus dem Pietismus der erste, sein Lehrgang bei Kant der zweite, so ist dieser Briefwechsel mit Goethe der dritte Akt in der denkmäßigen Ausbildung des klassischen Schrifttums. Diese brieflichen Unterredungen, 1795 begonnen, erreichten 1797 ihren Höhepunkt. Sie betrafen Epos und Drama. Sie fanden ihre Bestätigung in einem mannigfaltigen gemeinsamen Werk. Das eine waren „Die Horen", deren Vorwort mit dem 10. Dezember 1794 gezeichnet ist, das andere der „Musenalmanach", den Schiller 1796 aus Bürgers Händen übernahm, das dritte die 414 „Xenien", boshafte Doppelverse auf das literarische Deutschland der Gegenwart, 1797 im Almanach gedruckt, das vierte die Balladen, die 1797 in gemeinsamem Wetteifer geschaffen wurden. Im Dezember 1799 schlug Schiller sein Haus in Weimar auf. Nun wurde Weimar ein Begriff, der sich seitdem im Bewußtsein der Welt eingelebt hat.

Wielands **Wieland** im Weimar dieser hohen Zeit war ganz Lukian. Dieser asiatische *hohe Zeit* Hellene aus der Euphratstadt Samosata, um 120 bis 185 nach Christus, ein Spötter, der weder den Göttern ihre Gottheit noch den Menschen ihre Menschheit glaubte, konnte nach Geist und Laune und geistesgeschichtlicher Stellung zwischen Mutterland und Siedelgebiet keinen verwandteren Nachfahren haben als Christoph Martin Wieland. Vorerst übersetzte Wieland 1788 bis 1789 Lukians sämtliche Werke. Dann nahm er den Wettkampf mit Lukian

selber auf. Das war Wielands Gesprächsroman „Peregrinus Proteus" 1791, in dem er, so wie Lukian die Mysterien und das junge Christentum, seinerseits Lavater und die romantischen Vorerscheinungen verspottete. Zwischen wechselnden Vergötterungen und Entzauberungen hin und her geworfen, offenbart Peregrinus Proteus alle Tiefen wie Untiefen der untergehenden Antike, das heißt des zeitgenössischen Deutschlands. Lag diese Welt im Zwielicht gespielter Wunder, so rückte Wieland in seinem letzten großen Roman „Aristipp und einige seiner Zeitgenossen" 1800/1802 diese Welt in die Beleuchtung des griechischen Mittags, da Sokrates in Athen den Schirlingsbecher trank und Plato von den ewigen Ideen in Gesprächen und Mythen redete. Der Held wird durch die Irrtümer und den Selbstbetrug eines ganzen Zeitalters zu dem einen Grundsatz der Lebensweisheit erzogen, Herr seiner selbst zu bleiben trotz allen Versuchungen der Vernunft und des Gemütes. Darstellerisch wird in einem weitgespannten Briefwechsel das ganze hellenische Mittelmeer des vierten Jahrhunderts vor Christus zu einem erschöpfenden Bilde der griechischen Hochkultur eingefangen. Und da ist wahrhaftig die Sprache der Gegenwart. Nicht einer dieser Sätze klingt wie aus dem Griechischen übersetzt. Wielands Ironie zielt auf die Kunstvergötzung des Hellenentums, auf den Selbstbetrug mit Gedanken Platos, auf die schwärmerischen Mysterien, die der Romantik voraufzogen. In einem Zeitalter, das von großen Dingen berauscht, sich so leicht ins Wortemachen verlor, brachte Wieland, so vielerlei schwäbisches Wesen in Schiller, Hölderlin, Schelling, Hegel sich offenbarte, den heilsamsten, den unentbehrlichsten schwäbischen Zug zum Wirken: jene überlegene Besonnenheit, vor der keinem Ding die Maske der Begeisterung nützte.

Hellas im Roman

Wieland löst den griechischen Zauber

Herder brachte in dieses Weimar der hohen Zeit die tragische Bewegung. Schiller war zwischen Goethe und Herder hineingewachsen und Herder löste 1795 den Dreimännerbund, noch ehe er sich hatte schließen können, allein nicht durch eigene Schuld. Denn Goethe und Herder und damit Herder und Schiller wurden auseinandergerissen durch die Spaltung der deutschen Bildung, die endlich dem vielhundertjährigen innern Druck nachgeben mußte. Diese letzten drei Jahre des alten Jahrhunderts brachten Herders dreifachen Wurf gegen den Geist Weimars, gegen den Geist der Zeit, eine dreifache Gebärde des Unwillens an die Kirche, die Wissenschaft, die Kunst des Zeitalters. „Vom Geist des Christentums" 1798 meinte ein bekenntnisfreies Christentum und bereitete Schleiermacher den Weg. Die „Metakritik" 1799 galt nicht minder Kant als den Kantschülern in Herders nächster Nähe, indem sie die erkennende Kraft mit der Naturkraft gleichsetzte, die im ganzen Weltall

Der vereinsamte Herder

lebt. „Kalligone" 1800 wandte sich über Kant hinweg gegen die Kunstbe-
griffe, auf die sich Goethe und Schiller soeben geeinigt hatten. Über diesem
dreifachen Gedankenwerk vergaß Herder seine eigentümlichste Aufgabe
nicht, ein Sammler und Deuter halb verschollenen Volksgutes zu sein. „Zer-
streute Blätter" faßten literargeschichtliche Aufsätze und Proben altdeutscher
Dichtung, „Terpsichore" die Übersetzungen von Jakob Baldes Gedichten
zusammen. Zur Jahrhundertwende 1801 ließ Herder die Zeitschrift „Adra-

„Adrastea" stea" erscheinen, die nach rückwärts gewendet das Antlitz des achtzehnten
Jahrhunderts nachzeichnete, mit dem Blick in die Zukunft aber Wunschbilder

Der erste der kommenden Kunst entwarf und einen Schöpfer des Musikdramas weis-
Weimarer Tote sagte. Den Seinen hinterließ Herder zwei Dichtungen, das Chordrama „Ad-
metus' Haus" und die Nachdichtung spanischer Romanzen „Cid". Als der
erste aus den Weimarer Vier ist Herder 1803 gestorben. In seinem Werk hat
sich der Geist des achtzehnten in den des neunzehnten Jahrhunderts verwan-
delt und der Begnadete selber hat diesen Vorgang dargestellt.

Goethe und Schiller arbeiteten enger als irgendwo an der Weimarer
Bühne zusammen. Goethe hatte deren Leitung 1791 übernommen. Er hielt
sie unter dem stärksten Einfluß der Wiener Theaterkunst. Bei jährlich 159
Spielabenden fielen nicht weniger als 300 auf das Wiener Drama und min-
destens ebenso viele auf das Wiener Singspiel und die Wiener Oper. Der
Stil dieser Bühne unterlag jähen Schwankungen. Hatte anfangs Ekhofs
Sprechkunst das Beispiel gegeben, so siegte 1796 Iffland und sein natür-
licher Redeton, während Schillers Verstragödie einen rhythmischen Vortrag
erzwang und jenen erhöhten Wirklichkeitsstil, der als „Kunstnatur" immer
heftigere Angriffe auf sich zog. An dieser Bühne wirkten Goethe und Schil-
ler als Dramaturgen zusammen.

Schillers Auf dieser Bühne sind *Friedrich Schillers* klassische Dramen in Erschei-
Weimarer nung getreten: am 30. Jänner 1799 „Die Piccolomini"; 1800 „Maria Stuart";
Premieren 1801 „Die Jungfrau von Orleans"; 1803 „Die Braut von Messina"; 1804
„Wilhelm Tell". „Demetrius" war schon das letzte und blieb ein Riesen-
bruchstück. Die sechs Dichtungen müssen als ein Ganzes erfaßt werden, da-
mit die Leistung dieses knappen Jahrzehnts gewürdigt sei. Schillers Jugend
fiel in die Jahre erbitterter Verfassungskämpfe des Württemberger Volkes.
Das kurze Jahrzehnt seiner reifen Mannesjahre sah den gewaltigsten staat-
lichen Wandel, den Europa seit Karl dem Großen erlebte. Als Mann der
Geschichte begriff Schiller im Staat die Form geschichtlichen Seins und ge-
schichtlichen Denkens. Der Staat in seinen Beziehungen auf den einzelnen
war der Vorwurf seiner Jugenddramen gewesen. Der Staat in seiner Bezie-

hung auf den Träger der Gewalt war der Gegenstand seiner klassischen Dra- *Schillers*
men. Inmitten der Verwandlung des alten Reichs in die neuen Staaten der *klassische*
Revolution verfocht Schiller auf seiner Bühne das Gesetz der Rechtsmäßig- *Dramen*
keit, der Rechtseinheit, der Rechtsnachfolge. Das war der gemeinsame Ge-
halt dieser Dramenreihe, gleichviel an welchen wechselnden Gestalten er
aufgezeigt wurde, an welchen Völkern er sich erprobte, gleichviel welch
andere Bezüge mit dieser Grundfrage verknüpft waren. Die Form dieser
Bühnenspiele war auf eine deutsche Weise antik klassisch. Antik klassisch
war es, daß aller Stoff zu reiner Form gebändigt war, daß alles Handlung
war, daß immer und jedesmal die ganze Welt im Einmaligen jedes Dramas
zusammengedrängt war, so daß man nicht einen Vers aus „Wallenstein" in
den „Tell" und keinen einzigen aus der „Jungfrau von Orleans" in die
„Braut von Messina" verlegen kann. Denn in jedem spiegelt sich eben die
ganz besondere Welt des jeweiligen Stückes. Antik war es, daß der Idealis-
mus dieser Bühnenkunst in die gehobene Form gebundener rhythmischer
Rede gefaßt war. All das Große, Weltumspannende, das in Schillers Dramen
zur Darstellung kam, war auf deutschen Bühnen nur einmal bereits da ge-
wesen, auf den Barockbühnen des österreichischen Volkes. Diese großen
Staatstragödien Schillers waren nichts anderes als eine ungleich feinere, tie-
fere und kunstgemäßere Wiederkehr der alten „Haupt- und Staatsaktionen".
Die bairische Bühnengeschichte von Celtis zu Grillparzer hat nur das voraus,
daß sie sich als ein lückenloser Wandel verfolgen läßt, während sich die
schwäbische Entwicklung Humanismus—Barock—Klassizismus nur in den
drei vereinzelten Absätzen Frischlin—Bidermann—Schiller zu erkennen
gibt. Gerade dieser barockhafte Stil ist es, der als gemeinsamer Zug durch
die klassischen Dramen Schillers hindurchgeht. Von „Wallenstein" bis zu
„Wilhelm Tell" nähern sich Schillers Bühnendichtungen mehr und mehr
dem Musikdrama. Und so erscheint „Wilhelm Tell" als Schlußglied der Ent- *Musikdrama*
wicklung Humanismus—Barock—Klassizismus. Da die Wiener Oper und
das Wiener gesprochene Drama zu dieser Zeit den Weimarer Spielplan be-
herrschten, Ausläufer der Barockkunst, da Goethe selber nachweisbare und
starke Einwirkungen aus dieser Richtung empfing, so werden sie auch an
Schiller nicht spurlos vorübergegangen sein. Doch darauf kommt es gar nicht
an. Allein das ist das Ziel der Erkenntnis, daß Schiller ebenso wie Grillpar-
zer, jener für den Südwesten, dieser für den Südosten, am Ziel der Theater-
entwicklung aus dem Humanismus und dem Barock steht. Hatte nicht Her-
ders „Adrastea" einem neuen tragischen Stil aus der Musik das Wort geredet?
Herder aber war durch Jakob Balde im Barock heimisch geworden.

Goethes
Lebensstil

Goethe wurde durch Schillers Riesenschritte mitgerissen. Auch Goethe hatte auf seine Weise den Kreislauf vom Barock über Renaissance und Antike zu Renaissance und Barock auf seine Weise abgeschlossen, indem er mit seinem Bühnenspiel „Torquato Tasso" die Tragödie des modernen Dichters formte. Er gab sich neben Christiane Vulpius dem Behagen des Lebens hin und genoß es in seinen „Römischen Elegien". Mit allzuleichten Spielen, „Der Großkophtha", „Der Bürgergeneral", „Die Aufgeregten" folgte er dem Gange der Zeit. Wissenschaftlich fesselten ihn die Pflanzen, das Licht, die Farben. Was er in solcher Tätigkeit dachte und grübelte, trug er in den „Unterhaltungen deutscher Ausgewanderter" zusammen, verkleidet und geheimnisvoll bedeutend gemacht im „Märchen". Er zog mit seinem Herzog zu Felde, hörte den Donner von Valmy und stand vor Mainz, wo betrogene deutsche Schwärmer ein unreifes Volk betrogen. Und so erneuerte er im Stil dieses satten Bürgerlebens 1793 die alte Mär von „Reineke Fuchs". In dieser

Der Brief
von Schiller

Lage traf ihn Schillers Brief aus Jena und brachte das stockende Leben abermals in Fluß. Die Versnovelle „Hermann und Dorothea", September 1796 begonnen, April 1797 vollendet, war das erste Lebenszeichen des wiedererwachten Dichters. Den Umwälzungen der Zeit war hier ohne große Worte

Neues Tempo

etwas Geistiges und Dauerndes entgegengesetzt: das ewige Feuer des häuslichen Herdes. Das war aber auch die Dichtung, die das Formgesetz der Antike zu reinem deutschen Stil machte, indem er Homer nicht die Masse selber, sondern nur die Verhältniszahlen entnahm. Der Roman „Wilhelm Meisters Lehrjahre", aus der Theatralischen Sendung umgearbeitet zu einem Bildungsroman, in dem der Schauspieler nicht mehr das Ziel, sondern das Mittel der Bildung war, 1794/1796 gedruckt, war schon die Bürgschaft, daß nun ganz andere und allzulange ruhende Dinge sich vollenden würden. Das Schauspiel „Die natürliche Tochter" 1803, das Marionetten über eine schattenhafte Bühne gleiten ließ, bezeugte doch das eine, daß Goethe über keine neuen Kräfte verfügte, um es Schiller auf dessen eigenstem Gebiete gleich zu tun. Aber Herders Straßburger Erziehungswerk, der Einfluß Roms und Siziliens, Schillers lebensprühender Gedankenaustausch wurden jetzt überstrahlt von der wahrhaft rettenden Anteilnahme, die der fördersame Schwabe dem unseligen Faustbruchstück zuwandte. Der junge Goethe hatte 1775 ein Bündel Blätter mit nach Weimar gebracht. Sie enthielten als eine kecke Folge von Auftritten ein paar Bilder aus dem Leben eines dunklen Humanisten und

Angeraucht
Papier

die ergreifende Geschichte einer blonden Unschuld. Die gelb und brüchig gewordenen Blätter verjüngten sich auch in Rom nicht, nur daß ein weniges hinzuwuchs, und wurden als hoffnungsloses Bruchstück 1790 unter die Presse

gelegt: „Faust, ein Fragment". Da kam die neue Freundschaft. Schon am *Die Rettung Fausts* 29. November 1794 stellte Schiller die Gewissensfrage nach Faust. Nach drei Jahren gab sich Goethe endlich gefangen. Es entstanden die Walpurgisnacht, die Zuneigung, das Vorspiel und der Vorspruch im Himmel. Das Helenaspiel begann sich zu bilden. Ende 1802 weist Goethes Tagebuch zum letztenmal Schillers Anteil aus. Das Werk war gelungen. Am 13. April 1807 konnte Goethe niederschreiben: „Schluß von Faust, 1. Teil". Der Stil des Gedichts, wie es nun umgestaltet, fortgeführt und schließlich vollendet wurde, näherte sich abermals der barocken Kunstweise, wie Goethe selber sie auf seiner Weimarer Bühne aus den Wiener Spielen aufklingen ließ.

An einem Mainachmittage, dem 9. des Jahres 1805, schloß Schiller die *Der zweite Tote von Weimar* Augen. Der Bruch mit Herder und Schillers Tod verarmten Goethe und entlasteten ihn. Alle inneren Hemmungen fielen. Der echte Goethe kam wieder zum Vorschein und begann sich zu formen, wie er zu erscheinen wünschte. Rings um ihn hielt der Tod seine Ernte. Das Herzogtum wurde 1809 sauber zwischen Karl August und Goethe geteilt. So lebte der Dichter fortan als vornehmer Höfling, schrieb und briefwechselte, spielte Theater und beauf *Goethe, Kaiser und Kaiserinnen* sichtigte, verfügte sich im Sommer in die böhmischen Bäder, Hofdichter kaiserlicher Badewochen und Frauenlob der beiden Kaiserinnen aus dem gleichen Hause, der östlichen und der westlichen, und wurde am 2. Oktober 1808 zu Erfurt von Kaiser Napoleon empfangen. Drei Prosawerke, scheinbar ohne Beziehung auf einander, lagern sich um das Trümmerfeld dramatischer Arbeiten und Entwürfe, in denen sich gleichwohl ein wichtiger geschichtlicher Abschluß ausdrückt. „Winckelmann und sein Jahrhundert" 1805 bildet den Übergang zu Goethes eigengeschichtlichen Büchern. Der tote Winckelmann wurde als Zeuge gerufen für Goethes klassische Sendung und gegen die altdeutschen Strebungen der Romantik. Das Buch „Zur Farbenlehre" 1810, nicht sehr glücklich und zerstückt angelegt, zeigt den Künstler weggewandt von der zerklüfteten Wissenschaft der Zeit und einverstanden mit der Weltbetrachtung der französischen Enzyklopädisten. Der Roman „Die Wahlver *„Die Wahlverwandtschaften"* wandtschaften", 1808 gearbeitet und 1810 erschienen, wollte im Gegensatz zu „Werther" nicht Gesetze der Gesellschaft, sondern der Natur formen. Stehen die Menschen allein unter dem Naturgesetz, so handeln sie nicht unsittlich, wenn sie nach Erkenntnis des Gesetzes sich trennen, sondern wenn sie sich gegen das Gesetz und eigenmächtig zusammenfinden. Der Vorwurf, den Goethe gestalten wollte und den er wirklich gestaltet hat, die stimmen nicht zusammen. Über diesen innern Bruch täuscht lediglich die unvergleichliche Prosa hinweg, die weder Bilder noch Musik macht, sondern mit greif-

barer Gegenwart die Dinge selber vor dem Auge vorüberführt. Indessen die rhythmischen Schläge von Goethes fortgeleitetem Leben waren in den Bruchstücken und Entwürfen seiner dramatischen Muse zu hören. Hier wölbten sich die klassischen Abschlüsse der römisch-deutschen Lebenseinheit. Hier wirkte der Wille nach einem neuen tragischen Stil aus der Musik weiter. Hier ließ sich das Tiefengeräusch der verdeckten Arbeit am Abschluß des „Faust" vernehmen. Das war im Sommer 1805 der Entwurf für eine Totenfeier Schillers, 1808 das unvollendete Festspiel „Pandora", 1813 das Siegesspiel „Des Epimenides Erwachen".

Der dritte Tote
von Weimar
 Am 18. Februar 1813 hielt Goethe dem dritten Toten der Weimarer Vier, Christoph Martin Wieland, in der Loge „Anna Amalie" den Nachruf. Die Zeit des deutschen Klassizismus und das Schicksal Napoleons hatten sich erfüllt. Mit Goethe hatte sich die römisch-deutsche Lebenseinheit künstlerisch vollendet, der deutsche Klassizismus an die fränkisch-französische Renaissance des Kaisertums Napoleons hingegeben. Das romantische Werk war eine Tat, die getan werden mußte.

II. STAATSNATION
1786 bis 1814

Die große abendländische Krisis war zu Anfang des fünfzehnten Jahrhunderts in Böhmen ausgebrochen. Sie war zu Wittenberg an der Hand der Bibel ins Deutsche übersetzt worden. Sie wurde jetzt zu Paris mittels der Menschenrechte ins Europäische verdolmetscht.

Preußen hatte durch seine Teilnahme an den Teilungen Polens die staatliche Einigung des Ostraumes abgeschlossen. Preußen hatte durch den Einmarsch in Schlesien und durch den deutschen Fürstenbund dem Deutschen Reich den Todesstoß gegeben. Im Kampf um die französische Revolution verwandelte Preußen sich durch seinen Zusammmbruch aus roher Gestalt eines Kriegerstaates in ein ganzheitliches geistiges Gebilde und legte also den Grund zu seiner deutschen Vormacht. All diese Durchgänge und Abschlüsse verweben sich zu der romantischen Bewegung, die nach Herkunft ihrer persönlichen Träger und nach dem Spielraum ihrer überpersönlichen Kräfte, die nach Ziel und Bezug eine ostdeutsche Bewegung gewesen ist.

Die romantische Handlung, die nun zu rollen begann, wurde geistig ausgelöst durch die geheimen Gesellschaften der Freimaurer und Rosenkreuzer sowie durch das pietistische Glaubenswesen. Beide Kreise, so wesensfremd sie einander scheinen mögen, überschnitten einander mit jenem gemeinsamen Gedankengut, in dem altdeutsche Mystik und alchimistischer Naturglaube seltsam zusammengemischt waren. Hier gingen die Geheimnisse und Botschaften der Gemeinde Jakob Böhmes, der Brüderkirche, der Rosenkreuzerbrüder um. Das war die Gesinnung und das war der Gedankenbesitz, der um 1785 in der Person des neuen Preußenkönigs Friedrich Wilhelm II. durch seinen Staatsmann Johann Rudolf von Bischoffswerder und seinen Lehrmeister Johann Christoph Woellner staatlich zu handeln begann und den Grundriß einer neuen preußischen Staatsgemeinschaft zu entwerfen begann: eines bäuerlich untergründeten Gemeinwesens, das dem mit leerem Boden übersättigtem menschenarmen Staate Menschen erzeugen, versorgen und aufwärts bilden sollte.

Ein Zeugnis, nicht umzustoßen, spricht für das Gleichmäßige und Gleichartige des ganzen Vorganges. Fast gleichzeitig brechen überall im Osten Stellen auf, durch die von unten her jene neue Gesinnung an den Tag tritt.

Gleichzeitiger Nur eines kann die Plötzlichkeit erklären, mit der die Fülle verwandter und
Aufbruch innerlich oft so gleichgerichteter Begabung emporschießt. Nach langem, stillem Wachstum sind eine neue Zeit und ein neues Volk reif. Und die Bewegung schlägt auf allen Gebieten geistigen Lebens durch: in Religion, Sitte,
Philosophie; in Dichtung, Malerei, Tonkunst; in Gesellschaft, Wirtschaft,
Staat. Körperlich und geistig ist ein neuer Menschenschlag geboren worden,
mit verwandtem Antlitz des Leibes und der Seele. Die romantische Bewegung ist so wenig wie die deutsche Renaissance ein Anfang, sondern die
Höhe eines laufenden Vorganges, der völkisch seit rund 1200, geistig seit
etwa 1500 einsetzte.

1. NORDDEUTSCHE LANDSCHAFTEN

Ihre Kraftquellen hat die Bewegung überall in Niedersachsen und im
deutschen Osten. Aber auch die deutsche Romantik ist wie der deutsche
Klassizismus auf die drei Bildungsherde des frühen achtzehnten Jahrhunderts hin zu triangulieren: auf Hamburg, Königsberg, Zürich. Von Königsberg her empfängt die deutsche Romantik durch Hamann über Reichardt bis
zu Wackenroder, Tieck und Werner das Wunschbild einer christlichen Kunst,
wie es schon Pyra und Klopstock geträumt hatten. Aus dem skandinavischen
Norden rührt sie über Niedersachsen der Mythus des nordischen Germanentums an und drängt sie zu artverwandten dichterischen Gebilden. Aus den
vorbereitenden Händen der Zürcher hat sie die wiederentdeckte mittelalterliche Dichtung und die poetische Legende der Kunstfrömmigkeit, in der
Bodmer und Hamann einst einander begegnet waren.

Mitte Berlin Wie der deutsche Klassizismus in Weimar, so hat die deutsche Romantik
ihre schöpferische und staatlich handelnde Mitte in Berlin gefunden, der
Hauptstadt des deutschen Oststaates. Was dort Wieland und Herder, Goethe
und Schiller bedeuten, das stellen hier, in ganz anderen Größenverhältnissen,
Wackenroder und Tieck, Arnim und Kleist dar.

Sächsische *NIEDERSACHSEN.* Nicht früher als anderswo, weil überall gleichzeitig,
Vorereignisse aber hier mit eigentümlicher landschaftlicher Kraft bricht die romantische
Bewegung in Niedersachsen auf. Es sind die mystischen Räume des Landes
geschildert worden, vor allem Quedlinburg und Münster. Leibniz wurde von
Hannover aus wirkend gedacht, indem er aus mystischem Inhalt und scholastischer Form den geistigen Vorbesitz des Mutterlandes für die neue sächsisch-ostdeutsche Lebensgemeinschaft zurechtbildete. Um Männer, wie Klop-

stock, Claudius, Stolberg, Jung, ließ sich der gläubige Verband einer neuen christlich-deutschen Kirche beobachten und die Anfänge eines christlichen Kunstverlangens. Zu Münster flossen um die Fürstin Gallitzin und Hamann die Strebungen und Voreignisse der Romantik zusammen, einer Bewegung, die aus gesonderten Tiefen aufstieg und mit dem ostdeutschen Zuge Ziel und Mittel zu teilen suchte. Niedersachsen bedeutet für die romantische Bewegung einen zweifachen Antrieb: die geschulte Vernunft der Göttinger Hochschule und die erregende Kraft der nordländischen Einbildung. *Göttingen*

Göttingen hatte schon um 1772 durch literaturkundige Schwaben das altdeutsche Schrifttum an die einflußreiche sächsisch-ostdeutsche Gruppe von Klopstocks Schülern vermittelt. Jetzt schoß der gesamte geschichtliche und sprachwissenschaftliche Bildungsgehalt der Hochschule, die im ersten Alter ihrer männlichen Reife stand, in die romantische Bewegung ein. Von den beiden Brüdern, die dem mittleren der drei Schlegelbrüder, Adolf, zu Hannover geboren wurden, ist nur *August Wilhelm Schlegel*, 1767 bis 1845, *August Wilhelm Schlegel* durch Christian Gottlob Heyne und Gottfried August Bürger ein rechter Schüler Göttingens geworden. Schiller und der holländische Klassizismus prägten den Stil von Schlegels mäßigen eigenen Dichtungen. Aber Bürger und Herder, jener das persönliche und dieser das geistige Erlebnis seiner Göttinger Schulzeit, haben Schlegel zu dem gemacht, wofür er geboren war: zum großen Übersetzer und Beurteiler. Seine von Herder angeregte Arbeit an Dantes „Divina Commedia" trat schließlich hinter der Shakespeare-Übersetzung zurück, die schon 1789 geplant, dann zusammen mit Bürger begonnen, endlich aus eigener Kraft durchgeführt, Shakespeare zu einem deutschen Klassiker machte. Seit 1796 in Jena und mit Karoline Michaelis verheiratet, *Gesiebte Literatur* sichtete Schlegel mit rastloser Ausdauer das gesamte zeitgenössische Schrifttum, auch als Beurteiler völlig Übersetzer und Vermittler und der beste Schüler, den Herder haben konnte. Er schmiegte sich fast jeder Form an. Sein Urteil antwortete beinahe selbsttätig auf jeden Reiz. Seine Schreibart war bewußt an Goethes glashellem Tatsachenstil geschult. Schlegel war von der Geschichte besessen und konnte nicht anders als geschichtlich denken und beurteilen. Mit seinem Göttinger Rüstzeug hat er dann jenen denkwürdigen Feldzug um den geistigen Besitz von Berlin geführt und also die Zukunft der ganzen Bewegung entschieden. Wie Friedrich Schlegel von Dresden, so ist August Wilhelm Schlegel von Göttingen zu Macht und Einfluß aufgestiegen.

Die niedersächsische Landschaft erzeugte auf allen Gebieten ihr eigentümliche Abbilder zu Neugestaltern des geistigen Lebens. Wie *Karl Ritter*, *Ritter und Herbart* 1779 bis 1859, aus Quedlinburg in Herders Sinne die moderne Erdkunde

schuf, so gründete *Johann Friedrich Herbart,* 1776 bis 1841, aus Oldenburg, auf Leibnizens Spuren seine mathematische Seelenkunde, die Voraussetzung seiner Erziehungskunst und Schönheitslehre. Ritters geisteswissenschaftlich gedachte Naturkunde und Herbarts naturwissenschaftlich gemeinte Geisteskunde haben sehr wesentlich am romantischen Weltbilde mitgeschaffen, beide mit ihrer sächsischen Verständigkeit gleich weit entfernt von jeglichem Abenteuer. Romantisches Sondergewächs aus sächsischem Boden waren dann die drei Männer, von denen jeder auf eine andere Art Dichter gewesen *Krummachers* ist. *Friedrich Adolf Krummacher,* 1767 bis 1845, aus Tecklenburg und Pre-
„Parabeln" diger an der berühmten Bremer Ansgarikirche, hat zu seinen verdienstlichen Volksbüchern und Kinderschriften nach Herders Vorbildern mit seinen „Parabeln" 1805 eine anmutige Abart der Erzählung wiedergeschaffen. Es sind, ob sie nun im Lande der Bibel, in Indien, in Athen oder in einem der drei Naturreiche spielen, Anekdoten, die über ihren sinnlichen Sinn hinaus etwas „bedeuten". Das zierliche Schlüßlein zu diesem ihrem geistigen Sinn hängt überall bequem, doch schicklich am rechten Platz. Es sind Kunstwerke von kleinsten Verhältnissen. Es sind Novellen in der verkürzten Bilderschrift des evangelischen Dichters. Wieder anders hat *Franz von Sonnenberg,* 1779 bis 1805, aus Münster, sein tragisch gelebtes und tragisch geendetes Dasein an *Sonnenberg* die große vaterländische Ode und an das epische Weltgedicht gesetzt, ein
und Klopstock Jünger Klopstocks und Schicksalsgefährte Kleists. In mächtigen Vorgesichten, mit hinreißendem, lyrischem Schwunge schildert er die erwarteten Schlachten um Deutschlands Befreiung als schon geschlagen, Zukunft als Vergangenheit. Und sein Großgedicht „Donatoa", 1801 bruchstückweise, 1806 als Ganzes gedruckt, gibt ein Rundgemälde der zerstörten und wieder neu geschaffenen Welt, ihres Untergangs und ihrer Wiedergeburt. Dieses scheinbar so verwirrende, mit Kämpfen, Weltgeschehnissen, Einzelzügen überfüllte und bis in die letzte Silbe seiner reizbaren, stürmenden, gleitenden, rieselnden Sechsfüßler berechnete Gebilde trägt den sächsischen Willen zur Romantik über die Schwelle des Jahrhunderts. Milton, Klopstock, Sonnenberg — welch unbegreiflich gerader Weg aus der gemeinsächsischen Fülle von beiden Ufern des Weltmeeres mitten in die deutsche Romantik hinein. Franz von Sonnenberg und Zacharias Werner, „Donatoa" und „Die Söhne des Tals": ein Bogen der Einheit, des gleichen neuen Geistes von Münster bis Königsberg. *Kanne* Und abermals anders hat *Johann Arnold Kanne,* 1773 bis 1824, aus Detmold,
und Hamann sein abenteuerliches Leben zunächst in kleine humoristische Büchlein von der Art Johann Paul Richters eingefangen, um dann den Ertrag seiner Göttinger Sprachstudien und seines Erlanger Lehramtes zu mythenvergleichen-

den Büchern auszumünzen. Auf der Linie Hamann—Herder—Schubert suchte Kanne mit dem Schlüssel der Dreieinigkeit Mythus—Sprache—Dichtung das Geheimnis der menschlichen Uranfänge zu öffnen. In Sprachbildern dichtend wie Hamann, geschichtlich sondernd wie Herder, wie Schubert dem Glauben verfallen, daß der Mensch in unermeßlicher Vorzeit gleichmäßig Bürger beider Reiche war, der Natur und des magischen Geistes, versuchte Kanne jene Weltwende zu durchleuchten, da Götter zu Menschen wurden, zu Urmenschen, das ist zu Gottmenschen. So kam Kannes „Erste Urkunde der Geschichte" 1808 zu der Erkenntnis: „Alle Patriarchen, Richter, Propheten, Könige sind Götter gewesen. Der Mensch ist sich nirgends selbst zum Mythus geworden, zum Heros und Gott, sondern umgekehrt der Gott zum Menschen; und die erste Menschengeschichte ist eine Götterhistorie. Was der Mensch anfangs war, ist sicher dasjenige, was er sein soll und kann, und in der Geschichte liegt die Philosophie." Diese Erkenntnis war für einen Gläubigen gleich Kanne so gut ein staatliches wie ein kirchliches Grundgesetz. Johann Arnold Kanne gehört eng neben Adam Müller. Ihm ist aus seinen Mythenforschungen eine ähnliche staatbürgerliche Anschauung erwachsen wie diesem aus seinem staatswissenschaftlichen Denken.

Damit ist das letzte Stichwort gefallen. Die romantische Welle, die von Sachsen gegen den Mittelpunkt des Ostens heranrollte, erhebt sich in *Friedrich von Hardenberg*, 1772 bis 1801, zu gekrönter Höhe. Zu Oberwieder- *Der Magier* stedt, im Wuppertal, im südlichen Ostfalen, unfern Quedlinburg geboren, kann Hardenberg nur aus dem ganzen Gewebe der Zeit, in das er verstrickt war, begriffen werden. Durch ihn erhält die ganze Reihe Krummacher—Sonnenberg—Kanne ihr eigentümliches Licht. Ein strenger biblischer Zug, der Blick und Wille ins Kosmische, ein Sprachstil der getragenen Weihe, der großräumigen Gebärde, ein Sprachstil, der die Worte zweisinnig gebraucht, mit dem, was sie sagen, und mit dem, was sie bedeuten. Und gemeinsam ist ihnen der aufgeschlossene Verstand für den Mythus, aus dem ihre Schöpfungen leben, auf den sie zielen. Wenn Romantik die Farbe der Stimmgabel ist, an der jeder einzelne abzuhören ist, so steigt der Ton von Krummacher, wo er nur leise schwingt, über Sonnenberg und Kanne mit wachsender Kraft an, bis er sich bei Hardenberg im vollen Aushauch erschöpft. Von Ostfalen lief Klopstock aus und beschrieb einen lebenerweckenden Kreis durch Sachsen hin. In Ostfalen rundet sich dieser Kreis ins Volle mit Hardenberg. Beide, Klopstock und Hardenberg, stehen einander im Raumbereich ihrer Heimat so nahe wie Ausgang und Eingang, durch die gleiche Tür geöffnet und geschlossen.

Vaterhaus Mystische Sinne und Seele hatte Hardenberg von dem sächsischen Edel-
Herrnhut mann empfangen, der sein Vater war. Den Gedankeninhalt seines Lebens
der Mystik aber hatten ihm der Herrnhuterglaube des Vaterhauses und die
pietistische Erziehung eingegossen. Es war nur eine Wiederbegegnung mit
dieser Gedankenwelt, als er im Frühjahr 1797 die älteren Naturphilosophen
zu lesen begann, als er Jakob Böhme und Ende 1798 Plotin kennenlernte. In
Jena wurde ihm Schiller das große Vorbild. In Jena ging er durch Kants und
Fichtes Schule. In Jena lernte er 1797 — eine der entscheidenden Szenen des
romantischen Schauspiels—Johann Wilhelm Ritter kennen. Hardenberg ging
im Winter 1798 auf die Bergakademie Freiberg. Hier fand er sich Abraham
Der Lehrling Gottlob Werner gegenüber. Friedrich Schlegel war ihm von Dresden her
von Sais Jugendfreund. Ritter und Werner wurden ihm Lehrer. Hardenbergs ganzes
Seelenleben wurde vom reinen Geist auf die gegenständliche Natur um-
geschaltet. Wie Werner durch seine Beobachtungen ein wohlgeordnetes Gan-
zes der Mineralien gewonnen hatte, so suchte nun Hardenberg auf verwand-
tem Wege ein ebensolches Ganzes menschlicher Begriffe und Erkenntnisse
zu finden. Er suchte nach einer Verwandtschaftslehre der Gedanken, nach
einer Gedankenverbindungskunst. Rasch kam er so über das Erfahrungs-
mäßige der Wissenschaft hinweg zur alten mystischen Naturphilosophie. Die
ganze Natur im einzelnen wie in der Gesamtheit wurde ihm zu seelischem
und geschlechtlichem Sinnbild. Die magische Einheit mit allem, was da ist,
die Fähigkeit, durch alle Dinge angesprochen zu werden, war ihm der ur-
sprüngliche menschliche, lediglich durch den Abfall ins Leibliche gestörter
Zustand. Mit der Seele in das All hineinwachsen, das hieß nur dieses Ur-
sprüngliche wiederherstellen. Er glaubte, diese Fähigkeit durch Steigerung
der seelischen Kräfte zurückzugewinnen. Er glaubte an Magie und dünkte
Hilfreicher sich ein Magier. Und nun kam ihm der Schmerz zu Hilfe. Der Tod der Braut
Schmerz und des Lieblingsbruders 1797 stürzten ihn in völlige Vernichtung und lie-
ßen ihn als einen, der zu einem zweiten Leben erwacht ist, wieder aufer-
stehen.

Wie Seuse lebte er in den Dahingegangenen und umgab sie mit religiöser
Verehrung. Schmerz war sein Tagewerk, fast sein Gottesdienst. Wie die
Männer und die Frauen der Mystik führte er ein Doppelleben zwischen
äußerer Heiterkeit und innerer Verliebtheit in den Tod. Sein Spiel mit Chri-
stus und Sophie, wenngleich an den Namen seiner Braut geknüpft, wieder-
holte fast Seuses Zwiegespräche mit der göttlichen Weisheit. Wenn Harden-
berg religiöse und geschlechtliche Vorstellungen vermischte, so bewegte er
sich allerdings zunächst in den Kreisen der Herrnhuter. Doch es waren vor-

geprägte Gedankenverbindungen der altdeutschen Mystik. Es war Hamann gewesen, der sie zuletzt gedacht hatte.

Es war nur ein schmales dichterisches Werk, mit dem dieses unermeßlich reiche Innenleben sich gar nicht verströmen konnte. Der Kindertod seiner Braut hatte ihm 1797 die Zunge gelöst. Er sang sich in seinen „Hymnen an die Nacht" das hohe Lied auf Eros Thanatos, der Leben und Tod, Geburt und Vernichtung in einem ist, die Verwesung des Verweslichen zum wahren Wesen ewigen Seins im Schoß der göttlichen Liebe. Schwankend zwischen Haß und Zuneigung ließ er den eben erschienenen Roman Goethes „Wilhelm Meister" auf sich wirken und antwortete 1798 auf diesen zwiespältigen Eindruck mit seinem eigenen Roman „Heinrich von Ofterdingen", der Bildungsgeschichte des Dichters schlechtweg. Die „Blaue Blume" suchen und finden heißt nichts anderes als zur wahren und echten Dichtung gelangen. Der Roman war als Glied einer ganzen Kette von Romanen gedacht, die gleicher Art alle Gebiete des geistigen und menschlichen Lebens behandeln sollten. „Die Lehrlinge zu Sais" sind ein dichterischer Versuch, jene Vermenschlichung des ganzen Alls darzustellen, zu der ihn das eigene Erlebnis wie die Naturwissenschaft Werners und Ritters geführt hatten. Hardenbergs Grundschrift, die geistige Botschaft der gesamten romantischen Bewegung, ist die kleine geistesgeschichtliche Abhandlung „Die Christenheit oder Europa", die ursprünglich für das „Athenäum" seiner Schlegelfreunde bestimmt war. Sie knüpft an Herders allbewegende schmale Schrift „Auch eine Philosophie der Geschichte" an. Sie gibt die Entwicklungsgeschichte des modernen Europa aus dem Europa der Reformation, die als Verfall, weil Abfall vom Mittelalter erscheint. Und sie stellt an einem Aufriß der mittelalterlichen Ordnung den Aufriß eines neuen Europa dar, wie es nach dem Urbilde des mittelalterlichen Europa wieder aufzubauen wäre. Die Aufklärung ist die naturgegebene Feindin der Religion, Sittlichkeit und Kunst. Sie ist eine Tochter der Kirchentrennung. Diesen ersten und zweiten Umsturz muß eine neue „Regeneration" wieder gutmachen. Diese „Wiedergeburt" ist in Deutschland eben in vollem Gange. Hardenberg faßt also die Bewegung, die von ihm und seinen Freunden geführt wurde, als eine staatlich-religiöse Unternehmung auf, dazu bestimmt, die alte religiöse Einheit und das alte christliche Europa wieder herzustellen. Durch Friedrich von Hardenberg ist aus dem meißnisch-ostfälischen Grenzgebiet die Mystik der ostmitteldeutschen Seele wieder wirksam geworden.

PREUSSEN *und* MEISSEN. Aus der größten geschichtlichen Tiefe bricht die romantische Bewegung in der Lausitz und in Schlesien auf. Es ist eine

Liebesspiel mit dem Tode

Hardenbergs Dichtungen

„Die Christenheit oder Europa"

„Wiedergeburt"

Tiefe, die über Zinzendorf und Böhme bis auf Schwenckfeld hinabführt. Die religiöse und sittliche Aufgabe stand auch hier im Mittelpunkt. Auch hier ging es um Regeneration und Wiedergeburt. Aber hier zielte die Bewegung gleichermaßen auf Geist wie auf Natur. Zweimal zwei gepaarte Erscheinun-

Ich-Philosophie gen. *Johann Gottlieb Fichte,* 1762 bis 1814, aus Rammenau in der Oberlausitz, hatte 1792 zu Königsberg Kant kennengelernt. Er übernahm dessen kritisches Verfahren und glich Kants Gedankengänge bis zu den äußersten und letzten Folgen aus. Kant hatte das große Unbekannte bestehen lassen und nur bedauernd erklärt, wir könnten davon nichts wissen, weil wir nur seine Erscheinung sähen. Fichte leugnete, daß hinter diesen Erscheinungen das stecke, was der gemeine Mann bis auf ihn, Johann Gottlieb Fichte, dahinter vermutet und geglaubt hätte. Das Ich ist zugleich Träger und Gegenstand des Vorstellens, Vorstellendes und Vorgestelltes selber. Was nicht diese Vorstellung seiner selbst ist, das ist Nicht-Ich. Beide, Ich und Nicht-Ich, können nur so im gleichen Bewußtsein vereinigt werden, daß das Ich sich in der Vorstellung des andern selber anschaut. Indem das Ich, wenn es das Nicht-Ich anschaut, in diesem Spiegel wieder nur sich selber erblickt, als ein anderes, das mit ihm selber identisch ist, aus dieser Tat des Selbstbewußtwerdens geht das hervor, was der gemeine Mann bis auf Fichte die wirkliche Welt nannte. Das Ich erscheint sich selber. Dieses freie Ich ist Grundgesetz alles Wissens, aller Vernunft, aller Erkenntnis. Alles war auf eine Grundtat zurückgeführt, auf das reine Denken. Denken ist schaffen. Denken ist handeln. Denken ist Sein. Ins Sittliche übertragen: das Ich muß zum vollen Sein gelangen, indem es nur dem unbedingten Sollen, dem Gewissen folgt. Werde, was du bist. So neu als sie umstürzend aussah, war diese Tat nun doch nicht. Durch Fichte schien die aufgeklärte Vernunft zu sprechen. Doch was er redete, war die Sprache der altdeutschen Mystik. Fichte hatte nur das mystische Beschauen wieder zu Ehren gebracht. Ja, das Ich zu spalten, die eine

Ekstasis der Mystik Hälfte der andern gegenüber und aus dem Beschauenden gewissermaßen herauszustellen, daß das Ich seine eigenen Gedanken vor sich selber bildhaft spielen sieht, war ein ganz geläufiger seelischer Vorgang, auf den sich die meisten Gesichte der Mystik zurückführen lassen. Das Ineinssetzen des Denkens mit dem zu erkennenden Gegenstande begründete schon Meister Eckeharts Philosophie. Und der Geist, der selbst ist, was er erblickt, und der durch sein Denken aus dem Einen die Unendlichkeit der Erscheinungen entwickelt, das war schließlich der „Geist" Plotins und der hellenistischen Philosophie.

Durch *Friedrich Daniel Schleiermacher,* 1768 bis 1834, einen Breslauer,

brach die religiöse Kraft der Lausitzer Brüdergemeinde wieder auf. In den *Werde,* *der du bist* Herrnhuter Schulen zu Barby und Niesky erzogen, war Schleiermacher nach Hamanns Art von Haus aus an einen unmittelbaren Umgang mit Gott gewiesen. Doch Seelendürre schlug in Zweifel aus und der Zweifel reifte zur Frucht des Unglaubens. So gesinnt und gestimmt sah Schleiermacher sich an der Universität Halle in die Werke Kants und Platos eingeführt. Er fühlte sich bestätigt und nährte nun seinen Unglauben mit dem asketischen Glück des Glücksverzichts. Gegen 1796, in der Zeit, da er geistig mit Baruch Spinoza und persönlich mit Friedrich Schlegel bekannt wurde, erwärmte sich auch sein Herz wieder und wandte sich zurück zum Glauben seiner Herrnhuter Jugend. Dieser religiöse Wandel ist Inhalt und Handlung seiner beiden ersten und zeitbewegenden Bücher. Die „Reden über die Religion" 1799 *„Reden über* *die Religion"* kehrten sich ganz in Hardenbergs Sinne gegen die Aufklärung als die schlechthin religionsfeindliche Macht, aber auch gegen Kant, indem sie gegen die reine Vernunft das reine Gefühl bejahten. Was Kant, was Fichte, was Spinoza! Die heimische und ihm von Herrnhut her vertraute Mystik redete aus diesen Reden, mochten sie vorerst auch geschämig statt Gott „Universum" und statt Gottvereinigung „frommes Gefühl" sagen. Da stehen sehr eindeutige Dinge. Anschauen Gottes ist dessen Handeln in Beziehung auf uns. Religion ist Sinn und Geschmack für das Unendliche. Jede ursprüngliche und neue Anschauung Gottes ist eine Offenbarung. Unsterblichkeit heißt fast mit den Worten Johannes Schefflers „mitten in der Endlichkeit eins werden mit dem Unendlichen und ewig sein in einem Augenblick". Religion ist mehr als Kunst, mehr als Wissenschaft, mehr als Sittlichkeit, weil diese alle in der Enge des Endlichen beschlossen liegen und die Religion allein durch die Kraft des Gemütes und den Flug der Beschauung über Zeit und Raum hinweg in die Stille des Ewigen und Unendlichen trägt. Religion ist das Persönlichste. Wer sie als hohe Kunst zu üben vermag, besitzt die Welt jenseits der Sinne. In den „Reden" hatte Schleiermacher die Religion an sich, reinlich geschieden von Zwecken und Absichten, entwickelt. In den „Monologen" von *„Monologen"* 1800 bestimmte er den Begriff des Sittlichen an sich. Und wie er dort, getreu dem Geiste der Mystik, die Religion als Sache des persönlichen Erlebens gefaßt hatte, so deutete er hier die Sittlichkeit als Fülle persönlich eigentümlichster Pflichten aus. Verdoppelt war die Nachwirkung seiner Herrnhuter Jugend gewachsen. Er fand, das Gleichmaß von Erkennen und Begehren sei in der hohen Selbstbetrachtung gegeben. „In sich selbst zu schauen", das war die Kunst des Pietismus, der Herrnhuter Brüder, der altdeutschen Mystik. *Ansichschau der* *Mystik* Jeder Mensch soll auf seine persönliche Art die Menschheit an sich selber

darstellen. Höchstes Gesetz des sittlichen Handelns ist, immer mehr zu werden, was man ist. Das heißt, sein Eigentümlichstes ausbilden. So entwickelt Schleiermacher ein sittliches Idealbild, indem er eine ausgeprägte Persönlichkeit, indem er sich selber darstellt. Die „Monologen" sind in der Hauptsache ein Bekenntnisbuch, Reden mit sich selbst und an sich selbst. Beinahe zeitlos stehen Schleiermachers „Monologen" und Seuses Selbstbetrachtung *Seuse und* nebeneinander. Seuse wie Schleiermacher zeigen ihrer Zeit am besonderen *Schleiermacher* Falle des eigenen Bildungsganges, wie sittliche Vollkommenheit zuverwirklichen sei. Kein Eigenleben und keine Bildung sind möglich ohne die Liebe. Nicht sinnliches, sondern sittliches Wohlsein ist das Ziel der Gesellschaft. Ohne hilfreiche Gemeinschaft der Geister keine Vollendung der Sittlichkeit. Freundschaft, Ehe, Staat, die engeren und weiteren geselligen Bindungen müssen vergeistigt und verinnerlicht werden.

So lag Fichtes Ichgefühl in der ganzen Mystik ausgebildet, wie Schleiermacher aus der alten schlesisch-lausitzischen Innerlichkeit zu begreifen ist. Nicht anders wie diese Richtung auf den Geist die gleichzeitige landestümliche Richtung auf die Natur. Fichte wollte die Welt der Erscheinungen nur als volkstümliche Anschauung des gemeinen Mannes gelten lassen, wie man etwa sagt, die Sonne geht im Osten auf und im Westen unter. Diese vorgebliche Erscheinungswelt des reinen Geistes wurde gleichzeitig im gleichen *Richtung* Raum auf eine neue Weise Gegenstand der naturwissenschaftlichen Erkennt- *auf die Natur* nis und abermals aus den landschaftlichen Überlieferungen heraus. Ein Lausitzer war *Abraham Gottlob Werner,* 1750 bis 1817, der an der Freiberger Akademie ein ganzes Geschlecht von Naturforschern erzogen hat, der die Kennzeichenlehre ausbildete, klassische Mineralbeschreibungen lieferte und die naturwissenschaftlichen Erkenntnisse der deutschen Romantik entschei- *Theosoph* dend bestimmte. Ein Schlesier war *Johann Wilhelm Ritter,* 1776 bis 1810, *und Physiker* der nach zwei Seiten mit der altdeutschen Mystik verknüpft ist. Der Nürnberger Pietist Johann Gottfried Schöner war der Freund seines Vaters und Jakob Böhme sein eigener vertrauter Umgang. Ritter ist ein moderner Nachkomme der alten Theosophen. Seine Naturphilosophie, die auf weit bessere Sachkenntnis gegründet war als jene Schellings, kommt erst in zweiter Linie in Betracht gegenüber Ritters genialen Versuchen und Entdeckungen und gegenüber seiner erfahrungsmäßigen Behandlung der Naturvorgänge. Wie durch Herder die Geschichte, so wird hier durch Ritter die Natur für die ostdeutsche Bewegung gewonnen.

Die *MARK BRANDENBURG* gab der romantischen Bewegung den stärksten und entscheidenden Auftrieb. Dumpf und widerspruchsvoll gärten die

entbundenen Kräfte der neuen Zeit in der Persönlichkeit des Königs Friedrich Wilhelm II., der 1786 seinen kriegerischen Oheim Friedrich II. beerbt hatte. Der König, sinnlich und übersinnlich, hing an Magie und Alchimie, *Der Hof der Rosenkreuzer* fieberte vor abenteuerlicher Frömmigkeit, ließ an seinem Hofe mystisch dunkle Feste feiern, deren Hohepriester der einflußreiche Ratgeber Johann Rudolf von Bischoffswerder war. Der herrschende Minister des Königs und sein persönlicher Vertrauter, Johann Christoph von Woellner, war Rosenkreuzer und in diesem Geheimbunde war das Gedankengut der Mystik und Aufklärung ein seltsames Ganzes geworden, ohne sich organisch miteinander verbinden zu können. So spiegelte der Berliner Hof den unsicheren Widerschein der geistigen Dinge, die sich im Osten ankündigten und begaben.

Karl Philipp Moritz, 1757 bis 1793, als Sohn eines preußischen Soldaten *Pietist und Freimaurer* zu Hameln geboren, drückt körperlich, seelisch und geistig diesen frühen Zustand der ostdeutschen Bewegung aus. Von einem widerspruchsvollen Triebleben beherrscht, Vernünftler und Schwärmer, auf der Wanderbühne wie auf der Kirchenkanzel gleich unmöglich, Pietist und Freimaurer, hat Moritz in seinen zahlreichen Schriften das Vorspiel für das gestaltenreichste Stück deutscher Geistesgeschichte gegeben. Seine „Götterlehre" leitet zu den mythologischen Neuschöpfungen und seine Sprachschriften zu den volksbildnerischen Bestrebungen der Romantik hinüber. Seine Zeitschriften, so „Italien und Deutschland", 1789/1793, arbeiteten Heinrich von Kleist und Adam Müller vor. Sein Epos „Der Ritter des Geistes" zeigt freimaurerische *Romantische Seelenkunde* und romantische Absichten. Seine Schriften zur Seelenkunde mit ihren Neigungen für alles Nachtseitige und ihrer Zergliederungskunst vermitteln von der Seelenmeisterschaft der Mystik und des Pietismus zur romantischen Wissenschaft von der Seele und zu jenen zahlreichen romantischen Dichtungen, die sich in den unbekannten Abgründen der Seele verstiegen. Seine selbstdarstellenden Dichtungen, vor allem der Roman „Anton Reiser" 1785/1790 verschmolzen am vollständigsten Pietismus und Aufklärung im Zeichen der Freimaurerei und sie gehören mit dem gleichen Recht wie Goethes „Wilhelm Meister" zur Ahnenschaft des romantischen Bildungsromans. Mit Karl Philipp Moritz setzt zu Berlin der erste Herzschlag des neuen Geisteslebens deutlich vernehmbar ein.

Der Aufstieg zur christlich-deutschen Höhe der Bewegung vollzog sich in den beiden gegensätzlichen und desto innigeren Freunden *Ludwig Tieck,* *Die beiden Freunde* 1773 bis 1853, und *Wilhelm Wackenroder,* 1773 bis 1798, die das kurze gemeinsame Leben, das ihnen gegönnt war, auf eine wahrhaft gemeinsame Weise gelebt haben. Wackenroder, aus einer hohen Berliner Beamtenfamilie,

feinen Körpers und ohne persönlichen Mut, war eine zarte Blüte pietistischer
Seelenkultur. Er hing dem Freunde bräutlich an, war von willensstarker
Klugheit nur dort, wo er Gefahr für seinen Freund witterte, und ein beschei-
dener Liebhaber aller Künste. Tieck, aus einem wohlhabenden Berliner
Handwerkerhause, war auf geistige Weise der erste Großstädter, ein wage-
halsiger Reiter, unternehmungslustig wie ein junger Amerikaner, unruhig
lebhaft, voll kecker Zuversicht, fröhlich und harmlos, als gäbe es weder
Gemeinsame Feinde noch Alter noch Tod. Sie kannten einander von der Schule her und
Schule wurden getrennt, als Tieck zu Ostern 1792 nach Halle und dann nach Göt-
tingen auf die Hohe Schule ging. Aber sie blieben beisammen in den kost-
baren Briefen, die sie einander über alle Trennung hinweg schrieben. Ge-
meinsam bezogen sie 1793 die Hochschule Erlangen, dann Göttingen, und
gemeinsam lebten sie seit 1794 in Berlin, Tieck als rasch berühmter Schrift-
steller in seinem Sommerhause, Wackenroder dem Vater zuliebe als Rechts-
beamter. Von den beiden Freunden war Tieck der versprühende Blender.
Ein gieriger Leser im Bücherschatz seines Vaters, ein unersättlicher Gast im
Berliner Theater, ein bestrickender Komödiant auf den kleinen Berliner
Liebhaberbühnen, geriet der junge Tieck immer tiefer in die Hochgefahr
einer verderblichen körperlich-seelischen Anlage, die er noch künstlich über-
Tieck und steigerte. Er führte ein angstvolles Traumleben, verlor sich selber zu Zeiten
Wackenroder aus dem Bewußtsein und fühlte sich dem blinden Ungefähr einer Überwelt
ausgeliefert, die jeder Vernunft und Ordnung spottend in die Wirklichkeit
des Alltags hereinspukte. In kleinen Dichtungen, die ihm genial-spielerisch
von der Hand gingen, suchte er sich all dieser Gespenster zu entledigen. Das
ritterliche Schicksalsdrama „Karl von Berneck" und der Verführungsroman,
den er Rétif de la Bretonne nacherzählte, „Die Geschichte des William Lo-
vell" — beide 1795 — reichen schon in die Gewähr einer gewissen jugend-
lichen Reife herein. Von den beiden Freunden war es nun Wackenroder, der
Das längst unterwegs war auf die Höhe. In dem Jahr der Trennung war Wacken-
getrennte Jahr roder zu Berlin durch Erduin Julius Koch in die altdeutsche Sprache und
Literatur eingeführt worden. In Göttingen hatte er diese Studien aus eigenem
vertieft, indem er sich in die lyrische und epische Dichtung des hohen Mittel-
alters einlas, sich mit Hans Sachs befreundete und seinem Lehrer Koch Bei-
Wackenroders träge für dessen Literaturgeschichte lieferte. Sogleich wurde spürbar, wie
Vorsprung sehr der Bescheidene auf den glanzvoll führenden Freund zu wirken wußte.
Tieck hatte sich auf Friedrich Nicolais Verlagsgeschäft ein ebenso nahrhaftes
wie unterhaltliches Unternehmen gegründet, indem er dessen Sammlung
verdeutschter französischer Erzählungen, die „Straußfedern", weiterführte,

in diese Reihe sogleich eigene Geschöpfe einschmuggelte und Nicolais auf-
geklärte Vernünftigkeit mit dem Roman „Peter Leberecht" 1795 verulkte.
Da wies nun Wackenroder den Freund auf die altdeutschen Volksbücher und
die Literatur des siebzehnten Jahrhunderts. Tieck griff zu und machte mit
seinen drei Bänden „Volksmärchen von Peter Leberecht" 1797 aus diesen
Anregungen ein wunderbar neuartiges Ganzes. Stücke wie „Haimons Kin-
der" machten den altdeutschen Erzählstil wieder munter. Andere, wie das
Märchen „Der blonde Eckbert", waren Geschöpfe seiner frei waltenden Bild-
kraft. Oder er formte alte Gebilde wie „Die Schildbürger" zu moderner *Tiecks*
Satire um. Schließlich gab er im „Gestiefelten Kater" diesen alten Geschich- *Nachdichtung*
ten eine bestrickend eigentümliche Form, das ironische Märchenspiel, wie er
es noch als Junge bei Shakespeare und dann in der italienischen Urform der
commedia del'arte bei Carlo Gozzi kennengelernt hatte. Da war schon das
deutsche Mittelalter, aber noch lange nicht die Kunstfrömmigkeit von Nürn-
berg und Florenz.

Zum letzten Schritt auf die christlich-deutsche Höhe, den Wackenroder *Das gemeinsame*
seinem Freunde voran mit der Seele tun mußte, bedurfte es dreier Begeg- *Erlebnis*
nungen, die sie beide gemeinsam und die doch eigentlich nur Wackenroder
hatte. Die eine war auf ihrer Erlanger Ostfrankenfahrt die Begegnung mit
der Nürnberger Bildkunst und mit der Bamberger Kirchenmusik. Die andere
war zu Göttingen die Begegnung mit dem Zeichenlehrer und Kunstforscher
Johann Dominik Fiorillo, das ist mit der frühen italienischen Malerei. Die
dritte war die entscheidende und wurde durch den königlichen Kapellmeister
Johann Friedrich Reichardt, 1752 bis 1814, aus Königsberg vermittelt. *Reichardt*
Reichardt gehörte von Königsberg her zu den jungen Freunden Johann *und Hamann*
Georg Hamanns, stand mit dem Magus in Briefwechsel, sammelte und besaß
die meisten seiner kleinen Schriften. Tieck war schon als Jüngling auf der
Hausbühne bei Reichardt aufgetreten, heiratet in die Familie und auch
Wackenroder stand dem Meister um der Musik willen nahe. Reichardt hat
nachweisbar die reichhaltigste Sammlung von Hamann-Schriften an Tieck
und damit ebensogut an Wackenroder gegeben. Johann Georg Hamann,
Ludwig Tieck, Wilhelm Wackenroder: das ist die entscheidende Begegnung
in der Frühgeschichte der romantischen Bewegung. Im Sommer 1796, auf
der gemeinsamen Pilgerschaft zu den Dresdner Kunstschätzen, verriet Wak-
kenroder dem Freunde verschämt, daß er heimlich einige Blätter mit Ge-
danken über die Kunst gefüllt hätte. Tieck gab diesen Blättern eine gemäßere
literarische Gestalt, fügte einiges Verwandte hinzu, brachte mehrere dieser
Blätter in Reichardts neuer Zeitschrift „Deutschland" unter und spielte den

Verkünder, als das Ganze 1797 und 1799 erschien: „Herzensergießungen eines kunstliebenden Klosterbruders" und „Phantasien für die Kunst."

„Herzens-ergießungen" Die „Herzensergießungen" haben das Angesicht der deutschen Jugend vom antiken Rom weg und in eine ganz neue Himmelsgegend gekehrt. Man kann es wohl ein Buch der beiden Freunde Tieck und Wackenroder nennen. Denn wenn Wackenroder daran das Recht der geistigen Erstgeburt hatte, so Tieck das Recht des brüderlichen Mitbesitzes und der literarischen Gestalt. Das Buch ist, was es heißt: Ergießung aus vollem und religiös bewegtem Herzen, eine lose Folge von andächtigen Betrachtungen über Musik und *Zwei Offenbarungs-sprachen* Malerei. Die alten Meister, Musik die Kunst aller Künste, Natur und Kunst die beiden Offenbarungssprachen Gottes: das ist der dreifache Ruf der Erweckung und Verkündigung, mit dem dieses Buch das Deutschland der antiken Kunstvergötzung in das Deutschland der mittelalterlichen Kunstfrömmigkeit verwandelt hat. Weder ist Kunst Religion noch ist Religion Kunst. Aber Kunst ist offenbarendes Gotteswort, Kunst ist Gottesdienst, Kunst ist reine Sprache der Empfindung, in der sich Gott und Mensch einander kundtun. Die beiden Freunde haben im geschwisterlichen Erlebnis von Nürnberg *Nürnberg und Florenz: Dürer und Raffael* und Florenz mit der einen und gleichen Wahl des Herzens aus den Werken der alten Meister, vorab Raffael Santis und Albrecht Dürers, die Offenbarung der Kunst empfangen. Was erlebt werden mußte, das hatten die beiden Freunde an Bamberg und Nürnberg erlebt; was an alten Bildern zu sehen war, das hatten sie in Berlin und Dresden hängen sehen; was man wissen mußte, das fanden sie für Italien bei Giorgio Vasari und für Deutschland bei Joachim von Sandrart, den beiden Kunstgeschichtlern des sechzehnten und siebzehnten Jahrhunderts. Allein, wer hatte sie sehen gemacht? Da war *Die „Aesthetica in nuce"* offenbar die „Aesthetica in nuce. Eine Rhapsodie in Kabbalistischer Prosa", das aufrüttelnde Hauptstück in Hamanns „Kreuzzügen des Philologen". Zu Hamann stimmen Geist und Ton der Herzensergießungen, ihre Vorstellung von Sprache und Offenbarung, das Verhältnis, in das sie Bild und Ton setzen, die sakrale Natur der Kunst. Kaum daß Hamann die Augen geschlossen hatte, war seine „Aesthetica in nuce" durch die „Herzensergießungen" verwirklicht und wirksam geworden. Hamann lebte durch Herder, er lebte durch Wackenroder und Tieck mitten auf der Höhe des Zeitalters, das er geistig begründet hatte.

Der verwaiste Tieck Tieck hatte sich ganz auf seinen Freund gestimmt und fühlte sich nun als Wackenroders Ausleger und Verkünder, als der Freund ihn, wie ein holder Traum verlöscht, erwacht und hoch am Tage zurückließ. Die altdeutsche Geschichte „Franz Sternbalds Wanderungen" 1798, mit Moritzens „Anton

Reiser" und Goethes „Wilhelm Meister" gleichermaßen versippt, diente zum
erstenmal diesem Vermächtnis. Sie begleitet einen jungen Maler aus Dürers
Werkstatt nach Rom und wieder zurück und ist auf den Grund des sechzehn-
ten Jahrhunderts gezeichnet. Sie ist die Ahnfrau aller künftigen Malerromane.
Tieck und Wackenroder hatten Berlin zur Ausgangsstätte des romantischen
Kunstgedankens und der romantischen Dichtung gemacht.

MEISSEN hatte seit dem sechzehnten Jahrhundert jenen Schulhumanis-
mus entwickelt, der sogleich dem deutschen Schrifttum so ungemein frucht-
bar geworden ist. Aus diesem Schulhumanismus ist von den beiden Brüdern
der jüngere, *Friedrich Schlegel*, 1772 bis 1829, herausgewachsen. An der *Winckelmann,*
Göttinger Hochschule trennten sich die Wege der beiden Brüder, als August *Herder,*
Wilhelm nach Holland und Friedrich nach Leipzig ging. Mehr als Leipzig *Schlegel*
ist ihm Dresden geworden: durch die Sammlung antiker Bildwerke, durch
den heilsamen Umgang mit Christian Gottfried Körner, durch das anspor-
nende Vorbild Johann Joachim Winckelmanns. In Dresden ist denn auch jene
Aufsatzreihe entstanden, die seit 1794 in Berliner und Leipziger Zeitschrif-
ten erschien, die ihn an der klassischen Sprachwissenschaft zur Literaturge-
schichte bildete und die 1798 von seinem ersten Buch „Geschichte der Poesie
der Griechen und Römer" gekrönt wurde. Herders und Winckelmanns Er-
gebnisse und Anregungen waren in Aufsätze und Buch eingegangen. Fried-
rich Schlegel, der Gesinnungsgenosse und Kunstverwandte des deutschen
Klassizismus, hat die romantische Bewegung nicht angetrieben, er ist von ihr
ergriffen worden: durch Friedrich von Hardenberg, den er schon 1791 zu *Schlegel,*
Leipzig, durch Fichte, dessen Gedanken er 1795, durch Schleiermacher und *Hardenberg,*
Tieck, die er 1797 zu Berlin kennenlernte. Überall stieß er auf eine Be- *Tieck*
wegung in vollem Gange, und es war nirgends die seine. Nachdem Friedrich
Schlegel diese Begegnungen gehabt hatte, erörterte er bei zwei Gelegen-
heiten seine Forderungen an die Dichtung. Mit dem Blick auf Goethes „Wil-
helm Meister" behauptete er, der Roman als eine gegliederte Lebenseinheit
sei der Inbegriff alles Dichterischen und die Bestimmung „der romantischen
Poesie" sei, die Einheit von Dichtung und Leben wieder herzustellen. Und
mit dem Gedanken an Fichtes Philosophie riet er dem Dichter, sich dichtend
zu seiner Dichtung so zu verhalten, wie Fichte im Philosophieren zur wirk-
lichen Welt. Er solle Poesie der Poesie, ein Spiegelbild des Spiegelbildes
geben um sich also immer selber mitzuparodieren. Das sei die „romantische *romanhaft,*
Ironie". Das Wort „romantisch" war dem Sprachgebrauch des achtzehnten *romantisch,*
Jahrhunderts nur im Sinne unseres heutigen „romanhaft" geläufig. In diesem *dichterisch*
Sinne verwendet es auch Friedrich Schlegel. „Romantische" Dichtung heißt

also bei ihm einfach Romandichtung und da er im Roman den Inbegriff aller Dichtung sieht, so ist romantisch lediglich ein anderes Wort für poetisch oder dichterisch. Das Leben „romantisieren" heißt es zur Dichtung machen. Das Wort „romantisch" und alle Begriffsbestimmungen, die Friedrich Schlegel daran knüpft, hat nicht das mindeste mit dem „Wesen" der geistesgeschichtlichen Bewegung zu tun, die sich seit Hamann und Herder aus dem deutschen Osten zu entfalten begann. In Friedrich Schlegel hatte sich diese Bewegung den Sprecher und publizistischen Anwalt gewonnen.

*„romantisieren"
heißt zur
Dichtung
machen*

Die Hochschulstädte Jena und Halle wurden gegen Ende des achtzehnten Jahrhunderts zur Szene, auf der sich die geistigen Träger der romantischen Bewegung zu einem kurzen Gastspiel trafen. Jena wurde es durch Johann Gottlieb Fichte, der hier am 23. Mai 1794 seine Vorlesungen eröffnete. Lernend und lehrend entwickelte er in Jena seine Philosophie, daß nur das Ich wirklich, daß die Welt lediglich ein Spiegelbild des Ich im Ich, ein Ganzes von Vorstellungen sei. Seine vielfach hochbegabten Anhänger sammelten sich in der „Gesellschaft der freien Männer". Wie ein Dämon herrschte Fichte über die Seelen dieser jungen Männer. Ihm entgegen bildete Friedrich Wilhelm Schelling seine eigene Lehre in einer Reihe bedeutsamer Grundschriften aus. Um die beiden Philosophen gruppierten sich persönlich und geistig die jungen Vertreter einer jungen Naturwissenschaft: *Heinrich Steffens,* 1773 bis 1854, ein Holsteiner aus dem norwegischen Stavanger, der Verfasser des beneidenswerten Erstlings „Beiträge zur inneren Naturgeschichte der Erde" 1801 und auch dichterisch begabt; *Gotthilf Heinrich Schubert,* 1780 bis 1860, aus Hohenstein im Erzgebirge, Arzt und bald ein hervorragender Kenner des Seelenlebens, zunächst freilich noch von dem Ehrgeiz nach dichterischen Erfolgen getrieben; *Johann Wilhelm Ritter,* 1776 bis 1810, aus dem schlesischen Samitz, der Naturphilosoph und geniale Naturbeobachter, ein Anhänger Jakob Böhmes, der auf dem Gebiet des Galvanismus, der Polarisationserscheinungen und der Galvanoplastik grundlegende Erkenntnisse hatte, von wenigen begriffen und eigentlich nur von Goethe erkannt. Um diese Denker und Forscher schloß sich jene große Kameradschaft der Dichter zusammen, die das neue Reich des Geistes und der Natur in einen Zaubergarten der Poesie verwandeln wollten. Seit Sommer 1796 saßen die *Brüder Schlegel* in Jena, nun beide in atemlosem Wettbewerb mit dem Klassizismus durch ihre Zeitschrift „Athenäum", deren erstes Heft zu Ostern 1798 herauskam. Hier gab Friedrich Schlegel dem Wort „romantisch" eine geschichtliche Deutung. Mit dem Blick auf den Versroman der romanischen Völker gebrauchte er es im Sinne von „romanisch". Und schließlich übertrug er es von

*Hochschule
Jena*

Die Philosophie

*Die Natur-
wissenschaften*

*Das
„Athenäum"*

der Romandichtung der mittelalterlichen Romanenvölker auf die Dichtung des Mittelalters schlechtweg und allgemein. So ist das Wort in seiner Feder spielerisch zu jener Namensmaske geworden, die er bald der romanhaften Dichtung, bald der Romandichtung der Romanen, bald der Dichtung des romanischen Mittelalters aufsetzte. „Romantisch" ist in seinem Sprach- *romanhaft,* gebrauch weder ein Synonym noch ein Homonym, sondern einfach ein Wort *romanisch,* *romantisch,* mit fließenden Bedeutungsgrenzen. Insofern die ostdeutsche Bewegung sich *mittelalterlich* geistig und künstlerisch um den Rückgewinn der romanhaften Formenwelt des romanisch-deutschen Mittelalters bemühte und nach Friedrich Schlegel darin ihren höchsten schöpferischen Ehrgeiz finden sollte, wurde sie in den Geltungsbereich des Wortes mit einbezogen. Aber ihre räumliche und gei- stige Herkunft wurde von dieser Namengebung in keiner Weise berührt oder verändert. Diese Namengebung vollzog Friedrich Schlegel in dem großen Aufsatz des „Athenäum": „Gespräch über die Poesie". Romantisch-roman- haft heißt nun ein „sentimentaler" Stoff in „phantastischem" Gewande. An der frühitalienischen Dichtung und an Shakespeare wird der „romantische" Stil als Gegensatz zum „klassischen" erkannt. Indem er auf den Wurzelsinn von „romanhaft" zurückkommt, erklärt Schlegel nun richtig, die neuzeitliche *Das Klassische* Dichtung habe mit Romanen begonnen, wie die altzeitliche mit dem Epos. *und das* *Romantische* Er findet nun das „Romantische" in der romanischen Dichtung des Mittel- alters, „aus welchem die Sache und das Wort selbst herstammen". Also eine Wiedergeburt des hohen Mittelalters, wie auf der Gegenseite an einer neuen Gestalt der Antike gearbeitet wurde. Er betrachtete Europa unter dem Ge- sichtspunkte eines großen Doppelspiels, das zu versöhnen die römische Kirche berufen sei. Ihm schwebte eine Verbindung des Nordens mit dem Morgen- lande vor. Der uralte Zusammenhang der Länder jenseits der Elbe mit dem fernen Osten wurde wieder kundbar. Den Ehrgeiz nach dem frischen Kranz des Dichters konnte er mit seinem „Roman" „Lucinde" 1794 bis 1799 und mit dem klassisch-romantischen Dramenzwitter „Alarcos" 1801 so wenig stillen, wie sein Bruder August Wilhelm den seinen mit dem Drama „Jon" 1803, das als Gegenstück zu Goethe und Euripides gedacht war.

Ludwig Tieck hatte sich im Oktober 1799 zu Jena niedergelassen, nicht *Tieck in Jena* zuletzt um der Freundschaft willen, die ihn seit 1796 mit Friedrich, seit 1798 mit August Schlegel verband. Von Weißenfels kam Hardenberg ab und zu einmal herüber. So lernten, zwei füreinander Vorbestimmte, Hardenberg und Tieck einander kennen. Tieck fand in Hardenberg seinen Wackenroder wie- der, und Hardenberg spürte, daß der Dichter des „Sternbald" sein Bruder sei. Und Tieck tat an dem neuen Freunde abermals, was er an Wackenroder

getan hatte. Er löste ihm die Flügel von der Schwere des Gedankens und lehrte ihn schreiben. Doch es währte nur einen beseligenden Atemzug. Denn schon 1801 verlöschte Hardenberg dem Freunde Tieck so still von der Seite hinweg, wie einst Wackenroder verlöscht war. Tieck wurde auch diesmal reicher durch Freundestod. Die Kunstfrömmigkeit, die ihm aus Wacken-roders Seele zugeströmt war, wurde ihm durch Hardenberg vertieft und *Seine* stofflich bereichert. Nun entstand oder wurde vollendet jene Fülle von Dich-

Seine
„Romantischen
Dichtungen" tungen, die Tieck 1799 bis 1800 als „Romantische Dichtungen" herausgab.

Dem verwegenen Maskenspiel der Geister fehlten die großen Zuschauer nicht, die Sinn und Bedeutung dieses Dramas wohl verstanden. Da kam von Weimar Goethe herüber und mischte sich unter Gelehrte, Schüler, Frauen. Nur unter die Zuschauer gehörte Clemens Brentano, der mit Sophie Mereau sich ein ergreifendes Zwielied des Verlangens und Fliehens sang. Von den beiden märkischen Edelleuten wurde Wilhelm von Humboldt Schillers Ver-trauter, beide einander geschichtsphilosophisch verwandt, während Alexan-der von Humbolt, der Naturforscher, durch Goethe in Anspruch genommen wurde.

Hochschule Mit Beginn des neuen Jahrhunderts wurde Jena von Halle abgelöst. Auch
Halle an der hallischen Hochschule standen auf engem Raume Klassizismus und Romantik zusammen. Halle, die hohe Schule des Pietismus zugleich und der Aufklärung, war eine der Stammwurzeln für die Bildungsgeschichte der Ro-mantik, und ein Jahr in Halle bedeutete für die romantische Jugend beinahe eine Rückkehr ins Vaterhaus. Den Klassizismus vertrat zu Halle mit Glanz der klassische Sprachgelehrte *Friedrich August Wolf*, 1759 bis 1824, ein Thüringer aus Hainrode. Der trieb die Altertumswissenschaft nicht um des *Klassische* Inhalts oder des Vorteils willen, sondern als ein Mittel zu höherer Kenntnis
Philologie des Menschen, um der Wirkungen willen auf Geist und Gemüt. Im Sinne Herders suchte er die antiken Träger des Schrifttums aus Ort und Zeit zu er-fassen. Sein Buch „Prolegomena ad Homerum" 1795, ein Buch in einem La-tein, wie es nur wenige Deutsche geschrieben haben, handelte von der echten Form der homerischen Dichtung und sprach, was Heyne und Herder schon geahnt hatten, wagemutig aus: die homerischen Gedichte seien das Werk von ganzen Geschlechtern, nicht das Werk eines einzigen Dichters. Diesem einen Klassizisten standen in Halle drei Mitschöpfer der romantischen Bil-*Natur-* dung gegenüber: der Arzt *Christian Reil*, ein Vorkämpfer für die Einheit und
wissenschaften Gleichartigkeit aller Naturvorgänge und Lebenserscheinungen; der Natur-forscher *Heinrich Steffens*, der in Halle sein Buch „Grundzüge der philo-*Philosophie* sophischen Naturwissenschaft" 1806 fertigstellte; der Theologe *Friedrich*

Schleiermacher, wie Steffens seit 1804 Lehrer an der Hochschule, der in seiner Platoübersetzung durch Anordnung von Platos Schriften die Einheit seiner Gedankenwelt anschaulich zu machen suchte, ohne doch den Eindruck des zwanglosen Plauderns zu zerstören. Man muß es in Zweifel lassen, wer mehr zu beneiden war: die Jugend Halles um ihre Lehrer oder diese Meister um ihre Schüler. Der Berliner Johann Gustav Büsching und der Uckermärker Friedrich Heinrich von der Hagen machten ihre ersten germanischen Studien. Der Priegnitzer Friedrich Ludwig Jahn, der künftige Rekrutenmeister der deutschen Heere, trieb Theologie und Sprachwissenschaft. Zu Wolfs Füßen saßen die großen Sprachgelehrten des frühen neunzehnten Jahrhunderts, Gerhard Friedrich Strauß aus Iserlohn empfing hier die Offenbarung des Gottmenschen in Christo. Hier fanden die beiden Brüder, der Geschichtsschreiber Friedrich und der Naturforscher Karl von Raumer ihre entscheidende Richtung. Und da waren, nicht zuletzt die beiden feinen Edelleute aus Oberschlesien, *Wilhelm* und *Josef von Eichendorff.* Die Romantik selber aber hielt in fraulicher Gestalt ihren Hof auf dem Giebichenstein, wo *Friedrich Reichardt* seit 1795 Wohnung genommen hatte. In Reichardts Hause fand es zum erstenmal bestrickenden Ausdruck, was man seitdem romantische Geselligkeit genannt hat. Die Landschaft selber, die schönen Frauen, die Tonkunst machte dieses Haus über dem Saaletal zum lebendigen Ausdruck der neuen romanischen Lebensart. Reicharts Töchter haben den Siegeszug des neuen, des romantischen Liedes angeführt und die Frauen seines Hauses verbanden bedeutende Führer der ostdeutschen Bewegung zu einer großen Familie. Tieck war Reichardts Schwager. Heinrich Steffens und Karl von Raumer wurden seine Schwiegersöhne. So kamen und gingen die Gäste auf dem Giebichenstein: Goethe und Fichte, Johann Paul Richter und Josef Schelling, Voß und die beiden Schlegel, Hardenberg und Arnim. Wolf, Schleiermacher, Steffens, Tieck waren Hausfreunde. So nahm Gedachtes, Gefühltes, Gewolltes die Gestalt des täglichen Lebens an.

Um *BERLIN* wurden seit der Jahrhundertwende heftige Federkämpfe ausgefochten. Die Romantik war eine ostdeutsche Bewegung. In der Mark Brandenburg hatte sich ein wichtiger Teil ihrer Bildungsgeschichte abgespielt. Berlin war die Hauptstadt des ostdeutschen Staates. Berlin war sein geistiger Mittelpunkt. Der geistige Zusammenschluß des Ostens hing von dem Besitz dieser Großstadt, der Masse ihrer Gebildeten, vom Gewinn ihrer geistigen Machtmittel ab. Dieser Kampf, in dem abwechselnd der alte Nicolai, August Kotzebue, Garlieb Merkel auf der einen, Ludwig Tieck, August Wilhelm Schlegel und ihre Freunde auf der andern Seite standen, wurde

Giebichenstein Friedrich Reichardt

Reichardts Gäste

Kampf um Berlin

Schlegels Berliner Vorlesungen durch *August Wilhelm Schlegel* mit einem geschickten Handstreich entschieden. Das waren die Vorlesungen, die August Wilhelm Schlegel vom Winter 1801 bis zum Winter 1803 hielt. Die Entscheidung fiel in den beiden Vorlesungen Winter auf 1803 und auf 1804: „Über schöne Literatur und Kunst" und „Über die romantische Poesie". Die erste Vorlesung gab die Naturgeschichte der Dichtung. Indem Schlegel der Gedankenfährte von Hamann *„antik" und „modern"* und Herder her folgte, faßte er die Begriffe „antik" und „modern" als geschichtliche Gegensätze, wandte sich gegen Kants und bekannte sich zu Schellings Philosophie, nach der er den Begriff des Schönen bestimmte, und ordnete die Künste zu einer organischen Einheit. Poesie ist die Kunst, die alles umfaßt. Im Sinne des Hamann-Herder-Gedankens, daß Sprache, Mythus, Dichtung urtümlich eines gewesen seien, erkannte Schlegel: Sprache ist die erste und älteste Dichtung, weil in ihr alles, was da ist, zum Bilde wird. In diesem Zusammenhange behandelte er die gesamte Poetik, mit dem besonderen Nachdruck auf der Verslehre. An diese Naturgeschichte der Dichtung schloß die zweite Vorlesung, die Kunstgeschichte der Dichtung. Er ging von einer vernichtenden Betrachtung des zeitgenössischen Geisteslebens *Idee des Mittelalters* Europas aus, ein Strafgericht über den bodendumpfen, „ökonomischen", diesseitsgebundenen, nützlichkeitssatten Geist der Aufklärung. Ihm entgegen beschwor er die große Idee des Mittelalters herauf, das Gesetz der Ehre als die Mutter der ritterlichen Tapferkeit und Liebe. Die Kirchentrennung hat die Aufklärung geboren, die Kunst zerstört, Europa gespalten. Soll Deutschland geholfen werden, so muß die Bildung der Gegenwart wieder mit dem guten Geist der Vergangenheit durchsetzt werden. Wie harmonisch waren an dieser Stelle Herders Bückeburger Aufsatz „Auch eine Philosophie der Geschichte" und Hardenbergs Weltschau „Die Christenheit oder Europa" aus Schlegels Zorn und Begeisterung zu hören. Die Vorlesung gab nun einen Aufriß der Weltliteratur. Am Eingang steht die Betrachtung über die griechische Literatur. Die Wende bildet der Abschnitt über den Ursprung des neuen Europas aus dem germanisch-romanischen Völkerchaos zwischen Spät- *Völkerwurzel Europas* antike und Frühmittelalter. Dieses Völkerchaos war für August Wilhelm Schlegel noch keine Blutfrage, sondern lediglich ein Sprachproblem. Aus diesem Chaos ist die geordnete Welt des Mittelalters und des neuen Europa entstanden. Romanisch habe man die neuen germanisch-römischen Mundarten genannt; Roman die Dichtung dieser Mundarten; romantisch sei daraus abgeleitet; das Wesen dieser Dichtung habe im Verschmelzen des Altdeutschen mit dem späteren christlich gewordenen Römisch bestanden; alle Bestandteile würden schon durch den Namen angedeutet. In den altdeut-

schen Abschnitten konnte Schlegel an die Arbeit der Berliner Literatur- *Literatur-*
kenner Erduin Koch, Wilhelm Wackenroder, Ludwig Tieck anknüpfen. Was *geschichte*
er immer predigt, ist der christliche Europäer des Mittelalters. Er besprach
das Nibelungenlied. Eines der Abenteuer, modern überarbeitet, las er vor.
Von der Hagen war unter den ungewöhnlich zahlreichen Zuhörern. Die Ge-
schichte der romanischen Literaturen schloß die ganze Vortragsreihe ab. Als
Geschmacksproben waren seine „Blumensträuße italienischer, spanischer und
portugiesischer Poesie" 1804 gedacht wie auch die verdeutschten Stücke
Calderons, die als „Spanisches Theater" 1803 und 1809 erschienen sind. Man
begreift die ungewöhnliche Wirkung und geschichtliche Bedeutung dieser *Richtung der*
Vorträge: Herders gründende Vorarbeiten, Friedrich Schlegels Ergebnisse *Romantik auf*
das Mittelalter
aus antiker Literaturbetrachtung, Schellings Philosophie, Wackenroders und
Tiecks Kenntnisse des altdeutschen Schrifttums und über allem Hardenbergs
Aufsatz; all das verarbeitet von einem so geistvollen Kopfe, bestrickend vor-
getragen von einem Sprecher, der sich stürmisch und vorsichtig, gewinnend
und überwindend jedes Zuhörers bemächtigte. Das Ziel der ostdeutschen Be-
wegung hieß nun, von August Wilhelm Schlegel ins Geschichtliche übersetzt:
Romantik. Romantik bedeutete jetzt das Schrifttum des Mittelalters, unge-
fähr wie Humanismus der Ausdruck für das Bildungsmaterial der italieni-
schen Renaissance war. Die ostdeutsche Bewegung strebt „Romantik" an,
das heißt nach August Wilhelm Schlegels eigenen Worten: den Bildungs-
besitz der alten römisch-germanischen Lebenseinheit, den sich die aus dem
Völkerchaos geborenen neuen Einheiten außerhalb des antiken Zusammen-
hangs gewonnen hatten. Berlin war erobert.

„Nordstern" nannte die Gruppe junger Leute, die sich von Schlegels Vor- *Der „Nordstern"*
trägen besonders angesprochen fühlte, ihren literarischen Freundesbund.
Unter ihnen der Bescheidenste war überraschend auch der Erfolgreichste,
Adelbert von Chamisso, 1781 bis 1838, der vom Schloß seiner Väter Bon-
court in Berlin eingewandert und 1801 preußischer Leutnant geworden war.
Auch er wurde durch den Zusammenbruch Preußens aus seiner Bahn gewor-
fen. Dumpf und ziellos lebte er ein paar Jahre zwischen Deutschland und
Frankreich dahin. Dann kam sein Blut wieder ins Kreisen. Seine Lyrik reifte.
Und einunddreißig Jahre alt, wurde Chamisso an der neuen Berliner Hoch-
schule Schüler der Arzneiwissenschaft. Der Heimatlose, der 1813 sich über-
all als fremd erkannt fühlte, weil er keinen Schatten warf, empfand seine
Lage als peinlich und tragisch. Er stellte sie in seiner Märchennovelle „Peter *„Peter*
Schlemihls wundersame Geschichte" dar, wobei er den Vertrag mit dem *Schlemihl"*
Teufel aus seinem Faustplan, den Glückssäckel aus seinem abgebrochenen

Fortunatusdrama und die Siebenmeilenstiefel aus Tiecks Märchen vom Däumchen übernahm. Der Schattenverlust geht nicht auf eines der verbreiteten Volksmärchen, sondern auf ein Scherzwort Fouqués zurück. Der Schlemihl als unrettbarer Pechvogel gehört der jüdischen Überlieferung an. Vom Tragischen ins Tragikomische gewendet, ist es die Geschichte jener ungezählten Fremden, die ihren Schatten verloren, als sie Deutsche wurden.

Umschwung der Gesinnung August Wilhelm Schlegels Berliner Vorlesungen bewirkten durch die Literaturgeschichte und die altdeutschen Sammelbücher Johann Gustav Büschings und Heinrichs von der Hagen im Verein mit Tiecks „Minneliedern" eine allgemeine Verwandlung der öffentlichen Gesinnung. Henriette Herz erzählt sehr überzeugend, wie die gebildeten Männer und Frauen still und vorsichtig die französische Literatur beiseite legten und zur deutschen griffen, zur altdeutschen, weil man die von allen romanischen Einflüssen frei glaubte. So hielt *Johann Gottlieb Fichte* nicht nur im zeitlichen, sondern auch im geistigen Anschluß an Schlegel im Winter 1804 auf 1805 seine Vorträge über die „Grundzüge des gegenwärtigen Zeitalters". Schon hier führte wie manches rückwärts zu Schlegel, so auch vorwärts zu Arndt. Unter dem Druck des Tages von Jena aber nahm Fichtes Denken eine neue, jetzt ausgesprochen völkische Richtung. Vom 13. Dezember 1807 an begann er in dem Akademiegebäude Unter den Linden seine „Reden an die deutsche Nation".

Fichtes „Reden an die deutsche Nation" Ihren Kerngedanken — „Ihr seid euren Bedrückern überlegen!" — hüllte Fichte in den akademischen Vergleich zwischen rassereinen und römisch gewordenen Germanen, spann ihn zu langen Erörterungen aus und schnellte endlich den so umständlich geformten Pfeil als verächtliches Urteil über französische Art, Wissenschaft und Literatur ab. Die ersten drei Reden entwickelten das Idealbild einer neuen Erziehung. Die vierte und fünfte Rede gab den bevölkerungsgeschichtlichen Aufbau des modernen Europa unter *Lebende und tote Sprachen* dem Gesichtspunkt deutsche und verwelschte Germanen oder Völker lebender und Völker toter Sprachen. Soweit hielt Fichte sich auf Schlegels Seite. Nun wechselte er zu Arndt hinüber, indem die sechste, siebente und achte Rede die Grundzüge der deutschen Geschichte zeichneten und sie im Sinne der künftigen Tat, die zu tun sei, auslegten. Die Deutschen sind ein Urvolk, das Volk Europas schlechthin, und der Aufbau einer mechanischen Staatsmaschine ist eine verruchte Frucht des welschen Wesens. Die folgenden Reden bis zur dreizehnten kehrten zu dem Entwurf einer volkhaften Erziehung zurück und forderten den reinen Volksstaat innerhalb der natürlichen Grenzen. Die vierzehnte Rede beschwor mit Leidenschaft die einzelnen Stände und Alter und schnitt mit dem grellen Schlußruf ab: „Wenn ihr versinkt, so

versinkt die ganze Menschheit mit, ohne Hoffnung einer einstigen Wiederherstellung." Fichtes „Reden an die deutsche Nation" stehen nach beiden Seiten abhängig zwischen Schlegels Berliner Literaturvorträgen und Arndts Buch „Geist der Zeit". Wenn Fichte den geschichtlichen Schlüssel zum modernen Europa im germanisch-romanischen Völkerchaos fand, so stimmte er grundsätzlich mit Schlegel überein. Wenn Fichte dem mechanistischen Staate und den stehenden Heeren alles Unheil aufbürdete, so teilte er Arndts Gedanken.

Der Berliner *Adam Müller*, 1779 bis 1829, hat den märkischen Junkern *Der Schüler* ihre staatlichen Pläne europäisch vorgedacht. Er war in Göttingen und als *von Gentz* Schüler von Gentz gebildet, hatte den europäischen Norden bereist und war durch August Wilhelm Schlegel in den romantischen Gedanken zu Hause. Seine geniale Jugendschrift „Die Lehre vom Gegensatz" 1804 lehrte das ganze All als eine gegliederte lebendige Schöpfung sehen. Er wollte mit seiner Schrift den Irrtum vom Unbedingtsubjektiven, dem reinen Ich, und dem Unbedingtobjektiven, dem Ding an sich, zerstören. Denn in seinem Organismusgedanken gab es kein Unbedingtes, sondern nur Beziehungen. Dasselbe Glied war Teil zugleich und Ganzes, je nach seiner Stellung im Gefüge. Herbst 1805 hielt er zu Dresden seine Vorlesungen „Über die deutsche Wis- *Müllers* senschaft und Literatur", die ersten literarhistorischen Vorträge der ostdeut- *Dresdner* schen Bewegung, die als Buch allgemein zugänglich wurden. Wie vor ihm Arndt, wie nach im Fichte, so sprach auch Müller zu der umsturzfeindlichen europäischen Bildungsgemeinschaft. Hier lehrte der erste moderne Literaturhistoriker, der das Wesen geschichtlicher Vorgänge tiefer begriff als der ältere Schlegel mit seinen ästhetischen, der jüngere mit seinen ideengeschichtlichen Becherspielen. Um Neujahr 1809 kehrte Adam Müller von Dresden nach Berlin zurück. Hier hielt er seine Vorträge „Die Elemente der Staatskunst" sowie 1810 „Über König Friedrich II.". Schon jetzt führte Müller die *und Berliner* Sache der märkischen Junker. Sein Wirtschaftsgedanke spielte das Beweg- *Vorlesungen* liche gegen das Unbewegliche, Erwerb gegen Besitz, Tat gegen Geist aus. Mit diesen Sätzen wandte er sich gegen den Engländer Adam Smith. Dagegen setzte Müller als Mittler zwischen Gott und Mensch die Kirche, als Mittler zwischen Menschheit und Einzelwesen den Volksstaat. Er meinte Preußen. Die Schrift über „König Friedrich II." erwies, daß das Schicksal Preußens in Wahrheit das Schicksal des märkischen Adels sei. Nicht erst bei Hardenberg oder gar dem jüngeren Schlegel, bei Herder trieben schon alle Keime der romantischen Staatsphilosophie. Schon in Herders Kopf standen über *Adam Müllers* der mechanisch-willkürlichen Gesellschaft geographisch und sprachlich um- *politischer Entwurf*

grenzte Einheiten als organischer Ausdruck des gesamten Volkslebens. Es
fehlte nur die schaffende Tat, um sie staatlich zu erfassen und an Stelle des
Kabinettsstaates oder des Gesellschaftsvertrages zu setzen. Adam Müller
ging es vor allem um die Einheit der Gesinnung. Das aber ist die Religion.
Staatseinheit und Volkseinheit sind von der Glaubenseinheit wesentlich be-
dingt. Das legte sich Müller zurecht, als er auf der Seelenlage des märkischen
Junkers sein christlich-germanisches und ständisch-genossenschaftliches Ge-
sellschaftsideal begründete. Religion und Volkstum werden jetzt als trei-
bende Kräfte der romantischen Wiedergeburt erkannt und ohne Mißverständ-

*„christlich-
deutsch"* nisse ausgesprochen. Die Verbindung christlich-deutsch heißt Wiedergeburt
aus der Gesinnung des Mittelalters. Daher freie Einheit der deutschen Staa-
ten und Stämme unter einem neuen Kaisertum und durch die Kirche ein heil-
sames Bündnis aller Volksstaaten Europas zu einem großen Organismus, in
dem staatlich alle Gegensatzpaare ausgeglichen sind. Auf der Linie Hamann-
Herder hatte Hardenberg sich in Adam Müller durchgesetzt. Denn Müllers
Entwurf hieß ja: „Die Christenheit oder Europa". Und der neue Mensch,
der herangerufen wurde, das war der christliche Europäer.

*Theater,
Liedertafel,
Tischgesellschaft* Diese allgemeine Verwandlung des Geistes erwirkte sich am Berliner
Theater, das seit Ende 1796 August Wilhelm Iffland leitete, nur langsam
und begrenzt. Hier hielten einander Klassizismus und Romantik die Waage.
Friedrich Schiller war im Mai 1804 Gast und Augenzeuge einer ganzen
Reihe seiner gespielten Stücke und seit 1805 setzte sich Zacharias Werner
mit seinen ersten Dichtungen im Spielplan durch. Desto kräftiger wirkte der
Geist, den Schlegel, Fichte, Müller erweckt hatten, durch seine neu gebilde-
ten Organe. Das waren die Berliner Liedertafel 1809, und die christlich-
deutsche Tischgesellschaft, 1811 gestiftet, beides gesellige Vereine, in denen
sich der Adel, die Offiziere, die romantischen Dichter zusammenfanden, um
mit Wort und Tat auf die politische Erneuerung Preußens hinzuarbeiten.
Das waren die „Berliner Abendblätter", hinter denen die Patrioten der
Tischgesellschaft standen, seit 1. Oktober 1810 unter der Leitung Heinrichs
von Kleist. Das war die neue Berliner Universität, beauftragt, das Werk der

*Hochschule
Berlin* Wiedergeburt Preußens von innen her zu begründen, im wesentlichen die
Schöpfung Wilhelms von Humboldt und am 15. Oktober 1810 feierlich er-
öffnet. Und das war der Turnplatz auf der Hasenheide, 1811 von Friedrich
Ludwig Jahn, dem Verfasser des Buches „Deutsches Volkstum" 1810 ein-
gerichtet, das deutsche Volk vom Geist auf die Tat umzustimmen. Schlegels,
Fichtes, Müllers Berliner Vorträge, Kleists Abendblätter, die Berliner Hoch-
schule, Jahns Turnplatz: zehn kurze Jahre. Ein Zeitalter ist hinabgestoßen

und ein versunkenes wieder heraufgeholt. An Stelle eines künstlichen Staates war das lebendige Ganze einer geschichtlichen Gemeinschaft getreten, die nicht von Fehrbellin und Leuthen lebte, sondern aus dem deutschen Gesamtbesitz.

Die neue geistige und völkische Gemeinschaft im deutschen Osten drückte sich künstlerisch in den vier Märkern aus: Kleist, Fouqué, Arnim, Tieck. *Die vier Märker*

Heinrich von Kleist, 1777 bis 1811, aus einer pommerschen Soldatenfamilie im märkischen Frankfurt geboren, Mitkämpfer im rheinischen Feldzug und dann Gardeleutnant zu Potsdam, als Offizier wie als Beamter auf eigenen Wunsch verabschiedet, hat einen weiten Umweg machen müssen, über Paris, die Schweiz und Paris, über ein kleines Königsberger Amt, französische Kriegsgefangenschaft und die Dresdener Freundschaft mit Adam Müller, über das Schlachtfeld von Aspern, Prag und wieder Berlin, in den selbstgewählten Tod und das Grab am Wannsee. Es war ein Umweg von dem mechanistischen Preußenstaat Friedrichs II., den Kleist ablehnte, über den Traum von einem erneuerten österreichischen Reichskaisertum zu dem romantischen Preußen der deutschen Erhebung. Kleist war mit den geheimen Widerstandskräften der napoleonischen Zeit so mannigfach verstrickt, daß er zweifellos an der Vorbereitung auf 1813 stärker beteiligt war, als die erhaltenen Urkunden erkennen lassen. Als Dichter erwacht ist Kleist 1802 in der Schweiz unter gleichaltrigen Freunden wie Heinrich Zschokke, die jungen Wieland und Geßner. Seine schöpferische Entwicklung liegt nicht zwischen der abenteuerlich gräßlichen „Familie Schroffenstein" 1802 und dem märkischen „Prinzen von Homburg" 1810, sie liegt, ein gewaltiger Sprung, zwischen „Schroffenstein" 1802 und dem Riesenbruchstück von 1803 „Robert Guiscard". Diese Kluft haben die späteren Dramen ausgefüllt. *Kleists Dramen*

Der Gardeleutnant

Kleists Weg von Preußen zu Preußen

Zwei Lustspiele geben vorerst Kleists seelische Entwicklung von der „Familie Schroffenstein" bis „Robert Guiscard" zu erkennen. Kleist, der mystische Selbstbeschauer, erscheint im Sternbild Fichtes. Die Anschauung vom gespaltenen Ich, die beide Lustspiele ausweitet, muß ihm bereits 1802 vertraut gewesen sein. „Der zerbrochene Krug", 1802 in der Schweiz nach einem Kupferstich entworfen, in Königsberg vollendet, in Weimar 1808 gespielt, ist gerade aus dieser Anschauung heraus geformt. Mit grausam-fröhlicher und tiefsinniger Behaglichkeit wird das Spiel aus der tragikomischen Lage entwickelt, die den Richter zugleich zum Ankläger und zum Angeklagten macht. Noch während dieser Arbeit ging Kleist daran, Molières „Amphitryon" zu bearbeiten. Zwischen zwei Paaren — Herren und Dienern — und den zwei männlichen Betrügern — Jupiter in Gestalt des Königs Amphi-

tryon, Merkur in Gestalt des königlichen Dieners Sosias — wirrt sich die
Handlung zusammen. Kleists Eigentum ist es, wie er alle Komik auf die
Dienergruppe Sosias, Charis, Merkur einschränkte und wie er die Handlung
Amphitryon, Alkmene, Jupiter ins Christlich-mystische umdeutet. Allein es
war verlorene Mühe, aus dem plumpen Götterabenteuer mehr machen zu
wollen als eine Burleske. Das Dunkel löste sich. Auch die nächsten zwei
Stücke gehörten zusammen: „Penthesilea" tragisch dem „Guiscard" ver-
wandt; „Das Käthchen von Heilbronn" zu den „Schroffensteinern" zurück-

von „Schroffenstein" zu „Guiscard" kehrend. „Penthesilea", 1806 bis 1808 gearbeitet, macht aus dem Spiel vom
Seelentausch die Tragödie des ausgetauschten Geschlechts. Penthesileas Weib-
lichkeit ist ins Männliche verkehrt, Achills Männlichkeit war schon durch die
griechische Sage mit weiblichen Zügen ausgestattet. Sie zerstören einander,
weil sie keine reinen geschlechtlichen Gegenpole sind. Eben Adam Müller
war es, der „Das Käthchen von Heilbronn", die Kehrseite des Penthesilea-
stoffes, „ihren andern Pol" nannte. In diesem liebenswürdigsten Schauspiel

Kleist und Müller Kleists ist das Weib nichts als weiblich und der Mann ausschließlich männ-
lich. Magnetismus, Wahrträume und weissagende Ahnungen, das hatte Kleist
mündlich von Schubert. „Penthesilea" und „Käthchen" offenbaren, was zwi-
schen der „Familie Schroffenstein" und „Robert Guiscard" in Kleist vorge-
gangen sein mag. Kleist rang um einen Durchpaß zwischen Antike und
Mystik, was nichts anderes bedeutete als ein Durchweg zwischen Gestalt
und Idee. „Penthesilea" und „Käthchen" spiegeln dieses Schwanken noch
einmal. Dann ging es in gerader Richtung von „Schroffenstein" über „Krug"
und „Käthchen" weiter. Adam Müllers Einfluß zeigen die beiden letzten,
abermals gepaarten Dramen am stärksten: 1808 „Die Hermannschlacht",
1810 „Der Prinz von Homburg". Angeregt oder selbständig, Kleist zog aus
Müllers Dresdner Vorträgen die wirksamen Folgen. „Die Hermannschlacht"
ist ein Zeitstück, kein Geschichtsstück. Es ist ein Maskendrama, in dem Varus
einen Marschall Napoleons, Marbod das zertretene Preußen, Hermann das
rettende Österreich darstellt. Das Stück entstand am Vorabend des öster-
reichischen Freiheitskampfes und sollte Preußen an Österreichs Seite ziehen
helfen. Es umreißt den gemeinsamen Feldzug, wie er 1809 hätte geführt
werden müssen und wie er 1813 tatsächlich geführt wurde. Als Preis des
Sieges erscheint die erneuerte deutsche Kaiserkrone auf dem Haupte Habs-
burgs. Es ist kein Zweifel, daß Kleist, wieder Adam Müller folgend, mit dem
„Prinzen von Homburg" den staatsphilosophischen Gegensatz von Eigen-
willen und Staatswillen, tragisch verstrickt und glücklich gelöst darstellen
wollte. Trotz vieler Einwände: als Spiel genommen, das märchenstill und

traumhaft erregt vorüberzieht, halb dunkel im verdämmernden Bewußtsein und singspielmäßig erhellt, wo stärkere Lichter fallen müssen, ist es ein kostbares Stück, das feinste und kostbarste, das der Dichter geschaffen hat, das echteste seines Wesens und das sinnreichste seiner mystischen Reihe. Wohl die reinsten tragischen Vorwürfe — „Michael Kohlhaas" 1810 — und *Kleists Novellen* im höchsten Sinne komischen Stoffe — „Das Erdbeben in Chile" 1807 und „Der Zweikampf" 1811 — hat Kleist in seinen Novellen geformt. „Das Bettelweib von Locarno" 1811 ist ein kurzes Nachtstück, „Die heilige Cäcilia" 1811 eine Legende. Kleist hat der Novelle die sachliche Wirklichkeit, die problematische Gestalt als Helden, die psychologische Entwicklung als Kunstweise, für die Darstelung den Tatsachenstil gewonnen.

Kleists Verhältnis zur Bühne ist durch höchste dramatische Anlage und nur geringe dramaturgische Erfahrung bedingt. Die Bühne verlangt, auf Fernsicht berechnet, Einfachheit und kräftige Linien. Kleists Gestalten aber sind mit überfeinem Stift gezeichnet. Was sich in ihrer Seele begibt, ist zumeist von so zarter Natur, daß es in den letzten Bänken entweder nicht verstanden würde oder an dem zu starken Wort zerbräche, das notwendig wäre, es bis dahin zu tragen. Kleist hat weder das eine noch das andere Glück gehabt. Er fand keine bewährte Bühnengemeinschaft, auf deren dramatischen Stil er sich hätte einspielen können, noch hatte er Gelegenheit, sich selber jenes Theater zu schaffen, das auf seine Kunst abgepaßt wäre. Kleist und das Theater seiner Zeit, das ist eine Tragödie mit der Schuld auf beiden Seiten. Der Dichter hatte weder die Geduld noch die Kraft zu einer neuen Bühne und das zeitgenössische Theater hatte keinen Willen zu diesem Dichter.

Friedrich de la Motte Fouqué, 1777 bis 1843, kam zu Brandenburg auf *Kunstgewerbe* die Welt von einer Familie, die aus der Normandie in die Mark eingewan- *der Romantik* dert und längst völlig verpreußt war. In ritterlichen Erinnerungen und durch vortreffliche Hauslehrer großgezogen, las er sich über Klopstocks nordische Träume, über Stolbergs junkerliche Frische bis in die ritterliche Dichtung seines eigenen Zeitalters ein. Bei den Kürassieren machte auch er den rheinischen Feldzug mit. Bald stand er mit der großen Literatur des achtzehnten Jahrhunderts auf vertrautem Fuß. Unter der Zucht August Wilhelm Schlegels trieb er Spanisch und Italienisch. Er lernte Jakob Böhmes Schriften kennen und fühlte sich zu schlichtem Glauben zurückgeführt. Fouqué hat *Fouqués* die Romantik buchmäßig verarbeitet und für die Lesermassen zurechtge- *Dramen* fühlt. Wie Aischylos die episch vorgebildeten völkischen Sagen als tragische Bühnenspiele wieder auferstehen ließ, so hat Fouqué die altdeutsche Heldendichtung in moderne Trauerspiele umwandeln wollen. Mit ihm hebt die

durchaus neudeutsche Nibelungendichtung an. Seine Siegfriedstrilogie „Der
Held des Nordens" 1810 ist ein Geschichtsspiel in Shakespeares Art. Doch
der ganze lyrische Unterton, zahlreiche alliterierende Gesätze, den Eddalie-
dern nachgebildet, machen es wahrscheinlich, daß Fouqué die Dichtung sich
als Spielbuch einer Oper dachte. Wie Kleist und Arnim aus der Gesinnung
der Berliner Abendblätter, so bemühte auch er sich um eine märkische Büh-
und „kleine nenkunst. Fouqués Novellen, die er 1814 bis 1819 als „Kleine Romane" sam-
Romane" melte, sind stofflich mit dem gesamten romantischen Schaffen der Zeit ver-
woben. Die drei Novellen „Das Galgenmännlein" 1810, „Undine" 1811,
„Erdmann und Fiametta" 1826 bildeten eine innere Einheit, gehen auf ein
Buch des Paracelsus zurück und behandeln die Naturgeister in Erde, Luft,
Wasser. Eine Gruppe für sich bilden die Rittergeschichten. „Sintram und
seine Gefährten" 1814, sind über Albrecht Dürers Stich Ritter, Tod und Teu-
fel Nachfahren von Heinrich Seuses mystischem Miles christianus. Fouqués
Fouqués „Zauberring" 1813 war der Roman der Hochromantik. In dem schwäbischen
„Zauberring" Ritter Hugh von Trautwangen, der sich auf seinen Heldenfahrten mit Mäd-
chen verschiedener Völker und Wendekreise ein widerspenstiges Geschlecht
von Kindern erzeugte, wollte Fouqué sinnbildlich darstellen, wie das ger-
manische Blut, neue Völker zeugend, in die alte Welt verströmte und wie sich
von Deutschland aus auf diese natürliche Völkerfamilie die einheitliche Kul-
tur des Mittelalters gründete. In diese Geschicke verflocht der Dichter die
Geschichte seines eigenen Geschlechtes. Hardenbergs Schau von der euro-
päischen Christenheit, August Wilhelm Schlegels Gedanken von der Abklä-
rung des mittelalterlichen Geistes aus dem germanischen Völkerchaos Euro-
pas, die staatsmännische Überzeugung Adam Müllers von der vermittelnden
Stellung des geeinten Deutschlands im neuen christlichen Europa, all das ist
in Fouqués „Zauberring" gestaltet, mitten inne zwischen den beiden anderen
Dichtungen von der fortwirkenden Macht des Blutes: Hoffmanns „Elixiere
des Teufels" und Brentanos „Romanzen vom Rosenkranz".
Der Landjunker *Ludwig Achim von Arnim*, 1781 bis 1831, aus altem Gutsadel zu Berlin
geboren, war der echte und rechte märkische Junker. Er hat mit seinem Bru-
der, im Gegensatz zu Kleist und Fouqué, bürgerliche gelehrte Bildung ge-
nossen. In Halle war er bis an die Seele dem Burschentreiben verfallen. Bei
Reichardt, dem Freunde seines Vaters, lernte er Ludwig Tieck, an der Göt-
tinger Hochschule Klemens Brentano kennen. In den Jahren 1801 bis 1804,
zur selben Zeit und fast auf den gleichen Wegen, die Kleist von seinem Dä-
mon geführt wurde, durchstreifte Arnim mit seinem Bruder Europa: Dres-
den, den Rhein, Paris, England und Schottland. Nach mehrfachem Aufenthalt

zu Heidelberg, wo „Des Knaben Wunderhorn" entstand, lebte Arnim, seit *Märkische* *Heimatkunst* März 1811 mit seiner jungen Frau Bettina Brentano, zumeist in Berlin.

Arnims literarisches Schaffen wurde von umfassenden Plänen beherrscht. Wie er 1805 bis 1808 die gesamte deutsche Lyrik der Vergangenheit sichtete und dieser Arbeit in der „Zeitung für Einsiedler" eine Pflegestätte stiften half, so bearbeitete er in der Sammlung „Der Wintergarten" 1809 altdeutsche Novellenstoffe und plante eine Ausgabe älterer deutscher Stücke, aus der nur seine „Schaubühne" 1813 herauswuchs. So ist denn auch fast alles, was er schrieb, alten Büchern nachgedichtet. Die Ungeduld und Unrast seines Stegreifschaffens eilte von Gestalt zu Gestalt und war außerstande, sie in geduldigem Basteln episch miteinander zu verbinden. Dagegen konnte er sie auf der bunten Szene, das Epische mit einer kurzen Bühnenanweisung erledigend, sofort in Bewegung setzen und sprechen hören. Seine Kunstform war die Stegreifskizze. Arnim ist barock wie das siebzehnte Jahrhundert, das er sosehr liebte. Wie Kleist und Fouqué erstrebte er eine märkische Bühnenkunst, zweierlei Stiles. Der österreichische Barock der alten Haupt- und Staatsaktionen war es in seinen geschichtlichen Schauspielen von der Art des „Echten und falschen Waldemar". Das ironische und märchenhafte Puppenspiel war es in der komödienhaften Heimatkunst der „Appelmänner" und des „Stralauer Fischzug". Wie der „Zauberring" der Roman der Hochromantik, so ist das Doppeldrama „Halle und Jerusalem" 1811 ihr Drama. Es ist aus *„Halle und* *Jerusalem"* des Andreas Gryphius Trauerspiel „Cardenio und Celinde" 1657 weitergedichtet. Von dort stammen Handlung und Gestalten, von dort der echte Barockgedanke des Gegensatzes himmlischer und irdischer Liebe in Olympia und Celinde. Geist des alten Barocktheaters ist der Glaube an jene Gnade und Erlösung, der die Paare Olympia und Lysander, Cardenio und Celinde aus der bunten Welt des Scheines und der Irdischkeit hinübertreibt in das heilige Land der Gnade, der Erlösung, des Erdengrabes und der geistigen Auferstehung. Diese Pilgerfahrt von Halle nach Jerusalem, die Lebensreise aus der Zeit in die Ewigkeit, auch hier ist alles Irdische nur ein Gleichnis. Barock ist die Form des Doppeldramas, die opernhaften Bestände, das Zusammenspielen von Erde und Himmel. Auf das Wiener Volksstück weisen die Volksszenen, die komischen Bühnenanweisungen, das Märchen von der Riesenjungfrau, das Spiel im Spiel und die Parodie, die ihre funkelnde Brücke zwischen Himmel und Erde baut. Arnims Novellen vermitteln von den Dramen zu den großen Romanen. Da bot Arnim eine wohlgefüllte bunte Fruchtschale. Märkische Heimatgeschichten, romantische Nachtstücke, Tiecksche *Arnims Novellen* Gesellschaftsnovellen, Künstlergeschichten, technische Zukunftsbilder locken

Arnims Romane rings um das vielseitigste Werkstück „Isabella von Ägypten" 1812 zum Zu-
greifen. Aus dieser Novellenarbeit erwuchs dem Dichter der erste große Ro-
man. Das ist „Armut, Reichtum, Schuld und Buße der Gräfin Dolores" 1810,
der alle Zeitfragen um Staat und Gesellschaft, Ehe und Adel im Sinn der
märkischen Junkergruppe erörtert. „Halle und Jerusalem" dort, „Die Kro-
nenwächter" hier, das sind die mächtigen Doppelgipfel, zu denen sich Ar-
nims Schaffen aufbaute. Der Roman sollte in vier Bänden Deutschlands Ge-
schichte, Sitten und Gebräuche während des frühen sechzehnten Jahrhunderts
darstellen. Da der erste Band nur in der Umarbeitung von 1817, der zweite
in der ursprünglichen Fassung, wie sie 1854 gedruckt wurde, erhalten ist, so
stimmen die beiden Bände nur schlecht zusammen. Ein Geheimbund, die
Kronenwächter, hütet auf der Kronenburg am Bodensee die Kaiserkrone der
Staufer. Aus dem erbberechtigten Geschlechte wählen sie den Tüchtigsten
aus, erziehen ihn und hüten geheimnisvoll in grausamer Rechtspflege ihr
Dunkel. So verschlingen sich ein Bundesroman, ein Abenteuerbuch, eine Fa-
miliengeschichte zu einem fantastisch wirklichen Gewebe. Im Kern ist es aber
eine Bildungsgeschichte, die den Staufererben Berthold durch ein erstes kauf-
männisches und ein zweites ritterliches Leben führt und in seinem Sohn, der
ein Sohn zweier Väter ist, die Ansprüche der beiden Stauferlinien auf die
Krone ausgleicht. Dieser Sohn und Erbe sollte Protestant werden und die
Krone Deutschlands durch geistige Bildung wiedergewinnen. Auch hier ist
es also die Frage und wirkende Macht des fortgeerbten Blutes wie in Bren-
„Kronenwächter". tanos „Romanzen", wie in Fouqués „Zauberring", wie in Hoffmanns „Eli-
„Romanzen",
„Zauberring", xieren". Anders aber als Brentano und Hoffmann verknüpft Arnim wie Fou-
„Elixiere" qué den Gedanken des erneuerten Blutes mit dem der romantischen Wieder-
geburt. Die Erfolge in der Kette des Geschlechts begründet das Recht auf die
alte Krone. Die künstliche Blutübertragung von Anton auf Berthold, gewiß
zunächst ein ärztlicher Einfall, ist gleichnisweise zu verstehen, „daß dieselbe
Herrlichkeit aus dem Stamme immerdar wiedergeboren werde". Bertholds
Erneuerung aus dem Blute Antons ist ein Sinnbild für den entwicklungs-
geschichtlichen Vorgang der romantischen Wiedergeburt, geprägt aus Arnims
junkerlichen Überzeugungen, gefunden unter dem Eindruck der Kämpfe um
Hardenbergs preußisches Verfassungswerk. Im Drama „Halle und Jeru-
salem" hat Arnim also den Gedanken der persönlichen Wiedergeburt gestal-
tet, im Roman „Die Kronenwächter" den völkergeschichtlichen Vorgang.

Der Berliner *Ludwig Tieck,* 1773 bis 1853, durfte mit seinem Abschied von Jena durch
neue Schulen gehen, Einsamkeit und Bücher, Menschen und Weltstädte,
Krankheit und Reisen. Aus der verlorenen märkischen Stille zu Ziebingen,

wo er sich niedergelassen hatte, wanderte er abwechselnd ins Weite und Ferne. In München und Paris fesselten ihn altdeutsche Handschriften. In Rom lockten nicht bloß die Bücherei des Vatikans, sondern auch die Werke *Tieck in Rom* Raffael Santos, Kirchenfeste und köstliche Aufzüge. Die zwei Versbücher, die er „Reisegedichte eines Kranken" und „Rückkehr des Genesenden" nannte, haben keinen Hauch des antiken Rom aufgenommen. Aber es ist, als hätte die römische Sonne alles Spukhafte und Dunkle aus Tiecks Seele verweht, so durchsichtig und heiter strahlen sie von Wirklichkeit. Wenn es in Tiecks römischen Versen noch ein Spiel gibt, so ist es die heitere Überlegenheit des ironischen Geistes, der die Dinge bewegt wie der sanfte Sommerwind die Blätter der festgegründeten Bäume. Zu London suchte er Shakespeare *Tieck in London* und dessen Vorgänger in den Büchern des British Museum, auf den Bühnen der Stadt. Als ein Epimetheus trug sich Tieck nun nachträglich die Tatsachen jener versunkenen Welt zusammen, die er als erster schöpferisch wiedererweckt und verklärt hatte. Den „Minneliedern" von 1803 sollte als Ergebnis der Büchereien zu München, im Vatikan, zu Paris eine Erneuerung des Nibelungenliedes und des Heldenbuches folgen. Mit Arnim gleichgerichtet unternahm er das brüderlich gepaarte Werk „Altenglisches Theater" 1811 und „Deutsches Theater" 1817, Sammlungen aus dem Werdegang des englischen und des deutschen Dramas.

Die alten Meister: hatte es in der Zeit mit Wackenroder geheißen. Die *Das toskanische* alten Dichter hieß es nun in Tiecks italienischer Zeit. Von dem toskanischen *Dreigestirn* Dreigestirn Dante Alighieri, Francesco Petrarca, Giovanni Boccaccio war Dante bereits in den „Herzensergießungen" verkündet worden. Boccaccio war der Meister von Tiecks reifster Dichtung. Es war ein Irrtum der Poetik Friedrich Schlegels, den Roman zur eigentlichen modernen Form der Dichtung auszurufen, wie das Epos die dichterische Großform der Antike gewesen sei. Dem antiken Epos entspricht das moderne Novellenbuch. Denn der *Tiecks* entscheidende Vergleichspunkt ist der mündliche Vortrag. Wie das antike *Neuschöpfung* *der Novelle* Epos, so ist die moderne Novelle nach Herkunft und Stil aus mündlichem Vortrag hervorgegangen und auf mündlichen Vortrag ursprünglich gerichtet. Sie setzt also einen bestimmten Zustand der Gesellschaft und einen gewissen Stil der Geselligkeit voraus, gepflegte Geistigkeit und ein literarisches Unterhaltungsbedürfnis. Das war die Geselligkeit der Renaissance und der Romantik. Das war der Gesprächsstil der Novelle Boccaccios und Tiecks. Die romantische Geselligkeit hatte das Gespräch und seine literarischen Formen zum Erblühen gebracht. Das Landgut zu Ziebingen, auf dem Tieck Jahre hindurch als Gast lebte, war ein solcher Mittelpunkt gesellig geistreicher

Unterhaltung. Die Kunstgespräche dieses Kreises um den abendlichen Familientisch haben ihren unmittelbaren und sichtbaren Niederschlag in vielen Novellen des Dichters gefunden. So ging denn Tieck gerade in diesen Ziebinger Jahren an seinen „Phantasus" 1812 heran. Das Buch verbindet eine Gruppe älterer und neuerer Dichtungen zu einem künstlerischen Ganzen.

„Phantasus" Sein Vorbild war eben das „Decamerone". Indessen Tieck, der ein vollkommener Weltmann geworden ist, der sich auf Lebenskunst verstand und ein Gesellschaftsdichter von Rang sein wollte, hat nun den Rahmenstil des Boccaccio weit über sein Vorbild hinaus gestaltet. Boccaccio hatte nur gedrängte dialogische Brücken von Novelle zu Novelle geschlagen. Tieck stillte sein ganzes Vergnügen gerade an den überleitenden, breit ausgeführten, immer geistreichen und spannenden Gesprächen. Das anmutigste Spiel im Spiel sind die sieben Personen, zwischen denen das Weberschiffchen des Gesprächs und der Erzählung ein so buntes Gewebe des menschlichen Daseins wirkt. So geht der Wert des Rahmens über das Bild, das er umschließt. Die eingelegten Dichtungen selber zeigen alle Stilarten, deren dieses formenreiche Ingenium fähig war: Märchenspiele und Erzählgut jeglicher Gattung. Der „Phantasus", der jedem der sieben Teilnehmer siebenmal das Wort geben wollte, ist 1816 abgebrochen worden. Spätere Versuche, in weitere Bände des Werkes die anwachsende Ernte zu sammeln, blieben stecken.

Tiecks *Neuschöpfung* *des Märchens* Tieck stand im Mittelpunkt, um den sich die Dinge drehten. Wie war die neue Erkenntnis von der Fragwürdigkeit der Sinne und der spukhaften Wirklichkeit der Geistwelt dichterisch zu bewältigen? Gegen die Antike des deutschen Klassizismus hatte man sich zu den alten Meistern der italienischen und deutschen Kunst gerettet. Vor dem Zusammenbruch der vernunftgemäßen Wirklichkeit barg man sich in das Spiel des deutschen und italienischen Märchens. Die commedia dell'arte war in Süddeutschland seit dem späten sechzehnten Jahrhundert ein integraler Bestandteil des Theaters. Tieck suchte sie zum Stil des ostdeutschen Theaters zu machen. Was für die ernste Kunst Toscana, das war für die heitere Venedig. Und wie Tieck im Novellenbuch Boccaccio gefolgt war, so folgte er im Märchenspiel Carlo Gozzi, der aus den Masken der Stegreifkomödie im Venedig des späten achtzehnten Jahrhunderts das Märchendrama entwickelt hatte. So waren unter Tiecks Händen „Rotkäppchen" und „Däumling", „Gestiefelter Kater" und „Ritter Blaubart" entstanden. So entstand, stofflich und stilhaft völlig venezianisches

„Zerbino" Theater, „Zerbino oder die Reise nach dem guten Geschmack" 1799, das umfangreichste und eigentümlichste unter Tiecks Märchenspielen. Ein Singspiel schäferlichen Stiles, anmutig und schlicht, die Trennung und Wiedervereini-

gung zweier Liebespaare, rahmt arabeskenartig die burleske Handlung ein, wie der Prinz Zerbino, in dem die Krankheit der idealistischen Philosophie ausgebrochen ist, und sein Diener Nestor die vergebliche Reise nach dem guten Geschmack unternehmen. Ein Bild des gesellschaftlichen und geistigen Lebens seiner Zeit aufzurollen, war der Sinn dieses Spieles. Kunst und Natur, das sind die beiden Reiche, die der Prinz durchreist, beide unbegriffen, unbekannt, unbetretbar für den gemeinen Wirklichkeitssinn des Zeitalters. Das Wunder inmitten des Alltags und der Alltag mitten im Wunder, ohne daß er zu fühlen vermag, was ihm geschehen könnte. Kunst und Natur, die beiden Offenbarungssprachen des Göttlichen in der Welt, sein Lied in allen Tönen singend, aus Farben, Musikgeräten, Blumen, Tieren, Elementen, und nur hörbar dem begnadeten Ohr, dem geöffneten Herzen. Das arme, vernunftbetörte, unverzauberbare menschliche Herz, kein Held und Gegenstand für eine Tragödie, sondern nur für jene Stegreifkomödie, wie sie das Leben täglich vor uns abspielt. Das ist nun auch der Stil der beiden großen Schauspiele, „Genoveva" 1799 und „Octavianus" 1804, die das Mittelalter in seiner ganzen verwirrenden Fülle über die geöffnete Szene ziehen lassen. Shakespeare, Gozzi, Calderon sind die Vorfahren von Ludwig Tiecks romantischem Bühnenstil. Jakob Böhme heißt das geistige Mysterium, aus dem sie hervorgegangen sind.

Gegenüber Ludwig Tieck bilden die drei märkischen Junker eine geschlossene Gruppe. Gemeinsam ist ihnen die Mischung von Wirklichkeit und Phantastik, der Schicksalsgedanke, der geringe Bühnensinn, das Streben nach weltumspannenden Dichtungen, der Organismusgedanke, Humor in wechselnder Gestalt, eine Fülle skurriler Züge, vielleicht bewußte Selbstironie, ein gewisses heimliches Verhältnis zur alten Kirche, das man ihnen nicht anmerken soll, Stilzüge des Barock und der Wille zu einer märkischen Heimatkunst. Mit Tieck und Wackenroder hatte die Bewegung in Berlin deutlich erkennbar eingesetzt. Sie hatte sich die Stadt erobert. Die Junker hatten sie zur Bewegung der Mark Brandenburg und des ganzen Ostens gemacht. Nach Adam Müllers Entwürfen weitete sich der ursprünglich sittliche, der ästhetische Gedanke der Wiedergeburt zu einer umfassenden nationalstaatlichen Erneuerung aus. Gegenüber den drei märkischen Junkern und deren bürgerlichem Vordenker Adam Müller verkörpert Ludwig Tieck den weltbürgerlichen Dichter, dem sein Schönheitsgefühl Religion und Vaterland ersetzt. Er war der reine Künstler. Einsam stand er mit Wackenroder am Anfang. Einsam mit sich stand er am Ende.

Die märkische Romantik

OSTPREUSSEN hatte mit Kant, Hamann, Herder die ostdeutsche Bewe-

Drei Ostpreußen

gung ausgelöst, Ostpreußen gab ihr mit Werner, Hoffmann, Schenkendorf
die letzte Wendung.

Von den beiden Königsberger Freunden erlitt *Zacharias Werner*, 1768 bis
1823, den tragischen Widerspruch von Naturtrieb und Vernunftgesetz. In
Königsberg lebte er seinen Gelüsten und spielt er mit seiner Apostelrolle.
In Warschau formt er sich aus seinen Dichtungen ein Werkzeug seines Apo-
stelwillens. In Weimar versucht er sich an Goethes Persönlichkeit zum voll-
kommenen Menschen und gültigen Dichter zu bilden. In Wien wird er ein
erfolgreicher Kanzelredner und Seelenführer. Werner ging von der Frei-
maurermystik der Loge aus und kam über die kosmische Mystik Jakob Böh-
mes zu seinem Plan eines „gereinigten Katholizismus". Zur Verwirklichung

Zacharias dieses Planes gedenkt er sich einen welterneuernden Orden zu gründen. Das
Werner:
Der Orden ist also Ort und Stunde, wo die aufgeklärte Zuneigung für das pruzzische
Urvolk in die gegensätzliche romantische Begeisterung für den Deutschen
Orden umschlägt und aus Hippels satirischem Kampf gegen das Ordenswesen
sich in Werners religiösen Werbefeldzug für den Ordensgedanken verwan-
delt. Werner gedachte seinen Feldzug vom Theater aus zu führen. Das Dop-

Die Templer peldrama „Die Söhne des Tales" 1803, dessen erster Teil „Die Templer auf
Cypern" am tragischen Untergang des Templerordens die Maurergedanken
der Zeit anschaulich macht, dessen zweiter Teil „Die Kreuzesbrüder" den
Sinn der Freimaurerei gestaltet, vollzog den Wandel der preußischen Ideo-
logie zunächst nur im Bereiche des allgemeinen Ordensgedankens. „Das

Die Ritter Kreuz an der Ostsee" 1805 führte diesen Wandel ganz gegenständlich von
den heidnischen Pruzzen zum Deutschen Orden durch. Die von Herder und
dessen zeitgenössischen Landsleuten als reine Urmenschen geliebten Pruzzen
sind bei Werner kein paradiesisches Volk, sondern ein Volk von Dämonen
und Teufeln. Dieses altpruzzische Volk führt der erste Aufzug mit erstaun-
licher Gestaltungskraft als ein volkskundliches Ganzes vor. Der zweite und
dritte Aufzug zeigt das Bild von der Ordensseite, und zwar gedoppelt: in
einer Wirklichkeitshandlung den Einzug des Deutschen Ordens in Preußen
und in einer wunderbaren Sinnbildhandlung, wie durch die ersten Märtyrer

Osten die Gnade des Glaubens auf die Pruzzen herabgezogen wird. Das Stück trägt
und Westen starke Züge barocker Kunst und ist opernhaft angelegt. Werner erweiterte
dann das Blickfeld auf den gesamten Osten, indem er an „Wanda, Königin
der Sarmaten" 1808 um die tschechische Libussasage den Zusammenstoß von
slawischer Urzeit und deutschem Mittelalter darstellte und mit „Attila" 1808
den Riesenkampf seiner eigenen Zeit im Bilde des einstigen Weltkampfes
zwischen barbarischem Osten und christlich-römischem Westen. Als Künstler

hatte Werner also den Vorwurf Preußen aus der gedanklichen Haltung einer neu anbrechenden Zeit gestaltet. Als Mensch hatte er für das, was ihn entzweite, eine Lösung gefunden in der Antwort: Liebe ist nicht Eros, sondern Caritas. Er wandte sich von Preußen weg und im Sinne Hamanns dem Geschäft seiner eigenen Seele zu. Das Lutherdrama „Weihe der Kraft" 1807 stärkte ihn am Vorbild des handelnden religiösen Helden. Das Legendendrama „Kunigunde" 1809 zeigte den Dichter bereits bei dem Gedanken der geschlechtlichen Enthaltsamkeit angelangt. Am deutlichsten wird Werners religiöser Wandel aus dem Drama „Der vierundzwanzigste Februar" 1815, wo sich die Handlung um freies Handeln, Fluch und Sündenstrafe und am wenigsten um das Schicksal dreht. Als Werner zu Rom 1810 katholisch, zu Aschaffenburg 1814 Priester und zu Wien 1815 Prediger geworden war, hatte sich ein Kreis und eine Handlung geschlossen. Kunstform und Stil seiner Dramen wurzeln in dem Gesetz, das Hamann rhapsodisch verkündet und Herder zu klarer Forderung erhoben hatte: Sprache, Mythus, Dichtung sind eine Ureinheit und das Drama der Zukunft muß alle Künste in sich vereinen. Denn Werners Dramen sind mehr barocke als romantische Musikspielbücher und liegen auf dem Wege von Herder zu Wagner.

Werners Musikdrama

Von den beiden Königsberger Freunden erlitt *Ernst Theodor Amadeus Hoffmann*, 1776 bis 1822, den tragischen Widerstreit zwischen Sinnentrug und Geisteswelt. Er hat in doppeltem Sinne ein dreifaches Leben geführt. Einmal das jugendlich übermütige in den neupreußischen Kanzleien Polens bis 1806; dann das des fahrenden Künstlers bis 1813 in Kunststädten und Künstlerstädten wie Bamberg und Dresden; schließlich bis zu seinem Tode in Berlin das des gewissenhaften Beamten. Und zugleich ein dreifaches Leben in dreierlei Künsten: der Töne, des Griffels, des Wortes. Aus dem Karikaturenzeichner und Musikdeuter wurde der Schriftsteller. Nur zweimal hat Hoffmann Mut und Kraft zu größeren Werken gefunden. „Die Elixiere des Teufels" 1815, sein Bamberger Buch nach Erlebnis, katholischer Luft und Entstehung, hatte die Erbsünde ins Mystisch-Neuplatonische gewandelt und die Vererbung zum Gegenstande. Der einzelne erlöst sich durch Kasteiung aus dem sündigen Zwange des Blutes und entsühnt durch stellvertretendes Leiden die ganze Sippe. Schicksal also in doppelter Gestalt, das angeborene und das von außen wirkende. Noch einmal baute er aus den gleichen Grundstoffen einen Roman auf, um seinem Bamberger Liebeserlebnis und seiner Rollenfigur, dem Kapellmeister, Genüge zu tun. Das waren die „Lebensansichten des Kater Murr" 1819, diesmal eine Hofgeschichte. Scheinwelt und Künstlertum, Aufklärung und Romantik spielen schon in der äußeren Anlage

Der Kapellmeister Kreisler

„Die Elixiere des Teufels"

„Lebensansichten des Kater Murr"

Hoffmanns des Buches zusammen, das die Blätter von Kater Murrs Leben und die Lösch-
Erzählungen blätter der Kreislerbiographie sinnlos sinnvoll durcheinanderbringt. Hoff-
manns Aufgabe war es vielmehr, das weite Feld der Novelle nach allen Er-
tragsmöglichkeiten zu bestellen und zu nutzen. Von seinen Nachtstücken ist
„Der Sandmann" 1817 gar keine Spukgeschichte dem Stoff, sondern lediglich
der Darstellung nach. Sie gibt vollkommen gegenständlich und wirklichkeits-
treu einfach die Zerrüttung einer Seele. Hoffmann liebt die ungewöhnlichen
und dunklen Vorgänge auf der Nachtseite des Seelenlebens wie alles den
Sinnen Unbegreifliche. Er liebt die Überwelt und die Unterwelt, zwischen
denen hindurch der schmale Saum unseres Tagbewußtseins führt. Die Cha-
rakternovellen, in denen sich seine ganze Meisterschaft bewährt wie „Der
Schüler Tartinis" 1819 sind ein Geschenk seines zeichnerischen Auges und
seiner außerordentlichen mimischen Fähigkeiten. Wahrhaft neu geschaffen
hat Hoffmann: die Märchennovelle, indem er nach allen Gesetzen des Seelen-
lebens aus dem Keim der Wirklichkeit die Handlung des Unwirklichen er-
blühen läßt, so „Der goldene Topf" 1813, „Nußknacker und Mausekönig"
1816, „Klein Zaches" 1819, „Die Königsbraut" 1821, „Meister Floh" 1822;
die Künstlernovelle, in der mit Vorliebe die eingeborene Tragik des Künst-
lertums dargestellt wird, so „Rat Krespel" 1818 und „Signor Formica" 1819;
die kulturgeschichtliche Erzählung, in der sich Hoffmann um die Farbe von
Ort und Zeit bemüht, wie „Meister Martin" 1818 und „Meister Wacht" 1822,
Bilder des berufsstolzen deutschen Handwerks; die Gerichtsnovelle, so „Das
Fräulein von Scudéri" 1820 und „Marquise de la Pivardière" 1820, von denen
sich jene gegen den Indizienbeweis und diese gegen die Kinderaussage wen-
det. Hoffmanns Novelle wuchert mit dem, was er überkommen hat. Lücken-
los schließt er an die italienischen, französischen, spanischen Vorläufer an,
wie er sich die deutsche Vorarbeit zunutze macht. Was an seiner Kunst ver-
gänglich ist, fällt seiner Zeit und der Verführung zum Schnellschreiben zur
Last. Was er Gültiges schuf, ist sein eigenstes Werk. Die Freude am Men-
Widerstreit schen und am Mienenspiel des Geistigen im Körper war Hoffmanns künst-
von Poesie lerisches Vermächtnis an Zeitgenossen und Nachwelt. Der Vordergrund von
und Prosa Hoffmanns Gedanken ist leicht zu übersehen. Da spielt sich, sein stehender
Vorwurf, bald tragisch, bald launig, bald grotesk der Widerstreit von Poesie
und Prosa ab. Sein Bild dafür ist die Liebe des Künstlers. Aber was ist ihm
Hoffmanns Poesie und was Prosa? Es sind zwei Welten, eine diesseitige und eine jen-
Weltgefühl seitige, beide nach Ort und Zeit in einem gegenwärtig und wirksam, ohne
daß Vernunft und Erfahrung sagen könnten, was eigentlich echt und wirklich
und jedesmal das andere ist. Dieses wehrlos preisgegeben sein ist Hoffmanns

Weltgefühl, ein grauenvolles Erlebnis, vor dem es nur Flucht in die künstlerische Schöpfung gibt. Wie ein Mensch aus Entsetzen schreit, um sich Luft zu machen, so schüttelt Hoffmann seine Weltangst in seine Dichtungen ab. Nur so wurde er dieses schreckenvollen Widerspruchs Herr, der bald den Stoff zu einem seelischen Automaten, bald den Geist zu einer stofflichen *Der Automat* Fratze machte, das eine so gespenstig wie das andere, jedes ein Spuk im Reiche des andern, beide Doppelgänger ihrer selbst. Hoffmanns Lage war tragisch und grotesk zugleich. Und das ist auch die Haltung seiner Kunst. Hoffmann setzt den großen Zug der humoristischen Literatur Ostpreußens von Hamann und Hippel her fort, nur ist bei ihm der Humor aus dem bloßen Wort in die beherrschende Situation gedrungen. Hoffmanns zwiespältiger Zweiweltenstil war in der Literatur Preußens seit Hamann Stilüberlieferung.

Werner und Hoffmann waren Freunde. Das Gemeinsame liegt neben allem *Werner* Gegensätzlichen zutage. Der Dichter barockstilisierter Dramen Werner und *und Hoffmann* der Bamberger Spieleinrichter Hoffmann, der um Calderon bemüht war, der Tonsetzer Hoffmann, der zu Werners „Kreuz" die Musik schrieb, sie erschienen beide im Dienst an einem verwandten Bühnengedanken. Das innerlich Zwiespältige Hoffmanns, sein Verhältnis von Eros und Sexus, die Richtung auf das Mystische, Okkulte, Irrationale wiederholt nur die gleiche Erscheinung Werners.

Zu den beiden Königsberger Freunden fügt sich mit der Vergangenheit des Landes im Herzen der Landjunker *Gottlob Ferdinand Max von Schenken-* *Der Herold* *dorf,* 1783 bis 1817, aus Tilsit. Der kam schon aus romantischer Vorschule. *des Ordens* Auf Schloß Karwinden war er mit der Familie des Burggrafen Alexander von Dohna pietistisch fromm und bei dem Dohnaschen Pfarrer Johann Christoph Wedeke zu Hermsdorf lernte er die frühromantischen Bücher kennen und für den Deutschen Orden schwärmen. Er sah die Marienburg, war von ihrer Verwüstung bestürzt, brandmarkte sie 1803 im Berliner „Freimütigen" und wurde so der erste Anreger zur Wiederherstellung des Schlosses. Wie Wer- *Rettung der* ner vom Ordensgedanken her, so gab Schenkendorf von der Marienburg aus *Marienburg* der preußischen Denkweise ihre neue Richtung, vom Pruzzenlande weg und auf den Ordensstaat hin. In Königsberg warb er mit den beiden Zeitschriften „Vesta", die Napoleon, und „Studien", die der König verbot, 1807 und 1808 für den Einklang von Kunst, Religion, Liebe, für eine tatbewußte Romantik, für eine persönliche und nationale Wiedergeburt, für die Idee des Mittelalters. Mit seinen Freunden gründete er 1809 die Gesellschaft „Blumenkranz des baltischen Meeres", eine Art religiös-nationalen Ordens, der die Zeitschrift „Spiegel" herausgab. Schenkendorf gehörte zu den geistigen Vor-

kämpfern der deutschen Erhebung und wurde 1813 ihr Waffensänger. Verklärt durch einen frühen Tod und in vielgesungenen Liedern geliebt, ist Schenkendorf fast zu einer Legendengestalt geworden. Seine Lieder, die als *Schenkendorffs* „Gedichte" 1815 gesammelt wurden, sind die schlichtesten, die es in deutscher Sprache geben kann, fast ohne Kunstmittel außer den geläufigen des Volkes. Sie sind aus Eingebungen des Augenblicks entstanden und außerhalb aller künstlerischen Berechnung. Sie haben nur eine Quelle: frommes, religiöses Gefühl. Seine Liebeslieder sind ein religiöser Minnedienst. Sein Krieg ist ein Kreuzzug und er selber ein Ritter im Dienste Gottes. Alle Menschen sind ihm Brüder ohne Ansehn des Standes und des kirchlichen Bekenntnisses. Er lebte aus dem Gedanken des Deutschen Ordens. Daher erlebt er den Befreiungskrieg als Erneuerung des mittelalterlichen Kaisertums, und darum wünscht er die Kaiserkrone wieder auf das gleiche Haupt, von dem sie niedergelegt worden war. Das Eiserne Kreuz des preußischen Heeres feiert er als erneuertes Ordenskreuz. Er glaubt an die Heraufkunft einer gemeinsamen, einer volkstümlichen, einer germanisch-katholischen Kirche. Die neue preußische Ordensideologie führt bei Schenkendorf ungefähr in die gleiche religiöse Richtung wie bei Werner. Schenkendorf war an der Marienburg zum Deutschen Orden und durch die westdeutsche Ordensrittergesinnung zum mittelalterlichen Reichskaisergedanken erwacht.

<div style="margin-left:2em">

Schenkendorffs „Gedichte"

Religiöser Minnedienst

germanisch-katholische Kirche

</div>

Werner, Hoffmann, Schenkendorf bedeuten erste künstlerische Offenbarung Preußens und Königsbergs in den drei Grundarten: Drama, Erzählung, Lied.

Etappe Königsberg
So wurde Königsberg zur Angel der Ereignisse. Im Sommer 1812 rollte die Große Armee durch die Stadt an der Memel. Am 4. Jänner 1813 zogen die letzten Franzosen ab und die ersten Kosaken ein. Das wurden dann die Tage, da Ernst Moritz Arndt in Königsberg den dritten Teil vom „Geist der Zeit" schrieb, im wesentlichen die Geschichte des russischen Feldzuges. Schöpferisch formte Arndt, Steins Gedanken nachdenkend, die staatlichen Aufgaben der nächsten Zukunft: Einigung Deutschlands gleichläufig mit der Einigung Italiens; Freiheit des Kirchenstaates; europäisches Gleichgewicht; der Rhein als Deutschlands Strom; die Habsburger Deutschlands Retter. Er entwarf eine Reichsverfassung, die aus dem Werk von 1870 vieles vorwegnahm. Der Gedanke der romantischen Wiedergeburt war endlich zur Tat geworden.

„O Täler weit, o Höhen"
Wieder hatte *SCHLESIEN* das Wort. Ein schlesischer Junker hat das romantische Lied gefunden, das einzige, was aus der Romantik so volkhaftes Gemeingut geworden ist wie aus dem Klassizismus die Bühnenstücke Schil-

lers. *Josef von Eichendorff*, 1788 bis 1857, von Lubowitz, stammte aus einer ursprünglich niedersächsischen Familie und teilte Glück wie Bildung der Jugendzeit mit seinem wenig älteren Bruder. Er kam aus einem Vaterhaus von großem Lebensstil und zerbröckelndem Wohlstand. Von den Breslauer Schulen auch literarisch vorgebildet, hat der Dichter alle Mittelpunkte romantischen Geisteslebens und romantischer Geselligkeit durchkreist; seit 1805 Halle, wo er das Burschenleben, Tiecks, Richters, Goethes Bücher kennenlernte; seit 1807 Heidelberg, wo ihn der Zauber der Landschaft, Görres, Arnim, Brentano fesselten; seit 1809 Berlin und die christlich-deutsche Tischgesellschaft; seit 1810 Wien, die große Gesellschaft und der kleine Hof Friedrich Schlegels; dazwischen hinein aber immer wieder Lubowitz, das Rauschen der oberschlesischen Wälder, der Schlag der Nachtigall auf den feuchten Niederungen, der Lerchenwirbel über den Feldern. Die „Schlesischen Provinzialblätter" brachten 1803, im gleichen Jahr, da auch Hoffmann und Schenkendorf zu sprechen begannen, Eichendorffs erstes Gedicht. Vom Zobten aus, 1804, hat der Jüngling mit dem Blick von oben zum erstenmal seine heimatliche Landschaft erlebt. Schon seit Halle läßt das Tagebuch die rasche Reife seines lyrischen Vermögens erkennen. Eichendorffs „romantische" Landschaft, das ist das ostdeutsche Landschaftsbild Schlesiens und Mährens. Seine Liedkunst ist aus der romantischen Bewegung nicht abgeleitet, sondern ihr selbständig hinzugewachsen. Kunstgewerklich hat Friedrich von Hardenberg nennenswerten Einfluß auf ihn nicht ausgeübt. An Ludwig Tiecks Farbenempfinden reifte seine Art, die Stimmung durch locker nebeneinander gestellte Sinneseindrücke auszusprechen. Das Volkslied führte den Dichter auf sein eigenes Wesen. Mit Achim von Arnim hat Eichendorff die bildlose Zustandslyrik gemein, mit Clemens Brentano nicht viel mehr als gelegentliche Motive. Auch sein Erwecker zu staatspolitischem Denken war in Berlin Adam Müller. Eichendorffs erstes Liederbuch steht in dem Roman, in dem er seine Bildungsgeschichte von Lubowitz bis Wien darstellte und abschloß. In dieser Gedichtlese stehen Lieder, die bereits alle Bestände seiner reifsten Kunst nach 1824 enthalten: „In einem kühlen Grunde", das Mühlenlied; „Wenn die Sonne lieblich schiene", drei unerhört einfache Gesätze, ganz Bild, Sinnlichkeit, Musik; „O Täler weit, o Höhen", das weniger entweihte seiner Waldlieder, das schon im ersten Wort ein armausbreitendes Verlangen ausspricht, gebärdenhaft-sinnbildlich. Eichendorff hat das Bild entdeckt vom Mädchen, das sich am morgenfrischen Fenster in körperlichem Lebensgefühl dehnt. Es gehörte der Gesellschaftswandel einer ganzen Zeit, der neue Adel des Volksliedes, die Kühnheit eines selbstsicheren Künstlers dazu, in dieser Körper-

Lubowitz, Halle, Heidelberg

Ostdeutsche Landschaft

Eichendorffs frühe Lyrik

gebärde von wahrhaft lyrischer Sinnlichkeit edel zu machen, was minderem
Taktgefühl unedel erscheinen mußte.

Eichendorff in
Berlin und Wien
Josef von Eichendorff setzte, kaum zwanzigjährig, in den entscheidenden
Jahren der romantischen Bewegung zu Schöpfungen an, die sich da und dort
bis in seine fernsten Mannesjahre auswirkten. Aus den Heidelberger Erleb-
nissen entsprang 1809 das Märchen „Die Zauberei im Herbste“, der Kern
seiner späteren Novelle „Das Marmorbild“. Aus dem Berliner Aufenthalt
stammt der flüchtige Entwurf zu dem Schauspiel „Hermann undThusnelda“.

Eichendorffs
„Ahnung und
Gegenwart“
Das Ergebnis der Wiener Jahre ist der erste Roman. „Ahnung und Gegen-
wart“ ist vom Herbst 1810 bis zum Herbst 1812 in Wien gearbeitet worden.
Erschienen ist er 1815, von Fouqué getauft und herausgegeben. Zwei ver-
schiedene Entwürfe aus erheblich verschiedenen Zeiten hat der Dichter mit-
einander verwoben und durch einen Leitgedanken nachträglich zur Einheit
gemacht, indem er vier Erlebnisgruppen, die Lubowitzer, die Heidelberger,
die Berliner, die Wiener ineinanderschob. Sehr früh schon scheint es ihn ge-
lockt zu haben, das Leben auf den schlesischen Schlössern zu einem Gesell-
schaftsbilde auszumalen. Das ist der Stoff des ersten Buches. Beträchtlich
jünger, obwohl schon in dem Heidelberger Romanentwurf „Marien Sehn-
sucht“ vorgebildet, ist die Geschichte Rudolfs, der Zug vom Doppelgänger
und die Schicksalshandlung auf italienischem Hintergrunde. Unabhängig von
beiden Vorwürfen bildete sich der einheitliche Innenkern des Ganzen. Der
Held Friedrich findet auf Abenteurerfahrten sein verschollenes Heimatschloß
und sinnbildlich von seiner wiederentdeckten irdischen den Weg zur himm-
lischen Heimat. Das ist deutlich genug der Grundgedanke von Arnims „Halle
und Jerusalem“. Eichendorffs eigentümliches Verhältnis zum romantischen
Gedanken der Wiedergeburt ist in Berlin und Wien durch Adam Müller aus-
gelöst worden. Im Sinne Müllers wandte sich der Vierundzwanzigjährige
— wahrhaftig, er war nicht älter — gegen das „Verpoetisieren“ der Glau-
benssätze, Wunder und Wahrheiten. Er verhöhnte die flittrige romantische
Schöngeistelei mit seinem Spott auf deutsche Worte, spanischen Satzbau,
welsche Bilder, mittelalterliche Redensarten. Bei Eichendorff war das ein
Gesinnungswandel: „Er hatte endlich den phantastischen, tausendfarbigen
Pilgermantel abgeworfen und stand nun in blanker Rüstung als Kämpfer
Gottes gleichsam an der Grenze zweier Welten“. Diesen Wandel wollte der
Roman beispielhaft darstellen. Es ist die erste wirklichkeitstreue, weil erlebte
Gegenwartsdichtung der Romantik und bezeichnend genug ist es dieses
Buch, in dem sich das neue Wort zum erstenmal findet: „Sie sind ein Natura-
list in der Poesie.“ Die Einheit der Dichtung liegt nicht bloß im Gedanken,

nicht bloß in der Handlung, die auf den Punkt zurückführt, von dem sie aus-
ging, sie liegt in der inneren Form. Es ist eine Dichtung des Bewegungs-
gefühls und als solche ganz lyrisch. In diesem Buch lebt die Welt des schle-
sischen Adels, das ist die kulturgeschichtliche Fuge Österreichs und Schle- *Österreich*
siens. Es war die Welt des Barocks, aus der den Jungen gerade noch in diesem *und Schlesien*
verspäteten Winkel ein lebendiger Nachhauch berührt hatte. Diese Barock-
welt der Gärten und Schlösser, der Maskenzüge und Stegreiffeste war ebenso
schlesisch wie österreichisch. Eichendorff hat Barock und Romantik zu einem
Stil gemacht.

Am 25. Jänner 1813 kam der Hof zu Breslau an. Am 15. März war Ernst
Moritz Arndt da im Gefolge des Freiherrn vom Stein und des siegreichen
Kaisers von Rußland. Am 20. März erging der Aufruf „An mein Volk". Frei- *Etappe Breslau*
korpsführer schlugen ihre Werbetische auf. Josef von Eichendorff trat zu
Breslau in Lützows Freischar und rückte mit der fünften Kompanie ins Feld.

NIEDERSACHSEN. Seit dem Anfang des achtzehnten Jahrhunderts hatte
sich das sächsische Geistesleben an der Wurzel Jütlands aus dem Zusammen-
spiel der beiden Großstädte Kopenhagen und Hamburg sowie dem Zuschuß
des zwischenliegenden flachen Landes bereichert. Das war die Lage, die um
die Jahrhundertwende geschichtlich ausreifte.

Friedrich Gottlieb Klopstock hatte durch seinen dänischen Schüler Johan-
nes Ewald der jungen dänischen Dichtung den Zug auf die zeitgenössische
klassische Dichtung der Deutschen gegeben. *Heinrich Steffens* gab ihr die
Wendung auf den Stil der deutschen Romantik. Denn durch seine „Inledning *Deutsche*
til Filosofien", Vorlesungen, die er seit November 1802 in Kopenhagen hielt, *Romantik*
gab er der dänischen Jugend einen Überblick über die deutsche Philosophie *in Dänemark*
im Sinne Schellings und über die Weltliteratur vom Standpunkt der Brüder
Schlegel. Durch diese Vorlesungen hat Steffens den kommenden großen
dänischen Dichter Adam Öhlenschläger zur deutschen Romantik gebildet.
Was die Straßburger Begegnung zwischen dem Mentor Herder und dem
Telemach Goethe vor dreißig Jahren dem deutschen Geistesleben bedeutet
hatte, das bedeutete jetzt die Begegnung zwischen dem Mentor Steffens und
dem Telemach Öhlenschläger für den skandinavischen Norden. Beide haben
sie als das große Ereignis ihres Lebens empfunden. Öhlenschläger schwur
ab, was er bisher gedichtet hatte, und schrieb unter dem umwandelnden Ein-
druck der Vorlesungen in dänischer Sprache das Gedicht „Die Goldhörner". *„Die*
Das ist die Dichtung, von der die Wiedergeburt des skandinavischen Nordens *Goldhörner"*
ausgeht. In epischer wie in dramatischer Gestalt, in deutscher zugleich und
in dänischer Sprache, im Stil des deutschen Klassizismus und der deutschen

Die Legende Romantik hat Öhlenschläger die nordische Vorzeit, ihre Mythen und Geschichten dichterisch wiedererweckt. Durch Öhlenschläger ist der skandinavische Norden in der zeitgenössischen deutschen Dichtung aufgegangen.

Zwischen diesen Offenbarungen einer nordländischen Natur und einer östlichen Frömmigkeit suchte der Wendensachse seinen künstlerischen Stil. *Gotthard Ludwig Kosegarten*, 1758 bis 1818, aus dem mecklenburgischen Grevesmühlen, hatte als Übersetzer englischer und schottischer Dichter, mit Dichtungen aus der nordischen Natur und Vergangenheit begonnen. Als Pfarrer von Altenkirchen war er unter dem Eindruck, den Schleiermacher auf ihn gemacht hatte, zu Romanen frühromantischen Stiles übergegangen. Geist und Stil, die er gesucht hatte, fand er endlich, Herder folgend, mit seinen „Legenden" 1804, einer Sammlung von 84 Dichtungen, die aus der „Legenda aurea" des Jakob von Voragine, aus dem „Dialogus miraculorum" des Caesarius von Heisterbach, aus den Gesprächen Gregors des Großen schöpften. Um einen ähnlichen Stil, Jenseitiges sinnlich auszudrücken, rang die Malerei. *Kaspar*
romantische *David Friedrich*, 1774 bis 1840, aus Greifswald, war in Kopenhagen geschult
Malerei und begann, wie Kosegarten dichterisch, so malerisch mit Sepiazeichnungen nach Rügener Landschaften. Er wurde der erste romantische Maler, der mit Stift und Farbe dichterische Gebilde geschaffen hat, indem er mit Nebel, Bergeshöh und Heide, mit Meerflut und Sturm die innern Gesichte dieses neuen romantischen Menschenschlages schilderte. Seine Kunst war jenes Gemälde von ihm, „Der Regenbogen", eine Brücke, von dem einsamen, gedankenschwer gestützten Träumer rechts über Fluß und Insel hinweg nach links geschlagen, in ein Jenseits aller Gestalt und Farbe und Sprache. *Philipp Otto Runge*, 1777 bis 1810, aus Wolgast, ging gleichermaßen durch die Kopenhagener Kunstschule. In Dresden aber lernte er Jakob Böhmes Schriften kennen. An Ludwig Tieck fand er einen Herzensfreund. Runge bildete sich aus den Gleichnissen Jakob Böhmes eine bildhafte Zeichensprache, in der er dann, seines frühen Todes gewärtig, die Schöpfung als Offenbarungsgeheimnis Gottes zu malen begann. Seine beiden niedersächsischen Märchen „Von dem
Friedrich, Machandelboom" und „Von dem Fischer" lassen ahnen, welch ein ursprüng-
Runge, licher Dichter mit diesem Maler vor seiner Zeit verlöscht ist. Friedrich und
Overbeck Runge haben mit Stift und Farbe den Grundstil der romantischen Bildkunst gefunden. Von ihren beiden Landsleuten, die auf diesem Wege zum Ziele schritten, kam Friedrich August von Klinkowström aus Stralsund und Friedrich Overbeck aus Lübeck.

HAMBURG lag in der Mitte. Von England getrennt, für Frankreich unzugänglich, bekannte die Stadt sich geistig zu Spanien und legte damit zugleich

ein politisches Bekenntnis ab. Ihr Handel hatte seit alters Beziehungen zur *Hamburg und die spanische Literatur* pyrenäischen Halbinsel geschaffen. In Hamburger Bürgerhäusern hing manches spanische Bild. Die französischen Adler führten dann 1807 eine spanische Division nach Hamburg. Die Truppe gab sich keine Mühe, ihren Franzosenhaß zu verbergen. Sie war der Liebling der Stadt. Ihr zuliebe hielten sich die Buchläden einen Vorrat an spanischen Büchern. Und aus Liebe zu Spanien wurde Hamburg die Stadt einer reichen Übersetzungsliteratur. *Dietrich Wilhelm Soltau* hatte seit 1800 bereits den „Don Quixote" und die Erzählungen des Cervantes in deutscher Sprache erscheinen lassen. *Johann Nikolaus Böhl von Faber*, 1770 bis 1836, Kaufmann im spanischen Geschäft seines Vaters, mit einer Spanierin verheiratet, Generalkonsul Hamburgs für das ganze Königreich Sevilla, sammelte eine unschätzbare Bücherei altspanischer Druckwerke und machte sie durch Neuausgaben seinen Zeitgenossen bekannt. *Johann Dietrich Gries*, 1775 bis 1842, fügte seinem deutschen Tasso und Ariost das Meisterwerk seines deutschen Calderon hinzu. Er krönte die dichterischen Beziehungen zwischen Hamburg und Spanien. Sprachliche Treue und ebenbürtige Schönheit, schmiegsamer Fluß des Tonfalles, makellose Wiedergabe der Bilder waren die Tugenden dieses Meisters, die er nur mit wenigen zu teilen hatte. Im Nacherschaffen romanischer Sprachmusik und welscher Reimspiele war Gries zu seiner Zeit ohne ebenbürtigen Wettbewerber. Aus dem Nacherlebnis der romanischen, vorab der spanischen Schöpfungen war dem Hamburger Geiste ein neues Formgefühl erwacht.

Was aber floß ihm an Gehalt zu? Schon in den neunziger Jahren läßt sich *Die vaterländische Richtung* an den Hamburger Zeitschriften rasch wachsende Neigung für vaterländische Geschichte im engeren und weiteren Sinne beobachten. Männer wie der Oldenburger *Gerhard Anton von Halem,* 1752 bis 1819, förderten diesen Zug mehr durch ihre rein geschichtlichen Arbeiten als durch ihre Gedichte. Um wieviel fruchtbarer, wenn schöpferische Anlage hinzukam. So kann denn das Werk von *Leonhard Wächter,* 1762 bis 1837, aus Ülzen, sicherlich nicht über- *Leonhard Wächter* schätzt werden, wenn es sich um Erweckung des nationalen Sinnes unter den breiten Massen der Bücherfreunde handelt. Sein Werk, das sind die „Sagen der Vorzeit" 1787 bis 1798, sieben Bände. Für Wächter war das Rittertum der Kern des Mittelalters. Getreue Zeitfarbe strebte er immer an. Besonders sorgsam verfuhr er mit Brauch und Sitte. Volksbücher hat er kaum gekannt. Echt und alt sollte an seinen Werken alles sein, sogar die eingelegten Lieder. Sonst war ihm vorbildlich der Ton von Bürgers Balladen. Die altertümliche Patina der Farbe suchte er beinahe allein durch das Einzelwort zu erreichen. Daß Wächter, soweit das zu seiner Zeit möglich war, echtes Mittelalter zu

geben suchte und zumeist auch wußte, diese geschichtliche Sachlichkeit war, wenn man an den Stil dachte, wichtiger als der geschichtliche Idealismus Friedrichs von Hardenberg.

Ob Romantik nun Romanismus, ob sie Mittelalter bedeutete, beide Seiten ihres Wesens waren zu Hamburg bodenständig ausgebildet.

Doch Romantik hieß in ganz Niedersachsen politische Tat. Sie rüstete sich *Die Historie* in drei Männern und begann auf weite Sicht zu wirken. *Barthold Niebuhr,* 1776 bis 1831, ein Sachse von Kopenhagen, unter den Marschbauern von Meldorf aufgewachsen, zu Hamburg in Klopstocks, zu Kiel in Stolbergs Kreise gebildet, war Niebuhr von drei Leidenschaften bewegt: für England, gegen Frankreich, wider den allgemeinen Umsturz. Als Leiter der ostindischen Bank zu Kopenhagen wandte er sich der Erforschung des römischen Eigentums- rechts und der römischen Ackergesetze zu. Er wurde Geschichtschreiber und Ahnherr der vier Geschichtschreiber aus dem sächsischen Eiderlande: Waitz, Mommsen, Müllenhoff, Wattenbach. Und da er 1806 als Leiter der Seehand- lung nach Berlin berufen wurde, wurde aus dem Geschäftsmann und Ge- schichtschreiber ein Staatsmann. *Johann Heinrich Dräske,* 1774 bis 1849, aus Braunschweig, entwickelte sich, seit er 1804 Pfarrer zu Ratzeburg geworden *Die Kanzelrede* war, zum gewaltigsten Kanzelredner seiner Zeit. Alle seine außerordentlichen Mittel der Persönlichkeit und der Sprache setzte er an die eine große Auf- gabe, seine Gemeinde auf den Augenblick der inneren und äußeren Befrei- ung vorzubereiten. „Teutschlands Wiedergeburt, verkündigt und gefeiert durch eine Reihe evangelischer Reden im Laufe des Jahres 1813" war seine *Arndt „Geist* klassische Ratzeburger Predigtfolge. *Ernst Moritz Arndt,* 1769 bis 1860, von *der Zeit"* Schoritz auf Rügen, war von Jugend auf durch ein gesundes Naturleben ge- stählt, durch weite Fußreisen mit dem europäischen Zusammenbruch aus eigener Anschauung vertraut, seit 1805 Hochschullehrer zu Greifswald, wurde aus Not und am Anblick des deutschen Unterganges „ein politisch schreibender und handeln müssender Mensch". Während das deutsche Fie- ber seinem Höhepunkt zuflog, seit Herbst 1805 rang er mit dem ersten Ent- wurf des Buches, das zu seinem und zu Deutschlands Schicksal geworden ist: „Geist der Zeit", dessen erste zwei Bände 1806 und 1809 erschienen sind. Das Buch wollte sein übergeistigtes Zeitalter in den feurigen Tod der Ver- wandlung hineinpeitschen. Die deutsche Geschichte, die beiden verantwort- lichen Großmächte Österreich und Preußen werden vor das Gericht des deut- schen Unterganges gezogen, auf Schuld und Verdienst geprüft. Mit geschärf- tem Ingrimm wendet Arndt sich gegen die unpolitische Geistigkeit sowohl der klassischen wie der romantischen Bildung. Vom ersten zum zweiten Bande

verwandelt sich seine versteckte preußische Gesinnung in eine offene Zu-
neigung für Österreich. „Republiken taugen nicht." Arndts politisches Be-
kenntnis ist die verfassungsmäßige Monarchie. Die Tat, auf die es Arndt an-
kam, war, dem Werk und Wesen Napoleons den lähmenden Zauber zu neh-
men. Und diese Tat hat sein Buch getan. Es rückt den Kaiser der Franzosen
in das unbetrügliche Mittagslicht der kritischen Vernunft: ein Nachtgespenst
der deutschen Furcht und Feigheit. Beide Bände entluden auf sein Haupt
die Rache Napoleons. Landflüchtig trieb sie ihn nach Schweden, Berlin, Prag,
Petersburg. Ernst Moritz Arndt war die Nachhut der vertriebenen und die
Vorhut der wiederkehrenden deutschen Freiheit. Die drei niedersächsischen
Männer Niebuhr, Dräseke, Arndt sind der tatbereite Geist der deutschen
Romantik.

Die unbezwingliche Freiheit des Geistes verkörperte sich in Hamburg und *Hamburger*
zu Hamburg in *Friedrich Perthes,* 1772 bis 1843, aus Rudolstadt in Thürin- *Buchhandel*
gen. Ohne einen Groschen eigenen Geldes machte Perthes 1796 zu Hamburg
seinen Buchladen auf, war in wenigen Jahren Herr der Lage und bald konnte
ihn Niebuhr „den Buchhändlersouverän von der Ems bis an die Ostsee"
nennen. Welch ein Schauspiel, wie Perthes das freie Meer sich dienstbar
machte, um die geistige Zufuhr des gepreßten Landes aufrechtzuerhalten.
Ganz Holland, das nordwestliche Deutschland, England und der Norden
Europas bildeten den gewaltigen Spielraum seines Bücherhandels. Da alles
verzweifelte und selbst Josef Görres meinte, es werde nicht Frieden werden,
bis das ganze Geschlecht ausgerottet sei, das den Aufruhr gesehen, da behielt
Perthes seine tröstende Heiterkeit und Zuversicht und leitete sie durch seinen
umfangreichen Briefwechsel über Deutschland hin.

Am 24. Februar 1813 erhob sich Hamburg. Unter Glockengeläute, Roß
und Reiter blumengeschmückt, rückte der Russe Tettenborn in die Stadt ein.
Es war zu früh gewesen. Bald waren die Franzosen unter Davoust wieder da
und mit ihnen der verdoppelte Schrecken einer zurückeroberten Stadt.

Nach *MEISSEN* kehrte die Romantik räumlich und zeitlich in ihre Aus- *Rückkehr in*
gangsstellungen zurück. Hier erschienen zur selben Stunde Vorläufer und *die Ausgangs-*
Nachzügler auf der Szene. Um Dresden und Leipzig wurde politisch und *stellung*
soldatisch die Schlacht geschlagen, zu der die Romantik geistig aufmarschiert
war.

Im Zeichen des edlen meißnischen Schulhumanismus rundet sich der Um-
lauf der romantischen Bewegung von Johann Gottfried Seume zu Otto Hein-
rich Graf von Loeben als geschlossener Kreis. Beide Männer stehen wie Ein-
gang und Ausgang nebeneinander.

Weltwanderer *Johann Gottfried Seume,* 1763 bis 1810, aus Poserna bei Weißenfels hatte schon als Junge seinen „Julius Cäsar" in der Tasche, wenn er Tage und Nächte unter sächsischen Truppenübungen verlief. Er verließ die Leipziger Hochschule 1781, um auf die Metzer Artillerieschule zu kommen, doch hessische Werber pressen ihn zum englischen Söldner und entführen ihn nach Amerika. Mit Horaz und Vergil durchpirscht er die Indianerwälder von Akadien. Vom Frieden in die Freiheit entlassen, entspringt er dreimal drohendem Solddienst und schließt in Leipzig so verspätet als Magister seinen Schulgang ab. Als russischer Offizier entrinnt er mit Mühe dem Warschauer Blutbade. Um sich „wieder ein wenig auszulaufen" wandert er Ende 1801 bis Syrakus, 1805 nach Rußland und Schweden. Ein heiterer Held der Schmerzen wurde er im Heilbade Teplitz, wie er sich soldatisch ausdrückte, abgelöst. Unter anderen Freunden ging Fichte hinter seinem Sarge. Als erster deutscher Amerikafahrer wies er mit seinem unvergänglich sachlichen Buch „Mein Leben" 1813 den Postl, Gerstäcker, Hackländer Lebenswege und Bücherziele. Er gehört in die Mitte zwischen die beiden großen Publizisten Görres und Arndt. Seume hat ein nicht sehr umfangreiches aber vielfältiges Werk hinterlassen. Seine lateinischen Anmerkungen und sein Vorwort zu Plutarch fand keinen Verleger, der tollkühn genug war, Palms Schicksal zu wagen. Sein
Seumes „Miltiades" 1808 war ein Spiel, um die Jugend zu begeistern, und seine
Prosakunst „Apokryphen", 1807 vollendet, 1811 gedruckt, bilden in Sprüchen ein Gegenstück zu Arndts „Geist der Zeit" und Fichtes „Reden". Auch Seume wollte das Schreckbild der Zeit als einen Popanz erweisen und den Deutschen durch Hohn zur Tat stoßen. „Eine Nation nenne ich eine große Volksmasse, die durch ihre freien Abgeordneten gesetzlichen Anteil an ihren öffentlichen Verhandlungen hat. Wer die Deutschen zur Nation machen könnte, machte sie zum Diktator von Europa." In den drei Büchern, die mit Georg Forster so verwandt sind wie sie zeitlich von Goethe und von Nietzsche abstehen, „Spaziergang nach Syrakus" 1802, „Mein Sommer" 1806, „Mein Leben" 1813, liegt die neue Prosa des reifsten neunzehnten Jahrhunderts vor. Das Schicksal schien mit Seume nie ins reine zu kommen, ob es aus ihm einen großen Soldaten, einen schöpferischen Staatsmann, einen Weltweisen oder einen Schulmann machen sollte. Er ging mit den Menschen der Antike um, wie er mit Indianern, russischen Generalen und verzweifelten Söldnern umgegangen ist. Er hat auf Wielands Spuren im Verkehr mit der Antike den Realismus entdeckt. In seiner Schreibart liegt der Beweis, daß er im Innersten eine Soldatennatur war. Seumes Fußmärsche haben seine Sinne erzogen und seinen Stil gebildet. Seine Technik des Schreitens: „langsam und fest, ohne abzu-

setzen, fortzugehen", die gleichmäßige, sparende, fließende, ruhige Bewegung des Soldatenmarsches, das ist Seumes Stil. Die deutsche Geschichte reichte ihm nur von Varus bis Bonifacius. Papst, Napoleon, deutscher Kaiser waren ihm nur wechselnde Masken für das eine Unheil: staatliches Römertum. Johann Gottfried Seume war das Gegenteil von einem Schwärmer und von einem Vernünftler. Mit ihm ist unter den ersten der neue Menschenschlag geboren worden, aus dem die romantische Bewegung bestand.

Otto Heinrich Graf von Loeben, 1786 bis 1825, aus Dresden, war von dem Herrnhuter Christentum tief berührt. August Wilhelm Schlegel und Friedrich von Hardenberg stimmten sein Herz auf Romantik. Über das „Wunderhorn" las er sich nach rückwärts bis zu Opitz und Böhme durch. Der Roman seiner Heidelberger Rauschwochen „Guido" 1808 wollte der zweite Teil von Hardenbergs Roman um Ofterdingen sein. Der Held sollte die ganze Welt befahren und mystischer Kaiser werden. Die lyrische Sammlung „Blätter aus dem Reisebüchlein eines andächtigen Pilgers" 1808 sucht es Ludwig Tieck gleichzutun. Auf seinem Lausitzer Familiengut ging er völlig in den romanischen Literaturen auf, übersetzte aus Dante, Petrarca, Guarini und machte sich an Lustspiele nach Calderon. Aus seinem Wiener Aufenthalt reifte ihm der Schäfer- und Ritterroman „Arkadien" 1811 und 1812 zu, in dem sich des Cervantes „Galathea" sowie Eichendorffs „Ahnung und Gegenwart" spiegeln. So fließen in Loebens Dichtungen die schäferliche Welt des siebzehnten und die ritterliche des dreizehnten Jahrhunderts ineinander und das Ganze überhaucht jener milde sächsische Humanismus, wie er in Friedrich Schlegels Romantik landschaftliche Erscheinung geworden war. Otto Heinrich Graf von Loeben war aus dem Geist seiner Geburtsheimat, der Lausitz, und seiner Bildungsheimat, Meißens, ein echter Sprosse der romantischen Bewegung, aber ein unfruchtbarer Spätling, mit dem sie unter den ersten abzusterben begann.

Auf die Landschaft, die man vom Dom zu Meißen überblickt, hat Friedrich Schlegel das Wort „romantisch" geprägt. Ludwig Richter, dem Maler und Zeichner, ist am gleichen Anblick dasselbe Erlebnis aufgegangen. Die beiden Herrensitze der Miltitz beiderseits Meißen, Scharfenberg und Siebeneichen waren Heimsitze der Romantik. Hier waren Friedrich von Hardenberg und Friedrich de la Motte Fouqué zu Gaste. Hier hing *Karl Borromäus von Miltitz*, 1780 bis 1845, seinen dichterischen Liebhabereien und seinen ernsten tonkünstlerischen Bestrebungen nach. In einem Mitglied dieses miltitzischen Freundeskreises, in dem rittermäßigen Leipziger Stadtjunker *Johann August Apel*, 1771 bis 1816, in seinen antikischen Tragödien und volksmäßigen Ge-

Loeben, der erste Spätling

Andächtiger Pilger

Meißen, Scharfenberg, Siebeneichen

spenstergeschichten gingen Humanismus und Romantik eine seltsame aber sehr landestümliche Kameradschaft ein.

Dresdner Romantik Die Meißner Romantik inbegrifflich, das war die kurfürstliche und königliche Hauptstadt Dresden. Sie hat für die ganze romantische Jugend bedeutet, was für den Klassizismus Rom und Florenz gewesen waren. Sie bedeutete das durch die Musik der katholischen Hofkirche und die Sixtinische Madonna der Bildersammlung. Einmal war jeder von ihnen in Dresden. Manche sind erst hier geworden, was sie waren. Von Dresden aus, dem heimatlichen Boden seiner Familie, hat Friedrich Schlegel dem romantischen Gedanken *Die Sixtinische Madonna* die entscheidende Wendung gegeben. In der Dresdner Gemäldesammlung schlossen die beiden Berliner Freunde Wackenroder und Tieck ihr Innerstes einander auf. Hier waren Josef Schelling, August Wilhelm Schlegel, Friedrich von Hardenberg zu Besuch. Heinrich Steffens brach vor der Sixtinischen Madonna in Tränen aus. In Dresden sind Philipp Otto Runge und Kaspar David Friedrich die Schöpfer der romantischen Bildkunst geworden. Hier rundeten sich dann feste romantische Kreise, der eine um den romantischen Naturphilosophen Gotthilf Heinrich Schubert, der andere um Adam Müller und Heinrich von Kleist. *Adam Müller* hielt im Winter auf 1806 seine Vorträge über deutsche Wissenschaft und Literatur, *Gotthilf Heinrich Schubert* begann im Spätherbst 1807 mit seiner Vorlesung über die Nachtseite der Natur-*Die Zeitschrift „Phoebus"* wissenschaften. Die Dresdner Zeitschrift „Phoebus", die *Heinrich von Kleist* und Müller 1808 herausgaben, faßte zusammen, was die beiden Kreise wollten. Es war ein „erweiterter und modifizierter Horenplan", aber so erweitert und umgestaltet, daß es gar kein Horenplan mehr war, sondern die neue romantische Zeitschrift auf der Wende zur staatsbürgerlichen Tat. Kleist und Müller beherrschten mit ihren Beiträgen die Zeitschrift. Aber der ganze Dresdner Kreis der Romantik arbeitete mit. Keine romantische Zeitschrift war mannigfaltiger und bedeutender im Inhalt, keine blieb dem Verständnis fremder, keine war einflußloser, keine konnte den Dresdner Geist, so vollständig sie auch die romantischen Charakterköpfe des Jahres 1808 umfaßte, schiefer widerspiegeln. Denn die Aufnahme des „Phöbus" gerade in Dresden hatte gezeigt, in welcher Richtung sich die Meißner Romantik keinesfalls entwickeln würde. Die Musik der Hofkirche und die Bildersammlung hatten die junge Welt ins Gären gebracht. Überschwang vor diesen Tönen und Bildern wurde Mode. Diese Kunstwerke wirkten gar nicht mehr als gegenständliches und sinnliches Sein. Wie beim Doppelsehen erblickte der junge Schwärmer neben dem Bilde, das als sinnliche Tatsache an der Wand hing, ein anderes unsinnlich verschwommenes, das nur eine Ausgeburt seines heißen

Kopfes oder seines glühenden Herzens war. In der Dresdner Hofkirche und vor der Dresdner Madonna hat die literaturfertige Mittelmäßigkeit des Meißner Volkes jene verspielte, unwahre Moderomantik erzeugt, in der sich die echte romantische Gesinnung schließlich erschöpfte. *Moderomantik*

Ernst Theodor Amadeus Hoffmann war im April 1813 nach Dresden gekommen. Er spielte Theater und arbeitete an seinen dichterischen Erstlingen. Sein Tagebuch hält aus aufregender Nähe und mit unheimlicher Treue die beiden Schlachten fest, die unter seinen Augen am 26. und 27. August um Dresden, am 16. bis 19. Oktober um Leipzig geschlagen wurden. Mit den *Das meißnische Kriegstheater* siegreichen Heeren der Verbündeten war Ernst Moritz Arndt in Leipzig eingetroffen und faßte in seinen kleinen Schriften zusammen, was er als Sinn der geistigen, staatsmännischen und kriegerischen Ereignisse erkannt hat.

2. SÜDDEUTSCHE LANDSCHAFTEN

Die fränkisch-alamannisch-bairischen Landschaften vom mittleren Rhein bis zur mittleren Donau hatten die humanistisch-barocke Kultur, Bildung, Dichtung geschaffen. Der Fortwuchs hatte sich am Gegensatz der religiösen Bekenntnisse in zwei Äste gespalten. Auf evangelischer Seite war aus der humanistischen Bildung eine deutschsprachige klassische Dichtung geworden. Auf kalvinistischer und katholischer Seite hatte sich die barocke Kultur zu einer deutschsprachigen romanischen Kunst umgebildet. Die deutschsprachige Dichtung barocken Stiles war älter als die deutschsprachige Dichtung *Die Lage in Süddeutschland um 1720* klassischen Gepräges. Sie war der künstlerische Ausdruck des deutsch-romanischen Weltreiches der Habsburger. Mit dem Zusammenbruch dieses Weltreiches durch den spanischen Erbkrieg und mit dem Übergang der europäischen Vormacht von Frankreich an England verlor die romanistische Kunst barocken Stiles ihren Rückhalt und geschichtlichen Sinn. Im ganzen süddeutschen Raume vom Mittelrhein bis zur Mitteldonau beginnt sich seit der Mitte des achtzehnten Jahrhunderts unter dem Gewicht dieser weltgeschichtlichen Kräfteverschiebung eine altdeutsch gesinnte Gegenkraft durchzusetzen, die sich gleichermaßen gegen die antikische Überfremdung der klassischen wie gegen die romanische Überfremdung der barocken Dichtung wendet.

Sowohl der deutsche Klassizismus wie die deutsche Romantik haben sich außerhalb der süddeutschen Landschaften im mittleren und nördlichen Deutschland herausgebildet. Und sowohl die klassische wie die romantische *Weder Klassik noch Romantik* Geistesart sind in ihrer dichterischen Ausprägung jünger als die gesinnungs-

mäßige und dichterische Reaktion Süddeutschlands gegen Klassizismus und Barock. Aus dieser Lage empfing dieses süddeutsche Gegenspiel seine zweifache Haltung. Einmal macht die ältere Geistesbewegung sich die reinen Kunstformen der jüngeren klassisch-romantischen Dichtung zu eigen. Zugleich aber wendet sie sich aus dem altdeutschen fränkisch-alamannisch-bairischen Eigenbesitz heraus einer landestümlich bestimmten künstlerischen Eigenschöpfung zu, die trotz klassischer und romantischer Formbestände weder klassisch noch romantisch genannt werden kann, am allerwenigsten aber auch eine Verschmelzung von Klassizismus und Romantik darstellt. Diese *Süddeutsche* süddeutsche Geistesbewegung stuft sich je nach den geschichtlichen Bedin-*Restauration* gungen der fränkischen, alamannischen, bairischen Landschaften dreifach eigentümlich ab. Aber es ist eine geschlossene Bewegung. Und sie ist allerdings Reaktion gegen den fremdländischen Geist der humanistisch-klassischen und der barock-romanistischen Dichtung. Doch sie erschöpft sich nicht in diesem Nein, sondern sie ist ein fruchtbares Ja auf seine bodenständige Natur, ist wirkliche Schöpfung wie der deutsche Klassizismus und die deutsche Romantik und wird diesen gegenüber am besten mit dem Eigennamen deutsche Restauration bezeichnet.

Ihre Kraftquellen hat die Bewegung überall in Franken und Schwaben, Baiern und Österreich. Aber auch die deutsche Restauration ist wie der deutsche Klassizismus und die deutsche Romantik auf die drei Bildungsherde des frühen achtzehnten Jahrhunderts hin zu triangulieren: auf Hamburg, *Hamburg,* Königsberg, Zürich. Sie empfängt aus Hamburg durch Klopstocks Dichtung *Königsberg,* die frühesten und stärksten Antriebe, aus Königsberg alles, was Gottsched *Zürich* oder Kant oder Herder heißt, vor allem aber durch Hamann Richtung und Stil der humoristischen Dichtung, aus Zürich Sinn und Verständnis für das eigene landestümliche Mittelalter. In der Mitte dieses Kräftedreieckes erwirkt sich die geistige Selbstvollendung der deutschen Restauration.

Wie der deutsche Klassizismus in Weimar und die deutsche Romantik in Berlin, so hat die deutsche Restauration ihre geistig schöpferische und staat-*Mittelpunkt* lich handelnde Mitte in Wien gefunden. Was in Weimar Wieland und Her-*Wien* der, Goethe und Schiller, was in Berlin Wackenroder und Tieck, Arnim und Kleist darstellen, das sind in Wien zunächst die großen Meister der Tonkunst Haydn, Mozart, Beethoven und dem Zuge der Zeit gemäß doch später als zu Weimar und Berlin die Meister der Dichtung Grillparzer und Raimund.

BAIERN. Restauration hatte für Baiern seinen besonderen Sinn. Hier setzt sie zufrühest in ganz Süddeutschland ein. Hier ging es darum, seit der Barock sich ausgewirkt hatte, ein modernes deutsch-sprachiges Schrifttum zu

schaffen. Hier galt es, die Pflege der modernen Bildung aus der geistlichen in die weltliche Schule und aus den Händen der Kirche in die des Staates zu legen. Der Vorgang fiel mit einem Erbgang des Herrschergeschlechtes und mit dem völligen Umbau des Staates zusammen. Der Einzug der rheinischen Wittelsbacher in München öffnete dem Zustrom rheinischer Beamter, Künstler, geistig Schaffender alle Dämme und als sich vollends, dank dem Bündnis mit Frankreich, ein großbairischer Staat aufbaute, erfuhr das altbairische Volk aus dem Gewinn Ostfrankens einen organischen Wandel seines Körpers. So waren es ebenmäßig geistesgeschichtliche, staatliche, volksgeschichtliche Ursachen, die an der bairischen Restauration zusammenwirken.

Verwandlung Baierns vom Rhein her

Diese Restauration deutschen Wesens und deutschen Schrifttums ist bereits im ersten Viertel des achtzehnten Jahrhunderts von München ausgegangen. Schon 1702 hatte sich zu München eine vaterländisch gesinnte Gesellschaft „Die vertrauten Nachbarn am Isarstrom" gebildet. Drei Augustiner nun, volksbewußte Männer aus dem gleichen Orden wie Martin Luther und Abraham a Sancta Clara, Männer der Wissenschaft und der Kanzel, *Eusebius Amort, Agnellus Kandler, Gelasius Hieber* knüpften an diese Bestrebungen an, indem sie 1722 den „Parnassus Boicus" gründeten. Das war, noch vor Gottscheds Anfängen und fast gleichzeitig mit den Zürchern, die Zeitschrift, in der Gelasius Hieber und seine Freunde den Wandel vom Barock zu einem neuen deutschen Schrifttum vollzogen. Hieber berichtete im „Parnassus" über die Geschichte der deutschen Sprache, auf deren Reinheit und Volksgehalt bedacht. Hieber entwarf in seinem Aufsatz „Von der Poeterey" eine Kunstlehre der Dichtung, die lange vor Gottsched gegen den Hanswurst eiferte. Hieber wies, lange vor Bodmer, auf die mittelalterliche Literatur hin, suchte die höfische Liedkunst zu kennzeichnen und druckte die ältesten deutschen Sprachdenkmäler ab. Da die nun einsetzenden erbitterten Kämpfe zwischen Barock und Aufklärung um die Landeshochschule Ingolstadt zu keiner Entscheidung führten, wurde 1759 als eine neue und darum unbelastete Anstalt die bairische Akademie der Wissenschaften gegründet. Der Traum des „Parnassus" war erfüllt und die Arbeit Gelasius Hiebers bestätigt.

Vaterländische Spracharbeit

„Parnassus Boicus"

Die Bairische Akademie der Wissenschaften

In der Arbeitsgemeinschaft der jungen Akademie wirkten drei Männer zusammen. Der Rheinfranke *Peter Osterwald*, 1718 bis 1778, der Philosoph des neuen bairischen Geistesleben, stützte seine Wissenschaftslehre für die Geisteswissenschaften auf die Vernunft und für die Naturwissenschaft auf die Erfahrung. Der Tiroler *Ferdinand Sterzinger*, 1721 bis 1786, übernahm als Leiter der „Monumenta Boica", die seit 1763 von der Akademie herausgegeben wurden, die geschichtswissenschaftlichen Arbeiten. Der Altbaier

Heinrich Braun, 1732 bis 1792, Lehrer für deutsche Sprache, Dichtung, Rede-
kunst an der Akademie, schuf nach der Aufhebung des Jesuitenordens 1773
das moderne bairische Schulwesen. Er führte die sinnvolle Stufenfolge Volks-
schule, Realschule, Gymnasium, Lyzeum durch, schrieb die Lehrbücher und
sicherte der deutschen Sprache innerhalb der Lehrpläne ihre Vormacht.

Literarischer Abbau des Barock

 Drei Männer hatten die Erneuerung Baierns vorbereitet. Drei hatten sie
durchgeführt. Drei machten sie für das neue bairische Schrifttum fruchtbar.
Alle drei waren Münchner. *Anton Bucher,* 1746 bis 1817, kämpfte mit seinen
satirischen Parodien das barocke Schrifttum der Jesuiten nieder: die allge-
meine Haltung des Ordens mit „Jesuitischer Eulenspiegel", in Form eines
witzigen Wörterbuches; die scholastische Denkkunst mit „Auserlesenes Deli-
berirbüchlein", einer ungemein lebendigen Gesprächsschrift; die barocke
Landpredigt mit „Kinderlehre auf dem Lande"; das geistliche Volksspiel
barocken Stiles mit „Entwurf einer ländlichen Charfreytags-Procession",
eine der ergötzlichsten literarischen Parodien. Bucher kennzeichnete eine
erbarmungslose Naturwahrheit, die nach Schubart kein Lächeln „sondern
hochaufschallende herzliche Lache" erregt. *Dominik Zaupser,* 1748 bis 1795,
führte den Kampf gegen die Jesuiten, ihre Bildung und Kunst mit gerad-
aushauenden Schriften von beispielloser Heftigkeit, klärte sich später zu
reinen Dichtungen, zumal Oden ab, und knüpfte mit seinem Versuch eines
bairischen Wörterbuches an die Wünsche des „Parnassus" an. *Lorenz Westen-
rieder,* 1748 bis 1829, setzte als Geschichtschreiber die Arbeitsgedanken
Johannes Turmairs fort, gab Zeitschriften heraus, versuchte sich in drama-
turgischen Lehrschriften, folgte mit kleinen Erzählungen dem Engländer
Richardson und schrieb den Erziehungsroman „Das Leben des guten Jüng-
lings Engelhof".

Restauration des Theaters

 Indessen der Kampfpreis der neuen Bewegung war die Bühne. Träger der
barocken Spielüberlieferung war zu München das Handwerkertheater, das
aus dem Meistergesange herausgewachsen war. Auf der Handwerkerbühne
wurde mit Verbot und Erlaubnis der Kampf um das barocke Drama ausge-
tragen. Nach mannigfachen Wandlungen kam sie schließlich beim stehenden
Theater und einem Spielplan aus „regelmäßigen" Stücken an. Neben dieser
handwerklichen Volksbühne entwickelte sich seit 1753 „presso la residenza"
— „nächst der Burg" — das spätere Residenztheater. Es begann schon 1765
mit dem regelmäßigen Schauspiel, übernahm nach dem Erbgang der Pfäl-
zer Wittelsbacher die erprobten Mannheimer Kräfte und machte seit der
„Agnes Bernauerin" 1780 Josef Augusts von Törring das Ritterstück zu sei-
ner Besonderheit. Die dritte Bühne war das Stadttheater im Faberbräu, das

Haus Lipperls, des Münchner Hanswursts, und seiner Stegreifspiele. Das Faberbräu gab dem Spielplan des Wiener Volkstheaters Heimatrecht.

Die bairische Restauration setzte sich geradewegs in einer stammestüm- *Restauration* lich gerichteteten Deutschkunde fort. *Bernhard Josef Docen,* 1782 bis 1828, *der Sprache* ein Baier aus Osnabrück, barg an der Hofbücherei den handschriftlichen Reichtum eines Jahrtausends, den die bairische Klosterverwüstung empor- schwemmte, und erschloß ihn mit seinen Ausgaben. *Johann Gottlieb Radlof,* 1775 bis 1827, aus Lauchstädt bei Merseburg, Beamter der Hofbücherei und ein Vordenker Jakob Grimms, plante eine „Allgemeine Provinzen Gram- matik" und diente dem echten Geist des „Parnassus Boicus", wenn er 1811 das Büchlein schrieb „Trefflichkeiten der süddeutschen Mundarten zur Ver- schönerung und Bereicherung der Schriftsprache". *Johann Andreas Schmel- ler,* 1785 bis 1852, aus Tirschenreuth suchte nach Mitteln, wie man Volks- bildung verbreiten und dennoch das ursprüngliche Volkstum erhalten könne, begann jetzt schon für seine „Wortstammkunde" zu sammeln und sich für seine große Aufgabe als Deuter der lebendigen Sprache und Schöpfer des *Das bairische* bairischen Wörterbuches zu rüsten. *Wörterbuch*

Dieser gerade Zug der bairischen Restauration von Gelasius Hieber bis zu Johann Andreas Schmeller wurde seit dem Thronwechsel von Karl Theodor zu Max IV. Josef, das ist seit 1799, durch den landesfremden Gegenzug des klassischen Humanismus auf kurze Sicht gekreuzt. Vor fünfzig Jahren war der Baier ein Wilder gewesen, weil er besser Latein sprach als Deutsch, und jetzt war er ein Barbar, weil er besser Deutsch sprach als Latein. Das mach- *Barock,* ten die Fremden im Lande. Josef Schelling und Heinrich Paulus kamen nach *Restauration,* Würzburg, Anselm Feuerbach nach Landshut, Friedrich Heinrich Jacobi *Neuhumanismus* und Friedrich Emanuel Niethammer nach München. War wenige Jahrzehnte zuvor das Übermaß an Schulantike Ziel aller Angriffe gewesen, so sollte der Baier jetzt durch bessere Kenntnis des griechischen Aorists aus seinem Sumpf gezogen werden. Zwei Thüringer aus dem klassischen Lande des neuen Schulmeisters, Friedrich Jacobs und Friedrich Thiersch wurden dafür ver- schrieben, jener ans Münchener Lyzeum, dieser ans Münchener Gymnasium. Doch dieser gerade bairische Zug war nicht zu verwirren. Die sachwissen- schaftliche Erziehung des bairischen Volkes begann in den drei großen bai- rischen Taten, der Kurzschrift Franz Xaver Gabelsbergers, dem Steindruck Alois Senefelders, dem Glasschliff Josef Fraunhofers zu triumphieren. Und die beiden großen ostdeutschen Naturforscher der Akademie, Johann Wil- helm Ritter und Samuel Sömmerring hielten sämtlichen schwäbischen und thüringischen Humanisten im Lande das Gegengewicht.

Erbkrieg
um Österreich

ÖSTERREICH. Der Familientod der Habsburger rief 1740 die Lothringer in Wien zur Macht. Der vieljährige Kampf gegen Preußen und zu Zeiten mit ganz Europa um das deutsche Erbe der Habsburger setzte ihre Erblande in ein neues Verhältnis zum Deutschen Reich. Die Lothringer waren gezwungen, den ererbten Hausbesitz straffer nach der Mitte hin zusammenzufassen. Das Sudetenbecken, schon seit 1621 seiner geschichtlichen Hauptstadt beraubt, ließ nun durch die mährische Senke seinen Überschuß ins Donautal abströmen. Die volkhafte Umbildung Wiens und seines Hinterlandes ins Ostmitteldeutsche setzte sich in geistige Werte um und war eine wesentliche Ursache für die kommende Kulturverschiebung. Die österreichische Restauration vollzieht sich unter verwandten Antrieben wie die bairische.

Das
Bildungswerk
Maria Theresias

Die Kaiserin und Königin Maria Theresia legte dem Umbau ihrer Erbländer ihr neu geordnetes Schulwesen zugrunde. Die Schöpfung der Ritterakademie bei den Benediktinern zu Kremsmünster 1744 und des Theresianum bei den Jesuiten zu Wien 1746 schien die Erneuerung des mittleren und höheren Unterrichts selbst unter Mitarbeit der bisherigen Alleinbesitzer zu gewährleisten. Mit der Gründung das Waisenhauses auf dem Rennweg 1759 war die neue Volksschule geschaffen. Am 2. Jänner 1771 wurde die Wiener Normalschule eröffnet. Nach der Aufhebung der Gesellschaft Jesu 1773 wurden deren Lateinschulen in deutsche umgewandelt. Der schlesische Schulmann Abt *Johann Ignaz von Felbiger* wurde als Gesamtleiter des österreichischen Schulwesens 1774 nach Wien berufen. Am 6. Dezember 1774, dem schönsten Tag der Kaiserin, kam die allgemeine Schulverfassung heraus. Nach Wien richtet nun auch die aufstrebende deutsche Literatur Wunsch und Willen. Gottsched und seine Frau kamen 1749 auf Besuch. Wieland und

Besuch
aus dem Reich

Lessing sahen sich nach Möglichkeiten um, in Wien zu leben und zu wirken. Klopstock wollte 1768 zu Wien eine deutsche Akademie gründen, als Herz des gesamten deutschen Geisteslebens, in dem sich die freundschaftlichen Pläne des Reichsfeldherrn Prinz Eugen und des Wortführers der Deutschen Wilhelm Leibniz verwirklicht hätten. So wird dieses kaiserliche Wien im achtzehnten Jahrhundert die Vermittlerin, durch deren treue Hände die Völker des süddeutschen Europa das Schrifttum der Franzosen, Engländer und Deutschen empfangen.

Die österreichische Restauration vollzieht sich in drei Bereichen: in der Dichtung der ehemaligen Jesuiten; im jungen Burgtheater; auf der Bühne des Kärntnertors.

Österreichischer
Abbau des Barock

In der Gesellschaft Jesu selber drängt die dichterische Kunstübung längst nach einem modernen nationalen Stil, der sich gleichermaßen vom humani-

stischen wie vom barocken frei hielte. Dieser Gruppe reifer und junger Män-
ner, die mit der Aufhebung des Ordens in ein neues Berufsleben traten,
waren zuerst die Träger der österreichischen Restaurationsdichtung. *Michael
Denis*, 1729 bis 1800, aus Schärding, an der Passauer Jesuitenschule und in
Wien für den Orden erzogen, dann Lehrer am Theresianum und Beamter
der Hofbücherei, vollzog den unmittelbaren Übergang von seinen lateini-
schen Oden und Schuldramen zu seiner Übersetzung der eben erschienenen
Gedichte Ossians 1768 und zu seinen eigenen Gedichten im Ossianstil. Seine
lyrische Stimmung ist echt und tief, seine Form naturgetreu bis zur Mundart.
Denis hat deutsche Sprache und Literatur als Schulgegenstand am Theresia- *Die Jesuiten
num eingeführt — seine „Literaturgeschicht" 1778 — und erwies sich durch *und ihre Schüler*
seine Nachdichtungen aus dem Altnordischen als einen Vermittler germani-
scher Wortkunst, wie es damals kaum jemanden gab. *Alois Blumauer*, 1755
bis 1798, aus Steyr, zuerst Jesuit, dann Benediktiner, endlich weltlichen
Standes, schulte sich mit seinen ernsten und heiteren Balladen an Bürger.
Die besten Deutschen dieses Zeitalters sahen in dem jungen Kaiser Josef II.
die Goldene Zeit heraufkommen und fühlten sich stimmungsmäßig eins mit
dem Verkünder des augusteischen Imperiums, mit Vergil und seiner „Aeneis".
Kein anderes Gedicht konnte den Übermut gegenüber einer nicht mehr ernst
genommenen Antike besser verkörpern als „Vergils Aeneis travestiert" 1784 *Aeneis
von Alois Blumauer. Dieser geborene Spötter hat aus Vergils Gedicht vom *travestiert*
Ursprung des Julischen Hauses und römischen Reiches parodistisch das Ge-
dicht vom Ursprung der römischen Kirche und ihres Gegenspielers, des deut-
schen Kaisertums gemacht. Die gewandten jambischen Strophen, die vor
unserem Ohr ein geistreiches Spiel der Reime aufführen, sind ganz von dem
Leben des Josefinischen Wien erfüllt. Sie gefallen sich in jenem ehrfurchts-
losen Witz, durch den sich der Wiener Geist jener Jahre aller Verantwortung
und dem Glauben an die beständigen Mächte des Lebens entzog. Doch wie
Vergil sein Gedicht in eine Feier des Caesar Augustus aufklingen ließ, so
Blumauer das seine in eine Huldigung vor Kaiser Josef. *Johann Baptist von* *Ritterdichtung
Alxinger*, 1755 bis 1797, aus Wien, Jesuitenschüler und ein fein gepflegter *ernst*
Laie, gab sich alle Mühe, nach den Oden, Liedern, Sinngedichten seiner
Sammlung von 1784, in den Rittergedichten „Doolin von Mainz" 1787 und
„Bliomberis" 1791 die altdeutsche Welt des Mittelalters ernst und gläubig
darzustellen. *Lorenz Leopold Haschka*, 1749 bis 1827, aus Wien, doch von
sudetendeutscher Abkunft, der Mentor Alxingers, vieler Gesinnungen mäch-
tig in einer Zeit, die viele verbrauchte, hat neben dem, was ihm vergeben
sein mag, zu Josef Haydns Volkshymne den ersten Wortlaut geschrieben.

Die Wiener Dichtung stand unter dem Einfluß Klopstocks und Wielands. Die breitwuchernde Broschürenliteratur nahm sich Voltaire zum Vorbilde. So vertrieb der Niederbaier *Johann Pezzl,* 1756 bis 1823, den Wienern auf eine sehr geistreiche und witzige Weise die Langweile mit seinen „Marokka-

nischen Briefen" 1784, mit der „Skizze von Wien" 1786 bis 1790, mit den „Briefen aus dem Novizat" 1787, während der Wiener *Josef Richter,* 1749 bis 1813, das eigenartigste Witzblatt, das Wien besessen hat, schuf: „Briefe eines Eipeldauers an seinen Herrn Vetter in Kagran". Das Blatt erschien mit kurzen Unterbrechungen von 1785 bis 1813 und übertrug die Form des Stegreiftheaters auf das Zeitungswesen. Was Hanswurst, Bernardon, die späteren Leopolde und Taddädl als Spielmaske waren, das war dieser Eipeldauer Junge, der Wien betrachtet und geistreich unbefangen sagt, was er sieht.

Gesellige Treffpunkte der neuen Wiener Literatur waren das Café „Zum Kramer" im Schloßgäßchen, die Loge „Zur wahren Eintracht" und die böhmisch-österreichische Hofkanzlei — das Ministerium des Innern — in der unter dem Hofrat Josef Sonnenfels sowie dem Unterkanzler Tobias Philipp von Gebler die Hofbeamten Weidmann, Ratschky, Sonnleithner, Alxinger dienten, also ein ganzes Dichterkränzchen. Johann Franz von

Ratschky und Gottlieb Leon schufen dem Kreise im *„Wiener Musenalmanach"* seit 1777 eine öffentliche Stimme. Die „Realzeitung", die Alois Blumauer leitete, stellte ein vollständiges österreichisches Literaturblatt dar.

So bietet die Kaiserstadt ein Bild gelöster Ordnungen, schwebender Entscheidungen, harrender Bindungen, noch ungewordener Schöpfungen. Nur eines hatte Bestand, wie immer in dieser Stadt, nur eines hatte Überlieferung und zugleich die Kraft zu Neuem: die Bühne. Das Theater am Kärntnertor war nach dem Erlöschen der alten barocken kaiserlichen Festspiele um 1740 die einzige Wiener Anstalt, Hofbühne zugleich und Volksbühne, das Haus des klassischen Stegreifspiels. Also stand das Theater am Kärntnertor im Kreuzfeuer des Kampfes, der seit der Mitte des Jahrhunderts in Wien um das

regelmäßige Schauspiel entbrannte. Unter Regeldrama verstand man das Dichterdrama im Gegensatz zum stegreifmäßigen Schauspielerstück. Das Regeldrama war ein Wunschbild des norddeutschen Theaters, wie es Johann Christoph Gottsched nach dem Vorbild des französischen Klassizismus vorschwebte. Der französische Klassizismus war zu Wien längst durch die Bühnenstücke *Josefs von Petrasch* — „Schauspiele" 1765 — und *Cornelius Hermanns von Ayrenhoff* — „Der Postzug" 1769 — vertreten. Doch geführt wurde der Kampf in der kritischen und dramaturgischen Literatur. Gottsched besaß seit geraumer Zeit in Wien seinen Anhang. Wirksam wurden seine

Gedanken durch eine einflußreiche Gruppe von Leuten, die nach der Mitte *Die Regelmäßigen*
des Jahrhunderts in Wien aus dem mittleren und nördlichen Deutschland
einwanderten: *Christian Gottlieb Klemm*, 1736 bis 1810, aus Schwarzenberg
im sächsischen Erzgebirge, der 1759 nach Wien kam, in seinen Wochenschrif-
ten „Die Welt" und „Der österreichische Patriot" für das Regeldrama ein-
trat und 1766 Theaterbeamter am Kärntnertor wurde; *Tobias Philipp von
Gebler*, 1726 bis 1786. aus Zeulenroda, seit 1768 Staatsrat für innere Ver-
waltung, Lessings Gönner in Wien und Mitbegründer des Burgtheaters;
Josef Sonnenfels, 1733 bis 1817, aus Nikolsburg, 1761 Vorstand der eben
gegründeten Deutschen Gesellschaft, in der sich die Regelmäßigen vereinig-
ten, mit seinen Wochenschriften und den „Briefen über die Wienerische
Schaubühne" 1767 der eigentliche Wortführer im Kampf gegen den Wiener
und für den norddeutschen Stil auf der Bühne. Es war viel Lärm um Nichts.
Friedrich Wilhelm Weiskern, 1711 bis 1768, aus der Lutherstadt Eisleben, *Die Stegreifspieler*
selber ein Stegreifspieler von wunderbarer Begabung, der über hundert Steg-
reifspiele entworfen hat, führte diese Bühne sehr klug und vorsichtig zur
Literatur und zum Dichterdrama hinüber. Er spielte die deutschen Dramen
der Zeit, er spielte Corneille, Racine, Voltaire, Marivaux. Er ließ aber auch
nach wie vor aus dem Stegreif spielen und stellte Goldoni beinahe in den
Mittelpunkt des Spielplanes. Weiskern hatte das Glück, im rechten Augen-
blick den richtigen Spielbuchdichter zu finden. Das war ein echtes Wiener
Kind, *Philipp Hafner*, 1735 bis 1764, noch ein Jesuitenschüler, ein Mensch, *Der Erbe Stranitzkys*
der sich aus Lebenslust versprühte, ein ebenbürtiger Fortsetzer der Reihe
Stranitzky, Prehauser, Kurz. Hafners Schrift „Verteidigung der Wieneri-
schen Schaubühne" 1761 schuf eine klare Lage, die durch Sonnenfels und
seine Leute nicht mehr verwirrt werden konnte. Mit Weiskern sah Hafner
ein, daß die Zeit des Stegreifstückes vorüber sei. Er verstand aber auch, daß
der Übereifer der Regelmäßigkeit eine Gewalttat am Wiener Geiste sei. Er
kam zu dem Schluß, daß das Kärntnertor zwar künftig ausgearbeitete Stücke,
„Dichterdramen" spielen müsse, aber Dichterdramen, die den eingespielten
Stil des Kärntnertores festhalten müßten. Diesem Vorsatz entsprachen Haf-
ners eigene Stücke. Das Lustspiel „Der von dreyen Schwiegersöhnen ge-
plagte Odoardo" 1760 verarbeitete uralte Lustspielzüge zu einer ganz ein-
fachen Handlung und verknüpft die Hanswurstspässe mit ihr organisch. Das
Zauberstück „Megära die förchterliche Hexe" 1763 zeigt eine „regelmäßige" *Erneuertes Volkstheater*
Liebeshandlung. Träger des Stückes sind die Gestalten des Stegreiftheaters,
darunter Hanswurst und Colombine. Es ist das klassische Maschinenstück:
Verwandlung von Felsen in Menschen; Tod und Teufel; Riesen und Zwerge;

Wellen, Blitze, Donner; Tanz, Gesang, Lieder. Barocktheater und Hofoper
sind moderne volkstümliche Bühnendichtung geworden. Hafners Entwürfe
zu Stegreifstücken sind eine geistreiche Satire dieser Bühnenform. In den
erstgemeinten Skizzen sind lange Strecken genau in Alexandrinern ausge-
führt. Französische Auftritte mitten drin und die langen epischen Einzel-
reden werden bei Raimund und Nestroy wiederkehren. Das Theater am
Kärntnertor war durch Weiskern und Hafner eine moderne literarische Bühne
geworden, die das stegreifmäßige Schauspielerstück zum Dichterdrama um-
gebildet hatte, um seinen vom Barock überkommenen Bühnenstil desto
treuer bewahren zu können. Das war der erste Akt der deutschen Restaura-
tion in Wien.

Das Burgtheater
Der zweite Akt spielt auf dem Burgtheater. Die strittige Frage hieß längst
nicht mehr Stegreifspiel oder Regeldrama, sondern wie soll neben der Volks-
kunst am Kärntnertor die Burgbühne ein „Nationaltheater" werden? Maria
Theresia hatte am 14. März 1741 das an die Burg anstoßende Ballhaus dem
Theater am Kärntnertor als Hilfsbühne übergeben. Dieses neue „Königliche
Theater nächst der Burg" übernahm vorerst vom Kärntnertor die Opernvor-
stellungen. Hier gingen seit der „Semiramis" vom 14. Mai 1748 die neuarti-
gen Tondramen Christoph Glucks in Szene. Hier herrschte von 1766 bis 1776
das Tanzspiel unter Jean Georges Noverre. Da die Regelmäßigen am Kärnt-
nertor nicht durchdringen konnten, so wurde die Frage nach dem Regel-
drama mit der inzwischen zeitgemäßeren nach dem Nationaltheater ver-
knüpft und die Antwort darauf dem Burgtheater zur Pflicht gemacht. Jetzt
und hier griff Kaiser Josef II. persönlich ein. Sein Erlaß über die Neuordnung
des Wiener Theaterwesens vom 22. März 1776 machte einer vieljährigen Ver-
wirrung mit einem Schlage ein Ende. Beide Anstalten wurden nach Aufgabe
und Verwaltung sauber getrennt. Das Burgtheater wird deutsches National-
theater, eine Pflegestätte für das hohe und strenge Drama, wird vom Hofe
mit allen Lasten und Rechten übernommen. Das Theater am Kärntnertor
bleibt eine Volksbühne und wird ohne Pachtzins an Truppen vergeben. Das
Burgtheater wird ein selbstgeleiteter Künstlerstaat. Jede Woche versammeln
sich die älteren Mitglieder zur Auswahl der Stücke, Feststellung des Spiel-
planes, Rollenbesetzung. Jede Woche wird ein Spielleiter gewählt. Der Wille
Kaiser Josefs Nationaltheater
des Kaisers war nur auf eines gerichtet: gute, regelmäßige Eigenstücke und
wohlgeratene Übersetzungen. Johann Heinrich Müller unternahm auf Befehl
des Kaisers 1776 eine Reise durchs Reich, um nach dem Zusammenbruch des
Gothaer und nach dem Niedergange des Mannheimer Theaters die Lage zu
nützen. Es gelang, die deutschen Schauspieler von Rang nach Wien zu brin-

gen und es gelang, den Spielplan langsam zu füllen. *Johann Friedrich Schink,* *Der Kritiker* 1755 bis 1835, aus Magdeburg, berühmt durch seine Schrift „Über Brockmanns Hamlet", hat den Aufbau des Burgtheaters durch seine „Dramaturgischen Fragmente" 1781 und seine Bearbeitungen von Spielbüchern nicht sehr bescheiden, doch nützlich unterstützt. Der Dichter des Josefinischen Burgtheaters war *Paul Weidmann,* 1744 bis 1801, ein Wiener von fränkischer *Der Bühnendichter* Herkunft. Im Theater der Jesuiten war er mit Calderon und Lope vertraut worden. Weidmann war das Urbild des österreichischen literarischen Beamten. Kränklich und schwermütig, schrieb er unehrbietige Gesuche an seine Vorgesetzten und sehr gereizte an den Kaiser. In Massen von Tragödien, Lustspielen, Singspielen, Oratorien verarbeitete er seine Amtsstubenerfahrungen — das Ministerium des Innern — und verhöhnte das, worüber er dienstlich zu schweigen hatte. „Stephan Fädinger" 1781 war sein bestes Drama. Berühmt wurde er durch das Lustspiel „Der Bettelstudent" 1776, nach einem Zwischenspiel des Cervantes die uralte Geschichte vom Schüler als Teufelsbanner. Das Stück war im Volk und bei Hofe gleichermaßen beliebt. Weidmanns Lustspiele beherrschten das Burgtheater der siebziger und achtziger Jahre. Paul Weidmann hat den Kampf der österreichischen Restaurationsdichtung gegen das romanische Theater, vor allem gegen das italienische Singspiel, entschieden. Denn er hat für den Wiener Tonsetzer Ignaz Umlauf das erste deutsche Singspiel „Die Bergknappen" geschrieben. Es *Das erste deutsche Singspiel* wurde, ein Kranz auf den Wiener Ehrgeiz, vor dem Kaiser in einer Sondervorstellung am 16. Januar 1778 und für die Öffentlichkeit am 17. Februar zum erstenmal aufgeführt. Paul Weidmann war der Dichter des ersten Bühnenfaust. Sein „Johann Faust" 1775 wurde Lessing zugeschrieben und in Süddeutschland viel gespielt. Sein „Eroberer. Eine poetische Phantasie in fünf Kaprizzen" 1786, eine furchtbare Satire auf den aufgeklärten Machthaber, in der Form eines abenteuerlichen Hexenspiels von Hexametern, romantischen Strophen und Knittelversen, enthält alles das, was man später „romantische" Ironie nannte. Paul Weidmann, der geniale Dichter der Wiener Restauration, steht auf der Brücke vom Barocktheater zur Burgbühne Franz Grillparzers.

Wie zu Wien, so vollzog sich in allen österreichischen Landschaften die *Salzburger Restauration* Verwandlung der barocken und romanistischen in eine volkstümliche nationale Dichtung auf der Bühne. Am schwersten waren die Bildungskämpfe in Salzburg, weil sie hier um die Hochschule geführt werden mußten. Salzburg zog aber auch seinen Nutzen von den altbairischen Kräften, die durch die kirchenfeindliche Münchner Aufklärung ins Erzbistum abgedrängt wurden. Ja,

die Restaurationsbewegung wurde in Salzburg von zwei Altbaiern geführt. *Lorenz Hübner,* aus Donauwörth, Jesuit und dann Weltpriester, gründete 1784 zu Salzburg die „Oberdeutsche Staatszeitung" und zweigte ihre Lite- *„Literatur-* raturbeilage 1788 als selbständige „Oberdeutsche allgemeine Literaturzei- *zeitung"* tung" ab. Es ist die älteste deutsche Literaturzeitung, älter als die Jenaer Ber- tuchs. Mit einem rühmenswerten Freimut geleitet, vertrat das Blatt den ge- mäßigten Fortschritt, war österreichisch gesinnt, erkannte die Bedeutung der humanistischen klassischen Dichtung zögernd an, lehnte die Romantik ab, erschien bis 1811 und war der Hort der süddeutschen Erneuerungsbewegung. *Josef Wismayr,* aus Freising, seit 1788 Lehrer an der Salzburger Hochschule, setzte die alte Münchner Spracharbeit seit Gelasius Hieber mit seinen Lehr- büchern, zumal „Grundsätze der deutschen Sprache" 1795, in Salzburg durch. Die beiden Freunde arbeiteten einander schön in die Hände. Hübner gab seit 1787 den „Salzburger Musenalmanach", Wismayr seit 1797 „Blüten und Früchte" heraus. Als Hübner nach München zurückkehrte, übernahm Wis- mayr die „Literaturzeitung" und gab 1801 bis 1805 die wertvollen „Ephe- meriden der italienischen Literatur" heraus. Die landestümliche Pflege der *Theater* Bühnenkunst ging seit dem frühen siebzehnten Jahrhundert allmählich an die Schiffergilde zu Laufen über. Sie spielten ohne feste Bühne in Wirtshäu- sern, im Schloß, zu München und Freising. Ihr Spielplan war volkstümlich gewandelt der des Akademietheaters, der Bauernbühne, des Stegreifdramas. Er nahm schließlich die höhere deutsche Bühnendichtung auf. Mozarts Sing- spiele wurden als Sprechdramen gegeben. In Oberösterreich übernahm das *Oberösterreich* Stift Lambach die Führung. *Maurus Lindemayer,* 1723 bis 1783, aus Neun- kirchen, der dem Stift seit 1746 angehörte, spielte 1770 der künftigen Köni- gin von Frankreich, Maria Antoinette, auf ihrer Brautfahrt das köstliche Lust- spiel „Kurzweiliger Hochzeitsvertrag". Er spielte seinen „Argonautenzug" — wichtig für den Blick auf Grillparzer —, die Parodie „Reisende Ceres" und schließlich den „Unentbehrlichen Hanswurst", die dichterische Gestalt des Stegreiftheaters. Alles war einfach gebaut, knapp und schlagend, Gesang- einlagen, Mundart des Hausruckviertels neben hochsprachigen Alexandri- nern, dramatisch in jeder Zeile, Früchte einer siegreichen Bühnenlaune. Tirol erschien mit der ganzen Breite des Volkes auf der Szene seines Bauernthea- ters. Allein von 1750 bis 1800 sind in 160 verschiedenen Orten gegen 800 Volksaufführungen gezählt worden. Sterzing, Hall, Innsbruck, Telfs stehen an erster Stelle. Der Tiroler Bauer hat in diesem halben Jahrhundert einfach alles gesehen, was seit 1600 über deutsche, vieles was in dieser Zeit über europäische Bühnen gegangen war. Da sind Staatstragödien großen Stils,

Passionsspiele, Weltgerichtsspiele, deutsche und italienische Singspiele; da sind Legenden; da sind Komödien und Tragödien aus dem Spielplan aller deutschen Hoftheater; da sind vaterländische Stücke und Nachklänge des deutschen Schuldramas, alte Fastnachtstücke und zurechtgestutzte Prachtwerke des Barocktheaters. Beliebt sind Genoveva, Hildegardis, Griseldis, Johann von Nepomuk. Neben Voltaires „Zaire" steht schon 1767 eine „Maria Stuart" aus dem Spielplan der Jesuiten. Peterl, der Held der Höttinger Bühne, ein echter Bruder des Kasperl, spielt auf seinem Puppentheater in allen Stücken, in einer Enthauptung Johannis wie im Doktor Faust, in einer Judith wie im Don Juan. Er spielt neben Max auf der Martinswand und neben Sankt Georg mit dem Drachen. Wie auf der Bühne ließ das Tiroler *Tiroler* Volk seine Stimme in einer ganzen Literatur von Kampfliedern hören, als es *Kampflieder* von 1703 bis 1813 seine angestammte Freiheit gegen den Einbruch der Baiern und Franzosen, die jedesmal Verbündete waren, verteidigen mußte. In diesem Chor der Spiele und Lieder fügten sich volksbewußte Dichter wie *Karl Franz Zoller* und *Alois Weißenbach*, die beide aus Telfs stammten, mit ihren Landsturmliedern und *Johann Friedrich Primisser* aus Prad mit seinem Drama „Martin Sterzinger" 1782, einem tüchtigen Bühnenstück, das die Ta- *Steiermark* ten vom 23. bis 27. Juli 1703 auf einen einzigen Tag zusammendrängt und um das Dorf Zirl vereinigt. Die Steiermark erhielt durch den volkstümlichen Erzherzog Johann, 1782 bis 1859, und seine Schöpfung von 1811, das Joanneum, das in einem Museum, Bücherei und Lehranstalt war, einen unvergleichlichen geistigen Mittelpunkt. Die Gründung des Grazer Landestheaters lockte die Begabung aus dem bühnenfreudigen Volke. *Johannes von Kalchberg*, 1765 bis 1827, aus dem Mürztal, einer der Mitgründer des Joanneums, wurde der landestümliche Dichter der steirischen Bühne. Seine zahlreichen geschichtlichen Dramen — „Agnes von Habsburg" 1786 bis „Attila" 1806 — mit ihrem echt steirischen Schwung der Rede und ihrem deutlichen Gefühl für antiken Rhythmus spiegeln die gesamte österreichische Restaurationsbewegung zwischen dem Barocktheater und der Bühne Franz Grillparzers wider.

So ist auf der Bühne die künstlerische Erneuerung des österreichischen *Wiener* Volkes Erscheinung und Wirklichkeit geworden. In Wien wie in den öster- *Vorstadtbühnen* reichischen Landschaften hat sich vom Barock her über das Stegreifspiel in einer neuen Bühnendichtung ein gleichmäßiger und einheitlicher Theaterstil herausgebildet. Verkörpert, dargestellt und vollendet für das ganze Reich wird er durch das Burgtheater und das Theater am Kärntnertor. Und so spielt der dritte Akt der österreichischen Restaurationsbewegung in Wien. Die Vor-

macht hat immer noch die alte Bühne Josef Anton Stranitzkys. Vom Kärntner-
tor wurden die ersten Dramen Goethes und Schillers der Kaiserstadt einge-
spielt. Vom Kärntnertor strömte die Freude am Schauen, die Lust an frei-
bewegter und fesselnder Menschlichkeit in alle Vorstädte Wiens. Als der
Sturm des achtzehnten Jahrhunderts, der mit einem so gewaltigen morgend-
lichen Wetterschlag begonnen hatte, sich mit verdoppelter Wucht in seinem
Abendgewitter entlud, wurde die Stadt von der Hofburg bis nach Penzing
von einem wahren Rausch des Spieles erfaßt. In Mariahilf war auf dem Spit-
telberge Anfang der siebziger Jahre eine Volksbühne entstanden. Die Josef-
stadt erhielt 1776 in der Schwibbogengasse ihr Theater. Die Vorstadt Wieden
hatte seit 1776 mehrere und die Vorstadt Landstraße seit 1789 eine feste
Bühne. Die Roßau konnte seit 1792 in der Porzellangasse und Margareten
seit Anfang der neunziger Jahre bei sich selber spielen. Die Bühne der Leo-
Leopoldstadt poldstadt seit 1776, ein Holztheater mit Galerien für Oper, Singspiel und
Tanzspiel, trat, bald mächtig aufblühend, nach Stil und Rang ebenbürtig
neben das Kärntnertor. Doch in der Leopoldstadt wurde auch beim Schwar-
zen Adler und im Gartengebäude des Grafen Czernin gespielt. Dann kam für
Wien ein großer Tag, als 1781 Karl Marinelli in der Praterstraße der Leopold-
stadt sein Theater eröffnete. Das war die Bühne für Gluck und Mozart, aber
auch die Bühne für Volksposse und Zauberstück. Es war das Haus, in dem
Kasperl herrschte. Das war die Wiege der Kunst, aus der die Jugend Grill-
parzers, Raimunds, Nestroys aufgeblüht ist. *Karl Friedrich Hensler,* 1759
bis 1825, aus Vaihingen an der Enz und *Joachim Perinet,* 1763 bis 1816, aus
Wien, haben mit ihren Kasperlstücken, Zauberopern, Ritterdramen, Gespen-
sterspielen aus Marinellis Bühne nach Sache und Wort „Die Leopoldstadt"
gemacht. Indessen, was alles überbieten konnte, das leistete *Emanuel Schi-
kaneder,* 1751 bis 1812, der Mann aus Regensburg, ein kunstfertiger, wenn
auch kein schöpferischer Schauspieler, der als Hamlet in München geglänzt
hatte, ein großer Verdiener, ein großer Vergeuder, der seit 1778 eine eigene
Truppe führte. Er bezauberte ganz Süddeutschland mit dem besten Spiel-
plan der Zeit, der von Shakespeare bis Mozart reichte. Er leitete das Theater
am Kärntnertor seit 1783 und das Theater im Freihaus auf der Wieden seit
1789 zu Erfolgen, wie Wien und ganz Deutschland sie bisher nicht gekannt
hatten. Schikaneder war leibhaftig die Wiener und die österreichische Bühne,
in der sich die österreichische Verwandlung aus dem Barock verkörperte.

die Schöpfung Der Tonkünstler, und noch nicht der Dichter, hat zuerst durch die Musik
des Singspiels den gemeinsamen Stil für die Kunst gefunden, die am Kärntnertor und in der
Hofburg gemeinsam ausgebildet worden war. *Wolfgang Amadeus Mozart,*

1756 bis 1791, aus Salzburg, war dieser Vollender. Mag die Familie Mozart aus Augsburg stammen; mögen die Mozart, Vater und Sohn, zu Salzburg wie in unwürdiger Haft gelegen haben; mag der Meister zu Wien das gedrückte Leben eines verkannten Kapellmeisters gelebt haben: die unerschöpfliche Tatsache bleibt, daß sich in Mozart das österreichische Theater aus einem neuen schaffenden Spiegel verklärte und die erste Gestalt einer neuen Bühnenkunst erzeugte. Indem seine heitere Reife sich aus der Vorerziehung Italiens löste, indem sich sein nationales Bewußtsein an Paris läuterte, blühte er, wie sich das Gesetz des Lebens in der Natur erfüllt, zu dem unbegreiflichen deutschen Wesen seiner letzten drei Bühnenwerke auf. In jedem Glied dieser Dreiheit erfüllte sich ein anderer Wunsch aus dem späten Barock in die neue österreichische Kunst hinüber. Aus dem gefesselten Verlangen des Barocks, mit mächtigen Sinnbildern die Fülle der eigenen Zeit auszudrücken, wird die frische, reine Menschlichkeit des „Figaro" 1786 Lustspiel, mit üppiger Wirklichkeit über dem gärenden Verderben des französischen Umsturzes schwebend. Aus der heldischen Gebärde, mit der sich die Kunst des Barocks bemühte, die ewigen tragischen Gegensätze von Welt und Leben in einem Willen zu bändigen, wird im „Don Juan" 1787 eine überlegen leichte, fröhlich-sichere Handbewegung: tragischer Wille und kosmische Lust heiter versöhnt, tragische und komische Kunst zu einem Stil verschmolzen, der ewige Widerspruch des Daseins heiter aufgelöst im Einklang der Musik. Und aus dem hohen Gesetz des Barocks, durch Schein und geheime Bedeutung Sinn und Sein der Dinge auszusprechen, wird, wahrhaftig eine fröhliche Wiederkehr, „Die Zauberflöte" 1791, deren umfassende tiefsinnige Bildwelt den gesamten Gedankengehalt ihrer Zeit aufgenommen und bewältigt hatte. Durch Mozart erzeugte sich aus dem Erbbestande Österreichs jene neue hohe nationale Kunst, auf die in ganz Süddeutschland seit dem zweiten Drittel des achtzehnten Jahrhunderts die Erneuerung hindrängte. Wer mit der einen Hand auf Goethe zeigt und die Vormacht der westdeutschen humanistisch-klassischen Kultur meint, muß billig mit der anderen auf Mozart weisen und sich die Größe der süddeutschen barock-volkhaften Kultur gefallen lassen. Goethe und Kant, ja, aber Haydn und Mozart nicht minder. Was die einen in Versen und Vernunft zuviel haben, das haben die andern in Noten und Spielen voraus. Es bedarf der Künste vieler, um die richtige Lage eines Ortes im geistigen Gradnetz zu bestimmen.

FRANKEN, die Landschaften beiderseits des Mains und des Rheins, waren die geschichtlichen Schlagadern der römisch-deutschen Lebensgemeinschaft gewesen. Sie waren einst die verschränkten Klammern des franzö-

Der Meister Mozart:

„Figaro"

„Don Juan"

„Zauberflöte"

Restauration in Franken

sischen Weststaates und des fränkischen Oststaates. Sie waren der Raum der kirchenfürstlichen Dynasten und durch sie das Trümmerfeld der altdeutschen Reichseinheit. Sie waren die ersten deutschen Glieder im Reich Napoleons, das sich anfangs als Erneuerung des fränkischen Kaisergedankens Karls des

Beständiges Mittelalter Großen gab und sich als Scheitelhöhe der romanischen Renaissance enthüllte. Da vollzog sich im deutschen Franken die seelische Wendung. In dem Augenblick, da sich der gemeinfränkische Freistaat als Fußschemel eines neuen römischen Weltimperators verriet, rissen vor den Augen des ganzen Volkes alle Täuschungen; verstand man, warum man solange Latein wie seine Muttersprache gesprochen und geschrieben hatte; erinnerte man sich mit einer wahren Leidenschaft seiner deutschen Vergangenheit. Sie redete am Rhein und am Main lauter als irgendwo in Deutschland. Das mittelalterliche Schrift-

durch Dichtung tum war hier nicht lediglich in Form eines sachlichen Darumwissens immer lebendig gewesen. Es ist tatsächlich niemals völlig aus dem Strom des literarischen Geschehens abgedrängt worden. Im Betriebe meistersängerlicher Kunst wie unter den Reimfreunden des siebzehnten Jahrhunderts waren Sprache und Dichtung des Mittelalters immer wirkendes Lebensgut. Die Rit-

und gotische Bauwerke terburgen, Aachen mit seiner Gruft, Speyer mit seinem Gräbermünster, der Frankfurter Römer, der Kölner Dom, der Bamberger Reiter, das war ein Geschichtsunterricht in Bildern, gegen den keine Vernunftgründe und Gedankenschlüsse der Gegenwart etwas vermochten. So erwachte am Rhein und Main das gewaltige Gegenspiel gegen die vergriechte und verrömerte Klassikerdichtung von Weimar, weil sie als Bahnbrecher des neuen romanischen Imperators empfunden wurde, aber auch gegen das künstliche und empfindsame Mittelalter von Berlin, weil man es als immerdar wirkende Kraft im Leibe hatte. Altes Reich waren in Franken noch immer die Kurfürstentümer und geistlichen Wahlstaaten. Was am Rhein und Main zuletzt gelebt hatte, war der geistliche Barock gewesen. Darum kommt auch die fränkische Re-

Abbau des Barock stauration aus den Barocklandschaften und ist Überwindung der barocken Gegenwart mit dem Ziel einer deutschbewußten Wirklichkeitsdichtung gegen gespielte Antike und künstliche Romantik. Die humanistisch-klassische Dichtung kam aus Franken, aber sie hat sich außerhalb Frankens gebildet. Franken selber wird seiner durch die Dichtung der deutschen Restauration bewußt.

MAINFRANKENS Wesensart hatte einst durch Wolfram von Eschenbach gültigen Ausdruck gefunden. Sie erscheint sich nun abermal so getreu, daß

Gegen das „sieche" Jahrhundert ihre Abbilder lebhafter denn je an Wolfram von Eschenbach erinnern.

Wilhelm Friedrich von Meyern, 1759 bis 1829, aus dem ansbachischen

Frauental, weit gereist und im österreichischen Heere rühmlich emporgestie-
gen, ist der Dichter des Romans „Dya-Na-Sore oder die Wanderer" 1787,
der aber erst in seiner zweiten Fassung von 1800 seine rechte Gestalt gefun-
den hat. Das Buch schildert die Erneuerung eines zerstörten Volkes. Ein Kreis
von Brüdern wird auf Bergwanderungen und Stromfahrten gebildet, mit
Freunden, Meistern, Gesinnungsgenossen zusammengebracht und für seine
Aufgabe geschult. Es schließt sich um sie ein Bund von Verschwörern. Der
bereitet den Wiederaufbau des gestürzten Volkes in allen Verhältnissen des
geistigen, kriegerischen und wirtschaftlichen Lebens vor und führt ihn durch.
Die Handlung ist in die Heimat der Menschheit verlegt, in das gewaltige
Bergland zwischen Indien und Tibet. Meyern denkt sehr allgemein an die *„Dya-Na-Sore"*
österreichischen Zustände aus dem Zeitalter der schlesischen Kriege und spä-
ter an die Erhebung Deutschlands. Das Buch ist Schlüsselroman und Utopie
zugleich. Eine Fülle von glücklichen Geschichtsformeln hat er geprägt, wenn
schon nicht gefunden, so die vom „Kreislauf der Künste von Volk zu Volk"
oder die vom Stufenwachstum des einzelnen und des Volkes. Geschult war
der Dichter an Wieland. Er hat sich für seinen Roman eine streng gegliederte
rhythmische Prosa geschaffen, der die Dreizahl gleich bemessener Sätze und
die Vorliebe für gehäufte Hauptwörter eigentümlich ist, die rhythmische
Prosa der lyrischen Seelenfülle und der gedankenschweren weltlichen Pre-
digt. Das Sinnbildhafte seiner Landschaftsschilderung, das zarte Abtönen
des wallenden Gemüts, seine scharfe Wendung gegen den „falschen Sinn
eines siechen Jahrhunderts", gegen das klassische wie gegen das entstehende
romantische Weltbild: Wilhelm Friedrich von Meyern und sein Roman sind
Vorform und Bahnbrecher der ernsten Männlichkeit von Johann Paul Rich-
ters „Titan".

Johann Paul Richter, 1763 bis 1825, aus Wunsiedel, eines früh verstor- *Kunst des Humors*
benen Pfarrers Sohn, ist sich selbst überlassen zwischen Lesen und Abschrei-
ben aufgewachsen. Als Leipziger Student griff er aus Not zur Feder und
brachte 1782 nach dem Muster von Swift und Liscow das unreife und be-
klemmende Buch „Grönländische Prozesse oder satirische Skizzen" zu Papier.
Unfertig kehrte er 1784 zu seiner armen Mutter zurück und schleppte sich
jahrelang als Hauslehrer fort. Er drohte sich in die gespenstigen Massen sei-
ner Sammelhefte zu verlieren, als er 1789 seine Leipziger Anfänge mit der *Richter*
„Auswahl aus den Papieren des Teufels" fortsetzte. Dann wagte er sich an
kleine Lebensbilder wie „Des Rektors Fälbels und seiner Primaner Reise
nach dem Fichtelberg". Und als ihm 1790 das „Leben des vergnügten Schul-
meisterlein Maria Wuz" gelungen war, hatte er endlich begriffen, was das

„Loge",
„Hesperus",
„Fixlein"

Schicksal mit ihm wollte. Aus diesen kleinen Lebensbildern wurden größere, so „Die unsichtbare Loge" 1793 und „Hesperus" 1795, bis der große Wurf gelang, der „Leben des Quintus Fixlein" 1796 hieß. Hatte sich in „Loge" und „Hesperus" die weltfremde Innerlichkeit des jungen Mannes in erfundenen Menschen und in einem geträumten Leben verwirklicht, redeten die Liebenden dort miteinander die Sprache der Engel, waren die Geschehnisse des Herzens blau auf Goldgrund gemalt: Quintus Fixlein und die Seinen, das sind wohl seltsame aber wirkliche Menschen aus einem entlegenen deutschen Weltwinkel, Menschen, die wie irdische Menschen reden und handeln, so wie es die Not des Daseins gebietet. Alles, was später realistische Kleinkunst heißt, und zwar gerade bis auf Gottfried Keller, das hat Richter nun zum erstenmal gefunden, wenn er runde, gestaltenreiche Bilder aufbaut, sie unter der Gewalt der Stimmung beben und schüttern läßt und keinen Knopf vergißt, daß er an der Stelle sitzt, wo er sitzen muß. Er war so weit, daß er, der kindhafte Dorfschulmeister, seinen Schulweg durch die vornehme Gesellschaft der Zeit, durch die großen Städte und kleinen Höfe nachholen konnte. Er war 1796 in Weimar, hielt seine Augen offen, sichtete diese Welt der Überbildung und des Titanismus für sein im Doppelsinne größtes Buch. Das

„Titan":
Geist der Zeit

war sein Roman „Titan", 1800 bis 1803, der eigentlich „Gegentitan" heißen müßte. Es war Richters „Geist der Zeit", lange ehe Arndt zu seinem Buch die Feder ansetzte. Das Deutschland der kleinen Staaten, des Klassizismus und der Romantik, es litt in Richters wie in Arndts Augen an überzüchteter Geistigkeit. Die Eisenteile im Menschen haben sich nicht auf die Hand, sondern auf die Stirn und das Herz geworfen. Überall ein Nachspielen und Nachahmen, ja ein Nachahmen nicht einmal des Tanzes, sondern nur der Tänzer; das Liebäugeln mit allen Ideen; das dünkten ihn die schneidenden Linien im Antlitz des Zeitalters. So wandte er sich denn gegen die Ichsucht, das Freibeutertum und den Müßiggang der höheren Stände, gegen den Brotdienst, gegen das lächerliche Nichtverstandensein, gegen die „Abgebrannten des

Richter

Lebens" und „die gelben Maroden des Jahrhunderts". Richter begegnet sich hier mit Meyern, dessen Roman zur gleichen Zeit in zweiter Fassung herauskam. Die Dichtung, die in der höfischen Umwelt des Jahrhunderts spielt, arbeitet mit allen Mitteln des Bundesromans und ist wie ein Barockdrama angelegt, dessen Gestalten in Calderons Art von einem Spielleiter planvoll gelenkt werden, unter großem Aufwand von Maschinenkünsten und Zauberstücken aller Art. Es hat den Stil der Wiener Vorstadttheater. Das Buch ist ein Erziehungsroman, der den Helden Albano, einen vertauschten Prinzen, zur Tat bildet, und richtet sich allerdings gegen Goethes „Wilhelm Meister",

wo die Bühne als trefflichste Vorschule des Lebens gepriesen war. In Ro- *„Titan" gegen „Meister"*
quairol führt Richter einen solchen Zögling der Bühne vor. Doch weit mehr.
„Titan" ist der Widerspruch des Dichters gegen das ganze geistige Deutsch-
land um 1800, gegen das klassische wie gegen das romantische. Albanos
Freund Schoppe wehrt sich mit Aufgebot all seines Tiefsinns gegen Fichte.
Abgesehen von dem leichten Schlag, daß Albano ein Minister und in den
Freistunden nebenbei ein Dichter und Weltweiser sein soll, ließ sich gar
nichts Schärferes gegen Goethe einwenden, als was Richter seinen Roquairol
treiben läßt. „Er stürzte sich in gute und böse Zerstreuungen und Liebes-
händel und stellte hinterher alles auf dem Papier und Theater wieder dar,
was er bereute oder segnete, und jede Darstellung höhlte ihn tiefer aus."
Konnte man deutlicher werden? Albanos Fahrt nach Italien, das ist der Kern
der Sache, um die es ging. Es darf keine Kunstreise sein. „Die Alten wirken
mehr durch ihre Taten als durch ihre Schriften auf uns, mehr auf das Herz als
auf den Geschmack; ein gefallenes Jahrhundert um das andere empfängt von
ihnen die doppelte Geschichte als die zwei Sakramente und Gnadenmittel
der moralischen Stärkung." So ist es denn der Tatmensch Albano, der zu Rom *Der Tatmensch Albano*
seine letzte Weihe erhält. Hier erschließt ihm Schoppe das innerste Wesen
von Kampf und Krieg, lehrt ihn Verachtung gegen alle Freiheit, die gelernt
und erworben, die nicht angeboren ist. Während Richters „Titan" erschien,
kam Seumes „Spaziergang nach Syrakus" heraus. In diesem Verhältnis zur
Antike stimmten sie beide gegen den Klassizismus überein. Im „Titan" hat
Richter das mainfränkische Deutschland der kleinen Fürstenhöfe verklärt,
ehe es zugrunde ging. Die Dichtung auf ihrer barock gestellten Spielbühne
ist ein neuer Beweis dafür, wie tief der Barock die altdeutsche Seelenlage
durchwachsen hat. Weder klassisch noch romantisch, sondern wesenhaft
deutsch: am Abschluß dieses Weges stehen die „Flegeljahre" 1804, die Dich- *„Flegeljahre"*
tung von dem ewig deutschen gegensätzlichen Brüderpaar. Auch das ist ein
Erziehungsbuch und nicht weniger wunderlich aufgemacht wie der „Titan".
Es ist ein wehmütig-fröhliches Lebensbild auf dem Untergrunde von Hof
und Bürgertum, ein mainfränkisches Heimatbuch, grotesk und stimmungs-
reich vom galligen Spott bis zum Lächeln unter Tränen. Der großen deut-
schen Welt im „Titan" steht in den „Flegeljahren" nur eine beschränktere
Kleinwelt gegenüber. Aber es ist das kräftige und fröhliche deutsche „Ja"
gegen das harte „Nein", das Richter im „Titan" gesprochen hatte. Hier zeigte
der Dichter das ungeleckte, unverbildete deutsche Brüderpaar, das fern von
Klassik und Romantik seine ungekünstelte deutsche Seele ins Weite schickte.
Hier waren die Gesunden, die Unverbrauchten und Unverbrannten des

der reine Tor neuen Jahrhunderts, der reine Tor Walt wie jener reine Tor Parzival. Wie viele Bildnisse waren die sechshundert Jahre her dem deutschen Jungen als Vorbilder entgegengehalten worden und jedem hatte er nachzustreben versucht. Richter belebte das erste Bild des deutschen Jungen wieder, das Jahrhunderte zuvor in der gleichen Landschaft Wolfram von Eschenbach gezeichnet hatte. Die Schaffensfreude der „Flegeljahre" ließ Richter in zwei Lebensbildern 1809 nachbrennen: „Dr. Katzenbergers Badereise" und „Des Feldpredigers Schmelzle Reise nach Flätz". Über das „Leben Fibels" 1812 hinweg versuchte der alternde Dichter 1820 in „Komet" eine Art höheres Narrentum zu zeichnen nach dem Vorbilde des „Don Quixote" und des „Gargantua". Von der „Friedenspredigt an Deutschland" 1808 bis zu den „Politischen Fastenpredigten" 1816 hatte der Dichter die staatlichen und kriege-

„Ästhetik" und „Levana" rischen Taten und Untaten begleitet. Der neidlos Empfängliche und besonnen Wägende sprach aus der „Vorschule der Ästhetik" 1804, die mit dem Auge auf Johann Georg Hamann die humoristische Dichtung rechtfertigte, und aus dem Erziehungsbuch „Levana" 1807 der Mann, der in allen seinen Dichtungen die Helden erzogen werden ließ. Richter ging es wie seinem Helden Albano, „der unter der einsamen und poetischen Bücherwelt eine höhere Zartheit gewonnen, als die Wirklichkeit lehrt". Der beste Boden für solche Menschen war die entlegene Landschaft an den Quellen des Mains

Richter und Goethe und der Saale. Dieser Ursprünglichkeit und innerlichen Einfachheit mußte der romantische Mensch mit seinem verwickelten Verhältnis zu sich und Außenwelt ebenso unheimlich fremd sein wie die raffinierte Kühle und überlegene Blässe klassischer Kunsterben. Es war der Dorfjunge in ihm, der sich gegen beides sträubte. In Richter lebten die Barockstilmittel mit saftgrüner Frische fort. Und darum hat sein Stil seinesgleichen nicht. Er läßt sich auf einen einfachen Nenner bringen: jedes Wort zugleich in seiner sinnlichen und seiner sinnbildlichen Bedeutung gebraucht. Dieses fortlaufende Aneinanderrücken der Ähnlichkeiten im Gegensätzlichen war weder allein Humor noch allein Barock. Es war das Seltene und Unvergängliche an diesem Menschen: barocker Humor. Daß Goethe und Richter jeder von beiden sein eigenes Kunstwerk war und seinen eigengesetzlichen Stil hatte, das zeugt für die Fruchtbarkeit der deutschen Fülle.

Kreislauf des Jahres *Johann Wagner,* 1769 bis 1812, aus Roßdorf in der Rhön, war der Kanzler, Gutsverwalter, Gerichtspfleger seines Gutsherrn, des Freiherrn von Wechmar, dann herzoglicher Beamter zu Meiningen. Trotz seinen „Reisen aus der Fremde in die Heimat" 1808 und flachen Novellen ist Wagner der Mann eines Buches, seines Erstlings, „Willibalds Ansichten des Lebens" 1804, einer

der besten deutschen und der kunstvollste Roman seiner Zeit. Alles, was Handlung heißt, besteht hier darin, eine zahlenschön gegliederte Gruppe von Menschen, drei Männer und drei Frauen, so umzugruppieren, daß der Held der Dichtung allgemach in den Mittelpunkt rückt und jeder der drei Frauen *„Ansichten* zum Schicksal wird. Von seinem Vaterhaus und seinen Jahren als Gutsver- *des Lebens"* walter her war Wagner mit dem jährlichen Kreislauf der bäuerlichen Arbeiten und Feste vertraut. Er schöpfte die Sinnbildfülle der Jahreszeiten aus und gliederte den Roman mit seinen äußern und innern Geschehnissen nach der naturhaften Stufenfolge Winter, Frühling, Sommer, Herbst. Wie in der Furche keimen während des Winters die Schicksale seiner Menschen, sie schlagen im Frühjahr aus, sie reifen unter Sommergewittern und beugen sich im Herbst der Sichel. Den letzten Sinn spricht der sterbende Minelli aus: „Es blüht eine Unsterblichkeit, und endlos windet Gott ein helles Grün des Le- bens um die mystische Schlange der Ewigkeit." An Richter hat Wagner sich geschult. Aber der Schüler versucht, die Sprechweise des schlichten Volkes naturgetreu wiederzugeben, wo der Meister im gleichmäßigsten Tonfall schwelgt. Und wenn Richter seine Einfälle und Lesefrüchte wahllos ver- schüttet in Vergleichen, Bildern, Seitensprüngen, Wagner rundet sie zu ge- *Wagner* schlossenen, sachlich ausgeführten, knappen Sondergebilden von oft erstaun- *und Richter* licher Tiefe. Denn ließ Wagner sich hier von der Überfülle Richters berau- schen, so gab er sich dort in die strenge Zucht Goethes. Und so entstand das überraschende Gebilde: „Titan", gezügelt und geformt durch „Wilhelm Meister". Wie Wagner den Stil seines Meisters und Landsmannes gegen Goethe zu abbaute, so verglättete er ihn in der Richtung auf Tieck. Wagner verwertete Züge des Magischen und des gespenstigen Grauens, so, wenn Marianne sich für ihre längst begrabene Muhme hält und an diesem Wahn- sinn im Fieber zugrunde geht. Entscheidend ist das andere. Wagners Kapell- meister Minelli ist mit der einen Seite seines Wesens Wackenroders from- mem Tonkünstler Berglinger und nach der andern Seite Hoffmanns genial zerrissenem Kapellmeister Kreisler zugekehrt.

„Dya-Na-Sore", „Titan", „Willibalds Ansichten" bilden die organische *Die drei Romane* mainfränkische Reihe dieser Jahre, wenngleich sich in ihnen der dreifach ge- wandelte Stil eines Menschenalters ausdrückt.

RHEINFRANKEN, das waren Mainz und Koblenz. Die Erzbistümer Mainz und Trier waren ansehnliche staatliche Gebilde. Ihre Kurfürsten hat- ten durch Jahrhunderte Reichsgeschichte gemacht. Sie suchten durch halbe Taten dem drohenden Verhängnis zuvorzukommen. Sie wurden durch den Umsturz aus unmittelbarer Nähe und mit voller Wucht getroffen. Über sie

gingen die ersten Gegenstöße der Abwehr hinweg. Das war der Boden, auf dem sich die entscheidende Wende des deutschen Geistes vollzog.

MAINZ hat sich nach der Aufhebung des Jesuitenordens durch seine Hochschule erneuert. Deutsche Sprache und Literatur sollten in die wirkende Mitte der Bildung treten. Gelehrte von Ruf, meist Protestanten, wurden gewonnen. Der Mann des Umschwungs, *Georg Forster*, 1754 bis 1794, aus Nassenhuben bei Danzig und von schottischer Abkunft, kam im Zuge dieser Berufungen 1788 nach Mainz an die Hochschule. Er schloß die Augen und suchte sich abzulenken, indem er im Winter 1791 nach der englischen Übersetzung des William Jones das indische Drama „Sakontala" nachdichtete. Da fiel 1792 Mainz unter dem ersten Ansturm der Franzosen. Forster ließ sich rasch in den Vordergrund schieben, trat in die Jakobinerregierung ein, predigte, das Land durchziehend, den Anschluß an Frankreich, war Geist und Seele des Mainzer Konvents, ging 1793 als Gesandter des rheinisch-deutschen Konvents nach Paris, wo er nach wenigen Monaten starb und also vom Fallbeil verschont blieb. Georg Forster hat das Böse gesollt und das Gute geschafft. Mit James Cook hatte er 1772 bis 1775 die berühmte Weltreise gemacht. Und abermals ein Weltentdecker, war er mit Alexander von Humboldt 1790 den Rhein hinunter nach London gefahren und über Paris zurückgekehrt. Die beiden Bücher, in denen er den Ertrag der zwei Reisen festhielt, haben, jedes auf andere Art, in Deutschland einen Umschlag der Witterung ausgelöst. „Des Kapitän Cook dritte Entdeckungsreise" ist 1777 in englischer und 1787 in deutscher Sprache herausgekommen. Forster baute seine Darstellung auf die beiden Widerlager Urzustand und Kulturleben. Die Dichtung des Buches ist die Idylle Tahiti. An ihr wird ihm die Erkenntnis Bild: Völker auf gleicher Kulturstufe sind in den entferntesten Räumen einander ähnlich. Und so vergleicht er hellenische Flotten und spartanische Tapferkeit mit den Kampfmitteln und Kriegertugenden der hellbraunen Helden von Tahiti. Er prüft die Wahrhaftigkeit homerischer Schilderung an den Festen und Arbeiten, Fahrten und Kämpfen kleiner Südseevölker. Das ist nicht nur Herders Schule. Da hat ein Gleichbegabter und Geistverwandter unter den tausend Wegen einer Weltreise den rechten Weg der Erkenntnis gefunden. Das Buch ist ein klassisches Kunstwerk deutscher Prosa. Der Wirkung dieser entzückend ursprünglichen Sätzchen voll Gegenwart und Tatsache kann sich auch das verwöhnteste Sprachgefühl nicht entziehen. Das Buch überwand den ganzen Gedankenkreis, der sich um Rousseau drehte, und entzauberte die deutsche Bestrickung durch die Antike. Denn es führte die Natur beinahe im Urzustand vorüber und zeigte, daß es eben nur ein Lebensalter der

Forster und die französische Revolution

Forsters Weltreise

Hellas und Tahiti

Menschheit sei, nicht mehr zu errufen, wenn es vergangen wie Kindheit und Jugend. Und es fügte Hellas und Tahiti gleichartig und gleichwertig eines zum andern. „Ansichten vom Niederrhein" 1791 bis 1794 schildern nur in ihrem ersten Viertel die Reisestrecke von Boppard bis Lüttich. Das Auge des Weitgereisten, des Forschers, des Erdkundigen erfaßt den ganzen Gau in all seinen räumlichen, geschichtlichen, völkischen, geistigen Einzelheiten und macht ihn mit ausgereifter Sprachkunst anschaulich. Doch was im Vordergrund steht, das ist die rheinische Kunst. An den Düsseldorfer Bildern, die Heinse so anregend geschildert hatte, geht Forster mit eiskalter Nüchternheit vorüber. Köln war ihm finster. Allein hier begab sich das Wunder. Er sah den Kölner Dom. Er trat ein. Und da beginnen nun seine Lippen überzuströmen, so nüchtern er vergleichen möchte. „Die griechische Baukunst ist unstreitig der Inbegriff des Vollendeten, Übereinstimmenden, Beziehungsvollen, Erlesenen, mit einem Worte des Schönen. Hier indessen an den gotischen Säulen, die, einzeln genommen, wie Rohrhalme schwanken würden und, nur in großer Anzahl zu einem Schafte vereinigt, Maße machen und ihren geraden Wuchs behalten können, unter ihren Bogen, die gleichsam auf nichts ruhen, luftig schweben wie die schattenreichen Wipfelgewölbe des Waldes — hier schwelgt der Sinn im Übermut des künstlerischen Beginnens. Jene griechischen Gestalten scheinen sich an alles anzuschließen, was da ist, an alles, was menschlich ist; diese stehen wie Erscheinungen aus einer andern Welt, wie Feenpaläste da, um Zeugnis zu geben von der schöpferischen Kraft im Menschen, die einen isolierten Gedanken bis auf das äußerste zu verfolgen und das Erhabene selbst auf einem exzentrischen Wege zu erreichen weiß. Es ist sehr zu bedauern, daß ein so prächtiges Gebäude unvollendet bleiben muß. Wenn schon der Entwurf, in Gedanken ergänzt, so mächtig erschüttern kann, wie hätte nicht die Wirklichkeit uns hingerissen." Diese Sätze sind die wichtigste Urkunde zur Geschichte der rheinischen Restauration. Sie überwanden die kanonische Geltung der hellenischen Baukunst, indem sie ihr als andersartig und gleichwertig die gotische Bauweise zugesellten. Und sie haben die Begeisterung Sulpiz Boisserées entzündet. Georg Forster kannte alle Zweige der Naturkunde. Er zeichnete mit vollendeter Fertigkeit Pflanzen und Tiere. Er trieb Kunst und Literatur, Geschichte und Erdkunde. Er schrieb Latein, verstand Griechisch und sprach oder schrieb oder las fast alle europäischen Sprachen. Das war der Mann, der am Erlebnis Tahitis und des Kölner Domes der rheinischen Restauration Bahn gebrochen hat.

KOBLENZ war der Sitz des Kurfürsten von Trier, der Waffenplatz der französischen Flüchtlinge, die Vaterstadt der deutschen Wendung gegen den

„Ansichten vom Niederrhein"

Der Kölner Dom

hellenischer und gotischer Stil

Görres und die
französische
Revolution französischen Umsturz. *Josef Görres,* 1776 bis 1848, aus Koblenz, stammte
von einer italienischen Mutter. Von der Schule her mit Liebe zur Naturkunde
und den antiken Sprachen angesteckt, schlug das Herz des frühreifen Jungen
schon mit den ersten Regungen des französischen Umsturzes. Der Jakobiner-
klub, der sich Anfang 1797 zu Koblenz auftat, anerkannte den Einundzwan-
zigjährigen sogleich als seinen Führer. Er predigte den Anschluß des Rhein-
tales an den französischen Freistaat. Doch das sollte nur die Vorstufe sein.
Er gedachte aus den gemeinsamen Franken des Ostreiches und des West-
staates, die so geteilt ein Spielball fremder Geschichte waren, frei und selb-
ständig einen mächtigen Rheinstaat aufzurichten. In seinen Blättern und
Schriften focht Görres schwergewaffnet für seine Pläne. „Der allgemeine Frie-

„Der allgemeine
Frieden" den, ein Ideal" 1798 entwarf das Bild eines platonischen Weltstaates mit
volksfreier Verfassung. Neben Kant und Fichte, Rousseau und Condorcet
steht überragend der Einfluß Sieyès. Mit seinen beiden Zeitschriften „Das
rote Blatt" und „Rübezahl" verfolgte Görres zunächst berichtend den Gang
der Zeitereignisse. Dann zeichnete er mit gewaltiger Kraft und unwider-
stehlicher Überredungskunst seine Blendbilder, in denen er das Angesicht
der Erde zu erneuern gedacht. Die zündenden Schlagworte der Jakobiner
werden in seinem Stil zu einer furchtbar gegenständlichen Macht. Mit dem
gleichen Ingrimm wie gegen Kirche und Reich stürmt er gegen die Verderb-
nis der neuen Machthaber an. Sein Abgott ist der allgemeine Verfassungs-
staat und der sittliche Fortschritt der Menschheit. Als ihm sein guter Blick
für alles Tatsächliche zeigte, daß mit den Mitteln des Umsturzes der sittliche
Staatszweck nicht zu erreichen sei, kehrte er in seiner Ehrlichkeit und Ent-
schlossenheit um. Das geschah, als er mit zwei Gefährten nach Paris ge-
schickt worden war, um das Direktorium mit der Verderbnis der französi-
schen Verwaltung im Rheintal bekanntzumachen und die Aufnahme der
Rheinlande in die Republik zu betreiben. Er sah die Republik tatsächlich
vernichtet und Napoleon an die Stufen seines Aufstieges treten. So legte er
denn ein öffentliches Bekenntnis alles dessen ab, was er gestrebt, geirrt, er-
hofft und nicht gefunden hatte: „Resultate meiner Sendung nach Paris." Er

„Resultate
meiner Sendung
nach Paris" trat als Lehrer am Gymnasium seiner Vaterstadt ein. Nun sah er nur noch
einen Weg, nämlich durch Erneuerung aus dem Erbe der Nation zu einer
Wiedergeburt Rheinfrankens zu gelangen. Er lehrte am Gymnasium Natur-
geschichte und gab sich selber Rechenschaft über seine gedanklichen Mög-
lichkeiten in den Schriften „Aphorismen über die Kunst" 1801 und „Aphoris-
men über Organonomie" 1803, die beide noch für die Antike und die italie-
nische Kunst eintraten. Zeigt er sich in seiner Kunstlehre von Schiller und

Winckelmann abhängig, so folgte er in der Naturphilosophie den Pfaden Schellings. Die Entdeckung des Galvanismus machte damals ebenso gewaltigen Eindruck, wie etwa hundert Jahre später die des Radiums. Man glaubte die vielgesuchte einheitliche Lebenskraft entdeckt, die erlaubte, alle Lebensvorgänge gleichzusetzen. So wollen seine oft verspotteten „Aphorismen" verstanden sein. Geschichtliche Gedanken legte er in einer Reihe von Aufsätzen nieder, die er 1804 bis 1805 für die Münchner Zeitschrift „Aurora" des Freiherrn von Aretin schrieb. Es sind Betrachtungen über die Begriffe antik und modern, über deutsche und französische Literatur, über die Lebensstufen in Goethes Werken. Und deutlich spricht es für das fränkische Gefühl der Zusammengehörigkeit, daß dem Rheinfranken Josef Görres der Ostfranke Johann Paul Richter der Vertreter der Moderne war.

Görres: Aphorismen

Rheinfranken, das waren Düsseldorf und Köln. Beide Städte haben das gemeinsam, daß sie im aufgeregten Staatsgetriebe des Rheintales das gesunde Beharrungsvermögen vertraten, daß die rheinische Restauration sich auf ihre Kulturgüter und Kunstschätze gründete, daß Düsseldorf nach wenig Jahren in Peter Cornelius den großen schöpferischen Geist und Köln in Sulpiz Boisserée den Entdecker und Kleinodbewahrer dieses erneuerten rheinischen Lebens stellte.

DÜSSELDORF verkörpert sich in zwei Brüdern, die einander auf eine seltene brüderliche Weise ergänzten. *Johann Georg Jacobi,* 1740 bis 1814, selber ein zarter, feiner, anmutiger Meister kleiner dichterischer Formen, gab 1774/1776 eine Zeitschrift heraus, die sich vor allem an die Frauen wandte und „Iris" hieß. Sie wurde von *Wilhelm Heinse* geleitet. Düsseldorf besaß eine berühmte Gemäldesammlung, die, später nach München überführt, den künstlerischen Ruhm der bairischen Hauptstadt begründete. Heinses „Briefe aus der Düsseldorfer Gemäldegalerie" 1776/1777 schilderten und entdeckten sie für das Bewußtsein des Zeitalters. Diese Briefe waren in ihrer Art unerhört neu, ganz auf Farbe gestimmt, und wie sie das gemalte Bild und das erschaute Gefühl in Worten wiedergaben, ein vollkommenes Gegenstück zu Winckelmanns Nachdichtung der römischen Standbilder. All diese Bilder von Raphael, Michelangelo, Dolci, van Dyck, Leonardo, Reni, Tizian, Carracci waren so beschrieben, daß der blinde Pfeffel, da sie ihm vorgelesen wurden, meinte, er hätte sein Augenlicht wiedererhalten. Der Hymnus über Peter Paul Rubens hielt den Gipfel. *Friedrich Heinrich Jacobi,* 1743 bis 1819, gehörte zu Goethes Jugendfreunden und kehrte von seinem Ausfluge in die Dichtung — der Roman „Woldemar" 1777 — bald zurück. Mit dem Ernst der Zeit sah er eine ganz andere Aufgabe winken und er nahm sie auf sich.

Heinse, „Briefe aus der Düsseldorfer Galerie"

Der Düsseldorfer Philosoph

Er begann an einer Sammlung aller beharrsamen Kulturkräfte zu arbeiten.
Er verschwor sich mit gleichgesinnten norddeutschen Freunden. Mit Johann
Georg Hamann kam er in die gleiche geistige und persönliche Freundschaft
wie zuvor Johann Kaspar Lavater. Er pflegte jene Gefühlsphilosophie, die
eben damals in beiden Kirchen immer stärker Raum gewann, und so hatte
er Freunde und Feinde in beiden Bekenntnissen. Sein anmutiger Landsitz
in Pempelfort war ein Sammelplatz für die erhaltenden und rettenden Ge-
danken der Zeit. Die besten Männer waren hier seine Gäste: Hamann, Stol-
berg, Herder, Goethe. Gegen den Umsturz erhob er sich sofort, und so mußte
er 1794 nach Norddeutschland flüchten. Peter Cornelius, 1783 bis 1867, der
Schüler und Leiter der Düsseldorfer Akademie, in Köln, in Frankfurt, in Rom
angeregt, gelenkt, entscheidend geformt, hat dann das Vermächtnis der alt-
deutschen Malerei und Dichtung ergriffen und von seiner Vaterstadt Düssel-
dorf aus die rheinische Restauration künstlerisch verwirklicht.

Jacobi, Hamann, Goethe

KÖLN verkörpert sich in zwei Brüdern, die auf eine seltene Weise an der
einen und gleichen Aufgabe zusammenarbeiteten. Von ihnen war *Melchior
Hermann Boisserée*, 1786 bis 1851, der treue, sachverständige, geschichts-
kundige Begleiter. *Johann Sulpiz Boisserée*, 1783 bis 1854, war der kluge,
vorausblickende, führende Unternehmer. Schon früh belesen, vor allem in
Johann Paul Richter, kam Sulpiz 1798 als Kaufmannslehrling nach Ham-
burg, wo ihn der literaturkundige Buchhändler Friedrich Perthes unter sei-
nen Schutz nahm. Hier lernte er aber auch Bauzeichnen und wußte noch
nicht, warum, als er 1800 nach Köln in die sonnige Behaglichkeit eines wohl-
habenden Bürgerhauses zurückkehrte. Nun aber fügte es sich Zug um Zug.

Boisserée auf Forsters Spuren am Niederrhein

Die erste Begegnung. Forsters „Ansichten vom Niederrhein" fielen ihm in
die Hände. Er las den strömenden Hymnus auf den Kölner Dom und war
gefangen. Er nahm sich das Buch als Reiseführer auf seine Fahrt nach Ant-
werpen mit und betrachtete in seinem Lichte die Kunstwerke am Nieder-
rhein. Die zweite Begegnung. In Düsseldorf lernte er den jungen Peter Cor-
nelius kennen. Die dritte Begegnung. In Paris traf er Friedrich Schlegel, der
dort Vorträge hielt und seine Zeitschrift „Europa" herausgab. Boisserée und
Schlegel kehrten 1804 über Flandern nach Köln zurück und erlebten mit An-
dacht die flämischen Bauwerke und Bilder des Mittelalters, zu Brüssel die
Gudulakirche und zu Löwen das Rathaus. In Köln waren inzwischen die
Klöster aufgehoben und geplündert worden. Unermeßliche Kunstschätze
wurden sinnlos verschleudert. Doch gerade die Zerstörung erweckte das Zer-
störte zu neuem Leben. Die Brüder bargen und erwarben, was sie erreichen
konnten. An die 200 Bilder des vierzehnten bis sechzehnten Jahrhunderts

Flämische Bauwerke

Die Kölner Bilder

brachten sie zusammen, später der wertvollste Besitz der alten Pinakothek in München. Es war im buchstäblichen Sinne eine Restauration. Denn die beschmutzten und oft beschädigten Bilder mußten sorgsam gereinigt und erneuert werden. Hand in Hand ging damit die kunstgeschichtliche Forschung, die vor allem Melchior auf sich nahm. Vor und neben den beiden Brüdern hatten nicht wenige Kunstfreunde und Raffer das gleiche getan. Doch die beiden Brüder brachten den großen Zug in den Betrieb, den zielbewußten Kulturgedanken, die Geschicklichkeit des Kaufmanns. Nachdem die Bilder geborgen waren, begann zu Anfang 1808 Sulpiz Boisserée den Kölner Dom *Der Kölner Dom* auszumessen. Denn er gedachte, nun Hand an seine Lebensarbeit für die Geschichte des Bauwerkes zu legen. Das waren gerade die Tage, da Napoleon als neuer Kaiser der welschen und deutschen Franken gewaltig einherfahrend, von Karls des Großen Grabe zu Aachen her Köln besuchte. Mit so mächtigen Bildern wurde das Zeitalter angeredet. So lebte die rheinische Restauration nicht aus dem Gedanken der ostdeutschen Romantik. Das Gegenteil ist die Wahrheit. Sulpiz Boisserée hatte Friedrich Schlegel das flämische und rheinische Mittelalter mit den Augen Georg Forsters sehen gelehrt. In Köln hielt Friedrich Schlegel jene Vorträge und in Köln hatte er die Erlebnisse, die ihn durch seine letzte Verwandlung führten. Im deutschen Rom, im Kölner Dom legte er am 16. April 1808 das tridentinische Glaubensbe- *Forster, Schlegel, Boisserée* kenntnis zur römischen Kirche ab. Nun galt auch ihm Friedrichs von Hardenberg Erkenntnis „Die Christenheit oder Europa". Und nun, 1808, trennten sich wieder die Lebenswege des Sprechers der deutschen Romantik und des Schatzhüters der deutschen Restauration. Friedrich Schlegel übersiedelte nach Wien. Sulpiz Boisserée fuhr rheinaufwärts bis Basel und mainentlang bis Würzburg, überall auf der Suche nach Bauwerken und Gemälden. Und 1810 ließen sich die Brüder mit ihrer Bildersammlung inmitten neuer Freunde zu Heidelberg nieder.

Rheinfranken, das waren Frankfurt und Kassel. Beide Städte waren die Heimat, aus der die rheinische Erneuerung des ursprünglichsten und ältesten deutschen Volksgutes hervorgegangen ist.

FRANKFURT spiegelte sich im Werk zweier Männer, die einander nach der Herkunft und Persönlichkeit so unähnlich wie möglich waren und doch durch die Richtung ihres Geistes, durch Schwester und Frau beinahe brüderlich vereinigt wurden. *Friedrich Karl von Savigny,* 1779 bis 1861, zu Frank- *„Das Recht des Besitzes"* furt geboren, stammte aus einem lothringischen Rittergeschlecht, das seinen Namen von dem Schloß südlich Nancy hatte. Sein erstes Werk, das ihn berühmt machte, „Das Recht des Besitzes" 1803 war mitten im Umsturz Euro-

pas eine Tat von sinnbildlicher Kraft. Savigny leitete alles Recht aus dem Wesen des Volkes und seiner Geschichte ab. Der wahre Ursprung des Rechts liegt nicht im Gesetz, sondern im Gemeinbewußtsein des Volkes. Er suchte den Geist des Gesetzgebers aus dem Wort zu erfassen, ohne sich an das Wort zu klammern. So hat Savigny die Rechtskunde auf geschichtlicher Grundlage wieder zur Wissenschaft gemacht. *Klemens Brentano,* 1778 bis 1842, kam im Hause seines mütterlichen Großvaters zu Ehrenbreitstein auf die Welt. Seine Familie stammte aus Italien. Der Vater war durch seine erste Frau Herr eines reichen Handelshauses in Frankfurt geworden. Seine zweite Frau, Maximiliane Laroche, schenkte ihm ein Nest voll genialer Kinder, deren eines, Kunigunde, die Frau Savignys wurde. Der Dichter wuchs bei einer mütterlichen Tante in Koblenz auf, wo Josef Görres sein Mitschüler wurde. Als alle Versuche, aus ihm einen Kaufmann zu machen, mißglückt waren, ließ man ihn 1797 auf die Hochschule Jena frei. Von den Trägern der romantischen Bewegung, die hier für kurze Zeit beisammen waren, wurde ihm mancher Freund. Doch keiner hat ihm geben können, was er aus eigenem überreich besaß. Und Brentanos frühe Dichtungen sind weder ein Bekenntnis zur Partei noch ein Ertrag aus dem Geist der romantischen Bewegung. Denn die „Satiren und poetischen Spiele. Erstes Bändchen: Gustav Wasa" 1800 verschossen ihre Pfeile nur nach Laune auf Anhänger und Gegner der Romantik. Und der Roman „Godwi" 1801 ist kein Seitenstück zu „Lucinde". Denn einmal stammt Friedrich Schlegels „Roman" mit seinen ersten Entwürfen aus einer Zeit, da er selber mit Romantik noch nichts zu tun hatte. Und dann rückt Klemens Brentanos „Godwi" mit seinem Kerngedanken, daß wahre Sittlichkeit in der Unbefangenheit der Sinne, Unsittlichkeit in der Verleugnung der Sinne bestehe, neben Wilhelm Heinses „Ardinghello". Bücher wie „Godwi" und „Lucinde" sind einfach Altersstufenliteratur der Zwanzigjährigen und sind einander ohne Unterschied der Zeit und der literarischen Richtung zum Verwechseln ähnlich. „Godwi" ist ein Briefroman und verrät in all seiner zügellosen Gesinnung — die doch wohl nicht für ein romantisches Merkmal gelten soll — ein solch schöpferisches Vermögen, soviel Sprachkunst und Herrschaft über die Mittel der Darstellung, wie sie keinem Romantiker der Zeit eigen waren. Der Wert des Romanes liegt in seinen lyrischen Beständen. Und im „Godwi" gab Brentano die erste Form seines Singspieles von 1802, „Die lustigen Musikanten". Neben dem Roman lief die Arbeit an dem Lustspiel „Ponce de Leon" her. Es ist Shakespeare und Calderon gleichermaßen verpflichtet, setzt seine Wirkung weder auf Handlung noch auf Spielmaske, sondern auf den Wortwitz und ist also kein

Der junge Brentano

„Godwi"

„Ponce de Leon"

„Schau"spiel, sondern ein „Hör"spiel. Brentano hatte in Jena die geistreiche und anmutige Sophie Mereau, eine zarte Dichterin und kluge Übersetzerin, kennengelernt. Sie ließ sich scheiden, heiratete Brentano 1802 und starb ihm schon 1806 an der Geburt eines Kindes hinweg. Das Glück dieser Liebe, der Frieden des Heimes, das Leid dieses Todes, die dem Dichter mit der Frau die Mutter zum zweitenmal gaben und raubten, sind die lichten und die dunklen Genien seiner reifen Dichtung geworden. Der Schatten der mädchenhaften Mutter und die helle Gegenwart dieser mädchenhaften Frau verschwammen unsagbar sanft und rein zu der Novelle von 1803 „Aus der Chronika eines fahrenden Schülers". Sie zieht ihren mittelalterlichen Duft aus der unvergleichlichen „Limburger Chronik" des frühen vierzehnten Jahrhunderts, die er wohl durch Savigny kannte. Geplant war ein ganzer Kreis altdeutscher Erzählungen. Das Bruchstück der „Chronika" ist ein schmerzliches Bruchstück dieses versagten Novellenbuches. Als begnadeter Neuschöpfer baute Brentano den Eindruck des Mittelalterlichen aus der Stimmung auf, aus dem Tonfall, in dem die Handelnden reden, aus der Art und Weise, wie sie handeln, Brentano hat ein so reines Abbild altdeutschen Lebens vom versunkenen Grunde heraufgeholt, wie es keinem der romantischen Dichter an der Oberwelt folgte. Der Einfluß dieser einzigartigen Dichtung auf die deutsche Novellenkunst ist unübersehbar. Hier stehen die schönsten und reifsten Lieder, die Volkslied in edelster Gestalt sind. Darunter sind Strophen, aus denen die Frömmigkeit der altdeutschen Mystik atmet. Wie der Dichter in der „Chronika" die altdeutsch treuherzige Geschichte von Mutterliebe und süß beweglichen Gemälden alter Meister erzählte, so begann er um dieselbe Zeit, 1804, das gotisch zierliche Schnitzwerk seiner „Romanzen vom Rosenkranz" aus Spitzbogen, Türmchen, Elfenbeinfigürchen zusammenzufügen. Wie die Brüder Boisserée von altdeutschen Bildern und Bauwerken, so ging der leidenschaftliche Büchersammler Brentano von dem altdeutschen Buch, dem Buch als Werkstück des Schreibers, Druckers, Buchbinders, Besitzers aus. Wie die Boisserée die altdeutschen Bilder und Savigny das altdeutsche Recht, so hat Brentano das altdeutsche Buch erneuert.

KASSEL verkörpert sich in den zwei Brüdern, die das Beispiel der beiden Kölner Brüder in der untrennbaren Hingabe an das eine und gleiche Werk verdoppelten. *Jakob Grimm,* 1785 bis 1863, und *Wilhelm Grimm,* 1786 bis 1859, sind zu Hanau geboren und, früh verwaist, in Marburg als Schüler Friedrichs von Savigny gebildet. Als Beamte der Kasseler Bücherei legten sie den Grund zu ihrer gemeinsamen umfassenden Lebensarbeit an der gesamten geistigen Altüberlieferung der Germanen und Deutschen. Während Jakob

„Chronika"

Brentano „Romanzen"

Das alte Buch

Deutschkunde

in den folgenden Jahren seine wissenschaftlichen Werke zur Geschichte der deutschen Sprache, des deutschen Rechts, der deutschen Mythologie schuf, widmete sich Wilhelm der deutschen Heldensage. Früchte ihrer gemeinsamen Arbeit dieser Jahre sind die „Kinder- und Hausmärchen" 1812, mit denen sie einfach auf eine künstlerische und doch volkstreue Weise diese uralten Geschichten wiedererzählen wollten. Für den ersten Band ihres Buches zeichneten sie aus mündlicher Überlieferung auf, was sie selbst im Rheintal und Maingau gesammelt hatten. Für den zweiten Band hörten sie die Märchenfrau Viehmännin in Zwehren bei Kassel ab. Die Brüder Grimm hielten aus Gründen des Gewissens an der bezeugten Überlieferung fest. Denn ihnen galt die Volksliteratur nicht als herrenloses Gut, sondern als Eigentum des schöpferischen Volksgeistes. Aus mündlicher Überlieferung stammte nun freilich die Mehrzahl dieser Märchen nicht. Ja, die besten Stücke gewann man aus schriftlichen Quellen, wo solche Schätze gar nicht erwartet werden konnten. Französische Schriften sind reichlich ausgeschöpft. Viel Stoff boten die verbreiteten Schwankbücher des sechzehnten Jahrhunderts. Auch altdeutsche lateinische Gedichte, Lügenmärchen des vierzehnten Jahrhunderts, die Literatur der Barockzeit war ergiebig. Bestimmte Ortsangaben und die genaue Zeit ließen die Brüder fallen, wenn die Quellen das hatten. Den Ton volkstümlicher Sprache erreichten sie durch Sprichwörter, durch häufigen Gebrauch der geraden Rede, durch formhafte Wendungen und Wiederholungen, durch Kleinmalerei, vor allem durch den Personenwechsel im Selbstgespräch. So sind die „Kinder- und Hausmärchen" als Kunstwerk ähnlich dem „Wunderhorn" zu werten.

Brüder Grimm, „Kinder- und Hausmärchen"

So hat die rheinische Restauration das geistige Leben in seinem ganzen Umfange aus der zeitlichen Tiefe der Nation erneuert: das alte Bild, das alte Bauwerk, das alte Recht, das alte Buch, das alte Wort.

Das Tübinger Stift und seine Jahrgänge

SCHWABEN. Württemberg hatte seit dem sechzehnten Jahrhundert die Landschaft mit seinem humanistischen Schulwesen völlig durchwachsen. Eine gleichartige Bildung gab der geistigen Oberschicht ein ebenmäßiges Gesicht. Der Klassizismus entwickelte sich daher nur in Schwaben zu geschlossener Einheit und drang auch in die ferneren Kanäle des Literaturbetriebes ein. So wird beinahe begreifbar, was überall sonst als ein Wunder erschiene. Das Tübinger Stift, die geistliche Pflanzschule des ganzen Landes, hatte in dem einen Jahrgang 1791 die drei Studenten Schelling, Hegel, Hölderlin. Sie sind Abbilder humanistischer Geistesart. Doch ihr Antlitz ist in dreierlei Richtung bereits der süddeutschen Erneuerung des nationalen Geisteslebens zugewendet.

Friedrich Wilhelm Schelling, 1775 bis 1854, aus Leonberg, war von den Dreien der Glückliche, dem Lehrer und Kameraden das Größte zutrauten. Er las mit seinen Freunden Plato, Spinoza, Kant. Bedurfte Schelling also des Lehrganges bei Fichte, als er an der Jenaer Hochschule zu lesen begann? Am 9. September 1794, als Fichte erst in einer Besprechung Andeutungen von seiner neuen Philosophie gemacht hatte, vollendete Schelling seine Schrift „Über die Möglichkeit einer Form der Philosophie überhaupt". Da bekannte er sich schon allen vernehmlich zur Idee des „Ich". Fichtes Wissenschaftslehre entstand bogenweise im Winter auf 1795 und im Anfang dieses Jahres, gleichzeitig hatte Schelling die Schrift „Vom Ich als Prinzip der Philosophie" fertig. Auf diesen Blättern wird Fichte mit keinem Wort genannt, aber immer wieder Spinoza. Die ganze Reihe der ostdeutschen Philosophie, die mit den böhmischen Brüdern und Jakob Böhme begann, die mit Fichte und Schleiermacher schloß, war durch das jahrhundertelange ununterbrochene Zuströmen alamannischer Gedanken geschaffen und genährt worden. Die Landpfarrer Schwabens predigten ihren Bauern von der Wiederkehr Platons in der güldenen Zeit. Unmittelbar vor Schelling hatten Bengel und Öttinger, die Schwaben, und ihre zahlreiche schwäbische Schule Plotin und Kabbala, Mystik und Naturphilosophie erneuert, und Schelling kannte ihre Schriften. Selbst als Mitarbeiter von Fichtes „Philosophischem Journal" 1795 schwärmte Schelling — war das Fichte? — für die „Ruhe im Arm der Welt" und sprach sogar jetzt schon von einer unendlichen „objektiven" Macht. In einem anderen Aufsatz bewies er die Gleichwertigkeit der Gedanken des Platon und Leibniz mit dem neuen Idealismus. Schon im Sommer 1797 entwarf er — kein größerer Gegensatz zu Fichte war denkbar — „Ideen zu einer Philosophie der Natur", und im Jahr, da er auf Fichtes Anregung nach Jena kam, 1798, erschien voller Anklänge an Hölderlins Hellenismus, sein glühendes Buch „Von der Weltseele". Bis Ostern 1799 entstand der „Erste Entwurf eines Systems der Naturphilosophie", in dem die alte Doppelheit Natur und Geist in ungeminderter Pracht fortlebte. Das „System des transzendentalen Idealismus" 1800, ein einziger Widerspruch gegen Fichte, war entscheidend durch seinen kunstwissenschaftlichen Inhalt. Schelling wiederholte Schillers Lehre vom Spieltrieb. Mit Schiller war er eins über die Bedeutung des Mythus. Und so bildet ihm die Mythologie, die Schleiermacher zerstört hatte, das Mittelglied für die Rückkehr der Wissenschaft zur Poesie. Hier steht der Satz, der in die tiefe Kluft zwischen Romantik und Klassizismus leuchtet: die Natur ist die Schöpfung des erkennenden, nicht des tätigen Ich. Auf diesen Satz zielte die Abhandlung: „Über den wahren Begriff der

Der Philosoph der Weltseele

Schellings Bildungsgang

Schelling und Fichte

Wissenschaft, Mythus, Poesie

Naturphilosophie." Es ist unmöglich, die Natur aus dem Ich abzuleiten. Wer sich nicht tätig, sondern rein erkennend verhalten wolle, der müsse das Ich aus der Natur ableiten. Im Menschen erhebt sich die Natur bis zum vollen Bewußtsein. Mit dem Aufsatz „Darstellung meines Systems der Philosophie"

Philosophie der Mythologie und der Offenbarung
1801 war nun alles gesagt. Schelling erklärt, daß die Gesamtheit alles Seins, die Kant, Fichte, Schleiermacher als Gegenstand des Erkennens geleugnet hatten, eben der eigentliche Gegenstand des Erkennens sei. Er setzte Wahrheit und Schönheit einander gleich. Grenzen zwischen Philosophie und Kunst, Denken und Schaffen gab es nicht mehr. So ging es nun folgerichtig weiter über „Philosophie und Religion" 1804 und „Freiheitslehre" 1809 zu der Schrift „Die Weltalter" 1811 und der Festrede „Die Gottheiten von Samothrake" 1815, nämlich zu der Erkenntnis: die höchste Philosophie ist Religionsphilosophie. Da Gott sich in zweifacher Weise kundgibt, seine Natur in der Naturreligion oder Mythologie, seine Persönlichkeit in der geoffenbarten Religion, so erhebt sich alle Philosophie zu ihrem letzten Doppelgipfel: Philosophie der Mythologie und Philosophie der Offenbarung. Der Weltgrund ist für den erkennenden Verstand unzugänglich. Er muß sich offenbaren und kann nur angeschaut werden. Schellings Philosophie ist von ihrer ersten bis zu ihrer letzten Bezeugung Naturphilosophie gewesen, und ihre scheinbaren Wandlungen sind nichts anderes als immer neue Fassungen der einen und gleichen Schau. Daß er zuletzt Gedanken Jakob Böhmes gedacht hat, will nichts bedeuten. Denn Jakob Böhme, das war ja auch nur Paracelsus, Eckhart, Plotin. Schellings Philosophie, das ist die Philosophie aller Mystik von der Aufhebung aller Gegensätze in Gott.

Dialektik des absoluten Geistes
Wilhelm Friedrich Hegel, 1770 bis 1831, aus Stuttgart, hat zu den Benachteiligten gehört, denen man nichts zutraut. Verschwiegen und einsam hieß er schon im Tübinger Stift „Der alte Mann". Hölderlin riß ihn mit hinein in seinen glühenden Glauben an das Hellenentum. Er liebte Schillers ästhetische Briefe. Der Zauber, den Schelling auf ihn ausübte, ist eigentlich nie ganz von ihm gewichen. Hauslehrerjahre zu Bern und Frankfurt waren 1794 bis 1800 auch sein Schicksal. Das erste, was er schrieb, war ein Leben Jesu und das andere, was er versuchte, war der politische Aufsatz. Um die Jahrhundertwende wandte er sich wie einer, der sich zu handeln entschließt, der Philosophie zu. Und schon der erste handschriftliche Satz stand und galt: das Absolute ist Geist und es ist von dialektischer Art, das heißt in beständiger Entwicklung begriffen. Er begann im Jänner 1801 an der Jenaer Hochschule zu

Hegel und Schelling
lesen. Sein Mentor war Schelling. Für Schelling schrieb er die „Differenz des Fichteschen und Schellingschen Systems". Mit Schelling gab er das „Kritische

Journal" heraus. In Schellings Geist ist die Abhandlung „Über das Wesen der philosophischen Kritik" gehalten. Der Bann des Freundes lockerte sich mit dessen Weggang von Jena. Hegel begann sich selber zu haben und mit dem schwierigen Buch „Phänomenologie des Geistes" 1807 legte er den Grund zu *„Phänomenologie des Geistes"* seinem eigenen Gedankengebäude. Das Schicksal meinte es gut mit ihm, als es seine akademische Laufbahn unterbrach und ihn 1807 zum Leiter der Bamberger Zeitung, 1808 zum Leiter des Nürnberger Gymnasiums machte. Denn im Schulunterricht lernte er endlich leidlich schreiben und fand er den Antrieb, sein Gedankengebäude aufzuführen und auszugestalten. In Nürnberg ist die „Wissenschaft der Logik" 1812 bis 1816 entstanden und die einzige Gesamtdarstellung seines Gedankens, die „Enzyklopädie der philosophischen Wissenschaften" 1817 vorbereitet worden. So gerüstet, konnte er 1816 ins akademische Lehramt zurückkehren und den Ruf an die Heidelberger Hochschule annehmen. Sein Lebenswerk stand. Es ist die Vernunft, die sich durch den Stoff in rastlosem Werden zur Welt verwirklicht, indem sie sich ununterbrochen in Satz und Gegensatz spaltet und im Einklang zwischen beiden zu sich als zur Einheit aus dieser Dreiheit zurückkehrt. Indem wir das Dasein in so gedritteltem Begriffen denken, denkt in uns die Dreifaltigkeit des Daseins. Die Vernunft als Idee an und für sich ergibt die Wissenschaft als Logik. Die Vernunft in ihrem Anderssein als Natur ergibt die Wissenschaft als Naturphilosophie. Die Vernunft, die aus diesem Anderssein der Natur als *Hegels Trinität* Geist in sich zurückkehrt, ergibt die Wissenschaft als Geistesphilosophie. Die Logik drittelt sich zu der Dreifaltigkeit der Lehre vom Sein, vom Wesen, vom Begriff. Die Naturphilosophie drittelt sich zur Dreifaltigkeit der Lehre von Mechanik, von Physik, von Organik. Die Geistesphilosophie drittelt sich zu der Dreifaltigkeit der Lehre vom subjektiven Geist: Anthropologie, Phänomenologie, Psychologie —, vom objektiven Geist: Recht, Persönlichkeitsethik, Sozialethik —, vom absoluten Geist: Kunst, Religion, Philosophie. Da aber alles Denken und Werden begrenzt und endlich ist, muß es wie einen Ursprung so auch ein Ziel haben. Die Dialektik, die zugleich Denken und Werden ist, beginnt mit dem Bewußtsein und verläuft über die Stufen des Selbstbewußtseins, der Vernunft, des Geistes, der Kunst, der Religion bis zum *Vernunft als Weltgrund* absoluten Wissen, in dem die Vernunft sich in sich selbst und in der Geschichte begreift. Hegels Lehre geht von der Vernunft als Weltgrund aus und ist keine Metaphysik, sondern Logik, Naturphilosophie und Geschichtsphilosophie.

Friedrich Hölderlin, 1770 bis 1842, aus Lauffen am Neckar, ist in dem anmutigen schwäbischen Unterland aufgewachsen, dessen milde Lüfte beinahe schon Italien spüren lassen. Das ist die Naturlandschaft seiner Dichtung. Er

Hölderlin hat sie mit allen seinen empfindlichen Nerven aufgenommen. Seine Kunst hat sie mit allen Schattierungen der Farbe und des Klimas immer wieder von neuem abgespiegelt. Der frühe Tod des Vaters wie des Stiefvaters, die zwei- *Die Mutter* fache Trauer und die gedoppelten Tränen der Mutter, fast täglich in so rasch wiederholter Witwenschaft vergossen, haben die Seele des Knaben schon mit jenem elegischen Lebensgefühl überhaucht, das aus allen seinen Gedichten weht. Hölderlin ist den Schwabenweg zum Pfarramt gegangen wie die meisten seiner begabten Landsleute, von der Nürtinger Lateinschule bis in das berühmte Tübinger Stift. Er fand sich nicht zurecht und schloß sich ganz nach innen ab. Das einzige, was ihn entlastet und befreit, ist das strömende Wort, das ihm schon von früh auf eine wunderbare Weise zu Gebote stand. Verse sind der Inhalt schon seines Knabenlebens. Der Widerstreit zwischen dem, was er soll und will, steigert sich auf jeder Stufe seines Schulweges. Schon seinen Mitschülern galt er als vollkommener Kenner des Hellenentums. Die schönste Bezeugung aber aus seinem frühen Leben ist die Aussage seiner Freunde: wenn er sich zeigte, schien es, „als schritte Apollo durch den Saal".

Der Flötenspieler Er spielte Klavier und Geige, am liebsten aber und bis in die letzten Dämmerungen seines Geistes die Flöte. Im freundschaftlichen Zusammenleben mit Hegel und Schelling bildet sich Hölderlins Weltanschauung und seine erste große Dichtung heran. Nur zum Predigtamt fühlte er keine Berufung und er sah es nur als ein kindliches Opfer an, das er seiner Mutter brachte. In dieser entscheidenden Stunde handelte das Schicksal für ihn. Hölderlins Landsmann Friedrich Schiller, eben damals auf Besuch in der Heimat, vermittelte ihm eine Hauslehrerstelle, über die ihn mancherlei Irrwege zunächst in die persönliche Nähe Schillers nach Jena und schließlich nach Frankfurt in das Haus Suzette Gontards führten, der Diotima seines Herzens und seiner *Diotima* Dichtung. Sie wurde ihm die leibliche Erscheinung seines Hellenideals. Die erzwungene Trennung von dieser Frau gab seiner Dichtung den schmerzlichen Inhalt und sie brachte die Hochgefahr seines Lebens zum Ausbruch. In die Schweiz und nach Frankreich führten die letzten Wege seines Hauslehrerdaseins. Und so kehrte er, der all die Jahre her so oft die Mutter als ein Gescheiterter hatte aufsuchen müssen, im Sommer 1802 zum letztenmal gesund zu ihr zurück. Dann löste sich sein Geist mit einem vierzigjährigen Sterben in die wirren Träume seines Irrsinns auf. Die Vollendung, die ihm das Leben versagte, hat ihm seine Dichtung gewährt. Der Briefroman „Hy- *„Hyperion"* perion" reicht mit seinen frühesten Anfängen in Hölderlins Tübinger Studentenzeit zurück. Über allerlei Wandlungen seines Gehaltes und seiner Form ist er 1797 und 1799 in zwei Bänden erschienen. Er stellt — das Lieb-

lingsthema des deutschen Romans seit Wolframs „Parzival" — die Entwick-
lung eines Jünglings zum Manne dar, das ist „aus der Phantasie ins Reich der
Wahrheit und Freiheit". Der Roman spielt in dem Hölderlin zeitgenössischen
Griechenland. „Der liebe Vaterlandsboden gibt mir wieder Freude und
Leid." Mit diesem Satz beginnt der Roman. Es ist also die Heimat, von der *Hellas ist Heimat*
die lebensheilende Wirkung ausgeht. Damit tritt uns aus der hellenischen
Traumwelt die deutsche Wirklichkeit entgegen. Hellas ist ein Gleichnis für
Deutschland. Hellas ist nicht gegen Deutschland ausgespielt. Der beginnende
Freiheitskampf der Griechen mit der Seeschlacht von Tschesme 1770 im Hin-
tergrunde hat in einer Art auf den Roman eingewirkt, die wohl nicht mehr
festgestellt werden kann. So ergeben sich Beziehungen zur französischen Re-
volution und weiterhin zum beginnenden Kampf um die Erhebung Deutsch-
lands. Die Lebensbeziehungen der Dichtung sind also dicht verwoben, so
unlösbar und nicht zu sondern wie das Geflecht des Lebens selber. Hölderlins
„Hyperion" wird als ein Ganzes zu einem Gleichnis für die Erhebung der
deutschen Seele und des deutschen Vaterlandes aus dem Glauben an ein ver-
lorenes und wiederzugewinnendes Goldenes Zeitalter. Wie endet der Ro-
man? Es ist falsch, seinen Schluß mit dem angeblich schwebenden Schluß *Hyperion*
von Goethes „Tasso" zu vergleichen. Der Schluß des „Tasso" ist ein Unter- *und Tasso*
gang. Hyperion aber beginnt ein neues Leben. Nur das Wie und Was ließ
der Dichter „in Schwebe". „Nächstens mehr." Der Roman ist zu Ende. Der
Held steht dort, wohin er gelangen wollte. Er ist zur Verkündigung der
Schönheit berufen. Er ist bereit. Die Fortsetzung des Romans bildet das nun
reife Leben und dichterische Schaffen Hölderlins. Das hymnisch-musikalische
Spiel „Empedokles" ist ein vollendetes Drama. Es ist die gleiche Tragödie *„Empedokles"*
wie Goethes ursprünglicher „Faust": durch Vernunfterkenntnis und durch
das entweihende Wort in das sakrosankte Geheimnis der Gottheit einzu-
brechen, in ein Geheimnis, das verschwiegenen Herzens geglaubt und ver-
ehrt werden muß, aber nicht dem Widersinn der erkennenden und sprechen-
den Vernunft preisgegeben werden darf. Es ist bei Faust wie bei Empe-
dokles die Urschuld des Menschen, seine Schuld an sich, und sie kann nur
durch seine Ursühne, die Sühne an sich wieder gutgemacht werden. Das aber
ist nicht der gemeine Tod, die Auslöschung des vitalen Daseins, sondern der
Persönlichkeitstod im höchsten Sinne, Wiedergeburt durch Rückkehr in die
schuldvoll gelöste göttliche Gemeinschaft. Zu diesem Gedanken und zu die-
sem Entschluß sich durchzuringen und ihn zu vollstrecken, diese Verwand-
lung der Seele, das ist die Handlung des Dramas. Man muß in dem Gedan-
kenkreis bleiben, dem die Idee des Dramas nun einmal entstammt. Das ist

Hölderlin die Vorstellungswelt jener Religionen und Kulte, die um den Logos-Gott-Schöpfer geordnet sind. Hyperion und Empedokles sind Brüder. Hölderlins lyrische Dichtung kreist erlebnismäßig und gedanklich um die Ideen, die in den beiden großen Gebilden „Hyperion" und „Empedokles" Form geworden sind. Der Stil seiner Lyrik, das ist überwiegend die große Form der antiken Lyrik. Angefangen von der Tübinger Elegie „Griechenland" über alle folgenden Gedichte führt wie eine goldene Spur der Gedanke des Wunscheilandes und des Kindheitsparadieses herauf zu dem Gedicht „Der *„Archipelagus"* Archipelagus", das den Mittelpunkt in Hölderlins lyrischer Dichtung darstellt. Das geschichtliche Gemälde des alten Hellas gipfelt in einer Prophetie und in einem Zuruf an die eigene Nation. Deutschland ist zum Erben von Hellas und zur Wiederherstellung des goldenen Zeitalters berufen. Hölderlin aber, der Dichter, fühlt sich als Bote der Götter, als Verkünder der kommenden neu geordneten Welt, als Beauftragten des Vaterlandes und Erzieher seines Volkes.

In Schwaben hat sich durch die drei Freunde ein geistiges Ereignis ohnegleichen vollzogen. Die beiden Denker richten nebeneinander im ebenmäßig-*Die zwei* sten Gegensatz aus dem hellenisch-deutschen Baustoff vieler Jahrhunderte *Philosophen* zwei Bauwerke entgegengesetzten Stiles auf. Josef Schelling arbeitet von der Welt her, die ein Gefüge von polaren Gegensätzen ist, auf Gott zu, das All-Eine. Die Weltgegensätze drängen den denkenden Verstand zu einem Monismus, zu einem Weder-Noch, in dem sie zusammenfallen, zu einer coincidentia oppositorum, zu Gott, dem reinen Sein. Das Sinnbild dieser Denkweise ist der Kreis, in dessen Mittelpunkt, Gott, alle Strahlen der Welt enden. Von der Welt her ist Gott unbegreiflich. Er muß sich offenbaren. Das Gebäude Schellings ist eine induktive, irrationale Philosophie der Identität aller Dinge in Gott. Sie hat ihren Ahnherrn in Nikolaus von Kues. Wilhelm Hegel arbeitet von Gott her, dem einen Urgrunde, auf die Welt zu. Mit Gott fängt alles an. Dieses All-Eine drängt den denkenden Verstand in ein Sowohl-Alsauch, in zwei zeugungsfähige Gegensätze zu spalten, damit daraus ein Drittes hervorgehen kann, die Welt aus der Trinität Gottes zur Trinität aller Dinge, das beständige Werden. Das Sinnbild dieser Denkweise ist das gleichseitige Dreieck, von dem jeder Winkel sich zu zwei entgegengesetzten öffnet und durch die Gegenseite wieder zur alten Einheit geschlossen wird. Von Gott her ist die Welt begreiflich. Sie kann erkannt werden. Das Gebäude Hegels ist eine deduktive, rationale Philosophie der Trinität Gottes und der abbildlichen Trinität aller Dinge und Begriffe der Welt. Sie hat ihren Ahnherrn in Meister Eckart. Die beiden Wege gottaufwärts und weltabwärts

waren nicht zwei, es sind die beiden einzigen Möglichkeiten der Philosophie. Sie unterscheiden sich nur in der Richtung des einen Weges. Schelling und Hegel bedeuten eine Wiederherstellung, wenn auch Verweltlichung der beiden altdeutschen Denkweisen, der monistischen durch Schelling, der urbildlichen Trinität durch Hegel. Das Größte aber war dieses, daß der dritte, der *und der Dichter* Dichter, Friedrich Hölderlin, den Satz der beiden Denker, deren jeder des andern Gegensatz war, in seiner Dichtung künstlerisch verwirklichte, Schellings Rücksturz in den Schoß Gottes und Hegels beständig werdende Welt, Schellings goldene Zeit, die hinter uns liegt, und Hegels Vollendung im Schoße der Zukunft. Denn Hölderlin machte aus dem verlorenen hellenischen Paradies der ersten das deutsche Paradies der letzten Tage.

Auf Ludwig Uhland und seine Freunde wartete ein Tagwerk, das bescheidener war. Auch sie waren, minder groß, zu dritt. *Johann Ludwig Uhland,* *Drei* 1787 bis 1862, aus Tübingen, sorgfältig erzogen, in Körperübungen gewandt *schwäbische* und auch seines lateinischen Verses mühelos sicher, trieb seit 1801 an der *Dichter* heimischen Hochschule pflichtgemäß die Rechte. Was ihn wirklich fesselte, waren die germanischen und romanischen Sprachen. Er begann schon jetzt in der mittelalterlichen Literatur zu stöbern. Am fruchtbarsten war für ihn eine Schülerfreundschaft. *Justinus Kerner,* 1786 bis 1862, aus Ludwigsburg, war von kleinauf gewohnt, zu zwei älteren Brüdern ehrfürchtig emporzublikken, zu Georg Kerner, der in Paris ein Jakobiner und in Hamburg ein deutscher Volksmann wurde, zu Karl Kerner, den General, Freiherrn, Minister. Auf der Schule hatte ihn ein Arzt durch ein paar magnetische Striche gesund gemacht. Das bestimmte seine Geistesrichtung. Er schrieb sich die Gabe vorausahnender Träume zu und glaubte an Geister. Frühreif, begann er mit zwölf Jahren zu schreiben. Und mit zweiundzwanzig Jahren war er schon Arzt. Auch für Kerner war die Freundschaft mit Uhland ein Erlebnis. Der dritte war *Karl Friedrich Mayer,* 1786 bis 1870, aus Bischofsheim. Man traf sich auf Kerners Stube. Hölderlin galt ihnen als der große Dichter. Der Kreis erweiterte sich und hatte berühmte Besuche, so von Jens Baggesen und Adam Öhlenschläger. Die Freunde begannen Volkslieder zu sammeln. Ihre ersten Gedichte erschienen in Cottas „Morgenblatt", im Wiener „Musenalmanach", in der „Zeitung für Einsiedler", im Wiener „Prometheus". Um eine eigene Tribüne zu haben, setzten sie Cottas „Morgenblatt für gebildete Stände" *Morgenblatt* wenigstens handschriftlich ein solches für ungebildete Stände entgegen. Es *für ungebildete* lag seit Anfang 1807 in Kerners Stube auf. Hier standen Gedichte von Ker- *Stände* ner und Uhland, Aufsätze und Bruchstücke aus dem Nibelungenlied von Uhland, Bleistiftzeichnungen von Mayer. Dann gingen die Freunde auf Rei-

sen. Kerner besuchte 1809 die großen Spitäler in Hamburg, Berlin und Wien, um seine ärztliche Ausbildung abzuschließen, und brachte die „Reiseschatten. Von dem Schattenspieler Luchs" 1811 mit, das erste selbständige Buch des Kreises. Uhland ging 1810 nach Paris, vertiefte sich in altfranzösische und altdeutsche Handschriften, schrieb ab, übersetzte, dichtete und legte seine Studien in dem Aufsatz „Über das altfranzösische Epos" 1812 nieder. Als die Freunde wieder daheim waren, fanden sie die Lage verändert. Inzwi-

*Uhlands
Dichtung*

schen war Gustav Schwab, 1792 bis 1850, aus Stuttgart so weit. Sein Tübinger Freundeskreis schloß sich 1813 zu der farbentragenden Verbindung „Romantika" zusammen. Aber dort hatten die Norddeutschen weitaus das Übergewicht. Zwischen den Freunden Uhlands und Schwabs ergab sich ein Verhältnis. Und so erschien denn als gemeinsames Unternehmen 1811 der „Poetische Almanach", besorgt von Justinus Kerner. Der Beitrag Uhlands und Kerners bildete das Hauptstück. Das meiste stammte von norddeutschen Romantikern und ihren Mitläufern. Die zweite Sammlung von 1813 hieß „Der deutsche Dichterwald". Er war schon kein schwäbisches, sondern ein romantisches Unternehmen. Fouqué zeichnete als Mitherausgeber. Eichendorffs Gedichte gaben ihm Glanz und Ansehen.

Nur Ludwig Uhlands Liedkunst hebt sich schon jetzt als künstlerisches Ergebnis gemeinsamen Strebens der schwäbischen Jugend ab. Was Uhland gedichtet hat, ist in dieser Zeit entstanden. Seine Lyrik ist schier mehr als bei anderen der getreue Abdruck seines Wesens. Er war ein Mann von unbestechlichem Pflichtgefühl und unbeugsamem Rechtssinn. Daher versteht er weder zu spielen noch zu glänzen. Aber alles das, was eine gerade, aufrichtige, tätige Männerseele umspannen kann, das geben seine Gedichte in reichen Übergängen und Farben wieder. Die Leidenschaft fehlt seinen Versen.

*Das Genaue
und Pünktliche*

So liegt über seinen Liedern ein gleichgestimmter Hauch der Kühle. Von den schwäbischen Klassizisten hatte er die musterhafte Sorgfalt für Vers, Reim, Rhythmus, das Genaue und Pünktliche. Was er macht ist ganz und gar fertig. Unreifes gibt es unter seinen Gedichten nicht. Was den größten Anteil an seiner künstlerischen Durchbildung hatte, das waren Kultur und Dichtung des Mittelalters. Uhlands Dichtung ist durchaus geschichtlich gerichtet. Er hat ein besonderes Gefühl für den Ton des Volksliedes. Neben Eichendorff und Brentano ist er der Mitschöpfer des modernen deutschen Liedes. Alle seine Gedichte scheinen bereits auf eine Singweise geschrieben und viele von ihnen sind auch immer wieder vertont worden. Seine staatsbürgerlichen Gedichte wirken durch den edlen Wortschwung, der die schwäbische Literatur als Ganzes auszeichnet. Die Form, die seinem ganzen geschichtstreuen We-

sen wie keine zweite entsprach, hat er sich in seinen epischen Gedichten, den Balladen und Romanzen geschaffen.

Das Gegenspiel zu Uhlands Kunst war in jeder Weise die Lyrik Kerners. Sie ist Stegreifdichtung. Sie ist naturgetreu, in jedem Zuge erlebt, aber eben darum fehlt ihr die höhere Form. Kerner kannte stets nur eine erste Niederschrift. Er brachte das Herz nicht auf, die Massen seiner Gedichte zu sieben. Sie waren ihm alle gleich lieb. Nach seiner Anlage war er ein Formkünstler. Aber er gab nichts auf Haltung und Sauberkeit, weder als Dichter in seinen Versen, noch als Mensch in Kleidung und Gehaben. Dazu kam eine mißverständliche Auffassung vom Wesen des Volksliedes. Er nahm die oft nur scheinbare Unform des Volksliedes für die Hauptsache. Daher bemühte er sich, diese Unform bewußt und genau nachzubilden. Das gelang ihm bei seiner Anlage, so oft er wollte. Diesen Mangel an künstlerischer Selbstzucht muß man besonders bei seinen Balladen und Romanzen fühlen. Doch auch da gelangen ihm Kunstwerke wie „Kaiser Rudolfs Ritt zum Grabe". *Kerners Dichtung*

Die Führung innerhalb Schwabens und die Führung durch Schwaben in der Bewegung der süddeutschen Restauration lag nicht bei Uhland und dem Kreise um ihn, sondern bei dem Dreigestirn Schelling, Hegel, Hölderlin. Die schwäbische Restauration ist aus dem schwäbischen Humanismus hervorgegangen.

Baiern war nach Vereinigung mit Kurpfalz in den Napoleonkriegen durch den Zugewinn vor allem Mainfrankens ein mächtiger deutscher Staat und 1806 Königreich geworden. Man fühlte sich in München für diesen politischen Aufstieg auch geistig verpflichtet. Ein umfassender Kulturplan wurde verwirklicht. Männer von Rang und Namen wurden nach München und zumal in die mainfränkischen Städte berufen, um deren verkümmertes Geistesleben wieder aufzuwecken. So schlossen sich gerade an der Mainlinie überall die geistigen Fugen zwischen dem nördlichen und südlichen Deutschland und sie verklammerten örtlich und persönlich die vielfach gleichlaufenden Bestrebungen der ostdeutschen Romantik und der süddeutschen Restauration. *Großbaiern*

LANDSHUT wurde Heimsitz der Hochschule. Sie war, um die barocke Vergangenheit endgültig und sinnbildlich zu Gunsten der neuen Richtung abzutun und die neue Richtung sichtbar zu bezeugen, 1800 von Ingolstadt nach Landshut verlegt worden. Mit ihr übersiedelte, als Bürge für den geraden Zug der bairischen Restauration, *Johann Michael Sailer*, 1751 bis 1832, aus Oberbaiern. Er trug in Landshut Sittenlehre und angewandte Theologie vor. Er war der Prediger der Hochschulkirche. Zu freundschaftlichem Verkehr empfing er des Abends seine Schüler und Freunde. Wie ein Wander- *Hochschule Landshut*

prediger besuchte er seine Pfleglinge am Rhein, in Schwaben, in Sachsen, in
der Schweiz. Man muß sich weit zurück bis ins vierzehnte Jahrhundert er-
innern, um auf einen Priester von gleich allgemeinem und tiefem Einfluß zu
treffen. So geistreich und fesselnd Sailers Gespräche waren, so schlicht sind
seine Bücher. Er hatte das Vermögen, aber nicht den Ehrgeiz zur Literatur.
Die religiöse Bewegung um Sailer hat mit den gleichzeitigen religiösen Strö-
mungen innerhalb der Romantik nichts zu tun. Es war eine Bewegung im
Bereiche der römischen Kirche selber, wie sie seit je mit dem steigenden und
fallenden Rhythmus gläubiger Innerlichkeit gegeben war. Unter den anderen
Hochschullehrern war die Ästhetik Schillers und die Philosophie Fichtes ver-
treten. *Friedrich Ast,* der Lehrer der klassischen Altertumskunde, ein Thü-
ringer, gab in Landshut 1808 bis 1810 die „Zeitschrift für Wissenschaft und
Kunst" heraus, in der frühe Dichtungen Eichendorffs erschienen. Glanz ver-
lieh der Hochschule 1808 bis 1810 Friedrich Karl von Savigny. Er zog zu
Zeiten mit Klemens und Bettina Brentano den ganzen rheinhessischen Kreis
nach Landshut. In seinem Hause verkehrte Johann Michael Sailer. Ein Kreis
von Schülern der Heilkunde um den später so berühmten Arzt *Johann Nepo-*
muk Ringseis, 1805 bis 1812 Landshuter Student, las die Bücher der jungen
Romantik und füllte mit seinen Gedichten das 33. Stück der „Zeitung für
Einsiedler", Verse, die sich gegen die Feinde Deutschlands, gegen die nord-
deutschen Widersacher Baierns, gegen alle Unterdrücker des Werdenden
richteten, aber auch die neue Naturerkenntnis und die ärztliche Chemie
feierten.

WÜRZBURGS Ruhm waren seit 1803 Josef von Schelling und das alte
Juliusspital, das von Richters „Titan" bis zu Immermanns „Münchhausen"
in der deutschen Dichtung seine Legende hat. In die örtliche und geistige
Umwelt des Juliusspitals und des „Titan" gehört das rätselhafte Buch von
1804, das der Bibliothekar Schoppe geschrieben haben könnte: *„Nachtwachen*
von Bonaventura", kein romantisches Buch. Denn es setzt Richters Titanspott
über die Schlegel und in schärfster Art die Fichteparodien von Richters Lieb-
lingsgestalt, Schoppe, fort. Der Held des Buches ist der Findling Kreuzgang,
Bänkelsänger, Dichter, Schauspieler, Hanswurst, Nachtwächter, der das er-
zählt, was er auf seinen nächtlichen Gängen an anderen und seiner eigenen
Vergangenheit erlebt. Weder der Stil, der auf Doppelarbeit deutet, noch die
Weltanschauung, die mit Absicht spielt, um eigene Spuren zu verwischen
und fremde vorzutäuschen, sind Beweise für oder gegen den unbekannten
Verfasser. Schelling und seine Gattin Karoline als Verfasser würden Geist,
Absicht und Zwiespältigkeit des Buches am besten erklären.

NÜRNBERG war nicht mehr die Stadt des Meistergesangs, der 1787 in der Katharinenkirche sanft entschlummert war, wohl aber des Blumenordens. Nur war an ihm Singen und Sagen nicht mehr das Wesentliche, sondern jener alte und geheime Sinn, der sich mit der Endschaft aller Dinge befaßte. Im Haus zur Weißen Rose hatte der Rosenbäcker *Matthias Burger* eine un- *Der Rosenbäcker und sein Kreis* schätzbare Sammlung aller Bücher, „welche von der Ewigkeit handeln", von Tauler bis zu Swedenborg vereinigt. Burger hatte seine Kenntnis aller Geheimlehren vom Reiche Gottes in Schwaben unter den Vorläufern Schellings abgerundet. Aber er war nicht nur ein Leser geschriebener Weisheit, sondern wie die Theosophen des siebzehnten Jahrhunderts Rechenkünstler und Glasschleifer, ein Kenner verwickelter Uhrwerke und ging mit Erdkugeln wie mit Fernrohren um. An Wochenabenden und Sonntagnachmittagen kamen unter seinen Büchern die Freunde zusammen: schlichte Bäckergesellen, kunstfertige Meister, vornehmer Stadtadel, Gelehrte und Geistliche, Gottsucher und Weise im Herrn. Es war, als senkte sich sichtbar über diesen Kreis das Reich Gottes nieder, da das alte Reich der Deutschen von dieser Welt verging. Im Blumenorden und in diesem Hause des Rosenbäckers machte *Gotthilf Heinrich Schubert*, 1780 bis 1860, aus dem sächsischen Hohenstein, durch Schellings Vermittlung seit 1809 Leiter der Realschule, seine entscheidende Wandlung durch von dem Jugendroman „Die Kirche und die Götter" 1804 über sein erstes naturwissenschaftliches Buch „Ahndungen einer allgemeinen Geschichte des Lebens" 1806 wie „Ansichten von der Nachtseite der Naturwissenschaft" 1808 zu seinem umfassenden Werk „Die Symbolik des Trau- *„Symbolik des Traumes"* mes" 1814, das überall die Gedankenspuren des Rosenbäckers und seines Kreises verrät. Traum, Dichtung und Offenbarung werden mit der Natur auf eine Stufe gestellt, weil sie alle die eine und gleiche Sprache reden: das Bild. In allem findet Schubert jene große Weltlaune wieder, der Leben und Tod gleichbedeutende, leicht vertauschbare Begriffe sind. Seelenkunde, Arznei- *Schubert, Kanne, Hegel* kunst, Naturwissenschaft, wie sie Gedanken der Romantik ausgebildet hatten, löste der Romantiker Schubert in bildhafte Anschauungen zurück und vermittelte sie an die künstlerischen Schöpfer der Zeit. Das war Schubert durch Nürnberg geworden. Doch das war nicht das ganze Nürnberg. Denn neben ihm wirkte an der gleichen Anstalt der Altertumskenner und Erforscher des Morgenlandes Johann Arnold Kanne als Geistesverwandter. Als Gegenspieler aber hatte er den Leiter des Gymnasiums Wilhelm Hegel, der gleichzeitig zu Nürnberg seine Philosophie von der Trinität aller Begriffe und Dinge zu Ende dachte.

BAMBERG rundete wie die Stadt des Hans Sachs und Albrecht Dürer lose

Die Kapellmeister Berglinger, Kreisler, Hoffmann Glieder zu einer Kette. Bamberg hatte am Frühmorgen der Romantik dem jungen Wilhelm Wackenroder seinen Kapellmeister Josef Berglinger ein- gegeben und lebendig werden lassen. Nach Bamberg kam im Frühherbst des Jahres 1808 *Ernst Theodor Amadeus Hoffmann*. Er kam an die kleine Bühne der Stadt, zunächst als Kapellmeister, um ihr dann als Theaterkomponist zu bleiben. Er besorgte die Tonstücke, entwarf die Spieleinrichtung, und was das Wichtigste war, er machte den Maschinenmeister. Unter seinen kunst- fertigen Händen gingen „Die Andacht zum Kreuze", „Der standhafte Prinz", „Die Brücke von Mantible" über die Bühne. Hoffmann also war es, der in der alten Bischofsstadt Bamberg, unweit von Bayreuth, auf der Grenze zwi- schen den bairischen Barocklandschaften und den ostdeutschen Landschaften

Der Bamberger Spielleiter Hoffmann der Romantik mit Calderons Dramen im Zusammenwirken aller Künste wie- der religiöse Festspiele auf die Bühne brachte, wenige Jahrzehnte, nachdem der bairische Barock sich ausgelebt hatte, wenige Jahrzehnte, ehe das große romantische Musikdrama entstand. Doch was Schubert durch Nürnberg, das geschah Hoffmann durch Bamberg. Er durchschreitet seine entscheidende Verwandlung. Durch musikkritische Aufsätze wird aus dem Tonkünstler der Dichter. All die kleinen Bamberger Aufsätze über das Wesen der Musik, über Beethoven, Mozart, Bach wurden dem erdichteten Kapellmeister Johann Kreisler zugeschoben. Kreisler, der Mensch, dessen Gehörsnerven offen lie- gen; das Genie der höchsten Einseitigkeit; der Künstler, der zu seinem Fluch die Fülle der Welt durch einen einzigen Sinn und daher mit unerträglicher Spannung in sich einströmen lassen muß: das ist Hoffmann selber. Er hat sich vor Kreislers Schicksal, dem Wahnsinn, dadurch gerettet, daß er von der Musik zur Dichtung überging. So stehen die beiden Bamberger Kapellmei- ster Josef Berglinger und Johannes Kreisler als Brüder nebeneinander.

Die jüngste Hochschule *HEIDELBERG* ist durch das Umstecken der Grenzsteine 1803 für Baiern verlorengegangen. Es kam an Baden. Ein gemeinsames Leben vereinigt hier für einige Jahre Führer der ostdeutschen Romantik und Träger der rheini- schen Restauration: Ludwig Tieck, die Brüder Eichendorff, Otto von Loeben, Achim von Arnim; Josef Görres, Georg Friedrich Creuzer, Klemens Brentano. Und damit das Sinnbild nicht fehle: Die Brüder Boisserée übersiedelten 1810 mit ihren Bildern nach Heidelberg.

Die Hochschule wurde von dem neuen Herrn frisch eingerichtet. Schellings Philosophie war fast ihr ausschließliches Bekenntnis. Unter ihren Lehrern war seit 1806 *Josef Görres*. Er ist in Heidelberg menschlich und literarisch ausgereift. Auf die Zuhörer machte er einen ungewöhnlichen Eindruck. Unter dem gleichen sittlichen Gesichtspunkt, unter dem er am Rhein Staatskunst

getrieben hatte, faßte er sich jetzt auf die Geschichte zusammen. Er las sehr anregend über altdeutsche Literatur. Das warf ihm seine „Teutschen Volks- *„Teutsche* bücher" 1807 ab. Sie sind in der Art der „Kinder- und Hausmärchen" angelegt *Volksbücher"* und durch einen großartigen Überblick eingeleitet. Die Art seiner geschicht- lichen Studien wird durch einen Aufsatz „Religion in der Historie" 1807 be- zeichnet. Die geistmächtigste und sprachgewaltigste Schrift des Jahrhunderts sind die „Schriftproben von Peter Hammer" 1808, wo Görres, versteckt hin- *„Schriftproben"* ter vorgespiegelten Probesätzen in den verschiedenartigsten Schriftarten, die zeitgenössischen Zustände grell und grausam geißelt. Die Aufgabe, die auf Görres wartete, beginnt vor dem Hintergrunde dieser beispiellosen Satire sichtbar zu werden.

Die Stadt besaß einen unternehmungsfrohen Verleger. *Johann Georg Zim-* *Firma Zimmer* *mer*, 1777 bis 1853, von der Untermühle bei Homburg, lernte in Frankfurt *und Mohr* und Göttingen den Buchhandel und hörte Vorlesungen. Friedrich Perthes zu Hamburg gab ihm seit 1800 den letzten Schliff. Johann Georg Zimmer und Jakob Benjamin Mohr schlossen sich 1805 zu einer Buchhandlung zusammen, die ihren Namen fortan auf unvergängliche Druckwerke setzte.

„Des Knaben Wunderhorn", 1806 bis 1808, drei Bände, war das eine. Das einleitende altfranzösische Gedicht, „lai du corn", gab der Sammlung den Namen. Zu den reichlich 120 wirklichen Volksliedern kommen Balladen und Romanzen, Legenden und geschichtliche Lieder, Beiträge aus der älteren deutschen Lyrik von Opitz bis Pfeffel. Was die beiden Sammler und Heraus- geber Achim von Arnim und Clemens Brentano geben wollten, war also kein Volksliederbuch, sondern ein Hausbuch der deutschen Lyrik vom sechzehn- ten bis ins neunzehnte Jahrhundert. Keines dieser Gedichte ist aus münd- licher Überlieferung aufgezeichnet. Die gedruckten Vorlagen, aus denen ge- schöpft wurde, sind auf den Zeitraum von 1537 bis 1807 verteilt. Die leitende *Buch der* Kraft des Unternehmens war Arnim. Zu seinen Lasten gehen auch die ge- *deutschen Lyrik* wagten Eingriffe in den überlieferten Wortlaut. Brentano hat ihm hierin Widerstand geleistet, soviel er konnte. Grundsatz der beiden Freunde war es, ein leicht lesbares, auch feineren Bedürfnissen entsprechendes Volksbuch zu bieten. Sie unterdrückten allzu Derbes, und was sich nicht unterdrücken ließ, das verglätteten sie. Scharfe Ausfälle auf die Frauen wurden umgedeu- tet. Was allzu aufdringlich einem der deutschen Kirchenbekenntnisse ent- sprach, wurde verwischt oder fortgelassen. Es sollte ein Hausbuch sein. An die Spitze der Lobredner stellte sich Goethe. Für Tadler sprach am verbind- lichsten Friedrich Schlegel.

„Zeitung für Einsiedler" 1808 war das andere. Es war das Blatt des gan- *Einsiedlerzeitung*

zen Freundeskreises. Mit Hamanns Laune und in Hamanns Stil war im Jän-
ner 1808 das Unternehmen angekündigt worden. Goethe und Schiller waren
wider Willen und ehrenhalber vertreten. Die Beiträge der Brüder Schlegel
Alte und neue und Tiecks — von diesem ein Stück aus „König Rother" — waren unbedeu-
Sagen und tend. Johann Paul Richter war mit seiner „Friedenspredigt" zur Stelle. Als
Wahrsagungen geschlossene Gruppe rückten die Schwaben mit ihrer morgenfrischen Lyrik
auf, als geschlossene Gruppe auch die Landshuter. Das war die Jugend. Von
hohem Wert war die Mitarbeit der Brüder Grimm. Sie verliehen dem Blatt
einen gewissen wissenschaftlichen Ernst und verdienten sich hier die Ritter-
sporen. Der dritte Bruder Grimm, Ludwig, steuerte die meisten Kupfer bei.
Philipp Otto Runge war ohne sein Wissen mit zwei Märchen vertreten, Josef
Görres mit dem Aufsatz „Der gehörnte Siegfried und die Nibelungen",
Achim von Arnim mit Sonetten und „Alten Briefen eines Einsiedlers", Bren-
tano mit Gedichten, Übersetzungen aus Froissarts Chronik und italienischen
Novellen. Die Romantik hatte an dem Blatt so gut wie keinen Anteil. Arnim
war ja lediglich Herausgeber. Die „Zeitung für Einsiedler" ist ein Unter-
nehmen der süddeutschen Restauration. Sie wollte, wie Görres es treffend
ausdrückte, ein Feuer anzünden, um den übelriechenden Heerrauch der Zeit
zu vertreiben. Man sollte die altdeutsche Literatur wie eine lebendige lesen.
Die Mitarbeiter waren bemüht, eine Literatur der guten Laune zu bieten.
Alle literarischen, wissenschaftlichen, künstlerischen Kräfte, die aus der Ver-
gangenheit an einer Erneuerung des nationalen Lebens arbeiteten, sollten
zu einem gemeinsamen Unternehmen gesammelt werden. Das Blatt hat den
Wert einer geschichtlichen Urkunde. Als es schon Ende August 1808 auf-
gegeben werden mußte, sammelte Armin die losen Blätter und gab sie 1808
„Tröst als Buch heraus: „Tröst Einsamkeit, alte und neue Sagen und Wahrsagungen,
Einsamkeit" Geschichten und Gedichte."

„Heidelberger 　　　Mehr Glück hatten die Freunde mit ihrer zweiten Zeitschrift „Heidelber-
Jahrbücher" ger Jahrbücher", die seit Jänner 1808 erschien und in fünf Abteilungen das
gesamte Gebiet des Wissens umfaßte. Die wichtigste fünfte Abteilung
Sprachwissenschaft, Geschichte, Literatur, Kunst leitete Georg Friedrich
Creuzer. Der fleißigste Mitarbeiter war Josef Görres.

　　　WIEN. Im Sommer 1812 blickte die geknechtete Welt auf Petersburg, im
Frühjahr 1813 auf Berlin, im Sommer 1813 auf Wien. Die Träger der poli-
tischen Romantik hatten den Hebel in Berlin, in Königsberg, in Breslau
angesetzt. Nun behielten jene recht, die nach Österreich gegangen waren, in
das bei zwanzigjährigem Ringen im Stich gelassene Österreich. Zu Wien
wurde vereinigt, was getrennt angestrebt worden war, und durch die Tat

verwirklicht, was die ostdeutsche Romantik und die süddeutsche Restauration geistig entworfen hatten.

Es ist das Antlitz eines neuen Staates, die Züge wechselnd im Feuerschein des endlosen Krieges, das sich aus den geistigen Kämpfen der Jahrhundertwende dauernd ausprägen will. Drei Männer, mehr geistige Arbeiter schlechthin als dichtende Schöpfer und Gestalter, drücken die drei Richtungen aus, für die es sich zu entscheiden galt. *Heinrich Josef Collin,* 1771 bis 1811, aus Wien, Piaristenschüler und Hofbeamter, mit Goethe und Metastasio gleichermaßen vertraut, geriet von Iffland und Kotzebue her an Metastasios Oper von 1740 „Attilio Regolo". Er machte daraus sein erstes Stück persönlichen Stiles „Regulus", das 1801 unter stürmischem Beifall gespielt wurde. Indessen das Wetter aller seiner späteren Stücke, „Coriolan" 1812 bis zu „Die Horatier und Curatier" 1810 schwankte zwischen Trüb und Heiter. Collin ist über Ayrenhoffs Alexandrinertragödien und Weidmanns Jambenstücke durch Metastasio unmittelbar auf den Barock zurückgegangen. Josef II. wollte aus Österreich einen deutschen Staat machen. Collins Staatsgedanke aber lautet: Österreich muß aus der Gesamtheit seiner Völker hervorgehen. Die deutsche Bildung soll führen, kann aber nicht herrschen. Daher suchte er in der römischen Virtus die Staatstugend zu vorbildlicher Größe zu steigern. *Josef von Hormayr,* 1781 bis 1848, von Innsbruck, der aus seiner Teilnahme am Freiheitskampf von 1797 seine Liebe zur Geschichte gefunden hatte, sah in der gemeinsam durchlebten Geschichte Österreichs das bindende Gefühl für alle österreichischen Staatsvölker. So war sein „Österreichischer Plutarch" 1807 bis 1812 gemeint. Das Verhältnis der Staatsvölker zueinander erschien ihm als eine Art Kameradschaft, die sich auf soviel gemeinsam Durchlittenes und Ersiegtes gründete. Verkörpert sah er diese gemeinsame Geschichte im Fürstenhaus. Für ihn war das nicht mehr ein Geschlecht deutscher Kaiser, sondern nun, da es eine österreichische Kaiserkrone aufs Haupt genommen und die deutsche niedergelegt hatte, wirklich das Haus Österreich. Die Taten und die Geschichte des Fürstengeschlechtes sollten der gemeinsame Gegenstand aller österreichischen Dichtung werden. Wo immer in Wien Verse gemacht wurden, da warb Hormayr für eine österreichische Heimatkunst. Durch die Dichtung sollte die geschichtliche Wesenheit dieses Staates Gemeinbewußtsein seiner Völker werden. Selbst ein Beispiel zu geben, begann er auf der Flucht vor Napoleon zu Pest an einem Heldengedicht „Rudolf von Habsburg" zu arbeiten. Matthäus Collin gab sich im Wetteifer mit Shakespeares Königsdramen alle Mühe, die Wiener Bühne mit seinen österreichischen Stücken zu bevölkern. *Josef von Hammer,* 1774 bis 1856, aus Graz, setzte in

Das heroische Drama

Der österreichische Plutarch

Dolmetsch des Morgenlandes

dem Augenblick ein, da mit den Jahren 1804 und 1806 die deutsche Ver-
gangenheit des Staates abschloß und seine Ostaufgabe wieder wegleitend
wurde. Seit dem siebzehnten Jahrhundert war Wien die Schule der morgen-
ländischen Studien geworden, vor allem durch die Akademie der morgen-
ländischen Sprachen, die Maria Theresia 1754 gegründet hatte. An diese
Akademie kam Hammer. Er wurde Dolmetsch bei der kaiserlichen Gesandt-

Mittelalter des Abendlandes und Morgenlandes

schaft in Konstantinopel. Als Sprachkenner begleitete er den englischen See-
führer Sidney Smith nach Ägypten. Mit einer Zeitschrift „Fundgruben des
Orients", 1809 bis 1818, leitete er sein Lebenswerk ein unter höchsten Ge-
sichtspunkten. Die Gedichtsammlungen des Ostens begann er in Verse zu
übertragen, so 1812 die des Persers Hafis. Durch Hammers nachgestaltende
Verse blühte aus dem vermeintlichen Dunkel des Morgenlandes eine ganze
Welt der Dichtung auf. Was Hammer entdeckte, war das mittelalterliche
Morgenland, jene Hochblüte, die sich zur Zeit der Kreuzzüge mit der goti-
schen Kultur des Abendlandes mannigfach verflochten hatte. Hammer zeigte,
daß es sich auch geistig lohnte, die starken Mittel einer Großmacht nach dem
Osten hin in Bewegung zu setzen. Seine „Fundgruben" wurden ein Durch-
gangsfeld westöstlichen Gedankenverkehrs. Das ganze Deutschland der
nächsten dreißig Jahre, von Goethe über Rückert und Platen zu Bodenstedt,
zog Hammer damit in seine Kreise. Über das Deutsche hinaus zum Ganzen
strebend, bearbeitete Hammer gemeinösterreichische Sagen und schilderte
1812 in Hexametern „Wiens Gärten und Umgebungen", jene Barockgärten,
die zur gleichen Zeit mit ihrem Duft und dem matten Glanz ihrer Marmor-
bilder dem Romane Eichendorffs den letzten Schimmer Altösterreichs liehen.

Der Salon dieses neuen geistigen Wien war das Haus in der Alservorstadt,
das 1804 *Karoline Pichler*, 1769 bis 1843, bezogen hatte. Wie im Haus ihres
Vaters, des Hofrats Franz von Greiner, Mozart, Sonnenfels, Denis verkehrt

Der Wiener Salon

hatten, so waren bei ihr Collin, Hormayr, Hammer zu Gaste. Durch Hormayr
für die vaterländische Richtung gewonnen, eröffnete sie den österreichischen
Balladenbetrieb. Sie begann mit bürgerlichen Geschichten auf Wiener Hin-
tergrunde. Aus ihren Balladen wurden Romane und ihre Wiener Geschichten
übersetzte sie ins Geschichtliche. Sie hat die neue Literatur klassischen und
romantischen Stiles dem Wiener Bürgertum mundgerecht gemacht. Aber das
neue Österreich als Staat konnte weder aus dem Klassizismus noch aus der
Romantik geistig aufgefüllt werden. Sein Bug stand in gerader Fahrt nach
einem neuen selbstgemäßen Ausdruck seines inneren Wesens. Wie aber
wirkte sich der Doppeldruck vom Klassizismus und von der Romantik her auf
die Stadt Wien aus?

Der aufstrebende Klassizismus hatte Österreich stark befruchtet. Wieland, *Klassizismus in Wien*
der in Wien von je eine Schule hatte, und Schiller, dessen Stücke auf den Vor-
stadtbühnen früh gespielt wurden, sahen sich rasch durch Goethe überflügelt,
als er von den böhmischen Bädern her die Fäden seiner persönlichen Be-
ziehungen in Wien zu einem dichten Netz zusammenzog. Goethe hat als
erster und wohl einziger die ganze Vielheit und Fülle, das einmalige Sonder-
wesen dieses Staates von Völkern begriffen und sie als Menschengenießer in
einer Auslese auf sich wirken lassen. Zwei seiner Verehrer, der Mainfranke
Leo von Seckendorf, 1775 bis 1809, und der Wiener Josef Ludwig Stoll, 1778
bis 1815, die einander von Weimar her kannten, gaben 1808 die Zeitschrift
„*Prometheus*" heraus. Ihr Vorbild waren die „Horen". Ihre Mitarbeiter wa- *„Prometheus"*
ren Wieland und Voß, ihre Leitsterne Winckelmann und Lessing. „Prome-
theus" brachte aus dem Kreis der Romantik nur unwesentliche Beiträge. Ihr
Glanzstück war Goethes „Pandora". „Prometheus" war das Blatt, das unter
Goethes Schutz und Namen zu Wien, dem einzigen sicheren deutschen Bo-
den, dem Klassizismus eine ruhige Stätte schaffen wollte.

Die Romantik begann seit dem November 1806 nach Wien, der Freistatt
für die Geächteten des deutschen Gedankens, umzuziehen, nicht mit ästhe-
tischen, sondern mit politischen Heften. Denn sie kamen alle in die Haupt-
stadt eines völkerreichen Großstaates. Zacharias Werner, dem das ungläubige
Berlin nicht einmal sein „gereinigtes" Christentum verziehen hatte, war
schon 1807 da. Dann 1808 Ludwig Tieck, der die Witterung um das Burg- *Romantischer Zuzug*
theater in Augenschein nahm und für alle Fälle den ersten Aufzug seines
„Donauweibs" fertig machte. Im gleichen Jahr rückte der Berliner Vortrags-
meister *August Wilhelm Schlegel* auf. Josef von Eichendorff, Otto Heinrich
von Loeben, Klemens Brentano gingen durch und vorüber oder verweilten.
Nicht als Märchenerzähler, Geiger und Volkssänger sind die romantischen
Führer nach Wien gekommen. Die Verbindung vollzog sich keineswegs über
den Wurstelprater, sondern über die Staatskanzlei. *Friedrich Gentz*, der
schon 1793 seine Burkeübersetzung an die Staatskanzlei geschickt hatte, trat
1802 in Wiener Dienste. Seine beste Schrift, „Fragmente aus der neuesten
Geschichte des politischen Gleichgewichtes von Europa", 1806 griff durch
und erhellte die Köpfe. Als sein Schützling kam nach dem Scheitern seiner
Berliner Pläne *Adam Müller* und wurde 1813 in den Staatsdienst übernom-
men. *Friedrich Schlegel* war, frisch bekehrt, 1808 in Wien eingetroffen. Man *Friedrich Schlegels Zeitblätter*
verwendete ihn zunächst 1809 im Lager des Erzherzogs Karl, wo er Armee-
befehle und Aufrufe an die Deutschen zu schreiben und die Feldzeitung zu
leiten hatte. Tatsächlich hat die romantische Bewegung in Wien nur ein neues

wertbeständiges Werk gezeitigt, die politische Presse. Vorangegangen war
der Schwabe Johann Melchior Armbruster, der 1805 die amtliche „Wiener
Zeitung" übernahm und seit 1808 mit den „Vaterländischen Blättern" öffent-
liche Meinung zu machen begann. Friedrich Schlegel, der während des Feld-
zuges von 1809 die „Österreichische Zeitung" geleitet hatte, führte seit 1810
den eben gegründeten „Österreichischen Beobachter". Die „österreichische
Reaktionspresse" ist keine österreichische Erfindung. Sie war eines der
romantischen Angebinde an den Donaustaat. Doch wie überall, die beiden
Brüder hielten es mit öffentlichen Vorträgen. August Wilhelm Schlegel ver-
suchte es 1808 mit Vorlesungen über dramatische Kunst und Literatur und
kaum war er fort, so nahm Friedrich Schlegel das Wort, 1810 über neuere

und Wiener Vorlesungen Geschichte, 1812 über Weltliteratur. Seine Vorträge gingen aus von der Ein-
heit des Menschengeschlechts, von dem einen ewigen Wort und von dem
Gedanken, daß es der Geist ist, der Blut und Erde umwandelt. Sie boten im
Anschluß an die Berliner Vorlesungen von August Wilhelm Schlegel und
Johann Gottlieb Fichte, vielleicht schon von Wilhelm Hegel beeinflußt, weil
alle Literaturbewegungen auf metaphysische Gegensätze im „Innern des
Menschengeistes" zurückgehen, die entwicklungsgeschichtlich letzte Fassung
des Gedankens der romantischen Wiedergeburt. Literatur ist ein Gegebenes.
Er fragt nicht nach den Wurzeln, nur nach den Wirkungen, als ob irdische
Dinge nur wirkten und nicht bewirkt wären. Die Literaturen stammen ein-
fach — das Wie bleibt offen — aus dem Geiste der Völker, aus demselben
Geiste, den Schlegel sich in wunderlichem Ringelspiel aus eben diesen Lite-
raturen abzieht. Friedrich Schlegels Wiener Vorträge schlossen die große
Reihe romantischer Vorlesungen ab. Im Frühling 1812 zu Wien, im Tanzsaal
des „Römischen Kaiser" hat die Romantik ihr letztes, reifstes und größtes
Wort gesprochen. Drei literargeschichtliche Vortragsreihen: August Wilhelm
Schlegel behandelte in Berlin den Gegenstand vom kunstwissenschaftlichen
Standpunkte; Adam Müller sprach in Dresden darüber als Geschichtsschrei-
ber, indem er die Literatur aus Ort und Zeit entstehen und auf Ort und Zeit
zurückwirken ließ; was Friedrich Schlegel in Wien gab, war nicht Literatur-
geschichte, sondern Philosophie der Literaturgeschichte. Der romantische
Staatsgedanke bedeutete Hochgefahr für den österreichischen Völkerstaat.
Die romantische Literatur forderte, was es in Wien längst gab, und stieß
offene Türen auf.

Das Gewissen der Stadt Der getreue Eckart des Wiener Geistes, das literarische Gewissen der
Stadt, das ist *Josef Schreyvogel*, 1768 bis 1832, aus Wien, gewesen. Polizei-
lich beargwöhnt hatte er einst Wien verlassen müssen und 1794 bis 1796 zu

Jena gelebt, im Umgange mit Schiller, Wieland, Herder, als Mitarbeiter der Literaturzeitung. Das „Sonntagsblatt", aus einem älteren Plane 1807 herausgewachsen, war Schreyvogels Waffe und Werkzeug. Die Leser des Blattes waren die Stillen in Wien, die gegen allen Lärm das Wien und Österreich gehütet haben, ohne das es weder einen Grillparzer noch einen Stifter gäbe. Ihr Wortführer war der gereiste, weltläufige Wiener, der nach beiden Seiten die verwirrenden Einflüsse vom Klassizismus wie von der Romantik her abdämmte und den Platz freihielt für die kommende große Wiener Literatur. *Weimarer und Wiener Bühnenstil* Gegen den Klassizismus nahm er sich den „Prometheus" vor, nicht weil es um Goethe, sondern weil es um die Schauspielkunst des Burgtheaters ging. Schreyvogel meinte, die Weimarer Bühnenkunst tauge nichts für Wien, weil es der Bühne einer kleinen Stadt an dem Publikum fehle, nach dem sie sich bilden könne. Gegen die Romantik hatte Schreyvogel es leichter. Er umriß ironisch August Wilhelm Schlegels Brustbild. Er druckte Friedrich Schlegels Gedankensplitter ab und parodierte sie. Lessing nahm er gegen Schlegel in Schutz, was ein Lob verdient, wenn es in Berlin, und einen Tadel, wenn es in Wien geschieht. Schreyvogels innere Schlichtheit wehrte sich gegen alles, was wie Rummel aussah. Seinen geschärften Blick bestachen weder die Haltung des Olympiers noch die frischbekehrten Christenbekehrer. Er hat den Klassizismus nicht als Dichtung, sondern als Bühnenkunst für Wien bestritten. Und die Romantik besaß nichts, was sie hätte nach Wien bringen müssen. Die wissenschaftliche Kenntnis des Morgenlandes war hier seit alters heimisch. Die spanische und italienische Literatur waren beinahe Eigenbesitz gewesen. Und den Glauben der alten Kirche? Und das nationale Bewußtsein? Und das „Heldenbuch" trotz Kaiser Maximilian? Klassizismus und Romantik waren geschichtlich umgrenzte und abgeschlossene Bewegungen. Sie konnten in Wien nur Mode werden. Josef Schreyvogel hat verhindert, daß sie Wiener Mode geworden sind. Dieser Sieg des künstlerischen Wienertums war zugleich ein Sieg über die romantische Staatskunst in Österreich.

Alle Not hatte ein Ende. Denn 1814 wurde Josef Schreyvogel Leiter aller *Schreyvogel und das Burgtheater* drei großen Wiener Bühnen, des Burgtheaters, des Theaters am Kärntnertor, des Theaters an der Wien. Und fast gleichzeitig entdeckte er Franz Grillparzer.

ROMANTIK UND REVOLUTION

DIE FLURBEREINIGUNG DES WIENER KONGRESSES *hatte unter Anerkennung von Napoleons fachmännischer Vorarbeit die deutsche Landkarte sehr vereinfacht. Zwischen den beiden Großmächten Preußen und Österreich war eine Gruppe von kleinen Staaten übriggeblieben, zwar abgestuft nach Quadratmeilen und Kopfzahl doch ungefähr gleichen Ranges. Die Lage in diesen Kleinstaaten und in den zwei Großmächten war geistig und politisch wesentlich verschieden. Je geringer die Reichweite der eigenen Macht war, desto mehr lebte man nach Innen und ließ sich an den schönen Gütern genügen, die man aufgespart hatte. Die Begrenzung des gemeinsamen Daseins rückte auch die Stände enger zusammen und ließ „das Volk" zur Geltung kommen. Diese Enge machte aber auch radikal. Sie trieb die Gedanken statt in die Breite in die Tiefe und Höhe. In den süddeutschen Kleinstaaten und ehemaligen Reichsstädten trug man das alte Reich und eigene demokratische Einrichtungen lebhaft im Gedächtnis. Freiheit und Einheit, das ist Sicherheit gegen den Zugriff der Großen, gab es nur in einem neuen Reich. Alle radikalen Gedanken und Strebungen, die Revolution des Denkens, freies Volk und deutsche Republik sind in den Kleinstaaten aufgebrochen. In den beiden Großmächten hatte man Spielraum und wenig Bedürfnis nach Abenteuern. Man war nach so viel Seiten abgelenkt, daß man geistig nicht auf der Stelle zu treten brauchte. Man war in einem großen Vaterlande zu Hause, lebte in seiner Sicherheit und ein übergeordnetes Reich war kein Gewinn, sondern eher ein Opfer. Man hatte aber auch eine geräumige, geistige Welt um sich, in der man eigengesetzlich und eigenmächtig leben konnte. Der Landesfürst hatte den Staat geschaffen und war ein so großer Herr, daß der Abstand von ihm gar nicht zu überbrücken war. Ständische Verfassungen hatte man nie gekannt oder gänzlich vergessen. Die deutschen Großmächte waren Heimat und Rückhalt aller konservativen Gedanken und Mächte.*

Als die Deutschen aus dem Kriege heimkamen, den sie zu ihrer Freiheit und Einheit geführt zu haben meinten, fanden sie kein Vaterland, kein Reich und keinen Staat vor, sondern einen losen Verband ihrer Heimatstaaten, der staatsrechtlich kaum ein Begriff war und Deutscher Bund hieß.

I. GEISTIGE KRÄFTE

1814 bis 1866

Die kleinstaatlichen Landschaften von der Elbe und von Sachsen herüber *Die große Kleinwelt*
bis an den Rhein und nach Hessen sowie den Main hinauf bis an die böh-
mische und den Rhein empor bis an die Schweizer Grenze, das war der
Raum, in dem sich seit dem frühen Mittelalter dicht und lückenlos das jeweils
große Schrifttum zusammendrängte, die entscheidenden Wendungen voll-
zogen, die Spitzenwerke ans Licht traten. Hier blühte die ritterliche Lyrik
und der ritterliche Roman. Hier blühte die mystische Literatur beiderlei Ge-
schlechts. Hier hatte der Humanismus seine Hohen Schulen und seine Mei-
ster in Vers und Prosa. Hier geschah die deutsche Reformation und die Bibel
deutsch. Hier sind die deutschsprachigen Kunstwerke des Barock geschaffen
worden. Hier im Süden sind die Klassiker und in der Mitte die ersten Roman-
tiker geboren worden. Und hier versammelte sich alles, was in den Jahren
der Klassik und Romantik Namen und Rang und Leistung hatte.

An diesem schmalen Rain aus bescheidenen Fürstenhöfen, Hochschulen *Grenzrain der Zeiten*
und Städten aller Größen und Gewerbe scheiden sich die beiden Zeitalter,
deren Grenze nicht zwischen Österreich und Preußen, sondern mitten durch
den Rhein und den Main, durch Heidelberg, Frankfurt, Weimar, Jena, Leip-
zig, Dresden läuft. Wenn man dieser Scheidelinie folgt, so ist einem zumute,
als hätten über Nacht Vater und Sohn, Herr und Gesinde gewechselt. Eine
andere Generation ist da und plötzlich blickt man in neue Gesichter. Man
darf sich nur nicht durch den alten Herrn täuschen lassen, der in Weimar
noch immer regiert. Denn nicht einmal der tut so, als wäre nichts gewesen.
Auch er hat plötzlich ganz andere Dinge unter den Händen. Und er fängt
noch einmal auf andere Weise zu leben an.

Was aber hat sich über Nacht verändert? Diesmal nicht die Welt des Gei- *Heimkehr der Jugend*
stes, sondern der Dinge. Ein Krieg ist aus und die Jugend kommt heim. Sie
gibt das Zeichen. Und nun beginnen zwei Jahrzehnte lang überall in diesen
Kleinstaaten die Sprengschüsse zu rollen, die alles Gewordene durcheinander-
werfen. Das ist der Unterschied zwischen dieser kleinstaatlichen Welt und
der Großmacht Preußen. Die thüringische, die hessische, fränkische, schwä-
bische Jugend redet ihre eigene Sprache, die der Jugend.

1. DEUTSCHE MITTE

*Weimar
und Jena* An den Höfen und Hochschulen der drei benachbarten fränkisch-thürin-
gischen Landschaften, die immer geistig auf eine besondere Weise zusam-
mengespielt hatten, lösten Alter und Jugend einander ab.

THÜRINGEN hieß noch immer mit einem stürmischen Doppelwirbel des
Ruhmes Weimar und Jena. Doch in Weimar ging das Reich der Eumeniden
zu Ende und in Jena wollte das Reich der Jugend aufgehn.

*Goethes
Nachsommer* Das Deutschland Napoleons war für *Johann Wolfgang Goethe,* der In-
begriff des romanisch gestimmten Frankentums, der gemäßeste Spielraum
gewesen. Nun hoben ihn zwei einander widerstreitende Kräfte aus dieser
Umwelt heraus: das abendländische Mittelalter Boisserées und das morgen-
ländische Mittelalter Hammers. Zwischen beiden schwärmte sich Goethe in
das neue Zeitalter hinein. Sulpiz Boisserée schien es seit 1811 zu gelingen,
den Liebhaber der Hellenen für die gotische Baukunst und für die alt-
deutsche Malerei zu gewinnen. In den ersten zwei Heften seiner Zeitschrift
„Propyläen" gab Goethe mit gewohnter Sicherheit wieder, was er so nach
und nach aus Boisserée herausgeholt hatte. Aber gerade auf der Rheinreise,
die sie zusammen machten, mußte Boisserée Zeuge sein, wie sich Goethe aus
seiner Nähe wieder wegverwandelte. Denn im Frühjahr 1813 war Goethen
„Diwan" der „Diwan" des Schems-ed-din-Hâfiz, deutsch aus dem Persischen von Josef
Hammer, in die Hände gefallen. Goethe war hingerissen und eben auf jener
Rheinreise im Sommer 1814 begann er dem Hâfiz eine Reihe von Sprüchen
und Strophen nachzudichten. Zu Frankfurt, im Umgange mit der Linzerin
Maria Anna von Willemer, schoß die einigende Vorstellung in die Masse der
entstehenden Verse. Aus Wechselgedichten zwischen Marianne-Suleika und
Goethe-Hatem entstand die am schönsten gerundete Sammlung von Liebes-
liedern, das „Buch Suleika". Und so erschien 1819 der „West-östliche Di-
*Beiderlei
Mittelalter* wan", der dann 1827 und aus dem Nachlaß 1837 um weitere Stücke vermehrt
wurde. Es ist der letzte auserwählte Inbegriff von Goethes lyrischer Kunst in
Stimmungen, Rhythmen, Formen, Bildern, alles in der maßvollen Schönheit
lyrischer Kleinkunst. Gegen Boisserées malerisches deutsches Mittelalter hatte
Goethe sich für die Mystik des morgenländischen Mittelalters entschieden.
Die abendländische Mystik des Mittelalters war Goethen durch junge und
späte Ableitungen im Umkreis des Urfaust vertraut gewesen. Seit dem Zu-
sammenbruch seiner Welt von 1813 brauchte auch Goethe eine Restauration
aus seiner erstarrenden Antike heraus. Aber ihm widerstand der Gehalt, auf
den sich die deutsche Restauration bezog, ihm widerstand das abendländische

Mittelalter mit seinem Kruzifixus im Herzraum, ihm widerstand eine Mystik, der alles Diesseitige nur ein Jenseits versinnbildete. So vertauschte er das morgenländische Mittelalter mit dem abendländischen. Für den unausweichlichen Kruzifixus und seine Askese rückte die Sinnlichkeit Mohammeds ein und jene andere Mystik, der alles Jenseitige ein Abglanz des Diesseits war. *Das letzte Liederbuch* Goethe lebt sich in den Gesamtbesitz des Morgenlandes ein, entwickelt sein letztes Liederbuch aus Hâfis heraus und formt seine neue Faustschöpfung auf Moses zu. So haben Boisserée und Hammer an Goethe zusammengewirkt. Goethe hat Romantik und Restauration in beiderlei Gestalt, des Abendlandes und des Morgenlandes, genossen.

So verjüngt betrieb Goethe den Abschluß seines Daseins. Es sind drei Stufen, die zum krönenden Abschluß des „Faust" emporführen. Die erste Stufe bildet die Selbstschilderung, zu der ihn die zwölfbändige Ausgabe seiner Werke von 1808 genötigt hatte. Das wurde „Dichtung und Wahrheit", *„Dichtung und Wahrheit"* die mit Goethes Eintritt in Weimar abbrach. Bruchstücke aus der nun nur in der Vorstellung bestehenden Lebensgeschichte boten 1816 und 1817 die „Italienische Reise", 1822 die „Campagne in Frankreich" und „Die Belagerung von Mainz". Die zweite Stufe bildete die endgültige letzte Ausgabe von Goethes Werken, die in vierzig Bänden durch den Jenaer Philologen Karl Wilhelm Goettling im Verein mit Friedrich Wilhelm Riemer und Johann Peter Eckermann 1825 bis 1831 durchgeführt wurde. Die dritte Stufe bildete die neuerliche Beschäftigung mit Moses, zu der sich Goethe 1811 und 1812, *Moses* besonders aber 1819 durch die Noten zum „Diwan" gedrängt fühlte. Die Selbstschilderung zwang, das Faustgedicht noch einmal zu durchdenken. Die *Goethes letztes Geschäft* Werkausgabe nötigte zu einem äußeren Abschluß. Das Wiedererscheinen der Mosesgestalt brachte den schöpferischen Vorgang in den letzten Fluß.

Die beiden Teile des „Faust", wie sie 1808 und 1833 erschienen, sind in Wirklichkeit zwei Gedichte. Nicht sechzig Jahre des Schaffens trennen das Bruderpaar. Denn Goethe hat ja nur drei verhältnismäßig kurze Zeiträume an das Werk gewendet; 1773 bis 1775, die Jahre seiner stärksten Schöpferkraft; 1797 bis 1801, die Zeit der Freundschaft mit Schiller; 1825 bis 1831, sein letztes Geschäft. Es sind zwei Gedichte geworden, weil der gleiche Stoff zweimal aus verschiedenen Bildungskreisen um verschiedene Helden angeschlossen ist.

Der erste Faust lebte aus den Monaten der Frankfurter Genesung, aus den *Der erste Faust* Gedanken, die durch das Fräulein von Klettenberg, durch Goethes chemische Küche, durch seinen Umgang mit Paracelsus, durch seine plotinische Weltanschauung bezeichnet sind. Es war der gleiche Gedankenbereich, aus dem

354

Einbruch in die Werkstatt des Lebens das Faustbuch einst entstanden war. Fausts Magie im Volksbuch wie im ersten Faustgedicht ist der Versuch, sich mit dem Daseinsgrund der Natur mittels „imaginatio" vertraut zu machen. Sie ist ein frevelhafter Versuch, in das Schöpfungsgeheimnis einzudringen, ein Versuch, das Mysterium des Lebens mit Gewalt zu enthüllen und die verschlossene Werkstatt der Natur zu erbrechen. So liegt die schwerste tragische Schuld in diesem Sich-in-die-Natur-Vergaffen, weil es ein Mißbrauch des Doppeltriebes Erkennen und Zeugen ist, tragisch nicht minder wegen der notwendigen Folgen: geistiger Hochmut und sinnliche Vergeudung. Indem sich Faust dazu verführen läßt, durch „imaginatio" in den Lebensgrund der Natur einzudringen, macht er sich zwangsläufig mit ihr gemein. Er verfällt unter die Natur, da doch der Mensch geschaffen ist, über ihr zu stehen. Dieser sittliche Vorgang ist in drei Stufen dargestellt: Geisterbeschwörung und Teufelsbündnis; magische Verjüngung und ihre Folgen; die höllische Einweihung Fausts auf dem Blocksberge. Und diesen Ablauf spiegelt die Handlung des ersten Faustgedichtes tatsächlich ab. Die höllische Einweihung auf dem Blocksberge ist im ursprünglichen Sinne nicht mehr ausgeführt worden. Der unfaßbar gedankenmächtige Stoff dazu wurde unter die Abfälle geworfen. Das Chorlied gibt unwiderlegbaren Aufschluß:

Aufs Angesicht nieder,	Vernehmet die Worte,
Verehret den Herrn,	Er zeigt euch die Spur
Er lehret die Völker	Des ewigen Lebens,
Und lehret sie gern.	Der tiefsten Natur.

Der Magier In diese Umwelt gerät Faust durch seine Magie. Es ist die letzte Folge davon, daß er die Doppelwurzel des Geistes in der Erkenntnis und Zeugung aufstörte und damit die Samenkraft der Natur mißbrauchte. Diese unerhörten Zynismen lassen das Urmysterium des Lebens, Wollust und Blutrausch, Zeugen und Zerstören, Geburt und Tod in abgründiger Dunkelheit aufglänzen. Und Faust sollte hier nicht bloß Gretchens Tod, er sollte seine eigene Verdammnis erfahren. Bei solcher Anlage des Ganzen mußte ihn der Dichter zugrunde gehen lassen. Der Vorwurf des Faustbuches wie der ersten Faustdichtung Goethes ist die geschöpfliche Tragik des Menschen schlechthin als eines erkennenden und schaffenden Wesens, die letzte, die äußerste Tragik, die je ein Mensch erfaßt hat und zu formen verwegen genug war.

Der zweite Faust Aus gelehrter Forschung, aus Bibel und Religionswissenschaft war die Gestalt des Moses von früh auf für Goethe ein Mittler geworden, an dem er zu erschöpfender Einsicht in die Natur vorzudringen und sich selbst zu begrei-

fen versuchte. Im entscheidenden Jahr 1797 beschäftigte sich Goethe mit der geschichtlichen Wahrheit des Moseslebens. Und nochmals 1811 und 1812 sowie 1819 in den Noten zum „Diwan" versenkte er sich mit besonderem Ernst in die vieldeutigen Untergründe des Stoffes. Die mystischen Gedankengänge, einst im Kreise der Klettenberg angeschlagen, öffneten neue Adern, als er sich an Giordano Bruno hingab, als er die mystisch gestimmte Mosesschilderung des neuplatonisch gerichteten Kirchenvaters Gregor von Nyssa kennenlernte. Das Jahr 1797 spaltete dann den Neuerwerb vom älteren Gedankenbesitz. Aus dem Urmagier Moses wurde der Tatmensch. Es blieb der Name Faust, aber er füllte sich mit dem Gehalt des Helden Moses. Überall *Moses,* spaltete sich der Gedankenboden der ersten und zweiten Faustdichtung. War *der Tatmensch* dort der Schöpferdrang des Geschöpfes auf Einbruch in das Geheimnis des zeugenden Lebens gerichtet, so hieß es hier: nur wenn die gottsuchende Seele gereinigt wird zum klaren Spiegel, vermag sie das göttliche Bild aufzunehmen, das Göttliche sich einzu„bilden". „Imaginatio" und „schaffender Spiegel" bezeichnen die Endpunkte des Spaltrisses, durch den sich der Vorwurf des zweiten Faust von dem des ersten trennte. Was den Riß erzeugte, war der Lebensdruck der ausreifenden Mosesgestalt. Indem das menschliche Le- *Goethe* ben gleichgesetzt wurde dem ewigen Streben zum Höchsten, nach der nie- *in der Rolle* mals erreichbaren Anschauung Gottes, wurde Moses urbildlicher Vertreter *des Moses* dieses strebenden Menschen: Vollkommenheit ist nur erreichbar durch zweckfreies Bemühen um das Gute. Diese Umleitung des Lebensvorganges von Faust auf Moses wurde gefördert durch das persönliche Verhältnis des Dichters. Er hatte ehemals die Rolle des Faust gespielt und lebte jetzt, zumal seit 1797, in der Rolle des Moses. Und Goethe spielte die Rolle des einen so gut wie die des anderen, da er sich entschloß, die aufgelaufene Lebensfülle nicht in der neuen Gußform Moses zu gestalten, sondern dafür das vorgeprägte Gefäß der ersten Faustdichtung zu benützen.

Das ist abermals in dem großen Jahr 1797 geschehen. Von Schiller um die *Das Arbeitsjahr* „Fortführung" des Faustgedichtes bedrängt, entwarf Goethe am 23. Juni *1797* 1797 „ausführliches Schema zum Faust". Es war der erste Entwurf zu einem neuen Gedicht, dessen Held Faust nun eigentlich nur die Rolle des Moses spielte. So war denn die Arbeit von 1797 in Wahrheit kein „Abschluß" des ersten Faustgedichtes, sondern eine rückschreitende Umdeutung dieses Gedichtes, seine Umschaltung von Faust auf Moses. Die Auftritte, die 1796 bis 1801 entstanden sind, waren Mörtel in die Lücken der ersten Dichtung: Fausts Selbstgespräch, Selbstmordversuch, Ostergesang, Vor dem Tor, Spaziergänger, Faust und Wagner, Studierzimmer, Beschwörung des Pudels,

Umbau und Abschluß Mephistopheles, Zauberschlaf, Fausts Fluch, Geisterchor, Verschreibung. Hier arbeitete Goethe mit ältestem Stoff seines ersten Entwurfs. Der setzte dem Zugang der Mosesbestände spröden Widerstand entgegen. Dann, noch 1797, griff Goethe umstürzend ein. Jetzt schob er, dreifach in die neue Faust-Moses-Dichtung einleitend, Zueignung, Vorspiel auf dem Theater, Prolog im Himmel dem Gefüge der ersten Dichtung ein. Das Jahr 1800 brachte neue Nachträge: den Valentinauftritt und die Walpurgisnacht. Das Jahr 1800 ist die Grenzscheide zwischen der rückdeutenden Absicht aus den Mosesbestän-

Helena den und dem vorwärtsstrebenden Aufbau der neuen Dichtung. Der Übergang schwingt im Helenadrama, das zum großen Teil um 1800 geschrieben und 1827 als dritter Akt der zweiten Dichtung zu Ende geführt worden ist. Aus dem Mutterreich der Urbilder hat sich der neue Faust die Schönheit geholt und mit ihr vermählt. Darum ragt in diesen Teil der Klassizismus am tiefsten hinein, und darum ist der Mosesgedanke gerade hier am weitesten zurückgedrängt. Erst 1827 bis 1829, da der erste und zweite Aufzug geschrieben wurden, steigt die Moseshandlung hochgespannt empor. Die ersten Auftritte des ersten Aufzuges, der reinigende Schlaf, das Selbstgespräch, der Sonnenaufgang, tragen die Farbe des Mosesgedankens. Die Homunkulus-gruppe des zweiten Aufzuges, fremd in dieser Umgebung und als Übergang zur Helenadichtung viel zu erzwungen, ist sichtlich Restbestand aus der Umwelt der ersten Faustdichtung, aus dem Gedankenkreis vom gewaltsamen Einbruch in das Geheimnis der Schöpfung. Der vierte Aufzug und der Anfang des fünften, Faust-Moses als Landgewinner und Kulturgründer, sind 1831 entstanden. Der Abschluß des zweiten und das Ende des fünften Auf-

Fausts Tod zuges waren 1830 geschrieben. Fausts Tod, nicht als Zoll an die Natur, sondern auf besonderen Befehl Gottes, die Umstände des Todes und die Grablegung sind stark bewegt von der rabbinischen Sage über des Moses Tod. So war dieser Held denn von einer neuen Tragik gezeichnet, da er wie Moses von der Höhe des Lebens mit dem Ausblick auf das unerreichbar nahe Land der Verheißung stirbt. Und dieses Land hat zweifachen Sinn: die unerreichbare Vollkommenheit und die neue Kulturschöpfung. Das gedankliche Doppeldrama hat baukünstlerisch keinen Ausdruck gefunden in einem gleichmäßig gestaffelten Gebäude nach dem Gesetz der Zweizahl. Was zustande kam, glich einer weiträumigen Stadt mit scharf erkennbaren Bauarbeiten.

Stil des Doppeldramas Die alte Volksspielform der ältesten Abschnitte, in Shakespeares Stil erhöht und melodramatisch durchklungen; dazwischen die streng geformten, im Fluß so unvergleichbar abgetönten Gesprächsgruppen vom Stile Schillers und der Tassozeit; dann aus jenen Jahren, da Schiller schöpferisch und Herder

gedanklich um die Geburt einer neuen Tragödie aus der Musik rangen, der Singspieleinsatz des zweiten Teiles; im Stil der Renaissance wie des Barock die Maskenspiele und Festaufzüge am Kaiserhof; die stumme Komödie des Rittersaales, ein Spiel im Spiel; die antike Strenge des Helenadramas; das Trochäenstück, romanisch und romantisch, um Philemon und Baucis; und die Rückkehr des Schlusses zur Derbheit und zur herben Anmut der alten Mysterienbühne: jeder dieser Stile höchste Vollendung in seiner Art; kein Spiel in gleich vertonten Gesätzen, sondern ein durchkomponiertes Stück; doch die vorgetäuschte Einheit zweier gegensätzlicher Entwürfe, die nur wie ein Dom in zwei Türmen Gestalt werden durften.

„Diwan" und „Faust", der Ertrag von Goethes Leben, Inbegriff seines *„Diwan"* *und „Faust"* schöpferischen Vermögens, sein Vermächtnis an die deutsche Bildung des neunzehnten Jahrhunderts, stammen aus der einen Bildungsmasse, aus sechzigjährigem Streben nach dem Erwerb des Morgenlandes, des Morgenlandes in den zwei Vertretern Moses und Mohammed. In Goethes „Diwan" wie im „Faust", soweit die Mosesmythe eingegangen ist, kündigte sich der abendländische Neuerwerb des Morgenlandes im neunzehnten Jahrhundert an. Die christlichen Bestände des zweiten Faust sind nicht mehr als Bild und Spiegel, in denen die verschmolzene Gedankenwelt des Abendlandes und Morgenlandes angeschaut wurde. Was da von Moses, von Christus, von Mohammed her lebte, war in einen Erguß aufgelöst, in jene urmenschliche Mystik, die den ersten Faust, den „Diwan", den zweiten Faust durchtränkt, gleichviel ob in der Fassung der Kabbala, des Sufismus, des griechisch-christlichen Morgenlandes.

Goethe hatte recht, sich mit Moses gleichzusetzen. Denn es war ein tra- *Goethes Tod* gisches Schicksal, das sich mit dem zweiten Faust und an jenem 28. März 1832 erfüllte. Tragisch hat Goethe sein eigenes Leben empfunden. Tragisch war das Leben seines Sohnes, den er noch 1830 verschwinden sah, tragisch das Leben seiner Enkel, tragisch der Ausgang seines ganzen Geschlechts, mit den eigenen Worten Walthers von Goethe, „der Überbliebenen von Tantalus' Haus". Und tragisch war um die Wende nach 1830 Goethes Abschied. Nicht bloß, daß er wie sein Faust das Ziel der Vollkommenheit in ungreifbarer Nähe sah, nicht bloß, daß ihm, wie seinem Moses, nur der Blick ins Land der Verheißung gestattet war. Konnte Goethe, zwei Jahre nach der Pariser Julibewegung, sich in dem Glauben wiegen, daß die Bildung des heraufziehenden Zeitalters jene sein werde, die er hatte schaffen helfen? Sollte er nicht das Gefühl gehabt haben, das sein Enkel Walther in die Worte faßte: „Das Reich der Eumeniden geht zu Ende"?

Jena Dem alten Herrn zu Weimar sekundierte in *JENA* die Jugend. Die deutsche Jugendbewegung ist von Jena nicht ausgegangen, aber sie hat in Jena ihre sichtbare Gestalt angenommen. Jahre volkhafter Not hatten diese Jugend *Die Ur-* vorgeformt. Sie suchte sich in Geheimbünden einen Tatkörper. Die Jenaer *burschenschaft* Landsmannschaft der Vandalen feierte in der sechsten Septembernacht 1812 auf der Kunitzburg ein Rütlifest. Ein anderer Nährboden war Lützows Freischar, in der neun von den elf Gründern der Jenaer Burschenschaft dienten. Der deutsche Einheitsstaat war der wehrhaften Jugend Kriegsziel gewesen. Die jungen Leute hatten den Tod erlebt. Das hatte sie reifer und tiefer gemacht. Sie kehrten an die Hochschulen zurück und wandelten die Lebensformen, die bisher galten. Jena wurde zur Wiege der Urburschenschaft durch die Gründung vom 12. Juni 1815, bei der die Landsmannschaft Vandalia führte. Diese Urburschenschaft zählte zu Beginn 113 Mitglieder, darunter bedeutende und führende Köpfe der folgenden Jahrzehnte. In Jena kam *die Burschenschaft* zur Welt. Durch das Wartburgfest, das am 18. Oktober 1817 zum Gedächtnis der Reformation gefeiert wurde, hat sie sich von Jena aus durchgesetzt. Zu Jena wurde auf dem Burschentag vom Oktober 1818 die *Das* Allgemeine Deutsche Burschenschaft gegründet. Im August 1819 erstach *Wartburgfest* Ludwig Sand zu Mannheim August von Kotzebue, um eine fortreißende Tat zu stiften. Im Mai 1820 wurde er hingerichtet und die Burschenschaft als geheime Verbindung verboten. Abermals zu Jena, am 26. November 1820, löste sie sich selber auf.

Burschenschaft Die Burschenschaft hat die Lebenswerte der deutschen Romantik um-
und Romantik gebildet, volkstümlich gemacht, verwirklicht. Sie war eine nichtpolitische Schöpfung mit weiten politischen Wirkungen. Das Wartburgfest war die erste gemeindeutsche Feier, der viele andere folgten. Feste der deutschen Schützen, Sänger, Germanisten, Naturforscher. Die Einheitsburschenschaft war als Grundzelle für den Einheitsstaat, der ihr Ziel war, gedacht. Ihre staatsbürgerlichen Gedanken gingen auf Religion, Sittlichkeit, Gesellschaft. Sie träumte von einer gemeinsamen deutschen Volkskirche. Vaterlandsliebe galt als religiöse Tugend. Sie wollten den christlich-deutschen Staat und lebten einer allgemeinen sittlichen Erneuerung der Nation. Auch die Burschenschaft war eine der Überwindungen Goethes, freilich des alten, nicht des jungen Goethe. Als eine Jugendbewegung hat die Burschenschaft den Seelenschwung der Romantik in die deutsche Dichtung gestrahlt. Sie hat der Seele festliche Ge-
Studentenlied legenheiten geschaffen und das Studentenlied geweiht. Das Lied der Bur-
und schenschaft, das war das Lied Arndts und Schenkendorfs. Ihr Dichter war der
Gesellschaftslied Kieler August Daniel von Binzer mit den beiden Kernliedern der Jenaer Bur-

schenschaft „Stoßt an" und „Wir hatten gebauet". Albert Gottlieb Meth-
fessel, der schon 1813 mit dem von ihm gedichteten und vertonten Liede
„Hinaus in die Ferne" den Rudolstädter Freiwilligen vorangeschritten war,
ist der Schöpfer des Allgemeinen Kommers- und Liederbuches, das zum
erstenmal 1818 zu Rudolstadt erschien. Am Dessauer Hofe entsprang aus
dem Bunde zwischen romantischer Musik und burschenschaftlicher Stimmung
das neue Gesellschaftslied. Die Schöpfer dieses neuen Gesellschaftsliedes
sind der Dessauer Kapellmeister Johann Christian Schneider und der Des-
sauer herzogliche Büchereiwart Wilhelm Müller, beide Freunde und Arbeits-
gefährten. Johann Christian Schneider, 1786 bis 1853, aus der Oberlausitz,
gründete mit Wilhelm Müller eine Liedertafel, hob den Kirchengesang, grün-
dete eine Musikschule und schrieb gegen 400 Lieder für Männerchöre. Er
leitete 1825 bis 1835 mit Louis Spohr die Musikfeste zu Madgeburg, Zerbst,
Halberstadt, Nordhausen, Halle, Dessau. So wurde er einer der einflußreich-
sten Förderer des Männergesangvereins. *Wilhelm Müller*, 1794 bis 1827, aus *Wilhelm Müller †*
Dessau, hatte die Schlachten von 1813 mitgeschlagen, in der spätroman-
tischen Umwelt Berlins sich zum Germanisten gebildet, war auf der Fahrt
nach Griechenland 1818 schon in Rom hängen geblieben und hatte in Albano
seine köstlichen Briefe „Rom, Römer und Römerinnen" geschrieben. Zusam-
men mit Eichendorff wurde er der volkstümlichste Liederdichter der Deut-
schen. „Gedichte aus den hinterlassenen Papieren eines Waldhornisten"
1821/1827 und „Lieder der Griechen" 1821/1826 hießen die fortgesetzten
Hefte, in die seine Lieder, wie sie entstanden, gesammelt wurden. Müllers
Liedkunst ist zugleich von der Wortromantik und der Musikromantik auf-
gegangen. Er fühlte sich geistig als Mitglied der Burschenschaft. Seine Kunst
war von der Burschenweise und dem Volkslied gleichmäßig befruchtet. Sie
war Rollendichtung. Der Müllerjunge, der Jäger, der Wanderbursche, der
Waldhornist, immer sprach er mit dem Munde eines Standes. Das machte
sein Wort so echt und verlieh ihm die Treue, da er dem neugriechischen Volke
ein Fürsprecher in Liedern wurde. Wie seine Kunst aus den Sängerrunden
der Burschenschaft und der aufschwingenden Liedertafeln sich ablöste, so
wurde sie durch eben diese Mächte und ihre Gesangbücher zu unbeschreib-
licher Wirkung fortgetragen. Johann Christian Schneider, Albert Gottlieb
Methfessel, Franz Schubert wurden seine klassischen Tonsetzer. Müllers Neu-
schöpfung des deutschen Gesellschaftsliedes war eine Tat, die mit ihrem vol-
leren Werte weit über alle Literatur hinaus der deutschen Sozialgeschichte
angehört.

Denkweise und Stimmung, die in der deutschen Burschenschaft leibhaftige

Gestalt annahmen, stammten von den führenden Männern des Jenaer Lehr-
körpers. Sie waren mit ihren Schülern durch die Erlebnisse von 1813 und
Der Lehrer:
Fries 1814 eins geworden und wirkten auf sie zurück. Einer für alle ist *Jakob Fried-*
rich Fries, 1773 bis 1843, aus Barby und herrnhutisch erzogen, ein Schüler
Fichtes. Fries hatte mit seinen Flugschriften 1813 eine Wiedergeburt des
Volkes aus Wahrheit und Gerechtigkeit gefordert. Er hatte in seinem Roman
„Julius und Evagoras" den kommenden Staat als bewußt gewordenen Ge-
meingeist des Volkes entworfen. Als er 1816 nach Jena berufen worden war,
verfiel ihm die Jugend nach wenig Wochen mit Leib und Seele. Ihr widmete
er seine Schrift „Vom deutschen Bund und deutscher Staatsverfassung" und
seinen jungen Freunden von der Wartburg gab er 1818 sein Bestes, die Sit-
tenlehre. Mitverstrickt in das Wartburgfest mußte er den beiden deutschen
Großmächten geopfert werden. Unter schweigendem Verzicht sah er, 1824
zurückberufen, das deutsche Leben in andere Geleise einbiegen, als er ge-
wiesen hatte.

Der Thüringer: Das Thüringen dieser Jahrzehnte verkörperte der Weimarer *Ludwig Bech-*
Bechstein *stein*, 1801 bis 1860, Büchereibeamter in Meiningen, Gründer des Henne-
berger Altertumsvereines. Bechsteins Werk ist kaum zu übersehen. Aus rühm-
licher Formanlage pflegte er die lyrisch-epische Versdichtung der Zeit — ein
„Faustus" 1833 und ein „Luther" 1834 —, er pflegte in erstaunlicher Fülle
die „historisch-romantische" Prosaerzählung. Doch der unsterbliche Bech-
stein ist ein anderer. Schon früh und von den Büchern des Musaeus begleitet,
regten sich sein unvergleichlicher Märchensinn und seine schwärmerische
Naturliebe. So begann er schon 1823 mit „Thüringischen Volksmärchen". Er
hat dann in kostbaren Sammlungen, in treuer, schlichter Prosa, die Sagen-
schätze Thüringens, Ostfrankens, Österreichs gehoben und mit zwei so schö-
nen Werken wie „Deutsches Märchenbuch" 1845 und „Deutsches Sagen-
buch" 1853 gekrönt. Bechstein war ein gottbegnadetes Gefäß des volkstüm-
lichen Geistes dieser Landschaft, ein Erforscher altdeutscher Kulturzustände,
dem die Türen der Vorzeit wie von selber aufsprangen.

Die Deutschen *GIESSEN* und seine Jugend war durch den Geist Friedrichs vom Stein
Gesellschaften und Ernst Moritz Arndts in Feuer gesetzt worden. In einer Flugschrift hatte
Arndt 1814 verlangt, man solle „Deutsche Gesellschaften" gründen, und
dafür sogleich einen Entwurf gegeben. Die Deutschen sollten durch sie von
Schreibern zu Rednern, von Träumern zu Tätern erzogen werden. Der Justiz-
rat Karl Hoffmann in Rödelheim bei Frankfurt gab diesen Bünden 1815 Ver-
fassung und Gesetze. Die beiden Brüder Ludwig und Wilhelm Snell führten
noch 1814 die Gründung der Idsteiner Gesellschaft durch. Ihre Ziele waren:

Kampf gegen ungemäße Gesinnung und Sitte, für deutsche Art und Denk-
weise. Dem bürgerlichen Leben äußere Gestalt zu geben, Verfassungen zu
erlassen, das Einheitsreich zu schaffen, sei Sache der Fürsten, denen man ver-
traue. Eine Tochtergesellschaft der Idsteiner war die Wiesbadener. Und mit
der Idsteiner eng verbunden waren die Kreuznacher, Heidelberger und Gie-
ßener Gesellschaft. Die kräftigste Nachwirkung ging von der Butzbacher
Gesellschaft aus, die im November 1814 von dem Konrektor *Friedrich Lud-
wig Weidig* gegründet wurde. Sehr widerstrebende Absichten, deren jede die *Der Konrektor
Weidig*
andere auszunützen meinte, schossen also in dem Hoffmannschen Bunde zu-
sammen, der sich zu Frankfurt im Oktober 1815 bildete. Aus eigenen An-
trieben, wenn auch von Idstein her beeinflußt, ging die Gießener Bewegung
im Herbst 1814 von der „Deutschen Lesegesellschaft" aus. Hier war die
Führung bei den beiden Brüdern *August Adolf Follen*, 1794 bis 1855, aus
Gießen, und *Karl Follen*, 1795 bis 1839, aus Romrod. Sie hatten bei den
hessischen freiwilligen Jägern gedient und wollten die deutsche Einheits-
republik. In der Lehre dieses engsten Kreises um die Brüder heiligte die Ge-
sinnung alle Taten, fielen Mord und Opfertod zusammen. Dieser Bund der
„Gießener Schwarzen" gab 1819 sein Liederbuch „Freye Stimmen frischer *Die Gießener
Schwarzen*
Jugend" heraus. Die entscheidenden Beiträge „Turnerstaat" sowie „Bursch
und Philister" stammten von Karl Follen. Diese Lieder bewahrten die große
Stimmung von 1813 und hegten den Gedanken der Todesweihe. Sie verwer-
teten germanische Götterformeln wohl zu mehr als sinnbildlichen Zwecken
und prägten den Gegensatz Bursch und Philister ins Sittliche, Völkische,
Staatsbürgerliche um. Das eigentümlichste Zeugnis dieses Geistes war Karl
Follens sogenanntes „Großes Lied" von 1818, melodramatisch, mit wechseln- *Das Große Lied*
den Rhythmen in der Anlage und der eindeutigen Überschrift „Deutsche
Jugend an die deutsche Menge (30 oder 3 und 30 — gleichviel)": nämlich
dreißig Tyrannen in Athen, dreiunddreißig Tyrannen in Deutschland. Die
Stimmen der Jugend und des Volkes sind mit der Leidenschaft des Glaubens
und mit kriegerischem Lärm zu einem Zusammenklange vertont, nach dem
Leitmotiv:

> „Spruch des Herrn, du bist gesprochen,
> Volksblut, Freiheitsblut, du wirst gerochen,
> Götzendämm'rung, du bist angebrochen."

Der hessischen Bewegung wurde wie der Jenaer die Ermordung Kotzebues
zum Verhängnis. Die Brüder Snell wie die Brüder Follen mußten sich 1819
nach der Schweiz in Sicherheit bringen. Diese geistige Bewegung, wie sie in

Hessen von den deutschen Gesellschaften ausgelöst wurde, spaltete sich in drei Äste: einen sozialistisch-materialistischen in Hessen-Darmstadt; einen bürgerlich-verfassungsmäßigen in Hessen-Kassel; einen konservativ-soziologischen in Hessen-Nassau. Jeder von ihnen erzeugte ein gemäßes Schrifttum.

HESSEN-DARMSTADT war sozial ein heißer Boden. Die rasch verbrauchten Gedanken von 1813 begannen in der Zugluft des Pariser Aufruhrs von 1830 wieder Feuer zu fangen. Im Gegenstoß wider das kriegerische Frankreich Napoleons war die hessische Nationalbewegung aufgeschossen. Das freiheitliche Frankreich kam ihr zu Hilfe und verwandelte sie in eine

Georg Büchner sozialistische Bewegung. *Georg Büchner*, 1813 bis 1837, aus Goddelau stammte von einer geistig ungemein fruchtbaren Familie. An der Gießener Hochschule wurde er 1833 in die Geheimbünde gezogen, deren Mittelpunkt Friedrich Ludwig Weidig war, ein begnadeter Volksführer, der nun mit dem sittlichen Ernst der „Deutschen Gesellschaften" durchzudringen hoffte. Sein Mitarbeiter war Büchner. Und Büchner glaubte nicht mehr an die schöpferische Kraft des Bürgertums. Nur der besitzlosen Masse traute er den Schwung zu, mit einem gewaltigen Ruck die Republik, dies alte Kampfziel der hessischen Jugend, zu ersiegen. Um die Arbeiterschaft auf dieses Ziel in Marsch

Büchners Gesellschaft der Menschenrechte zu bringen, müsse man sie zum Bewußtsein ihres Elends erwecken. Das war die Stunde, da die alte hessische Jugendbewegung von nationalen zu sozialen Taten einschwenkte. In Gießen gründete Büchner 1834 die geheime „Gesellschaft der Menschenrechte" und schickte er den Ingrimm seines „Hessischen Landboten" auf Werbung. Man legte ihm sofort das Handwerk. Weidig endete 1837 durch eigene Hand im Darmstädter Arresthaus. Büchner hatte sich nach Straßburg gerettet. Was sich ihm im Bereich des Handelns als unreif erwiesen hatte, das erwog er nun im Weltraum der Dichtung. Das sind die drei Bühnenspiele „Dantons Tod", „Leonce und Lena", „Woyzek". Sie bilden eine Dreiheit gegensätzlichen Stiles, gegensätzlichen Spielfeldes,

„*Dantons Tod*" gegensätzlicher Beleuchtung. „Dantons Tod" ist weder eine Zweckdichtung noch ein Problemstück. Es ist nicht mehr als ein tatsachengetreues Geschichtsbild, der Ablauf eines großen Umsturzes in seinem unerbittlich gesetzmäßigen Gange. Aber Büchner war ein gepflegter Jüngling mit Ansprüchen. Und so mag er wohl seinen eigenen Zwiespalt zwischen dem armseligen Rock, dessen Sache er führte, und dem feinen Zylinder, den er zu tragen pflegte, an Robespierres Gegner zu Ende gedacht haben. „Totgeschlagen, wer kein Loch im Rock hat." Hier spielt sich alles in der Luftschicht einer grimmigen guten Laune ab. Der Witz Dantons und seiner Freunde kämpft über das karikierte Pathos des Wohlfahrtsausschusses hinweg mit dem grausam be-

haglichen Lachen des Volkes der Schließer, Marktweiber, Fuhrleute. Nichts an diesem Stück ist aufs Auge berechnet, alles aufs Ohr. Man müßte es aus der Versenkung des Orchesters spielen. „Leonce und Lena" ist ein Puppenspiel aus der Welt der Märchenkönige, hölzern bewegte Figuren auf dem schmalen Steg und hinter ihnen eine einzige Stimme, die für alle redet, nur mäßig abgetönt, damit die Täuschung nicht vollkommen sei. Ein uralter Lustspielstoff: zwei sollen einander heiraten und wollen einander daher nicht; sie finden sich ungesollt aus Zufall zusammen, weil jedes vor dem andern floh, und erkennen einander als die Vorbestimmten. Der Riß zwischen der gebildeten und „ungebildeten" Gesellschaft, aus dem Dantons Tragik aufgestiegen war, trennt hier komödienhaft die Zukunftswünsche des jungen Königs — alle Uhren zerschlagen, alle Kalender verbieten, die Zeit nur nach der Blumenuhr zählen — und des Hanswursts Valerio: „Dann legen wir uns in den Schatten und bitten Gott um Makkaroni, Melonen und Feigen, um musikalische Kehlen, klassische Leiber und um eine kommende Religion." Das ist das gewünschte Paradies des Volkes, das hinauf will. Georg Büchner wußte, daß man die Bildung eines neuen geistigen Lebens im Volk suchen müsse. „Woyzek", das ist ein solcher Volkskeim, der hinauf will. Der Wehrmann und Füsilier Johann Frank Woyzek ist nur insofern ein Unterdrückter, als er unter den Begriff „arme Leute" fällt. Aber seine Vorgesetzten behandeln ihn gut. Denn in diesem Soldaten steckt etwas Besseres. In seinem ganzen Umkreis ist er der geistig Bedeutendste. Wenn ihm nun das Emporkommen nicht glückt, woran liegt es? An den Lumpen, die er zu seinesgleichen hat. Das schlecht überlieferte Stück hat abermals einen anderen Stil. Augenblicksbilder, scheinbar wahllos aufgefangen, blitzen aus dem sinnlosen Gewühl der Masse auf. Wie aber diesen drolligen, im tiefsten Grunde unsoldatischen Feldhauptleuten und Regimentsscherern dennoch der echte Unterton der Soldatensprache, wie eine Spur des Hauches nur, anzuhören ist, das bleibt eines der vielen Wunder, die in Büchners Kunst sich auftun. Naturwissenschaftlich dachte Georg Büchner als Volksführer wie als Dichter. Soviel er von Shakespeare gelernt und so manches ihm das romantische Märchenspiel abgelassen hat, seine Kunst ist etwas durchaus Neues. Eine neue Gesellschaftsklasse, die neue Weltanschauung, aus der sie sich rechtfertigte, die neue Kunst, in der jene und diese zuerst Erscheinung wurden, all das in einem trat durch Büchner zutage. Diese hessische Jugend war es, die zuerst die Masse der verarmten Bauern und des neuen Standes der Arbeiter gegen den Geldstaat hin in Schwung brachte. Sie gab diesem sozialen Aufbruch die gemäße Weltanschauung und Literatur. Doch in der Erkenntnis, in seinen Ta-

Büchners
Nachfolger gen käme jede Tat zu früh, gab Büchner dem Volkstribunen den Laufpaß, um sich auf Philosophie und Anatomie zu werfen. Kaum hatte er sich im Herbst 1836 an der Zürcher Hochschule als junger Lehrer niedergelassen, da riß ihn ein hitziges Fieber hinweg. Die Arbeitermassen, deren geborener Führer er war, fielen dennoch Hessen zu, vorerst Gottfried Kinkel, dann Karl Liebknecht.

Das also, Schritt für Schritt in Hessen vorbereitet, ist die große Wendung: Georg Büchners Übergang vom Idealismus zum Materialismus, von der schöngeistigen Literatur zur Wissenschaft, vom Bürgertum zum vierten Stande.
Der hessische Die Umkehr der deutschen Zustände konnte weder aus dem Idealismus noch
Materialismus durch die landesübliche Literatur kommen. Die Massen ließen sich nur durch eine neue Weltanschauung in Marsch setzen. Und die ist zu Gießen geschaffen worden durch die Reihe: Justus Liebig, 1803 bis 1873, aus Darmstadt, der Mitüberwinder der denkerischen Naturphilosophie, Schöpfer der modernen Chemie, Verfasser der klassischen „Chemischen Briefe"; Karl Vogt, 1817 bis 1895, aus Gießen, der Tierkundler, der die materialistische Weltanschauung staatsbürgerlich ausgewertet, der sie in Büchern wie „Physiologische Briefe" 1845, „Ocean und Mittelmeer" 1848 schrifttümlich ausgeformt hat; Ludwig Büchner, 1824 bis 1899, aus Darmstadt, der Bruder des Dichters, der mit seinem einst so berühmten Buch „Kraft und Stoff oder Grundzüge der natürlichen Weltordnung" 1855 erst einem späteren Menschenalter zur vollen Wirkung kam.

Der hessische *HESSEN-KASSEL* stritt die ernsten staatsbürgerlichen Kämpfe aus und
Literalismus erzeugte eine bürgerlich-fortschrittliche Literatur. Im Großherzogtum Hessen trugen die beiden Gegner die Masken der Burschenschaft und der staatlichen Restauration. Im Kurfürstentum Hessen traten einander noch die alten Widersacher von 1789 gegenüber: der Kurfürst auf der einen, der Dritte Stand auf der andern Seite. Den Dritten Stand verkörperte literarisch der Fuldaer *Hein-*
Heinrich König *rich Josef König*, 1790 bis 1869, der Ahnherr der neuen hessischen Zeitungsleute. Dieser kräftige und männliche Altliberale hatte am Rhein alle Herren kommen und gehen sehen, kämpfte im hessischen Landtag seit 1832 gegen den kurfürstlichen Gewalthaber Hans Daniel Hassenpflug und zog sich schließlich ganz auf die Literatur zurück. Im Anschluß an Walter Scott formte er sich die geschichtliche Heimaterzählung und den selbsterlebten Zeitroman zu Darstellungsmitteln, um dem heranwachsenden Geschlecht des neuen Umsturzes den großen französischen Aufruhr gegenwärtig zu halten und zeitgemäß zu färben. Auf der Linken bewegten sich seine ersten Romane, von denen „Die hohe Braut" 1832 zur Zeit der Umwälzungen im französisch-

italienischen Grenzgebiet spielt, während „Die Waldenser" 1836 kirchliches und außerkirchliches Christentum gegeneinanderstellten. Zwei dieser Bücher — „Die Clubisten in Mainz" 1847, „Haus und Welt" 1852 — erneuerten das Andenken an den Weltfahrer und rheinischen Freiheitsmann Georg Forster. Einer der Helden jener rheinischen Freiheitsjahre sollte mit stummer Gewalt zu Kurhessen und anderen Deutschen reden. Das Königreich Westfalen hatte er miterlebt. Als er nach so weitem Abstande an den Geschichtsroman „König Jérômes Karneval" 1855 ging, da durfte er diese harte Zeit wohl ins grimmig Launige verkehren. Es ist ein hessischer Heimatroman, nun schon nach allerlei Vorbildern, wie Wilhelm Häring und Hermann Kurz sie boten, entworfen; aus Histörchen, Erinnerungen, mündlichen Berichten erzählt; mit ausgezeichneten Brustbildern nach der Natur, aber auch mit allerlei Beiläufigem über Kunst und Wissenschaft ausgestattet. All diese Bücher sind anregend und mit abgewogener Spannung erzählt, immer nach einem Ganzen aus Landschaft, Volk, geschichtlicher Färbung strebend. Zu beiden Seiten Josef Königs stehen die zwei Opfer der kurhessischen Verfassungskämpfe. *Silvester Jordan*, 1792 bis 1861, aus Omes bei Innsbruck und 1821 nach Marburg berufen, lebte der Überzeugung, der Staat als Form des Volkslebens müsse sich aus dem Volke selber entfalten. Er wurde der Führer des hessischen Landtages. Bei seinem Bemühen, weder das Alte gewaltsam zu zerstören noch das Neue gewaltsam zu verhindern, kam er unter die Räder und wurde jahrelang in grausamer Haft gehalten. Vielen jungen Leuten war er akademischer Lehrer, allen aber ein Unterpfand der bürgerlichen Güter, um die der Kampf ging. Seine staatsrechtlichen Schriften werden gekrönt durch die „Wanderungen aus meinem Gefängnisse" 1847, einem ergreifenden Buch des Leidens und der Tapferkeit. *Ernst Koch*, 1808 bis 1858, aus Singlis, war Jordans Schüler und schrieb in den „Verfassungsfreund" seine freiheitlichen und launigen „Vigilien". Als er 1832 ins Innenministerium berufen wurde, galt er den Freiheitsmännern für einen Abtrünnigen. „Prinz Rosa Stramin" 1834, aus dem Briefwechsel mit seiner Braut geformt, im Stil Johann Paul Richters eine Sammlung von Idyllen, Liedern, Schwänken, ist das Büchlein dieser Zeit. Die Lieder sind vornehm verhalten, volksmäßig, zuweilen Goethisch. Des Widersinns von Amt und Überzeugung nicht länger mächtig, floh er 1834 in die französische Fremdenlegion, diente in Afrika und focht mit der todgeweihten Truppe in Spanien. Zu Pamplona wurde er katholisch und nach der Heimkehr als Lehrer an das Luxemburger Athenäum berufen. „Erzählungen" 1847, Geschichten aus seinen Söldnerfahrten, sind das Buch dieser Zeit. So machte sein Los ihn beinahe zum Gefährten jener Kurhessen, die sechzig

Silvester Jordan

Ernst Koch

Jahre zuvor an England verkauft wurden. Leben und Wirken dieser drei
Franz Dingelstedt Hessen machte der vierte, *Franz Dingelstedt*, 1814 bis 1881, aus Halsdorf zu
einem persönlichen Ganzen. Der Marburger Hochschüler gründete ein litera-
risches Kränzchen, das akademische Lesemuseum, kam damit zu Silvester
Jordan in enge Beziehungen und faßte 1838 Vers wie Prosa des ganzen Krei-
ses im „Hessischen Album für Literatur und Kunst" zusammen. Als Ober-
lehrer 1841 strafweise nach Fulda versetzt, schloß er sich Heinrich König an.
Er führte die Klinge für Ernst Koch, der ihm als der weitaus Begabteste unter
all diesen jungen hessischen Dichtern galt. Franz Dingelstedt war aus Natur
und Zucht ein vornehmer Mensch, der es notwendig hatte, zwischen die
Der Zeitungsmann Welt und sein Herz Schutzmittel und Masken zu legen. Überlegen lächelnd,
spöttisch abwehrend, das Gültige in Zweifel ziehend, so hielt er Grenze und
Abstand zwischen sich und den Dingen wie Menschen. Dies zusammen mit
dem eingeborenen Gefühl für Form machte ihn zum vorbestimmten Meister
der kleinen Prosa unterm Strich. Mit unleugbarem Geschick leitete er das
Beiblatt der „Landeszeitung", „Die Wage". Lewalds „Europa" stattete er
mit den „Bildern aus Hessen-Kassel" aus. Er gründete das Zeitblatt „Der
Salon". Im Auftrag der „Allgemeinen Zeitung" ging er als Berichterstatter
nach Paris und London. Diese Ernte seiner freien Feder stapelte er 1839
Der Wanderer bis 1843 in seinem „Wanderbuch" auf, das die empfindsame Weserfahrt,
die Rhönwanderungen, holländische Schildereien, das Briefe aus Paris und
und ein Tagebuch aus Ostende, das neuhessische Märlein, kleine Novellen,
Bosheiten über zeitgenössische Dichter brachte. Diese landschaftlich-ge-
schichtlichen Betrachtungen setzten um eine Stufe höher Dingelstedts Ro-
mane fort, hessische Heimatromane wie „Die neuen Argonauten" 1838, der
gekreuzte humoristische Roman von Johann Paul Richter und Charles Dickens;
wie „Unter der Erde" 1840, in Georg Büchners Sinne das Buch vom arbei-
tenden Volke; wie „Sieben Jahre" 1849, die unvollendete Tragikomödie des
Königreiches Westfalen. Dingelstedts ursprüngliche Anlage, die lyrische,
mußte in der ätzenden Nachbarschaft des Witzes verkümmern. Die „Spazier-
Der kosmo-politische Nachtwächter gänge eines Kasseler Poeten" 1837 ergingen sich in ehrfurchtslosen Angrif-
fen auf den Landesfürsten, in Lobreden auf Verfassungen, in verstellten
Klagen über das Verschwinden der Zöpfe. Die „Lieder eines kosmopoliti-
schen Nachtwächters" 1841 hatten keinen Ehrgeiz, Taten zu wecken. Ihr
aufs Gran berechneter Witz, ihre ausgeglichenen Rhythmen, ihre schulge-
mäße Form boten Mittel auf, die bei Zuhörern von der Gasse weder lohnend
Dingelstedt geht zu Hofe noch rätlich waren. Dingelstedts Verse konnten nur denen gelten, die keine
Aufläufe machen und sich lediglich mitbefreien lassen. Die „Gedichte" 1845

waren längst über jene Aufwiegelungen hinaus. Denn inzwischen war Din-
gelstedt zu Paris gewesen, hatte gesehen und war gesättigt. Das republika-
nische Gebaren der deutschen Flüchtlinge reizte ihn zum Spott. Seine edel-
männischen Neigungen schlugen wieder durch. Um die Sängerin Jenny Lut-
zer heiraten zu können, nahm er als Vorleser Hofdienste in Württemberg
und ging dann durch die Bühne den Weg zur Macht.

Im Großherzogtum Hessen vollzog die Hochschule zu Gießen alle entschei- *Das konservative Marburg*
denden weltanschaulichen Wandlungen vom philosophischen Idealismus zum
naturwissenschaftlichen Materialismus. Das kurfürstliche Marburg hatte nur
bescheidene Bedeutung und beharrte geistig auf dem, was bestand und also
gut war. Heinrich Sybel, der Westfale aus Düsseldorf, redete an der Hoch-
schule dem preußischen Königtum das Wort und zeigte im Sinne Georg
Büchners den französischen Umsturz nicht als einen Kampf um Verfassun-
gen, sondern als einen gewaltigen ständischen Besitzwechsel. Der Hesse
August Vilmar führte die Sache der guten alten Zeit vor der Bürgerschaft
mit seinen warmherzigen und redlichen Vorlesungen „Geschichte der Deut-
schen National-Literatur" 1845, mit seinen volkskundlichen Arbeiten, mit
dem Zeitblatt „Hessischer Volksfreund", das 1848 zum Kurfürsten stand.

Von *HESSEN-NASSAU* waren die Deutschen Gesellschaften ausgegan- *Hessische Volkskunde*
gen. Ihre Gesinnung hatte sich in Hessen-Darmstadt zum sozialistischen Ma-
terialismus verschärft, in Hessen-Kassel zu einem gemäßigten Liberalismus
verflacht. Sie gewann, wenn auch nach rechts umgebogen, in Hessen-Nassau
ihre ursprüngliche Richtung auf die Deutschkunde zurück. Schöpferisch
fruchtbar und großzügig arbeitete *Wilhelm Heinrich Riehl*, 1823 bis 1897, *Wilhelm Riehl*
aus Biebrich, von Innen her an der Überwindung all dieser hessischen Radi-
kalismen. Sein Vater, ein Tapezierer, besaß, was sich selten schlichte Bürger
so auserlesen zu eigen machen können: eine kleine Bücherei, eine beschei-
dene Gemäldesammlung, ein Hausquartett. Der Sohn, dem das alles zugute
kam, hörte an den beiden hessischen Hochschulen zu Marburg und Gießen,
ließ sich aber zu Tübingen durch Philosophie und Kunstwissenschaft, zu
Bonn durch Völkergeschichte und Staatskunde formen. Seit 1844 widmete
sich Riehl ganz „dem Studium des deutschen Volkes und seiner Gesittung"
Im Dienst der Rechten gründete er 1848 die „Nassauische allgemeine Chro-
nik" und führte er das Wiesbadener Hoftheater. An diesem Doppelberufe
ist Riehl zu seiner gesellschafts-wissenschaftlichen Lebensaufgabe herange-
reift. In den Städten und Stadtdörfern der Rheinfurche und des Maintales,
in den Bauerndörfern des Taunus und Westerwaldes drängte sich ihm der
Gegensatz einer stürmisch erregten und einer zäh beharrenden Volksschicht

auf. Früchte seiner Wanderfahrten und Beobachtungen waren die Schrift über das Volkslied und 1850 der erste Aufriß seiner rettenden Gesellschaftslehre „Der deutsche Bauer und der moderne Staat".

*Hessisches
ver sacrum* Das war Hessen. Der wesentliche Teil der geistigen Geschichte dieser Landschaft spielte sich in andern Räumen ab: durch Gervinus in Heidelberg, durch Diez und Friedrich Gottlieb Welcker in Bonn, durch Karl Theodor Welcker in Freiburg, Riehl und Liebig und Carriere in München, die Brüder Snell und Follen in der Schweiz. Sie schickte die Brüder Grimm nach Göttingen und Berlin, Dingelstedt nach Weimar, München und Wien, Vogt nach Genf. Sie schuf in den Brüdern Grimm die germanische, in Diez die romanische Volkswissenschaft. Fast mystisch geheimnisvoll aber offenbart sich das hessische Schicksal in jenen vier Söhnen, die hessischen Vätern außerhalb Hessens geboren wurden: Feuerbach in Landshut, Kinckel in Bonn, Herwegh in Stuttgart, Geibel in Lübeck. Und wenn man an die Grimm, die Snell, die Follen, die Welcker, die Büchner denkt, Dioskurenpaare sind es gewesen damit zuverlässig erreicht werde, was das Geschick im Sinne hatte.

Thüringen, Hessen, *MEISSEN*. Gegenüber dem hessischen Triptychon der neuen Zeit erschienen Thüringen und Meißen nach dem Gesetz der Zweizahl ausgegliedert. Hof und Hochschule sind es hier wie dort. Und was in Thüringen Weimar und Jena heißt, das ist in Meißen Dresden und Leipzig. Zu Leipzig wie zu Jena erhob sich jetzt und hier um 1830 wie einst und dort um 1815 die Jugend der Gegenwart gegen den großen Dichter zu Weimar und Dresden, als den Inbegriff einer schönen, aber ausgelebten Vergangenheit.

Ludwig Tieck *DRESDEN* hatte den schöpferischen Künstler der Frühromantik, *Ludwig Tieck*, 1796 vor den Bildern der Galerie durch Wackenroder zu sich erweckt. Nach Dresden kehrte Tieck 1819 aus der märkischen Einsamkeit des Schlosses Ziebingen zurück, berufen, in verwandelter Gestalt der schöpferische Dichter der verwandelten Zeit zu werden. Tieck sah sich gedrängt, gegen den Verfall wie gegen den Umsturz dieser Jahre Ansehen und Strenge der Kunst zu wahren, mit der das Deutschland der Weimarer und Jenaer Tage stand und sank: gegen den heiligen Schwarmgeist der Burschenschaft; gegen den Schwarmgeist der neuen Jakobiner; gegen die entartete und ausgeronnene Romantik. Zur Waffe dieses Dreiseitenkrieges formte er sich die Novelle. In den verschiedensten Blättern und Taschenbüchern ließ er 1822 bis 1841 deren vierzig drucken. Sie wurden 1852 bis 1854 gesammelt. Für die seelischen Abenteuer der burschenschaftlichen Jugend fühlte er sich nicht *und die neue
Novelle* mitverantwortlich. Was an ihr romantisch war, das war eine sehr späte Ab-

wandlung der Romantik. Es war ein stiefgeschwisterliches Verhältnis, das zwischen Tiecks Jugend und den neuen Jenaer Geheimbündlern. Und so ließ er es bei einem spöttischen, mitleidig wohlwollenden Tone bewenden, wenn er im „Geheimnisvollen" 1823 die großen Worte, das Wichtigtun, die Geheimniskrämerei jugendlicher Verschworener, das Blindverworrene in den staatsbürgerlichen Zielen geißelte. „Die Reisenden" 1823, „Die Gesellschaft auf dem Lande" 1825, „Glück gibt Verstand" 1827, „Waldeinsamkeit" 1841 verteilen sich von außen her um den gleichen Binnengedanken. Zu abseits lagen ihm diese Dinge, als daß sie mehr denn spöttische Aufmerksamkeit des Unbeteiligten geweckt hätten. Zu leidenschaftlicher Abwehr scheuchte ihn die ostdeutsche Jugend von Wienbarg bis Laube auf. Denn da waren, neu benannt und in Szene gesetzt, die Zerrissenheit, Verzweiflung und die dunklen Begierden des Kopfes, mit denen sich Tieck und seine Freunde gebrüstet hatten, ehe Hardenberg ihre wahren Tiefen aufschloß. Es sind die Novellen, von denen Heinrich Heine sagte, Tieck verleumde in ihnen die großen Schmerzen der deutschen Jugend: „Der Mondsüchtige" und „Der Wassermensch". Doch „Eigensinn und Laune" 1835 war die eigentliche Kampfschrift. Es ging um die „Befreiung der Frau". Die schöne, geistreiche Tochter eines Bankherrn sinkt zur Dirne herab und endet als Hälterin eines öffentlichen Hauses. Die Novelle wirkte auf die Gemeinten wie ein Peitschenhieb und reizte sie zu lauter Erbitterung. Die Pflicht des Angriffs endlich wurde Tieck auferlegt durch die Verderber und Verfälscher des romantischen Werks. Und die saßen, ausgespült von dem großen Zeitstrom, gerade in Dresden. Es waren die kleinen literarischen Handwerker der „Abendzeitung", ein Blatt, das seit 1817 gewissermaßen ein älteres, gleichnamiges Unternehmen fortsetzte, das Friedrich August Schulze 1805 zu Dresden gegründet hatte. Das war die Börse, wo die Fertigware des scheinromantischen Kunstgewerbes, Novellen und Lieder gehandelt wurden. Die Lüge war die Wurzel dieses Unwesens. „Die Gemälde" 1822 züchtigten die Frömmelei, „Musikalische Leiden und Freuden" 1824 die Unwahrheit in der Tonkunst. „Pietro von Abano" und „Das Zauberschloß" 1829 haben es auf die Spukgeschichten und Schicksalsstücke abgesehen. „Der Wundersüchtige" 1831 zeichnet die spukhaften Gedanken der Zeit als das, was sie waren, als sittliche Krankheit. Die beste Spielart der Gruppe ist wohl „Die Klausenburg", die sich gegen ganz bestimmte Ziele, Arnims „Majoratsherren" und Hoffmanns „Majorat" richtet. Den härtesten Streich gegen die Dresdner Talmiromantik führte Tieck in Goethes Fechtweise 1834 mit der „Vogelscheuche". Die Hohlheit dieser literarischen Geister, ihre hochmütige Verachtung alles

Tieck gegen die Afterromantik

„Die Vogelscheuche"

24

Großen wird schonungslos an den Pranger gestellt. All diese Novellen waren Kampfschriften, bestimmt, einen Geist zu zerstören, der Formen weder zu erfüllen noch zu bewahren noch zu erzeugen vermochte. Allein Tieck verlor das eigene große Ziel nicht aus dem Auge. Wie Hoffmann und Eichendorff bürgerte auch er das lebendige Wesen der Romantik in eine neue Zeit hinüber. Nach zwei Richtungen. Er gab der Künstlernovelle und der Geschichts-

*Die Künstler-
novelle*

erzählung die letzte romantische Form. Von Tiecks reifsten Künstlernovellen galt „Dichterleben" 1826 dem Genius seiner frühen Jugend und dem Gegenstand seiner schaffenden Mannesjahre, Shakespeare. Wie ein großer Gedanke, fertig aber noch unbewußt, mit wachsender Klarheit und endlich überwältigend vor die Seele tritt, so schreitet Shakespeare aus matt erleuchtetem Hintergrunde vorausverkündet und immer höher nahend, dem Bewußtsein jenes Zeitalters ins Licht. Das Gegenstück dazu ist „Der Tod des Dichters"1834, des Camôes, auf dem Hintergrunde des untergehenden Portugal. Wie der Held hier aus dem Leben in die Unsterblichkeit hineinwächst,

*Geschichts-
novellen*

wie sein Schatten immer mächtiger in den kleinen Kreis seiner Getreuen fällt, den Totgeglaubten vorherverkündend, das schuf zwischen beiden Novellen ein schönes Ebenmaß. Tiecks Geschichtsnovellen gingen von Walter Scott aus. „Der Aufruhr in den Cevennen", Bruchstück 1826, stellt die Verheerungen des religiösen Wahnsinns dar. „Der wiederkehrende griechische Kaiser" 1831 verwertet einen Demetriusstoff und entrollt ein Kulturbild des gräkolateinischen Kaisertums. „Der Hexensabbath" 1831 schildert ein Hexengericht, das 1459 in Burgund gehalten wurde. Die Renaissancegeschichte „Vittoria Accorombona" 1840 mißglückte. „Der Gelehrte" und „Der Alte vom Berge" 1828 sind Charakternovellen, nicht in Hoffmanns Art genial flüchtig radiert, sondern mit breit arbeitendem Pinsel gemalt. Anschluß an die spanischen Spitzbubengeschichten und die romantische Gerichtsnovelle finden 1832 „Der Jahrmarkt" und 1837 „Wunderlichkeiten". Eine ernste Gestaltung romantischer Gedanken war „Der fünfzehnte November" 1828, wo nicht der spöttische Seitenblick auf die Schicksalsdichtung das Wesentliche ist, sondern dieses: der Irrsinnige trifft mit seinem wunderbaren Ahnungsvermögen von langer Hand Anstalten für die Rettung der Familie aus einer Gefahr, die niemand vorauszusehen vermag. In gewisser Beziehung zur

*„Des Lebens
Überfluß"*

jungen Bewegungsliteratur stehen zwei Novellen. „Des Lebens Überfluß" 1839 wird wohl die beste Geschichte dieser Reihe sein. Mit goldener Laune ist die Armut des Lebens kostbar gemacht. Die Zeitfarbe verrät die Tage der Carbonari und der burschenschaftlichen Umtriebe. Und wie Wetteifer mit Laubes neublanker Novellenform nimmt sich Tiecks „Sommerreise" 1834 aus.

Das war die Reise, die Tieck 1803 mit lieben Freunden gemacht hat. Es sind Blätter der Erinnerung an die schönsten Tage des Dichters. Tieck galt nun wieder neben Goethe als der große Dichter und neben Alexander von Humboldt als Erbe von Goethes Stellung und Ruhm. Er ließ 1825 bis 1833 neun Bände „Shakespeares dramatische Werke" erscheinen, Durchsicht und Abschluß der von August Wilhelm Schlegel begonnenen Arbeit. Nur die Anmerkungen waren Tiecks Eigentum. Die Übersetzungen stammten von seiner geistig ebenbürtigen Tochter Dorothea und dem sächsischen Grafen Wolf Baudissin. Tieck hatte einen Hofstaat um sich, einen geistig bedeutenderen als der des alten Goethe war. In diesem Kreise lebte sich Tieck, wofür er sich so lange geschult hatte, als dramatischer Vorleser aus. *Tiecks Hofstaat*

Nicht der Berliner, sondern der Dresdner Hof hatte den Weimarer beerbt. *Dante deutsch* Miene und Haltung des Hofes im Geistigen bestimmte Herzog Johann, 1801 bis 1873, der seinem Bruder 1854 auf den Thron folgte. Er war ein trefflicher Kammerredner, nicht selten im Widerspruch zur Regierung, und hatte sich früh zum Gelehrten gebildet. In Italien gab 1821 der zufällige Fund einer Dante-Ausgabe zu Pavia seinem Streben ein hohes Dauerziel. Eine ganze Academia Dantesca zog er um sich heran, aus deren beratender Teilnahme des Herzogs deutsche Divina commedia hervorging. Sie ist 1839 bis 1849 erschienen. Als Herzog und König hat Johann bis zu seinem Tode an diesem Werk gebessert. Sein Wert ruht mehr in der großen Leistung als im dichterischen Kunstwerk. Denn der Herzog beherrschte das gesamte Rüstzeug, die ganze mittelalterliche Bildung, soweit sie in Dantes Dichtung vorgeformt war. Sein Werk ist Ergebnis, Inbegriff, Abschluß der romantischen Übersetzungskunst am größten Gegenstande, dem Ergebnis, Inbegriff und Abschluß mittelalterlichen Wesens.

LEIPZIG war der Vorort des deutschen Buchhandels und also die Stadt *Leipziger* der mildesten Presseaufsicht. Die Leipziger Literatur aber, das war aus- *Buchwesen* schließlich die Presse. Von England her war der Bildergedanke dem deutschen Buchdruck wieder geläufig geworden. So lebte nun abermals wie im sechzehnten Jahrhundert mit dem Holzschnitt die stärkste Werbekraft für Volksbildung und bürgerliche Freiheit auf. Ein Basler, Johann Jakob Weber, der 1834 seinen Verlag aufmachte, hat zu Leipzig den Holzschnitt für das deutsche Buch zurückgewonnen. Seine „Illustrierte Zeitung", 1843 gegründet, brachte Aufruhr in Buchbetrieb, Zeitschriftenwesen, Literatur, allgemeine Bildung. Indessen die engste Arbeitsgemeinschaft zwischen Verleger und Buchbildkünstler, das Zusammenspiel von buchhändlerischen Absichten und dem Bildungsaufstieg des Bürgertums verkörperte der Göttinger Georg

Wigand, der seit 1834 in Leipzig ansässig war. Er brachte die erste deutsche Volksausgabe Shakespeares. Er brachte die drei Standwerke dieses erneuerten künstlerischen Volksgeistes: Dullers „Geschichte des deutschen Volkes"; die unschätzbaren zehn Bände „Das malerische und romantische Deutschland"; die dreiundfünfzig Hefte „Volksbücher" des Schlesiers Gotthard Oswald Marbach. Hauskünstler Wigands war Ludwig Richter. So erschienen denn auf allen Gebieten die führenden Zeitschriften in Leipzig. Mit dem Thüringer Ernst Keil und dem Dresdner Ludwig Ferdinand Stolle begegneten einander gerade noch literarische und schon durchaus tagespolitische Neigungen. Keil, der als Buchhandlungsgehilfe in freien Stunden zu schreiben begonnen hatte, richtete für mancherlei Blätter sachlich gesehene Lebensbildchen in novellenartiger Form zu, übernahm 1840 die „Blätter für Unterhaltung, Literatur, Kunst und Theater", und führte sie unter mannigfachem Wechsel der Titel und Aufmachungen an seine spätere „Gartenlaube" heran. Stolle gründete 1844 zu Grimma das Wochenblatt „Der Dorfbarbier", verlegte es 1852 nach Leipzig und brachte zunächst als Beilage Keils „Gartenlaube". Ignaz Kuranda, Berichterstatter der „Augsburger Allgemeinen Zeitung" in Brüssel, gründete dort 1841, von Henrik Conscience unterstützt, für die flämische Bewegung „Die Grenzboten", verlegte die Zeitschrift 1842 nach Leipzig und schaltete sie in das abgebrochene Fernsprechnetz zwischen Österreich und Deutschland ein. Bei reichem Inhalt und vornehmer Tonlage war es das einzige Blatt, in dem der freiheitlich gesinnte Österreicher zu Worte kam. Die gleiche Rolle wie gegenüber dem beharrsamen Österreich spielte Leipzig im Verhältnis zu Preußen, soweit dieses bleiben wollte, was es war. An der Leipziger Presse reifte und wandelte sich die preußische Jugend.

Leipziger Zeitschriften

„Gartenlaube" und „Grenzboten"

Zwei dieser Leipziger Blätter hatten bereits eine Geschichte und machten vor allem die literarische Meinung des gebildeten Bürgertums. Das „Literarische Wochenblatt" August Kotzebues hatte 1820 Friedrich Arnold Brockhaus in das täglich erscheinende „Literarische Conversationsblatt" und dieses 1826 in die „Blätter für literarische Unterhaltung" verwandelt. Heinrich Brockhaus leitete das Unternehmen 1823 bis 1853 in fortschrittlichem Sinne. Bei dieser Zeitschrift machte Theodor Mundt, als er 1832 nach Leipzig kam, die Schule des Tagesschriftstellers durch. Zwischen hinein versuchte er es 1834 mit einem eigenen Unternehmen „Schriften in bunter Reihe", die er noch in Leipzig durch seinen „Literarischen Zodiacus" 1835 fortsetzte. Mundt wußte die geschichtlichen Bewegungen der Zeit sinnfällig zu fassen und zu benennen. Die Ablösung vom Klassizismus und der Aufmarsch gegen die

Theodor Mundt

Romantik machten in Mundts Leipziger Schriften weitere Fortschritte. Theodor Mundt war der schwergerüstete, mit Sachwissen bepackte Tagesschriftsteller, der im Lehrton redete. Die „Zeitung für die elegante Welt", 1801 von Karl Spazier aufgemacht, hatte sich in den Geisteskämpfen jener Tage auf die romantische Seite geschlagen. Sie war reich ausgestattet mit Bildnissen bedeutender Zeitgenossen, mit Modebildern, Kunstbeilagen, Tonstükken. Als frische, zeitgemäße Kraft wurde 1833 *Heinrich Laube* auf die Stube dieser Zeitschrift gesetzt. Leipzig war die große Zeit seiner Feder. Eben erschienen seine „Politischen Briefe", halb Zeitgeschichte, halb Zeitungsplauderei, und das Buch „Polen", in dem Rußland die europäische Gefahr hieß. Er stellte 1835 die Aufsätze des Blattes zusammen: „Moderne Charakteristiken". Wienbarg kam nach Leipzig und Laubes „Zeitung" schien die Tribüne der links abstürmenden Jugend zu werden. Da griff Preußen ein. Laube wurde in Berlin verhaftet, auf freien Fuß gesetzt, wegen literarischer Vergehen und Burschenschaft zu sechs Jahren Festung verurteilt, diese auf achtzehn Monate ermäßigt mit der zusätzlichen Erlaubnis, sie in dem bequemen Muskau absitzen zu dürfen. Die Werke von Laubes Leipziger Zeit sind der Roman und das Novellenbuch. Der Romandrilling „Das junge Europa" 1833 bis 1837 versammelte in seinem ersten Teil „Die Poeten", Abbilder seiner Breslauer Jugendfreunde, indem er dem Ganzen das lebhafte Treiben des Jäschkowitzer Herrenhauses zum Hintergrunde gab, und verfolgte in den beiden andern Teilen „Die Krieger" und „Die Bürger" die Lebensschicksale dieses Kreises. Bei dürftiger Handlung war in Briefform lediglich die genaue Zeichnung verschiedener Menschenarten versucht. Die „Reisenovellen" 1834 bis 1837 sind die Frucht der Sommerfahrt, die er 1833 mit Gutzkow nach Oberitalien gemacht hatte. Indessen, was er Reisenovellen nannte, sind keine Novellen, sondern vollendete Stücke jener Zeitungskunst, für die der Deutsche kein deutsches Wort, sondern nur französische hat. Bald sinnt er sich, durch eine Stadt streifend, ein novellenartiges Gebilde zusammen, bald behorcht er eine erzählte Geschichte; dann wieder hört er aus fremdem Mund seine eigenen Erlebnisse; oder er zettelt eine Handlung an und stellt die Szene dazu; ja er spielt, was ein Dritter erzählte, auf eigene Faust weiter. Aber immer ist er der Held, sei es als Schöpfer oder Zuhörer, als Mitspieler oder Zuschauer, wie ein Wandelstern von den wechselnden Lichtern der Orte und Menschen beleuchtet. Dieser Ringelreigen von Geschichten gleitet, stets vom gebrochenen Lichte eines Raumes besonnt, aus Schlesien über Baiern und Tirol herab, erhält in Venedig mit der Byronerscheinung einen großartigen Mittelpunkt und schlingt sich über Triest wie-

Laube in Leipzig

„Das junge Europa"

„Reisenovellen"

der nordwärts zum Ausgangspunkte zurück, einer schönen Feier des Sprot-
Der letzte Krieg tauer Pfingstschießens. Das Buch ist zart und frech und nicht ohne Größe.
Zwischenhinein wahrsagt Laube den letzten großen Krieg zwischen Stettin—
Königsberg—Breslau, der durch Dampfwagen und Geld entschieden wird.
Nimmt man noch die Bildkunst hinzu, mit der Laube so manchen seiner
Zeitgenossen schildernd bewältigte, so darf man sagen: in Laubes Leipziger
Werk ist die moderne Zeitungskunst Erscheinung geworden. Als er im Jän-
ner 1839 frei gelassen war, ging er auf Reisen, die ihn bis Algier führten,
und übernahm 1843 wieder die Leitung seines Blattes. Jetzt entstand 1840
bis 1847 die Reihe seiner Dramen: „Monaldeschi", „Rokoko", „Die Bern-
steinhexe", „Struensee", „Gottsched und Gellert", „Die Karlsschüler". Im
Frühjahr 1846 brachte die „Allgemeine Zeitung" seine „Briefe über das
deutsche Theater" mit der Wiener Bühne im Mittelpunkte. Und über diese
Brücke schritt Laube aus der papiernen Welt Leipzigs in das Leben der
Wiener Bühne hinüber.

Dresdner DRESDEN war der erste und ist nun der dritte Akt des meißnischen Zeit-
Theater dramas. Gottfried Semper machte mit seinem neuen Dresdner Theaterbau,
den am 12. April 1841 Goethes „Tasso" einweihte, die Zeitwende sichtbar.
Was war geschehen?

Ludwig Tieck Ludwig Tieck war 1825 Dramaturg des Dresdner Hoftheaters geworden.
Er hatte mit wechselndem Erfolg sowohl gegen die Handwerker der Schein-
romantik wie gegen die Unzufriedenheit der radikalen Jugend zu kämpfen.
Und was hätte er ihnen im Spielplan aus landestümlichen Kräften entgegen-
setzen können? Der kommende Bühnendichter Otto Ludwig, seit 1843 in
Dresden, grübelte noch immer seinen Plänen nach. *Julius Mosen*, 1803 bis
1867, aus Mariney im Vogtlande, der seit 1834 als Rechtsanwalt in Dresden
lebte, war ein Künstler musikalisch feiner Lieder und seelenkundig abgerun-
deter Novellen. Von seinen Epen waren „Ritter Wahn" 1831 und „Ahasver"
1838 ein gedankliches Geschwisterpaar, die Geschichten der beiden Helden,
von denen jener dem Tode um jeden Preis entfliehen will, während dieser
Mosens den Tod mit all seinen Listen vergeblich sucht. Aber Mosens Bühnenspiele
Bühnenspiele — ein „Heinrich der Finkler", ein „Otto III.", ein „Herzog Bernhard von
Weimar" — zehren von der Geschichte im Sinne Hegels, dröhnen in zu er-
regtem Schwung der Worte und bedeuten der Bühne nicht viel. Doch da war
Karl Gutzkow ein Landesfremder. *Karl Gutzkow* war zu Hamburg unter die Bühnendich-
in Dresden ter gegangen und hatte das Zweckdrama der linksgerichteten Jugend ge-
schaffen. Eines von diesen Stücken, „Richard Savage", war 1840 auf die
Dresdner Bühne gekommen. Mit einem seiner geschichtlichen Dramen, „Zopf

und Schwert", errang er im Jänner 1844 zu Dresden seinen ersten Dauer-
erfolg. Und seine hohe Verstragödie, ein Meisterstück französischer Schule,
„Uriel Acosta", im Dezember 1846 in Dresden gespielt, krönte sein drama-
tisches Werk. In dreifachem Widerspruch hatte Gutzkow den neuen Stil der
Sachlichkeit durchgesetzt: gegen die Jambentragödie der Schillerschüler, ge-
gen das romantische Lustspiel, gegen die Naturform Grabbes. Wie Laube
nach Wien und Dingelstedt nach München, so bahnte Gutzkow sich mit sei-
nen Stücken den Weg zum Dramaturgen des Dresdner Hoftheaters, wohin
er 1846 berufen wurde. So geschah es denn, daß zu Dresden der eine Ber-
liner, der Schöpfer der modernen Novelle, von dem andern, dem Schöpfer
des modernen Zeitromans, am Theater abgelöst wurde, an dem sie beide ein-
ander nur mit einem Ausschnitt ihres Werkes begegnet waren. In Dresden
vollzog der dichterisch Begabteste aus der jungen Gruppe seine Wendung
zur reinen zweckbefreiten Kunst. Freilich zu weitgezielten Plänen reichte
sein Amt nicht mehr. Denn im Zusammenhang mit den Dresdner Ereignis-
sen von 1849 wurde auch Karl Gutzkow entlassen.

Doch der Umschwung des Zeitalters auf der Dresdner Bühne hieß nicht *Richard Wagner*
Drama und Karl Gutzkow, sondern Oper und Richard Wagner. Eine Fülle *in Dresden*
von Kleinzügen verwoben sich hier zu einem großen Sinn. *Richard Wagner,*
1813 bis 1883, kam aus dem romantischen Leipzig von 1813 und jenem
Dresden, wo Arthur Schopenhauer wenige Monate später die Welt als Wille
und Vorstellung erkannte. Alle Dämonen dieses überfüllten Raumes um
Leipzig und Dresden drängten sich in seine Seele. An der Dresdner Kreuz-
schule entwarf der Knabe Trauerspiele nach jenem Leipziger Johann August
Apel, der sein vaterländisch erregtes Antlitz hinter der starren Maske der
griechischen Tragödie verborgen hatte, und der Knabe ließ den Dresdner
Shakespeare Tiecks auf sich eindringen. An der Leipziger Nikolaischule be-
geisterte er sich für den romantischen Kapellmeister der Leipziger und
Dresdner Kriegsmonate, Ernst Theodor Amadeus Hoffmann. Und wie aus
dem romantischen, so aus dem radikalen Halbkreis der beiden vaterlän-
dischen Städte. Er freundete sich mit Heinrich Laube an und gab in dessen *Wagners*
Leipziger Zeitung seinen ersten schriftstellerischen Versuch, den Aufsatz *Anfänge*
über die Oper. Das Spielbuch „Rienzi" entstand 1838 nach Edward Bulwers
Roman. Und wie die andern ging Richard Wagner 1839 nach Paris, wo er
1841 den „Fliegenden Holländer" dichtete und vertonte. Nach seiner Heim-
kehr wurde zu Dresden im Oktober 1842 „Rienzi" und im Jänner 1843 „Der
fliegende Holländer" gespielt. Anfang 1843 war Richard Wagner Kapell-
meister des Dresdner Hoftheaters geworden. „Tannhäuser", die erste frei-

schöpferische Musikdichtung, die Tannhäusersage und Wartburgkrieg ver-
knüpft, wurde im Oktober 1845 zu Dresden aufgeführt. Der Plan für „Mei-
stersinger" und „Lohengrin" ging ihm 1845 auf. Die Musik diente nun ganz
dem Drama. Aus Hoffnungen für das Kunstwerk der Zukunft hatte Wagner
sich an den Sozialismus seines Freundes, des Kapellmeisters August Röckel,
Dresdner
Maiaufstand hingegeben. Er bewegte sich in der Umgebung des Russen Michael Bakunin,
sprach und schrieb für die Sache des Volkes. Als die Dresdner Maierhebung
1849 gewagt und von Preußen niedergeworfen war, als Bakunin gefangen,
Semper und Wagner geflüchtet waren, hatten freilich die politischen Absich-
ten verspielt. Aber als Gewinn der Dresdner Volksbewegung sagte sich die
neue Kunst der Bühne an, vorgezeichnet durch die zwei Schriften Richard
Wagners aus dem Keimen jener kriegerischen Wochen: „Die Kunst und die
Revolution", „Das Kunstwerk der Zukunft".

„Die Kunst und
die Revolution" Wie so oft in der Geistesgeschichte des deutschen Ostens eine Kunstlehre,
doch nun begleitet von der Tat. „Die Kunst und die Revolution" erwog, wie
auf den Trümmern einer lügenhaften Kunst das neue Kunstwerk erstehen
könnte. Die griechische Hochkultur krankte am Sklaven. Indem der grie-
chische Staat am Sklaven zugrunde ging, zerstörte er das griechische Thea-
ter. Dieser Zusammenbruch wirkte sich künstlerisch dahin aus, daß das Thea-
ter in seine Einzelbestände Rede, Bildnerei, Malerei, Musik zerfiel. Nur der-
selbe große Menschheitsumsturz, der an seinem Beginn das griechische Thea-
ter zertrümmerte, vermag das neue und echte Kunstwerk zu erzeugen. Und
diese Neuschöpfung muß sich folgerichtig dahin aussprechen, daß die ge-
trennten Einzelkünste wieder zum Theater vereinigt werden. Wie der
Der griechische
Sklave und die Grieche die gemeine Sorge um das Dasein auf den Sklaven ablud, so wird
moderne der Mensch der Zukunft diese Sorge auf die Maschine abwälzen. Die Ma-
Maschine schine muß statt zum Herrn zum Diener der Kunst werden, indem sie den
Menschen für die Kunst entlastet. Der Altar der Zukunft gehört den zwei
erhabensten Lehrern: Jesus, der uns alle zu Brüdern machte; Apollon, der
uns das Siegel der Stärke und Schönheit aufdrückt. Die zweite Schrift, „Das
Kunstwerk der Zukunft", bestimmte zunächst das Volk als den Inbegriff
aller, die ihre eigene Not als eine gemeinschaftliche empfinden, führte alle
großen Schöpfungen wie Sprache, Religion, Staat auf das Volk zurück und
ging dann zur eigentlichen Kunstlehre über. Die drei menschlichen Grund-
arten Tanzkunst, Tonkunst, Dichtung gehen auf den Menschen zurück, so-
weit er sein eigener künstlerischer Gegenstand ist. Es sind drei urgeborene
Das Kunstwerk Schwestern, die durch den Verfall der Kunst getrennt worden sind. Wieder-
der Zukunft vereinigen kann sie nur das Drama. Das wahre Drama, das Kunstwerk der

Zukunft, ist nur denkbar aus dem gemeinsamen Drange aller Künste an eine *„O einziges, herrliches Volk"*
gemeinsame Öffentlichkeit. Wer aber wird der Künstler der Zukunft sein?
Dasselbe Volk, dem wir selbst heutzutage das in unserer Erinnerung lebende,
von uns nur mit Entstellung nachgebildete einzig wahre Kunstwerk, dem wir
die Kunst überhaupt verdanken. Und indem Wagner seinen „Wieland" in
Umrissen blicken ließ, schloß er: „O einziges, herrliches Volk! Das hast du
gedichtet, und du selbst bist dieser Wieland! Schmiede deine Flügel und
schwinge dich auf!" Johann Gottfried Herder hatte um die Jahrhundertwende
in seiner „Adrastea" das Gesamtkunstwerk der Zukunft und seinen Schöpfer
gewahrsagt und angekündigt. Richard Wagner erfüllte die Sehnsucht dreier
Jahrhunderte nach der Selbstoffenbarung des Volkes im Musikdrama: eine
Sehnsucht, die mit fremden Worten in der Allkunst des Barocks gesprochen
hatte; die um die Wende zum neunzehnten Jahrhundert unter den Wei-
marern zu mannigfachen Versuchen drängte; die durch Ernst Theodor Ama- *Das Musikdrama*
deus Hoffmanns Bamberger Spielleiterkunst ihrem Ziele angenähert wurde;
die in der Romantik sich vergeudete. Herders Werk war der Pfeiler, von dem
sich der Bogen der Vollendung herüber zu Wagners geglückter Tat wölbte.
Denn mit Herders Gedanken, ja mit Herders Worten begründete Wagner im
Gefechtslärm des Dresdner Maiaufstandes seinen großen Wurf: das Volk
Schöpfer und Träger der Kunst; Wort, Gesang, Gebärde nur Dreifaltigkeit
der einen menschlichen Urkunst; der Mythus einzig würdiger Stoff des Kunst- *Herder, Schopenhauer Wagner*
werkes. Längst lief Wagners Wille in der Richtung Schopenhauers, bis sie
einander als Doppelgänger der einen Erscheinung gewahr wurden: das Leid
der Welt und Pflicht des einzelnen zum Mitleiden; Überwindung der Welt
im Musikdrama; Wiederkehr des Gemeindebewußtseins in die Mystik und
den Mythus des neuen Weihespiels. Nach der Schriftsprache, der Kunstprosa,
dem Vers, dem Volksbegriff schließt Richard Wagners Musikdrama die lange
Kette der ostmitteldeutschen Schöpfungen eines halben Jahrtausends ab. Der
Gipfel der romantischen Bewegung lag in Dresden, der Gipfel der radikalen
Bewegung in Leipzig. Im werdenden Werk Richard Wagners, diesem In-
begriff thüringisch-ostmitteldeutscher Musikbegabung, bahnte sich die Ver-
söhnung des ostdeutschen Zwiespalts der Seelenhaltung an.

So hat sich aus der deutschen Mitte heraus die künstlerische Wendung von *Von Goethe zu Wagner*
Johann Wolfgang Goethe zu Richard Wagner vollzogen.

2. SÄCHSISCHE LANDSCHAFTEN

Zum erstenmal, wenn auch lange vorbereitet, schafft sich das sächsische
Volk im neunzehnten Jahrhundert eigene, lückenlos erfüllte geistige Form
durch ein selbständiges Verhältnis zur Antike, durch die Schöpfung der Ge-
schichtskunst, durch eine große Reiseliteratur. Und an diese Hauptadern
schließen sich alle übrigen Gebilde, das selbständige Drama, die sächsische
Lyrik und Novelle, der neue Mythus, die ganze Welt des befreit auftreiben-
Der sächsische den sächsischen Sprachwillens. Es bildet sich ein ganzer sächsischer Kosmos
Kosmos der Kunst in allen Gattungen. Und er wölbt sich über dem Rundbogen eines
neuen eigenartigen geschichtlichen und geographischen Weltbildes.

DAS ALTE OSTFALEN war politisch in den beiden Welfenstaaten ge-
einigt, von denen das Herzogtum Braunschweig seit vielen Jahrhunderten
sein artgemäßes Geistesleben führte, während das Königreich Hannover seit
1714 durch die englische Krone mit dem britischen Weltreich verbunden war.
Der englische Thronwechsel von 1837 löste diese Verbindung auf. Das fest-
ländische Königreich, bisher als Statthalterei verwaltet, fiel an die deutschen
Welfen zurück.

Die Göttinger Die schöpferische Kraft des Raumes straffte sich und die zeitgeschicht-
Hochschule lichen Übergänge vollzogen sich in der Göttinger Hochschule. Im Sommer
1825 erreichte sie bei 1545 Besuchern ihren Höchststand. Wie von Anbeginn
war es die Hochschule der Historie, jetzt insbesondere der Wissenschaft vom
deutschen Volke. Georg Friedrich Benecke, 1762 bis 1844, aus Mönchsroth
im Fürstentum Öttingen, doch aus Braunschweiger Familie, übertrug die
Arbeitsweise der klassischen Altertumskunde auf die germanistische Wissen-
schaft, begründete die mittelhochdeutsche Verslehre, machte die ersten Aus-
gaben mittelalterlicher Dichtungen und legte den Grund zu dem späteren
mittelhochdeutschen Wörterbuch. Dichtung und Wissenschaft lebten fast
noch ungeschieden nebeneinander. An Beneckes Vorträgen entzündete sich
der volkhafte Geist der Jugend. Von Benecke mittelbar ging das Münsterer
Dichterkränzchen aus. Örtliche Göttinger Überlieferungen flossen ein. *Ernst
Schulze*, 1789 bis 1817, von Celle schrieb zur Feier der Leipziger Schlacht
„Caecilia" und und zu Ehren der früh verstorbenen Cäcilie Tychsen das Gedicht „Cäcilie.
„Die bezauberte Eine Geisterstimme". Seine beiden Epen schufen und formten dann jenen
Rose" Cäcilienmythus, der die Zeit zu weichmütiger Teilnahme stimmte: „Die be-
zauberte Rose" 1817, ein vollendetes Stanzenwerk, und „Caecilia" 1818, in
Fouqués Stil eine Feier des christlichen Sieges über das nordische Germanen-
tum. In dieses romantische, von Benecke befeuerte, von Cäciliens Tod ge-

stimmte und von Schulzes Stanzen gerührte Göttingen zog um 1813 eine neue sächsische Jugend. Unter fröhlichen Gesellen von später berühmten Namen bildete sich die antik gerichtete „Gesellschaft der Ungründlichen". Ihr entgegen bildete sich zur Pflege von deutscher Kunst und Dichtung im romantischen Sinne die „Poetische Schustergilde". Deren Zeitschrift „Wünschelrute" erschien vom 1. Jänner 1818 an ein halbes Jahr. Es ist eine der feinsten romantischen Zeitschriften gewesen, aufs sorgfältigste gemischt, in gedämpftem sächsischem Tonfall gehalten. Diese Schustergilde lebte 1815 bis 1818 und hat ihre Spuren im ganzen neueren Schrifttum der Sachsen hinterlassen. Dieser Göttinger Geist, Einheit von deutscher Wissenschaft und deutschem Leben, von Dichtung und Wissenschaft, vertiefte sich, als 1830 die Brüder Jakob und Wilhelm Grimm nach Göttingen kamen. Sie waren schon unter den Mitarbeitern der „Wünschelrute" gewesen. Sie eben hatten das Ethos der Wissenschaft, der sie dienten, an ihrem persönlichen Wesen schön und groß herausgearbeitet. Die Brüder Grimm machten Göttingen zum Hochsitz der deutschkundlichen Wissenschaft. Um sie bildete sich ein vielfarbiger Kreis niedersächsischer Volksforscher. Dieser Geist wurde von Georg Gottfried Gervinus in den wenigen Monaten, die er zu Göttingen wirkte, in feste geschichtswissenschaftliche Bahnen gelenkt durch den Fortgang seiner Literaturgeschichte und eine so fördersame Schrift, wie es seine Göttinger „Grundzüge der Historik" 1837 waren. Nur auf dem Hintergrunde dieser welfischen Welt von Schustergilde und Wünschelrute wird ein Mann und ein Werk wie *Karl Goedeke,* 1814 bis 1887, aus Celle, verständlich. Da wurde, was diesem Jahrhundert seinen Reichtum und seine Armut schuf, ein Dichter zum Gelehrten. Dieser Göttinger Schüler ist zur Literaturgeschichte auf weiten Umwegen gekommen. Er füllte das Stuttgarter „Morgenblatt" und die „Didaskalia" mit seinen zarten Versen. Der Gegenwart, die er erlebte, sprach er 1838 im Stil von Platens erneuertem Aristophanes das Urteil: „König Kodrus. Eine Mißgeburt der Zeit." Und 1841 sammelte er seine „Novellen". Da war aber schon eine erste Wendung, noch eben dichterisch wählende und schon begrifflich bildende wissenschaftliche Arbeit: „Deutschlands Dichter von 1813 bis 1843", das erste seiner fruchtbaren Sammelbücher, 1844 gedruckt und literarhistorisch ausgerüstet. Nach Landschaften angelegt, erkannte und würdigte das Buch die Eigenart der deutschen Stämme und den raumerfüllten Ablauf des geistigen Lebens. Dieser Weg führte zu seinem mächtigen Lesebuch „Elf Bücher deutscher Dichtung. Von Sebastian Brant bis auf die Gegenwart" 1849 und 1852 nach rückwärts ergänzt mit „Deutsche Dichtung im Mittelalter". Und nun nahm er rasch Besitz von allen Feldern

*„Schustergilde"
und
„Wünschelrute"*

*Göttingen
und die
Deutschkunde*

Karl Goedeke

des literarhistorischen Betriebes und machte daraus sein eigenes Königreich,
„Grundriß" den „Grundriß zur Geschichte der deutschen Dichtung", in dem sein Name
fast zum Mythus geworden ist, zum Namen der Sache selber, die er geschaf-
fen hat: Urgrund, auf dem die Literaturwissenschaft ruht und aus dem sie
lebt.

Literatur heißt in den welfischen Landschaften rings um Göttingen ein
dreifacher Ausblick in die Welt.

Hannover:
Johann Detmold Den preußischen Ausschnitt fing *Johann Hermann Detmold*, 1807 bis 1856,
aus Hannover im Hohlspiegel seines Witzes auf. Von Beruf Anwalt, ein be-
gabter Zeichner, umgänglicher Freund von Künstlern und Schriftstellern,
erzog sich Detmold zu seiner Form an den kleinen Begebenheiten der gären-
den Zeit. So geißelte er, angeregt durch die Hannoversche Gemäldeausstel-
lung, die landläufige Art zu urteilen, in dem satirischen Büchlein von 1834
„Anleitung zur Kunstkennerschaft". So gab er mit Freunden während der
Ausstellungen 1835 und 1836 die „Hannoverschen Kunstblätter" heraus. Und
so ließ er 1844 die ergötzlichen „Randzeichnungen" erscheinen: ein poli-
tisches Kindermärchen und die Verhandlungen eines Kunstklubs über die
Reinigung des berühmten Körperteiles der Venus von Medici. Sein beißen-
der Witz in Vers und Prosa machten ihn zum Schrecken der Frankfurter Na-
tionalversammlung, in der er, zuletzt dreifacher Minister des abgehenden
Reichsverwesers, die gegenpreußische Politik Hannovers und Österreichs ver-
trat. Mit dem Maler Adolf Schrödter schuf er den genialen Bilderkreis „Taten
„Taten und und Meinungen des Herrn Piepmeyer", die Satire auf jene Volksvertreter,
Meinungen des die in stetem Zweifel sind, ob sie nicht doch ein wenig mehr nach Rechts oder
Herrn
Piepmeyer" Links rücken sollen. Detmolds Stichblatt war der Philister, der Kunstbanause,
der bürgerliche Lautsprecher. Detmold zog in gehaltvollen Ätzstoff zusam-
men, was sich um 1848 von Hannover aus über Preußen und seine Partei-
gänger sagen ließ.

Franz Junghuhn, Die Welt hinter den Meeren hat *Franz Wilhelm Junghuhn*, 1809 bis 1864,
„Java" aus Mansfeld vor den Augen der Deutschen aufsteigen lassen. Er besaß den
besonderen Sinn des Landschaftskünstlers. Dafür zeugten 1845 seine „Topo-
graphischen und naturwissenschaftlichen Reisen durch Java" mit Naturbil-
dern, die in Erstaunen setzen. Gleichzeitig auch holländisch erschienen 1847
„Die Battaländer auf Sumatra", denkwürdig durch die Kunst, natürliche Zu-
stände aufzufassen, zumal dann, wenn es um die Ganzheit eines Volkswesens
ging. Die großartige Sonderdarstellung „Java", 1849 holländisch, 1852
deutsch, nennt Ratzel eines der vollendetsten Werke aller Völker in der an-
schauenden Bändigung tropischer Naturfülle.

Die Welt des Ostens hat *Friedrich Bodenstedt*, 1819 bis 1892, aus Peine dichterisch erschlossen. Dieser wunderliche Stegreifkünstler und hinreißende Erzähler eigener Erlebnisse wurde in Tiflis zum Dichter. Frucht jener Jahre war das Buch von 1848 „Die Völker des Kaukasus und ihre Freiheitskämpfe", aus eigener Anschauung ein völkerkundliches Gesamtbild und Quellenwerk für die Kenntnis des russischen Morgenlandes. „Tausend und ein Tag im Orient" 1850 gaben in gelöster Ordnung westöstliche Bilder des Landes und Volkes. Die eingestreuten Lieder von einem vorgeblichen Dichter Mirza Schaffy, die 1851 als „Lieder des Mirza Schaffy" gesondert gedruckt wurden, hatten unerhörten Erfolg. Mit Ausnahme des Gedichtes „Mullah, rein ist der Wein" waren alle Stücke Bodenstedts Eigentum. Dennoch können sie für Übersetzung gelten. Denn sie trafen Stimmung und Umwelt, Sprachgeist und Vers einer angenommenen morgenländischen Urschrift so vollkommen wie keine andere Dichtung in der Ebene Hammer, Goethe, Rückert, Platen, Schefer. Dies geniale Vermögen, sich in die Seele fremder Völker einzufühlen, ließ Bodenstedt zum ersten großen Vermittler der jungen russischen Literatur werden. Schon 1843 hatte er von Moskau aus „Kaslow, Puschkin, Lermontow. Eine Sammlung aus den Gedichten" gegeben. „Die poetische Ukraine" 1845 war eine glänzende Übertragung kleinrussischer Volkslieder. Und es gelang ihm dann das große russische Triptychon: 1853 „Michael Lermontoffs poetischer Nachlaß"; 1854 „Alexander Puschkins poetische Werke"; 1864 „Iwan Turgenieffs Erzählungen". Bodenstedts eigene Gedichte tönen nur Nacherinnerungen dessen aus, was er übersetzte. Seine Verserzählungen, echtes, feines, episches Kleinwerk, tragen das Doppelgesicht der englischen und russischen Versgeschichte. Von den andern sächsischen Meistern unterscheidet Bodenstedt wohl, daß er Dichter war und auf der russischen Schwelle des Morgenlandes lebte, während sie als Naturforscher oder Geschichtler Afrika durchzogen. Doch gemeinsam mit allen hatte er die überlegene Gabe des völkertümlichen Blicks und das Vermögen, die landvölkische Ganzheit eines Raumes schildernd auszuschöpfen.

DIE NORDSÄCHSISCHEN HERZOGTÜMER standen zu Dänemark in einem ähnlichen Verhältnis wie Hannover zu England. Ihr Schicksal löste die deutsche Frage aus und besiegelte sie.

Hier führte das Wort die Kieler Hochschule, wie es im Welfenland die Göttinger führte. Die „Kieler Blätter", die seit August 1815 herauszugeben sich eine „Gesellschaft Kieler Professoren" vereinigt hatte, brachten im August und September des Jahres den Aufsatz „Ein Wort über Verfassung". Hier stand, wie in Stein gemeißelt, der Satz: „Eine heilige Sache ist der Staat."

Bodenstedt

„Lieder des Mirza Schaffy"

„Die poetische Ukraine"

Kiel: „Ein Wort über Verfassung"

„Eine heilige Sache ist der Staat" Verfassungen „sind wie jener fabelhafte Speer, der die Wunden, die er geschlagen, auch wieder heilt". Die werdende niedersächsische Geschichtschreibung war hier als Zeugin des Staatsbesten aufgerufen, und zwar nicht als Lehrmeisterin, sondern sie war zur Erzieherin des Volkes bestellt. Fähigkeit und Recht der Schleswig-Holsteiner zu einer Verfassung wurden aus der Art des sächsischen Volkes abgeleitet. Die gewaltsame Eingliederung in das fränkische Reich wird als Ursache erkannt, daß den deutschen Sachsen eine Verfassung nach angelsächsischer Art versagt blieb, wie denn der bewegende Unterschied, daß die Angelsachsen römischen Untergrund hatten, die deutschen Sachsen aber nicht, schlüssig ausgewertet wird. Der ursächsische Staatsgedanke war aus dem angelsächsischen gedeutet und dem fränkischen bewußt entgegengestellt. Verfassungswerk und Staatsschöpfung waren als eine zunächst binnensächsische Aufgabe dargetan. Der Staat erschien als die Hebellast, die durch die Hebelkraft der Geschichte zu bewegen war. Zum Staat durch die Geschichte hieß die neue Losung.

Die sächsische Historie: Dahlmann, Droysen, Waitz An der Kieler Hochschule wurde die Vorschöpfung des deutschen Staates durch die Geschichte Ereignis. Denn der Verfasser dieser Abhandlung, der Pommer *Friedrich Christoph Dahlmann,* 1809 der Gefährte Heinrichs von Kleist, wirkte 1813 bis 1829 an der Kieler Hochschule, und seit 1840 lehrte an ihr der andere Pommer *Johann Gustav Droysen,* der 1843 bei der Verdenfeier, die sich gegen Dänemark richtete, die Festrede hielt. Eben diese Feier erweckte Georg Waitz, der seit 1843 in Kiel lehrte, zu dem Gedanken einer deutschen Verfassungsgeschichte, die schon 1844 herauskam. Während Droysen mit der Feder die Kämpfe Schleswigs und Holsteins ausfocht, gab Waitz seit 1844 die Zeitschrift der Gesellschaft für vaterländische Geschichte heraus: „Nordalbingische Studien." Hier lehrte seit 1843 Karl Müllenhoff. Und da war die große Jugend der Landschaft: seit 1837 Theodor Storm, seit 1838 Theodor Mommsen, die mit Tycho Mommsen 1843 das „Liederbuch dreier Freunde" herausgaben. *Georg Waitz,* 1813 bis 1886, von Flensburg hat eigentlich die alten deutschen Geschichtsquellen erschlossen, entdeckt, was unecht schien, als echt erwiesen. Fast ein Sinnbild war es, daß er 1841 zu Merseburg die Zaubersprüche entdeckte. Der Nordalbinger Georg Waitz hat die germanische Grundlage des deutschen Königtums verfochten gegenüber

Deutsche Altertumskunde: Müllenhoff dem Rheinsachsen Heinrich Sybel, der es auf römisches Recht zurückführte. Im Zusammenwirken von Volk und König bestand für ihn der germanische Staatsgedanke. Die volkhafte Urvergangenheit brachte *Karl Müllenhoff,* 1818 bis 1884, aus Marne zum Wirken. In seinen nordalbingischen Jahren wurzeln alle seine großen Entwürfe. Mit einer grundlegenden Einleitung gab er 1845

„Sagen, Märchen und Lieder der Herzogtümer Schleswig, Holstein und Lauenburg" heraus, half die Rechtschreibung von Klaus Groths „Quickborn" feststellen und erschloß 1847 mit seinem Aufsatz „Über Tuisko und seine Nachkommen" die Erkenntnis, daß die ältesten deutschen Stämme Kultgemeinschaften gewesen seien. Die Mythen, die sich an diese Stammeskulte knüpften, lebten in der deutschen Heldensage fort. So legte Müllenhoff den Grund zu seiner „Deutschen Altertumskunde", dem Gegenstück zu der deutschen Verfassungsgeschichte von Waitz, Kunde des Volkes zur Kunde des Staates.

Die antike Welt hat *Theodor Mommsen*, 1817 bis 1903, aus Garding bei Eiderstedt zum sächsisch-nordischen Eigenbesitz gemacht. Die ländliche Umwelt seines Dorfes begabte ihn mit Begriff und Sinn für den altitalischen Bauernstand. Die klassische Altertumskunde gab ihm die Arbeitsweise. Am rechtswissenschaftlichen Denken wurde er zum Forscher. Noch schwärmte und spottete er in Versen. Er schrieb für die „Neuen Kieler Blätter". Er sammelte mit Storm für das „Volksbuch" nordalbingische Sagen. Er machte sich Rom und dessen ungehobene steinerne Urkunden zu eigen. Mommsen hat, was Waitz und Müllenhoff für die Deutschen betrieben, dem römischen Volke geleistet, indem er die altitalienischen Mundarten aus dem Stimmengewirr der Überlieferung abklärte, das römische Münzwesen aufschloß, Inschriften und Steine zu redenden Quellen versammelte und die lebendige Gestalt des römischen Staatsrechts mit seiner „Römischen Geschichte" unter den modernen Staatsvölkern Europas wieder erscheinen ließ. Der angelsächsisch-germanische Staat, den Dahlmann predigte, mußte in Mommsens antik-römischem Kaisertum ein Gegengewicht finden, damit das neue deutsche Staatsvolk über seinem nordischen Bau nicht des älteren Gemäuers vergäße, aus dem es seit Jahrhunderten seine Steine gebrochen hat.

Römische Geschichte: Mommsen

Im Vergleich zu dieser nordsächsischen Schöpfung der Geschichte fiel gar nicht ins Gewicht, was herkömmlich Literatur heißen konnte: Johann Christoph Biernatzki aus Elmshorn, der mit seiner Novelle „Die Hallig" 1836 die mächtigsten Naturereignisse schildernd bewältigte; Theodor von Kobbe, der mit Wilhelm Cornelius für das „Malerische und romantische Deutschland" die volkskundlichen „Wanderungen an der Nord- und Ostsee" beisteuerte; Karl Leonhard Biernatzki aus Altona, der Herausgeber des heimatkundlichen „Volksbuch", 1844/1851, das glücklich zuerst Theodor Storms „Immensee" brachte. Wessen also wäre der übliche *Ludolf Christian Wienbarg*, 1802 bis 1872, aus Altona, Herold gewesen, da er 1834 die Kieler Vorlesungen seiner kurzen Lehrtätigkeit drucken ließ unter dem Titel „Ästhetische Feldzüge,

Kleine Literatur

dem jungen Deutschland gewidmet"? Dieser ebenso kenntnislose wie Herder fälschende Widerspruch gegen das Mittelalter, dieser Schrei gegen die Historie, dieses Durcheinander vom Hundertsten ins Tausendste, dieses Brüsten mit einer neuen Zeit: das ganze Buch hatte wie Wienbargs fanatische Kampfschriften wider das Plattdeutsche das Verdienst, daß sie Wort für Wort vom Aufwuchs der Landschaft widerlegt worden ist.

„Die sieben Haimonskinder"

WESTFALEN hat die großen Dichter des niedersächsischen Stammes hervorgebracht. Der geistige Ausgangsraum des Münsterer Kränzchens, das Benedikt Waldeck, der spätere „Bauernkönig" gründete, waren die Poetische Schustergilde und Beneckes Vorlesungen zu Göttingen. Sie nannten sich „Die sieben Haimonskinder". Ihr volkskundliches gemeinsames Werklein „Münsterische Geschichten, Sagen und Legenden" 1825, von dem Rheinländer Friedrich Arnold Steinmann betreut, brachte die münsterländische Mundartdichtung in Fluß. Noch herrschte der Junker. Die meisten Mitglieder der Familie Haxthausen waren Sammler, zumal an den „Kinder- und Hausmärchen" beteiligt. *August von Haxthausen* machte in den zwanziger- und dreißiger Jahren sein Schloß Bökendorf zu einem Sammelplatz der Germanisten und Schöngeister. Bei der Ausgabe der großen Volksliedersammlung seiner Familie kam er allerdings nur bis zu den geistlichen Liedern. Mit russischen Freunden arbeitet er an der Vereinigung der griechischen und

Die Haxthausen

lateinischen Kirche. Sein Bruder *Werner von Haxthausen,* mit Arndt, Görres, Boisserée befreundet und die Seele der Erhebung im Königreich Westfalen, trieb morgenländische Forschungen, zeichnete aus dem Munde griechischer Matrosen Volkslieder auf und übersetzte sie ins Deutsche. Die Sammlung wurde 1815 Goethe bekannt aber nicht gedruckt. Von seinen vielen formvollendeten Gedichten ließ er nichts an den Tag kommen.

Die drei Dichter der Landschaft sind Annette von Droste-Hülshoff, Christian Dietrich Grabbe, Ferdinand Freiligrath.

Traum, bist du Leben? Leben, bist du Traum?

Annette von Droste-Hülshoff, 1797 bis 1848, von Schloß Hülshoff, war durch ihre Mutter die Nichte der Brüder Haxthausen. Das Vermögen für Spuk und Grauen, Freude und Fertigkeit der Musik hatte sie mit dem Vater gemein. Nach des Vaters Tode, 1826, zog sie mit der Mutter auf Gut Rüschhaus bei Münster. Hier nun lebte sie ihr rechtes Leben, mit ihrer alten Amme viel allein, lesend, betend, schreibend, durch Feld und Busch schweifend. Eine seltene Meisterin der Erzählung, plauderte sie gerne mit ihren Gästen vom Volk, von Gespenstern und Vorgesichten. Unter Spuk und Einsamkeit verlor sie fast den Zeitsinn. So floh sie, erschreckt vor sich und dem Leben in die Dinge der Natur. Aus ihrem mütterlichen Verhältnis zu Levin Schücking,

den sie 1831 kennengelernt hatte, wurde eine literarische Freundschaft mit
erotischen Untertönen, als Schücking ihr auf Schloß Meersburg, dem Besitz *„Gedichte"*
ihres Schwagers Laßberg, Gesellschaft leistete. Es war Annettes Nachsommer.
Schücking wurde der „Befreier ihrer Lieder". Die besten Gedichte entstan-
den. Sie konnten 1844, diesmal von Schücking erfolgreich beraten, bei Cotta
als „Gedichte" neu erscheinen. Es war ein großer Bucherfolg. Annette liegt
in Meersburg begraben. Die Dichterin hat sich nur langsam vom sächsischen
Beruf zum Epos frei gemacht. Das Rittergedicht „Walter", 1817 bis 1818
entstanden, arbeitete mit dem romantischen Werkzeug Fouqués. „Das Hospiz
auf dem großen Sankt Bernhard", aus den Jahren 1827 bis 1834, war ein
Mosaik aus Gelesenem und Gehörtem, doch erfüllt von dem einen großen
Gedanken: die Gaststätte der Barmherzigkeit auf Bergeshöhe. „Des Arztes
Vermächtnis", aus Annettes schwerer Krankheit 1828 bis 1830 entstanden,
scheint auf ein wirkliches Erlebnis des Württemberger Arztes Justin Röser
zurückzugehen. „Traum bist du Leben? Leben, bist du Traum?" Was eigent-
lich ist das Wirkliche? Diesen Vorwurf wußte Annette bald sachlich, bald
traumhaft schildernd, mit hastigen, abgerissenen Worten unheimlich gegen-
wärtig zu machen. „Die Schlacht im Loener Bruch", seit 1836 geplant und *„Die Schlacht*
als „Christian von Braunschweig" begonnen, ging erst nachträglich auf ge- *im Loener Bruch"*
schichtliche Quellen und wurde 1838 unter Einfluß Walter Scotts abgeschlos-
sen. „Der Spiritus familiaris des Roßtäuschers", sieben Balladen um einen
geretteten Teufelsbündler, 1842 vollendet, gingen auf eine Sage der Brüder
Grimm zurück. Der Doppelstrom ihrer Prosaepik versickerte in mächtigen
Entwürfen. Aus der Mitte der zwanziger Jahre stammte das Romanbruch-
stück „Ledwina" und 1842 erschien im „Morgenblatt" die Kriminalgeschichte
„Die Judenbuche", nach einer wahren Begebenheit. Mit dieser Erzählung *„Die Judenbuche"*
griff Annette den Ball von Kleist her auf und spielte ihn Hebbel zu. Denn sie
erzählte dramatisch gedrungen, ohne Beiwerk, aber mit kräftiger Gesprächs-
führung, sachlich gegenständlich und episch unbeteiligt, mit einer Bildhaftig-
keit des Auges, die unerhört war. Das Rückgrat ihres Schaffens bildet „Das
geistliche Jahr", schon 1818 begonnen, 1851 erschienen, 72 Gedichte, Be- *„Das*
kenntnisse des Suchens, nicht des Besitzes, religiöse Betrachtungen nach dem *geistliche Jahr"*
Gegenstand der Sonntagsevangelien. Die erste Sammlung Annettes von 1838
hatte epischen Stil. Seit 1840 gewinnt ihre lyrische Seelenlage den Durch-
bruch. Die zweite Sammlung von 1844 ist ein lyrisches Buch. Aufs stärkste
verpflichtet blieb sie Freiligrath. In Annette wurde die alte Lebensgemein-
schaft zwischen dem altsächsischen und dem angelsächsischen Sprachbereich
wieder lebendig. Walter Scott, der Dichter schottischer Hochlandheiden und

der heimatlichen Clans, hat die Westfälin entscheidend gefördert. Noch mehr aber Lord Byron, der angelsächsische Lord die altsächsische Lady. Annette war ein Nervenbündel der westfälischen Landschaft. Ihr kurzsichtiges Auge *Geschärfte* besaß für das Nahe die Schärfe eines Mikroskops. Ihr Gehör vermochte die *Sinne* Geräusche der Stille eindeutig auszumachen. Um die Neuwerte ihrer Sinneseindrücke zu bezeichnen, schöpfte sie neue Worte aus ihrem angehäuften Vermögen oder aus der Mundart. Annette hatte das geschwisterliche Verständnis des Tieres, jene ursächsische Gabe, die ihr mit Storm, Hebbel, Reuter, Speckter gemein war. Aus dieser Gabe schuf sie dem Tierleben wunderbare Offenbarungen. Verwandt und dennoch fremd: in dieser Stimmung wurzelt das Nächtlich-Gespenstige ihres Wesens, die Dämonie der Natur und ihrer Seele. Ihr Spielbereich ist nicht eigentlich die Welt des Junkers, sondern des einen ungeteilten Volkes. Nicht minder stark war an ihr der sächsische Geschichtssinn. Immer wieder fiel sie in die Ballade zurück, diese größte Leistung ihres Könnens.

Christian Dietrich Grabbe, 1801 bis 1836, aus Detmold, ist mit seiner ganzen Mannesart schon in der Gestalt des Jungen da, in seiner Lesewut, in *Grabbe, Norden* seinem Selbstgefühl, seiner verzerrten Laune, in seinem Redefluß, wie in *und Süden* seiner Verschlossenheit. In Leipzig und Berlin führte er ein wildes Leben und verwildert kehrte er nach Detmold zurück. Er wurde mit sechsundzwanzig Jahren Auditor, verfiel, legte sein Amt nieder, wurde von Immermann nach Düsseldorf eingeladen und kehrte, rettungslos preisgegeben, nach Detmold zurück. Ein Roman „Ranuder", die Dramen „Kosciuszko", „Christus", „Alexander", sowie das Lustspiel „Till Eulenspiegel" blieben in Ahnungen oder Entwürfen stecken. Kein Stück zeugte so einwandfrei für die Abkehr des sächsischen Lebens von der Weimarer Bildung wie Grabbes „Herzog Theodor von Gothland". Ein edel angelegter Held wird durch die Ränke seiner Umwelt zum Verbrecher. Aus der Lust am Entsetzlichen, Tierischen, an den Abgründen des Menschen geboren, war das Stück wahrhaftig, wie Immermann es nannte, „ein Konzert der Verzweiflung". Die letzten Züge der romantischen Literaturkomödie trug das Lustspiel „Scherz, Satire, Ironie", 1822 vollendet, 1827 gedruckt, ein Lustspiel nicht durch Handlung, sondern durch sein Beiwerk und den absichtsvoll verzerrten Naturalismus. Grabbes Weg war der des sächsischen Geschichtsgeistes in dessen dreifacher Verzweigung. Da war einmal der nordisch-südliche Widerspruch der deutschen Seele. „Don *„Don Juan* Juan und Faust" 1829 macht nicht den Verstandesmenschen und den Sinnes- *und Faust"* menschen zu Gegenspielern, sondern die beiden ewigen deutschen Zwillinge und die beiden europäischen Menschenarten. Den gleichen Gegensatz stell-

ten Grabbes zwei Hohenstaufendramen auf die Szene, „Barbarossa" und „Kaiser Heinrich der Sechste", beide 1829 abgeschlossen. Sie sollten mit „Karl der Große und die Sachsen" ein Vorspiel erhalten und im Gegensatz von Sächsisch und Fränkisch, Waiblingern und Welfen, den Gegensatz zweier Kulturen und Weltbezirke, den fast metaphysischen Gegensatz von Nordisch und Südlich anschaulich machen. Da war sodann die sächsische Wendung zur Antike. „Marius und Sulla", 1823 begonnen, 1827 mit den Umrissen dessen, was fehlte, gedruckt, zeichnet den Machtmenschen von eigenen Gnaden und den Gefahrenpunkt eines geschichtlichen Ablaufes. Masse und Auslese sind hier die Gegenspieler. „Napoleon oder die hundert Tage" 1830 will zeigen, *„Napoleon"* wie ein großer Mann entsteht und aussieht. Der Held ist ein Abbild der Sehnsucht, mit der es der Menge nach dem großen Mann gelüstet. Neu und ohnegleichen war hier Grabbes Kunst, das Volk in Szene zu bringen. „Hanni- *„Hannibal"* bal" 1834 mag aus der persönlichen Stimmung eines verfehlten Lebens geflossen sein. Es geht darum, ob die Welt karthagisch oder römisch werden soll und warum sie römisch wurde. Der größte Feldherr scheitert am Gesetz des Geschehens: eine Kaufmannsstadt muß gegen den Kriegerstaat unterliegen. Das war ganz im Sinne Mommsens und Hebbels gedacht. Grabbes Stil ist auf die Spitze getrieben in dieser Gruppe gesprochener Augenblicksbilder und in einer Sprache, die bis ins letzte Wort persönlich und völlig unerhörter Lakonismus ist. Und zu dritt endlich der Stil des naturwirklichen, heimattreuen Geschichtsbildes. Diesen Stil hatte er mit Annette von Droste- *„Die Hermanns-* Hülshoff gemein. „Die Hermannsschlacht" war 1835 geplant, wurde fünfmal *schlacht"* umgearbeitet, im Sommer 1836 abgeschlossen und 1838 gedruckt. Im Lande selbst kannte Grabbe Weg und Steg. Er wollte die Wesenheit einer wilden Landvolknatur auf der Szene haben. Die Landschaft selbst kämpft in dieser Varusschlacht mit. Held ist nur die Masse Mensch. Einzelwesen sind nichts als gesteigerte Eigenschaften des Volkes. Grabbes Germanen sind greifbare, tagtägliche Natur, westfälisch-lippische Bauern. Aus diesem Kern trieb er den Widerstreit Germanentum-Römertum. Diese Aufgabe war so völlig neu, daß sie der erste, und gar da es ein Sterbender war, noch nicht und nicht mehr bewältigen konnte.

Ferdinand Freiligrath, 1810 bis 1876, aus Detmold, hat schon die Zeit von morgen. Der Soester Kaufmannslehrling berauschte sich an Reisebeschreibungen. Der Amsterdamer Handlungsgehilfe sah das Meer und fand den Stil seiner überseeischen Gedichte. Im Almanach von Schwab und Chamisso erschienen 1835 seine ersten Strophen, darunter „Der Löwenritt". Das gleiche *„Der Löwenritt"* Jahr 1838, das die „Gedichte" Annettes von Droste-Hülshoff brachte, führte

Freiligraths erstes Versbuch heran, neben den eigenen Dichtungen verstän-
dige Übersetzungen aus dem Englischen und Französischen. Mehr durchs
Auge denn durch das Ohr bedingt, verlegte Freiligrath die Wirkung vor allem
in die neuen Reimwörter. Ein eigener Sprachschatz, eine besondere Behand-
lung des Tonfalles, Schilderungen nach gereihten Eindrücken, das Phantasie-
erleben ferner Länder: Freiligrath hatte seinen Stil gefunden und handhabe
ihn treffsicher. Wie Annette von Droste-Hülshoff aus der westfälischen Land-
schaft den Realismus erweckt und Grabbe dem sächsischen Drama vorge-

Freiligrath, arbeitet hatte, Freiligrath wurde der Reimsprecher des Dampfschiffes, der
Dolmetsch
der Dichtung Eisenbahn, des Weltverkehrs: Gefährte der sächsischen Reiseliteratur wie
Grabbe der sächsischen Historie. Seit Anfang der vierziger Jahre machten
ihn seine neuen Gedichte mit ihren erschreckenden Schilderungen des Ar-
beiterelends landflüchtig, bis ihn die Düsseldorfer Geschworenen freispra-
chen. Vor einem neuen Haftbefehl brachte er sich nach London in Sicherheit.
Von dort schlugen ab und zu Gedichte, wenn besondere Gelegenheit war,
zündend herüber. Mochte er die Verse Alfreds de Musset und Viktor
Hugos verdolmetschen, es gab den Ausschlag, daß er den Deutschen mit
gediegener Meisterschaft Longfellows „Sang von Hiawatha", Robert Burns
und Thomas Moore vermittelte, seine Landsleute auf die Amerikaner Walt
Whitman und Bret Harte hinwies. Ein Sachse wie so viele also, der am gei-
stigen Zusammenspiel des sächsischen Weltvolkes mitwirkte.

3. SÜDDEUTSCHE LANDSCHAFTEN

Süddeutsche Nur ein Umsturz, der seine Minengänge unter die härtesten Grundfesten
Sprengungen
des Gewordenen trieb, sie aufriß und umpflügte, konnte die beiden Grund-
säulen des geschichtlichen Daseins der Deutschen, den klassischen Humanis-
mus und das immerwährende Reichsbewußtsein mit einem Schlage zerstören.
Dieser Umsturz ist in den drei süddeutschen Landschaften geschehen. In
Schwaben wurde die Geschichte entgöttert und aus dem Gottmenschen ein
Mythus gemacht. In der mainfränkischen Landschaft trat der vergottete
Mensch in den Mittelpunkt des Gottesraumes. Im oberrheinischen Tieflande
erhob sich der moderne Machtstaat gegen den Volkswillen zum erneuerten
Reich und zwang ihm mit der letzten Schlacht die endgültige Niederlage auf.
Der humanistische Klassizismus wie die süddeutsche Restauration sind der
unbedingten Vernunft und der schrankenlosen Ichsucht, wie sie beide sich

im modernen Staat verkörperten, hoffnungslos und auf unbegrenzte Sicht erlegen.

Die *MAINFRÄNKISCHE LANDSCHAFT* erlebt die letzte Erscheinung seiner alten Reichsunmittelbarkeit und die erste Verwirklichung des bairischen Staates. Mit Johann Paul Richter, dem verkörperten kleinstaatlichen Ostfranken, starb auch das ganze künstlerische Vermögen ab, das von weither in Richter gipfelte. Nur wie Herbstzeitlosen wuchsen noch zwei Geschöpfe nach: *Karl Heinrich von Lang,* 1764 bis 1835, aus Balgheim bei Nördlingen, der parodistische Verspotter des alten Deutschland, des deutschen Bundes, des bairischen Staates, vor allem in den elf Fahrten der „Hammelburger Reisen", 1817/1833, gelehrig im Stil Rabelais', Fischarts, Abrahams a Sancta Clara; *Karl Julius Weber,* 1767 bis 1832, aus Langenburg, der Verfasser der elfbändigen Essaysammlung „Dymokritus", 1832 bis 1835, ein lebhafter, feuriger Geist, der auf die Welt, die er nicht mehr verstand, mit einem matten spöttischen Lächeln antwortete. Gleichzeitig verblühte Richters Geist in den ostfränkischen Volkserzählern wie dem ehrwürdigen *Christoph Schmid,* 1768 bis 1854, aus Dinkelsbühl, der an die fünfzig Kindergeschichten geschrieben hat, meist aus der vorromantischen bairischen Literatur des Ritterbuches. Es sind schlichte Bilder, mit Naturschilderungen hold bekränzt und alle von dem kindlichfrohen Gedanken erfüllt, wie Gottes fühlbare Hand das mutwillig gestörte Glück guter Menschen wieder herstellt. Schmids Art verjüngte sich in dem Amberger *Ottmar Lautenschlager,* 1809 bis 1878, der seinen „Erzählungen" 1836, wie Stifter es in den „Feldblumen" machte, meist Aufschriften aus der Blumenwelt gab. Der evangelische Seitentrieb *Karl Stöber,* 1796 bis 1865, aus Pappenheim, freundete sich, für seinen Vater, den Apotheker, Kräuter sammelnd, durchs ganze Altmühltal dem Land und seinen Leuten an. Die Lebensgewohnheiten der Heimat stecken denn auch in seinen Erzählungen und Kalendergeschichten.

Fränkische Herbstzeitlosen

Die Volkserzählung

Unberührt blieb in allen staatlichen Wandlungen der Landschaft jenes schöpferische Sprachvermögen, seit Wolfram von Eschenbach und Ulrich von Hutten ebenso ostfränkisch, wie es eben noch Richters Wesensart war, und es wuchs und wurde zeitgemäß Erscheinung in der fränkischen Vielheit nachgestaltender Spracherkenntnis: durch Kaspar Zeuß aus Vogtendorf bei Kronach und seinem Riesenwerk der „Grammatica Celtica"; durch den iranischen Sprachforscher Friedrich Windischmann aus Aschaffenburg; durch den genialen Sprachvergleicher August Schleicher aus Meiningen, den Entdecker organischer Sprachgesetze. Eben dieser Sprachbetrieb, dichterisch verfeinert, verzweigte sich in zweierlei Offenbarung: Rückert und Platen.

Fränkischer Sprachtrieb

„Die Poesie in allen ihren Zungen" *Friedrich Rückert*, 1788 bis 1866, aus Schweinfurt, stellt den neuen Menschenschlag des bairischen verstaatlichten Landes dar. Die Familie stammte aus dem südlichen Meiningen. Nach Semestern an der Würzburger und Heidelberger Hochschule, las er seit 1811 in Jena über allgemeine Mythengeschichte und entwarf wie wenige Jahre später Platen Dramen nach Aristophanes und Calderon. Des Lehramtes müde, kehrte er bald nach Hildburghausen zurück. Dahinzudämmern schien dem gedrückten berufslosen Jüngling bestimmt, als ihm doch 1813 ein großer Antrieb wurde. Das „Lied der

„Geharnischte Sonette" fränkischen Jäger" und „Geharnischte Sonette" erschienen 1814 als „Deutsche Gedichte". Und wieder wie später Platen, anders als Richter und Meyern, goß er seinen Ingrimm aus in die aristophanische Lustspielreihe „Napoleon". Sie gab der formlos schweifenden fränkischen Zeitsatire Stil. Ein milder Widerschein der alten fränkischen Freude am Kindlichen und Kleinweltlichen waren die „Fünf Märlein zum Einschläfern für mein Schwesterlein" 1813 wie die Idylle von 1814 „Rodach". Nach seiner Römerfahrt 1820 lebte er ohne Amt zu Koburg Forschungen des Morgenlandes. An Luise Wiethaus-

„Liebesfrühling" Fischer, mit der er 1821 getraut wurde, ist die Liederfolge „Liebesfrühling" gerichtet. Das Heim zog das Amt nach. Rückert wurde 1827 in Erlangen zum Hochschullehrer für morgenländische Sprachen bestellt. In zahlreichen Zeitschriften und Almanachen verstreute er seine Gedichte, und was daraus 1834 bis 1838 vorläufig zu sechs Bänden gesammelt wurde, war nur Auslese. Nach dem Berliner Zwischenspiel 1841/1848 kehrte er mißmutig nach Neuses zurück. Seine Dichtung wurde zur „Haus- und Jahrespoesie" und quoll aus seinen Taschenbüchern unaufhaltsam weiter, als der Dichter längst im Grabe lag.

Rückert, Hammer, Hafis Es war Friedrich Rückert wie Wilhelm Müller ergangen. Nicht in Rom, wohin der altdeutsche Jüngling mit der Sehnsucht eines Nazareners gewallfahrtet war, zu Wien, auf der Rückreise 1818, begegnete er seinem Schicksal. Er fand zu Josef Hammer und lernte von ihm Persisch. Statt der Kleinwelt seines Herzens wurde das weltweite Morgenland sein Acker. Und wo Goethe aus Übersetzungen übersetzte, wurde Rückert der Eigner der Urschrift. Indem er Dschelâl-eddin 1821 übersetzte, gewann er den Deutschen das Ghasel. Als Frucht seiner Hafislesung erschienen 1822 die „Östlichen Rosen". Und wie der östlichsten Formen wurde er der westlichsten mächtig, des Ritornells, der

Rückert und das arische Morgenland Sestine und Oktave, der Siziliane. Wenn Rückert auch seit 1820 an den „Makâmen" des arabischen Dichters des elften Jahrhunderts Hariri arbeitete und diese Verdeutschungen 1826/1837 drucken ließ, es sind die gewaltigen Übersetzungswerke aus dem Kulturbereich des persischen und indischen Arier-

tums, die seine Stelle in der Weltliteratur bestimmen: „Nal und Damajanti"
1828, „Sieben Bücher morgenländischer Sagen und Geschichten" 1837, „Ro-
stem und Suhrab" 1838, „Brahmanische Erzählungen" 1839, das Hauptwerk
„Weisheit des Brahmanen" 1836/1839; aus dem Nachlaß Saadis Lehrgedicht
„Bostan" 1882, „Firdusi" und die Versübersetzung aus Hafis. Wenn man
Rückerts gleich schöpferische Nachbildungen der abendländischen mittel-
alterlichen Minnesänger und Gottfrieds von Straßburg mit demselben Blick
erfaßt, verschärft sich die Erkenntnis, daß es hier um den Rückgewinn eines
ganzen Weltalters ging, einer Weltaltersstufe in Schellings Sinne.

Friedrich Rückert hat 1839, den Evangelien treulich fromm, das „Leben
Jesu" nacherzählt, David Strauß zu bewußtem Widerspruch, ein Zeugnis für *„Leben Jesu"*
den kindhaften Sinn ostfränkischen Wesens nicht minder wie ein Schlüssel
zu Rückerts Gesamtwerk. Sprachfrömmigkeit war seine seelische Haltung.
Er gehörte als unsichtbarer Gast zur Münchner Gesellschaft der drei Schilde.
Solche Frömmigkeit wußte den einen Gott in tausend Gestalten. Rückert
lebte in einem Urbilde aller menschlichen Mystik. Was ist, das redet; alles
ist, um zu reden; alles Sein ist Sprache. Diese Vorstellung hatte die Romantik
von Hamann und der hatte sie aus den Mysterien der Völker. Eins mit dieser
Vorstellung von einer Allsprache, die nur Gegenseite zu Fechners gleich-
zeitigem Glauben an eine Allbeseelung ist, war der Begriff einer Ursprache.
Rückert gab ihm Herders Fassung: „Die Poesie in allen ihren Zungen / Ist
dem Geweihten eine Sprache nur." Jegliche Sprache ist abgewandelter Ton-
fall des einen Mundes. Übersetzen bedeutet daher nicht seitliche Verschie-
bung von Sprache zu Sprache, sondern Rückbeziehung auf die eine urtüm-
liche, die sich in allen mystisch birgt: heimführen aus der Fremde des Um-
kreises in die allmenschlich vertraute Mitte. Gleichviel wie Rückert als Ge-
lehrter zur Frage des sprachlichen Stammbaumes stand, ob er an eine einzige
Muttersprache glaubte oder deren wie sein Landsmann Schleicher mehrere *Im Dienst*
annahm, seine Alleinsprache vermag die Stimme des Logos nicht zu ver- *des Sprachlogos*
hehlen, die er aus dem vielzungigen Raunen der Völker hörte. Geheimdienst
des Sprachlogos, nur den Eingeweihten zugänglich, das ist Rückerts sprach-
wissenschaftliche Arbeit in Doppelgestalt: erkennend und bildend. Wie Brü-
der gleichen sich Rückert und Feuerbach in dem einen. Was jener Allsprache
nannte, daß hieß dieser Allmenschheit. Es kam freilich darauf an, ob man
diesen Logos göttliches Wort oder Menschenvernunft nannte.

Rückerts Werk zielte auf die Schöpfung eines umfassenden geschichtlichen
Weltbewußtseins, gleich dem Werk Goethes. Und wie Goethe so ging auch
Rückert von der morgenländischen Schule Wiens aus. Im Binnenkern war

Rückerts Werk auf das gemeinsame arische Mittelalter des Morgenlandes und Abendlandes gerichtet.

August Graf von Platen-Hallermünde, 1796 bis 1835, tritt neben den Norddeutschen Mörike in Schwaben. Platens Familie stammte wie die Arndt und Ruge von Rügen und ist erst durch des Dichters Vater nach dem damals preußischen Ansbach verpflanzt worden. Seine Art läßt sich nicht aus der völlig verwelschten Mutter deuten und so romanischer Formtrieb nennen. Platen war etwa von Kleists Art. Wie dieser ein Selbstquäler, Zweifler, sich selber ungenügend. Wie Kleist machte er seine Schweizer Reise. Wie Kleist wurde er mit Heinrich Zschokke bekannt. Wie Kleist schwelgte er in uferlosen Reiseplänen. Hätte Kleist ein Tagebuch hinterlassen, es würde wohl dem von Platen gleichen. Daß Platen ein schlechter Offizier war, beurlaubt auf Hochschulen ging, sich in Wissenschaften aller Art umtrieb, immer wieder verwarf und endlich zum großen Wurf ausholte: Zug um Zug gleichen einander zwei nordländische Junker, bis in den übereilten Tod und die versagte Stillung eines dämonischen Ehrgeizes. Aber man sehe doch, was aus diesem wortschweren, verschlossenen Menschenschlage im mainfränkischen Erdreich und an der Sonne Rückerts geworden ist.

Denn von den drei Räumen, die Platen durchlebt hat, erfüllte München wohl die Einbildung des Kadettenschülers mit dem Glanz der Hoffeste und gab Italien ihm Bedingnis und Reife des Daseins. In seiner fränkischen Zeit aber, an den Hochschulen von Würzburg und Erlangen, wurzelt alles, was Platen je geschaffen hat. Während der Erlanger Lehrzeit 1819/1826 fielen mit der männlichen Reife die entscheidenden Anregungen zusammen. Er wurde Schellings Schüler, Rückerts Jünger, Johann Paul Richters Gast. Durch Hoffmanns Bamberger Theater waren Calderons Spiele der Landschaft zugänglich geworden. Um die gleiche Zeit versuchte sich Rückert in Calderons Stil. Den Weg schlug auch Platen ein. Viele Seiten des Tagebuchs aus der Würzburger und Erlanger Zeit reden von Calderon. Das alles wurde in dem späteren Schauspiel „Treue um Treue", 1825 zu Erlangen gespielt, wirksam. Platen kannte aber auch Tieck. Und die Wiener Weise des Märchendramas wird ihm nicht entgangen sein. Jedenfalls, dieser Stil zeichnet sich in einer ganzen Gruppe von Lustspielen ab. „Der gläserne Pantoffel" 1823 war das Aschenbrödelmärchen; „Berengar" 1824 ein Ränkespiel von spanischer Form; „Der Schatz der Rhampsinit" 1824 inszeniert unter Seitenhieben auf Hegel die bekannte altägyptische Erzählung; „Der Turm mit sieben Pforten" 1825 schöpft aus dem Volksbuch von den sieben weisen Meistern. Indessen, er sah, wie sehr er sich im Hergebrachten verlaufen hätte und glaubte, mit der Ko-

„Denn der
Natur gleich sei
das Festlied"

Platen
und Kleist

Platens Spiele

Calderon

mödie des Aristophanes die Spielform gefunden zu haben, durch die sich die *Aristophanes* falsche Romantik und was er dafür ansah, totlachen ließe. Gleichwohl traf „Die verhängnisvolle Gabel" 1826 mit dem deutschen Schicksalsstück schon Abgetanes und „Der romantische Ödipus" 1828 stieß schon nicht mehr auf romantische Nachzügler, sondern auf den Vortrupp junger Kräfte. Denn das war ja Immermann, dem das Lustspiel galt. Das war getan und Platen glaubte seinen Weg nun frei. „Die Liga von Cambrai" 1833, das große geschichtliche *„Die Liga von Cambrai"* Schauspiel aus dem Venedig der Renaissance, mit dem Staat als Helden und bis ins letzte Wort geschichtstreu, sollte nur ein Markstein dieses Weges sein. Zwischen Entwürfen zu Trauerspielen wie „Meleager" oder „Tristan und Isolde" brach dieser Weg jählings ab.

Und Rückert hieß der Antrieb zu dem zweiten großen Unternehmen, auf das wohl Platens eigenste Bestimmung lautete. Auf der Burg zu Nürnberg, wo einst Konrad Celtis zum Dichter gekrönt worden war, holte sich Platen 1820 bei Friedrich Rückert den ersten Unterricht im morgenländischen Schrifttum. Was braucht da Schlegels und Goethes Name bemüht zu werden. Platen trat in den mittelbaren Schülerkreis Josef Hammers. In wenig Monaten war er so weit, daß er schon eine Sammlung „Ghaselen" 1821 vorlegen konnte. *„Ghaselen"* Sie litten am Zwiespalt des Stiles, sosehr sie sich mit bewußter Fremdheit morgenländisch gaben. Wie mit gedämpfter Stimme hielt er diesen Ton das ganze Jahrzehnt hindurch gegen den Überhall antiker Rhythmen. Das zweite Büchlein „Neue Ghaselen" 1823 war schon Meisterschaft, Zustände des Abendlandes und einer abendländischen Seele im Stil des Morgenlandes. Als sein Leben zur Neige ging, ließ er diesen Ton gedoppelt wieder vorbrechen. Im Sinne Rückerts trug er mittelalterliches Abendland und Morgen- *Abendländisches und morgenländisches Mittelalter* land wie Bild und Gegenbild als Einheit vor. „Die Hohenstaufen" in Nibelungenstrophen sollten seine Ilias werden, „Die Abbasiden" aber seine Odyssee: ein Doppelepos. Während Platen die östliche Seite Italiens durchwanderte, Tempel und Paläste sich durchs Auge gehen ließ und Venedig genoß, reifte der Plan der „Abbasiden". In Neapel belebte er sich an Meer und Sonne und Märchenluft und gedieh zu neun Gesängen reimloser fünffüßiger Trochäen. Die Dichtung wurde noch 1829 abgeschlossen und 1834 gedruckt. Den vielen, die ihn als bitter verschrien, wollte der Dichter einmal seine Süßigkeit beweisen und denen, die sein Wesen allzu kunstreich fanden, bequem und schlicht erscheinen. Das glückte. Bei einfachstem Aufbau, mit dem Munde des unbefangenen Erzählers, in der sanften Stimmung inneren Gleichmaßes rückt der Dichter Märchenbild um Bild an den Beschauer heran und stellt sie wieder weg. Ihm aber, der die Geschichte Italiens so trefflich

kannte, blieb mit dem Gegenstück der Hohenstaufen die runde Ganzheit
versagt.

Der Dichter des Dramas befreite sich vom jüngst Überkommenen und
barg die Wünsche für sein Vaterland im Heldenspiel des italienischen Frei-
staates. Der Dichter des Epos suchte Weltwesten und Weltosten bis zu Hör-
weite einander zu nähern. Wir fragen endlich nach der Wesenheit dieses
Menschen. Da sind wir an den Lyriker gewiesen. Bunte Garben nur sind die
Die lyrischen Formen zwei Gruppen „Lieder und Romanzen", „Vermischte und Gelegenheits-
gedichte". Sie fallen vor 1824, das war die erste Fahrt nach Italien. Platens
lyrische Form ist die stilgebundene Reihe. Deren sechs hat er geschaffen. Sie
drücken in ihrer Aufeinanderfolge ebensosehr den Fortschritt von Kunst zu
Kunst wie das innere Wachstum des Dichters aus. Die ersten wie die letzten
drei bilden unter sich ein Ganzes und beide Gruppen stehen gegeneinander.
Ghaselen, Sonette, Oden bilden die erste Gruppe und führen von der Me-
lodie zur Architektonik des Rhythmus. Die Ghaselen sind reine Melodie. Ihr
Ehrgeiz ist der Zusammenklang. Sie haben keinen Innenbau. Gedankenpaare
werden einwärts nur durch den Zusammenklang eines umlaufenden Reim-
Platens „Festgesänge" wortes zum Ganzen gebunden. Das Sonett ist Melodie und hat Gestalt. Wie
ein Tanzspiel der Gedanken führen zwei Reimpaare verschlungenen Ganges
eine in sich geschlossene Figur durch. Die Ode ist nicht Melodie, sondern
ein Gefüge. Sie hat Teile und ist Architektonik. Zahl und Ebenmaß sind ihr
Gesetz. Sie gleicht auch hierin dem Bauwerk, daß alles vorausberechnet ist.
Platen hatte sein Gesetz gefunden. Die zweite Gruppe zeigt es an dreierlei
Gehalt: Eklogen und Idyllen, Festgesänge, Epigramme. In ihr stehen, ein-
gerahmt vom Kleinwerk der Stimmung und des Gedankens, die vollkommen-
sten rhythmischen Gebilde: Platens Festgesänge. In feierlichen Riten des
Wortes wird den hohen Gelegenheiten der Seele, wird Fürsten und Freun-
den gehuldigt, einem toten Kaiser abgesungen und dem Lande gedankt, das
Platen eine neue Heimat geworden war.

> „Denn der Natur gleich sei das Festlied,
> Die den Tag nicht bloß, den erfreulichen, uns
> Durch farbige Gebilde reizend ausschmückt,
> Nein, dem Dunkel sogar der Lichtfunken stets wachen
> Glanz verlieh."

Platens Bewunderer und Nacheiferer Johannes Minckwitz hat den Gezeiten-
wechsel dieser Rhythmen in glücklichen Worten festgehalten: „Ernste, durch

schwerwiegende Spondeen feierlich gehaltene Melodie; anmutig und in reiz-
voller Gemessenheit fortrückend; gemischt zwischen Heiterkeit und erhabe-
nem Ernst; eine rasch sich entfaltende Kette von leichten und schwerrollenden
Wogen."

An welchen Mitteln lag es? Platen hat den scheinbar unversöhnlichen
Widerstreit zwischen deutschem und antikem Versgesetz ausgeglichen: den *Platens*
von Tonstärke und Tondauer. Rhythmusbildend ist auch bei ihm der Wechsel *Versgesetz*
von Hochton und Tiefton. Aber er nahm die schweren deutschen Silben,
zumal in zusammengesetzten Wörtern, nie an tonschwache Versstellen. Er
gab sie als Längen. Und so entstanden jene wundervollen hymnischen Ge-
bilde, mit Akzentrhythmus als Oberstimme, mit gemessenem Rhythmus in
der Unterstimme, spondeenreiche Rhythmen mit trochäischem Fluß. Denn
Platen mochte die Weise stimmen wie er wollte, immer schlugen die schwe-
ren Worttöne vor die leichten. Ein erstaunlicher Vorgang. Platen kehrte trieb-
haft auf die sächsische Linie Klopstock-Voß zurück, machte diesen sächsischen
Rhythmus zum Gesetz seiner Kunst und verriet damit gegen allen Einfluß
der Umwelt seine sächsische Uranlage. So hielt er aber auch Schritt mit der *„Meine behelmte*
zeitgenössischen sächsisch-norddeutschen Bildnerei antiken Stiles. Denn Pla- *Kunst"*
tens Gesänge sind keine Musik und Architektonik, wie die Bauwerke und
Standbilder der Klenze, Thorwaldsen, Rauch, Schadow. „Dies erzgetriebene
Bildwerk des Lieds", „meine behelmte Kunst", „das silberne gefäßtiefe
Kunstwerk", in solchen Bildern spricht er von seinen Festgesängen.

So spielten sich die ostfränkischen Ereignisse dieser Jahre zwischen dem
Absterben von Richters alter Welt und der Vorbereitung auf Bayreuth ab.
Die Wende vom fünfzehnten zum sechzehnten Jahrhundert hatte die Reihe
der ostfränkischen Aufrührer erzeugt. Die innere Wirrnis der neuen Zeit rief
verwandte Erscheinungen. Jetzt wurden Christentum und Religion über-
haupt verneint. Diese Ostfranken kehrten sich gegen ihren Lehrer Hegel
und überboten einander mit verzweifelten Übertreibungen.

Ludwig Feuerbach, 1804 bis 1872, zu Landshut als der vierte Sohn des *Homo homini*
Strafrechtslehrers Anselm aus hessischer Familie geboren und ein Schüler *deus*
Hegels, lebte amtlos wie all diese Minengräber und völlig vereinsamt zu
Bruckberg bei Ansbach. Eine gewisse akademische Haltung verriet noch sein
wuchtiges Hauptwerk seit 1833, die „Geschichte der neueren Philosophie".
Es handelt im ersten Bande von der Dreiheit Bacon-Böhme-Spinoza, im
zweiten Bande von Leibniz. Doch diesem Aufwiegler gegen den Gott des
Christentums, der in seiner anspruchslosen Bescheidenheit und seiner mild-
tätigen Herzensgüte persönlich so wenig vom Aufwiegler hatte, gelangen die

größten Zerstörungen mit kleinen Schriften, für die er, Künstler eines fremd-
wortreinen Stiles voll Bildern und zugespitzten Gleichnissen, die gemäßeste
Begabung hatte. Feuerbach hat Hegel aus dem gleichen Grunde überwun-
den, aus dem der mitteldeutsche Osten Hegel widerstand: zurück zur Natur,
die Hegel nicht erklären könne. Philosophie müsse „Wissenschaft der Wirk-
lichkeit in ihrer Wahrheit und Totalität" werden. Auch mit Feuerbach wurde
der Nominalismus gewalttätig rege, entschlossene Gegenwehr wider die
herrschenden Allgemeinbegriffe zweier Menschenalter. Nachdem er in „Ge-
danken über Tod und Unsterblichkeit" 1830 die persönliche Unsterblichkeit
verneint hatte, steckte seine Schrift „Über Philosophie und Christentum"
1839 den Weg aus, den er zu gehen gedachte: Religion ist Beziehung auf
das Ich, Philosophie Beziehung auf das Du. Dann führte er den gepaarten
Angriff gegen den herrschenden Glauben und gegen die herrschende Philo-
sophie. „Das Wesen des Christentums" 1841 behauptete, alle Erkenntnis
Gottes sei nur Selbsterkenntnis des Menschen. Gott als metaphysisches We-
sen sei lediglich die in sich selbst befriedigte Vernunft des Menschen. Alle
Mysterien der Religion seien Mysterien der menschlichen Natur. Homo
homini deus! „Grundsätze der Philosophie der Zukunft" 1843 faßten den
Widerspruch gegen Hegel in das Hohnwort zusammen: Hegel mache das
Sinnliche zum Unvernünftigen. In Wirklichkeit könne aber wahr und gött-
lich nur das sein, was unmittelbar durch sich gewiß ist, nämlich das „Wirk-
liche". Was also waren die Götter und was ist Religion? Feuerbach gab zwei-
mal Antwort. „Das Wesen der Religion" 1845 entwickelte: das Gefühl der
Menschen, von der Natur abzuhängen, ist die Quelle der Religion, indem der
Mensch sich infolge seiner Wünsche außer sich setze. Religion ist ein Ge-
spräch des Menschen mit sich selber. „Theogonie", 1857, erklärte die Götter
für persönlich gedachte menschliche Wünsche. Feuerbach war dem Wider-
spruch zwischen Theologie und Philosophie bis in die letzten Seitenstollen
nachgegangen. Was er als rettenden Gewinn heraufzubringen meinte, war
die Vorstellung, daß die Menschheit in der Religion sich selbst vergotte.
Indessen sein Aufruhr gegen Hegel hatte, wie ihm sofort mit schneidendem
Hohn dargetan wurde, wieder nur zu einem allgemeinen Begriff geführt.
Seine Meuterei hatte lediglich einen Gott an die Stelle des andern gesetzt.
Aber Feuerbachs „Wesen der Religion" untergründete Richard Wagners
frühe Kunstschriften und damit geriet Feuerbach in das Vorfeld Bayreuths.
Feuerbach hat zwei ostfränkische Überwinder gefunden: Johann Kaspar
Schmidt und Georg Friedrich Daumer.

Die Landschaft glich einem fiebernden Gehirn, in dem Gedanke sich wider

Wissenschaft der Wirklichkeit

Feuerbach, religions-philosophische Schriften

„Theogonie"

Ostfränkische Paradoxen

Gedanken empörte. Feuerbach hatte soeben den Widerpart der Natur, den
Geist, für ein theologisches Gespenst erklärt, den sinnlich handelnden und
sinnlich erfaßbaren Menschen aber als die einzige Wirklichkeit ausgerufen.
Da überschrie ihn schon vom selben Platz aus ein anderer. Feuerbachs Gat-
tungsbegriff Menschheit ist nichts als ein letzter Schatten jenes Priester-
gespenstes und das wirklich Wirkliche ist nur das Ich, Ich, der Eigner.

Diese Stimme kam von dem Bayreuther *Johann Kaspar Schmidt*, 1806 bis
1856, der in Berlin, ein Eigner seiner selbst, mit seiner Not einen hoffnungs-
losen Zweikampf führte und 1844 unter dem Namen Max Stirner sein
Evangelium ausschickte: „Der Einzige und sein Eigentum." Es geht gegen *„Der Einzige*
beide: gegen Schopenhauers Verneinung des Wirklichen durch Askese und *und sein*
Feuerbachs Verleugnung des Besonderen durch den Gattungsbegriff. Nach *Eigentum"*
dem Unfug, den zwei Menschenalter mit dem Ich getrieben hatten, nahm
Schmidt dies Ich weder bildlich noch allgemein, sondern wörtlich und eigenst.
Indem er sich im Mittelpunkt dieses sehr ernst und wirklich gemeinten Ich
aufstellte, zog er die Folge aus der gesamten Ichphilosophie. Dieser mäch-
tigste deutsche Aufruhr gegen jedes „Wesen", jeden Geist, jedes Allgemeine
zerstörte die verkappten Reste des philosophischen Realismus im scholasti-
schen Sinne. Bei sehr zweifelhafter Geschichtskenntnis im einzelnen verfuhr
Schmidt im verneinenden Hauptteil seines Buches durchaus geschichtlich
und das unleugbar mit eindrucksvoller Handgebärde. Es beklemmt den
Atem, wie er in großartiger Steigerung dartut, die durch Jahrhunderte ein-
ander übersteigernden Radikalismen hätten gerade das Christentum und
damit das mongolische Schamanentum zu voller Entfaltung gebracht. Die
evangelische Kirche habe weit über die römische hinaus den Sieg des Geistes
erst vollständig gemacht. Der französische Umsturz habe die beschränkte
Monarchie der Könige in die unbeschränkte des Volkes verwandelt. Das fort-
schrittliche Bürgertum habe der religiösen Freiheit die staatliche zur Schwe-
ster gegeben und so die Sklavenkette um das Einzelwesen verdoppelt. Der
letzte Gipfel dieser Entwicklung sei der Kommunismus. Die ganze Ge-
schichte sei ein fortschreitender Sieg der Allgemeinheiten, der abgezogenen
Begriffe, des Du über das Besondere, über die Erscheinung, über das Ich.
Und ein Hohn von besonderer Art: am besten ging es verhältnismäßig dem
Ich noch im Christentum vor Luther. „Volk heißt der Körper, Staat der
Geist jener herrschenden Person, die seither Mich unterdrückt hat." Gegen
jede „Freiheit", die ja nur einem andern freie Verfügung über mich gibt;
gegen jede Allgemeinheit, heiße sie nun Gott, Menschheit, Staat, Volk; gegen
jede Wahrheit, die immer zur Herrin wird, setzt Schmidt das Ich, sein Ich,

Der Freie und der Eigner nicht mit der Pflicht, sich nach irgendeinem Urbild erst zu vollenden, sondern mit dem Recht, sich auszuleben. „Du mußt nicht bloß loswerden, was du nicht willst, um ein Freier zu werden; du mußt auch haben, was du willst, ein Eigner werden." Du wirst ein Eigner der Dingwelt und ein Eigner der Geistwelt sein. Der Untergang der Völker und der Menschheit wird dich zum Aufgange laden. Wenn du das Heilige verzehrst, hast du's zum Eignen gemacht. Laß dich von keinem Gedanken unterjochen. „Alle Wahrheiten unter Mir sind Mir lieb; eine Wahrheit über Mir, eine Wahrheit, nach der ich Mich richten müßte, kenne Ich nicht. Für Mich gibt es keine Wahrheit, denn über Mich geht nichts." Greif zu und nimm, was du brauchst. Krieg aller gegen alle. Der Starke siegt. „Über der Pforte unserer Zeit steht nicht jenes

Stirner: „Verwerte dich" apollinische: Erkenne dich selbst, sondern ein: Verwerte dich." Der Zauberkreis des Christentums ist gebrochen, wenn die Spannung zwischen mir, wie ich bin, und mir, wie ich sein soll, aufhört. Mein Verkehr mit der Welt besteht darin, daß ich sie genieße und sie zu meinem Selbstgenuß verbrauche. Schmidts Buch, in spielenden Beweisgängen und mit der kalten Leidenschaft der Überlegung geschrieben, entsprang einem doppelten Abwehrbedürfnis: gegen Hegels Verwandlung der Welt in Begriffe als letzte Folge des deutschen Idealismus und gegen den wachsenden Druck gesellschaftlicher Bindungen vor dem Hintergrunde des aufsteigenden deutschen Staates.

Rohmer: Die Doppelnatur Gottes Was daran zu überbieten war, wurde überboten. *Friedrich Rohmer*, 1814 bis 1856, aus dem mittelfränkischen Weißenburg, fühlte in sich die Eigenschaften aller Menschenwesen vereinigt und erklärte sich für die größte Persönlichkeit, die je von der Menschheit hervorgebracht worden sei. Mystische Aussagen über das Wesen Gottes, phantastische Geschichtsbilder, in messianischem Ton verkündet, brachte sein Buch „Deutschlands Beruf in der Gegenwart und Zukunft" 1841, und seine „Lehre von den politischen Parteien" 1844 erregte auch bei denen Aufmerksamkeit, die den Propheten verlachten. Schließlich bog er freilich wieder zum Ausgange der ganzen Bahn zurück, wenn er in späteren Büchern von der männlichen und weiblichen Doppelnatur Gottes sprach und zuletzt den unbegrenzten Organismus als den einen lebendigen Gott faßte. Wenn man es so sehen will, dann war das vielleicht die Rückkehr zu Johann Georg Hamann und zu seinem Gott-Welt-Geheimnis mit dem Geschlecht im Mittelpunkte.

Wie vieles in Franken hatte nun schon auf Richard Wagner vorausgedeutet. Mit Johann Kaspar Schmidt geschah in derselben Landschaft das Vorereignis zu Friedrich Nietzsche. Der weltanschauliche Gegensatz Wagner-Nietzsche ist im Ostfranken der vierziger Jahre zuerst erlebt worden.

Nürnbergs eigenster Kern schlug immer wieder von neuem aus. Mit dem *Nürnberg*
Vermächtnis der Stillen und Frommen um den Rosenbäcker, um Schubert
und Kanne hing die Auferstehung der alten evangelischen Kirchenmusik zu-
sammen. Der Stadtjunker Gottlieb von Tucher, 1798 bis 1877, war zu Hei-
delberg, wo Thibaut diese alten Lieder pflegte, und zu Berlin auf die ältere
Kirchenmusik getroffen. Er begeisterte sich in den zwanziger Jahren an den
Gesängen der päpstlichen Kapelle. Von den Chorälen des sechzehnten Jahr-
hunderts kam er auf die Eigenart der evangelischen Kirchenweisen. Und so
erschien nach vieljähriger Arbeit 1848 seine Sammlung „Schatz des evange- *Evangelischer*
lischen Kirchengesangs" und war eine wichtige Fundgrube für Choralbücher. *Kirchengesang*
Tuchers Werk fügt sich zu den verwandten Unternehmen der Silcher, Schelble,
Erk, Thibaut und war das Gegenstück zu Kaspar Etts Münchner Entdeckung
des altkirchlichen Gesanges. Sinn und Ehrfurcht für die Väter, die aus Tu-
chers Weisen sprachen, pflanzten nun in dieser Stadt neben die Sammlung
Boisserée und die Vollendung des Kölner Domes das anschaulichste Werk der
deutschen Restauration: das Nürnberger Nationalmuseum. Hans von und zu *Nationalmuseum*
Aufseß, 1801 bis 1872, von altem fränkischen Adel, Mitglied der Erlanger
Burschenschaft und der Münchner Gesellschaft zu den drei Schilden, hatte
sehr früh und sorgfältig Bücher wie Altertümer gesammelt. Für solche
Zwecke einen Verein zu gründen, scheiterte 1833 wie 1846 an Ungeschick
und Mißverständnis. Als aber bei Beginn der Unruhen von 1848 viele frän-
kische Edelleute in den Städten Schutz suchten, brachte auch Aufseß seine
Sammlungen in einem eigenen Hause am Nürnberger Tiergartentor unter.
Und am 17. August 1852 beschloß unter Vorsitz des Prinzen Johann die
Dresdner Versammlung deutscher Geschichtsforscher, ein germanisches Mu-
seum zu gründen mit dem Sitz in Nürnberg.

In dieser Umwelt, eben zu Nürnberg, wird der rückläufige Gedankengang *Die Mysterien*
verständlich, der sich in dem Nürnberger *Georg Friedrich Daumer*, 1800 bis
1875, vollzog. Als Gymnasiallehrer zeitig zur Ruhe gesetzt und mit eigenem
Willen einsam, hat Daumer nur das Leben gekannt, wie es sein sollte. Er
hielt es in seinem innersten Kern für gut. Und so suchte er denn zu erkennen,
wie sich etwa Tod und Vernichtung überwinden und zu einer höheren Wirk- *Daumer:*
lichkeit vordringen ließe. Die erste Gruppe seiner Arbeiten spürte in der *Todesreligion —*
alten Geschichte, in der Bibel beider Testamente Kräften nach, die er durch *Lebensreligion*
die ganze Menschheitsgeschichte am Werke sah, um die Natur und ihre
Zeugungen zu bekriegen und den wirklichen Gehalt der Welt zu vernichten.
Daumer sah diese Religion der Vernichtung im semitischen Molochdienste
wirksam, während ihm Theseus als Retter der Lebensreligion erschien. Den

Atlantis Ursprung dieser Todesmysterien vermutete Daumer in Amerika, ihre erste Herkunft aus Atlantis, woher die Alte und Neue Welt bevölkert wurden. Im Christentum, dünkte ihn, sei dieser semitische Molochdienst von neuem erwacht. Daumer verfolgte also, belesen und ein Tatsachenverknüpfer wie wenige, den Widerstreit zwischen arischen und semitischen Bildungskräften durch die ganze Welt. Eine zweite jüngere Gruppe von Arbeiten deckte die Urbestände einer Religion des Lebens unter allen Völkern auf. Es ging ihm darum, die Religion des neuen Weltalters zu ergründen. Er predigte die schöpferische Kraft des Islam und verfocht den jüdischen Messiasgedanken. Damit betrat er die dritte Stufe seines Gedankengebäudes. Er suchte seine bisherigen geschichtsphilosophischen Gedanken mit naturwissenschaftlichen zu verschmelzen. Noch vor Darwin an Charles Nodier anknüpfend, machte er sich Darwins Anschauung zu eigen, der Mensch könne nicht die höchste Staffel auf der Lebensleiter sein. Es müsse und werde sich aus dem Menschen eine neue Gattung erzeugen, und diese höher gezüchtete Gattung werde die Trägerin der wahren Lebensreligion werden. Christus war dieser

Christus, erste Übermensch. Hatten Kanne und Görres verkündet, der Übermensch *der erste* *Übermensch* liege hinter uns, so suchte ihn Daumer, abermals wie Kaspar Schmidt ein Vordenker Nietzsches, vor uns. Das Christentum war ihm kein Ausläufer semitischer Todesmysterien und keine Religion des Todes mehr, sondern Anbruch eines neuen und höheren Gottesdienstes des Lebens. Daumer war 1859 in die römische Kirche eingetreten. Durch die Verkündung des Unfehlbarkeitsdogmas 1870 enttäuscht, machte er seine vierte Wendung: von der reinen Geschichtsphilosophie seiner Anfänge zu der reinen Naturphilosophie seiner letzten Tage, in der Erwartung, die Offenbarungen der Natur würden ihn über den Menschen hinaus führen. Daumers Dichtungen waren Niederschläge dieser rastlosen Gedankenarbeit. Weil für ihn die Frau leibgewordene Natur war, Mutterboden für ein neues höheres Dasein, gab er in dem

„Hafis" und Buch „Bettina" 1837, dem Schönsten aus Bettinas Briefwechsel mit Goethe, *„Polydora"* dichterische Gestalt. Die vollkommenste Frau ist die Mutter Christi. Und so stimmte er sich — „Die Gloria der heiligen Jungfrau Maria" 1841 — durch seine Marienlieder auf das Gegenspiel seiner Todesmysterien des Christentums. „Hafis" 1846 war ihm der tiefsinnige Erfasser des Lebensdranges der Natur. Und seine Lese der vollkommensten Liebeslieder aller Völker, „Polydora" 1855, wollte Eros als die gemeinsame Urkraft der Menschheit, als das Urmenschliche schlechthin bezeugen. Daumer formte Ghasele und fand Lieder, die Platens Formstrenge ebenbürtig sind, deren Urgewalt des Erlebten wie bei Brentano mit dem Naturlaut der Seele ergreift.

Daumer ist die wesenhaft ostfränkische Gestalt dieser Jahrzehnte, geisti- *Feuerbach, Schmidt, Rohmer, Daumer*
ger Knotenpunkt der Landschaft. Er hat zur selben Zeit die Stufenfolge von
Feuerbach zu Schmidt und Rohmer gedanklich durchlebt. Durch sein Gedan-
kenfeld laufen die landschaftlichen Übergänge zu den beiden Meissnern
Wagner und Nietzsche.

Die *SCHWÄBISCHE LANDSCHAFT* wurde vom Staat Württemberg
geistig überwachsen. Und in Württemberg wurden nun die räumlichen Zu-
schüsse aus dem Fränkischen lebendig. Aus der Reichsritterschaft Hohen-
rechberg kam Johannes Scherr, aus dem geistlichen Gebiet Ellwangen Karl
Josef Hefele, aus der Reichsstadt Reutlingen Hermann Kurz und Friedrich
List, aus der Reichsstadt Heilbronn Wilhelm Waiblinger und Eduard Eyth,
aus der Reichsstadt Hall Friedrich Gräter, aus der Reichsstadt Biberach Jo- *Württembergs Zuwachs aus dem Reich*
hann Pflug, aus Ravensburg Gustav Rümelin, aus Vorderösterreich Karl
Weitzmann. In den kleinen reichsfreien Gebilden steckte mehr deutsche
Kraft, als die Beweger zum Einheitsstaate wahrhaben wollten. Den Aus-
schlag gab das: Württemberg hörte auf, ein rein alamannischer und rein
evangelischer Staat zu sein. Es war ein Vorgang, wie ihn zur gleichen Zeit
Baiern durchmachte.

Ulm war in Schwaben was Nürnberg in Franken. Zu Ulm war es die ger-
manische Sprachwissenschaft. Friedrich David Gräter von Schwäbisch-Hall,
Lehrer am Gymnasium und einer der frühesten wissenschaftlichen Entdecker
der Mundarten, stiftete 1822 die „Gesellschaft der Dänenfreunde an der
Donau". Konrad Dieterich Haßler aus Altheim und durch die Mutter aus
einer Ulmer Familie, Lehrer am Gymnasium, wurde der Wiedererwecker *Der Ulmer Dom*
des Ulmer Münsters. Er führte dem neugegründeten Ulmer Liederkranz
1826 die letzten Getreuen des alten Ulmer Meistergesanges zu, vier einfache
Bürger. Haßler wurde Mitarbeiter, Vorstand, erfolgreichster Werber des Ver-
eins für Kunst und Altertum zu Ausbau und Verjüngung des Münsters. Und
mit dem erneuerten Münster von Ulm hatte sich das oberdeutsche Bürger-
tum ein Denkmal gestiftet seiner Rückkehr zu sich selber und zum selbstver-
antwortlichen Handeln in der Gemeinschaft.

Und so das alte Buch, aus dem im Grunde ja diese ganze Restauration ge-
wachsen war. Die wissenschaftliche Deutschkunde war das Binnenmark, von
dem der mächtig aufschießende Stamm der Restauration genährt wurde.
Josef von Laßberg, aus einer oberösterreichischen Familie zu Donaueschin- *Die Meersburg*
gen geboren und streng katholisch erzogen, war schon früh dem Zauber alter
Bücher verfallen. Er lebte auf der Meersburg am Bodensee. Er war kein
„Sammler". Er ließ die Glasgemälde aus den Fenstern leuchten, fügte Ge-

täfel und Holzbilder in die Wand und machte väteraltes Hausgerät zum Gebrauch des Alltags. Die alten Bücher waren ihm Hausrat der Seele wie die anderen Dinge des Leibes. So war Laßberg auch kein „Herausgeber". Seine vier Bände „Liedersaal, das ist Sammlung altdeutscher Gedichte aus ungedruckten Quellen", 1820/1825, sind aus der Seelenhaltung jener frommen alten Schreiber zu verstehen, die in die Seele der Bücher eingingen, nicht indem sie lasen, sondern indem sie abschrieben und das Buch gewissermaßen aus eigener Kraft erzeugten.

Das alte Buch Ein Werkstück aus demselben Geiste, der den Dom zu Ulm erneuerte, der die Meersburg ausbaute und mit stilgleichen Schätzen füllte, war die „Bibliothek des literarischen Vereins". Als Gesellschaft von Bücherfreunden wurde der Literarische Verein 1839 in Stuttgart gegründet und durch Adalbert von Keller betreut. Zerstreute, verschollene, bis auf wenige Stücke vernichtete Bücher wurden hier in jener vornehmen Schlichtheit, die von würdiger Selbsterfüllung kommt, wiedergedruckt. Dies Heilswerk wandte sich deutschen und welschen Büchern zu, erfaßte die Literatur im weitesten Sinne und steigerte mit der Voraussicht auf viele Jahrzehnte diese schwäbische Restauration zu einem umfassenden nationalen Unternehmen. Der Brüder Boisserée rheinisches Heilswerk an Bildern und Bauten, dies schwäbische an Büchern und Handschriften setzt überzeugend die Eigenart des sinnlich genießenden Rheinfranken gegen das magisterliche Schwabenglück an Büchern ab.

Schwäbische Während die alten Bestände an Kunstwerken und Büchern durch ihr Jung-
Mundart bad gingen, strömte im mundartlichen Schrifttum der Landschaft urschwäbisches Wesen weiter, keines Retters und keines Heilstrankes bedürftig. Von den zweierlei Arten, die da im Spiele waren, schlug nicht Peter Hebel, sondern Sebastian Sailer durch.

Sailers *Karl Borromäus Weitzmann*, 1767 bis 1828, aus dem vorderösterreichi-
dramatischer Stil schen Städtchen Munderkingen, Beamter und Anwalt, hatte mit seinen derben und naturhaften Gedichten im gleichen Jahr 1803 wie Peter Hebel begonnen. Es war Sebastian Sailers dramatischer Stil, dem Weitzmann mit seinem „Bauernkongreß in Poppelfingen" und mit der tragikomischen Bauernoper „Das Weltgericht" nacheiferte. Nicht anders der Schulmeistersohn aus Reusten *Gottlieb Friedrich Wagner*, 1774 bis 1839, der selber Schulmeister und später Schultheiß zu Maichingen wurde. Sachgetreu, ohne zu verzerren, ohne zu färben, ohne gewollte Roheit gab er lustspielmäßige Bilder des bürgerlich-bäuerlichen Gemeindebetriebes wie 1824 „Die Schulmeisterwahl zu Blindheim". Die Mundart ist, was ja für den Eingeweihten nicht schwer

war, lautgtreu gehört. Doch sie schriftlich festzuhalten, das war Wagners persönliche Kunst.

Wie hätte in Schwaben auch diesmal der Magister fehlen können. Es war *Der magister artium* der zweite Sohn des Stuttgarter Kunstfreundes, *Karl Moritz Rapp*, 1803 bis 1883, aus seinem Vaterhause mit bildender Kunst und Musik vertraut, im Leben freilich ein Hagestolzsonderling. Nach weiten Reisen las Rapp an der Tübinger Hochschule über vergleichende Sprachwissenschaft. Man hat seine Arbeiten, die gelehrten wie die dichterischen, nicht verstanden, weil man ihren Punkt nicht fand, wo das Leben sitzt. Sein Grundwerk „Physiologie der Sprache" 1841 sagt: „Gewiß ist es, daß die nächstkünftige Redaktion der deutschen Sprache unsern Dialekten ähnlicher sein wird als die jetzige Schriftsprache." Rapp war auf dem Wege Johann Jakob Bodmers, der zuerst auf dieses erkannte Ziel hingearbeitet hatte. Bei solcher Einsicht in den kommenden Verlauf der Sprachbildung erlag Rapp der Ungeduld, diesen erkannten Verlauf künstlich zu fördern und zu beschleunigen. Den gemeinen Mann, der seine Sprache leidend überkomme, erklärt er als den lebendigen Quell *Rapp, das Recht auf* der Überlieferung. Die Wege des Sprachgelehrten und des mundartlichen *Sprachschöpfung* Dichters hielt er auseinander. Während er den Sprachforscher der Mundart gegenüber auf das strenge Gebot der bloßen Beobachtung verpflichtete, gab er dem mundartlichen Dichter Recht und Pflicht der freien Sprachschöpfung. Mundartdichter sei nicht der, der singe, wie ihm sein Volksstamm den Schnabel wachsen ließ, sondern wer mit Bewußtsein die Mundart forme. Vom lyrischen Gebrauch, der nur mit einer Mundart zu tun hat, verschieden sei der dramatische. Denn der müsse die mannigfachen Sprechweisen einer Stammsprache einander gegenüberstellen und sie absichtsvoll zum Wider· klang bringen. Eine Mundart, die literaturfähig sein solle, dürfe dem Buchdeutsch nicht zu nahe stehen. Sie müsse Gattung, dürfe nicht Spielart sein. Zu seinen Dichtungen kam Rapp aus Heimweh wie Hebel zu den seinen. Aus Paris richtete er im Winter auf 1828 an seinen Vetter Gustav Schwab die „Wintordraim", darin ein Literaturgeschichtlein „De deitsch poesi". Sein echtes Handzeichen tragen die zwei Sammlungen „Atellane" 1836 und 1842, *„Atellane"* mundartliche Bühnenspiele, außer dem Historienstück „Die Gegenkaiser" zwei von besonderer Art: „Der Student fon Coimbra" aus der Umwelt der Tübinger Hochschule; „Es Aristoffanes Acharner oder der Separatfriede", staatsbürgerlich gemeint und den Schwabenvetter ins Griechische verkleidend. Wie Schmeller mit einem Ohr begabt, das haarscharf selbst die Gesellschaftsschicht aus der Mundart des Sprechers heraushörte, führte Rapp nicht bloß die Gestalten, sondern die Farbtöne ihrer Sprache dramatisch wider-

einander: Landbewohner und Städter, schulmäßig Gebildete und schlichte Leute. Wie er die Aussprache schriftlich bezeichnete, vermochte er sie hauchgetreu zu erfassen. Und was er schrieb, war weder eine verschönerte noch verhochdeutschte Mundart, sondern eine, die er gemäß ihren eingeborenen Gesetzen stilgemäß ausgeformt hatte. „Sechzig portugiesische Sonette in oberschwäbischer Übersetzung" sind ein sprachgelehrtes Zierstück, rückerschlossenes Schwarzwalddeutsch von etwa 1400, doch recht gemeint. Das aber gilt. Moritz Rapp hat die Volkssprachenbewegung des Rheintales auf ihren geschichtlichen Richtpunkt eingestellt: einem neuen Gemeindeutsch

Von Bodmer zu Rapp vorzuschwärmen. Diese Richtung läuft von Bodmer zu Rapp, weiter zurück von der oberdeutschen Dichtersprache des dreizehnten Jahrhunderts her, weiter nach vorwärts auf die neue mundartlich gesättigte Dichtersprache einer noch fernen Zukunft hin.

Uhlands hohe Zeit Solche Geschlossenheit und solches Gleichmaß im Streben eines ganzen Landes wies auf einen Mann der Mitte, durch den wie von innen her alles Leben in diesem Volkskörper bewegt werde. Der Mann war *Ludwig Uhland.* Wo er in dieser Zeitspanne wirkte, dort saß dem schwäbischen Volke das Herz. In dreierlei Gestalt wurde sein Eigenwesen Gemeingut. Die erste, die dichterische, war ausgeformt, ehe die zwei andern sich entfalteten. Denn

Der Dichter seine „Gedichte", im Sommer 1815 erschienen, brachten die Ernte seiner Jugendjahre. Und nur wie Hilfstruppen setzte er während der Verfassungskämpfe 1816 „Vaterländische Gedichte" auf Kriegsfuß. Schon früh hatte er dramatische Pläne. Probegriffe in verschiedene Stilarten, so „Die Nibelungen" 1817 und „Der arme Heinrich" 1818 umschreiben seine Absichten. „Ernst Herzog von Schwaben" 1818 und „Ludwig der Baier" 1819 sind allein fertig geworden. Und von ihnen ist nur „Ernst" am 29. Oktober 1819 zur Feier der eben geglückten Württemberger Verfassung gespielt worden.

Der Volksbote Uhlands andere Gestalt, die staatsbürgerliche, begann sich zu formen, als er 1814 zu Stuttgart Rechtsanwalt geworden war. Er stand in den Verfassungskämpfen seinen Mann. Tübingen schickte ihn dann in den Landtag. Er sprach bei gewissenhaftem Besuch nicht oft. Er sprach nicht gewandt. Doch er sprach in großen Augenblicken wunderbar ergreifend. Das mächtige Aufgebot dieses hartköpfigen, im Auftreten sachlichen, gemessenen Volksmannes verpufften in dieser Enge. Als ihm in der Frankfurter Paulskirche ein größeres Spielfeld gegeben war, da erwies sich, daß er auf der schwächeren Seite stand, ohne andere Waffe als unfügsame Ausdauer bis ans Ende. Vergleicht man Uhland mit den zwei andern im Sternbild des demokratischen Bürgertums, so hebt sich gegen den altsächsischen Ackerbürger Arndt und

den rheinischen Publizisten Görres der schwäbisch magisterlich durchgei- *Der Forscher*
stigte Uhland als jener ab, dem die geschmeidige Tat am wenigsten lag.
Uhlands dritte Gestalt, die deutschwissenschaftlich gelehrte, war die ur-
sprünglichste. Sie umschloß den eigentlichen Kern seines Wesens. Seit 1829
außerordentlicher Lehrer für deutsche Sprache und Literatur in Tübingen,
las er über ältere Literatur und Sagenkunde. Er las nach wohlgeschriebenen
Heften und hielt fördersame Stilübungen ab. Spätmittelalterliche Volkslite-
ratur und Volkskunde waren sein liebstes Arbeitsfeld, vor das er seinen
„Walther von der Vogelweide" 1822, ein Hauptwerk der jungen Wissen- *Uhlands*
schaft als Ausweis seiner Meisterschaft gepflanzt hatte. Die Arbeit am Volks- *deutschkundliche*
liede läßt sich seit 1828 nachweisen. Sie verlockte ihn zu weiten Forscher- *Arbeiten*
reisen bis Wien, bis Dänemark, bis Belgien. Sie erfüllte sich 1844 und 1845
in seiner wertvollen Ausgabe: „Alte hoch- und niederdeutsche Volkslieder".
Denn es war die erste Sammlung nach den Grundsätzen der werdenden
deutschen Philologie. Was Uhland aber im geistigen Gefüge Schwabens be-
deutet, das offenbaren seine sagenwissenschaftlichen Arbeiten. Der erste
Band seiner „Sagenforschungen" kam 1836 heraus. Seit 1846 plante er eine
„Schwäbische Sagenkunde", an der er auch zu schreiben anfing. Anders als
Jakob Grimm ermaß er die Weltverbundenheit des deutschen Volkes auch
in den Sagen. Er nahm deren Aufwuchs aus fremdvölkischen und antiken
Zuflüssen zur Kenntnis. Seine Art, Mythen aus Naturerlebnissen zu deuten,
wurde Vorbild. Von Uhland weg verzweigte sich der Wille zum Mythus ins
Schöpferische bei Eduard Mörike, ins Religionsgeschichtliche bei David
Strauß.

Das ist nun die Stunde, da das straff gefügte Erziehungswesen Württem-
bergs seine Früchte trug. Jährlich wurden dreißig bis vierzig der fähigsten
Knaben durch die Landprüfung, meist aus Pfarrhäusern und Beamtenfami- *Schwäbische*
lien, in die vier Klosterschulen ausgesucht. Diese Auslesen der Besten sam- *Jahrgänge*
melten sich dann in der Hauptstadt, im Tübinger Stift. Es bildeten sich also
gemeinsam erzogene gleichklassige Jugendgemeinschaften, und diese gleich-
gezeichneten Jahrgänge — Hölderlin, Hegel, Schelling waren schon eine
solche Hetärie gewesen — bedingten nicht bloß die beispiellose Fruchtbar-
keit des kleinen Landes, sondern auch die Züge seines geistigen Antlitzes.
Drei solcher Hetärien des Tübinger Stiftes waren es, aus denen sich, um mit
Hegel zu sprechen, wie durch These, Antithese, Synthese die neue Gegen-
wart Schwabens erwirkte.

Der schwäbische Wille zum Mythus, in Uhland wissenschaftlich verkör-
pert, gewann mit der älteren Hetärie des Stiftes Gewalt über Leben und

Form der Dichtung. Es war eine merkwürdige Dreierreihe. Ein Franke, der
sich wie seine zeitgenössischen Landsleute gab und die echteste Schwaben-
rolle, die Hölderlins, mit anderer Seele nachspielte, Waiblinger; ein unver-
kennbarer Norddeutscher und in vielem verschwäbelt, Mörike; und der ein-
zige Schwabe von Herkunft, Bauer.

Waiblinger　　　Wilhelm Friedrich Waiblinger, 1804 bis 1830, der Sohn eines kleinen
Heilbronner Beamten, wurde nur mit besonderer Vorsicht ins Stift aufge-
nommen und bald wieder entfernt. Er befreundete sich und zerfiel mit Bauer
und Mörike. Mit Besuchen und auf Spaziergängen war er um den kranken
Hölderlin. In Rom, seit Herbst 1826, kam er zu seiner zweiten Rolle, der
Byrons. Er ging mit Platen um. Ecco il poeta, riefen dem Zerlumpten die
Gassenjungen nach. Ein letzter Ruck hob den Absinkenden noch einmal ans
Licht eines Scheinglücks, um ihn dann endgültig unterzutauchen. Ludwig
Bauer　　Amandus Bauer, 1803 bis 1846, von Orendelsall, wandte sich in Tübingen
der Geschichte zu. Von Waiblinger trennte ihn bald der große innere Ge-
gensatz. Mit Mörike schuf er sich eine künstliche Mythenwelt. Über das
Pfarramt zu Ernsbach und Lehrstellungen in Stuttgart ging er seinen schlich-
ten Weg, durch seinen frühen Tod eher vor offenkundiger Niereife bewahrt
als um seine Vollendung betrogen. Die volle Lebensspanne war nur dem
Mörike　　dritten gegönnt, Eduard Mörike, 1804 bis 1875, der zu Ludwigsburg gebo-
ren war. Die Familie soll, mit Luther als einem Ahnen, durch eine der weib-
lichen Reihen aus der Mark Brandenburg stammen. Der Name ist jeden-
falls niederdeutsch. Mehr als irgendeine Schule hat an Mörike der ältere
Bruder getan, der auf gemeinsamen Spaziergängen der gewöhnlichsten Er-
scheinungen einen höheren und geheimnisvollen Reiz zu geben wußte. Der
Junge verlebte eine seltsam traumhafte Knabenzeit. In der Klosterschule
Urach und ihrer Umwelt von prächtigen Bergen setzte er seine Bildung zum
Mythus fort. Im Stift seit 1822 verzauberte ihn die griechische Dichtung. Mit
Bauer und Waiblinger ersann er neue Mythen. Sie spannen sich um Homer,
Shakespeare, Calderon, Goethe. Ihr Schauplatz war ein Brunnenhäuschen,
am Tage künstlich verdunkelt. Zu gleicher Zeit schenkte Mörike den jünge-
ren Strauß und Vischer seine Freundschaft. Seit Herbst 1826 zog Mörike als
Helfer durch manchen schwäbischen Ort, bis er 1834 im Pfarrhaus zu Clever-
sulzbach landete. Nachbarn oder Freunde wurden ihm da Kerner und
Mayer, Schwab und Uhland. Nachdem er 1843 auf sein Pfarramt verzichtet
hatte, lehrte er seit 1851 an der Mädchenschule des Stuttgarter Katharinen-
stifts und lebte seit 1866 in Stuttgart und Nürtingen oder ländlich abgeschie-
den zu Lorch und Bebenhausen.

Den schwäbischen Bildungsklassizismus glattzustellen, darauf lief es bei allen dreien hinaus. Der Humanismus der Württemberger Schulen, die klassische Überlieferung der Landschaft, das magisch wirkende Vorbild Schillers und Hölderlins wiesen sie eine vorgezeichnete Bahn, die auszuschreiten keinen Sinn mehr hatte. Jeder von ihnen bog auf seinen besonderen Weg aus.

Wilhelm Waiblinger besaß die Gabe der Selbstberückung in einem so *Der Rollenspieler*
hohen Maße, war innerlicher Erlebnisfähigkeit, des unbefangen reinen Gefühls, des philosophischen Sinns so völlig bar, daß ein solches Vermögen bei solchem Mangel einen Rollenspieler aus ihm machen mußte. Gespielter Hölderlin war das Buch „Phaethon", 1823 gedruckt, durch das er triebartig auf die Begegnung mit Hölderlin und auf die Lesung des „Hyperion" anwortete. Empfindung und Sprache sind das Beste und Schönste an dieser Briefdichtung, die nach Modellen seiner selbst, seiner Umgebung und den Gedankenbeständen des Tagebuchs gearbeitet ist. Die Urbilder Waiblinger und Hölderlin verschwimmen ineinander wie Rolle und Schauspieler. „Phaethon", dies Neugriechentum als Träger einer verschwärmten Antike, war schon der erste Absatz solch überstiegenen Klassizismus. „Lieder der Griechen" 1823, *Hölderlin*
aus Widerspruch gegen Wilhelm Müller geschrieben, verblaßten ins We- *und Byron*
senlose. Denn sie enthielten keinen Zug wirklichen Griechentums. Gespielter Byron waren die Versgeschichten „Vier Erzählungen aus der Geschichte des jetzigen Griechenlands" 1826, rednerische Ausbrüche des Geschlechts. Lebensunreife, die sich als „finstrer Geist" gefiel, verwechselte die ungezogene Haltung des kleinbürgerlichen Tübinger Schülers mit der großartigen Zuchtlosigkeit eines Genies, das an den Schranken der Welt rüttelt. Sie spielte Byron in falscher Tonlage. Über die beiden Selbstbezeugungen „Drei Tage in der Unterwelt" und „Olura der Vampyr" 1826, Wendungen gegen die Romantik in romantischen Formen, ging es nach Rom. Hier geschah nun Waiblinger das, was Wieland als Entzauberung seiner Helden zu schildern nicht müde wird. Belanglos, was er noch aus Brothunger geschrieben hat, neben der kalten dramatischen Stilübung „Anna Bullen" 1829 die zwei Jahrgänge „Taschenbuch aus Italien und Griechenland", 1829 und 1830, mit *Waiblinger*
flüchtig hingeworfenen Schildereien: Waiblingers letzte Erscheinung war an *in Rom*
sich schon ein Ereignis. An Rom, aber nicht an römischer Antike, sondern am Volkswesen des modernen Rom und zuletzt an der ewig jungen Üppigkeit und großartigen Einsamkeit Siziliens ist Waiblinger den Fluch seiner verlogenen Antike losgeworden und hat er die bewußtlos wuchernde Südnatur von Land und Volk gefunden. Mehr war ihm nicht mehr zugemessen. Nur

ferne Möglichkeiten der Vollendung vermochten die Liederkreise dieser letzten Zeit anzudeuten. Das waren die römischen Oden und Elegien, die „Lieder des römischen Karneval", die „Bilder von Neapel", die „Pompejanischen *Italienische* *Lieder* Lieder", die Lieder von Capri und aus Sorrent, die „Sizilianischen Lieder", zuvörderst aber jene Verse aus dem Seelenbereich der schönen ländlichen Olevaneserin, um die er in einer letzten Stunde warb, die „Lieder der Nazarena" und die „Lieder der Untreue". An Waiblingers Irrgang ist nicht zuletzt jenes geistig verengte und spießbürgerliche Tübingen schuld, das Waiblingers Geist und Unzucht überschätzte, weil sie lediglich verhältnismäßig freier und erheblicher waren als zu Tübingen üblich. Liest man aber, wie Waiblinger in seinem Tagebuch eingebildete Abenteuer als wirklich erlebt in allen Einzelheiten ausmalte, so weiß man auch, daß er sich wie die beiden andern zuweilen an einem Ersatz-Mythus berauschte.

Der heimliche *Maluff* *Ludwig Bauer* dagegen hat die klassische Schule keine Seelenstörungen bereitet. Er arbeitete flott und klassenreif seine Jambentragödien herunter, ob nun einen Alexander in drei Teilen, einen Kaiser Barbarossa oder sonstige Hohenstaufen. Und so hat denn Bauer auch schwerlich aus eigener Not die tastenden Versuche ins Mythische unternommen. Er wurde zwischen Waiblinger und Mörike mitgerissen. Der zu eigenem Bedarf ersonnene Orplidmythus der drei Freunde gab Bauer Anlaß zu den zwei Märchenspie*„Orplids letzte* *Tage"* len „Der heimliche Maluff" 1828 und „Orplids letzte Tage",1847 gedruckt. Bauer und Mörike haben eine Übersicht über diesen Mythus gegeben, jener im Vorwort zu „Maluff" wortreicher, dieser in „Maler Nolten" gedrängt und also: „Wir erfanden für unsere Dichtung einen außerhalb der bekannten Welt gelegenen Boden, eine abgeschlossene Insel, worauf ein kräftiges Heldenvolk, doch in verschiedene Stämme, Grenzen und Charakterabstufungen geteilt, aber mit so ziemlich gleichförmiger Religion, gewohnt haben soll. Die Insel hieß Orplid, und ihre Lage dachte man sich in dem Stillen Ozean zwischen Neuseeland und Südamerika... Orplid, einst der Augapfel der Himmlischen, mußte endlich ihrem Zorne erliegen, als die alte Einfalt nach und nach einer verderblichen Verfeinerung der Denkweise und der Sitten zu weichen begann. Ein schreckliches Verhängnis raffte die lebende Menschheit dahin, selbst ihre Wohnungen sanken, nur... Burg und Stadt Orplid durfte, obgleich ausgestorben und öde, als ein traurig schönes Denkmal vergangener Hoheit stehenbleiben." Und durchaus, wie Waiblinger das in seinem Tagebuch trieb: „Stückweise und nach den wichtigsten Zeiträumen erzählten wir uns die Geschichte dieser Völker." Das war aber nur der eine Weg Bauers aus dem überkommenen Bildungsklassizismus heraus. Den

andern führte ihn sein richtiges Schwabentum, der krittelnde Mutterwitz und das überlegene Besserwissen hart an den zeitgemäßen Stil heran. In Stetten, wohin er 1831 als Lehrer gekommen war, übersetzte er mit Gfrörer den „Don Quixote". Und von da war nur ein kurzes Stück zu seinem Zeitroman „Die Überschwänglichen", der 1836 zugleich mit Immermanns „Epigonen" herauskam. Bauers Buch ist formverwandt mit Wielands „Abderiten", ebenso wie es von Johann Paul Richter und Walter Scott Vorteile hatte. Der Dichter läßt vor seinem spöttisch gekniffenen Auge das Zeitalter in seinen wesentlichen Strömungen vorüberziehen: die Revolution von 1830, den emporstrebenden dritten Stand, Fabrik und Maschine, die Restauration, das zeitgenössische Schrifttum. Freilich stellt er die Dinge nie zwischen Ja und Nein. Denn das Buch ist kein satirischer Zeitroman mit der Absicht aufzuräumen. Es ist eine Parodie mit bewußtem Stich ins Groteske und überträgt, ohne Partei zu ergreifen, alle Züge des Zeitalters in das Gradnetz eines lächerlich entstellenden Hohlspiegels.

Bauer: „Die Überschwänglichen"

Was sich an den zwei vorzeitig Verlöschten nicht vollenden konnte, bei Waiblinger aus Mangel, bei Bauer aus Überfluß an Naivität, das glückte dem dritten, Eduard Mörike, dessen „Gebet" lautete: „Wollest mit Freuden Und wollest mit Leiden Mich nicht überschütten! Doch in der Mitten Liegt holdes Bescheiden."

Eduard Mörikes Dichtungen atmen alle ein so gleichmäßiges und würziges Aroma, daß Lied und Märe gar nicht zu unterscheiden sind. Und in seinen Mären gibt es weder den Unterschied von Roman und Novelle, der ohnedies nur in der Einbildung der Schulmeister vorhanden ist, noch den Unterschied von Wirklichkeit und Erfindung. Alles liegt im Wachstum. Der starke Band des „Maler Nolten" könnte ohne Gefahr auf ein schmales Büchlein zurückgeschnitten werden und die paar Zweiglein der „Lucie Gelmeroth" ließen sich mühelos zu einem ziemlichen Gebüsch austreiben. „Real" und „imaginär" sind bei Mörike nicht Eigenschaften des Stoffes wie etwa Holz und Metall, sondern lediglich des Vortrages wie etwa heiter und ernst. „Das Hutzelmännlein", obwohl völlig phantastisch, wird wie die wirklichste Sache von der Welt vorgetragen und eine so wirklich geschehene und hinterher einleuchtende Geschichte wie „Der Schatz" erscheint durch ein paar Kunstgriffe als hübsch erlogen. Die geheime Weihe der Erzählungskunst besteht ja in dem Vermögen der Magie, den Zuhörer zu verzaubern und zu entrücken, daß er alles glaubt und nicht mehr weiß, ob er außer sich oder bei sich war. Mörike hat wie wenige Menschen die Gabe dieses Zauberwortes besessen.

„Doch in der Mitten liegt holdes Bescheiden"

„Real" und „imaginär"

Der Einsatz von Mörikes erzählendem Werk wandelt den gleichen Stil und das gleiche Grundmotiv dreifältig ab. Das Motiv ist eine Kinderliebe und der Stil das Helldunkel für das Zwischenreich der Seele. In den Gärten zu Hohenheim war zum Teil das Buch geschrieben, mit dem Mörike als *„Maler Nolten"* Vikar in Eltingen bei Leonberg 1832 hervortrat: „Maler Nolten." Das erfolgreiche Buch war bald vergriffen. Der Dichter verweigerte einen Neudruck der alten Fassung. Vom Alternden überarbeitet und von fremder Hand ziemlich eigenmächtig fertig gemacht, erschien es erst 1877 wieder unter den Lesern. „Maler Nolten" ist weder ein Bildungsroman noch ein Künstler-*Drei kranke* roman. Es ist einfach die Geschichte dreier kranker Seelen, die einander zer-*Seelen* stören und zwei andere mitreißen. Es ist auch kein Schicksalsroman. Denn was sich vollstreckt, ist nichts als die logische Selbstzerstörung des Lebens. Der Keim, aus dem sie hervorbricht, ist die doppelte Kinderliebe Noltens zu der fremdartigen Zigeunerin Elisabeth und der geschwisterlich vertrauten Agnes. Konstanze und Larkens sind Hilfskräfte, die fördernd, hemmend, wendend in der einmal ausgelösten Bewegung wirken. Die Dichtung handelt nicht anders als das Leben selber, wenn sie durch die Wiederkehr des Gleichen die Einmaligkeit und Beständigkeit des Zuverlässigsten, das es zu geben scheint, die Persönlichkeit, in Frage stellt. Denn die Dichtung verdoppelt einen Menschen, und zwar gleichzeitig den einen im Nacheinander der Zeit — Loskine und Elisabeth, Mutter und Tochter — sowie im Nebeneinander des Raumes — die Freunde Nolten und Larkens. Sie stellt damit *Mörikes* Agnes und Nolten vor die gespenstige Frage: bist das du oder der andere? *Seelenkunst* Es ist kein Künstlerroman. Doch die Dichtung begibt sich in den abgegrenzten Bereichen dreier Künste und sie handelt in jedem mit der dieser Kunst eigentümlichen Mitteln. Die Gruppe Nolten-Elisabeth-Loskine wird durch die beiden Gemälde verknüpft, zu denen Loskine und Elisabeth Modell standen. Das ist der Bezirk des Malers. Die Gruppe Nolten-Larkens-Agnes ist ein szenisches Intrigenspiel, der Bereich des Schauspielers. Beide Gruppen verwebt die Musik. In dieser Dichtung geht alles mit natürlichen Dingen zu, nach den Gesetzen des Seelenlebens. Was ist an ihr spukhaft? Nichts als Stimmung und Vortrag. Was sich am Schluß vor der Orgel begibt, ist Schau des Blinden. Und der Schauspieler Larkens, der so verwegen Schicksal spielt, bringt das „Schicksal" nur zur Entladung. So ist das Orgelspiel vor Toten als Zuhörern auf dem Gemälde wie in der Wirklichkeit das gleichnishafte Doppelstück, das die Dichtung einrahmt. Von Klassik und Romantik ist in dem Buch wohl die Rede. Sein Stil hat weder mit der einen noch mit der andern zu tun. Es ist das erste Meisterstück moderner Seelenkunst.

„Maler Nolten" hat im zweifachen Sinne ein Gegenbild. Da ist „Die ge- *„Die geheilte Phantastin"*
heilte Phantastin" aus der unmittelbaren zeitlichen Nachbarschaft des Maler
Nolten, ein Entwurf, so weit ausgeführt und durchgeformt, daß man sieht,
wo er hinaus will. Die Erzählung spielt in englischen Kreisen Deutschlands,
dreht sich um entgegengesetzte Fälle des Glaubenswechsels, bewegt sich im
Zwischenreich der Seele und sollte ähnlich wie das Buch vom Maler Nolten
offensichtlich aus einer Reihe von Sondergeschichten zusammengearbeitet
werden. Eine daraus ist die kleine Erzählung „Lucie Gelmeroth" 1834, die
zugleich als reizenden Binnenkern die Kindergeschichte enthält. Und da ist
„Der Schatz" 1836, die am völligsten verkannte unter Mörikes Novellen. *„Der Schatz"*
Zwei junge Menschen, die einander als Kinder geliebt haben und dann ge-
trennt wurden, finden einander zur rechten Stunde wieder. Es geschieht auf
seltsame Weise, doch nur darum, weil bloß das Mädchen den Jüngling im
Auge behalten, der Jüngling aber die Totgeglaubte vergessen hatte. Die
Rolle des Schicksals spielen ein paar Kalendersprüche, die gerade an den
kritischen Tagen der Handlung eintreffen, weil der Jüngling nach ihnen han-
delt. Das ist weder eine Märchennovelle noch ein Novellenmärchen noch ein
Rahmenbüchlein. Was der Held im Scharlachfieber, im Rausch, im Traum
erlebt, ist Seelenleben und kein „Märchen" und wenn ihm eine Sage erzählt
wird, die zur Sache gehört, warum soll man davon in einer Wirklichkeits-
dichtung nicht ebenso gut sprechen wie vom Wetter. Wahrscheinlichkeit hin,
Wahrscheinlichkeit her. Was die Gestalten dieser Dichtung tun und was
ihnen geschieht, ist das gegenständliche, erweisbare und bezeugte Leben.
„Der Schatz" ist die eine von den beiden vollkommenen Novellen Mörikes.

Die Mitte von Mörikes erzählendem Werk bilden drei Geschichten, die, *Idyllen*
gleichgültig ob in Vers oder Prosa, fertig oder nur angefangen, ein Ganzes
sind, dem Ton und Vortrag nach. Aus dem Anfang der vierziger Jahre
stammt der Entwurf „Die silberne Kugel", Franzosenzeit und bürgerliche
Kleinwelt Rotenburg, sicherlich auf zierliche Schilderung altfränkischen Tage-
werks berechnet. Heitere Gegenwart und Nachbarschaft ist die „Idylle vom
Bodensee" 1846, eine Versnovelle in sieben Gesängen Hexametern. Um
einen Jugendstreich, den der Fischer Martin einem ungebührlichen Braut-
paar gespielt hat, kreist ein anderer, mit dem er jetzt einen Glockendieb hin-
einlegt. Der See und das Dorf und der Himmel darüber verschmelzen zu
einem wundersamen Ganzen aus Sonne, Leben und Frohmut. „Das Stutt-
garter Hutzelmännlein" 1852 in unsagbar naiver Prosa schlingt auf ähnliche
Art um die „Historie von der schönen Lau", der Donaunixe im Blautopf von
Blaubeuren, die anmutige Fabel vom Schustergesellen Seppe, der Vrone

Kiderlen und ihrem Gönner, dem Pechschwitzer, Hutzelmännlein und Trö-
ster. In Blaubeuren, Ulm und Stuttgart wird das Leben der Werkstätten und
Wirtshäuser mit bedächtigem Behagen geschildert. Das also ist allen drei
Geschichten gemeinsam, daß sie die Welt und die Menschen, wie sie sind,
mit breitem Pinsel vortragen, ohne den Unterschied von glaubhaft und ge-
fabelt, von Wunder und Wirklichkeit auf die Goldwaage zu legen.

Märchen Zwei kleine Geschichten, die im Zwielicht des künstlerisch Unbestimm-
baren spielen, säumen diese Mitte ein, ihr mit keinem andern Zuge ver-
wandt als dem Wunderbaren, sonst aber unter Mörikes Dichtungen eine
Landschaft für sich, an die jede andere nur grenzen konnte. „Der Bauer und
sein Sohn" 1839 ist eine Tierlegende von der Barmherzigkeit gegenüber dem
Arbeitsgehilfen und der „Heilung" aller Kreatur. „Die Hand der Jezerte"
1853 ist eine Kunstlegende. Sie meint die magischen Wechselbeziehungen
zwischen Abbild und Urbild. Sie kehrt zu dem Maler Nolten zurück und
geht dem Musiker Mozart voran, um den Ring der Vollendung zwischen
dem ersten und letzten Werk zu schließen.

„Mozart auf der „Mozart auf der Reise nach Prag" 1855 gibt einen Begriff davon, wie der
Reise nach Prag" „Maler Nolten" hätte angelegt und vorgetragen werden müssen, um ein fast
makelloses Gebilde zu sein. Dort hätte das Bild von der Orgelspielerin so in
der Mitte stehen müssen, wie hier das Singspiel um Don Giovanni. Denn
das macht hier den gelungenen Wurf. Zwischen epischem Vorspruch und
Abgesang wird eine einzige große Szene gestellt: die Vollendung und Vor-
probe des „Don Juan" auf einem mährischen Schloß zwischen Wien und
Prag. Bezaubernd ist die Art, wie kongenial der Dichter vom Tonkünstler
spricht. Das ganze Gedicht wird vorgetragen sozusagen als Duett von Wölf-
chen und Stanzel. Unvergeßlich aber haftet die anmutige Gebärde im Auge,
wie der Meister weltvergessen in seine hohle Hand die reife Orange faßt,
der verklungenen Weise von Neapel nachsinnend und aus ihr Zerlinas un-
sterbliches Liedchen empfangend. Das ist der eine, der ewige, der göttliche
Griff, mit dem das Genie vom grünenden Baum des Lebens sich die Gold-
frucht pflückt.

Mörikes Gedichte Mörikes erste Gedichtsammlung kam 1838 heraus. Sie wuchs und reifte
mit den folgenden Auflagen von 1845, 1856, 1867, 1878, Jahresabstände, die
einen sehr zögernden Sieg und also die Güte dieser Verse bezeugen. Sie
blicken doppelt, auf den Mythus und auf die Volksweise, aber sie sehen nur
eines: das Alleine. Eichendorff hatte die Natur zum Sinnbild der Seele ge-
macht, durch Einfühlung Außen und Innen verschmolzen. Mörike richtete
die Natur wieder zu sich selber auf, ließ sie in Mythen handeln und in Men-

schengestalt auf den Menschen wirken. Wenn das „Märchen vom sichern
Mann" noch aus der Orplidmythe weiterwuchert, so geben Gedichte wie
„Gesang zu zweien in der Nacht", „Der Feuerreiter", „Um Mitternacht"
Naturmythen, die fast die Gegenständlichkeit und das Eigenleben des ge-
glaubten Mythus haben. Sie sind antik. Eben dahin zielen Mörikes Volks-
lieder. Sie können nur grobgeschätzt für das gehalten werden. Natürlich ist
ihre Herkunft aus dem ganzen weiten Bereich des „Wunderhorns" offen-
kundig. Doch diese Gebilde täuschen Volkslieder vor nur durch die Schlicht- *Antik
heit des Vortrags. Ihr Ton ist nicht die erste Einfalt, die von kommender *und modern*
Kunst nichts weiß, sondern die letzte, die alle Kunst hinter sich hat. Es ist die
Schlichtheit nicht des altdeutschen, sondern des griechischen Mundes. Auch
diese wenigen Lieder, die nach Wunderhorn klingen, sind antik. Das also ist
diese Sammlung durch und durch. Vers und Rhythmus sind, so frei auch Mö-
rike gerade den Hexameter behandelt, reimlos, unstrophisch, durchkompo-
niert. Antik ist das Gelegenheitliche und Inschriftliche, der Grundzug dieses
Gedichtbuches, die Anschrift, die am Besonderen immer ein Gültiges ent-
wickelt. Denn Mörike redet immer an, sei es in der Art des Horaz, sei es des
Catull. Von den einfachsten Gebilden der griechischen Anthologie bis zu
Theokrit, von den Römern bis zum Barock ist kaum eine Gattung, ein Stil,
eine aparte Regung der Seele, die Mörike nicht wiedergefunden und wieder-
geprägt hätte.

Im Spiegel von Mörikes Lyrik sieht man nun auch tief in den Hintergrund
seiner Erzählkunst. Auch sie ist antik, weil sie im Mythus lebt und webt. *Der Mythus*
Denn sie lebt und webt im Mythus nicht auf romantische und schon gar nicht
christliche Weise. Mörike hat den Mythus nicht, wie Homer ihn hat, fromm-
gläubig wie ein Kind, sondern wie Lukian, überlegen, doch ohne Macht
gegen das Gruseln, das auch dem Klugen beim Anblick des Unfaßbaren über
den Rücken läuft. Das ist nicht die Antike aus der schwäbischen Schulstube
und der klassischen Poetik. Diese Antike ist eine sehr lebendige und lebens-
gefährliche Sache. Sie ist kein Abbild, sondern die Wirklichkeit selber.

> „Rosengeruch ist klassischer Art und stärkend, dem Wein gleich;
> Heliotrop und Jasmin edel, doch immer modern."

Mörikes dichterisches Aroma ist nicht die Mischung von Klassisch und Ro-
mantisch, sondern von Antik und Modern. Der Mensch Mörike war so ver-
wickelt wie seine Kunst: ein stiller Mann, nach innen gerichtet, weltfremd,
ohne Bezug auf handelndes Leben, mit Einbildung und Verstand wohl aus-

gewogen, ein Vertrödler des Tags, ein Musiker, ein Zeichner, ein Schau-
spieler, nichts aus Mache, aber alles aus Eingebung, so geduldsam, daß er
kaum ein ungereiftes Wort niederschrieb. „Sieh, so seltsam sind des Herzens
Wünsche, das sich müßig fühlt im Überflusse." Der Urtrieb des Spiels. Bei
hellem Sonnenschein unter dem Dachboden sitzen und vor brennender Kerze
Märchen erzählen. Künstlich verdunkeln, auf daß man künstlich beleuchten

„Ha! Wie sehn'
ich mich, mich so
zu sehnen"

könne. „Ha! wie sehn' ich mich, mich so zu sehnen." So haben alle drei ge-
spielt, Waiblinger, Bauer, Mörike, und ihr gemeinsamer Spielbereich war der
Mythus.

Die zweite Hetärie des Stiftes, der Jahrgang 1825, ging weiter und deu-
tete Ursprung wie Fortwuchs des Christentums in einen mythengeschicht-
lichen Vorgang um. Und diese Hetärie war gleichfalls durch eine Dreiheit
vertreten: David Friedrich Strauß, Friedrich Theodor Vischer, Gustav Pfizer.

Der kritische
Theologe

David Friedrich Strauß, 1808 bis 1874, von Ludwigsburg, ist durch alle
Wandlungen seiner Heimat hindurchgeschritten und gegen Schleiermacher
zu seinem Jesusbild gekommen. Als er 1832 Repetent am Tübinger Stift ge-
worden war, schrieb er in Jahresfrist und ließ er 1835 erscheinen: „Das Leben
Jesu kritisch bearbeitet." Das Ereignis wirkte wie ein Sprengschuß. Es machte
ihn unmöglich am Tübinger Stift, unmöglich an der Zürcher Hochschule,
machte ihn berufslos und unstet, so daß er erst kurz vor seinem Tode nach
Ludwigsburg zurückkehrte. Strauß arbeitete, ohne daß damit zunächst die
Geschichtlichkeit Christi selber zur Frage stand, an dem Nachweis: die Evan-
gelien sind keine Geschichte, sondern Gedichte. Sie sind Erzeugnisse des
urchristlichen Gemeingeistes, Umbildung der Geschichte ins Mythische, so-
wohl um den Stifter des Christentums zu verherrlichen als um die Erfüllung

Lebensbilder

des Alten Testamentes darzutun. Strauß machte die Lebensbeschreibung
zum Kunstwerk, indem er drei Männern Denkmäler setzte, von denen zwei
seine Landsleute und einer sein Geistesbruder war: Schubart, Frischlin, Hut-
ten. Er hat literarhistorisch über Justinus Kerner und Ludwig Bauer, über
Klopstock und Lessing gehandelt. Von seiner Hochschulzeit bis hart an sei-
nen Tod lief die lückenlose Lebensreihe seiner Gedichte. Sie wurden 1876
aus dem Nachlaß als „Poetisches Gedenkbuch" gedruckt. Es deckt sich über-
raschend mit dem Versbuch Mörikes. Das „Gedenkbuch" ist ein rühmliches
Denkmal dieses herben und tiefen Menschen, dessen Sprachmeisterschaft in
jeder Zeile ursprünglich und vom guten Adel des Geistes ist. Der Geschichts-
forscher und Staatsbürger, der Schriftsteller und Kulturdenker, der richtige
schwäbische Bildungsmensch offenbarte sich selbsttreu und überzeugend in
der furchtbaren Satire, die er 1847 gegen Friedrich Wilhelm IV. von Preußen

richtete: „Der Romantiker auf dem Throne der Cäsaren oder Julian der Ab- *Zwei Romantiker*
trünnige." Es ist einer der frühesten und kühnsten Versuche, mit der Sonde
der Seelenkunde geschichtliche Gesetze aufzudecken. Schöpferisch und in *Der siegreiche*
Herders Art gedacht ist der Obersatz, der die Romantik für einen wesenhaft *Galiläer*
wiederkehrenden geschichtlichen Vorgang erklärt. Aus diesem Obersatz ent-
wickelt Strauß die gesetzmäßige Seelenlage solch „romantischer" Zeitstufen
und Geistesträger. Ein Urbild dessen war Julian. Nun rollt sich ein ungemein
fesselndes Schauspiel ab, wie Strauß mit fortlaufenden stummen Bezügen
auf Friedrich Wilhelm IV. einen Aufriß Julians und seines Zeitalters entwirft.
Zug auf Zug stimmt es bis auf Julians Tempelbau zu Jerusalem und Friedrich
Wilhelms IV. Kölner Dom. Aus dem legendenhaften Todeswort Julians, „Du
hast gewonnen, Galiläer", schöpft Strauß die „auch für uns tröstliche Wahr-
heit", „daß unfehlbar jeder Julian, das heißt jeder auch noch so begabte und
mächtige Mensch, der eine ausgelebte Geistes- und Lebensgestalt wieder-
herzustellen oder gewaltsam festzuhalten unternimmt, gegen den Galiläer
oder den Genius der Zukunft unterliegen muß".

Friedrich Theodor Vischer, 1807 bis 1887, aus Ludwigsburg, ist mit Strauß *Der Repetent*
den gleichen Bildungsweg gegangen durch Blaubeuren und das Tübinger
Stift, durch Bauers Lehre, durch die Bücher Schellings, Böhmes und Baaders.
Er konnte noch Uhland hören, besuchte Kerner, sah den kranken Hölderlin
und ging mit Mörike um. Aber er witterte auch um die Bühne, streifte in den
Tübinger Ateliers um, ahnte am Maulbronner Klostergebäude, was Baukunst
ist, und sah auf seiner Magisterreise die Dresdner Kunstsammlungen. Es war
ein seltenes Ereignis. Der Jüngling und Greis gehörte der Dichtung, der reife
Mann gelehrter Arbeit. Als Repetent am Stift las er im Sommer 1834 zum
erstenmal über Goethes „Faust" und ließ sich 1836 neben Adalbert von
Keller an der Tübinger Hochschule für deutsche Literatur und Kunstlehre
nieder. Er ging von Solger aus, indem er 1837 mit der Schrift „Über das Er-
habene und Komische" den Grund zu seiner Wissenschaft vom Schönen legte.
Aus dem Einfachschönen entwickelte er das Erhabene und Komische als die
Gegensätze im Schönen. Zwischen seiner italienisch-griechischen Reise 1839
und der Berufung nach Zürich 1855 ist seine „Ästhetik oder Wissenschaft des
Schönen" 1846/1848 erschienen. Sie beruht auf der Metaphysik Hegels. Von *„Ästhetik"*
dem übernahm er den Begriff des Schönen: „Die Idee in der Form begrenz-
ter Erscheinung." Von Hegel übernahm Vischer die Form der Begriffsent-
wicklung. Sein Werk ist die Kunstlehre der Hegelschule. Solger und Schleier-
macher hatten, moderne Platonschüler, im Schönen Gott oder das Schöne im *Vischers*
Jenseits der Sinne gesucht. Vischer verlegte es in die sinnliche Erscheinung. *Kunstlehre*

Planmäßig wie kein anderer baute er eine umfassende Lehre auf: das Natur-
schöne und das geschichtlich Schöne; Kunstschaffen, Kunstlehre, Kunst-
geschichte. Er war Denker zugleich und Künstler wie Strauß. Den Begriff
des Stiles hat er als erster in den Mittelpunkt der Betrachtung gerückt. Als
eifriger Mitarbeiter der hallischen „Jahrbücher" leistete er 1838 seinem
Freunde Sekundantendienste: „Dr. Strauß und die Wirtemberger." Da stellte
er neben das geschichtliche Verfahren des Freundes eine neue Art geschicht-
licher Anschauung. Auf dem Hintergrunde des unterschiedlichen süddeut-
schen und norddeutschen Wesens gab er einen Umriß schwäbischer Art und
Bildungszustände. Aus diesen Grundfarben ließ er das geistige Bild seines
Freundes Strauß sich mischen und aufhellen. Die gemäßeste Form für seine
glücklichen Gaben, lebhafte Einbildungskraft, geschultes Denken, kühle
„Kritische Kennerschaft der Seele, sattes Wissen um Welt und Leben, fand Vischer im
Gänge" kritischen Versuch. „Kritische Gänge" 1844 sind sein Meisterwerk. Mit wei-
testem Umblick gab er auf jedem Gebiet, das er beherrschte, kleine Kunst-
werke, verständnisvoll eindringende, nachschaffende, aufbauende, wie Her-
der sie gefordert und als erster gefördert hatte. Er schrieb forsch und rück-
sichtslos, volksmäßig saftig, mit Eigensinn und Streitlust. Er dachte Begriffe
und sprach Bilder. Seit Schiller war Vischer wieder der erste große schwä-
bische Sprecher und Redekünstler.

Der Publizist *Gustav Pfizer*, 1807 bis 1890, aus Stuttgart, war Dichter von Berufs wegen
in Versen und doch kein Künstler wie es die beiden Dichter im Nebenamt, Strauß und
Vischer, gewesen sind. Er leitete zuzeiten den literarischen Teil des „Mor-
genblattes" und wurde später Lehrer am Stuttgarter Gymnasium. Er über-
setzte aus dem Englischen und Mittelhochdeutschen. Er gab 1831 mit seinem
Bruder Paul und Hermann Hauff „Fünfzehn politische Gedichte" heraus und
mehrfach eigene Sammlungen, so 1840 und 1844 den Romanzenkranz „Der
Welsche und der Deutsche. Aeneas Sylvius Piccolomini und Gregor von
Heimburg". Pfizer nahm leicht auf, verarbeitete tief, aber er vermochte das,
was er wollte, kaum je in strenge Form überzuführen. Er war ein Publizist
in Versen und das in keinen guten.

Kein Wunder, daß nun die Altwürttemberger biblisch-pietistische Richtung
Johann Albrecht Bengels und die Theosophie Christoph Friedrich Ötingers
wieder Oberwasser und Vertreter unter dem Nachwuchs gewann. Denn der
ganze Stiftsjahrgang 1834 leugnete bis auf drei in der Prüfungsarbeit die
Unsterblichkeit der Seele.

Die dritte Hetärie des Stiftes, die von 1832, vertritt diesen Widerstand
Die dritte Hetärie gegen Hegel und Strauß. Christoph Hoffmann, 1815 bis 1885, wollte das

biblische Volk Gottes wieder versammeln und gründete nach den Vorschrif-
ten des mosaischen Bundes eine neue Gemeinde. Der spätere Oberhofpredi-
ger Karl Gerok, 1815 bis 1890, stellte von „Palmblättern" bis „Unter dem
Abendstern" zahlreiche Sammlungen seiner malerischen und bilderreichen
Gedichte aus. Gustav Rümelin, 1815 bis 1889, der spätere Kultusminister,
führte dann schon in ein neues Zeitalter hinein.

Nicht Cotta, sondern der staatsbürgerliche und schöngeistige Trieb haben
Schwaben zum Träger der großen Presse gemacht. Der Klassikerverleger *Cottas „Morgenblatt"*
Johann Friedrich Cotta hatte 1807 das „Morgenblatt für gebildete Stände"
begründet. Hermann Hauff führte in den langen Jahren 1827 bis 1865 die
Zeitschrift und übte als Berater des Verlags einen ungemeinen Einfluß aus.
Für den dichterischen Teil des Blattes waren 1816 Friedrich Rückert, 1828
bis 1837 Gustav Schwab, 1838 bis 1845 Gustav Pfizer verantwortlich. Uhland
war der Wissenschaft, Kerner dem Geisterwesen hingegeben. Gleichwohl hat
der dritte, Gustav Schwab, die altschwäbische Überlieferung dieser Drei- *Gustav Schwab*
männerfreundschaft dem „Morgenblatt" fruchtbar erhalten. Schwabs Samm-
lungen, „Die schönsten Sagen des klassischen Altertums" seit 1838, „Die
deutschen Volksbücher" 1835, „Deutsche Prosa von Mosheim bis auf unsere
Tage" 1842 sind der deutschen Jugend wahre Grundbücher geworden. Für
das „Malerische und romantische Deutschland" hat er den schönen Band
„Wanderungen durch Schwaben" beigesteuert. Er übersetzte Lamartine und
Hugo. Er versuchte mit seinen Dolmetschungen seit 1827 die antike Literatur
volkstümlich zu machen. Von ihm her wurde die ganze vielgestaltige Über-
setzerarbeit Schwabens mit Anregungen gespeist.

Die gemeinschwäbische Literaturbildung, wie Uhland und seine Freunde
sie geschaffen hatten und wie das „Morgenblatt" sie verarbeitete, ging durch
mannigfache Formen in das Zeitalter der staatsbürgerlichen Bewegungen ein.

Da war die Erzählungskunst. Hier gab der Stuttgarter *Wilhelm Hauff*, *Schwäbische Erzähler*
1802 bis 1827, den Ton an. Er kam von der verwegensten Gruppe der Bur-
schenschaft, von den Feuerreitern. Davon verriet der Dichter nichts. Unklar
bleibt, was in seiner Novelle „Der Mann im Monde" 1826 Ernst und was
Parodie auf Heun-Clauren ist. „Mitteilungen aus den Memoiren des Satans"
1826 und „Phantasien im Bremer Ratskeller" 1827 sind nur Nachzeich-
nungen. Seine fesselnden Märchen wie seine spannenden Novellen sind
lediglich gut erzählt. Und sein Württemberger Geschichtsroman „Lichten-
stein" 1826, der erste besonnene Versuch an Walter Scott, verträgt nur soviel
Licht, als von dem Meister auf ihn fällt, dem er voranging. Und dieser Mei-
ster war der Reutlinger *Hermann Kurz*, 1813 bis 1873, den das Stift bildete

Hermann Kurz und verstieß; der als rühmlicher Übersetzer englischer Gedichte, als Nach-
bildner Ariosts und Gottfrieds von Straßburg begann; dessen Gedichtbuch
von 1836 lebhaft an Mörikes Weise anklang. Nicht der Stiftler, sondern der
Reichsstädter ist in Kurz dichterisch Erscheinung geworden. Schon das Prosa-
buch „Genzianen" 1837, Kleinbilder reichsstädtischer Vergangenheit, wies
auf Heimat und Geschichte, auf Erlebtes und Erlesenes. So sind dann auch,
aus Urkunden, Umfragen, eigenem Augenschein seine großen Romane ge-
arbeitet worden. „Schillers Heimatjahre" 1843 ist kein Literaturroman, son-
dern an einem frei erfundenen Helden soll die Bildungsgeschichte eines
Menschen und das Antlitz einer Zeitkultur anschaulich gemacht werden: die
des Herzogs Karl mit Schubart und dem jungen Schiller, mit Oberst Rieger
und Pfarrer Hahn als den Opfern landesväterlichen Schicksals. „Der Sonnen-
wirt" 1854 ist der Stoff von Schillers „Verbrecher aus Infamie". Das flache
Land, seine Triebe und Belange sind an einem Menschenleben zum tra-
gischen Wirken gebracht. Handwerklich ging Kurz von Walter Scott und
Wilhelm Hauff aus. Seine Kunst ist der strenge epische Bericht; die lücken-
lose Ganzheit, in der heimische Landschaft und Menschenschlag zusammen-
leben; die unwiderlegliche Sachtreue des persönlichen Erlebnisses und der
geschichtlichen Quelle. Der gemeinschwäbische Hang zu burlesker und
satirischer Laune, in der stilvollen Epik der Romane nur verhalten, gab den
„Erzählungen" 1858/1861 das eigentümliche Gesicht. Hermann Kurz hat die
ganze schwäbische Entwicklung in seine Kunst aufgesaugt, die landschaftlich
betonte Geschichte Uhlands, die schwäbische Sachtreue Rapps, die Genauig-
keit seelischer Vorgänge, die Mörikes Sache war. Es ist die Reichsstadt, die
diese Kunst erzeugt hat. Daß es eine schwäbische war, ist nur Farbton.

Schwäbische Da war die lyrische Kunst. *Karl Mayer*, 1786 bis 1870, von Neckarbischofs-
Lyriker heim, war im Umgang mit Uhland und Kerner ein Freundschaftskünstler,
zartfühlend wie aufopfernd. Er ging von Kerners Poetischem Almanach 1812
und dem Deutschen Dichterwald für 1813 aus und entwickelte in seinen Ge-
dichtsammlungen seit 1833 das kleine landschaftliche Naturbild.

> „Ruhepunkt.
> Die Alpen silbergrau in Duft,
> Des Sees sonnig blaues Grüßen,
> Davor Fischreiher in der Luft,
> O welche Welt vor meinen Füßen."

Diese Kunst, nach Wolfgang Menzel „Tauperlen, die in ihrem kleinen Raum
Erd und Himmel zeigen", nach Hermann Fischer „ein poetisches Vademekum

durch Schwabens Wälder und Gefilde". Mayers Kunst gab im winzigen lyri-
schen Gebilde genau wie Kurz im großen epischen den reinen sachlichen Zu-
stand. Und Mayers Kunst der naturversunkenen Beschauung war der äußerste
Gegenpol zu einer Lyrik des handelnden Wortes. Auf diesem Wege lag schon
der Nachlaß des jung verstorbenen Grafen *Alexander von Württemberg*, *Alexander von Württemberg*
1801 bis 1844, Versbücher, die er bezeichnend „Lieder des Sturmes" 1838
und „Gegen den Strom" 1843 nannte. Seine Soldatennatur zerrieb sich an
dem dumpfen Frieden der dreißiger Jahre und gab sich in der Tatkraft seiner
Wünsche aus. Für die Nachtseite der Natur und des Lebens war ihm der
rechte Sinn und das treffende Wort gegeben. In den Zeitgedichten ringt der
Mann um Geltung, der Fortschritt mit Liebe zum Mittelalter paarte und
deutsch im Geiste der Burschenschaft dachte. Für den vollkommenen Vers
besaß er weder Ehrgeiz noch Ruhe. Er blieb beim ersten Wort und ver-
schmähte die Feile. Den politischen Vers hatte, wie in Rheinfranken Kinkel,
so Herwegh in Schwaben, die leidenschaftlichsten Trommelschläger, beide
hessischer Abkunft. Denn *Georg Herwegh*, 1817 bis 1875, aus Stuttgart, *Georg Herwegh*
sticht von dieser schwäbischen Umwelt grellstens ab. Sein Vater war aus
Hessen eingewandert und Zeitgenossen schrieben ihm das Aussehen eines
Armeniers zu. Der Ungebärdige wurde 1836 aus dem Stift entlassen. Vor
dem Soldatenrock ging er als Ausreißer über die Schweizer Grenze. Seine
Anfänge liegen bei den schwäbischen Übersetzern. Seine Verdeutschung von
Lamartines Werken seit 1839 ist rednerisch nüchtern und von reizlosem Ton-
fall. In Zürich lernte er 1840 Julius Fröbel kennen, und in dessen Verlag
erschienen 1841 die „Gedichte eines Lebendigen". Allgemeines Stilmuster
war Platen. Die rein lyrischen Stücke atmen seltsame Schwermut. Die poli-
tischen Gedichte, Ausbrüche eines unbestimmten Freiheitsverlangens, sind
klangvoll geverste Zeitungsschlager. Beiträge, die für die ersten Monatshefte
seines angekündigten „Deutschen Boten aus der Schweiz" bestimmt waren,
wurden 1843 als Buch „Einundzwanzig Bogen aus der Schweiz" gedruckt
und 1844 ein zweiter Teil, „Gedichte eines Lebendigen". Herweghs Verse
haben die Schlagworte der Zeit in gangbare Münze geprägt, für den be-
quemen Verstand der Menge mit jener Einseitigkeit, die überzeugt. Der
Dichter, wenn man ihn so nennen will, hat Lust und Leid des Eintagsruhmes
bis auf die Neige gekostet. Im Herbst 1842 fuhr er im Triumph durch
Deutschland und wurde vom preußischen König empfangen. Von Frankreich
her führte er 1848 einen Trupp Arbeiter ins Verderben und verscholl dann
ins Vergessen des Asyls.

Die schwäbische Idylle war aus und die Zeit zum Handeln gekommen. Da

hatte Cotta und seine Presse wieder das Wort, das Wort in zweifacher Richtung.

Cotta hatte 1819 vom „Morgenblatt" als selbständige Erscheinung ein *Das „Literatur-* „Literaturblatt" abgetrennt. Es wurde eine Macht, da es 1826/1849 Wolf-
blatt". Menzel gang Menzel leitete. Dieser alte Burschenschafter hat durch ein Vierteljahr-
hundert die burschenschaftliche Weltanschauung im weiten Bereich des
„Literaturblattes" zum geltenden Recht erhoben. Menzel hat einen ehrlichen
Kampf gekämpft, indem er gegen Hegel Schelling setzte, gegen Goethe wie
die neue Aufklärung zahlreiche Gefechte lieferte und die gefährliche Wir-
kung der französischen Zeitliteratur für die deutsche Zukunft aufdeckte. Denn
hinter seinem Schilde standen immer Überzeugungen. Und wenn er den
Staat an seine Pflichten gegen die Jugend der Linken erinnerte, hatte der
Staat sie nicht ziemlich grausam gegen die Jugend der Rechten geübt?

Cotta hatte am 9. September 1798 zu Stuttgart das erste Blatt seiner „All-
„Allgemeine gemeinen Zeitung" ausgehen lassen. Vom Herzog verboten, übersiedelte die
Zeitung" Zeitung 1803 nach Ulm und 1810 nach Augsburg, und als „Augsburger All-
gemeine Zeitung" ist das Blatt, ohne je Partei zu sein, eine politische Macht
geworden. Inzwischen hatte der staatsbildende Wille Schwabens in Männern
von geistigem Rang und schöpferischem Wort Gestalt gewonnen. Der Reut-
linger Friedrich List, 1789 bis 1846, der Vorkämpfer eines deutschen Eisen-
bahnnetzes und des deutschen Zollvereins, prägte die Losung „Durch Wohl-
stand zur Freiheit", weil er wußte, daß die deutsche Duckmäuserei und das
deutsche Wolkenkuckucksheim von der deutschen Armut abstammten. Der
Stuttgarter Robert Mohl, 1799 bis 1875, übersetzte 1828 das Buch des Eng-
länders Hamilton „Parlamentarische Logik, Taktik und Rhetorik". Sein
„Staatsrecht des Königreiches Württemberg" 1829 war das erste Recht eines
deutschen Staates. Der Stuttgarter Paul Pfizer, 1801 bis 1867, arbeitete aus
„Briefwechsel seinem Briefwechsel mit Friedrich Notter 1831 sein bestes, das berühmte
zweier
Deutscher" Buch zusammen: „Briefwechsel zweier Deutscher." Es zeichnete das deutsche
Bild nach Kirche, Staat, Literatur und dachte die logische Entwicklung zum
deutschen Staat voraus: Ausschluß Österreichs, Verminderung der Kleinstaa-
ten, Vormacht Preußens. Das war der Markstein auf dem Doppelwege zur
deutschen Einheit und Freiheit. Diese staatsbürgerliche Geistesmacht des
Landes wurde in der Zeitung wirksam, als sich Cotta 1826 den Stuttgarter
Gustav Kolb Gustav Kolb, 1798 bis 1865, nach Augsburg holte. Dieser Mann hat die „All-
gemeine Zeitung" weltbürgerlich zugleich und deutschbewußt gemacht, zu
einem Weltblatt von vornehmer Gebärde, das zu Gebildeten redete, unab-
hängig und parteilos, kaum zu beeinflussen, heute von den Mächtigen be-

droht und morgen umworben. Durch Kolb wurde die „Beilage" klassisches
deutsches Feuilleton. Sein Haus in der Karmelitergasse war für die Mit-
arbeiter wie List, Dingelstedt, Laube, Auerbach, Bodenstedt, Fallmerayer,
Riehl, Steub der gesellige und geistige Treffpunkt. Kolbs Gehilfen waren
der gelehrte Mebold und der bissige Humanist Altenhöfer, jeder auf sei-
nem Platz das Beste. Kolb war schwarzgelb, und so hatte Altenhöfer, der *Von Österreich*
schon 1849 kleindeutsch dachte, die Zeitung allgemach auf Preußen zuzu- *zu Preußen*
steuern.

DIE OBERRHEINISCHE TIEFEBENE, diese Wiege der deutschen
Volkskunst und Mundartliteratur, ist durch die zweiräumige Landschaft um
Darmstadt an Hessen geschlossen und durch Basel mit dem Raum zwischen
Alpen, Jura und Oberrhein verbunden. „Das freundliche, gewerbereiche
Städtchen Lörrach, dessen nahe Anhöhen einen herrlichen Ausblick nach der
Schweiz, dem Elsaß und hinein in die Täler des Schwarzwaldes gewähren",
ist räumlich wie geistig der Standpunkt, von dem aus sich der Gehalt dieser
Landschaft überblicken läßt.

Der SCHWARZWALD hat die drei Männer verwandten Schlages hervor-
gebracht: den evangelischen Prediger Hebel, den jüdischen Rabbinatsschüler
Auerbach, den katholischen Priester Stolz.

Johann Peter Hebel, 1760 bis 1826, ist aus Zufall in Basel geboren von *Der rheinische*
einer Basler Mutter, einem Vater, dessen Heimat Simmern auf dem Hunsrück *Hausfreund*
war. Der Haushalt wechselte halbjährig zwischen dem Breisgaudorf Hausen
und der Stadt Basel. So Zwischenalamannisch ist der Junge denn auch auf-
gewachsen. Seine Bildung rückte immer weiter von Basel ab, nach Karlsruhe,
wo er das Gymnasium, nach Erlangen, wo er die Hochschule besuchte. Man
gab ihm 1783 zu Lörrach ein Lehramt, die fruchtbarste, die am reichsten
gesegnete Zeit seines Lebens. In diesem Fleck Erde, dem Wiesetal, wurzelte
all sein Wesen ein. Er wurde 1791 nach Karlsruhe versetzt. Seine Wende.
In Karlsruhe und aus Heimweh nach dem Wiesetal reiften die „Alemanni- *„Alemannische*
schen Gedichte", deren erste Sammlung 1803 erschien. Nach seinen eigenen *Gedichte"*
Worten herrschte diese Mundart „in dem Winkel des Rheins zwischen dem
Fricktal und ehemaligen Sundgäu und weiterhin in mancherlei Abwand-
lungen bis an die Vogesen und Alpen und über den Schwarzwald hin in
einem großen Teil von Schwaben". In diesem einen Ausbruch des Heimwehs
erschöpfte sich Hebels lyrisches Bedürfnis. Die zweiunddreißig Stück der
ersten Auflage, auf die es ankommt, geben vom Rückerlebnis des Heimwehs
gesehen ein Gesamtbild des Tales, das aber nicht gut angeordnet ist. Voran
die „Wiese". Der Lauf des Flüßchens von der Quelle bis zur Mündung ist

ein ganzer Mythus geworden, Lebensgang des Mädchens bis zur Vermäh-
lung. Bekenntnis und Volkstracht, Art und Gewerbe der Talschaft sind mit
diesem mythischen Mädchenbilde in einem Blick anschaulich gemacht. Dann
im einzelnen Gewerbe und Stände. Dann, wovon sich das Volk unterhält,
tiefsinnig abgewandelt; der Großvater behaglich erzählend „Der Karfun-
Der Mythus
des Wiesetales
kel“; Mutter und Bub, „Der Mann im Monde“; seelenkundige Ablenkung
der Angst während des Gewitters, „Der Statthalter von Schopfheim“. Das
ländliche Tagwerk wird mit einem geschickten Griff zweimal gezeigt: einmal
vom Morgen gegen den erwachenden und einmal vom Abend auf den schlie-
ßenden Tag zurück. Wochenrast ist „Sonntagsfrühe“. Der Kreislauf des
bäuerlichen Arbeitsjahres rollt in dem unerschöpflichen Gedicht „Das Haber-
mus“ ab. Die festliche Innerlichkeit des Familienlebens ist gefühlsgerecht
und wahr auf die Zeit um Weihnachten verlegt und wieder zweifach emp-
funden; mit dem Blick ins Mutterherz: „Die Mutter am Christabend“; mit
dem ständisch geschärften Blick ins Dorf: „Eine Frage.“ Und nach beiden
Seiten rundet sich der Rahmen mit zwei so herrlichen Stücken wie „Der
Winter“ und „Der Jänner“. Und der Beschluß für alle: „Auf einem Grab.“
Großartig weit über das Tal hinaus ins Allgemeine zielt das Gespräch „Die
Vergänglichkeit“ und nicht minder groß nach rückwärts deutet „Wegweiser“.
Die Zusätze der späteren Auflagen fügen sich irgendwie in diese Rundung
ein, ausgenommen die gelegenheitlichen Gedichte. Der Dichter war mit die-
ser Welt so verwachsen, daß ihm das Unbelebte und Sächliche belebte Ge-
stalt wird aus einer Mundart, die so unnachahmlich etwa „Maideli“ und
„Maidli“ auseinander hält. Diese Mundart bot alle Kunstmittel für den
gegenständlich epischen Grundzug, zumal keine Mundart wie diese wegen
ihrer streng bewahrten Längen und Kürzen, wegen ihrer langen Silben, wo
die Schriftsprache den bairischen Zwielaut hat, geeignet war, den antiken
Hexameter nachzubilden. Organisch wuchs daraus seine zweite Schöpfung
„Der Rheinländische Hausfreund“, Karlsruhe 1808 bis 1811, Abkömmlinge
und Nachfolger des „Badischen Landkalenders“. Die Jahrgänge bis 1811
stellte er 1811 zusammen: „Schatzkästlein des rheinischen Hausfreundes.“
Hebel hat da den alten alamannisch geformten Schwank wieder lebendig
gemacht und den Kalender zur stilgemäßen Kunstform erhoben. Da war eine
Mundartliche
Kunstdichtung
folgenreiche Erneuerung geschehen. Von den beiden Mundarten, die keinen
Anteil an der Schriftsprache hatten, der sächsischen und der alamannischen,
gewann zuerst die alamannische eigene künstlerische Geltung. Vor Hebel ist
mundartlich geschrieben worden. Doch Hebel ist der erste Schöpfer einer
mundartlichen Kunstform, indem er stammestümlichen Gehalt mundartlich

beredt machte. Mit Hebel setzt die neue, unvergleichbare, besondere Literatur des Mittelrheins von Basel bis Darmstadt ein.

Die sogenannte Dorfgeschichte war schon da als fränkisch-bairisches Erzeugnis und sie war durch Friedrich Lentner, Melchior Mayr, Josef Rank in voller Ausbildung. Sie hatte an einem zweiten Ast aus den bäuerlichen Beständen der Berner Landschaft, bei Albert Bitzius, längst klassische Form erhalten. *Die Dorfgeschichte*

Berthold Auerbach, 1812 bis 1882, aus dem vorderösterreichischen Nordstetten, fügte sich in diese Richtung ein. Äußere Umstände drängten ihn vom Rabbinerberuf ab. Seine Erstlingsschrift, „Das Judentum und die neueste Literatur" 1836, ging von der religiösen Frage aus. Auerbach bestritt Börnes schöpferische Anlage und lehnte Heine ab. Das Judentum müsse sich religiös erneuern und werde die höheren Bedürfnisse der Menschen aller Zeiten befriedigen. Die Einigung des Glaubens und Wissens sei den Juden nicht Zeitbedürfnis, sondern dauerndes Gesetz. Dieser zuversichtliche Glaube gab ihm die Sätze ein: „Ja, wir achten und lieben deutsche Sitte und deutsches Herz, denn es ist auch unsere Sitte, unser Herz." Die Wendung kam ihm ähnlich wie Hebel. Er lebte Ende der dreißiger Jahre am Rhein, so im Bonner Hause Kaufmann, und machte in diesen Kreisen für Hebels Gedichte den Werber. Da starb sein Vater. Zum Schmerz überkam ihn das Heimweh. Die flüchtigen Entwürfe zu Dorfgeschichten vom Juli 1840 erhielten einen neuen Gefühlswert. Und es mag wohl sein, daß Auerbach im Spätherbst 1840 unter der großen Buche bei Plittersdorf im Siebengebirge die ersten acht dieser Erzählungen im Gedanken entwarf. Karl Mathy brachte 1843 die Sammlung heraus: „Schwarzwälder Dorfgeschichten." Sie stehen von Peter Hebels Geschichten nicht weit ab. Denn manche von Auerbachs Erzählungen sind nur gestreckte Anekdoten. Sie sind nicht einseitig vom bäuerlichen und nicht einseitig vom städtischen Standpunkt aufgenommen. Sie sind mündlich erzählt gedacht. Die Mundart geben sie nicht nach ihrem strengen Lautstande, sondern nach Geist und Sprachstil wieder. Ungefähr wie in Hebels erster Sammlung sollten alle Seiten des damaligen Bauernlebens sichtbar werden. Absichten auf Zweckwirkung, wie Bitzius sie leiteten, hatte Auerbach nicht, ließ sie aber gelten. Die Geschichten sind in Nordstetten angesiedelt. Ein ganzes Dorf vom ersten bis zum letzten Haus sollte mit seinen Gebräuchen und Liedern gegenwärtig sein. Groß und bedeutsam waren zwei Gedanken, die Auerbach selber ausgesprochen hat. Einmal: „Die neuere Volksdichtung kann zugleich mit Bewußtsein aufgreifen und fortsetzen, was ehedem die Sage in rein naiver Weise tat, indem sie bestimmte Orte mit ihren Gebilden umwob." *Hebel, Blitzius, Auerbach* *Der Kalender*

Das ließ sich ja auch an Hebels Sammlung wahrnehmen. Und dann: „Die aus dem Volkstum gewonnene Poesie wird sich daher ähnlich der neueren Richtung geschichtlicher Forschung auf das Provinzielle immer mehr lokalisieren müssen." Auerbach leitete 1843 und 1844 in Karlsruhe die ersten Bände vom „Deutschen Familienbuch" und ging dann seinen Hebelweg fort, indem er 1845/1848 einen neuen Kalender für Stadt und Landbürger schrieb, den „Gevattersmann".

Wie der Kalender und die Dorfgeschichte, so hatte auch die religiöse Betrachtung längst eine volkstümliche Literatur entwickelt. Auch sie wurde nun von dieser alamannischen Bewegung ergriffen.

„Kalender für Zeit und Ewigkeit" *Alban Stolz,* 1808 bis 1883, stammte aus Bühl. Sein Vater, ein Apotheker, war ein Sonderling und der Apfel fiel nicht weit vom Stamme. Nach seinem Schulweg, auf dem ihm zu Heidelberg Creuzer und Schlosser begegneten, lehrte er an der Freiburger Hochschule die Fächer für den angehenden Seelsorger. Er lehrte fleißig, aber weder fesselnd noch gelehrt. Alban Stolz hat zu einer Zeit, da die freisinnigen Gruppen sich der Volksliteratur bemächtigten, den Kalender dem kirchlich-religiösen Einfluß zurückgewonnen und das mit einem großartigen, Diesseits und Jenseits umfassenden Stichwort: „Kalender für Zeit und Ewigkeit", seit 1843 erscheinend. Hierin sowie in der rücksichtslos volkstümlichen Haltung seines Stiles, im Schwung des Sittenpredigers, in der Liebe des Volksbildners, im Schwarzwaldton seines ganzen Wesens bildet Stolz, dessen Schriften unter allen Bekenntnissen verbreitet waren, mit Auerbach und Hebel eine so runde Einheit, als sich nur denken läßt. Die gleiche Wendung gab er der modischen Reisebeschreibung: 1853 *„Spanisches für die gebildete Welt"* „Spanisches für die gebildete Welt", 1857 „Besuch bei Sem, Cham und Japhet". Er hat die katholische Legende erneuert und er war, durch viele Jahrzehnte ein gleichmäßiger Tagebuchführer, zum Mystiker geboren und verschloß sich, sittenstreng, eigensinnig, ungesellig in harte Askese.

Diese beiden, Peter Hebel und Alban Stolz, bilden den Binnenkern, an dem sich die mächtige alamannische Volksliteratur und dies gedrungene mundartliche Schrifttum erfassen läßt. Im Schwarzwald hat sich die Gattung erfüllt. Sie nahm allerorten landschaftliche Eigenart an.

Im *ELSASS* zielte alles auf Mundartdichtung. Der Straßburger Protestant *Georg Daniel Arnold,* 1780 bis 1829, Göttinger Schüler der Rechte und auf der Rückreise 1803 mit Schiller und Goethe bekannt, war 1809 Lehrer für *„Der Pfingstmontag"* Geschichte in Straßburg geworden. Sein Lustspiel „Der Pfingstmontag" 1816 sind fünf Akte in Straßburger Mundart. Arnolds alamannische Hexameter hören sich nicht minder fein an als die Hebels. Sicherlich läßt sich über das

Stück, das die Zustände des alten Straßburg vor 1789 schilderte, nicht mehr
sagen, als was Goethe in „Kunst und Altertum" feststellte: „ein unvergleich-
liches Denkmal altstraßburgischer Sitte und Sprache, ein Werk, das an Klar-
heit und Vollständigkeit des Anschauens und an geistiger Darstellung unend-
licher Einzelheiten wenig seinesgleichen finden dürfte." Der Vorwurf: die
andre liebt einen andern, ist mit anmutiger Abwechslung durchgeführt. Die
Mundart ist Mittel, nicht Zweck. Der Sprechton alamannischer Frauen ist
zumal bei Lissel, der Unbefangenen, hinreißend getroffen; bei Christinel, *dütsch*
wenn sie künstelt, hört ihn wohl nur das ganz vertraute Ohr. Das papierne *und deutsch*
Geräusch der Schriftsprache verrät sich mit grellem Abstich in den schrift-
deutschen Absätzen. Die breiten Abschweifungen in der Art der Spruch-
sprecher an vielen Stellen sind eigentlich zurückgehaltene Arien und Duette.
An solchen Schwellen ruht die Handlung und die Stimmung atmet rhythmisch
auf und nieder. Der Realismus des Stückes wird durch die Strenge der Vers-
form in Zucht gehalten, ein Stil, der aus elsässisch-französischer Bildung an-
mutig gekreuzt ist. So dämpfte Arnold die innere Feindschaft dieses Schick-
salraumes zu den täglichen Häkeleien einer Familie, und er löste die schwere
Kulturspannung über dem Lande in ein fröhliches Gewitter von sprachlichen
Mißverständnissen auf. Gut dütsch, doch gut französisch, das war, man mag
es drehen wie man will, das äußerste Zugeständnis dieses „Pfingstmontag".

Der Umschwung von der französischen auf die deutsche Seite vollzog sich
in einer Familie, im Geschlecht der Stöber. Ein Prediger führte die Familie *Familie Stöber*
ins achtzehnte Jahrhundert. Elias Stöber, 1719 bis 1778, war mit dem Zür-
cher Kreis um Bodmer freundschaftlich verbunden. Sein Großneffe Daniel
Ehrenfried Stöber, 1779 bis 1835, hatte durch Pfeffel Zugang zum rechts-
rheinischen Geistesleben. In seinem Hause waren Tieck, Voß, Jakob Grimm
Gäste. Die Bekanntschaft mit Hebel gab ihm die Richtung. Und um die Jahr-
hundertwende gehörte er mit Arnold jener literarischen Gesellschaft an, die
sich bewußt elsässisch hielt. Wie Arnold pflegte er in Hebels Stil alaman-
nische Dichtung. Stöber gab 1817 die Monatsschrift „Alsa" heraus und *„Alsa"*
schrieb 1826, wie vordem Arnold auf französisch die Literatur des Elsasses
behandelt hatte, „Kurze Geschichte und Charakteristik der schönen Lite-
ratur der Deutschen". Seine Verse glitten gefällig. Er fand in Berangers Art
glückliche Kehrreime. Der Mundart war er sicher. Er formte Romanzen wie
die Schwaben. Schon er schrieb für 1818 ein „Neujahrsbüchlein in Elsasser
Mundart". An Frankreich hing er mit Treue. Doch seinen Söhnen, die den
Umschwung mit ihrer neuen Zeitschrift „Erwinia" auslösten, hat er durch
Form und Ziel seines Schaffens den Weg bereitet.

„Erwina" Diese Zeitschrift „Erwinia" war Stimme eines Kreises, in dem die beiden
Straßburger Söhne Ehrenfried Stöbers führten. Der ältere, *August Stöber,*
1808 bis 1884, versammelte in Mühlhausen, wo er zuletzt Oberlehrer war
und die Stadtbücherei betreute, seine Freunde in der literarischen Gesell-
schaft Concordia. Mit den Baslern und den Schwaben hielt er enge Verbin-
dung. Seine jungen Gedichte waren von Hölty und Schiller angeregt. Doch
nicht der Dichter, sondern der Erneuerer altelsässischen Volksgutes leistete
„Elsässisches sein Bestes. Das „Elsässische Volksbüchlein" 1842 war ursprünglich als An-
Volksbüchlein" hang zu dem „Oberrheinischen Sagenbuch" 1842 gedacht, wo Stöber in Ver-
sen Volksgut der Landschaft neu ausmünzte. Das „Volksbüchlein" war die
erste selbständige Sammlung der Art in einer oberdeutschen Mundart. Als
Vorläufer konnten nur die dem „Wunderhorn" beigegebenen Kinderlieder
und eine plattdeutsche Sammlung gelten, die Stöber aber damals nicht kannte.
Das Büchlein umschloß die ganze Welt des Kindes in Volksreimen. War da
Peter Hebels Sinn, so in den „Sagen des Elsasses" 1852 der Geist der Brüder
Grimm. Mundartliche Forschungen liefen nebenher. Schon 1846 druckte Stö-
ber Proben eines landschaftlichen Wörterbuchs. Er schrieb über die Elsässer
Literatur des sechzehnten Jahrhunderts wie über den Straßburger Kreis
Goethes. Er tat sich in der Altertumskunde des Landes um und gab 1843 bis
„Elsässische 1848 zu Straßburg, später zu Basel, „Elsässische Neujahrsblätter" heraus.
Neujahrs- Indessen auch der Dichter August Stöber hat seinen vollen Wert. Die Elsässer
blätter" Schwänke und Novellen des sechzehnten Jahrhunderts wußte keiner so glän-
zend wiederzuerzählen wie er. Seine kleinen mundartlichen Gedichte sind
Hebels würdig. Land und Volk von Elsaß aber lebt in der würzigen Dich-
tung, die 1845 Wilhelm Wackernagel gewidmet wurde: „Weinblüth-Phan-
tasien auf Hohkönigsburg." Diese milden, überlegen gemütvollen, heimat-
lich empfindsamen, reimlosen Trochäen, die alle Weine des Landes, ver-
körperte Gestalten eines Sommernachtstraumes, zusammenführen, formten
schon in Geist und Sprache bis an den Tonfall beliebter Satzwendungen Stil
und Art Josef Scheffels vor. Bescheidener lebte neben ihm der jüngere Bruder
Adolf Stöber, 1801 bis 1892, Pfarrer der reformierten Gemeinde Mülhausen,
in seinen Gedichten den Schwaben und dem Bruder geistig verwandt.

Mundart Der Schwarzwald Peter Hebels und das Elsaß August Stöbers bezeichnen
die Schwelle, auf der einander zwei brüderliche Stämme begegnen: von den
Quellen des Rheines flußabwärts und in einem vielhundertjährigen staat-
lichen Eigendasein gestählt das oberalamannische Volkstum; aus der Main-
landschaft flußabwärts und durch die Geheimbünde in der Tiefe aufgewühlt
der hessische Glaube an das werktätige Volk.

Am *UNTERMAIN* erzeugten sich die ersten Wirbel in *Mainz* und Frank- *Mainz:*
furt. *Friedrich Lennig,* 1797 bis 1838, aus ostfränkischer Familie zu Mainz *Friedrich*
geboren, empfing den Blick für die scharfgeschnittene Vielheit der Men- *Lennig*
schengesichter im väterlichen Stoffladen am Mainzer Markt. Da er dann
Kaufmannslehrling in Sankt Gallen war, kann ihn hier aus nächster Nähe der
Aufstieg der Schweizer Mundartliteratur mitbewegt haben. Lennig schrieb
die Donnersberger Mundart, die zwischen der Pfalz und dem fränkischen
Mittelrhein hin und her klingt. Seine Gedichte „Etwas zum Lachen" be-
gannen 1824 zu erscheinen und brachten es 1839 auf die dritte Auflage.
„Lennig besitzt den ganzen rheinischen Humor, Humor der Charakteristik,
Humor des Wortes, Humor der Situation." Das Treiben des Volkes war ihm
Gegenstand. Er hat mit erstaunlichem Realismus das widersprüchige Wesen
des Volkes festgehalten und die Kunst besessen, in scheinbar so kunstlosen
Gebilden je nach Bedarf mit dem Ton zu wechseln. Und so bezeugt uns denn
Wilhelm Riehl, daß viele von Lennigs Versen, obwohl Alexandriner, in den
Mund des Volkes übergegangen sind. Zwischen diesen Mainzer Anfängen *Darmstadt:*
und den Frankfurtern, die eine eigene Geschichte haben, gedieh solch Schrift- *Ernst Elias*
tum im südmainischen Hessen zu einer großen und ernsten Sache. Der Darm- *Niebergall*
städter *Ernst Elias Niebergall,* 1815 bis 1843, Sohn eines Thüringer Musikers
und einer Darmstädter Mutter, war an der Gießener Hochschule mit Karl
Vogt und Georg Büchner befreundet. Eine Reihe von Erzählungen aus den
Jahren 1835 bis 1840, erst 1896 aus den zerstreuten Beilagen des „Frank-
furter Journal" gesammelt, mögen dahin stehen. Es verschlägt nur wenig,
daß Niebergall an den Jakobinerplänen seiner Gießener Freunde keinen Ge-
fallen fand. Von Georg Büchners Weltanschauung und Dichtung führt den-
noch eine ergiebige Ader zu den zwei Lustspielen, die Niebergall geschrieben
hat: „Des Burschen Heimkehr" 1837 und „Datterich" 1841, beide im Darm-
städter Tonfall. Wen sie nur zum Lachen reizen, der lacht über sie hinweg.
Der Gießener Hochschüler, der dort nach lustigen Dummejungenstreichen
zum Metzgerhandwerk seines Vaters zurückgekehrt, und der Schmarotzer
des Bürgertums, der hier in der vollen Meisterschaft seines Gewerbes auf-
tritt, das sind Gestalten und Vorwürfe aus Büchners geistiger Nachbarschaft.
„Des Burschen Heimkehr" setzt noch Zuversicht auf diesen jungbürgerlichen
Nachwuchs. „Datterich" ist hoffnungslos und gibt das Bürgertum dem un- *„Datterich"*
barmherzigen Gelächter preis. Wie bei Büchner so fehlt auch bei Niebergall
jede Zweckabsicht. Aber diese Stücke, in satzgetreuer Mundart allein aus
dem Wesen der handelnden Gestalten herausgespielt, von genialer Laune,
schöpferisch und zutreffend in jeder Handbewegung, waren wie die von

Büchner gerade darum unwiderleglich und zwangen zu unerbittlichen Folgerungen, weil sie nichts als Tatsachen feststellten. Lachen und Weinen sind Zustände des Beschauers, und sie berühren oder verändern das unbewegliche Antlitz der Dinge nicht. Abermals aus einer andern Ecke des Daseins sah *Ludwig Schandein*, 1813 bis 1893, von Kaiserslautern, die Welt. Er schrieb in seinen „Gedichten in Westricher Mundart" 1854 eine örtlich scharf begrenzte Sprache, und er redete im Namen eines bestimmten Standes, des Bauern aus dem Mittelland des Westrich, heimwehselig und sozial. Frankfurt machte aus dieser Volksdichtung großstädtischen Literaturbetrieb.

Frankfurt Karl Malß — Und die Frankfurter Volksdichtung hing durch einen merkwürdigen Zufall mit Straßburg zusammen. Der Kaufmannssohn *Karl Malß*, 1792 bis 1848, diente 1813/1815 bei den Frankfurter Freiwilligen. Vor Straßburg, im Umgang mit seiner Mannschaft, scheint ihm der erste Gedanke zu seinen mundartlichen Possen gekommen zu sein. Auch er besuchte dann die Gießener Hochschule. Am 13. August 1821 wurde unter großem Erfolg sein erster Wurf „Der alte Bürger-Capitain" gespielt. Der Erfolg wiederholte sich bei den späteren Stücken: November 1832 „Die Landpartie nach Königstein";

„Herr Hampelmann" — Dezember 1833 „Herr Hampelmann im Eilwagen"; Februar 1834 „Herr Hampelmann sucht ein Logis"; Februar 1835 „Die Jungfern Köchinnen". Malß hatte Überlieferungen hinter sich. Verloren sind zwei mundartliche Lustspiele in Sachsenhäuser Mundart, wahrscheinlich von Heinrich Wilhelm Seyfried. Die nachweisbare Reihe eröffnete Karl Ludwig Textor mit seinem Lustspiel „Der Prorektor", Schulbilder aus dem Frankfurter Gymnasium. Davon wurde Malß angeregt. Den szenischen Grundriß seiner Spiele entlieh er französischen Stücken. Held ist der Frankfurter Kleinbürger. Ernste Züge und witzige sind wohl überlegt gemischt. Was Arnold für Straßburg, Niebergall für Darmstadt, das war Malß für Frankfurt. Mit breiter Fülle ergoß sich nun die Freude an spielmäßig geformtem Frankfurter Leben. Von dem

Wilhelm Sauerwein — Schneidersohn *Johann Wilhelm Sauerwein*, 1803 bis 1847, einem lebensfrohen rheinischen Menschen, stammen wahrscheinlich die Lieder „Fürsten zum Land hinaus" und „Wie wir dich beklagen, deutsches Vaterland". Sauerweins arglose Possen „Der Amerikaner", „Der Gräff, wie er leibt und lebt", „Frankfurt, wie es leibt und lebt", legten alle Absicht darauf, Volksgestalten täuschend hörbar zu machen. Mundart war ihnen nicht Mittel, sondern Zweck. Elegisch ausbegleitet und in eine neue Zeit hinübergespielt wurde

Friedrich Stoltze — diese umfangreiche Gattung durch *Friedrich Stoltze*, 1816 bis 1891, der durch den Vater aus dem Waldeckschen stammte. Wie Sauerwein gehörte er zu den jungen Frankfurter Aufrührern hessischer Richtung. Stoltze hielt es

mit Malß, schrieb Kleinbilder aus dem Frankfurter Leben, manche darunter
von bitterer Wahrhaftigkeit, schilderte das Frankfurter Judentum, Volks-
bräuche und Aufzüge und redete dem seiner geschichtlichen Freiheit beraub-
ten Altfrankfurt das Wort: „Gefühle einer Stadtwehruniform." Und so in
allen Noten. Für seinen Sohn zur Weihnachtsgabe entwarf der Arzt *Heinrich
Hoffmann*, 1809 bis 1894, ein unvergängliches Buch, das 1845 gedruckt
wurde: „Struwwelpeter". *„Struwwelpeter"*

HEIDELBERG gab nun dieser Volksdichtung einen höheren städtischen
Stil. *Karl Gottfried Nadler*, 1809 bis 1849, war an seiner heimischen Hoch-
schule rechtswissenschaftlich gebildet. Thibaut zog ihn zu seinem Gesang-
verein heran, ein fröhlicher Trupp junger Leute, der Bund „Faustina", der
Kunst hold und am Werke, allerwärts Volkslieder aufzuspüren. Männer von
späterem Ruf wie August Reichensperger oder Franz Kugler und bedeu-
tende Rechtsgelehrte gehörten dem Kreise an. Nadler versuchte sich schon
jetzt und hier in launiger Rede, gebunden wie ungebunden. Er wurde in
Heidelberg Rechtsanwalt. „Fröhlich Palz, Gott erhalt's. Gedichte in Pfälzer *„Fröhlich Palz"*
Mundart" erschienen 1847, „Das Titelblatt wie ein Brevirarium rot und
schwarz gedruckt". Nadler wollte selbst einmal über sein Leben den Leit-
spruch setzen: „Kommt der Tag, so bringt der Tag." Dies und der Vorsatz
„mores maiorum" zeichnen künstlerisch und weltanschaulich das Wesen
dieses Mannes. Auch sein Ahne war Peter Hebel. Nadler schrieb die städtische
Heidelberger Mundart und die des halbstädtischen Bauern von der Berg-
straße. Er schrieb sie wissenschaftlich genau mit allen alamanischen Ein-
schlägen. „Es ist der vormärzliche pfälzische Liberalismus, den wir hier mit
Händen greifen, der Begeisterungstaumel freisinniger Zweckessen und *Revolution
in Krähwinkel*
Zweckräusche, die Wichtigtuerei mit weltbewegenden Kammerreden, Aus-
schußvorträgen und Zeitungsartikeln, das ganze südwestdeutsche politische
Gebummel und Gebrummel der Jahre 1846 und 1847, wozu der Zopf klein-
städtischen Gemeinderegiments und krähwinkeliger Bürgerwehrfatalitäten,
endlich aber auch manche Züge echten und unverwüstlichen Volkslebens in
bunten Bildern." Kaum eine andere Mundart war besser gestimmt als diese,
den politischen Zeitungsschwung jener Jahre zu parodieren und homöopa-
thisch zu heilen. In seiner verwegenen Laune, von der Nadlers Briefe an
August Reichensperger Zeugnis geben, führte er zum Sprechen getroffen die
mittelrheinischen Revolutionshelden vorüber. Der feine Mensch, der froh-
sinnig geistreiche Trinklieder zu reimen wußte und dem Ernst des Lebens
in gehaltvollen Versen nicht minder gerecht wurde, wäre um ein Haar vor
seinem eigenen Hause drei Schnapphähnen aus dem Gefecht von Waghäusel

zum Opfer gefallen. Seine kühne Offenheit rettete ihn für diesmal. Wenige
Wochen später holte ihn doch der Tod ins Stroh.

Das mundartliche Schrifttum der oberrheinischen Tiefebene bedeutet eine
gewaltige geistige Volkserhebung. Die gemachte Dichtung ging bachab. Das
Arsenal
des Freisinns Volk selber führte sein Wort. Und es führte seine Sache. Die staatsbürger-
liche Tat des mittleren Rheintales, die im Frankfurter Volkshaus zu handeln
begann, zog aus diesem Raume ihre Leidenschaft und ihre Besonnenheit.

Sie ist von den beiden Hochschulen der Landschaft wissenschaftlich zuge-
rüstet worden. Das alamannische Freiburg ging wie billig voran. Karl von
Rotteck, dessen „Allgemeine Geschichte" seit 1812 Gemeingut von Hundert-
tausenden wurde, und Karl Theodor Welcker, der aus den hessischen Jugend-
bünden kam, vereinigten sich seit 1834 zu ihrem „Staatslexikon". Aus die-
sem staatsbürgerlichen Nachschlagewerk, das eben der Verbreitung freisin-
niger Gedanken diente, schöpfte der Mittelstand sachliche Kenntnisse, Ge-
sinnungen, Überzeugungen. Rotteck und Welcker haben den freien Volks-
staat aus einer Parteiangelegenheit zu einer Weltanschauung gemacht. Das
pfälzische Heidelberg blieb nicht zurück. In Heidelberg steckte der Friese
Friedrich Christoph Schlosser zwei seiner Schüler mit seiner demokratischen
Geschichtsanschauung an. Der eine war der Elsässer Ludwig Häusser, ein
Jenaer Burschenschafter, der die französische Geschichtslegende der Rhein-
bundzeit erledigte, aber nicht zugunsten Österreichs, sondern Preußens.
Dieser Lobredner Friedrich II. hat die mit zweierlei Maß messende Betrach-
tung in Schwung gebracht: die gleiche Tat mit den gleichen Worten zu ver-
dammen oder zu preisen, je nachdem sie von Preußen oder von Österreich
ausging. Der andere war der Hesse Georg Gottfried Gervinus. Mit seiner
fünfbändigen „Geschichte der poetischen Nationalliteratur der Deutschen"
1835/1842 erfaßte er zum erstenmal das geistige Leben des deutschen Volkes
als gewordene Einheit, erklärte er den geschichtlichen Literaturbegriff für
ausgelebt und erschöpft, forderte er den Übergang der Nation vom schön-
geistigen zum staatsbürgerlichen Leben. Gervinus und Häusser gründeten
„Deutsche am 1. Juli 1847 die „Deutsche Zeitung". Sie hat die Lehre des deutschen
Zeitung" Freisinns entwickelt und das Bewußtsein aufgeweckt, daß es eine deutsche
Frage gebe. Sie brachte am 26. März 1848 aus der Feder Roberts von Mohl
den Wahlaufruf, der in dem alten westdeutschen Ruf nach einem österreichi-
schen Kaisertum ausklang.

FRANKFURT, das war der weltgeschichtliche deutsche Wandel vom
Frankfurter Römer zur Paulskirche. Die Stadt hatte ein eigenartiges Kulturgerät. Zu dem
Institute medizinischen Institut, das 1763 Johann Christian Senckenberg gestiftet

hatte, fügte 1816 Vermächtnis und Tod des Bankherrn Johann Friedrich Staedel das Kunstinstitut. In diesen Umrissen haben zwei Frankfurter ihrer Vaterstadt das Gesicht gemacht. Der eine war der Sohn von Goethes Schwager, *Friedrich Schlosser,* 1780 bis 1851, zu Jena, unter den Augen Goethes und Schillers gebildet und Rechtsanwalt. Schlosser führte auf seinem Sommersitz zu Stift Neuburg bei Heidelberg ein gastliches und kunstfrohes Haus. Der andere war *Johann Friedrich Böhmer,* 1795 bis 1863, Schüler von Heidelberg und Göttingen, mit Brentano, Görres, Döllinger eng befreundet, von der Verfassungsgeschichte her der Kunstwissenschaft zugewandt. Eines Sinnes waren die beiden Männer in der Pflege jener rheinisch-vaterländischen Güter, die von den Brüdern Boisserée und durch den Freiherrn vom Stein wieder zu Wert und Ansehen gebracht worden waren. Schlosser gehörte 1819 zu den Gründern der Gesellschaft für ältere deutsche Geschichtskunde und des gewaltigen Quellenwerks der „Monumenta". Böhmer wurde dann der Leiter dieser Gesellschaft, der grundlegende Vorarbeiter der „Monumenta" und Verwaltungsmitglied des Staedelschen Kunstinstituts. Die Freunde dieser beiden Männer, die zwei Vettern Passavant, wirkten schöpferisch in der Richtung der beiden Frankfurter Institute. *Johann Karl Passavant,* 1790 bis 1857, faßte seinen ärztlichen Beruf als Dienst am Reiche Gottes. Als Naturphilosoph stand er zwischen Schelling und Baader. Religiös hielt er zu Diepenbrock wie zu Sailer. Er wollte die Philosophie zur Theosophie machen. In der Welt des Geistes und des Stoffes walten verwandte Gesetze. Die höhere Ordnung der Welt leuchtet in den Wundern auf. Das letzte Ziel des Menschen ist die Vergottung. Sein Glaube an den Lebensmagnetismus ließ ihm Gottesdienst und Heilsmittel der Kirche als heilige Magie erscheinen. Und so sah er die Sehnsucht der Natur, Organ des Geistes zu werden, in den Sakramenten gestillt. All diese Vorstellungen vereinigten sich in seiner Schrift „Das Gewissen" 1857, die eine Darstellung der religiös-sittlichen Welt im Lichte der letzten Dinge gab. *Johann David Passavant,* 1787 bis 1861, war zu Paris und Florenz, zu Rom im Umgang mit Overbeck, Cornelius, Veit gebildet. Am Staedelschen Institut malte der Protestant Madonnen und ging mehr und mehr zur Kunstforschung über. Und als die Lage der römischen Malerschule der Nazarener schwierig zu werden begann, bereitete er ihr zu Frankfurt eine Stätte. Frankfurt wurde die Hochburg der Nazarener. An zwei Bildern entschied sich sichtbar der Umschwung der Zeit. Für das neue Haus der Kunstschule an der Mainzer Gasse malte Philipp Veit 1833 das große Bild, durch das er nach seiner Weise die Stadt auf ihren alten Kaisergedanken stimmte: „Einführung der Künste in Deutschland." Gegen seinen Willen

Schlosser und Böhmer

Die beiden Passavant

Umschwung in der Kunst

kaufte 1842 das Institut Karl Friedrich Lessings Gemälde „Hus vor dem
Konzil" an. Es war nicht allein der entgegengesetzte Stil, es war die entge-
gengesetzte Gedankenwelt dieser beiden Bilder, in denen die Kunstfrömmig-
keit des kaiserlichen Mittelalters von dem freiheitlichen und fortschrittlichen
Willen zur Gegenwart überwunden wurde.

Die Paulskirche Am 18. Mai 1848 trat in der Paulskirche das erste deutsche Parlament zu-
sammen. Kein Volk sah sich jemals von einer so glänzenden geistigen Aus-
lese seines Daseins vertreten, um seine Freiheit zu beurkunden und seine
staatliche Einheit zu gründen. Es war ein Schauspiel ohnegleichen, wie sich
die angehäufte wissenschaftliche, literarische, staatsmännische, staatsbürger-
liche Bildung in Rat und Beschluß umsetzte und sich zu der jüngsten deut-
schen Kunstform, zur Staatsrede, auswirkte. Am 28. März 1849 wurde Fried-
rich Wilhelm IV. mit 290 Stimmen bei 248 Enthaltungen zum Kaiser ge-
wählt und die Reichsverfassung ausgerufen. Am 28. April lehnte der König
von Preußen die deutsche Kaiserwürde ab. Nur die kleinen Staaten bekann-
ten sich zu der neuen Verfassung. Am 25. Mai wurde auf Ludwig Uhlands
Antrag ein Hilferuf an das deutsche Volk beschlossen. Am 30. Mai ging das
Frankfurter Parlament auseinander. Am 18. Juni wurde die verstümmelte
Versammlung zu Stuttgart mit Waffengewalt zersprengt.

„Gaudeamus" Diese ganze Welt hat ihren dichterischen Abgesang, *Josef Viktor Scheffel*,
1826 bis 1886, aus Karlsruhe. Im Vaterhaus atmete er die Luft Peter Hebels.
In München stimmte er sich auf „Fliegende Blätter". In Heidelberg kneipte
er mit der modernen Wissenschaft. Scheffels Familienheimat war durch viele
Generationen die Landschaft zwischen Schwarzwald und Hegau. Die ist
unsagbar echt Gestalt und Stimmung in dem heiteren Sange „Der Trompeter
von Säckingen" 1853 und in dem schwermütigen Roman „Ekkehard" 1855,
Stil der Düsseldorfer und Münchner Malerdichter, der Urkundenschreine
und Zeitbuchschreiber. Aus dem zerronnenen Plan eines Romans vom Wart-
Scheffels burgsängerkrieg sind die Gedichte eines Kreuzfahrers „Juniperus", das Ge-
Abgesang sangbüchlein „Frau Aventiure", die hymnischen „Bergpsalmen" übrig ge-
blieben. Sein eigenes Liederbuch „Gaudeamus" hält ihn bei seinen unnach-
ahmlichsten Gebärden fest. Das Lebensgefühl dieses Mannes war weder
gewaltsame Galgenlaune noch Maske tragischen Überdrusses, sondern das
Gesicht eines edlen Herzens, das zum bösen Spiel des Verstandes gute Miene
macht. Scheffel hat dieses alamannische Rheinland der Volksdichtung, Natur-
kunde, Kulturgeschichte, der Fortschrittsmänner und Krügelredner in die
anmutigen Figuren der rheinisch-bairischen Malerdichtung verzaubert, in
das überzeitliche Deutschland jenseits der Volkstribunen und Imperatoren.

II.
STAATLICHE MÄCHTE
1814 bis 1866

Österreich und Preußen waren weit mehr als nur Nebenbuhler um die Vormacht in Deutschland. Sie waren Kulturpersönlichkeiten sehr verschiedenen Schlages. Was geistig zwischen ihnen stand, forderte kein Schlachtfeld und konnte auf keinem entschieden werden. Aber der Würfel, der politisch gegen Österreich fiel, ist geistig gegen Deutschland gefallen.

Österreich und Preußen

Soviel Zutreffendes und Geistreiches schon über Ursache und Wesen der unterschiedlichen österreichischen und preußischen Kulturkreise gesagt worden ist, Gewicht hat nur die Frage, warum es Österreich nicht gelungen ist, sich in Deutschland geistig in dem Maße durchzusetzen wie Preußen. Diese Frage kann nur geschichtlich beantwortet werden. Man könnte versucht sein, die Schuld auf das Schicksal zu schieben und zu sagen: Kant, Hamann, Herder seien leider in Ostpreußen und nicht in Niederösterreich geboren worden. Aber Preußen hat von diesen gebürtigen Preußen so wenig gehabt wie Österreich, dagegen sehr viel von den nicht gebürtigen Preußen wie Pufendorf, Leibnitz und Hegel. Hier ist nicht Schicksal, sondern selbstverantwortlicher Entschluß. Österreich hat sich seit dem dreizehnten Jahrhundert mehr und mehr aus Deutschland heraus und Preußen seit dem achtzehnten Jahrhundert beständig nach Deutschland hineinentwickelt. Der Besitz an Land und Leuten gibt auch für die geistige Durchdringung den Ausschlag. Auf dem Wiener Kongreß nahm Österreich nur das, was ihm gehört hatte, und nicht einmal alles das. Preußen aber nahm das halbe Sachsen und die Rheinlande. Und eben die geistige Festsetzung Preußens am Rhein, nach der politischen, ist einer der wichtigsten Vorgänge in der deutschen Geistesgeschichte des neunzehnten Jahrhunderts. Die verschiedene Art, wie Preußen und Österreich 1814 aus dem Felde heimkehrten, hat seinen Einfluß auf die literarische Entwicklung Österreichs, Preußens und Deutschlands.

Die geistesgeschichtliche Frage

Ihr Einfluß auf die Vorgänge in Deutschland

Beim Endkampf um die Vormacht in Deutschland hatte Österreich fast alle deutschen Staaten auf seiner Seite, Preußen aber die geistigen Rücklagen, die es seit 150 Jahren in Deutschland gemacht hatte. Österreich hat diese Rücklagen in seinen östlichen Ländern angelegt, anstatt in Deutschland. Sie konnten geistig für Königgrätz nicht mobilisiert werden.

1. PREUSSEN

Romantische
Kräfte in Berlin

Berlin und Halle haben die Spannungskräfte erzeugt, die nach und nach alle preußischen Landschaften durchdrangen. Friedrich Schleiermacher verkörperte in Berlin die geistige Umwälzung, die das Preußen von 1813 geboren hatte. Von zwei Stellen aus redete durch seinen Mund das religiöse Gewissen des deutschen Ostens: von der Kanzel der Dreifaltigkeitskirche, wo er die politischen Ereignisse auf ihren sittlichen Wert prüfte; von der Lehrkanzel der Hochschule, wo er gegenüber der sogenannten natürlichen Theologie den geschichtlichen Standpunkt vertrat. Seine Theologie war Religionsgeschichte. Aus einem Kreis religiös erweckter Geister heraus gründete der Danziger Karl Ernst Jarcke, Konvertit und Strafrechtslehrer an der Universität, 1831 das Berliner „Politische Wochenblatt", um die Revolution in jeder Gestalt und vor allem den Verfassungsgedanken zu bekämpfen. Und aus der gleichen Gruppe heraus führte der Offizier Josef Maria von Radowitz im „Politischen Wochenblatt" seinen Kampf gegen die falsche Freiheit und besorgte die Spalte der äußeren Politik. So ging es herüber zu Schleiermachers Gegenspieler Ernst Wilhelm Hengstenberg, einen alten Burschenschafter, der durch seine „Evangelische Kirchenzeitung" die christlich-germanische Bewegung in Reih und Glied brachte, auf seiner Hochschulkanzel die Offenbarung gegen die neue Aufklärung zu halten wußte und als harter Wiederhersteller der evangelischen Lehre der bestgehaßte Mann seines Zeitalters war.

Die Wissenschaft

Die deutschromantische Wissenschaft verfolgte durch Friedrich Karl Savigny das römische Recht auf seinen Wegen durch das Mittelalter; schuf durch Friedrichs von Raumer Geschichte der Hohenstaufen ein kunstvoll gebautes Geschichtswerk und der Dichtung eine unerschöpfliche Stoffquelle; erweckte sich in Karl Lachmann einen der ersten germanistischen Philologen an der

Karl Wilhelm
Solger

Hochschule. Der Märker Karl Wilhelm Solger aber krönte sein eigenes Werk und die romantische Kunstlehre mit „Erwin. Vier Gespräche über das Schöne und die Kunst" 1815 und „Philosophische Gespräche" 1817, liebenswürdige Zwillinge platonischer Unterhaltung. Schleiermacher hielt ihm 1819 die Grabrede. Tieck und Raumer gaben seinen Nachlaß heraus. Durch Spinoza und Schelling war er aus dem engen Bezirk Fichtes herausgeleitet worden. Mystik war ihm die gemeinsame Mutter der Religion und Kunst. Mystik war ihm Erkenntnis und Gestaltung des Ewigen in seiner unmittelbaren Gegenwart. Höchste Mystik dünkte es ihn, die ganze Wirklichkeit ohne Hilfe des Begriffs als Offenbarung zu fassen. In der Kunst unterschied er be-

wußte Mystik, die Allegorie, und unbewußte, das Symbol. Die Allegorie kann Verstandesspiel, das Symbol kann Nachahmung der Natur werden.

Da stieg aus dem Gegenpol zu Schleiermacher wie zu Hengstenberg die dritte Kraft auf.

Wilhelm Hegel, 1770 bis 1831, der Schwabe, wiederholte, was einst durch Spener geschehen war. In beiden Fällen war der Gedanke eines Alamannen Weltanschauung des preußischen Staates geworden. Hegel war, fertig und abgeschlossen, 1818 nach Berlin berufen worden. Staat ist für ihn sichtbar gewordener Volksgeist. Ungehemmt entfaltet sich der Lebenszusammenhang der Einzelwesen, der objektive Geist, nur in der Weltgeschichte. Die Einzelstaaten sind wie Spieler. Auf ihr Stichwort treten sie in die Weltgeschichte und verbraucht treten sie wieder ab. Den Staat überhöhen Kunst, Religion, Wissenschaft. Hegels Kunstlehre war eine geschichtliche Zusammenschau der künstlerischen Urbilder der Menschheit. Unter Religion begriff er das Verhältnis des endlichen Geistes zum unendlichen in der Form der Darstellung. Er sah sie verwirklicht von der niedersten zur höchsten, die Gott als das vorstellt, was er ist, als dreieinigen Geist. Jedes Einzelding hat seine Wahrheit und Wirklichkeit nur darin, ein Glied in der Entwicklung des Ganzen zu sein. In diesem Sinne ist, was vernünftig ist, wirklich und was wirklich ist, auch vernünftig. Hegels Philosophie, der rücksichtsloseste Historismus, den es je gegeben hat, formte den gesamten Gedankenstoff der Geschichte in ein geschlossenes Gebilde. Dem preußischen Staat war eine Weltanschauung gerüstet und der Grundriß entworfen. Ihn auszufüllen und auszuführen, rückten die Wissenschaften wie in vorbestimmte Stellungen ein.

Preußische Staatsphilosophie

Leopold Ranke, zu Ostern 1825 an die Berliner Hochschule berufen, schuf dieser geschichtlichen Seelenlage eine Geschichtswissenschaft. In Leipzig hatten ihn Fichtes Schriften ergriffen. Er hatte Thukydides und Niebuhr gelesen. Auf einer rheinischen Fußreise hatte ihn das Mittelalter bestürmt. An den Gesandtenberichten venezianischer Beobachter und Menschenkenner schulte er sich zu der Kunst, Köpfe zu zeichnen und das Leben selber mit dem Schlag des Wortes vors Auge zu zaubern. Zu Wien und im Gespräch mit Gentz unterrichtete er sich staatsmännisch. Endlich wurden ihm Venedig, Florenz, Rom geschenkt. Der Heimgekehrte ließ seine Hauptwerke „Die römischen Päpste" 1834/1836, „Deutsche Geschichte im Zeitalter der Reformation" 1839/1843, „Neun Bücher preußischer Geschichte" 1847/1848 erscheinen. Ranke hat die kritische Behandlung der Quellen nicht gefunden, sondern wie andere auch von Niebuhr her auf die neuere Geschichte übertragen. Ranke bemühte sich um die kritisch gesicherte Aussage der Quelle.

Die kritische Geschichtswissenschaft

Diese Arbeitsweise setzte voraus, daß sich die Geschichte der Menschheit in den Staatskanzleien vollziehe. Es war eine widerromantische, eine Geschichtsauffassung gegen Herder. Sie „konstruierte", indem sie der schöpferischen „Konstruktion" ausweichen wollte, ein Bild des Geschehenen aus dem Zufall des Geschriebenen und zufällig Aufbewahrten. Hegels Philosophie und Rankes Historie sind im Sinne der Geometrie „kongruent", Deckbilder der einen Weltanschauung: der im Staat sichtbar gewordene Volksgeist und die durch den Staat von Amts wegen protokollmäßig vollzogene und endesgefertigte Geschichte. Die Schöpfung der deutschen Geschichtskunde ist nicht Rankes, sondern seit Niebuhr ein sächsisches Werk. Ranke gliedert sich bewirkt und wirkend in diesen sächsischen Ablauf ein, indem er von Niebuhr ausging und die sächsischen Meister der Geschichte schulmäßig erzog. Rankes Werk ist die deutsche Geschichtskunst. Er spürte in seiner Darstellung mehr als er wußte an jedem Pulsschlag des Geschehens die Fülle vergangener und künftiger Augenblicke, die angehäuften Wirkungen und die gespannte Kraft neuer Ursachen.

Die Erdkunde *Karl Ritter* fügte in die geschichtliche Seelenlage Hegels und in Rankes Geschichtswissenschaft die Wissenschaft vom geschichtlichen Spielraum. Ritter war 1820 nach Berlin berufen worden als Geographielehrer an die Kriegsschule, für Erdkunde und Völkerkunde an die Hochschule. Seine mächtig angelegte „Erdkunde" hatte 1817 zu erscheinen begonnen. Sie führte Herders Gedanken von der Lebensgemeinschaft zwischen den Geschicken und den Wohnräumen der Völker folgerichtig durch. Wie aus höchster Höhe lehrte Ritter die Reliefkarte der Länder sehen, den Ringplatz der Völker, ihre Wiege, ihre Schule, ihr Grab.

Die Kriegs- *Karl von Clausewitz,* aus einer polnischen Familie geboren und in den
wissenschaft letzten Feldzügen gegen Napoleon russischer Soldat, hat die Wissenschaft von den Mitteln geschaffen, wie die Völker sich in ihren geschichtlichen Räumen behaupten und ihre geschichtlichen Sendungen vollstrecken.

Die Wissenschaft von Hegel bis Clausewitz hat den preußischen Staatsgedanken und Staatswillen zur Unterwerfung unter den geschichtlichen Ruf, zur verkörperten Allmacht und zu seinen geschichtlichen Aktionen erzogen. Und diese Berliner Wissenschaft hat alle Gebiete des geistigen Lebens in
Hegels ganz Deutschland durchdrungen. Philipp Marheineke übertrug Hegels Lehre
Philosophie in auf die Theologie und Heinrich Gustav Hotho auf die Kunstwissenschaft.
der Geistkunde Hegels Freunde und Schüler schufen sich 1827 in den „Jahrbüchern für wissenschaftliche Kritik" ein Machtmittel. Rankes Arbeitsweise durchsetzte den gesamten Betrieb der Geschichtswissenschaft, drang durch Hermann Hettner

seit 1838 in die Literaturgeschichte und durch Jakob Burckhardt seit 1840 in die Kunstwissenschaft. Der Zusammenhang der neuen Geschichtsschreibung mit Hegel und der sächsische Fortschritt über Ranke hinaus beurkundet sich in den Sätzen, die Rankes sächsischer Schüler Heinrich von Sybel seiner Erstlingsarbeit über die Quellen des Jordanes beigab: „Ohne Philosophie kein ordentlicher Historiker"; „Die Kunst der Geschichtschreibung blüht, wenn die Objekte der Geschichtschreibung in Blüte stehen"; „Der Geschichtschreiber soll cum ira et studio schreiben". Die Wissenschaft, Philosophie und Geschichte hat den preußischen Staat auf seine neue Aufgabe in Deutschland umgedacht.

„Der Geschicht-schreiber soll cum ira et studio schreiben"

Mit dem Staatsbewußtsein wandelte sich auch die Literatur sehr jäh vom christlich-germanischen Ideal zum praktischen Handeln der absoluten Vernunft.

Den verschiedenen romantischen Dichterkreisen Berlins stiftete 1824 Julius Eduard Hitzig, jetzt Untersuchungsrichter beim Kammergericht, die „Mittwochsgesellschaft". Untereinander hielten die alten Freunde zusammen. Achim von Arnim lebte abwechselnd auf Gut Wiepersdorf bei Dahme und in Berlin. Nicht unfruchtbar waren die Berliner Jahre Josefs von Eichendorff, der seit 1831 als Rat im Kultusministerium diente. Klemens Brentano, der zwischen 1814 und 1818 in Berlin wohnte, hatte das Erlebnis mit Luise Hensel, brachte unter schweren Seelenkämpfen, von Sailer beraten, sein Verhältnis zur Kirche in Ordnung und hatte einen schöpferischen Nachsommer. Durch Luises Bruder Wilhelm Hensel spannen sich Beziehungen zu einem Kreise junger Männer, die einander während des Feldzuges kennengelernt hatten, dichtende Edelleute, in ihrer Mitte Wilhelm Müller. Sie gaben 1815 das gemeinsame Büchlein „Bundesblüten" heraus, in denen Müllers erste Gedichte standen. Der Dichter der bedürfnisloseren christlich-germanischen Lesermassen, Friedrich de la Motte-Fouqué, war von zahlreichen Schützlingen umgeben, führte immer neue Anhänger in die Literatur und gedieh in dieser abgespiegelten Jugend weiter. Die Pflege des romantischen Geistes von 1813 machte Friedrich Christoph Förster zu seinem Lebensberuf. Er hatte mit Körner in Lützows Freischar gekämpft. Ein tapferer, ritterlicher, fröhlicher Mann, hütete Förster, Lehrer an der Berliner Artillerieschule, als Dichter und Geschichtsschreiber in Wort und Schrift das Vermächtnis jener Jahre. Seine Neujahrsgabe für Freunde der Dichtkunst und Malerei, „Die Sängerfahrt", versammelte 1818 die romantischen Meister und Lehrlinge zu einer künstlerischen Heerschau, wie sie in Wort und Bild kaum im „Athenäum" und in der „Zeitung für Einsiedler" vorübergeführt worden war.

Berliner „Mittwochs-gesellschaft"

Romantische Kreise

Innerhalb der romantischen Bewegung hatte es von je Kräfte gegeben, die sich künstlerisch an die unmittelbare Erfahrung der Seele und die gegenständliche Wirklichkeit der Dinge hielten, ohne auf die nationalen, religiösen, politischen Gedanken der Bewegung einzugehen. Und es gab unter der *Ausgleich der Gesinnungen* nachwachsenden Jugend solche, die an sich unromantisch dachten, mitten in der Wirklichkeit standen und doch Gefühl für die unbestimmbare Witterung der romantischen Dichtung, für das Poetische schlechthin, hatten. Diese Richtungen wuchsen einander entgegen und erzeugten aus ihrer Mitte einen Stil, in dem sich Romantik und Realismus wiedererkennen konnten. Dieser Ausgleich hat sich sehr überzeugend eben in Berlin vollzogen.

Romantischer Realismus Von der Romantik her kam *Ernst Amadeus Hoffmann.* Er wurde 1814 ans Berliner Kammergericht ernannt. Aus dem genialen Bamberger Bühnenleiter war ein musterhafter Beamter geworden. Er bewährte sich vor der Nachwelt in der Untersuchungsbehörde von 1819 zur Ermittlung staatsgefährlicher, das ist burschenschaftlicher „Umtriebe". Er starb 1822 an Rückenmarksdarre, bis zum letzten Aufzucken des Lebensfunkens der dienenden Feder seine wunderlichen und lebensechten Geschichten einsprechend. In Hoffmanns Werk entblättert sich die Romantik, und zum Vorschein kommt mit den ersten Zügen das Antlitz einer neuen Kunst: der seelenkundliche Realismus, wobei selbst Spuk und Märchen nur wie Spiegelungen aus dem Zwielicht der Seele erscheinen. Hoffmann hat nicht wenige Entwürfe späteren Kunstrichtungen vorangestaltet: die Vererbung und den familiengeschichtlichen Reihenroman; die Kenntnis der kranken und verwirrten Seele; Verbrechen als Krankheit. Von allem aber unabhängig gilt: Hoffmann ist der erste großstädtische Heimatkünstler, nicht bloß im Bereiche Berlins. Von der Romantik her kam *Adelbert von Chamisso.* Er machte vom Sommer 1815 bis Herbst 1818 als Naturforscher die russische Südseereise mit, wurde Verwalter am botanischen Garten und spann sich trotz kleinen Wanderfahrten in einer behaglichen Ehe ein. Die „Entdeckungsreise in der Südsee" kam 1821, die „Gedichte" 1831 heraus. In dieser Sammlung mit ihren volkstümlichen, lebenstreuen, launigen Balladen, mit der berühmten Terzinenerzählung „Salas y Gomez", mit ihrer bürgerlich-fortschrittlichen Gesinnung und der sachlich-gegenständlichen Kunstweise stimmte sich der Mensch fühlbar von Romantik auf Realismus. Der „Deutsche Musenalmanach", von Amadeus Wendt 1830 gegründet, von Schwab und Chamisso 1834/1839 geleitet, brachte diesen Umschwung in voller Breite zur Geltung.

Chamissos Freunde Die Jugend, die schon jenseits der Romantik reif wurde, vertraten zwei Freunde Chamissos. *August Kopisch,* 1799 bis 1853, aus Breslau, war ein

Schüler Mansos, sprang aber zur Kunst ab. In Wien wurde er durch Wuk Stephanowitsch zu volkstümlichen Dichtungen angeregt. Seine verletzte Malerhand zu heilen, reiste er nach Italien, durchforschte Küsten und Inseln um Neapel und entdeckte die blaue Grotte. Im Umgang mit dem Lustspieldichter Camerano, „dem Inbegriff des neapolitanischen Volkslebens", bildete er sich zum seelenverwandten Dolmetsch italienischen Wesens. Freund Platen wurde ihm Vorbild der strengen Form. Kopisch lebte seit 1833 in Berlin als Beamter des Hofmarschallamtes und Beschreiber der Potsdamer Gärten und Schlösser. Gemalt hat er nicht viel. Ihn hemmte die wunde Hand wie Reinick die kranken Augen. Mit dem Volksleben des Südens wie der Heimat gleich vertraut, verdeutschte er „Agrumi, volkstümliche Poesien aus allen Mundarten Italiens" 1837, „Die göttliche Komödie des Dante" 1842 und hinterließ die Tragödien „Walid" und „Chriemhild". Unerreichter Meister war er in jenen launigen Versgeschichten, in denen sich der Schwarm der Naturgeister und der Querkopf des Philisters auslebte. Sieht man es mit dem richtigen Auge an, so war das die gleiche Naturphilosophie, die Fechner gelehrt und gedichtet hat. *Franz von Gaudy*, 1800 bis 1846, von Frankfurt an der Oder doch aus schottischer Familie, hatte die gute Schule von Pforta und nahm 1833 aus seinem Garderegiment Abschied. Zusammen mit Chamisso gab er 1838 „Berangers Lieder. Auswahl in freier Bearbeitung" heraus. Im Stile Wilhelm Müllers und Johann Paul Richters schilderte er seine Wanderfahrten durch Italien: „Mein Römerzug" und „Portogalli". Da läßt er weiße Häuser, von der Sonne beglänzt, lustjauchzend aus der violetten Folie des Gebirges „aufschreien", wilden Wein und Efeu in grünen Wellen an den Steinwänden „herniederfließen". Da bezeichnet er die preußischen Kadettchen als Verbindungsstrichlein zwischen Tschako und vernietetem Säbel. Das ist schon der Tonfall der einst romantischen und nun radikalen Jugend. Die meisten Erzählungen stellte Gaudy als „Venetianische Novellen" zusammen oder reihte sie ohne jeden Rahmen auf, darunter einige hübsche Schülergeschichten. Er lehnte sich gerne an, so in seiner Erzählung „Aus dem Tagebuch eines wandernden Schneidergesellen" an Josef von Eichendorff und Wilhelm Müller. Neu sind seine Soldatenschwänke. In einer launigen Selbstausfrage heißt es: „Herr Franz Gaudy äußerte sich ziemlich wegwerfend über die Neueren, namentlich über die Neuesten, dagegen sprach er wieder seine Bewunderung für Männer wie Achim von Arnim, Klemens Brentano, Eichendorff, Hempel aus." Dieses Zeugnis bezeichnet nicht nur für Gaudy, sondern auch für Kopisch den Platz, wo sie standen.

Der bewußte Ausgleich zwischen Romantik und Rationalismus, das ist

*Kopisch,
der Maler*

*Gaudy,
der Soldat*

zwischen Raumer und Hegel, ist auf der Bühne, wo er versucht wurde, nicht *Drama aus Raumer und Hegel* gelungen. *Ernst Benjamin Raupach,* 1784 bis 1852, aus Straupitz bei Liegnitz, war in Halle gebildet, in russischen Anstellungen gereift und seit 1823 in Berlin ansässig. Seine Anfänge wie „Die Erdennacht" 1820 waren ziemlich hilflos. Hier ist der Vorwurf, wenn der Vater ein Gewaltherrscher wird, muß sich der Sohn für das Vaterland entscheiden, nicht dramatisch aus der Anlage der Menschen, sondern nur dialogisch durch politische Gespräche gelöst. Das russische Stück „Die Leibeigenen" 1826 wies ihn schon als bühnenfertig aus. Sein erstes Lustspiel „Laßt die Toten ruhn!" 1826 setzte Raupach in Berlin durch und lieferte ihm rasch den Spielplan des Hoftheaters in die Hand. Indessen seine Lustspiele sind über einen Leisten gearbeitet. Ein Deus ex machina, satirisch und spöttelnd, spielt die Rolle des Schicksals und zeigt, wie das Geschick es machen müßte, um die widerstreitenden Gegensätze zu bereinigen, gewissermaßen Hegels Synthese „an und für sich". Diese stehende Figur ist bald ein Bedienter, bald ein Steuerbeamter, ein Arzt, ein Kaufmann. Sie hat ebensoviel vom Eulenspiegel wie vom alten Hanswurst und der Hegelphilosophie und ist im Grunde ein logischer Handstreich. Mochten diese Stücke nach Aufbau, Witz und Sprache ziemlich hölzern sein, *Historie und Philosophie* sie fanden Beifall. Raupachs Historien wollten den vollen Ausgleich, indem sie Raumer im Stoff und Hegel weltanschaulich folgten. Die fünfzehn Hohenstaufenstücke sind 1825/1832 entstanden. Raupach wollte Sage und Geschichte zum Atemraum des Theaters und zum nationalen Bildungsgut machen. Des Glaubens nun, der Bühnendichter müsse reine Geschichte geben, ohne sie mit Erfundenem zu versetzen, schrieb er meist seine Quelle, Raumers Hohenstaufengeschichte, einfach in Wechselrede um. „Der Nibelungenhort" 1834 drängte alle Begebenheiten von Siegfrieds Kampf mit Fafner bis zum Untergange in Etzels Palast zu fünf Aufzügen zusammen. Raupach, eine hagere, knochige Gestalt mit ehernem Gesicht und verschiedenfarbigen Augen, war hart und rauh, konnte aber bezaubernd liebenswürdig sein. Er hatte eine schlechte Literaturgeschichte. Denn er war ein Anhänger *Das Drama des Königtums* des unumschränkten Königtums. Seine Spielweise war ein Ausdruck des schlesischen Theatertriebes und half von Berlin aus das neue Preußen im Sinne Hegels formen.

Hegel war die Mitte. Doch man konnte ihn haben und rechts wie links von ihm stehen, immer ihn eingeschlossen und mit ihm als Flügelmann. Dieses war Preußen zu seiner Rechten. Nun aber das zu seiner Linken.

Der preußische Fortschritt Der Osten lebte seit je von Zweifelderwirtschaft. Die Ernte der Romantik war für die Scheuer reif. Also bestellte man wieder die Brache der Aufklä-

rung. Freiheit und Fortschritt, staatsrechtlich unbestimmbar und unverbind-
lich, hatten ihre Fürsprecher an den Brüdern Humboldt, von denen Wilhelm
sich zu Tegel in seine Sprachforschungen einspann, seit 1822 die berühmten
„Briefe an eine Freundin" schrieb und die Sintflut seiner nässenden Sonette
ausgoß, während Alexander mit seinen öffentlichen Vorträgen den Bohrer
an die schwächste Stelle von Hegels Werk setzte, an die Naturphilosophie, *Die Brüder*
sich des Erbes von Goethes Ruhm erfreute und den „Kosmos" niederzuschrei- *Humboldt*
ben begann. Die beiden Humboldt waren staatsmännisch einflußlos. Doch sie
galten mit Recht als die Aldermänner des preußischen Fortschritts. Friedrich
August Stägemann wiederum mit seinem staatsmännischen Ruhm von 1813
bewährte sich als Vorkämpfer der Verfassung und Pressefreiheit. Er leitete
die seit 1. Jänner 1819 erscheinende „Preußische Staatszeitung", wo er dem
Verfolger der Burschen und Turner Karl Christoph vom Kamptz die Spitze
bot. Und Karl August Varnhagen von Ense vertrat dies freiheitliche und
fortschrittliche Preußen in der Literatur und hielt ihm einen Salon. Er hatte
im Zuge einer aussichtsreichen staatsmännischen Laufbahn 1814 Rahel Levin *Rahels Salon*
geheiratet und sich mit ihr, in dieser Laufbahn jäh unterbrochen, 1819 zur
Ruhe gesetzt. Die seelischen Problemnovellen, die er schrieb, und die Ge-
dichte, die er mit der Zeit sammelte, haben das Bild des Zeitalters nicht ver-
ändert. Varnhagen ließ sich in der langen Reihe seiner „Biographischen
Denkmale" 1824/1830 und 1837/1852 als zweiter Plutarch bewundern. Er
tat an Hegels „Jahrbüchern" mit, hielt hier Goethe einen Stuhl warm und
arbeitete rastlos an seiner eigenen Goethemaske. Unter vier Augen dachte
Varnhagen sehr frei und das Empfangszimmer seiner Frau war einer der
Erregungsherde des jungradikalen Fiebers. Da wurden die jungen Leute
politisch aufgeklärt. Rahel, die niemals schön und schon über vierzig war,
als sie sich von Varnhagen heiraten ließ, wirkte allein durch ihren Geist fort- *Die Jugend*
reißend auf die Jugend. Sie prägte und gab die Zündworte aus, die dann
auf den Fahnen der Jugend erschienen. Sie vermittelte zwischen Goethe und
der reif gewordenen Zeit. Durch sie lernten Heine, Gutzkow, Laube den
Alten von Weimar bewundern.

In diese Bereitschaft, die von der älteren Generation her offen stand, schlug *Hegel wird von*
der Pariser Umschwung von 1830 ein. An diesen älteren Berliner Freiheits- *links her sichtbar*
männern, wie dem einflußreichen Kritiker der „Vossischen Zeitung" Ludwig
Rellstab und Friedrich Gubitz, dessen „Gesellschafter" sich anfangs roman-
tisch hielt und dann der linksgesinnten Jugend diente, fand das aufstrebende
Geschlecht einen Rückhalt. Hegel wird von links her sichtbar. Theodor Mundt
und Gustav Kühne saßen zusammen auf dem Joachimsthalschen Gymnasium

und waren Kameraden an der Hochschule. Beide begeisterten sich für die Bruderschaft zwischen Glauben und Wissen, die Schleiermacher suchte, und beide schwärmten für Hegels selbstherrliche Vernunft. Sie bewegten sich beide um Varnhagen und gingen durch Rahels Besuchszimmer. Der Magde-

Gustav Kühne burger *Gustav Kühne*, 1806 bis 1888, entpuppte sich in seinen ersten Novellen als Schüler Tiecks. Er näherte sich über die Erzählung „Die beiden Magdalenen" 1833 und „Quarantäne im Irrenhause" 1835 der radikalen Bewegung, bog aber seit dem Bannspruch des Bundestages gegen Heine und Genossen wieder in sein eigenes Fahrwasser und nahm in den „Klosternovellen" 1838 sein Steuer mehr auf die Mitte zurück. Kühnes eigentliche Arbeit

Theodor Mundt ist mit Leipzig verknüpft. Die Bewegung, das war zunächst *Theodor Mundt*, 1808 bis 1861, aus Potsdam. Er suchte das Lebensgesetz dessen zu erkennen, was um sein Werden rang, und gab davon unter ziemlich anspruchsvollen Aufschriften wie „Kritische Wälder" 1833 und „Die Kunst der deutschen Prosa" 1837 Nachricht. Er stimmte Johann Paul Richter bei, wenn er den Weimarer Geist als „Theaterbildung" bezeichnete, und sprach Börne nach, indem er aus der Mischung von Literatur und Zeitgeist eine neue Kunst forderte. Und er ging, bei jedem Anlauf von der Preßpolizei unterbrochen, zur Tat über mit seinen kurzlebigen Zeitschriften. Nicht mehr als Aufguß von Richters und Heines Kunstweise war, was er an eigenen Werken bot, „Das Duett" 1831, „Madelon oder die Romantiker in Paris" 1832, „Der Basilisk" 1833, überdies mißverstandene und übel ausgedrückte Philosophie

„Unterhaltungen Hegels. „Madonna, Unterhaltungen mit einer Heiligen" 1835 waren Guck-
mit einer kastenbilder von Reisegeschichten, Novellen, Erörterungen, mit dem vergöt-
Heiligen" terten Fleisch als Lockspeise in der Auslage. Glücklich war der Gedanke, in „Moderne Lebenswirren" 1834 den inneren Widerspruch der Zeit abzuschildern, die für Bewegung und Ruhe, für Volksherrschaft und Fürstengewalt schwärmte. Jenseits von 1840 wird Mundt in schärferem Lichte erscheinen.

Der Sprecher Erst durch *Karl Gutzkow*, 1811 bis 1878, erhielt die radikale Jugendbewe-
der Jugend gung ihr Gesicht. Sein Vater, ein Pommer, Freiheitskämpfer von 1813, war Bereiter beim Prinzen Friedrich Wilhelm. Aus dieser bildungsarmen Umwelt löste der Knabe sich ab, unbeugsamen Willens, gesellschaftlich emporzusteigen. Er hörte an der Hochschule bei Lachmann, Schleiermacher, von der Hagen, vor allem aber bei Hegel. Ein geborener Vielleser und nach einem eigenen Weltbilde strebend, sog er mehr in Zeitungshallen und Kaffeehäusern denn an der Hochschule ein reiches und verworrenes Wissen in sich. Auch sein Frühmeister des Stiles war Johann Paul Richter. Wolfgang

Menzel lud ihm 1831 zu einer kurzen Gehilfenschaft am „Morgenblatt" in *Gutzkow,*
Stuttgart ein. Nach Richter und Börne schrieb er sein erstes Buch „Briefe *Richter und*
eines Narren an eine Närrin" 1832, ging als Rechtshörer nach Heidelberg *Menzel*
und München, ging mit Laube nach Italien, worüber er in das „Morgenblatt"
„Reiseskizzen" gab. „Maha Guru. Geschichte eines Gottes" 1833 wurde von
Menzel noch laut gelobt. Aber 1834 kam es zum Bruch. Gutzkow machte sich
selbständig. In der „Frühlingszeitung für Deutschland", der Beilage zum
Frankfurter „Phönix", begann er 1835 seine Kritik der Kritik Börnes und
Menzels. Er wandte sich gegen Börnes Einseitigkeit, der nicht zum Führer
der Jugend tauge, wandte sich gegen Ludwig Tieck, gegen die „Wald- und
Wiesenromantik" der Schwaben. Kampf sei die Losung der Zeit, Gedanken-
kampf. „Der Roman ist die Blendlaterne des Ideenschmuggels." Das war
Gutzkows Frankfurter Zeit. Er gab 1835 Schleiermachers Briefe über Schle-
gels „Lucinde" heraus und suchte den Nachweis zu führen, daß sich der
„Sensualismus" seiner Gesinnungsgenossen gedanklich mit der „Frühroman-
tik" decke. Das wuchs sich 1835 nach dem Vorbilde von George Sands „Lélia" *Aufklärung,*
zu dem Roman „Wally, die Zweiflerin" aus. In der Tat ein plattes und trau- *Sozial-*
riges Buch. Die erotische Sinnlichkeit wird als „Philosophie" ausgerufen. Der *revolution,*
abgestandene Rationalismus des achtzehnten Jahrhunderts und die franzö- *Frühromantik*
sische Sozialrevolution werden frisch zusammengerührt. Es mag sein, daß
sich Wolfgang Menzel durch Gutzkows Plan einer großen Zeitschrift bedroht
fühlte. Es war sein gutes Recht, gegen dieses Buch seine Stimme zu erheben, *Die Berliner*
wie ja Börne und Heine gegen andere Bücher ihre Stimme erhoben hatten. *Polizeiaktion*
Am 11. und 14. September 1835 erschienen im „Literaturblatt" jene Angriffe
Menzels, die das öffentliche Gewissen gegen diese Richtung des Zeitgeistes
aufriefen. Bereits am 18. September gab die Berliner Zensurbehörde ihr Gut-
achten über Gutzkows Buch ab. Am 24. September wurde es verboten. Bei
so knappem Zeitabstande war schwerlich Menzels Aufsatz die Ursache des
Berliner Gutachtens. Das war Gutzkows Buch. Er hatte aber auch ein Lite-
raturblatt geplant, das alle fortschrittlich gesinnten Schriftsteller zusammen-
schließen sollte. Und dagegen entschloß sich der Bundestag zu handeln. Er
stellte am 10. Dezember Verfasser, Verleger, Drucker und Verbreiter einer
vorgeblichen „Schule", die polizeilich als „jungdeutsch" bezeichnet wurde, *Aktion*
unter Strafe. Das war ganz etwas anderes als das Verbot eines Buches. Hier *des Bundestags*
wurde eine willkürlich begriffene und abgegrenzte Gesinnungsgenossen-
schaft für allfällige künftige Vergehen vorsorglich im voraus bestraft und zu
wechselseitiger Haftung verhalten. Gutzkow saß die vier Wochen Haft, die *Gutzkow in Haft*
ihm auferlegt war, ab und begann von neuem. Und dieser Einsatz war be-

zeichnet durch die Romane „Seraphine" 1838, „Blasedow und seine Söhne"
1839, jener ein sachtreuer seelenkundlicher Versuch, dieser mehr giftig als
launig gegen die Erziehungsirrtümer der Zeit gerichtet. Er übersiedelte nach
Hamburg, ging zum Drama über und fand in Dresden einen vieljährigen
Wirkungskreis.

Diese Gruppe der ostdeutschen Bewegung war auf Tagesschrifttum ein-
gestellt, freisinnig und freiheitlich gerichtet und der französischen Revolu-
tion verbrüdert. Ihr war Kunst nicht Zweck, sondern Mittel. Sie hatte keine
Die Berliner eigene Form. Sie hatte nur wenig selbständige Gedanken, meist die der alten
Gruppe Aufklärung, einige der Frühromantik, einige der Franzosen und der Ausge-
wanderten zu Paris. Es war eine kleine Berliner Gruppe. Ihr Aufruhr war
nur wie ein Sturm im Wasserglase gemessen an den geistigen Sprengungen,
die sich gleichzeitig in Oberdeutschland entluden.

HALLE war vordem, solange die Mark Brandenburg keine Hochschule
Aber Halle hatte, der geistige Vorort Berlins. Jetzt konnte es nur die Vorstadt des gro-
ßen Sammelbeckens Berlin sein. Dennoch erfolgte der Umschlag nicht in
Berlin, sondern in Halle. Denn in Halle und nicht in Berlin sind die entschei-
denden Kämpfe ausgefochten und die Losungen des Zeitalters gefunden wor-
den. Es war die Stadt der „Allgemeinen Literaturzeitung", die Stadt der
„Allgemeinen Enzyklopädie", seit 1818, zu der sich der Großglogauer Jo-
hann Samuel Ersch und der Naumburger Johann Gottfried Gruber zusam-
mengeschlossen hatten. Es war die Stadt der beiden feindlichen Brüder Pie-
tismus und Rationalismus. Der Vorkämpfer im Streit wider Hegel und die
Hegelinge, das war der Hochschullehrer für Geschichte Heinrich Leo aus
Rudolstadt.

Die hallischen Denn die Hegelinge hatten nun das Wort. Die Schüler zu Halle hatten es
Hegelinge stürmischer als es der Meister bei seinen Lebzeiten zu Berlin gehabt hatte.
Amtliche Dolmetsche von Hegels Philosophie zu Halle waren der Livländer
Johann Erdmann und der Magdeburger Julius Schaller. Diese älteren Hegel-
schüler waren den jüngeren viel zu zahm. Und unter diesen jüngeren war
einer der ältesten der Magdeburger *Karl Rosenkranz.* Der wandte sich, was
sein Aufsatz über Titurel und Dante bezeugte, von der Romantik ab, ließ
sich 1828 an der Hochschule zu Halle nieder und las, ein vielseitiger Kenner
und fabelhaft leichter Schreiber, über Nibelungen, Religionsphilosophie,
Sittenlehre, Kunstwissenschaft. Gegen die Romantik richtete sich seine „Ge-
schichte der deutschen Poesie im Mittelalter" 1830, ein wichtiges Buch. Denn
es vermittelte Geschichte und Stoffe in Hegels Aufmachung, so die Kenntnis
von Merlin an Immermann. Sein „Handbuch der allgemeinen Geschichte der

Poesie" war in Hegels Sinne auf dem Grundgedanken einer fortschreitenden Entwicklung aufgebaut. Im Herbst 1833 wurde er nach Königsberg berufen. Von Bergen auf Rügen kam *Arnold Ruge*, 1802 bis 1880, in Halle, Jena, Heidelberg gebildet und Burschenschafter, ein gemütlicher, burschikoser nordischer Recke, wie Gerok ihn schildert. Seine beste Schule war das Lauenburger Tor zu Kolberg, wo er, vor dem Angesicht „die alte freie Ostsee", für seine Burschenschaft fünf Jahre Festung absaß. Denn dort in Kolberg trieb er Griechisch, übersetzte er Sophokles, Aischylos, Theokrit, las auch er Johann Paul Richter und die englischen Humoristen. Die romantische Tragödie „Schill und die Seinen" 1830 spricht vernehmlich für seine damalige Gesinnung. Da wurde er 1831 Hilfslehrer an der Franckeschen Stiftung zu Halle und begann im folgenden Jahr an der Hochschule zu lesen. Nun packte es ihn. Sein Amtsgefährte an der Schule war *Theodor Echtermeyer*, 1805 bis 1844, aus Liebenwerda, wie Ruge ein Meister im literarischen Gebrauch des Lateinischen. Denn er war zu Pforta gewesen und Kobersteins Schüler. In Berlin war er ein kundiger Anhänger Hegels geworden. Und Hegels Verständnis erschloß er nun dem Neuling Ruge. Und Ruge stürzte sich mit Feuereifer in die Sache.

Ruge und Echtermeyer

Echtermeyer war es, der zuerst den Plan für eine Zeitschrift entwarf, die, gestützt auf die jüngeren Schüler Hegels, die Philosophie des Meisters zur Triebkraft der staatlichen Umbildung zuformen sollte. Das Blatt sollte sich vor allem gegen das „Organ der Knechtschaft", gegen die Berliner Jahrbücher für wissenschaftliche Kritik richten. Ruge gewann rasch genug die überlegene Seite. Das Blatt sollte eine Art Zeiger auf der Uhr des deutschen Lebens sein, indem es bedeutende Köpfe zeichnete, Richtungen und einzelne Zweige der Kunst und des Wissens überblickte, Briefberichte von Hochschulen und Akademien brächte. Ruge brauche, wie Ludwig Preller aus Kiel ihm schrieb, nicht bange zu sein. „Es hat sich aus diesen verschiedenen Wehen und Miasmen der Zeit, Hegelianismus, Heinianismus, alter und neuer Germanismus, ordinärer und extraordinärer Mystizismus, immer noch ein gutes Völkchen junger Leute aufs Freie gerettet, die gesunden Geistes geblieben und allenfalls mitsprechen können. Diesen tragen Sie nur mutig die Fahne voran." Es erschienen also 1838 bis 1841, von Ruge und Echtermeyer herausgegeben, „Hallische Jahrbücher für deutsche Wissenschaft und Kunst". Verleger war Otto Wigand in Leipzig.

„Hallische Jahrbücher"

Es war das Blatt der linksgewendeten Philosophie der jüngeren Hegelschüler. Ruge, Strauß, Feuerbach, Bruno Bauer standen mit dem Anspruch auf, die echten Ausleger von Hegels Lehre zu sein. Zu Recht besteht das

Die radikale Hegelschule

Urteil Rudolf Hayms. „Es war die vornehmste Erscheinung des deutschen
Journalismus und das wirksamste Organ desjenigen Teils der Hegelschen
Schule, der das friedliche Reich des absoluten Idealismus zu einem kriegeri-
schen und erobernden machte. Wir rissen uns um jede neuerschienene Num-
mer und leisteten den tapferen Führern, so oft sie mit klingendem Spiel ge-
„Die gen einen neuen Feind und ein neues Gebiet vorrückten, willig Folge, über-
fundamentalste zeugt, daß an ihre Fahnen der Sieg geknüpft sei." Unzweideutig erklärte
Aufklärungs-
periode" Ruge: „Unsere Zeit ist die fundamentalste Aufklärungsperiode, die es je ge-
geben hat, und es wird nötig, wie Voltaire und Rousseau zu schreiben, ja sie
erscheinen als große Vorbilder, und nicht nur das, man ist sehr unwissend,
wenn man ihren Inhalt nicht mit gehöriger Anerkennung aufnimmt." Stür-
Manifest der mischen Umschwungs vollzog sich in diesem Blatt der radikale Ablauf. Es
„Jahrbücher" ging vor allem gegen die Romantik. Man wollte dem kommenden preußi-
schen Thronwechsel vorbauen, wie Ruge an Strauß schrieb: „Im ganzen
haben wir die nächste Zeit die Aufgabe, überall in Literatur, Theologie,
Poesie die Romantik vollends zu Tode zu jagen. Wir fürchten, daß diese alte
unpraktische Dame sich doch in nächster Zeit noch in Praxis werfen könnte."
„Der Gegen den Anwärter Friedrich Wilhelm IV. richtete sich also der Aufsatz
Protestantismus
und die Romantik Ruges und Echtermeyers 1839: „Der Protestantismus und die Romantik. Zur
Verständigung über die Zeit und ihre Gegensätze. Ein Manifest." Der Pro-
testantismus wurde nach Hegels Vorgang als die Selbsteinkehr des Geistes
gefaßt, als die Zurückverlegung der Verwirklichung des Ewigen in den sub-
jektiven Geist. Im Protestantismus stellte der Aufsatz einen Abfall, eine rom-
freudige Richtung fest, die mit den Anfängen des neudeutschen Idealismus
begänne. In diesem Sinne bezeichnete sich Ruge als Vorkämpfer des prote-
stantischen Lebens. Indessen, das war nicht der Protestantismus der Kirchen-
bewegung. Denn Ruge machte Haym deutlich: „Der Protestantismus unserer
Zeit, die Philosophie." Mit gleicher Schärfe wandten sich die „Jahrbücher"
gegen die jungen Leute um Gutzkow, weil sie ganz unphilosophisch waren.
Und mit Erbitterung gegen Heine. Da waren sie unbestechlich. Da gab es
kein Ansehn der Person. Sie gingen auf Mensur.

Freilich bei diesen Kernpunkten, das protestantische und demokratische
Preußen Deutschlands Führer, gab es keinen Halt. Es ging beschleunigt wei-
ter. Von Hegel her fanden sie, daß es außer der Wahrheit des Geistes und
seiner Geschichte nichts anderes gebe, und daß das Eintreten des Christen-
tums nur eine Stufe in diesem geistigen Ablauf sei, so gut wie das Eintreten
von Hegels Lehre oder der Kirchenbewegung oder der Aufklärung. Gott-
mensch sei jeder, der in der Idee und in dem die Idee aufgeht. Und im

Kampf gegen die Romantik fand Ruge: „Die Jahrbücher müssen die neue
Philosophie sein und bleiben, und diese ist extrem, ist reine und vollkom-
mene Negation des Christentums und des christlichen Staates im Absolutis- *„Negation*
mus, alles Dualismus und aller ironischen oder Scheinbewegung gegen ein *des christlichen*
Jenseits zu, das sie nicht anerkennt." Ebenso wohlfeil wurde ihm bald das *Staates"*
Deutschtum. Hatte er schon 1841 gemeint: „Es ist ganz barbarisch und un-
christlich, so einen Unterschied zwischen französischer und deutscher Frei-
heit zu statuieren und das Allgemeinste, die Staatsentwicklung, die Geistes-
bildung und ihre Form, auf den nationalen Naturunterschied zu ziehen", so
lautete der Schlußsatz von Ruges Entwicklung 1844. „Das Vaterland ist die
Fahne des Zwiespalts der Völker, die Freiheit ist das Zeichen ihrer Versöh-
nung. Ohne den Sturz des Patriotismus kann Deutschland nicht für die Frei-
heit gewonnen werden." Diese Gruppe von Hegels Schülern stand schon sehr
nahe bei Marx.

Die Zeitschrift bot den zeitgenössischen deutschen Geist in seinen eigen- *Die Mitarbeiter*
artigsten Vertretern auf. Ruge schrieb über Droysens deutschen Aristopha- *der „Jahrbücher"*
nes. Er gab die glänzende Schilderung Heines. Er schrieb über Pietismus,
Jesuiten, Preußentum. Echtermeyer vernichtete Laubes „Literaturgeschichte".
Strauß umriß das Bild Schleiermachers, Daubs, Kerners. Friedrich Vischer
lieferte die klassische Stammesschilderung „Dr. Strauß und die Württem-
berger", Reinhold Köstlin den Beitrag über Seydelmann und die deutsche
Schauspielkunst. Rosenkranz schrieb gegen Tieck und die Romantik, über
Hegel und die Königsberger Hochschule. Droysen, Duncker, Pott, Jakob
Grimm gehörten zu den Mitarbeitern. Robert Prutz erstrebte gegenüber dem
weltfernen Ruge Ziele, die sich verwirklichen ließen, und suchte zwischen
der jungen Generation und der nationalen Bewegung zu vermitteln.

Die Stimmung der christlich-deutschen Kreise zeigte 1838 Karl von Rau- *Die Gegenstimme:*
mer brieflich Ruge an, indem er auf die Christophoruslegende anspielte: *Karl von Raumer*
„Ich habe auch manchem Starken gedient, bis ich denselben Stärksten fand,
fürchte auch nicht, daß Ihre Mitarbeiter diesen überwältigen werden. Es ist
partie inégale, sagt der alte Claudius, und ich rate Ihnen, liebster Ruge, aus
alter Freundschaft, einen so ungleichen Kampf gegen den aufzugeben, wel-
cher nicht erst pro venia zu disputieren nötig hat, da er sich seit 1800 Jahren
hinlänglich nicht in Worten, sondern in Kraft ausgewiesen. Er wird seine
Opponenten richten, nicht sie ihn." Raumers Brief bezeichnet nicht alle, aber
die wesentlichsten Gründe, warum den „Jahrbüchern" 1840 nur noch ge-
stattet wurde, in Halle und unter preußischer Presseaufsicht zu erscheinen.
Die Maßregel kam einem Verbot gleich. Echtermeyer trat zurück. Ruge

setzte das Blatt als „Deutsche Jahrbücher" in Dresden fort. Sie wurden 1843 auch von der sächsischen Regierung unterdrückt.

Die „Hallischen Jahrbücher" hatten von der alten Jugendbewegung die mehr freiheitlich als deutsch, mehr geistig als tätig gerichteten Gruppen abgespalten und gegen den christlich-germanischen, gegen den romantischen Staatswillen in Stellung gebracht. Sie waren ein großartiger Versuch, die radikale Richtung der Hegelphilosophie zum Tatwillen des preußischen Staates zu machen.

Der ostdeutsche Junker SCHLESIEN und die LAUSITZ waren Landschaften des Grundadels. Und der Landjunker nahm nun im Zuge der romantischen Bewegung die Pflichten wahr, auf die er ein Recht hatte.

Die erste Gruppe dieser ostmitteldeutschen Junker verkörpert den Wandel des Stils von der Romantik her in eine neue Zeit.

Ernst Freiherr von Houwald, 1778 bis 1845, war zu Straupitz geboren, der Lausitzer Standesherrschaft seines Vaters, wo die Familie seit der Mitte des siebzehnten Jahrhunderts saß. Zusammen mit dem kleinen Dichter Wilhelm Contessa war er auf dem Pädagogium Halle gebildet und lebte dann, von den Ständen der Niederlausitz zu ihrem Sachverwalter bestellt, in Neuhaus bei Lübben. Dieser treffliche, tätige, von Standesgenossen und Mitbrüdern in Apoll geehrte Mann wob all seine Tage an dem Erlebnis des altertümlichen, hochgiebeligen, vom Spreewald umrauschten väterlichen Schlosses.

Schicksalsdrama? Dieses Bewußtsein und die fördernde Freundschaft mit Contessa nährten das Werk des Dichters. Houwald? Schicksalsdrama! Sicherlich ist in den Stücken „Der Leuchtturm" wie „Fluch und Segen" der Schicksalsgedanke lebendig. Schon „Das Bild" streifte ihn nur. Das Ritterstück „Die Heimkehr" gar lebt aus dem Vorwurf des wiederkehrenden Gatten. Neben dem Überkommenen der ganzen Gattung wirkte an diesen Stücken mindestens ebenso stark das Spukhafte und Gespenstige des Volksglaubens. Indessen Houwald, das ist gar nicht der Schicksalsdichter, sondern der Kinderschriftsteller: das

Das Buch für Kinder „Buch für Kinder" 1819/1824, die „Bilder für die Jugend" 1829/1832, die „Abendunterhaltungen für Kinder" 1833; kleine Spiele, belehrende Geschichten, zuvörderst aber erquickliche Märchen, selbsterfundene, aus dem Leben herausgesponnene. Das ist der echte Houwald, und darin steckt die Fülle ostmitteldeutschen Lebens, Hang und Anlage zum Magistertum, der Drang, jedwedes Ding zu beseelen. Von Houwalds Kinderbüchern führt ein landschaftlich überschatteter Weg zu Fechner, zu Fechners Weltbeseelung und gelehrten Schwänklein.

Heimkehr *Josef von Eichendorff* erlebte in seiner Heimat den sanften Gipfel und den

schönen Abschluß seines Daseins. Seit Ende 1816 diente er in Breslau als Verwaltungsbeamter, mit Friedrich von Raumer und Karl von Holtei befreundet. Nach dem Tode des Vaters 1818, ging der Familienbesitz, nach dem Tode der Mutter 1823, auch das geliebte Lubowitz verloren. Nach wechselnden Stellungen in der preußischen Fremde kehrte er 1855 heim, nach Neisse, wo er 1857 starb. Eichendorffs reifste Entwicklung und also die letzte Stufe der Romantik, schließen die Jahre 1814 und 1848 ein.

Unverkennbar stand sein Ehrgeiz nach der Bühne. „Krieg den Philistern" 1822, „Meierbeths Glück und Ende" 1827 waren nur ironisch-satirische Märchenspiele. Voller Ernst aber war es ihm mit den zwei Trauerspielen. „Ezzelin von Romano" 1828 deutete im Anschluß an Raumers Hohenstaufengeschichte den wilden Ghibellinenführer in der Richtung auf Napoleon und Macbeth. „Der letzte Held von Marienburg" 1830 spielt die Tragik des Deutschen Ordens. Er tummelte Lope de Vegas Stil durch das kecke Stück „Die Freier" 1833 und hetzte in „Wider Willen" noch einmal Klassik und Romantik gegeneinander. „Das Inkognito", ein Puppenspiel, ein Spiel des Unmuts über eigene Zurücksetzung, sieht das Preußen jener Jahre mit den Augen des östlichen Statthalters Schön, der Eichendoffs Freund und Gönner war. In dieser erstaunlichen Satire auf den neuen König Friedrich Wilhelm IV., den Romantikerkönig, steckt der Pfeil der Königsberger Fronde. Im Wetteifer mit dem Breslauer Romanismus dichtete Eichendorff — „Geistliche Schauspiele" 1846/1853 — Calderons elf schönste Autos sacramentales um. Nicht minder spürbar wurde Eichendorffs Ehrgeiz nach einem neuen Stil der Novelle. Er hat den Kampf gegen die entartete Romantik geräuschloser und wirkungsvoller geführt als gleichzeitig Tieck. „Das Marmorbild" 1817 war noch ein Schulstück nach Arnim und Hoffmann: Zusammenspiel von toten Bildwerken und lebenden Menschen, italienische Umwelt, Nachklänge aus Lubowitz. Dann begann sich die romantische Erzählungskunst aufzulösen. Nun griff Eichendorff, gleichzeitig mit Tieck, ein Neugewandelter, in das Chaos ein: fort mit der Vorliebe für die kranke Seele, Vorzug dem Gesunden, neue Gestalten und Lebenswerte. So wurde „Aus dem Leben eines Taugenichts" 1826 die Schöpfung der lyrischen Novelle. Wie im lyrischen Gedicht wird eine geschlossene Stimmung gewollt. Die Handlung ist das Instrument, das lyrisch gespielt wird. Da der Fluß des epischen Geschehens das Traumschiff der Gefühle nicht mehr zu tragen vermag, werden neue Kunstmittel not. Die Natur wird wie ein zweites Instrument zur Begleitstimme aufgenommen. Mit dieser Neuschöpfung gewann Eichendorff jenseits von 1848 die Herrschaft über den künstlerischen Nachwuchs. „Die

Eichendorffs Drama

Eichendorffs Novelle

Eichendorffs Lustspielnovelle

Glücksritter" 1841 sind der Taugenichts im Stil von Callots Radierungen. Die geschichtliche Novelle „Schloß Dürande" 1836 verrät die Nähe von Kleists Kohlhaas. „Eine Meerfahrt" 1835 schloß an Schnabels Insel Felsenburg an. „Die Entführung" 1838 ist eine romantische Geschichte von Irrungen und Wirrungen. Wir stehen schon wieder dicht am Lustspiel. Novelle und Spielszene, wer weiß, wo die Grenze läuft, wenn es eine gibt. Und wirklich. Da sind „Viel Lärm um Nichts" 1832 und „Auch ich war in Arkadien" 1834, sehr verwandt mit der ersten Gruppe von Tiecks neuen Novellen. Geschildert wird, wie die romantische Bewegung sich verwirrt. Gestalten aus Eichendorffs älteren Dichtungen treten auf und treiben ihren Schabernack, jenen Volkssagen vergleichbar, wo die Toten auf ihren Gräbern tanzen. Die Novelle fließt ins Lustspiel zurück, aus dem sie gekommen ist. Eichendorff und Tieck, das ist eines und dasselbe. Sie lösen sich von der geschichtlich gewordenen und abgelebten romantischen Bewegung los, indem sie ihr satirisch den Garaus machen und ihr Unvergängliches in die neuen Schöpfungen herübernehmen, die sie ihr entgegensetzen.

Eichendorffs Liederbuch Diesen Akt der Ablösung und Neuschöpfung hat Eichendorff am folgenreichsten in seinem eigensten Bereiche, in der Kunst des Liedes vollzogen. Zwei Sammlungen, Anklang und gehaltener Ton, bezeichnen die äußeren Grenzen: 1826 die Zugabe zum „Taugenichts" und 1837 das selbständige Gedichtbuch. In dieser Zeit erst wuchs Eichendorffs Lyrik aus der bunten Stilfülle bis 1813 und nach einer Pause bis 1824 zur modernen Kunst und zur schönen Vollendung heran. Das Naturbild wird Ausdrucksmittel des reifen Schaffens. Diese Kunstweise hängt mit der Romantik nur insofern zusammen, als Hardenberg sie lehrhaft durchdacht hatte, ohne sie wirklich üben zu können. Vorgeschichte und Bedingnisse lagen bei den Schwaben. Uhland vor allem hat Eichendorff geholfen, seinen reifen Stil zu finden. Gegen 1824 trat Eichendorff zugleich mit Heine, Müller, Fallersleben wie eine junge Kraft in das Konzert der neuen Lyrik. Sein Naturbild ist nun Landschaft. Sie wird im Rundblick und mit wechselnder Beleuchtung gezeigt. Die Natur wird — und wieder ist Fechners Gegenwart zu spüren — durch Einfühlung beseelt. Der lyrische Rhythmus gewinnt an Mannigfaltigkeit. Aus dem geruhsamen Auf und Ab der Gefühle wird ein kunstvoller Wellenschlag nach vorwärts: Entfaltung und Fortschritt. Das Naturbild ist beinahe das einzige Instrument, aus dem die Stimmung hörbar wird. So hat Eichendorff die Natur, statt sie gleichnisweise belebt zu denken, als wirklich beseelt erfühlt, und aus der Willkür der Metapher in den modernen Realismus gerettet.

Mit Eichendorffs Werk war die Romantik auf der ganzen Linie in den neuen Stil des Jahrhunderts übergegangen. Seine literarhistorischen Arbeiten über die Romantik 1847, über den Roman 1851, über das Drama 1854, über die „Geschichte der poetischen Literatur Deutschlands" 1857 brachten die Tatsache zu Gehör: mit Eichendorff ist die Romantik als geschichtliche Bewegung abgeschlossen und beginnt nun in die Zukunft hinein ihr zweites Leben als erworbener Besitz. *Eichendorffs Literatur- geschichte*

Peter Friedrich von Üchtritz, 1800 bis 1875, aus Görlitz, der Sohn eines weitbegüterten Grundherren, geriet als Rechtsschüler zu Leipzig seit 1818 unter den starken Einfluß Adam Müllers. Er lernte Lehre und Verwaltungsgefüge der römischen Kirche bewundern. Mit Ludwig Tieck wurde er zu Dresden bekannt und zu Berlin mit Varnhagen, Heine, Grabbe, Raumer. Von Novellen und kleinen Gedichten wandte sich Üchtritz 1823 dem geschichtlichen Trauerspiel zu. Das beste, „Alexander und Darius", wurde 1826 in den deutschen Hauptstädten gespielt und dann mit Tiecks Vorrede gedruckt. Die Tragödie aus den Nürnberger Kämpfen zwischen Stadtjunkern und Zunftbürgern, „Das Ehrenschwert", ging 1827 zu Berlin über die Bühne. Am Landgericht zu Düsseldorf, seit 1829, war Üchtritz einer von den Vorposten, die Preußen zur geistigen Eroberung der politisch angeeigneten Rheinlande einsetzte. Dann gab er mit Stücken wie „Rosamunde" 1830 und „Die Babylonier in Jerusalem" 1836 der tragischen Muse den Abschied und ging, von Rankes Reformationsgeschichte angeregt, zu dem siebenbändigen Geschichtsroman „Albrecht Holm" 1851/1853 über. Die Freundschaft mit Hebbel ehrte den Menschen. Sie ehrte den Dichter Üchtritz. Der Stilwechsel vom Schönen zum Erhabenen, der eigentümlichste Zug der romantischen Kunstlehre, wurde bei Üchtritz, wenn auch unzulänglich, sichtbar. Er hat die großen Aufzüge der Weltgeschichte ins Erhabene gesteigert, zum Stil des Bildhauers und Frieskünstlers, der das bewegte Leben in Stein verwandelt. Indem er mit seinem Drama „Die Babylonier" die Ekstasis des jüdischen Propheten und der jüdischen Frau nachspielte, indem er in seinem Roman „Eleazar" 1867 das christliche Messiasideal über den jüdischen Volksgott erhob, gab auch Üchtritz der Wendung zum Morgenlande nach. *Die Tragödie des Erhabenen*

Moritz Graf von Strachwitz, 1822 bis 1847, war aus streng katholischer Familie auf dem Erbgut bei Frankenstein geboren und auf weiten europäischen Reisen gebildet, ohne daß er je den tiefen Eindruck seines heimatlichen Riesengebirges vergessen hätte. Die unberührte Reinheit dieser lyrischen Seele hat sich die neue gärende Welt ferngehalten. In den zwei kleinen Sammlungen „Lieder eines Erwachenden" 1842 und „Neue Gedichte" 1848 *„Lieder eines Erwachenden"*

konnte er ein feines Vermächtnis niederlegen. Wider die Philister: das war der Grundton seiner Lieder. Also nicht der Tyrann, sondern der Philister. Daher auch nicht Bürgerfreiheit, sondern Burschenfreiheit. Strachwitz war der reisige Edelmann, dem der Getreidekrämer und Viehzüchter zuwider war. Seine kleinen, lebhaften Lieder haben die Bodenfrische des Landjunkers. Er hat mit dem bürgerlich-fortschrittlichen Edelmann nichts zu tun. Ihn bewegt nicht der Gehalt seines Zeitalters, sondern das schleichende Zeitmaß, die Halbheit, die Anbetung der rechten Mitte.

Nicht Bürgerfreiheit, sondern Burschenfreiheit

> „Mich quält ein sonderbar Verlangen
> Nach Sorg' und Müh, Gefahr und Streit,
> Es ist mir stets zu gut gegangen
> In dieser seid'nen Friedenszeit.
> Mir ward kein Banner, es zu schirmen,
> Kein Kranz, dieweil ich nichts getan,
> Mir ward kein Gipfel zum Erstürmen
> Und zum Durchrennen keine Bahn."

Verjüngter Eichendorff

Strachwitz hat der gesellschaftlich gehobenen burschenschaftlichen Seelenhaltung die strenge Form gefunden. Die deutsch-christlichen, die romanischen, die morgenländischen Farbschatten der Zeit spiegeln sich in seinen nordischen Balladen, in seinem Formzauber, in seinen Ghaselen. Seine Meister waren, wogegen die kleinen Liebeslieder in Heines Stil nicht irreführen, Platen, Uhland, Auersperg. Seine Elfenlieder und kleinen Naturgeister weisen auf Kopisch und Hauenschild. Strachwitz war der in eine neue Zeit verjüngte Eichendorff.

Die fortschrittlichen Junker

Die zweite Gruppe ostmitteldeutscher Junker hielt die romantische Form noch fest. Doch sie vollzog den weltanschaulichen Wandel aus der Romantik. *Konrad Adolf Graf von Dyhrn*, 1803 bis 1869, aus Reesewitz, der Dichter des Trauerspiels „Konradins Tod" 1827, gründete, wobei er den weitesten Abstand zwischen sich und die lärmende Schulweisheit der Volksmänner legte, die altliberale Partei Schlesiens. Übergänge zum Bürgertum erschienen in *Richard Georg von Hauenschild*, 1825 bis 1855, aus Breslau. Er nannte sich Max Waldau und lebte auf seinem Stammgut bei Ratibor. „Ein Elfenmärchen" 1847 erinnert an Kopisch und Fechner. „Es schaut ein freundlich Geistergesicht — Aus jeder duftigen Blüte." Seine Gedichte „Blätter im Winde" 1848, mächtig im Ausdruck und freiheitlich besonnen im Gedanken, stimmen zu Strachwitz. Hauenschild lebte in der Welt der Provenzalen. „Nach

der Natur" 1850, ein Roman in lockeren Bildern und ohne Handlung, wandte sich gegen den Trug des gesellschaftlichen Lebens, gegen das rückschrittliche Preußen, gegen das betonte Berlinertum, gegen die landläufige Volksmeierei, ohne Preußens Beruf zu verkennen. Die launig eingeflochtenen Dorfgeschichten bezeugen diesen Junker als trefflichen Beobachter. „Aus der Junkerwelt" 1850 steht zwischen den Romanen Immermanns und Freytags. Die Macht des Geldes besiegt das Vorrecht der Geburt. Der Frühvollendete, ein stets erregter liebenswürdiger Schwärmer mit ungemein empfindsamen Sinnen, nahm seinen Abgang mit zwei Versbüchern: „Cordula" 1851, von der Selbstbefreiung der Bauern zu Camogast; „Rahab" 1855 nach dem Buch Josua. *Vorrecht der Geburt, Macht des Geldes*

Der Dritte stand im Knotenpunkt des landschaftlichen Gewebes. *Friedrich von Sallet,* 1812 bis 1843, von Neisse stammte aus der litauischen Adelsfamilie Salleyde, die seit dem achtzehnten Jahrhundert in Schlesien ansässig war. Dieser preußische Offizier blies Flöte, machte Gedichte und ließ unter vollem Namen eine Novelle gegen seine Standesgenossen drucken. Er hat ähnlich wie Kleist um seinen Dichterberuf gerungen. Des Waffenrocks überdrüssig, nahm er 1838 seinen Abschied. Aus der rheinischen Soldatenzeit stammen die Frühwerke, darunter die Novelle „Kontraste und Paradoxen", die Bildungsgeschichte einer Dichterseele in der Widerwelt des Philistertums und phantastisch aus Alltag und Märchen gemischt. Die reiche Berliner Zeit, da er 1835 die Kriegsschule besuchte, bei Ritter Erdkunde trieb und aus dem Altenglischen übersetzte, ist gewiß überschätzt, wenn man Sallets reife Bildung auf Hegel zurückführt. Romantischen Sinns beseelte er wie Fechner Blumen, Käfer, Vögel. Sallet wollte jeden Menschen zwingen, sich für oder gegen Gott zu entscheiden. Zu diesem Kampf setzte er 1842 sein „Laienevangelium" ein, die Umschreibung einer Evangelienharmonie in vierzeiligen gereimten Jambenstrophen. Sie wandten sich gegen das geschichtliche Christentum. Wie Christus der erste Mensch gewesen, in dem Gottheit und Menschheit ungeschieden waren, so muß jeder den Gott in sich selbst erkennen. Nur als du selbst, in dir kann er dein eigen werden. Bei so überzeugendem Gleichklang mit Schefer und Scheffler kann Sallets Allgott unmöglich von Hegel stammen. Seine „Gedichte", seit 1843 gesammelt, sind eines der ernstesten Versbücher der Zeit, eine spätromantische Schöpfung. Mystisches Allgottgefühl ist sein Kern. Da klingen so abgründig mystische Gedichte auf wie der großartige „Titanentraum", „Fortdauer", „Unendliche Reihe", hinab über Scheffler, Böhme, Eckhart. So bewußt geformte Gruppen wie „Naturleben und junge Liebe", „Pantheismus und reife Liebe" mit ihrem Sinn „Nur Weltentfaltung ist uns Pflicht" klingen dem geistverwandten *Ein Kamerad Kleists* *Sallet, „Laienevangelium"* *Schefer und Scheffler*

Fechner und Dehmel Landsmann Richard Dehmel voraus. Mitten aus Fechners Gedankenkreise strebt das unsäglich zarte „Begräbnis der Rose". Aus dieser Umwelt entfaltet sich wie bei Hauenschild und Strachwitz „Elfenwirtschaft". Daher kann Sallets freiheitliche Weltanschauung trotz dem Gedicht „Börne" nicht mit dem Willen der Radikalen zusammengebracht werden. Sie liegt, wie „Reimspiel" erweist, notwendig beschlossen in jenem mystischen Gottgefühl, das teilhat an Gottes Schöpferwerk und mit Gott weltfrei, weltmächtig ist. Sallets Freiheit ist kein staatsbürgerliches Wunschbild, sondern eine metaphysische Pflicht. „Als Gott den ersten Mann erschuf / Mit einem Worte: Sei! / Scholl in der Tiefe nach ein Ruf, / In Gottes Tiefe: frei!"

Das Theater Alles, was lebte, gedieh hier in gesellschaftlichen Verbänden. So der Stand der Junker und so die Genossenschaft des Theaters. Spieltrieb, das ist der innerste Seelenwinkel Schlesiens. Keiner verkörperte ihn mit echteren schlesischen Gebärden als der Breslauer Kaufmannssohn *Karl Schall*, 1780 bis 1833, eine Gestalt, wie sie nur in mittleren Landstädten wächst. Schall hatte *Schlesiens Freuden-marschall* schon 1817 seine Lustspiele gesammelt. Er gründete und leitete die „Neue Breslauer Zeitung". Mit Holtei gab er 1823 die „Deutschen Blätter für Poesie, Literatur, Kunst und Theater" heraus. Wenige Männer bescheidenen Zuschnitts sind so oft und so glänzend von bedeutenden Zeitgenossen geschildert worden wie Karl Schall. Keiner aber hat ihn mit so glücklicher Laune und so bitterm Ernst gezeichnet wie Heinrich Laube. Er nennt Schall den großen Freudenmarschall, die lustige Person Schlesiens, den besten Schauspieler unter den Schriftstellern. „Mit seiner Zeitung begann sein schlesisches Konsulat des Amüsements. Schall brachte moderne Formen, wie er denn überhaupt Schlesien modernisiert hat, ohne es oft zu wissen und zu wollen ... Schall ist für einen Teil des Breslauer Adels ein unersetzlicher Verlust, er war dessen Universität der freien Künste und Wissenschaften . . . Absichtslos konnte er die ergötzlichsten Zustände als Lustspiele dichten, er konnte einer unserer besten Komödiendichter werden, denn er hatte alles Zeug dazu." Karl Schall also, das war, wenn wir Laube recht verstehen, die leibhaftige Stegreifkunst des schlesischen Volkes.

Schlesische Bühnenkünstler Vom Theater her begegnete den ostmitteldeutschen Junkern die andere Spielart der einen schlesischen Seelenlage. Die großen schlesischen Schauspieler Johann Friedrich Fleck und Karl Seydelmann waren vorangegangen. Jetzt folgten die Spielbuchdichter und Spielleiter nach, die den Gang der Dinge in jenen beiden Hauptstädten bestimmten, denen Schlesien nacheinander angehört hat: in Wien und Berlin. *Ernst Benjamin Raupach*, 1784 bis 1852 aus Straupitz bei Liegnitz, hat sich wohl außerhalb Schlesiens entwik-

kelt und ausgewirkt. Doch seine Anlage und Bildung wurzelt in der Heimat. Seine Stellung neben Holtei und Laube spricht für die schlesische Eigenart seines Werks. Richtiges Komödiantenblut und schlesische Gestalt lebten in *Karl Holtei*, 1797 bis 1880, dem verwandelten Ebenbilde Karl Schalls, der *Der Komödiant* den verunglückten Landwirt und Rechtsschüler wieder ans Theater brachte. Holtei gab 1822 die Wochenschrift „Der Obernigker Bote" heraus, leitete mit Schall 1822 das „Jahrbuch deutscher Nachspiele" und 1823 die „Deutschen Blätter". Zuvor und nachher entführten Kunstreisen den Ruhelosen immer wieder durch Europa von Paris bis Riga. Holtei war der letzte vom Stamme des fahrenden Volkes, komödienhaft und dilettantisch, warmherzig und voll naiver Menschlichkeit. Seine Dramen und Singspiele lassen sich *Holteis Dramen* kaum überblicken. Zwei davon sind kostbare Urkunden seiner Persönlichkeit und des südlichen Einschlages im schlesischen Wesen. „Die beschuhte Katze" 1843 parodiert Münch-Bellinghausens „Sohn der Wildnis" durch eine Parodie von Tiecks „Gestiefeltem Kater", ein Ding zwischen zwei Spiegeln und also witzig ins Unendliche verzerrt. „Don Juan. Dramatische Phantasie in sieben *„Don Juan"* Akten" ist 1834 ungenannt und als Privatdruck erschienen. Von Mozart angeregt, hatte er die Absicht, den Irrtum einer großartigen Persönlichkeit durchzuführen, die hochbegabt in Wollust untergeht. Das Stück hat mit dem dritten Testament des Fleisches derer um Heine nichts zu schaffen. Tragische Wendung und tragischer Abschluß vollziehen sich im untersten Bezirk des Geschlechtlichen. Es ist Komödienstil von Arnims Art. Leporello ist Hanswurst. Es geht gegen den Spießbürger wie bei Arnim, Eichendorff, Sallet. Grelle Wortwitze funkeln durch die Mundart. Das Verhältnis Leporello-Juan ist den weltliterarischen Paaren Wagner-Faust und Sancho Pansa-Don Quichotte angenähert. In den Romanen seiner späteren seßhaften Zeit suchte Holtei diese schlesischen Triebe episch zu formen. Freilich hatte dieser Taugenichts Eichendorffs nur jene Kunstmittel, die der Leib bietet: Gebärde und Stimme. Unvergänglich, treuer Wortlaut seines Wesens, blieb das Bändchen, das er 1830 herausgab: „Schlesische Gedichte". Man weiß, daß Hebel in der *„Schlesische Gedichte"* Fremde und aus Heimweh zu seinen alamannischen Gedichten kam. Holtei nicht anders zu den seinigen. „Heem will ihch, suste weiter nischt, ack heem!" So schließt die erste Verserzählung des Bandes. Die Mundart tut es nicht, sondern das, was durchscheint: das echte ostmitteldeutsche Volk; die Eigenart im Handeln und Leiden. Nicht in seinen Spielen und Romanen, in den Schwänken und Einfällen seiner „Schlesischen Gedichte" hat Holtei dem, der kommen sollte, den Menschenstoff vorweggeformt. Den Roman seines Lebens schrieb Holtei in der ergreifenden, quellenreichen Selbstdarstellung

„Vierzig Jahre" „Vierzig Jahre" 1843/1850, in der alles preisgegeben ist, was Menschen sonst dem fremden Auge verbergen.

Der Stand der Junker, die Genossenschaft des Theaters, der Verband der Hochschule. Zum erstenmal, seit sie bestand, war sie ein stammestümliches Lebensorgan. An ihr erwirkte sich der nationale Gedanke, die Gemeinschaft mit der romanischen Welt, die slawische Renaissance. Mit den älteren *Schlesische* heimatkundlichen Liebhabereien des Landes war an der Hochschule der erste *Literatur-* deutschwissenschaftliche Betrieb zusammengeflossen. In Breslau spielten die *geschichte* Nibelungenforschungen und entstanden die Nibelungenausgaben Heinrichs von der Hagen. Hier vertrat Friedrich Wachler die junge Germanistik. Der Oberschlesier Karl Ernst Schubarth wirkte mit seinen Goethebüchern für den Weimarer Meister. Der Breslauer Karl August Kahlert schrieb auf der Fährte älterer landeskundlicher Vorgänger 1835 „Schlesiens Anteil an deutscher Poesie". Zwischen beiden Außenpunkten, dem Dienst an einem Menschen und an einer Landschaft, weitet sich die Gestaltenfülle schlesischer Literaturgeschichte durch alle Möglichkeiten der weltanschaulichen und kunstgesetzlichen Richtung: Wolfgang Menzel, Heinrich Laube, Hermann Hettner, Rudolf Haym, Rudolf Gottschall, Karl Bartsch, Josef von Eichendorff. Allgemach war Literaturgeschichte zum weltanschaulichen Bekenntnis geworden. Sie wurde im weiteren Verlauf antreibende Kraft zum neuen Staat, weil sie der Quell des nationalen und freiheitlichen Gedankens war. Das machte der Ostfale August Heinrich Hoffmann aus dem hannoverschen Fallersleben. Mit jungen Gelehrten, Künstlern, Kunstfreunden gründete er 1826 die „zwecklose Gesellschaft". Und ihr, diesem Bildungsherd des freiheitlichen Gesellschaftsliedes, galten seine ersten kleinen Liedsammlungen. In dieser erstaunlich fruchtbaren Breslauer Zeit hat Hoffmann die bedeutendsten seiner deutschwissenschaftlichen Arbeiten gefördert. Sein Schüler war jener Gustav Freytag, der 1839/1844 an der Breslauer Hochschule über deutsche Sprache und Literatur las und der seit 1848, Menzel überflügelnd, Laube ablösend, mit dem Rüstzeug des öffentlichen Wortes das Werk des deutschen Staates bewegen und vollenden half. An der Hochschule erwirkte sich von der Ro- *Schlesische* mantik her die Pflege romanischen Volksgutes. Ihre Vertreter hatte die roma- *Übersetzungs-* nische Sprachkunst nicht in der philosophischen, sondern in der rechtsgelehr- *kunst* ten Fachgruppe. Karl Witte förderte zu Breslau die Vorarbeiten für seine große Ausgabe der „Divina Commedia", ließ er seine Ausgabe der Dantebriefe und seine Übersetzung des „Decamerone" erscheinen. Und so wurde Breslau ein Übersetzernest. In die Breslauer Zeit Karl Friedrich Kannegießers fielen seine Übertragungen Byrons, Chaucers, Scotts, Mickiewicz',

Silvio Pellicos, Leopardis. Johann Gottlob Regis übertrug Bojardo, Macchiavelli, Michelangelos Gedichte, das Liederbuch vom Cid und gab ein Swiftbüchlein heraus. Sein Hauptwerk war der deutsche „Gargantua und Pantagruel" des Franz Rabelais. Und aus der Romantik heraus entwickelte sich der slawische Gegenstoß. In Breslau bildeten sich die Führer der tschechischen und wendischen Renaissance, die letzte und folgenschwerste Wirkung der deutschen Romantik. Johann Ernst Schmaler aus dem Oberlausitzer Merz- *Slawische* dorf verkehrte als Breslauer Hochschüler mit den beiden Tschechen, mit dem *Renaissance* Naturwissenschaftler Purkyne und dem Dichter Celakowsky. Unter den Lausitzer Hörern der Hochschule gründete er einen „Verein für lausitzische Geschichte und wendische Sprache". Er gedieh, indem er 1841/1843 mit dem Görlitzer Prediger Leopold Haupt wendische Volkslieder herausgab, indem er 1846 die von Johann Peter Jordan gegründeten „Slawischen Jahrbücher" zu Leipzig und 1848 wendische Wochenblätter zu Bautzen leitete, zum Vorkämpfer der wiederbelebten wendischen Sprache.

Innerhalb der junkerlichen Verbände, an der Deutschwissenschaft der *Von Menzel* Hochschule, am Theaterbetrieb hatte sich durch Ausprägung eines neuen *zu Laube* Junggeschlechtes weniger ein künstlerischer als ein weltanschaulicher und staatsbürgerlicher Wandel vollzogen. Dieser Wandel kreiste in der Umlaufsbahn burschenschaftlicher Gedanken und drückte sich als Platzwechsel von Wolfgang Menzel zu Heinrich Laube aus.

Wolfgang Menzel, 1798 bis 1873, aus Waldenburg, gehörte als Schüler *Burschen-* des Elisabethgymnasiums zu den Vorkämpfern des Turnplatzes. Dieser schle- *schafter rechts* sische Jungturner hat in ganz Deutschland den Geist des Turnplatzes und der Burschenschaft an sich selbst am vollkommensten herausgearbeitet und zum Grundgesetz seines Denkens wie Handelns gemacht. Soldat 1815, Jenaer Burschenschafter 1818, Lehrer zu Aarau 1820/1822 und seit 1825 zu Stuttgart im Dienst von Cottas Blättern, ist Menzel seiner Heimat früh und dauernd entfremdet worden. Dennoch hat kein Schlesier dieser Altersstufe schlesisches Wesen und schlesische Überlieferung so sinnfällig ins Leben geformt, keiner auch den deutschen Willen der Breslauer Hochschule so treu und zäh verwirklicht wie Wolfgang Menzel. So der Zeitungsmann und so der Dichter. Schon die deutschen „Streckverse" 1823, ein sehr eigenartiges Bekenntnis- *„Streckverse"* buch, zeigen Menzels Wesen vorgebildet. Die Aufschrift stammt gewiß aus Johann Paul Richter. Das Buch aber ist Eigentum des jungen Wagemuts vom innersten Gedanken bis zum äußersten Rund der Form. Der christlichdeutsche Leitgedanke der Burschenschaft verschwor sich hier wider die Aufklärung, empörte sich gegen den Neuhumanismus wie gegen die Abgötterei

Wolfgang Menzel mit Goethe und schreckte selbst vor der Frage nicht zurück, ob Luthers Werk die deutsche Einheit zersprenge. Diese Aphorismen, schwärmend für Johann Paul Richter, Jakob Böhme feierlich verehrend, durch Weltbild und Form von den verwandten Erzeugnissen der Romantik geschieden, bezeugen zu frühest den tiefsten Umsturz dieses Jahrhunderts: vom Kulturvolk zum Staatsvolk. Diese Streckverse Menzels sind das Gegenstück zu den Sinngedichten Johannes Schefflers. In zwei Märchenspielen ging die schlesische Innenfülle *„Rübezahl"* dieses Menschen auf: Romantik und Barock. „Rübezahl" 1829, die heimische Riesengebirgssage, doch an der Fassung des Musäus entwickelt, war ein romantisches Erzeugnis im Stile Tiecks, in der Haupthandlung die unberührte Echtheit der Natur, in der Nebenhandlung die Satire auf all die Unnatur und Enge des Zeitalters. Mundartliche Einlagen wahren den heimatlichen Ton *„Narcissus"* des Ganzen. „Narcissus" 1830, der antike Mythus, züchtigte in der barocken Spielform Wiens die heidnische Vergaffung in sich selbst. Der wohlgezielte Schlag traf den verhaßten Humanismus. Beide Märchenspiele fügen Menzel zu Eichendorff und Loeben als den Vertretern romantisch barocker Stileinheit. Er faßte die Romantik als nationale Wiedergeburt, empfand die romantische Aufgabe noch unvollendet, wandte sich wie Günther gegen die „heidnische Philosophie" und verleugnete seine volkserzieherischen Absichten nicht. Gotisches Christentum gegen römischen Katholizismus darf Menzels besondere Haltung heißen, so schwer zu trennen beide Begriffe auch sein mögen. Der Dichter, der Deutschkundler, der Zeitungsmann: burschenschaftlich und schlesisch war Menzels Gesinnung. Der Dichter Menzel kann mit Grillparzers Wort beurkundet werden, der sich nach Lesung des „Narcissus" im Tagebuch verzeichnete: „Dieser Mann ist wirklich ein Stück von einem Dichter, wenn nicht ein wirklicher ganzer."

Burschenschaftler links *Heinrich Rudolf Laube,* 1806 bis 1884, aus Sprottau, schien mit seinen auffällig sarmatischen Zügen weit eher zum Umherschweifen bestimmt als Holtei, war auch lange genug ein Herumtreiber, doch nicht wie Holtei als Komödiant und Rhapsode, sondern als Bursch mit Ränzel und Knotenstock. Denn Heinrich Laube, das war der burschenschaftliche Widerpart zu Wolfgang Menzel. Wie Menzel Vorturner der Jugend von 1814 war, so das Abbild der Jugend von 1830 Laube. Früh, schon 1818, trat ihm das Theatervolk *Heinrich Laube* einer fahrenden Truppe nahe. Und fast ebenso früh las er sich am Glogauer Gymnasium auf eigene Faust in ein mächtiges Stück Literatur ein. Schon in Breslau, seit 1827, schulte er sich auf den Doppelgriff seiner Anlage. Er spielte als Leiter eines Winkelblättchens „Aurora" den literarischen Scharfrichter, erwarb sich durch seine Keckheit Schalls Freundschaft und einen Platz unter

den Mitarbeitern der „Breslauer Zeitung". Gleich verwegen, setzte er 1830 seinen Erstling „Gustav Adolf" hin und ließ ihn spielen, ein Stück, äußerst *Die Bühne* geschickt verfertigt und in der Wendung bedeutend, wie Gustav Adolfs Tragik aus seinem Abfall vom Glaubensstreiter zum Eroberer aufgeht. Die heimische Hochschule sah ihn nahe am Entgleisen. Gefangene Burschenschafter der Festung Glogau hatten ihm die Kunst des Fechtens und den Heldenmut ihres Gedankens gegeben. So wurde Laube ein preiswürdiger Zweikämpfer und Haupthahn der Burschenschaft. Die Pariser Julitage von 1830 scheuchten *Julius 1830* ihn auf. Er wurde Hauslehrer an der polnischen Grenze, konnte hier den Dingen aus nächster Nähe zusehen und seine ersten selbständigen Arbeiten schreiben. Saint-Simons Werk fesselte ihn. So trat er entschlossen 1832 zu Leipzig an die Spitze der „Zeitung für die elegante Welt". Damit begann ein *Die Zeitung* Aufstieg, der den unternehmenden, waghalsigen, klugen Menschen über allerlei Zwischenfälle zu vieljähriger Tätigkeit auf den verantwortungsvollsten, künstlerischen Posten führte, der in Deutschland zu vergeben war: an das Steuer des Wiener Burgtheaters. Ein Janus, verkörpert Heinrich Laube mit dem einen Antlitz gegen die Fülle schlesischer Bühnendichter und Theatermeister und mit dem andern Antlitz gegen die Masse ostmitteldeutscher Zeitungsleute gerichtet, die schlesische Uranlage: den Tatentrieb im Spiel der Gebärden und der Worte zu befriedigen.

Wie arm erscheint auf den ersten Blick vor dieser wortreichen, gestaltenbelebten schlesischen Fülle die karge Sparsamkeit der Lausitz. Doch was das Schicksal dort in ganzen Gruppen verschwendete, das brachte es hier durch wenige Einzelvertreter herein.

Die Herrschaft Muskau verriet wie in stark abkürzender Bilderschrift den *Herrschaft* Umschwung der Zeit und die allgemeine Richtung der ausgelösten Kräfte. *Muskau*

Da lebte *Leopold Schefer,* 1784 bis 1862, Sohn eines Muskauer Arztes, als *„Prometheus* Güterverwalter des Fürsten, sein Mitarbeiter beim Bau der Gärten, im eige- *und der* nen Häuschen, voll Muße sich „heiter auszubreiten in den Stunden" und nach *Nachtwächter"* dem Grundsatz: „Die Freude halte aus wie einen Ton der Flöte." Schefer hatte die Jahre 1816/1820 in Wien bei neugriechischen, in Neapel bei arabischen Sprachübungen zugebracht, in Rom verlebt, in Griechenland und Kleinasien verwandert. Als er heimkam, war er kein Neuer, sondern der Alte geworden, von Geheimnissen des Morgenlands umwittert, der Lausitzer Gottverkünder, der in immer neuen Verwandlungen kommt und nie stirbt. Seit seiner Bautzener Schulzeit bis zu seinem Tode hat Schefer in achtzig großen Heften Tagebuch geführt. Das war der Mann; der Selbstbeschauer; der mit sich selbst Redende; der Mystiker und ins All Verwobene; die Meditatio des

umfriedeten Mönchs. Die Masse seiner Romane und Novellen birgt landschaftliche Schilderungen von großer Pracht aus allen Zeiten und Wendekreisen. Seine erste Gedichtlese, die Pückler schon 1811 herausgab, wuchs bis zur dritten Auflage von 1847 zu einer vollen Übersicht von Schefers Wesen heran. „Jakob Böhms Verklärung" zeigt nach rückwärts auf den Meister, in dessen Spuren Schefer wandelte. Es weisen auf Fechner die beseelten Blumen. Es deutet nach vorwärts auf Richard Dehmel, der wieder Schefers Wege weiter verfolgte, das überraschende Gedicht „Frühlings Nachtgleiche". Und da sind die ersten Vorgewitter Nietzsches. Es ist das tragisch-ironische Gesprächsstück „Prometheus und der Nachtwächter". Unten in einem Kaukasusdorf der Ruf des Nachtwächters: „Bewahrt das Feuer und das Licht." Der Bringer des Feuers oben an den Felsen geschmiedet, Prometheus. Und nun, vom eintönig gleichen Ruf unterbrochen des Mannes mit dem Schafpelz, des Mannes mit dem Horn, mit dem Horne der Macht, die trotzig selbstbewußte, ironisch spottende Widerrede des Prometheus. Der Mann mit dem Horn nur ein verwegenes Sinnbild der wandelbaren Weltpolizei der Götter, indes Prometheus sich eins weiß mit der großen Götter Allergrößtem, mit dem urewigen Pan: „Du selbst, du alles selbst, des Orpheus Pan, der große, der die Welt ist, Himmel und Erde und Sterne, die leiblichen Glieder." Als Priester dieses Pan hat Schefer sich gefühlt. Und so gab er der geistlichen Folge seiner Bücher priesterliche Aufschriften: 1834 „Laienbrevier", 1843 „Vigilien", 1846 „Der Weltpriester", 1855 „Hausreden". Askese und Erotik lag wie in einem Keime schon in der mystischen Anlage dieser Menschennatur. Nur zögernd und von Hauenschild gedrängt, gab Schefer die letzten Bekenntnisse dieser Art preis, erotische Gedichte aus der Zeit seiner morgenländischen Reisen: 1853 „Hafis in Hellas", 1855 „Koran der Liebe". Wie im Mittelpunkt eines weithin rollenden Kreises scheint „Der Weltpriester" zu stehen. Hier liest man die Verse „Das deutsche Volk" mit seinen Nietzsche vorverkündenden Sätzen: „An ihren Göttern sterben alle Völker . . . Und wie sie ihre Götter fertig haben, dann sterben sie, dann sind sie selber tot." Schefer war wie der morgenländische Hierophant eines Gottnaturdienstes, der, den Menschen verlorengegangen, nur in Mysterien weiterlebte. Er hielt gegen den Andrang der Hegelphilosophie wie der materialistischen Naturwissenschaft die unbiegsame Lausitzer Linie von Jakob Böhme zu Richard Dehmel.

Hermann Ludwig Fürst von Pückler-Muskau, 1785 bis 1871, am Hauptort seiner Standesherrschaft geboren, wurde in der Herrnhuterschule zu Uhyst bei Bautzen erzogen. Doch zwischen Pückler und Schefer, Herr und Diener, steht der ostdeutsche Zwiespalt der Welterfassung. Schefers gott-

berauschter Hingabe an das All steht Pücklers herrischer Selbsterwerb der Erde gegenüber. Reisen war bei ihm nur ein Ausdruck schöpferischen Tatwillens. Seit 1828 war Pückler unterwegs, zuerst nach England und Frankreich, 1835 nach Algier und Nordafrika, 1836 Griechenland und Kreta, 1837 Ägypten und Kleinasien. Er hatte den Vorteil seines Standes. Reichtum und fürstliches Reisegerät erschlossen ihm Verhältnisse, zu denen kein anderer vordringen konnte. Romanhaft ist seine Zurüstung. Und romanhaft setzt er *Muskau,* sich sofort in Wechselverkehr mit den führenden Männern der bereisten Län- *Reisebücher* der, mit Abd el Kader, mit Mehmed Ali. Die andern strichen als Fremde und Geduldete zufällig durch Basare und Kaffeehäuser des Morgenlandes. Er setzte sich, gleichberechtigt und Gast, zur Rechten der Gewalthaber. Er tritt auf als sein eigener Gesandter und ehrt durch sein Auftreten den Rang des Muskauer Standesherrn daheim. Geschaffen hat er diese ganze Art nicht. Denn vor ihm oder doch gleichzeitig reisten die drei vornehmen Österreicher Anton von Prokesch-Osten, Karl von Hügel, Friedrich von Schwarzenberg. Ja, Prokesch-Ostens Karten und Reisewerke waren Pücklers Begleiter und Führer im Morgenlande. Doch schöpferisch neu war die Kunst, diesen Reiseerlebnissen Gestalt zu geben. Seine Bücher bilden eine große Weltbilderfolge von England über Algier und Ägypten, über Kleinasien und Griechenland zum Startplatz der Reisen in dem fürstlichen Muskau: 1830/1831 „Briefe eines Verstorbenen", 1835 „Jugendwanderungen", 1835 „Semilassos vorletzter Weltgang", 1836 „Semilasso in Afrika", 1838 „Der Vorläufer", 1840 bis 1841 „Südöstlicher Bildersaal", 1844 „Aus Mehemed Alis Reich", 1846/1848 „Die Rückkehr". Wohl das feinste, persönlich eigenste, am reinsten künstlerische seiner Reisewerke ist „Semilasso in Afrika". Der Pücklerbericht gleicht der Rahmenerzählung um einen Novellenkranz. In diesen eingelegten Stük- *Reisenovelle* ken wußte er ganz erstaunlich abzutönen. Da war die verschwiegene Klangfarbe der Jussufgeschichten; eine grausige Erzählung, „Die Pest", des polnischen Obersten; „Der Traum", ganz Ernst Amadeus Hoffmann mit Musikbeschreibungen; „Die Hasenjagd" von Pücklers Schreiber, ein gelungener Hallescher Studentenulk. Freilich mußte man den vollen Wert einer großen deutschen Standesherrschaft auszugeben haben, um zu reisen, wie Pückler reiste. Aber, er gab ihn aus. Fürst Pückler hatte immer Haltung. Zu Roß, auf anstrengenden Wüstenritten unter geborenen Reitervölkern; auf scheiterndem Seeschiff; an der Seite eines Gewalthabers wie Mehemed Ali; mit dem Gefolge eines Kleinkönigs auf eigener Nilbarke: er machte immer Gestalt und das in Lagen, wo der Mann als Mann und nicht als Fürst einzusetzen war. Ihm war Reisen eine Art Handeln, Welterwerb und Weltbezwingung,

Meisterschaft des Ich über die greifbar gefährlichen Dinge im Raum. Natur und Kunst zu Geschwistern zwingend, verwandelte Pückler die Muskauer Sandhalden in einen Garten, versetzte ganze Wälder und schuf künstliche *Gartenkunst* Gebirge. Und als er Muskau verkauft und sein väterliches Gut Branitz bei Kottbus wieder zu einem Garten umgebaut hatte, versuchte er arabische Pferde und afrikanische Neger zu züchten. So sagte denn der kleine Hof zu Muskau das heraufziehende Deutschland an: mit Schefers willenloser Preisgabe an die Natur und mit Pücklers tatkräftigem Übermut gegenüber den Dingen, den Gegensatz zwischen einem Bürgertum, das zu handeln außerstande war, und zwischen einer Herrenkaste, die vor nichts erschrak und Staaten hämmerte, wie sie die Natur bezwang. Vor Schefer und Pückler öffneten sich wieder die uralten halbverwehten Wege des Ostens nach dem *Aus dem Osten* Osten. Indem der Standesherr von Muskau sich der morgenländischen Art zu *in den Osten* denken, das Leben zu werten und zu formen, eingewöhnte, gab er unter den Deutschen das erste Beispiel westöstlichen Seelentausches.

Philosophie Mitten in den gewaltigen Sprengungen von Oberdeutschland, die nach *der Lausitz* Strauß, Feuerbach, Büchner heißen können, mitten im Aufbau des sächsischdeutschen Kriegerstaates wurde die Lausitz sich ihres verbürgten philosophischen Adels von Jakob Böhme, von Leibniz und Wolff, von Fichte, Ritter und Schleiermacher her bewußt. Die Landschaft erzeugte zwei brüderlich gerichtete Menschenwesen, die des Erfahrungswissens und des begrifflichen Denkens mit gleicher Sicherheit mächtig und ihrem Zeitalter weit voraus, diese Gefahren alle abdämmten.

Der Jüngere, der Schüler *Rudolf Hermann Lotze,* 1817 bis 1881, aus Bautzen, trieb bei Fechner in Leipzig Heilkunde, umfing schon früh Philosophie und Naturkunde mit gleicher Neigung und wurde 1844 Herbarts Nachfolger in Göttingen. Er stieg zu den großen Werken auf: 1856/1864 „Mikrokosmus, *Natur,* Ideen zur Naturgeschichte und Geschichte der Menschheit", ein Drilling zu *Geschichte,* Herders „Ideen" und Humboldts „Kosmos"; 1868 „Geschichte der Ästhetik *Kunst* in Deutschland"; 1874 „System der Philosophie". Wie Herder, ging Lotze auf eine Geschichtsphilosophie aus. Er kämpfte gegen zwei Seiten; gegen jene, die an eine besondere Lebenskraft glaubten und gegen die hessischen Verkünder von „Stoff und Kraft". Ihm waren das Unbedingte Geist und Schöpfer der Welt, die Naturgesetze Gewohnheit des göttlichen Wirkens. Lotzes Philosophie erhöhte und vollendet sich in dem kunstwissenschaftlichen Leitgedanken: Sinnliche Erscheinung, Schönheit und Bedeutung sind der wahre Zweck der Welt. „Der ganze gegliederte Mechanismus, durch den die Welt sich erhält und fortentwickelt", war ihm nichts anderes als „der Ge-

samtausdruck eines geistigen Entwicklungstriebes, durch den die absolute Substanz sich entfaltet". Herders Versuch, Natur und Geschichte mit einem großen Blick zu durchschauen und zu deuten, war so durch Lotze aus größerer Strenge des Sachwissens einer neuen Zeit zur Pflicht gesetzt. Diesem Metaphysiker um der Geschichtsphilosophie willen stand der Metaphysiker einer Naturphilosophie mehr entgegen als zur Seite. *Gustav Theodor Fechner,* *Gustav Fechner* 1801 bis 1887, aus Groß-Särchen bei Muskau, bildete sich an der Leipziger Hochschule seit 1817 zum Arzt. Er schien zu zürnen, zu scherzen, zu spielen, wenn er launige, zierliche Büchlein schrieb: „Beweis, daß der Mond aus Jodine bestehe". Doch unverkennbar funkelte ihm Ernst aus den fröhlichen Augen, wenn er in „Vier Paradoxa" die Sätze verfocht, der Schatten sei lebendig, der Raum habe viererlei Ausdehnung, die Welt sei nicht durch eine schaffende, sondern zerstörende Kraft entstanden, oder wenn das Märchen „Vergleichende Anatomie der Engel" Gedanken über ein höheres Lebe- *Magister-scherze* wesen nachhing, das ganz Auge als welttrunkene Kugel im Weltall schwebe und dessen Sprache das Licht sei. In der Tat, Spiel und Scherz waren nur Maske und Vorwand eines Geistes, der wachen Sinnes über den Rätseln des Daseins kreist und mit sich noch so wenig im Reinen ist, daß er lieber hinter den Schleiern seiner romantischen Ironie das, was er ernst meint, spielend im Dunkel läßt. Wogegen der Naturwissenschaftler sich lange gesträubt hatte, das setzte der Künstler endlich durch. Fechners Gedankenwelt kreist um die Seele. Seelisches Leben reicht über leibliche Dauer hinaus. „Büchlein *Vom Allreich der Seele* vom Leben nach dem Tode" 1836; es schlägt, über uns und die Tiere hinweg, auch in den Pflanzen: „Nanna oder über das Seelenleben der Pflanzen" 1848; es kreist über die Erde empor durch den Kosmos: „Zend-Avesta" 1851; überall ist Seele wie überall Leib. Denn was sich selbst als Geist erscheint, das tritt dem Du als Leib entgegen. Subjekt ist die Seite, die der Geist dem Ich zukehrt; Objekt jene, die er das Du sehen läßt. Gott aber hat nichts sich gegenüber und nichts zum Nachbar. Daher erscheint ihm weder eine körperliche Außenwelt noch erscheint er uns als körperliche Außenwelt. Diese Zwei- *Die Zweiseitenlehre* seitenlehre untergründet metaphysisch Fechners Naturphilosophie. Wenn er nun in seinem Grundriß des Kosmos einen Stufenbau der Welt von den Pflanzen bis zu Gott gegeben sah; wenn er die Einheit der Menschheit durch die Vermittlung des ganzen Erdreiches geschlossen glaubte; wenn er meinte, der Mensch lebe dreimal, vor der Geburt, zwischen Geburt und Tod, nach dem Tode: so dachte er Herders Gedanken ebenso weiter wie er sich gegen die Preisgabe der Deutschen an die Vernunftwissenschaft vom toten Stoff wehrte. Fechner erklärte schon 1851 gegen Darwin und die deutschen Darwinschüler

*Ewige
Wiederkehr*

den Aufwuchs ansteigender Lebensgebilde aus der fortzeugenden Tätigkeit der Erde. Die Welt nähert sich schließlich einem Zustand, wo die Teile in gleichen Zeitabständen in dieselben Lagen und Bewegungsverhältnisse zurückkehren. Und so spann sich abermals in einem Kopfe, lange vor Nietzsche, der Gedanke von der ewigen Wiederkehr an. Dieser Mann, der nie aus dem Kreise der Erfahrung ausbrach, wurde mit seinen „Elementen der Psychophysik" 1860 der Begründer einer neuen Wissenschaft, der auf Versuche gegründeten Seelenlehre. Von ihr zweigte er — „Vorschule der Ästhetik" 1876 — die experimentelle Kunstlehre ab: Sittlichkeit ist die größtmögliche Förderung der Lust im Weltall.

*Ostdeutsche
Gedankenfront*

Fechner und Lotze, Meister des erfaßbaren Wissens wie des begrifflichen Denkens, haben das von Herder vorgeschaute Weltbild in das Gradnetz der Erfahrung ihrer Zeit eingezeichnet. Sie haben die romantische Naturphilosophie zugunsten Herders überwunden und so vollendet. Ihr Gedanke baut mit Herder im Mittelpunkt, den rechten Flügel bei Günther, den linken bei Schopenhauer, die neue ostdeutsche Gedankenfront auf. Sie führt, wie so oft im Osten, philosophisch-lehrhaft den Vorkampf für eine neue Kunst. Denn Fechner und Lotze haben den Grund gelegt für eine kosmische Kunst der Allbeseelung, für eine Kunst der vergeistigten Naturtreue und für jenen Stil, der seine Gebilde aus Sinneseindrücken aufbaute und durch die Sinne zur Seele wie zu Gott vordrang. Das war verwandelt und in moderner Gestalt der Gedanke Hamanns und Herders.

*Ostdeutsche
Staatslehre*

Das *ÖSTLICHE* und das *WESTLICHE PREUSSEN* waren im Zeichen der wiederaufgebauten Marienburg 1824 für Heinrich Theodor Schön zu einer einzigen Statthalterei vereinigt worden. Und auf dieses vereinigte Preußen gründeten sich die beiden entgegengesetzten staatlichen Entwürfe. Die beiden Staatsrechtslehrer, der Danziger Karl Ernst Jarcke, 1801 bis 1852, und der Königsberger Georg Phillips, 1804 bis 1872, beide Konvertiten, vertraten überall in Deutschland, wo sie wirkten, ihre mittelalterlich-kaiserliche Staatsrechtslehre. Das war die umgedichtete Marienburg. Königsberg war nicht bloß die preußische Krönungsstadt, sondern auch im Bewußtsein ihrer altpreußischen Geschichte und im Vollgefühl der ständischen Verfassung der Herd des Fortschrittswillens für den ganzen preußischen Osten. Ihn vertrat der Statthalter selber, Theodor Schön, der Mann des Volkes, der Freiheit, der Verfassung. Im Herbst 1840 arbeitete er die Denkschrift aus „Woher und Wohin?" Er forderte im Anschluß an den Freiherrn vom Stein Nationalstände und suchte den neuen König für die Linke zu gewinnen. Ein reichskaiserliches oder ein königlich preußisches Deutschland, das war eine viel

spätere Frage gegenüber der dringlicheren: ein beharrsames oder ein fort-
schrittliches Preußen?

Die Albertusuniversität gab ein Beispiel, aber man ließ sie keines geben. *Die Albertus-*
Johann Friedrich Herbart entfaltete an ihr seit 1807 seine reichste und frucht- *universität*
barste literarische Tätigkeit gegen die „Modephilosophie" der Schelling und
Hegel, und noch in Königsberg erschien seit 1824 sein weit nachwirkendes
Hauptwerk „Psychologie als Wissenschaft". Eben die Modephilosophie kam
1833 mit *Johann Karl Friedrich Rosenkranz* an der Hochschule zur Macht.
Rosenkranz hat in Königsberg den ganzen Reichtum seines Wesens ent-
faltet, beinahe alle Felder der Philosophie mit je einem Steine besetzt, sein
Steckenpferd Dichtung geritten, als Hegeling über Tieck und gegen die Ro-
mantik gelesen, für Goethe geworben und mit seiner „Ästhetik des Häß- *Rosenkranz*
lichen" 1853 eine sehr reizvolle Frage der Kunstlehre aufgeworfen, indem er *in Königsberg*
das Häßliche zwischen das Schöne und Komische eingliederte. Was Rosen-
kranz als Vortragsredner, als hilfreicher Geleiter fremder Bücher, als brief-
licher Vertrauensmann in literarischen Dingen Gutes geleistet und Schlim-
mes verhütet hat, das entzieht sich heute noch genauer Kenntnis. Kein Bei-
spiel aber war es mehr, wenn die Universität endlich aus dem altersgrauen
Hause auf der kneiphöfschen Dominsel in das ziersame Gebäude am Königs-
garten übersiedelte. Den Grundstein hatte der König freilich 1844 gelegt.
Doch als man einziehen konnte, schrieb man schon 1862 und war längst über
diese Zeit hinaus.

Die Literatur trägt lauter neue Gesichter. Doch sind es fremde? Die neue *Spät-*
Königsberger Altersgenossenschaft der Jahrhundertwende vollzieht in allen *romantische*
Übergängen weltanschaulich und künstlerisch den Bruch mit der Romantik. *Generation*
Allein, so rasch sie gesinnungsmäßig die Linie Werner-Schenkendorff-Hoff-
mann hinter sich läßt, künstlerisch vollzieht sich der Fortschritt im Abstei-
gen. Der Königsberger *Ernst August Hagen,* 1797 bis 1860, hatte noch die
gute alte Zeit. Seine Erzählungen in Vers und Prosa leben treu aus Wacken-
roders „Herzensergießungen", spielen in Florenz und Nürnberg, spiegeln
die Kunst wider, der Hagen durch Gründung von Anstalten und Vereinen in
Königsberg gedient hat. Der Königsberger *August Lewald,* 1792 bis 1871,
hat sich ohne Hoffmanns Genie und Dämonie am breitesten in Hoffmanns
Schaffen ergangen. Er wurde Schauspieler, Theaterdichter, Theaterleiter,
hat wie Hoffmann gerade in Bamberg gewirkt und den größten Teil seines
langen Lebens in süddeutschen Kunststädten ausgegeben. Lewalds zwölf- *Lewald, „Ein*
bändige Gesamtausgabe, „Ein Menschenleben" 1843/1846 fügt in den selbst- *Menschenleben"*
erzählten Lebenslauf seine Werke ein. Sehr entfernt ist das die Form von

30

Hoffmanns „Serapionsbrüdern" und Laubes „Reisenovellen". Der Über-
gang von dem einen zum andern ist auch tatsächlich sein zeitlicher Fort-
schritt. *Gotthilf August von Maltitz,* 1794 bis 1837, aus der Königsberger
Umgebung, ist eine der sonderbarsten Gestalten deutschen Lebens und
Der deutscher Dichtung. Man weiß nicht recht, ist er aus Hoffmanns Erzählungen
landesübliche ausgekommen oder ein verzerrter Abkömmling Hamanns. Ist das der Stil
Sonderling Hippels und Hamanns oder einer völlig verlaufenen Romantik. Jedenfalls ist
Maltitz eine Beute der Grimasse. Das faustartige Gedicht „Gelasius, der
graue Wanderer" 1826 führt mit seinen geistreich-banalen Spottreden so-
wohl den aufgeklärten Fortschrittsgedanken wie das romantische Vergan-
genheitsideal in den Widersinn. Das Stanzengedicht „Hans Kix' Reise ins
Pomeranzenland" 1827 verulkt das klassische wie das romantische Italien-
erlebnis. Von seinen Dramen hört sich „Hans Kohlhas" 1828 wie ein Revo-
lutionsstück an, währenddem „Der alte Student" 1828 für Polen Partei er-
greift. In der Sammlung seiner Zeitungsbeiträge „Pfefferkörner" 1832/1834
finden sich „Reisen in die Ruinen des alten Europa im Jahre 2830", ein
merkwürdiges Stück. Es verlegt den großen russischen Krieg, diesen Alp-
druck jener Jahrzehnte, aus weiter Rückschau in den Anfang des zwanzig-
sten Jahrhunderts.

Die radikale Die nächste Generation, die begabten jungen Leute, die in den dreißiger
Generation Jahren Stadt und Hochschule bevölkerten — seit 1836 Julian Schmidt, seit
1837 Albert Dulk, seit 1838 Wilhelm Jordan und Ferdinand Gregorovius,
seit 1839 Friedrich Kreyssig, seit 1841 Rudolf Gottschall —, gerieten mittel-
bar oder unmittelbar, persönlich oder geistig unter den Einfluß des Königs-
berger Arztes Johann Jacoby. Der nahm ziemlich vorlaut und anmaßend
1841 das Wort zur preußischen Verfassungsfrage: „Vier Fragen, beantwortet
von einem Ostpreußen." Was sich hier abspielte, war die Lösung einer gan-
zen Altersgenossenschaft aus ihrer romantischen Bezauberung und ihre Ver-
pflichtung auf das Werk der deutschen Freiheit und Einheit.

Der Prophet *Albert Dulk,* 1819 bis 1884, aus Königsberg, war der eigentliche Schüler
aus dem Jacobys und Dichter des Kreises, der Rücksichtsloseste von allen und der
Morgenlande dichterisch Begabteste. Er hat den Königsberger Zwist von Wirklichkeit und
Idee, Diesseits und Jenseits, Sinnlichkeit und Geistigkeit verwegen nach der
Seite der sinnlichen Natur entschieden. Er lebte zu Königsberg und anders-
wo in Doppelehe, nachdem er in dem wilden Zeitdrama „Orla" 1844 diesen
Lebensstil dichterisch empfohlen hatte. Der Ideologie seiner jüdischen
Freunde redete das Drama „Lea", 1848 in Königsberg gespielt, das Wort.
Es ist die Geschichte, die Wilhelm Hauff in seiner Novelle „Jud Süß" erzählt

hatte. Seine Gesinnung nahm allgemein die Richtung auf das Morgenland. Er trat aus der evangelischen Landeskirche aus, reiste nach Ägypten und Arabien, lebte in einer Grotte des Sinai und bereitete sich auf eine Prophetenrolle vor. Entwürfe zu neuen Dramen stiegen ihm auf. In Stuttgart seit 1858 seßhaft, gab er ihnen Gestalt. Es war die Weltanschauung des Materialismus, die Dulk mit diesen späteren Dramen, den geschichtlichen wie den morgenländischen, in Szene setzte. „Jesus, der Christ", 1855 vollendet und als modernes Passionsspiel gemeint, spielte auf der Bühne vor, wie nach David Strauß ein Mythus entstand, indem er die Gestalt des Judas dämonisch erhöhte und die Wunder als natürliche Vorgänge gab. Dulk war ein genialer Kraftmensch, der die Gedankengänge Jacobys bis in die letzten gesellschaftpolitischen Folgen ausschritt und schließlich „Religion ohne Gottperson und Kultus" mit seinen freireligiösen Schriften unter die Arbeiter zu tragen versuchte.

Ferdinand Gregorovius, 1821 bis 1891, aus Neidenburg, ließ sich nicht minder scharf an, obwohl er wissenschaftlich ein Schüler von Rosenkranz war. Die Eindrücke, die er von dem gotischen Ordensschloß seiner Vaterstadt erhalten hatte, verblaßten in der modernen Luft Königsbergs, in der es von Hegel und Nationalkonvent brauste. Noch in Königsberg machte Gregorovius einen raschen und weiten Wandel der Gedanken und Formen durch. „Konrad Siebenhorns Höllenbriefe an seine lieben Freunde in Deutschland" 1843 sind Geist vom Geiste Jacobys. Sie verspotten jugendlich wagemutig das Zeitübliche. „Werdomar und Wladislaw" 1845 war schon ein Roman, parodistisch auf die Romantik gemeint, eine empfindsame Liebesgeschichte, schwulstig und verworren, offenkundig Polen zugewandt. Diesen Ton hielt Gregorovius, indem er 1848 — „Die Idee des Polentums" — eine völkerkundliche Darstellung und die Zeitgeschichte des polnischen Volkes gab, wie er mit den „Polen- und Magyarenliedern" 1849 dem Freiheitskampf der beiden Völker huldigte. In diesem Augenblick aber war Gregorovius schon weiter. Auf Rosenkranz wies die gehaltvolle Schrift von 1849 „Goethes Wilhelm Meister in seinen socialistischen Elementen". Das sollte heißen: Goethe habe in den „Lehrjahren" sein eigenes Zeitalter und in den „Wanderjahren" den Wandel des gesellschaftlichen Lebens der Zukunft entgegen zeichnen wollen. Seine Doktorarbeit hatte Gregorovius an Plotin gewendet. So war er nun von der Antike her an der letzten Wendung seines Weges, als er 1851 das Drama „Der Tod des Tiberius" und die kleine Arbeit „Geschichte des römischen Kaisers Hadrian" erscheinen ließ. Es war so weit, daß er 1852 nach Rom aufbrach, in seine zweite Heimat Italien.

Der Wanderer in Italien

Gregorovius, Polen, Goethe

Der Rhapsode *Wilhelm Jordan,* 1819 bis 1905, aus Insterburg, überwand die rebellischen
Gelüste seiner Königsberger Jugendlyrik „Glocke und Kanone" 1841 sowie
„Schaum" 1846 noch rascher denn Gregorovius. Als Redner der Paulskirche
einer der bedeutendsten Mitschöpfer der deutschen Staatsberedsamkeit, Mit-
verwalter der erwünschten deutschen Flotte, schonungsloser Zerstörer der
deutschen Polenideologie, war Jordan in seiner Altersgenossenschaft der
erste, der zu einflußreichem politischem Handeln kam. Er hat den Erträg-
nissen jener Hochschuljahre, der Hegelschen Philosophie, dem naturwissen-
schaftlichen Weltbild und der Mythenlehre von Strauß ebenso wie Gregoro-
vius die gemäße Form gefunden. Das Bild des Dichters ist eindeutig und
geschlossen. So verschieden seine beiden großen Schöpfungen, das episch-
„Demiurgos" dramatische Mysterium „Demiurgos" 1845 und die episch-stabreimende
und
„Nibelunge" „Nibelunge" 1868/1874 von außen erscheinen, so ebenmäßig wollen sie
beide von innen her die eine und gleiche Weltanschauung wie Absicht wahr-
machen. In beiden Fällen macht Jordan auf gut ostpreußisch Schluß mit allen
empfindsamen Glückseligkeitsansprüchen an die Welt. Nicht als Schlaraffen-
land, sondern als Welt des Kampfes und der Bewährung ist die Erde schön
und gut. In beiden Fällen sollten der Materialismus dieses Zeitalters dich-
terische Gestalt finden. Wie Dulk den christlichen, so suchte Jordan den ger-
manischen Mythus aus vernunftmäßiger Naturdeutung zu begreifen. Er
wünschte den Deutschen einen „deutschen Glauben", das ist den Imperativ
der Tatkraft und Schaffenslust einzupflanzen. Als wandernder Vortrags-
künstler seiner eigenen Werke trug er diesen Glauben über die ganze von
Deutschen bewohnte Erde. Weder seine Lustspiele noch die zwei späten
Romane, in denen er auf Herders und Schopenhauers Spuren das Christentum
von seinen jüdischen Beständen gereinigt wissen wollte und am Christentum
nur das Sittengesetz Christi gelten ließ, vermögen Jordans Bild zu be-
reichern.

Hamanns Das alte Preußen, Johann Georg Hamann, tauchte hinter den vergäng-
geistige
Nachkommen lichen Wirbeln dieses Jahrzehnts wieder aus der geglätteten Flut: die alte
Frömmigkeit gegen die modischen starken Geister; die unbegreifliche Seele
gegen den alles erklärenden Materialismus; gegen große Literatur die heim-
liche Dichtung; gegen überkluges Erwachsenentreiben einfältige Kindheit;
gegen den tödlichen Ernst einer blasierten Weltsattheit Witz und Laune des
reinen Toren; gegen wortreiches Gerede die urewige Sprache. Dieses Preu-
ßen, wieder bei sich selber, offenbart sich mit gewohnter Doppelheit in zwei
geistesverwandten, eng befreundeten Altersgenossen, die, ganz anders als
jene Schnellreifen und hastig Fertigen, zwischen 1795 und 1825 Geborenen,

spät zum Schreiben und desto ungestörter zum Denken wie Wirken gekommen waren.

Alexander Jung, 1799 bis 1884, aus einer Magdeburger Familie zu Rastenburg geboren, hat sich in herkömmlichen Erzählungen versucht und sich in vortrefflichen literarhistorischen Arbeiten — zumal „Friedrich Hölderlin" 1848 — hervorgetan. Will man wissen, was dieser schwer begreifliche und nie gewürdigte Mann, den Karl Rosenkranz mit eifersüchtiger Treue geliebt hat, für die Geistesgeschichte wert ist, dann muß man sich an seine zwei Bände „Das Geheimnis der Lebenskunst" 1858 halten. Jung nimmt damit seinem neunzehnten Jahrhundert gegenüber die gleiche Pflicht auf sich wie Hamann gegenüber seinem achtzehnten: die Pflicht des Zuchtmeisters und Seelenbildners. Er predigt mit neuen Worten die Kraft der Seele. In raschem Aufriß wird eine Philosophie der Natur und der Geschichte entworfen, nach Herder, auf den schon das Motto des Buches deutet. Sie wird auf den ersten und letzten Menschen hin visiert. Das ist Hamanns Genesis und Parusia. Die Phantasie wird als die schöpferische Kraft der Natur, der Geschichte, der Kunst bestimmt. Sie schaut und ordnet alles so, daß ein unstörbares seelisches Wohlsein entsteht. Dieses Wohlsein ist des Lebens Kunstwerk. Das Uratom ist die Urlüge. Dieser erkenntnistheoretische Selbstbetrug, daß in der Natur, in der Materie, im Bereich der rohen Erfahrung die Welturache liegt, ist zugleich der Grundirrtum der Kunst. Kunst ist nicht Abschreiben der Erdnatur — schon hier fällt in dieser Verbindung das Wort „Naturalist" — sondern schöne Wiedergeburt der Natur. Das eigentliche Geheimnis der Lebenskunst ist es, unausgesetzt Herr seiner Gedanken zu sein. Drei Mittel gibt es für den einzelnen, den Gedankenkosmos zu bewältigen: Musik, Astronomie, Gebet. Der Kern des Buches handelt an bestimmten Beispielen von der Anwendung der Lebenskunst auf den einzelnen Gebieten. Sie hat drei Mysterien: Schöpfung, Erlösung, Vollendung. Ihr Ausgangspunkt ist die Selbstbesinnung und ihr Ziel die Gottseligkeit. Jungs Lebenskunst will weder die Religion zur Kunst noch die Kunst zur Religion machen. Ebensowenig will sie dazu anleiten, die Welt so zu erleben, wie sie der Künstler erlebt. Der Mensch soll sein Innenleben so zu beherrschen und zu gestalten lernen wie der Künstler seinen Gegenstand, damit das zugemessene Leben selber im Menschen ein Wohlsein erzeuge, wie es die Kunst in ihrem einen und die Religion in ihrem andern Bereiche bewirkt.

Bogumil Goltz, 1801 bis 1870, im preußischen Warschau der Werner und Hoffmann geboren, hat den großen Gegenstand seiner Autorschaft, den Menschen in der Gesellschaft auf vielerlei Weise behandelt. Die ersten und

„Das Geheimnis der Lebenskunst"

Musik, Astronomie, Gebet

„Buch der Kindheit"

am nächsten liegenden Beobachtungen, der Gewinn eines sehr lebhaften und zuverlässigen Kinderauges, fanden ihre gemäße Form in den dichterisch verklärenden Kleinbildern seiner Erinnerungsbücher, dem unvergleichlichen „Buch der Kindheit" 1847 und dem dreibändigen „Ein Jugendleben" 1852, mit denen nach Hippel die preußische Heimatgeschichte sich in neuer Gestalt bezeugt. Eine zweite Form des Selbstgesehenen war das Reisebuch „Ein Kleinstädter in Ägypten" 1853, die erste Probe auf das Gemeingültige der Menschennatur. Eine dritte Form war die geschichtliche und vergleichende völkerkundliche Darstellung, in den Hauptzügen stark von Wilhelm Riehl beeinflußt. Das ist die allgemeine Völkerkunde. „Der Mensch und die Leute" *Der Mensch und die Leute* 1858, daraus als erstes Sondergebiet im Geiste Hippels und Scheffners „Naturgeschichte der Frauen" 1858 und als zweites Sondergebiet „Die Deutschen" 1860, drei Bände einer umfassenden und eindringenden Volkskunde. Die vierte Form, mit der sich Goltz der „Lebenskunst" Jungs nähert, das sind die gesellschaftspsychologischen und gesellschaftskritischen Schriften wie „Das Menschendasein" 1850 und „Hinter den Feigenblättern" 1862, eine Umgangsphilosophie. „Die Weltklugheit und Lebensweisheit" 1869 geht zu handsamen Anweisungen im einzelnen über und gipfelt in einer Gattungslehre der Stände.

Jung und Goltz Jung und Goltz zusammen sind überzeugend in ihrer Gemeinsamkeit zu erfassen. Sie haben beide Hamanns Sprachbegriff als den göttlichen Logos, das Erlebnis des Paradieses und der Kindheit, so daß ihnen Kinder kleine Paradiesmenschen sind. Die Menschheit ist ihnen Adam in seiner Verwandlung durch Zeiten und Räume, Kindheit, die sich selber vergaß und verlor, um in dem zweiten Adam sich und sein Paradies wiederzufinden. Wie sie beide, Hamann gleich, aus der gleichen geistigen Haltung heraus gegen ihr Jahrhundert ankämpfen, so sind sie ihm auch in Art und Stil verwandt durch das Sprunghafte und Aphoristische des Denkens, durch ein alles überwucherndes Denkvermögen, durch die fast religiöse Vorstellung von ihrer Autorschaft, durch ihre Freude an Leitspruch und Zitat, durch uferlose Belesenheit. Ihre literarische Form ist die „Charakteristik". Wohl hielten sie *„Lebenskunst und Menschenkunde"* beide an dem Grundsatz fest: „Es fällt der Mensch so wenig aus dem Schoße Gottes wie aus dem Bereich der irdischen Attraktion." Doch beide sind sehr unterschieden. Jung schwärmte ekstatisch. Goltz versprühte sich mit Behagen. Jung wurde von einem gepflegten Geschmack, Goltz von einem derben Bauernverstand am Zügel gehalten. Jung ging es um Lebenskunst, Goltz um Lebensklugheit. Jung ist ebenso offensichtlich ein Lehrling Herders wie Goltz von Hippel angezogen hat. Doch in ihrem tieferen Hintergrunde ste-

hen Kants Menschenlehre und Hamanns Logosglaube. Kommt man für Jung mit einer bloß bildungsmäßig erworbenen Gemeinsamkeit aus, so geht es bei Goltz um zweifellos mehr. Zu deutlich ist seine wesenhafte Verwandtschaft mit Hoffmann und Hippel, zu spukhaft erscheint er in all seiner paradoxen Unergründlichkeit, in seinem skurrilen Tiefsinn wie ein wiederkehrender Hamann, als daß man hier Offenbarungen einer gemeinsamen volkhaften Wesenheit übersehen könnte. Während Jung vergeblich nach dem Dichter rief, der die Mysterien des Christentums in Szene setze — denn Werner mochte, Dulk konnte er nicht anerkennen —, führt Bogumil Goltz auf der Binnenlinie preußischen Wesens und Denkens und sogar im persönlich Eigenartigen, zwischen beiden vermittelnd, von Johann Georg Hamann zu Arno Holz weiter.

Literatur und Geist Westpreußens tragen bis weit in eine ganz andere *West-preußisches Kleinwerk* romantische Zeit romantische Züge. *Friedrich August von Heyden,* 1789 bis 1851, aus Nerfken bei Heilsberg, pflegte die Novelle jeder Stilart, legte aber seine beste Begabung in der romantischen Verserzählung an. Er hatte sich den Gedanken vom gleichläufigen Bildungsgange des Abendlandes und Morgenlandes zu eigen gemacht und führte ihn aus in kleinen epischen Gebilden, die abwechselnd verwandte Vorgänge und Zeitstufen je des Abendlandes und Morgenlandes vergegenwärtigen. Der Danziger Kaufmannssohn *Otto Friedrich Gruppe,* 1804 bis 1876, führte mit satirischen Schriften den Kampf gegen Hegel, bezeugte die bildkünstlerischen Neigungen der Stadt in Kunstberichten und Kunstessays und übte die Verserzählung ähnlich wie Heyden. Stilecht in dieser Stadt war das Streben zu einer neuen Kunst aus der Gemeinschaft aller Sinne. Und so ist das Danzig dieser Jahrzehnte in dem Danziger Großkaufmannssohn *Robert Reinick,* 1805 bis 1852, am rein- *Robert Reinick* sten verkörpert. Der junge Mann, der schon als Kind mit Tusche zu zeichnen und in Wachs zu formen begonnen hatte, schwankte lange zwischen Dichtung und Bildkunst, bis er sie beide geschwisterlich treiben lernte. Reif geworden ist Reinick zu Berlin im Kreise Kuglers, auf weiten Wanderungen durch Deutschland, an der Düsseldorfer Akademie und in Italien. Seßhaft wurde er in Dresden. In diesem mittelgroßen und schlanken Manne, über dessen kindlichheiteren, blauen Augen sich eine hohe Stirne wölbte, Kopf und Kinn von braunen Haaren umbuscht, war das Urbild des Künstlers sinnliche Erscheinung geworden. Reinicks Neuschöpfung seit dem sechzehnten Jahrhundert ist das Bildergedicht. Er näherte sich dieser Form in den Bilderbeschreibungen zu den Berliner Dürerfesten von 1830 bis 1831, er vollendete sie in den Worten zu Rethels Totentanz. Sein Werk entfaltete sich zu

vier Gebilden. Es sind das „Liederbuch für deutsche Künstler" aus dem Ber-
liner, die „Lieder eines Malers" aus dem Düsseldorfer, das „ABC-Buch"
Wort, Bild, Weise und der „Jugendkalender" aus dem Dresdner Künstlerkreise. Wort und Bild
sind in all diesen Schöpfungen nicht von außen her miteinander verkoppelt,
sie stammen aus einer künstlerischen Eingebung und sind wechselweise be-
dingte Träger eines Gedankens und einer Stimmung. Zu Wort und Bild fügt
sich schließlich ein drittes, die Weise, die jene beiden vertonen soll. Stil die-
ser Gebilde ist es, die drei Künste im Buch gewissermaßen zu einem Dienst
und zu einer Wirkung zusammenzufügen. Dieser Stil entsprang der festlich
gestimmten Gelegenheit und wollte ihr Ausdruck verleihen.

In diesem weiten romantischen Umkreis, dessen Mittelpunkt das bau-
künstlerische Erlebnis Danzigs von sich selbst innehatte, besaß auch eine
Philosophie, die im wesentlichen Kunstphilosophie war, die aus der Roman-
tik kam und künstlerisch letzte Träume der Romantik erfüllen half, den Stil
und die Gemäßheit des Ganzen.

Die Welt als Wille und Vorstellung Es ist gleichgültig, wie *Arthur Schopenhauer*, 1788 bis 1860, persönlich
zu seiner Vaterstadt stand, gleichgültig auch, wie lang oder kurz er ihre
Luft geatmet hat. Es ist das hansische Patriziat, hier holländischen Ursprungs,
das sich in Schopenhauer verkündete. Das Kind, das auf dem reizenden
Landsitz zu Oliva, das Meer vor Augen, in englisch gepflegtem Vaterhause
aufwuchs; der Knabe, der in Gesellschaft seiner Eltern, der rastlos reisen-
den, Holland, England, Frankreich sah; der Jüngling, der nach dem Willen
seines Vaters zu Hamburg Kaufmannschaft trieb und qualvoll leidenschaft-
liche Verse fügte: unverkennbar litt dies Menschenwesen am Widerspruch
des Elternerbes, am Gegensatz des harten väterlichen Willens und des müt-
terlichen heiteren Kunstverlangens. Ein empfindsames Herz und überrege
Einbildung machten ihn zum Mitleidenden jeglichen Geschöpfes. Nach des
Vaters dunklem Tode 1806 zog die Mutter nach Weimar und begann der
Sohn zu Gotha eine späte Schulzeit. Er wurde in Göttingen von Kants Philo-
sophie ergriffen und fühlte sich fortan als einzigen und echten Schüler des
Königsberger Meisters. Dessen Lehre fortzubilden, wurde ihm Lebensberuf.
Unheilbar enttäuschten ihn seit 1811 zu Berlin Schleiermacher und Fichte.
In dem stillen Rudolstadt machte er 1813 die Schrift fertig: „Über die vier-
fache Wurzel des Satzes vom zureichenden Grunde." An Platos Hand ging
es aufwärts. Im Umgang mit Goethe 1813 wurde seine Metaphysik reif. Da-
zu Schellings Abguß von Platos Lehre. Rasch genug und für immer schied er
dann aus Goethes und Schellings Welt. Dafür ging ihm die indische Weisheit
auf. Sein Vorsatz war es nun, mit Kants kritischem Verfahren, das keine

Metaphysik zu dulden schien, eine wirkliche Weltanschauung zu formen. So erschien 1818: „Die Welt als Wille und Vorstellung", Welterkenntnis, Weltwesen, Weltschönheit, Weltüberwindung — vier Bücher. Innerlich gerettet, ging der Hochgestimmte nach Italien. Er begann 1820 erfolglos in Berlin zu lesen und ließ sich endlich 1831, auf der Flucht vor der Cholera, zu Frankfurt nieder. Ein Weltmann, adelig in Haltung und Weltanschauung, litt er unsäglich an seiner Einsamkeit, ohne je sein Grauen vor dem Menschen überwinden zu können. Der gefürchtete Tod nahm ihn still und ohne Schmerzen hinweg, nachdem er sein Grundwerk mit Einzelarbeiten gestützt, seine Aphorismen 1851 zu den „Parerga und Paralipomena" gestaltet und die ersten Schüler seines langsam siegenden Werkes gesehen hatte. *Schopenhauers Philosophie*

Mit einer Kunst, die vordem unter deutschen Denkern keine Liebhaber hatte, baute Schopenhauer sein Werk auf zwei je zweifach gegliederte Teile. Jener erste: die Welt als Erscheinung — Erkenntnislehre; die Welt an sich — Metaphysik. Dieser zweite: Weltüberwindung — in den Erscheinungen durch die Kunst; — im Weltwesen durch Verneinung des Willens.

I. Die Welt als Erscheinung und wie sie erkannt wird. Die Vorstellung von den Dingen ist die erste Tatsache des Bewußtseins. Die Wirklichkeit der Dinge ist eine Vorstellung des Ich, desjenigen, der alles erkennt und von keinem erkannt wird. Das Ich ist die Bedingung alles dessen, was erscheint, des Du. Ursache, Raum, Zeit sind nur Anschauungsformen des Verstandes und sie eignen nur den Erscheinungen. Zu dieser Welt der Vorstellung, zum Du des Ich, gehört auch der Leib. *Die Welt als Erscheinung*

II. Die Welt, was sie an sich ist. Die Brücke vom Ich zur Welt bildet der Leib. Denn es ist dem Ich in doppelter Weise, als Vorstellung und als Wille, gegeben. Wenn wir der Körperwelt die wirklichste und bekannteste Wirklichkeit beilegen wollen, so geben wir ihr die Wirklichkeit, die für jeden der eigene Leib hat. Die „Kraft" ist unter dem „Willen" zu begreifen, weil wir allein den Willen und die Kraft nicht erkennen. Wille ist das Wesen der Welt, das Ding an sich. Der Wille ist grundlos, Eines, ohne Vielfalt. Die Welt ist sichtbar gewordener Wille. Nur in seinen Erscheinungen tritt der Wille unter die Gesetze der Ursache, des Raumes, der Zeit. Nur indem er leibhaftig wird, offenbart sich der Wille als zahllose Einzelwesen. Das Sichtbarwerden des Willens in den Erscheinungen ist die Geburt der verschiedenen persönlichen Ich. *Die Welt an und für sich*

III. Die einzelnen Stufen des sichtbar werdenden Willens entsprechen dem, was Plato „Ideen" nannte. Wir können uns von der Erkenntnis der Einzeldinge zur Schau der betreffenden Ideen nur erheben, indem wir eine *Weltschönheit*

reine, willenlose Erkenntnis werden. Bei solcher Hingabe wird das einzelne Ding für uns zur Idee seiner Gattung, zu einem Ding an sich. Diese Erkenntnis ist die Kunst. Die Erkenntnis der Ideen ist Ursprung der Kunst und Mitteilung dieser Erkenntnis ihr Ziel. Kunstgenie ist also die Fähigkeit, sich in die Anschauung der Dingideen zu verlieren, die Menschen von der Herrschaft des Willens zu befreien, ist vollkommenes Entwerden der Persönlichkeit. Genie ist höchstes Vermögen, an der Welt zu leiden und die Welt, soweit sie Wille ist, erkennend und schaffend zu überwinden. Kunst ist also ein Doppeltes: Erkenntnis des Du als einer platonischen Idee und im Erkennenden ein reiner willenloser Spiegel der Erkenntnis. Jedes Ding ist schön, da jedes frei von Ursache, Raum, Zeit gedacht werden kann. Schön vor allem ist der Mensch, und die Offenbarung seines Wesens höchstes Ziel der Kunst. Sofern er sich durch Gestalt und Mienenausdruck mitteilt, ist er Gegenstand der bildenden Kunst. Sofern er sich durch Handlungen, Gedanken, Gefühle mitteilt, ist er Gegenstand der Dichtung. Gipfel der Dichtung ist das Trauerspiel. Denn hier erscheint der Widerstreit des Willens mit sich selber auf der höchsten Stufe. Was der tragische Held abbüßt, ist nicht irgendeine persönliche Schuld, sondern die Schuld des Daseins schlechthin. Der Künstler, den das vor allem anging, Friedrich Hebbel, hat wohl verstanden, daß diese Metaphysik seine eigene tragische Kunst untergründete. Über alle Künste hinaus ist die Musik das Höchste. Die Musik ist ein unmittelbares Abbild des ganzen Willens, wie die Welt selber und die Ideen es sind. Die Welt der Wirklichkeit und der Musik sind lediglich verschiedene Erscheinungen des gleichen Willens. Wie dort zu Hebbel, so führt der Weg hier zu Wagner. Das Ansich des Lebens, der Wille, das Dasein selbst sind ein stetes Leiden. Nur rein geschaut und durch die Kunst wiederholt, wird das Dasein frei von Qual. Kunst ist höchste Einsicht in das Wesen der Welt und erste Stufe der Weltüberwindung. Wie Hebbel und Wagner erst in Schopenhauers Licht volle Erscheinung gewinnen, so der dritte, Stifter.

Die Kunst

Weg zu Hebbel und Wagner

IV. Die Kunst vermag vom Leben nicht auf die Dauer zu erlösen. In der Welt als Vorstellung ist dem Willen sein Spiegel aufgegangen. Und mit wachsendem Grauen erkennt er in diesem Spiegel sich selber. Wo Wille ist, da ist Erscheinung und also Leben. Wille ist ruheloses Streben. Tod ist keine wirkliche Vernichtung. Wer die Geburt des Ich in ihrem Wesen durchschaut, der muß sein Ich verneinen. Vollkommene Keuschheit und freiwillige Armut sind der erste Schritt zur Verneinung des Willens. Mit dem letzten, wenn die Erkenntnis völlig aufgehoben würde, schwände die Welt ins nichts. Denn ohne Ich kein Du. Diese Selbstaufhebung des Willens ist das gleiche, was in

Welt-überwindung

Schopenhauer: Kein Wille, keine Vorstellung, keine Welt

der Kirche Wiedergeburt und Gnadenwirkung heißt. Metaphysisch richtig versinnbildet die Kirche im Urmenschen Adam und in der Erbsünde die Bejahung, im Erlöserwerk des menschgewordenen Gottes die Verneinung des Lebenswillens. Ein solches Nichts des aufgehobenen Willens, warum sollte man es nicht Entrückung, Vereinigung mit Gott nennen? Kann doch ein solcher Zustand — kein Ich, kein Du — nicht mehr Erkenntnis genannt werden. Kein Wille, keine Vorstellung, keine Welt.

War das nicht Hamanns Weg von der Genesis durch Entkleidung und Verklärung zur Parusia: zur Verneinung von Zeugen, Reden, Erkennen? Mit Schopenhauer kehrt das romantische Denken zu seinen Ursprüngen, zur Mystik zurück. Er beruft sich an entscheidenden Stellen auf Meister Eckhart, Johannes Scheffler, Jakob Böhme. Und bei Gelegenheit von David Humes Dialogen kennt und nennt er Hamanns Übersetzung. Danzig also und Königsberg. Was Herdern versagt war, das ist Schopenhauer gelungen: die Vereinigung der beiden gegensätzlichen Königsberger Denker Hamann und Kant. Mit dem kritischen Verfahren Kants hat Schopenhauer das Denkgebäude aufgeführt, das dem Grundriß Hamanns entsprach. Damit hat Schopenhauer ähnlich wie vordem Hamann so nun den künstlerischen Wandel der neuen Zeit bewegt: Alltragik; Schönheit in jedem Ding; Weltmitleid; Vorrang der Musik. Eine neue Welle der Romantik ging durch die Welt. Sie goß sich durch Schopenhauers Pessimismus auf die gewaltige östliche Dreiheit aus: Richard Wagner, Friedrich Nietzsche, Leo Tolstoi. Welch ein geistiger Innenwandel Preußens. Schopenhauer hat Hegel beerbt. Doch es war ein Umschwung, der sich um Königsberg drehte. Denn wenn Hegel wie Schopenhauer mit der kritischen Pflugschar Kants geackert hatten, so war in Hegels Trinitätsphilosophie wie in Schopenhauers Weltverneinung Hamanns Gedanke von der dreifacheinen Wurzel und von der Endschaft der Welt mitverwirklicht.

So, nicht bloß eine staatliche, sondern auch eine geistige Großmacht, erschien Preußen am Rhein.

In den *RHEINLANDEN* aber stieß Preußen auf eine moralische Großmacht. Das war *Josef Görres*. Am 12. April 1816 zog der Rheinhesse Friedrich Graf zu Solms-Laubach, der Geistesgefährte des Freiherrn vom Stein, feierlich in Köln ein, der Hauptstadt seiner rheinpreußischen Statthalterei. Die weltgeschichtlichen Gegensätze zwischen dem ältesten Mutterlande deutscher Kultur und seinem neuen Herrn, dem jüngsten Siedelgebiete, waren staatsbürgerlicher, gesellschaftlicher, wirtschaftlicher und geistiger Art. Der rheinische Wille zu bleiben, und die preußische Macht zu werden, wider-

Schopenhauer und Hamann

Nietzsche

Schopenhauer Wagner, Tolstoi

Preußen am Rhein

stritten einander mit geschärftem Widerstande. Es galt, die rheinischen Pro-
testanten an die preußische Landeskirche zu gewöhnen und mit den rheini-
schen Katholiken Formen des Gemeinlebens zu finden. Justus Gruner, der
Gesamtverwalter des Mittelrheins im Auftrage der Verbündeten, hatte 1814
Görres zum Leiter des öffentlichen Unterrichts im befreiten Rheintal bestellt.
Wenige Wochen nach Blüchers Rheinübergang, am 23. Jänner 1814, ließ
Der rheinische Görres das erste Blatt seines „Rheinischen Merkurs" erscheinen. Indessen
Merkur" hatte sich eine klassische Prosa gebildet. Die drang in die Zeitungen ein und
hob die Gattung. Görres hat diesen Vorgang gekrönt. Wie kein zweiter Deut-
scher besaß er dafür seit seinen ersten Jakobinerblättern die Erfahrung. Stets
war es sein persönliches Blatt gewesen, das er gerade leitete. Und die von
einem persönlichen Geist durchwehte Zeitung, das war der „Rheinische Mer-
kur" in höchster Vollendung. Hinter Görres stand keine Partei, sondern das
deutsche Volk. Er hat nicht das Handeln derer, die sich stark genug zur Ver-
antwortung fühlten, begleitet, er hat es beraten, ihm den sittlichen Inhalt
eingegossen, es beredt gemacht. Der Feldzug rollte noch. Görres pflanzte
Sinn und Ziel des Krieges wie eine Standarte auf. Er legte die Bewegungen
der verbündeten Heere aus. Und ein Prophet, der er immer war, sagte er
voraus, was geschehen müsse oder kommen werde. Unerhörtes geschah. Die-
ser eine Mann stählte vor schwierigen Lagen den Heerführern und Staats-
männern die Nerven. Er steckte ihre Herzen mit seinem eigenen Starkmut
an. Görres hat diesem Kriege den gerechten Sinn erhalten, als die Fürsten
über den ursprünglichen Schwung des Volkes wieder Herr zu werden be-
gannen. Die Rheinbundfürsten hatten ein zu schlechtes Gewissen, als daß
sie diese Stimme zu ihren Völkern dringen lassen konnten. Schon im Som-
mer 1814 wurde der „Merkur" in Baden, Württemberg, Baiern verboten.
Als sich Görres schließlich gegen die „Reaktion" in Preußen wandte, wurde
es am 3. Jänner 1816 eingestellt und Görres aus der Leitung des rheinischen
Schulwesens entlassen. Görres wollte ein deutsches Blatt. Ein preußisches zu
schreiben, verschmähte er.

Görres Aber er schwieg nicht. Sein Haus in der Koblener Schloßstraße war da-
in Koblenz mals der Mittelpunkt des Rheintales. Ihm war die Presse genommen. Also
fuhr er mit Flugschriften fort. „Teutschlands künftige Verfassung" 1816 ver-
warf den Bundesgedanken und verlangte ein einheitliches Kaiserreich. Die
Bluttat an Kotzebue zu verantworten, das schob er 1819 dem Rückschritt zu
mit dem Aufsatz „Kotzebue und was ihn gemordet". In die Stimmung, die
Wartburgfest und Karlsbader Beschlüsse erzeugt hatten, schlug 1819 die
Schrift „Teutschland und die Revolution". Da wird den deutschen Fürsten

ein böser Sündenzettel seit dem Wiener Kongreß vorgehalten: die ver-
pfuschte Bundesverfassung, Verfolgung der Jugend, nichts gelernt und nichts
vergessen. Die Schrift gipfelt in dem verwegenen Satze: „Revolutionen sind
wie der Tod, vor dem nur Feige zagen, mit dem aber nur die Frivolität zu
spielen wagt. So furchtbarer Bedeutung sind diese Katastrophen in der Ge-
schichte und so ernsten Inhalts, daß nur Verrückte oder Verzweifelte sie her-
beiwünschen mögen. Eine Staatsumwälzung kann einzig das Werk der Lei-
denschaften sein." Die Schrift war ein europäisches Ereignis. Der König be-
fahl, ohne richterliches Urteil, sofortige Verhaftung. „Ich will kein Narr
sein, daß ich mich diesen Polizeischinderknechten zum Abmergeln in die
Hände gebe." Am 9. Oktober 1819 überschritt Görres das Grenzflüßchen, die
Lauter, und war am folgenden Tag in Straßburg.

Unerhört die Sprache, mit der er Frankreichs Schutzpflicht anrief. Er
wurde wie Großmacht behandelt. Der französische Minister des Innern be-
antwortete seine öffentliche Erklärung mit einer eigenen Note. Den franzö-
sischen Wirt zu schonen, setzte Görres auf einem Aargauer Zwischenauf-
enthalt 1821 den Kampf gegen Preußen fort: „In Sachen der Rheinprovinz
und in eigener Angelegenheit." Und in Straßburg 1822: „Die heilige Allianz
und die Völker auf dem Kongreß zu Verona." Die wichtigste Schrift der Zeit,
„Europa und die Revolution", war gleichfalls in Aarau geschrieben und 1821
gedruckt. Görres zwang sich, vorsichtig über Frankreich und die französi-
schen Parteien zu sprechen. Trocken erklärte er, der Aufruhr werde die Um-
reise halten um ganz Europa. Er verlangte ein starkes Königtum. Er sprach
sich für Kirche und Papsttum, für Adel und ständische Verfassung aus. Die
Schrift bot einen großartigen staatsbürgerlichen und religiösen Rundblick
über die Entwicklung der Menschheit und sie zog Schlüsse auf die Zukunft.
Die Reformation erklärte Görres jetzt für den „zweiten Sündenfall", wies
aber die große Schuld noch immer der Mittelalterlichen Kirche zu. Kein Zwei-
fel: Görres näherte sich mit beschleunigten Schritten wieder der römischen
Kirche. Dahin wiesen seine geschichtlichen Arbeiten. Er sammelte in Straß-
burg und in der Schweiz für altdeutsche Literatur, und Stein hörte seinen
Rat bei Gründung der „Monumenta". Er veröffentlichte zum Thronwechsel
in Baiern 1825 das Manifest: „Der Kurfürst Maximilian I. an den König
Ludwig von Baiern bei seiner Thronbesteigung." Da hieß es: „Sei ein
christlicher Fürst, Säule zugleich dem Glauben und Schützer der Geistes-
freiheit, und dein Beispiel möge die Zeloten von zweierlei Art verstummen
machen." Ludwig I. verstand diesen Anruf wie Ludwig II. den Richard
Wagners. Der Fürst rief Görres 1826 an die Münchner Hochschule.

Die geschichtliche und natürliche Hauptstadt der Rheinlande war Köln. Die Stadt hatte im Chor der deutschen Dichtung die Jahrhunderte her eigentlich nur Pausen gehabt. Bei dieser Partitur blieb es. Doch mit dem Sinn für die alte Kunst war auch die Liebe zur alten Literatur erwacht. Dafür standen jetzt drei Kölner Zeuge. Dem Heidelberger Schüler Eberhard von Groote, 1789 bis 1864, war zum guten Teil die Rückgabe der geraubten Kunstschätze zu danken. Er gab 1816 das „Jahrbuch für Freunde altdeutscher Zeit und *Kölner* Kunst" heraus. In deutschkundlichen Arbeiten nahm er sich der älteren Köl-*Deutschkunde* ner Literatur an. Johann Matthias Firmenich-Richartz, 1808 bis 1889, wußte hübsche Volkslieder zu reimen und in mehr als einer Sprache zu dichten. Dieses Vermögen, in vielen Zungen zu reden, begabte ihn zu dem eigenartigsten Werke. Unter Mitwirkung vieler Gelehrter stellte er Dichtungen und Sagen aller deutschen Sprachen zu der großartigen Anthologie der deut-*„Germaniens* schen Stämme und Mundarten zusammen: „Germaniens Völkerstimmen" *Völkerstimmen"* 1846/1866, in drei großen Bänden. Jakob Grimm und Gottfried Herder rief er als Zeugen an. Dreihundertundfünf Mundarten sind vertreten in Dichtungen aller Art, in Sagen, Märchen, Volksliedern, in Denkmälern der aufblühenden kunstmäßigen Mundartliteratur. Johann Wilhelm Wolf, 1817 bis 1855, ging in die Tiefe, wo Firmenich in die Weite gestrebt hatte. Wolf sammelte nach Jakob Grimms sagengeschichtlichen Grundsätzen, was er auftreiben konnte. Er schuf der flämischen Bewegung die Zeitschrift „Wodana" und leitete sie seit 1843 in Gent. Er gründete 1845 ein zweites Blatt, „De Broederhand". Zur Pflege der Legende gründete er 1852 die Volksbücherei „Katholische Trösteinsamkeit". Und 1853 machte er die „Zeitschrift für deutsche Mythologie und Sittenkunde" auf. Sein Sinn war auf den einen Mittelpunkt gerichtet: „Die heilige Kunst feiert neue Triumphe, und von dem ewigen Dome Kölns aus fliegen fruchtbare Samenkörner in alles deutsche Land."

Teile Preußens Arithmétique politique am Rhein lief darauf hinaus, Köln zu *und herrsche* dritteln und was herauskam über das ganze Land zu verteilen. Die Regierung kam nach Koblenz, die Universität nach Bonn, die Kunstakademie nach Düsseldorf. Und von diesen drei Punkten aus sollten die Rheinlande geistig in den preußischen Großstaat eingegliedert werden.

Hochschule Zu Bonn wurde 1818 die neue preußische Universität gestiftet. Miß-*Bonn* trauisch und zögernd setzte Preußen den einzigen berufenen Mann nach Bonn, den es aufzubieten hatte, Ernst Moritz Arndt. Die Geschichte stellt die großartigsten Schauspiele. Arndt zu Bonn und Görres zu Koblenz, Dioskuren der deutschen Einheit und Freiheit, Zwillingsbrüder ihres preußischen Schick-

sals. Görres zur Seite, gab Arndt 1815 in Köln zwanglose Hefte, das Blatt „Der Wächter" heraus, wie Stein, Solms, Görres den Habsburgern die Kaiserkrone zuwünschend. Freilich forderte Arndt in der gleichzeitigen Schrift „Über Preußens rheinische Mark" für Preußen die Vorhand im Schutz der Westmark gegen Frankreich. Als gewaltiges Gegenstück zu Görres' „Deutschland und die Revolution" schrieb Arndt seinen vierten Teil „Geist der Zeit". *Arndts Flugschriften* Er setzte den Fürsten das Recht des mündigen Volks entgegen. Er rief nach dem freien Volksstaat. Er forderte Preßfreiheit, Turnen, Pflege von deutscher Sprache und Art. Im Jänner 1819 ließ ihn der König darob verwarnen, weil das Buch Dinge enthalte, „die besonders einem Lehrer der Jugend übel *Bonner Wissenschaft* anstünden". Sein Haus wurde durchsucht. Im November 1821 wurde er seines Amtes enthoben, nach qualvoller Untersuchung für schuldlos befunden, ohne daß man ihn freizusprechen wagte. Bei solcher Lage konnte es der Hochschule nicht gelingen, Macht über das Leben zu gewinnen. Sie verschloß sich in jene Forschung, von der weder Staat noch Kirche unmittelbar berührt wurden. Literatur und Kunstgeschichte lehrte August Wilhelm Schlegel, seinem Ruhm langsam nachsterbend [sein Ruhm ist schon vorher gestorben und nun stirbt er ihm physisch nach]. Die indische Altertumswissenschaft schuf der Norweger Christian Lassen, die Sprachvergleichung August Schleicher, die romanische Sprachwissenschaft Christian Friedrich Diez. Zu Barthold Georg Niebuhr, der in lockerer Verbindung mit der Universität über alte Geschichte und Länderkunde las, rückten dann mit einer freieren Zeit die Rankeschüler Heinrich Sybel und Friedrich Christoph Dahlmann ein.

Rheinische Dichtung war nicht, was zu Köln oder Düsseldorf getrieben *Bonner Dichtung* wurde, sondern was zu Bonn die vereinigten Häuser Kaufmann-Simrock-Kinkel pflegten. Hier lebte die feine rheinische Bildung des achtzehnten Jahrhunderts fort und hier verschmolz sie mit dem Zugewinn aus der neuen Hochschule. Die Häuser Kaufmann und Simrock beerbte schließlich der Kreis Kinkel, in dessen Mitte die trefflich gebildete Frauenvorkämpferin stand, Johanna Kinkel, seit 1843 die Gattin des Dichters. Ihr Einfall war der „Maikäferbund", der seit Sommer 1840 ein handschriftliches Wochenblatt herumgab. Aus dieser Umwelt wuchs eine eigentümliche rheinische Dichtung heraus. Der Bonner *Karl Simrock*, 1802 bis 1876, ein Schüler Arndts, Schlegels, Lachmanns, hielt zu Bonn behaglich Haus, übersetzte handwerksmäßig beinahe die gesamte mittelalterliche Dichtung und legte sich mit dem gleichen Fleiß auf eigene Gedichte. Er pflegte das Gesellschaftslied, die geschichtliche Ballade, den holzschnittmäßigen Schwank, urwüchsige Kernsprüche, Knittelverse. *Gottfried Kinkel*, 1814 bis 1882, aus Oberkassel, doch von hessischer

Herkunft, stammte aus einer zwiespältigen Ehe. Der Vater dichtete in Gellerts Art. Der Mutter, einer pietistischen Wuppertalerin, waren Dichtung und Bühne Teufelswerk. Zwischen diesen Gegensätzen schwankte Kinkel von einer weltverachtenden Theologie zu einer weltfreudigen Kunstwissenschaft. Wie Herwegh, wie Dingelstedt, wie die übrigen Hessen war er zum *Gottfried und* *Johanna Kinkel* Meister des Prosawortes berufen. Ohne allen Wert sind die Dramen seiner Bonner Zeit. In „Gedichten" 1843 war er ein Leitartikler in Reimen. Nur die Todeserwartung zu Rastatt gab ihm die erlebten Verse „Vor den achtzehn Gewehrmäulern" ein. Kinkel war der Mann der damaligen Modeform, des „lyrischen Epos" von „Otto der Schütz" 1843 bis zu der schönen altgriechischen Künstleridylle von 1882 „Tanagra". Unter den beiden Gatten war nicht der Mann, sondern die Frau der lobwürdige Dichter. In den gemeinsamen „Erzählungen" 1849, worunter die sozialistischen „Heimatlosen", die rheinische Dorfgeschichte „Margret", der prächtige „Hauskrieg", stammt das Wertvollste von Johanna. *Alexander Kaufmann*, 1817 bis 1893, der das Kleingetriebe der drei Häuser in allen Tönen besang, spielende Abart dieser idyllischen Rheinwelt, hat es erst später zu ernsteren Leistungen gebracht.

Stil *der rheinischen* *Dichtung* Der Stil dieser Dichtung war Ausdruck einer kameradschaftlichen Geselligkeit, die Kunst und Natur, Natur und Geschichte, Geschichte und Gegenwart, die Mensch und Natur und Geschichte, die alle drei Künste der Sprache, der Töne, der bildenden Hand verschwisterte. Ein Stil, so gelöst, daß er im Gesange mitschwingen konnte, und körperhaft genug, um Zeichnung und Gemälde zu werden. „Epischlyrisch" ist nur ein matter Wortzwitter, der die Einheit und Gemeinsamkeit der Lebensformen und Künste nicht zu treffen vermag. Dieser Stil ist im überschnittenen Lebensbereich der Kunststadt Düsseldorf und der Hochschulstadt Bonn aus Künstlerschaft und Studententum gefunden worden, nicht ohne Einverständnis von Rheinfranken und Mainfranken. Alexander Kaufmann setzte sein reiferes Leben an Übersetzung und Deutung des altrheinischen Geschichtenbuchs des Caesarius von Heisterbach. Er legte in den Spuren Simrocks und mit Daumer zusammenarbeitend sein episches Vermögen in der „Mythoterpe, ein Mythen-, Sagen- und Legendenbuch" 1858 an. Sagen aus dem Slawischen, Nordischen, Spanischen hat er für dieses Buch übersetzt oder umgegossen. Der Pfälzer Gustav *Wolfgang* *Müller von* *Königswinter* Pfarrius hatte mit seinem „Karlmann" schon 1844 ein solches lyrisch-episches Gebilde gegeben. Wolfgang Müller aus Königswinter, in Düsseldorf unter Malern erzogen, in Bonn Genosse der Simrock und Kinkel, hat diesen rheinischen Stil am vollkommensten und liebenswürdigsten in seinen frohen Versen ausgegossen, deren keiner die Doppelkunst des Wortes und der Pa-

lette verleugnet. Er begann 1846 mit dem epischen Gedicht „Rheinfahrt" und hat dann die Melodie in allen Tonlagen durchgespielt: 1851 als Rheinsagenbuch „Lorelei", 1852 als Dorfgeschichte in Versen „Die Maikönigin", 1854 als Mitsommerabendmärchen „Prinz Minnewein", 1854 als rheinische Kleinstädtergeschichte „Der Rattenfänger von St. Goar", 1853 als Heldenlied „Johann von Werth". In Speier förderte Oskar von Redwitz seine „Amaranth" 1849 und der rheinverwandte Franzose aus dem deutschen Osten, Otto Roquette, empfing für „Waldmeisters Brautfahrt" 1851 Stimmung und Laune zu Heidelberg. Der Triumph dieses rheinischen Stiles hieß dann Josef Viktor Scheffel. *Redwitz, Roquette,*

Zu Düsseldorf im Schlosse wurde von Preußen die Kunstakademie erneuert. In der Leitung wurde 1825 der Düsseldorfer Peter Cornelius von dem Berliner Wilhelm Schadow abgelöst. Der brachte viele seiner Schüler mit. Der Danziger *Robert Reinick* verkörpert mit seinen „Liedern eines Malers", Düsseldorf 1838, Inbegriff und Ergebnis dieses rheinisch-preußischen Austausches im Zeichen der Romantik. Und es war ein Danziger, *Karl Schnaase*, 1798 bis 1875, der zu Düsseldorf aus dem Zusammenleben mit der Kunst die Kunstgeschichte geschaffen hat. Ihm wiederholte sich auf einer Reise durch Holland das Erlebnis, das einst auf der gleichen Reise der andere Danziger, Georg Forster, gehabt hatte. Und wie Forster mit seinen „Ansichten vom Niederrhein" 1791, so gab Schnaase 1834 mit „Niederländischen Briefen" Kunde von seinem Erlebnis. Es war die erste Urkunde der neuen Wissenschaft. Schnaase suchte, indem er die Kunstwerke aus den geschichtlichen Bedingnissen und dem waltenden Volksgeiste begriff, die innere Einheit der Kunstentwicklung darzutun. Aus Vorträgen im häuslichen Kreise erwuchs seine „Geschichte der bildenden Kunst" 1843/1864, sieben Bände bis zum Ausgang des Mittelalters. Für Franz Kugler war Kunstbetrachtung eine Formfrage. Schnaase sucht die Erscheinungen der Kunst „aus den physischen und geistigen, sittlichen und intellektuellen Eigentümlichkeiten der Völker abzuleiten und den Prozeß der Durchdringung des Kunstlebens mit den sonstigen Lebenselementen aufzuzeigen". Er ging den Weg, den Winkelmann und Herder gewiesen hatten. Das Werk war in der edlen Haltung seines Stiles eine ruhmwürdige Leistung. Es war das Werk eines Selbstbildners. Denn Karl Schnaase war höherer Gerichtsbeamter. Er gehört zu den an den Rhein versetzten preußischen Beamten. Preußen und die Rheinlande hatten in diesem Falle davon die Schöpfung der Kunstgeschichte. *Die Düsseldorfer Akademie* *Von Forster zu Schnaase* *Kunstgeschichte*

Zu den an den Rhein versetzten preußischen Beamten, und richterlichen Standes wie Schnaase, gehörte *Karl Immermann*, 1796 bis 1840, aus Magde- *Immermann in Düsseldorf*

burg. Bühnenverstand und Künstlersinn hatte er von der Mutter. Sein deut-
scher Ingrimm stammt aus dem Königreich Westfalen, zu dem Magdeburg
seit 1807 gehörte. Die Romantik hatte er von der Hochschule Halle, wo ihm
vor allem Arnims „Gräfin Dolores" zueigen geworden war. Von Ligny und
Waterloo, wo er als Jäger mitfocht, strömte sein gehaltenes vaterländisches
Gefühl. Aus der Wirrnis seines Herzens hatte er 1822 seinen ersten Roman
entwickelt, „Die Papierfenster eines Eremiten", eine bunte Briefdichtung.
In Magdeburg hatte er sich 1825 mit der Novelle „Der neue Pygmalion"
versucht. Er war in Heines Schlingen geraten und gab mit seinen hergelie-
henen Spottgedichten in dessen zweitem Teil der „Reisebilder" unmittel-
baren Anlaß zu dem unwürdigen Streit mit Platen. Und so war er gezwun-
gen, 1829 auf dessen „Romantischen Ödipus" mit der Schrift zu antworten:
„Der im Irrgarten der Metrik umhertaumelnde Kavalier". Sie bestand aus
einer ernsten kritischen Abhandlung und zweiundzwanzig parodistischen
Gedichten, fein und sauber, aber künstlerisch matter als Platens „Ödipus".
Das komische Heldenepos „Tulifäntchen" war schon 1820 geplant. Es zielte
wohl auf Fouqué, entrollte sich aber zu einer allgemeinen Zeitsatire, der
feinsten und zierlichsten, die in deutscher Sprache zu lesen ist. Immermanns
Lebenswende wurde Düsseldorf. Immermann war 1819 Auditor in Münster,
1823 Strafrichter in Magdeburg, Arbeitsräume, von denen der Dichter nicht
viel hatte. Da wurde er 1827 nach Düsseldorf versetzt. In diesem Wirbel von
Jugend, Übermut, gelebter Poesie wurde er noch einmal jung. Das war viel.
Das größte aber war, daß ihm diese preußisch-rheinische Kulturdichtung vor
eine ebenbürtige Aufgabe stellte.

Kleine Dichtung (margin, left of "henen")

Diese Aufgabe hieß Bühne und also Drama. Noch am Gymnasium hatte
sich Immermann ein Lieberhabertheater eingerichtet. In seiner Hochschul-
zeit zu Halle genoß er mit Entzücken die Gastspiele der Weimarer Truppe.
Von seinen dramatischen Jugendarbeiten folgte „Das Tal von Ronceval"
Tieck, „Edwin" aber Shakespeare. Beide behandelten Rechtsfragen. Eine
gewisse Vorhöhe wurde in drei Absätzen erreicht. Das Trauerspiel „König
Periander und sein Haus" 1823 suchte in Kleists Art den Stil der Antike und
Shakespeares zu verschmelzen. „Cardenio und Celinde" 1826, Gryphius
nachgedichtet, zeigte sich schon überraschend bühnenfügsam. „Das Trauer-
spiel in Tirol" 1827, in einem Geist von Schillers „Wilhelm Tell" und Kleists
„Hermannschlacht", die Stimmung von 1813 und 1830, erwies Immermanns
theatralische Sendung. Ähnlich wie Gutzkow war er nun des Glaubens, den
Deutschen könne nur mit dem Familiengemälde und noch nicht mit der hel-
disch staatsbürgerlichen Tragödie gedient werden. Schon dem Hohenstufen-

Immermanns Dramen (margin, left of "Shakespeares")

drama „Friedrich II." hatte er das Gesicht nach der Seite der Familientra- *Der Spielleiter Immermann*
gik gewendet. Und diese Wendung ging am weitesten in der letzten Arbeit,
der Trilogie „Alexis" 1831, mit den Teilstücken „Die Bojaren", „Das Gericht
von St. Petersburg", „Eudoxia". Görres faßte den Sinn dieses Kunstwerkes
in den Satz: „Der Dämon des Verstandes und der Aufklärung wird durch
die Natur besiegt." Was als Kampf zwischen Vater und Sohn erscheint, ist zu-
gleich Widerstreit zwischen Helden und unheldischer Masse. Hier spricht
der von 1830 Enttäuschte.

Der Umbau der armseligen Düsseldorfer Bühne gab Immermann das Stich- *Die Düsseldorfer Bühne*
wort. Im Herbst 1832 gründete er einen Theaterverein und gab zu Werbe-
zwecken einige geschlossene Vorstellungen. Am 1. Februar 1833 fand mit
„Emilia Galotti" die erste Musteraufführung statt. Die zweite brachte, von
Üchtritz eingerichtet, ein Lustspiel Schröders. Die dritte zeigte Calderons
„Standhaften Prinzen". Es gab großen Beifall. Im Winter auf 1833 hielt
Immermann zugleich dramatische Vorlesungen, mit klangvoller Stimme und
bei spärlichen Gebärden durchs Auge hinreißend. Diese Bühne wurde
unter Immermanns Leitung Stadttheater und am 28. Oktober 1834 mit dem
„Prinzen vom Homburg" eröffnet. Man spielte Shakespeare, Goethe, Schil-
ler, Tieck und ausnahmsweise Immermann. Einige Hilfe fand Immermann
durch seinen Gast und Schützling Grabbe. Man gab Gastspiele in der reichen
Fabrikstadt Elberfeld. Immermann rang vergeblich um den Dauererfolg.
Aus Mangel an Mitteln mußte am 31. März 1837 mit Halms „Griseldis"
geschlossen werden. Immermann wollte eine Dichterbühne, Zusammenspiel,
ein Sprechtheater. Er versuchte eine großzügige Erneuerung von Goethes
Weimarer Bühnenkunst. Das ostdeutsche Ringen der Zeit um einen großen
Theaterstil spielte sich mit Tieck, Gutzkow, Wagner an der Dresdner, mit
Immermann an der Düsseldorfer, mit Laube an der Wiener Bühne ab.

Drei große Dichtungen nahmen den Ertrag dieses beklagenswert kurzen
Lebens auf.

„Merlin", den altfranzösischen Roman, hatte Immermann schon als Kind „*Merlin*"
in der Übersetzung Dorothea Schlegels kennengelernt. Tieck 1829 und Ro-
senkranz 1830 erfrischten Immermanns alte Neigung. Im Frühjahr 1831 be-
gann er das Drama auszuführen. „Mein Satan ist nicht der Mephistopheles,
der böse Lakai Gottes, er ist der alte berechtigte Titan, dem Unrecht ge-
schehen, und etwas vom gnostischen Demiurgos." Die Dichtung wurde 1832
abgeschlossen und gedruckt. Belanglos sind die Einflüsse von Goethes
„Faust" her. Entscheidend ist der Einschlag der Romantik. Merkwürdig Ge-
meinsames zielt auf Brentanos „Romanzen vom Rosenkranz". Immermann

ging von Hegels Gottgeist aus, der sich zur Vielheit der Erscheinungen ent-
faltet. Dieser Gottgeist ist Satan, insofern er in die Vielheit eingeht. Darum
ist er Weltbildner, Demiurgos. Der göttliche Geist zerbricht sich, wenn er
Erscheinung wird, an diesem Erscheinen. Immermann hat die Metaphysik
Hegels an diesem Merlin, der, ein Sohn des Teufels und einer Christin, der
Widerchrist des Gottessohnes sein sollte, zum Mythus verwandelt. Erst nach-
träglich und nicht überzeugend hat Immermann diesen weltlichen Heiland
zu einem Bekehrten Gottes umgedeutet. „Merlin" ist insofern ein Wider-
faust, als Immermann die Tragik in den Gottschöpfer verlegte, Goethe in
das Menschengeschöpf. Immermanns Tragik rollt von Gott weltwärts, Goe-
thes Tragik steigt vom Menschen gottwärts.

Zeitromane Dem innern Widersinn als dem Unheil der Welt ging Immermann mit
zwei epischen Schöpfungen nach, indem er — nach Hebbels Tagebuch — in
der einen die ernsthaften Richtungen der Zeit abspiegelt, soweit sie sich
fratzenhaft darstellen, und in der andern die fratzenhaften, die sich ernsthaft
gebärden.

„Die Epigonen" „Die Epigonen" 1836 sind aus sehr frühen Entwürfen seit 1822 über ein
humoristisches Vorhaben zu einem Zeitroman herangediehen. Immermann
selber fühlte sich im Widerspruch zu seiner Zeit, die Zweideutigkeit ihrer
Zustände, den Unsegen der Nachgeborenen, die „Buhlschaft mit geputzten
Leichen". Dies zerspaltene Wesen wurde ihm gegenwärtig in dem Kampf
zwischen Industrie und Grundadel. Er hatte ihn um Magdeburg und in der
Grundadel Altmark beobachtet. Er fand ihn am Rhein wieder. Er fand, der Adel hätte
und
Industrie das bürgerliche Leben zerrüttet und der dritte Stand führe jetzt mit seiner
Waffe, dem Geld, gegen den Adel einen kaltblütigen Vernichtungskrieg.
Daraus „entspringen dritte, fremdartige Kombinationen, an welche niemand
unter den handelnden Personen dachte. Das Erbe des Feudalismus und der
Industrie fällt endlich einem zu, der beiden Ständen angehört und keinem".
Ungefähr so hatte das auch Arnim schon mit seinen „Kronenwächtern" ge-
meint. Immermanns Buch ist zeitgeschichtliche Quelle, spiegelt die Zustände
in voller Breite, arbeitet mit romantischem Werkzeug und fällt ins Ohr durch
seinen ungekünstelten „Meister"stil.

„Münchhausen" „Münchhausen" 1838 ist aus dem Kerngedanken der „Epigonen" als der
ursprüngliche humoristische Roman aufgegangen. Die innere Unwahrheit,
die Lüge, war für Immermann das wesentliche Merkmal des Epigonentums.
Zu dieser leibhaftigen Lüge machte der Dichter seinen Münchhausen, einen
Abkömmling jenes durch Raspe und Bürger berühmt gewordenen Helden.
Dieser Dämon der Lüge ist fast ein verzerrter Zwilling jenes Satan Demi-

urgos. Denn er ist ein schöpferischer Lügner, der eine Welt, die in Einbildungen lebt, um sich aufbaut, sie durchsonnt und bewegt. Wie im Wiener Volksstück hat der phantastische Münchhausen in Karl Buttervogel den nüchternen Diener zur Seite — das Verhältnis Don Quixotes zu Sancho Pansa — und dem phantastischen Schloß Schnick-Schnack-Schnurr ist die gesunde Wirklichkeit des Schulzengutes Oberhof entgegengestellt, dem Sinnbild des *Der Oberhof* modernen Zeitgeistes das Wahrzeichen der versinkenden Zeit. Parodistisch ist die ganze Anlage des Buches, das verwickelte Einschachteln, der Briefwechsel zwischen Dichter und Buchbinder, das handelnde Auftreten des Dichters an der Schwelle des Ausganges. So decken sich die beiden Romane wie das Positiv und Negativ eines Lichtbildes. Und dieses Lichtbild ist eine astronomische Fernaufnahme der metaphysischen Sterngruppe, in der „Mer-Ludwig Börne aus Frankfurt gegen Karl Marx aus Trier?

Düsseldorf, das war die preußische Welt am Rhein gegenüber der rheinischen in Bonn. Für Köln war nichts übriggeblieben. Nur sein Dom war nicht durch drei teilbar. Den nahm nun Preußen als Ganzes in seine rheinische Arithmétique politique auf. Sulpiz Boisserée hatte den Dom gründ- *Das unteilbare* lich vermessen. Er war die treibende Kraft aller derer, die das Bauwerk in *Köln* seiner ursprünglichen Schönheit wiederherstellen und vollenden wollten. Endlich, am 2. September 1842, konnte das Fest der Grundsteinlegung ge- feiert werden. Der neue Preußenkönig Friedrich Wilhelm IV., umgeben von *Kölner Domfest* einem Schwarm deutscher Fürsten, begrüßte in einer seiner schönsten Reden die Tore, zu denen er den Grundstein legte, als Tore einer neuen, besseren Zeit, durch die niemals Zwietracht zwischen Fürsten und Völkern, zwischen den Bekenntnissen und den Ständen einziehen möge. Der Dom zu Köln war eine politische Losung geworden.

Wie hatte sich der Wind gedreht. Der preußische Staat, der am Rhein vordem auf Görres und Arndt, auf den Widerstand der Kirche und eines selbstbewußten Volkstums gestoßen war, sah sich jetzt 1840 dem Pariser Bündnis zwischen der kommenden französischen und deutschen Revolution gegenüber. Hatte es eben noch am Rhein die Grundsätze seiner Verwaltung zu verteidigen gehabt, so ging es jetzt um seinen Bestand, sei es zu Gunsten einer gemeindeutschen Republik, sei es auf Rechnung des Arbeiterstaates *Rheinische* der Zukunft. Denn was bedeuteten noch Heinrich Heine aus Düsseldorf und *Fronten* Ludwig Börne aus Frankfurt gegen Karl Marx aus Trier!

Was aber geschah unter dem neuen romantischen König Friedrich Wil- *Der romantische* helm IV. zu BERLIN? Es war eine schöne Gebärde der Dankbarkeit, wenn *Hof* der neue König in seiner Nähe jenen Männern ein Ausgedinge gewährte,

deren Werk die zeitgenössische Bildung Preußens mitbegründet hatte. Nur
wenige waren am Leben, um noch geehrt zu werden: Tieck, Fouqué, Schel-
ling; von den jüngeren Rückert und im Bereich der Hochschule die Brüder
Grimm. Der Aushauch des romantischen Geistes und allerlei Zuschuß aus
den wechselnden Strömungen der Zeit schlugen sich in der Kunstgeschichte
nieder. Sie waren das Sammelbecken des künstlerischen Willens der Stadt.
In sie ging das beste Wollen des Königs ein. Diese Männer wurzelten per-
sönlich alle in der Romantik, viele in den Gedanken Hegels. Neben Tiecks
Neffen Gustav Friedrich Waagen, dem Leiter der Galerie, und Karl Schnaase,
der seit 1848 in Berlin wirkte, der dritte Mitbegründer der wissenschaft-
lichen Kunstgeschichte — alle drei Niedersachsen — war der Stettiner Franz
Berliner *Kunstgeschichte* Kugler. Er kam von der Germanistik und lehrte seit 1833 an der Hochschule
Kunstgeschichte. Er hat in seiner „Pommerschen Kunstgeschichte" und in
den „Baltischen Studien" die erste Wesensformel des gotischen Stils der
norddeutschen Ebene gefunden. Sein „Handbuch der Geschichte der Ma-
lerei" 1837 war die erste Gesamtdarstellung und das zumeist aus dem Eigen-
Franz Kugler *und sein Haus* erwerb seines Auges. Kugler hat durch persönlichen Umgang und sein gast-
freies Haus unübersehbaren Einfluß auf das heranwachsende Geschlecht
ausgeübt. Aus seiner geistigen Umwelt ist Paul Heyse aufgestiegen. Wil-
helm Lübke, Emanuel Geibel, Jakob Burckhardt, Gottfried Keller und wie
viele sonst sind durch sein Kraftfeld gegangen. Kugler war die Binnengestalt
des neuen Berlin, und da dies ganze norddeutsche Geschlecht einmal von
Berlin berührt wurde, auch eine der Binnengestalten des aufsteigenden alt-
sächsischen und wendensächsischen Neulebens.

Dieser kunstwissenschaftliche Betrieb war das Klima, das eine vaterlän-
dische, brandenburgisch-hohenzollerische Kunst herangedeihen ließ. Dazu
gehörte manche Vorbedingung. Ludwig Erk von Wetzlar, die hessische Dop-
pelerscheinung zu den Brüdern Grimm, am Berliner Seminar für Stadtschulen
Märkische *Heimatkunst* tätig, gab dem Volksgesang mit seinen Sammlungen „Die deutschen Volks-
lieder" 1838, „Singvögelein" 1842, „Deutscher Liederhort" 1856 die herbe
Anmut wie Würde seines Ursprungs wieder und führte ihn in Schule, Haus
und Leben zurück. Der Neumärker Albert Kuhn erschloß mit Sagenbüchern
der schaffenden Dichtung anschauliche Lebensfülle. Der Berliner Karl Fried-
rich von Klöden machte die Brandenburger Ortsgeschichte lebendig. Er
speiste die ganze märkische Literatur bis zu Fontane und Wildenbruch. Der
Berliner Ludwig Schneider, Schauspieler und Geschichtenerzähler des Kö-
nigs, brachte diese märkische Literatur in Aufnahme und sicherte ihr mit
seiner Zeitschrift „Der Soldatenfreund", seit 1833, breite Lesermassen.

Diese märkische Kunst, in der Dichtung wie in der Malerei ist, so gehörte es sich, die Schöpfung zweier Schlesier.

Der Breslauer *Wilhelm Häring*, 1798 bis 1871, ein Freiwilliger von 1815, hatte die romantische Überlieferung der Stadt aus erster Hand. Seine Novellen haben den Stil Ludwig Tiecks. Dann übertrug er den Historienstil Walter Scotts auf märkische Stoffe. Er hat in seinen Romanen alle Zeitwenden Brandenburgs abgehandelt: 1832 „Cabanis", 1840 „Der Roland von Berlin", 1842 „Der falsche Waldemar", 1846 „Die Hosen des Herrn von Bredow", 1848 „Der Werwolf", 1852 „Ruhe ist die erste Bürgerpflicht", 1854 „Isegrimm". An schwierig verschlungenen Romanhandlungen wird das ganze Innengefüge eines Zeitalters sichtbar gemacht. Das fein behandelte Gespräch nahm schon Fontanes Bestes vorweg. Die Höhen der Handlung werden dramatisch aufgegipfelt. So wird erschütternd in „Bredow" Lindenberg, indem er von dem überfallenen Krämer erkannt wird, aus höchster Ehre jäh in tiefste Vernichtung gestürzt. Aber es fehlt auch an üblen Theaterworten nicht und an Schleichwegen über die Hintertreppe. Sprachpatina wird höchstens dem Satzbau und nur selten den Worten aufgelegt. Härings Sachlichkeit und die Bildkraft seiner Vorstellung haben aus Geschichte, Land, Volk der Mark, das erste Kunstwerk gemacht. Rings um Häring schlug ein weiter Markt seine literarischen Buden auf.

Der Geschichts-roman

„Ruhe ist die erste Bürgerpflicht"

Aus dem „Berliner Sonntagsverein", den Moritz Saphir 1827 gegründet hatte, wurde in wenig Jahren die Sammelstätte des romantischen und vaterländischen Berlin: „Tunnel über der Spree." „Liberal mit Anlehnung an Rußland" hat Fontane die Gesinnung genannt, die da herrschte. Gesellschaftliche Unterschiede galten nicht. Politik war verboten. Man las, lobte und rügte. Der ganze Betrieb spielte sich unter einem Schleier von Laune und Festen ab. Dieser Verein trieb das märkische Staatsbewußtsein in den Blutkreislauf der Kunst und färbte sie bis ins feinste Geäder geschichtlich hohenzollerisch. Den Ton gab Moritz Graf Strachwitz an. Sein „Herz von Douglas" wurde Leitstil des Tunnels in seiner besten Zeit. Hier las der Anekdotenkünstler Hugo von Blomberg; der gerissene Fadenspinner Heinrich Smidt; Franz Kugler, aller Künste Meister, dessen Lieder aber zu vornehm gemessen, dessen Novellen zu akademisch empfunden wurden; Friedrich Eggers mit seinen schottisch-englischen Balladen; Wilhelm von Merckel, der das berühmte Lied reimte „Gegen Demokraten helfen nur Soldaten"; Bernhard von Lepel mit seinen Oden und Hymnen im Platenstil; Christian Friedrich Scherenberg mit seinen vorsichtig ausgewählten, doch geräuschvollen Wortsymphonien über preußische Schlachttage wie „Ligny" oder „Leuthen"; Theodor Fon-

„Tunnel über der Spree"

tane, der Zeitungsmann, Kriegsberichterstatter und Mann der klassischen „Wanderungen durch die Mark Brandenburg" 1862, der Meister der geschichtlichen Kurzgeschichte und schottischen Ballade, der Inbegriff des ganzen Berliner Tunnels.

Das preußische Geschichtsbild

Der Breslauer *Adolf Menzel*, 1815 bis 1905, hat, was der Tunnel dichtete, zum Bilde gemacht. In der Dreiheit der großen ostmitteldeutschen Künstler folgte er auf den Deutschböhmen Josef Führich und den Meißner Ludwig Richter. Aus dem brotverdienenden Steinzeichner wurde früh der gestaltende Künstler. Seine Holzschnitte zu Franz Kuglers Buch über Friedrich II. machten ihn berühmt. Nachdem ihm im „Tunnel" die brandenburgisch-hohenzollerische Dichtung zu Gehör gekommen war, malte er in jenen acht Bildern 1850/1860 die Geschichte Friedrichs II. Die Verse Lepels haben 1854 den Eindruck getroffen, den Menzels „Überfall bei Hochkirch" machte. „Das nennt man einen Überfall / Von neuester Bekanntschaft! / Aufschrecken Porträt und Pferdestall, / Das Genre und die Landschaft." Menzel hat dann den Waffengang der Zeit mit Gemälden begleitet. Der Schlesier ist schließlich wie so viele seiner Landsleute in den Atemraum Österreichs zurückgekehrt, indem er aus Sommererlebnissen Täler weit und Höhen, „Jesuitenkirchen, Prozessionen, Straßenprospekte und Hochämter vor dem Allerheiligsten" malte.

Die Mitte der Mißvergnügten

Eine vornehme Gruppe von Mißvergnügten bildete die Mitte zwischen Rechts und Links. Für sie kann *Bettina von Arnim* stehen, die seit dem Tod ihres Mannes, 1831, in Berlin lebte und ein Haus machte. Von ihren vier Briefwerken zeigte sie „Goethes Briefwechsel mit einem Kinde" 1835 gegenüber Goethe; „Die Günderode" 1840 mit der Freundin; „Klemens Brentanos Frühlingskranz" 1844 mit dem Bruder; „Ilius Pamphilus und die Ambrosia" 1848 gegenüber Philipp Nathusius. In der Kunstweise dieser Briefdichtungen war 1843 das Werk gehalten, das ihren freiheitlichen Absichten dienen sollte: „Dies Buch gehört dem König." Diese Plaudereien in stark frankfurtisch gefärbter Sprache fordern Verfassung und Preßfreiheit, religiöse Freiheit und Vertrauen zwischen Fürst und Volk. Der Staat muß durch Erziehung retten, was er durch Strafe nicht vermag. Das letzte Werk dieser Art, „Gespräche

„Gespräche mit Dämonen"

mit Dämonen" 1852, ist das seltsamste. Es handelt über das Judentum. Den Kern bilden die Gespräche des schlafenden Königs mit seinem Dämon. Hier steht das Beste, was über Friedrich Wilhelm IV. gesagt worden ist. Fürst Pückler hat ihr einmal gesagt: „Beste Bettina — nicht überspannt, wenn ich bitten darf." Macht man das? Diese Frage gab es für Bettina nicht. Doch die seltene Frau hatte richtige „Zivilcourage". Ihre Teilnahme für das Volk und

ihre Begeisterung für die Freiheit waren ehrlich. Sie hütete in dieser Stadt Goethes reine Überlieferung und sie hat diese Pflicht an ihre Tochter Gisela und deren Mann Hermann Grimm weitergegeben.

Gegen den märkisch-hohenzollerischen Tunnel, gegen Häring, Fontane, Menzel stieg die Widerwelt der echten Linken auf, Wort und Bild wie auf der Gegenseite. Der Sprecher war der Berliner *Adolf Glaßbrenner*, 1810 bis 1876, durch seinen Vater ein Schwabe. Das erste Heft seiner Folge „Berlin wie es ist und — trinkt" wurde 1832 ausgegeben und bis 1850 sind daraus zweiunddreißig Hefte geworden. Gleichen Schrittes gingen 1835/1852 die dreizehn Hefte „Buntes Berlin". Der „Komische Volkskalender" kam seit 1846 heraus. All diese Schriften und andere kleine Hefte deutschten dem einfachen Mann zwischen 1830 und 1870 das verworrene Geschrei des Zeitalters aus. Doch er hatte Mühe. Von oben her sah man an ihm vorbei und die Linke selber nahm ihn nicht für voll. Doch Brennglas, wie er sich witzig zutreffend nannte, hat auf die Bewegung der Linken unberechenbar eingewirkt. Glaßbrenner hob die Berliner Volksgestalten aus: den Eckensteher, die Hökerin, die Köchin, den Fuhrmann, den Nachtwächter, den Guckkästner. Er zeigte das Volk bei seinem Vergnügen in Moabit, in Tempelhof, in den Puppenspielen. Der Bürger erscheint in seiner Werkstatt, Herr Buffey in der Zaruckgesellschaft und im Tugendverein. Der Guckkästner bot sich glücklich dar, um in rasch wechselnden Bildern deutsche und europäische Ereignisse vorzuführen. Und das alles in dramatischer Form, ansteigend von kleinen Szenen bis zu einem ganzen Lustspiel wie „Nante Nantino, der letzte Sonnenbruder, oder die Entstehung der norddeutschen Volkspoesie". Da ist Raimunds Art — Glaßbrenners Frau, eine Schauspielerin, war Schülerin Raimunds — wie überhaupt die ganze Folge „Berlin" unter Wiener Einflüssen steht. „Schöpfer der demokratischen Anschauungsweise des Berliner Bürgers", das ist mit den Worten von Karl Rosenkranz dieser Mann gewesen. Er wäre es nicht geworden ohne den begleitenden Stift eines überlegenen Meisters. Das war Friedrich *Wilhelm Hosemann*, 1807 bis 1875, aus Brandenburg, durch den Vater hessischer Herkunft. Von Haus aus Steinzeichner, hat Hosemann in Hunderten von Büchern den unvergleichbaren Zauber seiner Wasserfarben spielen lassen. Er fand sich 1834 mit Glaßbrenner zusammen und wurde nun zum verliebten Schilderer des einfachen Volkes, ein Maler der Bierkeller und Kegelbahnen. Zwei Männer aus oberdeutschem Volkstum, ein Schwabe und ein Rheinhesse, haben dem Berliner das demokratische Bewußtsein wecken helfen, es literarisch-bildnerisch geformt, Gegenspiel zu der junkerlich-hohenzollerischen Haltung des „Tunnels".

Die Linke

Berlin, wie es ist und — trinkt"

Die Zeit in Wasserfarben

Gesellschaft "Rütli" Die Gesellschaft „Rütli" hatte sich im Winter auf 1846 in der Bierstube Lauch der Werderschen Rosengasse gebildet, im wesentlichen eine schlesische Landsmannschaft. Der humoristische Kreis pflegte eine Rütlizeitung und legte eine zeichnerische Rütlimappe aus. Die meisten Mitglieder hielten zur äußersten Linken. Diese schlesische Landsmannschaft war der Fruchtboden des modernen Witzblattes, dessen erste Nummer am 7. Mai 1848 in den Straßen Berlins als „Organ für und von Bummler" ausgerufen wurde. Es war eine ostdeutsch-jüdische Gründung: der Breslauer David Kalisch, der Breslauer Ernst Dohm, der Breslauer Rudolf Löwenstein. Allgemeines Vorbild war der Londoner „Punch". Der „Kladderadatsch" wurde eine einflußreiche Stimme der öffentlichen Meinung. Sein Witz bestimmte das Urteil der Masse. „Die Wespen" des Hamburger Juden Julius Stettenheim und der „Ulk" des schlesischen Juden Siegmund Haber waren seine Nachbilder.

"Kladdera-datsch"

Haym und Lasalle Damit nicht genug. Schlesier waren Rudolf Haym, 1858 Mitbegründer und Leiter der „Preußischen Jahrbücher", das Blatt des deutschgesinnten Liberalismus und des preußisch-deutschen Einheitsstaates, sowie Ferdinand Lasalle, 1863 Gründer des „Allgemeinen deutschen Arbeitervereins".

Zwischen Rechts und Links, zwischen Junkertum und Bürgertum, schattierte sich eine mannigfaltige und figurenreiche Literatur ab. In ihr bildete der Schlesier Hermann Goedsche von Trachenberg eine Sonderklasse. Das war der Mann, der unter dem Decknamen Sir John Retcliffe in zahlreichen *Homer der Hintertreppe* Romanen das geschichtlich-politische Weltepos seines Zeitalters geschrieben hat, den Kampf um Indien und um Mexiko, um das Schwarze Meer, um Österreich, Italien, Frankreich — so „Sebastopol" 1856 und „Villafranca" 1860 —, eine abenteuerliche Leistung, Reportage und Kolportage, phantastisch und greuelvoll wie die Wirklichkeit, mit ungezügelten welträumigen Verknüpfungen und wilden politischen Auslegungen, Weltgeschichte als Ränkespiel, Hirngespinste neben hellseherischen Wahrsagungen, tiefer Verfall der alten und Vorläufer einer neuen Literatur.

Der Querschnitt durch diese preußische Literatur läuft als kühn geschwungene Linie von dem baltischen Junker des ancien régime zu dem ostelbischen Bürgerlichen der verhinderten deutschen Revolution.

ancien régime *Alexander von Ungern-Sternberg,* 1806 bis 1868, aus der Revaler Gegend, hatte sich mit seinen Romanen, Feenmärchen, Erinnerungsbüchern als einen glänzend begabten Unterhaltungsschriftsteller französischer Schule ausgewiesen. Was er vor 1848 betrieb, war die Libertinage des altfranzösischen Edelmanns. So stellte er — „Diane" 1842 — die Berliner Gesellschaft an den Pranger. Nach 1848 schlug er sich allzu eifrig auf die preußische rechte Seite.

Er verleugnete wechselweise die Bücher vorher und nachher. Was er aber nie verleugnete und seine gerade Linie war, das ist die tändelnde Philosophie und schlüpfrige Erotik des französischen Zopfes. Das satirische Märchen „Tutu" 1841 war das Kennwerk dieses Mannes, dem sich Wort und Griffel zu gleicher Fertigkeit fügten.

Friedrich Spielhagen, 1829 bis 1911, aus Magdeburg, war vom Rhein her mit der Volksbewegung bekannt und mit der englischen Literatur vertraut, als er 1862 nach Berlin übersiedelte. Er stand auf Seiten des preußischen Fortschritts, eiferte für das Allheilmittel Verfassung und legte in seinen frühen Romanen „Clara Vere" 1857, „Auf der Düne" 1858, „Problematische Naturen" 1861 die Zustände zwischen 1848 und 1860 parteimäßig aus. Seit er in Berlin lebte, brachten „Die von Hohenstein" 1864 die Revolution bedeutsam in Erinnerung, schilderte „In Reih und Glied" 1867 Bismarcks Kampfzeit, verkoppelte „Sturmflut" 1877 den Ostseesturm von 1872 sinnbildlich mit den wirtschaftlichen Zusammenbrüchen jener Jahre. „Der neue Pharao" 1889 mußte schließlich den allgemeinen Abfall von den Grundsätzen der Fortschrittspartei zur Kenntnis nehmen. Spielhagen war der Zwischenmann von Gutzkow zu Freytag, Kleinmaler zugleich und Zweckschreiber, nüchterner Beobachter des Alltäglichen und romantischer Liebhaber des Seltsamen. „In Reih und Glied" verkündete die Götterdämmerung des Heldentums. Statt „Einer für alle" rief es „Alle für alle". Da hieß es Demokratie. Sie teilt jedem nur soviel zu, als er zu tragen vermag. Die guten Menschen aller Länder bilden eine einzige große Armee. „Der einzelne ist nichts weiter als ein Soldat in Reih und Glied." Miliz also, keine kriegerische Heldenkaste. Seine Edelleute sind hochmütig, genußsüchtig, verfault. Seine Volksmänner sind edel und kerngesund. Seine Sozialisten sind ehrgeizig und verroht. Über so einfachem Nenner steht bei ihm das Leben. Alle Fragen gehen restlos in einem schönen Bruch auf. Seine Helden kehren von Roman zu Roman wieder. In keinem seiner Bücher ist die ganze Welt. Der Guckkastenausschnitt ist sein Horizont. Dies alles, sein „hochpoetischer Idealjargon", die nichts als pommerische Naturerfahrung, die Männern des Tages mühsam nachgekneteten Gestalten, die aus der Zeitung wohlbekannte Lehrformel: Spielhagens Kunst tröpfelt aus der Weltanschauung des Liberalismus. Und was sie, auf weite Entfernung wenigstens, geschmückt erscheinen läßt, das stammt aus dem Werkkasten einer mißverstandenen Romantik.

Die Grenze zwischen Preußen und dem verbündeten Deutschland lief mitten durch MEISSEN. Das Königreich Sachsen lag an Österreichs Seite gegen Preußen zu Felde. Das sächsische Bürgertum stand auf Preußens Seite

Demokratie in Reih und Glied

Kleinmaler und Zweckschreiber

Spielhagens Schwarzweiß-Kunst

Dresden und Leipzig

Meißen in beiden Lagern zu einem neuen deutschen Reich. Zwischen Dresden und Leipzig ging das ostdeutsche Bürgertum aus der Revolution von unten zu der Revolution von oben über. Hier wurde die vom Umsturz zerstörte künstlerische Welt wieder aufgebaut. Hier wurden Presse und Buchhandel für die preußische Reichsschöpfung zugerüstet und aufgeboten.

Die meißnischen Gefängnisse beschleunigten diesen Wandel vom Volkstribunen zur Selbsteinkehr des Dichters. Was im einsamen Kerker dieser literarischen Barrikadenmänner wie Theodor Ölckers, August Peters, Adolf Heerklotz vorging, das brachte der Urenkel des Göttinger Dichters, *Robert Giseke*, 1827 bis 1890, für das ganze Zeitalter zu Buch. Dieser Marienburger wollte an einer Runde von Zeitromanen den Umschwung des Jahrzehnts, die Bekehrung und Enttäuschung, das Geducktwerden und Zukreuzekriechen der Himmelsstürmer von ehedem darstellen. „Moderne Titanen" 1851 geben im Durchschnitt das achtundvierziger Chaos. Köpfe wie Friedrich Rohmer und Max Stirner, die „freien Geister", ihre Stimmung und ihr Wortgebrauch, waren zum Sprechen getroffen. „Pfarr-Röschen" 1854 gab das Gegenbild auf kirchlicher Seite. Giseke hatte sich schon ausgeschrieben, als es galt, mit dem *Carrière* Buch „Carrière" 1852 den Himmelsstürmern bei der Rückkehr zur Erde und bei der Eingewöhnung in die neugesicherte bürgerliche Welt behilflich zu sein. Ob gebrochen oder geduckt, sei es um einen glatten Preis, sei es aus *Die Arrivierten* ehrlicher Einsicht, sie schlossen Frieden und verstärkten von Jahr zu Jahr die Mehrheit jener, denen Einheit mehr als Freiheit galt, die sich Preußen und dem Umsturz von oben her zuwandten und das Feld wieder einer zweckentlasteten Dichtung überließen. Zwei Preußen vollzogen diese Überzeugung an sich selber vollkommener, als Giseke sie zu schildern vermochte.

Der Breslauer *Rudolf Gottschall*, 1823 bis 1909, war an der Königsberger Hochschule der Philosophie Hegels und der Freiheit Preußens gewonnen worden. Er schoß die Brandraketen seiner Verse ab und führte während des Sturmjahres die Königsberger Bürgerwehr. Im Dienst der Presse landete er endlich zu Leipzig. Sein Übergang zu den bürgerlich Besonnenen und zur reinen Dichtung ist ihm nicht ohne Zwischenfälle gelungen. Die Fahne der Freiheit ist ihm lange noch über das einige Vaterland gegangen, zumal in seinen Dramen. Indessen Gottschalls künstlerische Übergänge spielten sich auf der epischen Linie ab. Hatte „Die Göttin, ein hohes Lied vom Weibe" 1852 noch der „Befreiung" der Frau gegolten, so berauschte sich der Dichter bei „Carlo Zeno" 1854 schon am Machtgedanken des nationalen Aufschwungs. Über „Sebastopol" 1856 und die Hindugeschichte „Maja" 1864 führte die „*König Pharao*" Reihe zu zwei eigenartigen Gebilden: dem komischen Epos „König Pharao"

1872, wo am Hasardspiel das ganze moderne Schwindelwesen verspottet wird, und „Merlins Wanderungen" 1887, Gesellschaftsbilder im Rahmen der alten Sage. Schimmernde Beredsamkeit und Glanz der Schilderung machen seinen Stil. Gottschall gehörte zu jenen redlichen literarischen Handwerkern, die mit Anstand und Würde den Schein wahrten, als es mit der Herrlichkeit der herkömmlichen „Dichtung" längst zu Ende war.

Der Berliner *Karl Gutzkow,* 1811 bis 1878, verkörperte diesen Umschwung von Links zur Mitte, von der Republik zum Reich, von der Tagesliteratur zur Kunst sinnfälliger, weil bei ihm der Abstand zwischen den Gegenpolen am größten war. Seine „Carrière" im Sinne Gisekes hatte damit begonnen, daß er schon 1846 an das Dresdner Hoftheater berufen wurde. An den Iden des März stand er bereits auf Seiten derer, die „vermitteln" wollten. Er verlor seine Stelle, doch er kehrte von Berlin nach Dresden zurück, und er verlebte hier, Beherrscher des literarischen Treibens, bis 1861 seine beste Zeit. In Dresden entstanden seine großen Schöpfungen, die kulturgeschichtlichen Zeitromane „Die Ritter vom Geist" 1850 bis 1852 und „Der Zauberer von Rom" 1858/1861, je neun Bände. Während seine Ansprüche an die Dichtung zu steigen begannen, begriff er auch, wie wenig ihm die dramatische Form abzugeben willens war. Dennoch kam er nicht aus künstlerischen Erwägungen, sondern von der Beobachtung des Lebens zu seinem neuen Stil. Ein so kühler Rechner erkannte, wie stark der moderne Mensch von Umständen und Umgebungen bedingt wurde. Gesellschaft, Öffentlichkeit, Reiseverkehr verweben den einzelnen mit Menschen, Dingen, Zuständen in ein dichtes Geflecht. Das hieß nun Leben. Das mußte Vorwurf der Kunst und also Bedingnis des Stiles sein. Es konnte nicht mehr um den folgerichtigen Ablauf eines Sonderschicksals gehen. Ins Gewicht mußte das zufällige Nebeneinander vieler fallen. Die „problematische Natur" ist der neue Held, „gemischte Charaktere", zwischen Willen und Umwelt schwingend. Ein „Roman des Nebeneinander" war die entsprechende Kunstform. Sie beerbte, wenigstens bei Gutzkow, das Drama, das nicht mehr imstande war, die verwandelten Lebensbedingungen der Gegenwart künstlerisch zu bewältigen. „Die Ritter vom Geiste" mit dem Spielraum Berlin sind ein Bundesroman. Die zerspaltene Gesellschaft soll im Hochgedanken der Menschlichkeit geeinigt werden. Der Roman wurzelt in der Zeit nach 1848, deren Menschen und Zustände gezeichnet sind. Ein geistiger Ritterbund im Dienste der Menschlichkeit wird dem Zeitalter wie ein schaffender Spiegel vorgehalten. Den gleichen Vorwurf, der hier im protestantischen Deutschland abrollt, verlegte Gutzkow mit dem „Zauberer von Rom" in den katholischen Bereich. Die zeitgenössi-

Nach den Iden des März

Gutzkows Romane des Nebeneinander

„Die Ritter vom Geiste"

„Der Zauberer von Rom"

Gutzkow schen Vorgänge der römischen Kirche treten zu großartigen Bildern zusammen. Die katholischen Landschaften werden in befugten Vertretern zum Handeln erweckt. Ein zeitmächtiges Gesicht soll dem Ganzen Sinn und Ziel geben. Ein Deutscher besteigt den Thron des Apostelfürsten und legt, den Katholizismus zu „erneuern", seine Gewalt in die Hände einer allgemeinen Kirchenversammlung. Es steckt eine unermeßliche aufnehmende und schöpferische Arbeit in den zwei Romanen, da Gutzkow die beiden christlichen Kirchen sich gewissenhaft aus den Quellen vertraut machte, da er das Erträgnis eines ungewöhnlich aufnahmefähigen und betriebsamen Lebens in diese Bücher einschloß und da er, wozu wir kaum mehr ein Verhältnis haben, die ungeheuren Stoffmassen in ein umsichtig berechnetes Gefüge brachte. Beide Romane sind preußischer Stil: gewaltige Massen, nicht durchgeistigt, aber mit einem verblüffenden Mechanismus beherrscht und geordnet. Der Gedanke war nicht neu. Denn es war Karl Postl, dem an der amerikanischen Welt dieselbe Frage aufgegangen war. Nur nannte Postl „Volk", was Gutzkow „modernes Leben" hieß.

Also mußte auch in Gutzkows Dresdner Nähe ein Dichter, der das mehr als Gutzkow war, an dem Versuche scheitern, dem modernen Leben mit dem überlieferten Handwerk beizukommen.

Otto Ludwig Das war *Otto Ludwig*, 1813 bis 1865, von Eisfeld. Man könnte ihn nur landschaftlich einen Thüringer nennen. Denn stammlich ist er ein Ostfranke. Sein Vater wie seine Mutter stammten aus wohlhabenden Familien Hildburghausens. Ludwigs väterlicher Großvater hinterließ dramatische Arbeiten. Der Vater, herzoglicher Hofanwalt, gab ein Bändchen Gedichte heraus. Schwere Schläge trafen den körperlich überaus zarten Knaben. Und als 1825 der Vater, wirtschaftlich zugrunde gerichtet, starb, wurde der Einfluß der dichterisch begabten Mutter doppelt stark. Sie hielt den dreifach veranlagten, auf Musik, *Am Dreiweg* Bühne, Dichtung gerichteten Knaben der Welt des Wirklichen nur allzu ferne. *der Künste* Sein eigener Lehrer und ein geborener Einzelgänger, wandte sich Ludwig ruckweise von der einen Seite auf die andere, in Versuchen und Ansätzen aller Art, bis sich die rechte Tür zu öffnen schien. Bei Mendelssohn ein Musikmeister zu werden, ging Ludwig 1839 nach Leipzig, blieb, ein unberührbarer, überreifer Jüngling, in der erregten und verderbten Stadt gräßlich einsam, linkisch im Umgang wie Ausdruck, vermochte den quälenden und beglückenden Trieb in der Musik nicht zu entladen und kehrte enttäuscht nach Eisfeld zurück. Schöpferische Pläne fühlt er mit unwiderstehlichem Druck auf sich eindringen, ohne daß er die Kraft hat, in sie einzugreifen. Da geht er 1843 nach Dresden. Und hier geschieht ihm ein Doppeltes, das eine

gut, das andere schlimm. Er beginnt Novellen in die „Zeitung für die elegante Welt" zu schreiben. Der Schauspieler Eduard Devrient berät ihn bei der Umarbeitung für fertig gehaltener Dramen. So wird der „Erbförster" spielbar und März 1850 zu Dresden mit großem Erfolg aufgeführt. Das war sein Unglück. Auf der Jagd nach Stücken, die bühnengerecht zugleich und dichterisch werden sollten, sah er sein Zielband in immer weitere Fernen entflattern. Und nur „hinter seinem Rücken" schrieb er 1854, als Eisfelder Dorfgeschichte, „Die Heiterethei", 1855 die Erzählungen „Zwischen Himmel und Erde", „Aus dem Regen in die Traufe". Zunehmende Schmerzen standhaft ertragend, mit der Not des Lebens ringend, Entwürfe um Entwürfe wälzend, verbrauchte er die Dresdner Jahre. Von Gesichten gepeinigt, denen er keinen Körper zu schaffen vermochte, zerstörte er 1864 eine ganze Kiste voll Handschriften.

Novelle oder Drama

Zwischen Himmel und Erde

Es ist zu leugnen, daß Otto Ludwig durch seine Shakespearestudien die eigene schöpferische Zuversicht gebrochen hätte. Die hat er nie besessen. Er stand gar nicht, wie er meinte, unter dem Triebe der Tonkunst. Er litt an der Bildnerei. Er hat lediglich zuerst die Oper und dann das Drama für ein Mittel gehalten, seinen Bildtrieb zu entlasten. An seinem Vorwurf der „Agnes Bernauer" verirrte er sich mit immer neuen Bearbeitungen immer tiefer in das dramatische Labyrinth, um sich schließlich an dessen Mittelpunkte, in die Shakespearefrage zum Sterben einzukapseln. Seit 1846 lebte er in dem Vorwurf „Der Erbförster". Diese „Waldtragödie", wie sie mit einem älteren unter vielen anderen Titeln heißen sollte, hat erst in der scharfen Luft der Revolution die Farbe seines heimatlichen Waldes bekommen. Was der Erbförster hier verteidigt, ist das Recht auf eine Sache, das er gar nicht hat; ist ein Unrecht, das er tut. Er ist nicht einmal ein Michael Kohlhaas. Der wird aus einem berechtigten Verteidiger seines gebührenden Rechts ein Gewalttäter. Der Erbförster verteidigt nichts als eine Schrulle. Und das Stück, in dem dies alles geschieht, ist keine Tragödie, sondern beinahe die Parodie einer Komödie der Irrungen. An Ludwigs neuem Stück „Die Makkabäer" wird alles offenbar. Ludwig war ein Nachläufer Schillers und gefiel sich gerade in dem, was er an Schiller tadelte. Ludwig suchte das Drama, wie andere Gott suchen, und jede Enttäuschung ließ er wie eine Stufe hinter sich, auf der er sich zu einer höheren aufschwang. Gegenüber solcher Gedankenflucht war der Wille lahm. Er hatte Gesichte und suchte vergebens nach einem Machtwort, diese Gesichte festzubannen. In seinen Shakespearestudien suchte er mit der besinnungslosen Hast des Verzweifelnden dieses fluchtbannende Zauberwort: Steht! Wie hoffnungslos altmodisch stand Ludwig gegen die

Labyrinth zu Shakespeare

„Der Erbförster"

„Die Makkabäer"

Weltanschauung einer neuen Zeit. Die hatte dem Menschen bewußt gemacht, daß er ein Glied am Riesenkörper geschichtlicher Organismen sei. Es gab keine Helden Shakespeares mehr. Wie müßig also und fruchtlos, nach dem Griff zu suchen, der diese leere Mühle wieder in lärmenden Gang brächte.

Otto Ludwig, der Waldroman

Als sich Ludwigs dramatische Begierde müde gerast hatte und er zum Sterben kam, wurde er echt. Zu Eisfeld, nach seiner Rückkehr aus Leipzig, entwarf Ludwig eine Novelle „Der Pfaffel": „Schilderung der Waldnatur, des südlichen Charakters, namentlich der Waldmädchen . . . Sagen von den Veneziern . . . Die Waldgrazie, ein wunderbares Bild von Fülle und Kraft . . . In der Nähe das Schloß des Grafen Pfaffel . . . Der einsiedelnde Schuster. Böhmische Glasmacher . . . Auswanderer mit ihrem Lied, daß die armen Waldteufel nicht fort mögen." Ein Roman aus dem fränkischen Walde und gewiß mehr im Stil von „Willibalds Ansichten" seines Landsmannes Wagner als im Sinne von Immermanns „Epigonen". Das war Ludwigs Linie. Er mußte erst bis auf die letzte Planke an seinen Theaterplänen scheitern, ehe er dieses

„Die Heiterethei"

Tau ergriff. Im Sommer 1854 beendete er die Dorfgeschichte „Die Heiterethei" und gab ihr das Widerspiel „Aus dem Regen in die Traufe". „Heiterethei" stellt den Liebeskampf zweier Trotzköpfe, indem sie ihn fast zum mythischen Kampf der Geschlechter steigert, nicht mit dem kürzesten Abstand der Worte dar, sondern auf den Umwegen über das Städtchen. In der einleitenden sinnbildhaften Szene am Schubkarren steckt die ganze Geschichte. Die Novelle gleitet von einer Charakterlustspielszene zur andern und jede ist behaglich ausgekostet. Hier ist das „Tragischkomische" wirklich Ereignis geworden. Diesem launig vergrößerten Kraftmenschenpaar antworten „Aus dem Regen in die Traufe" ebenso launig verkleinerte Menschen.

Tragödie unter Schieferdeckern

Ein entschlossener Schwung brachte Ludwig 1856 auf die einsame Höhe der tragischen Novelle „Zwischen Himmel und Erde". Bitzius, Stifter, Auerbach waren schon Gemeingut. Doch 1856, das war die Zeit, die Storm und Raabe, die beiden großen Träger der sächsischen Erzählungskunst, reifte. Und im Sinne Storms hat Ludwig mit dieser Novelle, die bald in alle Literatursprachen übersetzt wurde, dem tragischen Anspruch Genüge getan. Eine Tragödie zwischen Schieferdeckern, und das mit aller Wirklichkeitstreue der Sache. Da war alles, was das junge Geschlecht um 1885 lehrhaft verlangte und vor der Hand schöpferisch noch nicht konnte. Es war das letzte Stück Heimat, das Ludwig sich nachzog in die fremde Welt, wo er nicht einzuwurzeln vermochte. Niemals hat ein Thüringer ausgesehen wie Otto Ludwig. Ein ostfränkisches mystisches Genie war er. Seine flammenden und tönenden Gesichte vermochte er nicht zu beschwören. Es war der Irrtum seines Lebens,

mit Shakespeares Gebärden und Worten solche „Erscheinungen" zu „materialisieren". Seine geniale epische Anlage ist zugrunde gerichtet worden durch den Modezwang der Vergaffung ins Theater. Otto Ludwig ist der leibhafte ostfränkische Erzähler, der die Reihe Meyern, Richter, Wagner, Meyr folgerichtig fortsetzte. Dieser Tor des Lebens, dieser Reine und Herbe, dem falsche Scham den fragenden Mund verschloß, war eine echte Parzivalgestalt.

Fränkische Erzähler

Das Leipziger Buchwesen wuchs ins Große. Das machte nicht allein der Zuwachs an Verlagshäusern. Das machten neue zeitmächtige Unternehmungen. Otto Spamer begann 1851 mit seiner vorbildlichen „Illustrierten Jugend- und Hausbibliothek" und Anton Philipp Reclam begann 1867 mit seiner „Universalbibliothek", dem größten Verlegergedanken neuerer Zeiten, der dem werdenden Staatsvolk in Groschenbüchern eine allumfassende Handbücherei schuf. Das machten vor allem die Zeitschriften. Gustav Kühne führte Lewalds „Europa" nach Leipzig. Robert Prutz gründete 1851 das „Deutsche Museum". Die „Blätter für literarische Unterhaltung" erhielten 1854 in Hermann Marggraff und 1865 in Rudolf Gottschall einflußreiche Leiter. Den größten Aufschwung nahm die „Illustrierte Zeitung" des Verlags Johann Jakob Weber. Ferdinand Stolle wandelte 1852 sein volkstümliches Wochenblatt in den „Illustrierten Dorfbarbier" um und gab ihm am 1. Jänner 1853 eine Beilage: „Die Gartenlaube". Den Gedanken dazu hatte der Verleger Ernst Keil im Gefängnis gefaßt. Das Blatt begann mit einer Auflage von 5000 und brachte es bis 1881 auf 378 000 Bezieher. Es hat auf Bildung und Haltung des freisinnigen Bürgertums unabschätzbar eingewirkt und ihm die materialistische Weltanschauung mundgerecht gemacht. Die beiden Verleger August Velhagen und August Klasing schlugen 1864 mit ihrer Zeitschrift „Daheim" sofort ein. Hinter ihr standen die Rheinlande und Westfalen. Sie machte sich die christliche Weltanschauung der deutschen Familie zum Gesetz.

Leipziger Buchwesen

„Universalbibliothek"

„Illustrierte Zeitung"

„Die Gartenlaube"

„Daheim"

Bei Ausbruch der Revolution von 1848 hatte Ignaz Kuranda seine „Grenzboten" an Julian Schmidt, 1818 bis 1886, von Marienwerder übergeben. Dieser machte zusammen mit Gustav Freytag am 1. Juli 1848 „Die Grenzboten" als neues Blatt auf, das nicht mehr an Österreich, sondern an Preußen gerichtet war und für die staatliche Umbildung Preußens, das heißt Deutschlands, arbeitete. Bis zum Tage von Olmütz haben „Die Grenzboten" Vertrauen und Zuversicht des Bürgertums für Preußen warm gehalten. Dann aber trat die Politik zurück und das geistige Leben vor. Das war die Zeit, da Freytag das Blatt mit den Entwürfen zu den „Bildern" und der „Technik des Dramas", Schmidt mit den Vorarbeiten seiner Literaturgeschichte füllte. Julian Schmidt wurde durch den Dresdner Moritz Busch, 1821 bis 1899, ersetzt, den ein

„Die Grenzboten"

Schmidt, Freytag, Busch

amerikanischer Aufenthalt von Demokratie und Republik bekehrt hatte, der
Anfang 1870 Bismarcks Gehilfe in Presseangelegenheiten wurde und das
Blatt mit nach Berlin nahm. Freytag schied aus. Die Stimme der „Grenz-
boten", die mit einem hinreißenden Fanatismus für Preußen warb, das war
der Dresdner Heinrich von Treitschke, 1834 bis 1896, aus einer Familie tsche-
chischer Glaubensflüchtlinge, der spätere Berliner Hochschullehrer und Ver-
fasser der „Deutschen Geschichte". Die mächtige ostmitteldeutsche Spannung
seit dreihundert Jahren entlud sich in diesem tiefsinnbildlichen Triumvirat
der Presse Schmidt, Freytag, Busch, das sich durch die beiden Nachkommen

Treitschke und Haym böhmischer Protestantenfamilien Heinrich von Treitschke und Rudolf Haym
zu einer Fünfmännergruppe erweiterte. Ostmitteldeutsche habe dem preu-
ßischen Werk das Werkzeug der Presse geschaffen, Schmidt und Freytag in
den „Grenzboten", Haym in den „Preußischen Jahrbüchern". Das Magde-
burg der Reformationszeit hieß unsers Herrgotts Kanzlei. Das Leipzig dieser
Zeit war die Kanzlei des werdenden deutschen Staates.

Der Schlesier *Gustav Freytag*, 1816 bis 1895, der Sohn des Bürgermeisters
von Kreuzburg, war durch das Gymnasium von Öls gegangen, hatte in Bres-

Poet von prosaischer Größe lau unter Hoffmann von Fallersleben, in Berlin unter Lachmann die junge
Germanistik getrieben, hatte sich an der Breslauer Hochschule für deutsche
Sprache und Literatur niedergelassen, hatte 1844 unbefriedigt seine Vor-
lesungen eingestellt und war nach Leipzig, später nach Dresden gezogen.
Was er schuf, stand unter dem Gegendruck gepaarter Widerkräfte. Er war
Gelehrter mit den Absichten eines Volkserziehers. Die „historische Entwick-
lung der deutschen Volkstümlichkeit" schwebte ihm als Lebensaufgabe vor.
Doch erwarb er sich auch 1851 zu Siebleben bei Gotha ein Landhaus. Dies

Gustav Freytag und die Bühne bürgerlich-bäuerliche Dasein vermittelte ihm vertiefte Einsichten in bürger-
liches Gewerbe, in bäuerliches Tagwerk, ja in die Verfassung des benach-
barten kleinen Hofes. Durch die Wissenschaft hatte er Fühlung zur Roman-
tik. Der Staatsbürger hielt gleichen Schritt mit den Freiheitsmännern des
Sturmjahres. Und durch diese Linke fühlte er sich dem französischen Bühnen-
stück verpflichtet. Dagegen zur Rechten empfand er über die Romantik die
geistige Nachbarschaft des englischen Romans. Aus dem heimatlichen Tem-
perament seiner Zeit glaubte er seines Berufes zum Drama sicher zu sein. In
der Tat wurde sein geschichtliches Lustspiel „Die Brautfahrt oder Kunz von
Rosen" 1841, ein Stück von schlesischer Fröhlichkeit, öfters gespielt. Er
horchte bei Schauspielern herum. Er nützte Holteis Erfahrungen. Er schmö-
kerte in der Kunstweise französischer Spielbücher. Also gelang ihm 1846 das
Ränkespiel „Die Valentine". Es gelang ihm das Schauspiel deutschbürger-

licher Lebensmeisterung „Graf Waldemar". Freytag schien auf dem Wege seiner Landsleute Raupach, Holtei, Laube. Noch während 1848 kam und ging, verfing sich ihm die deutsche Revolution in dem heiteren Komödienspiegel von 1852, „Die Journalisten". Da war mit vollendeter szenischer Kunst eines der reinsten schlesischen Gebilde und aus eigenem Erlebnis das Treiben der deutschen Parteien und die „vom anmutigen Leichtsinn der Jugend erfüllte Presse" geschildert. Es war wie bei Gutzkow ein Abschied von der erfolgreichen Bühne.

„Die Journalisten"

Der Gelehrte, der deutschgesinnte Vertraute romantischer Neigungen, der Zögling des englisch-nordischen Stiles, schlug vor, als Freytag zu jener Gattung überging, in der sich die Wendung des Zeitalters zur Prosa, zur Geschichte, zur sachlichen Weltdarstellung vollzog, zum Roman. Sein Landsmann im weiteren, Moritz Haupt, regte „Soll und Haben" an. Das Buch, 1853/1855 entstanden, folgte Walter Scott bei Aufbau und Kostümtreue, Charles Dickens aber in der launigen Führung des Griffels. Allerdings ein Roman des Handels und der Landwirtschaft, doch nicht zu sattem Genügen an der Welt, wie sie wirklich ist, unternommen, sondern um dem schöngeistig-adligen Bildungsziel des versinkenden Zeitalters ein anderes, ein bürgerlich-sittliches aufzurichten. Haupt hatte „Soll und Haben" angeregt. Für den zweiten Roman, „Die verlorene Handschrift" 1864, stand er Modell. Hier ging es um die gelehrte Arbeit, um Freytags Sieblebner Erfahrung, den Gegensatz von Gelehrtentum und Fürstenhof. „Soll und Haben" lebte in der schlesischen Grenzlandschaft, „Die verlorene Handschrift" in der Welt von Leipzig und Gotha.

Der Roman

„Soll und Haben"

„Die verlorene Handschrift"

Indessen, auch „Die Grenzboten" förderten, und nicht zum Schaden des Dichters, ihr Teil. Während politisch stiller Wochen hatte Freytag mit allerlei zeitlosen Aufsätzen einspringen müssen. Die eine Gruppe verarbeitete er 1862 zu dem Buch „Die Technik des Dramas". Aus der anderen Gruppe erwuchs 1859/1861 sein eigentliches Meisterwerk „Bilder aus der deutschen Vergangenheit". Dies Buch des geschichtlichen Querschnittes machte am kulturgeschichtlichen Wandel der deutschen Seele die Gezeiten des deutschen Schicksals, Form und Rhythmus des deutschen Außenlebens sichtbar. Die Urkunden, aus denen es gearbeitet ist, werden in gehobener oder bedrängter Stimmung redend eingeführt. Literaturgeschichte und Kulturgeschichte waren die Innenausstattung, die der Mitteldeutsche an den Aufbau der sächsischen Historie beisteuerte. Ein neues Zeitalter ging der deutschen Geschichtskunst aus Freytags farbensatter Darstellung auf. Wieviel Niedersachsen hatten ihr dichterisches Pfund in der Werkstatt ihrer Wissenschaft

Technik und Kulturgeschichte

eingeschmolzen. Dieser Schlesier, der dem Bildniskünstler Karl Stauffer als „ausgeprägt slawischer Kopf" erschien, unternahm es, sein gelehrtes Metall zu dichterischen Gulden zu schlagen. Indessen diese Gegenstücke zu seinen *„Die Ahnen"* „Bildern", die neun Erzählungen der „Ahnen" 1872/1880, die das Schicksal einer deutschen Familie von der Mitte des vierten bis zur Mitte des neunzehnten Jahrhunderts verfolgen wollten, vermochten weder die Abfolge der Kulturstufen noch das geheimnisvolle Band von Zeugung zu Zeugung glaubhaft zu machen. Sie stehen selbst als künstlerische Gebilde ebenso tief unter den „Bildern", wie sie von diesen mit ihrem geschichtlichen Werte überragt werden. Gustav Freytag also war, „wenn man will, gleich Hans Sachs in der Periode der Reformation, der geborene Poet eines Zeitalters von prosaischer Größe. Allein dieser neue Meistersinger und Liebhaber technischer Tabulatur trieb die edelste Hantierung bürgerlich höchstkultivierter Zeit, die Wissenschaft, und erkundete darin für sich und andere das deutsche Wesen". Gustav Freytag ist in den deutschen Werdejahren 1848/1870 der Vorredner, Anwalt und Schriftleiter des deutschen Staates gewesen.

NIEDERSACHSEN dem preußischen Staate einzufügen und das deutsche Küstenland landeinwärts der Nordsee und Ostsee in seiner vollen Tiefe vom Rhein bis zur Memel zu einigen, war Zweck und Preis des deutschen Bruderkrieges. Das war aber eine geistige Welt, die Preußen wohl hinzugefügt, aber ihm nicht eingefügt werden konnte. Sie machte Preußen ganz aber nicht eins und verdoppelte das geistige Gewicht des Staates, ohne das eigene aufzugeben.

Die *HANSASTÄDTE* hatten nach den Napoleonkriegen ihre Freiheit zurückgewonnen. Der Aufstieg Preußens ging an ihnen vorbei. Und sie fügten sich ungeschmälert in das neue Deutsche Reich. Jede von ihnen hatte ein *Hamburger* bescheidenes Eigengesicht. Hamburg, das war die Buchfirma seit 1810 Hoff- *Buchwesen* mann und Campe, die Julius Campe zum Verlag der freiheitlichen und fortschrittlichen Bewegung machte. Selbst der Bundestagsbeschluß vom 10. Dezember 1835, der sein ganzes Geschäft als staatsgefährlich verbot, vermochte es nicht lahm zu legen. Die Buchhandlung an der Bohnenstraße war der Treffpunkt aller Federleute. Sie vermittelte den Buchverkehr mit England und Deutschland. Hamburg betrieb ein ziemliches Zeitschriftenwesen und *Bremens* hatte ein vielseitiges Theater. Der Bremer Kaufmann Johann Michael Speck- *Buchbild* ter gründete 1818 in Hamburg die erste Steindruckerei Norddeutschlands. Von seinen beiden Söhnen war Erwin der frühvollendete romantische Maler, dessen „Briefe eines deutschen Künstlers aus Italien" ein Schmuckstück ihrer Gattung sind, während Otto mit seinem Zeichenstift viele Bücher berühmt

machte. Bremen war die alte kirchliche Metropole des Nordens. Ihre kleine Literatur vermittelte durch Adolf Laun und Otto Gildemeister englische und romanische Dichtung. Der Braunschweiger Johann Dräseke, seit 1814 Prediger an der Ansgarikirche, lebte aus dem Glauben an eine neue große sichtbare Verwirklichung des Reiches Gottes, wie drei Bände Predigten, „Das Reich Gottes" 1830, bezeugen. Lübeck war ein Kunstwerk aus Backstein. *Lübecker Zeichner* Dem Stadtstil wahlverwandt, zeichnete, malte, schnitzte Karl Julius Milde, Zeichenlehrer an der Katharinenschule und gab 1843/1847 „Denkmäler bildender Kunst" heraus, darunter den Totentanz der Marienkirche.

Vor Bremen, Hamburg, Lübeck lag die See und machte sie gemein. Reisen, Reiseliteratur, Reisedichtung, das war der hansische Beitrag zum Schrifttum des neuen Deutschland, als es noch lange keine deutsche Flotte gab. Da macht aber doch die jütische Halbinsel einen Unterschied zwischen Nordsee und Ostsee, zwischen Bremen und Hamburg auf der einen, Lübeck auf der andern Seite. Was man fünfhundert Jahre früher, als die Hansa blühte, ver- *Hansische Reiseliteratur* geblich suchte, die Literatur eines Seefahrervolkes, das gedieh nun im Aufgang eines neuen hansischen Zeitalters.

Also Bremen und Hamburg. Der Unterschied liegt nur in der letzten literarischen Form. Von Bremen kamen Johann Georg Kohl, der in zahlreichen Büchern Rechenschaft von seinen Reisen durch Europa und Amerika gab; *Amerika und Afrika* Gerhard Rohlfs, Wundarzt in der Fremdenlegion, der meist auf eigene Faust Nordafrika in den verschiedensten Richtungen durchquerte und in seinen Büchern die Kunst der Darstellung kaum zu streifen vermochte; Adolf Bastian, gegenüber dem Reisekünstler Kohl und dem Abenteurer Rohlfs der gelehrte Völkerkundler, der an den uralten Tempelstätten der Menschheit den Grund zur vergleichenden Mythologie und Religionsgeschichte gelegt hat; Hermann Albert Schumacher, der aus den Büchereien Neuyorks, aus den Urkundenschreinen Spaniens und Deutschlands die Entdeckungsgeschichte Amerikas förderte; Ludwig Christian Seipel, der Weitgereiste, der in seinen Bildern das dämonische Wesen, Licht und wechselnde Gestalt des Meeres festhielt. Von Hamburg kamen Johann Eduard Wappäus, vom Schiff seines Vaters mit der See vertraut, der Südamerika als günstiges übersächsisches Siedelgebiet nachwies; Heinrich Barth und Adolf Overweg, zusammen mit dem Krefelder Eduard Vogel, Erforscher der Sahara, der Länder um Timbuktu und den Niger, ein Unternehmen, das Barth zu der großen literarischen Schöpfung ausformen konnte: „Reise und Entdeckungen in Nord- und Zen- *Die großen Entdecker* tralafrika" 1857, fünf Bände mit Karten und Bildern, deutsch und englisch; Albrecht Roscher, der am Nyassa ermordet wurde; Johann Gabriel Pfund,

der in El Fascher starb. Was aus dieser Reiseliteratur Dichtung wurde, das ist es in Hamburg geworden. Heinrich Smidt, 1798 bis 1867, von Altona, sah die Welt als Kajütenjunge und Steuermann, zuletzt auf eigenem Schiff, gab *Das Seebuch* 1823 das Seeleben auf und wurde Büchereibeamter im Berliner Kriegsministerium. Seine Seebücher weckten unter der Jugend des Binnenlandes die Lust an Meer und Schiffahrt. Sie machten dem Ohr der Städter und Ackerbürger das Räderspiel des Schiffsbetriebes und die Sprache des Seemannes *Friedrich Gerstäcker* notdürftig vertraut. Der Hamburger Friedrich Gerstäcker, 1816 bis 1872, stammte durch den Vater aus Schmiedeberg im sächsischen Erzgebirge, eine Tatsache, die durch die Landsmannschaft Eduard Pöppigs, Otto Ruppius' und Karl Mays ein merkwürdiges Licht empfängt. Gerstäcker hat in den Jahren 1837/1868 das nördliche und südliche Amerika, Kalifornien und Australien, Ägypten, Mexiko und Venezuela bereist. Er war kein Forscher, kein Abenteurer, kein Weltbummler. Gerstäcker lebte wenigstens auf seinen ersten Reisen von seiner Hände Arbeit. Hunderttausende von Deutschen waren als Völkerdünger in Amerika verbraucht worden. Nun beginnt der volksbewußte deutsche Arbeiter um den Erdball zu haften und mit seinesgleichen Klasse zu werden. Ein Vorgang, kaum erst zu spüren. Doch Gerstäcker sagt ihn mit seiner persönlichen Haltung an. Dieser Mann hat so wenig einen neuen Stoff wie eine neue Form gefunden. Das war Postls Verdienst. Und Gerstäcker war sein Schüler. Doch der Matrose, der Holzknecht, der Farmer, deren Mühsal und Arbeit Gerstäcker nacheinander erfuhr und schaffte, bedingten den Stil, die Lebensbeziehung, das innere Gesicht all seiner Bücher. Die eine Gruppe, sachverläßliche Schildereien wie „Reisen" 1853 nähert sich dem wissenschaftlichen Reisebericht durch Bürgschaft für das, was dargestellt wird. Die andere Gruppe, romanhaft arbeitende Erzählungen, spielt unter allen Wendekreisen, die Gerstäcker gekreuzt hat. In der Handlung sorgfältig, ja überlegen gebaut, dem Leben mehr nachgeahmt als üppig und frei erfunden, meistern sie ihre Kunst in „Tahiti" 1854, „Die beiden Sträflinge" 1857, „Gold" 1858 mit lässiger Sicherheit. Diese Kunst war bereits in dem frühesten Doppelstück gewonnen. Denn die beiden Romane „Die Regulatoren in Arkansas" 1845, „Die Flußpiraten des Mississippi" 1848 bilden schon durch die Strominsel und die Entlarvung eines verbrecherischen Doppellebens ein Ganzes. Nach Karl Postl noch einmal war hier der Umbruch der Menschenwildnis zur Kultur, der Zusammenstoß zwischen den vorauseilenden verlorenen Haufen und der nachrückenden Gesittung in Bildern festgehalten, denen der Urkundenwert Homerischer Dichtungen zukommt.

So denn Lübeck. Von dieser Stadt aus, unter deren Schiffen so manche *Lübeck und der Hellenismus* Meere rauschten, erschließt sich die Umwertung der Antike von Italien auf Griechenland und der neue Hellenismus nach Sinn und geschichtlicher Folge. In Wagrien waren einst die ersten Spuren eines abendländisch-griechisch-russischen Gütertausches sichtbar geworden. Die griechische Mystik hat immer wieder das ostdeutsche Denken befruchtet. Zwischen Sachsen und Griechentum gab es seit den ältesten Zeiten geheimnisvolles Einverständnis. Johann Joachim Winckelmann hatte die hellenische Kunst, Johann Georg *Niedersächsische Griechenkunde* Hamann die hellenische Philosophie wieder erweckt. Friedrich Leopold zu Stolberg und Johann Heinrich Voß hatten diesem sächsisch-nordischen Helle-nismus dichterischen, Asmus Carstens und Berthel Thorwaldsen bildkünst-lerischen Antrieb gegeben. Leo Klenze, Karl Friedrich Schinkel, Gottfried Semper erfaßten ihn mit monumentalen Schöpfungen. Griechischer Gutshof und griechischer Stadtstaat waren für Johann Karl Rodbertus, Makedonier und Diadochen für Johann Gustav Droysen die Richtpunkte, nach denen jener die Staatswirtschaft und dieser die deutsche Staatsschöpfung weltge-schichtlich durchleuchteten. Alle deutschen Jahrhunderte bis an die Schwelle des neunzehnten hatten die griechische Welt aus griechischen Büchern ge-deutet. In diesen stubenblassen Hellenismus fuhr der Freiheitskampf der *Griechische Volkslieder* Gräkoslawen. Er brachte die sächsische Jugend in Aufruhr: die Griechen-lieder des Dessauers Wilhelm Müller seit 1821; die griechischen Volkslieder des Westfalen Werner von Haxthausen; um 1825 die neugriechischen Schil-dereien Karl Ikens von Bremen und Harro Paul Harrings aus dem Husumer Ländchen; um 1833 das griechische Tagebuch des griechischen Freiwilligen Friedrich Joachim Suckow aus Mecklenburg. Am 6. Februar 1833 hielt Otto von Wittelsbach seinen feierlichen Einzug in Nauplia. Nun erschloß sich das Land selber der abendländischen Kenntnis. Der griechische Wohnraum, die fortzeugende Natur, die redenden Denkmäler des Bodens rücken an Stelle der nachgeschriebenen Bücher. Die griechischen Menschen verdrängen die Heroen und Götter, von denen nur die Dichter gewußt hatten. Bairische Beamte haben das Land verwaltet. Entdeckt und zum Reden gebracht hat es der Sachse und Nordländer. Ludwig Roß aus Bornhöved, seit 1833 Pfleger der griechischen Altertümer zu Athen, entzauberte die wissenschaftliche Be-fangenheit seines Zeitalters, indem er die Vorbesiedler von Hellas aus Ägyp-ten und Kleinasien kommen ließ; indem er sich gegen den fanatischen Glau-ben an die Ursprünglichkeit der griechischen Kultur wandte; indem er so, wie Fallmerayer, die Schwärmerei um die Neugriechen ernüchterte; indem er die Pyramiden Ägyptens, die Palasttrümmer Ninives, die Schatzhäuser des *Schatzgräber*

Atreus und Minyas für die griechische Abhängigkeit von der älteren Ost-
kultur zeugen ließ. Mit jener Einseitigkeit, deren es damals bedurfte, wies
Peter Wilhelm Forchhammer aus Husum auf die Sachwerte des hellenischen
Nachlasses. Bei seinen Reisen hielt er sich an das Volk. Und durch seine Reise
kam er zur Ortskunde, zum Mythus, zur Archäologie. Er fand diese Mythen
nur an Ort und Stelle verstehbar. Diese nordisch-griechische Neuwelt stand

Ernst Curtius um den Lübecker Ernst Curtius, 1814 bis 1896, Szene. Ende 1836 wurde
Curtius Hauslehrer bei seinem Lehrer Christian August Brandis, der als
Berater des jungen Königs Otto für Hochschulangelegenheiten nach Athen
berufen worden war. Mit Strabos Buch in der Hand durchstreifte Curtius die
griechische Landschaft. So erwarb er sich das wunderbare Vermögen, grie-
chischen Himmel und griechische Erde in ihrem Zusammenspiel zu erfühlen.
Die drei Bände seiner „Griechischen Geschichte" 1857/1861, sorglos gegen-
über den Quellen und kein Gegenstück zu Mommsen, sind ein darstellendes
Kunstwerk mit seinen gemeißelten Standbildern und körperhaften Kultur-

Olympia räumen. Vom Reich unterstützt, konnte er 1876/1881 glücklich Olympia dem
Licht der Sonne zurückgeben. Er hat die Gründung des deutschen archäolo-
gischen Instituts in Athen ermöglicht. Curtius also hat dieser sächsischen
Neigung Ziele gesetzt und die Grabscheite in Bewegung gebracht. Sachsen
waren schließlich die großen Unternehmer und Schatzfinder: Heinrich Schlie-
mann aus Neubuckow in Mecklenburg, der nach abenteuerlichen Weltfahrten
aus dem Mecklenburger Schatzgräberglauben und frühester Homerlesung
seinen Spürsinn auf urgriechische Denkmäler entwickelte, der 1868 in Ithaka
begann und seit 1871 die trojanischen Burgschichten aus dem Boden wühlte;

Troia Wilhelm Dörpfeld, von Barmen, der in Olympia arbeitete und Schliemanns
Gehilfe wurde; Karl Heumann aus Steele an der Ruhr, der nach Curtius'
Winken Pergamon ergrub. All das bedeutete für Altsachsen und Wenden-
sachsen ein neues und erstmalig organisches Verhältnis zu Griechenland,
Rettung aus einer Dämonie, für die Droste-Hülshoff, Grabbe, Hebbel, Storm
zeugen, in die Helle von Hellas.

WESTFALEN und die sächsischen Rheinlande auf der einen Seite, Pom-

Soziale Frage mern und Mecklenburg auf der andern Seite stellten in Niedersachsen und
auf Sächsisch also in Preußen die soziale Frage. In Westfalen war es das Nebeneinander
von Bauernlandschaft und Industrielandschaft, an der Ostsee von Grund-
herrschaft und Landproletariat.

Westfälische Der westfälische Adel hatte im Schrifttum keinen Sprecher mehr. Denn
Romanhistorie *Levin Schücking*, 1814 bis 1883, aus Klemenswerth bei Meppen, aus einem
alten Geschlecht der Stadt Koesfeld bei Münster, nahm seinesgleichen nicht

mehr ernst. Sein Vater wie seine Mutter wußten einen schönen Vers zu *Levin Schücking*
machen. Die Mutter hatte im Kreise der Fürstin Gallitzin verkehrt und war
mit Annette von Droste-Hülshoff befreundet. Das Leben des Dichters spielte
sich zwischen dem großen Kunstpark des Schlosses Klemenswerth ab, wo sich
der Knabe tummelte, und dem Stammgut Sassenberg bei Warendorf, das
sich der reife Mann zurückkaufte. Von Annette, die ihm eine ältere Freundin
war und bei seinen ersten Büchern half, löste er sich, als das Geschlecht ins
Spiel zu kommen schien. Schückings Fall war der Roman. Walter Scott und
Alexander Dumas heißen auch hier die europäischen, Immermann, Häring,
Gutzkow die deutschen Grenzen, die Levin Schückings Eigentum einengen.
Er hat zu jenen gehört, die ein volles Menschenalter nach dem Untergang des
alten Reiches, das versunkene Leben wieder beschworen, um es zu recht-
fertigen oder zu beerdigen oder mit der neuen Zeit zu messen, immer aber
mit jener heimlichen Zärtlichkeit, die gewesene und begrabene Dinge in uns
locker machen. Ihm war es Westfalen, das Leben der kleinen geistlichen
Höfe und der reichsfreien Herren, die ganze Welt von Bauer und Bürger,
Domherr und Edelmann, wie sie langsam aber zuverlässig von Preußen ver-
schluckt wurde. Dies alte Westfalen von 1789 handelt wahrhaftig noch, meu-
tert wider die Franzosen und Preußen, wehrt sich gegen das neue Jahrhun-
dert, macht ihm Zugeständnisse oder läßt sie sich abzwingen. Schücking setzt
also diese engbegrenzte westfälische Welt in Beziehung zur Gegenwart. So
in den „Ritterbürtigen" 1846 launig und spöttisch, indem er diese Junker
und ihr spleeniges Treiben allzu dicht an die mittägige Sonne rückt. So „Der
Bauernfürst" 1851, wo das morsche Westfalen und die Revolution aufein-
ander stoßen. So „Die Königin der Nacht" 1852, wo der Einzelne sich aus
dem Netz der Familie und des Standes löst. „Die Heiligen und die Ritter" *„Die Heiligen*
1873 aber sagen den erneuerten Zweikampf zwischen dem unsterblichen vor- *und die Ritter"*
preußischen Westfalen und dem mächtigen Reich von 1870 an. In einer
andern Reihe von Romanen ließ Schücking das Gestirn der Welt auf dieses
verengte Westfalen scheinen, indem er die Landschaft mit europäischen
Handlungen verknüpfte. Schücking arbeitet mit abenteuerlichen Verwick-
lungen und Ränkespielen, mit plötzlichen Enthüllungen. Er wird nicht selten
unwahrscheinlich und benützt die Wege des Hintertreppenromans. Denn er
schrieb zuviel und mußte sich gehen lassen. Aber unwiderstehlich ist seine
Kunst des bodenechten Beiwerks und sein Vermögen, bei kleinstem Aus-
schnitt schärfste Bilder zu geben.
 Da war er wieder, der eingeborene Widerspruch des Deutschen mit sich *Sachsen*
selber und mit der Welt, in die er gesetzt ist. Er hatte einst Sachsen und *und Franken;*
Sachsen
und Preußen

Franken geheißen und ihn zu stillen, waren Widukind und die Seinen über das Taufbecken gebeugt worden. Er hieß jetzt Sachsen und Preußen. Ihn zu stillen, bot in den Rheinlanden Preußen seinen Staat und Bismarck sein Reich gegen das römische Kirchentum auf. So wie Schücking das vorpreußische Westfalen in Beziehung zu seiner preußischen Gegenwart gesetzt hatte, so bezog Pape das alte Reich nun auf das neue.

Josef Pape, 1831 bis 1898, aus Eslohe war ein Bauernsohn und zuletzt Rechtsanwalt in Büren. Gleichgültig sind seine Dramen, unwesentlich seine *Norden und Süden* Novellen, entscheidend seine Epen. „Der getreue Eckhart. Epos von deutscher Entzweiung" 1854 verlegt den Vorwurf in die Sachsenkriege Kaiser Heinrichs IV. „Schneewittchen vom Gral" 1856 gibt ihm den Spielraum der kaiserlosen Zeit um 1250 zwischen Staufern und Habsburgern. Der deutsche Zwiespalt ist von zweierlei Art. Der eine geht wie bei Grabbe so bei Pape durch das Gesamtvolk und bedeutet Widerstreit zwischen Germanisch-nordisch und Deutsch-südisch. Den andern erlebt jede deutsche Seele. Denn er ist Widerspruch zwischen Glauben und Unglauben. Beide Entzweiungen bezieht Pape zurück auf die metaphysische Zweiheit alles Seins. Seine epische *Advent des Reiches* Dichtung wirkt durch das mächtige Grunderlebnis, Advent und Weihnacht des deutschen Reiches, und durch ein neues episches Rüstzeug. Aus Geschichte und Märchen bildete sich der Dichter einen gemäßen Mythus und eine stehende Formelsprache. Er hat die epischen Stilmittel der ritterlichen, volksmäßigen, romantischen Dichtung verschmolzen zu einem Stil von Wucht und Schlichtheit. In Pape drückte sich abermals der epische Trieb des Sachsen aus wie zuvor in den Schöpfungen Klopstocks und Sonnenbergs. „Das Lied von der Welt Zeiten" ist in dunklen Gesichten eine geschichtliche Apokalypse, Weissagung aus der Rückschau, und beginnt die Reihe der Menschheitsdichtung Pape-Schack-Hart.

In der Ruhrgegend war seit dem Anfang des achtzehnten Jahrhunderts eine eigentümliche Hausindustrie im Gange. Mystiker reformierten Glau-*Ursprung der Arbeiterdichtung* bens teilten hier ihr Leben zwischen Handarbeit, innerer Schauung und dem Erguß religiöser Gedichte. Gerhard Tersteegen, 1697 bis 1769, arbeitete hier als Bandweber und Seelenführer der niederrheinischen Erweckten. Ein ähnliches Sozialgebilde zeichnete sich mit dem Anfang des neunzehnten Jahrhunderts im *WUPPERTAL* ab: Handel und Wandel, Maß und Ordnung die Bibel, lyrische Dichtung für die Nebenstunden. Goethe hat die gewerbliche Tüchtigkeit des Wuppertales aus dem religiösen Eifer hergeleitet. Das geistliche Haupt des Tales wurde Friedrich Wilhelm Krummacher, 1796 bis 1868, der Sohn des Parabeldichters und Neffe des großen Pfarrers von Elber-

feld. Als Jenaer Burschenschafter hatte er das Wartburgfest mitgemacht. Er kannte Pascals „Pensées" und Hamanns Schriften. Als Pfarrer in Ruhrort war er von dem christlichen Leben nach Tersteegens Art ergriffen worden. In der Pfarrei Barmen sammelte er seit 1825 um seine Kanzel eine weite Gemeinde. *Barmen* Friedrich Roeber schließt in seiner Novelle „Marionetten" die Schilderung des Wuppertales. „So hatte sich auf dem Boden der christlichen Gemeinsamkeit zwischen den beiden Gesellschaftsklassen eine Art von patriarchalischem Verhältnis herausgebildet, das nicht ohne einen Anflug von Idealität war, und in dem beide sich wohl fühlten", Brotherr wie Arbeiter. In den vierziger Jahren zerriß es. Die freisinnige Bibelkritik wurde volkstümlich. Unternehmer und Gebildete verloren ihren frommen Glauben. Die Arbeiter begannen wie Marx und Engels zu denken. Ernst Wilhelm Hengstenberg *Hengstenberg* aus Fröndenberg und Friedrich Engels aus Barmen bezeichnen die gegen- *und Engels* sätzlichen Gesellschaftsschichten und Weltanschauungen, die aus dem gewerblichen Boden der Ruhrlandschaft und des Wuppertales hervorgegangen sind. Ende der vierziger Jahre nun versammelten sich in einem Kaffeehaus am Altenmarkt zu Barmen junge Männer und stifteten den „Wupperbund". Man hielt Vorträge über Geschichte und Literatur. Man machte Verse. Man las Dramen mit verteilten Rollen. Wie in München herrschten auch hier Wort, Bild, Weise schwesterlich nebeneinander. Die Wege dieser Männer gingen weit auseinander, der eine zum kraftbewußten Aufstieg der Arbeiter, der *Die Schüler* andere zu den kleinen Dingen eines flauen und tatenscheuen Bürgertums. *Freiligraths* Zu den Wortführern der Sozialrevolution gehörte der Elberfelder Schüler Freiligraths Adolf Schults, 1820 bis 1858, der das Beste in seinen kleinen lyrisch-epischen Gedichten gab. Und Freiligraths Wege ging Karl Siebel, 1836 bis 1868, aus Barmen, der in England unter den Einfluß von Friedrich Engels und der englischen Demokraten kam. Was er wollte, bezeugt sich in seinen Liedern der Armut und Not. Reinhard Neuhaus, 1832 bis 1892, aus *Reinhard* Barmen, trat mit seinen leidenschaftlichen Anklagen neben Marx und Engels, *Neuhaus* einer der ersten sozialistischen Dichter, der auch sehr gemütvoller Lieder fähig war. Dem starken, wenn auch meist formlosen Gehalt dieser Arbeiterdichter entsprach bei den Wuppertalern bürgerlichen Gebarens eine glatte aber leere Form. Aus dieser Umwelt ist der eigentliche Hausdichter des Zeitalters hervorgegangen, durchgesetzt von seinen Gesinnungsgenossen und der „Gartenlaube", Emil Ritterhaus, 1834 bis 1897, von Barmen. Seine „Ge- *Emil Ritterhaus* dichte" erschienen 1856/1906 in zehn Auflagen. Sie sahen immer „fast wie neu" aus. Ritterhaus war das Urbild des „harmonischen" Bürgers zwischen 1848 und 1870: Freiheit mit Vernunft und „gut deutsch alleweg". Das waren

die Menschen des Übergangs aus jener Landschaft, die dem neuen Reich die
Waffen erzeugte und zum Angelpunkt des deutschen Schicksals wurde.

Die Stettiner Wieder anders schallte es aus Mecklenburg und *POMMERN*. Nieder-
sachsen hatte die deutsche Historie geschaffen und als Motor in das Trieb-
werk zum deutschen Staat eingesetzt. Doch Gesellschaft und vierter Stand?
Der Frage sannen ein Sohn der pommerschen Hafenstadt und pommerscher
Landjunker nach. Die östlichste der wendensächsischen Städte, dasselbe Stet-
tin, wo Heinrich Ludwig Giesebrecht einen ganzen Kreis von Schülern erzog
und Johann Karl Löwe die Tonkunst betreute, erzeugte aus dem Wohlstande
eines Patrizierhauses den Künstler und Kunstkenner Franz Kugler, aus ihrem
jungen Preußentum den Schlachtensänger der Hohenzoller Christian Sche-
renberg, aus verarmter Kaufmannssippe, den Dichter des Proletariats, Ro-
bert Prutz. Die andern fanden in Berlin ihren Nistplatz. Dieser kehrte in
seine Heimat zurück und leistete hier sein Bestes.

Fabrik *Robert Prutz*, 1816 bis 1872, bezeugte durch seine zahlreichen literar-
und Handwerk historischen Schriften, daß er gleich seinen Landsleuten zur Geschichte be-
rufen war. Er wurde ihr entführt durch die Hingabe an die Pflichten des
Tages: durch „Gedichte" 1841, die voll Redeschwall und ohne Einfalt des
Herzens waren; durch gutgemachte Jambendramen, in denen er geschicht-
liche Helden für oder wider die Gegenwart mißbrauchte. Durch sie aber und
Robert Prutz das „aristophanische" Lustspiel „Die politische Wochenstube" 1843, das so
dicht bei Droysens Aristophanesbuch lag, wurde er wieder zur sozialen Dich-
tung gebildet und so vor Gustav Freytag zum Wortführer des arbeitenden
Volkes. Diese Romane seiner reifsten Jahre waren vorzüglich gebaute Ge-
bilde eines Künstlers, der grell beleuchtete, aber sparte, wenn es mit Laune
zu erwärmen galt. Ätzender Hohn und schonungslose Sachlichkeit waren ihm
Vorsatz und Kunstgesetz. „Felix" 1851 sieht in das Zeitalter wie durch ab-
gehobene Dächer hinein. „Der Musikantenturm" 1854 gibt die Binnenwelt
des armen und verkommenen Volkes und die Kehrseite der Gesellschaft.
Der „Das Engelchen" 1851 läßt den dämonischen Zauber der Maschine aufgehen,
soziale Roman der die Welt verhext. Da hebt das erbitterte Ringen zwischen Arbeitgeber
und Arbeitnehmer an. Da schießen zwischen Weberhandwerk und Weber-
fabrik Verbrechen und Laster auf. Prutz weiß nur ein Mittel, um das Hand-
werk zu retten. Die Weberfabrik geht in Flammen auf. Mit der Rückkehr
des Handwerks wird das Leben wieder schön, ehrlich und gut. Auch das war
eine der sieben Geburten des deutschen Realismus. Prutz wog die soziale
Frage auf der allzu schmalen Schneide des Gegensatzes von Fabrik und
Handwerk. Doch er öffnete dem Arbeiter die Literatur, um die Kunst zu

einem neuen Amt zu verpflichten. Es war eine grausame und brutale Kunst. Sie meinte das Leben, wie es ist, und nicht, wie es sein sollte.

Nach Niebuhr, Mommsen, Droysen wurde nun auch auf dem Felde der Volkswirtschaft die Antike zu Nutz und Frommen der Gegenwart befragt. *Niebuhr, Mommsen, Rodbertus*

Johann Karl Rodbertus, 1805 bis 1875, von Greifswald, reifte, nachdem er seine gelehrte Bildung abgeschlossen hatte, als Landwirt auf Gut Jagetzow zum staatswirtschaftlichen Denker. Doch was er bewohnte, war kein Wolkenkuckucksheim. Er führte zu Greifswald den „Baltischen Zweigverein für das Wohl der arbeitenden Klassen". In der Berliner Nationalversammlung war er der Führer des linken Zentrums. Unter Auerswald war er Minister für Kultus und Unterricht. Seit 1850 gewann er aus der Erkenntnis des antiken Wirtschaftslebens klare Einsichten in das, was die Gegenwart heischte. Ihm hoben sich nun drei staatswirtschaftliche Weltalter ab. Das erste war das heidnisch-antike, da Mensch, Grund, Geld in gleicher Weise Eigentum waren. Dann kam das zweite, das christlich-germanische, da der Arbeiter aus dem Eigentum fiel und nur noch Grund wie Geld Eigentum blieben. Jetzt ziehe ein drittes Weltalter herauf. Auch Grund und Geld werden aufhören, Eigentum zu sein. Eigentum wird es nur noch aus Einkommen geben, und das nur soviel, als der einzelne an Arbeit leistet. Wie das römische Kaisertum der Siegespreis des Kampfes war, den die großen Grundherren um den Besitz des ganzen griechisch-römischen Junkerstaates auskämpften, so muß der neue Cäsar zugleich Schöpfer des neuen Staates und der neuen Wirtschaft werden. Und mit Beziehung auf Karl den Großen als den Schöpfer der christlich-abendländischen Ordnung: „Die soziale Frage ist der Initialbuchstabe wiederum einer neuen und andersartigen, politischen Epoche . . . Sie ist ohne Blasphemie, abermals ein Stück Christentum, das im Recht Fleisch werden will!" Niebuhr, Mommsen, Rodbertus; Rom und die römischen Ackergesetze — welch eine Bezeugung des einen sächsischen Willens. *Das soziale Kaisertum*

MECKLENBURG, wo die Ritterschaft in jahrhundertealten Staatsgrenzen befriedet war, schien zunächst auch dichterisch von der Ritterschaft vertreten zu werden. Herr von Normann, die Gräfin Hahn, Graf Schack bezeichnen hier drei Bildungsstufen. *Die Ritterschaft*

Wilhelm von Normann, 1802 bis 1832, aus Neustrelitz, war ein Nachgeborener seines Vaters wie er seinen eigenen Sohn nicht mehr gesehen hat. Er hat die Pyrenäen sowie das Land beiderseits, Italien und die Schweiz bereist. Das Beste davon ist in seine Dichtungen eingegangen, die zumeist Erzählungen in Stanzen sind. Die Jambentragödie „Der deutsche Bauernkrieg" hört sich, so unwirklich sich das alles in stilvollen Versen ausnimmt, *„Der deutsche Bauernkrieg"*

wie ein Abschnitt an aus des Rodbertus späteren Arbeiten. „Briefe über die Pyrenäen" 1829 fügen sich als die ersten ihrer Art in die anschwellende Pyrenäenliteratur ein. Normanns werdendes Wesen und Werk schillert in dem Gegensatz zwischen nordischem Schicksal und Willen zum Süden.

Die Gräfin Hahn-Hahn *Ida Gräfin Hahn-Hahn*, 1805 bis 1880, aus Tressow, die Tochter des Theatergrafen, wuchs in Unliebe auf, wurde gleichgültig mit ihrem Vetter zusammengetan und von ihm wieder geschieden, bereiste die Länder um das Mittelmeer, im Norden und im Morgenlande und lebte von den Reisebüchern, die ihr diese Fahrten eintrugen. Ihr Leben stellte sie zwischen zwei Männer, den Politiker Heinrich Simon und den Balten Adolf von Bystram. Dieses Erlebnis führte zum Roman. Zwischen Abbildern beider Männer erschien sie fortan in allen ihren Büchern. Die erste Gruppe wie „Aus der Gesellschaft" verfocht die Freiheit des Herzens gegen jede Bindung. Über „Gräfin Faustine" schritt sie innerlich zu der Gruppe um „Sybille" vor, ihren wesentlichen Roman, der bei vollkommener innerer Form nach Frieden mit der Gesellschaft strebt, Verlangen nach Mittelalter und römischem Christentum verrät. Diese letzten Romane sind Wegmarken zur römischen Kirche, in die sie 1850 zu Berlin eintrat. Die Gräfin hatte im Sinne des englischen Adels streng junkerliche Haltung. Stil und Zurüstung ihrer Romane weisen auf

Die Weltdame George Sand. Seelische Zustände wußte sie mit wunderbarem Feingefühl wiederzugeben. Geziert und anspruchsvoll im Tonfall, unruhig und aufreizend im Rhythmus, fremdwortreich in der Sprache, malte sie vornehme Innenräume, wie ja auch für Storm Häuser und Stuben fast zu Helden wurden, Raabe den umhegten Raum der Städte liebte, die Droste Getäfel und Hausgerät dämonisch zu beleben wußte. Die Vorstellung „Jerusalem und

„Jerusalem und Babylon" Babylon" beherrscht ihre späteren Bücher: auf der einen Seite leidensstarke, gläubige Menschen, auf der andern ihr altes Modell, die „coquette, kalte, stolze Weltdame". Diese Frau war wie kaum ein anderer Mensch das Spiegelbild jenes ruhelosen, ungeduldigen Geschlechts vom Vorabend der Revolution.

Graf Schack *Adolf Friedrich Graf von Schack*, 1815 bis 1894, aus Brüsewitz, für Musik, Dichtung, Bildkunst gleichmäßig erweckt, hat auf seinen Reisen durch Südeuropa und das Morgenland überall Museen, Büchereien, Urkunden durchstöbert. Seit 1858 lebte er, von Maximilian II. eingeladen, zu München und legte in der Briennerstraße die kostbare Bildersammlung an. Sein erstes Gedichtbuch kam 1866, seine Werke 1882 heraus. Entstanden ist das meiste weit früher. Sein hoffnungsloser Ehrgeiz war das Drama. Sächsischer Stil war sein Epos. Jede Form hat er sich zu eigen gemacht: „Durch alle Wetter"

1870 das Komische; „Lothar" 1872 das Zeitgeschichtliche; „Die Plejaden" 1881 das Geschichtliche, den Kampf zwischen Persern und Griechen; „Nächte des Orients" 1874 in traumhaftem Miterleben der verschiedenen Weltalter Aufstieg und Geschichte der Menschheit. Und das war die Schöpfung, die von Josef Pape zu Heinrich Hart die Brücke der epischen Überlieferung Sachsens schlug. Schacks Dichtung war nur äußere Form einer Welterfassung, die aus Urkunden und durch Reisen über Völker und Erdteile zum Ganzen der Menschheit strebte. Vor allem versuchte er mit forschenden Arbeiten über die „Geschichte des spanischen Dramas und Theaters" 1845, über „Poesie und Kunst der Araber in Spanien und Sizilien" 1865, über „Geschichte der Normannen in Sizilien" 1889 den arabisch-normannischen Kulturkreis des Mittelmeeres zu durchleuchten, in dichterischen Nachbildungen die ebenmäßig gepaarte Kunst des Morgenlandes anschaulich zu machen und die Ganzheit der Weltliteratur mit einer lyrischen Auslese zu bezeugen. Schack ist mit Gobineau verglichen worden. Die großen Romanen waren seine Vorbilder. Das Erbe der Rückert und Platen hat er unter ganz neuen weltpolitischen Einsichten fortgemehrt. Nur ein Weltreisender von seiner umfassenden Bildung und seiner geschichtlichen Schule vermochte den Weltraum geistig zu beherrschen, den die neue deutsche Seeflagge zu bewimpeln begann.

„Nächte des Orients"

Graf Schack

Der deutsche Gobineau

Die drei Mecklenburger Junker verkörpern drei Bildungsstufen und Zeitalter. Weltfahrer waren alle drei. Und hierin mit gemeinsamen Zügen war Normann ein Spätling der romantischen Empfindsamkeit; die Gräfin Hahn-Hahn, die problematische Frau der übergeistigten Hegelzeit; Graf Schack aber, dieser Vertreter des norddeutschen Hellenismus und des ostdeutschen Orientalismus, war der Dichter des neuen Zeitalters: der deutschen Weltreisenden, der aufsteigenden Weltpläne, der anwachsenden Flotte. Mit der Richtung auf den Grafen Schack haben die beiden westfälischen Brüder Hart ihr Fähnlein gesammelt.

Die drei Mecklenburger Junker

Die soziale Frage um Rittergut und Dorf brach in der mundartlichen Literatur Niedersachsens durch. Sie hatte in den einzelnen Landschaften ihre eigentümlichen Ansätze. In Westfalen übertrug Bernhard Godfrid Bueren, 1771 bis 1845, lediglich schriftdeutsch Empfundenes in heimatliche Lautformen, während Theobald Wilhelm Broxtermann, 1771 bis 1800, englische und schottische Volksdichtung nachbildete. Den eigentlichen Anstoß zur neuen Mundartdichtung des Landes gaben die „Münsterischen Geschichten, Sagen und Legenden" 1825 von Matthias Sprickmann. Diese Dichtung gewann in den Händen dreier Meister bald Fertigkeit und Ansehen. Der Osna-

Dichtung auf Niedersächsisch

brücker Friedrich Wilhelm Lyra, 1794 bis 1848, stellte altertümlich und
bissig das dörfliche Volksleben und die guten alten Zeiten dar. Der Mün-
sterer Ferdinand Zumbrook, 1816 bis 1890, erfand gitarrespielend Wort
zugleich und Weise seiner Lieder, die sich um den münsterländischen Spieß-
bürger und Bauer, seine Haustöchter und Kindermädchen drehten. Zum-
Döhnken
und Läuschen
brooks Döhnken sind weit älter als Reuters Läuschen. Friedrich Wilhelm
Grimme, 1827 bis 1887, aus Assinghausen, ließ das ganze Sauerland und
seine Bewohner in seine Schwänke und Lustspiele eingehn. In Jütland gab
diesen Anstoß Karl Müllenhoff, 1818 bis 1884, aus Marne, ein Schüler Nie-
buhrs und Lachmanns. Mit einer grundlegenden Einleitung gab er 1845
„Sagen, Märchen und Lieder der Herzogtümer Schleswig, Holstein und
Lauenburg" heraus. Aus seiner Grundeinsicht, die ältesten deutschen Stämme
seien Kultgemeinschaften gewesen, entwickelte sich sein mächtiges Werk
„Deutsche Altertumskunde", von dem er 1870 und 1883 nur zwei Bände
erleben konnte. Hier kamen der Forscher und der Dichter zusammen. *Klaus
Groth*, 1819 bis 1899, aus Heide, war als eines Müllers Sohn mit Land und
Leuten vertraut, und hatte als Schullehrer zu Heide den Ehrgeiz, die säch-
sische Sprache in eine Kunst hohen Stiles zu retten. Sein lyrisches Buch
„Quickborn"
„Quickborn, Volksleben in plattdeutschen Gedichten dithmarscher Mundart"
1852 ist während der Dänenkämpfe auf der Insel Fehmarn entstanden. Nicht
das Zufällige, sondern das Allgemeingültige war ihm Gegenstand. Rollen-
dichtung waren viele seiner Stücke. Die nordsächsische Landschaft, wie sie
mit Wald und Heide, Marsch und Watt nur hier und einmal ist, wurde nicht
in Versen abgeschildert, sondern wie Leben wirkend gezeigt, verkörpert zu
mythischer Gestalt. Die altgermanische Kameradschaft von Mensch und Tier,
bei der Droste, bei Hebbel, bei Storm, bei Speckter mit Hingabe gehalten,
spiegelt sich in Bildern der Laune. Es war ein lyrisches Buch, das in jeder
Form das Beste brachte. Doch das war nur das Grundgefühl. In Balladen und
Idyllen aus der sächsischen Gegenwart, die das Geheimnisvolle und Gespen-
stige Storms und Hebbels hatten, in größeren Epen und Prosaerzählungen,
in selbstdarstellenden Schilderungen war eine ganze Literatur geschaffen und
Grammatische
Dichtung
durch die „Briefe über Hochdeutsch und Plattdeutsch" 1858 sachlich gerecht-
fertigt. Groth hat das Rüstzeug dieser Literatur auf Sächsisch zubereitet.
Peter Hebel und der schottische Volksdichter Robert Burns haben ihm man-
chen Handgriff gewiesen. Das Niedersächsische hatte niemals aufgehört,
Schriftsprache zu sein. Klaus Groth war weder ihr Erwecker noch ihr Voll-
ender. Aber er war eine Stafette am Kreuzweg dieses Staffellaufs. Er hat den
Gewinn der hohen deutschen Dichtung an die Dichtung der sächsischen

Mundart weitergegeben. Karl Müllenhoff war sein Mitarbeiter, indem er zum „Quickborn" den Vorbericht, die Grammatik und das Wörterbuch schrieb. Und so ist es nun einmal nicht anders. An der sächsischen Dichtung dieser Werdestufe haben Sprachwissenschaft und Dichtkunst zusammengewirkt.

Da geschah es nun in MECKLENBURG ganz anders als in Westfalen und in den Herzogtümern. Die mundartliche Dichtung Mecklenburgs ist unmittelbar hervorgegangen nicht nur aus der gesprochenen Sprache, sondern auch aus der „gesprochenen Literatur" des unmittelbarsten Lebens. *John Brinck-* *John* *Brinckman* *man,* 1814 bis 1870, war der Sohn eines Rostocker Schiffers, den samt seinem Fahrzeug das Jütenmeer verschlungen hatte, und einer Schwedin, war mit seines Vaters Schiff „Blücher" gegangen, wegen „Teilnahme an verbotenen Verbindungen" verfolgt worden, kam aus Nordamerika so aussichtslos zurück, wie er gegangen war, und schlüpfte schließlich als Lehrer an der Güstrower Realschule unter. Brinckmans Anfänge stecken in den mündlichen Schiffergeschichten seines Vaters wie in der umlaufenden plattdeutschen *Der Kapitän* Literatur. Burns und Dickens hat er vielleicht, die junge flämische Literatur zuverlässig gekannt. Peter Hebel und Klaus Groth war er in gleicher Weise verpflichtet. Schon im Jahrbuch „Mecklenburg", das seit 1843 der unruhige Anwalt Wilhelm Raabe und der strebsame Verleger Hinstorff herausgaben, kam er mit junkerfeindlichen Versen zu Worte. In Güstrow reifte seine niederdeutsche Dichtung. Denn 1854 erschien: „Aus dem Volk für das Volk, plattdeutsche Stadt- und Dorfgeschichten. Erstes Heft. Voss und Swinegel." Es war das erste Probestück des neuen plattdeutschen Stiles in bewußter Abwehr der junkerlichen Dichtung. Als zweites Heft dieser Sammlung erschien 1855 „Kasper Ohm un ick". Es ist die Selbstschilderung, die ein Ro- *Schiffergarn* stocker Kapitän von seinen Flegeljahren gibt. Der bestrickende Reiz dieses unwiederholbaren Gebildes liegt in der dreifachen Spiegelung: im Auge des halbwüchsigen Jungen, im Auge von dessen Mutter, im Auge des Kasperohms. Die Geschichte wahrt den Ton des Erzählers. Und dennoch läßt sie alle Klangfarben der handelnden Personen durchklingen. Ernst und groß, die verschwiegenste Seite urmenschlichen Gemeingefühls aufweckend, braust sie aus in das Abenteuer des Tambourmajors „Monsüre Butong". Das ist Brinckmans Franzosentid. Nach Geschichten ähnlichen Stils, aber bescheidener Haltung, kam Brinckman bei reifen Jahren zur plattdeutschen Lyrik. Begonnen hat er früh und in hochdeutscher Sprache mit romantischen Balladen, mit Meerliedern und satirischen Stücken, schwer im Vorwurf, spröde im Ausdruck. Zwischen dem hochdeutschen Romantiker und dem plattdeut-

schen Realisten Brinckman spielte sich der Übergang ab von der erworbenen hochdeutschen zu der eigenwüchsigen sächsischen Literatur. Mit dem Landvolke zusammenlebend, überwand er seine Abneigung vor dem plattdeutschen Vers. Die Form hatte Groth gefunden. Den lebendigen Inhalt fand Brinckman. Die Brücke schlug das „Döhnken", das Histörchen, weil *„Vagel Griep"* es festen Anschluß hatte an seinen Prosakleinbildern. So entstand „Vagel Griep" 1859; das plattdeutsche Versbuch. Brinckmans lyrische Kunst hält sich streng im Kreise dessen, was ein Landeskind zu sagen vermag. Die Erde war ihm nicht trübe verschleiert. Auch wenn er nicht lachte, blieb er froh. Seine Schreibung suchte anfangs das gesprochene Wort nachzuschaffen, unerbittlich gegen jede Regel. Später näherte er sich Reuters Schreibweise. In der Gemessenheit seines Auftretens konnte Brinckman für einen Großkaufmann gelten, „dessen Schiffe auf allen Meeren schwimmen", und er war doch nur ein armer Schulmeister.

So hatte sich die mundartliche Literatur in Mecklenburg von der Klassik und Romantik weg zum Realismus gewendet und der sozialen Frage auf dem Lande angenommen. Diese Wendung prägte sich nun überzeugend ein.

Fritz Reuter *Fritz Reuter*, 1810 bis 1874, war des Bürgermeisters Sohn von Stavenhagen, der selten „de korte Jack" anhatte, und einer von Krankheit früh gebrochenen Mutter. Von dieser stillen Dulderin hatte er die Liebe zur deutschen Dichtung und vom „Ratsherrn Herse", dem Spielerfinder, Märchendichter und Vogelstimmenkenner, bekam er den Antrieb, Menschenwesen in die Natur zu sinnen. Mit dem Zeichenstift zuerst und schon auf der Schule schuf er seiner frohen Laune und dem Zustrom des Gegenständlichen Luft. Und schon auf der Schule las er Walter Scott, wie Brinckman und Groth sich an dem andern Schotten Burns erweckten. Am letzten Tage des Oktober 1833 wurde der Jenaer Hochschüler in Berlin verhaftet, wegen versuchten Hochverrats zum Tode verurteilt, zu dreißig Jahren Festung begnadigt und von einer preußischen Kasematte in die andere geschleppt, sieben Jahre lang. Aufgegeben, mittellos, verkannt, war er 1840 bis 1850 Landwirt, ohne vorwärts zu kommen, und wurde seiner Frau zuliebe 1850 Lehrer zu *Der Burschen-* Treptow, bis er 1868 das schmucke, weiße Haus beziehen konnte, das er sich *schafter* am Fuß der Wartburg erbaut hatte.

In jene Bauernzeit gehen die schriftdeutschen Anfänge der „Reis' nah Bellingen" und der „Stromtid" zurück. Beiträge zum mecklenburgischen Volksbuch zeigen ihn ebenso junkerfeindlich wie die andern der Gruppen. Groths *„Läuschen* „Quickborn" gab ihm wohl nur den Mut des Weges und den Mut in die *un Rimels"* Öffentlichkeit. Also ließ er Herbst 1853 seine „Läuschen un Rimels" er-

scheinen, gereimte Schwänke, wie sie ihm der Treptower Freundeskreis zu-
getragen hatte. Reuter sollte nicht sobald von der Einbildung loskommen,
„Poesie" müsse geverst und gereimt sein. Immerhin bot „De Reis' nah Belli-
gen" 1855, obwohl nur ein ins Epische gedehntes Läuschen, nach Gestalten
und seelischen Vorwürfen schon Ansätze zu den späteren Prosadichtungen.
Allein auch diese epische Form selber streckte und füllte sich: von den zwei
beziehungsreichen Gegenstücken 1857 „Kein Hüsung" und 1860 „Hanne *„Kein Hüsung"*
Nüte". Die römischen Ackergesetze, von den drei Sachsen, Niebuhr, Momm- *und*
 „Hanne Nüte"
sen, Rodbertus wie Schlüssel zu Staat und Wirtschaft der Gegenwart um-
worben, waren in „Kein Hüsung" eine Mecklenburger Forderung. Da sind
zwei Leibeigene, einander liebend, ihr Kind erwartend und verzweifelt um
ein Stück Heimat ringend, damit ihr Kind einen ehelichen Namen habe.
„Hanne Nüte" hat die sächsische Kameradschaft mit dem Tier, wie sie
Speckter, Hebbel, die Droste hatten. Tiere, wie Menschen denkend und han-
delnd, sind hier dem Mensch zu geschwisterlichen Gefährten gegeben. Mit
beiden Dichtungen war ein Mann, dem Staat und Gesellschaft das Härteste
angetan hatten, seines berechtigten Ingrimms Herr geworden. Das war keine
Lösung der Schwäche, sondern einer großmütigen Seele, sich mit Laune über
Widerspruch und Unzulänglichkeit der Weltunordnung zu erheben.

Als Stilwende Reuters kann der Klingenwechsel mit Klaus Groth gelten. *Kampf*
In der neueren plattdeutschen Dichtung gab es kein Erstgeburtsrecht. Es ist *um den Stil*
so früh sächsisch wie überhaupt deutsch geschrieben worden. Und seit dem
„Heliand" gab es keinen plattdeutschen Dichter, der nicht einen Vorgänger
hätte. Das Früher oder Später spielt zwischen Klaus Groth und irgendwem
keine Rolle. Der Dithmarsche hatte Reuters Realismus für „durch und durch
gemein" erklärt. Der Mecklenburger nannte Groths Kunst einen „sentimen-
talen Nebel von selbstgeschaffener Volksauffassung". Also der ewige Ge-
gensatz von Idealismus und Realismus, hier insbesondere zwischen der ver-
schleiert hochdeutschen Dichtung Groths und der rücksichtslos sächsischen
Literatur Reuters, vielleicht zwischen Altsächsisch und Wendensächsisch.

Die Übergänge steckten in Reuters seit 1855 erscheinendem „Unterhal-
tungsblatt für beide Mecklenburg und Pommern", in den hochdeutschen Bei-
trägen wie „Meine Vaterstadt Stavenhagen", in den Briefen des „immeri-
tierten Inspektors Bräsig", in dem karikierten „Abenteuer des Entspekters
Bräsig", diesen Verbindungsstollen von der schriftdeutschen zur plattdeut-
schen „Stromtid". So kam Reuter zum sächsischen Kulturroman, Walter Scott
verwandt, soweit es sich um kostümtreue Geschichte handelt, Johann Paul
Richter ebenbürtig, sofern es humoristische Romane waren. Jede dieser

33*

Schöpfungen war ein kräftiger Wurf. „Ut de Franzosentid" 1860, vollkommen gebaut, Scherz und Ernst in jener heiligen Mischung, die das Leben selber hat, die große Welt im Auge des Mecklenburger Landstädtchens. „Ut mine Festungstid" 1862, das am feinsten erzählte Werk, ein unvergängliches Zeugnis für das aus den Leiden der Jugend geborene Deutschland und aus jenem „olim meminisse juvabit" frisch und lauter emporgehoben. „Ut mine Stromtid" 1862/1864, Vorwürfe von „Kein Hüsung" humoristisch und humanistisch gelöst: „Die Überwindung und Versöhnung der ständischen Gegensätze innerhalb der menschlichen Gesellschaft auf dem Boden der reinen Menschlichkeit." Zugunsten unsagbar voller Menschenbilder war die Handlung nur mit sparsamen Behelfen und in behaglichen Schritten vorwärts geschoben. Was karikiert erscheinen möchte, ist in Wahrheit jene groteske sächsische Laune, die unter den Angelsachsen beider Meere wie unter sächsisch redenden Schotten Meisterwerke erzeugt hat. „Stromtid" ist auf dem Festlande, was die „Pickwickier" auf den Inseln. Drei letzte Werke umwucherten diese mecklenburgisch-bäuerlichbürgerliche Welt, in dem die „Urgeschicht von Meckelnborg" 1859/1862 den Ton der Historie launig nachmachte, „Dörchläuchting" 1866 den patriarchalischen Lebensbereich der Landschaft bis „an die Stufen des Thrones" erweiterte, „De meckelnbörgschen Montecchi un Capuletti", eine große Schnurre, dies Mecklenburger Gewächs sich an fremder Sonne bewähren ließen.

Die mecklenburgischen Sozialromane

NIEDERSACHSEN INSGESAMT, das sind die drei großen Dichter dieses deutschen Zeitalters zwischen dem klassisch-romantischen Abgang und dem Aufgang einer neuen romantisch-klassischen Kunst. Sie verkörpern das neunzehnte Jahrhundert. Denn was sie beerbten, war das achtzehnte, und wovon sie beerbt wurden, das zwanzigste Jahrhundert.

Der Dichter des tragischen Weltgefühls

Friedrich Hebbel, 1813 bis 1863, ein Norderdithmarsche aus Wesselburen, hat über das, was ihm die Umwelt des väterlichen Maurerhäuschens vermittelte, von außen her keinen nennenswerten Zuwachs mehr erhalten. Hamburg seit 1835; Heidelberg, wo zwecklose Vorlesungen gehört wurden; München, wo 1836/1839 seine Keime aufgingen; wieder Hamburg und Kopenhagen, Paris und Rom: es waren Stufen seines äußeren Menschen, Durchgangstüren des Lebens, die geöffnet wurden und sich hinter ihm wieder schlossen. Sächsisch waren die Antriebe und Hemmnisse seiner Kunst. Gemeinsam hatte er mit seinesgleichen den Bezug auf heimatliche Umwelt und Geschichte, Geschichte aus der Welt des Schiffers, das Sturmgefühl des winterlich einsamen Reiters wie bei Storm, wie bei Storm das gespenstige Vorgesicht und die nebelnde Heide, Taten schon im Traum vorausgetan, nor-

disch-mythische Anschauungen. „Mutter und Kind. Ein Gedicht in sieben *„Mutter und Kind*
Gesängen" heißt Hebbels reinste sächsische Schöpfung. Aus den sozialen
Verhältnissen Hamburgs stellte und löste Hebbel die Frage, wie erbloser
Reichtum und Nachwuchs der Armut zueinander kommen können. In eigenen
Anmerkungen hat Hebbel den sächsischen Gehalt des Werkes erschlossen.
Die Handlung, die ein inneres Aufwachen bewirkt, setzt am frühen Morgen
des Heiligen Abends ein und gleitet den Kreis des Jahres hindurch. Nur die
Mundart fehlt, daß es sich unvergleichlich zu Groth und Brinckman und
Reuter füge. Was sich der Erzähler lehrweise aneignete, ging in Wessel-
buren auf die Romantik und in München auf Johann Paul Richter zurück:
Nachtgemälde, Märchen, Seelenporträts, Anekdoten. Sieben solcher Stücke,
die sich in Zeitschriften verstreut hatten, stellte Hebbel zu der Sammlung
‚ Erzählungen und Novellen" 1855 zusammen.

Hebbel war der erste und gültige Bühnendichter des sächsischen Volkes.
Geworden ist er es aus seinem mißverstandenen Vermögen und er war es
aus der grundlosen Tiefe sächsischer Art. Hebbels Begriff des Tragischen
entsprang seiner mystischen Uranlage. Sie ist schon durch die vielen Träume *Begriff des Tragischen*
und Vorgesichte des Tagebuchs bezeugt und durch die Spaltung des Ich,
für die sich an gleicher Stelle überraschende Belege finden. Mit ihm formt
sich seit Kleist zum andernmal das mystische Weltgefühl zu tragischen Kunst-
werken aus. Hebbel verlegte das Tragische wie Schopenhauer in die Welt- *Friedrich Hebbel und Schopenhauer*
geburt des Ich. Diese Tragik zu verkörpern, blieb Hebbel, da freie Erfindung
wertlos und der Mythus verloren war, nur die Geschichte. Auch das stimmte
zu Schopenhauer. „Die Weltgeschichte sucht aus spröden Stoffen / Ein reines
Bild der Menschheit zu gestalten, / Vor dem, die jetzt sich schrankenlos ent-
falten, / Die Individuen vergehn, die schroffen." Geschichte ist sozusagen
die Atmosphäre seiner Tragödien. Sie wird durch den Vorgang der Ichwer-
dung geladen und durch die Vernichtung des Ichbewußtseins wieder ent-
spannt. Es ist eine religiöse, gottbewußte Kunst. „Nur was von Gott selbst *Mystik und Historik*
ausging, ist Gegenstand der höchsten Kunst." So von sächsischer Mystik und
Historik gebannt, machte Hebbel einen metaphysischen Vorgang, die Ich-
werdung des Gott-All und seine Rückkehr zu sich selbst durch Aufhebung
dieser Ichwerdungen im Bilde geschichtlicher Ereignisse schaubar. Das per-
sönliche Ich reibt sich im Kampfe gegen die Gott-All vertretenden gesell-
schaftlichen Bindungen auf. Hebbel sprach Mommsens Gedanken aus: „Die
sogenannte Freiheit des Menschen läuft darauf hinaus, daß er seine Ab-
hängigkeit von den allgemeinen Gesetzen nicht kennt." Mommsen dachte
juristisch und Hebbel metaphysisch, wenn sie beide, jener geschichtlich und *Hebbel und Mommsen*

dieser dramatisch darstellend, das Einzelwesen lediglich den Weltwillen voll-
strecken oder an der Weigerung, ihn zu vollstrecken, zugrunde gehen ließen.
Diese metaphysische und geschichtlich schaubar gemachte Tragik hat Hebbel
folgerichtig in das Geschlecht verlegt: Kampf zwischen Mann und Weib.

Wien, die Frau,
das Burgtheater

Der szenische Meister dieses tragischen Gedankens ist Hebbel in Wien
und an der Wiener Bühne geworden. Hier traf er im November 1845 ein
und brach alsbald alle Brücken hinter sich ab. Hier erwarb er sich das Gefühl
bürgerlicher Sicherheit. Hier fand er an der Burgschauspielerin Christine
Engehausen die Frau. Hier gewann er, was ihm bisher gefehlt hatte, die
Anschauung einer großen Bühne. Der Dichter Hebbel, das ist der Wiener
Hebbel. Was vorausliegt und der spröden Reife seiner ersten Jugend abge-
wonnen wurde, das waren dramatische Dichtungen voll des unmittelbar und
persönlich Erlebten, aber Stücke ohne durchgehenden und einheitlichen Stil.

Die drei
Frauendramen

„Judith" 1840, „Genoveva" 1841, „Maria Magdalena" 1843, drei Tragö-
dien um die Frau, sind aufs Ganze gesehen, verschiedene Versuche in drei-
facher Richtung: heroisch pathetisch, religiös legendenhaft, modern sozial.
Diese drei Frauendramen bilden untereinander ein in sich geschlossenes
Mysterium, dergestalt, daß „Judith" und „Genoveva" gegenüber „Maria
Magdalena" untereinander enger verknüpft sind. Gleichwohl kann man nicht
sagen, daß Hebbels Schaffen in den Jahren seiner Lehrzeit geraden Weges
angestiegen wäre. Denn die beiden Stücke aus seiner italienischen Zeit, 1847,
„Ein Trauerspiel in Sizilien" und „Julia", gleiten, zudem offenbar mißglückt,
von seiner großen Linie ab.

Hebbel in Wien

Mit dem Aufbau seines neuen Daseins in Wien bricht für den Dichter eine
neue Zeit an. Er betritt mit einem Ruck die freie und beherrschende Höhe
seines Schaffens. Nun zog er alle Folgerungen aus seinen dramaturgischen
Grundsätzen, die urtragische Spannung zwischen Einzelwesen und Welt-
einheit an geschichtlichen Begebenheiten und Gestalten szenisch sichtbar zu
machen. Jetzt gelangen ihm Schlag auf Schlag jene mächtigen Bühnendich-
tungen, die sein tragisches Weltgefühl im Spiel der geschichtlichen Kräfte
verkörperten. Mit einer einzigen Ausnahme sind alle seine Wiener Tragödien
zugleich auch in dieser Wiener Zeit entworfen und ausgeführt worden.

Die großen
Tragödien der
Wiener Zeit

„Herodes und Mariamne" 1848 wird zu einer wahrhaften Tragödie der un-
bedingten Notwendigkeit, die sich aus dem männlichen Eigentumsanspruch
an die Frau und aus dem Selbstbehauptungswillen der Frau entwickelt.
„Agnes Bernauer" 1851 gestaltet sich zu dem tragischen Verhängnis der
Persönlichkeit, die ungewollt und unbewußt allein durch ihre Vorzüge die
Ordnung des Staates stört. „Gyges und sein Ring" 1854 sind ein Spiegel der

alten Wahrheit, daß die Sitte alles bedingt und bindet. „Die Nibelungen"
1855/1860 beschwören jene gewaltige weltgeschichtliche Wende auf die
Szene, da die Germanen im Zeichen des Kreuzes Hand an die neue Ordnung
einer chaotischen Welt legen. „Demetrius" 1863, gerade noch ein Bruchstück
wie Schillers trümmerhaftes Gedicht und kein Versuch, Schillers Drama zu
vollenden, vielleicht Hebbels mächtigste Schöpfung, macht nach dem Abbild
seiner eigenen stolzen Persönlichkeit den falschen zum echten Prinzen, der
nachträglich und allzu gerechtfertigt wird. Gewiß, man scheint in diesem
heroischen Zuge mythischer und geschichtlicher Gestalten vergeblich nach
Zügen zu suchen, die für Hebbels geistige und dichterische Einbürgerung
in Wien sprächen. Und man wäre gerne bereit, sich überraschen zu lassen.
„Der Rubin" 1849 ist ein Märchenspiel — „Wirf weg, damit du nicht ver-
lierst" —, komödienhafte Umkehr der tragisch gestellten und tragisch ge-
lösten Fragen in „Gyges" und „Herodes", und es fügt sich, so fremd es auch
in dieser Umgebung sich ausnimmt, in die lange Überlieferung des Wiener
Märchenspiels ein.

Unser Blick verfängt sich in den „Nibelungen". Wer immer die Dichter *„Die*
gewesen sein mögen, die dem Nibelungenliede, wie wir es heute lesen, die *Nibelungen"*
letzten Gestalten gegeben haben; das Donautal mit seiner Landschaft, mit
seinen Städten und Burgen, mit dem Abglanz seines Babenbergerhofes, mit
seiner Völkerstraße und seinen weltgeschichtlichen Begegnungen ist im Nibe-
lungenliede so völlig Gegenwart und Wirklichkeit geworden, daß wir es als
ein Gebilde österreichischen Lebens wiedererkennen dürfen. Dieses Lied ist
es gewesen, das sich in Hebbels gewaltige Nibelungentragödie verwandelt
hat. Hebbel hat mit warmen und tief verehrenden Worten dem dramatischen
Ingenium gehuldigt, dessen überlegenes Wirken ihn aus diesem Gedicht an-
sprach. In einem mächtigen Gesichte, die geschichtlichen Bilder der Roman-
tik zurückrufend, stellt Hebbel den heidnischen Norden und das christlich-
rheinische Germanentum einander gegenüber: Burgund und Isenland, nach
Brunhilds Worten zwei ganz verschiedene Welten. Ein Witterungswechsel,
eine Götterwende wie in „Gyges" und „Herodes" und auf das Fest der Son-
nenwende lautet absichtsvoll die Ladung. Das aufsteigende germanische
Christentum, wie Gyges durch ein unsichtbar machendes Gerät geschützt,
stürzt das germanische Heidentum. Die Deutung steckt in der ausgeschie-
denen Szene. Der letzte Kampf der Riesen und Menschen sollte im Schicksal
Siegfrieds, Brunhilds, Kriemhilds sich abspielen. Dietrich von Bern, Christ
aus Überzeugung, höchster Held und demütiger Selbstüberwinder, schreitet
als erster Vertreter des neuen Geistes aus dem Chaos und tritt Etzels Erbe

„Demetrius"

an: „Im Namen dessen, der am Kreuz erblich". In anderer Weise wieder fesselt uns „Demetrius". Es ist ein Akt aus der Geschichte des europäischen Ostens, mit dem die Donaumonarchie durch Jahrhunderte zusammenspielte. Der erste Gedanke an die Dichtung reicht in das Jahr 1838 zurück. Der Dichter ging die Quellen gewissenhaft durch. Er reiste nach Krakau, um seine Bildkraft mit echten Anschauungen zu speisen. Im fünften Aufzuge, hart vor dem Ziel, wurde er durch den Tod unterbrochen. Sein Demetrius ist ein Bastard des Zaren Iwan von einer Zofe der Gemahlin Marfa und in der Wiege nur scheinbar mit dem echten Demetrius, der dann ermordet wird, vertauscht. Demetrius soll das Werkzeug der römischen Kirche sein, um das Schisma zwischen Abendland und Morgenland zu schließen. Hebbels Wiener Stücke werden in raschem Zuge wirkliches Theater. Man kann es Schritt für Schritt verfolgen, wie er in Wien sehr bald aller gestaltenden Kunstmittel Herr wird. Die Idee wird beinahe ohne Rückstand szenische Erscheinung. Aus Figurinen des Gedankens werden lebende Menschen, die ein Künstler zu spielen vermag. Die Gestalten, die Taten, die Begebenheiten bewegen sich und geschehen aus Motiven des wirklichen Lebens. Überall dort, wo Hebbel seine Szene in eine geschichtliche oder mythische Ferne verlegt, da strebt er nun eine glaubhafte Wirklichkeit an, jenes stilvolle Ganze, an dem die Menschen, ihre Antriebe, Kostüm und Farbe der Zeit miteinander übereinstimmen.

Hebbels Stil der Wiener Zeit

Die „Religionsstiftertragödie"

Die „Religionsstiftertragödie" 1837 war einer der ältesten Entwürfe Hebbels. Daraus wurde bald ein „Moloch", zu dem ihm der Hamburger Brand von 1842 das Bild des brennenden Karthago gab. Hieram, der Unterfeldherr Hannibals, bringt aus dem brennenden Karthago das Götzenbild des Molochs nach Thule, um durch den Gott das wilde Volk an sich zu fesseln und gegen Rom zu bewaffnen. Er schafft unter den Germanen mit den ersten Umrissen von Staat und Kirche eine urtümliche Kultur. Da er aber den Gott endlich zum Diener seines Eigennutzes machen will, wird er von dem erregten Gottesglauben des Volkes vernichtet und stirbt in der Erkenntnis, daß selbst die roheste Gestalt des Göttlichen mächtiger ist als der gewaltigste Mensch. Seit 1861 gab Hebbel diesen „Moloch"plan auf und ging 1862 zu einem Christendrama über. Christus war ihm die höchste sittliche Erscheiunng der Weltgeschichte, der einzige Mensch, der durch Leiden groß geworden. Schließlich wurde daraus „Demetrius", ein Thronbewerber wie Christus, der für seine Sendung, wie es scheint, vergeblich stirbt. „Moloch"-„Christus"-„Demetrius": vielleicht ist Hebbel in diesem Unvollendeten, um das er sein Leben lang gerungen hat, am größten gewesen.

Theodor Storm, 1817 bis 1888, aus Husum, stammte von Erbpachtmüllern der Rendsburger Gegend. Vom Vater, der Rechtsanwalt war, einem leidenschaftlichen Erzähler, von der Großmutter und einer Jugendfreundin empfing der Dichter einen dauersamen Märchenschatz. Die Bildkraft des Knaben sättigte sich an der Marsch mit ihren weidenden Rindern, am Meer, an fern vorübersegelnden Schiffen. An der Lübecker Lateinschule lernte er Geibel, an der Kieler Hochschule Theodor Mommsen und durch diesen Mörikes Gedichte kennen, sein Erlebnis. Vor den Dänen wich der junge Rechtsanwalt 1853 nach Potsdam. Trotz Fontane und Kugler und dem „Tunnel" sehr einsam, erlebte er nun erst so recht das ferne Marschland, wie Wilhelm Raabe zur selben Zeit in Berlin und aus ähnlichen Stimmungen seine „Chronik der Sperlingsgasse" schrieb. Heimgekehrt, wurde Storm 1856 Amtsrichter zu Heiligenstadt, 1864 Landvogt von Husum, ließ 1868 die erste Ausgabe seiner Schriften erscheinen und setzte sich 1880 in Hadamarschen im eigenen Haus zur Ruhe. Das kleine Lied war ihm Goldprobe des höchsten Könnens. Das „Tirili" müsse jedes Lied haben. Und das hatte schon Hamann wörtlich so gesagt. Storm wollte Liederdichter im Sinne des Volksliedes sein. Das Naturbild war sein Stil. Von Matthias Claudius bis zu Josef von Eichendorff laufen die Vorklänge seiner lyrischen Kunst. Storm hat alle seine Lieder zu Kränzen geordnet, weil sie sich zu Kränzen formten, wenn schon nicht in Kränzen entstanden. Unmittelbar erlebt, echt lyrisch und nicht rednerisch sind die politischen Gedichte, mit denen er sich zu den Ereignissen in den Herzogtümern bekannte. Sechs Verse sagen Storms Wesen und Kunst aus:

> Das ist die Drossel, die da schlägt,
> Der Frühling, der mein Herz bewegt;
> Ich fühle, die sich hold bezeigen,
> Die Geister aus der Erde steigen.
> Das Leben fließet wie ein Traum —
> Mir ist wie Blume, Blatt und Baum.

Diese Gedichte waren Keime für viele Novellen. Storm ging von Eichendorffs eigentümlichster Schöpfung, der lyrischen Novelle aus. So verklären Dichtungen wie „Marthe und ihre Uhr" 1847, „Immensee" 1849 seine Erstlingsliebe auf dem Hintergrunde des Waldes und der Schauplätze Eichendorffs. Auf die gleiche romantische Umwelt deuten „Der kleine Häwelmann" 1849 und „Hinzelmeier" 1850, die frühen keimhaften Märchennovellen. Eine dritte Gruppe von Ansätzen zu seiner späteren Kunst vertrat die Novelle der

„Mir ist wie Blume, Blatt und Baum"

Storms Leben

Das „Tirili"

Die Novellen

Potsdamer Zeit „Im Sonnenschein" 1854, ein Rokokobild aus dem preu-
ßischen Sanssouci, eine Entsagungsnovelle. Die Übersiedlung nach Heiligen-

Heimat und Schmerz — stadt, die Rückkehr nach Husum, der Tod der Gattin, Heimat und Schmerz
schufen seinem Werk Ernst und Größe. Ehefragen schärften sein Auge für
das Wirkliche. Am Fragespiel der Stände wandelt Storm sich zum Gegen-
ständlichen und zum Vermögen der scharfen Linie. Doch die sechziger Jahre
tragen das Doppelgepräge der Entsagung und des Märchens. Diese Lebens-
wende Storms ist durch die drei Märchennovellen des Jahres 1864 bezeichnet:
„Bulemanns Haus", ein grausiges Nachtbild mit einem alten Seefahrer als
Helden; „Der Spiegel des Cyprianus"; „Die Regentrude", der Mythus vom
Dämon des Regens und der Fruchtbarkeit inmitten einer wirklichkeitssatten
Dorfgeschichte. Schwer und düster wie diese Märchen sind die Novellen der

Konstanze Esmarch — Entsagung. Der Tod Konstanze Esmarchs hat diese Seelenhaltung nicht be-
dingt. Denn sie stammt aus dem kleinstädtischen, hypochondrischen Wesen
Storms. Doch dieser Frauentod am siebenten Kinde wurde den zwei letzten
und vollkommensten dieser Entsagungsnovellen zum Heile, beide von 1867:
„Eine Malerarbeit" und „In St. Jürgen". Eine neue Zeit hub an. Durch die
siebziger Jahre hin wuchs der Grundstock von Storms seelenkundiger, tat-
sachentreuer Kunst auf. Alles Lyrische wird völlig gegenständlich episch:
„Viola tricolor" 1873, der Kampf der zweiten Gattin mit dem Totenschatten
der ersten; „Im Nachbarhause links" 1875, die vereinsamte Schöne, die einst
ihr Spiel mit Männerherzen getrieben hatte; „Die Söhne des Senators" 1880,
Kleinstadtidyll und Wohnzauber nordischer Patrizierhäuser; „Bötjer Basch"
1885, ein Handwerkerleben voll Liebe für den kleinen Mann. Dieser Haupt-
stamm einer sachlichen Seelenkunst trieb schließlich den Doppelast von

Novellen der hohen Zeit — Storms reifem Werk, die tragische und die geschichtliche Novelle. Beide
wuchsen die siebziger und achtziger Jahre hindurch. Tragische Aufgaben
stellte sich der Dichter aus seinen richterlichen Erfahrungen, indem er —
„Ein Doppelgänger" 1886 — den Vorbestraften zum Helden machte, oder
die Frage der Vererbung aufgriff — „Carsten Curator" 1877 — mit der Stel-
lung Sohn gegen Vater, oder er läßt es — „Pole Poppenspäler" 1874 —
erleben, wie das heilige Spielzeug der Jugend durch das Leben geschändet
und gemein gemacht wird. Den Dämon hörte Storm wie aus der Natur so
aus der Geschichte. In „Eekenhof" 1879 wird nach Stifters Art erzählt, wie
der Haß des Vaters gegen den Sohn doppelt tragisch ein ganzes Geschlecht
endet. „Zur Chronik von Grieshuus" 1884, im Schleswig-Holstein des sieb-

Storms „Schimmel- reiter" — zehnten Jahrhunderts, mischt aus Zartheit und Grauen das Schicksal einer
todgeweihten Liebe. „Der Schimmelreiter" 1888, Storms letzte Schöpfung,

läßt „einen tüchtigen Kerl" an dem Einenmal zugrunde gehen, da er gegen seine Natur dem Schlendrian der andern nachgab, und dann, „nur weil er uns um Kopfeslänge überwachsen war, zum Spuk und Nachtgespenst" werden. Ein neuer Mythus, verschwimmend in den alten von Wodan zu Roß.

„Wenn wir uns recht besinnen, so lebt doch die Menschenkreatur, jede für sich, in fürchterlicher Einsamkeit; ein verlorener Punkt in dem unvermessenen und unverstandenen Raum", meinte Storm einmal und erklärte das plötzlich eintretende Bewußtsein dieser kosmischen Einsamkeit für das Grauen. Aus diesem Grauen der Einsamkeit stammte die triebhafte Witterung für den Dämon in der Natur, den Storm mit so vielen Niedersachsen teilte. An zwei Dichtungen, wie Storms „Regentrude" und Stifters „Heidedorf", wird der *Die „epische Schwester des Dramas"* Unterschied zwischen nordisch-germanischer und südlich-deutscher Art begreiflich. Bei Stifter ist die schmachtende und dann regengesättigte Natur nur ein Gleichnis seelischer Vorgänge. Bei Storm ist es ein Geschehnis der Gottnatur, in die gemeinverständliche Sprache der Seele übertragen. Storms Ausdrucksstil ist die Novelle. Er sah in ihr die „epische Schwester" des Dramas. Doch er hielt sich streng an den Ursprung der Novelle als einer mündlichen Erzählung. Der Held ist zugleich Sprecher. Daher die oft so verschachtelten Icherzählungen. Daher der einfache und natürliche Stil mit seiner Abneigung vor jeder Bildlichkeit. Handelnde Seele und sichtbarer Vorgang sind nur Innen und Außen derselben Sache. Doch Handlung, Menschenart und Schicksal erscheinen wechselseitig verkettet. Mit Hebbel hat Storm eine wenig bewegliche Einbildung gemein. Und wie bei Hebbel ist auch bei ihm zuviel erdacht. Storms Novelle ist die hochgezüchtete Enkelin des Döhnkens. Sie muß erzählt werden, damit sie ans Ohr gelange, zu dem sie will.

Wilhelm Raabe, 1831 bis 1910, war geboren zu Eschershausen, wuchs auf *Die Rettung der Seele* und wurde gebildet zu Holzminden und Stadtoldendorf, alles Orte des Wesergaues. Er lebte zuletzt und auf die Dauer in Braunschweig. In der Landschaft jener Walddörfer lagen Stätten wie Bodenwerder, der Stammsitz des Meisterlügners Münchhausen, und das Kloster Amelungsborn, gradüber der Weser die alte Abtei Korvei. Raabes väterliche Großmutter stammte von dem Dichter Schottelius ab. Sein Vater, Kreisbeamter, besaß eine schöne Bücherei, neben den Klassikern, wichtig für den Dichter: Reisebücher, Volksmärchen, Jakob Böhmes „Aurora". Der Dichter lernte 1849/1853 zu Magdeburg den *Raabes Familie und Heimat* Buchhandel. An den Altbüchern des Geschäfts wurde sein Geschäftssinn flügge. Die Gassen und Märkte der Stadt, ihr ländlicher Rahmen, schlugen sich als Stimmung in ihm nieder. In Magdeburg ist Raabe Dichter geworden. Als Hörer der Berliner Hochschule schrieb er 1854/1855 seinen Erstling,

„Die Chronik der Sperlingsgasse". Bis Sommer 1862 lebte er zu Wolfen-
büttel und er fühlte in angeregtem Umgange einen Quell nach dem andern
aufspringen. Seine Reise führte ihn 1859 über Dresden nach Süddeutsch-
land. Er sah Prag, Wien, den Rhein und wäre beinahe in Stuttgart hängen
geblieben. Schließlich kehrte er 1870 und für immer heim nach Braunschweig.

„Chronik der
Sperlingsgasse" „Die Chronik der Sperlingsgasse" 1857 war ein erstaunlich reifer Einsatz,
eine Kleinwelt aus Vergangenheit und Gegenwart, überfüllt von Gesichten
und Gesichtern. Hier rundete ein Anfänger mit eigenen Gebilden einen so
weltweiten Kreis, den der hinkende Teufel des Franzosen René Lesage, das
Bilderbuch ohne Bilder des Dänen Hans Christian Andersen, die Pendennis
des Engländers William Thakeray umschrieben. „Die Kinder von Finken-
rode" 1859 erweiterten die Gasse zur Stadtidylle. Da setzte Raabe zu drei
wechselbezüglichen Erzählungen an. „Nach dem großen Kriege" 1861 läßt
aus den getäuschten Hoffnungen der heimgekehrten Freiheitskämpfer die
Zuversicht auf den kommenden Staat emporsteigen. „Der heilige Born" 1861
— das ist der Pyrmonter Gesundbrunnen des sechzehnten Jahrhunderts —
sucht aus dem lockern Stil der Romantik nach einer geschichtlichen Form.

„Unsers Hergotts
Kanzlei" „Unsers Herrgotts Kanzlei" 1862 erzählt, zuweilen wörtlich, nach hand-
schriftlichen Quellen den Magdeburger Kampf gegen das Interim und die
Heimkehr eines verlorenen Sohnes, der sich an der bedrängten Vaterstadt
die Verzeihung des Vaters und die Hand der Geliebten verdienen muß. Die

„Hollunder-
blüte" Geschichte vom Prager Judenfriedhof „Die Hollunderblüte" 1863, das gleich-
zeitige Buch „Die Leute aus dem Walde", in Johann Paul Richters Art „Drei
Federn" 1865, diese Dichtungen nehmen den letzten Anlauf zur Höhe. Und
auf dieser Höhe steht die Trilogie um die Abschlußjahre des deutschen Staa-

„Der
Hungerpastor" tes. Humor in allen Farben spielt „Der Hungerpastor" 1864 auf dem Hin-
tergrunde des Deutschen Bundes die beiden widereinander aus: Hans Un-
wirrsch, den Pfarrer von Grunzenow, den Hunger nach Licht und Vollendung
des Herzens, und Moses Freudenstein, den Spitzel der preußischen Regie-
rung, den Durst nach Macht und Wollust. „Abu Telfan oder die Heimkehr
vom Mondgebirge" 1867 ist die Geschichte eines Mannes, der zehn Jahre
Sklave eines Negerstammes war zu Abu Telfan am Mondgebirge, und in der
Heimat die ärgere Sklaverei der Familie, der Ehre, der Rache findet. Das
ist das Buch, in dem sich Raabe zum Kleinleben der deutschen Kleinstaaten
bekennt und von Feuerbach den ersten Schritt zu Schopenhauer hinüber-

„Der
Schüdderump" setzt. „Der Schüdderump" 1870, am Harz und in Wien spielend, hat das
Mädchen zur Heldin, das sieghaft stolz durch die Gemeinheit des Lebens
hindurchstirbt, eine aus der schauerlichen Last des mythischen Pestkarrens,

von dem aus Vernichtung des Leibes der Sieg der Seele aufsteigt. Das war
die Trilogie des deutschen Bürgers im Aufgange des Deutschen Staates: beim *Die große Trilogie*
„Hungerpastor" der Sieg des Willens zur Vollendung; in „Abu Telfan"
Überwindung des Lebens durch Schmerz und Liebe und Glaube an das
Leben; im „Schüdderump" Rettung der Seele durch „Verwesen des Ge-
schöpflichen". Die drei Romane waren nicht zur Trilogie angelegt, aber sie
sind es geworden: eine Geschichte der deutschen Seele von 1814 bis 1870 in
ihrer Verwandlung aus der Geistnation zur Staatsnation.

Man beobachtet, daß Raabe in der Art, wie er seine Leute sterben läßt,
mit der sachlichen Sorgfalt des Kenners verfährt. Das war aber nicht die
Haltung des Ekels, der das Leben kennt. Es war vor allem nicht Schopen-
hauer, obwohl Raabe ihn kannte und immer besser verstehen lernte. Am
allerwenigsten war es die romantische Vergaffung in die holde Fratze des
Todes. Es war ein sächsischer, ein germanischer, ein mystischer Zug. Es war
die Stärke des Mannes, der besonnen zu jeder Stunde dem Leben in die
leeren Augenhöhlen zu blicken vermag. Mystische Naturgedanken hatten
von je der „Verwesung" mit Inbrunst nachgegrübelt. Das war Jakob Böhme, *„Verwesung"*
mit dem Wilhelm Raabe lebte, und der Ursinn des Wortes „verwesen", der
entwerden und also ewiges Sein bedeutet. Und so war, was Raabe Glück
nannte, weder Abwesenheit noch Aufhören des Schmerzes. Das Leid des
Lebens selber verwandelt sich ihm zu Glück und Schönheit. Raabes Humor *Raabes Humor*
ist also auch kein Mittel der Versöhnung, weil er die weder will noch braucht.
Sein Humor stammt aus dem Wissen, daß Schmerz und Tod nicht nehmen
können, sondern schenken müssen. Narren und Käuze sind die geborenen
Träger dieser Weltanschauung. Durch Selbstüberwindung und Selbster-
kenntnis werden sie die wahren Weisen, die dem Leben überlegen sind. So
zahlreich und vielfältig wie die Weise zu sterben ist Raabes bunte Reihe der
Käuze.

Raabes Kunst hat dreierlei Meistergriffe. Der eine ist der des Binnen-
raumes. Das war sächsischer Stil, bei der Gräfin Hahn-Hahn und der Droste-
Hülshoff die Liebe für die bewohnte Stube, bei Storm das Eigenwesen des
Hauses, das fast ein spukhaft belebtes Geschöpf wird. Raabe gab die ge-
schlossene Gasse und den Binnenraum der Stadt hinzu, ein großes Gemach,
in dem das Leben aus hundert Spiegeln sein Antlitz sieht und aus tausend
Winkeln seine eigene Stimme hört. Der zweite ist: Raabe verörtlicht jedes
Geschehnis und jeden Menschen. Er gibt allem die Farbe von Ort und Zeit.
Er stimmt Stamm gegen Stamm, Landschaft gegen Landschaft, Stadt gegen
Stadt. Das dritte war sein Geschichtssinn. Er sucht das Gewesene und Ge-

wordene festzuhalten, deutlich in den geschichtlichen Erzählungen, nicht
minder aber in den andern, wo sich, den Blick über die Schulter rückwärts
gewendet, Gegenwart in Vergangenheit wandelt. Alle drei Kunstgriffe stam-
men aus dem einen: Raabe strebt zur Ganzheit des Lebens im räumlichen,
zeitlichen, gedanklichen Sinne. Sein „Realismus" ist in Wahrheit „Historis-
mus". Mit seinen eigenen Versen: „Was die Historie vergessen, Vergaß der
Hirt und Fischer nicht. Zum Wohllaut ward die Tat des Helden, Das Wort
des Weisen zum Gedicht". Das Groteske, ja Skurrile ist nicht seine persön-
liche Art, sondern wesenhaft sächsisch und selbst bei Storm bezeugt. „Abu
Telfan" hat mit größerer Kunst als Gerstäcker Vorwürfe der sächsischen
Reiseliteratur und der sächsischen Afrikafahrten verarbeitet. „Der Hunger-
pastor" ist gedanklich verklammert mit Immermanns „Epigonen" und steht
gegen Freytags „Soll und Haben". Raabe sah in schreckbarer Nähe, indes
jedes seiner Bücher den werdenden Staat von einer andern Seite oder auf
einer besonderen Stufe zeigte, was Immerman vorausgesagt hatte und Frey-
tag als das echte neue deutsche Leben pries: den restlosen Verbrauch des auf-
gespeicherten Geistgutes, indem sich der deutsche Idealismus in die Ge-
schäftstüchtigkeit des neuen Staates verwandelte.

„Was die Historie vergessen . . ." (margin note)

2. BAIERN

Das Kunstwerk München (margin note)

Die geistige Gestalt des Landes fiel wie noch nie in seiner Geschichte mit
der Hauptstadt München zusammen. München aber wurde wie ein Kunst-
werk aus freier Hand neu und schön geschaffen. Fast als wäre es vorbedacht,
teilten sich zwei Könige, Vater und Sohn Ludwig I. und Maximilian II. in
den Ausbau des neuen Großbaiern, indem jener Portal und Fassade, dieser
die geistige Inneneinrichtung schuf.

Ludwig I., 1786 bis 1868, zu Straßburg geboren, in Landshut von Sailer
gebildet, in Göttingen durch Johannes Müller für den nationalen Gedanken
erweckt, unternahm, als er 1825 König geworden war, den letzten großen
Versuch, Mittelalter und Antike zu einem Guß zu verschmelzen. Seinen
Willen vollstreckte Leo Klenze aus dem Hildesheimschen und Friedrich
Gärtner von Koblenz, beide zu Paris an der Baukunst Napoleons und an den
Stadttrümmern griechisch-italienischer Pflanzungen geschult. Sie haben das
neue München gebaut.

Hochschule und Akademie (margin note)

In dieses aus Straßen und Wiesengründen märchenhaft aufwachsende
Stadtgehäuse atmete zuerst die neue Hochschule ein ebenbürtiges Geistes-

leben. Sie wurde, eine der ersten Taten des neuen Königs, 1826 aus dem kleinen Landshut herübergeholt. Naturphilosophie, das war ihr Gepräge durch zwei Freunde und Gegner.

Friedrich Wilhelm Schelling, 1775 bis 1854, aus dem schwäbischen Leonberg, hatte sich als Mitglied der Münchner Akademie ohne Lehramt 1806 bis 1820, als Ehrengast der Erlanger Hochschule 1820/1827, als Lehrer der Münchner Hochschule 1827/1841, als Vorstand der Akademie und oberster Pfleger der wissenschaftlichen Staatssammlungen eine so unantastbare Macht gewonnen, daß ihm auf keinem Gebiete außerhalb Hochschule und Akademie ein anderer entgegenragte. Durch seinen Freund Baader mannigfach angeregt und auf Jakob Böhme gewiesen, wandte sich Schelling von der Naturphilosophie also zur Mystik und Magie; von der Natur, die bewußtloser Geist und Entwicklung des einen und gleichen Lebens ist, zur Natur, dem Organ dunk- *Schellings positive* ler Willenskräfte im Menschen. Geistig und menschlich vollzog er mit solcher *Philosophie* Wendung den Bruch mit Fichte wie mit Hegel. Entwicklungsgeschichte Gottes ist fortan Schellings Philosophie. Sie ist ihm Gottes Selbstoffenbarung durch die Welt hindurch und darum in gewaltigen Stufen, die er Weltalter nannte: die Zeit vor, in, nach der Welt. Als Naturvorgang oder Theogonie wird Gott erlebt in der Mythologie, als erschauter Gott in der Offenbarung. Schellings neue Philosophie gipfelt in dem großen und nur für große Seelen erlebbaren Satz: alles Seiende, selbst Gott, muß verlassen werden, auf daß man zur wahren Erkenntnis durchdringe. Wer Gott erhalten will, der wird ihn verlieren; und wer ihn aufgibt, der wird ihn finden. Es gelte einen Durchbruch aus der „negativen" Philosophie, aus jener der Notwendigkeit und Vernünftelei, in die „positive", in die der Freiheit und Schauung. Es gibt ein wirkliches Wissen von Gott im Gegensatz zur Philosophie der Vernunft, nämlich das Schauen, die Denkweise der Theosophie, der forschenden Mystik. Ihr Urbild sei Jakob Böhme. Das Wirkliche oder das Seiende kann durch keine Vernunftphilosophie erfaßt werden. Es muß als Tatsache der Erfah- *Jakob Böhme* rung gelten. Religion ist Weltmysterium, unsichtbares und verborgenes Band zwischen Gott und den Dingen, Ursprung aus Gott und Rückkehr zu ihm. Ewiger Inhalt der Religion ist die Wiederherstellung der göttlichen Einheit. Schelling sah in Hegel den Aneigner und Übertreiber seiner eigenen einstigen „negativen" Philosophie. Nun hing mit den Hegelschülern Feuerbach und Strauß der Baum der „negativen" Philosophie voller Früchte. So standen in Schelling und Hegel, Baiern und Preußen einander feindlich gegenüber, vorerst nur in der Philosophie. Und Hegels Werk an Ort und Stelle zu zerstören, folgte Schelling 1841 dem Ruf des romantischen Königs nach Berlin. *Franz*

Baaders Theosophie *Benedikt Baader,* 1765 bis 1841, von München, war durch Abraham Werners Schule der Naturwissenschaft gegangen und kam nach mannigfacher Tätigkeit an die Hochschule seiner Vaterstadt, wo er über Jakob Böhmes Schriften, über Erkenntnislehre und Religionsphilosophie las. Der Schriftsteller zersplitterte sich in kleinen Heften, die er 1831/1832 sammelte. Dieser Befahrer englischer Erzgruben besaß das Geheimwissen, das sich in allerlei verborgenen Gesellschaften mündlich und schriftlich fortgepflanzt hatte. In der Umgebung des Matthias Claudius lernte er die Kabbala kennen, durch Hamanns Freund Johann Friedrich Kleuker die Schriften von Louis Claude Saint-Martin und durch diese Jakob Böhme. So selbständig Baader die neuere Philosophie des Abendlandes durchmusterte, indem er Thomas von Aquino gerecht wurde, des Descartes übertriebene Sonderung von Natur und Geist bekämpfte, Spinoza für einen Doppelgänger Jakob Böhmes erklärte, Leibniz sich verwandt fühlte, die künstliche Verfeindung von Verstand und Vernunft durch Kant begriff: im Grunde beschränkte sich Baader auf eine sachgemäße Erneuerung Jakob Böhmes. Er hat eigentlich nur Jakob Böhme verdeutlicht wie Herder Hamann übersetzt hatte.

Schelling, Baader Es ist schon ein seltenes Schauspiel, wie sich mit dem Tagwerk dieser beiden Männer die politische Stellung Baierns zwischen Preußen und Österreich, zwischen Westen und Osten geistig abzeichnet. Der Schwabe Schelling setzte Baiern auf Kriegsfuß gegen das philosophische Preußen des andern Schwaben Hegel. Und der Baier Baader richtet sich als Vermittler ein zwischen der byzantinischen Allerheiligenkirche seiner Vaterstadt und dem gräkoslawischen Königtum der Wittelsbacher in Athen, sinnverwandt den österreichischen Vermittlern zwischen Osten und Westen Fallmerayer, Hammer, Prokesch. Schelling und Baader haben ihre bairische Philosophie auf den

und der Dritte Lausitzer Jakob Böhme bezogen. Sie hätten sich auf die Logosphilosophie des Ostpreußen Johann Georg Hamann beziehen müssen, von dem sie sicherlich wußten. Denn eben zu ihrer Zeit und in eben ihrem München gab ja 1821/1825 Friedrich Roth die gesammelten Schriften und Briefe Hamanns heraus, in denen seit reichlich 50 Jahren stand, was Schelling und Baader philosophierten.

In der Mitte ragt zu München das fränkische Werk. Mit den rheinischen Wittelsbachern war aus dem ehemals und noch immer bairischen Rheinfranken rheinischer Kunstsinn nach München umgezogen. Das neu erworbene Ostfranken warf zu München sofort auch seine geistige Macht in die Waagschale. So gehört, was nun zu München geschah, nicht nur in die geistige Geschichte Baierns. Es ist zugleich ein Akt des rheinischen Dramas.

Josef Görres, 1776 bis 1848, von Koblenz, war 1826 durch König Ludwig aus seiner Elsässer Verbannung erlöst und für Geschichte an die Münchner Hochschule berufen worden. Hier verarbeitete er seine Straßburger sagengeschichtlichen Sammlungen in „Die christliche Mystik", 1836/1842, vier Bände. Man kann das Werk belächeln. Es schließt die Theogonie Schellings und Baaders zu einer Dreiheit ab. Zum drittenmal kehrte Görres auf das Schlachtfeld zurück, und es war wie 1789 und 1814 noch immer das alte, das rheinische. Denn das gleiche Jahr 1837, das in Baiern mit dem Ministerium Abel die äußerste katholische Rechte zur Macht rief, sah den Erzbischof von Köln verhaftet und durch preußische Reiter abgeführt. Der neue Kampf zwischen Staat und Kirche, der dritte rheinische in einem Menschenalter, das war der letzte große Streit, den Görres durchgefochten hat: 1837 „Athanasius", 1838 „Die Triarier", 1842 „Kirche und Staat nach Ablauf der Kölner Irrung". Rheinischen Anlegegenheiten galten die zwei letzten großen Flugschriften: „Der Dom von Köln und das Münster zu Straßburg" 1842, die Kerngedanken seiner Heidelberger, Straßburger, Münchner Jahre zusammenfassend; „Die Wallfahrt nach Trier" 1845, wo er in einer legendengeschichtlichen Darstellung das Recht auf lebendiges Zeugnis für den Glauben an Christus vertrat. „Zum Sehen geboren, zum Schauen bestellt", war Josef Görres Türmer auf der Zinne der Zeit, um 1800 Anwalt des rheinischen Volkes, um 1814 Sprecher der Nation, um 1840 Vorkämpfer der deutschen Katholiken. Görres hatte München zum Waffenplatz der römischen Kirche in Deutschland gemacht. Denn in den „Historisch-politischen Blättern", die sein Sohn Guido Görres und die beiden Preußen Jarcke und Phillips 1838 gründeten, nahm sein politischer Wille über Jahrzehnte hinweg dauernden Einfluß auf das katholische Deutschland.

Sulpiz Boisserée, 1783 bis 1854, aus Köln, war mit seinen Bildern, die 1827 König Ludwig angekauft hatte, nach München gekommen. Die Brüder und ihr Freund Johann Bertram gaben dem altdeutschen Kunsteifer einen gesellschaftlichen Mittelpunkt. So gründete denn der Erforscher und Meister des Spitzbogenstiles, der Mannheimer Friedrich Hoffstadt 1831 eine Art altdeutscher Bauhütte, die „Gesellschaft für deutsche Altertumskunde zu den drei Schilden". Der literarische Sprecher der Gesellschaft war Friedrich Beck aus Ebersberg. Er prägte in philosophischen Aufsätzen die kunstwissenschaftlichen Anschauungen des Kreises aus und schrieb mit seinem Roman „Geschichte eines deutschen Steinmetzen" 1835 das Grundbüchlein der Gesellschaft. Der Kreis, in dem Sulpiz Boisserée verkehrte und aus dem mit dem Freiherrn von Aufseß das Germanische Museum zu Nürnberg hervor-

Franken in München

Görres und sein Münchner Waffenplatz

Boisserée und der Münchner Spitzbogenstil

„Drei Schilde" ging, hat im Münchner Kunstleben ungemein tief gewirkt. Aus dem Gedanken dieses wesenhaft fränkischen Kreises, „Zum Klange wurde ihm des Bildes Umriß und Farbe", lebte eine neue Dichtung auf und mit ihr ein älterer Stil zusammen. Der diese Kunst verkörperte, war Franz Graf Pocci, 1807 bis 1876, aus München. Im Kreis der „Gesellschaft", die für die Einheit von Wort, Bild, Weise schwärmte, entstanden Poccis mit Arabesken ausgestattete Klavierstücke. Er schrieb die Wortbildgeschichten deutscher Märchen und stimmte zu den Holzschnitten gelegentlich Weisen. Für das Puppentheater schrieb er 1859/1877 die heitersten Jugendspiele „Lustiges Komödienbüchlein". „Der Festkalender" 1834, die erste bildergezierte Jugendzeitschrift, die er mit Guido Görres herausgab, vereinigte die ganze Runde der „Drei Schilde". Die gaukelnde Anmut seiner Bildkraft und die wunderbare Leichtigkeit zu arbeiten, vermögen die Tiefen nicht zu verdecken, die seine heitere Seele hatte.

Der „Apokryphen- schreiber" *Klemens Brentano*, 1778 bis 1842, von Ehrenbreitstein, ist auf seltsamen Umwegen nach München gekommen, „Apokryphenschreiber und Stadtpoet", wie Görres ihn scherzend nannte. Er nahm zu Dülmen 1818/1824 die Gesichte der Nonne Anna Katharina Emmerich auf. Bei seinen Irrfahrten hatte er Paris und immer wieder Frankfurt gegrüßt. Als Besucher kam er 1834 nach München und blieb. Er ging mit seinen rheinischen Landsleuten um, trat in die Gesellschaft zu den „Drei Schilden" und lernte 1837 den durchreisenden Eduard Steinle kennen, mit dem er nun, Dichter und Maler, zusammenarbeitete. Brentano hatte von Jugend auf mit dem Holzschnittbuch in Herzensgemeinschaft gelebt. Er hatte „von allen deutschen Dichtern am meisten Musik im Leibe". Er war der Schöpfer des Stiles: Einheit der Künste im Buch. Er hat diesem Stil zugleich das große Ziel gesetzt: einen neuen christlichen Mythus. Brentanos Mythus von Gott und Welt, von Seele und Geist, von Mensch und Gemeinschaft kehrt sein Doppelgesicht in zwei entgegengesetzte Himmelsgegenden. Zuerst die „Romanzen vom Rosenkranz". Zwischen 1803 und 1812 entstanden, können die zwanzig vollendeten Romanzen für das wesentliche und größere Stück aus Brentanos Plan gelten. Eine *„Romanzen vom Rosenkranz"* männliche und eine weibliche Dreiheit von Geschwistern entsühnt in wechselweisem Zusammenspiel ihr sündiges Geschlecht. Die Handlung spielt um 1200 in Bologna. Der Grundgedanke deckt sich fast mit dem ursprünglichen Faustentwurf Goethes und spielt zwischen Hamanns, Schellings und Baaders Anschauung: „erkennen" im Doppelsinn von Vernunft und Geschlecht. Der Menschenadam als der eigentliche Held wirkt in den einzelnen Abkömmlingen seines Geschlechts. Erkennen und Zeugen sind schlechthin Erbsünde

des Menschen, weil Folge der Weltspaltung, weil Teilnahme am Gegensatz des guten und schlechten Weltgrundes. Daher liegt auch im doppelsinnigen „Nichterkennenwollen" die Erlösung, die Entsühnung des Menschenadams. Das Kind ist reiner Urzustand vor dem „Erkennen", das „Kind im Auge" ein Abglanz des seligen Zustandes vor der Spaltung des Lichts. In der Sprachform ist das Urbild Wortmusik schier vollkommen erreicht. Die einzelnen Romanzen sind nach den jeweiligen beiden Assonanzlauten auch im Binnenvers auf einen Lautfarbenzweiklang gestimmt. Dieser kosmisch-religiöse Mythus, stellenweise zu völlig neuen Naturmythen aufblühend, wird versinnlicht durch das beispiellose Vermögen, mit allem und jedem im Bilde zu bleiben, und durch eine Kunst, der alles Gegenstand sowohl wie Gleichnis ist. Sodann „Die Gründung Prags" 1815, das Drama, das aus Brentanos *„Die Gründung Prags"* böhmischen Aufenthalt seit 1812 entstanden ist. Was die Rosenkranzromanzen an einer Familie anschaulich machten, ist hier an einem Volke ausgeformt. An einer Stadt versinnbildet, soll durch einen kunstvollen Mythus der Werdegang vom Einzelnen zum Volk, zur Kulturgemeinschaft, zum Staat dargestellt werden. Auch hier sind die Gestalten Geiseln der zwei Weltmächte, gleich dem Menschenadam in den Romanzen, verstrickt vom Kampf des weißen und des schwarzen Gottes. Die Dichtung ist kein Spieldrama, sondern ein lyrisch-dramatisches Epos. Schließlich die Niederschrift der Dülmener Gesichte. Brentano war, indem er durch eine Mittlerin göttliche *Gesichte von Dülmen* Offenbarungen empfing, beinahe wie einer der drei Rosenbrüder geworden, auf das „erkennen" verzichtend, um sich zu entsühnen. Das Dülmener Buch bildet das letzte Glied in der Kette seiner mythischen Gebilde. Dieser dreifach gestufte Mythus war mit der einen Seite dem Göttlichen zugekehrt, mit der andern, in seinen Märchen, der Natur. Darstellerisch strebte Brentano *Die Märchen* auch in den Märchen zum Ringe, doch nicht im Sinne einer nur äußerlich verbindenden Rahmenerzählung, sondern mit der Absicht eines kunstvollen Organismus, der Rahmen und Binnengeschichten zum Ganzen verwob. Der eine Rahmen, „Das Tagebuch der Ahnfrau", blieb mit dem überarbeiteten Gockelmärchen stecken. Mit dem zweiten, der Familiengeschichte des Müllers Radlauf, hatte Brentano alles zur Aufnahme seines gesamten Märchenschatzes vorbereitet. Auch die Märchen sind auf Wortmusik angelegt. Steinles Bilder kamen zu spät. Und so mußte sich Guido Görres, als er Brentanos Märchen 1846/1847 gesammelt herausgab, darauf beschränken, den bloßen Wortlaut zu bieten, in dem Wort und Musik zusammenklangen.

Aus diesem rheinischen München der Spitzbogen und altdeutschen Bilder begann ein bairisches aufzuwachsen, das auf die heimatlichen Berge ge-

„Bairisches Wörterbuch" und „Bayerische Sagen"

stimmt war. Es wurde gleichzeitig in der Malerei und in der Dichtung leben-
dig, indem es die Berge rings um die Stadt und den ländlichen Menschen auf-
weckte. Soweit es um die Dichtung und den Geist der Heimat ging, wirkten
diesem bairischen München zwei Oberpfälzer voran: Johann Andreas Schmel-
ler mit seiner Grammatik der bairischen Mundarten und seinem „Bairischen
Wörterbuch" 1827/1837, vier Bände, sowie Friedrich Panzer mit seinen
„Bairischen Sagen und Gebräuchen" 1848, zwei Bände. Hatte Schmeller vor
Jakob Grimm das voraus, daß er von der lebenden ungeschriebenen Sprache
ausging, so hielt Panzer seinen Zeitgenossen das Fortleben altbairischer Ur-
zeit unter dem Landvolk vor Augen. Das wurde vorerst freilich nur eine
sehr bescheidene bairische Dichtung. So bei dem Münchner Friedrich Lent-

„Bavaria"

ner, 1814 bis 1852, der von Ferne noch den Geist der „Drei Schilde" hatte,
altertümelnde Bilderchroniken schrieb, aber auch schon für die spätere „Ba-
varia" des Kronprinzen Maximilian sammelte, in der Meraner Landschaft auf
den Bauer kam, noch vor Auerbach Dorfnovellen zu schreiben begann und
sie 1848 als „Ein Novellenbuch", 1851 als „Geschichten aus den Bergen"
zusammenstellte. So der Münchner Eduard Fentsch, 1814 bis 1877, ein be-
rühmter Kneipredner, der Lentners Erbe bei der „Bavaria" übernahm, mit
seinen „Geschichten aus der Heimat" 1855 und Ludwig Steub, 1812 bis 1888,
von Aichach, aus dem Stand des Schreibervolkes, das er in allen Tonarten
verspottete. Steub, der in Griechenland gedient hatte, frönte in einer Reihe
von Wanderbüchern seiner volkskundlichen Neigung und brachte seine Fech-
sung erst spät in den „Gesammelten Novellen" 1881 unter. Inzwischen war
aber auch der Malerdichter des Kleinfügigen und Verwinkelten, des lächer-
lich und einfältig Lebendigen, Karl Spitzweg herangediehen. Und der brachte
die Literatur wieder ein Stück vorwärts. Man merkt das an den Volksbüch-
lein und Jugendbüchern des Schwaben Ludwig Aurbachers und an dem
Münchner Franz Trautmann, dem novellistischen Chronisten seiner Vater-
stadt.

„Fliegende Blätter"

Das war das München, aus dem am 7. November 1844 mit dem ersten
Heft lachend und beglückend die „Fliegenden Blätter" aufgegangen sind.
Sie kamen aus der neuen Holzschnittanstalt des Aschaffenburgers Kaspar
Braun, der sich mit dem buchhändlerisch geschulten Leipziger Friedrich
Schneider zusammengetan hatte. Was die „Fliegenden Blätter" geworden
sind, das hat Kaspar Braun aus ihnen gemacht. Wen gab es in ganz Deutsch-
land, der an diesen Blättern nicht mitgearbeitet und der sie nicht gelesen
hätte.

Der neue König Maximilian II., 1811 bis 1864, war zu Göttingen gebildet

und durch die Geschichtswissenschaft für den deutschen Staat erwärmt. Der *Hofstaat von Dichtern* Künstler Ludwig I. hatte der Stadt das Antlitz des Künstlers gegeben. Maximilian hatte die Haltung des Hochschulgelehrten und er stimmte München darauf. Der bairische Gleichschritt mit Österreich reißt ab. Wohl hält der König politisch noch zu Österreich. Doch geistig fördert er die sächsisch-nordische Richtung. Einmal die Woche versammelt er in seinem Rokoko-zimmer seine Freunde. Da gibt es keine Jodlerquartette. Denn Geibel, Heyse, Schack, Bodenstedt können zuverlässig nicht jodeln. Kobell und Pocci, die es könnten, sind in diesem Rokokozimmer die minderen. Wer nicht hoffähig ist, den tröstet die Gesellschaft „Das Krokodil", die kameradschaftlich das ganze geistige München zusammenfaßte.

Von den Professoren des Königs waren zwei richtige Dichter, der eine eigentlich fachwidrig, doch desto fachgemäßer der andere. Der Pfälzer Franz Kobell, 1803 bis 1882, lehrte seit 1826 an der Hochschule Mineralogie. Seine Bergfahrten und Pürschgänge erschlossen dem Gemsjäger die zwei Reiche, *Gemsjäger und Steinklopfer* zu denen der Steinklopfer keinen Zugang hatte, das der jagdbaren Tiere und der oberbairischen Wilderer. Das bairische Waidwerk hat Kobell in einem der schönsten deutschen Bücher, „Wildanger" 1859 geschildert. Das Reich der Wilderer aber ließ er in allen drei Gattungen aufleben und in seinen drei Mundarten, hochdeutsch, oberbairisch und pfälzisch: Lieder in „Tryphilin" 1839, mundartliche Spiele 1847 im Hoftheater, Erzählungen 1863 als „Pfäl-zische G'schichte" und 1872 als „Schnadahüpfln und Geschicht'ln". Kobell hat das Oberbairische und Pfälzische, die er beide lautsicher beherrschte, zu gültiger Literatur gemacht. Der Stuttgarter Schwabe Wilhelm Hertz, 1835 *Germanist* bis 1902, las seit 1861 an der Münchner Technik deutsche Literaturgeschichte. Er hat die mittelalterliche Dichtung nach Stoff und Form erneuert — „Lan-zelot und Ginevra" 1861, „Hugdietrichs Brautfahrt" 1863, „Heinrich von Schwaben" 1868 — und völlig persönlich umgeprägt. Ja, nicht einmal bei seiner Bearbeitung des Rolandsliedes, des Tristan und Parzival ist man sicher, ob man sie Umdichtung oder Eigenarbeit nennen soll. Gewiß hat kein Zweiter so wie Hertz den schwierigen Reimvers des Mittelalters zu meistern gewußt.

Am nützlichsten unter den Berufenen erwiesen sich die Hessen. Es waren *Die Hessen* deren drei.

Wilhelm Riehl, 1823 bis 1897, aus Biebrich, wuchs literarisch mit seinen soziologischen Kulturstudien aus der „Allgemeinen Zeitung" heraus, die er seit 1851 leiten half. Der König zog ihn 1854 nach München, wo Riehl die „Neue Münchener Zeitung" führte. Und 1857 übernahm er das Sammelwerk

„Bavaria", das dem König sehr am Herzen lag. Zwei Jahre später erhielt er als der rechte Mann am rechten Ort den Lehrstuhl für Kulturgeschichte. Seine Wendung zur Kulturgeschichte, von Romantik und Germanistik bewirkt, bezog sich auf die Geschichte der Völkergesittung. Ihre Teilbetriebe sind Volkskunde und Kunstgeschichte. Riehl strebte zum Ganzen und hatte doch alles Einzelne fest in der Hand. Volk ist ihm Ganzheit aus Stamm, Sprache, Sitte, Siedlung. „Die Pfälzer" 1857 machten die Probe auf den Sonderfall. Die grundlegende Bücherfolge „Die bürgerliche Gesellschaft" 1847, „Land und Leute" 1853, „Die Familie" 1854, „Wanderbuch" 1869, faßte er zu einem Ganzen zusammen: „Naturgeschichte des deutschen Volkes als Grundlage einer deutschen Sozialpolitik". Alle seine Arbeiten waren „erwandert" und bauten einem Kosmos des Volkslebens, der Politik, vor. Und so war sein schöpferisches Buch „Die deutsche Arbeit" 1861 gemeint. Proletariat sind für ihn alle, die ihren Stand verloren haben und in keinen andern eingewachsen sind. Die drei Stände Bauer, Adel, Bürger vermögen sich gegen den vierten nur zu halten, wenn sie zu sich selber zurückkehren. Nur durch die Familie, in der die Frau inbegriffen ist, kann die Frau rechtsbegrifflich frei werden. Diese Arbeit wurde Dichtung. Riehl hat die kulturgeschichtliche Novelle geschaffen, deren er gegen fünfzig in sechs verschiedenen Sammlungen 1856 bis 1880 zusammenstellte. Gestalten und Handlung sind erfunden, doch gedankenwahr und kostümtreu in den Teppich der Geschichte verwebt. Der deutsche Mensch ist in diesen Gebilden, deren jedes den Reiz des Neuen hat, „durch alle Jahrhunderte dekliniert und konjugiert nach keiner andern Grammatik als der des Herzens und der Leidenschaft". Riehls Novellen bilden Wilhelm Schäfers „Anekdoten" vor.

Franz Dingelstedt, 1814 bis 1881, aus Halsdorf, übernahm 1851 die Oberaufsicht des Hoftheaters. Dieser Platz war der erste rechte, auf den er gekommen ist. Durch Shakespeare und die deutschen Klassiker räumte er mit dem französischen Geschmack auf. Er gab Münch-Bellinghausen ebenso Raum wie Gutzkow. Er hielt auf gutes Zusammenspiel. Er behandelte die Ausstattung mit Sorgfalt und bewies auch in Nebendingen einen guten Geschmack. Seine große Leistung war das Gesamtgastspiel von 1854, das in zwölf Vorstellungen „Minna von Barnhelm", „Faust", „Kabale und Liebe", „Maria Stuart", „Die Braut von Messina", „Nathan", „Emilia Galotti", „Clavigo", „Egmont", „Der zerbrochene Krug" herausbrachte. Es waren vollendete Darstellungen mit zwölf Gästen und zehn Einheimischen. Die Gunst des Königs hatte Dingelstedt nicht. Er wurde 1857 unschön entlassen.

Emanuel Geibel, 1815 bis 1884, zu Lübeck einem hessischen Vater ge-

*„Naturge-
schichte des
deutschen
Volkes"*

*Der Herr
der Szene*

boren, war der Dichter dieses Münchner Äons. In Berlin hatte er Chamisso *Der Dichter des Münchner Aeons*
wie Eichendorff kennengelernt. Franz Kugler tat an ihm sein Bestes. Sein
Jugendfreund Ernst Curtius brachte ihn als Hauslehrer zu Athen unter. Sie-
ben Wanderjahre trieb er sich seit 1842 um, am Rhein mit Freiligrath be-
freundet, in Württemberg bei Kerner, in Hannover bei Goedeke, in Schlesien
bei Strachwitz, in Berlin bei Kugler und Curtius. In Lübeck unterrichtete er
1849 kurze Zeit. Geibel hat sich beizeiten auf Adel der Haltung und Feier-
lichkeit gestimmt. Als er 1852 nach München berufen wurde, fiel ihm die
Führung der königlichen Freundesrunde von selber zu und in seinen Händen
lagen die folgenden Berufungen. Mit Schack übersetzte er „Romanzen der
Spanier und Portugiesen" und mit Leuthold aus dem Französischen. Nicht
einzugewöhnen, entzweite sich Geibel wegen der Schlußverse seines Gedich-
tes an den Preußenkönig mit Ludwig II., zog mit einem preußischen Gehalt
1868 nach Lübeck um und begleitete die nun kommenden Ereignisse mit
immer spruchfertigen Versen. Sein westgotisches Drama „König Roderich"
1846 ist eine platte und mißverständliche Nachahmung Shakespeares. „Mei-
ster Andrea", 1847 im engsten Kreise des Prinzen Friedrich Wilhelm zu Ber-
lin gespielt, gefällt mit seinen feinen Künstlerbildnissen. Beide Frauentragö- *Emanuel Geibel*
dien, „Brunhilde" 1857 und „Sophonisbe" seit 1861, bewegen sich in dem
dunklen Zwischenreich der Haßliebe und des Liebeshasses. Geibels Lyrik ist
keine künstlerische, sondern eine Zeitfrage. Die erste Gedichtsammlung von
1840 blieb unbeachtet. Man suchte sie dann um so empfänglicher auf, je
satter man des Geschreis der Herwegh und Genossen wurde. Seit 1846 wuchs
sein Ruhm von Auflage zu Auflage. Auch Geibel war durch Franz Kuglers
lyrisches Skizzenbuch gestimmt. Indem er die geläufigen Empfindungswörter
der Romantik sanft, ehrbar, unverbindlich den wirklichen Dingen auferlegte,
langte er breit malend immer wieder bei sittlich lehrhaften Schlüssen an. Seit
der griechischen Reise wurde Platen sein Vorbild. Er fand nun wohl auch
solche Worte, die beinahe wie ungetragen aussahen. Es gelang ihm auch im
Versmaß zu wechseln. Doch nach wie vor sprach er das Gewöhnliche gewöhn-
lich aus und nannte auch noch diese zahme Haltung des Alltags „odi pro- *„odi profanum"*
fanum". Erregend sind wohl nur die „Zeitstimmen" von 1841 gewesen. Sie
hatten gegenüber den reimenden Zeitungsverkäufern wenigstens die not-
dürftige Form der Ballade. Man darf Geibel nicht um dessentwillen, weil er
verste und reimte, was die Spatzen von den Dächern pfiffen, einen Herold
des kommenden Reiches nennen. Bei weniger Gefahr ist selten gewahrsagt
worden. Die „Juniuslieder" 1847 waren bildlich gemeint: Junius, gefühls-
reife Mannheit. Er dämpfte und verschleierte auch hier, was ohnedies nicht

brannte oder Scham erregte. Immerhin war er da am vollkommensten, was er zu sein imstande war. Schon mit der billigen Vornehmheit der „Neuen Gedichte" 1856 bog Geibel ums Ziel. Und wie die späteren Sammlungen alle heißen, sie unterschlugen keinen einzigen Gemeinplatz mehr. In Geibels Todesjahr erschien die hundertste Auflage seiner Gedichte. Das war das Volk des Staates von Versailles. Der Mann hatte keinen Zug von dem Lande, in dem er geboren war. Geibel ist die Vollerscheinung der südwestdeutschen Trivialliteratur, die nach Verbrauch der letzten Körner aus Klassizismus und Restauration zwischen 1848 und 1880 das Feld beherrschte.

Die Staatsbaiern

Melchior Meyer

Da konnten die Staatsbaiern freilich nicht mit. *Melchior Meyr,* 1810 bis 1871, aus Ehringen bei Nördlingen, also von der bairisch-schwäbischen Grenze Ostfrankens und in München gebildet, erhielt für seine ersten Gedichte 1831 eine aufmunternde Antwort, eines der letzten Schreiben Goethes. Sein Hexametergedicht „Wilhelm und Rosine" 1835 schilderte Land und Leute des Ries, der Nördlinger Ebene zwischen Fränkischem und Schwäbischem Jura. Es war einer der ersten Anfänge der „Dorfgeschichte" und knüpft an die stilverwandte ostfränkische Reihe an, die schon bei Johann Paul Richter sichtbar geworden war. Meyr kam in die Jahre, bis er mit seinen „Erzählungen aus dem Ries", die seit 1856 auf vier Bände anwuchsen, diese Linie weiterverfolgte. Umwelt und Gestalten des Ries sind leicht ins Schönere und Belangreichere gemodelt. Bei breiter Anlage und lehrhaften Unterstreichungen viel beiseite redend und dem Leser ins Gesicht erklärend, launig überlegen und nicht mit gerunzelter Stirn vorgetragen, sind diese Geschichten in ihrer Art vortrefflich. Melchior Meyr landschaftlich und künstlerisch genau entgegengesetzt war *Hermann Lingg,* 1820 bis 1905, aus Lindau am Schwäbischen Meer. Zum Arzt gebildet und von Geibel entdeckt, kam Lingg 1854 mit seiner ersten Gedichtsammlung heraus. Sein Betrieb war neben der Ballade das geschichtliche Gedicht und Gipfel dieser ganzen Art die vierundzwanzig Gesänge „Die Völkerwanderung" 1865/1868, Aufbruch der Hunnen, Schlacht bei Adrianopel, Erstürmung Roms, Schlacht auf den Katalaunischen Feldern. Diese vortrefflichen Geschichtsbilder wurden damals für Dichtung genommen. Linggs Lyrik ist männlich, hart und spröde. Von seinen Erzählungen geben die „Byzantinischen Novellen" 1881 einen merkwürdigen Gleichklang zu Fallmerayers Geschichtsbüchern.

Hermann Lingg

Man kann nicht von einer Münchner Schule reden. Wenn man ein Dutzend Fäden von verschiedenem Stoff und verschiedener Farbe zu einem Knoten knüpft, so ist dieser Knoten nicht ihr Inbegriff. Doch die führenden Köpfe des neuen München waren von dem wesentlichen künstlerischen Geist des-

selben Berlin gezeichnet, das nun die staatsbürgerliche Haltung Baierns zu bedingen begann. Und diesen Geist verkörperte der Dichter, der als einziger von all diesen Fremden in München wahrhaft eingewurzelt ist.

Paul Heyse, 1830 bis 1914, zu Berlin geboren, stammte aus einer Thüringer Philologenfamilie, die sich an Wörterbüchern und Sprachlehren aufarbeitete. Heyses Mutter gehörte zur Verwandtschaft des Hauses Mendelssohn. Der verwöhnte, glänzend ausgestattete Jüngling wurde von Geibel betreut. In der Umgebung Kuglers und Mendelssohns reifte er aus. Diez in Bonn gewann ihn für die junge romanische Sprachkunde. Geibel brachte Heyse mit seiner jungen Gattin Margarethe Kugler 1854 nach München. Heyses Haus wurde zum künstlerischen Mittelpunkte der Stadt. Vom Schillerpreis 1884 bis zum Nobelpreis 1911 hat Heyse, wie seit Goethe kein deutscher Dichter mehr, die höchsten Ehren, die von außen kommen, genossen. Bürgerliches Trauerspiel und antike Vorwürfe haben es seinem Ehrgeiz nach der Bühne in gleicher Weise angetan. Der Hundertste, kam er 1850 auf „Francesca von Rimini". Der heikle Vorwurfe wurde unleugbar ins Frivole gewendet und nach Shakespeares Griffen ausgearbeitet. Sein erster Erfolg waren „Die Sabinerinnen" 1858, doch „Maleager" 1861 und „Hadrian" 1865 gelangen am besten, Allein auch sie verfolgten Eros auf seinen zweideutigen Wegen. Geschichtliche Stücke wie „Elisabeth Charlotte" und „Ludwig der Bayer" 1860 wurden dem König zu Liebe geschrieben. „Hans Lange" 1866 und „Kolberg" 1868 galten Pommern und der preußischen Heimat. Fast so fleißig wie der dramatische war der lyrische Dichter. Bis weit in seine reifen Jahre hinein haben seine Verse den Duft der herbstlichen Romantik, in der noch der ganze Sommer nachblüht. Ein Anempfinder wie Geibel und Bodenstedt, gab er 1852 das „Spanische Liederbuch" heraus.

Doch all das war es nicht, sondern die Novelle. In zweimal gedoppelter Gattung wurde sie Heyses Neuschöpfung: Verserzählung und Prosabuch; italienische Dorfgeschichte und moderne Gesellschaftsnovelle. Die Verserzählungen bewegen sich in dem Doppelgeleise deutscher und italienischer Überlieferung. „Urica" 1851, der Erstling, stilisierte vorsichtig ein Begebnis des französischen Umsturzes. „Die Braut von Cypern" 1856 wurde Boccaccio nacherzählt. Die Legende „Thekla" 1858 macht den Zusammenstoß von antiker und christlicher Kultur anschaulich. „Die Hochzeitsreise an den Walchensee" 1858 formt eigene Erlebnisse. „Raffael" 1863 war eine Künstlernovelle. „Der Salamander" 1865, das ist die alte Geschichte von der Nixe, die den Menschenmann ins Netz lockt, „Syritha" 1866 an nordischem Stoff der Vorwurf, wie allzu große Unschuld verkannt wird und nicht weiß, was

Berlin in München

Paul Heyse

Dorf und Gesellschaft in Vers und Prosa

sie empfindet. „Das Feenkind" 1868, ein Gebilde aus Wielands Laune, und „Die Madonna im Ölwald" 1879, aus Heyses italienischem Lebenskreise, schließen die bunte Reihe. Diese Gedichte wurden 1863 und 1870 gesam-

Der Meister der Novelle melt. Die Grundmasse von Heyses Dichtungen waren Prosanovellen. Sie wurden sehr früh und fast durchwegs in geschlossene Gruppen zusammengestellt und die einzelnen Stücke zumeist mit dem Blick aufeinander geschrieben. Die frühesten, das sind die „Italienischen Novellen". Heyse war in Italien so gut wie eingebürgert. Er kannte Land und Leute von vielen Reisen. Er hat all diese Erlebnisse in Novellen abgeformt, die nicht leicht ihresgleichen haben. Die älteste, wie ein Ereignis wirkend, „La Rabbiata", erschien zuerst in dem Jahrbuch „Argo" 1854, das Theodor Fontane und Franz Kugler herausgaben. Es ist eine Schiffergeschichte von der Widerspenstigen Zähmung. So sind die „Meraner Novellen" 1864, und so die „Moralischen Novellen" 1869 ein Ganzes. Heyse hat in wohlerwogenem Abstand von Ludwig Tieck in der Einleitung zu dem „Deutschen Novellenschatz" sein Kunstgesetz der Novelle entwickelt. Seine Geschichten sind etwas

Stil der Dichtung breit eingeleitet, aber sparsam ausgestattet, die Handlung einfach und auf den ersten Blick überschaubar. Doch in dieser scheinbaren äußeren Einfachheit steckt oft eine äußerst schwierige Verwicklung. Zumal bei den Vorwürfen aus dem Seelenleben ist das Gespräch, Quelle der reinsten Wirkung, mit unnachahmlicher Feinheit behandelt. Bis ins Kleinste ist der Aufbau berechnet. Der Widerstreit zwischen der Naturgewalt der Liebe und dem Gesetz der Ehe ist beständig der Gegenstand. Genuß des Lebens in vornehmer Haltung ist das einzige, was sich in diesen Gebilden als Weltanschauung bezeichnen läßt.

Heyses Größe, und das ist es immerhin, ist die unbegrenzte Herrschaft über Form und Sprache. Goethes Werk war ihm völlig zu eigen geworden. Kugler gab ihm die freie Geisteshaltung, Geibel den Sinn für Antike, Diez das erste Bewußtsein der romanischen Kunst. Ohne Brentano und Eichendorff

Stil des Lebens kein Heyse. Seine hochgepflegte Kunst war nur Ausdruck eines streng beherrschten Lebens. Hüter und Pfleger der überkommenen Kunstweise zu sein, war sein Beruf. Er war kein Schöpfer, aber ein Erzähler und Nachgestalter. Sein Weltsinn war gewiß nicht das Auge, sondern das Gehör. Gemüt verrät er kaum. Seine Welt ist die beste, die sich denken läßt. Er stilisiert ihr alles weg, was häßlich ist. Und weil nur die Form seine Sache war, konnte er so erstaunlich fruchtbar sein. Denn er zahlte nicht mit verbrauchter Lebenskraft. In Heyses Kunst ist das sprachliche Feingefühl und die arbeitsame Gewissenhaftigkeit seiner philologischen Vorfahren zum Höch-

sten gezüchtet, eine Kunst des Thüringer Schulmanns und der Thüringer Sinnenfreude. Heinse und Heyse, das ist mit dem Abstand eines halben Jahrhunderts die Linie. Das Jahr 1871, da Heyses erste Gesamtausgabe erschien, bezeichnet die beginnende Höhe seines Schaffens und seiner Wirkung.

3. ÖSTERREICH

Das ist das Zeitalter der glanzvollen österreichischen Dichtung, die nicht als silberne Zeit auf die goldene von Jena und Weimar folgt, sondern aus eigenem Metall geschlagen ist. Österreich hatte den Krieg um die Freiheit Europas entschieden. Es erntete, was ein solcher Sieg auf die Tenne schüttet. Im September 1814 trat mit 700 Gesandten und bei 100.000 Fremden der Kongreß zusammen, der das befreite Europa nach Macht und Recht ordnen sollte. Das dankbare Gefühl wiedergeschenkten Lebens strömte in Kunst und Dichtung. Man richtete sich auf ein neues Dasein ein. *Der Wiener Kongreß*

Da war die Kirche. Der Tod war überstanden. Nun konnte man daran denken, die Frömmigkeit wieder aufzuwecken, die seit Kaiser Josef II. im Unterbewußtsein der Menschen schlummerte. Es waren Ostdeutsche, die sich von dieser Aufgabe ergreifen ließen und sie für Wien ergriffen: Clemens Maria Hofbauer, 1751 bis 1720, aus Taßwitz in Mähren, der als Prediger und Beichtvater eine ganze Literatur von religiöser Haltung um sich erweckte; Johann Emanuel Veith, 1787 bis 1876, aus Kuttenplan, Prediger und Kaplan der Pfarrkirche Am Hof; Zacharias Werner, 1768 bis 1823, aus Königsberg, seit 1814 Priester und in Wien ein Prediger von Eindruck und Wirkung. Der vierte aber war der geistig und literarisch Tätigste. *Neue Frömmigkeit*

Anton Günther, 1783 bis 1863, aus dem nordböhmischen Dörfchen Lindenau, ein armer Landjunge, ist von Johann Gottfried Herder und Johann Paul Richter her durch die gesamte romantische Dichtung und von Immanuel Kant durch die europäische Naturphilosophie gewandert. Durch Hofbauer erweckt und durch ihn mit dessen geistlichen Freunden Friedrich Schlegel, Zacharias Werner, Adam Müller persönlich bekannt, wurde er 1820 Priester, Erzieher des Prinzen Friedrich von Schwarzenberg, des späteren Kardinals, und begann in den Wiener „Jahrbüchern der Literatur" den Grund zu seinem philosophischen Lebenswerk zu legen. Indem er vom Bewußtsein ausging, wollte er die beiden Grundtatsachen des Christentums, den Gott-Schöpfer und den Gott-Erlöser, aus der Vernunft bestätigen, nicht weil das der Glaube nötig hätte, sondern um der Theologie eine philosophische und *Der letzte romantische Philosoph* *Anton Günthers Schriften*

der Philosophie die einzig würdige Aufgabe zu setzen. In rascher Folge er-
schienen seine Bücher: 1828 „Vorschule der spekulativen Theologie", 1830
„Peregrins Gastmahl", 1832 „Süd- und Nordlichter", 1833 „Janusköpfe",
1834 „Die letzten Symboliker", 1835 „Thomas a Scrupulis", 1838 „Die
Juste-Milieus in der deutschen Philosophie", 1843 „Eurystheus und Herak-
les", 1849/1854 die fünf Jahrgänge der „Lydia" und 1857 als Privatdruck
„Lentigos und Peregrins Briefwechsel". Alle seine Bücher streben nach ge-
hobener literarischer Form. Im Stil beinahe Dichtung ist „Peregrins Gast-
mahl". Mit diesem humoristischen Roman von der Art Johann Paul Richters
und Ernst Amadeus Hoffmanns, in seiner ersten Hälfte mehr gelehrt und in
seiner zweiten ganz dichterisch, hat Anton Günther, in der Darstellung so
kühn wie im Denken, das vollkommenste Bild seiner Lehre gegeben. Gün-
thers Philosophie wollte das antikische Denken in der deutschen Philosophie
mit der Wurzel ausrotten, weil er in ihm den ewig wuchernden Keim des
deutschen Heidentums zu sehen glaubte. Er hat sich als Fortsetzer und Voll-
ender der romantischen Philosophie seit Jakob Böhme gefühlt. Um das Jahr
1848 lehrten Günthers Schüler schon an den meisten katholischen Anstalten.
Baiern und Preußen boten ihm Lehrstühle an. Österreich hatte für ihn
keinen. Im Jänner 1857 wurden seine Schriften auf den Index gesetzt. Gün-
ther unterwarf sich. So endete der Versuch, von Wien aus große Philosophie
zu machen.

„Peregrins Gastmahl" (margin)

Die Soldaten (margin) Da war die Armee. Sie rückte wieder in ihre Standorte ein, eines langen
Friedens gewärtig. Die österreichischen Offiziere haben seit dem frühen
achtzehnten Jahrhundert geistig weit über ihren Stand gelebt und regen
Anteil an der Dichtung genommen. Sie machten sich jetzt, ob im Dienst oder
verabschiedet, geistig Bewegung. Es war eine lange Reihe, noch bunter als
die Farben auf ihren Kragenspiegeln. Unter ihnen war August von Steigen-
tesch der beste Lustspieldichter des Burgtheaters, Josef Christian von Zed-
litz, der Dichter des lieblichen Spessartmärchens „Waldfräulein", der Kan-
zonen „Totenkränze", der „Nächtlichen Heerschau", des „Soldatenbüchlein"
1849, einer Reimgeschichte des Radetzky-Feldzuges. Bei der italienischen
Garnison Italien (margin) Armee gehörte der Feldmarschalleutnant Wilhelm von Marsano zu den
besten Mitarbeitern der Zeitschrift „Echo", die Graf Pachta in Mailand her-
ausgab, indes der Armeebeamte Ludwig Halirsch — „Verona illustrata"
und „Erinnerungen an Venedig" 1831 — volksmäßige und keckwirkliche
lyrische Gebilde formte. Heinrich von Levitschnigg suchte in seiner Samm-
lung „Westöstlich" 1846, zwischen Abendland und Morgenland zu vermit-
teln. Auf dem rechten Flügel stand der Erzherzog Karl, der die Geschichte

seiner Feldzüge schrieb, auf dem linken Flügel aber der Kleinste und Unge-
bärdigste, der Oberleutnant Cäsar Wenzel Messenhauser, der sich in allerlei
literarischen Dingen versuchte, den Wiener Aufstand 1848 führte und dafür
erschossen wurde.

Unter ihnen waren drei, die sich auf eine Weise ausgaben, wozu nur ein
langer Frieden verführen kann. *Karl Alexander von Hügel,* 1796 bis 1870,
aus Regensburg, Offizier der Befreiungskriege, Staatsmann, Weltfahrer, hat
seine Reise in zwei holzschnittreichen Werken — „Kaschmir" 1840, „Der
Stille Ozean" 1860 — geschildert. Gemacht hat er seine Reise im Stil des
Fürsten Hermann Pückler-Muskau und dargestellt in der Art Alexanders von
Humboldt. *Anton Prokesch,* 1795 bis 1876, aus Graz, 1814 Adjutant des
Fürsten Schwarzenberg, war eine Künstlernatur. Feine Gedichte und die
Novelle „Gegensätze" um eine Abessinierin sind ihm gelungen. In Triest
hatte er das dreifache Erlebnis des Meeres, der Verse Byrons, des Hellenen-
tums. Der Infanteriehauptmann führte 1824 die Kriegsbrigg „Veloce" sechs
Jahre lang durch das Mittelmeer. Er lebte unter Griechen und Türken, Fran-
ken und Arabern. Er betrieb die Erhebung des Herzogs von Reichstadt auf
den Thron der Hellenen. Er vertrat Österreich beim bairischen Griechen-
könig in Athen, später unter ungewöhnlichem Einfluß bei der Hohen Pforte.
Das schönste seiner Bücher über das Morgenland war 1831 die „Reise in das
heilige Land". Weltmännische Bildung und staatsmännische Erfahrung ver-
einigt Prokesch mit wissenschaftlicher Einsicht in die Dinge, die er gesehen
hat. Es hat nicht viele Meister der Prosa wie ihn gegeben. Sein Stil ist voll
der drei persönlichen Tugenden: wissenschaftliche Genauigkeit, soldatische
Knappheit, männliche Klangfarbe. Der Abenteuerlichste von den dreien, der
unruhigste Soldat und wirklichste Dichter war *Friedrich von Schwarzen-
berg,* 1800 bis 1870, der Sohn des Oberfeldherrn von Leipzig. Dieser Sports-
mann des Krieges kämpfte auf eigene Faust überall dort, wo nicht ein Recht
in Gefahr, sondern einfach eine Sache auf dem Spiele stand. Als einfacher
Landesschütze aber stand er 1848 für Tirol und 1849 für den Kaiser als
König in Ungarn vorm Feinde. Zu Reisebüchern und zwei Sammelbänden,
die er leichthin „Fidibusschnitzel" nannte, stellte er 1844/1845 die vier
Bände „Aus dem Wanderbuche eines verabschiedeten Lanzknechts". Sorg-
fältig und geschmackvoll gedruckt, mit Holzschnitten von fast gestochener
Feinheit, breitet das kostbare Buch vornehm lässig die Beutestücke dieses
Lebens aus: Berichte aus dem spanischen Bürgerkrieg und aus Algier, ge-
dankliche Einfälle mit der Echtheit des Augenblicks, Soldatenlieder ohne den
leisesten falschen Nebenton, und Novellen, die das Leben selber ohne künst-

*Offiziere
auf Weltfahrt*

*Der Sportsmann
des Krieges*

*Friedrich von
Schwarzenberg*

lichen Beisatz sind. Sie sind Reisenovellen, wie Heinrich Laube sie sich dachte, völkerkundliche Dichtung, wie Fallmerayer sie vorschwebte und Postl sie wahrmachte, Kurzgeschichten aus den Standorten der ganzen damaligen Monarchie und darüber hinaus im Umriß Europa. Ein Stil von vorbildlicher Sicherheit für Ferdinand von Saar.

Marianne von Schwarzenberg

Die Fürstin Marianne von Schwarzenberg, die Mutter des Dichters, die im „Nachsommer" so schön wie wahr gezeichnet ist, lebte mit einer Gesellschafterin zusammen. Das war Babette Elisabeth Glück, 1814 bis 1894, eine Wienerin, die als Erzieherin in Rußland und Polen herumgekommen war. Sie übersetzte aus den meisten Sprachen. Sie schrieb für den „Wiener Lloyd" die Berichte aus dem Burgtheater. Ihre drei Bände Novellen „Die Welt und mein Auge" 1844 sind Seelengeschichten der Frau. Ihre „Gedichte" 1841/1869 in sechs Bänden haben den Stil einer leidenschaftlichen und leidensstarken Frau. Schranke, Maß und Abstand, wie ihr dienendes Leben es sie gelehrt hatte und wie die Welt, in der sie lebte, es forderte, machen ihr Wesen wie ihr Gedicht. In diesem Hause verkehrte Adalbert Stifter während seiner Wiener Hofmeisterjahre. Hier nahm er einen Ausschnitt der adeligen Lebenskultur auf, die er im „Nachsommer" verewigte. Und im „Nachsommer" hat er die Fürstin zusamt ihrer Gesellschafterin abgebildet.

Von Böhmen und Ungarn her gab das fremdartige Seelenleben der kaiserstaatlichen Völker dieser Wiener Dichtung erst den Ton, der die Musik macht. Diese Völker hatten seit Menschenaltern nur ein verkümmertes Eigenleben ihrer Sprache und ihres Volkstums geführt. Im Erwachen begannen sie Ehrgeiz zu spüren, da sie sich einem blühenden Kulturleben gegenüber

Die Stimme Böhmens und Ungarns

fanden, das ihnen so schön wie fremd und nicht erreichbar erscheinen mußte. Die natürliche Schwermut ihrer Volksseelen und die Schmermut jedes Volksliedes, auf das sie zunächst angewiesen waren und das sie allein vorzeigen konnten, mischte sich mit dem schmerzlichen Gedanken an die eigene Vergangenheit, nach einer noch fernen Zukunft, mischt sich aus Nichthaben, Habenwollen und Nichthabenkönnen mit dem Gefühl des Ungenügens und dem Bewußtsein aller innern Hemmungen, verschmilzt zu dem Unterton, der nun in der Wiener Dichtung hörbar wird. Der Böhme Ludwig August Frankl vermittelte diese Stimmung von den Tschechen und Juden, mit der Sammlung „Gusle" 1853 von den Serben her, der Ungar Karl Isidor Beck mit seinem Versroman „Jankó" 1841 von den Magyaren und mit „Jadwiga" 1863 von den Polen her.

Der Europamüde

Nikolaus Niembsch von Strehlenau, 1802 bis 1850, hat diese Stimmung aus eigener Natur persönlich aufs höchste gesteigert und bis in die Selbstauf-

lösung des Geistes tragisch ausgelebt. Von schlesisch-schwäbischer Herkunft und auf der kleinen deutschen Insel Csatad bei Temesvar zwischen Magyaren, Rumänen, Slawen geboren und aufgewachsen, hatte Lenau aus Natur und verfehlter Erziehung keine Kraft, das Schicksal zweier Vaterländer und zweier Kulturen zu bewältigen und zu seinem Glück zu machen. Statt in einem Vaterlande Wurzeln zu schlagen, suchte er immer neue. Er übersiedelte 1831 von Wien, wo er seine entscheidenden Wandlungen durchgemacht hat, nach Stuttgart. Da waren Freunde. Da war anregende Natur. Da war eine Frau. Er übersiedelte 1832 von Europa nach Amerika und kaufte sich in Pennsylvanien ein Landgut. Er fürchtete, am Urwald zu ersticken, und übersiedelte 1833 von Amerika nach Europa und also von Schwaben wieder nach Österreich. Zu Wien, im Herbst 1834, war es wieder eine Frau, Sophie Löwenthal. Überraschend früh brach es mit Nervenschlag und Tobsucht aus. Seine Heimat wurde nun die Heilstätte in Oberdöbling. Dieser Schmerz also war nicht künstlich gewesen, sondern ein Bote des erkrankten Geistes. Lenau hatte einen triebhaften Drang, vielleicht eine kranke Sucht nach dem Worte. Davon geben, was er seine Dramen und Epen nannte, einen Begriff. „Faust" 1836 ist eine Szenenfolge erzählter Bilder. Das Romanzenbuch „Savonarola" 1837 ist kein Epos, sondern eigene Gedanken über Gott und Welt, bei dem Florentiner Prediger an den Mann gebracht, der sehr einseitig als mystischer Denker und Vorkämpfer einer freien Kirche aufgefaßt ist. Das Romanzenbuch „Die Albigenser" 1842 ist jedenfalls keine geschichtliche Dichtung, sondern ein Maskengedicht, aus dem die Zustände der Gegenwart reden. Das Romanzenbuch „Zizka", 1838/1842 mühsam mitgeschleppt, suchte nur nach einer neuen Rolle für die Sätze, die Lenau an seine Zeitgenossen richten wollte. „Don Juan" 1844 wendet sich gegen Gesetz und Schranke in der Ehe wie im Leben. An Lenau kann nur das lyrische Gedicht, und mit einem kleinen Ausschnitt, Bestand haben. Den Mißton von Herz und Welt hat der Jüngling zuerst in den Worten Höltys und Klopstocks auffangen wollen. Die Versöhnung des Widerstreits von Geist und Natur suchte er in der Philosophie Schellings. Die Kunstweise die ihm lag, war längst ausgebildet im Natursinnbild der Romantik und der österreichischen Landschaftsmalerei. Hinzugefunden hat Lenau lediglich eine bestimmte Landschaft, und das war nicht die See und nicht der Urwald, die bereits häufig zu werden begannen, sondern die ungarische Pußta, deren unbegrenzte Einsamkeit ihm von den Ritten seiner Jugend her ein Erlebnis war. Lenau war von der Musik besessen. Seine Rhythmen lassen das nur gelegentlich und nicht häufig spüren. Sein Instrument ist, gedämpft oder

Das Schicksal zweier Vaterländer

Lenaus Romanzenbücher

Urwald und Pußta

laut, das rednerische Wort. Und nur Worte sind seine farbigen Bilder. Man folgt der Bewegung seiner Finger, und was man bewundert, ist ein Virtuose gewesen. Die schimmernde Form erschreckt durch ihre Kälte.

Der Herr Biedermeier

Was nun noch bleibt, ist der redliche Durchschnitt, eben der Herr Biedermeier. Zuweilen heißt er sehr ehrenwert Johann Gabriel Seidl, 1804 bis 1875, sammelt Schnadahüpfel als „Almer" 1850 und trifft mit „Flinserln" 1828/1838 die Mundart so echt, wie sie der Eingeborene ohne sonderliches Verdienst eben treffen muß. Oder er gefällt sich mit einem Doppelgänger zum Seidl, mit dem Johann Vogl, 1802 bis 1866, der in mehr als einem Bande alles, was je geschehen ist, zur Ballade macht, das „Österreichische Wunderhorn" 1834 zusammenträgt, slawische Volksmärchen und serbische Heldensagen in Wien einbürgert und ein sehr zeitgerechter Kalendermann und Almanacherzähler ist. Anspruchsvoller heißt er Otto Prechtler, 1813 bis 1881, bewegt sich mit Anstand in der Nähe der Großen, ist in Gedichten, zumal in Sonetten, beinahe ein Meister, kann ein Stanzengedicht wie „Das Kloster am Traunsee" 1874 und ist auf dem Burgtheater zu Hause. Zuweilen heißt er auch Ignaz Franz Castelli, 1781 bis 1862, und ist mit einem „Kriegslied" so gefährlich, daß Napoleon ihn ächten muß, läßt kein Gebiet der Dichtung unbetreten, übersetzt für das Wiener Theater, was nur brauchbar ist, gibt in endloser Folge Taschenbücher heraus und ist der Mann, um mit seinen „Gedichten in niederösterreichischer Mundart" 1828 den Späteren Mut zu einer ganzen Literatur zu geben. Das ist der Wiener Biedermeier, eine verzweigte Familie, die keiner bei der durchgehenden Ähnlichkeit verleugnen kann. Mit dem Jahre 1848 ist er ausgestorben, ohne Nachkommen zu hinterlassen.

Wiener Mundart

„Diätetik der Seele"

An diesem Jahr 1848 sind mehr zugrunde gegangen, als nur diejenigen, die erschossen wurden. Jedenfalls gehört unter diese Opfer einer der besten Menschen, die zu Wien in jenem halben Jahrhundert gelebt haben. *Ernst von Feuchtersleben*, 1806 bis 1849, der Arzt, hat zwei Männern wie Grillparzer und Stifter so nahe gestanden, als man bei dem einen wie bei dem andern vermochte. Feuchtersleben hat durch eine früh geübte Askese das Geschäft seiner Seele bis zur Vollendung betrieben. Man sagt nicht zuviel, wenn man ihn den kunstverständigsten Menschen im Wien jener Jahrzehnte nennt. In seinen „Gedichten" 1836, die es bei seinen Lebzeiten auf vier Ausgaben brachten steht das vielgesungene Lied „Es ist bestimmt in Gottes Rat". Feuchtersleben hoffte auf eine Wiedergeburt der deutschen Dichtung aus Österreich. Seine Seelenkunde als innerlich lebender Mensch und heilender Arzt befugte ihn, der Welt das Buch „Zur Diätetik der Seele" 1838 zu schen-

ken, das Buch von der Kunst, den Körper durch Geist und Willenskraft gesund zu machen und zu erhalten.

So hätte die Wiener Dichtung von 1814 bis 1866 ohne das Theater, ohne Grillparzer und Raimund, ausgesehen.

In den österreichischen Ländern rings um Wien wuchs die Literatur je nach der heimatlichen Witterung auf die Höhe der Zeit.

STEIERMARK wurde 1811 vom Erzherzog Johann mit seinen großartigen Sammlungen an Tieren, Pflanzen, Steinen beschenkt. Die Stände gaben dafür in Graz ein Haus. So ist das Joanneum entstanden, mit seinem botanischen Garten, seinem Urkundenschrein, seinen Münzen und Büchern, eine Landeskundliche Anstalt für heimatliche Forschung und Lehre. In mehr oder minder enger Verbindung mit dem Joanneum, jedenfalls vom Geiste der Anstalt getrieben, entwickelte sich das landeskundliche Schrifttum, Zeitschriften und Darstellungen. Für die Dichtung unmittelbar fiel noch wenig ab. Der Straßburger Franz Julius Schneller, der 1823 seinen Lehrstuhl verlassen mußte, Bühnendichter im Stile Kotzebues, hat hier das Herz seiner Schüler der Dichtung zugewendet. Der eine von ihnen, der Grazer Karl Johann Schröckinger, 1798 bis 1819, konnte so früh verstorben, die Verheißungen seiner ersten Trauerspiele nicht erfüllen. Der andere, der Grazer Karl Gottfried von Leitner, 1800 bis 1890, war, ohne daß seinen Dramen und düstern Novellen Unrecht geschieht, der Dichter des Liedes und der Ballade. Seine Dichtungen sind Gesänge der heimatlichen Landschaft, ihrer Berge und Waldrosen, ihres Erzes und Weines. Kärnten hatte unter minderen seinen Adolf von Tschabuschnigg, 1809 bis 1877, der ungemein fleißig in Gedichten und Erzählungen war — „Der moderne Eulenspiegel" 1846 — und seine landschaftlichen Schilderungen, sein Bestes, zum „Buch der Reisen" 1842 und andern Sammlungen einfaßte.

Der führende Dichter aus den südöstlichen Alpenlandschaften wurde von dem gleichen Adel des Ländchens Krain gestellt, der seit Siegmund von Herberstein im geistigen Leben so geschlossen hervortrat.

Anton Alexander Graf Auersperg, 1806 bis 1876, aus Laibach, gehörte wie Leitner zu der kleinen Gruppe der fortschrittlichen Ritterschaft. Daher fühlte er sich auch zu Ludwig Uhland, dem getreuen Eckart der Württembergischen Verfassung und des guten alten Rechts, persönlich hingezogen. Aber er handelte klug, wenn er den Grafen Auersperg und den Dichter Anastasius Grün getrennt auf der politischen Bühne spielen ließ. Die „Juliussonne" zu Paris 1830 hat also nicht seine Gesinnung geweckt, sondern seinen Mut zum Handeln gereift. Freund Leitner betreute den Druck seines ersten Büchleins

Grazer „Joanneum"

Steirer und Kärtner

Anastasius Grün

„Blätter der Liebe" 1830 und beriet ihn bei seinem Romanzenbuch „Der letzte Ritter" 1830, mit dem Auersperg den Kampf um den Durchbruch einer freiheitlichen und fortschrittlichen Gesinnung eröffnete. Der Held, Kaiser Maximilian, hatte die Tore einer neuen Zeit aufgemacht. Mit seinem Munde und an ihn gerichtet ließ sich manches sagen, was mit eigenen Worten noch nicht gesagt werden konnte. Schon bald hat Auersperg für gut befunden, offenherziger zu werden. „Spaziergänge eines Wiener Poeten" 1831, „Schutt" 1835, „Gedichte" 1837 waren für ihre Zeit kühne Kundgebungen. Wie alle Gedichte aus der Familie des „garstigen Liedes" reden sie getragen und,

Auersperg und die Slawen wenn man den Grafen mit anschlägt, in starken Worten. Sie berauschen sich, wie in solchem Falle immer und überall, an der Idee, die leichter zu feiern als die Wirklichkeit zu meistern ist. Als Auersperg dann in der ständischen Ratsstube zu verantworten hatte, was wirklich zu tun sei, fiel noch immer seine freisinnige Haltung auf, aber der Dichter hatte nun doch — „Nibelungen im Frack" 1843 — Zweifel an seiner Gesinnungstreue niederzuschlagen. Rechts und links sind verhältnismäßige Begriffe. Krain schickte ihn 1848 in die Frankfurter Paulskirche. Vor seiner Abreise wandte er sich mit der Flugschrift „An meine slowenischen Brüder" an die Südslawen, um sie mit Österreich beim Deutschen Bunde zu halten. Als er wiederkam, hatte die Frankfurter Mehrheit sich für einen preußischen Kaiser entschieden. Nun wußte er, daß es ohne die Slawen kein neues Europa gäbe. Von dieser Einsicht legten die „Volkslieder aus Krain" 1850, Nachdichtungen slowenischer Volks-

Freisinn vom Kahlenberg lieder, Zeugnis ab. Doch mit der Einheit war die Freiheit nicht preisgegeben. Was Auersperg trotz den Frankfurter Erfahrungen geblieben war, das bestätigte sein ländliches Gedicht „Der Pfaff von Kahlenberg" 1850, das Lied vom freisinnigen Fürsten und Priester. So gesinnt, hat Auersperg im verstärkten Reichstag und im Herrenhaus für Österreich mit Ungarn gesprochen und gestimmt. Das Balladenbuch von Schottlands lustig grünem Walde „Robin Hood" 1864 und die dichterische Nacherte „In der Veranda" 1877 fingen den Ausklang eines Mannes auf, dessen Freisinn aus dem alten lutherischen Junkertum stammte und der gegen den Landesherrn die noch unverjährten ständischen Rechte vertreten hat.

TIROL spürte erst jetzt, daß ihm die Josefinische Aufklärung in den Kreislauf des Blutes gegangen war. Sie wurde wirksam. Der Widerstand gegen die verbrauchten und gleichwohl so anspruchsvollen Mächte von gestern, gegen die lahme Selbstgenügsamkeit und den geruhsamen Schlendrian, der

Tiroler Ehrgeiz rühmliche Ehrgeiz zu einem ebenbürtigen Tirol verkörperte sich in Johann Senn, 1792 bis 1857, aus Pfunds. Er haderte mit aller Welt. Doch er war ein

begabter und in seinen „Gedichten" 1838 ein formstrenger Dichter. Sein Lied, das wie aus Erz gegossen ist, „Adler, Tiroler Adler, Warum bist du so rot?" hat ihn berühmt gemacht. Die weltanschaulichen Gegensätze drohten das Land zu zerreißen. Der Zwist zwischen zwei Südtirolern hat wirklich die junge dichterische Kameradschaft des Landes gesprengt. Es war der Zwist von Meran und Bozen. Der Geistliche, der Benediktiner, der sprachkundige *Der Zwist* Schulmann von Meran war Beda Weber, 1798 bis 1858, aus Lienz. Sein erstes *der Südtiroler* Versbuch „Lieder aus Tirol" 1842 steht unter dem Einfluß gleichzeitiger Arbeiten über die Verzückte Nonne von Rovereto, Giovanna Maria della Croce. Es sind Gedichte eines christlichen Weltschmerzes, romanische Mystik in barocken Formen. Der Laie, der Weltmann, der Rechtsanwalt von Bozen war Josef Streiter, 1804 bis 1873, der sich an Lord Byron und Moores „Irish melodies" hielt, aber über kleine Dichtungen nicht hinauskam. Streiter erließ 1843 in der „Allgemeinen Zeitung" eine Kundmachung, „Poetische Regungen in Tirol", die alles, was seit 1800 im Lande geschrieben worden war, durchs Sieb schüttelte. Viel behielt er nicht zurück. Beda Weber sorgte für den Gegenschlag. So gab es nun eine freisinnige und eine Alttiroler Literatur, eine, die für und gegen Meran oder Bozen war. Genauer: für oder gegen Schloß Payersberg. Denn dort über Bozen hielt der Schloßherr Streiter offene Herberge für alles, was den Brenner herabkam. Das waren alles Leute, die zur Augsburger „Allgemeinen Zeitung" standen: Friedrich Lentner, der immer noch ein bißchen zu Weber hielt; Ludwig Steub, der an dem Zwist seine ironische Freude hatte und ihn kaum merklich schürte; Jakob Fallmerayer, der über alle Tirolerei hinaus war und es auch mit seiner meisterlich gespielten Demut sagte.

Da nun die klassische und romantische Dichtung Gemeingut geworden *Das Fähnlein* war, konnte auch in Tirol keine mehr Gehör finden, die nicht mit deren Maße *der Nordtiroler* gemessen war. Zweimal ist in Innsbruck zu einer solchen Dichtung strengen Stiles angesetzt worden. Das erste Mal war es Johannes Schuler, 1800 bis 1856, aus Matrei, den drei gelungene Novellen zum ersten dichterischen Sachverständigen des Landes gemacht haben. Mit seinem Taschenbuch „Alpenblumen aus Tirol" 1828 fängt die moderne Literatur des Landes zu zählen an. Weber und Streiter waren seine Gefährten. Das zweite Mal war es Alois Flir, 1805 bis 1859, aus Landeck, ein Geistlicher und seit 1853 Lehrer für Kunstwissenschaft an der Innsbrucker Hochschule. Der gab sich als Kunsterzieher und faßte die jungen Leute also von dieser Seite. Unter seinen Anhängern waren mehr junge Volkskundler, so der Vorarlberger Franz Josef Vonbun und der Tiroler Ignaz Vinzenz Zingerle. Flirs Anhang

war in der Zeitschrift „Phönix" 1850/1853 und in der Sammlung „Tirol"
1852 zu hören.

Das freisinnige Jungtirol trat mit dem Almanach „Frühlieder aus Tirol"
1846 vor das Land. Aus diesem Büchlein ist mit zwei artverschiedenen, doch
einander würdigen Nordtirolern die Dichtung, nach der es den Ehrgeiz ver-
Spruchredner und Frauenlob langte, im Leben erschienen und zu Ansehen gekommen. *Hermann von Gilm,*
1812 bis 1864, aus Innsbruck, stammte von einer alamannischen Familie. Er
machte seinen Weg als Verwaltungsbeamter. Der rednerische Stil all seiner
Dichtungen ist Schiller. Gesinnung und Form seiner Sonette stammen von
Senn. Gilms unnachahmliche Kunst, ein Erlebnis zu einem Kreise von Ge-
dichten auszurunden, ohne sich zu wiederholen, führte ihn ungefährdet von
Wagnis zu Wagnis: „Märzveilchen", „Sommerfrische zu Natters", „Theo-
delinde", „Lieder einer Verschollenen". Ohne ein Freigeist zu sein, stand
Gilm bei den Neinsagern. Seine „Jesuitenlieder" und die „Zeitsonette aus
dem Pustertal" wandten sich offen gegen die Kirche und als dem Tiroler
Volke der Stutzen 1845 zurückgegeben wurde, machte Gilm mit seinen
„Tiroler Schützenliedern" die Dreizahl seiner politischen Büchlein voll. Seine
schönsten, die „Sonette an eine Roveredanerin" 1845, halten die Komtesse
Festi auf dem farbigen Hintergrunde des kleinen welschen Städtchens und
des rosig leuchtenden Kalkgebirges fest. Ausschließlicher konnte man gar
nicht dem lyrischen Gedicht verfallen sein als diese erotische Natur. Er
wünschte sich alle Welt zum Zeugen seiner verliebten Stunden, die sehr rasch
den Gegenstand wechselten. Daher die Miniaturen seiner Mädchenköpfe, die
er reihenweise herstellte. Er war ein Stegreifritter der Liebe und des Verses.
Diese Gedichte sind nicht im Gesang entstanden und können auch nicht ge-
Natur in Blankversen sungen werden. Es sind Sprechverse. Es sind Schillerverse. *Adolf Pichler,*
1819 bis 1900, aus dem armen Zollhaus bei Erl, war Zug um Zug der Gegen-
mensch. Sein Lehrmeister war der Mangel. Sein Erlebnis war die Natur. Er
hat sich die erhabene Schönheit der Alpennordkette erobert. Pichler lehrte
die Naturwissenschaften, zuerst am Innsbrucker Gymnasium, seit 1867 an
der Innsbrucker Hochschule. Als wahrer Steinklopferhans der Wissenschaft
hat er sich die Heimat mit dem Hammer gewonnen. Nach den ersten sehr
angriffslustigen Versen sind dann seine Sammlungen von den „Gedichten"
1853 bis zu den „Spätfrüchten" 1895 Jahrzehnt um Jahrzehnt erschienen.
Was er auf seinen wissenschaftlichen Bergfahrten erschaut hatte, das legte er
Pichlers Wanderbücher und Tiroler Geschichten in seinen Wanderbüchern an. Und nach den Wanderbüchern gestaltete er
sein Erlebnis von Land und Leuten zu sehr sachgerechten Novellen: „Aller-
lei Geschichten aus Tirol" 1867, „Jochrauten" 1897, „Letzte Alpenrosen"

1898, Vers und Prosa. Pichler hat die Natur wie die alten Meister gelesen als Zeichensprache des Geistes und Buch der Seele. Seine Sprache war das kühne und stolze Gedankengedicht. Er hat die volle Bildung der Antike besessen. Sie machte seine reimlosen, hochtönenden, hymnischen Rhythmen groß wie die Dinge, die sie besangen. Ein Kämpfer aus Anlage und Fechtmeister aus Zucht, hat er die Klinge des Spruches mit dem Anstand des Fechtsaales geführt. Der Vorwurf seiner Novellen ist Wirklichkeit, Bergbauer und Dorf, die Sprache Alltag. Der reimlose Blankvers ist der ideale Stil für diese erfahrungsmäßig gesicherte Wirklichkeit. Adolf Pichler hat das Erlebnis seiner Tiroler Heimat in der klassischen Form von Weimar abgegossen. Josef Streiter hatte in seinem berühmten Aufsatz „Poetische Regungen" Gilm und Pichler als „neu aufkeimende Talente" angekündigt. Derlei Vorhersagen treffen nicht immer ein. Diese hat wahr gesprochen.

Von Krain war vor dreihundert Jahren Siegmund von Heberstein nach Rußland aufgebrochen, um diesen Erdteil für Europa zu entdecken. Von Südtirol brach nun Jakob Philipp Fallmerayer auf nach Byzanz, um hinter das Rätsel Rußland zu kommen.

Jakob Philipp Fallmerayer, 1790 bis 1861, aus dem Weiler Baierdorf bei Brixen, war als Hirtenjunge durch die Griechischstunden der Brixener Domschule, als Hochschüler durch die Geschichtskunde Salzburgs, als bairischer Leutnant durch den Anstand französischer Schlösser gegangen und also aus einem Bauernjungen ein Weltmann geworden. Der Lehrer am Landshuter Gymnasium zeigt mit seiner „Geschichte des Kaisertums Trapezunt" 1827, was er kann. Und seine „Geschichte der Halbinsel Morea" 1830 zerstört die liebste Legende des Abendlandes, dem die griechischen Freiheitskämpfer der Gegenwart Urenkel der Helden von Marathon waren. Dann geht Fallmerayer dreimal ins Morgenland: 1831 nach Ägypten, Kleinasien, Griechenland; 1840 in das immergrüne Paradies von Kolchis und in die fromme Abgeschiedenheit des Hagion Oros; 1847 nach Athen, Jerusalem, Trapezunt. Der Heimgekehrte besteigt den verwaisten Lehrstuhl des Josef Görres, geht als einer der Getreuesten mit dem Frankfurter Parlament nach Stuttgart und geächtet in die Schweiz. Zwei Zeitungsbücher haben Fallmerayer berühmt gemacht: „Fragmente aus dem Orient" 1845 und „Neue Fragmente aus dem Orient" 1861, zusammengestellt aus seinen Berichten an die „Allgemeine Zeitung". Seine Landschaftsschilderungen sind Gedichte. Seine geschichtlichen Betrachtungen spannend wie ein Roman. Seine Auseinandersetzungen bereiten das Vergnügen geistreicher Lustspiele. Fallmerayers großräumige Satzgebilde lösen sich mit einem einzigen verborgenen Griff in locker und

„Das Fatum von Byzanz"

Fallmerayers „Fragmente"

flüssig gleitende Rede auf. Die erste Sammlung der Fragmente schildert an Trapezunt, dem letzten Spätling byzantinischen Wesens, den griechischen Geist des Morgenlandes; an Konstantinopel den verbrauchten Platzhalter; im Heiligen Berg Athos die Seele russisch-byzantinischer Macht als der kommenden Anwärterin; im neuzeitlichen Griechentum den komödienhaften Nebenbuhler russischen Anspruchs. Die zweite Sammlung umreißt in drei unvergleichlichen Aufsätzen den Spielraum der kommenden Dinge. Fallmerayers geschichtliche Arbeiten hatten gezeigt, wie aus dem Verwachsen byzantinischen und russischen Wesens eine neue weltgeschichtliche Macht im Werden war. Seine Reisen im Morgenlande hatten dies aufsteigende „Fatum von Byzanz" als dem Abendland entgegengesetzte Machtbildung erlebt. Sein Freimut war nun am Werke, das Trugbild eines bairisch-griechisch-byzantinischen Reiches zu zerstören und die Vollstreckung des europäischen Schicksals durch das byzantinische Rußland zu verkünden.

Es ist schon ein außerordentliches Ereignis, drei Männer der Alpenländer, Hammer, Prokesch, Fallmerayer, mit so verschiedenen Rollen auf der einen Szene zu sehen, die Morgenland und russisch-griechischer Osten heißt. Bei diesem einen Ereignis blieb es nicht.

Lilienfeld, Horn, Melk

Das österreichische *DONAULAND* hatte wie immer seine andersgeartete geistige Geschichte. In Niederösterreich hörte man seit langem wieder von den Klöstern durch einzelne ihrer Mitglieder: aus dem bisher so stillen Lilienfeld durch Johann Ladislaus Pyrker, 1772 bis 1847, von Langh in Ungarn, aber von Tiroler Herkunft, den späteren Erlauer Erzbischof, dessen dichterische Werke, Legenden und vaterländische Epen homerischen Stiles, „Tunisias" 1816 und „Rudolph von Habsburg" 1824, auf seine Lilienfelder Zeit zurückgehn, und aus Horn durch den Piaristen Josef Misson, 1803 bis 1875,

„Da Náz"

der einer romanischen Familie entstammte und den alten Schwank vom Bauernburschen in der Fremde zu dem richtigen niederösterreichischen Dorfepos „Da Náz" 1850 gemacht hat. Kloster Melk aber, das ist *Michael Leopold Enk von der Burg*, 1788 bis 1843, aus Wien, der mit seinem klösterlichen Beruf nicht fertig wurde und sich in der Donau ertränkte. Enk, einer der gebildetsten und fruchtbarsten Männer seiner Zeit, inmitten eines Kreises von guten Schülern und großen Freunden, hat mit seinen ästhetischen Schriften für Goethe und die alten Spanier gewirkt. Seine philosophischen Betrach-

„Bildung und Selbstbildung"

tungen — worunter „Über Bildung und Selbstbildung" 1842 — bezeugen sein reiches und schwieriges Innenleben. Er war ein Meister jener kleinen Geschichten, die als „exempla" im Sinne der antiken Redekunst zu Betrachtungen über ein bestimmtes Thema dienen. So ist „Don Tiburzio" 1831 ein

humoristischer Schelmenroman, gesprächsweise erzählt, von mehr spanischem als französischem Stil, und „Dorats Tod" 1833 gibt Gespräche mit sich selbst und andern über den Sinn des Lebens, anknüpfend an die Anekdote von dem französischen Dichter, der den Tod geputzt in seinem Sessel erwartet. Hier hat ein Humanist philosophiert, wie Marcus Tullius Cicero und Annaeus Seneca philosophiert haben. Denn hier ist nicht die kritische Vernunft am Werke, sondern die Lebensklugheit der Erfahrung, die Frage nach Sinn und Bestimmung des persönlichen Lebens. Vielleicht war es das fruchtlose Grübeln darnach, das ihn dem allmächtigen Rätsellöser, dem Tode, in die Arme getrieben hat. In Oberösterreich ist es die mundartliche Dichtung. Anton von Spaun aus Linz und sein Buch „Die österreichischen Volksweisen" 1845 hat der mundartlichen Dichtung wie ihrer Erforschung wertvolle Antriebe gegeben. Karl Adam Kaltenbrunner, 1804 bis 1867, aus Enns, hat neben seinen mundartlichen Sammlungen — zuerst „Obderennsische Lieder" 1845 — mit *„Obderennsische Lieder"* einem Drama, mit Dorfgeschichten und schriftdeutschen Versen die ganze Feldmark anzubauen gesucht. Die Sprache ist echt, indessen nur so gut getroffen, wie es sich für den Stadtherrn geziemt, wenn er auf Sommerfrische geht und Mundart spricht. Der Meister in diesen Bezirken, *Franz Stelzhamer,* *Franz Stelzhamer* 1802 bis 1874, aus Großpiesenham, hat diesen Liedern den großen dichterischen Stil eingeschaffen. Denn er war ganz Volk und dazu der Künstler, der immer aus der Art schlagen muß. Er ist kein geistlicher Herr geworden, wie der Vater wollte, nur ein kleiner Hofmeister und verunglückter Malschüler und fahrender Tragöde, den die Mutter auslösen mußte. Über Nacht war er der Dichter, den Grillparzer im Café bemerkte. Die letzte Begegnung war die rechte, die zu Graz mit Peter Rosegger. Das Erbe ging von Rhapsoden zu Rhapsoden. Seiner ersten Sammlung „Lieder in obderennsscher Mundart" 1837 folgten von 1841 bis 1868 vier weitere Büchlein. „D'Ahnl" 1851 erzählt in homerischen Versen eine ländliche Heiratsgeschichte, die kein Liebesroman ist, sondern eine rechte Dorfehe wird. Stelzhamers schriftdeutsche Gedichte und Erzählungen beweisen nicht mehr, als daß er zur Not auch das konnte. Das Rätsel des Lebens, nicht umgrübelt, sondern aus dem bäuerlichen Herzen gewußt, tritt in Stelzhamers Versen den Menschen an wie die Natur mit ihrem fraglosen Dasein. Unbegreiflich einfach ist hier das *Der ewige* Erlebnis der Welt Wort geworden, wie das Gefühl der Welteinsamkeit als *Vierzeiler* die höchste Qual des Daseins empfunden wird. Der Tod ist auch für Stelzhamer der allwissende, allmächtige, allgütige Wunscherfüller. Der Tanzrhythmus des Schnadahüpfels, diese urmenschlichen und ewigen Vierzeiler sind Stelzhamers liebste Form. Seine Sprache redet wörtlich, und redensart-

lich nur mit den Bildern, in denen sich der Bauer von Geschlecht zu Geschlecht das Unsägliche sagbar gemacht hat. Kein falscher Ton der Bildung trübt die reine Natur des Wortes. Der Vers Homers ist durch die vokalreiche Fülle dieser Mundart so jung und völlig Natur, als wäre er seit Jahrhunderten nicht von stolpernden Zungen geschändet worden. Auf einmal wacht in der Volkssprache dieser Verse das Gedächtnis des Nibelungenliedes auf und man hat, wie wenn es heute wäre, den Tonfall des Vogelweiders im Ohr. Das war so oder so die Kunst der Wirklichkeit, keine „Richtung" der Kunst, Kunst schlechthin und immerdar. Stelzhamer sagte es so: „As had sie hald so zuetragn, Zwö sollt i's den nöt aussagn?" Und zur gleichen Zeit, 1844, sagte Postl „Faktische Poesie". Das war kein Unterschied.

Weltosten-Weltwesten Hammer, Prokesch, Fallmerayer hatten sich nach Osten gewendet. Hammer diente der morgenländischen Dichtung als Dolmetsch. Fallmerayer weissagte ein russisches Zeitalter. Stifter und Postl wandten sich nach Westen. Stifter ließ sich von der amerikanischen Dichtung ergreifen. Postl predigte die Vereinigten Staaten.

„Faktische Poesie" *Karl Postl,* 1793 bis 1864, aus Poppitz bei Znaim, war ein Priester der römischen Kirche. Dem jungen Prager Kreuzherrn erschloß sich die Prager Gesellschaft. Wenn er Zweifel hatte, dann kamen sie aus dem Herzen und nicht aus dem Kopf. Der Großmeister und minder bevorzugte Ordensbrüder wurden unzufrieden. Auf der Suche nach einem Staatsamt ging Postl 1823 mit Urlaub zunächst nach Karlsbad und dann heimlich nach Wien. Er hatte kein Glück. Anstatt ins Kloster zurückzukehren, landete er Ende August 1823 in Neu-Orleans, ließ sich in dem pennsylvanischen Städtchen Kittaning nieder und vollzog die Verwandlung aus einem österreichischen Priester in einen amerikanischen Bürger. Die Verwandlung vollzog der Schriftsteller durch *„Austria as it is"* zwei Bücher. Das eine „Austria as it is", das Schärfste, was über das Österreich Kaiser Franz II. geschrieben werden konnte, trägt keinen Verfassernamen. Denn es war der Abschied. Das andere, „The Americans as they are", *„The Americans as they are"* schildert die Vereinigten Staaten in allen ihren Verhältnissen. Als Verfasser nennt sich ohne Namen „The author of Austria as it is". Das war eine Begrüßung. Beide waren englisch geschrieben und beide sind 1828 in London erschienen. Das eine wie das andere waren Schilderungen von Land und Volk und Staat. Die englische Sprache mußte es zunächst auf alle Fälle sein. Das kämpferische Zeitalter der angelsächsischen Siedlung ging eben in der jungen amerikanischen Literatur auf mit Timothy Flint und James Fenimore Cooper. Und um dieselbe Zeit veröffentlichte der Franzose François René de Chateaubriand seinen Roman „Natchez" 1825 vom Untergange des India-

nerstammes. In diese Literatur fügte sich Postl ein. Er schrieb in seinem Heim zu Kittaning das Indianerbuch „Canondah", das als Land-Volk-Darstellung fortfuhr, wie Postl in seinem Österreichbuch und Amerikabuch begonnen hatte. Als „Tokeah or the white rose" 1828 ist der Roman englisch erschienen.

Postl hat sein Leben lang zwischen Amerika und Europa gelebt, bald in Amerika und bald in Europa öfter daheim. Er hat kaufmännische und politische Geschäfte getrieben, man kann wohl sagen als Geschäftsträger der Familie Napoleons, in Amerika Josef Bonapartes, in der Schweiz der Königin Hortense und Louis Napoleons. In New York, London, Paris verkehrte er mit den wichtigsten Staatsmännern. Seit 1831 wuchs er langsam in der Schweiz fest, nicht ohne den Aufenthalt öfter zu wechseln. Das letztemal ging er 1853 nach den Vereinigten Staaten. *Postl und die Bonaparte*

Aus der Entfernung von der Neuen Welt nun, in der gesicherten Ruhe des ältesten Freistaates Europas hat Postl die achtjährigen Erlebnisse Amerikas zu einer geschlossenen Reihe von Kunstwerken ausgeformt. Von der Land-Volk-Schilderung war er ausgegangen. Diesen Weg schritt er nun bis ans Ziel. Der angelsächsische Schriftsteller wurde ein deutscher Dichter. Durch wirklichkeitsgetreue Romane über die vorbildliche Volksherrschaft der Vereinigten Staaten wollte er in Deutschland wie Walter Scott in England zur staatsbürgerlichen Bildungsmacht werden. In überwältigend gedrungener Folge erscheinen nun seine großen Werke: 1833 „Der Legitime und die Republikaner", eine verbesserte deutsche Ausgabe des „Tokeah"; 1834 „Der Virey"; 1834 „Transatlantische Reiseskizzen"; 1834/1837 „Lebensbilder aus der westlichen Hemisphäre"; 1835 „Morton oder die große Tour"; 1839/1840 „Neue Land- und Seebilder" oder „Die deutsch-amerikanischen Wahlverwandtschaften"; 1841 „Das Kajütenbuch"; 1842 „Süden und Norden". *Karl Postls Amerikaromane*

Im Zuge der amerikanischen Völkerwanderung verdrängte der Angelsachse das Romanentum, Franzosen und Spanier, von Herrschaft und Scholle. Diese gärende Welt, Farmer und Kaufleute, Glücksritter und Edelleute, den sterbenden Indianer, spanisches, französisches, deutsches, angelsächsisches Volkstum, diese Welt behandelte Postl, der unglaublich rasch eingelebte Fremdling, als seinen Rohstoff, um daran das überlegene staatsschöpferische Genie, die vorbildliche staatsbürgerliche Haltung des Angelsachsentums anschaulich zu machen. Das angelsächsische und das lateinische Amerika stellte Postl in den beiden Romanen einander gegenüber, die fast im gleichen Jahr spielen und zusammen entstanden sind: „Der Legitime und die Republikaner"; „Der Virey und die Aristokraten". Der erste Roman spielt zur Zeit *Das angelsächsische und das lateinische Amerika*

des englisch-amerikanischen Krieges, 1812, da der Häuptling Tokeah an einem letzten Bündnis des Roten gegen den Weißen Mann zettelt und das englische Mutterland den letzten Waffengang mit der abtrünnigen Siedlung führt. Als literarische Schulübung arbeitet der Roman Vorwürfe von Chateaubriands „Atala" und Coopers „The Spy" zusammen. Der zweite Roman führt in die Vorbereitung des lateinisch-amerikanischen Freiheitskampfes.

Pflanzerleben In starken Vertretern wird der Gegensatz von spanischem Mutterstaat und spanisch-indianischem Tochtervolk, von unbeschränkter Beamtenherrschaft und adeliger Monarchie sichtbar gemacht. Nach Anlage, Fragestellung und Stil folgte hier Postl schon seinem neuen Meister Scott. Mit Schilderungen amerikanischen Bürgertums in „George Howards Brautfahrt" und „Ralph Doughbys Brautfahrt" leitete Postl zu seiner wundervollen Trilogie über: „Pflanzerleben", eine Farmeridylle, völlig neu als Gattung mit ihrem sprechenden Gegensatz von lateinischen und angelsächsischen Amerikanern und der feinen Abstimmung amerikanischer Stämme und Landschaften; „Die Farbigen" mit dem Vorwurf der Blutmischung; „Nathan", der Zusammen-
Weltmacht des Geldes stoß von Angelsachsen und Spaniern im Grenzraum von Texas. Auf diesem Untergrunde erhebt sich „Morton oder die große Tour", dieses gewaltige Vorgesicht von der Weltmacht des angelsächsischen Geldes. Die beiden gestaltenmächtigsten Bücher Postls kehrten zu seinem Ausgangspunkt zurück: „Das Kajütenbuch", das staatsbürgerliche Wesen der Vereinigten Staaten inbegrifflich, indem die Dichtung den Freiheitskampf von Texas und Südamerika absichtsvoll getont nebeneinander gliedert; „Süden und Norden", voll Handlung und sinnbestrickender Landschaftskunst, im mexikanischen Raume von Oaxaka spielend zu Zeit des mexikanischen Freiheitskampfes.

Szenische Kunstweise Postls Kunstweise ist wesenhaft theatralisch durch den häufigen Gebrauch von Regieausdrücken, durch die bühnenhafte Anlage von Szenen und ganzen Romanen, durch die unnachahmliche Kunst, die Menschen mit ihrer Sprechart nach Völkern und Rassen zu zeichnen, durch die unerhört sachliche Gesprächsführung der Romane, in der alle Schattierungen der Sprecher schwingen und die das erregte Stimmengewirr widerstreitender Meinungen wie von der Platte herunterspielt. Postl fand sich ganz neuen, in deutscher Sprache noch nie festgehaltenen Naturerscheinungen gegenüber: die Blu-
Tonfilm menprärie in Texas; der erschreckende mexikanische Golfsturm, das Chaos von Tieren und Pflanzen; Präriebrand und Nachtszenen wie die am Schluß der „Farbigen". Für all das hat Postl, wahrhaftig ein Adam im Paradiese, das erste namengebende Wort gefunden. Postl sah sich in den Staaten dem Nebeneinander fast aller lebenden Sprachen gegenüber. Auch das war eine

Wirklichkeit, die festgehalten werden sollte. Er war der Zunge für das Auge wie für das Gehör in gleicher Weise mächtig. Er hat all diese Sprachen wenigstens in Wortfetzen festgehalten um der Welt willen, zu der sie gehörten. Postl hat sich eine vollendete epische Kunstweise geschaffen, indem er jede Erzählung einrahmte und sehr kunstvoll die Rahmen ineinanderschachtelte und miteinander verzahnte. Seine künstlerische Entwicklung ging von Cooper und Chateaubriand aus, schulte sich seit dem „Virey" unter höchsten Absichten an Walter Scott, übte sich in „Pflanzerleben" am Nachtstück in der Art Richters, Hoffmanns, Stifters, bot in dem Hagestolzen des „Morton" eine Vorstufe zu Stifters „Hagestolz", während die Naturschilderungen im ersten Teil des „Kajütenbuch" ganz an Stifter heranrücken. *Postl, Cooper, Chateaubriand*

Auch wenn wir alles wüßten, was über einen Menschen wißbar ist, dieser Mann bliebe ein Rätsel. Er hat seine Rolle zu gut gespielt, dieser seltsame, wohlhabende Kleinbürger unter Schweizer Spießbürgern, den niemand mochte, der jedermann unheimlich war, dessen fremdartigem Zauber sich keiner entziehen konnte. Mit allen Kniffen war er bemüht, auf offener Szene eine Begegnung der beiden Doppelgänger Doktor Sealsfield, wie er sich als Amerikaner nannte, und Pater Postl, wie er auf österreichisch hieß, zu verhindern. Postl war nicht nur ein Prager Kreuzherr, sondern auch ein politischer Makler der Bonaparte. Das wissen wir. Was er sonst noch war, das wissen wir nicht. An dem Prager Kreuzherrn, gegen den außer seiner Klosterflucht nichts vorlag, konnte der österreichische Polizei nichts mehr liegen. Desto mehr vielleicht an dem Makler der Bonaparte. Darum kam dem exotischen Fremden in der Schweiz alles darauf an, daß Postl und Sealsfield nicht miteinander gesehen wurden. *Pater Postl Doktor Sealsfield*

Adalbert Stifter, 1805 bis 1868, aus Oberplan im südlichen Böhmerwald, hing nach dem frühen Tode seines Vaters mit desto stärkerer Kraft an seiner Mutter. Der Knabe hütete das Vieh. Er half beim Pflügen und Eggen. Er wurde von den väterlichen Großeltern erzogen. Vielleicht verdankt er der Großmutter den ersten Antrieb zum Fabulieren. Der mütterliche Großvater brachte den Jungen 1818 nach Kremsmünster, ein geistlicher Herr zu werden. Was Stifter war, das ist er in Kremsmünster geworden. Hier hat er durchs Auge die barocke Kunst und durch die Schule die benediktinische Lehre der ars sacra empfangen. An der Wiener Hochschule, seit Herbst 1826, begann er mit den Rechtswissenschaften. Was er mit Eifer trieb, war Naturkunde. Wien wurde die hohe Schule seines persönlichen Wesens und seiner Menschlichkeit. Der Mensch Stifter ist ein Zögling der Kaiserstadt. Als ewiger Hauslehrer ging er durch die ersten Wiener Häuser. Mit Grillparzer, *„Das sanfte Gesetz"* *Von Wien nach Linz*

den er tief verehrte, war er in der politischen Runde zusammen, die Anton von Doblhoff um die Wende auf 1848 im Wiener Ständehaus versammelte. Nach den Unruhen übersiedelte Stifter nach Linz und fand hier seine zweite Heimat. Er wurde Landesschulinspektor. Was er immer gewesen war, ein Erzieher, das ist der Dichter nun in Linz ins Große und Tiefe geworden. Vom Schmerz eines furchtbaren Leidens überwältigt, brachte Stifter sich mit dem Rasiermesser einen Schnitt am Halse bei. Der Dichter hat darnach noch zwei Tage gelebt und ist nicht an diesem ungefährlichen Schnitt, sondern an seiner unheilbaren Krankheit gestorben. Was an diesem Leben menschlich ist, war ein verhaltener Schmerz, der nur der Schönheit ins Angesicht gelächelt hat.

Vom Maler
zum Dichter
 Adalbert Stifter war aus Natur und Willen ein Maler. Seine Wendung vom Maler zum Dichter ist gleichbedeutend mit der künstlerischen Entdeckung des Salzkammergutes. Diese Landschaft hat Stifter als Maler betreten und als Dichter verlassen. Was Ferdinand Waldmüller und Friedrich Gauermann als Malerdichter auf der Leinwand begonnen haben, das hat Stifter mit Worten vollendet. Er hat das Salzkammergut 1829, 1836, 1845 von Wien aus besucht. Er malte aber unter freiem Himmel keine Sittenbilder und keine Tiere. Er malte allein die Berge und nichts als Berge, höchstens daß er einmal ein paar kleine Gestalten, die gar nicht wissen, wie sie auf das Bild kommen, in eine Ecke stellte. Da sah er sich als Maler persönlich vor den Grenzen seiner Ausdruckskunst. Er hat diese Grenze auf der Brücke zu einer andern Kunst, des Wortes, überschritten. Die Landschaft, die er als Maler betreten hat, die hat er 1836 als Dichter verlassen. Daß sich

„Der Kondor"
dieser Übergang im „Kondor" vollzogen hat, liegt am Tage. Wie man leicht sieht, ist die ganze Novelle dichterische Ausführung malerischer Motive. Was auf kein Bild ging, die Unermeßlichkeit der Natur, ausgedrückt durch das Mißverhältnis zwischen der überwältigenden Größe des Raumes und der winzigen Kleinheit des Menschen, das gelang ihm in seiner Novelle festzuhalten: in den Menschen der Ballongondel, wie sie zwischen Himmel und Erde schwebt, ein Nichts inmitten des Alls. Was also Stifter nicht malen konnte, was überhaupt nicht malbar war, das hat er gedichtet.

Stifters
Novellen im
Salzkammergut
 Am Salzkammergut nun hat sich seine Dichtung entfaltet. Es ist eine in sich geschlossene Folge von Novellen. In der Mitte steht die gedoppelte Dreiheit „Narrenburg", „Mappe", „Prokopus"; „Hagestolz", „Waldsteig", Bergkristall". Dieses Binnenstück wird sinnvoll eingerahmt durch die aufeinander erlebnismäßig bezogenen Novellen „Feldblumen" und „Nachkommenschaften". Die Gruppe setzt das Leben des Dichters und des Salzkam-

mergutes in ein innerliches Verhältnis. Die „Feldblumen" schildern Stifters
Reise von 1836 ins Salzkammergut. Sie siedeln sein Wunschbild einer frei-
gewählten Gemeinschaft von auserlesenen Menschen, das Attika der Zu-
kunft, in Traunkirchen an. Die beiden reisenden Freunde rasten in Scharn-
stein. Nach dieser Burg nannte Stifter eine Herrenfamilie, die Scharnast.
Und die Scharnast verbinden die drei Novellen der ersten Gruppe zu einem
Ganzen. „Die Narrenburg" 1842 ist die Familiengeschichte der Scharnast,
des Geschlechtes Niedergang durch Kultur und Wiedergeburt aus Natur, im
Stil eine Rahmenerzählung, die zur Aufnahme der einzelnen Lebensge-
schichten der Scharnast bereit war. Ein solches Einzelbild aus der Reihe der
Scharnast ist „Prokopus" 1847, und als ein solches Einzelbild ist ursprüng-
lich „Die Mappe" 1840 gedacht worden, wo die Scharnasttochter Margarita
einen Mann aus dem Volk nimmt, wie in der „Narrenburg" der letzte Schar-
nast mit einem Mädchen aus dem Volke das Geschlecht zu neuem Leben
erweckt. Die drei Novellen sind also ursprünglich Bruchstücke eines Fami-
lienromanes gewesen, dessen Entwurf und Rahmen in der „Narrenburg" *Der
vorliegt, kein kulturgeschichtlicher, sondern ein biologischer und sozialer Familienroman*
Familienroman. Gleich bedeutsam und schön bilden auch die drei andern
Novellen ein Ganzes, die zur gleichen Zeit, 1844 und 1845, entstanden sind:
„Der Hagestolz", „Der Waldsteig", „Bergkristall". Jede von ihnen spielt an
einem der drei bevorzugten Orte der Landschaft: bei Gmunden, um Ischl,
bei Hallstatt. Jede gibt die Landschaft bei einer andern Stimmung und Be-
leuchtung wieder: „Der Hagestolz" tragisch die düstere Verschlossenheit der
felsigen Insel, für die Traunkirchen Modell stand; „Der Waldsteig", humo-
ristisch die heitere Zutraulichkeit beschwingter Ferienwochen; „Bergkristall",
die schöne und erhabene Gefährlichkeit des winterlichen Gebirges. Dem Vor-
wurf nach bilden die drei Geschichten eine gedankentiefe Einheit um die
Ehe: der unheilbare Menschenfeind; der gerettete Kranke; die Kinder, die
alles, was fremd ist, zusammenbringen. Hier überall bildete der Dichter *Stifters
Stifter ab, was auf seinen Gemälden fehlen mußte, das Volk des Salzkam- Novellen im
Böhmerwald*
mergutes in Tracht und Brauch, Lebensart und wohlgeordnetem Alltag.
„Feldblumen" waren mit dem Blick auf den Scharnstein ein Aufgesang.
„Nachkommenschaften" 1863 sind ein Abgesang, der die Gruppe sinnge-
bend durchdringt.

Der Dichter des Böhmerwaldes ist Stifter nur mit dem kleineren Teil sei-
nes Werks. So bildet „Heidedorf" 1840 einen neuen dichterischen Einsatz.
Vom Salzkammergut geht Stifter zum Böhmerwald über und von seinen zeit-
genössischen Erlebnissen zur Erinnerung seiner Kinderzeit. Sein Modell ist

nicht mehr der Maler, sondern der Dichter. Zu „Heidedorf" gehört die Pech-
brennergeschichte „Granit" 1849, anekdotisch ein Stück Jugendgeschichte
und in diesem Rahmen die märchenhafte Vorgeschichte der Pechbrenner-
familie. Beide Novellen rücken dicht aneinander als sagenhafte Vergangen-
heit und selbsterlebte Gegenwart des heimatlichen Oberplan. Für sich steht
„Der Hochwald" 1841, ein allgemeines Kulturbild aus dem Dreißigjährigen
Kriege. Die Wildschützengeschichte stammt aus Coopers „Hirschtöter". Das
Erlebnis des Waldes ist in das Wunder der geschichtlichen und märchen-
haften Ferne abgerückt und zu dem wahren Geheimnis des webenden Le-
bens gemacht. Wieder ein Paar bilden „Der beschriebene Tännling" 1844
und „Katzensilber" 1852, jener eine schlichte Geschichte aus dem Volke vor
dem sagenhaften Hintergrunde Oberplans, dieses zwar in einem oberöster-
reichischen Landhause angesiedelt, aber durch und durch böhmerwäldlerisch,
beide Rahmenbüchlein für Heimatsagen. Wie schön stehen auch diese fünf
Geschichten als ein Ganzes beisammen: zwei Kindheitserinnerungen, zwei
Sagenbüchlein, in der Mitte groß und erhaben der Hochwald, mit dessen
Leben sie alle eins sind.

Stifters Mitte des Lebens, die Bildung, des Schaffens war Wien. Es ist die
Stadt seiner Arbeit. In seine Werkstätte geben die drei Novellen „Kondor"
1836, „Die Feldblumen" 1838, „Die drei Schmiede ihres Schicksals" 1844
einen Blick frei. Sie zeigen die Schule Johann Paul Richters und Ludwig
Tiecks. „Kondor", die Geschichte der solzen Frau mit dem Ehrgeiz des Man-
nes, ist tragisch und mit Worten gemalt, völlig Gemälde. „Schmiede", die
Geschichte der stolzen Frau, die den Mann nicht aus der Hand des Zufalls
will, ist ein Komödie, deren Szene gänzlich mit Worten gestellt ist. „Feld-
blumen", eine anmutige Folge von brieflichen und tagebücherlichen, tragö-
dienhaft und lustspielartig gemischte Begegnungen, verschweben heiter im
Malerischen. Dann wieder drei: „Das alte Siegel" 1844, die zweckbewußte
und gelenkte Verführung eines reichen Jünglings zur Liebe und einer jun-
gen Frau zum Ehebruch, ohne daß sie beide um ihre Spielpuppenrolle wis-
sen; „Turmalin" 1852, die Verführung einer jungen Frau als Vorgeschichte
für die Seelentragödie eines krankhaft verkümmerten Kindes; dazwischen
„Bergmilch" 1843, heiter auf dem Untergrunde eines mißglückten Lebens
und der kriegerischen Gefahr. Und nochmals drei, die nicht enger beisam-
menstehen könnten. „Abdias" 1843, wo der afrikanische Wüstenjude und
Liebling des Unglücks seinen Schatz, das Kind, in ein österreichisches Bergtal
birgt; „Zwei Schwestern" 1845, angeregt durch die kindlichen Meistergei-
gerinnen Therese und Marie Milanollo; „Brigitta" 1843 auf einem ungari-

schen Gut das Seelendrama der getrennten und wiedervereinigten Gatten. Diese drei sind Geschichten um das Kind: die sehend gewordene blinde Tochter, die der Vater sehen lehrt; das Seelenleben des Wunderkindes; der Sohn, der die Eltern wieder vereinigt. Jeder Novelle geht es um das Urbarmachen des Bodens. Die beiden Erzählungen „Der Waldgänger" 1846 und „Kalkstein" 1848 fassen diese dreifache Dreiheit zusammen, vielleicht Stifters persönlichste Schöpfungen, ausgefüllt von seinem versagten Lebenswunsch nach dem eigenen Kinde und dem Ersatzglück der Entsagung im Dienst am fremden Kinde. Stifters Sammelwerk „Wien und die Wiener" 1843 hat den Rahmen um Stifters Wiener Werk begonnen, die sechs kostbaren Bände der „Studien" 1844/1850 haben ihn geschlossen.

Sein Linzer Werk hat Stifter mit den „Bunten Steinen" 1853 begonnen, zwei schmucke Kästchen, in die er je drei seiner Geschichten aus der Welt des Kindes ohne ersichtliche Ordnung einlegte. Das Linzer Werk sind die drei Romane „Nachsommer", „Witiko", „Die Mappe meines Urgroßvaters". Alle sind aus dem Ertrage der „Studien" gearbeitet. *Die Linzer Romane*

„Der Nachsommer" 1857 hat seine Vorgeschichte in mehr als einer von Stifters Novellen. Die nachweisbare erste Vorfassung des Romans ist die Novelle „Der alte Hofmeister", die 1848 für das Taschenbuch „Iris", die Wiege so mancher Novelle Stifters, geschrieben werden sollte. Der Roman, seit 1852 entstanden, ist Selbstdarstellung in Gestalt eines Bildungsromans. Der Dichter hat sich selber Modell gestanden, aber er hat auch nicht wenige Menschen aus der Gesellschaft seines Lebens sehr getreu in den Gestalten des Buches nachgezeichnet. Die eigentliche Selbstdarstellung sättigt sich an der Ausbildung des innern Menschen, wie der Roman sie entwickelt. Da war Goethes „Wilhelm Meister" das alles beherrschende Vorbild. Was Stifter wiedergibt, ist freilich nicht sein wirklicher Bildungsgang, sondern wie er wünschte, daß er ihm gegönnt worden wäre. Nachsommer heißt die geträumte Erfüllung eines verwehrten Lebenstraumes. Es ist ein Buch der Erziehung zur Kunst. Zur Kunst bilden heißt, zur Überwindung des Lebens stark und zur Erkenntnis der Welt reif machen. Kunstschaffen wie Kunstempfangen sind Handlungen der Askese. Beide sind der einzige wirkliche Genuß der Welt. Stifter wußte, setzte voraus und lehrte: Kunst ist Vorzug, aber kein Herrenluxus, für den der Sklave aufkommen müßte. Kunst ist Überschuß aus dem Ertrag der eigenen wertschaffenden Arbeit. Der Sinn der Arbeit ist nicht der gesteigerte Umlauf der Güter, sondern die zunehmende Vollkommenheit der Kunst. *„Der Nachsommer"*

„Witiko" 1867 geht als Plan zu einem geschichtlichen Roman der Ottokar- *„Witiko"*

„Die
Weltgeschichte
das
künstlerischste
Epos" zeit in das Jahr 1850 zurück und ist im Fortschreiten immer wieder durch den Nachsommer aufgehalten worden. Die Jahre 1139 bis 1184 begrenzen das europäische Zeitalter, das Stifter darstellte. Die Grundrisse der Begebenheiten, so weit sie geschichtlich sind, fand er bei dem tschechischen Geschichtsschreiber Franz Palacky. „Der Nachsommer" ist die Bildungsgeschichte einer idealen Persönlichkeit und weltanschaulich Goethe verpflichtet. „Witiko" ist die Bildungsgeschichte einer idealen Menschengemeinschaft, und sie lebt aus Herders Geist. Stifter glaubt daran, daß Natur und Geschichte unter dem einen und gleichen Gesetz des Kreislaufes stünden von der Wildnis über die Kultur zur Wildnis, vom Aufstieg über Höhe und Tiefe zum Aufstieg der Geschlechter. Und seine künstlerische Einsicht wußte: „Die Weltgeschichte als ein Ganzes, auch die ungeschriebene eingerechnet, ist das künstlerischste Epos". Die Dichtung ist ungemein durchsichtig angelegt. Sie ist aus zwei Teilen aufgegliedert. Der erste Teil gibt Witikos Aufstieg und setzt sich aus vier Ausritten zusammen. Der zweite Teil zeigt Witiko auf der Höhe des Lebens und Wirkens durch drei große Szenen: im Rat des Fürsten; auf seinem Eigenbesitz; im Felde. Ein dreifacher Ausklang schließt die Dichtung: der Reichstag von Worms; die Vollendung des Nibelungenliedes; die Errichtung des Schlosses Krumau. Den Kern der Dichtung bildet der Aufbau einer bäuerlichen Waldgemeinschaft. Witiko kommt in den Wald, lernt den Bauernbetrieb kennen, lebt als Bauer, entwickelt sich zum Volksmann und Schöpfer eines Kulturverbandes, schult seine Waldleute in den Waffen, erschließt sein Lehensgebiet wirtschaftlich, gibt ihm eine Verfassung und die Grundlagen des Bildungswesens. Der Stil ist zuweilen erschöpfende sprachliche Wiedergabe der Wirklichkeit. Die Darstellung ist stark vom Gesetz der Malerei beherrscht. Dreiklänge von Farben gehen leitmotivisch durch die ganze Dichtung. Der Roman ist ein gewaltiges Rundgemälde des böhmisch-deutschen Mittelalters.

„Die Mappe" „Die Mappe meines Urgroßvaters" ist das Herzstück in Stifters gesamtem Schaffen. Sie ist über zwei Novellenfassungen schließlich ein zweibändiger Roman geworden, der unvollendet erst aus Stifters Nachlaß bekannt wurde. Diese letzte Dichtung ist der Roman eines Arztes, dessen heilende und bildende Tätigkeit an vielen Einzelheiten des ärztlichen Tagewerks sichtbar gemacht ist. Und da es ein Landarzt ist, so erscheint in all diesen leidenden, sterbenden, geretteten Menschen die Kleinwelt des Dorfes, das Leben selber wie es ist, mit allen seinen Gestalten. Als der ursprünglichere dichterische Entwurf vereinigt „Die Mappe" gedanklich und künstlerisch die beiden jüngeren Romane. Denn sie ist eine geistige Bildungsgeschichte wie „Der Nach-

sommer" aber zu einem tätigen Gemeinschaftsleben wie der „Witiko". Denn auch in der „Mappe" geht es um den Aufbau eines bäuerlichen Gemeinwesens, dessen Führer und zugleich Diener der Arzt Augustinus ist. Hier hat Stifter fast alle Freunde und Bekannten und die Landschaft seiner Jugend abgebildet. „Die Mappe", das ist ganz und gar Stifters Weltanschauung. Der Arzt mit seiner Kunst des Heilens und also des Lebens, der Todüberwinder, der Wiederhersteller des gesunden und schönen Leibes, das ist der Künstler rundweg. Augustinus ist vollkommen geworden im Vollzug des alltäglichen und allstündlichen Heldentums. Er ist die letzte Erscheinung des Gedankens, unter dem Stifters gesamtes Künstlertum gestanden hat: Großes ist mir klein und Kleines ist mir groß.

Drei Novellen, die letzten, spiegeln uns den Dichter noch einmal von allen Seiten seines Wesens zu: „Der Waldbrunnen" 1866, „Der Kuß von Sentze" 1866, „Der fromme Spruch" aus dem Nachlaß. Sie stehen gemeinsam unter dem Gedanken: Ehen werden im Himmel geschlossen, wenn Gott sich ein wenig von den Menschen helfen läßt. Und gemeinsam ist ihnen die herbe Frau, die Herrin über sich selber. „Der Waldbrunnen" ist „Nachsommer" und „Heidedorf", nichts als Erinnerung und Rückkehr in die Jugend. „Der Kuß von Sentze" ist „Nachsommer" und „Siegel". Wie herrlich bleibt der unbekannte Kuß im Dunkeln. „Der fromme Spruch", Goethes Novelle „Der Mann von fünfzig Jahren" nacherzählt, ist „Nachsommer" und „Hagestolz". Diese letzte und schönste und völlig verkannte Novelle Stifters ist ein Lustspiel, so angelegt und szenisch auch heruntergespielt. Eine kaum spürbare hintergründige unsagbar liebenswürdige Ironie durchhaucht die unnachahmliche Geschichte, die übers Kreuz Tante und Neffen, Onkel und Nichte, Neffen und Nichte in eine Komödie der Irrungen verstrickt. Die Dreiheit dieser letzten Novellen hat von jeder der vielen Erzählungen Stifters eine leise Spur des Nachhauches. Aus ihnen allen kommt das kostbar gemischte Aroma, das sie ausströmen.

„Waldbrunnen" „Kuß", „Spruch"

Wien und seine große Dichtung war das Theater. Karl Bernbrunn kaufte 1838 das Leopoldstädter Theater, baute es 1845 um und eröffnete es, das jetzt Carltheater hieß, am 20. Dezember 1874 von neuem. Die Bühne verfügte über einen wohlversorgten Spielplan. Ihre Wirkung ging aber nicht so sehr von den Stücken, sondern von den Schauspielern aus: von dem Tiroler Wenzel Scholz, von der Schlesierin Therese Krones, von dem Wiener Friedrich Josef Korntheuer. Der beste Schauspieler der Leopoldstadt kam aus der Josefstadt.

Wiener Theater

Ferdinand Raimund, 1790 bis 1836, der Wiener Drechslersohn, hatte sich

Volksbühne

36

an der Josefstädter Bühne seit 1814 langsam einen komischen Stil geschaffen.
An das Leopoldstädter Theater kam er 1817, wurde 1821 Spielleiter und trug
seit 1828 die Verantwortung für die gesamte Bühne. Eine Laune des Schick-
sals schien Raimund beinahe alles versagt zu haben, was ein Mensch zum
Schauspieler braucht. Doch sie hatte ihm eine ungewöhnliche Beredsamkeit
des Leibes gegeben. Sein unendlicher Fleiß brachte es dahin, daß er die
ganze Wirkung seines Spieles auf die sprechende und oft nur leise bewegte

Raimunds
Spielbücher Gebärde stellen konnte. Damit hing die unglaubliche Verwandlungsfähigkeit
zusammen, mit der er in verschiedenen Rollen des gleichen Stückes verblüffte.
Raimunds Stil war die Kunst, die Dinge gleichzeitig von beiden Seiten sehen
zu lassen, von der heiteren und von der ernsten, damit ihr Widerspruch mit
sich selber ins Auge falle. Das war sein Stil auf der Szene. Das ist der Stil
seiner Spielbücher. Der Dichter ist aus den Rollen des Schauspielers heran-
gewachsen.

Raimunds Stücke scheiden sich in zwei Gruppen, deren jede einen andern
Versuch darstellt, die eine und gleiche künstlerische Aufgabe zu lösen. Die

Die
Rahmenstücke eine Spielgruppe bilden „Das Mädchen aus der Feenwelt" 1826, „Moisasurs
Zauberfluch" 1827, „Die gefesselte Phantasie" 1828, „Die unheilbringende
Krone" 1829 gespielt. Es sind Rahmenstücke. Sie sind alle nach dem gleichen
Grundriß angelegt. Die Rahmenhandlung knüpft der Wille überirdischer
Gestalten an die Lösung schwieriger Aufgaben, über deren auftraggemäßen
Vollzug am Schluß entschieden wird. Die Binnenhandlung zeigt die Lösung
dieser Aufgaben durch die Menschen, die dazu ausersehen waren. Von den
vier Spielen gehören wieder je zwei enger zusammen, indem sie beinahe den
gleichen Vorwurf gestalten. „Das Mädchen" und „Moisasur" zeigen in der
Binnenhandlung den Dämon des Geldes, der ein schuldloses weibliches We-
sen mißhandelt. Es sind ungemein lebensechte Sittenbilder der bäuerlichen
Natur, soziale Dichtungen von hintergründigem Ernst. „Die Phantasie" und
„Die Krone" spielen um die Dichtung und den Dichter. „Die Phantasie" ist
eine Tragikomödie des geistigen Schaffens mit einem Dichterwettbewerb in
der Mitte. „Die Krone" ist eine Gleichnisdichtung von der Leuchtkraft der
Poesie, die mit ihrem holden Truge den Augenschein des wirklichen Lebens
in sein schöneres und besseres Gegenteil verwandelt. Die vier Rahmenstücke
bilden zeitlich die Mitte von Raimunds dichterischem Schaffen. Die andere
Spielgruppe sind „Der Diamant des Geisterkönigs" 1824, „Der Alpenkönig
und der Menschenfeind" 1828, „Der Verschwender" 1834 gespielt. Es sind

Die
Charakterstücke Charakterstücke. Die Handlung wird nicht automatenhaft durch äußere An-
triebe ausgelöst. Sie entwickelt sich von innen her aus dem Charakter. Hier

ist jeder selbst seines Glückes Schmied. „Der Diamant" ist kein Rahmenstück. Mit einer übermütigen Kühnheit ohnegleichen ist in der Maske des Kaisers Franz — Longimanus, der Geisterkönig — Gottvater und sein Weltregiment auf die Szene gebracht. Eduards märchenhafte Fahrt nach seiner Almine ist nur ein beispielhafter Zug für die Art, wie Longimanus sein Regiment führt. Wieder anders „Der Alpenkönig". Das ist Raimunds persönlichste Dichtung, die erträumte Heilung einer gallsüchtigen Natur durch den Anblick seines Spiegelbildes. Mit der Doppelrolle Rappelkopf-Silberkern stellte der Dichter das Verwandlungsvermögen des Schauspielers vor die schwierigste und ruhmvollste Aufgabe. Endlich abermals anders „Der Verschwender". Die Märchenhandlung, die schon im „Alpenkönig" sehr vermenschlicht war, läßt „Der Verschwender" nur noch als einen feinen Silberfaden im Gewebe der völligen Wirklichkeit erkennen. Hier ist nichts als ein Charakter, ein edler Verschwender mehr des Lebens als seines Geldes, seiner Güte, seiner Großmut, seines Herzens. Verschenkte Güte ist ein Sparschatz für die Not. Dieser Sparschatz ist die Treue von Flottwells ehemaligem Diener Valentin. Und so hat Raimunds letzte Bühnendichtung eine einzige, unendlich oft gespielte Szene aus dem alten Wiener Theaterbestande zur letzten Vollendung gestaltet: der Herr und sein Diener.

Longimanus, Rappelkopf, Flottwell

William Shakespeare und Ferdinand Raimund sind der gleiche Fall. Ihr Werk stellt die Schlußredaktion einer langen Spielüberlieferung dar. Raimunds Dichterstil besteht in dem naiven Zusammenspiel zweier Welten: der sinnlichen des Diesseits und der geistigen des Jenseits. Dieses Zusammenspiel, auf der barocken Bühne herausgebildet, war ein Spielmythus von der gleichen Art wie der Theatermythus der attischen Bühne. Der Spielmythus des barocken Theaters stammte aus Glauben und Bildung, aus dem christlichen Himmel und aus dem antiken Olymp. Er ging an die Wiener Volksbühnen über wie die ernste Ballade zum Bänkellied wurde. Und da er nicht mehr geglaubt werden konnte, wurde er zum Theatermärchen, das keinen Glauben verlangt, sondern mit einer ironischen Teilnahme zufrieden ist. In diesem Zustande hat Raimund die Wiener Spielüberlieferung vorgefunden und sich in sie eingespielt. Er hat dann diesem entgöttlichten, zum Märchen gemachten Spielmythus die Glaubwürdigkeit und zugleich den Adel des hohen Dramas wiedergegeben. Raimunds geistige Welt des Jenseits ist das wirkliche Reich des Geistes. Sein Spielmythus ist nichts anderes als eine großartige dichterische Metapher für den Plan der Vorsehung, ihre unerkennbaren Zwecke, für den Sinn, den wir der Welt durch unser frei wählendes Handeln geben. Raimunds sinnliche Welt des Diesseits geht dichterisch auf die meist

Der Spielmythus

bäuerlichen Zwieschenspiele des barocken Stildramas zurück. Die Wiener Volksbühne hatte sie zur selbständigen Posse und zum realistischen Sittenstück entwickelt. Aus diesen gestaltete der Dichter seine Binnenstücke. In ihnen schildert Raimund mit einer unglaublichen Naturtreue das Österreich nach dem Kongreß. Es ist Raimund, bei dem die moderne Bauerndichtung anfängt, die dann Anzengruber und noch später Hauptmann hieß. Raimunds
Spielbücher sind eine soziale Tat. Er hat den dienenden Menschen aus der Erniedrigung der Volksposse erlöst und menschlich zu Ehren gebracht. Der Florian seines ersten, der Valentin seines letzten großen Dramas sind das Alpha und Omega in Raimunds hohem Liede vom echten und rechten Menschen. Was das eigentümliche Wesen der Wiener Sprache ausmacht, das besondere Vermögen, bildhaft und bildlich zu reden, hat Raimund auf eine Weise gekonnt, die wie eine Offenbarung wirkt. Raimunds Schauspiele sind im Ganzen wie im Einzelnen Metaphern, Übersetzungen des bildlich Gesagten ins wörtlich Gemeinte. So versagen die Dichter im Wettspiel, weil ihre Phantasie wörtlich gefesselt ist. So sieht der zornwütige Rappelkopf buchstäblich sich in seinem Spiegel. Da so sprechen die gemäße Form des so Denkens ist, dürfen wir sagen: der metaphorische Stil von Raimunds Dramen kommt aus dem metaphorischen Denken der Wiener Sprache. Die Metapher
nun, das Wechselspiel von wörtlich gesagt und bildlich gemeint, von bildlich gesagt und wörtlich gemeint, erzeugt jenes Nichtwissen, ob das Gesagte ernst oder heiter zu nehmen sei, das man in bezug auf Raimunds Schauspielstil tragikomisch nennen muß. Es kommt nicht auf den Ausgang an, der bei Raimund immer „gut" ist. Was bleibt und was wir unauslöschlich mit uns wegtragen, ist die Einsicht: das ist das Leben. Seine Spielbücher stellen das Rätsel des Lebens nicht und sie suchen daher auch keine Lösungen. Sie geben lediglich in wechselnden Szenen das Bild des Lebens so, wie es in seiner sinnlichen Diesseitigkeit ist, und den geistigen Himmel darüber, der sich in den wechselnden Szenen spiegelt. Raimunds Bühnendichtungen wollen keinen
gegenständlichen Affekt erwirken, den man, sein Herz befragend, tragisch oder komisch nennen könnte. Sie lösen jene unbestimmbare, rauschhafte Erschütterung aus, wie das unausdenkbare, unbegreifliche, immer nahe und doch stets so ferne Wunder des Lebens selber, jene Erschütterung, die das Vorrecht der Jugend ist: man weint, und weiß nicht warum; man lacht, und weiß nicht worüber. Sie haben und sie wollen keine andere Wirkung als
die Träne und daß sie fällt. Das ist die grundlose Träne, in ihrem Quell so geheimnisvoll und unerforschlich wie das Leben, die Liebe, die Kunst sie auspressen. Sie ist gefallen, mögen wir sie Schmerz oder Freude heißen. Sie hat

weggewaschen, rein gemacht, vergessen lassen, was sie im Auge löste. Vielleicht hat Ferdinand Raimund von allen Dichtern, die für die offene Szene geschrieben haben, mehr als irgendeiner um das Geheimnis gewußt, was die Griechen Katharsis genannt haben: Läuterung unserer Menschlichkeit durch die Kunst von den Schlacken des Lebens.

Der Held auf der Szene bedarf eines Gegenspielers, damit es eine Handlung gebe.

Johann Nestroy, 1802 bis 1862, aus Wien, dessen Vater aus Österreichisch-Schlesien zugewandert war, hatte zum Unterschied von Raimund schulmäßige Bildung. Auf Hausbühnen wurde er zum Künstler, in Graz zum Komiker. Vom Theater an der Wien kam Nestroy 1845 auf das Theater in der Leopoldstadt. Von 1854 bis 1860 hat er es geleitet. Mit Nestroy wiederholt sich der gleiche Vorgang wie bei Raimund: Stegreifspiel wird Bühnenstück. Gegenüber Raimund fehlte Nestroy das Unsägliche, das Dichtung ist. Seine Stücke machen keine Träne. Als Schauspieler wie als Bühnenschriftsteller hat Nestroy anfänglich, um in Form zu kommen, Raimund, dem Schauspieler und Dichter, nachgeeifert. Als er so weit war, verriet er sich, indem er nach Art ehrfurchtsloser Schüler den Lehrer spöttisch nachäffte. Man sieht, Nestroy war es nicht um das heilige Lachen zu tun, sondern um das Gelächter, das Klatschende und Beklatschte erniedrigt und das gemeinsame Opfer adelt. „Der böse Geist Lumpacivagabundus" 1833, der Tiefe und Anmut von Raimunds „Verschwender" lächerlich machte, zog eine Reihe ähnlicher Parodien nach sich. Eine Sache verekeln, das konnte niemand besser als Nestroy. Indessen, so fing es nur an. Nestroys Bühnenwerk ging literarisch über zwei Stufen. Er hat der Wiener Stegreifkomödie die Form des Spielbuchs gegeben und er hat das französische Lustspiel ins Leopoldstädtische übersetzt. Jene Arbeit ergab das Wiener Volksstück und diese das bürgerliche Sittenstück. Nestroys Wiener Volksspiel ist die gute alte Stegreifkomödie. Es wandelt den stehenden Vorwurf ab, wie ein glücklich liebend Paar mit Hilfe eines geriebenen Helfers zum Jawort des Vaters oder Vormundes kommt. Hinter der Maske dieses Ränkespinners steckt Hanswurst, der Erbe des Harlekin und also der europäischen Theaterliteratur. Die Einfälle hat bei Nestroy immer der Schauspieler und der Bühnenleiter. So quartierte „Das Haus der Temperamente" 1837 die vier Gemütsarten vierer Väter in einem Wiener Hause ein. Jeder hat je einen Sohn und je eine Tochter. Die Sache läuft darauf hinaus, den vielfach verwickelten Viererzug glücklich ins Ziel zu lenken. Das bürgerliche Sittenstück, wie Nestroy es geschaffen hat, begleitet den europäischen Siegeszug des französischen Lustspiels. Einfuhr aus Paris

Einen Jux will er sich machen

Nestroys Parodien

Nestroys Sittenstück

ist also bei Nestroy alles, was allein das französische Kunsthandwerk erzeugen konnte, der modische Stil der Inneneinrichtung. Heimisches Erzeugnis sind die Figuren, die sich in diesen Räumen bewegen und alles, was sie denken, sagen und singen. In diesen Stücken konnte sich der Dämon der scharfsichtigen mephistophelischen Vernunft, den Nestroy an Stelle des Herzens in der Brust trug, ungehemmt ergehen. Seine Spielbücher wuchsen gewissermaßen erst bei den Proben heraus, auch das ein Zeugnis für das alte Stegreifspiel.

Nestroy und Raimund

Raimund und Nestroy gehören wie Ja und Nein zusammen. Jeder hat in seiner Art die nie verlorenen uralten Stilmittel des Wiener Theaters zu einer zeitgemäßen Kunst erhöht: Raimund die barocke Welt des Hoftheaters, Nestroy den Harlekin der Renaissancekomödie. Alles, was aus dem Singspiel stammt, Musik, Tanz, Melodrama, das haben sie gemeinsam. Beide sind als Schauspieler nur Verwandlungen des alten Stegreifkünstlers. Man muß sie beide zusammen als ein Ganzes nehmen ohne Rücksicht auf den Geschmack, der unter ihnen entscheiden möchte.

Das Burgtheater

Das Burgtheater sah 1814 Josef Schreyvogel an der Macht. Im Zuge mannigfacher Umgestaltungen wurde er 1823 in aller Form, was er längst gewesen war, Leiter der Anstalt. Er verjüngte den Chor der Schauspieler. Er schuf einen umfassenden Spielplan, in dem die Spanier wieder zu Ehren kamen. Shakespeares Dramen wurden Zug um Zug in ihrer geschichtlichen Gestalt auf die Szene gestellt. Die deutschen Klassiker mußten so gespielt werden, daß sie bei Hofe keinen Anstoß erregen konnten. Die Bühne brachte im Durchschnitt jährlich zwölf bis fünfzehn Neuheiten und ebenso viele Neueinrichtungen. Schreyvogel hat sein Theater als redlicher Kaufmann und als

Josef Schreyvogel

Mitarbeiter seiner Dichter geführt. Sein letztes Werk war am 24. Mai 1832 die Trauerfeier für Goethe. Das rohe kaiserliche Handschreiben vom 12. Mai 1832 stieß ihn weg. Zwei Monate später war er ein toter Mann. Das Zwischenreich war damit beschäftigt, dieses Theater unter Johann Ludwig Deinhardstein zu verlottern und unter Franz Ignaz von Holbein wieder ins wirtschaftliche Gleichgewicht zu bringen. Dann aber, 1849, sah die Bühne sich unter Heinrich Laube wieder geborgen. Das war der Mann, der sich in allen Sätteln bewährt hatte. Der Menschenkenner hatte Geschick und Glück und bald die besten Schauspieler. Laubes Spielplan verwirklichte den Gedanken: gemäß der modernen Bildung so vollständig als möglich; alle lebensfähigen Stücke seit Lessing; von Shakespeare alle wirklichen Spielbücher; von den Romanen alles Wesentliche; von den Franzosen alles, was gut in der Form und sittengerecht. Der Zuwachs der modernen Bühnendichtung wurde von

Laube, soweit als möglich, eingefangen. Sein Theater war Organ des atmenden Lebens. Er leitete seine Bühne nicht vom Amtszimmer, sondern von der Szene aus. Ein ausgezeichneter Sprecher und Vorleser, spielte er seine Leute persönlich ein. Er duldete kein Vordrängen. Er steigerte das Zusammenspiel zur Vollendung. Als man Miene machte, ihn seine Vollmachten zu verkürzen, trat er 1867 zurück. Das war ja ohnedies die Zeitwende.

Die Szene zwischen Schreyvogel und Laube, wo es nicht so genau genommen wurde, beherrschte *Eligius Franz Josef von Münch-Bellinghausen*, 1806 bis 1871, aus Krakau, seit dem Melker Gymnasium der künstlerische Zögling Michael Enks. Wie die vortrefflichen Novellen Münchs beweisen, war er nur eine abgeleitete dramatische Natur. Er schrieb und ließ sich unter dem Decknamen Friedrich Halm spielen. Mit seinem Erstling, dem Novellenstoff aus dem Artuskreise, „Griseldis" 1835, hatte er gleich Erfolg. Seine Dramen sind von da bis zu „Wildfeuer" und „Begum Somru" 1863 in fast lückenloser Folge über die Burgbühne gegangen. Münch suchte es allen recht zu machen mit Stücken spanischen und antiken Stils, romantischer und moderner Haltung und scheut den Wettbewerb weder mit Shakespeare noch mit Grillparzer. Seine Vorwürfe waren gern absonderlich, bizarr und peinlich, soweit man es den Komtessen im Burgtheater andeuten konnte. Es ist immer der Vorwurf und nie die Gestalt, wovon er ausging. Daher ist die Handlung sorgfältig geführt und die Gestalten sind nicht recht zu greifen. Die Handlung bleibt mager, weil er sich nicht auf Nebenzüge und Beiszenen verstand. Es entsprach seiner Neigung zum Absonderlichen, wenn die Männer auf seiner Szene weibisch und die Frauen männlich sind. Weil Münch sich auf das Spielwerk seiner Stücke nicht verlassen konnte, suchte er die Wirkung in der lyrischen Erregung des Gefühls und in der rechnerischen Überredung des Verstandes. Alles, was gemacht werden kann, das hatte er weg. Die reine Natur versagte sich seiner Kälte.

Friedrich Halm

Das Burgtheater mochte führen wer wollte und durfte, sein Stammdichter von 1823 bis 1890, war *Eduard Bauernfeld*, 1802 bis 1890, der Schottenschüler, Grillparzerfreund und ewige Wiener, der sich so viel Mühe gegeben hat, als Mensch wie als Dichter den Tod nicht zu sehen. Das Burgtheater hat Bauernfeld bei dessen Lebzeiten mit 43 Stücken an über tausend Abenden das Wort gegeben. Der Dichter wollte es mit dem Eigensinn des Benachteiligten zur Tragödie bringen, da es doch kaum zum Schauspiel reichte. Denn das Feld seiner reichen Gaben war das Lustspiel. Und immer einmal machte er aus dem Alltag der Gegenwart gern einen Ausflug in die Geschichte oder unter das Volk. In dem breiten Zeitstreifen vor 1848 und dem weit

Das Lustspiel des Burgtheaters

Echo
des Freisinns schmäleren darnach spickte er seine Stücke mit politischen Anspielungen, ob es nun mit „Großjährig" 1846 der Rechten oder mit der „Republik der Tiere" 1848 der Linken galt. All das gibt den Unterschied nicht. Bauernfeld folgte mit seinen Stücken, ob sie nun „Bekenntnisse" 1834, „Bürgerlich und romantisch" 1835, „Der kategorische Imperativ" 1851, „Moderne Jugend" 1868, „Die letzte Fee" 1877 hießen, den Wiener Tagen und Jahren. Er war der Wortführer des freisinnigen Bürgertums und von Bühne wie Zuschauer abhängig. In seinen Sprechstücken unterhielt sich das wohlhabende Bürgertum über die Fälle, die der Tag brachte und wieder vergaß. Bauernfeld hat, wie alle Welt, bei Kotzebue begonnen. Er hat aber auch von dem österreichischen Lustspiel der Steigentesch und Ayrenhoff gelernt. Ja, das Wunderbare des Zauberstücks ist in seinen Spielen gerade noch da. Raimund, Nestroy, Bauernfeld. Das ist die Reihe. Bauernfeld hat das Stegreifspiel der Hanswurstkomödie in die feste Form des Burgtheaters gebracht. Er hat die überlieferten stehenden Gestalten in den Salon des Bürgertums und des Adels von Schwert wie Geld verpflanzt. Die Handlung bedeutet in seinen Stücken nicht viel. Die menschliche Gestalt ist alles. Er spielte aber nicht für das Auge, sondern für das Ohr. Der anmutige Plauderton des gebildeten Gesprächs, das ist seine Kunst. Er ist der Schöpfer und er ist der Meister des Unterhaltungsstückes. Ein moderner Mensch, sein Leben lang ein Zweifler und erst im Alter kirchengläubig, hat Bauernfeld mit seiner untrüglichen Witterung für das Wetter des Tages zwei Menschenalter hindurch im Burgtheater die Kosten der Unterhaltung bestritten. Er hat von der Szene aus Staat und Gesellschaft spöttisch gemeistert.

Die Tragödie
des
Burgtheaters Das war die Stadt und die Szene für die österreichische Tragödie hohen Stiles. Den großen Bühnendichter des Burgtheaters hat Schreyvogel entdeckt.

Franz Grillparzer, 1791 bis 1872, ist zu Wien geboren und hat seine ganze frühe Bildung in der Vaterstadt empfangen. Sein Vater stammte aus einer oberösterreichischen Familie und war Rechtsanwalt geworden. Die Mutter gehörte zu der musikalisch begabten Wiener Familie Sonnleithner, in der der Knabe schon früh die Künstler der Stadt kennenlernte und durch die Hausbühne mit dem Theater vertraut wurde. In kleinen Ämtern der Finanzverwaltung diente er sich empor, wobei es ihm gut und schlecht ging. Der Finanzminister Graf Stadion zog ihn in seine Nähe. Auch der Staatskanzler Fürst Metternich begünstigte ihn anfangs und suchte in Italien die Bekanntschaft des Dichters. Zögernd und gehemmt rückte er dienstlich auf, bis man ihn 1832 zum Direktor des Hofkammerarchivs machte. Das Amt ließ ihm viel freie Zeit. Er nützte sie zu umfassenden Studien auf allen geistesgeschicht-

lichen Gebieten. Sein Lustspiel und die große Dreiheit seiner letzten Tra- *Franz*
gödien sind am Hofkammerarchiv gefördert und abgeschlossen worden. Die *Grillparzer*
deutsche und europäische Politik zwischen 1830 und 1848 hat Grillparzer
aus teilnehmender Ferne miterlebt. Er hat immer gewußt, was geschah, aus
welchen Triebkräften es kam, welchen Zielen es zustrebte. Er hat diese Poli-
tik nach den obersten Grundsätzen bewertet, die ihm aus der Natur der
menschlichen Einrichtungen einleuchteten, und nach den Einsichten, die er
aus seinen Studien über die Natur der europäischen Großvölker gewonnen
hatte. Die Deutschen, meinte er, hätten durch Hegel den entscheidenden
Schritt vom Wege und in die falsche Richtung getan. Er hat Hegel und Preu-
ßens Anspruch auf die Führung in Deutschland mit Schärfe und guten Grün-
den bekämpft. Grillparzer gehörte zu dem freisinigen und freiheitlichen
Kreise, den im Winter auf 1848 Anton von Doblhoff im Ständehaus ver-
sammelte. Doch als es dann um den Bestand des Vaterlandes ging, bezog er
in der Mitte unerschütterlich Stellung. Er wurde 1861 in die vornehmste
politische Körperschaft, ins Herrenhaus berufen und nahm hier auf der Lin-
ken Platz. Sein achtzigster Geburtstag im Jänner 1871 wurde unter Teil-
nahme der europäischen Öffentlichkeit gefeiert und als man ihn begrub,
säumten hunderttausende den letzten Weg, den er gefahren wurde. Herren-
haus, Abgeordnetenhaus, Stadtrat widmeten dem Verewigten ehrfurchtsvolle
Nachrufe.

Franz Grillparzer hat bis in seine letzten Jahre an sich selbst, an seiner *Europäische*
Bildung und Vollendung gearbeitet. Er hat die antike Welt lesend und den- *Bildung*
kend durchdrungen, sich gegen Latium und für Attika entschieden. Platos
Philosophie und des Euripides Kunst der Szene waren der persönliche Ge-
winn, den er aus diesen griechischen Studien gezogen hat. Er hat sich plan-
mäßig in die Sprachen und Literaturen der europäischen Großvölker ver-
tieft. Sein frühestes und stärkstes Erlebnis war Frankreich, um Voltaires
willen, und die zeitgenössische französische Literatur hat er mitgelesen. Bei
England lief es auf Meister William und Lord Byron hinaus, in dem er sich
spiegelte. Das engste und fruchtbarste Verhältnis hatte er zu Italien, das ja
mit starken Strahlen im Wiener Geisttum fortleuchtete. Gozzis Märchenspiel
hat er nachgebildet. Machiavelli hat er zur Federprobe übertragen. Torquato
Tasso war sein italienischer Spiegel. Spanien um Lopes und Calderons willen
hat ihn nicht mehr beschäftigt als die andern Sprachen und Literaturen. Er
hat darüber nur mehr zu Papier gebracht. Durch Augenschein hat Grillparzer
sich einen fast vollständigen Überblick über die deutsche Literatur vom Mit-
telalter bis in seine Tage verschafft und darüber schöne und geistvolle Nie-

derschriften hinterlassen. Der Widerspruch gegen Hegel trieb ihn zu um-
Hamann fassenden philosophiegeschichtlichen Studien. Mit ihnen ist Grillparzer frei-
und Kant lich sehr früh und fast gleichzeitig von den beiden Gegenspielern Kant und
Hamann ausgegangen. Zu Kant stand er wie etwa zu Goethe mit der Ehr-
furcht vor der großen persönlichen und geistigen Leistung. Hamann, der in
Grillparzers Aufzeichnungen von den frühen bis in die späten Jahre eine
Rolle spielt, muß auf Grillparzer sehr tief gewirkt haben. Noch stärker ist die
Fülle der inneren Beziehungen von Grillparzer zu Hamann. Wie Hamann
die hellenische Philosophie zu der seinen gemacht hat, so hat sich Grillparzer
die moderne Philosophie ins Attische übersetzt und so verstanden.

Erlebnis Bildung seiner selbst ist nur das eine. Das andere ist, wie der Mensch sich
seiner Selbst selbst erlebt. Man kann die Tragödie, die Grillparzers Leben im Grunde ge-
wesen ist, nicht aus den Umständen verstehen, unter denen es gelebt werden
mußte, sondern nur aus dem innern Gesetz, unter das es gestellt war. Franz
Grillparzer hat zweifellos durch den Vater wie durch die Mutter eine Last
empfangen, die nicht leicht zu tragen war. Der Dichter ist niemals ernstlich
krank gewesen, wenn man unter Krankheit angegriffene oder bedrohte
Organe versteht. Wenn an diesem Menschen etwas krank war, dann die
Seele. War sie es, dann ist es die Berufskrankheit des Ingeniums gewesen.
Grillparzer hat alles getan, daß wir um seinen Zustand Bescheid wissen. Er
hat fast sein ganzes Leben lang Tagebuch geführt, wiederholt zu Selbstdar-
stellungen angesetzt und ist bei der letzten tief in sein Leben hineingekom-
men. Die schwere Dauerkrise Grillparzers zwischen 1823 und 1830 ist von
der Krise seines Seelenlebens ausgelöst worden. Wer vermöchte zu sagen, ob
die gleichzeitigen Beziehungen zu drei Frauen Ursache oder Anzeichen dieser
Heloise Seelenkrise waren. Außerhalb dieser Reihe ist Heloise Hoechner gewiß die
geistig bedeutendste Frau gewesen, die vor seine Wahl getreten ist. Sie haben
beide gewollt. Es ist vielleicht nur für ihn zu spät und für sie zu früh ge-
wesen. Die beiden Gedichte „Begegnung" und „Entsagung" waren für beide
das rechte Wort. So ist Kathy Fröhlich geblieben, das gelöste Band der Liebe
Kathy und das neu geknüpfte der Freundschaft, die herbe Gewohnheit des Lebens,
beständige Nähe und Ferne in einem. Franz Grillparzer ist nach so vielen
Umwegen bei Kathy in dieselbe Lage zurückgekehrt, in der ihn die Mutter
einst verlassen hatte: das geschlechtslose Zusammenwohnen mit der Frau.

Gefahren Aus Natur, Bildung und Erlebnis das Werk. Grillparzer ist bei seinem
der Dichtung Schaffen so einsam gewesen wie ein Mensch nur sein kann. Dabei war er der
Umwelt gegenüber sehr gesellig. Die Dichter, die ihm persönlich sehr nahe-
standen, Zedlitz und Auersperg, haben für sein Werk künstlerisch nichts

bedeutet. Diejenigen aber, die ihn sehr gefördert haben aber ihm stilver- *Grillparzers Werk*
wandt waren, Zacharias Werner und Ferdinand Raimund, sind ihm persön-
lich ferner geblieben. Wie Zusammenarbeit sieht Grillparzers Verhältnis zu
Schreyvogel, Bauernfeld, Beethoven aus. Doch da macht der Schein alles.
Schreyvogel hat ihm und er hat Bauernfeld die Hefte durchgesehen. Was
aber die gemeinsame Arbeit von Grillparzer und Beethoven an der „Melu-
sine" anlangt, so wissen wir darüber nur aus den Gesprächen, da Beethoven
keine Note hinterlassen hat. Adalbert Stifter und Franz Grillparzer aber
hatten ein viel zu unterschiedliches Werk, um einander mehr zu sein als
ebenbürtige und voneinander überzeugte Freunde. So muß es dabei bleiben.
Grillparzers Werk ist Grillparzers Werk.

Grillparzer ist kein Dichter von gesammelten Werken. Nicht viel mehr als *Novellen und Gedichte*
Gelegenheit waren seine zwei Novellen. „Der arme Spielmann" gehört alles
in allem zu den selbstdarstellenden Werken und in die Gruppe der aufgege-
benen Lustspiele. „Das Kloster bei Sendomir" verrät sich zu deutlich als
erzähltes Szenar und ist Schreyvogel zuliebe für sein Taschenbuch geschrie-
ben worden. Auch Grillparzers Verse sind in der Hauptmasse Gelegenheit.
Es sind darunter vollkommene Gebilde. Der Zyklus „Tristia ex Ponto" ist
auch musikalisch durchkomponiert ein Büchlein von hoher Meisterschaft. Die
vaterländischen Gedichte, die gleichfalls ein rundes Büchlein ergäben, sind
Gesinnung, Bekenntnis, Werbung, als es im Vaterlande und darüber hinaus
auf diese drei Dinge ankam. Nichts von dem, was Grillparzer ausgeformt aus
der Hand gegeben hat, ist seiner unwert.

Aber Grillparzers Werk ist Bühnendichtung, ein beispielloser Spielplan für *Die Spiele*
das zeitgenössische Wiener Theater, sein gültiger Bestand, in den das ganze
Wiener Theater eingegangen ist. Die europäische Bühnenliteratur, die zu-
mal der werdende Grillparzer verarbeitet hat, ist gut zu übersehen. Im all-
gemeinen war es natürlich das attische Theater, vorab Euripides, ohne das
Grillparzers Lebenswerk nicht zu denken ist. Die französische Bühne hat
kaum auf ihn gewirkt. Der Klassizismus war überwunden, als Grillparzer zu
schreiben begann. Für den Siegeszug des französischen Lustspiels war er mit
seiner ausschließlichen tragischen Neigung nicht anfällig. Während vom eng-
lischen Theater die unvergleichbare Leistung auf Grillparzers Jugend wirkte, *Lehrmeister*
war es das spanische und italienische Theater mit der Ganzheit seines natio-
nalen Stils. Unter den Deutschen war das Vorbild der einflußreichsten Büh-
nenschriftsteller, Ifflands und Kotzebues, schon nach wenigen Schritten über-
standen. Von Goethe sind in Grillparzers Gesamtstil weder die Form des
„Götz" noch der „Iphigenie" zu erkennen. Schillers geschichtliche Jamben-

tragödie hat sicherlich länger nachgehalten. Der deutsche Bühnendichter, der von allem Anfange an und bis in die dreißiger Jahre immer wieder Grill- *Grillparzer* parzer zum Studium und als Muster gereizt hat, war Zacharias Werner. *und Werner* Grillparzer hat ihn als den besten Meister der Szene nach den deutschen Klassikern anerkannt und Werner hat öffentlich und in aller Form an Grill- parzer den Bogen des Odysseus zum Spannen weitergereicht. Das euro- päische Theater ist also mehr mittelbar durch Bestand und Stil des Wiener Spielplans Grillparzers Vorschule gewesen. Sein Drama hat den Stil der Wiener Bühnen, wie er sich seit Jahrhunderten herausgebildet hatte.

Dreifacher Stil Der Dichter hat vom Anfang an zu dem dreifachen Stil angesetzt, den er dann sein Leben lang festgehalten hat. Durch das Dickicht des modernen Schauspiels schlug er sich zur geschichtlichen Tragödie durch, wie sie sein *„Alfred"* „Alfred der Große" 1812 in mehr als zwei Aufzügen darstellte. Shakespeares Historienstil und Werners „Kreuz an der Ostsee" sind die Lehrmeister dieses Erstlings. Wenig später, 1818, begann er nach Carlo Gozzi die Chordichtung *„Der Rabe"* „Der Rabe" und übersetzte gleichzeitig zwei Aufzüge aus Gozzis Märchen- spiel „Il Corvo". Nicht minder zeitig hat Grillparzer die Richtung auf die hellenistische Tragödie eingeschlagen. Er ging dabei von der musikalischen Chordichtung aus. Das ist der dreifache Ansatz zu einer Friedensoper, in der sich Goethes und Schillers Stil verschwistern. Sie hieß 1809 „Irenens Wieder- *„Scylla"* kehr", 1811 „Psyche" und 1812 hieß sie „Scylla". Der Stadt Megara den Frieden zu bringen, schneidet Scylla dem Vater die rote Locke ab, an die seine Herrschaft geknüpft ist, bringt sie dem Minos ins feindliche Lager, wird um ihres Frevels willen verschmäht und in einen Meervogel verwan- delt. Grillparzer kehrte 1815 noch einmal zu diesem Plan zurück. Gleich- zeitig übersetzte er auch ein Stück aus der Chordichtung „König Ödipus" von Sophokles. Das ist die Wendung zum hellenistischen Drama. Und so steht das geringe Bruchstück „Scylla" an der wichtigsten Schwelle, die Grill- parzer überschritten hat: wo sich der Tonkünstler für den Dichter und der Dichter für die attische Seelentragödie entschieden hat, für Medea, für Sappho, für Hero.

Die Von „Alfred der Große" her hat Grillparzer in einer Reihe den Stil der ge- *geschichtliche* schichtlichen Tragödie abgewandelt. „Blanka von Kastilien" 1808/1810 ist *Tragödie* geschichtlich nur im allgemeinen Hintergrund und Gang der Handlung. Das Ränkespiel der Liebe füllt den Vordergrund völlig aus. Bei der zahlenmäßi- gen Aufstellung der wenigen Figuren — je zwei für und gegen den König — *„Blanka"* könnte man an die Technik Goethes in „Iphigenie" und „Tasso" denken. Das wäre aber auch alles. Denn das sittliche Triebwerk der Dichtung —

Kampf zwischen Pflicht und Neigung — weist auf Schiller. Führung der Handlung und Anlage der Szenen verrät Begabung und Schule. Nur mit den Gestalten wurde die mangelnde Erfahrung der Jugend nicht fertig. Am unreifsten ist die Sprache, obwohl sie wahrhaft dramatisch ist und auf der Höhe der jeweiligen Aufgabe steht. „König Ottokars Glück und Ende" 1819/1823 *„König Ottokar"* wurde am 19. Februar 1825 am Burgtheater gespielt. Diese Aufführung war für Grillparzer kein großes Glück. Die Tragödie ist weder ein Gleichnisspiel um den Satz, daß Hochmut vor dem Falle kommt, noch ein maskiertes Spiel um Napoleon, obwohl das eine wie das andere hereinwirkt. Es ist nichts als die Tragödie dieses einen und bestimmten geschichtlichen Menschen Przemysl Ottokar II. Sie stellt nichts anderes dar als ein geschichtliches Ereignis, das über mehr als ein halbes Jahrtausend europäischen Zusammenlebens entschieden hat. Und nur weil diese geschichtliche Entscheidung gegen die Przemysliden gefallen ist, kann man sie eine Tragödie des tschechischen Volkes nennen. Ihr Stil verzichtet auf die kleinen Mittel geschichtlicher „Echtheit". Es ist einfach der Stil einer idealen Wirklichkeit. Selbst die Liebeshandlung, in die Grillparzers gleichzeitige Herzenswirrnis eingegangen ist — der Mann gegenüber drei Frauen — ist dem geschichtlichen Vorwurf eingeordnet. „Ein treuer Diener seines Herrn", 1826 geschrieben und am 28. *„Ein treuer Diener"* Februar 1828 gespielt, ist noch immer ein „geschichtliches" Schauspiel. Doch Wiedergabe einer geschichtlichen Wirklichkeit ist nicht mehr die Aufgabe, die sich der Dichter gestellt hatte. Es kommt hier nicht auf das geringste Maß der geschichtlich verbürgten Tatsachen an, sondern allein darauf, daß das geschichtlich Verbürgte für die Lösung der dichterischen Aufgabe keine Bedeutung mehr hat. Es ist ein Charakterstück, und wenn man will, im Sinne des spanischen Theaters ein Thesenstück. Dem Helden wird am Beginn eine Aufgabe gestellt, über deren Lösung er sich am Schluß ausweisen muß. Das könnte ebenso gut in einem Märchen geschehen. Und so spielt denn auch das geschichtliche Schauspiel ins Märchenhafte hinüber. Es ist ein Charakterschauspiel. Bancban und Otto, Gertrude und Erny gehören zu den schwierigsten Seelenbildern, die sich Grillparzer vorgenommen hat. Sie sind ihm gelungen, wie ihm dann die großen Figuren seiner letzten Tragödien gerieten. *Die Märchenspiele*

Grillparzers Märchenspiele durchlaufen einen viel weiteren Bogen. Märchen kann hier nichts anderes heißen als das Land Nirgends, in dem die Dinge nur gedacht geschehen. Es macht nichts aus, ob man sie Sage, Märchen oder Traum nennt. In diesem Sinne steht „Die Ahnfrau" wie gebührlich am *„Die Ahnfrau"* Anfang der Reihe. Grillparzer hatte im Winter auf 1815 eine Novelle oder einen Roman zu schreiben begonnen, deren Held ein Jaromir war. Diese

Schreyvogel und „Die Ahnfrau" Fabel hat er im Sommer 1816 Schreyvogel erzählt und auf dessen Ermun-
terung daraus in wenigen Wochen sogleich das Drama gemacht, das am
31. Jänner 1817 als erstes seiner Stücke gespielt wurde. Er hat viel, aber doch
nicht alles getan, um dieses Gebilde reiner Einbildung als Wirklichkeit mög-
lich zu machen. Er entrückte das Erlebnis seiner Figuren in die spukhafte
Witterung einer allgemeinen Angst, der alles für wahrzuhalten möglich ist.
Dabei hat ihm freilich Schreyvogel den Entwurf gestört. Eigentlich ist der
unerkannte Heimkehrer, der alles verändert findet, und sich in die alte Ord-
nung nicht finden will, eine sehr wirkliche Sache. Nur wie das alles geschieht,
sich verwickelt und entwirrt wird, das ist gespenstig und unwirklich gemacht,
„Melusina" nicht viel anders als im Angsttraum geschieht. „Melusina" ist ein wirkliches
Märchenspiel, wie deren viele über die Wiener Bühnen gegangen sind und
nachher immer wieder gingen. Der erste Entwurf schließt zeitlich unmittel-
bar an die „Ahnfrau" an, im Sommer 1817, und sollte wenige Wochen spä-
ter ein Kinderballett werden, ein Zaubermärchen mit komischen Szenen. Der
dritte Entwurf, ein Singspielbuch vom Winter auf 1819 wurde in wenigen
Tagen des März 1823 für Beethoven abgeschlossen. Konradin Kreutzer hat
es dann vertont. Damit hatte Grillparzer und nicht Raimund als zeitlich
erster den modernen Stil des Wiener Märchenspiels geschaffen. Die märchen-
hafte Begebenheit ist lediglich die Trägerin gedanklicher Vorgänge, die sicht-
bar zu machen des Dichters Absicht gewesen ist. So ist „Melusina" zugleich
ein Denkspiel: um Grillparzers eigene persönliche Natur, die so schmerzlich
entbehrte, was sie besaß und nur besaß, was sie entbehrte; um die hohe Sen-
dung des Dichters, für den es keine Wiederkehr aus dem einmal betretenen
Reich der Auserwählung gibt; um den Dichter, der als Schauender näher an
die Idee herankommt als der Denkende, ohne daß auch er bis ins Innerste
„Der Traum, ein Leben" des Unbetretbaren eindringen könnte. „Der Traum, ein Leben", 1817/1831
geplant und geschrieben, am 4. Oktober 1834 gespielt, ist wieder auf eine
andere Weise ein Märchenspiel. Das Stück, zugleich mit „Melusina" und
dicht nach der „Ahnfrau" im Herbst 1817 begonnen, verrät sich und die
andern durch diese Nachbarschaft. Das Märchen der Binnenhandlung wird
als Traum gespielt, die wache Wirklichkeit als Rahmen, der diesen Traum
mit Vorstellungen speist und seine Erfahrungen in sich aufnimmt. Man darf
schon die überlegene Sicherheit bewundern, die den gesamten Spielplan der
Wiener Vorstadtbühnen in den Schmelztiegel warf und die so bunt ge-
mischte Masse zu drei so stilverwandten und doch versonderten Gebilden
umgoß, wie es „Die Ahnfrau", „Medea", „Traum, ein Leben" sind.

Das hellenistische Drama ist nach der Modellarbeit an Scylla mit Medea,

Sappho, Hero so unvergleichlich lautere Form geworden, daß alle Versuche *Das* *hellenistische* des achtzehnten Jahrhunderts, ausgenommen Goethes „Iphigenie", nur wie *Drama* Vorstufen des Ehrgeizes erscheinen. Das reinste Glück des Schaffens hat Grillparzer an „Sappho" genossen, dem Stück, das in dem einen Monat Juli *„Sappho"* 1817 begonnen und vollendet und sogleich am 21. April 1818 gespielt wurde. Der arithmetische Aufbau Goethes ist hier auf die einfachste und gerade noch mögliche Form gebracht. Es ist ein Spiel unter nur dreien. Die Figuren sind aufgestellt und nun läuft die Handlung, von innen getrieben, nach der natürlichen Spielregel des Herzens ab, bis geschehen ist, was geschehen mußte. Weil nur eine Frau den beruflichen Verzicht des Künstlertums auf das Glück des reinen Daseins bis zum letzten Schmerz ausleiden kann, hat Grillparzer eine Frau zu seiner Heldin gemacht. Denn nur um diesen Verzicht und Schmerz geht es hier. Es ist die Tragik des Künstlertums, die der hellenische Mensch vielleicht gar nicht kennen konnte, die nur der moderne Mensch kennen kann, der aus der Einheit von Leben und Kunst herausgefallen ist, zwei Hälften, die in ihm kein Ganzes mehr werden können. Bei „Medea" ist es die Tragik, die eigentlich nur für den Griechen eine sein *„Medea"* konnte. Aber wir wissen nicht, ob sie es einem Griechen, der über das gewöhnliche Menschenmaß hinausragte, wirklich einmal gewesen ist. Denn die unvereinbare Lebensgemeinschaft von griechischer und nichtgriechischer Seelenhaltung, das ist die Aufgabe, die Jason und Medea gestellt ist. Und so darf denn für Grillparzers „Medea" gelten: wenn es nicht wahr ist, so ist es gut erfunden. Das dreifache Stück ist seit 1818 in harter und zuweilen hoffnungsloser Arbeit entstanden, aber dann rasch, am 26. und 27. März 1821 als großer Erfolg gespielt worden. „Des Meeres und der Liebe Wellen", *„Hero"* 1820/1829 entstanden, am 5. April 1831 gespielt, gehört zu den spät ergriffenen und langsam ausgereiften Dramen. Auch die drei hellenistischen Stücke sind Abwandlungen des einen Stils. Alle sind transparent und lassen durch das griechische Gemälde den verdeckten modernen Lebensgrund durchschimmern. Bei Hero ist der hellenische Faltenwurf fast nur Kostüm. Wenn Sappho in Wahrheit Grillparzers eigenen Schmerz mit sich von der Klippe stürzt, wenn Medea Charlottens von Paumgartten Liebestrotz und Jason den Verrat Grillparzers spielt, so ist Hero keine griechische Tempeljungfrau, sondern eine christliche Nonne und zwischen hellenischen Säulen begibt sich nur, was sich im zeitgenössischen Wien auf der Bühne in einem Kloster nicht begeben durfte. Der gemeinsame Stil der drei Bühnendichtungen besteht gleichwohl nicht in der griechischen Ausrüstung der Szene und im Kostüm *Seelendramen* der handelnden Gestalten. Er entfaltet sich von innen her. Es sind Seelen-

dramen. Und wenn Grillparzer von Euripides gelernt hat, dann hat er seine Kenntnis der attischen Tragödie in diesen drei Stücken an den Mann gebracht. „Melusina" ist im Wiener Märchenstil Platos Gedankenwelt. Sappho, Medea, Hero spielen attische Tragödie, so vollkommen sie ein Moderner auffassen und für Moderne nachgestalten konnte.

Einheitsstil

Seit dem Roman mit Heloise Hoechner und der Heimkehr aus Westeuropa, inmitten seiner umfassenden Studien hat sich die allseitige Durchdringung der drei Stilformen vollzogen, die Grillparzer bisher getrennt als geschichtliche Tragödie, als Märchenspiel, als hellenistisches Schauspiel herausgebildet hatte. Man erkennt diese Absicht zuerst in dem Spiel „Weh dem, der lügt", weil es sich so schwer einer bestimmten Stilart zuordnen läßt. Die Vorgeschichte des Stückes reicht in das Jahr 1818 zurück. In den zwanziger Jahren kam Grillparzer wiederholt darauf zurück. Wirklich begonnen wurde es 1834 und im Frühjahr 1837 wurde es abgeschlossen. Das Stück steht innerhalb einer dreifachen Verwandtschaft. Die älteste ist das kulturgeschichtliche Drama in der Art des „Alfred" und der „Drahomira", sichtbar als Gegensatz von Kultur und Lebensweise unter Franzosen und Deutschen. Die zweite Verwandtschaft verbindet das Stück mit den gedanklichen Spielen von der Art der „Melusina", die dritte mit den Märchenspielen. Das Märchenhafte verrät sich in einzelnen Zügen, in der Herkunft Edritas aus der Familie der Wiener Theaterfeen und in der verborgenen Anlage des Ganzen. Neuartig ist auch die Aufstellung der Figuren: drei Männer und eine Frau, vom Rande her als Gegenspieler Gregor und Kattwald. All das ist genug, um zu sehen, daß Grillparzer zu einem neuen Stil unterwegs ist. Da ist kein Bruch, nicht einmal eine erkennbare Stufe. Die Formen fließen wie von selber ineinander und hinterlassen auf jedem Gebilde ihre besonderen Akzente.

„Weh dem, der lügt"

Kulturdrama, Denkspiel, Märchenstück

Die Trilogie des Verzichts

Der großen Trilogie des Verzichts „Die Jüdin von Toledo", „Libussa", „Ein Bruderzwist" ist vieles zu Hilfe gekommen, daß bei aller Eigenart jedes der drei Gebilde ein so vollkommenes Ganzes geworden ist. Nicht zu unterschätzen ist ihr gemeinsames und gleichzeitiges Entstehen. Es ist wohl beispiellos in der Geschichte der deutschen Dichtung, daß ein Meister auf der Höhe seines Lebens nebeneinander drei so mächtige Gebilde wie diese schafft. Denn wenn „Libussa" auch schon 1822 begonnen wurde, „Die Jüdin" und „Ein Bruderzwist" zusammen seit etwa 1824, so sind die drei Stücke doch gleichzeitig in den dreißiger Jahren vorwärts gebracht und bis gegen 1848 vollendet worden. Wichtiger wurde, daß in sie der eine und gleiche Ertrag von Grillparzers Studien und politisches Zeiterlebnis eingegangen ist.

So sind alle drei Spiele aus Platos Geist. Der Gedanke vom geistigen Vorda- *Spiele aus Plato,*
sein der Dinge in den Ideen, der Mythus vom Eros und die Harmonie der *um den Staat,*
Sphären klingen zwar in den einzelnen Dichtungen mit wechselnder Deut- *zum Selbstbildnis*
lichkeit auf. Sie sind aber allen dreien gemeinsam. Alle drei sind Spiele um
den Staat und politische Bekenntnisdichtungen von hinreißender Überzeu-
gung. Und schließlich sind es als Abschluß von Grillparzers vieljähriger
Selbstbetrachtung Selbstbildnisse des Dichters von erschütternder Wahrhaf-
tigkeit. Daher kommt nun auch ihr gemeinsamer Stil. Man kann das indessen
nicht so verstehen, als ob sie nur drei verschiedene Abgüsse aus der einen
und gleichen Form wären. „Ein Bruderzwist" ist eine geschichtliche Charak-
tertragödie. Aber da sind doch wenigstens szenische Einfälle, die am Mär-
chenhaften hinstreifen. „Libussa" steht den Märchenspielen sehr nahe und *„Ein Bruder-*
ist beinahe eines, ohne daß die mythischen Züge und manches andere die *zwist"*
„Libussa"
Verwandschaft mit den hellenistischen Dramen völlig verleugnen könnte. *„Die Jüdin"*
„Die Jüdin" hat ebensoviel mit den geschichtlichen Tragödien zu tun wie
mit den Zaubergeräten der Märchenspiele und dem Seelendrama hellenis-
tischen Stiles. Und so laufen die Fäden bunt zwischen den einzelnen Dich-
tungen hin und her. Nach dem wechselnden Einfall des Lichts und der Hal-
tung des betrachtenden Auges stehen immer zwei von den drei Stücken ein-
ander näher als beide dem dritten. Nach Landschaft, zukunftsweiten Aus-
blicken und weltanschaulichem Gehalt stehen „Libussa" und „Bruderzwist"
dicht beieinander. Die politische Hochgefahr und das bedrohte Königtum
machen beinahe aus „Jüdin" und „Bruderzwist" ein Ganzes. Das beherr-
schende Liebesspiel stellt „Jüdin" und „Libussa" zusammen auf eine Seite.
In diesem gemeinsamen Gewebe also, nicht in dem durchgehenden Muster,
besteht der Einheitsstil der drei Dichtungen. Niemals sind im Sinne Attikas *Die Trilogie*
drei Dramen eine solche Trilogie in deutscher Sprache gewesen. Und da die *und ihr*
Satirspiel
attische Bühne zu drei schweren Stücken immer ein leichteres aber nicht un-
schweres als Satirdrama spielte, siehe, da ist „Weh dem, der lügt" zu diesen
drei sehr ernsten Tragödien das ernsteste Satirspiel, das die deutsche Dich-
tung hervorgebracht hat. Grillparzer hatte nicht unrecht, wenn er nach dem
beiderseitigen Verhältnis zu ihren Vaterstädten in Euripides sein anderes
Ich sah. Hat die attische Bühne, seitdem sie abgeräumt war, jemals wieder
irgendwo ihresgleichen gefunden, dann in der Wiener Bühne, wie Grillpar-
zer sie aufgerüstet hat.

Franz Grillparzer hat ein Werk hinterlassen, von dem nur der dichterische
Aufbau frei und hoch in die Ewigkeit ragt, während der gedankliche Unter-
bau fast unsichtbar in seinen persönlichen Niederschriften vergraben liegt.

Wie mächtig dieses Ganze ist, kann man nur ermessen, wenn man die weiten und hohen Gänge dieses Unterbaues durchschritten hat.

Bezieht man Grillparzers Werk auf einen Bereich, der außerhalb der schaffenden Persönlichkeit liegt, dann kann man es nur auf Überlieferung und zeitgenössischen Bestand der Wiener Bühnen beziehen. Grillparzers dramatisches Werk ist nach Zeitfolge und Stil aus dem Stil und der Literatur der Wiener Bühnen herausgewachsen. Das ist eine ausgemachte Sache. In dieser Bühnenliteratur war das Romantische mitenhalten, und zwar längst, ehe es so hieß. Das Klassische aber hat Grillparzer an der Wiener Bühne erst herausgearbeitet, indem er ihrem Spielplan nach den Ansätzen des achtzehnten und frühen neunzehnten Jahrhunderts die antik stilisierte Tragödie einfügte. So aber wie Goethe und Schiller Klassiker heißen, ist Grillparzer der Klassiker des Wiener Theaters, weil er dem szenischen und dichterischen Stil dieses Theaters kanonische Gültigkeit verliehen hat.

Der europäische Dichter Franz Grillparzer und sein Werk sind mehr und wesentlich anderes als nur ein kunstwissenschaftlicher Begriff. Sie sind persönlich, geistig, politisch die letzte Erscheinung des Deutschen Bundes, in dem immer noch zu Frankfurt der österreichische Gesandte den Vorsitz führte. Das war die letzte Ordnung, die Europa notdürftig zusammenhielt. Grillparzers dichterische und politische Wahrsagungen sind tief in die Zukunft eingedrungen, die noch dunkel über den Ereignissen von 1848, 1866, 1870 lag. Darüber hinaus hat er gesehen, was wir heute wissen.

MATERIALISMUS UND IDEALISMUS

DAS JAHR 1866 LEGT ZWISCHEN DEUTSCHLAND UND ÖSTER-
*reich, das Jahr 1914 zwischen Deutschland und die Welt eine Grenze. Beide
Grenzen haben mehr geistigen als räumlichen und zeitlichen Sinn. In ihrer
Mitte bildet sich keine neue Lage, sondern reift die alte aus, die das frühe
neunzehnte Jahrhundert geschaffen hatte.*

*Die Vormacht der Naturwissenschaften und die Revolution der Technik, der
Aufstieg der Industrie sowie der Arbeiterschaft zu politischem Einfluß und
geistiger Bildung, soziale Not und sozialistische Lehre werden in der Dich-
tung wirksam. Was sie auslösen, ist keine Revolution der künstlerischen
Form, sondern weltanschauliche Entscheidungen. Die Berliner und Münch-
ner Stilversuche um 1890 und 1910 sind nur örtliche und zeitliche Zwischen-
fälle, erfolglose Widerstände gegen den allgemeinen und großen Zug des
Zeitalters. Der setzt mit Wagner und Nietzsche ein. Der sogenannte Natura-
lismus ist eine ganz allgemeine Darstellungsform, die es zu allen Zeiten
neben andern gegeben hat. Er ist keine Stilepoche der Gesamtliteratur, son-
dern persönliche Entwicklungsstufe gewisser Dichter, die jeder rasch über-
wunden hat. Der allgemeine und große Zug des Zeitalters drängt unab-
hängig von den weltanschaulichen Entscheidungen auf einen hohen und
getragenen Stil. Er ist keine Wiederkehr, sei es der Klassik, sei es der Ro-
mantik. Er ist eine neue und persönliche Schöpfung des Zeitalters. Denn er
formt sich aus dem ganz frischen und selbständigen Erlebnis der Antike, aus
bisher verschlossener Kenntnis des westlichen und östlichen Asien, aus einem
erstmaligen unmittelbaren Wissen um das deutsche und romanische Mittel-
alter. All diese Elemente durchdringen einander so mannigfaltig und natür-
lich, daß man diesen Stil weder klassisch noch romantisch nennen kann. Er
ist einfach die gemeinsame Kunstsprache des Zeitalters.*

*Die sachliche und dichterische Kunstprosa hat diesem Stil aus natürlichen
Gründen im allgemeinen widerstanden. Seine großen Formen sind das*

lyrische Gedicht und das dramatische Spiel. Gegenüber ihren vollkommen-
sten Ausprägungen hat das späte achtzehnte und frühe neunzehnte
Jahrhundert nichts, womit sie der Art nach
verglichen werden könnten.

I. DEUTSCHLAND

1866 bis 1914

In der fast staatenlosen Zeit des deutschen Volkes war die Literatur, als Inbegriff des geistigen Lebens, beinahe das einzige Organ seines nationalen Daseins. Daher kommt es, daß sie seit dem späten achtzehnten Jahrhundert immer stärkeren Einfluß auf die staatliche Neugestaltung zuerst Preußens und dann Deutschlands gewonnen hat. Die deutsche Erhebung gegen Napoleon, die Zerstörung des Rheinbundgeistes, die Schöpfung des deutschen Staates waren geistig das Werk der Philosophie und Dichtung, der Geschichtskunde und Publizistik. Sie haben die Gedanken erzeugt, nach denen in den Staatskanzleien gehandelt wurde, und den Willen erweckt, den die Staatsmänner vollzogen.

Der deutsche Staat zwischen 1870 und 1914 wird in der Dichtung des Zeitalters nur spürbar mit dem Enthusiasmus, den seine Gründung auslöste, und mit der Bangnis der Gefahren, die er zuletzt heraufbeschwor. Die Literatur als ein Ganzes hat er nicht verwandelt. Es war umgekehrt. Die Literatur sucht, so vielerlei Sinnes sie auch war, ihn auf sich hin zu verwandeln. Alle literarischen Bewegungen des Zeitalters laufen darauf hinaus, ihm den Geist auszutreiben, durch den er zu Leben gekommen war, und ihm den einzuhauchen, ohne den er nicht leben konnte.

So gerieten der Staat und der Geist des Zeitalters mit sich selber in Widerspruch. Den stärksten löste die Gliederung des Staates in die Höhe und in die Breite aus. Das Vorrecht der Stände, in deren Hand der Staat war, vertrug sich immer weniger mit dem Ausschluß der Klasse, auf deren Arbeit der zunehmende Wohlstand beruhte. Und so durchdringt die soziale Frage weit über die Arbeiterliteratur hinaus die gesamte Dichtung. Das Vorrecht der Mitte aber, um die der Staat sich ordnete, löst, ohne Rücksicht auf die einzelstaatlichen Grenzen, überall landschaftliche Bewegungen aus, die von sich aus nach dem Gleichgewicht zwischen Einheit und Vielfalt suchen und mit der bundesstaatlichen Verfassung des Reiches nichts zu tun haben.

Die geistige Lage und die Haltung der Literatur sind im Deutschen Reich nach 1870 fast die gleichen wie nach 1814 im Deutschen Bund.

1. BRENNPUNKTE

Berlin und München

Das sind Berlin und München. Sie verstärken sich mehr und mehr zu Gegenpolen. Sie heißen nicht mehr Norden und Süden, sondern verschiedene Wunschbilder des neuen Deutschlands, das seit 1870 im Werden ist. Um beide Kraftfelder richten sich die drei deutschen Großräume aus und gliedern sich nach wechselnder Absicht und Überlieferung auf diese Pole ein.

Das Festspielhaus Bayreuth

DEUTSCHE MITTE ist zunächst Bayreuth. Richard Wagner hatte 1848 die Verfassung eines Nationaltheaters entworfen und im Vorwort zur Nibelungendichtung 1862 gesagt: nur ein König könne diese Schöpfung bewirken. Ludwig II. von Baiern verstand den Anruf und gab ihm Gehör. So konnte Wagner, als 1870 die Vorbedingungen erfüllt waren, Bayreuth wählen. Schon der Entwurf des Gebäudes war eine Tat. Bühnenraum und Schauhaus wurden ebenso kühn getrennt, wie verbunden: getrennt durch das versenkte Orchester, den „mystischen Abgrund“, aus dem die Musik aufklingen sollte; verbunden zunächst durch zwei Proszenien. Der Zuschauerraum stieg als Ausschnitt eines Amphitheaters auf und fügte also jeden Zuschauer in die proszenische Perspektive ein. Dies Theater, auf Täuschung der Perspektive angelegt, war vollkommener Barockgedanke. Es faßte 1500 Teilnehmer. Im Mai 1872 wurde der Grundstein gelegt. Und 1876 wurde zum erstenmal der „Ring der Nibelungen“ gespielt. Die folgenden Jahre brachten alle Dramen

Spielplan Richard Wagner

Wagners, 1882 zum erstenmal „Parsifal“. Bis 1848 war die erste Dreiheit von Wagners Dramen aufgewachsen, schon reine Dramen mit zielstrebiger Handlung, die dichterisch geschaute Szenen tonkünstlerisch wiedergaben. Im „Fliegenden Holländer“ 1841 und im „Tannhäuser“ 1845 ist es Erlösung durch die reine Liebe der Frau, in „Lohengrin“ 1847 das Verlangen des hohen Geistes in die Tiefe der Liebe. Die zweite Gruppe stammt aus der Zürcherzeit und nach der Begegnung mit Schopenhauer. „Tristan und Isolde“ 1859 ist bei sparsamstem Aufwand ein Drama der Seele, Weltverachtung und Weltüberwindung, an einer todgeweihten und todbringenden Seele dargestellt. „Die Meistersinger“ 1867 spalteten Wagners Modell seiner selbst in den reifen Hans Sachs und in den Anfänger Walther. Sie zeugen für einen Meister, der sich gutgelaunt am Gegensatz von Kunsthandwerk und genialem Schaffen entlastet und die Kraft rühmt, die verzichtet, damit sie andere beglücke. Um den „Ring der Nibelungen“, dies vierteilige Kernwerk seines

„Der Ring der Nibelungen“

Lebens, hat Wagner 1848/1874 gerungen. Der deutsche Idealismus macht sich hier das Werk der deutschen Staatsschöpfung zu eigen und schied aus, was an bösen Begierden und üblen Folgen in diesem Werke mitlebte. Im

Herzen des Helden Wotan kämpfen Eigensucht und Nächstenliebe wider- *Welttod*
einander, bis er seinen selbstischen Daseinstrieb besiegt, seine Allmachtsgier
und seinen Allwissenheitshunger preisgibt und sich freiwillig für die Schöp-
fung opfert. Walhall verbrennt. Die schuldbeladene Welt findet im Unter-
gang Frieden. Indem er auf den nordischen Mythus zurückging, fand Wagner
der Nibelungensage eine letzte künstlerische Form, den Stabreim, und eine
Sprache, die von halbechtem Altertum und schwierigen Wortspielen strotzte.
Diese metaphysisch-kosmische Tragödie war zugleich ein Traumbild jener
Sorge um Staat und Volk, unter der die edelsten Herzen und schärfsten Köpfe
des Zeitalters litten, Weltuntergangsstimmung aus Rückblick, Miterlebnis,
Vorgesicht empfangen. Wagners erste Werkgruppe klang in „Lohengrin"
aus: du sollst mich nicht befragen; die zweite 1882 in „Parsifal": die Frage
des Mitleids ist Pflicht. Aus dem Machtzeichen des Nibelungenhortes ist das
Gralsinnbild der hingebenden Liebe geworden. Das stellvertretende Leiden
Christi und das persönliche Leiden des Helden werden zum Heil der Welt.
„Erkennen" hat auch hier seinen ewigen Doppelsinn. Das Weib erkennen, *„Erkennen"*
heißt Begehren und Leiden, Lust und Buße, Sünde und Erlösung in ihrer
wechselseitigen Bedingnis durchschauen. Schopenhauers Metaphysik war
zum schaubaren Bühnenbilde geworden, wie er gefordert hatte. Der germa-
nisch-heidnische Weltuntergang der Nibelungen hat sich zu Parsifal arisch-
christlicher Welterlösung gewandelt. Dieses Spielhaus sollte dem barbarisch
gewordenen Zeitalter den magisch schaffenden Spiegel einer edlen Kunst
vorhalten. Von ihr sollten Wissenschaft, Philosophie, Religion neue Antriebe
empfangen. Aus der vollkommenen Theaterform des Barock hatte sich das
romantische Kunstverlangen verwirklicht, die Bühne des „musikalischen
Mimen", auf der sich statt Gestalten Klänge bewegen, die in Worten singen, *Licht-Klang-*
eine Licht-Klang-Bühne, Erfüllung und Abschluß der romantischen „Pro- *Bühne*
gressiven Universalpoesie".

Auf dem einen Gegenpunkt, zu Meiningen, entstand um die gleiche Zeit *Die Meininger*
das echte Klassikertheater. Als Georg II. von Sachsen-Meiningen 1866 Herr *Bühne*
geworden war, löste er die Oper auf, um alle Mittel an das Schauspiel wen-
den zu können. Der Fürst, ein begabter Liebhaber in vielen Künsten, gab
diesem Theater rasch seinen Stil. Seit dem Abgange seines Geschäftsleiters
Bodenstedt, 1870, führte er selber die Zügel. Gespielt wurden Shakespeare
mit Vorliebe und antike Tragödien, wie sie Wilbrandt bearbeitete. Von 1874,
da man in Berlin mit „Julius Cäsar" begann, bis 1890 wurden in 38 Städten
Europas 81 Gastspiele gegeben. Vorbildlich wirkte diese Bühne weniger
durch den Spielplan, der allerdings Wildenbruch, Björnson, Ibsen einführte

und grundsätzlich den echten Wortlaut bot, sondern durch die Spieleinrichtung. Nach verwandten englischen und den gleichzeitigen Bayreuther Leitsätzen wurde volle Täuschung angestrebt: wirkliche Massenszenen und malerische Umwelt; geschichtliche Treue im Raum, Gewand, Gerät; Wiener Stil des Zusammenspiels und Kunst der stummen Gebärde; körperhafte statt nur gemalter Versatzstücke; „Andacht zum Kleinen der Innendekoration". Von darstellenden Künstlern ist Josef Kainz durch diese Schule gegangen. Wildenbruch wurde der Dichter, Reinhardt der Spielleiter des Meininger Stils.

Das Harzer *Bergtheater* Auf dem andern Gegenpunkt, bei Thale, wurde 1903 von Ernst Wachler das Harzer Bergtheater errichtet. Mit dem Blick gegen Quedlinburg, Halberstadt und das fern verdämmernde Magdeburg wurden 21 Felsstufen zu 1400 Plätzen ausgesprengt und gegen das Freie hin ein Spielplatz aufgeschüttet. Fast wie aus Wagners „mystischem Abgrund" klangen die Worte und Weisen von unten herauf. Die reinste Luft hielt Spieler und Zuschauer frisch. Man hörte die leiseste Tonfarbe. Geschöpf und Schöpfung, Natur und Kunst, Volk und Landschaft, Leben und Spiel waren wieder eins geworden. Dem Harzer Bergtheater winkte von Ferne die Freilichtbühne der Griechen, die uralten Volksbühnen Oberdeutschlands, Klopstocks nationales Harztheater, Herder, dem die naturhafte Ganzheit von Mensch und Erde, Sitte und Jahreslauf, Kunst und Gesellschaft am Herzen lagen. So verschmolz zu Thale der Nationaltheatergedanke mit dem noch älteren der Freilichtbühne, leistete dem Fremdentheater der Großstädte Widerpart, ging den Bayreuther Weg auf Mythus und Volksdienst und den Meininger Weg auf stiltreue Wirklichkeit bis zu Ende, entschlossen zu einer stammeskünstlerischen Landschaftsbühne, deren Stoff Mythus, Brauch und Gaugeschichte sein sollten, deren Kunstmittel schlichte Zurüstung, Chor und Reigen. Gespielt wurde jeden Sommer und alles, was sich szenisch fügte: Sophokles, Shakespeare, Sachs; der klassische Grundbestand, nach der einen Seite Klopstock, nach der anderen Mozart eingeschlossen; von Hauptmann „Die versunkene Glocke", von Ibsen die „Nordische Heerfahrt". Nordischen Mythus und Schelmenstück und Jahresfestspiel besorgten Wachler und Lienhard.

Wunschtraum *vom* *Oberdeutschen* Hat man auf der einen Seite die dröhnenden Theaterburgen und Waldbühnen mit ihren fahrenden Göttern, gepanzertem Heldentum, kecken Schelmenstreichen und auf der andern den Propheten, der sich im Wipfel seines Selbstbewußtseins verstieg, mit den Göttern schalt, sich an den Anfang eines neuen Äons setzte, so muß man sich schon ein Herz fassen, den Mann nicht nur zu verzeichnen, sondern auch zu begreifen, der im Traum seiner Wünsche Taten vollbrachte, die über alles gesungene Heldentum gingen und den Über-

menschen zu einer banalen Selbstverständlichkeit machte. Seine Bücher waren keine Literatur. Denn von ihnen allein kann man sagen, sie waren ohne Unterschied des Alters und Geschlechts und der Bildung in den Händen der gesamten Nation.

Karl May, 1842 bis 1912, aus Hohenstein-Ernsttal im Erzgebirge, ist der leibhaftig gewordene Massengeist seines Zeitalters. Dieser Mann suchte mit dem einen Aufstieg aus dem Weberelend seines Vaterhauses und aus dem sittlichen Fall eines gescheiterten Lehrerdaseins auf die Höhe zu kommen. Er hat mit Kalendererzählungen, Dorfgeschichten, erdkundlichen Schilderungen begonnen. Zu größeren Leistungen wurde er durch eine Literatur emporgetragen, die sich einerseits in den Amerikabüchern von Ruppius und Gerstäcker, andererseits in dem politisch-geschichtlichen Intrigenroman von Goedsche bezeugte. Es war eine mitteldeutsche, insbesondere erzgebirgische Literatur. Was Karl May daraus machte, war eine in sich geschlossene Gattung. Sie kreist mit derselben Inbrunst um die Untergangstragödie der roten Rasse wie um das Mysterium des islamitischen Morgenlandes. Sie ergreift mit gleicher Leidenschaft Partei für das Recht schuldloser Naturvölker. Was Unterschiede macht, ist lediglich der jeweils bevorzugte Schauplatz, die zwischen „ich" und „er" wechselnde Erzählweise und der Gesamtstil, der notwendig aus diesem Wechsel folgt. So schließen die ersten sechs Reisegeschichten 1880/1887 beinahe einen Kreis um das Mittelmeer von Algier bis nach Albanien. In seiner Mitte bewährt sich als Abbild des Morgenlandes der gute Hadschi Halef. So steigt vor uns in die frühe Vollendung des Todes das Urbild der roten Rasse, der Held „Winnetou", 1876/1892, widerspruchsvoll ausgeformt. Zwischen den so vermenschlichten Geist der beiden Welten tritt als gemeinsamer und verbindender Freund, ein Wunschbild, der weiße Mann, der Abendländer, der Christ, der das alles zugleich bewirkt und erlebt und darstellt: Ich, Karl May. Die Romane, die Karl May für den Hausierhandel geschrieben hat, weisen in der Richtung Goedsche. „Waldröschen" 1882 und „Die Liebe der Ulanen" 1884 verbinden eine Familiengeschichte, die dort zwischen Deutschland, Spanien, Mexiko, und hier zwischen Deutschland und Frankreich spielt, mit einer abenteuerlichen Staatshandlung: dort das Kaisertum Maximilians, hier der deutsch-französische Machtkampf. „Deutsche Herzen, deutsche Helden" 1885 sind eine private Familiengeschichte, die zu ihrer Lösung des Aufgebots von Abendland und Morgenland bedarf. Mitten in dem vierbändigen Roman „Im Reich des silbernen Löwen" 1897/1903 änderte May seinen Stil, indem er nun nur noch übertragen verstanden wissen wollte, was doch bisher offenkundig wörtlich gemeint war.

Old Shatterhand

Hadschi Halef und Winnetou

„Ich"

So vollzieht sich in diesen mehr als sechzig Bänden eine einzige menschliche Begebenheit, die den erschüttert, der sie verstanden hat. Hier hat ein geschlagener Mensch sich in edlen Lehrrollen sittlich gerettet und in fremden *Die rettende* Ichmasken seine Wunde zugleich verbergen und zeigen wollen. In diesem *Maske* Ich, das sich mit starken Worten und Taten zu sich selber Mut macht, offenbart sich das deutsche Weltvolkbewußtsein, das eben erwacht, das also noch jung und noch unsicher ist, das starker Worte und Taten bedarf, um an sich glauben zu können und glauben zu machen. So erscheint denn diese maskenreiche Gestalt als Vollstrecker der sozialen und sittlichen Gerechtigkeit. Karl May ist die aufschlußreichste Aussage über den deutschen Seelenzustand zwischen dem ohnmächtigen und dem machtberauschten Deutschland. Man muß die ganze Rechnung aufmachen und alle drei Meißner einsetzen: Richard *Die drei* Wagner, Friedrich Nietzsche und was nach dem Abzug bleibt, Karl May. Sie *Meissner* haben, unbeschadet des Ranges und Abstandes, Wesentliches gemein: die krankhafte Übersteigerung des Selbstbewußtseins, Bedürfnis nach einem Dasein auf gestellter Szene, Flucht aus der Wirklichkeit und Gegenwart in ein Traumreich des Ich und der Zukunft, Gedankenspiel mit einem ins Halbgöttliche überhöhten Menschentum und den hochgetragenen Ton nationaler Leidenschaft. Dieses Gemeinsame über weite Abstände hin, das ist die Sache, die Grillparzer meinte: „Von dem Wortwechsel weinerhitzter Karrenschieber spinnt sich ein unsichtbarer, aber ununterbrochener Faden bis zum Zwist der Göttersöhne."

Weimar Weimar, war das nun wieder die Stadt der Göttersöhne? Das war seit 1859 die Stadt der Schillerstiftung und seit 1885 des Goethearchivs. Sie war in ihr alexandrinisches Alter getreten, die Stadt der Goethegelehrten, der Goethebeamten, des Goethedogmas. Was konnte zufälliger sein als die Wohngemeinschaft, die sich hier zusamenfand: der Holsteiner Adolf Bartels, der Elsässer Friedrich Lienhard, der Ostfale Paul Ernst, der Schlesier Ernst Wachler. Ein Weimarer Kind, *Helene Böhlau,* 1859 bis 1940, gab dieser unvereinbaren Literatur die Farbe von Ort und Zeit, indem sie aus Familienüberlieferungen zwar Goethes Zeit, aber das Weimar, das an Goethe vorbeigelebt hatte, schildert und in sozialen Frauenromanen den Gleichwert des Weibes und das Recht der unehelichen Mutter verfocht. Und der Thüringer *Johannes Schlaf,* 1862 bis 1941, aus Querfurt, der schließlich auch nach Weimar zog, stammt aus dem alten Thüringen und hat nicht viel von der neuen Zeit. Lediglich als „tief beteiligter Mitläufer" ist Schlaf durch die junge Magdeburger und Berliner Literatur gegangen. In den Wintern auf 1888 und auf 1889 nahm Arno Holz ihn mit nach Pankow zu gemeinsamer Arbeit.

Trotz dieser zweisamen Bücher — „Neue Geleise" und „Papa Hamlet" —
gehören Holz und Schlaf auf verschiedene Sterne. Mit den unnachahmlichen
Kleinstadtskizzen „In Dingsda" 1892 und dem mundartlichen Charakter- *„In Dingsda"*
drama „Meister Ölze" 1892 hatte er seine Spur wieder aufgenommen und
im gleichen Jahr seinen mystischen Durchbruch erlebt. Er wurde Schüler,
Übersetzer, Vorkämpfer Walt Whitmans und trat für Verhaeren wie Maeter-
linck ein. Er wandte sich dem heimatlich benachbarten Friedrich von Har-
denberg zu und empfing neue Aufschlüsse zu dem, was er suchte. Denn
Schlafs Novellen, die mit Himmel und Sonnenschein und Wolken die seelische
Witterung heimatlicher Kleinwelt malten, und Schlafs mißratene Romane
voll unsäglicher Naturschönheiten, die sich mit dem Vorwurf des gefährdeten
Deutschen beschäftigten, sollten weniger Formgebilde eines Dichters als
Offenbarungen eines Mystikers sein, der dem unmittelbaren Sein begegnen
möchte. Sein Buch „Das absolute Individuum und die Vollendung der Reli- *„Das absolute*
gion" 1910 gab seinen Gedanken geschlossenen Ausdruck. Neue Mannheit, *Individuum"*
neue Weibheit, vollendetes Christentum, vollendete Menschheit sind eines
und dasselbe, letztes Ziel der menschlichen Gesellschaft. Christus war der
erste Vertreter der kommenden menschlichen Einheitsart. Das war Schelling
und Hardenberg in neuer, Nietzsche und Häkel in gegensätzlicher Fassung.
Diesem Naturanbeter, der den rauschenden Sonnenhymnus „Frühling" sang,
der aus Whitmans meerweiter Prosa das Europa fremdgewordene „große
selige Identitätsgefühl" schöpfte, hat sich die Großstadt von der Seele gehal-
ten und die Gedanken des Raumes, Wagners und Nietzsches, umgedacht.
Von Meister Eckhart her und Hardenberg war die verschüttete thüringische
Mystik wieder ans Licht gestiegen und war in Weimar so unauffällig als
möglich heimisch geworden.

Bayreuth, Wagner, Nietzsche. Da war Ostfranken geistig sehr beteiligt. *Bayreuth,*
Während Wagner im Parsivalsinnbild Ostfrankens aufgeht, deutet Nietzsche *Wagner,*
auf die geschlossene Reihe ostfränkischer Mystiker und Mysterienfrevler, *Nietzsche*
vollendet Feuerbachs Verrückung des Weltmittelpunktes vom Göttlichen ins
Menschliche, steigert den Gedanken der absoluten Persönlichkeit bei Schmidt,
Rohmer, Daumer zum Übermenschen und krönt die Sprachkunst der Richter,
Rückert, Platen. Die Trennung zwischen Wagner und Nietzsche zu Bayreuth
1876 ist die große Scheidung der Geister. Das Jahr scheidet nicht Theater
und Dichtung. Es scheidet Dichtung und Dichtung. Nicht mit den sogenann-
ten Naturalisten zu Paris und Berlin, mit Friedrich Nietzsche 1876 zu Bay-
reuth beginnt der Umbruch der deutschen und europäischen Dichtung, ein
Umbruch des Geistes und der künstlerischen Gestaltung. Das reine Wort,

seine Magie und Musik, seine gedankengebärende Kraft, die Einheit von Name und Ding wird wieder Dichtung.

Ecce Homo 　　*Friedrich Nietzsche,* 1844 bis 1900, aus Röcken, stammt beiderseits von fruchtbaren Pfarrerfamilien. Seine meißnische Heimat hatte bei nur bescheidenem schöpferischen Anteil die Kultur des achtzehnten Jahrhunderts sehr fein an sich herausgebildet. Seine Schule, das berühmte Gymnasium zu Pforta, war stolz auf seinen Ruhm, die dichterische Jugend jenes Zeitalters heran-

Friedrich Nietzsche gebildet zu haben. In Pforta entfalteten sich Nietzsches frühe Gaben: Verse zu machen, Musik zu treiben, Homer mit Hingabe zu verehren. Der strenge klösterliche Stil, der zu Pforta herrschte, hat Nietzsches Leben zu jener festen Zucht geformt, die es bis in den Tod auszeichnete. Es ist die Haltung Klopstocks, der wie Nietzsche durch Pforta seine unverwischbare Prägung erhalten hat. Philologe, im wörtlichsten und höchsten Sinne dieses auszeichnenden Wortes, war Nietzsche aus dem innersten Wesen seiner Natur, als Schüler von Pforta, als Student der beiden damaligen Hochsitze philologischer Kunst Bonn und Leipzig, als akademischer Lehrer, 1869/1879, der Baseler Hochschule. In diese geistige Form ergoß sich das verwandelnde Erlebnis, das in Nietzsche alle schöpferischen Kräfte freimachte und zur vollen Entfaltung drängte. Das war, beides zu Leipzig, 1865 Schopenhauers Philosophie und 1868 die Musik Richard Wagners. Schopenhauer und die Griechen, das hellenische Drama und Wagner zu einem vereinbaren Ganzen zu versinnen, daraus eine neue Kultur zu rechtfertigen, das unternahm 1872 Nietzsches Schrift-

„Die Geburt der Tragödie" chen „Die Geburt der Tragödie". Hoffnungslose Erkenntnis und künstlerische Bewältigung zusammen hätten die attische Tragödie erzeugt, wobei die Hellenen zwischen sich und die schreckliche Welterkenntnis den Schutzschirm des Mythus einschoben. Das Drama ist „apollinische Versinnlichung dionysischer Erkenntnisse und Wirkungen". Der Spieler stellt die Erkenntnisse des berauschten Sehers dar und vertritt sie vor dem Volke. Mythus, Musik und Kultur sind durch Wagners Musikdrama neugeboren. Indessen ungleich stärker als die Begegnung mit Wagner und Schopenhauer hat auf Nietzsche die Trennung von ihnen gewirkt. Aus dem Jünger wird durch die Überwindung seiner Anreger ein Meister und aus dem Zuhörer ein Verkünder. Mit dieser inneren Verwandlung Nietzsches wandelt sich auch die Art und Form seiner Schriften. Der Philologe, der nie ein Schulgelehrter war, verwandelt sich in den Dichter, der ohne Beispiel in seiner Zeit, wieder Seher und Wahrsager ist.

Der Dichter 　　Denn das ist Nietzsches Bestimmung: der Dichter. Die Einsichten des Philosophen stammen aus der Vernunft und die des Dichters aus der unmittel-

baren Schau der Dinge. Der Philosoph redet von ihnen wörtlich und der *Friedrich Nietzsche* Dichter bildlich. Nietzsches Einsichten sind Eingebungen außerhalb der Vernunft, die nicht bewiesen werden können, sondern geglaubt werden müssen. Nietzsches Werk ist nicht das Vernunftgebilde eines Stilkünstlers, sondern grundsätzlich ein ganz anderes: das Weltbild eines Sehers in der Sprache, die allein die Dichtung zu sprechen vermag. Als Nietzsche durch das Erlebnis Schopenhauer-Wagner hindurchgegangen war, gab er die Darstellung geschlossener Gedankengänge auf. Was er fortan festhält, das sind Einfälle, wie sie ihm offenbar die weiten Wanderungen schenkten, die er so sehr liebte. Die literarische Form dafür liegt zwischen Aphorismus und Denkspruch. Nietzsche versah diese kleinen künstlerischen Gebilde gern mit gesonderten *Kunst des Denkspruchs* Überschriften. Wir haben also ein Tagebuch vor uns, wie es immer wieder von Menschen geführt wird, die geistig tief und lebhaft empfangen und diesen Reichtum in die gemäße Form des Augenblicks umsetzen. Es ist eine anspruchsvolle und in der Weltliteratur uralte Form. Aus solchen Aphorismen nun hat Nietzsche seine Bücher zusammengestellt, indem er sie sehr ungefähr nach sachlichen Gesichtspunkten ordnete. In leitmotivischer Art geht eine Vorstellung oder ein Gedanke durch das ganze Buch hindurch. Es sind also im Grunde geistige Tagebücher in einer Form, die eigentlich dichterisch heißen muß, auch wenn es in den weitaus meisten Fällen Prosa ist. Das ist nun der Stil aller Bücher Nietzsches seit seiner Trennung von Richard Wagner, das ist seit der Zeit, da er ein Eigner geworden war und in einer neuen Sprache redete. Es sind die Bücher, die seine geistigen und seelischen Witterungen festhalten, die Bücher all seiner Häutungen und Überwindungen, die Stufen seines Aufstieges ins hohe Land seiner Wunschbilder. „Menschliches, *„Menschliches Allzumensch-liches"* Allzumenschliches" 1878 ist dem Sinne nach eine Rechenschaft in dem Augenblick, da er sich von allem, was er geliebt hatte und liebte, getrennt sah. An Stelle des Künstlers ist nun der Wissenschaftler Träger der Kulturschöpfung. Gegenüber dem Genie wird jetzt die handwerkliche Kunst gerühmt. Der Ruf nach einer edlen und stolzen Minderheit des Geistes wird zur führenden Stimme. Aus Schopenhauers Weltleid wird eine naive Weltfreude. Wagners Entwurf einer nationalen Kulturgemeinschaft verwandelt sich in die übervolkliche Vorstellung vom guten Europäer. Das Buch „Morgenröte" 1881 *„Morgenröte"* strahlt von wiedergewonnener Gesundheit. Es ist das Buch des Genesenen, der auf der Suche nach dem heilsamsten Klima die mittelländische Seite der Alpen abwandert. Es ist das Buch des Kampfes gegen den grundsätzlich angefochtenen Zustand des allgemeinen Lebens und all seiner Vorurteile. Es *„Die fröhliche Wissenschaft"* ist das erste Buch seines Sendungsbewußtseins. „Die fröhliche Wissenschaft"

Deutschtum ist ewiges Werden 1882 beginnt mit der Verkündigung der künftigen Gemeinschaft der freien Geister und guten Europäer. Mit dem romantischen Wortgebrauch der Fichte, Schlegel, Hardenberg wird die Bestimmung des Deutschtums als ein ewiges Werden gefaßt, als ein beständiges Übersichhinauswachsen und das Sichentdeutschen der wahre Auftrag an die Deutschen. Man weiß, wie sehr das deutsche Volk von je dazu neigte, außerhalb seiner Gegenwart und Wirklichkeit das Jenseits von Gestern und Morgen mit seinen Träumen zu bewohnen. Nietzsche sagte ihm das Bedrohlichste, indem er aus der deutschen Not die deutscheste Tugend machte und es aus dem zuverlässigen Sein in den Zustand eines ewigen Beinahe verwies. Das nun ist die Stelle in Nietzsches Gedankengängen, wo die Vorstellung vom deutschen Auftrag des beständigen Werdens und die Vision des Übermenschen miteinander verschwimmen. Der Stil des Spruches und der Vorgedanke des Übermenschen führen an die Dichtung heran, zu der sich Nietzsches gesamtes Werk aufgipfelt.

Kunst des Verses Nietzsches Verse beginnen den andern Aufstieg zu diesem Gipfel. Das allabendliche Gedicht, das sich schon der Knabe vornahm, bedeutete ihm offenbar Tagebucheintrag, Rechenschaft über den zurückgelegten Tag. Seine Meister zeigen uns ganz offen ihr Gesicht. Es sind vor allem Schiller und dann sehr widerspruchsvoll Heine neben Hölderlin und Lenau. Doch auch das Volkslied kann man in seinen frühen Versen mitschwingen hören. Es sind zumeist ganz sanfte Landschaftserinnerungen, mit dem Willen zur Sangbarkeit. Eines von 1862 ist völlig pietistisch und merkwürdig zu Hause in einer fast herrnhutischen Ausdrucksweise. Seit 1871 hat Nietzsche mit einem Ruck dichterische Eigenart. Das Feld beherrschen Sinngedichte. Vorläufer seiner späteren Wortspiele ist das Behagen an gehäuften Reimen. Mit einem Male *„Flamme bin ich sicherlich"* tritt uns das erste meisterliche Gebilde an, das erste „Ecco homo", jenes Selbstbildnis: „Ja! Ich weiß, woher ich stamme! Ungesättigt gleich der Flamme Glühe und verzehr ich mich. Licht wird alles, was ich fasse, Kohle alles, was ich lasse: Flamme bin ich sicherlich." Einige wenige Vorstellungen *Der Dithyrambus* verdichten sich zu leitmotivischen Symbolen, lyrischen Formeln, fast mythologischen Anschauungen: Meer und Flamme, Wüste und Stern, hoher Mittag und süßer Honig. Das große Erlebnis ist da. „Hier saß ich, wartend, wartend — doch auf Nichts, Jenseits von Gut und Böse, bald des Lichts Genießend, bald des Schattens, ganz nur Spiel, Ganz See, ganz Mittag, ganz Zeit ohne Ziel. Da, plötzlich, Freundin! wurde Eins zu Zwei und Zarathustra ging an mir vorbei." Das ist das Erlebnis einer zeitlosen Unio mystica. Jetzt und hier ist der freie Dithyrambus gefunden, die lyrische Form des Weltgefühls und der Weltschau. Das, die Jahre 1882/1884, das war die Morgenfrühe seiner

großen lyrischen Dichtung. Nun wird deutlich, wie die kunstvollen Prosagebilde Nietzsches, die Aphorismen und Denksprüche, zu fassen sind. In den späteren Büchern werden schon solche Dithyramben gleichen Rechts mitten in die Prosa gestellt. Später sollten die „Dionysosdithyramben" und die „Medusenhymnen" zu selbständigen Versbüchern zusammengestellt werden. Der hymnische Stil des Dithyrambus und das visionäre Erlebnis des vorüberschreitenden Zarathustra haben von der andern Seite an Nietzsches dichterisches Gipfelwerk herangeführt.

Das ist das Buch „Also sprach Zarathustra". Auf dieser Dichtung beruht alles, was Nietzsche wollte und bedeutet. Die höchste Leistung war für ihn die althellenische Philosophie. Die frühgriechischen Philosophen waren ihm zugleich Denker und Dichter. Was für Hamann Sokrates, das war für Nietzsche Heraklit. Schon zeitig war er vom Ehrgeiz gepackt, für die neue Kultur zu leisten, was Heraklit der alten geschaffen hat. Mit der Erscheinung Zarathustras, die sich bei Nietzsche schon lange ankündigt, wird in seinem Werk stärker denn je das achtzehnte Jahrhundert wirksam. Zoroaster, ein persischer Priester, war der wirtschaftliche und sittliche Erzieher der Nomadenstämme Ostirans. Hamanns Freund, der Kieler Professor Johann Friedrich Kleuker, hatte 1778 Zoroasters Verspredigten aus einer französischen Fassung ins Deutsche übertragen. Dieses Buch, das für Hamann viel zu spät gekommen ist, hat auf die deutsche Literatur einen unermeßlichen Einfluß ausgeübt. Zoroaster wurde eine gleichnishafte Gestalt: der weise Prophet, der sein Volk zu Reinheit und Wahrheit erzieht, der es zu einer höheren Menschlichkeit emporbildet. Nietzsche dachte nicht an die Gnosis, ihre Äonen und deren Archonten, als er sagte: „Ich mußte Zarathustra, einem Perser, die Ehre geben. Perser haben zuerst Geschichte im Ganzen, Großen gedacht. Eine Abfolge von Entwicklungen, jeder präsidiert ein Prophet. Jeder Prophet hat seinen Hazar, sein Reich von tausend Jahren. Vorstufen zur dichterischen Wirklichkeit dieser Gestalt waren Schopenhauer der Philosoph und Wagner der Künstler, die Nietzsche beide zu Zeiten über sich selbst hinaus erhöht hat. Zarathustra ist mit Nietzsche nicht gleich zu setzen. Doch er hat, wie es in der Dichtung fast stets geschieht, seinem Helden Modell gestanden. Denn beide sind Verkünder des neuen und höheren Menschen. Nietzsche wollte sein Wunschbild leibhaftig vor sich schreiten und handeln sehen. Darum erschuf er sich Zarathustra. Die vier Teile des Buches sind vom Jänner 1883 bis zum Winter auf 1885 in der anmutigstillen Bucht von Rapallo, in Sils Maria, Nizza und Mentone entstanden.

Zarathustra ist in dieser Dichtung eine gegenständliche, lebendige, sinn-

„Also sprach Zarathustra"

„Jeder Prophet hat seinen Hazar"

wirkliche Gestalt, ein persönlicher Mensch, mit allen Zügen eines gelebten Daseins. Was dargestellt wird, ist ein Lebensroman. Zarathustra zieht sich in seinem dreißigsten Lebensjahr in die Einsamkeit zurück und beginnt dann seine Wanderung unter die Menschen. Wir erleben diese Wanderug in allen Einzelheiten, den Verkehr mit den Jüngern und die Predigten vor dem Volke. Da sind eine Fülle wunderbarer Ereignisse, das Schiff am Feuerberg, der Feuerhund, Zarathustras Schlaf und seine Vision, seine Tränen und sein Abschied, sein Blick vom Berge herab auf das Meer und die Welt. Es folgt die Stunde der Verzweiflung, die Erkenntnis der Verlassenheit und schließlich die Gipfelszene: Zarathustra gibt neue Tafeln. Über diese vollendeten Teile hinaus sollte der Held in die Hände seiner Feinde fallen, sie durch eine gewaltige Rede überwinden, seine neue Weltordnung stiften und von seinem gesicherten Werk scheiden. Man sieht, an dem Buch hat das Evangelium mitgedichtet und die Legende aller großen Religionsgründer, Buddhas wie Mohammeds. Die Sprache des Buches ist die Sprache der Bibel und des Korans. Man kann die franziskanischen Predigten durchhören. Die morgenländische Landschaft muß überall im Auge mitgenommen werden. Das ist kein Rahmen für einen Lehrvortrag so wenig wie Goethes „Faust" und Hölderlins „Hyperion". Was Nietzsche in Wahrheit gibt und geben wollte, das ist die Vita des großen Verkünders, der unmöglich der Inhalt der Verkündung fehlen durfte. Nein, „Also sprach Zarathustra" ist zuerst und zuletzt eine Dichtung. Wenn man das Buch einen autobiographischen Prophetenroman nennt, so hat man sich nicht sehr geirrt. Mit der Sorgfalt, die Nietzsche eigen war, hat er sich bei der Ziselierarbeit an seinen Prosasprüchen und hymnischen Dithyramben genau so auf die Kunstform wie bei der Durcharbeitung seiner Gedanken auf die Großidee des „Zarathustra" geschult. Das Buch ist ein Organismus vielfältiger dichterischer Kleingebilde, eingebettet in den Bildgrund eines Seelenromans, ein Mosaikbild östlichen Geschmacks und Stils. Denn das Buch i st die Schöpfung eines östlichen Menschen. Nur im deutschen Osten ist bei so vielen Menschen dieser leidenschaftliche Lyrismus der Seele bezeugt, dieser Fanatismus zu diesen letzten Dingen, dieser unerbittliche Wille, bis auf die Wurzel zu roden, der Anspruch auf unbedingte Geltung der verkündeten Gesichte. Das ist jene östliche Mystik, die von Jakob Böhme bis zu Rainer Rilke in der deutschen Dichtung immer wieder aufgebrochen ist.

Was vor „Zarathustra" liegt, ist Aufstieg, was nach ihm kommt, Abstieg. „Jenseits von Gut und Böse" 1886 ist das erste Buch, das durch Übertreibung der persönlichen Stilkunst erste Anzeichen des Verfalls gibt. Das hem-

Der Lebensroman

Christus, Buddha, Mohammed

Nietzsche, der östliche Mensch

Zarathustras Abstieg

mungslose Aufschäumen des Affekts gefällt sich in gereizten Scheltworten. Gedankengänge wiederholen sich und kehren um. Der Übermensch wird schlicht zum guten Europäer, der alle Vaterländerei und Schollenkleberei überwunden hat. Das Buch „Zur Genealogie der Moral" 1887 begann die Paradoxen auf die Spitze zu treiben. Gegen Schopenhauers asketische Ideale des Genies und des Heiligen erheben sich die Idole des Machtwillens. Nun beginnen jene Schlagworte zu schallen — „Sklavenmoral", „Blonde Bestie", *Schlagworte* „Herdeninstinkt" — die ihm zuerst den Halbverstand der Allzuvielen ge- wonnen haben, die das Abbild seiner Welt in Mißverhältnisse verzerrten und die Köpfe verwirrten. Die vorletzte Stufe seines Abstieges sind die hemmungslosen Streitschriften gegen Richard Wagner, gegen das Christen- tum, dessen Wurzelfasern tödlich schmerzend in ihm schwärten, gegen das Christentum, in dem er sein eigenes Wesen verwünschte. Die letzte Stufe ist das Selbstbildnis „Ecce homo" 1888, eine Rechenschaft, wie auf der ersten Stufe 1878 „Menschliches, Allzumenschliches". Dieses ist unter den vielen Selbstbildnissen schöpferischer Menschen, die wir besitzen, das merk- würdigste, von eiskalter Einsicht in das eigene Wesen, frevelhaft überstei- gertes Selbstbewußtsein, von der ausbrechenden Krankheit morbid gefurcht.

Die drei Bücher, in denen sich das kurze schöpferische Jahrzehnt dieses *Trilogie der* Lebens entladen hat, bilden zusammen die Trilogie der Leidenschaft einer *Leidenschaft* Sendung: „Menschliches, Allzumenschliches" Berufung und erster Wurf; „Also sprach Zarathustra" Wunschbild des Verkünders und seines Werks; „Ecce homo" tragischer Abgesang der vollbrachten Tat, Gedankenflucht und feierlicher Kalauer. Diese Trilogie ist das Werk eines Künstlers, der aus einem Philologos ein Poietes geworden war. Nietzsche war vom Wort besessen. Seine „Wortspiele" sind nicht das Vergnügen eines Intellekts, überraschende Bezüge zwischen den Worten zu setzen, und die Musik seiner Sätze nicht der Wunsch, dem Gehör einen Schmaus zu bereiten. Zwischen den Worten bestehen durch Gleichklang oder Anklang natürliche Beziehungen des Sinns. Diese Gedankenverbindungen sind es, für die Nietzsche ein besonderes *Wortfährten* Organ hatte. Diese Fährten der Worte brachten ihn auf die richtige Spur der *des Denkens* Gedanken. Die Worte haben aber auch ihre natürliche Musik. Dafür hatte er ein ungemeines Empfinden. Nietzsche war ein Wortdenker und Worthörer, nicht von Schule, sondern von ursprünglicher Anlage. Das Wort ist gleich- bedeutend mit schaffender Kraft. In diesem höchsten und eigentlichsten und wörtlichsten Sinne ist er Poietes: der Dichter.

Von Hamanns „Entkleidung und Verklärung" sind es über Hegel und *Von Hamann* Schopenhauer genau hundert Jahre bis zu Nietzsches „Zarathustra". Wie- *zu Nietzsche*

vieles ist zwischen Hamann und Nietzsche gemeinsam; angefangen von ihren frühen Bemühungen um die hellenischen Mysterien und ihren Beziehungen zum Morgenlande; angefangen von ihren leidenschaftlichen Spielen durch Masken zu reden bis zu ihrem verwegenen Ringen um den dithyrambischen Stil der hohen Verkündigung; angefangen von der Kunst aphoristischer Darstellung bis zu der weitausschwingenden Wirkung ihrer Prophetie, durch die sie ein ganzes Zeitalter, jeder das ihm folgende, erschüttert haben. Doch das ist alles nichts gegen die Kette, in der sie stehen. Sie haben die hellenische Philosophie ins Moderne umgedacht, Hamann die nachsokratische und Nietzsche die vorsokratische, beide im Bannkreis der iranisch-hellenischen Gnosis. Beide hatten die apokalyptische Vision des neuen Menschen mit einem neuen Namen. Mochte dieser neue Mensch geschichtlich am Anfang oder am Ende der Tage stehen, er war für beide die Aufgabe der Gegenwart. Denn er ist die Schöpfung eines persönlichen Willensschwunges über sich selber hinaus. Er war eine Forderung nicht an die Gattung, sondern an die Persönlichkeit Mensch. Er ist etwa das, was die deutsche Mystik mit dem innerlich zunehmenden Menschen meinte. Die Vision beider stammt aus dem ekstatisch-dithyrambischen Rausch einer begnadeten Stunde und sie erzeugte in ihnen dieses erhöhte Lebensgefühl immer wieder aufs neue. Allein von Hamann zu Nietzsche sind es hundert Jahre. Hamanns neuer Mensch war das christlich-asketische Ideal. Nietzsches neuer Mensch stammt von dem Baume inmitten des Gartens. Nietzsche sagte nicht Lucifer, sondern Dionysos. „Dionysos gegen Christus."

Die apokalyptische Vision

„Dionysos gegen Christus"

In seiner Schrift „Deutsche Kunst und deutsche Politik" 1868 bestimmte Richard Wagner die künftige Stellung der beiden Staaten dahin: deutscher Beruf Preußens sei der Nützlichkeitsstaat, deutscher Beruf Baierns Schönheit und Kunst. Baiern solle jenen deutschen Geist, der Preußens Aufstieg erst möglich gemacht habe, zum Kraftvorrat des Reiches einfassen.

„Drei Einzüge"

BERLIN wird Großmacht. „Bonsoir, messieurs, nun ist es genug." So entläßt bei Fontane — „Drei Einzüge" — Friedrich II. die heimgekehrten Sieger von Sedan. Ein tragischer Irrtum. Weder der ausgelöste Schwung noch die Verkettung von Ursache und Folge gestatteten, zu beliebiger Stunde haltzumachen. Die Armee herrschte. Die Herrenkaste, die das gewaltige Werk kriegerisch und staatsmännisch ans Ziel geführt hatte, sah ihre ständischen Wertbegriffe vom Bürgertum bejaht und übernommen. Die Berliner Literatur hält den Ton von 1870 aus, teilt ihn den Dingen der Vergangenheit und Gegenwart mit, verschmilzt ihn vorempfindend mit dem Sturm von 1914, zu dem die drei Preußenkriege ja nur der Auftakt waren. Das Schicksal fügte es,

daß ein Franzose, ein Hohenzoller, ein Rheinländer die Kette von 1870 zu 1914 bildeten.

Der Franzose war *Theodor Fontane*, 1819 bis 1898, von Neuruppin. Er hatte die drei Kriege bei den Nachhuten mitgemacht, in schildernde Bücher aufgefangen. Der weltblickschärfende englische Aufenthalt, die wohltätig verengenden märkischen Wanderungen, das Erlebnis der drei Kriege drängten ihn über die Ballade hinaus. Der märkische Volksroman der Julius von Voß, Wilhelm Häring, Heinrich Smidt, George Hesekiel, den er selber aufgehen und abblühen gesehen hatte, wurde ihm Wegweiser, Walter Scott große Form. Bisher hatte Fontane sich groschenweise ausgegeben. Nun konnte er mit selbstgeprägter Goldmünze den großen Herrn spielen. Sein Erstling war „Vor dem Sturm" 1878, fast noch Gutzkows Gewicht von vier Bänden, die lauernde Zeit vor Tauroggen. „Grete Minde" 1880 und die Dorfgeschichte „Ellernklipp" 1881 gingen ziemlich umständlich nach Theodor Storm. „L'Adultera" 1882, ein Berliner Roman von Börsenleuten und Ehebruch, ging schon ziemlich sicher nach Paul Heyse. „Schach von Wuthenow" 1883, eine preußische Offizierstragödie dicht vor 1806, macht die Gruppe rund und fertig. Dann aber stand Fontane, ohne mehr daneben zu treten, auf Eigenem. Wo er stand, kreuzten Junkertum und Bürgertum ihre Wege und seine Haltung war „gesinnungsvolle Kritik". Junkertum, das war Offizier, und Bürgertum also kleines Mädchen. So der Halbweltroman „Stine", 1890 verspätet gedruckt, „Irrungen, Wirrungen" 1889, wo alles gut in zwei Durchschnittsehen aufgeht. Doch die beiden Stände sind auch so ziemlich unter sich: die Bürgerlichen um „Frau Jenny Treibel" 1892, „Die Poggenpuhls" 1896, eine verarmte Offiziersfamilie. In beiden Fällen ist es wohl kein Humor, sondern sehr ironisch gute Miene zu einem unguten, wenn auch alltäglichen Spiel. Indessen die Junker sind nicht in der Kaserne, sondern auf ihrem Gut zu Hause. Da gab es freilich aus der Natur der Frau Geschichten, die man nur geschehen lassen konnte, ohne seinen Verstand zu befragen. Balladenhaft geht — „Unwiederbringlich" 1891 — die Edelfrau von der Hochzeitsnacht mit ihrem das zweite Mal angetrauten Gatten in den Schloßteich. Und man kann nur sein Herz mit beiden Händen halten, wie „Effi Briest" 1895 das schale Glück einer unbedachten Stunde mit dem Leid eines kurzen Lebens bezahlt. Fontanes Romankunst ist das Kleinbild und das unnachahmlich bezaubernde Gespräch. Man versteht das aus dem Beruf des Zeitungsmannes und dem Esprit des Franzosen, der er war. Und das war ein Südfranzose. Das schnellfertige Urteil war jederzeit bereit, sich immer aufs neue zu berichtigen. Mit einem Blick waren Menschen und Dinge abge-

Gesinnungsvolle Kritik

Theodor Fontane

„Schach von Wuthenow"

„Frau Jenny Treibel"

„Effi Briest"

schätzt. Von den Preußen hatte er das Unbedingte des Ausdrucks gelernt. Doch was er nicht nachmachte und gar nicht konnte, war der Sinn für das *„Der Stechlin"* Feierliche. Jugendfrisch ergriffen, verdeckte das märkische Wesen die angeborene französische Natur und je mehr mit den Jahren die Kraft des Einschmiegens sank, verblaßte die Deckfarbe und desto farbiger brach das Ererbte durch. Das läßt den jungen Fontane deutscher und den alten französischer erscheinen, als beide waren. Wahrscheinlich hängt damit auch sein spätes Künstlertum zusammen. Aus der angeborenen Freude an der Gloire bejahte Fontane den soldatischen Junkerstaat. Sein ererbter Esprit bezweifelte die Kultur dieses jungen Staates. Fontane stimmte immer mit dem dritten Stande. Sein Herz schlug eher nach Rechts in der Richtung auf den Landbaron. Da also ist „Der Stechlin" 1898, das Vollkommenste, was Fontane und sein Zeitalter vermochten, ein Rundbild um Berlin und den märkischen Gutshof, fix und fertig bis in die letzte der zahlreichen Figuren. Wenn diese Welt so war, wie dieser unbestechliche Franzose sie sah, da sie sich dem Untergange zuneigte, dann war sie es wert, gelebt zu haben.

Anfänge in Novellen Der Hohenzoller war *Ernst von Wildenbruch*, 1845 bis 1909, zu Beirut als Enkel Louis Ferdinands geboren, im Morgenlande aufgewachsen, als Gardeleutnant nicht glücklicher denn Heinrich von Kleist, zuletzt Beamter im Auswärtigen Amt. Wildenbruch hat mit Schlachtbildern in der Art Scherenbergs begonnen. Die seinen aber hatte er selbst gesehen und erlebt. Sie bedeuten künstlerisch nichts. Seine beiden frühen Dramen „Harold" 1875 und „Die Karolinger" 1878 gestalten die beiden zeitverwandten Trauerspiele der Sachsen auf britannischem und der Franken auf gallischem Boden. Dem schamvoll Verschlossenen blieb zunächst die Erzählung als einzige Möglichkeit, sich mitzuteilen. Bald ist es der Künstler, bald der Offizier, dann wieder der Beamte Wildenbruch, die sich kundgeben möchten. Die einen dieser Geschichten halten sich an Theodor Storm. Andere sehen wie Ferdinand von Saar aus. Sie spielen vor Gericht, zeigen sich von Fragen der kranken Seele gefesselt, sind Erinnerungen aus dem Kriege. Sie wissen wohl auch — „Der Meister von Tanagra" 1879 — mit Praxiteles Bescheid um die Kunst, die auf die Unsterblichkeit den Preis des Todes gesetzt hat, und mit Myrtolaos um die kleine Kunst des holden Lebens. Mit hastigen, theatralisch übertreibenden Gebärden, mit überhitzten Gefühlsworten und abgegriffenen Beiwörtern werden die unwahrscheinlichsten Dinge erzählt, unglaubwürdig der ganze Menschenschlag, seine Hintergründe des Handelns und das Handeln selber. Dieser verbürgerte Hohenzoller beherrschte die natürliche bürgerliche Redeweise nicht.

Der Rheinländer war *Karl Bleibtreu,* 1859 bis 1928, aus Berlin, der Sohn jenes niederrheinischen Malers, der die Schlachten der drei deutschen Kriege in Bildern nachgedichtet hat. „Revolution der Literatur" 1886 nannte Bleibtreu einige seiner Aufsätze. Sie waren weder eine Revolution noch leiteten sie die ein, die auch keine war. Was die Herkunft seines Stiles anlangt, so ist er der dritte Mann nach Grabbe und Büchner. Und was die preußische Richtung seines Stiles angeht, so verhielt er sich wieder als der dritte nach Scherenberg und Fontane, indem er den Gemälden seines Vaters nachdichtete, wie Scherenberg und Fontane die Holzschnitte Menzels in Worte gesetzt hatten. Mit Bleibtreu fängt kein neuer Stil an, sondern erfüllt sich ein alter. Da sind seine Dramen gar nicht zu widerlegen. Die Übergänge liefen von dem Byronroman 1880 zu dem Byrondrama 1886 herüber. In offenem Wettbewerb zu Wildenbruch trat Bleibtreus „Harold" 1887, wo es nicht wie bei Wildenbruch darum geht, daß aus zwei Völkern eines werde, sondern daß sich das sächsische gegen das normannische behauptet. Die Tragödie ohne Helden, „Weltgericht" 1888, brachte die ganze französische Revolution in fünf Akte. Das Cromwelldrama „Ein Faust der Tat" 1889 zeigt, wie das Normannentum Karls I. durch Cromwells Sachsentum wieder ausgestoßen wird. So schließt sich dieser englische Bogen. Was Bleibtreu geben wollte, war strenge und ganze Geschichte, sachliche Darstellung des tatsächlich Geschehenen auf einigen Quadratfuß Bühnenbodens. Dafür hatten Grabbe und Büchner schon dem Drama den Stil der geschichtlichen Filmaufnahme gefunden. Das und nicht mehr und eine alte Sache ist Bleibtreus Stil. Das ist aber gar kein dramatischer, also Handlungsstil, sondern ein epischer, nämlich Erzählstil. Und wirklich besteht Bleibtreus Leistung darin, diesen Filmstil auf die epische Geschichtsdarstellung übertragen zu haben. Es spielt dabei keine Rolle, daß Bleibtreu sich völlig auf die Schlachtdichtung warf. Das Jahr 1884 brachte drei Erstlinge: „Dies irae", Sedan; „Wer weiß es?" aus dem spanischen Kriege; „Napoleon bei Leipzig". So hat dann Bleibtreu Wagram 1887, Kolin 1888, Marston More 1889, Talavera 1890 dargestellt und eine Reihe solcher Prosaballaden zu der Sammlung „Heroica" 1890 vereinigt. Natürlich konnten daraus auch kriegswissenschaftliche Studien werden wie „Der Imperator" 1891, der Feldzug 1814 in Frankreich. Weit über die literarische Leistung dieser Prosakunst geht ihre psychologische Wirkung. Bleibtreu hat das Nacherlebnis von 1870 in das Vorgesicht von 1914 verwandelt. Denn aus der Stimmung von 1887 beschwor er die Zukunftsbilder der „Entscheidungsschlachten des europäischen Krieges 18 .."; die mit erschreckender Gegenwart geträumten und bald wirklich geschlagenen Schlachten von Boch-

Kein neuer Anfang

Geschichte im Drama

Kriegshistorie

Bleibtreus bestätigte Prophetie

nia, Belfort und Châlons. Der Roman „Weltbrand" 1913 gab dann schon den ganzen grausigen Rundblick. Da ist nicht Jules Verne auf Kriegsfuß. Da ist die Prophetie der Dichtung. Da ist das lähmende Entsetzen, das von Kassandra ausgeht. Da ist das Furchtbare, das Wallenstein weiß: „Müßt' ich die Tat tun, weil ich sie gedacht?"

Historie in Berlin — Revolution ja wohl! Die war längst im Gange. Sie bestand im Zusammenfluß geistiger Menschen in der Hauptstadt des so groß gewordenen Preußen und in der wechselseitigen Durchdringung ihrer Leistungen. Die Niedersachsen hatten dank ihrer Geschichtswissenschaft in Berlin eine herkömmlich starke Stellung, die ihnen Hochschule und Akademie verbürgte. Mommsen, Curtius, Müllenhoff hatten unantastbares Ansehen. Nach und nach rückten die andern sächsischen Geschichtswissenschaftler ein. Auf der sächsischen Historie beruhte der Gedanke des sozialen Kaisertums. Die Revolution kam *Die Natur-wissenschaften* vom Rhein. Der Koblenzer Johannes Müller bildete an der Berliner Hochschule für alle Gebiete jenen großen Kreis von Naturforschern heran, der fast ausschließlich aus Ostdeutschen bestand und auf den sich der geistige und wissenschaftliche Umsturz des Jahrhunderts gründete. Johannes Müller und seine märkischen Schüler ersetzten die philosophisch-begriffliche Denkform durch die naturwissenschaftlich-anschauende. Die Wissenschaft vom Leben in all seinen Formen hatte den einfachsten Kern, die Zelle, entdeckt, mit ihr die Kluft zwischen Pflanze und Tier überbrückt und die einheitliche Anschauung der Lebensentwicklung begründet. Der Aufbau des Stammbaumes jeglichen Lebens wird die alles bewegende Frage. Der Gegenstand der Geschichte, der Mensch, erscheint nun als genealogischer Erbe des Alls. Naturwissenschaft wird Soziologie und Geschichte. Dieser wissenschaftlichen Welle folgt vom Rhein her die politische auf dem Fuße. Der Frankfurter Johann *Der rheinische Sozialismus* von Schweitzer-Allesina tritt 1864 Lasalles Berliner Erbe an und erstrebt durch Gewerkschaft und Parlament verfassungsmäßig die Macht im Staate. Der Gießener Wilhelm Liebknecht verschmilzt die althessische Sozialbewegung mit dem modernen Arbeitergedanken, ringt die Richtung Schweitzers nieder und gliedert sie auf dem Gothaer Tage 1875 in seine, auf die Rhein-*Marx und Engels; Liebknecht und Bebel* länder Marx und Engels vereidigte, sozialistische Partei ein. Der Kölner August Bebel gewinnt dem rheinischen Sozialismus die Massen und wird zum Sprecher des Staatssozialismus. Während der junkerlich-bürgerliche Staat mit dem Sozialistengesetz 1878/1890 die letzte nationale Spur in der Arbeiterschaft austilgt, führen sie Liebknecht und Bebel durch Jahre des Leidens auf den Gipfel der staatlichen Macht. Das ostdeutsche Denken war von Idealismus auf Materialismus umgestimmt. Der rheinisch-hessische Sozialis-

mus war weltanschaulich mit diesem Materialismus eins geworden, hatte den preußischen Staat von Grund auf verwandelt und ihm wesenhaft rheinische Züge gegeben.

Die Gruppe junger Dichter, die sich aus Niedersachsen und vom Rhein her in Berlin zusammenfand, zeigt die mannigfachsten Durchdringungen von Historie, Naturwissenschaften und Sozialismus. Sie sucht die geistige und soziale Verwandlung des Zeitalters in Gehalt und Stil der Literatur wirksam zu machen. *Niedersächsische Dichter in Berlin*

Die Brüder *Heinrich* und *Julius Hart* waren 1877 mit großen Plänen von Münster nach Berlin gekommen. Sie mußten um den Tag schreiben. Ihre losen Hefte „Kritische Waffengänge" 1882/1884 setzen die Gesamtlage Niedersachsens unmittelbar nach 1871 voraus. National, gegenwartsbewußt, ideal gesinnt, wollten sie nichts als eine Kunst, die des Reiches würdig wäre. Sie klügelten nichts aus. Sie zeigten nichts vor. Was sie ablehnten, war Zolas Realismus und Haeckels Materialismus. Sie mochten das „Klassische" nicht, das heißt, was nur Form wäre. Modern hieß ihnen einfach nationale Gegenwart des neuen Staates. Woran sie dachten, hat dann Julius Hart mit seinen freireligiösen Gedichten und Heinrich Hart mit dem großen Bruchstück seines Weltepos gezeigt. Bei ihnen lag der Ton auf Historie und auf einem reinen Sozialgefühl.

Karl Henckell, 1864—1929, aus Hannover, doch von niederhessischer Herkunft, lebte tatsächlich in der sozialrevolutionären Überlieferung Hessens. Seine innere Haltung war eigentlich bürgerlich. Zur Partei hat er nicht gehört. Sehr wichtige Grundsätze von Marx hat er nicht angenommen. Seine hessischen Vordermänner waren Herwegh, Dingelstedt, Kinkel. Doch Henckell hat seit seinem „Skizzenbuch" 1884 in zahlreichen Sammlungen sein persönliches Sozialbewußtsein und die proletarische Massenseele schwungvoll beredt gemacht. Von ihm stammte der Gedanke eines modernen Dichterbundes. Mit dem Buch „Moderne Dichtercharaktere" 1885 gab Henckell für ihn die Karte ab. Da standen zwei Aufsätze: einer von Conradi, der die Dichter als Ärzte und Priester des Menschen bezeichnete und die germanische Wiedergeburt feierte; einer von Henckell, der behauptete, auf den Dichtern des Kreises beruhe die Zukunft der Literatur. Die Wirkung war schwach. Man hatte Geistesverwandte übersehen, sich mit Fernstehenden belastet und am Mittelmaß genügen lassen. Nein, auch das war keine Revolution. *„Moderne Dichtercharaktere"*

Wilhelm Bölsche, 1861 bis 1939, von Köln, stammte durch den Vater aus Fallersleben. Die Mutter soll von dem Holsteiner Alchimisten Johann Kunckell stammen, eine Nachricht, an der uns der Sachse wichtiger ist als der Alchimist. *Kulturgeschichtliche Naturkunde*

Der Dichter
der Kosmologie

Bölsche hat mit dem religiösen Roman „Paulus" 1885 aus der Zeit des Kaisers Marcus Aurelius begonnen und diese Reihe bald mit dem Roman „Die Mittagsgöttin" 1891 geschlossen. Im stimmungsvoll gezeichneten Spreewalde und im Luftbereich der wendischen Sage vollzieht ein junger Darwinschüler das Bekenntnis zur verschwisterten Erlösungslehre der Naturwissenschaften und des Sozialismus. Der Roman, das war also nichts. Bölsche hatte 1887 die „naturwissenschaftlichen Grundlagen der Poesie" zu bestimmen gesucht. Das war sein Feld. Das wurde sein Stil. Immer mit dem Stammbaum der Weltkörper und des Lebens im Auge, malte er in Kleinbildern beständig Wiederkehr und Geltung der gleichen Gesetze, mochte er nun 1891 „Das Liebesleben in der Natur" oder 1915 den „Mensch der Zukunft" betrachten. Das war Dichtung und Wahrheit, Forschungsgeschichte und geschichtliche Naturkunde. Bölsche gab in diesen zahllosen Kleinbildern nicht die Naturgeschichte, sondern die Kulturgeschichte des Alls, unter den einfachsten Zellenverbänden wie unter den höchsten Organismen das eine und gleiche Streben aller Lebensgebilde zur Kultur. Gegen diesen stark religiösen Selbstbildner, der so glücklich auf sich nahm, was die Wissenschaft verschmähte, die volkstümlich-künstlerische Darstellung, verfängt keines der geläufigen Schlagworte. Bölsche hat das neue Naturwissen zu Gemeingut gemacht. Die Zeit war wiedergekehrt, da der Dichter die Kosmogonie und ihre Sage aufschloß.

„Einsiedler
und Genosse"

Bruno Wille, 1860 bis 1928, aus Magdeburg, hatte einen Schlesier aus dem berühmten Neumarkt zum Vater. Seine Mutter stammte aus einer junkerlichen Familie bei Magdeburg. Über Feuchtersleben und Büchner wurde ihm die naturwissenschaftlich-sozialistische Weltanschauung zu eigen. Auch er war kein Parteisozialist. Wille steht in der mystisch-romantischen Lebenskette seiner väterlichen Heimat. „Einsiedler und Genosse" 1890 hieß sein erstes Gedichtbuch. Das war er wirklich. Ein Träumer und Aufwiegler. Aber ein Aufwiegler nur der Herzen. Er hatte die Gabe des Volkserziehers. Den

Erziehung
des Arbeiters
zur Kunst

Arbeiter durch Kunst zu erziehen, gründete er 1890 die „Freie Volksbühne" und nach seiner Trennung von der Partei 1894 die „Neue freie Volksbühne". Mit Bölsche schuf er 1901 die „Freie Hochschule", die 1914 mit der Humboldtakademie zur „Humboldthochschule" vereinigt werden konnte. Bei Wille war es der Roman. „Offenbarungen des Wacholderbaumes" 1895 spielen zwischen märkischem Moor und Wasser und sind der Anlage nach ein romantisches Buch aus Lebenserinnerungen, Gesprächen, Traumbildern, redenden Dingen, Gedichten von unsäglicher Schönheit und Güte, alles gefügt in den Rahmen einer nach und nach enthüllten tragischen Liebes-

geschichte. Es ist die Geschichte einer aufwärts ringenden Seele zur seligen *Wille und Fechner*
Gewißheit der Alleinigkeit, die Vollendung einer Seele durch Naturandacht
und eine hilfreiche letzte Opfertat. Es ist das Buch eines Dichterphilosophen,
der Fechners idealistische Weltanschauung auf naturwissenschaftlich künst-
lerisch verwirklicht. Es erlebt sich alles und alles Dasein ist Erlebnis. Jedes
ist persönliche Allseele. Alle Völker, ja der ganze Erdball sind genealogisch
in mir. Daher wurzelt jedes Wesen an jedem Punkte der Welt. Daher ist jeder
für jede Schuld auf Erden verantwortlich. Ich bin du und du bist Ich. Wille
hat Schopenhauer durch Fechner, den Allwillen durch die Allseele über-
wunden. „Die Abendburg" 1909 erzählt, aus dem blauragenden Riesen-
gebirge aufsteigend, vor dem Hintergrunde des brennenden Magdeburg die
Geschichte eines Gottsuchers, der zum wahren Schatz des Seelengoldes be-
kehrt wird. „Das Gefängnis zum preußischen Adler" 1914, Willes Festungs-
tid, ist das groteske, tragikomische Schauspiel zwischen dem preußischen
Staat, einem Provinzialschulkollegium, einem Gemeindepolizisten und dem
freireligiösen Jugenderzieher Bruno Wille.

Bölsche und Wille bilden ein freundschaftliches Paar von seltener Ganz- *Bölsche und Wille*
heit. Bölsche hat Tierfreundschaft und Geschichtsinn des Sachsen in eine neue
künstlerische Anschauung erhoben, indem er, mit dem Tier im Mittelpunkte,
die Welt natur-geschichtlich in beständiger Bewegung sieht. Wille hat von
der Pflanze aus das neue naturwissenschaftliche Weltbild durchgeistigt und
sich wie durch unio mystica in die Allgegenwart der Weltseele eingefühlt. Ihr
gemeinsamer Nenner ist Johannes Scheffler und seine gottnaturselige Spruch-
dichtung.

Endlich sind die zwei, die nur eine große Stadt zusammen haben kann,
damit sie alles sei. Keiner von ihnen braucht um seinetwillen da zu sein. Doch
sie bedeuten und vertreten. Der Epoche fehlte das geschriebene Handzeichen,
daß sie gültig macht, wenn ihr Name nicht auf der Urkunde stünde.

Peter Hille, 1854 bis 1904, im westfälischen Erwitzen geboren, doch aus *Der Habenichts*
jenem ostmitteldeutschen Winkel, wo die Schwenckfeld und Böhme und
Zinzendorf und Hamann zu Hause sind. Nachdem er ein großes Stück Welt
gesehen hatte, kam er nach Berlin, damit er zu wandern hätte. Was er bei
sich hatte, mehr besaß er nicht. Dieser Stadt, die immer mächtiger und
reicher wurde und immer lauter zerstritten um den sichersten Weg ins
irdische Paradies, lebte dieser wiederkehrende Bettelmönch das Beispiel be-
dürfnisloser Armut vor. Er trug inmitten einer kostbaren und üppigen Lite-
ratur seine Dichtungen auf Papierschnitzeln in einem Sack bei sich von
Nachtquartier zu Nachtquartier.

*Das
schamlose Herz*

Hermann Conradi, 1862 bis 1890, aus Jeßnitz bei Dessau, kam von der Magdeburger Schule her 1884 nach Berlin. Ein früher Tod nahm ihn, nachdem er sich an Nietzsche und Hegel zergrübelt hatte, wie einen erkannten Irrtum zurück. Unmöglich, was dieser junge Mann geschrieben hat und was man ihm druckte, Machwerke die „Brutalitäten" 1886, Fetzen der vorgebliche Roman „Phrasen" 1887, wenigstens begreiflich „Adam Mensch" 1889, erschütternd jedoch und gültig die „Lieder eines Sünders" 1887, dies Denkmal eines verlorenen Daseins. Nur wie er die Seele entschleierte, darin bezeugt sich ein erster Wille zur Ausdruckskunst und jene dichterische Verseelung, die der geschichtlichen Diltheys und der kosmischen Willes gleichlief. Was sich für und gegen Conradi sagen läßt, muß sich auf seine letzte

*Hermann
Conradi*

Schrift gründen, „Wilhelm II. und die junge Generation" 1889, in der sich sein Übergang zum christlich-sozialen Gedanken des Berliner Hofpredigers Adolf Stöcker vollzogen hat. Diese Schrift, in der Form versudelt, schwulstig, eine Orgie von Fremdwörtern und naturwissenschaftlich gespreizten Ausdrücken, ist das Schreckhafteste, was über dieses Zeitalter gesagt worden ist. Sie untersucht im Sinne Richard Wagners die Tragik des Fürsten an sich und gibt eine bestechende Sinnbestimmung des Hohenzollerntums und Preußens. Sie gibt das Seelenbild des Zeitalters so seherhaft berückend, so karikiert übertrieben, wie dann in hundert Abwandlungen nachgesprochen wurde. Sie wendet sich gegen den „Positivismus" und prägt die Forderung nach „Synthese". Sie verlangt Wiederaufnahme des romantischen Erbes. Indem sie die zeitgenössischen Geistesströmungen stammlich-landschaftlich sondert, begreift sie Conradi und seinesgleichen als Erben der Romantik, als „ein Ergebnis niedersächsisch-ostfränkisch-slawischer Naturingredienzien". Die

*Blick
in die Zukunft*

Schrift schließt mit dem schauerlich gegenwärtigen Satz: „Die Zukunft, vielleicht schon die nächste Zukunft, sie wird uns mit Kriegen und Revolutionen überschütten. Und dann? Wir wissen nur, die Intelligenz wird um die Kultur, und die Armut, das Elend, sie werden um den Besitz ringen . . . Vorher jedoch wird diese Generation der Übergangsmenschen . . . mit ihrem roten Blute die Schlachtfelder der Zukunft gedüngt haben — und unser junger Kaiser hat sie in den Tod geführt. Eines ist gewiß, sie werden uns zu Häupten ziehen in die geheimnisvollen Zonen der Zukunft hinein, die Hohenzollern. Ob dann eine neue Zeit ihrer noch bedürfen wird? Das wissen wir abermals nicht." Conradi sah aus der Not der Seele das gleiche Bild, das Bleibtreu kriegswissenschaftlich errechnete und Wildenbruch in vorahnenden Dramen beschwor.

Der Osten war schon preußisch, als der Staat noch klein und selber nichts

als Osten war. Die Jugend, die von daher nach Berlin kam, die kam aus ent- *Östliche Jugend in Berlin*
legenen kleinen Orten, wo es keine geistige Überlieferung gab. Mancher
unter ihnen mußte in Berlin vom Knaben zum Jüngling werden und die Nöte
proletarischen Daseins am eigenen Wesen erfahren. Die erlebte Großstadt
mußte dieser kleinstädtischen Provinzjugend ein umwandelndes Begegnis
bedeuten. Doch das war erlebter Inhalt der Dichtung und hatte mit der
Frage nach einer möglichen neuen Form nichts zu schaffen.

Max Kretzer, 1854 bis 1941, von Posen und aus der verarmenden Familie *Der Dichter der Großstadt*
eines Gastwirtes, der von Berlin stammte, kam mit dreizehn Jahren also in
seine Heimat zurück. In einer Fabrik, bei langer Tagesarbeit und kargem
Wochenlohn, lernte das verwöhnte Bürgerkind ausleiden, was andere nur
von ferne beschrieben. Er las sich empor, begann mit kleinen Schilderungen
und nützte die Gabe vom Vater her, der sich einen Naturdichter nannte und
gelegentlich Klaus Groths Zufriedenheit erfahren hatte. Der wirklichkeits-
treue Berliner Roman war, als Kretzer begann, schon da. Nur war es der Ro-
man des alten Berlin. Kretzer schrieb den des neuen. Das ist alles. Was daran
viel ist, das ist die Leistung. Die Zeitung brachte Kretzers erste Romane.
„Die Verkommenen" 1883 fassen in der Mietkaserne den ganzen Organis-
mus deklassierten Lebens zusammen vom erwerbslosen Arbeiter hinüber
zum Leihhaus, herüber zur Kupplerin, hinab zum Fuselverkäufer, hinauf
zum Bücherhausierer; Volkssänger, Winkeladvokaten, Dirnen, Zuhälter. Das
Hauptwerk und Mittelstück war „Meister Timpe" 1888, in einer Familien-
geschichte von drei Generationen bürgerlicher Niedergang an der neuen Zeit,
Vernichtung des Kleingewerbes durch die Fabrik, schlichtes Heldentum des
Drechslermeisters, der sich vergeblich gegen das Rad stemmt. Auf der Gegen-
seite kann sich „Der Millionenbauer" 1891, der plötzliche Krösus an dem
emporschnellenden Bodenwert, zur Verhöhnung der Gesellschaftsordnung
den zynischen Spaß leisten, den junkerlichen Offizier und seinen Burschen
zu Schwägern zu machen, indem er jedem eine seiner Töchter gibt. „Die
Bergpredigt" 1890 und „Das Gesicht Christi" 1896 sind einig in der Zuver-
sicht, das Christentum sei unser aller Gewissen. Wenn Rosegger auf ein Jahr
seinen Stadtherrn zum Bauernknecht macht, so läßt Kretzer — „In Frack und
Arbeitsbluse" 1911 — den reichen Erben ein Jahr lang Fabrikarbeiter sein,
ein Gedanke übrigens, den schon Ungern-Sternberg und Dingelstedt gehabt
hatten. Kretzer ist nicht von Zola, sondern von Dickens ausgegangen. Seine *Kretzer und Dickens*
breite niederdeutsche Gegenständlichkeit gibt wie der englische Meister des
Schuldgefängnisses und der Londoner Armenviertel Idyllen des Elends und
der Verzweiflung, an denen eben gerade nur jener eine Meisterstrich ungetan

bleibt, der ein weinendes in ein lachendes Antlitz verwandelt. Aus reinem Herzen, ohne Haß und Anklage, spiegelt Kretzer den dreifachen Kampf des Proletariats gegen die Not des Leibes, der Seele, des Geistes. Ob er es wußte oder nicht, Kretzer hat den Faden dort aufgenommen, wo ihn der Stettiner Robert Prutz mit seinen Erzählungen fallen gelassen.

Arno Holz, 1863 bis 1929, von Rastenburg in Ostpreußen, kam mit zwölf Jahren nach Berlin. Gewandt und glatt erwarb er sich die geläufigen Stilmittel der Zeit, die von Wolff und Geibel, von Eichendorff und Heine. „Das Buch der Zeit" 1885 mit seinem sozialen Mitleid, mit seinem Großstadtfrühling, mit Fabrik und Hinterhaus begleitete lyrisch Kretzers Romane. Der Mißerfolg des Buches weckt ihm Zweifel, nicht an der persönlichen Leistung, sondern am „Ding an sich". Er schrieb es den Versen zu. Da mußte ein Fehler stecken. Also setzte er sich hinter Bücher, um ihn da zu finden. Er stößt auf den Begriff des Naturgesetzes und glaubt in sinngemäßer Übertragung den Begriff des Kunstgesetzes gefunden zu haben. Zwei Welten tun sich auf. Der Süddeutsche Friedrich Beck war des Glaubens gewesen: die Natur strebt Kunst zu werden. Der Norddeutsche Arno Holz fand: Kunst hat den Trieb die Natur zu sein. Das nannte er „konsequenten Realismus". Es war aber der romantische Gedanke von der Rückkehr des abgefallenen Menschen zur ursprünglichen Schönheit, Weisheit, Güte der Natur. Es war der Weg, den Herder in seiner Sprachschrift angeschritten hatte. Durch den romantikfeindlichen Zeitgeist ließ sich Holz über den Sinn seines Fundes täuschen. Nun galt es zu verwirklichen, was die Vernunft gesehen hatte. Arno Holz setzte sich im Winter auf 1889 mit Johannes Schlaf zusammen. Sie schrieben gemeinsam die drei Erzählungen „Papa Hamlet" und ließen sie als vorgebliche Übersetzungen aus dem Norwegischen drucken. Sie schrieben das Drama „Die Familie Selicke". Raum und Zeit waren atomweise aufgenommen. Gespräche wurden restlos wiedergegeben. Ausgezählte Punkte und Striche stellten eine Art seelischer Notenschrift dar. Das ganze lief einfach darauf hinaus, Sinneseindruck neben Sinneseindruck zu setzen. Was war daran neu? Bis auf die Punkte und Striche gar nichts. So hatte es schon Stifter in seinem „Witiko" gemacht. Die Freunde trennten sich. Holz legte 1891 „Die Kunst, ihr Wesen und ihre Gesetze" dar. Ihm wurde die Pause in seinem Schaffen aufgezwungen, die so verhängnisvoll war. In dieser Pause ging es um das Drama.

Gerhart Hauptmann, 1862 bis 1946, aus Obersalzbrunn in Schlesien, lebte seit 1885 in Berlin, ein junger Mann mit guter bürgerlicher Erziehung, aus qualvollem Schwanken zwischen der Kunst des Meißels und des Wortes soeben gelöst und wirtschaftlich unabhängig. Hauptmann kannte die natur-

Der konsequente Realismus"

Kunst will Natur sein

„Die Familie Selicke"

wissenschaftliche und sozialistische Literatur der Zeit. Nicht Kunstgenuß, *Gerhart Hauptmann*
sondern soziale Einsicht zu wecken, schien ihm Dichterberuf. Dabei wälzte er
Plan um Plan, machte die Novelle „Bahnwärter Thiel" 1887 fertig, wie Böl-
sches „Mittagsgöttin" und Willes „Wacholderbaum" aus der Traumstille
märkischen Waldes empfangen, und suchte einen Ausdruck für seine Kunst,
die nur Natur sein sollte, wie er in römischen Kunstwerkstätten gelernt hatte.
Das war indes die Natur, wie man sie seit Winckelmann meinte. Hauptmann
lernte Kretzer persönlich kennen. Und er kannte die Berliner Gegenwarts-
literatur, wie sie frisch aus der Presse erschien. Im Kreise der Brüder Hart
stiß er auf Arno Holz. „Papa Hamlet" wurde ihm Erleuchtung und Wegfin-
dung. „Vor Sonnenaufgang" 1889, schon hier und schon im Titel das Sinn- *„Von Sonnenaufgang"*
bild, hieß das neue Ereignis. Ein soziales Drama auf schlesischem Hinter-
grunde. Auf der Szene ein Fanatiker seines Gedankens und eine Liebesge-
schichte, die durch seine Vererbungsbedenken jäh ernüchtert wird. „Was wie
eine soziale Tragödie ausgesehen hatte, kommt auf eine medizinisch-soziolo-
gische Spitzfindigkeit heraus." Doch daran ist kaum mehr etwas neu. Echt
und schön ist nur das leidende Mädchen, unter Larven die einzige fühlende
Brust. Am 20. Oktober 1889 mittags wurde das Stück von der Freien Bühne
im gemieteten Lessingtheater gespielt. Das war der Irrtum. Gerade auf dem
Theater hat „die Kunst die Tendenz, wider die Natur zu sein". Denn ge-
spielte Natur, eine Theaternatur, ist Widerspruch in sich wie hölzernes Eisen,
Triumph weder der Kunst noch der Natur. Das war das Stichwort für den
dritten Ostdeutschen.

Hermann Sudermann, 1857 bis 1928, vom Gut Matziken im Memellande, *„Die Ehre"*
stammte aus einer niederfränkischen Familie Westpreußens. Er war seit 1877
in Berlin, fand als Zeitungsmann bald eine sichere wirtschaftliche und als
Mann von Welt eine gemäße gesellschaftliche Stellung. Er hatte also weder
die zigeunerlichen noch die proletarischen Anfänge mancher seiner Mitstre-
benden. Er hatte weit außerhalb von Kretzers Bereich mit sicherm Einsatz
sofort seine richtige Stimmlage, den ostpreußischen Heimatroman, und selb-
ständig wie in allem setzte er auch auf der Bühne an. Kurz nach Hauptmanns
Stück brachte das gleiche Spielhaus, das Lessingtheater, aber auf eigene
Rechnung, Sudermanns Schauspiel „Die Ehre". Ein Erfolg und ein Theater- *Sudermann und die Bühne*
ereignis. Holz und Hauptmann hatten einen dichterischen Stil gefunden, der
neu aussah. Sudermann gab eine Bühnenleistung, die sich aus dem Wesen
der Sache selber mit dem Gesetz von Holz und Hauptmann nicht decken
konnte. Noch war es erst ein Anfang, den wirklichkeitsnahen Gesprächstil für
ein formstrenges Bühnenwerk zu verwerten, in dem französische Szenen-

führung, Ibsens Fragen und die Gegenwartsforderungen der Gruppe Holz und Hauptmann ein rundes Stilgebilde werden konnten. Sudermann hat diese Aufgabe erfolgreich gelöst, indem er Holzens Gesprächsweise, so weit das möglich war, dem Spielbuch zubildete, dem geschichtlichen Drama einen sachlichen Stil schuf und die überlieferten Spielformen einem zeitgemäßen Geschmack zurückgewann. Es war nicht seine Schuld, wenn Berlin durch ihn nicht das erhielt, was Wien durch zwei Menschenalter durch Bauernfeld hatte.

Weder Revolution noch Reaktion — Weder der alljährliche Frühling noch der regelmäßige Säugling sind Revolutionen. Alles fließt. Beständig durchdringen die rhythmischen Veränderungen des Lebens die Literatur und sie sucht ihrer durch ihre beständigen Grundformen Herr zu werden. Die jüngsten geschichtswissenschaftlichen und naturwissenschaftlichen Vorstellungen, die ausreifende soziale Bewegung wurden vom Bewußtsein der eben mannbaren Generation ergriffen und dichterisch verarbeitet. Das ist in Berlin geschehen. Das war keine „Revolution". Und daher auch keine „Reaktion", was gleichzeitig oder nachher anders aussah als „Papa Hamlet" oder „Familie Selicke". Man zog der Natur nach, die man erkannt hatte. Bölsche und Wille sammelten ihre Freunde, worunter die Brüder Hart, in der Friedrichshagener Gemeinde seit 1890, eine persönliche Lebensweise, die Kameradschaft von Kopfarbeitern und Handarbeitern, die Ganzheit von Gesellschaftslehre, Naturwissenschaft, Religion und Philosophie zu pflegen. Die Brüder Hart sonderten sich 1900 mit ihren engsten Freunden in Schlachtensee zum religiösen Brüdertum ihrer *„Neue Gemeinschaft"* „Neuen Gemeinschaft" ab. Mit zunehmender Reife rückten jene in den Vordergrund, die von Natur mystisch und romantisch gerichtet waren. So auf seinem deutschen Umweg aus der polnischen in die polnische Literatur der Pole Stanislaw Przybyszewski, der Zacharias Werner so verwandt war. So *Jugend in Berlin* vor allem Richard Dehmel, wenn er 1904 auf dem Gegenpol der Berliner Trustliteratur die erlesen ausgestattete, teure Kunstzeitschrift „Pan" aufpflanzte als einigende Standarte zwischen Kunst und Literatur. Soweit waren das geistige Vorgänge innerhalb Preußens gewesen. Berlin war im vollen Sinne die Hauptstadt des groß gewordenen preußischen Staates geworden. Nun schickte es sich an, geistige Hauptstadt des Reiches zu sein. Vom mittleren und oberen Rhein, aus Schwaben und Österreich drängten sich die jungen Leute zu, die aus alten und festen künstlerischen Überlieferungen stammten: der Rheinländer Stefan George und die uralte Formstrenge seiner Heimat; der Alamanne Friedrich Lienhard, der den Machtanspruch der Stadt so leidenschaftlich verneinte, wie er die geistige Führerschaft Weimars bejahte und suchte; der Österreicher Hermann Bahr, der sein barockes Stilgefühl

vorerst noch als westeuropäischen Kunsttrieb verstand. Das alles waren Bewegungen, die man als zeitliches Nebeneinander verstehen muß ohne Rücksicht auf den geringen Abstand der Jahre, der zwischen dem einen oder anderen Ereignis liegt.

Die beiden alten und großen deutschen Theaterstädte waren mit äußerstem räumlichen Abstande in Norddeutschland Hamburg und in Süddeutschland Wien. Über der Schneide Berlins suchten sie das Gleichgewicht. *Otto Brahm,* 1856 bis 1912, von Hamburg, kunstgeschichtlich und germanistisch geschult, entwickelte sich in Berlin zum führenden Spielleiter dieser Zeit. Das Deutsche Theater, das 1883 von dem Hamburger Adolf L'Arronge gegründet worden war stellte er seit 1894 auf Shakespeare und Molière, auf Schiller, Kleist, Grillparzer, auf Ibsen und die Jungen um. Am Lessingtheater, das 1888 der Berliner Oskar Blumenthal gegründet hatte, steuerte Brahm in gleiche Richtung. Die Freie Bühne, die 1889 die beiden Berliner Theodor Wolff und Maximilian Harden gegründet hatten und die im gemieteten Lessingtheater spielte, eine Art Versuchsbühne, hielt Brahm dem Auslande frei, Ibsen, Björnson, Strindberg, Tolstoj, den deutschen Dichtern ein Ansporn zu sein. Brahm stellte auf der Szene, wie das dem norddeutschen Sinn entsprach, das Wortkunstwerk heraus. *Max Reinhardt,* 1873 bis 1944, aus Baden bei Wien, war bei Brahm emporgekommen, ging durch das Überbrettl und übernahm 1905 die Leitung des Deutschen Theaters. Ihm gliederte er 1906 die Kammerspiele an und 1911 ging er zu gewaltigen Massenaufführungen in den Zirkus. Gegensätzlich zu dem Hamburger Wortfanatiker Brahm rief der Wiener Reinhardt wieder das Spiel der Sinne auf die Bühne. Wie die altösterreichischen Spielleiter des siebzehntes Jahrhunderts, nützte er alle technischen Hilfsmittel der Zeit, ließ Scheinwerfer spielen und den Bühnenstil aller Theatervölker an schicklichen Vorwürfen wieder lebendig werden. Das war wirklich ein Rollenwechsel von der hamburgischen Dramaturgie Brahms zum oberdeutschen Kulttheater Reinhardts.

Auf der Bühne nun verkörperte diese Hohenzollernzeit der Hohenzoller. *Ernst von Wildenbruch* war durch die Lesung des Aischylos und durch die Reichstagsverhandlungen des Jahres 1885 auf das nationale Heldendrama gedrängt worden. Eine solche Kunst begannen ja eben zu dieser Zeit die Brüder Hart und Bleibtreu zu fordern. Wildenbruchs Drama ist eine Kreuzung aus sächsischer Historie und märkischer Literatur. Die Reihe seiner Hohenzollerdramen „Die Quitzows" 1888, „Der Generalfeldoberst" 1889, „Der neue Herr" 1890, die zuweilen wie Fronde gegen das allmächtige Kriegertum aussahen, brach er mit Rücksicht auf den Hof ab. Sein erstes Kaiser-

Das Berliner Theater

Brahm und Reinhardt

Der Spielbuchdichter

Das Reich auf der Bühne stück, „Das neue Gebot" 1885, vom Kaiser verboten und im Ostendtheater kümmerlich gespielt, hatte großen Beifall, aber den Beifall der Frondeure. Denn es war, eine schwache Übung um Heinrich IV., ein Kulturkampfstück. Erst aus der Schule der Hohenzollernreihe sind Wildenbruchs deutsche Kaiserspiele hervorgegangen, die das waren, auch wenn sie durch die Maske der deutschen Heldensage redeten. „Heinrich und Heinrichs Geschlecht" 1895 war eine Trilogie im Sinne von Schillers Wallenstein. „König Laurin" 1902, das ist der schwarze Zwerg, der den Wurm in seinen Eingeweiden mit Gold füttern muß, sonst frißt er ihn. „Ermanarich" 1906, das ist im Bilde des Gotenkönigs der deutsche Zweiseitenkrieg der Zukunft. „Der deutsche König" 1908, der Sachse Heinrich I., mit der Avarenschlacht bei Merseburg im Mittelpunkte, spricht das Gefühl der deutschen Weltverlassenheit aus. Wildenbruchs geistiger Querschnitt läuft durch die drei, scheinbar so beziehungslosen Stücke. „Die Tochter des Erasmus" 1899 meint im Protestantentum das germanische Christentum und im lateinischen Erasmus den Verderber des deutschen Volkes. „Die Rabensteinerin" 1904 feiert in Bartolme Welser den kriegerischen Weltkaufmann, verlangt Anteil an der verteilten Erde und fordert für den Arbeiter statt Knechteslohn Anteil am Gewinn. *Kassandra* „Die Lieder des Euripides" 1904 preisen in Euripides, der die Gefangenen freisingt, den Dichter als Erlöser seines Volkes. Der Stil von Wildenbruchs Dramen, die jede Bedrängnis des Zeitalters über die Szene führen, ist zugleich ein vollkommener Querschnitt durch dieses Zeitalter. Zu den Merkmalen versteinerter Schillerschule fügen sich Bestände genauer Wirklichkeitskunst, symbolhafte Züge, ja unverkennbare erste Anzeichen einer neuen Ausdruckskunst, lang ehe derlei Schulmode wurde. Es scheint, daß Wildenbruchs szenische Kunst ziemlich von Grillparzer gewonnen hat. Durch alle zeitgenössischen Stilhemmungen drängte er im Sinne Herders auf das musikalische Drama, und obwohl er der Meininger Bühnendichter war, auf Bayreuth. So halten „Die Lieder des Euripides" mit ihrer feierlich kultischen Bewegung, ihren Chorliedern und ihrer Begleitmusik einsam auf der Höhe der Zeit. Dieser Beamte des Auswärtigen Amtes steigerte die von der Kriegsgefahr des Jahres 1887 ausgelöste Ahnung zu jenen Seherdramen, in denen mit immer neuen Bildern der kommende Weltbrand vorausschwelte. Im Werk dieses Hohenzollern erstarrte das Reich am eigenen Anblick zur tragischen Maske.

Der letzte König MÜNCHEN, das war die Tragödie der Schönheit. König Ludwig II., 1845 bis 1886, der Sohn des Wittelsbachers und der Hohenzollerin, lebte die Tragödie zwischen zwei Männern, die sie ihm groß und erhaben zu machen

suchten. Ignaz Döllinger, der die Jahresringe seines Zeitalters gleich Narben in der Seele trug, hatte dem Großvater wie dem Vater die Totenrede gehalten, dem Enkel die Schwelle des Thrones gesegnet, war „sein Bossuet" und geistiger Gefährte seiner Einsamkeit geworden. Richard Wagner deutete ihm Königtum und Künstlertum, weil Inbegriff des Weltleides, als das Tragische an sich und wurde sein Freund. Der fünfzehnjährige Prinz war von Schiller erweckt worden. Von Wagners Zuruf getroffen, holte er sich 1864 den Meister nach München und mußte ihn schon nach Jahresfrist dem aufgeschürten Widerspruch seines Landes opfern. Aber er gründete im Sinne Schillers und Wagners sein ganzes menschliches Dasein auf die Bühne. Josef Kainz wurde sein Schauspieler, Karl von Perfall sein Theatermeister. Ludwigs II. Bühnenstil hatte das Gesetz der Meininger. Aus Gründen der künstlerischen Täuschung, nicht der Menschenscheu, ließ der Menschenscheue sich Sondervorstellungen bereiten. Er hatte zwei Vorbilder, ihn abzuschrecken und ihn emporzuziehen. Heinrichs des Löwen warnendes Beispiel trieb ihn zum Dienst am deutschen Einheitswerk. Als König und Bauherr aber wünschte er Ludwig XIV. zu gleichen. Dieser Märchenfürst war gelebtes Meiningertum, der stilecht inszenierte König. Die entartete Zeit adelte dieser edle Verschwender des Königtums. Er war der letzte König und seine früh vollendete Jugend wurde von Greisen beerbt. Er mußte es sich versagen, mit dem letzten Theologen des Zeitalters, dem er so verpflichtend beigestimmt hatte, ans Ende zu gehen. Sein Volk trennte ihn vom letzten Künstler des Jahrhunderts. So fielen sie einsam, jeder für sich, ein Wahrzeichen dessen, daß das in Wagners Sinne dreieinige Reich von Kirche, Kunst, Königtum zu Ende war.

Kein Dichter konnte auf seine Art den Stil dieses Königs haben. Die Königsrunde seines Vaters war bis auf einen Mann zusammengeschmolzen. Das war *Paul Heyse*, der Berliner, der beinahe ein Münchner geworden war und zugleich mit dem neuen Reich auch dichterisch den Versuch zu einem neuen Dasein machte, indem der Meister von Tanagra zum großräumigen Roman überging und in ihm die Welt von Berlin und München vereinigte, daß es wie ein Ganzes aussah. „Die Kinder der Welt" 1873, das sind Berliner Kinder und „Im Paradiese" 1876 leben Adam und Eva von München, nur nicht ganz so, in holder Unschuld. Der märkische „Roman der Stiftsdame" 1877 ist eher Wildenbruch als Fontane und so verwickelt vorgetragen, daß es Storm nicht besser konnte. Mit der Jugend des Tages setzte sich „Merlin" 1892 auseinander und „Über allen Gipfeln" 1895 mit Nietzsche, wie Heyse ihn verstand. „Crone Stäudlin" 1905, „Gegen den Strom" 1907, „Die Geburt

der Venus" 1909 waren ein dreifacher Abschluß. Von „Skizzenbuch" 1877
bis zum „Wintertagebuch" 1903 holte Heyse die lyrische Nachernte eines
matten späten Herbstes ein. Auf der Bühne verstand er von seinen Novellen
her sich ausgezeichnet auf das Wort, das das andere gibt. Doch er hatte kein
Vermögen für die rund gesehene Szene. Was soll man zu „Maria von Mag-
dala" 1899 sagen? Doch nur, daß das Evangelium keine Sprache war für
diese moderne Geschichte: ein freireligiöser Werbeprediger, sein abgefallener

Der Münchner
Wildenbruch

Freund, der Neffe des Amtsrichters, der Sohn des Pastors und zwischen den
dreien die Emanzipierte, der die freie Liebe über geworden ist. Und *Martin*

Martin Greif

Greif, 1839 bis 1911, von Speier, ein verunglückter Offizier, ist der Münchner
Wildenbruch, angefangen von dem epischen Kriegsgedicht „Die Schlacht von
Leipzig" 1863 durch alle Epochen des geschichtlichen Dramas, worunter früh
ein „Prinz Eugen" 1879 und zuletzt ein „General York" 1899, um ganz ge-
recht zu sein. Was Greif ist, das ist er im kleinen Vers. Die zweite Sammlung
seiner Gedichte von 1868 brachte es 1881 auf eine zweite, 1883 auf eine
dritte Auflage. Das scheinbar Einfältige, äußerlich Hilflose, das leidenschafts-
los Stumme, das Greif vom Volksliede her mit Eichendorff und Uhland ge-
meinsam hatte, ist wie bei Mörike Überkunst gesättigter Kultur, schlichte
Lebensart des reichen Mannes, der sich nichts aus seinem Gelde macht. Die
Kleinheit der Gebilde und die unausgegebenen Worte verraten diese Hal-
tung ebenso wie die Paarung von kaltem Formgefühl und sinnlichster Laut-
kunst. Das alles ist weniger denn „elementar". Es ist zweierlei, ob man sich
aus Entbehrung oder Entsagung der irdenen Mundschale bedient.

Kein Wunder. Die Münchner Bewegung der Jugend ging gegen Heyse
und sie nahm Greif mit.

Das
ostfränkische
München

Schon unter Maximilian II. war das staatlich längst gewonnene Ostfranken
im Münchner Spektrum aufgetreten. Jetzt setzte sichs durch. Den fränkischen
Kampfmenschen, dessen Waffe das öffentliche Wort war, hatte das Mainland
des sechzehnten Jahrhunderts in zweierlei Aufzucht reif gemacht: die feinere
und besonnene Willibald Pirkheimers, die draufgängerische Ulrichs von Hut-
ten, des Landknechts der Freiheit und Deutschheit. Mochte er sich auch für
den „reaktionärsten aller Konservativen" erklären, wie ein Enkel und neuer
Ahnherr solcher mainländischer Kampfgestalten ragte Ignaz Döllinger zu
München auf. Seine Landsleute Johann Kaspar Schmidt, der zugunsten des
Ich alle Bindungen verneinte, und Friedrich Rohmer, der sich als Messias
fühlte und den literarischen Kampf gegen Rom führte, sie alle waren Ableger
der einen Urpflanze. Abermals erschien dieser Schlag in seiner ritterlichen
und lanzknechtischen Art. Der Ritter war der Oberst *Heinrich von Reder,*

1824 bis 1909, aus Mellrichstadt. Er hat in seinen „Soldatenliedern" wie in
seinem Epos von Bauernkrieg und Paviaschlacht, „Wotans Heer", die krie-
gerische Seite, er hat mit seiner Starnberger Dorfgeschichte „Fischer-Rosl"
1893, in seinen stimmungsvollen Kleinbildern „Lyrisches Wanderbuch" und
in seinen landschaftlichen „Federzeichnungen" die idyllische Seite gezeigt.
Die Doppelgabe des Wortes und Stiftes wies ihn ebensosehr als Vertreter
des älteren Münchner Geschlechts wie als Geistesverwandten der ostfränki-
schen Jugend aus. Der Lanzknecht war *Michael Georg Conrad*, 1846 bis
1930, ein Bauernsohn aus Gnodstadt. Lehrend und schreibend traf er mit
Nietzsche, in Paris mit Zola zusammen. Und als er 1883 nach München kam,
brachte er die Lebensanschauung der Loge und den deutschen Ehrgeiz mit,
es den westlichen Literaturen gleichzutun. Und das war der Mann.

 Paul Heyses Kreis gab den Anlaß. In München lebte Wolfgang Kirchbach,
1857 bis 1906, von deutschen Eltern zu London geboren. Das Münchner
Kunsttreiben zeichnete sein Malerroman „Salvator Rosa" 1880 und „Kinder
des Reiches" 1883 war ein Novellenbuch. Etwa in der Art von Laubes Reise-
novellen wurden mit dem Blick auf das Reich die deutschen Stämme und
Landschaften gezeichnet. Kirchbach verkehrte bei Heyse. Er ließ sich bei-
fallen, für Martin Greif das Wort zu nehmen. Aus Heyses Kreise wurde er-
widert. Im Hin und Her ging den jungen Leuten die Gefahr unduldsamer
Kunstherrschaft auf. Reder, Conrad, Kirchbach traten zusammen. Karl Bleib-
treu kam hinzu. Und am 1. Jänner 1885 erschien unter Conrads Leitung das
erste Blatt einer neuen Zeitschrift „Die Gesellschaft". Sie hat bis 1902 ausge-
halten. Es hieß: „Diese Zeitschrift ist ein Werkplatz des aus ungeheuren
Wehen und Nöten wiedergeborenen deutschen Geistes in Dichtung und
Kritik, in Kunst und Leben, in Politik und Volkswirtschaft . . . In Gedanken,
Worten und Werken den Charakter des eigenen Landes und Volkes deutlich
und in seiner ursprünglichen göttlichen Schönheit widerzuspiegeln, heißt der
Entwicklung einer vollkommenen Menschheit dienen." Da jede selbständige
Kunstblüte die bewußte Meisterung aller bis jetzt erreichten Kunstfertigkeit
voraussetzte, so gelte es, alles zu erforschen, was besser entwickelte Völker
zur Ausprägung ihrer Eigenart hervorgebracht hätten. Die echten und gro-
ßen Werke des Auslandes, nicht dessen Schund, gelte es lernend aufzuneh-
men. Die Gesellschaft wurde als schöpferische Gegenspielerin des kultur-
hemmenden Staates und der bremsenden Vergangenheit aufgerufen. Martin
Greif und mancher von den Älteren ging unter die Mitarbeiter. Von den Jun-
gen fehlte kaum ein Name, der etwas bedeutete. Sie setzten Kraft gegen die
glatte Formschönheit und das Recht des modernen Gedankens auf allen Ge-

*Fronde
gegen Heyse*

*„Die
Gesellschaft"*

bieten. Eine zweite Gruppe bildete sich um den Münchner Julius Schaum-
Münchner berger, der gleichfalls durch die westeuropäische Schule gegangen war. Er
Zeitschriften gründete zum 1. November 1889 die Zeitschrift „Münchener Kunst", ein
Rundschaublatt für alle Künste. Hier wollte man weg vom Dienst am Nichts-
alsschönen. Man wollte Wirklichkeit, Eintracht von Kunst und Leben. Man
versprach Ehrfurcht vor älteren Leistungen. Zu den Mitarbeitern gehörten
Otto Julius Bierbaum; der Landshuter Hanns von Gumppenberg, der in
Sehnsuchtsliedern um das verlorene Ideal klagte; Heinrich von Reder mit
Beiträgen aus seinem „Skizzenbuch"; der Ansbacher Georg Schaumberg; der
zu Zürich geborene Pfälzer Julius Hillebrand, der das geschichtliche Trauer-
spiel pflegte. Beide Zellkerne verschmolzen, als 1890 unter Conrads Vorsitz
die „Gesellschaft für modernes Leben" gegründet wurde. Sie wollte den
modernen schöpferischen Geist in Gesellschaft, Literatur, Kunst und Wissen-
schaft pflegen, wobei man unter modern verstand: alles vom freien Geist Ge-
wollte, Schönheit nur in der Wahrheit, Wahrheit aber im Leben und in der
Kunst. Man dachte an Sonderausstellungen, Vortragsabende, eine freie
Bühne, deren Gründung mißlang, und an eine eigene Zeitschrift, die März
1891 erschien, „Moderne Blätter" hieß und von Julius Schaumberger geleitet
wurde.

Fortschritt Das war eine ganz andere Sache als in Berlin. Hier ging es, nicht ohne
mit dem Reich Respekt, gegen die Kunst von gestern, die Paul Heyse vertrat. Hier ging es
einfach um Fortschritt mit der Zeit, mit dem Reich, mit Wagner und Nietzsche.
Hier gab es kein Dogma der Form. In München sagte man: leben und leben
lassen. Und was kam dabei heraus? Weder ein „Phantasus" noch „Die
Weber". Denn Kunst ist mit oder ohne Dogma immerhin Können.

Michael Georg Conrad hatte in Paris angefangen. Seine Bücher suchten wie
„Parisiana" 1880, gegen den herrschenden Geschmack, Emile Augier und
Emile Zola zu erheben. Sie gaben wie „Madame Lutetias Töchter" 1883
handgreifliche Schilderungen der Weltstadt. Wie Zola mit den „Rougon-
Macquart" Paris, so wollte Conrad das München Ludwigs II. in der Roman-
„Was die Isar folge „Was die Isar rauscht" 1887 und „Die klugen Jungfrauen" 1889 dar-
rauscht" stellen: den geistigen Niedergang der Stadt, den Verschleiß des edlen Men-
schen in einer Welt von Kunstgauklern, Dirnen, Bauernfängern. Keines die-
ser Bücher unterschied sich im Stil von der seit langem ausgebildeten Sach-
lichkeit. Und alles waren Versuche von einem zum andern: 1893 die Christus-
Conrad, novellen „Bergfeuer"; 1895 der Roman aus dem dreißigsten Jahrhundert „In
Langbehn, purpurner Finsternis"; 1902 der Seelenroman Ludwigs II. „Majestät"; 1905
Conradi der fränkische Dorfmonarch „Der Herrgott am Grenzstein". Heimatlich,

fränkisch, bäuerlich ging mit leisen mystischen Untertönen über seinem Leben von „Salve Regina" 1900 bis „Am hohen Mittag" 1916 der Bogen von Liedern auf, kräftige Farben und natürliche Rhythmen einer Männerseele ohne Furcht und Tadel. Indessen selbst diese lyrischen Gebilde sind nur Sonntagswerke eines geborenen Ritters der freien Feder. Conrad gehört zu den sprachmächtigsten Zeitungsleuten dieses Menschenalters. Seine „Deutschen Weckrufe" 1889 haben gleichzeitig mit Conradis „Wilhelm II." und Langbehns „Rembrandt" — alle drei lebten damals in München — der Epoche jenen Ausweis mitgegeben, nach der sie fortan literarisch behandelt wurde: byzantinische Knechtsgesinnung, blinde Verehrung alles Fremden, Abfall vom Klassikervolk. Der zornige, gradaushauende Krafton seiner Zeitreden wie die volkstolze Kämpferstellung gegen alles Welsche verraten die enge Verwandtschaft: Hutten und Conrad.

Oskar Panizza, 1853 bis 1921, von Kissingen, war durch den Vater italienischer, durch die Mutter hugenottischer Herkunft. Panizza und Conrad waren Landsleute und Freunde. Und wie Conrad ist auch Panizza früh dem Einfluß Richard Wagners erlegen. Er kam nach München, wurde nach einem Pariser Aufenthalt Irrenarzt, ohne sich selber helfen zu können. Denn er starb geisteskrank in einer Bayreuther Heilanstalt. Seine Schriften mögen auch früher als man denkt dem Arzt ebenso merkwürdig erscheinen wie dem Geschichtsschreiber. Nach den „Düsteren Liedern" 1885 von Heine und Tieck her sind wesentlich allein seine Streitschriften aus der Seelenlage wie in den Formen fränkischer Aufwiegler. „Dem Andenken Max Stirners" war das weltanschauliche Bekenntnis „Der Illusionismus und die Rettung der Persönlichkeit" 1895 gewidmet. In der Flugschriftenfolge „Züricher Diskussionen", die er 1897/1899 fast allein füllte, erschienen seine „psychopathologischen" Abhandlungen über literarische und religiöse Gegenstände. Von seinen „Dramen" hat „Das Liebeskonzil" 1894, eine lästerliche Weiterbildung von Evariste Parnys „La guerre des dieux", deutsche Vorläufer in „Luzifers Fall" von Sebastian Sailer und in „Germania, ein Trauerspiel von Pater Elias", das 1800 zu Eichstätt erschienen war. „Dialoge im Geiste Huttens" 1897 handeln von weltanschaulichen und zeitpolitischen Dingen. Worauf es ankommt, das sind „Parisjana, deutsche Verse aus Paris" 1899, zehnzeilige Stanzen, ein zügelloser Tanz ums Fallbeil.

Das also, Conrad und Panizza, sind die jüngste Gruppe aus dem Fähnlein der mainfränkischen Partisanen in der deutschen Literatur. Sie waren in München zu Hause, seit Franken bairisch war. Und alles, was sich um die „Gesellschaft" bewegte, hatte bairischen Stil.

Arzt heile dich selbst

Die neuen Hutten

Ibsen
in München München war nun auch eine Fremdenstadt, wenn sie es in den letzten Jahrzehnten auch nicht immer gern gewesen war. Sie lud die Dichter nicht mehr zu Hofe. Doch wer auf eigene Rechnung und Gefahr kam, konnte so auch dichten, was er wollte. Und von dieser Freiheit wurde reichlich und freimütig Gebrauch gemacht. Henrik Ibsen lebte 1875/1892 in München. Der norwegische Geschichtskult und die Reihe der philosophischen Heldendramen lag hinter ihm. In München begann er Prosa zu schreiben und von den „Stützen der Gesellschaft" 1877 bis zu „Wildente" 1884 die Gesellschaftslüge zu enthüllen. München sah seine neue Wende. Er wandte sich dem Sinnbilddrama zu, indem er in „Rosmersholm" 1886 die Erziehung des Edelmenschen erwog, in „Hedda Gabler" 1890 die Tragödie der freigewordenen Nora und in „Baumeister Solneß" 1892 die Tragödie des Künstlers gab. In Berlin war der niedersächsische Zuzug auf Bewegungen gestoßen, die

Sachsen
in München sich seiner Formanlage entzogen. In München traf er es besser. Hier gab es weder einen maßgeblichen Stil, noch eine vorherrschende Gruppe. Hier gab es Maskenfreiheit. So haben sie sich in München alle ungehemmt entwickelt: Christian Morgenstern zu seinen grotesken wie zu seinen gedankentiefen Versen; Heinrich Mann zu seinen erotischen, wie Thomas Mann zu seinen ironisch angehauchten Romanen. Und es gab zu Ibsen kein schärferes Gegenspiel als die phantastisch-grotesken Stücke Frank Wedekinds.

München bei sich Da hatte es der gebürtige Münchner bei sich zu Hause mit der Literatur gar nicht leicht. Das Beste war ein weites Herz. Franz Bonn, 1830 bis 1894, stand mit seinem Terzinenepos „Jacopone da Todi" noch in der Nähe Brentanos, mit seinem berühmten Volksstück „Gundel am Königssee", schon unter den Bauerndichtern. Max Haushofer, 1840 bis 1907, trieb es mit Geibel und Scheffel, war Volkskundler und Alpenschilderer, verstand sich auf die Grenzfälle zwischen Diesseits und Jenseits ebenso wie auf Jules Verne und übertraf endlich alles, was er gekonnt hatte, mit „Prinz Schnuckelbold" 1906, dem Märchenepos vom Wechselbalg, der die Schönheit sucht. Karl Stieler,

Stilkunst 1842 bis 1885, erging sich in kulturgeschichtlichen Bergschilderungen wie bäuerlichen Kleinbildern und verstand sich auf die lyrische Mundart, ohne den Oberbaier ins Schöne oder Häßliche zu verfälschen. Anton von Perfall, Hans von Hopfen, Karl August von Heigel hielten die Mittellinie des Gesellschaftsromans, worunter sie seinen Verzicht auf das verstanden, was rechts und links davon im Kloster oder auf dem Dorf geschah. Ferdinand von Hornstein, der die satirisch bittere Novelle ebenso konnte wie den hinreißenden Schwank, wagte sich an eine großartig entworfene Trilogie: „Buddha" 1899, auf indisch die Legende, wie ein Mensch zum Propheten wird; „Mohammed"

1906, auf arabisch das Spiel vom betrogenen Propheten; „Mysterium" 1913, auf abendländischem Hintergrunde Christus als Aufrührer der Gegenwart. Das ist alles in allem schon eine Reihe von Charakterköpfen, die sich nicht überfremden ließen, und eine Dichtung, die so fest im Mittelpunkt des Wirklichen hing, daß sie schon einen kräftigen Umschwung durchs Jenseits wagen konnte. Bairisch hieß keineswegs bäurisch.

Aber die bairische Bauernkunst trieb immer neue Schößlinge. Der Münchner *Konrad Dreher*, 1859 geboren, gründete 1893 das Schlierseer Bauerntheater, führte es auf Gastreisen und schrieb dafür erfolgreiche Stücke. Drei Baiern bezeugen die Fortbildung des alten und die Findung des neuen bairischen Stils. Jeder von ihnen glich dem Manne mit den zwei verschiedenen Gesichtshälften, der ernsten und der fröhlichen. Der Landshuter *Hanns von Gumppenberg*, 1866 bis 1928, hat in der allgemeinen Richtung gleichläufig zu Wildenbruch den Weg Martin Greifs wieder aufgenommen. Aus Grundsatz Dichter der Wirklichkeit zu sein, hat er ebenso abgelehnt, wie aus bloßer Ehrfurcht sich den klassischen Formgesetzen zu unterwerfen. Er hat die jeweilige Aufgabe aus keinem anderen Gesichtspunkte gelöst als dem des Theaters, bei dem „Messias" 1890 ebenso stilgemäß wie bei den morgenländischen Stücken „Alles und nichts" 1894, „Der Einzige" 1907, „Der Pinsel Yings" 1914 oder bei „König Konrad I." und „König Heinrich I.", den deutschen Vorwürfen. Mit gleicher Sicherheit sind die gegensätzlichen Ansprüche gemeistert, die das schwere Gedankenspiel und der anmutige Scherz stellen. Schließlich hat Gumppenberg sich in der Parodie glänzend ausgewiesen, wenn er — „Das teutsche Dichterroß" und „Die elf Scharfrichter" 1901 — die zeitgenössischen Stilarten des Dramas und die deutsche Lyrik von Heine bis George lachend nachmachte. Der Münchner *Josef Ruederer*, 1861 bis 1915, karikierte den Bauer ins Boshafte, eine ebenso weite Linksabweichung von der Natur, wie die Schönfärber nach rechts gesündigt hatten. Was in Sichtweite der bairischen Berge seit Menschenaltern Kunstübung war, kann bei Ruederer unmöglich Stil der „Familie Selicke" heißen. Von seinen Dramen berichtigte „Die Fahnenweihe" 1894 das rührsame Bauernstück mit grimmiger Laune ins Gegenteil, verhöhnte das Lola-Montez-Stück „Die Morgenröte" 1904 Freiheitshelden und Philister, erneuerte „Wolkenkuckucksheim" die „Vögel" des Aristophanes und stellte „Der Schmied von Kochel" 1910 ein volkstümliches Trauerspiel. „Ein Verrückter" 1894 schildert den verzweifelten Kampf eines Lehrers mit seinen kirchlichen Vorgesetzten. Novellenbücher wie „Tragikomödien" 1897 sowie „Wallfahrer-, Maler- und Mördergeschichten" 1899 bezeugen die Grausamkeit des Weltwillens, den

Bauernkunst

„Das teutsche Dichterroß"

„Die Fahnenweihe"

man durchschauen muß, um ihn lächelnd überwinden zu können. *Ludwig Thoma*, 1867 bis 1923, aus Oberammergau, gab die bäuerliche Welt so wie sie ist, ohne Abzug oder Zusatz. Seine Komödien „Die Medaille" 1901, „Die Lokalbahn" 1902, „Moral" 1909, „Erster Klasse" 1910 spielen um die kleinen Vorfälle der Amtsgewalt und der bürgerlichen Staatsbeziehung, Idyllen des Unzulänglichen und der Scham, die sich verrät. Sie haben immer den besonderen Fall im Auge, den jedermann aus dem Leibblatt oder der eigenen Wahrnehmung bestätigen kann. Wenn einer den bairischen Bauer kannte, so war es Thoma. Allerdings erscheint der Bauer, wie er in dem Geschichtenbuch „Agricola" 1897, in den Romanen und Erzählungen „Hochzeit" 1901, „Die Wilderer" 1903, „Andreas Vöst" 1905, „Der Wittiber" 1911 geschildert wird, als von Natur schlecht, wie der Mensch überhaupt, und daher von seinen üblen Seiten. Doch nirgends nimmt Thoma den Bauer tragisch oder verzweifelt, sondern überall bejahend, wie er das Leben bejaht. Und da er sich in der Bürgerstube ebenso gut auskennt, rückt er auch dort, in den klassischen „Lausbubengeschichten" 1904, „Kleinstadtgeschichten und Moritaten" 1908, Hauptsächelchen und Nebendinge aus dem keuschen Winkel ans offene Fenster. Die Begabteste war wohl die vierte zu diesen dreien, *Lena Christ*, 1881 bis 1920, aus Glonn in Oberbaiern. Ihre „Erinnerungen" 1912 machen eine ungewöhnlich harte Jugend wieder lebendig, das ungeliebte Dasein eines ledigen Kindes. Der Mann, der ihre Gaben entdeckte, hat ihr dann das kurze Glück einer zweiten Ehe geschenkt. Mit ihren „Lausdirndlgeschichten" 1913 ging sie Ludwig Thoma nach. Als sie es dann besser konnte, stand sie sich selber Modell. „Madam Bäurin" 1920 wurde die glückhafte Geschichte, wie ein Stadtmädel Bäurin lernt. In dem Band „Bauern" 1919 treten Bilder, Vorgänge und Gestalten des Dorfes zu einem kraftvollen Reigen der Wirklichkeit zusammen. Das ganze bäuerliche Dasein mit Lebensweise und Brauchtum, mit seinem Lied und seiner Laune, schwer von Gott und voll des Ackers, das Bauerntum in Gestalt des oberbairischen Hofes lebt durch die Erfahrung dieser Frau in ihren Büchern, lebt völlig ungewollt und unbezweckt, so triebhaft, wie es nicht der Mann, sondern nur die Frau vermag. Vergnügte Parodie, bittere Karikatur, Sankt Grobianus, das war die bairische Tonleiter dieser Vierheit, in der Hanns von Gumppenberg und Lena Christ am weitesten von einander abstehn.

Die angesammelte Spannung dieser Stadt entlud sich, als der Verleger nordischer Literatur Albert Langen 1896 das bebilderte satirische Blatt „Simplicissimus" gründete. Die ersten und führenden Zeichner waren Theodor Thomas Heine, Olaf Gulbransson, Ferdinand von Reznicek, Wilhelm Schulz.

„Erster Klasse"

„Madam Bäurin"

„Simplicissimus"

Literarische Mitarbeiter unter den ersten waren Karl Kraus und Ludwig Thoma. Der Standpunkt wechselte je nach den Beiträgen: Quartier latin, der Raunzer, der Gesellschaftskritiker, der Aufwiegler. Im „Simplicissimus" hat sich der Wandel des Stils und der Gesinnung von Michael Georg Conrad zu Heinrich Mann vollzogen: die Zerstörung der Kaiserlegende, die Entmutigung des Bürgertums durch seine gefälschte Jammerfratze, der deutsche Umsturz. Dagegen schuf der Verleger der „Münchner Neuesten Nachrichten" Georg Hirth im Jänner 1896 die bürgerliche Bilderwochenschrift „Jugend". *„Jugend"* Ihre Haltung war national-liberal. Diese farbige Zeitschrift, ernst, launig und nicht aus Grundsatz, sondern mit Verantwortung satirisch, setzte auf eine neue Art die Altmünchner Überlieferung der Wort- und Bildkunst fort. Beide Unternehmungen waren wirksame Stilherde, der gemeinsame Tummelplatz der eingebürgerten Münchner Fremdkunst. Otto Julius Bierbaum entwickelte sich zum Kunstschriftsteller. Er gab 1893/1894 das Sammelbuch der Münchner Gruppe, den „Modernen Musenalmanach" heraus. Franz Blei und Karl *„Moderner Musen-almanach"* Sternheim gründeten 1908 die Zweimonatsschrift „Hyperion", ein buchkünstlerisches Unternehmen. Und 1912 gründeten der Bremer Rudolf Alexander Schröder, der Königsberger Rudolf Borchardt, der Wiener Hugo von Hofmannsthal den Verlag der „Bremer Presse" für Ausgaben von Rang.

Kräfte des Aufbaues und der Abwehr wurden nach guter alter Münchner Sitte vom Rhein her in Bewegung gesetzt. Von Wilhelm Weigand aus Gissigheim in Baden, einem gelassenen Bespöttler literarischer Torheiten, aber auch Lyriker von Wohllaut und Glanz, und von Nikolaus Cossmann aus Baden-Baden, einem Aphorismenkünstler, wurde 1904 die große Zeitschrift „Süddeutsche Monatshefte" gegründet. Der Schwabe Josef Hofmiller aus *„Süddeutsche Monatshefte"* Kranzegg gab der Zeitschrift mit glänzenden Arbeiten kritisches Ansehn. Karl Muth aus Worms, der gelegentlich mit Conrad zusammengearbeitet hatte und von Richard Wagner kam, ließ 1898 die Flugschrift erscheinen: „Steht die katholische Belletristik auf der Höhe der Zeit?" Die Flugschrift erregte Sturm. Und als Muth die Aussprache fortsetzte — „Die literarischen Aufgaben der deutschen Katholiken" 1899 — kam es zu einem regelrechten Krieg, wobei der Wiener Kralikkreis eine Gegenstellung ausbaute. Und 1902, im selben Jahr, da Conrads „Gesellschaft" einging, gab Muth seine Monatsschrift „Hochland" heraus. Mit modern hergestellten Kunstblättern ausge- *„Hochland"* stattet, war es das erste würdige Unternehmen der deutschen Katholiken. Sie umfaßte alle Kulturgebiete, pflegte vor allem die Prosadichtung und hielt Kritik. Die Zeitschrift stand allein, bis der Lausitzer Expeditus Schmidt 1908 sein Blatt „Über den Wassern" ins Leben rief.

Das war längst nicht mehr die Stadt des Königs der Schönheit. Aus ihr erhob sich Jugend von zweierlei Art und Maß. Maximilian Kronberger, der 1904 mit sechzehn Jahren starb und Verse von der Reife eines Fünfundzwanzigjährigen hinterließ, sah als Erfüllung von Jahrtausenden alle Ketten brechen und der weitgeborstenen Erde einen neuen Halbgott entsteigen. Der zweiundzwanzigjährige Johannes Robert Becher schleuderte 1913 die erste *„De Profundis"* Fackel des Aufruhrs „De Profundis Domine". Zwischen solchen Jünglingen hüben und drüben stand die Waage der Zukunft.

2. DER UMKREIS

Die drei Land-
schaftsgruppen Das sind die großen Landschaftsgruppen: die ostdeutsche, die niedersächsische, die rheinische. Von ihnen gehn die geistigen Ereignisse des Zeitalters aus, die sich in Berlin und München zusammendrängen und vollstrecken. Aus diesen heimatlichen Bereichen, denen sie entstammen, empfangen sie ihren geschichtlichen Sinn, und nicht von den Mittelpunkten, an denen sie sich erwirken. Das ist eine Tatsache, die nicht nur zu erkennen ist, sondern vielen Trägern des geistigen Lebens persönlich bewußt war.

Der Osten DER DEUTSCHE OSTEN ist nun seit Opitz zum viertenmal, Ostpreußen seit Gottsched zum drittenmal der Bewegungsherd eines neuen Schrifttums. Wenn es auch Lehre und Beispiel immer zusammen waren, die Lehre, nicht das Beispiel hatten im Falle Opitz, Gottsched, Herder den Ausschlag gegeben. Diesmal war es die schöpferische Tat. Wohin immer Schopenhauers Schüler und Nachdenker seine Ideen verzettelten, Schopenhauer selber war die nächste Vorstufe dessen, was nun geschah: seine Wendung zum Morgenlande, seine Seelenwanderung, sein Weltleid. Vor allem war es sein Grundsatz: jedes Ding ist schön, da jedes frei von allen Beziehungen betrachtet werden kann und in jedem der Wille auf irgendeiner Stufe der Verwirklichung erscheint. Dieser Satz bereits hob den Unterschied von „poetischen" und „unpoetischen" Gegenständen auf und machte sie zu Verwandlungsgesichtern des einen Urwesens.

Altpreußen Von Ostpreußen kam der Mann, der diese ostdeutschen Kunstlehrmeister durch Tat und Beispiel ablöste und zugleich wie Schopenhauers Weltwille sich selbst als das All in seinen Verwandlungen erlebte und diesem Erlebnis das Formgesetz gab: Kunst ist Natur.

„Schläft ein
Lied in allen
Dingen" Arno Holz, 1863 bis 1929, aus Rastenburg, war wie die meisten schöpferisch bildenden Köpfe des Landes mitteldeutscher Herkunft, durch den

Vater aus einer Apothekerfamilie des preußischen Städtchens Saalfeld, durch *Arno Holz.*
die Mutter aus einer zugewanderten Gutsbesitzerfamilie. Alle seine Werke *Das Drama*
sind auseinander, miteinander, wegeneinander entstanden. Sie gehen alle auf
das „Buch der Zeit" 1886 zurück als auf den einen und gleichen Binnenkern.

„Buch der Zeit", der eine Grundbestand, war Tadel des geltenden Schrift-
tums und Kampf um eine neue Kunst. Von seiner Werkstatt her aufs Drama
eingeschossen, suchte Holz zunächst im Drama seine große Form. „Berlin,
die Wende einer Zeit in Dramen" sollte eine Folge von zwölf Stücken wer-
den. Es blieb bei dreien, von denen das erste, die Komödie „Sozialaristokra-
ten" 1896, jenen Literatursatiren am nächsten stand und den Stil der gesuch-
ten Natur überzeugend traf. In jedem Wort und jeder Gebärde mit Selbst-
erlebtem geladen, nimmt sie die Frage der neuen Kunst von der lächerlichen
Seite und ist die gültige Komödie jeder literarischen Handwerkerei. Das Ent-
hüllungsdrama „Sonnenfinsternis" 1907 stellt sie ernst im Sinne der vor-
geschrittenen Zeit. Ein gemalter Baum bleibt auch bei größter Naturtreue
von der gewachsenen Wirklichkeit unendlich entfernt. „Gib mir . . . eine Idee,
an die ich wieder glauben darf." Der Wahnwitz des Lebens, hier das Urweib,
das alles, selbst den eigenen Vater unbewußtwissend verführt, ist wie das
Fegefeuer. Man muß hindurch, um ihn darzustellen. Und darstellen, heißt
der Sinnlichkeit des Lebens Sinn geben. Hier der großartige Schlußplan eines
Marmorbildes, „Berg des Lebens", worauf es in hundert Gestalten von Liebe
wimmelt: „Taumel und Anbetung, Inbrunst und Brunst, Cherub und Tier."
Das ist nicht mehr Natur um der Natur willen, sondern Natur um der Idee
willen, Weltüberwindung durch Weltdarstellung. Holz ist auf ungefähre
Höhe mit Schopenhauer gelangt. Die Enthüllungstragödie „Ignorabimus"
1913 fügte zu diesem Trauerspiel der Kunst die Tragödie der Wissenschaft.
Wenn es hier um das dunkle Geheimreich der Seele geht, um die Lebens-
einheit der lebenden mit der toten Schwester, um die gerächte Schuld der
Ahnfrau durch Austilgung bis ins letzte Glied, all dies Schicksal dreier Gene-
rationen auf einen Tag zusammengedrängt und als Schicksalstragödie durch
ein unheilbringendes Gerät entladen, so können wir nicht wacher inmitten
der Romantik stehen. Wie Eichendorffs Lieder, so streben diese Spiele die
ständige Gegenwart aller Sinne an. Die Großstadtgeräusche, der Beleuch-
tungswechsel des Tages, Vogelstimmen, das Rauschen des Hagels und des
Regens an den Fenstern, der Schlag der Uhren, alles wird Begleitmusik und
wirkt wie instrumentierte Stadt und Natur. Es ist ein Naturmusikdrama als
äußerster Gegenpol zu Richard Wagner.

„Buch der Zeit", der zweite Grundbestand enthielt bereits Formsatiren

Stilparodie und Stilulk. Fritz Mauthner war schon 1878 und 1880 — „Nach berühmten
Mustern" — vorangegangen, jüngst noch 1901 Hanns vom Gumppenberg
mit seinem „Teutschen Dichterroß". So ist, ein satirisches Zerrbild der geg-
nerischen Stilarten, das phantastische Drama „Die Blechschmiede" entstan-
den. Die rohe Urfassung erschien 1902, ein Neudruck 1917, wurde 1921 in
fünf Aufzüge und vier Zwischenspiele gegliedert und erhielt 1924 ihre jüngste
Gestalt. Dabei ist das Drama über die Stilparodie Stephan Georges und
Richard Dehmels hinausgewachsen zu einer modernen Walpurgisnacht und
einem „grotesk-erotesken" Schaubilde: die Welt als Geschlechtsakt. „Blech-
schmiede" ist ein Kinodrama, und zwar von barockem Stil, wie schon der
Titelsatz in Art der Barockbücher unterstreicht. Die Hauptgestalten bleiben
durch das ganze Stück im Vordergrunde und wahren die Einheit: Kampf des
Dichters wider seine ungemäße Zeit. Holz bekennt sich zu Heine, Swift,
Cervantes, Rabelais, Aristophanes als seinen Vorgängern. Fischart, zumal
dessen Trunkenlitanei, ist nicht zu verkennen. Dieses „Zirbeldrüsendrama"
ist der Form nach Parodie auf Goethes „Faust", dessen Blocksberg auf die
letzte Höhe des Frevels gesteigert wird, eine Abrechnung mit George, dem
Meister des Schwulstes, eine „Chrie gegen jegliche Hysterie". Johann Georg
Hamann und seine „Wolken" 1761; Reinhold Lenz und sein „Pandaemo-
nium Germanicum" 1775; Arno Holz und seine „Blechschmiede" 1924; zwei
Ostpreußen mit dem Balten in der Mitte. Anderthalb Jahrhunderte ostdeut-
schen Ringens um das eigene Selbst gipfeln in dem schneidenden Gegensatz
der drei Zeitgedichte und Zeitgerichte.

Stilporträt „Buch der Zeit", der dritte Grundbestand, die Gleichheit von Sache-Wort,
erzeugte das dritte Gebilde, das Gegenstück zur Stilparodie, das Stilporträt.
„Dafnis" 1904, die Schlußfassung von „Lieder auf einer alten Laute" 1903,
steht als Liederbuch gegen die Dramen und als ernst gemeinte Gesichtsmaske
gegen den parodierten Zeitstil der „Blechschmiede". Mit Sprache, Vers,
Druckbild täuschend wirklich, ist „Dafnis" vollkommen echt, was das Buch
sein soll, ganz Natur seines Gegenstandes.

„Buch der Zeit", mitten aus seinem Kern ist „Phantasus" aufgewachsen.
Name wie Keim dieses Großgedichts ruhen in jener Gedichtgruppe des
„Buch der Zeit", wo immer abwechselnd in je einem Gedicht die Außen-
schicksale und die Innenbilder eines verhungernden jungen Dichters geschil-
Arno Holz. dert sind. Diese Gruppe ist „Phantasus" überschrieben. Das erste gestaltlich
„Phantasus" phantasusähnliche Gedicht stammt aus dem Jahre 1886 und wurde in der
zweiten Auflage des „Buch der Zeit" 1892 gedruckt. Neun weitere Gedichte
dieses Stils erschienen 1893 in Bierbaums Musenalmanach. Das erste Phan-

tasusheft kam 1898, ein zweites 1899 heraus. Die gleichzeitige Schrift „Revolution der Lyrik" gab die kunstgesetzlichen Unterlagen. Doch das war nur ein Anfang. Es waren einzelne Gedichte, kein Weltgewebe. Das wurden sie nach und nach durch vierzigjährige Arbeit, ausgehämmert zu wahren Streckversen. So 1916 die Neuausgabe, so 1925 die jüngste Fassung. Sie waren ein Weltbild in geordneten Worten und in neun Büchern geworden. Und diese Bücher gliedern sich selber wie ein Phantasusgedicht. Das erste Buch steht für sich und faßt das Ichallerlebnis des Dichters, seine Wiedergeburten, in ein weltumspannendes, zeitenerfüllendes Vorgesicht zusammen, indem es mit dem Machtrausch des asiatischen Eroberers beginnt und dann aus der Rückschau die Geschichte hinunter, den Lebensstammbaum hinabsinken läßt bis zum Protoplasmaklümpchen. „Ich bin, was meine Zellen sind." Darunter stehen, auf gleicher Linie gegeneinander ausgewogen, als zweites das Buch der Kindheit — die Rastenburger Kinderidyllen — und als drittes das Buch der Liebe — der Berliner Liebesroman des jungen Herzens. Wiederum darunter und abermals auf einer Linie, drei Bücher als großartiges Mittelstück: zu viert das Buch vom Traumglück; zu fünft das Buch vom Traumhelden und seinem Liebeserlebnis im Mythus aller Länder; zu sechst das Buch der Traumreisen. Darunter auf gleicher Linie siebentens das Buch der Götter, erlebter Gestaltenwandel der Gottesbilder, und achtens das Buch der Spötter, der Dichter als Gastgeber in seiner Dachkammer. Zum Beschluß für sich, dem ersten Buch entsprechend, das neunte, noch einmal die ganze Tonleiter vom Zartesten zum Grellsten, vom Hauch bis zum Brausen der Welt hindurchspielend, das Buch der Bekenntnisse. „Alles durchrann mich. — Höher und höher — strebt — mein Geist, — läutert sich, erlöst sich, — hebt sich, — verschwebt sich, verwebt sich — ins All. — Mein Staub — verstob; — wie ein Stern — strahlt mein Gedächtnis." Dieses Großgedicht drängte Harts Riesenplan vom „Lied der Menschheit" in eine Fünfminutenschau des Lebensstammbaumes, der Religionswandlungen und Kulturgeschichte zusammen und erschöpfte zugleich die Weltalldichtung Willes und Bölsches in einer lyrischen Rhapsodie. So war jener „Berg des Lebens" entstanden, von dem Holz in „Sonnenfinsternis" geträumt hatte.

Gleichermaßen neu und groß war hier das Was und das Wie. Keine „gesammelten" Gedichte, die, wenn es hoch kam, zu Reihen oder Kränzen geordnet waren, sondern: eine Welt, eine Seele, ein Gedicht. Doch jedes Gesicht, jede Regung, jeder Ausdruck hatte seinen eigenen Rhythmus. „Schläft ein Lied in allen Dingen", hatte es bei Eichendorff geheißen. „Du greifst den Rhythmus, wenn du die Dinge greifst", hieß es gleichen Sinnes bei Holz.

„Revolution der Lyrik"

„Alles durchrann mich"

Eine Welt — ein Gedicht

Also unter Verzicht auf den Reim, der zur Mitnahme der zugehörigen Vorstellungskreise zwingt; unter Verzicht auf die Strophe, die durch Wiederholung die erste Schönheit banal macht; unter Verzicht auf jede selbsttätige *Der Vers* Wortmusik: nichts als Gleichartigkeit, Gleichzeitigkeit, Dreieinigkeit von Gegenstand, Rhythmus und Wort. Das waren keine „freien", sondern die denkbar zahlenstrengsten Rhythmen. Einheit ist die Zeile. Ihr Wortbestand steht unter dem Gesetz der Zahl. Die geraden Zeilen teilen und grenzen ab. Die ungeraden Zeilen überschneiden und verbinden. Die Zeilen sind nach Maß und Gewicht von der Mitte her halb zu halb ausgewogen. Die durchlaufende Mittelachse, nach der die Zeilen geordnet sind, war nicht bloß bequem und handlich, sie ergab sich notwendig aus dem Wesen der Sache. Und doch war hier keine „Revolution" geschehen, wie Holz seine Schrift in der ersten Ausgabe nannte, sondern eine „Evolution", wie sie in den Werken heißt. Das gehäufte Beiwort war religiöse Ursprache, der homerischen Hymnen, der christlichen Litanei, des islamitischen Korans. Das Fangballspiel der Sprache hatten Fischart und Abraham a Sancta Clara kunstvoll ausgebildet. Rückert und seine „Makamen" hatten die reimverschlungene Prosa, Platen die Fülle der zusammengesetzten Worte bis an die Grenze des Möglichen geführt. Um all das muß Holz gewußt haben. Der alamannische Mönch des zehnten Jahrhunderts, Notker, hatte zu Sankt Gallen die Sequenz geschaffen. Er wog je zwei Verspaare gegeneinander ab, wie Holz zwei Zeilenhälften. Schriebe man Notkers paarige Verse nebeneinander oder Holzens Hälften untereinander, so hätte man das Gesetz, das, freilich zwiefach, in ihnen wirkt. Das bedeutet: Holz führt die Spirale eines Jahrtausends über die Stelle des Ausgangs zurück. Arno Holz selber bezieht sich an einer wichtigen Stelle seiner „Evolution der Lyrik" auf den „vorausahnenden" Herder. In der Tat. Hundert Jahre nach Herders Sprachschrift hatte Herders Landsmann Herders Gedanken von der ursprünglichen Einheit Sprache-Mythus-Dichtung wahr gemacht. Und Holz hat es getroffen. „Für solche Dinge muß man wie ich aus dem bittersten Nordnordosten sein."

Altpreußische Heimat Wo das Ich mit so wurzellösender Fliehkraft in das Grenzenlose der Zeit und des Raumes gerissen wurde, mußte die Ziehkraft des Wir sich verstärken und den Drang ins Jenseitige um so fester im Diesseits verankern. Die Metaphysik des Werdens und Entwerdens bedurfte eines ruhenden Bürgerdaseins. Bürgertum aber hat in Preußen nie etwas anderes als Freisinn bedeutet. Diesem ostpreußischen Bürgersinn lag eine nicht unbeteiligte lustspielmäßige oder erzählende Kritik der Gesellschaft, Sitte, Wirtschaft. Ihm lag ein heimatlich zuständliches Geschichtsgefühl. Diese Haltung verkörperte Ernst Wi-

chert, 1831 bis 1902, aus Insterburg. Er war ein sehr geschickter literarischer *„Litauische Geschichten"* Aneigner mit bescheidenen künstlerischen Ansprüchen, in Roman und Drama ein Aufarbeiter preußischer Gesellschaftsfragen und preußischer Geschichte, mit seinen „Litauischen Geschichten" 1881 hart am Stichwort der Zeit. In seiner Selbstschilderung hat Wichert die Lage getroffen: „Sitten und Gebräuche hatten sich länger als anderswo halten können. Auch wenn ich ein paar Jahrhunderte zurückging, versagte die Anlehnung an Selbsterlebtes nicht ganz." Ernst Wichert war die allgemeine Ausgangsstellung, über die es nun vorging.

Hermann Sudermann, 1857 bis 1928, stammte vom Gut Matziken im *Sudermanns Romane* Memellande. Vom Vater war es eine holländische Mennonitenfamilie der Weichselgabeln bäuerlichen Wesens. Die Familie der Mutter war seit alters landsässig. Mit zwanzig Jahren kam Sudermann nach Berlin und wurde Leiter des freisinnigen „Deutschen Reichsblatt", später des „Reichsfreund". Die Widerpaare der Zeit heißen nicht Holz und Hauptmann und nicht Hauptmann und Sudermann, sondern Sudermann und Holz. Sudermann aber war auf eigenem ostdeutschem Grunde ein selbständiger Einsatz. Sein ursprünglicher künstlerischer Wille hieß Heimat. Darauf wies von seinen Erstlingen „Die Geschichte der stillen Mühle". Und dafür zeugten seine drei Romane. „Frau Sorge" 1887 ist harte Arbeit um einen Hof und Erweckung eines vergrübelten Menschen zum Gemeinschaftsleben. Das Buch hat die Stimmung dieses Landes der langen Winter, des grauen Himmels, des feierlich weiten und stummen Raumes. „Der Katzensteg" 1889 erzählt, wie ein halbpolni- *„Frau Sorge"* scher Junker 1807 sein Gut durch Verrat ins Verderben stürzt und sein Sohn 1813 den Namen wieder ehrlich macht. „Es war" 1894 ist abermals ein ostpreußisches Gut mit allem, was dazu gehört, unter dem Einfluß der Norweger und Russen seelisch mit satteren Farben gemalt. Der Erzähler Sudermann wußte zuverlässige Eindrücke wortsicher wiederzugeben. Er konnte sich auf seine erfinderischen Einfälle verlassen und baute bei sparsamem Stoffaufwand zierlich und tragfähig. Was immer erzählt wird, ist eine Geschichte ohne seelisches Herumdröseln, ohne säumiges Weltanschauungsgerede, ohne zwecklose Stimmungsmalerei. Es sind, was auf einen geborenen Komödienmeister deutet, wirklich bewegte Gestalten eines Spiels. Sie erzählen durch Gebärden und durch das, was sie vorstellen. So hat sich dieser Ostpreuße nicht an der Großstadt, sondern gegen sie entwickelt. Dafür sprechen die plaudernd erzählten Geschichten „Im Zwielicht" 1887, die das Allzumenschliche der Berliner Gesellschaft aufs Korn nehmen.

Sudermanns Wendung von der Heimat zur Großstadt war zugleich Schritt-

wechsel vom Roman zum Drama. Es war ein Anfangssprung mit beiden Füßen. Denn „Die Ehre" 1889 und „Sodoms Ende" 1891 sind ein Paar. Beide spielen, wie längst zu Wien gebräuchlich, zwischen Vorderhaus und Hinterhaus. Es sind keine Auseinandersetzungen, sondern einfach Spiegeldramen der Berliner Gesellschaft. Sie halten die literatenhafte Scheinkultur der Stadt fest. Dort geht es um die Ehre und hier um die Sittlichkeit. Entscheidende Wandlungen bereiten sich vor. Das war eine Komödie, „Die Schmetterlingsschlacht" 1895, ein ironisch verstecktes, ein bürgerlich verkleidetes Märchen, die Geschichte von dem heimlichen Prinzeßlein, an dem kein Schmutz zu haften vermag. Und das sind die beiden Einakter von 1896 „Fritzchen" und „Das Ewig-Männliche", tragisch und schwankhaft die ernste und die nur gespielte, die wirkliche und die geheuchelte Todesweihe. Zwischen beide Einakter hindurch ging Sudermann nun seinen Großstadtweg zu Ende mit Stükken, deren Eigenstil eine sorgfältige Sachlichkeit war: nach der einen Seite „Es lebe das Leben" 1902, wo auf die Frage nach dem Sinn des Lebens „Opfer und Wirken" geantwortet wird; „Das Blumenboot" 1905 mit dem Kerngedanken „Müßiggang ist aller Laster Anfang"; nach der andern Seite

„Der Sturmgeselle Sokrates" 1903, wo komisch an der Demokratie das Banale als Auslauf aller geistigen Bewegungen gezeigt wird; „Stein unter Steinen" 1905, wo die Zurückgabe des Selbstbewußtseins als einzige Rettung des entlassenen Strafgefangenen erscheint. Der Roman „Das hohe Lied" 1908, vorgeblich ein Weltbild, in Wirklichkeit nichts als das Weib zwischen Bürgertum und Halbwelt, schloß dies Zwischenspiel ab. Denn es war nicht mehr gewesen. Es war Schuld der andern, wenn sein Stil mit dem verwechselt wurde, was unsichere Sucher aus „Papa Hamlet" und „Familie Selicke" gemacht hatten. Sudermann hatte sich vor dem Verfall an Berlin bewahrt, indem er sein Heimaterlebnis ins Dramatische übersetzte. Die Brücke von den Heimatromanen zu den Heimatdramen schlug die kunstvolle Rahmengeschichte „Jolanthes Hochzeit" 1892, komödienhaft der Mann von fünfzig Jahren auf ostpreußisch-junkerlich. Die drei Stücke „Heimat" 1893, „Das Glück im Winckel" 1896, „Johannisfeuer" 1900 formten endlich an ostpreußischen Menschen den Gegensatz von Ich und Gemeinschaft sowie die Spannung von Junkertum und Bürgertum heraus.

 In dieser wirklichkeitstreuen Gegenwartskunst steckte seit dem „Katzensteg" ein geschichtlicher, seit der „Schmetterlingsschlacht" ein verdeckt mythischer, seit „Das Ewig-Männliche" ein klassisch-romantischer Kern. Aus diesen Beständen trieb Sudermann nun sein Werk weiter. Der Einakter „Teja" 1896 wies ebenso auf Dahn wie auf Wildenbruch und ließ Suder-

manns neue Linie bereits klar erkennen. Da ist eine einzige Szene: die erste *„Das Bilderbuch*
und zugleich letzte Nacht des Gotenhelden mit seiner eben angetrauten *meiner Jugend"*
Gattin vor der Todesschlacht am Vesuv. Die Tragödie „Johannes" 1898 gab
Gegenwartsfragen in biblischer Fernsicht, das staatliche Trauerspiel eines
Volkes in seiner ganzen Breite. Johannes ist der Prophet, der an seiner Zeit
irre geworden und um eines Größeren willen verlassen wird. „Die Lob-
gesänge des Claudian" 1914 haben, was Wildenbruch erstrebte, in einem
höheren Bereich verwirklicht. Der Kampf des großen Mannes, des Vandalen
Stilicho, gegen den unabwendbaren Weltuntergang, der pflichtbewußt sich
Opfernde zwischen dem noch nicht reifen und dem nicht mehr gesunden
Volk, diese Tragik an sich ward nicht durch Stilicho selber szenisch sichtbar,
sondern durch die Gestalt seines „Pressechefs" Claudian, der verstoßen, sich
rächend, zu spät bereuend mit dem außerhalb der Szene gehaltenen Stilicho
untergeht. Das waren die geschichtlichen Stilzüge. Nur wenig später baute
Sudermann die mythischen aus. Da war das Märchenspiel um den Sinn der
Ehe und das unechte Königtum, „Die drei Reiherfedern" 1899 in freien und
frei gereimten Versen. Da war, von Zacharias Werner her, das Schauspiel
„Strandkinder" 1909 aus dem nur äußerlich bekehrten Preußen der Ritterzeit
mit dem Nebenzug der heimlichen Fürstentochter. Da war „Der Bettler von
Syrakus" 1911, der Odysseus-Telemach-Stoff, nur daß die Odysseusgestalt
hier aus Verlangen nach der letzten Vernichtung, dem Vergessensein, seine
Maske bis in den Tod bewahrt. Der klassische Sprechvers dieses Stückes gibt
den weitesten Abstand an vom Erstling, der „Ehre". Der Stilicho der „Lob-
gesänge" war Ahnung des Kommenden. Das Geschehene führte der Drilling
„Das deutsche Schicksal" 1921 über die Szene. In den drei seiner letzten Dra-
men, „Die Raschhoffs" 1920, „Die Denkmalsweihe" 1923, „Der Hasenfell-
händler" 1925 ließ Sudermann noch einmal wie im Genuß seines ersten Kön-
nens das sichere Spiel aller seiner Stilarten durch die Finger gleiten. „Ent-
götterte Welt" 1915 und die „Litauischen Geschichten" 1917 lassen den Er-
zähler zum Schluß kommen. Das ist der Roman „Der tolle Professor" 1926,
mit vielen Modellzeichnungen ein Bild der Königsberger Hochschule aus
Sudermanns Jugend, die Tragödie des geistigen Menschen durch das Bis-
marckreich, wie sie der freisinnige Ostpreuße sehen mußte. „Das Bilderbuch
meiner Jugend" 1922 hat dieses alte Ostpreußen noch einmal geschildert in
hübsch gerundeten Einzelbildern, übermütig und salopp, selbstbewußt und
so farbig, wie es die Palette dieses Landes hergab.

Sudermann stand auf dem Gegenpol zu Holz. Gleichläufig mit Ibsen und *Sudermann*
selbständig knüpfte er an das Gesellschaftsstück der Franzosen an. Während *und Holz*

Holzens tragischer Pause zwischen der „Familie Selicke" und den „Sozial-
aristokraten" ist Sudermann es gewesen, der als erster den neuen Zeitgehalt
bühnengerecht verarbeitete. Beide Ostpreußen tragen die polaren Züge des
Ostens, jeder in seiner Weise. Holz hat den verdichteten Geist des Ostens,
Sudermann dessen breites Leben. Holz ist das zu unberechenbaren Ausbrü-
chen stets Bereite, nur scheinbar Gebändigte, dem Westen Mißtrauende, Su-
dermann das endgültig Eingefügte und Beherrschte, das dem Westen Ver-
wandte.

Danzig Der Raum um Danzig erzeugte diesmal bei größerem Reichtum des Über-
lieferten zwar die zarteren und feineren Formen dieses Gehaltes, aber doch
nur Nachgebilde dieser beiden östlichen Gestalten: einen im Stil Holzens,
einen im Stil Sudermanns.

Der Kosmos *Paul Scheerbart,* 1863 bis 1914, von Danzig, stammt aus der Stadt Robert
Reinicks, der des Wortes und des Bildes gleich mächtig gewesen war, und
war ebenso doppelt begabt. Aus dem hanseatischen Reisetrieb, aus der säch-
sischen Mythenfreude Runges, aus der Altdanziger Griffelfertigkeit Reinicks,
aus der ostdeutschen Weltverseelung Fechners hat Scheerbart das kosmische
Abenteuer zu Weltanschauung und Stil gemacht. Da betäubte sich die ost-
deutsche Vernunft im Rausch des unendlichen Raumes und wehrte sich gegen
das „Natürliche" und „Gläubliche", für die eine Hälfte des Ostens die höch-
sten Vernunftideale. Da schwelgte der Maler im farbigen Widersinn, in Ko-
metentänzen, und ließ ein Gedankenbastler auf dem Monde den großen Auf-
ruhr geschehen und sich auf Sternen mystische Sehnsüchte erfüllen. Grund-
anschauungen der zeitgenössischen Naturwissenschaft werden spielerisch ver-
kehrt oder umgestellt. Metaphysische Vorstellungen werden an burlesken
Mythen verdeutlicht. Der „Asteroidenroman", „Lesabéndio" wird zur Phi-
losophie des Schmerzes an der Schwelle von 1914: „Wir haben kein Recht,
uns vor dem Entsetzlichen zu fürchten. Es wandelt uns um. Und wir sind
nicht imstande, uns umzuwandeln, wenn wir Schmerz und Qual fliehen."
Weltuntergänge sind nur Geburtsschmerzen einer besseren Neuschöpfung.

Mutter Erde *Max Halbe,* 1865 bis 1944, aus Gütland im Danziger Werder, hatte von
der Mutter her slawisches Blut. Er ging zuerst durch den Münchner Kreis
Conrads, dann durch den Berliner Wirbel, um sich schließlich doch in Mün-
chen anzusiedeln. Wie Scheerbart in Holzens Phantasusbereich, so gehört
Halbe in Sudermanns Umkreis. In sechs Heimatdramen spielte er die Ton-
leiter der weichselländischen Bäuerlichkeit herunter: den Zusammenstoß zwi-
schen Landjunker und Landarbeiter in „Eisgang" 1892; Liebe des jungen
Herzens am polnisch-deutschen Pfarrhaus Westpreußens in „Jugend" 1893;

das Verlangen des Großstadtmenschen nach ländlicher Heimat in „Mutter *Max Halbe*
Erde" 1897; die Tragik des Kleinbesitzes in „Die Heimatlosen" 1899 und
„Haus Rosenhagen" 1901; den Bruderkampf um das Erbe in „Der Strom"
1904, wo der Gleichlauf zwischen Menschenschicksal und Naturgeschehen am
vollkommensten erzielt ist. Aus dieser Grundstellung heraus strebte Halbe
mit immer neuen und sieglosen Ansätzen nach Rückgewinn des überlieferten
Dramenstils, sei es, daß er — „Der Eroberer" 1899 — an einem Vorwurf
der Renaissance Wirklichkeit und Ideal verschmelzen wollte, sei es, daß er
den Versuch des geschichtlichen Schauspiels machte, ernst mit „Das wahre
Gesicht" 1907, komisch mit „Der Ring des Gauklers" 1913; sei es, daß er das
geschichtliche Zeitbild „Freiheit" 1913 oder das kosmische Spiel „Schloß
Zeitvorbei" 1913 gab. Im Ringen um die Wiedererlangung des „Jugend"-
erfolges verlor sich dieser Stimmungskünstler ohne Lieder, dieser Erotiker
und idyllische Tragiker immer tiefer in Zugeständnisse, die er ebensosehr der
ihm ungemäßen Bühne wie dem wechselnden Geschmack seiner tastenden
Zeit machte. Genug getan hat sich eine so ausgesprochene lyrisch-epische
Gabe nur in einer Prosa von zweierlei Form: mit der Leidensgeschichte einer
weichselländischen Bäuerin, „Frau Mesek" 1897, die zur Reihe der Heimat-
dramen gehört, und mit dem Danziger romantischen Roman „Die Tat des
Dietrich Stobäus" 1911, der, Hoffmanns Fragestellungen zugewandt, auf sei-
ten der Stilsucherdramen gehört. Max Halbe hat seiner zwischen dem Acker-
dorf und dem Bauwerk Danzig geteilten Seele jenen Stilausdruck nur unvoll-
kommen gefunden, der der bäuerlichen Wirklichkeit ebenso sachlich wie dem
Doppelgebilde von Renaissance und Romantik Herr geworden wäre.

Das war der erste Aufzug der neuen Geistigkeit des Ostens. Helden im
Spiel waren die Altpreußen zwar auf wechselnder Bühne, aber vor altpreu-
ßischem Hintergrunde.

Das schlesische Gegenlager zeigt das gleiche Herüben und Drüben. Der *Schlesien*
Spaltriß lief hier mitten durch jenen Stand der Junker, der das Menschen-
alter zuvor Pflicht und Verantwortung der Literatur getragen hatte.

Der Breslauer Prinz *Emil von Schönaich-Carolath*, 1852 bis 1908, Reiter-
offizier und Weltfahrer, der letzte aus der Reihe jener dichtenden Junker,
stand noch herüben. Vom Elternhause her war er mit Gustav Freytag und
Friedrich Bodenstedt bekannt. In Zürich stimmten ihn Johannes Scherr und
Gottfried Kinkel auf demokratische Weltanschauung. Spätromantik und
deutscher Freisinn haben an seinen Balladen und Liedern gleichen Anteil.
Den Stil Kinkels und Bodenstedts umwarb er 1878/1890 mit ungekrönten
Entwürfen. Von Storm und Raabe hatte er nach Gattung und Tonart die

Schlesische
Junker

Charakternovelle, das Sittenbild, die soziale Geschichte. Die soziale Frage —
„Bürgerlicher Tod" 1894 — nahm er mit der Gesinnung eines außerkirch-
lichen Christentums. Was er vertrat, war der demokratische Freisinn Kinkels
und Scherrs und nicht der Sozialismus der jungen Generation. Trotz seiner
Meisterschaft in klassischen und romantischen Stilformen war Schönaich-
Carolath mit seiner letzten Sammlung „Gedichte" 1903 wieder modern,
aber nicht der Romantiker für die Zeit eines „neuromantischen" Ehrgeizes,
sondern für das Geschlecht eines neu gesteigerten Innenlebens. Schon drüben
stand der Oberlausitzer *Wilhelm von Polenz,* 1861 bis 1903, aus Obercune-
walde bei Bautzen. Doch von Schönaich zu Polenz lief der unsanfte Weg des
sozialen Gewissens. Vielseitig gebildet und nach Berliner Literaturgastspielen
auf dem ererbten Lausitzer Schlosse hausend, war Polenz wieder der be-
wußte Landjunker, der sich auf die bäuerlichen Pflichten seiner Kaste zurück-
besann. Er ging am Sonderfall seiner Heimat durch alle Stände den Gefahren
des Zeitalters nach: „Der Pfarrer von Breitendorf" 1893, die soziale Frage
und die Kirche; „Der Büttnerbauer" 1895, Niedergang des Bauernstandes
durch die wirtschaftliche Überlegenheit der Zeit; „Der Grabenhäger" 1897,
der Junker, dem Grundbesitz nicht Geschäft, sondern Kulturverpflichtung ist;
„Thekla Lüdekind" 1900, das Geschlecht als der große Zwiespalt der Welt;
„Wurzellocker" 1902, der moderne Schriftsteller und die Überwindung der
modernen Gefahren von Zola bis Nietzsche. Schlicht und schwerfällig hat die-
ser Junker, der seinem Stande so sehr entfremdet war und sich dem Literaten-
tum so wenig einfügte, dem Grundbesitz seine ständischen und sittlichen
Pflichten so herb und sachlich ins Bewußtsein gebracht, daß Leo Tolstoj
„Büttnerbauer" und „Grabenhäger" für die einzig guten Romane der deut-
schen Literatur erkannte.

Schlesisches
Bürgertum

Die andere Seite zeigt das Bürgertum. Durch Wesen und Werk der Brüder
Hauptmann und Richard Dehmels läuft wie ein Erdgleicher die schlesisch-
lausitzische Doppellinie eines Gottgefühls, das gleichermaßen ins Sinnliche
wie ins Seelische, ins Vernünftige wie ins Mystische ausschweift. Man muß
das Werk dieser drei Dichter auf diesen heimatlichen Erdgleicher visieren,
um die Richtung ihrer Bahn zu erkennen.

Gerhart Hauptmann, 1862 bis 1946, aus Obersalzbrunn, hat mit seinen
ersten Bühnendichtungen, die „Vor Sonnenaufgang" 1889 einleitete, dem
künstlerischen Willen der jungen ostdeutschen Generation entscheidenden
Ausdruck gegeben. Das gesamte Werk dieses Dichters ist Summe und Inbe-

Die Brüder
Hauptmann

griff der Dichtung dieses Zeitalters. Die ungewöhnliche Dauer und die unge-
brochene Schöpferkraft seines Lebens haben indessen Gerhart Hauptmann

so über alle Jahrzehnte hinausgehoben und sein Werk ist in solchem Maße ein unteilbares Ganzes, daß es erst von der erreichten Höhe aus überblickt werden kann.

Karl Hauptmann, 1858 bis 1920, aus Obersalzbrunn, hat das Hauptmann-sche seines Bruders reiner und voller herausgebracht als dieser. Nicht das, was Holz meinte, aber das, was seine Nachahmer aus ihm machten, war längst bairisch-bäuerliche Überlieferung. In der Tat, auf gleicher Höhe mit der junkerlichen Bauernwelt von Polenz weisen sich Karl Hauptmanns bäu-erlich-schlesische Dichtungen als vom Stile Anzengrubers aus. Und sie hatten jenen unnachahmlichen Tonfall, der nicht durch Mundart und Ortsfarbe zu erreichen ist, weil er aus der Seele der Heimat stammt. Hauptmanns drama-tischer Bogen fällt aus dem schlesischen Berglande von „Marianne" 1894, „Waldleute" 1895, „Ephraims Breite" 1898 über die bäuerliche Ehetragödie „Die Austreibung" 1905 künstlerisch gegen „Die lange Jule" 1912, diesen theaterhaften Kampf um die Scholle, ab. Sein epischer Bogen steigt von den kleinen Erzählungen „Aus Hütten am Hange" 1912 über den großen Roman einer armen Frau „Mathilde" 1912 zu den zwei Künstlerromanen „Einhart, der Lächler" 1907 und „Ismael Friedmann" 1913 auf. „Einhart" war die Geschichte einer weltfremden, einsamen Künstlerseele, in deren Weltallsehn-sucht Traum und Wirklichkeit zusammenrinnen. „Ismael" war die Zeit der hohen deutschen Industrie und ihrer Widerwelt der Seele, von dem Leben, das nicht gedacht werden kann, sondern gelebt werden muß. Über diesen auseinanderstrebenden Bögen wölbte Hauptmann vom Heimatlichen und vom Zeitlichen her ins Sinnlich-unwirkliche einen Spitzbogen, der schloß. Aus dem Heimatlichen stammt das schlesische Märchen in dem zeitlosen Drama „Die Bergschmiede" 1902, während sich in dem Spiel „Die armseligen Be-senbinder" 1913 schlesische Wirklichkeit und Wunderwelt mischen. „Rübe-zahlbuch" 1915 läßt in neun Geschichten, die aus freier Hand gedichtet sind, das Riesengebirge wie ein lebendiges Wesen erscheinen. Vom Zeitlichen her zeigt „Krieg. Ein Tedeum" 1913 dem bangen Vorgefühl des Zeitalters das noch verborgene Antlitz des Kommenden. „Der abtrünnige Zar" 1914 erhofft den Aufbruch der Freiheit und eines neuen Menschentums. Und als Schluß-stein des Spitzbogens setzte Hauptmann „Die goldenen Straßen" 1918, eine Trilogie vom unschöpferischen und vom schöpferischen Menschen, vom Rin-gen mit dem Gott und dem Tier in der Brust, von der Bürgerschaft beider Welten, der göttlichen und irdischen. Wie eine geistliche Übung, Betrach-tungen und Gedichte, war Karl Hauptmanns Einkehr „Aus meinem Tage-buch" 1900 gewesen. Hier ging es gegen beide, die dieser Generation das

„Die Welt ist Seele"

Karl Hauptmanns Doppelbogen

„Rübezahlbuch"

Karl Hauptmann Entweder-Oder waren, gegen Zola und Nietzsche. Hauptmann glaubte: „Die Welt ist Seele". Weder um Befreiung von der Natur noch um die Wiedergabe ihrer Urschrift geht es ihm, sondern um die Auflösung der Natur in die Brüderschaft alles Geschöpflichen. Das ist nicht Pans breites Lachen. Das ist die lächerliche Einfalt dessen, der Seele schaut und Seele ist, ein Lächeln der Demut, die Demut zum Schutz, das Lächeln zum Trotz. Diese Paradiessehnsucht, diese magische Verseelung der Welt, dieses Alleinsbewußtsein von Ich und Welt und Gott war wieder die Romantik und die ganze schlesische Tiefe von Böhme, Scheffler, Schefer, von Eichendorff und Fechner. Gegen Gerhart den kühleren Berichterstatter und allgemeinen Menschenfreund, war Karl der lyrisch Aufgelöste und Gottallverbundene, gegen den Bildner der Musiker, gegen den größeren Dichter vielleicht der tiefere Denker und ursprünglichere Künstler.

„Aber die Liebe" *Richard Dehmel,* 1863 bis 1920, aus dem märkischen Wendisch-Hermsdorf, von einem schlesischen Vater, dessen beiderseitige Ahnen aus der Löwenberger und Hirschberger Gegend stammten, von einer Mutter aus Spreewälder und Thüringer Blute, hat sein ostdeutsches Wesen auf den Satz gebracht: „Und bin ich nicht wirklich auch ein wenig mit Hamann und Herder, Böhme und Eckart verurenkelt, wiewohl ich mich nicht zum prophetischen Prediger, sondern mehr zum poetischen Künstler eigne?" Dehmel hat den Gang des Zeitalters von der Heimat zur Großstadt und wieder zur Heimat ausgeschritten: der Berliner Hochschüler und Großstadtdichter, der Durchwanderer Europas, der Siedler auf eigenem Grunde, der Kriegsfreiwillige. Auf einem weiten Wege von den drei Gedichtbänden „Erlösungen" 1891, „Aber die Liebe" 1893, „Lebensblätter" 1895 erreichte er mit der tragikomischen Parodie des Übermenschen „Der Mitmensch" 1895 seinen ersten *Dehmels* Absatz, die Abkehr von Nietzsche. Er hatte den unbeschwerten Redeschwung *lyrisches Werk* seines ersten Versbuches, die Erotik einer späten Mannbarkeit — „Aber die Liebe ist das Trübe" — verwunden und sich im dritten Gedichtbuch ein leidliches Maß von schlichter Form gesichert. So gelang ihm mit „Weib und Welt" 1896 das erste reife Werk und mit der Pantomime „Lucifer" 1899 die Erkenntnis: der Lichtbringer Lucifer und Venus die Liebe im Kampf um die Welt. Er war in den Hamburger Hafen, seines zweiten Eigenheimes, eingelaufen. Eine neue Ausfahrt ging von der phantastischen Komödie „Michel Michael" 1911, wo er die guten Geister des deutschen Volkes das Vaterland verlassen ließ, über das Versbuch „Schöne, wilde Welt" 1913, schien mit dem Schauspiel „Menschenfreunde" 1915 auf lange Fahrt zu weisen und drehte mit dem Kriegstagebuch „Zwischen Volk und Menschheit" 1919 bei. Deh-

mels hohe Zeit waren die Jahre 1906/1909, die Jahre des großen Wagemuts, da er alle seine Werke noch einmal bearbeitete und zu einem natürlich gegliederten Ganzen dessen machte, was er bis dahin nur dunkel gewollt. So hat er seine Werke zweimal geschaffen. Die hohe Zeit zu Blankenese, das sind zwei Ringbücher, in ihrer Art ohne Vorläufer, ohne Nachbarn. „Zwei Menschen. Roman in Romanzen" 1903 war der Roman von Dehmels zweiter Ehe. Was an diesem Buch den Verstand besticht — denn das Herz bleibt unbewegt — das ist die ausgeklügelte Kunstfertigkeit des Gebildes. Wie die Gedichte seines Gegenfüßlers Holz steht auch dieses von Dehmel unter dem formenden Kunstgesetz der Zahl. Sechsunddreißig Romanzen zu je sechsunddreißig Versen sind in je drei „Umkreise" geschlossen: „Die Erkenntnis", „Die Seligkeit", „Die Klarheit". Es sind eigentliche Bilder, Innenraum oder Landschaft, und immer nur zwei Menschen, er und sie, auf der Szene. Der Wortlaut beschreibt den Bildvorgang, gibt je eine Rede und Gegenrede, das Gespräch der beiden, und schließt in je einer Verszeile mit der gleichgebauten „Unterschrift" des Bildes. Zwei Menschen weisen einander „Gott entgegen". „Die Verwandlungen der Venus" 1907 sind das andere Ringbuch. Aus „Der Nacht der blinden Süchte" eines Menschen, der sich zu kasteien in einem Keller lebt, treten die Gestalten der Liebe in einunddreißig Gesichten hervor, Abwandlungen des unausrottbaren Triebes, Verwandlungen des Gottes und des Tieres, bis der Morgen graut und der Held sich zur Klarheit durchgerungen hat: zurück ins Leben. Jedes Bild steht für sich und starr in seinem besonderen Rhythmus. Verbunden werden sie durch gleichgestimmte Zwischensprüche, deren jeder das vorhergehende Bild deutet und in kräftiger Biegung zum nächsten führt. Zweifellos war Dehmel ein geborener Mystiker. In jüngeren Jahren hatte er von Zeit zu Zeit Anfälle, in denen sich ihm durch seltsame sinnbildliche Vorgänge und Handlungen Erkenntnisse seiner selbst mitteilten. So ist unter anderm „Venus mater" entstanden. Mit geballten Fäusten, wie im Bann liegend, hatte er halbwach Offenbarungen, das Gefühl des Doppelseins und sah sich körperlich draußen. Indessen, so einfach liegt die Sache nicht. Dehmel war mit gleicher Stärke ein Vernunftmensch. Die beiden großen Gedichtringe sind Gebilde des Verstandes. Zuvor wurden Umfang und Gliederung ausgemessen und dann die erforderlichen Gedichte gearbeitet. Zutreffend konnte Dehmel von sich sagen, er habe gewissermaßen Hegels Gedankenwerk ins Gefühlsleben übersetzt. Er hatte den Kindheitsgedanken, wie diese Ostdeutschen alle, und wußte hübsche Kinderbücher zu erfinden. Und wie sie alle, hatte er das empfänglichste Sozialgefühl und konnte es mit dem Munde des Arbeiters aussprechen. Aus dem Naturerlebnis

„Zwei Menschen"

„Die Verwandlungen der Venus"

Dehmel — Vernunft und Mystik

seines väterlichen Forsthauses war er Meister von Bildern der Nacht und der Dämmerung. Auch er steht in der Reihe von Böhme, Scheffler, Fechner her. *Holz und Dehmel* Arno Holz und Richard Dehmel sind die beiden lyrischen Gegenspieler des Ostens, bei verwandtem Gehalt und gleichlaufendem Formwillen Dichter, die sich unter das Weltformgesetz der Zahl beugten. Das macht zwei scheinbar fast unvereinbare Gebilde wie Holzens „Phantasus" und Dehmels „Zwei Menschen" eigentlich zu Spielarten des einen Formgesetzes der Zahl. Holz entwickelte die Welt aus der Eins des Allich. Daher ist seine Zahlenreihe und sein Formgesetz nach außen offen und unendlich. Dehmels Welt geht aus der Zweiheit des Ich und Du hervor. Seine Zahlenreihe und sein Formgesetz sind nach außen geschlossen und endlich. Das Zahlenformengesetz des „Monisten" und des „Dualisten", dem so gemäß das seine wie dem andern.

Spielleute und Komödianten Der Gottsucher und Gottseher war ostmitteldeutsch echt. Nicht minder der Spielmann und Komödiant. In Breslau sind der Gedankenträger des Überbrettls Ernst von Wolzogen und des Naturtheaters Ernst Wachler geboren worden. Nicht durch neue Funde, sondern aus dem Überlieferten Bühne wie Drama gegenwartskräftig zu beleben, war jenseits von Gerhart Hauptmann *Renner und König* wieder schlesischer Wille geworden. *Gustav Renner*, 1866 geboren, aus dem schlesischen Freiburg, den traumhafte „Gedichte" 1904 zwischen Eichendorff und Holz bei eigener Haltung zeigen, strebte nach mancherlei Versuchen zu einem Drama, das wie seine „Alkeste" 1912 vom Stimmungswirbel der Musik begleitet würde. *Eberhard König*, geboren 1871 in Grünberg, drängte aus seiner Bühnenromantik heraus mit Schelmenspielen, vaterländischen Festspielen, mit einer antiken Burleske wie „Alkestis" 1910, später mit großangelegten Heldensagendramen auf Naturtheater und Gemeinschaftsbühne zu. Das schlesische Komödiantentum blieb freilich im Literarischen stecken *In allen Tonarten* wie der Spielmann. Der Grünberger *Otto Julius Bierbaum*, 1885 bis 1910, hatte das Zeug dazu. Dieser lyrische Stegreifkünstler hat Lyrik jeglichen Stiles rollenmäßig vorgetragen, das Legendenhafte und Bänkelsängerische, das volksmäßige Tanzlied, Eichendorffs Nachtlied, die Schlichtheit Goethes wie des Claudius fromme Tüchtigkeit. Dieser Revenant des frühen achtzehnten Jahrhunderts, der den galanten Zeitroman wieder entdeckte, hätte ein echter Komödiant und Spielmann sein können. Aber bei ihm war es nur die ostmitteldeutsche Betriebsamkeit und literarisches Gründertum, womit er freilich dem Buchwesen seiner Zeit verdienstliche und verdienstschaffende Anregungen gegeben hat. Aus diesem vielstimmigen Chor klingt auch diesmal voll und lauter jener gemeinsame Grundton auf, den zuletzt August Kopisch hatte, die Märchenbildergabe der Seele, die Kind geblieben ist. Nun

hatte sie *Paul Keller*, 1873 bis 1932, aus Arnsdorf bei Schweidnitz. Ihr wurde
die soziale Fragequal zu lauterer Heimatkunst, die Landschaft zu reiner
Stimmung, die Natur zum Gesundbrunnen des Lebens, der weltanschaulich
überlastete Mythus zum vertrauensvollen Märchen. So nahe Paul Keller dem
Wendekreis der Unterhaltungsliteratur stand, seine Bücher und seine Zeit-
schriften „Guckkasten" wie „Bergstadt" hielten dies „Lied in allen Dingen",
den romantischen Unterton im Bereiche dessen, was das Volk liest, sinn-
getreu fest.

Das war der zweite Aufzug der neuen Geistigkeit des Ostens. Helden im
Spiel waren die Schlesier, zunächst dem ostpreußischen Stoß nachgebend,
dann aber mit einem neuen romantischen Gegenstoß antwortend. Doch wie
der Abbruch des gültigen, so war die Neubildung eines Erbes, Stoß wie Ge-
genstoß, die eigenste Angelegenheit Preußens.

Altpreußen hatte seinen Formsucher aus dem Mittelalter her, den Grau-
denzer *Ernst Hardt*, 1876 geboren, der Griechenland und das romanische
Westeuropa aufsuchte, westeuropäische Literatur verdeutschte und nach be-
scheidenen lyrischen und erzählenden Anfängen zu Versdramen mittelalter-
lichen Stoffes und romantischen Stiles ansetzte, in „Tantris, der Narr" 1907
noch unwahrscheinlich und schwülstig, in „Gudrun" 1911 ohne jene schlichte
Menschlichkeit, die solcher Vorwurf verlangte. Und Altpreußen hatte seinen
Formsucher aus der Antike, *Thassilo von Scheffer*, 1873 zu Preußisch-Star-
gard geboren, der dann zwischen Schröder und Borchardt um den Rück-
gewinn altgriechischer Dichtung rang. Ein Versuch, zwischen den drei Un-
vereinbaren, Holz, George, Dehmel, sich den eigenen Sinn zu schaffen, wurde
es bei dem Königsberger *Walther Heymann*, 1882 bis 1915, der sich an der
preußischen Küstenlandschaft, ihren geschichtlichen Fernblicken und dem
Naturwuchs deutscher Vergangenheit in deutsches Leben einzufühlen be-
gehrte. Er hat das Opfer des Schlachtfeldes gebracht. Heymann war trotz
einem Novellenbuche Hymnensänger. Von den „Nehrungsbildern" 1909 bis
zum Nachlaßbuch „Von Fahrt und Flug" 1919 klafft kein wesenhafter Ab-
stand. Eigenwillig geformt und nur mit Ernst zu erarbeiten, geben sie in der
Ichempfindung des Alls ausgesucht feine Seelenregungen bizarr und düster,
Zwielicht und Zwiestimmung. Ihre Sätze wagen sprachlich das Verbotenste.
Was Heymann sagen wollte, steht in den achtzig gereihten Gedichten „Die
Tanne" 1917, Gleichnisse für das Leben der Seele. Hardt, Scheffer, Heymann
waren entgegengesetzte Außenpunkte. Zwischen ihnen führte aus Heimat
und Historie, gegensätzlich zu Holz wie zu Dehmel, Agnes Miegel diese
Linie erneuerter Überlieferung, Strenge, Zucht steilauf.

Neubildung eines Erbes Abermals von Ostpreußen ging die Neubildung eines Erbes aus, ein drei-
facher Wurf, erstaunlich in seiner Gleichzeitigkeit und gleichem Ziel, in sei-
ner philologischen Zuverlässigkeit, in seiner wie verabredeten Rollenweiter-
gabe.

Konrad Burdach, 1859 bis 1936, aus Königsberg, Hochschullehrer zu Halle
und dann Mitglied der Preußischen Akademie, erfaßte forschend in einem
Die preußischen Philologen den Ursprung der modernen Bildung aus dem europäischen Humanismus
und der neuen deutschen Dichtersprache, aus der Verschmelzung des jungen
östlichen Kanzleideutsch mit dem alten westlichen Dichterdeutsch. Man
wußte seitdem, daß man mit den Früchten dieses Sprachbaumes stündlich
Sonne und Fruchtbarkeit des Abendlandes und Morgenlandes mitgenoß.
Burdach hat mit dieser Erkenntnis, wie die fortwachsende Schriftsprache sich
beständig aus der mittelalterlichen Dichtersprache veredelt und bereichert,
der neuen Dichtung des Jahrhunderts eine Aufgabe gesetzt. *Paul von Win-
terfeld*, 1872 bis 1905, aus dem westpreußischen Tynwalde, an der Berliner
Hochschule Vertreter der mittelalterlichen Lateinliteratur, war auf der Suche
nach der Fuge zwischen spätantiker und frühdeutscher Bildung. Er schloß
den Wortlaut der karlingischen Lateindichter und der Werke Hrotswiths zu
klassischen Ausgaben auf. Er formte diese frühe deutsche Lateindichtung zu
vollendeten deutschen Gebilden um. Er fand, ergründete, verdeutschte jene
altkirchlichen Sequenzen, deren rhythmisches Gesetz Arno Holz unwissend
wieder entdeckt hatte. Auch damit war dem Dichter der Zeit eine neue Auf-
gabe gestellt.

Die Kunst des Mittelmeers *Rudolf Borchardt*, 1877 bis 1945, aus Königsberg, der Heimat seiner Fa-
milie, ist durch die Marienburger Schule gegangen und ein Philologe von
hoher Kunst geworden. Eine Welt zu erwerben, weil sie nicht ererbt war,
Erbe als Adel, Erbe als geschichtliche Kette der Form, das wird sein Leit-
gedanke. Wie Burdach und Winterfeld, drängt sich auch ihm alles um diese
Fuge zusammen, die antike Bildung, Landschaft des Mittelmeeres, germa-
nische Völkerjugend in eins verschloß, und wurde Werk. Vom östlichen
Becken des Mittelmeers machte er die „Altionischen Götterlieder" in der
Sprache des restlos geklärten und geformten Schriftdeutsch wieder hörbar.
Um das westliche Becken des Mittelmeers erkannte er in den „Großen Tro-
badors" die dichterische Kernfrage der germanisch-lateinischen Länder. Nur
von diesem Dreiweg her, wo sich das Werk der Provenzalen ins Europäische
verzweigt, in das Deutschland Wolframs und Hartmanns, das England Wil-
helms des Eroberers, das Italien Dantes, läßt sich Borchardts Werk über-
sehen. Schon in dem denkwürdigen Aufsatz „Dante und deutscher Dante"

1909 wußte er, daß es unmöglich sei, ein Buch des dreizehnten Jahrhunderts, *Dante deutsch*
das in einer nie gesprochenen, höchst literarischen Sprache geschrieben sei,
„in den Alltagsjargon einer Verfallszeit ohne lebendige Literatur zu über-
setzen". Gewinne aller Art aus der klassischen, romanischen, germanischen
Sprachwissenschaft; eingelebte Kenntnis mittelländischen Landes und Vol-
kes; der Lebensertrag zweier Jahrzehnte sind in Borchardts Neuschöpfung
von Dantes „Divina commedia" eingegangen. Borchardt hat sie in das ein-
zige Deutsch, das jemals volle Dichtersprache gewesen ist, die zugleich welt-
anschaulich und zeitlich Dante gemäß war, in ein organisch fortgebildetes
Mittelhochdeutsch übertragen. Aus dieser Welt leben alle Dichtungen Bor-
chardts. So „Der Durant", diese freie Neuschöpfung deutschmittelalterlichen *„Der Durant"*
Stils, die tragische Versnovelle des höfischen Mannes, der den Sinnen ver-
fällt, weil er die Frau nur als Gegenstand übersinnlicher Verehrung kennen
wollte. So das Spiel „Verkündigung", das innerliche erotische Entscheidun- *„Verkündigung"*
gen in atembeklemmende Worte ausströmt. So mit dem sachlichen Stil von
Luthers deutscher Bibel abermals andere erotische Gewitter im „Buch
Joram". In drei Sammlungen vereinigt, zeugt Borchardts Lyrik für die Tat- *„Buch Joram"*
sache, daß soviel Bildung, Stilformen, Sprachwesen aus allen Zeiten und
Räumen des Abendlandes in dieser Seele sich nur ins Spektrum zerlegten, die
Seele selber aber menschlich unberührt ließ. Borchardt hat sich zu Herder
bekannt. Die sächsische Sachphilologie und der ostdeutsche Romanismus des
neunzehnten Jahrhunderts waren triebhafte Versuche, sich von den süd-
deutschen Vermittlungen freizumachen und mit eigener Seele an diese Dinge
heranzugehen. Und so unterschied denn auch Borchardt zwischen einem pro- *Rückgewinnung*
venzalisch und einem französisch beeinflußten Deutschland. Aus dieser Ge- *des Erbes*
sinnung heraus hat er sich erbittert gegen die Verderber der deutschen Seele
gewehrt. Visiert man von Borchardt zu Holz, so sinkt das Gegensätzliche tief
ab, und es tritt hinter ihnen der gemeinsame ostdeutsche Wille hervor: aus
eigenwilliger Sprachschöpfung Wiedergeburt der deutschen Kunst aus dem
Osten, Abhub des unechten und Rückgewinn des echten Erbes.

Die *NIEDERSÄCHSISCHEN LANDSCHAFTEN* heben sich wesentlich
anders geartet gegen den deutschen Osten ab. Sie bilden unter sich geschlos-
sene Gruppen, die nach ihren Strebungen oder nach dem ausgebildeten Stil
oder weltanschaulich jede ein anderes Gesicht haben.

In Mecklenburg und Pommern hing noch durch Friedrich von Schack, dem *Pommern und*
Dichter dieses Zeitalters, der verführerische Schleier sächsischer Reisekunst *Mecklenburg*
und griechisch-italienischer Spiegelungen des Mittelmeeres über der wen- *Mittelmeer,*
densächsischen Küste. Doch er verblaßte von Jahr zu Jahr vor der Wirklich- *Griechentum,*
Renaissance

keit und dem Alltag der Heimat. Der Pommer Richard Voß, 1851 bis 1918, in seiner Villa Falconieri bei Frascati, setzte in seinen zahllosen Romanen, auch wenn sie italienische Szene hatten, der zeitgenössischen Gesellschaft zu, und der Stettiner Hans Hoffmann, 1848 bis 1909, in Italien wohl bewandert, fügte zu seinen italienischen Novellen schon Geschichten aus Hinterpommern. Der Stettiner Konrad Zitelmann, 1854 bis 1897, ein Freiheitsapostel und Gesellschaftsverbesserer, ging aus seinem italienischen Wohnbereich zur pommerschen Dorfgeschichte über, während sich der Rostocker Gustav Floerke, 1846 bis 1898, länger als irgendwer mit seinen Caprigeschichten *Adolf Wilbrandt* „Die Insel der Sirenen" gehalten hat. Der Rostocker Adolf Wilbrandt, 1837 bis 1911, war im italienischen Umgang mit Heyse, Lenbach, Böcklin aus einem Zeitungsmanne ein Dichter geworden. Seine antikische Haltung hielt er nur in seinen frühen Römerdramen und in seinen späteren Griechenstücken fest. Das Leben des Zeitalters formte er in den Masken seiner Romane, die dicht bei Heyse stehen. „Die Osterinsel" 1895 erwartet nach den ersten beiden Stufen hoher Menschlichkeit — Griechentum und Renaissance — die dritte, die Züchtung des Göttermenschen, auf der berühmten Insel des Stillen Ozeans. „Franz", 1900, ein Vorspiel zu Hauptmanns „Narr" und Frenssens „Hilligenlei", verkündet einen deutschen Messias und, die Christusgeschichte umdichtend, eine deutsche Religion. „Adams Söhne", 1890, spiegeln alle politischen Wünsche der Zeit, träumen von den kommenden Seeschlachten und vom Rückgewinn der Baltenländer. Bei Wilbrandt gehen Gedanken Darwins und Platons durcheinander. Er befehdet Schopenhauer und verkündet Nietzsche. Das Blonde, Reckenhafte, „Germanische" ist bei ihm zur Forderung geworden. Mit seinen mecklenburgischen „Novellen aus der Heimat" 1882 hatte der Grundstamm Brinckmans und Reuters wieder *Heinrich Seidel* ausgeschlagen. Der Mecklenburger Heinrich Seidel, 1842 bis 1906, aus Berlin, war schon wieder ganz zu Hause. Im Berliner „Tunnel" war dieser Eisenbahningenieur kunstreif geworden. Die humoristische Literatur Deutschlands, der Skandinavier, der Angelsachsen war ihm vertraut. Sein Eigenstil wurzelte im Erdreich der „Fliegenden Blätter", des „Kladderadatsch", der „Musenklänge aus Deutschlands Leierkasten", dem damals weitverbreiteten *Leberecht* Buch des blühenden Unsinns. „Fidele Männlein poetisch eingemacht", die *Hühnchen* Menschengestalt in burlesker Charakterkomik abgewandelt, das ist Seidels Kunst. Wie Brinckman seinen Kaspar Ohm und Reuter seinen Onkel Bräsig, so hatte Seidel seinen Leberecht Hühnchen zum komischen Mythenhelden. Alles andere ist Szene, Weltanschauung, Gefühlslage, Schattenwurf. In den Rollen seiner Gestalten genoß er, ein vergnügter Lächler, das Glück der klei-

nen Dinge. Mochte auch sein „Glockenspiel" 1889 die beste aller Welten
beläuten, in den „Vorstadtgeschichten" 1880 und in den Bücherfolgen von
„Leberecht Hühnchen" 1882/1890 steckt Seidels Werk. Und es bedeutet
jene sächsische Dreiheit: Tierfreundschaft, burleskes Menschenwesen, Bru-
derschaft von Griffel und Feder bei Seidel wie bei Busch und Morgenstern.
Es gab kein besseres Gleichnis für die Verwandlung griechischer in säch-
sische Volkskunst, als den Mecklenburger August Dühr, 1841 bis 1907, der *Ilias und Odyssee plattdeutsch*
Ilias und Odyssee in „de geborne Schipper un Seesprak" der Niedersachsen
umgoß.

Von Schleswig-Holstein drängte dithmarsisches Bauerntum in die Litera- *Holstein*
tur. Von Storm zu Groth hießen hier die Übergänge, indem die Holsteiner,
wie Wilhelm Jensen und Ottomar Enking, Storms Kunst vorerst zu klein-
bürgerlichen Gebilden aufarbeiten und dann, wie Johann Hinrich Fehrs oder
Charlotte Niese, durch Groth zu gegenständlicher Bauernkunst reiften. Der
Meister der nordalbingischen Bauerngeschichte wurde jener *Timm Kröger,*
1844 bis 1918, der aus Haale bei Hademarschen stammte, bis zu seinem
neunzehnten Jahre hinter dem Pfluge ging, dann sein eigner Herr und Rechts-
anwalt wurde, um als Vierundvierzigjähriger, von Liliencron entdeckt, seine
ersten Entwürfe drucken zu lassen. Kröger fühlte sich Groth verpflichtet.
Doch im Landschaftlichen war er von Storm angeregt, und Björnsons nor-
wegische Bauerngeschichten wie der Däne Jens Peter Jakobsen gaben ihm
nordische Haltung. Seine Bauern reden Hochdeutsch, doch so, daß man nach
Satzbau, Gedanken, Gedankenverbindung den sächsischen Seelenton heraus-
hört. „Der Leser soll herausfühlen, daß er Plattdeutsch vor sich hat. Zweck-
mäßig ist es, ihn hieran dann und wann durch kurzen Trommelschlag zu er-
innern." Wie Storm und Groth war Kröger der Dichter der Heide: „Eine *Dichtung der Heide*
stille Welt" 1891, sein erstes Buch; „Der Schulmeister von Handewitt" 1893;
„Hein Wieck, eine Stall- und Scheunengeschichte" 1900; „Um den Wegzoll"
1905; „Des Reiches Kommen" 1909 und, 1908/1913 gearbeitet, „Dem unbe-
kannten Gott". Obwohl die Stimmung der wolkenverhangenen Landschaft
auch Storm nicht fühlbarer zu machen wußte, duldete Krögers streng epische *Timm Kröger*
Anlage keinerlei lyrische Seitentriebe. Auch das war eine Kunst der Sehn-
sucht nach Jugend und Heimat. Den wortkargen Marschbauer kannte Kröger
aus dem Mitbewußtsein eigenen Bauerntums und mit dem wissenden Blick
des Rechtsanwaltes. Wie Storm, fand er den heimatlichen Naturgewalten
mythische Bilder. Er hatte den naturfrohen Sinn des urtümlichen Acker-
manns. „Ich bin des Glaubens, daß in einem unserer Erfahrung verschlos-
senen Sein eine besser gelungene Welt besteht, von der die uns umgebende

nur ein Traum, ein Abbild ist. Mein Optimismus wurzelt also im Transzen-
Adolf Bartels dentalen." Wie Kröger die Kette von Storm zu Groth, so schloß *Adolf Bartels,*
1862 bis 1945, aus Wesselburen, die Kette von Hebbel zu Groth. Die trieb-
hafte Bauernnatur schärfte und trübte diesem Nachkommen von Leibeigenen
den Weltsinn. Mit seinen Dramen und sehr entfernt in Hebbels Sinn ging er
Rom an, das Rom der Antike, des Mittelalters, der Renaissance. Von den
beiden Romanen schilderten „Die Dithmarscher" 1898 Höhe, Hochgefahr,
Untergang dieses bäuerlichen Freistaates, während „Dietrich Sebrandt"
1899 aus der Erhebung Schleswig-Holsteins ein Buch der Sorge und War-
nung wurde. Er setzte germanischen gegen römischen Freistaat, „germani-
sches" gegen „römisches" Christentum, glaubte an die „arische" Abkunft
Christi und predigte ihn als „deutschen" Heiland einer Laiengemeinschaft
Gustav von Katholiken und Protestanten. *Gustav Frenssen,* 1863 bis 1945, aus Barlt
Frenssen bei Meldorf, hatte als junger Pfarrer seinen Dithmarscher Bauern wöchent-
lich von so schwierigen Dingen zu reden, ohne eine sattelfeste theologische
Schule zu haben. Er hatte mit den Worten zu ringen und suchte daher nach
einer glückhafteren Form der Aussprache. Mit der phantastisch-romantischen
Marschgeschichte „Die Sandgräfin" 1896 hatte er sie zuerst gefunden. Nun
folgte ein rascher Aufstieg. Um den inwendigen Menschen geht es ihm bei
„Jörn Uhl" 1901, wo der Hof als ein Hohes und Heiliges, Menschentum und
Seele aber als das Höchste und Heiligste erscheinen. Das Reich Gottes auf
Erden ist es in „Hilligenlei" 1906, wo Christus als der vollkommenste Heilig-
landsucher gezeigt wird. Und in „Peter Moors Fahrt nach Südwest" 1907 ist
es das heimatliche Seefahrervolk. „Der Pastor von Poggsee" 1921 prüft die
deutsche Verwandlung durch den Krieg. Die Romane, die Frenssen an diesen
Verwandlungen Büchern vorbei oder darüber hinaus geschrieben hat, verlieren sich immer
Gottes tiefer in die Politik zeitgenössischer Tage. Der Dichter war ein verträumter
Lebensgläubiger mit allen Merkmalen einer bäuerlichen Natur, die sich an
den Geist verloren hat. Er stand Dickens näher als den nicht unverwandten
Storm, Freytag, Keller, und war mit Groth eines Herzens. Dieser Bauernsinn
hat den mittelländischen Allvölkergott in die völkerferne Einsamkeit seines
schmalen Küstensaumes zurückverwandelt. Krögers Gott des Jenseits war
bei Barthels ein deutscher Lutherchristus und bei Frenssen ein germanisch-
heidnischer Heiland geworden.

Was aber ist nun eigentlich in diesen kleinen Leuten nordalbingischen
Schlages vorgegangen? Das erfährt man durch die zwei größeren, die ein-
ander nicht schärfer entgegengesetzt sein konnten.

Detlev von Liliencron, 1844 bis 1909, aus Kiel, stammte durch die eine

Großmutter von Leibeigenen, durch die Mutter von einem amerikanischen *Acker und* *Schlachtfeld*
General, durch den Vater von kleinen Beamten, die man erst im siebzehnten
Jahrhundert geadelt hatte. Bei solchem Junkertum trifft wohl das Stichwort
des Dichters: „Plebeische Gesundheit". Das Hemmungslose und ewig Jun-
genhafte; Prassen, wenn man es hatte; Pochen, wenn man Hunger litt; das
war eher der emporgekommene Freigelassene, als der ins Bäuerliche ge-
duckte Junker. Doch nicht genug. Durch den preußischen Waffenrock war er
in die Kriegerkaste des neuen Staates gehoben, aus eigener Schuld wieder in
sein armes Häuschen zurückgesetzt worden. Dehmels Frage, welcher Lilien-
cron eigentlich der echte gewesen sei, der Jasager oder der Verneiner des
Lebens, der Freiluftmensch oder der Traumjäger, der empfindsame Lobprei- *Detlev von* *Liliencron*
ser oder der behäbige Spötter seines Winkels, der Allerweltskumpan oder
der vornehm Einsame, der Gottsucher oder Gottflieher, kann nur eine Ant-
wort finden. Gleich echt war der Gestiegene und der zweifach Gestürzte. So
lebte denn Liliencron zwischen den Ständen, in der Spannung seines großen
Erlebnisses von Königgrätz und Metz dort und seines täglichen Lebens hier,
weltanschaulich zwischen Schopenhauer und Nietzsche, die er beide gar
nicht verstehen konnte, 1878 dem Katholizismus nahe und 1909 des Glau-
bens, daß Gott nicht zu finden sei, ohne Stil im Leben, ohne Stil in der
Dichtung. Sehr viel war Ausschuß. So der rohe Krawall seiner Dramen, so
aber auch Romane, die keine waren: die kindliche Geschichte aus Nirgendwo
„Der Mäcen" 1889; die gequälte süddeutsche Erzählung „Mit dem linken *„Der Mäcen"*
Ellbogen" 1899; die selbstschildernden Bücher „Breide Hummelsbüttel"
1887, „Leben und Lüge" 1908, um nichts zu verschweigen. „Entsetzlich
wär's für mich, sähe ich aus wie ein Dichter." Liliencron gab sich aber alle
Mühe, mit so sämtlichen Werken auszusehen wie ein Dichter. Sein echtes
Werk entflammte sich zwischen den beiden Polen Heimat und Krieg. „Ad-
jutantenritte" 1883, „Eine Sommerschlacht" 1886, „Unter flatternden Fah-
nen" 1888, sind in keinerlei Sinne Novellen. Es sind die ersten Kunstgebilde,
die der sächsischen Historie und der sächsischen Reiseschilderung gleichartig
sind, Kleinbilder aus dem engen Blickfeld des Schützenzugführers, Aussage
von Tatsachen und wie sie erlebt wurden. Die Sachprosa Mommsens und
Barths und wie sie alle hießen, ist zweckentlastete reine Kunst geworden.
Was von diesen Kriegsbildern gilt, das trifft auch auf die Heimatbilder zu.
All diese bürgerlichen Geschichten auf dem Hintergrunde von See und
Heide, nordisch grausam und grell mit tobendem Meer, flackernden Feuer-
bränden begehrlicher Jagdlust, sind Landschaftsaufnahmen und sie gehen
im übrigen von der menschlichen Gestalt aus, von jenen nordisch-sächsischen

Käuzen, die seit Jahren die Skizzenbücher sächsischer Dichter zu füllen be-
gonnen hatten. Insgesamt sind es Prosaballaden, wenn das Ding schon einen
Namen haben soll. Doch der Vers macht da gar keinen Unterschied. Lilien-
cron ist der einzige Dichter des Krieges gewesen, kein Scherenberg, sondern
ein Künstler des Kleinbildes und der Kurzgeschichte. Die Natur, graues
Nordmeer, baumlose Inseln, fette Flachtrift, Buchenwald, blühende Heide,
wird nicht anders erlebt als das Niemandsland zwischen den Heeren: aus
dem Sattel, mit tierhafter Sinnenschärfe, mit der lauernden Waffe. Da be-
deutet Weib Bauerndirne und Liebe ins Heu werfen. Zwiespalt der Stände
ist höchstens Zwiespalt des Gefühls. Die Maschine steht so selbstverständlich
da wie die Natur. Das ist die Stimmungskunst eines Geistes, der weder ge-
dankliche Tiefe noch weltanschauliche Gelüste hatte, sondern in einem natur-
verstrickten Triebleben atmete im Kreislauf der lebensausbrütenden und
blutverzehrenden Scholle: des Ackers und des Schlachtfeldes. So sickerte dies
Dasein in das unmöglichste aller Gebilde, in das „kunterbunte" Epos „Pogg-
„Poggfred" fred" ein, das 1896 mit zwölf, 1904 mit zwanzig Gesängen ausgegeben
wurde. Der Grundriß zu diesem Traumschloß „Froschfrieden" war sehr alt.
Das Gedicht wurde wie eine Honigwabe, die um immer neue Zellen wuchs
Das und sich mit dem Ertrage der Gärten und Heiden füllte. Dies Traumschloß
Traumschloß war dem Dichter, jenem Orplid vergleichbar, die Freistatt auf den Fluchten
vor sich selber, wo der Schuldenbaron reich und allmächtig war, von wo er
Ausflüge in alle Zeiten und nach allen Sternen machte. „Poggfred" war für
Liliencron, was der „Nachsommer" für Stifter, „Phantasus" für Holz, „Phan-
tas Schloß" für Morgenstern bedeutete. Auch hier war das Ziel des Grotesken
und Kosmischen erreicht. Liliencrons sprachliche Wirtschaft war so ungeord-
net wie seine häusliche. Er malte Bilder. Sein Zeitwort macht persönlich.
Er schuf Sagen. Neuworte, Koppelgespanne, Zeitwörter einer vollkommenen
Ausdruckskunst sind ihm gelungen. Bei meist strengen Reimen verfügte sein
ungewöhnliches rhythmisches Gefühl über den umfangreichsten und wechsel-
vollsten Versvorrat. Sächsisch waren die Meister seiner Anfänge, Droste-
Hülshoff, Storm, Groth. Zu ihnen tritt der Russe Turgenjew. Der Staat Bis-
marcks war Liliencrons gemäße Umwelt.

Rembrandt **Julius Langbehn,** 1851 bis 1907, stammte kleinbäuerlich aus der Lübecker
als Erzieher Bucht, war durch die schleswigsche Mutter zu Hadersleben geboren und im
holsteinschen Kiel aufgewachsen. Die mütterlichen Vorfahren waren Ge-
lehrte, der Vater ein trefflicher Altsprachenkenner. Ihren Weg ist der Jüng-
ling, nachdem er 1870 die Schlachten der Loirearmee mitgeschlagen hatte,
durch München und Venedig gegangen. Dann ging er den einsamen Weg des

Mannes, der auf eigene Faust Mensch ist und die zugemessene Kraft an einem großen Gedanken verbraucht. Und dieser Gedanke war: dem deutschen Staat eine Seele. Um 1887 schrieb Langbehn eine dünne Folge von Blättern nieder, die er „Niederdeutsches" nannte. Es war ein Wesensbild der Ingwiaiwen des Tacitus. Indem der altvenezianische Staat als Hilfspunkt gesichtet, Blut als mächtiger denn Staat und Sprache erkannt wird, heißen Bauernadel, Grausamkeit, Wahrheitsliebe, Grämlichkeit, Verschmitztheit, Feldherrngabe, Staatsklugheit, Humor, Mystizismus die niederdeutschen Wesenszüge. Bismarck, Shakespeare, Rembrandt, Beethoven werden als Abbilder niederdeutscher Art gezeichnet. Die Niederdeutschen sind sowohl den Römern durch Staatssinn wie den Griechen durch Kunstsinn naturverwandt. Das Buch, das aus diesen Blättern wurde, „Rembrandt als Erzieher" 1890, rief niederdeutsches Wesen als Bildungskraft und Bildungsziel aus. Der erste Abschnitt „Deutsche Kunst" möchte dem Staat die Seele Kunst ein- *Deutsche Kunst* schaffen. Kunst gründet sich auf Sonderart. Sonderart haben heißt Seele haben. Und Seele entspringt nur aus Stammestum. Nur der Geist, nicht das Werkzeug, darf an der Antike gebildet werden. Nur die Denkweise, nicht die Malweise Rembrandts gilt es nachzuahmen. Was Rembrandt als Mensch, das ist Venedig als Staat für die Deutschen. Der zweite Abschnitt „Deutsche *Deutsche* Wissenschaft" fordert statt falscher Fachlichkeit und Sachlichkeit Sinn für *Wissenschaft* Ganzheit aus Kunst und Philosophie. Den Wissenschaften werden zeitgerechte Aufgaben gesetzt, Heimatkunde und Geistesgeographie, „eine wissenschaftliche Zurückführung der Einzelindividualitäten des deutschen Geisteslebens in Religion, Poesie, Kunst und Wissenschaft auf die betreffenden landschaftlichen sowie Stammesindividualitäten". Der dritte Abschnitt *Deutsche* „Deutsche Politik" setzt Preußen, dem deutsch-slawischen Staate, Altvenedig *Politik* zum Vorbilde, das aus italienisch gewordenen Germanen und Slawen gekreuzt sei. Es gelte Preußen zu verbauern und zu verholländern, Altpreußentum gegen Berlinertum, Offiziersgeist gegen Unteroffizierssinn, die Landschaften gegen die Hauptstadt zur Geltung zu bringen. Der vierte Abschnitt *Deutsche* „Deutsche Bildung" fordert die Achsenverschiebung von der Ostsee auf die *Bildung* Nordsee, eine dritte Reformation, die Griechentum gegen Römertum aufbieten müsse. Wie Weltmann und Künstler, so gehören Künstler und Krieger zusammen. Der fünfte Abschnitt „Deutsche Menschheit" meint: „Drei Auf- *Deutsche* gaben sind es, welche jetzt der Deutschen harren: nämlich ihren Geist erstens *Menschheit* zu individualisieren und zweitens zu konsolidieren und drittens zu monumentalisieren." Jeder der deutschen Stämme hat sein eigentümliches Amt. Nach der lateinischen verlangt Langbehn eine griechische Wiedergeburt und

ruft auf die falsche Bildung ein innerliches Sedan herab. Nordalbingien, Venedig, Holland sind die drei Punkte, durch die eine neue deutsche Bildung bestimmt wird. „Das neue geistige Leben der Deutschen ist keine Sache für Professoren; es ist eine Sache der deutschen Jugend." Das Buch, in einem Zuge gearbeitet, ist kein Mosaik, sondern ein Organismus von Aphorismen. Es an sich selber zu verwirklichen, war fortan Langbehns einziger Beruf. Aus dem Lübecker und oberdeutschen Mittelalter wurde er 1900 zu Rotterdam katholisch .Lyrisch-hymnisch klang das griechische Deutschtum dieser

Liliencron und Langbehn Seele in den „Vierzig Liedern" 1891 auf. Langbehn hat die sächsische Staatsschöpfung entgiften und niederdeutsch beseelen wollen. Indem er den Schwerpunkt aus dem lateinischen in den griechischen Bereich verschob und das alte Kreuzritterideal wieder beschwor, suchte er dem germanischen Herrenstolz das Christentum von neuem schmackhaft zu machen so wie einst der „Heliand". Sein Buch war Gemeingut der Zeit und hat auf die Dichtung mächtig gewirkt. Julius Langbehn steht gegen Friedrich Nietzsche, in dem er den zerstörenden Dschingis Khan sah.

Liliencron ist der Dichter und Langbehn der Philosoph dieser niederdeutschen Elementarwelt, beide Soldaten von 1870, aber Liliencron der Junker auf eine geistige Art deklassiert, während der bürgerliche Langbehn sich durch seine Gesinnung adelt. Von dem triebhaften Dasein des einen führt keine Brücke zu dem reinen Verstandesleben des andern. Ihre Traumburgen standen, wenn auch tief getrennt, dicht nebeneinander.

Westfalen Westfalen zeigt die alte und die neue Zeit, katholisches und evangelisches Gottbewußtsein, Stil von gestern und Kunst von heute in mannigfacher Durchdringung.

Übergänge weltanschaulicher und persönlicher Art führen an den Dichter heran, der vielleicht kein glücklicher Künstler, aber ein rechter Seher gewesen ist. *Friedrich Wilhelm Helle*, 1834 bis 1901, aus Böckenforde, nahm nach romantischen Epen noch einmal den Klopstockkampf auf mit dem gewichtigen Großgedicht „Jesus Messias" 1870, während *Friedrich Wilhelm Weber*, 1813 bis 1894, aus Ahlhausen, ein beredter, aber naturfrischer Lyriker, eben jenen romantischen Epen den Stil seines stürmisch ergriffenen Sachsengedichtes „Dreizehnlinden" 1878 abgewann, dann aber viel tiefer und gegenwärtiger die nordische Verserzählung „Goliath" 1892 formte und rühmlich aus romantischen Dichtungen Skandinaviens übersetzte. Da war schon etwas

Die Brüder Hart von dem, was die „Kritischen Waffengänge" 1882/1884 der Brüder Hart forderten. „Das Heil kommt weder aus Ägypten noch Hellas. Aus der germanischen Volksseele muß eine neue Kunst geboren werden . . . Wir brau-

chen keine weitere Formglätte, aber mehr Tiefe, mehr Glut, mehr Größe."
Heinrich Hart, 1855 bis 1906, aus Wesel, war dazu unterwegs. Von dem
Gedichtbuch „Weltpfingsten" 1872 führte das Prophetische, von dem Drama
„Sedan" 1882 das Nationale, von der Novelle „Kinder des Lichts" 1894,
Vorboten höherer Menschlichkeit, zu Harts epischem Wurf der Jahre 1887 bis
1896 „Das Lied der Menschheit". Vierundzwanzig Einzellieder waren ge-
plant. Drei wurden fertig: „Tul und Nahila" 1886, der erste Mensch; „Nim-
rod" 1888, das erste Königtum; „Mose" 1896, der erste Priester. Spätere
Lieder sollten die ganze Menschheitsgeschichte heraufführen. „Baldurs
Heimkehr" sollte einen Ausblick in die Zukunft und „Gesicht von den Sie-
ben Flammen" dem Gedicht einen seherischen Abschluß geben. Die Mensch-
heit erscheint hier als organisches Gewächs, der Keim zum Baum, Kindheit
zum Mannestum. Also Herder. Harts Vers ist das Reimpaar jambischer Fün-
fer. Dieses Lied der Menschheit Harts hat einen vollen Ton von Holzens
Phantasus. Es steigt zwischen den verwandten Dichtungen Papes und Schacks
auf, eine Kulturdichtung aus den geschichtlichen und naturwissenschaftlichen
Ansichten hier der neueren wie dort der älteren Zeit, abermals eine Offen-
barung des epischen Triebes der Sachsen, aber schon auf der Grenzscheide
von Historie und Philosophie. *Julius Hart,* 1859 bis 1930, aus Münster, kam
von lyrischen Sammlungen her zu dem Buch „Der neue Gott" 1899, in dem
er sich mit den Religionsstiftern Asiens auseinandersetzte. Er kämpfte gegen
Nietzsche wie gegen Tolstoj, weil jener unter das Joch südlicher, dieser öst-
licher Weltanschauung zurückführe. Hart war wie Schopenhauer altindischer
Weisheit voll, umfaßte Buddha und Christus wie Brüder, nahm Welt und
Ich nur als verschiedene Worte für eine Sache. Er meinte den „letzten" Gott,
den „Gott der Kausalität", den ältesten und jüngsten der Götter, den Er-
zeuger und Verschlinger aller Gottheiten zerstört zu haben. Zwischen den
Brüdern Hart wuchs auf und barg sich der echte Dichter und rechte Seher.

Peter Hille, 1854 bis 1904, aus Erwitzen, mutet fremd in dieser westfäli-
schen Landschaft an. Er hat seine weitverzweigten Namensvettern im nörd-
lichen Böhmen. Im mitteldeutschen Osten sind seinesgleichen seit alters zu
Hause. Hille hat mit Heinrich Hart zu Münster auf der gleichen Bank geses-
sen und das ganze Elend eines ungemäßen Schulbetriebes ausgekostet. Die
Freunde berauschten sich an Byron, Shelley, Grabbe. Sie haßten Vergil und
Geibel. Das „finstre Münster" zu erhellen, gründeten die Jungen einen
„Westfälischen Verein für Kunst und Literatur". Nach wunderlichen Wan-
derungen kam Hille 1885 ausgeplündert nach Berlin, zurück zu den Brüdern
Hart. Auf Papierschnitzeln aller Art verkrümelten sich seine Dichtungen, mit

„Das Lied

„Der neue Gott"

„Ich heiße Peter"

41*

Peter Hille innerm Gehör im Lärm der Straßen und unter nächtlichem Himmel empfangen, im Gehen aufgeschrieben. Nur Sonnenblicke einer abgeblendeten Seele sind ins Auge zufällig Begegnender gefallen.

Weltstaub kreist hier dicht und dichter um den schweren Kern eines Gestirnes. Weit draußen, wo göttlicher Tiefsinn und göttliche Torheit durcheinander wirbeln, wehen einem die ersten Flocken entgegen, das „Büchlein der Narrheit". Dann Wolken von Aphorismen, an Weltgehalt und Stoffgewicht den Gebilden Friedrichs von Hardenberg vergleichbar. Das Gottesbuch „Büchlein der Allmacht" ist ein hohes Lied der Mystik. Sie ist das Gesetz des Lebens, und „der Schüler der Mystik ist ein Afrikareisender der Seele". Gott ist das lebendige Märchen, die Speise der Geister. Frommer Übermut im Schoße Gottes, das ist die Grundstimmung, jenes naive und *„In Gottes Küche"* große Stück „In Gottes Küche", wo „Lieben Gotts Lieschen" Menschen bäckt. Da ist schon fester Boden erreicht. Himmelwiese von den Kindern aus, Weltwiese von Gott her gesehen, wo die Engel fliegen lernen, vom kleinen Dante und dahinter die Verführung einer Berliner Tanzdiele. Dann fest wandelnde „Gestalten", geschichtliche Szenen aufs äußerste verdichtet wie „Sophokles" und „Salome", eine biblische Burleske wie „Goliath der Wiederauferstandene", der von David nur „beinahe totgemacht" wurde. „Blätter vom fünfzigjährigen Baum" wollte Hille seine Gedichte nennen. Da ist Klopstock wieder, aber um ein Jahrhundert reifer, in diesen freiflutenden Hymnen. Sie schwärmen zwischen Welt und Erde. „Sonnenkreise wandelt die Erde mondumwandelt". Diese Ätherschicht wirbelt um einen festen Kern, in dem ihre luftigen Weltstoffe Metalle geworden sind. Die Galgenlaune sei- *Landfahrer* ner frühen Hungerjahre und Landfahrten erzeugte sein erstes Buch, den Ro- *und Schloßherr* man „Die Sozialisten" 1887, Hille der Darber. Hille als Schloßherr aber, in seinem „Nachsommer" und in seinem „Poggfred", das ist der Teutoburger Heimatroman „Hassenburg". An dem fast metaphysisch ausgespitzten Vorwurf Erzeuger und Erzeugter formte Hille sein eigenes tragisches Verhältnis zu Schule und Kirche, die Bildungstragödie seiner Zeit, das Bildungsverhältnis des sächsischen Volkes: „Des Platonikers Sohn" 1896, äußerlich scheinbar lose Szenen von innerlich beispielloser Dichte. Die Widerwelt der Väter und Söhne, dargestellt in der Widerwelt des Humanismus und der Fahrenden: Petrarca und Petrarcas Sohn. Der Humanismus, verzerrt und verhöhnt als Schulfuchserei und Knechtung des Lebens, wird mit der pedantischen Sprache *Die Korybanten* des achtzehnten Jahrhunderts gemalt, salbungsvoll und geistlichen Tones. *der Musen* „Weiß Cicero", heißt es einmal vergnüglich. Das Volk der fahrenden Schüler, „Die Korybanten der Musen und des Geistes", „der Most der Erde",

werden auf ihrer Kneipe inszeniert mit echten Vagantenliedern und litur-
gischen Parodien. Petrarcas Sohn Giovanni geht an des Vaters Humanismus
zugrunde, nachdem er sich bei den Fahrenden bestätigt gefunden hat. Bei
Petrarca aber bricht schließlich die gesunde Menschennatur durch die ange-
bildete Unnatur. Hille dachte wie Langbehns Rembrandtbuch. Schullatein,
nein, Hellenentum ja!

Wie Hilles Welt war sein Stil das Universum, feierlich heilig und grotesk, *Stil Universum*
kindlich unschuldig und verrucht zweideutig, krasse Sachlichkeit und inner-
liche Ausdruckskunst, zart wie ein Hauch und derb wie Hofgeruch. Wenn
Hille jenseits des Bürgers stand, er, der von London bis nach Rom wanderte
und nie hatte, wohin er sein Haupt legen konnte, so stand er drüben und
drüber wie ein Bettelmönch. „Eine Weltwonnen schlagende Nachtigall, ein
Franz von Assisi wäre er gern gewesen." Dies Gottesfriedenskind, dieser
dem Logos Nachgrübelnde, der sich Dante verwandt fühlte, war vom Schlage
jener Mystiker, die der Kirche als Irrende galten. „Religion: ich heiße Peter.
Das heißt Fels. Und so ein Fels, ein fester, fühlender, das Wirkliche, Gott
fühlender Fels will ich sein; zusammengehen, daß nicht ein Bläschen in mir
bleibt. Gott will ich haben, wie ich ihn nur haben kann und mit ihm die ju-
belnden Wunder seiner Welt."

Otto zur Linde, 1873 bis 1938, aus Essen, hat die Hingabe an den lyri- *Fahrtvater*
schen Beruf bis auf den First des kosmischen Denkens getrieben. Sein Vater *Charon*
stammte von Solling, seine Mutter vom Niederrhein. Zu Zeiten muß Christus
und Christi Mutter sein Binnenerlebnis gewesen sein. Eine Mittelachse christ-
licher Vorstellungen läuft durch sein ganzes Werk. Fast im Sinne von Bach-
ofens Allmutter hat er sich die Gottesmutter über die Gleichung Maria-
Moira zur Weltgebärerin umgedeutet. Seine Weltanschauung läßt sich auf
die Kreuzform zweier Grundgedanken zurückführen: jedwedes ist zugleich
sein Gegenteil und alles fließt. Alles, was lebt, ist nur „Zustand" seiner
„Wirklichkeit", seines eigenen Wirkens. Daher gibt es keine Wiederkehr des
Gleichen, sondern nur Wiedererkennung seiner selbst auf den Stufen seiner
Zustände. Daher stammt auch das Vermögen, alles Mißglückte immer von
neuem zu gebären und besser zu machen. Das soll heißen: an sich selber
emporklettern. Jede Seele muß sich ihrem jeweiligen Zustande gemäß be- *Otto zur Linde*
nehmen. Alles Festgelegte wird abgelehnt, jedes „Dogma", jede „Unio my-
stica", jedes „Nirwana". Keine Schöpfung jenseits und kein Schicksal über
mir. Wir sind nicht „erschaffen", sondern „wirklich". Dieser Zustand ist unser
Werk. Nicht „Gott" ist, sondern „wir" sind der Welt verantwortlich. Zwei
Bilder drücken das Wesen dieser Welt aus: die Kugel, soweit die Welt Chaos

ist, Einheit aller Gegensätze; die Spirale, soweit die Welt ewiges Fließen ist. Je einem dieser Bilder entspricht ein anderes für die Welteinwirkung des Ich: Kugel - Insel; Spirale - Schiff. Dem Zustandsbild der Kugel entspricht das Wirkbild Insel. Sie ist die erste „Zelle" der Ordnung. Sie liegt hinter uns zugleich und vor uns. Sie ist verlorene Heimat und erstrebtes Wunschland. Abendrot und Morgenrot. Sie ist gegenüber dem „Nichts" des Chaos die Insel „Uecht", Osten und Jenseits des Weltalls. Sie ist einsame Gemeinde des Dichters. Sie ist aus germanischer Vorstellung Thule. Doch sie spielt ins Antike-Atlantis wie sie ins Biblische-Kana und Bethlehem spielt. Dem Bewegungsbild der Spirale entspricht das Schiff, der Kahn der Sehnsucht nach dieser Insel. Aus antiker Vorstellung ist es das Charonschiff, das Schiff des Fahrtvaters Charon, der das Erdensteuer hält, der die Erde durch die Himmelswelt rudert, der zum ewigen Morgenrot fährt und verborgene Inseln weiß. Und dies ursprünglich antike Bild wandelt sich ins Übervolkliche zu der Menschheit Argoschiff, das neualtes Menschheitsland ersegeln soll, aber auch ins Germanische als Wikingerschiff „unsichtbar lenkend eures Volkstums Meeresfahrt". Das sind alles Denkbilder zugleich und lyrische Formeln.

Denkbilder und lyrische Formeln

Für diese Weltanschauung, die alles „ein"fach sah, gab es nur eine Kunst. Sie ist nichts als Sprache. Es ist das Unendliche, das sich von Endlichkeit zu Endlichkeit mit sich selber verständigt. „Kontakt der Sprachseele mit dem Objekt", das ist alles. Du sollst nicht den Baum singen, der Baum muß sich singen. Die Eigenbewegung der Vorstellung und die Eigenbewegung des Rhythmus müssen sich decken. Eigenbewegung der Vorstellung ist gewissermaßen natürlicher Ablauf des Gehwerks im Leibe der Vorstellung. Eigenbewegung des Rhythmus, das ist der einer Sache innewohnende Rhythmus wie Bahnfahrt oder müdes Gehen. Der Rhythmus hat zweierlei Neigung: zur Seitengliederung und zum Fortschritt. Und es gibt zweierlei Arten von Rhythmus: zeitmaßhaltenden und lautmalenden. Jeder Rhythmus kann jede Form haben. Der Leierkasten, den Holz abstellen wollte, ist immer da. Nur hat jedes Ding seinen eigenen Leierkasten. Zur Linde verneinte jede vorgängige Kunstform. Sag alles wörtlich. Der Dichter ist alltäglich und bürgerlich, wie auch Langbehn wollte. Kunst ist nicht Selbstzweck, aber auch nichts als Betätigung des Künstlers. Religion durch Kunst zu ersetzen, ist Gotteslästerung. Kunst ist bestenfalls Herberge auf dem Wege zu Gott. Natur ist eine höhere Kunst und einziger Wertmesser der, daß ein Gedicht der Werdestufe des Dichters gemäß sei.

„Kontakt der Sprachseele mit dem Objekt"

Sag alles wörtlich

Nachdem zur Linde 1909 seine weit ältere „Philosophie in Versen", „Die Kugel", hatte erscheinen lassen, gliederte er seit 1910 sein lyrisches Werk in

„Charontischer Mythus"

sechs einzelne und je ein Doppelbuch auf. „Thule Traumland" 1910 sind Traumliebesidyllen, aus Goethes Thulelied ausgesponnen, und Christuslegenden wie Marienlieder von apokrypher Art. Die „Lieder der Liebe und Ehe" 1910, formstreng und wohllautend, geben den kindlichen Urgrund dieser Seele frei. „Stadt und Landschaft" 1911 waren neue Kunst einer vergeistigenden Sachlichkeit. Diese erste Dreiheit wurde von einer zweiten überhöht. „Charontischer Mythus" 1913, Gesicht und Sage des Sehers von der Ungestalt des Chaos, ist ein rätselhaftes episches Bilderbuch, das erst durch die späteren Bücher erschlossen wird. „Menschen, Wege und Ziele" 1913 enthält, um einen Kern von Idyllen des Hauses und der Natur geordnet, Anklagen und Ahnungen des heraufziehenden Gerichtstages, Stimmungen des Dichters aus seiner tragischen Volksverlassenheit. Das Buch „Abendrot" 1914 webt in der kindlich reinen Zufriedenheit des Abgetanen. Die beiden Doppelbücher „Lieder des Leids", „Denken, Zeit und Zukunft" klären die Weltanschauung des Dichters verständlich auf. Seine Tonleiter der Form läuft von der Grenze, wo Arno Holzens Reich endet, über strophisch gebundene, doch frei geverste Gebilde und romantisch-volksliedhafte Lieder bis hart an die Grenze, wo Stefan Georges Einsamkeit beginnt. Das war der verwegene Versuch zu einer Dichtersprache des Überweltlichen, die den bildlosesten Ausdruck selbst in reinen Stimmungsgedichten verantwortet, die aus allen Wurzeln wie von Natur neue Wörter grünen läßt. Von den Jugendgenossen war es wohl Bleibtreu, der zur Linde Mut gemacht hat, und Holz, durch den er vor sich selber gerechtfertigt wurde. Aus der Romantik haben ihn Hardenberg und Tieck angeregt, vor allem aber Schellings Philosophie. Von fernher war es das Zwielicht der Scholastik und Renaissance. Auf Nikolaus von Kues weist schon das Kugelbild. Des Kusaners kühne Sprachbildungen hat zur Linde wiederholt. Auf den Kusaner weist der Zusammenfall aller Gegensätze. Ja, bis von Heraklit her sind Wirkungen spürbar. Nicht wenige Vorstellungen sind altgermanischer Herkunft. Auf Wodanstraßen und Normannsmeeren zieht der germanische Mühegott durch die Welt. In „Deutsche Weihnacht" setzt sich der Dichter gerecht mit dem Judentum auseinander. Und er hat den deutschen Weltsendungsgedanken.

Die Monatsschrift „Charon", die seit 1904 Otto zur Linde und Rudolf Pannwitz herausgaben, wollte aus Religion, Philosophie, Dichtung, Leben wieder ein ganzes Menschentum bilden helfen und faßte wirklich die lyrisch gestimmte Jugend des gesamten Raumes in eine Gemeinschaft: Karl Röttger aus dem westfälischen Lübbecke, Erich Bockemühl aus Bickenbach, den Lübecker Friedrich Ranke, den zu Berlin geborenen „Urenkel von Walfisch-

Zwischen Arno Holz und Stefan George

Heraklit und Cusanus

„Charon" und sein Kreis

fängern" Rudolf Paulsen. Manche aus diesem Kreise verstummten oder ver-
pflichteten sich tätigen Berufen. Rudolf Paulsen und Rudolf Pannwitz wuch-
sen zu sich selber heran. Der Gesellschaftsdenker, Schulerneuerer, Spracher-
zieher Berthold Otto erfüllte die jungen Leute mit seinen Gedanken. Otto
zur Linde und der Charonkreis bedeuten: Wiedererwachen des großen, gott-
erfüllten sächsischen Liedes, entgegen der ostdeutschen und der rheinischen
die sächsische Lösung der neugestellten Frage Kunst - Form - Lyrik.

Welfenland Über die beiden deutschen Welfenstaaten war das preußische Schwert von
1866 gekommen. Es gab in Braunschweig und Hannover niemanden, der
sich vom Reich ausgeschlossen hätte. Doch nicht alle wollten preußisch sein.
Hier saß der Widerstand gegen das, was Deutschland wurde, mit seiner über-
zeugtesten Gesinnung.

HANNOVER war auch diesmal die Hochschulstadt Göttingen. Unlängst
waren es sieben gewesen, die um der Verfassung willen dem König absagten.
Jetzt war es nur einer und seine Absage galt den Hohenzollern.

Paul de Lagarde *Paul de Lagarde,* 1827 bis 1891, aus Berlin, hatte seinen Vaternamen Böt-
ticher mit dem der pflegemütterlichen Großtante Lagarde vertauscht. Er war
niedersächsischer Herkunft und kehrte auf den Göttinger Ruf, 1869, in den
stammesväterlichen Bereich zurück. Hier lehrte er dem Namen nach morgen-
ländische Sprachen, tatsächlich aber Religionswissenschaft. Gedankenfor-
mende „Gedichte" 1886 und „Deutsche Schriften" 1878/1881 sind seine
Beisteuer zur Literatur. Er gehörte zu denen, die nach 1871 das Recht des
Anklägers besaßen, weil sie vor 1870 die Pflicht der Warnung erfüllt hatten.
Es war die alte deutsche Geistigkeit der spätromantischen und nachklassi-
schen Zeit, die ihn vor der Haltung des neuen Staates warnen hieß. Er hat
immer wieder das ärztliche Messer für die Körperfehler des Reiches gefor-
dert, von denen er wußte, daß sie keine Geburtsmängel waren, sondern von
weither erbliche Belastung. Als Sprachgelehrter und Theologe war er mit
den Bildungsvorgängen des Judentums, der christlichen Kirchen, der süd-
westdeutschen Lateinbildung vertraut wie wenige seiner Zeitgenossen. Und
aus dieser Kenntnis schöpfte seine Kritik. Er meinte, die deutsche Haltung
gegenüber dem Judentum könne nicht durch Nächstenliebe, sie müsse durch
Feindesliebe bestimmt sein. „Ultramontanismus und Protestantismus" müß-
ten durch eine höhere Gesinnung überwunden werden. Alles, was unfrei
macht und bevormundet, das Übermaß an Staat wie Schreibermacht hat er
durch vierzig Jahre bekämpft. Wie seine Kritik, so flossen auch seine Rat-
schläge aus Sachkenntnis. Religion muß das ganze Leben durchdringen, muß
volkhaft und persönlich sein. „Humanität, Nationalität, Stammeseigentüm-

lichkeit, Familiencharakter, Individualität, eine Pyramide, deren Spitze näher an den Himmel reicht als ihre Basis." Lagarde hat um den Niedergang der Hohenzoller gewußt. Seine Gedanken waren die Vorstufen zum Werke Langbehns. Sie waren ein Ganzes, ohne als Ganzheit in Erscheinung zu treten.

Was hat die Literatur aus Lagarde und Langbehn gemacht! Der große und ernste und schöpferische Zweifel an Haltung und Gesinnung des neuen Staates wird durch die Literatur zur Bezweiflung des Bürgertums, der Gesellschaft, des Staates selber von Stufe zu Stufe gesteigert bis auf den Gipfel eines „durch Handlung unbefleckten Nihilismus". Die ganze sächsische Literatur des Zeitalters löst sich in den Ausdruck einer grotesken Laune auf vom leisen Anflug der Ironie bis zum gewalttätigen Hohn. *Langbehn, Lagarde und die Literatur*

Wilhelm Busch, 1832 bis 1908, aus Wiedensahl, zuerst Ingenieur dann Maler, lebte die längste Zeit in München, um schließlich in die Heimat und an den Harz zurückzukehren. Busch war ein Jünger der Niederländer und Schopenhauers, wie so viele dieser Sachsen ein Freund des Tieres. Die ältere sächsische Satire von Kortum her, die gemeinsächsische Satire Swifts lebt in den Geschöpfen dieses Künstlers fort. Gewollt primitiv wie die Kortums, offenbaren sie ihr Innerstes mit einem Strich und mit einem Wort. Die eisige Ruhe seiner wissenden Miene strahlte auf die Ausgeburten des Gehirns jene Wirklichkeit, die geglaubt wird. Grausamkeiten, übrigens von der Art, wie das Volksmärchen sie liebt, verlieren, so ins Unmögliche übertrieben, ihren Schrecken. Diese groteske Kunst zielte noch romantisch auf den Philister, der die Welt bedeutet. Im Kulturkampf wurden es groteske Satiren römischen Kirchentums — „Die fromme Helene" 1872 — Form und Geist bürgerlicher Selbstzersetzung. Der scheinbar nur launige Spötter unbenannter Menschlichkeit hatte in Wahrheit die tötende Kälte des Nihilismus. Fortgang und Erlebnis eines Menschenalters deutschen Staatsbürgertums machten die arglos lachende Runde um Wilhelm Busch für den andern reif. *Wilhelm Busch*

Frank Wedekind, 1864 bis 1918, aus Hannover, hatte einen Vater, der lange in Amerika lebte, und eine Mutter, die als Schauspielerin weit herumgekommen war. Der Dichter selber führte, nachdem das väterliche Vermögen vertan war, ein Zirkusleben. Unbeschadet seiner Novellen und Gedichte wurde das Prosadrama seine Form. Er hatte sein Kinderland. Ja, er ist über die Not seiner ersten Mannbarkeit nie hinausgekommen. Dies Kindliche in dem Märchendrama „Die junge Welt" 1889 und in der Kindertragödie „Frühlings Erwachen" 1891, gewollt oder ungewollt ins Spöttische und Groteske gezogen, war der Keim seines ganzen Stiles. Die russische Burleske „Der Liebestrank" 1894, eine Preisrede der Körperkunst und des Zirkus, *„König Nicolo"*

Frank Wedekind

ging ihm wie ein heiteres Vorspiel voran. „Erdgeist" 1893, „Die Büchse der Pandora" 1901, „Franziska" 1911 spinnen an dem Vorwurf: alles Verderben durch die Frau. „Karl Hetmann („Hidalla") 1904, „Tod und Teufel" („Totentanz") 1905, „Schloß Wetterstein" 1910 gefallen sich in dem Gegensatz von Familie und Dirne. Die Groteske „Der Kammersänger" 1897, das Hochstaplerdrama „Der Marquis von Keith" 1900 und das Gesprächspiel „Die Zensur" 1907 mischen die Farben und üben den Witz für die Münchner Lite-

Das groteske Drama

raturgroteske „Ooha" 1908, die sich um die Gründung des „Simplicissimus" dreht. Neuartig war das alles, vielleicht zum Lachen, aber sehr traurig. Und im Traum suchte Wedekind nach dem Pfad über sich hinaus. So ist „König Nicolo" 1901 das schönste, tiefste und regelmäßigste seiner Dramen geworden. Mit „Simson" 1913 und „Herakles" 1919 war es zu Ende. Wedekind hatte, wie er sagt, bei der Versform seiner ersten Stücke 1887 an Raimunds Märchenspiele gedacht. Doch was vermochte damit ein Unbürgerlicher, der das Leben umkreiste, ohne dessen Mitte auch nur zu ahnen. Von sich selber, vom Leben, von der Kunst in seinen Ansprüchen enttäuscht, mißbrauchte er die Szene, um auf ihr die Welt so grotesk zu verzerren, wie er sie aus dem Blickwinkel der Dirne und des Hochstaplers sah. Auf der Szene stand sein Reck, um seine absonderlichen Einfälle zu turnen. Er veräffte die bürgerliche Haltung mit ihren eigenen Gebärden und die Kunst durch ihre eigenen Mittel. Wedekinds tragische Rolle spielt ergreifend der entthronte König in „Nicolo": ein Possenreißer, dem man sein heimliches Königtum nicht glaubt und der am drolligsten wirkt, wenn er am ernstesten ist. So tragisch wie hier der Fahrende in seiner Jahrmarktbude, nahm sich dicht neben ihm der Eulenspiegel in der Schenke aus.

Der Kleinmeister der Burleske

Otto Erich Hartleben, 1864 bis 1905, aus alter Bergmannsfamilie zu Klaustal, darf geistig nicht mit dem ewigen Studenten verwechselt werden, in dessen Gestalt er sein unbürgerliches Leben geführt hat. Das Lachen, dessen Hartleben Meister war, das wirkte gefährlicher als kalter Hohn. Er hat in seinen durchsichtigen Versen, mit nicht sehr begabten Spielen, mit seinen unwiderstehlichen Schwänken und Novellen immer wieder die drei aufs Korn genommen, auf denen der deutsche Staat beruhte: den Bürger, den Beamten, den Soldaten. Hartleben war mit tödlichem Ernst der tollsten Dinge mächtig. Seine Gabe war es, alles, was ihn reizte, ins Lächerliche zu verzerren. Er hat allein diese sächsische Groteske zu einem fast reinen Stil ausgebildet. Er ziselierte an seinen kleinen Sachen mit der Geduld eines Kleinmeisters und mit der Verantwortung eines großen Künstlers. Sein Griff war es, das Bedenkliche und Zweideutige so diskret zu drehen, daß es nur

einem wissenden Auge auffiel. Aber wer glaubte diesem legendenhaften Zecher den Ernst seines Lebens? Nur einmal wäre er beinahe verstanden worden, als er die Tragödie „Rosenmontag" 1900, die lediglich besser als seine sonstigen Stücke war, in das sittliche Halbdunkel der adeligen Offizierskaste leuchten ließ.

BRAUNSCHWEIG, uraltes Welfenland, hatte als Herzogtum den deutschen Krieg überdauert und eine lange, reiche geistige Geschichte. Hier war Sinn für Vermächtnis und Haltung. Von Braunschweig gingen Ernst und Strenge der Gesinnung und des Stiles aus.

Raabe und das Reich

Wilhelm Raabe, 1831 bis 1910, war durch das Truppengewühl des Aufmarsches 1870 in seine Heimat zurückgekehrt, diesmal und für immer nach Braunschweig. Sein erstes Buch „Des Reiches Krone" 1873 galt dem neuen Staat. Der Roman spielt im Nürnberg und Böhmen des fünfzehnten Jahrhunderts um die alte deutsche und um die Krone des ewigen Lebens. „Gutmanns Reisen" 1891, bei Bismarcks Abgang geschrieben, überblickte noch einmal den geschichtlichen Vorgang der deutschen Einswerdung. Was zwischen beiden Romanen liegt, ist sorgenvolle Erkenntnis, wie schreckhaft sich die neuen Dinge zu gebärden begannen. „Der Dräumling" 1872 verfolgt mit fühlbarem Kummer den deutschen Schichtwechsel von den bescheidenen Geistmenschen, deren Starkmut die reichsgestaltenden Schlachten schlug, zu den Pochern und Auftrumpfern, die jene Schlachten verwerten. „Stramm, stramm, stramm; Alles über einen Kamm" war in „Horacker" 1876 zu lesen. In den kleinen Geschichten „Prinzessin Fisch" 1883 und „Pfisters Mühle" 1885 marschierten alle die Gestalten auf, für die Königgrätz nur geschlagen worden, „um das Zehn-Pfennig-Porto einzuführen". In „Deutscher Adel" 1880 predigt er wider törichtes Auftrumpfen von der Pflicht, den Geistschatz der Zeit vor Versailles zu hüten und zu mehren. Er wurde nicht müde, in „Kloster Lugau" 1893 abermals auf dem Hintergrunde des Krieges die stillen Pflichtmenschen zu feiern, die ausrückenden Krieger und die zurückbleibenden tapferen Frauen, die wahren Schöpfer des Dauernden. Er ließ — „Alte Nester" 1880 — Heimkehrer aus der Fremde im neuen Reich ein neues Leben aufbauen. Gegenüber dem Deutschland, das nach Kolonien verlangte, zeigte „Stopfkuchen" 1891, wie in der Stille der Heimat mehr gelernt, erlebt, geleistet wird. Dies erkämpfte und herausgearbeitete Menschentum, wie die selbstsichere Frau im „Horn von Wanza" 1881, von der die Jungen das Leben lernen, das ist Raabes heilige Sache. Der Abend führte ihn an seinen Aufgang zurück, „Die Akten des Vogelsangs" 1895 zur Kunstweise seiner ersten Novelle und der große Roman „Hastenbeck" 1898 zur Geschichtsdichtung.

„Horn von Wanza"

Der Nachruf Abschiednehmend suchte der nachgelassene Roman „Altershausen" 1911 die Stätten der Jugend auf. Den Toten zu seiner „leidlos, friedvollen Geborgenheit" beglückwünschend, schrieb Wilhelm Jensen ihm zum achtzigsten Geburtstage und der guten alten Zeit 1911 den Nachruf: „Wir ahnten damals nicht, daß die Zeit sich anschicke, eine große Totengräberschaufel zu handhaben, mit ihr eine schreckensvolle Grube auszuhöhlen, um darin alles zu verschütten, was uns von Vätern her als edelste, wertvollste Güter der Menschheit überliefert worden."

Die sächsische Frau *Ricarda Huch,* 1864 bis 1947, aus Braunschweig, stellte neben diese Strenge der Gesinnung die Strenge des Stils. Sie gehörte zu den vielen sächsischen Frauen von gelehrter Bildung und den wenigen Deutschen, die sich in das Schrifttum der Schweiz wirklich eingelebt haben. Ihr Weg führte sie von geschichtlichen Dichtungen zu reinen Geschichtswerken. „Erinnerungen von Ludolf Ursleu" 1893 war, auf Schweizer Boden erzählt, die zeitbuchartige Geschichte einer untergehenden Hamburger Patrizierfamilie. Die Dichterin wiederholte den Vorwurf in „Vita somnium breve" 1903, später „Michael Unger" geheißen. Sie ließ — „Aus der Triumphgasse" 1902 — den patrizischen Besitzer eines Triester Zinshauses die vielfältig verzahnten Geschichten eines Armeleuteviertels erzählen und hatte so wenigstens im Stil *Historien und Historie* den Eindruck der Geschichte. Zuerst verwandelte sich die gedichtete Romantik kleiner Erzählungen, deren einige nach Kellers Art ins Legendenhafte spielen, die gedichtete Romantik „Von den Königen und der Krone" 1904, die sich wie eine bizarre Nachzeichnung von Arnims Kronenwächtern ausnahm, zu der Brustbildmalerei ihrer Romantikbücher, die zwischen Dichtung und Wahrheit schimmert. Schließlich wurde das nach Meyers Vorbild beliebte Italien und der von Handel-Mazzetti vorgedichtete Barock gerade noch Dichtung in den Geschichten von Garibaldi 1906 und „Der große Krieg" 1912, um dann mit „Menschen aus dem Risorgimento" 1908 und „Wallenstein" 1915 ganz geschichtliche Darstellung zu sein. Das selbstbewußte Luthertum der Dichterin kam in Weltanschauungsbüchern zur Geltung. Was hier Erscheinung wurde, war eine kunstmäßige und fast akademische Kunst, über Natur und Leben hoch hinausstilisiert, doch von starker Sinnlichkeit, halb romantisch, halb barock sehr beredt in der Sprache der Sinnbilder. Und über alles die Macht wie Fülle ihrer Rhythmen, die gleichermaßen ihre Prosa wie ihre lyrischen Verse durchströmen.

So standen diesmal in Hannover und Braunschweig einander dichterisch Gesinnung und Stil gegenüber, in denen das alte und das neue Deutschland einander ablösten.

Die Zeit der großen epischen Formen, der besinnlichen musischen Geduld *Die Ballade*
von Dichtern und Lesern, ging zu Ende. Die epischen Kleingebilde, Kurz-
geschichte und Ballade, waren an der Reihe. Die deutsche Ballade ist seit
Gottfried August Bürger eine ostfälische Schöpfung. Das war sie jetzt von
neuem. *Börries Freiherr von Münchhausen,* 1874 zu Hildesheim geboren,
stammte aus dem weitverzweigten sächsischen Geschlecht, das nicht nur den
Lügenbaron Hieronymus, sondern auch den berühmten Söldnerführer Hil-
mar und den Gründer der Göttinger Hochschule Gerlach hervorgebracht hat
und daneben manchen Schriftsteller. Der Dichter war vom Volkslied, von
Bürger und Meyer, vom Berliner Tunnel angeregt. Die neue Blüte der Bal-
lade ging von seinem „Göttinger Musenalmanach" 1898/1905 auf. Seine
Sammlungen kamen seit 1900 und die Gesamtausgabe, „Das Balladenbuch"
1924 heraus. Es ist ein Weltbuch in Balladen, ein Buch des Lebens, Kriegens,
Sterbens; des Alltags; der Schwänke und Schnurren; rundgefügt um den all-
menschlichen Kern der Märchen und Legenden. Münchhausens Balladenstil
hat mit der überlieferten Gattung kaum mehr zu tun. Denn seine Balladen
sind geschichtliche Augenblicksbilder. Sie sind „Herz im Harnisch", eine
junkerliche Weltreimchronik, deutscher Weltdrang in der Tracht der Zeiten
und Völker. Ihre künstlerische Spannweite reicht vom stabreimenden Edda-
stil, wie er schon Peter Hille im Ohr lag, bis zu den geschmeidigen Pagen-
balladen von französischer Tonführung. Sie sind hell, scharf, von entschlos-
senem Wort. Sie singen sich. Die Bilder jagen wie von flinker Kurbel ge-
dreht. Kein größerer Gegensatz als die gleichzeitigen Gebilde der Frau, *Lulu*
von Strauß und Torney, die 1873 zu Bückeburg als Enkelin des Dichters *Lulu von Strauß*
Viktor von Strauß geboren war. Sie ging von der Dorfgeschichte und ge-
schichtlichen Heimaterzählung ihres Weserlandes aus. Ihr erstes Balladen-
buch ist 1902 erschienen. Unsagbar, schwer, von grauer Tiefe und geschlos-
sener Masse, wie von benommener Hand beschworen, ziehen ihre Bilder
zögernd vorüber. Lange Verse, die ihr Grundgewicht nicht rollen läßt, und
selbst die kurzen werden paarweise wie eine germanische Langzeile emp-
funden. Wie auf Umwegen und aus traumbeschwerter Besinnung gewonnen,
fügt sich Sinn zu Sinn. Allgemein und scheinbar beziehungslos im sprach-
lichen Ausdruck gleichen diese Gebilde einem Heiligen oder Schrecklichen
oder Verborgenen, das „Es" bleibt, wie nur Kinder sich ausdrücken. Die be-
gleitenden Handgebärden werden mitgezeichnet. Fast nur Sinnworte und
Bildworte, keine, die Beziehungen ausdrücken. Gruppen fügen sich zu klei-
nen Epen. Nur gelegentlich, wie um Wert auf Überlieferung zu legen, eine
schottische Ballade. Sonst nordisch-germanische Stoffe. Und immer wieder

das dämonische Wesen des Wassers. Überlebensgroß als Ballade wie die Ilias als Epos: „Chronik". Ein Dorf, durch Krieg und Pest verödet. Vom Pestkarren erstanden die einzig Überlebende, eine Jungmagd. Ein zugelaufener Knecht. Sie nehmen den herrenlosen Hof. Sie paaren sich, Saatkorn des Lebens, und lassen es nachwachsen.

Bremen Unter den Hansastädten fehlte es Bremen nicht an allerlei literarischem Tagwerk. Geschehenswürdiges aber geschah, als 1895 der Ostfale Fritz Mackensen zu Worpswede bei Osterholz eine sächsische Malergruppe sammelte, die unter den Torfbauern im Moorland der Weser die Natur suchte.

Hamburg Hamburg war seit alters Theater, und Dichtung war zu Hamburg immer wieder gegen alle Moden sächsische Dichtung geworden. Wilhelm Mielck, von holsteinischer Abkunft und seines Zeichens Apotheker, hatte von Jugend auf den niederdeutschen Mundarten nachgespürt und wurde die Seele des 1874 gegründeten „Vereins für niederdeutsche Sprachforschung". Seine Arbeiten zum sächsischen Volksliede und zum Wortgebrauch der einzelnen Stände waren unschätzbar für das erstarkende Sprachbewußtsein und die aufblühende Literatur sächsischen Mundes. Neben dem älteren Volkstheater in der Vorstadt St. Pauli wurde während der Kriege das plattdeutsche Karl-Schultze-Theater gegründet. Den Spielplan bestritt seit 1870 der Holsteiner
Sächsisches Julius Stinde. Dem sächsischen Theater gingen große Hoffnungen auf. *Fritz*
Theater *Stavenhagen*, 1876 bis 1906, war in Berlin von Otto Brahm gefördert worden und hatte sich wie so viele Sachsen in München gebildet. Er kam von Ludwig Anzengruber. Denn am österreichischen Volkstheater war allerlei zu lernen. Er ging durch Gerhart Hauptmanns Schule. „Jürgen Piepers" 1901 hieß sein Erstling, ein formloses Stück, das aber des Zuständlichen schon kraftvoll Herr wurde. „Der Lotse" 1902 zeugt schon von Bühnenfertigkeit. „De
„De dütsche dütsche Michel" 1902 war keineswegs ein Gegenstück zu Hauptmanns „We-
Michel" bern", sondern wieder ein Ableger österreichischen Stils, Ferdinand Raimunds und seines Verschwenders. Erst nach solcher Vorschule gelangen ihm die eigentümlichen Stücke „Mudder Mews" 1903, die Schwiegermuttertragödie einer jungen Fischerin, und „De ruge Hoff" 1905, eine Bauernkomödie. Stavenhagen hatte wie all diese Sachsen den Menschen im Auge, seine Gestalt und Persönlichkeit. Doch er wußte auch Massen zuverlässig über die Szene zu bewegen. *Johann Kinau*, 1880 bis 1916, der Sohn eines Fischerbauers von der Elbinsel Finkenwärder, Buchhalter bei der Hamburg-Amerika-Linie, schrieb unter dem Namen Gorch Fock und ging in der Schlacht am Skagerrak mit dem Kreuzer „Wiesbaden" unter. Kinau begann 1907 mit kleinen Schilderungen aus dem Leben der Fischer und Kaufleute.

Er stellte den Band „Schullengrieper un Tungenknieper" zusammen, meist hochdeutsche, aber plattdeutsch gespickte Geschichten von Elbe und Nordsee. „Hein Godenwind" 1912 übertrug Brinckmans „Kaspar Ohm" ins Hamburgische. Der Roman „Seefahrt ist not" 1912 ist schriftdeutsch erzählt mit plattdeutschen Gesprächen. Das Schwankbuch „Hamburger Jannmooten" 1914 ist plattdeutsch und die Seegeschichten „Fahrensleute" 1915 hochdeutsch. Mundartliche Possen sowie die mundartlichen Dramen „Doggerbank" 1911 und „Cili Cohrs" 1913 waren sein Ansatz zum sächsischen Theater. Kinaus Erlebnis ist seine Finkenwärder Jugend, der harte Beruf des Hochseefischers, die Vernichtung des Hochseeseglers durch die Fischdampfer, der Heimat durch die wachsende Großstadt. Dieses Erlebnis hat er, dem nur Schwank und Geschichte glatt durch die Hände liefen, nicht zum epischen Großgebilde steigern können.

„Seefahrt ist not"

Lübeck, das keine dichterische Überlieferung hatte, ist zu den Brüdern Mann nicht anders gekommen als zu Ernst Curtius und Emanuel Geibel: durch Adoption. Wie über Geibel die hessische, über Curtius die baltische, so sagt über die Brüder Mann die fränkische Herkunft mehr aus als die hanseatische Vaterstadt über alle drei.

Lübeck

Heinrich Mann, 1871 bis 1950, setzte nicht unfern seiner wendensächsischen Landsleute Richard Voß, Hans Hoffmann, Konrad Zitelmann. Gustav Floerke, Adolf Wilbrandt ein. Hinter der modisch schiefen Vorstellung Renaissancemenschen her fühlte die eine Gruppe seiner Bücher, „Die Göttinnen" 1902, „Die kleine Stadt" 1910, der nordsüdliche Entscheidungsroman „Zwischen den Rassen" 1907 das, was er zu haben wünschte, in italienische Zustände ein. Die andere Gruppe, Gebilde des grotesken Stiles, zeigte das zeitgenössische Deutschland in jeder seiner Erscheinungen von keiner andern als von der schlimmsten Seite. „Im Schlaraffenland" 1900 ist die Berliner Börse der Schriftsteller und Geldleute vom Tisch des Literatencafés aus. „Jagd nach Liebe" 1903 verfolgt den Münchner Tummelplatz der Gelüste mit dem Auge eines Lebejünglings. „Professor Unrat" 1905 ist der deutsche Schulmeister, wie ihn der Pennäler sieht. „Der Untertan" 1915 kann das deutsche Bürgertum sein, wie es die Pariser Boulevardpresse haben wollte. Auf die Dauer hatte er Mühe, Abwechslung in sein Spiel der Geschlechter zu bringen. „Heinrich IV. von Frankreich" 1935/1938 wurde auch wieder nur ein Dank mehr an das galante als an das politische Frankreich. Wir kennen genug überragende Künstler der deutschen Novelle. Dieser Mann ist nicht darunter. Er ist rechtzeitig und folgerichtig beim theoretischen deutschen Kommunismus gelandet. Das deutsche Bürgertum des späten

Heinrich Mann

„Der Untertan"

neunzehnten Jahrhunderts ist bei Heinrich Mann so. „Tatsächlich ist bei mir jede Bewegung zu Ende; ich glaube an nichts, hoffe nichts, erstrebe nichts, erkenne nichts an, kein Vaterland, keine Familie, keine Freundschaft. Und nur der älteste Affekt und der letzte, der stirbt, macht mir noch zu schaffen. Ich habe ihn kaum, aber ich gedenke noch seiner. Die Liebe. Alle die Grausamkeiten, alle die Lust an Gefahren, all der Wille zu zerstören und selbst aufzugehen in einem andern Wesen, woher nähme ich letzter schwacher Bürger so viele Gewaltsamkeiten." Heinrich Manns Drama „Madame Legros" 1913 ließ den Pariser Umsturz von 1789 unbewußt aus der Seele einer kleinen Bürgerfrau hervorgehen. Von einer deutschen Bürgerfrau war solches nicht zu erwarten. Heinrich Mann ist der logische Abschluß dieser Literatur, für die Lagarde und Langbehn weder ein Beispiel noch eine Frage waren. Denn es war eine Literatur der unfruchtbaren Verneinung.

Thomas Mann **Thomas Mann**, 1875 bis 1955, ist trotz seiner Jugendeindrücke aus russischen, englischen, skandinavischen Büchern zunächst im geistigen Bereich seiner Heimat geblieben. Die Novellen seiner Anfänge wie „Der kleine Herr Friedemann" 1899 und „Tristan" 1903, umwarben die gleichen Käuze und lächerlichen Vorwürfe, die den sächsischen Humoristen geläufig waren: so etwa den Mann, der will, daß sein gesunder Hund sich wie ein krankes Hühnchen benimmt. Aber da träumen auch junge Leute von einem Leben in Schönheit und sie verlieren über dem Warten auf Glück den Besitz der Stunde. Und sie erfahren, ob sie nun ernst gemeint sind, schrullenhaft erscheinen oder bizarr verzerrt werden sollen, daß der Künstler einsam außerhalb des behaglichen Lebens stehen muß. „Es ist aus mit dem Künstler, sobald er Mensch wird und zu empfinden beginnt." Wer das Menschliche künstlerisch gestalten will, muß es ins Unbeteiligte abgerückt haben. Das klingt fast nach dem Gedanken vom Kainsmal des Genies, ist aber durchaus bürgerlich gedacht. Thomas Mann nimmt die Frage nicht vom Künstler, sondern vom Bürger her, wenn er gegensätzlich zu Langbehn, der den Künstler wieder verbürgert wissen will, meint, Künstler werden heiße sich entbürgerlichen, heiße „entarten", aus seiner Umwelt heraustreten. „Die Budden-

„Die brooks" 1901 entarten bürgerlich und kaufmännisch, indem sie sich ins Künst-
Buddenbrooks" lerische wandeln. Diese Geschichte einer Lübecker Familie zeugt wenigstens allgemein für die norddeutsche Geisteshaltung Thomas Manns. Mit dem Leben zugleich und mit der Kunst fertig werden, Bürger und Künstler sein, das bürgerliche Dasein zur Kunst und die Kunst zum bürgerlichen Leben machen, das was man in Oberdeutschland naiv bewältigte, war für die norddeutsche Vernunft eine Aufgabe. Peter Hille, Detlev von Liliencron, Frank

Wedekind, Thomas Mann, ebenso viele Lösungsversuche als Menschen. Diese Buddenbrooks, deren Niedergang ein Ring von Familienbildern darstellt, haben auch als Kaufleute keine Haltung. Weder sieht man sie bei der Arbeit noch spürt man die Kräfte, von denen sie zerstört werden, noch hört man ihre Gegenwehr. Ruckweise verlischt ihr kaufmännisches Gebaren und ebenso ruckweise treten Züge des Künstlertums an die Stelle. Unleugbar ist künstlerisches Vermögen hier Verfallserscheinung. Das bezügliche Gegenstück nach Standesbereich, Stil und gestaltender Laune ist der Roman „Königliche Hoheit" 1909 geworden. Hier geht es im Bilde des beispielhaften Fürsten um die Lebensferne des Künstlers. Hört man von dem Dichter Axl Martini noch immer: „Die Entsagung ist unser Pakt mit der Muse, auf ihr beruht unsere Kraft, unsere Würde und das Leben ist unser verbotener Garten", so findet der Fürst am Ende den Entschluß: „Das soll fortan unsere Sache sein, beides, Hoheit und Liebe, ein strenges Glück". Berückung durch den Tod, der leise Nebenton beider Romane, verdichtete sich zu dem Leitmotiv der beiden Werke, mit denen Thomas Mann das Zeitalter des großen Sterbens umgrenzte. Auch diese beiden stehen gegeneinander. „Der Tod in Venedig" 1913 vertont die Hadesfahrt des Dichters, der von der Liebe zu einem schönen Knaben zerstört wird, wie ein traumhaftes, gespenstig emporrückendes Tonbild. „Der Zauberberg" 1924 sollte ursprünglich den gleichen Vorwurf grotesk ins Komische ziehen. Die „Bekenntnisse des Hochstaplers Felix Krull" 1923 haben schon in dieser ersten Fassung in ihrer Art Schule gemacht. Der Vierbänder „Joseph und seine Brüder" 1933/1944 ist das langweiligste und der autobiographische Musikerroman „Doktor Faustus" 1947 das widerspruchvollste seiner Bücher. Thomas Manns Stil hat viele Züge, die durch die ganze sächsische Literatur des Zeitalters hindurchgehen. Die Dinge, die er schildert, sind „von einem unangreifbaren Spott umspielt". Grotesk sind die übergenauen Zahlen und die geflissentlich betonten Einzelheiten. Selbst in Nebensachen werden herausfordernde Lichtpünktchen aufgesetzt. Dieses Nichtwissen, wie es eigentlich gemeint sei, ließ in „Königliche Hoheit" beinahe einen satirischen Simplicissimusroman vermuten. Peter Hille hatte den Nagel auf den Kopf getroffen. „Ist nicht Redekunst höher als Dichtung, wirksamer? Die alten Unterscheidungen im ganzen und einzelnen sind überhaupt gefallen." Thomas Manns Kunst ist sachliche Mitteilung in der zufälligen Form des Romans. Das Sprechende wird bis in die letzte Einzelheit angestrebt. Und wenn es auch Manns Absicht war, von Wagner beeinflußt, ein neues Prosaepos zu schaffen, das mit dem tonkünstlerischen Pessimismus Schopenhauers und der Verfallspsychologie Nietzsches gesättigt wäre, diese

„Königliche Hoheit"

„Der Zauberberg"

Redekunst höher als Dichtung

Kunst ist mindestens ebensosehr zeichnerisch, Bildkunst des menschlichen Antlitzes. Unverkennbar hat sie das Kühle, Verhaltene der sächsischen, hanseatischen Sprachlandschaft. Und es mag richtig sein, daß sich hier die Kunst der Darstellung sehr eng mit Meer und Musik verschwistert hat.

„Liberaler Sozialist"

Von der deutschen Briefmarke bis zum Nobelpreis ist Thomas Mann einschließlich Goethe der meist dekorierte und preisgekrönteste deutsche Schriftsteller. So gutgläubig kann kein Mensch sein, daß er diese schwelgerisch behängte Brust Geleistetem zuschriebe. Das ist der Dank der geheimnisvollen Mächte, die die Welt regieren. Er war zu vorsichtig, um so weit zu gehen wie sein Bruder. Er hat sich als „liberalen Sozialisten" bezeichnet aber er hat daran den Vorbehalt geknüpft: den Kommunismus als Schrecken zu erachten, das hielte er für „die Grundtorheit unserer Epoche". Immerhin ist er nicht nach Moskau sondern nach Kalifornien USA ausgewandert. Und es war unvorsichtig von ihm, von dem „Plebejer mit Volksschulbildung" zu sprechen, „die ins Philosophieren geraten ist". Alles, was sich gegen Vater und Oheim sagen läßt, steht bei Klaus Mann, von dem weiter nicht die Rede sein soll.

Sächsische Mitte

Niedersachsen hatte von Natur keine räumliche Mitte. Seine geistige Auslese hat sich nicht zu Berlin, sondern zu München ausgelebt und herausgestaltet. Sucht man nach einer geistigen Mitte, in der sich alle niedersächsischen Strahlungen aus dem Münchner Brennpunkte sammeln, so stößt man *Christian Morgenstern* auf *Christian Morgenstern*, 1871 bis 1914, bei dem alles zusammentraf. Da wird ein Hamburger zu München ein angesehener Landschaftsmaler und heiratet eine Pfälzerin. Deren Sohn wird zu München geboren, wieder Landschaftsmaler und heiratet eine Schwäbin. Auch deren Sohn wird zu München geboren und ist der Dichter Christian Morgenstern. So durchsichtig sächsisch ist trotz dreier Münchner Menschenalter das Wesen dieses Mannes geblieben, daß es alle diese sächsischen Fäden wie in einem Knoten verschlingt. Da sind die grotesken Gedichte „In Phantas Schloß" 1895, „Horatius trave- *„Galgenlieder"* stitus" 1897, „Galgenlieder" 1905, „Palmström" 1910, Lieder von lebendig und körperhaft gewordenen Begriffen, Ausgeburten „zwanghafter Assoziationen". In ihnen war der Eingang von Lagarde her, den Morgenstern verehrte und dem er mit dem Gedanken nahestand: „Man dient seinem Volke am besten, wenn man seinem politischen Leben in toto widerspricht." In ihnen war die Abkehr von Wedekind und der Ausgang zu Thomas Mann, wenn Morgenstern meinte: der Bürger, nichts als Bürger sei ein trauriger Anblick; aber der aus jeder Bürgerlichkeit hinausgeschreckte Mensch, der verfluchte Bürger sei der Untergang selber. Diese grotesken Gedichte waren Schutzgebärde eines Mannes, der sich dem Großen hilflos preisgegeben sah.

Hinter ihnen bildete sich seit 1905 ein neuer Mensch, der sich von Nietzsche und Wagner über Lagarde zu Rudolf Steiner entwickelte. Die Gedichtbände „Einkehr" 1910, „ich und du" 1911, „Wir fanden einen Pfad" 1914 und das kostbare Tagebuch „Stufen" 1918 beurkunden ihn. Da hatte er das Erlebnis *„Stufen"* der Mystik. Natur und Mensch wurden ihm Geist. Das Johannesevangelium ging ihm auf. Christusdichtungen entstanden. Seine Gedanken klingen seltsam im Tonfall Ottos zur Linde. Die Kugel wird ihm eine Anschauungsform für Gott, „die Welt eine in sich zurücklaufende Spirale". Zur Lindes Grundanschauung von „Ich-mir" hat Morgenstern in der Fassung: „Ich und mich, der Freund ist immer erst der dritte." Zur Lindes Fahrt nach der Insel „Uecht" heißt bei Morgenstern: Leben ist die Suche des Nichts nach dem Etwas. Er hat zur Lindes Vorstellung vom Baum als dem Urbild der Welt und des Lebens. Ja er druckt zuweilen ganze Worte groß wie zur Linde. *Charonfahrt* Morgenstern hat wie die Reihe zu Paul Ernst und Rudolf Schröder um großen und strengen Stil gerungen. Er weiß: „Zugleich aus dem Leben gegriffen und zugleich typisch, das ist höchste Kunst." Sein Satz, wir stünden nicht am Ende, sondern am Anfang des Christentums, mag andere Ursprünge haben. Es war aber auch Paul Ernsts Gedanke. Morgenstern hatte das starke sächsisch-nordische Gemeinschaftsgefühl, wenn er die gültigen skandinavischen Dichter übersetzte. Und 1907 hat er sich gewünscht:

> „Zu Niblum will ich begraben sein,
> Am Saum zwischen Marsch und Geest."

Die *RHEINISCHEN LANDSCHAFTEN* bieten den Anblick einer beharrsamen Entwicklung, eines steten Fortwuchses, wie ihn der Rhythmus der geschichtlichen Jahreszeiten mit sich bringt.

Beiderseits Lahn und Mosel wird von Kassel bis Trier ein volkstümliches *Hessen* Schrifttum von epischer Haltung sichtbar. Merkwürdig stark treten die Frauen hervor. Für sie alle kann die eine stehen, die es verdient. *Malwida von Meysenbug*, 1816 bis 1903, aus einer Hugenottenfamilie zu Kassel geboren und früh an künstlerischen Umgang gewöhnt, eine Vorkämpferin für Frauenrechte und Frauenbildung, teilte freilich ihr Leben zwischen den *Die Frau* Hauptstädten Europas. Sie war die Freundin Richard Wagners und zu Sorrent die Gefährtin Friedrich Nietzsches. Ihr Platoroman „Phädra" gab ein Bild der Welt, wie sie wollte, daß sie wäre. Der Wille nach vorwärts war bei den Männern. Der alte Volksfreund und Mitbegründer des Nationalvereins, *Friedrich Oetker*, 1808 bis 1881, der nach der Besetzung des Landes erfolgreich für kurhessisches Eigenrecht kämpfte, ließ seine zum Teil platt-

Der Bauer deutschen Novellen von Jugend und Heimat, „Aus dem norddeutschen Bauernleben" 1880, in diesem Sinne wirken. Und Oetker gehörte zu denen, die dem flämischen Volkstum Kenner und Freunde warben. Das hessische Bauerntum, wie er es sah und wie der Bauer zu allen Zeiten gewesen ist, gab *Alfred Bock*, 1859 bis 1932, aus Gießen: den Bauer der genußfrohen Gurgel und der sachlichen Erotik, aber auch den harten Arbeiter und listigen Er-raffer, alles derb wirklich, aber spöttisch wohlgesinnt. Volksbildungswesen, Kleingewerbe gegen Warenhäuser, ländliche Genossenschaftsbanken, Sektenwesen sind die Fragen, die er abhandelt. Die hessische Mundart wird nur angedeutet, das Sprachgefüge, nicht die Lautformen. Die oberhessische Heimat ist ihm stellvertretende Anschauungsform der Welt und des Lebens. So waren „Die Pflastermeisterin" 1900, die Ehe der Witwe mit dem jungen Mann, und „Der Flurschütz" 1901, Vater und Sohn als Nebenbuhler um das gleiche Mädchen, Meisterwerke. Es ist die Kunst eines kräftigen und behaglichen Bürgersinns, der die Menschen als Naturgeschöpfe und die Welt ohne Farbglas nimmt.

Geschichtliche Landschafts-Kunst Unter dem künstlerischen Anhauch rheinischer Städte verwandelten zwei Hessen diese Landschaftskunst in Geschichtsdichtung. *Wilhelm Holzamer*, 1870 bis 1907, aus Niederolm bei Mainz, empfängt sein Gesicht weder durch *Wilhelm* sein dramatisches Stimmungsspiel noch durch seine verträumten lyrischen *Holzamer* Verse. Es ist das hessische Dorfleben, das er in seinen ersten Prosabüchern fast zeichnerisch flüchtig wiedergab. Aus diesen Federübungen wuchsen ihm zweierlei geräumige Vorwürfe heran. Nach der einen Seite kam er über den Heimatroman „Peter Nockler. Die Geschichte eines Schneiders" 1902, über den Priesterroman aus der Hussitenzeit „Der heilige Sebastian" 1902 zu dem heimatlich Mainzer Buch „Vor Jahr und Tag" 1908, der Prosadichtung des Deutschen Krieges. Nach der andern Seite aber gelang ihm „Der arme Lukas" 1902, ein Buch des Entsagens und Verzeihens, sowie „Der Entgleiste" 1910, der Entwicklungsroman des eigenen Lebens. Die herbe Gemütswelt seiner Dörflichkeit stand im ererbten Gegensatz zur Kirche und sie wußte sich im Banne des Mainzer Rheintales eins mit südlichem und antikem *Wilhelm* Dasein. *Wilhelm Schäfer*, 1868 bis 1952, aus dem Schwalmdorf Ottrau, ist *Schäfer* ohne Bücher und in strenger Feldarbeit aufgewachsen. In Düsseldorf, wohin er samt der bäuerlichen Familie verschlagen wurde, blieb er fremd. Er wurde Lehrer, weil er das für einen Weg zur Kunst hielt. Statt zur Staffelei kam er zu den Büchern. Gerhart Hauptmann, die Skandinavier, die Russen verehrte er schwärmerisch. Durch Björnson kam er zur Bauerngeschichte. Aus unbefangenem Nichtwissen schrieb er ein Volksstück. Dehmel entdeckte ihn. Mit

dem Drama „Jakob und Esau" 1896 formte sich ihm der Zwiespalt von hellenischem und semitischem Menschentum. Es war Berlin, wo Schäfer zwischen Dehmel und Scheerbart den Rückweg zu seinen Bauerngeschichten fand. Der Kalendermann Johann Peter Hebel erweckte ihm die rechte rheinische Seele und lehrte ihn, das Bedeutende einfach sagen. Die Fremde hatte ihm den Rhein erfühlbar und lebenswert gemacht. Die geistigen und künstlerischen Kräfte des gesamten Rheintales zusammenzufassen, gründete er 1900 seine Kunstzeitschrift „Die Rheinlande" und 1904 den „Verband der Kunstfreunde in den Ländern am Rhein". Mit den „Anekdoten" 1908/1911 *„Anekdoten"* *und* *„Rheinsagen"* und den „Rheinsagen" 1914 ging ihm endlich sein dichterisches Wesen auf. Die echte alte Novelle der Italiener und des deutschen Mittelalters ist aus dem Erzählvermögen des rheinischen Volkes wiedererstanden. Statt des kleinen persönlichen das große Geschehen der Welt, doch in den drei Worten einer Kurzgeschichte. Der mündlich erzählende Stil ist an Hebel, dem rheinischen Antiquarius, am epischen Ausdruck und an der redenden Sprache geschult. Der umständlichen Art, Landschaft und Stimmung zu geben, ist Fehde angesagt. So sind Schäfers Anekdoten „ein Rosenkranz, der Perle für Perle abgebetet werden muß". „Die Halsbandgeschichte" 1910, der Versuch, ein Weltereignis episch zu bezwingen, und „Karl Stauffers Lebensgang" 1912, der Wunsch, die Grausamkeit der Künstlerleidenschaft an einem gültigen Falle zu zeigen, hat Schäfer so beurteilt: dort wäre ihm das Sittliche gelungen, aber das Künstlerische mißglückt, und hier umgekehrt.

Zwischen den Völkern, zwischen Westen und Osten, das war das weltgeschichtliche Erlebnis der Rheinlande. Zwei Frauen haben es in diesem Zeitalter dichterisch zu bewältigen gesucht. *Nanny Lambrecht*, 1868 geboren, aus *Wallonisches* *Grenzland* Kirchberg im Hunsrück, stammte vom Vater her aus einer Thüringer Familie. Ihre väterliche Großmutter war eine Französin. Sie selber wurde Lehrerin. Das Kohlenrevier des wallonischen Grenzlandes war ihr frühestes Erlebnis. Die Wildheit dieser Welt, längst moderne, frisch blutende, noch drohende Gewalttaten ließen sich weder verschweigen noch ins Liebliche umstimmen, als die Dichterin in dem Eifelroman „Das Haus im Moor" 1906 die bäuerliche Trägheit wider alles Neue schilderte, als sie in der Hunsrückgeschichte „Armsünderin" 1909 die Tragödie der ledigen Mutter gab und in dem völkischen Zwischenlande Neutral-Moresnet „Die Suchenden" 1911 nach einer Weltreligion ausschickte, als sie — „Notwehr" 1912 — den tragischen Roman der Ungeborenen schrieb. Auch sie bog nach Düsseldorf aus, indem sie — „Die tolle Herzogin" 1912 — das tragische Schicksal der Jülicher Herzogin Jacoba schilderte. Sie war bei solcher Vorgeschichte mitten

drin und dicht an der Zeit, als ihr Roman „Eiserne Freude" 1914 in Flammen ausbrechen ließ, was bisher in ihren belgischdeutschen Grenzgeschichten geglommen hatte. Es waren Weibesfragen, die an den Menschen dieses Raumes erlebt wurden, Freiheit der Frau, die Gefallene, das Recht des Kindes, Keuschheit um der unversorgten Kinder willen, Verlangen nach dem neu gedeuteten Evangelium. Und das alles erlebt von einer trotzigen, leidenschaftlichen Frau, die von Mitleid brannte und ihre gutmütige Laune nur mühsam verbarg. Diese Frauenbücher sind Urkunden eines schmerzlichen Losringens und Losgerissenwerdens von der Kirche. Die ewige Frage des

Westöstlich
Klara Viebig

Raumes, „westöstlich" wurde von *Klara Viebig*, 1860 geboren, von Trier, aus angeborener östlicher und eingelebter westlicher Seelenkenntnis in ihrem weiten Pendelschlage erfaßt. Die Familie der Dichterin stammte aus der Posener Landschaft und sie hat ihre Jugend in der rheinischen Geburtsheimat verlebt. Sie malte die Ganzheit von Eifellandschaft und Eifelbauer, die kahlen, düsteren, schwermütigen Moorflächen, die einfachsten seelischen Zustände und Schicksale, triebhaft ungehemmte Geschlechtlichkeit in „Kinder der Eifel" 1897, „Das Weiberdorf" 1900, dessen Männer jahrüber in den Fabriken des Rheinlandes arbeiten, „Das Kreuz im Venn" 1908, wo es um das religiöse Leben der Landschaft geht. Die Eifelnovellen „Naturgewalten" 1905 erzählen von Elementarausbrüchen des menschlichen Herzens. Zu dieser westlichen die östliche Gegenwelt. Der Großstadtroman „Das tägliche Brot" 1900 stellt das Schicksal zweier Dienstmädchen gegeneinander. „Das schlafende Heer" 1904 meint die polnischen Ritter im Innern der Lysa Gora. „Die vor den Toren" 1910, das sind die Bauerndörfer, die, von Branntwein und Inzucht entartet, durch das wachsende Berlin aufgesogen werden. Das

„Die Wacht
am Rhein"

Kernwerk der Dichterin nun, „Die Wacht am Rhein" 1902, bringt die beiden Widerwelten des Ostens und Westens in ihre geschichtliche Beziehung. Denn diese abgekürzten „Rougon-Macquart" stellen an drei Generationen einer Familie den westöstlichen, rheinisch-preußischen Ausgleich dar. Die Handlung spielt in Düsseldorf und setzt um 1830 mit einem altpreußischen Feldwebel des niederrheinischen Füsilierregiments 39 und einer rheinischen Gastwirtstochter ein. In deren Kindern werden alle Farbschatten der Blutmischung und des Zusammenspiels von Preußen und den Rheinlanden aufgezeigt. Der Ausgleich geht über die älteste Tochter dieses Paares. Sie heiratet schlicht und sachlich abermals einen ostdeutschen Unteroffizier des gleichen Regiments. Ihr Junge will Maler werden und fällt bei Spichern. Mit dem Krieg von 1870 gipfelt und schließt der Roman. Nicht ohne weiten Ausblick. Denn das Buch klingt in eine Absage an den Krieg aus.

Die alamannischen Landschaften vom Schwarzwald bis in die Vogesen erhielten in Anton Birlingers Zeitschrift „Alemannia" seit 1873 die gemeinsame Stimme der Mundart und Sage.

Der Schwarzwald lebte in den Volkserzählern und Erben Peter Hebels *Der* fort. *Heinrich Hansjakob,* 1837 bis 1916, aus Haslach im Kinzigtal und zuletzt Stadtpfarrer von Freiburg, war an Schilderungen seiner Jugend, seiner Kulturkampfgefängnisse, seiner Reisen zum Schriftsteller geworden. Er brachte seine Handwerkerkäuze mit „Wilde Kirschen" 1888, seine Kultur- *Heinrich* bilder mit „Schneeballen" 1892 ergötzlich zur Versammlung. „Bauernblut" *Hansjakob* 1896 und „Erzbauern" 1899 machten seinen kernig-drolligen Dorfleuten eigene Bücher auf. Aus ortsgeschichtlichen Arbeiten mit seiner Landschaft vertraut, ging er mutig an größere Geschichtserzählungen heran. „Der Vogt auf Mühlstein" 1895 schildert die französische Revolutionszeit, „Der Leutnant von Hasle" 1895 den Dreißigjährigen Krieg und „Der steinerne Mann von Hasle" 1898 gibt Kleinbilder aus dem Mittelalter. Von Hebbel, Stolz, Scheffel laufen alle Schwarzwaldlinien in Hansjakob zusammen. Der Freiburger Stadtpfarrer leistet dem Berner Bauernpfarrer Albert Bitzius eine späte Gesellschaft. Mit Hansjakob meutert das bäuerliche Kulturbewußtsein gegen alle neuzeitlichen Einrichtungen. Das Grundgefühl dieses immer gereizten Raunzers ist vergällte Wehmut und zornige Enttäuschung, Feindschaft des Bauern gegen die Schreiberwirtschaft, des Süddeutschen gegen das Preußentum, des Einschichtigen gegen das Weibervolk. Der Prediger war gewöhnt, die Schrift auszulegen. Er hat die Kunstweise der Kirchenkanzel zu seinem Buchstil gemacht: ermahnen, ausdeutschen, untermalen.

Die Vogesen meldeten sich noch aus dem Lärm der Schlacht zum Worte. *Das Elsaß* *Karl Klein,* 1838 bis 1898, aus Hirschland seit 1867 Pfarrer zu Fröschweiler, erlebte hier mit seinen Pfarrkindern die Schlacht bei Wörth. Erlebnis und Stimme des Volkes aus jenen Schicksalstagen war Kleins „Fröschweiler Chronik" 1876, ein echtes Volksbuch, das einen seltenen Erfolg hatte. Vier Jahre später trug Klein aus Heimaterinnerungen die Vorgeschichte nach: „Vor dreißig Jahren". Während die deutsche Verwaltung vergeblich an ihrem rheinischen Brückenschlage arbeitet, zog sich das Land immer mehr in seine Mundart zurück. *Hans Abel,* 1876 zu Bärental in den Nordvogesen von einer französischen Mutter geboren, schrieb zunächst für das Elsässische Theater Straßburgs mundartliche Stücke, gab mit dem Straßburger Maler Georges Ritleng elsässische Monographien, allein Gedichte in oberelsässischer Mund- *Mundart* art heraus und stellte in dem Volksroman „Die elsässische Tragödie" 1911 an der Zeit 1845/1900 die geistige Lage des Landes dar.

Der Spielmann des Elsaß

Friedrich Lienhard, 1865 bis 1929, aus Rothbach, hat die elsässische Frage Westosten ins Menschheitliche zu Ende gedacht. Er stammte aus einer Familie von Bauern und Schmieden, die seit dem siebzehnten Jahrhundert im Unterelsaß bekannt ist. In Obersulzbach erlebte der Junge den Krieg. Noch in seiner Straßburger Hochschulzeit las er Bleibtreus „Revolution der Literatur" und verkehrte 1888 deren Sinn zu seiner eigenen Bekenntnisschrift „Reformation der Literatur". Durch Langbehns Buch sah er sich auf ein großes Ziel gewiesen. Und seine Heimat wurde ihm das Erlebnis, von dem

„Wasgaufahrten" und „Wege nach Weimar"

seine „Wasgaufahrten" 1895 ebenso kühl wie berauscht reden. Das Buch sagt der Moderne ab. Form kann nur aus dem Herzen kommen. Land gegen Stadt und hinein in den alloffenen Weltraum. Nordlandsfahrten paarten sich mit Anregungen von Burns, Ruskin, Carlyle, Emerson. Und um des Elsasses willen richtete er seine Aufsätze „Die Vorherrschaft Berlins" 1900 gegen den „Berliner Literaturpartikularismus". Er forderte Heimatkunst als Vorstufe der Höhenkunst. Und die „Wasgaufahrten" 1895 erhielten das „Thüringer Tagebuch" 1903 zum Gefährten. Die „Wege nach Weimar" 1905/1908, auf denen er sich das Vermächtnis der Stadt zu erwerben suchte, waren Wege über Weimar hinaus, sowohl nach Eisenach wie nach Bayreuth. Das schöpferische Werk, in dem dies Leben sichtbar wurde, ist nach Umfang und Be-

Das Drama Elsaß

deutung Drama. Ein Zwischenland, so hat Lienhard zuerst seine Heimat erlebt. Das war „Naphthali" 1888, das Drama des ägyptischen Auszuges und also ein Befreiungsdrama, der Jude inmitten zweier Frauen und zweier Völker. Und es war „König Arthur" 1900, der Zusammenbruch des sagenhaften Keltenreiches vor dem Zudrang der Angelsachsen, der mißlungene Versuch, aus nordischer Naturkraft und südlicher Feinkultur eine neue Glockenspeise zu gewinnen. Das Legendenspiel „Odilia" 1898 versuchte es, am Elsaß des siebenten Jahrhunderts, zwischen Merowingern und Karlingen, zu zeigen, wie ein Staat zu verseelen sei, Geist gegen Gewalt. Das Schauspiel „Gottfried von Straßburg" 1897, dem es um Art und Bildung des Dichters geht, setzte die Enge und Gebundenheit der Stadt gegen das starke und freie heimatliche Menschentum. Zu allen Zeiten hatte der Elsässer den Schwankhelden geliebt. Lienhard prüfte die beiden norddeutschen Schelme und Spottvögel auf ihre Seele und fand, daß es die Seele des Dichters sei. Denn sowohl „Till Eulen-

Lienhards Schelmenspiele

spiegel" 1894 wie „Münchhausen" 1899 sind Schelmenspiele vom heimlichen Dichter. Nur ist Eulenspiegel erst noch der seelische Rohstoff zum Dichter, ein edler Mensch, der zum Schutz wider seine greuliche Zeit die Tarnkappe der Narrheit aufsetzt und fällt. Münchhausen, der Liebhaber der Wahrheit, dem das Gaukelspiel der Lüge nichts als Verlangen nach einer schöneren

Welt ist, bleibt Sieger. Im Bann seines Elsässer Erlebnisses war für Lienhard der leibhaftige Dichter Gottfried von Straßburg gewesen. Nach der Thüringer Begegnung wurde es der Held des Wartburgkrieges, „Heinrich von Ofterdingen" 1903, der Mensch, der sich aus Sinnenkraft zu geklärtem Dichtertum emporringt und das Volksgedicht von der Nibelungen Not schafft. Nun ist es aber der Dichter nicht mehr allein. Der Gralgedanke des werktätigen Christentums — „Die heilige Elisabeth" 1904 — und die Macht des Gotteswortes — „Luther auf der Wartburg" 1906 — geben mit dem Dichtertum erst das Ganze: die Wartburgtrilogie, das Gedicht von den drei Siegreichen, die ihr Lebenslied gefunden haben. Die letzte Gestalt des Dichters ist der heldische Künstler, „Wieland" 1905, das Lied von dem geschmiedeten Schmerz, der zur Freiheit läutert. Diese sechs Stufen der einen Bildwerdung des Dichters sind Lienhards Stufen zu den Lebensmeistern. Seine höchste Aufgabe schien ihm die Verseelung des Reiches. Mit „Weltrevolution" 1889 hatte er den kommenden großen Umsturz geschildert. „Ahasver" 1903 geißelte die moderne Wissenschaft. Über beide Dramen hinaus entwarf „Der Spielmann" 1913, ein Bildungswanderroman, die deutsche Seelenkarte an der Schwelle von 1914 und aus dem Gefühl der herannahenden Zeitwende. In dem Roman „Oberlin" 1910 ließ er seinen Helden den Weg, den er selber gemacht hatte, den vom Grenzland ins Hochland, durchschreiten und sah — „Westmark" 1918 — die Heimat wieder dort, wo sie ihn bei seiner Geburt empfangen hatte. Die lyrische Weise seines Lebens klang in den „Liedern eines Elsässers" 1895 auf, gewann in den „Nordlandsliedern" 1898 Rhythmus des Meeres und Eddastil und wurde, von Kinderland zu Kinderland klingend, mit „Hochzeit zu Schilda" 1900 Symphonie eines ganzen Frühlings. Größer als der Künstler ist diesmal der Mensch, der Sonntägliche und Festspielhafte, der die drei Berge Golgatha, Akropolis, Wartburg wieder in ein gerechtes Dreieck brachte, der Wegöffner der Seelenkultur, der Frauenlob und Freund der Jugend, dem die Familie Wurzel des Staates war. Friedrich Lienhard hat aus der Volksliteratur zwischen Schwarzwald und Vogesen Dichtung hohen Stiles gemacht.

Schwarzwald und Vogesen antworten einander wie Ruf und Echo über die Rheinebene. Breisgau und Schwaben haben den Schwarzwald zwischen sich und leben auf verschiedenen Wetterseiten.

Breisgau ist diesmal zweifache Überwindung des Ungemäßen. *Albert Geiger,* 1866 bis 1915, aus Bühlertal, hatte sich durch Feuerbach von Schopenhauer frei gemacht. In dem schlicht volksmäßigen, vollen Gedichtbuch „Duft, Farbe, Ton" 1894 war dieser Wandel schon vollzogen. Das umwor-

Die Wartburg-
trilogie

Die deutsche
Seelenkarte

Golgatha,
Akropolis,
Wartburg.

Breisgau

bene Traumland, die Liebe als Urgrund und Ziel alles Daseins, das steht
Lienhard recht nahe. Und zu Lienhards mittelalterlich elsässischer Welt
fügen sich Geigers „Tristan"dramen, „Blancheflur" und „Isolde" 1905 sowie
Legende von der Frau Welt „Die Legende von der Frau Welt" 1906, Dichtungen aus Gottfrieds und
Hartmanns Bereich. Doch „Maja" 1900 und „Das Weib des Uria" 1908 über-
längen Lienhards Breitegrad. Von alter Sippe war die Erziehungsgeschichte
„Roman Werners Jugend" 1904, vom Landjungen, der Künstler wird. Geiger
gründete 1902 die „Freie Vereinigung heimatlicher Kunstpflege" und gab
1904 die Auslese „Badische Dichter" heraus. Der andere, *Emil Gött*, 1864
bis 1908, aus Jechtingen, wollte, wo Lienhard nur an Seele dachte, auf die
harte Wirklichkeit einwirken. Er stammte von einer Mutter, die für den
Lahrer „Hinkenden Boten" Kalendergeschichten schrieb, und einer Erzäh-
lung dieses Kalenders folgte 1889 sein erstes Lustspiel. Nach einem Zwischen-
spiel des Cervantes entstand im folgenden Jahr „Der Adept", dem er nach
immer neuer Knetarbeit schließlich die Aufschrift „Der Schwarzkünstler"
gab. „Edelwild" 1893/1901 stammt stofflich aus „Tausendundeiner Nacht".
Ein Bekenntnisstück wurde „Fortunatas Biß". Nach Lopes „Gärtnershund"
arbeitete er das Lustspiel „Mauserung" 1908, zierlich und von deutscher
Laune. Gött wollte sich selber vollenden und im Ausgleich von Nietzsche
und Tolstoi ein Führer der Menschheit werden: „Das eigene Leben herrisch
Nietzsche und Tolstoi leben und dem Ganzen dienend untergehn". Seine Losung war „Spatenkul-
tur". Er wurde Bauer. Und aus diesem alamannischen Bauerntum schrieb er
seine Kalendergeschichten. Von seiner „Leihalde" bei Freiburg suchte der
nicht zu Enttäuschende in die Räder der großen Welt einzugreifen. Bastler
und Dichter, heckte er eine Erfindung nach der andern aus. Seinen Freunden
war er Prophet und Heiliger, sich selbst in Briefen und Tagebüchern ein
Spatenkultur grausamer Selbstzergliederer. „Ein Siegerlächeln, das war das Ende. Mit dem
Volleinsatz seiner Persönlichkeit hatte er am Gebäude des Unendlichen ge-
schaffen. Sein Leben war ein Lustspiel höherer Ordnung mit tragischem
Einschlag geworden. Und seines Wesens ein Abbild sind die Helden seiner
Dichtungen."
Der Meister der Novelle *Emil Strauß*, 1866 bis 1960, aus Pforzheim, hat Geiger und Gött in sich
vollendet. Er stammt aus einer altösterreichischen Familie, die sich im frän-
kischen Baden eingebürgert hatte, und wurde nach weiten Reisen im ala-
mannischen Baden heimisch. Die drei Tragödien, die 1899/1923 sein Schaf-
fen gliedern, sollen mit ihrem vollen Wert gelten. Strauß ist einer der Mei-
stererzähler des deutschen Volkes. „Menschenwege" 1898, Geschichten bra-
silianischer Auswanderer, sowie „Hans und Grete" 1909, eine Heimat-

geschichte, drehen sich um die Freundschaft zwischen dem Starken und Schwachen. „Der Spiegel" 1919 ist eine Novelle und zugleich eine Folge von Novellen um eine Familie in der Not des Krieges und ein rechter Schwabenspiegel. Die sechs Novellen „Der Schleier" 1931 geben Lösungen einer gemeinsamen Aufgabe: Schuld der Liebe durch verfrühtes oder verspätetes Zugreifen. Aus Novellen wurden kleine Romane. „Der Engelwirt" 1900 ist ein ausgerissener und reuig heimgekehrter Ehemann. „Freund Hein" 1902 gilt einem Karlsruher Jungen, seinem Todeserlebnis der Geschlechtsreife und der Tragik seines Musikgenies. Diesem epischen Werk setzte der Dichter einen Doppelgipfel auf. „Der nackte Mann" 1912 ist eines der vielen zeitgenössischen Vorgesichte des Weltbrandes. Es geht um die Bewährung des badischen Bürgertums, seiner Rechte und seiner Sendung gegen Recht und Sendung seines einheimischen Fürsten, des Markgrafen Ernst Friedrich von Baden. Darum schreitet Wodan einäugig unter seinem Schlapphut durch Pforzheims nächtliche Gassen als vorverkündendes Gespenst des Dreißigjährigen Krieges. „Das Riesenspielzeug" 1934 meint Chamissos bekanntes Gedicht und ist ein Buch der Erinnerung wie der Selbstdarstellung. Es schildert das Zusammenleben der beiden Emilie, Gött und Strauß, und ihre genossenschaftliche Siedlung von Tolstoigläubigen. Ihre „Bruderschaft von Pflug und Spaten" will den Ichgeist der neunziger Jahre überwinden, ohne aus dem Bauer ein Spielzeug zu machen. Vier Frauen geben dieser Schloßgemeinde Bewegung und Leidenschaft. Mit dem Bastler Onimus, der die alte Schloßuhr wieder in Gang bringt, ist Emil Strauß ein religiöser Mensch aus der eingepflanzten Unruhe, eins zu werden mit Gott. Gelassen, vornehmschlicht und Form von Innen her, hat Emil Strauß der Novelle wie dem Roman die herbe Anmut jenes Stils gegeben, der keine Schule verrät, weil er keine hat, sondern nichts als angeborene Haltung ist.

„Der nackte Mann"

„Das Riesenspielzeug"

Schwaben ist alles, was eine Landschaft in diesem Zeitalter sein konnte. Hier sind die beiden Generationen des Jahrhunderts, die überall miteinander um die Erbfolge hadern, und wider alles Schwabentum, beinahe eines Sinnes. Der bäuerliche Bildungsdichter *Christian Wagner*, 1835 bis 1918, aus Warmbronn, schritt mit seinen lyrisch-balladenhaften „Sonntagsgängen" seit 1885 den Gedanken vom ewigen Formenwechsel des allerbeseelten Seins aus. Das ging auf Heinrich Hart und Arno Holz zu. Seine lebendigen Pflanzen- und Blumenlegenden, seine modernen Mythen und kosmischen Ausflüge, sein Naturevangelium und Tierheiland haben die alamannische Nachbarschaft zu Spitteler und Widmann. Der gebildete Naturdichter *Caesar Flaischlen*, 1864 bis 1920, von Stuttgart, traf mit seinen Dramen „Toni Stürmer" 1891 und

Schwaben

Pflanzenlegenden

„Martin Lenhardt" 1895 ebenso am Drama vorbei wie mit seinem Roman
„Jost Seyfried" 1905 am Roman. Er war der geborene Lyriker, von schwä-
bischer Weltfreude zehrend und dem Traum des All nachgrübelnd. Der
genießerische Gedanke, ich bin ein Dichter, ist ihm Inhalt seines Werkes.
Seine Lebensstimmung spielt auf nur zwei Saiten: Wehmut und Begeiste-
rung. Er glaubt an das Gesetz alles Geschehens und an ein beständiges Auf-
wärts von Stufe zu Stufe. Sein Gottvertrauen ist schicksalsgläubig. Die Sonne
ist das lyrische Sinnbild seiner Gedichte. Sie haben an nur wenig Landschafts-
formen ihr Genüge. Mit den Mundartgedichten „Vom Haselnußroi" 1892
hielt er sich in der Fremde die Heimat warm. Sein Wesen ist „harter Wille,
keusches Gefühl, nüchterner Verstand". Wagner und Flaischlen hielten es
gleichermaßen mit Darwin, nur Wagner zusätzlich mit der indischen und
Flaischlen mit Nietzsches Philosophie. Beide singen die Seele, die es neu zu
schaffen gilt, das Gottvergnügen, dem die Werkwoche nur Vorabend des
Sonntags ist. Peter Hebel also und schließlich doch auch Konrad Kümmel.
Die Erbin in Schwaben war die geistige Erbtochter ihres Vaters, *Isolde Kurz*,
1853 bis 1944, aus Stuttgart, die klassisch gebildete Frau und Bürgerin von
Florenz. Das Vermächtnis redet aus der feierlichen Schönheit ihrer bräut-
lichen Totenklagen um den Geliebten, „Asphodill", und aus dem Renaissance-
helden, in den sie den Italiener der Gegenwart zurückdichtete. Gepaart ste-
hen „Florentiner Novellen" 1890 und „Italienische Erzählungen" 1895
nebeneinander. Die Florentiner Novellen sind Renaissance von ihrem Auf-
gange zur Kunst bis zu ihrem greuelvollen Niedergange, Renaissance um die
beiden Gegenpole, die kunstberückte Herrschermacht Lorenzo und den aske-
tischen Volksfreund Savonarola. In den italienischen Erzählungen tummelt
sich das moderne italienische Volk, Handwerker und ihr Aberglauben, indes
über allem die Mittagsstimmung der Campagna flimmert. Diese kühle, vor-
nehme, geräuschlose Kunst war an Paul Heyse geschult und Conrad Fer-
dinand Meyer verwandt. Auch diese Frau, wie alle schwäbisch vergrübelt,
kehrte — „Von dazumal" 1900 — gut gelaunt wie Gottfried Keller zu hei-
matlichen Vorwürfen zurück. Der schwäbische Sprung nach vorwärts, das
war der Sohn des Dichters, *Max Eyth*, 1836 bis 1906, aus Kirchheim. Dieser
Mann hat auf eine hinreißende Weise seine Tage und Werke geschildert, die
dem Maschinenbau gegolten hatten. Und im verschämten Feuer seines Her-
zens beginnt der dichterische Zauber der Maschine aufzuglühen. Er setzte
einen „Kampf um die Cheopspyramide" 1902 in Szene, auf der der eine Bru-
der die Steine der Pyramide zu einem Stauwerk verbauen will, indes der
andere das Königsgrab verteidigt. „Der Schneider von Ulm" 1906, der erste

„Vom
Haselnußroi"

Die Bürgerin
von Florenz

Der Ingenieur

deutsche Flieger, lebt der Welt die Philosophie und Tragik des zu früh ge-
borenen Erfinders vor. Das sind die eingeborenen Schwaben.

Indessen da sind auch zugereiste und man muß sehen, wie sie sich gebah-
ren. *Karl Vollmoeller*, 1878 zu Stuttgart geboren, war von niedersächsischer
Abkunft. Vollmoeller sieht in Schwaben eigentlich niemandem ähnlich. Zu
den sächsischen Balladenkünstlern stimmt „Katherina, Gräfin von Armagnac"
1903, ein feierlich vorgetragenes Balladenspiel, und des Aischylos „Oresteia"
1908 zu der sächsischen Arbeit an einer neu verdeutschten Antike. Dies und
das Fliegerstück „Wieland" 1911 sieht eher nach Paul Ernst aus. „Das
Mirakel" 1912, ein Gebärdenspiel, könnte vom Barock der Hofmannsthal und
Reinhardt her verstanden werden. Der Wille zum hohen Stil, der bei George
vor die unrechte Schmiede geraten war, fügt Vollmoeller sächsisch-ostdeutsch
zwischen Rudolf Alexander Schröder und Rudolf Borchardt ein. *Hermann
Hesse*, 1877 zu Calw geboren, hatte einen Estländer zum Vater und eine
Stuttgarterin zur Mutter, die wiederum von einer wälschen Neuenburgerin
stammte. Hesse hat sich immer als Alamanne gefühlt. Das Deutsch des
Schwaben wie des Schweizers ist ihm gleich geläufig. In der alamannischen
Mitte zwischen Gottfried Keller und Heinrich Hansjakob, zwischen Hölderlin
und Mörike lag seine Heimat, bis ihn der Krieg aus dieser geistigen Mitte
wegschob. Jugenderlebnisse sind es in seinen Novellen „Diesseits" 1907 und
in seinen Erzählungen „Nachbarn" 1908 Sonderlinge. Dann ist die Ge-
schichte eines verträumten Naturburschen. „Peter Camenzind" 1904, der
vom Bauer kommt, die Kultur durchläuft und wieder beim Bauer anlangt.
Dann ist die Geschichte eines Jungen, „Unterm Rad" 1905, der äußerlich heil,
innerlich schwer beschädigt, sich von der Klosterschule losreißt. „Gertrud"
1910 gilt einem Schüchternen, dem der entschlossene Freund bei der Gelieb-
ten zuvorkommt, der aber dennoch der Witwe Freund und Weggefährte
wird. „Roßhalde" 1914 ist das Buch einer Ehe, die dem Kinde zum Verhäng-
nis wird. Über die Kindheitsgeschichte „Demian" 1919 geht es schließlich in
ein Werk hinein, das immer fremdartiger wird und wie „Der Steppenwolf"
1928 zeigt, nur noch zunahm, ohne sich zu verändern. Der utopische Bil-
dungsroman „Das Glasperlenspiel" 1943 meint den Einklang, zu dem eine
künftige Mönchsgemeinschaft alle Widerklänge abstimmt. Vielleicht ist all
diese Prosa nur Befreiung von verquälten und beängstigenden innern Zustän-
den, damit die Seele sich desto reiner in den lyrischen Versen aussprechen
konnte, die Hesse seit den „Romantischen Liedern" 1899 immer wieder neu
gesammelt hat. Auch in den Prosabüchern ist es das traumhafte Gleiten, der
zarte Ton des Gefühls und das Gewitterliche der Stimmung, die über das

*Balladenstück
und
Gebärdenspiel*

Hermann Hesse

*Geschichten
der Seele*

Unerfreuliche hinweghören lassen, das sich begibt. Wie ein Fremdling dieser Erde, dem unhörbaren Aufbrechen der Knospen lauschend, in unbenennbare Sehnsucht vertieft, hat Hesse seine schlichten Lieder von der Zeit weg in sich hineingesprochen. Auf italienischem Boden mit Sankt Franziskus vertraut, den ältesten und jüngsten italienischen Erzählern zugeneigt, vernahm und *Nordische* verhörte er den Zuruf: sein Geschick durch Form zu meistern. Nordische Ro-*Romantik,* *östliche Mystik* mantik, östliche Mystik, gegen das hat Hermann Hesse von seiner halben schwäbischen Kindschaft wenig genug gehabt.

Und wieder *Hessen* Rittlings des Mittelrheins, in der Pfalz und in Hessen ist von je das Unge-wöhnliche geschehen. Durch Blut, milde Luft, Anmut der Landschaft, unaus-tilgbares Römertum, Höflein und Bildungsstätten hat es hier immer von Kreuzwegen des Geistes gewimmelt. In diesem Zeitalter brodelte hier wun-derlicher Stoff und Gewürz. Die Antike warf seltsame Blasen auf. In Ro-manen führte der Gießener Ernst Eckstein, 1845 bis 1900, römische Sklaven-aufstände und Christenverfolgungen vor, der Darmstädter Wilhelm Walloth, 1854 bis 1932, die Kaiser, Schauspieler, Dichter, Fechter des entarteten Rom, der Heidelberger Hochschullehrer Adolf Hausrath, 1837 bis 1909, seine Mär-*Fresken* tyrer. Das war alles in den achtziger Jahren. Heinrich Vierordt, 1855 geboren, *und Gemmen* aus Karlsruhe, trotz weiter Reisen von Schwarzwald und Bodensee gefesselt, arbeitete wie mit Meißel und Grabstichel seine landschaftschildernden Ge-dichte — „Akanthusblätter", „Fresken", „Gemmen und Pasten" — und er-zielte kostbare Gebilde von vollendeter Sprachschönheit. Alfred Mombert, 1872 bis 1942, aus Karlsruhe, auch er ein Weltreisender, dichtete priesterlich und prophetenhaft seine Seelenzustände in den Weltraum hinaus, verwan-delte Gedanken der jüdisch-griechischen Gnosis in neue Mythen und stellte in dem Drillingsdrama „Aeon", 1907/1911, den ewigen Menschen auf die *Der Archont* Beine. Das sind immerhin stilvolle Kulissen, damit der Archont seines Aeons *des Aeons* aus ihnen auf die irdische Szene treten könne.

Stefan George, 1868 bis 1933, eines Weingärtners Sohn aus dem rhein-hessischen Büdesheim, wenn auch von Lothringer Herkunft, konnte sich wohl auf dieses rheinische Römerland, seinen tausendjährigen Bischofsboden, die ältesten Kirchen von Trier und Mainz, auf rheinischen Rittergeist und Ritter-lied bezogen fühlen. Die Riten der römischen Kirche waren ihm heimatver-traut. Den Bamberger Dom und seinen Standbildkünstler kannte er. Dante hatte er zu übersetzen gewagt. Die englischen Präraffaeliten waren an ihn herangekommen. Die engere Quadratur schloß ihn ein: rheinaufwärts Meyer und Spitteler, rheinabwärts das von Langbehn verkündete Holland, rhein-östlich Nietzsches frevelhaftes Selbstbewußtsein, rheinwestlich die wälsche

Dichtung fin de siècle. Der geistigen Geselligkeit von Paris verdankte er die Anregung, Freunde von gleicher Art um sich zu versammeln. Diese Freunde hat er in München und Wien gefunden. Sich und den Seinen gaben die „Blätter für die Kunst" 1892/1919 Stimme und Rückhalt. Georges Werke bilden keine Pyramide, die mit der Höhe nach Innen wächst und sich in einer Spitze selbstvollendet. Alle Werke stehen auf gleicher Ebene eines neben dem andern. Sie sind zweckbestimmt zusammengefügt. Jedes ist, besser oder minder geglückt, ein lyrischer Versroman, in dem der Dichter sich selbst in wechselnden Rollen seine Seelengeschichte handeln läßt. „Und einsam gibst du dir ein wildes Spiel." *„Blätter für die Kunst"*

Das Erste, die „Hymnen" 1890, sind schon der verjüngte Grundriß jedes folgenden Buches. Diesmal ein Traum in Blau und Gold ein Jahr hindurchgespielt. Selbst dieser winzige Umlauf ist dreiteilig gegliedert. Das Schlußgedicht mit dem Schlußvers „Pilger" ist die Schwelle zu „Pilgerfahrten" 1891, dem nächsten Büchlein. Dieser runde Versroman, abermals dreiteilig, zeigt den Dichter in der durchgehaltenen Maske des Pilgers auf der Suche nach einem Mitleidenden. Nun nach dem Barock des ersten Büchleins romantischer Stil, romantisch der strömende Hauch der Verse und Gesätze, romantisch die Stimmung, romantisch die Maske und ihre Farben aus frühitalienischen Bildern. An ungestillter Liebe jäh umschlagend verhärtet sich das Herz des frommen Pilgers zum Bild des lasterhaften Priesterkaisers, zu „Algabal" 1892, dem Spender „von gierig erwartetem Grauen". Dreiteilig auch dieses Büchlein. Rolle und Maske stammen von dem verrufenen spätrömischen Kaiser Heliogabal und der Vortrag ist Selbstgespräch. Macht ist hier der Schrei, angebetet zu werden und verprassen zu können, Mord und Blut, Umkehr zu menschlicher Antike ist „Das Buch der Hirten und Preisgedichte" sowie brüderlich zugehörig „Das Buch der Sagen und Sänge" 1894, beide zweiteilige und episodenreiche Kleinromane. Der erste gibt das antike Hirtenleben und bringt zum erstenmal Preisgedichte auf junge Männer und Frauen. Der zweite gibt das deutsche Mittelalter, den Gedanken der Auslese, des Dienstes, der Treue, der Frömmigkeit und Frauenliebe. Beide Büchlein führen den Dichter auf sein dichterisches Selbst zurück, indem jenes den Barock zur Antike und dieses die Romantik zum Mittelalter läutert. „Das Buch der hängenden Gärten" 1894 ist ungeteilt. Es handelt den gereinigten Vorwurf des Algabal auf morgenländisch ab. Das Büchlein schimmert von Kindheitserinnerungen. Außerhalb des Vorspiels der „Hymnen" bilden diese vier Büchlein Georges selbstdarstellenden Bildungsroman in vier Schichten und Geschichten. *„Hymnen"* *„Pilgerfahrten"* *„Algabal"* *„Hirten- und Preisgedichte"* *„Hängende Gärten"*

„Das Jahr der Seele" Aus den gepaarten zwei folgenden Gebilden klingt, auf neuen Ton gestimmt, zuerst der Mensch und dann der Dichter. Der Mensch, das ist „Das Jahr der Seele" 1897, dichterisch eine überaus schwer gemachte Aufgabe. Von den dreien ist der erste Hauptteil ein lyrischer Gezeitenroman der Seele, der zweite ein Versuch der Selbstdeutung, der dritte allgemeine Bilder im Ton des ersten Teiles. Das war der Mensch, rein, echt, nichts als menschlich und der Stil ganz Natur und Seele. Der Dichter, das war „Der Teppich des *„Der Teppich des Lebens"* Lebens" 1899, mit einem Vorspiel, das Dichterlehre und Dichterweihe gibt. Der erste Teil ist der lyrische Roman des Dichters mit einer Absage an das Kreuz und dem Bekenntnis: Hellas unsere ewige Liebe. Der zweite Teil ist eine Art Rahmenerzählung mit eingelegten Novellenballaden und gibt ein Bild dieses schöneren Lebens. Der dritte Teil stellt dem wahren Sein des ersten und zweiten die Welt der Erscheinung, des Scheins, der Maja Schopenhauers gegenüber. George hatte den Fuß zur Schwelle des dreißigsten Jahres noch nicht erhoben und war ausgeformt. Zehn Jahre Schweigen, Hochgefahr, *„Der siebente Ring"* tragischer Frevel. „Der siebente Ring" 1907, Heraufkunft des Mannes von vierzig Jahren. Hier ist die Zahl das Baugesetz. Sieben Teile. In der Mitte das Buch „Maximin", dreimal drei, zweimal drei, dreimal drei Gedichte. Algabal tritt ins Leben der Gegenwart. Ein Jüngling wird zum Gott ausgerufen. Ritenformen und Ritensprache der römischen Kirche sind zur Feier dieses Gottes preisgestellt. Auf die anbetende Trauer um diesen Knabengott werden die ersten drei Teile hingeordnet und die letzten drei Teile werden von ihm feierlich weggerückt. Das magische Buch und Weltbild um den *„Der Stern des Bundes"* neuen Knabengott, „Der Stern des Bundes" 1914, fügt sich zum „Siebenten Ring" wie der „Teppich" zum „Jahr der Seele".

Die Erscheinung George bestand nicht durch ihre Kunst, sondern durch ihren Willen. Ungeschieden bleiben in seiner Sprache Ewiges, Reines, Maßloses. Dieser Stil, der auch in den schlichtesten und gültigsten Werken seine barocke Herkunft nicht verleugnen kann, läßt sich auf ein Kleinmaß immer neu abgewandelter Grundbestände zurückführen: den Relativsatz von französischer Bedürftigkeit, der alles wegwuchert, der das Einfachste verwickelt, das Gesättigste verdünnt; Beiwörter, die unweigerlich vorspringend jedem Hauptwort den Weg vertreten; Mehrzahl tunlichst statt Einzahl; Steigerun-*George und Nietzsche* gen in jeder sprachlich möglichen Form. Nur der Eingeweihte findet die Worte, deren keines an seinem Platze steht. Wo George die Natur, das Leben selber gibt, wirkt er bestrickend unmittelbar. Doch seine enge Verwandtschaft mit dem Stil des Barock wird dort sichtbar, wo er mit seinen Lieblingsvorstellungen auftritt, nackten Epheben, Räucherpfannen, Edelsteinsamm-

lungen, kostbaren Geweben. George ist dem Rausch der Sprache verfallen. Seine strenge Scheidung von Schriftsteller und Dichter, von Leben und Kunst, seine Abkehr von der Welt, sein Vermögen, Unnennbares anklingen zu lassen, ohne daß der Hörer weiß, wie es zugeht, sein klösterlich einsames Leben für die Kunst, sein ganzer von heiligen Grundzahlen beherrschter Stil, das erinnert sehr an die Kunst der Beuroner Mönche. Die antikheidnische Schicht des Rheintales konnte für verschüttet gelten. Siehe, da tritt wieder der civis romanus der letzten Heidenzeit ans Licht, der Cäsar und Pontifex in einem ist. Unheimlich deutschfremd ist diese großartige Wiederkehr des antiken Heidentums und der hellenischen Mysteriensucht. In dieser Magie des Wortes ist die druidische Kunst und Kraft, zu beschwören und zu verfluchen, wieder aufgestört. Ein Denkvorgang von eisiger Schärfe, ausgelöst von der Entdeckung eines dämonischen Sprachvermögens, verwandelt sich in schrankenlose Macht und übersteigert sich in frevelhaftes Selbstbewußtsein. Mit dem Jahrbuch „Hesperus" 1909 rückte die reifgewordene Jugend von ihm ab: Hofmannsthal, Schröder, Borchardt. Da ist die Widerwelt: Westen und Osten, Klassik und Romantik, der Mysteriengründer und der Mysterienfrevler, George und Nietzsche. Man sieht diesen Priestererben mit angstvoller Miene den Gott verlachen und sich in den Traum vom Übermenschen flüchten. Und da ist der römische Weltbürger, der sich gelassen den nächsten Menschen zum Gott erhöht und ihm das erste Opfer darbringt. So traten die Deutschen 1914 ihren Schicksalsgang gegen Osten und Westen an, den zwiespältigen Urgeist des Ostens und Westens, Nietzsches und Georges, im Leibe.

II.
WELTGEMEINSCHAFT
800 bis 1914

Mit dem Aufbruch ins Feld während jener Augusttage des Jahres 1914 schlossen sich hinter Deutschland die Tore einer Welt. Was das bedeutete, *Das Tor zur Welt* kann man nur an der Geschichte des deutschen Geistes ermessen. Alle Völker leben beieinander und jedes ist im Lande des andern zu Gaste gewesen. Fiele Deutschland nur unter dieses allgemeine Gesetz, so bliebe die Tragödie unverständlich, die sich damals abgespielt hat. Aber das Lebensverhältnis Deutschlands zu Rom war von anderer Art als das eines Reisenden zu seinen Gastwirten. Es gibt kein Volk in Europa, das durch tausend Jahre so zum französischen gestanden wäre wie das deutsche. Zwischen Rußland und Deutschland spielte mehr als Nachbarschaft. Da das deutsche und englische Volk Vettern sind und Deutschland zum Aufbau des amerikanischen Volkes reicher beigesteuert hat als außer den Angelsachsen irgendein anderes Volk, so ist auch das Verhältnis Deutschlands zur britischen Insel und zum westlichen Festlande gegenüber jedem andern Falle unvergleichbar. Mit den Toren, die sich 1914 hinter Deutschland schlossen, fiel mehr als nur eine Vergangenheit ins Schloß. Ein Leben hatte ausgeatmet. Und was tot ist, kommt nicht wieder. Man kann ohne diesen Besitz weder die deutsche Geistesgesellligkeit vor 1914 verstehen noch ohne diesen Verlust die tödliche Einsam- *Tödliche Einsamkeit* keit, der Deutschland nach 1918 verfallen ist.

1. ROM

Die Stadt ist seit jenem Weihnachtstage des Jahres 800 ein Organ des deutschen Daseins gewesen, das Organ, aus dem Deutschland lebte und durch das es sich verbrauchte. Rom, ist die deutsche Geschichte.

Drucken hat Italien von den Deutschen gelernt. Schon im Mittelalter kamen Deutsche wie Dietrich von Nieheim und Nikolaus von Kues in Rom zu Ehren. Der Elsässer Johannes Burchard war seit 1483 päpstlicher Hofmeister. Seit dem Anfang des sechzehnten Jahrhunderts kann man an Porta del Popolo wie an einem Pegel den Stand der deutschen Bildung ablesen. *Die Stadt der Künstler* Scharen deutscher Humanisten strömten zu und es kamen die Männer, die

über Glauben und Frömmigkeit entschieden wie Luther, Hutten, Eck. Holländer, Alamannen, Baiern waren die ersten deutschen Künstler. Deutsche *Mengs und Winckelmann* Malerschulen entstanden. Der Maler Anton Raphael Mengs und der Kunstgelehrte Johann Joachim Winckelmann, die 1755 einander zu Rom begegneten, machten im Kunstleben der Stadt Epoche und durch Rom in Deutschland. Winckelmann, der Freund des Kardinals Alessandro Albani, der Oberaufseher der römischen Altertümer, der Beamte der Vatikanischen Bücherei, hat in Rom sehen und schreiben gelernt und mit seiner Kunstgeschichte 1764 den Deutschen die Welt der griechischen Schönheit aufgeschlossen. Die Begeisterung, deren Prediger Mengs und Winckelmann waren, ergriff ganz Deutschland. Deutsche Fürsten, deutsche Künstler und Dichter, meist arme Schlucker, kamen mit Geschenktem, Erspartem, Erdarbtem über die Alpen. Der vornehmste Fremdenführer und Kunstmakler wurde im achtzehnten Jahrhundert der Ostpreuße Johann Friedrich Reiffenstein. Mit dem Pfälzer Friedrich Müller kam 1778 der erste deutsche Dichter von Rang in Rom an. Hier wandte sich der Enttäuschte von der Malerei zur Dichtung, wurde zum Römer und einer der einflußreichsten Fremdenführer. Von Wilhelm Heinse bis zu Zacharias Werner sind fast alle Römergäste durch sein Leben gegangen.

Die Stadt der Dichter Den achtziger Jahren machen drei Dichter das Gesicht. Das sind Heinse, Klinger, Goethe. Was immer Rom für jeden der drei bedeutet hat, der deutschen Dichtung wirksam ist das römische Erlebnis nur durch Goethe geworden. *Heinse und Klinger* Der Thüringer Wilhelm Heinse war seit Sommer 1781 in Rom, längst der Antike zugewendet und schon in Deutschland mit der Übersetzung des Ariost beschäftigt. Er hat auch immer an Hellas gedacht, wenn er antik sagte und seine Tassoübersetzung war schon vor seiner Ankunft zu Venedig abgeschlossen worden. Der Roman seiner römischen Zeit ist „Ardinghello oder die Inseln der Glückseligen" 1786, obwohl er in den norditalienischen Städten der Renaissance spielt. Seit Februar 1782 war der Frankfurter Friedrich Maximilian Klinger in Rom als russischer Leutnant und Begleiter des russischen Kronprinzenpaares. Klinger hat Rom und römische Antike durch Heinse erlebt. In die „Geschichte vom goldenen Hahn", die er 1784 im Feldlager am Bug schrieb, ist der Aufenthalt in Rom und der Umgang mit *Goethe in Rom* Heinse geistig und dichterisch eingegangen. Johann Wolfgang Goethe war vom 29. Oktober 1786 bis zum 22. Februar 1787 und wieder vom 6. Juni 1787 bis zum 22. April 1788 in Rom. Dazwischen hatte er in Süditalien und auf Sizilien gelebt. Goethe hat Rom im großen und kleinen, das alte wie das moderne wahrhaft gesehen. Aber er hat es auch als ein Stück Wirklichkeit

mit dem Verstande aufgenommen. Er ist an Rom persönlich und künstlerisch der Mensch geworden, der er von Natur war und unter den Hemmungen der Heimat nur nicht hatte werden können. Wie er sich die Stadt erarbeitete, so hat er an dieser Stadt seine alten Dichtungen, „Iphigenie", „Tasso", „Egmont" so vollkommen als möglich herausgearbeitet. Aber er hatte Maß gehalten. Die Antike hieß ihm Rom. Was er in Süditalien an griechischer Kunst und griechischer Natur genossen hatte, rundete seinen Besitz nur ab. Die römische Antike aber hatte er nicht anders angesehen als der Barock und die Spätrenaissance: mit den Augen Michelangelos. Gegenüber Heinse, dem reinen Hellenen, und Winckelmann, dem reinen Künstler, war Goethe wiederum der klügere Sparer. Er hatte die römische Antike in sein modernes Menschentum aufgenommen, ohne sich an sie auszugeben.

Nach Goethes Abreise verlor das Bild der Antike, wie Winckelmann es gesehen und gezeichnet hatte, an Kraft und Geltung. Die meisten der Deutschen, die zu Rom unter Winckelmanns Einfluß gestanden hatten, kehrten in ihre Heimat zurück. Und von den neuen Italienfahrern waren Männer wie Herder und Lessing schon zu reif, zu fertig, zu weit über Winckelmann hinaus. Eine neue Kunst ging in Rom mit Asmus Jakob Carstens, einem Niedersachsen aus Schleswig, auf. Carstens, seit 1794 in Rom, entthronte Mengs. Er *Carstens in Rom* verhöhnte das stumpfsinnige Aktzeichnen. Er malte aus dem Kopf wie der Dichter dichtet. Er gründete alles auf die Antike. Er liebte die reine Form im Umriß und stellte sich gegen die Farbe. Die erste Ausstellung seiner Werke, nichts als antike Vorwürfe in Zeichnung, Tempera, Wasserfarben wurde von den Deutschen abgelehnt, von Engländern und Italienern desto williger anerkannt. Seit Mengs und Winckelmann war kein Deutscher mehr so warm von den Römern aufgenommen worden. Wenn man obenhin sah, konnte Carstens für einen Klassizisten gelten. Doch seine gezeichneten Gedanken wie „Die Geburt des Lichts" und „Die Nacht mit ihren Kindern", sein Verneinen alles Handwerksmäßigen, sein völliges Zusammenfassen auf das innere Erlebnis, sein Ruf nach Geist und Inhalt und Genie, seine Sinnbilder und seine belebte Natur: Carstens ist ein Romantiker, der erste Romantiker in Rom. Der Däne Bertel Thorwaldsen wurde sein Erbe und Fortsetzer. Die *Thorwaldsens* römische Werkstatt dieses Dänen erzog ein ganzes junges Geschlecht für das *Werkstatt* neue Hellas, wie es eben damals aus dem befreiten Boden Griechenlands aufstieg. Doch nicht nur die antike auch die neue deutsche Kunst in Rom hatte den Sachsen Carstens zum Ahnherrn. Um die Jahrhundertwende lebte in Wien ein Kreis junger Leute, in ihrer Mitte der Lübecker Friedrich Overbeck, die der Wiener Kunstbetrieb leer gelassen hatte. Sie fühlten sich von den

Die Nazarener Büchern Tiecks und Wackenroders erweckt. Unter sie trat der Schwabe Eberhard Wächter, der von Rom her noch Carstens kannte, und brachte sie mit des Carstens Vermächtnis, mit der Sehnsucht nach Rom in Aufruhr. Sie taten sich zu Wien, Herbst 1809, in der Sankt-Lukas-Gilde zusammen und gingen dann nach Rom. Overbeck mietete sich mit seinen Freunden in dem verlassenen Kloster San Isidoro ein und jeder verpuppte sich in seiner Zelle. Davon hießen sie spöttisch „Klosterbrüder" und schließlich Nazarener. Zu dieser nordischen Gruppe, die Overbeck führte, stießen mit Peter Cornelius die Düsseldorfer, die nach der altdeutschen Dichtung malten, und zu beiden wiederum eine ostmitteldeutsche Gruppe um den Leipziger Julius Schnorr von Carolsfeld und den Nordböhmen Josef Führich. So hatte sich das Rom von Mengs und Winckelmann über Asmus Carstens und die „Herzensergießungen" von Wackenroder-Tieck in das Rom der romantischen Maler verwandelt.

Wilhelm von Humboldt Das Reich der klassischen Dichtung in Rom verwaltete als Statthalter Wilhelm von Humboldt, seit 1802 zu Rom preußischer Ministerresident. Unter allen Deutschen war wohl Humboldt am gewaltigsten von Roms Gedanken und Erscheinung gepackt. An Rom ging ihm die Ganzheit von Menschengeschichte und Menschennatur auf, die er so lange gesucht hatte. Die Stadt wurde ihm zum Sinnbild der allgewaltigen Zeit. Er atmete den Geist dieser Stadt mit allen Sinnen seines weltumfassenden Wesens ein. In seinem Hause hatten die Deutschen Roms eine Heimat. Das alles war gerade noch schön und groß, da es sich gegen Abend neigte. Man sehe sie doch kommen und gehen.

Deutsche Dichter auf Besuch Das römische Jahr 1804 August Wilhelm Schlegels war ein Pflichtbesuch im Gefolge der Frau von Stael. Ludwig Tieck, dessen Bücher die Nazarener in ihre Kunst verzaubert hatten, schrieb 1805 in der Vatikanischen Bücherei Dichtungen des deutschen Mittelalters ab und stimmte die „Reisegedichte eines Kranken". Verspätet und unbeachtet kam und ging 1819 Friedrich Schlegel. Nein, da war, mit Johann Georg Hamann zu reden, keine Empfängnis, die ein Magnifikat verdiente. Spukhafte Wahrzeichen sagten sich an. Im Spätherbst 1830 brach zu Rom Goethes Sohn August jähen Todes zusammen und seit dem Ende der vierziger Jahre pflegte Goethes Enkel Maximilian zu Rom einen kranken Leib und Nerven, die den Ausgang dieses Geschlechts nicht mehr vertrugen. In drei tragischen Dichtergestalten löste *Grillparzer, Waiblinger, Platen* diese alte Welt sich auf. Franz Grillparzer war 1819 zu Rom, niedergedrückt von den Trümmern und der päpstlichen Pracht. Die zwei andern starben in Italien: der Schwabe Wilhelm Friedrich Waiblinger Anfang 1830 zu Rom, August Graf von Platen 1835 zu Syrakus. So sehr jeder der drei in seiner

tragischen Beziehung zu Rom vorerst für sich persönlich haftet, sie bezeugen zusammen über ihr Einzelwesen hinaus den Abschluß eines großen Zeitalters: Grillparzer die mürbe Überreife der geschichtlichen Antike im deutschen Erleben; Waiblinger die ausgelebte Rolle eines jungen Menschenschlages, der einst Vorbild war; Platen das Zeitwidrige einer Lebenshaltung, für die es kein Vorrecht mehr gab.

Ein neues Lebensjahr zwischen deutscher und römischer Bildung hebt an. Das alte Deutschland ist nicht mehr. Dafür ist das neue Preußen. Preußische Staatsmänner, geistig von hohem Rang, Wilhelm von Humboldt, Barthold Niebuhr, Christian Karl Josias Bunsen, betreuen als römische Gesandte, was es zwischen Deutschland und Rom zu betreuen gibt. *Preußische Staatsmänner*

Da verwandelt sich für die Deutschen die Antike aus Rom in Hellas und aus Buchwissen in Sachwissen. Griechenland wird frei und wieder ein Staat. Überall um das östliche Becken des Mittelmeers setzen sich die Grabscheite in Bewegung und entdecken unter dem Boden ein neues Hellas, das mit Steinen anders redet als es bisher aus Büchern gesprochen hatte. Aus „Philologie" wird „Archäologie". Von Carstens und Thorwaldsen her baut sich bis zu Curtius und Schliemann die neue sächsisch-griechische Welt auf. Johann Joachim Winckelmann kommt wieder zu Ehren. Denn die neue Archäologie als wissenschaftlicher Schlüssel zur Kunde der antiken Vorzeit ist von Johann Joachim Winckelmann, dem Deutsch-Dänen Georg Zoega, dem Italiener Ennio Quirino Visconti geschaffen worden. August Kestner, der Geschäftsträger Hannovers zu Rom, hielt den Deutschen ein gastliches Haus, wo Goethebriefe vorgelesen, griechische Dichter gedeutet, Kunstwerke vorgezeigt wurden. Die Freundesrunde gab sich 1824 einen Namen: Kapitolinische Gesellschaft; später „Römische Hyperboräer". Daraus ist, von Bunsen gegründet, 1829 das Istituto di corrispondenza archeologica hervorgegangen, das Archäologische Institut. Es hatte seit 1835 auf dem Kapitol neben der preußischen Gesandtschaft sein eigenes Heim, wurde 1871 preußische Staatsanstalt und 1874 vom Reich übernommen. Hier ist die moderne Altertumskunde als „monumentale Philologie" geschaffen worden, als die Kunst, die antike Kultur aus den Denkmälern zu erkennen und zu erklären. Hier prüfte 1840 Ernst Curtius an den griechischen und römischen Schriftwerken nach, was er in Hellas an den Bodenfunden gesehen hatte. Hier auf dem Tarpeischen Felsen wurde Theodor Mommsen während der Jahre 1844/1847 der große Zauberer, der jeden Stein zum Reden bringen konnte und aus dem verglichenen Zeugnis der gemeißelten und geschriebenen Worte die Römische Geschichte wiederherstellte. In Mommsen gipfelt nach *Die Archäologie* *„Römische Hyperboräer"*

soviel Übergängen dieses Zeitalter wie das frühere inbegrifflich Goethe gewesen war.

Das moderne italienische Volk Da verwandelt sich für die Deutschen Rom in das moderne italienische Volk. Die alten Beziehungen von Kunst zu Kunst, von Gelehrsamkeit zu Gelehrsamkeit waren hüben wie drüben auf die beiden Völker übergegangen. In dieser Bewegung führte die Literatur. Das sind jetzt andere Gesichter. Die deutschen Dichter, wie sie kamen, Wilhelm Müller 1818, Leopold Schefer 1819, Wilhelm von Normann 1828 gingen am päpstlichen wie am antiken Rom vorüber, hielten sich an Römer und Römerinnnen, an das moderne Menschenwesen, an italienische Natur oder gemeinitalienische Geschichte. August Kopisch seit 1822 und Robert Reinick seit 1838 verkörpern diesen Wandel. Sie sind Maler. Doch sie frönen der Dichtung. Sie sitzen nicht in Rom fest. Sie mischen sich unter das Volk der Berge und Großgriechen-

Kopisch, Reinick, Gaudy lands. Kopisch durchforscht die Inseln und Küsten des Golfs von Neapel, entdeckt auf Capri die Blaue Grotte, bereist Sizilien und verdolmetscht den Deutschen nicht die hohe Literatur des klassischen Italien, sondern die Lieder, Märchen, Spiele des Landvolkes, ohne mit seinem Dante ein gleiches Glück zu haben. Reinick ist nur im Winter zu Rom. Sonst herbergt er auf Capri, in den Albanerbergen, auf Sizilien. Er leitet die römischen Feste und dichtet die Lieder dazu. Franz von Gaudy seit 1835 und Levin Schücking 1847 nennen die Bücher, in denen sie von ihrem italienischen Erlebnis Kunde geben, im selben Sinne und fast mit dem gleichen Wort, das die mittelalterliche Beziehung von Volk zu Volk ausdrückt: „Mein Römerzug" 1836 Gaudy, „Eine Römerfahrt" 1848 Schücking. Da ist wieder der große Sachse und

Hebbel zeugt für die verwandelte Seele. Friedrich Hebbel, von Herbst zu Herbst 1844/1845 in Italien, ist sichtlich ohne Organ für die Stadt, empfängt nur den Anhauch einer ewigen Natur, schnitzt an wenigen Sinngedichten, bannt im Kolosseum den ersten Auftritt des „Moloch" und was er heimträgt, ist ein modernes Geschenk: der Stoff zum „Trauerspiel in Sizilien".

Diese Vermittlung von Volk zu Volk war zu frühest mit Norditalien ver-

Rehfues, Reumont, Gregorovius knüpft. Sie wird spürbar durch den Tübinger Philipp Josef von Rehfues, der 1801 das erstemal nach Italien gekommen war und später meist in Florenz lebte. Er hat Alfieris Dramen übersetzt, alte italienische Novellen nacherzählt, italienische Geschichtsromane geschrieben und in seinen Zeitschriften beiden Völkern zu dienen gesucht. Der preußische Geschäftsträger bei Toskana, Alfred von Reumont aus Aachen „war ein Gesandter deutschen Geistes und deutscher Wissenschaft bei der italienischen Nation". Sein Mittleramt, das später von Karl Hillebrand so erfolgreich fortgesetzt wurde, wirkte sich

aus durch seine regelmäßigen Berichte über italienische Kunst und Literatur an Friedrich Wilhelm IV.; in dem Jahrbuch „Italia", das er 1838 und 1840 mit August Kopisch herausgab; in den „Römischen Briefen von einem Florentiner" seit 1840, einem erschöpfenden Handbuch für deutsche Italienfreunde. Soviel verging und rief im Vergehen dem Manne, der die Bücher abschlösse. Das war der Neidenburger Ferdinand Gregorovius. Er ist 1852 *Ferdinand* nach Italien gekommen und hat sich das italienische Volk erwandert, wie *Gregorovius* zuvor Lentner das bairische und gleichzeitig Riehl das deutsche. Das Buch „Corsica" 1859 und die fünfbändige Sammlung „Wanderjahre in Italien" 1856/1877 krönten diese deutsche Mühe um ein Bild Italiens aus eigenem Augenschein. Sie schufen eine neue literarische Gattung: die historische Landschaft. Auf der Tiberbrücke, im Anblick der Engelsburg überfiel ihn 1854 die Eingebung, eine Geschichte der Stadt Rom im Mittelalter zu schreiben. Noch wehte der Zauber mittelalterlicher Verwitterungen durch Rom. Noch schritten Papst und Kardinäle, das Bild beherrschend, durch das öffentliche Leben ihrer Stadt. Man schrieb 1859, als der erste Band herauskam, und man schrieb 1872, als mit dem achten der letzte erschien. Schritt für Schritt, wie das päpstliche Italien verfiel und das königliche aufstieg, rückte das Werk vor, und als der letzte erschien, hatte Rom gerade aufgehört, die Stadt des Papstes zu sein, fortan die Hauptstadt des neuen Königreiches Italien. Es war der Nachruf eines Mannes von protestantischer und ghibellinischer Überzeugung auf das abgelöste Jahrtausend deutsch-römischen Gemeinlebens.

Der wachsende Zustrom deutscher Dichter und ihre Niederlassung in Italien täuscht über die Veränderung des geistigen Klimas lange hinweg. Der Vertreter dieses ganzen Zeitalters von sechzig Jahren ist Paul Heyse. *Paul Heyse* Alles an seinem Verhältnis zu Italien ist sinnbildlich und bedeutsam. Er war ein Preuße. Niemand ist sooft und soviele Jahre hindurch in Italien gewesen. Keiner hat das italienische Volk so gut gekannt und in so bezaubernde Kunstgebilde gefaßt wie er. Wer hätte italienische Dichtung gefälliger verdolmetscht. Die Gesinnung und der Gefühlston, die sein Verhältnis zum italienischen Volke begleiten, konnte diesem Zeitalter gar nicht gemäßer sein. Denn es ist herzlich ohne irgendeine Empfindsamkeit, ungemein sachlich und verständig, aufgeklärt und frei von jedem Gefühl für römisches Christentum. In den schönsten Jahren, 1852, ist Heyse zum erstenmal nach Italien gekommen, und die Villa, die er 1899 erwarb, stand am Gardasee, zu Gardone. Man vermißt etwas und weiß nicht was, wenn man diesen Dichter, sei es noch so hinreißend, italienische Landschaften und die Tragödien italienischer

Herzen schildern hört. Es ist möglich, daß das der heimliche Dünkel der Herablassung ist. Eben das aber war die andere Note, die von Staat zu Staat in diese Beziehungen gekommen ist. Zur rechten Zeit, am 2. April 1914, ist Paul Heyse gestorben.

2. FRANKREICH

Die Nebenbuhler in der Gestaltung

Das Unbegreiflichste, was es geben kann, Deutschland und Frankreich, ist auf die menschlichste Weise zu verstehen. Beide waren einmal, um 800, ein Ganzes und haben sich dann getrennt. Frankreich trägt davon noch heute den Namen. Seitdem sind sie die beiden großen Nebenbuhler gewesen bei dem vielhundertjährigen Werk der politischen und geistigen Gestaltung Europas. Dieser Wettbewerb bestimmte alle Beziehungen von Volk zu Volk. Eifersucht und Ehrgeiz waren die seelische Atmosphäre, in der sich die deutsch-französische Bildungsgeschichte abgespielt hat. Das geistige Verhältnis der beiden Völker gleicht dem zweier junger Menschen, von denen der eine um einen Schritt älter und reifer ist. Deutschland war der jüngere. Denn Frankreich hatte ein paar Lebensjahre gallischer Latinität und ein besonderes Talent für alles, was Literatur heißt, voraus. Seit der karlingischen

Schutz der Literatur

Trennung der beiden Völker hat das französische alle wesentlichen Formen literarischen Ausdrucks entwickelt und an das deutsche vermittelt: alle Stilarten des Theaters, fast alle Gattungen der Prosa vom Roman bis zum Essay und zum Aphorismus, die wesentlichen Gebilde lyrischen Ausdrucks. Fast jede literarische Bewegung, die sich in Deutschland durchsetzte, hat ihre starken Antriebe von Frankreich her empfangen. Und es ist keine, die sich nicht mit ihren Leistungen an Frankreich gemessen hätte. Wie oft hat Deutschland den französischen Geist in sich innerlich überwunden und wie oft hat es erfahren, daß er an allem teilhatte, was den Deutschen Großes gelang. Wie abfällig haben sie zu Zeiten von der klassischen Tragödie, vom Lustspiel, vom Roman der Franzosen gesprochen. Doch in welcher vollkommenen deutschen Tragödie steckt nicht ein Bruchteil der Kunst Corneilles und Racines. Wo gäbe es ein deutsches Lustspiel, für das die Franzosen vergeblich auf ihrer Bühne gespielt hätten. Und von welchem deutschen Roman könnte man sagen, er stehe außerhalb des französischen Stammbaumes. Die Deutschen haben von den Franzosen schreiben gelernt und verdanken ihnen sehr viel, wenn es ihnen gelungen ist, die dunkle und hintergründige Art ihres Denkens in die Sprache des gesunden Menschenverstandes zu übersetzen. Es ist freilich für Deutschland kein leichter Weg gewesen. Man sagte

zuviel, wenn man vorgäbe, daß bei diesem Lehrgange das deutsche Herz im *Ehrgeiz und Mißtrauen* Spiele gewesen wäre. Deutschland setzte Verstand gegen Verstand, weil es wußte, daß es in Europa nur etwas gelten würde, wenn es den Franzosen in allen Künsten des Wortes ebenbürtig wäre. Immer wieder trieb die Deutschen der nationale Ehrgeiz und immer wieder warnte sie das nationale Gewissen auf der Hut zu sein, da diese blendende Literatur die Verbündete sehr verwegener Waffen und einer überlegenen Staatskunst war. Daher gab es Zeiten, da die Deutschen sich dessen schämten, was sie gelernt hatten und es Überfremdung ihres eigenen Wesens nannten. Aber hätten sie, wenn sie Lessing hießen, das Rappier so vollkommen gegen die französische Dialektik führen können, wenn sie nicht zuvor durch die französische Fechterschule gegangen wären. Die Deutschen haben die französische Literatur so vollständig mitgelesen wie kein anderes Volk, aber auch so gründlich und so mißtrauisch und so voller Einwände, daß sie hierin niemand übertreffen konnte. Deutschland hat diese Literatur so verzweifelt ernst genommen, wie *Der deutsche Mitleser* man nur den Tod nehmen kann, den man zum täglichen Gesellen hat. Die Deutschen sind damit fertig geworden und es hat sich gelohnt. Als die Deutschen endlich soweit waren, nahmen die Franzosen sie mit dem gleichen Ernst zur Kenntnis, nicht nur Goethe, sondern auch die ganze Romantik, und mehr noch als die Dichtung die deutsche Philosophie, vielleicht das einzige, in dem sie es den Deutschen nicht gleichtun können, es sei denn, sie veränderten ihre Natur.

Indessen auf geistige Weise so miteinander zu leben, dazu kann jedes Volk in seinem Lande bleiben. Geht es um die ausgetauschten Gastfreundschaften, so steht es umgekehrt wie in der Literatur. Die französischen Universitäten übten, seit sie bestanden, einen starken Reiz auf die deutsche Jugend aus. *Der Gastfreund* Sie wurden zumal im siebzehnten Jahrhundert, da der deutsche Kavalier auf Reisen ging, Mode. Doch das gab nicht viel aus. In entgegengesetzter Richtung waren die Straßen weit mehr befahren. Seit der Aufhebung des Ediktes von Nantes, 1685, bevölkerten sie sich mit Hugenotten, die in Deutschland Zuflucht fanden. Man weiß, was die französischen Kolonien, die sich überall, vor allem in Brandenburg und Preußen, bildeten, für Kultur und Gewerbe bedeutet haben. Wieviele Mütter aus der Kolonie haben Deutschland Söhne geboren, ohne die es um soviel geistig ärmer wäre. Im achtzehnten Jahrhundert fehlt nicht viel, daß in Deutschland ein zweites Frankreich entsteht. Die französische Akademie zu Berlin ist sein geistiger Kern. Die große Revolution bringt neues Leben auf die Landstraßen. Deutschland nimmt auf, was Zuflucht sucht. Und auch diesmal hat daraus die deutsche Dichtung ihren

Gewinn. So wäre denn das in manchen Punkten die Wahrheit. Was Italien für Deutschland, das ist Deutschland für Frankreich. Paris konnte für Deutschland niemals Rom sein.

Der Fall der Bastille

Da machte der Fall der Bastille Epoche. Jetzt drängten zunächst die deutschen Freiheitsmänner nach Paris. Man sieht Georg Forster, Josef Görres, Adam Lux, Georg Kerner. Napoleon macht Paris für Millionen Deutsche zur staatlichen Hauptstadt. Sie wird für die Deutschen die hohe Schule der morgenländischen Sprachwissenschaft. Die Werkstätten der Pariser Maler füllen sich mit deutschen Schülern. Hier schulen sich deutsche Baumeister. Die kaiserliche Bücherei wimmelt von jungen Deutschen, die den geraubten Handschriften ihrer Heimat wieder begegnen oder romanische Sprachen und Schrifttümer kennenlernen wollen. Hier sammeln Friedrich von Savigny und

Deutsche Jugend in Paris

Jakob Grimm. Hier schult sich Ludwig Uhland für seine Arbeit „Über das altfranzösische Epos". Hier vollendet der Aachener Gotthard Reinhold seine Petrarcaübersetzung. Dazwischen kamen und gingen — die Begegnung mit Paris für jeden ein anderes Erlebnis — junge deutsche Dichter, die Brüder Arnim, die Brüder Eichendorff, die Brüder Boisserée, die zwei einsamen Schicksalsgefährten Kleist und Sonnenberg, der unvermeidliche Varnhagen und schwingend zwischen zwei Vaterländern Adelbert von Chamisso. Und als Geschäftsträger der deutschen Romantik bei seiner Majestät dem neuen Europa waltete Friedrich Schlegel in den Jahren 1802 bis 1804 seines Amtes, um eine Aussprache zwischen mittelalterlichem Abendland und Morgenland bemüht. Die Vertretung des geistigen Deutschland lag in andern Händen.

Geschäftsträger und Botschafter

Es waren auch hier die Preußen wie in Rom, doch in Paris ohne staatlichen Auftrag. Der Stettiner Gustav von Schlabrendorf, 1750 bis 1824, durch Jahrzehnte der Mittelpunkt des deutschen Verkehrs in Paris, hauste, ein zweiter Diogenes im Hôtel des Deux Siciles der Rue Richelieu. Er schrieb wenig, verschenkte sein geistiges wie sein wirtschaftliches Eigentum und machte nur einmal mit seiner Schrift „Napoleon Bonaparte und das französische Volk unter seinem Konsulate" 1804 eine Ausnahme. Er sah die Ursache des französischen Schicksals im Abfall vom Werke Karls des Großen. Schlabrendorf war ein mystischer und aphoristischer Denker und Dichter von der Art Johann Georg Hamanns. Der Berliner Alexander von Humboldt, 1769 bis 1859, bereitete seit 1798 zu Paris seine große Amerikafahrt vor und verarbeitete seit 1804 zu Paris mit einem ganzen Stabe von Gehilfen deren Ergebnisse zu dem gewaltigen Werk „Voyage aux régions équinoxiales", das seit 1807 in dreißig Bänden erschienen ist. Humboldt war der Schutzherr seiner geistig gerichteten Landsleute in der fremden Stadt.

So haben Deutschland und Frankreich geistig nie zusammengearbeitet wie *Schule der Wissenschaft* zu Paris in diesen Jahrzehnten. Deutsche wirkten als Lehrer an den höheren Pariser Schulen. Alle deutschen Kenner der morgenländischen Sprachen sind in die Pariser Lehre gegangen. Der erste Meister der romanischen Sprachwissenschaft Christian Friedrich Diez, der Schöpfer der deutschen Chemie Justus Liebig, der Tierforscher Karl Vogt, saßen zu Füßen französischer Lehrer. Franzosen übersetzten die großen Werke deutscher Denker und Dichter. Mit breiter Fülle strömte der deutsche Geist nach Frankreich ein, „am sichtbarsten in der Lyrik und der lyrisch gefärbten Poesie, am gründlichsten in der Geschichtsschreibung, Philologie und Unterrichtslehre, am nachhaltigsten in der Philosophie". Die zeitgenössische Französische Literatur aber begann die deutsche vom Grund auf umzuwühlen. Und was noch nie geschehen war, in Paris bildet sich eine deutsche Binnenstadt. Zu den wirt- *Die deutsche Binnenstadt* schaftlich Gesicherten der ersten Jahrzehnte strömten seit 1830 politische Flüchtlinge zu; Schaffende, die der Überzeugung waren, geistige Arbeit stehe in Paris höher im Preise als daheim; Tausende von Handwerkern und Arbeitern, die hier ihr Glück zu machen hofften. Arnold Ruge schätzte 1843 die Zahl dieser Deutschen in Paris auf über achtzigtausend. Das war der Boden, aus dem die drei rheinischen Juden Börne, Heine, Marx heranwuchsen.

Ludwig Börne, 1786 bis 1837, ist zu Frankfurt in der ungemilderten Strenge des Talmud auferzogen und an die Gunst der französischen Rheinherrschaft gewöhnt worden. Er ging durch die romantischen Bildungskreise auf Arndt und Görres zu und ließ sich 1818 evangelisch taufen. Zu Wien war man bereit, Börne in das Erbe Friedrich Schlegels und Adam Müllers zu setzen. Er gab zu Frankfurt 1818 bis 1821 „Die Wage. Eine Zeitschrift für Bürgerleben, Wissenschaft und Kunst" heraus. Börne ist kein Held für Trauerspiele. Ein hübsches Vermögen nach dem Tod seines Vaters machte ihn zum Freiherrn. Und aus freier Wahl übersiedelte er nach dem Juli 1830 in die französische Hauptstadt. Die Zeitschrift „La balance", nur drei Hefte, *Ludwig Börne* sollte deutschen und französischen Geist auf ihre Schalen nehmen. Der Schriftsteller Börne ist Zeitungsmann. In seiner „Wage" begann er damit, die zeitgenössische Dichtung zu besprechen. Er machte rasch daraus verdeckte Zeitkritik. Seine „Briefe aus Paris" 1830/1831 gewannen ihm den größten Einfluß. An Johann Paul Richter hat er sich für die launigen und scheltenden Kleinbilder des Lebens geschult. Eine neue Form hat er mit seinen „Briefen" nicht gefunden. Er hat nur einer längst geübten zeitgemäßen Inhalt gegeben. Der deutsche Bundestag hat Börne mit dem Verbot seiner „Briefe" den größten Dienst erwiesen. Börne suchte den deutschen Widerstand gegen

eine Revolution an zwei entscheidenden Stellen zu treffen. Die eine war das
Mißtrauen gegen Frankreich. Auf diese Stelle zielte seine Streitschrift „Men-
zel der Franzosenfresser". Die andere war die geschichtliche Bildung der
Deutschen. An diesem Punkte ging er aufs Ganze. Denn sein verzweifelter
Feldzug gegen Goethe galt natürlich nicht dem Weltbürger, nicht einmal
dem Unpolitischen, er galt dem Kern von Goethes Kunst: „Er hasset alles
Werden, jede Bewegung, weil das Werdende und das Bewegte sich zu kei-
nem Kunstwerk eignet". Also forderte Börne gegen Goethes gültige, monar-
chische, adelige Kunst die bewegte, republikanische, demokratische Kunst
eines neuen Zeitalters. Den herausfordernden Gelegenheiten des Tages preis-
gegeben, ist Börne der Mitschöpfer des modernen Feuilletonstiles, ohne
dieses Stiles ein Meister zu sein. Ein Charakter, das ist Börne sicher gewesen.

Heinrich Heine *Christian Johann Heinrich Heine,* 1799 bis 1856, aus Düsseldorf, ist wie
Börne im gesetzestreuen Judentum und in französischer Umwelt aufgewach-
sen. Und wie Börne ist der verunglückte Banklehrling durch die roman-
tischen Kreise Bonns und Berlins gegangen. Bei Hegel traf sein Intellekt auf
die rechte Dialektik und war gefangen. In Göttingen schloß er ab, ließ sich
„Buch der Lieder" taufen und wurde Anwalt zu Hamburg. Das „Buch der Lieder" 1827 faßte
die Reihe seiner ersten Sammlungen in ein absichtsvolles Ganzes. Für einen
Erfolg traf alles glücklich zusammen. Die empfindsame Romantik mochte
man noch. Minnelieder und spanische Romanzen waren gerade Mode. Die
großartigen Meeresbilder waren neu. Die Schreckensnot des Krieges und die
Scham der Rheinbundzeit begannen zu verblassen. Napoleon starb aus der
Zeit in die Ewigkeit. Und so wurde Heines Trommelwirbel der gloire von
denen, die sehr schnell vergessen, nicht mehr peinlich empfunden. Der kecke
Ton gefiel wie immer. Und es war ein großes, wenn auch zweideutiges Ta-
lent, das sich hier kundgab. Das aber, was diesem Stil seine Note gab, der
Bruch der Stimmung, ist gar nicht Heines Eigentum. Dieses jähe Kehrum
war längst im Tanzrhythmus des Schnadahüpfels da und diesem volkstüm-
lichen Vierzeiler hatten eben auch Josef von Eichendorff und Wilhelm Müller
„Reisebilder" den gleichen Kunstgriff abgewonnen. Die „Reisebilder" 1827/1830 waren
Heines Erfolg und Unglück. Denn sie lockten ihn aus dem bürgerlichen Be-
ruf in alle moralischen Zeitgefahren des freien Schriftstellers. Sie sind der
Ertrag der herbstlichen Fußwanderung durch den Harz 1824, der Reise nach
Helgoland 1828, nach Italien 1829, bestachen durch den freien Wechsel von
Vers und Bruchstückprosa, schufen den neuen Modestil des „geistreichen"
Feuilletons und brandmarkten ihn. Denn im dritten Teil standen die schmut-
zigen Angebereien gegen Platen. Heinrich Heine übersiedelte 1831 nach

Paris. Er richtete sich auf Dolmetsch zwischen Frankreich und Deutschland ein. Nach Osten sprachen die Berichte „Französische Zustände" 1832, nach Westen das Buch „De l'Allemagne" 1835, nach beiden Seiten das stillose Sammelwerk „Der Salon" 1834/1837, vor allem mit der Dreiheit „Zur Geschichte der Philosophie in Deutschland", „Die romantische Schule", „Elementargeister". Diesen drei Prosabüchern entsprachen drei Versbücher. „Neue Gedichte" 1844, sehr reine und sehr abscheuliche Töne nebeneinander, machten aus seiner Erotik nicht weniger als eine „neue" Weltanschauung, die sich im „Dritten Testament" verwirklichen sollte. „Deutschland. Ein Wintermärchen" 1844, die Ausbeute eines Hamburger Besuches, und „Atta Troll" 1847, ein komisches Romanzengedicht, verhöhnten beides, sein Geburtsland, das er sich freilich nicht hatte aussuchen können, und die religiöse Gemeinschaft, in die er doch ungezwungen eingetreten war. Heine hat den Zwiespalt seines Schicksals aus dem Judentum und seines Willens zum Abendlande zweifellos tragisch empfunden. Die Dichtung, die sein eigentliches Bekenntnis hätte werden sollen, die Novelle „Der Rabbi von Bacherach" 1824/1840, ist weniger als unvollendet. Aber wir wissen genug aus seinem ersten Werk, dem Drama „Almansor" 1820 und aus dem lyrischen Buch „Romanzero" 1851, das sein letztes geworden ist. Die Welt, die er in „Almansor" und in den „Hebräischen Melodien" beschwor, war der echte Inbegriff der abendländisch-jüdischen Bildung, das spanische Judentum. Wie das Verlangen der Germanen nach Rom und der Deutschen nach dem Mittelalter geht es durch Heines Verse, sobald er auf die blühende Kultur der spanischen Juden zu sprechen kommt. Sie hätte sein Kunstverlangen stillen können. Heine hat seinem tragischen Lebensgefühl nur burlesken Ausdruck zu geben vermocht. Ein Talent, das ist Heine sicherlich gewesen.

Karl Marx, 1818 bis 1883, aus Trier, hatte in Paris einen andern Hintergrund. Hier war 1836 der „Bund der Kommunisten" gegründet worden. Und mancherlei Gesinnungsverwandte fanden sich zu verwandten Bünden zusammen. Marx war seit 1843 in Paris und gab 1844 mit dem wunderlichen Schulmeister Arnold Ruge die „Deutschfranzösischen Jahrbücher" heraus. In diesen Blättern entwarf Marx die ersten Umrisse seiner Gesellschaftslehre: „Zur Kritik der Hegelschen Rechtsphilosophie" und „Zur Judenfrage". Erklärte er dort die Staatswirtschaft als Grundlage des ganzen gesellschaftlichen Lebens, so verlangte er hier an Stelle des christlichen Staates eine Gesellschaft ohne Gott und von Volkes Gnaden.

Um Börne oder Heine gruppierten sich irgendwie alle Schriftsteller, die nach Paris kamen. Zu Börne hielten Karl Gutzkow, der mit seinen „Briefen

„Französische Zustände" und „De l'Allemagne"

Das „Dritte Testament"

Der Kommunismus

Deutscher Besuch

aus Paris" 1842 nach Börnes Erfolgen schielte, und Jakob Venedey, der Herausgeber der Pariser Monatsschrift „Der Geächtete". Heines Anhang waren der böhmische Dichter Alfred Meissner und Karl Hillebrand, der später den Franzosen die neue Entwicklung in Preußen vor und nach 1866 schmackhaft zu machen suchte. Ziemlich selbständig hielten sich Heinrich Laube, Levin Schücking, Franz Dingelstedt. Franz List hat zu Paris ein paar Jahre ruhigen Schaffens gefunden, in denen er für die „Allgemeine Zeitung" und die „Deutsche Vierteljahreszeitschrift" seine handelspolitischen Aufsätze schrieb. Sehr angeregt ging 1836 Franz Grillparzer, stolz und einsam 1843 Friedrich Hebbel durch Paris. Wer immer von Deutschland nach Paris kam, fühlte sich beschenkt. Nur die Musiker wußten, daß das Schenken an ihnen war. Es *Deutsche Musik* kamen 1823 Franz Liszt, 1827 Henriette Sontag, 1837 Johann Strauß und 1825 leitete Jakob Meyerbeer die erste Pariser Aufführung einer seiner Opern. Richard Wagner war im September 1839 eingetroffen, blieb bis April 1842 und machte in Paris den Schritt von „Rienzi" zum „Fliegenden Holländer". Im September 1859 erschien er wieder. Napoleon III. befahl die Aufführung des „Tannhäuser" in der Großen Oper und im März 1861 ging das Stück in wildem Sturm über die Bühne. Diesem Ereignis auf der Ferse folgte das zweite: Botschafter Preußens wurde 1862 Otto von Bismarck. Besuche von anderer Art kamen und gingen.

Dann waren wieder die Dichter an der Reihe. Seit den späten siebziger Jahren fehlt kaum einer von denen, die auf sich hielten, in den Fremdenlisten der Stadt. Bei Michael Georg Conrad und Stefan George sowie bei dem und jenem war es mehr als nur Besuch. Wirklich gelebt haben zu Paris ein östlicher und ein westlicher Deutscher. Der östliche war Rainer Maria Rilke. Er hat die Stadt und das Land, das Land und seine Kathedralen mit den Augen *Rainer Maria Rilke* seines Freundes Auguste Rodin erlebt. Frankreich, das sind für Rilke „Das Buch der Bilder" 1902, „Das Stundenbuch" 1905, „Neue Gedichte" 1907 bis 1908, „Malte Laurids Brigge" 1910, im Leben Rilkes nur eine zugemessene Spanne. Doch sie erneuert die alte luxemburgische Geistesfreundschaft *Albert Heinrich Rausch* Böhmen-Frankreich. Der westliche war Albert Heinrich Rausch. Der Dichter ist gleichzeitig mit Rilkes Einkehr Schüler der Sorbonne geworden und Frankreichs Hausgenosse, am liebsten nächst dem Mittelmeer, geblieben. Was Rausch geschaffen hat, ist aus dem Boden seiner hessischen Heimat aufgegangen. Aber es ist im Klima Frankreichs zur edelsten Frucht gereift. Rausch hat das karlingische Europa geliebt. Die karlingische Einheit Frankreich-Deutschland, die ist der Mann und sein Werk, ihre Gesinnung und ihr Stil.

3. RUSSLAND

Deutschland und Rußland sind erst spät, indem sie einander entgegen-
wuchsen, Nachbarn geworden. Die Deutschen in den Baltenländern waren
eine Brücke. Wenn Rußland Vertreter deutscher Wissenschaft und Dichtung
früher bei sich zu Gaste hatte als umgekehrt, so lag das an der Geistesge-
schichte herüben und drüben.

Die Literatur der Baltenländer ist bis auf Peter I. vom Zufall nur verein- *Die Baltenländer*
zelter Erscheinungen gezeichnet. Heinrich von Lettland schrieb um die
Jahreswende von 1226 auf, wie die Baltenländer deutsch, lateinisch und
christlich wurden. Die ältere livländische Reimchronik aus der Zeit um 1290
fand ein Gegenstück in der jüngeren Arbeit des Priesters Bartholomäus
Hoeneke, der aus der Gegend von Osnabrück stammte und in niederdeut-
schen Versen die Geschichte des Landes von 1315 bis 1348 erzählte. Das
Werk ist nur in späteren Prosaauszügen erhalten. Das Jahr 1522 brachte
Livland den Sieg des Luthertums. Der hessische Mönch im Rigaer Barfüßer- *Riga*
kloster, Burkard Waldis, zog die Kutte aus, wurde Zinngießer und heiratete.
Am 27. Februar 1527 ließ er auf dem Markte in niederdeutscher Sprache sein
Spiel vom verlorenen Sohn aufführen. In Riga entstand ein Teil der Fabeln,
die er als „Esopus" 1548 drucken ließ und im Gefängnis „Der Psalter" 1552,
eine Umdichtung in deutschen Reimen. Gustav Adolf gründete am 30. Juni
1632 die Dorpater Hochschule. Um diese Zeit lebte Joachim Rachel in Dor- *Dorpat und Reval*
pat. Er schrieb hier lateinische und deutsche Sinngedichte. Im Gefolge der
berühmten Gesandtschaft des Herzogs Friedrich von Holstein war der Dich-
ter Paul Fleming 1635 und 1639 in Reval. Um ihn schloß sich ein Kreis von
Schöngeistern, Prediger und Lehrer, darunter Reiner Brocmann, einer der
Mitschöpfer der estnischen Literatur. Der schwedische General Gustav von
Mengden steuerte seine „Sonntagsgedanken" und eine Psalmendichtung,
beide 1686, zur deutschen Dichtung des Landes bei. Und Johann von Besser,
1654 bis 1729, aus Frauenburg in Kurland, ist der erste deutsche Dichter,
den das Land hervorgebracht hat. Die ersten Buchpressen sind zu Riga 1599,
zu Dorpat 1642, zu Reval 1691 entstanden. Im Frieden von Nystadt 1721
fielen Estland und Livland von Schweden an Rußland.

Rußland selber begann die deutsche Literatur kennenzulernen. Durch
Übersetzungen aus dem Polnischen und Tschechischen kamen die deutschen
Volksbücher nach Rußland. Und im Freidorf Sloboda bei Moskau spielte
1674 ein Deutscher zum erstenmal Theater. Peter I. wandte sich unmittelbar
an das westliche Abendland und baute Petersburg als Hauptstadt des neuen

Rußland auf. Am 27. Dezember 1725 wurde die Petersburger Akademie feierlich eröffnet. Nicht wenige deutsche Forscher wurden zur Mitarbeit herangezogen. Männer wie August Ludwig Schlözer, der 1761/1770 in Petersburg wirkte, haben aus diesen russischen Jahren beide Völker bereichert. In diesen geistigen Wechselverkehr fügte sich die Stadt Riga ein. Sie war der wichtigste Reisehalt zwischen Deutschland und Rußland, zwischen Königsberg und Petersburg. Die Stadt blühte eben damals von neuem auf. Das machte der Kreis von Freunden um den Ratsherrn Johann Christoph

Berens, 1729 bis 1792, dem nacheinander Johann Georg Hamann und Johann Gottfried Herder angehörten. Der Briefwechsel der Zeit gibt ein lebhaftes Bild von den dichten persönlichen und geistigen Beziehungen, die zwischen dem westlichen Rußland und dem östlichen Deutschland spielten. Herders Landsmann Johann Gottlieb Willamow, 1736 bis 1777, Leiter der deutschen Schule in Petersburg, schrieb Preisgesänge im Stil Pindars und meist selbsterfundene Fabeln. Besonders lebhaft war das literarische Leben in Kurland. Das Herz des geistigen Lebens waren Verlag und Buchhandlung, die der Ostpreuße Johann Friedrich Hartknoch 1764 in Riga aufmachte. In diesem Verlage sind die Grundbücher der neuen deutschen Bildung von Herders „Fragmenten" bis zu Kants „Kritik" erschienen.

Großfürst Paul hatte zwei deutsche Dichter in seiner Umgebung, deren jeder auf seine Weise diese deutsch-russischen Beziehungen verkörpert. Der

Straßburger *Ludwig Heinrich Nicolai*, 1737 bis 1820, war 1769 der Lehrer des fünfzehnjährigen Großfürsten geworden. Man machte ihn 1798 zum Vorsitzenden der Akademie und 1803 zog er sich auf sein Landgut bei Wiborg zurück, das er in seinem Blankversgedicht „Das Landgut Monrepos" 1804 sehr weltmännisch, stimmungsvoll und gegenständlich geschildert hat. Dichterisch war Nicolai ein Parteigänger des französischen Klassizismus gegen Klopstocks deutsch-englische Art. Der gewandte Stilkünstler war Philosoph des goldenen Mittelwegs und auf Wieland eingeschworen. Mit zwei Trauerspielen folgte er den Franzosen, mit zwei Lustspielen Goldoni. Der

Frankfurter *Friedrich Maximilian Klinger*, 1752 bis 1831, kam im Herbst 1782 mit dem Großfürstenpaar nach Rußland. Er machte als Soldat eine glänzende Laufbahn, wurde 1798 General und war 1802/1817 Pfleger der wieder errichteten Dorpater Hochschule. In seinem ersten Petersburger Jahrzehnt rang er mit ungestilltem Ergeiz weiter um die große deutsche Tragödie, indem er hinter der Maske antiker Stoffe russische Fragen behandelte. Mit einer Auswahl seiner umgearbeiteten Dramen 1792 nahm Klinger Abschied von der tragischen Muse. Die Kunstform seiner russischen Zeit war der Ge-

sprächsroman. Ihre ganze Reihe, „Fausts Leben" 1792, „Raphael de Aquillas" 1793, „Giafar" 1794, „Reisen vor der Sündflut" 1794, „Der Faust der Morgenländer" 1795, dreht sich um die Frage, wie das Böse in die Welt kommt und wie es zu heilen sei. Seine Selbstdarstellung „Der Weltmann und der Dichter" 1798 gibt der Reihe einen persönlichen Abschluß. Voltaire, Rousseau, Kant stecken die geistige Umwelt ab, in der sich diese Romane bewegen. Gleich seinem Jugendfreund Goethe hat Klinger seinem ersten deutschen Faust einen zweiten Faust des Morgenlandes zum Gegenspieler gegeben. Wie Goethe langte Klinger im Morgenlande des Moses und Mohammed an. Wenn er fast wie Hamann in der Vernunfterkenntnis die Quelle des Bösen sah, so zog er sich auf morgenländische Art in die Lösung zurück: alles steht im Buche verzeichnet. Die umfangreichen Koranauszüge in den „Reisen" zünden ein seltsames Licht über der Tatsache auf, wie Goethes und Klingers Wege, die soviel äußere Ähnlichkeit haben, sich schließlich im Weltweiten wieder auf dem gleichen Punkte begegnen. Durch keinen Großfürsten ist *Jakob Michael Reinhold Lenz*, 1751 bis 1792, ein Livländer von pommerischer Abkunft, nach Moskau gekommen. An der Königsberger Hochschule zwischen Kant und Hamann gebildet, kam Lenz als Hofmeister nach Straßburg und folgte Goethes Fährten bis nach Weimar. Wie Hölderlin stürzte er vom Grat des Genies und zu Moskau in den Wahnsinn. Lenz war der Schüler Hamanns und also der Stiefbruder Herders. Seine „Anmerkungen übers Theater" 1774 arbeiteten von Shakespeare und Plautus her einer neuen Bühne vor. Lenz war der Sprecher des Mittelstandes, des sozialen Kampfes für Menschenwürde und gegen den Verfall der Kultur. „Lustspiele nach dem Plautus" 1773 verlegten die Szene des römischen Spötters mitten nach Deutschland. „Der Hofmeister" 1774 galt dem mißachteten Erzieher und „Die Soldaten" 1776 forderten für das Söldnerheer eine bürgerliche Ordnung. „Der neue Menoza" 1774 spiegelt die fragwürdige Welt des weißen Mannes im erstaunten Auge des roten. „Pandämonium Germanicum" 1775 stellt die ganze Literatur der Zeit unter das Gericht des einsamen Vorläufers, als den Lenz sich gefühlt hat. Das Bruchstück „Katharina von Siena" ist das Drama der erotischen Askese. Von Hamann oder mit Hamann gemein hat Michael Reinhold Lenz die erotische Wurzel des Denkens, die Kampfgesinnung gegen die aufgeklärte Vernunft, den sittlichen Unwillen gegen sein Zeitalter, den Glauben an das Urerlebnis der Sprache, die ironische Haltung, den rhapsodischen Stil, das Bewußtsein der sittlich-religiösen Sendung. Lenz war der erste romantische Dichter, unterwegs in der Richtung auf Hardenbergs „Hymnen an die Nacht", Werners „Söhne des Tals", Kleists „Penthe-

„Der Weltmann und der Dichter"

Der erste romantische Dichter

Hamann und Lenz

silea". Hier gibt sich ein Schauspiel kund. Hamann hat durch Herder über
Goethe auf den Westen und durch Lenz über Karamsin auf den Osten ge-
Klinger und Lenz wirkt. Und von den beiden Dichtern, für die in Weimar kein Platz war, hat
jeder in Rußland Raum gefunden, Klinger in Petersburg und Lenz in Moskau.

Während Moskau 1812 brannte, sammelten sich zu Petersburg deutsche
Soldaten, Dichter, Staatsmänner, Gelehrte, um Rußland zur Rettung Deutsch-
lands und der Freiheit Europas mitzureißen: Friedrich vom Stein, Ernst
Moritz Arndt, August Wilhelm Schlegel.

Zwischen Petersburg und Moskau lebten die deutschen Balten ihr geistiges
Dasein sicherlich nicht abgeschieden. Nur brauchte es seine Zeit, bis sie nicht
nur die deutsche, sondern auch die russische Dichtung mitlasen.

Kurland Kurland war von je auch geistig Königsberg am nächsten benachbart. Der
Mitauer Ulrich von Schlippenbach, 1774 bis 1826, hatte mit Zacharias Wer-
ner vertraut verkehrt, schwärmte für Friedrich Schiller und Johann Paul
Richter, wußte in gewählten Worten vorgeprägte Gedanken auszudrücken
und sammelte seine versfrohen Landsleute um das Taschenbuch „Kuronia".
Mit Georg von Fölkersahm gründete er 1816 die kurländische Gesellschaft
für Literatur und Kunst. Livland hatte den Zug ins Größere voraus. Der
Malerdichter Karl Gotthard Graß, 1767 bis 1814, dessen größte Erlebnisse
Schiller und Sizilien waren, bezeugt das. Nur hat dieser verinnerlichte, sanfte
Rigaer Theater Schwärmer nicht auszureifen vermocht. Riga hatte die Macht auf dem Thea-
ter. Schon 1711 spielte hier eine deutsche Truppe auf dem Bischofsberge zu
Ehren von Peter I. Rückkehr aus dem Auslande. Auf dem Paradeplatz baute
man 1768 und an der Königstraße 1782 ein festes Gebäude, das mit „Emilia
Galotti" eröffnet wurde. Dieser Bühne dienten 1837/1839 Karl von Holtei
als Leiter und Richard Wagner als Kapellmeister. Und Riga hatte die Macht
in der Presse. Von den zahlreichen baltischen Blättern vor und nach 1800
sind die meisten zu Riga erschienen. In der Dichtung herrschte der Adel.
Einen schönen Querschnitt zeichnet die Sammlung „Schneeglöckchen", die
1838 Arnold Tideböhl und Wilhelm Schwartz herausgaben. Der Übergang
von Matthisson und Salis, die bisher die jungen Balten beherrscht hatten, zu
Uhland und Eichendorff kommt hier gut zum Ausdruck. Estland hatte die
Führung. Dafür zeugt schon der Maler und Kunstforscher Otto Magnus von
Estland Stackelberg, 1787 bis 1837, der sich an Italien auslebte. Die deutschen Wech-
sellichter der Zeit spiegelt Estland mit Schärfe und rascher Fertigkeit wieder:
der frühvollendete Revaler Alexander Rydenius die Romantik Tiecks und
Hoffmanns; der Revaler Karl Stern die Romantik Tiecks und Eichendorffs,
die Formstrenge Platens, Heines Scharfrichterspuk. Nikolai Graf Rehbinder,

1823 bis 1876, der Vorkämpfer gegen das Lehenswesen, feierte die See und machte im Drama einen weiten Weg von dem romantischen Stück „Der Liebestrank" 1848 bis zu „Jesus von Nazareth" 1875, dem modernen Mysterienspiel. Er gab das „Baltische Album" 1848 und „Musenalmanach der Ostseeprovinzen" 1854 heraus. Von den beiden Revalern schilderte Andreas Wilhelm von Wittorf in raummalenden Rhythmen die russische Steppe und dichtete baltische Sagen, während Alexander Heinrich Reuß estnische Märchen und Volkslieder dergestalt übersetzte, daß er mit deutschen Altertümlichkeiten die Eigenart der estnischen Sprache zu malen suchte. Haupt und Meister war in Estland Roman von Budberg, 1816 bis 1858, ein Freund Lenaus und Mitglied des Berliner „Tunnels". Er holte die Balten in seine Schule. Im Winter auf 1845 hielt er zu Reval dem baltischen Adel Vorträge über zeitgenössische deutsche Literatur. Er war um geistige Vermittlung zwischen Russen und Deutschen bemüht. Dichtungen von Lermontow brachte er deutsch in dem Buch „Aus dem Kaukasus".

Die Dorpater Hochschule wurde am 21. April 1802 mit neunzehn Studenten von neuem eröffnet. Die Höhe des Domberges verwandelte sich in einen Park, der die wissenschaftlichen Anstalten umhegte. Die Ruinen des Domes verwandelten sich in das Heim für die Bücherei. Dorpat wurde in jedem Sinne eine Musenstadt. Zahlreiche Zeitschriften lösten einander ab. Das Zepter führte die Wochenschrift „Das Inland". Sie erschien von 1836 bis 1863 als der geistige Spiegel Estlands. Die musische Seele der Stadt war der Dorpater Karl Friedrich Petersen, 1775 bis 1822, wie eine ganze Schar von Balten zu Jena gebildet, und zu Dorpat Lehrer für Deutsch. Ein unbedingter Anhänger Goethes, sprühte er Leben, Anmut und Laune aus. Er schuf feine Nachgebilde aus dem Finnischen und Estnischen. Die Knittelverse seiner „Abenteuer von Reineke dem Fuchs" 1814 und seine Burleske „Die Prinzessin mit dem Schweinerüssel" 1816 funkeln von allen Lichtern seines Wesens. Und die Laune des jungen Goethe ist in dem Schwank von der Widerspenstigen Zähmung, „Die Wiege", mit ihren frischen und kecken Reimworten. Die Dorpater Hochschuljugend stellte sich in den „Balladen und Liedern" 1846 insgesamt vor. Und der Livländer Jegor von Sivers, 1823 bis 1879, Farmer in Mittelamerika und Landwirt in Livland, wurde mit seiner allseitigen Auswahl „Die deutschen Dichter in Rußland" 1855 der erste Literaturhistoriker der baltischen Länder.

Gleichzeitig mit der Eingliederung der baltischen Länder in die russische Kultur setzt sehr allmählich der Abbau des deutschen Geisteslebens in Petersburg ein. Sein Rückhalt waren Zeitblatt und Theater gewesen. In den hohen

Die Dorpater Hochschule

„Die deutschen Dichter in Rußland"

Reichsämtern gehen die Beamten deutscher Herkunft zu einer vermittelnden *Abbau des deutschen Geisteslebens* Literatur über. Der Beamte im Innenministerium, der Revaler Georg Julius von Schultz, 1808 bis 1875, gab neben baltischen Skizzen und Erinnerungen finnische Märchen und Sprichwörter sowie episch geformte estnische Sagen. Der russische Gesandte Wilhelm von Kotzebue, 1813 bis 1887, erschloß mit seinen Übersetzungen rumänischer Volksgedichte und seinem moldauischen Kleinbild „Laskar Vioresku" 1863 einen neuen literarischen Bereich. Der Beamte im Ministerium des Äußern, der Petersburger Ludwig von Jessen, 1828 bis 1888, übersetzte Tolstoi, Nekrassow, Golemischew-Kutusow. Und der Dorpater Ewald Simson, Abteilungsvorstand im Ministerium des Äußern, ließ gegen Ende des Jahrhunderts mit seinen Erzählungen und Gedichten diese Überlieferung abklingen.

Dieses Bild bietet das ganze Land. Russen von Geburt schreiben deutsch und übersetzen wie Andreas Ascharin, 1843 bis 1896, von Pernau, russische Dichtungen ins Deutsche oder verdolmetschen wie Viktor von Andrejanow, *Geistige Vermittlungssprache* 1857 bis 1895, den Deutschen lettische Volksdichtungen. Ja für diese national so gemischte Oberschicht wird deutsche Dichtung die geistige Vermittlungssprache. Lou Andreas-Salomé, 1861 bis 1937, zu Petersburg einem russischen General von französischer Abkunft geboren, an einen Berliner Hochschullehrer verheiratet, die Freundin Nietzsches und Geistesverwandte Ibsens, stellt in deutscher Sprache mit Vorliebe das Seelenleben halbwüchsiger Mädchen dar. Frances Külpe, geboren 1862, aus der Gegend von Orel, von einem englischen Vater und einer Kurländer Mutter, durch Heyse und Dehmel der deutschen Literatur gewonnen, beginnt mit „Freilichtskizzen aus Rußland" 1901 und schildert dann in dem Roman „Mutterschaft" 1907, in den Novellen *Rückwanderung* „Rote Tage" 1911 baltische Verhältnisse. Aber es gab auch überall in Rußland zahlreiche Zufallszellen deutscher Reichsbürger, die nicht hafteten. Kaufleute, leitende Industriebeamte, Lehrer, Prediger. Solchen Schicksals war Eduard Stucken, 1865 bis 1936, zu Moskau als Sohn eines hanseatischen Großkaufmanns geboren und noch als Knabe nach Deutschland zurückgebracht. Indem er zwischen der Tragödie „Irsa" 1896, neuseeländischen Verssagen „Hine-Moa" 1901 und dem Trauerspiel „Die Gesellschaft des Abbé Châteauneuf" 1908 schwankte, fand er seinen Stil in der Feierlichkeit romantischer Mysterienspiele aus dem Artuskreise. Und solchen Schicksals war Korfiz Holm, 1872 zu Riga geboren und gleichfalls jung nach Deutschland zurückgekehrt. Er wurde 1896 Leiter des „Simplicissimus" und spielte in den geläufigen Formen der Zeit die geläufigen Anregungen seiner Münchner Umwelt durch. Deutlich hebt sich eine Gruppe von Alàmannen ab. Der

Elsässer Karl August Candidus, 1817 bis 1872 wirkte als reformierter Pfarrer zu Odessa. Er war aus dem Kreise der Brüder Stöber hervorgegangen. In Odessa entstand das „Evangelium aeternum" 1866, den Bedürfnissen der Zeit zugewendet. Samuel Keller, 1856 bis 1924, aus Petersburg, von Schaffhauser Herkunft, war Prediger an verschiedenen Orten in Rußland und kehrte 1891 nach Deutschland zurück. In seinen Erzählungen aus dem russischen Leben wie „Steppenbilder und Steppenleute" 1894 hat Keller die alamannische Volksgeschichte als Sinn und Form, die russische Volksgeschichte als Gattung und Erlebnis miteinander verbunden.

Unter den Balten scheiden sich die Geister. Zunächst innerhalb der Junker. *Baltische Scheidung der Geister* Der Kurländer Karl Freiherr von Fircks, 1828 bis 1871, verspinnt sich in die Renaissance und der Revaler Nikolai von Glehn, geboren 1841, Dichter von „Nordischen Liedern" 1877, baut sich bei Reval eine altdeutsche Burg und haust in ihr. Aber da ist auch Waldemar von Uxküll, geboren 1860, der, von Tolstoj bekehrt, der Bekehrer seiner Bauern wird. Von Osseten eingeladen, geht er in den Kaukasus und wird an dieser Landschaft wie vordem die Russen zum Dichter des Berglandes. Es scheiden sich aber auch die Geister des Junkertums und des Bürgertums. Der baltische Bürger übernimmt die Führung. Er schafft sich in Riga eine bürgerliche und deutsche Presse. Viktor Wittrock und Karl Hunnius gründen und geben 1904/1912 das Jahrbuch „Heimatstimmen" heraus, das ausschließlich von Balten geschrieben unter den Balten in aller Welt Eigenart und Kultur des Landes pflegen wollte. Vorzüglich gemischt brachte es Baltendichtungen in Vers und Prosa, Aufsätze über Natur und Geschichte, abgeschlossene Zeitfragen des Landes und Lebensbilder bedeutender Balten.

Zwei dieser bürgerlichen baltischen Dichter stehen für das Ganze. *Eberhard Kraus,* geboren 1857, hatte einen besonderen Sinn für das Steinwerk *Baltisches Bürgertum* baltischer Städte, für das Farbenspiel des nordischen Himmels und die nordischen weißen Nächte, wie es seine Gedichte, baltischen Erzählungen und Skizzen „Zwischen Narwa und Niemen" 1891, „Germanenblut im Osten" 1894, „Im Zuge der Pest" 1895 bezeugen: „Rot der Herbstwald, Rot das Feld, Rot der Fuchs, der schnelle, Übers goldne Himmelszelt Eine Purpurwelle" *Karl Worms,* 1857 geboren, hat in den Zeitromanen „Du bist mein" 1898, „Thoms friert" 1900, mit den baltischen Geschichten und Skizzen „Überschwemmung" 1905 seinen Stil an der jungen Kunst der Wirklichkeit geschult. Entgegen der Augenlust von Kraus fängt der Lyriker Worms die Klangfülle der Welt auf, den letzten Hauch „aus feierlich altem Kirchengesang", Taubengirren und Finkenschlag, einen verlorenen lettischen Ruf.

Baltische Diaspora Die Bildung einer baltischen „Diaspora", schon im achtzehnten Jahrhundert erkennbar, geht auf tiefere, allgemeinere, mannigfachere Ursachen zurück als die Umkehr der russischen Politik gegenüber den Balten gewesen ist. Die Einsamkeit und Lebenshärte des Landes trieb Kranke, nach Weltmitte Verlangende, künstlerisch Ringende in Räume des Weltverkehrs, der ewigen Sonne und der Künste. Deutsche Hochschulen holten viele in ihre Ämter. Der Tod des Gatten oder der Eltern entführte andere der Heimat. Und da diese Balten zweierlei Not litten, staatliche und schöpferische, so gabelte sich ihr Weg nach zweierlei Wunschländern, nach Preußen und nach dem Süden.

Berlin war das Ziel der Zeitungsleute. Der Livländer Julius Eckart half zuletzt Gustav Freytag bei den „Grenzboten". Der Estländer Erwin Bauer gab 1890 „Das zwanzigste Jahrhundert" und 1891 die „Neue Deutsche Zeitung" heraus. Theodor Pantenius, 1843 bis 1915, aus Mitau, der Sohn eines lettischen Volksschriftstellers, hat die baltische Heimaterzählung nach zwei Modellen gestaltet: das livländische Geschichtsbild in „Die von Kelles" 1885;

Balten in Preußen die Dorfgeschichte, „Im Gottesländchen" 1880 und „Kurländische Geschichten" 1892; immer ein guter Erzähler und ein echter Humorist. Er hat das Treiben der Kurländer Literaturklüngel geschildert, den das Volk verachtenden Edelmann, den sinkenden deutschen Pächter, den aufsteigenden Letten mit dem unauslöschlichen Gedächtnis. Jeannot Freiherr von Grotthuß, 1865 geboren, aus Riga, gab evangelisch-altgläubig die Bekehrungsgeschichte „Der Segen der Sünde" 1897 und „Die Halben" 1900, einen Zeitroman. „Aus deutscher Dämmerung" 1909 zeichnet Schattenbilder einer Übergangskultur. „Gottsuchers Wanderlieder" 1898 sind das Jahrbuch seiner Seele. Grotthuß hat eine Tat gestiftet, als er 1898 die Monatsschrift „Der Türmer" gründete, die ähnlich wie der „Kunstwart" über das gesamte geistige Leben berichtete und für besonnene Schonung des älteren Kulturgutes eintrat. Seiner Heimat hat er „Das baltische Dichterbuch" 1894 geschaffen. Der Rigaer Karl Manfred Kyber hellte mit seinen vergnüglichen Märchen in Vers und Prosa dieses schwere Berliner Baltenbild ins Heitere auf und der Dorpater Hermann Anders Krüger brachte mit seinen Erziehungsromanen die Herrnhuter Frömmigkeit zur Geltung.

Italien zog die Balten an, denen die Kunst am Herzen lag. Aber nicht wenige wurden schon an den Zugängen nach Italien seßhaft.

Balten in Österreich Österreich wurde die Heimat von drei Frauen. Die Kurländerin Elisabeth von Grotthuß, 1820 bis 1896, behandelte in ihren Romanen russische Fragen nach ihrer katholischen Weltanschauung. Die Rigaerin Elfriede Jaksch, 1844 bis 1897, bevorzugte Livländer Vorwürfe. Die Estländerin Ursula Zoege von

Manteuffel, 1850 bis 1910, schrieb Romane aus der großen Welt. In Ober-
österreich landete nach weiten Irrfahrten der Revaler Maurice Reinhold von
Stern, 1860 bis 1938, der Sohn des Dichters, ein verunglückter russischer
Offizier, in Amerika Arbeiter, in Zürich Schriftsteller und politisch beständig
verfolgt. Er ist den weiten Weg von Marx zu Christus gegangen. Trotz seinen
amerikanischen Skizzen „Von jenseits des Meeres" 1890, der Novelle „Das
Richtschwert von Tabor" 1901, der epischen Dichtung „Die Insel Ahasvers"
1893 war Stern Lyriker. Von seinen „Proletarierliedern" 1885 sind seine
Versbücher in langen Reihen bis zu „Gesammelte Gedichte" 1906 erschienen.
Gesiebt bleibt schon ein reiner Bestand. Von dem rundgestaltigen Sagen-
bilde „Triumphzug der Nacht" bis zu dem schlichten Herzensruf „Nacht-
gebet", von den gottabsagenden Arbeiterliedern bis zu der aufwühlenden
Christuslegende „Erscheinung am Meer" hat Stern die Weite des Menschen-
herzens ausempfunden und alle Möglichkeiten des Stils erprobt. Ein Ton
aber herrscht vor: durch Leidenschaft ausgeglühte Weltmüdigkeit und
rauschsüchtige Hingabe an die Reize des Auges und Ohrs.

Baiern sammelte eine starke baltische Gruppe: die Rigaer Bernhard Stern *Balten in Baiern*
und Kurt Bertels, den Petersburger Paul Fuhrmann. Der Kurländer Eduard
Graf Keyserling, 1858 bis 1918, ging als Erzähler über Fontane von der
Wirklichkeit aus, kam rasch zu strenger Form, schilderte mit Vorliebe, wie
junge Menschen an der Luft des Überkommenen langsam ersticken und
stellte zuletzt in dem Roman „Abendliche Häuser" 1914 schwermütig und
der vornehmen Pracht gerecht, das innere Absterben des baltischen Adels
dar. Der Livländer aber, Karl von Freymann, 1878 bis 1907, der tiefer als
irgendwer den „Geist der livländischen Kolonisation" ergründete, der das
Schauspiel der lettischen Revolution „Der Tag des Volkes" 1907 schrieb und
ihm die drei geistreichen Einakter „Francesca. Nach dem neunten Thermi-
dor. Masken" 1908 folgen ließ, starb zu Meran an der Schwelle Italiens und
am Vorabend der baltischen Wende den sinnbildlichen Tod des allzufrüh
und schonzuspät.

Italien hat seit Otto Magnus von Stackelberg nicht wenige Balten einge- *Balten in Italien*
bürgert. Diese Überlieferung verdichtete sich. Der Dorpater Karl Eduard
von Liphart, 1808 bis 1891, der in seinem Dorpater Heim einen Schatz von
Kunstwerken hatte, spielte zu Florenz im kleinen die Rolle, die zu Rom Wil-
helm von Humboldt gespielt hatte. Die Livländerin Emilie von Hörschel-
mann, geboren 1844, war in den großen Galerien Italiens zu Hause und hielt
hier wissenschaftliche Vorträge. In Italien lebte Karl Gottfried Ritter, 1830
bis 1891, von Narwa, der Freund Richard Wagners und in der Schweiz dessen

Genosse. Er rang, und das trennte ihn von Wagner, auf eigene Weise nach dem Drama und er gab 1880 seine „Theorie des deutschen Schauspiels". Ein Freundespaar, der Estländer Elisar von Kupffer und der Petersburger Eduard von Mayer, bereisten seit 1897 Deutschland, Italien, Griechenland und lebten 1902 bis 1915 in Florenz. Sie gaben 1907/1911 eine Sammlung „Lebenswerte" heraus, worin Kupffer Gedanken einer neuen Glaubenswelt und Sittlichkeit vertrat, während Mayer sie geistesgeschichtlich und naturwissenschaftlich untergründete. Diese Lehre wurzelt in der Eigengesetzlichkeit des freien Menschenwesens und sie strebt nach einer verklärenden Überwindung der ewig chaotischen Weltgegensätze.

Turgenjew, Tolstoi, Dostojewskij, Gorki haben ungemein stark auf die deutsche Dichtung gewirkt.

Rainer Maria Rilke Mit der Jahrhundertwende beginnt eine junge deutsche Generation Rußland aufzusuchen. So wie Rainer Maria Rilke ist keiner gekommen und keiner gegangen. Ende April 1899 ging er mit seiner Freundin Lou Andreas-Salomé nach Moskau. Eine Woche lang war er mit nichts beschäftigt als mit dieser Stadt. Dann wurde Tolstoj besucht. Petersburg feierte gerade Puschkin. Das gab der Stadt ein festliches Gepräge, das Rilke voll ausgekostet hat. Nach der Heimkehr verarbeitete er das russische Erlebnis und begann mit Ernst seine russischen Studien: Sprache, Kunst, Literatur, Geschichte. Er übersetzte das Igorlied. Im Mai 1900 fuhr er mit Frau Lou das zweitemal nach Rußland. Er reiste wie Gogol und Puschkin gereist waren, mit läutenden Geschirren und galoppierenden Pferden, besuchte bei Tula Tolstoj, sah Kiew, die Steppe bei Poltawa, die Wolga bei Saratow, lebte eine Woche auf dem Dorf bei dem Bauerndichter Spiridon Dimitritsch Droschin und kam über Großnowgorod wieder nach Petersburg. Ein Zeugnis für die tiefen und fast mystischen Beziehungen, durch die sich Rilke mit Rußland verbunden fühlte, sind die acht Gedichte in russischer Sprache, die er hinterlassen hat. Lou Andreas-Salomé nennt sie „obwohl grammatikalisch arg, doch irgendwie unbegreiflich dichterisch". Der Dreiklang von Land, Volk, Gott, das ist Rilkes Rußlanderlebnis. *„Geschichten vom lieben Gott!"* Seine „Geschichten vom lieben Gott" haben es ausgeatmet.

4. DIE ANGELSACHSEN

Als die sächsische Stammesgemeinschaft nach der Abwanderung der Angelsachsen auf die Insel in einem kurzen, beinahe gemeinsamen Schrifttum erlosch, hat es lange gebraucht, bis sich persönliche Beziehungen, die literarisch greifbar sind, von Volk zu Volk knüpften. Sie sind nie sehr dicht geworden.

Sehr schön fängt es mit dem Buchdruck an. William Caxton, der in der West- *Deutsche in England*
minsterabtei die erste englische Druckerei einrichtete, schloß 1471 zu Köln
seine erste Schrift ab, und der Kölner Theodor Rudt ging 1478 über den
Kanal und begann in England zu drucken. Ab und zu wird ein Deutscher von
Rang nach England verschlagen. Der Humanist Nikolaus Kratzer von Mün-
chen, Mathematiker und Astronom, wird 1521 an die Oxforder Hochschule
berufen und dient Heinrich VIII. auch in staatsmännischen Geschäften. Der
schwäbische Dichter Georg Rudolf Weckherlin war um 1630 in London eine
Art Unterstaatssekretär und hierin der Vorgänger John Miltons. Johann
Georg Hamann hatte 1758 zu London sein großes religiöses Erlebnis. Seit
dem späten achtzehnten Jahrhundert setzen die Wanderfahrten deutscher
Dichter nach England ein, unter nicht wenigen Achim von Arnim, Franz Grill-
parzer, Theodor Fontane. Und nur um die Mitte des neunzehnten Jahrhun-
derts waren es politische Flüchtlinge, die in London eine deutsche Kolonie
bildeten. In Richtung auf Deutschland ging seit dem späten sechzehnten Jahr-
hundert der Strom der englischen Komödianten. Im siebzehnten Jahrhundert
trugen eine Reihe deutscher Höfe diesen Verkehr. Im achtzehnten Jahrhun-
dert, während Hannover und England vereinigt waren, zog ihn die Göttinger
Hochschule auf sich. Von den nicht wenigen Engländern, die in Deutschland *Engländer in Deutschland*
heimisch geworden sind, haben John Henry Mackay und Houston Stewart
Chamberlain im späten neunzehnten Jahrhundert deutsch geschrieben. In
den letzten drei Jahrhunderten war England die Zuwaage, die Deutschland
gegen Frankreich im Gleichgewicht gehalten hat. Die ganze neuere Dichtung
der Engländer ist in der deutschen wirksam geworden. Die englische Philo-
sophie des achtzehnten bildet mit der deutschen des neunzehnten Jahrhun-
derts erst das Ganze, das vollkommen macht. England hat den Deutschen
zum Bürgertum Mut gemacht, da sie sich als Nation im achtzehnten Jahrhun-
dert verbürgerlichten. Die geduckte Art, zu der sie ihre zahlreichen kleinen
Fürsten erzogen hatten, wollte aus ihnen heraus. Die Gefahr, in die franzö-
sische Libertinage zu fallen, war groß. Da war der englische Freimut ein heil-
samer Augenspiegel. Die Deutschen sind wohl zu keiner Zeit einander und
sich selber so ähnlich gewesen wie im achtzehnten Jahrhundert. Die große
nationale Dichtung, in der sie damals ihr eigenstes Wesen ausdrückten, ist
ein Ergebnis dieser innerlichen Selbstbefreiung durch England.

Die volkhafte Vereinigung von Deutschen und Engländern hat sich in den *Die Vereinigten Staaten*
Vereinigten Staaten vollzogen. Der Hundertsatz des deutschen Anteils am
Aufbau des Staatenvolkes kann, überzeugend berechenbar oder nicht, auf
sich beruhen. Was in der deutschen Literatur davon sichtbar wird, überzeugt.

Die ersten **Der** verfolgte Londoner Quäker William Penn legte an der Delaware-
Deutschen mündung 1682 die Siedlung Pennsylvanien an, um die Hauptstadt der Bru-
derliebe Philadelphia, Glaubensflüchtlingen eine Freistatt. In den Tagen der
Befreiung Wiens, am 6. Oktober 1683, gingen zu Philadelphia die ersten
rheinischen Mennoniten an Land und legten wenig nördlich ihre Stadt Ger-
mantown an. Sie erhob 1688 den ersten Ruf gegen die Sklaverei. Von da an
folgten Welle auf Welle deutsche Bauern. Salzburger seit 1734 machen ihr
Ebenezer zu einem ähnlichen Sammelort wie die Pfälzer ihr Germantown.
Urzelle der deutschen Kultur im neuen Lande war die bäuerliche Kirchen-
Germantown gemeinde. Und deren gab es drei. Einmal Germantown. Hier schafft der
Gründer und geistige Führer, der Richter, Bürgermeister, Lehrer Franz
Daniel Pastorius, 1651 bis 1719, aus dem fränkischen Sommerhausen, der
jungen Gemeinde ein handweisendes und lehrhaftes Schrifttum. Und hier
schafft, nachdem soeben Benjamin Franklin in Philadelphia die ersten deut-
schen Bücher und die erste deutsche Zeitung gedruckt hat, der Niederhesse
Christoph Saur aus Laasphe der Gemeinde das Rüstzeug: 1738 eine deutsche
Presse; 1739/1777 einen regelmäßigen Kalender; 1739 die erste deutsche
Zeitschrift; 1743 die erste deutsche Bibel, die zugleich die erste in einer euro-
päischen Sprache war. In Philadelphia entstanden rasch weitere deutsche
Druckereien. Und 1762 gab es in Pennsylvanien schon sechs deutsche Zeitun-
Religiöse gen. Die zweite Urzelle war das Kloster. Der Siebenbürger Johann Kelpius,
Gemeinden 1694 gelandet, hatte am Wissahickon eine Einsiedlergemeinde von Rosen-
kreuzern um sich versammelt. Als er 1708 starb, hinterließ er ein lateinisches
Tagebuch und geistliche Lieder vom Stil schäferlicher Mystik. Der Rest seiner
Genossen wandte sich dem Kloster Ephrata zu, das der Pfälzer Schwärmer
Konrad Beissel 1735 am Cocalicofluß gründete. Die Gemeinde bestand bis
1814 und wollte auf Grund der Tunkerlehre, der Mystik Jakob Böhmes, der
thebaischen Einsiedleraskese ein erneuertes Christentum leben. Sie stellte
Bilderhandschriften her. Sie ließ zunächst bei Franklin arbeiten. Der druckte
ihre Liedersammlung, „Goettliches Liebes und Lobesgethoene" 1730, das
Die Herrnhuter erste deutsche Buch. Dann ging sie zu Saur über. Und 1745 legte sie sich
eine eigene Druckerei zu. Sie entwickelten eine reiche Liederliteratur Herrn-
huter Stiles, worunter vieles von Beissel. Die dritte Urzelle war die Herrn-
huter Gemeinde Bethlehem, die 1741 im Beisein des Grafen Nikolaus von
Zinzendorf gegründet wurde und 1743 im benachbarten Nazareth eine
Schwester erhielt. Auch hier entwickelte sich eine Liederliteratur. Den größ-
ten Einfluß gewannen die Herrnhuter durch ihre Erziehungsanstalten. So ist
aus diesen Zellen ein deutscher Kulturkreis entstanden. Das Pfälzische und

Alamannische wird, mit Englischem gemischt, bodenständige Mundart, Penn- *Die Mundart*
sylvanisch. Der Kolonialbund war so stark geworden, daß er sich am 4. Juli
1776 unabhängig erklären und diesen Entsluß in einem achtjährigen Kriege
durchfechten konnte, mit Heeren, die Friedrich Wilhelm von Steuben ge-
schult hat und deren Kern geschlossene deutsche Verbände bildeten.

Von der späteren deutschen Zuwanderung drängte sich weit über die *Der große Strom*
Hälfte auf der Landzunge zusammen, die Ohio und Mississippi von ihrer
Mündung bis zu ihren Quellen mit den großen Seen einschließen. In diesem
Raume hat sich das moderne deutsche Geistesleben herausgebildet.

In Ohio, im Kreise Crawford, hatte Nikolaus Lenau 1832 eine kleine Farm *Ohio*
erworben. Nachdem er Urwald und Niagara, Indianer und Blockhaus lyrisch
erlebt hatte, verschwand er wieder, ein Wahrzeichen dessen, was Amerika
verlangte und was es nicht brauchen konnte. Cincinnati sah beinahe wie eine
deutsche Stadt aus. Hier erschien die stolze geschichtsforschende Zeitschrift
„Der deutsche Pionier" 1869/1887, der der Hannoveraner Heinrich Armin
Rattermann verdientes Ansehn gab. Das Vogelstimmenbüchlein „Nord-
amerikanische Vögel in Liedern" 1904 stammt von ihm. Der Schwabe Johann
Martin Bürkle gab das launige Blatt „Der Vetter aus Schwaben" und schwä-
bische Mundartgedichte heraus. Der eine Rheinländer Gustav Brühl betrieb
ausgedehnte Forschungen über die Kulturvölker Altamerikas und schrieb
Indianerballaden, der andere Rheinländer Karl Knortz wandte sich den In-
dianersprachen zu, dichtete Indianersagen nach und übersetzte amerikanische
Dichtungen. Der Rheinhesse Konrad Nies, einer der begabtesten Lyriker,
wollte mit seiner Monatsschrift „Deutschamerikanische Dichtung" 1888/1890
der landesüblichen Selbstgenügsamkeit zu Leibe rücken und auf Leistung
dringen. Leistung und eine neue Note zeigen der Jesuit Franz Finn aus St.
Louis, und seine flotten Erzählungen aus dem amerikanischen Schülerleben,
von denen ein seltsamer Zauber ausgeht.

Michigan ist eine dreifache Wiege. Hier wurde 1857 die erste ausgespro- *Michigan*
chene Staatshochschule nach deutschem Muster und dem Grundsatz der
freien Forschung gegründet. Zu Detroit gab Konrad Marxhausen 1856 die
erste dichterische Auslese des neuen Landes, den „Deutschamerikanischen
Dichterwald" heraus. Und Detroit ist die Heimat der deutschen Arbeiter-
dichtung. Das sind die „Parabasen" 1875 des Würzburgers Eduard Dorsch
und der Schopfheimer Robert Reitzel, ein freireligiöser und sozialistischer
Wanderprediger, der mit Karl Henckell befreundet war und 1884 seine Wo-
chenschrift „Der arme Teufel" gründete.

Illinois war dichtwachsendes Literaturland. Hier herrschten die Presse und *Illinois*

die Niederdeutschen. Der Westfale Kaspar Butz gehörte zu den Mitgründern
der republikanischen Partei Chikagos und gab während des Bürgerkriegs das
wirksame Werbeblatt „Deutsche Monatshefte" heraus. Der Magdeburger
Willibald Winckler leitete das Sonntagsblatt der „Illinois Staatszeitung"
und schrieb humoristische Schilderungen amerikanischen Lebens. Der Ilsen-
burger Paul Carvus, Verfasser religiöser und buddhistischer Dichtungen, gab
Niederdeutsche englische Zeitungen heraus. Das Bild macht vielleicht die niederdeutsche
Mundartdichtung Mundartdichtung, so der Reuterschüler Alfred Arnemann zu Omaha und Karl
Münster zu Indiana. Die Art Klaus Groths brachte zu Chikago Ferdinand
Lafrentz, von der Insel Fehmarn, mit seiner Sammlung „Nordische Klänge"
1881 zu Ehren. Aber auch die Stände gaben sich kund. Der Farmer Karl de
Haas, ein Wuppertaler, wirkte mit seinem Buch „Nordamerika, Wiskonsin"
1846 mächtig auf den deutschen Zuzug und formte farmerhafte Bilder aus
dem Waldleben. Alexander Conze, ein Bückeburger, Lehrer zu Milwaukee,
stimmte unter andern Kampfgesängen das marschkräftige „Oregonlied" an
und fiel 1847 achtundzwanzigjährig vor Buena Vista gegen die Mexikaner.
Der Stadtbürger Rudolf Puchner, ein Württemberger, pflegte Naturbilder
und Indianergeschichten. Die Süddeutschen in Illinois stimmten sich auf die
verbürgte deutsche Dichtung, auf pfälzische Mundart und Lieder im Stile
Heines und Eichendorffs.

Wisconsin Wisconsin sieht wiederum anders aus. Da ist sichtbare Leistung und da
sind Männer von Rang. Otto Ruppius, 1819 bis 1864, aus Glauchau, war als
politischer Flüchtling in die Staaten gekommen, hatte sich in Tennessee und
Kentucky als Musiklehrer versucht und lebte seit 1853 als Schriftsteller zu
Milwaukee. Er gründete ein Unterhaltungsblatt und gab mit den beiden
vielgelesenen Romanen „Der Pedlar" 1857 und „Das Vermächtnis des Ped-
lars" 1859 in einem straff gezogenen Gewebe das Schicksal des gebildeten
deutschen Einwanderers auf dem Hintergrunde des gesamten Lebens nord-
Karl Schurz südlichen Grenzgebiets. Karl Schurz, 1829 bis 1906, aus Liblar bei Köln,
hatte 1852 amerikanischen Boden betreten und 1856 in Wisconsin eine Farm
erworben. Dann wurde er Rechtsanwalt, Vorkämpfer Lincolns, General im
Bürgerkriege, Staatssekretär des Innern. Deutsch und englisch gleich gut
schreibend, ebenso groß als Redner wie als Zeitungsmann, hat Schurz dem
deutschen Bürger der Staaten ein vorbildliches Leben vorgelebt und mit sei-
nen klassischen „Lebenserinnerungen" 1906 dargestellt. Milwaukee wurde
für die seit 1840 zahlreicher zuwandernden Katholiken kirchlicher Mittel-
punkt und 1844 Bischofssitz. Auch diese Schicht kam, etwa durch den Lehrer
Michael Lochemes, der schon zu New York geboren war, literarisch zur Gel-

tung. Die Stadt hatte durch den Deutschböhmen Hans Balatka einen Musikverein erhalten, der Oratorien und Opern aufführte und 1868 ein Theater. Der Baier Ernst Zündt leitete es. Er bearbeitete für seinen Spielplan französische und englische Trauerspiele. Er schrieb im Stil seiner Geburtsheimat Zauberpossen und Feenmärchen. Diese Bühne suchte sich gegen Ende des Jahrhunderts neben der New-Yorker den zweiten Platz zu erobern.

Missouri, das war vor allem St. Louis, wo um 1900 von allen Zugewanderten mehr als die Hälfte deutsch war. In der sehr vielfältigen Dichtung überwogen die Südwestdeutschen. Unter ihnen muß aus mehr als einem Grunde Johannes Ernst Rothensteiner auffallen, der Eingeborene aus Sankt Louis, der katholische Pfarrer zu Fredericktown, der Dichter von „Indianersommer" 1906 und „Am sonnigen Hang" 1909, darunter lyrisch kräftige amerikanische Verserzählungen, die nichts Balladenhaftes vortäuschen. In St. Louis, dem damaligen Karawanenknotenpunkt, malte der Siegburger Karl Ferdinand Wimar, 1828 bis 1862, das Leben des Westens, Pfadfinder, Pelzjäger, indianische Büffeljagden. Also gemalt und nicht gedichtet ist dem westlichen Deutschen die neue Heimat Kunsterlebnis geworden. Auch Sankt Louis bekam ein richtiges Theater. Heinrich Börnstein, ein Hamburger, aber in Wien zur Bühne gebildet, führte es seit 1859 und stiftete ihm — „Der Einwanderer" — ein gutes Stück aus dem amerikanischen Volksleben. Für dieses Theater hat dann der Paderborner Friedrich Schnake in den sechziger Jahren die amerikanische Geschichte zu Dramen verarbeitet: „Die Unabhängigkeitserklärung", „Montezuma", „Maximilians letzte Tage". *Missouri*

Zwischen Missouri und Arkansas trieb sich seit 1837 der Hamburger Friedrich Gerstäcker in allen Berufen um und schuf mit seinen „Mississippibildern" 1847, mit seinen Romanen „Die Regulatoren in Arkansas" 1845, „Die Flußpiraten des Mississippi" 1848 Ansätze zu einer heimatlich amerikanischen Literatur, wie sie keiner der im Lande Verbleibenden weiterfördern konnte. In Texas lebte der Kasseler Friedrich Strubberg als Blockhausmann, Indianerkämpfer und Städchengründer. Erst der Heimgekehrte schilderte in Jagdbüchern, Indianergeschichten, Sklavenromanen, Kriegserzählungen, was er an Land und Leuten erlebt hatte. Zu San Antonio saß seit 1904 der Rostocker Hugo Moeller als Verleger und Zeitungsherausgeber und schrieb Präriegeschichten. Hinter zwei Männern aus Baden her, dem Pelzhändler Johann Jakob Astor und dem Siedler Johann Sutter, wurde endlich die Westküste erreicht. Die Wege zum Stillen Ozean hatte der Bonner Balduin Möllhausen in den Jahren 1850, 1853, 1858 vermessen helfen und dann in Büchern, die mehr und mehr Romane wurden, das Land und seine Erlebnisse geschildert. *Wildwest*

Unter den nicht wenigen lyrischen Dichtern Kaliforniens fesselt der Göttin-
ger Friedrich Wilhelm Wedekind, Franks Vater, mit kalifornischen Fest-
gesängen. San Franzisko erhielt 1891 seine Hochschule nach deutschem Mu-
ster. Der Frankfurter Julius Goebel, der an dieser Schule deutsche Sprache
und Literatur lehrte, schrieb zarte, blasse Liebesgedichte und kräftige vater-
ländische Lieder.

Der alte Osten Der alte Osten, um so viel weiter voraus, hat eigentlich erst entwickelt,
was man eine geschlossene Literatur nennen kann. Sie sammelte sich um die
geschichtlichen Einfallshäfen Philadelphia und New-York.

Pennsylvanien Pennsylvanien sah nach ziemlich ungewöhnlichen Dingen aus. Der größte
deutsche Dichter, der die Staaten sein Vaterland nennen konnte, Karl Postl,
ließ sich 1824 in Kittaning nieder. Hier schrieb er nach seinem Buch „Die
Karl Postl Vereinigten Staaten von Nordamerika" 1827 seinen ersten Roman „Tokeah"
und gab ihn 1828 in englischer Sprache heraus. So wenig fehlte und die
Deutschen Amerikas hätten ihren Dichter gefunden, der den Einklang zwi-
schen der werdenden deutschen und englischen Literatur des Landes her-
stellte. Pennsylvanien war noch immer die geistig fruchtbare Mutterland-
schaft des östlichen Amerika. Das Gesetz von 1837 sprach die Gleichstellung
der Schulen beider Sprachen aus. Den Zuschub bestritten fast ausschließlich
die Pfälzer und Rheinländer. Sie beherrschen auch die Literatur, der es an
bescheidenen Gebilden der Kleinkunst nicht fehlt. Hier allein hat sich eine
bodenständige Dichtung der Mundart gebildet. Der politische Flüchtling
Ludwig August Wollenweber, aus der Zweibrückener Gegend, gründete
1839 den „Philadelphia Demokrat", der das ganze Jahrhundert überdauerte.
Seine „Gemälde aus dem pennsylvanischen Volksleben" 1869 gaben in Vers
und Prosa pennsylvanische Mundart. Dieser Mundart wurden eingeborene
Dichter. Heinrich Harbaugh, 1817 bis 1867, der Sohn eines Schweizers aus
Waynsboro, fand in Hebels Art schlichte, einfältige, überaus unmittelbare
Gedichte, die 1874 als „Harbaughsharfe" erschienen. Der Rechtsanwalt
Heinrich Heinrich Fischer aus dem pennsylvanischen Washington schöpfte Brauch und
Harbaugh Sprache des Alltags aus. Pennsylvanisch war die „Mundart" der Staaten.
Ganz fremde Amerikabürtige schrieben, wenn sie Mundart schreiben woll-
ten, pennsylvanisch, so der New-Yorker Nikolaus Lochemes. Der Geschichts-
forscher des Landes aber war, wie es sich gehörte, ein Sachse, Oswald Seiden-
sticker aus Göttingen, Lehrer der deutschen Sprache an der Hochschule zu
Philadelphia. Alle Künste hatten in dieser Landschaft Wurzeln. Mit dem
Männerchor entstand hier 1835 der älteste deutsche Gesangverein. Hier
blühte die deutsche Malerei. Ein eigenes Theater ist freilich erst um die Jahr-

hundertwende entstanden. Zu Philadelphia gründete 1889 Charles Hexamer, der Sohn eines badischen Flüchtlings, den Deutschamerikanischen National-bund zur Einigkeit, zur Pflege der Muttersprache, zur Verbreitung der deut-schen Literatur, zum Schutz der deutschen Schule.

Die Küstenstaaten von südlich Philadelphia bis nördlich New-York. Zu *Die* Charleston leitete in den dreißiger Jahren der Niedersachse Johann Andreas *Küstenstaaten* Wagener die erste deutsche Zeitung der Südstaaten und focht auf deren Seite als General. Der Beamte des Washingtoner Schatzamtes Ernst Reinhold Solger, ein Stettiner, schrieb 1860 einen der besten Romane der Staaten, „Anton in Amerika". In Maryland war Baltimore der Mittelpunkt. Die Balti- morer Blumenspiele wurden 1903 von dem Berliner Ernst Henrici gegründet *Baltimorer* und Baltimore schuf 1876 mit der John-Hopkins-Universität die erste Hoch- *Blumenspiele* schule von strenger deutscher Art, nach der alle neuen Hochschulen ein- gerichtet und die bestehenden umgestaltet wurden. Massachusetts war es unter den Neuenglandstaaten. Boston hatte sich 1815 eine Händel- und Haydn-Gesellschaft gegründet. Der „Pionier" 1853/1879, von dem Rhein- länder Karl Heinzen in Louisville gegründet und bald nach Boston verlegt, war eines der wenigen Blätter von Stil und sprachlicher Verantwortung, die Amerika besessen hat, ein sehr ehrliches Blatt der wirklichen Linken. An der Landeshochschule zu Cambridge lehrte der 1824 zugewanderte Hesse Karl Follen deutsche Sprache und Literatur, brachte deutsche Bücher in Umlauf und die Bostoner dazu, sie zu lesen. Diese Harvard-Universität eröffnete *Die Harvard-* 1903 ihr Germanisches Museum und begann 1905 den Lehreraustausch mit *Universität* Berlin. Von den Lehrern dieser Hochschule wußte der Danziger Hugo Mün- sterberg einen lebhaft spielenden Vers nach Heines Art zu schleifen, während der Kieler Kuno Francke ein Meister kleiner naturfrommer lyrischer Gebilde war, fast wie sie Martin Greif gerieten. Kuno Francke, das war der gelehrte Gemeingeist beider Völker, wie Karl Schurz ihr staatsbürgerlicher.

New-York war deutscher Weltbetrieb. Man muß ein wenig zurückdenken. *New-York* Drei Rheinländer. Peter Minnewit aus Wesel, 1626 bis 1631 Hollands Statt- halter der Kolonie, legte, indem er die Insel Manhattan erwarb, zu New-York den Grund und brachte die Siedlung zur Blüte. Der Frankfurter Jakob Leis- ler, der englische Verwalter New-Yorks, berief 1690 den ersten Kongreß der amerikanischen Kolonien und fiel als erster Vorkämpfer der Volkspartei und Blutzeuge der Freiheit 1691 unter dem Henker. Der Pfälzer Johann Peter Zenger errang mit seiner New-Yorker Volksparteizeitung und dem mächtigen Gerichtshandel von 1735 der amerikanischen Presse ihre Freiheit. Die Deut- schen dieses Zeitalters stellen sich mit zwei gegensätzlichen Männern vor.

Der Berliner Franz Lieber lehrte seit 1856 an der Hochschule Geschichte und Staatswissenschaft. Dieser seltene Mann, der so großartige Naturschilderungen in freien Versen wie „Der Sturm" vermochte, hat mit seinen englisch geschriebenen Werken dem staatsrechtlichen Denken Amerikas einflußreich vorgearbeitet. Der Magdeburger Wilhelm Weitling, das Kind einer Arbeiterin und Schneidergeselle, seit 1849 in New-York ansässig, hat vor Marx und Engels die erste deutsche Verfassung des Kommunismus entworfen, bildete in Amerika den ersten Gesamtausschuß der vereinigten Gewerkschaften und gründete ihnen 1851 das Blatt „Republik der Arbeiter". In New-York drängte sich die Literatur dicht zusammen, schwäbische, hessische, plattdeutsche Mundart und was an Bildungsdichtung mit hereingebracht wurde. Die Grenzfälle des Zeitschriftenwesens waren das von Josef Keppler gegründete Witzblatt „Puck" und die „Deutschamerikanischen Monatshefte", die seit 1864 Rudolf Lexow herausgab. Ein Gesicht erhielt diese Literatur erst spät. Der Schwarzwälder Hugo Bertsch hielt mit seinen Romanen und dem „Bilderbuch aus meinem Leben" 1906 die Linie des Schwarzwaldstiles. Der Heilbronner Wilhelm Heinrich Benignus gab Arbeiterlieder. Gotthold August Neeff, von schwäbischen Eltern zu New-York geboren, bot neben kunstvollen Gedichten das Peruaner Trauerspiel „Atahualpa" und stellte die neue amerikanische Auslese „Vom Lande des Sternenbanners" 1905 zusammen. Georg Silvester Viereck, aus München, gab mit seinem Vater 1907/1911 die Monatsschrift „Der deutsche Vorkämpfer" heraus und setzte sie als „Rundschau zweier Welten" fort. Viereck schreibt deutsch und englisch. In beiden Sprachen sind seine „Gedichte" 1904, „Ninive und andere Gedichte" 1906, die Erzählung „Das Haus des Vampirs" 1909 erschienen. New-York war die einzige große Theaterstadt. London, wo deutsche Klassiker in englischer Sprache gespielt wurden, war zunächst der Bühnenmakler zwischen Deutschland und Amerika gewesen. So waren noch im achtzehnten Jahrhundert wie zu Philadelphia und Baltimore auch in New-York Schillers Dramen in englischer Sprache aufgeführt worden. Das Bedürfnis nach deutschen Aufführungen wurde zunächst durch Liebhabervereine gestillt, bis der außerordentliche Zustrom, der seit den dreißiger Jahren Gebildete aus Deutschland heranführte, deutsche Bühnen erzwang. Der Schauspieler Otto von Hoym und Eduard Hamann gründeten 1853 an der Bowery das „Deutsche Stadttheater" und konnten am selben Platz 1864 ein eigenes großes Haus, das „Neue Stadttheater", eröffnen. Gespielt wurde alles, was ins Fach fiel: Schauspiel, Lustspiel, Oper, Operette. Man sah und hörte Gäste aus Deutschland. Diese Bühne schloß 1872 und 1872 machte Adolf Neuen-

Wilhelm Weitling

George Silvester Viereck

New-Yorker Theater

dorff das „Germaniatheater" auf. Ein zweites, das „Thaliatheater" schloß
sich 1879 an. Gastspiele der Münchner, der Schlierseer, der Meininger lösten
einander ab. Eine neue Wendung brachte Heinrich Conried aus dem öster- *Gastspiele*
reichischen Bielitz. Er war am Burgtheater geschult und kam 1878 an das
Germaniatheater. Er übernahm 1892 das Theater am Irvingplatz und führte
hier den Meininger Stil durch. Und nachdem 1884 der Posener Leopold
Damrosch mit Wagners Musikdramen Glück gehabt hatte, führte Conried
an der Metropolitanoper, die er 1903/1907 leitete, „Parsifal" und „Salome"
auf. Conried legte den Nachdruck auf Geist und Gehalt des Bühnenwerks.
Seine Grundsätze wurden Gesetze der amerikanischen Genossenschaftsbüh-
nen. Das waren nun schon die Zeiten, da man zu New-York auf einem Platz
die besten und berühmtesten Künstler sehen konnte, die in der Alten Welt
über alle Hauptstädte zerstreut waren.

Über fünf Millionen Deutsche sind im neunzehnten Jahrhundert nach
Nordamerika eingewandert, mehr als von irgendeinem andern Volke. Und
das ist ihre Literatur. Doch Literatur ist nicht gleich Literatur. Was in den
Vereinigten Staaten deutsche Literatur heißt, wurde nur von einer Genera-
tion, von der zugewanderten, erzeugt. Nur wenige der Schaffenden gehörten
der landbürtigen, der zweiten, an. Und aus der dritten, die von amerikani-
schen Eltern stammte, hat kaum einer mehr in deutscher Sprache gedichtet.
Es ist eine Literatur, die nicht aus dem Wachstum der Geburten, sondern
vom Zuschub über See lebte.

Deutsche Dichtung in Rom und Paris ist etwas anderes als deutsche Lite-
ratur in den Vereinigten Staaten und bei den Balten Rußlands. Paris und
Rom sind Herbergen des Geistes gewesen, wie viele Völker sie bei einander
genommen haben, und fallen nicht unter den Begriff Landesliteratur. Was *Grenzfälle*
die Balten Rußlands und die Deutschen der Vereinigten Staaten erzeugt *der Literatur*
haben, hat alle Merkmale einer geschlossenen Literatur. Aber es sind die
beiden entgegengesetzten Ausnahmen von der Regel Literatur. Die Balten
waren nur Oberschicht ohne volkhaften Organismus, Kopf auf einem frem-
den Körper. Die Amerikadeutschen waren Zwischenschicht ohne organische
Bindung, Zellen in einem fremden Körper. Weder die einen noch die andern
waren „Volk" im soziologischen Sinne. Der natürliche Lebensvorgang, dem
sie unterlagen, war längst im Gange. Gleichwohl ist über all diese Weltver-
bindungen des deutschen Volkes im August 1914 die Entscheidung gefallen.
Denn wieviel an diesen Weltverbindungen auch lebensfähig oder dem Tode
geweiht sein mochte, sie wurden durchschnitten, ohne daß die Natur an
ihnen weiter wirken konnte, ob nun zum Leben oder zum Tode.

HUMANISMUS UND NATIONALISMUS

WEDER DAS RÖMISCH-DEUTSCHE REICH NOCH DER KLEIN-
*deutsche Staat kannte einen Widerstreit zwischen dem Recht, auf persönliche
Art ein Mensch zu sein, und der Pflicht, die zu allen Zeiten die Nation an
ihresgleichen gestellt hat. Denn das römisch-deutsche Reich dachte universal
ohne Unterschied der Völker und der kleindeutsche Staat setzte Staat vor
Sprache und Herkunft. Jenseits der immer enger werdenden Grenzen des
römisch-deutschen Reiches und der Gebilde, die es ablösten, waren mit der
Zeit Staaten entstanden, in denen die Bürger deutscher Zunge mit Bürgern
anderer Sprachen auf eine organische Weise zusammengewachsen waren. In
der Donaumonarchie und in der Eidgenossenschaft ging erst recht Staat vor
Sprache und Herkunft. Die Deutschen im kleindeutschen Staat, in der Eid-
genossenschaft und in der Donaumonarchie lebten also nach der gleichen
Ordnung der Werte, deren oberste Bürgerrecht und Bürgerpflicht waren.
Jenseits ihrer staatlichen Grenzen waren diese Deutschen füreinander alle
Ausland. Es gab keinen Widerstreit der Rechte und Pflichten nach jenem
menschlichen Maß, das überall und jederzeit gegolten hat und nun einmal
an der schwankenden Harmonie von Sollen und Wollen leidet. Diese Ord-
nung hatte der Ausgang des Krieges von 1918 insofern gestört, als er den
Begriff der Gleichheit aller Bürger vor dem Gesetz mit dem zusätzlichen oder
abträglichen Recht der Minderheiten kreuzte. Doch unangetastet war das
organisch gewachsene Zusammenleben der Völker in den alten und neuen
Staaten geblieben. Völlig aufgehoben wurde diese Ordnung erst durch die
dreifache „Umwertung aller Werte“. Nation wurde vor Staat gesetzt. Die
Nation wurde nach körperlichen Typen rangmäßig eingestuft. Andere Natio-
nen wurden gezwungen, zu leben wie sie nicht leben wollten. Die Vernunft
hatte sich für absolut erklärt. Sie glaubte, die Geschichte rückgängig machen
und das Gesetz des Lebens unter ihr Diktat stellen zu können. Das bedeutete*

Zwiespalt aller Rechte und Pflichten. Die Harmonie von Humanismus und Nationalismus war aufgehoben.
Die deutsche Literatur im kleindeutschen Staat, in der Eidgenossenschaft, in der Donaumonarchie war also ein Ganzes, solange sie aus der gemeinsamen Ordnung der Werte lebte. Dieses Ganze verfiel in dem Maße, wie diese gemeinsame Ordnung der Werte verfallen ist.

I. SPRACH-LANDSCHAFTEN

im 19. und 20. Jahrhundert

Der allgemeine Gang der geistigen Entwicklung in der Schweiz und in Österreich stimmt nur in dem einen überein, daß sie dicht mit dem Gange des staatlichen Lebens verwoben ist. Die Schweiz wie Österreich rangen im neunzehnten Jahrhundert um eine neue und endgültige Gestalt ihres politischen Daseins. Beide Länder hat dieses Ringen Blut gekostet. Den Unterschied macht die Höhe dieses Preises ebenso wenig wie der Gläubiger, der ihn eintrieb. Den Unterschied macht nur, daß er in der Schweiz den Gewinn *Die Schweiz* wert war, während er in Österreich vergeblich erlegt wurde. In der Sache selber ist die literarische Entwicklung beider Länder so verschieden wie möglich. Der Schweiz gelingt es erst im neunzehnten Jahrhundert, zugleich mit dem Abschluß der staatlichen Gestalt, eine Dichtung zu schaffen, die ihr selbst gemäß und den großen Erscheinungen in Deutschland wie in Österreich ebenbürtig ist. Österreich ist seit dem achtzehnten Jahrhundert im vol- *Österreich* len Zuge, bei allen tragischen Wandlungen, die es durchzumachen hatte, in seinem gesamten Raume, soweit er von Deutschen bewohnt war, eine geschlossene Dichtung aufzubauen. Und sie hat, nachdem das staatliche Gefüge zerfallen war, als geistige Schöpfung die staatliche überdauert. Es ist unmöglich, diese geistigen Vorgänge in der Schweiz wie in Österreich losgelöst von den politischen Bildungen wie Umbildungen sich als reine geistige und künstlerische Erscheinungen verständlich zu machen und vorzustellen.

1. DIE EIDGENOSSENSCHAFT

Die Schweizer Dichtung des frühen neunzehnten Jahrhunderts, vor allem *Der neue Einsatz* in Appenzell und Basel, in Luzern, Solothurn, Sankt Gallen ist Mundart. Sie hat ihre bewegende Mitte in Bern. Gottlieb Jakob Kuhn, 1775 bis 1845, Pfarrer zu Sigriswil am Thuner See und dann im Emmental, begann, noch ehe er Peter Hebels Gedichte kennengelernt hatte, mit Liedern in Mundart und Hochsprache. Seine „Kuhreihen" 1798 entstanden meist zugleich mit der *Berner Mundart* Weise am Klavier. In allen rein liedhaften Stücken ist die Stimmung so vollkommen gegenständlich geworden wie kaum in den weit späteren Liedern

Eichendorffs. Viele davon wurden Volkslieder. Der Berner Johann Rudolf
Wyss, 1782 bis 1830, der nicht nur Sagen und Legenden seiner Heimat
formte, sondern auch geschichtliche Stoffe in der Sprache der jeweiligen Zeit
zu meistern wußte, hat diesen Kunststil weithin durchgesetzt. Zusammen mit
Bernern, worunter Jakob Kuhn, und Zürchern, worunter Martin Usteri, gab
er seit 1811 den Almanach „Die Alpenrosen" heraus, das literarische Organ
dieser Oberländer Bewegung und für die Schweiz ein geistiges Band der
Einheit.

Berner
Bauernspiegel *Albert Bitzius,* 1797 bis 1854, aus Murten, doch von einer alten Berner
Familie, hat diese bäuerliche Volkskunst, die bäuerliche Volkserziehung, wie
sie eben der Berner Emanuel von Fellenberg zu Hofwil betrieb, und die
Burgdorfer Volksbewegung, die politisch siegreich die Landschaft gegen die
Stadt durchsetzte, in seinem dichterischen Werk vergeistigt. Der junge Ber-
ner Schüler war von Herders „Ideen" ergriffen. Als Pfarrhelfer zu Herzogen-
buchsee und Lützelflüh im Emmental lebte er sich in den bäuerlichen Alltag
dieser Hoflandschaft ein und setzte hier seinen Schälpflug auf den Boden.
Das waren seine ersten gepaarten Ichromane. „Bauernspiegel oder Lebens-
geschichte des Jeremias Gotthelf" 1836 schilderte das Elend eines armen
Burschen und zielte auf Heilung der bäuerlichen Übel. „Leiden und Freuden
eines Schulmeisters" 1838 nahm sich der Unbilden der Lehrer an und rügte
das Berner Volksschulwesen. Das ebenso gepaarte Doppelstück seines Mei-
*Uli
und Anne Bäbi* sterwerks, „Wie Uli, der Knecht, glücklich wird" 1841 und „Uli, der Pächter"
1849, zeigten als Lösung den Weg vom Knecht zum eigenen Herrn. Der
Doppelband „Wie Anne Bäbi Jowäger haushaltet" 1843 geht den heilkund-
lichen Aberglauben des Landvolkes an. Ein üppiges Geranke von kleineren
Arbeiten und Geschichten wuchert um diesen Hauptstamm: Bilder und Sa-
gen, kurze religiöse und sittenbildende Aufsätze, Kalendergeschichten. Wert-
*Bitzius,
Pestalozzi,
Fellenberg* volle Arbeiten hielt Bitzius vor seinen Zeitgenossen zurück. Die Bewegung
des Berner Oberlandes hatte bäuerliches Land und Volk, die Sprache der
bäuerlichen Gemeinschaft künstlerisch erschlossen. Sie drang durch die hei-
tere Luft des Liedes und der Schalmei, der Tänze und Feste zum Ernst des
bäuerlichen Menschen selber vor. Diesen sprachlichen Vorgang hat Bitzius
künstlerisch abgeschlossen, indem er die Mundart des Emmentals seine Bü-
cher durchklingen ließ. Mit Pestalozzi war Bitzius als Freund und Lehrer dem
armen Manne entgegengetreten. In Emanuel von Fellenbergs Erziehungs-
anstalt zu Hofwil war Ackern, Säen, Ernten als vornehmstes Mittel erkannt
worden, den Menschen zu sich selber und eine bessere Gesellschaft zu bilden.
Diesen erzieherischen Gedanken hat Bitzius ausgeschöpft. Ihm ist der rich-

tige Bauer die wahre Gestalt des menschlichen Daseins und der menschlichen *Der Stil*
Kultur. Bitzius dachte sich Bauern als Leser seiner Bücher und hatte keine
künstlerischen, sondern lehrhafte Absichten. Darum sind seine Geschichten
schön wie die Natur schön ist. Denn sie fangen den Ablauf des bäuerlichen
Daseins in den sittigen Gebärden und Zeremonien der bäuerlichen Lebens-
haltung auf, wie sie durch die Pflege von Jahrhunderten geheiligt sind. Pre-
digt und Schwank, Kalendergeschichte und Zwiegespräch, der gemessene
Rhythmus nachdenklicher Erzählung sind nur stilgemäßer Ausdruck dieser
inneren bäuerlichen Form. Dieser Bauerndichter verwirklicht den Sinn eines
ganzen Berner Jahrhunderts. Denn von Albrecht Haller zu Albert Bitzius
führt ein gerader Weg.

Zürich hatte durch Johann Jakob Bodmer den Gedanken von der Einheit *Zürcher Mundart*
Wort und Bild aufs neue ausgesprochen. Das traf in einer Stadt der Doppel-
begabungen den Nagel auf den Kopf. *Martin Usteri*, 1763 bis 1827, war
seiner innersten Anlage nach ein Bildner, dem alles sich gestaltlich rundete,
ob er nun die Dinge zeichnete oder in Worte ausformte, ob er geschichtliche
Begebenheiten in der Sprache ihres Zeitalters oder die Gegenwart in ihrer
Mundart abbildete. Und so ist denn auch ursprünglich der Bildner und nicht
der Dichter an die Zürcher mundartlichen Idyllen in Hexametern „De Herr
Heiri" und „De Vikari" herangegangen. Da er Lebensbildchen im Ge-
schmack Hogarths und Chodowieckis liebte, wie er ganze launige Romane in
Bildern zusammenstellte, so entwarf oder plante er eine Bilderreihe, für die
jene Idyllen den Wortlaut abgeben sollten. Das wiederholte sich. *August
Corrodi*, 1826 bis 1885, der Prediger, der er werden sollte, und der Maler,
der er werden wollte, hat an der Münchner Kunstakademie die Gabe des
Wortes gefunden. Als Zeichenlehrer zu Winterthur konnte er beiden Künsten
frönen. Er zeichnete die Zierstücke zu seinen Schriften und die Bilder seiner
Kinderbücher. Seine Lieder pfeifen allen Meistern nach. Mit seinen breitaus-
malenden mundartlichen Idyllen des ländlichen und kleinstädtischen Lebens
— „De Herr Professer" 1857, „De Herr Vikari" 1858, „De Herr Dokter"
1860 — fuhr er mitten auf der Schweizer Straße. „Ernste Absichten" 1860,
eine Doppelnovelle von mißgeschickten und törichten Liebhabern, Münche-
ner Maler, die mit dem Leben nicht zurechtkommen, hatte sich mit ihrer
erlebten Wirklichkeit, mit ihren seltsamen Menschenkäuzen, mit ihrer aus-
malenden Gegenständlichkeit schon nahe an den Punkt herangetastet, den
zu Zürich eben ein anderer mit seinen „Leuten von Seldwyla" getroffen *Hoher Stil*
hatte. *Heinrich Leuthold*, 1827 bis 1879, aus Wetzikon, offenbarte aus der
gleichen Münchener Umwelt das gleiche Doppelvermögen. Nur entlud es sich

bei ihm nicht in zweien, sondern in der einen Kunst des Wortes. Leuthold trieb an den drei deutschen Hochschulen des Landes, was es da zu lernen gab. Von Frau zu Frau suchte er sich 1854 nach Italien und 1857 nach München zu retten. Mit Geibel übersetzte er, der berühmte Name und die geleistete Arbeit, die „Fünf Bücher französischer Lyrik". Unter rasch erlahmender Gegenwehr verfiel er von Stufe zu Stufe dem Wahnsinn. Was auch in dem gesiebten Nachlaß Leutholds Kunst heißen darf, drängt sich zu einem schmalen Fries fremdartiger Gebilde zusammen: „Gaselen" 1854, „Sonette" 1855, „Lieder von der Riviera" 1857 und wie ein Hauch entschwebend die „Gereimte Sapphische Ode". Das ist Platen. Doch der vergleitende Tonfall der Rhythmen, der traumstörende Schlag der Nachtigall, die trümmerhaften Götterbilder und der verwilderte Lorbeer, das ist Eichendorff. Diese Mittelstellung zwischen Platen und Eichendorff bedeutet in einem Bildwerk und Tonkunst. In beiden Fällen „redet" nicht das Wort, sondern der Klang, den es auslöst, und das Bild, das ihm urtümlich innewohnt. Leuthold hat zu zwei größeren epischen Dichtungen angesetzt. Die eine war ein „Hannibal", die andere eine „Penthesileia". Biegt man bei „Hannibal" die über nur leise Einschnitte gefalteten Kurzzeilen zu den Langzeilen auseinander, die man deutlich hört, so hat man in beiden Dichtungen das gleiche Bild. Zunächst fällt immer eine Gruppe von Langzeilen ein. Sie berichtet. Hier redet das Wort, der Sinn, den es trägt. Dann bricht aus dem Reigen eine kleine Zeile heraus. Sie tritt vor und steht allein auf der Szene. Sie ruft das Auge an. Denn sie ist ganz Bild. Um dieses schmale Bild, in das sich die Berichtzeilen zusammendrängen, schlingt eine letzte Zeile sich wie ein rhythmischer Kranz von Tönen. Damit war Leuthold an den andern Punkt gekommen, den eben ein anderer mit „Huttens letzte Tage" getroffen hatte.

Bildwerk und Tonkunst

Nun wiederholt sich alles im Großen und gedoppelt und auf einmal.

Gottfried Keller, 1819 bis 1890, ist durch die deutsche Schule gegangen. In München geriet er vom Malen an das Schreiben. Zu Heidelberg 1848 tauschte er, indem er Ludwig Feuerbach zuhörte, gegen den Gott seines Vaterhauses einen andern ein, dessen Angesicht von Weltlichkeit strahlte. Zu Berlin 1850 kam er aus der Schule der Bildung in die harte Zucht des Lebens und lernte er, sein tägliches Stück Arbeit tun. In Berlin wurde sein erstes und größtes Werk geschrieben und fast alles empfangen, was ihm dann die Heimat zur Reife brachte. Man mußte ihn loskaufen, um ihn 1855 wieder in Zürich zu haben. Man machte ihn 1861 zum ersten Staatsschreiber und gab ihm also das Amt, das von je die bürgerliche Daseinsform des Schweizers gewesen war. So hob nach Jahrhunderten wieder das große Schauspiel an,

Der Staatsschreiber

daß die eine Feder die staatlichen und geistigen Geschäfte des Gemeinwesens zu Buch brachte.

„Der grüne Heinrich" wurde als ausgereiftes Werk von fünf Berliner Lehrjahren am Palmsonntag 1855 mit dem vierten Bande abgeschlossen. Eine der vielen romantischen Künstlergeschichten oder mehrere zusammen haben dem Anfänger dabei vorgeschwebt. Aus dem romantischen Malerroman wird ein Goethesches Bildungsbuch. Es wird Abrechnung über seine verworrenen Ansätze, Entscheidung seines Schwankens zwischen Bildkunst und Wortkunst, wird Antrieb zur Arbeit und hebt ihn mit einem kräftigen Schwung aus der Gefahr des Selbstverlustes auf den sicheren Boden des Selbstgefühls. Er hat etwas getan und ist gerettet. Sein Buch war in dem Augenblick geglückt, und mit diesem Buch sein Leben, da er zu wissen begann, diese Erziehung ziele nicht auf die Kunst, sondern durch die Kunst auf das Leben. Leben aber hieß für den Bürger eines Freistaates staatsbürgerliche Arbeit am Gemeinwesen. Indessen es gab kein Kunstmittel gegen den Sprung, der durch diese Umbiegung des Gedankens vom ersten Entwurf zur ersten Fassung entstanden war. Der Held bezahlt mit seinem Tode statt mit seinem Leben zu sühnen. Die Dichtung hatte dazu noch andere Mängel. Die Selbstdarstellung des Helden und die Erzählung seiner späteren Schicksale standen in keinem Verhältnis. Bestände der Wirklichkeit und eines romantischen Traumlebens, Stilzüge Goethes und Richters, ja solche von Bitzius, standen unvereinbar nebeneinander. Der Doppelkern dieser Jugenddichtung — Künstler und Bürger — schlug über Jahrzehnte hin nach zwei Seiten aus. Das war hier der zweite „Grüne Heinrich" und dort „Martin Salander". Keller hatte inzwischen Erfahrungen der Kunst und des Lebens gemacht. Der zweite „Grüne Heinrich" 1879/1880 ist beinahe ein neues Buch. Die Darstellung ist jetzt durchgängig Icherzählung. Die Kindheitsgeschichte ist an den gehörigen Platz, an den Anfang, gerückt. Allzu dünne Stellen wurden durch Neuerfundenes verdichtet oder durch kunstreiche Querzüge gefestigt. Neu zu machen war der Schluß. Der Held starb nicht mehr. Heinrich und Judith beginnen, nebeneinander und jedes für sich, ihr neues Leben im Dienst an Volk und Staat. „Martin Salander" 1886 steht auf der andern Seite, bei Albert Bitzius. Aus der Schweiz der vierziger Jahre war ein tüchtiges Betriebsland geworden. Der Bauer begann sich in den Arbeiter zu verwandeln. Man hatte gelernt, das Geld durch das Taschenspiel der Börse zu jagen. Der schlechtbezahlte Beamte begann die Schleichwege der Glücksverbesserung zu gehen. Keller handelte wie der Pfarrer von Lützelflüh. Als ein Greiner und Lobredner der guten alten Zeit vollzog er in dem vollendeten ersten Bande das Strafgericht an

„Der grüne Heinrich" von Berlin

„Der grüne Heinrich" von Zürich

„Martin Salander"

dem angefaulten Vätergeschlecht. Der zweite Band, der die Heraufkunft der gesunden Söhne bringen sollte, blieb liegen. Es geht um einen zweifachen Vorwurf: um den Gegensatz von Vater und Sohn im Hause Salander und um den Widerstreit zwischen dem alten Bürgertum in Martin Salander und dem neuen Schwindelgeist in Louis Wohlwend. „Grüner Heinrich" und „Martin Salander" stehen fast zueinander wie Goethes „Lehrjahre" und „Wanderjahre": der Bildungsroman einer Jugend und das Buch der Volkserziehung.

„Die Leute von Seldwyla"

Gottfried Keller war der geborene Histörchenerfinder und Märchenerzähler. Er hatte das Auge des Malers. Und Mären müssen in die Luft gemalt werden mit Worten und Gebärden. „Die Leute von Seldwyla" 1856/1873 sind Bürger einer vorgespiegelten Stadt. Was dem einen sein Orplid, das ist dem andern sein Seldwyla. Diese Stadt ist die ganze Schweiz. Sie ist aber auch nichts anderes als schlechthin die Menschenstadt, Gemeinwesen in eidgenössischer Gestalt. Der erste Band der Sammlung ist dem „Grünen Heinrich", der zweite dem „Martin Salander" zugekehrt. Die beiden Bände sind sehr kunstvoll angelegt und ihre Geschichten entsprechen einander. Sie weben im Stil zwischen Hoffmann, Richter, Bitzius. Sie zeigen die deutsche Novelle in neuer Gestalt, indem sie viele der Stilarten abwandeln, die möglich sind. Das Schicksal hatte Meister Gottfried noch keinen Wink gegeben, daß er außer dem Tagebuch der Gegenwart auch das Zeitbuch der Vergangenheit führen sollte. In dieser Stadt war alles vorbereitet, als Keller einen Band

„Züricher Novellen"

„Züricher Novellen" 1878 wagte. Doch den Rahmen, den Berg und See in flachem Rund gebogen darboten, legte der Dichter prüfend wieder aus der Hand und nahm dafür eine seiner unverscheuchbaren Schnurrpfeifereien. Ein junger Zürcher der zwanziger Jahre wird von dem Kummer geplagt, daß ihm die platte Zeit verwehre, ein Originalmensch zu werden. Sein Pate führt ihm gesprächsweise drei solcher erzursprünglichen Menschen vor und gibt zwei Geschichten als Zugabe. Weder im großen Wurf des Ganzen noch in der Arbeit der einzelnen Stücke ist geschichtliche Dichtung geleistet. Da glänzt kein Fries vom Giebel, den zugewogenen Raum stilvoll zu füllen. Die gewohnten fünf Stücke, die Keller einander beizugesellen liebte, stehen ungesellig im freien Raume. Geschichten in der überkommenen Art so zu „rahmen", war ein roher Notbehelf. „Das Sinngedicht" 1882 ist ein völlig neues

„Das Sinngedicht"

Werk. Rahmen und Binnenwerk sind hier eins. Der junge Naturforscher, der seine verdorbenen Augen und sein ausgehungertes Herz auf dem Wege, den das Sinngedicht ihm weist, heilen will, gibt mit seinen Liebesversuchen Gelegenheit zu anmutigen Geschichten. Aber Keller hütete sich, einen Gedanken, der ohnedies nur Anlaß zu drei Novellen geboten hätte, sofort zu Tode

zu hetzen. Er begnügte sich fürs erste mit zwei sanft umrissenen Kurz- *Gottfried Keller*
geschichten, die den Liebesversuch zweimal mißlingen lassen. Das Gelingen
des dritten Versuches wird kunstvoll verzögert und vom Ausgang eines Ge-
dankenkampfes über das Verhältnis von Sinnlichkeit und Sitte abhängig ge-
macht. Gerade auf diese Frage aber, zugleich beglückt lachen und schamvoll
erröten, laufen eben Sinngedicht und Liebesversuch hinaus. Die „Sieben *„Sieben*
Legenden" 1872 enthalten zwei Gruppen. Die antiken Legenden werden so *Legenden"*
erzählt, wie sie etwa ursprünglich geklungen haben mögen. Er wollte die
Legende entzaubern, aber nicht den Helden der Legende. Es sind bei ihm
keine Gebilde des Spottes, sondern der guten Laune. Die Marienlegenden
dagegen waren echtes Mittelalter, in allem göttlich zugleich und menschlich
wie der Glaube ihrer Zeit. Der Dichter hatte das Höchste geleistet, wenn er
den Ton so treu und kindhaft traf, wie er einst gemeint war. Schwerlich hat
Keller jemals eine seiner goldenen Mären aus ernsterem Herzen gesprochen
als diese. Wenn dabei sein Auge heiter funkelte, so war das gefreut und
nicht verlacht.

Unter diesem Lebenswerk steht wie unter dem gelungenen Gemälde, das
seinen Meister lobt, der gereimte Vers. In den „Gesammelten Gedichten" *Der Vers*
1883 führt alles, was es zu erzählen gibt, den Reigen: das Begebnis und seine
Deutung, Zustände und ihre Schilderung. Es ist wenig darunter, was gesun-
gen werden könnte. Es sind die Gedichte des männlichen Alters. Ihre Stim-
mung ist erkämpfte Ruhe. Ihr Gehalt stammt aus gesammeltem Nachdenken.
Ihre Form ist Augenbeute aus dem goldnen Überfluß der Welt. Es sind die
Gedichte eines geübten Beschauers. Wahrhaft groß an ihnen ist die Freske
des staatsbürgerlichen Gemeinbewußtseins. Es sind die Gedichte eines
Schweizer Staatsschreibers.

Conrad Ferdinand Meyer, 1825 bis 1898, hat durchgesetzt, daß der Künst- *„Die Versuchung*
ler seiner Rechtfertigung durch seine Gemeinschaft mit dem Bürger nicht *des Pescara"*
mehr bedurfte. Für diesen Stadtjunker gehörte der Staatsschreiber schon in
die väterliche Vorgeschichte. Der vorzeitige Tod des Vaters hinterließ den
Jungen einer Frauenerziehung, die aus allzu naher geistiger Verwandtschaft
Unheil stiftete. Friedrich Theodor Vischer machte ihn von der zermürbenden
Aufsicht der Mutter frei und brachte die schleichende Lebenskrankheit zum
Ausbruch. Romanische Freunde der Westschweiz machten ihn wieder ge-
sund. Der langsam reifende Dichter erlebte das Christentum des Franzosen
Blaise Pascal. Die Reisen ins Waadtland und nach Graubünden, der Besuch
von Paris und Rom gaben ihm, der keine Jugend hatte, die Reife der Jugend. *Das erste*
Dieser Mensch brauchte das erste gelungene Gedicht wie einen greifbaren *gelungene*
Gedicht

Conrad Ferdinand Meyer Halt, an dem man sich aus dem Wasser ans Land schwingt. Von der Schwester ermutigt, die Unvergeltbares an ihm getan hat, stellte er 1864 die „Zwanzig Balladen von einem Schweizer" zusammen und wagte 1870 schon, unter die „Romanzen und Bilder" seinen verantwortlichen Namen zu setzen. Die geringe Ernte an Liedern mußte noch lange mit Erzähltem gestreckt werden. Ja selbst die Versidylle „Engelberg" 1872, aus alten Keimen spät reifend, mußte mit unterschlüpfen. Endlich 1882 konnte ein ansehnlicher lyrischer Versband gesammelt und 1892 mit letzter Hand überprüft werden.

Lebensgefühle Conrad Ferdinand Meyers Grundgefühl war Sehnsucht. Seine Hand war immer nur im Traum gefüllt. Leben war ihm Schmerz. Von sich wegrücken, nicht mehr empfindbar, wie mit fremder Hand beschaubar machen, ist Wesen und Inbegriff seiner Kunst. Daher seine Leidenschaft für den kalten Marmor, dessen leuchtende Starrheit der ungestörten Ruhe des Todes so verschwistert ist. Zuletzt lief es bei ihm immer darauf hinaus, die Sprache der bildenden Künste in Worten nachzusprechen. Diese Art zu schaffen, stillte nicht bloß sein Lebensbedürfnis. Menschen seines Wesens haben Mißtrauen zu allem, was leicht geht, und den Ehrgeiz der schwersten Aufgabe. Sein Verkünsteln ist eine Sache des Gewissens, das sich selbst im Preis überbietet. Für ihn gab es keine andere Möglichkeit des Daseins, als sich vor jedem Anspruch in die *Traumwelt* Traumwelt des Kunstwerks zu flüchten. Wo könnte man den Zweck dieses heilenden Aufenthaltes besser vertuschen, als wenn man in die Geschichte flüchtet. In diese Heilanstalt verschwand denn der Dichter immer wieder, um die ihm unentbehrliche heilsame Behandlung seines Ich vorzunehmen. Geschichte war ihm geborgenes Leben im Verschwundensein. Für ihn war es der europäische Geistesraum der Schweiz aus dem sechzehnten und siebzehnten Jahrhundert, die Schweiz mit ihrem Geistverhältnis zum evangelischen Deutschland, zum hugenottischen Frankreich, zum humanistischen Italien. Der geschichtliche Lebensraum Meyers heißt nicht Renaissance, sondern protestantischer Humanismus, jenes dreieinige lateinische Wesen, das die Schweiz in sich zur Einheit gebunden hatte. Der erste Schritt — „Huttens *„Huttens letzte Tage"* letzte Tage" 1871 — führte in die evangelische Latinität Deutschlands. Wo faßte Meyer Huttens Leben und wie machte er es dem seinen gleich? Er betrachtet es auf der Ufenau mit den Augen des sterbenden Hutten nur noch als ein Abgetanes. Erinnerungsbilder werden in Holzschnittweise aufgebaut und aus dem Ausgang gedeutet. Man spürt, daß Meyer sein eigenes Unvermögen zum Handeln nicht aus dem Unwert einer bestimmten Tat, sondern aus dem Unwert des Handelns überhaupt entlasten möchte. Das ist der Vorwurf seiner Novellen.

Der Lebensuntüchtige sah über sich das Lebenssichere. Dieses vor sich selber zu seiner eigenen Entlastung unwert zu machen, war die Absicht seiner Kunst. „Der Schuß von der Kanzel" 1877 zog einen solchen kraftbewußten ins Burleske und „Plautus im Nonnenkloster" 1881 setzte einen solch Lebenstüchtigen ins sittliche Unrecht. „Der Heilige" 1880 aber ging der bedrückenden Vorstellung vom Ausnahmemenschen auf dem kürzesten Wege zu Leibe: dem König wie dem Heiligen. Der Starke, der englische König Heinrich II., wird aus der Ferne durch den Schwachen, seinen Erzbischof Thomas Becket, besiegt. Das scheinbar Wunderbare wird menschlich begreiflich. „Das könntest im Grunde Du auch." Der Dichter hat den großen *Der Starke und der Schwache* Menschen zu sich herabgezogen und sich zugleich in ihn hinaufgesteigert. Du bist jeder pausbäckigen Gesundheit überlegen. Du brauchst keinen Nahkampf. Bleib abseits und triff aus der Ferne. So fand der Dichter für sich eine Lösung nach beiden Seiten. „Gustav Adolfs Page" 1882 sagt: Dienst macht Großes und Kleines einander gleich und also das Kleine groß; diene! „Das Leiden eines Knaben" 1883 sagt, indem es die eigene Jugend an den Hof Ludwigs XIV. abrückt: Deine Schwäche ist Dein Heldentum.

Indessen, verantwortlich blieb man in allen Fällen für die ungetane Tat *Schicksal oder Wille* und für das unzureichend Geleistete. Und so gab es ein Drittes. Man konnte die Verantwortung abwälzen und mit ihr jenen Druck von der Seele, den man im Angesicht des eigenen Ungenügens empfand. „Das Amulett" 1873 versagt im Grauen der Pariser Bluthochzeit bei dem Katholiken, der an die Wunderkraft glaubt, und es rettet den Protestanten, dem es nichts bedeutet. Handle wie du willst, du entrinnst dem Schicksal nicht. „Die Hochzeit des Mönchs" 1884 dreht sich nur scheinbar um die Frage des Berufswechsels gegen Überzeugung und Gewissen. In Wirklichkeit heißt der Vorwurf: Schicksal oder freier Wille? Die glänzend erzählte Novelle ist innerlich so verzeichnet, daß die Frage keine Antwort finden kann. Der Untergang des entmönchten Mönchs geschieht nur darum, weil er das Kloster überhaupt verlassen hat und sich in der Welt nicht mehr zurechtfindet, also unabhängig davon, ob er es aus freiem Willen oder infolge der väterlichen Erpressung verließ. Mit seiner ersten und mit seiner letzten großen Dichtung hat Conrad Ferdinand Meyer unter Aufwand eines ungewöhnlich reichen Geräts einen *„Jenatsch" und „Pescara"* allgemeinen Angriff auf die Frage, die die Frage seines Lebens war, unternommen: Was ist die Tat? Was ist die Entscheidung? „Jürg Jenatsch" 1874 und „Die Versuchung des Pescara" 1887 verraten sich schon dem ersten Blick als Geschwister: mächtige Rundbilder ganzer Zeitalter; das im Kampf mit sich selber verkrampfte Europa; zwei Krieger und Staatsmänner; Verrat und

Treue als Beweger einer mächtigen Handlung. Im „Jenatsch" hören wir:
Alles Handeln ist Gewalt, und der Täter nichts als ein Werkzeug des Welt-
willens, das weggeworfen wird, sobald es die gesollte Tat getan hat. Im
„Pescara" sieht man: Versucht wird einer, der gar nicht mehr fallen kann,
weil er außerhalb der Möglichkeit des Handelns steht. Die Wunde, die er
Das Glück der heimlichen Wunde heimlich trägt, ist seine Stärke und sein Glück. Jenatsch und Pescara haben
dem Dichter das rettende Wissen von sich selber geschenkt. Nichttun ist
besser als Handeln. Das Unvermögen zur Tat macht den Schwachen frei und
stark. Der Dichter hat sein Leiden an der Welt in das Glück über der Welt
verwandelt. Das ist die hohe Ironie der Selbsterkenntnis. Meine Wunde stellt
mich außerhalb des Spiels, dem die Welt sich mit soviel Leidenschaft hingibt,
diesem Spiel um nichts. Als „Angela Borgia" 1891 noch einmal zwei Frauen
zu demselben Spiel aufstellte, erschien dem Dichter der Schatten am Spiel-
brett, der Pescaras Hand stillgelegt hatte.

Schauspiele wie dieses Zürcher werden einem Gemeinwesen nur einmal
geschenkt. Beide Dichter sind sehr spät reif geworden, Keller aus Härte und
Meyer aus Schwäche. Der Träge und der Überreizte, der Bejaher und der
Bezweifler, der Wirklichkeitsmensch und der Traumgänger, der Volksmann
und der Junker, der Launig-Burleske und der Leidvoll-Ironische, der Bürger
und der Künstler halten den ruhelosen Geist dieses Gemeinwesens in schö-
nem Gleichgewicht.

Und nun war Basel dran. Die „Basilea poetica" 1874, zu der sich die klei-
nen Liebhaber aus der Singschule Wilhelm Wackernagels versammelten,
hatte nur noch die gestrige Zeit. An der Universität, die mit einem Male jäh
aufleuchtend wieder da war, wurde Wackernagel von Dichtern ganz anderen
Burckhardt, Nietzsche, Böcklin Schlages abgelöst. Denn der Basler Stadtjunker Johann Jakob Bachofen,
1815 bis 1887, der aus uralten Völkermysterien die Mutter als Schöpferin des
Lebens, des Glaubens, des Rechts, als den Ursprung aller organischen Ord-
nung lehrte; der Basler Humanist Jakob Burckhardt, 1818 bis 1897, der den
Untergang der antiken und den Aufgang der modernen Bildung beschrieb;
der Stadtfremde Friedrich Nietzsche, 1844 bis 1900, der aus dem morgen-
ländischen Zwischenreich von alten und neuen Mysterien ein neues Äon mit
seinem künftigen Menschen heraufzubeschwören meinte: alle waren Asketen
ihres Gedankens und Dichter im Sinne der Vorzeit, weil sie um die Dinge
wußten, die man nicht erkennen, sondern nur haben kann. Der Basler Arnold
Böcklin, 1827 bis 1901, hat in dem schrägen Schein, der aus Rom und Florenz
in Basel weiterglänzte, wahrhaft ihrer aller Gedanken gedichtet, das Grauen
der Welt im funkelnden Auge des Meerweibes, das Ungewisse aller Mensch-

lichkeit in dem höhlendrachenbedrohten Schluchtweg, das ewigruhende me-
dusische Urnichts auf der Toteninsel, das heitere Grauen des Lebens, mit
dem Pans mittägliches Flötenspiel das Menschenherz urewig berückt. Das
alles ist in der Basler Dichtung zu hören. Sie kam aus Liestal und zweimal für
einmal.

Josef Viktor Widmann, 1842 bis 1911, war von österreichischen Eltern zu *„So lebt und sterbt denn wohl"*
Liestal geboren und ist hier im Wiener Lebensstil aufgewachsen. Seine Basler
Lehrer Wackernagel und Burckhardt haben ihn bis in die siebziger Jahre
dichterisch beraten. Der mißglückte Pfarrhelfer von Frauenfeld und politisch
anstößige Mädchenschullehrer von Bern wurde schließlich von dem Berner
Blatt „Der Bund" auf den Platz geholt, wo die Literatur unter dem Strich
zu zügeln und zu striegeln war. Hier ist er ein Feger der Tenne und Vorkoster
des Schweizer Gaumens geworden. Der Dichter Widmann hat zwei Vater-
länder. Ein leichter Hervorbringer, voll des süßen Wortes, hat er das unver-
kennbare Wiener Gesicht. Aber sein gradaus hauendes deutliches Wort ist
das freie Wort eines Freibürgers. Österreichische Geistigkeit ist von eidge-
nössischem Freisinn gezügelt. Seine Stücke sind nicht Ehrgeiz zum Drama,
sondern Leidenschaft am Theaterspielen. Er hat sich von diesem Form-
zwange freigemacht zu kleinen erzählenden Dichtungen, in denen sein hei-
terer Geist anmutigen Tiefsinn entfalten konnte. „Buddha" 1869 bezeugt
sein Ringen um Gott und seine Gedankenarbeit an einem persönlichen Welt-
bild. „Der Wunderbrunnen von Is" 1871 machte aus einer bretonischen Sage *Weltangst*
das Gleichnis der Angst, die damals erst die Weitsichtigsten zu würgen be-
gann. Staat und Kirche zittern vor dem unheimlichen Schlüssel, der die ver-
nichtenden Fluten des Wunderbrunnens entfesseln kann. Das Gefühl des
Weggeschwemmtwerdens weht entfesselt und dann launig gebannt durch
das ironisch glimmende Gebilde. Widmann hat es nun gelernt, geflügelte
Wahrheiten zu bilden, die über der Wirklichkeit kreisen. Längst bedrängte
ihn ein Geschöpf, das in solcher Weise fliegen wollte. Der Knabe hatte die
Tiere geliebt. Dem Hochschüler wurde das Schicksal des Tieres zum Inbe-
griff aller Einwände gegen einen planvollen Weltgedanken. So ist die „Mai- *„Maikäfer-Komödie"*
käferkomödie" 1897 eine erste Erfüllung alter Pläne. Das Maikäfervolk fliegt
vertrauensvoll ins Himmelland aus und in tausendfachen Tod. Doch es stirbt
dankbar für das karge Glück. Die Welt wird Gott verziehen um ihrer Schön-
heit willen. Das Tier steht nicht für den Menschen. Es ist eine wirkliche Tier-
dichtung. „Der Heilige und die Tiere" 1905 ist die Tragödie des Tieres und *„Der Heilige und die Tiere"*
der Erlösung zugleich. Widmann dachte an den Leitspruch: „Ich und der
Vater sind uneins." Christus ist entschlossen, die väterliche Schöpfung dort

zu heilen, wo sie am tiefsten krank ist, im Tier. Er wendet sich mit seinem Erlösungsversuch zuerst an die Tiere. Da er die verlorene Mühe erkennt, geht er zu den Menschen mit den Abschiedsworten: „So lebt und sterbt denn wohl, so gut ihr könnte". Als dieses Gebilde fertig stand, die Tragödie des Helden, des Heiligen, des Erlösers aus dem unstillbaren Weltleid, hatte der Dichter sein Tagwerk getan.

„Das Epos ist das königliche Vorrecht"

Karl Spitteler, 1845 bis 1925, hieß der Dreizehnjährige, dem der sechzehnjährige Widmann 1858 begegnete. Eros schwebte unsichtbar über den beiden, die sich schwärmerisch zusammenlebten, bis Widmann 1865 die gemeinsame Huldin ihrer Freundschaft, Spittelers jugendliche Tante, aus der brüderlichen Mitte herausheiratete. Widmann hat den zögernden und auf ein Wunder Wartenden zur Arbeit getrieben. Er hat ihm als Herold Bahn durch die öffentliche Meinung gebrochen. Öfter räumlich getrennt, kamen sie immer wieder zusammen, bis Spitteler sich 1892, wirtschaftlich unabhängig, ganz seinem Werk widmen konnte. Burckhardt steckte Spitteler ein Licht auf, das dem jungen Menschen den Weg durch die ganze Zukunft erhellte: „Das Epos ist das königliche Vorrecht, alles in lebendiges Geschehen zu verwandeln." An Ariosts „Rasendem Roland" entschied sich der Beruf des Dichters. Der andere Wegweiser hieß Schopenhauer. Spitteler gehört zu den früh Berufenen und spät Auserwählten. So war ihm zu Heidelberg schon das erste Gesicht des Prometheus gezeigt worden. Zu bergen vermochte er es nicht, bis ihn endlich innere Not zwang, mit diesem einen Gebilde alle andern, die ihn bedrängten, abzutun.

„Prometheus und Epimetheus"

„Prometheus und Epimetheus" 1882 ist, da der Dichter keine Verse zu machen verstand, in rhythmische Prosa aufgefangen worden. Der Engel Gottes stellt die Brüder vor die Wahl, ihre Seele für den Eintausch des Gewissens hinzugeben. Epimetheus wird durch diesen Tausch König und liefert die Menschenkinder, mit denen er nichts anzufangen weiß, dem Nachbarkönig Behemoth aus. Prometheus aber folgt dem Ruf seiner bewahrten Seele und rettet das letzte der Kinder, den Messias. Er findet seinen Bruder verzweifelt im Sumpfe, richtet ihm das Angesicht wieder gegen den Himmel und kehrt mit ihm in das Tal, an den Bach, in die alte Heimat zurück. Nur Bilder schreiten an uns vorüber. Sie reden nicht. Sie zeigen nur. Man müßte mitträumen, um im Bilde zu sein. Man begreift, woran dieser Künstler stockte. Spitteler ist ein verdrängter Maler, der Bilder sah und glaubte, sie wären gedichtet, wenn er sie schriebe, statt malte. Spitteler hatte das Geheimnis des Wortes noch nicht. Er hatte nur den Bildentwurf zu einer Dichtung gekonnt.

Studien und Sagen und Singen

Das erkannte er. Also übte er sich im Redenlernen, das ist im Dichten.

„Extramundana" 1883 sind sieben Gesichte des einen Vorwurfs „Weltschöpfung als Pfuschwerk". Dann wandte er sich mit den Erzählungen „Die Mädchenfeinde" 1890, „Friedli der Konderi" 1891, „Gustav" 1892, „Konrad, der Leutnant" 1898 an die vertraute Wirklichkeit. Es sind Studien nach bewährten Musterstücken. Nun konnte er, was er mit dem „Prometheus" noch nicht gekonnt hatte, nämlich sagen. Das Singen wollte noch hinzugelernt sein. In den „Schmetterlingen" 1889 lernte er erstaunlich rasch, Verse und Reime fügen. Es waren Versnovellen aus dem Schmetterlingsleben, ein Tierbuch, wie Widmann es längst geträumt hatte. Die volle Höhe sind „Literarische Gleichnisse" 1892 und „Balladen" 1895, beides, kaum zu unterscheiden, das gleiche. Die einzelnen Stücke sind handliche Gipsmodelle. Und sie reden jetzt.

„Prometheus, der Dulder" 1924 heißt der nun geglückte Neuguß des ersten Prometheus. In schlichter Schönheit tritt der Gedankengang des neuen Gedichtes heraus. Prometheus nimmt für die Treue zu seiner Seele das Kreuz auf sich. Er duldet das Leid des Schöpfertums und trägt die Last des gemeinen Lebens. Er rettet das Kind. Und in der Versöhnung werden Prometheus und Epimetheus wieder ein brüderliches Wesen. Der Dichter ist der wahre Herrscher des höchsten Reiches. Erkennen kann er die Seele nicht. Doch er glaubt ihr um ihrer Schönheit willen. Aus dunkel flutender Prosa sind durchsichtig strenge Verse geworden. „Prometheus"

„Olympischer Frühling" 1900/1906 in vier, 1910 in zwei völlig überarbeiteten Bänden, ist zwischen den beiden Prometheus als neues Weltalter und Hochland der Seele aufgegangen. Hier ist eine wirkliche epische Handlung, Ablösung und Aufzug zweier Lebensalter. In mühsamem Aufstieg begegnet „die auserlesene Mannschaft eines nachkommenden Geschlechts" dem abstürzenden Geschlecht und nimmt seinen Umweg über den christlichen Himmel in sein vorbestimmtes Hochland, den Olymp. Das Höhenmenschentum entfaltet sich in goldener Weltfriedenzeit zu allen Abarten. Der Olymp soll „eines besseren Lebens Werkstatt sein". Das sind nicht Götter in Menschengestalt, sondern Menschen in Göttergestalt. Das Wort Mythus ist hier nicht am Platze. Der Olymp ist nichts als eine Übererde. Bilder der Seele und der Zeit spielen nach den Gesetzen des Ich und des Lebens. Das sind keine Mythen, sondern Gleichnisse. Der junge Spitteler hatte wortlose Gesichte. Der reife hat Wortanschauungen. Die verdichtet er zu Bildern und Gestalten. Jetzt ist die Redensart das Ursprüngliche, und nicht mehr das Bild. Das Wort schafft die Gestalt. Redensarten werden ins körperhaft Handelnde übertragen. Das wörtlich zu nehmen, was die Sprache übertragen meint, so verfuhr „Till Eulenspiegel", das „Narrenschiff", Ferdinand Raimund. Schopenhauers „Olympischer Frühling"

Kettenschluß des Gefühls ist auch der Spittelers: Weltleid, Weltmitleid, Tier-
liebe. Das Land Meon, wo der Welterlöser heranwächst, ist das Land des
Nichtseins, ist Nirwana. Die Schöpfung ist im Kern verpfuscht und also heißt

*Die
„Mißgebär-
anstalt"* die Natur eine „Mißgebäranstalt". Der Gedanke der ewigen Wiederkehr
trägt die wuchtige Sibyllenszene des Eingangs. Im Sinne von Richard Wag-
ners „Ring" liegt der Weltbranduntergang. So bewegt sich die Dichtung im
Reiche Schopenhauers. Sie streift die Grenzen bei Wagner und bei Nietzsche.
Stilbrechung ist der Stil des Gedichtes. Wie in der Legende vom wiederkeh-

*Die Seelen-
geschichte des
Höhenmenschen* renden Heiland stehen am Schluß der verkleidete Wanderer Zeus und das
verzerrte Deutschland des letzten Kaisers einander gegenüber. Die Technik
der Zeit wie das Luftschiff ist homerischen Bildern benachbart. In paarweise
gereimten sechsfüßigen Jamben, die zuweilen echte Alexandriner werden,
atmet das Gedicht die Seelengeschichte des Höhenmenschen in all seinen Er-
scheinungen und in seiner zeitgeschichtlichen Verstrickung.

Das Bild als Jugenderlebnis und das Bild als Absicht des reifen Künstlers
waren Spittelers Schicksal. Bild, „Imago" 1906, nannte er den Prosaroman
seines eigenen Lebens. Und aus dem Frühling seiner olympischen Tage klan-
gen wie von Götterferne hergeweht die „Glockenlieder" 1906, der unsagbar
zarte und reine Abgesang seiner hohen Zeit.

*Der
Dichtermaler* Vor Bern steht die Tragödie eines Dichtermalers. *Karl Stauffer*, 1857 bis
1891, aus dem Emmental, hatte den Ehrgeiz, mit dem Ruhm seiner Kunst
der Stadt einen neuen hinzuerwerben. Als ihn eine Frau zu Fall gebracht
hatte, wurde dem Todgeweihten in einem italienischen Gefängnis die späte
Gnade, in Liedern zu sagen, was er litt. Auf leeren Buchrändern und auf
Gefängnisbogen sind sie uns aufbewahrt. Sie sind in lebhaftem Formen-
wechsel bunte Gebilde vom schlichtesten volksmäßigen Vierzeiler bis zum
getragenen Wort weitausholender Rhythmen. Es sind urkräftig ausbrechende
Gefühle, die ans Herz greifen. Am Schluß aber steht, zu Florenz Ostern 1890

*„Der Tod
von Bern"* entstanden, Stauffers Abgesang, „Der Tod von Bern", ein Totentanzgedicht,
eingeleitet durch das gutgelaunte, bärenhaft tapsige Zwiegespräch zwischen
Tod und Berner Mutz, dann die Reihe entlang die einzelnen Stände und zum
Schluß die hoffnungsvolle Wechselrede von Tod und Dichter. Bernerdeutsch
und Hochsprache tanzen hier je nach dem Partner einen kräftig geschwun-
genen Reigen, der schon verrät, wonach dem Berner längst das Gelüste steht.
Karl Stauffer erinnert an Niklaus Manuel.

Hinter dieser Tragödie wuchs eine sehr verschiedene Literatur heran. Bern
spielte in seinem geschichtlichen Raume mit seinem alten Untertanenland,
dem Aargau, und seinem alten Verbündeten, Solothurn zusammen. Vom

Aargau her führte *Jakob Frey*, 1824 bis 1875, mit künstlerisch gepflegten Novellen und Dorfgeschichten im Stile des Bitzius an die neue Berner Dichtung heran. Die entscheidenden literarischen Antriebe kamen von Solothurn. *Antriebe von Solothurn* Dort war eine mundartliche Dichtung im Werden, die weniger in die Breite als in die Höhe strebte und einen eigenwertigen Kunststil wollte. Der Arzt *Franz Josef Schild*, 1821 bis 1889, aus Grenchen, bedeutet mit seiner Sammlung „Dr Grossätti us em Leberberg" 1863/1881 die Wendung der Volkssprachendichtung zur Kunstdichtung. Schild hat die ländliche Novelle geschaffen. Der Bauernsohn *Josef Reinhart*, 1875 in Rüttenen geboren, umkreist *Mundart erzählt* mit seinen Liedersammlungen „Liedli ab em Land" 1897 und „Im grüene Chlee" 1913 die tapfer umgrenzte Welt des Hauses. In seinen Erzählungen — „Gschichtli ab em Land" 1900, „Heimelig Lüt" 1905, „Waldvogelzyte" 1917 — gelang es ihm, den Formzwang der schriftdeutschen Novelle abzutun. Seine Kunstweise wurde der Stil des gesprochenen Worts. Roseggers Gesellschaftsziele und des Bitzius Bauernspiegel gehen hier gut zusammen. *Simon Gfeller*, 1868 in der Emmentaler Gemeinde Trachselwald geboren, ist *Berndeutsch* gegenüber dem verträumten, gelassen spielenden Solothurner die kraftbewußt lachende Derbheit Berns. In bunter Reihe ziehen seine Gebilde vorüber, Märchen, Schwänke, Liebesgeschichten, Bauernköpfe wie aus Holz geschnitzt, fröhliche Bilder aus dem Kinderleben. Gfeller hat den großen Roman gewagt. „Heimisbach" 1910 ist die Geschichte eines Lehrers, der den schweren Weg des Irrtums gehen muß, bis er das Vertrauen seiner Gemeinde findet. Auch hier wird die Gegenwart Roseggers spürbar. Berner Stil ist an seinen Büchern die Laune, die hinter dem Gewölk unerschütterlichen Ernstes wandelt und durchbricht, wo Not am Mann ist. Die Stadt Bern gab dieser Dichtung den letzten Schliff. *Rudolf von Tavel*, geboren 1866, wurde nach hochdeutschen Dramen rasch ein sicherer Erzähler. Die drei Bände „Jä gäll, *Berner Geschichte* so geit's" 1901, „Der Houpme Lombach", „Götti und Gotteli" 1906 bilden ein Ganzes. Sie verfolgen durch die Schicksalsjahre 1798/1832 die Familiengeschichte der Landorfer. Nachdem er so Geschmack gefunden hatte an der starken Luft der Berner Geschichte, schritt er immer tiefer in sie hinein. Das Bern zwischen den beiden Vilmergener Kriegen 1656 und 1712 wurde — „Der Stärn vo Bubebärg" 1907, „D' Frou Kätheli und ihri Buebe" 1909 — an der Familiengeschichte des Obersten Wendschatz und seiner Söhne sichtbar gemacht. Das Zeitalter der Mailänderkriege und der Kirchenbewegung ist in der Novelle „Gueti Gspane" 1912 erstanden. Das sind die beiden Berner, der Malerdichter Nikolaus Manuel und der Söldnerführer Albrecht vom Stein. Das fröhliche Hirtenfest zu Unspunnen 1805 macht den Hintergrund

für die Erzählungen „D' Haselmuus" 1922 und „Unspunne" 1924, worin die
Eidgenossenschaft an der Wende vom achtzehnten zum neunzehnten Jahr-
hundert erscheint. Die Novelle „Der Donnergueg" 1916 langt mitten im
neunzehnten Jahrhundert bei den letzten Schweizer Söldnern in Neapel an.
Die Mundart macht den Berner beredt und nimmt ihm die Scheu vor dem
Wort. Sie taucht alle Stände in die gleiche lebenswarme Luft und sie rötet
den verblaßten Gesichtern der Urkunden und Zeitbücher die Wangen. Die
Erzählungen Rudolfs von Tavel sind mehr als eine Sache der Berner Litera-
tur. Sie sind eine künstlerische Lösung von allgemeiner Bedeutung. Der
Dichter erzählt als Berner Junker und macht aus seiner Weltanschauung kein
Hehl. Ein Hauch ungreifbarer Ironie ist die Stimmung dieser patrizischen
Zurückhaltung. Dieser berndeutschen Geschichtsdichtung fügte der Berner
Otto von Greyerz, 1863 bis 1940, das berndeutsche Lustspiel hinzu. Der
Schulmann ist für die mundartliche Dichtung der Schweiz wohl wichtiger als
„Im Röseligarte" der Dichter. Er hat mit den fünf Bänden „Im Röseligarte" 1908/1912 ein
vorbildliches Liederbuch der Stadtberner aller Stände aufgebaut.

Im Aargau ruht die Waage im schönen Gleichgewicht zwischen dem
Kunstvermächtnis einer alten Dichterlandschaft und dem naturnahen Geist
eines aufgesparten Volkstums. Die eine Schale trägt die Not der geistig
Schaffenden, die andere das Elend der wirtschaftlich Leidenden, und inmit-
ten lacht das ewige Kind, von mütterlichen Liedern behütet. *Walter Siegfried,*
Der Aargau 1858 in Zofingen geboren, hat in dem Künstlerroman „Tino Moralt" 1890
die Selbstzersetzung des bildenden Geistes und in „Fermont" 1893 das Heil-
werden einer zerrütteten Seele dargestellt. In den drei Novellen „Gritli",
„Ein Wohltäter", „Die Fremde" 1904 werden Bildnisse ungewöhnlicher
Seelen entworfen. *Paul Haller,* 1882 bis 1920, aus Rein bei Brugg, hat sein
Pfarramt aufgegeben und das Leben freiwillig verlassen. Er hat außer „Ge-
dichte" 1922 nur zwei Dichtungen hinterlassen. Sie zählen wie Kriegsjahre
doppelt. Die Verserzählung „Juramareili" 1912, die Geschichte eines un-
glücklichen Mädchens, ist dem Dichter von der Not in seiner Kirchenge-
meinde abgerungen worden. Das Schauspiel „Marie und Robert" 1916 ver-
strickt einen jungen Arbeiter und seine ehemalige Braut zu schuldvollem
Geschehen. *Sophie Hämmerli-Marti,* 1868 zu Othmarsingen geboren, ist un-
beschadet ihrer späteren Bücher die Dichterin der Mutterlieder „Mis Chindli"
1896, in den späteren Auflagen von Ernst Kreidolf mit launig bewegten Zier-
leisten geschmückt. Der spröden Mundart ist ein Wunder geschehen. Das
Büchlein hat drei Gesätze. Das erste ist Wachsen und Werden von der Wiege
bis zum ersten Schulgang. Das zweite singt die aufgehende Welt des Kindes

vom Abendstern bis zum Kaminfeger. Das dritte sagt, wie ein Kind seine Mutter erzieht. Das Ganze sind hauchdünne Flöckchen von Worten, ein Nichts, von der flachen Hand in den lachenden Himmel geblasen.

Schaffhausen hat immer seine seltenen, doch großartigen Eigenbrötler aus- *Schaffhauser* gesendet. Diesmal war es *Arnold Ott*, 1840 bis 1910, zu Vevey von einer *Drama* romanischen Mutter geboren, in Schaffhausen beheimatet, durch den Vater, der ein Drechsler, Bürger von Seldwyla. Vom Spiel der Meininger angesteckt, kam er wirklich auf die Meininger Bühne. Seine Meister waren Aischylos, Shakespeare, Schiller. „Karl der Kühne" 1897 war seine große Leistung. Zweihundertfünfzig Jahre zuvor hatte der Sankt-Galler Josua Wetter in sei- nem Burgunderdrama die hohe Welt der Herren und die niedere des Bauern durch Vers und Sprache unterschieden. Nach Gerhart Hauptmanns „Florian Geyer" wagte Ott nicht mehr viel, wenn er Wetters Einfall wiederholte und die breiten Volksaufzüge seines Trauerspiels in der ungefügen Mundart der Waldstätten aufbrausen ließ. Dieses Stück mußte ins Freie. Das alte Rhein- städtchen Dießenhofen werkte mit einer bürgerlichen Spielschar und spielte *Dießenhofener* dann im Freien. Schillers „Tell" war 1896 der eine Höhepunkt und der *Theater* andere war 1900 Otts „Karl der Kühne". Der Maler August Schmid machte aus dem Lindenplatz vor dem Tor eine stimmungsvolle Naturbühne.

Die Landschaft Zürich war mit der Stadt nicht eines Sinnes. Es gibt keinen Gesichtspunkt, unter dem man die beiden großen Dichter der Stadt und die Literatur der Landschaft irgendwie als Einheit begreifen könnte. Jakob Heer aus Töss und Ernst Zahn aus Zürich haben untereinander manches, aber durch ihre Romane nichts mit der Überlieferung der Stadt gemein. Der Dich- ter der Zürcher Landschaft ist *Jakob Bosshart*, 1862 bis 1924, aus Stürzikon bei Embrach, ein Bauernsohn und Lehrer. Unter dem wenigen, was er früh *Der Dichter* gelesen hat, waren Pestalozzis Buch von „Lienhard und Gertrud" und *der Zürcher* Zschokkes Novelle „Das Goldmacherdorf", die immer wieder auf junge *Landschaft* Schweizer gewirkt haben. Seine Form wurde die kleine Erzählung von meist bäuerlichen Schicksalen. Seine Helden sind die Männer und Frauen des Zür- *Jakob Bosshart* cher Dorfes, Menschen, die überwinden und dabei gut bleiben. Seine Stärke ist nicht das Erfinden sondern das Herausarbeiten und Ausmalen. Rein und schlicht geben seine Geschichten das Leben, am Himmel, wie es der Dichter geträumt, und im Tal, wie er es erlebt hat. Das schmale Bändchen seiner Gedichte, Vierzeiler, die an Stimmung und Wort wie ein milder Herbsttag sind, bezeugt die durch Leid gereifte Gesinnung dieser gedämpften und ver- haltenen Kunst. Sie weist auf Peter Hebel mit ihrer anekdotischen und auf Albert Bitzius mit ihrer sittenschildernden Haltung.

Der Bauer selber, so lange Zielscheibe oder Wunschbild oder ungefragt Modell der städtischen Bildungsliteratur, wurde endlich sein eigener Anwalt. *Alfred Huggenberger,* 1867 im thurgauischen Weiler Bewangen geboren, ist viel mehr als herkömmliche Bauerngeschichte. Die bäuerliche Arbeit selber wird Gedicht. Der Bauer blickt in den Spiegel seines Werks und seiner selbst. Huggenberger hat mit seinen zwei Händen das Sorgengut seines Vaters in die Höhe gearbeitet. Der Junge empfand eine fast gewalttätige Liebe zu den Büchern. In seinem mißverstandenem Drange begann er ähnlich wie Rosegger mit nachgemachter Bildungsliteratur. Und als er längst seinen Stil gefunden hatte, verführte es ihn immer einmal, es „wirklichen" Dichtern gleichzutun. Von den mundartlichen Schwänken, die echt thurgauisch sind, nüchtern, gescheit und rücksichtslos, und von dem Lustspiel des thurgauischen eingebildeten Kranken — „Dem Bollme sy bös Wuche" 1914 — über ein halbes Dutzend Novellenbände und drei große Erzählungen bis zu den Gedichten reiht sich Feld an Feld. Dazu kommt noch gewissermaßen ein Pachtstück, von dem Wilhelm Busch seinen Zins bezieht. Das sind die Bildergedichte „Der Hochzeitsschmaus" und „Jochems erste und letzte Liebe". Man verstehe. Dieser Bauer spinnt seine Geschichten bei der Arbeit. Aus der Arbeit rinnt die Fülle des Erlebten, über das der Dichter nicht hinausgeht. *„Ein Stall ist
keine Fabrik"* Die Grenzen des Ackers sind die Grenzen seiner Welt. „Ein Stall ist keine Fabrik. Wenn einer das Vieh verachtet, ist selten mit ihm etwas los." Der Bauer werkt nicht an totem Stoff, sondern am Leben, wo es lebendigst ist, im Saatkorn und vor der Sense. „Vom Segen der Scholle" 1928 heißt das Hausbuch, in dem er von jedem seiner Felder eine Ernteprobe zusammentrug, und „Brunnen der Heimat" 1927, in dem er seine Jugend erzählt.

In den Waldstätten ist es nicht mehr die Stadt, sondern das Dorf. *Heinrich Federer,* 1866 bis 1928, ist zu Brienz geboren und zu Sarnen aufgewachsen. Die Mutter stammte von Glattfelden. Der kunstbegabte Vater vermachte ihm Wesen und dichterisches Vermögen, Sehnsucht nach Italien und das brausende Blut. *Der Seelsorger* Die Seelsorge in Toggenburg schürfte dem Priester die Seele auf für die Erfahrung dieser Welt. Der Dichter ist früh ausgeschlüpft und spät flügge geworden. Seine Erstlinge, die beiden Bergromane, sind gute Kopistenarbeit nach Ganghofer, Heer, Rosegger. „Berge und Menschen" 1911 wehren die Eisenbahn des Baukünstlers siegreich ab und lassen sich nur die naturfreundliche Straße gefallen. „Pilatus" 1912 macht den Übermut und das Herrschgelüste eines Bergführers tragisch zunichte. Die Natur ist stärker als der Mensch mit seinem dreifach gepanzerten Herzen und seinen hochmütigen Maschinen. An Seldwyla erinnern die „Lachweiler Geschichten"

1911 und die „Jungfer Therese" 1913 ist daraus eine Gestalt für sich. Es sind
Bücher der Selbsterziehung aus der Gefahr eifervollen Übermaßes. Nur eine *Seldwyla*
hochgemute Seele konnte es wagen, so ernste Dinge zwischen Tragik und
Ironie hindurchzusteuern. Nun wurden unter seinen Händen so rasch die un-
vergleichbaren kleinen Gebilde fertig, daß er kaum Zeit fand, sie wegzustel-
len. „Sisto e Sesto", „Das letzte Stündlein des Papstes", „Der Fürchte-
macher", „Das Wunder in Holzschuhen", „Gebt mir meine Wildnis wieder",
„Eine Nacht in den Abruzzen", sie spielen bald in den Waldstätten, bald in
Italien, wo es am heiligsten, am menschlichsten, am verrufensten ist. Sie
machen Päpste und Räuber, Heilige und Weltleute, Greise und Kinder zu
Helden des verwickelten Spiels, in dem Mensch und Gott um den Preis des
Lebens und um das Wunder der Gnade ringen. Aus Größerem fügte sich
die Dreiheit: die geschichtliche Erzählung „Spitzbube über Spitzbube" 1921,
die moderne Geschichte „Regina Lob" 1926 und dazwischen „Papst und *„Papst und*
Kaiser im Dorf" 1925, der ewige deutsche Krieg zwischen Welfen und *Kaiser im Dorf"*
Ghibellinen. Im „Mättelisepp" 1916 hatte der Dichter seine eigene Jugend
zur bittersüßen Märe gemacht. Zwei Bücher über den Bettler von Assisi
schließen den Rahmen um das Werk des Dichters. „Der heilige Franz von
Assisi" 1908 hieß das eine, „Der heilige Habenichts" 1926 das andere. Er *„Der heilige*
war selbst ein wenig der Spielmann Gottes, den er an dem Heiligen seines *Habenichts"*
Herzens bewunderte. Die große Freude lenkte seine Hand, daß sie in seinen
Geschichten alles zur Güte und zum Erbarmen mit der Kreatur schlichtete. In
diesem Bauernkopf mit seinen vergeistigten Leidenszügen schlugen die Schlä-
fen von ungebrochener Natur.

Meinrad Lienert, 1865 bis 1933, aus Einsiedeln, war der ältere Spielmann.
Mit dem ersten Wort wußte er, was er wollte: Gedichte, die Land und Volk
der Urschweiz wären. Schon seine erste Sammlung „Flüehblüemeli" 1890
brachte der Mundart als Doppelgewinn die erste kunstmäßige Geschichts-
novelle und die erste soziale Erzählung. Mitten durch diese tastenden Stil-
versuche begann sich schließlich die eigene Linie abzuheben von den „Ge-
schichten aus den Schwyzerbergen" 1893 bis zu den „Schweizer Sagen und
Heldengeschichten" 1914, die einen Rundblick über die Kleinwelt des Lan-
des auftun. Über dem Märenerfinden war der Liedersänger unversehens reif
geworden. Drei Bände konnten kaum die Fülle fassen, die er „'s Schwäbel- *„'s Schwäbel-*
pfyffli" 1913/1920 nannte. Er meinte mit dem Wort die Querpfeife, hinter *pfyffli"*
der sich seit alters die Schweizer Fähnlein in jede Ferne verlocken ließen. *Lyrisches*
Hier ist die Gemeinschaft Stimme geworden. Diese Schwyzer singen beim *Gemälde*
Spiel, bei der Blustfahrt im Mai, beim Alpenauftrieb der Herden. Sie singen *von Schwyz*

den Kilbitanz und das Treiben der Nachtbuben. Sie werben und freien, sie
taufen und weihnachten mit Gesang. In diesen Liedern ist ihre ganze Fröm-
migkeit, die geduldete der Nachtgespenster, der Hexen, der Naturgeister,
und die gesegnete der Legende, des Umzugs, des Gottesdienstes. In diesen
Liedern halten die Jahreszeiten ihren ewigen Kreislauf. Die Ganzheit einer
Landschaft wird in einem vielstimmigen Massenchor gesungen. Es ist in vie-
len Liedern ein Lied, ein lyrisches Gemälde. Das Gegenstück dazu ist der
„Der doppelte Matthias" Roman „Der doppelte Matthias und seine Töchter" 1929, das epische Gedicht
der Land-Volk-Einheit Schwyz. Die Handlung zeigt an zwei Abenteuern,
wie dieser kleine Weiberstaat sich behauptet, und in fünf Mären, wie er
durch die Wahl des Herzens zu neuen Zellen der Gesellschaft auseinander-
fällt. Lienerts Buch ist ein komischer Roman, der die Wirklichkeit durch lau-
nige Verkürzungen und Überschneidungen in Stil bringt. Die Sprache ist in
den Lautformen schriftdeutsch, im Geiste aber, im Wortschatz, im Zeitmaß
und Herzschlag Mundart. In Spittelers „Olympischem Frühling" steigt ein
junges Menschengeschlecht den Götterberg empor, um die Welt zu besitzen.
In Lienerts Roman schreitet vom Berge, wo es zu olympischer Kraft auf-
gewachsen ist, ein Geschlecht von Mädchen in die Täler hinab, Frauen und
Mütter zu werden, und trägt die Gesundheit des einsamen Berghofes in die
Dörfer. Meinrad Lienert ist der große alamannische Lyriker dieses Zeitalters
und der fast ebenbürtige Prosadichter der Waldstätte.

Lyrik im Übergang Über die große Schweizer Dichtung der breiten Jahrhundertwende hinaus
gab es nur noch den Fortschritt der Zeit. Die Wandlungen des lyrischen Stils
zeichnen sich bei Konrad Bänninger ab. Seine Sammlungen von „Stille Sol-
daten" 1917 bis „Nimmer vergeht der Mensch" 1938 zeigen einen großen
Abstand der Entwicklung. Was früher wuchtige Versgebäude waren, ist jetzt
in locker gleitende Strophenfolgen aufgelöst. Und für Hölderlins breit ent-
faltete Rhythmen stehen dann die flinken freien Verse Goethes. Abgeklärte
Sprüche reden die Sprache der Erfahrung und des Gewissens. Weitab liegt
der Schwulst, der in dem Jahrfünft nach dem Kriege zu Zürich Lyrik hieß.

Roman im Wandel Der Roman in seiner breiten Entfaltung wendet sich bei Paul Vetterli dem
Tier, bei Gustav Renker dem Flieger, bei Lisa Wenger der Frau zu, ist auf
weiten Strecken Bildungsroman und Geschichtsroman. Eine neue Note hat
ihm *Otto Wirz* aus Olten gegeben. Als Naturwissenschafter und Maschinen-
bauer ließ er sein persönliches Leben kräftig durch seine Dichtungen strö-
men. Aber er ist sehr einsame Wege durch den Tag mit seinen verwunder-
lichen Begegnungen gegangen. Sein Gedanke ist das magische Ich. Die drei
Romane „Gewalten eines Toren" 1923, „Die geduckte Kraft" 1928, „Pro-

phet Müller-zwo" 1933 versuchen ihn auf eine phantastische und doch wie- „Prophet Müller-zwo"
der auch geflissentlich sachliche Weise zu verdeutlichen. Das geistige Ver-
hältnis des Dichters zu Dostojewskij und Rolland, zur deutschen Mystik und
zum deutschen Idealismus hat seine Gültigkeit. Doch sein magisches Welt-
bild gründet sich auf das naturwissenschaftliche Erlebnis des modernen Geist-
denkers und auf die Tatsache von mancherlei okkulten Erscheinungen. In
jene Bezirke, wo Stoffwelt und Geistwelt eins sind, aus denen die okkulten
Erscheinungen wirken, kann man nicht durch gesetzmäßige Erkenntnis der
Natur, sondern nur durch schauhafte Erfassung des Seins vordringen. Wir-
kende Kraft und erkennende Schau ist die zweifache Macht des magischen Das magische Ich
Ich, in dem sich die Gemeinschaft aller Wesen „verkörpert". Das magische
Ich umfaßt alles Geschöpfliche. In ihm geht das persönliche Ich auf. Das
magische Ich muß zum mystischen Ich werden. Der Dichter wollte die Denk-
weise und Lebenshaltung der Menschheit überwinden, die zum Kriege führ-
ten. *Bernhard Diebold* hat in seinem Zeitroman „Das Reich ohne Mitte" „Das Reich ohne Mitte"
1938 geschildert, das Deutschland von Anno Dollar bis dicht an die tragische
Wendung, breit malend, nicht unsachlich, aber ungläubig.

Der weiteste Abstand zwischen Gestern und Heute wird im Drama der
Schweiz sichtbar. *Konrad Falke,* 1880, aus Aarau, der eigentlich Karl Frey
heißt, bedeutet den ersten starken Einsatz eines neuen dramatischen Willens.
Von den schönen drei Einaktern „Dante Alighieri", „Michelangelo", „Gior-
dano Bruno", 1909 als „Träume" zusammengefaßt, steigt der Bogen seines
Schaffens zu großen Tragödien auf — „Caesar imperator" 1911, „Astorre"
1912, „Echnaton" 1928, „Don Juan" 1929 — die weniger als Bühnenwerke,
denn als Dichtungen einen neuen Stil anstreben. Jetzt wird man beweglich
und beginnt, sich auf die verlangten Formen der Großstadtbühne einzuspie-
len. Das sind Rudolf Graber und Cäsar von Arx. Und im Drama spielte sich
die geistige Auseinandersetzung der Schweiz mit sich selber ab. *Jakob Bührer* Drama auf der Suche
suchte in seiner Spielsatire „Das Volk der Hirten" 1918, in dem modernen
Sittenstück „Marignano" 1918, in der Groteske „Die Pfahlbauer" 1932 nach
Formen für seinen Zweifel an der geschichtlichen Schweiz. *Paul Schoeck* griff
auf den Schweizermythus zurück. Sein „Tell", 1920 zu Zürich gespielt, erhob
den ursprünglichen Gemeinschaftsgeist der Waldstätte gegen den Tag, dem
er nichts mehr zu sagen schien. Das Stück ist durch die schlimmste Gefahr,
Schiller zu wiederholen, hindurchgekommen. Seine Mundart redet beide
Wahrheiten, der Natur und der Seele.

Die Waldstätte hatten eine alte Überlieferung. Die katholische Jugend, Junges Schwyz
um eine zeitgemäße Bereitschaft des Geistes bemüht und zu mancherlei Ge-

Eberles Bühne meinschaften versammelt, suchte ihren Glauben von der Scholastik, vom Barock, von der Romantik her zu einer lebendigen künstlerischen Tatsache zu machen. Auf der Bühne entfaltete die Spielbewegung *Oskar Eberles* mit jungen Kräften die schöne Überlieferung der Landschaft. Er erneuerte „Das Luzerner Passionsspiel", „Das alte Urner Spiel vom Tell", „Es Fritschi-Fasnachtsspyl", schrieb sich für seine Bühne einen „Chlaus vo Flüe", übertrug Hofmannsthals „Jedermann" in Schweizer Mundart und setzte auf all das den Trumpf des fröhlich hintergründigen Verlustspiels „Der Lätz gwünnt die Rächt". *Meinrad Inglin*, 1893, aus Schwyz, machte, „Die Welt in Ingol-

Inglins Welt in Ingoldau dau" 1922, eine ganze Stadt zur Heldin mit ihrem Absterben der Alten und ihrem Aufwachsen der Jungen. Es ist eine Schweizerwelt wie bei Lienert und eine Kirchengemeinde wie bei Federer. „Über den Wassern" 1925 und „Die graue March" 1935 sind Bilder von der antiken Naturdämonie Arnold Böcklins. „Jugend eines Volkes" 1933 sind Novellen aus den frühen Tagen der Eidgenossenschaft und „Schweizerspiegel" 1938 ist der Roman der Eidgenossenschaft im Widerschein des Weltkrieges. Die Erzählungen „Güldramont" 1943 schildern die Seele junger Menschen auf der Schwelle der Ge-

Cécilie Lauber schlechtsreife. *Cécilie Lauber,* 1887, aus Luzern, hat sich von „Robert Duggwyler" 1922 bis zu dem Novellenbuch „Die Kanzel der Mutter" 1936 sprunghaft entwickelt. In der Mitte stehen zwei Romane von unnachahmlicher Eigenart, gepaarten Vorwurfs und zweifachen Stils. „Die Wandlung" 1929 gehört äußerlich in die Nähe von Otto Wirz. Ein unscheinbares Ereignis reißt einen Menschen aus seiner Bahn und stürzt ihn in den feurigen Ofen der Verwandlung. „Stumme Natur" 1939 ist das Gegenstück. Ein paradiesisches Eiland, mit einer dunklen Sage gegen den Einbruch der Menschen bewehrt, wird von einem jungen Paar besiedelt und in den Strudel menschlicher Leidenschaften gerissen. Auch das sind zwei Bücher des magischen Ichs, der ungetrennten Weltseele, der dunklen Mächte über und unter dem Menschen, mit bedeutsam verschweigenden Worten erzählt, alles Begebenheit und alles Bild.

Wieder Bern Bern ist nebeneinander noch immer ländliche und städtische Dichtung. Die Bücher von Lisa Wenger, Maria Waser, Alfred Fankhauser zeigen keine wesentliche Änderung des erprobten Lebens. Doch da sind zwei andere, die aus der Art zu schlagen scheinen. *Albert Steffen*, 1884, aus Murgental, gehörte der religiösen Genossenschaft Rudolf Steiners an. Seine Dichtungen, ob nun Roman oder Drama, sind Ausdrucksformen religiös-sittlicher Inhalte. Die Dramen — inmitten „Das Viergetier" 1924 — sind im Grunde Mysterienspiele. Alle wollen die Bewährung der Seele am Widerstande der

niedern Natur gleichnisweise darstellen. Reine Kunstgebilde, in denen der *Albert Steffen*
Lehrzweck völlig Gestalt geworden ist, sind Steffen nur in seinen kleinen
Dichtungen gelungen. So „Die Heilige mit dem Fische" 1919, ein Buch No-
vellen. Das Eigentümlichste und Schönste sind die Kurzgeschichten „Kleine
Mythen" und „Pilgerfahrt nach dem Lebensbaum" 1925, zwischen anmu-
tigen Betrachtungen Parabeln, Legenden, Novellen der Selbsterinnerung,
das Ganze eine Art „Legenda aurea" der Dornacher Steinergemeinde. Es
sind die Bücher eines Weltverbesserers, der sich als Seelenarzt fühlt und sein
Menschenalter vom Ungeist der Gewalttat und der Machtgier entgiften
möchte. Sein Gleichnis für die reinste Unschuld des Daseins sind Pflanze und
Kind. *Max Pulver*, 1889, aus Bern, ist durch Paris und München wohl über *Max Pulver*
seine Vaterstadt hinausgebildet worden. Von seinen frühen Dramen 1916
galt „Robert der Teufel" dem Zweiseelenmenschen, während „Alexander der
Große" die Sehnsucht des Helden nach dem Heiligen darstellt. An der mittel-
alterlichen Sage vom bösen Weltbaumeister und Gegenerlöser entfaltet sich
der Dichter gedanklich wie gestalterisch in zweifacher Richtung. Die Ro-
manzenfolge „Merlin" 1918 umgrübelt die Frage nach der Herkunft des
Bösen. Das Drama „Igernes Schuld" 1918 verwirrt sich gleich dem antiken
„Amphitryon" in den Betrug mit den vertauschten Gestalten. Das Versbuch
„Auffahrt" 1919, die Komödie des deutschen Umsturzes „Das große Rad"
1921, der Roman „Himmelpfortgasse" 1927 zeigen ihn näher an der Zeit.
Max Pulver ist beim Stil seiner Dramen von Calderon ausgegangen. Er ver-
knüpft damit die modische Kunst, der schlafenden Seele ihr Unbewußtes ab-
zufragen.

Zürich ist mit großer Stete bei sich selber geblieben. Der Lyriker, der Thea- *Wieder Zürich*
traliker, der Dichter in allen Formen vertreten die Stadt. Der Lyriker ist *Karl
Stamm*, 1890 bis 1919, aus Wädenswil am See, ein junger Lehrer, der als
Grenzsoldat den Gefahren eines zarten Herzens ausgeliefert war. Die zö-
gernde Herankunft eines frühen Todes schenkte ihm jene Vollendung der
Seele, die sich mehr in seinen kostbaren Briefen als in seinen letzten Dich-
tungen bezeugt. Sein erster Wurf, „Das Hohe Lied" 1913, war sein höchster.
Von den drei Gesängen erlebt der erste die Welt im Zustand der Schöpfung,
der zweite im Zustand des persönlichen Geborenseins, der dritte als Rück-
kehr in Gottes Brust. Das letzte, was Karl Stamm selber noch verantwortete,
„Der Aufbruch des Herzens" 1919 ist ein kleines Versbuch, in dem sich der
letzte Reichtum dieses kurzen Lebens zusammendrängt. Stamms lyrischem
Werk fehlt noch eine Feile. Vielleicht ist gerade das sein Vorzug. Seine Verse
haben die Reinheit, die dem Menschen nur durch Leiden abgerungen wird.

Verzicht und Ergebung ist ihr Adel. Der Theatraliker ist *Max Eduard Meyer*, 1899, aus Zürich und der Familie des Dichters. Er nennt sich nach einem Sonderzweig des Geschlechts Liehburg. Sein Drama hat einen dreifachen Einsatz. Da ist die Antike. Meyer dichtet des Aischylos „Prometheus" zu einem Menschen um, der die Menschheit aus eigener Kraft erlöst und durch Sprache, Schrift, Feuer, Kunst zur Vollendung führt. Da ist der späte Barock. Der Dichter hat Bachs „Passionen" als hohe Bühnenkunst entdeckt und neu gedeutet. Da ist das Mysterienspiel. Der Dichter läßt Geburt, Passion und Messe, Werk und Wirkung, Erlöser und Kirche zu dem heiligen Drama „Christus" zusammenklingen. Da hat Meyer aus der einräumigen wieder die

„Schach um Europa" zweiräumige Bühne gemacht. „Schach um Europa" 1930 und „Hüter der Mitte" 1934 führen diese wiedergefundene Spielweise vom Geistlichen ins Weltliche und von der zweiräumigen zur dreiräumigen Bühne. Beiden Spielen geht es um den Sinn des eidgenössischen Staates in Vergangenheit, Gegenwart und Zukunft. Die drei Bühnen der beiden Spiele gleichen kunstvoll gegeneinander gestellten Prismenflächen, die das eine Geschehen gleichzeitig in seine zeitliche, urbildliche und vorbildliche Bedeutung zerlegen. Es sind Gedankenspiele. Musik, Glockengeläute, Donner der Kanonen und der Gewitter, der Schrei des Geschehens durchklingt die drei getrennten Handlungen, vertont sie zur gedanklichen Einheit und bringt sie aus dem mystischen Abgrund zu Gehör. Der Dichter in allen Formen ist *Robert Faesi*, 1883, aus Zürich. Der Erzähler hat mit der feinen Goldschmiedearbeit „Das poetische Zürich" 1913 zusammen mit Eduard Korrodi begonnen. Drei Novellen aus der französischen Revolution sind Zeitbildnisse. Die drei Vers-

„Das Antlitz der Erde" bücher „Aus der Brandung" 1917, „Der brennende Busch" 1926, „Das Antlitz der Erde" 1936 sind wohl das gestaltlich lauterste lyrische Bekenntnis ihrer Zeit. Die früheren Verse singen den Menschen, die späteren der Natur. Es sind die Stimmungen eines hochgemuten Mannes, der inmitten der Welt auf einem selbstgewählten Standort steht. Nichts ist an diesen weltfrommen und gottgläubigen Versen hängengeblieben, was mit irdendeiner Mode vorübertrieb. Der Spieldichter ging mit „Odysseus und Nausikaa" 1911 von dem neuklassischen Bühnenstück aus, wie es etwa Paul Ernst vorschwebte. Er kam bei dem Mysterienspiel an vom ungefähren Stil Hugos von Hof-

Faesi / „Das Opferspiel" mannsthal und Max Mells. Es ist das „Opferspiel" 1925, ein Werk der Stilbühne, nach durchgehendem Rhythmus und zahlenmäßigem Ebenmaß aufgebaut, nach farbigen Gestalten gegliedert und mit gottesdienstlicher Würde vorgetragen. Krieg und Aufruhr, Versöhnung und Friede, das Schicksal des Zeitalters wird in den Scheinwerfer der Ewigkeit gerückt. Die Gestalten tra-

gen keine Namen. Dennoch sind es lebende Menschen. Sie leuchten aber von innen heraus als Gleichnisse des allgemein Gültigen. Der Rhythmus des Geschehens schwingt über wenige weithin sichtbare Hochtonstellen. Die Sprache hat die edle Schönheit eines Adels, der nicht erworben, der nur erboren werden kann. Die ungeheuren Umbrüche seines eigenen Zeitalters erlebte er auf der Szene, die die französische Revolution dem Schweizervolk in Paris stellte. Es ist der Romandrilling „Die Stadt der Väter" 1941, „Die Stadt der Freiheit" 1944, „Die Stadt des Friedens" 1952, mit kluger Geduld vor dem fallenden Vorhang.

Basel ist die Stadt des eidgenössischen Romans. Er strahlt von der Basler *Wieder Basel* Mitte in die Weite der Erde, in die Tiefe der Geschichte, in alle Bezirke der Gegenwart aus. *Gustav Keckeis*, 1884, aus Basel, konnte es in seinem Kolumbusroman „Die spanische Insel" 1926 und „Der Seefahrer" 1928 nicht vermeiden, den Zusammenstoß zwischen weißer und farbiger Menschheit mit seinen ersten Erschütterungen spüren zu lassen. Doch wesentlich geht es um das seelische Geheimnis des Entdeckers. Der Roman hat persönlichen Stil. Alles ist Tatsache. Die Sprache hat eine unglaubliche Kraft, zu färben, die Erscheinungen zu verwandeln, den Dingen Wärme und Kühle zu geben. *Emanuel Stickelberger*, 1884, aus Basel, hat sich an zwei Novellenbüchern — *Der Roman* „Der Kampf mit dem Toten" 1922 und „Ferrantes Gast" 1924 — geschult und jedem seinen eigenen Stil gegeben. Ungewöhnliche Lagen und Abgründe der Seele werden ausgelotet, unbegreifliche Taten mit gelassener Hand nachgezeichnet. Von seinen Romanen gibt „Zwingli" 1925 nur die Gipfelszenen. „Reformation" 1928 hält, ohne gemeinsamen Helden, dichterische Geschichtsbilder fest. „Der graue Bischof" 1931 ist der Kanzler Rudolfs I. von Habsburg. Und „Der Reiter auf dem fahlen Pferd" 1937 ist der Roman des Mongolen Dschingis-Khan sowie seiner abendländischen Gegenspieler. Ungemein fruchtbar als Finder immer neuer Mären bevorzugt Stickelberger solche mit religiösem Gewebe. Sein episches Großwerk wurde ihm spät geschenkt in Gestalt des Romandrillings 1942/1946 über den Maler Hans Holbein. Der Dichter ist auf Hochdeutsch und Alamannisch eines rührsamen Verses mächtig. *Carl Albrecht Bernoulli*, 1868, aus Arlesheim, ist nach vielen Vorübungen zu dem späten Buch „Ull, der zu frühe Führer" 1931 gekommen, einem Rundgemälde der Zeit um die tragische Gestalt eines jungen Gelehrten. *Jakob Schaffner*, 1875—1944, aus Basel, von einem Basler Vater und einer badischen Mutter, hat literarisch bei der Werkstatt, der kleinen Basler Gasse und den sozialen Zeitschmerzen der Jahrhundertwende angefangen und schon sehr früh die Schweiz, wie Deutschland mit der gleichen

Johannes
Schattenhold

Neigung geschildert. Seine künstlerische Wende und erste große Bewährung war der zweibändige selbsterlebte Bildungsroman. „Johannes" 1922 schilderte Elternhaus und Armenanstalt, „Die Jünglingszeit des Johannes Schattenhold" 1930 die Lehrzeit in der Basler Schusterwerkstatt. Rührend schön und lehrreich ist es, wie das Reich Gottes, für das der Knabe im ersten Bande erzogen wird, sich im zweiten zu der harten Wirklichkeit des Lebens verwandelt. Zwischen diesen beiden Büchern hat der Dichter sich auf seiner Höhe entfaltet. „Die Glücksfischer" 1925 spielen an einer kunstvollen Doppelhandlung die stilvolle Tragikomödie der neu erwachten lebenshungrigen Frau, die ein reizendes Dreieck von Basler Fischerleuten verwirrt. „Das große Erlebnis" 1926 stellt verwandte Szenen im zeitgenössischen Berlin. Jakob Schaffner war 1918 Deutschland treu geblieben. Er folgte ihm auch auf seinem letzten Wege, machte ihm den Herold und ist zu Straßburg dem Kampf aus der Luft zum Opfer gefallen. Der Dichter hat sich nicht mit ergrübelten Fragen gequält. Sein Gegenstand ist das Leben, der Mensch mit den triebhaften Wurzeln seines Daseins, Mensch zu Mensch in seinen ursprünglichen Beziehungen: Mann zu Frau, Bruder zu Bruder, Mutter und Sohn, Mutter und Tochter. Das Fleisch hat das Recht, zu blühen und zu verderben. Man kann das Leben nicht „verstehen". Man muß damit fertig werden. Im Netz dieses Lebensfischers verfangen sich immer wieder die Frauen. Der tragische Selbstbetrug reifender Frauen, nicht das erste Aufbrechen des Gefühls, fesselt ihn. Der Dichter beherrscht das lebendig bewegte Gespräch und ist darin fast jeder Mundart sicher.

„Die
Glücksfischer"

Asylverlag

Die Eidgenossenschaft war die geschichtliche Freistätte. Die beiden Zürcher Unternehmen, der Verlag Emil Oprecht und der Europaverlag nahmen sich der deutschen Literatur an, die in Deutschland nicht erscheinen konnte. Und eben in dieser Richtung begann sich das lauteste eidgenössische Schrifttum zu entwickeln. Das waren der Zürcher Max Frisch, 1911, mit seinen dramatischen Moritaten und späteren Erzählungen sowie der Berner Friedrich Dürrenmatt, 1921, der mit seinen anarchischen Spielen nach 1945 auch nur von der Piscator-Bühne abstammt. Man wird ja sehen, wie es weitergeht.

2. ÖSTERREICH-UNGARN

Seit dem Mittelalter hatte sich innerhalb der Grenzen der späteren österreichisch-ungarischen Monarchie aus den einzelnen deutschen Siedlungen ein mannigfaltiges Schrifttum entwickelt. Es war in den böhmischen und ungari-

schen Ländern von der Wurzel auf verschieden. In Böhmen setzte es sofort mit Dichtungen von Rang ein, während es sich in Ungarn erst allmählich aus einer Bedarfsliteratur zu einer Kunstliteratur aufarbeitete. In Böhmen blühte diese Literatur während der Ritterzeit, in Ungarn während der Barockzeit.

UNGARN war die Heimat zerstreuter deutscher Siedlungen, die nur im Osten und Süden des Landes zu mehr oder minder geschlossenen Gruppen zusammenwuchsen. Die ältesten waren die Siebenbürger Sachsen. Ihr Geistesleben wurde durch den Humanismus und die Reformation begründet. Der Kronstädter Johann Honter, 1498 bis 1549, in Wien, Krakau und Basel gebildet, war nicht nur der Vater der evangelischen Kirche, sondern auch der modernen Bildung in Siebenbürgen. Nach den politischen und kriegerischen Wirren des siebzehnten Jahrhunderts und neuem Zuzug von deutschen Bauern schuf der siebenbürgische Staatsmann Samuel von Brukenthal einen neuen Mittelpunkt im Lande, indem er 1817 das Hermannstädter Museum für Literatur, Kunst, Naturwissenschaft stiftete. Und der Hermannstädter Schulmann Johann Karl Schuller, 1794 bis 1865, begründete die volkskundliche Forschung, bereitete ein Wörterbuch sowie eine Sagengeschichte vor und gab mit Anmerkungen „Gedichte in siebenbürgisch-sächsischer Mundart" 1840 heraus. Der Pfarrer Stephan Ludwig Roth, 1796 bis 1849, griff mit seiner Schrift „Der Sprachenkampf" 1842 in das Spiel der Kräfte ein. Die Dichtung des Landes im neunzehnten Jahrhundert nahm Fülle und Stil an. Der Pfarrer Friedrich Wilhelm Schuster, 1824 bis 1914, selbst ein Lyriker von akademisch gemessenen Versen, gab „Siebenbürgisch-sächsische Volkslieder" 1866 heraus. Heinrich Melas, 1829 bis 1894, hat Petöfi am schönsten übertragen. Michael Albert, 1836 bis 1893, drückte in seinen Gedichten reine Naturempfindung aus. Seine gedankenüberladenen und schwerfälligen Novellen sind Zeitgeschichten, vielleicht Immermann nachgeformt. Seine Dramen folgen Schiller und Shakespeare. Mit den Dramen und geschichtlichen Romanen des Kronstädter Traugott Teutsch, 1829 bis 1913, hatte die Literatur des Landes jeden Anschluß an die Zeit verloren. Und so ließ denn der Kronstädter Adolf Meschendörfer, 1877 geboren, zu Kronstadt 1907 seine Zeitschrift für Kultur und Kunst „Die Karpathen" erscheinen, mit der landesüblichen Selbstzufriedenheit Schluß zu machen und auf strenge Leistung zu dringen. Die jüngsten dieser Siedlungen lagen im Banat und seiner Nachbarschaft. Hier drängte sich auf engem Raume die Fruchtbarkeit. Stefan von Millenkovich, 1836 bis 1915, wurde zu Wien ein feiner Lyriker und Erzähler. Eugenie Delle Grazie, 1864 bis 1931, aus einer venezianischen Familie, war nicht nur eine sehr blickscharfe Mädchenschilderin, sondern sie

Siebenbürgens geistige Frühzeit

Vorblüte

Die gute alte Zeit

„Die Karpathen"

wußte auch die Zigeunerweiber und Bauernfrauen zwischen Theiß und
Donau prächtig auf die Füße zu stellen. Otto Hauser, 1876 geboren, war ein
Übersetzer aus nur allzuvielen Sprachen. Der richtige Schwabe, Adam
Das Banat Müller-Guttenbrunn, 1852 bis 1923, der Wiener Theatermann, hat seit 1913
fast zu fachlich die Geschichte des Banats in der Romanreihe „Von Eugenius
bis Josephus" aufgerollt. Über all dem war für die ungarischen Länder das
Jahr 1914 angebrochen.

BÖHMEN hatte um die Wende zum neunzehnten Jahrhundert für Tsche-
chen und Deutsche ein neues Buch aufgemacht. Herder mit seinem Zuruf an
die Slawen im sechzehnten Buch seiner „Ideen" und Goethe mit seinem Ge-
Goethes danken von der „Volkheit" machten den Tschechen Mut zu ihrer nationalen
böhmische Wiedererhebung. Goethe, der seit Jahrzehnten die Heilbäder des Landes be-
Freunde suchte, hatte in den Klöstern Ossegg und Tepl wie in der Stadt Eger begei-
sterte Pfleger und Verbreiter seiner Werke. Was in Bildung begriffen ist, das
will eine böhmische Landesliteratur werden, ein Schrifttum aus gemeinsamer
Gesinnung und nur unterschieden durch die beiden Landessprachen. In die-
sem Sinne wirkte zu Prag Goethes Freund, der Regensburger Domherr Kaspar
von Sternberg, 1761 bis 1838, der 1818 das vaterländische Museum nach
dem Vorbild des Grazer Joanneums gründete und dafür seine reichen natur-
wissenschaftlichen Sammlungen schenkte. Unter dem Einfluß der deutschen
Romantik und nach den Wiener Anregungen Josef Hormayrs, durch Goethes
Beispiel gerechtfertigt, nahmen sich die Deutschen ohne Unterschied des
Literatur ohne Herzens der deutschen und tschechischen Sagen, Märchen, Volkslieder an.
Unterschied Der Prager Karl Egon Ebert, 1801 bis 1882, gab mit seinen Dramen „Bretis-
des Herzens law und Jutta" wie „Czestomir", mit seinem „Böhmischen Nationalepos"
„Wlasta" 1829, mit seiner Versnovelle „Das Kloster" 1833 für diese gemein-
böhmische Dichtung den Ton an. Und diesen Absichten wollte die Zeitschrift
„Ost und West" „Ost und West" dienen, die 1837 der Beamte an der Hochschulbücherei,
Rudolf Glaser, 1801 bis 1868, begründete. Sie wollte literarisch zwischen
Osten und Westen vermitteln, die Dichtung aller slawischen Völker durch
Übersetzungen den Deutschen bekannt machen und zog, um auch den Sla-
wen eine Vorstellung der zeitgenössischen deutschen Literatur zu geben, fast
alle deutschen Dichter von einigem Rang zur Mitarbeit heran. Kein Gerin-
gerer als Paul Safařik steuerte Übersetzungen aus dem Tschechischen bei,
neben ihm die Prager Josef Wenzig und Siegfried Kapper. Um eine Dichtung
im Sinne von „Ost und West" bemühten sich Alfred Meissner, 1822 bis 1885,
aus Teplitz, mit seinem Epos „Zizka" 1846; Uffo Horn, 1817 bis 1860, aus
Trautenau, mit seinen Dramen „Horimir" und „Otakar" sowie mit seinen

Novellen „Böhmische Dörfer" 1847; Moritz Hartmann, 1821 bis 1872, aus *„Böhmische Dörfer"*
Duschnik, mit seinen Gedichten „Kelch und Schwert" 1845 sowie mit seinem
Roman „Der Krieg um den Wald" 1850, der Horns „Böhmischen Dörfern"
verwandt ist.

Böhmen ist plötzlich ohne Nachwuchs. Und auf einmal ist es Mähren. In
Brünn erschien 1890 „Moderne Dichtung, Monatsschrift für Literatur und
Kritik". Das stattliche Blatt, das alle modernen deutschen Dichter in Bei-
trägen, Bildern, literarischen Porträts vorüberführte, war um diese Zeit viel-
leicht die beste und vollständigste Revue der modernen Literatur. Sie stand
im Lande nicht allein. Der Nikolsburger *Heinrich Landesmann*, 1821 bis *Mähren*
1902, der unter dem Namen Hieronymus Lorm schrieb, steht zeitlich gerade
in der Mitte. Früh taub und halbblind war er auf sein Innenleben angewie-
sen. Versbücher entlasteten nicht sein Gemüt, nur seine Gedanken. Die bei-
den Romane „Ein Zögling des Jahres achtzehnhundertachtundvierzig" 1855
und „Die schöne Wienerin" 1866 umschreiben den äußeren Kreis seiner Er-
lebnisse. *Jakob Julius David*, 1859 bis 1906, aus Mährisch-Weißkirchen, kam
mit dem Drama nicht zurecht. Im Erzählen erwarb er sich, dank Conrad
Ferdinand Meyer, eine mühsame und späte Meisterschaft. Sie bewegt sich
— „Das Höferecht" 1890, „Troika" 1901, „Die Hanna" 1904 — auf der
Linie der jüdischen und mährischen Dorfgeschichte. Sie widerstreiten, ge-
waltsam und düster, allen dreien seiner Meister, dem Zürcher Patrizier Meyer
ebenso wie dem Wiener Humoristen Anzengruber und dem adeligen Russen
Turgenjew. *Philipp Langmann*, 1862 bis 1931, aus Brünn und in Brünn
Fabrikarbeiter, in Wien Schriftsteller, begann mit Proletariererzählungen
und fand mit dem Arbeiterdrama „Bartel Turaser" 1897 im Gefolge Gerhart
Hauptmanns den Beifall des Burgtheaters.

Nur der böhmische Adel hatte sich zumeist die sprachlich parteilose böh- *Der böhmische Adel*
mische Landesgesinnung bewahrt. Er drückte sie aus, soweit er schrieb. Und
niemand konnte es vornehmer tun als die drei Frauen, die für ihn die Feder
führten. Lola Kirschner, 1854 bis 1934, die Tochter eines Prager Gutsbe-
sitzers, die sich Ossip Schubin nannte, hatte Turgenjew, George Sand, Alfred
Meissner mit Nutzen gelesen. Ihre zerrütteten Nerven witterten triebhaft
den Verfall der Gesellschaft, die sie in ihren Romanen schilderte, weit voraus.
Berta von Suttner, 1843 bis 1914, als Gräfin Kinsky zu Prag geboren, ergriff
die letzte Waffe, die diesen Staat zu retten vermocht hätte, die Waffe gegen
den Krieg. Mitten unter Gesellschaftsromanen ähnlicher Art trat sie der Ge-
fahr ihrer Tage mit dem Buch entgegen „Die Waffen nieder" 1899, gründete
die österreichische Friedensliga und leitete deren Zeitschrift.

Die Freifrau *Marie von Ebner-Eschenbach,* 1830 bis 1916, war eine Gräfin Dubsky vom Schloß Zdislawitz, die Tochter eines tschechischen Edelmanns, der in der österreichischen Armee gefochten hatte, und einer Mutter aus deutscher Protestantenfamilie. Grillparzer fand ihre ersten Gedichte gut und ließ sich von ihr gelegentlich eines ihrer Dramen vorlesen. Einige ihrer Stücke, die gutes Burgtheater waren, sind gespielt worden. Ihre Kunst wurde die Erzählung. Sie wagte sich auf das mährische Dorf, indem sie in „Božena" 1876 die Geschichte einer Magd erzählt. Sie wagte sich in die Stadt zu „Lotti, die Uhrmacherin" 1879, die an einem Dichter ein so großmütiges Rettungswerk unternimmt. Sie fand in ihrer nächsten Umgebung die Modelle für ihr erstes Meisterwerk, „Die Freiherrn von Gemperlein" 1881, die humoristische Geschichte von den zwei feindlichen Brüdern oder was sich liebt, das neckt sich. Alle ihre Novellen, von denen auch die umfangreicheren keine Romane sind, messen räumlich die gesamte Monarchie aus. Die meisten spielen in Wien und Mähren. Ihr allgemeiner Vorwurf ist: der Adel unter sich und im Verhältnis zu Dorf wie Stadt. Und in diesem allgemeinen Vorwurf gibt es kein anderes Motiv, als das einzige, das zugleich der Mensch ist, die Ehe. Alle die

Die Frau Gestalten, in die der Mensch beiderlei Geschlechts durch die Ehe verwandelt
und ihr Stil wird, schlingen ihren Reigen durch die Geschichten dieser seltenen Frau. Sie steht nicht außerhalb ihres Standes, sondern immer über ihm, ohne ihn jemals preiszugeben. Selbstüberwindung, Haltung, das in jedem Fall Gemäße, als Mensch immer in Form sein, das ist ihr Beispiel, das die richtigen Menschen in ihren Geschichten geben. Ihre Novellen sind erzählte Tragödien und Lustspiele. Ihr Vortrag ist so vielfältig, wie Überlieferung und eigene Einfälle nur gelehrt haben können. Von einem schmalen Bündel Postkarten über den Bericht am Teetisch und die gemeinschaftliche Erzählung im Wechselgespräch bis zur fortlaufenden Darstellung durch die Dichterin selber sind alle Möglichkeiten des Erzählens ausgenützt, die dazwischenliegen. Gleichwohl hat dieser Stil ein einziges Gesetz: nichts mit Worten, alles durch Ge-

Die Gebärde bärden. Es ist der Stil der Sache selbst. Solche Gebärden in Worten sind die „Parabeln und Märchen" der Dichterin. Solche Gebärden sind ihre „Aphorismen" 1879, aus Erfahrung geprägte Lebensweisheit, aus denen man beliebig die Aufschriften ihrer Novellen machen könnte. Und solche fast wortlose Gebärden sind ihre Gedichte. „Ein kleines Lied, wie geht's nur an, / Daß man so lieb es haben kann / Was liegt darin? Erzähle! / Es liegt darin ein wenig Klang, / Ein wenig Wohllaut und Gesang / Und eine ganze Seele." Die schönsten Aphorismen stehen in den Dichtungen dieser Frau, der ersten, die als Frau solche geschrieben hat. Nur sie konnte Inhalt, Sinn und Laune

ihrer Geschichten in die zwei Worte fassen, in denen man Handbewegung und Gesicht der Frau sieht, der Frau, die all ihre Mütter vor all ihren Töchtern entschuldigen will: „Sterben ist nichts. Aber heiraten, das ist gewagt."

Über all dem war für die böhmischen Länder das Jahr 1914 angebrochen.

WIEN war zwischen 1866 und 1914 die geistbewegende Mitte dieser österreichisch-ungarischen Literatur. Gleichviel, wo die Dichter des Zeitalters auch geboren waren, in Wien haben die meisten gelebt und sich gebildet. In Wien zu gelten, war ihr Ehrgeiz. Von Wien empfing die Literatur ihre Antriebe und durch Wien ist sie Stil geworden. Das Burgtheater blieb die Mitte von Wien. Am 12. Oktober 1888 wurde das alte Haus am Michaelerplatz geschlossen und am 14. Oktober 1888 das neue am Franzensring geöffnet. Max Burckhard, der es 1890 bis 1898 leitete, stellte es auf die neue Bühnendichtung Europas, Deutschlands, Österreichs um. Beiden Wiener Dichtern, die ihre Vaterstadt zwischen Franz Grillparzer und Hermann Bahr verkörpern, ist das Burgtheater versagt geblieben. Dem einen, weil er zum Erzähler geboren war, dem andern, weil er von der Vorstadtbühne kam. *Das Burgtheater*

Ferdinand von Saar, 1833 bis 1906, stammte von beiden Seiten aus Wiener Familien. Mit dem Wiener Hausregiment der Deutschmeister lernte er 1849/1860 die halbe Monarchie kennen. Der Verabschiedete reifte zum Dichter der Gesellschaft, die sich vom deutschen Bund in die Dreibundmacht umlebte. Dieser Dichter wurde er während des sieglosen Ringens um das geschichtliche Schauspiel, da er sich weltanschaulich an Schopenhauer, dichterisch an Turgenjew festigte, da er Charles Darwin wie Gottfried Keller las. Vierzehn seiner Erzählungen seit 1866 stellte er zu den zwei Bänden „Novellen aus Österreich" 1897 zusammen. Die späteren wurden erst in den „Werken" von 1909 eine äußere Einheit. Es sind meist selbsterzählte Geschichten, in denen sich durch zufällige Begegnungen Vertreter aller Stände zusammenfinden. Da ist der junge Truppenoffizier mit der grauen Poesie seines Dienstes und seinem glänzenden Elend, das einen Selbstbewußten, wenn Zufälle zusammenwirken, in den tragisch gerächten Größenwahn treibt. Gerecht ausgleichend wird erzählt, wie ein adeliger Offizier die Ehe eines Staatsmannes und ein Volksredner die Ehe eines Generals zerstört. Da ist der entsagende Priester; der Arzt, der das heilbringende Messer verachtet und dafür büßen muß; der Dichter in mancherlei Gestalt. Wiener Volk aller Stufen, Proletarier noch nicht als bewußte Klasse, sondern nur gemeinmenschliche Not erduldend, Adel auf mannigfachen Stufen der Entartung, jedes ist jeweils auf seinem eigenen Bilde festgehalten. Saar wählte mit Vorliebe Frauen und später Frauen, die an verirrter Liebe leiden. Es war eine Nacht, die allgemach in *„Novellen aus Österreich"* *Gestalten*

diesen Bildern hereinbrach. Sie erstarrte in Saars letzter Novelle „Die Pfründner" nicht ohne einen leisen Schimmer untilgbaren Menschentums: durch schlechte Ehe herabgekommen, ein Bürger und seine ehemalige Magd, Genossen im Armenhaus und doch im äußersten Elend noch der Zärtlichkeit *Wie Saar erzählt* und eines ritterlichen Opfertodes fähig. Saars Kunst muß Zeichnung heißen. Denn es sind immer Bildnisse und von der äußeren Gestalt nach innen gesehen. Saar war kein Erfinder. Er brauchte Modelle und arbeitet so getreu, daß oft Schlüsselgeschichten daraus wurden. Fast immer ist es ein ganzer Lebenslauf und erinnerungsweise vom Dichter selbst erzählt. Seine Hand zergliedert nicht. Sie berichtet. Umständlich, aber mit großer Kunst und Vielfalt wird die einfädelnde Rahmengeschichte gewendet, bis der Held der Geschichte im Viereck erscheint. Und da alles dem scheinbaren Zufall des Begegnens, Auseinandergehens, Wiederbegegnens zwischen dem Dichter und seinem Helden oder Gewährsmann überlassen bleibt, entsteht der Eindruck kunstloser Natur. Saars „Gedichte" 1882, Sachlichkeit aus Aug und Ohr, sind die Lyrik eines kräftig blickenden, mißtrauischen, tatenscheuen Menschen von stürmischem Lebenswillen und jener derben Offenheit, die den Soldaten nicht minder als das Wiener Blut verrät.

Wie es im Leben zugeht *Ludwig Anzengruber,* 1839 bis 1889, war Wiener nur durch Geburt und Mutter. Erst der Vater war aus Oberösterreich nach Wien gekommen. Und dieser Vater war ein nicht unbegabter Spielbuchdichter. Aus dem mißglückten Schauspieler und kleinen Beamten machte sich das Vorstadttheater seinen letzten Klassiker. Anzengruber ist vom Wiener Lokalstück ausgegangen, wie es in seinen sehr mäßigen bürgerlichen Dramen „Elfriede" 1872, „Das vierte Gebot" 1877, „Heimg'funden" 1885 fortlebt. Dann hat Anzengruber den Bauer zum Träger seiner Weltanschauung gemacht. Das ist der Binnenblock seines Werks, die vier Bauernstücke, zwei tragische und zwei Komödien. Tragisch ist der Entsagungspriester, der „Pfarrer von Kirchfeld" 1870, da er sich, zwischen freie Menschlichkeit und strenge Kirchensatzung gestellt, für *Die Volksstücke* den Glaubensfrieden seiner Gemeinde opfert. Tragisch ist der „Meineidbauer" 1871, wo der Gegensatz ganz allgemein auf Gottesglauben und gottfreies Menschentum bezogen ist. Stück um Stück entsprechen den zwei tragischen die beiden komischen Spiele. „Die Kreuzelschreiber" 1872 zielen auf den erst so entschlossenen und dann so rasch zusammengebrochenen deutschen Widerstand gegen die Unfehlbarkeitslehre. „Der G'wissenswurm" 1874 bringt den Scheinheiligen in seinem Widerspruch zwischen Weltabscheu und Weltfreude auf die Szene. Von da ging es hinab ins Possenhafte und sicherlich nicht hinauf mit seinen schriftdeutschen Spielen. Nur wenige

Stücke hatten, wie man begreift, nachhaltigen Erfolg. Daher mußte Anzen- *Der Kalendermann*
gruber als Leiter des Familienblattes „Die Heimat", des Witzblattes „Fi-
garo", als Kalendermann und Erzähler verdienen. „Dorfgänge" heißt die
Sammlung seiner Kalendergeschichten. Ihre Kernstücke sind die sechs „Mär-
chen des Steinklopferhans" 1874/1875, der Inbegriff von Anzengrubers
Weltanschauung. Sie können wohl neben Rilkes „Geschichten vom lieben
Gott" stehen. Von den beiden Romanen war „Der Schandfleck" 1876 nur im
dörflichen Teil echt, im städtischen gespreizt, während der „Sternsteinhof"
1883 ebenbürtig neben den dramatischen Gipfeln liegt. Anzengrubers Werk
ist bäuerliche Aufklärungsdichtung. Er wollte den Bauer zum Denken er-
ziehen. Seine Helden reihen sich auf vom Strolch bis zum Großbauer, vom
Landedelmann bis zum Schulmeister. Im Schnittpunkt steht der Pfarrer.
Anzengrubers Sprecher sind die Dorfketzer und die Dorfphilosophen. Auch *Dorfketzer*
wenn der Bauer ihm nur Gedankenleib ist und auch wenn er vom naturwah-
ren Bauer weder herkommt noch auf ihn zustrebt, seine Bauern sind dennoch
echt. Seine Dorfsprache ist nicht bestimmte örtliche Mundart, sondern allge-
meine österreichische Sprechweise. „Geschichten, die nur aufweisen, wie es
im Leben zugeht", dies Kunstgesetz Anzengrubers deckt sich mit Stelzhamers
Fassung: „As had si halt so zuetrag, Zwö sollt i's nöt aussag." Seine Spiel-
kunst ist die überlieferte österreichische. Die Handlung ist einfach und dürf-
tig. Gestalt und Gespräch sind alles. Bewegtes Seelenleben will er gestalten.
Die Dinge laufen wie am Schnürchen. Und so spielt viel Unwahrscheinliches
mit. Meist kommt ein Gestern auf. Seine Stücke wimmeln von Hanswurst.
Der Steinklopferhans ist ein Echter derer von Harlekin. Die bühnenmusika- *Der Stein-
lische Note des österreichischen Barocks klingt überall durch. Ganze Strecken klopferhans*
sind zum Melodrama verdichtet. Anzengruber war kein Schwarzseher. Er
glaubte an eine Art tausendjähriges Reich und durch den Segen der Maschine
an einen künftigen Himmel auf Erden. Irdische Mitte ist seine Philosophie.
„Bissel christlich, bissel gottlos, bissel schön, bissel schiach, Bissel gottlos
beim Dirndl, bissel frumm in der Kirch! Dulidieh."

Von dieser Generation, die Saar und Anzengruber vertreten, bis zur näch-
sten, die Kralik und Bahr heißt, ist Außerordentliches geschehen, das der
Verstand nur zum geringsten Teil bewältigen kann. In den böhmischen und
österreichischen Ländern bricht eine Fruchtbarkeit an Talenten auf, die sich
jeder Berechnung entzieht. Die meisten dieser schöpferischen Menschen,
nicht aus den österreichischen, wohl aber aus den böhmischen Ländern, strö-
men in Wien zusammen und geben der Stadt ein europäisches Geistesgesicht.
Das größte Ereignis ist der Aufstieg der Arbeiterklasse ins geistige Leben *Der Arbeiter*

und die Bildung einer ständischen Arbeiterdichtung. Christiane von Breden, 1844 bis 1901, die unter dem Namen Ada Christen schrieb, hat mit ihren „Liedern einer Verlorenen" 1869 und mit ihren Prosabüchern das erste Beispiel einer proletarischen Dichtung in Österreich gegeben. Und Alfons Petzold, 1882 bis 1923, ein Wiener von mitteldeutscher Herkunft, hat ihr mit seinen Gedichten, Novellen, Romanen den höheren Stil des reinen Menschentums zu schaffen gesucht. Indessen den Ausschlag gaben nicht solche Einzelleistungen, sondern die geschlossene Arbeiterbewegung.

Die Verwandlung Wiens ist von drei geistigen Anregern ausgegangen, die zusammenwirkten und einander zeitlich ablösten.

„Der entfesselte Prometheus" *Siegfried Lipiner*, 1856 bis 1911, aus Jaroslaw, war schon als Knabe nach Wien gekommen und ließ sich später taufen. Er wechselte mit Nietzsche Briefe und lebte kurze Zeit bei Wagner in Bayreuth. Sein feuriger Geist zog eine Gefolgschaft junger Leute an. Unter ihnen war Viktor Adler, der die Arbeiterschaft politisch einigte, und Engelbert Pernerstorfer, der sie für geistige Dinge erzogen und zur Dichtung reif gemacht hat. Lipiners Epos „Der entfesselte Prometheus" 1876 machte den befreiten Titanen zu einem Jünger Christi und bereit, für die Menschheit den entsühnenden Opfertod zu sterben. Die letzten Jahre lebte Lipiner einem fast vollendeten Osterspiel, einer Trilogie mit dem Vorspiel „Adam" und den Teilen „Maria Magdalena", „Judas Ischariot", „Paulus in Rom". Hier trat der Ablöser an.

Antike, Christentum, Germanentum *Richard von Kralik*, 1852 bis 1934, aus Leonorenheim im Böhmerwalde, ist nach Hochschuljahren zu Wien, Bonn, Berlin durch die seltsam verschwisterte nationale und sozialistische Bewegung der Zeit hindurchgeschritten. Nach seiner italienischen Reise kam er 1878 zu Siegfried Lipiner. Die griechische Reise und das Erlebnis Oberammergau 1880 schenkten ihm die Einsicht in Wesen und Stil einer nationalen Kunst, der er fortan, nichts als Künstler, dienen wollte. Nach dem Besuch von Bayreuth 1884 nahm er das dramatische Feld unter seinen Pflug. Langbehns Rembrandtbuch 1890 ermutigte ihn zu seinen philosophischen Büchlein. Seit 1900 faßte er fortschreitend seine Aufsätze und Vorträge zu den vier „Kultur"büchlein zusammen. In seiner Villa zu Währing hat er inmitten eines wechselnden und beständigen Kreises von *Richard von Kralik* Schülern und Freunden forschend, dichtend, musizierend, vortragend ein Leben fast nach attischem Zuschnitt wahrhaft ausgelebt. Kralik hat seine Kerngedanken vom Urbild des Hellenentums und von der dreifachen Wurzel der abendländischen Bildung aus Antike, Germanentum, Christentum zu Ende gedacht und dichterisch zu verwirklichen gesucht. Dabei hielt er sich innerhalb der beiden Bezirke, die das nahelegten und erlaubten: „Sage" und

„Spiel". Der Sage galten die beiden umfassenden Neudichtungen „Das deutsche Götter- und Heldenbuch" 1900/1904 sowie „Gralsage" 1907, das wundervolle Prosabuch „Hugo von Burdigal" 1901, die „Heimaterzählun- *„Sage" und „Spiel"* gen" 1909/1910, in hundert Kurzgeschichten die Märe Österreichs aus der Götterzeit der Ostara bis in Kraliks Tage. Bei der Sage ging es um eine Gesamtredaktion. Beim Spiel konnte es sich nur um einen umfassenden Spielplan handeln. Er baute ihn auf aus seiner Trilogie der christlichen Heilsgeschichte im Stil des Mysterienspiels, aus deutschen Sagenstücken im Stil der attischen Tragödie und Komödie, aus Nachdichtungen Calderons und eigenen Festspielen, aus den sieben Geschichtsbildern „Die Revolution" 1908, dem Abschluß seiner dramatischen Dichtung. Die Freilichtbühne und der Laienspieler, die sind es, für die Kralik gearbeitet hat.

Hermann Bahr, 1863 bis 1934, aus Linz, und einer schlesischen Familie, *„Die Moderne"* hat Wien 1881 als Student betreten und in der Burschenschaft für Bismarck geschwärmt. Der Soldat von 1887 kam aus der Berliner Schule der Volkswirtschaftler und hielt es über Engelbert Pernerstorfer mit Viktor Adler. Der Heimkehrer aus Petersburg 1891 war nur noch Zeitungsmann und richtete sich auf Bleiben ein. Für die Monatsschrift „Moderne Dichtung", die 1890 in Brünn erschien, schrieb er den richtunggebenden Aufsatz „Die Moderne". Er war bei der Gründung des Wochenblatts „Die Zeit" 1894 darum bemüht, eine österreichische Kunst heranzuziehen, die sich weder vor Europa fürchtete noch Europa verleugnete. In seinem Blatt hat er den älteren Meistern das Wort gegeben und den Nachwuchs sich zum Wort erziehen lassen. Hier wurde die bodenständige Kritik im Angesicht der Stadt niedergekämpft. Es war durchaus keine Entdeckung, als Bahr hinter Barrès her die österreichi- *Bahr und Barrès* schen Länder entdeckte und zum Angelpunkt der österreichischen Frage machte. Das sind die Tage seines Gerichts über die österreichische Dichtung der Vergangenheit und Gegenwart. Ein gläubiger Katholik geworden, ging *Hermann Bahr* er 1906 als Spielleiter zu Max Reinhardt nach Berlin, war 1908 wieder da und setzte nun im „Neuen Wiener Journal" bei völlig veränderter Lage seine alte Tätigkeit als Zeitungsmann fort. Es blieb bei dieser Arbeit, als er 1912 nach Salzburg übersiedelte. Hermann Bahr in Wien und die moderne österreichische Dichtung, das ist kein Kapitel der Poetik, sondern der Kritik. Er hat nicht gezeigt, wie man's machen müsse, sondern einfach gesagt, was an der Leistung, die er zu beurteilen hatte, gut oder schlecht war. Er hat das Tagebuch seiner Zeit geführt und das vor aller Augen und Ohren. Er hat keine „Richtung" verfolgt. Er hat von Wien nicht den oder jenen Stil gefordert, sondern nur eine österreichische Literatur. Von der verlangte er ledig-

Österreich und Europa lich das eine, daß man aus ihr die europäischen Leistungen spüren und daß sie in Europa gelesen werden müßte. Von ihr wußte er, daß sie mehr aus Natur, als aus Überlieferung barock und daß sie landschaftlich bedingt sei. Herman Bahr und die moderne österreichische Dichtung, das ist mehr ein Verhältnis von Mensch zu Mensch als von Zeitung und Buch. Seine Persönlichkeit, das Gespräch ist das Geheimnis und das Mittel seiner Wirkung. Er hat keine Grundsätze, sondern Ideen in Umlauf gesetzt. Die geistige Haltung Wiens zu seiner Zeit und also die Wiener Literatur seiner Tage ist im wesentlichen sein Werk. Er hat die Menschen einfach mit dem Willen und der Zuversicht angesteckt, etwas Rechtes zu machen. Er hat die Stadt in den Rausch des Schaffens versetzt.

Lipiner, Kralik, Bahr Lipiner, Kralik, Bahr sind die drei Erreger und Anreger der Stadt, jeder anders, als der andere, mit ihren Freundeskreisen einander mannigfach überschneidend, doch eins in ihrem Willen, aus Österreich einen Augenspiegel Europas zu machen.

Arthur Schnitzler *Arthur Schnitzler*, 1862 bis 1931, aus Wien, der Sohn eines Arztes und selber wieder Arzt, spiegelt dieses von Hermann Bahr aufgescheuchte Wien in seiner Art wieder. Von seinen Dichtwerken sind rund 50 als Erzählungen, rund 30 als Einakter, rund 17 als Stücke bezeichnet. Das macht zusammen mit den Versbüchern reichlich 100 einzelne Arbeiten. Alle Gebilde Schnitzlers stammen aus der Dialektik des Nachdenkens. Auf ein anderes Blatt gehört die Tatsache, daß er für seine Führung des Gesprächs sehr viel von der Gesprächskultur des Burgtheaters, des Wiener Salons, des Marmortisches im Künstlercafé gelernt hat. Über das kleine Seelenbild, gleichviel, ob als Novelle oder als Einakter bezeichnet, reichte Schnitzlers Vermögen nicht hinaus. Zur erzählenden Großform fehlte ihm der Zugang. Das Buch „Der Weg ins Freie" 1908, das er als Roman bezeichnete, ist gar keiner. Eine Möglichkeit gab es nur über den Einakter zum Bühnenstück. Keines von ihnen, weder das Schauspiel vom süßen Mädel „Liebelei" 1895 noch „Der Ruf des Lebens" 1906 noch „Der junge Medardus" 1910, der verhinderte Freiheitskämpfer der Franzosenzeit, noch das berufliche Schlüsselstück „Professor Bernhardi" 1912, noch das jambische Seelendrama „Der Gang zum Weiher" 1926, keines ruht auf einer festgefügten wirklichen Handlung. Sie sind zusammengereihte oder aufgeschwellte Einakter. All dieses Befragen des Unterbewußtseins, Traum und Spuk, leise oder lärmende Plötzlichkeiten, frivole Zynismen und schwermütige Empfindsamkeit, vermögen das Geheimnis nicht zu verdecken, daß dieser Arzt alles Ach und Weh nur aus dem einen Punkt zu heilen meint, den Mephistopheles im Auge hat. Es handelt sich nicht um den „Reigen",

jenen Einfall, den nur Schnitzler haben konnte. Es handelt sich um Wien, um Schnitzlers Stadt der Lebemänner und Schürzenjäger, der gepflegten Tagediebe, der Kavaliere und Grisetten, um die verzerrte Legende einer Stadt, die schwer arbeitete und einem tragischen Schicksal entgegenlitt. Richard Beer-Hofmanns Novellen, dramatische Dichtungen wie „Der Graf von Charolais" 1904 und „Jakobs Traum" 1918, „Schlaflied für Mirjam" runden das Bild nach der einen Seite ab, wie nach der andern Peter Altenbergs kleine Prosa und lyrische Lokalspalte.

Richard Beer-Hofmann

Da erscheint das andere Österreich und andere Wien als lebendige Wirklichkeit oder geschichtliche Legende. *Fritz Stüber-Gunther*, 1872 bis 1922, hat die ganze Literatur der Wiener Sittenschilderung, der Friedrich Schlögl, Vinzenz Chiavacci, Eduard Pölzl, Rudolf Stürzer mit seinen Wiener Volksstücken und Romanen anspruchsvoll gehoben. „Rappelkopf" 1921, der Roman Ferdinand Raimunds, enthüllt in letzter Stunde Stübers Herz. Das ist der Dichter, von sich selbst abgerückt in das schon ferne Wien seiner schönsten Tage, die Sehnsucht nach Verstandenwerden und der Schmerz des Unverstandenseins, das Leid und die Lust in demselben Pulsschlage. Charles Dickens und Fritz Reuter waren Stübers Meister. Seine Romane sind nicht lyrisch, sondern stimmungsvoll. Man kann von diesen Büchern nicht sagen, daß sie humoristisch wären. Sie haben nur die Heiterkeit des Überstandenen und des gelassenen innern Friedens. *Emil Ertl*, 1860 bis 1935, stammte aus einer alten Familie von Wiener Seidenwebern auf dem Schottenfeld. Auch er hat — „Der Neuhäuselhof" 1913 — einen Probegang durch die Wiener Vorstadt gemacht. Sein großer Vorwurf, das Werk seines Lebens, ist in der Art Gustav Freytags das Wiener Volk bei der Arbeit, wie „Soll und Haben", und zugleich eine Abfolge mehrerer Geschlechter wie in den späteren Geschichten der „Ahnen". Ertls Dichtung sind keine Wiener Buddenbrooks. Er hat der Wiener Sittenschilderung die geschichtlichen Durchblicke gegeben aus der Gegenwart in die Vergangenheit. Seit dem Anfang des Jahrhunderts entstanden, folgt diese Romanreihe in vier Bänden, „Ein Volk an der Arbeit", den Schicksalswenden des Staates durch hundertfünfzig Jahre. Die Geschichte einiger Familien ist der Stoff, an dem die Verwandlung des Menschen in eine Maschine als die Ursache der beiden entgegengesetzten weltgeschichtlichen Abläufe dargestellt wird: die Vaterländer der Menschen schrumpfen bis auf einen kleinen Winkel der Seele ein und das Reich der Maschine breitet sich über die ganze Erde aus. In Österreich wird dieser weltverwandelnde Vorgang, dessen treibende Kraft das Schwungrad der Maschine ist, am körperlich nächsten und darum spürbarsten erlebt, am Verhältnis der Völker zum

Wiener Sittenschilderer

„Ein Volk an der Arbeit"

Das Reich der Maschinen

Enrica von Handel-Mazzetti

Staate und untereinander im Staate. *Enrica von Handel-Mazzetti,* 1871 bis 1955, aus Wien, schien über die Wiener Novelle in den Wiener Gesellschaftsroman vom Stil der österreichischen Komtesse hineinzuwachsen. Es ist die Kunst der Marie von Ebner-Eschenbach, die in ihrem ersten Urteil über Enrica diese innerliche Verwandtschaft mit ihrem mütterlichen Herzen herausgespürt hat. Der Wiener Gesellschaftsroman ist dann durch die altchristliche Märtyrerlegende verdrängt worden. Nur war es das barocke Zeitalter der Glaubenskämpfe, in deren Denkart, Szene, Kostüm sie ihre Glaubenshelden verpflanzte. Schon der erste Roman, „Meinrad Helmpergers denkwürdiges Jahr" 1897/1900, der Bekehrungskampf um die Seele eines englischen Knaben, wird wenigstens von einem Kremsmünsterer Pater erzählt. Die Romandreiheit, von der der dritte abermals ein Drilling ist, „Jesse und Maria" 1906, „Die arme Margaret" 1910, „Stephana Schwertner" 1912/1914 spielte völlig im österreichischen Donautal der Gegenreformation. So war die denkbar wirklichste geschichtliche Echtheit und heimatliche Moderne für die jungfräuliche Glaubensheldin gewonnen. Nur beiläufig vollzog sich ein Wechsel des Geschlechts, der Zeit und des Ortes in dem Roman um Erzherzog

Märtyrerlegenden

Karl „Der deutsche Held" 1920 und in der Romandreiheit 1924/1927 um Karl Sand. Der Zeit und dem Geschlecht nach kehrte die dritte Gruppe der Romane an den Platz der ersten zurück. Das ist nach dem Vorspiel „Johann Christian Günther" 1928 der Romandrilling „Frau Maria" 1929/1931, der die Wirkung von Günthers Büßertod auf das Keuschheitsopfer eines reinen Mädchens darstellt, und „Die Waxenbergerin" 1934 aus der zweiten Türkenbelagerung Wiens. Wie das religiöse Barockdrama arbeiten diese Romane

Die Gestalt und der Stil

mit einer stehenden Handlung. Der Quäler oder die Gequälte sind abwechselnd katholisch oder evangelisch. Die heiligen Ekstasen der römischen Blutzeugen, die fromme Schwärmerei der Legendenjungfrau, der christliche Eros Thanatos, durch Klostererlebnis und Klosterlektüre zuerst erregt und genossen, haben diese Gebilde erzeugt. Diese Prosaepen sind dramatisch angelegt. Dramatisch ist die Behandlung der Spielbühne, dramatisch die Führung der Wechselrede und der Szene, dramatisch die geballte Kraft des Vorganges. Es sind kulturgeschichtliche Heimaterzählungen, wie die Ortslegende mit Stadt und Flur versponnen. Sie reden die Mundart der dargestellten Zeit. Sie haben einen Stil, der die heldische Größe der Handlung und die getragene Würde des Barock mit einer einzigen Gebärde gibt.

„Die Fackel"

Karl Kraus, 1874 bis 1936, aus Jičin, der schon als kleines Kind nach Wien gekommen war und hier in jedem Sinne seine Schule durchgemacht hat, erhob Anfang April 1899 mit dem ersten Heft „Die Fackel", um in das Zwie-

licht der Wiener Marktliteratur hineinzuleuchten und in Brand zu stecken, *Karl Kraus*
was nicht brennen wollte. Es war ganz und gar seine Zeitschrift. Das wesent-
liche der Fackelbeiträge ist im Lauf der Jahre zu Sammelbänden eingefaßt
worden: „Sprüche und Widersprüche" 1909, „Pro domo et mundo" 1912,
„Nachts" 1919, die Aphorismen; „Sittlichkeit und Kriminalität" 1908, „Die
chinesische Mauer" 1910, die Essays; „Weltgericht" 1919, die öffentlichen
Anprangerungen. Indessen, auch die Gedichtbände „Worte in Versen" 1916
bis 1930 haben zumeist ihre Wurzeln in den Aphorismen der Zeitschrift. Karl
Kraus und seine „Fackel" sind nicht für oder gegen die zeitgenössische Lite-
ratur. Sie verneinen den Geist des Zeitalters schlechthin, weil es der Ungeist
ist. „Satire" ist keine Literaturgattung, sondern Kunststil. Kraus hat ja auch
aus dem gleichen Stil nicht nur Essays, Glossen, Aphorismen, sondern auch
Sinnsprüche und Gedichte geschaffen. Sein Werk ist nicht um seiner Sprache
willen, sondern von Wurzel und Wesen auf Kunstwerk, das erste und zu-
nächst letzte Kunstwerk, das die Welt „schlecht" macht aus dem tiefsten
pessimistischen Glauben an ihre unrettbare Bestimmung.

In den letzten Tagen des Oktober 1918 war nach vier Jahren Krieg alles
zu Ende. Karl Kraus hat das Ereignis — „Die letzten Tage der Menschheit"
1918 — in ein Drama gefaßt, für das es keine Bühne gibt. Das untergehende
Österreich ist der Schauspieler dieser Tragödie des apokalyptischen Ent-
setzens.

Die *ÖSTERREICHISCHE LANDSCHAFT* war zwischen 1866 und 1914
in ihrer Weise fruchtbar und folgte ihrem eigenen Gesetz. Das Donautal gab
sich unter der Enns und ob der Enns in zwei Dichtern kund, deren jeder seine
Zeit hatte und die beide Schulmeister waren. *Robert Hamerling*, 1830 bis *Der Dichter der*
1889, aus Kirchberg am Walde, ist zwischen Grillparzer und Bahr der Dich- *Zwischenzeit*
ter. Seine Lyrik, die er in Bücher mit schwungvollen Aufschriften sammelte,
trägt schön Gedachtes schön gesprochen vor. Seine umfassende Gebärde und
Vermögen des getragenen Worts legten ihm das Großgedicht nahe. Sie haben
alle den Stil einer grellen Schwarz-Weiß-Kunst: „Ahasver in Rom" 1866 mit
seinem Widerstreit von Leben und Tod; „Der König von Sion" 1869 mit
seiner Spannung von sinnlicher Schönheit und christlicher Entsagung; das
Drama „Danton und Robespierre" 1871 mit seinem Kampf zwischen Genuß-
sucht und Sittenstrenge. Nicht minder bequem machten es sich die Satiren,
das Drama „Teut" 1871 als Abrechnung mit dem zeitgenössischen Deutsch-
land und Österreich, das Epos „Homunkulus" 1889 mit seinem Angriff auf
die modernen Naturwissenschaften, den kommenden Arbeiterstaat, den che-
mischen Krieg der Zukunft. Doch sein altgriechisches Zeitgemälde um Perik-

les „Aspasia" 1876 und das anmutig tiefsinnige Märchen „Amor und Psyche" 1882 zeigen alles, was ihm lag, und verrieten, was er auf dem Herzen hatte. „Die sieben Todsünden" 1872, nach dem Geist und Stil ein barockes Bild der Seele und Welt sowie das Hanswurststück „Lord Lucifer" 1880 bezeugen, daß Hamerling auch anders konnte. Dieser Dichter steht großartig eigenwillig zwischen der vorigen und der künftigen Zeit. Er hat Wieland und Schiller im Rücken. Doch vor sich, von seinem triestinisch-venezianischen Bildungsraum aus, über seinen Wortschwung, seinen epischen Stil, seine geschichtsphilosophischen Gesichte hinweg, hat er Theodor Däubler. *Edward* *Samhaber,* 1846 bis 1927, aus dem oberösterreichischen Freistadt, wußte unnachahmlich Märchen wiederzuerzählen und als geschulter Sprachkenner mittelalterliche Dichtungen nachzubilden. Samhabers „Lyrische Dichtungen" 1887 sind ein wundervolles Buch. Mundart und Hochsprache klingen rein zusammen. Oden in der Weise des Horaz, Lieder im Tonfall Walthers von der Vogelweide, Gesätze wie aus dem Munde Stelzhamers geben eine einzige Melodie.

Horaz, Walter, *Stelzhamer*

Die Steiermark Steiermark zeigt einen vielfarbigen Querschnitt. *Wilhelm Fischer,* 1846 bis 1932, aus Csakathurn, doch in Graz völlig zu Hause, konnte mit „Atlantis" 1880 das Epos höheren Stiles, spanische Erzählungen nach Paul Heyse, Renaissancegeschichten nach Conrad Ferdinand Meyer, „Grazer Novellen" 1898 nach Gottfried Keller. Und „Sonnenopfer" 1908 stellte am steirischen Sensengewerbe den Kampf zwischen Handarbeit und Maschine dar. *Ottokar* *Kernstock,* 1848 bis 1928, aus Marburg an der Drau, doch von sudetendeutscher Herkunft, Mönch zu Vorau und Pfarrer zu Festenburg am Wechselgebirge, sang in seinen Gedichten die mittelalterliche Spielmannsweise überzeugend nach. Sein altertümlicher Stil ist echt, weil er sich modern gibt, und ohne Manier, weil er eine wirkliche Gesinnung ausdrückt. *Hans Grasberger,* 1836 bis 1898, aus Obdach, hat gleich gute Gedichte auf Schriftdeutsch und in der Mundart zustande gebracht. Er hat in Italien wirklich gelebt, sich Sprechweise und Kunstart römischer Maler zu eigen gemacht. Also ist auch in seinen glänzenden Novellen nicht die bäuerliche Umwelt das, worauf es ankommt, sondern die Gestalt des Künstlers. Seine „Sieben Kaiserlegenden" 1899 bestätigen gar nicht den Bauerndichter, der Grasberger nicht gewesen ist, sondern den Dichter rundweg. *Hans Rudolf Bartsch,* 1873 zu Graz geboren, hat in dem heißblütigen, weichen, lyrischen Prosateil seiner Bücher die epische Gegenweise zum lyrischen Spielmannston gefunden. Seine frühen Novellenbücher sind moderne, anmutige Nacharten jener kleinen Gebilde, die das Mittelalter „Märe" genannt hat. Mit dem Schubertroman „Schwam-

„Grazer *Novellen"*

Der Spielmann

Künstler- *geschichten*

„Die Märe"

merl" 1912 ist Bartsch von der alten romantischen zur modernen geschicht-
lichen Musikerdichtung übergegangen.

Peter Rosegger, 1843 bis 1918, vom Hof des Untern Kluppeneggers in Alpl *„Waldheimat"*
bei Krieglach, hat Österreich von 1866 bis 1918 schaffend durchlebt. Der
Bauernjunge wurde, da ein kleiner Pfarrer nach dem Wunsch der Mutter
mißriet, Lehrling und Gehilfe eines Wanderschneiders. Das war Roseggers
hohe Dorfschule: werktags Schneider, feiertags Dichter. Er wurde entdeckt
und erhielt an der Grazer Handelsakademie den herkömmlichen Mattschliff
der Bildung. Rudolf Falb, der Wetterforscher, katholische Priester und spä-
ter Protestant, hat den Waldjungen ins Weltleben gesteuert. Es wurde ein
rascher Aufstieg und ein plötzlicher Halt: 1869 die zwei mundartlichen
Bände, 1870/1872 die zwei volkskundlichen Bände, 1872 das Novellenbuch,
1873 „Waldheimat", 1875 „Die Schriften des Waldschulmeisters". Die zwei
mundartlichen Bände sind „Zither und Hackbrett" lyrisch, „Tannenharz und
Fichtennadeln" Prosa. Das lyrische Buch ist der uralten österreichischen See-
lengemeinschaft von Lied und Saitenspiel entsprungen, sprachlich silberfein
abgetönt zwischen Mundart und Bildungssprache und von jener kecken Fröh-
lichkeit beschwingt, durch die der Ernst nur wie abgeblendet funkelt. Das
epische Zwillingsbuch bietet aus der überlieferten Erzählkunst des Volkes
mundartliche Geschichten, Sagen, Märchen, Naturbilder. Von den beiden
volkskundlichen Büchern gibt „Volksleben in Steiermark" 1870 Haus und
Tag und Jahr des steirischen Waldbauern, während „Die Älpler" 1872 sich
schon im Nachzeichnen bestimmter Stände und einzelner Dorfgestalten üben.
Die drei Bände „Buch der Novellen" 1872 sind Lehrstücke, die eben darum *„Die Älpler"*
die Verwandtschaft mit der gedichteten Literatur nicht ganz verleugnen kön-
nen. Die zwei Bände „Waldheimat" 1873 sind die Krone und für die zeit-
genössische Dichtung ein Ereignis. Erlebnis und Dichtung sind eins. Kunst
ist hier nichts als erzählen, wie das Jungsein im Walde gewesen ist. Das Buch
gibt davon Zeugnis, daß Rosegger zwei gefährliche Spannungen überwunden
hat, die von Bauernmensch und Stadtmensch, die von Dichter und „Dichter". *Dichter*
und „Dichter"
Er ist in die Stadt und in die Literatur übersiedelt, ohne aus der Natur und
der Dichtung ausgezogen zu sein. „Die Schriften des Waldschulmeisters"
1875 gehen in Geist und Form von Stifters „Mappe" aus. Ein Lehrer macht
aus Holzknechten und Kohlenbrennern Bauern und aus Bauern eine Ge-
meinde. Mit dem Tod seiner jungen Frau 1875 erlebte der Dichter gleich-
zeitig den Niedergang seines Vaterhauses und der bäuerlichen Wirtschaft im
Lande. Um sich durch regelmäßige Pflichtarbeit zu retten und durch bestän- *„Heimgarten"*
digen Zuspruch den Menschen wieder für ein natürliches Leben zu gewin-

nen, ließ Rosegger am 1. Oktober 1876 seine Zeitschrift „Heimgarten" er-
scheinen. Mit dieser Zeitschrift wurde Rosegger das Gewissen Österreichs,
das unablässig mahnte: zurück aufs Land. Die Fruchtbarkeit, die diese Zeit-
schrift von ihm forderte, sammelte sich in den nachwachsenden Bänden seiner
Werke. Rosegger ist nicht selten der Versuchung unterlegen, ein „Dichter"
zu sein. Doch mit dem dritten und vierten Bande der „Waldheimat" und mit
den nie versagenden Schwänken aus dem Volksleben erzählte er sich immer
wieder in sein echtes Wesen zurück. Sechs Romane begleiten Roseggers Grat-
Roseggers wanderung auf der Höhe seines Lebens. „Heidepeters Gabriel" 1882, „Der
Romane Gottsucher" 1883, „Jakob der Letzte" 1888 zeigen die bäuerliche Lage von
der düstern, „Das ewige Licht" 1897, „Erdsegen" 1900, „I. N. R. I. Frohe
Botschaft eines armen Sünders" 1904 von der zuversichtlichen Seite. Natur
als Lebenskraft, Natur als sittlicher Grundsatz, Natur als Stilgesetz, daran
hat sich Rosegger als Mensch und Dichter gehalten. Rosegger folgt geistes-
geschichtlich auf Stifter und Postl. Er steht ebenbürtig neben Saar, Ebner-
Eschenbach, Anzengruber.

Tirol Tirol fand zu keiner rechten geistigen Einheit mehr, seitdem im Lande das
Josefinische Fieber ausgebrochen war. Das gute Herkommen und der wackere
Fortschritt, der fromme Glaube und der aufgeklärte Freisinn haderten auch
in der Dichtung miteinander. Auf der Linken kam im Laufe der Jahre bei-
nahe die ganze Tiroler Literatur zusammen. Sie ist auf weiten Strecken nichts
als Roman und so gut wie immer Tiroler Heimatroman, bei Rudolf Greinz,
Hans von Hepperger, Albert von Trentini, Hans Schrott-Fiechtl, Heinrich von
Domanig Schullern. Die Leistung Tirols ist diesmal das Drama. *Karl Domanig*, 1851
bis 1913, aus Sterzing, hat ziemlich altmodisch mit der Verserzählung „Der
Abt von Fiecht" 1887 und zeitgemäßer mit heimatlichen Prosageschichten
begonnen. Über alles ragt die mächtige Trilogie „Tiroler Freiheitskampf"
1885/1897 hinaus. Der handelnde Held, durch den diese Dreiheit ein Ganzes
wird, ist das Tiroler Volk. Um den Unterschied des Tons in die immer gleich-
gestellte Szene zu bringen, reden die Gestalten bald mit Schiller, bald mit
Kranewitter Anzengruber. *Franz Kranewitter*, 1860 bis 1938, aus Nassereith, stellte in-
mitten der Erbhoftragödie „Um Haus und Hof" 1895 und der Künstlertra-
gödie „Wieland der Schmied" 1905 zweimal den Bauernrebellen auf die
tragische Szene. Das eine Mal war es der Bauernbefreier von 1525, „Michel
„Andre Hofer" Gaißmayr" 1899, das andere Mal der Held vom Berge Isel „Andre Hofer"
1902, beide Male der Gutgläubige in den arglistigen Schlingen seiner Gegner
oder Verbündeten. Was Kranewitter konnte, das bezeugt der gewaltige Fries
von Einaktern, der diesen Dichtungen entlangläuft. Das sind „Die sieben

Todsünden" 1905/1926, eine Spielfolge von den Abgründen der menschlichen Seele, Hochmut und Geiz und Unkeuschheit, der Neid, Völlerei und Zorn und Trägheit. „Der Totentanz" beschließt die sieben bäuerlichen Szenen, in denen der Bauer nicht um seinetwillen, sondern für die menschliche Natur auf der Bühne steht. *Karl Schönherr*, 1867 bis 1943, aus Axams, hat sich im Nachleben der Tiroler Marterl einen Stil von fruchtbarer Sachlichkeit und Kargheit gewonnen und das Herz auf jene Verwegenheit gestimmt, die selbst dem Tode lachend begegnet. Die tragische Laune seiner Spiele ist Geist dieser einfältigen Tiroler Volkskunst. „Der Bildschnitzer" 1900, „Sonnwendtag" 1902, wo der Sohn zum Schmerz seiner Mutter nicht geistlich werden kann, und „Karrnerleut" 1904, die Tragödie eines Landstreicherjungen, spielten dem Dichter rasch einen echten Wahrhaftigkeitsstil in die Hände. Die Bauernkomödie des Unverwüstlichen, „Erde" 1907, und „Der Weibsteufel" 1915, Hebbels Vorwurf vom Weib als Ware auf bäuerlich, gehören innerlich ebenso zusammen wie die beiden geschichtlichen Tiroler Stücke „Glaube und Heimat" 1910 aus der Zeit der Gegenreformation sowie „Volk in Not" 1916 um die Iselbergschlacht. Aus dieser Reihe schweifte „Familie" 1905 auf die dürre Weide Ibsens ab und verdarb, „Das Königreich" 1908 aber auf die grüne Weide Raimunds und gedieh. Gewaltige Bühnenkraft, die im Darstellen, nicht im Fragestellen liegt, das ist der wesentliche Zug an Schönherrs Kunst. Sie hat zwei Merkmale: die stumme sinnbildliche Gebärde an einzelnen Gestalten, im Aufbau ganzer Szenen, zumeist am Schluß des Spiels und an gehobenen Stellen die Wiederkehr derselben Wendungen, „Leitmotive", ein Ersatz für die fehlende Musik. Bei Domanig, Kranewitter, Schönherr ist es im Grunde dieselbe Kunst. Der Unterschied liegt nicht im Was, sondern nur im persönlichen Wie.

Ludwig von Ficker gründete im Juni 1910 zu Innsbruck die Halbmonatsschrift „Der Brenner". Sie hieß nach dem Berg, der eine Wasserscheide zugleich und ein Paß zwischen Norden und Süden ist. Sie wollte über alle Tirolerei hinaus. Rasch wurde man gewahr, daß hier ein Geist sich durchrang, der ganz Österreich anging und nach Europa wollte. Unter den Mitarbeitern erschienen viele Wiener: Robert Michel, Richard Smekal, Peter Altenberg, Franz Theodor Csokor, Otto Stößl. Die beiden Tiroler waren Arthur von Wallpach, in farbigen und sehr zarten Versbüchern ein Naturheide, nur auf den Gott getauft, der allein mit den Dingen ist, und Karl Dallago, ein Meister gedankenvoller Aphorismen. Rabindranath Tagore, Fedor Dostojewskij, August Strindberg wurden gedruckt. Theodor Haecker machte Soeren Kierkegaard und das Christentum zum beherrschenden Ge-

„Glaube und Heimat"

Schönherr, Ibsen, Raimund

„Der Brenner"

genstande der Zeitschrift. Schon der erste Jahrgang brachte eine tiefgehende
Anzeige von Theodor Däublers Großgedicht „Nordlicht". Seit dem Maiheft
1912 erschien keines mehr, das nicht ein Gedicht Georg Trakls gebracht hätte.

Die Großwelt Österreich-Ungarn zerfiel 1918 in Kleinwelten wie ein gro-
ßer Würfel in kleine. Aus einem Völkerstaat waren deren fünf geworden. Die
Deutschen lebten sich seit 1918 in ihren neuen Heimatstaaten zurecht. Und
da viele der Schaffenden zu dieser Zeit auf der Höhe des Lebens standen,
also in vollem Schwunge waren, so läßt das Gesamtgesicht der Dichtung auch
vorerst keine wesentlichen Veränderungen erkennen.

Siebenbürgen Die *UNGARISCHEN LÄNDER* zeigen zwischen 1918 und 1938 Fülle
und Höhe, ein geschlossenes Bild, nur in dem Raume, der an Rumänien fiel.
Das ist Siebenbürgen. *Adolf Meschendörfer* hatte seine Zeitschrift „Die Kar-
paten" 1914 geschlossen. Sein eigenes Werk ist von bescheidenem Umfange:
„Die Stadt im Osten" Gedichte, Dramen, Romane. „Die Stadt im Osten" 1931 ist eine Bildungs-
geschichte und siebenbürgisches Zeitgemälde. Das Gefühl dichterischer Ver-
antwortung, das Meschendörfer geweckt hatte, ist weitum zu spüren. *Richard
Csaki* unternahm es ernstlich, seiner Vaterstadt Hermannstadt die Führung
im geistigen Leben des rumänischen Deutschtums zuzuschlagen. Seine Kul-
turzeitschrift „Ostland" begann 1919/1921 zu erscheinen und sie wurde
1926/1931 fortgesetzt. Indessen, es blieb bei Kronstadt. *Heinrich Zillich,*
„Klingsor" 1898, aus Kronstadt, gründete 1924 die Zeitschrift „Klingsor". Sie bekannte
sich zur Verständigung mit den Rumänen. Der Dichter ist ein Erzähler mit
der gelassenen Freude an den Dingen. Seine Form ist die gedrungene No-
volle. Sie steht als Kurzgeschichte in den Sammlungen, die von „Siebenbür-
„Siebenbürgische Flausen" gische Flausen" 1926 bis zur „Reinerbachmühle" 1935 eine schöne Kette bil-
den. Das sind Menschen aus dem Leben, wie es ist, ungemein lebendig
wiedergegeben, Geschehnisse von unerbittlicher Schlüssigkeit und mit ver-
haltenem Gefühl sachlich berichtet. Das Zeitbuch „Zwischen Grenzen und
Zeiten" 1936 schildert den Untergang der Monarchie und die Wendung
Siebenbürgens vom Westen zum Osten. Rings um Kronstadt stehen die Kar-
paten. Ihre Wälder und freie Wildbahn hat *Emil Witting*, 1880, aus Kron-
stadt, zur Dichtung gemacht, der Förster und Jäger der Siebenrichterwälder.
„Hirtenfeuer" 1932, der unvergleichliche Roman, schildert ein Jahr aus dem
verschollenen Leben der rumänischen Karpatenhirten. Seine Helden sind die
Der Karpatenbär und der Berghirsch Bergtiere. Sie erscheinen in ihren Jagdrevieren: „Frate Nicolae" 1931, der
gewaltige Karpatenbär, und „Der Fechter" 1935, der tapfere Berghirsch.
Eine Welt wie die, menschenferne, erhaben, unergründlich, muß ihre eigene
Sprache haben. Die redet das unentweihte Jägerdeutsch des Dichters, seine

erregenden Geheimworte, seine Sätze, in denen das aufgescheuchte Blut des Beschleichers und heimlichen Belauschers klopft. Der Hermannstädter *Erwin Wittstock*, 1899 geboren, rundet nun doch diese Zweiheit aus Kronstadt und Hermannstadt zu einem schönen siebenbürgischen Ganzen. Schon seine erste Probe, „Zineborn" 1927, Novellen aus dem Volksleben der Landschaft, war gelungen. Der Roman „Bruder, nimm die Brüder mit" 1933, ein breiter Querschnitt durch das erste rumänische Jahrzehnt Siebenbürgens, läßt alle Kräfte erkennen, durch die sich dieses Volk acht Jahrhunderte lang behauptet hatte, und die schwer lösbaren Bindungen, die es im gleichen Raume mit Magyaren und Rumänen verflochten. „Die Freundschaft von Kockelburg" 1935 ist ein schön gerahmtes Buch von wahren Meisternovellen. Sie werden vorgetragen von sieben Freunden, die einander nach Jahren der Trennung in einem Waldwirtshaus wiederbegegnen. Von guter Laune bis zu tragischer Erschütterung spielen sie alle Tonarten des Lebens durch, wie es aus der Einheit von Landschaft und Mensch an den Tag tritt und wieder ins Dunkel stürzt. „Die Gesetze sind streng, und wir können jenen bedauern, den sie treffen — aber wir können sie nicht ändern." — Wittstock ist der geborene Erzähler, kaum zu übertreffen in seinem zögernden, hinhaltenden, steigernden, jäh niederschmetternden Vortrag, durch den er seine atembeklemmenden Spannungen erzielt.

„Die Freundschaft von Kockelburg"

Die *BÖHMISCHEN LÄNDER* haben in diesem Zeitalter zwischen 1918 und 1938 eine Literatur erzeugt, die an Fülle beinahe über die Kopfzahl der deutschen Bevölkerung hinausgeht. Ihre Träger sind, wie natürlich, alle in der Monarchie geboren, viele noch in ihrem fernsten und tiefsten Frieden. Aber erst in diesen Schicksalsjahren hat sich diese Literatur entfaltet. Die einzelnen Landschaften heben sich voll und deutlich heraus.

Im Böhmerwald war eine ziemlich reiche bodenständige Literatur, zumeist von Lehrern geschrieben, im Werden, Sittenschilderungen bei Johann Peter, die üblichen Landromane bei Anton Schott, anspruchsvollere Geschichten bei Josef Gangl. Die jüngere Generation, wie die beiden Budweiser Karl Franz Leppa und Friedrich Jaksch, vertiefte sich dichterisch in die Geschichte und räumliche Lage des Landes. Von der älteren Generation hat *Hans Watzlik*, 1879, von Unterhaid, seine Gabe für die balladenhafte Erzählung, wie sie das frühe Buch „Im Ring des Ossers" 1913 offenbart, wahrhaftig nicht vergraben. Seinen Romanen hat er einen gemäßen Stil nicht sogleich gefunden. „Phönix" 1916 geriet zu weit in die Geschichte und „O Böhmen!" 1917 zu nahe an die Gegenwart heran. Das menschliche Herz, naturdämonisch verstrickt in seine aufgestörten Gelüste, angsterfüllt und dem Unsichtbaren aus-

Der Böhmerwald

Hans Watzlik

geliefert, dieses arme Herz, das am Boden flattert und auf in den Tag fliegen möchte, wurde der Held in allen Geschichten des Dichters. Dieses besessene und verschreckte Herz verstieß der Dichter in die dunklen Abgründe des heimatlichen Waldes und vergangener Tage. „Der Alp" 1914, der Roman von den kometengeschreckten Einödbauern bis zu dem Buch „Der Teufel wildert" 1933, das sind keine Geschichtsromane aus dem Grenzgebiet des Waldes, sondern Mythen. „Das Glück von Dürrnstauden" 1927 und „Die Leturner Hütte" 1932 machen diesen Dämonenzauber im wachen Tagwerk der Wirtschaft spürbar. Zuletzt werden es ziemlich heitere Geschichten und tragische Helden der Geschichte. Es ist der gleiche Dorfbarock, wie er in den

Hilda Bergmann Spielen Richard Billingers und Max Mells erscheint. *Hilda Bergmann,* 1878, aus Prachatitz, aber von einer nordböhmischen Bauernfamilie, ist eine glückliche Märchenerzählerin. All ihre Gedichte, „Die heiligen Reiher" 1925, „Die stummen Dinge" 1933, „Zünd Lichter an" 1936, sind aus der Wiener Ferne der unvergessenen Heimat zugesprochen. Es sind ausgerundete Bilder der Andacht, aus der Seele herausgebetet und weihevoll vor das betrachtende Auge hingestellt. Die Andacht der Welt, festlich mitten im Leben gehalten, nicht ohne mystische Inbrunst, Andacht des Menschen ohne Unterschied des Geschlechts.

Das Egertal Das Egertal, der Zug des Erzgebirges, der es nördlich, die Höhen, die es südlich begleiten, machen die Landschaft zwischen dem Fichtelgebirge und dem Engpaß der Elbe zu einem schön gegliederten Ganzen. Anton Günther von Gottesgab, Dichter und Tonsetzer zugleich, sprach in seinen Liederheften und Bilderkarten jene empfindsamen Weisen des Heimwehs aus, das den weitgereisten Erzgebirglern von je ein tröstlicher Begleiter war. Das Egerland und seine bürgerliche Kleinwelt hat *Rudolf Haas,* aus Mies, in seinen zahlreichen Büchern lebensgläubig festgehalten. *Anton Franz Schmidt,* aus Teplitz-Schönau, erzählte von „König Tod" 1918 bis „Die Flucht" 1932, eine knappe Folge von Novellen, die gern von der Bewährung und Erfüllung des Todes handeln. Seine Stücke suchten die mannigfaltigen Stilgedanken zu entwickeln, die von der Bühne des Mittelalters, aus der Jugendbewegung, durch die Wanderbühnen in die Spielpflege des Bühnenvolksbundes eingegangen

Saazer Landschaft waren. *Emil Merker,* aus Mohr bei Podersam, preist in Versen von wuchtigen Rhythmen die fast mythische Fruchtbarkeit der Saazer Landschaft, die smaragdenen Rübenäcker, die geheimnisvoll wehenden Girlanden der Hopfengärten, die weizenbraunen und roggenblonden Felder, die kaum sichtbare fette schwarze Erde. Der großangelegte ländliche Roman „Der Weg der Anna Illing" 1938, erzählt das Opferleben eines hochherzigen Mädchens.

Hans Deisinger, aus Mies, fängt in seinen heiteren und beschwingten Strophen den Kreislauf des Jahres ein. Der Roman „Das ewige Antlitz" 1937 spielt im Frankreich des großen Krieges und meint das ewige Menschentum, in dem der Haß der Völker erlischt. *Wilhelm Pleyer,* aus Eisenhammer, aber von erzgebirgischer Herkunft, packte in seinen Versen „Aus der Spaßvogelschau" 1924 und in seinen Kalendergeschichten den Bauer sehr handfest an. *Bruno Brehm,* von Laibach, doch aus einem Egerländer Bürgerhaus, hat sich einen öffentlichen und privaten Doppelstil geschaffen; den öffentlichen durch die lange Reihe geschichtlicher Romane, worunter „Die schrecklichen Pferde" 1934, die wahren Helden des Welserzuges nach Venezuela; den privaten durch die bezaubernde und völlig persönliche Erlebnisdichtung in den Sammelbänden kleiner Geschichten, die ganz menschliche Komödie sind. Von Egerländer Bauern stammte *Augustin Popp,* 1873 bis 1944, aus Wscherau bei Pilsen, und zu Wien hat er priesterlich in Schule und Seelsorge gewirkt. Dieser Dichter ist so spät gereift wie selten einer. „Die Antlitzgedichte" 1927 heißen so von ihrem Leitmotiv: Gottes Angesicht in den Dingen. Sie sind Rilke und Trakl verwandt. Und also tönen sie um das andere Leitmotiv: der Wurm des Todes im Fleische des Lebens. „Die milde Stunde" 1933 ist von ländlicher Natur, männlicher Laune und irdischer Sterblichkeit. Alle, meist strophisch gebundene Gedichte, haben einen odenhaften Klang. Sie führen eine hohe und feierliche Sprache. Denn selbst das Häßliche wird durch gottverwandte Schau in gelassene Freude am Sein verwandelt. Es sind priesterliche Gedichte, jedes eine heilige Handlung, mit Andacht und bedeutsamer Gebärde vollzogen, alle gehandelt und jedes voll kreatürlicher Natur. Das Dunkel in allen Dingen ist Gott. „Immer singen die Grillen, ich weiß nicht, was: Kleine, eintönige Geigen aus Glas." Aus dieser hohen Kunst fehlt der Zug ins Possenhafte nicht, der übermütigen Spieles den Tag in die Ewigkeit mengt. Popps Roman „Lumpen und Liebende" 1930 fischt mit dem Schleppnetz Gottes Gewimmel aus dem Großstadtgewässer Wiens, Geglückte und Mißratene, insgesamt Gottes Schöpfung. Das schönste Buch solch burlesker Laune ist „Hildemichel" 1933, Märchen von Brentanos Art. *Erwin Guido Kolbenheyer,* 1878, aus Budapest, stammt von einer Karlsbader Mutter, ist in Westböhmen aufgewachsen, in Wien zu wissenschaftlicher Seelenkunde geschult. Im Mittelpunkt seines Gesamtwerks steht „Die Bauhütte" 1925, eine Auseinandersetzung mit der gesamten idealistischen Philosophie. Ihr entgegen geht Kolbenheyer vom Lebensplasma aus und versucht auf die Lebenskunde eine Metaphysik zu gründen. Dichterisch wird diese Mitte sichtbar durch das „Lyrische Brevier" 1928, ein Buch der Natur, ebenso an-

„Immer singen die Grillen"

„Die Bauhütte"

mutig in seinen malerisch gegenständlichen Landschaftsbildern wie tief in seiner Naturphilosophie. Aus der innersten Mitte dieses Buches strömt der Gedichtreigen „Fons Carolinus", ein sechsteiliger Hymnus auf den heilbringenden Wasserstrahl des Karlsbader Sprudels, der schlank und zierlich aus abgründigen Tiefen sprühend ans Licht dringt, ein mythischer Hymnus auf das Leben, das nach Ursprung und Natur göttlich ist. Um diese Mitte kreist *Erwin Guido* das Werk, die eine Hälfte Roman, die andere Drama. Die Entstehungsfolge *Kolbenheyer* der Romane ist zugleich der Bildungsstufengang des Dichters. „Amor dei" 1908 ist das Holland des späten siebzehnten Jahrhunderts um Rembrandt und Spinoza, Zusammenklang von hundertstimmigen Ausbrüchen scheinbarer Gottesliebe und vermeintlichen Gotteshasses. „Meister Joachim Pausewang" 1903, um Jakob Böhme der Roman einer ganzen Zeit im Ringen um das Durchleben der „Umstände", die Rilke „Dinge" nennt. Indem man sein Eigentum aus den „Umständen" zieht, „wie der Chimist die Quinta Essentia aus der groben Natur der Matrix zeucht", geschieht im unendlichen Gott, im *„Paracelsus"* Heiland als Menschensohn, in jeder Kreatur das gleiche. Die Trilogie „Paracelsus" 1917/1925 verfolgt an dem großen Arzt des Humanismus den Gedanken, dem deutschen Volk sei es für die nächsten Jahrhunderte bestimmt, durch die Fremdheit seiner Religion hindurchzuwachsen zum eigenen We- *„Das gottgelobte* sen. „Das gottgelobte Herz" 1938 bewältigt das Zeitalter der drei mystischen *Herz"* Meister Eckhart, Tauler, Seuse, das Zeitalter der Seelennot und Herzensfrömmigkeit. Diesmal ist es die Frau, die Nonne Margarete Ebner zu Medingen. Das Gottgeheimnis der menschlichen Frömmigkeit konnte mit seinem letzten unbetretbaren Bezirke nur aus der Natur der Frau angedeutet werden: Einswerden mit Gott aus bräutlichem Verlangen und durch mütterliche Empfängnis. Wie ein Schauspieler alle Leidenschaften, so spricht Kolbenheyer alle Mundarten und Sprachen. Von Kolbenheyers Dramen ist „Die *Die Dramen* Brücke" 1929 ein gleichnishaftes Spiel um einen Architekten, die Jugend an die goldene Brücke aus der Vergangenheit in die Zukunft zu erinnern, während „Jagt ihn — ein Mensch" 1931 zu dem Gedanken strebt, daß jede Erfindung ein Geschenk der Natur ist, bestimmt zum Gemeingut der Menschen, indes „Gregor und Heinrich" 1934 den weltgeschichtlichen Kampf zwischen Papst und Kaiser aufrollt. Die Fuge aller Dramen ist die Tragödie, die 1903 „Giordano Bruno" und 1929 „Heroische Leidenschaften" hieß. Die erste Fassung war eine Tragödie des Freigeistes, die zweite ist die Tragödie des Genies. Bruno verneint Gedächtniskunst und Denkgeleise. Er will dem Le- *Freiheit aus* ben selber auf die Spur kommen. „Der Seher wird frei, kraft des Verlangens *dem Urlicht* derer, die sich nicht selbst erlösen können, und die Gebundenen werden frei,

kraft des Verlangens, das der Seher aus dem Urlichte empfangen hat." Die Selbstdarstellung „Sebastian Karst" 1957 f., drei Bände, gibt von einem Leben und einer Leistung Rechenschaft, die nur von seinesgleichen gewürdigt werden kann.

Die nordböhmische Landschaft, die sich vom Gebirge her gegen die Elbe *Nordböhmen* herabsenkt, lebt auch in denen fort, die diese Heimat schon in ihren Eltern oder in jungen Jahren verlassen haben. Der Lehrer Gustav Leutelt aus Josefstal hat mit Vorliebe an Kinderschicksalen die wirtschaftlichen und gesellschaftlichen Fragen dieser waldbewachsenen kargen Landschaft anschaulich gemacht. *Robert Michel*, 1876, aus Chaberic, stammt aus einer Familie der Gegend von Leipa, ist auf einem Gut bei Leitmeritz aufgewachsen und Offi- *Robert Michel* zier des Kaisers geworden. In seinen „Geschichten von Insekten" 1911 hat er mit gespitztem Griffel das heimliche Leben der Kleinsten unter den Tieren nachgezeichnet. Er hat Karstlandschaft und südslawisches Volksleben, wo sie farbiges Morgenland sind, gemalt — „Die Häuser an der Džamija" 1915 bis zu „Halbmond über der Narenta" 1940 — und mit „Jesus im Böhmerwald" 1927 die Nachfolge Christi eines Knaben erzählt, ähnlich wie Gerhart Hauptmann. „Die Burg der Frauen" 1934 rollt wie unmittelbare Gegenwart die Urgeschichte des tschechischen Volkes auf, die kriegerisch wilde und ackerlich fromme Märe von Libussa und Primislaus. *Franz Nabl*, 1883, aus Lautschin, *Franz Nabl* ist schon als Kind seiner Heimat entführt worden, lebte zu Wien und Baden, bei Mariazell und am dauerhaftesten zu Graz. Er hat sich in wirksamen Dramen erprobt, seine Meisternovellen, zumeist aus dem Leben des Kindes, zu dem Buch „Das Meteor" 1935 zusammengefügt. Künstlerisch in der Mitte dieses nur mäßig weitgespannten Werkes stehen die beiden älteren Romane „Der Ödhof" 1911 und „Die Ortliebschen Frauen" 1936, ein bezügliches Paar. Der Mann und die Frau, die Übersteigerung ihrer natürlichen Triebe bis in den Widersinn der Natur, die Zerstörung aller Persönlichkeit und Gemeinschaft durch die Ichsucht des vereinsamten Geschlechts, das ist der gemeinsame Gegenstand der beiden Bücher. Sie stammen aus dem unmittelbaren Erlebnis des Dichters. Sie entfalten sich nicht aus Begebenheiten, sondern aus Charakteren. Eine überlegene Laune macht die tragischen Schlagschatten, die Nabls Gestalten werfen, nur desto dunkler. *Josef Mühlberger*, *Josef* 1903, aus Trautenau, durch seine Mutter mit dem Böhmerwalde und weiter- *Mühlberger* zu mit dem tschechischen Volkstum verschwägert, steht durch seinen Sinn für slawisches Wesen Michel, durch sein Vermögen seelischer Tiefenschilderung Nabl nahe. In der Mitte seines Werks lebt Böhmen, das Land der beiden Völker. Der Roman „Hus im Konzil" 1931, das Drama „Ramphold Gorenz" *„Hus im Konzil"*

1932 bedeuten das: Der Krieg und Friede des Abendlandes heißt Böhmen.
Die Eintracht der böhmischen Brüder verbürgt den religiösen Volksfrieden
unter Deutschen und Tschechen, den Frieden des Abendlandes. Daher er-
scheint der Herzog von Friedland — „Wallenstein" 1934 — von neuem auf
der Szene als Bringer des Friedens. Das gemeinsame Land spricht sich rein
in den Versen, am vollkommensten in den Novellen des Dichters aus. Sie
durchschreiten die heimatliche Landschaft, „Aus dem Riesengebirge" 1929;
sie führen in das urtümliche Leben Dalmatiens, nach Wien und Prag, „Fest

„Fest des Lebens" des Lebens" 1931; sie erzählen seelenkundig und verhalten in der Landschaft
des mährischen Dorfes, „Die Knaben und der Fluß" 1934, die tragische Zer-
störung einer Knabenfreundschaft durch das gemeinsame Mädchen. Der
leidenschaftlich dunkle Roman „Die große Glut" 1935 spielt räumlich und
seelenhaft an den Lebensgrenzen der beiden Völker. Dann wurde dem
Dichter, der ohnedies im Felde stand, 1936 bis 1945 Schweigen auferlegt.
Der Band „Gedichte" 1948, Fülle der Formen und Strenge des Stiles, ge-
hörte zum ersten, mit dem er wieder zu Worte kam.

 Franz Karl Ginzkey, 1871, aus Pola, stammt durch den Vater aus der lan-
desüblichen Weberfamilie zu Dörfel bei Reichenberg und war ein Offizier
des Kaisers. Was er innerlich ist, das war er durch die Heimat seiner Väter.
Diesem Gemüte öffnete sich die anmutige Wiener Form. „Des Lebens bestes
Wunder geschieht uns von den Frauen", das ist von Erlebnis zu Erlebnis die
heimliche Geschichte der Romane, die Ginzkeys Innenleben zur Märe ma-

„Jakobus und
die Frauen" chen. „Jakobus und die Frauen" 1908 ist die selbstdarstellende Jugendge-
schichte des mutterlosen Salzburger Kadetten. Daraus entfaltet sich eine
schöne Dreiheit von Künstlerlegenden: „Die Geschichte einer stillen Frau"
1909, „Der von der Vogelweide" 1912, „Der Wiesenzaun" 1913, die Nürn-
berger Dürergeschichte. „Der Gaukler von Bologna" 1916 führt mitten hin-
ein in einen Kreis tragischer Ehegeschichten, „Maddalena Gondi" 1918, aus
denen „Der Weg zu Oswalda" 1924 mit der blinden, aber innerlich erleuch-
teten Frau wieder herausführt. Neben diesen herben stehen die drei dunklen
Geschichten „Brigitte und Regine" 1923, „Der Kater Ypsilon" 1926, „Der
Gott und die Schauspielerin" 1928 in jenem Dämmerbezirk der Seele, wo
Tote und Lebende, Götter und Menschen einander begegnen. Die ritterliche
Art gegenüber den Frauen und die heimatlich angeborene Schalkheit sind
die schönsten Tugenden seiner lyrischen Verse. Sie sind früh als „Erlebnisse"
1901, dann oft und schließlich in dem Buch „Vom tieferen Leben" 1938 ge-
sammelt worden. Lieder, Balladen, Sprüche, Hymnen, sie haben alle die
edle Form des rein Überstandenen und die Harmonie des oft geprüften

Herzens. Keines sucht mit Absicht die Nähe des Volkes. Die besten von ihnen haben den ungetrübten Laut des Dorfliedes. Es sind Verse aus frommer Gottgewißheit, wunschlosen Gedankenspinnens, Offenbarungen der tönenden Stille, andächtiger Naturmystik und einer kindhaften Seele, die aus dem Wundern nicht herausfindet. Wie ein Märchen sind die beiden Bücher aus der Soldatenjugend des Dichters. „Die Reise nach Komakuku" 1923 und „Der seltsame Soldat" 1925, Abschied an das alte österreichische Heer. Nur Franz Karl Ginzkey konnte sich selber, gegen seine bescheidene Natur, mit einem so herbanmutigen Kranz von Stanzen zum Dichter krönen. Das ist „Erschaffung der Eva" 1941, ein epischer Gesang. Tiefsinn und Anmut, Ernst und Laune, Ehrfurcht und Vertraulichkeit spielen den Ton von Strophe zu Strophe. Und ein Geheimnis bleibt, was Eva, behutsam sich auf den Zehen erhebend, in Gottes Ohr gesprochen hat. *„Die Reise nach Komakuku"* *„Erschaffung der Eva"*

　　Die östliche Landschaft, vom Altvater beherrscht, senkt sich zwischen Oberoder und Obermarch wie ein Keil tief nach Mähren. Hier machte *Bruno Hanns Wittik,* 1895 bis 1935, aus Freudenthal, 1920 den Versuch, durch seine Zeitschrift „Höhenfeuer" junge und reifende Dichter um sich zu sammeln. Sein Roman „Sturm überm Acker" 1927 gilt dem schlesischen Bauernsohn Hans Kudlich, der im Wiener Reichstag von 1848 seine Standesgenossen von Robot und Zehent freikämpfte. Der Roman „Peter Leutrecht" 1931 läßt während des Dreißigjährigen Krieges im Schutz der mährischen Waldgebirge eine rettende Notgemeinschaft erstehen. Das Buch „Schatzhauser" 1933 bietet Gedichte und schlesische Balladen. *Schlesien*

　　Dieser schlesischen Landschaft antwortet das südliche Mähren. Franz Spunda aus Olmütz ist durch seine Fahrt nach Griechenland aus dem dumpfen Zauber seiner ersten Spukromane gelöst worden, um fortan die gekreuzten Wege griechischen, lateinischen, germanischen Wesens zu verfolgen. Hans Giebisch aus Brünn hält in seinen romantischen Versen — „Wenn sich der Tag will neigen" 1934 — mit immer jungen, zarten, herzerfüllten Worten seine Erlebnisse fest und läßt durch seine „Waldviertler Sonette" 1938 Geschichte, Tagwerk, Jahreszeiten der Landschaft atmen. Karl Bacher aus Waltrowitz bei Znaim ist in Liedern und Mären, Geschichten und Spielen der mundartliche Sprecher seiner Heimat. Ilse Ringler-Kellner aus Sarajewo, umspannte mit ihrem Versbuch „Ahnenlandschaft" 1935 den weiten Bereich ihrer Vorfahren, Böhmerwald und Balkan, Riesengebirge und Erzgebirge. Die zartesten Lieder dieses wahrhaften Frauenbuches gelten der mährischen Erde, ihrer mythischen Fruchtbarkeit und immerwährendem Inbild der Mutterschaft. Karl Michael von Levetzow, 1871 bis 1945, aus Dobromiliz, machte *Südmähren*

seit seiner ersten reifen Tragödie „Der Bogen des Philoktet" 1907 mit seinem Schauspiel „Rembrandt unter den Blinden" einen eigenartigen Versuch, zwischen Sprechdrama und Filmspiel das Gesamtwerk aus Wort, Ton und Licht zu finden. Denn hier spielen Rembrandts Bilder mit. Sie werden auf der Szene gemalt oder umstritten oder verkauft. Sie treten aus dem Rahmen und werden Begebenheit der Bühne. Sie werden, Unsichtbare an der Wand, von den toten Augen des Volkssängers Jahn Steen gesehen und gedeutet.

Richard
Schaukal

Richard von Schaukal, 1874 bis 1942, aus Brünn, hat seine mährische Heimat nie vergessen. Er hat sein Leben selbst geschildert wie ein Märchen im Wunderlande seiner Vaterstadt. Vor diesem Hintergrunde wechseln die Gestalten und Begebenheiten: der Schüler des Brünner Gymnasiums, der Wiener Hochschüler, der junge kaiserliche Dragoner, der fast zu frühe Dichter, der Gast unter den Literatengästen des Café Griensteidl, der Beamte auf seiner raschen Laufbahn, der Künstler in seiner selbstgewählten Einsamkeit. In den drei Gesprächen, die „Literatur" 1906 überschrieben sind, ist ihm die Erkenntnis aufgegangen: was sich des Surrogats bedient, ist Literatur, und Kunst das Vermögen, ein jedes Ding mit dem ihm gebührenden Wort anzureden. Das Gesprächbüchlein „Giorgione" 1907 schloß diese Erkenntnis ab. Das Buch „Eros Thanatos" 1906 hatte in der Art des Dekamerone einige Intrigenstücke erzählt, heimliche Einakter als unauffällige Novellen verkleidet. Die „Schlehmile" 1908, Geschichten auf Wiener Art und aus Wiener Umgebung, verabschiedeten die ganze Gattung. Die Essays und Betrachtungen und Aphorismen wurden in einer stattlichen Reihe von Bänden gesammelt. Seine Versbücher sind das Ergebnis einer immer neuen und immer strengeren Prüfung. Erst mit den „Ausgewählten Gedichten" 1904 und den „Nachdichtungen" 1906 kam die Persönlichkeit völlig heraus. Von erster Echtheit war 1908 „Das Buch der Seele". Der Zuwachs wurde in den Bändchen „Neue Verse" 1912 und „Heimat der Seele" 1916 aufgefangen. „Ge-

„Herbsthöhe"

dichte" 1918, „Ausgewählte Gedichte" 1924, „Herbsthöhe" 1933 bezeichnen die Gratwanderung des Dichters auf der Höhe der Vollendung. So haben sich in diesen Sammlungen die Jahresringe der Seele abgesetzt. Die älteste Schicht verrät sich durch das herrisch-heroische Wunschbild, sich an den Tag zu verschwenden, bald in der Gestalt des Ritters, bald des Kavaliers. Der Stil ist gedrungen bildnishaft, balladisch im Ablauf des Geschehens. Die zweite Schicht kündigt sich durch den verwandelten Stil an. Aus Bild ist Sprache geworden. Die Dinge der Außenwelt werden zu Botschaften eines höheren Sinns. Der Sehende wird zum Hörenden. Der uralte Befehl aller

„Erblinde
zu dir selbst"

mystischen Ethik „Entwerde!" heißt bei Schaukal: „Erblinde zu dir selbst".

Die dritte Schicht ist gefärbt von dem Verlangen nach dem seligmachenden Urzustand. Der Reiter, der Horchende, das Kind. Kindheit ist unverweslicher Keim des Selbst, paradiesische Menschheitsjugend, Heimat von Raum und Zeit. Die vierte Schicht wird beherrscht von dem Bilde des Jahreskreises. Es ist das dreifach eine Jahr der Jahreszeiten, der Gottesfeste, des Menschenlebens. Sinnvoll wie die Ordnung und zufällig wie der Ablauf des Lebens stehen die Gedichte nebeneinander, eine bunte Kette wie die Reihe der Tage, die von den Knien Gottes gleiten und zusammen aus der Zeit das Jahr der Ewigkeit bilden. Lyrische Dichtung ist reines Wort geworden. Hier ist kein Bild, kein Schmuck, keine Kunst. *Das Jahr des Herrn*

Mähren, Groß-Pawlowitz, das ist die Heimat des Dichterphilosophen und Rilkefreundes *Rudolf Kassner,* 1873 bis 1959, des Essaykünstlers und Schöpfers des physiognomischen Weltbildes. Das Hauptwerk heißt in der endgültigen Fassung auf gut theosophisch „Von der Signatur der Dinge".

Prag schickte sich zum erstenmal an, sich in der deutschen Dichtung groß zur Geltung zu bringen. Zwar von den beiden Freunden Franz Kafka, 1883 bis 1924, und Max Brod, 1884 geboren, ging jener spurlos durch seine Zeit, während dieser höchstens mit seinem Roman „Tycho de Brahes Weg zu Gott" 1916 größeren Eindruck machte. Ihr Erfolg lag noch tief im Schoße der Zeit. Aber Gustav Meyer-Meyrinck fing in den Jahren der Wende das Bild der Stadt, wie sie gerade der Spitzhacke zum Opfer fiel, in den magischen Hohlspiegel seiner beiden Romane „Der Golem" 1915 und „Walpurgisnacht" 1916 ein. Ist es im „Golem" die spukhafte Traumlegende der Vergangenheit, so in „Walpurgisnacht" das Vorgesicht des verlorenen Krieges. Jeder der beiden Dichter, die von Prag ausgehn, läßt die Atmosphäre der Stadt in seiner Weise spüren. *Prag*

Rainer Maria Rilke, 1875 bis 1926, hat zwischen seinen gegensätzlichen Eltern keine sehr heilsame Jugend gehabt. Von der Kadettenschule Sankt Pölten, wo er ein schlechter Zögling war, kam er 1891 auf die Handelsakademie Linz, wo er sich plötzlich als guter Schüler entpuppte. Längst ein Dichter und mehrfach gedruckt, bestand er auf eigene Faust daheim die Reifeprüfung und begann im Herbst 1895 an der deutschen Universität zu Prag als ein Hörer, der er immer geblieben ist. Zu München fand er seine mütterliche Freundin Lou Andreas-Salomé, in Berlin zum erstenmal seinen Versstil, in Rußland 1899 und 1900 sein großes Erlebnis. Prosa und nicht Verse offenbaren zuerst, was mit Rilke geschehen ist. „Die Weise von Liebe und Tod des Cornets Christoph Rilke", Herbst 1899 entstanden, hinterließ dem Dichter die Einsicht: Tod, der große Vollender, die Schwelle von Leben zu Leben. *Rußland*

Die „Geschichten vom lieben Gott" 1900 sind fast gleichzeitig in sieben aufeinanderfolgenden Nächten geschrieben. Es sind zwölf, nicht gerahmte, sondern auf einen Faden gezogene Erzählungen, jede auf den jeweiligen Zuhörer abgestimmt. Stil und Vortrag sind zugespitzt geistreich, gut gelaunt oder ironisch, je nach dem Zuhörer. Gegenstand der Ironie ist die menschliche Vernunft und Zweckmäßigkeit, die durch all diese Dinge jenseits der Schulweisheit in Verlegenheit gebracht werden soll. Hier spricht der Glaube

Ein jedes Ding kann der liebe Gott sein" dem Unglauben von Gott. „Ein jedes Ding kann der liebe Gott sein. Man muß es ihm nur sagen." Rilke ging im August 1900 zu den Naturmalern der Siedlung Worpswede und fand hier seine Frau, die Bildhauerin Klara West

Paris hoff. Und im August 1902 suchte der Dichter Paris und den Bildhauer Auguste Rodin auf, um über ihn ein Buch zu schreiben. Die beiden Künstler wurden Freunde. Und von Paris aus begann Rilke seine großen Reisen: nach Deutschland, Österreich, Skandinavien, Capri, Rom, Venedig. Sein lyrisches Werk dieser anfänglichen Jahre, „Larenopfer" 1896, „Traumgekrönt" 1897, „Advent" 1898 bewahrt der Sammelband „Frühe Gedichte" 1908, der die Stimmung seiner Mädchenlieder in dem kleinen Drama „Die weiße Fürstin", ein sehr dunkles Gebärdenspiel werden läßt. Der Rilke dieser Pariser Jahre, das sind drei Gedichtbücher und der Roman, der keiner ist. „Das Buch

„Das Buch der Bilder" der Bilder" 1902 handelt in seinem ersten Teil vom Menschen und vom Leben, in seinem andern Teil von der Seele in ihrer heroischen und armen Gestalt. Es gibt eine innerliche, durchgehende, geistige und seelische Handlung, was weit mehr ist als eine bloße künstlerisch geordnete Folge von Bil

„Das Stundenbuch" dern und Bildnissen. „Das Stundenbuch" 1905 ist mit nichts zu vergleichen, was Rilke sonst geschaffen hat. Geist und Stil dieser Gedichte kommen aus einer Witterung der Seele, in der Rilke nur dieses eine Mal gelebt hat. Sprache, Wortbestand, Bildhaftigkeit sind die der christlichen Legende und Mystik. Diese Gedichte haben ihre letzten Wurzeln in der Frömmigkeit jenes Evangeliums, das der westlichen und der östlichen Kirche gemeinsam ist.

„Neue Gedichte" „Neue Gedichte" 1907 sind wirklich neuartig im Inhalt wie im Stil. Das Figürliche und Plastische herrscht. Das Buch ist bis an den Rand angefüllt von Paris. Auguste Rodin und Charles Baudelaire heißen die beiden französischen Meister, deren Einfluß diese neuen Verse so sichtbar spüren lassen. Bisher hatte der Dichter allzu bildlich gesprochen. Unvermittelt redet er nun auf eine neue Weise von den Dingen, wie sie sind, wörtlich und ohne Umschweife. So hat das Buch eine ironisch-groteske Mitte, von der es sich nach allen Seiten ins Zarte, Elegische, Hohe versenkt. „Die Aufzeichnungen des

„Malte Laurids Brigge" Malte Laurids Brigge" 1910 sind, wie es erdachte Gespräche gibt, ein er-

dachtes Tagebuch. Es ist Rilkes Pariser Buch, die lebensrettende Abwälzung der innern Not, die für ihn Paris so lange bedeutet hat. Furcht vor dem Leben und Furcht vor dem Tode, an dieser doppelten Angst geht Malte zugrunde. Der gleiche Akt, mit dem „Malte" seinen Dichter Rilke von der Gefahr des Unterganges im Meer der Lebens-Todes-Angst befreite, schnellte den Dichter zugleich auf eine höhere Stufe seines Daseins. So wollen die drei „Requiem" gelesen sein, die zusammen einen wundervollen Dreiklang bilden: „Für eine Freundin" 1908; „Für Wolf Graf Kalkreuth" 1908; „Auf den Tod eines Knaben" 1915; der Tod der Frau am Kinde, des Mannes an der versagten Tat, des Kindes an der Kindheit. Das Schloß zu Duino, wo *Schloß Duino* Rilke im Frühjahr 1910 zum erstenmal erschien, der Turm von Muzot, wo er die letzten Jahre lebte, schließen Wien, den Krieg und München ein. Dazwischen liegen seine Ausflüge nach Ägypten und Spanien. Zu Duino wartete er auf eine neue dichterische Eingebung. In dem bescheidenen Walliser Turm von Muzot überfiel ihn der letzte Sturm des Schaffens. Das sind die Vollendung der Elegien und die Schöpfung der Sonette. Beide gehören zusammen und bilden ein Ganzes nicht nur durch ihre Entstehung aus dem gleichen Erlebniskreis, sondern auch durch die Aussage, mit der sie einander wechselseitig aufhellen. „Die Duineser Elegien" sind im Jänner 1912 zu *„Die Duineser* Duino wie durch einen Anruf von drüben in Rilke aufgestört worden. Sie *Elegien"* sind in den folgenden Jahren zu Duino, in Spanien, in München aufgezeichnet und 1922 zu Muzot abgeschlossen worden. Sie sind ein Gedicht in zehn Elegien. Alle bestehen aus den gleichen verschiedenfarbigen Fäden: der Engel, die Liebenden und das Kind und der Held, das Tier und die Dinge und der Baum, die Toten. Alle diese Vorstellungskreise haben ihren gemeinsamen Schnittpunkt in Rilkes führender Erlebnisgestalt, dem Engel. Der nachzeichenbare Inhalt der Elegien ist das Verlangen nach lebendigem Einssein der menschlichen Seele mit dem außerräumlichen und überzeitlichen Sein, mit dem Sein an sich, also Gott. Dieses Streben ist aber kein erkennender, sondern ein schauender Akt. Die Elegien feiern das Verlangen der Seele nach völliger Aufgabe des eigenen Selbst, den großen Seelenschwung hinein in das Ewige, den Schwung, der Liebe und Tod in einem ist. Der Aufbau und die Anlage sind musikalisch: das Hindurchspielen einiger Melodien über den gleichen Satz. „Sonette an Orpheus" haben ihren Anstoß von außen her *„Sonette* empfangen durch den seltsamen Tod der jungen Tänzerin Vera Ouckama- *an Orpheus"* Knoop. Binnen kurzem, 1922, sind um dieses Erlebnis die rund vierzig Sonette entstanden. Orpheus, das ist der Dichter, der die Seele aus dem Reich des Todes ins Licht zurückführen will, aber auch der Dichter, der von den

Mänaden zerrissen auf eine mystische Weise in die Natur eingegangen ist. Die Sonette bewegen sich in dem gleichen Vorstellungskreis wie die Elegien. Die irdische Erfahrung der Seele muß sich verwandeln in das ganz reine beziehungslose Gefühl. Diese Verwandlung kann nur durch die Kunst vollzogen werden. Der dichterische Held, Orpheus, ist die vorbildliche Gestalt, durch die sich die Vereinigung mit dem unbedingten Sein vollzieht. „Elegien" und „Sonette" sind in jedem Sinne ein bezugreiches Ganzes. Mit ihm schließt Rilkes Schaffen irdischmenschlich ab. Die große künstlerische Leistung Rilkes besteht nicht in erstmaligen Erfindungen, die verblüffen, sondern ganz und gar im außergewöhnlichen Können.

„Der Weltfreund"　　*Franz Werfel*, 1890 bis 1945, hatte als junger Mensch das Gefühl, daß die Zeitgeschichte in ihrem Kreislauf eben jene Zustände durchschreite, aus denen einst die „Troerinnen" des Euripides hervorgegangen seien. Im Sommer 1913 dichtete er dem attischen Meister der Szene dieses Drama nach und schloß den Druck vom Mai 1914 mit dem ahnungsvollen Vorwortsatz: „Unsere Tragödie aber und die unselige Hekuba mögen nun wiederkehren, wie ihre Zeit gekommen ist". Diese Zeit hat Werfel wie nur einer ausgelebt und mit seinen Werken ihren Gang bezeichnet. Seine lyrischen Verse haben freilich daran den geringsten Anteil. Die zahlreichen Sammlungen „Wir

Werfels
lyrische Bücher　sind" 1914, „Der Gerichtstag" 1919, „Der Weltfreund" 1920, „Einander" und „Beschwörungen" 1923, „Gedichte" 1927, bewahren auf, was Werfel von seinem einundzwanzigsten Jahre an geschrieben hat. Schon die ersten Verse geben ein festes Bild, das sich nur noch im Ausdruck aber nicht mehr in der Art der Betrachtung wandelt. Denn es ist Betrachtungslyrik. Gefühl ist daran höchstens das schon sehr frühe Weh nach dem Vergangenen. Es sind mit Vorliebe Szenen aus dem Leben, wie es ist, mit zunehmender Breite und nicht selten mit sehr kunstvollen Rhythmen ausgeführt. Werfels lyrische

Die Dramen　Form ist sein junges Drama. Der klassische Stil der „Troerinnen" 1915 hat ihm offenbar einen so festen Halt gegeben, daß er über alle Versuchungen der Zeit, die Bühne gegen ihr eigenes Gesetz zu mißbrauchen, hinweggekommen ist. Die drei ersten Stücke fügen sich bezugreich zusammen. „Die Mittagsgöttin" 1919 ist ein lyrisch-musikalisches Märchenspiel um die religiöse Wiedergeburt. „Der Spiegelmensch" 1920 inszeniert am Doppel-Ich und auf dem Hintergrunde des Buddhismus die gleiche Verwandlung, befreit den Helden von seiner Selbstbespiegelung und läßt ihn ähnlich wie den Landstreicher der Mittagsgöttin als neuen und hohen Menschen im Kloster wieder erwachen. „Bocksgesang" 1921 führt die Vorstellung von der Naturdämonie — „Vision des Ganzen" — aus der Mittagsgöttin fort wie auch den

Gedanken der Wiedergeburt: „Er bleibt in der Welt. Ich habe ein Kind von ihm". So gedanklich, aber auch durch die slawische Umwelt, gehören Mittagsgöttin und Bocksgesang ganz eng zusammen. Man mag diese frühe Zeit Werfels wie immer bezeichnen, sie ist durch die Eigenart der Vorstellungen und nicht durch Besonderheit des Stiles bezeichnet. Mit drei Schritten stand er in einer ziemlich veränderten Welt. Das sind die drei Bühnendichtungen „Juarez und Maximilian" 1925, „Paulus unter den Juden" 1926, „Das Reich Gottes in Böhmen" 1930, ziemlich streng geformte Historienspiele mit Vorwurf und Gestalt des Führers. Um die gleiche Zeit, da Werfel sich der geschichtlichen Tragödie zuwandte, bekam er die epische Großform des Romans fest in die Hand und mit ihr die Bürgschaft für seine gültigste Leistung. Man kann verfrühte Ansätze auf sich beruhen lassen. Die Wendung ist um die Mitte der zwanziger Jahre eingetreten. Sie führte von dem Künstlerroman „Verdi" 1924 zu der Frage des mitschuldigen Richters in „Abituriententag" *Werfels Romane* 1928 und zu dem hohen Vorbild der Familieneintracht, das „Die Geschwister von Neapel" 1931 geben. Darüber erhebt sich der dreifache Gipfel. „Barbara oder die Frömmigkeit" 1929, „Die vierzig Tage des Musa Dagh" 1933, „Höret die Stimme" 1937, diese drei mächtigen Prosagebilde, sind untereinander mannigfach verwachsen. Alle drei sind geschichtliche Epen, „Barbara" zeigt an der Bildungsgeschichte eines jungen Arztes Ausgang und Untergang der Donaumonarchie. „Die vierzig Tage" schildern den erfolgreichen Widerstand, den fünftausend Armenier 1915 gegen die Türken auf dem nordsyrischen Berg geleistet haben. „Höret" ist die Geschichte des Propheten Jeremias. Der armenische und der jüdische Bericht stehen einander näher, weil es die Daseinskämpfe zweier Völker sind. „Barbara" und „Höret" werden auf die gleiche Weise vorgetragen. Beidemal bildet die Gebärde der erhobenen Hand zu Anfang und Schluß den Rahmen, in dem die Handlung abrollt. In „Barbara" ist diese Gebärde aber nicht mehr als ein bloßer literarischer Rahmen, in den der Dichter sein Bild einschiebt. In „Höret" dagegen ist während der unmeßbar kurzen Dauer dieser Gebärde der Erzähler, auf magische Weise eins mit Jeremias geworden, im Nu wieder bei sich selber. Und was er dann aus seiner Vision niederschreiben wird, das schiebt der Dichter in diesen Augenblick ein. „Das Lied der Bernadette" 1941 und „Stern der Ungeborenen" 1944, sind die letzten dichterischen Erscheinungen Franz Werfels. Sie bestätigen in letzter Stunde die geistige Haltung dieses ganzen Werkes. Der Dichter lebt aus dem Bewußtsein der allkreatürlichen Schuld und dem einen Verlangen nach allgemeiner Entsühnung. Die Wieder- *Schuld und Erlösung* geburt der Welt ist der einzige Weg zur Erlösung vom Urfluch. Die Welt

kann weder durch Revolution noch durch Reformation, sondern nur von
Innen her verwandelt werden. Nicht der Held, sondern der Heilige ist der
Erretter. „Erkennen und Liebe ist einerlei." Die Stanja des „Bocksgesangs"
empfängt mit dem Willen des reinen Opfers von der tierisch-menschlichen
Mißgeburt die Frucht, die sie zu einem neuen, reinen, höheren Menschen
austragen wird.

Werfel und Rilke Franz Werfel und Rainer Maria Rilke sind mit dem einen und gleichen
Gedanken nicht zu denken. Die Spannweite zwischen ihnen ist zu groß. Doch
im Göttlichen und im Willen über den Menschen hinaus, im Glauben an die
Sendung des Dichters sind sie eines Sinnes.

3. FREISTAAT ÖSTERREICH

Wien war gestern die Mitte eines großen Reiches gewesen und über Nacht
ein Haupt, das seinen Körper suchte. Was die Stadt in den vergangenen
Jahrzehnten aus dem ganzen weiten Raume angezogen hatte, das wachte
eines Morgens mit der Anwartschaft auf Heimatstaaten auf, von denen man
am Abend noch nichts gewußt hatte. Die meisten stammten aus den böhmi-
Österreicher aus der Monarchie schen Ländern: Franz Werfel, Franz Kafka, Paul Kornfeld; die Brüder Hans
Müller und Ernst Lothar; Robert Hohlbaum, Karl Hans Strobl, Franz Spunda;
Robert Michel, Franz Nabl, Bruno Brehm; Leo Slezak, Augustin Popp. Der
literarische Zuzug aus Galizien — Thaddäus Rittner; aus Ungarn — Adam
Müller-Guttenbrunn, Rudolf Lothar, Felix Salten; aus Jugoslawien — Mirko
Jelusich; war sehr dünn geworden, und diese Literatur konnte nicht „öster-
reichisch" werden, indem ihre Träger aus dem Großstaat in den Kleinstaat
umgebürgert wurden. Zu der Stunde, da die Monarchie entlang ihrer Bruch-
stellen aufriß, stand die Dichtung Österreichs in voller Blüte. Es war eine
Dichtung der Männer von vierzig und fünfzig Jahren, anerkannter Meister,
die Schule gemacht und der Kunst ihre Richtung gegeben hatten. Sie waren
Träger eines ungebrochenen Kulturbewußtseins. Die äußern und innern
Katastrophen des Staates trafen den Nachwuchs. All das macht begreiflich,
wie wenig sich der Stil der Dichtung rittlings der Grenze von 1918 verschoben
hat.

Das Österreich der breiten Zeitwende verkörpern Hermann Bahr und
Theodor Däubler, die beiden Dichter, die aus dem Kulturraum der Monar-
chie das artenreichste persönliche Werk entwickelt haben und beide in dem
Schicksalsjahr 1934 gestorben sind.

Hermann Bahr, 1863 bis 1934, hat das Erlebnis von Linz, wo er geboren
war, und von Salzburg, wo er die Schule besuchte, durch sein Leben bewahrt.
An den Hochschulen Wien, Graz, Czernowitz war er mithandelnder Zeuge
der beginnenden Auflösung des Gesamtstaates. In Berlin 1884/1887 zog ihn
bei großen Lehrern die junge Zauberkunst derVolkswirtschaft in ihren Bann.
In Paris 1888 wurde die französische Dichtung, die gerade Zola zu überwin-
den begann, die Sache seines Herzens. Er war 1891 in Petersburg. Bahrs un-
gemein vielseitiges Gesamtwerk gründet sich auf die natürliche Beredsamkeit
des ganzen Menschen, die er beständig geübt und ins Vollkommene gestei-
gert hat. Gesprächsstil ist der gemeinsame Zug aller seiner Werke. Bahrs
Romane sind Selbstgespräch und Wechselrede mit den Gestalten, die er um
seinetwillen in Szene setzte. Er begann mit den Künstlerromanen „Die gute
Schule" 1890, „Theater" 1897, „Die Rahl" 1908 und ging zugleich mit seiner
Wendung von der Literatur zu Staat und Kirche auch zu Romanen über, die
darstellen sollten, „welche geistigen Lebensmächte sich heute dem einzelnen
Menschen zu seiner Bestimmung, zu seiner Erfüllung anbieten". In all diesen
Romanen, „Drut" 1909, „O Mensch" 1910, „Himmelfahrt" 1916, „Die Rotte
Korah" 1918, man vergißt die Handlung, ob sie nun da ist oder fehlt oder
lediglich den Schauplatz der Gespräche verschiebt, weil man sich in den An-
blick der Menschen verliert, wie sie sich bewegen und sprechen und nichts
anderes tun als leben. Es ist unmöglich, sich an dem Zauber, der Tiefe und
Anmut und Echtheit dieser Wechselreden zu sättigen. Bahrs Spielbücher, die
ein Viertelhundert erreichen mögen, unterscheiden sich von den Romanen
gar nicht, wenn man sich die Begebenheiten der Romane in Szenenanwei-
sungen und die Szenenanweisungen der Lustspiele in romanhafte Begeben-
heiten umschreibt. Die Franzosen und Ibsen sind von diesen Spielen nicht
wegzudenken. Doch die volle Wahrheit ist, daß sie unmittelbar dort fort-
setzen, wo Bauernfeld aufgehört hat. Sie lachen nicht aus, sie lachen an.
Das ist ihre anmutigste Tugend. Alle Spielbücher Bahrs haben die Gegen-
wart ihrer Zeit. Er hat es so ziemlich mit allem versucht, was im Schauspiel
möglich ist, von dem Volksstück „Aus der Vorstadt" 1893 bis zu „Josephine"
1897, der geschichtlichen Komödie. Er hat die Ideen, die jeweils den Tag
hatten, stets gutgelaunt durch die Hechel gezogen. Das ist, wie bei Bauern-
feld, mit dem Tag vergangen. Doch die Stücke um das ewig Menschliche,
die seit dem attischen Theater dem Mann und der Frau auf der Fährte
bleiben, die sie hinter sich so gerne verwischen möchten, die haben den
Reiz des Unvergänglichen. „Ringelspiel" 1906, „Das Konzert" 1909, „Die
Kinder" 1910, so heikel diese Spiele sind, sie sind übermütig, nicht frivol.

Bahrs erdachte Gespräche sind das Beste, was man von ihnen haben kann. Es sind klassische Gebilde in der stolzen Reihe einer weltliterarischen Gattung, die mit Plato beginnt und bei Sokrates ihren Ursprung hat. Der „Dialog vom Tragischen" 1903 prüft Wesen und Aufgabe der Tragödie an der Schwelle zweier Zeitalter, verneint die tragische Kunst als Zukunftskultur, doch bejaht die Spielkunst, weil sie das Mittel der Verwandlung *„Dialog vom Marsyas"* in dem neuen Menschen ist, der kommen muß. Der „Dialog vom Marsyas" 1904 zielt auf den Schluß. Da das Leben mehr wert ist als die Kunst und da die Kunst schließlich das Leben wie den Künstler zerstört, darf die Kunst nur aus Überschuß, nicht aus Mangel an Leben betrieben werden. Schön sein ist mehr als schön tun. Bahrs kritische Schriften sind Selbstgespräche. Er konnte keinen besseren Mitunterredner haben. Die Bücher, „Adalbert Stifter" 1918, „Sendung des Künstlers" 1921 und das bezaubernde „Selbstbildnis" 1923 ziehen den großen Strich unter dieses Künstlerleben, das nicht für die Kunst, sondern für das Leben verzehrt worden ist. Hermann Bahr hat sich auf die wunderbarste aller Künste, die Denkkunst verstanden. Er hatte das Vermögen des Seelentausches. Er hatte es aus dem göttlichen Urgrunde des Wortes, das alles benennen und daher alles sein kann. Er hatte es aus dem Spieltrieb seiner Natur. Dafür hat er das griechische Zauberwort *Ekstasis* „Ekstasis" neu geprägt: Die Kunst des Menschen, aus sich herauszutreten. Dieses Vermögen hat er zur Forderung an sich und andere gemacht. „Die Kunst der ewigen Verwandlung wird uns die Normen geben, nach welchen allein wir über den Menschen gelangen, ins Freie, zur Höhe, wo alles, was an uns geschieht, nur noch ein Spiel der Elemente mit uns ist." Diese Ekstasis schwingt uns über das unrettbare Ich, diese Aushilfe unseres Denkens, hinweg. Diese Forderung, über sich hinaus, war an alle gerichtet, die Europa sein wollten und sollten. Dieses Europa vorzubilden, war die Aufgabe, die er dem Österreich seiner Tage gestellt hat. Diese Kunst der Ekstasis war für ihn der österreichische Barock. Er meinte damit eine untragische Kunst. Und wirklich, das ist die ekstatische Bühne des Barock gewesen, auf der immer das Gute und Obere siegte.

Däubler und das Mittelmeer *Theodor Däubler*, 1876 bis 1934, aus Triest, stammte von einem schwäbischen Vater und von einer schlesischen Mutter. Zu Triest ist er bis zu seinem einundzwanzigsten Jahr in dem wohlhabenden väterlichen Kaufmannshause aufgewachsen. Zu Wien und zu Paris und in den kunstberühmten italienischen Städten hat er gelebt. Griechenland und Ägypten hat er bereist. Berlin hat er bewohnt. Im Schwarzwald ist er gestorben. Seine Heimat ist der adriatisch-levantinische Kulturraum, den die österreichisch-ungarische Monarchie

von Venedig geerbt, bis zur letzten Stunde geistig besessen und mit ihrem *Die Adria* letzten Schiff, gleichviel an wen, vererbt hat, wie nur Tote vererben können. Es sind zwei österreichische Linien, die sich dort schneiden, wo Däublers Werk steht. Die eine Linie ziehen die großen österreichischen Reisekünstler und Schilderer des östlichen Mittelmeeres: Jakob Philipp Fallmerayer, der Deuter byzantinisch-russischen Seelentausches; Anton von Prokesch-Osten, der Schilderer der Levante und Ägyptens; Alexander von Warsberg, Österreichs Konsul zu Venedig und Korfu, der auf immer neuen Fahrten das griechische Meer durchstreift und in klassischen Büchern die homerischen und odysseischen Landschaften geschildert hat. Die andere Linie kommt von Christoph Martin Wieland, der ein Schwabe war und wie kaum ein anderer fremder Dichter in Österreich eingebürgert, von Robert Hamerling mit seinen geschichtsphilosophischen Dichtungen, von Wilhelm Fischer mit seinem Weltepos „Atlantis". Jenen Reisekünstlern hat es Däubler gleichgetan auf *Griechische Landschaften* seiner Fahrt nach Hellas, in seinen Schilderungen „Sparta" und „Der heilige Berg Athos" 1923; in seinem Reisebuch „Der Fischzug" 1930; in seinen Aufsätzen „Der Styx", „Theben", „Ithaka", „Delos", denen es versagt war, sich zu dem großen Hellasbuch von Dionysos und Apollon zu vollenden. Diesen, den hellenischen Dichtern und Geschichtsdenkern folgte er nach mit seinem kosmischen Riesenwerk. Es ist keine epische, sondern eine lyrische Dichtung. Sie bildet den Kern der gestirnten Welt von Gedichten, wie sie in fünf Bänden und, nochmals ausgelesen, in der Sammlung „Das Sternenkind" 1917 hervortraten. Alle Kunst dieser Gedichte besteht in der Schärfe des Gesichts, mit der die Wirklichkeit gesehen, und in der Kraft der Seele, mit der das Gesehene zum Sprechen gebracht wird. Die kosmische Dichtung „Das Nord- *„Das Nordlicht"* licht" 1910 ist ein Allbuch einheitlich abgestimmter Gedichte in einem zusammenhaltenden Gedankenrahmen. Das erste Gesicht dieses Buches ist dem vierzehnjährigen Knaben — „Mein Gemüt neigte zur Mystik" — in Triest aufgegangen. Die Stadt Venedig, das größte Erlebnis des Dichters, hat den Gedanken gereift. Zu Neapel kam ihm der Wille, daraus eine Dichtung zu machen. Zu Wien und zu Paris ist sie geschrieben worden. Der Rahmengedanke ist einfach und einleuchtend. Sonne und Erde waren am Anfange ein Körper. Die Erde hat sich von der Sonne losgerissen. Eine kosmische Anschauung. Nun führt die Erde ein Eigenleben. Ihre Natur ist die Schwerkraft. Pflanzen, Tiere, Menschen streben der Schwerkraft entgegen und vom Mittelpunkt der Erde weg. An den Polen der Erde, wo es am dunkelsten ist, sprüht das Nordlicht. Physikalische Tatsachen. Der Dichter deutet den kos- *Zur Sonne* mischen und physikalischen Sachverhalt dahin, daß die Erde den Trieb hat, *zurück*

Der
Nordlichtmythus zur Sonne zurück und wieder Sonne zu werden, ein Trieb, der sich im Nord-
licht geheimnisvoll kundgibt. Aus der kosmischen und physikalischen Tat-
sache macht Däubler eine geistig-seelische: wir selbst sind Sonne und Erde.
Das Nordlicht weist uns den Weg zur Sonne, den Weg zum Urlicht. Zurück
zur Sonne ist die sittliche Pflicht jedes einzelnen Menschen und der Sinn der
menschlichen Geschichte. Sie muß gedeutet werden als gemeinschaftlicher
Wille aller Völker, die Erdennatur zu überwinden und den Willen der Sonne
zu erfüllen. Kosmogonie — Erdphysik — Sittengebot — Geschichtsphiloso-
phie: das waren die Werdestufen von Däublers Nordlichtmythus. Sie bilden
zugleich den Aufbau der Dichtung und sie sind die Schichten, die sinnmäßig
das ganze Werk durchziehen. Es ist aus zwei Teilen zusammengefügt. Der
erste Teil handelt vom Sonnenpilgertum des persönlichen Menschen-Ich. Er
„Mittelmeer" heißt „Mittelmeer", weil das die Welt der Kultur ist, in der sich das Ich sel-
und „Sahara" ber findet. Der zweite Teil gibt die Sonnenpilgerschaft des überpersönlichen
Erden-Ich, dargestellt aus der Geschichte der Völkergemeinschaft. Er heißt
„Sahara", weil die Wüste Einsamkeit es ist, wo das Dasein der Erde sich
umzugebären beginnt, wo das Erden-Ich sich am reinsten verstrahlen darf.
So gemeinverständlich der Rahmengedanke ist, so schwierig sind viele der
einzelnen Gedichte zu deuten, die, jedes ein Gestirn für sich, die Sonne dieses
Dionysos Gedankens umkreisen. Den Gipfel der Dichtung bildet der mystische Berg
und Apollon Ararat, ein Gleichnis des arischen Sonnenmysteriums, das sie, großartig in
der Schau und gehemmt im Wort, verkündet. Im Hintergrund des Gedichts
steht das Werk Friedrich Nietzsches und aus dem hellenischen Glauben an
Dionysos und Apollon zieht Däublers Dichtung ihre unterste Wurzel.

Hermann Bahr ist aus Gesinnung und Stimmung des barocken Bauwerks
Salzburg, Theodor Däubler aus Natur und Kultur der Adria in die österrei-
chische Wirklichkeit seiner Tage getreten. Ihr Werk bezeichnet gemeinsam
die künstlerische Überlieferung der Monarchie, mit der sich der Freistaat ab-
finden mußte.

Von Bahr zu Däubler führen nur Leistungen aber keine Ismen. Weder das
Drama des Malerdichters Oskar Kokoschka, „Mörder, Hoffnung der Frauen"
1907 noch der Roman des Malerdichters Alfred Kubin „Die andere Seite"
1909, leiten eine neue österreichische Dichtung ein, noch ist Däubler für diese
„expressionistische" Überwindung Bahrs verantwortlich. Mit der tatsäch-
lichen Entfaltung und Leistung der österreichischen Dichtung zwischen 1918
und 1938 hat es sich nachweisbar also verhalten.

Der Wiener Von den dichterischen Großformen hat die epische durch Wien und die
Roman Wiener keinen neuen Stil, wohl aber mannigfaltige Abwandlungen der Gat-

tung gefunden. Hermann Broch, 1886 bis 1951, seit 1938 in Amerika, mag *Seine Formen*
mit seinem Romandrilling „Die Schlafwandler" 1931 gegen das „anti-
humanitäre" Deutschland auf sich beruhen, aber der Roman „Der Tod des
Vergil" 1945 ist eine große dichterische Leistung. Oskar Maurus Fontana,
1889, wechselt überraschend von Buch zu Buch Schauplatz, Vorwurf, Stil,
sichtlich bemüht, sich auf keinerlei „Richtung" festlegen zu lassen. Margarete
Seemann, 1893, hält sich an die weiblich vertraute mütterliche Welt und
weiß in den religiösen Spannungen des Herzens zuverlässig Bescheid. Erich
August Mayer, 1894, schildert in der Verserzählung „Paulusmarkt 17" mit
formvoller Schlichtheit an einem Stadthaus das Wien nach dem Kriege.
Heimito von Doderer, 1896, aus Weidlingau bei Wien, seit den zwanziger
Jahren literarisch tätig, unternimmt es nach den gewaltigen Baurissen „Die
Dämonen" und „Die Strudlhofstiege" in den fünfziger Jahren das gesamte
Leben Wiens in all seinen Gesellschaftsschichten zu gestalten, jeder Stilform
mächtig. Robert Neumann, 1897, zeigt bei Darstellung politischer Affären, die
er bevorzugt, ein immer anderes Gesicht. Wenn Lächerlichmachen wirklich
Töten wäre, so hätten die unvergleichlich echten Parodien seines Buches
„Mit fremden Federn" 1927 die zeitgenössische Literatur in ein Leichenfeld *„Mit fremden*
verwandelt. Es ist aber bei dem Jux geblieben, den er sich machen wollte. *Federn"*
Erich Landgrebe, 1908 von niederdeutscher Herkunft, Dichter und Maler
zugleich, erzählt zumeist nach dem Modell seines eigenen Lebens, das ihm
keinen Beruf erspart hat, immer überlegen und gut gelaunt.

Die epische Großform dieses Zeitalters hat ihren österreichischen Stil durch
DIE LÄNDER empfangen. Im Donautal dichtete Hans von Hammerstein- *Donautal*
Equord, 1881 bis 1947, aus Sitzental, die Edda nach, „Die Asen" 1928, und
hielt sich mit seinen Romanen ebenso an die selbsterlebte Gegenwart wie an
die Historie der Glaubenskämpfe. Hans Sterneder, 1889, von Eggendorf, gab
seinen Romanen aus dem eigenen Leben der Landstraßen den Hintergrund
kosmischer und astrologischer Träume. Die gleiche Natur aus Oben und
Unten hat Maria Grengg, 1898, aus Stein, zum Gegenstand ihrer Romane
gemacht. Sie begleitete ihre Bücher selbst mit Federzeichnungen und Bildern.
Die gleiche Natur als inwendiges Wunder ist das große Erlebnis, das Rudolf
Henz, 1897, aus Göpfritz, in seinen Romanen verkündet, von der Angst um
Europa bedrängt, ergriffen vom Geheimnis des Künstlertums und dem natür-
lichen Wunder der Welt. Henz ist darüber hinaus an einem vielgestaltigen
Werk. Egmont Colerus, 1888 bis 1939, aus Linz, hat von „Antarktis" 1920
bis zu „Zwei Welten" 1926 blendende Kulturgemälde entlegener Zeiten und
Räume aufgerollt. „Pythagoras" 1924 und „Leibniz" 1934 sind dichterische

Lebensbilder des mathematischen Genies. Julius Pupp, 1889, aus Linz, hat des Colerus Vorwürfe von kulturgeschichtlichen Gemälden zu einem einzigen Film der gesamten menschheitlichen Kulturgeschichte zusammengedrängt. Pupps Leistung ist die fast unbegrenzte Fülle der Gesichte und die lähmende *Salzburg* Echtheit des magischen Traumes. Salzburg heißt jetzt Land, und nicht die große, sondern die kleine Natur der Wiesen, Tiere, Menschen. Karl Heinrich Waggerl, 1897, aus Badgastein, hat mit Knut Hamsun begonnen. Sein fein-gespitzter Griffel hat so anmutige Feld- und Flurbilder wie das „Wiesen-buch" 1932 und „Wagrainer Tagebuch" 1936 vermocht. Die Salzburger Landschaft naturhaft und seelisch ist der Roman „Das Jahr des Herrn" 1933, der im Takt der täglichen Arbeit die Jahreszeiten über dem idyllischen Glück einer Kindheit durchs Bauerndorf kreisen läßt. Georg Rendl, 1903, aus Zell am See, hat das Erlebnis seiner Arbeiterjahre zu dem dreifachen Roman „Menschen im Moor" 1935, „Die Glasbläser" 1937, „Das Gespenst aus Stahl" 1938 aufgebaut. Sein Jahr des Herrn ist „Der Bienenroman" 1931, das heilige Jahr, das den Kreislauf der Tage und Monde im Tagwerk aller *Tirol* Tiere kommen und gehen läßt. Tirol mag anfangen, was es will, es wird ein geschichtlicher Roman daraus. Josef Weingartner, 1885, aus Dölsach, hat Altertum und Schönheit der kirchlichen und weltlichen Bauten seiner Heimat kunstgeschichtlich erschlossen und den Geist des Barock gedeutet. Unter gleichzeitigen Erzählungen ähnlicher Art steht „Abälard und Bernhard" 1937, der Roman des geistigen Mittelalters um die beiden Gegner, die für ihr Zeitalter gedacht und gelitten haben. Das Buch ist völlig durchdrungen von der gedanklichen Witterung des Jahrhunderts. Es ist reine Dichtung, völlig Begebenheit, menschliche Gestalt, Farbe und Rhythmus des Lebens. Josef Georg Oberkofler, 1889, aus Sankt Johann im Etschlande, hat sich einen viel-fältigen Bestand von gedankenschweren, wortkargen, spruchhaften Gedich-ten geschaffen. Er gliedert sich um die geschichtlichen Romane, von denen „Sebastian und Leidlieb" 1926 der Irrweg eines Tiroler Ritters zum Guten ist, während „Das Stierhorn" 1938 legendenhaft die Schuld und Sühne der Arnsteiner erzählt. Fanny Wibmer-Pedit, 1890, aus Innsbruck, hält so ziem-lich das Gleichgewicht zwischen Erzählungen aus dem Tiroler Bauernleben und der heimatlichen Geschichte. Erwin Rainalter, 1892, aus Tiroler Familie zu Istanbul geboren, wechselt mit seinem Vorwurf von Landflucht und Heim-kehr zwischen Geschichte und Gegenwart. Josef Leitgeb, 1897 bis 1952, von Bischofshofen, erzählt in der „Kinderlegende" 1934 den Hexentod eines Tiroler Bauernjungen, in „Christian und Brigitte" 1937 vom Weg eines jungen Menschen durch die Zusammenbrüche der Gegenwart. Seine lyri-

schen Verse sind von musikalischem Rhythmus. Maria Veronika Rubat-
scher, 1900, aus Hall, hält sich mit dem Künstlerroman „Der Lusenberger"
1930 an die Gegenwart, während „Das lutherische Joggele" 1935 in das
Tirol der Wiedertäufer und die „Meraner Mär" 1936 in das Tirol der Kai-
serin Maria Theresia führt. Steiermark lebt sich wie billig auch dichterisch *Steiermark*
in Gegensätzen aus. Neben Hans Kloepfer, 1867 bis 1944, aus Eibiswald, in
Gedichten und Geschichten dem mundartlichen Erben Roseggers, steht Julius
Zerzer, 1889, aus Mureck, der in seinen Erzählungen Stifter folgt. Da steht
auf der einen Seite Bruno Ertler, 1889 bis 1927, aus Pernitz, doch in der
Steiermark aufgewachsen, der am reichsten und fast allseitig Begabte. Er
grenzt mit seinen steirischen Geschichten an Rosegger und mit seinen Ge-
dichten an Rilke. Von seinen Spielen heben sich die russischen und von seinen
Novellen die dalmatinischen ab. Wohl die schönste ist die Malergeschichte
„Damenspiel", die sich auf einer Insel vor der Riviera begibt. Alles, was Ert-
ler gemacht hat, ist mit dem Silberstift geschrieben, von kecker Zartheit in
den Umrissen, mit behender Sorgfalt ausgefüllt und liebenswürdig getönt.
Da steht auf der anderen Seite Paula Grogger, 1892, aus Oeblarn, die am
Südrand des Dachsteins ihre Legenden aus fernen und nahen Zeiten sich be-
geben läßt. Der mystische Held des Romans „Das Grimingtor" 1926 ist der *„Das*
mächtige Bergstock nördlich des oberen Ennstales. Nach den vier Evange- *Grimington"*
listen, die am Fronleichnamstage an den vier festlichen Altären gelesen wer-
den, heißen die vier Söhne des Großbauern Andreas Grogger. Das trotzige
und wilde Lebensschicksal der vier Brüder ist der Gegenstand der Dichtung.
Das Buch macht in einem die berückende Gegenwart des Berges, Volkssage
und Kirchenlegende, die Ahnengeschichte der Dichterin, das Gemeinschafts-
leben eines Bauernhofes zu einem mystischen Ganzen. Was ist das Geheimnis
des Bergtores? Vielleicht das Geheimnis, das dem Menschen sich im Augen-
blick seines Todes enthüllt. Kärnten hält es beinahe ebenso. Josef Friedrich
Perkonig, 1890, aus Ferlach, widmet das Bilderbuch „Mein Herz ist im Hoch- *Kärnten*
land" und die Sagensammlung „Das verzauberte Gebirg" der Heimat. Seine
Geschichten — „Lopud, Insel der Helden" 1934 — spielen gern auf der
Völkergrenze des Landes. „Honigraub" 1935, wie ein armer Mann seine
hungernden Bienen in den Stöcken seiner reicheren Nachbarn naschen läßt
und sich zur Buße dafür durch Wohltun zur Honigwabe des Dorfes macht,
ist vielleicht Perkonigs schönste Erzählung. Wilhelmine Wieser, 1905, aus
Hüttenberg, hat sich zur Legendendichterin des Landes entwickelt: „Das Sin-
gerlein" 1928, der Einzug eines verwaisten Chorknaben zu Gott; „Der Gur-
nitzer" 1931, die Läuterung eines jungen Helden im Kärntner Türkenkrieg;

„Sankt Barbara" 1937, ein Kränzlein Gegenwartsgeschichten um die Heilige,
„Hemma von Gurk" die dem Menschen zu einer guten Sterbestunde verhilft; „Hemma von Gurk"
1938, der Roman des frühen Kärnten und seiner Landesmutter.

Wien WIEN wandelte sich ohne Unterschied der Weltanschauung in einer
Gruppe geistiger Menschen ab, die mit Ehrgeiz nach der hohen Form stre-
ben. Ihnen geht es mehr um das Wortkunstwerk an sich als um die besondere
Gattung. In den persönlichsten Abstufungen ist es ein Stil von ironischer Hal-
tung und geschliffener Dialektik. Das alles sieht sehr antikisch aus, ist aber
offenbar romanisch. Diesem Kunstwerk ist schwer ein Name zu finden. Man
kann wohl das, worauf es ankommt, essayistisch nennen.

Otto Stoeßl Otto Stoeßl, 1875 bis 1936, verrät seine Art schon durch das angenehme
Behagen, das seine Gebilde erregen. Es ist nicht Humorwärme aus dem Ge-
müt, sondern gedämpfte Beleuchtung eines farbigen Geistes. Stoeßl hat sich
für seinen Essaystil jede der literarischen Formen zurechtgehämmert wie ein
Goldschmied. In der Mitte steht die reine Sachprosa, der Essay an und für
sich, in seiner kunstvollen Gestalt. Stoeßl hat ihn selbst in einer bewunderns-
wert knappen Betrachtung mit dem Hinweis auf Montaigne bestimmt als
Der Essay „Versuch zwischen der fraglosen erfüllenden Gestaltung des Dichters und
der forschenden Auseinandersetzung des gelehrten Denkers", als einen
„Kampf mit allen Versuchungen des Geistes". Die Ausdrucksformen dieses
Essaygeistes sind bei ihm auf der einen Seite die Kleingebilde des Aphoris-
mus und des Gedichts, auf der anderen Seite die Großgebilde der Novelle
und des Dramas. Die meisten seiner zahlreichen Novellen haben keine Hand-
lung im Sinne einer dichterisch gelenkten Begebenheit. Sie erörtern ein
Thema. So „Nora, die Füchsin" und „Negerkönigs Tochter". So besonders
kunstvoll angelegt, das „Griechische Tagebuch", eine Griechenlandstudie als
Reisenovelle. Ganz ohne Beispiel, eben diesen Stil zwischen Dichtung und
Denkspiel, hat „Die wahre Helena", ein vollkommener Essay, gesprächs-
Stefan Zweig weise und mit verteilten Rollen. Stefan Zweig, 1881 bis 1942, der über den
Vater aus Mähren und über die Mutter aus Deutschland stammte, hat sich
offenbar bei Emile Verhaeren in Brüssel gebildet, wie er später an Romain
Rolland seinen Rückhalt gefunden hat. Auch wenn er seine frühen Verse noch
so streng für die „Gesammelten Gedichte" 1924 gesichtet hat, sie sind aus
Verstand nicht Herz geworden. Seine Stücke wie seine Novellen erörtern und
malen aus und keines bewegt sich aus einem Antriebe auf ein Ziel. Der Unter-
schied ist hierin nicht groß, mag man das Drama „Thersites" 1907 oder den
Novellenband „Verwirrung der Gefühle" 1926 vergleichen. Beides, sein Ver-
Der Essay mögen der Nachgestaltung als Übersetzer und sein Ehrgeiz zur dichterischen

Form vereinigen sich im reinen Essay. Das ist die große Form Stefan Zweigs. Er hat solche Geistesbildnisse seit „Paul Verlaine" 1905 zunächst einzeln geschaffen und sie dann nach der vollkommensten und schönsten Zahl zusammengestellt: „Drei Meister" 1920 — Balzac, Dickens, Dostojewskij; „Der Kampf mit dem Dämon" 1925 — Hölderlin, Kleist, Nietzsche; „Drei Dichter ihres Lebens" 1928 — Stendhal, Tolstoj, Casanova. Man sieht, daß in jeder Reihe der Westen und der Osten vertreten ist. *Robert Musil*, 1880 bis 1942, *Robert Musil* aus Klagenfurt, zeigt das gleiche Bild nur von einer anderen Seite. Das zwiespältige und ziemlich peinliche Schauspiel „Die Schwärmer" 1921, dem es um einen neuen und nicht sehr liebenswerten Menschen geht, weist keinen Bühnendichter, sondern einen Erzähler aus. Und der Erzähler des seelisch sehr schwierigen Novellenbuches „Drei Frauen" 1924 ist ein Erzähler von Rang. Doch er ist — „Über die Dummheit" 1937 — ein ebenso glänzender Essaykünstler. Musils einziges Großgebilde, „Der Mann ohne Eigenschaften" 1930/1933 ist denn auch ein Sammelbuch von erzählten Novellen und gesprochenen Essays, die an einer bindenden Schnur aufgefädelt sind. Diese *„Der Mann ohne Eigenschaften"* Schnur, die schwarzgelb durch das Ganze läuft, ist die „Parallelaktion", die Feier, die 1914 von einem auserlesenen Kreise Wiens zum siebzigsten Herrscherjahr Franz Josefs I. 1918 vorbereitet wird. Sie ist eine Art Wettbewerb zu dem für das gleiche Jahr 1918 erwarteten dreißigsten Herrscherjahr Wilhelms II. Der Mann ohne Eigenschaften, das ist der Österreicher und seine Monarchie, der Mensch und sein Land, die nur im Reich der Mütter, im Reich der unbegrenzten aber nie verwirklichten Möglichkeiten leben. Musils Mann ohne Eigenschaften, das ist der Schwierige Hofmannsthals. Sie kommen über einer unerhört reichen Speisekarte nicht zum Essen, da sie doch der Entschluß zu einem Butterbrot satt machen würde. Schließlich ist die Form des „Romans", der mit feiner, behaglicher, tragisch-grausamer Ironie zwischen erotischen Abenteuern, hinreißenden Gesprächen, gedachten Essays schwebt und eine Fülle unglaublich echter österreichischer Menschen zusammenhält, eine Form, die zu allem fähig und für die alles möglich ist. *Wladimir von* *Wladimir von Hartlieb* *Hartlieb*, 1887 bis 1951, aus Görz, hält sich freilich mit besonderer Strenge an die gültigen dichterischen Gattungen. Er hat sich seit dem vielleicht romantischen Drama „Noel" 1912 an mehr als einer schwierigen Aufgabe erprobt, so an einer „Esther", hat ein Stanzenepos „Herbert" 1912 gewagt und seit dem frühen Versbuch „Die Stadt im Abend" 1910 bezaubernde Gedichte, zumal Sonette, geformt. „Das Haus der Kindheit" 1936, das die Anmut eines Kinderpaares hütet und von so vergnüglichen Sonderlingen bevölkert wird, bezeugt einen Erzähler von Anmut und Gefühl. Gegenüber diesen Dichtungen

Das Reisebuch scheinen die „300 Epigramme" 1920 und die Aphorismen „Fortschritte ins Nichts" 1924 in keine Gegenschale zu fallen. Indessen auch bei Hartlieb gibt der wache Intellekt, die kritische und ironische Haltung den Ausschlag. Seine Essays, diese durchstilisierten Gebilde einer urbanen und überlegenen Laune, sind noch nicht gesammelt. Sie sind es, die über diesen Künstler schlüssig aussagen. Seine gemäße Ausdrucksform sind die beiden Reisebücher „Italien. Alte und neue Werte" 1927, „Das Antlitz der Provence" 1930, in denen modern und neu das klassische Reisebuch französischen Stils aus dem achtzehnten Jahrhundert wieder unter uns erschienen ist. Das ist der lateinische Süden, zu dessen Erlebnis Semmering und Görz Paß und Zugang waren.

Der Vorhang hatte sich gesenkt, als Ferdinand Raimund und Franz Grillparzer abgetreten waren. Da ging er wieder auf.

Welttheater *Hugo von Hofmannsthal*, 1874 bis 1929, von Wien, stammte durch seinen Vater aus Böhmen und durch seine Mailänder Großmutter aus Italien. Die wenigen lyrischen Verse, die wir von ihm kennen, sind unmittelbare Musik der Seele, und die Worte fast nur Klänge und Harmonie von Draußen und Drinnen. Sie zeigen sofort die Neigung, sich in zwei Stimmen zu teilen, um Duett und Gespräch zu werden. Lyrisches Urvermögen hat sich hier zu den Großformen der Prosa und des Dramas entfaltet. Vom Gespräch her griff es nach allen Seiten aus: zum Essay, zur Rede, zur Erzählung. All diese Prosastücke, wie „Die Frau ohne Schatten", „Das Märchen der 672. Nacht", „Lucidor", „Das Erlebnis des Marschalls Bassompierre" können ebensogut künftige oder restliche dramatische Pläne gewesen sein. All diese Prosa kritischen oder darstellenden oder erzählenden Stiles war für Hofmannsthal immer nur ein Seitenweg, der den geraden Zug seiner dramatischen Bahn begleitete oder kreuzte, wie das Bedürfnis, neben sich selber herzugehen, es jeweils empfohlen hat.

Die lyrische Szene Der Ursprung des Dramas aus Hofmannsthals lyrischen Wechselstimmen ist so bezeugt, wie sich derlei geistige Herkünfte überhaupt nur bezeugen lassen. Der Dichter hat durch keine andere Art als seinen genialen Fleiß aus kleinen lyrischen Szenen nicht nur ein paar vollkommene dramatische Großgebilde, sondern ein ganzes artenreiches Großwerk von Bühnenspielen herausentwickelt. Beispiellos ist der gerade Zug, der nach keiner Seite abwich. Jedes wächst gedanklich und gestaltlich aus dem andern. Und in jeder Frucht ist der Nachwuchs vom vorigen Jahr. Mit drei Einaktern setzt es ein. Das Künstlerspiel „Der Tod des Tizian" 1892 und die lyrische Szene aus einem Totentanz „Der Tor und der Tod" 1893 werden schon von dem antiken Duett „Alkestis" 1894 überklungen, dem Sieg der Liebe und des Lebens

Vom Einakter zum großen Drama

über den Tod. Dann schlägt schon das Motiv vom Kinde an. „Der weiße *Frau* Fächer" 1897 bringt auf dem Friedhof über zwei Gräber hinweg ein neues *ohne Schatten* Paar zusammen. „Der Kaiser und die Hexe" 1897 befreit einen Menschen von der angehexten Liebe. „Die Frau im Fenster" 1897 ist der erste, sehr unbestimmte Umriß einer Frau ohne Schatten. Es ist das letztemal eine einzige Szene. Liebe ist nun Sehnsucht nach dem Leben. „Die Hochzeit der Sobeide" 1899, schon deutlicher die Frau ohne Schatten, ist das Spiel von der jungen Frau, die um ein geträumtes Glück den Gatten verläßt und den Tod der Enttäuschung heimbringt. „Das Bergwerk von Falun" 1899 erscheint als erstes Märchenspiel auf Hofmannsthals Szene. „Der Abenteurer und die Sängerin" 1899 tun einen großen Schritt nach vorwärts. Das Stück vertauscht zum erstenmal in dem urmenschlichen Dreieck Mutter-Vater-Kind die Be- *Mutter-Vater-* ziehungen und zeigt bereits den verschleierten Stil der Maskenkomödie. Jetzt *Kind* kommt die Entscheidung. „Das gerettete Venedig" 1905 ist die erste und letzte Tragödie von herkömmlichem Stil in Hofmannsthals Werk. Die beiden antiken Stücke „Elektra" 1904, „Ödipus und die Sphinx" 1906 sind Familientragödien um Vater-Mutter-Kind. Sie hauchen beide die lähmende Kraft des Schicksals aus und schweben auf der Spitze ahnungslos wahrsprechender Worte von tragischer Ironie. Fortan herrscht bei Hofmannsthal auf der ganzen Linie der Stil der alten Wiener Volksbühne. Dieser Stil aber heißt Komödie, Singspiel, tragisch-komisches Doppeldrama. „Christinas Heimreise" *Wiener* 1908 hat Venedig zur Szene und auf ihr das atemlose Spiel des Hochstap- *Volksstück* lers Florindo und des allzu rasch gewitzigten Bauernmädchens Christina. „Ariadne auf Naxos" 1910 verwandelt mit einer fast lässigen Gebärde den antiken Mythus von der Wiedergeburt aus dem Tode durch Liebe in den Stil der Wiener Volksbühne, indem das Stegreifspiel der Maskenkomödie und *Opera buffa* das antikische Musikdrama, opera buffa und opera seria, in eine einzige Vor- *und opera seria* stellung verschmolzen wird. In der innersten Binnenzelle der Dichtung vollzieht sich das Mysterium, dem bisher fast jedes Spiel des Dichters gegolten hatte: die Verwandlung des Menschen durch Tod und Liebe, die eines und dasselbe sind, das Geheimnis der Gottwerdung. „Der Rosenkavalier" 1911, das Wiener Gegenstück zum venezianischen, macht aus allen Beständen der Wiener Volksbühne ein Ganzes. Es sind drei Einakter. Der erste ist ein Alkovenstück, der zweite ein Degen- und Mantelspiel, der dritte eine parodistische Zauberposse. Als ob es nie ein Regeldrama gegeben hätte, ist plötzlich das alte Wiener Volkstheater wieder lebendig, Mozart, Raimund, Grillparzer eingeschlossen. Die Stunde war gekommen, die Hofmannsthal jeder Aufgabe gewachsen zeigte, dem vollkommenen Sprechstück aus dem Wiener

„Der Schwierige" Alltag und der abenteuerlichen Zauberoper aus ferner antiker Vorzeit. „Der Schwierige" 1921 ist Hofmannsthals persönlichstes Stück. Es ist das Wien seiner ersten Nachkriegstage um einen Mann, der alle Züge österreichischer Wesensart in sich vereinigt. Der Kavalier ist hier der natürliche und richtige Mensch. Die Handlung läuft einfach darauf hinaus, diesen Mann in Szene zu setzen und an einer Aufgabe sich selber spielen zu lassen. Diesem lust-spielhaften Sprechstück gegenüber steht die tragisch bedrohliche Zauber-oper. „Die ägyptische Helena" 1928 ist ein Doppelakt, der die antike Sage über dem Wirbel der beständig verwandelten Doppelgängerinnen völlig ver-gessen läßt. Helena kann uns hier Hekuba sein. Denn das ausgetauschte Ich und das versetzte Bewußtsein sind nur ein Gleichnis jenes Seelenwandels, der aus dem einen Menschen den anderen macht. Traum, bist du Leben, Leben, bist du Traum? Das Spiel schwebt unentschieden auf der raumlosen

Traum, bist du Leben, Leben, bist du Traum? Schneide von Komödie und Tragödie, ungefähr so, wie das Ferdinand Rai-mund gehalten hatte. Zwischen dem Lustspiel und der Zauberoper steht diesmal kein Drama, sondern der Roman. „Andreas oder die Vereinigten" ist um die Zeit der Heimreise Christinas begonnen, Herbst 1912/Sommer 1913 niedergeschrieben, nach 1918 anders weitergedacht und schließlich lie-gengelassen worden. Er spielt in den letzten Tagen Maria Theresias zu Venedig. Es ist die abschließende Bildungsreise des jungen Wiener Herrn

Andreas von Ferschengelder Andreas von Ferschengelder. Die gleichzeitigen Beziehungen zu vier Frauen, mehr der halben als der großen Welt, die untereinander selber durch ma-gische Schicksale verknüpft sind, nehmen den unerfahrenen und reinen Jüng-ling in die Schule. Sein Erzieher ist ein Lebensmeister, der Malteser. Der Stil ist die gleichmäßige Sachlichkeit des reifen Stifter. Mit gleichem Ernst wird das Lächerliche und Grausige, das Rührende und Schöne erzählt. Wie Grillparzer mit seinem „Spielmann", so schob Hofmannsthal mit seinem „Andreas" einen epischen Horizont vor den letzten dreifachen dramatischen

„Jedermann" Gipfel, damit er desto ferner und höher abrücke. Das Mysterienspiel „Jeder-mann" 1911 führt zu dieser abschließenden Dreiheit „Die Frau ohne Schat-

„Welttheater" und „Turm" ten" 1919, „Das Salzburger große Welttheater" 1922, „Der Turm" 1925 herauf. Mit der Entfaltung der Spielformen hatte sich auch der Gedanke des Dichters von der Natur des Tragischen voll entwickelt. Das Abgetane erweist sich als die wahre Wurzel alles Geschehenden. Es wird dem Dichter, an Vor-würfen aus der Antike erlebt, zum Verhängnis, zum unentrinnbaren Schick-sal. Der Gedanke geht dann durch den Filter christlicher Weltanschauung — „Welttheater" — und gerinnt zur letzten Gestalt im „Turm". Schicksal heißt hier endlich nur die große Probe auf den freien Willen, zu wählen oder zu

verwerfen. Fast ebenso früh wie dieser verzweigte Gedanke begegnet die Anschauung, in der er gesehen wurde. Hofmannsthal hat den Gedanken, daß sich das Schicksal in der urmenschlichen Dreiheit Mann-Weib-Kind verkörpert, auf den letzten Sinn der Mutterschaft und Vaterschaft hin getrieben. „Die Frau ohne Schatten" gibt dem Gedanken von der Mutterschaft metaphysische Blickweite. Der Schatten der Frau, das ist die Mutterschaft, und Schattenwerfen der Preis, mit dem die Menschen der Erde ihr Dasein heimzahlen müssen. „Der Turm" gestaltet den Gedanken von der Vaterschaft zu einer heroischen Tragödie, in der sich das Schicksal von Vater wie von Sohn erfüllt. Die beiden Dichtungen, das Märchen und die Tragödie, bilden um ihres Kerngedankens willen ein Ganzes. Wie „Die Frau" und „Der Turm", so bilden „Der Turm" und „Das Welttheater" ein Paar. Beide gehn von Calderon aus. „Das Welttheater" hat zum Vorwurf Wesen und Sinn der sozialen Weltordnung. „Der Turm" gibt seinem Helden, dem Prinzen, einen doppelten Sinn. Der Prinz ist der Mensch, von seinem kreatürlichen Schicksal im Kerker der Leiblichkeit gehalten. Der Prinz ist das Volk, das aus Furcht im Dunkel und Unten eingeschlossen wird. Mit seinem doppelten Ausbruch vollzieht sich der Umsturz der alten und die Heraufkunft einer neuen Welt. Das Stück ist also zugleich die Tragödie der Kreatur, des Volkes und des Zeitalters mit seinen sozialen Erschütterungen. „Das Welttheater" und „Der Turm" sind soziale Dichtungen der Zeitwende.

„Die Frau ohne Schatten"

Hofmannsthals Freund, Leopold von Andrian, hatte im Sommer 1918 die Leitung der Hofoper und des Burgtheaters übernommen. Aus jener gemeinsamen Jugend stammt Andrians verhaltene Novelle „Der Garten der Erkenntnis" 1895, im reifen Stifterton erzählt er die Geschichte eines vornehmen Jünglings, der sterben muß, ohne erkannt zu haben, und ein paar leise Gedichte, die später in den „Blättern für die Kunst" erschienen. Andrian kam nicht mehr zum Wirken. Einige Monate später mußte er die Anstalten an den neuen Freistaat übergeben. Hofmannsthal dachte mit seinen Freunden an Salzburg. Seit 1916 vorbereitet, konnten endlich unter Mitwirkung von Max Reinhardt, Richard Strauß, Alfred Roller, Franz Schalk die Salzburger Festspiele gegründet werden. Sie wurden am 22. August 1920 auf dem Domplatz mit „Jedermann" eröffnet. In der Kollegienkirche wurde 1922 das „Große Salzburger Welttheater" zum erstenmal gespielt. Die Reitschule wurde zu einer Bühne umgestaltet und am 13. August 1925 mit dem „Welttheater" eröffnet.

Burgtheater

Salzburger Festspiele

Die Wiener Bühnendichtung löste sich in ein Chaos von Stilversuchen auf. Von Theodor Tagger wurde 1920 zu Wien „Annette", von Arnolt Bronnen

„Exzesse" 1925 zu Berlin „Exzesse" gespielt. War das „expressionistisch", dann weiß man nicht, wie das gleiche „naturalistischer" gesagt werden könnte. Hans Kaltneker, 1895 bis 1919, ist mit seinen drei Dramen um Dienst und Erlösung — „Die Opferung", „Das Bergwerk", „Die Schwester" — über den „ekstatischen" Stil nicht hinausgekommen.

Drei Bühnendichter Drei Bühnendichter haben verschiedenen Wegs die Schwelle von 1918 überschritten. *Anton Wildgans*, 1881 bis 1932, war zuerst und zuletzt, zeitlich und dem Wert nach verstanden, lyrischer Dichter. Seit seinen Versen „Herbstfrühling" 1909 sind eine Fülle von Auslesen schließlich zu dem *Anton Wildgans* „Buch der Gedichte" 1929 zusammengereift. Viele sind vollendet. Ihr Kummer leidet nicht an der Welt, sondern sehr gegenständlich am Leben. Daher sind sie voll Mitleid mit den Gedrückten und Armen. Die Heimat, aus der sie atmen, ist zugleich die Stadt und die Natur der westlichen Vororte, die sich zwischen Weinbergen verlieren. Die Kornfelder und das besonnte Holz der Bäume, Vogelstimmen und Blau des ländlichen Himmels werden mit dem empfindsamen Herzen des Städters erlebt. Den verlorenen Krieg hat Wildgans in der grotesken Fratze eines Dorfes erscheinen lassen, „Kirbisch oder der Gendarm, die Schande und das Glück" 1927, ein grausamer Bauernspiegel in homerischen Versen. Dem Lande, das der Krieg zurückgelassen hatte, galt am Neujahrstag 1930 seine tröstliche „Rede über Österreich". Das *„Musik der Kindheit"* stimmungsvolle Buch „Musik der Kindheit" 1928 schildert die eigene Jugend. Wildgans hat in den letzten Jahren vor seinem Tode das Burgtheater geleitet. Seine eigenen Bühnendichtungen haben mit dem Geschmäcklerstreit um „Richtungen", der überdies um des Kaisers Bart ging, gar nichts zu schaffen. Der junge Dichter ist einfach bei dem Größten seines Faches, bei Gerhart Hauptmann, in die Schule gegangen. Der Einakter im Zimmer des Untersuchungsrichters „In Ewigkeit Amen" 1913, das trostlose Wiener Familienstück „Armut" 1914, das Drama um die müdegewordene Ehe, „Liebe" 1916, die Tragödie Vater, Mutter, Sohn „Dies irae" 1918, alle sind begabte Arbeiten aus Hauptmanns Schule, wobei Strindberg und Ibsen mitgeholfen haben. „Kain" 1920, das erste fertige Stück aus der geplanten Trilogie Kain, Moses, Christus, ist eine Legende vom ersten natürlichen Ursprung menschlicher Schuld und Kultur. Der erste Tod, der gestorben wird, ist Tötung. Der Mensch kommt Gott und der Natur mit der Hand seines eigenen Willens zuvor. Der Gesprächsstil ist von der Art der altertümlichen Bühne und hier aus *Felix Braun* Kunst gewollt. *Felix Braun*, 1885, hat den Schritt über die Schwelle mit lyrischen Versen und Erzählungen getan. Es ist wohl Hofmannsthals verhaltene Stimme, die in Brauns gedämpften Melodien wenigstens der Anfänge zu

hören ist. Der Erzähler stimmungsvoller Novellen und Legenden kommt nicht unbemerkt aus Stifters Gesellschaft. Brauns Romane rollen gern Weltbilder auf. Die führende Linie durch dieses vielfältige Lebenswerk ist vielleicht doch das Drama. Hofmannsthal ist wohl auch der Meister der frühen antikischen Tragödien, von denen allein „Tantalos" 1917, der Hamlet der Antike, gespielt worden ist. Später war es zuverlässig Grillparzer. Gewiß ist „Esther" 1926 ein ganz anderes Stück, als es sich der große Vorgänger gedacht hatte. „Kaiser Karl der Fünfte" 1936 ist von Grillparzer gar nicht zu trennen. Es ist beinahe „Bruderzwist" I zu Grillparzers „Bruderzwist" II. Der Tod Maximilians I. in Brauns Vorspiel schlägt gedanklich einen gewaltigen Bogen zum Tode Rudolfs II. bei Grillparzer und macht aus dem, was sich von 1519 bis 1618 begibt, eine geschlossene szenische Handlung. *Franz Theodor Csokor,* 1885, hat nicht nur diese eine Grenze unverwandelt überschritten. Auch seine Gedichte von den Balladen „Die Gewalten" 1912 bis zu „Ewiger Aufbruch" 1927, persönlicher als die Dramen erwarten lassen, führen von drüben herüber. So ausschließlich und wesentlich wie keiner der österreichischen Dichter ist Csokor der Mann des Dramas. „Der große Kampf" 1915 ist ein Zeugnis der Stimmung, die uns in jenen sengenden Augusttagen alle überwältigt hat. Alles, was folgte, die Mythe „Der Baum der Erkenntnis" 1916, die Szenenfolge des gerahmten Traumspiels „Rote Straße" 1916/1918, die „Ballade von der Stadt" 1924, „Besetztes Gebiet" 1930, das Zauberstück „Die Weibermühle" 1932, „Dritter November 1918" 1936, erhält Mitte und Zusammenhang durch die Tragödie „Gesellschaft der Menschenrechte", die 1929 in Mannheim und 1931 am Burgtheater gespielt worden ist. Als Csokor 1926 Georg Büchners unvollendete Tragödie „Wozzek" abschloß, war er dem Mann, der Zeit, der Landschaft begegnet, in denen die deutsche Revolution mit all ihren tragischen, einander hemmenden Anlagen geboren worden ist, Anlagen, an denen ihre Mutter, die französische Revolution, und ihr Vater, der deutsche Befreiungskrieg, gleichen Anteil haben. Hier war die Revolution schlechthin, fast metaphysisch unbedingt, das Paradigma. Das Stück besteht ohne zusammenfassende Aufzüge aus zwölf Szenen, die kleine Einakter mit je abgerundeter Handlung sind. Das Ganze wird eingerahmt von Friedrich Weidigs Heimkehr aus dem Gefängnis und seinem Selbstmord im Gefängnis. Denn Friedrich Weidig ist der Lehrer Büchners und der Vater dieser hessischen und aufgeschobenen deutschen Revolution. Die dramatische Handlung geht ohne Hast und Zögerung mit der sichtbaren Gewißheit des Minutenzeigers. Was haben mit all dem irgendwelche künstlerische Ismen zu tun? Goethe hat in seiner „Natürlichen Toch-

Zweimal „Bruderzwist"

Franz Theodor Csokor

„Gesellschaft der Menschenrechte"

Erinnerung an die „Räuber"

ter" so gut wie Csokor in der „Roten Straße" unbenannte Typen spielen lassen. Und wo ist der künstlerische Unterschied zwischen „Räuber" und „Besetztes Gebiet"? Der junge Schiller würde an Csokors Stelle ähnlich gehandelt haben. Es ist die Kunst der Szene, der Stil von innen heraus und die überzeitliche Gültigkeit, die Csokors „Gesellschaft der Menschenrechte" zu einer Leistung von Rang machen. Csokors dramatisches Werk nach seiner Heimkehr 1945 blieb sich selbst getreu, aber es lebte aus der Fülle neu geschöpfter Erfahrungen.

Die Jahre von 1918 bis 1938 ließen jüngere Bühnendichter ausreifen, denen das Wie und Was des Künstlerstreits von gestern nichts mehr bedeuteten.

Richard Billinger

Richard Billinger, 1893, aus dem oberösterreichischen Marienkirchen, ist vielleicht der ursprünglichste Lyriker dieser österreichischen Jahrzehnte. Brot als Speise und Opfer ist sein Grunderlebnis. Der Bauer ist der Mensch an sich und schlechthin. So ist denn auch Billingers lyrische Sprache menschlich nackt und bloß, ohne künstliches Lendentuch, fast ohne Bild, wortwörtlich. Den Ausgang von Billingers Bühnendichtungen bilden „Perchtenspiel" 1928 von der gefangenen Göttin, „Rauhnacht" 1931 vom Dämonenspuk der Vorweihnacht, „Rosse" 1933 vom Kampf der Tiernatur gegen die Maschine. Unter Versuchen und Abwegen bedeuten „Die Hexe von Passau" 1935 aus dem bairischen Bauernkrieg, „Die Windsbraut" 1937 vom bäuerlichen Heimkehrer, „Der Gigant" 1937 vom Bauern, der die Maschine abwehrt, aber die Tochter an die verlockende Stadt verliert, eine Rückkehr. Nach dem Kriege hat Billinger, nur kurze Zeit ein wenig unsicher, seine Natur und seinen Stil im Ziel behalten. All diese Stücke spielen im Balladenstil den Triebmenschen in Gestalt des Innviertler Bauern. Sie setzen das ganze Dorf in Szene, diese Einheit vom Spuk und Wirklichkeit, Mensch und Tier, Gott und Teufel.

Hermann Heinz Ortner

Es sind Spiele des Dorfbarocks. *Hermann Heinz Ortner,* 1895 bis 1955, aus Bad Kreuzen, ist von der Legende ausgegangen, die das tägliche Brot der Laienspieler war. Die Wirbel, die das Wunder erzeugt, wenn es die Welt der Vernunft betritt, gehen mit „Tobias Wunderlich" 1928, „Sebastianslegende" 1929, „Himmlische Hochzeit" 1935 über die Szene. Der Bauernführer „Stefan Fadinger" 1933, das Lebensbild „Beethoven" 1934, das Geschichtsspiel „Isabella von Spanien" 1937 fügten sich in den Spiel-

Friedrich Schreyvogl

plan des Burgtheaters jener Jahre. *Friedrich Schreyvogl,* 1899, steht mit seinen Romanen mitten im Leben der Gegenwart und hat zunächst nur Wien zuliebe mit „Grillparzer" 1935 eine Ausnahme gemacht. Auch auf der Bühne blieb er anfänglich mit der handelnden Zeit in Fühlung. Mit der Demetrius-

tragödie „Der Gott im Kreml" erschien er um die Wintersonnenwende 1937/1938 auf der Szene des Burgtheaters. Die Komödie aus der Zeit des römischen Kaisers Marc Aurel „Die kluge Wienerin" 1941 ist das liebenswürdigste und erfolgreichste Spiel des Dichters und drückt seine Natur am vollkommensten aus. *Josef Wenter,* 1880 bis 1947, aus Meran, ist auf nicht *Josef Wenter* ganz einfache Weise zum Drama gekommen. Er strebte ursprünglich zur Tonkunst und zur Oper, entschloß sich dann zur Wortkunst und zum Drama, während er die Pause der Vorbereitung mit seinen Tierromanen ausfüllte. Von den beiden Wegen, die Wenter beim Aufbruch zur Wahl hatte, gab er den zum Zeitdrama sogleich wieder auf, um desto entschlossener dem geschichtlichen Drama zuzustreben. Hier war es zu frühest die Staatstragödie, „Der Kanzler von Tirol" 1926, „Der deutsche Heinrich" 1934, „Der sechste Heinrich" 1923/1938, später war es das legendenhafte Seelendrama, „Die Landgräfin von Thüringen" 1936 und „Die schöne Welserin" 1938, beidemal die Bewährung einer Ehe im Widerstreit gegensätzlicher Ordnungen.

Die Leistung und den Stil im ganzen genommen, zeigen die österreichische *Hugo von* Bühnendichtung dieses Zeitalters am Eingange bei Hugo von Hofmannsthal *Hofmannsthal* und am Ausgange bei Max Mell. Das ist nicht der Abstand, sondern der dop- *— Max Mell* pelte Gewinn einer Entwicklung.

Max Mell, 1882, aus Marburg, hat sich durch eigene Arbeiten in den österreichischen Humanismus und in den alpenländischen Dorfbarock eingelebt. Diese humanistische und barocke Latinität hat es gemacht, daß die drei dichterischen Urformen Sage, Lied, Spiel in Mells Dichtung reiner Stil geworden sind. Da sind die lyrischen Verse, nur für das Auge der schmalste Ertrag im Ganzen. Sie sind als „Das bekränzte Jahr" 1911 und als „Gedichte" 1920 bis *„Das bekränzte* 1929 gesammelt worden. Der österreichische Humanismus spricht sich in *Jahr"* ihnen vornehm, frei und gelassen aus. Diese Verse erscheinen so persönlich und apart, daß man vielleicht überhört, was in ihnen mitschwingt. Es ist das Volkslied. Volksliedhaft sind sie durch die Art, wie sie Seele ausdrücken. Sie setzen die Worte zögernd, ungewiß, verschämt, als wäre es ihnen ungewohnt, außerhalb des Alltäglichen zu reden. Da sind die Erzählungen, wie sie „Das *„Das Donau-* Donauweibchen" 1938 zu einer auserlesenen Runde versammelt. So einsam *weibchen"* wie nur ein ratloses Elend und erbarmungslose Verstoßung zu machen vermögen, steht inmitten dieser Runde „Barbara Naderer". Im Herzen dieser armen steirischen Häuslerin begibt sich eine der größten Tragödien der menschlichen Seele. Benachbart sind andere von gleicher Art. Um diesen Bezirk der Dämonen zieht der Dichter den heitern, menschlichwarmen Bann-

kreis der Wienerstadt. Das sind die Kindergeschichten von erleuchtender Seelenkenntnis und gutgelauntem oder elegischem Tiefsinn, Geschichten aus der unmittelbarsten Nähe des Volkes. Die beiden Kreise, der Dämonen und der Kinder, werden von einem äußeren umrundet, den legendenhaften Paradismärchen, in denen sich ringsum der Horizont Gottes ins Unendliche weitet. All diese Geschichten halten sich an den Stil, in dem sich das Volk von je erzählt und erzählen läßt. Es sind Kurzgeschichten mündlichen Vortrags, der Zuhörer vor sich sieht. Man hört aus ihnen die uralte Erzählkunst des österreichischen Alpenvolkes. Da sind die Spiele. Max Mell war mit dem Werk Hofmannsthals freundschaftlich vertraut und kannte das Volksspiel des späten Mittelalters aus eigener Beschäftigung. Da haben wir nun den Dichter, der auf andere Art als Hofmannsthal den Spielplan des Laienspiels vom *Vom Wiener Kripperl zur großen Tragödie* „Wiener Kripperl" 1919 über „Apostelspiel" 1923 und „Schutzengelspiel" 1923 bis zu „Nachfolge-Christi-Spiel" 1927 und „Spiel von den deutschen Ahnen" 1935 auf die Höhe einer anpruchsvollen Kunst gehoben hat. Alle diese Stücke haben nur einen Gedanken: die beispielhafte Rettung des Menschen aus der Seelennot des Krieges und des zermürbenden Friedens, der ihn ablöste. Max Mell hat den österreichischen Dorfbarock auf der Bühne der Großstadt eingebürgert. Richard von Kralik hatte sich ein Theater geträumt, auf dem die attische Tragödie und das deutsche Sagenspiel ein geschwisterliches Ganzes würden. Das ist Max Mells Leistung geworden. Aus der attischen Trilogie um Ödipus, den Töter seines Vaters und Gatten seiner Mutter, um die Brüder, die einander wegen Theben töten, um Antigone, die getötet wird, weil sie ihren Bruder bestattet hat, löste Mell heraus, was in einem *„Die Sieben gegen Theben"* Zuge gespielt werden konnte. „Die Sieben gegen Theben" 1932 sind kein Zweiakter, sondern ein Doppelstück mit zwei Helden, die einander folgen. Was Mell spielen läßt, ist eine Kulturwende, der Zerfall des Mutterreichs der Erde und der Aufgang der männlichen Gesetzesordnung. Es ist das tragisch verwirrte Theben, in dem mitten unter so chaotischem Werden nicht einmal die Wissenden wissen, was Recht ist. Jeder steht gegen jeden und jeder hat recht und unrecht. Da die Spielmannsdichtung von den Nibelungen österreichisch war, nahm Mell mit seiner Tragödie „Der Nibelunge Not" 1942 ein *„Der Nibelunge Not"* Recht in Anspruch und eine Pflicht auf sich. Die Lage am Burgunderhofe ist die gleiche wie am Hof zu Theben. Auch hier eine Kulturwende. Die Familie wütet gegeneinander und löscht sich aus. Den Goldhort, den Schicksalsträger und Urheber des Unheils, läßt Mell auf der Bühne sichtbar mitspielen. Aus der alten viertonigen Kurzzeile hat der Dichter mit allen Mitteln der Modulation einen unvergleichlichen Sprechvers gemacht. Was über dieser Dich-

tung wie kostbare Patina liegt, das ist die künstliche Verwitterung dieser Verssprache. So bilden „Die Sieben gegen Theben" und „Der Nibelunge Not" aus Attika und Österreich ein Ganzes. Sie sind ins Urzeitliche zurück-stilisiert. Max Mells Tragödie um die thebanische Königin-Mutter lenkt den Blick auf Grillparzers „Libussa", wo es ähnlich-anders um den Auszug des Menschen aus der Urzeit geht. Das Spiel um den Goldhort ruft Grillparzers „Vlies" heran, damit diese Medea und diese Brunhilde einander ins Auge fassen können. Es ist hier wie dort das gleiche Burgtheater und die hundert Jahre dazwischen sind nicht mehr als ein Tag.

Mell und Grillparzer

Es ist das erstemal in all seinen Jahrhunderten, daß Österreich sich in einer vielstimmigen und ebenbürtigen lyrischen Dichtung ausspricht. Alle Länder und die Stadt klingen in ihr zusammen. Ihre Melodie bewegt sich von Georg Trakl zu Josef Weinheber.

Von Trakl zu Weinheber

Georg Trakl, 1887 bis 1914, aus Salzburg, über den Vater von schwä-bischer, über die Mutter von tschechischer Herkunft, hat eigentlich zu Inns-bruck unter dem Schutze Ludwigs von Ficker gelebt. Seine frühen Dich-tungen aus den Jahren 1908/1912 verraten die Nähe Rilkes. Doch sie ver-raten keinen Schüler. Es sind unheimliche Dichtungen. Sie drücken das Grauen gelassen und kühl mit sparsamen Worten von polierter Schönheit aus. In „Traumland" sagt der Oheim zum Dichter: „Deine Seele geht nach dem Leiden, mein Junge." Das ist sehr selbsterkennend für einen unfaßbaren Seelenzustand. Nichts, was Trakl nach diesen frühen Blättern geschrieben hat, konnte aus einem tieferen Abgrund kommen. Aber es konnte steigen. Einer seiner letzten Freunde, Karl Röck, hat die Gedichte 1917 zuerst ge-sammelt. Es sind drei in sich wieder gedrittelte Bücher. Trakls Zwielicht des Gefühls aus dem dämonenhaften Urgrunde des Geschlechts hat sich in dem beständigen Formerlebnis der verwitternden Barockstadt Salzburg und dem Keltergeruch südländischen Herbstes verfangen. Beides sind nur gegen-ständliche Wahrnehmungen des innerlichen Erlebnisses, sterbendes Leben oder lebendiger Tod, gleichviel, da dieses Erlebnis sich nicht auseinander-denken läßt. Trakl fühlte sich als Todgeweihten. Und wie einer, der in den Tod stürzt, griff er im Absturz nach den vorübergleitenden Bildern seiner Kindheit: „Sebastian im Traum", „Herbst des Einsamen", „Siebengesang des Todes". Das Bewußtsein der persönlichen Todesbestimmung weitet sich in den Untergang der Familie und des gesamten Abendlandes, zu einer groß-artigen Schau des heraufziehenden Krieges, Erfüllung des persönlichen Schicksals und zugleich des Schicksals der Welt. Trakls Lebensstimmung steigt aus dem Abgrund des Geschlechts, wo Liebe und Haß, Zeugen und

Georg Trakl

Wortschatz des Todes

Töten, Same und Blut eine einzige Lust oder Unlust sind. Trakl war kein kranker, sondern ein starker Mensch mit einem dämonischen Triebleben. Weil er das Tierhafte des Menschen in jeder Welle des Blutes spürte, hat er auch die Widerwelt von Leib und Seele am grauenhaftesten empfunden. Daher sein Wissen um die Natur des Bösen. Gegen die verderblichen Mächte seines Wesens hatte er zwei Kampfstoffe: die große Gnade zur Natur und eine gnadenlose Todesbejahung. Trakl ist der verliebteste Liebhaber des Todes gewesen. Vielleicht hat nie ein Mensch einen so umfangreichen und ausgebildeten Wortschatz für Tod und Sterben besessen. Die Meister seiner Anfänge waren zwei Franzosen und zwei Russen: Verlaine und Rimbaud; Dostojewskij und Tolstoj. Als Protestant lebte er in der Vorstellungswelt der Bibel, die ihm göttliche Offenbarung gewesen ist.

„Der ewige Kreis" Einen ungefähren Längsschnitt durch das lyrische Schaffen des Landes lassen die Sammelbücher erkennen, die von Emil Alphons Rheinhardt, „Die Botschaft. Neue Gedichte aus Österreich" 1920 bis zu Otto Brandt, „Der ewige Kreis" 1935 einander in dichter Reihe ablösten. Man kann diesen lyri-

Sakrament des Brotes schen Chor hörbar machen an nicht vielen, aber ausgebildeten Stimmen. Dabei soll die Klangfarbe wechseln vom Wort, in dem das Geheimnis des bäuerlichen Ackers aufdunkelt, bis zu den Weisen, in denen der menschliche Geist seine Abenteuer beschwört. Die Welt des Bauern, das Sakrament des Brotes, das Mysterium der Arbeit und des Sterbens haben ihre vielen Verkünder in der weiten Spanne, die von Richard Billingers „Sichel am Himmel" 1931 bis zu Franz Schlögels „Wir Bauern" 1938 dem Erlebnis zugänglich sind. Ernst Scheibelreiter hat, zuerst in seinem Buch „Die frohe Ernte" 1935 alles, was Bauer heißt, zu balladenhaftem Geschehen und bildmäßigen Naturmythen gesteigert. Das Jenseits liegt hier mit den Dingen selber zutage und kann von ihnen gar nicht unterschieden werden. Indessen gibt es doch Stunden und Erlebnisse, in denen man es innerlich schauernd wie einen kalten Luftzug spürt. Guido Zernatto, der die kreatürliche Gemeinsamkeit aller Dinge im Gefühl hat, gibt solche Erlebnisse — „Die Sonnenuhr" 1933 — mit spukhafter Wirklichkeit wieder. Wilhelm Szabo hat schon in seinem ersten Buch

Das Dorf — die Stadt „Das fremde Dorf" 1933 das bäuerliche Leben gern als ein Ganzes genommen und von innen her erleuchtet, so daß die dunklen Scheiben plötzlich bunte Bilder werden. Das Dorf steht nur noch gerade über dem Gesichtsfelde und schon weit weg, weil nicht mehr eine Welt für sich, sondern nur noch ein unerläßlicher Teil. So bewegt sich Werner Riemerschmid mit seiner Sammlung „Das verzauberte Jahr" 1936 an der Grenze, wo Großstadt und Land ineinander übergehen. Das ist freilich eine magische Grenze, die von allerlei

Spuk behütet wird. Und Theodor Kramer haust mit seinen Versbüchern „Die *Die Heimat*
Gaunerzinke" 1929 und „Kalendarium" 1930 auf der Almende, die zwischen
Dorf und Stadt die Armut schafft, bei den Dorfarmen und in den Nacht-
quartieren der Großstadt. Hier wird der feierliche Friede des Dorfes, die
Mühsal der Steinbrecher und das Elend der Straßensänger zur Stimmung.
Bei Maria Neuhauser, „Die heilige Stunde" 1934, ist das Land fast nur noch
als Natur gegenwärtig und die Stadt als Arbeiterin. In der Mitte, die fast
überall bis an den Rand reicht, steht die Persönlichkeit, die Frau, mit ihrem
erfüllten Herzen. Das ganze ungeteilte Leben nimmt das Dorf nur noch als
Erlebnis der Heimat oder aus zufälligen Begegnungen in sein Bewußtsein
auf. So ist es bei Rudolf List, dessen Bücher „Tor aus dem Dunkel" 1935 und
„Wort aus der Erde" 1941 vom reinen unbegrenzten Dasein ihren Inhalt
empfangen. „Herr gib zum Frieden uns wieder die Welt / Zur Saat die Erde, *„Das Leben*
zur Ernte, der früchtereichen, / Zum Segen das Kreuz, zur Demut die Stirn, / *und der Tod"*
Die Sterne wieder zu Wundern und Zeichen!" Wie das Dorf dem allgemei-
nen Leben, so erscheint das Leben nun völlig der Wirklichkeit eingeordnet,
über der sich das Reich der Idee wölbt. Das ist der christliche Gedanke bei
Erna Blaas, deren Versbuch „Das Leben und der Tod" 1930 durch das Dop-
pelerlebnis des Witwenschmerzes und des Mutterglücks über die gemeine
Wirklichkeit hinausgehoben ist. Das ist Platos Gedanke vom Weltgesetz der
Zahl bei Arthur Fischer-Colbrie, der in „Musik der Jahreszeiten" 1928 aus *„Musik der*
dem Siebenklang des Orion, aus dem Fall des reifen Apfels, aus dem Stun- *Jahreszeiten"*
denschlag der Zeit die eine und gleiche Harmonie der Welt heraushört. Das
ist die allgemeine Gottesvorstellung in Richard Zeltners Buch „Der fremde
Gesang" 1935, das aus strengen Formen aufgegliedert, mit Gedichten von
der hohen Sendung des Dichters einsetzt, die Einsamkeit der Persönlichkeit
und die Zweiheit des liebenden Paares umkreist, die drei Gipfel von den *„Gott im*
großen Geistern der Menschheit, von den Landschaften der Seele, von der *Kinderspiel*
dunklen Drohung der Zeit überfliegt und endlich die Richtung auf Gott *kopierend"*
nimmt. Die Wirklichkeit erscheint nur noch als Gestalt der Idee und fordert
den höchsten Ehrgeiz der Form heraus. Ernst Waldingers Bücher „Die Kup-
pel" 1934 mit dem unwiederholbaren Sonettkränzchen „Uhrensammlung"
und „Der Gemmenschneider" 1937, „Gott im Kinderspiel kopierend", halten
sich keineswegs außerhalb des Tages, sondern nehmen, was er bringt, zum
Anlaß geistreicher Überlegung. Aber sie halten sich an „Gesetz und Ewig-
keit" in den Erscheinungen. Friedrich Sacher, der Meistererzähler und Lieb- *„Das Buch*
haber der kleinen Dinge, hat die Gedichte von sieben Jahren in „Das Buch *der Mitte"*
der Mitte" 1939 zusammengefaßt, fünf kleine Gruppen. Von ihnen gelten

die ersten zwei dem Gesetz, unter dem das Schaffen steht, das mittlere dem Zeitalter, die letzten zwei dem Mann unter seinem Gestirn und auf seiner Mittagshöhe. Über der Schneide von Gottes Willen schwebt das Gleichgewicht der Welt. Doch es ist, wie Plato gedacht hat, das Gesetz der Harmonie, nach dem in der Welt alles gezählt, gemessen, gewogen wird.

„Lob Gottes im Gebirge" Paula von Preradović hat sich über die drei Bücher „Südlicher Sommer" 1929, „Dalmatinische Sonette" 1933, „Lob Gottes im Gebirge" 1936 entfaltet; von der Kulturlandschaft der östlichen Adria zum österreichischen Gebirge; von bildnerischen zu hymnischen Formen; immer gegenständlich im einzelnen und ideal im Ganzen. „O Herr, wirf die Götzen nieder, / Erbarm dich dieser Zeit, / Deinen Sternenhimmel gib uns wieder / Und deine Dunkelheit" Alexander Lernet-Holenia und sein Werk, das ist, unbeschadet seiner Dramen barocken Stils und seiner unterhaltsamen Romane, das lyrische Gedicht. „Kanzonär" 1923 ist kein Stundenbuch und kein geistliches Jahr, sondern das göttliche Weltalter von der Schöpfung bis zum Gericht, ausgedichtet nach der Bibel, ein lyrisches Mysterium. Hier waren Abendland und Morgenland auf geistliche Weise in Gottes Hand eins, die Welt. Als das Reich

„Die Goldene Horde" der Formen macht sie „Die Goldene Horde" 1935 zu einem Ganzen. Das schmale Buch ist eingerahmt, voran durch den Triumph der Liebe in lateinischen Versen, zuletzt durch das Gedächtnisspiel auf Rilke, Triumph des Todes. Daran schmiegt sich nach innen zu ein zweiter Rahmen, Hellas, voran „Sapphische Gedichte", zuletzt die „Olympische Hymne". In diesem zweifachen Rund entfaltet sich mit kaum zwei Dutzend Gedichten die ganze Welt: griechische Oden und Hymnen, Lieder aus dem frühen Frankreich und Italien, biblische Rhapsodien, Vollbilder der Landschaft, zeitlose Natur, ewiges Sein. In der Mitte steht die mystische Ballade vom Tod des Zaren, von dem Rußland, das Rilke geliebt hatte. In makelloser Schlichtheit fügen sich Worte zu Worten, sind unauffällig ein Vers und werden mit unhörbaren Schritten zusammen eine Strophe. Hier ist keine Gemeinschaft als die der Sprache und keine Persönlichkeit als die der reinen Form.

Zweimal drei Büchlein *Josef Weinheber*, 1892 bis 1945, stammt aus der Vorstadt. Das ist diesmal wichtig und er selber hat darauf Wert gelegt. Er war ein kleiner Beamter. Seine reifen Verse sind ein Ganzes von zweimal drei Liederbüchlein. „Adel und Untergang" 1934, „Späte Krone" 1936, „Zwischen Göttern und Dämonen" 1938 bilden die erste Dreiheit. Jedes Büchlein ist aus wohlgezählten Gliedern zur Kette gefügt. Das erste Büchlein hat deren sieben. Drei haben lateinischen, drei deutschen Stil. Das siebente sagt vom Dichter selber: „Nimm das Leid und mach es zum Liede." Das zweite Büchlein hat fünf

solcher Glieder und sehr sachlich schlichte: von der Kunst und vom Künstler, Oden, Elegien und Hymnen, Lieder und Gedichte. Das dritte Büchlein hat zehnmal vier solcher Glieder, vierzig Oden von höchsten und größten Dingen. Solange er schön ist, hält der Mensch das Gleichgewicht von Oben und Unten, das Gleichgewicht durch seinen Mut zu sich selber, das Gleichgewicht von Göttern und Dämonen, die beide ihn brauchen. Denn der Mensch ist das Maß aller Dinge und die Schneide, die den Wagebalken der Welt trägt. Die zweite Dreiheit fügt sich aus „Wien wörtlich" 1935, „O Mensch, gib acht" 1937, „Kammermusik" 1939 zusammen. Das erste Büchlein hat seinen Namen, weil es die Stadt so gibt, wie sie wirklich ist, wörtlich so, wie sie redet. Wien mit seinen Bauten, Menschen, Ständen, Zeiten ist hier in einen Reigen von Gedichten geordnet, deren jedes ein gemaltes Bild ist, strahlend von Wirklichkeit und umdunkelt von Tiefsinn. Das zweite Büchlein trägt seine Aufschrift, weil es des Bauern Werk und Brauch im Monatslaufe eines ganzen Jahres hindurch begleitet. Das dritte Büchlein ist, was es heißt, denn es macht die Welt des ersten und zweiten, Wien und sein bäuerliches Stammland, das Leben des Dichters aus dem einen und andern, zu einem Tonstück von gedämpfter elegisch-heiterer Frömmigkeit, zur Stimme der beiden Geigen, der Bratsche und des Cellos, zu jener Sprache, die alle Zeiten die wahre Mundart Wiens gewesen ist. Und also stimmen die ersten drei Büchlein im Göttlich-Dämonischen des Menschen ebenso zusammen wie die zweiten drei im Zeitlich-Ewigen der Heimat. Beide Dreiheiten sind Büchlein des einen und gleichen Lebensgefühles, des Schmerzes aus dem Wesen der Welt und des Künstlertums. Sie meinen damit das Lebensgefühl, durch das der Wiener und Österreicher in die Dichtung ihrer Stadt und ihres Landes eingegangen sind. Inbegriff und Siegel seines Werks ist das lyrische Buch des Tiefsinns und vollkommenen Form jeglichen Stiles, „Hier ist das Wort" 1948, wie es der Krieg und der Tod als Vermächtnis frei gab. Der Dichter ist nach eigenem Zeugnis in seinen ersten Versen ein Zögling Hofmannsthals und Rilkes gewesen. Seine reife Meisterschaft ist Hölderlin verpflichtet, dessen unsterbliches Parzenlied er in einer Runde seiner Gedichte durch viele Tonarten abgewandelt hat. Josef Weinheber ist durch die heimatlichen Meisterklassen seiner Zeit hindurchgegangen. Aber er ist in keiner sitzengeblieben. Er hat, ohne die Klassen der humanistischen Bildung durchlaufen zu haben, sich die lyrischen Instrumente der Griechen und Römer erstaunlich gefügig gemacht. Wie ein wahrhaft Wissender scheint er mit allen Tiefen und Hintergründen der Sprache vertraut. Doch seine Kunst stammt aus der Heimat. Ein Mann aus dem Volke, das ist Weinheber gewesen. Er hat dem lebens-

Zwischen Göttern und Dämonen

„O Mensch, gib acht"

Kammermusik

„Hier ist das Wort"

Der Mann aus dem Volke

weisen und gefühlsechten Lied der Wiener Volkssänger die hohe Form
gegeben, die das Wiener Volksstück durch Franz Grillparzer und Ferdinand
Raimund seit einem Jahrhundert schon besaß. Er hat das Wiener Lied, ohne
dessen Ton zu trüben, in die Notenschrift der humanistischen Latinität
Österreichs übertragen.

Georg Trakl ist 1914, Josef Weinheber 1945 in den Tod gegangen.

II. DEUTSCHLAND

1918 bis 1945

Die Dichtung dieser Jahre erfüllt, was die vorangegangenen verheißen hatten. Der Mythus und die Mysterien der Hellenen werden ihr großes Erlebnis und stellen Deutschland mitten in die Entscheidung zwischen Apollon und Dionysos.

Hamann hatte die Mysterien wieder beschworen mit all ihren Vorstellungen: Charon und Orpheus, Apollon und Dionysos, den Gottmenschen und den Menschgott, das Geheimnis von Brot und Wein, die apokalyptische Prophetie. Herder hatte seine Vorstellungen mit den Mysterien der Ägypter verknüpft. Kleuker hatte ihnen Gestalt und Weisheit des iranischen Zarathustra beigesellt. Hölderlin hatte all diese Vorstellungen zu hymnischer Dichtung gemacht. *Die Mysterien*

Nietzsche hatte die delphische Gottheit der Weissagung in ihre ursprüngliche Zweiheit Apollon und Dionysos gespalten, sich in Zarathustra verwandelt und am Rande seiner Nacht 1888 die Dionysos-Dithyramben gesungen. In dem einen Jahr 1890 hatte von den beiden Niedersachsen Langbehn die Hellenen als Vorbild gesetzt und Rohde aus ihrem Seelenglauben ihre Mysterien gedeutet. Zur Linde stiftete den Charonbund, George schloß seinen Siebenten Ring. *Apollon und Dionysos*

Die Nation war mit Charon in die Unterwelt des Krieges gefahren und wie Orpheus stieg sie aus dem Schattenreich des Todes wieder ans Licht empor. Die Heimkehr und der Heimkehrer werden zum allgemeinen Gegenstand der Dichtung. Apollon oder Dionysos, das wird die Frage, die sie bewegt. Im Osten suchen die einen nach einer Vorstellung, in der sich Apollon und Dionysos vereinigen, während die andern sich zu Dionysos und Demeter, zu Wein und Brot bekennen. Im hessischen Weinland ist es Apollon. Sein Gefährte aus dem Osten ist nicht mehr Zarathustra, sondern Buddha. In Westfalen bleibt es bei Charon und Orpheus. *Charon und Orpheus*

In den Vorstellungen und Bildern des hellenischen Mythus hat dieses Zeitalter sich selbst gedacht und gedichtet. Und da der Durchleuchter und Begrenzer, der Gott der Klarheit und Beherrschung, seine Macht an den dämonischen Gott des Rausches und des grenzenlosen Ausschweifens verloren hatte, so war aus der einen Frage, Apollon oder Dionysos, die andere geworden: Charon oder Orpheus? *Der Mythus des Zeitalters*

I. BINNENRÄUME

November 1918 Im November 1918 hatten alle recht behalten, die den Gang des Reiches mit steigendem Mißtrauen, mit Sorge und Angst verfolgt hatten. Daraus war fast die gesamte deutsche Dichtung geworden. Sie stürzte sich nun aus allen Formen und Stilen heraus von neuem in jedes Abenteuer des Geistes, das einen Ausweg in die Weite der Welt versprach. Die geistige Revolution war der politischen und sozialen um Jahre voraus und längst im Gange. Sie hatte der deutschen Monarchie gegolten. Die deutsche Republik war weder ihr Werk noch ihr Gewinn. Dieser geistigen Revolution ging es um das deutsche Volk und dessen geistige Gestalt.

„Der Sturm" BERLIN hatte seit 1910 zwei Blätter, die miteinander im lebhaften Wettbewerb standen. Die Wochenschrift „Der Sturm" gab der Berliner Herwarth Walden heraus. Sie stellte sich noch künstlerische Aufgaben. Wissen, Bildung, Können hieß es, seien für die Gestaltung des Kunstwerkes belanglos. Der Künstler ist ein Mensch, der die Gabe hat, Gesichte zu erleiden und zu künden. Wer zum Künstler berufen ist, bedarf des Könnens nicht. „Die Aktion" *„Die Aktion"* wurde von dem Ostpreußen Franz Pfemfert geleitet. Er gab 1916 „Aktionslyrik", 1916/1921 „Literarische Aktionsbücher", 1917/1924 die Reihe „Der rote Hahn" heraus. Seine Mitarbeiter waren Max Oppenheimer, Max Herrmann, Viktor Fraenkl, Julius Moses, Alfred Ehrenstein, Erich Mühsam, Carl Sternheim, Max Brod, Alfred Wolfenstein, Salomon Friedländer, Alfred Kerr, Franz Werfel. Bei Kurt Hiller und Ludwig Rubiner lag die geistige Führung der „Aktion".

Von den beiden Männern war Hiller der Denker und Rubiner der Dichter. *Kurt Hiller*, 1885, aus Berlin, hatte 1915 für den Kampf um die Verwandlung der Welt das Stichwort „Aktivismus" geprägt. Er hat diesen Gedanken in *„Logokratie oder Weltbund des Geistes"* den fünf Jahrbüchern „Das Ziel" seit 1916 und in dem Buch „Logokratie oder ein Weltbund des Geistes" 1920 vertreten. Der Aktivist verneint den „Psychologismus", der überall nur zu verstehen trachtet, und den „Musivismus", der sich im Genuß der Formen auslebt. Aber er ist kein Feind der Kunst. Hiller beruft sich auf Nietzsche, lehnt mit Lagarde die Anschauung ab, daß der Staat die höchste Form des Menschenlebens sei und mag keine Verbesserung durch Wandlung der Seelen. „Wir wollen, bei lebendigem Leibe, ins Paradies." Durch Deutschland wird die Welt vergeistigt werden. Daher: „Gründung des Bundes der Geistigen deutscher Zunge". *Ludwig Rubiner*, 1882 bis 1920, sagte das alles dichterisch. Seine Sammlung „Kame-*„Kameraden der Menschheit"* raden der Menschheit. Dichtungen zur Weltrevolution" 1919 vereinigte:

Johannes Robert Becher, Walter Hasenclever, Paul Zech, Albert Ehrenstein, *Der Proletarier, der Dichter*
Carl Einstein, Ernst Toller, Franz Werfel, Alfred Wolfenstein. „Künstler-
ästhetik ist ein Denksystem des Bürgers." „Der Proletarier befreit die Welt
von der wirtschaftlichen Vergangenheit des Kapitalismus; der Dichter be-
freit sie von der Gefühlsvergangenheit des Kapitalismus. Kameraden der
Menschheit rufen zur Weltrevolution." Verführerischer als irgendein anderer
zaubert Rubiner — „Eine Botschaft" — die neue Welt der Schönheit und
des Glücks an das Gesichtsfeld dieser Zeit und so wirksam wie sonst keiner
preist er die Kraft des menschlichen Willens, der aus Traum Wirklichkeit
macht. Unüberbietbar sind die gnadenlosen Worte, mit denen er den groß-
städtischen Lebensekel schildert: „Der Marsch", „Die feindliche Erde", „Sieg
der Trägheit". Keiner war kühner, das Bild des Messias zu entwerfen, der
den Sieg der Trägheit in einen Sieg der Bewegung verwandeln kann: „Füh-
rer", „Die Engel", „Der Denker". In Versbüchern wie „Der Mensch in der
Mitte" 1917 und „Das himmlische Licht" 1920 und in Dramen wie „Der
Aufstand" 1914 und „Die Gewaltlosen" 1919 läßt er die Bekehrung zur klas- *„Die Gewaltlosen"*
senlosen Gesellschaft durch die Magie eines hinreißenden Vorbildes ge-
schehen, durch die waffenlose Preisgabe des Selbst an die Feinde der neuen
Ordnung. Der Kreis um Hiller und Rubiner vertrat die Anarchie der Sprache.
Da hieß es, daß der Heilige Geist von der Dirne Sprache geboren wurde. Da
verlangte Rubiner, die Sprache müsse zunächst einmal Chaos werden, wenn
sie dann Kosmos werden soll. Mit Berufung auf den „großen Aktiven von
Nazareth", der auch kein Bild und Ding geschaffen habe, lehnte Hiller ge-
radezu die Pflicht der künstlerischen Gestaltung ab. Und mit der gleichen
Berufung erklärte Rubiner, so wie der Mob aus anarchischen Revolten das
Christentum und die Reformation gemacht habe, so müsse der neue Dichter
sich jedes Ehrgeizes auf sein Werk entäußern zugunsten der Arbeit an der
Gemeinschaft.

Der Stil des „Sturm" und der „Aktion" wurde Stil der Dichtung. Der Ber- *„Berlin, Alexanderplatz"*
liner Arzt *Alfred Döblin,* 1878 bis 1957, aus Stettin, war ein fleißiger Mit-
arbeiter des „Sturm". Indessen ist seine Schreibart älter. Seine zahlreichen
Prosabücher wandten sich gleichermaßen gegen die Psychologie wie gegen
die Naturwissenschaften. Seine Art ist die Darstellung sozialer Zustände an
einer Fülle von Handlungen und Gestalten wie der Roman „Berlin, Alex-
anderplatz", der 1929/1931 nicht weniger als 45 Auflagen erlebte. *Gottfried
Benn,* 1886 bis 1956, aus Mansfeld, hat die Kreatur, wie sie auf dem Sezier-
tisch aussieht, zu Versen gemacht, die „Morgue" 1912, „Gehirne" 1916, *Kreatur auf dem Seziertisch*
„Fleisch" 1917 heißen und auf starke Nerven lyrisch wirken können. Sie

stehen als „Gesammelte Gedichte" 1927 beisammen. Klangvoll, rein und schön sind seine späteren Verse 1956: „Gesammelte Gedichte." Das Drama hat all diese Stilwandlungen durch Kaiser und Toller erfahren. *Georg Kaiser*, 1878, aus Magdeburg, hat sich an Dostojewskij und Hölderlin, an Wedekind und Sternheim geschult. Seine ersten Stücke verzerren große Vorwürfe der Weltliteratur ins Groteske, so den Tristan in „König Hahnrei".

„Die Bürger von Calais" Das Drama „Die Bürger von Calais" 1914 brachte ihn nach dem Kriege unvermittelt empor. Der Gedanke von der Geburt eines neuen Menschen war der bürgerlichen wie der kommunistischen Jugend durch Nietzsche geläufig. Er kehrt in vielen von Kaisers Stücken wieder. „Hellseherei" 1929 ist vielleicht sein zartestes Gebilde, ein Spiel von der sehend gewordenen jungen Frau, die nicht sehen wollte, und der Wiedervereinigung fast schon getrennter Herzen. All diese Stücke führen die chaotische Zeit über die Szene. Sie sind Erzeugnisse eines berechnenden Verstandes, der zum Herzen kein Organ hat. Doch sie sind mit jener Sachkenntnis gearbeitet, die den Werkstücken eines technischen Zeitalters gemäß ist. *Ernst Toller*, 1893 bis 1939, aus Samotschin, hat von dem Kriegsspiel „Die Wandlung" 1917 bis zu der Auseinandersetzung „Nationalsozialismus" 1930 der Zeit gegeben, was der Zeit war. In der Mitte seines dramatischen Werks steht

„Der deutsche Hinkemann" „Der deutsche Hinkemann" 1921, die Tragödie des entmannten Kriegsbeschädigten, für den es keine soziale Hilfe gibt. Das galante Puppenspiel „Die Rache des verhöhnten Liebhabers" 1925 sowie die Versbücher aus der Festungszeit „Gedichte der Gefangenen" 1921 und „Das Schwalbenbuch" 1924 legen um seine Werke einen menschlich verständlichen Rahmen.

Theater am Nollendorfplatz Den Schritt vom Stil des Dramas zum Stil des Theaters hat *Erwin Piscator*, 1893, aus Ulm, getan. Er war als Anhänger der „Aktion" 1915 an die deutsche Westfront gegangen und konnte an den verschiedenen Etappentheatern seinen schauspielerischen Neigungen nachgehn. Sein Theater am Nollendorfplatz 1928 war das folgerichtigste, unternehmungslustigste, erfolgreichste Werk kommunistischer Kunst in Deutschland. Gerade gegen die sozialistische Volksbühne, die sich die bürgerliche Kunstanschauung zu eigen gemacht hatte, richtete sich sein Unternehmen, das aus der proletarischen Laienspielbewegung ihre beste Kraft schöpfte. Seine Bühne war technokratisches Theater. Er arbeitete mit einer Theatermaschine, in der alle modernen Mittel der Beleuchtung, der Verschiebungen und Drehungen, Filmzellen und Lautsprecher, die gesamte Technik zusammenwirkten. Auf dieser Bühne erschien der Mensch als Klasse. Es ist nun einmal so und nicht anders. Dieser Bühne hat der andere Schwabe *Bert Brecht*, 1898 bis 1956, von Augsburg die

gemäße Dichtung gefunden. Er kam früh in Theaterstellungen, wanderte 1933 aus, wurde Mitarbeiter des deutschen Freiheitssenders und Herausgeber der Moskauer Zeitschrift „Das Wort" und kehrte als Spielleiter 1948 nach Berlin zurück. Die Höhenlinie seiner dramatischen Erfolge zeichnet sich ab: 1922 durch die Heimkehrertragödie „Trommeln in der Nacht"; 1928 durch die „Dreigroschenoper", nach der „Bettleroper" 1721 von John Gray; 1941 durch „Mutter Courage und ihre Kinder" nach Grimmelshausen. Die Mechanik und Technik all seiner Stücke ist die Szene der Piscatorbühne. Brecht ist der Schöpfer des kämpferischen Bänkelsangs, ein wahrer Meister des Blutrünstigen und Eindeutigen. Seine Lieder, Balladen, Bekenntnisgedichte, Gassenhauer haben den Stil des deutschen Spätbarocks.

Schüler des Steglitzer Gymnasiums, aus einem reichen Villendorf vor Berlin, hatten sich gegen 1900 um einige Führer gesammelt; sich vom Leben der Stadt freizumachen, unternahmen sie gemeinsame Fahrten in die Wälder und ließen sich von den heimlichen Schönheiten der Mark ergreifen. Das waren die Erstlinge des Bundes „Wandervogel". Daraus ist die Jugendbewegung geworden. Sie begann sich durchzugestalten und 1914 zählte sie bereits 200 Zeitschriften. Am 11./12. Oktober 1913 hielt sie auf der Felsplatte zwischen Thüringen, Hessen, Niedersachsen, auf dem Hohen Meißner, ihre erste Tagung. Viele aus ihr kämpften bei Langemarck. Und 1919 trat sie in Jena abermals zu einer Tagung zusammen. Mit ihren letzten Gedanken kam die Jugendbewegung von der Urburschenschaft und frühen Romantik her. Soviel unter dieser Jugend von Friedrich Nietzsche die Rede war, sie ist von keinem bestimmten Gedanken Nietzsches ergriffen worden. Julius Langbehn, Ludwig Klages, Rudolf Pannwitz, selbst ein Schüler des Steglitzer Gymnasiums, bezeichnen das Gedankengut der Jugendbewegung. Und an Stefan George ist sie künstlerisch herangereift. Um den schlesischen Maler Walther Blachetta und zu Jena bildete sich 1920 die erste Spielschar. Vom Rhein her empfing dieser Theaterwille den Willen sich durchzusetzen. Das war der Bühnenvolksbund, im April 1919 zu Frankfurt am Main gegründet, aus Theatergemeinden zu einem Reichsbunde aufgegliedert und seit Sommer 1925 von Berlin aus geleitet. Das dichte Netz seiner landschaftlichen Bühnenzeitschriften überzog das Reich und erhielt mit dem Zweimonatblatt „Das Nationaltheater" 1928 seinen ordnenden Mittelpunkt. Dem Puppenspiel, Heimatspiel, Jugendspiel galt die besondere Fürsorge des Bundes. Seine Wandertheater betreuten das offene Land und die bühnenlosen Städte. Hier fanden sich allmählich die meisten Dichter zusammen, auf denen die Hoffnungen eines nationalen und zugleich christlichen Deutschlands beruhten.

Der Wandervogel

Der Bühnenvolksbund

„Das Nationaltheater"

Von Nietzsche zu Christus *Reinhard Johannes Sorge,* 1892 bis 1916, aus Berlin, ist der Bühnendichter dieses Willens zu einem neuen Theater. Als Jenaer Hochschüler wurde er in die Richtung seines Weges gekehrt. Er hat Nietzsche gesucht und Christus gefunden. Im Granatfeuer von Ablaincourt ist er gefallen und auf dem Schlachtfelde bestattet worden. Der Einakter, in dem die Heimkehr des Odysseus als ewige Wiederkehr des Übermenschen gedeutet wurde, läßt zuerst den Standort des werdenden Dichters erkennen. „Zarathustra" 1911 heißt denn auch das früheste Zeugnis einer zunehmenden Reife. „Der Bettler" 1912 erinnert noch immer an Nietzsche. Aber es ist die Trennung von Nietzsche. Das Stück bildet den mystischen Akt dramatisch ab. Die Handlung stellt ein dreifaches Entwerden dar. Der Dichter löst sich von seiner Zeit, von seiner Familie, von seinem eigenen Werk, dessen Schöpfer und Held er ist. Was sich in dem Stück begibt, ist der mystische Akt selber, der Wegwurf alles Leiblichen und Gegenständlichen, Wegwurf des Letzten sogar, des nachschaffenden Wortes. Es ist der Aufdrang zur reinen Schau, von der man nicht in körperhaften Worten, sondern nur in Gleichnissen der Ewigkeit reden kann. Das lyrische Gespräch „Guntwar" 1914 bedeutet den vollen Durchbruch der christlichen Mystik. Dem Dichter offenbart sich seine Prophetensendung. Sorge ging zum reinen Mysterienspiel über. „Metanoeite" 1915

„Metanoeite" erhebt in den Szenen von Mariä Empfängnis, Christi Geburt, Darstellung Jesu den Ruf an die Zeit: Umdenken! Er entschlägt sich fast ganz des eigenen Wortes und bedient sich der zubereiteten Sätze des Evangeliums. Das letzte Stück „König David" 1916, ein formgerechtes Schauspiel, kündigt eine neue Stufe des Dichters an. In Sorges Stücken begibt sich nichts als Seele. Es begibt sich in lyrischen Selbstgesprächen. Es begibt sich auf einer Bühne, die jede Kulisse und jede Mithilfe der Einbildung ablehnt. Es ist eine Art Traumbühne. Das Spiel läuft vor einem Vorhang ab. Scheinwerfer heben nach Bedarf Spielgruppen und Szenen aus dem Dunkel des Ungeborenen. Der Mensch spielt drinnen zugleich und draußen. Wahrhaft bemächtigt haben sich dieser Stücke nur die Spielscharen.

„Das Dritte Reich" Vom Rhein war *Arthur Moeller van den Bruck* nach Berlin gekommen. Mit Gleichgesinnten fand er sich 1919 in der Wochenschrift „Das Gewissen" zusammen. Die Grundvorstellung seines Buches „Das Dritte Reich" 1923 hatte die eine Wurzel in Lessings Gedanken „Drittes Zeitalter", die andere im „Dritten Rom" der italienischen Jugend. Das Buch, an die Deutschen aller Parteien gerichtet, rief zu einer dritten Partei auf, „für die es keine Linke und keine Rechte mehr gibt, die sich vielmehr aus der Breite der Nation erhebt und den Augenblick vorbereitet, in dem sich die Nation in ihr wieder-

erkennt". *Hans Schwarz*, 1890, aus Berlin, als freiwilliger Reiter schwer verwundet, hat die Schriften seines Freundes Moeller herausgegeben und viel für ihr gerechtes Verständnis getan. Er suchte im Sinne Moellers nach dem preußischen Stil. Aus dem Dionysosdienst, der die griechische Tragödie geboren hat, glaubte er, eine neue Gestalt der deutschen Tragödie gefunden zu haben. „Pentheus" 1923 ist der König der Thebaner, der wegen seines Widerstandes gegen den neuen Dionysosdienst von den rasenden Frauen getötet wird. Das Stück mit seinen vierzehn Bildern war der kühne Entwurf eines neuen Volksdramas mit seinen hymnischen Worten, feierlich-stürmischen Chören und kraftvoll bewegten Massen. Nach dem Mythus die Geschichte. „Rebell in England" 1933, das ist der junge Graf Essex, der Führer der Erhebung gegen Parlament und Geldadel. „Prinz von Preußen" 1934 ist Louis Ferdinand, der Empörer gegen ein schwaches Königtum und eine fortschrittsfeindliche Staatsmacht.

Dionysisches Drama

Rheinischen Ursprungs war der Wille, die Großstadt aus dem Christentum zu erneuern. *Carl Sonnenschein*, 1876 bis 1929, aus Düsseldorf, war im November 1918 nach Berlin gekommen. Durch übermenschliche Arbeit baute er in wenigen Jahren ein umfassendes Werk der Weltstadtfürsorge auf. Seine Persönlichkeit und sein Glaube haben tief auf die Dichtung der Zeit gewirkt. Sein Seelsorgergedanke und der Kunstwille des Bühnenvolksbundes durchdrangen einander. In seinem Kreis verkehrten Heinrich Lersch und Jakob Kneip, Anton Schmidt und Leo Weismantel, Peter Dörfler und Paula Grogger, Gertrud Le Fort und Ilse von Stach. Die Dichtung dieser Männer und Frauen, was immer sie sonst bewegen mag, ist angehaucht von der Kraft werktätigen Christentums aus Sonnenscheins Schule. Der Magdeburger *Franz Herwig*, 1880 bis 1931, und seine Romanfolge „Sankt Sebastian vom Wedding" 1921, „Die Eingeengten" 1926, „Hoffnung auf Licht" 1929, „Fluchtversuche" 1930 spiegeln Sonnenscheins Werk dichterisch ab: gelebtes Vorbild rettet die Menschen der Großstadt.

Apostel der Weltstadt

„Sankt Sebastian vom Wedding"

Der Charonkreis Ottos zur Linde spannte sich vom späten neunzehnten Jahrhundert bis tief ins zwanzigste, weit nach Westfalen gegen den Rhein und weit nach Osten gegen die Weichsel. Aus diesem Kreise sind Rudolf Paulsen und Rudolf Pannwitz die eindruckvollsten Gestalter ihrer persönlichen Ideen geworden. *Rudolf Paulsen, 1883*, aus Berlin, stammte durch den Vater von einer nordfriesischen Schifferfamilie und durch die Mutter von einem Allgäuer Geschlecht. Die Persönlichkeit Ottos zur Linde ist ihm wie nicht wenigen Jünglingen des Zeitalters zum Heile gediehen. „Aus dem Geiste der Mystik lernte ich das Aussprechen der echten Regungen, die im

Der Charonkreis

Rudolf Paulsen

eigenen Innern keimen." Seine frühen Verse sind beinahe unbegabt, hart und bildlos, kühl gedacht und völlig eingenommen von einem beziehungslosen Ich. Über Jahre hinweg strömten dann die beiden kleinen Sammlungen „Im Schnee der Zeit", „Und wieder geh' ich unruhevoll" 1922, kindhaftes Geborgensein und beseeligtes Naturgefühl aus, Verse von der sanften Anmut des Volksliedes. „Wann der Tag getan" 1936, dämmerhaft zart und milde bewegt, bezeugen längst ausgereifte Meisterschaft. In der Mitte stehen die drei Bücher „Die Meduse": „Die kosmische Fibel" 1924, „Christus und der Wanderer" 1924, „Die Hohe Heilige Verwandlung" 1925; drei Dichtungen aus dem innersten Seelenraum der Zeit. „Die kosmische Fibel" gibt beinahe im Stil der Aktiondichter eine Schau der entgötterten und entmenschlichten Großstadt und vollzieht in Nachdichtungen großer Tonkünstler die Läuterung der Seele. „Christus und der Wanderer" läßt Sils-Maria und Golgatha zu einem Berg verschwimmen, auf dessen Höhe der Christ und der Antichrist, der Gottmensch und der Menschgott einander im Gedanken messen. Sie tauschen ihren Platz am Kreuz. Nun hängt der Wanderer und Christus wandert. So in ewiger Wiederkehr werden sie einander am Kreuz ablösen, die Pole alles Menschengeschehens. „Hohe Heilige Verwandlung", nach Gedanke, Bild, Stil vollendete Charondichtung, singt in wundervollen gedankensatten und gefühlstiefen Versen das hohe Erlebnis der zu Gott gewandelten Seele. Tod wird Leben und Leben wird Tod. Alles Geschehende ist nur Wandel der Gestalt durch den christlichen Eros. Pan-Proteus bläst dazu seine liebliche Flöte. So geschieht durch hohe heilige Verwandlung immer wieder aufs neue die Erschaffung der Welt. Auch Rudolf Paulsen wurzelt in der jonischen Naturphilosophie des Heraklit. In dessen Kernspruch „Alles fließt" glaubte er das „Kräutlein Stehauf wider die Verwesung" gefunden zu haben. In den Versen von Paulsen durchdringen einander diese altjonische, deutschmystische, deutschromantische All-Ich-Philosophie und das Bedürfnis des Herzens nach einem persönlichen Gott zu einem ebenso kosmischen wie volkstümlichen Madonnendienst. *Rudolf Pannwitz*, 1881, aus Croßen, hat zu Koločep bei Ragusa am Gestade der Adria ein nordsüdliches Leben geführt und es in „Dalmatinische Einsamkeit" 1924 seltsam farbig abgespiegelt. Otto zur Linde, mit dem zusammen er den „Charon" herausgab, hat ihm geholfen, zwischen den Gestirnen Nietzsche und George seine eigene Bahn zu finden. Pannwitz hat in Gedanken eine neue Ordnung des Lebens, das in einem Geist und Natur ist, entworfen. Die Form, in der dies ausgesprochen wurde, macht keinen Unterschied zwischen Denken und Dichten. Die eine Reihe seiner Schriften geht von der Erziehung aus, nimmt

Seelenraum der Zeit

„Christus und der Wanderer"

Das Kräutlein Stehauf

Rudolf Pannwitz

mit „Krisis der europäischen Kultur" 1917 ihre entscheidende Wendung und strebt mit „Kosmos Atheos" 1926 sowie mit „Logos, Eidos, Bios" 1930 ihrer Höhe zu. Die andere geht von den hellenischen Jugenddichtungen aus, verliert sich in die absonderlichen „Dionysischen Tragödien" 1913 und das Terzinenepos „Das Kind Aion" 1919, versteigt sich in den biblischen Zarathustrastil „Die Deutsche Lehre" 1919, aber sie findet mit den Versepen „Mythen" 1919, mit der Erzählung „Orplid" 1923, mit dem Roman „Das neue Leben" 1927, mit den Gedichten „Urblick" einen persönlichen künstlerischen Ausdruck. Pannwitz setzt die beiden Widerwelten Chaos und Kosmos. „Die Lehre vom Kosmos ruht auf den Beobachtungen des Kreislaufes. Darum wird sie beherrscht von den Gestirnen und Zahlen . . . Sie stellt sich dar als das göttliche Gesetz, nach dem das Weltwesen geregelt ist." Die Naturwissenschaften, die in Hellas aus den Mysterien, in Europa aus der Mystik erwuchsen, haben den Bogen geschlagen von der Urzeit der kosmischen Religion bis in die kommende Zeit des Übermenschen, der das Chaos wieder zum Kosmos machen wird. Pannwitz setzt die beiden Gegenmächte Apollon und Dionysos. Apollon wird in Dionysos Welt, indem er sich selbst aufopfert, und Dionysos, so Welt geworden, ist der andere Apollo. Die beiden sind eins, Urspaltung zugleich und Ureinheit. Pannwitz erschuf sich nach Nietzsches Ebenbilde als Wunschmenschen den „Hyperboräer", den hellenisch-nordischen Sonnensohn. Das ist der Mensch der Zukunft, der das große Mysterium vollziehen wird. Als Apollon wird er die kranke Menschheit erlösen, indem er sich als Dionysos mit ihr vermählt. Durch diese volle Hingabe der Person mit sich selber neu geeinigt, hat der Hyperboräer den Kosmos wieder hergestellt. Drei Fragen haben den menschlichen Geist von je bedrängt: wie das Denken die Einheit des Ich zerspaltet und sie im Gedachten wiederherstellt; wie das Ich der Liebe im Du sich auslöscht und durch den Tod der Hingabe sich schöner zurückgewinnt; wie der geschichtliche Mensch durch sein erwachendes Bewußtsein die Alleinheit des Kosmos zerstört und sie durch seine schöpferische Tat von neuem erschafft. Allen drei Fragen hat der Hyperboräermythos Apollo/Dionysos geantwortet. Pannwitz folgt in der Reihe der ostdeutschen Geister, die alle vom Logos besessen waren — Jakob Böhme, Johann Georg Hamann, Friedrich Nietzsche, Arno Holz — kosmische Boten voll delphischer Dunkelheit, alle von der Not ihrer Zeit gerufen und einfach Redende, die das Wort hatten.

Unter diese Verkündigungen gehört eine farbige Schlußvignette. Die malt mit zierlich gespitztem Pinsel unter soviel „Rettungen", deren Wahl dem Deutschen Qual bereitete, der Uckermärker *Hanns Meinke*, der fromme alte

„Dionysische Tragödien"

Der Hyperboraer

51

Meister in einer barbarisch wilden und geistig abenteuerlichen Zeit. Er zeichnete und schnitt die Bilder zu seinen Versen. Er druckte die schmalen Büchlein zumeist auf seiner eigenen Presse. Er machte aus ihnen kostbare Handschriften, indem er sie auf Pergament schrieb und mit unsäglich schönen Randleisten einfaßte. Er band sie selber in Metall und Seide. Zwischen den „Masken des Marsyas" 1910 und den „Verwandlungen des Proteus" 1936 steht ein Werk, rührend schmal, doch tief und dicht. „Die Flucht des Dionysos" aus dem Süden zu den Barbaren klingt gedanklich an Pannwitz an. Diese Verse können alles: die äußerste Strenge des Sonetts und die einfältige Schlichtheit des Spruches. Sie ergehen sich jenseits der Welt in den schwierigsten Gottgedanken und sie verwandeln sich in die körperlichste Sinnlichkeit eines warmen Märztages. Sie sind leidenschaftlich Kunst und völlig ungedachte Natur. In so verschiedenen Zungen sie von Gott reden, vielleicht meinen sie alle dieses eine: „Ich koche süß den guten / den Sonnenwein der Liebe / und ist er reif: verbluten / will ich in Gottes Kelter dann". Ist das nicht schön? Sein eigener Dichter und Drucker und Pergamentmaler und Buchbinder und Leser. Das ist der Dichter jenseits aller Untergänge und Rettungen und Aufgänge.

„Die Flucht des Dionysos"

MÜNCHEN — Thomas Mann, nur noch geistig anwesend, hat die jüngste Geschichte Deutschlands im Bilde seines Musikers „Doktor Faustus" dargestellt. Die Dichter waren schon immer im Zweifel, ob sie Faust in den Himmel oder in die Hölle fahren lassen sollten. Am besten soll Faust selber sagen, wie ihm beim Abschied ums Herz ist, nach dem alten Volksbuch, das größer war und bleibt, als alles, was je daraus gedichtet worden ist. „Endlich nun vnd zum Beschluß, ist mein freundliche Bitt, jhr wollet euch zu Bett begeben, mit ruhe schlaffen vnd euch nichts anfechten lassen, auch so jhr ein Gepölter vnd Vngestümb im Haus höret, wölt jhr darob mit nicht erschrecken, es sol euch kein Leid widerfahren, wöllet auch vom Bett nicht aufstehen, vnnd so jhr meinen Leib todt findet, in zur Erden bestatten lassen. Dann ich sterbe als ein böser vnd guter Christ, ein guter Christ, darumb, das ich ein Hertzliche Rew habe, vnd im Hertzen jmmer vmb Gnade bitte, damit meine Seele errettet möchte werden. Ein böser Christ, das ich weis, das der Teuffel den Leib wil haben, vnnd ich wil jhme den gerne lassen, er lasse mir aber nur die Seele zufrieden."

„Doktor Faustus" über sich selbst

München also erhielt 1913 die Halbmonatsschrift „Revolution". Sie vertrat die Sache der Berliner „Aktion". Die führenden Mitarbeiter waren Max Brod, Kurt Hiller, Else Lasker-Schüler, Erich Mühsam.

Münchner „Revolution"

Die Entscheidung des Geistes und der Gesinnung schwankte in weiten Pen-

delschlägen. *Johannes Robert Becher,* 1891 bis 1958, aus München, kam mit seinem ersten, vornehm gedruckten Büchlein „De Profundis Domine" 1913 aus den literarischen Bezirken der „Aktion" und „Revolution". Er hat diesen Ton geraume Zeit gehalten. „Verfall und Triumph" 1914 bringt kleine Geschichten aus dem Leben, wo es am grausamsten ist. Seine lyrischen Sammlungen kreisen strophisch und chorisch beinahe besonnen und zahm um die Gedanken, die in der Berliner „Aktion" angeschlagen worden waren. Das war immer wieder der „neue Mensch". Seit seinen Beiträgen zu der Sammlung „Kameraden der Menschheit" 1919 war er mit Übersetzungen und eigenen Dichtungen bemüht, die neue russische Literatur in Deutschland bekannt zu machen. Sicherlich sind die lyrischen Anfänge Bechers ein psychologisches Problem. Aber er ist auch eine dichterische Erscheinung. Er ist der begabte, gestaltungsreiche, wirksame Dichter des deutschen Kommunismus schlechthin, der einzige, den Spartakus in Deutschland hervorgebracht hat. Er wurde 1954 Minister für Kultur der Deutschen Demokratischen Republik. *Hermann Kaeser-Kesser,* 1880, aus München, ist Bericht. Er hat dieses Zeitalter, ihm immer auf der Ferse, dichterisch abgeschildert, nach seinen täglichen beruflichen Beobachtungen. Die Novelle „Die Peitsche" 1918 berichtet, wie der Wagenlenker Maro die Aufruhrstimmung der hungernden und gepeinigten Stadt beim Wettrennen im Zirkus entlädt, indem er im Vorüberfahren, Hieb und Blitz zugleich, seine Peitsche über das Gesicht des Kaisers knallen läßt. Die Spannung der Luft bis zum Gewitterblitz und die Entladung des Wagenlenkers bis zum befreienden Schlage, eines im andern, das ist schon ein großartiges Bild für die Stimmung und Ausbruch der deutschen Revolution. Kaesers Dramen führen von „Kaiserin Messalina" 1914 über „Die Brüder" 1921 zu der Tragödie „Rotation" 1931 mitten in die Begebenheit. Hier ist der Stil der Piscatorbühne. Der Vorhang dient dem Film als Leinwand. Auf ihr erscheinen die erläuternden Sprüche und Bilder. Rotation, das ist der Tagesbetrieb der „Internationalen Metropol-Zeitung". Der beißende Spott entblößt den tragisch-grotesken Widersinn der damaligen Weltlage. Das Stück besticht durch das schlagende Wort, durch Berufsechtheit, durch das geistreiche Spiel der Beweggründe. Es macht den geistigen und künstlerischen Abstand von 1918 und 1931, von Revolution zu Revolution sichtbar.

Gegen diese Verschiebung der Gewichte nach links stand die Stadt mit ihrem ganzen Eigengewicht. Die älteren Zeitschriften wie „Hochland" und „Süddeutsche Monatshefte" mit ihren weitgesteckten Zielen und ihrem ernsten Aufbauwillen beginnen das Bild zu beherrschen. Die „Neuen deutschen Beiträge" 1922/1924, die Hugo von Hofmannsthal herausgab, boten

Johannes Robert Becher

Hermann Kaeser-Kesser

„Rotation"

Münchner Zeitschriften

dem wiedererwachten Geschmack erlesene Nahrung. Die Monatsschrift „Zeitwende", seit 1925 von Tim Klein geleitet, diente einer neuen evangelischen Gesinnung. Die Zweimonatsschrift „Corona", 1930 von Martin Bodmer und Herbert Steiner begründet, stellte um die beste deutsche Dichtung wieder eine ehrenvolle Weltbürgerschaft her. Paul Alverdes aber und Benno von Mechow nannten die Zeitschrift, die sie 1934 begannen, „Das innere Reich".

München hatte seit den Tagen König Maximilians II. den Auftrag verloren, Dichtung ohne Unterschied ihrer Heimat gastlich zu versammeln. Dieser Auftrag kehrte zurück. Nicht nur an die Stadt. Das ganze bairische Oberland mit seinen bäuerlichen Landsitzen an den Seen und in seinen Bergen wird Herberge und Freistatt.

Walter von Molo — Das war eine Rückkehr in die alte Heimat. *Walter von Molo,* 1880 bis 1958, aus Sternberg im alten österreichischen Schlesien, hat gelegentlich den Zufall gescholten, der ihm den Geburtsort in dieser Landschaft bestimmte. Von bairischer Herkunft, hat er seine Bildung in Wien empfangen, zu Berlin das Werk seiner reifen Mannesjahre getan und sich in Baiern seine Heimat neu gegründet. Molos Dichtung ist der große Reihenroman. „Schiller" 1912/1916, vier Teile, ist als Dichtung jugendlichen Freiheitsdranges begonnen und als *„Der Roman* dichterisches Lebensbild abgeschlossen worden. „Der Roman eines Volkes" *eines Volkes"* 1924 gilt Preußen von seiner königlichen Höhe über den Sturz in die Tiefe bis zur deutschen Erhebung. „Bobenmatz" 1926 ist der Roman der ratlosen Zwischenzeit. Ein Mann, der das Gewissen des Menschentums in sich schlagen fühlt, möchte als Erlöser all den Bedrängten und Irrenden voranschreiten, ohne selbst des rechten Weges sicher zu sein. Es war wohl Einsicht, wenn Molo sich dann wieder geschichtlich bewährte Rollenträger suchte. Das ist nun die Reihe von Romanen, die in sich ein Ganzes bilden, obwohl sie nicht als sichtbare Einheit erscheinen. Da ist die „Legende vom Herrn" 1927, Christus selber, einer glaubenslosen und doch so glaubenssüchtigen Zeit dargestellt. Da ist „Mensch Luther" 1928, das Ringen Luthers und das Ringen um Luther, an zwei einzigen Tagen der Wormser Reichsversammlung die weltgeschichtliche Tatsache, wie dieser arme und machtlose Mönch das Züng*„Ein Deutscher* lein an der Waage bildet. Da ist „Ein Deutscher ohne Deutschland" 1931, *ohne* Friedrich List, der Vordenker gemeindeutscher Wirtschaft. „Holunder in *Deutschland"* Polen" 1933 ist ein kleiner Hauslehrer, der verschreckten Gutsleuten Mut und Glauben vorlebt. „Eugenio von Savoy" 1936 ist der heimliche Kaiser des Reichs, das in letzter Stunde gerettet wird. Walter von Molo hat seinen Stil von Buch zu Buch und nicht ohne Rückschläge ausgebildet. Die dramatisch bewegten Szenen seiner ersten Romane mit ihrer Fülle von Gestalten

verwandeln sich Schritt für Schritt in den gebändigten Fluß der epischen Erzählung und in den sparsamen Aufwand handelnder Menschen. Das getragene und erhitzte Wort des Schillerromans wird zum beherrschten Vortrag der jüngsten Bücher. Schwäbische Ahnen hin, bairische her! Molos ringende Helden, seine Gottsuchernaturen und Sendboten, der spielhafte Stil und die beschwingte Rede, der mystische Anhauch seines Gefühls erinnern sehr an schlesische Dichtung. Molos lyrische „Sprüche der Seele" vertonen Arno Holzens Phantasusgebilde in die schlesische Reimfreude und seine Denksprüche „Fugen des Seins" fügen sich in die altschlesische Überlieferung des mystischen Sinngedichts ein.

Und auch das war nur eine Rückkehr. *Henry von Heiseler,* 1875 bis 1928, *Henry von Heiseler* aus Petersburg, ist als Jüngling schon nach Baiern gekommen und hatte unter wiederholten Besuchen Rußlands in Brannenburg festzuwachsen begonnen. Dahin kehrte er 1922 zurück. Er ist ein großer Vermittler. Er hat auf der einen Seite Robert Browning, Charles Swinburne und die Dramen Yeats, auf der andern Seite die Dramen Puschkins, Dostojewskijs und Tolstojs in ein gemeinsames, aber nicht gleiches Deutsch verdolmetscht. Diese Nachzeichnungen bezeichnen zugleich die Kulturkreise, durch die seine Eigenschöpfungen bestimmt sind. Anfänglich war es Rußland in drei Dramen. „Peter *Russische* und Alexej" 1906 ist nicht der Kampf zwischen Kaiser und Thronfolger, son- *Dramen* dern zwischen Vater und Sohn. Dieser schwache Jüngling zwingt in seiner machtlosen Liebe den Vater, daß er ihm den Giftbecher reicht und also ganz zu sein, was er ist. Er hat damit zugleich in seiner letzten die einzige Tat getan, durch die er seines großen Vaters würdig ist. Dieses reine Spiel der Seele steigt aus jener Verwirrung des Herzens auf, die im russischen Volke durch die westliche Unterscheidung von Privat und Öffentlich entstanden war. „Die magische Laterne" 1909 verlegt den westöstlichen Gegensatz in den heitern Landsitz des Bojaren Andrej und in den Kreml des Zaren Iwan. Der schreckliche Zar wird durch die tapfere Treue und Liebe der lieblichen Axinja verwandelt. Gott ist mit dem Rußland der kleinen Leute und blühenden Gärten. „Die Kinder Godunows" 1923 spielen um den Falschen Demetrius. Nicht Zar und nicht Russe, sondern nichts als Mensch tritt Boris vor das Gericht des erregten Volkes. Entsühnt blickt er dem Sieg über die Lüge entgegen, die aus seiner Tat aufgestört worden ist. Das Trauerspiel „Grischa" 1916 und die Novelle „Wawas Ende" 1926 behandeln Erlebnisse aus dem neuern Rußland. Mit der Zeit wurde es Deutschland. „Alkestis" 1907, die *Griechische* griechische Legende von der Überwindung des Todes durch das Leben, hatte *und deutsche* den Dichter mit der heitern Anmut des Südens angeweht. „Die jungen Rit- *Legenden*

ter von Sempach" 1910, die vor der Schlacht alle Tod würfeln, folgen Kleists
Entwurf. „Der junge Parzifal" 1923 macht Kondwiramur zur Heldin. Sie
verteidigt sich aufs äußerste in der Burg ihres Magdtums gegen einen ge-
walttätigen Werber. Damit Parzifal sie retten könne, muß sie dem Unwissen-
den mit ihrem Wissen zuhilfe kommen. Das Weihnachtsspiel „Die Nacht der
Hirten" 1926 steht außerhalb aller Überlieferung. Das Wunder von Bethle-
hem geschieht jenseits der Szene, unsichtbar, unhörbar, unbegreiflich. Auf
der Szene geschieht nur die Wirkung des Sternes an denen, die ihn gesehen

Heiselers
lyrische Verse haben, die ihn sehen und nicht sehen wollen. In den „Blättern für die Kunst"
sind Heiselers erste reife Verse erschienen. Sein lyrisches Werk — „Die drei
Engel" 1922 und „Die Legenden der Seele" 1928 — ist eine Lyrik der Schau
und der Gesichte, die innere Erfahrungen von allgemeiner Gültigkeit ver-
mittelt. Ihre Sprache ist männlich, von herber Anmut, unerschöpflich im Fin-
den immer neuer Weisen und von einer solchen Klarheit des Ausdrucks, daß
der Hörende auf den ersten Anruf versteht, was ihm zugedacht ist.

Balten in
Deutschland Nicht wenige Balten sind in Deutschland bereits aufgewachsen und gebil-
det oder sie haben für Deutschland gekämpft. *Otto Freiherr von Taube*,
1879, aus Reval, ist durch Luther, Goethe, George in Deutschland, durch
Gogol, Lermontow, Puschkin in Rußland eingeweiht worden. Seine Verse
sind voll Europa, das der Dichter durchwandert und erlebt hat. Seine Er-
zählungen streifen das Deutschland seiner Tage satirisch oder sie beleuchten

Frank Thieß das moderne baltische Leben. *Frank Thieß*, 1890, vom Gut Eluisenstein bei
Üxküll, hat von seiner Frühnovelle „Angelika ten Swaart" 1920 bis zu seinem
Roman „Stürmischer Frühling" 1937 den Launen des Geschlechts nachgeson-
nen. Er hat den Krieg geschildert, in dem Roman „Der Tod von Falern"
1921 mythenhaft abgedunkelt und in der Dichtung „Tsushima" 1936 als
weltgeschichtliche Begebenheit. Er hat unter der Aufschrift „Jugend" die
vier Tagebücher des zeitgenössischen Deutschland geschrieben. Aus der zeit-
losen Kindergeschichte „Abschied vom Paradies" 1927 und aus dem Gym-
nasiastenroman „Das Tor zur Welt" 1926 entwickelt sich das deutsche Chaos
„Der Leibhaftige" 1924 und die deutsche Wende „Der Zentaur" 1931: das
junge Geschlecht der Kämpfer, Erfinder und Flieger, das Deutschland der
allmächtigen Chemie und Technik. Die fesselnde Kunst, aus vielen gleich-
laufenden Schicksalen und gegensätzlichen Menschenarten durch kleine Aus-
schnitte und bewegte Gespräche ein umfassendes Rundgemälde der Zeit zu
stellen, hat westeuropäischen Stil.

Dolmetsche
Rußlands Unter diesen Balten, gleichviel wo sie in Deutschland lebten, traten ge-
meinsame Züge hervor. Die einen waren Dolmetsche. So übertrug *Reinhold*

von Walter, 1882, aus Petersburg, zu den älteren russischen Meistern die neueren Berdiajew, Sologub, Briussow und *Johannes von Guenther*, 1886, aus Mitau, fügte ihnen Ostrowskij und Mereschkowskij hinzu. Beide Männer haben den westlichen Bestand der gesamten russischen Dichtung von neuem an Deutschland vermittelt. Andere lassen die Atmosphäre asiatischer Mysterien spüren. Da sind die drei Rigaer. *Manfred Kyber*, 1880 bis 1933, verkündete seine Weltanschauung des Geheimreiches und der Brüderschaft aller Geschöpfe in Tiergeschichten, Märchen, okkulten Romanen. „Es gleitet des Lebens Nachen / Weglos im Nebelgrau. / Ob wir träumen oder wachen, / keiner weiß es genau." *Bruno Goetz*, 1885, lebt mit seinen Erzählungen und lyrischen Versen im allgegenwärtigen und ewigen Land der Seele, von phantastischen Geschichten beglückt. „Ich blase meine Flöte: / mach dich zum Sprung bereit / in neuer Morgenröte! / Brich auf! Zerbrich die Zeit." *Werner Bergengruen*, 1892, führt seine phantastischen und okkulten Geschichten vor dem Hintergrunde des alten Kurlands vorüber und seine reizenden Kindergeschichten mitten durch den Alltag, dort wie hier romantisch in der Art Ernst Amadeus Hoffmanns. „Niemals würde eine Scheune brennen, / Sonntags nie ein trunkner Schädel bluten, / Wärst du, Kindchen, im Kaschubenlande, / Wärst du, Kindchen, doch bei uns geboren."

„Ob wir träumen oder wachen, keiner weiß es genau"

Die bairischen Landschaften rings um München werden lebendig: in den Schilderungen Otto Ehrhardts das Dachauer Moos; in den Romanen Maria Mayers der Bairische Wald; in den Erzählungen Marieluise Fleißners die obere Donau; in den Geschichten, Liedern und Spielen Heinz Schauweckers die Regensburger Landschaft. Der Oberbaier Willi Schmid, 1893 bis 1934, von Weilheim, aber hat neben anschaulichen Landschaftsschilderungen aus Deutschland und Italien kleine und sanfte Gedichte hinterlassen, manche nur aus ein paar Worten bestehend. Wahrhaft bairisches Leben hat wieder ausgeschlagen. Eine große Erfüllung.

Dichtung bairischer Landschaften

Hans Carossa, 1878 bis 1956, von Tölz in Oberbaiern, hatte zum Vater einen Arzt und der Dichter ist ein Arzt geworden. Diese oberbairischen Marktflecken mit ihren breiten Häusern und flachen Giebeln, mit ihren barock bemalten Häuserfronten, den weit und fest gefügten Straßen bergen noch altes Römertum. In diesem versteckten Baiern mit seiner südländischen Natur ist Carossa aufgewachsen. Er ist durch das Gymnasium derselben Stadt Landshut gegangen, in der Henri Beyle-Stendhal an den Frauen so viele römische Gesichtszüge wahrzunehmen glaubte. Als Zögling der Heilkunde zu Würzburg und München lebte er sich noch tiefer in diese klassische und barocke Umwelt ein. Der junge Arzt ging von Passau aus.

„Raube das Licht aus dem Rachen der Schlange"

Hans Carossa Der späte Mann kehrte nach Passau zurück, der letzten und beharrsamsten Römerstadt an der Donau. Carossas Selbstdarstellung „Führung und Geleit" 1933 berichtet von den Künstlern, die seinen Lebensweg gekreuzt haben: Alfred Kubin, „der Graphiker der Weltangst"; Rilke in einem Münchner Atelier; nur von ferne Hugo von Hofmannsthal und Richard Dehmel; vor einem Skodamörser in der Bukowina Max Mell. Seine Dichtungen bilden eine kurze, aber tiefe Reihe. „Eine Kindheit. Ver- *Verwandlungen* wandlungen einer Jugend" 1922/1934, „Rumänisches Tagebuch" 1924, *einer Jugend* „Die Schicksale Dr. Bürgers" 1930 und „Der Arzt Gion" 1931, „Geheim- nisse des reifen Lebens" 1936, alle diese Bücher zusammen sind Carossas Dichtung und Wahrheit. „Was mein dichterisches Bemühen anging, so wußte ich, daß mir um so eher etwas geraten konnte, je williger ich mich dem allgemeinen Los der Menschen unterwarf, je weniger ich mir ein Aus- nahmeschicksal wünschte." Er ist der Dichter nicht außerhalb des Tages, son- dern inmitten der Arbeit des Alltags. Das rumänische Kriegstagebuch macht gar kein Aufhebens, nicht vom Krieg und nicht von Soldaten. Was da ist, sind die kleinen Dinge, ein Grashalm, ein Licht, eine Stimme. Der Krieg ist stumme Gegenwart wie sonst das Leben. Und der Soldat ist nur eine vor- übergehende Art Mensch. Mensch ist hier gleichbedeutend mit Arzt. Arzt ist soviel wie Priester, der Vollstrecker eines höheren Auftrages, Mitwisser um das Geheimnis des Lebens und des Todes. „Raube das Licht aus dem Rachen der Schlange." Der Arzt, der Priester, der Dichter, das ist ursprünglich und immer eins gewesen, der Spender des Sakraments des Lebens zum Tode, des Todes zum Leben. Der Dichter schildert uns diesen dreifachen Dienst im *„Eine Kindheit"* Werden und Wirken. „Eine Kindheit" ist das Buch vom Werden. Die leib- lichen und seelischen Übergänge von der Kindheit in das Jünglingtum spielen sich in dem geschlossenen Rund von neun Schuljahren und eines geistlichen Knabenheims ab. Das Kind wird aus der Gemeinschaft des Vaterhauses ge- löst und in die der Erziehungsanstalt eingegliedert. Sanft und gelassen, spöt- tisch überlegen und gutgelaunt, teilnehmend und sachlich führt der Dichter dieses Anstaltsleben vorüber und auf den Gipfel seiner Umschwünge. Die- ses wissende Buch ist ein reines und keusches Kunstwerk inmitten einer mit- *„Der Arzt Gion"* unter sehr anrüchigen Gattung. „Der Arzt Gion" ist das Buch vom Wirken. Hier ist das München nach dem Zusammenbruch und der Revolution. Eine Stadt der verstörten Menschen, in denen die böse Zeit umgeht. Der Arzt nimmt sie in seine heilende und priesterliche und schöpferische Hand. Zwi- schen dem Fernrohr, durch das ein kleiner Junge um Geld den Vorüber- gehenden den Himmel erklärt, und dem Mikroskop, unter dem der Arzt seine

Blutproben macht; zwischen dem Atelier, in dem eine kleine Künstlerin um ihre Plastilingeburten ringt, und dem Sprechzimmer des Arztes, in dem Tod *Das Kind der Magd* und Leben ihre Sache ausfechten, in dieser Mitte geschieht das Größte, was geschehen kann. Eine arme Magd weigert sich gegen göttliche und menschliche Nachsicht, sich die Leibesfrucht nehmen zu lassen und gebiert bei vollem Bewußtsein unter Draufgabe des eigenen das neue Leben. Sie will Mutter sein. Was sind alle Kunstgeburten des Ateliers und alle Weisheiten des Laboratoriums gegen den Willen des natürlichen Lebens zum Leben. Die Mutter gebiert und stirbt. Der Arzt und die Künstlerin werden Mann und Frau zu einer enthaltsamen Ehe. Ihre Kinder sind das Töchterlein der armen Magd und der kleine Sterngucker. Doch das alles ist unsäglich, mit Rilke zu reden, das Verschwiegenste aus der Arbeit und Seele des Arztes wie der Künstlerin. Es ist ein Roman mit dem gesunden Herzschlag einer Handlung, nur ein Roman aus vierzehn gelassen ausgeschwungenen Novellchen, die wie *Klassischer Stil* Strophen eines Gedichts sind. Carossas Werkstil ist klassisch. Die Landschaften, in denen er geboren ist und wirkt, haben immer eine heimliche Latinität in sich gehabt. Die lyrischen Hauptakzente wie die Verse über die Alpen und über die Donau bezeichnen zugleich die Grenzen seiner Heimat: die südliche, hinter der die italienischen Städte anfangen, und die nördliche, an der es mit dem Barock zu Ende ist. Carossas Werkstil ist antikisch. Es ist die nichts als menschliche Schlichtheit, die mit nobler Volkstümlichkeit gleichbedeutend ist. Emerenz, die Mutter Magd, und Toni, der Sterngucker, sind bairisches Volk in Haltung und Rede, gar nicht stilisiert, höchstens daß sie sich mit sich selber ein bißchen Mühe geben. Wenn Vergil statt seiner Hirtengedichte Novellen geschrieben hätte, so würden sie wohl aussehn wie Carossas Geschichten. Denn die sind gar nicht hellenisch, sondern ganz und gar römisch, nicht auf Schönheit, sondern auf Virtus gerichtet. Virtus aber *Virtus* kann man weder ins Griechische noch ins Deutsche übersetzen.

BERLIN. Die Revolution von Links oder von Rechts hatten in Deutschland seit hundert Jahren ihre Literaturen. Das Pendel kreiste beständig und kam nicht zur Ruhe und widerrief im steten Wechsel den Sieg der einen wie der andern. So war es zuletzt 1918, 1933, 1945 gewesen. Die deutsche Literatur kam aus dem Zustande des grausamsten von allen, des Bürgerkrieges, nicht heraus. Es galt nicht mehr die Leistung, sondern die Narben, die man vorzeigen konnte, sofern sie gerade an der Reihe waren. Und in der Tat, phantastisch sind die Menschenschicksale, die sich aus ihrer Kunst zu schreiben zusammenwirkten.

Albrecht Haushofer, 1903 bis 1945, aus München und einer geistig hoch-

Berlin 1945 stehenden Familie, war an der Berliner Hochschule Lehrer für Erdkunde und Geopolitik. Von ihm gab es drei Dramen in strengen Jamben aus der römischen Geschichte: 1934 „Scipio", 1938 „Sulla", 1939 „Augustus". Man brauchte sie nicht unbedingt im Sinne einer Ablehnung der nationalsozialistischen Herrschaft zu lesen. Aber die mit seiner Persönlichkeit vertraut waren, die wußten, wie er gesonnen war. Schließlich ließ er sich in die Verschwörung gegen Adolf Hitler am 20. Juli 1944 verwickeln. Er wurde verhaftet, in das Gefängnis von Moabit gesetzt und kurz vor dem Ende am 23. April 1945 erschossen. Sein Bruder fand in der Hand des Toten die *„Moabiter* „Moabiter Sonette", die sogleich 1946 gedruckt wurden. Sie sind ein Zeugnis *Sonette"* und Vermächtnis für den Glauben an den Geist bis zum letzten Atemzuge. Und ein Zeugnis für Schicksal, das den Bruder rechtzeitig aus dem gleichen Gefängnis befreite, um dieses Vermächtnis aus der Hand des Toten zu bergen.

Theodor Plivier, 1892 bis 1955, war ein Arbeiterkind aus Berlin. Er hat die Landstraßen vieler Länder abgeklopft. Er ist auf vielen Schiffen gefahren. Er diente in der kaiserlichen Kriegsflotte. Er war an dem Matrosenaufstand in Wilhelmshaven beteiligt, 1918, setzte sein abenteuerliches Leben fort, wanderte 1933 nach Rußland aus, wurde Mitglied des Komitees „Freies Deutschland", kam mit der Roten Armee 1945 nach Deutschland zurück und wurde Lizenzträger des Kiepenheuer Verlages. Er ließ sich 1947 am Bodensee nieder. Sein abenteuerliches Leben steckt in seinen Romanen, so die wilde Fahrt auf dem Kaperschiff „Wolf", „Des Kaisers Kulis" 1929 oder „Haifische" 1945 über das Treiben der Guanoschiffe. Was will das alles be- *„Der Feldzug* deuten gegen den Tatsachenroman „Der Feldzug im Osten": „Stalingrad" *im Osten"* 1945, „Moskau" 1952, „Berlin" 1954, der auf Aussagen deutscher Kriegsgefangener, auf Tagebüchern und Briefen beruht. Ist das nicht phantastisch: von Wilhelmshaven bis Stalingrad, von Berlin bis Berlin, und alles erlebte Literatur?

Hermann Kasack, 1896 aus Potsdam, das ist dagegen ein Leben von zahmer Bürgerlichkeit. Es beginnt lediglich mit Gedichten in Pfemferts „Aktion" 1916, führt in die Kanzlei desselben Kiepenheuer Verlags und schließlich an die Spitze der Deutschen Akademie für Sprache und Dichtung.

Thüringen und Franken verändern ihr Gesicht. Das Weimar Goethes und Schillers wird von der frühen deutschen Republik sehr schief in Anspruch genommen, das Nürnberg des Hans Sachs und Albrecht Dürer zur Tribüne von Parteitagen. Die deutsche Dichtung macht sich aus den zwölf Standbildern der Stifter im Chor des Naumburger und aus dem Reiter des Bamberger Domes eine neue Legende.

THÜRINGEN selber gibt sich nur sparsam mit eigenen Leistungen kund. *Zwischen beiden Welten* *Walter Flex*, 1887 bis 1917, von Eisenach, und auf der Insel Ösel gefallen, wäre mit seinen Dramen und Bismarcknovellen kaum in das Bewußtsein des Zeitalters getreten. Sein Soldatentod machte seine Verse „Sonne und Schild" 1915, „Im Felde" und „Der Wanderer zwischen beiden Welten" 1917 leben- dig. Er kam von der Jugendbewegung, hatte den verjährten Stil Schillers und Körners, der Burschenschaft und zuweilen des Volksliedes. Sein Tod und dieser Stil machten ihn zumal dem Wandervogel kostbar und verständ- lich. *Karl Linzen*, 1874 bis 1939, aus Weimar, von schlesischen und west- *Karl Linzen* fälischen Vorfahren, wies sich seit 1909 mit seinen Novellenbänden und später mit seinen Romanen aus. „Die gefrorene Melodie" 1926 umgrübelt das Tiefengeheimnis des deutschen Künstlertums, den blutsbrüderlichen Zwiespalt von südlicher Sonne und nordischer Nacht, von lichter Gestalt und dunklem Gedanken, von klassischem Geist und romantischer Seele. Aus dem Zauberspuk eines alten Hauses, aus dem angehäuften Schatz von fremdarti- gen Dingen, dämonisch toten und magisch lebendigen, kämpft sich der deutsche Maler, Kain über Abel, ans Licht.

FRANKEN hatte sich zwischen dem literarischen Wirrwarr von 1890 und dem geistigen Chaos von 1918 in seinem stellvertretenden Dichter behaup- tet. *Wilhelm Weigand*, 1862 geboren, aus Gissigheim, hat sein Landhaus zu Bogenhausen bei München und sein Leben zu einem gelassenen Kunstwerk gestaltet. Denn sein Sinn stand auf den Adel der Schönheit. Ein abgesagter Feind der zeitgenössischen Wirklichkeitskunst, hat Weigand auf der Szene Nietzsches Gedanken in Bewegung gesetzt. Das sind seine frühen Dramen der neunziger Jahre. Das alte Frankreich, dessen Adel von Brief und Geist, war die Welt, in der Weigand lebte. Er hat das Leben Montaignes und Stendhals geschrieben, die Briefe des Abbé Galiani übersetzt, mit Gobineau gewetteifert. Italien kannte er aus der Beute seiner Augen. Das Erlebnis beider Völker vermählte Weigands Dramenkreis „Die Renaissance" 1899, *„Die Renaissance"* der bei aller geistigen Verpflichtung frei und eigentümlich neben Gobineaus Szenengruppe „La Renaissance" 1877 steht. Der Reichtum des Lebens, der Glanz der Bilder, die edle Größe der menschlichen Gestalt, der lyrisch-tragi- sche Wohllaut der Sprache, sondern diesen Ring von Dramen einsam aus ihrem Zeitalter aus. Seine kostbaren Novellenbücher, zu frühest „Der Ring" 1912, zu jüngst „Von festlichen Tischen" 1930 und manche seiner Romane *Weigands Novellenbücher* durchschreiten das geistige Europa, wie es der Dichter sich zu eigen gemacht hatte. Sein fränkisches Dorf hat er im Herzen durch alle schönen Fernen der Welt getragen, die drei Romane „Die Frankenthaler" 1889, „Die ewige

Fränkisches Spektrum Scholle" 1926, „Die Gärten Gottes" 1936 sind durch sein Leben eine natürliche Einheit geworden, in der das alte idyllische Franken der Leibgeber und Siebenkäs sich ernst und launig zu dem neuen Deutschland des Spatens entfaltet. Zum Liede geworden ist dieses Leben in den glückatmenden Versen „Der verschlossene Garten" 1909, und Geschichte in dem Buch der Selbstschau „Welt und Weg" 1940, der Geschichte eines reingestalteten Menschen. In Wilhelm Weigand hat noch einmal die von fränkischer Kraft geformte Welt — Deutschland, Frankreich, Italien — als ein Ganzes gelebt.

Leonhard Frank Grell flammt vor dieser gebändigten Ordnung der Widerschein des Chaos auf. In Franken freilich hat alles Form, auch der Abbruch. *Leonhard Frank,* 1882, aus Würzburg, hat mit einem Roman der Jugend begonnen, „Die Räuberbande" 1914, wie eine Knabenschar von Abenteurern durch die Probe des Lebens entzaubert wird. In Romanen und Novellen wurde Frank ein Lobredner der allgemeinen Brüderlichkeit und ein dichterischer Anwalt der Arbeitslosen. Das Leben in seinen Büchern ist ohne Gnade. Doch die Stunde der Erkenntnis in unberührten Seelen hat dieser Kenner des Herzens zart *Konrad Weiß* und ehrfurchtsvoll dargestellt. *Konrad Weiß,* 1880, aus Rauhenbretzingen, war der Sprecher der katholischen Geistigkeit. Die vier Erzählungen „Die Löwin" 1928, die Traumgesichte „Tantalus" 1929, die Verse „Das Herz des Wortes" 1929 sind Denkgedichte und Begebenheiten, die im Ungefähren verschweben. In ihnen wird immer gewandert ohne Woher und Wohin. Traumhaft, unwirklich, rätselvoll geschehen ihre Begegnungen. Gleichwohl bestricken sie durch den fremdartigen Glanz und die ahnungsvolle Schönheit des Vortrages. *Anton Dörfler,* 1890 zu München geboren, erzählt in langer *Julius Maria Becker* Reihe die Schicksale mainfränkischer Handwerker. *Julius Maria Becker,* 1887, aus Aschaffenburg, spiegelt alle Rettungsversuche aus dem Chaos in sein Drama. Der Roman „Syrinx" 1914/1918 gibt die Tragödie eines Nietzschejüngers, der die Sphärenorgel erfindet und aus der tragischen Einsamkeit der zwölf Töne in die unertragbare Fülle der Allmusik stürzt. Den Zustand dieser Seele tragen die harfentönigen, schwebend verhaltenen, weitgespannten Rhythmen des Versbuches „Ewige Zeit" 1923/1928 vor: den dionysischen Rausch der Liebe, orphisch dunkle Erkenntnisse, lodernden Zorn über die Schmach der Zeit. Beckers Bühnenspiele ringen alle um die Lebensform des neuen Menschen. „Der Brückengeist" 1929 ist eines der schönsten Mysterienspiele. Es besteht in der nächtlich sanften Erhellung, daß hier zwei unbewußt Liebende einander begegnet sind, zur gleichen Stunde gestorben und vom Tode zusammengeführt auf der Brücke des Diesseits und Jenseits. *Eugen Ortner,* 1890, aus Gleishammer, hat wieder

anders die Zeit auf seiner Szene spielbar gemacht. „Meier Helmbrecht" *Eugen Ortner*
1927, die entwurzelte Nachkriegsjugend in der Rolle des mittelalterlichen
Bauernjungen; „Insulinde" 1928, wo man beim Einbruch Europas in das
Kulturvolk von Java an den Einbruch Amerikas in Europa denken soll;
„Europa tötet Alexei" 1931, die Tragödie beider Rußland in der Tragödie
des Zarensohnes: überall drückt die geschichtliche Lage die gegenwärtige,
die dargestellt werden soll, aus. Ortners Künstlerromane „Albrecht Dürer"
1933 und „Balthasar Neumann" 1937 bestätigen die barocken Stilzüge dieses
Werks, die mit der Zeit immer deutlicher hervortreten.

Das alte Ostfranken hat zwei Männer von entgegengesetzter Weltrichtung *Östliche*
hervorgebracht, das Chaos wieder zu ordnen. Der Denker und Maler *Josef* *Lebensweisheit*
Schneiderfranken, 1876, von Aschaffenburg, der Nachkomme von Forstleu-
ten und Weinbauern, Bergsteiger und Gartenkünstler, in München und Paris
geschult, in Griechenland beinahe eingebürgert, hat unter dem Decknamen
Bô Yin Râ eine lange Reihe von Büchlein geschrieben, die aphoristisch die
wirtschaftlichen und politischen Fragen seiner Zeit deuteten und Anweisun-
gen zu einem gesteigerten Leben gaben. Er sieht im göttlichen Urgrund alles
Geschehens eine mann-weibliche Polarität, die sich in allen Erscheinungen
weiterzeugt, so daß auch im Menschen das Göttliche nur als Mann und Weib
erfühlbar ist. „Wahre Religion ist frohgemute Freiheit. Mißtraue darum
allem, was als religiöses Fühlen gelten möchte, ohne in der Heiterkeit des
Herzens sich bestätigt zu erweisen." Dieser östlichen Lebensweisheit steht
die westliche Frömmigkeit gegenüber. Der Denker und Übersetzer *Theodor* *Westliche*
Haecker, 1878, aus Eberbach, der Kulturphilosoph und Tennenfeger einer *Frömmigkeit*
zuchtlosen Zeit, von der Hand Sören Kierkegaards und John Newmans zu
einem lateinisch strengen Christentum geführt, hat der Jugend mit der Ehr-
furcht des Wortes den Glauben an die Rangordnung des Geistes zurück-
gegeben. Das Nachwort zu seiner Übersetzung von Hilaire Belloc „Die
Juden" 1927 stellte die Lebensfrage der Deutschen unter das Gesetz des
Christentums. Sein Buch „Vergil, Vater des Abendlandes" 1931 galt in fest-
licher und gefahrvoller Stunde dem gemeinsamen Ursprung aller europäi-
schen Gesittung.

Die fränkische Stimmung ist das lyrische Gedicht. *Hans Heinrich Ehrler,* *Das lyrische*
1872, aus Mergentheim, hatte einen frommen Wachszieher zum Vater. Die *Gedicht*
verwunschene Stille des Deutschordensstädtchens ist noch in den Versen des
Dichters zu hören, wie das andächtig verhaltene Summen der väterlichen
Bienenvölker. All sein Werk ist reine Stimme der Seele. Vieles ist eigene
Lebensgeschichte. Lyrische Gebilde sind reine Novellen. Wachstum der Seele

Hans Heinrich Ehrler und nicht Begebenheit macht seine Künstlerromane. Die seraphische Liebe Johann Paul Richters, die geheimnisvollen Seelenschwingungen seiner Gestalten, der paradiesische Zustand ihrer Herzen sind in die Dichtungen Ehrlers zurückgekehrt. Es sind lyrische Tongemälde der von Gott gestimmten Seele. Die „Lieder an ein Mädchen" 1912 und die Gedichte „Unter dem Abendstern" 1937 umgrenzen zeitlich dies lyrische Werk. Wie das Evangelium die schwierigsten Dinge in der Sprache der Fischer und Zöllner sagt, so redet Ehrler mit der Zunge des natürlichen Menschen von den Unwahrheiten, die nicht gewußt, sondern geglaubt werden, beschwingt, doch gemeinverständlich. *Ludwig Derleth*, 1870 bis 1948, aus Gerolzhofen, hat die Jugend in seiner fränkischen Heimat verlebt und dann sein Leben zwischen Rom und Paris im Weiten, zwischen Wienerwald und dem Tessin im Engeren geteilt. Viele seiner frühen Gedichte sind in den „Blättern für die Kunst" gedruckt worden. „Der fränkische Koran" 1933 ist sein Werk. „Phantasus" von Arno Holtz ist ein biologisches, „Das Nordlicht" von Theodor Däubler ein *„Der fränkische Koran"* kosmogonisches Weltgedicht. „Der fränkische Koran" von Ludwig Derleth ist ein mystisches Seelengedicht. Ein einziger Pindarischer Hymnus aus fünfzehntausend Versen, singt es die Pilgerfahrt der Menschenseele von Gott zu Gott über die wogende See eines Menschenlebens. Die mystische Handlung des Buches ist der Goldgrund, in den die Gedichte eines ganzen Lebens wie farbenbuntes Email eingegossen sind. Die schönsten von ihnen hat der Dichter zu dem Büchlein „Die Lebensalter" 1937 ausgesondert. So ist „Der fränkische Koran" eine Symphonie von Gedichten und Stilarten: Hymnen und Reimgesätze; Gebete, Litaneien, Koranverse; Naturbilder, Trinklieder, Liebesgedichte; Idyllen, Schwänke, Parodien. Das Buch „Seraphinische Hochzeit" 1939, Legenden und Hymnen des Bruders Immerwach, läßt ahnen, was *Walther Niemeyer* sich in der Seele dieses Mannes begeben hat. *Walther Niemeyer*, 1874, aus Barchfeld, hat seine Heimat im fränkisch-thüringischen Grenzgebiet des Werratales. Die niederdeutsche Familie kommt aus Hessen. Seine geistige Gestalt tritt wirkungsvoll neben Ehrler und Derleth. Das ist ein Dichter, der die Worte vor sich sieht und wie farbige Schmuckbuchstaben ausmalt. Seine frühen Verse der Jahre 1900/1914 sind in den beiden Sammlungen „Lieder der Einmut" 1928 und „Feier der Flur" 1936 aufgegangen. Sie haben sogleich den eigentümlichen Stil. Nur wenige sagen, fast alle malen. Sie sind *„Sanggespräche"* ganz Naturstimmung. Die „Sanggespräche" 1929 leiten zu einem neuen Stil hinüber. In Gestalt von Wechselgesängen werden an evangelischen und antiken Szenen metaphysische Fragen dargestellt. „Die Bordesholmer Hymne" 1928 und „Runen" 1931, Kurzverse von äußerster Dichte des Sinnes und

Wortes, verwandeln die Erscheinungen der Dinge in eine stark abkürzende *Kosmische Lyrik* Zeichensprache. „Russische Bilder" 1932 und „Gärten des Südens" 1936 kehren zum strengen und reinen Strophenstil der ersten Versbücher zurück. In der mundartlichen Erzählung „Martin Moser" 1930 läuft der Totschläger auf der Flucht vom Tatort in den Freitod, in die Klarheit und in den Frieden. Niemeyers kosmisch-mystische Lyrik hat die vertrauten Worte neu, fremd, wunderbar gemacht. Viele von ihnen sind auserlesen schön. Das Bild wird im Stil altskandinavischer Dichtung zum Rätselwort und Spielgefährten des Tiefsinns. So heißen die Stabreime „Brüder des Blicks", „Flurgefährten", „Düfte der Sicht". Und so folgt der stummen Rätselfrage die Lösung dicht auf dem Fuße: „Raumrager, Flurfunkler, Waldwölber. Ihr Bäume, Uns Brüder!" Die drei, Ehrler, Derleth, Niemeyer, sind bei allem persönlichen Eigensinn ihres Stiles eins im Ichgefühl der Gottnatur und in der fränkischen Meisterschaft des Wortes.

Die gleiche Gesinnung hat ein jüngeres Geschlecht in den mannigfaltigen Formen des Schrifttums erwirkt.

Leo Weismantel, 1888, aus dem Rhöndorf Obersinn, hat sich als Volkser- *Dorf Sparbrot* zieher gefühlt. Das war seine Schule der Volkschaft für Volkskunde und Er- *und Familie* ziehungswesen zu Marktbreit. Als Spielbuchdichter wurde Weismantel zum *Herkommer* Treuhänder zwischen Bühnenvolksbund und Jugendbewegung. „Die Reiter der Apokalypse" 1919 leiteten eine Reihe von Zeitstücken ein. Dann hat er mit seinem „Werkbuch der Puppenspiele" 1924, mit seinem „Krippenbuch" 1930 der Schule der Volkschaft gedient. Nach nicht wenigen Vorübungen gelang dem Dichter der große Wurf mit den drei Romanen, die „Das alte Dorf" 1928, „Das Sterben in den Gassen" 1932, „Die Geschichte des Hauses Herkommer" 1932 hießen und zu dem Ganzen „Vom Sterben und Unter- gang eines Volkes" zusammengefaßt wurden. Aufstieg und Sinken des wirt- schaftlichen Deutschlands 1840/1920 ist der Vorwurf dieser Dreiheit. Dorf *Weismantel* Sparbrot und Familie Herkommer, ihr gemeinsames Leben vollstreckt das *erzählt* deutsche Schicksal eines Jahrhunderts. Von da an zeigte sich die Gestaltungs- kraft des Dichters allen Aufgaben gewachsen. Die religiösen Lebensbücher „Elisabeth" 1931 und „Maria" 1933, die Landgräfin von Thüringen und die Mutter des Herrn, halten ehrfürchtig die Mitte zwischen verbürgtem Zeug- nis und dichterischer Legende. „Rebellen in Herrgotts Namen" 1932 sind die nothaften Kämpfer des großen Bauernkriegs. „Gnade über Oberammergau" 1934 ist der Durchbruch der Erkenntnis von der stellvertretenden Opferkraft der Spielkunst. „Dill Riemenschneider" 1936 heißt die Geschichte des Bild- schnitzers und Bürgermeisters von Würzburg, der sich erkühnte, das Reich

Gottes auf Erden niederzuholen und darob vom Henker seines Bischofs an seinen kunstfertigen Händen verstümmelt wurde.

Seltsame Bahnen der Vorfahren müssen sich in den beiden Brüdern geschlossen haben, deren Dichtungen den Märchenzauber des unberührten Gottesgartens ausstrahlen.

Anton Schnack, 1892, aus dem unterfränkischen Rieneck, der Jüngere und Spätere, hat sich nach den frühen Ausbrüchen lyrischer Bildstürme zu reinen und zarten Versen gesänftigt, die den fränkischen Alltag von Monat zu Monat begleiten; zu lauterer Prosa aus der kleinen Welt; zu kleinen Novellen, die das menschliche Antlitz umrahmen.

Brüder Schnack

Friedrich Schnack, 1888, von Rieneck, hat aus diesem heimatlichen Waldlande eine ganze Welt von Ländern, Menschen, Tieren, Blumen anmutig hervorgezaubert. Die Erzählung trägt das Werk des Dichters wie der Stamm die Krone. Sie ging aus dem verwehten Samen der Romantik auf und nährte sich am phantastischen Brodem der Zeit. Das sind die beiden Bücher „Die goldenen Äpfel" 1923 und „Die Hochzeit zu Nobis" 1924, Novellen, jene von märchenhafter Art, diese grotesken Stiles. Nobis, die Stadt des letzten Augenblicks, wo die Seelen der Verstorbenen auf ihre Bestimmung zum Himmel oder zur Hölle warten, berauscht sich im Bacchanal einer sinnlosen

„Sebastian im Wald"

Hochzeit. Jäh ist der Dichter ein anderer. „Sebastian im Wald" 1926 hat das legendenhafte fränkische Städtchen Hammelburg zur Szene. Ein brasilianischer Heimkehrer schafft sich im einsamen Blockhaus des Waldhüters ein sanftes Glück zu zweit und dritt. Das Feuer vernichtet Wald und Haus und

Das Kinder-liebespaar

man versteht, wie an diesem Feuer seine Seele mitverbrennt. „Beatus und Sabine" 1927 sind ein Kinderliebespaar. Der ältere Knabe führt seine jüngere Freundin in alle Geheimnisse der Natur ein. Das Kinderspiel wird durch Eros, der es in den Ernst der Geschlechtsliebe verwandeln will, tragisch gestört. Der Knabe ertrinkt im Neckar und das Wasser spült barmherzig das geendete Reich der Kindheit hinweg. „Orgel des Himmels" 1927 ist der fränkische Roman einer alten Frau, die sich durch Erinnerung und Ahnung aus der Wirklichkeit hinaus verklärt zur Weisheit der Erde und Übererde. Der Dichter hat diese Bücher zu dem Roman der drei Lebensalter „Die brennende Liebe" 1935 zusammengefaßt. Diese Frömmigkeit des fränkischen Waldes wird mit schönen und fügsamen Worten erzählt. Die drei Reiche der Natur, die Beatus seiner jungen Freundin aufschließt, hat der Dichter dann in köstlichen Kunstwerken abgebildet. „Das Leben der Schmetterlinge" 1928

Schmetterlinge und Heilkräuter

gliedert zwischen das Buch der Tagfalter und das Buch der Nachtfalter das Buch der Falterlegenden ein. Es macht den Sommervogel zum Mitwisser und

Teilhaber am göttlichen Geheimnis. „Sibylle und die Feldblumen" 1937, „Cornelia und die Heilkräuter" 1939 sind Kunstwerke durch ihren Vortrag. Eine kleine Geschichte macht hier wie dort das Gewebe, in das die einzelnen Pflanzen, ihre Lebensweise und Tugenden, ihre Legenden und Geheimnisse eingestickt sind. Die blühende Krone dieses tiefverwurzelten Baumes sind die Gedichte. Friedrich Schnack hat 1913/1933 seine Verse in sechs Bücher geerntet und ihre Auslese in dem siebenten, „Gesammelte Gedichte" 1938, gekeltert. Es sind die reinsten Strophengedichte, ohne künstlichen Rhythmus, nichts als Tonfall des Wortes und völlig Melodie. Die Verse bestehen aus wenig Takten. Die Worte sind wörtlich gemeint, meiden das Bild und wirken kraft ihrer sinnlichen Bedeutung. Die Natur ist nichts als irdisch, weder kosmisch noch menschlich noch göttlich, lebendige Erscheinung eines beglückenden naiven Seins. Sie ist auf eine wunderbare Weise bewegte Gestalt und strahlt von farbigem Lichte. Ihre Stimme beherrscht der Vogellaut. Die vollkommene Schönheit dieser Gedichte entfaltet sich in drei Kreisen. „Tagwerk und Werktag" ist der fränkische Umlauf von Jul zu Jul. „Kreuz des Südens" sind die Gedichte einer Afrikareise. „Asche und Geist" meinen die menschliche Wesenheit, die aus dem Stoff der Natur herausgeglüht wird. Aus all diesen Dichtungen, die lautere Poesie sind, spricht der Weltfranke, sein schöpferischer Reichtum, die Anmut und Schönheit seines Sprachgeistes.

Josef Magnus Wehner, 1891, aus dem Rhöndorf Bermbach, ist von den verschollenen Bergsiedlungen eines urtümlichen Menschentums gekommen. Der Dichter hat sich zu frühest in Tonstücken Luft zu machen versucht. Gestalten faßte und hielt er erst in den Sextener Dolomiten, da er isländische Balladen, Hymnen vom Gestaltenwechsel der Götter schrieb und den Untergang der alten Welt in der Dichtung „Der sterbende Faun" 1917 feierte. „Der Weiler Gottes" 1920 heißen sechs Geschichten im klassischen Versmaß des Sechstaktes. Das ist nur der Aufgesang zu den beiden Romanen „Der blaue Berg" 1921 und „Die Hochzeitskuh" 1928, alles zusammen die dichterische Eigengeschichte des Menschen von der Kindheit zur Ehe. Die Seelengeschichte des Soldaten erzählen die Bücher „Als wir Rekruten waren" 1938, „Stadt und Festung Belgerad" 1936, „Sieben vor Verdun" 1930 mit dem phantastisch-grotesken Nachspiel, das „Die Wallfahrt nach Paris" 1932 heißt. In der Mitte stehen, gleichen Stiles, die beiden großen Dichtungen Belgrad und Verdun, der Waffenkrieg und der Maschinenkrieg. Sie sind eine Gattung für sich unter den deutschen Kriegsbüchern gleichen Ranges. Denn sie sind Dichtung. Kindhaft natürlich ist das Erhabenste und Entsetzlichste gesagt. Eine fromme und heitere Laune umspielt die Dinge und Begeben-

„Die Gedichte"

Attische Heiterkeit

„Der Weiler Gottes"

heiten. Da ist die Stelle, wo der junge Franzosenhengst durch sein Erscheinen zwischen den Schützengräben die Schlacht plötzlich in urweltliche Ruhe versenkt. „Es war ein paradiesischer Augenblick, selbst die Toten rochen nicht mehr." Das könnte Wolfram von Eschenbach gesagt haben. „Das Land ohne Schatten" 1929 gibt beglückt von der Hellasreise Kunde, zu den nordischen Burgen von Sparta und zu Pallas Athene auf dem Tempelberg von Athen Die Sprache des Buches ist lauteres Kristall, strahlend von leisem Pathos und sanfter Ironie. Von den homerischen Versen im Weiler Gottes bis zu der attischen Heiterkeit des schattenlosen Landes durchwaltet das Werk des Dichters jene edle Zucht des Geistes, die von je des Franken Anteil war.

„Das Land ohne Schatten"

So kommen sie Welle auf Welle. *Karl Bröger*, 1886, aus Nürnberg, der Arbeiter, Feldsoldat, Zeitungsmann, ist immer unterwegs gewesen von der Klasse zum Volk. Seine Geschichte aus dem Krieg, „Kamerad, als wir marschiert" 1916 und „Soldaten der Erde" 1918 sind nicht selten reine Volkslieder. Viele von ihnen sind kraftvolle Balladen. Brögers erster Roman „Der Held im Schatten" 1920, auch eine Jugend, schildert den Anfang und das Buch „Deutschland, ein lyrischer Gesang in drei Kreisen" 1924 deutet die Richtung seines Weges an. Der Dichter und Bildhauer *Ernst Penzoldt*, 1892 bis 1955, aus Erlangen, zaubert mit seinen Versen, Geschichten und Spielen die fränkische Hinterwelt in die Gegenwart zurück. Der Dichter hat mit seinen „Idyllen" 1923 den Deutschen die Kunst des kleinen Glücks zurückgewonnen. *Wilhelm von Schramm*, 1898, aus Hersbruck, Soldat und Zeitungsmann, hat zwischen Kriegsgeschichten und Dramen „Die Allgäuer Botschaft" 1929 bis 1931 ausgesandt. Homerische Verse erzählen in sieben Tagwerken, wie ein lebensübermütiger schwäbischer Jungpriester sich in einen Werkmann der Barmherzigkeit verwandelt. *Ludwig Friedrich Barthel*, 1898, aus dem unterfränkischen Marktbreit, hat die Antigone des Sophokles nachgedichtet und in seinen Novellen eine edle Prosa gepflegt. Sein Werk ist lyrisch und die hymnische Ode sein Ehrgeiz. Acht Versbücher —„Gedichte der Landschaft" 1931 bis „Dom aller Deutschen" 1938 — hat der Dichter in so wenig Jahren erscheinen lassen. Auch mit seinen jüngsten Sammlungen „Kelter des Friedens" 1952 und „Die Auferstandenen" 1958 hatte er nichts zu widerrufen. Ihre Grundstimmung ist hymnisch entrückt und gottversunken. Sie liebt die Dämmerung und die Nacht, die Ferne und die Stille. Das Auge der Seele sieht nicht die Dinge selber, sondern nur die weiten Umrisse der Welt. Es sieht nicht das Jetzt und Hier der Natur, sondern ihr Immerdar, den Raum und die Zeit Gottes. Eine wissende, erfüllte, ergebene Frömmigkeit, die Ruhe des Seins, spricht aus dem „Schwangauer Vaterunser".

„Der Held im Schatten"

Dichter und Bildhauer

„Allgäuer Botschaft"

„Schwangauer Vaterunser"

Der Mensch, den diese fränkische Dichtung gestaltet, ist ein Bürger im Reich Gottes, ein irdischer Mensch, beschlossen im Maß der heiligen Ordnung.

2. DER UMKREIS

Im Schein der beiden Kriege und vor den Schatten, die sie im Verlöschen warfen, heben sich die Gesichtszüge der drei Großlandschaften schärfer denn je gegeneinander ab. Es sind geistige Gesichter, die von innen her bewegt sind, mit dem beschäftigt, was geistig aus Deutschland zu machen wäre, wenn es heil überstehen sollte, was es noch lange nicht hinter sich hatte.

Löns und Stramm

Die *NIEDERSÄCHSISCHEN LANDSCHAFTEN* vom Rhein bis zur Oder gehn durch die gleiche Verwandlung. Das bezeugt die Stimme des Soldaten. Sie kam aus dem Jenseits. Hermann Löns, der 1914 im Westen gefallen war, hatte wie vorausahnend in seinem Roman „Der Wehrwolf" 1910 einen Schutzbund niedersächsischer Bauern geschildert, der sich im Dreißigjährigen Kriege zur Rettung des Volkes zusammenschließt. August Stramm, den 1915 im Osten ein Sturmangriff gefällt hatte, konnte mit seiner ekstatischen Stammelkunst gerade nur noch das frühe Erlebnis des Krieges aussprechen. Löns war Niedersachse aus Wahl und Stramm durch Geburt aus Münster.

Bücher der Heimkehrer

Dem niedersächsischen Feldsoldaten war die Darstellung des Krieges zugefallen. Von Franz Schauwecker, der 1890 zu Hamburg geboren war, bis zu Erich Maria Remarque, der 1898 in Osnabrück zur Welt kam, ist die deutsche Kriegsliteratur in fast allen ihren merkwürdigen Erscheinungen niedersächsischen Ursprungs. Walther Georg Hartmann, 1892, aus Strelitz, „Der begeisterte Weg" 1919, und Ulrich Sander, 1892, aus Anklam, „Pioniere" 1933, geben persönlichen Bericht. Georg Grabenhorst, 1899, aus Neustadt bei Hannover, hat die Überwindung des Krieges durch die Kraft des Herzens sehr schön an beiden Geschlechtern geschildert. In „Die Gestirne wechseln" 1929 ist er selbst der Heimkehrer. In „Merve" 1932 ist es ein junges Mädchen. Am

Rückverwandlung des Künstlers

vollkommensten hat sich diese Verwandlung dort vollzogen, wo es eine Rückverwandlung von Künstler zu Künstler war, mitten durch den Soldaten. Georg von der Vring, 1889, aus Brake an der Unterweser, war der Nachkomme von Schiffbauern und Seekaufleuten. „Der Soldat Suhren" 1927 ist sein Kriegsbuch. Sein „Goldhelm" 1938 warb um Freundschaft zwischen Frankreich und Deutschland. Er folgte seinen Vorfahren auf Werften und Schiffen mit Romanen und Novellen. Was machte dieser Soldat aus sich?

52*

Einen Meister fein gestrichelter Zeichnungen und sorgsam gesetzter Versworte, die zusammen mit einer leisen Wendung ins Blaue zielen. Sie hießen „Verse" 1930, „Blumenbuch" 1933 und sie wurden 1938 als „Bilderbuch für eine junge Mutter", als „Garten der Kindheit" gesammelt. Sie umweben das Glück im Winkel, das erstaunliche Dasein des Kindes, die schmalen Häfen, über denen die weiße Perle des Mondes hängt. Und das in zwei, drei kurz geschwungenen Worten. Es sind Zaubersprüche, die mit einem machen, was sie wollen. Das also war aus solchen Feldsoldaten geworden. Und es tut nichts zur Sache, wenn der gerettete Maler in „Magda Gött" 1948 natürlich ein politisch Verfolgter ist.

Der Krieg an sich Aber der richtige Krieg, der Krieg an sich: das war den drei jungen Menschen zugemessen, die durch Abkunft oder Geburt aus Niedersachsen stammten. *Ernst von Salomon*, 1902, von Kiel und von einer Familie, die aus Venedig über das Elsaß nach Preußen gekommen war, gehörte dem letzten vom Kriege verschmähten Jahrgange an und focht als Freischärler, wo man noch um Deutschland fechten konnte. Seine drei Bücher „Die Kadetten" 1933, „Die Geächteten" 1930, „Die Stadt" 1932 sind das Tagebuch einer ganzen Altersgruppe. Da leiden sie, all die unseligen Jungen von sechzehn und siebzehn Jahren, gerade stark genug, ein Gewehr und am Gürtel ein Bündel Handgranaten zu tragen und sterben wie erprobte Veteranen. Nichts ist gedichtet, alles nur erzählt. Krieg ist hier äußerste Notwehr, Urtrieb des Lebens, Zwang der Natur. *Edwin Erich Dwinger*, 1898, aus Kiel, der Sohn eines holsteinischen Vaters und einer russischen Mutter, war 1915 in seinem ersten Gefecht vor seinem Dragonerzug verwundet und von Kosaken gefangen worden, dann immer auf der Flucht, bis ihm 1921 die Heimkehr gelang. In dreifacher Ausführung erwogen seine Romane „Korsakoff" 1926, „Das letzte Opfer" 1928, „Die zwölf Räuber" 1932 die Möglichkeiten heimatlos gewordener Menschen, neue Wurzeln zu schlagen. Dann wechselte er das Feld vom Roman zur unmittelbaren Aussage. „Die Armee hinter Stacheldraht" 1929, „Zwischen Weiß und Rot" 1930, „Wir rufen Deutschland" 1932, diese drei *„Deutsche Passion"* Bücher wurden zu einem Ganzen, „Deutsche Passion", vereinigt. Dieser Bericht wird aus dem Abstande so sachlicher Worte vorgetragen, daß sie desto kühler werden, je entsetzlicher die Dinge sind, von denen sie reden. Dwinger schwieg nicht, weder zu der volksdeutschen Passion „Der Tod in Polen" 1940, noch zu dem Untergang Ostpreußens „Wenn die Dämme brechen" 1950, noch zu der Tragödie „General Wlassow" 1951 und der Kosakenvölker. Auch das war der Krieg an sich, der Krieg des Krieges gegen den Krieg. *Ernst Jünger*, 1895, aus Heidelberg, hat eine fränkische Mutter und ist durch den

Vater Niedersachse. Von der Schulbank weg kam er aufs Schlachtfeld. Seine Kriegsbücher—„In Stahlgewittern" 1920 sowie die beiden Kampfausschnitte „Feuer und Blut", „Das Wäldchen" 1925 — sind weder Persönlichkeitsschilderung noch Erlebnisdichtung. Sie geben inbegrifflich das Wesen der Sache: Krieg. Man darf hier nicht von Wahrheit, man muß von Richtigkeit sprechen. Jünger redet die Sprache eines geborenen Denkers. Seine Kriegsbücher sind um des Ganzen willen wichtig, von dem sie ein Teil sind. „Krieg und Krieger" 1930, „Die totale Mobilmachung" 1931 enthalten die Metaphysik des Krieges als der Gestalt des Seins und des gesetzmäßigen Lebens. Krieg ist die Ordnung einer neuen Welt. Das Buch „Der Arbeiter. Herrschaft und Gestalt" 1932 gibt den Entwurf dieser neuen Ordnung. Die Verwandlung der Welt, die der Bürger beherrschte, ist durch die Technik geschehen. Die Technik aber bedarf eines Meisters, der sich ihrer so unbewußt bedient wie das Tier seiner Glieder. Das wird der Arbeiter sein. Das aber ist kein Stand, sondern die Gestalt des neuen Menschen, dem die Technik Werkzeug und Waffe sein wird. Der Arbeitermensch wird ein Arbeitsreich schaffen, in dem der Arbeitsplan das gesamte Handeln bestimmt. Das gesamte Leben wird sich nach Befehl und in soldatischen Formen vollstrecken. Krieger und Arbeiter sind ein und dieselbe Gestalt. Sie sind der neue Übermensch. So eindeutig man die 1944 abschriftlich verbreitete Schrift „Der Friede" lesen muß, so richten sich die drei Bücher „Auf den Marmor-Klippen" 1939, „Heliopolis" 1949, „Gläserne Bienen" 1957 auf andere Sorgen als den Nationalsozialismus.

„Der Arbeiter Herrschaft und Gestalt"

Gleichviel, ob Krieg oder Friede, ob Sieg oder Niederlage, die Entscheidung hieß Seele, Sozialismus, Preußentum. Der sächsische Grenzraum um den Harz hat über Niedersachsen immer das Wetter gemacht. Diese mütterliche Landschaft der Deutschen, die Gesichte hatten, ist selten so beharrlich gewesen, zu sagen, was sie wollte.

Oswald Spengler, 1880 bis 1936, aus Blankenburg und Naturwissenschaftler von Fach, hat seine Kulturgeschichte der menschheitlichen Weltgefühle, „Untergang des Abendlandes" 1918/1922, nicht auf diesen Titel hin geschrieben. Er hat Kernstücke seiner Betrachtungen der unmittelbaren Gegenwart zugewendet, „Preußentum und Sozialismus" 1920, den „Neubau des Deutschen Reiches" 1924, das Verhältnis „Der Mensch und die Technik" 1931 erwogen und fühlte sich zu der Rechenschaft „Jahre der Entscheidung" 1933 gedrängt. Daß das geschichtliche Geschehen logischen Gesetzen unterliegt und daß sich aus der Erfahrung Schlüsse auf das Kommende ziehen lassen, haben die Menschen schon immer gewußt und geübt, vermutlich seit

„Untergang des Abendlandes"

Philosophie der Kulturkreise

sie denken können. Wie die Kulturen aus ihrer mütterlichen Seelenlandschaft pflanzenhaft emporwachsen, welken und absterben und wie sich also die Menschheitsgeschichte in Kulturkreisen bewegt, das war bei Johann Gottfried Herder sehr schön nachzulesen. Aus dieser Anschauung hatte sich logisch ebenso längst die Vorstellung von jungen und alten Völkern ergeben. Spenglers Abneigung gegen das Römertum war niedersächsisch und der Vorzug, den er dem heldischen, raumgewaltigen Barock gab, bereits der Vorzug seines Zeitalters. Spengler sah die deutsche Zukunft mit der unlösbaren Durchdringung von Preußentum und Sozialismus verknüpft. Und er wußte, was nicht schwer zu wissen war, daß Sozialismus kein Zweckverband von Mitleid und Fürsorge, sondern Wille zur Macht ist. „Das Russentum ist das Versprechen einer kommenden Kultur". Das stand seit Jahrzehnten bei Fallmerayer und Grillparzer geschrieben. Und der Gedanke, daß nun ein slawisches Weltalter an der Reihe sei, war vor mehr als hundert Jahren zuerst von Herder gedacht worden. „Heroischer Pessimismus" gegen „trivialen Optimismus", so sah Spengler selber sich auf der Szene, die Nietzsches Szene war. Spengler wirklich, das ist Verlangen nach Seele inmitten des Zwangreichs der Ursächlichkeit.

Heroischer Pessimismus

August Winnig, 1878, aus Blankenburg, eines Totengräbers Sohn, hat vom einfachen Maurer rasch alle Stufen des sozialistischen Parteiadels überstiegen bis zur höchsten Verantwortung. Winnig wollte aus der Arbeiterbewegung eine Volksbewegung machen. Die drei Schriften „Der Glaube an das Proletariat", 1924, „Das Reich der Republik" 1928, „Vom Proletariat zum Arbeitertum" 1930 bezeugen das Wachstum dieses Gedankens und Willens. Aus „Kollektiv" wird ihm „Gemeinschaft". Aus „Proletariat" keimt „Arbeitertum". August Winnig hat also mit Wilhelm Riehl gedacht: „Stand heißt wuchshafte Schichtung des Volkstums. Stand heißt bluthaft begründete und geschichtlich geschlossene Gemeinschaft". Die Masse, die Proletariat geworden war, weil sie ihren Stand verloren hatte, findet zu ihrem Stand zurück und wird wieder Volk. Und mit dem Wortgebrauch der Lehre von den jungen Völkern: dem Arbeitertum gehört die Zukunft, weil es ein „junger" Stand ist. In drei wundervollen Büchern hat Winnig den Ablauf seines Lebens zu einem literarischen Kunstwerk gestaltet. „Frührot" 1924, „Der weite Weg" 1932, „Heimkehr" 1935 sind eine der schönsten deutschen Lebensgeschichten, dichterisch in der Nachgestaltung der heimatlichen Natur, von weiser Meisterschaft in der Kenntnis der menschlichen Seele, sittlich vornehm in der Betrachtung des erlittenen Leides. Der Weg und das Ziel dieses Mannes hießen: Arbeitertum — Volkheit — Abendland.

„Vom Proletariat zum Arbeitertum"

Paul Ernst, 1866 bis 1933, aus Elbingerode und eines Bergmanns Sohn, *Der Weg zur Form* hat sein Leben zwischen dem niedersächsischen Harz und den steirischen Bergen vollendet. An der Göttinger wie an der Tübinger Hochschule blieb er seinen religiösen Zweifeln ausgeliefert. Zu Berlin, in der greulichen Wirklichkeit einer Mietskaserne wurde er zu gleicher Zeit von Karl Marx und Leo Tolstoj ergriffen. Er löste sich aus der Vorstellung des Klassenkampfes. Er sah Italien. Er lernte die italienische Novelle kennen. Er hatte sich zum Dichter durchgerungen. Und es war ein Bekenntnis, als er 1903 nach Weimar übersiedelte. Das war die hohe Zeit seiner Dramen. In den Stunden des allgemeinen Zusammenbruchs machte er in sich reine Rechnung. Er kehrte zur *Um den Marxismus* Scholle zurück, die er so leidenschaftlich gepredigt hatte. Er ist zu Sankt Georgen in der Steiermark auf seinem Landgut gestorben, mitten im Anbruch der Zeit, von der man heute nicht mehr sagen kann, daß sie die seine gewesen ist. Seine zahlreichen Aufsätze ordneten sich zu Sammelbänden. „Der Weg zur Form" 1906 und „Ein Credo" 1912 sind seine Kunstlehre. „Der Zusammenbruch des deutschen Idealismus" 1918 und „Der Zusammenbruch des Marxismus" 1919 — erweitert zu „Grundlagen der neuen Gesellschaft" 1930 — geben seine Weltanschauung. Wundervoll auf geschichtlichem Hintergrunde in Szene gesetzt erscheinen die Weltgedanken des Dichters in dem Bande „Erdachte Gespräche", der ein Weltdrama des menschlichen Geistes ist. Denn der Dichter spricht durch den Mund der Unsterblichen aller Zeiten und Völker eine Weisheit aus, die zugleich die seine und die ewige des Menschen ist.

Der Dichter Paul Ernst ist kein Weitersager des deutschen Klassizismus, *Ernsts Dramaturgie* sondern der Bildner eines persönlichen Stils. Es war ein weiter Weg von der Werkstätte Holz-Schlaf bis zu dem letzten Drama „Chriemhild". Ernst hat sich als Erbe des Sophokles gesehen. Sein Drama bedeutet Kampf um die Verwirklichung des persönlichen im überweltlichen Ich. Ernsts Dramaturgie wendet sich gegen die drei beherrschenden Gedanken seiner Zeit: Ursächlichkeit, Vererbung, Umwelt. Er setzt gegen sie die höhere überweltliche Notwendigkeit, das kosmische Weltgesetz. Paul Ernsts hohe Dramen reihen sich diesseits und jenseits des geistigen Umschwungs, durch den sich sein weltanschaulicher Übergang von der Verzweiflung zur Erlösung, von der Freiheit zur Gnade und vom Menschen zu Gott vollzog. Die Jahre 1905 und 1918 begrenzen sein dramatisches Schaffen. Bei 1911 liegt der Umschwung. Vor ihm liegen „Demetrios", „Canossa", „Brunhild", „Ninon". Nach ihm fallen „Ariadne", „Manfred und Beatrice", „Preußengeist", „Kassandra", „York", „Chriemhild". Zwei Versuche zeigen, daß es den Dichter doch auch

nach andern Früchten gelüstete. So hat er ein Stück von Lope de Vega 1913 unter dem Titel „Der Gärtnerhund" umgedichtet. Und so schuf er 1914 das Mysterienspiel „Weltwende". Beide Arbeiten weisen auf den dramatischen Stil, den Hugo von Hofmannsthal hat. Für Paul Ernst waren Drama und *Die Novelle* Novelle Geschwister. Er hat sich an der altitalienischen Novelle geschult. Alle seine Novellen sind Rahmendichtungen in gehaltvollen Sammelbänden, die 1900/1922 erschienen sind: „Die Prinzessin des Ostens", „Der Tod des Cosimo", „Hochzeit", „Die Taufe", „Der Nobelpreis", „Okkultistische Novellen". Sein feiner Geist behandelt den Rahmen unnachahmlich ironisch. Dieser Übermut gegen die Täuschung stammt aus der italienischen Novellenkunst, nicht aus der deutschen Romantik. Der gemeinsame Stil dieser Novellen ist berechnete Schlichtheit, das scheinbar unbeholfene Wort, die nur mittelbare Redeweise und der Verzicht auf überraschenden Schluß. Alle Meisterschaft ist in der einzigartigen Gruppe der „Komödianten- und Spitzbubengeschichten". Die Spitzbubengeschichten behandeln, zumeist im spätbarocken Rom, den unerschöpflichen Meisterdieb. Der Spitzbube lockt die bezahlte Ehrlichkeit in jede Falle. Es ist der Weltgeist, der sich in diesen erzählten Lustspielen zu seinem eigenen Vergnügen von seinem Widerspiel überrumpeln läßt. Die Komödiantengeschichten sind skizzierte Stegreifspiele, um die stehenden Figuren der Commedia dell'arte geschrieben, wobei mit vollendeter Kunst unsicher bleibt, ob da Komödianten in der Maske des Menschen oder Menschen in der Maske des Komödianten spielen. Vielleicht *„Komödianten-* ist das, was Paul Ernst als Dichter gewollt hat, in den „Komödianten- und *und* *Spitzbuben-* Spitzbubengeschichten" am vollkommensten gelungen. Die sechs Romane, *geschichten"* die der Dichter geschrieben hat, bilden zwei Gruppen zu je drei. Die erste *Die Romane* Gruppe sind ein Ganzes durch die Lebensgeschichte des Dichters. „Der schmale Weg zum Glück" 1901, eher ein Novellenbuch, gibt die Bildungsgeschichte Paul Ernsts. „Die selige Insel" 1909 — ein Adriaeiland — ist der Schauplatz eines Lebens zu dritt. „Saat auf Hoffnung" 1913 schildert in einem Harzer Bergdorf die neu geordnete soziale Welt, wie sie sich der Dichter dachte. Die zweite Gruppe sind ein Ganzes durch den Vorwurf eines neuen Deutschlands. „Grün aus Trümmern" 1923 ist der Roman des zusammenbrechenden alten Deutschlands. „Der Schatz im Morgenbrotstal" 1926 schildert, wie nach dem Dreißigjährigen Kriege ein verlaufener Junge den Hof wieder aufbaut. „Das Glück von Lautental" 1931 gründet sich bergmännisch auf einen wiederentdeckten Erzgang. Paul Ernsts Romane leben aus dem Glauben an die Vorsehung, an die gesunde Natur des Menschen, an die Lösbarkeit aller Fragen, an die Möglichkeit einer neuen gerechten Ge-

sellschaft. „Das Kaiserbuch" 1928 setzt diesem Lebenswerk die Krone auf. *„Das Kaiserbuch"*
Es ist kein Epos im geschichtlichen Sinne der Gattung, sondern ein gereimtes
Zeitbuch im Sinne der mittelalterlichen Dichtung. Es erzählt Deutschlands
Geschichte vom Anfang der sächsischen bis zum Niedergang der schwäbischen
Kaiser. Mannigfach wie Menschen und Zeiten sind die Mittel des Vortrages.
Bald umreißt der Dichter die geschichtlichen Bilder mit zwei kräftigen Stri-
chen, bald spitzt er den Pinsel zu Kleinbildern des täglichen Lebens. Jetzt
hebt er einen einzigen Helden lebensgroß und frei vors Auge. Dann läßt er
wieder das bunte Gewühl der Menge dahinwimmeln. Der Vers dieses einzig-
artigen Geschichtenbuches ist der gereimte jambische Fünftoner, wunderbar
lebendig durch kunstvolle Zeilenbrechung und den überlegten Wechsel von
stumpfen und klingenden Schlußsilben. Das altdeutsche Reimpaar und der
archaische Satzbau geben dem Gedicht jene gedämpfte Patina, die ein Kenn-
zeichen alles echten Werkstoffes ist.

Paul Ernst hat sich selber dargestellt in den zwei Büchern „Jugenderinne- *Selbstgestaltung*
rungen" 1928 und „Jünglingsjahre" 1930, und er hat sein Leben und Schaf-
fen in zwei religiöse Dichtungen von tiefer Gläubigkeit ausgeatmet. „Der
Heiland" 1930 wird zur Aufgabe der Gegenwart gemacht. „Beten und Arbei-
ten" 1932 bezeugt den Einklang des Dichters mit der christlichen Weltord-
nung.

Das waren die drei Männer vom Harz, Ausspürer der verlorenen Seele, *Um die Seele*
Preußen verfallen, gefangen vom Geheimnis der Urmutter Erde, auf eine fast
apokalyptische Weise der herankommenden Weltwende gewiß und alle drei
geborene Dichter, verschieden nur an Werkstoff und Stil.

Anders wurde die Entscheidung in den Hansastädten gesucht. Lübeck
spiegelt sich nur in dem Jahrbuch „Der Wagen", das Paul Brockhaus heraus-
gab. Diesmal sind es Bremen und Hamburg.

Bremen, das war *Rudolf Alexander Schröder*, 1878 geboren, voll des Gei- *Bremen*
stes, den das Gemeinwesen unwandelbar ausströmte. Er hat den einen säch-
sischen Weg hellenenwärts bis ans Ziel verfolgt und den andern von den
Römern wegstrebenden wieder zurückgelenkt. Von den frühen lyrischen
Büchlein ist in „Empedokles" 1901 der Beruf des Dichters, der sich festge-
bunden wissend, mit offenem Gehör dem verderblich schönen Liede des
Lebens zuwendet, zum Bilde des Odysseus vor dem Sirenenfelsen geworden,
während im „Elysium" 1905 die Hadesfahrt des Odysseus bildgebende Mitte
ist. Heimkehr zur Scholle und im Gleichnis des hellenischen Seefahrers, war
die innerste Erfahrung des jungen Menschen. Unfern Bremens, an der Küste
des Landes Hadeln, hatte Johann Heinrich Voß der Nordsee Bilder und Vor-

Homer deutsch stellungen für seine Odyseeübersetzung abgewonnen. Es war das deutsche
Homerbuch der klassisch-romantischen Zeit geworden. Rudolf Schröder gab
mit seiner hochdeutschen Odyssee von 1912 eine andere Lösung. Sein wun-
derbarer Erzählvers ließ diesen verseelten Abenteuerroman wie einen neu
entdeckten Fluß dahinströmen. Die Sprache hat einen leichten Stich ins Alter-
tümliche und Volksgebräuchliche. Was konnte dieser alten Seefahrerstadt
schicklicher nahekommen als diese griechische Schiffergeschichte. Aber die
Nordsachsen hatten den Römer preisgegeben und Bremen war das älteste
Haupt lateinischer Bildung des Raumes. Die ackerlich umringte Stadt erhielt
ein neues Römerbild, wenn Schröder endlich den Bauer im Römer vors Auge
Römisches rückte: die Bauernlehre, Vergils Georgica; Ciceros bauernstolzes Gesprächs-
Bauerntum büchlein vom Greisenalter; „Die Gedichte des Horaz" 1935, das Größte. Das
waren drei Übersetzungen, deren jede dem staatlich und wirtschaftlich be-
drohten Deutschland ein Vorbild ackerstarken Gemeinbewußtseins aufrich-
tete. Aus Schröders lyrischem Werk gab die neue Ausgabe „Gedichte" 1935,
auf knappem Raum eine Lese, wie sie strenger nicht gedacht werden kann.
Das geistliche Zwei stattliche Bände, „Die Aufsätze und Reden" 1939, sammeln, was der
Gedicht Dichter bei bedeutsamen Gelegenheiten gesagt und geschrieben hat. Die
Frömmigkeit der Stadt war auf englische Art gestimmt. Der mütterliche
Großvater hatte der Brüdergemeinde angehört. Das brach in der Seele des
Dichters wieder auf. Er hat sich des evangelischen Kirchenlieds angenommen
und in eigenen Liederbüchlein ausgesprochen. Sie haben eher den Stil der
Brüdergemeinde als Martin Luthers. Wenn ihm aber nachgesagt wird, daß
er in dem Nachtgespräch „Der Mann und das Jahr" 1946 die Schuld des
deutschen Menschen darstelle, so ist an sein Wort zu erinnern „Ich such den
Splitter nicht" und an den evangelischen ersten Stein. Freilich, das gilt nur
für Völker, die an das Evangelium glauben. Rudolf Alexander Schröder hat
die große Form, das Sonett, die Elegie, die Ode, das Kirchenlied. Sein Stil
ist antik groß, schlicht, abgewogen. Er ist nicht Bild und nicht Weise, sondern
gebaut, gemeißelt, gegossen nach den Gesetzen der Alten. Er ist wie Klop-
stock, der sächsische Liederdichter, staatsbürgerlich, volkhaft, gottesdienstlich
in der Formensprache einer neu gewonnenen Antike.

Hamburg Hamburg, das war *Hans Friedrich Blunck*, 1888 geboren und von Abkunft
Dithmarscher. Seine Vorfahren waren mehr Bauer als Schiffer. Die frühe
Jugendbewegung war die seine. Er hat als Schüler Deutschland, als Student
Europa durchwandert, als reifer Mensch Nordafrika und Südamerika durch-
reist. Bluncks Werk baut sich aus Romangruppen auf. Eine erste, „Die
Väter", schildert den Ursprung des nordischen Menschentums und seiner

Religion in „Gewalt über das Feuer" 1928, „Kampf der Gestirne" 1926, „Streit mit den Göttern" 1925, von der ausgehenden Eiszeit bis in die Bronzezeit. Eine zweite Gruppe geleitet durch das geschichtliche Dasein des niedersächsischen Volkes. „Hein Hoyer" 1919 ist der hanseatische Söldnerführer des fünfzehnten Jahrhunderts, „Berend Fock" 1921, das Halbmärchen von einem niederdeutschen Ahasver-Heiland, „Stelling Rotkinnsohn" 1923, ein Gottsucher von franziskanischer Art aus der Zeit der fränkisch-sächsischen Kriege. Eine dritte Gruppe sind die Auslandromane: „Die Weibsmühle" 1927, ein Lebensbuch deutschbrasilianischer Siedler, und „Land der Vulkane" 1929, eine Novelle aus Mittelamerika. Eine vierte Gruppe von großen Prosaepen gibt im Rundblick eine germanische Gesamthandlung. „Die große *„Die große Fahrt"* Fahrt" 1934 meint den isländischen Statthalter Diderik Pining und seinen Kampf um die Entdeckung der dämonisch lockenden Westwelt. „König Geiserich" 1936 ist der Vandalenzug von der Elbe bis Karthago. „Wolter von Plettenberg" 1938, ist der Landmeister des Deutschen Ordens zu Livland im Kampf mit dem Zaren Iwan. In der Mitte dieses Werks steht der Roman „Volkswende" 1930, der in einen breiten Kreisbogen rings um Hamburg die Vorkriegszeit, den Krieg und die Nachkriegszeit einfängt und dieses Zeitbild mit einer unübersehbaren Fülle von Gestalten bevölkert. Den Mythus zu dieser irdischen und wirklichen Welt erzählen die „Märchen von der Niederelbe" 1922/1928, drei Bände. Erzähltes Gut seiner Eltern hat der Dichter in *Märchen von* die ihm eigene Art, zu denken und zu sprechen, umgeschrieben. Echte Mär- *der Niederelbe* chen, novellenhafte Spukgeschichten, Tierfabeln, Legenden, offenkundige Satiren stehen beisammen. Sie wollen die Übergänge aus der taghellen Menschenwelt in die benachbarten Dunkelreiche spürbar machen und die Gemeinbürgerschaft der Geister, die jenseits der Vernunft besteht. Die uralte Angst des Menschen vor dem Zwielicht steigt hier aus seiner „Unterfurcht" auf und wird leibhaftig. Der alte Götterhimmel stirbt in diesen Geschichten aus unter dem Zusammenprall von nordischem Heidentum und südlichem Christentum. Inmitten des Sagenwerks erhebt sich, groß und kühn entworfen, das Epos „Sagen vom Reich", in wechselnden Rhythmen, von der Schöpfung beginnend, auf zwei Bände angelegt, Bruchstück wie das Reich selbst. Ein Lebensbericht, mächtig in zwei Bänden, „Licht auf den Zügeln" und „Unwegsame Zeiten" 1952 f. gibt die Überschau auf dieses Leben, das in vollen schöpferischen Zügen gelebt worden ist.

Bremen und Hamburg liegen nicht ganz im Gleichgewicht. Bei Bremen *Hanseatische* muß man vielleicht wiegen statt zählen. Wilhelm Scharrelmann, 1875, hinter *Dichtung* Wilhelm Raabe und Knut Hamsun her, läßt seine Romane gern zum Zwie-

licht der Worpsweder Moorlandschaft spielen. Moritz Jahn, 1884, aus Lilien-
thal bei Bremen, stellt in seinem Totentanz „Ulenspegel un Jan Dood" 1933
die beiden größten Wunder, das des Lebens und das des Todes einander
gegenüber und spricht dazu ein ziemlich künstliches Platt. Gottfried Hasen-
kamp, 1902, war auf Wiederherstellung des christlichen Theaters gerichtet.
Er hat von Vergil gelernt und von Claudel. Sein geistiger Atemraum ist die
mittelalterliche Liturgie. Bei Hamburg verwirrt beinahe die Fülle der Er-
scheinungen: die Kaufmannsgeschichten von Martin Schupp; die Zeichnun-
gen, Romane und Verse von Hans Leip, der die traumhafte Stille ferner In-
seln, den Lärm der Werften, den Dunst der Matrosenschenken mit gleicher
Sicherheit nachspielt; die Arbeitslosenromane und Anklagedichtungen von
Bruno Nelissen-Haken; die absonderlichen und vergrübelten Kriegsbücher
von Ludwig Tügel; die mystischen Kriegsgeschichten und breiten Zeitromane
von Edgar Maass. Den Ausschlag gab: Hamburg hatte das Wort. Wilhelm
„Deutsches Stapel, 1882, aus Calbe in der Altmark, in der Schreibstube des „Kunstwart"
Volkstum" vorgeschult, gab 1919/1938 zu Hamburg die Halbmonatsschrift „Deutsches
Volkstum" heraus. Stapel kam weltanschaulich von Johann Gottlieb Fichte
und Wilhelm Riehl, von Paul de Lagarde und Houston Stewart Chamber-
lain. Mit seinen Büchern versuchte er dem Christentum seine Stellung im
neuen Staat zu sichern. Seine Überzeugung lautete: deutsches Wesen lebens-
artlich erfaßt als Volk, politisch gemeistert als Staat, christlich empfangen
als Gnade.

Die Lyrik Von einem Lübecker Vater und einer Hamburger Mutter 1882 in Vene-
Lehmanns zuela geboren und in Hamburg aufgewachsen, hat *Wilhelm Lehmann* seit
seinem ersten Roman „Der Bilderstürmer" 1917 bis zu seinem späten „Ruhm
des Daseins" 1953 einen ziemlich geraden Weg verfolgt. Lehmanns Werk
besteht in seinen lyrischen Gedichten — „Antwort des Schweigens" 1935,
„Der grüne Gott" 1942, „Meine Gedichtbücher" 1957 — deren Wahrheit
der wirklichen Natur entlockt ist.

Lied und Spiel, der gehemmten sächsischen Natur von je ein Widerstand,
gingen diesmal von der sächsischen Urheimat um die jütische Halbinsel aus.
Das Drama *Ernst Barlach*, 1870 bis 1938, aus Wedel an der Niederelbe und Sohn eines
Barlachs Arztes, lebte zuletzt zu Güstrow in Mecklenburg völlig seinen Gesichten.
Barlach war Bildkünstler. Aus dem ihm gefügigsten Werkstoff, Holz, arbei-
tete er seine mystischen Gesichte zu menschlichen Gestalten heraus, die mit
seltsam verhaltener Bewegtheit aufwärts ringen in eine Überwelt, die sich
nur in ihrer Haltung spiegelt. Die gleiche Sehnsucht aus dem Urstoff ins Ur-
sein sucht er dann in die Gebärde des Dramas zu übersetzen. „Der tote Tag"

1912 zeigt den Sohn, dem die Mutter das Märchenpferd tötet, seinen erharr-
ten Träger ins hohe Leben. „Der blaue Boll" 1926, das ist ein Schauspiel, wo
der sehr irdische Gutsbesitzer Boll den geistigen Menschen Boll zur Welt
bringt. „Die echten Sedemunds" 1930 führen in schwindelnder Bilderfolge
Menschen des Scheins und Menschen des Seins aneinander vorüber. Immer
und überall der gleiche Gedanke und dasselbe Gesicht: aus der alten schlech-
ten in die neue gute Natur. Im Bildwerk bot sich dafür die schauhafte Ge-
bärde dar. Das Drama hatte dafür keinen Ausdruck. Das Wort mußte vor
dem Unsagbaren „versagen", wo das Bildwerk sich und seinen Sinn gebär-
denhaft „äußern" konnte. *Ernst Bacmeister*, 1874, aus Bielefeld, von einem *Das Drama Bacmeisters*
Holsteiner Vater, suchte an Paul Ernst vorbei einen zweiten Weg über Heb-
bel hinaus zur Tragödie strengen Stiles. Man kann seinen Prosaband „Über-
standene Probleme" 1922 als gedankliche und seine Erzählungen „Erleb-
nisse der Stille" 1927 als gestaltende Zwischenstufen zu seinen Dramen den-
ken. „Tragisch ist die Umwandlung eines leidenschaftlichen Menschen durch
Leiden, die seiner Leidenschaft entspringen, in einen sittlichen Menschen,
wodurch er sich im Sinne der Entwicklung erhöht." Bacmeisters Dramen
— „Andreas und die Königin" 1922, „Arete" 1925, „Siegfried" 1935, „Kai-
ser Konstantins Taufe" 1937, „Theseus" 1940 — sind nur aus knapp um-
rissenen, scharf durchgearbeiteten Aufzügen ohne Szenen aufgebaut und wie
die Stücke Barlachs vom Gedanken her gestaltet. Doch während sich Barlach
vergeblich um das darstellende Gleichnis bemühte, hielt sich Bacmeister an
den bewährten Werkstoff der Geschichte. Zum Spiel das Lied. *Hermann* *„Wie ich den lieben Gott suchte"*
Claudius, 1878, aus Langenfelde in Holstein, war des Matthias Claudius Ur-
enkel. Er hat sich in hochdeutschen und mundartlichen Erzählungen mehr als
nur versucht. Doch er ist der Liederdichter, und das abermals in zweien
Sprachen, Niedersächsisch und Hochdeutsch. Mit dem Bändchen „Mank-
Muern" 1912 begann es. Das ist Hamburg. Feierabend im Hafen und Streik
im Hafen, alles ohne Haß und Klage, nur die Tatsachen. Doch auch in dieser
Großstadt ist die Natur: die Tageszeiten, die Jahreszeiten, die Kinder. Und
sogar die Nachtigall. Seine hochdeutschen Versbücher — „Hörst du nicht
den Eisenschritt" 1914 bis „In meiner Mutter Garten" 1953 — sind in zahl-
reichen Sammlungen erschienen. Stimmung und Gestalt kommen zu immer
reinerer Schlichtheit und Einfachheit heraus. Frei flutende und weitgespannte
Gedichte, die um eine Mittelachse geordnet sind, werden zu unscheinbaren
Gebilden von wenigen kleinen Gesätzen. Wie leicht schwebt diese Seele in
ihrer Sicherheit. Die schwierigste Weisheit Meister Eckharts von Gott und
Welt ist mit zwei Worten gesagt: „Siehe, Gott hat sich auseinandergetan:

/ Da ward die Welt. / Wisse, daß jedes Wesen vom ersten der Tage an / sich Ihm wiedergesellt." Im Munde dieses Meisters ist das Singen wahrhaftig zum Sagen geworden, zum wörtlichen Sagen, wie ihm ums Herz ist. Er hat das Volkslied wieder unter uns erscheinen lassen. Die Kindheitserinnerungen „Armantje" 1934 und das Bekenntnisbuch „Wie ich den lieben Gott suchte" 1935 bekränzen ein Leben der Erfüllung.

Der ewige Acker Mecklenburg hat sich zu keiner Zeit so niedersächsisch bewegt wie in jenen Jahren. Dafür zeugen die beiden Lehrer. *Friedrich Griese,* 1890, aus Lehsten bei Waren, macht die Landschaft zu einem mythischen Begebnis. Er hat Mecklenburg dichterisch nachgebildet: zeitgenössisch und landesgeschichtlich. Bedrängende Fragen der Gegenwart werden abgehandelt. In die Mitte sind wohl die Dichtungen um das Dorf zu rücken. „Die letzte Garbe" 1927 sind drei Novellen, drei bäuerliche Schicksale, verstrickt in die dunkle Wirrnis früherer deutscher Kriege. Es ist der Mythus des unaustilgbaren irdischen Ackers und des unscheinbaren gelben Körnchens, in dessen ewigem Sprießen alles beschlossen ist, was Menschentum heißt. „Das Tal der Armen" 1929 zeigt das Dorf in Gegensatz und Wechselbeziehung zur Stadt. Zeitlich und geistig in der Mitte steht der Roman „Winter" 1927, der ebensogut letzte Garbe wie Tal der Armen heißen könnte. Im Chaos der gelösten Klimagesetze geht eine Hofgemeinde zugrunde und baut sich aus einem jungen Menschenpaar wieder auf. Das Leben ist stärker als alle Gestalten des Todes und der Mensch zusammen mit seiner Ackerscholle beharrsamer als alle Launen der Natur. So „Der Zug der großen Vögel" 1951 das ewige deutsche Dorf gegen alle Zerstörungen vom Mittelalter bis zu den jüngsten Kampfgeschwa-

Die Kunst des dern. *Hans Franck,* 1875 bis 1955, aus Wittenburg, hat mit ungewöhnlichem
Kleingebildes Fleiß ein umfangreiches Werk gefördert. Die frühen lyrischen Verse sind Gedankengedichte ohne lyrische Schwingungen. Sie kreisen um die Gegensätze der Welt und des Lebens. Sie suchen nach einem Standpunkt, unter dem diese Gegensätze sich in Harmonie auflösen. Die Dramen machen entweder einzelne Menschen oder das Volk als Ganzes zum Kampffeld der widerstreitenden Weltkräfte. Die erzählenden Werke sind Dichtungen eines Gestalters. Sie geben Welt und Leben wie sie sind. Sie reden durch Geschehnisse und sind völlig Begebenheit. Sie haben den fortreißenden Schwung, der in den Dingen selber steckt. Das heiße Herz erlebt, daß der ewige Sinn den irdischen Dingen nicht erst gedanklich beigeschrieben werden muß. Öffne die Augen, und du siehst, was ist. Die beiden Künstlerdichtungen „Das Dritte Reich" 1921 und „Meta Koggenpoord" 1926, der Zeitroman im Auge einer mecklemburgischen Kleinstadt, „Minnermann" 1926, die Dichterro-

mane, die Hamann in „Reise in die Ewigkeit" 1934 einleitet, das ist ein
achtunggebietendes Werk. Vollendung sind bei Hans Franck die kleinen
Gebilde zwischen Novelle und Kurzgeschichte. Sie bilden immer einen Kör-
per. „Pentagramm der Liebe" 1919 und „Septakkord" 1926 heben alle
Gegensätze in der Liebe auf. „Der Regenbogen" 1927 und „Zeitenprisma"
1931 sind zwei Bücher deutscher Geschichte in durchgehämmerten Kurzge-
schichten. „Recht ist Unrecht" 1928 kreist um den tragischen und doch tröst- *„Recht ist
Unrecht"*
lichen Gedanken, daß ein menschliches Auge im menschlichen Tun Recht und
Unrecht nicht unterscheiden kann. Das Werk Hans Francks erinnert sehr an
Friedrich Hebbel: Vergrüblung in das Wesen der Dinge, eisige Denkschärfe,
mystisches All-Eins-Gefühl, Glaube an die Tragik aus dem Urgrunde der
Welt, Dichtung der gesetzten Fälle, herbe Anmut der Gestalt und Sprache.

Ostfalen hat seine dichterische Pause. *Rudolf Huch,* 1862 bis 1943, aus *Ostfalen*
Porto Alegre, hat die meisten seiner Bücher auf Harzspaziergängen erdacht.
Sie lieben dunkle Träume und spukhafte Vorfälle, sind religiös und hätten
gern dem Geistesleben der Deutschen seine adelige Haltung zurückgegeben.
Konrad Beste, 1890, aus Wendeburg bei Braunschweig, hält es gegen Huchs
Bürgerlichkeit mit dem Bauer. Die Dämonie des Dorfes spielt in seinem
Schauspiel „Bauer, Tod und Teufel" 1933 und sie ist in seinem Prosaepos
„Das heidnische Dorf" 1933 lebendig.

Westfalen ist voller Ereignis. *Karl Wagenfeld,* 1869, aus Lüdinghausen, *Westfalen*
bannte die Seelennot der Kriegszeit in die gewaltige Schau „De Antichrist"
1916, in die Dichtung „Usse Vater" 1916, in das Mysterienspiel „Luzifer"
1920, das nur ein kleines Häuflein hinter Christus her den Steilweg der Er-
lösung emporführt. *Max Bruns,* 1876, aus Minden, der Übersetzer Charles
Baudelaires, hat unter seiner phantastischen und hymnischen Prosa eine so
ergreifende Dichtung wie „Totenmesse für ein Kind" 1926: „Leid ist die
Herbheit einer edlen Furcht / Aus Gottes Garten, die zur Süße will." *Adolf*
von Hatzfeld, 1892, aus Olpe, der blinde Dichter, ist ein farbenfreudiger *Der blinde
Dichter*
Verkünder der sichtbaren Welt. Kraftvoll und tief atmet die westfälische Hei-
mat in diesen Gedichten, die von ritterlicher Gesinnung sind. Seit Annette
von Droste-Hülshoff hat kein westfälischer Dichter die Heide, ihr geschöpf-
liches Leben und den Himmel darüber mit gleicher Wirklichkeit empfunden.
Die westfälische Frömmigkeit lebt in den Zeitromanen Hans Roseliebs, in *Erscheinung
der Landschaft*
den legendenhaften und volkskundlichen Büchern Heinrich Luhmanns, in
den Legendenspielen und Zeitdichtungen Franz Johannes Weinrichs. Stren-
ges und anspruchsvolles Formgefühl hat an den naturfrommen Gedichten
und Novellen Will Vespers, an der Lyrik und den erlebten Landschaften

Hans Brandenburgs gebildet. Verkörpert ist Westfalen, das fromme und das musische, durch zwei beinahe entgegengesetzte Männer.

Charon Der Charondichter *Karl Röttger*, 1877, aus Lübbecke, stammt von kleinen Leuten. Ob Drama oder Roman, in diesen ausgewachsenen Großformen verbirgt sich der ursprüngliche und im Kleinen große Kern dieses Lebens und Werks. Dieser Kern hatte Art und Zucht der Charonfreunde. Er schrieb in *Der* zweierlei Formen: Lieder und Legenden. Die lyrischen Sammlungen — *Apokryphen-* „Wenn deine Seele einfach wird" 1909 bis „Buch der Mysterien" 1928 — *dichter* haben zeitlich und seelisch einen weiten Raum durchmessen. Sie kommen vom Charon und zielen auf Meister Eckhart. Legenden sind die Dichtung, die unnachahmlich Röttgers ist. Die Sammlungen führen von den „Christuslegenden" 1914 über „Das Gastmahl der Heiligen" 1920 zu dem „Heilandsweg" 1935 herauf. Es sind gedichtete Mythen eines mystischen Metaphysikers. Sie sind wundervolle Apokryphen. Der Heiland erscheint mitten unter den Menschen des Nordens. So hinreißend sind diese Legenden erzählt, daß sie schier aufhören Legenden zu sein. Den gleichen Stil haben seine Novellen. *Die* Die Sinnbildworte der Charonfreunde sind in allen seinen Dichtungen: Weg, *Gelassenheit* Fahrt und Wandern; Stimme, Dinge und Abendrot. Meister Eckharts Lehre von der Gelassenheit, deren höchster Grad die Armut ist, das ist auch sein Bekenntnis. Einsamkeit ist das Schicksal des Künstlers. „Wann er die heilige Kunst aus den Himmeln und Höllen holt, ist niemand bei ihm. Das ist so die Notwendigkeit."

Orpheus Der Orpheusdichter *Victor Meyer-Eckart*, 1889 bis 1952, aus Hüsten, ist der glückliche Nachkomme von Bauern, Dichtern, Malern. Schon in jungen Jahren hatte er das Erlebnis der griechischen Kunst. Conrad Ferdinand Meyer und Stefan George waren seine Meister. Das Versbuch „Der Bildner" 1921, antikisch in Stimmung und Form, atmet sinnliches Heidentum, und der Gedichtkreis „Dionysos" 1924 feiert mit priesterlicher Gebärde die Fruchtbarkeit und den Mutterschoß aller Dinge, wie Johann Jakob Bachofen und Ludwig Klages sie in den uralten Mysterien der Menschheit erkannt hatten. „Orpheus" 1939 steht über dem Bande, der das neue lyrische Werk in klassischer Schönheit zusammenhält. Indessen Meyer-Eckart ist ein Dichter der Prosa und der Novelle. „Die Möbel des Herrn Berthélemy" 1924, „Der Graf Mirabeau" 1940 und „Der Herr des Endes" 1948 sind nur weitausgeschwungene Novellen. Der Dichter hatte viele Künste in seiner Gewalt. Das Novellenbuch „Die Gemme" 1926, gibt deren viele, der wuchtige Band *„Menschen* „Menschen im Feuer" 1939, Novellen aus zwei Jahrtausenden, gibt sie alle *im Feuer"* an den Tag. Verstört und spukhaft, aus dem Tiefengrunde der Leibseele

ausgebrochen, walpurgisnächtlich sind die Begebenheiten, die diesem Dichter die liebsten sind. Die vollkommene Form, die glatten Gesichter seiner Gestalten, selbst ihre leuchtende Nacktheit macht das Dunkel nur noch schwärzer, das dämonisch mit ihnen an den Tag bricht. Das alles ist auf eine seltsame Weise geschlechtlich fromm. Es wird durch die polierte Form aus dem Unwahrscheinlichen möglich. Die Naturdämonen des germanischen Nebelheims und des hellenischen Südmeers haben sich in dieser Dichtung gepaart. So hat noch kein westfälischer Dichter ausgesehen. Aber viele hessische. Das Geschlecht des Dichters saß zu Brilon, dicht an der hessischen Grenze Westfalens.

Das Reich der Mütter erstreckt sich über ganz Niedersachsen. Aber es hat zwei Provinzen. *Das Reich der Mütter*

Die eine betreibt zuverlässig ihr erdenhaftes Tagwerk und hält sich an die vertraute Wirklichkeit. So erzählt *Alma Rogge* aus Rodenkirchen an der Wesermündung hochdeutsch das Schifferleben der „Leute an der Bucht" 1935 und plattdeutsch, was sich an heitern Dingen ereignet. So hat sich die Lehrerin und Malerin *Josefa Berens-Totenohl* aus Grevenstein für ihre Bauerngeschichten einen Sagastil geschaffen und mächtige Rhythmen, um auf eine sehr fromme Art von der Erde, der Mutter und dem Brot zu singen. *Margarete Bentlage*, 1891, vom Hof Bentlage, hat in ihrem Novellenbuch *Tagwerk der Erde* „Unter den Eichen" 1933 nur einen Vorwurf, die Paarung der Geschlechter. Es sind Frauen, die den Rhythmus der Handlung führen. Tonfall und Stimme wechseln in diesen zwölf Kurzgeschichten von der derben Groteske zur heiteren Idylle, von der tragischen Ballade zum märchenhaften Ungefähr. Die Novelle ist ihr Stil. Denn auch wenn es, wie „Das blaue Moor" 1934, ein Roman werden soll, so wird es doch nur ein Rahmen für die Streiche, Abenteuer und Liebesspiele der heranwachsenden Jugend in den Höfen ringsum. Natur und Mensch, Gesetz des Lebens und freier Wille, die verläßliche Erde und der Zauber unsichtbarer Gestirne sind in den Erzählungen dieser Dichterin völlig eins. Es ist die Sprache einer Frau, verständig und ein wenig eigensinnig, eine sehr irdische und in keiner Weise wundersüchtige Sprache, die sich beinahe aus eigenem eine Erzählform geschaffen hat, die Bild und Handlung zugleich ist. Die an Lebensjahren reifste, *Helene Voigt-Diedrichs*, 1875 auf dem schleswigschen Gut Marienhoff geboren, hat sehr jung mit ihren Schilderungen schleswig-holsteinscher Landleute begonnen. Vor allem in drei Romanen hat sie, wohl zumeist aus unmittelbaren Erfahrungen, die Welt der Frau gestaltet. „Dreiviertel Stund vor Tag" 1905 ist die Geschichte eines holsteinschen Landmädchens, das durch die Mutterschaft das Leben

meistern lernt. „Auf Marienhoff" 1925 ist die Heldengeschichte der Mutter, die Familie in der Arbeitsgemeinschaft des niedersächsischen Gutshofes. „Ring um Roderich" 1929 bewegt auf der Szene einer kleinen Hochschulstadt um einen tätigen Menschen drei Frauen, die Gattin, die Freundin, die Geliebte, damit das Spiel den Mann für die mütterliche Frau an seiner Seite reif mache. Kindergeschichten halten mit Frische und Anmut eigene Erinnerungen lebendig. Persönlichkeit und Werk dieser Frau leben aus der mütterlichen Erde, die ihre Heimat ist. Sie reden die zuchtvolle Sprache des Niedersachsen, in der Bauer und Edelmann eins sind.

Geistliches Frauenleben

Die andere Provinz wird von Frauen bewohnt, die ein geistliches Leben von übersinnlicher Art zu führen scheinen. Sie sind zumeist als Neubekehrte in die römische Kirche eingegangen und lebhaft bewegt von der Umartung ihrer Seele, haben sie ihre neugestimmte Frömmigkeit in die Dichtung ergossen. So mag wohl manches an diesen Äußerungen irdisch fremd, allzu vergeistigt und gelegentlich verspielt erscheinen. *Ilse von Stach,* 1879 auf Haus Pröbsting in Westfalen geboren, drückt in geistlichen Gedichten ihre persönlichen Empfindungen durch gottesdienstliche Formeln aus, beinahe wie die mittelalterlichen Tropen. Von ihren Spielen ist das Weihnachtsmärchen „Christelflein" 1906 mit den Weisen Hans Pfitzners auf den Bühnen heimisch geworden. Das Gesprächbuch „Die Frauen von Korinth" 1929 stellt in sechs Unterredungen weltgeschichtliche Männer und Frauen einander zum Meinungskampf gegenüber um die bevorrechtete Ordnung der Welt durch den Mann und die weiße Rasse. *Margarete Windthorst,* 1884, auf Haus Hesseln in Westfalen geboren, hat sehr früh mit Gedichten und Novellen dem übernatürlichen Wirken des geoffenbarten Gottes nachge-

Erinnerung an Droste-Hülshoff

spürt. Noch ihr Roman „Die Taustreicherin" 1922 schwelgt in geheimnisvollen Beziehungen zwischen irdischen Dingen, menschlichen Taten, jenseitigen Mächten. Die Gärtnerin, die Hirtin, die Seherin sind gleichnishafte Gestalten der mystischen Einheit von Natur und Seele. Vieles erinnert an Annette von Droste-Hülshoff. Der Roman „Die Sieben am Sandbach" 1937, die Lebensgeschichte einer tapferen westfälischen Bäuerin und eines bedrohten Hofes, läßt den Umschwung des Geistes und des Geschmacks erkennen, der ein Umschwung war von der Frommheit des Geistes zur Frommheit der Natur. *Gertrud von Le Fort,* 1876 zu Minden aus einer Hugenottenfamilie geboren, die seit dem achtzehnten Jahrhundert in Mecklenburg ansässig war, ist denkend und gestaltend in den Wesenskern der römischen Kirche einge-

„Hymnen an die Kirche"

drungen. Ihre Dichtung war zuerst Bekenntnis. Das sind die „Hymnen an die Kirche" 1928, Psalmen, mit einer erschütternden Heilsgewißheit und in

bezauberten Rhythmen vorgetragen, und das sind die „Hymnen an Deutschland" 1932, in mächtig gewölbten Wortbrücken der kühne Zug der Gedanken vom Jenseits Gottes, zu dem von Gott gekrönten „Kaiservolk der Erde" im Diesseits der Völker. Ihre Dichtung war sodann Bericht. Der Roman „Das Schweißtuch der Veronika" 1929 und 1946 läßt das dreifache Rom, das antike, das romanische, das mystische, menschliche Gestalt werden. Die Handlung des Buches wird sehr vorsichtig die eigene Seelengeschichte der Dichterin mitdenken. „Der Papst aus dem Ghetto" 1930 ist der Mann aus der getauften Judenfamilie Pier Leoni, der sich 1130 als Anaklet II. dem Papst Innozenz II. entgegenstellte. Heidentum und Judentum stürzen das Christentum in Verwirrung. Der Roman ist wie mit verteilten Rollen erzählt, indem das Wort bald einem römischen Zeitbuch, bald den Aufzeichnungen des Kardinals, dann wieder den Aussagen der römischen Juden oder den Ereignisse selber erteilt wird. Die Novelle „Die Letzte am Schafott" 1931 läßt das Wunder geschehen, daß die ängstlichste der sechzehn Karmeliterinnen in ihrer Schwäche auf dem Schafott das tapferste Zeugnis ablegen darf. In der Sprache der frühmittelalterlichen Epen wird „Das Reich des Kindes" 1934 erzählt, die Legende der letzten Karlinge und des Gedankens vom geheiligten Reich. „Die Magdeburgische Hochzeit" 1938, „Die Abberufung der Jungfrau von Barby" 1940, „Das Gericht des Meeres" 1943 spielen im innersten Bezirk des Weiblichen. „Die Frau des Pilatus" 1955 und „Der Turm der Beständigkeit" 1957 sind Märtyrergeschichten des freiwilligen Opfers und der Sühne. Die Frage nach dem kosmischen und religiösen Sinn der Geschlechter stellt das Buch „Die ewige Frau" 1934, in schwierigen Gedankengängen Gleichnisse der heimlichsten Wahrheiten. Es wird unternommen, die Seinsweisen der Frau als virgo, sponsa, mater, die ewige Frau, die Frau in der Zeit, die zeitlose Frau aus der Urbestimmung des Weiblichen zu deuten. Der Mann vertritt die Kräfte des sichtbar werdenden Gottes, die Frau den verborgenen Gott und seine verdeckt wirkenden Kräfte. „Auch im Leben der Kirche ist das Verborgene der eigentliche Mutterschoß der Dinge." Und mit einem Wort von Paul Claudel: „Priester ist der Mann, aber dem Weibe ward gegeben, sich zu opfern". *Ruth Schaumann*, 1899, aus Hamburg und seit 1918 in München zur Bildhauerin geschult, hat die Gedanken dieser katholischen Frauen in die Kunst des Griffels und des Wortes übersetzt. Ihre reifen Anfänge sind das lyrische Gedicht, zu den Bänden „Die Kathedrale" 1920, „Der Knospengrund" 1924, „Der Rebenhag" 1927, „Der Siegelring" 1937 gesammelt. Sie sind aufs kunstvollste durchgegliedert, entwickeln sich von George und Rilke zu eigenem Stil, deuten die Welt aus dem Geheimnis

*Erzählwerk
von Le Fort*

*„Die
ewige Frau"*

*Knospengrund
und Rebenhag*

der Mutterschaft und lassen den Kosmos ganz mütterlich in seiner Einheit erscheinen. Mutter und Kind werden Vorwurf der Künstlerin. Es entstanden die drei Kinderfibeln „Die Rose" 1925, „Die Kinder und die Tiere" 1929, „Die geliebten Dinge" 1930 sowie aus der gleichen kindlichen Haltung „Der Krippenweg" 1932 und „Der Kreuzweg" 1934, zwei legendenhafte Gegenstücke. Es sind Hefte von bescheidenem Umfange, links das Gedicht, rechts der farbige Holzschnitt, Gebilde zweier verschwisterter Künste. Die Mutter *Mutterschaft als Mittlerin* erscheint als die erste Bildnerin des Menschen zum Göttlichen und Ewigen, als Ordnerin und Deuterin der Welt, von sich her und auf das Kind zu. Aus andern Erlebniskreisen stammen die Sammlungen „Die Vorhölle" 1944, „Klage und Trost" 1945 sowie „Ländliches Gastgeschenk" 1949 an den Schwarzwald. Die Prosabücher der Dichterin entfalten das Leben, wie es ist mit einer dichterisch gedämpften Wirklichkeit um sehr persönliche Mütter und Kinder. Von den zwei Novellenbüchern hat „Der blühende Stab" 1929 neun, „Siebenfrauen" 1933 sieben Geschichten, alle ungerahmt erzählt, doch durch die gemeinsame Aufschrift zu einem höheren Sinn gebunden. Auch von den romanhaften Prosabüchern „Amei" 1932, „Yves" 1933, „Der Major" 1935, „Die Uhr" 1947, „Die Karlsbader Hochzeit" 1953 besetzt jedes ein anderes Feld mit einem Stein. Die bildende Meisterin von Madonnen und Müttern hat den Kosmos der Frau aufgebaut. Wie durch das Kind in der Frau der Sinn für den Wesensgrund der Welt aufwacht und wie die Mutterschaft die Mittlerin ist zwischen dem schaffenden Geist und dem wirkenden Leben, dieses Allerlebnis hat Ruth Schaumann in stilgemäßen Kunstwerken auf eine gültige Weise dargestellt.

Martha und Maria, jede der beiden Schwestern aus dem evangelischen Bethanien, ist in dem Frauentum dieser niedersächsischen Dichterinnen verkörpert. Die tüchtig diesseitige Martha lebt in den Bäuerinnen der einen, die fromm jenseitige Maria in den Christusbekennerinnen der andern Gruppe. Indessen die Legende sondert nur, was das Leben gemischt erzeugen muß.

Ina Seidel, 1885, aus Halle, stammt von Mecklenburg und einer wahren Dichterfamilie. Vielfältige lyrische Büchlein reiften zu dem Bande „Gesammelte Gedichte" 1937 heran. Ihre Weltinnigkeit wohnt in einer andern Himmelsgegend des weiblichen Herzens als das kosmische Allschöpferbewußtsein der Ruth Schaumann oder die kirchliche Weltordnung der Gertrud von Le Fort. Doch dort, wo es um die Seele geht, wartet auch auf Ina Seidel der Ewige. „Sieh — um Gott, die schwere Honigblüte / Summt die Seele, durstig *„Sieh, der Immen Spiel"* nach der Güte, / Nach des Saugens hingegeb'ner Ruh — Sieh, der Immen Spiel: Stille ist das Ziel — Laß dich ziehn von Gottes Duft auch du." Diese

Frau hat sich mit Strenge zur Erzählung gebildet. Eine Reihe von Romanen haben ihr die Sicherheit des eigenen Stils gegeben. Das Herzstück im Werk der Dichterin ist der Roman „Das Wunschkind" 1930 und wird es bleiben. Das kriegsgequälte Deutschland zwischen 1792 und 1813 ist hier zum Bilde geworden. Es läuft zuerst um die Mitte Mainz ab und wird dann um die Mitte des junkerlichen Gutes in die Priegnitz wieder eingerollt. Von Mitte zu Mitte schreitet und in jeder Mitte wirkt Cornelie von Echter mit ihren zwei Kindern; dem Knaben, den sie ihrem todgeweihten Gatten in der Abschiedsstunde abgerungen hat; der Tochter ihrer elend gestorbenen Schwester. Christoph von Echter, so als Wunschkind geboren, fällt als Opferkind 1813 in der ersten Befreiungsschlacht bei Groß-Görschen. Der Atemraum der Dichtung ist von mystischen Erlebnissen aus dem Jenseits der Sinne gesättigt und von einem sanften weiblichen Spott durchstrahlt. Ihr Geist ist ein unauffälliges, kirchlich nur leise schattiertes Christentum. Die Dichtung schließt: „Der Tag wird kommen . . . da die Tränen der Frauen stark genug sein werden, um gleich einer Flut das Feuer des Krieges für ewig zu löschen. Der Tag, da der Geist — die Taube — unter dem heiligen Regenbogen über der wiedergeborenen Erde schwebt — und dann . . . dann setzt der Sohn der Mutter die Krone aufs Haupt."

„Das Wunschkind"

DIE RHEINLANDE sahen durch Krieg und Umsturz die Jugend in Aufruhr. Ihr erschüttertes Herz, die ratlose Gestalt ihrer Dichtung macht die Verwirrung einer Zeit sichtbar, die alles, was galt und gültig schien, von neuem in Frage stellte. Das ist kein Feld für irgendeinen Ismus. Es ist die rheinische Jugend, von dem einen und gleichen Umschwung mitgewirbelt, der im August 1914 mit sommerlicher Glut der Herzen aufging und in den Novemberstürmen 1918 die letzte Hoffnung vor sich herfegte.

Rheinische Jugend

Das sind sie. *Gustav Sack,* 1885 bis 1916, aus Schermbeck bei Wesel, ist im Angriff auf Bukarest gefallen. Seine Bücher und die Kräfte, an denen er sich gebildet hat, spiegeln den ganzen Widerspruch seines Lebens: Lord Byron und die Edda, Spinoza und Schopenhauer, Nietzsche und Goethe. Alles, was Sack geschrieben hat, die Romane „Ein verbummelter Student" 1917 und „Der Namenlose" 1919 sowie das Schauspiel „Der Refraktair" sind Selbstdarstellung. Ihm galt der Mann nur als Soldat, Matrose, Flieger und Weltfahrer. *Fritz von Unruh,* 1885, von Koblenz, stammte aus einer preußischen Soldatenfamilie und schien der Sprecher des freisinnigen rheinischen Bürgertums zu werden, das auf Abstand von Preußen hielt und an die Nachbarschaft der französischen Bildung gewöhnt war. Jene Dramen, die zum Teil noch im Felde entstanden waren, richteten sich gegen die alten wie

Deutschland und Frankreich

„Heinrich von Andernach" gegen die neuen Gewalthaber. Er war um das bemüht, was damals Aussöhnung mit Frankreich hieß. Ihr sollte das Festspiel „Heinrich von Andernach" 1925 zur Jahrtausendfeier der Rheinlande dienen. Das Schauspiel „Bonaparte" 1927 atmet die Enttäuschung des Verständigungsfreudigen. Wie bei Kleist, so finden sich auch bei Unruh seltsame und übersteigerte Szenen, weitgebauschte Bilder und Redensarten. Fritz von Unruh hat, des szenischen Bildes und des Tonwerks aus Worten mächtig, den mysterienhaften Bühnenstil auf das moderne Zeitdrama übertragen. *Walter Hasenclever*, 1890 bis 1940, aus Aachen, erschien mit seinen sorgfältigen Versen

„Der Sohn" gern in der Gesellschaft Rubiners. Das peinliche Drama „Der Sohn", 1916 zu Dresden gespielt, und das Friedensstück „Antigone" 1916 führten die ehrfurchtslose Sprache des früh Verdorbenen. Im Stil seiner späteren Stücke gehen Mysterienspiel und Kinobild zweideutig ineinander über. *Reinhard*

„Seeschlacht" *Goering*, 1887, von Schloß Bieberstein bei Fulda, hat in dem Drama „Seeschlacht" 1917 die Erscheinung des Krieges als erster zu bändigen gesucht. Von den Sieben im Panzerturm überleben nur zwei die Schlacht, die beiden in gleicher Weise, wenn auch verschiedenen Willens, Tapferen, der Gehorsame und der Empörer. Das Drama „Scapa Flow" 1920 setzte auf diese Tragödie des Sterbens das Schauspiel einer Tat, die über Tod und Niederlage hinweg Willen zum Leben bedeutete. Goerings dramatische Kriegsdichtungen sind unter Verzicht auf jede gleichnishafte Aufmachung vergeistigte und beseelte Wirklichkeit. Der Darmstädter *Eduard Schmidt*, Kasimir Edschmid,

„Tribüne der Kunst und Zeit" leitet seine Schriftensammlung „Tribüne der Kunst und Zeit" seit 1919 mit einer Abhandlung ein: „Über den Expressionismus in der Literatur und die neue Dichtung". Das war ein Versuch, die mannigfaltigen Erscheinungen der Zeit auf den gemeinsamen Nenner des Geistes und des Stiles zu bringen. Doch was an dieser Übergangsliteratur 1912/1920 als eigentümlich und neu bezeichnet wird, gehört entweder zum Wesen der Dichtung schlechthin oder war bereits durch geschichtliche Bewegungen — so die Romantik — verwirklicht. Was gefordert und beschrieben wird, ist Stil einer Altersstufe, aber kein Zeitstil. Und was über die ererbte Form hinausstrebt, ist wieder kein neuer Zeitstil, sondern der Stil einer neuen dichterischen Gattung, des Kinobuchs. Der seelische Zustand aber, die Erschütterung, die ekstatische Bereitschaft ist Rausch der Jugend und einmalige Wirkung des Krieges. Nein! Es gibt keine Formel, in die sich diese jungrheinische Dichtung zusammen mit der Berliner Aktionsdichtung bringen ließe.

Der Rhein Der Rhein ist der Vater der deutschen Geschichte. Der Rhein ist der gewaltige Arbeitsgefährte des deutschen Volkes, einst der Beweger seiner Räder

und immer der Träger seiner Lasten. Der Rhein von seinen Alpenquellen bis
zu seinen Mündungen ist der deutsen Jugend die große Straße in das Aben-
teuer der Welt. Der Rhein mit seinen vielen und mächtigen Brücken war den
Deutschen von jeher der Mittler zwischen Osten und Westen.

Die größte Verwandlung geschah am fränkischen Niederrhein. Erdhafte
und wirtschaftliche Kräfte hatten aus dem niederrheinischen Land eine
Arbeitslandschaft gemacht. Die gleichen Kräfte gaben der Arbeitslandschaft
dichterische Gestalt. Und so geht nun abermals das alte und erregende Er-
lebnis auf, das Niedersachsen und Niederfranken über und unter der gemein- *Werkleute und
samen Erde, die ihre Schätze für sie hegt, zu Gesinnungsgenossen und Ar- Haus Nyland*
beitsgefährten macht. Auf der Suche nach einer künstlerischen Bewältigung
von Herrschaft und Kultur, von Industrie und Kunst, von Wirtschaft und
Freiheit hatten sich noch vor dem Kriege Jakob Kneip, Josef Winckler, Wil-
helm Vershofen zusammengefunden. Sie hatten ihrer Bonner Freundschaft
zu Dritt Rahmen und Standarte der „Werkleute auf Haus Nyland" gegeben.
Das gemeinsame Versbuch „Wir drei" 1904 zeugte ebenso für sie wie ihre
Kriegsgabe „Das brennende Volk" 1915, die Zeitschriften „Quadriga" und
„Nyland". Der Bund strahlte seine Kraft auf die werdende Arbeiterdichtung
aus.

Aus den Massen, die sich im Dienst der Maschine zu einem neuen Stand *Rheinische
vereinigen, die dieser Dienst zu immer feineren Kenntnissen zwingt, bricht Arbeits-
ein erschütterndes Bildungsbedürfnis auf. Es wird genährt und gestillt durch landschaft*
Bildungsvereine, Büchereien und Bühnen, Volkshochschulen. Die verkürzte
Arbeitszeit ermöglicht dem Arbeiter, die angesammelten Kulturgüter nicht
nur mitzugenießen, sondern an ihnen auch mitzuschaffen. Der werktätige
Arbeiter beginnt die ihm eigentümliche Welt dichterisch zu formen. Diesen
Vorgang vollzieht die rheinische Arbeitslandschaft. Hier waren die drei Ur-
bestände beisammen: Industrie und Arbeiterschaft in ihrer stärksten Zusam-
menballung; ein kunstfroher Menschenschlag von sehr ursprünglicher künst-
lerischer Begabung; eine gewisse arbeitermäßige Stilüberlieferung aus der *Arbeiter-
alten Webindustrie des Wuppertales. Der Werkroman ist die Schöpfung des dichtung*
Gebildeten, des Ingenieurs, der von seinem Mittelpunkte aus diese Hierarchie
der Arbeit überblickt und leitet. Das Drama der Arbeiterspielscharen ist eine
ganz unselbständige Gattung. Eigentümliche Gestalt hat die Arbeiterdich-
tung in der Lyrik gefunden, die den Rhythmus der Maschine in den Tonfall
ihrer Verse verwandelte. Arbeit in der riesenhaften Maschinenhalle bedeutet
Einsicht in ungeahnte Weltzusammenhänge. Der unaufhaltsame Rhythmus
der Maschine wird dem Arbeiter zum Erlebnis des beherrschenden Welt-

rhythmus. Die eingeborene Tragik der Arbeit werden ihm zum Inbegriff des
Weltleides. So einig alle dieser Lieder im kleinen Glück des Feierabends und
in der großen Sehnsucht nach einem Stück eigenen Bodens sind, so verschie-
den malen sie die Heraufkunft und das Angesicht eines neuen Reiches.

Herz-
bereitschaft

Über drei Stufen ist diese Arbeiterdichtung Wirklichkeit geworden. *Gerrit
Engelke*, 1892 bis 1918, aus Hannover, ist von Haus Nyland ausgegangen.
Er schwebte des Tags als Tüncher auf hohen Gerüsten und stürzte sich des
Abends in den Abgrund seiner erdarbten Bücher. Er zog unter den ersten ins
Feld und ist unter den letzten dieses Krieges gefallen. Sein schmales Werk
umfaßt den „Rhythmus des neuen Europa" 1921, „Briefe der Liebe" 1926
und „Vermächtnis" 1937, von Jakob Kneip herausgegeben. Engelke war eine
Begabung von seltener Ursprünglichkeit. Mit der Seele des Arbeiters hat er
die Welt erlebt. Was den Arbeiter bewegt, hat niemand in so volksliedhaften
Versen auszusprechen vermocht. Doch auf den rauschenden Schwingen seiner
Rhythmen schwebte er hoch über allem, was Stand und Klasse ist, im Äther
des reinen Menschentums. Sein Ruf galt der „Herzbereitschaft" für die
Alleinheit des Menschen in Gott. „Werdet wieder kindergroß!" *Otto Wohl-*

Der Bergmann

gemuth, 1884, aus Hattingen an der Ruhr, hat fünfundzwanzig Jahre lang in
den rheinischen Gruben unter Tag geschafft. Das ist der Veteran der Arbeiter-
dichtung. Seine Verse sind seit 1908 erschienen. „Aus der Tiefe" 1937 ist die
reife Lese seiner Gedichte. Großräumig, hochgewölbt, tiefverschattet sind sie
voll Begebenheit. Sie verraten weit über den Lichtkreis der Grubenlampe
hinüber sachverständiges Wissen von der Natur und vom Bau der Erde. Wer
könnte inbrünstiger von der Erde, ihrer Schönheit und Größe, ihrer Offen-
barung und Treue singen als dieser Bergmann, der in ihrem Schoße lebt,
schon geboren und noch nicht gestorben, ihres Anfanges wie ihres Endes teil-

Der Dichter,
der mit dem
Hammer singt

haftig. *Heinrich Lersch*, 1889 bis 1936, aus Mönchen-Gladbach, eines Kessel-
schmieds Sohn und wieder Kesselschmied, hatte die fränkische Weltlust im
Blute und ließ sich von ihr über viele Landstraßen in viele Länder und Städte
treiben. Er hat den Krieg in allen seinen Gestalten erlebt, gehärtet durch
seinen berühmten Vers: „Deutschland muß leben, und wenn wir sterben
müssen." Lersch war der erste deutsche Arbeiter, der Welt und Erlebnis des
werktätigen Volkes, der die dämonische Wirklichkeit der Maschine und den
harten Alltag der Arbeit in eine Dichtung aller Gattungen, in ein ganzes
artenreiches Schrifttum umsetzte. Den ersten lyrischen Sammlungen seit
„Abglanz des Lebens" 1914 folgte nach dem Kriege das Jahrzehnt des Er-
zählers: „Manni" 1927, das Buch des Vaters über seinen Jungen; „Hammer-
schläge" 1931, der Bildungsroman eines jungen Arbeiters; „Die Pioniere von

Eilenburg" 1934, der Roman der frühen Arbeiterbewegung; „Im Pulsschlag *Walt Whitman* der Maschinen" 1935, die Selbstdarstellung. Was Heinrich Lersch bedeutet, das sagt der gewichtige Band „Das dichterische Werk", der die beiden Sammlungen „Mensch im Eisen" 1925 und „Mit brüderlicher Stimme" 1934 vereinigt. Der Dichter redet mit einer zweifachen Stimme. Die weit geschwungenen, hymnisch gestimmten, frei gefügten Verse, die fast Prosa sind und Walt Whitman verraten, sprechen von Arbeit, Maschine, Werk. Die melodisch beherrschten, strophisch gebändigten, sparsam geversten Gedichte, die sehr zart und beinahe wie Volkslied klingen, singen von dem innern, von dem seelischen und geistigen Menschen. So vereint die Sammlung das homerische Epos der Arbeit mit dem dionysischen Chorgesang der Herzen. Von Gott *Dionysischer* erfüllt, ein Denker und Seher der Arbeit, hat dieser Dichter aus einer Klassen- *Chorgesang* bewegung die Menschwerdung der unsterblichen Seele gemacht.

Die Werkleute auf Haus Nyland haben der Arbeiterdichtung geholfen, für die Welt der Technik das darstellende Wort zu finden. Und sie haben dem Zeitalter die Schönheit der Maschinendinge entdeckt. Gleichwohl ist es die persönliche und eigenhändig gezeichnete Leistung eines jeden der drei, in der sich der Geist des Bundes kundgibt.

Josef Winckler, 1881, aus Hopsten bei Rheine, durch den Vater wie durch *„Murmelnde* die Mutter aus einem westfälischen Geschlecht von Beamten und Offizieren, *Mütter neuer Äonen"* hat an der Bonner Hochschule seine Freunde Kneip und Vershofen kennengelernt. Hans Pumpernickel bei Honnef am Rhein ist ihm zur zweiten Heimat geworden. Seine beiden Sammlungen „Eiserne Sonette" 1914 und „Eiserne Welt" 1930 haben die Maschine aus einem toten Ding zu einem Gegenstande des menschlichen Gefühls gemacht, gleich dem Tier und der Pflanze. Und sie haben die eigentümliche Schönheit der technischen Gebilde entdeckt, sie auf gleiche Stufe mit den gewachsenen Dingen gestellt und ihnen gemäße Ausdrucksmittel gefunden. Der Dichter besucht die neuen Meister dieser Zeit bei der Arbeit im Laboratorium und im Operationssaal, beim entspannenden Sport auf dem Wasser, im Hochgebirge, im Flugzeug. „Maschinen, summende Arbeitsbienen, / Ihr Wunderwesen, ihr Gnome und Hünen, / Formen heißt Fronen; / Weltgebundene, weltumgestaltende, / Geistergefundene, geisterhaft schaltende, /Murmelnde Mütter neuer Äonen." Die drei Bücher „Mitten im Weltkrieg" 1915, „Die mythische Zeit" 1916, „Ozean" 1917 verwandeln das Geschehnis des Krieges in nüchterne Tatsachendichtung. Die beiden Dichtungen „Irrgarten Gottes" 1922 und „Der chiliastische Pilgerzug" 1923 sind übersteigerte Gleichnisse für die unrettbar scheinende Welt, *„Trilogie* die der Krieg hinterlassen hatte. „Trilogie der Zeit" 1924 gibt allen drei *der Zeit"*

Josef Winckler Gruppen von Dichtungen die gedankliche Wende. Hier läßt der Dichter das Gesicht des Roboters aufsteigen, der, in Einheitstypen hergestellt und zu Serienpreisen verkauft, den Raubsinn und die Genußsucht der Menschheit ins Übermenschliche steigert. Wincklers Maschinenmensch, der Inbegriff technischer Machtsucht, ist das Gegenspiel zu Faust, dem verantwortungslos Erkenntnissüchtigen. „Der Ruf des Rheins" 1924, der in geschichtlichen Bildern alles beschwört, was aus dem Strome stammt oder an ihn gebunden war, sei es nun wirklich geschehen oder in der Sage geträumt, kann als Abgesang dieser dichterischen Reihe und Vorspruch zu neuen Werken gelten. Der Dichter war inzwischen zu Prosadichtungen anderer Art übergegangen: zu romanhaften Schilderungen seiner beiden heimatlichen Landschaften, der westfälischen und der rheinischen: zu Schwankbüchern „Der tolle Bomberg" 1923 und „Doctor Eisenbart" 1929; zu geschichtlichen und legendenhaften Erzählungen. Mitte dieses reifen Prosawerks ist das Buch „Pumpernickel" 1926, Menschen und Geschichten um Haus Nyland, Gipfel aber „Das Mutterbuch" 1939, Dichtungen wechselnden Stiles und Maßes. Der Dichter hatte mit seinen frühen Gedichten den Gesetzen der Mechanik in den toten Dingen und mit seinen späten Erzählungen dem Geheimnis der Seele nachgespürt. In der Gestalt des Roboters ist das Gespenst verkörpert, als das die beiden Doppelgängerinnen Seele und Sache im selben Leibe einander begegnen. Es war ein Dichter aus dem westfälischen Gespensterlande, der solchem Spuk bis in die letzten Urgründe nachgesonnen hat.

Der Dichter der Wirtschaft *Wilhelm Vershofen*, 1878, aus Bonn, stammte von bäuerlichen Sippen, die sich über rheinische Dörfer in die Stadt gearbeitet hatten. Winckler hatte die Technik verseelt. Vershofen machte Wirtschaft und Geld zur Dichtung. Das Schwierigste war, eine Form zu finden, in der sich mächtige wirtschaftliche Handlungen anschaulich machen ließen. Der Dichter hat es zweifach versucht. „Der Fenriswolf" 1914 stellt den Kampf um ein Staatsmonopol, die Wasserkräfte Norwegens, dar, „Das Weltreich und sein Kanzler" 1917 den Kampf um ein amerikanisches Kupfermonopol. Beidemal wird, scheinbar ohne Zusatz dichterischer Farbstoffe, lediglich der ganze Akt von Entwürfen, Sitzungsberichten, Geschäftsbriefen, Telegrammen und Zeitungsausschnitten gegeben. Der Wirtschaftsführer spricht urkundlich mit der eigenen Stimme seines Herzens, der Kanzlei. Anders in abermals zwei Büchern. In „Swennenbrügge" 1928 ist es ein westfälisches Dorf und in „Poggeburg" 1934 ein westfälisches Bauernhaus, die über weite Zeiträume hin den Wandel der Wirtschaft erleben. Und dieses Erleben wird in Kurzgeschichten, dem hoch-
Dämon der Seele und der Maschine gezüchteten „Dönken" erzählt. Die ganze Fülle der Tonarten, die diesem

Dichter gefügig ist, bezeugen die beiden Sammelbände „Rhein und Hudson" 1930 sowie „Seltsame Geschichten" 1938, beides Bücher, die aus dem Hinterhalt rheinischer Laune vom Zusammenspiel der rheinischen Arbeitslandschaft und der amerikanischen Spekulationsfelder, vom Wirtschaftsgeist der kleinen Kniffe erzählen. Hinter allem lauert auch hier das Auge des Spökenkiekers, das über die nahe Wirklichkeit hinweg ins Unbestimmte und Ferne gerichtet ist. Die Novelle „Zwischen Herbst und Winter" 1938 verrät, wie kräftig dieser Dichter das andere Gesicht hatte. Es ist wie bei Winckler, wie bei Vershofen, der Dämon der Seele, unheimlich gegenwärtig in allen Berechnungen der Vernunft und in allen Erzeugnissen der Maschine, der im Verborgenen die Gesetze des Lebens beherrscht.

Jakob Kneip, 1881, aus Morshausen im verkümmerten Hunsrück, hat uns selbst erzählt von seinem Vorfahren, dem Simon Kaspar, dem Bildschnitzer und Eulenspiegel des Mosellandes. Kneips schönstes Buch „Hampit der Jäger" 1927 hat diesen Ahnen wieder aufgeweckt in der Gestalt eines urtümlichen Hunsrückbauern, der in den Waldbergen seiner Heimat das freie und wilde, stolze und fröhliche Abenteuer des Lebens jagt, ganz Natur und nichts als Mensch. Die Lebenseinheit mit diesem Ahnen wird in dem Romandrilling Kneips offenbar. „Porta Nigra" 1932, „Feuer vom Himmel" 1936, „Der Apostel" 1955 sind die Geschichte eines jungen Menschen der Mosellande, der vor seiner Berufung zum Priester in die Pflicht zum Feldsoldaten ausweicht und vom Krieg im Innersten getroffen, endlich der Stimme folgt, die ihn an den Altar ruft. Was dem Dichter auferlegt ist, sprechen mit ungetrübter Stimme seine lyrischen Verse aus. „Ein deutsches Testament" 1916 sind hymnische Kriegsdichtung. „Bekenntnis" 1917, „Der lebendige Gott" 1919, „Bauernbrot" 1934 sind ohne Unterschied geistlich und weltlich, geistig und bäuerlich, reine Frömmigkeit des menschlichen Herzens. Die drei Bände geben das christliche Erlebnis der Seele, eingefaßt in das eine Jahr der bäuerlichen Arbeit und der kirchlichen Feste, geborgen im Dorfe. Es sind die sichtbaren Riten einer von Gott völlig durchwalteten Gemeinschaft. Ihr Rhythmus ist mit Vorliebe der frei und faltenreich wehende Vers. Also hat Kneip wie Winckler die Maschine und Vershofen die Wirtschaft, so das bäuerlich-kirchliche Dorfleben, dichterisch gestaltet.

Der Rhein hat an seinen Ufern viele Weltfahrer erzeugt. Zu keiner Zeit aber erwies sich die fränkische Sucht in die Ferne so allmächtig wie in den Jahren der dumpf gärenden Unruhe, mit der sich der große Krieg ansagte. *Alfons Paquet*, 1881, aus Wiesbaden, hat die Alte und die Neue Welt von Kap zu Kap bereist. Mit zwei, drei erregenden Worten, sei es nun Roman

Bäuerlich-kirchliches Dorfleben

„Bauernbrot"

Rheinische Weltfahrer

*Rheinische
Weltstraße* oder Reisebericht, zaubert er eine ganze Landschaft oder die Seele einer Rasse vors Auge. Aus allem aber dringt immer wieder die Stimme des Rheins hervor. *Armin T. Wegner,* 1886, aus Elberfeld, hat alle Länder zwischen Rhein und Euphrat durchwandert, alle Berufe ausgeprobt und davon erzählt. Sein lyrischer Gesang gilt der „Straße", die ihm ein Gleichnis ist für die Lösekraft aus der bindenden Erde. *Carl Haensel,* 1889, aus Frankfurt, hat in der großen Natur die Befreiung von der Weltstadt gesucht und in Romanen das Abenteuer der großen Berge gedichtet. *Eduard Schmidt,* 1890, aus Darmstadt, der Edschmid auf dem Titelblatt seiner Bücher, hatte den Ehrgeiz zum Dichter der Städte und Meere, zum Weltdichter, hat in der Fülle seiner Verse und Erzählungen die ganze Welt eingefangen und die Romane der Erdteile gedichtet, in einem Stil des späten Barocks und der atemlos jagenden Handlung. *Ernst F. Löhndorff,* 1899, aus Frankfurt, mexikanischer Offizier, Goldgräber in Alaska, Fremdenlegionär, hat alle Welt befahren und in seinen Geschichten von Schiffsjungen, Legionären, Hindufrauen, Meutereien, Walfischfahrt, Tigerjagden die romanhafte Geschichte seiner selbst geschrieben. *Hans Grimm,* 1875, aus Wiesbaden, Kaufmann in Deutsch-Südwestafrika und nach dem Kriege wieder auf dem Familiengut Ödelsheim bei Lippoldsberg, schickte seine „Südafrikanischen Novellen" 1913 als Vorboten eines Werkes aus, das sich in dem zweibändigen Roman „Volk ohne Raum" 1926 erfüllte. Gegen den Wortrausch und Bildertaumel dieser rheinischen Reiseliteratur brachte er die verantwortliche Schlichtheit der Sprache wieder zu Ehren.

*Rheinisches
West-Osten* Der Rhein war ein Mittler zwischen Westen und Osten. Westfälische Ahnen, westpreußischer Geburtsort, rheinische Wahlheimat wirkten bei *Paul Zech,* 1881, aus Briesen bei Thorn, zusammen. Zech, auf der Flucht aus dem Bürgertum Arbeiter und dann doch wieder Beamter, hat die französischen Meister des Verses übersetzt und jede dichterische Gattung vom Blatt weg gespielt. Die Welt des Arbeiters hat er wie jede andere auch gestaltet. Ostpreußische und rheinische Vorfahren wirkten in *Heinz Steguweit,* 1897, aus Köln, zusammen. Er ist der Erzähler unwiderstehlicher Schwänke, der Schilderer des Kampfes um den Rhein und der Dichter von aufmunternden Laienspielen. Östliche Landschaften und westliche Frömmigkeit klingen zusammen bei *Karl Benno von Mechow,* 1897, aus Bonn, Reiter und Landwirt im Osten. Er hat in die Mitte seiner feinen Bücher den Roman „Vorsommer" 1933 gestellt, die Geschichte von dem Mädchen Ursula, das „ein heilig gewordener Mensch von der Straße" ist. Westen und Osten als Geschichte, das ist *Josef Ponten,* 1883 bis 1940, aus Raeren bei Eupen, ein Meister in allen Künsten,

die den Geschichtschreiber zum Künstler machen. Er hat den Weltosten Ruß-
land, den Weltwesten Amerika bereist, dazwischen die alte Geistesmitte der
Welt, Griechenland/Italien in sein Bewußtsein aufgenommen und in seinen
Büchern nachgedichtet. „Volk auf dem Wege", seit 1932 geplant, sollte in *„Volk auf dem Wege"*
acht Bänden Osteuropa, Nordamerika, Südamerika als die drei Wanderziele
des deutschen Ver sacrum schildern. „Die Väter zogen aus" 1934, „Der rhei-
nische Aufbruch von 1689", „Im Wolgaland" 1933, „Rheinisches Zwischen-
spiel" 1937, das sind die drei Bände, die fertig geworden sind. Hier erschei-
nen die Deutschen so wie Fichte und Nietzsche sie sahen, als das ewige
Werdevolk. Hier ist auf dichterische Weise die Wahrheit zu Ehren gebracht,
daß die Deutschen aller Welt mit ihrer Unrast und Arbeitskraft und Ord-
nungstreue ihre Vorfahren in den Bauerndörfern und Handwerksstätten des
Rheintales haben. Westen und Osten politisch, das war *Arthur Moeller van
den Bruck,* 1876 bis 1925, aus Solingen. Nach Paris kam er mit einer Absage
an sein Vaterland und zu Paris ging ihm die Möglichkeit eines geistigen
Deutschlands auf. Mit einer Absage an den Westen verließ er Paris, lernte
er durch Dostojewskij Rußland kennen und übertrug nun diese Liebe auf
jenes Deutschland, das sich ihm zu Paris geoffenbart hatte. Das Letzte
geschah ihm zu Florenz im Umgang von Barlach und Däubler. Mit einer
erstaunlichen Witterung spürte er damals schon vor dem Kriege den Durch-
bruch einer neuen Jugend. Vor Karl Friedrich Schinkels Neuer Wache in Ber-
lin ging ihm auf, was Preußen sein könnte. Mit seinen drei Büchern „Der
preußische Stil" 1915, „Die Rasse des Blutes und die Rasse des Geistes" *„Der preußische Stil"*
1915, „Das Recht der jungen Völker" 1918 hat er auf das erste Jahrzehnt
nach dem Kriege einen außerordentlichen geistigen Einfluß ausgeübt.

Die einzelnen rheinischen Landschaften haben sich gegenüber diesen
mächtigen Bewegungen, die von der rheinischen Arbeitslandschaft und vom
Rheinstrom insgesamt ausgingen, nur in bescheidenen Grenzen entfaltet.

Am Niederrhein stand Hanns Heinz Ewers, 1871, aus Düsseldorf, mit *Rheinische Städte*
seinen Romanen von den geschlechtlichen und spukhaften Untergründen der
Seele offensichtlich im Banne Edgar Allan Poes. Hinwiederum gehört Hans
Leifhelm, 1891, von Mönchen-Gladbach, mit seinen Erzählungen und Schil-
derungen, mit seinen Gedichtbänden „Hahnenschrei" 1926 und „Gesänge
der Erde" 1933 seiner steirischen Wahlheimat an. Doch durch den seelen-
tiefen Zauber dieser Worte ist das frische Gedächtnis der niederdeutschen
Heimat zu spüren. Und so bleibt es bei Otto Brües, 1897, aus Krefeld, der in
seinen geschichtlichen Spielbüchern, in seinen kräftigen, sinnlich vollen Ver-
sen, in der langen Reihe von Romanen und Novellen an rheinischer Ver-

Köln und Bonn gangenheit und Gegenwart dieses schwergeprüfte Menschenalter dargestellt hat. Er hatte die Vision von Christophorus, der, auf der Schulter das Bild des neuen Vaterlandes, durchs Wasser schreitet. Nur Köln war am Niederrhein ein Ganzes. Aber es spricht sich nicht als Ganzes aus. Herbert Eulenberg, 1876, war vor allem Spielbuchdichter, ein Schüler Shakespeares und der Romantik, ein Meister musikalischer Kunstmittel. Seine Romane und Novellen sind größer an Aufnahmefähigkeit als an bändigender Gestaltungskraft. Adele Gerhard, 1868, die aus der sozialen Bewegung der Jahrhundertwende herausgewachsen ist, hat ihre neue Heimat Berlin mit manchen ihrer Werke bedacht, doch mit Vorliebe den Aufstieg ihrer rheinischen Vaterstadt geschildert. Theodor Seidenfaden, 1886, hat unter Legenden und Legendenspielen gleich den Gesellen des alten Heidelberger Kreises die mittelalterlichen Dichtungen und Sagen der Gegenwart mundgerecht gemacht. Anton *„Über dem Strom"* Betzner, 1895, hat unter seinen Romanen eine Novelle von der jungen Frau. Sie wird zweimal durch den Arzt vor die Wahl gestellt: ich oder das Kind. Das erstemal entscheidet sie aus Lebenshunger für sich. Das zweitemal wählt sie das Kind und schenkt damit durch ihren Tod dem Hof einen Knaben und den künftigen Bauer. Diese Novelle heißt bedeutsam: „Über dem Strom." Das Aachener Land hat seinen Sprecher in Ludwig Mathar, 1882, aus Monschau, der es aus dem Schelmenroman „Die Monschäuer" 1922 und aus dem *Schelme und Landstreicher* Tuchmacherroman „Das Glück der Ölbers" 1923 reden läßt. Wilhelm Matthießen, 1891, von Gemünd, widmet sein Werk vornehmlich der Jugend und beherrscht großartig den Ton, auf die selbstverständlichste Weise von den unglaublichsten Dingen zu reden. Auch Bonn hat seine Leute. Wilhelm Schmidtbonn, 1876, hat, wenn er rheinisches Leben schilderte, es mehr in der Seele des Menschen, als auf den Straßen der Städte und in den Winkeln der Landschaft gesucht. In seinen Stücken liebte er es, den Bürger und den Standeslosen, Landstraße und Heim gegenseitig ins Unrecht zu setzen. Verlorener Sohn und Schauspieler waren für solchen Widerstreit geeignete Dulder und *Der Spielmann* Kämpfer. Heinrich Zerkaulen, 1892, trägt in seinen Liedern die rheinische Stimmung spielmannsmäßig vor — „Liebe schöne Laute" 1916 —, jungenhaft und studentisch. Rheinische Menschen in rheinischer Landschaft bevölkern die nicht wenigen Novellen des Dichters, alles Geschichten, die von Heiterkeit strahlen. Das Schauspiel „Der Reiter" 1936 stellt die Bürger eines deutschen Städtchens, den Prager Kaiser Rudolf II., seinen Hexenrichter und seinen Sendboten zu einem lyrischen Mysterium der Gerechtigkeit, Liebe und Gnade.

Moselfranken links und gegenüber Hessen rechts des Rheines haben sicher-

lich den einen gemeinsamen Zug, jene strenge Form der Latinität, mag sie nun klassisch oder romanisch heißen, die aus dem ältesten Römertum alle Jahrhunderte durchwachsen und überdauert hat. Nur erscheint diese Latinität an der Mosel christlich, in Hessen naturwüchsig heidnisch. Der Gott des Westens ist Apollon.

Moselfranken zeigt ein priesterliches Gesicht von bäuerlichem Schnitt, das der Landwirt Albert Bauer, 1890, aus Ravensbeuren, mit seinen Dorfromanen bestätigt. *Josef Matthias Tressel*, 1878, aus Beurig, Ernst Thrasolt, war zu Berlin der Mitarbeiter Carl Sonnenscheins, widmete sich dem „Dienst am deutschen Volk aus christlich-deutschem Bauerntum", arbeitete mit seinen Zeitschriften „Das heilige Feuer" und „Vom frohen Leben" für den Frieden, wurde in seinen mundartlichen Gedichten den schwer arbeitenden Menschen des Eifellandes ein Sachwalter und gab, wo es sein konnte, in der Art Peter Hebels gemütvolle Kleinbilder des alltäglichen Lebens. Daneben stehen zwei Anwärter des Priestertums, *Jakob Kneip*, der dichterische Künder des ganzen Mosellandes, und *Stefan Paul Andres*, 1906, von Breitwies, der seine heimatlichen Winzer und Schiffer beredt machte und in seinen „Moselländischen Novellen" 1937 schicksalsdunkle und lebensheitere Begebenheiten erzählt. Dann aber folgt abermals ein Priester, *Johannes Kirschweng*, 1900, aus Wadgassen, der das Märchen wieder zu Ehren brachte und die modernen Kunstmittel an die Darstellung seiner saarländischen Heimat gewendet hat. Die Novelle „Der Überfall der Jahrhunderte" 1928 macht in der Gegenwart des Landes auf eine magische Weise seine ganze zeitliche Tiefe wirksam bis hinab ins letzte Gedächtnis der Kelten und Druiden. Die spukhafte Art, wie Kirschweng von diesem Land und seinen Dingen redet, erinnert an die Gabe des zweiten Gesichts und die beschwörende Kunst der Darstellung bezwingt wie die Macht uralter Sagen.

Hessen bietet bei einem ungleich größeren Reichtum des Geschehens dazu seltsam verwandte Züge. Da ist einmal die unbegreifliche Magie der Sprache, die gewußt und geübt an den Sprachzauber antiker Kulte denken läßt. *Richard Knies*, 1886, aus Offenstein, hat die Gedichte von Wladimir Solowjev übersetzt und als Erzähler das Leben dort getroffen, wo immer etwas los ist. Seine Lyrik kreist getragenen Tones um das Urgeheimnis Sprache-Paradies-Offenbarung, tief überzeugt, daß dem ersten Menschen „Wort, Sinn, Bild, Geistleibes Klang" eine Einheit gewesen seien. Die modische Traumwissenschaft und die religiöse Traummystik der Romantik bilden an seinem Gedanken von der allnächtlich sich erneuernden Offenbarung Gottes. Wortgebrauch und Wortstellung verdunkeln nicht selten eigensinnig den Sinn, vielleicht mit

Moselfranken

Winzer und Schiffer

Tiefe der Zeit

Hessen

„Geistleibes Klang"

Ackerlegende Absicht, da doch absichtsvoll von Mysterien geredet wird. *Elisabeth Lang-gässer*, 1899 bis 1950, aus Alzey, erzählt etwa in den „Rettungen am Rhein" 1938 so, wie im Film Zeitschichten ineinander übergehn. Denn ihr Gegenstand ist, ob sie nun singt oder erzählt, das wahre Wunder der Beständigkeit in aller Verwandlung. In ihren lyrischen Gedichten „Hymnen von der letzten Saat" wirkt die Welt ringsum und die Erde unter uns mit all ihrer sinnlichen Gegenwart. Namenkundig singt die Dichterin dem „wilden Unkraut" ein Preislied. Denn die Erde selber ist mit ihrer heiligen Fruchtbarkeit in diesen unscheinbaren Kindern der Äcker und Feldraine groß. Da wird nun abermals der Laut wach, der dieser hessischen Dichtung so geläufig ist, eine antikische Naturfrömmigkeit, beinahe horazisch in die Ackerlegende geformt: „Ein jeder Stein wird endlich wieder Erde / Schoß und Gefährte / Von Trespe und Korn." Das ist ein Gedicht, aufgestiegen aus der Alleinheit von Mensch und Furche, voll des Wissens um den unbewegten Wandel zwischen „lebenden"

„Braus aus und „toten" Dingen. *Fritz Usinger*, 1895, aus Friedberg, hat seine Werke
schütternden durch die Darmstädter Handpresse Joseph Würths gehen lassen. Essays be-
Pedalen" gleiten den stattlichen Zug seiner Versbücher. „Der ewige Kampf" 1918 leitet ihn ein. „Das Wort" 1931, „Die Stimmen" 1934, „Die Geheimnisse" 1937, „Hermes" 1942 führen den Reigen. „Wir lieben Griechenland, weil wir Deutschland lieben." Darum haben sie den hohen Stil hellenisch-deutscher Antike, seien es nun Strophen, Hymnen, Oden. Sie sind des orphisch-dunklen Wortes kundig und sprechen in makellos gesetzten Doppelstrophen Gottesweisheit griechischer und deutscher Frömmigkeit aus. Die nymphische Nacht, die sie preisen, ist eine deutsche Nacht und der Forst, den der Waldgott mit seiner Flöte verzaubert, den die Kentaurenhorde durchtobt, ist ein hessischer Forst. Goethe und Hölderlin, Rilke und George sind die Meister dieser klassischen Verse, die voll göttlicher Natur sind. „Aus dem Holze, dem Metalle / Langsam lösend Stimm um Stimme / Daß das Tote plötzlich schalle / Summend erst wie eine Imme / Dann sich hebend zum Gesange / Wie mit Feuern will es strahlen / Endlich schwillt zum Weltenklange / Braus aus schütternden Pedalen." *Werner Bock*, 1893, aus Giessen, der Sohn des hessischen Dichters, Hochschullehrer in Montevideo, gewährt durch seinen Auswahlband von Prosastücken „Blüte am Abgrund" 1951 und seine „Ausgewählten Gedichte" 1958 einen schmalen Einblick in ein vieljähriges ernstes und strenges Schaffen. *Carl Zuckmayer*, 1896, aus Nackenheim, hat in mehr als einem seiner stilvollen Gedichte das Lebensbild der beständigen Verwandlung aller Dinge ausgedrückt. Die Naturwärme dieses Gefühls ist in allen Novellen und Spielbüchern dieser Zeit zu spüren, lediglich am sinnlichsten in

dem Stück „Der fröhliche Weinberg" 1925: Natur kennt keine Scham. Zuck- *„Der fröhliche Weinberg"*
mayers Dramen bewegen sich alle auf dem Grenzrain, der die beiden Gat-
tungen nicht trennt, sondern eben verbindet, auf dem Grenzrain der Ballade
und Komödie. Sie haben den Bänkelsänger in sich. Es gibt keine Szene, die
so rheinisch ist wie diese, wo der Hauptmann von Köpenick, nachdem ihm
sein Streich gelungen ist, auf dem Polizeirevier noch einmal die Uniform an-
zieht, vor den Spiegel tritt, sich zum erstenmal selber in seiner Verkleidung
erblickt und bei diesem Anblick, das Weinglas des Polizeibeamten hebend,
in ein von innen emporquellendes Lachen ausbricht und in die brennenden,
erlösenden, versöhnenden Worte: „Unmöglich." Man müßte das Blatt wen-
den, um zu sehen, was darnach aus Zuckmayer geworden ist. *Manfred Haus-* *Salut gen*
mann, 1898, aus Kassel, ist durch die Jugendbewegung und den Grabenkrieg *Himmel*
gegangen. Zufrühest erscheint er unter den Laienspielern. „Marienkind"
1927 klingt auf und verklingt wie ein zartes Singspiel in einer geheimnis-
vollen Wolke von Gottvertrauen, Frömmigkeit, Erdenleid. „Lilofee" 1936
ist ein Märchenspiel aus dem Weserlande, ein Spiel von der Menschenfrau,
die, am Glück unter ihresgleichen verzweifelnd, sich vom Wassermann holen
läßt, ein Spiel zwischen Traumwelt und Tagwelt. Die Stimmung der beiden
einfältig großen Dichtungen halten Hausmanns Lieder fest. Auch hier das
Erlebnis der Beständigkeit bei ewigem Wechsel in Gedichten von Scholle
und Wald. Hausmanns Spielballaden und Stimmungsweisen erschließen den
Sinn für seine erzählenden und schildernden Prosawerke. Von Novellen her
hat Hausmann den Übergang zu Ichromanen gefunden. Doch auch diese *Der Held*
größeren Gebilde — „Lampioon küßt Mädchen und kleine Birken" 1928, *der Landstraße*
„Salut gen Himmel" 1929, „Kleine Liebe zu Amerika" 1930, „Abel mit der
Mundharmonika" 1932, „Abschied von der Jugend" 1937 — bauen sich aus
Novellen auf. Er hält Kameradschaft mit dem Tier und ist ein Meister der
Vogelstimmen. Wandervogel und Kriegsfahrt sind die beste Schule für die
Größe und Schönheit der kleinen Dinge geworden. Hausmanns Wanderer
ist weder Eichendorffs Taugenichts noch Müllers Handwerksbursch, sondern
der echte Pennbruder und Held der Landstraße. Und dieser Held der Land-
straße verkörpert den letzten und äußersten mystischen Gedanken aller Zei-
ten und Religionen: aller Dinge bloß und ledig werden. Hausmanns Land-
streicher ist ein Abbild Peter Hilles und ein Nachkomme Knut Hamsums. Das
Geschichtenbuch „Demeter" 1937 leitet zu dem schönen Gipfel hinauf mit
seinem beglückenden Rundblick auf ein erfülltes Dasein und eigenes Heim:
„Martin" 1949, „Isabel" 1953, „Andreas" 1957 mit Sohn, Mutter und Vater,
jung wie der Tag, der über die Schwelle tritt.

„Schwebend im Gleich des All"

Zwei Dichter, die das, sofern man nur das Dichterische anschlägt, inbegrifflich gewesen sind, stehen für diesen hessischen Stil.

Rudolf Georg Binding

Rudolf Georg Binding, 1867 bis 1938, zu Basel durch Vater und Mutter aus dem Stadtpatriziat Frankfurts geboren, spürte erst als Vierzigjähriger, nachdem er Toskana und Olympia erlebt hatte, im Zustand körperlicher Genesung in sich die Gabe des schöpferischen Worts aufbrechen. Es war aber, selbst an der sparsamen Fruchtbarkeit dieses Mannes gemessen, nur ein schmales Werk, das sich bis zu den Augusttagen 1914 zusammengefügt hat. Es hatte sich mit der Novelle „Sankt Georgs Stellvertreter" 1900 angekündigt, zu den beiden Novellenbänden „Legenden der Zeit" 1909 und „Die Geige" 1911 geweitet, um mit den beiden Erzählungen „Keuschheitslegende" 1913 und „Weihnachtslegende vom Peitschchen" 1917 in den Aufruhr des Krieges zu verklingen. Wenn Binding mit Vorliebe Legende sagt, so meint er das auf seine Art. Die Begebenheiten des irdischen Alltags erscheinen als Wunder nur dem Auge, das Gott berührt hat. Die Bürgersfrau, die zur Weihe der Kapelle kommt, ist nur für Cölestina die heilige Jungfrau, und allein der Rittmeister weiß, daß der Büttel in Wahrheit der Tod ist. Diese Geschichten bewegen sich durch die erotischen Seitenwege verwirrter Seelen. Da kam der Krieg. Mit siebenundvierzig Jahren ging Binding als freiwilliger Reiter mit und kam als ein anderer Mensch zurück. Der Bindungslose fühlte sich eins mit der natürlichen Gemeinschaft. Er glaubte, die Prüfung des Krieges werde die Völker wieder zu Persönlichkeiten machen. Volkspersönlichkeit heißt gegenseitige Achtung von Volk zu Volk. Diese Achtung aber jätet den Krieg mit der Wurzel aus. Das Kriegserlebnis auch denen zu vermitteln, die seine Wirklichkeit nicht erfahren hatten, übersetzte er 1920 die Rede des Perikles für die Gefallenen. Überwunden, besiegt muß der Krieg werden. Man muß mitgestorben sein, um auf eine neue Weise leben zu können. Das Novellenbuch „Unsterblichkeit" 1921 und die Erzählung „Wir fordern Reims zur Übergabe auf" 1935 finden Bindings Erlebnissen dichterische Gestalt. Seine lyrischen Sammlungen „Gedichte" 1913, „Stolz

„Stolz und Trauer"

und Trauer" 1922, „Sieg des Herzens" 1937 halten auf drei Stufen die Begegnungen dieses männlichen Herzens fest. Zuerst ist es die Haltung eines Menschen, der sich im Sinne Zarathustras jeder Bindung entledigt hat. Gott und Mensch, keiner ist für den andern erreichbar. Sodann ist es die Wendung durch den Krieg. Er hat dem Dichter ein neues „Maß" geschenkt, die Kraft zum Unerbittlichen. Und schließlich ist es die letzte Weisheit vom Leben und vom Tode. Nun ist der Mensch allein mit der Natur, wahrhaftig in dem seligen Zustand der Schwebe. „Sterb ich dir heute nicht, / sterb ich dir mor-

gen: / Schwebend im Gleich des All / sind wir geborgen." Die Sprache dieser
Gedichte ist antikisch und von einem leisen Reif späten Herbstes überhaucht.
Drei Gebärden können dieses männliche Leben zusammenfassen. Die „Reit-
vorschrift für eine Geliebte" 1926 zeigt den ritterlichen Menschen, „Mosel-
fahrt aus Liebeskummer" 1932 bewährt den lebensfrohen Menschen. Die
„Antwort eines Deutschen an die Welt" 1933 gilt Romain Rolland. Der
Mensch ist sich selbst Urbild und Genüge. So hat Binding von Plato und
Nietzsche her geglaubt.

Albert Heinrich Rausch, 1882 bis 1949, aus Friedberg, hat über sein Werk *Stoa
und Nirwana*
den Namen Henry Benrath gesetzt. Er hat in Gießen und an der Sorbonne
romanische Geisteskunde getrieben. Er hat Frankreich, Italien, Spanien,
Afrika bereist. Paris ist so wie ihm kaum einem zweiten Deutschen die Stadt
persönlichen Lebensgefühls und Lebensstils geworden. Doch was es zu vol-
lenden galt, das ist ihm fast immer in Deutschland vollendet worden. Da
hören wir es. „Jedes deutsche Erleben nahm in mir von einem an die Erde
gebundenen heimatlichen Erleben seinen Ausgang. Meine Heimat war Süd-
deutschland, verkörpert in der Wetterauer Limeslandschaft. In jedem seiner
Erde verhafteten Künstler muß Heimat zu Schicksal werden." Im Rhythmus
dieses Lebens war der Krieg keine Cäsur. „Das Erleben dieses Krieges
wurde durch harte tägliche Arbeit für Deutschland ausgetragen." Die gro-
ßen Akzente seines Schaffens sind zwei Jahre, die ihr Gewicht von innen her
empfangen. Es ist das Jahr der Berufung 1907, da ihm Debussy das Wunder *Jahr
der Berufung*
der Musik pure und George das Wunder der Poésie pure erschließt, und das
Jahr 1934, da nach fünfundzwanzig Jahren Aufstiegs sich auf erreichter Höhe
stufenlos der stoisch-apollinische Auftrag seines Lebens vollzieht. Zwischen
Sein und Formen gibt es in diesem Menschen, da er einmal reif geworden,
keinen Unterschied mehr. Und selbst der Unterschied der dichterischen Gat-
tungen schmilzt in der reinen Flamme solchen Stilwillens aus jeder Form
hinweg. Benraths Verse, fast von der Kindheit an, läuterten sich und wur-
den Einheit in den beiden letzten allumfassenden Sammlungen. „Stoa" 1933
ist ein Band von meist kleinen strophischen Gedichten. Er hat die drei Grup-
pen Erkenntnis, Geschehnis, Erfüllung. „Stoische Haltung ist nicht — wie
viele irrtümlicherweise annehmen — Verzicht (Resignation), sondern, ganz
im Gegenteil, Bejahung des Täterischen und Treue gegen den erteilten Auf-
trag: ohne Hoffnung auf Belohnung, sei diese Belohnung nun Paradies oder
Erlösung. Stoa ist der Glaube an die Erfüllung des Lebens durch das Werk."
Diesen unlehrbaren Glauben beispielhaft vorzuleben, ist der Sinn dieses *„Dank an
Apollon"*
Buches. „Dank an Apollon" 1936 ist die endgültige und abgeschlossene Ge-

Toskanische und hessische Sonette

samtausgabe von Benraths Gedichten, ein unvergleichliches Buch, die Gedichte eines ganzen Lebens zur Gestalt dieses Lebens aufgegliedert, sechs Bücher, davon das fünfte das schönste, die Sonette der Liebe, die toskanischen und die hessischen. Die Aufschrift gibt diese Gedichte dem Urheber zurück, „dem großen Durchleuchter und Begrenzer, dem Gott der Klarheit und der Beherrschung, dem Gott, der über allen Zeiten ist, obwohl in allen: Apollon". Die Stoa ist der Weg, Apollo der Herr des Weges und sein Ziel.

„Paris"

„Paris" 1938 sind ein schmaler Kranz gleichgewachsener Gedichte um das Bild der Stadt. Die Schlußgebärde weist rheinostwärts: „Dort ist die Hand, die du ergreifen mußt, / Willst du dich unversehrt der Welt bewahren: / Sei dir der Himmelszeichen wohl bewußt: / Wie tief die Nornen schon in Wolken fahren." Noch viel weiter ostwärts weisen Benraths Prosasprüche. Die Verwandtschaft von Stoa und Nirwana ist Benrath früh bewußt geworden. Jetzt, beinahe am Grenzstein seines Lebens, vereinigte er die Bildnisse des Apollon von Delphi und des Buddha von Sawankalok. „Leukas Petrae" 1942 — „weißleuchtender Felsen" — vollzieht in Sprüchen die Reinigung des eigenen Wesens und empfängt die göttlichen Erleuchtungen. „Nirwana" 1942 vereinigt in Sprüchen und erregenden Zwiegesprächen Apollon und Buddha.

„Welt in Bläue"

Die Landschaftsbücher, „Südliche Reise" 1914, die Benraths Mittelmeer dichtet, und „Welt in Bläue" 1938, die italienischen Gefilde und Städte seines Herzens, halten die Waage zwischen seinen lyrischen Versen und der epischen Prosa im Gleichgewicht. „Ball auf Schloß Kobolnow" 1931, „Die

Die Romane

Mutter der Weisheit" 1938, „Erinnerung an Frauen" 1936, „Paris" 1939 sind eine Comédie humain. Weltgeschichtliche Erinnerung an Frauen kann die Folge der drei großen Romane heißen: „Die Kaiserin Konstanze" 1935, die mit ihrer Hand das italienische Normannenreich dem gewaltigen Staufer Heinrich VI. vermählte; „Die Kaiserin Galla Placidia" 1937, die letzte Römerin und Gotenkönigin, die ihr Grabmal zu Ravenna verkündet; „Die Kaiserin Theophano" 1940, die byzantinische Prinzessin, die an der Seite Ottos II.

Die Stimme Delphis

eine so deutsche Kaiserin geworden ist. „Der Weg" 1942 heißt Benraths Selbstdarstellung von stolzer Sachlichkeit und Größe. Sie schließt mit einem Zuruf an die Mutter: „Ruhe, bis du in mir erwachen darfst zu unsrem vereinigten Schlaf. Der Gott der Erfüllung hält die Wacht über dir und mir. Wie licht ist alles Leben nun geworden. Wie sollte ich nicht heiteren Fußes gegen den Hingang schreiten." Albert Heinrich Rausch ist der Dichter des karlingischen Europa, an das er immer geglaubt hat. Die hellenische Sophrosyne und die Verachtung aller menschlichen Hybris bewegen seine moralische Haltung. Die Sprache Luthers und Homers hat sich in seinem Wort zur

Sprache Apollons verklärt. Aus seinem Werk redet Geist und Stimme Delphis. Er ist, über die Vorstufe hinweg, die Stefan George, sein hessischer Landsmann heißt, der Dichter dieses Äons. Von seiner Dichtung gilt: „Ihr Gang und ihre Sprache sind sakral, feierlich wie die Mittagsluft über der Landschaft und dem Tempel von Segesta." Seine Erzählungen aber sind das heiterste und anmutigste Abenteuer aus Geschehnis und Gespräch, Ironie und Güte, poésie pure, humanité pure.

Die breite Landschaft, die sich von der Hardt herab auf den Rheinboden senkt und dann wieder sanft zu den Neckarbergen erhebt, ist durch Staatsgeschichte und Feldmesser in jener Geschlossenheit gestört worden, wie sie mundartlich und stammestümlich in Begriff und Namen Pfalz zum Ausdruck kommt. Hier war *Friedrich Alfred Schmid Noerr*, 1877, aus Durlach zu Hause, durch den Vater von oberalamannischer, durch die Mutter von unterfränkischer Abkunft. Seine frühen Novellen haben kunstwissenschaftliche Neigungen. „Der Hergottsturm" 1911 hat es mit dem Antiquitätenhandel. „Das Leuchterweibchen" 1928 schwebt über einem verhaltenen Erlebnis, das Albrecht Dürer, dessen Frau Agnes und Freund Pirckheimer verstrickt. Die Gesprächsnovelle „Wie Sankt Antonii Altar zu Isenheim durch Meister Matthias Grünewald errichtet ward" 1919/1921 gibt Geschichte und Deutung dieses Kunstwerks. Die Novelle leitet zu den mythischen Dichtungen Schmid Noerrs hinüber. Sie wurden eingeleitet von den „Mythischen Erzählungen" 1927, fortgepflegt von den Märchengeschichten „Drache über der Welt" 1932 und erhöhten sich zu der mythischen Geschichte von der leiblich-geistigen Durchdringung des Germanentums und Christentums: „Unserer guten Frauen Einzug" 1936, der germanische Schöpfungsmythus, und „Frau Perchtas Auszug" 1928, die Göttin als Menschenmutter. Hier ist *Richard Sexau*, 1882, aus Karlsruhe, alamannisch-fränkischen Stammes zu Hause. Der Roman „Venus und Maria" 1932 und 1933 ist zunächst auf die beiden gegensätzlichen Formen des Liebeslebens gerichtet. Doch er läuft durch alle Gesellschaftsschichten und den größten Teil Europas, indem er sich zu einem Zeitgemälde der Jahre vor und nach dem Kriege aufrollt. Hier hatte *Otto Gmelin*, 1886 bis 1940, aus Karlsruhe und von alamanischer Herkunft, seine Heimat. Der Vielgereiste läßt vor dem zauberhaften Hintergrunde Altmexikos „Das Mädchen von Zacatlan" 1931 erscheinen und bringt — „Sommer mit Cordelia" 1932 — im holden Reigen der Jahreszeiten die Neigung eines Vaters zu seiner unerkannten Tochter ins Blühen. Andere Bücher spiegeln die Gegenwart in die Vergangenheit hinein. „Dschingis Khan, der Herr der Erde" 1925 stellt durch Rückverwandlung der Städtelandschaft in Steppe für seine

Kunstdichtung

Frau Perchta

„Venus und Maria"

Begriffe die göttliche Ordnung wieder her. Das Reich verstrickt sich — der Hohenstaufenroman „Das Angesicht des Kaisers" 1927 — tragisch in sein Anderich Italien. Und das Prosaepos der Völkerwanderung, „Das neue *„Das neue* Reich" 1930, spannt das Menschenalter Weltgeschichte vom Aufbruch der *Reich"* Hunnen 375 bis zu Alarichs Zug nach Afrika 410 in den Gedanken eines neuen Deutschland. Hier hauste *Emil Belzner,* 1901, aus Bruchsal und als Nachfahr schwäbischer Bauern und Handwerker. Sein Werk erhöht sich in der Seefahrerlegende „Kolumbus vor der Landung" 1933 und in dem englischen Rebellenroman „Ich bin der König" 1940 um James Monmouth und Jakob III. Die Pfalz beiderseits des Rheins ist fränkisch überschichtetes altes Alamannenland. Sie führt vom fränkischen Mittelrhein zum alamannischen Oberrhein.

Und wieder rücken die Ufer herüber und drüben die Landschaften nachbarlich aneinander.

Elsaß Das Elsaß sah zu Beginn des Jahrhunderts eine Gruppe junger Leute am Werk, die zu Europa gehören und vor ihm etwas gelten wollten. *René Schikkele,* 1883 bis 1940, aus Oberehnheim, empfand das Geistesleben des Landes als Zwiekultur, ließ Voltaire wie Goethe gelten und stellte in seinem vielgespielten Drama „Hans im Schnackenloch" 1917 den Großbauern tragisch in die Mitte zwischen zwei Frauen und zwei Völker. Als das Los von neuem *„Das Erbe* gefallen war, machte Schickeles Romandrilling „Das Erbe am Rhein" 1925 *am Rhein"* das nun französische Elsaß zum Helden. Und es ist sehr vergnüglich zu lesen, wie der Dichter die abermalige Wandlung der Herzen sich und andern verständlich zu machen sucht. Ein aphoristischer Künstler und lyrischer Landschaftsmaler, triebhaft sinnlich und jederzeit des bezeichnenden Wortes *Frankreich* mächtig, hat Schickele immer näher bei Frankreich als bei Deutschland ge- *und Deutschland* standen. Verwandte hatte seine Gruppe an den beiden Metzern Otto Flake und Wilhelm Michel. Dagegen ist Bernd Isemann mit seinen innerlichen und zarten Geschichten bald eigene Wege gegangen. *Ernst Stadler,* 1883 bis 1914, aus Kolmar und in Flandern gefallen, hat mit der „Aktion", die aus seinem Nachlaß manches druckte, nichts zu tun. Seine Verse sind von strenger Zucht, und was sie atmen, ist die rheinische Mystik. Es war der Zugewanderte, *Hermann Stegemann,* 1870, aus Koblenz, der in seinen elsässischen Romanen am alamannischen Volk das Deutschland von 1870/1914, seine Arbeit und seinen Aufschwung, seine Schwäche und Größe dargestellt hat. *Getrennte Wege* Als Straßburg 1918 wieder französisch war, gab es drei Elsaß. Eines lebte in Deutschland, ein anderes in Frankreich und ein drittes bei sich selber. Dieses Elsaß zu Hause ließ Raymond Buchert, 1893, aus seinen mundartlichen und

hochsprachigen Versen hören, Franz Büchler, 1904, der sich auf die große Tragödie verstand, aus seinen sanftbewegten Seelengedichten, während Morand Claden, 1895, seinen Heimkehrer unerlösbar zwischen Deutschland und Frankreich wandern ließ, sich aber auch mit übermütigen Liedern auf die Weine des Landes verstand. Louis Spielmann, 1905, pries in seinen Gedichten den Winzer, den Illfischer, den Bauern. Das Elsaß in Frankreich ist eine kleine Gruppe: Franz Reiner aus Gebweiler mit seinen Gedichten und Emil Usselmann aus Hagenau mit seiner kleinen Prosa; Leonhard Riedweg aus dem Sundgau und seine flammenden Verse an das Straßburger Münster. Elsaß in Deutschland fand sich rasch seine Form. An der Frankfurter Hochschule wurde 1920 „Das wissenschaftliche Institut der Elsaß-Lothringer im Reich" eröffnet. Und die Dichtung kam zu Wort. *Eduard Reinacher*, 1892, aus Straßburg, fand in seinem Landstreicher „Runold" 1919 eine Gestalt für die Unrast der Zeit und in seinem Geschichtenbuch „Die Hochzeit des Todes" 1921 rührende Legenden, so die von dem dreizehnjährigen Mädchen, das mit dem Tode um seinetwillen geht, weil er so schön und liebenswert ist. Die beiden schweren lyrischen Bände „Elsässer Idyllen und Elegien" 1925, „Harschhorn und Flöte" 1926, umfassen im heroischen Versmaß der Antike die ganze alamannische Welt des Oberrheins. Das Laienspiel „Lapp im Schnackenloch" 1930, Schickele entzückend nachgespottet, heilt auf eine handfeste Weise den elsässischen Bildungsbauer von seinem ausgegrübelten Kummer der vielen Möglichkeiten. In seinem Totentanz hat der große Bruder „An den Schlaf" 1939 nicht gefehlt. Reinachers einfache, chorische, bildhafte Spielweise hat ihre letzten Wurzeln in dem oberrheinischen Totentanz und Bilderspiel. Sein Todesgedanke ist uralte rheinische Mystik. *Paul Alverdes*, 1897, aus Straßburg, ist schon durch die Jugendbewegung gegangen und von der Schulbank in den Schützengraben. Sein Werk ist in einem höheren als bloß stofflichen Sinne vom Kriegserlebnis erfüllt. Die Kurzgeschichten und Novellen geben den Ausschlag. Der Opfergedanke bricht immer wieder durch, so in der Sammlung „Reinhold oder die Verwandelten" 1932, die alle den Tod durch die offene Pforte gesehen haben. Zusammen mit Karl Benno von Mechow gründete Alverdes 1934 die Zeitschrift „Das innere Reich", der gültigen Kunst eine Stätte.

Der Breisgau rheinüber stellt sich am schönsten durch einen Malerdichter dar, der unter den vielen alamannischen Doppelmeistern der nächste bei Gott und seinem Volk am ähnlichsten gewesen ist. *Hans Thoma*, 1839 bis 1924, aus Bernau, hatte in seinen ungezählten Bildern sich und anderen die Schönheit der Welt gezeigt. Da überkam seine Augen jene abendliche Feier-

Elsässer im Reich

Eduard Reinacher

Paul Alverdes

Breisgau

Hans Thoma

stille, in der die aufgesparten Worte der Seele hörbar werden. Die drei Bände „Im Herbste des Lebens" 1909, „Im Winter des Lebens" 1919, „Jahrbuch der Seele" 1922 machten aus Vorträgen, Lebenserinnerungen und Gedichten den Abgesang eines wunderbar erfüllten Daseins. Der Aufgesang des Menschen, der schon drüben zu sein begonnen hat, Bangnis, Zuversicht, Erwartung geht in den zwei Büchlein auf. „Die zwischen Zeit und Ewigkeit unsicher flatternde Seele" 1917 und „Seligkeit nach Wirrwahns Zeit" 1918, Dichtungen aus dem Geist des cherubinischen Wandermanns. Und in der Sprache seiner Mutter, das ist in alamannischer Mundart, sprach er sich noch einmal „Biblische Geschichten" 1921 vor. In Thomas' Dichtungen hatte der nüchterne, kühle Schwarzwaldbauer die Oberhand über den schönheitssüchtigen Märchenmaler gewonnen. Das Antlitz dieses Schwarzwaldbauern hat

Hermann Strübe

rein, groß, uralt in die Dämmerung aller Götzen geleuchtet. Einer von Thomas vielen Schülern war der Markgräfler *Hermann Strübe,* 1879, aus Maulburg, auch ein Malerdichter, der von seinen weiten Reisen heimgekehrt, den Zustand, in dem er sein Vaterland wiederfand, in dem Roman „Wiltfeber, der ewige Deutsche" 1912 ausdrückte. Der Dichter Burte war in vielem mit

„Wiltfeber der ewige Deutsche"

Langbehn einig. Der „reine Krist" ist der künftige Gottmensch aus dem deutschen Volke, sein Vollstrecker und Führer. Alle Dichtung Strübes ist im Sinn dieses Buches ein Ringkampf zwischen Einzelmensch und Gemeinschaft, zwischen Natur und Geist im Menschen. Der Ort dieses Zweikampfes ist die Bühne. In den ersten beiden Tragödien „Herzog Utz" 1913 und „Katte" 1914 geht es um den todgeweihten Helden nach dem Satz: Es ist besser, daß er stirbt, als daß die Justiz aus der Welt kommt. „Simon" 1917, „Warbeck" 1920, „Apollon und Kassandra" 1926, „Krist vor Gericht" 1930, „Prometheus" 1931 sind so viele Stücke wie Stile, doch einig in Schillers Forderung, Schönheit sei Einklang von Pflicht und Neigung. Nach den beiden Frauen des Wiltfeber heißen die zwei reifen Versbücher: „Madlee" 1923 nach der schwarzbraunen Markgräfler Magd alamannische Gedichte von Volk, Weib und Wein; „Ursula" 1930, nach der adeligen vergeistigten Blonden, Verse von Menschen und Erde, Gott und Geist, Weib und Welt. Ältere und späte Verse stehen in den Sammlungen „Das Heil im Geiste" 1953 und „Stirn unter Sternen" 1957 beisammen. Und ein Schüler des bäuerlichen Feldblumenmalers war *Eris Busse,* 1891 bis 1947, aus Freiburg, der aber der Sohn eines schlesischen Webers und einer alamannischen Mutter war. Aus dem Lehrer, Tonsetzer und Verskünstler wurde ein Meister des erzählenden Wortes, der die schlesische und die alamannische Märe, schlesische Weite und alamannische Gründlichkeit wundervoll verschwisterte. Seine ersten

Bildungsromane sind Hermann Stehr sehr verwandt. Über bäuerliche Romane hinweg erhebt sich „Der Erdgeist" 1939, die Sage der Hegauer Berglandschaft, ein Prosaepos von vielen Geschichten. Neben dem geborenen Meister der Szene Hermann Stehr steht der geborene Erzähler Eris Busse. Hans Thomas Kunst grünt und blüht in den Dichtungen von *Franz Schneller,* 1889, aus Freiburg, dem Sprossen einer oberrheinischen Winzerfamilie, dem Vetter und Zögling Emil Götts. In seinen Büchern wird nicht gehandelt, aber es begibt sich vieles, Menschliches und Wunderbares. Die schönsten sind „Blaubuch eines Herzens" 1935 und „Ein Mädchen in Blüte" 1937, weil sie mit zarten Pastellfarben Gestalten malen, die eine so köstlich milde Art haben, Mensch zu sein. Ein sehr gegenständlicher Humor läßt nichts Trübes aufkommen. Der Wein — die Arbeit, die Sorge, der Genuß, der Mensch, die er macht — verzaubert die Sprache dieser Bücher. Es gibt keinen größeren Abstand, sei es des Alters, sei es des Menschseins und der Kunst als von Hans Thoma zu *Reinhold Schneider,* 1903 bis 1958 aus Baden-Baden, der im Dreieck von Essay, Geschichtsdichtung, Sonett zu einem weiträumigen Werk angesetzt hat. Das Reisetagebuch „Portugal" 1931, die geschichtlichen Szenen „Las Casas vor Carl V." 1938, die Gedichte „Jetzt ist es Heilige Zeit" 1940 können für jede der drei Richtungen zeugen. Er war im dritten Reich eine Säule geistigen Widerstandes und ist dafür ausgezeichnet worden wie wenige Deutsche. So ist auch im Breisgau alles beisammen, vom naiven Malerdichter bis zum geistbewußten Formkünstler.

Allgäu und Schwaben, das Land zwischen Bodensee, Lech und Rhein, fügt sich noch immer geistverwandt in dieses Raumganze, zumal wenn man von der andern Seite des Oberrheins die Eidgenossenschaft auf die andere Waagschale legte. Der Allgäu hat *Wilhelm Frick,* 1874, aus Kleinwinaden, der sich Schussen nennt. Seine Verse und Geschichten loben die Natur, Gott, zwischen ihnen das Menschenherz und sind Stoßgebete einer rührenden Andacht zum Leben. Durch nicht wenige Romane und Novellen ziehen drei Bücher eine goldene Mittelspur: „Vinzenz Faulhaber" 1907, ein moderner Schelmenroman; „Der abgebaute Osiander" 1923, ein Stück eigener Lebenslegende; „Die Geschichte des Apothekers Johannes" 1935, der lebensfremde Erfinder des Gemütsschwebstoffs. Fricks Kunst ist „Entführungslust ins Ewige und Unvergängliche". „Man tut viel, ehe man stirbt", sagt der Apotheker Johannes zu seinem Töchterlein. „Komm, Mutterle, tu doch wieder mal ein bißchen jammern, bloß ein bißchen jammern", bettelt ein halbwüchsiger Junge die Leiche seiner Mutter. *Peter Dörfler,* 1878 bis 1955, aus Untergermaringen bei Kaufbeuren, Dichter und Priester wie in alten Zeiten, hat

„Der Erdgeist"

„Blaubuch des Herzens"

„Jetzt ist es Heilige Zeit"

Allgäu

„Der abgebaute Osiander"

Peter Dörfler　ziemliche Umwege zur großen Form machen müssen. Mit Geschichtsromanen begann es. Dörfler ließ sie nach und nach im Allgäu spielen. Und auf dieser Unterlage baute er nun ein mächtiges Werk auf, zwei Romandrillinge, die zusammen wieder ein Ganzes sind: die wirkende Frau im Hause und der schaffende Mann in der Gemeinschaft. Die Romanfolge „Apollonia" — „Die Lampe
„Apollonia"　der törichten Jungfrau" 1930, „Apollonias Sommer" 1931, „Um das kommende Geschlecht" 1932 — gilt der Frau, die, ohne geboren zu haben, Mutter dreier Geschlechter wird. Sie konnte in ihrer Jugend nicht jung und sie durfte im Alter nicht alt sein. Der Preis für eine solche Mutterschaft der Tat ist der Verzicht auf die leibliche Mutterschaft. Das Haus, in dem sich dieses Mysterium begibt, ist von abgründiger Gleichniskraft eine Mühle. Die Geschlechter zeugen an der vorbei, die das Leben hütet, ohne in seiner Kette zu stehen. Am Tage ihres Todes wird die Mühle für eine Stunde abgestellt. Das Leben verhält, seine Herrin zu ehren, einen Atemzug, das Äußerste, was es kann. Die Romanfolge „Allgäu" — „Der Notwender" 1934, „Der Zwingherr" 1935, „Der Alpkönig" 1936 — gilt dem Manne, der in der Gemeinschaft wirkt wie die Frau im Hause. Der mechanische Webstuhl hat den Allgäuer Kleinbauern die Heimarbeit genommen. Da kommt dem Jungbauern Karl Hirnbein der Gedanke, den ganzen erliegenden Hofbetrieb auf Milchwirtschaft umzustellen. Sein Vorbild wirkt und rettet ein ganzes Land in neuen Wohlstand. Beide Romanfolgen bieten eine runde Welt auf, ein Zeitalter und eine Landschaft. Das Volk und sein Land, mit der Sachkenntnis des Eingeborenen verstanden, erscheinen so wirklich, wie sie sind. Ihr Brauchtum waltet wie eine heilige Gebärde in allem, was geschieht, und ihre Sprache prägt den ganzen Ausdruck vom Wortschatz bis in den Satzbau.

Schwaben　Schwaben ist bevorzugt auf epische Dichtung gerichtet. August Lämmle, 1876, aus Oßweil-Ludwigsburg, gab in seinen schwäbischen Erzählungen das gehobene Volksleben. Ludwig Finckh, 1876, aus Reutlingen, ist seit seinem Roman „Der Rosendoktor" 1906 romantischen Neigungen in vielen Novellen, Gedichten und Romanen nachgegangen. Heinrich Lilienfein, 1879, aus Stuttgart, verströmt seine gemütvolle Innerlichkeit fast lyrisch in seinen Novellen und Romanen, die gleichwohl auf Handlung angelegt sind und wirklich erzählen. In seinen Dramen hat sich Lilienfein an vielen Stilarten, Vorwürfen, geschichtlichen Gestalten gemessen und auch Auseinandersetzun-
Erscheinung der Landschaft　gen mit seiner Zeit nicht gescheut. Max Reuschle, 1890, aus Stuttgart, pflegt mit reiner Hingabe den lyrischen Vers. Die Gesänge „Poseidonia" 1932, den Tempeln von Paestum gewidmet, tönen hymnisch aus der Weite und Tiefe Gottes. Und die Seele Hölderlins weht aus der Andacht zu diesen ungebro-

chenen Säulen hellenischer Frömmigkeit. Otto Heuschele, 1900, aus Schramberg, Hölderlin seelenverwandt und eine lyrische Natur, läßt den Krieg nur gedämpft in seine Erzählungen hineinspielen. Seine Versbücher wandeln sich vom persönlichen Naturgefühl zur Teilnahme am Geschehen der Zeit. Artur Miller, 1901, aus Mindelheim, hat mit einem Lehrerroman, „Das Jahr der Reife" 1931 begonnen. Das „Mindelheimer Weihnachtsspiel" 1936, „bäuerlich schwäbisch, adelig gotisch", ist sicherlich die kostbarste Dichtung schwäbischer Mundart. Zwischen diesen beiden schwäbischen Altersgenossenschaften steht der Dichter, dessen Leben dem älteren, dessen Werk dem jüngeren Geschlecht zugehört. Das ist *Georg Schmückle*, 1880 bis 1948, aus *Der* Eßlingen, dessen geistiges Wirken aus der Lage entsprang, die der Krieg am *Bund* Oberrhein geschaffen hatte. Zusammen mit Hans Heinrich Ehrler und Hermann Missenharter gründete er die Monatsschrift „Der Schwäbische Bund", deren erstes Heft im Oktober 1919 ausging. Sie nannte sich vom dritten Jahrgang an „Oberdeutschland". Nach dem Vermögen der Zeit bebildert und von Beiträgen aus dem gesammelten alamannischen Raum getragen, diente sie vor allem der Dichtung. Georg Schmückle hatte das Schwabenalter erreicht, als er mit seinen Dichtungen hervortrat. Sie waren mit den Jungen jung und ihnen an Reife des Lebens überlegen. Es wurde ein gleichmäßig ausgewogenes Lebenswerk aller Dichtungsgattungen, einheitlich im Stil und rein in seiner Sprachkunst. Vier lyrische Bände, „Lichter überm Weg" 1921, „Die Muschel des großen Pan" 1923, „Die schaffende Freud" 1925, „An der goldenen Schnur" 1935, enthalten Verse, die älter sind als die Bücher. Übermütige Naturlaune und helle Lebensfreude drängen sich zu kleinen Gebilden von wenig Worten zusammen. Der Stil schwingt volksliedhaft und balladisch zwischen Rokoko und Antike. Die Schwabenweisheit der Denksprüche, boshaft und heiter, ratsam und gütig, ist der Ertrag eines Lebens, das geradeaus geführt worden ist. Die Mitte dieses Werks bildet das Erzählbare, *Schmückles* Roman, Novelle, Legende. Der Roman „Engel Hiltensperger" 1929, ein *Erzählungen* Rundgemälde des frühen sechzehnten Jahrhunderts, macht den Rechtskampf *und Spiele* eines Allgäuer Dorfes zu einem Kampf ums Reich. Die erzählten Szenen des Buches fließen in einem kräftigen, satten, schlichten Gemeindeutsch episch breit und getragen daher. Die gesprochenen Szenen reden ein altertümliches Schwäbisch. „Die rote Maske" 1933 vereinigt hinreißend erzählte Kurzgeschichten. „Das Wunder des heiligen Remaklus" 1939 ist die ausgelassen ernste Legende jener Stunde, da Heinrich IV. wahrhaft der König war. Die drei Tragödien, eines in Vorwurf und Gedanken „Karl IX. von Frankreich" 1932, „Mariza Messlay" 1933, „Engel Hiltensperger" 1936, empfangen ihr

Licht vom Schlußwort der Remakluslegende. Alle drei, das tragische Satyr-
spiel Karl IX., das barockhafte Volksstück Wallenstein, die hohe Tragödie
Hiltensperger spielen in der Historie Gegenwart. Ihnen folgen die beiden
heitern Nachspiele „Das Wunder" 1935 und „Hyanzinth Bißwurm" 1936,
jenes von Eulenspiegel und der heiligen Cäcilia, diese vom Schwaben, der
das Leberlein gefressen. Es sind Gebilde einer anmutigen Laune in bestrik-
kenden Szenen und Versen. Die Zeit war auch in Schwaben voller Gegen-
Bruno Frank sätze. *Bruno Frank*, 1887 bis 1945, aus Stuttgart ließ sein Herz lyrisch mit
Mörike schlagen. Den Erfolg seiner Dramen „Zwölftausend" 1927, „Sturm
im Wasserglas" 1930, „Die verbotene Stadt" 1954 war dann der der Linken.
Für den Roman „Die Tochter" 1943 und die verfolgten Juden, diesmal in
Polen, stand das Schicksal seiner Frau Modell. *Georg Schwarz*, 1902, aus
Nürtingen atmet in vollen Zügen alamannische Heimat und vorab seine lyri-
schen Verse — „Froher Gast am Tisch der Welt" 1940, „Die Liebesranke"
1956 — ergießen sich sinnenfreudig in fast barocker Stilart. Sein Zeitroman
„Makarius" 1949 gibt der deutschen Tragödie den menschlichen Anteil, der
ihr zusteht.

Der Bodensee Der Bodensee wurde von Einheimischen und Fremden umwohnt. Die
beiden Alamannen zeigen nur die zwei verschiedenen Haltungen der einen
Seele. *Emanuel von Bodman*, 1874, aus Friedrichshafen, war auf das hohe
Stildrama gerichtet. Seine Novellen durchlaufen eine schön gerundete Bahn
von den übermütigen Kleinstadtgeschichten „Jakob Schläpfle" 1901 bis zu
der Sammlung „Das hohe Seil" 1924 mit ihren gutgelaunten Berichten von
wunderlichen Lebensläufen. Der Ton seiner lyrischen Verse ist gedämpft,
ihre Haltung männlich, ihr Ausdruck gemessen. *Alexander von Bernus*, 1880,
aus Lindau, lebte wie Bodman nach Soldatenjahren völlig seinem geistigen
Menschen. Für die Schwabinger Schattenspiele schuf er deren sieben, körper-
lose Gebilde, nichts als Seele und Geist. Sie schweben traumhaft unwirklich,
zierlich heiter, ein Hauch aus dem Unendlichen an Aug und Ohr vorbei. Das
ist der Stil, der auch in seine größern Dramen hineinwirkt. Das Mysterium
„Der Tod des Jason" 1912 läßt den Gewinner des Goldvlieses aus den far-
bigen Flammen seines morschen Argoschiffes, ein Gesang, zu den Sternen
aufschweben. Das Spiel mit dem Feuer der Johannisnacht, „Guingamor"
1916, verlöscht die ungetreue Königin und den getreuen Königsritter in die
unheimliche Schattennacht des Val sans retour. Das Schauspiel „Der getreue
Val sans retour Eckart" 1916 verwandelt die Sage in ein Marionettenspiel und gipfelt in
einer phantastischen Spukszene des Venusbergs. Das Traumland der deut-
schen Romantik, ihr Seelenwort und ihre verhauchenden Gestalten haben sich

in diese Spielen wieder aufgetan. Der Dichter hatte unterdessen Rudolf Steiner kennengelernt. Die dichterische Aussage seiner neuen Weltanschauung ist das lyrische Gedicht. „Gold um Mitternacht" 1948 stellt neben die älteren *„Gold um Mitternacht"* Verse mit ihrer dämonisch bedrängenden Natur diese jüngeren des Rosenkreuzers und Alchimisten. „Der Garten der Liebe" 1947 und „Traumfahrt im Zwielicht" 1952 fassen die Umdichtungen zusammen. Die Novellen des Dichters spielen auf dem Grenzrain von oben und unten. Alexander von Bernus ist die schwäbische Wiederkehr der Retortenträume des Paracelsus und der Rosenkreuzergelüste des Andreae. Schiller und Hölderlin sind ihm nicht minder gegenwärtig. Es ist die alte deutsche Theosophie, die in seinem Leben mit Hilfe der Anthroposophie wieder aufgebrochen ist. Diese Neigungen mögen Bernus zu verwandten Seelen der englischen Dichtung geführt haben. Zu diesen Eingeborenen führte das Schicksal drei Deutsche aus den drei *Drei Ansiedler* deutschen Weltgegenden an den See. Ludwigshafen wurde es für den Hessen *Wilhelm Schäfer,* der sein Lebenswerk mit Novellen um die Altersliebe schalkhaften Herzens abrundete und in „Die dreizehn Büchr der deutschen Seele" zusammenfaßte. Wangen wurde es für den Niedersachsen *Ernst Bacmeister,* der auf dem Wege zu einem Drama strengen Stils war. Und Schloß Seeheim bei Konstanz wurde es für den Ostdeutschen, der hier seiner zweifachen Seele nachlebte. Das ist *Wilhelm von Scholz,* 1874, aus Berlin, durch *Wilhelm von Scholz* den Vater wie durch die Mutter schlesischen Stammes. Er hat sich die Heimat seiner Wahl erwandert. Er hat ihre Seele erfühlt durch Versenkung in die oderdeutsche Mystik und durch Nachgestaltung des alamannischen Minnesangs. Sein Geleiter war der holde Mund der göttlichen Weisheit, Bruder Heinrich Seuse von Überlingen. Scholzens Auslese „Der See. Ein Jahrtausend deutscher Dichtung" 1915 gibt Kunde vom Besitz der alamannischen Wahlheimat. Die acht lyrischen Bücher von „Frülingsfahrt" 1896 bis „Lebensjahre" 1939 atmen auf der Schwelle traumhaften Wachseins zwischen den hellen Mächten des Tages und den dunklen Botschaften aus den Nächten. Zwielicht heißt hier auch das Drama. Bei Scholz ist es schlesischen Ursprungs, *Doppelleben auf der Bühne* kommt von der Romantik und schreitet durch die Wunderwelt der Dämmerseele. So machen „Vertauschte Seelen" 1910 aus dem indischen Karma eine heitere Komödie. So begibt sich „Gefährliche Liebe" 1913 in Eichendorffs gefälligem Rokoko. So spielt „Das Herzwunder" 1918 eine mittelalterliche Legende. „Der Wettlauf mit dem Schatten" 1922 stellt dem Dichter die Gestalt, die er eben schaffen will, als Nebenbuhler gegenüber. „Die gläserne Frau" 1924 gilt dem Vorwurf des mystischen Doppellebens. Die drei Spiele Don Pedro Calderons, die Scholz in den dreißiger Jahren so anmutig für die

deutsche Bühne neu gestaltete, waren zugleich ein Dank an den Meister aller
Die Heilige romantischen Spielkunst. Die offene Szene versagt sich nun keineswegs einer
und die Hexe Kunst, die das Reich der Mütter beschwört. Doch die Freiheit des Erzählers
ist ihr gefügiger. Zahlreiche Kurzgeschichten aus dem Reich unterhalb der
Tagseele hat der Dichter zu den beiden Bänden „Erzählungen" 1924 und
„Die Gefährten" 1937 gesammelt. Das Wunderbare ist eine Tatsache, die
nicht bestritten und nicht erklärt, sondern schweigend hingenommen werden
muß. Und nun rollte der Dichter in großen Romanen die Hinterwelt der
Dinge auf. „Perpetua" 1926 geschieht in der Augsburger Umwelt der Re-
naissance. Dieselben dunklen Seelenkräfte machen von nicht unterscheid-
baren Zwillingsschwestern die eine zur Heiligen, die andere zur Hexe. Wehe
dem Menschen, der da, wo zwei Gestalten eine Person sind, zum Richter
gesetzt ist. Die beiden andern Romane „Weg nach Ilok" 1930 und „Unrecht
der Liebe" 1931 gehen ähnlichen Fragen nach. Ist nicht das Walten des Ge-
heimnisvollen gleichermaßen in allen fünf Dichtern zu spüren, die dieser See
an seinen Ufern zusammengelockt hat?

Vorarlberg Vorarlberg liegt am Bodensee und nachweisbar am Oberrhein. Hier ist aus
dem Unterwuchs alamannischer Verse endlich das Bauerntum ausgeschlagen.
Franz Michael Felder, 1839 bis 1869, aus Schoppernau, selber ein Bauer, hat
sein kurzes Leben aufgebraucht, um aus sich einen wissenden Menschen und
einen wahrhaften Dichter zu schaffen Er stand sich selber Modell in seinen
Romanen und machte sein Werk menschlich vollkommen durch die ergreifend
wahre Geschichte „Aus meinem Leben". Die breiten Übergänge vom neun-
zehnten ins zwanzigste Jahrhundert bestreitet eine bunte Bildungsliteratur:
die österreichischen Gesellschaftsromane des Bregenzers Karl von Bayer; die
Kalendergeschichten des Bludenzers Josef Wichner; die akademischen Dra-
men des Bregenzers Alfred Ebenhoch; die geschichtlichen Heimatromane
Albert Ritters aus Weiler. Felders Enkel, *Franz Michel Willam*, 1894, aus
Schoppernau, hat mit Kalendergeschichten begonnen und sich dann an grö-
ßeren Aufgaben erprobt. So führen „Die sieben Könige" 1926 in die Vorzeit
des Landes und so liefert „Der Mann mit dem Lächeln" 1928 in einer Schutz-
hütte des rhätischen Hochgebirges drei Verbrecher einem tragischen Schicksal
aus. *Albert Welte*, 1902, aus Frastanz, erzählt — „Das dunkle Erbe" 1933 —
lyrisch und märchenhaft die Geschichte eines jungen bäuerlichen Einzelgän-
gers. „Die große Flucht" 1939 meint den Zug der Walser, Alamannen aus
dem Rhônetal, die sich 1313 zu den Alamannen vor dem Arlberg retten. Den
lyrischen Ton halten die eingebürgerte Frau und der bodenständige Mann.
Die Flöte *Paula Ludwig*, 1900, aus Altenstadt, doch von schlesischer Herkunft, war als

Malerin, Schauspielerin, Dichterin den drei nächstverwandten Künsten ergeben. „Ich kann nur die Flöte spielen / und nur fünf Töne." Doch diese scheinbar kunstlosen Töne besänftigen, besprechen, bezaubern. Sie locken wie die lyrische Prosa des Büchleins „Traumlandschaft" 1934 ferne Dinge heran und neue aus der Nähe. Es ist eine Seele, die in dem Wunschlande zwischen Hölderlin und Mörike lebt. *Armin Diem,* 1903, aus Dornbirn, Holzarbeiter und Forstmann, faßt in dem vielfältig bebilderten „Dornbirner *Der Schwank* Heimatbuch" 1932 ein preisliches mundartliches Werk zusammmen, Spiele, Schwänke und die balladenhafte geschichtliche Erzählung „Schanaro Hannos". Das war vor Zeiten auf dem Dornbirner Hoch-Knopf ein bußfertiger Einsiedler. Das ganze Volkstum des Stadtländchens lebt urtümlich in den Versen, die an Mutterwitz Peter Hebels und an Sprachkunst Hermann Strübes würdig sind. Zählt man noch die Abgewanderten mit, so ist es *Gertrud Fußenegger,* 1912, aus Pilsen, in Tirol seßhaft, von einer Dornbirner Familie. Ihre „Mohrenlegende" 1937 versöhnt die Rachegelüste eines verlassenen Mohrenknaben am Anblick des schwarzen Königs, der in einem Dreikönigs- *Die Legende* spiel gleichgeehrt neben seinen beiden andersfarbigen Gefährten einherzieht. Der ernsten Anmut dieser Kindergeschichte aus den Kreuzzügen steht die düstere Schönheit einer starken Frau, „Geschlecht im Advent" 1937 gegenüber. Es ist die herrenlose Zeit zwischen den letzten fränkischen und den ersten sächsischen Kaisern. Eine todgeweihte Welt vernichtet sich selber und ein edleres Menschentum kommt herauf. Die mächtigen epischen Schöpfungen der Dichterin kehren in das Land ihrer Geburt, das war Pilsen, und also nach Böhmen zurück. Das waren die ungleichen „Brüder von Lasawa" 1948 und das Land, in dem der Dreißigjährige Krieg ausbrach und erlosch. Das war „Das Haus der dunklen Krüge" 1951, Pilsen selber, der Verfall eines Geschlechtes von Brauherren. Das war „Das verschüttete Antlitz" 1957, das Böhmen des greuelvollen Unterganges einer tausendjährigen Kultur und seines schöpferischen Volkes.

DIE OSTLANDE stimmen sich von neuem auf die Lebensgemeinschaft *Dionysos* mit dem hellenischen Süden. Dionysos und Demeter schreiten beinahe mit *und Demeter* wacher Wirklichkeit über die Fluren zwischen Weichsel und Memel. Das kosmische Gesetz der Zahl, seine heilige Ordnung wird wieder erkannt und anerkannt. Die Seele wird hellhörig für den geheimnisvollen Einklang zwischen den Bahnen der Gestirne, den Furchen des Ackers, den Begebenheiten des Herzens. Die gesamte Dichtung des Ostens nimmt eine kosmische Haltung an, mag das nun Bachofen, Klages, Pannwitz oder noch unmittelbar Nietzsche heißen. Dieser Geist ist wohl am stärksten in Meißen und Preußen.

Schlesien hat keine andere Gesinnung, aber seine eigenen Mysterien seit alters. Der Gott des Ostens ist Dionysos.

Meißen Meißen war unter den drei geschichtlich verschwisterten Ostlandschaften am lebhaftesten mit der Revolution der Literatur beschäftigt. Das machte Leipzig. Hier sammelte Kurt Pinthus von Erfurt die Leute um sich, die zwischen Berlin, München und Leipzig beständig unterwegs waren. Und Karl Sternheim, 1878, war von Leipzig, wenn auch selten daheim. Das war der Mann von Komödien, die er später Lustspiele nannte, aber gleichviel auch von Erzählungen. Sie verfuhren mit dem Bürgertum sehr streng. Und beinahe ebenso grausam mit der deutschen Sprache.

Die anmutig herbe Vielgestalt der Landschaft, die kostbare Stadt fürstlicher Bauherren und bürgerlicher Gesittung wirkten ungetrübt in der Seele einer reiferen Generation. Lyrisch und hymnisch ist die meißnische Dichtung des Zeitalters, gleichviel nach welchen Formen es sie sonst noch gelüsten mag. *Baldur und Dionysos* **Kurt Geucke**, 1864 aus Meerane, hat sich dem alten Zauber der Dresdner Kunst mit Willen hingegeben. Auf der Suche nach einem dramatischen Stil und im Gedenken an Baldur, der Dionysos verwandt sei, hat er um das mythische Weihespiel gerungen. Seine Gedichte, „Scholle und Stern" 1924 sind das beste. Geuckes gottfrommes Weltgefühl ergeht sich in den künstlich verschlungenen Gedankenspuren der Worte, die zwischen Endreim und Binnenreim gleiten. Wie bei Nietzsche erzeugt das Wort und seine klanglichen Verbindungen die sinnvolle Kette der Gedanken. *Friedrich Kurt Benn*-*Wortgemälde und Sprachmusik* *dorf*, 1871, aus Chemnitz, hat von seinen Versen gemeint, sie seien in der Hauptsache ein Landschaftswerk: „wurzelnd in der Erzgebirgs- und Elbe-Natur. Sich darstellend sprachmalerisch und sprachmusikalisch als persönlich magische Durchdringung der Wirklichkeit". Sein Liedbuch faßt die „Kreise" 1900/1922 und „Die Jahreszeiten" 1930 zusammen. Die Darstellung fängt den Zauber der Landschaft musikalisch-stimmungshaft mit der gleichen Sicherheit ein, wie sie wachen Auges die wirkliche Dorfwelt in malerisch-plastische Bilder bannt. Eichendorffs Taugenichts hat sich durch dies Liederbuch in das mystisch-dionysische Abenteuer einer Musikantenseele verwandelt. *Joachim Ringelnatz* *Hans Bötticher*, 1883 bis 1934, Matrose und Schausteller, seit der Frühreife seines sechsten Lebensjahres Maler und Dichter, Schauspieler und Vortragskünstler, hat in all diesen Berufen, die ihm keine waren, die Rolle Joachim Ringelnatz' gespielt. Seit seinem ersten Buch „Gedichte" 1910 hat *„Denn es macht traurig, unbequem zu sein"* Hans Bötticher seine Verse zu immer neuen Sammlungen aufgeboten. Er hat sein Leben in den Büchern „Als Mariner im Weltkrieg" 1928 sowie „Mein Leben bis zum Kriege" 1931 geschildert. Vielleicht steckt die schönste Echt-

heit dieses Geistes in dem „Kinderverwirrbuch" 1931 und in seinen Gedan- „Humorgemüt ins Große" kenspielen. Hans Böttichers Kunst ist das Lied. Seine Gedankenverbindungen sind kindhafte Einfälle des Bastelsinnes, seine Verse nicht Groteske, sondern „Humorgemüt ins Große". Ihre Grundstimmung ist elegisch. „Denn es macht traurig, unbequem zu sein." Selbst die übermütigsten dieser Gedichte wiegen sich über dem Tiefsinn des Weltabgrundes. Spielerische Einfälle mögen das Lächeln locken, wie etwa der Wunsch des Dichters, dereinst in einer Gasse spuken zu dürfen, die nach ihm selber benannt ist. Es steckt in ihnen mehr, als der Kabarettbesucher mit seiner Karte bezahlen konnte. Joachim Ringelnatz hat nur die tragische Posse geheißen, in der das ausgeartete Ingenium einer begabten Bürgerfamilie die Tragödie der deutschen Seele einem Zeitalter vorspielte, das nicht wußte, worüber es lachte. Der Mensch Hans Bötticher hinter dieser Maske hat das menschlichste Leben, das sich denken läßt, Sehnsucht, Leid, Liebe mit der Sprache eines kindhaften Herzens ausgesagt. Das ist er wirklich, ganz und ohne Falte: „Ich bin zum Glück nicht sehr gesund / Und — Gott sei Dank — / Auch nicht sehr krank." *Max Barthel*, 1893, *Der Arbeiter* aus Loschwitz, der Sohn eines Maurers, ist durch vielerlei Fabriken und über nicht wenige Landstraßen Europas gegangen. Er hat in den Argonnen, bei Verdun, am Hartmannsweilerkopf gefochten und das Rußland der Sowjet bis nach Sibirien bereist. Die Bücher seiner Gedichte spannen von „Verse aus den Argonnen" 1916 bis zu „Argonnerwald" 1938 einen weiten Bogen. Dieser Dichter der Arbeit und der Arbeiter kam aus der Schule der großen deutschen Lyrik, die Goethe und Volkslied heißt. Man spürt sie an Wort und Vers. Was Barthel bewegt und ihm das Auge mit Bildern füllt, ist nicht die Maschine und die Maschinenkameradschaft des Arbeiters. Er macht sich zum Sprecher des menschlichen Herzens und seiner unabdinglichen Rechte. Man kann sich seine Sprache und seine Vorstellungen, wenn sie Freiheit und Zwang, Arbeitsmuß und Aufschwung des Herzens meinen, sehr leicht in Gefühlsweise und Ausdruck des jungen Goethe zurückübersetzen. Max Barthel, *Der klassenlose Dichter* der Arbeiter, der Soldat, der Wanderer, ist der klassenlose Dichter, der zufällig aus dem Arbeiterstande kommt, wie andere von bäuerlicher oder adeliger Herkunft sind. Die mystische Stimme der Landschaft ist Friedrich Nietzsche. Sie setzt in den Versen Geuckes und Benndorfs kraftvoll ein. *Kurt Liebmann*, 1897, aus Dessau, von Johann Jakob Bachofen und Rudolf Pannwitz angeregt, hat in seiner Schrift „Dionysos-Apollo" 1927 diese Nietzsche- *Der dritte Dionysos* bewegung zu deuten versucht und ihr ein Zukunftsziel gewiesen: „Der dritte Dionysos"; die kosmische Vereinigung von Apollo und Dionysos, „Das Mensch-Paar". Liebmanns „dramatische Vision" „Kleist" 1932 zeigt in hym-

nischen Szenen, in gleichnishaften Vorgängen und Gestalten Kleists Leben
und Ringen um den kosmischen Menschen des dritten Dionysos. Sein Opfer-
tod besiegt und erlöst den Dämon in der Seele des deutschen Volkes und
macht ihn zum Diener Apolls.

Unter diesem kosmischen Himmel mit seiner lyrischen Witterung liegt die
sehr kräftige Wirklichkeit der Meißner Landschaft. *Kurt Arnold Findeisen,*
1883, aus Zwickau an der Mulde, hat die Legende der Musiklandschaft Mei-
ßen geschaffen. Wie Wackenroder seinen Kapellmeister Berglinger und Hoff-
mann seinen Kreisler, so hat sich Findeisen seinen Wendelin Dudelsack be-
stallt, durch die Blume seines musikalischen Balladenbuchs „Dudelsack" 1929
zu sagen, was er persönlich nicht sagen wollte. Die Hochtonstellen des Buches
bilden jene Wortgemälde, in denen die Gestalt oder die Musik großer deut-
scher Tonkünstler dargestellt ist. Solcher Nachdichtung der Musik in Worten
ist Findeisen Meister. Er hat in reizenden Kurzgeschichten die Legende be-
rühmter deutscher Lieder nacherzählt, viele Novellen dem Reich und dem
Gerät der Frau Musika gewidmet, Leben und Werk deutscher Tonschöpfer
in geräumige Romane gefaßt. Das war aus Tönen die Seele der meißnischen
Heimat, in deren Volk soviel vom musikbeschwingten Wesen der Thüringer
steckt. Die Landschaft selber ist in Findeisens Versbüchern beschworen, ihre
Romantik in dem alten erzgebirgischen Raubschützen Karl Stülpner, dessen
Leben der Roman „Der Sohn der Wälder" 1922/1934 erzählt. *Kurt Kluge,*
1886 bis 1940, aus Leipzig, entstammte dem Mansfelder Seekreis und hatte
Waffenschmiede des Klosters Mansfeld zu Vorfahren. Sein Vater war Musi-
kant und wurde Lehrer. Die Waffenschmiede und der Musikant sind für den
Dichter bedeutsam geworden. Denn er war Bildhauer und Erzgießer, ehe er
Bücher schrieb, und als er diese Bücher schrieb, da galten sie der Werkstatt
und der Freude am tönenden Kunstwerk. Kluges Erzählungen sind erfüllt
vom Erlebnis seiner Südlandreisen und Bildwerke. Die Komödie „Ausgra-
bung der Venus" 1933, das Novellenbuch „Der Nonnenstein" 1936, die Er-
zählung „Die gefälschte Göttin" 1935, alle bewegen sich heiter in einer Luft,
die aus heimatlichem Behagen, genossener Ferne und musischer Beschaulich-
keit gemischt ist. Sie alle sind Studien zu dem großen Werk, „Der Herr Kor-
tüm" 1938, eine humoristische Dichtung, die deutschen Pickwickier. Friedrich
Joachim Kortüm aus Hamburg setzt hinter seine Weltreise den Schlußpunkt,
indem er auf den Höhen des Thüringer Waldes ein Berggasthaus aufbaut,
dem Kleinbürgervolk der Nachbarschaft zum Leid und zum Nutzen, um diese
Gaststätte ein ganzes Bergmärchen von Museen und Maskenfesten, von
Schauspielen und Lichtspielen, von Malerei und Musik hervorzaubert und so

*Wendelin
Dudelsack*

*Bildhauer
und Dichter*

mit Kochen und Weinschenken, mit Reden und Schweigen das Unvergäng-
liche bodenständig macht. Herr Kortüm ist das dichterische Abbild des
ewigen Deutschen, der sich in seiner Welt und nur anderen zum Genuß, ein
unermüdlicher Planer, mit dem „Es werde!" plagt. *Johannes Linke*, 1900,
aus Dresden, hat sich als Schreiber, Fabrikarbeiter, Bauernhelfer durchge-
kämpft, ist Schullehrer geworden und hat im Bairischen Wald seine Wahl-
heimat gefunden. Der Wald und der Urgrund seines Lebens, das Wasser,
sind Linkes große Liebe. „Ein Jahr rollt übers Gebirge" 1934 ist das Tage-
buch eines Dorfes zwischen Herbst und Herbst. „Lohwasser" 1935 ist die
Geschichte von dem Waldhof, der auf der Suche nach Wasser Gold ergräbt,
das Wasser verschmäht um des Goldes willen und erst von äußerster Not
getrieben den Brunnen wieder frei legt. Der Wald ist der Held zumal in
Linkes hochgestimmten lyrischen Gedichten. Wenn „Das festliche Jahr" 1928 *„Das festliche Jahr"*
in gemessener Führung der Rhythmen das Leben des Dorfes feiert, so wen-
det sich das Buch „Der Baum" 1934 dem gewachsenen Leben zu, dessen
Blüte der Mensch ist, und preist mit dem Walde das gemeinsame Sinnbild
für alles, was aus dem Mutterschoß der Erde geboren ist.

Das Drama der Meißner wird von drei Feldsoldaten dem kommenden Um-
schwung zugelenkt. *Wolfgang Goetz*, 1885, aus Leipzig, hat den deutschen
und den irischen Freiheitskämpfer „Neidhart von Gneisenau" 1925 und
„Robert Emmet" 1927 auf die Szene beschworen. Der Generalstäbler *Hans
Gobsch*, 1883, aus Chemnitz, macht den persönlichen Menschen wieder zum *Meißner Drama*
dramatischen Träger der Idee und fast im Sinne Hebbels zu einem Gleichnis
der metaphysischen Wirklichkeit. Seine großen Tragödien „Der Zar" 1927
— Nikolaus II. — „Der andere Feldherr" 1935 — Samsonow in der Tannen-
bergschlacht — sind „auf den intimen Ton des Kammerspiels" gestimmt.
Hans Johst, 1890, aus Seerhausen bei Dresden, gab mit der ekstatischen
Szene „Der junge Mensch" 1916 ein Bild der Vorkriegsjugend, folgte mit
„Stroh" 1915, „Wechsler und Händler" 1923 dem wirtschaftlichen Verfall
der Zeit, stellte mit Grabbe — „Der Einsame" 1917 — den Dichter, mit
Luther — „Propheten" 1922 — den Gottesmann auf die Bühne und hielt in
politischen Dramen Schritt mit dem Gang der Zeit.

Ostpreußen allein hatte den Krieg gesehen. Es war geistig so sicher im *Ostpreußen*
fernen Paradies seiner Einsamkeit, daß die Versuchungen der großen west-
lichen Städte an die Landschaft gar nicht heranreichten. In Königsberg gab
es weder eine Aktion noch einen Sturm. Die Zeiten gingen friedlich inein-
ander über. Der Anteil der schaffenden Frauen stieg von Jahrzehnt zu Jahr-
zehnt: Johanna Wolff, Frieda Jung, Gertrud Prellwitz, Katharina Botsky,

Margarete von Olfers. Die Brüder Fritz und Richard Skowronnek bedienten das Land mit ihren sehr sachverständigen Jagdgeschichten und Gutsromanen. Der Westpreuße Paul Fechter, 1880 bis 1958 aus Elbing, und der Ostpreuße Walter Harich, 1888 bis 1931, aus Mohrungen, Zeitungsleute von Rang, führten die Sache ihrer Heimat in der Presse und zeigten von immer neuen Seiten ihr Bild in den Romanen, zu denen sie selber gerne Modell standen.

Helios oder Orion

Die Dichtung beider preußischen Landschaften entfaltet sich zu einem fast erhabenen Ebenmaß. Sie leuchtet durch die geschliffene Kante des Ewigen in allen Farben, die das menschliche Auge zu sehen vermag, vom strahlenden Gold des Tages bis zum mystischen Violett der Nacht.

Tassilo von Scheffer

Das fromme hellenisch-deutsche Helldunkel geht aus den Werken der beiden westpreußischen Namensvettern hervor. *Tassilo von Scheffer,* 1873, aus Preußisch-Stargard, hatte sich früh in die religiösen Geheimnisse der altgriechischen Kultbünde vertieft, in den Dienst der Ackergöttin Demeter und des schwärmenden Freudengottes Dionysos. Scheffer hat mit unsäglicher Arbeit des Ägypters Nonnos Werk übersetzt, das den abenteuerlichen Zug des Dionysos nach Indien erzählt. Homers Weisheit und Schönheit, die Gedichte „Ilias" und „Odyssee", die urtümlichen Götterhymnen Homers, hat Scheffer aufs neue den Deutschen verdeutscht. Und einer Zeit, die den Pflug wieder als ein heiliges Werkzeug erkannte, hat Scheffer Bauernlehre und Bauernkalender des altgriechischen Dichters Hesiodos geschenkt. Die Göttersagen der Römer 1926 und der Germanen 1931 hat der Dichter ohne Unterschied des Herzens neu erzählt. Das einzige Buch mit der stolzen Aufschrift

In allen Spiegeln Gottes

„Die Gedichte" 1939 birgt den Ertrag dieses deutsch-hellenischen Lebens. Der Tag in diesem Buch ist ein hellenischer Tag, den Göttern ein Zeitvertreib und dem Mann ein heroisches Fest. Auf goldenen Klang gestimmte Hymnen feiern die Götter und Helden und die Gestirne am Himmel, Helios oder Orion, gleichviel, Licht ist Licht. Das Mysterium gebietet: Suche nicht, was dir verschlossen, und bewahre, was du weißt. Ganz ferne steht ein schöner dunkler Bote, der Tod. Und nur die eine Frage bewegt das hellenische Herz: geht dein Weg in die Sonne oder in die Nacht? Die Nacht in diesem Buch ist eine deutsche Nacht. Sie schweigt des Wunders voll. Sie redet von Gott. Da ist der Wanderer Eichendorffs zu Hause, dessen Seele unterwegs ist von der einen Heimat in die andere. Da gilt die letzte Weisheit: „Suche, Seele, dein Bild / In allen Spiegeln Gottes; / Sucht doch Gott seinen Geist / Ruhend nur in dir". Es sind dieselben Saiten, aus denen die hellenischen Götterhymnen und die Lieder einer preußischen Dorfjugend aufklingen. Dies Buch — ein

Albrecht Schaeffer

Leben und ganz Romantik. *Albrecht Schaeffer,* 1885 bis 1950, aus Elbing, er-

scheint mit seinen frühen Gedichten „Attische Dämmerung" 1914 nahe bei Friedrich Hölderlin und fernab von Stefan George. Immer einen Schritt hinter Scheffer hat Schaeffer seine „Odyssee" 1927 in reimlose Trochäen, seine „Ilias" 1929 in den Urvers übersetzt und auch die griechischen Heldensagen 1929 neu erzählt. „Der goldene Esel", der Prosaroman des afrikanischen Dichters Apulejus, deutsch, ist Schaeffers Eigentum. Unter seinen Händen werden aus dem althellenischen Schiffer und Heimkehrer deutsche Gottsucher in kleinen Epen: „Der göttliche Dulder" 1920, das kunstvoll gereimte Lied des Heimwehs! „Helianth" 1920 und „Gevatter Tod" 1921, deutsche Gegenwart; „Parzival" 1922, das Gedicht von der Sucherin Seele, die erst nach hundert Verwandlungen die letzte erfährt und darnach keine mehr, den Gral, der aus ihrer eigenen Mitte aufstrahlt. Schaeffers Romane behandeln Vorwürfe, die in irgendeiner Gestalt der Zeitliteratur geläufig waren, so „Cara" 1936, das Buch von der Erlösung eines bäuerlichen Heimkehrers durch eine mütterliche Frau. Abbild dieses schöpferischen Geistes und Bewährung in allen Künsten bedeuten die Novellen. In sorgfältig abgestimmten Bänden gesammelt, „Das Prisma" 1924, „Der goldene Wagen" 1927, „Mitternacht" 1928, „Das Opfertier" sowie „Knechte und Mägde" 1931, sind sie alle Bücher eines hohen und sehr persönlichen Eigenstils. Geisterhafte Vorgänge, Dämonenzauber, teuflische Berückungen werden mit einer Sicherheit des Worts vorgetragen, die Magie ist. In den Gedichten wird aus attischer Dämmerung eine geheimnisvolle deutsche Nacht. Reimlose Oden werden zu kunstvollen Reimgedichten. Kristallene Bilder verdunkeln zu Begriffswörtern. Sinnerfüllte Gestalten lösen sich in Musik und Tanz der Worte auf. Der Gedanke des Entwerdens und der Wiedergeburt gewinnt die Oberhand und vermählt sich mit Urworten der deutschen Mystik. „Die Toten kehren wieder in wundervolle Glieder, / Sie funkeln von Gewesen und von Vergessenheit." Das Licht des Lichts in dem hohen Bekenntnisgedicht „Magnifikat" ist ein übernatürlicher Glanz, der sich verkündet: „Ich bin der Weg, die Wahrheit und das Leben." Das ist der Schlüssel. „Aphaia" 1937 ist ein Büchlein, in dem Platon auf sokratische Weise mit zweien seiner Schüler das heilige Gesetz der Zahl erörtert, wie es durch den Tempel auf Ägina baumeisterlich sichtbar geblieben ist. Dieses Buch der Gespräche vom Weg der Götter, Völker, Zahlen beweist, daß hellenischer Mittag und deutsche Nacht auch in der Dichtung dieses Mannes eins sind. Scheffer und Schaeffer gemeinsam ist jenes Gott-Welt-Gefühl, wie es einst der Romantik aus Plotin und Eckart in die Seele gedrungen war.

Urtümliche Frömmigkeit, wie aus der geschichtlichen Tiefe des Landes aufgestiegen, atmen irdisch triebhaft und heidnisch dunkel die Dichtungen

„Die Toten kehren wieder in wundervolle Glieder"

„Aphaia"

der beiden Ostpreußen. Die Urzeit dieses Landes selber, ihr Leib und ihre Seele, der unwiderruflich Letzte ist *Alfred Brust*, 1891 bis 1934, von Inster-burg, gewesen, der Einsiedler von Cranz im Samlande. Brust hat an sein pruzzisches Blut geglaubt. Nach Versuchen, die zwischen reiner Wechselrede und geballtem Drama schwangen, nahm er mit „Cordatus" 1927, einem apokalyptischen Mysterium, von der Bühne Abschied. Geweissagt wird jene nahe Zeit, da alle noch unerlösten Erdenseelen einen irdischen Körper finden werden und die wiedergeborene Seele eines Toten, ein letzter Heiland, lebt der Menschheit den großen Willen zu dieser Erlösung vor. Solche Dinge ließen sich nur im Roman glaubhaft machen. Brusts Romane spielen in dem geheimnisdunkeln Raume von Königsberg bis Wilna, unter den Rassen und Religionen, die hier durcheinander geschichtet sind, vom Herrensitz bis ins Ghetto. „Die verlorene Erde" 1926 verstrickt zwei Menschenpaare und deren Kinder in ein Netz grausiger Gewalttaten und asketischer Entsühnungen. Doch die Erde mag sausen, wohin sie will. Der Herr sammelt die, so ihn erkennen. „Jutt und Jula" 1928 führt ein auserwähltes Menschenpaar in einem paradiesischen Heilkräutergarten zu einer reinen Ehe zusammen. „Festliche Ehe" 1930, romantisch gerahmt, erzählt in seiner Binnengeschichte wie zwei pruzzische Menschen, ihre Ehe unter pruzzischen Riten vollziehen und geheimnisvoll aus der Wirklichkeit verschwinden. Das Versbuch „Ich bin" 1929 sagt überraschend einfach, was die Dramen und Romane meinen. „Eva ist alles, was wir wissen." Keinen Mutterschoß zu finden, ist der Ur-schmerz. Der Wille zur gesegneten Ehe heiligt die Menschheit. Die Pura naturalia sind in deutscher Dichtung noch nie so wörtlich, naturhaft und züch-tig aufgedeckt worden. Brusts Dichtungen streben nach einem Bilde der kos-mischen Alleinheit. Er glaubte fest an die wiederaufbrechende Macht des Pruzzentums, übersetzte „Prusnan" mit „Geistgesicht" und sah in den pruz-zischen Priestern die Verweser einer großen Magie. Er nannte sich einen Hei-den und bekannte sich zu einem urweltlichen Naturgottesdienst. Die preu-ßische Heimat verkörpert er mythenhaft in dem vorweltlichen Tiertum des Elchs, der zuweilen mit Kuh und Jungtier, ein Gesicht, aus dem Gehölz tritt, steht und schaut, riesenhaft lautlos, und gespenstig dahingleitend wieder zwischen den Stämmen verschwindet. *Siegfried von der Trenck*, 1882, aus Königsberg, hat mit Dantes „Divina commedia" 1921 keine Übersetzung, sondern eine Umdichtung gegeben. Das Buch „Der Stier und die Krone" 1933 erzählt die Geschichte seiner Vorfahren und seines eigenen Lebens. Die Gedichtbände „Offenbarung des Eros" 1930 und „Wiedergeburt" 1937 schreiben den Sinn an den Rand seiner Bücher. Die Form dieses Dichters ist

Alfred Brust

„Eva ist alles, was wir wissen"

Der Elch

Siegfried von der Trenck

das kleine Epos. Eine Gruppe sammelt das dreiteilige „Lebensbuch". Der erste Band „Leuchter um die Sonne" 1925 gibt die großen Gestalten aller Religionen. Der zweite Band „Flamme über die Welt" 1926 stellt an Parzival, Tristan, Merlin die dreifache Liebe dar zwischen Mensch und Gott, zwischen Mensch und Mensch, zwischen Dämon und Mensch. Der dritte Band „Stern im Blut" 1928 singt dem Gottesglauben ein vieltöniges Preislied. Die beiden gepaarten Dichtungen von 1930, „Herakles-Christus" und „Don Juan-Ahasver" machen an Gestalten von entgegengesetztem Weltgehalt die Aufhebung aller Gegensätze in dem einen Sein der Idee sichtbar. „Fortunat" 1931 verfügt über den Wunschhut der Welt und den Säckel ihrer Fülle: Reichtum und Ferne. Auch für Siegfried von der Trenck ist alles Geschlecht. Eins sind dem Manne die Mutter, die Geliebte, die Frau, und dem Weibe sind der Vater, der Gatte, der Sohn eins: Geschlecht, getrennt und doch untrennbar, eines am andern brennend. Reinheit und Frevel. „Nur Schuld macht gut." Das Land lebt mit seiner ganzen Wirklichkeit in diesen Dichtungen, die Stadt der sieben Hügel, die Nehrung und das Haff, der Elch. Noch stärker lebt die Geistigkeit des Landes in diesen Dichtungen, heiße sie nun Hamann oder Holz. So wie Alfred Brust und Siegfried von der Trenck konnten selten zwei Dichter des gleichen Landes innerlich zusammengehören.

Die Frömmigkeit aber, die mit Demeter klar und gewiß über der ackerlichen Arbeit und der täglichen Pflicht steht, bekennt sich aus dem Werk des Mannes und der Frau.

Ernst Wiechert, 1887 bis 1950, aus Kleinort bei Sensburg, eines Försters *Ernst Wiechert* Sohn, hatte zu seinen deutschen Vorfahren masurische, litauische, romanische. Eine schwermütige Landschaft war seine Heimat. Er hat uns seine Jugend in dem ergreifenden Buch „Wälder und Menschen" 1936 geschildert. Der Dichter war nicht zum Tun und Singen, sondern zum Sagen geboren. Er hat den Reichtum an Novellen zu kunstvollen Sammlungen aufgegliedert. „Der silberne Wagen" 1928 und „Die Flöte des Pan" 1930 umfassen je sieben viel- *„Die Flöte des Pan"* fältige Erzählungen. Drei Kriegsgeschichten werden zusammen „Der Todeskandidat" 1934 genannt. „Das heilige Jahr" 1936 folgt mit seinen fünf Begebenheiten dem Umfang der Kirchenfeste. Man kann in seinen frühen Romanen den innern Fortgang des Menschen verfolgen, wenn „Die Flucht" 1916 aus der Stadt vergeblich in die Heimat zurückführt, wenn „Der Totenwolf" 1924 alle Hoffnung auf ein gottgläubiges Heidentum setzt und „Die blauen Schwingen" 1925 an einem Geiger die heimliche Sehnsucht des Dichters verraten. All seine Dichtung ist Heimkehr aus dem Kriege. „Der Wald" 1922 läßt den heimkehrenden Feldsoldaten an der Zerstörung der Seelen-

heimat zugrunde gehen. Aber „Der Knecht Gottes Andreas Nyland" 1926 bekennt sich schon zur Nachfolge Christi und „Jedermann" 1931 zur Tat, die getan werden muß. Und „Das einfache Leben" 1939 führt den Kapitän Thomas von Orla durch schlichte Handarbeit aus der Wirrnis der Heimkehr zum ewigen Sinn des Daseins. Zwei Romane und eine Novelle können für die Schönheit des Ganzen einstehen. Die beiden Romane sind wie zwei einsame Bäume, die untereinander ein Geheimnis haben. „Die Magd des Jürgen Doskocil" 1932 ist das Abenteuer Gottes, das sich am gewaltigen Strom der Memel mit dem treuesten Fährmann begibt, der ein wahrer Christophorus ist. Wie das Mädchen Marte sich von dem unheiligen Gelüste des Mormonen in die erlösende Mutterschaft für den Fährmann freikämpft, das begibt sich wie ein vorzeitlicher Mythus durch Taten, Worte, Gebärden. Das ist der Gegenstand dieses Buches, in dem sich der menschlichste aller Wünsche erfüllt: „Ein Feld und ein Sohn". Der Strom, der Wald, das Moor handeln gespenstig mit. „Die Majorin" 1934 rettet sich und einen totgesagten Heimkehrer durch alle Verwirrungen des Geschlechts in den reinen Zusammenklang, der Mutter und Sohn heißt. Diese Erde gehört den Auferstandenen, die den Tod für immer von sich abgeschüttelt haben. Alle Süßigkeit und

„Hirtennovelle" Kraft dieses Werks hat die „Hirtennovelle" 1935 in sich gesogen. Der Knabe Michael hat an der Leiche seines erschlagenen Vaters das rätselhafte Wunder des Todes erlebt und stirbt den Heldentod für das Lamm des ärmsten Mannes: der gute Hirt. Der getreue Fährmann und seine Magd, die ihm um des Kindes willen dient; der hundertfach gestorbene Mann vom Schlachtfeld und seine Herrin, die all ihren Stolz zerbricht, damit er durch ihre dienende Hand zur Ehre des Ackers zurückfinde; der Knabe, dem seine arme Mutter so verständig hilft, ein Held zu werden und für eine so geringe Sache einen so großen Tod zu sterben; wie könnte das Volk zwischen Weichsel und Memel an bessern Abbildern mit seinen zuverlässigen Tugenden vor das Auge gerufen werden. Der Untergang Ostpreußens verstrickte Wiecherts Roman „Die Jerominkinder" 1945/1947 in unlösbare Widersprüche mit sich selbst und dem Land seiner Liebe.

„Das Bernsteinherz" *Agnes Miegel*, 1879, von Königsberg, stammt aus dem Herzen der Stadt, aus dem Kneiphof und aus einem Kaufmannshause. Die Heimat ihrer Mutter war Salzburg. Sie hat in so gutgelaunten Büchlein, wie „Kinderland" 1930, „Der Vater" 1933, „Die Mutter" 1934, „Unter hellem Himmel" 1936, Bericht von ihrer Jugend gegeben. Aus dieser Kindschaft stammen die vielen gleichartigen Kinderköpfe, die sie gezeichnet hat, die Mütterchen, Ammen, Köchinnen, vor allem die goldechte Krupatsche, von denen sie die kleinen

und großen Kinder behütet sein läßt. Aus dieser Allgegenwart des Kindes *Agnes Miegel*
stammt der Grundzug ihres Stiles. Das Ureinfache, Sinnliche, Mythenhafte,
das nur der Augapfel eines Kindes widerzuspiegeln vermag. Der ersten
Sammlung des frühgereiften Mädchens, „Gedichte" 1901, folgten in gemes-
senen und erharrten Abständen „Balladen und Lieder" 1907, „Gedichte und *Gedichte*
Spiele" 1920, schließlich „Gesammelte Gedichte" 1927 und „Herbstgesang" *und Spiele*
1933, voll und schwer aus dem Erlebnis jener Zeit, das der Heimat die Krone
des Erlittenen geflochten hatte. Es sind lyrische Verse einer Frau, voll Erinne-
rung, Verse, die alles durchs Ohr und die Witterung des sechsten Sinnes
empfangen. Es ist das Naturverhältnis einer Städtebewohnerin mit Eichen-
dorffs Brunnen und Gärten. Erschreckend neu ist das „Bienenbrausen" des
fernbrandenden Meeres und in der Luft das Bernsteinkronenleuchten der
alten Pruzzengötter. Und wie die Meisterschaft wächst, so werden die kunst-
vollen, kleinen, ausgehämmerten Gesätze abgelöst von raumfüllenden und
wuchtig aufgegliederten Versgebilden, die keines äußeren Maßes mehr be-
dürfen, weil sie ihrer inneren Form gewiß sind. Das Ereignis ihrer blühenden
Jahrzehnte waren ihre Balladen. „Die Nibelungen." Da ist, was geschah und
was noch geschehen wird, zusammengedrängt in die eine Szene, wie Volker
spielt, noch enger in das dämonische Flammenzittern auf Kriemhildens Hän-
den, ja in den einen grausamen Lacher der Hunnenkönigin. Diese wählerische
und sparsame Kunst hat der ostpreußischen Wortkargheit Stil gegeben. Von
den Balladen zu den Spielen ist nur ein Schritt. Denn diese Spiele, die 1923
und 1937 erschienen, sind keine lyrischen Dramen, sondern dramatische Balla-
den, von wenigen Gestalten mit äußerster Kraft heruntergespielt. „Der Gauk-
ler", „Fasching", „Abschied" bilden eine sinnvolle Dreiheit: Liebe, die im
Kuß des Todes sich erfüllt. „Ein Zwiegespräch" und „Zein Alasman" sind zu
zweien ein wundervolles Doppelspiel: das Opfer des Verzichts schenkt dem
einen wie dem andern das Liebesglück der Dauer. „Die Schlacht von Rudau"
1934 feiert den gemeinsamen Sieg des greisen Heerführers Winrich von Knip-
rode und des jungen Helden Hans Sagan. Von den Balladen zu den Erzäh-
lungen war wieder nur ein Schritt. Die Geschichten der Dichterin gehen von
kleinen Gebilden aus wie „Die schöne Malone" und „Die Maar", Prosaballa-
den, in denen das Gedächtnis an den Götterdienst der alten Pruzzen lebt.
Aus einem Kranz von Geschichten, die, wie „Dorothee" 1931 und „Katrin-
chen kommt nach Hause" 1936, in der heimatlichen Gegenwart spielen, er-
heben sich die drei Bücher Novellen, die in abgekürzter Zeichensprache Be-
richt aus zwei Jahrtausenden geben. Sie kreisen um das Geschehnis, das die *Geschichten*
weltgeschichtliche Rolle dieser Landschaft war: Umschwung vom griechischen *aus Altpreußen*

Gang in die Dämmerung Morgenland zum lateinischen Abendland, jenen Ruck in der Türangel, der sich im Werk des Deutschen Ordens vollzug. Die „Geschichten aus Altpreußen" 1926 haben in vier Erzählungen das preußische Volk auf vier seiner Kulturstufen zum Helden. „Gang in die Dämmerung" 1934 schreitet mit acht Geschichten die geheimen Pfade der deutschen Seelengeschichte aus, vom Knaben Phidias bis zu den zwei Menschen, die aus dem alten in ein neues Land aufbrechen, immer der Heimat zu. „Das Bernsteinherz" 1937 begleitet sinnvoll den schweren Rhythmus von der Bernsteinküste zum Griechenmeer und vom Griechenmeer zurück zur Bernsteinküste. Denn das preußische Gold leuchtet urwelttief aus all diesen Geschichten. Agnes Miegel hat Maria, nach der die Ordensburg an der Nogat heißt, und Demeter, der hellenischen Ackergöttin, Preislieder gesungen. Der Ring von Scheffer zu Miegel ist gerundet.

Die Bombennacht von Dresden loderte tief in den Osten und verkündete, was Königsberg und Breslau bevorstand. Aber es schlugen junge Herzen bereit, das Gedächtnis des Landes weiterzutragen.

„Schwanengesang" *Ottfried Graf Finckenstein,* 1901, von der Ordensburg Schönberg, die 1945 in Flammen aufging, wuchs mit dem Lande auf und machte die beiden Weltkriege um Ostpreußen mit. Sein ganzes Werk ist mit dem schlichten und sparsamen Munde Ostpreußens erzählt und gilt dem Lande: Der Roman „Fünfkirchen" 1936 dem selbstverständlichen Leben, in dem Gutshof und Dorf ein Ganzes sind; „Das harte Frühjahr" 1937 den Wäldern und Seen, in deren Dasein der Mensch mit eingeschlossen ist; „Die Mutter" 1938, die nach dem Tode ihres Mannes ihrer selbstvergessen nichts als Mutter ihrer Kinder bleibt; „Schwanengesang" 1950 der versunkenen Heimat und dem Heimweh nach dem Lebensring der Geschlechter, der zerbrochen ist. Wie fern liegt der See und der Fischerhof, den der Dichter sich in letzter Stunde beim westpreußischen Buchfelde erworben hatte.

Willy Kramp, 1909 im elsässischen Mühlhausen durch Zufall aus einer westpreußischen Familie geboren, Schulmann in Ostpreußen und Kriegsgefangener der Sowjet, hat früh mit dem Roman „Die ewige Feindschaft" 1933 begonnen, der Geschichte eines Werkstudenten. Die ostpreußische Landschaft und das Schicksal, das sie den Menschen auferlegt, wurde und blieb bei reifenden Jahren der Vorwurf seiner Romane: 1939 „Die Fischer *„Die Pupurwolke"* von Lissau", 1943 „Die Jünglinge", 1954 „Die Purpurwolke", diese über dem Deutschland Adolf Hitlers. Hinter Stacheldraht, auf christliche Art durchlitten, das ist in den Erzählungen „Die Prophezeiung" 1951 und „Was ein Mensch wert ist" 1953 Gegenstand. Bei Kramp geht es immer um Verzicht und Überwindung durch die Kraft und die Pflicht des Herzens.

Arnold Krieger, 1904 zu Dirschau im Angesicht der schicksalhaften Weich- *Weichselbrücke*
von Dirschau
selbrücke geboren und in Thorn aufgewachsen, hat seine Heimat zweimal,
1918 und 1945, verloren und dazu seine zweite zu Misdroy auf der Insel
Wollin. Das Dach, nach dem er so lange vergeblich gesucht hat, das hat er
endlich in Darmstadt gefunden. Er ist einer der arbeitsamsten und frucht-
barsten Dichter dieses Zeitalters, obschon nur ein Bruchteil seines Werks
sichtbar geworden ist. Zu seinem so erfolgreichen epischen Werk hat er zwei-
fach angesetzt: in den Romanen „Das Blut der Lysa Gora" 1934 und „Em-
pörung in Thorn" 1940 auf Westpreußisch, „Mann ohne Volk" 1934 und
„Der dunkle Orden" 1940 auf Burisch. Wie immer man diese Bücher heute
auslegen mag, man kann sie nicht gegen das deutsche Recht auf die
Heimat kehren und von den Engländern nicht den Vorwurf wischen,
daß sie angesichts der schwarzen Rasse den Krieg gegen den Weißen
Mann geführt haben. Kriegers Negerroman „Geliebt, gejagt und unverges-
sen" 1955 gehört auf ein ganz anderes Blatt. Der Dichter hat sich bald bevor-
zugt der Ehe und des Kindes angenommen, immer dicht an der Selbstdar-
stellung vorbei, zuletzt 1959 in dem erschütternden Buch „Hilf uns leben,
Cordula". Vollendet und rund ist Kriegers lyrisches Werk, weil es bis in die
letzte Feinheit den Prägestock der Persönlichkeit angenommen hat. „Das
schlagende Herz" 1944, „Der singende Wächter" 1954, „Reichtum des Ar-
men" 1958 sind nicht neue Kunst sondern neue Leistung, ewiger, unwandel-
barer Stil des lyrischen Gesanges, vollkommene Lyrik schlechthin wie die
aller guten und großen Meister. Das Herz spricht, das Auge sieht, das Wort
trifft, der Vers klingt, alles, wie es muß und gilt, daß es ein Kunstwerk gibt.
Der Überschwang des Gefühls verliert nie die Besonnenheit, die Freude am
gelungenen Wort bleibt stets naiv und die Bezeichnungen der Dinge sind so
sachkundig wie echt. Seit der Dichter die Heimat verlassen hat, scheinen die
Erinnerungen seiner Sinne an die Ostsee, das Brausen ihres Windes, ihren
Salzgeruch und an den Harzduft ihrer Wälder hellwach geworden. Agnes
Miegel und Ernst Wiechert leben, was Natur und Geist der preußischen
Landschaft angeht, in den Versen Arnold Kriegers fort.

Schlesien strahlte nach einem Menschenalter noch immer von Leistung. *Schlesien*
Voll steht das Gestirn der Mystik über dem Gesichtsfelde. Und alles, was die
Landschaft dichterisch zu fassen und zu formen sucht, heißt Seele. Von den
beiden Dichtern Hermann Stehr und Gerhart Hauptmann steht jeder am
Eingang und jeder am Ausgang, und was zwischen ihnen geschieht, das ge-
schieht in ihrem Namen.

Hermann Stehr, 1864 bis 1940, von Habelschwerdt in den schlesischen Bergen und als Schullehrer viel gequält, hat das wahre Wort gesprochen: Alle echte Bildung läuft auf Schmerzvertiefung hinaus. Seine gesammelten Gedichte „Ein Lebensbuch" 1920 und „Der Mittelgarten" 1936 sind ein Jahrbuch nicht nur seiner Seele, sondern der ganzen Zeit, an deren Not sie sich zur Vollendung geläutert hat. Das Zunehmen eines innerlich werdenden Menschen ist der hohe Gegenstand von Stehrs Dichtungen. Seine Anfänge, der Novellenband „Auf Leben und Tod" 1898 ließen ihn in der Nähe des frühen Gerhart Hauptmann erscheinen. Der erste Roman „Leonore Griebel" 1900, die geheime Geschichte einer Frauenseele, und die Ehetragödie „Meta Konegen" 1905 bezeugen schon die Wendung zu sich selber. Da ist sogleich der Roman „Der begrabene Gott" 1905, eine der kühnsten und tiefsten neueren Dichtungen. Hier spricht zum erstenmal der Gottsucher und er redet die Sprache uralter Mystik. Die Frau, am Ende ihrer Leidensfähigkeit, zertrümmert buchstäblich und sinnbildlich den Gott und verbrennt sich mit dem Haus und ihrem mißgestalteten Kinde. Da ist der erste Teil des Mystikerwortes: wer Gott erhalten will, der wird ihn verlieren. Den zweiten Teil, wer

„Drei Nächte" Gott verliert, der wird ihn finden, macht der Romandrilling „Drei Nächte" 1909, „Heiligenhof" 1918, „Peter Brindeisener" 1924 zur dichterischen Legende. Die blinde Tochter des Bauern Andreas Sintlinger ist auf geheimnisvollere Weise sehend als die andern Menschen. Sie lehrt mit ihren Seelenaugen ihren Vater die Welt erkennen, daß er ein Weiser und Heiliger wird. Als aber das Mädchen, durch Geschlechtsliebe sinnlich sehend geworden, diese Welt verläßt, bleibt der Vater als ein Verzweifelter an dieser Weisheit zurück. Im Erlebnis der Heiligenhoftochter wiederholt sich das urmenschliche Mysterium: Geschlechtsliebe macht sehend. „Erkennen" ist der Fall in diese Welt. Wie alt ist diese Einsicht, auch wenn man erst mit Jakob Böhme zu zählen anfängt. Das zweite Werk Hermann Stehrs ist die Romandreiheit, aus der nur die Bände „Nathanael Maechler" 1929 und „Nachkommen" 1933 erschienen sind. Es ist durch die drei Menschenalter 1848/1918 die Geschichte einer schlesischen Familie, Begebenheiten der Seele und der Nation in der Wirklichkeit und aus dem Jenseits. Man hat den Zugang zu diesem Dichter in seiner späten Novelle „Meister Cajetan" 1931, die schönste unter allen.

*„Meister
Cajetan"* Meister Cajetan kennt das Behagen des Lebens nicht. Darum leiden alle seine Geigen, die den dunklen Schmerz und die himmlische Freude so vollkommen wiedergeben, an der klanglosen Mittelschicht des Tones. Die Begegnung mit einem seltsamen Bauernmädchen macht seine Seele und also auch seine Geigen in dieser Mittellage vollkommen. Der Dichter erzählt uns

selber, wie er oft in Dorfgasthäusern den Berichten von Bauern und Händlern, Fleischern und Holzknechten zugehört und an der plastischen Abrundung des Vergänglichen wie Persönlichen seine helle Freude gehabt habe. So ist der Dichter völlig ebenförmig dem schlesischen Volk in dessen geistig-seelischem Zustande und geschichtlicher Tiefe. Menschen von Gott geschliffen, das sind die Gestalten Stehrs. „Droben Gnade, drunten Recht." Der Dichter wie seine Gestalten sind Gottsucher. Ein Nachfahr Jakob Böhmes, gründet Hermann Stehr sein Weltbild auf die metaphysische Dreiheit Natur, Gott, Seele. „Die Augen sind nur ein Umweg." Woran Stehr glaubt, das ist *„Die Augen sind nur ein Umweg"* die Erlebniskraft des bewußten Seelenlebens, Verwandlungen des täglichen Ich, die auf wunderbare aber keineswegs übernatürliche Weise geschehen. Hermann Stehr ist der Dichter der Seele, der deutschen Seele, der Seele, wie sie uns in den besonderen Bezeugungen des deutschen Ostens entgegentritt. Er hat das selber immer gewußt.

Schlesien hatte an der Jugendbewegung führenden Anteil. Hans Blüher, aus Freiburg, hat nicht nur ihre Geschichte geschrieben — „Wandervogel" 1912 —, sondern auch ihre Metaphysik gedacht — „Die Rolle der Erotik in der männlichen Gesellschaft" 1917 — und mit der Schrift „Die Aristie des Jesus von Nazareth" 1921 ihren Beruf zu einer Neuordnung der Welt. Außerhalb der bündischen Jugend meuterten längst schlesische Jünglinge auf eigene Faust. Georg Heym, 1887 bis 1912, aus Hirschberg, ist einen frühen Tod gestorben. Gesicht und Schau sind diesem Jüngling alles: die beschworenen Dämonen der Stadt und der Leichenhallen, das menschliche Elend und der Ekel des Leibes, der Tod der Liebenden, die sich durch den Maelstrom in den mystischen Abgrund des Meeres ziehen lassen. Heyms Gedichte „Der ewige Tag" 1911, und „Umbra vitae" 1912 haben diese Gesichte *Schlesische Jugend* zuchtvoll gebändigt. Ludwig Meidner, 1884, aus Bernstadt, der Zeichner, blieb dem Grauen verfallen, das der Krieg aufgestört hatte. Seine Bücher „Im Nacken das Sternenmeer" 1918 und „Septemberschrei" 1920 übersteigerten das Verzerrte zu hymnischen Lästerungen. Kurt Heynicke, 1891, aus Liegnitz, hat mit den Büchlein „Rings fallen Sterne" 1919 und „Gottes Geigen" 1920 begonnen. Es sind meist hymnisch frei schwingende Verse, erfüllt von dem Erlebnis der kosmischen Musik, die der Dichter aus dem großen Schweigen der Nacht heraushört. Einträchtig klingen die beiden Vorstellungen von der Gottgeburt und der Volkskindschaft des Menschen zusammen in dem gemeinsamen Bilde: „Aus gottgepflügter Scholle blüht ein Baum ins Licht". Heynicke hat die Ereignisse 1806/1812 zu den eindrucksvollen Szenen „Kampf um Preußen" 1926 zusammengeballt. Richard Schiedel, 1890, aus

Breslau, ließ in zahlreichen kleinen lyrischen Büchern gefühlvolle und gedankenschwere Verse hören.

Querschnitt — Der Querschnitt durch den schlesischen Baum dieser drei Jahrzehnte zeigt zwischen Rinde und Mark vielerlei Lebensstoff. Aber es ist das eine Leben des Baumes, dessen Wurzeln alle den gleichen Boden durchdringen und dessen Äste demselben Himmel zuwachsen.

Der heilige Vater — Das Land und die Zeit in ihrer naturhaften Unrast ist *Arnold Ulitz*, 1888, aus Breslau, von einer slawischen Familie und einer schwäbischen Mutter. Rußland und das russische Volk waren ihm ein starkes Erlebnis. Er hat sich mit in die Gefahren der Zeit gestürzt. Seine Romane, wie das Rußlandbuch „Der Bastard" 1927 und das Kriegsbuch aus der Etappe „Worbs" 1930, scheuten vor keiner Wirklichkeit zurück. Die Novelle „Romfahrt" 1934 zeigt einen schlesischen Künstler, der anstelle des Papstes seinen polnischen Vater als „Heiligen Vater" malt. All seine Unrast war im Grunde die schlesische Unrast zu Gott. Er hat es in einem schönen Bilde aus diesem wasserreichen Lande gesagt: „Ich sehne mich, in Gottes Meer zu fahren / Mit diesem stillen Segel auf dunklem unendlichem Fluß." Beruf und Dichtung gingen in Schlesien wundersame Bünde ein und machten ganze Menschen. *Georg Langer*, 1867, aus Breslau, hat mit „Schlesischen Dorfgeschichten" 1903

Der Richter — begonnen und mit „Grodzisko, das wilde Lied vom Oberschlesien" 1935 das Land der Schlote zur Legende gemacht. Langer war Richter. „Christel Materns weiße Seele" 1927 ist die Geschichte einer Geschändeten, die sich den Gewalttäter aus dem Gefängnis an den Altar holt, um dem Gebesserten nach einer Frist der Bewährung mit ihrer Liebe ein neues Leben zu schenken und das Unrecht auszulöschen. „Richter Wichura" 1928 ist der Roman des Richters schlechthin. Die Stimme des Gerichtes ist Gottes Stimme. Nur der Verletzte und der Verletzer zusammen vermögen das Böse durch ein neues

Der Schauspieler — Gutes auszutilgen. Wie der Richter, so der Schauspieler. *Friedrich Kayßler*, 1874, aus Neurode, hat als Berliner Schauspieler edle und verinnerlichte Männlichkeit verkörpert. Seine „Schauspielernotizen" 1929 gehören ebenso zu seinem Beruf wie seine Stücke. Die Märchen und Sagen, die er tiefsinnig und übermütig zu erzählen weiß, sind persönliche Laune des Dichters. „Pan im Salon" 1907 sind sicher grotesk gemeinte Stücke, die an Morgenstern erinnern. Kayßlers Gedichte von „Kreise" 1913 bis „Wege, ein Weg" 1929 sind innerlich sehr zarte Gebilde, zuweilen ganz flügge Volkslieder, die nur aufzufliegen brauchen. All diese Verse atmen eine gottvergnügte Seele, die alle Geschöpfe liebt und in den Spiegel ihrer Weisheit lächelt. Siehe „Heimkehr", vom Hirtenjungen, der die Herde eintreibt: „Die stille Hand bewegt den

Stab, / die Schafe gehn im gleichen Trab. / Gesenkt die Häupter tauchen die
acht / in ihres Hauses kleine Nacht. / Fernab schlägt eine Türe zu. / Nun, kleine
Herde: kurze Ruh'! / Unhörbar donnert durch das All / der Sternenherde
Widerhall." Das ist eines der ewigen deutschen Abenlieder, das seinen Mei-
ster lobt. In der Mitte der Dichter von Beruf. *Hans Waldemar Fischer*, 1876, *Der Dichter*
aus Schweidnitz, ist der Herr über ein vielfältiges und umfängliches Werk.
„Lachende Heimat" 1933, versammelt 888 Kleingeschichten. Die beiden
kostbaren Bücher „Tristan und Isolde" 1932 sowie „Götter und Helden"
1934 sind keine Nacherzählungen, sondern Eigengebilde aus freier Hand.
Von seinen Dramen gestalten „Flieger" 1913 und „Der Motor" 1919 sehr
straff die Kämpfe, wie sie unter Männern ausgefochten werden. Das unge-
druckte Stück „Der Jäger", 1923 in Düsseldorf gespielt, ist ein Liebesdrama
großen Stils. Das Weihnachtsspiel „Die Wanderung zur Krippe", 1922 zu
Dresden mit erstaunlichem Erfolg aufgeführt, dichtet aus dem deutschen
Schatz der Märchen, Lieder, Rätsel das Wunder der Weihnacht zu einem
urtümlichen Fest des Volkes. Das Gedichtbuch „Mann und Mächte" 1937 ist
aus den drei Teilen, „Die Kette" 1910, „Das Schwert" 1920, „Die Krone"
1936, zusammengefügt. Durch dieses zahlenhaft raffiniert ausgegliederte
Buch kreist das Leben des Kosmos mit den Umlaufzahlen der Gestirne. Ihre
schwingende Bewegung entfaltet die Dreieinigkeit aller Dinge. Kette,
Schwert, Krone bedeuten: Blut, Erde und Himmel; Natur, Wille und Geist;
Arbeit, Kampf und Sieg; Persönlichkeit, Gemeinschaft und Alleins; Geburt,
Tod und Vollendung. Hinter allem aber lodert die diamantene Flamme
Gott, die Kette, Schwert, Krone zu sich verbrennt. Das unerschöpfliche Wort
meistert hier jeden lyrischen Stil vom hymnischen Feierton der Hellenen bis
zur kindhaften Einfalt des deutschen Volksliedes. *Hans Christoph Kaergel*, *Gottsucher und*
1889, aus Striegau, ist Lehrer geworden und Hermann Stehr auf eine sehr *Schwankhelden*
innerliche Weise verwandt. Von Jakob Böhme sichtlich beeinflußt, hat Kaer-
gel in drei Romanen das menschliche Ringen um Gott und höchste Erkenntnis
dargestellt. „Des Heilands zweites Gesicht" 1919 ist die eigene Jugendge-
schichte. „Heinrich Budschigk" 1925 erzählt die Geschichte eines Bauern-
burschen, der als Gottsucher, an der Wirklichkeit gescheitert auf die Land-
straße zieht. „Ein Mann stellt sich dem Schicksal" 1929 meint die wahre
Nachfolge Christi. Drei Dramen Kaergels spiegeln Gestalt und Gedanken des
schlesischen Theaters wider: das Volksstück „Hockewanzel" 1934, das Natur-
märchenspiel „Rübezahl" 1936, das Freilichtspiel „Das Tor im Osten" 1937
um Kaiser Heinrich IV. Eine Fülle von Novellen bezeugt, daß von den drei
schlesischen Tugenden nicht die Liedseele und nicht der Spieltrieb, sondern

Friedrich Bischoff die dritte, das behagliche Wort den Dichter auszeichnet. *Friedrich Bischoff*, 1896, aus Neumarkt, einer der ältesten Städte Schlesiens, und in einem Hause geboren, wo sich an den Wochenmärkten allerlei Volk zusammenfand, sah die ersehnte Stunde mit den beiden Romanen gekommen, die zueinander in einem geschwisterlichen Verhältnis stehen. Sie haben die schlesische Wunderwelt, aus der die Dichtung des Landes von je gelebt hat, selber zum *„Die goldenen Schlösser"* Gegenstande. „Die goldenen Schlösser" 1935, das sind die Berge, aus denen der Findling Agnete herab ins Dorf kommt. Sie schlägt dieses Dorf auf eine Zeit in ihren Bann und verschwindet wieder in die unbekannte Überwelt des Gebirges. „Der Wassermann" 1937 verheert mit seiner Hochflut ein ganzes Bergdorf, das bedeutsam Himmelsgrund heißt. Er treibt die Menschen, sich mit einer gewaltigen Talsperre gegen die wilde Naturkraft zu schützen und lockt das Dorf aus dem Tal auf die Höhe zu einem neuen Leben. Beide Bücher sind lautere Dichtung. Aus Märchenstoff gebildet und märchenhaft erzählt, wecken sie das Wunder im schweren Schlaf des Alltags auf. Ob sie nun zu den Menschen herabsteigt oder die Menschen zu sich hinaufruft, sie ist die Seele, die Hohe, die Ferne, die Schöne, die Gute, die Verwandlerin, das Wunder aller Wunder. Unfaßbar, dunkel, geheimnisvoll ist alles, was sie *„Schlesischer Psalter"* treibt. Die lyrische Stimme des Dichters, „Schlesischer Psalter" 1936, „Das Füllhorn" 1939, singt in verwandlungsfähigen Versen das Land der Heimat, alle seine Vergangenheit und Gegenwart, Natur und Kunst, Geschichte und Legende, die kleinen Leute und die großen Männer, gespiegelt aus den Gewässern des Landes, die von geheimnisvollen Quellen kommen. Schlesische Dichtung ist immer dieselbe, immer wieder neu. Der Gottsucher *Joseph* *Josef Wittig* *Wittig*, 1879 bis 1949, aus Schlegel, ein Glatzer Bergmann und eines Zimmermanns Sohn, ist den Weg des begabten Dorfjungen gegangen, vom armen Häuschen am Hange in die Seelsorge seines Priestertums und vom Lehramt der Breslauer Hochschule zurück in das eigene Haus des heimatlichen Dorfes. Es war nicht der Forscher, sondern der Verkünder, den die römische Kirche 1926 aus ihrer Gemeinschaft schloß. Kirche, die Selbstverwirklichung der christlichen Seele, diesen Zuruf hat der Mann des Wortes an ein Volk gerichtet, das, vom Schlachtfeld verzweifelt heimgekehrt und von Gott verlassen, nach Botschaft hungerte. Wittigs viele kleine Geschichten — „Herrgottswissen" 1921, „Das verlorene Vaterunser" 1933 — stellten an den schlichtesten Menschen, die um den Glatzer Annaberg zu finden waren, das Walten des einfältigen Glaubens dar. Aus ihrer Mitte aber erheben sich die beiden Bücher, die Wittigs Schicksal geworden sind, vielen ein Berg des Ärgernisses *„Höregott"* und ihm des Leidens. „Leben Jesu in Palästina, Schlesien und anderswo"

1925 sowie „Höregott" 1928 bilden ein Ganzes. „Leben Jesu" ist imitatio Christi und evangelium secundum Wittig, geschehen an einem Glatzer Bergjungen, auf schlesische Weise szenisch vorgetragen und von Zwischenreden der Gottesgelehrten begleitet. „Höregott" ist Darstellung des eigenen Lebens und Vorgeschichte seines Kindes, Tragödie des geistlichen Amtes und Versuch zu einem neuen Leben. Der Gott Jakob Böhmes und der Gott Joseph Wittigs erweisen sich als schlesische Volkskunst aus derselben Werkstatt der Herrgottschnitzer.

Oberschlesien war mehr als nur Schlesien. Die Landschaft hatte dieses *Oberschlesien* ganze Menschenalter hindurch eine kluge und nachdrückliche Stimme. Das ist die Zeitschrift „Der Oberschlesier", aus einem Abstimmungsblatt hervorgegangen und von Karl Schodrok in Oppeln vorbildlich geleitet. Bruno Arndt, 1874 bis 1922, aus Kattowitz, ein Mann der schlichten Verse und Geschichten, hat an seiner Kattowitzer Schule manchen jungen Dichter des Landes herangebildet. Hier war eine bescheidene Arbeiterdichtung zu Hause. Zwar Paul Barsch, 1860 bis 1931, aus Niederhermsdorf bei Neisse, ist als Tischlergeselle gewandert, aber er hat sein Leben lang zu seiner Heimat gehalten. Sein leidvolles Leben ist in zierliche Verse und in dem Roman „Von einem, der auszog" 1905 eingegangen. Die Landschaft lebt in den kleinen Geschichten, die Herta Pohl gelenk und sachlich erzählt. Der Bergmann Paul Habraschka aus Rokettnitz hat sich aus dem Rhythmus seiner Arbeit einen eigentümlichen Stil gebildet um den ewig währenden Gegenstand „Schwarzes Brot". Oberschlesien mit seinem Eichendorffzauber und seinen Gruben ist gegenwärtig in den Versen und Erzählungen Willibald Köhlers, in den Märchen, Romanen, Dramen von Hugo Gnielczyk, Rudolf Fitzek, Hans Niekrawitz. Alfons Hayduk. Alles, was in diesem Lande Schicksal hieß, hat August Scholtis, 1901, aus Bolatitz, in seinen Büchern dargestellt, die von einem grausamen Humor sind, in „Ostwind" 1932, in „Baba und ihre Kinder" 1934, in „Schlesischer Totentanz" 1938, dargestellt natürlich auf seine Weise, die aus urwüchsiger Derbheit immer mehr zu gelassener Sachtreue heranreifte. „Das Eisenwerk" 1939 war schon eine gültige Dichtung, in der die oberschlesische Industrielandschaft sichtbar und hörbar schafft. In allen Tonarten ziehen die Kurzgeschichten „Die Katze im schlesischen Schrank" 1958 die Menschen und Zustände östlicher Landschaft durch die Hechel.

Da war schon die junge schlesische Altersgenossenschaft, die in die Fremde *Ausgetrieben* getrieben wurde. Gerhart Pohl, 1902, aus Trachenberg mit seinen Romanen schlesischer Menschen, worunter der zeitgeschichtliche „Flüchtling" 1955; Horst Lange, 1904, aus Liegnitz, mit seinen Dichtungen aus der Oderland-

schaft; Edzard Schaper, 1908, aus Ostrowo mit seinen Erzählungen aus der
Ostkirche im Gleichnisstil; Wolf von Nibelschütz, 1913 aus Berlin und einer
alten schlesischen Familie mit seiner formstrengen Lyrik im Musikstil und
seinem Roman „Der blaue Kammerherr" 1949 nach einem Bruchstück Hof-
mannsthals.

 Gerhart Hauptmann, die Erfüllung eines persönlichen Lebens und eines
geschichtlichen Zeitalters, fallen so gültig zusammen, wie es nur Verdienst
und Gunst zu fügen vermögen. Ihr Einklang lenkte die Rhythmen des wer-
denden Werks. Er gab ihm den Sinn. Er bestimmt die Sicht auf das Voll-
endete. Schlesien, Deutschland, Europa verkörpert sich mythenhaft in Per-
sönlichkeit und Werk dieses Mannes, mit dem der letzte Dichter aus dieser
Welt gegangen ist.

Dichtung und
Wahrheit
 Gerhart Hauptmann hat sich selber angeschaut in jenem zweifachen Bilde,
das Dichtung und Wahrheit ist. Das Stanzengedicht „Promethidenlos"
1884/85 fängt das Erlebnis jener Mittelmeerfahrt ein, die dem Dichter am
Anblick spanischer und italienischer Städte die soziale Not jener Jahre ins
Bewußtsein brannte. Das ländliche Liebesgedicht „Anna" 1919/1921 gilt der
Neigung des Breslauer Akademieschülers zu der landwirtschaftlichen Schü-
lerin auf dem Gut seines Oheims. Beinahe lyrische Selbstdarstellung ist das
Stanzengedicht „Die blaue Blume" 1923/1924, eine mystische Begegnung
des Dichters mit lieben Toten auf einer Toteninsel, die an Capri erinnert. Die
Frau kehrt wieder in „Mary" 1923/1939, wie eine Tote beschworen. So ist
der Dichter immer tiefer in die Erinnerung hineingeschritten, die nicht Ver-
gessenheit, sondern Unsterblichkeit bedeutet. Wahrheit, wie sie dem Selbst-
darsteller erscheint, hat der Dichter mit jener Meisterschaft erzählt, die alle
seine Dichtungen bezeugen. „Griechischer Frühling" 1907/1908 ist aus die-
sem Leben vielleicht die beglückteste Szene, die Mitte und Wende, die Fahrt
nach Griechenland. „Buch der Leidenschaft" 1905/1929 schildert romanhaft
verschleiert die Krisis seiner ersten Ehe. „Die Spitzhacke" 1930 ruft das
Vaterhaus in die Erinnerung. „Das Abenteuer meiner Jugend" 1929/1937 ist
breit und farbig gemalt die Frühgeschichte des Dichters, weit über den per-
sönlichen Anlaß hinaus ein kulturgeschichtliches Denkmal, wie unsere Lite-
ratur nur wenige besitzt.

Die Romane
 Romane bezeichnen die großen Absätze von Gerhart Hauptmanns Ent-
wicklung. Ihrer vier und das zugeordnete Epos stehn wie Monumente. „Der
Narr in Christo Emanuel Quint" 1901/1910 schart um sich die einfachen
Menschen des Ostens, all die Arbeitenden und Gedrückten, die sich immer
wieder in die letzten Dinge des christlichen Glaubens vergrübelten. Es ist das

kritische Auge des Seelenbeobachters, das diesen kleinen Leuten bei ihrer *Gerhart Hauptmann* Nachfolge Christi zusieht. „Atlantis" 1909/1912 ist beinahe ein autobiographischer Roman. Der Dichter wollte 1894 zu seiner Frau nach Meriden im Staate New York und hatte mit dem Schnelldampfer „Möwe" eine ungewöhnlich stürmische Überfahrt. Derselbe Dampfer ging genau vier Jahre später im Kanal unter. Beides, die Lage des Dichters und das Schicksal des Schiffes, Innen und Außen, sind zu einer Dichtung verschmolzen, die eine unheimliche Bannkraft ausstrahlt. Es ist die Verstörung und Erkrankung einer Seele, ihre langsame Aufhellung und Heilung, begleitet von all den rätselhaften Begebenheiten, bei denen man nicht weiß, was Erscheinung aus dem Dunkel der Seele oder Spiegelung des fiebernden Gehirnes ist. In der Mitte und auf dem Gipfel steht „Der Ketzer von Soana" 1911/1918, das Buch der Leidenschaft aus jener Bergeinsamkeit, die dem Dichter und Anja ein so wohlbehütetes Glück geschenkt hat. Der Priester Francesco Vela löst alle seine Bindungen, feiert auf den Bergen mit dem Naturkinde Agata sein Liebesfest und wird durch sie zum reinen Hirtendasein zurückgeführt. „Die Insel der großen Mutter" 1916/1924 ist das Geheimreich des Geschlechtswunders, für das Anjas Mutterschaft dem Dichter den Sinn erschlossen hatte. Gestrandete Frauen und Mädchen bilden auf einer Südseeinsel einen Weiberstaat. Geheimnisvolle Schwangerschaften unter ihnen erklären sich endlich durch den einzigen Knaben, der bei ihnen war und der inzwischen mannbar geworden ist. Die Insel kommt wieder zu Männern. Der Vortrag verschleiert, was geschieht, in eine heitere Ironie. Hinweg über diesen dreifachen Roman des Anjaerlebnisses „Atlantis", „Ketzer", „Insel" antworten einander sinnvoll verschränkt die beiden Dichtungen vom reinen Toren und vom göttlichen Schalksnarren. „Till Eulenspiegel" 1920/1927, dieses Epos im homerischen *„Till Eulenspiegel"* Vers, war vielleicht Hauptmanns größtes Wagnis. Der abgedankte Fliegeroffizier wandert auf einem elenden Wägelchen als Gaukler und überlegener Beobachter von Schlesien nach Wittenberg, wo er ein phantastisches Kirchenkonzil mitmacht, verlebt mit einem halbgöttlichen Mädchen auf dem Taygetosgebirge ein tausendjähriges Liebesidyll, durchfliegt auf dem Rücken des Kentauren Cheiron die chaotischen Räume der Welt und stürzt sich zwischen den Schweizer Bergen freiwillig in den Fliegertod. Es ist weit mehr als ein Zeitgedicht, eine Weltdichtung, in der Goethes „Faust" und Dantes „Commedia" widerspruchsvolle und tiefsinnige Verbindungen eingegangen sind. Die fünf großen epischen Dichtungen bilden also ein gedanklich ausgefülltes, erlebnishaft verbundenes Ganzes, in dem des Dichters Leben unerkannt Gestalt geworden ist.

Gerhart Hauptmanns Erzählungen bezeichnen vielleicht die Stellen der dichterischen Rast oder aufgearbeitete Rückstände, die sich keiner andern Form hatten fügen können. Sie begleiten sein gesamtes Schaffen. Doch ihre Reihe wird mit den letzten Jahrzehnten immer dichter. „Fasching" 1887 und *Die* „Bahnwärter Thiel" 1888 gefallen sich auf eine jugendliche Art breitaus- *Erzählungen* malend im Gräßlichen. „Der Apostel" 1890, „Lohengrin" 1913, „Parzival" 1914 sind Studien, späteren Werken vorangeschickt. Drei Novellen üben sich an der gefährlichen Kunst, das Seelenleben verwirrter Menschen abzuleuchten: „Phantom" 1923, wie man dem Verbrechen verfällt und wieder ins bürgerliche Leben entrinnt; „Die Hochzeit auf Buchenhorst" 1927, wie ein Klavierkünstler seiner spukhaften Seelenangst erliegt; „Wanda" 1928, wie ein Zirkusmädchen einen Bildhauer aus der Bahn wirft und versklavt. Und drei Novellen bewegen sich auf dem Grenzrain, der zwischen Oben und Unten hinläuft: „Das Meerwunder" 1934, auf romantische Art eine Geschichte, die Spuk und Wirklichkeit phantastisch und gespenstig mischt; „Im Wirbel der Berufung" 1936, aus Eigenerlebnissen die seelischen Wirrnisse eines jungen Künstlers, der durch seine Hamlet-Einrichtung ein andrer wird; „Der Schuß im Park" 1941, um einen Hochstapler die abenteuerliche Verbindung von afrikanischem Busch und schlesischer Heimat. All diese Erzählungen haben das eine gemeinsam, daß sie seelisch zerrüttete Menschen unter die Sonde nehmen.

Schlesischer *Kern des* *Werkes* Der Rang von Gerhart Hauptmanns Schöpfung gründet sich auf die ungemeine Erlebniskraft seiner Seele, auf die Reinheit seines teilnehmenden Gefühls, auf die Vielfalt seines bildnerischen Vermögens, das jeder Aufgabe gewachsen ist. Der Kern dieses Werks ist triebhaft schlesisch. Dafür kann der Dichter nicht. Als bildender Künstler war er gewöhnt, nach Modellen zu arbeiten. So stellt denn die Fülle seines Werks schlesisches Leben und schlesische Menschen in mannigfacher Stilart dar. Das gleiche Jahrzehnt 1894 bis 1904, in dem sich der Umschwung seines Lebens von Melitta zu Anja, aus seiner ersten in seine zweite Ehe vollzogen hat, war auch die Krisis seiner Irrfahrten. Und so ist das Jahrzehnt zwischen den beiden Frauen und Ehen, zwischen der Heimat und Welt zugleich auch die breite Zone der künstlerischen Verwandlung in einen Meister, schlesisch mit vielerlei Zungen und Stilarten zu reden.

Entfaltung *auf der Szene* Die Entfaltung des Dichters ist auf der Szene geschehen. Das dramatische Werk ist aus seinem schlesischen Kern dreifach aufgegangen: als Tragödie, als Komödie, als Märchen. Jede der drei Spielarten stellte die Zeit, an die sie gerichtet war, vor immer neue Überraschungen.

Die Tragödie des Dichters, leidenschaftlich hineingerissen in das Ringen der Zeit um neue Lebensformen, wurde vor allem durch solche Fragen bewegt, in denen sittliche und persönliche Pflichten sich mit naturwissenschaftlichen und gesellschaftlichen Forderungen kreuzten. Sie sind der Gegenstand der beiden ersten Dramen „Vor Sonnenaufgang" 1889 und „Das Friedensfest" 1889/1890, allein sie sind es beinahe in entgegengesetztem Sinne: Verzicht auf die Ehe aus erbbiologischem Verantwortungsgefühl. Damit die Frage so entgegengesetzt beantwortet werden konnte, mußte der Dichter vom ersten zum zweiten Stück die Grundlagen sehr wesentlich verändern. Die erbliche Belastung wurde aus dem körperlichen in den seelischen Bereich verschoben. Gesundung war also durch sittlichen Willen möglich. Die Wahl und Entscheidung wurde aus der Hand des Mannes in die der Frau gelegt, ein schöner Kunstgriff. Aus der Tragödie ist ein Schauspiel geworden. Der Dichter hat sich also rasch und für sein Leben entschieden: gegen den Materialismus und die Mechanik, für die Seele und für das Verlangen des Menschen nach einem höheren Dasein. Den innern Zustand des jungen Menschen seiner eigenen Jugend hat der Dichter sehr echt und seelenkundig ausgemalt in dem Stück, das heute ein zutreffendes geschichtliches Zeitbild ist, das „Einsame Menschen" 1890/1891 heißt, aber richtiger „Schwache Menschen" hieße.

„Vor Sonnenaufgang" und „Friedensfest"

Dieser schlesische Grundbestand von Hauptmanns dramatischem Werk begann sich nach diesen ersten Anfängen in zweifacher Richtung zu entfalten: mit den „Webern" 1891/1892 auf das Volksstück zu, mit „Hanneles Himmelfahrt" 1893/1894 dem Märchenspiel entgegen. „Die Weber" heißen im Untertitel „Ein Schauspiel aus den vierziger Jahren" und sie sind in Wahrheit auch ein geschichtliches Schauspiel. Der Dichter wollte den sozialen Zustand einer ganzen Arbeitslandschaft anschaulich machen. Es ist kein marxistisches Stück. Was hier die Fesseln der Not zu sprengen sucht, das ist der reine und ewige Aufdrang der menschlichen Sehnsucht nach einer besseren und schöneren Welt. Diese Wendung ins Geistige gibt der alte Hilse, eine der echtesten Gestalten des Dichters, dem dumpfen Aufruhr des Hungers. In der schlichten Menschlichkeit des alten Hilse spiegelt sich die ewige Schönheit und Gerechtigkeit, das Wunschland der Menschen, als ein überwirkliches Reich, das nicht von dieser Welt ist, aber desto zuverlässiger in der Sehnsucht des Herzens lebt, so wirklich wie die Welt der Not. „Hanneles Himmelfahrt" ist die leibhaftige Erscheinung dieser Sehnsucht. Man kann gar nicht in Versuchung kommen, dieses kleine Traumspiel als eine bloße psychologische Aufgabe zu betrachten, die weltanschaulich zu nichts verpflichtet. Durch „Han-

„Die Weber" und „Hanneles Himmelfahrt"

Sehnsucht über sich hinaus

Hanneles
Sterbeträume nele" gewinnt nun die Kunstform der „Weber" ein anderes Gesicht. Die Wirklichkeit wird durch die Erscheinung des alten Hilse transparent und beginnt von Ewigkeit zu leuchten. Was ist, fängt an zu scheinen. Die Vision des alten Hilse, die dort szenisch nicht mehr sichtbar wird, tritt durch die Sterbeträume Hanneles auf die offene Bühne. Aus dieser heimatlich vertrauten Welt der Menschen, Zustände, Begebenheiten hat der Dichter sich in schön geordneter Reihe einzelne Gestalten und das Schicksal ihres Wesens auf die Szene gerufen. Da sind die Liebestragödien aus der Natur des Geschlechts, einmal des Mannes „Fuhrmann Henschel" 1897/1898, der von einem Weibsteufel, und „Rose Bernd" 1903, die von einem Mann zugrunde gerichtet wird. Auch diese beiden Stücke sind von innen her durch eine höhere Wirklichkeit erhellt. Wohl nur Charakterstudien, die mehr psychologisch als szenisch zu fesseln vermögen, sind „Michael Kramer" 1900, dem das Stigma der Kunst versagt ist, und „Gabriel Schillings Flucht" 1905/1912, zwei gegensätzlich geartete Künstler zwischen je zwei Frauen.

Die Komödien Die Komödien des Dichters nehmen in seinem Werk keine gesonderte Stellung ein. Sie haben alle wie die Tragödien eine durchscheinende Fläche, durch die der metaphysische Tiefsinn ins Spiel des großen Lebens scheint. Am glücklichsten war der Dichter in dem Doppelstück, dessen beide Teile „Der Biberpelz" 1892/1893 und „Der rote Hahn" 1900/1901 heißen. Die einfache Frau aus dem Volke entwickelt im naiven Betrügen eine geniale Sicherheit und es gelingt ihr, ungefährdet gegen das Gesetz, bis zum Besitz eines Zinshauses, dem Triumph ihres Geistes, emporzukommen. Man mag sich diese Komödie, die ja schließlich eine aristophanische Satire auf die Berliner Gründerzeit ist, auslegen wie immer. Hier ist ein Mensch. Und jeder seiner Züge verrät die Familie, aus der er stammt. „A jeder Mensch hat halt a Sehnsucht", sagt der alte Hilse in den „Webern". Und im „Roten Hahn" tastet die nun alte Wolffen sterbend mit beiden Händen über sich: „Ma langt . . . ma langt nach was." Das ist die Gebärde und das ist das Wort und das sind Gerhart Hauptmanns Gestalten. Diese Weltanschauung ist es, die seinem Gesamtwerk ein so beispiellos einheitliches Gepräge gibt. „College Crampton" 1891/1892 und „Peter Brauer" 1908/1921 stehen auch hier als Charakterstudien einander gegenüber. Und dann das andere sinnverwandte

„Die Jungfern" Paar. „Die Jungfern vom Bischofsberg" 1904/1907 stellten anmutig heiter des Dichters Brautstand auf die Szene, gerade als er sich mit dem letzten Ruck von Mary-Melitta getrennt hatte. Um die vier verwaisten Schwestern in ihrer vornehmen Bischofsburg dreht sich verliebt, verlobt, verheiratet wie ein buntes Karussell aus Onkeln und Tanten, Anbetern und Kameraden,

Gästen und Vagabunden das ganze Leben eines Zeitalters, das in den Aug-
äpfeln der vier schönen Mädchen sich höchstens seltsam und zuweilen ein
bißchen unbequem spiegelt. „Ratten" 1909/1911 lassen dieses Karussell um *„Ratten"*
das alte Berliner Haus, das einmal eine Reiterkaserne war, als ein halsbre-
chendes Vergnügen erscheinen. Das Spiel läuft auf zwei Rädern: dem selt-
samen Theaterbetrieb des Herrn Hassenreuter im Dachgeschoß und dem
kleinen Schwindel, durch den Frau John im zweiten Stock zu dem ersehnten
Kinde gekommen ist. Es läuft bis zu dem unvergleichlichen Schluß des dritten
Aktes gradaus schnurrend als herzbewegende Komödie. Dann plötzlich, er-
schreckend jäh, verkehrt das Rad der Frau John seine Richtung. Das Spiel
dreht sich wie ein Kreisel rasend um seine Achse, schleudert Frau John tot
aufs Pflaster, setzt das Kind, das zuerst jeder und dann niemand haben will,
unsäglich sanft vor Hassenreuter ab und mit einem Ruck, der uns den Atem
zum Lachen und zum Weinen nimmt, steht es still. So hat denn wie Frau
Wolffen auch Frau John über sich hinaus gelangt.

Die Märchenspiele reißen einfach die Kulisse der Wirklichkeit, dort wo sie *Die*
schon immer durchsichtig war, auf und lassen sehen, was sichtbar werden *Märchenspiele*
wollte. „Die versunkene Glocke" 1896 ist einfach, wenn man das Geläute
nicht verwirrt, die Legende des Zwiespalts von Pflicht und Neigung, die Le-
gende des Künstlergefühls für das Unzulängliche des eigenen Werks.
„Schluck und Jau" 1899/1900 ist aus schlesischer Prosa und hochsprachigen
Versen ein Rüpelspiel. Die uralte Geschichte. Der Bauer trunken von der
Landstraße aufgelesen, in einem Schloß aufgewacht, trunken wieder auf die
Landstraße gelegt, weiß für sein ganzes Leben nicht mehr, was nun eigent-
lich das Wirkliche ist, sein Betteldasein oder sein Herrenleben. Die Komödie
ist nichts anderes als ein verwegener Wettlauf mit der ungreifbar schnell-
füßigen Frage aller Metaphysik: „Traum, bist du Leben, Leben, bist du
Traum?" Wahrhaftig! Jau weiß Bescheid, nachdem ihn die Landstraße wie-
der hat. „Ich bin hie, ich bin doa; ich bin getuppelt! Ich sitze eim Wirtshaus *„Ich bin*
— ich sitze eim Schlusse." Dieser schlesische Landstreicher hat den landes- *getuppelt"*
üblichen Sinn für die Hinterwelt. „Und Pippa tanzt!" 1905/1906 ist gar nichts
anderes. Einfach ein Glashüttenmärchen, ein Wintermärchen des Riesen-
gebirges, das Märchen von einer italienischen Glasbläsertochter, einem Wan-
derburschen und von dem Tanz mit dem Riesen, bis der Atem ausgeht. Sei
es sonst was immer: die zauberhafte Flamme, aus der sich die Glaskugel bil-
det, die Frau als Wunder des Lebens, die Reigenlust des Geschlechts, die
sich nur am Tanz mit dem Tode zu sättigen vermag. Hier ist nur die gegen-
standslose Sehnsucht, das Verlangen über sich hinaus. Hilses Vision, Hanne-

les Traum, Rautendeleins Verheißungen, Jaus Gewißheit seiner Doppel-
natur, Pippas betörender Tanz, alles das eine: aus sich heraus in das Höhere.

Das Märchen hatte dem Dichter großen Mut gemacht. Das Märchen spielt
im Ungefähr der Zeit und des Raumes. Gerhart Hauptmann verlegte seine
Szene nun in ein historisches Wareinmal und dann in ein geographisches
Anderswo. Man weiß nicht recht. Sollten dieser Art die Märchen erwachsen
oder Erwachsenes märchenhaft aussehen?

Spiele der
Zeitferne Wareinmal wird um die Jahrhundertwende die Szene. Das heißt nicht
Gewesen und schon gar nicht Historie. Es heißt einfach „nicht jetzt", weil es
nicht nach Wirklichkeit aussehen soll. Ein solches Ungefähr ist die Zeit der
deutschen Humanitas und Reformatio. Das verbindet die beiden artbezeich-
nenden Spiele „Florian Geyer" und „Magnus Garbe", die auch der Männer-
„Florian Geyer" name im Titel zusammenfügt. „Florian Geyer" 1894/1896 war das erste
und Werkstück dieser Art. Nur sehr ungefähr geht es um den gleichen Vorwurf
„Magnus Garbe"
wie in den „Webern". Denn was dort ein elementarer Aufstand des gequäl-
ten Volkes ist, das setzt hier die politische Berechnung in Bewegung. „Die
Weber" wie „Florian Geyer" mußten wohl von den Zeitgenossen, an die sie
gerichtet waren, mißverstanden werden, wenn man sie aus der nationalen
und sozialen Lage des Tages verstehen wollte. Beide Stücke zielen über die
Gegenwart hinaus ins zeitlose Gültige. Die Revolution der Klasse wird ver-
neint, die Erhebung der Nation wird bejaht, das eine wie das andere um der
Ordnung willen, die dem Menschen gesetzt ist. Seit „Florian Geyer" konnte
kein Zweifel mehr sein, daß der Dichter unter Gemeinschaft weder die so-
ziale Klasse noch die unterschiedslose Menschheit, sondern die Nation ver-
steht. Der deutsche Bauernkrieg war aus der Sehnsucht nach dem einigen
Reich die Erhebung der freien menschlichen Würde und der sozialen Gerech-
tigkeit. In der Dichtung ist dieser Bauernkrieg nicht viel mehr als das
zeitliche Gleichnis für die Legende des deutschen Willens zu sich selber.
„Magnus Garbe" 1914/1942 steht im Zusammenhang mit der Motivgruppe
Lohengrin-Elsa-Inquisition der kurz zuvor entstandenen „Gral-Phantasien".
Es ist das Drama einer altdeutschen Stadt im Zeitalter der Glaubenskämpfe
und der jungen humanistischen Bildung, die Tragödie des Massenwahns. Der
Bürgermeister und seine überirdisch reine junge Frau fallen als letzte und
ihr Tod löst die spukhafte Verkrampfung von Natur und Mensch. Mit seinem
Szenenstil ist es ein Drama der Botenberichte, wie es dem bühnenhaft Un-
darstellbaren und dem unbegreiflich dunklen Es gemäß war. Innerhalb des
Bogens zwischen „Geyer" und „Garbe" bilden die beiden zeitlich am wei-
testen abstehenden Stücke abermals ein bezügliches Paar. Das sind die bei-

den Frauenspiele, von denen „Elga" 1896/1905 die Vernichtung der ge-
schlechtlich hemmungslosen und „Griselda" 1908/1917 die Bewährung der
natürlich gesunden Gattin darstellt. In der Mitte dieser vier steht das wun-
dervolle Triptychon von der Liebe des männlichen Herzens: zur Linken „Der *Triptychon des männlichen Herzens*
arme Heinrich" 1897/1902, die mittelalterliche Legende vom Verzicht der
Liebe aus Liebe; zur Rechten „Der Bogen des Odysseus" 1907/1914, die
antike Legende vom heimkehrenden Gatten und dem zurückeroberten Glück
des Daheim. Das Herzstück aber ist „Kaiser Karls Geisel" 1906/1908, die
letzte Liebe des alternden Mannes, an der im Dunkel bleibt, was Eros in
diesem Greise und was er in diesem Kinde wollte. Bei keinem dieser Stücke
hat es irgendeine Bedeutung, ob und wann sie sich in Wirklichkeit begeben
haben. Sie sind reine Dichtung innerhalb einer Zeit, in der es keine Zeit gibt.

Anderswo wird rittlings des Kriegsjahres die Szene. Das heißt nicht Weit-
weg und am allerwenigsten Geradeda. Es heißt einfach „nicht hier", weil es
nicht nach Wirklichkeit aussehn soll. Der Hauch der Ferne, der das Nah- *Spiele der Raumferne*
gewohnte fremd und wunderbar macht, umwittert alle Dichtungen des
schlesischen Meisters. Der skandinavische Norden ist es in den gepaarten
Stücken „Winterballade" und „Veland". Im Innern gemeinsam ist ihnen der
Zug der Rache und der Haßliebe im Widerstreit mit dem evangelischen
Gebot der Feindesliebe. „Winterballade" 1912/1917 spielt in sieben rasch *„Winterballade" und „Veland"*
abrollenden Szenen. Aus der tatenlosen Lähmung der eingefrorenen Flotte
gären Spuk und Verbrechen auf. Einer der Söldner fühlt sich in dem Augen-
blick, da er ein Mädchen niedersticht, mit der Sterbenden bräutlich vereinigt.
Die Ziehschwester der Sterbenden nimmt im gleichen Augenblick die Tote
in ihr Leben auf und treibt den Mörder in einen Tod, an dem es unklar bleibt,
ob er Wille oder Gnade oder beides war. Genau dort, wo „Garbe" schloß,
setzte die „Winterballade" ein: mit der Liebesumarmung, die der Tod ist.
„Veland" 1898/1925 ist in der gleichen skandinavischen Umwelt die Tragö-
die des kunstfertigen und zauberkundigen Geistes in Gestalt des eddischen
Meisterschmiedes. Veland ist beides, das menschliche Urtier der Kulturge-
schichte und der urmenschliche Gott der Religionsmythe. Verstümmelt und
mißbraucht, stillt Veland seine Rache, indem er das Geschlecht des Königs
durch Tötung seiner Söhne auslöscht und ihm durch seine Tochter aus Haß-
liebe sein eigenes Blut einzeugt. Um diesen tierhaften Gott und seine Rache-
handlung künstlerisch möglich zu machen, hat der Dichter zweierlei getan.
Er verlieh seinem Helden Kräfte einer dämonischen Magie, so daß seine
Taten wie ein grauenhafter Spuk aus der Tiefe der urweltlichen Seele auf-
dringen. Er bändigte das Tun dieses unmenschlichen Gott-Tieres in den Stil

der attischen Tragödie, die in feierlichen Trimetern schreitet, und läßt die nordische Natur nur in wenigen chorischen Eddaliedern anklingen. Anders *„Heiland" und* bilden „Der weiße Heiland" 1912/1920 und „Indipohdi" 1913/1920 ein *„Indipohdi"* Paar. Sie spielen im Lande der roten Rasse. Sie sind vom Geheimnis der versunkenen Atlantis umwittert. Sie gründen sich auf die rätselhafte Verwandtschaft der christlichen und aztekischen Religion. Und sie hängen mit den gleichzeitigen „Gral-Phantasien" zusammen, mit dem Geheimnis des Gottes, der sich selbst in seinem Sohn opfert, um sein eigen Fleisch und Blut den Seinen zum Gastmahl darzubieten. Im „Heiland" wird Montezuma durch seinen Opfertod der rote Heiland und seine Marterung wird wie eine Szene aus der Passion Christi dargestellt. In „Indipohdi" opfert der göttliche Priesterkönig nicht mehr, wie seine Religion es wollte, den eigenen Sohn, sondern stürzt sich selber in das dunkle „Niemand weiß es". Wieder anders *Spuk* gepaart erscheinen die beiden Gespensterdramen, in denen beiden eine Vergangenheit aufgestört wird, aber sie sind tragisch und komisch, eines gegen das andere gepaart. „Die schwarze Maske" 1928/1929 zeigt ein Gastmal im Hause des reichen Bürgermeisters von Bolkenhain. Die Stimmung wird unheimlich rasch geladen, bis sie als hohe Stichflamme aufzischt. „Hexenritt" 1928/1929 führt in Schweden zwei Jäger in die Ruinen eines Schlößchens, wo einst eine Frau ähnlicher Art wie die Bürgermeisterin von Bolkenhain am Gastmahl des Lebens geschmaust hat. Sie weiß noch gar nicht, daß sie gestorben ist. So erleben die beiden Gäste auf eine groteske Weise den Spuk ihres Fortlebens. Und schließlich die beiden Gegenwartsstücke, die durch den Zusammenstoß zwischen Vater und Kindern in Gang gesetzt werden, äußerlich sehr vernünftige Spiele, doch auf eine ganz heimliche Weise spukhaft *Rückkehr* hinterhältig. „Dorothea Angermann" 1925/1926 ist eine andere Rose Bernd. *in die Nähe* Ihr wird vom Vater die Ehe mit dem Verführer aufgezwungen und damit ein langsamer Tod in der Gosse. Das Stück spielt zwischen Schlesien und Amerika. „Vor Sonnenuntergang" 1928/1932 wiederholt den Vorwurf von Kaiser Karls Geisel in der Umwelt des deutschen Großunternehmens. Das Stück spielt zwischen Deutschland und der Schweiz.

Weltstile Und nun, in der Zeit zwischen den beiden Kriegen, geschah etwas Beispielloses. Gerhart Hauptmann bildete die klassischen Spielarten des Welttheaters nach und in seine persönliche Kunst herüber. Daß sie gewollte Abbilder der großen Weltstile sind, und nichts anderes mehr, fügt die Spiele seiner letzten Epoche zu einem Ganzen zusammen.

Die erste Probe war das „Festspiel in deutschen Reimen" 1912/1913 für die Breslauer Jahrhundertfeier der Leipziger Schlacht. Die Szene wird von

der Orchestra und drei stufenweise aufsteigenden Bühnen gebildet. Das ist *Chronik in Bildern* die Mysterienbühne des Mittelalters. Gedacht ist das Ganze als Puppenspiel. Den Rahmen der Handlung bildet das Auspacken, Vorzeigen, Einpacken der Spielfiguren. Das war der Gedanke von Calderons „Welttheater", der in Goethes „Faust" fortklingt und in Hofmannsthals „Welttheater" wieder auflebt. Dargestellt wird das Stück in der Weise, daß Szenenbilder gezeigt und die geschehende Handlung dazu erzählend gesprochen wird. Das war der Stil der Bänkelsänger, die auf den Jahrmärkten ihre Zeitchronik in grellen Bildern zeigten und mit Knittelversen erläuterten. So also spielte Gerhart Hauptmann in Breslau die Chronik der französischen Revolutionskriege mit Hilfe des geflügelten Götterboten Hermes und zu Füßen der gerüsteten Friedensgöttin Athene. Das Festspiel vereinigt inbegrifflich alle Stile des europäischen Theaters.

Die reine Idee des modernen deutschen Dramas ist „Die goldene Harfe" *Deutsches Seelendrama* 1933, die aus dem „Lohengrin" der „Gral-Phantasien" stammt. Die Harfe nun, von der es heißt, trägt das ganze Stück. Der Schwan und der Schwarze See kehren wirklich und gleichnishaft wieder. Das alte mitteldeutsche Schloß, auf der diese Harfe spielt, ist eine Burg der Romantik. Die deutsche Spätromantik ist die Gegenwart der Dichtung, das Jahrzehnt nach der Schlacht bei Leipzig. Juliane hat drei Todgeweihte in den Krieg entlassen, den Bruder und die befreundeten Zwillinge. Der Bruder ist gefallen. Nun fordern die beiden Zwillinge ihre Entscheidung. Um den Ausschlag der Waage geht das Spiel, das unsagbar sanft und zart die dunkle Melodie der Harfe pausenlos durch fünfzehn Szenen in Schwebe hält, bis die eine Schale in den Abgrund des Todes sinkt und die andere in das Leben hebt, oder umgekehrt. Das eben bleibt in Schwebe. Auch dieses Spiel geht um die mystische Dreiheit des alleinigen Gefühls Liebe-Tod-Haß. Das Drama ist alles, was ein gesprochenes Prosastück nur zu sein vermag: ein Ausschnitt aus dem wirklichen Leben, geschichtlich leicht überhaucht, angerührt von der raumweiten Weltreise der Zwillinge, klassisches Seelendrama und romantisches Schicksalstück, Sprechdrama, von Musik untermalt.

Was anderes vom englischen Theater konnte für einen deutschen Dichter *Englisches Theater* letzter Wunsch und Krone sein als William Shakespeares „Hamlet". Der Dichter hat zu Shakespeares „Hamlet" weder einen ersten Teil geschrieben noch das Stück für die Bühne „bearbeitet". Er hat aus Neuguß und Umguß sein Doppelstück, seinen Hamlet geformt. „Hamlet in Wittenberg" 1924 bis *Hamlet in Wittenberg* 1935 ist Hamlets e i n e Tragödie, die Tragödie des Dichters, der seiner Bestimmung voraus den König spielt und aus Dichtung Wirklichkeit, das ist

Leben, machen will. Mitten in einer rohen Umwelt unberührbar ist er der
künftige König, der sein Königtum nur dichten und spielen kann. Wittenberg
ist nur die Szene und alle sind ihm nur Spielfiguren des Dramas, das er dichtet
und aufführt. Das Drama aber heißt „König Kophetua und das Bettelmäd-
chen". Das Königtum der armen Leute, „gut für eine Fastnacht", aber nichts
für die Wirklichkeit. Da kommt die Nachricht vom Tode des Vaters, Hamlet
ist ein König. Denn wie räumt er mit einer Handbewegung Dichtung und

Hamlet in Helsingör Spiel von der Szene. Er ist König. „Hamlet in Helsingör" 1927/1929 ist, aus
Shakespeares Drama entwickelt, Hauptmanns eigene Dichtung, Shakespeares
Hamlet steht im Mittelpunkt der großen Politik und handelt zweckbewußt.
Also ließ ihn Hauptmann handeln, indem er durch neue Szenen das politische
Spiel Norwegen-England gegen Dänemark sichtbar machte und das Gegen-
spiel Fortinbras-Hamlet neu schuf. Szenen werden umgestellt und geben eine
gedrungene Handlung. Hauptmann hatte ja nicht Shakespeare vor sich, son-
dern ein schleuderhaft nachgeschriebenes Spielbuch, das Shakespeares Namen
trägt. So ist unter Gerhart Hauptmanns Händen ein neues und modernes
Drama entstanden, das sein Eigentum ist und mit niemandem gewetteifert
hat, weder mit dem Schöpfer des ursprünglich Gewollten noch mit dem
Schreiber des tatsächlich Gebotenen. Hamlet in Wittenberg war der künftige,
Hamlet in Helsingör ist der gewesene Traumkönig. Doch der eine wie der
andere ist ein Dichter und Spielleiter. Mit dem gleichen Ernst und Zwiespalt
wie dort den künftigen, spielt er hier den verhinderten König. Der verhin-
derte König von Helsingör ist auch ein verhinderter Dichter, der mit seinem
Trauerspiel nicht fertig wird. Er sieht sich als Spieler in eine Tragödie des
Lebens verstrickt, aus der er weder dichtend noch handelnd ausbrechen kann,
um die Spielleitung in die Hand zu bekommen.

Spanisches Theater Das spanische Theater wirkt an zwei Dichtungen zusammen, die gedank-
lich und gestaltlich zusammengehören. „Ulrich von Liechtenstein" 1910/1939
ist Gerhart Hauptmanns kunstreichstes Werkstück. Herzogin Marie, der
lächerlich empfundenen Huldigungen ihres „Ritters" Ulrich müde, lockt ihn
auf ihr Schloß Runkelstein, um ihm statt ihrer seine Frau Katharina unterzu-
schieben, sich zur Rache, ihm zur Strafe, ihr zum Nutzen. Doch das Ränke-
spiel dieser flammenden Johannisnacht erweist die Reinheit seines Herzens
und läßt ihn den Sinn seines Lebens erkennen. Er hat seinen Heilschlaf ge-
tan. Es fällt schwer, das Drama ein Lustspiel zu nennen. Denn wie die irrende
Ritterschaft Don Quixotes, so hat auch die Dichterfahrt Ulrichs von Liechten-
stein ihr Doppelgesicht von Tiefsinn und Lächerlichkeit. Hier ist ein Held,
der mit der Dichtung Ernst macht und sie mitten im Leben der andern uner-

schütterlich würdevoll spielt. Ist es ein Lustspiel, dann allein durch diesen beispiellosen Vers, den spanischen Trochäus, der aufs schwierigste gereimt, als eine wirklich lustige Person mitspielt. „Die Tochter der Kathedrale" 1935/1939 stammt von den „Gral-Phantasien" ab und begibt sich legendenhaft im mittelalterlichen Irgendwann am Fuß des Montsalwatsch. Die beiden befreundeten und dann feindlichen Herzogshäuser von Foix und Andorra vereinigen sich in ihren Kindern, zwei Zwillingspaaren, den Söhnen von Andorra und den Töchtern von Foix. Es gesellt sich gleich zu gleich: der Troubadour Peter zu der Gottesbraut Gerlind und der Krieger Paul zu der Amazone Geralda. Doch welche Wirren des Herzens und welche Verwicklungen nach dem Willen des Dichters, bis sich alles entdeckt hat. Der Zauberwald von Bresilian, in dem Paul auf der Flucht vor sich selbst ganz vergißt, unwissend geworden, was Sein und was Schein ist, dieser Zauberwald ist ein Gleichnis für die allgemeine Verhexung, die „der kleine Gott, / der älter ist als Zeus und Uranos — / und mächtiger als sie und alle Götter" über die Herzen bringt. Als Ganzes ist das Stück auf spanische Weise gebildet, als ein Spiel, das „blind und sehend macht zugleich", vom Meister aller Meister „zwecklos und zu eigener Freude" auf die Szene berufen.

„Die Tochter der Kathedrale"

Das griechische Theater geht im Werk des Dichters erst zuletzt auf. Gerlind, die Tochter der Kathedrale, auf dem Altar der Kirche ausgesetzt, von ihrer eigenen Mutter „geopfert", kündigt nun große Dinge an: die Krönung von Gerhart Hauptmanns Dichtung durch die attische Tragödie. Die Gestalt, durch deren Schicksal das griechische Theater noch völlig Ursprung, nämlich Gottesdienst war, ist Iphigenie. Und Iphigenie heißt die Heldin, der des Dichters höchste Leistung gilt. Aus der zermalmenden und erhebenden Handlung der griechischen Trilogie Vater und Tochter, Sohn und Mutter, Bruder und Schwester, hat der Dichter das erhabene Doppelstück „Iphigenie in Aulis" und „Iphigenie in Delphi" gemacht. Es ist die Tragödie der Menschenfrau, die drei Tode gestorben ist. Noch einmal Liebe-Haß-Tod, Leben und Tod, Eltern-Kinder-Geschwister in solcher Verstrickung, wie es nur durch die Bilder der griechischen Sage dargestellt werden konnte. „Iphigenie in Aulis" 1943 weist aus der mythischen Vergangenheit mitten in die Gegenwart. Die Griechenflotte, fahrbereit gegen Troja, kann nicht auslaufen. Das Orakel verlangt vom König Agamemnon die Opferung seiner eigenen Tochter. Welch ein Kampf bis Iphigenies Wille durchdringt, sich aus freien Stücken zum Opfer zu bringen. Allen wird der Wille für die Tat gerechnet. Auf dem Altar verblutet eine Hirschkuh, durch die Göttin untergeschoben, indes Iphigenie sich und alle sie geopfert glauben. Das Schiff der Todesgöttin

Griechisches Theater

„Iphigenie in Aulis"

Hekate bringt Iphigenie als ihre Priesterin nach Tauris. Aus dem Opfer ist
eine Opfernde geworden. In der Zwischenzeit geschehen unmenschliche
Dinge. Klytemnästra, Iphigenies Mutter, läßt aus Rache für die geopferte
Tochter durch ihren Buhlen den siegreich heimgekehrten Agamemnon er-
schlagen. Aus Rache für den Vater tötet der Sohn Orestes mit Hilfe seiner
Schwester Elektra die Mutter. Das Orakel gibt dem Orestes zur Sühne den
Auftrag, das Bild der Schwester aus Tauris nach Delphi heimzuholen. Mit
dem Bilde der Todesgöttin Artemis-Hekate bringt Orestes zugleich deren
Oberpriesterin, die der Göttin so viele Griechen geschlachtet hat, in die

„Iphigenie
in Delphi"
Heimat zurück. „Iphigenie in Delphi" 1940/1941 hat nur eine Szene, den
Apollotempel. Es ist ein völlig verseeltes Spiel nach Innen, mit unerhörten
Spannungen, bis sich alles entdeckt. Orest und sein ganzes Geschlecht wird
durch die Priesterin von seiner Blutschuld gelöst. Die göttlichen und mensch-
lichen Geschwister, Apollo und Artemis, Elektra und Orestes, sind wieder
vereinigt. Hellas hat Frieden. Doch Iphigenie? Zweimal ist sie schon gestor-
ben; das erstemal als sie opferbereit im Tempel von Aulis stand; das zweite-
mal, als sie sich in Tauris als Priesterin der Todesgöttin verschwor. Für sie
gibt es keine Rückkehr mehr, weder aus dem Opfer von Aulis, das nicht
widerrufen werden darf, noch aus der Unterwelt von Tauris, an die sie durch
schreckliche Priesterhandlungen gebunden ist. Sie nimmt den dritten Tod auf
sich, indem sie den ersten vollzieht, und stürzt sich vom Tempel in die heilige
Schlucht. „Ich starb ins Göttliche hinein / und mag im Sterblichen nicht wie-
der leben." Die beiden Iphigenien, die sich zueinander wie die beiden Ham-
let verhalten, schließen in dem gedanklichen Doppelbezirk Gottesopfer-Men-
schenopfer, Eltern-Kinder, Liebe-Reue, Leben-Tod, Wille-Schicksal den lan-
gen Zug der Gedanken ab, der durch alle Dichtungen Gerhart Hauptmanns
hindurchging. Die beiden Spiele krönen, ohne den Stil der attischen Tragödie
zu kopieren, in attischer Gestalt das Werk des Dichters. Sie reden die voll-
kommenste Sprache. Sie sind ungetrübte Dichtung. Sie sind nicht das Ende,
sondern das Ziel. Sie sind der Gipfel.

Die Kunst
des Sprossers
Gerhart Hauptmann, das ist europäischer Stil auf deutsche, aber auch auf
ganz persönliche Art. In der „Goldenen Harfe" singt der Organist der Schloß-
kirche Gherardini das Loblied des Sprossers. „Dieser Vogel ist sicherlich
selbst unter seinesgleichen ein besonderes Genie. Er imitiert tausendfältig
das Drama seines Lebens mit den Stimmen seiner Akteure: Den Pfiff des
Stars, die Geige des Finks, die bescheidenen Liebeserklärungen seines brü-
tenden Weibchens macht er nach. Er scheint ein Konzert im lunarischen Halb-
licht zu dirigieren, darin die Geräusche der Grillen, der Heuschrecken, der

Libellen und viele andere mitwirken. Es sind Stimmen, die er in blitzschnellem Wechsel nacheinander, miteinander, gegeneinander von örtlich scheinbar getrennten Punkten wirken läßt. Und doch ist nur er allein der Sänger. Wenn er viele Glockentöne hören läßt, denkt man etwa an einen See im Elysium, auf dessen glänzendem Spiegel Tropfen von den regenfeuchten Flügeln eines Engels herabfallen, der darüberfliegt. Wieder von anderen seiner Töne ist zu sagen: sie spalten die Nacht wie fallendes Licht. Es ist die Liebe, nicht zu vergessen, die Liebe, die uns alle zu Sängern macht". Wie durch alle Spiele Gerhart Hauptmanns das eine Verlangen und Gebot waltet, über sich hinaus zu wachsen bis in die Gottheit, so haben sie auch alle ihren unnachahmlichen Stil. Alle diese Spiele, die frühen, die hohen, die späten, ihre Einheit und Ganzheit wird gern auf zweierlei Weise ausgemalt. Hindurchgeschlungen wird ein sichtbares Leitmotiv, wie eine Harfe, die immer wieder aufrauscht, oder ein Schachbrett, zu dem die Handelnden in gewichtigen Augenblicken *Leitmotiv und Rahmen* zurückkehren. Eingerahmt werden die Stücke fast noch lieber auf mannigfaltige Weise, sei es als Spiel im Spiel, sei es durch kleine Szenen wie die leere Wiege des „Garbe" oder das Bockspringen der „Winterballade" am Anfang und Ende, sei es durch das Wetter, das sich über der Eingangsschwelle zusammenballt oder über der Tür des Ausganges sich befreiend löst als strömender Regen oder Tauwind. Die schlichteste Prosa, der kunstvollste Reimvers, die Rede des Alltags, das getragene Wort, wer immer spricht, Gerhart Hauptmanns Dichtung redet die Sprache des Dichters und ist Dichtersprache.

Drei große Dichter, miteinander selbst eine mystische Einheit, bilden die *Das deutsche Geistesdrama* Trilogie, in der sich Beginn und Beschluß des deutschen Geistesdramas von 1749 bis 1945 vollstreckt. Jeder hat mehr als achtzig Jahre gelebt. Sie folgen aufeinander wie drei Dynasten kraft Erbrechts ihres fürstlichen Hauses und die übergreifenden Jahreszahlen ihrer Geburt und ihres Todes verketten die drei Leben zu dem lückenlosen Ablauf beinahe eines Lebens. Jeder von ihnen hat mit der zugemessenen Überdauer des Daseins geschaut, was außer ihnen keinem zu sehen auferlegt war. Ein Reich der Kunst unter dem Szepter dreier Dichter. Jeder von ihnen der letzte Überlebende seines Zeitalters. Drei Tragödien, die zusammen ein großer Untergang sind. Aber es ist die unsterbliche Tragödie, die Johann Wolfgang Goethe, Franz Grillparzer, Gerhart Hauptmann heißt.

Gerhart Hauptmann ist in seinem Hause Wiesenstein zu Agnetendorf im *Hiddensee* schlesischen Gebirge am 6. Juni 1946 gestorben und am 28. Juli auf der Ostseeinsel Hiddensee bei Sonnenaufgang bestattet worden.

INHALTSVERZEICHNIS

Wandervogel. Schlesische Jugend. 877. Der Querschnitt. Ulitz. Langer. Kayßler.
878. Fischer. Kaergel. 879. Bischoff. Wittig. 880. „Der Oberschlesier." Scholtis.
881. Gerhart Pohl. Horst Lange. Edzard Schaper. Nibelschütz. 881. Gerhart
Hauptmann. Dichtung und Wahrheit. 882. Episches Großwerk. 883. Die Erzäh-
lungen. Der schlesische Kern. 884. Die schlesischen Tragödien. 885. Die Komö-
dien. 886. Die Märchenspiele. 887. Spiele der Zeitferne. 888. Spiele der Raum-
ferne. 889. Weltstile. Chronik in Bildern. 890. Deutsches Seelendrama. Eng-
lisches Theater. 891. Spanisches Theater. 892. Attische Tragödie. 893. Die
Kunst des Sprossers. 894. Goethe – Grillparzer – Hauptmann. 895.

REGISTER

Personennamen; Werke ungenannter Verfasser; Zeitschriften

Die mittelalterlichen Dichter sind unter ihrem Vornamen verzeichnet
Die Ziffern der Hauptstellen in Schrägschrift

SÄMTLICHE WERKE
DES FREIHERRN
JOSEPH VON EICHENDORFF

Historisch-kritische Ausgabe.

Begründet von August Sauer und Wilhelm Kosch.
Fortgeführt und herausgegeben von Hermann Kunisch.

Gesamtplan der Ausgabe

Zu beziehen durch jede Buchhandlung

VERLAG JOSEF HABBEL REGENSBURG